THE
OXFORD COMPANION TO
TWENTIETH-CENTURY
ART

The
Oxford Companion to
Twentieth-Century
Art

Edited by
HAROLD OSBORNE

Oxford New York Toronto Melbourne
OXFORD UNIVERSITY PRESS
1988

Oxford University Press, Walton Street, Oxford OX2 6DP

Oxford New York Toronto
Delhi Bombay Calcutta Madras Karachi
Petaling Jaya Singapore Hong Kong Tokyo
Nairobi Dar es Salaam Cape Town
Melbourne Auckland
and associated companies in
Beirut Berlin Ibadan Nicosia

Oxford is a trade mark of Oxford University Press

First published 1981 by Oxford University Press
Reprinted with corrections 1984
First issued as an Oxford University Press paperback 1988

British Library Cataloguing in Publication Data
The Oxford companion to twentieth-century art.
—(Oxford paperback reference).
1. Art, Modern—20th century—
Dictionaries
I. Osborne, Harold
709'.04 N6490 .094 1988
ISBN 0–19–282076–1
68866
Library of Congress Cataloging in Publication Data
The Oxford companion to twentieth-century art.
(Oxford paperback reference)
Bibliography:
1. Art, Modern—20th century—Dictionaries.
2. Artists—Biography. I. Osborne, Harold, 1905– .
N6490.094 1988 709'.04'003 87–12316
ISBN 0–19–282076–1 (pbk.)

Printed in Hong Kong

PREFACE

THE decision to produce an Oxford Companion to contemporary art was taken as a result of the reception accorded to *The Oxford Companion to Art* when the latter book was published in 1970 and *The Oxford Companion to the Decorative Arts*, devoted to fine craftsmanship, was in preparation. At that time it very soon became apparent that many readers would welcome a reference book of the same sort dealing with personalities and movements in the world of contemporary art at greater depth than was possible or appropriate to a one-volume handbook covering the artistic activities of mankind from Palaeolithic times until now. But 'contemporary' is an elastic concept and several possibilities were open for determining the exact range of the new Companion. In the event it was decided to restrict its scope to the twentieth century rather than go back to the Renaissance or to Impressionism, leaving the period from the Renaissance to the end of the nineteenth century to be covered for the time being only by the more general *Companion to Art*. In this way the kaleidoscopic pattern of artistic activities and ideas, and the unprecedented multiplicity of articulate personalities, which have been a characteristic feature of the present century, could be presented in greater detail than would otherwise have been possible.

The new Companion has been planned and executed as a self-sufficient book of reference in no way dependent upon previous Companions. It is not a dictionary or an encyclopedia, but is intended as a handbook and a guide for students and others who wish to find their way intelligently through the exuberant jungle of contemporary art. Special attention has been given to the fluctuations of artistic ideas and to the changing aesthetic presuppositions underlying the sometimes bewildering conflicts of styles in an age which has often prided itself on throwing off the shackles of established tradition and repudiating the inheritance of the past.

Neither the lives of artists nor the activities of movements and associations coincide conveniently with the change of centuries and problems of inclusion and exclusion were inevitably met. As a general principle I have not included articles on the great forerunners when the bulk of their significant work was terminated within the nineteenth century, even though in some cases they lived on into the present century. There are not independent articles on such great precursors as Rodin and Renoir, Gauguin, Van Gogh and Cézanne, although of course the nature of their influence in the twentieth century is indicated in the relevant articles both on individual twentieth-century artists and on movements. Yet inevitably there are borderline cases, artists whose work or teaching straddled the centuries. Complete consistency was difficult to achieve and no attempt has been made to impose consistency for its own sake. There are, for example, *short* articles on such artists as Edvard Munch, so important for certain aspects of Expressionism, and on Gustave Moreau and Thomas Eakins because

of the importance of their teaching or example in the first decade of our century. There is no article on the Neo-Impressionist technique of Pointillism; but its successor, Divisionism, has a brief description because of its importance in the literature at and after the turn of the century. And so on.

The question of a cut-off date imposed a much more intractable problem as is inevitable for any handbook dealing with current matters. Many of the artists included in this Companion are in mid career. Changes and development are to be expected of their work, new and important events in their public lives. From one point of view it is obviously desirable that the material of the book should be as up-to-date as possible. But, for living artists, by being right up to the moment the book would become out of date within a very few years—or even in some cases in the interval which must elapse between the ending of the writing and the time when the completed book comes on to the market. In a book such as this yearly revision and up-dating of part of the material is not within the bounds of possibility. Compromise was therefore essential, and the following compromise was adopted. In the case of living artists articles purport to summarize their achievement and to indicate the nature of their performance up to the mid 1970s. Only when some significant development or radical change of style has taken place, or in the case of an important event such as an outstanding retrospective exhibition, has the survey been carried beyond that time.

As in *The Oxford Companion to Art*, the articles are of four main kinds: biographical articles, accounts of movements and associations, elucidations of special terms, and historical articles describing the development of the arts in particular countries or regions. The last group includes not only European countries, Russia and the Soviet Union, Britain and the U.S.A., but also Africa, South Africa, Australia, Canada and Latin America. The latter articles, contributed by leading experts, contain material which is not elsewhere accessible in handy form. The increasing internationalization of art since the mid century has tended to bring stylistic differences—geometrical abstraction or Constructivism, expressive abstraction whether it is named Abstract Expressionism, Tachism or *art informel*, Conceptual art, the New Realism and so on—into greater prominence than national distinctions. Nevertheless national characteristics persist and some knowledge of the artistic development which has taken place in various countries provides a necessary background for understanding what is taking place in the world of art now.

Biographical articles make no attempt artificially to match wordage to prestige. Indeed in some cases artists of eminence whose reputation has ensured for them a volume of readily available literature have been dealt with somewhat more concisely than others about whom information is less easily accessible outside their own countries. The latter include some of the more prominent Australian, Canadian and Latin American artists and a few others as, for example, the Swiss sculptor Alberto Giacometti and the Italian sculptor Giacomo Manzù. In a few cases articles have been perforce somewhat sketchy owing to lack of detailed information about the lives and doings of individuals. These last comprise some Soviet, some Japanese and some naïve artists. Furthermore, some artists have lived full and eventful lives, while others have lived more placidly without derogation from the quality or importance of their work.

In general I have avoided intruding my personal appraisals but have tried to

indicate by the tenor, not the length, of articles the sort of reputation and standing enjoyed by artists in their lifetime or afterwards. Therefore when appraisive judgements are introduced it is the intention to indicate, not my own personal assessment of an artist, but the general consensus—or divergence—of critical opinion.

HAROLD OSBORNE

LIST OF SPECIALIST CONTRIBUTORS

Jacqueline Barnitz Art and artists of Latin America
John E. Bowlt Art and artists of Russia and the Soviet Union
† Heather Martienssen Art and artists of South Africa
Marshall Ward Mount Art and artists of Africa
Dennis Reid Art and artists of Canada
Bernard Smith Art and artists of Australia

All other articles are by Harold Osborne

ACKNOWLEDGEMENTS

The Editor's acknowledgement and thanks are gratefully tendered to Dore Ashton, for valuable comments and suggestions on the articles dealing with American art and artists, to Bruce Phillips of the Oxford University Press for his patient editing of this project over the years, to Dorothy McCarthy for her meticulous and painstaking reading of the text and proofs, and to Charlotte Ward-Perkins for the work of picture research.

LIST OF PLATE SECTIONS

For a full list of illustrations, see pages 649–56

I FAUVISM AND EXPRESSIONISM

Between pages 54 and 55

Late Impressionism – Fauvism – Matisse 1907 – British Painting 1900–1930 – Forerunners of German Expressionism – *Die Brücke –Der Blaue Reiter* – Kandinsky 1923 – German Expressionism – *Neue Sachlichkeit* – French Expressionism – Flemish Expressionism

II CUBISM

Between pages 118 and 119

Early Picasso – Cubism – Futurist Sculpture – Cubist Sculpture – Cubist School – Purism – Synthetic Cubism – Futurism – Russian Rayonism – Cubo-Futurism – Vorticism – Orphism – American Synchromism – Independent Works

III SURREALISM AND INDEPENDENT WORKS

Between pages 182 and 183

Dada – Schwitters – Arp – Metaphysical Art – Duchamp – Surrealism – Lam – Fantasy Art – British Art 1914–1945 – European Sculpture 1913–1955 – Independent European Painting

IV CONSTRUCTIVISM AND *ART INFORMEL*

Between pages 246 and 247

Soviet Constructivism – European Constructivism – Post-War European Art: *Art Informel*

V AMERICAN ART TO 1960

Between pages 310 and 311

Early Realism – American Art Post-Armory Show 1913 – Social Realism 1930–1943 – American Art 1940–1950: Independent Works – Abstract Expressionism – Abstract Expressionist Sculpture – American Art 1950–1960: Independent Works

VI ABSTRACT ART AFTER 1960

Between pages 374 and 375

Abstract Sculpture: Smith, Caro – New York School Abstracts – Post-Painterly Abstraction – Minimal Art – Light Sculpture – Forerunners of Kinetic Art – Kinetic Art – Op Art – Geometrical Abstraction – Post-War Constructivism in Britain

VII POP ART

Between pages 470 *and* 471

British Pop – Forerunners of American Pop – Klein – American Pop – César – Junk Art – Pop Sculpture – Funk Art – Assemblage – Samaras – New Realism

VIII ARTISTS AND COUNTRIES OUTSIDE MAJOR MOVEMENTS

Between pages 566 *and* 567

Italy – *Arte Povera* – Spazialismo – Spain – Mexican Muralists – Canada – Australia – South Africa – Naïve Art: France, Britain, America, Yugoslavia

A

AALTO, ALVAR (1898–1976). Finnish architect, designer, sculptor and painter, born at Kuortane. He qualified in architecture at the Technical High School, Helsinki, in 1921 and subsequently studied in Italy. In 1937 he exhibited laminated wood sculpture as well as furniture and architectural designs in a one-man show at The Mus. of Modern Art, New York. Although chiefly known as an architect and the originator of the Artek furniture, Aalto was also prominent as a sculptor and was influential in introducing modern art—particularly the works of Alexander CALDER and Fernand LÉGER, his close friends—to the Finnish public. During the period 1927 to 1954, but particularly during the 1930s, he engaged in what have been described as artistic laboratory experiments, making both abstract reliefs and free abstract sculptures in laminated wood. These sculptural experiments, many of which were fine works of art in their own right, had the dual purpose of solving technical problems concerning the pliancy of wood in the manufacture of furniture and of developing spatial ideas which served as an inspiration for his architectural work. He said: 'It was always my dream to learn to create multidimensional, sculptural shapes in wood which could perhaps later lead to freer and more solid architectural shapes.' This close connection between his experimental wood sculpture and his architectural design may be seen in his Opera House at Essen and the Institute of International Education at New York, in which walls are conceived as abstract sculptural reliefs in wood. In the 1960s Aalto came to the fore as a monumental sculptor working in bronze, marble and mixed media. Outstanding among his monumental works are his relief for the head office of the Pohjois-maiden Yhdyspankki bank in Helsinki and his memorial for the Battle of Suomussalmi, a leaning bronze pillar raised 9 m on a stone pedestal set up in the arctic wastes of the battlefield.

AALTONEN, WÄINÖ (1894–1966). Finnish sculptor born outside Turku. Son of a village tailor, he became deaf in childhood and took to sculpture as a means of overcoming his disability, studying at the School of Drawing of the Turku Art Association. He came to public notice first for his commemorative monuments after the civil war of 1918, the most ambitious of which was *The Hero's Grave* at Savonlinna. His reputation grew and he came to be regarded as the personification of the Finnish patriotic spirit in the years between the two world wars. At the time of his large exhibition at Stockholm in 1927 he was enthusiastically hailed as the outstanding representative of Finnish national character and way of life. Among his most famous monuments were: the four *Granite Giants* at Tampere, commissioned in honour of the Finnish-speaking tribe of the Pirkkalaiset; the five allegorical figures on the theme *Work and the Future* for the assembly hall of the new House of Parliament opened in 1931; and the statue to *Alexis Kivi* in front of the Finnish National Theatre at Helsinki, set up in honour of the author of the Finnish masterpiece *The Seven Brothers*. Other works by Aaltonen are his bronze monument to the runner *Paavo Nurmi* (Turku and Helsinki, 1925), his granite nudes *Young Girls Paddling* (Aaltonen Mus., Turku, 1925) and *The Tax Collector* (Tampere, 1929). He also did portrait busts of Sibelius (1928) and Queen Louise of Sweden (1942).

ABC ART. Synonymous with MINIMAL ART.

ABEELE, ALBIJN VAN DEN (1835–1918). Belgian poet and painter, born at LAETHEM-SAINT-MARTIN. He was successively Alderman, Burgomaster and Commune Secretary of the village and was on friendly terms with both the First and the Second group of Laethem artists, more particulary with MINNE, Van de WOESTIJNE, and de SAEDELEER. He began painting *c.* 1874 without formal training and painted mainly landscapes of the Laethem district in a meticulous Late-Impressionist style.

ABRAMS, LIONEL. See SOUTH AFRICA.

ABSOLON, KURT (1925–58). Austrian graphic artist, born in Vienna and studied at the Vienna Academy under R. C. ANDERSEN and H. BOECKL, 1948–9. His first major exhibition was in 1957 a few months before his death in a car accident. He was given a commemorative exhibition at the Würthle Gal., Vienna, in 1961. He was particularly valued for the incisive delicacy of his spidery pen drawings.

ABSTRACT EXPRESSIONISM. The name which has come to be most generally current for the work done by the artists of the NEW YORK SCHOOL, most of whom reached stylistic maturity in the late 1940s and did their best work between that time and the mid 1950s. There was in fact little stylistic uniformity among the 15 artists who were considered to make up the School—e.g. in the exhibition 'The New York School—the First Generation Painting of the 1940s and 1950s' held at the Los Angeles County Mus. in 1965. Apart from the accident of time and place it would probably not have occurred to historians and critics to bring together into a 'school' the mono-

chromatic or near-monochromatic paintings of Barnett NEWMAN, REINHARDT and ROTHKO, the more impulsive, sometimes almost calligraphic, abstracts of KLINE and MOTHERWELL, the all-over drip paintings of Jackson POLLOCK and the paintings of DE KOONING, GOTTLIEB and HOFMANN. Nor was the title appropriate, since not all the work was abstract and not all was expressive. De Kooning made pretty consistent use of the figure, and residual figuration persisted in the work done during this period by BAZIOTES, Gottlieb (particularly in his *Pictographs*), Hofmann and GORKY. The paintings of Newman, Reinhardt and Rothko were not, typically, expressive in the same sense that those of Kline, STILL and Motherwell were, and did not exploit the self-revelatory brushwork which was thought to be the mark of ACTION PAINTING, the alternative name by which the work of this school was known.

From SURREALISM the Abstract Expressionists took over mainly the doctrines of psychic improvisation and AUTOMATISM in the belief that by unpremeditated spontaneity they could draw upon and release the universal creativity of the unconscious mind. As their self-confidence increased their work became more monumental and the importance they ascribed to Surrealist subject matter decreased. While insisting that their painting was not devoid of content, they argued that the painting process itself was the content and paid more and more attention to the sensuous qualities of the painting materials and to the techniques of their manipulation. By the end of the decade it became possible to distinguish two groups within the movement. One, led by de Kooning and Pollock, manifested an attitude corresponding to GESTURAL PAINTING in Europe, regarding the painting rather as a record of the process by which it came into being than as finished product, and therefore a concrete symbol of the inner mental states of the artist in the course of its creation. The other group, led by Newman and Reinhardt, was not expressive in this sense. In the early 1950s a new wave of artists adopted Abstract Expressionist methods: they included Philip GUSTON, Conrad MARCA-RELLI, James BROOKS, Bradley Walker TOMLIN. By the mid 1950s Abstract Expressionism had won international acclaim and reaction had set in. By the time of the Los Angeles County Mus. exhibition it was already part of American art history.

One of the most important contributions to the school was the emergence of a new concept of 'holistic' composition opposed to the traditional idea of composition as a unified configuration of intimately related parts—an idea which even MONDRIAN expressly endorsed. Instead of this the whole picture was to become a single undifferentiated image existing in an unbounded and unstructured picture space without segregable parts. This idea inspired equally the near-monochromatic paintings of Newman, Reinhardt, Rothko, the more expressive abstracts of Clyfford Still, Kline, Guston and the 'all-over' paintings of Pollock. The concept of the unstructured picture space was not, of course, completely without antecedents.

The *Water-Lily* series of Monet, for example, were all-over modulations of the picture surface with no particular focus of interest, and no natural boundaries. Of DERAIN's *Les Barques de Collioure* (1906) C. H. Waddington writes: 'Cover the one big boat with your hand and the rest appears almost completely abstract and non-representational, and shares with the Monet the characteristics of an all-over, edgeless distribution of interest and the implication, not of empty space containing some solid objects, but of a three-dimensional volume with every cubic inch occupied with something or other.' It was these hints that Abstract Expressionism developed into a major feature of style, the holistic composition which became a central doctrine in the non-relational theories of STELLA and the MINIMALISTS.

The term 'Abstract Expressionism' is also applied to a movement in metal sculpture which began a few years later. Its chief exponents were Seymour LIPTON, Ibram LASSAW, Herbert FERBER, Theodore ROSZAK, David HARE, Reuben NAKIAN and, less centrally, David SMITH. This was succeeded by the expressive JUNK sculpture of the California school and Richard STANKIEWICZ.

The prestige of Abstract Expressionism was enormous. It was aptly summed up by Maurice Tuchman when in 1971 he wrote in the Foreword to his revised catalogue of the 1965 exhibition: 'Virtually every important American artist to have emerged in the last fifteen years looks to the achievement of American abstract expressionism as the point of departure, in the same way that most European artists of the 1920s and 1930s referred in their work to the inventions of cubism.' The impact which Abstract Expressionism made on Europe, particularly the ÉCOLE DE PARIS, was also unprecedented. With Abstract Expressionism American art for the first time led the world.

ABSTRACTION. The term 'abstraction' is used with two different meanings in the literature of 20th-c. art. (1) Non-iconic abstraction, also called 'non-representational', 'non-figurative' and 'non-objective (*gegenstandlos*)' abstraction, is that mode of abstraction in which neither the work itself nor any of its parts represents or symbolizes objects in the visible world. (2) The second and more pervasive kind of abstraction is a mode of representing visible objects which reduces the amount or the particularity of the detail depicted. It is always a matter of degree.

(1) The former kind of abstraction is virtually specific to the painting and sculpture of the 20th c., although of course it has been common in the decorative art of the past. The latter kind has been common to most art of the past but has been carried further and used more self-consciously in the 20th c. than ever before. Together these two kinds of abstraction account for one of the most important features of 20th-c. art up to the emergence of a new taste for exaggerated Realism in the 1960s. Although different in principle, the two modes of

abstraction may occur together in a single work; or abstraction by the suppression of detail may be carried to a point where the representational element is no longer detectable—as for example in some works by Ivon HITCHENS, Roger BISSIÈRE, Jean BAZAINE, Maurice ESTÈVE, etc.

Non-iconic abstraction has two major modes, each prolific of diverse schools and stylistic manifestations. The major modes are Expressive Abstraction and Geometrical Abstraction. The reader will find Expressive (non-iconic) Abstraction discussed at greater length in ABSTRACT EXPRESSIONISM, TACHISM and related articles there referred to; Geometrical Abstraction is more fully dealt with in CONSTRUCTIVISM, SUPREMATISM, De STIJL, CONCRETE ART and related articles. Here something will be said about the historical development of these two modes of non-iconic abstraction and about the main principles of difference between them.

Geometrical Abstraction had its origins in the Suprematism of MALEVICH and the abstract constructions of TATLIN, RODCHENKO, POPOVA, ROZANOVA, KLIUN, Jean POUGNY and others up to about 1920, and then in the NEO-PLASTICISM of MONDRIAN and Van DOESBURG. Key points in the development of Geometrical Abstraction up to the mid century were: (i) The work and ideas of the PUTEAUX group of artists, who met informally in the studio of Jacques VILLON between 1911 and 1914 and originated the SECTION D'OR movement. They were interested in the mathematical basis of composition and believed that CUBISM could be developed in the direction of non-iconic abstraction. (ii) The systematic colour experiments begun by Robert DELAUNAY in 1912 on the basis of the colour theories of Eugène Chevreul and the parallel movement of SYNCHROMISM inaugurated by the expatriate American artists Patrick BRUCE, Stanton MACDONALD-WRIGHT and Morgan RUSSELL, although they did not wholly abandon representation until after their return to America. (iii) The development of CONCRETE ART by some members of the ABSTRACTION-CRÉATION group, particularly by Max BILL and his followers in Switzerland. There were in addition various experiments and anticipations: the versatile PICABIA made the occasional abstract from c. 1910; within the orbit of Cubism LÉGER experimented briefly with non-representational abstraction in 1913–14 in a series which he named Contrasts of Forms; in England Wyndham LEWIS exhibited non-representational abstracts from his Timon of Athens portfolio at the POST-IMPRESSIONIST exhibition of 1912 and non-iconic abstraction as well as iconic abstraction remained a feature of the VORTICIST movement.

The idea of Expressive non-iconic Abstraction was in the air before the turn of the century and developed along two parallel paths. On the one hand it was thought by some artists that abstract decoration could be elevated into an autonomous art form by rendering it expressive and on the other hand many artists were impressed by the analogy of music and argued that just as music is a non-representational structure of expressive sounds so there could be an art of non-representational coloured shapes expressively organized into aesthetic compositions. Adolf HOELZEL was evolving his own colour system by 1905 and over the years came very close to non-iconic colour abstraction, particularly in a series of compositions begun in 1917 on the theme of 'coloured sounds' which were to exemplify his concept of 'absolute art' with music as its paradigm. The eccentric Lithuanian artist ČIURLIONIS, who was trained as a musician, took up painting c. 1905 with the hope of being able to express in paint the transcendental ideas he had been unable to express in music. The analogy of music, the 'colour-music' of Scriabin, and experiments with the 'colour organ' by the FUTURISTS and others influenced the Czech Cubist and member of the Puteaux group František KUPKA in his attempts to work out a personal system of colour abstraction which would 'liberate colour from form'.

Perhaps the earliest artist to produce genuine colour abstracts before the breakthrough of KANDINSKY and the BLAUE REITER in 1911 was Augustus GIACOMETTI, uncle of the sculptor Alberto. Within the orbit of Futurism, BOCCIONI had grasped the essential notion of Expressive Abstraction when in 1910 he wrote that his ideal was an art which would express the idea of sleep without depicting any sleeping thing. Although he never entirely banished representation, his Stati d'animo (1911) came very close to this idea: the expressive mood was created by abstract forms which do not derive from natural appearances and the vague suggestions of representational content are subsidiary to these. About the same time the American painter Arthur DOVE began to do non-representational compositions conveying the expressive qualities of landscape, as in his Abstract Number 2 (Whitney Mus. of American Art). This was painted c.1911 and he continued to do non-representational abstracts, although he also painted pictures with residual suggestions of visual objects such as his well-known Fog Horns (1929), whose forms are supposed both to echo the mournful sound of fog horns and to suggest their shapes. Kandinsky painted his first completely non-figurative abstract, a gouache, in 1910 and in the same year wrote his pamphlet Über das Geistige in der Kunst (published 1912), which became the classical formulation of the underlying principles of Expressive Abstraction. The tendency achieved its most widely advertised flowering in Abstract Expressionism, the name usually given to the far from uniform style of the NEW YORK SCHOOL, which flourished in the decade roughly from 1945 to 1955, most of the artists reaching stylistic maturity c. 1947. The European counterparts of Abstract Expressionism were ART INFORMEL, Tachism and 'lyrical abstraction'. Like the American school, the European practitioners of Expressive Abstraction

repudiated formal composition or even the appearance of it, adopted an aggressively improvisatory approach and emphasized the expressive characteristics of the pictorial image.

The two main tendencies of non-iconic abstraction, namely Expressive Abstraction and Geometrical Abstraction, were opposed in almost every way. Expressive Abstraction was often said to exploit the expressive properties of shapes and colours, the sensuous qualities of the materials and the emotional effects of the brushwork in order to embody in the work of art the feelings and emotions experienced by the artist in its production, making it a kind of gestural or autobiographical record. Geometrical Abstraction on the contrary deliberately repudiated all these things. It avoided expressiveness in the elements from which the work was composed and for this reason showed a preference for geometrical elements—in the case of Neo-Plasticism for orthogonals—and it used colour not for its sensuous or expressive impact but rather to emphasize structural connections. The claim was usually made that these non-expressive structural elements were organized into rational and coherent constructions which were universally apprehensible and not the outcome of subjective whim. In technique it aimed at impersonal precision rather than emotive and sensuously appealing brushwork. The main differences of outlook between the two modes of non-iconic abstraction are summarized in the table below.

(2) So far this article has discussed the main modes of non-iconic abstraction. It remains to say something about the more pervasive subject of abstraction in representational art.

Some measure of abstraction is dictated by the medium in which a representational work is constructed and belongs to all works in that medium. The main parameters of abstraction inherent to pictorial art as such are connected with the representation of a moving and changing world in a static and unchanging medium (a primary concern with the Futurists); the representation of a three-dimensional world in a two-dimensional medium; and the representation of the much wider colour range of the visible world, particularly in regard to the dimension of brightness, by means of the narrower colour range that can be achieved by pigment colours, dyes or stains. Sculpture ordinarily eschews any attempt at naturalistic representation of colour.

Voluntary abstraction covers all ways of abstraction which are not dictated by the medium, i.e. all abstraction which the artist could have avoided even though he may not have been consciously and deliberately abstracting but perhaps following a current fashion. Voluntary abstraction in this sense has been prevalent from the earliest times and in practically every part of the world; it has been a major factor in the determination of the main national styles of the past (Egyptian, Assyrian, medieval, etc.). *Deliberate* abstraction, when an artist or a group of artists consciously and deliberately chooses to abstract for aesthetic purposes, has been a more prevalent and important feature in 20th-c. art than in any other period. Its modes and motives have been multifarious and cannot be reduced to one principle. In any one work of art a number of modes may overlap. The following, however, represent some of the modes and motives which have exerted a predominant influence through the century.

(i) The elimination of irrelevant detail in order to give prominence to a *message*. This is important in advertisement art, in politically oriented art such as MEXICAN mural painting and the art of SOCIALIST REALISM, and in social satire such as the NEUE SACHLICHKEIT of GROSZ, DIX and BECKMANN, and in the work of such American artists as Ben SHAHN and Jack LEVINE.

(ii) The elimination of irrelevant detail in order to emphasize decorative features of the subject as in some of the work of MATISSE, Arshile GORKY, Stuart DAVIS. With some artists this way of abstraction has become the basis of a personal style, e.g. Raoul DUFY, Cornelius Van DONGEN, Elie NADELMAN, the later Bernard BUFFET.

(iii) The suppression of individuating detail in order to bring into prominence the generic type to which a thing belongs. Generic abstraction has been very prominent in primitive art from Palaeolithic times until now, often in conjunction with emphasis on what Roger FRY used to call the 'quality of vitality'. In modern times the greatest master of generic abstraction has been the sculptor BRANCUSI in such works as *Maiastra*, *Bird in Space*, *The Seal*, etc. But in one form or another it has been very widely diffused in 20th-c. art. The PURISTS courted abstraction in order to reveal characteristic functional aspects of their *objets*

Expressive Abstraction	Geometrical Abstraction
Encouraged subjectivity and spontaneity	Aspired to objectivity and universality
Encouraged improvisatory and impulsive methods of production	Demanded that work be planned on rational principles in advance of production
Favoured expressiveness in the visual elements	Prohibited expressiveness in the visual elements, favouring neutral and usually geometrical elements
Emphasized sensuous and expressive appeal of artistic materials and facture	Excluded sensuous and expressive appeal of materials and favoured impersonality in the facture
Favoured unsystematic and unstructured composition	Favoured systematic and logically structured composition
Favoured vagueness, ambiguity and suggestiveness.	Favoured clarity, precision and explicitness.

types. Generic abstraction, as well as abstraction for decorative and aesthetic purposes, plays its part in the works of many still life painters, such as MORANDI, Georgia O'KEEFFE, William SCOTT. Some artists have used it in order to throw into prominence characteristic expressive aspects of townscapes and industrial scenes, as for example FEININGER and L. S. LOWRY.

(iv) The suppression of irrelevant or individuating detail is often combined with the imposition of favoured forms in order to build up a characteristic artistic *style*. For by 'style' we mean that certain ideal forms and preferred schemata are imposed upon the appearance of things in representation so that among the infinite ways in which things might be seen and depicted certain parameters are suppressed and representations are made to conform with certain formal preferences. In the past International Gothic, Neo-Classicism, Pre-Raphaelitism are examples of this. In this century ART NOUVEAU with its predilection for rhythmical, curvilinear lines, FAUVISM with its vividly contrasting colours, German EXPRESSIONISM with its harsh, angular schemata, Cubism with its bias in favour of geometrical forms, CUBO-FUTURISM in Russia and PRECISIONISM in America, Vorticism, Purism, RAYONISM, all fall into this category. Representational styles or styles in representational abstraction may be common to a whole movement or peculiar to an individual artist and his followers. Examples of individual styles are the heavy, cylindrical, machine-like forms imposed by Léger on his representations and the attenuated forms of Giacometti which emphasize the spatial interconnections between figures in a group by giving prominence to individual attitudes.

ABSTRACTION-CRÉATION: ART NON-FIGURATIF. The name taken by a group of ABSTRACT or NON-OBJECTIVE painters and sculptors formed in Paris in February 1931, following the first international exhibition of abstract art held there in 1930. It was successor to the group CERCLE ET CARRÉ, founded in 1930. The group was open to artists of all nationalities and the organization was loose so that at one time its numbers rose to as many as 400. As indicated by its title, the association was intended to encourage so-called 'creative' abstraction, by which was meant abstract works constructed from non-figurative, usually geometrical, elements rather than abstraction derived from natural appearances, such as was being developed by Roger BISSIÈRE among others in France and was called OBJECTIVE ABSTRACTION in England. The association operated by arranging group exhibitions and by publishing an illustrated annual with the title *Abstraction-Création: Art non-figuratif*, which appeared from 1932 to 1936 with different editors for each issue. Within this general principle the association was extremely catholic in its outlook and embraced many kinds of non-figurative art, from the CONSTRUCTIVISM of GABO, PEVSNER and LISSITZKY

and the NEO-PLASTICISM of MONDRIAN, VORDEMBERGE-GILDEWART and DOMELA to artists such as MAGNELLI and GLEIZES, who came to abstraction through CUBISM, the expressive abstraction of KANDINSKY and even the biomorphic abstraction of ARP and some forms of abstract SURREALISM. Owing, however, to the strength of the Constructivist element and the supporters of De STIJL the emphasis fell increasingly upon geometrical rather than expressive or lyrical abstraction. The French members of the group included GORIN, HERBIN and HÉLION. But although Paris offered welcome hospitality to non-figurative art of all kinds during the 1930s, the contribution of French artists was not the most important in this decade. After *c*. 1936 the activities of the association dwindled as some of the leading Constructivists moved from France to England. An exhibition 'Abstraction-Création', reviving the works of this group, was staged in 1978 at Münster and then at the Mus. d'Art Moderne de la Ville de Paris. The documentation of the association was painstakingly assembled by Gladys C. Fabre.

ABULARACH, RODOLFO. See LATIN AMERICA.

ACADÉMIES. Paris contained more than 20 *académies*, or private art schools, in addition to the State schools and the schools controlled by the municipality. Because entry to the official École Nationale Supérieure des Beaux-Arts (henceforth referred to as the École des Beaux-Arts) was difficult, and also because until the Second World War the teaching there was on traditional and conventional lines, the private academies played a very important part in influencing the development of *avant-garde* art, not only in France but in other European countries and America since many prominent artists obtained at least part of their training in one or the other of them. Among the best-known of these private academies were the following:

ACADÉMIE CARRIÈRE. An art school opened *c*. 1898 in the rue de Rennes, Paris, by Eugène Carrière (1849–1906). There was no regular teaching, though Carrière visited the school once a week, and young artists attended for the sake of drawing from the model and because of the respect in which they held Carrière for his liberality and his encouragement of new ideas. It was here that MATISSE met DERAIN and PUY, thus expanding the nucleus of the future FAUVES.

ACADÉMIE JULIAN. The first of the non-official art schools of Paris, opened in the Passage des Panoramas by Rodolphe Julian in 1860. Its most famous teacher was W. Bouguereau, its teaching was academic, and it was at first regarded as a preparatory school for the official École des Beaux-Arts. It came to greater prominence *c*. 1888 when it became the meeting place of the NABIS—BONNARD, VUILLARD, DENIS, VALLOTTON, etc. SÉRUSIER was also prominently connected with it. In the 1890s MATISSE studied there under Bouguereau

and G. Ferrier, and in the 1900s LA FRESNAYE, DUNOYER DE SEGONZAC, MOREAU, BOUSSINGAULT, LÉGER and DERAIN. It later became a popular resort for American artists who wished to study in Europe.

ACADÉMIE RANSOM. A private art school founded in 1908 by the French painter Paul Ransom (1864–1909) primarily as a centre for the NABIS, to whose association he belonged. SÉRUSIER, DENIS and Ker-Xavier ROUSSEL all taught there. Among later teachers the most prominent was Roger BISSIÈRE, who taught there from 1925 to 1938 and during the 1930s influenced many young painters, including LE MOAL, MANESSIER and VIEIRA DA SILVA, in the direction of expressive abstraction based upon the expressive characteristics of the seen world. Up to and after the Second World War the Académie Ransom remained a popular training centre for foreign artists.

ACADÉMIE SUISSE. One of the oldest of the private academies, founded by a model named Suisse. There was no formal teaching but artists attended in order to draw from the model. It was here that Cézanne first met Monet and Pissarro in the 1860s.

Other well-known art schools were the Académie de la Palette and the Académie Scandinave.

ACCARDI, CARLA (1924–). Italian painter born at Traponi and studied at the Academy of Art, Palermo. She was a founding member of the *Forma* group established at Rome in 1947 and a member of the CONTINUITÀ group founded in 1961. Her painting resembled automatic script on a monochrome ground in the manner of the 'white writing' of Mark TOBEY. But later she reacted against INFORMALISM in the direction of more deliberately planned composition.

ACKERMANN, MAX (1887–1975). German painter, born in Berlin. He studied (1907–12) in Weimar under Henri Van de Velde (1863–1957), at the Munich Academy, and in Stuttgart under Adolf HOELZEL. From 1936 he lived at Horn on Lake Constance and made an intensive study of the colour theories of Goethe and modern colour theories. He worked out a form of non-figurative colour abstraction which he called 'absolute' painting and in which colours were supposedly combined according to musical laws.

ACTION PAINTING. Term invented by the critic Harold Rosenberg with the painting of DE KOONING especially in mind. The term became current during the 1950s as an alternative name for ABSTRACT EXPRESSIONISM. It emphasized the view, which was popular at that time, that a picture should be not merely a finished product but a record of the process of its creation, i.e. the actions of the artist in painting it. See also GESTURAL PAINTING.

ADAM, HENRI-GEORGES (1904–67). French sculptor and graphic artist, born in Paris. He was apprenticed to a goldsmith and at first worked at engraving, being awarded the Blumenthal Prize for his etchings in 1938. He turned to sculpture in 1939 and quickly made his mark. His carving *Gisant* attracted the attention of PICASSO in 1943 and in the same year Jean-Paul Sartre commissioned him to design settings for *Les Mouches*. Among his monumental sculptures were a concrete work 22 m wide for the port of Le Havre (1955) and *Phare des Morts*, a monument commemorating Auschwitz (1957–8). From 1959 he taught sculpture at the École des Beaux-Arts, Paris. His figure sculptures were conceived in large expressive planes somewhat in the manner of BRANCUSI; but he also did geometrical abstracts, influenced by ARP, which he sometimes decorated with engraved patterns. He continued to do graphic work, including illustrations for Gérard de Nerval's *Chimères* (1947–9), and designs for tapestry. In 1955 he had retrospective exhibitions at the Stedelijk Mus., Amsterdam, and the Los Angeles County Mus. of Art.

ADAMI, VALERIO (1935–). Italian POP artist, born at Bologna and studied at the Accademia di Brera, Milan, 1953–7. He worked in London, 1961–2, and in Paris, 1962–4. He used pure, unmodulated colours and depicted his subjects against a background of advertisements and posters, framing his pictures with drawings in the manner of comic-strip cartoons. An element of SURREALISM and fantasy in his work was reminiscent of MATTA.

ADAMS, PAT (1928–). American painter, born in Stockton, Calif. After taking her degree at the University of California and studying at the Brooklyn Mus. School, she travelled in France and Italy and worked in Florence, 1950–1. She taught at Bennington College from 1967 and obtained a MacDowell Colony Fellowship in 1968 and a National Council of the Arts $5,000 award. Her first one-man exhibition was at the San Joaquin Pioneer Mus. and Haggin Art Gals., Stockton, in 1950. Since then she has become known particularly as a lyrical watercolourist and besides one-man exhibitions has participated in a number of collective shows, including The Mus. of Modern Art, New York, '41 Watercolorists', 1957 (circulated in Europe), American Federation of Arts, 'The New Landscape in Art and Science' (circulating 1958–9) and 'Lyricism in Abstract Art' (circulating 1962–3).

ADAMS, ROBERT (1917–). British sculptor, born and studied in Northampton. From 1949 he taught at the Central School of Art and Crafts, London. He worked in wood and stone and from c. 1955 also in metal and reinforced concrete. In 1959 he made a large relief of reinforced concrete for the Municipal Theatre at Gelsenkirchen and in 1962 he had a one-man exhibition at the Venice Biennale. He did both reliefs and free-standing

constructions of metal blocks interspersed with rods. His work was completely abstract and he was prominent in the English post-war CONSTRUCTIVIST movement together with Anthony HILL and Kenneth MARTIN.

ADLER, JANKEL (1895–1949). Polish painter born near Łódz. In 1922 he settled at Düsseldorf after having travelled to France and Spain. But on Hitler's accession to power in 1933 he left Germany and worked for a while in Paris with S. W. HAYTER. In 1935 he had a retrospective exhibition in Warsaw. On the outbreak of war in 1939 he volunteered for the Polish forces and went to Scotland with the Polish army, moving to London in 1943. Adler was a lifelong friend of the Jewish mystic Martin Buber and his painting, which sometimes featured Jewish subjects, reflected a profound mysticism impossible to pin down to any specific theme or characteristic. In keeping with this he evolved an intensely personal idiom both of abstraction and of iconography which precludes classification. His work made a strong impact on certain British artists after his arrival in Britain.

AEROPITTURA. *Aeropittura*, or portraying the sensations of flight, was the last concept to emerge from FUTURISM. A manifesto of *Aeropittura* was brought out in 1929, the year in which MARINETTI accepted membership of Mussolini's *Accademia Italiana*, hoping to make Futurism the official style of the regime. In so far as this was connected with the idea of representing the apparent movement of landscape from the point of view of an observer from a moving vehicle, this had been anticipated by pre-war Futurism. The idea of painting the *sensation* of flight was anticipated by the English artist NEVINSON in 1918.

No important work emerged from the school of *Aeropittura*.

A first *Aeropittura* exhibition was given in 1931, which included works by MUNARI and DOTTORI. The movement had the support of Goebbels and exhibitions were arranged at Paris in 1932 and Berlin in 1944. But it lost its impetus with the death of Marinetti in 1944 and came to an end in 1945.

AFFICHISTE. Name taken by the French artists and photographers Raymond HAINS and Jacques de la VILLEGLÉ, who met in 1949 and during the early 1950s devised a technique of making COLLAGES from fragments of torn-down posters. They used the word *décollage* for this technique (which carried further the idea of the SURREALIST Leo Malet, who in the 1930s had devised the method of partially tearing down posters and advertisements so as to leave bare part of the surface they had covered). They held a joint exhibition 'Affiches Déchirées' in 1957. While Villeglé tried to organize his *affiches lacérées* into aesthetic structures, Hains used them to demonstrate the aesthetic bankruptcy of the advertising world. In the Paris Biennale of 1959 they presented whole hoardings covered with these *affiches déchirées*, while a large canvas by Dufrène was fastened to the ceiling with the underside transformed into a collage of *affiches*. The same method was followed in Italy by Mimmo ROTELLA, who added the technique of photographing a *décollage* directly on to canvas.

AFRICA. Four distinct types of art have been produced in Africa in recent decades—art in traditional styles, mission-inspired art, souvenir work, and the new painting and sculpture—and they differ consistently in their aesthetic quality and importance. Traditional African art, now disappearing with the concepts that guaranteed its existence, is continuing in only a few areas with any degree of its former excellence. Souvenir work, the most commercially successful of recent African arts, has developed in response to demands having nothing to do with traditional cultures, and, in fact, the low aesthetic quality of this work reflects the lack of any incentive save a commercial one. Mission-inspired art, often strongly motivated by Christian beliefs, is at times more aesthetically successful than the souvenir work. Its possibilities, however, have not been fully realized.

The new African painting and sculpture has been inspired by the desire of Africans to become part of the larger, modern world. This new art, beginning only decades ago, is the most aesthetically interesting of all. The earliest of these artists, Njoya, was painting in the early 1920s and, in fact, may have created a few works even earlier. The new art, however, had its real beginnings in the 1930s, when independent artists such as Sekoto, ENWONWU and Ampofo started working and exhibiting. The earliest art schools were also established during this decade—the Trowell workshop, which became the School of Fine Arts at Makerere University College in Uganda; and on the West Coast the art department of Achimota College in Ghana. The first graduates of these schools came to prominence during the 1940s: Ntiro and Maloba in Uganda, for example, and Antubam in Ghana. It was this period, too, which saw the establishment of what is now the School of Fine and Applied Art in Khartoum and of the first art schools in a French-speaking area of Africa—the Desfossés school in Lubumbashi and the Académie des Beaux-Arts in Kinshasa, both in the Republic of Zaïre.

During the next decade, 1950–60, African art developed at an accelerated pace. Several new schools were founded: the Poto-Poto School in Brazzaville, People's Republic of Congo; the Nigerian art departments now at Ahmadu Bello University, Zaria, and Yaba Technical Institute, Lagos; the Académie des Beaux-Arts in Lubumbashi; the Fine Arts School, Addis Ababa; and the École Nationale in Dakar, Senegal. Graduates of schools founded in the 1930s and 1940s—such as Salahi, Shibrain, Kofi, Bela, Pilipili, Mwenze and

Mensah—began teaching a new group of students who were often only a few years younger than their teachers. These years also saw the emergence to prominence of Felix Idubor and Afewerk Tekle, artists working independently in Nigeria and Ethiopia respectively.

In the 1960s there was a burgeoning of excellent new artists in Africa. Many of them possessed real talent and often a considerable artistic sophistication, and even the youngest among them showed great potential. They included those who graduated in the early 1960s from Ahmadu Bello University and Yaba Technical Institute as well as recent graduates from Makerere's School of Fine Arts. Three fine artists trained in Europe and now teaching in African art schools also came to prominence during this period—Lattier, Skunder and Gebre Kristos—as did the independent artists Malangatana and Emokpae. In addition several new schools were founded in this decade: the Institut National in Abidjan, the tapestry school in Senegal, and the workshops in Oshogbo and Salisbury.

The chronology of the new African art reveals two groups of older artists who were historically of considerable importance in this evolution. The first group are the 'untrained' artists. They include those associated with African schools where teaching methods allegedly precluded any conventional art instruction. Among this group, largely found in the French-speaking areas of Africa, should be mentioned in particular the Desfossés students Bela, Pilipili and Mwenze, the Moonens-trained painters Kamba and Mode, and Poto-Poto students Thango, Zigoma and Ondongo. Of these the works of the Desfossés group and the Poto-Poto School painters are perhaps the best known. All these painters, it is true, were introduced to and employed new media, for instance gouache on cardboard or coloured paper. Their works usually depict similar subject matter, such as ceremonial or genre activities in traditional Africa or the flora and fauna of the continent. There is, however, a wide variety in their styles, ranging from often naïve paintings produced in the Desfossés school through some sophisticated Poto-Poto compositions reminiscent of CUBIST works. Despite this seeming variation all of the works created by this 'untrained' group display a highly decorative quality. Forms are flat with an emphasis on line and geometric pattern, space is negated, and bright colours are used. The decorativeness of style, frequently very marked, certainly owes something to the possibilities of the new media with their range of colours.

There appears to be less future potential, regardless of their early successes, for the early 'untrained' men than for any other group of present-day African artists. Although the majority of them have either stopped completely or paint only rarely, a few, such as Mwenze, Zigoma and Ondongo, have continued to paint steadily. But they usually repeat their earlier successful efforts and do not seem to be developing further.

The second group of older contemporary African artists are those trained in the more conventional art schools of Africa or Europe. They usually received a traditional Western-style art education, which often included the study of art history. Among them are Ntiro and Maloba, graduates of the Makerere School of Fine Arts, and the late Antubam, a graduate of the art department at Kumasi College of Science and Technology. Several independent artists, such as Sekoto, Enwonwu and Ampofo, received most of their training in English or French art schools, and consequently they too have a comparable background. These art-school trained men include some of the best-known African painters and sculptors. They have been working and exhibiting for many years, and in most cases their work has been shown in Europe and the U.S.A. as well as in Africa.

This group includes both painters and sculptors. They use both traditional African and Western materials and techniques in their new art. Although murals, a form of painting occasionally found in traditional African art, are produced, the pictorial works are predominantly Western-derived easel paintings executed in water-colour, gouache or oil. Their sculpture, on the other hand, usually employs materials and techniques common to traditional African art, such as wood-carving, bronze and brass casting, and clay modelling. Cement fondu, a medium unknown in earlier African sculpture, is on occasion used by Ampofo.

Most interesting, however, is the new importance of painting as a technique. Contrary to traditional art, where sculpture was of paramount importance, these contemporary artists consist of painters and sculptors in equal proportion, and two in this group, Enwonwu and Antubam, are equally adept in both media.

The subject matter used by these artists varies widely. Sometimes it is wholly Western-derived; for example, Sekoto has painted Paris street scenes and jazz musicians, Enwonwu has produced landscapes, and both he and Ntiro have occasionally utilized Christian subject matter. But all the men of this group, like the 'untrained' artists, are interested primarily in the ceremonial and genre activities of traditional African life. One painter, Sekoto, has even painted a number of scenes describing urbanized African life in the 'locations' ringing South African cities.

Like their subject matter, the styles of these artists are also heterogeneous, a result certainly of variations in the type and amount of art instruction they received. Most Western-oriented in style are artists like Ntiro and Maloba, who did not have a strong tribal artistic tradition and who received quite a bit of their art training abroad. Both of them spent several years studying art in England. Maloba's portrait busts closely approximate to those of EPSTEIN, while Ntiro's paintings display a *naïveté* reminiscent of European and American folk art.

The majority of these historically important art-school trained artists are, however, eclectic in style, combining both African and Western traits. Enwonwu, Sekoto and Ampofo, for example, frequently use the characteristic figure proportions and treatment of facial features found in specific African traditional art styles. Antubam also incorporated into his work Ashanti kingdom symbols. The composition of figures and their relationship in space are but a few of the stylistic similarities to Western art in the paintings of Enwonwu, Sekoto and Antubam; and the sculpture of Ampofo displays a greater realism in the handling of figure parts than is seen in traditional sculpture.

In the 1960s a group of younger African artists were prominent. Some of them were trained in conventional art schools in Africa, where curricula have included the study of African as well as Western art history. In most cases they have supplemented their education by work in Europe or the U.S.A. Most important among them are Salahi, Shibrain, Njau, the late Vincent Kofi, and in Nigeria Idehen and the so-called Zaria group. Several noteworthy artists developed in the workshops of Oshogbo and Salisbury, among them Twins SEVEN-SEVEN and Thomas Mukarobgwa. A few—N'Diaye, Tall, Lattier, Skunder and Gebre Kristos—studied exclusively in European art schools. And two important artists, Emokpae and Malangatana, were self-trained.

The media and techniques employed by these younger artists are similar to those pioneered in Africa by the older generation. There are some exceptions, such as the first important appearance of print-making in Africa, a technique employed by the painters Onobrakpeya and Musoke. In sculpture advanced Western methods of welding figures and casting reliefs in fibreglass are seen in the works of Kofi, Kakooza and Osifo. Thus, as with the previous generation of contemporary African artists, these younger men are Western-oriented in their use of media and techniques. More than three-quarters of them are painters, an even greater departure from the overwhelming predominance of sculptors in traditional art.

Although subject matter in this painting and sculpture is largely the same as that found in earlier works, there are two important exceptions. For the first time in African art painters, for example Nwoko and Salahi, represent and, most importantly, comment on social events occurring in the 'new' Africa. Malangatana deals with raw and basic themes of emotion in his works, while Salahi, Skunder, Twins Seven-Seven and Buraimoh are often occupied with fantasy and dream subjects, all innovations in contemporary African art. Most recently pure abstractions, such as the work of Gebre Kristos, have also appeared.

Some of the younger artists, resembling the older painters and sculptors, are eclectic in style. C. Uche Okeke, Idehen, Malangatana, Kofi, Salahi, Shibrain and Idubor often draw for inspiration on the arts of both Africa and the West. Most of these new artists—Akolo, Grillo, Nwoko, the late Simon Okeke, Onobrakpeya, Gebre Kristos, Skunder, N'Diaye, Tall and Emokpae—have, however, developed styles related in a general way to Western 20th-c. art. Like their counterparts in modern Europe and America they are interested in abstraction of form, design and composition, and the use of colour in a non-descriptive manner. Sometimes reminiscences in style from specific Western art movements and artists are seen: for example, *Beggars* by Nwoko conjures up some of the paintings of the NEUE SACHLICHKEIT. As yet most of these younger painters and sculptors have not been as original or daring in their use of advanced ideas as the *avant-garde* artists of the Western world. However, both those with eclectic styles and those whose work is largely Western-oriented are the most original, imaginative and creative of the painters and sculptors now active.

In the past the major sources of support for the new African art were the colonial governments; now the independent African states are supporting it. They have bought works, organized and subsidized art groups, and founded and financed museums that collect the new painting and sculpture. And most significant, these governments have also established and supported art schools. It is these schools that are training most of the important African artists.

(The foregoing article is taken, with permission, from *African Art. The Years since 1920* by Marshall Ward Mount (Indiana University Press, 1973).)

AFRO (AFRO BASALDELLA, 1912–76). Italian painter, born at Udine, brother of the sculptor MIRKO. After studying in Venice and Florence he went to Paris in 1931, returning to Rome in 1937. During the war period he taught occasionally at the Venice Academy and then in 1947 settled in Rome, where he joined the FRONTE NUOVO. In 1952 he joined the splinter group, GRUPPO DEGLI OTTO PITTORI ITALIANI. After passing through a CUBIST phase he evolved a personal idiom of LYRICAL ABSTRACTION and became one of the best-known Italian painters in this style. In 1955 he was represented in the exhibition 'The New Decade' at The Mus. of Modern Art, New York, and in 1956 he won First Prize for Italian Painting at the Venice Biennale. During the 1950s he painted murals for public buildings in Udine. In 1958 he executed a mural for the UNESCO Building, Paris, and taught at Mills College, Oakland, California. Subsequently he taught at the Academy, Rome.

AGAM, YAACOV (JACOB GIPSTEIN, 1928–). Israeli sculptor and experimental artist, born at Richon el Zion, Palestine. From 1946 he studied at the Bezalel School of Art, Jerusalem, under Mordecai ARDON (formerly Max Bronstein), who had been a pupil of Johannes ITTEN at the BAUHAUS. At the instigation of Ardon he went to Zürich in 1949 and studied under Itten at the

Kunstgewerbeschule, where he also attended lectures by Siegfried Giedion and met Max BILL. Under these influences Agam reacted against the impulsive subjectivism of TACHISM and ART INFORMEL, setting his feet firmly on the path of experimental CONSTRUCTIVISM. In 1951 he went to Paris without funds and with no knowledge of French, managing to survive by eating in Salvation Army soup kitchens and teaching at a Jewish school for kindergarten teachers. In order to obtain a residence permit he enrolled at the Atelier de l'Art Abstrait of Edgard PILLET and Jean DEWASNE and at the Académie de la Grande Chaumière. He also knew LÉGER and HERBIN and was introduced into SURREALIST circles. In 1953 he exhibited 45 pieces, mainly mutable paintings and transformable reliefs, at the Gal. Craven, Paris. In 1954 he exhibited 3 pieces at the SALON DES RÉALITÉS NOUVELLES and in 1955 he participated, with BURY, SOTO, TINGUELY, CALDER, etc., in the exhibition 'Le Mouvement' at the Denise René Gal., considered the definitive exhibition for the KINETIC movement. From this time Agam was recognized as a pioneer in those branches of non-figurative art which lay stress on movement and spectator participation. In 1963 he represented Israel at the São Paulo Bienale and was awarded a special prize for artistic research.

In his monograph on Agam, Günter Metken wrote: 'Agam's work marks the beginning of a movement centred in Paris which has devoted itself to transcending the boundaries between media and has introduced the elements of time, space and light into art.' Spectator participation and STOCHASTICISM were present in his 'mutable' paintings and constructions such as *Continuity*, *8 + 1 in Movement* and *Revolution of Established Forms* of 1953, in which abstract elements could be rotated or moved or changed by the spectator. He also pioneered 'paintings of polyphonic superimposition', in which a number of compositions were combined into one, varying optically as the position of the spectator was changed. Of these he said: 'Several visual themes, differing in structure and colour, interpenetrate and merge in counterpoint. The surface of these pictures consists of a relief of prisms mounted vertically and parallel to one another like a series of pointed waves, which gives a rhythmic system of measure into which the different themes are painted. I have succeeded in uniting as many as eight clearly differentiated themes in one work; you can see them integrated with one another when you stand directly facing the picture, and you can see how they slowly separate and then reunite when you move from right to left.' Agam specialized particularly in walls and ceilings which changed radically in appearance according to the position and the angle of vision of spectators. Examples are his *Double Metamorphosis 11*, 30 by 20 ft (9 by 6 m), consisting of 30,000 small square images, in the foyer of The Mus. of Modern Art, New York, and the relief 300 by 12 ft (91·5 by 3·6 m) for the National Convention Hall, Jerusalem. His kinetic painting for the Forum hall at Leverkusen created a total optical environment which he described as follows: 'Up to now we have viewed paintings as if through windows. In this piece for the Leverkusen Forum I have created an artistic space which surrounds us completely and in which we exist. The space is different for everyone depending on the way he confronts it; it moves as the viewer moves and presents a different aspect from each angle.' The Science Department of Montpellier University has a wall completed by him in 1971 consisting of 18 identical vertical panels which can be rotated in place or their positions changed.

Agam's sculptures executed after 1966, 'transformable transformables', introduced an element of play as the spectators were invited to rearrange elements so as to bring into being an 'unlimited number of spaces'. Some achieved monumental scale, as *Three Times Three* in front of the Julliard School of Music at the Lincoln Center, New York, *Thousand Gates*, Jerusalem, *All Directions*, La Roche-sur-Yon, etc. He also created light environments and experimented with effects of light, as when he set one of his 'polymorphous paintings' in rotation and bathed it in stroboscopic light at the Paris exhibition 'Lumière et Mouvement' in 1967 and in his *Fiat Lux*, which responded to the pitch and volume of spoken sound.

In 1972 he was commissioned by President Georges Pompidou to do an environment for the Palais de l'Elysée and in the same year he had a comprehensive retrospective at the Mus. National d'Art Moderne, Paris, which was later shown at the Stedelijk Mus., Amsterdam, and at Düsseldorf and Tel Aviv. In 1974 he designed two walls for the American Telephone and Telegraph Company, New York, and in 1975 he made monumental sculptures for the Quartier de la Défense, Paris, and for the Faculté des Sciences, Dijon. He was created Chevalier de l'Ordre des Arts et Lettres in 1974 and awarded a Doctorate of Philosophy *honoris causa* by Tel Aviv University in 1975.

AGAR, EILEEN (1904–). British painter, born in Buenos Aires. She came to England in 1906, studied in 1924 with Leon UNDERWOOD, at the Slade School, 1925–6, and at Paris, 1928–30. She was a member of the LONDON GROUP from 1933. During the 1930s she was associated with the SURREALIST manifestations in London and participated in the international Surrealist exhibitions at the New Burlington Gals., London (1936), The Mus. of Modern Art, New York (1936–7), and at Tokyo, Paris and Amsterdam in 1937 and 1938. She was also represented in 'The Art of Assemblage' exhibition at The Mus. of Modern Art, New York, in 1961. Her painting career was disrupted by the Second World War but was resumed in 1946. She had one-man shows in a number of London galleries from 1942, including retrospectives at the Brook Street Gal. in 1964 and at the Commonwealth Art Gal. in 1971. This was fol-

lowed by an exhibition of selected works at the New Art Centre, London, in 1975 and 1977. Her work is represented in a number of public and private collections, including the Tate Gal., the Victoria and Albert Mus., the Arts Council, the Contemporary Arts Society, London, Manchester University and the National Gal. of New Zealand. Her style developed from Surrealism in the 1930s to cool TACHIST abstraction with Surrealist elements in the 1950s and 1960s.

AGOSTINI, PETER (1913–). American sculptor born in New York, where he studied at the Leonardo da Vinci Art School. He had one-man exhibitions from the beginning of the 1960s and his work was included in collective exhibitions of the new American sculpture, e.g. 'Recent American Sculpture' at the Jewish Mus., 1964, and the International Sculpture Exhibition at Battersea Park, London, in 1963. Agostini made casts in quick-setting plaster of light objects such as rags, balloons, pillows, etc. and combined these in assemblages with replicas of commercial objects such as bottles, egg cartons, etc. His work had affinities with POP, ASSEMBLAGES and JUNK ART.

AGRARYKH. See STEPANOVA, Varvara Fedorovna.

AGUAYO, FERMIN. See SPAIN.

AGUIRRE, JUAN ANTONIO. See SPAIN.

AÏZPIRI, PAUL AUGUSTIN (1919–). French painter and graphic artist, born in Paris. His style of painting was a personal synthesis of EXPRESSIONIST and CUBIST elements with an interest in folklore to form an essentially decorative whole, often verging upon the fantastic. A typical example is his *Nature morte au pichet blanc* in the Mus. d'Art Moderne de la Ville de Paris. He also practised lithography, in which he made a name by his illustrations for Shakespeare's *Taming of the Shrew*. In 1951 he won the Prix National.

AKASEGAWA, GENPEI (1937–). Japanese painter born at Yokohama, studied at the Musashino Art Academy, Tokyo. He was a member of the NEO-DADA ORGANIZERS group and was influenced by SURREALISM. He made ASSEMBLAGES and 'packed objects'. In 1963 he was convicted of making counterfeit money.

AKhRR. Russian association of artists. Early in 1922 a group of artists, among them Aleksandr Grigorev, Evgenii Katsman, Sergei Malyutin and Pavel Radimov, organized the Society of Artists of Revolutionary Russia. After their first group exhibition in Moscow, 'Exhibition of Pictures by Artists of the Realist Direction in Aid of the Starving', the Society was renamed *Assotsiatsiya khudozhnikov revolyutsionnoi Rossii* (Association of Artists of Revolutionary Russia), i.e. AKhRR.

The primary aim of its members was to present revolutionary Russia in a realistic manner by depicting the everyday life of the proletariat, the peasantry, the Red Army, etc. In restoring tendentious themes to the picture they returned to the traditions of the 19th-c. Realists and came out in opposition to the Leftists. Apart from older Realists such as Abram Arkhipov, Nikolai Kasatkin and Konstantin Yuon, AKhRR attracted many young artists such as Isaak Brodsky, Aleksandr Gerasimov and Boris Ioganson. In order to acquaint themselves with proletarian reality many of the AKhRR members visited factories, iron foundries, railroad depots, shipyards, etc. By the mid 1920s AKhRR was the most influential single body of artists in Russia, having affiliations throughout the country, its own publishing house and, of course, enjoying direct government support. In 1928 its name was changed to *Assotsiatsiya khudozhnikov revolyutsii* (Association of Artists of the Revolution), i.e. AKhR, and in 1929 it established its own journal, *Iskusstvo v massy* (*Art for the Masses*). In 1932, together with all other art and literary groups, AKhR was dissolved.

ALBERS, JOSEF (1888–1976). German-American painter and designer, born at Bottrop, Westphalia. After studying at the Royal School of Art, Berlin, 1913–15, he did lithographs and woodcuts in the EXPRESSIONIST manner while teaching at the School of Arts and Crafts, Essen. He then studied painting at the Munich Academy under Franz Stuch, who had been a teacher of KANDINSKY and KLEE, from 1919 to 1920, when he entered the BAUHAUS and occupied himself particularly with glass pictures and designing stained glass windows. In 1925 he was made Master at the Bauhaus and broadened his activities to cover typography, designing glass and metal utility objects and furniture design. He stayed on at the Bauhaus after the departure of GROPIUS in 1928 and continued working there until it closed in 1933, when he made his first visit to the newly founded experimental Black Mountain College in North Carolina. Albers was one of the first of the Bauhaus teachers to emigrate to the U.S.A. and one of the most active in propagating Bauhaus ideas there, becoming an American citizen in 1939. From 1936 to 1941 he gave courses at the Graduate School of Design in Harvard University while continuing to teach at Black Mountain College until 1949. In 1950 he became Chairman of the Department of Architecture and Design at Yale University, remained in that position until his retirement in 1958 and then taught as Visiting Professor until 1960. He lectured and taught very widely in America during this period and received many academic honours, including: Doctor of Fine Arts at Hartford (1957); at Yale (1962); at California College of Arts and Crafts, Oakland (1964); Doctor of Law at Bridgeport and Doctor of Fine Arts at the University of North Carolina (1967); at the University of Illinois (1969); at Kenyon College (1969); at Minneapolis

(1969); Benjamin Franklin Fellow at the Royal College of Art, London (1970).

Between 1936 and 1941 Albers had more than 20 one-man shows of glass pictures from his Bauhaus period and of later pictures done in America. He had a show at the Egan Gal., New York, in 1946, a retrospective exhibition at the Yale University Art Gal. in 1956 and at the Stedelijk Mus., Amsterdam, in 1961. Among his better-known mural designs were: *America* for the Harvard Graduate Center (1950); *Two Structural Constellations* for the Corning Glass Building, New York (1958); *Two Gates* for the Time & Life Building, New York (1959); *The City* for the Pan-American World Airways Building, New York (1963); *Structural Constellations* for the façade of the new building of the Landesmus. für Kunst und Kulturgeschichte, Münster (1970).

In his pedagogic work Albers asserted that art cannot be taught and claimed that his object was to teach men to *see*. 'I want to open eyes', he said when he left Germany for America. He investigated systematically the intrinsic qualities of the elements of form and design and taught that art should be constructed on the basis of rationally controlled intuition. Except in his early work he eschewed representation: 'art should not represent but present'. He also aimed at economy of form and a balance between means and effect. His work lay in the field of geometrical abstraction or CONSTRUCTIVISM, substituting the anonymity of machine-like precision for any appearance of spontaneity or personal expressiveness. He was particularly interested in the square as an artistic element since he believed that of all geometrically regular shapes the square best distances a work of art from nature and guarantees its man-made quality. Indeed he was best known for his long series of paintings, begun in 1950, entitled *Homage to the Square*. These consisted of squares within squares of closely calculated sizes and subtly varied hues within a very narrow range of colour. As Kandinsky had done before him, he made deliberate use of the tendency of colours placed in proximity to expand or contract, recede or advance, in relation to each other and his basic research in this field, more systematic than that of Kandinsky, was published in *Interaction of Color* (1963). In the deliberate use of visual ambiguities some of his designs were on the fringe of OP ART, as for instance the lithographs *Shrine* (1942) and *Sanctuary* (1942). His exploitation of the optical fact that colours of closely related hues when juxtaposed create the illusion of a third colour also borders upon some of the devices and researches of Op artists.

The principles of Albers's work and teaching, based always on the Bauhaus aesthetic, are summed up in the following statement: 'Through discussion of the results obtained from the study of the problems of materials, we aim at exact observation and new vision. We learn which formal qualities are important today: harmony or balance, free or measured rhythm, geometric or arithmetic proportion, symmetry or asymmetry, central or peripheral emphasis. We discover what chiefly interests us: complicated or elementary form, mysticism or science, beauty or intelligence.'

ALBERT, CALVIN (1918–). American sculptor and graphic artist born at Grand Rapids, Mich., studied at the Chicago Institute of Design under MOHOLY-NAGY, KEPES and ARCHIPENKO. His first one-man exhibitions were at the Paul Theobald Gal., Chicago, 1941, and the Puma Gal., New York, 1944. He had a retrospective exhibition at the Jewish Mus. in 1960 and he participated in a large number of group exhibitions both of sculpture and of drawing. Among his commissions were decorative sculpture for St. Paul's Episcopal Church, Peoria, Ill.; Temple Israel, Bridgeport, Conn.; Park Avenue Synagogue, New York. As a sculptor he belonged to the school of ABSTRACT EXPRESSIONISM, using the technique of welding metal, and he worked out his own alloys for this purpose.

ALBERT, HERRMANN (1937–). German painter born at Ansbach, studied at the Hochschule für Bildende Künste, Braunschweig. His work belonged to the school of NEW REALISM and from the late 1960s he took part in many exhibitions in Germany. He painted figures realistically in harsh, flat colours and his peculiarity was to combine in one painting several representations of the same figure with a slight change of pose.

ALBRIGHT, IVAN LE LORRAINE (1897–1983). American painter born in Chicago, son of a portrait painter. He studied architecture at Northwestern University and the University of Illinois, 1915–17, while painting in his spare time. During the First World War he served in France as a medical draughtsman and worked with a meticulous detail and clinical precision which anticipated his later style. After the war he studied painting at the Art Institute of Chicago, 1919–23, the Pennsylvania Academy of Fine Arts, Philadelphia, 1923, and the National Academy of Design, New York, 1924.

Albright has been called a SURREALIST, although his style shows few if any of the characteristic features of Surrealism. He drew with meticulous attention to detail, working over the surface of the canvas inch by inch, and sometimes spending ten years or more on a single picture. The net result was to create a uniform graphic texture over the whole surface (a detail from one of Albright's pictures often conveys a remarkably similar impression to the whole), which suggests a *horror vacui* such as is sometimes found in the drawings of psychotics, and an evenness of emphasis into which the details sink and are lost. During the 1920s he had already gained notoriety for a

morbid obsession with death and corruption. His first solid success was with his picture *That Which I Should Have Done I Did Not Do* (Art Institute of Chicago, 1931–41), which was awarded the Temple Gold Medal as the best entry in the 'Artists for Victory' exhibition at The Metropolitan Mus., New York, in 1942. Other well-known pictures by him are *God Created Man in His Own Image* (1929–30), *Portrait of Mary Block* (Art Institute of Chicago, 1955–6) and *The Window* (1941–62). He had retrospective exhibitions at the Art Institute of Chicago in 1964 and the Whitney Mus. of American Art in 1965.

ALEATORY (ALEATIC). Depending upon an element of chance or randomness. (See STOCHASTICISM.)

ALECHINSKY, PIERRE (1927–). Belgian painter and graphic artist, born in Brussels of a Russian father. He studied at the École Nationale Supérieure d'Architecture et des Arts Décoratifs, giving particular attention to the techniques of book illustration and typography. In 1947 he became a member of the association JEUNE PEINTURE BELGE and in 1949 joined the COBRA group. In 1951 he severed his connection with COBRA and settled in Paris, where he studied graphic techniques at Studio 17 under S. W. HAYTER. At this time he made contact with Japanese calligraphers from Kyoto and in 1955 he travelled to the Far East and produced a film *Calligraphie japonaise.* In 1961 he visited the U.S.A. and during the 1960s he travelled there and in Mexico and the Canaries, afterwards settling in Paris.

Alechinsky painted in a style of vigorous, even violent, expressive abstraction which had closer affinities with nordic EXPRESSIONISM than with the classical restraint of the ÉCOLE DE PARIS. Residual figurative motifs remained constant to his work, however, and these were redolent of a turbulent fantasy often approaching SURREALISM. His debt to ENSOR is recognized by the paintings *Hommage à Ensor* (1956) and *Fête d'Ensor* (1963). Yet he remained one of the most aggressively individualistic painters of his time. In 1965 he abandoned oils for acrylic and about this time he began to surround his paintings with a border of small sketches in the manner of a mount or frame. But always his paintings were disordered, eruptive, volcanic and mythopoeic. He was also active throughout his career as a book illustrator.

Alechinsky's works were widely exhibited in Europe, the U.S.A. and São Paulo. A retrospective exhibition of his paintings and graphic works under the auspices of the Service de la Propagande Artistique du Ministère Belge de la Culture was shown at the Boymans-van Beuningen Mus., Rotterdam, in 1974, and at the Mus. d'Art Moderne de la Ville de Paris and the Kunsthaus, Zürich, in 1975. The many public collections in which he is represented include: The Mus. of Modern Art, the Solomon R. Guggenheim Mus., New York; Albright-Knox Art Gal., Buffalo; the Philadelphia Mus. of Art; the Carnegie Inst., Pittsburgh; the Walker Art Center, Minneapolis; The Power Institute of Fine Art, Sydney; the Mus. d'Art Contemporain, Montreal; Mus. Nacional de Arte Moderno, Mexico; Mus. de Arte Moderna, Sâo Paulo; Bridgestone Mus., Tokyo; Israel Mus., Jerusalem; Tel Aviv Mus; and many national collections in Europe, including: Mus. d'Art Moderne, Warsaw; Nasjonalgal., Oslo; Gal. Nazionale d'Arte Moderna, Rome; Stedelijk Mus., Amsterdam; Gemeentemus., The Hague; Mus. National d'Art Moderne, Paris, and Mus. d'Art Moderne de la Ville de Paris; Nationalgal., Berlin; Statens Mus. for Kunst, Copenhagen; Mus. Royaux des Beaux-Arts de Belgique and Bibliothèque Royale, Brussels.

ALIX, YVES (1890–). French painter, born at Fontainebleau. He entered the École des Beaux-Arts in 1908 and then studied at the Académie Ransom and the Académie de la Palette. He exhibited for the first time at the Salon des Indépendants in 1912 and he collaborated with Maurice DENIS in decorations for the theatre of the Champs-Élysées. Although he flirted with CUBISM and retained something of its structural firmness in his compositions, he belonged rather to the school of Expressive Naturalism represented by LE FAUCONNIER and Marcel GROMAIRE, his fellow pupil at the Académie de la Palette. His work was noted for sombre but luminous masses and strong modelling. Like Edouard GOERG, he sometimes castigated the social evils of his day. After the Second World War his style was both more colourful and more lucidly structured.

ALLADIN, M. P. (1919–). British painter born in Tacarigua, Trinidad, studied at the Birmingham College of Arts and Crafts, 1947–8, with a British Council scholarship and took an Art in Education course in 1953. He was at Columbia University, U.S.A., 1958–61. He exhibited in London, Birmingham, New York and the West Indies and in 1958 he was commissioned to paint a picture as Jamaica's official gift to Princess Margaret. His works were purchased for the Government of Trinidad collection and were represented in the exhibition 'Commonwealth Art Today' at the Commonwealth Inst., London, in 1962–3. In the 1960s he was Art Officer in the Division of Culture, Trinidad.

ALLEN, ELIZABETH (1883–1967). British NAÏVE artist born in London of a German father and an Irish mother, one of sixteen children. She was a cripple from birth and learnt sewing in her father's tailoring business. Her 'patchwork' pictures were 'discovered' in 1965 and from that time were exhibited in many galleries, including Crane Kalman, London; National Gal. of Modern Art,

Edinburgh; Salon Internationale de Arte, Barcelona; La Boétie Gal., New York; Fleischer Anhalt Gal., Los Angeles; Gal. Charlotte, Munich.

ALLIANCE OF YOUTH. See UNION OF YOUTH.

ALLIED ARTISTS' ASSOCIATION. A group of British artists formed by the critic Frank Rutter and artists in SICKERT's circle for the purpose of organizing annual exhibitions of independent progressive painters in the manner of the French SALON DES INDÉPENDANTS. The group was formed in 1908 and held the first of its exhibitions in the Albert Hall in that year. The artistic aims of the group as defined by Rutter were 'simplicity, sincerity and expression', words which at that time were current all over Europe and which might be adopted by artists of almost any persuasion. The artists of the Association wavered between what the Germans call *Natur-lyrismus*—poetic naturalism—and POST-IMPRESSIONISTS such as Van Gogh, Gauguin and Cézanne. In addition to Sickert the Association included Spencer GORE, Harold GILMAN the future president of the LONDON GROUP, Lucien PISSARRO, Augustus JOHN, Henry LAMB, Walter BAYES, Charles GINNER. It was from the Allied Artists' Association that the CAMDEN TOWN GROUP emerged in 1911.

ALL-OVER PAINTING. A term used for a style of painting in which the whole surface of the canvas is treated in a relatively uniform manner with little structural differentiation. It was first used of the 'drip' paintings of Jackson POLLOCK. It has since been applied to paintings of other artists where the over-all treatment of the canvas is relatively uniform, whether relying on texture or on 'scribbled' material as with Cy TWOMBLY or on colour as with the COLOUR FIELD painters. The German term is *Streu-Komposition*.

In this style attention is evenly diffused over the whole canvas and there are no outstanding points of interest linked together by balance, harmony, rhythm, etc. The picture is a single undifferentiated visual entity in a way analogous to the PRIMARY STRUCTURES of MINIMAL ART. It is 'non-relational' because there are no contained or subordinate elements to be related in this way.

ALLWARD, WALTER. See CANADA.

ALPUY, JULIO. See LATIN AMERICA.

ALSLEBEN, KURT. See COMPUTER ART.

ALTMAN, NATAN ISAEVICH (1889–1970). Russian painter, stage-designer and graphic artist, born at Vinnitsa. He studied painting and sculpture at the Odessa Art School, 1901–7. From 1910 to 1912 he lived in Paris, attending Vasilieva's Russian Academy. From 1912 to 1917 he contrib-uted to the satirical magazine *Riab* (*Ripple*) in St. Petersburg, was active in the UNION OF YOUTH and took part in many *avant-garde* exhibitions including 0.10 and KNAVE OF DIAMONDS. In 1918 he became professor at Svomas, member of IZO NARKOMPROS, and designed agit-decorations for Uritsky Square, Petrograd, and elsewhere. In 1919 he was a leading member of the Communist FUTURISM (*Komfut*) group. In 1921 he designed the décor for Vladimir Mayakovsky's *Mystery-Bouffe*. In 1922 he was a member of INKHUK. He lived in Paris, 1929–35, and in 1936 he settled in Leningrad.

ALTOON, JOHN (1925–69). American painter and draughtsman born and lived in Los Angeles. Although he painted in a gestural, ABSTRACT EXPRESSIONIST manner, his main forte was as a draughtsman. Extremely prolific, he produced a large body of drawings in the late 1950s and through the 1960s. Somewhat in the manner of Rowlandson, these had a penetrating satirical content combined with superb graphic technique. From 1957 until his death he held an influential position in the Los Angeles artistic community. His work was exhibited widely in America and was represented in collective exhibitions of modern American painting and drawing.

ALVAREZ, FRANCISCO. See SPAIN.

ALVERMANN, HANS PETER (1931–). German sculptor, born in Düsseldorf and studied at the Academy there, 1954–8. He combined painting, COLLAGES and ready-made objects into ASSEMBLAGES. These, often enclosed or partially enclosed in box-like cases, juxtaposed the most diversified functional objects and Alvermann used this technique for purposes of social criticism and ironical propaganda.

ALVIANI, GETULIO (1939–). Italian sculptor born at Udine. From 1959 he was interested in the problems of light and during the 1960s he constructed a series of works entitled *Lignes Lumineuses* consisting of aluminium surfaces broken up into conflicting optical fields by careful polishing. In this and other ways he sought to render his pictures and structures polyvalent and ambiguous. He was a member of the GROUPE DE RECHERCHE D'ART VISUEL and took part in exhibitions of the NOUVELLE TENDANCE. In 1969 he constructed an aluminium wall 3·20 by 5·60 m which he called *Vibrating Surface and Texture* and in 1964 he constructed a *Cubic Environment* for the exhibition 'Konstruktive Kunst' in Nuremberg. It was a roofed cube of aluminium plates measuring 3·30 m in all dimensions. In these works and also in his MULTIPLES—sculptures intended for mass production—he was concerned with spectator involvement and participation.

AMARAL, TARSILA DO (1886–1973). Brazilian painter and sculptor born at São Paulo, where she first studied painting with J. Fischer Elpons and Pedro Alexandrino. In 1920 she went to Paris and studied with Emile Renard and at the Académie Julian. In 1923 she studied with LHOTE, GLEIZES and LÉGER, learning the basic principles of CUBISM, which she was to apply to Brazilian subject matter. She first exhibited in Paris at the Salon des Artistes Français in 1922. With the modernist poet Oswald de Andrade, whom she married, and the Swiss-French poet Blaise Cendrars, she visited Rio de Janeiro in 1924 to see the carnival, and the mining towns in the state of Minas Gerais to see the baroque churches. This experience, the growing town of São Paulo and her childhood memories of the coffee plantation where she grew up, provided her with much of her imagery. With Oswald she initiated a *Pau-Brasil* (Brazilwood) phase of nativist subjects. In 1928 she entered her 'Anthropophagist' phase with a painting *Abaporu* which was exhibited in her second one-man show at the Gal. Percier, Paris, the same year. *Abaporu* combined the distortions of Cubism with rounded forms and exotic colour which reflected her Brazilian environment. Her figures of this period were painted in the clay, pink and orange colours of the Brazilian soil. *Antropofagismo* (Cannibalism) represented for modernists in many fields the means of fusing modern art and ideas with nativist themes, and it spread as a movement among other painters and intellectuals, including Oswald. In 1930 Amaral's life underwent a change with the downfall of the Paulista president, Julio Prestes, and the take-over by the Minheiro (from Minas Gerais), Getulio Vargas. Although the modernist movement continued, it was temporarily under a cloud and Amaral turned to more SOCIAL REALIST themes such as *Factory Workers*, following a visit to Russia in 1931. But later she returned to her *Pau-Brasil* style. Although her paintings of the 1940s were related to the *Pau-Brasil* and Anthropophagist periods, the extremely elongated limbs of the figures, the subdued colour and the oneiric atmosphere of these pictures place them within the context of SURREALISM. In the 1950s and 1960s Amaral returned to the vivacious and glowing pinks, blues and greens of her earlier phases. She had a retrospective exhibition at the Mus. de Arte Moderna, São Paulo, in 1950, and again in 1969 at the Mus. de Arte Moderna, Rio de Janeiro and the Mus. de Arte Contemporanea, São Paulo, covering fifty years of her work. Amaral also wrote art criticism for many papers and art journals in Brazil, including the *Diario de São Paulo*.

AMBLARD, JEAN. See FRANCE.

AMERICA. See LATIN AMERICA and UNITED STATES OF AMERICA.

AMERICAN ABSTRACT ARTISTS. An association of American abstract painters and sculptors formed in 1936 with the aims of making New York a centre for non-objective art, holding annual exhibitions and disseminating the principles of abstract art by lectures, publications, etc. Among the early members were: Josef ALBERS, Carl HOLTY, John FERREN, Karl KNATHS, Jean XCERON, Balcomb GREENE, who became the first President, George MCNEIL, Giorgio CAVALLON, Ad REINHARDT, Ilya BOLOTOWSKY, Willem DE KOONING, Fritz GLARNER, Burgoyne DILLER, David SMITH, Lee KRASNER and the abstract sculptor Ibram LASSAW. Some of the artists followed the late CUBISM of PICASSO in the 1920s, some followed PURISM and some worked within the conventions of NEO-PLASTICISM. Some were members of the French CONSTRUCTIVIST group ABSTRACTION-CRÉATION. The association was supported by the painter-critic George L. K. Morris and by the collector A. E. Gallatin, who exhibited non-objective art in his Mus. of Living Art established in New York University.

By the mid 1940s the battle was won. Abstract art had achieved recognition and the activities of the association dwindled, though it continued to stage exhibitions. In the 1950s, however, it became active again with more than 200 members.

AMERICAN SCENE PAINTING. By *c.* 1920 most of the American artists who had taken part in the ARMORY SHOW and the FORUM EXHIBITION of 1916, painting in derivative CUBIST or other modernist styles, had reverted to one or another form of naturalism. About the mid 1920s there began to manifest itself a more positive movement, which dominated the American art scene through the 1930s and into the early 1940s, to construct a nationalist American art by the naturalistic depiction of American scenes and life. The movement drew strength and appeal from the spirit of nationalistic isolationism which followed the First World War, while artistically it was in reaction against Cubism and other forms of modernism which had been introduced into America by the STIEGLITZ circle and the Armory Show. To some extent the movement may be seen as an attempt to revive and perpetuate the ideals of SOCIAL REALISM which had inspired the ASH-CAN school and the artists of Robert HENRI's circle. A group of mainly urban realists was centred in the Art Students' League, of which John SLOAN was made director in 1931. They dealt competently if not brilliantly with the themes which had been of central interest to artists of the Ash-Can school. Having repudiated *avant-garde* innovations, they tried to revive traditional and academic techniques of representation. Typical works from this group are: *I'm Tired* (Whitney Mus. of American Art, 1938) by Yasuo KUNIYOSHI, a former pupil of Robert Henri; *The Shopper* (Whitney Mus. of American Art, 1928) by Kenneth Hayes Miller (1876–1952),

also once a student of Robert Henri; *Office Girls* (Whitney Mus. of American Art, 1936) by Raphael Soyer; *Waiting* (Newark Mus., 1938) by Isobel Bishop.

The term 'American Scene painters' is also applied to the artistically more original school of REGIONALISM, which is discussed separately under that head. The movement had analogies in visual art with the contemporary movement in literature which was represented by Sinclair Lewis and Sherwood Anderson.

AMIET, CUNO (1868–1961). Swiss painter, born at Solothurn. He was a pupil of Frank Buchser (1828–90) and studied at the Munich Academy, 1886–8, and at the Académie Julian, Paris, 1889–91, where he made the acquaintance of Giovanni GIACOMETTI. In 1892–3 he visited Pont-Aven in Brittany and there came into contact with the work of Gauguin's circle. On his return to Switzerland he became a friend of HODLER and he exhibited with Hodler and Giovanni Giacometti at Zürich in 1898. From this year he lived and taught in the Oschwand. He was represented at the International Exhibition of the Vienna SECESSION in 1904, and in 1906, following an exhibition of his work at Dresden, he was invited to join the BRÜCKE.

With Hodler, Amiet was the principal exponent of ART NOUVEAU in Switzerland. His own work evolved from the Symbolist manner of the NABIS to a style of rich and brightly contrasting colours akin to that of the FAUVES. Despite his link with the *Brücke* his work had little in common with that of the German EXPRESSIONISTS. Examples can be seen at the Kunsthaus, Zürich, and the Stiftung Oskar Reinhart, Winterthur.

ANCESCHI, GIOVANNI. See GRUPPO T.

ANDERLECHT, ENGELBERT VAN (1918–61). Belgian painter born at Schaerbeck. He attended evening classes at the Academy of St. Josse ten Noode, where he won a Prix de Rome. He was an admirer of Cézanne, MATISSE and BRAQUE and he developed what he had learnt from them into a personal style of expressive abstraction, which has been compared with that of VANDERCAM but was more 'informal' than his and closer to the automatic spontaneity of SCHNEIDER. His work was impassioned and highly dramatic.

ANDERSEN, ROBIN CHRISTIAN (1890–1969). Austrian painter of Danish descent. He studied in Vienna, Munich and Italy and was among the *avant-garde* groups of Austrian artists, joining the HAGENBUND in 1899 and the WASSERMANN group in 1919. In 1920 he was one of the founders of the tapestry workshop in Vienna and he designed some of the first modern tapestries to be produced in Austria. From 1945 he taught a masterclass in painting at the Academy of Fine Art, Vienna.

ANDERSON, JEREMY (1921–). American sculptor born at Palo Alto, Calif., and studied at the San Francisco Art Institute, 1946–50. He taught at the University of California, 1955–6, and at the San Francisco Art Institute from 1957, obtaining the San Francisco Art Association sculpture prize in 1959. Among his commissions was a Fountain for the Golden Gateway Redevelopment Project, San Francisco. His first one-man show was at the Metart Gal., San Francisco, in 1949. Besides frequent individual exhibitions he was included in a number of important collective exhibitions, e.g. Whitney Mus. of American Art, 'Fifty Californian Artists', 1962–3; University of California, Berkeley, 'Funk', 1967; Los Angeles County Mus. of Art, 'American Sculpture of the Sixties', 1967. He had retrospectives at the San Francisco Mus. of Art and the Pasadena Art Mus. in 1966–7.

ANDERSSON, TORSTEN (1926–). Swedish painter and sculptor born at Östra Sallerup. He began to paint in 1955 under the influence of VASARELY and DEWASNE, making it his aim to master their formal idiom. His painting was strongly structured geometrical abstraction, but in it was reflected a romantic love of nature and the emotions of solitude and anxiety which were part of his Swedish heritage. His oil on wood *Källen 11* (Moderna Mus., Stockholm, 1962), a work in two parts, is representative of this trend. In the 1960s he also began to make three-dimensional constructions of wood and cloth. From 1960 he taught at the Stockholm College of Art.

ANDRE, CARL (1935–). American sculptor born at Quincy, Mass. He embarked upon sculpture from wood carving as a disciple of BRANCUSI and the influence of Brancusi is apparent in his early works such as *Last Ladder* and *Pyramid* of 1959. From 1960 to 1964 he worked on the Pennsylvania Railway, an experience which confirmed him in the use of standardized, interchangeable units. His *Lever*, a single row of 139 unjoined firebricks, was shown in the 'Primary Structures' exhibition at the Jewish Mus., New York in 1966. A similar collection of prefabricated bricks was bought by the Tate Gal., London, in 1972 and aroused controversy in the Press. He had a one-man show at the Tibor de Nagy Gal. in 1965 and 1966 and at the Solomon R. Guggenheim Mus. in 1970.

Andre's work comes within the category of MINIMAL ART and some of it has also been classified as SERIAL and SYSTEMIC art. He produced his works by stacking identical ready-made commercial units such as styrofoam planks, bricks, cement blocks, ceramic magnets, etc. according to a mathematically imposed modular system and without adhesives or joints. These works were dismantled when not on exhibition. From *c.* 1965 he abjured height and made his arrangements as horizontal configurations on the ground, using an orthogonal

grid determined by simple mathematical principles. He also became one of the pioneers of EARTHWORK art.

Andre advocated the 'scatter' principle of combination rather than traditional composition, saying: 'My general rule is to find a particle and from that selection or discovery of a single particle to create a set of them in which the rule for joining the particles together is characteristic of the single particle ... The scatter pieces were the solution to the problem of taking a very small particle and combining it by a rule which was characteristic of the first particle ... but if the particle itself is too small to maintain coherency in a large array, then the scatter of the particles *is* their coherency.'

ANDREOU, CONSTANTIN (1917–). Greek sculptor born in São Paulo. He moved to Athens in 1924 and attended the Industrial School of Art there, then in 1945 went to Paris with a travelling scholarship. From 1948 he worked for preference with sheets of hammered brass soldered together. In a style of somewhat academic elegance he composed abstract shapes based upon animal forms.

ANDREWS, BENNY (1930–). Black American painter, born in Georgia. He was Co-Chairman of the Black Emergency Cultural Coalition, a body formed to secure better representation for black artists. Andrews painted powerful images showing the black people of America wearing chains in their struggle to win an illusory freedom. He was also concerned to depict the horrifying effect of war on children, painting poignant metaphorical symbols rather than realistic horror records. His first one-man show was at the A.C.A. Gal., New York, in 1972.

ANDREWS, MICHAEL (1928–). British painter, born at Norwich and trained at the Slade School. His style was figurative with a certain monumental classicism which betrays the influence of the EUSTON ROAD SCHOOL tradition. His work is represented in the Tate Gal. and the Arts Council coll. among others.

ANGELI, FRANCO (1935–). Italian painter, born in Rome. He was active in the movement towards a new symbolic realism which during the 1960s succeeded expressive abstraction (INFORMALISM) in Italy. He incorporated in his paintings political and social symbols such as the swastika, the Cross, the Capitoline she-wolf, the papal keys, and also script and printed texts. He also used strongly painted 'signs', which were then veiled with coloured cloth through which they were vaguely seen, the intention being to eviscerate or emasculate the symbol of power after it had been isolated and displayed.

ANGRAND, CHARLES (1854–1926). French painter born at Criquetat-sur-Ouville, Seine Mar-

itime. He painted in the DIVISIONIST manner of Neo-Impressionism and was among the founders of the SALON DES INDÉPENDANTS in 1884. His *La Maison Blanche* is in the Mus. National d'Art Moderne, Paris.

ANKER, ALBERT (1831–1910). Swiss painter, born at Ins. After studying theology at Berne and Halle, he went to Paris in 1854 and studied painting under Charles Gleyre at the École des Beaux-Arts. He worked in a style of sentimental naturalism, his chief and perhaps only title to fame being the favour his works found with Adolf Hitler. He is represented in the collections of the Kunsthaus, Zürich, and the Stiftung Oskar Reinhart, Winterthur, at Berne, and elsewhere.

ANQUETIN, LOUIS. See SYNTHETISM.

ANTES, HORST (1936–). German painter, sculptor and graphic artist, born at Heppenheim. He studied from 1957 to 1959 at the Academy of Art, Karlsruhe, under H. A. P. GRIESHABER, who had an important influence on the direction taken by his work. In 1959 he won the city of Hanover prize for art, in 1961 the Junger Westen prize at Recklinghausen and a prize at the Second Paris Biennale for Young Artists, in 1962 the Villa Romana prize for Florence and in 1963 the Villa Massimo grant, Rome. In 1966 he was awarded the UNESCO prize at the 33rd Venice Biennale and in 1968 the Marzotto prize. He took part in many international exhibitions, including the Guggenheim International Award, New York, and DOCUMENTA III, Kassel, in 1964, the Montreal World Exhibition in 1967 and Documenta IV in 1968. From 1960 he had one-man shows in Cologne, Basle, Zürich, New York, London and elsewhere.

In one aspect of his work Antes represents an up-to-date version of German EXPRESSIONISM, linking the spirit of Max BECKMANN with modern figurative abstraction. He was best known for his 'Gnome' paintings, clumsy, heavily stylized figures, usually represented in profile, with eyes set one above the other and over-large, hulking hands and feet. Sometimes the limbs and head build up the figure without torso. A similar figuration appeared in his sculpture, though he sometimes employed a head, hand or limb in isolation, as in decorations he did for the Botanical Gardens at Karlsruhe in 1967, where a stylized hand reaches out towards a stylized cloud both enclosed in a wire cage. In his paintings from the late 1960s he often depicted a single head offset by some symbolic object such as a cock's comb or a letter. He described his work as 'codified speech' or 'self-communing'.

ANTI-ART. A term which came into use about the mid century. It carried a reference to DADA and similar revolutionary movements which had purported to debunk traditional concepts of art.

When applied to contemporary works it emphasized their novelty or unconventionality. The term was used very loosely and its exact significance and implications were not defined.

ANTI-FORM. A name originating with the Stedelijk Mus., Amsterdam, and the Kunsthalle, Berne, for a worldwide movement of revolt from traditional aesthetics and the aesthetics of the *avant-garde*, rejecting the very conception of an art work as an object created for aesthetic contemplation. The movement embraces EARTHWORKS art and some aspects of CONCEPTUAL ART. It covers the ARTE POVERA of Celant and such experimental artists as MANZONI, PISTOLETTO and PASCALL in Italy. Among the forerunners were SPOERRI and the Greek artist CANIARIS. In Germany the leader was BEUYS. In America the former MINIMAL artists Robert MORRIS, Robert SMITHSON, Walter DE MARIA, Sol LEWITT and the POP artist Claes OLDENBURG led the way. The rejection of art was regarded as a cultural manifestation spelling the radical repudiation of recognized values.

ANTIPODEAN GROUP, THE. An association of artists formed in Melbourne in 1959 with the object of defending the figurative image in opposition to the advocates of non-figurative Abstraction. See AUSTRALIA.

ANTRAL, LOUIS ROBERT (1895–1939). French painter, born at Châlons-sur-Marne. He studied at the École des Beaux-Arts, Paris, and from 1920 exhibited at the principal salons. He did mainly maritime and port scenes, which have been compared to those of MARQUET, but later in life turned to Paris views executed with masterly effects of atmosphere and light. His work also included many accomplished water-colours, lithographs and book illustrations. After his death an annual Antral prize was instituted for young painters of the École de Paris. Retrospective exhibitions of his work were staged at the Salon d'Automne in 1941 and the Galliera Mus. in 1951.

ANTROPOFAGISMO. See AMARAL, Tarsila do.

ANTÚNEZ, NEMESIO. See LATIN AMERICA.

ANUSZKIEWICZ, RICHARD (1930–). American painter, born at Erie, Penn., and studied at the Cleveland Institute of Art, 1948–53, Yale University, 1953–5 and Kent State University, 1955–6. He had his first one-man exhibition at the Butler Institute of American Art, Youngstown, Ohio, in 1955 and in New York at The Contemporaries in 1960. Anuszkiewicz did carefully designed geometrical abstracts which produced the curious hallucinatory and dazzle effects characteristic of OP ART. His work was included in important group exhibitions such as 'Painting and Sculpture of a Decade', Tate Gal., 1964, and 'The Responsive Eye', The Mus. of Modern Art, New York, 1965.

He was prominent among the artists who exploited the principles of Op art in the U.S.A.

APOLLINAIRE, GUILLAUME (1880–1918). Son of a Polish mother, Mme de Kostrowitzky, and an Italian of noble family, Francisco Flugi d'Aspermont, Apollinaire was one of the most important art critics of the early 20th c. He was an active influence in shaping many of the aesthetic movements which dominated the Paris artistic scene during the years before the First World War. He was among the first to acclaim PICASSO (in 1905), praised MATISSE (in 1907) and BRAQUE (in 1908), and eventually recognized the talent of Henri ROUSSEAU. He was, however, frequently wrong. He put Marie LAURENCIN on the same plane as Picasso, failed to understand BRANCUSI, thought that the animal sculptor Barye was 'perhaps the greatest of French sculptors' and praised the 'prodigious talent' of ZULOAGA. But he was one of the earliest champions of the CUBIST movement, publishing *Les Peintres cubistes* in 1913, and helped to found the SECTION D'OR, for whose theories he coined the name ORPHISM. He was a friend of the FUTURISTS and wrote one of the Futurist manifestos. He coined the word 'surréaliste' in 1917 to describe his own play *Les Mamelles de Tirésias* and through André BRETON he influenced the views of the SURREALIST school. He was known particularly for his *Calligrammes* and for his experiments in pictorial typography. He was one of the originators of the doctrine of SIMULTANISM.

APOLLONIO, UMBRO. See ITALY.

APPEL, KAREL (1921–). Dutch painter born at Amsterdam and studied at the Royal Academy of Fine Arts there. His first one-man exhibition was at the Beerenhuis, Groningen, in 1946 and in 1947 he was included in the exhibition 'Young Artists' at the Stedelijk Mus., Amsterdam, and was given a one-man show at the Guildhall there. In 1948 he helped to found the experimental group of Dutch and Belgian artists *Reflex*, from which the COBRA group sprang. In 1949 he was commissioned to do a mural *Questioning Children* for the cafeteria of the City Hall, Amsterdam; it caused a public outcry and despite protests from the younger artists it was whitewashed over. In 1950 he moved to Paris and with the help of the critic Michel Tapié he began during the 1950s to gain an international reputation. He was given a one-man show at the Palais des Beaux-Arts, Brussels, in 1953, and was included in the São Paulo Bienale of 1953 and the Venice Biennale of 1954, where he was awarded the UNESCO prize. In the same year he had his first one-man show at the Martha Jackson Gal., New York. He was the youngest of the artists chosen to decorate the new headquarters of UNESCO in Paris. In 1957 he was awarded the major prize for non-figurative painting at Lissone, Italy, and the international prize for graphics at the Ljubljana Biennale, Yugoslavia. He won the

international prize for painting at the 5th Sâo Paulo Bienale in 1959 and the First Prize of the Guggenheim International exhibition for his painting *Vrouw Met Strusvogel* in 1960. In the late 1960s he began to do sculptures and wall reliefs as well as paintings, and in 1971 began a series of large sculptures of polychromed aluminium in the U.S.A. He had a retrospective exhibition at Venlo, Netherlands, in 1969, a series of important retrospectives in Canada and the U.S.A. in 1972 and 1973, and one at the Wildenstein Gal., London, in 1975 in collaboration with the Gal. Ariel, Paris.

In his COBRA period Appel was among the most energetic exponents of expressive abstraction, anticipating ART INFORMEL. His work, executed in very thick impasto and violent colours, had the restless, agitated character of northern EXPRESSIONISM rather than the more restrained classicism of the French: in the words of Herbert Read, looking at his pictures one has the impression 'of a spiritual tornado that has left these images of its passage'. Latterly he often painted with a rather smoother facture and in a style somewhat closer to HARD EDGE. But his abstract images retained suggestions of human masks, animal or fantasy figures, which have often been regarded as fraught with terror as well as a childlike naïvety. He is regarded as the most powerful of the post-war generation of Netherlands artists. His works are included in many public collections. He was particularly popular in the U.S.A. and he is represented there in The Mus. of Modern Art and the Solomon R. Guggenheim Mus., New York; Albright-Knox Art Gal., Buffalo; Boston Mus. of Fine Arts; Carnegie Inst., Pittsburgh; Walker Art Center, Minneapolis, Phoenix Art Mus. and The Chrysler Art. Mus., Provincetown, among many others.

ARAKAWA, SHUSAKU (1936–). Japanese artist born in Nagoya. He was one of the founders of the NEO-DADA ORGANIZERS group in Tokyo and in 1960 he shocked the Japanese public by his series of *Boxes*, which were composed of strange figures made from cement-hardened cotton wads enclosed in coffin-like boxes symbolizing the sickness of the contemporary mind. In 1961 he emigrated to New York, where he produced his series of *Diagrams*. For these he placed banal everyday objects on canvas—combs, umbrellas, egg-beaters, gloves, coat-hangers, etc.—and blew paint over them with a spray-gun, leaving the silhouette of the objects on the canvas. These were exhibited at the Dwan Gal. in Los Angeles and New York. Subsequently he abandoned delineation altogether and used words instead of imagery (e.g. a recipe for a banana cake instead of an image of a cake). The technique was supposed to stimulate the pictorial imagination of the viewer.

ARCANGELO, ALLAN D'. See D'ARCANGELO, Allan.

ARCHIPENKO, ALEXANDER (1887–1964).

Sculptor, born at Kiev in the Ukraine. He worked mainly in Paris until 1923, when he moved to the U.S.A., taking American citizenship in 1928. He was the son of a Professor of Engineering at the University of Kiev and his paternal grandfather was an icon painter. He studied first painting and then sculpture at the Kiev Academy of Art from 1902 to 1905, when he was expelled for criticizing his teachers. In 1906 he went to Moscow and exhibited in several group shows. On arriving in Paris in 1908 he entered the École des Beaux-Arts but left after a couple of weeks, being impatient of discipline and preferring to familiarize himself with the art of the past by visiting the museums. Within a couple of years he was already producing sculpture which was revolutionary for its time and proving himself to be one of the more inventive of contemporary innovators. From 1910 he moved in CUBIST circles and worked for a decade or more, though not exclusively, in the Cubist manner. He exhibited at the Salon des Indépendants from 1910 and at the Salon d'Automne from 1911. In 1912 he held his first one-man exhibition, at the Folkwang Mus., Hagen, for which Guillaume APOLLINAIRE wrote an Introduction to the catalogue, as also for an exhibition at the STURM Gal., Berlin, in 1914. His work was first exhibited in America at the ARMORY SHOW of 1913. In 1912 he was among those who formed the SECTION D'OR group and he also opened his own sculpture school in Paris. He spent the war years outside Nice, working on his sculpture, and after the war he made an extensive tour of European cities with an exhibition of his works. In 1920 he had a one-man show at the Venice Biennale and in 1921 opened his art school in Berlin. In the same year he held a retrospective exhibition at Potsdam, a one-man exhibition at the Sturm Gal., Berlin, and his first one-man exhibition in the U.S.A., organized by The Mus. of Modern Art, New York.

Archipenko's early Paris sculptures, such as *Suzanne* (Pasadena Mus.), *Seated Figure* (Moderna Mus., Stockholm), *Seated Woman* (Tel Aviv Mus.), *Hero* (Darmstadt Mus.) and the *Repose* which was exhibited at the Armory Show, were conceived in a bold but somewhat mannered style of baroque EXPRESSIONISM. About 1911 he began to produce works in the Cubist manner, in which the human figure is treated primarily as an excuse for the analysis of volume into largely geometrical forms with sharp contours and rectilinear planes. This style is manifested from the *Madonna of the Rocks* (1912) and *Boxers* (1914) to the still more severely rectilinear *Standing Figure* of 1920 (Hessisches Landesmus., Darmstadt). Although these figures fall within the ambit of Cubist theory and practice at the time, as also do his polychrome constructions and reliefs to be mentioned later, Archipenko himself somewhat arrogantly denied his debt to Cubism when he wrote: 'As for my own work, the geometric character of three-dimensional sculptures (e.g. *Boxers*, 1913, *Gondolier*, 1914) is due to the extreme simplification of form and not to

Cubist dogma. I did not take from Cubism, but added to it.' But important and individualistic as it was, this strand of his very versatile output conformed with a current trend. Work in a similar style, exploring similar spatial and sculptural problems, was being done in these years by LAURENS, LIPCHITZ, DUCHAMP-VILLON and other sculptors in the Cubist circle.

Together with this Archipenko was among the first to experiment with the problem, novel at that time, of giving a positive character to spaces enclosed within the sculpture. This he did with certain rather mannered arabesque-like figures such as the bronze *Dance* of 1912 (which was caricatured in *The Sketch*) and *Blue Dance* of 1913 and also by the inclusion of spaces and bored holes in his more rectilinear figures such as the Darmstadt *Standing Figure* of 1920 already mentioned. In this he was experimenting along the same lines as Lipchitz, who in 1916 made a sensation by boring a hole which had no representational significance through his *Man with a Guitar* and who formulated the doctrine that enclosed voids should have as positive a sculptural significance as masses. It was an insight which had very important consequences in several schools of modern sculpture, being developed in their several ways by GABO in America and Henry MOORE in England, and which led on to the 'weightless' sculpture of MINGUZZI, David SMITH, COUTURIER, MIRKO, etc. Archipenko was also among the earliest to experiment with the use of concave shapes to suggest counter-volumes by defining the limits of form exteriorly and with constructing a counterpoint of convex and concave planes and profiles. This is a technique which Ossip ZADKINE made peculiarly his own. In the work of Archipenko suggestions of it may be seen in the *Seated Mother* of 1911 (Kunstmus., Duisburg); it is more fully developed in a number of later figures such as *Green Concave* of 1913 (illustrated on the cover of the *Sturm Bilderbuch* on Archipenko of 1922) and *Geometric Figure with Space and Concave* of 1920.

Archipenko was also a pioneer in the revival of polychromy in sculpture. He himself wrote in his autobiographical *Fifty Creative Years 1908–1958*: 'New polychromy consists of a new esthetic and technique which unifies forms with colors. Their reciprocal overlapping and interfusion, the domination of one over another, their harmony or contrast and their rhythm are all adjustable according to the symbolic or stylistic problems.' He experimented in coloured bronzes, such as the *Walking Soldier* of 1917. But more particularly, like others of the Cubists such as PICASSO, LÉGER, Laurens, Duchamp-Villon, etc., he delighted in the innovatory techniques of polychrome constructions in a variety of materials (a technique which had been predicted but not practised by BOCCIONI) and, from c. 1914, in polychrome reliefs which he called *Sculpto-Peinture*. By the use of a variety of materials—iron, bronze, wood and glass—it was possible to obtain effects which had not previously belonged to sculpture, including transparency, reflection, etc. Archipenko's polychrome construction *Medrano II* when exhibited at the Salon des Indépendants in 1914 was defended by Apollinaire in *L'Intransigeant* but attacked and ridiculed elsewhere. Other polychrome constructions, notorious in their day but since destroyed, were *Woman in Front of a Mirror* (1914) and the *Head* (1914) composed of four superimposed planes of glass and wood painted on the back with spots of colour which were reflected in a background of polished metal. The polychromed bronze reliefs, which bear a clear affinity to Cubist still life paintings, include *Woman with a Fan* (1914), *Española* (1916) and *Still Life with Book and Vase on the Table* (1918). Though Picasso, Laurens and others were doing similar reliefs, the style of each was distinctive.

In America Archipenko taught at Washington University, 1935–6, at the New Bauhaus in 1938 and at the University of Kansas in 1950. He opened his own school in Chicago in 1937 and in 1939 his own school of sculpture in New York, where he taught until his death. In 1924 he invented the *Archipentura*, an attempt to make movable paintings, and from c. 1946 he experimented with 'light' sculpture, making structures of plexiglass lit from within. He was given major memorial exhibitions by the Smithsonian Institution and the University of California at Los Angeles, 1967–9.

Archipenko had a considerable influence on the course of sculpture both in Europe and in America, particularly in the use of new materials and in pointing a way away from the sculpture of solid form towards a sculpture of space and light.

ARDON, MORDECAI (MAX BRONSTEIN, 1896–). Israeli painter, born at Tuchow, Poland. He studied under KLEE, ITTEN and KANDINSKY at the BAUHAUS, 1920–5, and at the Munich Academy, 1926. Then after teaching in Itten's school of art in Berlin he emigrated to Israel in 1933 and taught at the Bezalel Academy in Jerusalem, becoming Director in 1940 and Art Adviser to the Israeli Ministry of Education in 1952. During the 1950s he began to exhibit in Europe and gained a reputation as a distinguished colourist with a strong and near-SURREALIST imagination. Among his best-known works is the *Missa Dura* in the Tate Gal., London. He had an exhibition at the Stedelijk Gal., Amsterdam, 1960–1, and some of his triptychs may be seen there.

ARICÒ, RODOLFO (1930–). Italian painter born at Milan. After studying architecture at the Milan Polytechnic he studied painting at the Accademia di Brera. During the 1960s he was prominent in the movement away from expressive abstraction (INFORMALISM) and made 'picture objects' in which incongruous components were combined without SURREALIST implications but with the appearance rather of geometrical abstrac-

tion. His intention was to suggest the passing of subjective time by images which did not achieve definition but remained in a limbo between object and abstract form. His work has been regarded as an invocation of Existentialist alienation.

ARMAN (ARMAND FERNANDEZ, 1928–). French painter, born at Nice. In 1967 he joined Yves KLEIN and Claude Pascal on a hitch-hiking tour of Europe, when all three decided to be known by their first names only. The form 'Arman' was adopted in 1958 as a result of a printer's error on the cover of a catalogue. He studied painting briefly at the École Nationale d'Art Décoratif, Nice, and at the École du Louvre in 1949. But he repudiated everything which he had done before 1955, when he began his series *Cachets*. The *Cachets* (done 1955–60) are sheets of paper covered with designs formed from apparently random imprints of one or more rubber stamps. The *Allures*, which followed the *Cachets*, make use of actual objects instead of rubber stamps to produce the traces. During the 1960s he did *Poubelles*, *Accumulations* and pseudo-random designs (which he called *Colères*) composed from smashed objects such as typewriters or violins. The *Poubelles* were random collections of rubbish from a garbage can displayed in a glass box (*Poubelle, 1960*, Kaiser-Wilhelm Mus., Krefeld). The *Accumulations* were designs made up of a large ASSEMBLAGE of similar objects (combs, faucets, cogwheels, spoons, door handles, etc.) displayed in a box or set in polyester, plexiglass, etc. (*Nucléids*, Stedelijk Mus., Amsterdam, 1964). Sometimes the concepts of the *Poubelle* and the *Accumulation* were combined as in *Art by Telephone*, an *Accumulation* of garbage (Mus. of Contemporary Art, Chicago, 1969). The smashed object is sometimes used alone, with or without traces of paint (*Colère du violon*, Mus. Royal des Beaux-Arts, Brussels, 1962); sometimes many smashed, sliced or burned objects of the same kind are used to make an *Accumulation* (*Accumulation of Sliced Teapots*, Walker Art Center, Minneapolis, 1964; *L'Attila des violons*, Stedelijk Mus., Amsterdam, 1968).

In 1960 Arman became a founding member of the NOUVEAUX RÉALISTES. In 1963 he took up part-time residence in New York and in 1964 he had his first museum show, at the Walker Art Center, Minneapolis, followed in the same year by one in the Stedelijk Mus., Amsterdam. In 1965 he showed at the Haus Lange Mus., Krefeld, and in the following year was given a retrospective exhibition at the Palais des Beaux-Arts, Brussels. In 1967 he represented France at 'Expo '67', Montreal, and showed at the Venice Biennale and at DOCUMENTA IV, Kassel, in 1968. In 1967 he initiated 'art-industry' for multiples in collaboration with the French automobile designer Renault, and in 1969 their works were shown at the Stedelijk Mus., Amsterdam, and at the Mus. des Arts Décoratifs, Paris. In the same year Arman was exhibited at the Louisiana Mus., Copenhagen, the

Städtische Kunsthalle, Düsseldorf, and the Svensk-Franska Konstgal., Stockholm. In 1970 he exhibited at the French Pavilion in the World's Fair, Osaka, Japan; at the Helsinki Mus.; the Nationalmus., Stockholm; the Städtische Kunstsammlungen, Ludwigshafen; and the Kunsthaus, Zürich. In 1970 he began a series of *Accumulations* in concrete and in 1972 a new series of garbage embedded in plastic. Besides the above he has exhibited widely in commercial galleries in many countries, in particular the Sidney Janis Gal., New York, the Gal. Lawrence, Paris, and the Schwarz Gal. d'Arte, Milan. He represents trends in POP ART, NEW REALISM, ASSEMBLAGE and ARTE POVERA.

ARMITAGE, KENNETH (1916–). British sculptor, born at Leeds. After attending the Leeds College of Art for three years he began the serious study of sculpture at the Slade School, 1937–9. After serving in the War, he was head of the Sculpture Department at the Bath Academy of Art, Corsham, from 1946 to 1956. He first exhibited in 1952, when he was 36, and very rapidly established an international reputation. He was one of the three British representatives (with William SCOTT and S. E. HAYTER) at the Venice Biennale of 1968 and won the David E. Bright Foundation award for the best sculptor under 45. In 1969 he had a retrospective exhibition at the Whitechapel Art Gal., London. He worked in Berlin for two years, 1967–9, and in 1972–3 a travelling exhibition of his work was arranged by the Arts Council of Great Britain. He was made a C.B.E. in 1969.

Kenneth Armitage exhibited regularly in London and New York and his work has been widely shown in Europe. Among the important collective exhibitions in which he was represented were DOCUMENTA I, II and III, Kassel, 1955, 1959, 1964; 'New Images of Man', The Mus. of Modern Art, New York, 1959; 'Painting and Sculpture of a Decade', Tate Gal., 1964; '5th Guggenheim International—Sculpture', Solomon R. Guggenheim Mus., New York, 1967.

Armitage's characteristic work began in the mid 1940s, when he destroyed his pre-war carvings and began to model in plaster round an armature. Though not naturalistic, his sculpture was figurative and humanistic, capturing typical gesture and attitude, as for example *People in a Wind* (1951) and *Children Playing* (1953). At the same time all his work gave great prominence to the qualities of the material—usually at this period bronze—in which the sculptures were cast. For example he often used a screen of metal to unite the figures in his groups. From the mid 1950s his figures became more impersonal in character and often larger in scale, culminating in the nearly 4 m long polyester and glass-fibre *Arm* of 1967–8. A new phase began after his return to England in 1969, when he combined sculpture and drawing in figures of wood, plaster and paper as in *Figure and Clouds* (1972) and *Designs for a Wilderness* (1970–2).

ARMORY SHOW. A gigantic exhibition of *avant-garde* European and contemporary American art held at the 69th Regiment Armory on Twenty-fifth Street and Lexington Avenue, New York, 17 February–15 March 1913, and subsequently at the Art Institute, Chicago, and in Boston. The initiative came from three artists belonging to the realist circle of Robert HENRI, namely Jerome Myers, Walt Kuhn and Elmer MacRae, who in 1911 discussed holding a larger and more comprehensive exhibition of current American art than the democratic, unjuried 'Exhibition of Independent Artists' which had created a popular sensation the year before. For this purpose the 'Association of American Painters and Sculptors' was called into being, dominated at this time by members of The EIGHT and by the National Academy. As the project failed to get under way, Arthur B. DAVIES was invited to become President and to take over the organization of the show. He was in many ways admirably suited to the job. He bridged all parties, being well thought of in the Academy, a member of The Eight and also on terms with the STIEGLITZ circle. In addition to this he had connections which enabled him to raise the necessary funds. And Davies was a man of wide culture with a broad knowledge of European art and an enthusiasm for its contemporary *avant-garde* manifestations. The show aroused such mixed feelings even among the organizers that it is difficult *ex -post facto* to disentangle the exact course of events among the several versions current. But it seems clear that it was due to Davies that the original conception of an American exhibition came to be overshadowed by the idea of presenting for the first time in America a comprehensive collection of progressive European work. In 1912 Davies sent Kuhn to the exhibition of the Cologne *Sonderbund*, in which a fairly catholic presentation of modern European art had been assembled, and Kuhn was able to arrange to take over part of the exhibits. Then Davies and Kuhn met in Paris, where with the aid of the expatriate American artists Alfred MAURER and Walter Patch, who acted as the Association's European agent, they came in touch with the Paris *avant-garde* including the DUCHAMP brothers and the dealer VOLLARD, who had importantly assisted in the organization of the London POST-IMPRESSIONIST exhibitions. After visiting these Davies and Kuhn returned to the States with a fairly coherent idea for an exhibition of current innovative European art in its historical setting which should outdo the Post-Impressionist exhibitions of Roger FRY.

'The International Exhibition of Modern Art', as its official title was, turned out to be both a mammoth exhibition for sheer quantity (it is estimated that *c.* 1,600 exhibits were included) and a daring presentation of new and still controversial art. It was in effect two exhibitions in one. The American section, which was selected by a committee headed by GLACKENS and accounted for about three-quarters of the whole, offered a cross-section of contemporary American art with particular weighting in favour of modernistic or *avant-garde* tendencies. The foreign section, which was the real core of interest and became the focus of controversy, was a fairly coherent and comprehensive selection of current production in the ÉCOLE DE PARIS presented against a certain historical background. Despite some omissions it was on the whole well balanced and was probably more radical and inclusive than the London Post-Impressionist exhibitions of 1910 and 1912. The emphasis was rightly on the French painters. German EXPRESSIONISM was barely represented and the FUTURISTS had withdrawn because they could not exhibit as a separate group. A few examples pointed to the historical development of French painting from Ingres and Delacroix by way of Daumier and Corot to Manet. The major Impressionists were represented by 20 paintings. There were several canvases by the Neo-Impressionists Seurat, Signac and Cross. There was disproportionate emphasis on the Symbolists Odilon Redon (40 canvases), Puvis de Chavannes (15 canvases) and Maurice DENIS, and there were 38 paintings by the English artist Augustus JOHN. The Post-Impressionists were represented by 18 Van Goghs, 13 Cézannes and 12 Gauguins. The FAUVES had more than 40 pictures with MATISSE in the lead. Both the CUBISTS and the ORPHISTS were present in force and even the new movement of DADA was represented by DUCHAMP and PICABIA. Duchamp's *Nude Descending a Staircase* was a focus of the violent controversy which the exhibition provoked.

Despite outrage and incomprehension from a public unprepared to receive it, the show was a notable public success. It is estimated that in the three showings about 300,000 visitors paid to see it and perhaps almost as many saw it without payment. In the course of the exhibition 174 works (including 51 American) were sold. For the time these figures represent an astounding achievement. The impact was enormous. Though the first reactions were howls of ridicule or shocked indignation, the effect of the show was to revive public interest in the world of art. Established artistic values were shaken and from that time modern art did not cease to be a living issue in the U.S.A. Indeed the term 'modern art', which had come into circulation during the years 1905–10, now first acquired a positive content and it has become a commonplace to speak of the Armory Show as the beginning of an interest in progressive art in the U.S.A. (See also UNITED STATES OF AMERICA.)

ARMSTRONG, JOHN (1893–1973). British painter, born at Hastings, Sussex, son of a clergyman. After studying law at Oxford and serving in the First World War he attended classes irregularly at the St. John's Wood Art School, but he was largely self-taught as an artist. During the 1920s he did commercial work, painting lamp-shades and menu cards, and also did theatrical design, including the costumes and décor for the first perform-

of *Façade* in 1931. He became a member of . ιr ONE in 1933. At this time his work, done mainly in tempera, displayed even when abstract a fantasy which linked it with one aspect of SUR-REALISM and had affinities with work being done by Paul NASH at the same time. Armstrong was interested in the relation of painting to architecture and did murals as well as theatre and film design. Under the influence of the Spanish Civil War he painted during the 1930s some half-Surrealist pictures of bomb-destroyed buildings. During the Second World War he was an official War Artist and some of his best work was done in the 1940s, including *Icarus* (Tate Gal., 1940). After the war he painted mainly decorative abstractions. A retrospective exhibition of his work was given at the Royal Academy Diploma Gal. in 1975.

ARNAL, FRANÇOIS (1924–). French painter, born at La Valette, Var, of a French father and a Spanish mother. After studying law at Aix-en-Provence and after having worked for a time as an instructor of judo, he began to paint in 1940 without formal training. He went to Paris in 1948 and after a period of discouragement gradually won recognition, exhibiting at the Gal. Drouant-David and the Gal. Rive Droit, and being represented with DMITRIENKO, DUFOUR, GILLET, LAPOUJADE, REZVANI and others in international exhibitions of the latest French painting. In 1949 he won the Prix de la Jeune Peinture. His work belonged to the latest phase of TACHISM, sometimes distinguished as LYRICAL ABSTRACTION. Impatiently rejecting all traditional rules of composition he gave free rein to a violent and turbulent imagination, sacrificing everything to intensity of expression. His paintings often incorporated hieroglyphic signs and suggested the more horrific features of a SURREALISTIC world, as in *Les Sombres Fêtes de la Chair* (suggestive of the nastier aspects of a butcher's shop). He was also known for his abstract tapestry designs.

ARNATT, KEITH. See CONCEPTUAL ART.

AROCH, ARIEH (1908–). Israeli painter, born at Kharkov, Russia, and emigrated to Palestine in 1924. He worked in a style of expressive abstraction up to *c.* 1960 and was a member of the NEW HORIZONS group. But in the 1960s he evolved an archaic imagery, half popular and half childish, based on graffiti, COLLAGE, printed lettering, ASSEMBLAGE, photographs and free graphic work with Jewish motifs. His work had an influence on many of the younger Israeli artists.

ARP, JEAN (HANS ARP, 1887–1966). Painter, sculptor and poet. Born at Strasbourg, he was a German national although his sympathies were French. Fascinated by his contacts with modern artistic developments in Paris as early as 1904, he studied at Weimar (1905–7) and subsequently at

the Académie Julian in Paris (1908). In 1909 he went to Switzerland, where he met KLEE. In 1912 he went to Munich, where he knew KANDINSKY and exhibited with the BLAUE REITER, and in 1913 he took part in the exhibition of EXPRESSIONISTS organized by Herwarth Walden at the first Salon d'Automne in Berlin. In 1914 he was in contact with the French *avant-garde*—APOLLINAIRE, Max Jacob, MODIGLIANI, DELAUNAY, etc.—in Paris, but on the outbreak of war he retired to Switzerland. In 1915 he exhibited his first abstracts at Zürich and in the following year he joined the Zürich DADA group. During his wartime years in Switzerland he collaborated with Sophie TAEUBER, whom he married in 1922, in a distinctive mode of CON-STRUCTIVIST works while at the same time developing and maturing, in cut-outs done in wood or card as well as in paintings, his uniquely personal type of abstract compositions with oviform or curvilinear shapes lying on the borderline between Constructivism and SURREALISM. He also began his experiments with automatic composition (see AUTOMATISM), with random and chance elements (see STOCHASTICISM) and with collective composition. At the end of the war he left Zürich for Cologne, where he worked with Max ERNST and Johannes Baargeld on a series of collective works which they named *Fatagaga* (*Fabrication de tableaux garantis gazométriques*). He also made contact with the Berlin Dadaists and with SCHWITTERS, who published lithographs by him (*Arpaden*) in his Dadaist periodical MERZ. It was at this time also that he met LISSITZKY, with whom in 1925 he published *Les Isms de l'Art*, a survey of contemporary movements in art. In 1925 also he participated in the first Surrealist exhibition and became a member of the Surrealist group in Paris. He joined CERCLE ET CARRÉ in 1930 and in 1931 was a founder-member of the ABSTRACTION-CRÉATION group. During the same years he was practising the construction of pictures with torn paper, wire and sewn threads and beginning sculpture in relief. This followed the decoration of the restaurant L'Aubette at Strasbourg, together with Sophie Taeuber-Arp and Theo van DOESBURG, in Constructivist style.

During the Second World War he lived in retirement at Grasse, working with his wife, Sophie Taeuber-Arp, MAGNELLI, Sonia DELAUNAY and others, and during a clandestine visit to Switzerland in 1942–3 his wife died in an accident. On the conclusion of the war he returned to Meudon, near Paris, where he had made his home in 1926, and published a collection of poems *Le Siège de l'Air*. He had several important exhibitions in New York, where in 1948 he published *On my Way. Poetry and Essays, 1912–47*, and he himself visited the U.S.A. in 1949 and 1950, doing in 1950 a monumental wood relief sculpture for Harvard University. In 1953 he was commissioned to do a monumental sculpture in bronze entitled *Berger de Nuage* for the University City of Caracas. In 1954 he won the International Prize for Sculpture at the

Venice Biennale and in 1958 he did a mural relief for the UNESCO building in Paris and was given an important retrospective exhibition at The Mus. of Modern Art, New York.

Arp has been called by Michel Seuphor 'one of the strangest personalities of this century'. There were few groups to which he was not made welcome and few movements to which he was not attached—Expressionist, Constructivist, Dada, Surrealist. Yet a certain naïve and childish quality remained distinctive in his art throughout. He founded no school and had no disciples, yet cumulatively his influence on the development of contemporary art has been great. Because of the lack of coherent composition in his work he is among the few pre-war artists to win the approval of MINIMALISTS. Most of his reliefs consisted of one, or at most two, forms and did not depend upon any complex system of relations such as was set up by MONDRIAN and others.

ARSIĆ, MILUTIN. See NAÏVE ART.

ART ABSTRAIT, FORMES. A group of Belgian artists founded in 1952 with an interest in geometrical rather than expressive abstraction. Active among them were Jo DELAHAUT, Jean MILO, Jan BURSSENS, Georges COLLIGNON and Pol BURY.

ART AUTRE. A name for expressive or non-geometrical abstraction, virtually synonymous with TACHISM and ART INFORMEL. The expression originated with the critic Michel Tapié, who in 1952 published *Un art autre* and in 1960 *Morphologie autre*. Tapié emphasized the spontaneous, unorganized character of *art informel*—art without form. Following suggestions in KANDINSKY, he argued that expressive, non-geometrical abstract art is a method of discovery and of communicating intuitive awareness of the fundamental nature of reality. He cited among others DUBUFFET, MATHIEU, WOLS and MATTA as representatives of *Art Autre*.

ART BRUT. Term coined by Jean DUBUFFET for the art produced by people outside the established art world, people such as solitaries, the maladjusted, patients in psychiatric hospitals, prisoners and fringe-dwellers of all kinds. Dubuffet defined it as follows: 'We mean works executed by people free from artistic culture, for whom mimesis, as opposed to what happens to intellectuals, plays little or no part, so that their creators draw up everything (subjects, choice of materials, means of transposition, rhythms, way of writing, etc.) from their own depths and not from the stereotypes of classical art or of modish art. We have here a "chemically pure" artistic operation, an uncut diamond, re-invented in all its phases by its creator, touched off by his own impulses only. This, therefore, is art springing from pure invention and in no way based, as cultural art constantly is, on chameleon or parrot-like processes.' He claimed that these works are evidence of a power of originality which

all people possess but which in most has been stifled by educational training and social constraints.

In 1945 Dubuffet began to make a collection of works free from cultural norms and fashionable or traditional trends in art, and in 1948 he founded the *Compagnie d'Art Brut* together with André BRETON, Michel Tapié and others. His collection, numbering some 5,000 items, was exhibited in 1967 at the Mus. des Arts Décoratifs, Paris, and in 1972 was presented to the city of Lausanne, where it was inaugurated at the Château de Beaulieu in 1976.

Although nearly half the collection was produced by patients, usually schizophrenics, in psychiatric hospitals, Dubuffet repudiated the concept of psychiatric art, claiming that 'there is no art of the insane any more than there is an art of dyspeptics or an art of people with knee complaints'. He also distinguished *Art Brut* from NAÏVE ART on the more dubious ground that the naïve or 'primitive' painters remain within the mainstream of painting proper, hoping for public if not official recognition, whereas the *Art Brut* artists create their works for their own use as a kind of private theatre.

ART CONCRET (KONKRETE KUNST). See CONCRETE ART.

ART CONTEMPORAIN, L'. An association of artists formed in Antwerp by F. Franck in 1905. It organized an exhibition almost every year until 1955, promoting interest in *avant-garde* work. Among its associated members were: ENSOR, WOUTERS, SPILLIAERT, TYTGAT, BRUSSELMANS, PERMEKE, Van den BERGHE, De SMET.

ART D'AUJOURD'HUI. Magazine founded in 1924 by André BLOC.

ART DECO. Name for the decorative arts of the 1920s and 1930s in Europe and America. Art Deco was discovered by the Paris Exposition Internationale des Arts Décoratifs et Industriels Modernes, which was underwritten by the French Government in 1925. The emphasis of the exhibition on individuality and fine workmanship was at the opposite extreme from the contemporary doctrines of the BAUHAUS and the prototypes for machine production which were the ideals of many of those behind the Deutscher Werkbund. It was successful for a while in reasserting the position of the French artist-craftsmen as arbiters of world taste in the practical arts. But the position of Paris was soon challenged from the U.S.A., which then went into the lead although to a large extent it changed the concept of Art Deco created by the Paris exhibition.

By means of a fund created in 1922 the Department of Decorative Arts in The Metropolitan Mus. of Art, New York, was enabled to purchase examples of modern decorative art in Europe and

America. The nucleus of a collection of outstanding individual pieces of contemporary craftsmanship was built up by the curator, Joseph Beck, between the years 1923 and 1925. In 1926 an exhibition of loan pieces from the Paris Exposition toured the museums of the U.S.A., being shown first by The Metropolitan Mus. Commerce was not slow to crowd its way in upon the band wagon and an exhibition of contemporary decorative art under the title 'Art in Trade' was staged by Macy's Department Store in 1927, to be followed by a number of others. In this way the standard of the original Art Deco was vulgarized and a debased form of it was popularized under the name of the style 'Moderne'. In 1929, however, The Metropolitan Mus. held its own exhibition on the model of the Paris Exposition of 1925. The object of the exhibition was not only to show the best of what was being done but to encourage the creation of a new decorative style adapted to the needs of contemporary life. The exhibition was called 'The Architect and the Industrial Arts: An Exhibition of Contemporary Design'. The over-all layout was planned by the Finnish-born architect Eliel Saarinen (1873–1950) and the exhibition displayed a series of interiors planned by architect-designers and largely stocked with objects manufactured by firms in close consultation with the designers.

A second exhibition of Art Deco was held by The Metropolitan Mus. in 1934, in which the emphasis upon the general style and impression of an interior rather than upon the individual craft object was carried still further. Owing perhaps to the effects of the Depression, emphasis was also given to materials and forms which could be easily and economically mass produced.

Characteristic of Art Deco was the vogue for the streamlined style, which was hailed as the ultimate in modernity during the 1930s but within 20 years already seemed dated. Bevis Hillier has offered the following 'working definition' of Art Deco: 'an assertively modern style, developing in the 1920s and reaching its high point in the thirties; it drew inspiration from various sources, including the more austere side of Art Nouveau, cubism, the Russian Ballet, American Indian art and the Bauhaus; it was a classical style in that, like neo-classicism but unlike rococo or Art Nouveau, it ran to symmetry rather than asymmetry, and to the rectilinear rather than the curvilinear; it responded to the demands of the machine and of new materials such as plastics, ferro-concrete and vita-glass; and its ultimate aim was to end the old conflict between art and industry, the old snobbish distinction between artist and artisan, partly by making artists adept at crafts, but still more by adapting design to the requirements of mass production.' Art Deco is spoken about mainly in connection with a stylistic trend in what the museums call the 'decorative' arts. But in so far as one of the objects central to that trend was to whittle away the distinction between 'fine' and 'decorative' art, Art Deco cannot be neglected in a study of the art of the twentieth century.

A revival of interest in Art Deco during the late 1960s and 1970s had an air of historicism analogous to the earlier enthusiasm for Victoriana, tempered perhaps by a touch of nostalgia.

ARTE POVERA. A movement in Italian art analogous to 'Situations' art, CONCEPTUAL ART and some aspects of MINIMAL ART in America. The name was coined by the critic Germano Celant, who organized an exhibition of *Arte Povera* at the Museo Civico, Turin, in 1970 and who edited the basic book on the movement. It was opposed to the exploitation of traditional artistic form or iconography and found its most characteristic expression in the unstructured HAPPENING. Celant wrote: 'Arte Povera expresses an approach to art which is basically anti-commercial, precarious, banal and anti-formal, concerned primarily with the physical qualities of the medium and the mutability of the materials. Its importance lies in the artists' engagement with actual materials and with total reality and their attempt to interpret that reality in a way which, although hard to understand, is subtle, cerebral, elusive, private, intense.' In an article 'A propos de l'exposition de Turin' contributed to *Opus International* in 1971 Renato Barilli wrote: 'In refusing iconography it also refuses the painted surface, which is its most habitual mode of expression; in a more general sense it refuses to accept the concept of the "product", the "work", and offers us instead not the result of a process but the process itself in the act of becoming.'

The name *Arte Povera* was also given to a movement begun by artists such as Michelangelo Oliviero PISTOLETTO, Mario CEROLI and Mario Merz for making works of art from rough and worthless materials. Writing in 1970 the critic Gillo Dorfles described *Arte Povera* as 'a recent development in the panorama of Western art which arose as a counter-balance to an excess of refinement in the use of new plastic and metal materials'. One of the forerunners was the Greek Vlassis CANIARIS.

During the 1970s some adherents of *Arte Povera* turned to a politically engaged art of INSTALLATIONS, which became both esoteric and obscure. A representative example of this method is an exhibition staged in Berne in 1980, which was announced as 'Polemic and Integration'. In the introductory statement it was described as the 'reaction, criticism and answer of artists with the means of art to the prevailing political and cultural situation in Italy, also in Europe, an exhibition to be understood as Programme and Manifesto'. Luciano Fabro (1936–) showed an enormous glass bowl filled with lumps of clear glass on a large white tablecloth. This—the only Installation to which any key was offered—was entitled 'Bring me the head of John the Baptist on a dish'. The lumps of glass were to be interpreted as representing victims through history from Socrates to Pasolini. Mario Merz (1925–) built a 'space-object' from bundles of vines, posts, earth packed in alu-

minium foil, thin leather thongs, a beer bottle and an arch of neon tubes. In an otherwise empty room the Greek-born artist Jannis Kounellis (1936–) grouped casts of antique heads and lit the walls by fires at regular intervals with some 18 small metal plaques under the roof to catch the soot. Giulio Paolini (1940–) staged a complicated interplay of real and illusory perceptions to represent art as the semblance of reality.

ARTE PROGRAMMATA. Term in post-war Italy for KINETIC ART when works are motor-driven in a set sequence of movements, though random elements may be built into the movement programme. Within the term were also included OP ART, ENVIRONMENT ART and spectator involvement particularly in light environments. In 1963 an exhibition at Frankfurt called 'European Avant-Garde' was sub-titled 'Arte Programmata, Neue Tendenzen, Anti-Peinture, Zero'. In 1964 the Royal College of Art, London, staged an 'Arte Programmata' exhibition which was later circulated in the U.S.A. by the Smithsonian Institution.

ART INFORMEL (ART WITHOUT FORM). A movement in European painting which during the decade beginning *c.* 1945 ran parallel to ABSTRACT EXPRESSIONISM in America. The term was introduced by the French critic Michel Tapié in 1950 with WOLS primarily in mind but by 1951 he was using it also of the work of FAUTRIER, DUBUFFET, MICHAUX, RIOPELLE and others. The term has been adopted to cover the 'lyrical abstraction' (to use a phrase coined by Georges MATHIEU) which gives direct expression to subconscious fantasy in contrast to the more rigorous abstractionist tendencies deriving from CUBISM and to the various forms of geometrical abstraction such as those of MONDRIAN and De STIJL. One of the earliest manifestations of this trend were the *Hostage* pictures exhibited by Fautrier at the Gal. Druet in 1945. Pioneers of the movement were the two German *émigré* artists Wols and Hans HARTUNG. Besides Michaux, Riopelle and Mathieu the movement included the Italian BURRI and the Spaniard TÀPIES. In 1952 the critic Tapié organized exhibitions of paintings which he called 'Signifiants de l'informel' and 'Un art autre', and he used *Un art autre* as the title of a book published in the same year. In this book he emphasized the radically different character of the new art from what had gone before and tried to establish its very strangeness as a standard of assessment. In a book published in 1962 Jean Paulhan described *Art Informel* as a new way of looking at reality and as the expression of an 'obscure half-world' which eludes both reason and direct observation.

In 1954 the term TACHISM was introduced applying more generally to non-geometrical abstraction, and the denotation of the two terms has not been kept distinct.

ARTISTS' CLUB, THE. See UNITED STATES OF AMERICA.

ARTISTS' CONGRESS. An association of more than 300 painters, sculptors, designers and photographers formed in the U.S.A. in 1936 with the object of using their skills for anti-Fascist propaganda. The first meeting was addressed by Lewis Mumford. The Executive Secretary of the Congress was Stuart DAVIS, and he also edited the magazine of the Congress, *Art Front*, until 1939.

ART NOUVEAU. Term in art history and criticism commonly applied to a decorative style which spread widely over western Europe during the last two decades of the 19th c. and the first decade of the 20th c.

Art Nouveau was a deliberate attempt to create a new style in reaction from the academic 'historicism' of the second half of the 19th c. instead of imitating and varying styles of the past. It was primarily an art of ornament and its most typical manifestations occurred in the practical and applied arts, *Art Mobilier*, graphic work, and illustration. Whereas most of the new aesthetic movements in easel painting and sculpture originated in Paris, Art Nouveau spread to the Continent chiefly from London. In Germany the style was called *Jugendstil* (a name connected with the popular review *Die Jugend* founded in 1896); in Austria it was called *Sezessionstil*; in Italy *Stile Liberty* after the Regent Street store which had played so large a part in the dissemination of designs; in Spain the Catalan version of the style was known as *Modernista*; and in Paris in the 1890s the name 'Modern Style' reflected its English origin.

In England Art Nouveau style is traced back through William Morris, Dante Gabriel Rossetti and the Pre-Raphaelites, to William Blake. Its chief exponents were Arthur Heygate Mackmurdo, Aubrey Beardsley, Charles Ricketts, Walter Crane and in Glasgow the architect Charles Rennie Mackintosh and the sisters Frances and Margaret Macdonald. The style was also propagated by a number of periodicals, among which should be mentioned Mackmurdo's *The Century Guild Hobby Horse* (1884), Ricketts's *The Dial* (1889), and Beardsley's *The Yellow Book* (1894–5) and *The Savoy* (1896–8). *The Studio*, founded in 1893, also helped to publicize Art Nouveau, and on a different level the fabrics printed by Liberty did much to popularize it.

On the Continent Art Nouveau first assumed a clearly defined form in Brussels. Its chief exponents there were Victor Horta, who in the staircase of the Maison Tassel originated what later became known as the 'Belgian line', and Henry van de VELDE. Starting under the influence of the English style, the Belgian Art Nouveau soon acquired a character of its own. It was stimulated by a series of exhibitions organized by the GROUPE DES VINGT after 1884, in which products of the applied arts and books illustrated by Herbert Horne and

Selwyn Image, friends of Mackmurdo, were shown alongside *avant-garde* paintings. The famous painter ENSOR, one of the founders of the group, despite the highly personal character of his EXPRESSIONISM, was influential in contributing to this development.

In France, despite the Anglomania of the 1890s, English Art Nouveau style made little impact except in luxury and bibelot products. It is reflected in the jewellery and glassware of René Lalique (1860–1945) and in the glassware of Émile Gallé (1846–1904). In architecture it was exemplified by Hector Grimard (1807–1942) in his design for the Paris métros.

In Spain Art Nouveau flourished mainly in Barcelona, and Gaudí, who worked there, has later come to be considered an outstanding genius of the whole Art Nouveau movement. Besides his work should be mentioned the Palau de la Musica Catalana built (1906–8) by Luis Domenech y Montaner (1850–1923). This building blends Art Nouveau features with an eclectic amalgam of historical styles and has been described by Schmutzler as 'the most brilliant and important example of a "hybrid" Art Nouveau adulterated by historicism to be found anywhere in Europe'.

The German *Jugendstil* began in Munich virtually unheralded with an exhibition of tapestries by the sculptor Hermann Obrist (1863–1927), son of a Scottish mother and a Swiss father. *Jugendstil* split into two divergent currents. Floral *Jugendstil* was based on English floral Art Nouveau and is mainly to be found in the applied arts before 1900. Its leading exponent was considered in Germany to be Otto Eckmann (1865–1902), much of whose best work was done as illustrations for the periodical *Pan*. After about 1900 there emerged an abstract form of *Jugendstil* mainly under the influence of the Belgian architect van de Velde, who began to work in Berlin in 1899. Also working in this style was the architect Peter Behrens.

Austria took to Art Nouveau late in the century, when there developed in Vienna an almost geometrical style free from baroque and rococo elements but strongly under the influence of C. R. Mackintosh and Mackmurdo's pupil Charles Annesley Voysey. Its chief exponents were the architect Otto Wagner (after about 1895), the architects and designers Josef Hoffmann and Joseph Olbrich, and the designer Koloman MOSER. The style was propagated by the Viennese periodical VER SACRUM. Its name *Sezessionstil* was derived from Olbrich's hall for the exhibitions of the *Wiener Sezession* (1889–99).

Italian Art Nouveau was limited to details borrowed in the main from English architecture or from Vienna. Indeed Italy was little affected by the trend, achieving no integrated national Art Nouveau idiom. Its chief exponent was Giuseppe Sommaruga (1857–1932), who originated the *Floreale* style of decoration.

Art Nouveau is represented in the U.S.A. by two very different artists. The architect Louis Sullivan is considered to express the style in his decoration though not in his buildings themselves. Although he maintained that ornament should emphasize the structure and form an organic whole with the building, he applied this principle very loosely in his own practice. Louis Comfort Tiffany on the other hand developed a highly personal elegance of Art Nouveau forms in his designs for glassware between 1880 and 1890.

Art Nouveau displays a certain mood of *fin-de-siècle* and an artificial aestheticism which have caused it to be said that the aesthete and the dandy are the key figures of the movement. It was attacked in England by Thomas Graham Jackson in lectures given at the Royal Academy Schools in 1906 (published the same year under the title *Reason in Architecture*) and this was followed in 1908 by an attack on the Glasgow School in the *Architectural Review*. The movement nowhere survived the outbreak of the First World War to any significant extent.

ART OF THE REAL. Name of one of the trends in visual art which, chiefly in the U.S.A., succeeded the breach with ABSTRACT EXPRESSIONISM from the late 1950s. Its most important distinguishing feature was the attempt to abolish traditional distinctions between works of art and objects of everyday reality. The Art of the Real repudiated traditional 'realism' in the sense of veridical or illusory representation, claiming for the art object reality in the same sense that objects of everyday experience are real. It also repudiated traditional form in the sense of artistic composition, harmony, etc. The art object was to make no allusion to the perceived world by simulation, symbol, metaphor or suggestion. Emphasis was laid upon its physical reality, and an immediate aesthetic experience was claimed to result from the direct impact of this.

To some extent the Art of the Real overlaps with what has been called MINIMAL ART, or HARD EDGE or ABC art and to some extent with CONCEPTUAL art. Among its exponents have been such artists as KELLY, JUDD, STELLA, NOLAND, FEELEY and Tony SMITH, although not all the works of any of these artists can properly be brought within the category.

ARTSCHWAGER, RICHARD (1923–). American sculptor and experimental artist born at Washington, studied privately under Amédée OZENFANT. He exhibited from 1965 at the Leo Castelli Gal., New York, and was represented in a number of important group exhibitions, including: Jewish Mus., New York, 'Primary Structures', 1966; DOCUMENTA IV, Kassel, 1968; Kunsthalle, Berne, 'When Attitude Becomes Form', 1969. He became known chiefly for his 'pseudo-furniture', objects constructed usually of formica on wood such as *Table with Tablecloth* (1964), which was included in the 'Primary Structures' exhibition. In this kind of work Artschwager exemplified that aspect of the art of the 1960s in which it sought to ap-

proximate as closely as possible to factory-made consumer goods, differing from them mainly in the fact that the art work was not designed to serve any practical function. Comparing the pseudo-furniture of Artschwager with the 'Brillo boxes' of WARHOL, the critic Barbara Rose said in her essay 'A B C Art' (1965): 'since they approximate real objects with actual uses, they begin to raise questions about the utility of art, and its ambiguous role in our culture'. While these objects were not 'situational' or open-air sculpture, they were often of large dimensions as, for example, *High Rise Apartment* (1964), an architectural model of liquitex on celotex with formica, 68 by 48 by 4½ in. (1·7 by 1·2 by 0·11 m) in size.

ARTS COUNCIL OF GREAT BRITAIN, THE.

The Arts Council of Great Britain came into being when the Council for the Encouragement of Music and the Arts (C.E.M.A.) was incorporated under that name by Royal Charter in 1946. The decision was taken in 1945 by the wartime Coalition Government, the announcement was made by the 'Caretaker' Government and it was implemented by the Labour Government. Maynard Keynes, chairman of C.E.M.A. in succession to Lord Macmillan, was the chief architect of the project. By a new Charter of 1967 responsibility for the Arts Council was transferred from the Treasury to the Department of Education and Science and its objects were rewritten as follows: (*a*) to develop and improve the knowledge, understanding and practice of the arts; (*b*) to increase the accessibility of the arts to the public throughout Great Britain; and (*c*) to advise and co-operate with Departments of Our Government, local authorities and other bodies on any matters concerned whether directly or indirectly with the foregoing objects. At the same time the Scottish and Welsh committees were upgraded to the status of Arts Councils.

For the visual arts the major part of the Arts Council's work has in practice taken the form of providing an exhibition service. An Art Panel, set up in 1942 within C.E.M.A., acted as advisory body for planning exhibition programmes to serve London and the whole country. The Exhibition Service set up in the course of time a widespread exhibition circuit and from 1946 to 1970 mounted a total of 901 exhibitions of paintings, drawings, sculpture and the graphic arts plus 77 exhibitions of reproductions, photographs, etc. It is estimated that attendance amounted to some 20 million people. In 1968 the Arts Council took over direct management of the new Hayward Gal. in the South Bank complex, inaugurating it with exhibitions of Van Gogh and MATISSE, and in 1970 took over the Serpentine Gal. in Kensington Gardens.

From C.E.M.A. the Arts Council inherited the policy of purchasing works by living artists and in the 25 years up to the end of 1970 the Council had built up a collection of contemporary British art totalling some 1,000 items at a cost of about £200,000. Aid was also given to practising artists

in the shape of awards and studio space, and subsidies were allotted to organizations and associations of artists. In 1950 the Arts Council also inaugurated a service of art films in association with the British Films Institute.

By a White Paper of February 1977 the government awarded the Arts Council an inflation-proofed budget of *c*. £40m. For the year ending 31 March 1976, the Finance Director stated that direct gross expenditure on the visual arts amounted to £2,143,000, which excluded capital expenditure on projects for housing the arts such as art centres and community arts projects. It was stated that the 1976/77 budget for the visual arts would be spent on exhibitions, magazines and publications, works of art for public buildings, the provision of studios, film and film-making, an Artist in Residence scheme, grants towards gallery improvements, performance art events, awards to painters, sculptors, printmakers and photographers, a Work in Schools scheme and art film tours. Since its inauguration the Arts Council has established itself as the single most important source of patronage of the arts in Britain.

ASH-CAN SCHOOL.

An American school of realistic painting which flourished in the first decade of the 20th c. It was inspired largely by Robert HENRI and its nucleus was formed by the group of The EIGHT, which he founded. The core of the school were the four artists GLACKENS, SLOAN, LUKS and SHINN, who had gathered round Henri at his studio at 806 Walnut Street, Philadelphia, and who afterwards joined him in New York. All four had been artist-reporters on the *Philadelphia Press*. At a time when the camera was little used for press work the job of making rapid sketches on the spot for subsequent publication demanded a quick eye and rapid pencil and an exact memory for detail, and encouraged an interest in scenes of everyday life. These qualities were the basis of the 'New York Realism', which afterwards became known as the Ash-Can school. In painting style and technique the artists of this school had few features in common and are now seen to have differed less from contemporary academic painting than they themselves believed. The common feature that bound them together was their interest in depicting scenes and details from everyday life and commonplace objects which were significant for the day-to-day life of ordinary people. The themes of these painters had much in common with SOCIAL REALISM.

ASMUS, DIETER (1939–).

German painter born in Hamburg, studied at the Hamburg Academy of Fine Arts. He qualified as an art teacher in 1965. In 1965–7 he held a scholarship from the German Government and in 1967 obtained a scholarship from the French Government to work in Paris. In 1967–8 he received a scholarship from the German Academic Exchange Service to study in London. In 1965 he was one of the four artists

who founded the ZEBRA group. He painted in a style of precise PHOTOGRAPHIC REALISM and emphasized the distinction between the figure and the empty, though constructed space against which it was set. From 1963 his work was shown widely in Germany both with the *Zebra* group and in other collective exhibitions.

ASSELIN, MAURICE (1882–1947). French painter, born at Orleans. He entered the École des Beaux-Arts, Paris, in 1903 and from 1906 exhibited at the main Paris salons. He was on terms of friendship with the FAUVES but did not adopt their style. Rather, starting from the Impressionists and Cézanne, he became one of the most personal of the French Realist painters. He painted portraits, nudes and landscapes with a natural spontaneity which won him the respect of critics and writers such as Francis Carco, whose novel *Rien qu'une Femme* he illustrated.

ASSEMBLAGE. In 1953 DUBUFFET adopted the word *assemblages* for a series of lithographs which he made from paper COLLAGES, and in 1954 he extended the method to the making of small figures from fragments of papier mâché, scraps of wood, sponge and other debris. He thought that the word 'collages' should be reserved for the pasted pictures which were made by PICASSO and BRAQUE during the period of Synthetic CUBISM from 1912 until *c.* 1920.

The term 'assemblage' was adopted for an exhibition 'The Art of Assemblage' staged by The Mus. of Modern Art, New York, in 1961. The exhibition included collages and small constructions by Synthetic Cubists, FUTURISTS, DADAISTS, SURREALISTS, READY-MADES by Marcel DUCHAMP, boxed constructions by Joseph CORNELL, collages by DE KOONING, BAJ, MOTHERWELL, RAUSCHENBERG, etc., 'sacking' pictures by BURRI, sculptures by NEVELSON, TINGUELY, STANKIEWICZ, CROTTI, compressed automobile bodies by CÉSAR Baldaccini, tableaux by KIENHOLZ, and a very wide range of objects from every school and style. When a word is extended so widely and made to apply to so diverse a variety of objects with few features in common its usefulness is diminished, and in the years which followed this exhibition 'assemblage' has tended in practice to be applied more strictly to genuine groupings or assemblages of similar or diverse objects, usually enclosed in some sort of box or case. One may, however, see as the two poles of Assemblage the 'combine paintings' of Rauschenberg on the one hand, an extension of the SCHWITTERS type of collage into three dimensions, and on the other hand the *Accumulations* of ARMAN, an extension of DUCHAMP's idea of the ready-made.

ATELIER D'ART ABSTRAIT. An institution founded in October 1950 by Jean DEWASNE and Edgard PILLET for the promotion of CONSTRUCTIVIST or geometrical abstract art by teaching and collective research. In their programme they declared: 'Tout enseignement dogmatique, systématique ou personnel est évité.' Some teaching was, however, done by both Pillet and Dewasne. The spirit which animated the institution is indicated by the following sentence from a manifesto published by Pillet in *Art d'Aujourd'hui*, which he edited: 'Ceux qui viendront ici ne se contenteront pas de recevoir, ils doivent savoir qu'ils auront aussi à chercher et à découvrir, à s'enfoncer dans l'inexploré, source constante de fécondité.' ('Those who come here will not be content to receive, they should know that they will also have to search and discover, to immerse themselves in the unexplored, constant source of fruitfulness.') The founders were joined by HERBIN, DOMELA, DEYROLLE, VASARELY. Critics such as Seuphor, Estienne and Degand gave fortnightly lectures. The Atelier closed at the end of 1952.

ATELIER 17. See HAYTER, S. W.

ATKINSON, KEVIN. See SOUTH AFRICA.

ATKINSON, LAWRENCE (1873–1931). English painter and sculptor. He studied music, taught singing in Liverpool and London and gave concert performances. He was self-taught as an artist. Advancing from a derivative FAUVIST style in the direction of abstraction, he joined the REBEL ART CENTRE in 1914, signed the VORTICIST manifesto of BLAST No. 1 and exhibited at the Vorticist Exhibition of 1915. In 1916 he exhibited with the LONDON GROUP and in 1921 he had a one-man show at the Elder Gal. of Abstract Sculpture and Painting. He obtained the Grand Prix for a carving *L'Oiseau* at the Milan Exhibition of 1921 and subsequently concentrated upon sculpture.

ATLAN, JEAN-MICHEL (1913–60). French painter born at Constantine, Algeria, of Jewish-Berber stock. He went to Paris in 1930 and studied at the Sorbonne. He became interested in painting in 1941 but was arrested in the following year by the German occupying forces and saved his life by simulating madness, being consigned to the asylum at Sainte-Anne until the Liberation. In 1944 he published a collection of poems, *Le Sang profond*, and exhibited his first pictures. During 1945 he made black and white lithographic illustrations for Kafka's *Beschreibung eines Kampfes*. His first one-man show was given at the Gal. Maeght in 1947. Then, after ten years during which he did not exhibit, he had an exhibition at the Gal. Bing in 1956 and in 1957 at the Palais des Beaux-Arts, Brussels, and the Mus. d'Antibes. His work rapidly won recognition and for the next three years he exhibited frequently, at the Gal. Bing, the Salon de Mai, the Gal. Malaval, Lyons, the Kaplan Gal., London, and in international exhibitions at Liège and Tokyo. A posthumous exhibition of his latest works was given at the Contemporaries Gal., New York, in the spring of 1960.

Atlan turned to abstraction *c.* 1947 and developed a characteristic style of rhythmical forms in deep, rich colours painted in a mixture of oils and pastel often enhanced by thick black outlines. These paintings belong to the category known by the general terms ABSTRACT EXPRESSIONISM in America and TACHISM in France. He himself said: 'For me a picture cannot be the result of a preconceived idea, the part played by chance [*aventure*] is too important and moreover it is this part played by chance which is decisive in creation. At the outset there is a rhythm which tends to develop itself; it is the perception of this rhythm which is fundamental and it is on its development that the vital quality of the work depends.' (*Art d'Aujourd'hui,* 1953.)

AUBERJONOIS, RENÉ (1872–1957). Swiss painter, born at Lausanne. After studying at the University of Lausanne he made brief preliminary studies of painting at the Technical Schools of Art in Dresden and Vienna, and then in 1896 worked at the Kensington School of Art, London. In 1897 he was in Paris, where he studied at the École des Beaux-Arts and in the studio of J. A. M. Whistler. After visiting Florence in 1900 he returned to Paris in 1901 and lived there until 1914. He was a friend of the poet Charles Ferdinand Ramuz, for whom he did illustrations, and was in contact with the CUBISTS and others of the *avant-garde* Paris schools. From 1914 he lived in Lausanne, consolidating a style of personal eclecticism out of contact with later artistic movements. In 1948 he had a one-man show at the Venice Biennale. His painting was simple and direct in warm, bright colours, poetic in mood without sentimentality. After *c.* 1940 he gave much attention to graphic work.

AUJAME, JEAN (1905–65). French painter, born at Aubusson. After studying at the École des Beaux-Arts, Rouen, he moved to Paris in 1930. He painted landscapes in an emotionally expressive FAUVIST palette and, standing aloof from the *avant-garde* aesthetic movements of the 1930s, belonged to the *Néo-Réaliste* school represented by Maurice BRIANCHON and Roland OUDOT. He received the Prix Paul Guillaume in 1935 and in 1937 he executed a mural *Découverte des eaux souterraines* for the Palais de la Découverte at the Paris International Fair. He was a prisoner of war from 1940 to 1942 and afterwards resumed work, still concentrating mainly on landscape but in a less exuberant and rather more formal style. In 1949 he was awarded the Prix Hallmark.

AULT, GEORGE (1891–1948). American painter, born at Cleveland, Ohio. He lived in Britain, 1899–1911, and studied at the Slade School and at St. John's Wood Art School. He exhibited with the Society of Independents in 1921 and had a succession of one-man shows from 1922, including the Downtown Gal. in 1926 and 1928, and retrospectives at the Zabriskie Gal. in 1957, 1963,

1969. Some of his work in the 1920s—mainly cityscapes—anticipated the style of the CUBIST-REALISTS, with whom he is usually classified.

AURICOSTE, EMMANUEL (1908–). French sculptor born in Paris. He was a pupil of BOURDELLE and DESPIAU. His first one-man exhibition was in 1935, when he was modelling in clay for casting in bronze or plaster. He then turned to monumental sculpture, such as his reliefs for the Palais de Chaillot (1936), and after the war to hammered lead and iron. His work had strongly dynamic forms in a style of expressive and decorative Realism. He was one of the promoters of the SALON DE MAI after the war. He taught at the École des Beaux-Arts, Orleans, and at the Grande Chaumière, and École des Arts Décoratifs and the École des Beaux-Arts, Paris.

AUSTRALIA. An ART NOUVEAU style which often incorporated local flora and fauna characterized much Australian decorative art during the 1890s. The impact of the 20th-c. *avant-garde* styles, however, was long delayed. Australian artists who studied in Paris and London during the two decades prior to the First World War preferred academic and naturalistic styles. Indeed the full impact of modernism was not felt in Australia until the late 1930s. But there were forerunners. An interest in POST-IMPRESSIONIST art developed first in Sydney among the students of Dattilo Rubbo (1871–1955), a Neapolitan-trained artist who maintained an art school in the city from 1898 until 1941. It began with Norah Simpson, who after studying with Rubbo and later at the Westminster School, London, under GILMAN, GINNER and GORE (1912), visited Paris and saw original work by Cézanne, Gauguin, MATISSE and PICASSO in commercial galleries. Armed with books and photographs she returned to Sydney in 1913.

From the discussions and experiments which resulted three of Rubbo's students, Roland WAKELIN, Grace Cossington SMITH and Roy de MAISTRE, became seriously interested in Neo-Impressionist and Post-Impressionist painting. In the absence of originals and good reproductions, books such as A. J. Eddy's *Cubists and Post-Impressionists* (1915) and W. Huntingdon Wright's *Modern Painting: Its Tendency and Meaning* (1915) were important communicators. It was Wright's discussions of SYNCHROMISM that led De Maistre and Wakelin to experiment with pure colour and its relation to music. They held an exhibition of 'Synchromies' at Gayfield Shaw's Gal., Sydney, in 1919. It was vigorously attacked by Julian Ashton (1877–1964), who had studied at the Académie Julian, Paris, and was master of a rival art school to Rubbo's. A more formidable opponent was Max MELDRUM, who had recently returned to Melbourne after twelve years in France (1899–1911) and had begun to establish a school of tonal naturalism based upon a carefully argued theory. He exercised a dominant influence upon Australian painting for over thirty years.

The Australian pioneers of Post-Impressionism each developed a personal style: Cossington Smith a personal analysis of Australian light in broad but broken colour; Wakelin a romantic communion with nature; De Maistre (after settling permanently in London in 1929) an expressive CUBISM deeply touched by religion.

Although Frances HODGKINS received good reviews of her (then) freely decorative Impressionist work when she exhibited there in 1912, the modern movement did not reach Melbourne until the end of the First World War. Esmond Keogh, returning from the Western Front, brought with him publications which illustrated the work of Cézanne, Van Gogh and others and showed them to artist friends. One was William FRATER (1890–1974), who had studied at the Glasgow Art School under Legros, Greiffenhagen and Anning Bell while serving his articles as a stained glass craftsman and designer. Emigrating to Melbourne, Frater joined Brooks Robinson's Stained Glass Studio. Here together with Arnold Shore (1897–1963), a fellow-craftsman, he became increasingly interested in Post-Impressionism in the face of bitter opposition from the 'Meldrumites'. An influential recruit to their circle was George Bell (1878–1966), who had been academically trained in Melbourne, Paris and London but became dissatisfied with his work in the 1920s. In 1931 Bell and Shore established an art school to teach the principles of modern art. Bell went abroad in 1934 to refresh his knowledge, working at the Grosvenor School, London, under Iain McNab. After his return the partnership with Shore broke up, Bell continuing alone. His pupils included some of Australia's best-known artists: Russell DRYSDALE, Sali HERMAN, Peter Purves Smith and David Strachan.

In Sydney during the 1920s artists interested in the modern movement met in the workshop of John Young, a framer and restorer who in 1925, together with Basil Burdett, a critic and connoisseur, established the Macquarie Gal. The first exhibition was of Wakelin's work. The Contemporary Group, founded in 1925 by two academically trained artists, Thea Proctor (1897–1966) and George Lambert (1873–1930), also encouraged a more tolerant—although cautious—approach to modern art.

The impact of Cubism and CONSTRUCTIVISM was not felt until the early 1930s, though John Power, an Australian surgeon-turned-artist, was experimenting with Cubism in Paris during the early 1920s. But it was Grace Crowley, who studied first under Julian Ashton and later with LHOTE and GLEIZES, who did most to develop an interest in Cubist and Constructivist painting in Sydney. In 1932, with Ralph Fizelle (1891–1964), she opened a studio-school which emphasized geometrical form and dynamic symmetry. The Modern Art Centre established by Dorrit Black, who had also worked with Lhote and Gleizes, promoted similar trends. It held the first exhibition of Ralph

Balson's work. Yet another centre of importance was Ball Green, the home of Ethel Anderson, writer and poet, who encouraged a circle of writers interested in Constructivism. During the 1930s these small *avant-garde* circles were much influenced by Jay Hambidge's *Dynamic Symmetry* (1920) and Irma Richter's *Rhythmic Forms in Art* (1932). Eleonore Lange carried out experiments into problems of light, movement and the use of new materials in sculpture, and did much to inform Sydney about art education at the BAUHAUS. Closely associated with her were Frank Hinder (1906–) and his American wife Margel. Hinder, after completing his studies at the Royal Art Society School, Sydney, studied at the Art Institute of Chicago, the New York School of Arts, and the Master Roerich Mus. under Howard Giles and Emil Bisttram.

Light clear colour and sharp semi-abstract design with a strong interest in the portrayal of movement were a feature of the progressive art of Sydney during the 1930s. Best expressed in Exhibition I (Sydney, 1939), it was probably inspired by the UNIT I exhibition in London. Exhibition I included paintings by Balson, Crowley, Fizelle, Hinder and Frank Medworth, and sculpture by Margel Hinder, Eleonore Lange and Gerald Lewers.

During the 1930s the modernist groups both in Sydney and in Melbourne were small and separated from the main stream of taste, which was channelled skilfully and persuasively by Sydney Ure Smith, President of the Society of Artists and editor of the influential magazine *Art in Australia* (1916–38). Smith avoided confrontations with the *avant-garde* by ensuring that its leaders were offered membership in his Society after they had won a measure of public esteem. Wakelin and Shore both became members.

In Melbourne the lines between academic and contemporary were more sharply drawn. Conflict was inevitable when Sir Robert Menzies, then Federal Attorney-General, championed the proposal for the establishment of an Australian Academy of Art. Led by Bell, a large body of artists established the Contemporary Art Society of Australia in opposition. The spirited controversial atmosphere which resulted is admirably captured in Adrian Lawlor's *Arquebus* (1937). The Contemporary Art Society was a highly mixed grouping of artists stimulated variously by NAÏVE painting, Cubism, Constructivism, SURREALISM, EXPRESSIONISM and SOCIAL REALISM. It succeeded in gaining the use of the National Gal. of Victoria for its first exhibition (1939), which was opened by Mr. Justice Evatt (later a President of the United Nations), who was a keen supporter of advanced art and the leading political opponent of Menzies.

The new Society established branches first in Sydney and Adelaide, then in the other states. It became the main vehicle for the transmission of *avant-garde* taste to artists and public alike (for commercial galleries were then still few, art works

being sold mainly from the annual exhibitions of artists' societies). In its early years the Contemporary Art Society was split by disputes, when older members who tended to work in Post-Impressionist modes, led by Bell, objected to lay membership and the intrusion of politics into the Society. An unstable coalition of the remainder, which included Expressionists, Surrealists and Social Realists, successfully opposed them. Bell and his followers broke away to form the Contemporary Group.

In Melbourne the battle for a public audience for modern art was pursued vigorously. Sir Keith Murdoch, the Managing Director of the *Melbourne Herald* and a Trustee of the National Gal. of Victoria, took a keen but cautious interest in the new art. To make it better known among Australians he sent Basil Burdett (then art critic of the *Melbourne Herald*) to Europe to assemble a representative exhibition of modern masters. Burdett returned with the 'Exhibition of French and British Modern Masters' (1939). It consisted of over 200 paintings ranging from Cézanne to DALí and was undoubtedly the best and the most influential exhibition ever to be shown in Australia.

Whereas the First World War retarded the development of art in Australia severely during the 1920s, the Second World War, by contrast, acted as a stimulus. Young artists and art students studying in Europe were forced to return and the threat of Japanese invasion increased the sense of national identity.

Dalí's *L'Homme Fleur* gained wide publicity in the 'Murdoch' exhibition, and interest in Surrealism grew, notably in the work of James Gleeson (1915–) and Eric Thake (1904–). But it was Expressionism which developed as the lingua franca of Australian modernism, for it was the style which best accommodated the divided loyalties of Australian artists torn between the excitement of formal innovations derived from. Europe and the search for personal identity with their own environment and history.

Thus William DOBELL, trained first under Ashton and later under TONKS but deeply influenced by SOUTINE, brought an enviable skill in characterization to his portrayal of typical Australians. Russell DRYSDALE, turning his back upon the blue and gold *plein air* painting of Melbourne's Heidelberg School (which flourished in the 1890s), painted hot red landscapes of drought and rural poverty. Sidney NOLAN, stimulated by naïve painting, turned to folk history and transformed the bushranger Ned Kelly into a personal legend. Arthur BOYD's imagination, more broadly based and more prodigal, embraced both biblical history and Antipodean myth.

Many of these Expressionists were touched in some measure, particularly in their youth, by Social Realism. But the political element waned as the Cold War waxed. One component of Realism took root, however: the discovery of the suburb as an object of art. Most Australians live in suburbs,

but the predominant preoccupation of painters has been with the landscape. Danila VASSILIEFF, a Ukrainian, after much wandering about the world, settled first in Sydney and then in Melbourne to paint the life and society of the inner suburbs, then regarded as slums. For Sali Herman the inner suburbs of Sydney afforded a source of deep inspiration. He saw them not as slums but as possessing an unrecognized human beauty. One by-product of his work was a renewed admiration for Sydney's terrace housing.

In Melbourne the Expressionist circle of painters was supported by John Reed, a discerning patron of original art. The journal *Angry Penguins* (1941–6), jointly edited by Reed and Max Harris, a poet and journalist, became a radical vehicle for the expression of the aesthetics and politics of the circle. It included Albert TUCKER, Arthur Boyd and John PERCEVAL, who were among those who later formed the Antipodean Group in defence of the figurative image against abstraction in 1959. In Melbourne the Social Realist component of the Contemporary Art Society included two talented artists, Noel COUNIHAN and Josl Bergner (1920–), who later settled in Israel.

In the years following the end of the Second World War painting in Sydney acquired a Neo-Romantic elegance. Still predominantly figural, it acquired a taste for early Christian, Byzantine and primitive Italian art. The Sydney Group (established in 1945), a circle around the painter and critic Paul Haefliger (1914–) and his wife Jean Bellette (1919–), developed strong links with Renaissance tradition. Bellette, a sombre and monumental classicist; Donald Friend (1915–), a superb draughtsman, wit and colourist; Francis Lymburner (1915–72), a master of elegant arabesque and a virtuoso of lyrical painting; Cedric Flower (1920–), a gentle satirist; together with David Strachan (1919–70), Michael Kmit (1910–) and Justin O'Brien (1917–) were the leading artists of this genre. For a moment, before they were supplanted by younger and more intense men, Sydney art under their spell became sophisticated and urbane. Associated with the Sydney Group were the painters of the Merioola Group (established in 1947)—often Neo-Medieval—with eclectic interests but a common delight in sumptuous decorative effects. The group included Loudon Sainthill (1918–64), Peter Kaiser (1918–) and the sculptor Arthur Fleischmann (1896–). The medievalizing vogue continued into the 1950s, stimulated by the annual Blake Prize (established in 1951) for a religious painting.

The 1950s, however, witnessed a more general trend towards INFORMAL and expressive abstraction. It was stimulated first by an important exhibition of contemporary French art in 1953, which introduced to Australia the work of MANESSIER, de STAEL, SOULAGES, VIEIRA DA SILVA and Hans HARTUNG. Their work influenced many artists who were at that time completing their training under the post-war reconstruction training

scheme. The second stimulus was provided by three important artists and teachers: John Passmore (1904–), a London-trained follower of Cézanne and master of a lyrical and fluent post-Cubist manner; Godfrey MILLER, trained at the Slade School and an impressive mystic who owed much to Cézanne, Seurat and Oriental philosophy; and Ian FAIRWEATHER, a wandering Scottish solitary, also trained at the Slade, whose evocative and colourful arabesques achieved a personal fusion of Eastern and Western traditions comparable with the work of Mark TOBEY. Under the influence exercised by these men upon the art students of Sydney during the early 1950s dynamic modes of non-figurative and semi-figurative art (often inspired by the local landscape and environment) began to flourish.

The leader of Sydney's Abstract Impressionism, as it came to be called, though more French than American in its sources, was John OLSEN, who organized the influential 'Direction I' exhibition. It included work by Passmore, Olsen, Klippel, Eric Smith (1919–) and William Rose (1930–). The new mode was quickly accepted by local critics. The related movement in sculpture was led by Lyndon Dadswell. A Sculptor's Society founded in 1950 under his patronage encouraged an experimental approach to open-form, non-figurative and JUNK sculpture. Members included Margel Hinder (1906–), who was influenced by GABO; Robert KLIPPEL and Tom Bass (1916–).

The early 1960s were marked by a conflict between figurative and non-figurative painters, precipitated by the Antipodean exhibition and manifesto of 1959. Sydney became the centre of abstract painting; the most talented figurative painters resided in Melbourne. But Melbourne too produced some outstanding abstract artists, notably Roger Kemp (1908–), Donald Laycock (1931–) and the talented sculptor Norma Redpath (1928–), who lived for much of the time in Italy. The most original and impressive sculpture of the decade was in the opinion of many to be found in the mature work of Robert Klippel, who worked in the U.S.A. from 1958 to 1962. Standing somewhat apart from the neo-Byzantine trend which had developed in the 1950s, yet in a sense continuing it, is the work of Leonard FRENCH, semi-abstract and emblematic in imagery and hieratic in colour. In Sydney, John Coburn (1925–), who worked in a more abstract manner than French, owed not a little to Manessier. He also designed tapestry and a fine proscenium curtain for the Sydney Opera House. Elwyn Lynn (1917–), active also as a critic, helped to introduce texture painting to Australia. Notable in this field also was the work of Frank Hodgkinson (1911–), who was greatly influenced by the Spanish texturalists TÀPIES and SAURA.

During the 1960s Australian progressive art became for the first time closely attuned to American trends, a development assisted by artist visitors from the U.S.A. such as Charles Reddington and James Doolin. For the first time, too, a body of Australian artists began to work consistently over a continuous period within a totally non-figurative and non-referential style. Colour painting, as it came to be called, revealed itself in three modes: HARD EDGE, OPTICAL and COLOUR FIELD. It was championed in Sydney by a closely knit group of artists associated with the Central Street Gal., which included Dick Watkins (1937–), Anthony McGillick (1941–), Rollin Schlicht (1937–), Ron Robertston Swann (1941–) and Tony Coleing (1945–)—the last two also worked in sculpture. The pioneer of the Sydney group was Dick Watkins. In Melbourne an early phase of colour painting featuring pure curvilinear brushed colour and suffused edges was encouraged by Janet Dawson (1935–) at the Gallery A workshops (1962–4). But the work of James Doolin, symmetrical, emblematic and Hard Edge, was more influential. Associated with him were Dale Hickey (1937–), Robert Jacks (1943–), Trevor Vickers (1943–) and Mel Ramsden (1944–). The dominance of American influence led some artists to study and settle in New York. Sydney Ball of Adelaide (1933–) completed his training at the Art Students' League under Theodoros STAMOS, and became one of the finest Australian exponents of Hard Edge painting (notably in his *Cantos* series) on his return in 1965. Clement Meadmore, trained in Melbourne as an industrial designer, settled in New York in 1963 and gained a reputation there in MINIMAL metal sculpture.

During the 1960s *avant-garde* art was identified increasingly with American-style abstraction, while Antipodean-style figuration was promoted by the dealers. POP ART made little impact. The three artists Ross Crothall, Colin Lanceley and Michael Brown, who held exhibitions in Sydney and Melbourne in 1962 as the Annandale Imitation Realists, combined an interest in ASSEMBLAGE, Sepik artefacts and child art. Their disarmingly NAÏVE art attacked the art establishment and it brought Brown into the courts on charges of obscenity. He was a moralist with that new-found capacity for disgust which characterized many of his generation. His work foreshadowed the work of such artists as Martin Sharp and Garry Shead, who were associated with the Sydney-based magazine *Oz* (1963). Its editor, Richard Neville, was sentenced to six months hard labour, and spent much time in and out of the courts and the television studios before being acquitted two years later. In 1967 Neville launched a London *Oz* which provoked fresh charges under the United Kingdom Obscene Publications Act. Loosely associated with such protests was the more personal and Expressionist art of Brett Whiteley (1939–), and also the work of Richard Larter and Keith Looby.

In Australia sculpture has not achieved public acclaim, and sculptors have not been aware, as painters have, of the continuing presence of a local tradition. The history of sculpture has been provincial in a way that painting has not, each new

move in the art being wholly dependent upon overseas precedents. Yet notable work has been achieved that still remains little known. The work of George Raynor Hoff (1894–1937) has long been undervalued. Born in the Isle of Man, Hoff studied at the Royal College of Art, London, and relinquished a Prix de Rome scholarship in 1923 to accept an appointment as Head Teacher of Sculpture at the East Sydney Technical College. His monumental sculpture for the Anzac Memorial, Hyde Park, Sydney, is among the masterpieces of ART DECO sculpture that deserve to be better known. His pupil Lyndon Dadswell played a notable role, by his experimental approach to innovation and by his teaching, in combating the prevailing local indifference to sculpture. The Society of Sculptors and Associates was formed in Sydney in 1950, under Dadswell's patronage, in order to encourage an experimental approach to open-form, non-figurative and Junk sculpture, to improve professional standards, and to create a more receptive audience. Its members included Margel Hinder, a talented Constructivist, Robert Klippel, a lyrical exponent of Junk sculpture, and Tom Bass. In Melbourne the work of Vincas Jomantis (1922–) developed from Lithuanian folk-carving conventions; and Norma Redpath, who gained her inspiration from Italy, brought new life to the sculpture of the city during the 1950s. In recent years not only sculpture but also the many related forms of three-dimensional art which have sprung from it, such as HAPPENINGS, ENVIRONMENTAL and CONCEPTUAL ART, have successfully challenged the former priority of painting.

During a century marked by innovation the characteristic achievements of Australian art have been won within the limits of experiments originating abroad. The most original of Australian artists—Dobell, Drysdale, Nolan, Boyd, Miller—have achieved a high order of originality by turning stylistic innovations to their own purposes. This is not, as is often claimed, the result of isolation, for the links with Europe have continued to be strong and connections with the U.S.A. have steadily increased. It is due rather to the continuing effects of distance, which can be mollified by the growing speed of transportation and communication, but cannot altogether be removed.

AUSTRIA. Historicism and Biedermeier persisted longer in Austria than elsewhere and were still dominant at the time of the Vienna World Exhibition in 1898. Impressionism and Symbolism had had but a slight impact and Realism little more. The break towards a more modern outlook came abruptly with the formation of the Vienna SECESSION in 1897. 'The Association of Austrian Artists Secession' was first formed as a club within the Künstlerhaus (*Genossenschaft der bildenden Künstler Wiens*), which since 1861 had been the stronghold of academicism, but the 19 artists of the Secession resigned in the same year when the Künstlerhaus rejected an Impressionist painting by

Engelhart. The founding of the Secession has been called the most important single event in Austrian art history, and although its driving force diminished after the First World War, it remained active, and the reconstructed exhibition house, originally designed by Olbrich, was inaugurated in 1964 with an exhibition 'Vienna in 1900'. The most important painter members at the beginning were Gustav KLIMT (the President) and Koloman MOSER. It had a strong influence upon the development of Egon SCHIELE and KOKOSCHKA. In the opening years the dominant influence was ART NOUVEAU or *Jugendstil* and the first issues of the journal VER SACRUM, founded in 1897, were devoted largely to English Art Nouveau and particularly Charles Rennie Mackintosh. The Secession movement extended to architecture and the applied arts as well as painting and sculpture.

In 1899 another group was formed, also splitting off from the Künstlerhaus, which claimed to take a moderate stand between the extreme conservatism of the Künstlerhaus and the radicalism of the Secession. It went by the name of the HAGENBUND and remained active until the First World War. Like the Secession its aims were to renew artistic taste in Austria by arranging exhibitions of the European *avant-garde*.

Klimt, Schiele and Moser all died in 1918. Kokoschka was settled in Dresden. And although after the end of the First World War there was a strong impetus to foster a new and vital art, there were no artists of like stature to realize this ideal. DADA and the SURREALISM of the 1920s made little impression in Austria. The leading artists in the inter-war period were R. C. ANDERSEN, Anton KOLIG, Franz WIEGELE and Herbert BOECKL, Wilhelm THÖNY who founded a Secession in Graz, Anton FAISTAUER who died in 1930, Albin EGGER-LIENZ who died in 1926, and Albert Paris GÜTERSLOH who as a teacher was influential in guiding some of the artists who came to prominence in the movement of FANTASTIC REALISM after the Second World War.

About 1945 there began in Austria an artistic revival championed by a new generation of painters young enough to break with the old traditions and make a new start after the interruption occasioned by the Second World War. These stimulated two distinct trends, one towards abstraction and the other towards Fantastic Realism. The latter has gained international recognition and has come to be associated with post-war art in Austria. Representatives of the trend towards abstraction were Markus PRACHENSKY, Wolfgang HOLLEGHA, Josef MIKL, Arnulf RAINER and Johann FRUHMANN. Most of the artists who were responsible for making Fantastic Realism a movement of international significance had been pupils of Gütersloh. Chief among them were Erich BRAUER, Ernst FUCHS, Rudolf HAUSNER, Wolfgang HUTTER, Anton LEHMDEN and HUNDERTWASSER, who, however, transcended the style and evolved something of more individual and still more general significance.

Sculpture was very much subordinate to painting in Austria until after the First World War. The pioneer of a new era was Anton HANAK, who modelled himself on Michelangelo and Rodin and was important chiefly through his pupils, WOTRUBA and LEINFELLNER. Wotruba with his reduction of the human figure to solid, block-like structures was the real founder of the new school of abstract sculpture in Austria. Other members of the school whose work has won recognition were Wander BERTONI, Heinz Leinfellner, Otto EDER, Alfred HRDLICKA, Andreas URTEIL. Rudolf HOFLEHNER, who worked largely outside Austria, practised abstract metal sculpture and Josef PILLHOFER, Joannis AVRAMIDIS and Karl PRANTL, all talented sculptors, also stood somewhat outside the group.

From the time of the Secession Austria produced a considerable volume of graphic work, but the only artist who stands out of international importance besides Klimt and Kokoschka is the strange fantasist Alfred KUBIN.

AUTO-DESTRUCTIVE ART. Works of art not made to endure were no new thing in the 20th c. Of this sort were the butter sculptures of Tibet and the sand paintings of some North American Indian tribes. But from the 1950s onwards particular attention has been given to art works which by their construction and conception, by the factor of built-in chance or by their likeness to rehearsed or unrehearsed performances, are occasional and never precisely repeatable. To this class belonged the *Waves* of the German Hans HAACKE and *Hanging Water* of the Japanese Sadamasa Motonaga, both dependent upon patterns produced by random movement in confined bodies of water, the *Cloud Canyons* of the Philippine artist David Medalla, composed of random shapes produced by a foam generator, the 'light paintings' of PICASSO and others, the pyrotechnic displays of B. Aubertin and a kaleidoscopic variety of HAPPENINGS. But the durable construct deliberately fitted with a self-destruct device belongs in a different category from these. Its justification is difficult to find unless it is intended as an expression of fatalism at the impermanence of all things or unless its tactics are to shock and to scandalize. Yet critics treat these works seriously. Frank Popper wrote in *Origins and Development of Kinetic Art* (1968): 'Theory has preceded practice by at least a decade in auto-destructive art. But its place in the evolution of modern art is now assured. As far as the kinetic artist is concerned, there is no doubt that auto-destructive and auto-creative activity have enlarged the scheme of social reference, as well as helping considerably towards the objectivization of the element of movement in art.' This was written apropos of Gustav Metzger, whom he called 'the pioneer of auto-destructive art'. Metzger painted with hydrochloric acid upon nylon cloth. More dramatic was a self-destructive 'machine happening' called *Homage to New York* displayed by TINGUELY at The Mus. of Modern Art, New York, in 1960. Tinguely made a feature of self-destroying pseudo-machines.

AUTOMATISM. Term used for the central principle of the SURREALISTS, namely the suppression of conscious control over composition in order to give free rein to unconscious imagery and associations. The term was also applied to methods which deliberately exploit the element of chance, such as the ink blots of PICABIA and Jean ARP's method of dropping scraps of paper at random on to the floor. Automatism was taken over as an important principle by the New York Surrealists of the early 1940s and it was the feature of Surrealism which was most congenial both to ACTION PAINTING and to ART INFORMEL, which regarded the process of painting as automatic 'psychical improvisation', a means of expressing the artist's inner mental states. The Canadian AUTOMATISTES distinguished three types of automatic composition: 1. Those achieved by mechanical means such as the *frottage* or *grattage* of ERNST, the FUMAGE of PAALEN, the DÉCALCOMANIE of Oscar DOMINGUEZ. 2. Psychological automatism such as the use of dream images or the creation of unreal dream space by DALÍ and TANGUY. 3. 'Surrational' automatism, which was defined as the mode of composition in which one form gives rise to another form by an a-logical and unplanned association until a unity is achieved or until further elaboration destroys the composition. This is what BRETON, with reference to MATTA, called 'absolute automatism'.

With Jackson POLLOCK and others of the Action Painters, as with most of the TACHISTS or 'gestural' painters, the automatic method in principle permeated the whole process of composition, so that the completed picture by reflecting the process of its making revealed the unconscious mental states of the artist. With the Surrealists, however, once an interesting image or form or texture had been achieved by automatic or chance means it was often exploited deliberately with fully conscious purpose.

AUTOMATISTES, LES. A group of seven Montreal abstract painters active during the later 1940s. The oldest of them, mainly responsible for the formation of the group, was Paul-Émile BORDUAS. The others were: Marcel Barbeau (1925–), Roger Fauteaux (1920–), Pierre Gauvreau (1922–), Fernand Leduc (1916–), Jean-Paul Mousseau (1927–), Jean-Paul RIOPELLE. Members of the group were influenced by the SURREALISTS, from whom they took over their techniques of AUTOMATISM. Their first Montreal exhibition, in 1946, was the first exhibition by a group of abstract painters to be held in Canada. The name of the group was coined by the critic Tancrède Marsil in a review of the group show held in 1947. It was taken from the title of a picture by Borduas, *Automatisme 1.47*, exhibited at the show.

AVEDISIAN, EDWARD (1936–). American painter and graphic artist born at Lowell, Mass., and studied at the Boston Mus. School. He taught at the University of Kansas, 1969, and the School of Visual Arts, New York, 1970. His first one-man exhibition was at the Boylston Print Center Gal., Cambridge, Mass., in 1957, after which in addition to individual shows he was represented in a number of important collective exhibitions, including Whitney Mus. of American Art, 'Young America', 1965, and 'Under 40', 1968; The Mus. of Modern Art, New York, 'The Responsive Eye', 1965; 'Expo '67', Montreal, 1967. His work had close affinities with OP ART.

AVERY, MILTON (1893–1965). American painter, born at Altmar, N.Y. He was self-taught as a painter. Through the 1930s and 1940s he perpetuated in America MATISSE's Post-FAUVIST style of figure painting with flat areas of closely keyed but interacting colour enclosed in flowing outlines. Eliminating detail in search of formal simplicity he painted in thin veils of restrained but scintillating colour. Avery was the main and practically the only channel through whom Matisse's sophisticated innovations in the decorative use of colour survived in America until new interest was taken in them by younger artists such as ROTHKO and GOTTLIEB. Among his better-known paintings are: *Mother and Child* (1944) and *Swimmers and Sunbathers* (The Metropolitan Mus. of Art, New York, 1945). He also did EXPRESSIONIST seascapes stark in mood and more impulsive in technique. He had retrospective exhibitions at the Baltimore Mus. of Art in 1952 and at the Whitney Mus. of American Art in 1960.

AVIA, AMALIA. See SPAIN.

AVRAMIDIS, JOANNIS (1922–). Greek-Austrian sculptor born at Batum, Russia, of Greek parents. He studied art at Batum, 1937–9, then in Athens, 1939–43, having fled from Russia with his parents in 1939. In 1943 he was brought to Vienna as a foreign worker and after the defeat of the Nazis he studied painting at the Vienna Academy, 1945–53, and then sculpture under WOTRUBA,

1953–6. He taught at the Academy, 1965–6, and was visiting lecturer at the Academy, Hamburg, 1966–7. His work was exhibited both inside and outside Austria from 1956 and in 1962 he was represented at the Venice Biennale. In 1967 he had a one-man exhibition at the Kestner-Gesellschaft, Hanover. His figures and groups were carefully planned abstractions based upon the archaic style of Greek antiquity. He used aluminium filled with plaster or synthetic resinous marble.

AYASO, MANUEL (1934–). Spanish-American painter and graphic artist, born in Corunna, Spain. He emigrated to the U.S.A. in 1947 and settled in Newark, N.J. His work shows stunted and deformed, yet suggestively familiar human figures emerging dimly from a mysterious background and it has, typically, a nightmare quality of SURREALIST fantasy. He himself said: 'Look at the creased, weather-beaten and starved faces, the hollow pockets and glassy eyes of the peasants and poor people from where I come, and you see why I paint the way I do.' His preferred medium was silverpoint with water-colour washes. His works are represented in the Whitney Mus. of American Art, the Pennsylvania Academy of the Fine Arts, the New Jersey State Mus. and the Butler Institute of American Art. His work is discussed in Barry Schwartz, *The New Humanism* (1974).

AYRES, GILLIAN (1930–). British painter, born at Barnes, London, and studied at the Camberwell School of Art, 1946–50. She was one of the group of abstract COLOUR FIELD painters who came to public notice through the 'Situation' exhibition of 1960. Subsequently, however, she introduced into her work suggestions of decorative floral elements symptomatic of a revived interest in ART NOUVEAU.

AZUMA, KENJIRO (1926–). Japanese painter and sculptor born at Yamagata, studied at the Tokyo Academy of Art and at the Accademia di Brera, and settled in Milan in 1956. He did monochromatic or near-monochromatic paintings and made sculptures in the form of smooth-textured stelae.

B

BAADER, JOHANNES. See DADA.

BAARGELD, JOHANNES THEODOR (?–1927). A wealthy dilettante painter and poet who with Max ERNST and Jean ARP founded the Cologne DADA group in 1919 and was editor of the Communist paper *Ventilator* and the Dada journal *Schammade*. His artistic work, some of which was done in collaboration with Ernst, consisted of COLLAGES and MONTAGES. He abandoned it in 1921.

BABICHEV, ALEKSEI. See INKHUK.

BABOULÈNE, EUGÈNE (1905–). French painter, born at Toulon. He began to paint in 1945, up to which time he had occupied himself mainly with stage design. In 1950 he won the Esso Prize and in 1957 the First Prize at the Biennale of Menton. He was chiefly known for his broadly executed and expressive landscapes of Provence. He taught at the École des Beaux-Arts, Toulon.

BACA-FLOR, CARLOS. See LATIN AMERICA.

BACON, FRANCIS (1909–). British painter, born in Dublin of English parents. He came to London in 1925 and set up for a while as an interior decorator. His first drawings and water-colours were done in 1926–7 and his first oils *c.* 1929. He had no formal training as a painter but obtained some help with the techniques from his friend Roy de MAISTRE. In 1930 he held a joint studio exhibition with Roy de Maistre and in 1933 showed a few paintings in two group exhibitions at the Mayor Gal. In the same year he painted three *Crucifixions*, one of which was illustrated in Herbert Read's *Art Now*. In 1934 he exhibited seven oils and the same number of gouaches at the Transition Gal., which he himself had installed in the basement of Sunderland House. Disappointed by the failure of this exhibition to attract attention, he virtually ceased painting until 1944 although he had three canvases included in the group exhibition 'Young British Painters' at the Agnew Gal. in 1937. In 1944 he painted the well-known triptych *Three Studies for Figures at the Base of a Crucifixion* (now in the Tate Gal.), which was exhibited together with *Figure in a Landscape* in a collective exhibition at the Lefevre Gal. early in 1945 and made him overnight the most controversial painter in post-war England. John Russell has written of this triptych: 'British art has never been quite the same since the day in April . . . when three of the strangest pictures ever put on show in London were slipped without warning into an exhibition at the

Lefevre Gal. Visitors . . . were brought up short by images so unrelievedly awful that the mind shut with a snap at the sight of them . . .' These were rapidly followed by *Figure Study I* and *Figure Study II*, the latter bought by the Contemporary Art Society in 1946 and now in the Bagshaw Art Gal., Batley, and *Painting 1946*, bought in 1948 for The Mus. of Modern Art, New York. In 1946 he took part in an international exhibition of modern art organized by UNESCO and in 1949 he had a one-man show at the Hanover Gal., London, and did the first of his famous Pope paintings.

In 1950 he exhibited at the Knoedler Gal., New York, and the Carnegie International Exhibition, Pittsburgh, and in 1953 he had his first one-man exhibition outside England, at the gallery of Durlacher Brothers, New York. In 1954 he represented England, together with NICHOLSON and FREUD, at the Venice Biennale and in 1955 he had his first retrospective exhibition, at the I.C.A. Gals., London. During the 1950s and 1960s his work continued to be shown in many international exhibitions of importance and his personal exhibitions included retrospectives at the Richard Feigen Gal., Chicago, in 1959, at the University of Nottingham in 1961, at the Tate Gal. (with 91 works) in 1962, a travelling exhibition from the Solomon R. Guggenheim Mus., New York, in 1963–4, a travelling retrospective at the Hamburg Kunstverein in 1965, a retrospective at the Grand Palais, Paris, and the Kunsthalle, Düsseldorf, with 108 works including 11 triptychs, and an exhibition 'Recent Paintings 1968–1974' at The Metropolitan Mus. of Art, New York, in 1975.

Bacon satirized contemporary types with an eye for the timelessly disgusting and highlighted the repulsive in human shape and posture by an entirely individual idiom of representation in ambiguous space-frames. In a statement made in 1964 he said: 'I would like my pictures to look as if a human being had passed between them, like a snail, leaving a trail of the human presence and memory trace of past events as the snail leaves its slime.' There is no doubt that his phenomenal popularity depended in large part upon the strange fascination which the disgustingly repulsive has for art critics as for other men. Bacon concealed a weakness of drawing by breaking up and smudging the face and body of his figures into ill-defined jumbled protuberances suggestive of formless, slug-like creatures of nightmare fantasy. They are presented, typically, against empty space-frames of unreal, dream perspective. In the course of time he came to rely less on the intrinsic repulsiveness and horror of the subject and more on presentation

for the impression he wished to create. John Rothenstein wrote in 1974: 'The undisguised horrific subjects of many of his early paintings, most conspicuous of all in the "Three Figures", have on the whole been replaced by subjects not intrinsically horrific but imbued with his obsession with human cruelty, vulnerability, loneliness and the pitiful indignity of men, and occasionally women, in solitude, unobserved.' Henry Geldzahler concluded his Introduction to the catalogue of The Metropolitan Mus. of Art exhibition of 1975 with the sentence: 'His achievement is to have wrestled with his own inner vision, distorted and tortured as it sometimes appears, and come up with an honest alternative vision—his memorable gift—a personal demonology successfully visualized and made available to an audience hungry for intensity.' Bacon was an individualist belonging to no school or group. In 1976 the artist R. B. KITAJ wrote in his Introduction to the exhibition 'The Human Clay': 'Bacon is arguably the finest painter alive.'

BADII, LIBERO. See LATIN AMERICA.

BADODI, ARNALDO. See CORRENTE.

BAENNINGER, OTTO CHARLES (1897–1973). Swiss sculptor, born and trained in Zürich. In 1920 he studied at the Académie de la Grande Chaumière, Paris, and from 1921 to 1929 he worked with BOURDELLE. In 1929 he married the sculptor Germaine RICHIER. From 1939 he lived in Zürich. In 1941 he obtained a first prize at the Venice Biennale. Among his works is a set of bronze doors for the Minster at Schaffhausen.

BAERTLING, OLLE (1911–81). Swedish painter and sculptor, born at Halmstad. He painted at first in an EXPRESSIONIST manner but c. 1948, influenced by LHOTE and LÉGER, he turned to geometrical abstraction, at first following the NEO-PLASTICISM of MONDRIAN, dominated by rectangles and orthogonals, but later developing his own manner with highly simplified diagonal wedge shapes in hard blacks, reds and yellows. Done in harsh metallic colours, these paintings often made a considerable dynamic impact. In 1952 he was a founder member of GROUPE ESPACE. He began to do sculpture c. 1954 from welded and painted iron. His work was exhibited in Scandinavia, Paris and New York.

BAHUNEK, ANTUN (1912–). Yugoslav naïve painter, born at Varaždinske Toplice in the district of Varaždin. He showed great aptitude for painting at school but, forced by his family to learn a trade, he became a carpenter, painting in his free time. After the war he co-operated with the Culture Association of his village in organizing a painting section and he was able to obtain some instruction in painting technique. Under the influence of the Hlebine school (see NAÏVE ART) he first painted in oil under glass, finding his own style only in the 1960s when he reverted to oil on canvas. His most typical pictures are of buildings and grounds such as the castle in *Varaždin* (1965),

Old Zagreb and *Zagreb Cathedral*. In his mature style he built up his pictures with small blobs of brightly coloured paint representing individual bricks in a wall, leaves of a tree, etc. He has been exhibited widely both in Yugoslavia and abroad and is considered one of the most talented of the Yugoslav naïve artists.

BAIL, JOSEPH (1862–1921). French painter of religious and genre scenes, which he executed in a traditional style of poetic realism. Born at Limonest, he worked in Paris and his paintings had considerable success in their time.

BAIZERMAN, SAUL (1889–1957). Russian-American sculptor born at Vitebsk. After attending the Imperial Art School, Odessa, he went to New York in 1910 and studied at the National Academy of Design and the Beaux-Arts Institute of Design. He had his first one-man shows at the Dorien Leigh Gal., London, in 1924 and the Eighth Street Gal., New York, in 1933. His earliest work consisted of small naturalistic sculptures whose subjects were taken from daily life, as in the series *The City and the People* (1920–5). For these he used mainly the technique of beaten copper. In 1931 a fire in his studio destroyed nearly all his work. Subsequently his work, still mainly in copper, grew more heroic and monumental, consisting of the nude human figure or of anonymous groups which he called 'sculptural symphonies' and to which he often gave musical titles to emphasize the harmonious balance at which he aimed. Although his later work now seems to have a certain mannered elegance, it carried at its best a grandeur and classical quality reminiscent of the sculptural friezes of antiquity. The first showing of these larger copper sculptures was at the Artists' Gal., New York, in 1938. He had retrospectives at the Walker Art Center (circulating) in 1953, the Institute of Contemporary Art, Boston, in 1958 and at the Heckscher Mus., Huntington, N.Y., in 1961. He was awarded a Guggenheim Foundation Fellowship and the Alfred G. B. Steel Memorial Prize at the Pennsylvania Academy of the Fine Arts in 1952. Examples of his work are in the Pennsylvania Academy of the Fine Arts, Philadelphia, the Whitney Mus. of American Art and the Universities of Minnesota and Nebraska. Baizerman has been described as 'The most original of the American pioneer sculptors associated with the traditional wing'. In the 1940s and 1950s he developed a personal technique of beaten copper. Large sheets of copper were hammered out from the back leaving the back open so that they took on something of the quality of relief sculpture. But like ARCHIPENKO he regarded the hollowed spaces as equally important with the projecting planes of the front so that the works became a combination of positive and negative volumes. An example is his *Nike* (Walker Art Center, Minneapolis, 1949–52).

BAJ, ENRICO (1924–). Italian painter and

graphic artist born at Milan and studied at the Accademia di Brera, Milan, while reading for a degree in law. In 1951 he helped to found the *Movimento Nucleare* and in 1953 he founded, together with Asgar JORN, a *Mouvement International pour une Bauhaus Imagiste* at the Hochschule für Gestaltung at Ulm. In 1955 he helped to inaugurate the magazine *Il Gesto*. In the late 1950s he began the series of fantastic and imaginative COLLAGES for which he became chiefly known. These belong to the category of POP ART, manifesting cynical contempt and indifference for the recognized values of art. Showing great virtuosity in the use of a wide diversity of materials, they seemed to mock at and debunk dignity and power. In the 1960s he began constructing sculptures from children's building blocks.

In the development of Italian art Baj, with BERTINI and DANGELO, founded his *Arte Nucleare* movement at a time when expressive abstraction (INFORMALISM) was at its strongest and before the reaction from it had established itself. Catalogues to an exhibition *Omaggio a Baj* in *Alternative Attuali 2*, 1965, and to an exhibition at the Mus. of Contemporary Art, Chicago, 1971, contain fuller details of his life and work.

BAKIĆ, VOJIN (1915–). Yugoslav sculptor born at Bjelova, Croatia, and studied at the Academy of Art, Zagreb. After working in a style evolved from Rodin and MAILLOL he turned in the 1950s to organic abstractions in the manner of BRANCUSI. He became increasingly preoccupied with the quality of surface and in the 1960s made constructions with reflecting surfaces, discs and planes, which belonged to the category of OP ART. His *Reflecting Forms 5* (Gal. Suvremene Umjetnosti, Zagreb, 1964) is a typical example of this phase. His work was exhibited at the Gal. of Modern Art, Belgrade, in 1965.

BAKKER, KENNETH. See SOUTH AFRICA.

BAKST, LÉON (1866–1924). Russian painter and stage designer born at Grodno (although he often claimed to have been born in St. Petersburg). Bakst was his father's original name but his maternal grandfather insisted that his father should take his own family name on marriage, and therefore Bakst was legally born LEV SCHMULE ROSENBERG. He was trained at the Academy of Art, Moscow. He went to Paris in 1893, returning to St. Petersburg in 1900. There, befriended by the artist BENOIS and his family, he became a member of the MIR ISKUSSTVA circle, which was in close contact with DIAGHILEV. In the years that followed Bakst established himself as an illustrator, society portraitist and stage designer. He also opened his own school, which was attended among others by CHAGALL and the dancer Nijinsky. From 1903 he worked for the Imperial Theatres, and in 1908 designed a number of ballet sets for Fokine. His first ballet, *The Heart of a Marchioness*, was a resounding success at the Hermitage Theatre and was transferred to the Mariinsky. He collaborated with Benois in *Le Pavillon d'Armide* and was later commissioned by Telyakovsky to do the *Hippolytus* and *Oedipus*. In his illustrations the greatest influence upon him was that of the 'mad genius' Mikhail VRUBEL.

In 1909 Bakst joined Diaghilev in Paris and played a major role in the impact which the Russian Ballet made upon Europe. The uninhibited splendour of his spectacles revolutionized European stage design with their combination of Oriental magnificence and the gaudy colour of Russian peasant art. Bakst had his first London exhibition at The Fine Art Society in 1912. In the catalogue Huntley Carter spoke of 'his intense feeling for sex combined with an equally intense sense of undulating movement impelling him to create rhythmic form'. After more than half a century The Fine Art Society staged comprehensive Bakst exhibitions in 1973 and 1976. In the interval the influence of his grandiose and sensual design was crucial upon ART DECO.

BALAN, MARIA. See NAÏVE ART.

BALJEU, JOOST (1925–). Dutch experimental artist born at Middelburg, studied at the Institute of Design, Amsterdam. He was a leader of the post-war revival of CONSTRUCTIVISM in the Netherlands and made spatial structures following the theories of Charles BIEDERMAN. His wall structure *Synthesist Construction* (Rijksmus. Kröller-Müller, 1964) illustrates the way in which he developed his constructions in full three-dimensions. He was also founder and editor of the periodical *Structure* (see CONSTRUCTIVISM) and wrote in an editorial: 'The question left unanswered was whether an art using pure plastic means is based on environmental reality or whether its stimulus is to be found in the geometric character of these very means . . . the problem results in two distinct approaches: the one trying to extend the understanding of visible reality through pure plastic means (the heritage of Mondrian), the other developing the pure plastic means via a scientific translation of reality . . .'

BALL, HUGO (1886–1927). German poet, musician and theatrical producer who launched the Cabaret Voltaire, which was the meeting place of the Zürich DADA group.

BALLA, GIACOMO (1871–1958). Italian painter born at Turin, son of a photographer. He began to work as a lithographer in 1883 but moved to Rome in 1893, where he made his living as an artist. He was influenced by Giovanni Segantini (1858–99) and gained some reputation as a painter in the DIVISIONIST style. After spending seven months in Paris in 1900, he returned to Rome and taught BOCCIONI and SEVERINI the Divisionist methods. His painting at this time, exemplified in *Fallimento* (*Bankruptcy, c.* 1902), *Lavoro* (*Labour*,

c. 1902) and *La Giornata dell' operaio* (*The Work-man's Day*, *c*. 1904), was in a style of terse but powerfully evocative realism suggestive of the photographer's eye. *Lavoro* inaugurated a series of night scenes which led up to his transcendental cosmic paintings of the war years. In 1910, at considerable personal sacrifice, Balla associated himself with the FUTURIST movement by signing the manifesto of the Futurist painters together with Severini when Romolo Romani (1885–1916) and Aroldo Bonzagni (1887–1918) abandoned the movement. But he took no part in Futurist activities until 1913 and his picture *Lampe électrique*, listed in the catalogue of the Futurist exhibition at the Gal. Bernheim-Jeune in 1912, was not shown in the exhibition. This picture (The Mus. of Modern Art, New York, 1909) is in line with the philosophy of early Futurism. Inspired by the first electric lighting in the streets of Rome, it shows the lamp as an area of glare outshining the romantic moon, while in an almost ART NOUVEAU technique the irradiation is represented by a spreading arrangement of sharply defined arrowheads of brilliance against the surrounding gloom. His later picture *Guinzaglio in moto* (now named *Dynamism of a Dog on a Leash*, Albright-Knox Art Gal., Buffalo, 1912) conveys the impression of motion past a stationary spectator by blurred outlines, multiple legs and the repeated curves of the leash. A similar though more complex method of representing movement is used in *Ritmi dell' archeto* (*Rhythms of the Bow*), also painted in 1912. These pictures were painted during a stay in Düsseldorf, where during 1912 and 1913 he worked towards the abstract representation of velocity, using as his themes swallows in flight and the speeding automobile. The former theme is used in *Volo di rondini* (*Flight of Swifts*) and *Linee andamentali + successioni dinamiche* (*Paths of Movement + Dynamic Sequences*, The Mus. of Modern Art, New York). Increasing abstraction in the representation of speed with involvement of the spectator in the movement of the picture is seen in the four paintings *Penetrazione dinamiche d' automobile* (*Dynamic Penetration of an Automobile*), *Auto in corsa* (*Speeding Automobile*, Civica Gal. d'Arte Moderna, Milan), *Velocità astratta* (*Abstract Velocity*) and *Plasticità di luci* × velocità (*Plasticity of Light* × *Speed*). The *Spessori d'atmosfera* (*Densities of the Atmosphere*) from the same period was completely abstract. At the same time Balla was working on a series of studies in colour and light which he called *Compenetrazione iridescenti* (*Iridescent Interpenetrations*) and which conveyed the impression of movement by means of abstract arrangements of colour, thus anticipating one of the preoccupations of later OP ART. Balla in his pictures of this period advanced further than any other Futurist artist in the direction of non-figurative abstraction.

Balla was also interested in stage design and in 1914 composed a manifesto *Il Vestito antineutrale* (*Anti-neutral Clothing*) in which he advocated brightly coloured, simply tailored and easily renewable clothing. In the same year he responded to MARINETTI's appeal for artists to promote militant patriotism by a set of semi-abstract cosmic paintings depicting a partial eclipse of the sun by the planet Mercury and in 1915 by the completely abstract *Bandiera sull'altare della patria* (*Flag on the Altar of the Fatherland*). He had for some while been experimenting with sculptural constructs made from a variety of materials some of which involved movement, colour and sound. Some of these constructs, none of which survives, were illustrated in the *Manifesto for a Futurist Reconstruction of the Universe*, which he wrote in collaboration with DEPERO in 1915. Also in collaboration with Depero he invented a 'mechanical theatre' and experimented in 'sound poems' entirely in onomatopoeia. He was acknowledged as the leader of the reconstructed movement of Futurism which Marinetti brought into being in 1916, but his painting lost its earlier vigour and tended towards decorative mannerism, reverting to figural representation.

BALLESTER, JORGE. See EQUIPO REALIDAD.

BALTHUS (BALTHASAR KLOSSOWSKI DE ROLA, 1908–). French painter, born in Paris, son of the Polish painter and author E. Klossowski. He had no formal training but had the reputation of being an infant prodigy and was encouraged by BONNARD and DERAIN, who were family friends, while the poet Rainer-Maria Rilke also interested himself in his early productions. He passed his childhood in Switzerland and afterwards lived in seclusion outside Paris, shunning all publicity. In 1961 he was appointed director of the Villa Medici. His works up to the Second World War were street scenes and interiors in a style of poetic Naturalism akin to that favoured by the group FORCES NOUVELLES. His purpose was to endow the banalities of everyday life with monumental dignity. His later works consisted of interiors depicting adolescent girls absorbed in romantic dreams. Critics have differed about these. Some have regarded them as masterly expressions of Romanticism; it has also been said that 'no other painter has so shockingly depicted the stresses of adolescence'. He also did décors for *La Peste* and *L'État de siège* by Albert Camus. He exhibited in 1946 at the Gal. des Beaux-Arts and in 1966 the Mus. des Arts Décoratifs arranged a retrospective exhibition of his works, as did the Tate Gal., London, in 1968.

BANDAU, JOACHIM (1936–). German sculptor, born in Cologne. From 1957 to 1960 he was at the Academy of Art in Düsseldorf but he had no formal training in sculpture. He was one of the founders of the group K—66 and in 1970 he won a prize for sculpture from the city of Cologne. From 1966 he had one-man exhibitions in Cologne, Düsseldorf, Hamburg, Heidelberg and other German

towns. His best-known works were made by sawing up dressmaker's dummies and assembling the parts into new shapes. He also worked in polyester.

BANNARD, WALTER DARBY (1931–). American painter born at New Haven, Conn., studied at Princeton University. He was awarded a Guggenheim Foundation Fellowship in 1968. From the mid 1960s his work became known and exhibited with that of the more experimental artists. He was included in the exhibition '8 Young Artists' at the Hudson River Mus. in 1964, and by his cool, unemotional approach to abstraction and his exploitation of simplified and reduced forms he brought himself within the ambit of MINIMAL ART. Speaking of Minimal Art he said (*Artforum*, December, 1966) that 'the *meaning* of Minimal work exists outside the work itself. It is a part of the nature of these works to act as *triggers* for thought and emotion preexisting in the viewer . . .' His own work had a lyrical quality which increased as time went on and which removed it from the more extreme geometrical category of 'primary structures'.

BARANOFF-ROSSINÉ, VLADIMIR (1888–1942). Russian painter and sculptor born at Kherson. He studied painting at St. Petersburg and then spent the years 1910 to 1916 in Paris, where he passed from POST-IMPRESSIONISM to CUBISM. After the Revolution he was made Professor at the Moscow Academy, where he produced abstract paintings and constructions. An example of his work is *Symphony No. 1* (The Mus. of Modern Art, New York, 1913) made of polychrome wood, crushed eggshells and cardboard. This was shown at the exhibition 'Pioneers of Modern Sculpture' held at the Hayward Gal., London, in 1973. Baranoff-Rossiné was known for his 'polytechnic' sculptures or constructs, which he made from manufactured bits and pieces such as old gutter pipes, bedsprings, etc. He also constructed a 'colour piano' on which he gave 'visual' concerts. He left Russia and settled in Paris in 1930.

BARGHEER, EDUARD (1901–79). German painter born at Hamburg-Finkenwerder. He visited Florence 1925–6 and was in Paris 1926–7 and 1931–2. In 1938 he went to live on the island of Ischia. He was self-taught as a painter and at first did landscapes in a harshly EXPRESSIONIST manner. But in the late 1940s, under the influence of both ORPHISM and Paul KLEE, his colours became lighter and more luminous and he gave form to his compositions by a series of horizontal and vertical columns, calling them 'optical fugues'.

BARJOLA, JUAN. See SPAIN.

BARLACH, ERNST (1870–1938). German sculptor born at Wedel, Holstein, and studied at Hamburg and Dresden. In 1895 he studied at the Académie Julian, Paris, and then worked in Berlin from 1898 to 1901. Until he reached his thirties Barlach was equally attracted towards sculpture and ceramics. He found his personal style during a visit to southern Russia in 1906, when the sturdy peasant type led him to an interest in medieval German carving, with which he recognized both a spiritual and a technical affinity. In 1910 he settled at Güstrow and passed the rest of his life there. Barlach exemplified the sense of man's alienation which was typical of German EXPRESSIONISM, believing that, through the creation of visible artistic forms from the 'unknown darkness' within, man can rediscover himself and his lost God. Unlike the attenuated linear shapes of LEHMBRUCK, his figures express a wide range of emotions through solid, block-like forms. Though trained as a modeller and although he practised ceramics for many years, Barlach's sculpture has the condition of carving. He revived the tradition of medieval German wood-carving, and even when they are modelled and cast in bronze his figures have the broad planes and sharp edges typical of wood-carving. He executed a number of war memorials under the Weimar Republic, including one at the cathedral of Güstrow which was destroyed when his art was condemned as DEGENERATE in 1938 by the National Socialist regime but was subsequently restored and a replica made for the Antoniterkirche in Cologne. Barlach stands out as one of the leading figures representative of German Expressionism in his power to depict symbolically a wide range of emotions. After his death his studio at Güstrow was made a permanent museum and the collection of his works made by his patron, Hermann Reemtsma, was left in trust to the Barlach-Haus, Hamburg.

Barlach also wrote Expressionist plays (*Der tote Tag*, 1912; *Der Findling*, 1922), which he illustrated with woodcuts and lithographs.

BARLOW, PHYLLIDA (1944–). British painter born at Newcastle upon Tyne, studied at Chelsea School of Art, 1960–3, and at the Slade School of Art, 1963–6. From 1967 she taught at the Chelsea School of Art. She exhibited with the LONDON GROUP in 1965 and 1975 and in the 'Young Contemporaries' exhibition of 1965, the A.I.A. Gal. 'Print Exhibition' in 1966, at the Newcastle Calouste Gulbenkian Gal. in 1973 and in the 'British Sculpture—Attitudes to Drawing' exhibition of 1974–5. Her style combines geometrical abstraction with representational suggestions of rooms, courtyards, etc.

BARNETT, WILL. See MURRAY, Robert.

BARRAGÁN, JULIO (1928–). Argentine painter born in Buenos Aires, where he studied at the National School of Ceramics. He painted landscapes and city scenes reduced to virtually abstract patches of colour which expressed the emotional quality of the subject. He also did geometrical abstracts based in part on pre-Columbian decorative

patterns. His first one-man show was in 1948 at the Sociedad Argentina de Artistas Plásticos and this was followed by numerous shows in South America, Cuba, the U.S.A., etc. He was represented in a number of group exhibitions of Argentine painting, including '150 Years of Argentine Art' organized by the National Mus. of Fine Arts in Buenos Aires to commemorate the 150th anniversary of Argentine Independence, 'Argentine Painting' held in Rome in 1963 and 'Art in the Argentine' at the Wildenstein Gal., London.

BARRAGÁN, LEOPOLDO PRESAS. See LATIN AMERICA.

BARRAUD, FRANÇOIS ÉMILE (1899–1934). Swiss painter born at La Chaux-de-Fonds and worked mainly in Geneva. He was not related to the better-known Maurice BARRAUD. Sentimental in character, his painting during the 1920s was executed in minutely realistic detail approaching the *trompe l'œil*. His works are represented in the Werner Coninx coll. at Zürich.

BARRAUD, MAURICE (1889–1954). Swiss painter born in Geneva. After working on commercial posters he was trained as a painter by the Geneva artist Pierre Pignolat (1838–1913). From *c*. 1914 he spent much time in Paris, Brittany and the south of France. Between 1918 and 1931 he visited Spain, Algiers, Italy and Belgium. From *c*. 1938 he lived partly in Cassis-sur-Mer, partly in Geneva and the Tessin. He worked largely in pastel shades and was influenced by the Impressionists, particularly Renoir, and by MATISSE. Among his murals were ones for the railway station at Lucerne, a room in the Geneva Mus. d'Art et d'Histoire and a room in the Palais de la Société des Nations. His *Nu au Jardin* and *Le Colisée* are in the Mus. National d'Art Moderne, Paris.

BARRÉ, MARTIN (1924–). French painter born at Nantes, studied at the École des Beaux-Arts there. He went to Paris in 1943 and turned to abstract art in 1950. His first one-man exhibition was at the Gal. La Roue in 1955 and he exhibited also at the SALON DES RÉALITÉS NOUVELLES. His paintings were usually monochromatic forms, vertically ascending on a light monochrome ground.

BARRY, ROBERT. See CONCEPTUAL ART.

BARTA, LAZLO (1902–). Hungarian-French painter born at Nagykoros, Hungary, and trained at the Budapest Academy of Fine Arts. He settled in France in 1926 and devoted himself principally to book illustration. In 1948 he turned to abstract art in the TACHIST manner. He also learned the craft of mosaic at Ravenna and from 1945 executed remarkable abstract mosaics.

BARTH, PAUL BASILIUS (1881–1955). Swiss painter born at Basle. He studied at the School of Arts and Crafts there under the Austrian-born painter Fritz Schider (1846–1907) and then from 1902 to 1904 at Munich under Peter Halm and Heinrich Knirr. He was in Paris from 1906 to 1914, when he settled in Basle. He is particularly noteworthy for the sensitivity of his painting in subdued colours and for the insight into character reflected by his portrait studies.

BARTHOLOMÉ, PAUL ALBERT (1848–1928). French sculptor, born at Thiverval. His work was academic in style. He specialized in funerary monuments and he is chiefly known for his *Monument aux Morts* at the Père Lachaise cemetery.

BASALDELLA, AFRO. See AFRO.

BASALDELLA, MIRKO. See MIRKO.

BASALDUA, HECTOR. See XUL SOLAR.

BASCHANG, HANS (1937–). German painter and draughtsman born and studied at Karlsruhe. In 1962 he spent six months in Paris on a grant, in 1965 he held a prize from the city of Karlsruhe, in 1966 he won the Villa Romana prize, in 1968 a prize from the city of Bremen and in 1969 a grant for the Villa Massimo, Rome. He had one-man exhibitions at Bremen, Tübingen, Freiburg and other towns in Germany. His works were abstract and geometrical but developed an intrinsic anatomy vaguely suggestive of machine figures. Like those of Horst ANTES they have been described as a modern version of German EXPRESSIONISM.

BASCHLAKOW, ALEXEI ILJITSCH (1936–). Russian-German painter. Born in Slaboda, U.S.S.R., he became a German national in consequence of population adjustments after the Second World War. In 1957 he obtained a Henry Ford scholarship and in 1958–9 he attended the Werkkunstschule at Hanover. In 1962 he visited Florence. He won the Lower Saxony prize for painting in 1966 and in 1967 the Villa Massimo prize for Rome. He had one-man shows in Hanover and Berlin and participated in group shows both in Germany and abroad. Starting from a CONSTRUCTIVIST approach he organized HARD EDGE geometrical and tubular shapes into decorative compositions which emphasized the projection of forms into three-dimensional picture space and the simulation of movement in a rhythmical interplay between the observer and the picture plane. He painted in rich and sonorous colours.

BASKIN, LEONARD (1922–). American sculptor and graphic artist born in New Brunswick, studied at Yale University, the New School for Social Research, New York, the Académie de la Grande Chaumière, Paris, and the Academy of Fine Arts, Florence. He taught graphic art at the Worcester Art Mus., Mass. and was Professor of Art at Smith College, Northampton. In 1952 he founded

the Gehenna Press. In his art production Baskin was dominated by the themes of death and spiritual decay. He concentrated on the human figure, declaring that 'the human figure is the image of all men and of one man. It contains all and can express all.' There was an Existentialist spirit in his sculptures such as *Minotaure* and *Icarus* and in his graphics such as *Hydrogen Man* and *Tormented Man*, in which he created analogues of human vulnerability and the victimized abasement of 20th-c. man, images of 'injured and brutalized man, alone, naked, and defenceless', exploding the delusions of optimism and progress. 'My hero', he declared, 'stands stoopingly upright, pot-bellied and tight-assed, top-heavy on his thin legs. He is spent and bewildered, frail and human.' In his woodcuts he developed a distinctive linear style giving his figures a superficial likeness to anatomical charts, displaying nerves, muscles and tendons. A retrospective exhibition of his work was held at Bowdoin College Mus. of Art in 1962.

BASKINE, MAURICE (1902–). Russian-French painter, born at Kharkov. He was a hermeticist and the inventor of a system which he called 'Fantosophy'. Falling in with the interest of the SURREALISTS in hermeticism after André BRETON's second *Manifeste du Surréalisme* of 1930, he was a member of the Surrealist group from 1946 to 1951. He did strange, symbolic pictures which supposedly had an arcane significance. He also did engravings for Breton's *Arcane 17*.

BASTERRECHEA, NÉSTOR. See SPAIN.

BATEAU-LAVOIR (WASHERWOMEN'S BOAT). Name given by the poet Max Jacob to a cluster of tumbledown studios in the rue Ravignan, Montmartre, Paris, where c. 1904 van DONGEN, then PICASSO, and later Juan GRIS, Pablo GARGALLO and others lived and worked. André Salmon, Max Jacob, Pierre Reverdy and other leading literary figures of the day also lived there. Largely under the influence of Picasso's personality the place became an artistic and literary centre and it is usually regarded as the birthplace of CUBISM. Since the First World War the *Bateau-Lavoir* has been abandoned by its painters.

BATLLE-PLANAS, JUAN (1911–66). Argentine painter born at Torroella de Mongri, Catalonia, Spain. Taken to Buenos Aires as an infant, he studied engraving in the 1930s and was exposed to painting at an early age through his painter uncle Planas-Casas. Batlle-Planas began painting in 1932 in a Neo-Romantic style sometimes referred to as 'Superrealism' in Argentina because of its affinities with the Italian METAPHYSICAL school. According to the essayist and critic Aldo Pellegrini (who introduced SURREALISM into Argentina in 1928 with the first publication of the literary review *Que*), Batlle-Planas's painting was more related to the mystical teachings of the Paris-based Russian exile Gurdjieff than to the more orthodox Freudian form. He is, however, considered the father of Surrealist painting in Argentina. He exhibited the 'Radiografias Paranoicas' series of temperas for the first time in 1937 and began his 'Tibetan' series with images of legendary and fictitious worlds in the late 1930s. Some of these represented phantasmagoric personages in a submerged atmosphere or endless desolate landscapes sometimes likened to those of TANGUY. Batlle-Planas exhibited his COLLAGES in 1939 and in 1944 showed oils and temperas in the Gal. Müller in Buenos Aires. In *The Message* (1941) anonymous faceless figures move about a metaphysical space that combines geometric shapes with atmospheric effects. His interest in psychology and mechanics led him to investigate and give courses at the Institute of Form Research in Buenos Aires on human psychological reflexes and reactions to certain forms. He later became director of the Institute. He is said to have invented a system of psychological therapy based on an 'energetic automatism' which functioned as a catalyst for the collective unconscious and which Pellegrini said was mixed with *Gestalt* psychology. The use of letters and numbers within a metaphysical landscape has continued to be a favourite subject among younger Argentine artists. Batlle-Planas showed in New York at the Gal. Foussats in 1965 and exhibited widely all over Argentina. In 1961 he was awarded the Palanza prize at the National Academy of Fine Arts in Buenos Aires and was posthumously included in the 2nd exhibition of the Lorenzutti Foundation in 1969. In 1970 a retrospective of his work, 'Realistic Mechanisms', was staged at the Fundación Banco Mercantil Argentino in Buenos Aires. Batlle-Planas was also a muralist, poet and stage designer. He contributed 72 murals to public and private buildings and published numerous articles on his theories about the psychological response to form and colour.

BATTISS, WALTER WHALL (1906–82). South African painter born in Somerset East, Cape Province. He grew up in the Transvaal and was trained at the Witwatersrand Technical College Art School and the Johannesburg Teachers' Training College. Later he took a degree in Fine Arts at the University of South Africa. From 1936 he taught for many years at the High School for Boys in Pretoria and in 1953 became Principal of the Pretoria Art Centre, which had a brief but brilliant career under his control. In 1958 he returned to the High School. In 1965 he was appointed to the Chair of Fine Art and Art History at the University of South Africa, Pretoria, which he held until his retirement in 1972.

In his early years his interest in the rock art of South Africa (the so-called 'Bushman' paintings) led him to develop a vivid calligraphic style often including numbers of small figures in action and signs and marks bearing a strong affinity to those of the old rock artists. He was nevertheless a skil-

led and versatile craftsman who did not confine himself to these perhaps nostalgic images, though he frequently returned to them. Generally he was characterized by a fresh and vigorous, though always controlled, use of brilliant paint and produced paintings with a flickering reference to ABSTRACT EXPRESSIONISM, though usually on a small scale. His work, in spite of the influence of primitive symbolism and naturalism, was very personal, defying classification. Its unflagging vitality carried more than an individual meaning and could be read as a quality stemming from the inexhaustible energies of Africa.

Walter Battiss may in some respects be regarded as the doyen of art in South Africa. He figured continuously as an Art Examiner for the important art schools, and as a selector and judge for innumerable group shows and competitions of national significance. His opinion was invariably the first to be sought on controversial matters of all kinds and where artistic propriety was involved he was regarded as an authoritative adviser, never without a sense of humour.

He was an inveterate traveller, particularly in the eastern Mediterranean, and frequently represented South Africa in exhibitions abroad, notably the Venice and São Paolo Biennales. He also showed work in London.

BATTMANN, ALFRED OTTO WOLFGANG SCHULZE. See WOLS.

BAUCHANT, ANDRÉ (1873–1958). French NAÏVE painter born at Châteaurenault, Loire. He carried on his father's business of market gardening, painting as a hobby until 1918, when he gave up the business and devoted himself full time to painting. In 1921 he exhibited 9 canvases at the Salon d'Automne. He was patronized by LE COR-BUSIER, OZENFANT and LIPCHITZ and in 1928 he was commissioned by DIAGHILEV to design the décor for *Apollon Musagète*, the music for which was written by Stravinsky. Thus he won recognition as one of the more important of the French naïve painters, continuing to exhibit at the Salon d'Automne and elsewhere. In 1949 the Gal. Charpentier gave him a retrospective exhibition of 215 paintings, and he was included in all subsequent international exhibitions of naïve art, such as Recklinghausen, 1971; Amsterdam, 1974; Zürich, 1975. He worked in the meticulously realistic manner which is characteristic of most naïve artists, devoting himself for preference to historical themes for which he found inspiration in old illustrated books. After 1929 he also painted landscapes, flower pieces and biblical scenes.

BAUER, RUDOLF (1889–1954). Polish-American painter born at Lindenwald, Poland, studied in Berlin. He began as a caricaturist, later turning to abstraction. He was a member of the STURM group in Berlin and in 1929 he founded a private museum for abstract art called Das Geistreich. His work was introduced to America by the SOCIÉTÉ ANONYME and in 1939 he emigrated there.

BAUHAUS. A school of architecture and the applied arts which became the main centre of modern design in Germany during the 1920s and played a key role in establishing a relationship between design and industry. Through the emigration of its staff and students Bauhaus ideas were widely disseminated in many countries and became established almost as a symbol of modernity in the 1930s and 1940s. It was founded at Weimar in 1919 by GROPIUS, moved to Dessau in 1925 and was dissolved in 1933 by the National Socialist regime. Among the artists who taught at the Bauhaus were Johannes ITTEN, Lyonel FEININGER, Oskar SCHLEMMER, Paul KLEE, Wassily KANDINSKY, László MOHOLY-NAGY, Josef ALBERS, Herbert BAYER.

Longer articles on the Bauhaus will be found in *The Oxford Companion to Art* and *The Oxford Companion to the Decorative Arts.* See also GROPIUS, Walter.

BAUMEISTER, WILLI (1889–1955). German painter born at Stuttgart, studied at the Stuttgart Academy under Adolf HOELZEL. He stood outside the ambit of German EXPRESSIONISM and is regarded as the most 'European' in spirit of all contemporary German artists. During his student days he was a close friend of Oskar SCHLEMMER and other artists in the circle formed by the Swiss artist, Otto Meyer-Amden (1885–1933), who was also a pupil of Hoelzel. He visited Paris in 1912 and again in 1914 with Schlemmer, where he became interested both in the Neo-Impressionists and in CUBISM. Using simplified Cubist forms, mainly horizontals and verticals, he aimed during this period at achieving a synthesis of painting and architecture. His own style matured c. 1920, after he had served in the war, and found its first expression in a series of Wall Paintings (*Mauerbilder*), so called because he added sand, putty, etc. to his pigments to give a texture suggesting a wall. He also did sculpturesque Wall Paintings with geometrically simplified objects in a manner akin to that of the French PURISTS, and in 1924 he met OZENFANT, LÉGER and LE CORBUSIER. From 1928 to 1933 he taught at the Frankfurt Art School. During this period he painted a series which he called Palette Paintings, in which the lines became more flexible and the structure looser, and developed the 'sporting theme' in which representational elements were introduced with an emblematic function, occurring as if accidentally in the composition. In 1933 he was dismissed from his teaching post and forbidden to exhibit. During the rest of the 1930s and until the end of the Second World War he pursued his investigations into colour and his archaeological studies, painting clandestinely. From this period come his *Eidos* pictures, using organic, amoeba-like forms suggestive of primordial life, and his *African* and *Peruvian* paintings, evocative of

prehistoric memories by a sort of fragmentary ideographic script. He also experimented in low-relief and 'perforated' painted constructions. After the war he was reinstated and from 1946 taught at the Stuttgart Academy. In 1953 he began a series of pictures with extensive use of black, which he called *Montaru*, followed by a series—called by him *Monturi*—in which the black was replaced by white.

Baumeister's method during the 1930s of using pure pictorial signs from the deep unconscious had analogies in PICASSO, KLEE and others and was described by him in a book *Das Unbekannte in der Kunst* (*The Unknown in Art*), written in 1943 and published in 1947. He created in Germany an abstract art with SURREALISTIC overtones that has been likened to that of MIRÓ and MASSON.

BAWDEN, EDWARD (1903–). British painter and draughtsman born at Braintree, Essex. After studying at the Cambridge School of Art, 1919–21, he won an exhibition to the Royal College of Art in 1922 and a Travelling Scholarship in 1925. His first large commission was for decorations at Morley College, London, in 1928 (destroyed in 1941) and from 1928 to 1931 he taught book illustration and design at Goldsmiths' College and the Royal College of Art. He was appointed an official War Artist in 1940 and was awarded the O.B.E. in 1946. He was elected A.R.A. in 1947 and R.A. in 1956. He was Guest Instructor at Banff School of Fine Art, Alberta, Canada, 1949–50. In 1951 he was appointed Trustee of the Tate Gal. and in the same year did a large mural for the Lion and Unicorn Pavilion at the Festival of Britain. During the 1950s and 1960s he was occupied by a number of commissions for murals, including Morley College, The Morgan Crucible Co. (1958), Hull University (1963), Pilkington Bros. (1965), Queen's University, Belfast (1965), British Petroleum, Britannic House (1966), British Pavilion at 'Expo '66', Montreal. He had one-man exhibitions at the Zwemmer Gal. (1934, 1963), the Leicester Gals. (1938, 1952), The Fine Art Society (1973, 1975) and a touring retrospective exhibition from The Minories, Colchester in 1973. In 1963 he was appointed Honorary Fellow of the Royal College of Art, and in 1968 he was part-time teacher at the Royal Academy Schools and Senior Lecturer at Leicester College of Art and Design. In 1974 he was awarded an Honorary Doctorate from the University of Essex.

As a painter Bawden worked primarily in water-colour. He was probably more successful as an illustrator than a painter. Among the books for which he did illustrations are: *Oxford Illustrated Old Testament*; *Herodotus* and *Salammbô* for Limited Editions Club of New York; *Gulliver's Travels to Lilliput, etc.* for the Folio Society. Among the public collections in which his works are represented are: Tate Gal.; Victoria and Albert Mus.; Arts Council of Great Britain; Imperial War Mus.; British Council; Art Gal., Montreal; Art Gal.,

Toronto; National Gal. of South Australia; The Queen's University, Belfast.

BAYER, HERBERT (1900–). Austrian-American painter and graphic artist born at Haag. After studying architecture in Linz, 1919, and painting under KANDINSKY at the BAUHAUS, Weimar, he taught typography in the Bauhaus, Dessau, 1925–8. From then until 1937 he ran an advertising business in Berlin and did exhibition planning and typography while continuing to paint. After his first one-man exhibition, at the Gal. Povolotzki, Paris, in 1929, he took up PHOTOMONTAGE of a SURREALIST kind. Outside painting he was chiefly known for his book jackets, magazine covers and poster designs. He emigrated to New York in 1938 and worked as a typographer, architect and commercial designer. His first one-man exhibition in the U.S.A. was at Black Mountain College in 1939. He was represented in exhibitions at The Mus. of Modern Art, New York: 'Fantastic Art, Dada, Surrealism', 1936; 'Bauhaus: 1919–28', 1938; 'Art and Advertising Art', 1943; and in other important collective exhibitions in the U.S.A. and abroad. He had a retrospective exhibition 'The Way of Art' circulating from Brown University, 1947–9, and one at the Germanisches Nationalmus., Nuremberg, which circulated in Germany and Austria, 1956–7.

BAYES, GILBERT (1872–1953). British sculptor born in London, studied at the City and Guilds Institute and the Royal Academy Schools. He first came into prominence as a designer of medals and was commissioned to design the Great Seal of King George V. He mainly did romantic sculpture on themes taken from medieval chivalry, Wagner and the classics. Examples of his work are: *The Fountain of the Valkyries* (Auckland, New Zealand) in bronze, marble and mosaic; *Great Pan* (Greenwich, U.S.A.), a life-size stone garden figure; *The Frog Princess* (Santa Barbara, Calif.), a fountain figure in bronze on a coloured salt-glaze base set in a large, circular basin; *Sigurd* (Tate Gal.), an equestrian group employing bronze, coloured marble and enamel. He designed a low relief panel in cement for the Concrete Utilities Building at the Wembley Exhibition and a low relief frieze in artificial stone for the Saville Theatre, London.

Bayes won an honourable mention at the Paris Universal Exhibition of 1900. He remained, however, outside the *avant-garde* movements of 20th-c. art although his work was much appreciated by conservative critics. In his book *Modern Sculpture* (1933) Herbert Maryon described his *Sigurd*, judged as a 'decorative composition', as 'unsurpassed by any other equestrian group in existence'.

BAYES, WALTER (1869–1956). British painter born in London, studied at the City and Guilds Institute, 1886–1900, and briefly at the Westminster Art School under Frederick BROWN. He taught

at the City and Guilds Institute and at the Camberwell School of Arts and Crafts and he was Principal of the Westminster Art School, 1919–34. Succeeding Roger FRY, he was art critic on *The Athenaeum*, 1906–16. He was a member of SICKERT's circle at 19 Fitzroy Street and was a member of the CAMDEN TOWN GROUP and of the LONDON GROUP. His one-man exhibitions included ones at the Leicester Gals. in 1918 and 1951. He wrote: *The Art of Decorative Painting* (1927), *Turner, A Speculative Portrait* (1931) and *Painter's Baggage* (1932). The first of these he described as 'an attempt to rehabilitate eclecticism, not the old eclecticism which contemplated the combination in a single work of art of every kind of virtue, but a new eclecticism which shall accept the fact that there is hardly any quality in painting which *may* not under certain circumstances be a merit, hardly any which may not *sometimes* be a vice'. Walter Bayes was greatly appreciated as a teacher and his work had quality which has been seldom recognized.

BAZAINE, JEAN (1904–75). French painter born in Paris. He worked at sculpture from childhood and studied it at the École des Beaux-Arts, but in 1924 abandoned it for painting and worked at the Académie Julian. He exhibited at the Salon d' Automne from 1931 and had his first one-man exhibition in 1932, when he was encouraged by BONNARD and became a friend of GROMAIRE. He won the Prix Blumenthal in 1938 and in 1941 helped to organize the exhibition 'Jeunes Peintres de la Tradition Française', which marked the recovery of the French *avant-garde*. He was interested in religious art and designed stained glass windows for the church at Assy (1944–6), a ceramic mural for the church of Audincourt (1948–51) and a mosaic for the UNESCO building in Paris (1958). Exhibitions in Paris between 1948 and 1954 brought him international reputation, he was made a member of the jury at the Carnegie International in 1952 and was included in important international exhibitions such as 'The New Decade' (The Mus. of Modern Art, New York, 1955). He had a retrospective exhibition at the Kunsthalle, Berne, in 1958. During his earlier period his painting was in the mode of expressive Naturalism. After the Second World War he was one of the leaders of the TACHIST school of expressive abstraction. His paintings continued, however, to be based upon the expressive characteristics of natural appearances and although after 1945 the subject of a painting was not discernible, he denied that his work was abstract. His principle, in his own words, was that 'an essential quality of the object devours the complete object'. In 1953 he published *Notes sur la peinture d'aujourd'hui*, an excellent exposition of the principles of expressive abstraction as practised in the ÉCOLE DE PARIS.

BAZILE, CASTERA. See LATIN AMERICA.

BAZIOTES, WILLIAM (1912–63). American painter, born at Pittsburgh. In 1933 he went to New York and studied at the National Academy of Design. During the following years, from 1936 to 1941, he worked for the FEDERAL ARTS PROJECT/ WPA. During the war he became friends with the New York group of ABSTRACT EXPRESSIONISTS and in 1948 he founded with MOTHERWELL, NEWMAN and ROTHKO the art school 'The Subject of the Artist', from which grew a meeting centre of avant-garde artists known as The Club. Baziotes first came to public notice when his work was shown in 1944 at the Art of this Century Gal. of Peggy Guggenheim. From that time he had a number of one-man exhibitions at the Kootz Gal., New York, and in 1965 he was included in the exhibition of the NEW YORK SCHOOL staged by the Los Angeles County Mus. Also in 1965 a Memorial Exhibition was staged at the Solomon R. Guggenheim Mus., New York. From 1949 to 1952 he taught at Brooklyn Mus. Art School and from 1952 at Hunter College, New York.

Although he was classified as an Abstract Expressionist his work was not fully abstract. He often used strange biomorphic shapes akin to those of MIRÓ or shapes suggestive of imaginary monsters such as may be seen in the work of Karel APPEL. These he sometimes flattened into decorative patterns. Some critics have compared his haunting SURREALIST forms to those of KLEE. In common with the Surrealists he regarded inspiration as a form of psychic AUTOMATISM and painting as self-revelation. He said of his paintings: 'They are my mirrors. They tell me what I am like at the moment.' He claimed that he did not paint from memory or experience but that the act of painting was itself the experience embodied in the work and that its subject manifested itself only as the picture proceeded. More than most other Abstract Expressionists he regarded painting as an act of autobiographical improvisation. He also said: 'It is the mysterious that I love in painting. It is the stillness and the silence. I want my pictures to take effect very slowly, to obsess and to haunt.'

BEA, MANUEL (1934–). Spanish painter and graphic artist, born in Barcelona. In 1958 he settled in Zürich, where he had his first one-man exhibition at the Gal. Chichio Haller. Working both in Zürich and Barcelona, he had one-man shows in several towns of Switzerland and Spain, Cape Town, Munich, Hamburg, etc. and participated in collective shows including the São Paulo Bienale of 1969. In 1968 he was awarded the Premio de la Critica del Jurado de Radio, Barcelona. His works have been acquired by various public collections in Spain, including the Museums of Modern Art in Madrid and Barcelona, and are in private collections in many countries. Prominent among the younger artists of Spain, he worked in a typically Spanish version of ABSTRACT EXPRESSIONISM.

BEAL, JACK (1931–). American painter born

at Richmond, Va., studied at the College of William and Mary, the Virginia Polytechnic Institute and the Art Institute of Chicago School. He taught briefly at the universities of Indiana, Purdue and Wisconsin and at the Cooper Union. His first one-man exhibition was at the Allan Frumkin Gal., New York, in 1965 and he was represented in a number of collective exhibitions including: Whitney Mus. of American Art, 'Young America', 1965; Rhode Island School of Design, 'Recent Still Life', 1966. He belonged to the group of younger artists who in the late 1960s reverted to a tightly controlled Naturalism, his seductive nudes undergoing visual depersonalization by being integrated into dazzling passages of brilliant colour and patterned furniture accessories.

BEARDEN, ROMARE (1914–). Black American painter born in Charlotte, N.C. Working in a highly personal style of paper COLLAGE and synthetic polymer paint, Bearden created a vivid and expressive picture of Negro life and experience in America. His compositions were vibrant with energy, depicting the multiple facets of street life. An element of caricature in the exaggerated heads was subordinated to the expression of the main theme, as, most successfully, in *The Dove* (The Mus. of Modern Art, New York, 1946), in which 'the white bird of peace survives the tumultuous life that exists within the partitioned stone and brick structures'. Bearden worked indefatigably to secure equal recognition for black artists. In 1968 he had a retrospective at the State University of New York at Albany and he was given a one-man exhibition at The Mus. of Modern Art, New York, in 1970.

BEAUCHAMP, ROBERT (1923–). American painter born at Denver, Colo., studied at the University of Denver, Colorado Springs Fine Arts Center and the HOFMANN School. He was awarded a Fulbright Fellowship and a grant from the National Council on the Arts in 1966. His first one-man exhibition was at the Tanager Gal., New York, in 1953, and he continued exhibiting in New York galleries and elsewhere through the 1960s and 1970s. He was included in The Mus. of Modern Art, New York, collective exhibition, 'Recent Painting USA: The Figure', 1962–3. His work was in line with the new interest in the figure which came to the fore at the end of the 1960s.

BEAUDIN, ANDRÉ (1895–1941). French painter born at Mennecy, Seine-et-Oise, studied at the École des Arts Décoratifs, Paris, from 1911 to 1915. The most important event in his artistic development was his meeting in 1922 with Juan GRIS, whose method he studied with penetrating insight. Basing himself upon this and adapting to his own use certain lessons from DERAIN and from MATISSE's decorative manipulation of colour, he evolved a poetic style of sensitive, limpid colours and clearly patterned CUBIST structures. He painted for the most part in areas of flat delicate colour without modulation and he has been called the painter of morning light. He often painted in series, returning again and again to the same theme (*Chevaux, Fleuves, Villas, La Bicyclette*) until he felt it to be exhausted. His first one-man exhibition was at the Gal. Percier in 1923 and Max Jacob wrote the Introduction for the catalogue. Subsequently he exhibited mainly at the Gal. Simon Louise Leiris. He also did sculpture, employing block-like forms and superimposed planes in a manner parallel to the Cubistic structure of his paintings. Although he was virtually uninfluenced by SURREALISM, he had a number of Surrealist literary friends and he illustrated books by ÉLUARD, Hugnet, Frénaud and others.

BEAUX-ARTS, ÉCOLE NATIONALE SUPÉRIEURE DES. The chief of the official art schools of France. It was dependent upon the Académie, which was founded in the mid 17th c., and the teaching there remained traditional and conservative until after the Second World War. Entry was difficult—among the artists who failed were Rodin and VUILLARD—and many students preferred the private ACADÉMIES. Many progressive artists, however, obtained a sound technical and academic grounding there. The school had 4 ateliers for painting, 4 for sculpture and 7 for architecture, each atelier headed by an artist of standing.

BECHTEJEFF, VLADIMIR (1878–). Painter, born in Moscow. After beginning life as a cavalry officer he taught himself to paint in Munich, where he was a friend of JAWLENSKY, and in 1909 joined the NEUE KÜNSTLERVEREINIGUNG. He was among the more conservative members of this body and when KANDINSKY with Gabriele MÜNTER and Franz MARC left the association to found the BLAUE REITER he remained in it along with Jawlensky and Marianne von WEREFKIN. In 1912, however, he joined Jawlensky and Werefkin in their protest against Otto Fischer's *Das Neue Bild*, which condemned non-figurative painting in the name of the *Neue Künstlervereinigung*. An example of Bechtejeff's work is *Horse Trainer* (Städtische Gal., Munich; *c.* 1912).

BECHTOLD, ERWIN (1925–). German painter, born in Cologne. After working as a printer and compositor he studied for a year at an art school in Cologne and then in 1951 went to Paris, where he was a pupil of Fernand LÉGER. He then moved to Spain, where he made contact with the groups DAU AL SET and EL PASO, and in 1958 he settled at Ibiza. From 1950 he took part in a number of group shows in both Europe and America; from 1956 he had one-man exhibitions in Barcelona, Madrid, Hanover, Mannheim, Cologne, Freiburg and San Francisco; and from 1966 he took part in exhibitions of the group SYN in Spain and Germany. His painting had affinities with HARD EDGE abstraction but combined geo-

metrically precise with mushy and, as it were, melted and oozing forms.

BECK, GUSTAV K. (1902–). Austrian painter born in Vienna, studied at Rotterdam, 1920–1, and at the Vienna School of Arts and Crafts, 1923–6. In 1938 he went to Yugoslavia and Italy, settling in Rome in 1944. He returned to Vienna *c.* 1946, was one of the founders of the Vienna Art Club and its Vice-President until 1951. In 1952 he was co-founder of the Kunst der Gegenwart gallery at Salzburg. He was in Brazil 1953–5, moved to Salzburg in 1958 and settled in Wolfsburg in 1961. Between 1955 and 1963 he had one-man shows in São Paulo, Rome and various German towns, and in 1959 participated in the DOCUMENTA II exhibition at Kassel. His work was abstract but revealed its relation to the world of natural things.

BECKMANN, MAX (1884–1950). German painter and graphic artist born at Leipzig of a family of Brunswick millers. He studied at the Weimar Academy of Arts from 1899 and in 1903 went to study in Paris under the patronage of Julius Meier-Graefe. Here he built the foundation of his knowledge of the Impressionists, saw the work of Van Gogh and became interested in medieval painting through an exhibition of French Primitives. After visiting Geneva and Florence he settled in Berlin in 1904. In 1906 he was awarded the Villa Romana Prize, which enabled him to study for six months in Florence, and in the same year he joined the Berlin SECESSION, which was then strongly under the influence of Impressionism. He was elected to the Board in 1910, but resigned in 1911. His first one-man exhibition, at Frankfurt, was in 1911; he had a retrospective exhibition at Magdeburg in 1912 and a one-man exhibition at the Paul Cassirer Gal., Berlin, in 1913. The first monograph on him was written by Hans Kaiser in 1913. In 1914 he volunteered as a medical orderly and served in the Netherlands, but was discharged in 1915 owing to a nervous breakdown and settled in Frankfurt, where in 1925 he was appointed Professor at the Städelsches Kunstinstitut. His first exhibition of graphics was at the J. B. Neumann Gal., Berlin, in 1917; in 1922 he exhibited at the Venice Biennale; in 1925 he had a retrospective exhibition at the Frankfurter Kunstverein and exhibitions in Zürich and at the Paul Cassirer Gal., Berlin. His first American exhibition was organized by J. B. Neumann at the New York Art Circle in 1926. In 1924 a collective monograph was issued.

At the beginning of his career Beckmann was artistically conservative, a German Impressionist, though he was also impressed by the work of such artists as Piero della Francesca and Signorelli who sought to depict dramatic and philosophical themes with monumental grandeur and pathos. Many of his paintings in the years before the First World War were based on Christian or Old Testament themes or on themes drawn from classical mythology. During these years he also did graphic work and a few paintings which showed affinities with the outlook of the BRÜCKE, but in 1912 he put himself in opposition to the EXPRESSIONISM of the BLAUE REITER. From the time of his discharge from the forces in 1915 both his style of painting and his outlook abruptly changed. The influence of medievalism on his manner became more apparent and the change in the content of his work caused him for a time to be classified with the artists of the NEUE SACHLICHKEIT, with whom he exhibited at the Kunsthalle, Mannheim, in 1925. Indeed Friedhelm Fischer has said: 'In his painting during the war and immediately after it Beckmann subjected the vitalistic principle to ruthless criticism.' But unlike the uncomplicated social criticism of George GROSZ and Otto DIX, the ruthless realism of Beckmann's painting was usually intended to have a deeper philosophical import, as a symbolic depiction of lust, sadism, cruelty, etc. At this time he developed a vertical style of composition and a two-dimensional organization of space which remained a characteristic of his work. He also ceased to regard painting as a purely aesthetic matter, if at all, and thought of it as an ethical necessity, a form of knowledge and expression.

In 1928 he had a large retrospective exhibition at the Kunsthalle, Mannheim, and exhibitions at the Flechtheim Gal., Berlin, and the Günther Franke Gal., Munich. In 1929 he received an Honourable Mention at the Carnegie International, Pittsburgh, for his *Die Loge* (Staatsgal., Stuttgart, 1928) and in 1930 he had a large exhibition in the Kunsthalle, Basle, and the Haus der Kunst, Munich. In 1931 eight of his paintings were included in the exhibition of German painting and sculpture at The Mus. of Modern Art, New York. In 1933 he was dismissed from his teaching post by the National Socialist regime and painted his famous triptych *Departure*, now in The Mus. of Modern Art, New York, which sums up in a visual mythology his philosophy of life and society. Although Beckmann was neither a Jew nor a Communist, and although his work has sometimes been regarded as a typical expression of the Germanic spirit, it was subject to the National Socialist persecution of modern art. Ten of his works were included in the exhibition of DEGENERATE ART and more than 500, mainly graphics, were confiscated from German collections. At this time he painted his triptych *Hölle der Vögel*, representing Germany as a hell populated by birds. He left Germany and settled in Amsterdam, where he remained until 1947. In 1938 six of his paintings and one lithograph were included in the exhibition 'Twentieth Century German Art' put on at the New Burlington Gals., London, in answer to the German exhibition of Degenerate Art in 1937. At this exhibition Beckmann delivered his lecture *On My Painting* (*Meine Theorie der Malerei*) setting forth his aesthetic and social philosophy. Of this Friedhelm Fischer has said: 'It is hard to believe, as we read this lecture, that anyone in Beckmann's

audience felt they were gaining a proper understanding of his ideas . . . His remarks do not follow an ordinary logical course; they are more like a polyphonic composition, full of antitheses and contradictions, and it is appropriate that the painter ends his discourse by narrating a poetic dream.' At this time he also wrote his symbolic 'Mystical Pageant of the World'.

During the war years Beckmann did more than 200 pictures while in the Netherlands. Debarred from exhibiting in Germany, his works were exhibited at the Buchholz Gal., New York. In 1947 he went to the U.S.A. and was given a teaching post at the School of Fine Arts, Washington. He had a large touring retrospective exhibition in 1948 and in 1949 obtained a teaching post at the Brooklyn Mus. Art School. In the same year he was awarded First Prize for Painting in the United States at the Carnegie Institute, Pittsburgh. In 1950 he had a one-man exhibition in the German Pavilion at the Venice Biennale and was awarded the First Prize for Painting.

Beckmann has been hailed by German critics as a prophet and a seer; his *œuvre*, and particularly the triptychs, has been represented as the most authentic comment of German culture on the disorientation of the modern world. In fact, his very incoherent philosophical outlook was both egocentric and subjective. As he himself said: 'I can only speak to people who, consciously or unconsciously, already carry within them a similar metaphysical code.' As a painter, from 1915 he put the message of his work before aesthetic or painterly quality, in this respect differing from the French Expressionists. While recognizing their structural qualities, Lothar-Günther Buchheim said in his Introduction to the catalogue of Beckmann's 1974 London exhibition of his paintings after 1915 that 'they might have been executed by a barber who was also a Sunday painter. Beckmann rejected the virtuosity which . . . led to agreeable decorative effects but nothing more creative; with intense self-discipline, and using turbid colours if need be, he was resolved to develop a new style in order to grapple with the visions that filled his mind.' Stephen Lackner summed up one view of his significance with the words: 'Beckman was no degenerate, but a barometer registering the painful compression of the atmosphere of post-war Germany. By his sobriety, accuracy and force of expression he sought to master the horrors that he depicted.' And Lothar-Günther Buchheim added: 'The world that Beckmann presents to us is an evil, malicious world; it is our own, and he refuses to embellish or idealise it.' Others have taken a different view—both of the world and of the artist.

BÉGUIER, S. See MEC ART.

BELGIUM. At the back of modern painting in Belgium towers the dominant figure of James ENSOR, most of whose best work was done before 1900 but whose influence persisted unassailed. He was a powerful link with Symbolism, one of the main formative influences on Flemish EXPRESSIONISM and was claimed by the SURREALISTS as one of their forerunners.

The main trends in Belgian art during the first three decades of the century were (1) a characteristic adaptation of late Impressionism, FAUVISM and the schools of Paris; (2) Surrealism; and (3) Flemish Expressionism. Tendencies towards abstraction in such artists as Joseph LACASSE, Georges VANTONGERLOO and Karel MAES remained somewhat submerged.

The two most talented painters at the beginning of the century were Rik WOUTERS and Henri EVENPOEL. Both were attracted by the lure of Paris and both died before their talent was fully matured. With them should be mentioned Edgard TYTGAT, who combined a streak of NAÏVETY with a joyful, dreamlike vision, and Léon SPILLIAERT, whose calligraphic style derived both from Symbolism and from ART NOUVEAU and in certain respects paved the way towards Surrealism. The great Belgian Surrealists were Paul DELVAUX, whose images welled from dream and the subconscious, and René MAGRITTE, a more deliberate artist whose painting was described by BRETON as 'non-automatic' and 'fully thought out'. Both achieved international acclaim.

Expressionism was the dominant tendency up to 1939. Belgian Expressionism was calmer, less neurotic than the German variety and was more closely allied to SOCIAL REALISM. At the one pole it was connected with the second school of LAETHEM-SAINT-MARTIN, which had Symbolist associations, and at the other with the monumentality of PERMEKE, the outstanding figure in Belgian painting before the Second World War. Other exponents of Expressionism were Fritz Van den BERGHE, who combined it with leanings towards Surrealism, Jan BRUSSELMANS, who combined lyrical Expressionism with a feeling for abstract form, and Gust de SMET, whose work was characterized by bold and spontaneous naturalism.

After the end of the Second World War Surrealism suffered a temporary eclipse. The most noteworthy event was the formation in 1945 of the association JEUNE PEINTURE BELGE, which soon exhibited internationally. The painters were of very different temperaments and the association had no common programme, but basically they carried on the spirit of Flemish Expressionism with a tendency towards the expressive abstraction of the ÉCOLE DE PARIS, particularly after the exhibition 'Jeune Peinture Française' in Brussels in 1947. Louis Van LINT, in particular, developed a mode of expressive abstraction which did not exclude representation and which was close to that practised by the international COBRA group, of which he was a member. Antoine MORTIER has been described as the most worthy successor to Flemish Expressionism. Others who practised expressive abstraction were Engelbert van ANDERLECHT and

Pol MARA. The poet and draughtsman Henri MICHAUX comes into a different category, while the Russian-born artist ALECHINSKY, a member of COBRA, displayed an originality which forbids classification.

In 1952 the CONSTRUCTIVIST group ART ABSTRAIT was formed on the initiative of Jo DELAHAUT, who had turned from a FAUVIST manner to geometrical abstraction in 1945. In 1954 he published together with Pol BURY a manifesto entitled *Spatialism* dealing with the principles of visual and KINETIC research. Other members of the group, such as Bert de Leeuw, Maurice Wyckaert and Jan BURSSENS, turned in the 1960s to a more lyrical mode of abstraction and then to a new representation. Bert de Leeuw coined the term 'Matterism' for the style of painting which exploits the expressive qualities of pigment by the use of thick *pâtes* in the manner of DUBUFFET. J. M. Londot of Namur, Marc MENDELSON and René GUIETTE also painted in this way. Others, however, such as Jef VERHEYEN, practised COLOUR FIELD painting and others again, such as Walter LEBLANC, continued the trend towards Constructivism and experimental art.

In the 1960s the influence of POP ART was apparent in the work of such artists as Roger Raveel, and a revival of Surrealism can be illustrated by artists such as Jan COX and Octave LANDUYT, while new appreciation was accorded to the COLLAGES and ASSEMBLAGES of the writer E. T. L. MESENS.

Among Belgian sculptors Roel d'HAESE explored the possibilities of forged steel, Franz LAMBERECHTS carried out original experiments with polyester and Pierre CAILLE produced ceramics of artistic quality. The three Belgian sculptors who achieved international recognition were Pol Bury, Vic GENTILS and Paul van HOEYDONCK.

BELGRADO, GIOVANNI. See ITALY.

BELKIN, ARNOLD (1930–). Canadian-born painter who lived in Mexico from 1948 to 1968 and subsequently in New York. His work belongs to the New Humanism, depicting the existential predicament of the human condition in the contemporary world. He became known for his *Marat* series, exhibited in 1972, in which he used the story of Marat to symbolize the death of human freedom and of the aspiration to grandeur. He used an air-brush technique, HARD EDGE style with multiple outlines of his image.

BELL, CLIVE (1881–1964). British critic and aesthetician who with Roger FRY was largely responsible for propagating in Great Britain an appreciation of the Post-Impressionist painters and particularly Cézanne. His name is associated in art theory with the doctrines of Significant Form and of a unique aesthetic emotion, doctrines which were primarily set forth in the essays 'The Aesthetic Hypothesis' and 'The Metaphysical Hypothesis' contained in his book *Art* (1923). Bell wrote: 'The starting-point for all systems of aesthetics must be the personal experience of a peculiar emotion. The objects which provoke this emotion we call works of art. All sensitive people agree that there is a peculiar emotion provoked by works of art ... This emotion is called the aesthetic emotion; and if we can discover some quality common and peculiar to all the objects that provoke it, we shall have solved what I take to be the central problem of aesthetics.' Bell believed that the 'aesthetic thrill' is experienced in apprehension of the formal properties of works of art, which he called their 'significant form', rather than their subject matter, their moral message or anecdotal content. He linked this theory closely with his interpretation of Cézanne's painting and said of him: 'He was the Christopher Columbus of a new continent of form.' His writings together with those of Fry had an enormous influence in spreading a new attitude towards art appreciation among both connoisseurs and the general public, an attitude which demanded more rigorous attention to sensory and formal qualities, regarding them as always essential if not always sufficient for complete aesthetic enjoyment. But important as it was, the 'Bloomsbury' aesthetics was not without dissident voices. In reviewing Bell's book *Art*, SICKERT (*A Free House*, 1947) claimed that he (and Fry) were undermining appreciation of Cézanne's real qualities by building a nonsensical theory on his palpable and tragic defects (bad draughtsmanship and 90% failure). The whole idea of art and of appreciation as emotional apprehension of purely formal qualities was violently challenged by D. H. Lawrence in 1929.

Bell's theory that the appreciation of art is emotional response to purely formal qualities would have justified the various modes of abstraction, particularly OBJECTIVE ABSTRACTION, with which various English artists were occupying themselves in the early 1930s, although Bell's own appreciation did not extend so far. Yet against the background of taste prevailing at the end of the first decade of the century his appreciation was not uncatholic. When selecting the English section for Fry's Second Post-Impressionist Exhibition in 1912 he included not only Duncan GRANT, Roger Fry and Henry LAMB but also ETCHELLS, LEWIS, Spencer GORE and Stanley SPENCER.

BELL, GRAHAM (1910–43). British painter, born in the Transvaal. After studying at the Durban Art School he came to England in 1931 and was a pupil of Duncan GRANT and a friend of William COLDSTREAM. In the early 1930s he was one of the small group of painters who experimented with abstraction as a means of expressing feelings aroused in them by nature and he participated in the OBJECTIVE ABSTRACTION exhibition of 1934. Reverting to a poetic and unemphatic Naturalism in the rendering of the seen world, he became a founding member of the EUSTON ROAD SCHOOL in 1937. He volunteered for war service in 1939 and was killed in 1943.

BELL, LARRY (1939–). American painter and CONSTRUCTIVIST, born at Chicago and lived in Venice, Calif. He was one of the best known of the group of Los Angeles artists who came to artistic maturity in the 1960s. After a period during which he made shaped paintings incorporating geometrical configurations of glass and mirrors, he confined himself to making glass sculptures of refined simplicity from 1964. First came his well-known series of glass cubes framed by strips of chrome metal. The earlier cubes were decorated with geometrical patterns of embedded shapes made by aluminizing the glass, but this decoration was later abandoned in favour of subtly modulated tinting of the semi-transparent glass by a process of vacuum coating with various metallic compounds which Bell himself perfected. The cubes were set on a clear plexiglass base in order to allow the light to penetrate on all sides. About 1969 he abandoned the cube for tall two-sided glass panels and abandoned rainbow coloration for a neutral grey coating. Bell's elegant and immaculate glass structures, his alternately transparent and opaque boxes, his combination of reflection with transparency, represent an extreme application of the tendency among the younger Los Angeles artists to dematerialize the environment and to work with the pure qualities of light. His virtually invisible glass panels were the most dramatically novel exhibit at the exhibition 'Spaces' organized at The Mus. of Modern Art, New York, in 1970. He was also exhibited in the same year together with Robert IRWIN and Doug Wheeler at the Tate Gal., London, and in 1971 in the exhibition 'Transparency, Reflection, Light, Space: Four Artists' at the Art Galleries of the University of California in Los Angeles.

BELL, VANESSA (1879–1961). British painter, born in London, the eldest child of Sir Leslie Stephen by his second wife, Julia Duckworth (*née* Jackson). She studied, 1896–1900, under Sir Arthur Cope, R.A. and at the Royal Academy Schools, 1901–4. In 1904 she moved to 46 Gordon Square, which became the headquarters of the BLOOMSBURY GROUP, and in 1905 she organized the FRIDAY CLUB. In 1907 she married the critic and art theorist Clive BELL. Besides her own painting she did designs for Roger FRY's Omega Workshops and collaborated with Duncan GRANT in many decorative schemes. Like that of Duncan Grant, her work showed a close kinship with the decorative aspects of MATISSE and until the 1920s they were regarded as the leading British innovators in the realm of colour. She was, for example, represented in the exhibition 'Exposition de Quelques Indépendants Anglais' at the Gal. Barbazanges, Paris, in 1912 and showed four paintings at the Second Post-Impressionist exhibition in the same year; she was represented in 'Twentieth Century Art' at the Whitechapel Art Gal., 1914; in 'New Movement in Art' at the Mansard Gal., 1917; in 'Englische Moderne Malerei' at the Kunst-

haus, Zürich, 1918. From 1920 she exhibited regularly with the LONDON GROUP. Her first one-man exhibition was in 1922 at the Independent Gal. With Duncan Grant and Keith Bayes she selected the 'Contemporary British Artists' Coronation exhibition at Agnew & Sons in 1937 and in 1943 she was represented in 'Robert Colquhoun and Notable British Artists' at the Lefevre Gal. She continued to paint and exhibit until her death. Memorial exhibitions were staged by the Adams Gal., 1961, with a catalogue foreword by DUNOYER DE SEGONZAC and by the Arts Council in 1964, and a joint exhibition with Duncan Grant was given by the Royal West of England Academy at Bristol in 1966.

BELLEGARDE, CLAUDE (1927–). French painter, born in Paris. After studying privately he began to exhibit in 1946. Besides contributing to a number of group exhibitions in Madrid, Buenos Aires, Düsseldorf, etc., he had several one-man shows in Paris. Until 1952 his work was figurative but after then he worked in a style of expressive abstraction akin to TACHISM. In the 1960s he produced abstract works which he called *Typograms* and which were supposedly mystical explorations of the psychic and cosmic implications of pure colour.

BELLING, RUDOLF (1886–1972). German sculptor born in Berlin, studied at the Berlin Academy of Art, 1911–12. In 1918 he was a founding member of the NOVEMBERGRUPPE and during the 1920s he was influential in introducing both CUBIST and FUTURIST ideas into the art world of Berlin. He himself was strongly influenced by ARCHIPENKO, reproducing in his own work Archipenko's alternation of solids and voids and the positive significance given to negative forms. His style became more self-consciously formalized and his abstract *Head* of 1923 was built up of inorganic machine-like geometrical shapes. He also had an inclination for decorative effects which robbed his productions of genuine significance. His immediate influence in Germany was nevertheless important. From 1937 to 1966 he taught in Istanbul and then settled outside Munich.

BELLMER, HANS (1902–75). Polish-French painter and graphic artist born at Katowice. He attended the Berlin Technical School of Art in 1923 and then worked as a graphic artist. In 1923 he began to construct jointed and articulated dolls in the form of adolescent girls and photographed them in a variety of erotic postures. These photographs came into the hands of the Paris SURREALISTS and were published in *Minotaure*. Encouraged by this he joined the Surrealist movement and in 1938 settled in Paris. After the war he resumed etching, devoting a superb technique to his obsession with the female body which he treated in a fantastic manner evocative of the erotic yearnings of adolescence. In the words of Patrick

Waldberg: 'La chimère érotique échevelée, tentaculaire, issue du terreau des amours enfantines.' In the 1960s his works became more widely known and he had a retrospective exhibition at the Kestner-Gesellschaft, Hanover, in 1967.

BELLOWS, GEORGE WESLEY (1882–1925). American painter and lithographer, born at Columbus, Ohio. After studying at Ohio State University, where he was an outstanding athlete, he went to New York and became a pupil of Robert HENRI. He was not a member of The EIGHT but he exhibited at the Independents show organized by Robert Henri and Rockwell Kent in 1910. Thus Bellows belongs to the second generation of SOCIAL REALIST painters generally known as the ASH-CAN school. He was awarded a prize at the National Academy of Design in 1908 and became an associate member in 1909 at the age of 27, the youngest man to receive this honour. In 1910–11 he taught at the Art Students' League, in 1912–18 he taught with Henri at the Ferrer School and in 1913 he was made a full member of the National Academy. A retrospective exhibition of his work was held at the Art Institute of Chicago in 1946.

Bellows delighted in painting city and circus scenes, boxing matches, etc. He sprang to fame with his *Stag at Sharkey's* (Cleveland Mus. of Art, 1907), a vividly impressionistic picture of an illegal boxing match which has been called a 'landmark of realism'. Other pictures in this category are *Both Members of This Club* (National Gal., Washington, 1909) and *Polo at Lakewood* (Columbus Gal. of Fine Arts, Ohio, 1910). After the ARMORY SHOW his work became less directly impressionistic and began to show more attention to formal balance. This is apparent in *Dempsey and Firpo*, one of the best known of the nearly 200 lithographs which he did between 1916 and his death. In the last five years of his life he turned his attention to portraiture and was considered to be among the finest American portraitists of his day.

BELMONDO, PAUL (1898–). French sculptor born at Algiers. He did monumental sculptures, e.g. at the Palais Chaillot, and also portrait busts and medals in a style of elegant classicism. He was commissioned to copy *La Danse* of Carpeaux (1827–75) for the façade of the Opéra. From 1953 he taught at the École des Beaux-Arts, Paris, and in 1956 he won the Grand Prix of the Ville de Paris.

BELZILE, LOUIS. See PLASTICIENS, LES.

BENEŠ, V. See GROUP OF AVANT-GARDE ARTISTS.

BÉNÉZIT, EMMANUEL-CHARLES (1887–). French painter born in Paris, son of the author of *Dictionnaire des Peintres, Sculpteurs, Dessinateurs et Graveurs de tous les temps et tous les pays.* He was a pupil of the painter J. P. Laurens and studied at

the Académie Julian. He exhibited at the Salon des Indépendants, 1907–25, at the Salon d'Automne, 1922–33, and at the Salon des Tuileries, 1926–38. He was exhibited at the Mercury Gal., London, in 1973, 1974 and (pastels and water-colours) 1975. He painted and drew with great delicacy in a Late-Impressionist style and is aptly described by the French term *petit maître*.

BENGSTON, BILLY AL (1934–). American painter born at Dodge City, Kan., and studied at Los Angeles City College, Los Angeles State College, California College of Arts and Crafts and Los Angeles County Art Institute. He taught at the Chouinard Art Institute, 1961, University of California at Los Angeles, 1962–3, University of Oklahoma, 1967, University of Colorado, 1969. He obtained an award from the National Council on the Arts in 1967 and a Tamarind Fellowship in 1968. His first one-man exhibition was at the Ferus Gal., Los Angeles, in 1957 and in 1969 he had a retrospective exhibition circulating from the Los Angeles County Mus. of Art.

BENN, BEN. See FORUM EXHIBITION.

BENNER, GERRIT (1897–1981). Dutch painter born in Leeuwarden, Friesland. He began to paint in 1939 and worked in a manner close to the Flemish tradition of expressive Naturalism. In 1943 he shared a studio with Karel APPEL and became a member of the Dutch EXPERIMENTAL GROUP and of COBRA. But although his work became more abstract, it remained highly individual, reducing his subjects to large simple forms, and it lacked the violence and near-hysteria of some COBRA work.

BENOIS, ALEXANDRE (1870–1960). Russian painter, theatrical designer and critic, born at St. Petersburg into an artistic family of German, French and Italian ancestry. He was a leader and spokesman of the MIR ISKUSSTVA group, which during the 1890s represented the *avant-garde* in Russian art. He was in Munich in 1890 and wrote the chapter on Russian Art for Richard Muther's *Geschichte der Malerei im XIX Jahrhundert* (Munich, 1893–4). From 1896 to 1898 he was in Paris, returning to Russia to assist DIAGHILEV with the publication of the journal *Mir Iskusstva*. He published portfolios of the Art Treasures of Russia (1901–7) and a *History of Russian Painting* in 1902. In 1909 he returned to Paris and was associated with Diaghilev's Russian Ballet. After the Revolution he was made curator of paintings at the Hermitage Mus., but in 1928 he settled in Paris. Benois is chiefly known in the West for his theatrical designs, among the most famous being *Petrushka, Le Pavillon d'Armide*, which was commissioned by Telyakovsky, Director of the Imperial Theatres, in 1907, *The Nightingale* and *Nutcracker Suite*. He also did large and delicately sensitive water-colours of St. Petersburg and later of Paris and Versailles. From 1938 he designed for La Scala, Milan.

BENTON, THOMAS HART (1889–1975). American painter born in Neosho, Mo. In 1906 he worked as a cartoonist on a Missouri newspaper and in 1907 studied at the Art Institute, Chicago. In 1908 he went to Paris, where he remained for three years and became a friend of Stanton MAC-DONALD-WRIGHT. Back in New York in 1912, he continued for some years painting in abstract colour in Macdonald-Wright's SYNCHROMIST style, e.g. *Constructivist Still Life. Synchromist Color* (Columbus Gal. of Fine Arts, 1917). He was a friend of STIEGLITZ and a member of his circle. Having failed to win success in *avant-garde* styles of painting, he abandoned modernism *c.* 1920 and from 1924 travelled through the Southern and Midwestern states making drawings of scenes and types of American life. From *c.* 1929 he gained widespread popularity as the mouthpiece of the REGIONALIST group of AMERICAN SCENE painters. He claimed that the popularity enjoyed by himself, CURRY and Grant WOOD arose from the fact that they 'symbolised esthetically what the majority of Americans had in mind—America itself'. He inveighed in violent language both against urban industrial civilization and against modernism in art, dubbing the latter a foreign degeneracy. He called Stieglitz and his group of abstract artists 'an intellectually diseased lot, victims of sickly rationalisations, psychic inversions, and God-awful self-cultivations'. From 1930 Benton did a number of murals, including a set of large *City Scenes* (1930–1) at the New School for Social Research, New York; paintings of *Arts of the West* originally for the Whitney Mus., later removed to the New Britain Mus. of American Art, New Britain, Conn.; paintings for Kansas City Art Institute, where he taught; and for the state capitol building in Jefferson City, Mo. In later years he did murals for the Power Authority installation at Massena, N.Y. (1956) and for the Truman Library in Independence, Mo. (1961). In these murals he satirized city life and glorified the rural and small-town life of the Middle West and South. He also represented Greek myths (*Persephone*) and biblical stories (*Susanna and the Elders*), introducing American types into them. Similar subjects were used for his easel paintings, e.g. *Roasting Ears* (The Metropolitan Mus., New York, 1938–9).

At this time Benton was painting in a traditional style of melodramatic SOCIAL REALISM verging upon caricature but showing some affinities with the Mexican school of Social Realist muralists. His work lacked the keen perceptiveness and above all the power of 'magic' impact which accounts for the popularity of Grant Wood and Andrew WYETH. Its greatest merit artistically was probably derived from the energy and vigour with which it was infused. What it lacked in delicacy it made up for in muscularity.

During the Second World War Benton was employed as a draughtsman for the American Navy. He continued his violent defence of Regionalism during the 1940s as its popularity was diminishing and became something of a voice in the wilderness as a new school of abstraction arose which gave America world prominence in the arts. Benton wrote an autobiography, *An Artist in America* (1951). It is remembered that Jackson POLLOCK studied under Benton at the Art Students' League from 1929 to 1931 and something of Benton's influence may be discerned in Pollock's work during the 1930s.

BEN-YEHUDA, YEHUDA (1933–). Israeli-American sculptor, born in Baghdad. He settled in New York in 1965. Ben-Yehuda's work depicts the suffering of the victims of war and of those sacrificed to false ideals of progress. He creates a welter of writhing and agonized figures made life-size in latex and styrofoam from casts taken from live models. His work has been exhibited in the museums at Jerusalem, Tel Aviv and Haifa, at the New Vision Centre, London, and in Europe and America.

BÉOTHY, ÉTIENNE (1897–1962). Sculptor born at Heves, Hungary. After studying architecture he met MOHOLY-NAGY and under his influence turned to sculpture, which he studied at the Academy of Fine Art, Budapest, from 1920 to 1924. He settled in Paris in 1925. In 1932 he was a founding member of the ABSTRACTION-CRÉATION association, in 1946 a founding member and Vice-President of the SALON DES RÉALITÉS NOUVELLES and in 1951 a member of GROUPE ESPACE. From 1929 his work was CONSTRUCTIVIST and like Max BILL he sought a mathematical formula for geometrical abstraction, publishing in 1939 a book entitled *La Série d'Or* in which he analysed the mathematical basis of art. He carved slender and elegant abstractions based on the spiral and the parabola.

BÉRARD, CHRISTIAN (1902–49). French painter and designer born in Paris. He studied painting at the Académie Ransom under VUILLARD. Under the influence of Jean Cocteau he later turned to designing for theatre and film and the majority of his work was of this kind. His inventiveness and his gift of fantasy ensured his success in this field.

BÉRARD, MARIUS HONORÉ (1896–). French painter born at Salindres, Gard. After studying painting at Alès he entered the postal service, resigning from it in 1927. He exhibited in Paris and at various provincial centres and in 1946 was on the organizing committee of the SALON DES RÉALITÉS NOUVELLES. From *c.* 1921 he was interested in the relations between painting and music and he painted abstract compositions which were intended to be expressive of musical themes, particularly the music of Bach and Debussy. From 1950 he travelled and exhibited in South America.

BERDECIO, ROBERTO. See LATIN AMERICA, MEXICO.

BERGER, HANS (1882–1977). Swiss painter born

at Oberbuchstein. After being articled in an architect's office he was self-taught as a painter. In his earlier period he painted in dark earth colours with heavy impasto. About 1910 his palette lightened and he worked in a manner akin to the FAUVISTS. After a break during the Second World War he began to paint in still brighter colours with enamel-like texture.

BERGHE, FRITS VAN DEN (1883–1939). Belgian painter born at Ghent, studied at the Ghent Academy and taught there from 1907. In 1904 he settled in LAETHEM-SAINT-MARTIN and from 1910, with the brothers De SMET, he formed the core of the Second Laethem Group. He visited the U.S.A. in 1913 and during the First World War was in the Netherlands. Returning to Belgium in 1922, after a short stay in Ostend he settled in Ghent in 1925. He was supported by the periodical *Sélection* and by *Le Centaure*. His early work developed from an Impressionist to an EXPRESSIONIST idiom and he was prominent among the Flemish Expressionists. About 1912 he began to introduce decorative and symbolic features into his work, and from *c.* 1916 his distorted figures and sombre palette embodied an increasingly subjective vision. After a period of CUBIST influence *c.* 1920 he began, from 1922 to 1926, to paint compositions from rustic life in warmer colours as well as gouaches of a more tormented type, having closer affinities with German Expressionism. Towards the end of 1926 he turned also to SURREALISM and in his later years he was ranked among the Flemish Surrealists.

BERGMANN, ANNA-EVA (1909–). Swedish-French painter born in Stockholm, studied painting in Oslo and Vienna and turned to abstraction *c.* 1947. She had many exhibitions in Scandinavia, Germany and at the Gal. Ariel, Paris. Her style was quite original. She painted large, irregular monochromatic masses—which might have conformed to the canons of the PRIMARY STRUCTURES later favoured by MINIMAL ART—against an undifferentiated monochromatic background. At their best her pictures had a haunting, hypnotic effect. She was married to the painter Hans HARTUNG.

BERKE, HUBERT (1908–). German painter born in Buer, Westphalia. After studying philosophy and history of art at the universities of Munich and Königsberg, he studied at the Academy of Art at Königsberg and then at Düsseldorf under Paul KLEE, 1932–3. He joined the ZEN group. In 1960 he was appointed Professor at the College of Art in Aachen. His fantastic water-colours done in the 1930s show the influence of Klee. He later used harbours and factories as his main subjects and gradually came to emphasize the outstanding features of his themes until his paintings verged on the abstract. He painted in a wide variety of abstract styles from TACHISM to ART BRUT. He was given a retrospective exhibition at the Gesellschaft für Kunst, Mainz, in 1962.

BERLEWI, HENRYK (1884–1967). Polish artist, born in Warsaw, studied in Warsaw, Amsterdam, 1909–10, and Paris, 1911–12. In 1922 he came into contact with both El LISSITZKY and Theo van DOESBURG in Berlin and under the joint influence of Russian CONSTRUCTIVISM and Dutch NEO-PLASTICISM he took up abstract painting and evolved a system which he claimed was as near as possible to mechanical engineering. He named it *Mechanofaktur*. In 1924 he put out a manifesto of *Mechanofaktur* in Warsaw and exhibited works under this name in the STURM Gal., Berlin. In 1926 he returned to Paris and reverted to figurative painting.

BERMAN, EUGENE (1899–1972). Russian-American painter and stage designer, born in St. Petersburg. After studying privately in St. Petersburg under P. S. Naumov and S. Grusenberg he fled with his family to Paris in 1918. There he studied at the Académie Ransom under VUILLARD, DENIS and VALLOTTON. He became friendly with TCHELITCHEW and a group of painters who became known as 'Neo-Romantics', painting dreamlike scenes with mournful, drooping figures. He exhibited first at the Gal. Ganoff, Paris, in 1927. In 1935 he emigrated to the U.S.A. and became an American citizen in 1937. From this time he was active in designing stage sets for theatre and ballet, working among others for the Metropolitan Opera Company. He also gained some international reputation for his romantic imaginary landscapes. He had a retrospective exhibition circulating from the Institute of Modern Art, Boston, in 1941 and was awarded Guggenheim Foundation Fellowships in 1947 and 1949.

BERNARD, ÉMILE (1868–1941). French painter and writer born at Lille, studied at the Académie of Fernand Cormon, where he was a contemporary of Van Gogh and Toulouse-Lautrec. He then joined Gauguin at Pont Aven and later claimed that it was he who in 1888 introduced Gauguin to the SYNTHETIST manner. But although his elliptical style of drawing had superficial similarities with that of Gauguin, there can be no doubt that Gauguin's is the more masterly. In 1889 he returned to Paris, where he participated in the 'Synthetist' exhibition at the Café Volpini and joined the *Group Synthétiste* with Gauguin and other Pont Aven painters. In 1890 he arranged the first retrospective exhibition of Van Gogh's works, at the Le Barc de Boutteville Gal., and he founded the periodical *La Rénovation esthétique*, in which he published articles on Van Gogh and Cézanne and later autobiographical statements by painters and statements on artistic theory and practice. In 1893 he published Van Gogh's letters. Then after eight years teaching and travelling in Egypt and the Near East, he returned to Paris in 1901. In 1904 and 1905 he visited Cézanne and published important interviews with him. From 1921 to 1928 he lived in Venice and devoted himself to writing.

1. Edouard Vuillard: *Interior with a Lady and Dog*, 1910. Oil on mill board. 59 × 74 cm.

2. Pierre Bonnard: *Nude in the Bath*, 1935. Oil on canvas. 93 × 147 cm.

3. Henri Matisse: *The Open Window, Collioure*, 1905. Oil on canvas.
53 × 46 cm.

4. Georges Braque: *The St. Martin Canal*, 1906. Oil on canvas. 50 × 61 cm.

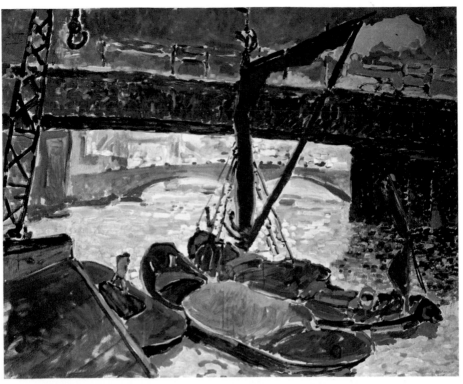

5. André Derain: *Barges on the Thames*, *c*.1906. Oil on canvas. 81 × 99 cm.

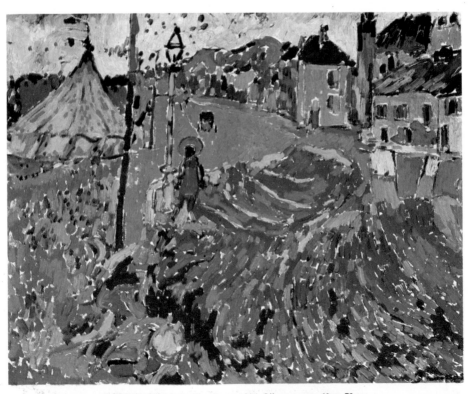

6. Maurice Vlaminck: *The Circus*, 1906. Oil on canvas. 60 × 72 cm.

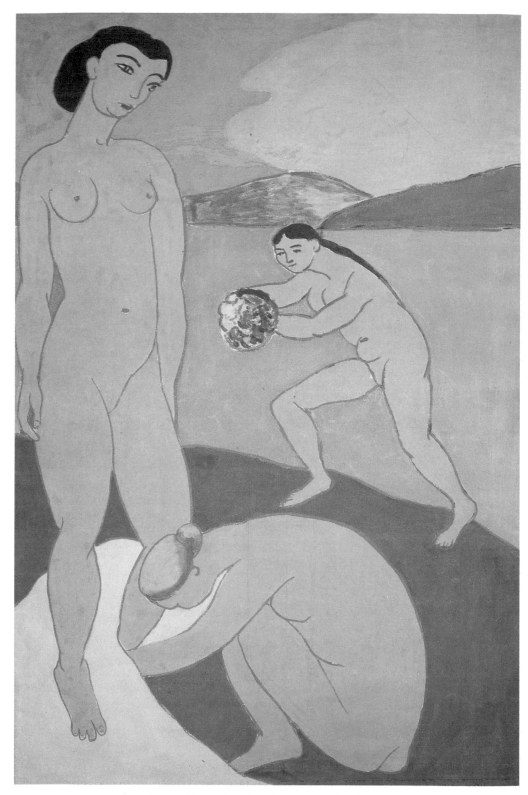

7. Henri Matisse: *Luxe II*, 1907. Distemper. 209 × 139 cm.

8. Walter Sickert: *The Mantelpiece*, 1907? Oil on canvas. 77 × 51 cm.

9. Matthew Smith: *Nude, Fitzroy Street, No.1*, 1916. Oil on canvas. 86 × 76 cm.

10. Harold Gilman: *Mrs. Mounter in an Interior*, 1916/17? Oil on canvas. 51 × 76 cm.

11. Augustus John: *Lady Ottoline Morrell*, 1926. Oil on canvas. 66 × 48 cm.

12. Edvard Munch: *Girls on the Bridge*, 1901. Oil on canvas. 136 × 125 cm.

13 (*far left*). Gustav Klimt: *Hope*, 1903. Oil on canvas. 180 × 66 cm.

14 (*left*). Egon Schiele: *Female Nude*, 1914. Gouache.

15. James Ensor: *Two Skeletons Fighting over a Dead Man*, 1891. Oil on canvas. 59 × 74 cm.

16. Emil Nolde: *The Last Supper*, 1909. Oil on canvas. 86 × 107 cm.

17. Ernst Ludwig Kirchner:
Street, Berlin, 1913. Oil on canvas.
121 × 96 cm.

18. Otto Müller: *The Large Bathers*,
1910–14. Distemper on canvas.
183 × 128 cm.

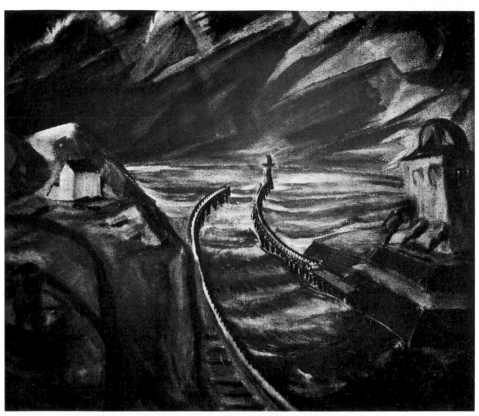

19. Erich Heckel: *Harbour Entrance, Ostend*, 1917. Oil on canvas.

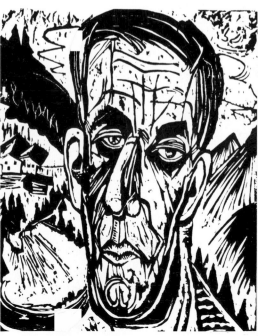

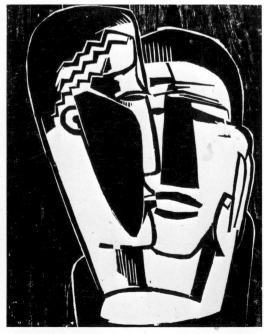

20. Ernst Ludwig Kirchner: *Head of Henry van de Velde*, 1917. Woodcut.

21. Karl Schmidt-Rottluff: *Woman's Solace*, 1920. Woodcut.

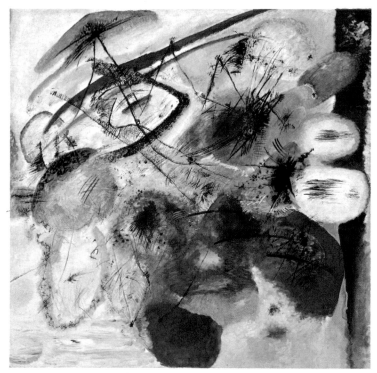

22. Wassily Kandinsky: *Black Lines*, 1913. Oil on canvas. 129 × 131 cm.

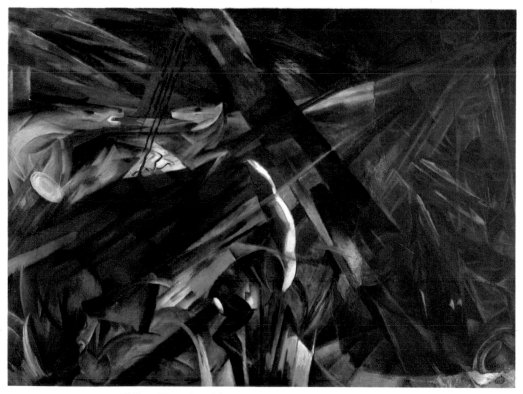

23. Franz Marc: *Animal Destinies*, 1913. Oil on canvas. 195 × 263 cm.

24. August Macke: *Landscape with Cows and Camel*, 1914. Oil on canvas. 50 × 54 cm.

25. Wassily Kandinsky: *Composition VIII No. 260*, 1923. Oil on canvas. 141 × 201 cm.

26. Ernst Barlach: *The Avenger*, 1914. Bronze. 44 × 58 × 20 cm.

27 (*right*). Wilhelm Lehmbruck:
Rising Youth, 1913. Cast stone. 234 cm.

28. Max Beckmann: *Departure*, 1932–3. Oil on canvas. Triptych. Centre panel: 215 × 115 cm. Side panels: 215 × 101 cm.

29. George Grosz: *Dr. Housenbeck Near the End*, 1920. Drawing
first published in *Ecce Homo*, 1923.

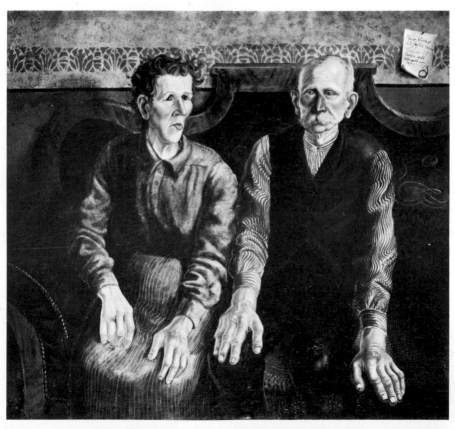

30. Otto Dix: *The Artist's Parents*, 1924. Oil on canvas. 117 × 130 cm.

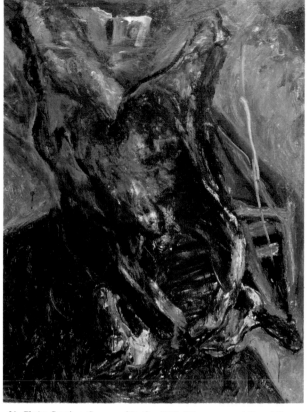

31. Chaïm Soutine: *Carcass of Beef*, *c*. 1925. Oil on canvas. 140 × 108 cm.

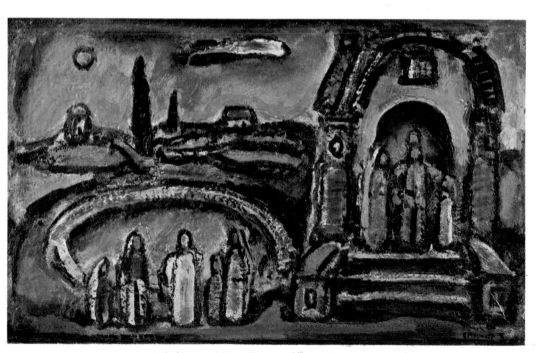

32. Georges Rouault: *Tiberiade*, 1948. Oil on canvas. 39 × 63 cm.

33. Andre Dunoyer de Segonzac:
Nude with a Newspaper, c. 1922–3.
Oil on canvas. 92 × 60 cm.

34. Marcel Gromaire:
Washerwomen by a River, 1933. Oil
on canvas. 100 × 81 cm.

35. Albert Servaes: *Pietà*, 1920. Oil on canvas. 88 × 96 cm.

36. Léon Spilliaert: *Dizziness*, 1908. Mixed media.
64 × 48 cm.

37. Frits van den Berghe: *The Prisoner*, 1927. Oil on canvas.
103 × 82 cm.

Under the influence of Van Gogh Bernard developed in the direction of CLOISONNISM and Symbolism and he may have influenced Gauguin and the Pont Aven painters in this way. His own painting had considerable influence on the NABIS. He was intelligent, of a philosophical turn of mind, and his publications contained important contributions to the history of art and art theory.

BERNARD, JOSEPH (1866–1931). French sculptor, born at Vienne-sur-Isère, son of a stonemason. He was trained at the École des Beaux-Arts, Lyons, and then at the École des Beaux-Arts, Paris. He worked in a style of elegant and rather mannered classicism, preferring the technique of direct carving in stone. He did the monument to *Michel Servet* erected at Vienne in 1910. Among his best-known works are *La Jeune Fille à la Cruche* and *La Femme à l'Enfant*, both in the Mus. National d'Art Moderne, Paris, *La Frise de la Danse* in the Chambre de Commerce, Paris, and *Faune Dansant* in the Parc de la Tête d'Or, Lyons.

BERNER, BERND (1930–). German painter born at Hamburg, where he studied lithography from 1949 to 1951. In 1959 he moved to Stuttgart, where he worked with Willi BAUMEISTER. In 1958 he was awarded the Prize for Young Artists by the city of Stuttgart and in 1967 the Villa Romana Prize. From 1959 he had one-man shows in various centres in Germany and took part in collective exhibitions, including those of the group SYN from 1965. He was interested in investigating the experience of colour perception and the creation of colour space, and he practised COLOUR FIELD painting though often with highly original border and background forms designed to heighten the colour-experience at which he aimed.

BERNI, ANTONIO (1905–). Argentine painter born in Rosario of Italian immigrant parents. Berni began studying as an apprentice in a stained glass workshop and attended children's drawing classes in Rosario. He had his first exhibition there in 1918. His work of this period showed the influence of the Spanish painter Sorolla and the Argentine Impressionist Fader. In the following years he went to live with the peasants in the pampas and painted landscapes. In 1925 he went to Europe on a scholarship awarded him by the Rosario Jockey Club. He went first to Madrid and the following year to Paris, where he studied with André LHOTE and Othon FRIESZ. He read Freud, Marx and Lautréamont and became involved with an international group representing third world countries from Asia, Africa and Latin America in a protest against colonialism. After travelling to Italy, Belgium and the Netherlands, he came into contact with the SURREALISTS in Paris, particularly Aragon, through whose influence he learned about the history of the Labour movement of Lenin, Engels and Marx. During this period he used Surrealist techniques such as PHOTOMONTAGE and

COLLAGE, which he was to apply again to his work from the 1950s onwards. Upon his return to Buenos Aires in 1931 he became aware of the serious problems of unemployment there caused by the world economic crisis. In 1932 he joined other artists in founding the 'New Realism' movement, somewhat similar in spirit to the German NEUE SACHLICHKEIT of the 1920s, and he began a series of large-scale canvases on themes of social and political protest with the collaboration of other members of the group, as an alternative to painting on public walls, which were unavailable in Argentina. His paintings of this period include *Unemployed* and *Demonstration*. When the Mexican Muralist SIQUEIROS travelled to Buenos Aires in 1933, Berni, Spilimbergo, Castagnino and other Argentinians collaborated with him on the mural *Plastic Exercise* in a private residence in the town of Don Torcuato just outside Buenos Aires. But subsequently Berni quarrelled with Siqueiros over the latter's attempt to impose his Mexican values on Argentina. Berni believed Argentine artists needed to find a more covert way than the Mexicans to express social and political concerns in order to be effective against the prevailing Argentine bourgeoisie.

From 1935 to 1945 Berni taught at the National School of Fine Arts in Buenos Aires and later painted popular subjects in the inhospitable and poverty-stricken regions of Santiago del Estero in the north of Argentina. He exhibited these works in 1955 at the Gal. Creuze in Paris as well as in Bucarest, Warsaw, Prague and Moscow. In 1958 he invented two characters, Juanito Laguna, a poor slum boy, and Ramona Montiel, a courtesan, through whose experiences he could express his social and political concerns in a narrative continuum of works. He dramatized the squalor of their lives by introducing materials such as rags, packing-crate slats, rusty bits of metal salvaged from refuse, to recreate the slum environments of the *villa miserias*. Ramona was also decked out in doily-like laces and glittering materials in her role as seductress of officials in high places, in a series culminating in *Wedding of Ramona Montiel*. Berni also translated his characters into embossed engravings. In the 1960s he created three-dimensional monsters and extra-terrestrial creatures bristling with diverse found objects, basketry, Coca-Cola bottle tops, broom bristles and an assortment of discarded metal pieces. He won first prize for engraving at the 1962 Venice Biennale and the same year exhibited at the Salon de Mai and the Salon Comparaisons, and in 1963 at the Mus. National d'Art Moderne in Paris with other Latin Americans and Argentinians. He was also represented in the travelling exhibition 'New Art From Argentina' in the U.S.A. (Walker Art Center, Minneapolis, 1964). In 1965 his work was included in the Paris Biennale in the show 'Narrative Representation in Contemporary Art' and he had a retrospective at the Instituto Torcuato di Tella in Buenos Aires, an exhibition that subsequently

travelled to the U.S.A., Mexico and Brazil. In 1966 he was given a retrospective at the Huntington Hartford Mus. in New York. In the late 1960s and 1970s he exhibited mural-scale ASSEMBLAGES and environments. These included *Ramona's Cave* in 1967–8 at the Rubbers Gal. in Buenos Aires, *The World in Question*, a group exhibition at the Mus. National d'Art Moderne in Paris, where he also had a retrospective in 1971, and *The World of Ramona*, an extravagant multi-media environment with assemblages, sound, lights and side-show at the 'Expo-Show' in Buenos Aires in 1970–1. Berni has also written on art. Besides books and articles there are films on his work. His character Juanito Laguna was even popularized on tango and *milonga* records.

BERNIK, JANEZ (1933–). Yugoslav painter and graphic artist, born and studied at Ljubljana. He painted in a mode of expressive abstraction with large expanses of modulated colour deriving from ruined walls or desolate landscapes, occasionally making use of symbols from archaic scripts. His pictures were sometimes divided between an unstructured 'material' part and a structured 'spiritual' portion.

BERRY, ERICA. See SOUTH AFRICA.

BERSIER, JEAN EUGÈNE (1895–). French painter and graphic artist born in Paris and trained at the Académie Julian. He painted realistic landscapes and still lifes, an example of which is his *Nature Morte aux Brioches* (1935) in the Mus. National d'Art Moderne, Paris. He won the Cottet prize and a gold medal at the Paris Exposition Universelle in 1937. He was, however, chiefly known as a graphic artist and he taught engraving at the École des Beaux-Arts, Paris, and wrote several authoritative works on the subject, including *La Gravure, les Procédés, l'Histoire* (1963).

BERTHOLLE, JEAN (1909–70). French painter born at Dijon. After studying at the Écoles des Beaux-Arts at Saint-Étienne and Lyons he went to Paris and there frequented SURREALIST circles. He became a friend of Roger BISSIÈRE, Jean LE MOAL and Alfred MANESSIER. For a time his work displayed CUBIST simplifications without being fully abstract, and then moved towards expressive abstraction of the TACHIST kind. He was obsessed by the hidden mysteries of the universe and the enigma of man's place in it, and he regarded his abstractions as a means of expressing the secret aspects of existence.

BERTINI, GIANNI (1922–). Italian painter born at Pisa. In 1951 he helped to launch the *Movimento d'Arte Nucleare* with BAJ and DANGELO in opposition to current INFORMALISM. He subsequently devised a technique using film projections on special canvases. See also MEC ART.

BERTOIA, HARRY (1915–78). Italian-American sculptor, born at San Lorenzo, Italy. He went to the U.S.A. in 1930 and was naturalized in 1946. He studied at the Society of Arts and Crafts, Detroit, and the Cranbrook Academy of Art, Bloomfield Hills, Mich., and taught at the latter, 1937–41. His first one-man exhibition was at the Karl Nierendorf Gal., New York, in 1940. He had a one-man circulating exhibition from the Smithsonian Institution and participated in a number of group exhibitions including 'International Sculpture Exhibition' at Battersea Park, London, in 1963. He was awarded the Gold Medal of the Architectural League of New York and a Graham Foundation Grant in 1957. He specialized in architectural sculpture and executed many commissions for work on public buildings, including: a 70 ft (21 m) metal screen for the Fifth Avenue Branch of the Manufacturers Trust Company, New York (1954); Dulles International Airport, Washington, D.C. (1964); the Kodak Pavilion, New York World's Fair (1964–5). His sculpture was abstract and decorative, the motifs sometimes deriving from plant tendrils, leaves and other organic forms. He used a technique of welding bronze, brass and nickel silver over a metal framework, with expressive modulation of molten surfaces. In addition to sculpture he also worked on interior decoration and furniture design and among other things designed a wire chair for Knoll Associates.

BERTONI, WANDER (1925–). Italian-Austrian sculptor born at Codisotto, northern Italy, and brought to Vienna in 1943 as a forced labourer. After the defeat of the Nazis he studied sculpture under WOTRUBA at the Vienna Academy. He was represented in group shows at Vienna in 1950 and Kapfenburg in 1959. He won prizes for sculpture at the São Paulo Bienale in 1954 and at the Brussels World Fair in 1958. Bertoni began with figural sculpture but *c.* 1952 turned to abstract works, notable among them his *Imaginary Alphabet* series. From the late 1950s he produced abstractions based upon the human figure analysed into planes, cubes and open-form compositions with wedge-shaped components. His work was highly decorative in a personal manner.

BERTRAND, GASTON (1910–). Belgian painter born in the village of Wonck, Belgian Limburg. He began to study classics in Brussels but was compelled to earn his living in a variety of jobs from carpenter to mechanic. During this time he attended evening classes at art schools and in 1933 joined the Académie des Beaux-Arts, Brussels. His first one-man show was at the Gal. Dietrich, Brussels, in 1942. During the 1940s his style moved to geometrical abstraction of a refined and personal sort, using sensitive but highly simplified geometrical forms. He was a member of the JEUNE PEINTURE BELGE group, with whom he often showed in European countries, and he became a prominent figure in the post-war innovative art of

Belgium. He exhibited at the Stable Gal., New York, and at the Gal. Colette Allendy, Paris.

BERTRAND, HUGUETTE (1925–). French painter, born at Écouen, Seine-et-Oise. She painted in an abstract style between LYRICAL and geometrical ABSTRACTION, giving particular attention to the organization of virtual space in the picture image. She is quoted as saying: 'My aim is to dismember and at the same time to reconstitute space, to render it paradoxically cut up into pieces, set in motion by a linear process which though it wrenches at the form is not a negation of form itself, thus making it possible in a sense to go into and out of the canvas freely in a back-and-forth movement—in short the canvas becomes a choreographic argument.' She exhibited in several collective shows of abstract art in Paris, and in New York in 1956, had one-man exhibitions at the Gal. Arnaud, Paris, and was considered one of the more original French painters of lyrical abstraction during the 1950s.

BEUYS, JOSEPH (1921–86). German sculptor born at Kleve, studied at the Academy, Düsseldorf. He was appointed Professor of Sculpture there in 1961, but was 'summarily dismissed' in 1971. Beuys constructed his sculptures from all kinds of refuse and junk, such as bricks and felt. He also organized HAPPENINGS, which consisted of the disintegration and reorganization of his ASSEMBLAGES.

In 1974 Beuys had an exhibition of drawings from 1946 to 1972, entitled 'The secret block for a secret person in Ireland', at the Mus. of Modern Art, Oxford, and in Edinburgh (National Gal. of Modern Art), London (I.C.A. Gals.), Dublin (Municipal Gal. of Modern Art) and Belfast (Arts Council Gal). In the introduction to the catalogue it was stated that for Beuys drawing was a way of thinking or a thinking form and speech a form of invisible sculpture. His drawings do not for the most part invite assessment by current or traditional standards. Also in 1974 he had an exhibition 'Drawings 1946–1971' in the Haus Lange Mus., Krefeld, and was represented in the 'Art into Society/Society into Art' exhibition of seven German artists at the I.C.A. Gals., London. He exhibited in the Venice Biennale of 1976. Beuys was considered one of the leaders of the ARTE POVERA or ANTI-FORM movement. There is a large collection of his assemblages at the Mus. in Darmstadt. A collection of his drawings from 1945 to 1975, after touring Bielefeld, Bonn and Karlsruhe in 1980, was destined for the Nationalgal., Berlin, on permanent loan.

BEVAN, ROBERT POLHILL (1865–1925). English painter born at Hove, Sussex, studied at the Westminster Art School under Frederick BROWN and then at the Académie Julian, Paris. In 1894 he was painting in Brittany and knew Gauguin at Pont Aven. Back in London he became a member of SICKERT's circle at 19 Fitzroy Street. With Harold GILMAN he founded the small Cumberland Market Group and in 1911 he was a founding member of the CAMDEN TOWN GROUP. He participated in the 'Post-Impressionist and Futurist' exhibition arranged in 1913 by the critic Frank Rutter to counteract what was thought to be the aesthetic bias of Roger FRY's two Post-Impressionist exhibitions and he was a founding member of the LONDON GROUP. Bevan painted in the DIVISIONIST manner of Lucien PISSARRO, whom he admired, but modified it in the direction of the pure colour and flat patterning of Gauguin. He is best known for his paintings of street scenes with cab ranks and horse fairs, e.g. *The Cab Horse* (Tate Gal., *c.* 1910).

BEZOMBES, ROGER (1913–). French painter and designer born in Paris, studied at the École des Beaux-Arts there. He first exhibited at the Salon d'Automne in 1937. His work was influenced by Oriental exoticism and he painted in a style of brilliantly contrasting colours. An example is his *Femme Marocaine* (1938) in the Mus. National d'Art Moderne, Paris. He wrote a book, *Exoticisme dans l'art et dans la pensée*. He did decorations for the President's apartment on the liner *Île de France* and for the Hôtel de Ville, Algiers. He also designed tapestry for Gobelins and Aubusson and made designs for Sèvres pottery.

BIASI, ALBERTO (1937–). Italian experimental artist born at Padua and a member of GRUPPO N. He exhibited with the ARTE PROGRAMMATA association and with the NOUVELLE TENDANCE at Zagreb and he won a First Prize at the San Marino Biennale. He worked chiefly on the distribution of light refracted through prisms.

BIDDLE, GEORGE. See FEDERAL ARTS PROJECT.

BIEDERMAN, CHARLES JOSEPH (1906–). American artist and theorist, born at Cleveland, Ohio. After being apprenticed in a commercial art studio he studied at the Chicago Art Institute, 1926–9. He moved to New York in 1934 and began to do completely abstract paintings and to make three-dimensional reliefs in the style of MONDRIAN's NEO-PLASTICISM. He went to Paris in 1936 and there saw works by members of the ABSTRACTION-CRÉATION group, being most strongly influenced by Mondrian. He met Antoine PEVSNER and was introduced by him to the principles of CONSTRUCTIVISM. On his return to the U.S.A. in 1938 he was deeply influenced by Alfred Korzybski's theories about the general structure of language, which he termed 'General Semantics'. From *c.* 1942 he lived in Red Wing, Minn. His book *Art as the Evolution of Visual Knowledge*, published in 1948, followed by *Letters on the New Art* in 1951 and *The New Cézanne* in 1952, provided the theoretical rationale and justification of post-war Constructivism. In England it was taken

up with enthusiasm and led to the emergence of a new school of Constructivism. His views were further developed in the book *Search for New Arts* in 1979.

Biederman argued that throughout history the mimetic function of art, to reproduce natural appearances, had hampered and thwarted the creative or inventive faculty. Since the invention of the camera the job of recording appearances could be done more efficiently by mechanical means and art should abandon representation and illusion of every sort, thus freeing the creative faculty. He condemned pre-war Constructivism, including the Neo-Plasticism of Mondrian and the SUPREMATISM of MALEVICH, because although they avoided the representation of natural appearances, they did create the illusion of three-dimensional space. The new Constructivism—which he named 'Constructionism' to distinguish it from the old—should avoid all illusion, including 'virtual' space. If a third dimension was needed, the art object should be constructed as a relief in real space. Biederman was accepted both in America and in Europe as the forerunner and theorist of the new art of the 'construction' bridging painting and sculpture.

In his *Art as the Evolution of Visual Knowledge* Biederman put forward the doctrine, which was also taken up by the Dutch artist Joost BALJEU, editor of the magazine *Structure*, that although Constructivist art does not reproduce any of the appearances of nature, it does reflect the *structure* of reality. This is a metaphysical and obscure doctrine and it is not explained how a work of art—particularly the sort of art which was being produced under the Constructivist banner—could reflect the structure of reality without reproducing anything of the appearance of reality. In 1952, however, Biederman repudiated Constructivism and began to produce a new type of construction in accordance with a theory which he named Structurism. He had previously made very large relief constructions in painted wood, glass, plastics, etc., sometimes using fluorescent light tubes. The later constructions, also large, were more three-dimensional and consisted of one-coloured rectangles and cubes set at right angles against a coloured background.

A retrospective exhibition of Biederman's works from 1936 to 1969 was staged by the Arts Council of Great Britain at the Hayward Gal., London, in 1969. The Walker Arts Center, Minneapolis had given an exhibition 'Charles Biederman: the Structurist Relief, 1935–1964' in 1965.

BIENNALE, BIENALE. An international art exhibition held every two years and adjudicated by an international committee. The Venice Biennale was instituted in 1895 and the first 'International Exhibition of Art of the City of Venice', purporting to represent 'the most noble activities of the modern spirit without distinction of country', numbered 156 artists from 15 nations exclusive of 129 Italians. The Committee included artists such

as Burne-Jones, Gustave MOREAU, Puvis de Chavannes, Max LIEBERMANN, Israels, Carolus-Duran, etc. The second exhibition was no less successful and the Venice Biennale turned into a regular institution whose prestige became world wide. In the 1920s and 1930s the basis was broadened so that salon art no longer predominated and the *avant-garde* was welcomed. After the interval of the Second World War the Biennale was resumed in 1948 and became the leading show-place for the established international *avant-garde*. In 1974 the Biennale was closed, mainly owing to the accusations of left-wing critics that the exhibitions were organized without regard for an art of social usefulness. It was revived under the socialist Chairman Carlo Ripa di Meana with emphasis on 'social reality' and priority for the theme of 'the environment'. This theme was understood in two ways, both as involving a documentary approach and in the sense of ENVIRONMENT ART or the creation of 'art environments'.

Other biennales were inaugurated on the Venice model, notably in São Paulo, Tokyo, Ljubljana, Paris, Menton, Tehran. Some were general and some were devoted to a specific category of art, e.g. NAÏVE art or graphic art. Of these, the São Paulo Bienale, founded in 1951, acquired the highest prestige after Venice. The Paris Biennale was inaugurated in 1959 on the initiative of the critic Raymond Cogniat for Young Artists (artists under 30 years of age) and through the 1960s was successful in doing for the newest experimental art what Venice had done for the international *avant-garde* in the period between the two wars.

BIGAUD, WILSON. See LATIN AMERICA.

BIGGE, JOHN A. (1892–1973). British painter born at Oxford. He began to study at the Slade School in the spring of 1914, but joined the army in the autumn of that year. After interesting himself in SURREALISM during the 1920s he abandoned it for abstract art at the beginning of the 1930s, although he participated in the Surrealist exhibition held at the Royal Academy, London, in 1936. He was a member of UNIT ONE and in the statement which he contributed to Herbert Read's *Unit One* (1934) he gave an account of 'the essentials of abstract painting' which may be regarded as the standard view in Britain at that time: 'An abstract picture, whether it makes use of real or imaginary forms (in any case imaginary forms are derived or distilled from visual experience) must keep its content pure; there must be no association of the forms either with function or symbol. It must be logical in construction, but with its own self-imposed logic. Its forms must appear solid within space (not like cut-out pieces of paper applied to a flat surface), and yet it must dispense with both modelling and perspective, which belong to the world of material experience. Its colour must be integral with its form, colour-form being a single concept, and tone-values being merged within

colour. It must be illuminated, but with its own internal illumination. It must retain an air of spontaneity and yet have the completeness of inevitability.'

BILL, MAX (1908–). Swiss painter and sculptor born at Winterthur, studied at the Zürich School of Arts and Crafts, 1924–7, and at the BAUHAUS, Dessau, 1927–9. From 1929 he engaged in a variety of occupations, working as painter, sculptor, architect and designer. From 1932 to 1936 he belonged to the ABSTRACTION-CRÉATION association. In 1936 he took up the term CONCRETE ART (*Konkrete Kunst*) proposed by Van DOESBURG in 1930, the year before his death, and popularized it in Switzerland in place of 'abstract'. In 1941 he went to Brazil and the Argentine and introduced the concept of Concrete Art there. He organized a number of exhibitions of Concrete Art, among them one in the Kunsthalle, Basle, in 1944, one at the Kunstgesellschaft, Zürich, in 1960 and one at the Helmhaus, Zürich, in 1964. Bill's own work was primarily of the kind then called *Kalte Kunst* (COLD ART), a form of geometrical abstraction or CONSTRUCTIVISM which relied upon mathematical formulae to engender the relations between the parts from which a work was constructed. It was taken up and developed in Switzerland chiefly by Richard LOHSE and Karl GERSTNER and later became known as SYSTEMIC art. In the exhibitions which he arranged, however, Bill brought a very broad spectrum of non-figurative art within the designation, using 'Concrete' as an umbrella term covering almost the same field as 'abstraction'.

In 1937 Bill joined the association of modern Swiss artists *Allianz* and in 1941 he founded the *Allianz* Press. From 1944 he taught at the Technische Hochschule, Zürich, and turned his attention particularly to product designing as an expression of the Bauhaus Functionalism which was central to his concept of art. In 1947 he founded an Institute for Progressive Culture based upon similar ideas. In 1948 he exhibited at Stuttgart together with ALBERS and ARP and in 1949 showed more than 50 works in a joint exhibition with PEVSNER and VANTONGERLOO at the Zürich Kunsthaus. In 1951 an important retrospective exhibition of his work was staged by the São Paulo Mus. and he was appointed Rector of a Hochschule für Gestaltung at Ulm, which he developed into a kind of university for plastic and design techniques. He designed the Swiss Pavilion at the Milan Triennale in 1951 and was awarded the Grand Prix. He also participated in the Lausanne 'Expo' of 1964.

Bill also worked on sculpture from *c.* 1935, producing works which have been considered to be precursors of the PRIMARY STRUCTURES of MINIMAL ART although in fact they were derived from quite complicated mathematical formulae. He was awarded a Grand Prix for sculpture at the São Paulo Bienale of 1951. Bill's influence was considerable not only in Switzerland but mainly in the Argentine and Italy, where he was the inspiration of a number of associations of Concrete Art. Although his influence has been repudiated by Minimalists such as JUDD and MORRIS, the trend in Constructivism which he did so much to foster had important implications for later movements in abstract and systemic art. Bill also wrote on the mathematical bases of abstract art.

BIRGFELD, DETLEF (1937–). German sculptor born at Rostock. After beginning a medical course at Hamburg University, he studied at the Hochschule für Bildende Künste there. Among his teachers was Eduardo PAOLOZZI, with whom he worked in London in 1963–4. In 1960 he won a competition for a monumental structure for Heligoland, on which he worked from 1961 to 1963. In 1964 he won the Lichtwark scholarship at Hamburg and in 1967 began to teach at the Werkkunstschule und Meisterschule für Mode there. In 1967 also he won the First Prize for Sculpture at the Paris Biennale. His work consisted of geometrical forms and volumes assembled so as to give a vague suggestion of machinery in a factory. He worked in chromed or unpolished steel or sometimes in pasteboard.

BIROLLI, RENATO (1906–59). Italian painter born at Verona. After studying at the Cignaroli, Verona, he moved to Milan in 1928, where with CARRÀ, ROSAI, SIRONI and others he belonged to the NOVECENTO ITALIANO. In 1938 he took a prominent part in founding the anti-Fascist CORRENTE association, to which GUTTUSO, MAFAI, etc. belonged. He was persecuted and imprisoned for his political activities. In 1947 he joined the FRONTE NUOVO DELLE ARTI association and in 1952 was one of the founders of the GRUPPO DEGLI OTTO PITTORI ITALIANI. In his early years his work was EXPRESSIONIST, influenced by ENSOR and Van Gogh. After the war he developed a more abstract, although still figurative, form of Expressionism under the influence of PICASSO and PIGNON. From *c.* 1952 his work conformed to the mode of TACHIST abstraction, called INFORMALISM, showing affinities with that of BAZAINE and MANESSIER, using a vivid colour key which reflected his earlier interest in the ORPHISTS.

Owing both to his political views and to his advanced and energetic artistic outlook Birolli exercised an important influence on the Italian *avant-garde*. His work was represented on several occasions at the Venice Biennale from 1948 and was much exhibited in Italy. He had a large retrospective memorial exhibition at Milan in 1960.

BISCHOFF, ELMER (1916–). American painter born at Berkeley, Calif., and studied at the University of California at Berkeley. After serving in the U.S. Air Force, 1942–6, he taught at San Francisco Art Institute, 1946–52 and 1956–63, and at the University of California at Berkeley from 1963. Among his awards were a grant from the National Institute of Arts and Letters in 1963 and

the Norman Wait Harris Medal of the Chicago Art Institute in 1964. His first one-man exhibition was at the California Palace in 1947. He continued with frequent individual exhibitions and was represented in important collective exhibitions, including Fort Worth, 'The Artist's Environment', 1962; The Mus. of Modern Art, New York, 'Recent Painting USA: The Figure', 1962–3, and 'Art USA: Now', 1962–7. Like Richard DIEBEN-KORN he was one of a group of Californian artists who in the 1960s showed a renewed interest in depicting the figure in a painterly manner derived from ABSTRACT EXPRESSIONISM. He used sharply contrasting colours in paintings which often carried a suggestion of loneliness and solitude.

BISHOP, ISABEL (1902–). American painter born at Cincinnati, Ohio, studied at the New York School of Applied Design and at the Art Students' League, where she taught in 1937. During the 1930s she exhibited at the Midtown Gal., New York, and during the 1940s she obtained the Isaac N. Maynard Prize, Andrew Carnegie Prize, Adolph and Clara Obrig Prize at the National Academy of Design and the Joseph S. Isidora Gold Medal in 1957. She had a one-man show of prints and drawings at the Brooklyn Mus. in 1964. Isabel Bishop was a painter of unsentimental SOCIAL REALISM and was prominent during the 1930s among painters of the AMERICAN SCENE.

BISSIER, JULIUS (1893–1965). German painter, born at Freiburg. After studying for a short while at the Academy of Karlsruhe he served in the First World War and afterwards resumed painting without formal training. His early style was representational and had affinities with the NEUE SACH-LICHKEIT, but in the 1930s he turned to abstraction under the influence of Willi BAUMEISTER and BRANCUSI. In 1927 he was introduced to Chinese culture by the Freiburg sinologist Ernst Grosse and partly under the influence of Chinese calligraphy he evolved the black and white style of symbolic forms by which he later became chiefly known. These symbolic drawings, based upon abstract shapes which Bissier called 'signs of bipolar life', were intended to induce meditation rather than to serve the purposes of symbolism. After the Second World War he became a member of the ZEN group and developed a more painterly style, exploring unusual colour combinations in precisely executed water-colours or egg tempera paintings of small format on irregularly shaped canvases. It was these paintings of his late period which first brought him widespread recognition. In 1973 he was given a retrospective exhibition for his 70th year at the Institute of Contemporary Art, Boston. A large memorial exhibition was staged in 1977 from the Kunstsammlung Nordrheinische Westfalen, Düsseldorf, shown in the National Gal., Ireland, and at Birmingham and Sheffield, England.

BISSIÈRE, ROGER (1888–1964). French painter born at Villeréal, Lot-et-Garonne. After studying at the École des Beaux-Arts, Bordeaux, he went to Paris in 1910 and earned his living as a journalist while continuing to paint. From 1911 to 1918 he was in North Africa, but this change of scene made little impression on his painting. His early paintings were chiefly landscapes which imbued his native countryside with a monumental dignity and a strange fascination. Entirely without sentimentality, they were none the less profoundly moving. After his return to Paris he exhibited for the first time in 1919 at the Salon d'Automne. At this time he met LHOTE and through him came into contact with OZENFANT and LE CORBUSIER, contributing to their journal *Esprit Nouveau*. During this period he studied CUBISM and produced works of outstanding value and sensitivity in a 'humanized' Cubist idiom. From 1925 to 1938 he taught at the Académie Ransom, where his influence on many of the younger abstract artists, such as MANESSIER, LE MOAL, BERTHOLLE and VIEIRA DA SILVA, was fundamental. He might justly be called the father of that section of expressive abstraction in the ÉCOLE DE PARIS whose TACHIST paintings derived from the expressive qualities of nature. His own work during the 1920s and 1930s remained highly individual but almost unknown and in 1938 he retired to Lot as a virtually unknown painter. During the war his sight was dimmed by a glaucoma to less than one-third of normal vision, and unable to paint he produced compositions pieced together from tapestry and other materials (a technique later taken up by the Spanish artist CLAVÉ). A successful operation in 1948 enabled him to resume painting and during the 1950s he achieved the resounding recognition which had so long escaped him. He exhibited at the Gal. Jeanne Bucher in 1951 and 1952 and in 1954 was awarded the Grand Prix National des Arts. His fame became international and just before his death he represented France at the Venice Biennale. His large, tapestry-like compositions in rich and glowing colours were exhibited in many countries and commanded some of the highest prices of any living artist. Abstract in appearance, they resulted from a careful and sensitive reduction of natural appearances to scintillating patterns of interacting colours, while retaining the expressive character of the scene, and Bissière himself always refused to accept the description 'abstract' for his own work. In England the work of Bryan WYNTER had some similarity to his.

The recognition accorded to the work of his later years induced the more discriminating collectors and connoisseurs to reassess the work of his early and middle periods, which Bissière himself used to say would in the course of time be valued even more highly than that which had brought him to fame. In a letter published in the catalogue

for an exhibition of his works at Amsterdam in 1958 he wrote: 'J'ai horreur de tout ce qui est systématique. De tout ce qui tend à m'enfermer dans des barrières. Ma peinture est l'image de ma vie. Le miroir de l'homme que je suis, tout entier avec ses faiblesses aussi. Devant ma toile je ne pense pas au chef d'œuvre . . . La perfection d'ailleurs serait inhumaine. Un tableau sans défauts perdrait son rayonnement et sa chaleur. Il cesserait d'être l'expression vivante et concrète d'un homme.' ('I have a horror of everything systematic. Of everything that tends to imprison me within barriers. My painting is the image of my life. The mirror of the man that I am, entire with his weaknesses also. Before my canvas I do not think of the masterpiece . . . Perfection would be inhuman. A picture without faults would lose its radiance and its warmth. It would no longer be the living and concrete expression of a man.') But despite such language his work and his method were far removed from the 'psychic automatism' of ART INFORMEL. While some of his tapestry-like compositions incorporate ideographic signs, his main method of abstraction was to render natural appearances into lyrical and carefully composed abstract compositions which retained the expressive features of their source although object-recognition was jettisoned.

He had a large memorial exhibition at the Mus. des Arts Décoratifs, Paris, in 1966.

BJERKE-PETERSEN, VILHELM. See SUR-REALISM.

BLADEN, RONALD. See PRIMARY STRUCTURES.

BLAINE, NELL (1922–). American painter and graphic artist born at Richmond, Va., studied at the Richmond School of Art, 1939–43, the HOFMANN School, 1943–4, and with S. W. HAYTER at Atelier 17, New York, and the New School for Social Research, 1952–3. After travelling to Europe, the Near East and the West Indies she returned to the U.S.A. and taught in Great Neck Public Schools. She was a member of AMERICAN ABSTRACT ARTISTS, 1944–57. Her first one-man show was at the Jane Street Gal., New York, in 1945. She continued to exhibit through the 1950s and 1960s and was represented in a number of important collective shows. She concentrated mainly on water-colours, including abstracts, and graphic art. Among her commissions were murals for Revlon Inc. and lithographs for the New York Hilton Hotel.

BLAKE, PETER (1932–). British painter born at Dartford, Kent, studied at the Gravesend Technical College and School of Art, 1946–51, and after serving in the R.A.F. at the Royal College of Art, 1953–6. In 1956–7 he studied folk art in the Netherlands, Belgium, France, Italy and Spain with a Leverhulme Research Award and in 1958

obtained a Guggenheim Painting Award. Between 1960 and 1964 he taught at St. Martin's School of Art, the Harrow School of Art and the Walthamstow School of Art and from 1964 to 1974 at the Royal College of Art. In 1961 he obtained First Prize in the Junior Section of the John Moores Exhibition, Liverpool. His first one-man show was at the Portal Gal., London, in 1963. Among the many exhibitions in which he participated were: 'New Realists', Sidney Janis Gal., New York, 1962; 'British Art Now', at San Francisco, Dallas and Santa Barbara, 1962–3; 'British Painting in the Sixties', Whitechapel Art Gal., 1963; 'Painting and Sculpture of a Decade', Tate Gal., 1964; 'The New Scene', Walker Art Center, Minneapolis, 1965; 'Pop Art Redefined', Hayward Gal., 1969; 'Pop Art in England', Kunstverein, Hamburg, and Städt. Gal. im Lenbachhaus, Munich, 1976. He had retrospectives at the City Art Gal., Bristol, in 1973–4, and at the Stedelijk Mus., Amsterdam, the Kunstverein, Hamburg, and the Palais des Beaux-Arts, Brussels.

From the early 1950s Blake painted in a figurative manner, depicting with an air of the *faux-naïf*, and the superb technique of a Victorian master, children or circus people together with banal consumer goods, advertisements, pin-up girls, etc. and all the iconography favoured by POP ART. In the catalogue to 'Pop Art in England' it was said: 'The theme of his pictures is civilization's inroads into the world of the naïve; child and comic, child and advertisement. He took over the media of trivial pictures into the realm of serious art; the child expresses itself in the style of the advertisement.' He presented the KITSCH of contemporary culture in the universal tradition of folk art.

BLANCHARD, MARIA (1881–1932). French painter born at Santander of a Spanish father and a Franco-Polish mother. After studying in Madrid she went to Paris in 1906, where she was introduced by Van DONGEN into the CUBIST circle. After returning to Spain for three years, she settled permanently in Paris in 1916 and was closely linked with the Cubists. Her own work, however, was not Cubist in spirit although she derived from Cubism certain structural mannerisms. Her works were expressive of the life of the people and had something in common with popular art. She was best known for her scenes from family life, of which *L'Enfant à la Glace* (Mus. National d'Art Moderne, Paris) is typical. An important collection of her works was left by Dr. Girardin to the Mus. d'Art Moderne de la Ville de Paris.

BLANCHE, JACQUES ÉMILE (1861–1942). French painter, born at Offranville. He was best known as a brilliant and facile portraitist and decorative artist. His work was appreciated in England, where he exhibited at the Royal Academy.

An example of his decorative work is *Hommage aux morts* in the church of Offranville. His portrait of Jean Cocteau is in the Mus. Carnavalet and his portrait of Stravinsky in the Mus. National d'Art Moderne, Paris. In 1935 he was elected to membership of the Académie des Beaux-Arts. His work, much of which is in the museum of Rouen, has an important documentary interest as a pictorial record of society at the beginning of the century.

BLANCHET, ALEXANDRE (1882–1961). Swiss painter, born at Pforzheim, Germany, of Swiss parentage. He studied at the School of Industrial Art, Geneva, 1898–1904. From 1905 to 1914 he lived in Paris, visiting Florence and Rome in 1906. In 1918 he studied sculpture under DESPIAU but soon reverted to painting. He settled at Confignon, near Geneva, in 1922 and taught at the École des Beaux-Arts, Geneva, from 1930 to 1942. He painted in a simplified style of modified Naturalism, using pastel or fresco-like colours, and was variously influenced by Cézanne, MUNCH and Renoir.

BLANES-VIALE, PEDRO. See LATIN AMERICA.

BLAS, CAMILO. See LATIN AMERICA.

BLASE, KARL OSKAR (1925–). German painter and graphic artist, born at Cologne, studied at the Werkkunstschule, Wuppertal, 1945–9. In 1950 he became a member of the German Werkbund and in 1952 manager of the America House atelier for graphic art in Germany. From 1958 to 1966 he taught at the Werkkunstschule, Kassel, and from 1966 was Professor at the Hochschule für Bildende Künste there. In 1964 he became a member of the *Alliance Graphique Internationale*. From 1952 his work was exhibited widely in Germany. It had affinities with POP ART, consisting of linear caricatures of male and female figures, non-naturalistically represented against flat areas of colour.

BLAST. Periodical of the VORTICIST movement. Its two numbers, published in June 1914 and July 1915, were edited by Wyndham LEWIS.

BLAUE REITER, DER. A splinter group formed in 1911 upon the resignation of KANDINSKY, Gabriele MÜNTER, KUBIN, MACKE and Franz MARC from the NEUE KÜNSTLERVEREINIGUNG, Munich. Although the occasion for its formation was afforded by the refusal of the more conservative elements of the NKV to go along with the more advanced ideas being evolved by Kandinsky and Marc, the new group had no precise artistic programme, unlike, for example, the BRÜCKE. Its activities consisted in the organization of exhibitions and it took its stand upon the freedom of experimentation and the unhampered development of

originality. In 1911 Kandinsky and Marc were preparing a collective work consisting of essays and illustrations formulating their more advanced aesthetic views and the name of the group they founded was taken from an abstract drawing of a mounted horseman in blue and black on the cover of this 'Almanac', which was published in 1912. On the title-page of the catalogue of the inaugural exhibition the aims of the group were stated as follows: 'We do not seek to propagate any precise or particular form; our object is to show, in the variety of forms represented, how the inner desire of artists realizes itself in multiple fashion.' The first exhibition (December 1911–January 1912) was held in the Thannhauser Gal., where the NKV exhibited. It was later taken to Berlin for the inaugural exhibition of the STURM gallery of Herwarth Walden, and it was shown with some additions in Cologne, Hagen and Frankfurt. It consisted of 43 paintings by the following artists: Kandinsky, Marc, Macke, Gabriele Münter, Heinrich CAMPENDONCK, Elizabeth Epstein, Eugen Kahler, J. B. Niestlé, Albert BLOCH, David and Vladimir BURLIUK, formerly of the NKV, the composer Arnold Schönberg, and the French artists DELAUNAY and Henri ROUSSEAU. In March 1912 a much larger exhibition consisting of 315 examples of new graphic art by German, French and Russian artists was organized in Munich. The group disintegrated with the death in the First World War of Franz Marc and August Macke.

Retrospective exhibitions of the movement were given in Munich in 1949, by the Royal Scottish Academy at Edinburgh in 1960, and at the Gal. Maeght, New York, in 1962. The *Blaue Reiter* is considered to be the high point of German EXPRESSIONISM.

BLAUEN VIER, DIE. An association formed in 1924 by KANDINSKY, JAWLENSKY, KLEE and FEININGER in succession to the BLAUE REITER. Exhibitions were held in various towns of Europe and in the U.S.A.

BLEYL, FRITZ. See KIRCHNER, Ernst Ludwig.

BLOC, ANDRÉ (1896–1966). French painter, sculptor and writer, born in Algiers. After studying architecture and engineering in Paris he became a friend of LE CORBUSIER and founded a periodical *Architecture d'Aujourd'hui*. He began to do sculpture in 1940 while in the south of France and was influenced by LAURENS. In 1949 he turned to abstract sculpture, was a founding member of GROUPE ESPACE and also launched the periodical *Art d'Aujourd'hui*, which continued until the end of 1954. It was the first periodical to be devoted solely to abstract art and was the leading journal in this field. Michel SEUPHOR said of it in his *Dictionary of Abstract Painting*: 'The complete collection of thirty-six parts, notwithstanding occasional errors, provides a unique documentation of ab-

stract art in France and indeed all over the world.'

BLOCH, ALBERT (1881–1961). American painter born at St. Louis, Mo., studied in New York and Paris but was chiefly influenced by KANDINSKY and Franz MARC at Munich, by whom he was invited to join the BLAUE REITER association. In a letter published in the catalogue to his retrospective exhibition he subsequently wrote: 'What wonder, then, that an obscure newcomer like me, still in his twenties, who had until then shown only an occasional picture or two at the jury-shows of the Berlin and Munich Secessions, should feel delighted and flattered to be asked by two such men to join them in their planned enterprise of *Der blaue Reiter*, which in itself interested me very little, despite my awareness (or suspicion) that the group or rather the team of Marc and Kandinsky was to make Central Europe art history.' He returned to the U.S.A. in 1921, taught for a year at the Academy of Fine Arts, Chicago, and then became Director of the Department of Drawing and Painting at the University of Kansas at Lawrence until his retirement in 1947. A retrospective exhibition was given at the University of Kansas in 1955.

BLOK. A CONSTRUCTIVIST group formed in Łódz, Poland, in 1922 by Władysław STRZEMIŃSKI, who had worked with MALEVICH during the war. It was also the title of a Constructivist magazine founded at Warsaw in 1924 and fairly close to the outlook of Soviet Constructivism. The editorial of the first number claimed that Constructivism 'proceeds from the primordial instinct of art that is manifested in every product of man's labour' and affirmed that in the construction of a thing the first and foremost aim must be its practical efficiency. Yet as a concession to European views it added that this 'does not mean that the programme of Constructivism would eliminate disinterested creative activity from art'.

BLONDEL, EMILE (1893–). French painter born at Le Havre. He was a NAÏVE artist, who worked as a sailor and then as a bus driver in Paris and devoted himself to painting only after his retirement in 1937. He is appreciated for his large landscapes scattered with innumerable small figures, which were often reminiscent of his past life and of scenes from Paris or Normandy. His pictures had the directness and the fairy-tale quality which is characteristic of many naïve artists.

BLOOM, HYMAN (1913–). American painter born in Latvia. He emigrated to the U.S.A. in 1920 and settled first in Boston, then at Brookline, Mass. He worked on the FEDERAL ARTS PROJECT/WPA during the 1930s and had his first important show in the 'Americans 1942' exhibition at The Mus. of Modern Art, New York. He was impres-

sed by the work of the French EXPRESSIONISTS ROUAULT and SOUTINE and he painted Jewish themes in an Expressionist style developed from a study of their works. From the 1940s he became obsessed with the themes of death and decay, beginning his *Corpse* series in 1945. As time went on the morbid and visceral character of his work became more pronounced, as in his *Autopsies* and dissection scenes. He was given an exhibition at the Institute of Contemporary Art, Boston, in 1954 and an exhibition of his drawings ,was held by the Connecticut Mus. of Art in 1968. The public collections in which his work is represented include The Mus. of Modern Art, New York, the Whitney Mus. of American Art, and the Smith College coll.

BLOOMSBURY GROUP. A loosely knit association of writers, artists and critics which had an important influence on the formation of taste in Britain during the early decades of the century. Among the writers were Lytton Strachey, Maynard Keynes, Virginia and Leonard Woolf, Desmond MacCarthy, E. M. Forster and David Garnett; the artists and critics included Clive BELL, Vanessa BELL, Roger FRY and Duncan GRANT. The group had no formal membership and was unified by no common social or aesthetic ideology but its adherents were linked rather by attitudes and interests which have caused them to be represented as an intellectual élite.

The association stemmed from student friendships formed at Trinity College, Cambridge, in 1899 between Lytton Strachey, Leonard Woolf and Saxon Sydney Turner, members of the semi-secret 'Apostles' society, together with Thoby Stephen, eldest son of Sir Leslie Stephen, and Clive Bell. These young men were deeply influenced by the Cambridge philosopher G. E. Moore and by Bertrand Russell. On the death of Leslie Stephen in 1904 his daughters, Virginia and Vanessa, moved from Little Holland House to 46 Gordon Square, Bloomsbury, and there they were brought into contact by Thoby Stephen with his Cambridge friends. On the marriage of Vanessa to Clive Bell in 1906 Virginia and Adrian Stephen moved to Fitzroy Square, where they introduced Duncan Grant into the group. Between 1910 and 1914 the aesthetic views of Roger Fry made a strong impact on Vanessa and Clive Bell and on Duncan Grant, while Desmond MacCarthy and Leonard Woolf were directly involved with his POST-IMPRESSIONIST exhibitions. It was partly under his influence that Clive Bell wrote the essays published as *Art* in 1914. Members of the group were also involved with his Omega Workshops, founded in 1913, and in the rift with Wyndham LEWIS.

It was during the 1920s and early 1930s that the influence of Bloomsbury was most effective. The persistent propaganda of Roger Fry for Cézanne and the Post-Impressionists converted ridicule and

outraged rejection into interest if not full understanding. Successive exhibitions of the LONDON GROUP were flooded with pastiches in the manner of Duncan Grant. The writings of Fry and Bell tended in the direction of a formalist aesthetic which played down the importance of content and paved the way for a new method of criticism in the visual arts. If with incomplete consistency, they heralded the reaction from the anecdotal sentimentalism of 19th-c. criticism and laid the foundation for a more just appreciation of the aims of contemporary art.

BLOORE, RON. See CANADA.

BLOW, SANDRA (1925–). British painter born in London, studied at the St. Martin's School of Art, 1942–6, and the Accademia di Belle Arte, Rome, 1947–8. From 1961 she taught painting at the Royal College of Art. In 1971 she was elected A.R.A. Her work oscillated from semi-geometrical to GESTURAL and expressive abstraction and she also practised COLOUR FIELD painting. Among the exhibitions in which she participated were: 'Painting in the Sixties', Tate Gal., 1962; 'Contemporary British Painting', Albright-Knox Art Gal., Buffalo, and 'Young British Painters', North Carolina Mus. of Art, Raleigh, 1964; 'Aspects of New British Art', Arts Council exhibition touring in Australia and New Zealand, and 'Recent British Painting', Tate Gal., 1967; 'British Painting '74', Hayward Gal., 1974.

BLUEMNER, OSCAR (1867–1938). German-American painter born at Hanover, studied at the Academy of Fine Arts, Berlin. He went to the U.S.A. in 1892 and practised as an architect from 1894 to 1912. He was one of the small group of artists who in the first two decades of this century brought America into contact with progressive European movements, himself painting in a manner derived from the FAUVISM of MATISSE. He was a member of Alfred STIEGLITZ's circle and a great admirer of the work done by Stieglitz to bring innovative European and American art to the notice of the American public. He was given his first one-man show in America by Stieglitz in 1915 and he also exhibited in the FORUM exhibition of American artists. In 1967 a retrospective exhibition of his work was staged by the Fogg Art Mus., Cambridge, Mass. Among other collections his works are in The Mus. of Modern Art, New York, the Boston Mus. of Fine Art and the Whitney Mus. of American Art. Bluemner's expressive and individualistic use of colour derived partly from Byzantine mosaics and medieval stained glass, but unlike the SYNCHROMISTS he did not go in for non-figurative abstraction. In his almost exclusive concentration on landscape he was to some extent influenced by the CUBISTS but unlike them he was primarily interested in romantic simplification.

BLUHM, NORMAN (1920–). American painter born in Chicago. He studied at the Illinois Institute of Technology and then, after serving in the U.S. Air Force, with the architect Mies van der Rohe, 1945–7. From 1947 to 1956 he lived in Paris, and during these years he worked in a delicately lyrical manner with patterns of opalescent shades. His first one-man show in America was at the Leo Castelli Gal. in 1957. He continued to exhibit both in America and internationally, in Italy, Paris, Brussels, etc., and was represented in important collective exhibitions of American art including 'Abstract Expressionists and Imagists' at the Solomon R. Guggenheim Mus. in 1961. Sometimes associated with the ABSTRACT EXPRESSIONISTS of the 1950s, his work belonged at that time rather to the COLOUR FIELD painters. In 1960 he collaborated with the poet Frank O'Hara in painting-poems based on the seasons of the year. After his return to Paris in the mid 1960s his work took on a more vigorous character with painterly qualities of pigment and rhythmical movement reminiscent of some ACTION PAINTING of the 1950s. Among other collections he is represented in the Massachusetts Institute of Technology, the University of New York, the State University of New York at Stony Brook and the Whitney Mus. of American Art.

BLUME, PETER (1906–). American painter born in Russia and emigrated to the U.S.A. in 1911. He was trained at the Art Students' League, New York. He used the meticulous technique of the PRECISIONISTS, as in *Parade* (The Mus. of Modern Art, New York, 1930) and *South of Scranton* (The Metropolitan Mus. of Art, New York, 1931), but superimposed upon it sophisticated SURREALIST imagery. He came to general notice with the latter picture, which won First Prize at the Carnegie International Competition, 1934. In 1932 and 1936 he went to Italy with Guggenheim Fellowships. At this time he began his large and most famous work, *The Eternal City* (The Mus. of Modern Art, New York, 1934–7), a Surrealist satirical attack on Mussolini and the social iniquities of Fascism. Blume believed that pictorial art should have a purpose in the communication of ideas. He said: 'Since I am concerned with the communication of ideas I am not at all ashamed of "telling stories" in my paintings, because I consider this to be one of the primary functions of the plastic arts.' But although he used the imagery of Surrealism, the appeal was intellectual and not, as with most European Surrealists, to associations or archetypal imagery of the unconscious mind.

BOCCIONI, UMBERTO (1882–1916). Italian painter and sculptor, born in Reggio Calabria. In 1900 he was in Rome, where he struck up a friendship with SEVERINI and with him learned the elements of the DIVISIONIST technique from BALLA. After travelling to Paris and St. Petersburg he settled in Milan in 1907 and there came into contact with MARINETTI. In 1910 he signed the manifestos

of the FUTURIST painters and thereafter became the most energetic of the Futurist group. He was regarded by APOLLINAIRE, writing in *L'Intransigeant* of 7 February 1912, as the most talented of the Futurists. Impressed by the industrialization of Milan and moved to enthusiasm by the ideas of Marinetti, he made it his aim to paint 'the fruits of our industrial age'. But to the somewhat hackneyed theme of cityscapes and the painting of city life he added the concept of 'Unanimism', by which he understood the pictorial representation of collective sentiment, movement and crowd emotion. Typical examples of this theme are *Rissa in galleria* (*Riot in the Gallery*) and *Città que sale* (*The Rising City*) (The Mus. of Modern Art, New York), both painted 1910–11. In more general terms Boccioni was centrally concerned with the two main preoccupations of the Futurists, the production of emotionally expressive painting (in contrast to the 'pure art' ideal of the CUBISTS) and the pictorial representation of the dimension of time. The latter took two forms. The one was the 'synthetic' suggestion of movement and speed in such a way that the spectator was empathically involved in the movement of the picture, and the other was the simultaneous representation of successive states of mind or memory-images in a manner suggested by Bergson's concept of 'psychic duration'. An outstanding example of a painting which universalizes an emotional state of mind is his *Lutto* (*Mourning*) of 1910. Of this painting he wrote in a letter: 'If it shall be in my power (and I hope it is), emotion will be suggested with the smallest possible recourse to the objects which have evoked it. For me the ideal shall be a painter who, wishing to suggest sleep, does not lead the mind to the being (man, animals, etc.) which sleeps, but by means of lines and colours could evoke the idea of sleep, that is, universal sleep beyond the accidentals of time and place.' His representation of the same woman from different points of view in *Lutto* is intended to suggest the passage of time. His masterpieces in the representation of collective emotions or states of mind which unite human beings in the dynamic environment of the machine age are the *Stati d'animo: Gli Addii, Quelli che vanno* and *Quelli che restano* (*States of Mind: The Farewells, Those who Go, Those who Stay*), executed in 1911–12. Earlier studies and drawings for this triptych are in the Gal. d'Arte Moderna, Milan, and The Mus. of Modern Art, New York. Following Bergson's philosophy, the Futurists believed that physical objects have as it were a personality and an emotional life of their own which is revealed by characteristic 'force-lines' (Boccioni himself had earlier referred to it as 'physical transcendentalism'). As it was stated in the Preface to the catalogue of the Futurist Paris exhibition: 'Objects reveal in their lines calm or frenzy, sadness or gaiety. These diverse tendencies give to their formative lines a sentiment and a character of weighty stability or of airy lightness.' This idea permeates such pictures as *Le Forze di una strada*

(*The Forces of a Street*) of 1911. A rather similar conception underlay the aesthetics of Seurat.

Boccioni was introduced to Cubism by SOFFICI in 1911 and came to know it at first hand on a visit to Paris in the autumn of that year and during the Futurist exhibition at Bernheim-Jeune & Cie in 1912. His painting took on more rigorous formal construction under Cubist influence, he became interested in the Cubist play of interpenetrating planes and although he was still wrestling with the Futurist problem of the synthetic representation of movement, the pictorial solutions to which he was now tending were different. This may be seen in such paintings from 1913 as *Antigrazioso* (*Anti-Graceful*), *Dinamismo di un footballer* (*Dynamism of a Football Player*) and *Dinamismo di un Ciclista* (*Dynamism of a Cyclist*). At this time Boccioni took up sculpture and published his *Technical Manifesto of Futurist Sculpture*. While reaffirming the Futurist doctrine that 'Only the most modern choice of subject will be able to lead to the discovery of new plastic ideas', he initiated two sculptural innovations which looked forward to developments much later in the century. The one was the rejection of traditional materials and the combination of a variety of materials in one piece of sculpture. The other, heralding the 'spatial' sculpture of ARCHIPENKO, MOORE and the CONSTRUCTIVISTS, was what he called the 'sculpture of environment'. By this he meant that sculpture should no longer be a mass or a silhouette standing out against the space which surrounds it, but rather that it should enclose and mould the space within itself. 'We therefore cast all aside and proclaim the absolute and complete abolition of definite lines and closed sculpture. We break open the figure and enclose its environment within it.' Boccioni exhibited 11 pieces of sculpture at the Gal. La Boétie, Paris, in June 1913, and 10 pieces at the Sprovieri Gal. Permanente Futurista, Rome, and the Gal. Gonnelli, Florence, in 1913–14. Most of his sculptural work has somewhat mysteriously disappeared and only four pieces are now known. Of these the still life, *Sviluppo di una bottiglia nello spazio* (*Development of a Bottle in Space*) and *Forme uniche della continuità nello spazio* (*Unique Forms of Continuity in Space*), both now owned by The Mus. of Modern Art, New York, are considered to be masterpieces.

By 1913–14 Boccioni was already showing signs of reverting to classical styles of construction and it is conjectured that his Futurist inventiveness was already spent. After the Futurist interventionist manifestos he volunteered for the army in 1915 and was enrolled in the Cyclists' Brigade. He was killed by a fall from a horse in August 1916.

BOCHNER, MEL. See SERIAL ART.

BÖCKSTIEGEL, PETER AUGUST (1889–1951). German EXPRESSIONIST painter born at Arrode-Werther, Westphalia, studied at the Bielefeld School of Arts and Crafts and at the Academy of

Art, Dresden. He was a friend of Otto MÜLLER and was influenced by NOLDE and the painters of the BRÜCKE. A memorial exhibition of his work was given at the Landesmus. für Kunst und Kulturgeschichte, Münster, in 1956 and he was represented in the exhibition of German Expressionist painters staged there in 1974.

BODMER, PAUL (1886–). Swiss painter born in Zürich, studied in the Textile Department of the School of Arts and Crafts, Zürich, and with a theatrical scene-painter, Albert Isler. After a period in Berlin and Düsseldorf he returned to Zürich, where he remained as an independent painter.

BODMER, WALTER (1903–). Swiss sculptor and painter, born at Basle. He began his training as a painter at the School of Arts and Crafts, Basle, and studied also in France and Spain. After working in a POST-IMPRESSIONIST manner he turned to abstraction in the early 1930s and in 1936 he began the abstract wire sculptures and open-space constructions and metal reliefs for which he is chiefly known. He was one of the main representatives of CONSTRUCTIVIST art in Switzerland, working both on abstract colour compositions and on elegant abstract linear designs, and he was one of the pioneers of wire sculpture. From 1939 he taught at the Technical School of Basle. He also did graphic work.

BODY ART. Body Art is defined by the fact that the human body, usually the body of the artist though sometimes the body of another person, is used as the artistic medium. In some of its manifestations Body Art came close to the 'event' or the 'performance' and from the late 1950s something like Body Art was an element in many HAPPENINGS. But works of Body Art as entities in themselves emerged only in the latter half of the 1960s and are best understood as a reaction from CONCEPTUAL art. The reaction was not in the direction either of EXPRESSIONISM or Realism. A work of Body Art is not an expression of the artist's emotions or presented as an event in his individual life-story but is as depersonalized as POST-PAINTERLY ABSTRACTION and MINIMAL ART. As was said by Willoughby Sharp, it is on the level of a statement about the body in general: 'It's more about using the body than autobiographical'.

Sometimes works of Body Art were executed in private and communicated by means of photographs or films; sometimes the execution of the 'piece' is public. Sometimes the demonstration was pre-choreographed (as with Gilbert and George); sometimes it was extemporaneous. Spectator participation was generally discounted rather than invited.

A forerunner of the type of Body Art in which the body is used as a *tool* is considered to be *Imprints* by Yves KLEIN, when in 1961 he had naked girls smeared with blue paint and dragged in the manner of living paint brushes over a canvas spread on the floor. Bruce Nauman executed his first body work, a performance resembling callisthenics, in 1965 while a graduate student at the University of California. In 1968 he made a series of holograms *Making Faces*, for which he distorted his face by pulling it with his fingers to the limits of flexibility. In his best-known piece, *Portrait of the Artist as Fountain* (1967), he was photographed squirting water from his mouth. At an exhibition 'Projections: Anti-Materialism' in the La Jolla Mus., San Diego, Calif., Barry LeVa executed a 'piece' which involved running at full tilt into one of the walls of the museum. The idea was taken further by John Van Saun, who in his 'piece' *Breakthrough*, performed in the garden of The Mus. of Modern Art, New York, ran through a specially built wooden partition. Terry Fox, Dennis Oppenheim, Dan Graham and Richard Long have photographed or made plaster casts of their footmarks after executing specially planned steps.

In continuation of the 'ready made' of DUCHAMP and the everyday banality sought both by some Minimalists and some POP artists, some body-work artists have presented photographs or films of the ordinary functions of the body as works of art. Bruce McLean has specialized in this, as for instance in his *Smile Piece* (1969), a vertical sequence of three photographs of the artist in the process of smiling. Vito Acconci, one of the most versatile and most outrageous of the body-work artists, in *Breathing In* (1969) practised taking deep breaths and holding them as long as he could.

Frequently the artists have misused or abused the body. In Paris Gina Pane cut herself with razor blades and in *Nourriture* (1971) she caused herself to vomit by eating 600 grammes of minced meat. In *Eleven Toothpick Expressions* (1970) William Wegman photographed himself with eleven toothpicks stuck into his gums. Larry Smith's *Line* was the scar of a six-inch cut he had made in his arm. In *Rubbing Piece* Acconci sat at a restaurant table and rubbed his left inside forearm with his right hand for an hour, photographing every five minutes the progress of the sore. In *Hand and Mouth Piece* he pushed his hand down his throat until he gagged. Oppenheim exposed his body to the sun on a Long Island beach and had colour photographs taken before and after the sunburn. Some artists have gone as far as self-mutilation and amputation. Keith Arnatt did a *Self-Burial* piece in 1969 which was filmed for television. Michel Journiac had the art gallery transformed into a medical laboratory. The philosophy behind such works is not clear. It has been stated in so many words by Willoughby Sharp that 'body works executed directly on the body are never intended either to beautify or disfigure the artist' but when the marks are permanent this is 'an unavoidable consequence of the work rather than a desirable effect'. Frank Popper, however, took the view that in the case of Gina Pane her 'main con-

cern is with the psychological transformation of the body and the identification between the artist and the others'. In general, however, except in the cases where Body Art involves performance, as with Gilbert and George, there seems to have been little or no interest in spectator participation or empathy between artist and spectator.

BOECK, FÉLIX DE (1898–). Belgian painter, born at Drogenbos. After studying the history of art at Brussels University, he returned to his family farm and painted in his free time. He was intimate both with Van den BERGHE and with MONDRIAN and after a period of lyrical FAUVISM, during the 1920s he evolved a personal idiom of geometrical abstraction. Based upon natural scenes, his compositions emphasized diagonals whose intersections moved towards a luminous centre. Later he converted familiar animals, portraits and urban scenes into poetic visions.

BOECKL, HERBERT (1894–1966). Austrian painter, born at Klagenfurt. After studying architecture in Vienna and becoming for a short time a pupil of Adolf Loos, he became a self-taught painter. In 1935 he was appointed Professor at the Vienna Academy of Art. His major work is his decoration of the interior of the Engelskapelle in Sekau, 1952–60. He also exhibited at the Venice Biennale in 1964.

Boeckl's early works were EXPRESSIONIST and elemental. In the 1940s they lost something of their bravura, although his water-colours retained an *élan* and an instinctive feeling for colour. As a teacher he influenced many of the younger artists such as Kurt ABSOLON and Carl UNGER.

BOEDEKER, ERICH (1906–71). German NAÏVE sculptor, born at Recklinghausen. He worked for 35 years as a miner and only began to do sculpture after his retirement in the 1950s. He worked in both wood and concrete. His figures had crude, post-like bodies surmounted by faces like expressive caricatures of puppets. The finished sculptures were brightly painted in strong colours. He did groups of figures, which have sometimes been described as the analogue in naïve art of the 'environments' of such artists as George SEGAL and Edward KIENHOLZ. His largest work in this genre was a composition of 21 life-size figures in painted concrete entitled *Modern Society Considering the Fruits of the Quarrel Between Adam and Eve*. He was awarded a sculpture prize at Bratislava in 1969 and at Zagreb in 1970. But apart from a lively and childlike gift for caricature there is little of artistic interest in his work.

BOERS, DIETER. See SYN.

BOFA (GUSTAVE BLANCHOT, 1885–). French humorous artist and illustrator, who worked for *Le Rire*. In 1920 he founded the Salon d'Araignée and in 1923 he published *Synthèses littéraires*.

BOGART, BRAM (1921–). Dutch painter born in Delft. He spent the years 1951 to 1961 in Paris and there developed a TACHIST style with affinities to ACTION PAINTING. He then settled in Brussels and took up the MATTERIST technique, which he developed in a very personal way. Heavy masses of pigment were built on to the canvas in broad bands of vividly contrasting colours, so that the expressive impact of the work depended upon a combination of the evocative value of the materials and the effects of these broadly contrasted masses.

BOGGIO, EMILIO. See LATIN AMERICA.

BOLOTOWSKY, ILYA (1907–81). Russian-American painter born at St. Petersburg, studied at St. Joseph College, Istanbul, and at the National Academy of Design, New York, 1924–30. He went to New York in 1923 and became an American citizen in 1929. He painted in a manner of CONSTRUCTIVIST abstraction from 1933 and during the 1940s he was one of the group of American artists who came most deeply under the influence of MONDRIAN. He was a founding member of AMERICAN ABSTRACT ARTISTS and of the Federation of Modern Painters and Sculptors. His teaching posts included Black Mountain College, 1946–8, University of Wyoming, 1948–57, State University of New York at Stony Brook, 1957–65. His mural for the Williamsburgh Housing Project, New York, in 1936 was one of the first abstract murals to be commissioned. He also made experimental films and was awarded First Prize for *Metanois* at the University of Chicago Midwest Film Festival.

BOLUS, MICHAEL (1934–). British sculptor, born at Cape Town. He was a pupil of Anthony CARO at the St. Martin's School of Art, 1959–62, and was prominent in the development of British MINIMAL sculpture. He exhibited at the Waddington Gals., London, in 1970 and 1971 and at the Kornblee Gal., New York in 1966. He developed the sculptural use of modules, arranging his 'installations' low on the floor from a few basic repeatable units. Many critics have recognized an element of playfulness in his work. Later he changed to painted steel grid-like structures, which he exhibited in 'The Condition of Sculpture' show at the Hayward Gal. in 1975.

BOMBERG, DAVID (1890–1957). British painter, born in Birmingham, son of an immigrant Polish leather-worker. While apprenticed to a lithographer he attended evening classes by Walter BAYES at the City and Guilds Institute and he was assisted by the Jewish Educational Aid Society to study at the Slade School, 1911–13. He was associated with Wyndham LEWIS's VORTICIST movement and exhibited in the 'Cubist Room' at the CAMDEN TOWN GROUP exhibition at Brighton, 1913–14. He helped to organize the Whitechapel Art Gallery's exhibition 'Twentieth Century Art'

in the spring of 1914 and participated in it. In the same year he was a founding member of the LONDON GROUP. He had a one-man exhibition at the Chenil Gal. in July 1914 and exhibited on invitation at the Vorticist exhibition of 1915. This period of his work is best known for his picture *The Mud Bath* (1914), in which, to quote from the review by T. E. Hulme, 'the figures are so abstract that they are not recognisable as such'. The picture and two preliminary studies for it are in the Tate Gal. His design for a Canadian War Memorial picture was rejected as too radical in 1918 and disillusioned by this and by the ill success of a one-man show at the Adelphi Gal., London, in 1919, he retired from active participation in the artistic life of the country and worked in isolation. He was in Palestine from 1923 to 1927 and from 1929 made a series of visits to Spain, Morocco, Greece and Russia. About 1929 he abandoned his abstract style and slowly developed a personal style of expressive brush-strokes. From 1945 to 1953 he taught at the Borough Polytechnic, Dagenham, and formed with some of his students the Borough Group, which lasted from 1947 to 1949. In 1953 he founded the Borough Bottega, in which exhibitions were held until 1955.

In his lifetime Bomberg's work in his later, EXPRESSIONIST style was little known or appreciated. Since his death it has come to be much more highly valued by critics and he has been regarded as the pioneer of Expressionism in Britain.

BOMBOIS, CAMILLE (1883–1970). French NAÏVE painter, son of a bargeman of Venarey-les-Laumes in the Côte-d'Or. He passed his childhood on barges along the canals of France and was afterwards a farmhand and a wrestler in a travelling circus. From 1907 he worked as a porter on the Paris Métro, as a navvy and a docker, and then took a night job in a printing establishment in order to have more time for painting. He served in the First World War and was awarded a Military Medal. In 1922 a pavement exhibition of his pictures attracted the attention of Wilhelm UHDE and other critics, by whom he was recognized as a naïve artist of merit and enabled to devote all his time to painting. Innocent of formal principles, his pictures have exceptional strength and vitality. Oto Bihalji-Merin has characterized his style aptly in the following words: 'What is striking in Camille Bombois is the ingredient of folk art deformed into colportage and injected with unconscious surrealism. Bombois gives everything he makes something of the abundant strength of his vitality. Landscapes and objects have their own plastic existence, and the spaces the painter leads us through, the bridges we cross, the tree-lined boulevards stretching into the distance, have a unique depth resulting from their brightness, the long shadows, and rapidly disappearing lines.' In particular his *œuvre* is redolent of the life of the circus and the fairground. Bombois has a place as one of the leading French naïve artists and has been widely exhibited both in France and abroad.

BONALUMI, AGOSTINO (1935–). Italian painter and sculptor born at Milan. He was active in the movement towards geometrical abstraction, called Neo-Concrete art, which succeeded IN-FORMALISM in Italy and he was chiefly known for his 'picture reliefs', in which a monochromatic canvas was stretched over a wooden framework which gave it relief. He began sculpture in 1958.

BONEVARDI, MARCELO. See LATIN AMERICA.

BONHOMME, LÉON (1870–1924). French painter, born in Paris and a pupil of Gustave MOREAU at the École des Beaux-Arts. He was a friend of ROUAULT and painted in a style of energetic realism resembling that of the early Rouault.

BONNARD, PIERRE (1867–1947). French painter, born at Fontenay-aux-Roses. He is considered to have been the most important 'pure' painter of his generation, in the tradition of the great colourists—the Venetians, Delacroix, Gauguin, Odilon Redon. After studying law, he worked at the École des Beaux-Arts and at the Académie Julian in 1888. There he met Édouard VUILLARD and Maurice DENIS, with whom he shared a studio in 1890, and through Paul SÉRUSIER became familiar with the theories of Gauguin. He began to exhibit at the Salon des Indépendants in 1891 and held his first one-man show, at the Durand-Ruel Gal., in 1896. Bonnard and his friends, who included Ker-Xavier ROUSSEL, brother-in-law of Vuillard, and Félix VALLOTTON, all young men, were known at this time as the NABIS (Hebrew: 'prophets'). They exhibited with the dealer Le Barc de Boutteville, contributed to the *Revue Blanche*, founded in 1891 by the brothers Alexandre and Thadée Natanson, and did decorations and stage designs for the Théâtre de l'Œuvre, founded by Aurélien-François Lugné-Poë in 1893. During the 1890s and 1900s Bonnard's decorative flair was particularly in evidence. His work during this period had affinities with ART NOUVEAU in its linear rhythms and decorative qualities. His admiration for Japanese woodcuts earned him the epithet 'the Japanese Nabi'. He was one of the first artists to be attracted to poster design and his first poster, *France-Champagne*, bought in 1889, was one of the factors which determined his decision to become an artist against family opposition. He was commissioned by Tiffanys to do a design *Maternité* for a stained glass window, which was included in an exhibition at the Société Nationale in 1895. In 1896 he collaborated with Claude Terrasse, his brother-in-law, in a presentation of Jarry's *Ubu Roi* at the Théâtre de l'Œuvre and in designing puppets for the Théâtre des Pantins. He illustrated Claude Terrasse's *Petites Scènes Familières au petit solfège* in 1893 and later did illustrations for VOL-LARD's editions of *Parallèlement* by Verlaine (1900) and the *Daphnis et Chloé* of Longus (1902).

His first major one-man show was in 1904 at the Gal. Bernheim-Jeune, with whom he had entered into an agreement in 1899. It was followed by one-man shows in 1906, 1909, 1910, 1911, 1913. He was represented in important exhibitions of French art at Oslo, Stockholm, Gothenburg in 1898, in 1907 at Prague, in 1910 at Leipzig, in 1913 at the Zürich Kunsthaus, in 1914 at Copenhagen, in 1915 at Winterthur, Switzerland. The first long articles about Bonnard appeared in 1912: a profile by Thadée Natanson and a critical study by Lucie Cousturier. The first monograph, by Léon Werth, appeared in 1919. In 1912, together with Vuillard, Roussel and Vallotton, Bonnard refused the Légion d'honneur.

Firmly established by the time of the First World War, Bonnard's position among French painters continued to strengthen in the inter-war years. He continued to exhibit at the Bernheim-Jeune Gal. and in 1924 had a large retrospective exhibition at the Gal. Drouet. In 1922 Bernheim-Jeune published a book on him by Coquiot and a book by his nephew Charles Terrasse was published in 1927. In 1926 he visited the U.S.A. as a member of the Carnegie International jury. In 1928 he exhibited 40 paintings in New York and in 1930 he was represented by 7 paintings in an exhibition 'Painting in Paris' at The Mus. of Modern Art, New York. He continued to exhibit during the 1930s and 1940s both in one-man shows and in important group shows of French art, including a large group of works at the Paris World's Fair in 1937 and a retrospective exhibition of 51 paintings at the Svenska-Franska Konstgal., Stockholm, in 1939. His wife, the former Maria Boursin or Marthe de Moligny, whom he had married in 1925, died in 1940 after the fall of France. To avoid difficulties Bonnard forged a will and this led to serious legal complications concerning his estate after the artist's death. In 1946, the year before his death, a retrospective show of 40 major works was given by Bernheim-Jeune, and Bonnard agreed to a large retrospective to be organized by The Mus. of Modern Art, New York. In the year of his death retrospective exhibitions were given in Copenhagen, Amsterdam, Stockholm and at the Orangerie, Paris. A large retrospective was organized by the Royal Academy, London, in 1966. Other important exhibitions were at The Mus. of Modern Art, New York (1948 and 1964–5); Royal Scottish Academy, Edinburgh, 'Bonnard and Vuillard' (1948); Kunsthaus, Zürich (1949); Boymans-van Beuningen Mus., Rotterdam (1953); Mus. National d'Art Moderne, Paris, 'Bonnard, Vuillard et les Nabis' (1955); Kunsthalle, Basle (1955).

Bonnard had a natural talent for expressive decorative painting, shown also in his illustrations, theatrical work and other decorative projects, and he was closely concerned with the revival of decorative painting during the 1900s. He was one of the earliest artists to be attracted by poster design. Yet his greatness lies particularly in his *intimiste* domestic interiors and his poetic interpretations of the Parisian scene. From *c.* 1910 he developed an enthusiasm for the landscape of the Mediterranean and southern France. About 1915 he became dissatisfied with his work and deliberately gave stricter attention to formal qualities. He was essentially a colourist with a deep feeling for the sensuous qualities of paint. But his later paintings had a structural strength which has not always been recognized. He was not hostile to abstraction, though his own work remained figurative throughout. In the words of Denys Sutton: 'His art illustrates his determination to create a pattern composed of calligraphy and colour and in which the final effects were shimmering and mysterious.'

BONNET, ANNE (1908–60). Belgian painter born in Brussels, studied at the Academies of Brussels and Saint-Joosse-ten-Noode. She was a founding member of the association *La Route Libre* in 1939 together with Gaston BERTRAND and Louis Van LINT. In 1941 she was an exhibitor at the Salon *Apport* and in 1945 was one of the founders of JEUNE PEINTURE BELGE, with whom she exhibited in a number of European countries. In 1958 she helped to found the Salon *Art Actuel*. She began to paint abstracts in 1950 and developed a lively quasi-geometrical style with sensitively subdued colours which, although entirely non-representational, sometimes suggests expressive features of natural appearances. Since 1941 her work has often been shown at the Palais des Beaux-Arts, Brussels, and in other Belgian centres. She was represented at the Venice Biennale in 1948 and 1956 and at the São Paulo Bienale of 1954. She has been exhibited in Paris, Berlin and elsewhere and by the end of the 1960s had earned the reputation of being one of the most important artists working in Belgium.

BONSET, I. K. See MÉCANO.

BONTECOU, LEE (1931–). American sculptor born at Providence, R.I., studied under William ZORACH at the Art Students' League, 1952–5, and then worked in Rome with a Fulbright Fellowship, 1957–8. She had her first one-man show at the 'G' Gal., New York, in 1959 and subsequently showed at the Leo Castelli Gal. At this time she emerged as one of the JUNK school, constructing ASSEMBLAGES from monochromatic grey canvas or tarpaulin cut into irregular shapes which were affixed to a support in faceted planes by wire with protruding hooks and barbs, and were often combined with welded steel and miscellaneous scrap. Dramatic intensity was given to the deliberate brutality of these constructions by dark cavities and sealed-off orifices. Her later work in painted plaster relief and free-standing or hanging plastic explored a fairyland of imaginary flora and fauna. She was represented in a number of important collective exhibitions, including 'The Art of Assemblage', The Mus. of Modern Art, New York, 1961, and DOCUMENTA III, Kassel, 1964, and

had a first retrospective at Rotterdam in 1968.

BONZAGNI, AROLDO. See FUTURISM.

BORDA, ARTURO (1883–1955). Bolivian painter born in La Paz. He began as a journalist and social activist. In 1921 he organized a confederation of workers, but he lapsed into alcoholism when he became disillusioned by the lack of success of his ideals. He was a self-taught painter although he had some knowledge of Western art through reproductions. He painted genre, landscapes and portraits; among his subjects were such personalities as Whitman, Gandhi, Tagore, Alfonse Daudet and Edgar Allan Poe, whom he painted from photographs. His subjects also included crucifixions, allegories and phantasmagoric scenes which led some critics to classify him as a Surrealist. But Borda detested SURREALISM, FAUVISM and CUBISM. His own style was a combination of naïve photographic realism with occasional Impressionism. He was known for his landscapes painted during the 1940s on his expeditions through the Bolivian mountains and valleys, such as *View of the Heights of Potosi*, *White Mountain* and *Vision of the Cordillera of Yungas*. His only recorded trip out of the country was to Buenos Aires, where he exhibited at the Salon Costa in 1919. Although his work is said not to have been shown again until his 1962 memorial exhibition in La Paz, the Bolivian critic Rigoberto Villaroel Claure refers to an exhibition of his work at City Hall in La Paz which took place in either 1949 or 1950. His best-known painting, *Leonor Gonzalvez y José Borda*, a double portrait of his parents in a symbolic landscape, was exhibited in 1966 in 'Art of Latin America Since Independence' at Yale University and other places in the U.S.A. At the time John Canaday wrote in the *New York Times* that Borda's work was the most interesting in the show. As a result of that exhibition and Canaday's comments a retrospective entitled 'A Forgotten Bolivian Artist Rediscovered in the United States' was organized the same year in La Paz and co-sponsored by the U.S. Embassy. Borda's chaotic writings were compiled and published posthumously in 3 volumes under the title *El Loco* in 1966.

BORDUAS, PAUL-ÉMILE (1905–60). Canadian painter, born at Saint-Hilaire, Quebec, a small village east of Montreal. At sixteen he was apprenticed to the church-decorator Ozias Leduc and assisted him with several commissions, including the decoration of the Bishop's Chapel at Sherbrooke and the baptistery of Notre-Dame in Montreal. Meanwhile he studied part-time at the École des Arts et Métiers at Sherbrooke, 1921–3, and full-time for a year at the École des Beaux-Arts of Montreal, 1923–4. In 1928 Leduc helped him to go to Paris to study under Maurice DENIS and Georges DESVALLIÈRES at the Ateliers d'Art Sacré. He remained in France, working with stained glass and assisting in church-decoration, until 1930. On his return to Montreal he tried to work as an independent church-decorator but met with little success and abandoned the attempt in 1933. Instead he supported himself by teaching. From at least 1930 he had been painting small canvases, usually on religious or sentimental themes and invariably influenced by the work of Leduc and Denis. Over the next three years he began to paint more landscapes, and these reveal a developing interest in colour. He married in 1935, and in 1937 began to teach at the École du Meuble. He now began to participate in the Montreal artistic scene, exhibiting his first painting at the Art Association of Montreal in March 1938. He met John LYMAN, and became first Vice-President of the Contemporary Art Society in 1939. By 1941 he had developed a boldness in generalizing form and in heightening colour (*Portrait of Madame G.*, Montreal Mus. of Fine Arts). He was also reading the works of the French SURREALISTS, and the return of Alfred PELLAN from Paris in 1941 inspired him to his first experiments in abstraction. Forty-five automatic paintings in gouache—'Peintures surréalistes'—were shown in a theatre lobby in April 1942. Strong, innovative works, they were warmly received by the advanced artistic community, and Borduas attracted a group of young followers dubbed 'Les AUTOMATISTES'. His own work continued to evolve, moving between figuration and abstraction but never far from the spontaneity of automatic production. While producing important paintings (e.g. *Sous le vent de l'île*, National Gal. of Canada, Ottawa, 1947) he was also deeply involved in a rigorous analysis of Quebec society in the light of Surrealist theories of individual creativity. The essay REFUS GLOBAL which he published in 1948 in a small collection of *Automatiste* essays of the same name vigorously attacked the Catholic Church among other repressive elements. Retaliation was sudden and vicious, and Borduas lost his teaching certificate and his livelihood. He suffered the rejection and corresponding isolation deeply, yet continued to write, publishing *Projections libérantes* in 1949. The same summer he underwent an operation for bleeding ulcers. In the next year or two he produced a number of water-colours of singular beauty, expressing his rapidly changing ideas, together with some small wood sculptures and some surprisingly joyful canvases (e.g. *Floraison massive*, Art Gal. of Ontario, Ontario, 1951). In 1951 his marriage collapsed under the years of stress, and in 1953, after some difficulty in obtaining his visa, he finally left Montreal for New York. He spent the summer with the painting colony at Provincetown, Mass., where as if in a burst of relief he painted forty canvases, shown the following year at the Passedoit Gal., New York. He met Robert MOTHERWELL and other American ABSTRACT EXPRESSIONISTS but he spoke little English and so found communication difficult. After another period of working in water-colour he produced some remarkable canvases, his most resol-

ved work to date. These new paintings, such as *Pulsation* (National Gal. of Canada, 1955), appear dynamic without disrupting the homogeneity of the image. In 1953 Borduas moved to Paris. Through contracts with the New York dealer Martha Jackson and the Dominion Gal., Montreal, he was able to devote the last five years of his life entirely to painting. The homogeneous appearance of the later New York pictures soon gave way to more formal structure, leading in the summer to works with large black forms situated within a more or less white field (e.g. *The Seagull*, National Gal. of Canada). By 1958 these blocky shapes, now sometimes red-brown, grey or blue, were roughly marshalled in regular order on the light ground. During 1959 the black areas were reduced in number but enlarged, establishing an unrelenting tension with the light.

During the late 1950s Borduas had many one-man shows, in New York, Toronto, Montreal, Düsseldorf, London and Paris. A 'mid-career' retrospective planned by the Stedelijk Mus., Amsterdam, became in December 1960 the first memorial tribute to this great courageous spirit. Subsequent retrospectives were organized by the Montreal Mus. of Fine Arts, shown also in Ottawa and Toronto (1962), and the Currier Gal. of Art, Manchester, N.H., shown also in Hanover, N.H. (1967). An extensive exhibition, 'Borduas et les Automatistes, Montréal 1942–1955', was shown at the Grand Palais, Paris, and afterwards in Montreal (1971).

BORÈS, FRANCISCO (1898–1972). Spanish painter, born in Madrid. After studying at a private Academy in Madrid he joined the *avant-garde* group *Ultraiste*. His work was first shown at the Salon Nacional de Madrid in 1922 and at the Salon des Artistes Ibériques in 1925. In 1925 he moved to Paris, where he had his first one-man show at the Gal. Percier in 1927. Under the influence of Juan GRIS he flirted for a while with CUBISM. Then after some experimentation in the SURREALIST manner he found his characteristic style of flat quasi-naturalistic compositions in unmodulated colours. In 1929 he stayed at Grasse and according to Jean Grenier it is from this time that 'his full originality arising from a poetic interpretation of the geometrical' may be dated. From 1944 he exhibited at the Gal. Louis Carré in Paris and widely both in Europe and America. From 1952 he exhibited regularly at the Salon de Mai in Paris and from 1954 in exhibitions of the ÉCOLE DE PARIS at the Gal. Charpentier. In 1954 and 1959 he exhibited at the Pittsburgh International and in 1958 his painting *Beach* (1957) won the Extra National Award at the Solomon R. Guggenheim Mus., New York. Borès is considered to be perhaps the most prestigious of the generation of artists who succeeded that of PICASSO and MATISSE, coming to the fore in the inter-war years. Although his work has been less in evidence since the end of the Second World War, he remains outstanding among the group of Spanish artists who contributed to the originality and achievement of the École de Paris.

BORGÉS, JACOPO. See LATIN AMERICA.

BORGES, NORAH. See XUL SOLAR.

BORGLUM, GUTZON (1867–1941). American sculptor born in Idaho of Scandinavian stock, studied in Paris but settled in England in 1896, where he achieved some success and came to know George Bernard Shaw and Ruskin. After he returned to America in 1901 he carried to extreme the cult for the colossal and gained notoriety by gigantic reliefs on mountain-sides executed with pneumatic drills and dynamite. The first of these, on Stone Mountain in Georgia, was never finished although he worked on it for 10 years from 1915. His best-known work was executed during the Depression in the 1930s, when he undertook the carving of a huge monument combining the heads of four famous Presidents from the 1,300 ft (396 m) high wall of Mount Rushmore, South Dakota. Washington's head was completed in 1930, Jefferson's in 1936, Lincoln's in 1937 and Theodore Roosevelt's in 1939.

Borglum was a member of the Association of American Painters and Sculptors formed in 1911. He withdrew from the Association in 1913 as a protest against the poor quality of the American sculpture included in the ARMORY SHOW. His own work, however, is regarded as traditional rather than *avant-garde* and he is not ranked among those who helped to create a modernist school of American sculpture.

BORIANI, DAVIDE (1936–). Italian sculptor born in Milan. He was a founding member of the Milan GRUPPO T, who were interested in KINETIC art, light environments and the 'disappearance of the object' through spectator involvement. He became known for his 'magnetic surfaces' in which iron dust was set in movement by invisible magnets and for his light effects based on the persistence of light on phosphorus. After the 'Kunst-Licht-Kunst' exhibition at Eindhoven in 1966 he carried his experiments still further in collaboration with Gianni Colombo and Gabriele De Vecchi. At the Venice Biennale of 1970 he constructed a 'perceptual environment', *Spazio della stimolazióne percettiva*, in collaboration with Livio Castiglione. This was intended to integrate perceptual stimuli of various kinds—sight, hearing, touch and spatial sense—with a view to modifying the response of the spectator. The 'environment' was delimited by trapezoidal surfaces set on non-orthogonal planes and was derived from the 'distortion rooms' investigated by experimental psychology. The enclosed spectator was able to manipulate light signals. In 1968 he had collaborated with Enzo MARI on a Mobile Theatre, called *Percórso a passaggi programmati*, in the Maison de Culture at

Grenoble. Visitors were made to pass through a series of cut-out silhouettes in polystyrene panels, placed at varying distance from each other, to the accompaniment of sounds and flashing lights. The artists described the intention of the project as follows: 'We wish to develop a project which makes use of the kinetic characteristics of the stage and the rest of the theatre. In this work the visitor is placed in the double role of actor and spectator. A series of successive stimuli and perceptual conditionings make up a pathway along which the visitor passes, transported by the mobile ring. In accordance with this exposé of the problem, we have elaborated a series of particular solutions—visual, acoustic and tactile—which are integrated in the overall structure.'

BOROUGH GROUP. See BOMBERG, David.

BOSHIER, DEREK (1937–). British painter born at Portsmouth, studied at the Yeovil School of Art, 1953–7, and the Royal College of Art, 1959–62, where he was a contemporary of HOCK-NEY, Allen JONES, Peter PHILLIPS and KITAJ. He was one of the group of young artists who in 1961 launched POP ART in Britain at the 'Young Contemporaries' exhibition in the R.B.A. Gals. His first one-man show was at the Grabowski Gal., London, in 1962. In 1963 he showed at the Paris Biennale. In 1964 he was included in the 'Pop' exhibition at the Hague, Vienna and Berlin and in 1976 in 'Pop Art in England' at Hamburg, Munich and York. He taught at the Central College of Art and Design and the Hornsey College of Art, London, from 1963, at the Royal College of Art from 1973 and in 1975 was Guest Teacher at the University of Victoria, Vancouver Island, Canada. In the content of his pictures Boshier showed man as 'manipulated man', according to the human figure the same treatment as to mass-produced consumer goods and making them coalesce. All the elements in his work were taken from printed representations, advertisements, etc., nothing from life. From the beginning of the 1960s he, like Richard SMITH, concerned himself chiefly with American motifs, space heroes, advertisements, magazine illustrations, etc. Size was a crucial factor. The paintings were 'blow-ups' oriented towards the larger-than-life hoarding or cinema advertisement.

BOSSNARD, LOLA. See SPAIN.

BOTERO, FERNANDO (1932–). Colombian painter born at Medellin. He moved to Bogotá in 1951 and there had his first individual show at the Leo Matiz Gal. In 1952 he went to Madrid, where he studied at the San Fernando Academy till 1953, then to Florence, where he studied fresco techniques and art history until 1955. After his return to Colombia in 1955 he exhibited at the Biblioteca Nacional in Bogotá. In 1956 he taught at the School of Fine Arts of the National University in

Bogotá and the same year went to Mexico, where he reacquainted himself with the work of RIVERA and OROZCO. From there he went to the U.S.A. on a short visit in 1957 to exhibit at the Pan American Union in Washington. His early work had been Post-Impressionist. He tried ABSTRACT EXPRESSIONISM for a while but soon found this style alien to his temperament and returned to figurative painting. After 1960, the year he went to New York, where he lived for the next ten years, he sought inspiration in the Italian Renaissance. He was also influenced by the retables and anecdotal painting of the Colonial period and by 19th-c. popular painting in Colombia. He replaced chiaroscuro with clear colour as a means of creating volume and emphasized volume by expanding the contours of his subjects and compressing them into disproportionately small spaces. His subjects included puffed-out still lifes, social, religious and political figures and parodies on the work of famous masters. In 1959 he painted *Mona Lisa Age 12*. He began a series of 'Mrs. Rubens' in 1963 based on Rubens's *Portrait of Suzanne Fourment*, his wife's sister, and also painted *Marie Antoinette According to Marie Louise Vigée-Lebrun* (1966) and *Santa Rosa de Lima According to Gregorio Vazquez Ceballos* (1968), the last based on the Colombian 17th-c. master's painting of the Peruvian saint. Botero's religious subjects included numerous cardinals and bishops eating, sleeping, bathing or lying dead in a heap. He also painted numerous family groups. *The Family* (1967) shows its members with his traditional comical disregard for correct proportions. His inflated representations of police and military figures are particularly eloquent. He makes no distinction between hard and soft textures or between still life and figures, all of which have a rubbery quality. In 1967 he began a series of charcoal drawings on canvas based on Dürer's prints. Botero has exhibited widely in Europe and North and South America. He participated in the São Paulo Bienale in 1959. In 1962 he was included in '7 Contemporary Painters' at the Mus. of Modern Art in Bogotá, where he was awarded the 'First Intercol' prize two years later; he also participated in the Córdoba Bienale in Argentina in 1964 and in 'Inflated Images' at The Mus. of Modern Art, New York, in 1969, and has received many major awards. In 1972 he had individual exhibitions at the Marlborough Gal. in New York, the Buchholz in Munich and the Claude Bernard in Paris. Since the early 1970s he has divided his time betwen Paris, Madrid and Medellin.

BOTO, MARTA. See LATIN AMERICA.

BOUCHARD, HENRI (1875–1960). French sculptor born at Dijon and studied there, then in Paris. In 1901 he obtained the Prix de Rome and afterwards taught at the École des Beaux-Arts, Paris. He worked in a traditional style of vigorous Realism. Among his public works were the *Monu-*

ment to the Reformation, Geneva (1909–14), a portrait of Claus Sluter at Dijon, the monument to the *Héros Morts Inconnus* at the Panthéon (1920) and the façade of the Church of St. Peter at Chaillot (1934).

BOUCHE, GEORGES (1874–1941). French painter born at Lyons, where he studied architecture. He went to Paris in 1894 and studied painting there. He was a friend of the painter Pierre LAPRADE but after the First World War he lived a solitary life and first became known as a result of an exhibition in 1939. His subjects were very simple, still lifes or landscapes, and he painted with extremely thick impasto and a subtle blending of tones. His work has been more highly valued since his death.

BOUCHÉ, LOUIS (1896–1969). American painter born in New York. After studying in Paris at the Académie Colarossi, the Grande Chaumière and the École des Beaux-Arts, he attended the Art Students' League and then taught there from 1934. In 1933 he obtained a Guggenheim Fellowship. During the 1930s he executed a number of murals in public buildings, including Radio City Music Hall, Rockefeller Center, New York, the Attorney General's Office, Department of Justice Building, Washington and the Home Building Center at the New York World's Fair, 1939. His easel paintings depicted scenes from popular life in the Realist manner of The EIGHT.

BOURDELLE, ÉMILE-ANTOINE (1861–1929). French sculptor, born at Montauban. As a boy he obtained practical experience of carving in the workshop of his father, a cabinet maker. In 1876 he began to study at the École des Beaux-Arts, Toulouse, from where he won a scholarship to the École des Beaux-Arts, Paris, in 1884. Finding the sentimental classicism of Jean-Alexandre Joseph Falguière (1831–1900) little to his taste, however, he shortly left the school and worked for a while with Jules Dalou (1838–1902). By 1893, when he received a commission for a War Memorial at Montauban, he was already an accomplished sculptor. During this period his work was much under the influence of Rodin (1840–1917) and from 1893 to 1898 he worked as Rodin's assistant. Yet even at this time he revealed himself as an independent artist of distinction and *c.* 1909, when he began to teach at the Grande Chaumière, he developed the 'monumental' style on which his fame and influence have chiefly depended. He himself used to explain this style somewhat confusedly as an attempt to achieve 'universal harmony' and he urged his pupils to make themselves 'musicians of proportions'. In his teaching he deprecated servile imitation 'since it is neither the model itself nor a new creation with its own destiny', and used to say that 'it is necessary to interpret in order to be true'. Among the more famous of his pupils were Germaine RICHIER and Alberto

GIACOMETTI. From 1922 he was one of the Presidents of the Salon des Tuileries.

Bourdelle was an artist whose genuine originality has sometimes been overshadowed by the association with Rodin, and in his own very extensive influence on younger sculptors he did much more than simply transmit Rodin's accomplishment. Among his best-known works are the *Hérakles Archer* exhibited at the Salon de la Société Nationale des Beaux-Arts in 1910, bought for the Mus. du Luxembourg in 1922 and re-exhibited at Toulouse in 1926 as *Monument to Sport*; the reliefs for the façade of the Champs-Élysées theatre in 1911 and for the theatre of Marseilles in 1924; the equestrian monument to General Alvear at Buenos Aires (1913–23); his monument to the poet Mickiewicz (1917–29); and his *Dying Centaur* of 1914. The most representative collection of his work may be seen at the Mus. Bourdelle, Paris.

BOURGEOIS, LOUISE (1911–). French-American sculptor born in Paris. After taking her degree at the Sorbonne in 1935 she studied at the École du Louvre and the Académie des Beaux-Arts, Paris, while at the same time attending a number of private schools, including the Atelier Bissière, the Académie Julian, the Académie de la Grande Chaumière and the Atelier Fernand Léger. She emigrated to the U.S.A. in 1938. Her first one-man show was at the Bertha Schaefer Gal., New York, in 1945. She started as a painter and engraver and turned to sculpture only in the late 1940s, coming to notice with her strange, elongated, carved wood figures and abstract shapes painted uniformly black and white and arranged in clusters suggestive of a human crowd. Her fantasy found fuller play in the 1960s when she turned to plaster for casting in bronze and built curiously distorted semi-anthropomorphic shapes with 'magic' interior cavities, taking full advantage of the flexibility of the material. Later in the 1960s she began to carve in stone and marble, building clusters of rounded, highly polished and coloured columnar forms, to which a phallic significance is sometimes ascribed, set on a rough-hewn base. Her work increased in size and she produced tall, slender, totem-like pillars grouped like forests which enveloped the viewer. Her *Destruction of the Father* (1974) of latex and wire, 7 ft (2 m) in length, creates a weird cave-like environment with globular and stalactite forms of unearthly colours. Her unbridled fantasy was such that it has been said that she is a sculptor 'almost impossible to classify in terms of contemporary trends'. Works by her are owned by The Mus. of Modern Art, New York, New York University and the Whitney Mus. of American Art among other collections.

BOUSSINGAULT, JEAN-LOUIS (1883–1943). French painter born in Paris into academic circles, his grandfather being a well-known chemist and Professor at the Collège de France. After studying

at the École des Arts Décoratifs, he worked as a lithographer and designer of advertisements, from which he derived a lifelong respect for craftsmanship. After doing his military service in 1902 he studied at the Académie Julian and the Académie de la Palette, where he knew LA FRESNAYE, DUNOYER DE SEGONZAC and Jean MARCHAND. During this time he did drawings for the popular journals and from 1911 he designed costumes and decorations for the fashionable dressmaker Paul Poiret, including a large composition *Promenade*, which was exhibited at the Salon d'Automne in 1913. During the 1920s he retired from active participation in the artistic movements of the day and endeavoured to find his personal mode of expression in still lifes and figure compositions, which he exhibited at the Salon des Indépendants. In this way he matured his style and in the 1930s produced his best works—nudes, portraits and particularly still lifes. In the 1940s he also did several large murals of considerable power and designed cartoons for tapestries.

Boussingault was a subtle and sumptuous colourist, a master of poetic elegance, who like Dunoyer de Segonzac and Charles DUFRESNE stood outside both the FAUVIST and the CUBIST movements which dominated the first decades of the century.

BOYADJIAN, MICHELINE (1923–). Belgian NAÏVE painter, born at Bruges. She was a secretary until her marriage and began to paint in 1954. Her style was completely original. She depicted interiors with minute precision and duplicated the figures in each picture. Thus in *The Easel* a prim young girl with black dress and narrow face stands in the far distance; in front are three easels one behind the other, each holding a picture of the same girl. In *Girl at the Window* identical girls with white aprons and braided hair down their backs look out of two windows to left and right of a patterned rug. *In Expectation* shows a table with artificial fruit and flowers in the foreground and against the far wall, beneath two windows, identical girls sit on chairs. The pictures are done with meticulous attention to detail. Boyadjian was included in many international exhibitions of naïve painting and was awarded a prize at Zagreb in 1970.

BOYD, ARTHUR (1920–). Australian painter, potter, etcher, lithographer, and ceramic artist, born at Murrumbeena, Victoria, into a family which had had close connections with the arts for three generations. His father, Merric, was one of Australia's first studio potters. Boyd's mother, herself a painter and a devout Christian Scientist, reared her children, Lucy (ceramic artist, 1916–), Arthur, David (potter and painter, 1924–), Guy (sculptor, 1925–) and Mary (painter, 1926–), in a family atmosphere which gave pride of place to art and religion. On leaving the primary school at Murrumbeena at the age of 14, Boyd

attended evening classes at the National Gal. of Victoria and worked in a paint factory owned by an uncle. In 1936 he began to paint landscapes while living with his grandfather (himself a landscape painter) at Rosebud, Victoria. A year later he held his first exhibition, consisting mainly of broadly painted Impressionist views in grey-blues and ochres, at the Westminster Gal., Melbourne. He met Josl Bergner, a young Polish refugee whose paintings introduced him to EXPRESSIONISM, and other friends such as Danila VASSILIEFF and Noel COUNIHAN directed his interest towards urban scenes with a social content. In 1939 he joined the Army Service Corps, where he met John PERCEVAL, a painter who later married his sister Mary, and began to move in the circle of artists associated with the CONTEMPORARY ART SOCIETY, in whose exhibitions he participated regularly from 1942 to 1946. His painting became more violent and more personal, drawing upon SURREALISM, SOCIAL REALISM and Expressionism to create a world in which beasts and monsters, the crippled and the maimed, abounded. His vitalistic vision of life, which then began to emerge, recovers in a fashion a medieval view of the Antipodes as a realm inhabited by benighted, sub-human creatures. In 1944 he left the army, married Yvonne Lennie, a former fellow-student at the National Gal. of Victoria, and with his brother-in-law, the artist John Perceval, established a pottery business, while continuing to paint. After 1945 his work began to reveal his deep affection for the art of Bosch, Bruegel and Rembrandt, and he began to paint some of his most memorable works such as *The Mockers* (1945) and *The Mourners* (1945). He experimented with casein tempera and oil, often painted over chalk grounds, developing beautiful mellow surfaces and fine gradations of tone. The themes of his paintings were often religious and concerned with sexual passion, guilt and betrayal. In 1948 he painted a series of murals on the walls of the dining-room of The Grange at Harkaway, the home of his uncle, Martin Boyd the novelist. Then in 1950 he turned to ceramic tiles and sculptures, such as his masterly *Saul and David* (1953). In 1951 he travelled in Central Australia, where he witnessed the poverty and dereliction of the aboriginal people of the interior. Some years later this experience inspired his *Love, Marriage and Death of a Half-Caste* cycle, which was exhibited in the Australian Gals. in 1958. Thenceforth most of Boyd's works have appeared in series form.

He and his brother David played an important role in the Antipodean Exhibition of August 1959, but later that year he left for London, settling in Hampstead while travelling frequently on the Continent. His first London exhibition, held at the Zwemmer Gal. in 1960, featured his *Half-Caste* cycle. In 1961 Boyd designed décor and costumes for Stravinsky's *Renard*, presented by the Western Theatre Ballet at the Edinburgh Festival and later at Sadler's Wells. During the 1960s his paintings

interpreted love myths of antiquity and the Renaissance, becoming increasingly personal and metamorphic. They took on the appearance of sexual fantasies, bodies blown across dark landscapes inhabited by strange, pathetic monsters. Star-crossed lovers, whether Paolo and Francesca, Diana and Actaeon or Romeo and Juliet, recurred. In 1964 a ceramic polyptych *Romeo and Juliet* was commissioned for the Shakespeare Quatercentenary Exhibition and he turned to pastels for a *St. Francis* cycle. He then produced lithographs based on the cycle to illustrate the second edition of Boase's *St. Francis of Assisi* (1968). Among his more notable works of recent times are the *Nebuchadnezzar* (1969) cycle of paintings and the *Lysistrata* (1970) etchings. Boyd was a visionary with a strong sense of place. He explored an unusually wide range of media and exploited the great themes of classical antiquity and Christianity in search of an art that was authentic both at a personal and a public level.

BOYS, GEORGE. See SOUTH AFRICA.

BRANCHO, GABRIEL. See LATIN AMERICA.

BRANCUSI, CONSTANTIN (1876–1957). Romanian sculptor born at Pestişani Gorj of a well-to-do peasant family. He ran away from home at the age of 11 and after wandering for 7 years was apprenticed to a cabinet-maker at Craiova and then entered the École des Beaux-Arts, Bucarest, in 1898. He left Romania in 1902 and made his way to Munich and then on foot to Paris, where he settled in 1904 and worked at the École des Beaux-Arts. At this time he was competent in the naturalistic tradition of Rodin (e.g. *The Prayer*, bronze, 1907), and indeed Rodin, impressed by his work exhibited at the Société Nationale and the Salon des Indépendants, offered to take him into his studio as a student-carver. Brancusi, however, refused this offer. Even as early as this he had made it his ambition to capture the 'essence' of things and he believed that this aim could not be achieved by depicting their surface appearances, however faithfully and however expressively. Pursuing this line he became the greatest master of generic abstraction (see ABSTRACTION) of this century. He simplified his forms by eliminating the distinguishing details in virtue of which one individual differs from others, while retaining, and therefore emphasizing, the characteristic form of the species. His ideals were simplicity and generic truth. From *c.* 1910 he reintroduced direct carving instead of employing craftsmen to do the carving as was usual at that time. He would execute the same subject a number of times, modifying and perfecting the forms, often treating it both in carving and in bronze, using a polished bronze without expressive surface textures. Among his best-known works in this mode are the several versions of: *The Kiss* (1910–21); *Maiastra* (1910–12); *Bird in Space* (1923–40); *Fish* (1924–30); *The Cock* (1924–49);

The Seal (1936–43). He also did similarly simplified portraits, the most notable of which were *Mlle Pogany* (1912–20) and *Nancy Cunard* (1925).

In 1920 Brancusi carved his wooden *Endless Column* for the garden of the photographer Edward Steichen in the outskirts of Paris. It was a 23 ft (7 m) column composed of 9 rhomboids diminishing in perspective. Brancusi cut the column down when Steichen left Paris and only two sections remain. It was a theme which he repeated several times, however, notably when he went to Romania in 1937 to make sculptures for the park at Tirgu Jiu and designed a cast iron *Endless Column* 29·33 m tall, consisting of 15 modules, resting on a half module and topped by a half module, threaded on an internal steel column of square section. Brancusi carved the wooden module for casting. Other sculptures for the park were *Gate of the Kiss* and *Table of Silence*.

In 1926 Brancusi had his first one-man show in America, at the Brummer Gal., New York. This was the occasion of the now famous trial at which it was claimed that his *Bird in Space* was not a work of art but dutiable metal.

Brancusi was interested in primitive sculpture and besides his refined generic abstractions he carved works which had the sharply defined planes and the general appearance of primitive art. Among the best known of these are: *Caryatid* (1915); *Adam* (1917); *Chimera* (1918); *Adam and Eve* (1921); *Socrates* (1923).

Brancusi's reputation was very high and his influence was great. Both EPSTEIN and ARCHIPENKO owed much to him and GAUDIER-BRZESKA was his professed admirer. Carl ANDRE claimed to have been inspired by Brancusi's *Endless Column*, converting it into a horizontal row of ready-made firebricks. Retrospective exhibitions were given in the Solomon R. Guggenheim Mus., New York, and the Philadelphia Mus. of Art, 1955–6. On his death Brancusi bequeathed to the French Government his studio and its contents, which included versions of most of his best works. The centenary year 1976 was officially designated 'Brancusi year' in Romania and in Britain a documentary film of Tirgu Jiu was made by Sean Hudson with the aid of the Arts Council: *The Romanian Brancusi*.

BRANDS, EUGÈNE. See EXPERIMENTAL GROUP.

BRANGWYN, FRANK (1867–1956). Painter and graphic artist born at Bruges of British parents. Apart from early teaching by his father and some training at South Kensington Art School he was largely self-taught. During the 1880s he designed tapestries for William Morris, was associated with the Arts and Crafts Movement and was befriended by Mackmurdo. He travelled widely during these years, including a visit to Japan and six months in South Africa. In 1891 he won the Gold Medal at the Chicago International Exhibition. In 1895 he was commissioned to decorate the exterior façade of Sigfried Bing's Maison de l'Art Nouveau and in

1922 designed the Occidental Mus. at Tokyo. His large decorative compositions include murals at the Courthouse, Cleveland, Ohio, the State Capitol, Missouri, the Rockefeller Center, New York, the Legislative Building, Winnipeg, the Chapel of Christ's Hospital, Horsham, and The Royal Exchange and Skinner's Hall, London. A mural designed for the House of Lords was rejected in 1930 and now hangs in the Brangwyn Hall, Swansea. Brangwyn was elected A.R.A. in 1906 and R.A. in 1919. From 1914 to 1918 he was President of the Royal Society of British Artists. A retrospective exhibition at Queen's Gate, London, was opened by the Prime Minister, Ramsay MacDonald, in 1924 and in 1952 a retrospective exhibition was given by the Royal Academy, the first to be given there for a living artist. In 1967 a Centenary Exhibition was staged by the National Mus. of Wales, Cardiff.

Brangwyn enjoyed a wide international reputation during his lifetime. A project for a Brangwyn Museum at Tokyo was set on foot in 1920 but was frustrated by an earthquake. Brangwyn Museums were founded at Bruges in 1936 and at Orange in 1947 and a Brangwyn Room was opened at Peking in 1953. Many of his works are now displayed at the Brangwyn Hall, Swansea. He was made Chevalier of the Légion d'honneur in 1901 and was knighted in 1941. Despite his many honours and wide reputation his works lay outside the main currents of *avant-garde* art and many critics find his greatest strength in his drawings and graphic work.

BRAQUE, GEORGES (1882–1963). French painter born at Argenteuil, near Paris, and brought up at Le Havre, where he was apprenticed to his father's trade of house painter and studied at the local École des Beaux-Arts. In 1900 he went to Paris and from 1902 to 1904 studied at the Académie Humbert. He made friends with Othon FRIESZ, also from Le Havre, and in 1906 they painted together at Le Ciotat and L'Estaque. Both adopted the new FAUVIST style and exhibited with other Fauvists at the Salon d'Automne and the Salon des Indépendants. Braque, however, was not by temperament in harmony with the subjective and impulsive aspects of Fauvism and after being immensely impressed by the Cézanne Memorial Exhibition at the Salon d'Automne in 1907, he began painting in a more logical manner of geometrical analysis which anticipated Analytical CUBISM. In 1907 he met PICASSO through the dealer D.-H. KAHNWEILER and working together the two artists brought into being the Cubist style. During the next few years their work was so similar that some of their pictures might equally well have been painted by either. In the autumn of 1908 Kahnweiler arranged an exhibition of Braque's pictures from the previous year, all but two of which had been rejected by the Salon d'Automne. Louis Vauxcelles (who had coined the word 'Fauves') described these pictures as being reduced to 'cubes' and wrote of Braque's pictures in the Salon d'Automne of 1909 as 'bizarreries cubiques'. Thus the name 'Cubism' was born. In 1911 and 1912 Braque was painting with Picasso at Céret and Sourgues and he was the first to begin the COLLAGES which heralded Synthetic Cubism. He also introduced real elements and commercial lettering into his pictures, combining and contrasting the real with the 'illusory' picture image. He worked hand in hand with Picasso on Synthetic Cubism until the interruption caused by the First World War.

Braque suffered a severe head wound in 1915, was discharged from the army and began painting again *c.* 1917. During a long convalescence he pondered the principles of his art, and his thoughts, mostly in the form of aphorisms, were published in *Le Jour et le Nuit. Cahiers, 1917–1952* (1952). Unlike Picasso and LÉGER, Braque remained entirely uncommitted to any ideology and kept his work aloof from all human or social interests outside it. In this, although he pursued a very different path artistically, he resembled MATISSE. He once declared that the fundamental principle of Cubism was 'the materialization of a new space' and that the purpose of the Cubist fragmentation of objects was to 'establish space and movement in space'. He continued to pursue this aim with single-minded consistency and complete integrity. Even his interest in things was restricted to their existence as 'aesthetic objects' for pictorial ends. He began by continuing the decorative patterning and flattened planes of Synthetic Cubism but through the 1920s progressed to greater freedom and by the beginning of the 1930s was internationally recognized as a world master of still life. Most famous of the works of this period are the *Canéphores*, large paintings of half-nude women carrying baskets of flowers and fruit. Supreme among all his works were, perhaps, the eight *Ateliers* painted between 1948 and 1955, in which the Cubist inspiration has lost its mannerisms and has been brought to the ultimate excellence of the composed still life.

His graphic work was connected primarily with an interest in Greek themes which began in the 1930s and includes 16 etchings for an edition by VOLLARD of the *Theogony* of Hesiod. From 1950 to 1958 he did a series of *Oiseaux* in which decorative quality is combined with extreme simplification.

In 1948 Braque was awarded the Grand Prix for painting at the Venice Biennale. In 1951 he was made Commandeur of the Légion d'honneur.

Braque was the most consistent of the original Cubist painters and within the strict limitations which he imposed upon himself was one of the half-dozen greatest painters of the century.

BRAŠIĆ, JANKO (1905–). Yugoslav naïve painter, born in the Serbian village of Oparić. He

was the founder and the central figure of the 'school' of Oparić (see NAÏVE ART). He began to draw during his brief period at the village school and continued to draw and paint while herding sheep and cows, making his own colours from elderberries. From the time of his marriage in 1928 requirements of work left him no time for painting until 1933, when he painted icons and frescoes for the new church which the village was building. In 1936 he was encouraged by the Belgrade writer Siniša Paunović. He showed his first paintings in the village school in 1937. After the war he was for five years unable to obtain painting materials but began to paint again in 1950. He also interested several young peasants in his own and neighbouring villages, acting as their teacher and inspirer. Thus he became the centre of a group of peasant painters, all of whom remained extremely individualistic in their manner.

Brašić, known in the village as 'Uncle Janko', painted landscapes, village scenes and also religious and historical pictures with expressive realism while continuing to work his land. His best-known painting is *Battle between the Turks and the Serbs*, a closely packed welter of horrific battle incidents on an enormous canvas 2 m high and 3 m long. His work was included in the exhibition of naïve Yugoslav painters at Belgrade in 1957 and has since been shown in many other European countries. Most of his paintings are in the gallery of self-taught painters at the Serbian town of Svetozarevo.

BRASILIER, ANDRÉ (1929–). French painter born at Saumur, studied at the École des Beaux-Arts under Maurice BRIANCHON. He obtained the Prix Blumenthal in 1952 and the Grand Prix de Rome in 1953. He exhibited in Paris from 1959 and in New York from 1962. He was primarily a figure painter and belonged to the new school of representational painting which followed TACHISM.

BRATBY, JOHN (1928–). British painter born at Wimbledon, studied, 1951–4, at the Royal College of Art, where he won the Abbey Minor Scholarship, the Italian Government Scholarship and the R.C.A. Minor Travelling Scholarship. His first one-man show was at the Beaux-Arts Gal., London, in 1954 and in 1955 he won a prize at the *Daily Express* 'Young Artists' Exhibition'. In 1956 he exhibited at the Venice Biennale and won a Guggenheim Award, which he obtained again in 1958 jointly with Ben NICHOLSON. In 1957 he obtained First Prize in the Junior Section of the John Moores Liverpool Exhibition. He was elected A.R.A. in 1959. In 1957–8 he designed sets for the film *The Horse's Mouth*. Among the murals which he executed were: *Feeding of 5,000*, Heythrop Hall, Oxfordshire, 1963; *Golgotha*, St. Martin's Chapel, Lancaster, 1965; mural for Frankfurt Finance House, 1969. Among the public collections owning his works are: Tate Gal. (5); The Mus. of Modern Art, New York· National

Gals. of Canada, Victoria, New South Wales, New Zealand; Arts Council of Great Britain; British Council; Victoria and Albert Mus.; Ashmolean Mus., Oxford.

Bratby was a versatile artist, doing portraits, still lifes, figure compositions, landscapes and flower pieces, in which he especially delighted. He is perhaps best known for his *intimiste* interior scenes worked not with the delicacy of a VUILLARD but in heavy impasto and with bright and often harsh colours. His forte lay in vigour rather than subtlety. In the years after the Second World War he was one of the group of harsh and austere realists who exhibited at the Beaux-Arts Gal. and were known as the KITCHEN SINK SCHOOL. Later his work became lighter and more exuberant.

Among his own publications are: the novel *Breakdown* (1960); *Painters of Today* and *Break-Pedal Down* (1962); *Stanley Spencer* (1970).

BRAUER, ERICH (1929–). Austrian painter born in Vienna, studied at the Vienna Academy of Art under GÜTERSLOH and BOECKL, 1943–51. He then travelled in France, Italy and Africa until 1958. On his return to Vienna he became a member of the Austrian school of FANTASTIC REALISM. He painted a bizarre world of mystical and fairy-tale figures in bright, dream-like colours set in an ensemble reminiscent of Hieronymus Bosch and the elder Bruegel, whom he had studied in the Kunsthistorische Mus., Vienna.

BRAUNER, VICTOR (1903–66). Romanian-French painter born at Pietra Naemtz, studied at the Academy of Fine Arts, Bucarest, where he exhibited first in 1924. In the same year he designed sets for a production of Oscar Wilde's *Salome* and collaborated with the poet Ilarie Voronca in founding a DADA magazine *75HP*. He was also connected with the SURREALIST magazines *Unu* (1928–31) and *Alge* (1930–3). He settled in Paris in 1930 and after working for a while with BRANCUSI was introduced by Yves TANGUY to the Surrealist circle, which he joined. In 1934 he had a successful exhibition of Surrealist pictures at the Gal. Pierre, Paris, for which André BRETON wrote an enthusiastic introduction. He returned to Romania in 1934 and painted a series of pictures figuring mutilations of the eye, including *Self-Portrait with Extracted Eye*. On his return to Paris in 1938 he was involved in a studio brawl between DOMINGUEZ and Esteban FRANCÈS in which he lost his left eye. This made such an impression on him that he painted a number of what he called 'magic' pictures featuring female spectres and symbolizing the supernatural conflict between the artist and his demons. In 1948 he left the Surrealist movement and painted pictures influenced by MATTA and by the Pre-Columbian art of Mexico. He had a one-man exhibition at the Alexander Iolas Gal., New York, in 1963.

BRAYER, YVES (1907–). French painter born

at Versailles, studied at the École des Beaux-Arts. In 1927 his painting *Manège d'équitation* gained him the Chanavard Prize, which enabled him to visit Spain, where his style was influenced by the structured naturalism of SOLANA and he continued to paint vivid and expressive landscapes and scenes from contemporary life. In 1930 he won the Grand Prix de Rome and visited Italy. In 1942 he did stage designs for the ballet and portraits of dancers, including Serge Lifar. He was chiefly known for his landscapes of southern France and his *La Plaine des Baux* (1947) and *La Plage aux Saintes-Maries* (1948) are in the Mus. National d'Art Moderne. He did a number of murals, including those for the Lycée Claude-Monet and the Post Office in the rue La Boétie, Paris, and illustrated a number of books, including *Les Bestiaires* and *Le Soulier de Satin* by Claudel and *Le Bateau Ivre* by Rimbaud. He was made a member of the Académie des Beaux-Arts in 1957.

BRECHERET, VICTOR. See LATIN AMERICA.

BRECHT, GEORGE (1925–). American sculptor and designer of HAPPENINGS, born at Halfway, Oreg., and studied at Philadelphia College of Pharmacy and Science, Rutgers University and the New School for Social Research. He taught at Leeds (England) College of Art, 1968–9, and founded a journal *Sight Unseen* for scientific research and speculative art. His first one-man exhibition was at the Reuben Gal., New York, in 1959 and he continued to exhibit both singly and in group shows, including: 'The Art of Assemblage', The Mus. of Modern Art, New York, 1961; 'Mixed Media and Pop Art', Albright-Knox Gal., Buffalo, 1963; 'Pop Art', Tate Gal., 1969. Through the 1960s he designed Happenings and Performance Art, and published *Water Yam*, scores for music, dance, events, etc. His POP pictures were often simplistic, consisting of a word painted on canvas (*SILENCE, NO SMOKING*) or an ASSEMBLAGE such as a kitchen chair on the seat of which were laid a walking-stick and an apple. Brecht also made 'boxes' in the manner of CORNELL and SAMARAS, sometimes designing them for the spectator to change the assemblage of contained objects in a spirit of play.

BREDER, HANS (1935–). German-American sculptor, born at Herford, Westphalia. From 1957 to 1964 he studied interior decoration and painting at Bielefeld and Hamburg. In 1964 he visited New York with a grant from the Studienstiftung des Deutschen Volkes and in 1965 he taught at the Summit Art Center in New Jersey. In 1966 he joined the staff of the Art Department of the University of Iowa. He had one-man exhibitions at the Feigen Gal., New York, and in Chicago and Iowa and participated in group shows in both North and South America. His works consisted in the main of constructions made from plexiglass, aluminium, steel, etc.

BREER, ROBERT C. (1926–). American sculptor born at Detroit, Mich., studied at Stanford University. He resided in Paris from 1949 to 1959 and was represented in the important exhibition 'Le Mouvement' at the Denise René Gal. in 1955. He was chiefly known for his combination of MINIMAL with KINETIC art, particularly for his *Crawling Objects*, which were basic geometrical shapes made from styrofoam with small motors embedded which imparted to them a very slow movement. He was also known for his animated films which obtained, among other awards, the Diplôme Speciale at Bergamo in 1962 and the Max Ernst Prize at the Oberhausen Film Festival in 1969. His work was included in many important collective exhibitions of CONSTRUCTIVIST and kinetic art.

BREITNER, GEORGE HENDRIK (1857–1927). Dutch painter born at Rotterdam, studied at Rotterdam, The Hague and Amsterdam and became one of the first Dutch Impressionists. He painted in a style of his own which varied little through his life, using a rich and oily impasto with broad brush-strokes and dark tones. He was chiefly known for his views of old Amsterdam, which earned him the sobriquet 'The Zola of Amsterdam'.

BRETON, ANDRÉ (1896–1966). French poet and writer, founder and chief theorist of the SURREALIST movement. Breton gained moral and executive control of the movement and was known unofficially as 'The Pope of Surrealism'. Besides the Surrealist Manifestos his most important works for the understanding of Surrealism were: *Les Champs magnétiques* (with Philippe Soupault, 1920), *L'Immaculée Conception* (with Paul Éluard, 1930), *L'Union libre* (1931), *Qu'est-ce que le surréalisme?* (1934). He also made ASSEMBLAGES of surrealistically juxtaposed objects, which he called 'Poem-objects'.

BRIANCHON, MAURICE (1899–). French painter, born at Fresnay-sur-Sarthe. After studying at the École des Beaux-Arts, Bordeaux, he attended briefly the École des Beaux-Arts, Paris, and then worked for six years at the École des Arts Décoratifs. He exhibited first in 1920 at the Salon d'Automne and in 1924 obtained the Prix Blumenthal. From 1928 through the early 1930s he frequented the theatre and music halls and did a number of stage designs in collaboration with Raymond LEGUEULT, whom he had known as a student. In 1937 he obtained a teaching post at the École des Arts Décoratifs and in 1939 he won a Carnegie Prize. In 1942 he executed decorative panels for the Conservatoire in collaboration with Marguerite Louppe, whom he had married. In 1949 he became Professor at the École des Beaux-Arts. Brianchon stood aloof from the *avant-garde* movements of the 1930s and 1940s and belonged to the school of *Néo-Réalistes*, 'painters of poetic reality', to which OUDOT, Legueult and AUJAME

also belonged. The bulk of his work consisted of expressive landscapes and interiors in a Late-Impressionist style developed from that of BONNARD, by whom he was influenced at the beginning of his career. He was known too for his female portraits, also in the Bonnard tradition, and he had a talent for decoration.

BRIGNONI, SERGE (1903–). Swiss painter and sculptor born at Chiasso. After training as a painter in Berne, he took up sculpture in 1927, formed a friendship with PAALEN, GIACOMETTI and HAYTER and joined the SURREALIST movement in 1929. From 1940 he lived in Berne. His chief contribution was his successful adaptation of the lyrical forms of Oceanic sculpture to contemporary Western ideas, and his wood sculptures of the early 1930s are regarded as one of the earliest accommodations of Surrealist principles in the field of sculpture.

BRISLEY, STUART (1933–). British painter and sculptor, born at Haslemere, Surrey. He studied painting at Guildford School of Art, 1949–54, the Royal College of Art, 1956–9, the Munich Academy, 1959–60, and Florida State University, 1960–2. He did part-time teaching at the Slade School and at the Maidstone and Nottingham Colleges of Art. He has exhibited both paintings and 'light' environments. From 1968 he devoted himself to performance and 'events'. In 1973 he collaborated with Ken Macmillan on a film entitled *Arbeit macht Frei*. By the mid 1970s he had consolidated a reputation both in Britain and abroad in the field of Performance art.

BRITAIN. (This article covers work by artists who were born in or lived in the United Kingdom.) During the last decade of the 19th c. Britain was the chief seat of ART NOUVEAU, which in architecture, *art mobilier* and the graphic and illustrative arts spread through Europe at the turn of the century under a variety of names. The main originators of the style were the Scottish architects and designers Charles Rennie Mackintosh (1868–1928) and Arthur H. Mackmurdo (1851–1942) and the painter-designer Charles Ricketts (1866–1931). It found a typical expression in the linear style of Aubrey Beardsley (1872–98) and had among its exponents members of the GLASGOW SCHOOL, who broke away from the NEW ENGLISH ART CLUB.

The dominant influences on British painting at the turn of the century were those of Whistler, who died in 1903, and the New English Art Club. That of Whistler made for the use of closely keyed sombre tones and restrained adumbrations of form. The New English Art Club had been the main channel through which a modified form of Impressionism had permeated British painting, but it had failed to keep pace with more recent innovative trends and up to 1910 it was still advocating a polite version of Continental DIVISIONISM and the *plein air* principles of the Barbizon school. But although conservative in the eyes of the more advanced painters, its principles were still anathema to the Academy and a certain liberality by which it continued to be animated permitted the admission to membership of a number of the most gifted artists of the decade. In 1910 SICKERT wrote: 'I doubt if any unprejudiced student of modern painting will deny that the New English Art Club at the present day sets the standard of painting in England. He may regret it or resent it, but he will hardly deny it.'

Britain had not been entirely cut off from French art. Manet had visited London in the summer of 1868 and had tried unsuccessfully to obtain an exhibition. In the war of 1870 Monet, Pissarro and Sisley had lived and painted in London. Monet had returned in 1891 and painted his well-known impressions of London, and had come back yet again in 1899. At the end of 1904 he had done his still more famous views of the Thames. In 1890 Lucien PISSARRO had settled in London and Camille Pissarro had visited his son in 1892 and 1897. Sisley had visited London four times between 1871 and 1897 and Toulouse-Lautrec several times between 1892 and his unsuccessful exhibition in 1898. In 1870 the Paris dealer Durand-Ruel had opened a gallery in New Bond Street and had put on 10 exhibitions before closing the gallery in 1875. In 1882 and 1883 he rented galleries and tried again ineffectively to interest the British public in the Impressionists. All these contacts were curiously abortive and it was not until the more successful exhibition of Durand-Ruel at the Grafton Gals. in 1905, which included a number of Cézannes, that the word 'Impressionist' became familiar to the general artistic public in Britain. Later developments were still virtually unknown.

In 1905 Sickert returned to London and made his studio at 19 Fitzroy Street the centre for an informal group of artists who found the New English Art Club too conservative for their taste. Harold GILMAN, Spencer GORE and Lucien Pissarro were soon joined by Robert BEVAN, Henry LAMB, Walter BAYES, Augustus JOHN, John NASH, Albert Rothenstein, Charles GINNER, C. R. W. NEVINSON and Jacob EPSTEIN. The critic Frank Rutter was also a member of the group and it was owing to his initiative and organizing ability that in 1908 the ALLIED ARTISTS' ASSOCIATION was formed on the analogy of the French SALON DES INDÉPENDANTS, in opposition to the Academy and the New English Art Club, to hold open exhibitions without selection committee. The first exhibition was held in 1908 at the Albert Hall and it was followed by others until 1914. These exhibitions were, however, too large and too inclusive to point in any particular direction and the artists in Sickert's circle, despairing of obtaining a controlling influence in the New English Art Club, formed their own association, the CAMDEN TOWN GROUP, in 1911 with Spencer Gore as its first President. The Camden Town artists were not revolutionaries

in the sense of the French FAUVES or the German BRÜCKE and were not tied to any specific doctrine which could be set forth in manifestos. For the most part they remained in harmony with Sickert's search for the poetic in the commonplace suburban scene; but their attitude was in most cases more objective and they refrained from the social comment which Sickert introduced into his work. Their attitude to POST-IMPRESSIONISM was ambiguous; they made colour more central to their work but without abandoning the DIVISIONIST techniques favoured by Lucien Pissarro. As against the Academy they rejected genre painting and anecdote and their choice of subject matter was in opposition to the romantic idealism of the Academy. They strove for a more solid pictorial structure and from the Impressionists they learned to open their eyes to the real world about them. But the bright colours of the Impressionists had little appeal for them and they rejected the scientific interest of the Neo-Impressionists in colour. Although some knowledge of Cézanne's advances in formal construction went with their interest in pictorial structure, their work still remained too close to realistic and illustrative depiction and their colour too murky. They represented, however, the more liberal aspect of British painting at the end of the first decade.

In this situation a new direction was given to British painting by two 'Post-Impressionist' exhibitions organized by Roger FRY at the Grafton Gals., the first from November 1910 to January 1911 and the second from October 1912 until the end of the year. London had not indeed been entirely cut off from more recent developments in French art. Cézanne had been represented in the Durand-Ruel exhibition at the Grafton Gals. in 1905 and with Rodin in 1906. Matisse and Gauguin had been shown at the New Gal. in 1908 and the Stafford Gal. held an exhibition of Cézanne and Gauguin in 1911, while PICASSO had his first one-man show in London in 1912, although only of his pre-CUBIST works. Some English artists had studied and worked abroad, but what they brought back had always been related to what they were conditioned to receive. Yet the impact made by Fry's exhibitions was so strong that modernism in British art can justly be said to have begun with them. In the controversy which they provoked, the astonished indignation and ridicule with which they were received by critics and the general public, their effect was comparable with that of the ARMORY SHOW in America. In fact neither exhibition was a completely well balanced representation of contemporary *avant-garde* movements in European art. The dominant position was given to Cézanne, Gauguin and Van Gogh with the Fauves coming as a rather poor second. This represented Fry's own taste and was the sense which 'Post-Impressionism' came to hold in England. It had of course nothing in common with the term 'Neo-Impressionism', and indeed the scientific interest in colour which had played so

important a part with Seurat, Signac and the originators of Divisionism had no appeal for British artists. Fry had been in two minds whether to use the term 'Expressionist', which was current at that time in almost the same way that 'creative' later became virtually synonymous with '*avant-garde*' or 'innovative'. But in fact his exhibitions gave no place either to German EXPRESSIONISM or to Italian FUTURISM. Cubism had a rather minor place in the second exhibition, but its impact in British art came much later. In an attempt to correct the aesthetic bias of Fry's exhibitions Frank Rutter organized a large exhibition at the Doré Gal. in the autumn of 1913 with the title 'Post-Impressionist and Futurist Exhibition'. Both Cubism and ORPHISM were included, Futurism was represented by SEVERINI, who had exhibited at the Marlborough Gal., London, in April 1913, and German Expressionism was represented by NOLDE, PECHSTEIN and Franz MARC. The English painters participating in this exhibition were the most advanced among the members of the Camden Town Group and made up the nucleus of the LONDON GROUP, which was formed by an amalgamation of that group with other smaller groups and organized a large exhibition at Brighton entitled 'An Exhibition of the Work of English Post-Impressionists, Cubists and Others' in November 1913. Though varying in importance the London Group survived through to the 1980s.

One of the results of Fry's Post-Impressionist exhibitions was to raise his authority in matters of taste to a dominant position until the 1930s and to lend force to the aesthetic views which he shared with Clive BELL. Basically these views were a restatement of certain aspects of the older French 'art for art's sake' doctrine. Thus Fry became the champion of the critical principle that formal coherence (called by Bell 'significant form'), including the harmonious and decorative use of colour, was so much more important than subject matter that it alone was adequate to sustain a painting independently of its degree of representation or what it represented. This is now, of course, a commonplace but was then new. Neither Fry nor Bell, however, was able to broaden his appreciation to encompass those modes of abstraction which interested some British artists in the late 1920s and early 1930s, although their artistic theories might have served as an ideal justification for them. In practice Fry's doctrines were most fully realized in his own work and that of the painters of the BLOOMSBURY GROUP, of whom Duncan GRANT and Vanessa BELL were the most prominent.

In 1913 Fry founded the Omega Workshops (active until 1919), an undertaking whose purpose was, by assembling *avant-garde* artists to design consumer goods (furniture, pottery, textiles, carpets, puppets, etc.), to bring within the ambit of the general public the new sensibility inherent in modern art. Within months of its formation a personal quarrel between Fry and Wyndham LEWIS

brought about a rift within the group. Lewis seceded with ETCHELLS, WADSWORTH and Cuthbert HAMILTON and in March 1914 set up the Rebel Arts Centre, from which emerged the movement christened VORTICISM by Ezra Pound. In its beginning Vorticism was almost certainly the most significant movement that took place in British art during the first half of the 20th c., although the violence of its polemic in its organ *Blast* and elsewhere tended to obscure its real importance until much later. The movement was overtly and belligerently anti-naturalistic. It favoured jagged, crisp, rhythmical linear forms, angular rather than curved, precise rather than nebulous, and accidentally or not forms sometimes having a certain affinity with those of Russian RAYONISM. In particular, machine forms were introduced though without the adoption of the machine image as was done by the American PRECISIONISTS later. In his Introduction to the catalogue of the Vorticist exhibition held in the Tate Gal. in 1956 Lewis wrote: 'Vorticism was dogmatically anti-real. It was my ultimate aim to exclude from painting the everyday visual real altogether. The idea was to build up a visual language as abstract as music ... Another thing to remember is that I considered the world of machinery as real to us as nature's forms, and that machine-forms had an equal right to exist in our canvases.' The moods which the movement promoted were energy, vitality and a sense of relevance to the present. In the first volume of *Blast* Lewis wrote: 'We do not want to change the appearance of the world, because we are not Naturalists, Impressionists, or Futurists (the latest form of Impressionism), and do not depend on the appearance of the world for our art. We only want the World to live, and to feel its crude energy flowing through us ... The artist of the modern movement is a savage ... this enormous, jangling, journalistic, fairy desert of modern life serves him as Nature did more technically primitive man.' Alongside Lewis the Vorticists whose reputations have proved most lasting are: GAUDIER-BRZESKA, EPSTEIN, BOMBERG, ROBERTS, Wadsworth. Ezra Pound, and later T. S. Eliot, were associated with the movement and the philosopher T. E. Hulme was its more restrained theorist. The impetus by which the movement was at first animated was dissipated by the First World War and after the war most of the former artists of Vorticism reverted to one or another form of naturalism. An attempt to revive the movement by an exhibition held under the name of a GROUP X in 1920 proved abortive. An exceptionally high proportion of works done under the cloak of Vorticism have disappeared or been destroyed so that even after the comprehensive exhibition organized by the Arts Council of Great Britain in 1974 it is difficult to judge the quality of the output as a whole. It seems reasonable, however, to suppose that had it not been for the interruption of the war the movement might have matured into something of more than local importance.

The 1920s was a time of calmer consolidation and cautious forward progress after the violence and flamboyance of the previous decade. A general 'back to nature' impulse took the form of a striving to recover the poetic realism and lyrical spontaneity which have been endemic to the English tradition of landscape, figure and still life. All forms of academicism were eschewed, whether the traditional formulae of the Academy or the more recent formulae of a new modernism, and artists sought to achieve a fresh expression of direct personal vision. The general note was a romantic naturalism deriving from a new experience of the visual world. Even the SEVEN AND FIVE SOCIETY, founded in 1919 to encourage a less anaemic art than that sanctioned by the aesthetics of the Bloomsbury Group under Fry's guidance, had this as its dominant note and made no great stir until the swing towards abstraction at the end of the decade.

At the same time, however, there were working great individualists who belong to no group or pattern. Stanley SPENCER, returning from his shattering wartime experiences, and combining a superficial debt to the Pre-Raphaelites with the visionary intensity of a Blake, was maturing the style in which he would present his native Cookham as 'a holy suburb of Heaven'. David JONES was working with Eric GILL at Ditchling and Capel-y-Ffin, maturing his attenuated and allusive visionary style of the early 1930s. With his portrait busts, his controversial *Christ*, the *Rima* for the W. H. Hudson memorial in Hyde Park and the figures *Night* and *Day* for the St. James's Park Underground Station Jacob Epstein represented the culmination of the Romantic tradition in sculpture. Matthew SMITH, working mostly in Paris, was turning his Fauvist colour into a medium for individualist expression. William Roberts was developing his Vorticist manner into a highly idiosyncratic concentration of stiffly stylized figure groups, with cylindrical forms reminiscent of LÉGER. Mark GERTLER, quietly pursuing his own path, was trying in his female figures and still lifes to impart to natural objects a limpid solidity which existed only in the depiction. These and others, individualists all, defy classification even when they were drawn by circumstance into this or that association.

In the late 1920s there was a tendency among many of the younger artists, which lasted until the mid 1930s, in the direction of one or another form of abstraction. In 1928 Ben NICHOLSON and Christopher WOOD, excited by the paintings of the NAÏVE artist Alfred WALLIS, were confirmed in their move towards flattened and simplified forms and emphasis on the tactile properties of pigment. In the early 1930s Nicholson and Barbara HEPWORTH visited Paris and made personal contact with BRANCUSI, BRAQUE and MONDRIAN, among others. They were from this time in the van of the abstract movement and are among the few British artists who have remained consistent to it. In 1933 Nichol-

son began to do the abstract reliefs for which he has since become internationally famous. Meanwhile the OBJECTIVE ABSTRACTION group was formed under the initiative of COLDSTREAM, PASMORE and Graham BELL, and held an 'Objective Abstraction' exhibition, in which Ivon HITCHENS participated, at the Zwemmer Gal. in 1934. Their aim, to which Ivon Hitchens remained faithful throughout his artistic career, was to convert natural scenes and objects into abstract compositions which, regardless of the degree of verisimilitude, would convey the emotional impression which the reality itself evoked. The 7 and 5 Society, whose members were required by its rules to be re-elected annually, had come to be increasingly dominated by artists interested—at least for the time being— in abstraction until in 1934 it was renamed 'The 7 and 5 Abstract Group' and in 1935 staged the first completely abstract exhibition in England. The event which had the most powerful reverberations at this time, however, was the formation of the association UNIT ONE in 1933 on the initiative of Paul NASH. Its secretary was Douglas Cooper and its spokesman Herbert READ, and although it held only one exhibition, in 1934, the impact for some reason was enormous. No common style or direction was claimed for the association but only that each member 'stands for the expression of a truly contemporary spirit'. The association contained within itself from the first the seeds of disintegration. Constructivist or quasi-geometrical abstraction was represented by Nicholson, Wadsworth and BIGGE; the sculptors Henry MOORE and Barbara Hepworth (at this time) represented biomorphic abstraction; and diverse elements of SURREALISM or fantasy were introduced by Paul Nash, Edward BURRA and John ARMSTRONG.

At this time and through the 1930s three great individualists who have since won international acclaim were working in close contact in Hampstead: they were Barbara Hepworth, Ben Nicholson and Henry Moore. Herbert Read, who aspired to become the mouthpiece of their ambitions and convictions, was popularizing the principles of modern art in a series of books which were widely read.

It was partly the efforts of members of Unit One that made possible the great 'International Surrealist Exhibition' which was opened in the New Burlington Gals. in 1916. Henry Moore, Paul Nash, Herbert Read and Roland Penrose made up the English members of the Committee. The exhibition was comprehensive, including examples of CHIRICO'S METAPHYSICAL painting and DADA works by Marcel DUCHAMP, MAN RAY and PICABIA. All aspects of Surrealism were represented—the imagery of the unconscious, AUTOMATISM, the juxtaposition of the incongruous and the use of alogical association, dream imagery, MAGIC REALISM or Verism in the depiction of the fantastic, and so on. The liberalizing effect was important but little or nothing of what was central to Continental Surrealism struck root on British soil. In Britain Surrealism was attenuated, with few exceptions, to the corroboration of imagination in the romantic tradition. 'British artists pursued Surrealist aims in a manner orderly, idiosyncratic and gentle by comparison with the continental pioneers.' In the second half of the 1930s Mondrian and a number of the leaders from the BAUHAUS—GROPIUS, Breuer, MOHOLY-NAGY, GABO and the architect Erich Mendelsohn—settled temporarily in England before seeking greater security in the U.S.A. They brought with them the CONSTRUCTIVIST principles of the ABSTRACTION-CRÉATION association, and the Constructivist manifesto CIRCLE, sub-titled 'International Survey of Constructive Art', was published in 1937 under the editorship of J. L. Martin, Ben Nicholson and Naum Gabo. While these Continental Constructivists made contact with many of Britain's leading abstract artists, the movement as a whole did not strike permanent root in Britain. Rather, towards the end of the decade, there was an inclination among many, including Paul Nash and John PIPER, to sit loose to the extremer forms of experimental art and revert to a sober naturalism. Symptomatic of this tendency was the foundation of the EUSTON ROAD SCHOOL in 1937 by Coldstream, Pasmore, Graham Bell and Claude ROGERS.

Official War Artists were appointed in the Second World War as in the First. The works which made the greatest impact were Henry Moore's drawings of people in the underground shelters and Graham SUTHERLAND's quasi-Surrealistic pictures of bomb damage. Foreign artists, refugees from Nazi Germany, who were working in Britain included Jankel ADLER, KOKOSCHKA, SCHWITTERS and Martin Bloch. During the war years also C.E.M.A. operated as a forerunner of The ARTS COUNCIL OF GREAT BRITAIN.

After the end of the Second World War British art became more closely integrated than before into the international art scene, although contacts were closer with the new American art than with current European movements. A number of British artists achieved international reputation, including Moore, Hepworth, Nicholson, BACON, HOCKNEY, CARO. Exhibitions of the younger British artists in both Europe and America became more frequent: in the 1960s 'British Art Today' (1962) and 'London: The New Scene' (1965) toured in America; 'Neue Malerei in England' was at Leverkusen in 1961 and 'Britische Malerei der Gegenwart' at Düsseldorf in 1964. A large retrospective exhibition of British art since the war was arranged by the Arts Council at Milan in 1976. London began to lose its provincial character in the art world. Exhibitions of the newest work from abroad became a frequent feature and a number of expatriate, foreign and Commonwealth artists settled and worked there. Work done by British artists themselves took on a more international character than heretofore.

In the early 1950s there emerged a loosely knit group of SOCIAL REALIST painters, who by their

choice of drab and sordid subject matter came to be known as the KITCHEN SINK SCHOOL. Its chief exponents were John BRATBY and for a time Jack SMITH, Edward MIDDLEDITCH and Derrick GREAVES. By their subject matter and their violently aggressive technique they gave expression to the postwar mood of the 'angry young men'. The mood did not last and the group was ephemeral. About the middle of the decade the much more important movement of POP ART originated from seminars held at the I.C.A. by the Independence Group led by the critic Laurence Alloway and the architectural writer Reyner Banham. The attitudes from which Pop emerged were predicted in such exhibitions as 'Parallel of Life and Art' (1953), 'Man, Machine and Motion' (1955) and 'This is Tomorrow' (1956). Pop art made its public début at 'The Young Contemporaries' exhibition of 1961. The pioneers were Eduardo PAOLOZZI, Richard HAMILTON, Joe TILSON and Peter BLAKE. Their successors included KITAJ, Hockney, BOSHIER, Richard SMITH, Allen JONES and Peter PHILLIPS. A large retrospective exhibition of British Pop was arranged by the Arts Council in 1976 and was shown in Hamburg and Munich.

The movement in abstract Colour Painting made its public appearance at the exhibition 'Situations: An Exhibition of British Abstract Painting' in 1960. Among the painters prominent in the movement were Harold and Bernard COHEN, William TURNBULL, Robyn DENNY, Gillian AYRES and later Patrick HERON, Paul HUXLEY and John HOYLAND. In their several ways they explored the aesthetics of pure colour without objective or symbolic reference. Their affinities generally were nearer to the American HARD EDGE and COLOUR FIELD painters than to European TACHISM.

The only artistic centre of importance outside London was at the Cornish village of St. Ives, where Barbara Hepworth and Ben Nicholson settled on the outbreak of war and gathered around them a group of younger artists including Terry FROST, Patrick Heron, Roger HILTON and Peter LANYON, while Bryan WYNTER, William SCOTT, Alan DAVIE and Victor Pasmore maintained connections with them. Apart from the strongly international outlook they shared in common these painters had insufficient similarity of aim or style to constitute a 'school'.

Standing rather apart from other trends has been an important development of post-war Constructivism led by Kenneth and Mary MARTIN, Anthony HILL and Robert ADAMS. Victor Pasmore, among his many stylistic changes, contributed importantly to this movement.

In sculpture a group of romantic figurative and metal sculptors, successors to Henry Moore, dominated the 1950s. Among them were Reg BUTLER, Lynn CHADWICK, Kenneth ARMITAGE, Bernard MEADOWS, Ralph BROWN. Like the Italian sculptors Marino MARINI, Giacomo MANZÙ and Emilio GRECO, they were trying to combine modernism—in particular exploitation of the aesthetic possibilities of wrought metal—with what sculpture was traditionally expected to be. Their work, however, proved not to be in the main line of progress and in the 1960s an entirely new generation of sculpture stemmed from the work of Anthony Caro, whose position in British sculpture compares with that of David SMITH in America. His uncompromising metal sculpture, often employing ready-made steel parts, often brightly coloured, its horizontal extension dispensing with the traditional plinth and occupying the groundspace to integrate it into its environment, ushered in a new concept of sculpture which has remained dominant since it was introduced at the second 'New Generation' exhibition in the Whitechapel Art Gal., in 1965. Among the most important of Caro's pupils and followers were Phillip KING, who worked in coloured fibreglass rather than metal, William TUCKER, Tim SCOTT and David HALL. Eduardo Paolozzi has pursued a line of his own from his Pop period in the late 1950s to the large pseudo-machines of the 1970s and 'box' reliefs reminiscent of the manner of Louise NEVELSON. It is in sculpture that British art from the 1960s stands most firmly upon its own feet.

An exhibition 'British Painting 1952–1977' staged by the Royal Academy in 1977 revealed both the strength and the weakness of British painting during these years but most of all was an eloquent testimony to the lack of any specific direction.

BRITTAIN, MILLER. See CANADA.

BRIZZI, ARY. See LATIN AMERICA.

BRODZKY, HORACE (1885–1969). British painter and draughtsman born at Kew, Melbourne, Australia. He studied briefly at the art class of the Melbourne National Gal., 1905–6, and then went to San Francisco and New York. In 1908 he settled in London. In 1911 he attended briefly the City and Guilds Arts School at Kennington, became an original member of the LONDON GROUP and travelled with the American poet John Gould Fletcher to Rome, Naples and Sicily. There he was inspired by the work of Piero della Francesca, to whom he owed his frontal grouping and foreshortened perspective as well as the sense of hieratic serenity which pervades his works. He was associated with the VORTICIST movement of Wyndham LEWIS and his style had something in common with that of BOMBERG and William ROBERTS at that time. He is also remembered for his fine pen-drawings of the nude, examples of which are in the Victoria and Albert Mus., the British Mus. and The Mus. of Modern Art, New York. In 1913 he met GAUDIER-BRZESKA, whose biography he wrote in 1933, and his bust by Gaudier-Brzeska is in the Tate Gal. From 1915 to 1923 he lived in New York, exhibiting there and in Pennsylvania. During this time he became a friend of PASCIN, on whom he wrote a monograph in 1946. After his return to London he continued to exhibit there

and in the provinces and in 1935 *40 Drawings by Horace Brodzky* was published with a text by James Laver. In 1947 he edited the drawings of Gaudier-Brzeska. A memorial exhibition of his work was staged at the Fieldborne Gals., London, in 1977.

BROOKER, BERTRAM. See CANADA.

BROOKS, JAMES (1906–). American painter born at St. Louis, Mo., studied at Dallas Art Institute, 1925–6, and at the Art Students' League, New York, 1927–31. During the 1930s he worked with the FEDERAL ARTS PROJECT in a style of vigorous and monumental realism. During the 1940s his style matured in the direction of abstraction and he was prominent among the ABSTRACT EXPRESSIONISTS of the 1950s, when he exhibited at the Peridot Gal. He had a retrospective exhibition circulating from the Whitney Mus. of American Art in 1963–4. His work figured in many collective exhibitions of advanced American art and is represented in leading public collections.

BROWN, FREDERICK (1851–1941). British painter, born at Chelmsford. After studying in France he became a founding member of the NEW ENGLISH ART CLUB in 1886. He was responsible for drawing up the rules of the club and was among the most energetic in its campaign against the conservatism of the Royal Academy. After teaching at the Westminster School of Art, 1877–92, he was made Professor at the Slade School in 1892. There his influence on students who were later to make their mark in British art was important.

BROWN, JOAN (1938–). American painter born in San Francisco. She studied at the California School of Fine Arts, 1955, and then with Elmer BISCHOFF, Richard DIEBENKORN and others. From 1961 she taught at the San Francisco Art Institute. Her first one-man show was at the Spasta Gal., San Francisco, in 1958. She was included in group shows at the San Francisco Mus. of Art, the Whitney Mus. of American Art, the Pennsylvania Academy of the Fine Arts, etc.

BROWN, NEIL DALLAS (1938–). British artist born at Elgin, studied at the Dundee College of Art and after a postgraduate year at the Duncan of Jordanstone College of Art, Dundee, was awarded a Scottish Education Department Travelling Scholarship to visit France, Italy and Spain in 1959–60. In 1960–1 he was at the Royal Academy Schools, London, with a Leverhulme Grant Award and he obtained a David Murray Scholarship in 1959 and 1961. In 1967 he obtained a Scottish Arts Council Award to visit New York and in 1970 he was a prizewinner at the Arts Council of Northern Ireland Open Painting Exhibition. From 1968 he was visiting lecturer at the Duncan of Jordanstone College of Art. In 1975 he was elected A.R.S.A. From 1959 he had a number

of one-man shows in Edinburgh, London and elsewhere and participated in many major group shows. In 1975 he had a one-man show at the Piccadilly Gal., London, and retrospectives at MacRobert Centre Gal., Stirling University, the Dundee City Art Gal. and the City of Edinburgh Art Centre. He painted in a highly original manner, representing human figures and birds against vaguely suggested backgrounds of trees or feathers, and his pictures often had the disturbing impact of dreams. They are represented in many public collections throughout Great Britain, in the Vincent Price Collection, U.S.A., and in the Skopje Mus. of Contemporary Art, Yugoslavia.

BROWN, RALPH (1928–). British sculptor born at Leeds, studied at Leeds, Hammersmith and the Royal College of Art, where he afterwards taught. In 1954 he worked under ZADKINE in Paris and in 1955 and 1957 he visited Greece and Italy with travelling scholarships. His first one-man show was at the Leicester Gals., London, in 1961. His work was subsequently exhibited frequently and was represented in most collective shows of British sculpture. His sculpture was based upon the human figure, which he treated in a style of expressive and somewhat mannered semi-abstraction. Thus he falls into the same general category as Lynn CHADWICK, Kenneth ARMITAGE and Bernard MEADOWS. Among the public collections in which he is represented are the Tate Gal., the Arts Council coll., and the Rijksmus. Kröller-Müller, Otterlo, Netherlands.

BROWNE, BYRON (1907–61). American painter born at Yonkers, New York, and studied at the National Academy of Design, 1924–8. His first one-man exhibitions were at the New School for Social Research, New York, in 1936 and 1937. He was a charter member of the AMERICAN ABSTRACT ARTISTS and was one of the artists who showed in their first exhibition. He continued actively to exhibit during the 1940s and 1950s and in 1962 a Memorial Exhibition of his work was put on by the Art Students' League, where he had taught from 1948 until his death. Among other collections his works are represented in the universities of Georgia, Nebraska and Oklahoma; the National Institute of Arts and Letters; the Pennsylvania Academy of the Fine Arts; Rio de Janeiro; Tel Aviv; the Whitney Mus. of American Art.

BRUCE, EDWARD. See FEDERAL ARTS PROJECT.

BRUCE, PATRICK HENRY (1880–1937). American painter, born in Virginia. He was a pupil of Robert HENRI, then went to Paris in 1907 and studied under MATISSE. He was a friend of Robert DELAUNAY and worked with him from *c.* 1912 to 1914. He was affiliated with the SYNCHROMIST movement of Stanton MACDONALD-WRIGHT and Morgan RUSSELL. His works were included in the ARMORY SHOW. During the 1920s he abandoned

Synchromism and painted mainly geometrically designed still lifes with flat blocks of colour. Disillusioned by his lack of success he destroyed all but about 15 of his paintings in 1932 and he committed suicide after a visit to the U.S.A. in 1936. His *Composition III*, a Synchromist work painted 1916–17, is in the Yale University Art Gal.

BRÜCKE, DIE. An association of painters formed by the young German architectural students Ernst Ludwig KIRCHNER, Erich HECKEL, Fritz Bleyl and Karl SCHMIDT-ROTTLUFF at Dresden in 1905. (In Kirchner's *Chronik der Künstlergemeinschaft Brücke* the date of foundation is given as 1903, the year in which Kirchner came into contact with Bleyl and Heckel. But a formal association did not come into being until 1905, when they were joined by Schmidt-Rottluff.) The association was expanded in 1906 by the accession of Max PECHSTEIN and Emil NOLDE (for the one year 1907–8). The Swiss painter Cuno AMIET, the Finnish artist Axel GALLÉN-KALLELA, the Czech Bohumil KUBISTA and in 1908 the FAUVIST Kees van DONGEN were invited to join and became sympathizing if not active members. Towards 1910 the *Brücke* artists moved to Berlin, where Max Pechstein with Emil Nolde had formed the *Neue Sezession* ('New Secession') in protest against the refusal of Nolde's painting *Pentecost* by the Berlin SEZESSION. Kirchner, Heckel and Schmidt-Rottluff joined the *Neue Sezession*, where they met Otto MÜLLER and brought him into the *Brücke* as the last member to join. They soon left the *Neue Sezession*, however, in order to preserve the separate integrity of the *Brücke* and Pechstein was expelled from the *Künstler-Gruppe Brücke* because of his continued adherence to the *Neue Sezession*. The *Brücke* took part as a group in the second exhibition of the BLAUE REITER in 1912, but in 1913 it was disbanded in consequence of disputes over Kirchner's statement of aims and policy in his *Chronik*.

The founders of the *Brücke* were young men with a strong sense of mission, deeply imbued with the soaring social aspirations of their day and determined to work towards a better future for mankind with painting as their medium. They regarded themselves as a revolutionary élite and were aggressively anti-bourgeois, taking as their motto the Horatian *Odi profanum vulgus*. The name of the movement—which means 'Bridge'—was chosen by Schmidt-Rottluff and was meant to symbolize the link which held the group together. It later came to be given a deeper significance as indicating their faith in the art of the future, towards which their own work was to serve as a bridge. In his letter inviting Nolde to become a member, Schmidt-Rottluff wrote: 'To attract all revolutionary and fermenting elements: that is the purpose implied in the name "Brücke".' But they never achieved a concrete definition of what this art of the future should be and their own aims remained vague in consequence; no clear artistic programme emerged from any of their publications. They were moved by an impulse to revolt and wanted, as others have wanted, to achieve 'freedom of life and action against established and older forces'. They were influenced by late Gothic German woodcuts, by primitive art as seen in the fine collection of wood carvings in the ethnographic department of the Zwinger Mus. at Dresden, and to some extent by the Fauves. In practice they set themselves against both anecdotal realism and Impressionism and under the influence of MUNCH and HODLER succeeded in creating a German version of the EXPRESSIONISM which stemmed from Van Gogh and Gauguin. Indeed it was due mainly to them that the term 'Expressionism' has come to be applied primarily to modern tendencies in German art.

The *Brücke* has sometimes been represented as the German analogue of the contemporary Fauvist movement in France. Like the Fauves they took their subjects directly from nature and were opposed to abstraction—Kirchner said: 'Every picture I paint has its roots in natural experience.' They had a common interest with the Fauves in primitive art and both groups favoured a non-naturalistic use of vivid colours for expressive purposes. But whereas for the French artists pictorial aims were always paramount, the Germans were to a greater extent concerned to give forceful expression to strong emotional attitudes of the artist to his subject and for this—which they thought of as 'the innermost essence of life'—they went further in the direction of distortion and harshness. German Expressionism placed greater emphasis on the instinctive, spontaneous and subjective; it lacked the feeling for classical discipline which has always remained a prominent element in the Latin temperament. In time the *Brücke* artists were behind the Fauves, and although both movements began in 1905 with somewhat similar aims of pure colours and abrupt draughtsmanship, deriving from roughly the same sources, both in revolt from the Impressionist ideas, the achievement of the German artists was in no way comparable to that of the French.

At the beginning, in 1905, the founders of the *Brücke* formed a small artistic community of the sort envisaged by Gauguin and Van Gogh. At this time their styles were almost indistinguishable from each other, but gradually each went his own way and by the time the movement was disbanded in 1913 much of the similarity had disappeared. Indeed it was Kirchner's attempt to give a historical record of their achievements which was the direct occasion for the disruption of the group. Their first two exhibitions, held in a lampshade factory in 1906–7, attracted little attention. But exhibitions held in prominent Dresden galleries from 1907 to 1910 set out to shock the public and achieved something of a *succès de scandale*. Each year a portfolio of woodcuts or lithographs was issued and these are now regarded as among the most important documents of early German Expressionism.

BRÜNING, PETER (1929–). German painter and sculptor born in Düsseldorf, studied under Willi BAUMEISTER at the Academy, Stuttgart, 1950–2, and then spent two years at Soisy-sur-Seine, where he came under the influence of Cy TWOMBLY. In 1956 he was awarded the Cornelius prize of the City of Düsseldorf, in 1961 the Villa Romana prize and in 1964 received an Honourable Award at the Third International Biennale for Young Artists at Tokyo. From 1953 he took part in many collective exhibitions, including DOCUMENTA II, III and IV, and he had one-man shows both in Germany and abroad. His speciality was the application of cartography to a new style of landscape painting for the depiction of the modern industrial environment and the development of an ALL-OVER style deriving from Twombly. His sculptures in painted iron, fibreglass and polyester with light effects, such as *Autobahndenkmal* (1968), *Strassenwand* (1968) and *Objektive Landschaft* (1969), continued this interest in the abstract interpretation of landscape in a three-dimensional medium.

BRUSSE, MARK (1937–). Dutch sculptor born at Alkmaar, studied at the Academy of Art, Arnheim. In 1961 he went to Paris and in 1965 moved to New York. While in Paris he joined the group NOUVEAUX RÉALISTES and built up his sculptures from real objects such as agricultural implements. He did not work in the manner of expressive abstraction or JUNK ART like MOOY and COUZIJN, remaining firmly with the outlook of the New Realism in its opposition to both representation and expression.

BRUSSELMANS, JEAN (1884–1953). Belgian painter, born in Brussels. After training as a lithographer-engraver, he studied painting at the Brussels Academy. He first painted realistically in the manner of Courbet but developed a 'studiously ascetic' Expressionist style with an 'intentional sparseness of form' which was not well appreciated until after his death. He is now regarded as one of the more important exponents of Flemish EXPRESSIONISM. L. M. A. Schoonbaert of the Royal Mus. of Fine Arts, Antwerp, has said of him: 'He was the constructivist-expressionist *par excellence*, severe and cool. He is a transitional figure in the development of non-figurative art and prepared the way for lyrical abstraction in Belgium.'

Examples of his work in this style are: *Pajotten Country* (Royal Mus. of Fine Arts, Antwerp; 1938) and *Golden Seascape* (Mus. Royaux des Beaux-Arts, Brussels; 1939). In the catalogue of an exhibition *Ensor-Magritte* arranged at the Palais des Beaux-Arts, Brussels, in 1975 his contribution is admirably summed up as follows: 'Although he is frequently classed as an Expressionist himself, Brusselmans had nothing of their passionate character, his own gifts being those of order and clarity.' In addition to themes from peasant life, he painted landscapes, still lifes and interiors.

BRYEN, CAMILLE (1907–). French poet and painter, born at Nantes. He went to Paris in 1926 and published *Opoponax*, his first volume of poems. Other volumes followed during the 1930s. These were in a style deriving from both DADA and SURREALISM, relying largely upon punning and sound effects. He began to exhibit automatic drawings *c.* 1934 and he was one of the forerunners of that kind of expressive abstraction, called ART INFORMEL, which claimed to be spontaneous 'psychic automatism'. His 'spot and sign mosaics' had something in common with the *Mouvements* of Henri MICHAUX. In 1946 he exhibited with ARP in Basle and the same year at the Gal. du Luxembourg, Paris, followed in 1948 by an exhibition at the Gal. des Îles introduced by Michel Tapié, the most vociferous protagonist of *Art Informel*.

BRZOZOWSKI, TADEUSZ (1918–). Polish painter born at Lwów, studied at the Academy of Art in Kraków and later taught at the Academy of Fine Arts, Poznań. Like NOWOSIELSKI, Brzozowski was deeply imbued with the spirit of the Polish icon painters and medieval Slavonic art. Upon this was grafted a strong SURREALIST bent, which led to grotesque distortions and an emotional affinity with expressive abstraction.

BUCCI, ANSELMO. See NOVECENTO ITALIANO.

BUCHHEISTER, CARL (1890–1964). German painter, born in Hanover. He began to paint in 1919 without formal training and at first worked in the style of the NEUE SACHLICHKEIT and was a member of the NOVEMBERGRUPPE. During the 1920s he went over to abstraction under the influence of the CONSTRUCTIVISTS and from 1933 to 1936 he was a member of ABSTRACTION-CRÉATION. After the Second World War he did abstract COLLAGES in a manner between expressive abstraction and Constructivism, sometimes favouring a style akin to ART BRUT. From 1945 he taught at the Hanover Academy.

BUCHHOLZ, ERICH (1891–1973). German painter and sculptor, born in Bromberg. From 1918 he was a member of the NOVEMBERGRUPPE in Berlin, where he was on friendly terms with El LISSITZKY. He worked in a mode of geometrical abstraction and was influenced both by SUPREMATISM and by De STIJL.

BUFFET, BERNARD (1928–). French painter, born in Paris. He entered the École des Beaux-Arts in 1944 but worked mostly in solitude. Through Jean AUJAME he obtained an exhibition at the Gal. des Impressions d'Art in 1947 but attracted no attention. About this time he found his individual style and in 1948 won the Prix de la Critique jointly with Bernard LORJOU. He joined the group HOMME-TÉMOIN and sprang overnight to popularity and renown. By 1953 he enjoyed the

greatest *réclame* of the younger French painters and during the 1950s he had a succession of exhibitions at the Gal. Drouant-David. Basing himself upon Francis GRUBER, he developed a highly mannered style immediately recognizable as his own. In sharp and spiky linear forms and with dismal greys and neutral tones he depicted emaciated figures and distorted still lifes which seemed to express the existential alienation and spiritual solitude of the post-war generation. It was upon 'this power to capture a mood that his great popularity depended. Later, overwhelmed by commissions and success, his work became more stylized and more decorative, losing in great measure its initial impact. Edward Lucie-Smith has said: 'Bernard Buffet had a spectacular success in the 1940s and 1950s with schematic figurative paintings which were literal interpretations of the gloomier and more superficial aspects of Sartre's existentialist philosophy. Buffet's interest really lies in the fact that quite a large section of the public received him so eagerly as an acceptable representative of modern art.' Buffet also did graphic work and his book illustrations included *Les Chants de Maldoror* of Lautréamont and *La Recherche de la Pureté* by Jean Giorno.

BUKTENICA, EUGEN (1914–). Yugoslav NAÏVE painter born on the Dalmatian island of Šolta, near Split, where he worked as a farmer and fisherman, painting in his spare time. At the age of 3 he lost his hearing and in consequence escaped military service in the Second World War. He was, however, involved in sabotage and spent the years 1941–4 in concentration camps. He began to draw and paint in 1946 after his return to Šolta. In 1950 he received some instruction in the preparation of canvases and the mixing of pigments from an academic artist Ante Kastelančić, whom he knew in Split, but he was otherwise untrained. He painted seascapes and genre scenes from the life of the island fishermen, carnival scenes in which he included figures of fantasy and landscapes of great charm. From the mid 1950s his work was exhibited extensively both in Yugoslavia and elsewhere in Europe.

BURCHARD, PABLO A. See LATIN AMERICA.

BURCHARD, PABLO E. See LATIN AMERICA.

BURCHFIELD, CHARLES (1893–1967). American painter born at Ashtabula Harbor and brought up in Salem, Ohio. He studied at the Cleveland Mus. School of Art, 1912–16, and on his return to Salem he underwent a psychological crisis attended by depression and obsessive fears. Working in water-colour he tried to evolve a set of archetypal pictorial analogues for childhood fears and obsessive moods, attributing these animistically to inanimate things. The scenes which he painted at this time, taken mainly from his Salem surroundings, were fraught with a melan-

cholic and depressive fantasy, e.g. *Church Bells Ringing, Rainy Winter Night* (Cleveland Mus. of Art, 1917) and *Noontide in Late May* (Whitney Mus. of American Art, 1917). After serving in the army, 1918–19, he moved to Buffalo and until 1920 earned a living as a designer of wallpaper while continuing to paint. His painting during the 1920s and 1930s veered in the direction of objective documentation of rural and small-town American life and he is thus classed as one of the earliest of the painters of the AMERICAN SCENE. Although his feeling for the weird and strange was still discernible in evocative perspectives or collocations of things, e.g. in *November Evening* (The Metropolitan Mus. of Art, New York, 1934), it notably diminished and was replaced by a fascination for the dreary, the commonplace and the dull. Depressive fantasy had merged into an obsessive hopelessness in face of ugliness and the banal. His later work revealed a growing feeling for the universal mystery and power of nature, e.g. *The Sphinx and the Milky Way* (Munson-Williams-Proctor Institute, Utica, 1946) and *An April Mood* (Whitney Mus. of American Art, 1946–55). He was given a retrospective exhibition at the Whitney Mus. of American Art in 1956.

BURGIN, VICTOR. See CONCEPTUAL ART.

BURLIUK, DAVID DAVIDOVICH (1882–1967) and VLADIMIR DAVIDOVICH (1886–1916). Russian artists, brothers, born at Kharkov. They studied at Munich from 1902 and were later friends of KANDINSKY there, associating themselves with him in the first BLAUE REITER exhibition of 1911. In Russia they at first worked in close association with GONCHAROVA and LARIONOV, adopting a style of deliberate and even exaggerated primitivism akin to theirs, and they exhibited at the first KNAVE OF DIAMONDS exhibition in 1910. They also contributed to subsequent Knave of Diamonds exhibitions and were influential in having German works shown at the second of these, in 1912, after Larionov had broken with the group. Together with the poet Mayakovsky and with a third brother, Nikolai (1890–1920), David and Vladimir, but above all David, were instrumental in creating a Russian variant of FUTURISM *c.* 1911. Vladimir, who was considered by Kandinsky to be the more talented of the two, was killed in the First World War. David was active both as a painter and as a poet. He left Russia in 1920 and, after a brief residence in Japan, settled in the U.S.A. in 1922 and became a citizen in 1930. In 1930 he launched the art magazine *Color Rhyme* and he owned an art gallery, the Burliuk Gal., Hampton Bays, N.Y. His first exhibition in the U.S.A. was with the SOCIÉTÉ ANONYME in 1924.

BURRA, EDWARD JOHN (1905–76). British painter and draughtsman born in London. Owing to chronic ill health he was compelled to leave school early and with the exception of three

student years he passed his life at Rye, Sussex. He studied at the Chelsea Polytechnic (1921–2) and at the Royal College of Art (1923). From his student days he painted and drew scenes of SOCIAL REALISM with a special addiction for squalid, cheap and meretricious subjects. This aspect of his work has been compared to that of George GROSZ, whom he admired. But whereas the satirical spirit of Grosz is linked with bitter castigation of evil and ugliness, Burra depicted his subjects impersonally without comment. Among the best known of his pictures in this style are a group of Harlem scenes done in 1933–4, one of which (*Harlem*, 1934) was bought by the Tate Gal. About the mid 1930s Burra's imagery underwent a radical change and he became fascinated with the grotesque and the bizarre—e.g. *Dancing Skeletons* (Tate Gal., 1934); *Skeleton Party* (Tate Gal., c. 1952–4). Many of his recurrent images—such as the bird-man—and his manner of juxtaposing incongruous objects acquired overtones of SURREALISM. The sense of tragedy evoked in him by the Spanish Civil War and the Second World War found expression in occasional religious pictures, a number of which were shown at his exhibition at the Lefevre Gal., London, in 1952. Examples are *Christ Mocked* (National Gal. of Victoria, Melbourne); *The Entry into Jerusalem* (Beaverbrook Gal., New Brunswick, Canada); *The Mocking of Christ* (University of Dundee). During the 1950s and 1960s his interest turned from people to landscape and some of the landscapes done during these years are among the most mature of his works, showing a gift for endowing inanimate objects with a quality of mysterious menace.

Burra's painting style remained remarkably consistent throughout his *œuvre*. He painted for preference in water-colour or gouache in sharp, clear colours with hard and precise outlines, somewhat in the manner of Paul NASH, who was among his friends. His paintings were lacking in atmospheric effects, distant objects being rendered in as precise detail as those in the foreground. In character Burra was reserved and retiring, holding himself aloof from artistic groups. The only association of which he became a member was UNIT ONE, formed by Paul Nash in 1933. In 1973 the Tate Gal. staged a retrospective exhibition covering 50 years of his work with some 150 exhibits.

BURRI, ALBERTO (1915–). Italian artist, born at Città di Castello, Perugia. He began to work as a doctor, was captured by the Americans during the war and began to paint in 1944 as a prisoner of war in Texas. In 1945 he returned to Rome and held his first exhibition there in 1948 at the Gal. Margherita. He exhibited at the Venice Biennale in 1952 and in 1960 was awarded the International Critics' Prize. His first one-man show in the U.S.A. was at the Allan Frumkin Gal., Chicago, in 1953 and in 1955 he was represented in 'The New Decade' exhibition at The Mus. of Modern Art, New York. Burri combined with abstract oil-painting techniques an individualistic method of COLLAGE with pieces of old sacking, charred wood, twisted and rusted metal, etc., building up constructs of elegance and beauty from these discarded and worn materials. His series *Catrami* (*Tars*) and *Muffe* (*Moulds*) of 1949–51 were followed by *Sacchi* (*Sacks*) from 1952 and *Bruciature* (*Burns*) from 1956, adding the feature of burning to dirt and wear, and these again by *Legni* (*Woods*) and *Ferri* (*Irons*) from 1957 and finally *Plastiche* (*Plastics*), in which an ambiguous and viscous material was made resplendent with colour. Burri won international fame for these works, which were among the first to exploit the evocative force of waste and trash, worn-out and discarded refuse, and looked forward to JUNK ART in America and ARTE POVERA in Italy. The Italian writer Piero Bargellini has said of his work that it affords a revelation of 'a world at once wretched and refined, ephemeral and at the same time eternal: the world of refuse and trash, which will always endure, resisting thanks to its wretchedness even the most destructive disasters'.

BURSSENS, JAN (1925–). Belgian painter born at Malines, studied at the Academy of Ghent, 1943–5. He was a member of the ART ABSTRAIT group in 1952 and worked in the manner of geometrical abstraction. Then under the influence of American ABSTRACT EXPRESSIONISM he turned to a more dramatic form of expressive abstraction. In the latter 1960s he again changed his style and applied the experience he had gained to a new form of Realism.

BURTON, DENNIS. See CANADA.

BURY, POL (1922–). Painter and sculptor born at Haine St. Pierre, studied at the École des Beaux-Arts, Mons, 1938–9. From 1947 he exhibited with the JEUNE PEINTURE BELGE group and was also active in the COBRA group. In 1953 he abandoned painting for mobile sculpture and took part in the 'Mouvement' exhibition at the Gal. Denise René, Paris, in 1955. His first KINETIC works were *plans mobiles* ('moving planes'), which could be rotated at will so as to produce different patterns and combinations of shapes, inviting spectator participation. He later incorporated motors into the *plans mobiles* and in other series, which he called *multiplans*. In his kinetics the movement was usually very slow and the impression made was humorous and poetic. Most of his work was small and *intimiste*. But in 1973 he created a series of 50 'Animated Columns' each 3 m high, exhibited under the title *Twenty-Five Tons of Columns*, and declared that the very scale of the work added to the psychological effect of the slow movement among the columns. See also MEC ART.

BUSH, JACK HAMILTON (1909–77). Canadian painter, son of a commercial artist, born in Toronto but grew up in Montreal. He studied there

with two academic painters, Edmond Dyonnet and Adam Sherriff Scott, 1926–8. He then began work as a commercial artist in Toronto, while studying in the evenings at the Ontario College of Art. His first exhibition was a two-man show with R. York Wilson in 1944 and the following year he began to exhibit with the Canadian Group of Painters. He was then working in the GROUP OF SEVEN landscape tradition, with strong elements of American-style REGIONALISM, popular with some Canadians during the 1930s (*Village Procession*, Art Gal. of Ontario, Toronto, 1946). In 1949 he held his first one-man show, at the Gavin Henderson Gals. in Toronto, and in 1952 he was taken on contract by the Roberts Gal., where he exhibited works made up of stylized, angular forms derived from CUBISM. Inspired by Jock MACDONALD and by BORDUAS's work, he also began to experiment privately with AUTOMATIC composition.

In 1952 he made the first of what became regular visits to New York. The influence of these, together with that of the Toronto abstract group, PAINTERS ELEVEN, with whom he began to exhibit in 1954, brought him, by the mid 1950s, to a type of ABSTRACT EXPRESSIONISM. However, the American critic Clement Greenberg suggested to him that he should pursue the simplified and more personal approach to colour evident in certain of his recent water-colours (e.g. *Theme Variation No. 2*, Art Gal. of Ontario, Toronto, 1955), and in his one-man show at Toronto's Park Gal. in 1958 a distinct new direction was evident. In works such as *Painting with Red* (Robert McLaughlin Gal., Oshawa, Ont.) there is a new simple structure, a moving awkwardness to the forms and a limited but unaffectedly direct use of colour. In New York, where he first exhibited in 1962 at the new Robert Elkon Gal., Bush met several painters—notably Kenneth NOLAND—who like him were concerned to emphasize colour and basic structure through ruthless simplification. His reputation increased greatly during these years: his first London show was in 1964, at the Waddington Gals., and the same year he was included in the important survey exhibition, POST-PAINTERLY ABSTRACTION, at the Los Angeles County Mus. of Art. Throughout the 1960s he continued to explore joyous, full colour, placed in great, broadly brushed bands. *Dazzle Red* (Art Gal. of Ontario, Toronto, 1965) is one of the most monumental of his works, bold without being brash, reflecting openly the joy of personal fulfilment. He continued to exhibit regularly, and in 1967 represented Canada at the São Paulo Bienale. The following year he finally retired from commercial design in order to devote his whole time to painting. He now began to loosen his handling of forms, allowing ragged edges where one colour-form overlapped another, and about 1970 he began to develop an earthy textured ground against which he played increasingly more eccentric, brightly coloured forms. *Polyphonic Fugue* (Edmonton Art. Gal., Alberta, 1975) is among the most ambitious and successful of these

weighty yet still lyrical late works. They secured his international reputation, and in his later years, as well as his regular one-man shows in Toronto, New York and London, he exhibited commercially in Montreal, Boston, Los Angeles and Zürich. Major exhibitions include: Norman Mackenzie Art Gal., Regina, Saskatchewan, also shown in Edmonton (1970); Mus. of Fine Arts, Boston (1972); Art Gal. of Ontario, Toronto, also shown in Vancouver, Edmonton, Montreal, Ottawa (1976–7). His graphic work was shown at the Edmonton Art Gal. (1973), and commercially at the Jack Pollock Gal., Toronto, and at Prints on Prince Street, New York (both 1975).

BUSSE, JACQUES (1922–). French painter born in Paris, studied at the Grande Chaumière and in 1942 joined the group L'ÉCHELLE, which exhibited at the Gal. Jacques Blot in 1943. He was deported to a labour camp for two years during the Second World War and on his return exhibited at the first Salon de Mai in 1949, becoming a member of the committee in 1956. Like other members of *L'Échelle* he was influenced by CUBISM but in the 1950s he abandoned representation for a TACHIST form of abstraction. He won recognition for his *Verreries*, richly coloured abstracts which gave the impression of reflection in glass. Later he painted *Carrières* in more austere tones of grey, dividing the canvas by rectilinear lines. From 1957 he exhibited at the Gal. Jacques Massol.

BUTLER, HORACIO (1897–). Argentine painter born in Buenos Aires, studied at the National School of Fine Arts. In 1922 he went to Europe and after spending 10 months with the artists' colony at Worpswede he studied in Paris at the studio of André LHOTE and Émile-Othon FRIESZ. From 1929 he exhibited at the Salon des Tuileries, the Salon d'Automne and the Salon des Surindépendants. Returning to the Argentine in 1933, he began to exhibit there and to participate in international group shows: Pittsburgh (1934); Paris and New York (1937); Brussels (1961). He was made a member of the Argentine National Academy of Fine Arts in 1943. He was represented in the exhibition of Argentine art at the Mus. National d'Art Moderne, Paris, in 1964 and in 'Art in the Argentine' at the Wildenstein Gal., London, in 1975. He painted landscapes, still lifes and group scenes in a decorative style which had about it something of the *faux naïf*. He also designed stage settings and costumes for the Colón Theatre, Buenos Aires, the Solís Theatre, Montevideo, and for La Scala, Milan. In 1965 he executed a monumental tapestry for the St. Francis Basilica at Buenos Aires.

BUTLER, REG (1913–81). British sculptor, born at Buntingford, Herts. He trained as an architect and taught at the Architectural Association School until 1939. Although he began sculpture in 1944, architecture remained his main preoccupation

until 1950 when he gave up his architectural prac-
tice and was Gregory Fellow at Leeds University
until 1953. In 1953 he was awarded First Prize in
the International Competition for a monument to
The Unknown Political Prisoner and during the 1950s
he won a high reputation among the generation of
metal sculptors which followed Henry MOORE.
Butler alternated female nudes modelled with a
frank but wry sensuality with CONSTRUCTIVIST
box-like towers. After experimenting with insect-
like figures fashioned from metal wire, he returned
to the female nude, often enclosing the figure in a
framework of metal grids. Among other public
collections he is represented in the Tate Gal., the
Arts Council and British Council collections and
The Mus. of Modern Art, New York.

C

CABALLERO, JOSÉ (1916–). Spanish painter, born in Huelva. After beginning engineering studies in Madrid, he abandoned these in 1933 to study painting at the School of Fine Arts, under the painter Vázquez Díaz. He was a friend of the poet García Lorca, with whom he collaborated on the university theatre La Barraca. They held a joint exhibition of drawings at the Huelva Atheneum in 1933 and Caballero designed sets for Lorca's *Bodas de Sangre*. In 1934 he began a friendship with the poet Pablo Neruda, which had considerable influence on his outlook as expressed in his work. His early painting was SURREALIST in manner but in the early 1950s he changed to a mode of TACHISM with a strong expressive flavour. In 1951 he won the Young Painting prize at the First Hispano-American Bienale, Madrid, in 1953 the Painting Prize in the Second Hispano-American Bienale, Havana, and in 1955 the Grand Prize for Painting at the Third Hispano-American Bienale, Barcelona. In 1959 he was awarded the Fine Arts scholarship by the Juan March Foundation. Outside Spain he exhibited in Lausanne, Lisbon and Washington and his works were included in many international exhibitions of contemporary Spanish art. They are represented in the Mus. de Arte Contemporaneo, Madrid, the Fundación March coll., Madrid, the Mus. de Arte Moderno, Bilbao, the University Mus., Austin, Texas, the Carnegie Institute coll., Pittsburgh, the Mus. Tamayo, Mexico, the Mus. Solidaridad, Santiago de Chile, the Mus. del Instituto delle Richerche Estetiche, Turin, and others.

CABARET VOLTAIRE. Founded in February 1916 by Hugo BALL, this became a meeting place for members of the Zürich DADA movement and a centre for Dada manifestations such as simultaneous poetry readings, exhibitions, etc. Members included Marcel JANCO, Jean ARP, Tristan Tzara, Richard Huelsenbeck, etc. In 1916 a pamphlet was published with the title *Cabaret Voltaire* but no further issues appeared and in 1917 the Dada activities in Zürich were transferred to the Dada Gal.

CABRÉ, MANUEL. See LATIN AMERICA.

CACHETAGE. A technique in which casual odds and ends such as nails, screws, bottle caps, studs, buttons, coins, etc. are sealed upon a picture ground in order to make an abstract pattern. The technique was principally practised by the German graphic artist Werner SCHREIB.

CADAVRE EXQUIS. Name given to a game in which a group of five or six persons contribute in turn to make up a sentence or a drawing, no member of the group being aware of what the others have contributed. This old party game was given a new seriousness and significance by the SURREALISTS as a device for tapping the collective unconsciousness or exploiting the element of chance, which they also believed to be a path to the creativity of the unconscious mind. The name derives from the fact that on the first occasion the game was seriously played (1925) the resulting sentence was: 'Le cadavre—exquis—boira—le vin—nouveau.' An example of a *Cadavre exquis* drawing from 1926 is in The Mus. of Modern Art, New York, the participants having been BRETON, Morise, Naville, Péret, Prévert and TANGUY.

CADELL, F. C. B. See FERGUSSON, John Duncan.

CADIOU, HENRI (1906–). French painter and graphic artist, born in Paris and studied lithography at the Estienne college in 1919. During the 1930s he allied himself with the painters who revived a style of expressive Realism in reaction from both CUBISM and SURREALISM and in 1937 he participated in the exhibition 'Les Maîtres populaires de la Réalité' at the Mus. Grenoble, Paris. In 1943 he organized an exhibition 'Cinq Peintres de la Réalité' and from 1955 he was the moving spirit of a Realist group at the Salon Comparaisons. In 1955 he wrote the Introduction to the first International Exhibition of 'Peintres de la Réalité'. He painted rustic landscapes, still lifes and scenes from everyday life in a manner of poetic naturalism.

CADMUS, PAUL (1904–). American painter, born in New York. Both his father and his mother were commercial artists. He studied at the National Academy of Design and the Art Students' League, New York. After working for an advertising agency he did murals during the 1930s for the FEDERAL ARTS PROJECT. Working largely in tempera he perfected a style of MAGIC REALISM and during the Second World War came to prominence for his realistic portrayals of themes of sex and horror which contrasted with the delicate precision of his technique. Barbara Rose has said of his work that 'it married a highly cultivated, precise technique and slick, polished surfaces with a perverse version of the everyday'.

CAGLI, CORRADO (1910–76). Italian painter born in Ancona, studied at the Academy of Fine Art, Rome. He went to Paris in 1938 and to New York in 1940. After serving in the forces he returned to New York in 1945 and then settled in Rome in 1948. Cagli worked in a number of different styles at different periods in his career. After beginning as a figurative painter working on large murals, he was influenced by the Italian EXPRESSIONISTS of the ROMAN SCHOOL of MAFAI and SCIPIONE and then took up SURREALISM. After the war he worked in both geometrical and expressive abstraction. During the early 1960s he experimented with *trompe l'œil* realism and from *c.* 1965 evolved a style of decorative linear arabesques. Besides Italy, he exhibited in New York, San Francisco, Paris and Zürich.

CAHÉN, OSCAR. See CANADA.

CAILLARD, CHRISTIAN (1899–). French painter, born at Clichy. In 1923 with the novelist Eugène Dabit and the anarchist painter Maurice LOUTREUIL he founded the group *Pré-Saint-Gervais*. In 1926 he began extensive travels, returning to Paris in 1933 after a journey round the world. During the 1930s he allied himself with the painters of expressive and poetic reality, winning the Prix Blumenthal in 1934 and the North Africa Prize in 1936. His painting was imaginative and exotic and he had a gift for rendering the picturesque character of a locality. He also executed a number of decorative murals, at the Palais de la Découverte (1937) and at the Mus. Guimet among others. His *Maison Blanche, St. Guénolé* (1945) is in the Mus. National d'Art Moderne, Paris.

CAILLAUD, ARISTIDE (1902–). French painter. He began to draw at the age of five and later painted for his own pleasure without formal training of any sort. In 1943 while a prisoner of war he underwent a mental crisis, managed to secure colours and covered the walls of his cell with large murals. On his return to France he devoted himself to painting, transforming his early memories into imaginative and poetic compositions which created a fairyland of their own, free from all laws of traditional composition and perspective. His large *Venise* was acquired by the Mus. National d'Art Moderne in 1957. He often introduced the same air of spontaneous wonder and magic into paintings on religious themes. Caillaud is sometimes classified with NAÏVE painters.

CAILLE, PIERRE (1912–). Belgian painter and sculptor born at Tournai. He returned from painting to ceramics and taught ceramics from 1949. Although he was a potter, his imagination and his feeling for the unusual and mysterious gave his works a genuine artistic quality. He has therefore a place among the Belgian sculptors.

CALDER, ALEXANDER (1898–1976). American sculptor and painter, born at Lawnton, a suburb of Philadelphia. His grandfather, Alexander Milne Calder, and his father, Alexander Stirling Calder, were sculptors and his mother was a painter. His father had charge of the sculptural work for the Los Angeles World Exhibition in 1912. Alexander Calder, however, studied mechanical engineering from 1915 to 1919 and began to take an interest in landscape painting only in 1922 after having tried his hand at a variety of jobs. In 1923 he enrolled at the School of the Art Students' League, New York, where George LUKS and John SLOAN were among the teachers. Calder and his fellow students made a game of rapidly sketching people in the streets and the underground and Calder was noted for his skill in conveying a sense of movement by a single unbroken line. He also took an interest in sport and circus events and contributed drawings to the satirical *National Police Gazette*. From these activities it was but a step to his wire sculptures, the first of which—a sun-dial in the form of a cock—was done in 1925. In 1927 he made moving toys for the Gould Manufacturing Company and small figures of animals and clowns with which he gave circus performances in his studio. His first exhibition of paintings was in the Artists' Gal., New York, in 1926; his first Paris one-man show was in the Gal. Billiet in 1929 and the Foreword to the catalogue was written by PASCIN, whom he had met the previous year. His wire figures were exhibited by Carl Zigrosser at the Weyhe Gal. and Bookshop, New York, in 1928 and at the Neumann and Nierendorf Gal., Berlin, in 1929, when they were made the subject of a short film by Dr. Hans Cürlis.

During the 1930s Calder became known both in Paris and in America for his wire sculpture and portraits, his abstract constructions and his drawings. In 1931 he joined the ABSTRACTION-CRÉATION association and in the same year produced his first non-figurative moving construction. The constructions which were moved by hand or by motor-power were baptized 'mobiles' in 1932 by Marcel DUCHAMP, and ARP suggested 'stabiles' for the non-moving constructions in the same year. It was in 1934 that Calder began to make the unpowered mobiles for which he is most widely known. Constructed usually from pieces of shaped and painted tin suspended on thin wires or cords, these responded by their own weight to the faintest air currents and were designed to take advantage of effects of changing light created by the movements. They were described by Calder as 'four-dimensional drawings', and in a letter to Duchamp written in 1932 he spoke of his desire to make 'moving Mondrians'. Calder was in fact greatly impressed by a visit to MONDRIAN in 1930, and no doubt envisaged himself as bringing movement to Mondrian-type geometrical abstracts. Yet the personality and outlook of the two men were very different. Calder's pawky delight in the comic and fantastic, which obtrudes even in his large works, was at the opposite pole from the Messianic seriousness of Mondrian.

Calder continued to do both mobiles and stabiles until the 1970s, sometimes combining the two into one structure. Some of these works were of very large dimensions: *Teodelapio* (1962), a stabile for the city of Spoleto, was 18 m high and 14 m long; *Man*, done for the Montreal World Exhibition of 1967, was 23 m high; *Red Sun* (1967) for the Olympic Stadium, Mexico, was 24 m high and the motorized hanging mobile *Red, Black and Blue* (1967) at Dallas airport was 14 m wide. His interest in animal figures and the circus also continued into the 1970s and in 1971 he was making 'Animobiles' reminiscent of animals. Although he had done gouaches since the late 1920s, he began to take a more serious interest in them and to exhibit them from 1952.

Calder's mobiles were among the forerunners of KINETIC ART and his great reputation depended in part on the fact that he was among the first to incorporate real movement into sculptural art. He concentrated chiefly, however, on free and uncontrolled movement rather than the carefully planned and controlled movements—planned even when they incorporated an element of chance—with which later kinetic artists have been mainly concerned. Among his more important exhibitions were: Gal. Louis Carré, Paris, 1946, for which J.-P. Sartre wrote a now famous essay; exhibition with LÉGER at Stedelijk Mus., Amsterdam, and Kunsthalle, Berne, 1947; retrospectives at The Mus. of Modern Art, New York (1943); Basle (1955); Amsterdam (1959); Solomon R. Guggenheim Mus., New York (1964); Paris (1965); St. Paul-de-Vence (1969); Gal. Maeght, Zürich (1973); Haus der Kunst, Munich, and Kunsthaus, Zürich (1975). A Calder Festival was staged in Chicago in 1974.

CALDERARA, ANTONIO (1903–). Italian painter born at Abbiategrasso. After training as an engineer he taught himself to paint, beginning in 1924. During the 1950s he came to prominence for his work in geometrical abstraction, large uniformly coloured canvases composed with a few large and well balanced squares or rectilinear forms.

CALLERY, MARY (1903–77). American sculptor born in New York. After graduating at the Spence School she studied at the Art Students' League under Edward McCarten. In 1930 she went to Paris and worked at the atelier of the Russian-born sculptor Jacques Loutchansky. During this time she was influenced in her work first by MAILLOL but also gained the friendship of PICASSO, LAURENS, OZENFANT and the critic Christian Zervos. Returning to the U.S.A. in 1940, she had her first one-man show at the Buchholz Gal., New York, in 1944, continuing to exhibit both in New York (Curt Valentine Gal. and Knoedler Gal.) and in Paris. In 1943 and 1949 she executed some works in collaboration with Fernand LÉGER. She did elongated figure studies with curious rubbery appendages which set up relations between the internal and external space of the work. During the 1950s these forms became more angular until in the late 1950s she was doing pure abstractions. The interest in spatial relations remained, however, and spatial organization was obtained by a balancing of circular discs with rectangular forms. In the course of the 1960s curvilinear forms became preponderant together with an enhanced interest in surface texture. Among other collections her works are owned by the Aluminium Company of America; the Cincinnati Art Mus.; the Detroit Institute of Arts; the Wadsworth Atheneum, Hartford, Conn.

CALLIYANNIS, MANOLIS (1926–). Greek painter born at Lesbos. After serving in the R.A.F. during the war he completed his architectural studies at the University of Johannesburg. In 1948 he settled in Paris, exhibiting there, in Amsterdam and at the Gimpel Gal., London. He painted in a style of expressive abstraction or TACHISM, using subdued ochres and earth colours and organizing his forms in strong balanced compositions.

CALMETTES, JEAN-MARIE (1918–). French painter born at Wissous, Seine-et-Oise. From 1935 to 1937 he studied at the École des Arts Appliqués and the École des Arts Décoratifs, where he devoted himself to sculpture, and then from 1938 to 1939 he studied painting at the École des Beaux-Arts. After serving in the war he joined the group L'ÉCHELLE in 1942 and exhibited with them in 1943. He obtained the Prix Carrefour de la Jeune Peinture in 1947, the Prix Hallmark in 1949, the Prix Othon Friesz in 1954 and the Prix du Dôme in 1955. Calmettes was noted mainly for his still lifes, vigorous of construction and expressive in their restrained colour.

CALO, ALDO (1910–). Italian sculptor born at San Cesario di Lecce. After studying at the Art School there and at the Istituto d'Arte, Florence, he settled in Volterra. After passing through a SURREALIST phase he evolved an individualistic style of expressive abstraction often combining wood and iron.

CALVO, MANUEL. See SPAIN.

CAMARENA, JORGE GONZÁLEZ. See MEXICO.

CAMARGO, SERGIO DE. See LATIN AMERICA.

CAMARO, ALEXANDER (1901–). German painter born at Breslau, studied at Breslau Academy of Art, 1920–5, under Otto MÜLLER. At the same time he studied dancing and worked with Mary Wigman at Dresden in 1928. From 1930 he worked as a freelance painter in Berlin and did not exhibit until 1946. He was appointed Professor at the Berlin Academy of Art in 1951. He painted in

a lyrical manner depicting imaginary subjects on a transparent ground, becoming increasingly abstract in the 1950s. In 1961 he had a one-man show at the Kunstverein, Wolfsburg.

CAMDEN TOWN GROUP. After SICKERT'S return to England in 1905 his studio in Fitzroy Street, Bloomsbury, became a rallying point for younger painters, including Harold GILMAN, Spencer GORE, Lucien PISSARRO, Augustus JOHN, Henry LAMB, Walter BAYES and the critic Frank Rutter. In 1911 they decided to found a formal association, which on Sickert's suggestion was called the Camden Town Group. Spencer Gore was chosen as President. The original members of the Group were: Walter BAYES, Robert BEVAN, Malcolm Drummond, Harold Gilman, Charles GINNER, Spencer Gore, J. D. Innes, Augustus John, Henry Lamb, Wyndham LEWIS, M. G. Lightfoot, J. B. Manson, Lucien Pissarro, W. Ratcliffe, W. R. Sickert, J. Doman Turner. Duncan GRANT became a member after the Group's first exhibition. These artists were very different in their aims and styles. What they had in common was dislike for the romantic idealizations of the Academy, indifference to Neo-Impressionist theories of colour and an inclination towards descriptive Realism in the depiction of ordinary things.

The Camden Town Group held two exhibitions at the Carfax Gal. in 1911 and a third in 1912. As the gallery then declined to put on more group exhibitions, they merged with a number of smaller groups to form the LONDON GROUP in November 1913. The new body organized a collective exhibition in Brighton at the end of 1913 but although the exhibition was advertised under the name of the Camden Town Group, it may be regarded rather as the first exhibition of the London Group.

Richard Morphet wrote in his Introduction to the exhibition 'British Painting 1910–1945' (Tate Gal., 1967): 'The Camden Town Group developed around Sickert and had in Lucien Pissarro a residual link with French Impressionism. Its orientation was however away both from the sense of social comment which Sickert could not help but convey and from Pissarro's restraint of colour and delicacy of touch, towards something more dispassionate and solid. The Camden Town painters looked clearly and precisely at the ordinary and often the suburban scene, and made paintings from their objective notations, the squared up preparatory drawing gaining a particular importance. They also gave colour a more central role; their attitude to Post-Impressionist innovation was equivocal, but they represent one of its first positive incursions into British art.' The group are sometimes referred to as the 'English Post-Impressionists'.

The chief collector of the works of the group was Robert Alexander Polhill Bevan, son of the painter. Part of his collection was bequeathed to the Ashmolean Mus., Oxford, which organized an exhibition of the bequest in 1975.

CAMINO BRENT, ENRIQUE. See LATIN AMERICA.

CAMOIN, CHARLES (1879–1965). French painter, born at Marseilles. He went to Paris in 1896 and was a pupil of Gustave MOREAU, in whose studio he made friends with Albert MARQUET. During his military service, 1899–1902, he paid a visit to Cézanne and remained in correspondence with him. He exhibited at the Salon des Indépendants in 1903 and from then at the Salon d'Automne until 1908. He was one of the less revolutionary members of the FAUVIST group. In 1912–13 he visited Morocco with MATISSE and Marquet and his pictures from that time show the influence of Matisse. During the war he was employed on camouflage and in 1916 he met Renoir. In his painting after the war the influence of Renoir and BONNARD is apparent. Although Camoin shared with the Fauvists a liking for pure and bright colours, he belongs more to the Impressionist tradition than to any of the great revolutionary movements of modern times. In 1953 he obtained the Prix du Président de la République at the Menton Biennale. His work was very varied, comprising portraits (e.g. Albert Marquet, Mus. National d'Art Moderne, 1904), still lifes (e.g. La Coupe Bleue, ibid., 1930), interiors, nudes and landscapes, all painted with an air of freshness and spontaneity.

CAMPENDONK, HEINRICH (1889–1957). German artist born at Krefeld, studied under the Dutch artist Jan Thorn-Prikker (1868–1952) at the Arts and Crafts School, Krefeld, and then in Munich. He was invited to join the BLAUE REITER in 1911. His painting at that time showed the influence of MACKE's interpretation of ORPHIC CUBISM combined with a taste for Bavarian folk art and glass painting. He was an admirer of CHAGALL, whose early paintings had been exhibited at the STURM Gal. in 1914. But his primitivism was more sophisticated than that of the French NAÏVE painters and he lacked Chagall's wealth of native imagery. He taught at Krefeld, Essen and Düsseldorf, from where he was dismissed by the National Socialist regime in 1933. He then moved to Amsterdam, where he remained until his death and taught in the Academy.

CAMPIGLI, MASSIMO (1895–1971). Italian painter born at Florence. After working as a journalist in Milan, he began as a self-taught painter in 1919. From 1919 to 1939 he worked in Paris, exhibiting there and in New York. He himself said that the main formative influences on his work during this time were the Neo-Classicism of PICASSO, the cylindrical forms of LÉGER in the 1920s and the corseted figures of Seurat. He was dominated by a fascination for the past, particularly Etruscan art and Egyptian and Pompeian tomb painting, which was fanned into flame by a visit to Italy in 1928. But instead of basing a contemporary Neo-Classical

style upon these sources, he used them more subtly as a background against which modern figures were ironically set. It was this interest which often gave to his easel paintings the character of murals. During the 1930s he was commissioned to do a number of large murals—for the Palace of the League of Nations at Geneva in 1931, for the Milan Triennale in 1933 and in 1940 a series for the University of Padua. These have a musical, rococo quality which lends them the artificial charm of an ancient minuet. From 1939 to 1949 Campigli lived in Milan and from 1949 in Paris. He was given a retrospective exhibition at the Stedelijk Mus., Amsterdam, in 1946 and a special exhibition at the Venice Biennale in 1948. He is represented in many public collections of Europe and America and has had several exhibitions in New York. By the middle of the century he was probably the best known internationally among contemporary Italian painters.

CANADA. There have been two major movements in Canadian art in this century. The GROUP OF SEVEN in Toronto during the 1920s and the AUTO-MATISTES in Montreal during the late 1940s and early 1950s each captured the imagination of a broad public, each in its time and place seeming to embody national aspirations of the grandest sort. They represent two peaks around which virtually all Canadian art has since revolved, and reflect as well what have been the major tensions in Canadian cultural life: those between Toronto and Montreal, between Francophone and Anglophone, between nationalism and internationalism.

The first consciously 'modern' art in Canada—as distinct from that striving merely to be 'current' —is to be found in the work of those artists who joined together in 1907 to form in Toronto the Canadian Art Club. Although it was the energy of Toronto artists such as Edmund Morris (1871–1913) and Curtis Williamson (1867–1944) that launched the venture, the consistent quality and stylistic cohesiveness of the eight exhibitions held in that city before dissolution of the club in 1915 were due largely to the inclusion of Montreal-based painters such as James Wilson MORRICE, Maurice Cullen (1866–1934) and Marc-Aurèle de Foy Suzor-Cote (1869–1937). The club members presented moody, atmospheric paintings derived variously from Impressionism, Whistler and his circle or the Hague School. Even when they worked in Canada (a good number were actively pursuing careers abroad), they tended to stress effects of atmosphere, often limiting their palettes to one or two richly toned hues. This somewhat sombre painterliness impressed Canadian collectors with its similarity to the currently popular international mode. But it lacked a sense of place, and it was this failing in the work of the 'Internationalists' which another, smaller and younger group of painters in Toronto in the years just before the war rallied to overcome.

During 1912 and 1913 this group found common ground around J. E. H. MACDONALD and Lawren HARRIS in their concern to develop an idiom that expressed the unique nature of the Canadian experience. And they found in the person of Tom THOMSON—a commercial artist recently turned to painting—the model of the new *Canadian* artist. The following year, 1914, their programme took concrete form. Housed in the new Studio Building of Canadian Art in Toronto, the assembled painters—Harris, MacDonald, A. Y. JACKSON from Montreal, Arthur Lismer (1885–1969) and Fred Varley (1881–1969) from Sheffield, England, and, of course, Tom Thomson—travelled into the northern bush around Georgian Bay and Algonquin Park for their inspiration.

The consequences of the outbreak of war in Europe that summer had touched them all by the following spring and during the next two years only MacDonald and Thomson remained in Toronto. Thomson in fact spent only the period of the deep winter snows in the city and lived nine months of the year in Algonquin Park, working as a guide or fire-ranger during the summer heat and painting hundreds of small, vibrant oil sketches in the spring and autumn. His artistic progress was astonishing, and the myth of the woodsman-artist, his art a seemingly natural consequence of seasonal change, was only enhanced by the mystery of his death by drowning in Algonquin Park in July 1917. There was soon a confirmed belief that Thomson's simple, responsive life in the bush had brought him closer to the 'Canadian' condition than any artist had ever come before. In a series of memorial exhibitions immediately following the war his full achievement was for the first time presented to the public. Then in May 1920 Frank Johnston (1888–1949) and Frank Carmichael (1890–1945) joined with Harris, MacDonald, Jackson, Lismer and Varley to exhibit as the Group of Seven. This first showing of the northern enthusiasts would doubtless have occurred earlier if the war had not intervened. But the Canadian effort in Europe, in which it was widely held that Canada had 'come of age', seemed now to make even more urgent the need that her painting too should demonstrate this new maturity. A distinctively Canadian art for Canadians became the battle-cry of the Group of Seven, and Thomson's special relationship to the land, literally working in the wilderness, they embraced as their working method too.

They were driven by a sense of mission and ceaselessly promoted their position by exhibitions in Toronto and across the nation for more than ten years. The initial response to their effort was mild, verging on the apathetic. But the group pressed on, and as they gradually achieved prominence they attracted controversy and passed through the mid 1920s with an air of notoriety which enhanced the sense of their modernity in the public eye. By the end of the 1920s they had generated a considerable artistic following in Toronto,

and in fact a few artists who worked in the Group of Seven manner could be found in most of the principal cities. The group had consciously sought a national role: in the specific landscape they depicted (by 1930 they had sketched on the Pacific coast, in the Rockies, in the High Arctic, in the Maritimes, as well as in the Pre-Cambrian shield north of the Great Lakes and along the St. Lawrence River); in the scope of their exhibiting policy; and latterly in an expanded membership (which finally included LeMoine FITZGERALD of Winnipeg and Edwin Holgate (1892–1977) of Montreal). But they were still seen outside Ontario as essentially Toronto artists, as yet another manifestation of the cultural and economic dominance of that city. They held their last exhibition in 1931 (although all but MacDonald were around for a retrospective survey staged by the National Gal. of Canada in 1936), and upon that occasion announced the desire to expand into a more truly national organization. The first exhibition of this new CANADIAN GROUP OF PAINTERS was held in the summer of 1933.

A statement prepared upon the occasion of this first showing stressed the continuity of the new group with Canada's 'national' painters. The CGP was even described then as an 'outgrowth' of the Group of Seven. It was intended to represent 'the modern movement in Canadian painting', a movement to build upon the earlier group's concern with 'landscape moods and rhythms', producing works 'strongly redolent of the Canadian soil' with 'a distinctively national flavour'. In fact the CGP exhibitions contained a good deal of dull landscape, repetitions of proven Group of Seven formulae. More positively a few painters such as Carl Schaefer (1903–) and Charles Comfort (1900–) in Toronto, or some of the younger painters working with Fred Varley in Vancouver (he had moved there in 1926), were working with landscape in a boldly expressive way that reflected the intense human struggle demanded by the Great Depression. And later in the 1930s figurative painters such as Paraskeva Clark (1898–) or Bertram Brooker (1885–1955), a little earlier a pioneer Canadian abstractionist, again largely based in Toronto, posited a new direction. But throughout this period and well into the 1940s the dominant personality in Toronto and within the CGP was A. Y. Jackson, affirming the nationalist goals and the landscape mode of the Group of Seven.

During these years of the growth of the Group of Seven and of its subsequent near-canonization in the CGP, the seeds of an alternative direction were sown and nurtured in Montreal. The orientation here was French, due as much to the influence of one great teacher, William Brymner (1855–1925)—who received his training and set the direction of his art in Paris in the late 1870s—as to the language and culture of a large proportion of the populace of Montreal. Brymner's students, except for Clarence Gagnon (1881–1942) and one or two others, were, in fact, Anglophone. But virtually all

completed their studies in the ateliers of Paris. The interest in the figure this training imparted is evident in the work of Prudence Heward (1896–1947), Lilias Newton (1896–1980) and Edwin Holgate among others. The force of the example of the Group of Seven, however, emphasized by the personal relationship which the Montreal-born and Brymner-trained A. Y. Jackson enjoyed with most of the Montrealers, drew them all as well to landscape of the Group sort and ultimately into membership in the CGP.

Activities in Montreal thus seemed to be in the shadow of Toronto until later in the 1930s, when the organizing of one remarkable man began to focus those unique characteristics Montreal painters brought to Canadian art. John LYMAN, the son of a prominent Anglophone family, received his art training in Paris, where he made the acquaintance of another, older Montrealer, James Wilson Morrice, and studied briefly with an associate of Morrice's, Henri MATISSE. When he finally returned to settle in Montreal, late in 1931, Lyman was, then, firmly committed to an aesthetic of 'pure' painting, free, he believed, of any content beyond its own formal excellence. The adulation accorded the Group of Seven in Canada amazed him. Its emphasis on the adventurous exploration of the Canadian landscape—which was almost alone responsible for attracting public approbation—seemed to him to have nothing to do with the art of painting, and he knew that the national aspirations of the Group, whose members were being acclaimed as the only true Canadian artists, precluded the acceptance of other painters who were as accomplished. 'The real adventure takes place in the sensibility and imagination of the individual', he wrote early in 1932. 'The real trail must be blazed towards a perception of the universal relations that are present in every parcel of creation, not towards the Arctic circle.'

Lyman advanced his views at every opportunity in a regular column of art reviews, in teaching and ultimately, in December of 1938, at the first exhibition of the Eastern Group, where he was joined by Goodridge Roberts (1904–1974) and a few other painters from Montreal (and Jack Humphrey (1901–67) from Saint John, N.B.), who shared his belief in 'pure' painting values and his taste for the ÉCOLE DE PARIS. By then utterly convinced that the CGP was incapable of adapting to a rapidly changing—and shrinking—world, two months later he held a meeting out of which was born the Contemporary Art Society, an organization devoted to the promotion on a broad base of a living modern art. Made up of both lay members and professional artists, exhibitions were held on a more or less regular basis, beginning in December 1939. Important initially as a support for individual painters of talent such as Goodridge Roberts, the CAS soon became the single most active forum for the expression of the aspirations of a community of young Francophone artists who were developing in the École des Beaux-Arts of Mon-

treal and the École du Meuble.

The stimulation for this development—and very soon the leadership—came from two teachers: Alfred PELLAN at the Beaux-Arts and Paul-Émile BORDUAS at the École du Meuble. Pellan had only recently turned to teaching after some fourteen years in Paris. The German invasion had forced his return to Canada early in 1940, and almost immediately, in June, he was given a large retrospective exhibition at the Mus. du Québec, shown in Montreal in October. Pellan's Parisian eclecticism found a firm base of support in the CAS, his MIRÓ-like SURREALIST abstractions in particular seeming to spring vigorously from the ground so carefully prepared by Lyman and his associates.

Borduas too had studied in Paris. But whereas Pellan had soon adopted the essentially foreign culture of café life, for Borduas in 1929 the experience—as a student in Maurice DENIS's Ateliers d'Art Sacré—simply affirmed the conservative route he had already been following for eight years. At the age of sixteen he had been apprenticed with Ozias Leduc (1864–1955), a remarkable if somewhat reclusive church decorator and in private life a Symbolist painter and poet. Leduc's fervent sense of calling inspired Borduas to persist as a religious painter for almost twenty years, years in which the genre literally died away in Quebec. During the last ten or so he did not even try to make a living from it, but turned more and more to teaching. It was upon joining the staff of the École du Meuble in 1937 that his outlook began to broaden. Colleagues there encouraged his involvement in the larger art world of Montreal and he soon met John Lyman (who was married to a French Canadian and was fluently bilingual). When the CAS was formed he was elected Vice-President, and by the time of Pellan's showing of his French paintings in 1940 Borduas was technically and intellectually in a position to respond. And respond he did, with a force that ultimately reverberated far beyond the limited circles of artists.

'Peintures surréalistes' he called his first exhibition, held in a theatre lobby in April 1942. Borduas had been reading the Surrealists since joining the staff of the École du Meuble, and although pictorial devices evident in some of the 45 gouaches that constituted the show were clearly inspired by Pellan's French works, he arrived at the decision to experiment with AUTOMATIC painting as a result of this reading. The show was a great success both critically and financially, and automatic painting with its promise of liberation from the constraints of convention assumed a dominant role in his teaching and his life. By 1943 he had attracted a number of disciples from among his students, who soon constituted a new aggressive force within the CAS. Pellan began teaching at the École des Beaux-Arts that June and by the late autumn he too had a circle of adherents in CAS. The combined forces of these young artists

for the first time gave the Francophone community a majority voice in that organization. But the conflicting personalities and goals of Pellan and Borduas—the latter, as his involvement with *automatisme* deepened, becoming more and more critical of any tolerance of the blocks to creativity thrown up by society—ultimately led to an open confrontation in 1948 when Borduas was elected President. The CAS had reached the extent of its flexibility, and collapsed. It could never have hoped to contain the vigorous force that already had given a new shape to Canadian art.

Borduas's group had first been called the AUTOMATISTES in a review of their second Montreal exhibition in February 1947. (They had first shown together in January 1946.) By then they had been identified by a number of Montreal critics as the distinct beginning of a new force in Canadian art. There were, coincidentally, seven members in this new group of artists which one critic even went so far as to say had produced the first painting that could be called 'Canadian'. All similarity to the earlier Group of Seven ended there, however. The *Automatistes* understood that their art derived its nature more from the exploration of personal conviction than from any shared national sensibility, and they believed that its radical form more naturally brought them into association with vanguard artists in New York and Paris than with a broad Canadian public. Fernand Leduc (1916–) and Jean-Paul RIOPELLE in fact moved to Paris in the winter of 1946–7, Riopelle to settle there permanently. And the principal inspiration of the Montreal movement remained international Surrealism, particularly as propounded in the writings of BRETON.

Over the winter of 1947–8 Borduas determined that his commitment to the realization of a fully free and creative life must be total. This determination resulted in what is perhaps the single most important social document in Quebec art history and the most important aesthetic statement a Canadian has ever made, the REFUS GLOBAL. Although the other *Automatistes* each contributed to the publication, the principal effort was Borduas's and it was his title essay that exploded upon Quebec society like a bomb. In it he described the forces that had kept Quebec intellectuals suppressed, afraid to think freely, trapped in a colony where the Church was central, its priests the guardians of the faith, of knowledge, truth and the national wealth. The solution he proclaimed was utter rejection of the claims of institutional authority and the uninhibited pursuit of the ideal of personal liberation. Official reaction was swift. Borduas was immediately dismissed from his teaching post at the École du Meuble and his teaching certificate was permanently revoked. He sought public support, but little was forthcoming. The directness of his attack on the Church, it seems, bordered on cultural treason. He persisted in the struggle, writing and exhibiting, and his courage and his leadership of the *Automatistes*

brought him honour in the eyes of an increasing number of artists and intellectuals (although Pellan sought to establish a moderate 'vanguard' group seemingly in opposition to Borduas). Finally, early in 1953, he moved to New York and two years later to Paris. Although he kept up contacts with Montreal, he never lived in his native land again.

While the *Automatistes* held sway in Montreal during the late 1940s and early 1950s, and were the main reason that Montreal was then the most important art centre in Canada, the CGP still contributed somewhat by offering a national forum to artists struggling in the smaller cities. Jack Humphrey and Miller Brittain (1912–68) in Saint John, N.B., for instance, welcomed the annual opportunity to exhibit in association with artists from across the country. But they still suffered from the isolation of Saint John, and no real art scene developed around them. It was a small university town, Sackville, N.B., that saw the beginnings of the principal current art activity in the Atlantic provinces. Alex COLVILLE taught there in the art department of Mount Allison University from 1946 to 1963. Colville's teaching and the influence of his own realist painting helped form many of the artists in the region. Two, Christopher Pratt (1935–) of St. John's, Newfoundland, and Tom Forrestall (1936–) of Fredericton, N.B., studied with him at Mount Allison in the late 1950s and their continued residence on the east coast has led to the suggestion of a regional 'school' of Realism there.

Modernism came to British Columbia on the West Coast as early as 1912. But it was a false start. That year Emily CARR exhibited in Vancouver FAUVE-like paintings she had completed in France the previous year. They were received with interest, but the following April a show of scenes of local Indian life painted with a similar boldness of colour and broad brushwork elicited a largely negative response. Emily Carr later claimed that as a consequence she was excluded from the small art circle there, and so she moved back to Victoria and virtually abandoned painting. Fred Varley of the Group of Seven reintroduced a concern for modernism when he moved to Vancouver in 1926, and the following year Emily Carr was invited to show her early paintings in Ottawa (and subsequently Toronto and Montreal) in an exhibition of native and white art of the West Coast organized by the National Gal. of Canada. She travelled east for the opening late in 1927, and in Toronto met some of the members of the Group of Seven. She was deeply moved by what she saw, and returned to Victoria recommitted to the art of painting at the age of 57. She soon laid aside her Indian themes and, encouraged by Harris in particular, achieved great success in communicating the surging fullness of the British Columbian rain forests. Although Emily Carr was concerned to develop a broad public appreciation for a native landscape art, no such following appeared in Victoria and

most of her painting sales were in the east, where a market for landscapes of the Group of Seven sort had by then developed.

It was around Varley and an associate of his, Jock MACDONALD, in Vancouver that a substantial scene was established that has continued up to the end of the 1970s. It had, as could be expected, a distinct bias towards landscape and virtually all the serious painters were members of the CGP. Jock Macdonald, however, began experimenting with abstractions as early as 1934, an interest that was greatly encouraged when Lawren Harris settled in Vancouver in 1940, for he had turned to geometrical abstraction in the mid 1930s. Harris was much involved with seeking a spiritual mode—he was a theosophist—and introduced Macdonald to KANDINSKY's writings. About this time Macdonald also began to read the Surrealists and, coincidentally with Borduas in Montreal, began to experiment with automatic painting. Nature is ever present in Vancouver, however, and it inevitably creeps into painting. By the mid 1940s Harris was concerned again with landscape forms and atmospheric space in his abstract paintings, and Jock Macdonald's automatic paintings usually evolved on a landscape or nature theme. Younger artists such as Jack Shadbolt (1909–) were encouraged by this to work in a similar vein and by the mid 1950s a distinct 'school' of LYRICAL ABSTRACT landscape artists was dominant in Vancouver. Shadbolt, Gordon Smith (1919–), Takao Tanabe (1926–), Donald Jarvis (1923–) and three or four others were in fact seen nationally in the late 1950s as the most coherent group working outside Montreal.

Whatever credit the CGP can claim for encouraging development in the smaller cities, its influence during the 1940s in Toronto lay like a dead hand. Except for the freshly individual work of the solitary David MILNE, most painting exhibited in Toronto was limited by conventions established by the Group of Seven two decades before. There were exceptions, but they were largely lost in the mediocre annual shows of the CGP, which had become indistinguishable from those of any other of the older established art organizations. At a time when Montreal literally could hardly contain the potent force of the *Automatistes*, Toronto painters were seemingly detached from most currents of international thought and were no longer really motivated by the nationalist-landscape movement. Then in 1947 Jock Macdonald moved to Toronto to teach at the Ontario College of Art.

One student in particular there, William RONALD, caught his attention, and even after his graduation in 1951 Macdonald continued to coach him. As a result of this encouragement Ronald visited New York in 1952 for six weeks to study with Hans HOFMANN. (Macdonald himself had studied with Hofmann during the summers of 1948 and 1949.) Other painters in Toronto were beginning to look outward in the early 1950s—principally to New York, although the spiky, abstracted forms

of the British painter Graham SUTHERLAND held considerable interest too—and in the autumn of 1953 Ronald arranged an exhibition of the work of seven of them for a local department store. 'Abstracts at Home', as the show was called, did not in itself make a great impact, but it was enough for the participants to see their work hung in sympathetic company away from the ubiquitous landscapes of the Society exhibitions.

Besides Ronald the seven consisted of: Kazuo Nakamura (1926–), another young man who, like Ronald, took only enough commercial work to support his painting time; Alexandra Luke (1901–67), from Oshawa, just east of Toronto, who studied with Hofmann during the summers of 1947 to 1954; two commercial artists from England, Ray Mead (1921–), then living in Hamilton, west of Toronto, and Oscar Cahén (1916–56); Tom Hodgson (1924–), a friend of Cahén's who had graduated from the Ontario College of Art the year before Macdonald's arrival there; and Jack BUSH, who although, like all the others except Luke, a commercial artist by trade, was also the only member then on contract with a dealer. They decided to continue to seek exhibiting opportunities together, and to the next organizational meeting Ronald brought Jock Macdonald; Mead brought Hortense Gordon (1887–1961), a teacher from Hamilton who had also studied with Hofmann, had held a one-man exhibition in a small New York gallery in 1952 and who at sixty-six was the oldest of the group; and Cahén brought two more young commercial artists, Walter Yarwood (1917–) and Harold Town (1924–). There were then eleven of them, and so they became PAINTERS ELEVEN.

Bush arranged for space at his dealer's, and in February 1954 the first of their shows was held. Painters Eleven never caused a furore like that in Montreal raised over Borduas and the *Automatistes* six years before. They never intended to be social critics. They were not even consciously committed, as were the *Automatistes* and particularly Borduas, to the presentation of a particular form of abstraction. No Painters Eleven style evolved, although those artists who were closest to Cahén—Town, Yarwood and Hodgson—shared many concerns with him until his tragic death in an automobile accident in 1956. The older painters who might have offered the kind of leadership provided by Borduas in Montreal, that is Gordon, Macdonald or Bush, chose not to seek to direct their colleagues. That is not to say that Painters Eleven had no direction. Particularly to the growing number of young artists in Toronto who saw in its shows something of the future of Canadian painting, it appeared clearly to point south and east, to New York.

William Ronald moved to New York in 1955 and as a result of his efforts Painters Eleven was invited to show there with AMERICAN ABSTRACT ARTISTS in April 1956. In Toronto the occasion was seen as an authoritative approval of the accomplishments of Painters Eleven. In New York little notice was taken of the group, although Ronald drew some attention and was soon taken on by one of the most important New York dealers. His subsequent meteoric rise in New York was followed with the closest attention back in Toronto, and during the latter 1950s he epitomized the success of Painters Eleven in bringing Toronto up to date with what then appeared to be the most important artistic expression in the world.

During the 1950s and early 1960s this pressing need to catch up with the international *avant-garde*—by then centred in New York—was felt pretty much right across Canada and had been, of course, one of the principal motivations of the *Automatistes* in Montreal during the 1940s. In the western prairies LeMoine FITZGERALD, working in solitary splendour at Winnipeg, was the only painter of importance up to his death in 1956. Although he had in the last few years of his life essayed the painting of abstractions, the vast bulk of his very personal work was involved with a painstakingly rendered Realism. And as suits the last painter to join the Group of Seven, FitzGerald throughout his life maintained a great interest in landscape.

It was in Regina, at the art school maintained there by the provincial university, that a group of teachers began to assemble which soon brought the artists of that part of Canada to an awareness of New York painting. In 1955 a summer school at Emma Lake in the north of Saskatchewan was extended for two weeks to accommodate a workshop for professional artists. Jack Shadbolt of Vancouver ran the first session and a Canadian headed the second year, but in 1957 Will Barnett (1911–) of New York was invited and until 1966 New York-based artists—including Barnett NEWMAN, the critic Clement Greenberg, Kenneth NOLAND and Jules OLITSKI—led the workshops. It was Newman in 1959 who made the greatest impact upon the artists already established in Regina (although it was Greenberg and his POST-PAINTERLY artists Noland, Olitski and in 1967 Frank STELLA who most influenced the younger art students, an influence still evident in much western Canadian art). Newman did no painting at Emma Lake that summer, but his intense commitment moved the Regina painters deeply. There was by then a distinct group at the art school, and in 1961 the Regina Five first exhibited together their largely contemplative abstractions. Made up of three native westerners, Art McKay, Douglas Morton and Ted Godwin, with Kenneth Lochhead from Ottawa and Ron Bloore from Toronto, the Regina Five soon attracted national attention. They did not long cohere as a group, though, and each soon turned to the exigencies of his own career, only McKay and Godwin remaining in Regina.

One other artist of note clearly benefited from the Emma Lake workshops: one of Canada's

major sculptors, Robert MURRAY. Sculpture, so dependent upon sustained patronage, has not flourished in modern times in Canada. Before the mid century there are few names one even need cite. Walter Allward (1876–1955) and Alfred Laliberté (1878–1953) pursued long careers as modellers of commemorative statuary, often of some elegance. In the late 1920s and early 1930s in Toronto Frances Loring (1899–1968) and Florence Wyle (1881–1968) worked with Elizabeth Wyn Wood (1903–66) in an attempt to foster more personal work through the establishment of a sculptors' society, but it was only in the later 1950s with the dominance of abstraction and more widespread free experimentation that any number of sculptors were sustained in Canada. And as at Regina, it was usually teaching opportunities in the universities that supported such activity outside the major cosmopolitan centres.

It is in these large urban centres, nevertheless, that the best of contemporary Canadian art has been regularly shown and usually produced. After the departure of Borduas in 1953 Montreal remained, with some ups and downs, a place of vigorous experimentation. The Surrealist–*Automatiste* tradition persisted most importantly in the work of the sculptors Robert Rousil and Armand Vaillancourt. Up from New York in February 1955 to view 'Espace 55', an important survey exhibition of current Montreal activity, Borduas publicly expressed his disappointment at the evidence of both a group of late arrivals to automatic painting and the revival of what he considered to be an archaic form of geometrical painting. This latter trend had been introduced by a group which had first shown together earlier that month in a local coffee-bar. Seeking to stress the formal qualities in their painting and to avoid what they felt to be the vague, allusive 'meaning' of Surrealist-derived composition, their dependence upon the painting and theory of those Dutch artists who assembled around Piet MONDRIAN and Theo van DOESBURG in the 1920s was declared in the name they chose for their group: the PLASTICIENS. Louis Belzile (1929–), Rodolphe de Repentigny (1926–59), Jean-Paul Jérôme (1928–) and Fernand Toupin (1930–) took part in this first showing. Fernand Leduc, one of Borduas's *Automatistes*, also soon joined the new group. Most painters in Montreal at this time (including Borduas for that matter) were looking to a greater sense of order and control in their painting.

The *Plasticiens*, however, failed to generate any systematic exploration of the formal problems they presented, and it was only when other painters turned to the large-scale simple colour compositions of New York COLOUR FIELD painting that the expressive successes of *Automatisme* were convincingly supplanted. Two young Montrealers, Guido MOLINARI and Claude TOUSIGNANT, were the ones to effect this reorientation, a shift signalled early in 1959 when they and two others with similar concerns—Jean Goguen (1928–) and Denis

Juneau (1925–)—began to be called the *Nouveaux Plasticiens*. These 'new' *Plasticiens* dominated the painting scene in Montreal throughout the 1960s, and Tousignant with his distinctive 'bulls-eye' chromatic paintings, and even more assuredly Molinari with his deceptively simple but subtle 'stripe' pictures, represented a standard of rigorous excellence in Canadian painting.

It is probable that art activity in Canada will never again be so centralized as it was in Toronto between the wars. It also seems clear that that city has nevertheless become the main focus of artistic activity for the nation. And although this is due largely to the fact that Toronto is the principal art mart, that status could not have been attained without the large number of painters of quality who assembled there during the late 1950s and early 1960s. Painters Eleven held their last Toronto showing in November 1958 (although they formally disbanded only in October 1960). There were by then a number of new commercial galleries showing contemporary work, and so there was no longer the need for an independent exhibiting association. William Ronald held frequent exhibitions in New York and Toronto into the 1960s. His large, aggressive canvases, usually composed around a roughly centred image, were most influential and kept the idea of ABSTRACT EXPRESSIONISM alive in Toronto throughout the period. Harold Town, also of Painters Eleven, enjoyed his best years too during the late 1950s and early 1960s, and for a short time during the mid 1960s eclipsed Ronald in Toronto as the popular image of the successful artist. But the real success story of Painters Eleven was that of Jack Bush. One of the older members, he was also one of the last to flower, really finding his strength only after the group had dissolved. His large canvases of the 1960s are rationally controlled, like those of the *Nouveaux Plasticiens* in Montreal, seeking to integrate colour with structure. He departed from the Montrealers, however, in that he stained his colour into raw canvas, as was done by Jackson POLLOCK in his late work, Helen FRANKENTHALER, Morris LOUIS and their followers. By the mid 1960s and increasingly as the decade progressed, Bush had become the single most influential artist in Toronto, and the direction pointed by his work drew a whole new generation of artists into the New York sphere.

It is misleading to speak too easily of 'generations' in the Toronto art world, however. There was no clear succession, as from the *Automatistes* to the *Plasticiens* in Montreal, each holding to a clearly stated, opposing position. Those artists who responded to their calling during the later 1950s found in Painters Eleven no definitive formula to contend with. They found simply an invitation to perform upon a wider stage, to enter a larger world of art than that of which for decades Toronto had been aware. As a consequence very few of the prominent artists worked only in Toronto. New York continued to attract, but resid-

ence there seldom remained necessary. In fact the Spanish island of Ibiza seemed at times to have drawn almost as strongly. This led to an openness, a certain diversity of styles, although an intense interest in music and a fresh, positive audacity linked many of the artists. For instance they frequently confronted the laws that seek to censor sexual imagery: vast areas of the work of Dennis Burton (1933–), Robert Markle (1936–) and Graham Coughtry (1931–) deal with sexual roles and relationships. These three and virtually all the other artists who gravitated to the Isaacs Gal. in the early 1960s—e.g. Richard Gorman (1935–), Gordon Rayner (1935–), John Meredith (1933–)—often turned to three-dimensional structure, film, still photography, or the exploitation of found objects as well as to their music to press beyond the bounds of painting and drawing. It was a yeasty mixture, an environment that constantly challenged perception. The two most important artists it produced, Michael SNOW and Joyce WIELAND, drew heavily on all it had to offer, and later enlarged the capacity of our perception in virtually every medium. Their brilliant individual work in film became world-renowned, and their paintings, constructions, drawings and music deserve equal acclaim.

A vigorous experimental scene also exists in Vancouver. Its opening to the larger world—Los Angeles and London as well as New York—was triggered by the arrival of Roy Kiyooka (1926–) from Regina in 1959. One of the teachers involved in the Emma Lake workshops, Kiyooka brought with him canvases that in scale and in their quality of brooding presence suggested to Vancouver artists some of the issues raised by New York art. Kiyooka soon evolved a lyrical HARD EDGE style of large-format colour painting which greatly influenced his students at the Vancouver School of Art. The moment was right, and by the mid 1960s there were a number of artists—including Michael Morris (1942–), Glenn Lewis (1935–) and Gary Lee-Nova (1943–)—who were producing work of high quality and in the international context fully contemporary.

One other community must be singled out as a centre of vital art activity. London, a small city in south-western Ontario, had supported artists for more than a hundred years, but it was only in the early 1960s that, particularly as a result of the efforts of Jack Chambers (1931–78), Tony Urquhart (1934–) and Greg CURNOE, a climate was established that has since supported experimental art. Curnoe in particular left his mark on this scene, although he led no school or movement and the artists who have since grown up there were in no way limited by his example.

Curnoe may one day be seen as the centre of a significant new trend in Canadian art, for, as in Toronto earlier in the century, there are now a number of artists (he was the first and has been the most consistent and persistent) who would question the direction Canadian art has taken. In recent years the fact that large areas of Canadian industry and commerce are owned and controlled by foreigners—usually Americans—and that American culture too, vigorous and expanding, has found a ready market in Canada, has caused alarm. Will Canada at some point become wholly absorbed in the American way of life, Canadian culture a mimic reflection of American? To many Canadians this is a crucial question of national survival. Curnoe and an increasingly large number of other artists are responding, however, as did the Group of Seven, with a whole-hearted assertion of distinctive Canadian values in art. For Curnoe this art must by necessity draw upon the real and immediate facts of Canadian life, of his life. An art that is content with formal problems cannot be in touch with that life. An art that contrives to look as though it belongs in New York can hardly belong in London, Ontario.

CANADIAN GROUP OF PAINTERS. A group of Canadian artists formed in Toronto as a successor to the GROUP OF SEVEN. Its policy was 'to encourage and foster the growth of art in Canada which has a national character'. Its first exhibition was held in Atlantic City, N.J., in the summer of 1933 and its second at the Art Gal. of Toronto in the following November. The group expanded and many of the best-known Canadian artists exhibited with it from the 1930s to the 1960s. It was disbanded in 1969. See CANADA.

CANDIA, DOMINGO (1897–). Argentinian painter, born at Rosario. He settled at Florence in 1914 and had his first exhibition there in 1921. In 1922 he moved to Paris, where he knew LÉGER and LHOTE. He exhibited at the Salon des Indépendants and had one-man shows both in Paris and in the Argentine. He had an important show at the Casa Argentina, Paris, in 1967 and retrospectives at the Juan Castagnino Mus., Rosario, in 1970 and at the Eduardo Sívori Metropolitan Mus., Buenos Aires, in 1973. Among his many awards were the First Prize at the National Salon, Buenos Aires, in 1958 and the Augusto Palanza Prize from the National Academy of Fine Arts in 1966. Candia's highly original style lies between the figurative and the abstract, finding its most characteristic expression in expressive compositions blended from subtle combinations of greys and blues. He is considered to have been one of the precursors of modernist trends in the Argentine.

CANIARIS, VLASSIS (1928–). Greek painter and sculptor, born in Athens. After studying medicine he completed his studies in art at the Athens School of Fine Arts in 1955, went to Rome in 1956 and settled in Paris in 1960. During the early 1960s he did a series of paintings in the style of the NEW REALISM based on the walls of Athens houses with their political slogans, symbolizing the political unrest of the country. He returned to Greece in 1967 but was compelled to leave the

country in consequence of a provocative exhibition symbolically criticizing the concentration camps of the regime. In 1973 he was invited by the 'Artists in Berlin' Programme of the DAAD (German Academic Exchange Service) to work on a project concerning foreign workers and in 1975 his exhibition of SITUATIONS entitled 'Immigrants' won a *succès de scandale*. It was shown in Berlin, Heidelberg, Ingolstadt and Bochum and in 1976 at the I.C.A. Gals., London. In 1976 Caniaris was appointed Professor of Fine Art at the Athens Polytechnic. His exhibition in 1960 of torn fragments of old clothes dipped in polyester was an anticipation of ARTE POVERA.

CANOGAR, RAFAEL (1934–). Spanish painter born in Toledo, studied under the artist Vázquez Díaz. He was a founding member of the EL PASO association formed in Madrid in 1957. At this time his work belonged to the category of expressive abstraction propagated by *El Paso*. It was an art of gesture executed in thick impasto and severe colours worked over with vigorous hatchings and violent arabesques, though he later incorporated representational elements with overtones of humour and satire, expressing human alienation in modern industrial society. He was visiting Professor at Mills College, Oakland, Calif., 1965–6 and Resident Artist at the Tamarind Studios, Los Angeles, in 1969, and in 1972 he was Resident Artist in West Berlin. He was awarded the Grand Prix at the São Paulo Bienale in 1971. Among others he is represented in the museums of Contemporary Art of Madrid, Barcelona and Seville, at the Mus. de Arte Moderno, Bilbao, the city galleries of Modern Art in Turin and Bologna, the Kunstmus. of Gothenburg, the Gemeentemus. at The Hague, the Carnegie Institute, Pittsburgh, The Mus. of Modern Art, New York, the Mus. de Arte Contemporáneo of the University of São Paulo. He was represented in the exhibition 'Arte '73' organized by the Juan March Foundation and shown, among other places, at the Marlborough Gal. of Fine Art, London, the Academia Española de Bellas Artes, Rome, and the Zunfthaus zur Meisen, Zürich. Canogar said of his work: 'The protagonist of my work, man, is a clear denunciation of industrial society which enslaves our urban existence and reduces the human being to pure functionalism, incapable of the most elementary co-existence and brotherhood.'

CANTATORE, DOMENICO (1906–). Italian painter born at Rivo di Puglia and self-taught as an artist. In 1932–3 he visited Paris and the influence of Cézanne and the expressive school of French landscape combined with that of CARRÀ to form his style. He settled in Milan in 1929 and taught at the Accademia di Brera there. In 1938 he was a member of the CORRENTE association. He painted landscapes and still lifes naturalistically with heavy impasto in a monumental style and sometimes with something of the magical effect of METAPHYSICAL painting.

CANTRÉ, JOZEF (1890–1957). Belgian sculptor and engraver born at Ghent and studied at the Academy of Fine Arts there. He was strongly influenced by the Flemish EXPRESSIONISM of the Second LAETHEM Group. During the Second World War he lived in the Netherlands, where he knew Gustave de SMET and Frits Van den BERGHE. In his early work he was influenced by both Meunier and MINNE, but while in the Netherlands he began to practise direct carving and also experimented with polychrome. In the mid 1930s his style became more free and was characterized by baroque elements. Cantré exercised an important influence on the development of Belgian art in the fields both of sculpture and of wood engraving.

ČAPEK, JOSEF (1887–1945). Czech painter. He was a member of the group of *avant-garde* artists formed in Prague in 1911 by Otto GUTFREUND and Emil FILLA with the object of combining CUBISM and German EXPRESSIONISM into a new national artistic style.

CAPOGROSSI, GIUSEPPE (1900–72). Italian painter born in Rome. After studying law he went to Paris in 1927 and began to paint in 1930. On returning to Italy he became a member of the ROMAN SCHOOL in 1933. Breaking with this in 1949 he evolved a pictorial style of 'sign' composition which was midway between expressive abstraction and *Arte Concreto*. It was subsequently taken up by a number of Italian artists in reaction against INFORMALISM. Capogrossi used a calligraphic symbol which has been likened to a comb, consisting of a curved back from which a number of 'teeth' protrude, and with this one basic image he gave to his surface rhythmic articulation and movement. Upon the surface so articulated he superimposed isolated but well-balanced elements of design resembling ideograms. With these he constructed an all-over pattern often capable of indefinite extension in all directions, as with his ceiling decorations for the 10th Triennale at Milan.

CAPPELLO, CARMELO (1912–). Italian sculptor born at Ragusa, studied at Monza. He settled and worked in Milan. Cappello's sculptures were geometrical abstractions fashioned from highly polished metal and emphasizing graceful linear rhythms. In certain of their aspects they have been thought to derive from the CONCRETE style of Max BILL. He had an individual exhibition at the Venice Biennale of 1958.

CAPPIELLO, LEONETTO (1875–1942). Italian-French painter and graphic artist, born in Milan. He was known chiefly for his caricatures and his posters. He also did book illustrations and designs for tapestry.

CARAN, STELUCA. See NAÏVE ART.

CARDELLA, JUAN. See EQUIPO REALIDAD.

CÁRDENAS, AGUSTÍN (1927–). Cuban sculptor, born at Matanzas. From 1953 he was one of the Cuban *avant-garde* group The Eleven. But *c.* 1955 he went to Paris and through the medium of semi-AUTOMATIC drawing reached a completely abstract idiom in sculpture. He carved graceful and rhythmical upright forms which he called 'totems' and achieved with them one of the most successful fusions of African sculptural traditions with modern European idiom.

CÁRDENAS, SANTIAGO. See LATIN AMERICA.

CARLES, ARTHUR BEECHER (1882–1952). American painter born in Philadelphia, studied at the Pennsylvania Academy of the Fine Arts there and between 1905 and 1907 in Paris, where he was a pupil of MATISSE. He exhibited at the 291 Gal. of STIEGLITZ and at the ARMORY SHOW. His FAUVIST paintings have been thought to be the best done by any American artist in this manner, e.g. *L'Église* (The Metropolitan Mus. of Art, New York, *c.* 1910) and *Bouquet Abstraction* (Whitney Mus. of American Art, *c.* 1930). During the 1920s and 1930s he ceased to exhibit but continued investigating the potentialities of colour in paintings of increasing abstraction while still retaining a more complicated and sophisticated version of the Fauvist range of colour: *Abstraction* (Joseph H. Hirshhorn Foundation, 1939–41). His later paintings have sometimes been spoken of as forerunners of ABSTRACT EXPRESSIONISM. In general, however, they are more closely planned and lack the spontaneity of ACTION PAINTING. He was given a memorial exhibition at the Pennsylvania Academy of the Fine Arts and Philadelphia Mus. of Art in 1953.

CARLSTEDT, JOHN BIRGER JARL (1907–75). Finnish painter, pioneer of non-figurative art in Finland. He studied at the Central School of Applied Art, Helsinki, and then worked in Paris, where he came under the influence of MONDRIAN and CONSTRUCTIVISM. His first one-man exhibition was in 1932 but he achieved general recognition in Finland only after 1945. Among his commissioned works were: interior decorations for the restaurant Le Chat Doré, Helsinki; murals for the Ahlstrom Company, 1950; for the Houtskärs People's School, 1959; for the Television Building, Helsinki, 1961. His works are represented in the Ateneum and other collections, Finland; the Nationalmus., Stockholm; at Lund, Paris, New York, etc.

CARLU, JEAN (1900–). French painter and graphic artist born at Bonnières-sur-Seine. He worked chiefly in the field of publicity and made a name with his posters, which were distinguished for their expressive simplification and brilliant colours. At the Paris Exposition Universelle of 1937 he was in charge of the decoration of the Palais de la Publicité.

CARMICHAEL, FRANK. See CANADA.

CARO, ANITA DE (1909–). American painter and graphic artist born in New York, studied at the Art Students' League under Max WEBER and Hans HOFMANN. During the 1930s she visited many countries in Europe, living in Zürich from 1935 until 1938, when she studied engraving under S. W. HAYTER in Paris. In 1939 she married the engraver Roger Vieillard. After the war her work became more abstract and she matured a style of delicate colour modulation in the TACHIST manner. She exhibited at the Gal. Jeanne Bucher, Paris, in 1950 and at the Hanover Gal., London, in 1953. From 1948 she exhibited at the Salon de Mai.

CARO, ANTHONY (1924–). British sculptor, born in London. He took a degree in engineering at Cambridge; then after serving in the Navy during the Second World War he studied sculpture at the Regent Street Polytechnic in 1946 and at the Royal Academy Schools, 1947–52. He was assistant to Henry MOORE, 1951–3, and subsequently taught sculpture at St. Martin's School of Art, London. In 1959 he spent two months in Mexico and the U.S.A., where he was impressed by the work of Morris LOUIS and Kenneth NOLAND and met David SMITH and the critic Clement Greenberg. In 1963–4 and in the spring of 1965 he taught sculpture at Bennington College, Vermont, and in 1968 he resumed teaching one day a week at St. Martin's School of Art.

In his earlier work Caro preferred modelling and he never developed the technique of carving. From 1960 he made metal sculpture using prefabricated elements such as I-beams, aluminium tubing, boiler tank tops, propeller blades, Z-shaped steel plates, etc. These elements, while retaining their individual identity, were linked together in a system of shapes which conveyed a distinctive mood sometimes suggested by the title, e.g. *Early One Morning* (Tate Gal.), *Slow Movement* (Arts Council coll.), *Away* (The Mus. of Modern Art, New York), *Wending Back* (Cleveland Mus. of Art). He attached particular importance to the process of welding as a means of uniting the elements of a composition and he allowed himself to be guided by the nature of the materials and the possibilities and limitations of the technique. He would paint the finished work in resonant and saturated colours suggestive of the mood to be conveyed. Caro was considered by many critics to have originated and developed a new sculptural aesthetic and his work had an important influence on younger artists. Clement Greenberg said of him: 'He is the only sculptor whose sustained quality can bear comparison with Smith's. With him it has become possible at long last to talk of a generation in sculpture that really

comes after Smith's.' Caro represented the peak of modernity in the 1960s.

Among contemporary sculptors Caro was prominent in challenging the 'pedestal' tradition, using the ground as his base in order to involve the spectators more intimately in the space occupied by the sculpture instead of segregating it artificially on a pedestal or plinth. But in his exhibition at Kenwood House in 1974 he showed sculptures made of rusted steel varnished over instead of the bright, smooth colour he earlier preferred, and resting on white box-plinths with overlapping lids. He also made 'table' sculpture.

Among his more important one-man shows were the following: Whitechapel Art Gal., London (1963); Washington Gal. of Modern Art (1965); Rijksmus. Kröller-Müller, Otterlo (1967). From 1964 he exhibited biennially at the André Emmerich Gal., New York. He was awarded the David Bright sculpture prize at the Venice Biennale in 1966, was included in an exhibition of 'American Sculpture in the Sixties' at Los Angeles County Mus. in 1967 and was shown with Noland and Morris Louis at The Metropolitan Mus. of Art, New York, in 1968. He had retrospective exhibitions at the Hayward Gal., London, in 1969 and at The Mus. of Modern Art, New York, in 1975.

CARON, MARCEL (1890–1961). French-Belgian painter born at Enghien-les-Bains, France, studied at the Academy of Fine Arts, Liège, 1905–10. At first painting in a Late-Impressionist manner, Caron moved during the 1920s towards the EXPRESSIONISM of the Second LAETHEM Group, sharing with Gustave de SMET a liking for *intimiste* compositions in delicately modulated colours. Although not basically influenced by CUBISM, his work during this time often carried reflections of Cubist stylizations. After abandoning painting for 20 years he took it up again in the 1950s, adopting a form of expressive abstract composition with echoes of SURREALISM.

CARR, M. EMILY (1871–1945). Canadian painter and writer, born in Victoria, British Columbia, first studied art in San Francisco, 1889–95. In 1899 she travelled to England, moving from the Westminster School of Art to the artists' colony at St. Ives, then to the Herkomer Art School in Hertfordshire, but she was taken ill with pernicious anaemia and spent eighteen months in a sanatorium before returning home. Back in Victoria she worked as a newspaper cartoonist, then in 1905 settled in Vancouver. During the summers she visited Indian villages, painting water-colours of the magnificent totem poles. In 1910 she studied briefly at the Académie Colarossi in Paris, but had to withdraw because of illness. After spending the winter in Sweden, she returned to France, staying in Brittany and studying for six weeks at Concarneau, probably under the New Zealand painter Frances HODGKINS, before going back to Canada. In 1912 an exhibition of her FAUVE-inspired

French work in Vancouver attracted interest, but a show the following year of Indian scenes in the same style was not well received. Emily Carr was deeply discouraged. She returned to Victoria and virtually stopped painting. In 1927 Marius Barbeau selected twenty-six of her 1912 paintings to stand as the central feature of an exhibition of West Coast art—both Indian and white—at the National Gal. of Canada in Ottawa. Emily Carr travelled east for the opening, and met members of the GROUP OF SEVEN. Encouraged by the enthusiastic reception of her own work, she began painting again as soon as she returned to Victoria. The next summer she made a heroic journey through the Queen Charlotte Islands and up the Skeena and Nass Rivers into the interior. Her new canvases were a complete departure from her earlier work, inspired by the monumental, generalized forms she had seen Lawren HARRIS use in Toronto (*Big Raven*, Vancouver Art Gal., 1928). In 1930 she exhibited with the Group of Seven and also showed her 'pole' paintings in Victoria and at the Seattle Art Mus. But after this year she moved away from explicitly Indian themes. In paintings like *Forest, British Columbia* (Vancouver Art Gal., c. 1932) she portrayed the rain forest itself, with its heavy, infolding sculptural forms. Later, on the sketching trips she now made annually, she sought out the swirling, airy images of loggers' clearings or of the seashore. By 1935 she was beginning to enjoy public recognition, although mostly in eastern Canada. In 1936 she had two one-man exhibitions in Toronto, in 1937 another one-man show at the Art Gal. of Toronto, and in 1938 a highly successful show at the Vancouver Art Gal. Her first show in a commercial gallery was in the Dominion Gal., Montreal, in 1944. After her death a memorial exhibition was mounted jointly by the Art Gal. of Toronto and the National Gal. of Canada in 1945. Several other exhibitions followed, and in 1972 the first scholarly retrospective was organized by the Vancouver Art Gal. and shown also in Montreal and Toronto.

Books written by Emily Carr include *Klee Wyck* (1941), stories about her life with the Indians; *Book of Small* (1942); *House of All Sorts* (1944); *Growing Pains, the Autobiography of Emily Carr* (1946); *Hundreds and Thousands, the Journals of Emily Carr* (1966).

CARRÀ, CARLO D. (1881–1966). Italian painter born at Quargnento, Piedmont. In 1895 he went to Milan, where he worked as apprentice to a mural decorator. In 1900 he was employed on decorations for the World Fair in Paris, where he stayed for the better part of a year with a brief visit to London. On his return he studied at the Accademia di Brera, 1905–8. He met BOCCIONI late in 1908 and in 1910 he signed the FUTURIST painters' manifestos. Little or nothing is known of his painting up to this time since he later destroyed his early works. During 1910 and 1911 he was painting cityscapes and UNANIMIST pictures, in which

mass movement and emotion are vigorously expressed and the spectator is drawn into the movement of the picture. *Uscita da teatro* (*Leaving the Theatre*, Estorick coll.) and *Funerali dell'anarchico Galli* (*Funeral of the Anarchist Galli*, The Mus. of Modern Art, New York) survive; *Martiri di Belfiore* was destroyed after being exhibited at the Free Exhibition of Futurist Painters. Like many of the Futurists, Carrà often over-painted his pictures later and it is therefore not possible to know in exactly what state they were originally shown. He was also inclined to antedate his works. In the autumn of 1911 Carrà visited Paris with his colleagues, RUSSOLO and Boccioni, and saw CUBIST paintings at the Salon d'Automne. His pictures painted for the 1912 Futurist exhibition at Bernheim-Jeune & Cie were evidence of the impression which Cubism made upon him. They are more rigorously constructed, the fragmentation of interlocking planes is more complex and the synchronization of different points of view, a technique which he had previously used both to give the impression of movement and to combine in a picture a prolonged 'state of mind' as in his *Sobbalzi di un fiacre* (*Jolts of a Cab*, The Mus. of Modern Art, New York, 1911), is more severe in its geometrical design. Yet in their 'battles of planes' and 'context of lines' his works still sought the dynamic quality so valued by the Futurists in contrast to 'the immobile, the frozen, and all the static states of nature' which they had accused the Cubists of painting. Noteworthy among the pictures shown in this exhibition were his *Ritratto di Marinetti* (*Portrait of Marinetti*), subsequently repainted, *Quello che mi disse il tram* (*What the Tram says to Me*) and *Donna e l'assenzio* (*Woman and Absinthe*). In 1913 Carrà wrote his Manifesto *La pittura dei suoni, rumori, odori* (*The Painting of Sounds, Noises and Smells*), in which he maintained that by abstract ensembles of dynamic colours, lines and shapes the painter can evoke a wide range of non-visual impressions: 'Our canvases will therefore express the plastic equivalents of sounds, noises and smells of the Theatre, Music Hall, cinema, brothels, railway stations, ports, garages, clinics, workshops, etc., etc.' His own painting, however, during this time displayed an increasing understanding of the austerity and rigorous construction of Cubism. At the same time he continued his preoccupation with the representation, by Cubist techniques, of dynamic speed and motion. This interest is apparent in his *Galleria di Milano* (*Milan Gallery*), *Velocità scompone il cavallo* (*Speed Disintegrates the Horse*), *Forze centrifugale* (*Centrifugal Forces*) and *Ritmi di oggeti* (*Rhythms of Objects*). Still more fully integrated with Cubist aesthetics were two masterly pictures which he painted early in 1913: *Donna + bottiglia + casa* (*Espansione sferica nello spazio*) (*Woman + Bottle + House* (*Spherical Expansion in Space*)) and *Simultaneità* (*Simultaneity*). In both pictures he used the female nude as his principal theme, despite the repudiation of the nude in earlier Futurist manifestos. In 1913 Carrà came into closer relations with SOFFICI and the Florentine Futurists and in the autumn of that year both he and Boccioni attempted to reassert the expressive character of Futurism, as was shown in Carrà's (destroyed) *Transcendenze plastiche* (*Plastic Transcendencies*) and a number of expressive drawings, some of which were reproduced in the Florentine periodical *Lacerba*.

In 1914 Carrà visited Paris again and was given a contract by the dealer KAHNWEILER. On his return he began a series of COLLAGES, which he described to Soffici as 'a cycle of works absolutely different from the preceding ones'. These include a portrait of Soffici and *Dipinto parolibero—Festa patriottica* (*Freeword Painting—Patriotic Celebration*). He responded to Marinetti's appeal for an art of wartime patriotism by a number of drawings and collages, which were published in his *Guerrapintura* in 1915. About this time, however, he became more interested in the classical painting of Giotto and the Renaissance and began to dissociate himself from Futurism. In 1916 he met CHIRICO in a military hospital at Ferrara and for a time assumed the style of METAPHYSICAL PAINTING, adopting Chirico's paraphernalia of shop-window dummies, etc. Examples of this style are *The Bewitched Room*, *Mother and Son* and *Oval of Apparitions*, done in 1917 and 1918. A reflection of Chirico's haunting and dreamlike depiction of unreal space is apparent even in later pictures such as *The Loggia* of 1942. Carrà did not return to Futurism but his subsequent work combined primitivism, as in *Antigrazioso* of 1916, with a monumental classicism as in *Barcinolo* (*The Boatman*) of 1930 and *L'ultimo bagnante* (*The Last Bather*) of 1938. During the years 1918 to 1920 he was closely associated with VALORI PLASTICI. He exercised a considerable influence on Italian painting in the decades between the two wars. He was also an active publicist, writing for *Lacerba*, *Valori Plastici*, *La Voce* and *Popolo d'Italia*. He had an important memorial exhibition at the Palazzo Reale, Milan, in 1967–8.

CARREÑO, MARIO. See LATIN AMERICA.

CARRINGTON, LEONORA (1917–). British painter born in Lancashire. A precocious child, she was expelled from convent school as an unteachable teenager and after studying in Florence and Paris went to art school in London. In 1937 she met Max ERNST, settled in Paris with him and exhibited with the SURREALIST group. From 1939 she began to publish her stories about an imaginary land of ghosts and wonders, where she-goats hatch the alchemical egg, hyenas go to the ball and white rabbits feed on human flesh. During the war she fled to Spain and there suffered a nervous breakdown, which is recounted in her story *Down Below*. After recovering in a clinic at Santander she went to New York and eventually to Mexico, where she married the Hungar-

ian photographer Chiqui Weisz. After the war she resumed painting and became internationally known for her strange pictures of insect-like humanoids which were exhibited in Mexico City, Paris, New York, etc. A typical example of her highly original style is *Lepidoptherus* (Gal. de Arte Mexicano, 1969). In 1975–6 a major retrospective of her work was exhibited in New York and Austin, Texas. Her novel *The Hearing Trumpet* (French, 1974, English, 1977) was hailed as a contemporary classic.

CARTON, JEAN (1912–). French sculptor, born in Paris, studied at the École des Beaux-Arts there. He exhibited in group shows from 1936 and had his first one-man show in 1938. In the 1940s he exhibited busts and drawings at the Salon des Tuileries, obtaining the Prix Blumenthal in 1946 and the Prix de la Villa Abd-el-Tif in 1948. He won a silver medal at the Brussels exhibition of 1958 and the Critics' Prize in 1960. His work consisted mainly of bronzes, busts and nudes, in a classical style based on that of MAILLOL and DESPIAU. He was also known for his engravings and pastels. Among other things he illustrated Paul Valéry's *La Jeune Parque* in 1961.

CARVALLO, TERESA. See SABOGAL, José.

CARZOU, JEAN (1907–). French painter and graphic artist born in Paris. He had no formal artistic training and began by doing illustrations for magazines. During the 1930s he experimented with abstraction and did COLLAGES. He won the Prix Hallmark in 1949 and 1951 and in 1953 he made his mark with an exhibition of pictures from Venice done in a curiously tight graphic style. From this time he developed a strange conception of a mechanical world depicted in fantastic SUR-REALIST compositions which he exhibited in 1957 with the name *Apocalypses*. Within the Surrealist manner he created a highly personal and evocative style. He was also known for his water-colours and lithographs.

CASCELLA, ANDREA (1920–). Italian sculptor born at Pescara. After passing through CUBIST and SURREALIST phases he found a more classical style and during the 1950s his sculptures were of great elegance, suggesting organic forms arranged in architecturally articulated structures. They were sometimes made in separate parts which locked intricately together.

CASCELLA, PIETRO (1921–). Italian sculptor born at Pescara and brother of the foregoing. His work was stronger and more monumental than that of his brother, seeking a reconciliation between the primitive and CONSTRUCTIVIST abstraction.

CASORATI, FELICE (1883–1963). Italian painter born at Novara, studied painting at the Acade-

mies of Padua, Naples and Verona, after first studying law. After serving in the Italian army during the First World War he began to teach at the Turin Academy in 1918 and over the years exercised an important influence on the Turin school. His early work under the influence of ART NOUVEAU was dominated by hard rhythmical outlines and harsh colours. After the war he was influenced by the ideas of VALORI PLASTICI and evolved a restless style with figures in modern dress painted in an exaggerated DIVISIONIST technique against a background meticulously designed in a Mannerist perspective. An air of unreality and strangeness deprived these compositions of expressive or naturalistic purport and turned them into symbols of an unexplained idea. In the 1930s he adopted a lighter and less harsh palette and reduced his subjects to a rhythmical and decorative arabesque. It has been said that together with the French artist BALTHUS Casorati 'most tellingly depicted the angular uncertainties of adolescence'.

CASSINARI, BRUNO. See CORRENTE.

CASTAGNINO, JUAN CARLOS. See LATIN AMERICA.

CASTELLANI, ENRICO (1930–). Italian experimental artist born at Castelmassa, studied at the Academy in Brussels from 1952 to 1956 and in 1959 founded the journal *Azimuth* with MANZONI for the propagation of advanced experimental ideas. He was chiefly known for his 'picture reliefs', which he made by fastening white or uniformly covered canvases on to reliefs built up from nails in such a way that the play of light upon the embossed surfaces was subject to continual change. In this way he secured a KINETIC effect without actual movement.

CASTELLANOS, JULIO. See MEXICO.

CASTRO, AMILCAR DE. See LATIN AMERICA.

CATTANEO, GIUSEPPE. See SOUTH AFRICA.

CAULFIELD, PATRICK (1936–). British painter born in London, studied first at the Chelsea School of Art, 1956–9, where he afterwards taught, then at the Royal College of Art, 1959–63. His first one-man show was at the Fraser Gal., London, in 1965; from 1969 he exhibited at the Waddington Gals. Among the collective exhibitions in which he was represented were: 'Young Contemporaries', 1961–3; 'The New Generation', Whitechapel Art Gal., 1964; 4th Paris Biennale, 1965; 'Jeunes Peintres Anglais', Palais des Beaux-Arts, Brussels, 9th São Paulo Bienale, 1967; 'European Painters Today', Mus. des Arts Décoratifs, Paris, Jewish Mus., New York, 1968; 'Pop Art', Hayward Gal., 1969; 'Junge Englander', Kunststudio Westfalen, Bielefeld, 1971; 'British Painting '74', Hayward Gal. His work was influenced by

Roy LICHTENSTEIN and by popular illustration but he evolved a distinct personal style: on large areas of bright unmodulated colour he drew his subjects—interiors, vases, still lifes, etc.—in unexpressive black outlines, the areas of colour partially coinciding with the outlines of the subject. The whole gave the effect of flat, decorative pattern.

CAVAEL, ROLF (1898–). German painter, born at Königsberg, studied at the Frankfurt Academy of Arts. He was in Dachau concentration camp 1936–7 and lived in Munich from 1953. He made his first experiments with abstract painting in 1927. Since his schooldays he was fascinated by the microscopic and in his abstract painting amoeba-like shapes, delicately drawn, float weightless against a background of overlapping blacks and greys.

CAVAILLÈS, JULES (1901–). French painter born at Carmaux, Aveyron, studied at the Académie Julian and exhibited at the Salon des Indépendants, the Salon d'Automne and the Salon des Tuileries. In 1936 he won the Prix Blumenthal. At one time influenced by FAUVISM, he turned in the 1930s to uncomplicated Realism expressive of a joy in life and love for natural things. He was a painter of atmosphere, an artist of great refinement in the poetical interpretation of nature. In 1949 he obtained the Prix Hallmark. In 1956 he exhibited at the Gal. Romanet with other painters of 'poetical realism'.

CAVALCANTI, EMILIANO DI (1897–1976). Brazilian painter and draughtsman born at Rio de Janeiro. Di Cavalcanti was an admirer of Beardsley and began as a caricaturist while studying law in Rio. In 1916 he exhibited his caricatures for the first time in Rio's First Caricaturist Salon. He moved to São Paulo in 1917 to continue his law studies, but soon devoted himself solely to art. He attended classes in the studio of the German Impressionist, J. Fischer Elpons, illustrated books by Oscar Wilde and in 1921 published a book of drawings, *Fantoches de Meia-Noite* (*Midnight Puppets*) with a text by Ribeiro Couto. In 1922, in collaboration with the modernist writers Oswald and Mario de Andrade, Guillermo de Almeida and Menotti del Picchia, he organized the *Semana de Arte Moderna* (Modern Art Week), a series of dance spectacles, poetry readings and an art exhibition in which he also participated. He went to Paris first from 1923 to 1925 as correspondent for Rio's *Correio da Manhá*, and again from 1935 until 1940, when the outbreak of the Second World War brought him back to Brazil. During his first trip to Paris he met PICASSO, LÉGER, BRAQUE, MATISSE and the FAUVES, Cocteau, Blaise Cendrars, Unamuno, Erik Satie and Elie Faure, among others. His work shows the combined influence of the Muralist Diego RIVERA, the Fauves and Picasso's monumental nudes of the 1920s, all of which Cavalcanti applied to high-keyed Brazi-

lian themes. His subjects included sensuous mulatto women, carnival and festival scenes, poor fishermen and prostitutes in extravagantly coloured compositions. Like PORTINARI, he also represented Brazilian ethnic types such as in *Tres Raças* (*Three Races*) of 1941. Women and prostitutes dominated his work at all stages of his career, for example *Women at the Window* (1926), *Circus Girls* (1938) and *Women in the Bar* (1954). He wrote two books of memoirs, *Viagem da Minha Vida* (*Voyage of my Life*) published in 1955 and *Reminiscencias Liricas de um Perfeito Carioca*, (*Lyric Reminiscences of a Perfect Carioca*, i.e. inhabitant of Rio), published in 1964. In the first he refers to the great impact of the Rio carnival on his painting. In 1928 he joined the Communist party but dropped out three years later on finding its demands too rigid for him. Besides Brazil his work has been exhibited in Montevideo, Buenos Aires, Mexico, New York, Paris, London, Lisbon, Berlin and Amsterdam. In 1951 he was represented in the first São Paulo Bienale and in 1953 won a joint prize with Alfredo VOLPI as best national painter. He was given a room to himself in the São Paulo Bienale in 1963. In 1954 he was honoured with a retrospective at the Mus. of Modern Art in Rio and his paintings have since been acquired by museums in São Paulo, Rio, Paris, Montevideo and elsewhere. He was represented in the exhibition 'Art of Latin America Since Independence' at Yale University in 1966. In the 1960s he designed jewellery and continued to divide his time between painting and writing.

CAVALLON, GIORGIO (1904–). Italian-American painter born at Sorio, Vicenza. He went to America in 1920 and studied at the National Academy of Design and at the Hans HOFMANN School. He was Mural Project Assistant to Arshile GORKY under the FEDERAL ARTS PROJECT and he was a member of AMERICAN ABSTRACT ARTISTS, 1936–57. His work was widely exhibited in America, including 'Abstract Painting and Sculpture in America' (1951) and 'The New American Painting and Sculpture' (1969) at The Mus. of Modern Art, New York. In 1950 he exhibited at the SALON DES RÉALITÉS NOUVELLES, Paris.

ČELEBONOVIĆ, MARKO (1902–). Yugoslav painter born in Belgrade. After reading law at Oxford he studied sculpture under BOURDELLE and took up painting in 1923. In the Second World War he fought with the French Resistance Movement during the German occupation and he was a member of the Yugoslav Embassy in Paris from 1949 to 1960, when he became Professor at the Belgrade Academy of Art. His early works, exhibited first at the Salon des Tuileries in 1925, were *intimiste* in the naturalistic style then current in the ÉCOLE DE PARIS. In the 1930s he developed a rich blended effect of coloration which had considerable influence on younger artists in Yugoslavia. From 1950 his style became simpler and he de-

voted himself mainly to still life with reliance on form rather than colour in a manner that had affinities with MORANDI.

ĆELIĆ, STOJAN (1925–). Yugoslav painter and graphic artist born at Bosanski Novi, studied at the Academy of Art, Belgrade, where he subsequently taught. He was editor of the art journal *Umetnost*. Ćelić painted in a TACHIST manner, basing his compositions on landscape or objects from the organic world. He exhibited at the Venice Biennale in 1964.

CENTAURE, LE. An art gallery and periodical founded in Brussels by W. Schwarzenberg in 1920 and operative until 1931. The periodical *Le Centaure* appeared from 1926 until 1938. Le Centaure was particularly interested in promoting Belgian EXPRESSIONISM and became a centre for Expressionist artists, many of whom were under contract to the gallery.

CERCLE ET CARRÉ. A discussion and exhibition society for CONSTRUCTIVIST artists formed in Paris by Michel SEUPHOR and the painter Joaquín TORRES-GARCÍA in 1929. A journal of the same name was founded, of which three numbers appeared in 1929–30.

Some years later Torres-García formed an *Asociación de Arte Constructivo* in Montevideo and edited a journal *Círculo y Cuadrado*, of which seven numbers appeared between 1936 and 1938.

CÉRIA, EDMOND. See FRANCE.

CEROLI, MARIO (1938–). Italian sculptor born at Castelfrentano, Chieti, studied at the Istituto d'Arte, Rome, 1949–55. He began 'object-sculpture' by making images of the city or people from rough planks taken from packing cases. In the latter 1960s he constructed enlarged replicas of artefacts such as telephones from rough timber and packing cases in line with the movement described by Gillo Dorfles as ARTE POVERA. He also made constructions like cages which were to be seen both from the inside and outside.

CÉSAR (CÉSAR BALDACCINI, 1921–). French sculptor born at Marseilles. After studying at the École des Beaux-Arts, Marseilles, he entered the École des Beaux-Arts, Paris, in 1943. He began making iron sculpture in 1947 and had his first one-man show at the Gal. Lucien Durand, Paris, in 1954. About this time he began to make his synthetic sculptures, which he called *amalgames*, from material which he found in refuse dumps—scrap iron, springs, tin cans, etc.—building these up with metal wire into strange winged or insect-like creatures. These had closer affinities, however, with the insect-creatures of Germaine RICHIER than with the ABSTRACT EXPRESSIONISM of the California JUNK school of sculpture. In 1956 he had a one-man show at the Venice Biennale, in 1959 he won the Carnegie Prize and a silver medal at the Exposition Internationale of Brussels. During the 1960s he became internationally known chiefly for his sculptures made by crushing automobile chassis with a hydraulic press, calling them *compressions dirigées*. He had a major retrospective exhibition at the Boymans-van Beuningen Mus., Rotterdam, in 1976.

CESCHIATTI, ALFREDO. See LATIN AMERICA.

CHABAUD, AUGUSTE (1882–1955). French painter born at Nîmes. After studying at the École des Beaux-Arts, Avignon, he went to Paris in 1899 and studied at the Académie Julian and the École des Beaux-Arts there. He exhibited at the Salon des Indépendants and the Salon d'Automne from 1902 to 1912, painting Paris street scenes, circus scenes, café scenes, etc. in a FAUVIST manner. His first one-man exhibition was at the Gal. Bernheim-Jeune in 1912. In 1921 he settled at Graveson in Provence and continued to paint the landscapes and peasants of Provence in more subdued but dramatic colours. He wrote *Peinture pure, Poésie pure.*

CHABOT, HENDRIK (1894–1949). Dutch painter, born at Sprang. He attended evening classes at the Academy of Fine Art in Rotterdam and from *c.* 1926 he inclined to the manner of Flemish EXPRESSIONISM. In 1930 he saw an exhibition of PERMEKE in Brussels and under his influence painted peasant scenes in strong colours although without the monumental character of the Flemish master. During the Second World War he painted refugees, prisoners of war and Resistance fighters, imparting to his themes a deeply moving pathos free from sentimentality or theatricality. A similar tone infused his paintings of destruction in Rotterdam after the bombardment of May 1940, which incidentally destroyed the artist's studio with the greater part of his works. Without embarking on innovative or *avant-garde* paths, Chabot was one of the more successful painters who concerned themselves with expressing the emotional atmosphere of the war and the Occupation.

CHADWICK, LYNN (1914–). British sculptor born in London. After working as an architect and furniture designer, he began to make constructions and MOBILES of metal and glass in 1945. He had one-man shows at Gimpel Fils, London, in 1950 and 1952, in New York in 1957, at Zürich in 1959, and at the Marlborough Gal., London, in 1961. In 1952 he exhibited in the British Pavilion at the Venice Biennale, in 1953 he won Honourable Mention in the International Competition for the Unknown Political Prisoner and in 1956 he won the International Prize at the Venice Biennale, where a retrospective exhibition of his work was shown. He is represented in public collections in the U.S.A. and Australia, in the Tate Gal., the Victoria and Albert Mus. and the Arts Council

coll. During the 1950s he was prominent among the group of metal sculptors who followed in the steps of Henry MOORE, and his works, although abstract, carried suggestions of the human figure. Notable among his works is *The Watchers*, a bronze cast from a reinforced plaster modelled upon a rigid framework. During the 1960s his work became more block-like and monumental, designed to be seen in the open.

CHAGALL, MARC (1887–1985). Born of a Hasidic Jewish family in the provincial capital Vitebsk on the river Drina in western Russia, Chagall displayed from his early schooldays the talent and vocation of an artist. After 3 months in the local art school he was able to go to St. Petersburg, where he studied for a short while at the school of the Society for the Protection of the Arts and privately under Léon BAKST. But he owed little to formal training and his work breathed the untutored spontaneity of folk painting enhanced by a touch of the more sophisticated naïvety of the FAUVES, who were at this time being exhibited in St. Petersburg, and the hint of a debt to MIR ISKUSSTVA, to which he was introduced by Bakst. In 1914 he was enabled to visit Paris by the generosity of a patron, Vinaver, and the greater part of his working life was spent there. He first lived in the tumbledown La Ruche, where SOUTINE, MODIGLIANI, LÉGER and ARCHIPENKO also had their studios. His work attracted the attention of the *avant-garde* literary personalities Blaise Cendrars, Guillaume APOLLINAIRE, Max Jacob and André Salmon and in 1913 he was brought by Apollinaire to the notice of Herwarth Walden, editor of *Der Sturm*, who exhibited three of his paintings at the first German Salon d'Automne and gave him a one-man exhibition at the STURM Gal., Berlin, in 1914. From Berlin he was caught by the outbreak of war on a visit to Vitebsk. There in 1915 he married Bella Rosenfeld, who figures in the famous *Double Portrait* of 1917 and in many other of his paintings. After the October Revolution in 1917 he was made Commissar for Fine Art at Vitebsk with the task of reorganizing the local art school. But his combination of individual fantasy with modern French techniques was incomprehensible to the local authorities and he was ousted from his position by MALEVICH, who introduced the official VKHUTEMAS teaching from Moscow. He therefore left Vitebsk for Moscow in 1919 and there he made murals and stage designs for the newly founded State Jewish Theatre and also began writing his autobiography. Finding the artistic atmosphere in Russia uncongenial, however, he returned to Berlin in 1922 to work on illustrations for the German edition of his autobiography which had been commissioned by Paul Cassirer. He wrote in his autobiography: 'Neither Imperial Russia, nor Soviet Russia needs me. I am a mystery, a stranger to them ... perhaps Europe will love me and, with her, my Russia.'

In 1923 he returned to Paris and made France his home until the Second World War. He was the centre of an enclave of *émigré* Jewish artists who met at the Café du Dôme: the Russian Chaim SOUTINE, the Bulgarian Jules PASCIN, the Pole Moise KISLING and the Italian Amedeo Modigliani. Besides his painting he was engaged during these years on numerous graphic works for Ambroise VOLLARD: 118 etchings for Gogol's *Dead Souls* (1923–5), 100 illustrations for the *Fables* of La Fontaine (1927–30), 105 illustrations for the Old Testament (1930–9). During this period he made visits to Egypt, the Lebanon and Palestine in 1931, to the Netherlands, to Spain in 1934 and to Poland in 1935. He had his first retrospective exhibition in Paris at the Barbazange-Hodebert Gal. in 1924 and his first one-man exhibition in New York in 1926. In 1933 he visited Switzerland on the occasion of a large retrospective exhibition of his work in the Kunsthalle, Basle. He became a French citizen in 1937 and on the outbreak of war was living in the Loire district.

In 1941 he was able to leave conquered France for America, where his wife Bella died in 1944. In 1942 he did designs and costumes for the ballet *Alekko* in Mexico City and in 1945 for Stravinsky's *Firebird*. In 1946 he had a large retrospective exhibition at The Mus. of Modern Art, New York. In 1947 he returned to Paris for the opening of his exhibition at the Mus. National d'Art Moderne and settled in France from 1948, making his home in Vence in 1950. On his return to Paris in 1948 he did a set of coloured lithographs to illustrate *The Arabian Nights*. At Vence during the 1950s he did some work in ceramics and some sculptural reliefs. He designed stained glass windows for the cathedral of Metz and for the Hebrew University Medical Centre at Jerusalem (1959–62). His ceiling for the Paris Opéra, commissioned by André Malraux as Minister of Culture, was unveiled in 1964. He visited New York in 1966 for the unveiling of two murals for the Lincoln Center and in 1967 for a production of Mozart's *Magic Flute*, for which he had designed the stage sets and costumes.

His autobiography was published under the title *Ma vie* in 1931 but the prints were issued in portfolio in 1922. The illustrations for *Dead Souls* were published in 1949, those for La Fontaine's *Fables* were published by Tériade in 1952 and the Bible illustrations in 1956. The thirteen illustrations for *The Arabian Nights*, commissioned by Pantheon Books, New York, were published in 1941. A collective exhibition of his graphic works was given in the Bibliothèque Nationale, Paris, in 1957. A set of colour lithographs on *Daphnis and Chloë* was commissioned in 1961 by Tériade and Chagall continued making colour lithographs and other graphic works during the 1960s.

Throughout his long life Chagall was prolific in paintings and gouaches. Like so many others who found the artistic atmosphere of France congenial, he is loosely classified with the school of painting

which flourished in Paris between the two world wars. Yet he stands out as one of the most original artists of his age. He used a rich repertory of images remembered from the Jewish life of his native land to construct a mythological world of unreality in which realistic representations are structured non-naturalistically and fragmentary scenes carry a pictorial symbolism which is not anecdotal. His paintings speak without being susceptible of literary interpretation. In 1946 he himself said of them: 'I don't understand them at all. They are not literature. They are only pictorial arrangements of images that obsess me . . .' He committed himself to none of the many movements or 'isms' which proliferated during the early decades of the century yet he absorbed from each the lessons that were useful to him. Apollinaire described his work as *sur-naturel*, heralding SUR-REALISM, and André BRETON wrote that with him 'the metaphor made its triumphant entry into modern painting'. But Chagall did not align himself with the Surrealists and expressly repudiated the Surrealist doctrine of the automatic venting of unconscious imagery in pictorial expression. His interest in CUBISM may be seen in such paintings as *Homage to Apollinaire* (Stedelijk van Abbe Mus., Eindhoven, 1911–12), *Self-Portrait with Seven Fingers* (Stedelijk Mus., Amsterdam, 1912), *Adam and Eve* (St. Louis City Art Mus., 1912), *Promenade* (State Russian Mus., Leningrad, 1917) and several still lifes of the period. But he was not a Cubist. He took over some of the discoveries made by the ORPHIC phase of Cubism in the use of colour and found affinities with DELAUNAY's notion of 'simultaneity'. Yet where he was influenced it was only for the clarification of tendencies already inherent in his work and those paintings which have been reckoned his greatest masterpieces are those in which he was most original (*I and the Village*, The Mus. of Modern Art, New York, 1911; *White Crucifixion*, Art Institute of Chicago, 1938; *Around Her*, Mus. National d'Art Moderne, Paris, 1945). Although his work was hailed by the German EXPRESSIONISTS, he had more in common with the French classical restraint and the decorative lyricism of a Gauguin than with the more brutal distortions of the BRÜCKE. Chagall was the painter of Hasidic Judaism *par excellence* and the nearest to him in spirit of all his contemporaries was perhaps the work of his compatriot Issachar RYBACK.

Throughout his life Chagall was obsessed with the Bible, which for him conveyed the message of the love of God in all things. In 1950 the abandoned Chapelle du Calvaire at Vence gave rise to the concept of 17 large paintings which should gather together and summarize all his earlier biblical works. In 1975 a musuem was opened at Nice designed expressly to house these biblical works. In 1975 he revisited Moscow by invitation and was received with the honour that was his due.

CHALUPOVA, ZUZANA (1925–). Yugoslav

NAÏVE painter born in Kovačica. She was the outstanding woman member of the Kovačica group of peasant painters. She depicted village scenes such as the *Barber's Shop* or the *Dressing of the Bride* with a woman's eye for decorative detail of clothing and household appurtenances. In the precise but awkward delineation of figures, the lack of perspective and the lively realism of these genre pictures she displayed the natural talent of the typical naïve artist.

CHAMBERLAIN, JOHN (1927–). American sculptor born in Rochester, Ind., studied at the Chicago Art Institute School, 1950–2, and at Black Mountain College, 1955–6. His first one-man exhibition was at Wells Street Gal., Chicago, in 1957. His early sculpture, made largely from iron pipes, was influenced by that of David SMITH. Towards the end of the 1950s he was associated with the school of JUNK art, bending and welding sheets of metal from derelict automobiles; although his interest was rather in the formal qualities of the finished product than in social comment, the origin of the material was not lost sight of and played its part in the total impression. The expressive energy of his work has been likened to ACTION PAINTING. In the mid 1960s he began working in materials such as urethane and fibreglass, moving on to galvanized steel and aluminium. During the 1960s he became one of the best-known artists of the Junk school of metal sculpture and his work was widely exhibited both in the U.S.A. and in Europe. His crushed automobile chassis made a particularly widespread impression.

CHAMBERS, JACK. See CANADA.

CHAPELAIN-MIDY, ROGER (1904–). French painter born in Paris. He entered the École des Beaux-Arts but his studies were interrupted by military service and after the war he frequented the academies of Montparnasse, working as a journalist for a living. In 1930 he obtained a commission to do decorative panels for the Town Hall of the Fourth Arrondissement and during the 1930s he exhibited frequently both in Paris and abroad. He belonged to the school of Expressive Realism and opposed CUBISM on the ground that it was too specialized and out of touch with human life. In 1935 he wrote: 'At the front, when it was impossible to work, I had leisure to meditate. Understanding the fragility and impermanence of certain theories . . . I came to see clearly the path it was necessary to follow. Moreover the continuous contact with humanity and nature, the formidable brutality of this war, helped my orientation.'

CHAPOVAL, JULES (1919–51). Russian-French painter born in Kiev. After studying medicine at Paris he embarked on an artistic career during the war and studied at the Écoles des Beaux-Arts in Marseilles and Toulouse. After beginning to paint in a figurative manner, he returned to Paris after

the Liberation and developed a style of geometrical abstraction concentrating his attention particularly on the spatial relations within the abstract picture image. He had a one-man show at the Gal. Jeanne Bucher and was represented in a number of collective exhibitions of abstract art. In 1947 he was awarded a prize by the *Jeune Peinture* association and at the time of his premature death he was considered one of the most promising of the younger abstract artists.

CHARAZAC. See HOMME-TÉMOIN.

CHARCHOUNE, SERGE (1888–). Russian painter born in Buruguslan, studied in Moscow and from 1912 in Paris. At first influenced by CUBISM, he had his first exhibition at the Salon des Indépendants in 1913. He spent the war years 1914–17 in Spain and was afterwards associated with the DADA movement. In 1922 he visited Berlin and exhibited at the STURM Gal. His works were shown also in Barcelona, Stockholm, Brussels, Prague and New York, and he had one-man shows at the Gal. Creuze, Paris, from 1947 to 1956. During the 1930s he became interested in the analogies between painting and music and developed the mature style by which he is best known. This consists of extremely delicate and fanciful abstract paintings in monochrome or near-monochrome with occasional figurative suggestions. Michel SEUPHOR wrote of his pictures in this style: 'His work reaches unequalled heights of delicacy in modulations of a single colour. These pictures, which are a kind of spiritual exercise for the eye, must be numbered among the best examples of pure painting.'

CHAROUX, LOTHAR. See LATIN AMERICA.

CHAROUX, SIEGFRIED (1896–1967). Austrian sculptor, studied at the Vienna Academy of Fine Arts. He was successful in an international competition for a *Lessing* memorial, but this work was afterwards destroyed by the National Socialist regime. Among other works commissioned by the municipality of Vienna were memorials to Richard Strauss (1955) and Hugo Breitner (1957). He migrated to England in 1935 and became an R.A. His work was included in the Arts Council exhibition 'Contemporary British Sculpture' in 1961 and is represented in the Tate Gal.

CHASTEL, ROGER (1897–1981). French painter born in Paris, studied at the École des Beaux-Arts there and at the Académies Julian and Ransom. His style was at first influenced by CUBISM but he later moved towards Realism. After the Second World War he evolved a highly personal style of abstraction within the school of TACHISM, forming compositions of elongated upright forms in rich colours. In 1951 he was awarded the International Prize for Painting at the São Paulo Bienale. The Mus. National d'Art Moderne has his *White Lily*

(1945) and *The 14th July at Toulon* (1955). He also did designs for tapestries for the Gobelins factory, theatre designs, book illustrations and a mural for the United Nations Headquarters at Geneva.

CHEONG SOO PIENG (1917–). British painter, born in Amoy. He trained at the Sin Hwa Academy, Shanghai, and the Amoy Academy, where he was taught by Chinese painters who had studied in Europe. In 1946 he settled in Singapore. He taught at the Nanyang Academy of Fine Arts, Malaya, founded in 1938 by the Chinese-born artist Lim Hak Tai, and in this way he exercised an important influence on younger Malayan painters. Works by him are in the National Gal. of Malaya and the Mus. of Sarawak and in private collections in India and Malaya. He was awarded the Meritorious Service Medal in 1962.

CHET, FLORIKA. See NAÏVE ART.

CHIARISTI. A group of painters formed in Milan *c.* 1930 in opposition to the classical formalism of the NOVECENTO and to superficial 19th-c. romanticism, favouring closer contact with Neo-Impressionism and FAUVISM. The name *Chiaristi* referred to the light backgrounds which the group cultivated in reaction from academic art. The group consisted of: Angelo Del Bon (1898–1952), Umberto Lilloni (1898–), Francesco De Rocchi (1902–), Adriano Spilimbergo (1908–) and Cristoforo De Amicis (1902–). They were supported from 1932 by the writer and publisher Edoardo Persico, who in 1928 had helped to form the *Gruppo dei 6* at Turin, which also worked for closer contact with international trends in opposition to the *Novecento*.

CHIGGIO, ENNIO. See GRUPPO N.

CHIGHINE, ALFREDO (1914–). Italian painter and sculptor born at Milan, studied at the Istituto Superiore d'Arte Decorativa, Monza, and then at the Accademia di Brera, Milan. After passing through a phase of CUBIST influence, Chighine painted in the manner of Italian INFORMALISM which developed during the 1950s. He painted rhythmically organized 'gestural signs' upon uniformly coloured grounds in a manner akin to that of Hans HARTUNG.

CHILLIDA, EDUARDO (1924–). Spanish sculptor in iron, born at San Sebastian. He carried on the tradition of sculpture in wrought iron initiated by his older compatriots GARGALLO and GONZÁLEZ, but he abandoned the figurative element which remained in their work. His sculptures, fashioned of twisted bars and strips of wrought iron, have such names as *La Musica Callada* (*Silent Music*, 1955), *Rumor de Limites* (*Murmur of Boundaries*, 1959), *Enclume de Rêve* (*Dream Anvil*, 1955), *Modulation of Space* (Tate Gal., 1963), and he often did several variations on

one theme, numbering them in order. The impact of these sculptures is made by the obscure emotional appeal of the contorted shapes in a stubborn material and not usually by figurative suggestions however remote. He also did a number of iron stelae in which stark and powerful shapes surmount a solidly squared plinth. Chillida was always true to the uncompromising qualities of his material without concessions to organic romanticism or the gentler, more versatile qualities of stone. No suggestion either of modelling or of carving remains in his work.

After studying architecture in Madrid, Chillida took up sculpture in 1947. He had his first show at the Gal. Clan, Madrid. In 1950 he participated in a group show at the Gal. Maeght, Paris, and the same gallery gave him one-man shows in 1956 and 1961. In 1954 he made four iron doors for the Basilica of Aranzazu and in 1955 did a monument to Sir Alexander Fleming in San Sebastian. In 1958 he was awarded a prize at the Venice Biennale and in the same year he was given an exhibition of sculptures, drawings and COLLAGES at the Solomon R. Guggenheim Mus., New York, and a fellowship by the Graham Foundation, Chicago. He had a one-man exhibition at the Kunsthalle, Basle, in 1962 and at the Mus. of Fine Arts, Houston, in 1966. In 1960 he was represented in the exhibition of 'New Spanish Painting and Sculpture' at The Mus. of Modern Art, New York. In 1971 he gave a course of instruction at Harvard. In 1980 he shared with Willem DE KOONING the Andrew W. Mellon Prize at the Pittsburgh International.

CHILLIDA, GONZALO. See SPAIN.

CHINORRIS (JUAN IGNACIO CÁRDENAS). See SPAIN.

CHIRICO, GIORGIO DE (1888–1978). Italian painter. The originator of METAPHYSICAL PAINTING, Chirico was born at Volo, Greece, of Sicilian parents and after studying painting in Athens was attracted to Munich by the work of Boecklin and KLINGER. There c. 1906–9 he became interested in the philosophy of Schopenhauer and Nietzsche. In 1909–10 he was in Italy and painted his first 'enigmatic' pictures, which convey an inexplicable atmosphere of strangeness and uneasiness by the immobility of empty spaces, the illogical shadows and the unexpected perspectives. After exhibiting these pictures in Paris (1911) he attracted the attention of PICASSO and became a friend of APOLLINAIRE. While in Paris he developed a more deliberate theory of 'metaphysical insight' into a reality behind ordinary things by neutralizing the things themselves of all their usual associations and setting them in new and mysterious relationships. In order to empty the objects of his compositions of their natural emotional significance he painted tailors' dummies as human beings (from 1914), statues, plaster heads, rubber gloves and the like, depending on juxtaposition and the formal qualities of his picture space to create the disturbing quality which belongs to certain situations. In this respect he anticipated one feature of SURREALISM. To this period belong the famous 'memories of Italy' or *piazze d'Italia* series.

In 1915 Chirico returned to Italy, was conscripted into the armed forces and sent to Ferrar. There he suffered a nervous breakdown, and in 1917 met CARRÀ in the military hospital and converted him together with de PISIS and his brother SAVINIO to his views, thus founding the *Scuola Metafisica,* whose organ was the journal VALORI PLASTICI and with which MORANDI was also briefly and peripherally connected. But the group broke up c. 1920 when Chirico wrote a critical review of Carrà's book *Pittura Metafisica.* After his exhibition in Rome in 1919 Chirico became interested in the technical methods of the Italian classical tradition, declaring that he had received 'a revelation of great painting'. In 1925 he returned to Paris and found himself hailed as a master and precursor by the Surrealists. Although he never adopted their devices of AUTOMATISM, the mysterious quality of his work with its half dreamlike and half pathological impact was close to the emotional effect at which they aimed and the movement was entirely at one with his belief that 'good sense and logic have no place in a work of art, which must approximate to a dreamlike or childlike state of mind'. But he was unable fully to recover this mysterious quality of his 'Metaphysical' period, although his fine series of baroque horses on unreal shores comes from this time, and after 1930 he broke with his past friends. His pictures became technical *tours de force* in which little of the earlier strangeness and compulsiveness remained. After the Second World War his painting became more minutely detailed and technically exacting, and still more devoid of meaning, while he set himself against most of what the modern movements stood for.

CHIRINO, MARTÍN (1925–). Spanish sculptor born at Las Palmas, studied at the San Fernando School of Fine Arts, Madrid, and in London. In 1957 he joined the EL PASO group in Madrid and in 1960 opened his own studio at San Sebastián de Los Reyes, Madrid, where he worked and taught. His sculptures were strong, mainly curvilinear shapes in iron, painted monochromatically. They were not elevated on pedestals but were intended to be placed on the ground to emphasize their continuity with the real space of the environment. He is represented at the Museums of Contemporary Art, Madrid and Barcelona, at The Mus. of Modern Art, New York, the Art Institute, Chicago, and the San Francisco Mus.

CHITI, GUIDO. See CORRENTE.

CHRISTO (CHRISTO JARACHEFF, 1935–). Bulgarian-American sculptor and designer born at Gabrova. He studied at the Academy of Fine Arts,

Sofia, 1951–6, and after one term at the Academy of Fine Arts, Vienna, in 1957 he moved to Paris in 1958. There he was a member of the NOUVEAUX RÉALITÉS group and founded the magazine *KWY* in conjunction with the Portuguese René Bertholo, the Argentinian Sergio Fernández Castro and the German Jan Voss. In 1964 Christo settled in New York. He is chiefly known as the originator of 'packaging' art, which consisted of wrapping familiar objects in canvas or semi-transparent plastic and dubbing them works of art. He made his first packaged objects in 1958. At first these were small in scale but they gradually increased in size and pretentiousness through trees and motor cars to architectural monuments, including the theatre and other old buildings of Spoleto. His theory was that packaging is a temporary transformative act, which by partially concealing the object calls attention more acutely to the fundamental forms beneath the packaging. He made ASSEMBLAGES of oil drums (Cologne, 1961; Rue Visconti, Paris, 1962). From 1964 he was interested in designing shop fronts and in 1968 he produced a series of aluminium shop fronts for the DOCUMENTA exhibition at Kassel. In 1969 he packaged the Mus. of Contemporary Art, Chicago, and in the same year he produced a project for an assemblage of 1,249,000 stacked oil drums at Houston, Texas.

CHRYSSA (CHRYSSA VARDEA MAVROMICHALI, 1933–). Greek-American sculptor born in Athens, studied at the Académie de la Grande Chaumière, Paris, 1953–4 and at the California School of Fine Art, San Francisco, from 1954 to 1955, when she moved to New York. Her first original work was the *Cycladic Books* of 1955, almost featureless clay tablets vaguely reminiscent of the flat masks of Cycladic sculpture. In 1956 she began her series of *Tablets* and *Plaques*, in which she used letter forms to construct general impressions of printed communications rather than specific messages. In these and in her 10 ft (3 m) *Magic Carpet* (1962), *Automobile Tyres* (1958–62) and *Cigarette Lighter* (1959–62) she devised a technique involving the repetitive use of banal images from Pop culture, which like the *Target* and *Numbers* of JOHNS pointed the way to POP ART. In 1962 she embarked upon LUMINIST sculpture under inspiration from the lights in Times Square, of which she wrote: 'The vulgarity of America as seen in the lights of Times Square is poetic, extremely poetic.' Her pioneering work in this mode was *Times Square Sky*. From this time she developed the use of neon lighting in dark plexiglass boxes with the working parts of the interior exposed to view. By programming her light boxes to light up and turn themselves off she introduced a KINETIC element into her work. Her masterpiece in this technique was *Gates to Times Square* (1964–6), a 10 ft (3 m) high construction of steel, aluminium and plexiglass in the form of an open three-dimensional triangle with steeply sloping roof supported by a grid of stainless steel as a frame-

work for a honeycomb of stacked rows of metal letters interspersed with flowing curves of neon script enclosed in grey plexiglass boxes. Her later work included *Clytaemnestra* (1968), exhibited at the Kassel DOCUMENTA and bought by the Nationalgal., Berlin, *Birds* (1919) and *Automat* (1971), in which she renewed the concept of her earlier *Plaques*, translating it into neon light.

Chryssa's work has been widely exhibited in North and South America, Paris, Germany and Britain. One-man shows included the Solomon R. Guggenheim Mus., New York (1961); The Mus. of Modern Art, New York, (1963); Institute of Contemporary Art, University of Pennsylvania (1965); Department of Fine Art, Harvard University, and Walker Art Center, Minneapolis (1968); Gal. d'Arte Contemporanea, Turin (1970); Whitney Mus. of American Art, New York (1973). Among the public collections owning her work are The Mus. of Modern Art, the Whitney Mus. of American Art and the Solomon R. Guggenheim Mus., New York; the Nationalgal., Berlin; and the Tate Gal., London.

CHUAH THEAN TENG (1914–). Painter, born in China and lived in Borneo, Indonesia and Thailand before settling in the early 1940s in Penang, where he taught. He made an exhaustive study of the technique of batik dyeing and the printing of Malayan sarongs and from this evolved a distinctive style of painting. He had one-man shows at the Commonwealth Institute, London, and in Penang, Kuala Lumpur and Singapore and also exhibited in India, Australia, New Zealand and the Philippines. He did murals for the Agricultural Department of the University of Malaya and for a large commercial undertaking in Kuala Lumpur.

CILLIERS-BARNARD, BETTIE. See SOUTH AFRICA.

CIMIOTTI, EMIL (1927–). German sculptor born at Göttingen. From 1949 to 1953 he studied at Stuttgart and Berlin and also under ZADKINE in Paris. In 1959 he was awarded the Villa Massimo scholarship for Rome and in 1963 was appointed to the staff of the Hochschule für Bildende Künste at Braunschweig. He had one-man shows at Munich, Cologne and Braunschweig and he participated in collective exhibitions, including the 29th and 30th Venice Biennale and the DOCUMENTA II and III exhibitions at Kassel. His sculptures consisted, typically, of abstract shapes based upon plant and flower forms in polished aluminium or polyester.

CINÉTISME. See OP ART.

CINTOLI, CLAUDIO. See ITALY.

CIRCLE. A collective manifesto edited by J. L. Martin, Ben NICHOLSON and Naum GABO, published in London in 1937. The manifesto, a volume of

nearly 300 pages with numerous illustrations, was sub-titled 'International Survey of Constructive Art' and is the best illustration of the meaning attached to the concept CONSTRUCTIVISM towards the close of the 1930s.

The volume contains an editorial by Gabo entitled 'The Constructive Idea in Art', Piet MONDRIAN's seminal essay 'Plastic Art and Pure Plastic Art' and a short statement by MOHOLY-NAGY on 'Light Painting'. There is a large section on architecture and town planning, which includes an essay by Marcel Breuer, 'Architecture and Material', with much to say on furniture design and one by S. Giedion, 'Construction and Aesthetics', which is sub-titled 'Notes on the Reinforced-Concrete Bridges designed by the Swiss Engineer, Robert Maillart'. There is a short essay by GROPIUS on 'Art Education and State'.

There are illustrations of works by MALEVICH, Mondrian, Nicholson, DUCHAMP, ARP, TAEUBER-ARP, VORDEMBERG-GILDEWART, LISSITZKY, Moholy-Nagy, Arthur Jackson, Jean HÉLION, John PIPER, DOMELA, John Stephenson, Hans ERNI, Winifred Dacre, Gabo, PEVSNER, Eileen Holding, Alexander CALDER, TATLIN, Kasimir MEDUNETSKY. But the illustrations also included CUBIST works by PICASSO, LÉGER, BRAQUE and GRIS, works by KANDINSKY and KLEE which do not conform with the theoretical concept of Constructivism, short statements and illustrations from MOORE and HEPWORTH and illustrations of works by BRANCUSI and GIACOMETTI, none of whom would now be regarded as strictly Constructivist sculptors.

CIRCULO Y CUADRADO. A CONSTRUCTIVIST periodical produced in Montevideo by the Uruguayan artist Joaquín TORRES-GARCÍA as a successor to CERCLE ET CARRÉ. It was founded in 1936.

ČIURLIONIS, MIKOLOJUS KONSTANTUS (1875–1911). Lithuanian painter born at Varena. He studied music at Leipzig and Warsaw and although he briefly attended the Warsaw Academy of Art, he was to all intents and purposes self-taught in painting. He began to do pastels in 1902 under the influence of Odilon Redon but did not take up painting seriously until 1905. He turned to it because he felt himself unable to give full expression to his transcendental mysticism through music. He conceived his paintings as musical abstracts in which the forms expressed cosmic forces and he gave them the titles of *Fugues* and *Sonatas*. Musical tempi were represented by flowing curves or shorter zigzags, pitch by nuances of colour and melody by line. The compositions were decorative in the ART NOUVEAU manner. They have sometimes been regarded as the earliest expressive abstracts, anticipating KANDINSKY and KUPKA, but it is doubtful to what extent they are to be regarded as 'non-objective', to what extent decorative and to what extent they are stylizations of naturalistic motifs. Čiurlionis suffered a mental collapse *c.* 1908 and died insane. A retrospective exhibition

was given by MIR ISKUSSTVA in 1912. His work may now be seen in the Mus. of Vytautas the Great, Kaunas.

CIVET, ANDRÉ. See FRANCE.

CIŽEK, FRANZ (1865–1946). Austrian artist and educator. Born in Leitmeritz, Bohemia, he entered the Vienna Academy of Fine Art in 1885 and there became a member of the Vienna SECESSION in 1897 and later of the *Wiener Werkstätte*. From 1906 Cižek taught in the School of Arts and Crafts, where KOKOSCHKA was among his pupils. He is chiefly notable for his revolutionary theories of child art, which exercised a profound and lasting influence on the teaching of art first in Germany and later in Britain and America. He originated the theory that child art is a special branch of art, *sui generis*, which can be produced only by children. 'People make a great mistake', he said, 'in thinking of Child Art merely as a step to adult art. It is a thing in itself, quite shut off and following its own laws, and not the laws of grown-up people.' Although this view is now thought to be one-sided, it long held the field in the educational world and some such concept lies at the base of the many exhibitions of children's art which still take place. In keeping with the educational philosophy of Friedrich Froebel (1782–1852) Cižek held that the art which comes naturally and spontaneously to children should be allowed to develop like a flower, free from adult interference. 'Education is growth and self-fulfilment', he said in *A Lecture by Professor Cižek* (Children's Art Exhibition Fund, London, 1921). 'Make your schools into . . . gardens where flowers may grow as they grow in the garden of God.' Cižek put these views into practice in weekend classes held for 35 years from 1903 in the Kunstgewerbeschule at Vienna. He thought that after the age of 14 children lose their freshness and spontaneity, their capacity to produce 'child art'.

CLARET, JOAN. See SPAIN.

CLARK, JUDY. See CONCEPTUAL ART.

CLARK, LYGIA (1921–). Brazilian painter, sculptor and experimental artist born at Belo Horizonte, Minas Gerais. After studying painting under Roberto Burle-Marx in Rio de Janeiro she went to Paris in 1950 and studied under LÉGER and SZENÈS. The same year she exhibited at the Ministry of Education and Culture in Rio and at the Gal. de l'Institut Endoplastique, Paris, where her work came to the attention of ARP, Yaacov AGAM and Michel SEUPHOR. Returning to Brazil in 1952, she joined the *Grupo Frente* in 1954 and became a leading member of the Brazilian movement of CONCRETE ART, being one of the founders of the Neo-Concrete Group at Rio in 1959 and exhibiting with them at Salvador, Bahia and the Museums of Modern Art in Rio (1960) and São

Paulo (1961). During the 1950s she painted abstract pictures with bold geometrical patterns in flat colours based on the theories of Max BILL. She called these paintings 'Modulated Surface' or 'Modulated Space'. But they gradually lost their orthogonal shape and in 1959 she turned to sculpture, beginning the series *Bichos* (*Animals*). These were mobile metal floor-pieces constructed from flat folding planes based on modular systems and hinged together in a way that suggested organic forms. They could be manipulated, changed and set in movement by the spectators and so invited spectator participation. They were exhibited at the Bonino Gal., Rio, in 1960 and were included in the International Award Exhibition of the Instituto Torcuato di Tella, Buenos Aires, in 1962. In 1964 she initiated 'vestiary' sculpture made of soft materials and designed to be worn by the spectators with the object of liberating them from conventional modes of behaviour. One of her first soft pieces, *Grub*, was a fungus-like work in green rubber, which she placed on a tree trunk like a spreading parasite. The 'vestiary' works included sensorial masks for two or more people, magnetized cavernous enclosures that either attracted or repelled participants, gloves with the hands sewn together, overall suits in which the participants could invent their own 'body language'. One of her best-known works of this period was *Dialogue of Hands* (1966), in which she handcuffed her own hand to that of another Neo-Concrete sculptor and environmentalist, Helio Oiticica, with a soft plastic band. Guy Brett described her work as 'kineticism of the body' since movement depended entirely on the participants' sensorial reactions and not on mechanical or optical devices. In her *Tunnels*, *Living Mandalas* and *Elastics* of the 1970s the art work as an isolatable object had disappeared and the whole emphasis was upon creating an 'environment' which would influence the activity and reactions of spectator-participants. She said: 'In reality it is a question of *ritual without myth*: mythology, which is a metaphysic external to man, is abandoned in order that man may take his place and perform his own myth in these ritual gestures.'

Lygia Clark's work was exhibited extensively in North and South America and in Europe. In 1969 she participated in the SALON DES RÉALITÉS NOUVELLES, Paris. In 1968 she had an exhibition at the Mus. of Modern Art, Rio, entitled 'The House and the Body' and in 1971 a one-man show at the Gal. Ralph Camargo, São Paulo. By the mid 1970s she had become one of the most widely known internationally of the 'experimental' artists concerned with creating 'situations' and 'environments' and with stimulating spectator participation.

CLARK, PARASKEVA. See CANADA.

CLARKE, GEOFFREY (1924–). British sculptor, studied at Manchester and at the Royal College of Art, where he was awarded a Gold Medal in 1952. His first one-man exhibition was at Gimpel Fils, London, in 1952. Among the group exhibitions in which he was represented are 'Sculpture in the '60s', London, 1965, and 'Contemporary British Sculpture', London, 1966. He executed commissions for, among others, Martin's Bank, the Playhouse, Nottingham, the Guards Chapel, London, and Coventry Cathedral. He is represented in The Mus. of Modern Art, New York, the Tate Gal. and the Arts Council coll. His sculpture was non-representational, often constructed from aluminium sheets. He also worked in enamel and stained glass.

CLATWORTHY, ROBERT (1928–). British sculptor born at Bridgwater, Somerset, studied at the Slade School, 1951–4. He belonged to the school of expressive figurative semi-abstraction to which such sculptors as Lynn CHADWICK and Ralph BROWN also belonged. He taught at the St. Martin's and the Chelsea schools of art.

CLAUSELL, JOACHIM. See LATIN AMERICA.

CLAUSEN, GEORGE (1852–1944). British painter born in London, son of a decorative painter of Danish descent. He studied at South Kensington art school and at the Académie Julian, Paris. He was a founding member of the NEW ENGLISH ART CLUB, 1886, A.R.A. in 1895 and R.A. in 1908. He was Professor of Painting in the Royal Academy Schools during the early years of the century and he published his lectures there under the titles *Six Lectures on Painting* (1904) and *Aims and Ideals of Art* (1906). He was knighted in 1927. Clausen painted mainly landscapes, specializing in scenes with horses, in a manner influenced by the French *plein air* school. He was not an innovative artist and his work has been described by John Rothenstein as 'an unreflective projection of the art of Bastien-Lepage'.

CLAVÉ, ANTONI (1913–). Spanish painter, graphic artist, sculptor and theatrical designer, born at Barcelona. At the age of 13 he was apprenticed to a sign-painter and poster artist while attending the School of Fine Arts at Barcelona in the evenings and painting in what spare time he had. He won a prize offered by the local *Caja de Ahorros* and in 1935 began doing COLLAGES from a variety of materials. He took up lithography and in 1939 had his first one-man exhibition at the Gal. Vivant in Perpignan, France. This was followed by an exhibition in 1940 at the Au Sans Pareil Gal., Paris. His *Images de Paris* attracted attention and his name became widely known for his graphic work, particularly coloured lithography, which was included in many international group exhibitions. About 1941 he came under the influence of VUILLARD and BONNARD and passed through an *intimiste* phase. From *c.* 1944 his painting became more powerfully expressive with

affinities to ROUAULT and by the end of the 1940s he had matured his own style, painting with rich and vibrant colour. Best known among his works of this period are his *Hommage à Zurbarán* and his illustrations to *Gargantua*. He exhibited at the Salon d'Automne from 1943 to 1950 and won the Prix Hallmark in 1949. In 1947 he had an exhibition at the Anglo-French Art Centre, London, and in 1955 one at the Tooth Gal., London. Towards the end of the 1950s he began to do the highly characteristic works for which he is best known, LYRICAL ABSTRACTIONS consisting of paint over damask tapestry collages. During the 1960s he began metal sculptures, plaques and free-standing figures, abstractions modelled with expressive roughness to bring out the quality of the material. From the time he settled in Paris Clavé became known also for his colourful and decorative theatrical designs.

CLAVO, JAVIER. See SPAIN.

CLOISONISM. A name given to the style of Gauguin and the Pont-Aven school, based upon areas of flat unmodulated colour bounded by emphatic outlines. The style was first developed by Louis Anquetin and Émile BERNARD from a study of Japanese woodcuts and medieval stained glass. The name was coined by the critic Edouard Dujardin in an article 'Aux XX et aux Indépendants: Le Cloisonisme' contributed to *La Revue Indépendante* for March 1888, reviewing the contribution of Anquetin to an exhibition of the Belgian GROUPE DES VINGT (XX). The term has remained in use for work done in a similar style during the 20th c.

COBRA. A group formed in Paris in 1948 by the Danish painter Asgar JORN, the Dutch painter Karel APPEL and the Belgian CORNEILLE together with Jean ATLAN and Pierre ALECHINSKY. The name was formed from the initial letters of the three capital cities Copenhagen, Brussels and Amsterdam. Their aims were to exploit free expression of the unconscious, unimpeded and undirected by the intellect. In their emphasis upon unconscious gesture the group had affinities with American ACTION PAINTING, but they tended to put more emphasis upon the development of strange and fantastic imagery related in some cases to Nordic mythology and folklore, in others to various magical or mystical symbols of the unconscious. Their approach was similar to the ART INFORMEL of FAUTRIER and WOLS, but its savage and vigorous expressiveness exceeded theirs.

The COBRA group grew out of the more extremist elements in the Dutch EXPERIMENTAL GROUP and the Belgian group JEUNE PEINTURE BELGE via the *Bureau International de Surréalisme Révolutionnaire*, formed in Brussels in 1947 by Asgar Jorn and the critic Dotremont. It published *Cobra Revue*, which ran to 8 issues, and some 15 monographs. It arranged COBRA exhibitions at Copenhagen (1948), Amsterdam (1949) and Liège (1951). But the members soon went their own ways and the impetus of the group was dissipated. A retrospective exhibition was given in Amsterdam in 1962.

CODESIDO, JULIA (1892–). Peruvian painter born in Lima. She studied at the Escuela Superior de Bellas Artes in Lima with the academician Daniel Hernandez and the indigenist painter José SABOGAL. She herself taught there between 1933 and 1943. She travelled to Mexico in 1935 and absorbed the influence of SIQUEIROS, but she adopted his plastic and evocative techniques of expression without his doctrinaire politics, and adapted them to an original type of indigenism. She also admired the form and colour in the work of CHAGALL and TAMAYO and incorporated these influences into her own simplified versions of Peruvian subjects. Her paintings were characterized by strong design, flattened high-keyed colour with a predominance of red, tonal contrasts and a conscious adaptation of the primitivism of local Indian art. Another of her sources was the work of Pancho Fierro, the 19th-c. Peruvian artist and satirist whose subjects were Indian themes, folk dances and religious processions. Codesido believed art to be the universal spiritual language of the people and she wished to express this belief in her own paintings. She lived in Switzerland for a while and travelled and exhibited in New York, Paris, Mexico and other cities, including exhibitions at the San Francisco Mus. of Art and the Mus. du Jeu de Paume, Paris. It was through her recognition abroad in the 1920s and early 1930s that she earned the professorship at the Escuela Superior de Bellas Artes. Her best-known paintings include *Jefe Indio* (*Indian Chief*) and *The Andes*. The latter was included in the exhibition 'Art of Latin America Since Independence' (1966) at Yale and at the University of Texas at Austin.

COETZEE, CHRISTO. See SOUTH AFRICA.

COHEN, BERNARD (1933–). British painter born in London, brother of Harold COHEN. After studying at the St. Martin's School of Art and the Slade School, 1950–4, he had his first one-man exhibitions at Gimpel Fils, London, in 1958 and 1960. He had a retrospective exhibition at the Hayward Gal. in 1972 and one-man exhibitions at the Waddington Gals. from 1973 onwards. Among the group exhibitions in which he participated were: 'Situation', R.B.A. Gals., London, 1960; Paris Biennale, 1961; 'British Painting in the Sixties', Whitechapel Art Gal., 1963; 'Painting and Sculpture of a Decade', Tate Gal., and DOCUMENTA III, 1964; 'London, The New Scene', Walker Art Center and touring in U.S.A., 1965; Venice Biennale, 1966; 'British Painting', Palais des Beaux-Arts, Brussels, 1967; 'British Painting and Sculpture', National Gal., Washington, 1970; 'La Peinture Anglaise d'Aujourd'hui', Mus. Natio-

nal d'Art Moderne, Paris, 1973; 'British Painting '74', Hayward Gal. His style of painting was akin to American COLOUR FIELD painting, but he gradually evolved a looser manner with TACHIST affinities.

COHEN, HAROLD (1928–). British painter, born in London. He studied at the Slade School, 1948–52, was lecturer in Art History at the Camberwell School of Art, 1952–4, Fellow in Fine Arts at Nottingham University, 1956–9, and lived in New York on a Harkness Commonwealth Fellowship, 1959–61. He taught at St. Martin's School of Art, Bromley College of Art and Ealing School of Art, 1961–2, and from 1952 at the Slade School. At the time of his visit to America he was painting in an ABSTRACT EXPRESSIONIST manner, making use of horizontal stripes of colour. In America he was influenced chiefly by Barnett NEWMAN while coming to doubt the finality of Abstract Expressionism. After his return to England his work was gradually invaded by more precise and complex images, often accompanied by calligraphic elements, and his style approached more nearly to that of TACHISM.

His work was included in many important collective exhibitions from 1953 and his one-man shows included a retrospective exhibition at Nottingham University in 1959 and at the Whitechapel Art Gal. in 1965.

COLD ART (KALTE KUNST). Term used for that branch of CONSTRUCTIVIST art which relies on mathematical systems and formulae either for the layout or for the development of a work. It was exploited in connection with CONCRETE ART (*Konkrete Kunst*) particularly by Max BILL and members of his group in Switzerland from the 1930s onwards. Max Bill claimed that mathematical thought is one form of conceptual or rational thinking, therefore 'one of the essential forms of primary thinking', and 'one of the chief intrinsic characteristics of man'. Hence the use of mathematical thought in the formation of works of art is one way in which human personality can be expressed in art. 'It is by rational thought that we are able to arrange the sensorial values in such a way as to produce works of art.' It was alleged that 'cold art', mathematically constructed, combined the 'purity' and severity of NEO-PLASTICISM— which was as much an expression of the personality of MONDRIAN as so-called 'expressive' art was an expression of the personality of others— with a rationally apprehensible structure. But in his book *Behind Appearance* (1969) C. H. Waddington stated that when he visited his studio in the 1960s Max Bill played down the function of mathematical structure. 'He stated that his main aim is still to produce visual works which have qualities of internal balance and self-sufficiency comparable to those of good music . . . His mathematics, he argued, did no more than provide formally defined and related units out of which compositions can be made as music is composed in terms of a defined scale of notes.'

The method of using mathematical formulae or sets of numbers to generate works of art, sometimes in conjunction with an element of planned chance, was adopted by a number of artists in the 1950s and 1960s within the fields of KINETIC ART and MINIMAL ART. In his Introduction to the catalogue of an exhibition entitled 'Art as Thought Process' arranged for the Arts Council of Great Britain in 1974 and including works by Kenneth MARTIN, Bridget RILEY, Keith MILOW, Richard SMITH and others, Michael Compton wrote as follows: 'Many artists in the last ten or twelve years have sought to direct attention more to the processes by which art is made (that is to the *work* that the artist does) than to the finished object. At the same time many artists have sought to reduce to a minimum the ambiguity of their work and to control as far as possible the way it is presented to the public. These two trends have produced works of art which, however distinct in their deepest significance or in the media in which they are executed, have in common a one to one correspondence between the idea of the object which it generates and the object which is generated; so much so that it may be possible for an independent person to execute the work for the artist without any supervision . . . Even though it involves thought on the part of the viewer rather than an instant perception, once worked out there can be no doubt about the process that generated the sequence: an absolutely simple and regular working out of a basic idea . . . The viewer of the work can know, therefore, exactly what was in the mind of the artist. It is the sheer simplicity of the thought process that gives it this quality of being perfectly understood . . . Such a condition is achieved at the apparent cost of the freedom of choice of the artist and of his personality. He presents himself as one dispassionately carrying out a piece of work based definitively on an idea of an apparent extreme banality. The value of such an art . . . is that it presents to the viewer both the subject (or idea) and the work in such a way that they interpret each other . . . There is also always a surprise. The simple formula generates a work's unexpected subtlety and complexity which is more effective for knowing the rules . . . They invite the viewer to follow the thought process of the artist as it can be discerned in his work and, by means of his consciousness of this very thought process and of his own attempts to deal mentally with what he discerns, to come to a new awareness.'

Michael Compton refers to Robert MORRIS and Sol LEWITT as examples of this method of work. The use of the computer to generate works of art is closely allied to it. (See COMPUTER ART.)

In Switzerland the ideas of Max Bill were developed by Richard P. LOHSE and Karl GERSTNER, who advocated the deployment of systems and sequential progressions in regard to colour. Gerstner published a book *Kalte Kunst* in 1954 dealing

with the arithmetical aspects of colour progressions.

COLDSTREAM, SIR WILLIAM MENZIES (1908–). British painter and educationalist. He was Slade Professor of Fine Art from 1949 and a member of the Arts Council of Great Britain from 1953. He was one of the founders of the EUSTON ROAD SCHOOL in 1937 and one of the perpetuators of the Euston Road style. He has works in the Tate Gal., the National Gal. of Canada and other leading public collections and from 1938 (New York World's Fair) he was represented in a number of international exhibitions of British art. He was made C.B.E. in 1952.

COLLA, ETTORE (1899–1968). Italian sculptor born at Parma. He started as a painter and settled in Rome in 1926, turning to sculpture in 1947. In 1951 he was a founding member of the *Origine* group. During the 1950s he was an outstanding figure in Italian sculpture, making his works from machine parts and scrap iron rusted over, or broken relics of war objects. From these he constructed symbolic machines which had the evocative effect of new life arising from the ruin and rubble, sometimes incorporating a fetishistic suggestion. In 1967 he had an important retrospective exhibition 'Lo Spazio dell' Imagine' at Foligno.

COLLAGE. The 'scissors and paste' method of combining ready-made images which, long popular as a leisure-time occupation for children and amateurs, first became an accredited artistic technique in the 20th c., when it drew its main material from the proliferation of mass-produced images such as newspapers, advertisements, cheap popular illustrations, etc. The CUBISTS were the first to incorporate real objects such as pieces of newspaper into their pictures, often deliberately giving them a dual function both as the real things they were and as contributing to the 'virtual' picture image. Collage was given a social and ideological direction by the FUTURISTS and was used by the DADAISTS for their own anarchical purposes. It was adopted by the SURREALISTS, who emphasized the juxtaposition of disparate and incongruous imagery. Among the best-known examples of Surrealist collage are *La femme 100 têtes* (1929) and *Une semaine de bonté* (1934) by Max ERNST.

COLLIGNON, GEORGES (1923–). Belgian painter born in Liège, where he studied at the Academy of Art. He began to paint in a manner of expressive abstraction *c.* 1949 and was a member of the JEUNE PEINTURE BELGE and the COBRA groups, winning the Prix de la Jeune Peinture in 1950. In 1950 he settled in Paris and in 1952 he was a member of the ART ABSTRAIT group.

COLLINS, CECIL JAMES HENRY (1908–). British painter born at Plymouth. He received his artistic training at Plymouth School of Art, 1923–7, and at the Royal College of Art, 1927–31. He taught at Dartington Hall, 1939–43, and at the Central School of Arts and Crafts, London, from 1956. Collins was of Celtic stock and was essentially a mystical and visionary artist. It has been said that all his painting was the exploration of another world, which was called by Kathleen Raine, the Blake scholar, 'The Lost Paradise'. An inherent vein of fantasy was released in him during his student days by the drawings of Paul KLEE and in the 1930s he was introduced by Mark TOBEY to the Ba'hai religion and to the art and philosophy of the Far East. The influence of Blake's prophetic writings upon his ideas is apparent and there is a superficial relation to Blake in his drawings of the 'Divine Fool', but his style remained more hieratic than Blake's and the influence of Eastern art was profound. He was represented in the London SURREALIST Exhibition of 1936 but he quickly repudiated Surrealism, declaring in 1947: 'I do not believe in surrealism precisely because I do believe in a surreality, universal and external, above and beyond the world of the intellect and the senses; but not beyond the reach of the humility and hunger of the human heart.' In 1947 he published his philosophy of art and life in *The Vision of the Fool*, in which he attacked the utilitarian standards of contemporary materialistic and technologically oriented civilization, speaking of 'a great spiritual betrayal . . . the betrayal of the love and worship of life by the dominance of the scientific technical view of life in practically all the fields of human experience . . . and by the teaching of philosophy of mediocrity, into which, with a sigh of relief, the heavy inert mass of mankind desires˙ to sink'. The artist, with the poet and the saint, 'is the vehicle of the continuity of that life, and its guardian, and his instrument is the myth, and the archetypal image'. Although written in the 1940s, *The Vision of the Fool* was read and quoted by students in California and elsewhere in America in the 1960s and 1970s. In 1940 Collins began a long series of paintings and drawings which he first called *The Holy Fool* but later *The Vision of the Fool* in agreement with the title of his book. *The Sleeping Fool* (Tate Gal., 1943) is an example of these. *Hymn to Death* (1953) and *The Golden Wheel* (1958), also in the Tate Gal., are typical of the visionary character of Collins's work.

He had his first one-man show at the Bloomsbury Gal. in 1935 and he was represented in the British Council's exhibition 'Contemporary British Art' which travelled in America in 1940. Despite a reluctance to show his works publicly, he was persuaded into a number of exhibitions, including successful shows at the Lefèvre Gal. in 1944, 1945 and 1948. A retrospective exhibition was given at the Whitechapel Art Gal. in 1959 and in 1962 he visited Greece for an exhibition at the Zyghoe Gal., at which four works were bought by the Greek National Gal. In 1949 he designed a large Shakespearian tapestry, woven by the Edinburgh

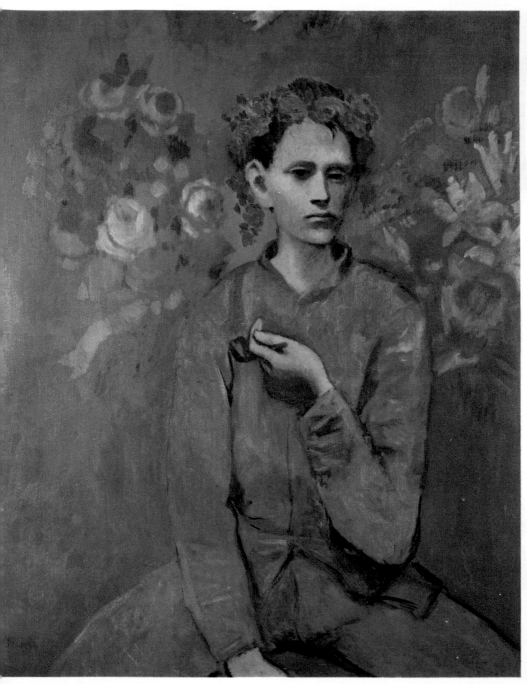

1. Pablo Picasso: *Boy with a Pipe*, 1905. Oil on canvas. 100 × 81 cm.

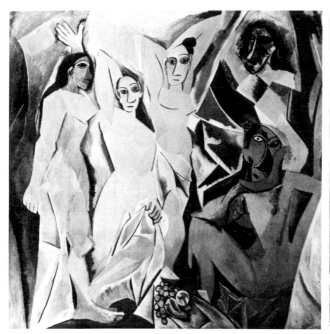

2. Pablo Picasso: *Les Demoiselles d'Avignon*, 1907. Oil on canvas. 244 × 234 cm.

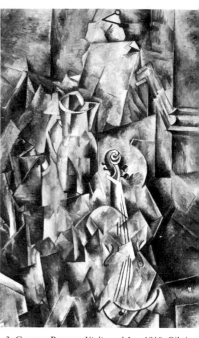

3. Georges Braque: *Violin and Jug*, 1910. Oil on canvas. 117 × 73 cm.

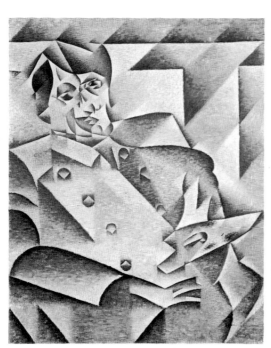

4. Juan Gris: *Portrait of Picasso*, 1912. Oil on canvas. 74 × 93 cm.

5. Juan Gris: *The Sunblind*, 1914. Mixed media drawing on canvas. 93 × 60 cm.

6. Umberto Boccioni: *Development of a Bottle in Space*, 1912. Silvered bronze (cast 1931). 38 × 32 × 60 cm.

7. Raymond Duchamp-Villon: *Le Grand Cheval*, 1914. Bronze.
100 × 100 × 53 cm.

8. Jacques Lipchitz: *Man with a Guitar*,
1918. Bronze. 71 × 39 × 34 cm.

9. Albert Gleizes: *Chartres Cathedral*, 1912. Oil on canvas. 73 × 60 cm.

10. Francis Picabia: *Udnie*, 1913. Oil on canvas. 300 × 300 cm.

11. Roger de La Fresnaye: *July 14th*, 1914. Oil on canvas. 114 × 145 cm.

12. Robert Delaunay: *The Eiffel Tower*, 1910–11. Oil on canvas.
195 × 129 cm.

13. Alexander Archipenko: *Medrano II*,
1914. Painted tin, glass, wood and

15 (*above*). André Lhote: *Rugby*, 1917. Oil on canvas. 127 × 132 cm.

14 (*left*). Jean Metzinger: *Still Life with Melon*, 1916–17. Oil on canvas. 162 × 97 cm.

16. Amedée Ozenfant: *Flagon, Guitar, Glass and Bottles at a Grey Table*, 1920. Oil on canvas. 81 × 101 cm.

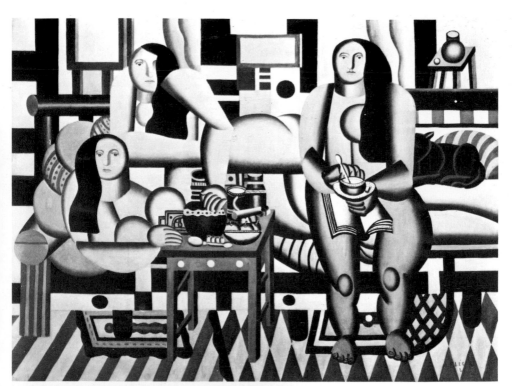

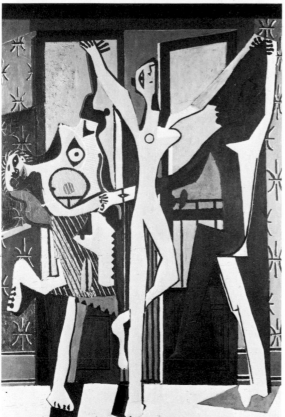

17 (*above*). Fernand Leger: *Three Women*
(*Le Grand Déjeuner*), 1921. Oil on canvas.
183 × 251 cm.

18 (*left*). Pablo Picasso: *The Three Dancers*, 1925.
Oil on canvas. 215 × 144 cm.

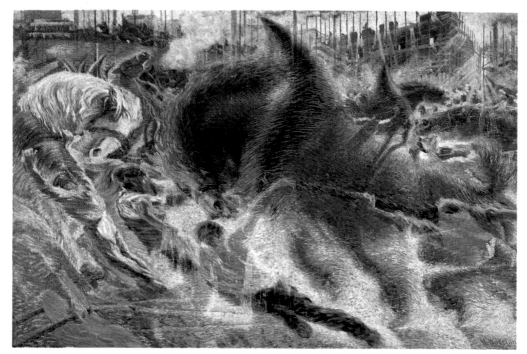

19. Umberto Boccioni: *The Rising City*, 1910. Oil on canvas. 200 × 301 cm.

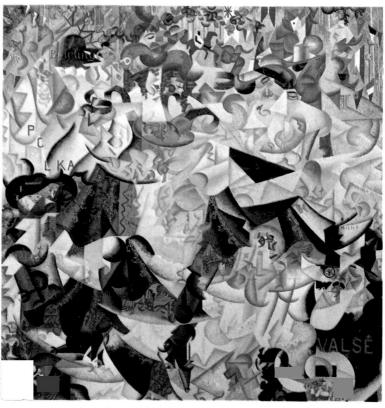

20. Gino Severini: *Dynamic Hieroglyphic of the Bal Tabarin*, 1912. Oil on canvas, with sequins.
162 × 156 cm.

21. Luigi Russolo: *Music*, 1911. Oil on canvas.
218 × 140 cm.

22. Giacomo Balla: *Girl Running on a Balcony*, 1912. Oil on canvas.

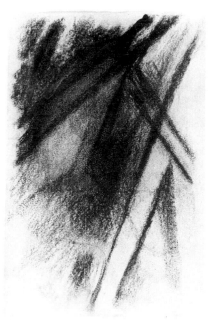

23. Mikhail Larionov: *Rayonist Drawing*, 1910–11. Charcoal on paper. 24 × 16 cm.

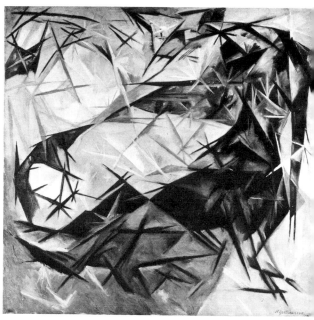

24. Natalia Goncharova: *Cats*, 1913. Oil on canvas. 84 × 84 cm.

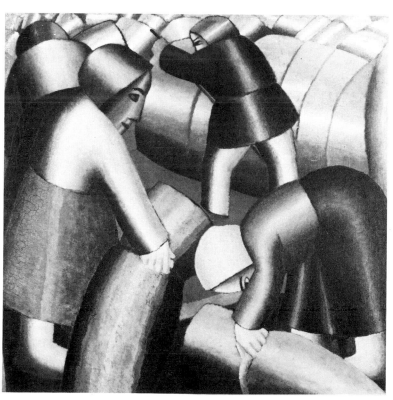

25. Kasimir Malevich: *Women Harvesting*, 1912. Oil on canvas. 72 × 74 cm.

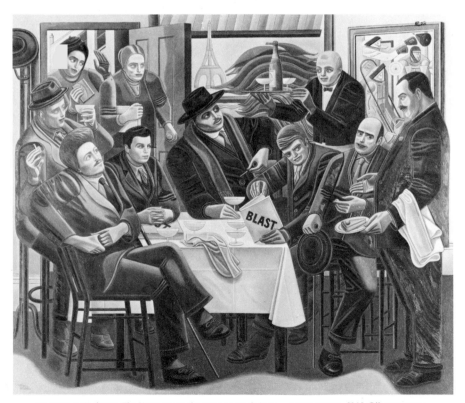

26. David Bomberg: *The Mud Bath*, 1912–13. Oil on canvas. 152 × 224 cm.

27. Wyndham Lewis: *Workshop*, 1914–15. Oil on canvas. 77 × 61 cm.

28. William Roberts: *The Vorticists at the Restaurant de la Tour Eiffel: Spring, 1915*. Oil on canvas. 183 × 213 cm.

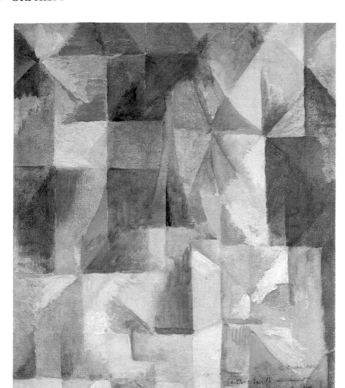

29. Robert Delaunay: *Winaows Open Simultaneously* (first part, third motif), 1912. Oil on canvas. 48 × 37 cm.

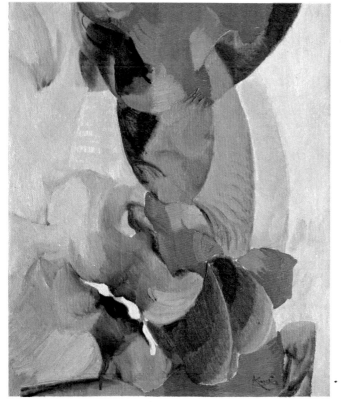

30. František Kupka: *Red and Green*, 1913. Oil on canvas. 66 × 38 cm.

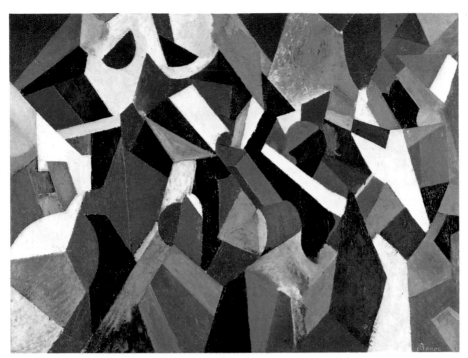

31. Patrick Henry Bruce: *Composition II*, before 1918. Oil on canvas. 97 × 130 cm.

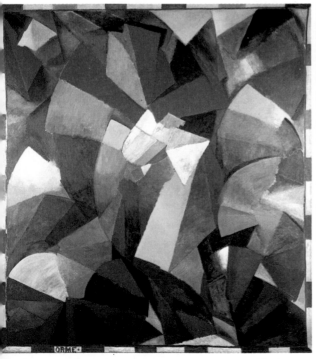

33. Stanton Macdonald-Wright: *Conception Synchromy*, 1915. Oil on canvas. 76 × 60 cm.

32. Morgan Russell: *Synchromy in Orange: To Form*, 1913–14. Oil on canvas. 343 × 309 cm.

34. Marcel Duchamp: *Nude Descending a Staircase No. 2*, 1912. Oil on canvas. 148 × 90 cm.

35. Oskar Schlemmer: *Instruction*, 1932. Oil on canvas over paper. 67 × 60 cm.

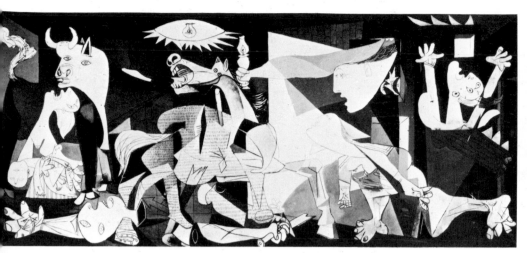

36. Pablo Picasso: *Guernica*, 1937. Oil on canvas. 321 × 777 cm.

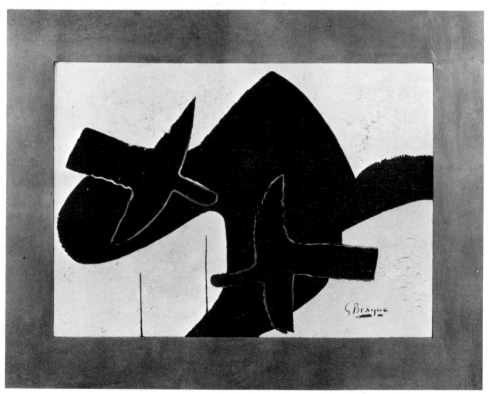

37. Georges Braque: *The Black Birds*, 1957. Oil on canvas. 129 × 181 cm.

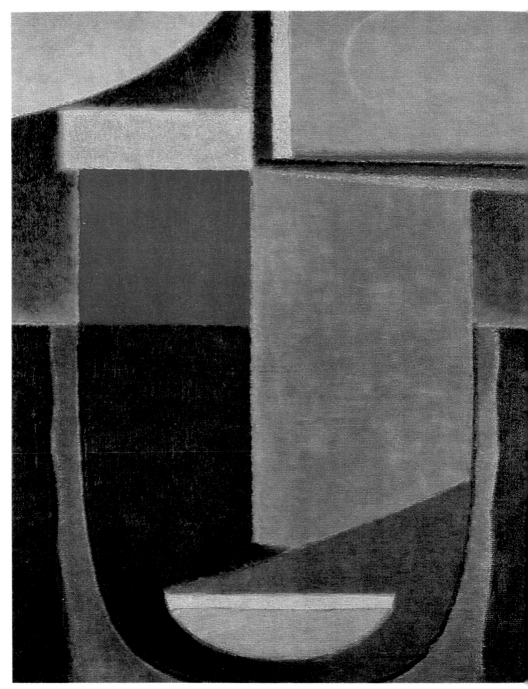

38. Alexei von Jawlensky: *Night*, 1933. Oil on paper. 42 × 32 cm.

Weavers, for the British Embassy in Washington and in 1973 he executed a commission for an altarpiece for Chichester Cathedral.

COLOMBO, GIANNI. See GRUPPO T.

COLOUR FIELD PAINTING. The term is used of monochromatic paintings, particularly those which rely upon the intensity and saturation of colour. In such paintings colour is 'freed' from shape and drawing and acquires a reality of its own which is purely visual. There is no longer any 'pictorial image' but the colour has its own independent, disembodied, non-tactile reality. Sometimes very large size creates an all-embracing impression which usurps the area of vision and introduces the impact of 'scale'. The precursor of this kind of painting is usually considered to have been Yves KLEIN. Modern monochromatic paintings were introduced by Ellsworth KELLY, painting in France c. 1952–3, Ad REINHARDT after 1952 and Barnett NEWMAN in the 1960s. See also COLOUR PAINTING and FIELD PAINTING.

COLOUR PAINTING. Term first used by the critic J. H. Greenberg in 1960 for stain painting such as that of FRANKENTHALER, LOUIS and NOLAND. The term carries the sense that when the canvas is stained and paint is poured, purely visual colour results, freed from the tactile associations of brush work and modulated surface texture.

The term has also been applied to the school of British painters which made its public début at the 'Situation' exhibition of 1960, including Harold and Bernard COHEN, William TURNBULL, Robyn DENNY, Paul HUXLEY, Patrick HERON and John HOYLAND.

COLQUHOUN, ROBERT (1914–62). British painter born at Kilmarnock, Ayrshire, studied at the Glasgow School of Art, 1932–7, where he became a lifelong friend of Robert MACBRYDE. Both obtained scholarships which enabled them to travel in France and Italy, 1938–9. Colquhoun served with the Royal Army Medical Corps as an ambulance driver in Edinburgh in 1940–1. On being invalided out of the army he settled in London with MacBryde, driving an ambulance in the Civil Defence Corps by day and painting by night. Within a few years their studio at Bedford Gardens, Campden Hill, had become a centre for a group of young artists and writers which included John Minton, John Craxton, Michael Ayrton, Keith VAUGHAN and Rodrigo MOYNIHAN. The Polish painter Jankel ADLER took a neighbouring studio in 1943. At this time Colquhoun, regarding himself as a cosmopolitan by virtue of his European year, had the ambition of revivifying the great European tradition of painting. Among English artists he found Wyndham LEWIS most congenial, and the admiration was mutual for Lewis wrote in *The Listener* of 13 February 1947 that Colquhoun 'is generally recognised as one of the

best—perhaps the best—of the young artists. That opinion I cordially endorse.' Colquhoun reached the peak of his powers about the middle of the 1940s. Outstanding from this time are: *Woman with Leaping Cat* (Tate Gal., 1945–6), *Seated Woman with Cat* (Arts Council, 1946), *Woman with Birdcage* (Bradford City Art Gal., 1946). He exhibited at the Lefèvre Gal. in 1943, 1944, 1947 and 1951, but the connection lapsed with the death of Duncan Macdonald in 1950.

Upon their eviction from their studio in 1947 progressive disintegration and waning of artistic powers set in. From 1947 Colquhoun and MacBryde lived in a studio at Lewes, Sussex, put at their disposal by Caroline Lucas and Frances Byng Stamper, the owners of Miller's Press for which they commissioned drawings and lithographs from the artists. From 1949 to 1954 they lived at the home of the poet George Barker near Dunmow, Essex. Colquhoun and MacBryde designed décor and costumes for a Scottish ballet *Donald of the Burthens* produced by Massine at Covent Garden in 1951 and for the *King Lear* produced by George Levine at Stratford in 1953. An important retrospective exhibition was organized at the Whitechapel Art Gal. by Bryan Robertson in 1958. A posthumous exhibition was given at the Douglas and Foulis Gal., Edinburgh, in 1963 and in 1972 a Colquhoun Memorial Gal. was opened in Kilmarnock with an annual Colquhoun Art Prize.

COLVILLE, DAVID ALEXANDER (1920–). Canadian painter, born in Toronto, grew up in St. Catharines, Ont., and Amherst, N.S., on the Bay of Fundy. He studied in the Fine Art Department of Mount Allison University, Sackville, N.B., 1938–42. In 1944 he was appointed an official War Artist, and in his paintings of Canadians training in England, the Royal Canadian Navy in the Mediterranean, and Allied operations in north-west Europe he developed his realistic style to a level of studied impact. (All these works are now in the collection of the Canadian War Mus., Ottawa.) After his discharge from the army in 1946, he taught art at Mount Allison. Here he experimented with various techniques of panel painting, executing a large mural in egg tempera, *History of Mount Allison*, for the university in 1948.

His paintings of the early 1950s show less concern for detail than do his war paintings, and the forms are more generalized. There is an interest in the precise, geometric articulation of space. Most of his paintings show figures in juxtaposition with inanimate objects, animals, or other human beings, carefully placed at the most concentrated point in that space, drawing substance from the charged atmosphere (e.g. *Nude and Dummy*, New Brunswick Mus., Saint John, 1950). His later work evolved slowly and steadily, with more attention often given to the details of how objects go together, although there was also a growing tendency to define the separate elements of an image

clearly. He was fascinated—as in *The Swimming Race* (National Gal. of Canada, Ottawa, 1958)—with the frozen moment. More recent work—e.g. *To Prince Edward Island* (National Gal. of Canada, 1965)—often expresses the strength of an individual during an unguarded moment of reflection or concentration.

Colville's first one-man show was at the Banfer Gal., New York, in 1963. He had further one-man shows at Hart House, University of Toronto, in 1966, at the Kestner-Gesellschaft, Hanover, in 1969, also shown at the Marlborough Gals., London, in 1970, and at the Kunsthaus, Düsseldorf, in 1977. In 1966 he represented Canada at the Venice Biennale, and the following year his austerely beautiful designs were used for the special issue of Canadian coinage commemorating the centenary of Confederation. He was Artist in Residence at the University of California at Santa Cruz, 1967–8, and in 1971 he was visiting artist at the Berlin Künstlerprogram.

COLVIN, MARTA (1917–). Chilean sculptor born at Chillán. She studied sculpture at the Academia de Bellas Artes, Santiago, with Julio Antonio Vasquez and exhibited widely throughout Latin America. She went to Paris in 1948 with a grant from the French government and there met LAURENS and BRANCUSI and studied at the Académie de la Grande Chaumière with ZADKINE. She travelled widely through Europe before her return to Chile in 1950. In 1952 she was invited by the British Council to spend 6 months in England and there met Henry MOORE. She then spent two more years in Paris and participated in the Salon de la Jeune Sculpture and exhibited at the Gal. de Verneuil in 1954. After her return to Chile she taught sculpture at the Academia de Bellas Artes in Santiago and introduced non-objective sculpture into her country in the 1950s with her monument for the tomb of the dancer Isabel Glatzel. Following trips through Bolivia, Peru and Easter Island she incorporated Andean and South Pacific art forms increasingly into her own work. *Gate of the Sun* (1964) is based on the architecture of the Bolivian culture of Tiahuanaco. Her monumental *Towers of Silence* of the same period is dedicated to General Sucre, the 19th-c. hero of Bolivian Independence. Her work has been referred to as organic geometry and is based on sensual evocations of flora, twisted vegetable and anthropomorphic forms and pre-Hispanic themes, most of which are carved directly in wood. Colvin returned to France in 1958 and continued to exhibit in Europe and South America. She was the recipient of the International Sculpture award at the São Paulo Bienale in 1965.

COMBINE PAINTING. A name given to a method first devised by RAUSCHENBERG in the early 1950s in which a painted surface is 'combined' with various real objects, or sometimes photographic images, attached to it. It may be regarded as a very radical development of the technique of COLLAGE used by SCHWITTERS, though in fact it was started by Rauschenberg under the influence of the philosophy of John Cage, whose basic idea it was that the mind of the spectator should be 'unfocused' by a flux of images which induce a mood of reverie. The technique was exploited by a large number of artists and for a variety of artistic purposes. It led on to the TABLEAU and the ASSEMBLAGE. The use of photographs in the combine painting was developed along a different path by the practitioners of MEC art.

COMFORT, CHARLES. See CANADA.

COMPUTER ART. Experimental interest in computer-produced or computer-aided art dates from the mid 1950s. The interest was world-wide and computer art was practised in the U.S.A., Britain, Japan, Germany, France, Italy, Canada, South America and elsewhere. For obvious reasons the main centres of activity were industrial companies with large research sections, such as The Boeing Company and The Bell Telephone Company, or universities with computer facilities. Experimentation with the aesthetic uses of the computer was an offshoot of investigation into its practical uses for industrial design, scientific research, psychological research into human perception and so on. It was mainly in the hands of engineers, mathematicians, psychologists, philosophers and those who had mastered the complicated techniques of computer programming for professional reasons, although some few artists collaborated. By and large, however, computer art was not produced by those who would be regarded as artists in the traditional sense of the word.

Among the more important organizations which included computer art in their programmes were the following: American Experiments in Art and Technology (EAT), set up in New York in 1966 with the object of encouraging collaboration between artists on the one hand and on the other engineers and scientists with technological know-how not accessible to the layman. It was described as 'an international network of experimental services and activities designed to catalyze the physical, economic and social conditions necessary for the inevitable cooperation between artists, engineers and scientists, and members of industry and labour'. In the Argentine the Centre of Art and Communication of the Foundation of Interdisciplinary Research (CEAC) was concerned mainly with investigating the techniques of communication as a link between the social, creative and technological aspects of contemporary life. The Computer Arts Society was formed in England in 1968 as a result of an exhibition 'Cybernetic Serendipity' organized by Jasia Reichardt for the Institute of Contemporary Arts, London. This was followed in 1969 by 'Computers and Visual Research', Zagreb. The Computer Arts Society became international in its scope and was the only

body whose principal aim was to popularize computer technology and promote its more general use among artists. The Computer Technique Group, established in Tokyo in 1967, took the view that the artist's work consists in designing a system of programming, that is of envisaging possibilities and a method of generating a given repertory of forms, rather than producing actual works of art. The most adventurous achievement of the Group was an Automatic Painting Machine, which was controlled manually, by a paper tape from a digital computer and by light and sound input from a linked 'happening zone'.

The first exhibition of computer graphic art was given at the Howard Wise Gal., New York, in April 1965. In 1970 the Department of Art at the Ohio State University celebrated its centenary with an exhibition of sound and visual systems which included computer art. The exhibition was organized by Charles Csuri, an artist who subsequently devised a technique for creating computer sculpture and evolved new techniques for film animation. Professor Robert Mallory of the University of Massachusetts also devised a technique, which he called TRAN 2, for generating sculpture by computer. The journal *Computers and Automation* held an annual competition for the best computer-produced drawings and in 1968 California Computer Products (CalComp) also offered prizes for the best computer graphics. EAT held a competition for works produced as a result of artist/engraver collaboration and submissions were shown in an exhibition called 'The Machine' at The Mus. of Modern Art, New York, in 1968. Prominent among independent workers in the field were: Leslie Metzei, Professor of Computer Science at the University of Toronto, who wrote a survey of computer art in 1964; Kurt Alsleben, whose computer graphics done in Hamburg in conjunction with Dr. Cord Passow were the subject of his book *Ästhetische Redundanz* (1962); Gustav METZGER, who devised a method of using a light source with a graphic plotter; Frieder Nake, who produced interesting computer graphics at Stuttgart during the 1960s; and Katherine Nash, Professor of Art in the University of New Mexico, who led the way in the educational applications of the computer in art.

The computer invaded the arts of music, choreography and 'concrete' poetry as well as painting and sculpture and its applications in many fields of architecture were on a par with its uses for industrial design where aesthetic quality is not in question. By the mid 1970s no visual art of significant quality had been produced with the aid of computers but the practice and investigation of computer art was held to be important because by removing it from the exclusive prerogative of traditional artists it tended to promote the 'democratization' of art, because it was thought to lead to closer links between art and technology and because it seemed likely to demonstrate that creativity is not a special gift but can be equated with the randomizing procedures which can be built into a computer program.

Apart from film animation, the role of computers in the visual arts in the 1970s was most prominent in the field of 'computer graphics'—a name coined by The Boeing Company in 1960. Computer graphics may be produced with a graphic plotter controlled by a computer by means of a magnetic tape, by a cathode ray or television tube, or by a printing machine which can be programmed to produce patterns with the typographical symbols at its disposal. The cathode ray tube is the most flexible method since it allows the artist to intervene and manipulate the image during the process of production as with ACTION PAINTING. With the graphic plotter the artist's activity is limited to programming in advance, although a random or fortuitous factor may be deliberately introduced as is done with some kinds of KINETIC ART and some CONCRETE ART which is generated from mathematical formulae.

A great deal of the research lavished upon non-utilitarian computer graphics was conditioned by the hope of perfecting techniques for the computerized reproduction of man-made works of art. The ultimate object of this line of research would be the production of an indefinite number of inexpensive copies each indistinguishable from the original, and it was argued that this possibility would not only guard against the inevitable deterioration of original art works but would further the democratization of art by rendering the artistic heritage of the world accessible to all. The champion of this project was Professor Abraham A. Moles, head of the Institut de Psychologie Sociale in the University of Strasbourg, who wrote: 'The problem which we must resolve consists in establishing an art which will no longer be the property of an individual, the artist, but of society as a whole. Hitherto art has always been information imparted by one individual to others. We need a new way of aesthetic communication. Will machines and their products, as some artists have foreseen, bring to being this new social dimension of art?' It was understood, however, that men have an instinctive desire to possess something unique and different, not one of an indefinite number of identical copies. Therefore the versatility of the computer was further exploited. Just as some artists produced MULTIPLES for cheap mass reproduction, so it was realized that the computer could be programmed to produce an unlimited supply of reproductions each of which would not be an exact copy but would differ slightly from the others. Professor Moles argued that in this way each buyer would have what was in fact an original. Others felt that the originality of an art work lies in the conception rather than the exact reproduction and that insufficient attention had been paid on the other hand to the possible, if not inevitable, weakening of aesthetic value by such indefinite if minute modifications of an artistic original in multiple copies.

CONCEPTUAL ART. Traditionally the term 'conceptual' has been applied to representational art which depicts not only what is seen but also what is known to exist. For example, a primitive artist may show the backbone and stomach of a swimming fish; the Egyptians combined a frontal and a profile view of one figure. The most important change which took place at the Renaissance is sometimes said to be that from a conceptual to a perceptual manner of representation. CUBISM again is sometimes said to have been a reversion to 'conceptual' art when for example it combined several incompatible points of view in one representation, as when a face was depicted both frontally and in profile.

Recently, however, 'Conceptual Art' has been adopted as the name of a style which emerged in the 1960s. Its manifestations have been very diverse. Their common characteristic is the claim that the 'true' work of art is not a physical object produced by the artist but consists of 'concepts' or 'ideas'. When a material thing is hung in a gallery or otherwise presented to spectators, this is regarded as no more than a vehicle for the communication of ideas or a means of reference to events or situations removed in space and time from the presentation. Photographs, texts, maps, diagrams, sound cassettes, video, etc. have been used as communication media. The expression was also used by Sol LEWITT to describe a new form of art and a new aesthetic ideology in connection with the PRIMARY STRUCTURES of Robert MORRIS, simple polyhedrons which, in his own words, can be readily 'visualized' from any point of view. Typically, however, it came to be used of all cases where a documentary record or a set of instructions has taken the place of the familiar physical or quasi-physical art object. Perhaps the earliest attempt at definition was in Henry Flynt's essay on Concept Art (dated 1961) in La Monte Young's *Anthology* (1963): '"Concept Art" is first of all an art of which the material is concepts, as the material of e.g. music is sound. Since concepts are closely bound up with language, concept art is a kind of art of which the material is language.' But a great assortment and variety of artistic enterprises have been brought beneath the umbrella. Examples are the act of self-burial, of which still photographs taken at various stages were the only surviving record, or Claes OLDENBURG's *Placid City Monument*, for which he commissioned professional gravediggers to excavate a large rectangular hole in Central Park behind The Metropolitan Mus. of Art and then fill it up again.

The Tate Gal. *Biennial Report and Catalogue of Acquisitions* (1972–4) contained a 'Note on Conceptual Art' purporting to justify and explain the Gallery's inclusion of this kind of art in its collections. The Note opened with the paragraph: 'Over the past decade an ever-increasing quantity of new art has taken forms that go outside painting and sculpture. The new forms are not supplanting the old modes; but just as fully as present-day painting and sculpture they constitute a central, continuous development from fine art produced earlier in the century, and the development of art in our own period cannot be understood without coverage of these new forms. In 1972 the Gallery made a start of representing this new field, to much of which the loose label "conceptual art" has been applied internationally.'

The artists listed in the Note are: Jan Dibbits, Dan Graham, Douglas Huebler, Sol LeWitt, Bruce NAUMAN, Denis Oppenheim, Klaus Rinke and, working in Britain, Keith Arnatt, Victor Burgin, Judy Clark, Michael Craig-Martin, Hamish Fulton, John Hilliard, Richard Long, Bruce McLean, David Tremlett. Others who contributed to the development of the movement are: Robert Barry, Richard SERRA, Michael Heizer, Joseph KOSUTH, Lawrence Weiner, Keith Sonnier, Eva Hesse.

The Note claims that Conceptual Art is a logical continuation of two important trends in 20th-c. art: the tendency to direct the attention of the spectator increasingly upon the process by which an art work comes into being (the idea of the work) and the tendency to demand an ever increasing measure of spectator involvement not only in the form of appreciation but by actual participation. With regard to the latter, however, it seems to be at least as true that many practitioners of Conceptual Art have preferred to tread esoteric paths even to the verge of solipsism. As Professor Sam Hunter said in his *American Art in the Twentieth Century*: 'The self-referential quality of the Conceptualists' propositions belongs less to the genre of audience-participation games than to a kind of nonmaterialized, visionary sculpture, which very often includes the performer's own body and physical actions. The Conceptual artist is too intent on redefining his own reality in relation to art and language to consider directly involving spectators in the creation of his piece.'

The Tate Gal. Note goes on: 'Thus in many "conceptual" works consisting of materials such as photographs, maps or texts and referring to activities occurring elsewhere in time or space, the entity presented in a gallery is far from being a "mere documentation". It is, in itself, a formative and expressive stage in the imaginative totality that is the work. It is both dependent upon, and intimately close to, the activities it refers to, and an autonomous entity with its own characteristics as such.' It adds: 'Characterised by many of its critics as the negation of art, "conceptual" art not only marks another stage in art's self-renewal, but develops with a new vitality its traditional preoccupations with the human figure and with its setting in interiors and in landscape.' It is clear, then, that by the mid 1970s the rationale of Conceptual Art had not been comprehended by gallery keepers and critics although they were willing to bestow the traditional language of approval upon it as each new experiment in art was welcomed in its turn. But the confusion of ideas is patent. Re-

garded as objects of visual art, things intended to stimulate interest in their own intrinsic visual qualities—as calligraphy differs from the printed word—they are for the most part obviously trivial. Indeed there is no room for doubt that most artists in the field of Conceptual Art deliberately render their productions uninteresting, commonplace or trivial from a visual point of view in order to divert attention to the 'idea' they express. This may be accepted. The notion that aesthetic qualities may belong to *concepts* is not new. Aesthetic delight in the elegance or economy or consistency of mathematical theorems or scientific and philosophical theories has long been recognized. Beauty prizes are even awarded in chess tournaments. But artists have not usually been notable for either profundity or beauty and elegance in the conceptual field and the ideas to which works of Conceptual Art lead the spectator seem in most cases to be themselves shallow, commonplace or trivial. Two examples may suffice. Joseph Kosuth's *One and Three Chairs* (The Mus. of Modern Art, New York, 1965) combines a real chair, a photograph of a chair and a dictionary definition of 'chair'. This work certainly makes no attempt to be a visually interesting composition in the traditional sense. Yet the idea which it presents—real, tangible chair; photograph; definition of concept—is trivial in the extreme to anyone accustomed to operate in the realm of ideas. Sol LeWitt caused a metal cube to be fabricated and buried it in the ground in the Netherlands. The photographs of the event are not, and were not intended to be, fine examples of photographic art. The idea was blatantly and no doubt intentionally banal.

This deliberate triviality of object and idea does not mean that Conceptual Art may not signify the beginning of a new phase in the age-long metamorphoses of art forms. But it does indicate that its purposes, principles and rationale were still obscure to museum men, critics and art theorists in 1976. And so long as this remained the case there could be no firm basis for discriminating successful from unsuccessful, professional from amateurish, good from bad, examples of Conceptual Art.

CONCRETE ART. The word 'concrete' has borne a variety of meanings in the literature of art as the antonym of 'abstract' since the middle of the 19th c. Gustave Courbet, for example, in his Realist *Manifeste* of 1861 meant by 'concrete art' an art which depicts 'real and existing things' in contrast to the historical and religious art of the Academies and imaginative art in general. It first became a technical term in 1930 when Van DOESBURG issued a manifesto entitled *Art Concret*, disguised as the first number of a review (no other numbers were issued), in answer to the formation of the CERCLE ET CARRÉ association, to which he had been vigorously opposed. The short manifesto ran as follows:

Basis of Concrete Painting. We declare:
1. Art is universal.

2. The work of art should be entirely conceived and formed by the mind before its execution. It should receive nothing from nature's formal properties or from sensuality or sentimentality.

We want to exclude lyricism, dramaticism, symbolism, etc.

3. The picture should be constructed entirely from purely plastic elements, that is to say planes and colours. A pictorial element has no other significance than 'itself' and therefore the picture has no other significance than 'itself'.

4. The construction of the picture, as well as its elements, should be simple and controllable visually.

5. Technique should be mechanical, that is to say exact, anti-impressionistic.

6. Effort for absolute clarity.

The manifesto was signed by Carlsund, Van Doesburg, HÉLION, Tutundjian, Wantz. This is in fact a good definition of CONSTRUCTIVIST principles. It differentiates the sort of non-representational abstraction for which Constructivism stood from representational abstraction, which reduces the amount of differentiating detail in the depiction of natural appearances, and also from expressive abstraction (see ABSTRACTION). But it introduces no new concept.

Van Doesburg died in 1931 and his term 'concrete art' was not pursued until 1936, when it was taken up by Max BILL and Jean ARP in Switzerland. Under the name *Konkrete Kunst* Bill organized several exhibitions, including one in the Kunsthalle, Basle, in 1944, one at the Kunstgesellschaft, Zürich, in 1960 and at the Helmhaus, Zürich, in 1964. In 1941 he went to Brazil and the Argentine and propagated the concept of *Konkrete Kunst* there.

Max Bill conceived *Konkrete Kunst* as a form of Constructivism or geometrical abstraction which relies on mathematical principles to determine the proportions and relations among the parts. In this respect he was followed by the Zürich artists Richard LOHSE and Karl GERSTNER. In the exhibitions which he organized, however, he included artists such as MONDRIAN, TAEUBER-ARP, ALBERS, REINHARDT, STRZEMINSKI, as well as those who adopted a mathematical approach.

The name 'Concrete', 'Concretist' was adopted pretty generally in Sweden in the post-war period for artists working in the style of geometrical abstraction. It was applied to artists as diverse in style as, for example, Arne JONES, Olle BAERTLING, Lennart RODHE. In Italy the *Movimento per l'arte concreta (MAC)* was formed in 1948 under the auspices of Atanasio SOLDATI, Bruno MUNARI and the critic Gillo Dorfles. Lucio FONTANA, recently returned from the Argentine, was also associated with the movement and Giuseppe CAPOGROSSI worked for a time in a similar manner. In 1951 some 70 painters were represented at an exhibition entitled 'Arte Astratta e Concreta in Italia' at the National Gal. in Rome.

That Concrete Art had become virtually

synonymous with geometrical abstraction may be illustrated by the first important exhibition of abstract art after the war, which was staged at the Gal. René Drouin, Paris, in 1945 and entitled 'Art Concret'. Assembled with the help of Madame van Doesburg, it included works by such artists as the DELAUNAYS, DOMELA, HERBIN, Mondrian, KANDINSKY, MAGNELLI, Taeuber-Arp and PEVSNER.

If there is to be maintained a distinction between Concrete Art and Constructivism, it must be on the basis that in Concrete Art illusion is eschewed, the work itself and the elements from which it is composed are presented for just what they are without 'virtual' qualities. The materials do not simulate anything other than themselves. The slogan 'real materials, real space' has frequently been employed in connection with Concrete Art.

CONDER, CHARLES EDWARD. See NEW ENGLISH ART CLUB.

CONNER, BRUCE (1933–). American sculptor and experimental artist born at McPherson, Kan. After taking a degree at the University of Nebraska he studied at the Brooklyn Mus. School and the Kansas City Art Institute and School of Design. He was interested in film and obtained a First Prize at the University of Chicago Midwest Film Festival in 1963, a Ford Foundation Grant in 1964 and a Tamarind Fellowship in 1965. He had a retrospective show at the Institute of Contemporary Art, University of Pennsylvania, in 1967. Conner made ASSEMBLAGES from diverse materials, such as his *Medusa* from wax, nylon, hair, cardboard, wood (Whitney Mus. of American Art, 1960). His predilection for the horrific and bizarre brought him within the category of FUNK art, an example being *Couch* (Pasadena Art Mus., 1963), which represents a dismembered corpse upon a Victorian sofa.

CONSAGRA, PIETRO (1920–). Italian sculptor born at Mazara del Vallo, Sicily, studied at the Academy of Palermo. In 1944 he went to Rome and was associated with GUTTUSO and the NEW REALISTS. He was a member of the association *Forma* in 1947 and of CONTINUITÀ in 1961. In 1960 he obtained the International Sculpture Award at the Venice Biennale. He started in a mode of EXPRESSIONISM but in the 1950s he turned to abstract metal sculpture and evolved an individual style of *ferri transparenti*, which were shaped sheets of metal overlapping to form a relief and painted in a uniform colour. By their jagged edges, irregular shapes and pierced holes, however, these sculptures retained an expressive character. They were exhibited at the Marlborough-Gerson Gal., New York, in 1967–8.

CONSTANT (CONSTANT A. NIEUWENHUIS, 1920–). Dutch painter and experimental artist born at Amsterdam, studied at the Academy of Art there. In 1948 he was a member of the EXPERIMENTAL GROUP and later joined COBRA, painting in a violent and vigorous expressive manner with some suggestions of harsh figure representation. He helped edit *Reflex*, the journal of the Experimental Group, and there defined the aims of the group in accordance with the principles of ART INFORMEL in the ÉCOLE DE PARIS. But in the 1950s he turned towards CONSTRUCTIVISM and made spatial constructions. He was chiefly known for his project of an ideal city which he called 'New Babylon'.

CONSTANT, GEORGE (1892–1978). Greek-American painter and graphic artist, studied at Washington University and then at the Art Institute of Chicago School, 1914–18. After travelling to Europe he taught at the Dayton Art Institute School, 1920–2. Among his awards were: The Metropolitan Mus. of Art, Alexander Shilling Prize, 1939, 1945, 1956; Audubon Artists Emily Lowe Prize, 1966; the Parish Mus., Southampton, N.Y., First Prize, 1966; Guild Hall, East Hampton, N.Y., First Prize for Best Abstract Painting, 1966. In 1963 he was awarded the Cross of the Phoenix Brigade by the Greek Government. Among the many group shows to which he contributed were: Brooklyn Mus., '10 Years of American Prints—1947–56', 1956; United States Information Agency, '20th Century Highlights', 1957–8; New School for Social Research, 'Humanists of the 60s', 1963 and 1965. Among other public collections he has works in The Metropolitan Mus. of Art and the Brooklyn Mus., New York; Stedelijk Mus., Amsterdam; the Pennsylvania Academy of the Fine Arts; the Philadelphia Mus. of Art; the Smithsonian; the Whitney Mus. of American Art.

CONSTRUCTIVISM. Like so many other terms incorporated into the literature of contemporary art, 'Constructivism' is not exactly defined and its use has been by no means uniform. The words 'construction' and 'constructive' were in the air during the first two decades of the century to describe art which was deliberately composed rather than impulsive and extempory, although certainly not always art of a kind which would have come under the umbrella of later Constructivism. In the 1920s the name 'Constructivism' was adopted by two movements opposed in their aims and their ideology. One was confined to Soviet Russia, the other had ramifications in most countries of Europe. The latter is nowadays usually referred to as 'International Constructivism' or 'European Constructivism' to distinguish it from Soviet Constructivism.

While Soviet Constructivism was quite specific, European Constructivism was much more loosely designated and came in the course of time to cover a very wide spectrum of different schools and styles having in common only the negative features that they were all non-representational and were

not Expressive. It is unfortunate that identity of name has caused these two movements often to be discussed together as if they were different versions of a common underlying idea, and confusion has resulted. For example in his collection of Constructivist documents entitled *The Tradition of Constructivism* (1974) Stephen Bann took up LISSITZKY's identification of Constructivism with the 'New Man', and wrote: 'What can be stated quite categorically about constructivism is that it rejects the comfortable assumption of a "given" harmony between human feeling and the outside world. In contrast, it implies that man himself is the creator of order in a world that is neither sympathetic nor hostile, and that the artist must play a central role in determining the type of order that is imposed.' In fact there is no significant school of European Constructivism which accepted the basic ideas of the Russian Constructivists, while the aims and products of European Constructivism fall clearly under the condemnations of 'pure art' in the Russian Constructivist manifestos. The brothers GABO and PEVSNER and the works of MALEVICH, TATLIN, RODCHENKO, POPOVA, KLIUN, PUNI, ROZANOVA done before 1920 are by general consent brought within the ambit of International Constructivism. But all these were repudiated by Russian Constructivism. The movement called Constructivism in Russia was a deliberate rejection of earlier work which had quite close affinities with European Constructivism although it was not known by that name in Russia. Only Lissitzky accommodated himself to both Russian and European Constructivism.

SOVIET CONSTRUCTIVISM. In Russia the basic concept of 'Constructivism' came into currency *c.* 1920 to describe the ideology of those non-objective artists who were in favour of what came to be called PRODUCTION ART as against 'pure' art and 'laboratory' art (see INKHUK). The words 'construction' and 'constructiveness', which came into vogue during the CUBO-FUTURIST period, were adopted by Tatlin in connection with his *Painterly Reliefs* of 1914 and his later *Contra-Reliefs* and *Corner-Reliefs*. In these constructions he used 'real materials' instead of simulated effects and 'real space' instead of 'virtual' picture space. The important principle involved—the denial of simulation—was in some respects akin to what in the West has been called CONCRETE ART, that is art in which illusion is eschewed. It was a principle which, along with social usefulness, later became a central tenet of Soviet Constructivism. So too Tatlin's doctrine of the 'culture of materials'—the investigation and exploitation of the actual properties, aesthetic and practical, of 'modern' materials—became one of the preoccupations of the artists who later called themselves 'Constructivists'. The term 'Constructivist' was perhaps first used to refer to Tatlin's aesthetic ideology vis-à-vis the *Realistic Manifesto* of the brothers Gabo and Pevsner issued in August 1920; and in 1921 the term was being used publicly as, for ex-

ample, at the exhibition of MEDUNETSKY and the STENBERG brothers in Moscow. In the *Realistic Manifesto* Gabo himself used the words 'construction' and 'constructive' as key terms to describe the kind of non-objective art which he advocated, although then and later he avoided 'Constructivism' and 'Constructivist' as too doctrinaire. The main point of difference between Gabo and the rival faction (known sometimes as the 'Productionists') lay in the question of social utility. Gabo believed that creative art must be non-social and non-utilitarian, although social benefits may derive from it indirectly. The Productionists held rather fanatically that art must contribute directly to the betterment of socialist society, and this became a major principle of Soviet Constructivism. It was his own type of Constructivism that Gabo carried to the West, while inside Russia 'Constructivism' came to be used more and more frequently to refer to the aims and ideas of those artists who desired an art of social utility.

Soviet Constructivism evolved in the years following the 1917 Revolution when in spite of difficulties people were in a ferment of enthusiasm for the building of a better society on socialist principles. The 'artists of the left' were eager to contribute actively in the work of reconstruction. At a discussion organized at the Winter Palace in November 1918 by IZO NARKOMPROS (i.e. the Visual Arts section of the People's Commissariat of Enlightenment), Mayakovsky declared: 'We do not need a dead mausoleum of art where dead works are worshipped but a living factory of the human spirit—in the streets, in the tramways, in the factories, workshops and workers' homes.' The most important arts in these Revolutionary years were architecture and town planning, popular theatre, posters and propaganda literature (called 'Agit-Prop') and industrial design. Tatlin's doctrine of the 'culture of materials'—the investigation and exploitation of the actual properties of industrial materials—came into its own. It was a time when industrialization and the machine were venerated as a liberating force making possible the new Utopia. The distinction between artist and engineer was broken down and artists held themselves to be justified only by the mass production of socially useful goods. Rodchenko and Lissitzky worked on typography and book design along with Aleksei Gan; Rodchenko also designed furniture, clothing, workers' interiors, etc.; Tatlin designed furniture, ceramics and workers' costume; Malevich designed ceramics for the State Pottery; Varvara STEPANOVA, Popova and others worked at textile design; and many artists also did stage design for the popular theatre. Those who were not content to abandon traditional art for industrial design left the country (KANDINSKY, the Pevsner brothers, CHAGALL, and for a time Lissitzky) or devoted themselves to ineffectual borderline projects such as the 'Planity' of Malevich—experiments in three-dimensional architectural drawings: *Future Planity. Homes for Earth-Dwellers;*

People (Stedelijk Mus., Amsterdam, *c.* 1924)—or the impractical, if aesthetic, flying-machine of Tatlin (1929–32). Through the 1920s little 'exhibition' or 'museum' art—'fine art' in the traditional sense—was produced by Constructivism in Russia, although a 'purist' faction continued to exist (ERMILOV with his reliefs, Medunetsky with his constructions).

From the time of Tatlin's *Monument to the Third Communist International*, which embodied those utilitarian principles so alien to Gabo's creed, the theoretical basis of Constructivist art was intensively debated, though the statements which have come down to us consist largely of propaganda slogans and apocalyptic utterances not easy to interpret in sober and considered language—although exceptions should certainly be made for the Constructivist/Formalist critics, Arvatov, Brik, Punin and Tarabukin. Tarabukin's writings, in particular, such as his books *From the Easel to the Machine* and *Towards a Theory of Painting* (Moscow, 1923), did much to clarify the direction of the new art; Punin's articles also manifested a clarity and conciseness lacking in the more ebullient prose of Aleksei Gan (e.g. his booklet *Constructivism*, Tver, 1922) or some of the declarations in the journals VESHCH/GEGENSTAND/OBJET (Berlin, 1922) and the famous *Lef*. Camilla Gray summarized one of the *Lef* manifestos of 1923 as follows: 'The material formation of the object is to be substituted for its aesthetic combination. The object is to be treated as a whole, and thus will be of no discernible "style" but simply a product of an industrial order like a car, an aeroplane and such like. Constructivism is a purely technical mastery and organization of materials on three principles . . .' The key terms, in addition to 'construction', were 'tectonic' and 'facture'. In the catalogue of the exhibition *Art in Revolution* Kenneth Frampton wrote, drawing on Gan's own definitions: 'The Productivist group based the definition of Constructivism upon the subsequent definition of two additional compound terms, *"tektonika"* and *"faktura"*; the first referring to a complex of societal and industrial techniques, the second to the synthetic "objectivity" of its unimpeded realisation. *"Tektonika"* is derived from the structure of communism and the effective exploitation of industrial matter. Construction is organisation. It accepts the contents of the matter itself, already formulated. Construction is formulating activity taken to the extreme, allowing, however, for further "tektonical" work. The matter deliberately chosen and effectively used, without however hindering the progress of construction or limiting the *"tektonika"*, is called *"faktura"* by the group.' Obviously, Gan's definitions do little to illuminate the range of Constructivist terms; and in the case of the Constructivist artists themselves—Popova, Rodchenko, Stepanova, Tatlin—theoretical statements are often ambiguous and contradictory. Among other principal factors, it was this lack of inner cohesion which contributed to the decline of the Soviet Constructivist movement itself. In any case it is this obscurity of theory which makes the study of Soviet Constructivism such a hazardous venture.

In his Trowbridge Lecture delivered at Yale University in 1948 Naum Gabo formulated his considered opposition to Soviet Constructivism in words which would be acceptable to European Constructivists generally. He said: 'The word Constructivism has been appropriated by one group of constructive artists in the 1920s who demanded that art should liquidate itself. They denied any value to easel painting, to sculpture, in fine to any work of art in which the artist's purpose was to convey ideas or emotions for their own sake. They demanded from the artist, and particularly from those who were commonly called constructivists, that they should use their talents for construction of material values, namely in building useful objects, houses, chairs, tables, stoves, etc., being materialist in their philosophy and Marxist in their politics. They could not see in a work of art anything else but a pleasurable occupation cherished in a decadent capitalist society and totally useless, even harmful in the new society of communism. My friends and myself were strongly opposed to that peculiar trend of thought. I did not and do not share the opinion that art is just another game or another pleasure to the artist's heart. I believe that art has a specific function to perform in the mental and social structure of human life. I believe that art is the most immediate and the most effective means of communication between the members of human society. I believe that art has a supreme vitality equal only to the supremacy of life itself and that it, therefore, reigns over all man's creations.'

INTERNATIONAL CONSTRUCTIVISM. European Constructivism in the 1920s represents a reaction from the irrationalist attacks of DADAISM on the fundamental bases of traditional art and also from the impulsive and intuitive ideas of composition which later found their apogee in SURREALIST doctrines of unconscious creation and AUTOMATISM. By contrast Constructivism stood for conscious and deliberate composition—for which the word 'construction' was preferred—in conformity with universal and objective aesthetic principles. This was the gist of the ELEMENTARISM for which Van DOESBURG appealed in his article 'Elemental Formation' published in 1923 in the first issue of Hans RICHTER's review G. There is some parallel between these theories and those of PURISM. The two movements also shared a new aesthetic outlook, which set the highest store by simplicity, clarity and precision. But the Constructivists went further and stood for non-representational abstract constructions composed from non-representational, non-expressive and geometrical or near-geometrical elements.

During the early years of the decade there was some contact with Soviet Constructivism appro-

priately modified for European taste by the abandonment of the Soviet rejection of non-utilitarian art. Their own version of Constructivism, which had been condemned in Russia by the Productivists, was carried to Europe by the brothers Gabo and Pevsner, of whom Gabo left Russia in 1921 for Berlin and Pevsner for Paris in 1922. In Poland a Constructivist group BLOK was formed at Łódz in 1922 by Władysław STRZEMINSKI, who had worked with Malevich during the war, and a review of the same name was started in Warsaw in 1924. Together with Ilya Ehrenburg, Lissitzky founded a tri-lingual review *Veshch/Gegenstand/ Objet* in Berlin in 1922 for the purpose of publicizing a modified form of Soviet Constructivism in the rest of Europe, and also in Berlin, in 1923, Hans Richter with advice and help from Lissitzky and Van Doesburg commenced his review *G*, which he declared to be 'the organ of Constructivism in Europe'. The great exhibition of Russian art staged in 1922 at the Van Diemen Gal., Berlin, contained a section of Soviet Constructivist art organized by Lissitzky, but also contained pre-1920 works by Tatlin, Lissitzky, Rodchenko and the Suprematists. The catalogue note did not clearly differentiate between the Constructivist work proper and pre-1920 non-representational works, and the European Constructivists immediately hailed SUPREMATISM and other non-representational work as early manifestations of Constructivism. Constructivist ideas were introduced into the teaching of the BAUHAUS by MOHOLY-NAGY after he succeeded Johannes ITTEN there in 1923. The Bauhaus published a collection of MONDRIAN's essays from *De Stijl* in 1925 and in 1927 a German translation of Malevich's *The Non-Objective World*.

The first formal declaration of a European Constructivist group occurred at the Congress of International Progressive Artists held at Düsseldorf in 1922, when Van Doesburg, Lissitzky and Hans Richter registered a joint protest in the name of an International Faction of Constructivists. Subsequently during the 1920s attempts were made without formal organization to extend the principles of Constructivism to the literary arts, architecture and cinema. Although the French made comparatively little contribution to the growth of Constructivism, Paris offered a welcome shelter in the late 1920s and early 1930s for expatriate Constructivist artists. In 1930 the Constructivist association and magazine CERCLE ET CARRÉ were inaugurated in Paris with the young Belgian NEO-PLASTIC artist Michel SEUPHOR as editor. The magazine ran to only three issues but a successor was produced by Joaquín TORRES-GARCÍA in Montevideo with the title CIRCULO Y CUADRADO and in Paris the association and journal ABSTRACTION-CRÉATION: ART NON-FIGURATIF organized by HERBIN and VANTONGERLOO lasted from 1932 to 1936. The organization of these associations was not exclusive or dogmatic and they brought together a large number of artists with a wide spectrum of styles and opinions. They included Mondrian, GLEIZES, MAGNELLI, BAUMEISTER, Ben NICHOLSON, Gabo, Pevsner, VORDEMBERGE-GILDEWART, Jean HÉLION, Jean GORIN, Jean ARP and Sophie TAEUBER-ARP, DOMELA, EGGELING and many more. They were open to virtually every non-figurative artist of standing. In Switzerland Jean Arp and Sophie Taeuber-Arp had developed their own version of Constructivism and had designed the interior of the famous restaurant L'Aubette in Strasbourg. Switzerland with its international temper provided a favourable climate for Constructivist exhibitions and in 1937 a large exhibition at the Kunsthalle, Basle, gave evidence how broadly the term had come to be understood and how many diverse styles were included under its banner.

In the late 1930s a number of Constructivist artists moved to England and settled in London. They included Gabo, Pevsner, Moholy-Nagy, Gropius and Mondrian. They were in touch with Barbara HEPWORTH, Ben Nicholson, Henry MOORE and the critic Herbert READ. With the outbreak of war, however, they moved on to the U.S.A. and there was no indigenous Constructivist movement in Britain until the 1950s. In 1937 Gabo collaborated with Ben Nicholson and the young architect J. L. Martin in editing a collective volume CIRCLE, sub-titled 'International Survey of Constructive Art', for which he wrote an article on 'The Constructive Idea in Art'. In this essay he expanded 'the constructive idea' until it became indistinguishable from 'creative human genius' in science, art or any other sphere. His thesis was that CUBISM had been wholly destructive of naturalistic art. 'Our generation found in the world of Art after the work of the Cubists only a conglomeration of ruins.' Nothing was left on which to base a reconstruction of naturalistic art. But never before had an art without 'representation of the external aspect of the world' been conceived and 'this was the main obstacle to the rejuvenation of Art' after Cubism. 'It was at this point that the Constructive idea laid the cornerstone of its foundation. It has revealed as universal law that the elements of a visual art such as lines, colours, shapes, possess their own forces of expression independent of any association with the external aspects of the world; that their life and their action are self-conditioned psychological phenomena rooted in human nature; that those elements are not chosen by convention for any utilitarian or other reason as words and figures are, they are not merely abstract signs, but they are immediately and organically bound up with human emotions. The revelation of this fundamental law has opened up a vast new field in art giving the possibility of expression to those human impulses and emotions which have been neglected. Heretofore these elements have been abused by being used to express all sorts of associative images which might have been expressed otherwise, for instance in literature and poetry.' This, of course, is to stretch the meaning of

Constructivism—or 'the Constructive idea'—to embrace all non-representational abstract art, including expressive abstraction. Indeed, the language is very close to Kandinsky and might apply better to expressive abstraction than to Constructivism as usually conceived, which avoided emotionally expressive elements.

In the U.S.A. the SOCIÉTÉ ANONYME, founded by Katherine DREIER, organized exhibitions of modern art at the Brooklyn Mus. from 1926 which included works by ARCHIPENKO, Mondrian and Malevich. Abstract art was also shown at the Montross and Carroll galleries. In 1936 A. H. Barr Jr. organized a historic exhibition 'Cubism and Abstract Art' for The Mus. of Modern Art, New York, followed in 1938–9 by a Bauhaus show. In 1936 also the AMERICAN ABSTRACT ARTISTS association was formed and held its first exhibition in 1937. In 1937 the Guggenheim Mus. of Non-Objective Art was established in New York. As well as the Cubists it included works by KLEE, FEININGER and Constructivists such as Ben Nicholson and Moholy-Nagy. But despite the efforts of the American Abstract Artists association to make New York a centre for non-objective art, Constructivism did not take root at this time. As Barbara Rose said in her book *American Art since 1900* (1967), 'in the late thirties abstract art in America was a voice crying in the wilderness'. Constructivism was nevertheless kept alive by a growing stream of refugees from Europe. ALBERS left the Bauhaus in 1933 and took a teaching post in Black Mountain College, North Carolina. Moholy-Nagy founded the New Bauhaus in Chicago in 1937 and in the following year opened his own School of Design. Gropius went to Harvard in 1937. Mondrian left London for New York in 1940, had a one-man show at the Dudensing Gal. in 1962 and was given a retrospective exhibition in 1945, the year after his death, at The Mus. of Modern Art, New York. Gabo moved from London to Connecticut in 1946. While this stimulus to interest in Constructivism certainly bore some fruit, the more important post-war development in America was rather in the direction of ABSTRACT EXPRESSIONISM.

A new impetus was given to Constructivism by the publication in 1948 of Charles BIEDERMAN's *Art as the Evolution of Visual Knowledge*, followed by *Letters on the New Art* in 1951 and *The New Cézanne* in 1952. (Biederman used the term 'Constructionist art' roughly in the sense usually given to 'Constructivist art' but with emphasis on those later developments of Constructivism, better classified as CONCRETE ART, that concentrated on reliefs and constructions from which the factor of illusion had been abolished.) He argued that from the beginning the making of art had been dominated by two rival and conflicting purposes, the imitation of natural appearances and the exercise of man's 'inventive' or 'creative' faculty, which had led artists to display the typical and generic or to search for the 'ideal' instead of literally recording the 'uniquely particular or individual characteristics of the objective world'. Since the invention of the camera, men had slowly come to understand that the job of recording could be done more efficiently by mechanical means and that artists might therefore put it on one side and give themselves up wholly to 'invention'. Hence non-iconic abstraction or Constructivism. He then went on to argue that since illusion is no longer necessary after art has ceased to be representational, the illusion of three-dimensional space must also be abandoned. This involved the repudiation of almost all the Constructivist painting which had been done up to then and the rejection of painting as an art form since painting almost inevitably creates some degree of 'virtual' or illusory space. The argument is not sound. If illusion is not *necessary* to a non-iconic abstract art, it does not follow that it is *wrong*: it could plausibly be argued that the creation of an illusory three-dimensional space is itself a creative act and enriches the possibilities for creative artistry by increasing the complexity of interaction among freely created forms. But the argument had a strong appeal for many artists who were experimenting with three-dimensional 'constructions' and later for MINIMAL sculptors who held it a virtue to present their works as real things in the real world and to make them devoid of all 'virtual' visual properties.

In 1958 the Dutch artist Joost BALJEU founded a magazine *Structure*, which continued until 1964, with the object of bringing together these scattered groups and formulating a centralized aesthetics of Constructivism. The main contributors besides Baljeu himself were Charles Biederman from America, Anthony HILL and Kenneth MARTIN from England, Richard P. LOHSE from Switzerland and Jean GORIN, who had been active in the organization of the Abstraction-Création group and participated in founding the SALON DES RÉALITÉS NOUVELLES. Central to the idea of Constructivism as it developed during the 1950s and 1960s was a new mode of art on the borderline between painting and sculpture, ranging from the relief construction to the free-standing construct in perspex, vinyl or metal. Thus Anthony Hill could write: 'Due to Charles Biederman these problems have been taken up by artists who accept the construction as the successor to the old domain of painting and sculpture.'

Many Constructivists, including Biederman, have claimed that although any reflection of natural appearances is rigorously excluded, Constructivist art does reflect the *structure* of reality. Joost Baljeu adds that it is dynamic: 'Basic in the constructive attitude to reality is the idea that nothing is inert, everything is continually in movement . . . Reality is seen as a dynamic process, that is the constructive approach is interested in the way reality operates rather than the outer appearances of the phenomena.' Kenneth Martin said: 'My work is kinetic, whether the result is still or moving . . .'

With the expansion of interest in making three-dimensional constructions completely free of 'illusion', the idea of *concrete* Constructivism, an art free of all 'virtual' qualities, proliferated in many directions. It had affinities on the one hand with developing KINETIC sculpture, LUMINISM and the new Space sculpture; but also with OP ART, MINIMAL ART, the sculpture of Tony SMITH, Anthony CARO, Robert MORRIS, Donald JUDD, etc.; with SYSTEMIC and SERIAL art; and with the Spatiodynamism originated by Nicolas SCHÖFFER. In Britain the leaders of the movement were Kenneth and Mary MARTIN and Anthony Hill. In France the Salon des Réalités Nouvelles and the GROUPE DE RECHERCHE D'ART VISUEL fell within the broadening ambit. And as the scope widened, the meaning of the term 'Constructivist' became more general and more vague until in 1968 George Rickey could write in his book *Constructivism: Origins and Evolution*: 'In the pages which follow, "constructivist" will refer to the work of a group of Russians between 1913 and 1922, which include Tatlin, Malevich, Rodchenko, El Lissitzky, Naum Gabo, Antoine Pevsner, and briefly Wassily Kandinsky. Their work was, in general, geometrical and non-mimetic. It will also refer to Dutch art which resembled that of the Russians but did not derive from it, to the ensuing painting and sculpture in Europe and America which emanated from the two groups, including "Concrete Art" and "Kalte Kunst", and to much of the work done in such groups as "Cercle et Carré", "Réalités Nouvelles" and "American Abstract Artists". The term will also encompass more recent work characterised by such neologisms as "hard edge", "post-painterly abstraction" and "primary structures", as well as the most all-embracing European term, "new tendency", which was a cry of mutual recognition rather than a definition of a style.'

In view of this very wide extension of meaning it is useful to speak of 'geometrical' as opposed to 'expressive' abstraction, the former being very roughly equated with Constructivism.

CONTEMPORARY ART SOCIETY OF AUSTRALIA. The main organization in Australia for the furtherance of progressive art, established in opposition to the Australian Academy of Art. See AUSTRALIA.

CONTEMPORARY GROUP, THE. An association of artists founded in 1925 by Thea Proctor (1897–1966) and George Lambert (1873–1930) in Sydney. See AUSTRALIA.

CONTINUITÀ. A group of Italian artists formed in 1961 with the critic Carlo Argan as its spokesman. The members, some of whom had previously belonged to the group *Forma* which had been established in 1947 in Rome, included: Carla ACCARDI, Pietro CONSAGRA, Piero DORAZIO, Gastone NOVELLI, Achille PERILLI, Giulio TURCATO. They were joined by Arnaldo and Giò POMODORO, Parmeg-

giani Tancredi and Lucio FONTANA. In the exposition of their aims the name *Continuità* was given a twofold meaning. On the one hand they called for an overhauling of current Italian painting and sculpture in order to re-establish continuity with the historical greatness of Italian art. On the other hand they stood for continuity or order *within* the art-work as opposed to the disorderliness of INFORMALIST art. Some members also held that there should be continuity of the art-work with its spatial environment in accordance with Fontana's doctrines.

COOL ART. Term used first by the critic Irving Sandler in 1965 for a type of SERIAL ART, whether abstract or POP, which he contrasted with EXPRESSIONISM as being characterized by calculation, impersonality, futility and boredom. Barbara Rose referred to the term as a synonym for MINIMAL ART or ABC art, which she described as 'an art whose blank, neutral, mechanical impersonality contrasts so violently with the romantic, biographical ABSTRACT EXPRESSIONIST style which preceded it that spectators are chilled by its apparent lack of feeling or content'. See also COLD ART.

CORBETT, EDWARD (1919–71). American artist born at Chicago, studied at the California School of Fine Arts. After travelling to Mexico and the Philippines and serving in the U.S. Merchant Marine, he taught at the California School of Fine Arts, 1947–50, Mount Holyoke College, 1953–62, and at the universities of California, New Mexico and Minnesota. He exhibited at the Grace Borgenicht Gal., New York, from 1956 and had retrospectives at the Massachusetts Institute of Technology, 1959, and the Walker Art Center, Minneapolis, 1961. Among the group shows in which he was represented were: Art Institute of Chicago, 'American Abstract Artists', 1948; The Mus. of Modern Art, New York, 'Fifteen Americans', 1952; Whitney Mus. of American Art, 'Art of the U.S. 1670–1966', 1966. Among other collections he has work in The Mus. of Modern Art, New York; Tate Gal., London; Whitney Mus. of American Art; San Francisco Mus. of Art; Albright-Knox Art Gal., Buffalo.

CORBUSIER, LE. See LE CORBUSIER.

CORDEIRO, WALDEMAR. See LATIN AMERICA.

CORINTH, LOVIS (1858–1925). German painter born at Tapiau, East Prussia, studied at the Academy of Königsberg (1876–80) and then until 1883 at Munich. From 1884 to 1887 he studied in Paris under Bouguereau and Robert-Fleury. After his return to Germany he lived in Königsberg (1881–91), Munich (1891–1900) and then Berlin. His reputation, like LIEBERMANN'S, was that of a leading representative of the German Impressionism which grafted certain of the newer French techniques on to the naturalistic German tradition and

against which the younger EXPRESSIONISTS were in revolt. In 1911 however, Corinth suffered a stroke by which his right arm was paralysed. He subsequently taught himself to paint with his left hand and his later landscapes are in a cruder, more violent idiom which brings them within the ambit of the newer Expressionist art.

CORNEILLE (CORNELIS VAN BEVERLOO, 1922–). Painter born at Liège of Dutch descent. He studied drawing at the Academy in Amsterdam but was self-taught as a painter. In 1948 he was a member of the Dutch EXPERIMENTAL GROUP and in the same year joined the COBRA group. In 1950 he went to Paris with Karel APPEL and settled there. He has been claimed both as a Belgian and as a Dutch painter, but after he settled in Paris his work showed little traces of either Dutch or Belgian tradition. He developed a style of expressive abstraction within the ÉCOLE DE PARIS based in part upon aspects of the work of PICASSO and MIRÓ, with decorative calligraphic ornamentation. He was awarded a Guggenheim Prize in 1956. In 1966 he had a retrospective exhibition at the Stedelijk Mus., Amsterdam.

CORNELL, JOSEPH (1903–73). American sculptor born at Nyack, N.Y. He was without formal training in art and his place in the development of American art depends chiefly on his 'boxes', housing surprising collections of romantic or Victorian bric-à-brac, which have been said to combine the formal austerity of CONSTRUCTIVISM with the lively fantasy of SURREALISM, and have been aptly called 'star-maps of a private universe'. Like Kurt SCHWITTERS he could create poetry from the commonplace. Unlike Schwitters, however, he was fascinated not by refuse, garbage and the discarded, but by fragments of once beautiful and precious objects, relying on the Surrealist technique of irrational juxtaposition and on the evocation of nostalgia for his appeal. His first one-man exhibition was at the Julien Levy Gal., New York, in 1932 and since that time his work has been included in many collective exhibitions of Surrealist and contemporary American art. He received awards from the Chicago Art Institute in 1959 and from the American Academy of Arts and Letters in 1968; he had retrospective exhibitions at the Pasadena Art Mus. in 1966 and at the Solomon R. Guggenheim Mus. in 1967. Cornell is honoured as a forerunner and pioneer in the art of ASSEMBLAGE and in this field his example has exercised a wide influence. In certain aspects of his work he is also regarded as a pioneer of American POP ART. The idea of 'box' sculpture has had a considerable following.

CORONEL, RAFAEL. See LATIN AMERICA.

CORPORA, ANTONIO (1909–). Italian painter born in Tunis of Sicilian parents. He studied in the Tunis Academy with Armand Vergeaud, who had been a fellow-student of MATISSE and DUFY under Gustave MOREAU. He then went to Florence in 1929, where he copied old masters in the Uffizi Gal. From 1930 to 1937 he worked in Paris with visits to Italy and Tunis, and in 1939 settled in Rome. In 1939 he had a one-man show at the Gal. del Millione, in which his works showed a CUBIST influence heightened by FAUVIST colour. In 1946 he became an active member of the FRONTE NUOVO and was in 1952 one of the GRUPPO DEGLI OTTO PITTORI ITALIANI. In 1952 he was the subject of an essay by the critic Christian Zervos, published in *Cahiers d'Art*. From Cubist and Fauvist influences Corpora developed in the direction of expressive abstraction and from the end of the 1940s he was painting in a TACHIST manner akin to that of BAZAINE and other followers of Roger BISSIÈRE, who based their abstractions on nature. Thus he was important in the development of Italian Informalism or ART INFORMEL. During the 1950s, however, he began to paint abstract colour compositions which had no basis in natural appearances. He had a one-man show at the Venice Biennale in 1960.

CORRENTE. An anti-Fascist association of young Italian artists formed by Renato BIROLLI in Milan in 1938 with GUTTUSO, MAFAI, MIRKO and AFRO among its members. The association had no fixed artistic programme beyond a desire to go further than the ROMAN SCHOOL in opposing what they regarded as the provincialism of the NOVECENTO and the official art. They stood for the defence of 'modern' art at a time when the Nazi campaign against DEGENERATE ART (*Entartete Kunst*) was spreading to Italy. The organ of the association was a review of literature, politics and the arts, edited by the young painter Ernesto Treccani (1920–), which appeared in January 1938 with the title *Vita Giovanile*, changed in the autumn of the same year to *Corrente di Vita Giovanile*. The association arranged an exhibition in March 1939, in which older Milanese artists were included, and a second exhibition in December of the same year in which only the younger set participated. The review was suppressed in 1940 but the association continued its activities in conjunction with the Gal. Bottega (later named Gal. della Spiga e Corrente) until dissipated by the war.

Other members of the association were: Arnaldo Badodi (1913–42); Domenico CANTATORE; Bruno Cassinari (1912–); Guido Chiti (1918–); Agenori FABBRI; Pericle FAZZINI; Antonio Ghezzi (1915–); Piero Martina (1912–); Giuseppe Migneco (1908–); Ennio MORLOTTI; Gabriele Mucchi (1899–); Aligi SASSU, who was arrested in 1937 for political activity; Giuseppe SANTOMASO; Fiorenzo Tomea (1910–60); Italo Valenti (1912–); Emilio VEDOVA.

CORTIJO, FRANCISCO. See SPAIN.

CORTOT, JEAN (1925–). French painter, born

in Alexandria, adopted son of the pianist Cortot. He entered the studio of Othon FRIESZ in 1942 and in the same year joined the group L'ÉCHELLE, exhibiting with them in 1943. His first one-man show was at the Gal. Visconti in 1944. After serving in the war he exhibited regularly at the Salon de Mai and won the Prix de la Jeune Peinture in 1948. He had a one-man show at the Gal. Valloton, Lausanne, in 1954 and exhibited at Brussels with CÉSAR at the Gal. Apollo the same year. From 1957 he exhibited at the Gal. Jacques Massol. Cortot developed from a form of neo-CUBISM in his student days to expressive abstraction, although his abstractions always had their point of departure in natural appearances and he would concentrate on a particular theme—the harsh landscapes of the Ardèche, the human face—for a period of years.

COSTA, GIOVANNI ANTONIO. See GRUPPO N.

COUGHTRY, GRAHAM. See CANADA.

COUNIHAN, NOEL (1913–). Australian painter and graphic artist born in Melbourne. His childhood was rendered unhappy by family differences due to his father's Roman Catholicism and drinking habits and his mother's Protestantism. From the age of 8 to 15 he served as a chorister at St. Paul's Cathedral, Melbourne. In 1930 he joined the evening classes in drawing at the National Art Gal. School, Melbourne, and became associated with the left-wing group of artists and writers who met in the workshop of William Dolphin, a violin maker, several of whom contributed to the periodical *Stream*. The group included the artists Herbert McLintock and Roy Dalgarno, the writers Judah Waten and Cyril Pearl, the bookseller Gino Nibbi and the Marxist intellectual Guido Barrachi. From this time Counihan read widely in Schopenhauer, Nietzsche, Dostoevsky, Balzac, Gorky, Marx and Engels. In a family dispute his father burnt many of his books and Counihan found shelter in the Workers' Art Club at Royal Lane, Melbourne. During the early years of the Depression in the 1930s he drew pencil portraits and caricatures, and took an active part in political demonstrations. Later he played a prominent part in the politics associated with the formative years of the CONTEMPORARY ART SOCIETY OF AUSTRALIA. In 1933 he visited New Zealand to sell drawings in order to finance a trip to Europe. With the outbreak of war he became involved in the anti-conscription campaign in New Zealand, was arrested and deported to Australia. He spent much of 1940 at the Gresville Sanatorium, Victoria, recuperating from tuberculosis.

Shortly after his discharge he met the Jewish artist Josl Bergner, who encouraged him to paint. His early paintings, such as *The New Order* (1940), carried a direct political message; but dissatisfied with this approach, he turned to personal recollections of the early Depression years in Melbourne, and in such paintings as *At the Start of the March* (Art Gal. of New South Wales, 1944) created some of his most memorable works. In 1945 he won first prize in the 'Australia at War' exhibition held in the National Art Gal. of Victoria. In 1946 Bergner, O'Connor and Counihan exhibited in the 'Three Realist Artists' exhibition at the Myer Gal., by which they sought to affirm their position and their discontent with the trends then prevailing in the Contemporary Art Society of Australia.

In 1949 Counihan attended the First World Peace Conference at the Salle Pleyel, Paris, as a member of the Australian delegation. There he arranged for a message signed by PICASSO, Neruda, Bernal, Joliot Curie, GROMAIRE and Fougeron to be sent to Australian intellectuals, urging support for the Conference. Addressed to the writer Vance Palmer, it was for reasons unknown not received. Counihan visited Czechoslovakia, Hungary and Poland and then settled in London, where he lived for two years at the Abbey Arts Centre, Hertfordshire, supporting himself as a press cartoonist and caricaturist. In 1951 he held an exhibition of drawings at the Irving Gal., Leicester Square, and later that year returned to Victoria, where he settled in the Dandenongs and painted for some years in Tom Roberts's former studio at Kallista. In June 1956 he visited the U.S.S.R. with a trade union delegation. On his return he completed a series of paintings based on Australian pub life, and won the Crouch Prize for 1956 with *On Parliament Steps* (Fine Art Gal., Ballarat, 1955). Two years later he won the John McCaughey Memorial Prize with *After Work* (National Art Gal. of Victoria, 1958). In 1960 he visited Moscow for an exhibition of Australian Realist art, which included also the work of Herbert McLintock, V. G. O'Connor and James Wigley.

During the 1960s Counihan painted many pictures based on the life of the Australian Aborigines and a series of mother and child paintings which were related to the Vietnam War. In 1969 he visited Mexico, France and eastern Europe, where he found new inspiration in the folk carving of Poland. On his return to Australia in 1970 he began a series of self-portraits. These and his *Laughing Christ* paintings brought a new expressive force to his realism which was revealed in a large exhibition held at the Commonwealth Gals., London, in 1973. Apart from his paintings, Counihan's drawings and graphic art are highly regarded.

COUTAUD, LUCIEN (1904–). French painter born at Meynes, Gard. After studying at the École des Beaux-Arts, Nîmes, he went to Paris in 1924 and worked in various private art schools, where he came under the influence of SURREALISM. He continued to paint in a style of fantastic and fairylike Surrealism in which parts of the human body and incongruous objects were linked in a semi-abstract design. A typical example is *La Jupe verte* (Mus. National d'Art Moderne, Paris, 1945).

From 1926 he did a great deal of work for the theatre and a considerable body of graphic work. He was a founding member of the Salon de Mai and he exhibited at the Venice Biennale in 1948.

COUTURIER, ROBERT (1905–). French sculptor born at Angoulême. He went to school in Paris, where his parents moved in 1910, and at the age of 13 began to learn lithography at the Estienne school. But on the death of his father in 1924 he was compelled to work with commercial lithographers and to take a number of other jobs in order to earn a living. From early boyhood he had been devoted to drawing and later he did not lose sight of his ambition to become an artist. He was first able to practise sculpture in the studio of Armand Bloch, for whom he posed as a model. He put in unsuccessfully for the Blumenthal prize in 1928, but was awarded it in 1930. In this way he met MAILLOL, who was one of the judges, and became his disciple and protégé. In 1929 he obtained a small teaching post and through the 1930s participated in various group exhibitions, including the Salon des Tuileries, the Salon du Temps Présent, and the Salon de la Jeune Génération. In 1936 he was commissioned to do the statue *Le Jardinier* for the esplanade of the Palais de Chaillot, Paris, and the Mus. du Petit-Palais bought his bronze *Fillette au Chapeau pyramidal*. He did 200 plaster figures, since destroyed, for the Pavillon de l'Élégance at the Exposition Universelle of 1937, which had a *succès de scandale*. In 1938 he was commissioned by the State to do a low relief 3 m high for the monumental portal of the Palais de l'Ariana at Geneva. Although he continued to speak of Maillol with gratitude and respect, he was conscious during these years of deliberately throwing off his influence and working towards a very different ideal of sculptural form, more attenuated, more open, and expressive by gesture rather than by statement. He himself declared that he had finally freed himself from the Maillol influence in his *Leda* of 1944 in which, while he retained fullness of volume, he employed a very different method in the articulation and movement of masses.

In 1944 he returned to Paris and resumed teaching, being appointed Professor of Sculpture at the École des Arts Décoratifs in 1945. His *Saint Sebastien*, done 1944–5, an image of wartime deportations, is a rare example of gravely expressive distortion and was described by the artist as the only one of his works which had dramatic feeling. To the same category belong his monument to the 16th-c. humanist Étienne Dolet—commissioned by the State in 1946 but not cast because of unfavourable comment when the plaster was exhibited at the Salon des Indépendants—the secularized *Adam and Eve* (Mus. National d'Art Moderne, Paris, 1946) and the bronze *Couple Debout* (1947), of which examples exist in several private collections. During the 1940s and 1950s, however, he was mainly, though not exclusively, developing the 'weightless', open style of sculpture with which his name is chiefly associated. It is a style in which more and more importance was given to enclosed spatial volumes until in some works the enclosed voids and suggested empty volumes are of greater significance than the solid bands by which they are demarcated. This development can be traced in a series of works from the *Fillette Sautant à la Corde* (*c.* 1950) in the open-air sculptural museum at Middelheim Park, Antwerp, and *Armature pour une Baigneuse* (Mus. d'Art Moderne de la Ville de Paris, 1954) to *Deux Nageuses* (School of the Mus. of Fine Arts, Boston, 1962). In many of his works he modelled the clay in such a way as to suggest the tattered materials and refuse which were actually used by the ARTE POVERA artists. Among others this method is employed in his *Femme s'essuyant la Jambe* (Mus. National d'Art Moderne, Paris, 1952), which provoked a scandal when it was included in a travelling group show in 1960. Couturier wished his figurative work to be regarded as realistic. But he was interested not in reproducing the shapes and forms of visual reality but in *suggesting* the attitudes, gestures, incipient movements which are most characteristic. Examples of this may be seen in *Jeune Fille Lamelliforme* (Mus. d'Arte Moderna, Rio de Janeiro, 1951) and *Femme qui Marche* (Groupe Scolaire de la Forêt, Évreux).

From the mid 1940s his work gradually became more widely known both inside France and abroad. He was one of the founders of the Salon de Mai in 1945 and exhibited there subsequently. He was represented at the Venice Biennale in 1945 and 1950 and at the first Bienale de São Paulo in 1951. In 1947 he was invited to exhibit and lecture by the Anglo-French Art Centre in London. He was made Chevalier de la Légion d'honneur in 1953 and Officier de l'Ordre du mérite in 1967. In 1959 he had a one-man show at the Maison de la Pensée, Paris, and in 1960 at the French Pavilion in the Venice Biennale. In 1963 he travelled to the Far East and carved the monumental abstracts *Manazaru* and *Jeune Fille Accoudée*. In 1966 he visited the U.S.A. and Mexico, being invited to lecture at the Boston School of Fine Arts, where he was also given a one-man exhibition. During these decades his works were increasingly included in collective exhibitions in Europe and Japan and elsewhere in the world.

Couturier also executed a number of medals for the Administration des Monnaies et Médailles, using a technique of line engraving upon a flat background rather than relief. A similar technique was employed by him on a much larger scale for murals done for the French Embassy at Tokyo in 1960. His medals include *Maillol* (1949), *Louis Braille* (1952), *David d'Angers* (1966), *Baudelaire* (1967) and *Nicolas Untersteller* (1969).

COUZIJN, WESSEL (1912–). Dutch sculptor born in Amsterdam, studied in the Netherlands but lived extensively in the U.S.A. (New York,

1915–29 and 1931–2; New York and New Orleans, 1941–6). He worked mainly in bronze and in the 1950s, under the influence of LIPCHITZ and the ABSTRACT EXPRESSIONIST sculptors, he moved from a simplified figural style to abstract spatial work such as was being done by Seymour LIPTON and Theodore ROSZAK in America. During the 1960s he began to incorporate real components in his work in the manner of the California JUNK school. He also began to create a world of imaginary beings with affinities to science fiction. In 1967 he was awarded the Dutch National Prize for sculpture, and in 1968 he had an important exhibition at the Stedelijk Mus., Amsterdam. His best-known work was his *Corporate Entity* (Rotterdam, 1962).

COVERT, JOHN (1882–1960). American painter born at Pittsburgh, Pa. He studied at the Pittsburgh School of Design, 1902–8, and in Munich, 1908–12, although he also visited Paris and England and exhibited at the Paris Salon in 1914. He was Secretary of the SOCIETY OF INDEPENDENT ARTISTS when it was formed in 1916 and the SOCIÉTÉ ANONYME was started with a gift of his paintings in 1923. Covert was one of the early American CUBIST painters, extending the Cubist concept of COLLAGE particularly in his 'string' paintings such as *Brass Band* (Yale University Art Gal.), 1919). He ceased painting in 1923 and took up a business career.

COX, JAN (1919–80). Belgian painter born at The Hague. He went to Belgium at the age of 17, first to Antwerp and then to Brussels. He was a founder member of the association *Jeune Peinture Belge*, although unlike most of the members he continued to paint in a figurative manner. In 1956 he went to teach in Boston. Cox has often been classified as a SURREALIST but although fantasy and dream function largely in his work, he repudiated this categorization.

COX, KENELM (1927–68). British painter and poet, studied at the Camberwell School of Art. He was a pioneer in England of the movement away from traditional modes of painting towards a form of concrete poetry, including KINETICS, which would form a bridge between the poetic word and the visual image. He was also a pioneer of the MULTIPLE. His first one-man show, at the Lisson Gal., included two reliefs, *Suncycle* and *Moontrack*, which were afterwards issued as multiples. In 1968 he contributed to the I.C.A. exhibition 'Cybernetic Serendipity'.

CRAIG, GORDON (EDWARD HENRY CRAIG, 1872–1966). British theatrical designer and graphic artist born at Stevenage, son of the actress Ellen Terry. Chiefly known as a theatrical designer and producer, Craig was also an artist in water-colour and engraving, working for the press over a number of years. He is also remembered as a pioneer of LUMINISM and KINETIC art in view of

experiments made at his centre, the Arena Goldoni, Florence, with moving geometrical blocks and light.

CRAIG-MARTIN, MICHAEL. See CONCEPTUAL ART.

CRAMPTON, ROLLIN MCNEIL (1886–1970). American painter born at New Haven, Conn., studied at Yale University and the Art Students' League. He worked as mural supervisor under the FEDERAL ARTS PROJECT. His first one-man exhibition was at the Woodstock Art Gal., New York, in 1958 and during the 1960s he exhibited at the Stable Gal. Among the collections in which he is represented are: Albright-Knox Art Gal., Buffalo; Massachusetts Institute of Technology; The Metropolitan Mus. of Art, New York; State University of New York at New Paltz; Whitney Mus. of American Art; Walker Art Center, Minneapolis. His work was often in advance of his time and he was recognized as a pioneer in certain of the techniques later exploited by MINIMAL artists.

CRAWFORD, RALSTON (1906–78). Canadian-American painter, born at St. Catherines, Ont., and lived in Buffalo, N.Y., from 1910. He studied at the Otis Art Institute, Los Angeles, 1926–7, the Pennsylvania Academy of the Fine Arts, 1927–30, and at the Académie Colarossi and the Académie Scandinave, Paris, 1932–3. His first one-man show was at Maryland Institute, in 1934, after which he exhibited widely in the U.S.A. and was represented in many group exhibitions. He had retrospectives at the universities of Alabama (1953), Milwaukee (1958), Kentucky (1961), Minnesota (1961) and Creighton (1968). He took as his subject matter the familiar imagery of the urban industrial scene, putting the emphasis on abstract pattern, and in this respect he has been likened to SHEELER. Like Sheeler, too, he became deeply interested in photography. During the 1940s his work became more abstract and, while he continued to work from industrial themes, he reduced his subjects to their elementary geometrical shapes so that recognizability was often lost, although he still communicated an impression of strength and power.

CREEFT, JOSÉ DE (1884–1982). Spanish-American sculptor born at Guadalajara. After studying in the atelier of Augustin Querol, Barcelona, he studied at the Académie Julian, Paris, in 1906 and at the Maison Greber, 1910–14. He went to the U.S.A. in 1929 and became a citizen in 1940. He taught at the New School for Social Research, 1932–48 and 1957–62, and at the Art Students' League, 1934–62. He was a member of the Federation of Modern Painters and Sculptors and their President in 1943. His commissions included: a War Memorial for Saugues, Puy-de-Dôme, France, 1918; 200 pieces of sculpture for the Fortress of Ramonje, Mallorca, 1932; 'Alice in Won-

derland' group for Central Park, New York, 1959; mosaics for the Bronx Municipal Hospital (nurses' residence), 1962. Among his awards were 'Officier de l'Instruction Publique', France; First Prize at The Metropolitan Mus. of Art 'Artists for Victory' show, 1942; George D. Widener Memorial Gold Medal at the Pennsylvania Academy of the Fine Arts, 1945; Audubon Artists' Gold Medal of Honour, 1954 and 1957; Therese and Edwin Richard Prize for Portrait Sculpture at the National Sculpture Society, 1969. His first one-man exhibition was at the Circulo de Bellas Artes, Madrid, in 1903 and his first in America at the Seattle Art Mus. in 1929. A circulating retrospective exhibition of his work was staged by the American Federation of Arts and the Ford Foundation in 1960.

CREUSETS. Name given to concave low-relief pictorial constructions developed particularly by Edgard PILLET.

CRIPPA, ROBERTO (1921–72). Italian painter and sculptor born at Monza, studied at the Accademia di Brera, Milan, under CARRÀ and FUNI. At the beginning of his career he painted in a style of expressive abstraction with SURREALIST overtones under the influence partly of MATTA. In the late 1940s he was influenced by the ideas of FONTANA and was a member of the Movimento Spaziale. He began to do three-dimensional constructions c. 1956 and is best known for his painted constructs and relief collages. His work continued, however, to have expressive quality which was to some extent in conflict with the cool objectivity of the SPAZIALISMO movement. He had an exhibition at the Kunsthalle, Mannheim, in 1965.

CROOKE, RAY AUSTIN (1922–). Australian painter, born at Auburn, Victoria, and studied at the Swinburne Technical College, Melbourne. After serving in the war he returned to Swinburne Technical College in 1946 as a member of the staff, teaching drawing and fabric design. In 1963 he was represented at the Tate Gal. Exhibition of Australian Art. In 1972 he had a retrospective exhibition at the Adelaide Festival of Art and in 1973 one of his paintings was presented by the Commonwealth Government on the occasion of the Independence of the Bahamas. His first one-man exhibition in Britain was in 1974 at the Leicester Gals. He is known particularly for his landscapes of North Queensland, Thursday Island, Fiji and New Guinea. These are executed for the most part in colours of low key, strongly delineated and often achieving startling impressions of space.

CROTTI, JEAN (1878–1958). Swiss-French painter born at Bulle in the Canton of Fribourg, studied for a short time in 1898 at the School of Decorative Arts, Munich. In 1901 he joined the Académie Julian, Paris, but began to paint on his own in 1902. He was influenced c. 1910 by CUBISM and also by FUTURISM but prided himself on retaining his artistic independence from both movements. In 1914 he went to New York, where he knew Marcel DUCHAMP and François PICABIA and joined the DADA movement. He returned to Paris in 1916 and in 1919 married the painter Suzanne Duchamp. In 1921 he exhibited Dadaist paintings with Suzanne Duchamp at the Montaigne Gal., Paris, and from that time he began to paint abstracts as well as characteristic and rather mannered heads, often using two heads to form a composition. In 1927 he became a French citizen by naturalization and he was made Chevalier de la Légion d'honneur in 1950.

In 1936 Crotti originated the technique of the *gemmaux*, compositions like mosaics made from splinters of stained glass built up in layers and lit from behind. Paintings by well-known artists were often reproduced in this medium. He had a retrospective exhibition at the Mus. d'Art et d'Histoire, Fribourg, in 1973.

CRUZ DÍAZ, MARIA. See SPAIN.

CRUZ-DIEZ, CARLOS (1923–). Venezuelan painter born in Caracas and studied at the Caracas School of Fine Arts, 1940–54, which he co-directed from 1958 to 1960. He also directed the art department of McCann Erickson, 1946–51, and founded the Estudio de Artes Visuales for graphic art and industrial design in 1957. During those years he also taught typography at the School of Journalism of the University of Venezuela and did illustrations for the Caracas newspaper *El Nacional*. He first exhibited in Caracas in 1947. In the 1950s he became interested in optical phenomena. In 1960 he went to France and joined the Denise René group. In the course of experimenting with the primaries in arrangements of thin intersecting bands he found that he could create the illusion of a third or fourth non-existent colour. This led him to further experiments in series entitled 'Chromatic Inductions', 'Chromointerference', 'Additive' and 'Physichromy'. In the last, which he began in 1959, he created shifting geometric images that emerge, intensify, change and dematerialize as the viewer moves from one side of the work to the other. He achieved this effect by means of narrow vertical strips of metal, or plastic bands appended to the flat surface, and vertical painted colour lines. Cruz-Diez has exhibited frequently in Europe and in North and South America from the early 1960s onwards. In 1967 he participated in the SALON DES RÉALITÉS NOUVELLES in Paris, and 'Latin American Art' at The Mus. of Modern Art in New York, and in 1976 he exhibited at the Denise René Gal. in New York. His awards include the Grand Prix at the Córdoba Bienale in Argentina (1966) and the International Award for Painting at the São Paulo Bienale (1967). There are several films on his work.

CSÁKY, JOSEPH (1888–1971). French sculptor, born at Szegred, Hungary, and studied briefly at the Budapest Academy of Applied Arts. He went to France in 1908, where he was influenced by MAILLOL and later by the CUBISTS, with whom he exhibited at the Salon d'Automne and Salon des Indépendants in 1911. He returned to Hungary to serve in the war but was back in Paris in 1919 and became a naturalized French citizen. He was among the earliest to construct figures of cones, cylinders and spherical segments and Cubism remained the dominant idiom of his work. But he did not enter into so deep an understanding of the principles of Cubism as did such sculptors as LAURENS, LIPCHITZ or DUCHAMP-VILLON, and his later work, particularly after 1935, was modified by tendencies to classicism.

CSONTVARY-KOSZTKA, TIBOR (1853–1919). Hungarian painter, born in Kisszeben. He was a pharmacist and later studied medicine. He began to paint in 1880 and in 1894 abandoned his pharmacy for an artist's career, travelling extensively outside Hungary. His painting had a childlike quality and spontaneity united with a rich personal fantasy. He is sometimes included in exhibitions of NAÏVE painting, but although self-taught he was not a genuine naïve. He adapted to his own purposes many features of Post-Impressionist European styles and achieved a creative stylistic synthesis of his own.

CUBISM. Cubism was created by PICASSO and BRAQUE, working at first along parallel lines and later in close collaboration. It is generally accepted that the movement was inaugurated by Picasso's picture *Les Demoiselles d'Avignon* (1906–7) and Braque's *Nude* (1907–8). The early period of Cubism, which lasted until about the autumn of 1912, is usually called Analytical Cubism and the later period Synthetic Cubism. The name 'Cubism' originated with Louis Vauxcelles, the critic of *Gil Blas*, who had been responsible also for 'Fauves' and 'Expressionism'. Reviewing an exhibition of paintings by Braque at the Kahnweiler Gal. on 14 November 1908, he referred to '*cubes*', and to '*bizarreries cubiques*' on 25 May 1909. The first reference to a Cubist school occurred in 1910 when Robert DELAUNAY, Henri LE FAUCONNIER, Albert GLEIZES, Fernand LÉGER and Jean METZINGER exhibited together at the Salon des Indépendants and the Salon d'Automne. Guillaume APOLLINAIRE described their paintings as a 'flat and lifeless imitation of Picasso'. During the winter of 1910–11 they formed themselves into a group and were able to exhibit as a group in a separate gallery at the Salon des Indépendants in the spring of 1911. In a neighbouring gallery were hung works by Roger de LA FRESNAYE, André LHOTE, Jean MARCHAND and André DUNOYER DE SEGONZAC. In the course of the year new recruits included the three DUCHAMP brothers, PICABIA, ARCHIPENKO, Mare, RETH, LÉGER and Marie LAURENCIN (who

was accepted among the Cubists though her work was not in fact Cubist). During 1912 new accessions included GRIS, SURVAGE, MARCOUSSIS, HERBIN, MONDRIAN, RIVERA and KUPKA. Some of these artists were only marginally Cubist in style and many of them abandoned Cubism within the next few years. Among the critics the movement was supported by Guillaume Apollinaire, André Salmon, Roger Allard and Maurice Raynal. Gleizes and Metzinger published their book *Cubisme* in 1912 and in 1913 appeared *Les Peintres cubistes. Méditations esthétiques* by Apollinaire.

From 1911/12 Cubism became more widely known internationally and provided the impulse which inspired a number of related movements. The Italian FUTURISTS, who already knew of Cubism through reproductions and through reports by SEVERINI, made direct contact when BOCCIONI, RUSSOLO and CARRÀ visited Paris in February 1911. Although they were irritated by the lack of concern shown by Cubist artists for vital human interests and were alienated by the lack of dynamism and movement in Cubist pictures, the Futurists learned much from the techniques of representation invented by Cubism and were perhaps closest to Cubism of all related movements. Indeed many artists of stature tried subsequently to amalgamate Cubism and Futurism into a single style. In Russia works by members of the Cubist school were included in the KNAVE OF DIAMONDS exhibitions and works by Picasso were being collected by Shchukin. MALEVICH used the term CUBO-FUTURIST of works which he exhibited in 1913 and Cubist as well as Futurist influences stimulated the RAYONIST movement launched by LARIONOV and GONCHAROVA. In Germany works by Cubist artists as well as the FAUVES were shown at Düsseldorf, Cologne, Berlin and Munich under the blanket title of 'Expressionism' and some Cubist influence contributed to the style developed by the BLAUE REITER group, particularly Franz MARC. In Czechoslovakia there arose an *avant-garde* school which tried to amalgamate Cubism and Germanic EXPRESSIONISM into a new national style. On the whole, however, the Expressionist enthusiasm of almost all the innovatory German artists proved to be infertile soil for the anti-Expressionist austerity of Cubism. While in England Cubism made little headway at this time, some Cubist works were included in the Second Post-Impressionist exhibition organized by Roger FRY and Cubism made a notable contribution to the style of the VORTICIST movement. Wyndham LEWIS, like the Futurists, accused Cubism of being too restricted to academic techniques of representation and lacking the 'quality of life', but he admitted that their works had a plastic grandeur which the Futurists missed. Cubist works were exhibited in Amsterdam by the Circle of Modern Artists in 1911 and 1912, in Barcelona in 1912, in Prague by the group of *avant-garde* artists in 1913 and 1914, and they made a strong impact in America at the ARMORY SHOW of 1913. A native American form of Cubism, referred

to as CUBIST-REALISM, grew up from *c*. 1915.

In its origins Cubism was a technique of Realism. In deliberate revolt against current Expressionism from Gauguin, Van Gogh and the NABIS to the Fauves, it rejected both sensuous and decorative appeal with devoted austerity. Because they were primarily concerned with evolving a new technique of representation, both Picasso and Braque during these early years preferred neutral subject matter, avoiding themes with any strong human appeal or emotional associations, and began to practise a near-monochrome, camaieu style of painting in order to eliminate the emotional overtones of colour. But they were equally in revolt from the optical realism of the Impressionists, which was still prevalent during the first decade of the century. Whereas the Impressionists had made it their aim to depict the coloured surfaces of things animated by changing light, the realism of analytical Cubism was descended from the 'perceptual realism' of Cézanne. They wished to depict the permanent structure of things as perceived in their solid, tangible reality. They adopted various devices for furthering this aim, many of them anticipated in a milder form by Cézanne, all of them now familiar though at the time they were strange and revolutionary. The picture space was made artificially shallow, i.e. recession from the eye was reduced in the manner of relief sculpture, in order to give greater emphasis to the picture surface. The shallow picture space was articulated by faceted planes running at fine angles, contiguous and overlapping. Objects—guitars, violins, heads, figures, etc.—were 'analysed' into planes revealing their voluminous structure and were then fragmented and brought within the system of planes articulating the picture space. Sometimes fragments of an object seen from different viewpoints were combined in one picture and sometimes a shifting perspective was introduced in the articulation of space, as had been done by Cézanne. The austere, rigorously logical technique which was devised by Picasso and Braque and mastered by Léger—though Léger preferred cylindrical and curvilinear to cubic and rectilinear forms—became a mannerism in the hands of artists who constituted the Cubist 'school' and often degenerated into nothing more than a fashionable disguise for traditional painting.

The second phase of Cubism, generally known as Synthetic Cubism, emerged from a new technique of PAPIERS COLLÉS begun by Braque in the autumn of 1912 and pursued by Braque, Picasso and Juan Gris in collaboration. Pieces of newspaper, wall-paper, oilcloth, match boxes, programmes, etc. were stuck on to the canvas 'and combined with drawing (Braque) or with drawing and oil painting (Picasso and Gris). The material stuck on to the canvas was made to perform a dual role. It was seen for what it was as part of the picture surface and at the same time fulfilled a representational function in the virtual space of the picture image. Soon an added ambiguity was in-troduced as pictures were painted wholly in oils simulating the works which combined *papiers collés* with drawing or painting. Brighter and more strongly contrasting colours began to be used and Picasso and Gris would thicken their pigment with sand and other materials. Whereas the earlier, so-called Analytical Cubism was developed primarily as a technique of representation, in Synthetic Cubism the construction of a stable and unified pictorial composition from fragmented figural abstractions became the paramount consideration. Synthetic Cubism was developed along parallel paths by Gris, Picasso and Braque. From 1918 Braque gave more attention to sensuous and tactile quality and to the expressive values of resonant colours and textures. The movement virtually ended in 1920 when OZENFANT and JEANNERET founded the review *L'Esprit Nouveau* to publicize the ideas of PURISM. Douglas Cooper with some justification considered Picasso's *Three Masked Musicians* of 1921 to be the last truly Cubist painting. The influence of Cubism nevertheless remained both widespread and strong until the 1940s.

Juan Gris said: 'Today I am clearly aware that, at the start, Cubism was simply a new way of representing the world.' In Synthetic Cubism, however, there was a change of emphasis. The analysis of solid forms into geometrical planes for the purpose of revealing structure gave way to an overriding interest in construction. As has been said, the dominant interest was now in assembling fragmented abstractions into a pictorial structure. The shallow picture space was retained but the restriction to neutral colours was abandoned. Local colour was used descriptively and monochromatic shading was used to define form and to position volumes in picture space by the differentiation of planes. Sometimes the picture plane functioned as background and the objects depicted were made to advance towards the observer in a virtual space in front of the picture plane. Brighter colours and stronger colour contrasts were allowed, though, except in the case of Braque, the sensuous and expressive qualities of colour were charily used. The change of attitude from analysis to pictorial construction may be what Gris had in mind when he made an often quoted statement in an article contributed to *L'Esprit Nouveau* No. 5 in 1921. 'I try to make concrete that which is abstract. I proceed from the general to the particular, by which I mean that I start with an abstraction in order to arrive at a true fact . . . Cézanne turns a bottle into a cylinder, but I begin with a cylinder and create an individual of a special type: I make a bottle—a particular bottle—out of a cylinder.'

CUBIST SCULPTURE. Cubist painting was concerned at the start with the problem of representing realistically in a two-dimensional medium the solid tangible reality of things perceived. Sculpture, however, is itself solid, voluminous, three-dimensional and its problem is therefore different. The basic problem of sculpture, explored from the time

of classical antiquity, has been to represent by means of a visible surface the internal structure and solidity of objects. This problem is not necessarily solved most effectively by the Cubist technique of analysing the surface into geometrical planes with sharply defined arrises. Sculpture was therefore of minor importance in the early history of Cubism.

Picasso was interested in sculpture for the bearings it had upon his pictorial problems and techniques. In 1909–10 he modelled *Woman's Head* (bronzes at Fort Worth Art Center Mus. and Los Angeles Mus. of Art) in which the analysis of the volume into faceted planes is analogous to the analytical and faceted heads he was drawing and painting at this time. In 1910 he did a painted bronze *Absinthe Glass* (Philadelphia Mus. of Art) more decorative in character and belonging rather to the category of the constructions to which he gave the name TABLEAUX-OBJETS. The opening up of one side of this construction to display internal volume was an early anticipation of a method developed by ARCHIPENKO and leading on to more recent Space Sculpture. In a small group of sculptures made by de la Fresnaye in 1911 and the *Standing Woman* of the Hungarian-born sculptor Joseph CSAKY (Mus. National d'Art Moderne, Paris) of 1913–14 the analysis of the form into broader planes is a stylistic mannerism derived from Cubist painting. The Czech sculptor Emil FILLA, who with GUTFREUND and the painter V. Beneš exhibited in 1913 at the STURM Gal., Berlin, used block-like forms with emphatic planes to create a feeling of mass and solidity. Working in Prague from 1912 Gutfreund used concavities and convexities with surface modelling to create a play of light which combined Expressionist with Cubist aesthetics. His *Cubist Bust* of 1912–13 and *Woman's Head* of 1919 (both in the Národní Gal., Prague) are, however, more closely in keeping with the style of Synthetic Cubism.

Raymond DUCHAMP-VILLON came into contact with members of the Cubist circle who met at the house of his brothers, Jacques VILLON and Marcel DUCHAMP, in 1912 and under their influence radically altered his manner of sculpture. His plaster *Seated Girl* of 1914 converts the human body into a system of rounded cylindrical and conical forms with a clear relation to the paintings of Léger. His bronze *Horse* also of 1914 (which exists in a smaller and a larger version) is the outstanding masterpiece of sculpture from the Cubist circle at this time. Representational features are reduced to a minimum and the system of dynamically interacting abstract forms evocative of the power and energy of a horse comes closer to the spirit of Futurism than to that of Cubism. It ranks with the two fine quasi-Cubist sculptures of the Futurist BOCCIONI, *Unique Forms of Continuity in Space* and *Development of a Bottle in Space* (The Mus. of Modern Art, New York, 1913 and 1912–13). In the latter work Boccioni anticipated Space Sculpture even more strikingly and illustrated the prin-

ciple enunciated in his Preface to the catalogue of the 'Exhibition of Futurist Sculpture' held in Paris in June 1913, that by the entrance of a void into a solid 'blocks of atmosphere' may be united with 'more concrete elements of reality'. A similar opening up of space was a feature of the single sculpture, *Spiral Rhythm* (1915), by the Russian-born American artist Max WEBER. Although it was based upon the human torso, figurative likeness had virtually disappeared.

Although these works are generally classed as 'Cubist' there is little similarity among them and no common trend. If there is a kinship with Cubist painting, it is certainly not closer than might equally be alleged of other sculptures, such for instance as EPSTEIN's *Rock Drill* and some of the sculptures of GAUDIER-BRZESKA. The three major sculptors who may justifiably be regarded as Cubist, at any rate for part of their careers, were Archipenko, LIPCHITZ and LAURENS.

Archipenko was associated with the SECTION D'OR in 1912 and developed a highly individual mode of sculpture with features derived from Cubism. His style was based upon formal abstractions, strong rhythms and a characteristic interplay between hollows and convexities, using voids in a positive way to replace or represent solid volumes. From *c.* 1915 he evolved his *Sculpto-Peinture* consisting of painted relief constructs in which abstraction was devoted to decorative aims. In 1921 he went to Berlin and severed his connection with Cubism. In his figurative sculpture Archipenko applied the principle of Synthetic Cubism as enunciated by Juan Gris: instead of abstracting from human figures he built them up architecturally from independently conceived sculptural elements. He was the first systematically to use concave shapes as sculptural components and so to convert space into a sculptural element. It was an innovation which had a long development.

The Lithuanian Jacques Lipchitz came to Cubism in 1914–15. From the *Sailor with a Guitar* (Albright-Knox Art Gal., Buffalo) of 1914, which is a naturalistically conceived figure made fashionably decorative with mannered Cubistic planes and faceting, he had progressed by 1916 to abstracts composed of vertical rectangular planes transversed diagonally to emphasize mass. In these the importance of the figurative content had receded and it was barely recognizable. By 1916, under the influence of Gris, he had evolved a more figurative style in which the figures were defined by chunky, geometrical forms articulated with advancing and receding planes to suggest mass. He also did painted pictorial reliefs of still lifes in the late Cubist manner. From the late 1920s he embraced a more expressive, baroque style which was no longer closely related to Cubism.

Henri Laurens, self-taught, came to Cubism in 1915 under the influence of Braque and Picasso. He at first made *papiers collés* and painted relief constructs in the manner of Picasso's *tableaux-objets*. These are described by Douglas Cooper as

'not, properly speaking, sculptures' but 'brilliant and inventive interpretations in three dimensions of Synthetic Cubist paintings'. In 1918 he abandoned these methods and began to carve directly in stone and model in plaster, evolving a highly individual mode of sculptural Cubism conceived in the round. These works were, typically, solid, chunky, squarish blocks, frontally conceived, which preserved a strong sense of the mass from which they were cut. They were articulated with broad, flat planes, penetrating the block in step-like recession, which carried the eye around and into the form, enhancing the impression of volume. Laurens also abandoned his Cubist style in the mid 1920s.

As a stylistic and fashionable mannerism Cubist influence survived. But there was nothing which could be called genuine Cubist sculpture except in the decade 1914–24. Even then the work done was highly individual to the few sculptors mentioned and nothing like a general style emerged.

CUBIST-REALISM. A native American form of CUBISM which was developed from *c.* 1915 onwards by Charles DEMUTH, Charles SHEELER and artists of the PRECISIONIST school. Unlike the European Analytical Cubists, the Americans did not regard their subject matter as neutral and indifferent but painted American themes. They simplified the forms of what they painted to the verge of abstraction but without abandoning recognizability, revealing the fundamental structure of things in near-geometrical pictorial compositions. But they did not disintegrate reality or use the simultaneous presentation of multiple viewpoints and their method was therefore closer to that of Cézanne than to the Analytical Cubism of PICASSO and BRAQUE. Besides being almost as closely wedded to American themes as the later painters of the AMERICAN SCENE, they selected for preference subjects, such as machinery and plant or simple, unadorned colonial architecture, which were intrinsically adapted for the simpler forms of geometrical abstraction.

CUBO-FUTURISM. The GOLDEN FLEECE exhibitions in Moscow of 1909 already revealed an incipient reaction on the part of some Russian artists against French Neo-Impressionism and FAUVISM. On the part of GONCHAROVA and LARIONOV this reaction took the form of a cultivated primitivism based upon Russian peasant art and sometimes linked with CUBIST mannerisms. A similar primitivism was apparent in the painting of the brothers Vladimir and David BURLIUK shown at the KNAVE OF DIAMONDS (*Bubnovyi Valet*) exhibition organized by Larionov in 1910 and the DONKEY'S TAIL (*Oslinyi Khvost*) exhibition of 1912. The term 'Cubo-Futurist' was applied by MALEVICH to works he submitted to the Donkey's Tail exhibition and to the TARGET exhibition of 1913, works in which the peasant subjects introduced by Goncharova were treated in the manner of the

early 'tubular' works of LÉGER. There are both Cubist and Futurist features in his picture *The Knife Grinder* (Yale University, 1912), which was shown at the Target exhibition. But in general, if one excepts RAYONISM, Futurism made a greater impact upon poets than upon painters in Russia. Some historians, however, have used the term 'Cubo-Futurist' to describe this primitivist reaction generally, far though it often is from either Cubism or Futurism.

CUENCA, JUAN. See EQUIPO 57.

CUETO, GERMÁN. See TORRES-GARCÍA, Joaquín.

CUEVAS, JOSÉ LUIS (1934–). Mexican painter born in Mexico City. Cuevas began drawing at an early age. While convalescing from a serious boyhood illness he became a voracious reader. At the age of 10 he enrolled as an irregular student at the School of Painting and Sculpture 'La Esmeralda' in Mexico City. He began exhibiting in the early 1950s and is regarded as one of the foremost representatives of the neo-figurative movements that emerged in Latin America from the late 1950s onwards. Cuevas specialized in incisive satirical ink, wash and pencil drawings of grotesque creatures and degraded humanity, often including self-portraits in his compositions. Although he followed the tradition of Goya, his work was strongly flavoured by 19th- and 20th-c. literature, contemporary life and horror and detective films. He made many drawings in insane institutions and represented the poor children and prostitutes of Mexico City. His distaste for the 'Mexican nationalism' of RIVERA and SIQUEIROS, and his rebellion against the Muralist establishment in Mexico, led him to coin the expression 'the Cactus Curtain'. However, he acknowledged a debt to OROZCO, whose own satirical sense, expressed in his murals and his early cartoons, perpetuates a Mexican tradition of black humour popularized by José Guadalupe Posada in the 19th and early 20th c. Following a first exhibition in a vacant lot, Cuevas had his first gallery exhibition at the co-operative Gal. Prisse in 1953 in Mexico City. In 1954 the Cuban art critic José Gomez Sicre organized an exhibition of his work at the Pan American Union in Washington, which launched the artist abroad. When he exhibited at the Gal. Edouard Loeb in Paris in 1955 PICASSO bought two of his drawings. From then on he exhibited regularly in the U.S.A., Europe and Latin America. He won the first international prize for drawing for his series *Funeral of a Dictator* (1958) in the São Paulo Bienale in 1959 and the same year showed at the Gal. Bonino in Buenos Aires. In 1960 he exhibited at the Art Center in Fort Worth and the Philadelphia Mus. of Art. His series *The World of Kafka and Cuevas* (1957) is in the collection of the latter museum. In 1962 he exhibited his series *Cuevas Por Cuevas* (also the title of an autobiography published in Mexico City in 1965) at the Gal. Silvan Simone in Los

Angeles and in 1963 at the Andrew-Morris Gal. in New York. He participated in several group exhibitions of a polemical nature such as 'The Insiders' in New York and Los Angeles in 1960. The exhibitions were named after Selden Rodman's book of that title, in which the author praises the work of Cuevas and other neo-figurative artists as representative of a new humanism. In 1961 Cuevas participated in an exhibition with Mathias GOER-ITZ and Pedro Friedeberg at the Gal. Antonio Souza in Mexico City entitled 'Los Hartos' (The Fed-Ups) as an indictment of the 'vacuity' of much modern art. Cuevas denounced the elegant Paris school especially. The French critic Jean Cassou found his work very Mexican in its 'passionate, cruel sense of truth' and, according to the Argentinian critic Marta Traba, Cuevas took part in a 'resistance' movement against international art-market demands by establishing a Latin American identity as an artist. Cuevas also designed theatrical sets and participated in many symposia and wrote two other autobiographies, *Cuevario* and *Cuevas Contra Cuevas*. He also illustrated numerous books, including *Recollection of Childhood* (1962) and *Crime by Cuevas* (1968). His work is in public and private collections in Latin America, the U.S.A. and France.

CUIXART, MODESTO (1925–). Spanish painter, born at Barcelona. After abandoning the study of medicine he devoted himself to painting in 1946. In 1948 he became a founder member of DAU AL SET and painted in the SURREALIST manner favoured by that group though with anticipations of expressive abstraction. After abandoning painting for a period he resumed again c. 1956, working in the manner of ART INFORMEL. His explosive and colourful style of rich impastos was enhanced by the use of sumptuous silvers and golds which he obtained by means of metal powders. In 1957 he was awarded the Torres García prize at the Salón de Mayo, Barcelona, and in 1959 the First International Prize at the São Paulo Bienale and the First Prize for Abstract Art at Lausanne. About 1965 his abstracts began to assume a more mystical and magical character with bizarre suggestions of faces, limbs or figures. An example of this manner is *Sentiments Capgirats per la Mort del Gos* (1972), which was included in the exhibition 'Arte '73' arranged by the Juan March Foundation and shown at the Marlborough Gal., London. In the late 1960s he also reverted to figuration, sometimes attaching real objects to the canvas surface.

He has shown in collective exhibitions at the Mus. des Arts Décoratifs, Paris, the Tate Gal., London, The Mus. of Modern Art, New York, the Solomon R. Guggenheim Mus., New York, and the Carnegie International, Pittsburgh. Outside Spain his work is represented at The Mus. of Modern Art, New York, and at Buenos Aires, Rio de Janeiro, São Paulo and Tel Aviv.

CULLEN, MAURICE. See CANADA.

CUMBERLAND MARKET GROUP. When the CAMDEN TOWN GROUP merged with the LONDON GROUP in 1913 a smaller group was formed and was named after 49 Cumberland Market, where Robert BEVAN had his studio, and where he, GILMAN and GINNER used to meet. In 1915 they were joined by John NASH and later by McKnight Kauffer and C. R. W. NEVINSON.

CURATELLA MANES, PABLO (1891–1962). Argentine sculptor born in La Plata. He first studied with Arturo Dresco, Lucio Correa Morales and at the Academia Nacional de Bellas Artes in Buenos Aires. In 1911, with a grant from his native state, he went to Europe, first visiting Florence, Rome and Milan, where he saw the work of the Renaissance masters and was equally impressed with BOCCIONI's *Technical Manifesto of Futurist Sculpture* of 1912. In 1914 he settled in Paris, where he studied with Bourdelle. He obtained the Silver Medal in the 1925 Exposition des Arts Décoratifs there. From 1926 onwards he embarked on a diplomatic career, which permitted him to remain in France and continue his sculpture although his official duties at the Argentine Embassy absorbed much of his time. In Paris his association with PICASSO, LAURENS, LIPCHITZ and Juan GRIS helped him to determine his direction as a sculptor. His work of the early 1920s such as *The Guitarist* (1921) and *Reclining Nymph* (1922) was strongly related to that of Lipchitz, but by the mid 1920s his sculpture had become lighter, airier and freer, as in *Rugby, Dance* and *The Bird* (1952). Curatella Manes was a pioneer of CUBIST sculpture in Argentina. When his work was first exhibited at the Gal. Witcomb in Buenos Aires in 1924 it was ill received by the public and by more conservative artists, as was the work of the Cubist painter PETTORUTI when it was shown in the same gallery. The Buenos Aires *avant-garde* at the time was represented by the movement created around the *Revista Martinfierro* and Alberto Prebisch defended Curatella Manes's work in an article in the November 1924 issue of the review.

The sculpture of Curatella Manes retained figurative elements within a Cubist aesthetic until 1940, then became purely abstract. He used Argentine national themes and evocations of tropical flora for a while in the 1920s and early 1930s, as in *Motivo Criollo* (1921) and *The Gaucho and His Horse*, and in 1937 he did a series of low reliefs for the Paris Exposition Universelle in his earlier style. But his *Torso Triangular* and *Torso Feminino* (1940–4) are totally abstract although they seem to allude to the human figure with their great curved masses. In 1947 he returned to Buenos Aires from Paris and after shorter official trips to Oslo and Athens in 1949 and 1950 settled in Argentina. In 1950 he was named Director of Cultural Affairs in Buenos Aires and in 1958 was appointed Argentine Commissioner to the Brussels World Fair.

Curatella Manes did not reap the financial rewards for his work nor have a studio of his own until 1961, the year before his death. He none the less participated in numerous international exhibitions, including the Venice Biennale of 1952 and the São Paulo Bienale of 1953. The work of his last period is judged to have been his most original and vital. He was awarded the first prize for sculpture at the Buenos Aires National Salon in 1947. But many of the works he had done between 1921 and 1943 were not shown in Argentina until 1964 when, at the insistence of the artist's widow, the painter Germaine Derbecq, a retrospective of his work was organized at the Mus. Nacional de Bellas Artes in Buenos Aires, in whose collection he is now represented.

CURNOE, GREGORY RICHARD (1936–). Canadian experimental artist, born in London, Ont., studied at Beal Technical School, London (1954–5), Doon School of Fine Arts, Kitchener (1956), Ontario College of Art, Toronto (1956–60), where he was failed in his senior year. He was encouraged by various Toronto artists, such as Graham Coughtry, Richard Gorman and Michael SNOW and Joyce WIELAND, with whom he kept in contact after his return to London. In London he helped to found a magazine, *Region*, the Nihilist Party of London, and a kazoo free-music group, the Nihilist Spasm Band. His first one-man show, an 'Exhibition of Things', was held in a public library in London in 1961. The following year he arranged a HAPPENING, *The Celebration*, at the London Art Mus. An exhibition at the Vancouver Art Gal. in 1966 featured paintings on plywood with COLLAGE and ASSEMBLAGE elements and rubber-stamped words and phrases. Subse-

quently, in frequent exhibitions at the Isaacs Gal., Toronto, he displayed collages of the paper scraps collected in his pockets, lettered diaries on plaques (the 'Time Series'), his huge *View of Victoria Hospital Second Series* (National Gal. of Canada, Ottawa, 1971), water-colour landscapes, life-study drawings, and various series of lettered paintings. In 1967–8 he designed a 560 ft (171 m) long mural for the Montreal International Airport, but it was removed shortly after its installation because it was alleged to express anti-American sentiments.

Curnoe represented Canada at the 10th São Paulo Bienale, and at the 1976 Venice Biennale he showed paintings on plywood of the views from his studio windows. These were displayed at the Canada House Gal., Trafalgar Square, London, England, in December that year. He exhibited in most major Canadian cities, and was known for his critical writing and film-making as well as for his painting and music.

CURRY, JOHN STEUART (1897–1946). American painter and muralist, born in Dunavant, Kan., and trained first at the Art Institute, Kansas City, and then at the Art Institute, Chicago. He came to public notice with realistic scenes of American life such as *Baptism in Kansas* (Whitney Mus. of American Art, 1928) and *Hog Killing a Rattlesnake* (Chicago Art Institute, 1930) and he became a leading artist of the REGIONALIST group, dramatizing and romanticizing the life of the Middle West and the sagas of the American pioneers. Notable among his works are the murals he did for the Department of Justice in Washington, D.C. and for the state capitol in Topeka, Kansas. From 1936 he was Professor of Art at the University of Wisconsin.

D

DACRE, WINIFRED. See CIRCLE.

DADA. The movement named 'Dada' was not a new style or technique like FUTURISM, CUBISM or NEO-PLASTICISM but, in the words of Tristan Tzara, 'a state of mind'. For this reason it is difficult to pinpoint its exact beginnings or its end. But although earlier anticipations of this or that aspect of Dada are continually being discovered by historians, it is generally agreed that the first concrete manifestations took place in New York and Zürich about 1915–16, at the height of the First World War. The nature of the movement and of its manifestations were closely conditioned by the time and circumstances in which it arose. It was a movement of young people—poets, writers, artists, musicians—who were profoundly disillusioned and disgusted by the senseless barbarities of the war and were in total protest against the traditional social values which had made the war possible, if not inevitable. They were subversive, iconoclastic, revolutionary. They took over and exaggerated the Futurist techniques of outrage and provocation in an unrestrained assault on the standards and conventions of respectable society, attacking by mockery and caricature a culture which seemed to them ripe for suicide. Included in their attack were the conventions of art—even and indeed especially the pre-war *avant-garde* artistic movements—and by the satirical parody of ANTI-ART they tried to undermine the very concept of art itself. While its noisy boisterousness made the movement difficult to ignore, the perverse cult of irrationality made it equally difficult to combat on equal terms and has constituted a perplexity and a dilemma to its later recording in history.

The core of positive purpose behind the nihilistic fireworks displays has proved particularly difficult to elucidate. Though the very existence of a positive purpose was apt to be contemptuously ridiculed during the movement's heyday, looking back in a calmer and more reflective mood many of the leaders have agreed that there was a positive as well as a negative aspect to their turbulence. For example the German painter and film producer Hans RICHTER, one of the Zürich Dada group, wrote in his account of the movement, *Dada. Art and Anti-Art*, in 1964: 'Dada had no unified formal characteristics as have other styles. But it did have a new artistic ethic from which, in unforeseen ways, new means of expression emerged. These took different forms in different countries and with different artists, according to the temperament, antecedents and artistic ability of the individual Dadaist. The new ethic took sometimes a positive, sometimes a negative form, often appearing as art and then again as the negation of art, at times deeply moral and at other times totally amoral.' He also says: 'It was not an artistic movement in the accepted sense; it was a storm that broke over the world of art as the war did over the nations. It came without warning, out of a heavy, brooding sky, and left behind it a new day in which the stored-up energies released by Dada were evidenced in new forms, new materials, new ideas, new directions, new people—and in which they addressed themselves to new people.'

There was in most of the adherents to the movement a leaning towards the fantastic, the marvellous and the irrational and it is not without justification that the exhibition 'Fantastic Art, Dada, Surrealism' arranged in 1947 for The Mus. of Modern Art, New York, by A. H. Barr, Jr. treated Dadaism as a 20th-c. episode in the long history of 'fantastic art'. When Dadaism broke up *c.* 1922 it was succeeded by SURREALISM and many of the leaders of Dadaism were subsequently prominent in the Surrealist movement. So far as regards this aspect of Dada, anticipations may be found in the strangely hallucinatory paintings of CHIRICO which were already attracting attention in 1913, just as the blatant desire to attract attention by shocking and outraging the public had been anticipated by the manifestos of Futurism. Another positive contribution of Dada was the concept of Anti-art. It is a concept which has appeared again and again in later decades of the century and the vitality which it has shown is evidence that it was not *merely* a repudiation by burlesque, parody and ridicule of the whole traditional concept of art but that it also involved the substitution of something new in its place by taking over the traditional temples of orthodox art, the galleries and the museums. This aspect of Dada was anticipated mainly in America by Marcel DUCHAMP and to some extent by MAN RAY and Francis PICABIA. In addition the Dadaists were among the first to make use as a matter of principle of *chance* in the composition of works of art (see STOCHASTICISM) and the first to experiment seriously with AUTOMATISM in artistic production—a principle later developed by the Surrealists and by various schools of ABSTRACT EXPRESSIONISM.

Despite these limited positive aspects the lack of a unified style or programme makes it difficult to give an over-all picture of Dadaism and essential for the student to follow its diverse manifestations

in the various centres where the movement was active. These were: in America, New York; in Europe, Zürich and later Berlin, Cologne, Hanover and Paris. In Russia the demonstrations by UNION OF YOUTH artists in Moscow and St. Petersburg were essentially Dadaist in character although they still went under the name of Futurism.

ZÜRICH. The Dada movement began in Zürich with the establishment of the CABARET VOLTAIRE at No. 1 Spiegelgasse by the German poet and musician Hugo BALL in February 1916 as a 'centre of artistic entertainment' and a 'revue internationale'. He was accompanied by the singer Emmy Hennings (1919–53) and was joined by the Romanian poet Tristan Tzara (1886–1963), later editor of the review Dada, by the German poet Richard Huelsenbeck (1892–1974) and towards the end of 1916 by the Austrian nihilist poet Walter Serner. The artists in the group were the Romanian Marcel JANCO, the Alsacian Jean ARP, Sophie TAEUBER, who married Arp in 1922, and from 1917 the German painter and film producer Hans Richter. A poster for the Cabaret was done by the Ukrainian artist Marcel Slodki.

There are different accounts of the origin of the name 'Dada'. Richter records that when he joined the group in 1917 he took it for granted that it represented the Slavonic Da-Da (Yes, Yes) as spoken by Tzara and Janco. Huelsenbeck, however, said that the word was discovered accidentally by himself and Ball while looking in a German-French dictionary. In French dada means hobbyhorse. Hugo Ball said: 'To Germans it is an indication of idiot naïvety and of a preoccupation with procreation and the baby-carriage.' The name caught on because of its very childishness. To quote Ball again: 'What we call Dada is foolery, foolery extracted from the emptiness in which all the higher problems are wrapped, a gladiator's gesture, a game played with the shabby remnants . . . a public execution of false morality.'

The Zürich Dada movement was preponderantly literary. Beyond masks made for the performers by Janco and Taeuber, which a decade later would have been called Surrealist, the work of the artists in the group came more or less within the orbit of CONSTRUCTIVISM. Ball's Dada Gal., which was opened in 1917, exhibited 'advanced' art from the STURM Gal., Berlin—KANDINSKY, KLEE, CHIRICO and some German EXPRESSIONISTS and Italian Futurists—rather than anything new or specifically Dada.

The performances at the Cabaret Voltaire included songs by Emmy Hennings accompanied on the piano by Hugo Ball, music by Scriabin, Varèse, etc. played by Ball, simultaneous poetry readings accompanied by 'noise music' on the analogy of the noise-music (Bruitism) of the Futurist RUSSOLO, Negro rhythms improvised on drums, and much other miscellaneous tomfoolery designed to shock and astound. Experiments were conducted (later to become a major feature with the Surrealists) in automatic poetry and in collective com-

position. Ball composed 'abstract' or phonetic sound-poems and read them to a mystified audience. Arp introduced the element of chance into drawings for his 'cut-outs' and Janco into constructions of plaster and wire. Hans Richter has described how Arp tore up a drawing with which he was dissatisfied and threw the pieces on the floor. He found that the chance pattern in which they lay was 'expressive' in the way that he wanted and pasted them up in the pattern they had made. Tzara transferred the technique to literature, cutting words from a newspaper and pasting them together at random to make 'chance' poetry. Tzara edited and directed the periodical Dada from 1917 to 1920.

In 1917 Hugo Ball left Zürich first to work as a journalist in Berne, afterwards retiring to a life of religious poverty in the Ticino. Huelsenbeck returned to Berlin in the same year. Picabia, who had started his Dada periodical 391 in Barcelona in 1917, contributed some of his 'machine pictures' to a large Dadaist exhibition at the Gal. Wolfsberg in Zürich in September 1918, and he himself visited Zürich briefly later in the year. His informal typographical techniques were used in the third Dada, published at the end of the year. In 1919 Tzara left Zürich for Paris and Arp for Cologne. This spelled the end of the movement. There is no doubt that Dada achieved a succès de scandale in Zürich, a neutral town tense with the unspoken threat of the German armies on the frontier and an enclave of international expatriates. But despite the brash boisterousness of ideas it gave birth to nothing of significance in the realm of visual art.

BERLIN. Dada was introduced to Berlin by Huelsenbeck, who gave his 'First Dada speech in Germany' at a meeting organized in the Saal der neuen Sezession in February 1918. This was followed in April by a Dadaist manifesto signed by Ball, Tzara, Janco and Arp as well as the Germans Raoul HAUSMANN, Franz Jung, George GROSZ and several Italians including Enrico PRAMPOLINI. In it Huelsenbeck attacked Expressionism and Futurism and claimed that in Dada alone 'reality comes into its own . . . Dadaism for the first time has ceased to take an aesthetic attitude towards life, and this it accomplishes by tearing all the slogans of ethics, culture and inwardness, which are merely cloaks for weak muscles, into their components.' Besides Huelsenbeck the leading figures of Berlin Dada were: the painter and pamphleteer Raoul Hausmann, the unrestrained poseur Johannes Baader, who assumed the name 'Oberdada', the brothers Wieland Herzfelde, who started the leftist publishing house Malik Verlag, and John HEARTFIELD. The April manifesto was followed by the formation of a Club Dada, which it had announced. There were many short-lived Dada journals, the most important of which were: Club Dada edited by Huelsenbeck, Hausmann and the writer Franz Jung, with one number only in 1918 (this imitated the irregular typography of

Picabia, which had also been adopted in the third issue of the Zürich *Dada*); *Der Dada*, edited by Hausmann with the help of Huelsenbeck and Baader—three issues in 1919–20; *Dada Almanach*, edited by Huelsenbeck in 1920; *Der blutige Ernst* (*Deadly Earnest*) and *Jedermann sein eigner Fussball* (*Every Man his own Football*) edited by Carl Einstein with photomontages by Heartfield and satirical drawings by Grosz. The movement culminated in the 'First International Dada Fair', held in the Burchardt Gal., at which provocative political polemic predominated over artistic motives. It was for this occasion that Grosz and Heartfield designed a poster announcing: 'Art is dead. Long live Tatlin's machine art.'

Dada in Berlin was predominantly political and revolutionary. Its positive artistic concerns were mainly with political social satire and were made significant by the contribution of the great satirist Grosz. Otto DIX contributed only to the 'Dada International Fair'. In addition the techniques of PHOTOMONTAGE were developed by Hausmann, Heartfield and Grosz.

COLOGNE. A brief Dadaist movement was initiated at Cologne in 1919–20 by Max ERNST, later one of the most famous of the Surrealist painters, the young amateur painter Johannes Theodor BAARGELD and Jean Arp, who left Zürich for Cologne immediately after the war. The first Dada 'event' was a provocative exhibition to which entry was through the *pissoir* of a beer hall and which attracted police intervention. In 1919 Baargeld founded a pro-Communist periodical *Der Ventilator*, to which Ernst contributed illustrations. This was followed in 1920 by Ernst's magazine *Die Schammade*, of which only one number appeared. Cologne Dada was made significant by the extraordinary COLLAGES of Ernst, in which he gave a new and haunting significance to banal illustrations by cutting them out and rearranging them suggestively—a technique later taken over by Surrealism. Ernst also developed the technique of FROTTAGE for artistic purposes. He also worked on 'collective' pictures with Baargeld and Arp and under the influence of Arp introduced a 'random' element in a series of collages called *Fatagaga* (*Fabrication des tableaux garantis gazométriques*). The collages of Ernst attracted the attention of Paul ELUARD and André BRETON, who arranged an exhibition in Paris which stimulated the Paris Dada movement. In 1922 Ernst himself moved to Paris and was adopted into the Surrealist movement.

HANOVER. As Max Ernst was the heart and soul of Dada in Cologne, so in Hanover Dada meant Kurt SCHWITTERS, so much so that there was barely a Dada movement apart from his activities. In 1918 Schwitters volunteered to join the Berlin Club Dada but was rejected at the instigation of Huelsenbeck. He thereupon started his own version of Dada under the name *Merz*. Schwitters did not at all go along with the Anti-art propensities of Dada. His collages made from discarded wrappings, tram tickets and other refuse were the an-

cestors of ARTE POVERA. His purpose was to free art from the burden of traditional techniques and materials and to prove that truly expressive art could be made from the detritus of society. Unlike the READY MADES of Duchamp and the OBJETS TROUVÉS of the Surrealists, these *merz* pictures of Schwitters, made from untraditional materials, were fine works of art by traditional canons of taste. Schwitters described art as 'a primordial concept, exalted as the godhead, inexplicable as life, indefinable and without purpose'. If a repudiation of the *concept* of art in favour of some Anti-art concept is held to be central to Dada and not merely one of its aspects, Schwitters must be regarded as only marginally within the Dada movement.

Schwitters also converted Van DOESBURG to a temporary flirtation with Dada and accompanied him on a Dada lecture tour of the Netherlands.

PARIS. By 1918 there had already been contacts between the French literary *avant-garde* and Dada. The poets André Breton, Louis Aragon, Philippe Soupault and Georges Ribemont-Dessaignes, later to become secretary of the Paris Dada group, had contributed to the Zürich *Dada*. Tristan Tzara had sent contributions to Pierre Reverdy's periodical *Nord-Sud* and to the periodical *Littérature*, which was edited by Breton, Aragon and Soupault. In their attacks upon accepted social and literary conventions these young French writers had embarked on a course closely parallel to the negative and destructive aspect of Dada, although without the name. There had been no indigenous French Dada in the visual arts. The movement proper was introduced to Paris in 1919 when Picabia published there the ninth number of his review *391*, in which he proclaimed the approach of the Last Judgement and the arrival of the Anti-Messiah of Dada, Tristan Tzara. Tzara himself arrived in the same year.

The activities of the Paris Dada with its manifestos and reviews, its poetry and play readings, its riotous 'events', its internecine squabbles and even its exhibitions, belong to literary history rather than the history of art. Ribemont-Dessaignes exhibited pictures among all his other activities. Ernst was introduced by André Breton. But the only other artists in the movement besides Picabia were Suzanne Duchamp, her husband Jean CROTTI, and the Russian, CHARCHOUNE. The movement was disrupted by a quarrel between Breton and Tzara culminating in Breton's riotous attack on Tzara's play *Le Cœur à gaz* at the *Soirée du cœur à barbe*. It received its death-blow when Breton, who did not share the Dadaists' nihilism, became sole editor of *Littérature* in 1922 and in 1924 published the First Surrealist Manifesto, which gave direction and a programme to Surrealism.

Hans Richter tells of a final meeting of some Dadaists at Weimar in May 1922, including himself, Arp, Tzara, Van Doesburg, Schwitters and LISSITZKY, at which Tzara delivered a funeral oration on the demise of Dada, published by

Schwitters in his review *Merz* as 'Conférence sur la fin de Dada'.

In a Postscript to Hans Richter's book *Dada* (1964) the German art historian Werner Haftmann wrote: 'Dada led to a new *image of the artist*. The Dadaist claimed Genius, as the term was understood by the Romanticists, as his natural prerogative. He saw himself as an individual outside all bounds, whose native environment was unrestricted freedom. Committed only to the present, freed from all bonds of history and convention, he confronted reality face to face and formed it after his own image ... Even though all the techniques used by Dada had had their origin elsewhere, and even though Dada's positive achievements remain comparatively uncertain and elusive, it remains true that Dada's conception of the artist was something quite new. From that time onwards it acted as a ferment. Dada was the freedom-virus, rebellious, anarchic and highly contagious. Taking its origin from a fever in the mind, it kept that fever alive in new generations of artists. We set out to identify Dada's contribution to cultural history; this is it.' This, or something like this, perhaps accounts for the vitality of Dada ideas and the renewed interest which Dada has evoked among young artists in the very different circumstances which followed the Second World War. It is this kind of idea, however vaguely formulated and conceived, which accounts for the revivals in NEO-DADA, POP and the wilder schools of the HAPPENING.

DADAMAINO. See ITALY.

DAEYE, HIPPOLYTE (1873–1952). Belgian painter born at Ghent, studied at the Academy of Ghent and then at the Institute of Higher Studies in Antwerp, where he settled in 1898. During the First World War he was in England, where he knew PERMEKE, TYTGAT and Van de WOESTIJNE. After working in a Late-Impressionist manner and undergoing FAUVIST influences before 1914, he turned to EXPRESSIONISM in the 1920s. He was a member of the groups connected with the Expressionist periodicals *Sélection* and *Le Centaure* and of *Le Groupe des IX*. His work had a poetic delicacy and a mannered refinement, which were achieved by a 'drawn-out, arabesque, elegance where the forms are refined, the subtle range of colour, in pale tones, is applied in thin, transparent coats and the whole is lit by an unreal, iridescent light'. Although he had none of the earthy robustness of the Expressionists such as Permeke, Daeye represents the poetic and meditative aspect of Flemish Expressionism.

DAHMEN, KARL FRED (1917–81). German painter born at Stollberg in the Rhineland, studied at the Art School of Aachen. In 1957 he joined a group of TACHIST painters in Düsseldorf and in 1958 he was awarded a Swiss prize for abstract painting. In 1961–2 he executed a large slate mural

for the new university of Heidelberg and in 1967 obtained a commission for a mural at the new theatre of Schweinfurt. In 1967 also he was appointed to a teaching post at the Akademie der Bildenden Künste, Munich. About the middle of the 1960s he began the 'object pictures' for which he was best known, incorporating objects such as ropes or nooses in a surface of thickly built up *pâte*. Besides Germany he had one-man shows in New York, Paris, Brussels, Oslo, etc. Like Emil SCHUMACHER, to whose work his has been compared, K. R. H. SONDERBORG and Bernard SCHULTZE, Dahmen belonged to the German school of *Informalismus* (see ART INFORMEL).

DALÍ, SALVADOR (1904–). Spanish painter born at Figueras, studied at the École des Beaux-Arts, Madrid, and there came under the influence of the METAPHYSICAL painting of CHIRICO and CARRÀ. At the same time he also admired the meticulous Realism of the English Pre-Raphaelites and 19th-c. painters such as Meissonier. From 1927 he began to exhibit with the *Sociedad de Artistos Ibericos* in Madrid and at the Dalmau Gal. in Barcelona, where he made a name for himself as one of the most promising of the younger generation of painters. In 1928 he made two visits to Paris, meeting PICASSO and MIRÓ, and arranged for an exhibition at the Goemans Gal. This took place in 1929 with pictures whose SURREALIST character brought him into the Surrealist movement, where he became one of the most spectacular and widely publicized members. In his autobiographical book *My Secret Life* (1942) Dalí claimed that his childhood was punctuated by fits of violent hysteria. He was suspended from the Madrid art school for inciting the students to insurrection, imprisoned briefly for subversive activity and expelled in 1926 for extravagant behaviour. Throughout his life he cultivated eccentricity and exaggerated his disposition towards megalomaniac exhibitionism, claiming that this was the source of his creative energy. He took over the Surrealist theory of AUTOMATISM but transformed it into a more positive method which he named 'critical paranoia'. According to this theory one should cultivate genuine delusion as in clinical paranoia while remaining residually aware at the back of one's mind that the control of the reason and will has been deliberately suspended. And he claimed that this method should be used not only in artistic and poetical creation but also in the affairs of daily life. Throughout his own life he courted publicity for wilful and not always felicitous acts of eccentricity (such as appearing in a diving suit at the opening of the London Surrealist Exhibition in 1936). By the meticulous detail of his painting, which has often been likened to Pre-Raphaelitism, he created a hallucinatory sense of reality (sometimes called MAGIC REALISM) which was contradicted by the unreal 'dream' space he depicted and by the strangely hallucinatory character of his imagery. He had certain favourite and recurring images such as the

human figure with half-open drawers protruding and watches bent and flowing as if made of wax melting in the sun. These were depicted with minute exactness against bleak Catalonian landscapes. It was this contrast between hallucinatory imagery and magic realism that made his pictures the most widely known even to a non-artistic public of all the Surrealist work. Among the most important of these works were: *La Persistance de la Mémoire* (The Mus. of Modern Art, New York, 1931), *The Origin of the Fleeting Wish* (Peggy Guggenheim coll., 1931), *Suburbs of the Paranoiac-critical Town* (Edward James coll., 1935), *Crâne atmosphérique sodomisant un piano à queue* (1935), *The Burning Giraffe* (Basle, 1936). He also illustrated the *Chants de Maldoror* of Lautréamont and he collaborated with Buñuel in the Surrealist films *Un Chien andalou* (1928) and *L'Âge d'or* (1931).

In 1937 he visited Italy and for a time changed to a more academic style under the influence of Raphael and Italian Baroque. He was expelled from the Surrealist movement by BRETON, who had enthusiastically supported him in 1929 and written an introduction to the catalogue of his exhibition. In 1940 he went to the U.S.A., where he remained for 15 years, returning to Spain in 1955. While in the U.S.A. he devoted himself largely to publicity, publishing his autobiographical work *La Vie Secrète de Salvador Dali* in 1942–4, and *Diary of a Genius* in 1965. He had a first retrospective exhibition at The Mus. of Modern Art, New York, in 1941.

DALWOOD, HUBERT (1924–76). British sculptor born at Bristol. After serving as an engineer in the Royal Navy he studied at Bath Academy of Art, Corsham, 1946–9. He then worked in Milan and Sicily with a travelling scholarship, and was Gregory Fellow in Sculpture at Leeds University, 1955–8. He was Visiting Professor at the University of Illinois in 1964 and at the University of Wisconsin in 1967. His first one-man exhibition was at Gimpel Fils, London, in 1954, after which he exhibited widely. He was awarded First Prize at the John Moores Liverpool exhibition in 1959 and was a prize winner at the Venice Biennale of 1962. In the mid 1950s Dalwood was doing massive female figures with striated bodies on tapering legs, figures with an austere but powerful beauty. From these he passed to sensitively modelled abstract images and reliefs. At the end of the 1960s he was making constructed abstracts which give the impression of architectural elements in a landscape setting. Dalwood was one of the most refined of the younger artists who in the 1960s were abandoning the exclusivity implied in the phrase 'the autonomy of art' and endeavouring to bring back art into direct contact with life and experience. His works of the 1970s had the effect of organizing space and made the impact of reality which may sometimes be noticed in large engineering works set in an appropriate environment.

DAMNJANOVIĆ, RADOMIR (1936–). Yugoslav painter and graphic artist born at Mostar and studied at the Academy of Art, Belgrade. He painted abstract canvases which had the clear-cut finish of CONSTRUCTIVISM combined with a strong sense of decoration derived from the Moslem tradition. These geometrical abstractions nevertheless often exuded an air of mystery and the geometrical forms carried incomprehensible suggestions of reality. He had a retrospective exhibition at Belgrade in 1968.

DANGELO, SERGIO (1931–). Italian painter born in Milan. He studied in Paris and Brussels, 1949–50, and was associated with the COBRA movement. On his return to Italy he collaborated in the founding of the *Movimento d'Arte Nucleare* with Enrico BAJ. His own work vacillated between expressive abstraction and romantic but fantastic representation. He contributed to the magazines *Phases* and *Phantomas*.

DAŇKO, ŠTEFAN (1912–). Czech NAÏVE painter, born at Geraltov. After working as a farm labourer, he entered monastic life in 1936 and worked as a baker. He took up painting in 1957. In 1962 he went to work in the mines and for a while abandoned painting. He painted religious themes and his works were reminiscent of the icons which he saw in the monastery of Michalovce. But the naïvety of their style brought them closer to children's drawings than to the Byzantine. In the 1960s he also did chalk drawings of the countryside where he worked. He was represented at the exhibition of naïve art in Czechoslovakia shown at Brno, Bratislava, Prague, Ostrava in 1963–4, and in exhibitions of naïve art at Salzburg, Graz and Linz in 1964.

DANTZIGER, YTSHAK (1916–). Israeli sculptor, born in Berlin and emigrated to Palestine in 1923. In his earlier, figurative style he was known for his statue *Nimrod* of 1938. Afterwards he turned to abstraction and in the mid 1950s he constructed a metal monument at the Yad Lebanim Memorial in Holon. He continued to make metal sculpture intended to be placed in the open and to fit into the environment. An example is the iron *The Burning Bush* (Mus. of Modern Art, Haifa, *c*. 1960). He designed imaginary gardens and water conduits for the desert of Negev and together with Shami HABER he designed a monument in iron and stone for the Israeli Mus. in Jerusalem.

DAPHNIS, NASSOS (1914–). Greek-American painter born at Krockeai, went to the U.S.A. in 1930. He was self-taught as an artist, had his first one-man exhibition at the Contemporary Arts Gal., New York, in 1938 and in 1969 had retrospectives at the Albright-Knox Art Gal., Buffalo, and the Everson Mus. of Art, Syracuse. Among the collective exhibitions in which his work was

represented were: Solomon R. Guggenheim Mus., 'Abstract Expressionists and Imagists', 1961 and Whitney Mus. of American Art, 'Geometric Abstraction in America', 1962. He is best known as a member of the group of young painters who in the late 1950s broke away from ABSTRACT EXPRESSIONISM with its emphasis on gestural and expressive brushstroke and explored the HARD EDGE colour image in the manner of POST-PAINTERLY ABSTRACTION. He favoured clear and sharp images which formed an incomplete *Gestalt*, carrying the eye outside the limits of the canvas.

DARANIYAGALA, JUSTIN PIERIS (1903–). Sri Lankan painter, born in Colombo. After studying law at Trinity College, Cambridge, he took up painting in 1925 and studied at the Slade School and in Paris, returning to Ceylon in 1929. He was a founding member of the '43 Group, with whom he exhibited in Ceylon. His first one-man show (of drawings) was at the Adams Gal., London, in 1938 under the name Justin Pieris. He also exhibited in Paris, at the Venice Biennale, where he was awarded a UNESCO Prize in 1956, at the Carnegie International, Pittsburgh, and elsewhere in America and in China.

D'ARCANGELO, ALLAN (1930–). American painter born at Buffalo, N.Y. He studied history at the University of Buffalo, 1948–52, and then at the New School for Social Research, New York, 1953–4, and Mexico City College, 1957–9. He taught at the School of Visual Arts, New York, 1963–8. His first one-man shows were at the Gal. Genova, Mexico City, 1958, Long Island University, 1961, and the Thibaut Gal., New York, 1963. During the 1960s he exhibited mainly at the Fischbach Gal., New York; the Dwan Gal., Los Angeles; Ileana Sonnabend Gal., Paris; Obelisk Gal., London; Hans R. Neuendorf Gal., Hamburg; Müller Gal. and Wurttembergischer Kunstverein, Stuttgart. He was represented in many group shows both in the U.S.A. and internationally, including: Albright-Knox Art Gal., Buffalo, 'Mixed Media and Pop Art', 1963; Gemeentemus., The Hague, 'New Realism', 1964; Stedelijk Mus., Amsterdam, 'New Shapes of Colour', 1966; Detroit Institute of Arts, 'Colour, Image and Form', 1967. He took his subjects during this time from the familiar appurtenances of city life, especially highway and automobile imagery, and for this reason his work was often classed as POP ART. Owing, however, to his predilection for sparse and economic design his work during the 1960s was also classed with MINIMAL ART. During the 1970s he continued to exhibit and his style became richer and more humane in a manner reminiscent of LÉGER's creative uses of machine imagery.

DASBURG, ANDREW (1887–). American painter born in Paris. He went to the U.S.A. in 1892 and studied at the Art Students' League and under Robert HENRI. During the first decade of the

century he was in Paris and later became one of America's early CUBIST artists, also painting colour abstractions in the manner of the SYNCHROMISM of Stanton MACDONALD-WRIGHT and Morgan RUSSELL. He exhibited in the ARMORY SHOW and was one of the 17 American artists who constituted the FORUM EXHIBITION in 1916. A large exhibition of his work was staged by the Dallas Mus. of Fine Arts in 1957 and a circulating retrospective by the American Federation of Arts in 1959. Dasburg's Cubism was derivative rather than fully realized and has been described by Barbara Rose as 'an eclectic mélange'. Perhaps realizing this, he wrote in an article 'Cubism—Its Rise and Influence' contributed to the journal *Arts* in 1923: 'One cannot write of "actual" Cubism in America, but only of the effort . . . We want instead to gather the best from many sources . . . This idea of combining a variety of forms of perfection into one complete ideal realisation prevents any creative work being done which possesses the contagious force of Cubism.' Dasburg abandoned abstraction in the early 1920s.

DAT, SIMONE. See HOMME-TÉMOIN.

DAU AL SET (DIE WITH THE SEVEN). An artistic association which was formed in Barcelona in 1948 and was active until 1953, publishing a periodical of the same name. Besides the poet Joan Brossa and the Existentialist philosopher and poet Arnaldo Puig, the group contained the four artist members Antoni TÀPIES, Modesto CUIXART, Joan PONÇ and Joan José THARRATS. The artists Jaume Muxart and José GUINOVART also collaborated, as did the critics Eduardo Cirlot and Alexandro Cirici-Pellicer. The expressed object of the association was to awaken Barcelona from the artistic and spiritual stagnation into which it had sunk and in pursuit of this aim the members not only encouraged SURREALISM, becoming the chief exponents of international Surrealism in Spain, but also acclaimed such diverse native artists as Gaudí and MIRÓ. The group played an important part in preparing the ground for the new indigenous *avant-garde* which established itself in the mid 1950s and for the introduction of INFORMALISM. The printing and format of the magazine *Dau al Set* were in the hands of Tharrats, who took up painting only in 1950. The illustrations by Ponçe, Tàpies and Cuixart helped to bring these artists to the notice of the public.

DAVIE, ALAN (1920–). British painter born at Grangemouth, Stirlingshire. His father was a painter and etcher, and he studied at the Edinburgh College of Art, 1937–40. After serving in the army he had his first one-man show in Edinburgh in 1946, one-man shows in Florence and Venice in 1948, his first one-man London show in 1950, and his first American show in New York in 1956. From this time he rapidly acquired an international reputation with frequent one-man shows in

Britain, Europe and America, and he participated in many important collective international exhibitions. He had his first retrospective at the Whitechapel Art Gal., London, in 1958 and touring retrospectives in 1962–3, 1970 and 1972. He was Gregory Fellow in Painting at Leeds University, 1957–9, and did part-time teaching at the Central School of Arts and Crafts, London, and at Leeds College of Art. He also worked as a professional jazz musician, giving his first public recital of music in 1971. Among his many awards were the prize for the Best Foreign Painter at the São Paulo Bienale of 1963 and First Prize at the International Graphics Exhibition, Kraków, in 1966. His works have been acquired by the Tate Gal., the Arts Council, the Contemporary Art Society and the Gulbenkian Foundation, London; by City Arts Galleries throughout Britain; and by many public collections in the U.S.A. and Canada, including The Mus. of Modern Art, New York, the Albright-Knox Art Gal., Buffalo, the Mus. of Fine Arts, Boston, the Carnegie Institute, Pittsburgh. In the catalogue to an exhibition 'Magic and Strong Medicine' (sponsored by the John Moores Charitable Foundation and the Walker Art Gal., Liverpool) in 1973 it was written: 'Many of his paintings end up with titles which suggest magic and it is not difficult to see that the signs and images of which they mainly consist belong to a mental world somewhere between dream and purposeful invention, a timeless and ancient world that responds with ambiguous emotions, fearful and joyful, to the experiences of life.' Davie was among the first of British artists to respond to ABSTRACT EXPRESSIONISM, particularly the works of Jackson POLLOCK and Willem DE KOONING, which he saw in Venice, 1948–9. He adapted this style to his own purposes, combining it with his rich colour heritage from the Edinburgh school of painting. His work was extremely personal in character, incorporating in an abstract framework images of a magical or ambiguous nature. Latterly he made more and more extensive use of pictographs taken either from the Carib Indians or from modern European life. These were often set against an unmodulated monochromatic or two-colour background.

DAVIES, ARTHUR BOWEN (1862–1928). American painter born at Utica, N.Y., studied at the Art Institute of Chicago and then in New York at the Gotham School and the Art Students' League. In 1893 he visited Europe, where he found the work of the English Pre-Raphaelites, Whistler and Puvis de Chavannes most congenial to his taste. He developed a conservative and romantic style of painting and was best known for idyllic landscapes inhabited by dreamlike, visionary figures of nude women or mythical animals: *Unicorns* (The Metropolitan Mus. of Art, New York, 1906); *Dream* (The Metropolitan Mus. of Art, New York, 1908). Although not a Realist, he was a member of The EIGHT and exhibited with them in 1908. In 1911 he

was made President of the Association of American Painters and Sculptors formed for the purpose of organizing what became the ARMORY SHOW. He was referred to by Jerome Myers as an American painter 'who painted unicorns and maidens under moonlight'. But he was a man of wide culture who bridged all parties in the American art world: he was well thought of in the National Academy, was associated with Robert HENRI's Realist circle and was on terms with the modernist group centred on Gal. 291 of Alfred STIEGLITZ, from whom he had bought a Cézanne and a PICASSO. He also had connections which enabled him to raise the money for the proposed exhibition. In these respects he was the ideal person to act as President and organizer. Despite his own conservative style of painting Davies was an enthusiastic admirer of the European *avant-garde* and it was mainly due to him that instead of being as originally planned no more than a gigantic display of work over the whole range of current American art, the Armory Show made its impact as the first massive introduction into America of the modernist work of Europe. At the time of the exhibition Davies himself was experimenting with CUBIST techniques, as may be seen in *Intermezzo* (Graham Gal., New York, *c.* 1913), an oil which simulates the effect of a Cubist collage. A memorial exhibition of his work was held at The Metropolitan Mus. of Art, New York, in 1930 and a Centennial Exhibition was given at the Munson-Williams-Proctor Institute, Utica, in 1962.

DAVIES, JOHN (1946–). British sculptor born in Cheshire, first studied painting at Hull and Manchester Colleges of Art, 1963–7, and then sculpture at the Slade School, 1967–9. He held a Sculpture Fellowship at Gloucestershire College of Art, 1969–70, and a Sainsbury Award, 1970–1. He had a one-man show at the Whitechapel Art Gal. in 1972 and a retrospective show at the same Gal. in 1975. In 1973 he was represented at the Biennale des Jeunes, Paris, and in 1974 he had a show at the Tooth Gal., London. He has works in the collections of the Tate Gal., the Arts Council and the University of East Anglia. His works consisted of clothed male figures, or heads, cast from the life in plaster. Sometimes, as in his *Bucket man* (1974), they were representative of a type. But in the main the vacant inexpressiveness of face and posture was reminiscent of shop-window display dummies.

DAVIS, GENE (1920–). American painter born in Washington, D.C., studied at the University of Maryland and the Wilson Teachers' College. He had his first one-man exhibition at the Catholic University of America in 1953 and during the 1960s exhibited at the Jefferson Place Gal., Washington, and the Poindexter Gal., New York. He had one-man exhibitions at the San Francisco Mus. of Art, the Washington Gal. of Modern Art and the Jewish Mus., New York, in 1968. He was included in the group exhibitions 'Post-Painterly

Abstraction', Los Angeles County Mus. of Art, 1964; 'The Responsive Eye', The Mus. of Modern Art, New York, 1965; 'The Washington Color Painters', Washington Gal. of Modern Art, 1965; and The Mus. of Modern Art's circulating exhibition 'Two Decades of American Painting', 1967.

Gene Davis belonged to the Washington group of Colour painters whose work followed the example of NOLAND in structuring pure colour into clearly defined shapes.

DAVIS, STUART (1894–1964). American painter, born in Philadelphia. He was the son of the art director of the *Philadelphia Press* who employed LUKS, GLACKENS, SHINN and SLOAN as artist-reporters. From 1910 to 1913 Davis was a student of Robert HENRI in New York. While he later paid tribute to the broadmindedness of this teaching, he was dissatisfied with the emphasis upon social subject matter, which, he later declared, 'tended to give subject matter, as such, a more important place than it deserves in art'. From 1913 he worked as an illustrator for the magazine *Masses*, edited by Max Eastman, but in 1916 he left it together with Sloan and others owing to an editorial directive designed to give the illustrations a political or sociological slant. Davis was at this time painting in a manner of simplified Realism and he exhibited five water-colours at the ARMORY SHOW. In his own words, the Show was 'the greatest shock to me—the greatest single influence I have experienced in my work. All my immediately subsequent efforts went toward incorporating Armory Show ideas into my work.' The first impact made was by the POST-IMPRESSIONISTS and by the end of the decade Davis was painting landscapes in the freer manner of Gauguin and Van Gogh, using colour for its expressive value instead of realistically, and in a way that betrayed some influence from the FAUVES. Before the 1920s he was also experimenting with abstract, as in *The President* (Munson-Williams-Proctor Institute, Utica, 1917), and in the early 1920s he did painted versions of the CUBIST COLLAGES, such as *Lucky Strike* (The Mus. of Modern Art, New York, 1921), into which he incorporated *trompe l'œil* labels which later on became the theme of a series of paintings. His use of lettering to emphasize the flatness of the picture plane showed an understanding of the Cubist method which the CUBIST-REALIST painters had not achieved. About 1927 he began a series of abstract Cubistic paintings based upon the theme of the egg-beater and percolator: *Percolator* (The Metropolitan Mus. of Art, New York, 1927) and *Egg Beater No. 2* (Whitney Mus. of American Art, 1927). On his return to the U.S.A. after a visit to Paris in 1928–9 he introduced a new note, basing himself on the Synthetic rather than the Analytic phase of Cubism. Using natural forms as his starting point, particularly forms suggestive of the environment of American life, he arranged them into flat poster-like patterns with precise outlines and sharply contrasted colours: *House and Street* (Whitney Mus. of American Art, 1931); *Garage Lights* (Rochester Memorial Art Gal., 1931).

In 1931 Davis taught at the Art Students' League, New York, and from 1934 he worked on the FEDERAL ARTS PROJECT, for which he did two murals. From 1936 he was active in the ARTISTS' CONGRESS and from 1940 he taught at the New York School of Social Research. During the 1940s he employed brighter, richer colours in flat patterns often directly related to themes of jazz, which was always a dominant motif in his work. In 1960 he said: 'For a number of years jazz had a tremendous influence on my thoughts about art and life. For me at that time jazz was the only thing that corresponded to an authentic art in America ... I think all my paintings, at least in part, come from this influence, though of course I never tried to paint a jazz scene.' During the 1950s he used larger, more monumental patterns though sometimes reverting to the earlier style as in *The Paris Bit*, a recapitulation of Paris scenes in which he used lettering and labels and combined positive and negative images (Whitney Mus. of American Art, 1959).

Davis was the one American artist who best comprehended the principles of European Cubism and succeeded in deploying them for his own purpose of creating an American art. Although he worked in the various modes of Cubism, he claimed always to be a Realist and stated that every image he used had its source in observed reality. He asserted that his work was a depiction of the American life and environment no less than that of the AMERICAN SCENE painters. 'I paint what I see in America, in other words I paint the American Scene.' By his adaptation of modernist techniques to this purpose Davis stands out as the most important link between American Realistic painting at the beginning of the century and the new abstract painting which grew up on American soil in the post-war years. He said: 'I want to paint particular aspects of this country which interest me. But I use, as a great many others do, some of the methods of modern French painting which I consider to have universal validity.' But no other American artist employed these methods so successfully for this purpose.

Davis was given retrospective exhibitions at The Mus. of Modern Art, New York, in 1945 and at the Whitney Mus. of American Art and the Walker Art Center, Minneapolis, in 1957. He held a one-man show at the Venice Biennale in 1952 and obtained the Guggenheim International Award in 1958 and 1960. In 1965 he was given a large memorial exhibition at the Smithsonian Institution, National Collection of Fine Arts, Washington, D.C.

DAVRINGHAUSEN, HEINRICH. See NEUE SACHLICHKEIT.

DAYEZ, GEORGES. See FRANCE.

DEAN, PETER (1936–). American painter born in Berlin. He came to America at the age of four, was a member of the Rhino Horn group, and recreated the myth and legend of the American past and a fantastic imagery of contemporary America in canvases which stand on the frontier between *faux naïf* and SURREALISM. He often painted on a very large scale. He exhibited widely in the U.S.A. and had several one-man shows, including one at the New Orleans Mus. of Art. His fantasy is often given the force of a comment on the hard realities of contemporary life.

DÉCALCOMANIE. A technique for the AUTO-MATIC production of pictures, said to have been invented by Oscar DOMINGUEZ *c.* 1936 and afterwards applied by Max ERNST to oil painting. Splashes of colour were laid with a broad brush on moderately thin white paper. This was then covered with another sheet of paper while wet and was rubbed gently so that the pigment flowed haphazardly. The resulting prints, resembling fantastic grottoes or jungles or underwater growths, were given titles. The point of the process, which had the blessing of BRETON, was that the picture was made without any preconceived idea of its subject or form (*sans objet préconçu*).

DECHELETTE, LOUIS-AUGUSTE (1894–1964). French painter born at Cours, near Lyons. He wandered through France as a house-painter and plasterer and painted pictures in his spare time without formal training as an artist. He was 'discovered' during the Second World War through his anti-Nazi pictures and has since been reckoned among the NAÏVE painters of France. He was exhibited at the Gal. Jeanne Bucher in 1942 and 1944 and was represented in a number of international exhibitions of naïve art, including 'Die Kunst der Naiven' at the Kunsthaus, Zürich, 1975.

DECO. See ART DECO.

DÉCOLLAGE. See AFFICHISTE; VOSTELL, Wolf.

DEGENERATE ART (ENTARTETE KUNST). After the coming of Hitler to power in 1933 the suppression of modern art in Germany, which had begun under the Weimar Republic, was put on a systematic basis along with the fostering of a Government-controlled, politically indoctrinated academic art. (See NATIONAL SOCIALIST ART IN GERMANY.) In 1932 the BAUHAUS had been compelled to leave Dessau for Berlin and in 1933 it was closed by Goering as a 'breeding ground of cultural Bolshevism'. From this time teachers and museum curators suspected of sympathizing with modern artistic movements were dismissed from their posts. Hitler made his first speech against 'degenerate art' at Nuremberg in 1934. The first of a number of exhibitions designed to bring modern

art into disrepute and ridicule was held at Karlsruhe in 1933 with the title 'Regierungskunst von 1918 bis 1933' and was directed against the Weimar Republic. It was followed in 1934 by 'Kulturbolschewismus' at Mannheim and 'Kunst in Dienste der Zersetzung' (Art in the Service of Demoralization) at Stuttgart. In 1936 the Kronprinzenpalais was closed. This form of attack culminated with the notorious exhibition of 'Entartete Kunst' in the arcades of the Hofgarten, Munich, alongside the exhibition of the new official 'German Art' at the House of German Art nearby. Twenty-five of the leading German museums were required to surrender works for this exhibition and from 1937 works of modern art, both German and foreign, were expropriated from collections throughout the country. It is estimated that more than 16,500 works were expropriated in all under the guise of 'degenerate art'. Some of them were sold by auction at Lucerne. Some were sold abroad through dealers for the enrichment of Nazi politicians. The rest were burned in Berlin in 1939.

The attack was directed not only against innovative art but also against artists and others who were in sympathy with it. Such persons were dismissed from their posts in museums and teaching institutions, deprived of their honours and degrees. In 1935 a decree brought all exhibitions, public and private, under the control of the Reichskunstkammer. Artists who refused to conform were forbidden to exhibit and in some cases were forbidden to work. The writings of Alfred Rosenberg as well as the speeches of Hitler served to link artistic production with political doctrines and racial theories. There is, however, much truth in what was said by G. H. Hamilton in *Painting and Sculpture in Europe, 1880–1940* (1967): 'But the fact that the greatest number of objects by any one artist which were declared degenerate was the work of Emile Nolde, who had been a member of the party, was of pure "Nordic" extraction, and not immune to ideas of "blood and soil", suggests that political expediency and racial theories were only temporary incidents in the longer history of the public's antipathy to new forms of expression and its belief that modern art is an insidious attack upon traditional culture, an experience which was not Germany's alone. This hostility had been fostered by reactionary critics many times over before 1933 ... But until the appearance of Hitler, the artist's person and his production had been immune from legal action by the state.'

DEGOTTEX, JEAN (1918–). French painter born at Sathonay, who settled in Paris in 1913. After passing through a period of expressive naturalism when he worked with a FAUVIST palette, he went over to abstraction *c.* 1950. He was much influenced by his reading in Oriental literature and introduced both calligraphic and gestural features into his style. His exhibition in 1960 at the Gal. International d'Art Contemporain, Paris, marked

him as one of the leaders in the later phase of LYRICAL ABSTRACTION. The impression was confirmed by his exhibition in the following year of his *Metasignes*, strange vertical paraphs with mysterious gestural significance. Like TAL COAT and MESSAGIER, he adopted a near-mystical attitude to his abstractions, regarding them as inarticulate material for contemplation.

DEHOY, CHARLES (1872–1940). Belgian painter born in Brussels. He was orphaned at the age of 14 and was self-taught as a painter although he received some instruction from Auguste OLEFFE, by whom he was befriended. He first painted in a Late-Impressionist manner and in 1901 exhibited Impressionist works at the Antwerp Salon. But his mature style sets him among the Brabant FAUVISTS and he was best known for his lyrical use of Fauvist colours in his still lifes and figure studies. After the mid 1920s his palette became duller and some of the spontaneity disappeared from his work.

DEINEKA, ALEKSANDR ALEKSANDROV-ICH (1899–1969). Russian painter, sculptor and mosaicist, born at Kursk. One of the Soviet Union's most distinguished artists, he was bearer of the Order of Lenin and the Order of the Red Banner and member of the Academy of Arts of the U.S.S.R. He attended VKHUTEMAS and studied under Vladimir Favorsky and Ignatii Nivinsky, 1921–5. His early painting was influenced by German EXPRESSIONISM but SURREALIST tendencies were also noticeable until *c.* 1934. From 1924 onwards he contributed to many exhibitions at home and abroad and began to illustrate magazines such as *Bezbozhnik u stanka* (*The Atheist at the Lathe*) and *Smena* (*Shift*). In 1925 he was a founder member of OST. He painted *Defence of Petrograd*, one of his most important works, in 1927. In 1928 he was a member of the *Oktyabr* (October) Group. During the early 1930s he abandoned formal experimentation and became one of the most successful interpreters of SOCIALIST REALISM. In 1941–5 he painted many dynamic war scenes such as *Defence of Sevastopol* (1942). After the war he continued to paint socially tendentious scenes of collective farm life, the Red Army, sports, etc.

DEIRA, ERNESTO. See LATIN AMERICA.

DEKKERS, ADRIAN (1938–74). Dutch experimental artist born in Nieuwpoort, studied Commercial Design at the Academy of Art, Rotterdam, 1954–8. He was associated with BALJEU and the magazine *Struktur* and he worked in a Neo-CONSTRUCTIVIST manner, making reliefs and space constructions of polyester. He made great use of the resources of light and specialized in the technique of presenting different views of the same geometrical design in one work. At the exhibition 'Space and Spatial Relations' at Arn-

heim in 1971 he was represented by a large U-shaped work.

DE KOONING, WILLEM (1904–). Dutch-American painter born at Rotterdam. He studied first at the Academie voor Beeldende Kunsten ed Technische Wetenschappen, Amsterdam, while apprenticed to a firm of commercial decorators, 1916–20, and then under the *avant-garde* artist Bernard Romein. On his arrival in the U.S.A. in 1926 his work was conservative and traditional, but he soon joined the circle of Arshile GORKY and other artists who later became prominent in the ABSTRACT EXPRESSIONIST movement and under their influence began to experiment in advanced techniques of abstraction deriving from KANDINSKY and the late CUBISM of PICASSO. During the 1930s de Kooning was painting in several manners simultaneously. His portraits and figure studies carried a suggestion of the late works of GIACOMETTI and signalled an interest in the figure which was perpetuated throughout his work until the 1970s. Indeed de Kooning stands virtually alone among the artists of his time in making the human figure, first male and then female, a central theme of his work. He also painted sensitive but energetic abstractions with organic and biomorphic forms expressed in a jagged linear counterpoint, although he did not betray the interest taken by Gorky and some others in the more fantastic aspect of SURREALISM. Indeed his essentially realistic stance was illustrated by the reflections of Picasso in his work, such as the sketch for a Williamsburg Federal Housing Project done for the FEDERAL ARTS PROJECT. During the 1930s he also did murals, including one for the New York World's Fair in 1939.

Although he did not exhibit until 1948, his abstractions in tones of muted grey with curvilinear shapes and vaguely biomorphic suggestions were a not unimportant influence among artists of the NEW YORK SCHOOL from the early years of the 1940s. After his first exhibition, at the Charles Egan Gal. in 1948, he shared with Jackson POLLOCK the unofficial leadership of the group of artists in the so-called Abstract Expressionist school who emphasized the importance of spontaneity and ACTION PAINTING. Among his outstanding works of this period were black paintings with white linear drawings done *c.* 1950, such as *Night Square*. In these works he matured a system of loose sliding planes and open contours, as with *Excavation* (Art Institute of Chicago, 1950), which was essentially his own and distinct from Kandinsky, Gorky, Picasso, Pollock, etc. His organization of space and the expressive energy of his brushstroke set him apart.

During the 1940s and 1950s de Kooning also developed the theme of the female figure for which he became notorious. Sometimes converting it into an erotic symbol, a vampire or a fertility goddess, he was always mainly concerned in his figural work with the same spatial problems that were

central to his more purely abstract paintings. Representing the figure without modelling and with broken contours allowing figure and environment to flow together, he created an ambiguous and chaotic space, a merging of figure and environment, which he referred to as 'no-environment', as may be seen in his *Pink Angels, c.* 1947. Sometimes the anatomical forms were fragmented and dislocated to create explosive linear abstracts such as *Sailcloth, c.* 1949, and *Woman VI* (Carnegie Institute, Mus. of Art, Pittsburgh, 1953). His figure paintings during the 1960s took on greater delicacy without losing in energy or in vigour of brushstroke—*Reclining Figure in Marsh Landscape,* 1967. From the late 1950s through the 1960s and into the 1970s he also executed brilliant abstractions, sometimes with the suggestion of a figure or part of a figure lurking in the background, as in *Montauk 1* (Wadsworth Atheneum, Hartford, 1969), sometimes purely abstract, as *Whose Name Was Writ in Water* (1975), in which brushstrokes and wormlike forms coalesce. During the 1970s de Kooning also turned to expressionistic figurative sculptures such as the bronze *Seated Woman on a Bench* (1972).

With his outstanding originality de Kooning was one of the most influential figures within the Abstract Expressionist movement and was one of those who throughout his artistic career never departed from Expressionism though he did not restrict himself to pure abstraction. In 1980 he shared with Eduardo CHILLIDA the Andrew W. Mellon Prize at the Pittsburgh International.

DELAHAUT, JO (1911–). Belgian painter and sculptor born at Vottem-lez-Liège. After studying art history he began to paint in a FAUVIST idiom, *c.* 1940, but went over to geometrical abstraction *c.* 1945. In 1952 he was instrumental in founding the Belgian groups ART ABSTRAIT, FORMES and *Art Construit.* In 1954 he published a manifesto *Spatialism* in collaboration with Pol BURY. He also produced MOBILES and spatial reliefs.

DELAUNAY, ROBERT (1885–1941). French painter born in Paris. After training as a decorative commercial painter he took up an artistic career in 1904. About 1906 he became interested in Neo-Impressionism and the colour theories of Eugène Chevreul and embarked upon the researches into the aesthetic applications of colour which remained the central motive throughout his artistic life. Instead of adopting the DIVISIONIST technique which emerged from the Pointillist principles of Seurat he began to investigate the interaction of larger areas of contiguous and contrasting colour, being particularly interested in the effects of light for breaking up colour-space and in the interconnections between colour and movement. The results of these early researches were embodied in such series of paintings as *L'Église Saint-Séverin, La Tour Eiffel* and *Les Fenêtres simultanées.* He associated with members of the CUBIST movement and exhibited with them at the Salon des Indépendants in 1911 and 1912, where his large painting *La Ville de Paris* (Mus. National d'Art Moderne, Paris) was declared by APOLLINAIRE to be the most important work in the exhibition. In 1910 he married Sonia Terk (see DELAUNAY-TERK, Sonia) and in 1911 he began to exhibit with the BLAUE REITER group in Germany, among whom Franz MARC, August MACKE and Paul KLEE in particular were influenced by his colour.

In 1912–13 Delaunay produced his series of *Disques* and *Formes circulaires cosmiques,* which took further the experiments in the simultaneous interaction of colours started in *Les Fenêtres simultanées* but were now purely abstract without any origin in concrete visual impressions. These works gave rise to the movement of 'colour Cubism' which Apollinaire named ORPHISM. Together with the work of KUPKA these were the earliest genuine colour abstracts in European art. Delaunay himself coined the word SIMULTANISME in opposition to the meaning given by the FUTURISTS to the term.

After visiting Spain and Portugal during the First World War Delaunay returned to Paris in 1921. During the 1920s he did a second *Tour Eiffel* series and began a series of paintings featuring football players, named *Les Coureurs,* in which he returned to the use of simplified representational forms. In the early 1930s he resumed his theme of abstract colour contrast with the series *Jeu des disques multicolores* and *Rhythmes* and also did plaster reliefs. He executed large coloured reliefs for the Palais des Chemins de Fer and the Palais de l'Air at the Exposition Universelle at Paris in 1937. In 1939 he collaborated in the organization of the first exhibition of the SALON DES RÉALITÉS NOUVELLES.

Delaunay's work on the aesthetic applications of the rhythmical interplay of abstract coloured forms had a considerable influence on the later development of abstract art, particularly on the growth of CONCRETE ART as promoted by Max BILL during the 1930s. His ideas about the expression of movement through colour contrast, harmonious colours suggesting slow movement and discordant or clashing colours abrupt movement, also served as a basis for later developments in KINETIC ART.

DELAUNAY-TERK, SONIA (1885–1979). Born in the Ukraine, Sonia Terk passed her childhood in St. Petersburg and after studying drawing at Karlsruhe under Schmidt-Reutter she came to Paris in 1905 and studied at the Académie de la Palette, where OZENFANT and DUNOYER DE SEGONZAC were fellow students. After a short-lived marriage with Wilhelm UHDE, she married Robert DELAUNAY in 1910. She was associated with Delaunay in founding the movement of ORPHISM, which Guillaume APOLLINAIRE ranked with CUBISM as the two most important 'new tendencies' in modern painting, and with her strong sense for

dramatic and decorative colour, derived in part from childhood remembrances of Russian folk art, she extended the principle of SIMULTANISME to the field of fabric design and applied art. One of her most important 'simultaneous' works at this time was the illustration of Blaise Cendrars's poem *La Prose du Transsibérien et de la Petite Jehanne de France*, a landmark in modern book production. In 1914 she exhibited at the Salon des Indépendants *Les Prismes Électriques*, now in the Mus. National d'Art Moderne, Paris. The Delaunays passed the war years in Spain and Portugal and in 1918 were commissioned by DIAGHILEV to design the costumes and décor for his ballet *Cleopatra*. Returning to Paris in 1920, they were for a time associated with the SURREALIST group. During the 1920s Sonia Delaunay worked mostly on hand-printed 'simultaneous' fabrics and tapestries; as a designer she made a strong impact on the international world of fashion, designing creations for such famous women as Nancy Cunard and Gloria Swanson, and she anticipated later trends in fashion. Her fabrics were exhibited at the 'Exposition des Arts Décoratifs' in 1925. In 1930 she turned primarily to painting and became a member of the ABSTRACTION-CRÉATION association. The Delaunays were commissioned in 1937 to design murals for the Palais des Chemins de Fer and the Palais de l'Air at the Paris Exposition Universelle and Sonia was awarded a gold medal for her work. In 1929 she helped organize the first 'Réalités Nouvelles' exhibition and after the war, in 1946, she helped to reorganize the SALON DES RÉALITÉS NOUVELLES.

After the death of her husband in 1941 she continued actively at work as painter and designer. She had retrospectives together with Robert Delaunay at the Mus. des Beaux-Arts, Lyons, and at Turin. In 1964 a gift of 49 works by Robert and 58 by Sonia Delaunay to the Mus. National d'Art Moderne, Paris, was exhibited at the Louvre (thus making Sonia Delaunay the first woman to be exhibited at the Louvre in her lifetime). In 1965 a large travelling exhibition of her works together with those of Robert Delaunay was shown in the main towns of Canada and a large retrospective exhibition was held at the Mus. National d'Art Moderne, Paris, in 1967. In 1970 one of her fabrics was given by President Pompidou to President Nixon on an official visit to the U.S.A. In 1972 a retrospective exhibition of Robert and Sonia Delaunay was held by the Gulbenkian Foundation, Lisbon, and exhibitions of tapestries by Sonia were held at the Mus. d'Art Moderne de la Ville de Paris and in Washington. In 1973 her tapestries were shown in Lausanne, Geneva and New York and she was awarded the Grand Prix de la Ville de Paris. In 1974 she had retrospective exhibitions at Grenoble, London, New York, Bielefeld and Tokyo.

DE LEEUW, BERT. See MATTERISM.

DEL PRETE, JUAN (1897–). Argentine painter and sculptor, born at Vasto, Italy, but lived in the Argentine from childhood. He was self-taught as a painter and began to paint in a FAUVIST manner, having his first one-man show in Buenos Aires in 1926. He obtained a scholarship from the Amigos del Arte Institution, with which he was able to reside in Paris from 1930 to 1933. There he became interested in LYRICAL ABSTRACTION and joined the ABSTRACTION-CRÉATION association. On his return to the Argentine in 1934 he exhibited abstract COLLAGES of paper and cord, some of the earliest abstract work to be produced in the Argentine. He went on to experiment with techniques of expressive abstraction such as splashing and dripping, which to some extent anticipated techniques of ABSTRACT EXPRESSIONISM. He also exhibited abstract constructions of wire, wood, iron, and he used materials such as wooden rods, pieces of frames, cloth patches, photographs, strips of paper, etc. in order to combine figurative and abstract images in his paintings. He had regular one-man exhibitions in many towns of South America and Italy, where he was well known, and he participated in a number of international group exhibitions. In 1937 he received a Gold Medal at the Exposition Universelle, Paris, and in 1958 the Augusto Palanza Prize at Buenos Aires and the International Grand Prix in Brussels.

DELVAUX, PAUL (1897–). Belgian painter born at Antheit, studied architecture and painting at the Academy of Fine Arts, Brussels, where he later taught at the Institut National Supérieur d'Architecture et des Arts Décoratifs. Delvaux progressed slowly towards his mature style of the mid 1930s. At first he painted realistic landscape in a *plein air* style on the edge of the Forêt de Soignes. This was succeeded by Neo-Impressionist Mosan landscapes and in the 1920s he gravitated towards EXPRESSIONISM in the manner of PERMEKE, Gustave de SMET and the Second LAETHEM Group. He was influenced towards SURREALISM by the work of MAGRITTE and by the METAPHYSICAL paintings of CHIRICO, which made a lasting impression upon him when he saw them exhibited in 1926. From *c.* 1934 he devoted himself more and more to Surrealist themes, creating an inner world of dreamlike unreality depicted with the veristic realism which many Surrealists affected. Although Delvaux was not formally a member of the Surrealist movement, and was not in sympathy with its political aims, the Surrealist character of his work was recognized by André BRETON and Paul ÉLUARD and he is regarded as one of the leaders of Belgian Surrealism. During the 1920s he was occupied by the study of the female form and in his Surrealist works the ideal female figure, nude or clothed, held a position of dominating importance. In *La Voix Publique* a nude Venus is pictured side by side with female figures clothed in the style of 1900. Delvaux combined the unreal space of the dream with a hallucinatory precision of detail and

a compelling yet unreal and almost Pre-Raphaelite eroticism. A sense of alienation and strangeness pervades his pictures of empty suburban railway stations, deserted vehicles and unpeopled landscapes. In the mid 1940s, following ENSOR, he became interested in the skeleton as a theme and in works such as the *Crucifixion* (1951–2) he achieved an austere monumentality in the genre of the grotesque.

DEMARCO, HUGO. See LATIN AMERICA.

DE MARIA, WALTER (1935–). American sculptor and experimental artist born at Albany, Calif., and studied at the University of California. After visiting Europe in 1968, he was awarded a Guggenheim Foundation Fellowship in 1969. He was one of the earliest exponents of MINIMAL ART, producing what was in effect Minimal art *c.* 1960, before the term was current. His work was included in the exhibitions 'Primary Structures' at the Jewish Mus., New York, in 1966 and 'American Sculpture of the Sixties' at the Los Angeles County Mus. of Art in 1967, and he participated in international collective exhibitions of the new art in Kassel, Düsseldorf, Berne, Amsterdam, etc. He collaborated with Robert MORRIS and Yvonne Rainer in Performance Situations from 1961 and with his (unexecuted) *Art Yard* project of 1961 he was also a pioneer in the art of EARTHWORKS. Some of his work belongs to the category of CONCEPTUAL ART, as for example *Mile Long Drawing* of 1968, two parallel chalk lines 12 ft (3·6 m) apart extending for 2 miles (3·2 km) in the Mojave desert. In 1968 he had a one-man show at the Heiner Friedrich Gal., Munich, at which he exhibited a room filled wall to wall with earth, 1,600 cubic ft (45·3 cubic m) in all.

DEMUTH, CHARLES (1883–1935). American painter born at Lancaster, Penn., studied first at the Philadelphia School of Industrial Art and then at the Pennsylvania Academy of the Fine Arts, Philadelphia, under Thomas Pollock Anschutz (1851–1912). In 1907–8 he made a trip to Paris, London and Berlin and he was again in Paris, 1912–14, when he studied at the Académie Julian and at the Académie Colarossi. Demuth was a close friend of Alfred STIEGLITZ and a member of the Gal. 291 circle. He was at this time primarily a watercolourist of great delicacy and precision and his work showed little evidence of influence from *avant-garde* European painting until 1915. From 1915 onwards he used his skill in watercolour to illustrate Zola's *Nana* and stories by Edgar Allan Poe and Henry James in a style akin to that of PASCIN with reminiscences of Aubrey Beardsley. From 1917 to 1919 he also did water-colours of vaudeville and circus performers with a rather stronger emphasis on rhythmical forms, and an awareness of contemporary experiments in abstraction manifested itself in his manipulation of light. An example of this phase is his *Acrobats* (The Mus. of

Modern Art, New York, 1919). In 1917 he visited Bermuda with Marsden HARTLEY and from about this time he began to paint with the simplified forms of the style which came to be known as CUBIST-REALISM, though in some of his pictures at any rate he made more use of the FUTURIST 'lines of force' than did SHEELER and the other PRECISIONISTS to whom this phase of his work was akin. Examples are *Trees and Barns, Bermuda* (Williams College Mus. of Art, Williamstown, Mass., 1917) and *Stairs, Princeton* (The Mus. of Modern Art, New York, 1920). During the same years he developed an interest in machinery as a pictorial theme, perhaps partly in consequence of his friendship with Marcel DUCHAMP, although his attitude to his subject matter remained more objective and uncommitted than that of most of the Precisionists and he avoided the excesses of the DADAISTS. He set the highest importance on impeccable craftsmanship and avoided any reliance upon the sensuous qualities of pigment or emotional involvement in his subject. Professor Sam Hunter has given an excellent account of the spirit and character of his work in this period, as follows: 'For all its charm, finesse, and structural integrity, Demuth's art of this period has no very profound spiritual resonance, nor was it meant to have. It is conceived in a more bland, objective, and even functional American spirit, retaining a canny hold on concrete visual facts. The selection of observed data, in Bermuda consisting of ships and wooden cottages, and later of the trim lines of Pennsylvania domestic architecture and the simple logic of industrial forms, is significant in itself. For Demuth was attracted, it would seem, to those aspects and surfaces of life whose structural simplicity and sober plainness he could match in an art that, while it lent itself to subtlety and refinement, allowed a minimum of sensuous elaboration.' His work at this time and in the 1920s reflected something of the simple formal elegance and orderly restraint of the Pennsylvania Dutch colonial architecture and folk art amidst which he passed his youth. In the 1920s, departing from the Precisionist style, he invented a type of oblique and symbolic portraiture, which he called the 'poster portrait' and in which he took over from the Cubists the use of words, letters or numerals as pictorial elements in a synthetic abstract design. The best known of these 'portraits' is *I saw the Figure 5 in gold* (The Metropolitan Mus. of Art, New York, 1928), in which he takes as his title the first line of a poem by his friend William Carlos Williams and incorporates the latter's initials as well as the figure 5 in a composition evocative of a fire engine (No. 5) rushing through the city streets. He had a retrospective exhibition at The Mus. of Modern Art, New York, in 1950.

DENIS, MAURICE (1870–1943). French painter, born at Granville. He was a school-friend of VUILLARD and Ker-Xavier ROUSSEL and a friend of BONNARD and SÉRUSIER, whom he met at the Aca-

démie Julian. He was a founding member of the NABIS and became their spiritual leader and chief theoretician. To him is owed the famous saying: 'Remember that a picture, before being a war-horse, a female nude or some anecdote, is essentially a flat surface covered with colours assembled in a certain order.' Denis combined erudition with a sense of purity and refined sensibility. In 1900 he painted his famous *Hommage à Cézanne* (Mus. National d'Art Moderne, Paris), featuring the principal *Nabis*, which was exhibited at the Salon de la Nationale in 1901 and bought by André Gide. He painted in light and clear colours, with flat planes and simplified forms. In 1899 VOLLARD had exhibited a set of coloured lithographs by him entitled *Amour*. He had a one-man show at the Gal. Druet in 1904 and an exhibition with Bern-heim-Jeune in 1907. When the Académie Ransom was founded in 1908 he joined the staff and taught there until 1919. His most important public work was the ceiling painting at the Champs-Élysées theatre, done in 1912. An intensely religious man, Denis set himself the task of reforming and renew-ing religious painting. In 1917 he did frescoes for the Church of St. Paul in Geneva and in 1919 he founded the Ateliers d'Art Sacré with George DESVALLIÈRES in 1922. In 1924 the Mus. des Arts Décor-atifs gave a retrospective exhibition of his works, and an important exhibition of his paintings, drawings and lithographs was given by the Mus. Toulouse-Lautrec at Albi in 1963. He wrote extensively on the theory of art and on sacred art, publishing *Théories, 1890–1910* in 1920 and *Nouvelles Théories* in 1922. In 1939 he published *Histoire de l'Art religieux* and in 1943 *Sérusier, sa vie, son œuvre.*

DENNY, ROBYN (1930–). British painter born at Abinger, Surrey, studied at the St. Martin's School of Art and the Royal College of Art. He was prominent among the British Colour Painters who made their debut at the 'Situation' exhibition organized by the critic Laurence Alloway in 1960. He had an exhibition at the Venice Biennale of 1966. He painted for the most part large symmetrical compositions constructed of rectilinear or geometrical shapes and exploring with great subtlety the aesthetics of pure colour.

DEPERO, FORTUNATO (1892–1960). Born in Fondo (Trento), he was an Austrian citizen al-though living in Italy. He moved to Rome in 1914 and was befriended by BALLA and MARINETTI, ex-hibiting in the Free Futurist Exhibition of that year in the Sprovieri Gal. He was one of the lead-ing members of the second phase of FUTURISM founded by Marinetti in Italy during the war. He collaborated with Balla in his *Manifesto for a Futurist Reconstruction of the Universe* in 1915 and also in his 'mechanical' theatre and his sound poems. He died in Rovereto, where there is now a Depero Museum.

DERAIN, ANDRÉ (1880–1954). French painter and sculptor born at Chatou, near Paris. He began to paint in 1895 and from 1898 studied at the Aca-démie Camillo, where he met MATISSE and Jean PUY. In 1900 he met VLAMINCK and shared a studio with him. In 1901 his ideas were revolutionized by the Van Gogh exhibition at the Gal. Bernheim-Jeune and when he began painting again in 1904 after a period of military service he adopted the manner of the FAUVES. He exhibited at the Salon des Indépendants in this year, spent the summer painting at Collioure with Matisse and partici-pated in the famous Fauve exhibition at the Salon d'Automne. He visited London in 1905 and again in 1906, from when he conceived a particular liking for things British. Indeed his pictures of London done at this time, along with some of those painted at Collioure, are among the finest of his Fauvist period (e.g. *Collioure, Le Faubourg*, Mus. National d'Art Moderne, Paris, 1905; *The Pool of London*, Tate Gal., 1906; *Barges on the Thames*, City Art Gals., Leeds, 1906). While he always continued to paint in the south of France, in 1907 he renewed his contact with PICASSO, whom he had met the previous year, and with the group of painters who frequented the BATEAU-LAVOIR. In this year also he made a contract with the dealer KAHNWEILER, for whom in 1909 he did woodcuts to illustrate APOLLINAIRE's *L'En-chanteur pourrissant* and in 1912 illustrations for Max Jacob's *Les Œuvres Burlesques et Mystiques de Frère Matorel, Mort et Couvent*. In 1910 he was painting with Picasso at Cadaques in Spain and when war was declared in 1914 he was with Picasso and BRAQUE at Montfavet, near Avignon. During these years he had much in common with the theories of the CUBISTS and although he never brought himself entirely within the movement, his paintings were not without influence on the de-velopment of Cubist aesthetics in the early years (e.g. *View of Cagnes*, Folkwang Mus., Essen, 1910; *Cadaques*, Národní Gal., Prague, 1910; *Nature Morte à la Table*, Mus. d'Art Moderne de la Ville de Paris, 1910; *The Table*, The Metro-politan Mus. of Art, New York, 1911). He was among the first to realize the importance of African primitive art for the new aesthetics, and his painting *Les Baigneuses* (Národní Gal., Prague, 1908), besides being one of the outstand-ing masterpieces of the decade, may be regarded as one of the forerunners of Cubism along with Picasso's *Les Demoiselles d'Avignon*.

After serving in the First World War Derain had his first one-man show in 1916 at the gallery of Paul Guillaume, who afterwards became his dealer. From *c.* 1911 he had begun to dissociate himself from the work of the Cubists and under the influence of the Italian and French primitives he entered upon what came to be known as his 'Gothic' period. From 1919, when he designed costumes and sets for the London performance of DIAGHILEV's ballet *La Boutique Fantasque*, he con-tinued to design for the theatre: in 1947 he visited

London for the Sadler's Wells Ballet production of *Mam'zelle Angot*, for which he had designed sets and costumes. In 1928 he was awarded the Carnegie Prize and in 1930 he was exhibited at the Knoedler Gal., New York, and the Cincinnati Art Mus.—the beginning of a long series of exhibitions in the U.S.A.

During his lifetime the opinion of critics was confused. Some blamed him as an apostate from the *avant-garde*; others spoke of him as the 'greatest living French painter'. He was, from the 1920s onwards, an essentially classical painter without ever becoming academic. In the Preface to the catalogue of his 1916 exhibition Guillaume Apollinaire wrote: 'Derain was a passionate student of the great masters. His copies show what trouble he took to understand them thoroughly. At the same time he had the unparalleled audacity to outdistance everything that was most audacious in contemporary painting, and rediscover, with simplicity and freshness, the principles of art and the disciplines derived from them.' Writing in 1957 of the impression made upon him by the 1954 retrospective exhibition at the Mus. National d'Art Moderne, Paris, Alberto GIACOMETTI said: 'Derain excites me more, has given me more and taught me more than any painter since Cézanne; to me he is the most audacious of them all.' These appreciations were quoted with approval by the critic Jean Leymarie in a Foreword to the catalogue of the important retrospective exhibition organized by the Arts Council of Great Britain at the Royal Academy in 1967.

Derain's sculpture had little in common with his painting. He began carving in stone *c*. 1905, doing stiff geometrical figures like caryatids. During the war years he made masks from granite shells and also carved block-like figures in stone with a somewhat mannered air of primitivism. He resumed sculpture *c*. 1939, carving heads, figures and reliefs in a style which carried reminiscences of both primitive carving and the Romanesque.

DE RIVERA, JOSÉ. See RIVERA, José de.

DE SMET, GUSTAVE. See SMET, Gustave de.

DESNOYER, FRANÇOIS (1894–1972). French painter and graphic artist born at Montauban, studied at the École des Arts Décoratifs, Paris, 1912–13 and later taught there. He exhibited at the Salon des Indépendants and the Salon d'Automne from 1922 and in 1924 was awarded the Prix Blumenthal. In 1937 he was awarded the Gold Medal at the Exposition Universelle. In 1946 he was invited to join the Salon de Mai. Desnoyer took what he needed from both FAUVISM and CUBISM to construct from them a mature personal style based upon the great colourists of the past, Titian, Veronese, Delacroix, Greco, whom he studied in the museums of Europe. He painted in well-defined planes distinguished by light and glowing colours without deep shadows. He was one of

those artists like GROMAIRE, GOERG, WALCH, who remained uncommitted to any of the *avant-garde* schools and cultivated an independent manner expressive of an uncomplicated attachment to the life and environment of their day. He painted expressive but superbly constructed landscapes, delighting particularly in port scenes such as *Le Port de Marseille* (Mus. National d'Art Moderne, Paris, 1940), but most of all he portrayed human life in figure studies and groups. He was a compulsive painter and the spontaneous delight he took in his subjects imparted a special charm to his work. He also did sculpture, whose sensuous forms reflected his warm personality and his delight in the physical. He did cartoons for tapestries and book illustrations, including the *Dies Irae* of La Fontaine.

DESPIAU, CHARLES (1874–1946). French sculptor born at Mont-de-Marsan in the Landes. From 1907 to 1914 he worked as assistant to Rodin. He made the war memorial at Mont-de-Marsan (1920–2) and in 1923 exhibited at the Salon d'Automne and the Salon des Tuileries, of which he was one of the founders. He had a one-man show at the Venice Biennale in 1930 and exhibited again at the 20th Biennale in 1936. He reacted from the Romanticism of Rodin and developed a sensitive, classical style which has certain affinities with that of Maillol. He is best known for his portrait busts with their intimate delineation of character (*Head of Madame Derain*, Phillips coll., Washington, 1922) but also made single figures and terracottas (*Assia*; one cast in Boymans-van Beuningen Mus., Rotterdam, 1938). His sculptural drawings have a directness of statement and a sensitive feeling for form which has caused them to be prized by connoisseurs.

DESPIERRE, JACQUES (1912–). French painter born at Saint-Étienne, son of the painter Edmond Céria (1884–1955). He studied at the Académie Colarossi and then at the Académie Scandinave under DUFRESNE and FRIESZ. He exhibited at the Salon de l'Œuvre Unique in 1935 and at the Salon des Tuileries in 1938, and won the Prix Paul Guillaume. Later he taught at the École des Arts Décoratifs. He painted in a manner of decorative Realism, delighting especially in compositions of figures in action and landscapes of the Loire valley.

DE STAEL, NICOLAS. See STAEL, Nicolas de.

DE STIJL. See STIJL, DE.

DESVALLIÈRES, GEORGE (1861–1950). French painter born in Paris, studied at the École des Beaux-Arts under Gustave MOREAU and was one-time President of the Salon d'Automne. In consequence of a vow taken on the death of his son in the First World War he devoted himself exclusively to religious art and in 1919 founded the

Ateliers d'Art Sacré together with Maurice DENIS. Although he is little remembered in the history of innovative art, he did murals and designed stained glass for many churches throughout France, elsewhere in Europe and in the U.S.A. He had a decorative but tortuous style and painted in harsh and realistic detail in order to convince the irreligious of the ugliness of society. Typical among his works in the Mus. National d'Art Moderne, Paris, is *L'Ascension du poilu* (1922).

DEWASNE, JEAN (1921–). French painter and sculptor, born at Lille. He began to paint at the age of 13 and when he was 18 he was already painting Pointillist pictures. He studied architecture for two years and then drawing at the École des Beaux-Arts, Paris. He began painting abstracts *c.* 1943 and was one of the group of abstract painters associated with the Gal. Denise René, exhibiting there from 1945 to 1956. In 1950 he was associated with PILLET in founding the Atelier d'Art Abstrait. He painted in a mode of geometrical abstraction akin to American HARD EDGE, with violently contrasting colours and geometrical forms which seemed to extend outside the frame. In the 1960s he began to use enamel paint put on with a spray-gun over masking tape. He also constructed sculptures from automobile parts which he afterwards painted, calling them 'Antisculptures'.

DEWING, T. W. See UNITED STATES OF AMERICA.

DEXEL, WALTER (1890–1973). German painter born at Munich and studied art history under Wölfflin at Munich University. From 1916 he lived and worked in Jena. Dexel began painting *c.* 1912, working at first in a manner which was a fusion of Cézanne and EXPRESSIONISM with CUBIST features. After the end of the First World War he moved in the direction of abstract art. From 1919 to 1925 he was in contact with the BAUHAUS and from 1921 he was influenced towards CONSTRUCTIVISM by Theo van DOESBURG. In 1923 he arranged a Constructivist exhibition at Jena. From 1923 to 1927 he was a member of the NOVEMBERGRUPPE. In 1935 his art was declared DEGENERATE and from 1936 to 1942 he taught at the Staatlichen Hochschule für Kunsterziehung in Berlin-Schöneberg. He began painting again in the 1960s. He also concerned himself with glass painting, serigraphs and screen printing. He was given a retrospective exhibition at the Städtisches Kunstmus., Bonn, in 1973.

DEYROLLE, JEAN-JACQUES (1911–67). French painter, born in Nogent-sur-Marne, studied at the École d'Art et de Publicité, Paris. In his first period his work showed the influence of CUBISM. In the early 1940s, however, he turned to abstraction under the influence of the Dutch painter César DOMELA NIEUWENHUIS, and was one of the group of painters associated with the Gal. Denise René and the SALON DES RÉALITÉS NOUVELLES.

Though his works in this period belonged to the category of geometrical abstraction, they had a certain lyrical element about them. From 1959 Deyrolle taught at the Munich Academy.

DIAGHILEV, SERGEI PAVLOVICH (1872–1929). Russian ballet impresario, born at Perm, near Novgorod. He was a cousin of Dmitri Filosofov, who later ran the literary section of the magazine *Mir Iskusstva*. In 1890 Diaghilev went to St. Petersburg and was introduced by Filosofov to BENOIS and other members of the MIR ISKUSSTVA group. In the same year he went to Paris with Filosofov. While studying law at St. Petersburg University he took music lessons with Rimsky-Korsakov. In 1895 he went abroad again and began the purchase of pictures. On his return to Russia he arranged exhibitions of 'English and German Watercolours' and of 'Scandinavian Painters' in 1897 and an exhibition of Russian and Finnish painters in 1898. In 1898 also the magazine *Mir Iskusstva* appeared under his general editorship.

When Prince Sergei Volkonsky was made Director of the Imperial Theatres he made Diaghilev his assistant. Volkonsky, however, was succeeded by Telyakovsky, who dismissed Diaghilev from his post in 1903. It was this which led to the formation of the *Ballets-Russes de Diaghilev*, which he brought to Paris. Through Diaghilev not only was the Russian ballet brought to western Europe in 1909 but the many Russian artists whom he employed to design costumes and décor caused a revolution in European theatrical design.

In 1903 also Diaghilev began the collection of 18th-c. Russian portraits, which were exhibited in 1905 at the Tauride Palace in St. Petersburg, the décor of the exhibition being designed by BAKST. In 1906 he organized a representative exhibition of Russian painting at the SALON D'AUTOMNE in Paris, which was the most comprehensive to have been seen in the West. Bakst again designed the décor of the twelve rooms occupied by this exhibition in the Grand Palais.

Diaghilev's resplendent career as an entrepreneur of ballet lies outside the scope of this book.

DIBBITS, JAN. See CONCEPTUAL ART.

DICK, AXEL (1935–). German painter and sculptor born at Dortmund. After studying in Berlin, 1956–60, he travelled in the U.S.A., Sweden and Portugal. From *c.* 1960 his work was much exhibited in Germany and the U.S.A. He did HARD EDGE painting with strongly contrasted colours and an emphasis upon light effects, which were his chief interest. He also made 'light objects' in contrasting coloured lights. Unlike most 'light' artists who were interested in the technical aspects, Dick declared that his primary concern was to reveal the 'magic of illumination'.

DICKINSON, EDWIN (1891–1978). American painter born at Seneca Falls, N.Y., studied at the Pratt Institute, 1910–11, and the Art Students' League, 1911–13, and then in Provincetown under Charles Webster Hawthorne, 1912–14. In later life he said that Hawthorne was the man who taught him the most. He travelled and painted in Europe in 1919–20 and again in 1937–8 and in 1952. From 1921 to 1937 he lived mainly in Provincetown and in 1944 moved to New York. In 1959–60 he visited Greece and the Near East. He taught at a number of different institutions in Provincetown, New York, Buffalo, Boston, etc. and he was exhibited widely. He was included in the exhibition '15 Americans' at The Mus. of Modern Art, New York, in 1952 and he had retrospective exhibitions at the Cushman Gal., Houston, and Boston University in 1958 and at the Graham Gal., New York, in 1961. Dickinson was basically a Romantic naturalist painter in the 19th-c. tradition, as is best seen in his small landscapes done on the spot. His large, monumental canvases have been called mystical or SURREALIST. Yet few of the typical Surrealistic features are present in them. Far from being spontaneous each canvas was often worked over for periods of as long as nine or ten years and he himself said that none of his large paintings 'is really finished'. Some of these paintings, such as *The Fossil Hunters* (Whitney Mus. of American Art, 1926–8) and *Composition with Still Life* (The Mus. of Modern Art, New York, 1934–7), contain superimposed and suggestive imagery but lack the special impact of material from the subconscious. Works such as *Anniversary* (Albright-Knox Art Gal., Buffalo, 1920) and *Ruins at Daphne* (The Metropolitan Mus. of Art, New York, 1943–53) are best regarded as a sophisticated culmination of the 19th-c. Romantic tradition.

DICKINSON, PRESTON (1891–1930). American painter born in New York, studied at the Art Students' League, New York, and at the École du Louvre, Paris. He is chiefly known as a pioneer of American CUBIST-REALISM based upon the structural features of Cézanne's composition. He was conservative by temperament and in the 1920s abandoned the high FAUVIST palette with which he had experimented earlier. Like others of the PRECISIONIST school he favoured American subjects which were adapted to representation in terms of semi-geometrical abstract design and in particular the machine. Typical of this tendency is his painting *Industry* (Whitney Mus. of American Art, *c.* 1924). His first one-man exhibition was at the Albright-Knox Art Gal., Buffalo, and he was subsequently exhibited extensively both in one-man and in group shows. He had retrospectives at Boston University, 1958, and the Whitney Mus. of American Art, 1965.

DIEBENKORN, RICHARD (1922–). American painter born at Portland, Oreg., studied at Stanford University, 1940–3, and the University of California, 1943–4. While serving during the war he came into contact with French POST-IMPRESSIONIST paintings and those of BONNARD, PICASSO, BRAQUE and MATISSE in the Phillips coll. at Washington and this had a decisive influence on his artistic outlook. After the war he taught at the California School of Fine Arts, San Francisco, from 1947 to 1950, and there under the influence of members of the NEW YORK SCHOOL, particularly Mark ROTHKO and Clyfford STILL, he abandoned the still lifes and interiors which he was painting and adopted a non-figurative style. Passing rapidly from a more geometrical mode of ABSTRACT EXPRESSIONISM he evolved a modified form of ACTION PAINTING, with the freer expressive brushwork and vigorous calligraphic line of DE KOONING, which inaugurated a distinctive West Coast movement. After 1955 he revolted from the subjective emotionalism of this way of painting and reverted to a mode of figurative abstraction in which he tried to apply the techniques of Abstract Expressionist brushwork to studies of figures in an environment, organizing his compositions into large rectangular areas of colour which owed much to the example of Matisse. He was also interested in exploring the kind of asymmetrical composition which balances a large area of blank colour against a small area of pictured incident, creating an atmosphere of calm and isolation. Examples of his work in this period are *Man and Woman in a Large Room* (Joseph H. Hirshhorn Foundation, Smithsonian Institution, 1957) and *Corner of Studio—Sinks* (1963). In the 1970s he abandoned the figure but not representation, turning to a kind of abstract architectural landscape into which he carried over the ambiguities implicit in both Abstract Expressionism and the severer paintings of Matisse. Abstract as they are, the works in his *Ocean Park* series, done from 1975, reflect the artist's extreme sensitivity to the qualities of light, constructing an illusory picture space by the perspectival means of planar design but using colour to create an ambiguous system of salience and recession with subtle effects of transparency. These were among the most complex and accomplished abstractions being painted in America at the time.

Diebenkorn's work was exhibited frequently from 1948 onwards in California and throughout the U.S.A. He also had exhibitions at the Tate Gal., London, in 1964 and at the Waddington Gals. in 1964 and 1967. He had retrospectives at the Washington Gal. of Modern Art and the Jewish Mus., New York, in 1964 and at the Pavilion Gal., Balboa, Calif., in 1965. He was also much exhibited in collective exhibitions both in the U.S.A. and abroad, including the São Paulo Bienale, 1957; Brussels World's Fair, 1958; The Mus. of Modern Art, New York, 'New Images of Man', 1959; Venice Biennale, 1959.

DIETRICH, ADOLF (1877–1957). The most prestigious of the Swiss NAÏVE painters, born of a

peasant family in Berlingen. He worked as a woodsman, railwayman, rope-maker, day labourer, factory hand and roadman, drawing and painting from an early age. He exhibited for the first time at Zürich in 1909 and in 1916 a collection of his drawings was published as *Book of Lake Constance*. From *c.* 1926 he devoted himself solely to painting. His reputation was European and his works were shown in international exhibitions of naïve art and were eagerly sought after for public and private collections. He painted animal scenes, still lifes, portraits and country scenes with the delicacy of an Old Master and with a hallucinatory realism which recalls that of the American REGIONAL painters. His drawings have a simplicity which combines meticulous detail with sharp observation.

DIETRICH, HANSJOACHIM (1938–). German sculptor, studied at the Werkkunstschule of Wuppertal, 1956–61. He worked as art director in several commercial agencies and founded the publishing firm Kalender in Düsseldorf. He made constructions, which he called 'Signal Objects', exploiting sound, movement and light, using in them a combination of electric light bulbs, sound producers, tapes, light cells or radios, sometimes enclosed in wire cages and sometimes with cushions or stuffed canvas bags. The noises, flashes and glaring coloured light signals were looked upon as a species of technological play. He claimed that the play of light alone was an aesthetic instrument needing no other medium.

DILLER, BURGOYNE (1906–65). American painter born in New York, studied at the Art Students' League. After passing through phases of Impressionism and CUBISM, he became interested in NEO-PLASTICISM and in 1934 was one of the earliest American followers of MONDRIAN. He was a member of AMERICAN ABSTRACT ARTISTS and from 1935 to 1940 Head of the Mural Division of the FEDERAL ARTS PROJECT. He taught at Brooklyn College and at the Pratt Institute, 1945–64. During the 1940s he was one of the group of artists most influenced by Mondrian and applied the principles of Neo-Plasticism rigorously. In the latter 1950s he reverted to an earlier style of composition with relatively few disconnected rectangular or vertical elements on an undifferentiated ground. He has been called one of the most imaginative and personal American artists who painted in the style of geometrical abstraction.

DINE, JIM (JAMES, 1935–). American painter and designer of HAPPENINGS, born at Cincinnati, Ohio. He studied at the University of Cincinnati, Boston Mus. School and Ohio University. He first exhibited with Claes OLDENBURG at the Judson Gal. in 1959 and had his first one-man show at the Reuben Gal., New York, in 1960. Since that time he has exhibited widely in America and Europe and has participated in important group shows.

Dine was a prominent figure in American POP ART and was best known for his combination of real objects—ties, lawn mowers, household appliances, wash basins, etc.—set against backgrounds of painterly textures. In 1959–60 he came to the fore as one of the pioneers of Happenings, sometimes collaborating with Claes Oldenburg. He collaborated with the British Pop artist PAOLOZZI in a series of COLLAGES and in the latter 1960s created a number of objects, such as a heart of sheet steel covered with straw (Sonnabend Gal., New York, 1966–9), whose impact depended on their dramatic unexpectedness or their sophisticated frivolity. Dine is considered to have been a pioneer of the 'process' or performance art of the late 1960s and early 1970s. Later he turned to representational painting of a traditional, classical kind, as in an exhibition 'New Works on Paper' at the Waddington and Tooth Gals., London, in 1977.

DISMORR, JESSICA (1885–1939). British painter born at Gravesend, studied at the Atelier La Palette, Paris, under METZINGER and DUNOYER DE SEGONZAC. She exhibited at the Allied Artists' Association Salons in 1912 and 1913 and at the Salon d'Automne in 1913. She met Wyndham LEWIS in 1913 and became a member of the VORTICIST group, signing the manifesto in BLAST No. 1 and joining the Rebel Art Centre in 1914. She participated in the London Vorticist Exhibition of 1915 and in the New York Vorticist Exhibition of 1917 and contributed to *Blast* No. 2. She exhibited with GROUP X at the Mansard Gal. in 1920 and in 1926 was elected a member of the LONDON GROUP. During the 1930s her work became completely abstract.

DISSIDENTS, THE. See OTERO, Alejandro.

DISTORTION. In the article on ABSTRACTION it was pointed out that whereas abstraction is to be defined as incomplete specification (the provision of *incomplete* information about the perceptible world) distortion means the provision of *incorrect* information. It was also pointed out that in practice a hard and fast line between abstraction and distortion cannot always be drawn.

Distortion has been deliberately employed by artists for a number of different purposes, of which the following are perhaps the most important.

1. Distortion has been widely used for primarily decorative purposes, as notably in the work of Beardsley, KLIMT, Obrist, Gaudí and others of the ART NOUVEAU movement. It is apt to bulk large wherever naturalistic motifs, including human figures, are stylized for the purposes of decorative art. It has been used in this way by MATISSE, DUFY, PIPER and a host of others.

2. Distortion, like abstraction, has been used to point up an extra-artistic message. Examples are the 'psychological perspective' of some Egyptian, Late Classical and medieval art, where psycholog-

ical importance is indicated by disproportionate size; the prominence given to sexual characteristics in some primitive and much pornographic art; the exaggerations universally used in the art of caricature. In contemporary art distortion has been used in this way by the MEXICAN Muralists and the 'New Humanists'.

3. One of the most important uses of distortion in contemporary art has been for purposes of expressiveness. Distortion is used to give prominence to certain expressive features in the object depicted by emphasizing or exaggerating these features in relation to others. Moreover, by the very fact that it departs from strict verisimilitude any distortion attracts attention and stands out as prominent in a representational work. This fact is often used to emphasize purely formal features in the composition.

4. A further more sophisticated use of distortion, combined usually with some measure of abstraction, is the pointing up of visual metaphor, as for example when a human figure takes on something of the appearance of a range of mountains. This mode of distortion may be seen notably in some of the work of Henry MOORE and Paul NASH.

5. It is worth mentioning as something more than a curiosity experiments made by some modern artists in colour distortion for the purpose of getting round the enormous limitations necessarily imposed by pigment colours upon the representation of colour in nature. The limitations are particularly serious in the range of brightness. For example, in a landscape the most striking object, that which has the greatest visual prominence or impact (*Auffälligkeit* in German), is the sun. But yellow has not great prominence among pigment colours and is not susceptible of a high degree of saturation. Therefore Paul KLEE sometimes painted the sun black (or some other strong colour) and modified all other local colours accordingly. Martin Bloch also used systematic distortion of hue in order to bring a whole picture into keeping with some central idea of representing prominence or illumination. In general contemporary art has paid less attention to exactness in the representation of local colour than was done in the past and has freely distorted hue in the interests of other aspects of colour.

There is no doubt that distortion makes a strong impact upon the average viewer particularly when it is of a new or unfamiliar kind. The violent antipathy to it expressed by many critics in the 1930s, which had almost disappeared by the 1950s, arose from an unexpressed assumption, now thought to be false, that a necessary function of representational art, though not its sole function, was to convey veridical information about the perceptible world. Distortion may be used for sheer fantasy—and in such case seldom arouses opposition. Apart from this it has, as indicated above, definite functions to perform.

DIVISIONISM. A method and technique of painting whereby tones and hues are obtained not by mixing pigments on the palette but by applying small areas of unmixed pigment on the canvas so that they combine 'optically' in the vision of a spectator viewing the picture from a proper distance away. By this method greater luminosity and brilliance are obtained because the 'optical' combination of adjacent colour patches is 'additive' whereas the admixture of pigments on the palette produces a subtractive result. In the former case the total gamut of light reflected by both pigments fuses and combines in vision; in the latter case only those wavelengths which are common to both pigments are reflected. The method can also be used so as to give to the canvas a certain textural quality which has been described as vibrancy or movement.

Although Divisionism is contrary to the principles of painting by superimposed glazes and scumbles handed down from the Renaissance, it has been employed by many artists in *alla prima* painting. Notable precursors of Divisionism were Watteau and Delacroix. It was also employed empirically by the Impressionists, and in particular by those who adopted the 'rainbow' palette of Renoir. It was developed systematically and scientifically by the Neo-Impressionists, culminating with them in the technique of Pointillism. The method was described by Signac, who first applied the term 'Divisionism' to it, as follows: 'Divisionism is a method of securing the utmost luminosity, colour and harmony by (a) the use of all the colours of the spectrum and all degrees of those colours without any mixing; (b) the separation of local colours from the colour of the light, reflections, etc.; (c) the balance of these factors and the establishment of these relations in accordance with laws of contrast, tone and radiation; and (d) the use of a technique of dots of a size determined by the size of the picture.'

In later terminology the word Pointillism has been applied to the scientific form of Divisionism initiated by Seurat, when unmixed pigments are juxtaposed in dots whose size is determined by the size of the picture (or rather, by the appropriate distance from which the picture is best viewed—which is connected with its size). The word 'Divisionism' is applied to the same technique when the juxtaposed areas of unmixed pigment are not in the form of graded dots but may be of any shape or size so long as the resultant colour impression is produced by optical admixture. This method was taught and practised widely during the first decade of the 20th c. and many artists who had an important influence on the development of 20th-c. painting started with a thorough grounding in the principles of Divisionism. Many of the leading figures in the FUTURIST movement, for example, began their artistic career versed in the methods of Italian Divisionism as it had been practised by Segantini (1858–99) and PREVIATI, who published books on the technique in 1905 and 1913.

DIX, OTTO (1891–1969). German painter and print-maker, son of an iron worker at Unternhausen, Thuringia. After serving in the First World War he studied at the academies of Dresden and Düsseldorf. In the 1920s he was, with George GROSZ, one of the more prominent figures in the NEUE SACHLICHKEIT. In his work SOCIAL REALISM predominated over artistic intentions and he at times produced a kind of deliberate ANTI-ART or KITSCH and veristic MONTAGES made up of deliberately ugly materials. Yet he was capable of the most penetrating insight and depicted the depravities of a decadent society and the disgusting nature of war with complete psychological truth. His set of etchings *Der Krieg* (1924) have been described by G. H. Hamilton as 'perhaps the most powerful as well as the most unpleasant anti-war statements in modern art'. The same writer states: 'It was this quality of unmitigated truth, truth to the most commonplace and vulgar appearances, as well as to the ugly realities of psychological experience, that gave his work a strength and consistency attained by no other contemporary realist, not even by Grosz, and which in the last years of the Weimar Republic, whose chronicler in a sense he became, brought him a measure of recognition.' In 1927 he was appointed a teacher at the Dresden Academy and in 1931 he was elected to the Prussian Academy. Dismissed from his academic posts in 1933, he settled at Hemmenhofen on Lake Constance. He fought in the Second World War and was a prisoner in France in 1945–6. He was reinstated after the war and returned to Hemmenhofen. During the 1930s he reverted in his painting to romantic EXPRESSIONISM, often producing pictures with eschatological implications.

DJANIRA. See LATIN AMERICA.

DMITRIENKO, PIERRE (1925–74). French painter of Russian descent on his father's side, born in Paris. He studied architecture and painting together in Paris and devoted himself entirely to painting from *c.* 1947. After flirting briefly with CUBISM under the influence of GLEIZES, he turned to LYRICAL ABSTRACTION and during the early 1950s painted with a sensitively organized palette of greys and blacks. His later work was more highly coloured with precise forms of exceptional luminosity. He first exhibited at the Gal. Maeght in 1948 and had one-man shows at the Gal. Lucien Durant, Paris, in 1953 and 1954. With DUFOUR, LAPOUJADE, REZVANI, GILLET and others he participated in collective exhibitions of French lyrical abstract art in Paris, Madrid, Edinburgh, New York, Zürich, Stockholm, etc. From 1950 he exhibited also at the Salon de Mai.

DOBELL, WILLIAM (1899–1970). Australian painter born in Newcastle, N.S.W. He entered into articles with a local architect, Wallace Porter, and remained with him for seven years before moving to Sydney to work as a designer with Wunderlichs, manufacturers of building materials, studying at night at Julian Ashton's art school. In 1929 he won the Society of Artists' Travelling Scholarship, went to London and began studies at the Slade School under Henry TONKS. In 1930 he won the prize for life drawing at the Slade and visited the Netherlands to study the Dutch masters. His painting at this time was muted in tone but crisp in brushwork and revealed the influence of SICKERT, Tonks and Van Gogh. A visit to France and Belgium in 1931 broadened the scope of his interests and his work began to reveal his admiration for the art of Rembrandt, Goya, El Greco, Daumier, Renoir and SOUTINE. In 1933 he exhibited *Boy at the Basin* (Art Gal. of New South Wales) at the Royal Academy. By 1933 he had begun to draw extensively upon London street life personally observed. Later he turned more to the depiction of character and social type in such paintings as *Tired Nippy* (Sydney University, 1937) and *Mrs. South Kensington* (Art Gal. of New South Wales, 1937). Some portraits of this time such as *The Irish Youth* are exceptionally sensitive and revealing. Others are executed more freely, with fluid paint and pure colour. A decisive break with the Slade tradition came with *The Red Lady*, where the influence of Soutine, so important for his later work, first appears.

In 1938 Dobell returned to Australia, taught for some years at the East Sydney Technical College and exhibited with the Society of Artists and the CONTEMPORARY ART SOCIETY OF AUSTRALIA. He now experimented with glazes and richer colour effects (*The Cypriot*, Queensland Art Gal., 1940), in which the impact of Mannerist portraiture, Bronzino particularly, first asserted itself. During the Second World War Dobell was employed by the Civil Construction Corps. His war paintings, such as *The Billy Boy* (Australian War Memorial Mus., Canberra, 1943), show his exceptional capacity to reveal the character and mood of his subjects. In 1944 he won the Archibald Prize for portraiture, awarded annually by the Art Gal. of New South Wales, with a portrait of his fellow-artist, Joshua Smith. The award, which was contested in the courts by two of the unsuccessful competitors on the grounds that it was not a portrait but a caricature, created a *cause célèbre* for modernism in Australia and Dobell's name became a household word. During the next decade he was much sought after for portrait commissions, among the finest being his portraits *Helena Rubinstein* and the poet *Dame Mary Gilmore* (Art Gal. of New South Wales, 1957). In 1949 and again in 1950 he visited the highlands of New Guinea. As a result of this tropical experience his work became broader in execution and more decorative. He died at Wangi Wangi, Lake Macquarie.

Dobell was unique among Australian artists in combining successfully a mastery of Renaissance tradition (particularly in portraiture) with a profound insight into the character and values of 20th-c. Australians. A retrospective exhibition of his work was held in the Art Gal. of New South Wales in 1964.

DOBSON, FRANK (1886–1963). British sculptor born in London. After studying at the Leyton School of Art he worked as an apprentice to Sir William Reynolds Stephens from 1902 to 1906. He was impressed by the POST-IMPRESSIONIST exhibitions organized by Roger FRY and for three decades moved with the *avant-garde* in Britain, being one of the earliest to practise direct carving. His first London exhibition of paintings and drawings was in 1914 and in 1920 he was associated with the GROUP X of Wyndham LEWIS. In 1922 he joined the LONDON GROUP and was its President, 1924–8. During the 1920s and 1930s his reputation in English art stood very high, his bronze figure *Truth* (Tate Gal., 1930) being presented to the nation by the Contemporary Art Society. In 1925 Roger Fry described his work as 'true sculpture and pure sculpture . . . almost the first time that such a thing has been even attempted in England'. Raymond Mortimer in 1926 said that Dobson was one of the three most interesting sculptors then alive in the world and the best that England had produced for about 600 years. After the Second World War appreciation of his work suffered from the swing of taste and a Memorial Exhibition given by the ARTS COUNCIL in 1966 was not received with enthusiasm by the critics. Dobson was a sculptor in the classical tradition of MAILLOL and DESPIAU, regarding sculpture as first and foremost an investigation into three-dimensional form, and like them he found the female nude the most satisfactory subject for three-dimensional composition. He was also outstanding as a portrait sculptor, as witness his bronzes of Lydia Lopokova and Robin Sinclair, and besides stone carving produced many exquisitely beautiful terracottas. Although now virtually forgotten, he was in his day one of the pioneers of modern British sculpture.

DOCUMENTA. An international exhibition of innovative art held every four years since 1955 at Kassel, Germany. The first Documenta exhibition, founded at the instigation of Professor Bode of the Kassel Academy, signified the reacceptance by Germany of *avant-garde* art, which had been banned by the National Socialist Party as DEGENERATE. The second Documenta, in 1959, contained an American section which demonstrated the achievements of the NEW YORK SCHOOL. The third was in 1964. The fourth, in 1968, was dominated by American COLOUR FIELD painting, POP ART and MINIMAL ART. Out of some 150 artists invited, 57 were from the U.S.A. and the works they exhibited were often of gigantic size.

DOESBURG, THEO VAN (C. E. M. KÜPPER, 1883–1931). Dutch painter and architect, born at Utrecht, the prime organizer of the De STIJL group. He was at first attracted to a theatrical career and he published a collection of his own poems in 1913. But he had begun painting by 1899 and held his first exhibition at The Hague in 1908. In 1912 he was writing as an art critic on Asian art, CUBISM, FUTURISM and KANDINSKY. From 1912 to 1916 his artistic career was interrupted by military service but in 1915 he made the acquaintance of MONDRIAN and published a eulogistic article on his work. Up to this stage Van Doesburg's work was within the ambit of POST-IMPRESSIONIST and FAUVIST influence. But in 1916 and 1917 he went rapidly through the transition to abstraction which Mondrian had accomplished more gradually between 1911 and 1914.

In 1917 he founded the periodical *De Stijl* and formed the association of the same name in collaboration with Oud and Wils and with the painters Mondrian, LECK and HUSZAR, the sculptor VANTONGERLOO and the poet Antony Kok. For the remainder of his life the propagation of the principles and the aesthetic beliefs of De Stijl remained his dominant interest. He did this both by writing and lecturing and by devoting himself to a series of architectural projects. During the years following 1917 he was painting pictures so similar in style and composition to those of Mondrian as to be almost indistinguishable from them. In 1921 he left the Netherlands for an extended tour of lectures, and made contact with LE CORBUSIER and with GROPIUS and Mies van der Rohe at the BAUHAUS, where his ideas made a considerable impression, particularly upon Werner Graeff (1901–) in the sphere of industrial design. He came into contact with personalities prominent in the DADA movement and in 1922 published a Dada supplement to *De Stijl* with the title *Mecano*, working in collaboration with ARP, Tzara and SCHWITTERS. From *c.* 1924 his painting began to depart from the stricter early principles of De Stijl in that he abandoned the rigid limitation to the vertical and horizontal planes and allowed a certain sense of movement and dynamism to intrude with the use of planes inclined to the vertical. These paintings he called 'Counter-compositions'. In keeping with this change he worked out a theoretical modification of NEO-PLASTICISM, which he called ELEMENTARISM, and expounded its principles in a 'Manifesto of Elementarism' published in *De Stijl* in 1926 and further elaborated in 1929. In 1930 he published the sole number of a new periodical, ART CONCRET.

Van Doesburg was interested in applying the principles of Neo-Plasticism to architecture and in working out a concept of architectural space constructed from geometrically simple elements and primary colours. It was largely owing to his energetic pursuit of this idea that *De Stijl* exercised so important a formative influence on the development of modern architecture. In 1916 he began his collaboration with the architects Oud and Wils and with them formed the short-lived group De Sphinx. In 1917, the year of the formation of De Stijl, he began the application of these principles in designs done in collaboration with Ouds for the latter's house at Noordwijkerhout, near Leyden, and in 1920 he worked on architectural projects, in conjunction with a Dutch architect, Boer, for workmen's houses and schools at Drachten. From 1922 to 1924 he lectured irregularly at the Bauhaus at Weimar and his book *Grondbegrippen der*

nieuwe beeldende kunst (1919) was published as a Bauhaus booklet in 1924 in a German translation with the title *Grundbegriffe der Neuen gestaltenden Kunst*. In 1923 he exhibited architectural projects with Van Eesteren (1897–) and Rietveld (1888–1964) at the Gal. de l'Effort Moderne, Paris; in 1924 he exhibited at Weimar and began his interest in town planning; and in 1925 he participated in an architectural exhibition at Nancy. When the restaurant L'Aubette at Strasbourg was reconstructed in 1926–7 Van Doesburg designed several of the rooms in collaboration with Arp and Sophie TAEUBER. The results of the Aubette project, now destroyed, were published in 1928. In 1930 he moved to Paris and built himself a studio at Meudon which became until his death in 1931 a new focus of the De Stijl movement. The movement collapsed with his death, although its influence has survived in many fields.

Besides his articles in *De Stijl* he published: *De Nieuwe beweging in de schilderkunst* (Delft, 1917); *Drie voordrachten over de nieuwe beeldende kunst* (Amsterdam, 1919); *Grondbegrippen der nieuwe beeldende kunst* (Amsterdam, 1919; German transl. 1924, published as Bauhaus booklet 6); *Klassiek, barok, modern* (The Hague, 1920); *Wat is Dada?* (The Hague, 1924); *L'Architecture vivante* (Paris, 1925).

DOLAMA, ANUTA. See NAÏVE ART.

DOLENEC, FRANJO. See NAÏVE ART.

DOMELA NIEUWENHUIS, CÉSAR (1900–). Dutch painter, born at Amsterdam. He left the Netherlands in 1919 for Ascona and Berne, where he painted from nature and experimented in CONSTRUCTIVIST and abstract art. He then moved to Berlin, where in 1923 he showed non-figurative work in an exhibition of the NOVEMBERGRUPPE. In 1924–5 he came into contact with Van DOESBURG and MONDRIAN in Paris and became a member of the De STIJL movement. He had a one-man exhibition at The Hague in 1924. From 1927 to 1933 he was in Berlin, where he came under the influence of Naum GABO and began the MONTAGES for which he is best known, seeking to exploit the contrasts of colour and texture of different materials. From 1933 he lived in Paris and was a member of the ABSTRACTION-CRÉATION group.

In 1937 he was co-editor with ARP and Sophie TAEUBER-ARP of the periodical *Plastique* and in 1939 he took part in the exhibition 'Réalités Nouvelles' at the Gal. Charpentier. In 1946 he was a founding member of the abstract group *Centre de Recherche*. Through the 1950s his constructions became less rigid, making use of curvilinear lines and even a certain amount of 'illusory' recession. He exhibited in Paris, London, Amsterdam and elsewhere in Europe and in 1954 he visited Brazil and exhibited there.

DOMINGUEZ, OSCAR (1906–58). Spanish painter and sculptor born at Tenerife. He taught himself to paint in the 1920s and settled in Paris in 1934. There he met BRETON and ÉLUARD and joined the SURREALIST movement, remaining with it until 1945. At first he painted veristic pictures in the manner of DALÍ, but from *c.* 1935 adopted techniques of AUTOMATISM and is credited with having invented the DÉCALCOMANIE method. Some of these automatic drawings were reproduced in the Surrealist journal *Minotaure* and there are examples in public collections, including The Mus. of Modern Art, New York. Dominguez also made Surrealist objects and produced visionary compositions of everyday things in fantastic conjunction. After *c.* 1940 his spontaneity left him and he did little more than plagiarize PICASSO and CHIRICO until 1954, when he sought to renew the automatic process.

DOMOTO, HISAO (1928–). Japanese painter born in Kyoto, where he studied at the Academy of Arts. In 1955 he emigrated to Paris and adopted the TACHIST style of LYRICAL ABSTRACTION then current in the ÉCOLE DE PARIS. In the 1960s he worked in a more formal and geometrical style and also made constructions of metal.

DONATI, ENRICO (1909–). Italian-American painter and sculptor born at Milan, studied at Pavia University. He migrated to the U.S.A. in 1934 and became an American citizen in 1945. In the U.S.A. he studied at the New School for Social Research and the Art Students' League, New York. He taught at Yale University, 1960–2. He was on the Advisory Board of Brandeis University from 1956, on the jury of the Fulbright Program, 1954–6, and on the Yale University Council for Arts and Architecture, 1962. His first one-man exhibitions in the U.S.A. were at the Passedoit Gal., New York, and the New School for Social Research, in 1942. From about this time he was a member of the SURREALIST group in New York and painted fantastic biomorphic forms with swirling organic arabesques. In the late 1940s he passed through a CONSTRUCTIVIST period and evolved a calligraphic style executed in melted tar. This led on to an interest in materials and texture and a style which had affinities with MATTERISM and DUBUFFET. The materials he used included pigment combined with dirt from a vacuum cleaner, e.g. his *Moonscape* series. He is best known for his *Fossil* series of the 1960s, in which colour and texture reinforced each other. He had a retrospective exhibition at the Palais des Beaux-Arts, Brussels, in 1961 and he was represented in a number of important group exhibitions in the U.S.A. and abroad, including the biennial exhibitions at Tokyo, Venice and São Paulo and the American Federation of Arts exhibition 'The Embellished Surface', 1953. He was a member of the MOVIMENTO SPAZIALE founded by FONTANA in 1947.

DONGEN, KEES (CORNELIUS) VAN (1877–

1968). Dutch painter and potter, born near Rotterdam. After working as a draughtsman for the Rotterdam *Nieuwsblad*, he settled in Paris in 1877, earning his living at first as a house-painter and porter. His heavy Dutch EXPRESSIONIST manner of painting was influenced by Late-Impressionism and by about 1905 he had come to the fore as one of the most dynamic of the FAUVISTS. His graphic work also gained liveliness and assurance under the influence of FORAIN and Toulouse-Lautrec. In 1913 he began to work for the *Folle Époque*. From about this time his work lost its dynamism and creative power and he became the popular portraitist of the beau-monde and *demi-monde* in a gay and hedonistic world. It is for his work before the First World War that he is now chiefly remembered.

DONGHI, ANTONIO (1897–). Italian painter born in Rome, studied informally at the Institute of Fine Arts, Rome. Working in isolation from the NOVECENTO, he developed a sharp-focused and meticulous Realism which had affinities both with NAÏVE art and with the precision of Cranach and Ingres.

DONKEY'S TAIL (OSLINYI KHVOST). A breakaway group formed by LARIONOV and GONCHAROVA when they dissociated themselves from the KNAVE OF DIAMONDS group in 1911. They accused the Knave of Diamonds group of being too much under foreign influence, specifically the followers of Cézanne and the FAUVISTS in Paris and the BLAUE REITER group of KANDINSKY in Munich, and they advocated a nationalist Russian art independent of outside influences. At this time Larionov and Goncharova were painting in their 'primitivist' manner based upon Russian peasant art and icon painting. The first exhibition of the Donkey's Tail was held at Moscow in March 1912 and they were joined by MALEVICH, who at this time was influenced by the primitivism of Goncharova, and by TATLIN, who exhibited costume designs for the *Emperor Maximilian and his son Adolf*, staged by the Moscow Literary Circle in 1911, and also a group of early nautical sketches. CHAGALL sent a painting entitled *Death* from Paris, but Kandinsky was not invited to participate. The exhibition caused a public outcry because of the inclusion of religious paintings such as *The Evangelists* by Goncharova, which was regarded as sacrilegious by the Establishment.

DORAZIO, PIERO (1927–). Italian painter born in Rome. After studying architecture he began to paint in a manner of SOCIAL REALISM. But in 1947 he joined the *Forma* group of abstract painters and signed their manifesto opposing Social Realism. He visited Paris, Austria and Germany in 1949–50 and in 1953 went to the U.S.A., where he had an exhibition at the Rose Fried Gal., New York, in 1953. He taught at the University of Pennsylvania from 1963 to 1967. After experiment-

ing with expressive abstraction Dorazio joined the CONTINUITÀ group in 1961 and began to work in the manner of the COLOUR FIELD painters deriving from Morris LOUIS, evolving during the 1960s a personal style of brightly luminous horizontal bands of colour. He also did virtually monochromatic paintings heightened by small flecks and spots of a contrasting colour over a pattern of diamonds or squares.

DOS PRAZERES, HEITER. See LATIN AMERICA.

DOTTORI, GERARDO (1888–1977). Italian painter, born in Perugia and studied at the Academy there. He came under the influence of FUTURIST techniques *c.* 1910 but did not join the movement until 1913. His main contribution was made within the ranks of the Second Futurist phase brought into being by MARINETTI in 1916 and he was particularly associated with AEROPITTURA, or the painting of the sensations of flight. He dissociated himself from the Futurists in 1922 and his work became increasingly formal and mechanical, attracting little attention outside Italy although four examples were included in the 'Exhibition of Italian Futurism' given at the Royal Academy, London, in 1973.

DOVA, GIANNI (1925–). Italian painter born in Rome, studied at the Accademia di Brera, Milan. After beginning in a style of fantasy bordering on SURREALISM, he came under the influence of Max BILL and VANTONGERLOO and developed in the direction of geometrical abstraction not unlike De STIJL. In 1948 he became a member of the MOVIMENTO SPAZIALE dominated by the ideas of FONTANA. During the 1950s, however, he evolved a style of expressive abstraction in which the influence of Chinese calligraphic paintings could be discerned.

DOVE, ARTHUR GARFIELD (1880–1946). American painter born at Canandaigua, N.Y., and educated at Hobart College and Cornell University. From 1903 he earned his living as a commercial illustrator and continued to do this until *c.* 1930. He visited Europe 1907–9 and came into contact with FAUVISM and other *avant-garde* movements. In 1910 he began his 'extractions', as he called them, which were among the first abstracts in modern art, paralleling KANDINSKY's abstracts of approximately the same date. These, mostly in neutral colours, were based on natural forms, suggesting the rhythms of nature with their pulsating shapes: *Nature Symbolised No. 2* (Art Institute of Chicago, 1914); *Abstraction No. 2* (Whitney Mus. of American Art, 1911). Dove wrote: 'I should like to take wind and water and sand as a motif and work with them, but it has to be simplified in most cases to color and force lines and substances just as music has done with sound.' He met Alfred STIEGLITZ in 1907 through his friend Alfred MAURER and in 1910 he was given an exhibition by

Stieglitz in the 291 Gal. He exhibited at the ARMORY SHOW, at the FORUM exhibition which followed it in 1916 and at the large exhibition of the SOCIETY OF INDEPENDENT ARTISTS in 1917. From 1912 to 1918 he painted while farming at Westport, Conn., and from 1920 to 1929 he lived and painted on a houseboat on the Harlem river. Dove was one of the minority of American innovative artists who did not revert to expressive naturalistic painting in the 1920s. He experimented with a form of abstraction which tried to create concrete images expressive of sounds, as in *Sentimental Music* (The Metropolitan Mus. of Art, New York, 1917) and *Fog Horns* (Colorado Springs Fine Arts Center, 1919). In the 1920s Dove also experimented with COLLAGES in which he used manufactured and discarded materials, such as *Portrait of Alfred Stieglitz* (The Mus. of Modern Art, New York, 1925) which used steel wool, clock and watch springs, camera lens and photographic plate on cardboard. From the late 1930s his abstractions tended to become less organic, less closely linked to nature, as he concentrated upon the balanced interplay of relatively flat areas of pigment: *High Noon* (Wichita Art Mus., 1944).

Dove was an intuitive and spontaneous abstractionist, inspired by a profound feeling for nature. His later painting has often been interpreted as a forerunner of ABSTRACT EXPRESSIONISM, but he worked in a different context and with a different motivation from the Abstract Expressionists. Professor Sam Hunter wrote in *American Art of the 20th Century*: 'An effort has been made in recent years to relate Dove to mid-century directions in abstract art, but the comparison is strained by the diverse aims and the unrelated artistic backgrounds of painters of the first and the contemporary periods of abstraction. Any resemblance, for example, between the paintings of Dove and Clyfford STILL, or the Mark ROTHKO of an early phase, must remain superficial despite obvious similarities in appearance . . . In his best work one feels the operation of a strange, luminous subjective consciousness, which is nonetheless firmly planted in external reality.'

DOWNING, THOMAS (1928–). American painter born at Suffolk, Va., studied at the Pratt Institute, 1948–50. He had his first one-man exhibition at the Jefferson Place Gal., Washington, and then exhibited at the Allan Stone Gal., New York. He was represented in the 'Post-Painterly Abstraction' exhibition at the Los Angeles County Mus. of Art, 1964; 'The Responsive Eye' exhibition at The Mus. of Modern Art, New York, 1965; 'The Washington Color Painters' at the Washington Gal. of Modern Art, 1965; and the 'Systemic Painting' exhibition at the Solomon R. Guggenheim Mus., 1966. He had a retrospective exhibition at La Jolla in 1968.

Downing belonged to the Washington group of Colour painters who followed NOLAND in structuring pure colour into contrasting areas with clearly defined boundaries.

DOYLE, TOM (1928–). American sculptor born at Jerry City, Ohio, studied at Miami University and Ohio State University. He taught at Brooklyn Mus. School and at the New School for Social Research, 1961–8. During the 1960s he exhibited at the Allan Stone Gal. and the Dwan Gal., New York, and in collective exhibitions of the most recent movements in American art. His work belonged to the category of MINIMAL ART and his dissociated extended sculptures had affinities with those of George SUGARMAN and David WEINRIB. In contrast to the 'unitary objects' of Robert MORRIS and Donald JUDD, and in contrast also to the CUBIST-oriented abstraction whose principle of unification was the rhythmic iteration of elements about a central core, Doyle juxtaposed disparate masses in sequence, incorporating organic as well as geometrical forms in one piece so as to obtain a great diversity of spatial and formal relations. He combined a great variety of materials—steel, aluminium, wood, linoleum, etc.—and like Sugarman, Weinrib and sometimes Bladen, he often painted the disparate elements in brilliant and contrasting uniform colours to enhance their dissociation. An example of his more felicitous combination of curvilinear and geometrical shapes is his sculpture *La Vergne* (1966), of which the critic Michael Benedikt wrote: 'Tom Doyle's *La Vergne*, which is a 7-shaped mast around which a sail-like shape is wrapped, conveys a feeling of weightlessness that is as rare in the context of American sculpture as it is frequent among recent British work.' Like other Minimalists Doyle dispensed with the pedestal, setting his sculptures directly on the ground, where they became a part of the environment, and he experimented with 'environmental' sculpture which invites the spectator to walk into it and not merely survey it from a distance. He often worked on an enormous scale, seeking immediacy of impact and the impression of grandeur resulting from size.

DREIER, KATHERINE S. (1877–1952). American painter and organizer, more often remembered in the latter capacity. After studying painting at the Art Students' League she went to Paris in 1907 and also visited London, Munich and Amsterdam, returning to the U.S.A. in 1913. She took part in the ARMORY SHOW, where she met Marcel DUCHAMP, and in 1920 together with him and MAN RAY she founded the SOCIÉTÉ ANONYME. The travelling exhibitions which she organized through the Société Anonyme, most of the catalogue entries for which were written by Duchamp, were a potent factor in bringing a knowledge of European abstract painters to the American artists and public. Her portrait of Marcel Duchamp, done in 1918, is in the collection of The Mus. of Modern Art, New York.

DRUMMOND, MALCOLM. See CAMDEN TOWN GROUP.

DRURY, ALFRED (1859–1944). British sculptor born in London, studied at the Oxford School of Art and then at the South Kensington Art School under Aimé-Jules Dalou (1838–1902). He worked on Dalou's large *Triumph of the Republic* (Place de la Nation, Paris, 1879–99). Drury exhibited at the Academy and was elected A.R.A. in 1900. He did decorative figures for the War Office in 1905 and for the façade of the Victoria and Albert Mus. in 1908. Among his portraits are *Sir Henry Roscoe* (Chemical Society, Burlington House) and the full-length bronze *Sir Joshua Reynolds* (Royal Academy, Burlington House).

DRYSDALE, RUSSELL (1912–81). Australian painter born in Sussex, England. The family had possessed pastoral holdings in Australia since the 1820s and as a boy he made several trips to Melbourne with his family. They settled there in 1923. Although intended for a life on the land, Drysdale was encouraged by the artist Daryl Lindsay to study painting. He joined George Bell's art school (see AUSTRALIA) in 1932 and visited Europe the same year. On his return to Australia he settled on the land briefly, then decided to study full-time with Bell. His early paintings such as *The Rabbiter and Family* (1938) reveal his interest in the country and the hardships of rural life in Australia. The influence of Christopher WOOD is apparent. In 1938 he visited London, and studied briefly at the Grosvenor School under Iain MacNab and later with Othon FRIESZ at La Grande Chaumière, Paris.

In 1939 he returned to Melbourne and showed in the first exhibition of the CONTEMPORARY ART SOCIETY OF AUSTRALIA. But deploring the controversies associated with the formation of the Society, he left the city to live briefly in Albury, N.S.W., before settling permanently in Sydney. Here he began to devote himself full-time to painting in 1940. In 1942 he held his first one-man show at the Macquarie Gals., Sydney. The work exhibited constituted the first important break in Australian landscape and figure painting from the blue and gold conventions established during the 1890s by Arthur Streeton and Hans Heysen. Many of his paintings of 1943 and 1944, such as *The Local V.D.C. Parade* (Art Gal. of South Australia, 1943), depict aspects of Australia at war. Drysdale rejected the *alla prima* techniques customary in Australia at this time. He built up his pictures by under-painting and glazing. In 1944 he was commissioned by the *Sydney Morning Herald* to record visually the effects of the drought in Western New South Wales. His work became well known throughout Australia during the 1940s. It revived in a new fashion the tradition of hardship, tragedy and melancholy associated with the Australian bush that had been obscured by the much more optimistic interpretation developed by the city-based painters of the Heidelberg School during the 1890s. His paintings in their desire for identity and realism may be compared with the poems and stories of Henry Lawson. In 1949 Lord Clark, on a visit to Sydney, encouraged Drysdale to exhibit in London and late in 1950 he held an exhibition at the Leicester Gals. It is to this exhibition that the beginning of a new interest in Australian art in London, which reached a peak in the early 1960s, may be traced.

In 1954 Drysdale was chosen to represent Australia at the Venice Biennale. During the 1950s he travelled widely throughout Australia, drawing and painting the life of the interior. The plight of the Australian Aborigines in contact with white settlement became an important and continuing theme in such paintings as *Mullaloonah Tank* (Art Gal. of South Australia, 1953). In 1957 Drysdale and his family lived for a time at Chelsea and he held a second exhibition at the Leicester Gals. in 1958. Returning to Australia later that year he accompanied his friend, the zoologist A. S. Marshall, on a scientific expedition to the Kimberleys and the Central Desert areas of Western Australia. A retrospective exhibition of his work was held at the Art Gal. of New South Wales, Sydney, in 1960. During the early 1960s he experienced periods of depression accentuated by the death of his son and his wife. From that time he continued to broaden and develop the themes and methods with which he began in the 1940s. Drysdale was a member of the Commonwealth Art Advisory Board from 1965 to 1972 and a Trustee of the Art Gal. of New South Wales from 1963.

DUART, ÁNGEL. See EQUIPO 57.

DUARTE, JOSÉ. See EQUIPO 57.

DUBUFFET, JEAN (1901–). French painter, born at Le Havre, son of a wealthy wine merchant. He had a brilliant childhood, began to paint early and revealed a gift for caricature. In 1918 he went to Paris and enrolled in the Académie Julian but did no serious study there. He lived the life of a wealthy man-about-town and dilettante of the arts, doing a little painting until 1924, when he gave it up altogether. In 1925 he took over his father's wine business at Le Havre and in 1930 he started his own wholesale wine business in Paris. During the 1930s he did a little painting again but did not take it up seriously until 1942. His first exhibition was at the Gal. René Drouin in 1945 when he was forty-four years of age. In 1946 he had an exhibition, which he called 'Hautes Pâtes: Mirobolus Macadam et Cie', consisting of pictures built up from plaster, glue, putty, asphalt, etc., embedded with pebbles, sherds of broken bottles and so on and scribbled and scratched to give the impression of the surfaces of old walls. Dubuffet stands out as the precursor and chief representative of the tendencies in contemporary art to disparage traditional artistic materials and, as he himself said in 1957, to 'bring all disparaged values into the limelight'. He was interested in the drawings of children, in graffiti on slum walls, in

the productions of the untutored and the insane, and all such immediate records of personal experience uninfluenced by cultural traditions. He 'took the flattened frontal and profile views, the grossly simplified outlines, the concentration on sex of such primitive and naïve works for his own figures and he scratched them into his "thick pastes" . . .'. Edward Lucie-Smith expressed the generally accepted view of the significance of his work when he said: 'Dubuffet seems to me to sum up many of the leading tendencies to be found in the visual arts in the period immediately following the war. The priority given to the inner world of the artist, and the rejection of the traditional claims of art to be more coherent, more organized, and more homogeneous than "non-art", or "reality", were pointers to the future.'

During the late 1940s and through the 1950s Dubuffet was the most active advocate for the interest in ANTI-ART which went back to the DADA movement. But whereas the Dada attitude was negative, a debunking of traditional cultural values, Dubuffet claimed a positive value for material hitherto neglected or despised. In 1947 he arranged an exhibition of objects produced by children, the mentally handicapped, psychotics and others isolated from the professional art world, coining the term ART BRUT. He founded a company, Compagnie de l'Art Brut, to promote this kind of art. In 1947 he had an exhibition in New York, organized by Pierre Matisse, which was a resounding success and in 1949 he paid a short visit to the U.S.A. In 1951 he was exhibited with FAUTRIER, MATHIEU, RIOPELLE and SERPAN with the title 'Signifiants de l'Informe' and he has been regarded as a forerunner of ART INFORMEL.

During the 1950s he continued successfully to integrate Art Brut with his own work as in his Corps de dames series of 1950–1 and his Beardman of 1959. In this period he also produced the Sols et Terrains and the Terres Radieuses series, in which the impasto was modelled to represent the earth with the impress of geological structures, telluric happenings, organic fossilized materials and so on. These, like his earlier use of wall graffiti etc., reflected the impress of 'experience'. In 1954 he exhibited at the Gal. Rive Gauche small figures built up from newspaper, clinker, foil and other discarded materials. In 1956 he exhibited ASSEMBLAGES which he made up of small pieces cut from painted canvases combined with tin foil, leaves, dried flowers, butterfly wings, etc. He had large retrospective exhibitions at the Mus. des Arts Décoratifs, Paris, in 1960 and at The Mus. of Modern Art, New York, in 1961. His collected writings were published in 1967 under the title Écrits de Jean Dubuffet.

Jean Dubuffet was an artist about whom opinions have widely differed. He was enthusiastically supported by many contemporary writers, among them Jean Paulhan, Paul ÉLUARD, Francis Ponge. Others belittled his work as insignificant and absurd. It is perhaps fair to say that the dilet-tantism which he displayed in life was not absent from his work and that the latter was 'an exegesis rather than a truly original contribution to modernism'. Yet he foreshadowed many of the more 'far out' trends of the 1950s and 1960s and G. H. Hamilton's summation may be accepted as not far from the mark. He wrote: 'By discrediting, even more thoroughly than Schwitters . . . all conventional artistic and aesthetic standards . . . Dubuffet made all aspects of our environment, without exception, available to the artist. By denying any possibility of distinguishing between beautiful and ugly objects he, as much as anyone else, created the aesthetic conditions for the "junk culture" and "Pop art" of the 1960s.' The appeal of his early work depended partly on the material he used, which he declared was 'pregnant with experience' and partly on the faux naïf impression of the intelligent and accomplished man donning the cloak of a simpleton or neurotic.

DUCHAMP, MARCEL (1887–1968). French-American painter and sculptor born near Blainville. His grandfather was a painter, as were one of his brothers, Jacques VILLON, and his sister Suzanne, while another brother, DUCHAMP-VILLON, was a sculptor. In Chess Game (1910) and Sonata (1911), both in the Philadelphia Mus. of Art, Duchamp depicted members of his family. He went to Paris in 1903 and studied for a short while at the Académie Julian, while between 1905 and 1910 he did cartoons for the Courrier Française and Le Rire. He first exhibited at the Salon des Indépendants in 1909. In this and the following years he was in touch with APOLLINAIRE and artists who were to belong to the CUBIST movement. He also met PICABIA, with whom he was later associated in the founding of American DADA. His own painting at this time showed an interest in movement which anticipated the FUTURIST exhibition in Paris of 1912. His famous painting Nude Descending a Staircase No. 2, which later made a sensation at the ARMORY SHOW, was first shown at an exhibition of Cubist works in Barcelona after having been rejected by the Salon des Indépendants and was later shown at the first exhibition of the SECTION D'OR, of which Duchamp was a founding member in 1912. His interest in the dynamics of machinery was manifested in a series of drawings and paintings on the themes of the Virgin and the Bride, done in Munich during the summer of 1912, which anticipated and provided material for his famous Large Glass of 1915–23. The year 1913 was crucial for Duchamp's development since it was then that he abandoned conventional media and became interested both in the three-dimensional object which suggests a scientific instrument or machine without functioning as such and in the READY-MADE. His first Ready-mades were later to become famous: Bicycle Wheel (1913) and Bottle Rack (1914). His 'machines' anticipated the functionless machines of MUNARI and TINGUELY.

At the beginning of 1913 Picabia went to New

York for the opening of the Armory Show. When Duchamp followed him in 1915 he found himself already notorious and the ground prepared for the foundation of Dada in America. From 1915 he worked on what is regarded as his masterpiece: *Large Glass: The Bride Stripped Bare by her Bachelors, Even*, constructed from lead wire and tin foil affixed to a sheet of glass 8 ft 11 in. (2·7 m) high by 5 ft 7 in. (1·7 m) wide, which he abandoned as 'uncompleted' in 1923. It was first shown in an International Exhibition of Modern Art at the Brooklyn Mus. in 1926. It was later found shattered and was restored without the glass by Duchamp in 1936, in which state it is now in the Philadelphia Mus. of Art. A facsimile was made by Richard HAMILTON for the Duchamp exhibition at the Tate Gal. in 1966. Among a whole series of provocative gestures made by Duchamp in the years after his arrival in America the two which made the greatest impact upon the public imagination were: (1) His submission in 1917 of a urinal under the title *Fountain* to an exhibition of the SOCIETY OF INDEPENDENT ARTISTS, of which he was a founder member and Vice-President; he resigned from the Society when it was rejected. Seen out of context, the significance of this gesture has usually been misunderstood. It was in fact the perfect *reductio ad absurdum* of Robert HENRI's 'democratic' principle of the large, unjuried exhibition, to which the Society was committed. (2) His submission to the Dada demonstration of 1920 in Paris of a coloured reproduction of the *Mona Lisa* to which he had added a beard and moustache with the title *L.H.O.O.Q.* (*elle a chaud au cul*). His *Rotary demisphere precision optics*, made in Paris in 1925, was a forerunner of modern KINETIC ART.

In 1923 Duchamp virtually abandoned work as an artist, devoting himself among other things to chess, although he kept an interest in experimental film in collaboration with MAN RAY and continued to organize exhibitions. The latter included the International Surrealist Exhibition at the Gal. des Beaux-Arts, Paris, in 1938. His interest in optical experiments led to the *Rotoreliefs* of the mid 1930s, i.e. discs patterned with coloured lines which created an illusion of three-dimensional objects when rotated like a phonograph record. Experiments of this sort had interested GABO since the 1920s and anticipated aspects of OP ART and kinetic art.

Duchamp's works began to be shown in international exhibitions in the 1930s and this continued through the 1960s. These included 'The Duchamp Brothers' at Yale University Art Gal. in 1944, 30 of his works from the Arensburg Collection at the Art Institute of Chicago in 1949 and another important exhibition 'The Duchamp Brothers' at the Solomon R. Guggenheim Mus. in 1957. A major retrospective exhibition was held at the Pasadena Art Mus. in 1963. There followed in 1966 his first major exhibition in Britain, held at the Tate Gal., and in 1967 an Exposition d'honneur in Paris to mark his 80th birthday.

Duchamp became a legend in his own lifetime. By his life as much as his artistic achievements he did more than any other one man to change the concept of art in the 20th c. He tried, unsuccessfully as he himself recognized, to destroy the mystique of taste and collapse the concept of aesthetic beauty. As he said about NEO-DADA in 1962: 'When I discovered ready-mades I thought to discourage aesthetics. In neo-Dada they have taken my ready-mades and found aesthetic beauty in them. I threw the bottlerack and the urinal in their faces and now they admire them for their aesthetic beauty.' Nevertheless, he was prominent among the few who revolutionized the notions of art and beauty in their generation. The Centre Georges POMPIDOU was inaugurated with a large retrospective exhibition of Duchamp's works in 1977.

DUCHAMP-VILLON, PIERRE-MAURICE-RAYMOND (1876–1918). French sculptor, born at Damville, Normandy, and brother of Jacques VILLON and Marcel DUCHAMP. After studying medicine he took up sculpture in 1898. From 1905 to 1913 he exhibited at the Salon d'Automne with works of expressive naturalism which at first differed little from those of others who were seeking a way to escape from the influence of Rodin. From about 1910 he came under the influence of the CUBIST group and by 1914 he was recognized as pre-eminent among the small number of Cubist sculptors. The rapid and radical change in his style of working may be seen by comparing three heads: the bronze of *Baudelaire* (Mus. National d'Art Moderne, Paris, 1911) is naturalistic, though with emphasis upon the sculptural planes and masses; the bust *Maggy* (Solomon R. Guggenheim Mus., New York, 1912) has much more radical and vigorous simplification of the masses with more sharply defined arrises in a manner reminiscent both of GAUDIER-BRZESKA and some African heads; the *Head of Professor Gosset* (1917), his last work, carries simplification much further still, reducing the head to a few large sculptural masses in which naturalistic likeness is virtually lost. In his Cubist period he suppressed the subtlety of modelling at which he had aimed in his earlier work, alleging that the domain of modelling was far removed from that of sculpture. In his low relief *L'Amour* (one example of which is in The Mus. of Modern Art, New York) he reduced a conventional theme to a few bold and suggestive puppet-like shapes. His *Seated Woman* of 1914 (Yale University Art Gal.), while retaining indications of characteristic attitude and pose, uses the human body as a theme upon which to build an orchestration of rounded (not rectilinear) masses. The work for which he was most famous, which was regarded as a prototype and exemplar of Cubist sculpture, was *The Horse*, upon which he worked from 1912 to 1914. (Versions are in the Mus. National d'Art Moderne, Paris, and The Mus. of Modern Art, New York.) In this, which has been

called by G. H. Hamilton 'the most powerful piece of sculpture produced by any strictly Cubist artist', naturalistic representation is abandoned and the tightly knit complex of balanced masses and planes has become as it were an abstract diagram—what used to be called an 'ideographic statement'—of the rhythms and tensions of a leaping horse. It is a masterpiece of controlled and leashed energy inherent in the interlocked forms themselves without support from what they represent. This work has been compared to those of the FUTURISTS and particularly BOCCIONI, who was known to Duchamp-Villon. In the success with which it expresses the taut energy of muscular movement in static forms it certainly achieves at least one of the things at which the Futurists were aiming in their attempts to represent the 'dynamics of movement'. Moreover, like the Futurists, Duchamp-Villon was interested in machines and in the likeness between machine movements and the rhythms of vital movement.

Duchamp-Villon joined the SECTION D'OR group and exhibited with them a rather unsuccessful façade for a Cubist House. With the outbreak of war he served in the French forces, and after spending two years in hospital died at the age of forty-two from septicaemia following typhoid fever. On the evidence mainly of his *Horse* many critics believe that had he lived, he would have proved himself one of the most powerful and original forces in contemporary sculpture.

Duchamp-Villon was given a retrospective exhibition at the Salon d'Automne in 1919. He was exhibited by the Société Anonyme, Brooklyn, New York, in 1921, by the Brummer Gal., New York, in 1929, with Villon and Marcel Duchamp at the Yale University Art Gal. in 1945, and at the Solomon R. Guggenheim Mus., New York, in 1957. He was represented in the exhibitions 'Le Cubisme' at the Mus. National d'Art Moderne, Paris, in 1953 and 'Sept Pionniers de la Sculpture Moderne' at Zürich in 1954. The Gal. Louis Carré, Paris, held an exhibition of his sculptures in 1963.

DUCMELIC, ZDRAVKO (1923–). Argentine painter, born in Zagreb, where he studied drawing. He went to study painting at the Academy of Fine Arts, Rome, and then at the Academy of San Fernando, Madrid. In 1949 he emigrated to the Argentine, where he lived in Mendoza and was Director and Professor at the Fine Arts School of the University of Cuyo. He painted a delicate SURREALIST world with dream-like figures in mysterious rocky landscapes bathed in an otherworldly calm. He was exhibited in the major cities of the Argentine and in 1967 the Panamanian Institute of Fine Arts organized a show of his works in Panama City. In 1968 he was awarded First Prize at the 5th Mendoza Bienale. He was included in the exhibition 'Art in the Argentine' sponsored by the Cultural Department of the Argentine Ministry of Foreign Affairs and shown at the Wildenstein Gal., London.

DUDREVILLE, LEONARDO. See NOVECENTO ITALIANO.

DUFFAUD, PRÉFÈTE. See LATIN AMERICA.

DUFOURT, BERNARD (1922–). French painter born in Paris. While studying agricultural engineering he attended the École des Beaux-Arts there. He exhibited at the Salon de Mai from 1949 and had individual exhibitions at the Gal. Jeanne Bucher from 1951 and the Gal. Pierre from 1954. He was one of the leading figures among the younger representatives of LYRICAL ABSTRACTION and was chosen with BISSIÈRE and GONZALEZ to represent the ÉCOLE DE PARIS at the Venice Biennale of 1964. Without representation he endeavoured in his abstractions to depict the expressive features shared in common by different landscapes.

DUFRESNE, CHARLES (1876–1938). French painter, born at Millemont, Seine-et-Oise. He was apprenticed to an industrial engraver and attended art classes in the evenings. Then against family opposition he entered the Department of Medal Engraving at the École des Beaux-Arts, working also as an attendant in the sculpture studio of Alexandre Charpentier to earn a living. He began to exhibit at the Salon du Nationale and the Salon des Indépendants in 1905 but he did little of note until 1908 after a visit to Italy with the engraver Lespinasse. In 1910 he was awarded the Prix de l'Afrique du Nord, which enabled him to spend two years at Abd-el-Tif in Algiers. This contact with an exotic civilization had the effect of stimulating his sense of colour, which has been compared with that of Delacroix, and was a contributory source of the strange imaginative element in his later work. During the war he was one of the group formed by DUNOYER DE SEGONZAC with Luc-Albert MOREAU and Jean-Louis BOUSSINGAULT. After the war he taught for a short while at the Académie Scandinave and had considerable influence on younger artists there such as Francis GRUBER. In 1923 he was one of the founders of the Salon des Tuileries and exhibited there in subsequent years. In 1924 he designed tapestries for the furniture emporium Sue et Mare which were one of the attractions of the Exposition des Arts Décoratifs in 1925, and he also designed tapestries for the Mobilier National. In 1937 he did two panels (*Le Théâtre de Molière*) for the Palais de Chaillot and began enormous murals for the École de Pharmacie. He also did a large number of engravings throughout his career.

Dufresne stood aloof from the *avant-garde* movements of his time, although he borrowed features from FAUVISM and CUBISM, integrating them into a personal style. He ranks beside Segonzac with the school of expressive and imaginative Realists. He did religious paintings and portraits, but his most characteristic work consisted of imaginative and vibrant landscapes recalling exotic features of his travels.

DUFY, RAOUL (1877–1953). French painter, born at Le Havre. From 1892 he attended evening classes at the municipal Art School, where he met Othon FRIESZ and Georges BRAQUE. In 1900 he went to Paris with a small scholarship from the city of Le Havre and was a pupil of Léon Bonnat at the École des Beaux-Arts. In 1901 his painting *Fin de journée au Havre* was accepted by the Salon des Artistes Français and from 1903 he exhibited annually at the Salon des Indépendants. His first one-man show was at the Berthe Weil Gal. in 1906. During this period Dufy was painting in a Late-Impressionist manner, influenced chiefly by Eugène Boudin (1824–98) and Camille Pissarro (1830–1903). In 1905 he saw MATISSE'S painting *Luxe, calme et volupté*, which was exhibited at the Salon d'Automne in that year, and its impact upon him was so strong that it caused him to revolutionize his style and to adopt the manner of the FAUVES. From 1907 he began to exhibit at the Salon d'Automne with the Fauves. In 1908 he visited L'Estaque together with Braque and under the influence of Cézanne's paintings he abandoned the spontaneous use of pure colour which characterized the Fauves and turned his attention to compositional problems. In 1909 he made a short visit to Munich with Othon Friesz. About this time he got to know Guillaume APOLLINAIRE and in 1910 did woodcuts for Apollinaire's *Bestiarium*. In the following year he made friends with the fashion designer Paul Poiret, who interested him in textile design, and he worked as a designer for Bianchini-Férier, a silk manufacturer of Lyons. Through his designs Dufy exerted a considerable influence on the world of fashion at this time.

During the war years Dufy was occupied largely with woodcuts, some on patriotic themes and others illustrating for example the works of Verhaeren and Remy de Gourmont. In 1920 he stayed at Vence and renewed his interest in landscape, turning also to lithography instead of woodcut. He travelled to Florence, Rome and Sicily between 1922 and 1923 and in 1925 went to Morocco with Poiret. In the same year he did 14 tapestries for Poiret which were shown at the Exposition des Arts Décoratifs. In 1923 he had his first exhibition in Belgium, where his work came to be particularly appreciated, and in the same year he became interested in the decoration of pottery. During this period his palette grew brighter and his use of colour more decorative, while his drawing became freer in the manner of linear arabesque, until in the late 1920s he approached the style for which he is most generally known: a style in which colour, virtually divorced from theme, becomes a bright, enamel-like background against which gay and lively subjects are drawn. He had an especial penchant for harbour and race-course scenes.

Dufy's position in the artistic world had become established by the mid 1920s and from 1928 the first monographs began to be written about him. In 1930 he won the Carnegie Prize. In 1936 he held his first American exhibition at the Carroll Cal-

stairs Gal., New York, and his first exhibition in Britain at the Reid and Lefèvre Gal., London. He was also working on his enormous decoration (10 m high by 60 m wide) for the Palais de l'Électricité at the Paris Exposition Universelle of 1937. About this time too he began his large decorations, finished in 1939, for the Monkey House in the Jardin des Plantes and (in collaboration with Friesz) for the theatre of the Palais de Chaillot. During the Second World War Dufy lived at Perpignan in the south of France, where he continued to paint and to make cartoons for tapestries. In 1949 he returned to Paris and in 1950 visited Boston for an operation on his hands, which had been affected by arthritis from the mid 1930s. In 1952 he won the International Grand Prize for Painting at the Venice Biennale and in the same year a large retrospective exhibition of his work was arranged at the Mus. d'Art et d'Histoire, Geneva. Among the many exhibitions that followed, his work was shown at the Tate Gal., London, the Kunsthalle, Basle, the Kunsthalle, Berne, the Mus. of Art, San Francisco, and the County Mus., Los Angeles, in 1954; at the Stedelijk Mus., Amsterdam, and the Albright-Knox Art Gal., Buffalo, in 1955; he was given a retrospective exhibition at the Salon des Indépendants, Paris, in 1957; exhibitions were given at the National Mus. of Modern Art, Tokyo, the Folkwang Mus., Essen, and the Mus. d'Art Moderne, Belgrade, in 1968, and there were major retrospective exhibitions at the Haus der Kunst, Munich, in 1973 and the Mus. National d'Art Moderne, Paris, in 1976.

DUGMORE, EDWARD (1915–). American painter born at Hartford, Conn. He studied at the Hartford Art School, 1934–8, the California School of Fine Arts, 1948–50, and took an M.A. degree at the university of Guadalajara in 1952. He was a co-founder of the Metart Gal., San Francisco, where he had his first one-man exhibition in 1949. He won the M. V. Kohnstamm Prize at the Art Institute of Chicago in 1962 and was awarded a Guggenheim Foundation Fellowship in 1966. Among the important group exhibitions in which he participated were: Solomon R. Guggenheim Mus., 'Abstract Expressionists and Imagists', 1961; San Francisco Mus. of Art, 'Directions—Painting USA', 1963; University of Texas, 'Recent American Painting', 1964 and 1968.

DUMILE, MSLABA. See SOUTH AFRICA.

DUMITRESCO, NATALIA (1915–). Romanian-French painter, born in Bucarest. She took a degree in Fine Arts in 1939 and after exhibiting in official shows in Bucarest came to Paris in 1947. She travelled to the Netherlands and Italy in 1948 and to Spain in 1953. After working for a number of years in black and white she developed a mature style of LYRICAL ABSTRACTION with semicalligraphic expressive forms in fresh but reserved colours. She participated in many Paris exhibitions

of abstract art and exhibited also at the SALON DES RÉALITÉS NOUVELLES. She was married to the painter ISTRATI.

DUNOYER DE SEGONZAC, ANDRÉ (1884–1974). French painter born at Boussy-Saint-Antoine, Seine-et-Oise, of an old family from Quercy. He enrolled at the École des Beaux-Arts, Paris, in 1902 but shortly left for the Académie de la Palette. This he also left in 1906 and decided to work on his own, sharing a studio with Jean-Louis BOUSSINGAULT. In 1910 he exhibited *Les Buveurs* at the Salon d'Automne and in 1911 *Vue de village* at the Salon des Indépendants. Both were powerfully expressive compositions, astonishingly mature in so young an artist. During the war he was in a camouflage section with DUFRESNE, CAMOIN, PUY and others under his command; they were known as the 'Black Band'. After the war his palette became both lighter and more colourful, moving from the heavy earth colours he had used before into a range which was closer to the Impressionists. He painted for preference landscapes from Provence or the Île de France in a style of poetic but vigorous naturalism. He also did a series of nudes during the 1920s. From *c.* 1909 he painted many water-colours, and after the war he perfected himself in this technique. He also did theatre design for the Russian ballet and the dance performances of Isadora Duncan and he became known for his graphic work and illustrations. Among his outstanding works are, from the early period, *Le Déjeuner sur l'herbe*, exhibited at the Salon d'Automne in 1913, and from later *Les Canotiers sur le marin* of 1921. Some of his water-colours, including *La Femme en chemise* (1925) and *Le Clocher de Vermenton* (1934) are in the Mus. National d'Art Moderne. Best known among his illustrations are those for *L'Éducation sentimentale* of Flaubert and the *Georgics* of Virgil.

DŽAMONJA, DUŠAN (1928–). Yugoslav sculptor born at Strumica, Macedonia, and studied at the Academy of Art, Zagreb. In the 1950s he produced abstract welded metal sculpture of wires and bands in 'open' form, including space as a sculptural element. From *c.* 1958 he made block-like figures of metal and wood, sometimes incorporating glass, in which affinities with Islamic architectural monuments have been perceived. They were often covered with minute spikes and coated with lead, which lent them brilliance. He exhibited at the Kunsthalle, Mannheim, in 1967.

DZUBAS, FRIEDEL (1915–). German-American painter born in Berlin. After studying under Paul KLEE at Düsseldorf, he went to the U.S.A. in 1939. He was awarded a Guggenheim Foundation Fellowship in 1966 and a J. S. Guggenheim Fellowship in 1968. Besides individual exhibitions during the 1950s and onwards at the Tibor de Nagy Gal. (1952), Castelli Gal. (1958), etc. he participated in a number of important collective exhibitions, including: The Metropolitan Mus. of Art, New York, 'American Painters under 35', 1950; Solomon R. Guggenheim Mus., 'Abstract Expressionists and Imagists', 1961; Los Angeles County Mus. of Art, 'Post-Painterly Abstraction', 1964; 'Expo '67', Montreal. In the late 1950s he was influenced by the move away from ABSTRACT EXPRESSIONISM in the direction of greater openness of design and image with repudiation of the 'painterly' expressive brushstroke. He did not, however, adopt the HARD EDGE technique but painted rather in the manner of the COLOUR FIELD artists who were inspired by Helen FRANKENTHALER and Morris LOUIS.

E

EAKINS, THOMAS (1844–1916). American painter born in Philadelphia, where he passed the majority of his life with the exception of a period of training in Europe, 1866–70. There he learnt much from the Spanish realists Velazquez and Ribera while from the taut and disciplined naturalism of his master, Jean-Léon Gérôme, he absorbed a precise and uncompromising sense for actuality, which he applied to portraiture and genre pictures of the life of his native city. His love of factual statement combined with a strong scientific interest, which culminated in an enormous painting, *The Gross Clinic* (Jefferson Medical College, Philadelphia, 1875). Eakins was interested in the subtle and dramatic play of light but preferred sombre Rembrandtesque tones to the scale introduced by the Impressionists. As a teacher at the Pennsylvania Academy of Arts he created a revolution by his emphasis on drawing from life. He was in advance of his time; his realistic approach to his subject matter was not then in vogue and it was only later that he began to be appreciated at his true worth. But he had a lasting influence on many of the younger painters and in particular upon Robert HENRI, who was his devoted admirer. Although his work belonged essentially to the 19th c., this influence justifies a brief mention in the present volume.

EARTHWORKS. Earthworks or Land Art emerged in the late 1960s partly in consequence of growing dissatisfaction with the deliberate boredom cultivated by the simple, undetailed forms of MINIMAL ART and partly as an expression of disenchantment with the sophisticated technology of an industrial culture. Instead of using the land as a site which should provide the environment for a work of art, the land itself was to be fashioned into the art work. The main practitioners of Earthworks art were Carl ANDRÉ, Robert SMITHSON, Walter DE MARIA and Robert MORRIS.

Egyptian pyramids, megalithic structures such as Stonehenge, Amerindian burial mounds, Zen rock gardens, etc. have been pointed to as historical precedents for the Earthworks idea, although all these in fact used the 'land' as an environment for the structure or art work instead of making the land itself an art work. The concept of Land art was established by an exhibition at the Dwan Gal. in 1968 and an exhibition 'Earth Art' at Cornell University in 1969. The Dwan exhibition included the photographic records of Sol LEWITT's *Box in a Hole* (the burial of a steel cube in the ground at Visser House, Bergeyk, Netherlands) and Walter de Maria's *Mile Long Drawing* (two parallel white lines traced in the Nevada desert). These and similar stunts have also been classified as CONCEPTUAL ART. Earthworks art proper is obviously unsuitable for exhibition in a gallery except by photographs, and owing to the difficulty of putting earthworks projects into practice they often existed only as projects. Hence the affinity with Conceptual art was close. Other artists who undertook work of this kind were Claes OLDENBURG, Michael Heizer, Richard SERRA.

ÉCHELLE, L'. A group of artists formed in Paris in 1942 by BUSSE, CALMETTES, CORTOT, Patrix and others. The first exhibition of the group was at the Gal. Jacques Blot in 1943. Influenced at one time by CUBISM, most of the members practised a TACHIST form of expressive abstraction in the 1950s.

ÉCOLE DE PARIS (SCHOOL OF PARIS). In the Middle Ages this term applied primarily to the manuscript illuminators who in the 13th c. made Paris the leading centre of book illustration in Europe. In the context of contemporary art it is applied loosely to those movements which followed Impressionism—the POST-IMPRESSIONISTS, the NABIS, the FAUVES, the CUBISTS, the PURISTS, the SURREALISTS and the practitioners of Expressive and Poetic Realism—which had their focus in Paris, although many of their exponents were from other countries. The term marks the intense concentration of artistic activity, supported by critics, dealers and connoisseurs, which made Paris the world centre of innovative art during the first 40 years of the 20th c. In 1951 an exhibition of the works of the École de Paris was given at the Burlington Gals., London, covering the period 1900–50. In his Introduction to the catalogue Frank McEwen said that Paris then had 130 galleries as opposed to the maximum of 30 in any other capital, where the work of some 60,000 artists was shown, of whom one-third were foreigners, and over 20 large Salons exhibiting annually an average of 1,000 painters each. The international character of the École de Paris has often been noted. G. H. Hamilton, for example, said that 'the term signifies not so much the continuation of French art as exemplified by the descendants of the Nabis and Fauves as it does the presence in Paris after 1900 of painters and sculptors from almost every civilised country of the globe. They had come because Paris offered the freest of conditions in

which to live and work, as well as unparalleled opportunities for the discussion and exhibition of their work.' Before the First World War the centre of artistic activity was Montmartre. After the war Montmartre was left to the tourists and artistic activity passed to Montparnasse on the Left Bank.

In a narrower sense the expression 'École de Paris' is sometimes used of the *Peintres Maudits*, those Expressive Realists, mostly foreign-born, who formed the nucleus of French EXPRESSIONISM. Prominent among them were SOUTINE, MODIGLIANI, CHAGALL, PASCIN, RYBACK and KISLING.

In the first four decades of the century the general tenor of the School of Paris, diverse though it was, had been figurative. Non-representational abstraction established no firm footing on French soil despite the formation of the association AB-STRACTION-CRÉATION in the early 1930s. In the 1950s the term 'École de Paris', or 'Nouvelle École de Paris', was revived and became the basis of the first Biennale de Paris. It referred very loosely to the expressive abstraction which became the vogue from the late 1940s onwards and also to the revivals of CONSTRUCTIVISM associated with the SALON DES RÉALITÉS NOUVELLES.

In a wider sense Bernard Dorival in his book *The School of Paris in the Musée d'Art Moderne* (English trans. 1961) lists among 'Painters of the Paris School' painters, both Frenchborn and expatriates, whose works are included in the collection of the museum.

Pierre Cabanne and Pierre Restany wrote in *L'Avant-garde au XXe siècle* (1969): 'In 1920 the École de Paris was Modigliani, Pascin, Chagall, Kisling, Soutine and a few others ... of lesser talent. The expatriates, linked by common bonds of age or race, fell in love with Paris and established themselves there, without succeeding in 'frenchifying' their art. But these individuals renewed the cosmopolitan role of Paris, unleashing a movement which became more clearly defined especially after 1945. Today "École de Paris" implies no aesthetic or ethnic correspondence but a simple sociological reference: it is the totality of that strangely motley artistic population which by its intermingling and contacts maintains a necessary basic intellectual cross-fertilisation.'

EDER, OTTO (1924–82). Austrian sculptor born at Seeboden, Carinthia, studied at Graz and in Vienna under WOTRUBA. He began working as painter and sculptor in 1952 and in 1962 was awarded the Austrian National Prize for Sculpture. He was a member of the new school of sculpture founded by Wotruba.

EECKHOUDT, JEAN VAN DEN (1875–1946). Belgian painter born in Brussels, grandson of the painter François Verheyden and nephew of Isidore Verheyden, by whom he was trained. From Realism he moved towards Impressionism and he was a member of the *La Libre Esthétique* group. From *c.* 1904 he spent much of his time in the south of France and in 1915 he settled at Roquebrune, returning to Belgium in 1936. From *c.* 1909 to 1919 he adopted the strong and expressive colours of the FAUVES and he is classed among the group of artists known as the Brabant Fauvists. In the 1920s he developed a stronger and more deliberate style with a more austere, though delicate, range of colours. His main themes were landscapes, flowers and still lifes.

EGGELING, VIKING (1880–1925). Swedish painter and film maker, born at Lund. After studying painting at Milan and teaching drawing in Switzerland he moved to Paris in 1911. There he met ARP in 1915, moved to Ascona and through Tristan Tzara became a member of the Zürich DADA group. He struck up a friendship with Hans RICHTER and collaborated with him in 'scroll' paintings and abstract films, 1919–21. These scroll paintings arose from experiments with the continuous transformation of abstract configurations by changing their component parts and consisted of sequences of images on long rolls of paper investigating all possible transformations of a given geometrical form. By multiplying, transforming and shifting the geometrical elements and combining them with curving lines it was intended to produce in the spectator the impression of continuous movement as he passed from one image to the next. Eggeling's scroll *Horizontal-Vertical Mass* is lost but preliminary drawings for it are in Yale University Art Gal. His film *Diagonalsymphonie*, first shown in 1922 in Berlin, is considered to have been the first purely abstract film. It was in essence an animated version of the drawings in the scroll paintings. An exhibition of his work was staged by the Nationalmus., Stockholm, in 1950.

EGGER-LIENZ, ALBIN (1868–1926). Austrian painter born at Striebach, near Lienz. Until *c.* 1905 he was known chiefly as a historical painter of the Munich school founded by Piloty, the result of his training under Franz von Defregger (1835–1921) at the Munich Academy from 1885. In the first decade of this century he evolved a style of rustic, monumental EXPRESSIONISM. He is chiefly remembered, however, for his war pictures, done between 1914 and 1918, and for the working drawings made in preparation for them. In the 1920s he developed a more painterly style and repainted many of his earlier pictures. An example of his work in this period is a fresco which he did in 1925 for the military chapel at Lienz. He taught at the Weimar Academy from 1912. In 1925 he received an honorary doctorate from Innsbruck University.

EHRLICH, GEORG (1897–1966). Austrian-British sculptor born in Vienna, studied at the Vienna School of Arts and Crafts, 1912–15, and took up sculpture in 1926. He emigrated to London in 1937 and became a British subject in 1947. In 1947 he visited New York and taught at the Columbus School of Fine Arts, Ohio. He was made an

Honorary Professor by the Austrian Government in 1956 and in 1963 was elected to the Royal Academy. He exhibited in New York, Vienna, London and other European centres and is represented in many public collections including the Tate Gal., the Arts Council, and the Victoria and Albert Mus. He was included in the Arts Council exhibition 'Contemporary British Sculpture' in 1961. He received a Gold Medal at the Paris Exposition Universelle of 1937 and he represented Austria at the Venice Biennale of 1958. His work belonged to the category of German EXPRESSIONISM, influenced by LEHMBRUCK.

EIGHT, THE. 1. A group of American artists formed by Robert HENRI for the purpose of independent exhibition after his breach with the National Academy of Design in 1907. The nucleus of the group was formed by the New York Realists, George LUKS, William J. GLACKENS, John SLOAN and Everett SHINN, disciples of Henri since his Philadelphia days. To them were added the Impressionist painter Ernest Lawson (1873–1929), the 19th-c. romantic Arthur B. DAVIES and the Neo-Impressionist Maurice Prendergast of Boston. The exhibition took place in February 1908 at the Macbeth Gal., New York. It won a *succès d'estime*, although it was attacked by the professional critics, the members of The Eight being referred to in academic circles as 'apostles of ugliness' and as Henri's 'revolutionary black gang'. The measure of the popular interest in non-academic, Realist art which was aroused by the exhibition may be gauged from the unprecedented popularity of an 'Independent' exhibition organized two years later by Henri and Rockwell KENT. Although not all members of The Eight were Realists, the importance of the group and the exhibition of 1908 lay in the effect they had in establishing the ASH-CAN school of American painting. The exhibition is now regarded as a landmark in the formation of a popularist, democratic American art. The significance at the time consisted in the gesture of revolt from the then current academic aestheticism and the movement to bring painting back into direct touch with life.
2. A group of progressive Czech artists formed in the winter of 1907–8 by FILLA, KUBIŠTA, PROCHÁZKA and other *avant-garde* artists. They wished to bring new life to traditional Czechoslovak art by finding a synthesis between CUBISM and Germanic EXPRESSIONISM. In 1909 the group merged with the MÁNES UNION OF ARTISTS.

EIKAAS, LUDVIG (1920–). Norwegian painter and graphic artist, who trained at the Academy of Art and the Industrial School of Art, Oslo. He made a number of mural decorations including the façade of the Kunstnärsförbundet House and (in collaboration with Gunnar GUNDERSEN) the Kemiske Factory, Oslo. These were quite abstract, echoing in the design the lines and shapes of the architecture. Later he evolved a mode of expressive abstraction in which fragments of objects were broken up into their elements and then recombined. Eikaas was also known as a portraitist and excelled in woodcuts.

ÉLAN, L'. A review founded by OZENFANT in 1915 which continued until 1917. In it he ventilated his objections to the decorative tendencies of Synthetic CUBISM and propounded some of the ideas which later contributed to PURISM.

ELEMENTARISM. A new concept of art embodying what became the central theme of European CONSTRUCTIVISM, namely that artistic composition should be conscious and deliberate, not impulsive and intuitive, and should be based on universal aesthetic principles. A manifesto of Elementarism signed by Raoul HAUSMANN, Jean ARP, Ivan PUNI and László MOHOLY-NAGY and published in *De STIJL*, Vol. IV, No. 10, 1922, contained the words: 'We pledge ourselves to elementarist art. It is elemental because it does not philosophise, because it is built up of its own elements alone. To yield to the elements of form is to be an artist. The elements of art can be discovered only by an artist. But they are not to be found by his individual whim; the individual does not exist in isolation and the artist uses only those forces that give artistic form to the elements of our world.' An Elementarist manifesto by Van DOESBURG was published in the first issue of Hans RICHTER'S review G in 1923.
Elementarism as a modification of the principles of NEO-PLASTICISM was propagated by Van Doesburg in *De Stijl* in 1924. While continuing MONDRIAN'S restriction to the right angle and straight line, Elementarism abandoned his insistence on the horizontal–vertical relation to the picture plane. Van Doesburg reintroduced inclined planes and diagonals and sought to achieve a more dynamic quality by importing a hint of deliberate instability. His views were followed for a time by César DOMELA, who used natural materials such as wood and metal in his constructions, and by the German VORDEMBERGE-GILDEWART.

ELEVEN, THE. Association of Cuban avant-garde artists. See CÁRDENAS, Agustín.

EL PASO. An association of Spanish artists formed in Madrid in 1957. Its founding members were the painters CANOGAR, FEITÓ, MILLARES and SAURA with the writers José Ayllón and Manuel Condé. In the following year they were joined by the painters Manuel VIOLA and Manuel RIVERA and the sculptor Martín CHIRINO. The group was a powerful force in establishing expressive abstraction or INFORMALISM as a major idiom in Spanish art and its work evoked a series of public demonstrations against it. It held exhibitions until 1960.

**ÉLUARD, PAUL (EUGÈNE GRINDEL ÉLUARD, 1895–1952). French poet and with

André BRETON leader of the SURREALIST movement until 1938. From 1939 he was linked more closely with the French Communist Party, which he joined in 1942. Unlike Breton he had little interest in the theory of AUTOMATIC composition and did not accept its validity for poetry. In 1930 he collaborated with Breton in writing *L'Immaculée Conception*.

EMMA LAKE WORKSHOPS. See CANADA.

ENCKELL, KNUT MAGNUS. See SEPTEM.

ENDE, EDGAR (1901–65). German painter born at Hamburg-Altona, studied at the School of Arts and Crafts there, 1915–17, and at the Academy of Arts, Hamburg, 1917–23. He moved to Bavaria in 1928 and lived the rest of his life at Munich, where in 1947 he founded the *Neue Gruppe* together with Rudolf Schlichter (1890–1955) and Ernst GEIT-LINGER. He was best known for his SURREALIST paintings depicting fantastic scenes enclosed in bare, featureless, ceilingless walls with breaks through which appeared vistas into limitless distance. He emphasized in these pictures a magical or dreamlike contrast between solid and detailed figures set obtrusively in the foreground and the vague outlines of formless space in the distance.

ENGELMANN, MARTIN (1924–). Dutch painter born at Hoenkoop, studied at the School of Graphic Art in Amsterdam and then at St. Gallen. In 1948 he settled in Paris and painted in a wholly SURREALIST manner, half realistic half abstract, which has been thought to have affinities with BACON. Like many Surrealists he created his own world of fantasy images.

ENGELS, PIETER GERARDUS MARIA (1938–). Dutch experimental artist born at Rosmalen, studied at the Academies of Art in Hertogenbosch and Amsterdam. From *c.* 1962 he produced 'projects', HAPPENINGS, etc., wrote poems and made short films in a style which belonged wholly neither to POP ART nor to CONCEPTUAL ART. He founded EPO (Engels Products Organization), Engels Institute for Research in Subcultural Brambuilding and ENIO (Engels New Interment Organization), purporting business enterprises for the perpetration of dead-pan jokes with a social import, tricks in the guise of repairs, etc. He worked by means of demonstrations, pamphlets, group activities and so on.

ENGONOPOULOS, NICOS (1910–). Greek painter and poet born in Athens, where he studied painting. He was Professor of Painting from 1967 in the School of Architecture at the National Technical University, Athens, and together with GHIKA, MORALIS and TSAROUCHIS he was one of the older generation of artists whose influence weighed strongest in directing the recovery of Greek art after the war. His work was SURREALIST and he combined fantasy with suggestions of Greek landscape and folk art. He also did stage designing and was well known as a Surrealist poet.

ENSOR, JAMES (1860–1949). Belgian painter and draughtsman born at Ostend of an English father and Flemish mother. Apart from the period of his training at the Brussels Academy (1877–9) he rarely left his home town. His mother kept a souvenir stall, and the Chinese porcelain, carnival masks, seashells, etc. which were sold there served Ensor as properties for his paintings. In his first period, 1878–85, the so-called 'dark period', he painted provincial bourgeois interiors, seascapes and townscapes in sombre hues and heavy impasto laid on with a palette knife, in a manner strongly contrasting with contemporary French Impressionism. At the same time he did quick and sensitively realistic drawings and a number of copies after Rembrandt, Turner, Callot, Daumier and Rowlandson. During the 1890s he began to paint in a lighter key, although his palette still remained somewhat muddy until *c.* 1885–6, when he adopted a different range of colours with more emphasis upon light, which became less tangible, more radiant, but also more destructive of form. Although the details are unclear, it is usually thought that this change was due to the influence of Turner (see discussion by L.M.A. Schoonbaert in the exhibition catalogue *Ensor to Permeke. Nine Flemish Painters 1880–1950*, Royal Academy of Arts, London, 1971). During the latter part of the 1880s his subject matter also changed and he began to introduce the fantastic and macabre elements with which his name is chiefly associated. He made much use of carnival masks, grotesque figures, skeletons, bizarre and monstrous imaginings with a gruesome and ironic humour reminiscent of Bosch and Bruegel. His paintings, and even more his graphic work, took on a didactic and satirical flavour involving social or religious criticism.

Recognition came late to Ensor. Although he was one of the founders of the *avant-garde* GROUPE DES VINGT (XX), his work was regularly refused for the group's exhibitions. The first work to be purchased by the Belgian state, *De Lampenjongen* from his early period, was acquired in 1896. The first monograph, by Emile Verhaeren, was published in 1908. His first large exhibition was at the Gal. Giroux, Brussels, in 1920 and outside Belgium at the Jeu de Paume, Paris, in 1927.

Most of Ensor's best work was done before 1900. Yet the importance of this highly original artist has been recognized as presaging much in the 20th c. He was one of the formative influences on Flemish EXPRESSIONISM and was claimed by the SURREALISTS as a forerunner.

ENTARTETE KUNST. See DEGENERATE ART.

ENVIRONMENT ART. The art of 'environment' began to establish itself in the mid 1960s and its

origin was usually credited to Allan KAPROW, who also pioneered the HAPPENING. An environment in this sense is an area of three-dimensional space pre-programmed or mechanically energized in order to enclose the spectator and involve him in a multiplicity of sensory stimulations—visual, auditory, kinetic, tactile and sometimes olfactory. There is sometimes a deliberate intention to create a sensory overload in order to disorient the senses. Environment art was closely linked with spectator involvement and 'ludic' art. Environments were deliberately planned with a view to forcing the spectator to participate in the happenings or the 'game'.

The word has been loosely used and sometimes it has been, wrongly, applied to EARTHWORKS art or its analogues—that is to a category of art which consists in manipulating the natural environment on a large scale instead of the art which *creates* an environment to enfold and absorb the spectator.

ENWONWU, BEN (1921–). Nigerian sculptor and painter, an Ibo born at Onitsha in Eastern Nigeria. His father was a carver of masks and traditional images for ceremonies and shrines. He entered the Government College, Ibadan, in 1934 and there came under the influence of Kenneth Murray. He began to teach in 1940 and in 1942 joined the staff of Edo College, Benin. In 1944 he was awarded a scholarship to study art in the United Kingdom and in 1947 he obtained a degree at the Slade School. His student work was exhibited at the Zwemmer Gal., London, in 1947 and at the Glasgow Empire exhibition in 1949. From that time his work was exhibited widely in Britain, America and Africa. His fine ebony carving *Grief* was shown in the exhibition 'Treasures from the Commonwealth' at the Royal Academy, London, in 1965. His bronze portrait statue of Her Majesty Queen Elizabeth II is in front of the Federal Parliament, Lagos. He did a group of 6 wood carvings for the *Daily Mirror* building, High Holborn, and his bronze figure *Anyanwu* is in the United Nations building, New York, and the National Mus., Lagos. In 1947 Enwonwu was appointed Art Supervisor by the Nigerian Government and Art Adviser to the Federal Government in 1959. He was made M.B.E. in 1955. In 1958 he was awarded the Commonwealth Certificate for contributions to art by the Royal Institute of Art, Commerce and Agriculture and he became a Fellow of the Royal Society of Arts, Commerce and Manufacture in 1976. He was Professor of Fine Arts at the University of Ife and received an honorary doctorate from Ahmadu Bello University, Zaria. In 1980 he received the Order of Merit from the Nigerian Government.

Enwonwu was supreme among African artists in uniting the magical quality of traditional African art with an understanding of contemporary aesthetic developments in Western art. In his more expressive style there are frequent reminiscences from traditional African tribal styles and in particular his own Ibo art.

EPSTEIN, SIR JACOB (1880–1959). American-British sculptor, born in New York of a family of Russian Jewish immigrants. In 1901 he attended evening classes in drawing at the Art Students' League while working in a bronze foundry, and then acted as assistant to the sculptor George Grey Barnard. From 1902 to 1905 he studied at the École des Beaux-Arts and the Académie Julian, Paris, and during this time visits to the Louvre aroused his interest in ancient and primitive sculpture. It was an interest which lasted all his life, influencing much of his carved work in a definite way, and his collection of primitive sculpture became famous (cf. the Arts Council's exhibition 'The Epstein Collection of Primitive and Exotic Sculpture', London, 1960). In 1905 he settled in London and became a British citizen in 1907. His first important commission was executed in 1907–8: 18 figures for the façade of the British Medical Association's headquarters in the Strand. Partly owing to the nudity of the figures and partly perhaps because the contrast between the expressive distortion of the bodies and the extreme realism of some of the heads offended public taste, this work aroused a furore of abuse such as continued to attend much of his monumental work. The figures were mutilated in 1935 when the building was occupied by the Rhodesian Government. From 1910 he worked on his monumental *Tomb of Oscar Wilde*, which was installed in the Père Lachaise cemetery, Paris, in 1912. In 1912 he met PICASSO, BRANCUSI and MODIGLIANI and this may have had some effect on his work during the next five years. The two versions of *Venus* (Baltimore Mus. of Art and Yale University Art Gal.) were austerely geometrical and seemed to echo the idea of a mechanistic culture which was prominently in the mind of Wyndham LEWIS and his group. The well-known *Rock Drill*, unique in his œuvre, was even closer to what the VORTICISTS stood for.

Returning to England in 1913, he exhibited at the Allied Artists' Association Salon, in the 'Post-Impressionist and Futurist Exhibition' and in the 'Cubist Room' section of the 'CAMDEN TOWN GROUP and Others' exhibition at Brighton, 1913–14. He had a one-man show at the Twenty-One Gal., 1913–14, and exhibited as a founder member at the LONDON GROUP exhibition of 1914 and in the exhibition 'Twentieth Century Art' at the Whitechapel Art Gal. He showed the original version of the *Rock Drill* at the London Group exhibition of 1915, participated in the Allied Artists' Association Salon of 1916 and had a one-man show at the Leicester Gals. in 1917. Although he was not a member of the Rebel Art Centre, he was for a short while closely associated with the Vorticists and contributed two drawings to the first number of BLAST.

By their primitivism, their deliberate uncouthness and their uncompromising use of expressive distortion, Epstein's large carved sculptures aroused public antagonism and widespread controversy. His main commissions were *Rima* for

the W. H. Hudson Memorial in Hyde Park and the figures *Night* and *Day* for London Transport Headquarters at St. James's Park. In 1919 his *Christ* caused a scandal. His other important carved sculptures include *Genesis* (1930), *Ecce Homo* (1934), *Consummatum Est* (1937), *Adam* (1939), *Lucifer* (1945), *Lazarus* (1949), *Virgin and Child* (1950), *Christ in Majesty* (1957). From the 1920s he devoted himself more and more to modelling portrait heads and busts for casting in bronze. In this he achieved exceptional sensitivity and psychological insight with prestigious mastery of expressive surface. These portraits have been regarded by some critics as his most successful work. In them he carried on the Romantic tradition of expressive naturalism which stems from Rodin and as a portrait sculptor he has not been surpassed in this style. He was knighted in 1954.

EQUIPO CRÓNICA. A team formed by the Spanish painters Rafael Solves (1940–) and Manuel Valdés (1942–) to work jointly on projects for 'chronicles', i.e. works of SOCIAL REALISM recording current events often with an ironic inflection. They were associated with the writer Tomás Llorens.

EQUIPO 57. An association formed by five Córdoba artists in 1957 as a breakaway group from *Grupo Espacio*, which had been founded in Córdoba in 1954. The members were José Duarte (1926–), Ángel Duart (1929–), Agustín Ibarrola (1930–), Juan Serrano (1929–) and Juan Cuenca (1934–). They were later joined by the Italian-born painter Marino di Teana. The group issued a manifesto in Paris in 1957 incorporating the CONSTRUCTIVIST principles of GABO and PEVSNER. They went in for collective work and made a point of anonymity. Their Constructivist principles favoured a rational and planned mode of abstraction in conflict with the expressive abstraction of ART INFORMEL which prevailed in Spain at this time.

The group exhibited at the Gal. Denise René, Paris, and with the SALON DES RÉALITÉS NOUVELLES in 1958; at the Mus. d'Ixelles, Brussels, in 1960; at the Gal. Suzanne Bollag, Zürich, in 1962; with the second NOUVELLE TENDANCE exhibition at Zagreb in 1963; and with the *Nouvelle Tendance* exhibition at the Mus. des Arts Décoratifs, Paris, in 1964. They were included in 'The Responsive Eye' exhibition at The Mus. of Modern Art, New York, and the exhibition 'Aktuel '65' at Berne and were shown at the Tel Aviv Mus., all in 1965. In 1966 they exhibited at the Gal. d'Art Actuel in Geneva and had a retrospective exhibition at Berne, after which the association was disbanded. Juan Serrano and Juan Cuenca continued to work on industrial design, which had been one of the interests of the group, while José Duarte and Agustín Ibarrola turned to Social Realism.

EQUIPO REALIDAD. A team formed at Valen-

cia by the Spanish painters Juan Cardella (1948–) and Jorge Ballester (1941–). Their general approach was similar to that of EQUIPO CRÓNICA but they somewhat aggressively emphasized the 'documentary' character of their work at the expense of the aesthetic.

ERBSLÖH, ADOLF. See NEUE KÜNSTLER-VEREINIGUNG.

ERHARDT, HANS MARTIN (1935–). German painter and graphic artist born at Emmendingen, Breisgau, studied at the Academy of Art, Karlsruhe, 1956–60, where he was influenced by GRIESHABER. He worked for preference in pastel or woodcut. His style was marked by extreme simplification of forms, meticulous technique and an objectivity sometimes bordering upon *trompe l'œil*. His work was exhibited widely in the towns of southern Germany and he participated in a number of collective exhibitions, but he was most generally known for his illustrations to the writings of Samuel Beckett.

ERIKSSON, ELIS (1906–). Swedish sculptor born in Stockholm. His early work was representational and reflected a fairy-tale fantasy. From this he turned to abstraction and in the 1950s made reliefs of rough-hewn and painted wood or polychrome plaster. In the 1960s he made COLLAGES from sawn-out pieces of plywood written over with exclamations and vulgarities. He also devised an original type of 'box' sculpture containing instructions etc. to the spectator. Great technical proficiency and imaginative fertility were united with a certain irresponsibility and lack of restraint in his work.

ERMILOV, VASILII DMITRIEVICH (1894–1968). Russian painter and designer, born at Kharkov. He studied at the School of Decorative Arts, Kharkov, from 1905 to 1909, at the Kharkov Art School in 1910–11 and in 1912 entered the Moscow Institute of Painting, Sculpture and Architecture and attended the studios of Petr Konchalovsky and Ilya Mashkov. Here he came into contact with some of the FUTURISTS, including David BURLIUK and Vladimir Mayakovsky. Up to 1915 he rapidly assimilated the principles of Neo-Primitivism, CUBO-FUTURISM and then SUPREMATISM. In 1917 he returned to Kharkov and in 1919–20 he designed agit-posters. In 1922 he was co-organizer of the Kharkov Art Technicum and lecturer at the Kharkov Art Institute. In the late 1920s and 1930s he worked on several architectural and theatrical designs. In 1937–8 with Anatolii Petritsky he designed the interior of the Ukrainian Pavilion at the All-Union Agricultural Exhibition in Moscow.

ERNST, JIMMY (1920–). German-American painter, born at Brühl, Cologne, son of the SURREALIST painter Max ERNST. He studied briefly at

the Altona School of Arts and Crafts and emigrated to the U.S.A. in 1938, being otherwise self-taught in art. His style underwent a number of fairly abrupt changes. A strong influence of Surrealism was apparent in his first one-man show, at the Norlyst Gal. in 1941. In the second half of the 1940s he went through a 'Jazz' period. From c. 1949 to 1956 he abandoned colour and painted geometrical abstracts in black and white. From c. 1956, when he exhibited at the Venice Biennale, his work became more decorative until his 'Rock' pictures of 1960 in brilliantly opposed colours. There followed in the 1960s a period of verticality with upright lines superimposed on a minutely subdivided background, giving his pictures the appearance of a stained glass window. His work was widely exhibited both in individual and in group shows. Among his commissions were murals for General Motors Technical Center, Detroit, 10 ft (3 m); Continental National Bank, Lincoln, Neb., 96 ft (29 m); Envoy Towers, East 46 Street, New York (relief mural). He taught at the Houston Mus. of Fine Arts in 1956, at Brooklyn College from 1951, at the Pratt Institute, and in 1961 he was sent by the U.S. State Department to the U.S.S.R.

ERNST, MAX (1891–1976). German-French painter, born at Brühl, Cologne. He studied philosophy at Bonn University, 1908–14, but neglected his studies for painting, being fascinated by the art of psychotics. In 1911 he made contact with the BLAUE REITER group through MACKE and he was represented at the First German Herbstsalon in 1913. After serving in the war he made himself the leader of the Cologne DADA group in 1919, working under the name of 'Dadamax', and was responsible for adapting the techniques of COLLAGE and PHOTOMONTAGE to SURREALIST uses. In 1922 he settled in Paris, bringing these techniques with him, and he joined the Surrealist movement on its formation in 1924. His pictures *L'Éléphant de Célèbes, Oedipus Rex* and *Hommes n'en sauront rien* are regarded as central masterpieces of Surrealism although painted before the movement was founded. The work of Ernst was irregular, imaginative and always experimental. At his best he produced pictures which are among the most important of all Surrealist work. In these pictures childhood memories played a prominent part, particularly the forest scenes and the bird Loplop, and he succeeded in creating with them a hallucinatory sense of otherworld reality. His use of collage was also highly individual, based upon the manipulation of banal engravings so that the contrast between the archaic appearance of the engraving and the startling novelty he created from it made an impact of strangeness and unreality. His masterpieces in this mode were *La Femme 100 Têtes* (1929) and *Une Semaine de bonté* (1934). In 1925 he introduced his method of FROTTAGE and published his first *frottage* drawings in *Histoire naturelle*. His paintings during the 1920s and 1930s

were based on a number of personal themes constituting a kind of private oneiric mythology. Outstanding among them are the *Forest* paintings, *La Ville entière* (1925), *Monument aux oiseaux* (1927), *Jardins gobe-avions* (1935), *Jungles* (1936). In 1937 he adapted the technique of DÉCALCOMANIE for oil painting and produced some of his finest paintings by this method, e.g. *L'Europe après la pluie* and *L'Œil du silence*.

In 1937 a number of *Cahiers d'art* was devoted to a review of his work from 1919 to 1936. In 1938 he broke with the Surrealist movement under BRETON in sympathy with Paul ÉLUARD but without any stylistic consequences. He was interned for a short while after the German invasion of France and in 1941 went to New York, remaining in America until 1948. While in the U.S.A. he collaborated with Breton and DUCHAMP in the periodical *VVV* and continued to paint, including the large canvas *Man Intrigued by the Flight of a Non-Euclidean Fly*. After his return to France in 1949 his painting became more lyrical and abstract and in 1954 at the Venice Biennale he received the Grand Prix for painting. He became a French citizen in 1958. Among his important exhibitions were retrospectives at Berne (1956), the Mus. National d'Art Moderne, Paris (1959), The Mus. of Modern Art, New York, and the Hayward Gal., London (1961), the Städtisches Mus. Wallraf-Richartz, Cologne (1963), Grand Palais, Paris (1974), I.C.A., London (Collages, 1976).

ESCHER, MAURITS CORNELIS (1898–1972). Dutch graphic artist born at Leeuwarden, studied at the Technical School of Art, Haarlem, 1919–22. His earlier work consisted mainly of landscapes and townscapes in Italy. Then, after a visit to Granada and the Alhambra, he began to construct over-all periodic patterns with repeating symmetrical configurations of animals, birds, fish, etc. From this he went on to make more sophisticated uses of visual illusion exploiting ambiguity between figure and ground and between flat pattern and apparent three-dimensional recession. From c. 1944 his work took on a SURREALIST flavour of visual unreality, in which two-dimensional representations of spatial constructions gave an air of rationality to what is absurd in experience, playing with visual illusion, reality and symbol, the relation between the visual and the conceptual, etc. Mathematical concepts played a key role in many of these prints and they have been of considerable interest to mathematicians. An exhibition of them was given at the International Mathematical Congress, Amsterdam, in 1964.

ESPACE. See GROUPE ESPACE.

ESPRIT NOUVEAU, L'. Title of a review founded in 1920 by OZENFANT and JEANNERET which publicized the ideas of PURISM and ran until 1925. The review announced enthusiastically the dawn of a new era of human creativity in all the arts

based upon the central ideas of synthesis and construction. 'The spirit of construction', they declared, 'is as necessary for creating a picture or a poem as for building a bridge.' The review had some influence chiefly by bringing together personalities from several of the arts with writers and aestheticians – including Louis Aragon, André BRETON, Roger BISSIÈRE, Blaise Cendrars, Jean Cocteau, Paul ÉLUARD, Charles Lalo, Maurice Raynal, Max Jacob, Erik Satie, Darius Milhaud, Carlo CARRÀ, Tristan Tzara, etc. The ideas it fostered were, however, too vague to make any permanent mark.

ESSCHE, MAURICE VAN. See SOUTH AFRICA.

ESTÈVE, MAURICE (1904–). French painter born in Culan, Cher. He went to Paris in 1919 in the face of opposition from his father and took a variety of jobs, including designer for a furniture factory, while familiarizing himself with art in the Louvre. In 1923 he worked as draughtsman for a textile factory in Barcelona. On his return to Paris he studied at the Académie Colarossi and had his first exhibition at the Gal. Yvangot in 1930. During the 1930s he exhibited at the Salon des Surindépendants and the Salon des Tuileries, selling his first picture in 1934 at a retrospective exhibition of French art in Gothenburg, Sweden. In 1937 he collaborated with Robert DELAUNAY on decorations for the Air and Railways pavilions at the Exposition Universelle. He was represented in the epoch-making exhibition 'Jeunes Peintres de la Tradition Française' in 1941 and from that time he exhibited at the Salon d'Automne. During the 1930s his style evolved in a manner akin to that of PIGNON. In his early days in Paris he planted the seeds of an enthusiasm for the Cézanne of *Les Joueurs de cartes*, as became manifest in his *La Partie de cartes* and *Canapé Bleu* of 1935. To this was added an influence from the post-CUBIST manner of PICASSO and BRAQUE, with both of whom he had a basic affinity as manifested in his *Cantate de Bach* of 1938. He gradually developed towards a colourful abstraction of semi-geometrical forms based upon the figure compositions, interiors and still lifes which had been his principal subjects from the early 1930s. By the 1950s he was recognized as an outstanding representative of the school of TACHISM whose members derived their abstractions from natural appearances in the manner taught by Roger BISSIÈRE. His colour remained always both subtle and bold. His reputation grew internationally and in 1956 he was given a one-man show in Copenhagen, in 1961 a retrospective at the Kunsthalle, Düsseldorf.

ETCHELLS, FREDERICK (1886–1973). British painter and architect born at Newcastle upon Tyne, studied at the Royal College of Art, *c.* 1908–11. While teaching part-time at the Central School of Arts and Crafts, London, he participated in Roger FRY's mural scheme for the Borough Polytechnic in 1911 and in 1912 collaborated with Duncan GRANT on a mural in Brunswick Square for Virginia Woolf. He contributed to the 'Second POST-IMPRESSIONIST Exhibition' of Roger Fry in 1912/13 and to the 'Post-Impressionist and Futurist Exhibition' of 1913. He joined Fry's Omega Workshops group in 1913 but left it with Wyndham LEWIS in 1914, joining the Rebel Art Centre. He participated in the London VORTICIST Exhibition in 1915 and in the New York Vorticist Exhibition in 1917 and contributed illustrations to BLAST in 1914 and 1915. He was a founding member of the LONDON GROUP and was represented in its exhibition of 1914. He was included in the GROUP X exhibition of 1920 at the Mansard Gal. but shortly afterwards abandoned painting for architecture. He designed the Crawford Building in Holborn and translated LE CORBUSIER'S *Towards a New Architecture*.

EUSTON ROAD SCHOOL. In the second half of the 1930s several British painters who had previously been experimenting with abstract art were turning to a lyrical and restrained naturalistic style of painting with the accent on simplicity. Repudiating the modernist theories both of abstraction and of SURREALISM, they reverted to a quiet and intimate art of commonplace themes—landscapes, still lifes, portraits and nudes. The trend was crystallized in a school of painting opened in 1937 by William COLDSTREAM, Victor PASMORE, Graham BELL and Claude ROGERS with the name Euston Road Group. The Euston Road painters found a rich aesthetic potential in the sober and accurate transcription of the visual world. They were influenced by current literary and political trends towards social relevance and exactness with emphasis on the factual and anti-romantic and they preferred delicate richness and clarity to emphatic colours or expressive distortions. The Euston Road school closed at the outbreak of war.

EVANS, BOB (1947–). British painter born at Cardiff, studied at the Cardiff College of Art, 1964–8, the Chelsea School of Art, 1968–9, and the Hornsey College of Art, 1970–1. He exhibited under the auspices of the Welsh and Scottish Arts Councils, at the Institute of Contemporary Art, the Serpentine Gal., the London Group and the 9th Paris Biennale. His more than life-size heads are reminiscent of Andy WARHOL but his style of expressive abstraction was original and distinguished.

EVANS, GARTH (1934–). British sculptor born in Cheshire, studied at the Manchester Regional College of Art and the Slade School of Fine Art, 1955–60. In 1969 he obtained a British Steel Corporation Fellowship. In 1973 he was Visiting Professor at the Minneapolis College of Art and Design and subsequently taught at the Camberwell School of Art and was visiting lecturer at the St. Martin's School and the Slade School. He was a MINIMAL sculptor and worked mainly in strip steel

and painted wood. He exhibited at the Rowan Gal., London, and at the Leeds Polytechnic Ferens Art Gal. and the Hull and Sheffield Schools of Art in 1971. Among the group shows in which his work was included are: Open Air Mus. of Sculpture, Middelheim Park, Antwerp, '10th Biennale for Sculpture', 1969; Royal Academy, London, 'British Sculpture '72', 1972; Peter Stuyvesant City Sculpture Project, Cardiff, 1972; Hayward Gal., 'The Condition of Sculpture', 1975.

EVE, JEAN (1900–68). French NAÏVE painter, born in the mining village of Somain near Douai. He was apprenticed in a machinery workshop but began to paint early in life. After a period of military service he worked successively in a foundry, a motor-car factory, on the railway and as a customs official. He first exhibited in 1930 and was encouraged by KISLING. In 1937 his pictures were included in the exhibition 'Maîtres populaires de la Réalité' at Paris and Zürich and he has been included in most subsequent exhibitions of naïve art, including 'Masters of Popular Painting', New York and London; at Knokke-Le Zoute, 1958; 'Naivi 70', Zagreb, 1970; and 'Die Kunst der Naiven', Zürich, 1975. In addition, he exhibited at the Salon des Indépendants and the Salon d'Automne. His favourite themes were urban landscapes, which he rendered with almost photographic realism but to which he gave an indefinable poetic appeal.

EVENPOEL, HENRI (1872–99). Belgian painter, born at Nice. After studying at the Brussels Academy, he went to Paris in 1892 and became a pupil of Gustave MOREAU with MATISSE and ROUAULT among his fellow students. He was a sensitive portraitist with a special talent for portraits of children and adolescents. He had the Impressionist gift of catching a fleeting moment in everyday existence and his main subject matter consisted of scenes from contemporary life of the Paris streets and market-places. Under the influence of a journey to Algeria in 1887–8 he adopted a brilliant palette which brought him to the verge of FAUVISM. 'His compositions were first sketched out in a rough, lifelike draft and despite an appearance of spontaneity, were carefully organized by a masterly manipulation of arabesques and a deliberately orchestrated colour with a basis of ochre lightened with white, touches of rose, blue, lemon and bright green.' His premature death at the age of 27 deprived Belgium of what might have been one of her greatest talents.

EVERGOOD, PHILIP (1901–73). American painter born in New York. He was educated in England, at Eton and Cambridge, and in 1921 studied sculpture at the Slade School. In 1923 he studied briefly at the Art Students' League, New York, under LUKS, and in 1924, after a short period at the Académie Julian, Paris, he travelled in southern France and Italy until his return in 1926 to New York, where he had his first one-man show in 1927. In 1929–31 he again visited France and Spain. Evergood's inclination for the bizarre and grotesque brings his works to the verge of SURREALISM, as may be seen in *Lily and Sparrows* (Whitney Mus. of American Art, 1939). But returning to settle in New York in 1931 at the height of the Depression, he was drawn into the ambit of the SOCIAL REALISTS, who looked upon their art as an instrument of social protest and propaganda, and was active in the Artists' Union and the ARTISTS' CONGRESS. Under the banner of the FEDERAL ARTS PROJECT he produced militant paintings of social protest from 1933, his best-known work in this genre being *American Tragedy* (1937), a depiction of the Memorial Day massacre in Chicago. Even his allegorical religious painting *The New Lazarus* (Whitney Mus. of American Art) has sociological overtones with its strange Crucifixion and its figures of starving children. He had retrospective exhibitions at the Whitney Mus. of American Art in 1946 and 1960.

EXACT 51. See PICELJ, Ivan.

EXPERIMENTAL GROUP. A group of Dutch artists formed in 1948 by Karel APPEL, CONSTANT, CORNEILLE with Anton ROOSKENS, Eugène Brands and Theo Wolvecamp. They started a journal *Reflex*, in which they advocated principles close to those of ART INFORMEL. The group merged with the COBRA group, which was founded the same year in Paris.

EXPRESSIONISM. The belief that all art is, or ought to be, by its nature 'expressive' has become so pervasive in the literature of the 20th c. as to virtually unchallenged by artists, critics and connoisseurs alike. But outside the narrow field of philosophical aesthetics there has been little attempt to elucidate the sense in which art is thought to be expressive. Sometimes it has been assumed that art 'expresses' the personality of the artist—as when Roger BISSIÈRE, who passed through a CUBIST phase to expressive abstraction, said: 'Ma peinture est l'image de ma vie. Le miroir de l'homme que je suis, tout entier avec mes faiblesses aussi.' ('My painting is the image of my life. The mirror of the man I am, complete with all my faults as well.') Sometimes it is assumed that by means of the works of art he creates the artist 'communicates' his emotions and feelings to his public: this was the central theme of the book by the French critic René Huyghe (English trans. *Art and the Spirit of Man*, 1962). Sometimes it has been assumed, with Tolstoy, that the artist 'communicates emotion' by 'infecting' his public with the emotional attitudes he expresses towards the situations he portrays or describes. Theorists have tended to hold that art is expressive by virtue of feelings or emotions which are 'embodied' in it without usually being specific about the meaning

or manner of this 'embodiment'. Yet none of these assumptions is self-evident. They would all have seemed either incomprehensible or patently untrue in the past, when it was assumed with equal conviction either that it is the nature of art to be 'mimetic', i.e. to portray some reality other than itself whether as it actually is or in an idealized form, or that it is the function of art to promote some religious, moral or social doctrine. Nor has this conception of art as 'expressive' ever been common in the East. In China it was, indeed, believed that the gentleman-artist expresses himself through the medium of his art and that this is more important than producing a naturalistic replica of his subject. But it was also held that he must first bring himself into accord with the Tao, the principle of justice and order in the cosmos, so that in expressing himself through his art he was in effect allowing the Tao to find expression through himself. In India the artist was expected to undergo spiritual disciplines of yogic meditation so that he might gain insight into a metaphysical world beyond the world of illusion, and self-expression in his art was held to be justified only in so far as through it he expressed not ephemeral desires and emotions but universal moods and sentiments. The Western doctrine of artistic expressiveness came in with the age of Romanticism along with the concept of 'genius'. It was believed that the man of genius in any sphere has by his nature insight into the spiritual world—the Absolute—superior to that of ordinary men and that therefore by 'expressing' his superior personality he can in some measure guide less favoured mortals to a similar insight. Eugène Véron (1825–89), one of the first exponents of the doctrine that art is expressive by communicating emotion, said that 'it is from the worth of the artist that that of his work derives'. It was in the 20th c. that the assumption gradually took root that expression in art is valuable of itself, regardless of the quality of what is expressed; that it is to be assessed only in terms of effectiveness and intensity. Speaking in his book *Oriental Aesthetics* (1965) of the 'subjectivism' of Western art and contrasting it with Oriental art, Thomas Munro said that one of its characteristic manifestations is 'the desire for self-expression by the individual artist—an aim which Oriental and medieval Christian religion would have regarded as ego-centric. The desire to express one's own personality does involve a special interest in oneself; in that which is to be expressed; in one's own inner attitudes, desires, emotions, and perhaps frustrations. Here again the Western artist, however self-conscious, differs markedly from his traditional Eastern counterpart. The latter, in theory at least, sought to achieve inner peace, serenity, and oneness with nature. Many Western artists are more eager to display before the public their moods of anxiety, frustration, discontent, mockery, rejection, exclusion, and resentment towards the modern world. Such attitudes are at the opposite pole from the Confucian ideal of inner harmony and the Taoist one of contentment with the natural course of things.' Something approaching the Oriental attitudes is to be found in such works as KANDINSKY's essay *Concerning the Spiritual in Art* (1912) and MONDRIAN's *Plastic Art and Pure Plastic Art* (1937), both of which were influenced by theosophical doctrines. 'Expressiveness' in art was, however, repudiated by CONSTRUCTIVISTS in most of the above senses.

As in the course of the 20th c. 'expressive' came to be used as a general term of approval, so it tacitly acquired a secondary layer of meaning to exclude such types of art as were not approved. A picture was no longer called expressive because it realistically depicted a scene fraught with emotion in the manner of Victorian narrative painting, nor because it depicted a person in the throes of some emotional paroxysm. The expressiveness had to reside in the impact made by the formal structure of colours, lines, planes and masses, or at the least in some imaginatively evocative and unusual depiction of a scene, as in the METAPHYSICAL paintings of CHIRICO and CARRÀ or the MAGICAL REALISM of some SURREALIST works. If Munch's famous lithograph *Le Cri* (1895) is regarded as a prototype and precursor of Expressionist art, it is not merely because it depicts a figure uttering a morbid shriek of terror, but because the organization of lines and masses seems to mirror the hysteria of the scene while the shriek seems so out of place in its environment as to be an indication of mental abnormality. With these qualifications Expressionism was virtually identified with whatever was thought best in modern art and Sheldon Cheney, for example, in his book *Expressionism in Art* (1934) used the term almost as a synonym of 'Modernism'. He wrote in the Preface: 'I believe Expressionism to be the name history will assign to the development in art that began with Cézanne in painting, with Sullivan in architecture, with Duncan in dancing, with Craig and Appia in the theatre. It seems to me the only term exact enough to describe alike the works of Cézanne and Picasso and Orozco and Wigman and Wright and Lehmbruck; even while broad enough to embrace the varied contributions of the so-called Post-Impressionists, Fauves, Cubists, Functionalists, Purists, etc.' In the Preface to the second edition, written in 1948, he repeated: '"Expressionism" as a name identifying the main current of creative art in the 20th century has steadily gained adherents among artists, writers and museum people.'

This very broad use of Expressionism 'as a label for the typical creative art of the early and middle 20th century' did not outlast the 1930s. It was succeeded by the idea that Expressionism is a persisting tendency peculiarly characteristic of Nordic and Germanic art from the Middle Ages until today, and standing in contrast with the Mediterranean or classical French traditions. Thus Expressionism was thought of as a principle opposed to the currents in art which ran from Impressionism through Post-Impressionism to Cubism.

The forerunners of modern Expressionism were held to be Van Gogh, ENSOR, MUNCH and HODLER. (The term 'Expressionist' was taken over by the critic Roger FRY as an alternative to Post-Impressionist. By it he intended to point a contrast with the 'naturalism' of the Impressionists, who, he thought, set themselves to produce a 'literal' representation of objective reality. The Post-Impressionists, on the other hand, according to Fry's interpretation, deliberately deviated from 'natural' appearances in order to express the emotional significance of things. Thus he said of Van Gogh that his paintings were 'not the least like other pictures. Their origin is different. . . . Vincent's paintings are pure self-expression . . . His vision of nature is distorted into a reflection of . . . inner condition.')

It is now generally accepted among historians of modern art that there are two main schools of Expressionism with some features in common but more than nationality differences to divide them. They are generally referred to as the Germanic and the French schools. The German school includes the BRÜCKE, the BLAUE REITER, BARLACH, BECKMANN, NOLDE, ROHLFS, etc. and the Austrians such as KOKOSCHKA and SCHIELE. But neither the constitution nor the defining characteristics of the school have been very precisely formulated. So, for example, Werner Haftmann speaks of Paula MODERSOHN-BECKER as one of the early north German Expressionists (*Painting in the Twentieth Century*, Vol. 2, p. 54) while the German art historian Wolf-Dieter Dube writes: 'Paula Modersohn-Becker did not paint personal confessions or emotions; she was not concerned with protest or with drama. That separates her, as will be seen, from the Expressionists.' Manifestations of Expressionism in Belgium—PERMEKE and the LAETHEM-SAINT-MARTIN school—and in Scandinavian countries had more or less close affinities with German Expressionism, though they lacked the extremism and hysteria of the latter. The French school, even less precisely defined, includes artists such as ROUAULT, PASCIN, DUNOYER DE SEGONZAC, GROMAIRE and artists of the ÉCOLE DE PARIS such as SOUTINE and CHAGALL, while many other French artists went through an Expressionist phase. (See also FRANCE.) While this represents the way in which 'Expressionism' was employed by most art historians during the 1950s and 1960s, usage was by no means uniform. For example Wolf-Dieter Dube's *The Expressionists* (1972) covers the Germans and Austrians and includes the Russians Kandinsky and JAWLENSKY, who worked for a time in Germany, but it has nothing to say about the Russians of the École de Paris such as Soutine or Chagall and nothing about any of the French Expressionists.

The origin of the term 'Expressionism' to describe a style or school of art is uncertain. From a pretty general term referring to the French *avant-garde* it came between *c.* 1910 and 1915 to refer to a specifically *Germanic* school. In the catalogue of an exhibition of the Berlin *Sezession* held in April

1911 'Expressionists' was used to refer to French artists—BRAQUE, DERAIN, DUFY, FRIESZ, MARQUET, VLAMINCK, etc.—and it was used in a similar way in the catalogue of an exhibition of the *Sonderbund* held two months later at Düsseldorf. It also referred to French artists in the literature of the first exhibition staged by the STURM Gal. in Berlin in 1912. About this time the word came to be used still more vaguely and generally of the 'new movement' in painting and to include those German artists whom we now call Expressionists. In 1913 a *Sonderbund* exhibition was held in Bonn with the title 'Rheinische Expressionisten' and in 1914 Paul Fechter, in the first monograph to be written on Expressionism, defined it as a *German* movement in reaction from Impressionism parallel to CUBISM in France and FUTURISM in Italy.

German Expressionism began as a movement of revolt against academic Impressionism—the French Impressionists were not exhibited in Germany until the beginning of the century, more or less simultaneously with the Post-Impressionists Seurat, Van Gogh, Gauguin and Cézanne, and the 'Germanic Impressionism' of LIEBERMANN and CORINTH was closer to the style of the Barbizon school. It was also in revolt against the Romantic landscape painting of the WORPSWEDE group and against early manifestations of JUGENDSTIL. What was sought was a freer, more personal manner in which the artist could give vent to his feelings and at the same time feel himself to be in touch with the essence of things. Social protest played a large part in the motivation of many German Expressionists. To achieve their ends they took over techniques from the Post-Impressionists, from the FAUVES, even from the early Cubists; they took over the crude and jagged stylizations of the medieval German woodcut; and they combined these with romantic admiration for the art of primitive peoples. German Expressionism has been called 'the contemporary phase of Romanticism', yet its distinguishing characteristics have always been difficult to formulate. In *Expressionism in Art: Its Psychological and Biological Basis* Oskar Pfister wrote: 'The Expressionist wants to reproduce the intrinsic meaning of things, their soul-substance . . . From this point of view Impressionism appears as mere surface-art, and therefore a superficial art, a mechanical craft and no art at all. The Expressionist on the other hand creates out of the depth of things, because he knows himself to be in those depths. To paint out of himself and to paint himself means to reproduce the intrinsic nature of things, the Absolute. The artist creates as God creates, out of his own inner Self, and in his own likeness.' Details of the specific 'schools' of Expréssionism in Germany will be found under the BRÜCKE and the BLAUE REITER.

A word should be said also about Flemish Expressionism, which developed along a path distinct from both the French and the German varieties. It has been said by W. Vanbeselaere that Flemish Expressionism 'remained rooted in the earth and

in the people, in the fundamental and traditional realism of the country. Its essence was visual, sensual experience, wholly devoid of preconceived theories (another characteristic element of our tradition). As such it distinguished itself as an independent phenomenon having nothing in common with what was happening in the intellectual, urban centres of France, Germany, England and elsewhere.' Flemish Expressionism was closely connected with the school of Laethem-Saint-Martin and developed partly in reaction from current Symbolist and Impressionist styles. Although there was some connection with German Expressionism, the Flemish variety lacked the neuroticism, the introversion and the social concern of the Germans. The Flemish artists rarely painted street life; they were more deeply rooted in the earth and more closely concerned with the rustic reality of peasant existence than their German counterparts. The religious painter Albert SERVAES with Frits van den BERGHE may be regarded as the founders of the movement. Gustave de SMET was its most classical exponent and Constant Permeke with his cosmic monumentality was its most powerful figure.

EXTER, ALEKSANDRA ALEKSANDROVNA (1882–1949). Russian painter, born at Belestok, near Kiev. Until 1907 she attended the Kiev Art School and from 1908 onwards was a regular visitor to Paris and other western European cities. She took part in several Kiev exhibitions, including David BURLIUK's 'The Link' and that of the journal *Mir Iskusstva* (The World of Art). She was also represented at the St. Petersburg New Society of Artists (1908, 1909), the 'Izdebsky Salons' (1909–10, Odessa and other cities; 1910–11, Odessa), the 'Moscow Salon' (1911–12), etc. In 1912 she moved to St. Petersburg although she continued to travel frequently, coming into closer contact with the Russian and Western *avant-garde*. She became particularly close to the poet Benedikt Livshits and gave him several of her works. She was also associated with the UNION OF YOUTH, contributing to its first and last exhibitions. In 1915–16 she contributed to the exhibitions 'Tramway V' and 'The Shop'. She began her professional theatre work for Innokentii Annensky's *Thamira Khytharedes*, produced by Aleksandr Tairov at his Chamber Theatre, Moscow—the first of several collaborations with Tairov. In 1918 she founded her own studio in Kiev, from which emerged many artists who were to achieve fame in later years— Ignatii Nivinsky, Anatolii Petritsky, Isaak Rabinovich, Nisson Shifrin, Pavel TCHELITCHEW, Aleksandr Tyshler. It was here that Exter and her pupils created huge SUPREMATIST designs for several agit-steamers on the Dnieper River. In 1921 she contributed to the exhibition '5 × 5 = 25'. She then turned to textile design while still maintaining her interest in theatrical design. In 1923 she began to work on her sets and costumes for the film *Aelita* (produced in 1924). With Nivinsky she designed decorations for the 'First Agricultural and Handicraft-Industrial Exhibition' in Moscow. In 1924 she emigrated and in emigration worked on designs for the stage, for fashion and for interior decoration.

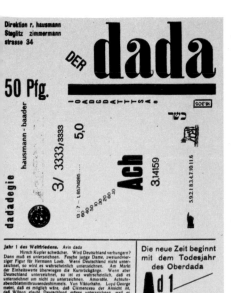

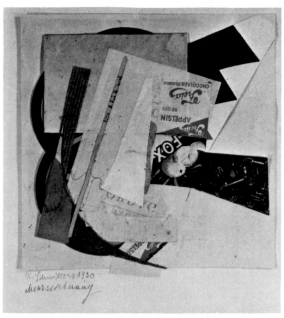

1. Cover of *Der Dada* No. 1, June 1919.

2. Kurt Schwitters: *Merz* drawing, 1930. Mixed media collage.

3. Jean Arp: *Constellation*, 1932. Painted wood relief, 70 × 85 cm.

4. Giorgio de Chirico: *Female Torso with Fruit*, 1913. Oil on canvas.

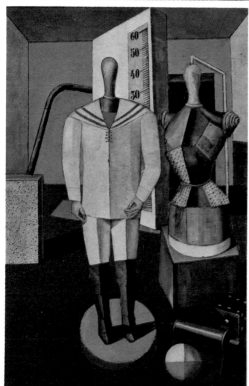

5. Carlo Carrà: *Mother and Son*, 1917. Oil on canvas. 90 × 60 cm.

6. Marcel Duchamp: *The Bride Stripped Bare by her Bachelors, Even* (The Large Glass), 1915–23. Replica by Richard Hamilton, 1965–6. Oil and mixed media on glass. 277 × 176 cm.

7. Joan Miró: *Maternity*, 1924. Oil on canvas. 92 × 73 cm.

8. René Magritte: *Black Magic*, 1933–4. Oil on canvas. 73 × 54 cm.

9. Max Ernst: *La Ville Entière*, 1935–6. Oil on canvas. 60 × 81 cm.

10. André Masson: *Battle of the Fishes*, 1926. Sand, gesso, oil-pencil and charcoal on canvas. 36 × 73 cm.

11. Salvador Dalí: *Suburbs of the Paranoiac-critical Town*, 1935. Oil on board. 46 × 66 cm.

12. Yves Tanguy: *Demain*, 1938. Oil on canvas. 54 × 46 cm.

13. Matta Echaurren: *Le Vertige d'Eros*, 1944. Oil on canvas. 196 × 244 cm.

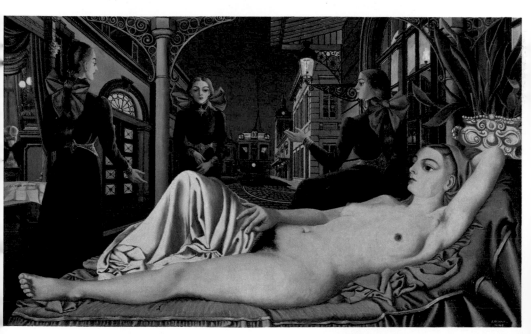

14. Paul Delvaux: *La Voix Publique*, 1948. Oil on wood. 152 × 254 cm.

15. Oscar Dominguez: *Untitled*, 1936. Gouache (decalcomania). 36 × 29 cm.

16. Wifredo Lam: *The Jungle*, 1943. Gouache on paper mounted on canvas. 239 × 230 cm.

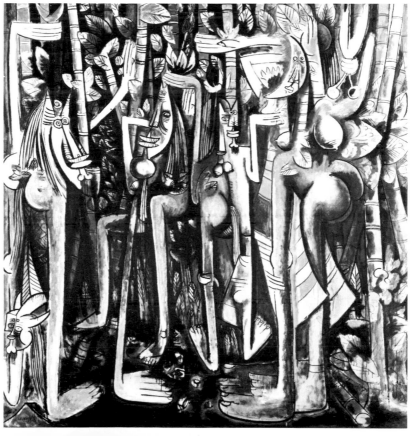

17. Alfred Kubin: *Kraken*, 1906–7. Pen, ink, and wash. 13 × 22 cm.

18. Gustave van de Woestijne: *Paysage Fantastique, c.* 1924.
Oil on canvas. 160 × 136 cm.

19. Maurits Cornelis Escher: *Other World*, 1947. Wood
engraving printed from three blocks. 31 × 26 cm.

20. Stanley Spencer: *Swan Upping at Cookham*, 1914–19. Oil on canvas. 148 × 116 cm.

21. Edward Burra: *Dancing Skeletons*, 1934. Gouache. 79 × 56 cm.

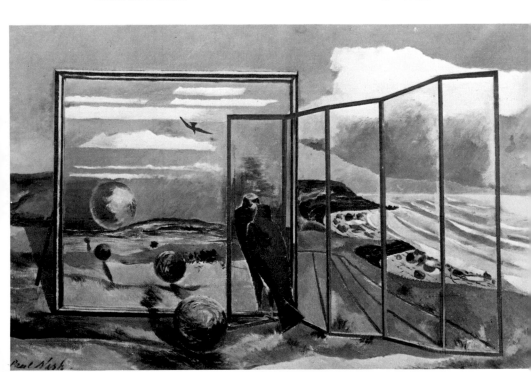

22. Paul Nash: *Landscape from a Dream*, 1936–8. Oil on canvas. 68 × 102 cm.

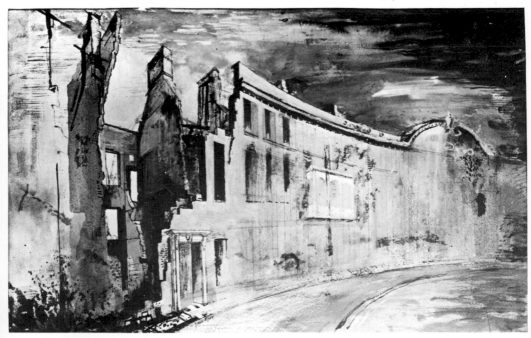

23. John Piper: *Somerset Place, Bath*, 1942. Watercolour. 49 × 76 cm.

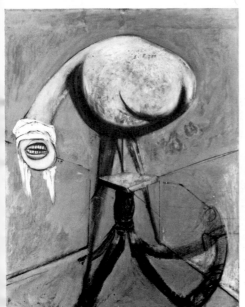

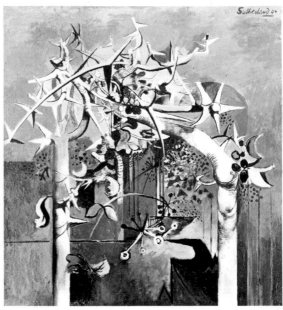

24. Francis Bacon: one of *Three Studies for Figures at the Base of a Crucifixion*, *c*.1944. Oil on board. 94 × 74 cm.

25. Graham Sutherland: *Thorn Trees*, 1945. Oil on cardboard. 109 × 101 cm.

26. Marc Chagall: *Around Her*, 1945. Oil on canvas. 131 × 109 cm.

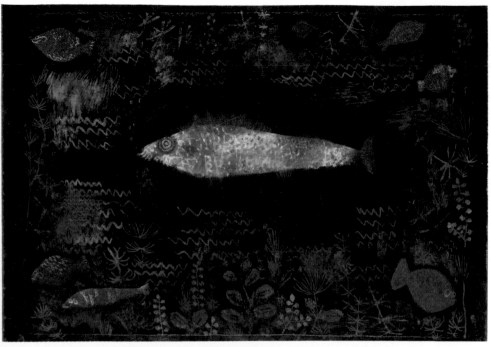

27. Paul Klee: *The Golden Fish*, 1925. Oil on cardboard. 50 × 69 cm.

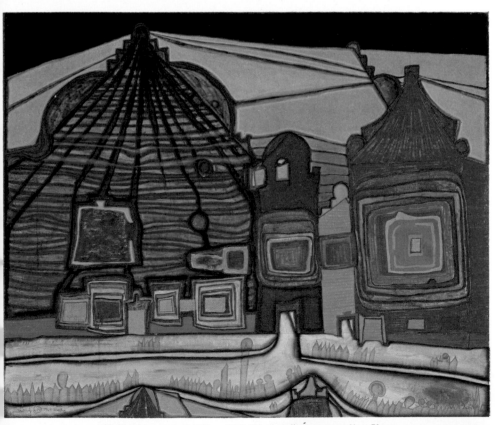

28. Hundertwasser: *Bethäuser*, 1964. Mixed media on canvas. 61 × 73 cm.

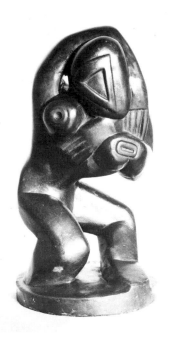

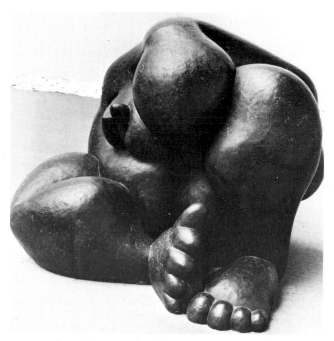

29. Henri Gaudier-Brzeska: *Red Stone Dancer*, c.1913. Stone. 43 × 23 × 23 cm.

30. Henri Laurens: *Adieu*, 1941. Stone. 73 × 85 × 69 cm.

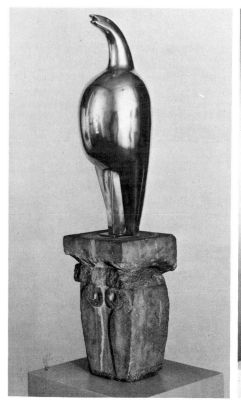

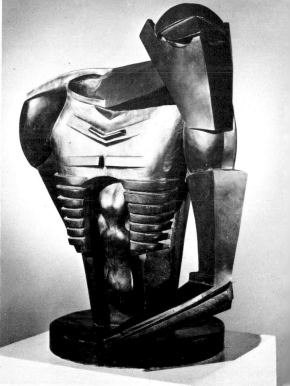

31. Constantin Brancusi: *Maiastra*, 1911. Bronze and

32. Sir Jacob Epstein: *Torso in metal from the Rock Drill*, 1913–14. Bronze. 70 × 58 × 44 cm.

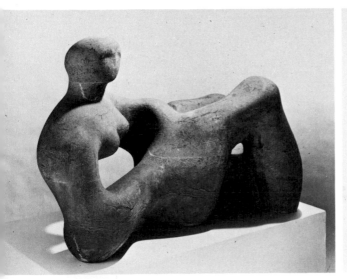

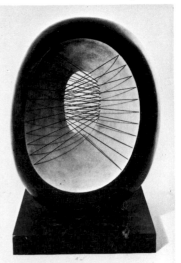

33. Henry Moore: *Recumbent Figure*, 1938. Stone. 89 × 133 × 74 cm.

34. Barbara Hepworth: *Spring*, 1966. Bronze. 77 × 51 × 38 cm.

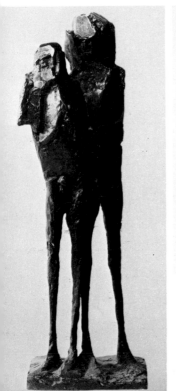

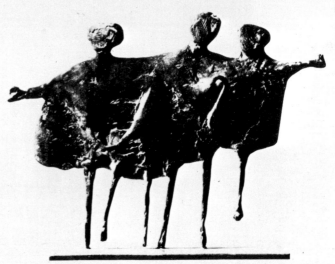

36. Kenneth Armitage: *Children Playing*, 1953. Bronze. 23 × 32 cm.

5. Elisabeth Frink: *Assassins No. 1*, 1963. Bronze. 56 × 17 × 12 cm.

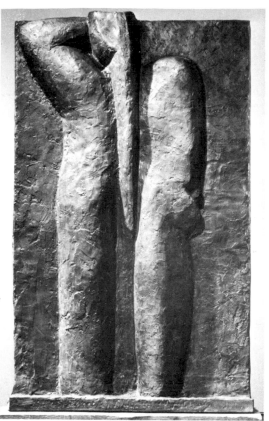

37. Henri Matisse: *Back IV*, 1930. Bronze relief. 189 × 113 × 16 cm.

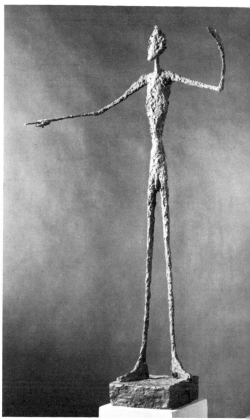

38. Alberto Giacometti: *Man Pointing*, 1947. Bronze. 177 × 90 × 62 cm.

39. Marino Marini: *Miracalo, 1959–60*. Bronze. 175 × 136 × 270 cm.

40. Giacomo Manzu: *Young Girl on a Chair*, 1955. Bronze. Height 112 cm.

41. Amedeo Modigliani: *Portrait of a Girl*, 1916. Oil on canvas. 81 × 60 cm.

42. Alberto Giacometti: *Caroline*, 1965. Oil on canvas. 130 × 81 cm.

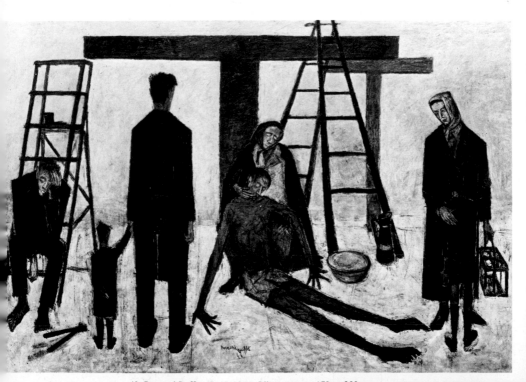

43. Bernard Buffet: *Pietà*, 1946. Oil on canvas. 172 × 255 cm.

44. Oskar Kokoschka: *Portrait of Marczell von Nemĕs*, 1928. Oil on canvas. 135 × 95 cm.

45. Raoul Dufy: *The Port of Marseilles*, 1926. Oil on canvas. 116 × 90 cm.

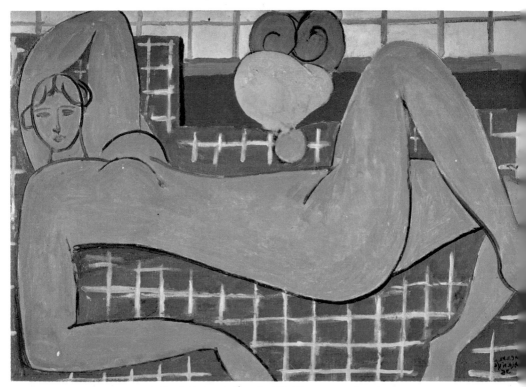

46. Henri Matisse: *Pink Nude*, 1935. Oil on canvas. 67 × 93 cm.

F

FABBRI, AGENORE (1911–). Italian sculptor born at Barba, Pistoia, studied at the Pistoia School of Art. During the 1920s he worked in a pottery in Albissola, Liguria, and after undergoing the influence of Marino MARINI and Arturo MARTINI he made haunting creatures of fantasy, mainly in coloured terracotta. His work was slight but among the most individualistic of contemporary Italian sculpture.

FADER, FERNANDO. See LATIN AMERICA.

FAHLSTRÖM, ÖYVIND (1928–76). Swedish painter and poet, born in São Paulo. He moved from Brazil to Sweden in 1939 and remained there until 1961, when he settled in New York. He was interested in theatre and in concrete poetry and in 1953 he published a manifesto in favour of concrete poetry which 'kneaded' the language irrespective of the conventional meanings of words. About the same time he was working on *Opera*, a strip painting 11 m long swarming with signs which, it has been said, 'set in motion happenings utterly remote from any possibilities of unambiguous interpretation'. In his first exhibition, in 1955, he showed abstract paintings which repeated forms serially with slight differences from one to the other. This was followed by a large painting, *Ade-Ledic-Nander 11*, to which he wrote a scenario which, in his own words, described the events in a 'nonsense-like, home-made nomenclature which might conceivably be read as concrete poetry'. At the end of the 1950s he was using comic strips, breaking them up in a way which led to wilful absurdity. From this he developed his 'playable' pictures, such as *Sitting* (1962), *The Planetarium* (1963), *The Cold War* (1963–5), which he described as 'somewhere at the point of intersection between paintings, games . . . and puppet shows'. In these pictures he used loose forms which the spectator could move about the picture surface with a magnet. After his move to America he became more deeply involved in social and political matters and in 1966 published a manifesto 'Take Care of the World', calling for a Utopian, de-politicized, non-aggressive society based on individual pleasure. The paintings of these years took on a more journalistic character, based on such subjects as the Vietnam War, the World Bank, an alleged kidnapping of Kissinger, etc., and were propagandist in purpose.

FAIRWEATHER, IAN (1891–1974). Australian painter born at Bridge of Allan, Scotland.

His interest in painting began during the First World War when he was billeted with a Dutch artist while serving in the British Army. In 1920 he commenced studies at the Slade School and developed a keen interest in Oriental art. Fairweather lived in Germany in 1924 and Canada in 1927. After working in Shanghai for three years, he then travelled about China, Japan, India and was later in Bali. In 1934 he visited Melbourne, where he met Gino Nibbi (whose bookshop was a centre for anyone interested in modern art) and obtained a commission to paint a mural for the Menzies Hotel, Melbourne. But because it was compared to the work of BRANGWYN he destroyed it and boarded a ship bound for the Philippines the following morning. In 1934 the Tate acquired *Bathing Scene, Bali* and from 1935 Fairweather exhibited with the Redfern Gallery. In 1935 he lived and painted in Peking and then for several years in the Philippines and in Northern Australia. From 1940 to 1943 he served as a captain in the British Army in India. On being invalided out in 1943 he lived in Melbourne and then near Cairns before moving to Darwin. In April 1952 he attempted to sail from Darwin to Dili in Timor on a raft made of softwood and petrol drums. He was presumed lost at sea and an obituary appeared in the *Melbourne Herald* on 13 May 1952. But thirteen days later he landed on a Timor beach. The Indonesian authorities refused him permission to stay and eventually deported him to Singapore, where he was placed in a home for the destitute. He was eventually returned to England as a result of the intervention of British government authorities, but after some disagreeable experiences, such as digging ditches in the winter to repay his fare, he returned to Sydney in 1953. Constructing a hut for himself on Bribie Island, off the Queensland coast near Brisbane, he lived and worked there until his death.

Fairweather painted mainly in earth colours used by the artists of South-East Asia and the Pacific and was one of the first artists to assimilate aboriginal art into his own personal style. He possessed also a great admiration for Chinese art and civilization. Fairweather was the master of a fluent, semi-abstract, calligraphic style in which the values of East and West are united in a manner that has rarely been achieved. He was a student of Chinese and made a translation of *The Drunken Buddha* based on the edition of 1894–5.

FAISTAUER, ANTON (1887–1930). Austrian painter born at St. Martin, near Lofer. He studied at the Vienna Academy of Art, 1906–9, but be-

cause of his admiration for French painting, which he saw in an exhibition of 1904, he seceded from the Academy with other young students and formed the *Neukunstgruppe*, which held its first exhibition in the Gal. Pisko in 1909. He also showed in the HAGENBUND exhibition of 1912. After the war he lived from 1919 to 1926 in Salzburg, where he founded the WASSERMANN group. He painted mainly still lifes but from 1919 began to take an interest in mural painting and did murals for the Morzger Church, 1922–3, and for the Salzburg Festival Theatre, 1926. In 1923 he published *Neue Malerei in Österreich* (Vienna).

FALK, ROBERT RAFAILOVICH (1888–1958). Russian painter and designer, born in Moscow. In 1903–4 he studied at Ilya Mashkov's private studio in Moscow and in 1905–10 at the Moscow Institute of Painting, Sculpture and Architecture under Konstantin Korovin, Valentin Serov, etc. In 1906 he began to contribute regularly to exhibitions. In 1910–11 he travelled to Italy. He was a founding member of the KNAVE OF DIAMONDS and from 1918 to 1928 he taught at the VKHUTEMAS/Vkhutein. In 1924 he had his first one-man show in Moscow. From 1928 to 1938 he lived in France; from 1938 to 1944 he worked in Soviet Central Asia. On his return to Moscow in 1944 he continued to work mainly on landscapes and portraits. In 1966 a comprehensive retrospective exhibition in Moscow completely rehabilitated him from the censure of the Stalin years.

FANTASTIC REALISM. A school of painting which arose in Vienna *c.* 1945 and came to be regarded as typical of post-war Austrian painting. Most of the young artists responsible for originating it had been pupils of A. P. GÜTERSLOH (see AUSTRIA). Though very different in their ways of painting and in the quality of their work, they had in common an interest in the art of the past, such as that of the elder Bruegel which they studied in the Vienna museums, and in the literary and anecdotal character of painting. They combined minute realism with a fairy-tale world of fantasy and imagination.

FARRERAS, FRANCISCO (1927–). Spanish painter born at Barcelona, studied first under the painter Gómez Cano of Murcia, then in 1942 at the School of Arts and Crafts, Santa Cruz de Tenerife, and in 1943 at the San Fernando School of Fine Arts, Madrid. In 1954 he received a scholarship from the French Institute at Madrid to study ceramics and in 1958 a grant from the Juan March Foundation. He lived in the U.S.A. from 1958 to 1966. In his earlier period his painting was figurative and he showed a preference for murals and worked with large-scale format. He also worked on mosaics and stained glass. Like many other Spanish artists he changed to an ART INFORMEL style of abstraction *c.* 1955, evolving an individual technique of COLLAGE and covering the

finished picture with a veil of thin gauze or other material in order to soften the harshness of contrasts. Outside Spain he exhibited in New York, Chicago, San Francisco, Los Angeles, Montreal, and his work was included in a number of international group exhibitions. The public collections in which he is represented include The Mus. of Modern Art and the Solomon R. Guggenheim Mus., New York, the Carnegie Institute, Pittsburgh, the Mus. of Modern Art, Tokyo, the Tate Gal., the Mus. National d'Art Moderne, Paris, and the Gemeentemus., The Hague.

FASSBENDER, JOSEPH (1903–). German painter, born in Cologne and trained at the Cologne Werkschule. In 1929 he was awarded the Villa Romana prize and spent one year in Florence. In 1954 he was visiting lecturer at the Hamburg Academy of Arts and in 1956 was put in charge of graphic art at the Krefeld Werkkunstschule. He used natural elements for purposes of abstract composition, setting delicate graphic lines against harsh contrasts of black on luminous colours. 'It is as if the painter wanted to refine the dull and the colourless, the rusty and patinated, and bring to the fore the beautiful which is buried under the grey monotony of everyday life. Welded and nailed, held together by bands and bent into loops, the unrolling wire-lines, forming wilful ornaments, seem to be inspired by the memory of bridges and other technical structures, and are utilised in an abstract and non-objective manner.'

FAUTRIER, JEAN (1898–1964). French painter, born in Paris. He came to England in 1909 and studied at the Royal Academy Schools and at the Slade School, returning to Paris in 1917. Throughout his life he remained isolated from groups and movements and his work is difficult to classify. In 1928 he did lithographs to illustrate Dante's *Inferno* which have been regarded as forerunners of ART INFORMEL. In 1943 he exhibited at the Gal. Drouin a series of *Otages* inspired by his horror of war. In these he developed his characteristic technique, building up by layer upon layer of paint, thickened with white, a heavy impasto into which he worked the representation of his subject. If in some aspects his work can be described as MAGIC REALISM, it is equally apt to speak of it as a 'poetic transformation' and he imbued his themes with an arcane hieroglyphic significance which the viewer must decipher. In addition to this atmosphere of mysteriousness his pictures often make an unexpected impression of profundity and power. He was regarded by Pierre Cabanne and Pierre Restany in *L'Avant-garde au XXe siècle* (1969) as one of the most important forerunners of the post-war school of expressive abstraction. From 1950 he was one of the first to develop the idea of 'multiple originals'. In 1957 he had an exhibition at the Gal. Rive Droit, Paris, 'Fautrier. 30 Années de Figuration Informelle'. In 1960 he was awarded the Grand Prix at the Venice Biennale.

FAUVISTS. A loose association of painters who in the early years of the century worked in a common and at that time startling idiom. The association comprised MATISSE, MARQUET, MANGUIN and CAMOIN, who all worked in the studio of Gustave MOREAU; DUFY, FRIESZ and BRAQUE from Le Havre; DERAIN and VLAMINCK from Chatou; Jean PUY; and the Dutch artist Van DONGEN. The movement was launched in opposition to the official art of the Academies and was also the most violent of the reactions from Impressionism which had occurred up to that time. The Fauvists agreed with Paul Signac and the Neo-Impressionists that Impressionism had been a superficial art, contenting itself merely with recording optical impressions, including light and atmosphere, on canvas. Reasoning that what we see affects not only the visual sense but the whole man, they made it their aim, in opposition to the Impressionist tradition, to express this total effect in the most vivid and direct way possible. And influenced largely by Gauguin and Van Gogh, they set themselves to do this by means of colour. Conceiving the picture as an alternative reality rather than a mere transcription of reality seen, they went further than any of their predecessors in the arbitrary use of colour, balancing pure colours in complex relations of complementaries and seeking strident and startling dissonances. Van Gogh had said: 'Instead of trying to render what I see before me, I use colour in a completely arbitrary way in order to express myself powerfully.' This sentence has been quoted as a formulation of Fauvism fifteen years in advance of the time. The Fauvists carried further what Van Gogh had begun. Unlike Seurat and the Neo-Impressionists they did not work with any theory of colour or colour harmonies but, in the words of Matisse, were 'simply seeking to transpose [their] feelings into colour'. This—and much that Matisse said—might be read as a formula for EXPRESSIONISM. Moreover the Fauvists deliberately sought an apparent clumsiness and even carelessness in their technique, dislocating the forms of objects, in order to enhance the expressive force of the picture. But in fact Fauvism always remained within the ambit of the disciplined, classical French tradition, opposed to the spirit of German Expressionism. While for the latter the object and the artist's reaction to it were often paramount, the Fauvists found their way of expression precisely in the creation of a balanced and unified composition. As Matisse, again, put it: 'My principal aim is to express myself ... Expression for me is the whole arrangement of my picture: the area occupied by the bodies, the spaces around them, the proportion, all this belongs to it. Composition is the art of making a decorative arrangement of the elements from which the painter can choose to express his feelings' (*Notes d'un Peintre*, 1908).

Pictures anticipating the Fauvist style were being painted in the 1890s. Marquet said: 'Matisse and I were already working, before the 1900 Exhibition, as far back as 1898, in what was later to be called the *fauve* style.' The movement reached its peak in the Salon d'Automne of 1905 and the Salon des Indépendants of 1906. The name of the group arose from a remark made by the critic Louis Vauxcelles in a review of the Salon d'Automne of 1905 in *Gil Blas*. Writing about a *Torso of a Child* by the sculptor Albert Marque, which stood among Fauvist paintings, he said: 'The purity of this bust comes as a surprise in the midst of the orgy of pure colours: it is Donatello among the *fauves* [wild beasts].' The name was significative of the view which prevailed among critics and connoisseurs at the time: that these were pictures by a group of competent and even talented artists who had lost their sense of proportion and run wild. By 1908 or 1909 the movement had in effect run its course. Most of the group had by then abandoned the Fauvist manner for other paths. Yet the movement is important in the history of 20th-c. painting both for the quality of the pictures produced and for the enormous influence which it had on later colourists. In Germany, particularly, the new use of pure colours practised by the Fauvists made a significant impact both upon the artists of the BRÜCKE at Dresden and upon the group of painters around KANDINSKY who founded the BLAUE REITER at Munich.

FAZZINI, PERICLE (1913–). Italian sculptor born at Grottamare and trained in Rome. He was a member of the CORRENTE association in 1938 and of the FRONTE NUOVO in 1946. Fazzini's sculpture was based on the human figure, which he represented in the manner of DESPIAU, whom he knew in Paris in 1934, and classical Italian sculpture.

FEDERAL ARTS PROJECT/WPA (WORKS PROGRESS ADMINISTRATION). A project instituted by the United States Government in 1935, and lasting until 1943, with the dual purpose of assisting artists who had been hard hit by the Depression and of deploying the artistic potential of the country in the decoration of public buildings and places. The Federal Arts Project grew out of previous projects which had been established as part of the New Deal. In 1933 the Public Works of Art Project was set up to assist artists over the winter of 1933/4, artists being employed on public works at a weekly salary. The following year the Treasury Relief Art Project (July 1935–June 1943) was set up under the painter Edward Bruce (1879–1943) for a similar purpose, while a new section of Painting and Sculpture established in the Treasury Department commissioned artists for specific tasks in connection with the embellishment of Federal buildings. The Federal Arts Project in the Works Progress Administration under Holger Cahill, a collector of American folk art, employed artists on a monthly salary. By June 1943, when the project was terminated, *c.* 3,600 artists had been engaged in the production of some 1,600 works; over 1,200 murals had been commissioned. Unfortunately

few of the murals made under the WPA project survive though one or two are known from preliminary studies. The latter include *Sweatshop* by George Biddle (1885–1973), a study for a fresco in the Justice Department building in Washington, D.C. (University of Maryland coll., *c.* 1935); *Suburban Post in Winter* by William GROPPER (University of Maryland coll., 1934–6); *Aviation: Evolution of Forms under Aerodynamic Limitations*, a study for a mural for the Administration Building at Newark Airport (The Mus. of Modern Art, New York, 1936) by Arshile GORKY. Holger Cahill was also responsible under the WPA project for an *Index of American Design*, a gigantic documentation of the decorative arts in America.

FEELEY, PAUL (1913–66). American painter born at Des Moines, Iowa. After private tuition in California he completed his studies at the Art Students' League under Thomas Hart BENTON and at the Beaux-Arts Institute of Design, New York. He came to the fore in the mid 1950s as one among the generation of artists in reaction from ABSTRACT EXPRESSIONISM, whose work was classified as POST-PAINTERLY ABSTRACTION, and he was chiefly known for his uninflected SYSTEMIC painting and for his experiments with the shaped canvas, often extending his painting ground out into three-dimensional space. He used simple abstract shapes such as the quatrefoil, subjecting them to symmetrical organization, and in his later years he also made three-dimensional constructions in the style of MINIMAL ART. He was influential as a teacher, having Helen FRANKENTHALER among his pupils, and he taught at Bennington College, 1940–66. A retrospective memorial exhibition of his works was given at the Solomon R. Guggenheim Mus., New York, in 1968.

FEHRENBACH, GERSTON (1932–). German sculptor born in Villingen and studied in Berlin under Karl HARTUNG. He was a member of the *Symposion europäischer Bildhauer* but he modelled for casting as well as carving in stone. He combined vegetable and mineral forms in his abstract carvings and like HAJEK he was concerned with spatial concentration and the unification of spatial and voluminous elements in sculptural works.

FEININGER, LYONEL (1871–1956). German-American artist, born in New York of a German-American family of musicians. In 1887 he went to Germany and began to study drawing at the Kunstgewerbeschule, Hamburg, and then at the Berlin Academy. From this time until *c.* 1909 he worked as a cartoonist, doing satirical drawings and illustrations for the humorous magazines *Humoristische Blätter, Berliner Blätter, Ulk, Lustige Blätter* and also for the American papers *Harpers* and *The Chicago Tribune*. In 1909 he took up serious painting and in 1911 exhibited six works at the Salon des Indépendants. At this time he came into contact with the CUBIST and the FUTURIST

movements in Paris, both of which influenced the development of his personal style of angular lines and transparent intersecting planes. In 1912 he met German EXPRESSIONIST painters of the BRÜCKE and in 1913 he exhibited at the first German Herbstsalon with the BLAUE REITER. From 1919 to 1933 he taught at the BAUHAUS and he did the woodcut *Kathedrale des Sozialismus* for the Bauhaus manifesto in 1919. With JAWLENSKY, KANDINSKY and KLEE he exhibited with the BLAUEN VIER group, formed in 1924. After a visit to the U.S.A. in 1936, he returned there for good in 1937 and from 1938 made his home in New York. His first large exhibition in America was at The Mus. of Modern Art, New York, in 1944, although he had won prizes in the 'Artists for Victory' exhibition at The Metropolitan Mus. of Art in 1942 and at the Worcester Mus. of Art in 1943. In 1947 he was made President of the Federation of American Painters and Sculptors, and became Honorary Vice-President of the same body in 1955.

Feininger was master of a wide variety of pictorial styles. A distinctively personal combination of Cubist and Futurist features, seen in such works as *Raddampfer 11* (Detroit Institute of Arts, 1913) and *Gelmeroda IV* (Solomon R. Guggenheim Mus., New York, 1915), left reflections in the famous 'Manhattan' series done between 1940 and 1944. A rather cooler, more CONSTRUCTIVIST style, though rarely if ever quite non-figurative, may be seen in such later paintings as *Dampfer 'Odin' 11* (The Mus. of Modern Art, New York, 1927) and *Deep, Sonnenuntergang* (Mus. of Fine Arts, Boston, 1930). The influence of his early satirical and Expressionist drawings remains apparent in such pictures as *Strasse in Paris* (University of Iowa Mus. of Art, 1909) and *Grosse Revolution* (The Mus. of Modern Art, New York, 1910). Sometimes he approached the Expressionist fantasy of CHAGALL, as in *Siegesrausch* (The Mus. of Modern Art, New York, 1918) and sometimes the delicate poetic fantasy of KLEE.

Feininger was an artist of distinction and originality who belonged to no one school though he borrowed from many, and who created no school of his own. He had retrospective exhibitions in Berlin in 1931, The Mus. of Modern Art, New York, in 1944, the Institute of Contemporary Art, Boston, in 1949, circulating exhibitions in Europe in 1950–1 and 1954–5, the San Francisco Mus. of Art in 1959–61, and at the Haus der Kunst, Munich, and the Kunsthaus, Zürich, in 1973.

FEITELSON, LORSER (1898–1978). American painter born at Savannah, Ga., and taught at the Art Center School, Los Angeles. His first one-man show was at the Daniel Gal., New York, 1924. He also exhibited frequently at the David Stuart Gal., Los Angeles, and elsewhere on the west coast and had a retrospective exhibition at the Pasadena Art Mus. in 1952. He was one of the early followers of SURREALISM in America, and among the collective exhibitions in which he was represented were The

Mus. of Modern Art, New York, 'Fantastic Art, Dada, Surrealism', 1936 and the Art Institute of Chicago, 'Abstract and Surrealist Art', 1948. He also sought OP ART effects and was included in The Mus. of Modern Art, New York, exhibition 'The Responsive Eye', 1965. Among other collections his works are in The Mus. of Modern Art, New York, the Los Angeles County Mus. of Art, the San Francisco Mus. of Art and Brooklyn Mus.

FEITÓ, LUIS (1929–). Spanish painter born in Madrid, studied at the San Fernando School of Fine Arts there. After a figurative and sometimes near-SURREALIST period, he turned to abstraction *c*. 1953 and became a leading representative of ART INFORMEL, banishing all formal structure from his work. In 1957 he was a founding member of the EL PASO group and in the same year was awarded a scholarship by the French government. In 1959 he obtained the UMAN prize at the Paris Biennale and in 1960 the David Bright prize at the Venice Biennale. He exhibited widely and is represented, outside Spain, at the Mus. National d'Art Moderne, Paris, the Gal. d'Arte Moderna, Rome, the Art Gal., Toronto, The Mus. of Modern Art and the Solomon R. Guggenheim Mus., New York, the Mus. de Arte Moderna, Rio de Janeiro and the Mus. of Modern Art, Tokyo. He was represented in the 'Arte '73' exhibition organized by the Juan March Foundation and shown at the Marlborough Gal. of Fine Art, London. His later paintings displayed isolated abstract or semi-abstract images upon a large monochromatic background of unmodulated colour, creating a vaporous world of mysterious suggestion.

FEJEŠ, EMERIK (1904–). Yugoslav NAÏVE painter, born in the Croatian village of Osijek. He was one of 14 children and was brought up in great poverty. In 1909 his family moved to Novi Sad, where he was apprenticed to a shopkeeper. Later he learned the craft of button and comb making and worked in Belgrade, Zagreb and Budapest. He returned to Novi Sad in 1945 and in 1948 opened a second-hand shop there. Later he worked as a turner and again as a comb-maker. He began to paint in 1949. He painted architectural and city scenes in minute detail, working from coloured postcards which he adapted with a lively imagination. His paintings have been compared to those of the French naïve painter VIVIN but Feješ was less prosaic and had greater fantasy. Applying his pigment with match-sticks and slivers of wood, he built up meticulously realistic townscapes which were almost entirely the fruit of his own imagination. The stylizations of particular items have the typical awkwardness of the naïve painter. Feješ has acquired a great reputation among connoisseurs of naïve painting; since the mid 1950s he has been exhibited widely in Yugoslavia, in other European countries and in New York, Rio de Janeiro and São Paulo.

FELGUEREZ, MANUEL. See LATIN AMERICA.

FENOSA, APELLES (1899–). Spanish sculptor born at Barcelona. After training under the sculptor Casanovas he went to Paris in 1925 and in the same year had his first one-man exhibition at the Gal. Percier with the support of Max Jacob. He made a name with his portrait busts of artists and celebrities, which included Cocteau, ÉLUARD, Henri MICHAUX, Poulenc, Dora Maar, Colette. After the war he did a number of mythological pieces, which included *Polyphème* (1950) and *Quatre Saisons* (1952). Fenosa's work was distinguished by its gracefulness and its fluid and supple line, sometimes reaching the borders of abstraction.

FÉRAT, SERGE JASTREBZOFF (1881–1958). Russian-French painter born in Moscow and migrated to Paris in 1901. He met PICASSO in 1910 and became a close friend of Guillaume APOLLINAIRE, with whom he edited the CUBIST periodical *Les Soirées de Paris* from 1912 to 1914. About 1913 he began to paint Cubistic compositions, but he never fully mastered the basic principles of Cubism and his paintings were built up of heterogeneous fragments of things put together with an eye to decorative effect. He later gave up painting and destroyed most of his works. Cocteau once said that his paintings 'had removed a source of embarrassment by taking the insulting sting out of the word "charming"'. But this may have been doing them more than justice.

FERBER, HERBERT (1906–). American sculptor, born in New York. He attended evening classes at the Beaux-Arts Institute of Design, New York, 1927–30, while studying dentistry at Columbia University, and subsequently continued both professions. His sculpture passed through many phases. He first carved massive nudes in the manner of MAILLOL. Then, influenced by Romanesque sculpture and German EXPRESSIONISM on a visit to Europe in the late 1920s, his work displayed increasingly violent expressive distortion and he had practically reached abstraction by the 1940s. In 1945 he abandoned representation altogether and developed a style of open-work expressive abstraction from welded rods and strips of lead, copper or brass. By the end of the decade he had achieved prominence among the group of sculptors, including LASSAW, LIPTON and ROSZAK, whose metal sculpture paralleled the work of the ABSTRACT EXPRESSIONIST painters. His open or cage-like constructions were suggestive of organic forms, contrasting with the work of the more objective and geometrical school. He was also one of the initiators of the technique of obtaining an expressively textured surface by the manipulation of molten metal. In 1951 he executed an important commission, for the façade of the B'nai Israel Synagogue, Millburn, New Jersey. This was followed by commissions for the Jewish Chapel at Brandeis University (1955), Temple Anshe Chesed,

Cleveland (1955), Temple of Aaron, St. Paul (1955) and the John F. Kennedy Federal Office Building, Boston (1969). In 1961 he was commissioned by the Whitney Mus. of American Art to do an *Interior* exemplifying the idea of sculpture as environment: a construction into which the spectator could enter and move, participating in the space defined, not displaced, by the sculpture. During the 1960s his forms became simpler and more flowing, though still sometimes on a monumental scale. The series called *Calligraphs* is typical. He was included in many important collective exhibitions both in the U.S.A. and abroad and he had retrospective exhibitions at Bennington College, 1958, the Whitney Mus. of American Art, 1961, the San Francisco Mus. of Art, 1962, and a circulating retrospective from the Walker Art Center in 1962–3.

FERGUSSON, JOHN DUNCAN (1874–1961). British painter, born at Leith and educated in Edinburgh. After beginning to study medicine he decided to follow an artistic career in 1894, but he had no formal training in painting apart from a brief period of study at the Académie Colarossi in the late 1890s. From *c.* 1895 he made frequent visits to Paris and finally settled there *c.* 1905–7. He exhibited at the Salon d'Automne 1907–12, and in England at the Royal Society of British Artists, 1899–1907, and the Allied Artists' Association, 1907–12, but not at the Royal Academy or the NEW ENGLISH ART CLUB. His first one-man exhibition in London was in 1905. Starting from Whistler and influenced by some of the GLASGOW SCHOOL, Fergusson's style of painting shows a logical development from the Impressionists to Toulouse-Lautrec and the FAUVES. A change came over his work *c.* 1910 when the nude for the first time became a dominant theme. He continued the Fauvist method of echoing the figure in the background, but his colours became less strident, his outlines more emphatic and a new formalization appeared. Except in the large nudes his work was distinguished from that of the Fauves by his more personal involvement with the subject. Deriving perhaps from his interest in ballet, the rhythms of his group pictures were now more vigorously emphasized. One picture entitled *Rhythm* (University of Stirling, 1911) was seen by Michael Sadleir and Middleton Murry at the Salon d'Automne and in consequence the word 'Rhythm' was taken as the title for a new magazine launched by Middleton Murry and Katherine Mansfield, of which Fergusson became art editor. In 1911 he was made a member of the Salon des Indépendants. In 1914 the war brought him back to London and in 1918 he joined the Royal Navy and did a series of war pictures of Portsmouth Docks.

In the inter-war years he moved between London, Paris, Scotland and the south of France. His first Scottish exhibitions were at Edinburgh and Glasgow in 1923. He was exhibited in New York in 1926 and 1928. During the 1930s he

became President of a *Groupe des Artistes Anglo-Américains* in Paris. With his old friends S. J. Peploe (1871–1935), Leslie Hunter (1879–1931) and F. C. B. Cadell (1883–1937) he formed a loosely associated group known as the Scottish Colourists and in 1940 he was President of the New Scottish Group of painters. His first retrospective exhibition opened in Glasgow in 1948. A Memorial Exhibition was organized in 1961 by the Scottish Committee of the Arts Council, a retrospective exhibition was shown at the Leicester Gals. in 1964 and a centenary exhibition by The Fine Art Society in London, Glasgow and Edinburgh in 1974. On his death Fergusson left instructions which resulted in the foundation of a J. D. Fergusson Art Foundation, one of whose aims was to establish a permanent exhibition of his works, and in consequence an important group of paintings was presented to the University of Stirling. Fergusson wrote *Modern Scottish Painting* (1943), an individualistic account of 20th-c. Scottish painting and its roots.

FERNANDEZ-MURO, JOSÉ ANTONIO (1920–). Argentine painter born in Madrid, Spain. He went to Argentina in 1938 and studied painting. He lived again in Madrid and Paris between 1948 and 1950 and in 1957 and 1958 he went to Europe and the U.S.A. on a UNESCO fellowship to study museology. He also exhibited at the Pan American Union in Washington in 1957. He had his first individual exhibition in 1944 at the Gal. Witcomb in Buenos Aires, where he exhibited again in 1946. He began painting still lifes and cityscapes in a FAUVIST style. After he became affiliated with the CONCRETE and abstract movements of the 1950s in Buenos Aires he turned to geometrical abstraction but without the rigidity of the Concrete painters. He used a Pointillist technique obtained mechanically with a stencil and a great variety of richly graded colours. In 1952 he showed in the *Grupo de Artistas Modernos*, at the Mus. de Arte Moderna, Rio; in 1953, in the São Paulo Bienale; in 1956, in the 27th Venice Biennale; and in 1959 he participated in 'South American Art Today' at the Dallas Mus. In 1961 he was included in an exhibition at the Mus. Nacional de Bellas Artes, Buenos Aires. He was awarded a Guggenheim Fellowship in 1960 and moved to New York in 1962, remaining there through the 1960s. His work became less formal after that. FROTTAGES, and embossed rubbings in metal foil of industrial products such as manhole covers with letters and numbers replaced the squares and circles of his earlier paintings. He used overlays of red, greys, white, black, yellow and dull ochres which blended into olive greens. In 1963 he had an individual exhibition at the Andrew-Morris Gal. in New York. The paintings of this period referred thematically to events and emblems. *Shot in the Back* (1963) commemorated the assassination of the civil rights worker Medgar Evers in the state of Mississippi. He also parodied flags, in a different

way from the U.S. artist Jasper JOHNS. *Secret Banner* and *To the Great People of Argentina* (1964), satirizing the solemnity of the subject, were exhibited in 1966 in 'The Emergent Decade' at the Solomon R. Guggenheim Mus. in New York. In 1960 he was awarded the National Prize at the Guggenheim International exhibition and in 1963 the first prize at the Arte Actual de America y España in Madrid. He also participated in the National and International award exhibitions at the Instituto Torcuato di Tella, Buenos Aires, in the 1960s. From the early 1970s he lived in Spain.

FERRARA, DANIEL (1906–). NAÏVE painter, born at Mers-el-Kebir. From childhood he showed an interest in drawing and modelling. Later, working as a sailor and dock labourer, he taught himself to paint without formal training. His principal subjects were simply conceived but poetic landscapes in light and delicate colours. From 1960 his works were widely exhibited, including one-man shows in Paris (1960, 1963, 1965), Zürich (1970), Vence (1972) and Munich (1973). He was shown at the Salon d'Automne, Paris, in 1963, 1967, 1969, 1970, and at the Bratislava Triennale in 1966, 1969, 1972, and was included in the exhibition '50 Contemporary French Painters' which toured Japan in 1971.

FERREN, JOHN (1905–70). American painter, born at Pendleton, Oreg. He studied at the Académies de la Grande Chaumière, Ransom and Colarossi, Paris, and attended the Sorbonne and the universities of Florence and Salamanca. From 1931 to 1938 he lived in Paris and on returning to America he was one of the first to exhibit with AMERICAN ABSTRACT ARTISTS. During the war he was employed by the War Department and worked in the Psychological Warfare Division of S.H.A.E.F., receiving a Bronze Star. Afterwards he devoted himself to teaching, at the Brooklyn Mus. School and the Cooper Union. He lectured widely and was a member of the Advisory Council to the School of Art and Architecture at Yale University, 1959–62. His works were widely exhibited both in America and in Europe. While he worked in Paris Ferren was a quasi-geometrical abstractionist though with a more lyrical manner than the artists of De STIJL, and this was his manner when he showed at the foundation exhibition of the American Abstract Artists. In the late 1940s and 1950s he was associated with the more lyrical group of the ABSTRACT EXPRESSIONISTS but his interest in the optical impact of contrasting colours came increasingly to predominate until in the 1960s he was making coloured constructions reminiscent both of Morris LOUIS and of SYSTEMIC painting.

FIAMINGHI, HERMELINDO. See LATIN AMERICA.

FIELD PAINTING. A style of painting inaugurated in America by Barnett NEWMAN *c.* 1950. The style emphasized the holistic character of a painting and no longer regarded it as a structure of interrelated elements but as a total field. In the words of Lawrence Alloway: 'The whole picture becomes the unit; forms extend the length of the painting or are restricted to two or three tones. The result of this sparseness is that the spatial effect of figures on a field is avoided.' In an interview with Bruce Glaser (edited later by Lucy R. Lippard and published in *Art News*, September 1966) Donald JUDD said: 'But when you start relating parts, in the first place you're assuming you have a vague whole—the rectangle of the canvas—and definite parts, which is all screwed up, because you should have a definite *whole* and maybe no parts, or very few ... The whole's it. The big problem is to maintain the sense of the whole thing.'

Field painting is sometimes called 'holistic', 'non-relational' as opposed to 'relational' painting. This idea is diametrically opposed to the older CONSTRUCTIVIST conception as expressed for example by the following statement of MONDRIAN in his essay 'Plastic Art and Pure Plastic Art' in CIRCLE (1937): 'Throughout the history of culture, art has demonstrated that universal beauty does not arise from the particular character of the form, but from the dynamic rhythm of its inherent relationships, or—in a composition—from the mutual relations of forms. Art has shown that it is a question of determining the relations. It has revealed that forms exist only for the creation of relationships; that forms create relations and that relations create forms. In this duality of forms and their relations neither takes precedence.'

Field Painting has affinities with unaccented grid painting, with symmetrical layouts and SYSTEMIC painting and with the ALL-OVER style initiated by Jackson POLLOCK. It has been known as COLOUR FIELD PAINTING when emphasis is placed upon brilliance and saturation of colour in monochromatic canvases. Rather than a specific style it may be regarded as an aspect of a very general tendency during the 1950s and 1960s to eschew traditional composition in favour of non-relational presentation of a single 'total' theme.

FIETZ, GERHARD (1910–). German painter born at Breslau, studied at the Breslau BAUHAUS and under Oskar SCHLEMMER, 1930–2, then at the Düsseldorf Academy, 1932–3, and in Berlin, 1937–8. After the Second World War he took up abstract painting and exhibited at the SALON DES RÉALITÉS NOUVELLES from 1948 and at the Venice Biennale in 1950. In 1955 he was included in an exhibition of German abstract painters at the Cercle Volney, Paris. He was a member of the German ZEN group. His pictures were composed of heavy and clearly defined shapes or linear constructions standing out from a neutral ground. Some of his forms were reminiscent of KLEE, although he lacked the subtlety and the fantasy of Klee's imagery.

FIGARI, PEDRO (1861–1938). Uruguayan painter born in Montevideo. Although Figari studied painting at an early age with an Italian artist, Godofredo Somavilla, in Montevideo, his career as an artist began late. He was also a lawyer, politician, journalist, essayist, poet and philosopher. In 1886 he received his law degree and became a successful defence counsel. As a journalist he founded the newspaper *El Diario*. As a politician he was elected in 1915 to a seat in the Chamber of Deputies and appointed director of the Escuela de Artes y Oficios. As an essayist and philosopher he published his *El Arte, La Estética y El Ideal* in 1912, and in 1930 a group of poems on regional themes of Uruguay and Argentina. He began painting seriously in Buenos Aires, where he went to live from 1921 to 1925, and in Paris, where he remained until 1933. Although he painted in a Post-Impressionist *intimiste* style related to BONNARD and VUILLARD, he developed a fresh and original approach, which he applied to American subjects. These included bourgeois salon life (*Sharp Tongue*), historical subjects (*Death of Facundo Quiroga*, the 19th-c. character immortalized by Sarmiento), Creole and Afro-American rituals and dances as in his *Candombe* paintings, scenes of daily life and popular customs, and landscapes of the pampas with gauchos and infinite skies. Figari returned to Montevideo in 1933, where he remained until his death. His work was exhibited regularly from 1921 in Buenos Aires, Montevideo, Paris, London, Seville, Los Angeles and New York. The Mus. National d'Art Moderne, Paris, held an exhibition of his work in 1960 and the National Mus. of Fine Arts in Buenos Aires in 1962. His paintings are in private collections in France, Argentina, Uruguay and the U.S.A.

FILIPOVIĆ, FRANJO (1930–). Yugoslav naïve painter, born at Hlebine. He was a farmer and a spare-time painter. His drawings were seen in 1945 by Ivan GENERALIĆ, who then taught him the technique of glass painting and instructed him to paint only what he saw, never to copy. Filipović was one of the most highly regarded among the younger generation of the Hlebine school (see NAÏVE ART) and was included in most exhibitions of naïve art both within Yugoslavia and abroad. Among his finest paintings is *Death Chamber* (1961), representing mourners around a dying woman lit by an exaggeratedly large candle in the foreground.

FILLA, EMIL (1882–1953). Sculptor born at Chropyne, Czechoslovakia. He studied at the Prague Academy 1903–6 and his early work was EXPRESSIONIST in manner. He was a member of the Czech *Groupe des 8 (Osma)*, whose aim was to give a new direction to Czechoslovak art. In 1911, under the influence of PICASSO and BRAQUE, he remodelled his style on CUBIST principles and became one of the most important exponents of Cubism in Czechoslovakia. From 1911 to 1914 he

was active in the MANÈS group. He passed the First World War in the Netherlands. A painter as well as a sculptor, during the 1930s he painted large compositions based on folk legend or illustrating the struggles of the oppressed masses. In the Second World War he was imprisoned in the concentration camp at Buchenwald. After the war he taught at the School of Industrial Art in Prague and painted a series of outsize landscapes. A relief entitled *Head of a Woman* from 1913 was included in the 'Pioneers of Modern Sculpture' exhibition organized by the Arts Council of Great Britain in 1973. Filla wrote *Kunst und Wirklichkeit: Erwägungen eines Mälers* (Prague, 1936).

FILONOV, PAVEL NIKOLAEVICH (1883–1941). Russian painter, born in Moscow. On being left an orphan he went to St. Petersburg, where after a brief period at the Higher Art Institute attached to the Academy of Fine Arts, he enrolled in the private studio of Lev Dmitriev-Kavkazsky (1849–1916). In 1910 he became a prominent member of the UNION OF YOUTH, thus coming into contact with many members of Russia's *avant-garde*—MALEVICH, ROZANOVA, TATLIN, etc. About 1914 he began to develop his theory of Analytical Painting, which he described in the following manner: ' "Realism" is a scholastic abstraction of only two of the object's predicates: form and colour ... My principle activates all the predicates of the object and of its orbit: its own reality, its own emanations, interfusions, geneses, processes in colour and form—in short, life as a whole.' After the Revolution Filonov continued to paint according to his own system, remaining untouched by the general trend towards CONSTRUCTIVISM and industrial design. In 1925 he founded his school named 'The Collective of Masters of Analytical Art' in Petrograd, which lasted until 1932 when the state disbanded all art groupings. His work, which has been likened to that of Paul KLEE and the German EXPRESSIONISTS, was of great delicacy and elaborately meticulous finish. Filonov died in the siege of Leningrad during the Second World War.

Among the exhibitions in which Filonov participated were: Exhibition by Petrograd Artists of All Trends, 1918–1923, Academy of Arts, Petrograd, 1925; one-man exhibition of over 300 paintings at Russian Mus., Leningrad (this exhibition was taken down without being opened to the public); Anniversary Exhibition of the Artists of the R.S.F.S.R. over the Last Fifteen Years, State Russian Mus. of Leningrad, 1932; exhibition in the Province's House of the Artist, Leningrad, 1933; Exhibition of Painting and Sculpture of the City Committee of Artists, Leningrad, 1941. In 1933 an edition of *Kalevala* illustrated by Filonov's students under his supervision was published in Leningrad. In 1967 a memorial exhibition was staged at Novosibirsk. An article by Filonov setting out the concept of his art, together with biographical material, was published in *Leonardo*, Vol. 10, No. 3, Summer 1977.

FINCH, ALFRED WILLIAM (1854–1930). Anglo-Belgian painter and designer born in Brussels and trained at the Académie des Beaux-Arts there. A friend of Seurat and Signac, he won recognition as a Neo-Impressionist painter and was one of the founders of the Belgian GROUPE DES VINGT (XX). After abandoning painting for ceramics he moved to Finland in 1897 and was put in charge of the Iris pottery factory at Porvoo, where he had a notable influence on the modernization of Finnish design. As a teacher of graphic art at the Drawing School of the Finnish Arts' Association, 1902–5, and at the Finnish Central School of Applied Art, 1905–30, he was a powerful force for bringing both the fine and the practical arts of Finland into contact with contemporary European trends. He resumed painting and from his earlier Pointillist style developed a more personal manner of Late Impressionism. As one of the leaders of the SEPTEM group he exerted an important influence on the course of Finnish painting in the two decades preceding his death.

FINI, LEONOR (1908–). Italian-Argentine painter born in Buenos Aires. She had no formal teaching in art but came under the influence of CARRÀ while living in Milan. In 1933 she moved to Paris and her work revealed a gift of fantasy which brought it within the ambit of SURREALISM. She also designed for ballet and film and made a name as a portraitist of well-known personages.

FIORONI, GIOSETTA. See ITALY.

FISCHER, LOTHAR (1933–). German sculptor born in Germersheim, studied at the Academy of Fine Art, Munich. In 1957 he was one of the founders of the group SPUR. In 1959 he won a Rome scholarship and in 1967 a scholarship to the Villa Massimo, Rome. In 1960 he obtained the Deutschen Kunstpreis der Jugend at Mannheim and in 1967 the Schwabinger Kunstpreis. His first one-man show was at the Gal. van de Loo, Munich, in 1963 and from that time his work was extensively exhibited in Germany and abroad. He worked for preference in clay and became known for his small terracottas, which have an air of the primitive and the grotesque.

FITZGERALD, LIONEL LEMOINE (1890–1956). Canadian painter, born in Winnipeg. He studied privately, and first exhibited with the Royal Canadian Academy in 1913. During the next seven years he worked as a commercial designer and interior decorator, painting in the evenings. *Late Fall, Manitoba* (1917) was bought by the National Gal. of Canada in 1918. In 1921 he held his first one-man show—all landscapes—at the Winnipeg Art Gal. He spent the winter of 1921–2 studying at the Art Students' League, New York, under Kenneth Hayes MILLER and Boardman Robinson. In 1924 he began teaching at the Winnipeg School of Art, and was appointed Principal in 1929. During the 1920s his work, doubtless reflecting his experience in New York, was realistic in style and regionalist in subject and mood. By 1931 and *Doc Snider's House* (National Gal. of Canada, Ottawa) his paintings, in subject still reflecting his immediate neighbourhood and in style still realistic, were smoothly painted, displaying a careful modelling of volumes, a precise description of space and of the forms within that space. Through a friend, Bertram Brooker, Fitz-Gerald was put in touch with Lawren HARRIS and with the artistic scene in Toronto. He joined the GROUP OF SEVEN in 1932, and was a founding member of the Canadian Group of Painters in 1933. In his work of the 1930s he was concerned to simplify his forms to their geometrical base, while keeping a keen sense of the organic, and in his paintings—e.g. *The Jar* (Winnipeg Art Gal., 1938)—he worked his surface into a sensitive texture. In 1940 he showed work in all media at the Winnipeg Art Gal. During the 1940s FitzGerald worked mainly in water-colour, although he also continued to draw. His work became introspective, focusing on self-portraits and female nudes (often together), or studies of rock and driftwood along the shore. When he returned to painting in oils, in 1947, his technique was virtually unchanged from that of the late 1930s (*The Little Plant*, McMichael Canadian coll., Kleinberg, Ont., 1947). In 1949 he resigned from the Art School, and that winter painted his well-known *From an Upstairs Window* (National Gal. of Canada). In 1951 he held a survey exhibition of paintings in the Winnipeg Art Gal. Probably later that year he at last turned to abstractions. These were the major concern of the last five years of his life, culminating in the beautiful *Green and Gold* (Winnipeg Art Gal., 1954). In 1958 the Winnipeg Art Gal. prepared a major retrospective, shown subsequently in Ottawa, Montreal, Windsor, London, Toronto, Regina, Vancouver, Calgary and Edmonton. In 1977 another major retrospective was held at the University of Manitoba in Winnipeg to mark the opening there of a FitzGerald Study Centre. A small but interesting show of drawings by Fitz-Gerald and Brooker was arranged by the Winnipeg Art Gal. in 1975 and was later circulated.

5 × 5 = 25. An exhibition held in Moscow in September 1921 and so called because it included five works by each of the organizing artists, RODCHENKO, STEPANOVA, POPOVA, EXTER and the architect Aleksandr VESNIN. The purpose of the exhibition was to sum up the achievements of LABORATORY ART, that is art done with a utilitarian purpose. In the name of CONSTRUCTIVISM the concept of 'fine art' was repudiated and an end of easel painting was announced.

FLANDRIN, JULES (1871–1947). French painter, born at Corenc, Isère. He was a pupil of Gustave MOREAU and a member of the *Société Nationale des Beaux-Arts*. From 1905 he exhibited at the Salon

des Indépendants and the Salon d'Automne and after 1923 at the Salon des Tuileries. He had considerable success with landscapes of Italy, France and Greece and also painted lyrical compositions inspired by the Ballets Russes.

FLANNAGAN, JOHN B. (1895–1942). American sculptor born at Fargo, N.D., and studied at the Minneapolis Institute School, 1914–17. He obtained a Guggenheim Foundation Fellowship in 1932. His first one-man exhibition was at the Whitney Studio Club in 1925 and he subsequently exhibited at the Weyhe Gal., the Arts Club of Chicago and elsewhere, and participated in various collective exhibitions. He had a retrospective at The Mus. of Modern Art, New York, in 1942. Flannagan's early work was a tortured fusion of Germanic EXPRESSIONISM with early Christian and Gothic art. During the 1930s his style broadened to a calmer and more Romantic expressive idiom with special emphasis on circular and spiral rhythms. His subjects were taken mainly from the insect and animal worlds combining vital symbolism with acute observation. His intensely personal art remained somewhat outside the mainstream of development in America.

FLAVIN, DAN (1933–). American sculptor and experimental artist born in New York. He studied at the U.S. Air Force Meteorological Technician Training School, the University of Maryland and the New School of Social Research, Columbia University, but he had no formal artistic training and did not take up art seriously until 1959. His technical training was apparent in his artistic approach. He specialized in LUMINIST art, creating 'static environments' by the use of fluorescent electric light and neon light. During the 1960s he also made a series of 'light icons', which were masonite boxes with their featureless front surfaces painted in monochrome and set with electric light bulbs round the edges. In general he eschewed complicated effects of pulsating or flashing lights, preferring the bare and simple presentation favoured by MINIMAL ART. It has been said: 'His resources rarely go beyond a few neon tubes, affixed to the walls at particular points, but his calculated effect completely strips away the inessential; the pure phenomenon of light is therefore undisturbed.' He practised the manipulation and vitalization of interior space by means of light strips and tubes and developed his principle of the 'diagonal' light tube from a study of the *Endless Column* of BRANCUSI. In the catalogue to an exhibition at the National Gal. of Canada, Ottawa, in 1969, he wrote: 'The *Endless Column* was like some imposing archaic mythological totem risen directly skyward. The *diagonal*, in the possible extent of its dissemination as common light repeated effulgently across anyone's wall, had potential for becoming a modern technological fetish ... Realising this, I knew that the actual space of a room could be disrupted and played with by careful,

thorough composition of the illuminating equipment.' This effect was first used for *Diagonal of Personal Ecstasy* in 1963. It was elaborated in his *Monument for Tatlin* (1968) and *Greens Crossing Greens* (dedicated to MONDRIAN) installed at the 'Kunst-Licht-Kunst' exhibition at the Stedelijk Mus., Eindhoven, in 1966. In 1967 the critic John Perreault wrote: 'He ... continues to produce very controversial works that attempt to stretch the boundaries of art with great detachment and adventurousness.' Although his scope and style were limited, Flavin was regarded as one of the most prominent among the 'cool' school of the Minimalists.

FLORES, LUIS MOLINARI. See LATIN AMERICA.

FLOUQUET, PIERRE-LOUIS (1900–67). Belgian painter, born in Paris. He studied at the Académie des Beaux-Arts, Brussels, where MAGRITTE and SERVRANCKX were among his fellow students. He was associated with many *avant-garde* groups in both Brussels and Paris and until the late 1920s was one of the leaders of Flemish abstract art, being a member of the circle connected with the weekly review *Sept Arts* after the First World War. His abstractions were often suggestive of machinery or machine parts. Besides Brussels, he exhibited at the STURM Gal., Berlin, and in America. About 1928 he underwent a mystical and visionary experience, ceased to exhibit and eventually abandoned painting but continued his career as poet and journalist. In 1931 he founded the *Journal des Poètes*.

FLUXUS. An international group of artists set up in Germany in 1962. *Fluxus* festivals were held in Wiesbaden, Copenhagen, Paris, Düsseldorf and then the headquarters were moved to New York. A *Fluxus* magazine was published and a *Fluxus* exhibition was held at Cologne in 1970. Like DADA and NEO-DADA, *Fluxus* was violently opposed to artistic tradition and to everything which savoured of professionalism in the arts. Its activities were primarily concerned with HAPPENINGS which demanded spectator participation and which combined various arts—visual, musical, literary, etc.—together with popular entertainment and vaudeville.

FONSECA, GONZALO. See LATIN AMERICA.

FONTANA, LUCIO (1899–1968). Painter born at Rosario, Argentina, of Italian parents. His family moved to Milan in 1905 and he passed his youth there, studying sculpture first in the studio of his father, who was a sculptor, and then from 1928 to 1930 at the Accademia di Brera under Adolfo Wildt (1868–1931). His exhibition at the Gal. del Millione, Milan, in 1930 was the first appearance of non-figurative sculpture in Italy and until *c*. 1935 he maintained a prolific output of abstract works, abandoning traditional art formulae and

seeking entirely novel modes and techniques with which he produced ornamental ceramics, graffiti and abstract statues in white, black and gilded plaster. In 1934 he joined the ABSTRACTION-CRÉATION association in Paris and in the following year signed the First Manifesto of Italian Abstract Artists and participated in the first collective exhibition of abstract art in Italy. In 1937 he had his first one-man exhibition of abstract ceramics at the Jean Bucher Gal., Paris. He spent the war years, 1940–6, in Buenos Aires, became a leader of the *avant-garde* there and in 1946 published his famous *Manifesto Blanco*, in which he put forward his idea of a new art in keeping with the new spirit of the post-war age with the employment of the most modern techniques such as neon lighting and television. The manifesto anticipated the ideas of the theory which was later known as SPAZIALISMO (Spatialism), repudiating the illusory or 'virtual' space of traditional easel painting and advocating instead the free development of colour and form in real space to create an art which would 'transcend the area of the canvas, or the volume of the statue, to assume further dimensions and become ... an integral part of architecture, transmitted into the surrounding space and using new discoveries in science and technology'. The theory attracted considerable attention both in the Argentine and in Italy, where Fontana returned in 1947.

From 1947 he issued a series of manifestos of *Spazialismo* in Milan (1948, 1949, 1950, 1952, and a *Manifesto Tecnico dello Spazialismo* in 1951). These were more specific in their negative than their positive aspects and the positive concept of Spatialism was carried little further than such vague statements as Fontana's assertion that its essence consisted in 'plastic emotions and [emotions] of colours projected upon space'. His influence, which was considerable, derived from his personality and the novelty of his artistic activities rather than his theories. He is considered to have been a pioneer and a forerunner of many innovatory developments which came to maturity in the second half of the century.

Fontana was one of the earliest to anticipate the idea of art as gesture or performance rather than the creation of an enduring art work and he was also a pioneer of ENVIRONMENT ART. In 1947 he created a 'black spatial environment' (a room painted black), which has been regarded as the ancestor of environment art, and in 1949 he exhibited his *Ambiente Spaziale* at the Gal. del Naviglio, a kind of anticipatory 'environment' making use of ultra-violet light and confronting the spectator with a deliberately distorted space. His decorations of the Palazzo dell'Arte for the Milan Triennale of 1951 were based upon the use of neon light. During the early 1950s, in reaction from ART INFORMEL and TACHISM, he was producing large canvases lightly painted in monochrome, where the superimposition of two or more layers of canvas created a disorientating effect somewhat akin to that which was later cultivated by OP ART.

He was speaking of *Concetti* (Concepts) as early as 1947, long before CONCEPTUAL ART had been heard of, and his *Concetti Spaziali* were developed over the years, from *c.* 1950 as monochromatic or near monochromatic 'holed' canvases and from 1958 as the monochromatic 'slit' canvases with which his name is chiefly associated. The idea of these 'holed' canvases and of the 'slit' canvases, called *Attese*, was to suggest an endless infinitude of space behind the canvas. But this was not done in the traditional way by creating a visual illusion of space before or behind the canvas: by rupturing the surface of the canvas the artist simply suggested to the spectator the possibility of *conceiving* such space. The slit canvases have also been held out as a culmination of that conception of art which regards it as a record of action and gesture. These works were explained by Gillo Dorfles as follows: 'The "holes" should be considered first as *signs* pointing to a compositional tracing, a two-dimensional design, and second as constituting a plastic, volumetric structuralisation ... the presence of an aperture in the canvas—and thus of an absence of the material constituted by the canvas—disrupts the two-dimensional spatiality, and allows the *void* behind the canvas to project in front of its surface. Thus the *hole* embodies in itself the double aspect of design and the modulation of volumetric spatiality ... The "slashes" can be discussed by analogy with the holes: here we are dealing with huge monochrome canvases with one or more clean slashes in them and where the shadow itself of the slash creates the relief that gives a greater spatial quality to the painting. The slash, a long and dramatic sabre-cut, ruptures the compact design of the canvas and by means of the unequal extensions of the borders, often chipped and open, offers that tiny element of chance which takes away any mechanical aspect of the work.'

In 1959 Fontana began his series of *Quanta*, which were irregularly shaped but smaller canvases, each with one or more slashes, intended to be grouped on the wall at will—thus inviting spectator participation in the creation of the completed art work. In 1964 he began the series of *Teatrini* in which lacquered wooden frames were cut into irregular shapes projecting on to the pierced canvases. In 1960 he also began massive sculptures, formless or crudely egg-shaped balls, which were slashed open like the canvases. They were described by Dorfles as an anticipation of ARTE POVERA.

Despite the incomprehensibility of his work to many, Fontana's reputation continued to increase during and after the 1950s, particularly with *avant-garde* groups such as ZERO in Germany. He had a following among the younger artists in Italy and elsewhere, although he created no 'school'. His first exhibition in the U.S.A. was at the Martha Jackson Gal., New York, in 1961. He had retrospectives at Amsterdam, Eindhoven and Stockholm in 1967; at the Mus. d'Art Moderne de la Ville de Paris and the Civica Gal. d'Arte Moderna, Turin, in 1970; at the Palazzo Reale, Milan, and

the Palais des Beaux-Arts, Brussels, in 1972; at the Mus. de Arte Contemporaneo, Caracas, in 1974; and at the Kunsthaus, Zürich, in 1976.

FORAIN, JEAN-LOUIS (1852–1931). French painter, lithographer and caricaturist, born at Reims. He studied at the École des Beaux-Arts under Jean-Léon Gérôme (1824–1904), where he was particularly interested in Rembrandt and Goya. He made his début as an illustrator and caricaturist in Paris journals such as Le Scapin, La Vie Parisienne, Rire, Figaro, La Vie Moderne, etc. As a social satirist it has been said that he belonged to the grand lineage of Rabelais and Molière. He combined the Realist eye of Manet with the mordant satire of Daumier and he had the gift of expressing disposition in a few lines by a characteristic attitude or gesture. Forain was on friendly terms with Manet and Degas and also numbered among his many friends Verlaine, Rimbaud and Toulouse-Lautrec. He exhibited in four of the Impressionist exhibitions between 1879 and 1886. As a painter he was uneven, sometimes influenced by Manet and Degas, sometimes adopting the restricted palette of Daumier as in the courtroom scenes Le Tribunal (1893–5) and Le Prétoire (1908), both in the Tate Gal. In 1898 he founded the journal Psst with Caran d'Ache and he was a founder member of the society Les Humoristes. He was Chevalier de la Légion d'honneur and President of the Société Nationale. In 1930 he was made an Honorary R.A.

FORBES, STANHOPE. See NEW ENGLISH ART CLUB.

FORCES NOUVELLES. An association of painters founded in Paris in 1934, whose nucleus was formed by HUMBLOT, ROHNER, DESPIERRE, Jean Lasne. They were joined by Francis Tailleux, Claude Venard and André Civet and had affinities with MARCHAND, BALTHUS and GRUBER. They were supported by the critics Waldemar George and Eugenio d'Ors, while Henri Héraut acted as the mouthpiece of their views. They exhibited as a group in 1935 and 1936 and enjoyed increasing popularity until the outbreak of the Second World War. They combined EXPRESSIONISM with poetic Realism and it was their ambition to bring into being a new painting of expressive naturalism relevant to the human values of contemporary life but embodying the rigorous craftsmanship of traditional French painting, by which they had been impressed at the exhibition 'Peintres de la Réalité en France au XVIIe Siècle' in 1934.

FORMA. See CONTINUITÁ and ITALY.

FORNER, RAQUEL (1902–). Argentine painter born in Buenos Aires. She studied at the Academy of Fine Arts in Buenos Aires and later taught there. In 1929 she had her first individual exhibition at the Gal. Müller, where she showed again in the years following. The same year she travelled to Spain, England, Morocco and France. In Paris she studied with Othon FRIESZ, and in 1930 joined the Paris-based Argentine group of artists. After her return to Buenos Aires she founded an independent art school, Cursos Libres de Artes Plasticas, in 1932 together with the painters Alfredo Guttero, Pedro Dominguez Neira and the sculptor Alfredo Bigatti, whom she married. During the following years she travelled frequently to Europe, the U.S.A. and to other Latin American countries. She began as a Neo-Romantic painter with strong social tendencies. Her painting Presage (1931) foreshadowed her later themes of destruction and violence. With the outbreak of the Spanish Civil War and the Second World War, her work dealt with biblical, mythological and apocalyptic visions of disaster in a SURREALIST style that focused on external phantasmagoric visions rather than on internal revelations, such as The Drama (1942) and The Tower of Babel (1947). In 1938 she began the 'Women of the World' series inspired by the Spanish Civil War. In 1958 she began the 'Cycles of the Moon' series inspired by space exploration linked with ancient mythologies and fantasy. In the 1960s she painted a series of 'Astroseres' (Astral Beings) and 'Mitologías Astrales' (Astral Mythologies) in a style that bore affinities with the COBRA painters and the Neo-Figurative painters in Argentina. She used brilliant colours to dramatize her prophecies of human annihilation, alienation and life transmuted by prolonged sojourns in space, with grotesque visions of organic beings, as in Spatial Monsters with Mutations (1973). She also painted multi-panelled compositions somewhat related to the work of the Argentine painter Luis Felipe Noé. In the 1950s and 1960s she exhibited extensively in Latin America, the U.S.A. and Europe. She had many exhibitions both in the Argentine and abroad, including shows at the Drian Gal., London, in 1967 and 1970. In 1974 exhibitions of her works were sponsored by the Argentine Ministry of Foreign Affairs in Ottawa, at the Corcoran Mus., Washington, and at Houston. She was represented in many group exhibitions, including the 6th São Paulo Bienale, where she was a Guest of Honour, an exhibition of 'Contemporary Argentine Art' shown in Switzerland and Germany, 1971 and 1972, and 'Art in the Argentine' at the Wildenstein Gal., London, in 1975. Her Return of the Moonnaut was acquired by the National Air Space Mus., Washington. Other public collections in which she is represented include the Museums of Modern Art, New York, Rio de Janeiro, Buenos Aires and Mexico City. Among her awards were a Gold Medal at the Expositon Universelle, Paris, in 1937, the Augusto Palanza Prize from the Argentine National Academy of Fine Arts in 1947, the Grand Prix d'honneur at the National Salon of Fine Arts, Buenos Aires, in 1955 and the Grand Prix d'honneur at the first Córdoba Bienale of American Art in 1962.

FORRESTALL, TOM. See CANADA.

FORTE, VICENTE. See LATIN AMERICA.

FORUM EXHIBITION. An exhibition arranged in New York in 1916 by the critic Willard Huntington Wright with the support of the magazine *Forum*, to which he was a regular contributor. The purpose of the exhibition was to pinpoint the best of American *avant-garde* painting in order to convince the public that it could stand up to the European *avant-garde*, which had captured public interest at the ARMORY SHOW. Both Robert HENRI and Alfred STIEGLITZ were on the selection committee. The exhibition consisted of *c.* 200 pictures by the following 17 artists: Thomas Hart BENTON; Oscar BLUEMNER; Andrew DASBURG; Arthur DOVE; George Of; Ben Benn; Marsden HARTLEY; Stanton MACDONALD-WRIGHT; John MARIN; Alfred MAURER; Henry McFee; MAN RAY; Morgan RUSSELL; Charles SHEELER; Abraham WALKOWITZ; Marguerite and William ZORACH.

FOUGERON, ANDRÉ (1912–). French painter, born in Paris and self-taught as an artist. After working for many years in the mines of northern France, he started painting as an EXPRESSIONIST and was later influenced by PICASSO. From *c.* 1948 he painted very large canvases with political implications and became known as the principal painter of SOCIALIST REALISM in France.

FOUJITA, TSUGUHARU or LÉONARD (1886–1968). Japanese-French painter and graphic artist, born in Tokyo of a *Samurai* family. He studied at the Imperial Academy of Fine Arts, Tokyo, 1906–10, and after visiting China and London settled in Paris in 1913. Except for a world tour in 1929 and residence in Tokyo during the Second World War he lived in Paris for the rest of his life. In 1959 he became a convert to Roman Catholicism and changed his personal name to Léonard in memory of Leonardo da Vinci. He was a member of the circle of *émigré* EXPRESSIONISTS in the ÉCOLE DE PARIS—SOUTINE, CHAGALL, MODIGLIANI—and he developed from *c.* 1925 a personal style of delicately mannered Expressionism which combined Western and Japanese traits. He began by doing Parisian landscapes and then became known for his nudes and for his compositions in which still life and figures were combined. An example of his work is his *Portrait de l'artiste par lui-même* in the Mus. National d'Art Moderne, Paris (1928). He was commissioned to do decorations for the Cité Universitaire at Paris. He excelled also in lithography and in 1963 wrote and illustrated a strange book, *La Mésangère*.

FRAILE, ALFONSO. See SPAIN.

FRAMPTON, SIR GEORGE (1860–1928). British sculptor, born in London, studied at the Lambeth School of Art and then at the Royal Academy Schools. He exhibited at the Royal Academy from 1884 and was elected R.A. in 1912. From 1894 he was joint head of the Central School of Arts and Crafts with W. R. Lethaby (1857–1931). He was President of the Royal Society of British Sculptors, 1911–12. He was also known as a leading figure in the British Arts and Crafts Movement. Frampton was a conventional and uninspired, though competent, sculptor, as may be seen from his bronze group *Saint Mungo* at Glasgow and his *Lamia* bust (Royal Academy, 1900) of ivory, bronze, marble and jewels. His best-known works were his *Peter Pan* erected in Kensington Gardens in 1911 and another, life-size version in Sefton Park, Liverpool, in 1928.

FRANCE. The work done in France, primarily in Paris, during the first four decades of this century was of crucial importance in establishing the foundations of contemporary art. Here new movements were born, new aesthetic attitudes were evolved and the *avant-garde* emerged. The rich and ebullient fermentation of ideas which proliferated in these years continued to make its impact felt even when, after the Second World War, the main centre of innovation had passed to the U.S.A. The history of art in France during these decades is in a real sense the story of the emergence of modern art. Therefore it will be dealt with in this article with rather greater attention to detail than elsewhere. It was not the work exclusively of French artists for a large part was played by foreign-born masters of the ÉCOLE DE PARIS who settled and worked in Paris. The article will cover the work of these as well as that of French-born artists.

BACKGROUND, 1895–1905. At the turn of the century people in France were being given the art they desired by the official Salon, connoisseurs had come to an appreciation of the Impressionists and were beginning to be interested in the NABIS, the *Rose-Croix* and the Symbolists, while a few had some insight into the innovations of Gauguin, Cézanne and Toulouse-Lautrec. Led by Auguste Pellerin collectors were beginning to buy the early Cézannes by 1895. Gauguin exhibited forty of his pictures from Tahiti in 1893, had exhibitions in 1894 and 1898, and in 1903, the year of his death, the first Salon d'Automne included a large Gauguin Memorial Exhibition, which laid the foundations of his fame. Cézanne had reached the summit of his powers and painted some of his finest pictures in the decade 1895–1905. His famous portrait of Gustave Geffroy, who had published a long article on him in *Le Journal* in 1894, was painted in 1895. In the same year VOLLARD arranged his first one-man show of *c.* 150 works. A second followed in 1899. The Mount Sainte-Victoire paintings were being done from *c.* 1888 to *c.* 1906, the year of his death. The *Grandes Baigneuses* (Philadelphia Mus. of Art) was painted from 1899 to *c.* 1906. Toulouse-Lautrec was contributing to the efflorescence of decoratively rhythmical graphic art by his posters and book

covers, while his paintings and his drawings for the illustrated papers were appreciated by connoisseurs in the name of Realism along with those of STEINLEN and FORAIN. Meanwhile the greatest of the NAÏVE painters, the Douanier ROUSSEAU, was painting some of his most splendid masterpieces and was exhibiting, still virtually unknown, at the Salon des Indépendants. *La Bohémienne Endormie*, which so strikingly anticipates the dreamlike atmosphere of CHIRICO's pre-war pictures, was painted in 1897; the famous self-portrait *Moi-même: Portrait-paysage* was done in 1889–90; *L'Enfant au Jouet* was exhibited in 1902.

The dealer Durand-Ruel staged large exhibitions of Renoir and Pissarro in 1892. In 1895 Monet exhibited the series of paintings in which he portrayed the changing effects of sunlight on the façade of Rouen cathedral. The Impressionists were comprehensively represented at the Exposition Universelle of 1900, where their international reputation was established. Seurat had a Memorial Exhibition in 1891 and nothing further until 1900, when a large exhibition of some fifty works was financed by the *Revue Blanche* at the instigation of Félix Fénéon and many of his masterpieces such as *Cirque, Baignade* and *Un Dimanche d'Été à la Grande Jatte* first came to the eyes of the general public.

The Symbolists were known through their work for the Théâtre d'Art (founded in 1890) and for the new Théâtre de l'Œuvre (founded in 1893 by Lugné-Poë). Led by Paul SÉRUSIER, they were in close touch with Odilon Redon (1840–1916) and the *Rose-Croix* group launched by the critic Joséphin Péladan. The *Nabis*, formed in 1892 with Maurice DENIS, Pierre BONNARD and Edouard VUILLARD, were also in touch with the Symbolists. Bonnard and Vuillard particularly made positive and important contributions to decorative art at the turn of the century. In 1899 the *Nabis* arranged an important exhibition with Durand-Ruel which they called *Hommage à Odilon Redon*.

Matisse made his début with four canvases at the Salon de la Nationale in 1896, when he was 27 years of age and still a pupil of Gustave MOREAU. His work was at that time in the tradition of Chardin and Corot. In the years to come he learned much from the Impressionists, particularly Renoir, and from Cézanne, Gauguin and Seurat. The originality of his talent was sufficient to enable him to mould these influences into a personal style, and despite its sombre colours his *Carmélina* (Boston Mus. of Fine Arts), painted in 1901, has been described as the first FAUVIST picture.

Matisse's large painting *La Desserte* was shown at the Salon de la Nationale of 1898 which was the scene of a violent controversy over Rodin's *Balzac*, which had been commissioned in 1888 by the *Société des Gens de Lettres* and now when completed was rejected by them as 'grotesque'. In 1899 VLAMINCK and DERAIN made friends at Chatou and Derain met Le PUY and then Matisse at the Académie Carrière. Matisse had kept in touch with his former friends from the atelier of Gustave Moreau and thus was formed the nucleus of the Fauves. In 1901 the Gal. Bernheim showed a large exhibition of Van Gogh whose impact gave the final stimulus for the creation of the Fauvist movement. Although the name was not coined until 1905, the movement was launched in 1903 when Matisse, Derain, Vlaminck, MARQUET and CAMOIN exhibited together at the nineteenth Salon des Indépendants followed by an exhibition organized by Matisse at the Gal. Weill, to which DUFY and FRIESZ also contributed. At this time Matisse was 33, Vlaminck 27, Derain 23, Marquet 28 and Camoin 24. The Fauvist movement continued until *c.* 1907 with BRAQUE, ROUAULT and Van DONGEN added to their number. It was in essence a vivid and excited use of colour for the sake of expression and for the sheer delight in colour rather than for purposes of realistic representation and it was a phase which most of the artists left behind within a few years, although Fauvist colouring exerted a long if spasmodic influence on French art through to the 1930s and 1940s.

In 1900 MAILLOL produced his first important sculpture, *La Pensée*, at the age of 39. In 1901 Toulouse-Lautrec died at the age of 37 and in 1902 the Salon des Indépendants gave a Memorial Exhibition of 50 of his works while Durand-Ruel showed a still larger exhibition of 200 paintings, lithographs and drawings. In the same year UTRILLO began to paint his pictures of Paris street scenes at the age of 19. In 1903 Gauguin died in the Marquesas, Whistler died in London and Pissarro in Paris. In the same year the SALON D'AUTOMNE was founded.

PICASSO's so-called 'Blue period' also fell within the decade. In 1895 he painted *La Fillette aux Pieds Nus* at the age of 14 in Corunna. His first, brief, visit to Paris was in 1900 and his second in 1901. On the latter visit he painted 100 pictures, including *Child Holding a Dove*, the *Portrait of Gustave Coquiot* (Mus. National d'Art Moderne, Paris), *Dwarf Dancer* (Mus. of Modern Art, Barcelona), *On the Upper Deck* (Art Institute of Chicago). He was given an exhibition by Vollard, for which Coquiot wrote the catalogue, and the exhibition brought him the friendship of Max Jacob. In 1903, however, he left Paris in disappointment at his lack of success and in Barcelona painted a number of pictures revealing his interest in beggars and outcasts. They included *Célestine, Le Vieux Guitariste* (Art Institute of Chicago), *The Blind Man's Meal* (The Metropolitan Mus. of Art, New York). Picasso's 'Saltimbanque and Rose' period fell between 1904 and 1906, when he was back in Paris painting at the BATEAU-LAVOIR. It included such masterpieces as *Woman in a Chemise* (Tate Gal.), *La Toilette* (Albright-Knox Art Gal., Buffalo), *Self Portrait* (Philadelphia Mus. of Art). At this time he became the centre of a circle which included Max Jacob, Guillaume APOLLINAIRE and André Salmon and began to sell to dealers and to collectors such as Wilhelm UHDE, Gertrude and

Leo Stein and the Russian SHCHUKIN.

THE PRE-WAR DECADE. The decade preceding the First World War was perhaps the most fertile of innovation and the most important for its enduring repercussions on the subsequent development of contemporary art. Fauvism flourished energetically, and almost as swiftly as it had arisen matured into a more munificently decorative abstraction, chiefly at the hands of Matisse. Its zenith was reached in Matisse's great painting *Bonheur de Vivre* of 1907, in which the aesthetic trend started by the SYNTHETISM of Gauguin reached its culmination. The Douanier Rousseau produced his maturest masterpieces: *Le Lion ayant Faim* and *Une Noce à la Campagne* in 1905, *La Muse inspirant le Poète* (for which Apollinaire sat as model) in 1909, *Le Rêve* in 1910. The 'discovery' of the Douanier by Picasso and his circle in 1907 may be regarded as the first step in the emergence of naïve painting as a significant artistic genre and one not unconnected with the important part played by sophisticated naïvety in much of contemporary art. NEGRO SCULPTURE in its formal aspects was 'discovered' by Vlaminck and Derain, who brought it to the notice of Matisse. It then became, with Cézanne, one of the two primary sources of CUBISM, which was introduced by Picasso and Braque in 1907. Analytical Cubism (1907–10) and Synthetic Cubism (from 1912) are by general consent accepted to have been the most widely influential artistic movements of the 20th c. and the most profoundly significant in their consequences.

In the same year as Matisse's *Bonheur de Vivre* Picasso painted his picture known as *Les Demoiselles d'Avignon*, which is generally regarded as the first Cubist painting. Although it was not exhibited publicly until 1937, in the words of Roland Penrose 'it assumed a legendary power in the minds of those who had seen it'. He goes on: 'The forms, broken and reassembled in angular design, herald the geometric discipline of cubism, and the shallow depth against which they appear is an essential characteristic of the new style.' In 1908 Matisse published 'Notes d'un Peintre', outlining his artistic philosophy. Although FUTURISM was an Italian movement, MARINETTI's 'First Manifesto' was published by the *Figaro* in 1909 and the Futurists held their great exhibition in Paris in 1912. Whether or not he knew the work of the Italian Futurists, Marcel DUCHAMP's *Nu descendant l'Escalier* (1912) was the most imposing of all pictures planned on Futurist principles. In 1912 also the ORPHIST movement of abstract colour composition was launched by Robert DELAUNAY.

In 1904 the Romanian BRANCUSI arrived in Paris. Leo and Gertrude Stein appeared on the scene as patrons and collectors. Braque arrived from Le Havre and made his début at the Salon d'Automne in 1905. In 1906, the year of Cézanne's death, MODIGLIANI and SEVERINI came to Paris from Italy, and Juan GRIS from Spain. The Salon des Indépendants, at which Marie LAURENCIN made her début, included many foreign artists in a vast show of some 5,500 exhibits. The Salon d'Automne staged a Gauguin retrospective, and a large exhibition of Russian art, arranged by DIAGHILEV, occupied 12 galleries in the Grand Palais. In 1907 Gertrude Stein bought Matisse's *Bonheur de Vivre* and Picasso's portrait of herself. Vollard bought all Picasso's remaining 'Blue period' and 'Pink period' pictures and the dealer Daniel-Henri KAHNWEILER began a long contractual association with him. A Memorial Exhibition of 48 Cézanne paintings was held in this year by the Salon d'Automne and his famous dictum, 'Tout dans la nature se modèle selon la sphère, le cône et le cylindre', which was made the cornerstone of Cubist theory, was published by Émile Bernard. It was from this time that Cézanne's general reputation began to grow. Despite the deep impression it made on the younger artists, his 1904 exhibition had been completely incomprehensible to the reviewers. *La Lanterne* referred to him as 'un lamentable raté' and *L'Univers* said: 'Les œuvres de Paul Cézanne sont ce qu'on peut rêver de plus abracadabrant . . .' The notices at his death in 1906 were equally uncomplimentary.

In 1908 Picasso gave a now famous studio party in honour of the Douanier Rousseau, who had been 'discovered' by his circle the year before. The word 'Cubiste' was coined by the critic Louis Vauxcelles in a review of works by Braque exhibited at the Kahnweiler gallery, after they had been rejected by the Salon d'Automne with Matisse on the Committee. In this year too a Cubist 'school' began to appear with a number of minor artists turning the techniques originated by Braque and Picasso into a mannerism. Among them were MARCOUSSIS, LE FAUCONNIER, Roger de LA FRESNAYE, GLEIZES, and LÉGER with a more individual style. In the same year Isadora Duncan gave her first public performance in Paris at the Théâtre de l'Œuvre and Diaghilev staged his first Russian ballet. In 1909 Monet exhibited his *Nymphéas* series, which carried Impressionism to the verge of colour abstraction. Ossip ZADKINE and Henri Gaudier (later known as GAUDIER-BRZESKA) arrived in Paris, both at the age of 19. Matisse had a one-man show at the STIEGLITZ Gal., New York.

In 1910 CHAGALL arrived, while the resplendent theatrical décors of his former teacher BAKST were taking Paris by storm. The First POST-IMPRESSIONIST exhibition arranged in London by the critic Roger FRY did not include Picasso or the Cubists and was received with incomprehension by the reviewers. The *Times* critic said: 'This art stops where a child would begin. . . . Like anarchism in politics, this art is the rejection of all that civilisation has done, the good with the bad. . . . The artists' aim is to *épater le bourgeois* and this aim is most completely realised by the painter Henri Matisse.' The Second Post-Impressionist Exhibition, in 1912, contained works by Picasso and the Cubist group. The Press had learned new attitudes in the interval and was more moderate in

its commentaries. *The Times* wrote: 'Most people look for beauty in a picture only in the objects represented, which they expect to remind them of beautiful real things. They have no notion of beauty created, not imitated, in a work of art, and created by the effort of expression. One may say, if one likes, that M. Matisse is attempting things impossible to his art, that he is trying to turn painting into music. But one need not therefore fall into a rage and accuse him of incompetence or wilful perversity . . . He is not incompetent but an artist of great powers.' In 1911 the Cubists first exhibited as a group at the Salon des Indépendants (where Marcel Duchamp and DUCHAMP-VILLON also made their début this year), at the Salon d'Automne and in a large exhibition at Brussels, for which Apollinaire contributed to the catalogue. A Rousseau Memorial Exhibition was held in the Salon des Indépendants and in the same year Uhde 'discovered' the naïve painter SÉRAPHINE at Senlis.

In the next few years there was a strange foreshadowing of things to come in the protoSURREALIST pictures of Chagall and CHIRICO. Chirico arrived from Florence with his *Nostalgie de l'Infini* (The Mus. of Modern Art, New York) and then painted his early METAPHYSICAL masterpieces, *La Conquête du Philosophe: l'Horloge* and *La Place*, which he exhibited at the Salon des Indépendants in 1913, and the *Rue Italienne: le Cerceau* of 1914. Paul Guillaume began to buy Chirico's pictures and in 1914 opened his Paris gallery with them. Guillaume Apollinaire coined the word 'Surnaturel' (anticipating 'Surréal') for *Moi et le Village* and *Paris par la Fenêtre*, which he saw in Chagall's studio, and in 1912 Chagall exhibited his masterly *Le Marchand de Bestiaux*.

Among the Impressionists Renoir had a new influx of creative energy at the age of 70 and, although crippled, was painting some of his finest works: *Les Femmes aux Chapeaux* c. 1910, *Les Grandes Laveuses* in 1912 and *Le Jugement de Paris* from c. 1912 to 1914. The much advertised Futurist exhibition of 1912 made remarkably little impact upon the Paris school of painting compared with the excitement caused by Futurism in Britain and Russia. The same year saw the SECTION D'OR exhibition arranged by the ORPHISTS with their interest in the mathematical principles of composition. Jacob EPSTEIN finished his monument to Oscar Wilde at the Père Lachaise cemetery. And most important of all, Picasso and Braque were working at the COLLAGES which were to inaugurate the new phase of Synthetic Cubism. Gleizes and Metzinger's book *Cubisme* was followed in 1913 by Apollinaire's *Peintres cubistes: méditations esthétiques*. Continuing his personal version of EXPRESSIONISM, ROUAULT painted his *Christ* in 1914. In 1913 SOUTINE came to Paris from Lithuania at the age of 19, destined to be a leader of classical French Expressionism and an inspiration to the Expressionist school in Italy.

THE WAR YEARS. The years of the First World War were inevitably an interlude in the pursuit of innovative trends in French art. Being Spaniards, Picasso and Gris were exempt from military service, but most of the Cubists, including Léger and METZINGER, served with the forces. Derain abandoned painting until 1918. Braque was wounded and invalided out in 1915 but developed away from Cubism. Chagall served with the Russian forces until the Revolution and Chirico fought in the Italian army. Gaudier-Brzeska, who had settled in London, was killed in 1915. Guillaume Apollinaire was wounded in 1916 and died in 1918. Of the older artists Odilon Redon died in 1916 at the age of 76, Degas and Rodin in 1917 at the age of 83 and 77 respectively. Among the collectors and dealers Kahnweiler spent the war years in Switzerland and Uhde was also outside France. A new dealer, Léonce Rosenberg, after supporting the Cubists when in Paris on leave, opened a gallery which he named 'L'Effort Moderne' in 1918. Paul Guillaume was the chief patron of Modigliani, who by 1915 had almost abandoned sculpture for painting and did most of his best paintings between 1916 and the end of the war.

Matisse continued to work through the war at Paris and Nice, tightening the structure of his decorative abstraction. He produced during these years such magnificent pictures as *Le Peintre et son Modèle* (Mus. National d'Art Moderne, Paris, 1916), *Les Coloquintes* (The Mus. of Modern Art, New York, 1915–16), *Les Marocains* (The Mus. of Modern Art, New York, 1916), *Arbre près de l'Étang des Trivaux* (Tate Gal., 1916), *La Leçon de Piano* (The Mus. of Modern Art, New York, 1916–17), *La Leçon de Musique* (Barnes Foundation, Merion, U.S.A., 1917), *Intérieur au Violon* (Statensmus. for Kunst, Copenhagen, 1917–18), and *Les Plumes Blanches* (Institute of Art, Minneapolis, 1919).

Picasso worked mainly in Paris during 1915 and 1916; in 1917 he visited Italy and Spain and in 1918 settled in a new studio in the rue de la Boétie. In 1917 he made contact with the Russian Ballet through Stravinsky and Cocteau and did designs for Cocteau's ballet *Parade*. During these years he continued in his painting to develop and humanize the ideas of Synthetic Cubism, culminating in the magnificent painting *The Three Musicians* (1921), the two versions of which are in The Mus. of Modern Art, New York, and the Mus. of Art, Philadelphia. He also did a number of drawings of his friends—Max Jacob, Apollinaire, Vollard—which have been compared to the drawings of Ingres for their 'assurance and purity of line'. After his visit to Italy he began a series of paintings of the female figure emphasizing classical fullness of form and monumental proportions. Famous among these are: *Femme et Enfant au Bord de la Mer* (1921), *Two Seated Women* (1920), *Nude Seated on a Rock* (1921), *Seated Woman* (Tate Gal., 1923).

The European DADA movement was launched in Zürich by the Romanians Tristan Tzara and Marcel JANCO, the Germans Hugo Ball and Rich-

ard Huelsenbeck, and the Alsacian Jean ARP. Marcel Duchamp, who had gone to the U.S.A. in 1915, and PICABIA were leaders of a parallel movement in New York. The movement evoked a somewhat half-hearted interest among French artists. The Dadaist review *Cabaret Voltaire* had among its contributors Picasso, Apollinaire and Modigliani as well as such diverse personalities as Marinetti and KANDINSKY. In 1916 a semi-Dadaist review *Sic* was started in Paris and in 1917 *Nord Sud*, also with Dadaist leanings, attracted such figures as André BRETON, Philippe Soupault and Louis Aragon, who were afterwards among the promoters of the Surrealist movement. In 1919–20 the Swiss and German Dadaists invaded Paris and began to stage their usual vociferous demonstrations. They won small sympathy in the Parisian art world and the movement disintegrated.

THE 1920s. In the immediate post-war years and the early 1920s there was rife a new aesthetic outlook which made obsolescent both the traditions of Expressive Realism and the ideals of decorative Abstraction. It was allied to the 'machine aesthetics' which permeated all the arts and it had affinities with the 'mathematical lyricism' which was the inspiration of CONSTRUCTIVISM, with the Functionalist movement in architecture and with the ideas of industrial design taught at the BAUHAUS. Its popular expression was 'le style mécanique' in France, later to appear as 'streamlining' in England. Its protagonists in the fine arts were Amédée OZENFANT and the Swiss painter and architect Charles-Édouard Jeanneret, who from 1921 took the name LE CORBUSIER. Their aesthetic doctrine they called PURISM. In his *Foundations of Modern Art*, published in 1931, Ozenfant tells how after 1916 he 'felt that Cubism was slipping into decorative art' and founded the review *L'Élan*, which appeared from 1915 to 1917 and in which he publicized his view that Cubism had entered a blind alley. In 1918 he began an association with Jeanneret whose object was 'a campaign for the reconstitution of a healthy art'. They collaborated in a book *Après le Cubisme*, in which they affirmed that 'art must tend always to precision' and 'laid down the foundations of a Purism that would ... inoculate artists with the new spirit of the age'. They attached especial importance to 'the lessons inherent in the precision of machinery and the imminent metamorphosis that must result therefrom'. They then founded the review L'ESPRIT NOUVEAU, which ran from 1920 to 1925, and in 1924 they published a joint work *La Peinture Moderne*, which Ozenfant later described as 'a résumé of the *L'Esprit Nouveau* campaigns'.

L'Esprit Nouveau was important as a platform which succeeded in bringing together artists, musicians and writers from many different fields rather than for the positive views which it expressed. As an artistic movement Purism produced works neither negligible nor outstanding: Ozenfant's *Accords* (1919–22) and *Still Life with Jug, Guitar, Glass and Bottles on Grey Table* (The Mus. of Modern Art, New York, 1920) and Jeanneret's still lifes of the same period (e.g. those in the Kunsthalle, Basle, and The Mus. of Modern Art, New York) are examples. It did not establish a school or a lasting style. Purism had the merit of being in the swim while it lasted. It gave expression to aesthetic ideas which were gaining the ascendant elsewhere but as yet had found little support in France.

The other, complementary strand which dominated *avant-garde* circles in the 1920s was fantastic and SURREALIST art. The movement was launched in 1924 by the publication of André Breton's *Manifeste du Surréalisme*, signed by a group of literary friends which included Paul ÉLUARD, Louis Aragon, Benjamin Péret, Philippe Soupault, and Roger Vitrac. Strongly influenced by Freudian psychology, the Manifesto declared that it was the central aim of the movement to explore the unconscious and to combine the reality of the dream world with the reality of the waking world in a single 'Over-Reality'. 'I have always been amazed at the extreme difference in weight and importance which the ordinary observer attaches to the events of his waking and his sleeping life. I believe that in the future the two apparently contradictory states—the dream and reality—will resolve into a reality-absolute, a surreality. It is that which I am out to conquer.' The chief instruments for this were to be the techniques of psychic AUTOMATISM and it was believed that the chief distinguishing characteristic of the 'new reality' was the emotive juxtaposition of the incongruous. Lautréamont's description of the 'beautiful' as 'the chance meeting on a dissecting table of a sewing machine and an umbrella' became a central text. With regard to visual art the aim was to provide a pictorial equivalent of the dream experience with typical juxtaposition of the incongruous and the unreal dream-space, both with the special emotional flavour of dream. The movement had its own premises, the Bureau des Recherches Surréalistes, and in December of the same year the first number of its own journal *La Révolution Surréaliste* appeared. Surrealist exhibitions were arranged in 1925 and 1928.

Chirico continued to paint his Metaphysical works, which were now fully Surrealist in spirit and feeling. Returning to Paris in 1925, he exercised a strong influence until 1930, when he abandoned Surrealism. Picabia, who had severed himself from the Dada movement in 1922, painted Surrealist works with transparent superimposed images *c.* 1927–9. Picasso, who was on terms of friendship with Breton and Éluard and appreciated the aims of the movement, allowed his works to be exhibited with those of the Surrealists although he never relaxed the formal control of his composition in the manner which their doctrines envisaged. In 1924 Max ERNST introduced the technique of Surrealist COLLAGE which he had devised in Cologne under the aegis of Dada and in 1925 invented the technique of FROTTAGE. MIRÓ,

who had come to Paris in 1919, did some Surrealist paintings c. 1926 and then under the influence of Kandinsky developed his personal style of abstract Surrealism. André MASSON did some Surrealist work and for a time adopted the automatic techniques of the Surrealists, participating in Surrealist exhibitions until 1928. Yves TANGUY joined the group in 1925, and with no previous experience or training began to paint what are perhaps the most dreamlike pictures of the whole movement. Pierre ROY, another newcomer, had been painting pictures since c. 1920 in which the strange and the familiar were combined in the manner of dream and he exhibited with the Surrealists in 1925. Jean LURÇAT, who had been in the Sahara, Spain and Turkey, returned and did some of his finest Surrealist paintings in the late 1920s. Finally, in 1929 Salvador DALÍ produced the film Un Chien andalou with Buñuel and began the series of pictures in the manner he called 'paranoiac criticism' which during the 1930s brought him international fame.

The 1920s was a decade of success and prosperity for artists and dealers alike. The international repute of living artists increased notably in Europe and in America and their works were bought for public and private collections. The position of Paris was established still more strongly as the centre of the art world and Montparnasse became the new haunt of tourists.

REALISM. Standing aloof equally from Fauvism, Cubism and Surrealism there were painters of distinction who carried on the Realist traditions of Manet or Courbet continuously until the Second World War. Undogmatic in their outlook, they took something from Late Impressionism and something from Cézanne, while working for the most part in the manner of Expressive Realism rather than veristic or academic naturalism.

Outstanding among them in the early decades was DUNOYER DE SEGONZAC, with whom must be mentioned his two friends from student days, Jean-Louis BOUSSINGAULT and Luc-Albert MOREAU. Others belonging to this first generation of Realism were: Charles DUFRESNE, Henry de WAROQUIER, Louise HERVIEU, Edmond Céria, Maurice ASSELIN, Georges BOUCHE, P.-F. Gernez.

In the 1930s there came to the fore a second generation, who had passed through the war years and more deliberately rejected Cubism from a deep-seated disillusionment with intellectualized aesthetics and the desire for a more direct and uncomplicated contact with nature. In L'Amour de l'Art (1935) Roger CHAPELAIN-MIDY wrote that he had the feeling that everything had been tried and the end had been reached. 'In its abstract, if necessary, researches Cubism lost sight of the true purpose and the human significance of art. The true spiritual values are at risk ... The Cubists and the Fauves rediscovered the solid foundations of painting but limited themselves solely to the optical, material aspect, which constitutes one of the essential truths of painting. It is for those who

follow to bring back to art the spiritual truths which are still lacking.' Others spoke with a similar voice. Besides Chapelain-Midy there were: Jean AUJAME, Yves BRAYER, Maurice BRIANCHON, Christian CAILLARD, Jules CAVAILLÈS, Jacques DESPIERRE, Raymond LEGUEULT, Philippe Le Molt, Jacques Lestrille, Roger LIMOUSE, Roland OUDOT, André PLANSON, Georges Poncelet, etc.

In the very different conditions which followed the Second World War a group of young artists, revolting from the 'distillers of the quintessence, abstractionists who split a hair into four' and advocating a down-to-earth art for the common man, banded themselves together in an association they called HOMME-TÉMOIN. They were: Bernard LORJOU, Paul REBEYROLLE, Michel de Gallard, Yves Mottet, and they were later joined by Bernard BUFFET, André MINAUX and others.

EXPRESSIONISM. Another group of artists who stood opposed to the avant-garde movements were those who made up what is sometimes called the French school of Expressionism, though in fact they were not a school and were united only by certain common attitudes and a broad similarity of outlook. An important part was taken by émigré artists of the ÉCOLE DE PARIS—Soutine, regarded as most typically Expressionist of all at least until the late 1920s, PASCIN, KISLING, Modigliani, Chagall, RYBACK—many of them combining nostalgia with the inherent sadness of the Jewish race. Among the French, Rouault after a brief adhesion to Fauvism went his own solitary way without rival or companion. Le Fauconnier abandoned Cubism c. 1912, or adapted mannerisms he had picked up from his association with the Cubist school to expressive purposes, and as teacher at the Académie de la Palette influenced among others Marcel GROMAIRE. Others who trod this path were Édouard GOERG, Amédée de LA PATELLIÈRE and FAUTRIER in the 1920s. As has been said, they were not a school: there was no organization binding them together and within very wide limits their work lacked uniformity. Some worked on the border between Expressionism and Expressive Realism, others on the borders of Cubism. They could freely learn from the avant-garde movements in matters of technique, though adapting what they learned to their own purposes. Like the Realists, they blamed the Cubists for too exclusive concentration on technical problems and for an intellectual outlook that admitted too little concern for human values. Their ideal was an art which would appeal to the humanity of the common man. Goerg declared, 'What I love in art is the human.' La Patellière described Cubism as 'a museum exercise, technique for its own sake, fruit removed from the tree'. Their criticism of Cubism had a great deal in common with that of Wyndham LEWIS and the VORTICISTS in England. They painted still lifes—e.g. Le Bœuf Écorché of Soutine (Mus. de Grenoble, 1926)—but beyond all else they preferred human subjects, such as Gromaire's Le Vagabond (Mus. National d'Art Moderne) and

La Guerre (Mus. des Beaux-Arts de la Ville de Paris, 1925).

French Expressionism and that of the École de Paris differed profoundly from Nordic and Germanic Expressionism. French Expressionism never aimed at, was never satisfied with, a visual display of personal emotions, fervours or prejudices, however violent or morbid. The universalization of emotion and its embodiment in an artistic form was always the primary consideration. This difference, often remarked, has been most admirably summarized by Bernard Dorival in the following statement: 'Organisées, pensées pictoralement, les œuvres des Expressionistes français sont, ainsi, plus voulues que celles des étrangers; elles sont également plus discrètes et accusent plus qu'elles un désir de tenue. Qui ne songe qu'a s'épancher ne veut aussi le faire qu'aussi complètement qu'il se peut: aussi les Expressionistes allemands ou mexicains ne parlent-ils pas; ils vocifèrent. Les Français, au contraire, cherchent moins à trouver le ton haut que le ton juste . . .' (Organized and thought out pictorially, the works of the French Expressionists are therefore more deliberate than those of others; they are also more reserved and manifest more interest in order. Those whose sole aim is to give vent to themselves want only to do this as completely as is possible. Thus the German or Mexican Expressionists do not speak, but shout. The French on the other hand are less interested in finding the most clamorous tone than in finding the apposite tone. . . .')

During the inter-war years a second generation of Expressionists emerged, either younger artists or artists who had developed later in the direction of Expressionism. Notable among them were: François DESNOYER, Charles WALCH, André MARCHAND, Georges ROHNER, Francis GRUBER, BALTHUS. In contrast to the emotions of desperation and revulsion which had earned for the earlier wave of Expressionists the name 'Peintres de l'Angoisse', these artists of the 1930s were imbued with an exuberant *joie de vivre*, a great pleasure in all manifestations of humanity whether effervescent with delight or fraught with sadness, and they made it one of their ambitions to recover for the present age the spirit of the past displayed in the 1934 exhibition 'Peintres de la Réalité en France au XVIIe Siècle'. The most characteristic manifestation of the Expressionism of the 1930s was the association FORCES NOUVELLES, which attracted the support of Waldemar George and the Spanish critic Eugenio d'Ors. In addition to those mentioned it brought together the artists Robert HUMBLOT, Claude VENARD, Henri JANNOT, Francis Tailleux, André Civet and the theoretician of the movement, Henri Héraut.

THE NAÏVE PAINTERS. Recognition of the work of the NAÏVE painters as a genre to be taken seriously was firmly established in France before they were acknowledged internationally.

It was heralded by the rise to fame of the Douanier Rousseau, who stood so far above all others as to belong in a class of his own. As has been mentioned, he was first accorded honour—if somewhat hesitantly—by Picasso and his circle in 1908. His reputation was established by the retrospective Memorial Exhibition put on by the Salon des Indépendants in 1911, the monograph by Wilhelm Uhde in the same year and by a special number of the *Soirées de Paris* devoted to him in 1913. From the 1920s monographs multiplied. Séraphine was 'discovered' by Uhde in 1912 and her works were exhibited in 1927 by the Gal. des Quatre Chemins. BAUCHANT, BOMBOIS, VIVIN, PEYRONNET and René RIMBERT came to notice increasingly through the 1920s and 1930s; Bauchant, Bombois and Vivin all had exhibitions in London in 1931. The reputation of CAILLAUD, DÉCHELETTE, EVE, Jules LEFRANC, VIVANCOS, etc. came only slightly later.

The seal was set upon the acceptance of the genre by the magnificent exhibition 'Les Maîtres Populaires de la Réalité' staged in the Mus. Grenoble during the 1937 Exposition Universelle—only the first of many international exhibitions. In 1944 the Mus. National d'Art Moderne put on a memorable Centenary Exhibition of the Douanier Rousseau. Important exhibitions of Vivin were arranged by the Gal. Bing in 1948 and of Bauchant by the Gal. Charpentier in 1949, while in 1951 a collection of Séraphine was sent officially to represent French painting at the first São Paulo Bienale. Collective exhibitions had been occurring at the Gal. Quatre Chemins in 1928, at the Gal. Drouet in 1929, at the Gal Bernheim-Jeune in 1932 and at the Gal. des Beaux-Arts in 1933. International exhibitions of naïve art were put on by the Kunsthaus, Zürich, in 1937 and by The Mus. of Modern Art, New York, in 1938. Perhaps the largest and most impressive ever to be assembled was shown at the Kunsthaus, Zürich, in 1975, where the French naïve painters dominated the rest.

THE 1930s. The halcyon days of the 1920s were ended abruptly by the slump of 1930–2—referred to as *la crise*. Museums and collectors ceased to buy and international prices sank catastrophically. Dealers were reluctant to renew contracts and many artists experienced difficulties and hardship.

Exhibitions nevertheless continued both in Paris and abroad. The Georges Petit Gal. put on a representative DUFY show in 1930 and a very large Picasso retrospective in 1932. In 1931 the Reid and Lefevre Gal., London, showed 'Thirty Years of Pablo Picasso'. The Mus. of Modern Art, New York, arranged an exhibition 'Painting in Paris' in 1930, the pictures being mostly lent by American collectors. This was followed by a large Matisse show in 1931 and by 'Cubism and Abstract Art' and 'Fantastic Art, Dada, and Surrealism', both in 1936. The Wadsworth Atheneum, Hartford, put on a Surrealist show in 1931 and a large Surrealist exhibition took place in London in 1936. The culmination was the 1937 Paris Exposition, which was accompanied by a magnificent series of art

exhibitions: a retrospective exhibition 'Chefs d'Œuvre de l'Art Français' at the Mus. National d'Art Moderne (constructed for the Exposition) covered French innovative art from the 1860s to the end of the last century, together with Degas and Van Gogh exhibitions at the Orangerie. The Petit Palais exhibition 'Les Maîtres d'Art Indépendant, 1895–1937' brought the story up to date. An exhibition 'Origines et Développement de l'Art Indépendant' at the Jeu de Paume showed the part played by the École de Paris in international Functionalist art and Geometrical Abstraction, while the naïve artists were represented by 'Les Maîtres Populaires de la Réalité' at the Mus. Grenoble. Many artists did murals for the Exposition, the major sensation being Picasso's most famous picture *Guernica* for the Spanish Pavilion.

Surrealism continued to flourish and was spreading outside France. MAGRITTE in Belgium was making a name and in Britain a number of artists had adopted Surrealist theories. In 1930 Dalí and Buñuel showed their film *L'Âge d'Or*, and Dalí continued to produce his sensational Surrealist pictures such as *La Persistance de la Mémoire* (The Mus. of Modern Art, New York, 1930). Masson had left the movement in 1928 after a quarrel with André Breton, but others had acceded: Alberto GIACOMETTI from *c.* 1929 to 1935, Hans BELLMER from *c.* 1934, Leonor FINI, who came to Paris in 1933, S. W. HAYTER from 1933 to 1940. An international Surrealist exhibition was held at the Gal. des Beaux-Arts in 1938.

Geometrical Abstraction had made small headway among French artists and with the exceptions of Auguste HERBIN, Jean GORIN and for a short while in the 1930s Jean HÉLION, few French painters were committed to it. But Paris provided a welcome refuge for expatriate CONSTRUCTIVISTS, especially after the Bauhaus was closed and National Socialism banned innovative art in Germany. During the early 1930s Paris became the centre for international Constructivism and abstract art generally. In 1930 the association CERCLE ET CARRÉ was formed with MONDRIAN as its central figure and with its journal edited by the Belgian Michel SEUPHOR. Van DOESBURG settled at Meudon in 1930 and put out his manifesto ART CONCRET in the same year. After his one-man show in 1930 at the Kestner-Gesellschaft gallery, Hanover, GABO left Germany in 1932 and joined his brother PEVSNER in Paris. Joaquín TORRES-GARCÍA from Uruguay helped with the administration of the *Cercle et Carré* group. Out of this group emerged the association ABSTRACTION-CRÉATION: ART NON-FIGURATIF with its own journal of the same name, which lasted from 1932 to 1936. The organization had no prescriptive policy and with an eventual membership of *c.* 400 embraced most artists of note in every genre of abstraction. It brought together Mondrian, Kandinsky and Arp and included Georges VANTONGERLOO, César DOMELA, Jean Gorin, Alberto MAGNELLI, and Friedrich VORDEMBERGE-GILDEWART.

The inter-war years in France had been a time when the revolutionary advances which had characterized the first decade of the century had to some extent spent their force and attention was focused on the humane content of art rather than on stylistic innovation. Surrealism, Expressionism and the poetic interpretation of natural appearances usurped the enthusiasm of the more creative artists. The situation was abruptly changed by the Second World War and occupation by an enemy who condemned as 'degenerate' everything which French culture admired. Defeated in the field, spiritual survival became for the French intellectuals a matter of opposition to the cultural barbarism of the occupying forces. The foreign-born artists of the École de Paris were no longer able to practise under the Occupation and had emigrated to America or elsewhere. Patriotism exalted the French tradition, and then a second École de Paris emerged.

The older galleries, which had so effectively supported the great figures of the past four decades, were no longer able to operate under the Occupation. But new galleries were opened and, strangely, were favoured by an unusual economic situation in which there was an abundance of currency which no one trusted and little or nothing to buy with it. Around these galleries there grew up a specifically French *avant-garde* of young artists who brought into being a new mode of abstraction which was expressive if contrasted with the geometrical abstraction of CONSTRUCTIVISM yet had not the unbridled disregard for formal construction which characterized Germanic Expressionism. The first manifestation of this tendency, in deliberate and blatant opposition to the occupying forces, was a show 'Jeunes Peintres de la Tradition Française' put on by the new Gal. Braun in the rue Louis-le-Grand behind the Kommandatur in the spring of 1941. It included representatives of many different trends—Cubist followers side by side with followers of Surrealism and supporters of the *Forces Nouvelles* movement—but among them was the nucleus of a genuine *avant-garde*, many of whom were pupils of Roger Bissière. They included BAZAINE, ESTÈVE, GISCHIA, LAPICQUE, PIGNON and the younger painters LE MOAL, MANESSIER, Robin, SINGIER, FOUGERON, Dayez, etc.

The older group were all in their several ways indebted to Cubism. They had the Cubist preference for still lifes, they broke up their objects into structured planes and they employed the Cubist device of multiple viewpoints. But if they looked back to Cubism, it was in order to transform it. If they learned much from Picasso and Braque, they learned also from Matisse and Bonnard, for whom they professed a profound admiration. By their different techniques they were all united in bringing back colour into painting: not the colour of realistic representation, not symbolic colour nor yet purely decorative colour, but an intensity of colour which imparts to their painting a dynamism hitherto unknown. It was by their dynamism that

they most importantly transformed the static quality of Analytical Cubism into something new. They endowed their works with movement and life, not by trying to represent objects in movement as the FUTURISTS had done, and not in the manner of the Section d'Or artists, but by an intrinsic dynamism which they achieved through the interplay of colours, the structural use of transparent planes and ambiguous or multivalent spatial signs. In the words of Lapicque: 'Immobility established itself at the Renaissance and reigned undisturbed for three centuries. Then that madman Cézanne took it into his head to distort things. In the light of what precedes we can better qualify these so-called distortions: they are distortion for those who refuse to move, but they are movement for those who consent to do so.' New ways of imparting intrinsic movement and dynamism provide the key to this new manifestation of French art.

The group exhibited again in 1942 at the Gal. Friedland and in 1943 at the Gal. Berri-Raspail and the Gal. de France. But their cohesion did not outlast the moral force of reaction against the Occupation, and disruption was rapid. In 1945 Bazaine, Estève and Lapicque had a collective exhibition at the Gal. Carré, followed by one-man shows of Lapicque in 1947 and Estève in 1948. Manessier, Singier and Le Moal went to the Gal. Drouin in 1945 and from there to the Gal. Billiet in 1946 with Gischia, Robin and Fougeron. By 1947 there was no longer in any sense a group, although individually the artists exhibited in the Salon d'Automne and were the main sensation of the new Salon de Mai inaugurated in 1949 by the critic Gaston Diehl.

Fougeron, who won the Prix National in 1946, reverted to SOCIALIST REALISM in 1948, as did the less well-known painters Jean Vénitien, Boris Taslitsky and Jean Amblard. Pignon, also a Marxist, though less extreme, devoted himself more and more to themes of social significance. Lapicque, increasingly interested in the problems of movement, began to depict racing scenes, regattas, etc. Tal Coat settled near MASSON in Aix and evolved an original manner of expressive landscape, while Gischia continued loyal to still lifes. In contrast with these, Estève, Bazaine, Le Moal, Singier and Manessier turned increasingly in the direction of abstraction. Their method was described by Bazaine in his *Notes sur la Peinture d'Aujourd'hui* (1953) as 'the absolute rejection of imitation, of the reproduction and even the distortion of forms from nature'. But their mode of abstraction was not that of the Constructivists and the Salon des Réalités Nouvelles, i.e. construction from non-figurative and preferably geometrical elements. Neither was it the impulsive 'psychic automatism' of ART INFORMEL, akin to American ACTION PAINTING. Rather, it was close to the method of Roger Bissière, of whom Le Moal and Manessier had been pupils. Starting from natural appearances seen or remembered and guided by aesthetic con-

siderations, abstraction was carried to the point where object recognition was lost. Of the work of Estève, Bernard Dorival has said: 'Une expérience vécue alimente presque toujours ses œuvres dont elle détermine le nom, donné ordinairement après coup.' ('His works were always infused by a lived experience, which also decided their name—which was generally given after they had been completed.') This was the method of Bissière, who refused to call his work 'abstract'.

In 1948 there also appeared the first indications of a contrary current combining the Social Realism of Rebeyrolle with the Expressive Realism of Bernard Buffet and Bernard Lorjou, relying to a greater extent than the *Forces Nouvelles* movement of the 1930s on expressive distortion. It started under favourable auspices with the formation of the association *Homme-Témoin*. It was well received by the ordinary public, to whom the works were more comprehensible than the new abstraction, and it had the support of the left-wing critics, who identified abstraction with effete American capitalism. The position of the critics was shown by their award of the Prix de la Critique jointly to Lorjou and Buffet. By 1953 Buffet was recognized to be the best known of all the young French painters. The movement centred on the left-wing Salon des Moins de Trente Ans and the Salon des Peintres Témoins de leur Temps, which consistently with the new interest in social subject matter set a theme each year for exhibitors, such as Work (1951), Happiness (1955), Sport (1957) and so on. Besides the members of *Homme-Témoin* a large number of young artists, and artists already established in other styles, sought to find a place on the band wagon. Their names are now forgotten.

Two independent Expressionist painters should be mentioned who belonged to neither stream. They were Fautrier and DUBUFFET, both of whom had their first exhibitions at the Gal. Drouin in 1945. Fautrier's entirely original manner in his *Otages* was an anticipation of GESTURAL painting and *Art Informel*. Dubuffet won enthusiastic support by a sophisticated puerility and by his combination of 'a childlike style with bold innovations of surface handling and a grotesque sense of humour'.

In 1945 the Gal. Drouin put on an exhibition entitled 'Art Concret' which brought together many different forms of abstraction. A vogue for abstract art was started and by 1950 was firmly established. In 1946 the SALON DES RÉALITÉS NOUVELLES was inaugurated by the dealer Fredo Sidès and became the leading exhibition centre in Europe for Constructivist art. The Gal. Denise René also became a recognized centre for Constructivism. In 1960 the GROUPE DE RECHERCHE D'ART VISUEL (GRAV) was formed at the instigation of the Argentine experimental artist Julio LE PARC and with François MORELLET as its leading theoretician. The group was particularly active in promoting experiment and research in KINETIC ART and OP ART and was instrumental in the formation of the

NOUVELLE TENDANCE, an international movement embracing many kinds of geometrical abstraction, environmental art and forms of experimental art involving group activity, spectator participation, etc.

In the realm of expressive abstraction a new École de Paris arose, whose chief contribution became known internationally by the terms TACHISM or *Art Informel*. This passed through three phases. (1) The first phase emphasized impulsiveness and spontaneity with rejection of formal composition. The leading masters were the German-born WOLS ('discovered' by the Gal. Drouin) and Hans HARTUNG, the Swiss-born Gérard SCHNEIDER, and the French-born Georges MATHIEU, Camille BRYEN and Pierre SOULAGES. The critic Bernard Dorival compared a typical *Art Informel* picture to the disorderly flight of ants whose hive has been destroyed and the main advocate of the movement, Michel Tapié, spoke even more strongly of the necessity for complete abandonment of planned composition. (2) The term *Tachisme* derived from an unfavourable review in *Art d'Aujourd'hui* of an exhibition given by the Gal. Craven in 1953. Typical of this phase are: VIEIRA DA SILVA, Nicolas de STAEL, Pierre DMITRIENKO, Jean-Michel ATLAN, Robert LAPOUJADE, Jacques BUSSE, Mario PRASSINOS, etc. in the 1950s. (3) The third phase, sometimes referred to as 'lyrical abstraction', embraced such younger artists as Bernard DUFOUR, François ARNAL, Serge REZVANI, Paul KALLOS, and Roger Edgard GILLET.

After the mid century Paris remained an active centre of the many branches of novel and experimental art, but the hegemony which it had enjoyed in the first half of the century was not recovered after the era of Tachism. Among the most significant events was the inauguration in 1959 of the Paris Biennale for artists under 30 years of age on the initiative of the critic Raymond Cogniat. Through the 1960s and into the 1970s this successfully did for experimental art what the Venice Biennale had done for the international *avantgarde* in the period between the two wars. Mention should also be made of the inauguration in 1975 of the Centre National d'Art et de Culture Georges POMPIDOU, whose many and various activities give to Paris a state-supported centre for the arts such as few other cities can boast.

FRANCÈS, ESTEBAN (1914–). Spanish painter, born at Port-Bou. He went to Paris in the 1930s, joined the SURREALIST movement and was one of the staunchest advocates of AUTOMATISM. He is credited with inventing the technique of GRATTAGE *c*. 1938 and with it he made fantastic landscapes with vague plant-like forms. During the Second World War he was in the U.S.A. and composed allegorical paintings in which the influence of PICASSO was apparent.

FRANCÈS, JUANA (1926–). Spanish painter, born in Alicante and trained at the School of Fine Arts, Madrid. After a period of quasi-SURREALIST MAGIC REALISM she turned to expressive abstraction in the mid 1950s and was a member of the group EL PASO. In the 1960s she abandoned ART INFORMEL for a highly personal style involving small pictorial elements set and as it were framed in large geometrical abstracts. The motive of these works was to express the spiritual solitude of urban man. The catalogue to the 'Arte '73' exhibition arranged by the Juan March Foundation contained the following description of her work: 'The characters that appear do not fight, do not shout, they are implacable, immovable. They do not represent man as such but the forces and the situations which may promote his shout, his anguish. They are like a great threat surrounding us. Something is drowning the most intimate and human conditions of man. Man is become a thing.' She is represented in the Mus. de Arte Contemporaneo, Madrid, and the museums of Cuenca, Villafamés, Lausanne and Helsinki.

FRANCESE, FRANCO. See ITALY.

FRANCHINA, NINO (1912–). Italian sculptor born in Palermo, where he studied. In 1935 he went to Milan and there joined the CORRENTE association. In 1947 he joined the FRONTE NUOVO. After working in a classical manner under the influence of DESPIAU and MAILLOL he changed to the 'archaic' style of Marino MARINI in 1947. During the 1950s he changed once more and made expressive abstractions from coloured metal sheets welded with automobile parts and enamelled. Towards the end of the 1950s he did thinner, upright constructions which have been described as 'slender ethereal apparitions'. He was one of the dominating figures in the sculpture of expressive abstraction in Italy.

FRANCIS, SAM (1923–). American painter, born at San Mateo, Calif. After studying medicine at the University of California at Berkeley, 1941–3, he took up painting in 1945 and studied under David Parks at the California School of Fine Arts, San Francisco, and then in Berkeley. He went to Paris in 1950, attended the Atelier Fernand Léger and was friendly with RIOPELLE and other ART INFORMEL painters, by whom his style was influenced as well as by the American ABSTRACT EXPRESSIONISTS, particularly Jackson POLLOCK. In 1957 he made a world tour, including a long stay in Japan, and afterwards the thin texture of his paint, his drip and splash technique, and his asymmetrical balance of colour against powerful voids, caused critics to speak of influences from Japanese traditions of contemplative art. In the mid 1960s his sensitive feeling for Oriental simplicity was enhanced to bring his work into closer affinity with certain MINIMALIST trends. His first one-man exhibition was at the Gal. Nina Dausset, Paris, in 1952, after which he exhibited at the Gal. Rive Droit and elsewhere in Paris, in Japan, Switzer-

land, London, and widely in America. He had retrospective exhibitions at Berne in 1960, at the Mus. of Fine Arts, Houston, Texas, jointly with the Art Mus. of the University of California at Berkeley in 1967 and in 1968 at the Stedelijk Mus., Amsterdam.

FRANKENTHALER, HELEN (1928–). American painter, born in New York. She studied art under Rufino TAMAYO and then took a degree at Bennington College, Vermont, in 1949. Under the influence of Arshile GORKY and then Jackson POLLOCK she evolved her own manner of ABSTRACT EXPRESSIONISM. She was particularly interested in exploring new methods of colour combination and her style c. 1950 was notable for small areas of abstract colour within a large expanse of naked canvas. Early in the 1950s she took over from Pollock an original method of staining unsized canvas by pouring pigment, thus eliminating the painterly brushstroke technique of most Abstract Expressionist painters. Her picture *Mountains and Sea*, done in 1952, attracted the attention of Morris LOUIS and Kenneth NOLAND and exercised a strong influence on their later development. She may therefore be regarded as an important pioneer of the breakthrough from Abstract Expressionism to COLOUR FIELD painting. From c. 1962 she used for the most part acrylic paints and her colours became stronger, though she retained the staining technique so that the painted image was completely identified with the surface of the canvas.

In 1958 she married the painter Robert MOTHERWELL. In 1968 she became the first woman to be elected Fellow of Calhoun College, Yale University; in 1973 she was made Doctor of Fine Arts at Smith College; in 1974 she was elected a member of the National Institute of Arts and Letters and Doctor of Fine Arts at Moore College of Art. Her work, almost always of large format, was very widely exhibited in group and one-man shows. A retrospective exhibition at the Whitney Mus. of American Art in 1969 subsequently travelled under the auspices of the International Council of The Mus. of Modern Art to the Whitechapel Art Gal., London, the Kongresshalle, Berlin, and the Kunstverein, Hanover. She had a one-man show at The Metropolitan Mus. of Art, New York, in 1973 and her 1974 paintings were shown at the Cologne Art Fair, Germany, and at the Waddington Gals., London, where successive exhibitions of recent paintings have been given.

FRANKL, GERHART (1901–65). Austrian artist born in Vienna, settled in London in 1938. He modelled his style on early Netherlandish paintings which he had seen in Vienna with the professed aim of reinterpreting these works in a contemporary manner. He also evolved a method of pastel which was vaguely reminiscent of Turner and Whistler. He had a retrospective exhibition at the Welz Gal., Salzburg, in 1962.

FRASCONI, ANTONIO (1919–). American graphic artist born at Montevideo, where he studied at the Circulo de Bellas Artes. He went to the U.S.A. in 1945 and in 1946 studied under Yasuo KUNIYOSHI at the Art Students' League and then at the New School for Social Research, where he later taught, 1951–2. He also taught at Brooklyn Mus. School, the Pratt Institute and Atlanta Art Institute. He obtained a Guggenheim Foundation Fellowship in 1952, a National Institute of Arts and Letters grant in 1954 and at the Venice International Film Festival in 1960 the Grand Prix for *The Neighboring Shore*. His first one-man show was at the Ateneo Gal., Montevideo, in 1939 and in the U.S.A. at the Brooklyn Mus. in 1946. He had retrospectives at the Cleveland Mus. of Art, 1952, the Smithsonian, circulating 1953–5, the Mus. Municipal de Bellas Artes, Montevideo, 1961, Baltimore Mus. of Art, 1963. His work is represented in many of the leading collections of graphic art in the U.S.A., the Arts Council of Great Britain, the Mus. Municipal de Bellas Artes, Montevideo, etc.

FRASER, JANET. See SOUTH AFRICA.

FRATER, WILLIAM (1890–1974). Australian painter, born at Ochiltree, Scotland. He attended the Glasgow School of Art, where he took classes with Maurice Greiffenhagen (1862–1931) while serving his articles as a stained-glass craftsman and designer. He also studied stained-glass design in London under Robert Anning Bell (1863–1933). Frater visited Melbourne in 1910 and attended life classes of the Victorian Artists' Society. In 1911 he returned to Europe, visiting London and Paris, then studied for two further years at the Glasgow School of Art (1912–13). In 1914 he settled permanently in Melbourne, being employed as a designer of stained-glass windows and doors by Brooks Robinson and Co. but continuing to practise as a painter. Though at first interested in the theories of Max MELDRUM, he became, in company with Arnold Shore, increasingly interested in the work of Cézanne. Their first essays in POST-IMPRESSIONISM were exhibited with the Society of Twenty Painters, a group founded in Melbourne in 1917, but aroused little interest. Frater, Shore and Bell were the three artists mainly responsible for winning an audience for Post-Impressionist painting in Melbourne during the 1920s and 1930s. (See AUSTRALIA.) A retrospective exhibition of Frater's work was held at the National Art Gal. of Victoria in September 1966.

FREILICHER, JANE (1924–). American painter and draughtsman born in New York, studied at Brooklyn College, Columbia University and the HOFMANN School. She taught in the Great Neck Adult Education Programme, New Jersey public schools and briefly at the universities of Pennsylvania and Boston. She exhibited at the Tibor de Nagy Gal., New York, from 1952 and participated

in a number of collective shows, including: The Mus. of Modern Art, New York, 'Recent Drawings USA', 1956, and 'Hans Hofmann and his Students', 1963–4. Her work consisted in large part of delicately executed cityscapes.

FREIMANN, CHRISTOPH (1940–). German sculptor born in Leipzig, studied at the Academy in Stuttgart, 1962–8. His work consisted of rectilinear geometrical relief or three-dimensional constructions usually made of painted wood and emphasizing the contrast of black and white. He participated in many collective exhibitions from 1965.

FRENCH, LEONARD (1928–). Australian painter born in Brunswick, Melbourne. He was apprenticed to a sign-writer, from whom he learnt to gild, glaze and design murals, and studied at night at the Melbourne Technical College, 1944–7, where the sculptor V. G. Greenhalgh encouraged him to paint. His first commission was for two frescoes in the Congregational Church, Brunswick, *To the War Dead* and *One World* (1948), executed in the manner of OROZCO. In 1949 he worked his passage to London and obtained a studio in the Abbey Arts Centre, New Barnet. There he developed a friendship with the Irish painter Gerard Dillon and met Alan DAVIE. Visits to Ireland deepened his interests in Celtic art. But the work of PERMEKE and GROMAIRE, and later that of LÉGER and DELAUNAY, exercised a more direct influence upon the work he completed after his return to Melbourne in 1952. A preference for a mural scale and epic themes then became apparent in his work. In 1952 he exhibited paintings based upon the *Iliad* at the Peter Bray Gal., Melbourne. In 1955 a series of paintings based upon the *Odyssey* was shown at the Victorian Artists' Society Gals. His work at this time was geometrical and flat, taut in line and strident in colour. In 1956 he painted the *Legend of Sinbad* for an expresso bar in Melbourne and a year later began a mural for the Beaurepaire Centre, University of Melbourne. From 1956 to 1960 he was Exhibitions Officer for the National Gal. of Victoria, and in 1960 won a scholarship to visit Indonesia, India, China and Japan.

During the early 1960s his painting attained greater formal and expressive subtlety. He studied enamelling techniques, building his colours glaze upon glaze, and profited from the involuntary modes of working advocated by the ABSTRACT EXPRESSIONISTS. 'I don't really know what I am going to paint, it has to grow up in the process of one colour on top of another,' he said. His *Genesis* paintings of the 1960s revealed his continuing interest in the beauty of Celtic and Byzantine art. His mature style emerged in a series of paintings which were inspired by a reading of Evelyn Waugh's book on Edmund Campion, which had been lent to him by the Catholic poet Vincent Buckley, a close friend. These paintings best express French's ideal of the heroic, in which the spiritual will battles with and yet is in a sense contained by the mechanical, the seasonal and the cyclical. They were exhibited in Sydney and Melbourne by the dealer Rudy Komon, also a close friend. French lived for a time during 1962–3 in Greece. On returning to Melbourne he was commissioned to design a stained glass ceiling for the Great Hall of the new National Art Gal. of Victoria. In 1965 he visited Japan, and later in September went to the U.S.A. on a Harkness Fellowship.

French also produced etchings and lithographs related to the themes which interested him. From 1973 he served as a member of the Visual Arts Board of the Australian Council for the Arts.

FRESNAYE, ROGER DE LA. See LA FRESNAYE, ROGER DE.

FREUD, LUCIAN (1922–). German-British painter born in Berlin, a grandson of Sigmund Freud. His father was an architect who had been a painter at the time of the Vienna SECESSION. Freud came to England in 1932 and was naturalized in 1939. He studied at the Central School of Art and at Goldsmiths' College and began to work full time as an artist after being invalided out of the Merchant Navy in 1942. His first show was at the Lefevre Gal. in 1944 with Julian TREVELYAN and Felix Kelly. He participated in the British Council exhibitions 'La Jeune Peinture en Grand Bretagne' (1948) at the Gal. René Drouin, Paris, and '21 Modern British Painters' (1951) at the Vancouver Art Gal., and with NICHOLSON and BACON at the Venice Biennale in 1954. A one-man exhibition was arranged by the British Council at the Hayward Gal. in 1974, and was also shown at Bristol, Leeds and Birmingham. During the 1940s and 1950s Freud matured a style of meticulous, hallucinatory realism individualized by a touch of weird whimsicality. In the latter 1960s he began to give more attention to dramatic contrasts of lighting and to painterly brushwork. Primarily, however, his work belonged to the category of hyper-realism and was distinguished by firm draughtsmanship.

FREUNDLICH, OTTO (1878–1943). German artist born at Stolp, Pomerania. After working as a shop assistant he studied history of art at Munich and Florence and began painting in 1905. He went to Paris in 1909 and had a studio in the BATEAU-LAVOIR, where he was a member of PICASSO's circle. After exhibiting with the CUBISTS in Paris, Cologne and Amsterdam, he began to do purely abstract painting *c.* 1919, composing with interlocking swathes of pure colour. He was a member of CERCLE ET CARRÉ and of the ABSTRACTION-CRÉATION association. During the 1930s he was classed as a DEGENERATE artist in Germany and he died in a concentration camp at Lublin. He was given a retrospective exhibition at the Gal. Rive Droit, Paris, in 1954.

FRIDAY CLUB. A club founded in 1905 by Vanessa BELL as a meeting place for progressive artists to discuss their work and theories, listen to lectures and occasionally hold exhibitions. After some five or six years the Club had ceased to function as a meeting place (meetings had usually been held at 46 Gordon Square) and exhibitions only were continued into the 1920s.

FRIESZ, OTHON (1879–1949). French painter, born at Le Havre. At the École des Beaux-Arts, Le Havre, he received a thorough grounding in the classical French painters, Poussin, Chardin, Corot, etc. He came to Paris in 1898 and there came into contact with the FAUVISTS, becoming one of the most enthusiastic and vigorous painters in this style. He exhibited at the Salon des Indépendants in 1903 and at the Salon d'Automne in 1904. During this period, until 1907, he did what is considered to be his most interesting work, painting at Cassis, Le Ciotat, Falaise and at Antwerp with BRAQUE. In 1908 he abandoned Fauvism and reverted to a more traditional style, giving more attention to the structural plan of his compositions and using simple, uncomplicated colours. In 1912 he opened his own studio and taught there until 1914. After serving in the First World War he settled in Paris in 1919 but his painting had lost much of its verve and he held aloof from the newer artistic movements. He won a Carnegie prize in 1924 and was made a member of the Carnegie Foundation jury in 1938, in which year he visited the U.S.A. In 1935 he did the design for a Gobelins tapestry entitled *Peace*.

FRINK, ELISABETH (1930–). British sculptor born at Thurlow, Suffolk, trained at the Guildford School of Art and then at the Chelsea School of Art under Bernard MEADOWS, through whom she underwent some influence from Henry MOORE. She was also influenced for a while by GIACOMETTI. Her first one-man show was at the Beaux-Arts Gal., London, 1951, and from 1959 she showed at the Waddington Gals. She taught at the Chelsea School of Art, St. Martin's College of Art and at the Royal College of Art. During the 1950s and 1960s she was associated with the British School of Sculpture, which included Kenneth ARMITAGE, Lynn CHADWICK and Reg BUTLER. Her own work could best be described as original and vigorous naturalism. Among her best-known works were *Blind Beggar and Dog* of 1956 and *Horse and Rider* of 1969. Her *Bird-Man* bronzes of the 1960s also attracted attention.

FRONTE NUOVO DELLE ARTI. An association formed in 1946 from the *Nuova Secessione Artistica Italiana* on the initiative of Renato BIROLLI, bringing together those Italian artists who welcomed the newer trends in European art which began to be exhibited in Italy after the war. A manifesto was signed by the painters Birolli, Bruno CASSINARI, GUTTUSO, Ennio MORLOTTI,

Armando PIZZINATO, Giuseppe SANTOMASO, Emilio VEDOVA, and by the sculptors Alberto VIANI and Leonardo LEONCILLO. It was supported by the critic Giuseppe Marchiori. This manifesto, in the words of Guido Ballo, was 'not a "group" manifesto but a united front of the most representative Italian artists of the post-*Novecento* generation who were at one in their demand for confidence in their work and in their determination to rise above the pessimism and general spiritual disintegration of their time'. At the exhibition held in 1947 in the Spiga Gal., Milan, the painter Cassinari withdrew his support and the movement was joined by the painters Giulio TURCATO and Antonio CORPORA and by the sculptors Nino FRANCHINA and Pericle FAZZINI. The association combined artists of very different styles and at the Venice Biennale of 1948 was disrupted by a split between the Neo-Realists and those who were moving in the direction of expressive abstraction (ART INFORMEL).

FROST, ARTHUR BURDETT. See SYNCHROMISM.

FROST, TERRY (1915–). British painter, born at Leamington Spa. He started painting in 1943 and in 1946 joined the St. Ives group of painters. He studied under Victor PASMORE at the Camberwell School of Art, 1947–50, and taught at the Bath Academy of Art, 1951–4. He was Gregory Fellow in Painting at the University of Leeds, 1954–6, taught at San José University, California, in 1964 and was Fellow in Fine Art at the University of Newcastle, 1964–5. In 1965 he was appointed to the Fine Art Department at the University of Reading. Besides one-man exhibitions he had a retrospective in 1964 at the Laing Art Gal., Newcastle, and at York, Hull, Bradford, and in California at San José and Santa Barbara. Group exhibitions in which he was represented include: 'Contemporary British Painting and Sculpture', Albright-Knox Art Gal., Buffalo; 'Painting and Sculpture of a Decade', Tate Gal., 1964; 'Recent British Painting', Tate Gal., 1967; 'British Paintings 1960–70', National Gal. of Art, Washington, 1970–1; 'British Painting 1974', Hayward Gal. His work is represented in many public collections, including: the Tate Gal., Arts Council of Great Britain, the British Council, Contemporary Arts Society, Victoria and Albert Mus., National Gal. of Canada, Gulbenkian Foundation, Scottish National Gal. of Modern Art, Art Gal. of New South Wales, Laing Art Gal., First National Bank of Chicago, etc. His work was abstract, using circles and ovals in high pitched and saturated colours, often juxtaposing segments of closely related colour to create a special sort of contrast.

FROTTAGE. One of the techniques of AUTOMATISM exploited by the SURREALISTS. A method analogous in principle to brass rubbing, its invention was attributed to Max ERNST, who related in *Histoire naturelle* (1926) how on 10 August 1925, while in a boarding house, he had noticed how the

grain of the floorboard beneath had impressed itself on the surface polish and had then made tracings of its random pattern and reproduced this on a sheet of paper. Later he did the same thing with the grooves of foliage, the texture of sackcloth, the brush marks in a modern painting, etc., using these chance patterns as the basis for pictorial designs. The method was later transferred to oil painting and was adopted by the Surrealists as a technique for gaining access to the subconscious.

FRUHMANN, JOHANN (1928–). Austrian painter born at Weissenstein, studied at the School of Applied Art, Graz, and at the Vienna Academy of Fine Art. He was one of the group of young abstract painters who emerged in the artistic revival of the 1950s in Vienna. His style was at first geometrical but later became a freer, quasi-calligraphic mode of 'gestural' or LYRICAL ABSTRACTION.

FRY, ROGER ELIOT (1866–1934). British painter and critic, born in London. After taking a degree in science at King's College, Cambridge, he studied art in Italy, 1891, and at the Académie Julian, Paris, 1892. He was a member of the NEW ENGLISH ART CLUB, 1893–1908. Although he himself regarded his painting as primary, he devoted much of his energy to criticism and it is as a critic that he is chiefly remembered and as a critic that he exerted a massive, even a revolutionary influence on the taste of his day. He was art critic of the *Athenaeum* in 1901, director of The Metropolitan Mus. of Art, New York, 1905–10, editor of the *Burlington Magazine* from 1910 to 1919. Up to *c.* 1906 his criticism was orthodox and his edition of Reynolds's *Discourses*, published in 1905, contained little to shock academic opinion. In 1906 he 'discovered' Cézanne and became the ardent champion of modern French schools of painting, introducing them to Britain under the name 'Post-Impressionists' by exhibitions which he arranged at the Grafton Gals. in 1910 and 1912. From this time his critical writing was aligned with the aesthetic outlook of Clive BELL and the BLOOMSBURY GROUP of artists and writers, assigning pre-eminent importance to plastic qualities and formal relations.

Fry coined the term 'Post-Impressionism' to distinguish the French artists in whom he was chiefly interested from the Neo-Impressionists (Seurat, Signac, etc.) and in preference to the term 'Expressionism', which had wide currency at the time but with Germanic implications that were foreign to Fry's tastes. The exhibition of 1910, comprising *c.* 150 works, was entitled 'Manet and the Post-Impressionists'. There were 8 Manets, including his *Bar aux Folies-Bergère*. There were no other Impressionists and the Neo-Impressionists were represented by only 7 canvases. The Symbolists were represented by 16, with the emphasis on Maurice DENIS and the minor painter Pierre Girieud (1876–1948). The greatest emphasis was upon Cézanne (21 pictures), Gauguin (37 pictures)

and Van Gogh (20 pictures). Prominence was given to the FAUVES with 39 paintings in all, the emphasis being on VLAMINCK and ROUAULT. There were only two paintings by MATISSE, though seven of his bronzes were included, and only two by PICASSO. The bias of the exhibition as a whole was towards the brilliant, patterned use of colour from Gauguin and Van Gogh to the Fauves, which corresponded with the taste of Fry and was reflected in the painting of Duncan GRANT and Vanessa BELL at this time. The term 'Post-Impressionist' denoted and to some extent has continued to denote this particular facet of taste. The exhibition of 1912, with the title 'Second Post-Impressionist Exhibition', signalled a shift towards younger contemporaries. A Russian section (including LARIONOV and GONCHAROVA) was selected by Boris Anrep and an English section by Clive Bell. In the French section, chosen by Fry, the accent was upon Cézanne; Matisse (20 canvases and 6 bronzes) and Picasso (13 canvases) were well represented and CUBISM was represented also by BRAQUE (4 Fauvist works and 1 Cubist), HERBIN, LHOTE and MARCHAND. As a whole the exhibition showed a shift from Symbolism and the expressive use of colour towards Cubistic forms of abstraction, but revealed no real understanding of the Cubist achievement.

The exhibitions provoked a good deal of controversy, with the members of the New English Art Club pretty solid in opposition and the more advanced among them, such as SICKERT and STEER, critical. But the impact was enormous and the total effect was to initiate a new era in British taste and appreciation.

In 1913 Fry founded the Omega Workshops for the production of well-designed objects of daily use instead of the pretentious and 'arty' artefacts which were then in fashion. His purpose was to disseminate his own ideas of taste among the general public by gathering around himself a group of 'advanced' artists to design in the new style. A personal quarrel with Wyndham LEWIS led to the secession of the latter and his friends, who founded the Rebel Arts Centre, from which arose the VORTICIST movement. Later Fry joined the LONDON GROUP when this emerged from the CAMDEN TOWN GROUP. As a painter Fry practised a careful but uninspired naturalism in accordance with the general style that prevailed among the Bloomsbury group.

Fry was a fine teacher and lecturer. As a critic it was said of him by Sir Kenneth Clark: 'In so far as taste can be changed by one man, it was changed by Roger Fry.' After being rejected by Oxford for the Slade Professorship in 1910 and 1927, he was appointed by Cambridge in 1933. For breadth and perceptiveness his unfinished Slade lectures, published posthumously in 1939 as *Last Lectures*, stand out as one of the greatest works of appreciative criticism produced in Great Britain during the first half of the century. His other writings on art and criticism are collected in *Vision and Design*

(1920) and *Transformations* (1926). He wrote monographs on *Cézanne* (1927) and *Matisse* (1930).

FUCHS, ERNST (1930–). Austrian painter, born in Vienna. He was trained at the Vienna Academy under GÜTERSLOH, 1946–50. He travelled in France, Italy and North America; exhibited in Paris during the early 1950s, in London and Madrid in 1952 and contributed several times to the Venice Biennale. He was one of the Austrian school of FANTASTIC REALISM which emerged in Vienna in the late 1940s. He painted biblical and mystical scenes in a Mannerist style based on Grünewald and the French Symbolists, particularly Gustave MOREAU. He also did important work as a graphic artist. In 1959 he began to publish *Pintorarium* with HUNDERTWASSER and Arnulf RAINER.

FUHR, XAVIER (1898–1973). German painter, born near Mannheim, self-taught as an artist. He was listed as a DEGENERATE painter under the Nazi regime and forbidden to work. He was Professor at the Munich Academy of Art, 1946–66, and from 1950 lived at Regensburg. In his painting a graphic framework of lines based upon an ornamental motif such as a balcony or grating, roof-ridges, gutter pipes, tree branches, etc. is set against a patinated background interspersed with splashes of colour which define the spatial dimensions. In his later phase he had affinities with the school of painters who, abandoning ABSTRACT EXPRESSIONISM, made it their aim to forge a new link between abstract art and the objective world.

FUKUDA, HEICHACHIRO (1892–1972). Japanese painter, born at Ōita City. He trained at the Kyoto Municipal School of Industrial Art, 1911–15, and then at the Kyoto Municipal Painting School, where he studied *Nihon-ga*. The *Nihon-ga* school of Kyoto is a combination of decorative aspects of Japanese 17th-c. and 18th-c. painting with the naturalism of Chinese bird and flower painting of the Sung and Yuan periods together with some adaptations of Western realistic perspective. Fukuda became the acknowledged master of this style in the present century. Painting mostly birds and flowers in opaque colours on silk or paper, he created a particular kind of decorative beauty, uniting artistic simplification with generic abstraction based upon close observation of the typical characteristics of organic forms. Even in the 1930s he had achieved what were virtually abstract paintings in such works as his *Ripples* (1932) and *Rain* (1935). The latter in particular, with its irregular pattern of raindrops gleaming against a background lattice of roof-tiles, exemplified the typical Japanese love of asymmetrical design. A retrospective exhibition of his work was shown at the Tokyo National Mus. of Modern Art and the Kyoto Municipal Mus. of Art in 1975.

FUKUSHIMA, NORIAKI (1940–). Japanese sculptor born at Tottori and studied at the Academy of Arts, Tokyo. After visiting the U.S.A. in 1965–6 he settled in Kyoto. He experimented largely with coloured sculpture and with space-modifying constructions standing directly on the ground.

FULLER, SUE (1914–). American painter, draughtsman and graphic artist born at Pittsburgh, Pa. She studied with Hans HOFMANN, 1934, S. W. HAYTER, 1943–4, and with Josef ALBERS. In 1936 she took a B.A. at the Carnegie Institute of Technology and in 1939 an M.A. at Columbia University. After travelling in Europe, Africa and Japan she taught at Minnesota University, 1950, Stourbridge School of Arts and Crafts, England, 1951, Georgia University, 1951–2, Teachers' College, Columbia University, 1958 and the Pratt Institute, 1964–5. Among her awards were the Charles M. Lea Prize, 1949; Guggenheim Foundation Fellowship, 1949; National Institute of Arts and Letters grant, 1950; Eliot D. Pratt Foundation Fellowship, 1966, 1967, 1968. Her first one-man show was in 1947 at the Village Art Center, New York and she continued to exhibit through the 1950s and 1960s. Among the collective exhibitions in which her work was represented are: The Mus. of Modern Art, New York, 'Abstract Painting and Sculpture in America', 1951, and 'The Responsive Eye', 1965; Whitney Mus. of American Art, 'The New Decade', 1954–5, and 'Geometric Abstraction in America', 1962; the Philadelphia Mus. of Art, 'A Decade of American Print Making', 1952 and 1964; American Federation of Arts, 'Collage in America', 1957–8, 'The New Landscape in Art and Science', 1958–9, 'Hayter and Atelier 17', 1961–2. Her work remained in the van of the abstract movement in graphic art.

FULTON, HAMISH. See CONCEPTUAL ART.

FUMAGE. A technique of AUTOMATISM introduced in the late 1930s by Wolfgang PAALEN. By moving a candle flame beneath a sheet of paper he deposited upon it strange and dreamlike formations of soot-blackening, which exemplified the SURREALIST theories of chance as a method for releasing imagery of the unconscious mind. Transferred to oil painting, this method led to a very supple rhythm of 'automatic' brushwork.

FUNI, ACHILLE (1890–1972). Italian painter, born at Ferrara. In his early years he studied the frescoes of the Palazzo Schifanoia and became fascinated by the problems of the large mural. He founded a group known as *Nuove Tendenze* in association with the FUTURISTS and was called by BOCCIONI 'one of the champions of Italian painting'. At this time he specialized in Futurist methods of breaking up an object into abstract forms and rhythmic sensations of colour. About 1920 he participated in the trend towards the Neo-

Classical Romanticism which then prevailed in Italy, and more temporarily in France, and in 1925 he became a member of the reformed NOVECENTO ITALIANO group. From this time he appears to have been content to follow in the path of the classical masters, holding aloof from experimental innovation.

FUNK ART. Sometimes called 'Sick Art', the term 'Funk Art' was applied to a style which originated with a group of artists in San Francisco, California, during the 1960s. The style was a combination of DADA and POP with a leaning towards neurotic exhibitionism and the macabre. In *Movements in Art since 1945* (1969) Edward Lucie-Smith characterized it as 'a liking for the complex, the sick, the tatty, the bizarre, the shoddy, the vicious, the overtly or covertly sexual, as opposed to the impersonal purity of a great deal of the most recent art'. Artists working in this manner were: Edward KIENHOLZ, Bruce CONNER, whose *Couch* is an assemblage consisting of an apparently dismembered corpse lying on a tatty Victorian sofa (Pasadena Art Mus., 1963), Paul THEK and the Englishman Colin Self.

FUTURISM. As Massimo Carrà says in his Introduction to the catalogue of the Exhibition of Italian Futurism organized by the Northern Arts and the Scottish Arts Council of Great Britain in 1972–3: 'Futurism was an essentially Italian cultural phenomenon, linked to particular historical and intellectual circumstances.' It was in effect the culmination of a series of attempts to break through the spiritual and intellectual stagnation of Italy and to bring about 'the cultural rejuvenation which Italians had impatiently awaited since the mid-nineteenth century, when the nation fought for political independence and unification' (W. W. Martin, *Futurist Art and Theory 1909–1915*, p. xxvii). As such it envisaged both an attack upon the entrenched establishment and a programme of creative reform designed to bring Italy back into the mainstream of European cultural progress. Similar aims inspired the slightly earlier and contemporary movement in Florence led by the philosopher Giovanni Papini in collaboration first with Prezzolini's reviews *Leonardo* and *La Voce* and later with SOFFICI in the review *Lacerba*. In its nationalistic origins Futurism was unlike other revolutionary movements in the arts such as FAUVISM and CUBISM, with both of which it had some features in common. It was unlike them also in that it was not exclusively or primarily concerned with the visual arts, or indeed primarily an aesthetic movement. Its principles were intended to apply not only to the arts but to the whole of life. It was initiated as a movement of literary reform, but it quickly expanded to embrace the other arts—painting and sculpture, architecture, theatre, music and cinema. But because of the high quality of the paintings produced under its aegis and because of its repercussions upon other artistic movements, Futurism, despite its aggressive nationalism and its overweening pretensions, is remembered today as one of the important progressive movements in 20th-c. European visual art.

The instigator and the dominant personality of the movement was the poet and propagandist Filippo Tommaso MARINETTI, whose first Futurist manifesto was published in the Paris newspaper *Le Figaro* on 20 February 1909, and rapidly disseminated in Italy. In bombastically provocative language the manifesto, violently anarchical in tone, announced the birth of a new literary and social movement and called upon the young to flock to the banner. ('The oldest among us are thirty; we have therefore at least ten years to accomplish our task. When we are forty let others, younger and more valiant, throw us into the waste-paper basket like useless manuscripts. We desire it.') The general tone of the manifesto with its exaltation of violence and conflict ('Beauty exists only in struggle') owed much to the influence of Nietzsche, who despite later repudiation had also influenced BOCCIONI and others of the young Futurists, and the passion for movement and change for their own sake derived from Bergson, who at that time enjoyed a vogue among the advanced intelligentsia of Italy. On its negative side the manifesto demanded the repudiation of traditional social values both cultural and political, the liberation of Italy from 'its rotten cancerous tumour of professors, archaeologists, cicerones, and antique dealers'. On its positive side it called on the young to immerse themselves in the dynamism of the modern age, which for Marinetti was symbolized by speed and by the technology of the machine. ('We declare that the world's splendour has been enriched by a new beauty; the beauty of speed. A racing motor car, its frame adorned with great pipes, like snakes with explosive breath . . . a roaring motor car, which seems to run on shrapnel, is more beautiful than the Victory of Samothrace . . .') These ideas were not new. The attacks upon accepted values had their precedents and the intoxication with the dynamism of speed and with the machine was anticipated in Marinetti's own review *Poesia*, in particular by his poems 'Le Démon de la vitesse' (1904) and 'A l'automobile' (1905, later entitled 'A mon Pégase'). But they gained a new force from the exaggerated violence of the language in which they were couched and perhaps also from the aggressively nationalistic tone of the manifesto. They remained the dominant ideas of the movement. Thus in 1913 SEVERINI could write: 'We choose to concentrate our attention on things in motion, because our modern sensibility is particularly qualified to grasp the idea of speed.' Marinetti was beyond all else a gifted impresario of ideas and his exaltation of modernity for its own sake found a ready response in the Italy of his day. In his periodical *Lacerba* Papini wrote: 'Futurism is the proof of our rehabilitation in a progressive, renascent Europe.'

The first painters' manifesto, signed by Boc-

cioni, BALLA, CARRÀ, RUSSOLO and Severini (the first two editions were signed by the Milanese painters Boccioni, Carrà, Russolo, Aroldo Bonzagni (1887–1918) and Romolo Romani (1885–1916)), was dated 11 February 1910, and was read on 8 March by Boccioni from the stage of the Teatro Chiarella, Turin. It was followed on 11 April by a 'Technical Manifesto of Futurist Painting'. The latter appeared under the title 'Le Manifeste des peintres Futuristes' in the Paris journal *Comoedia* on 18 May 1910. The former manifesto was addressed specifically to 'the young painters of Italy'. It exalted originality for its own sake 'even if foolhardy, even if utterly violent' and exhorted young artists 'profoundly to despise all forms of imitation'. Beyond this it reiterated the generalities of Marinetti's manifesto, urging painters to find their inspiration 'from the tangible miracles of contemporary life'. The Technical Manifesto attempted to give a more concrete programme, but the innovatory ideas it advanced did not achieve clarity. Its central theme was 'universal dynamism', the sensation and emotional character of which was to be expressed in paint and rendered 'eternal'. ('The gesture for us will no longer be an arrested moment of universal dynamism: it will be precisely the *dynamic sensation* itself made eternal.') The manifesto took account of the fact that moving objects are multiplied and distorted in perception, persisting in after-images ('On account of the persistence of an image upon the retina, moving objects constantly multiply themselves, they are deformed and succeed each other like vibrations in the space they move through'); the effects of light and movement destroy the material consistency of perceived things, so that they vibrate and interpenetrate; they are not seen in a stable and unified space. What was meant, no doubt, was that the artist should seek means to render in the static medium of paint his perception of things in movement and the emotional sensation of speed and of continual change. The method recommended for doing this was described as *complementarismo congenito* (innate complementarism), a form of DIVISIONISM which apparently meant something more than a painterly technique. In later practice the Futurists borrowed from the Cubists their techniques of interpenetrating planes and the simultaneous presentation of multiple viewpoints. But they used these for the purpose of suggesting movement and change rather than as the Cubists had originally devised them. The manifesto concluded with the claim: 'We are the primitives of a new and completely transformed sensibility.'

Historically Futurism divides into two phases, the first running from its inception in 1909 until its virtual dissolution with the death of Boccioni in 1916 and the second an attempted revival by Marinetti under the Mussolini regime after the First World War. The first phase is the one which has significance for the history of 20th-c. art. It too falls into two stages. The first extends from the first Painters' Manifestos and the exhibition of 50 paintings by the Milanese artists Boccioni, Carrà and Russolo at the 'Esposizione d'Arte Libera' at Milan in 1910 up to the Paris exhibition of 1912. The second stage comprises the theoretical and technical expansion consequent upon the contact with Cubism in 1911–12.

In the first stage the artists were endeavouring to work out a pictorial idiom which would do justice to the grandiloquent formulations of principle put forward in their manifestos. Working with the Divisionist technique of PREVIATI they painted emotionally expressive pictures into which they tried to incorporate the sensations of movement and change. The 'Unanimist' paintings were focused upon the communal existence of city dwellers, expressing collective sentiment and the violence of mass emotion. With a technique reminiscent of that of Seurat, Severini's *Le Boulevard* (*c.* 1910) carries suggestions of crowd movement by its enlarged angle of vision and by simultaneous changes of viewpoint, bringing the observer directly into the centre of the picture in a way which was to become characteristic of Futurist painting. In Boccioni's *Rissa in galleria* (*Riot in the Gallery*) of 1910 the scene of crowd agitation is emphasized by the high viewpoint and the exciting counterpoint of light reflecting from two electric light bulbs. His *Città che sale* (*The Rising City*, The Mus. of Modern Art, New York, 1910–11) has even greater violence of movement. It represents, in the artist's own words, his desire both to embody the 'fatal striving of crowds of workers' and to create 'a great synthesis of work, light and movement'. Carrà's *Uscita da teatro* (*Leaving the Theatre*), 1910–11, and his *Funerali dell'anarchico Galli* (*Funeral of the Anarchist Galli*, The Mus. of Modern Art, New York, 1910–11) also draw the spectator into the midst of a violent scene of mass movement and emotion.

During the same years Russolo was developing the concept of *la pintura degli stati d'animo* (the painting of states of mind) which, treated dynamically, seemed to exemplify the notion of the manifesto that 'universal dynamism' should be revealed as 'dynamic sensation'. While involving a shift from the anecdotal towards the subjective, these paintings also relied for their effect upon 'psychological' perspective and introduced the element of time and change by showing simultaneously different states or aspects of a thing (as in Boccioni's *Lutto* (*Mourning*), where two women are shown from multiple points of view). Russolo's *Profumo* (*Perfume*), 1910, illustrates the interest of the Futurists in the phenomena of synaesthesia, attempting to create a visual correspondence for the sensations of smell and their development in time, while his *La Musica* (1911–12), despite its use of more conventional literary means for suggesting the emotions it evokes, seems to attempt the colour–sound equation which had so interested the Symbolists. Both this and his *Ricordi di una notte* (*Memories of a Night*), 1911, illustrate Bergson's

notion of 'psychic duration' by bringing together in organic pictorial unity memories of events separated in time. Severini's *Souvenirs de voyage* (*Memories of a Journey*), c. 1910, also creates a synthetic unity of temporally disparate memory-images, although the effect is rather that of a montage of recollections than the expression of a unified state of mind. More sophisticated and more successful were his *Le Chat noir* (*The Black Cat*, National Gal. of Canada, Ottawa, 1911) and his *La Danseuse obsédante* (*The Haunting Dancer*), also of 1911. This genre of Futurist painting culminated in Boccioni's three *Stati d'animo: Gli Addii, Quelli che vanno, Quelli che restano* (*States of Mind: The Farewells, Those who Go, Those who Stay*) of 1911. While following the path indicated by Russolo, these paintings also evoke symbolic generalizations of collective sentiments. The synthesis of successive views is illustrated by his *Visioni simultanee*, 1911. Marinetti's obsession with the mechanical speed of the automobile and aeroplane was also reflected in Futurist painting, an example being Russolo's *Treno in velocità* of 1911, in which the rhythm of lights amidst the surrounding darkness suggests the speed of a train at night. This painting curiously suggests both the speed of the lighted train as seen by an observer in the dark landscape and the apparent movement of the lights outside as seen by a passenger in the train.

The Milanese Futurists came indirectly into contact with Cubism in 1911 through an article 'Picasso e Braque' by Soffici in *La Voce* of 24 August and through a visit of Severini to Milan. In the autumn of 1911 Boccioni, Russolo and Carrà visited Paris and in February 1912, 45 Futurist paintings were exhibited at the Gal. Bernheim-Jeune et Cie. The exhibition subsequently travelled to London (Sackville Gal.), Berlin (STURM Gal.), Brussels, Hamburg, Amsterdam, The Hague, Frankfurt, Breslau, Dresden, Zürich, Munich and Vienna. It was everywhere a *succès de scandale*, though the critics were at best lukewarm in their appraisals.

During 1911 the obscure doctrine of 'dynamic sensation' was amplified and developed by the concept of 'lines of force', which was first expounded in the explanatory Introduction to the catalogue for the Bernheim-Jeune exhibition as follows: 'objects reveal in their lines calm or frenzy, sadness or gaiety. These diverse tendencies give to their formative lines a sentiment and a character of weighty stability or of airy lightness. Each object reveals by its lines how it would be decomposed according to the tendencies of its forces. This decomposition is not guided by fixed laws, but varies according to the characteristic personality of the object and the emotion of the one who looks at it. Moreover, each object influences its neighbour, not by reflections of light (the basis of Impressionist primitivism), but by a real concurrence of lines and real conflicts of planes, following the law of the emotion which governs the picture (basis of Futurist primitivism). ... all

objects tend towards infinity by their lines of force, whose continuity is measured by our emotion.' This theory of reproducing the inner life or 'emotion' of objects combined ideas which went back to Seurat with suggestions of Bergson, who had said in his 'Introduction to Metaphysics' (incorporated in Papini's *La Filosofia dell' Intuizione* of 1909): 'Consider the movement of an object in space. My perception of the motion will vary from the point of view, moving or stationary, from which I observe it. My expression of it will vary with the symbols by which I translate it. For this double reason I call such motion relative: in the one case as in the other I am placed outside the object itself. But when I speak of an absolute movement, I am attributing to the moving object an inner life and, so to speak, states of mind. I also imply that I am in sympathy with those states and that I insert myself into them by an effort of imagination.'

Soffici had represented Cubism as an extension of the Impressionist revolution, a more integral projection of perceived reality on to a plane surface. Picasso, he said, 'goes around the objects themselves, considers them poetically from all angles, submits to and renders his successive impressions; in sum shows them in their totality and emotional permanence with the same freedom with which the Impressionists rendered only one side and one moment'. While accepting this, the Futurists attacked the Cubists for their disinterest in the object and their concern for purely pictorial values. In their Exhibition Catalogue they described Cubism as no more than a concealed Academicism. 'Is it not, in fact, a return to the Academy to declare that the subject in painting is absolutely insignificant?' Instead of the still lifes of the Cubists they sought to express through their images and representations the dynamic energies of contemporary life and their enthusiasm for modernity and the machine age. Unlike Cubism too was their desire to bring the spectator into the centre of the picture. 'The desire to intensify the aesthetic emotion consolidating in a manner of speaking the painted canvas with the soul of the spectator causes us to declare that henceforward the latter must be placed at the centre of the picture. He will no longer simply observe but will participate in the action ... The lines of force must envelop the spectator and draw him on so that in a way he is compelled also to fight along with the figures of the picture.'

If the response to their exhibition did not altogether come up to their exaggerated expectations, at least it spurred the artists to a new energy of creation and the years 1912 and 1913 saw some of the finest and most mature work produced within the movement. Boccioni took up sculpture at this time and his *Technical Manifesto of Futurist Sculpture* contains the best exposition of mature Futurist principles as well as foreshadowing ideas which were to be explored much later in the century. In particular his call for 'sculpture of environment'

('Let us open the figure like a window and enclose within itself the environment in which it lives') foretells the 'spatial sculpture' evolved in their several ways by ARCHIPENKO, MOORE and GABO, while his idea of using many different materials in one work has been exploited almost to excess in some trends of more recent sculpture. ('Deny the exclusiveness of one material for the entire construction of a sculptural ensemble. Affirm that even twenty different materials can compete in a single work to effect plastic emotion. Let us enumerate some: glass, wood, cardboard, iron, cement, horsehair, leather, cloth, mirrors, electric lights, etc.') The creation of visual analogues for other sense qualities, which was the theme of Russolo's *Profumo* and *La Musica*, was taken up in Severini's *Hiéroglyphe dynamique du Bal Tabarin* (*Dynamic Hieroglyphic of the Bal Tabarin*) (The Mus. of Modern Art, New York, 1912) and other paintings. Russolo published in 1913 his manifesto *L'arte dei rumori* (*The Art of Noises*) in which, anticipating Stockhausen and John Cage, he advocated a music made up wholly of natural noises. In 1912 also Carlo Carrà in his manifesto *La Pittura dei suoni, rumori, odori* (*The Painting of Sounds, Noises and Smells*), carrying to extremes a number of earlier pronouncements, advocated an art in which a broad range of non-visual sensations were to be evoked by abstract ensembles of colours and forms. ('We Futurist painters affirm that sounds, noises and smells are incorporated into the expression of lines, volumes and colours ... Our canvases will therefore express the plastic equivalents of sounds, noises and smells of the Theatre, Music Hall, cinema, brothels, railway stations, ports, garages, clinics, workshops, etc., etc.') For this the artist had to become 'a vortex of sensations, a pictorial force, and not a cold, logical intellect ... painting sounds, noises and colours the way drunkards sing and vomit'. Meanwhile Balla by his constructs made in a variety of materials incorporating even colour, movement and sound was anticipating certain aspects of later KINETIC sculpture.

During this time the Futurist artists continued to experiment with the synthetic expression of movement in an increasingly Cubistic idiom. But their strongly individualistic personalities carried them further and further apart and by 1914 they could hardly be considered any longer to constitute a coherent aesthetic group. The further history is that of the individual artists rather than that of the group, which lost its main impetus with the outbreak of war. Besides the artists mentioned, who formed the *gruppo dirigente* of the movement, others who subscribed to it or were closely associated with it included: Mario SIRONI, Fortunato DEPERO, the photographer Anton Giulio Bragaglia, and Arnaldo Ginna-Corradini; others, such as Ottone ROSAI, Gerardo DOTTORI, R. Baldessari

(1894–), E. PRAMPOLINI, A. MARTINI, G. Rossi, came to Futurism during or after the war.

In 1916 Marinetti attempted to revive Futurism with Balla taking the lead among a younger group of artists. It was his hope by means of Futurist principles to vivify the official art of the Fascist regime and to bring Italy abreast of modern ideas. But the creative vigour of the movement had spent itself by 1914 and the only new thing to emerge was AEROPITTURA, painting the sensation of flight—and this too had been anticipated by NEVINSON in England. A manifesto of *Aeropittura* was brought out in 1929, the year in which Marinetti accepted membership of Mussolini's *Accademia Italiana*.

Outside Italy, however, the influence of Futurism persisted importantly. Largely owing to the tireless energy of Marinetti as a traveller and lecturer in the years before the war, Futurist ideas made themselves felt in many European countries. His first manifesto was translated into Russian and was a formative influence in the Russian CUBO-FUTURIST school supported by LARIONOV, GONCHAROVA and MALEVICH. The RAYONIST movement had obvious affinities with the Futurist doctrine of 'force lines' and even copied the style of the Futurist manifestos. In Germany Futurism influenced the change of style which the BLAUE REITER artists MARC and MACKE underwent in 1912 and in England there were direct links with VORTICISM and Nevinson. Joseph STELLA was responsible for introducing Futurist principles and practice to America.

Some critics and historians of 20th-c. art have rated the ideas of Futurism and the enthusiasm with which they were held and propagated above the achievements. John Golding, for example, has said that 'it is deeply revealing of the climate which has informed much subsequent art that the modern world has been able to accept Futurism on the grounds of its aesthetic potential rather than on the merits of the artistic artefacts it left behind' (*Boccioni's Unique Forms of Continuity in Space*, Charlton Lecture of 1972). This sort of remark reflects the perhaps excusably lukewarm reaction of Paris critics such as APOLLINAIRE when they were first confronted with the paintings of the Futurist artists at the 1912 exhibition and illustrates the unfortunate way in which a critical appraisal once made is apt to be self-perpetuating. When the best works of the Futurists are assembled, as in the 1961 exhibition at The Mus. of Modern Art, New York, and the exhibition 'Futurismo 1909–1919' staged at the Royal Academy, London, in 1973, they are in no need of the support of manifestos or theory to arrogate for themselves a position in the artistic hierarchy at least equivalent to that of the FAUVISTS, the BRÜCKE, the *Blaue Reiter*, De STIJL, Rayonism or Vorticism. See also BOCCIONI.

G

G. The title—'G' stands for *Gestaltung* (Formation)—of a magazine founded by Hans RICHTER in 1923 with the intention of making it 'the organ of Constructivists in Europe'. The first number contained a seminal article by Van DOES-BURG entitled 'Elemental Formation'. He distinguished two opposing modes of expression. The art of the past, which he called 'decorative', depended on individual taste and intuition. In contrast to this the art of the present (by which he meant CONSTRUCTIVISM) he called 'monumental' or 'formative'. He claimed that Constructivist art is no longer impulsive or intuitional but composition in accordance with objective aesthetic principles and that the Constructivist has 'conscious control of his elemental means of expression'.

GABO, NAUM (NAUM NEEMIA PEVSNER, 1890–1977). Russian-American sculptor, born at Briansk, brother of Antoine PEVSNER. While studying medicine and natural sciences at the University of Munich, then engineering at the polytechnium school, he attended the lectures of Heinrich Wölf-flin on the history of art. In 1913 and 1914 he visited Paris and was introduced to *avant-garde* art by his brother Antoine, who was painting there. On the outbreak of war he went to Copenhagen, Stockholm and then Oslo, where he made his first constructions, using the name Gabo, in a manner combining features of CUBISM with geometrical abstraction which foreshadowed later European CONSTRUCTIVISM. In 1917 he returned to Russia with his brother Antoine and in 1920 they issued their famous *Realistic Manifesto*, which set forth the basic principles of European Constructivism as opposed to the so-called 'Productionist' group led by TATLIN. While in Russia Gabo held his first open-air exhibition on Tverskoi Boulevard, Moscow, produced a project for a radio station at Serpuchov, and made his first kinetic works operated by motor. When it became clear that official policy favoured the Tatlin group and the regimentation of artistic activity in the direction of industrial design and socially useful work, he left Russia for Berlin in 1922 and spent the next 10 years there. During these years he showed in the Erste Russische Kunstausstellung organized by the Soviet Government at the Gal. van Diemen, Berlin, in 1922, exhibited with Pevsner at the Gal. Percier, Paris, in 1924, had his first exhibition in America, with Van DOESBURG and Pevsner, at the Little Review Gal., New York, in 1926, and had his first one-man exhibition of constructions at the

Kestner-Gesellschaft, Hanover, in 1930. His main projects were: *Project for a Monument for an Observatory* (1922); *Project for a Monument for an Airport* (1924–5); *Project for a Monument for the Institute of Physics and Mathematics* (1925); designs for DIAG-HILEV's ballet *La Chatte* (1926); project for a *Fête Lumière* for the Brandenburg Gate, Berlin (1929); project for the Palace of the Soviets (1931).

In 1932 he moved to Paris and was active in the ABSTRACTION-CRÉATION association until 1935, when he went to England and remained there until 1946. In 1936 he participated in the exhibition 'Abstract and Concrete' at the Lefèvre Gal., London, exhibited with Pevsner at the Chicago Arts Club and had seven works included in the exhibition 'Cubism and Abstract Art' at The Mus. of Modern Art, New York. During his stay in England Gabo had a one-man exhibition at the London Gal. in 1938 and in the same year visited the U.S.A. In 1937 he was co-editor of CIRCLE with Ben NICHOLSON and J. L. Martin and in 1944 became a member of Design Research Unit, London.

In 1946 Gabo went to the U.S.A. and became an American citizen in 1952. In 1953–4 he was Professor at Harvard University Graduate School of Architecture and he was awarded a Guggenheim Fellowship in 1954. He was elected a member of the Institute of the American Academy of Arts and Letters in 1965, awarded an Honorary Doctorate at the Royal College of Art, London, in 1967 and awarded the Honorary K.B.E. in 1971. Among his most important commissions in these years were a construction for the Baltimore Mus. of Art (1951), sculpture for the Bijenkorf Building, Rotterdam (1955), relief for the U.S. Rubber Company, Rockefeller Center, New York (1956), fountain at St. Thomas's Hospital, London (1970–5), sculpture for the Nationalgal., Berlin (1973). In 1955–6 he had a retrospective exhibition at the Stedelijk Mus., Amsterdam, shown also at Mannheim, Duisburg, Zürich, Stockholm and the Tate Gal., a travelling exhibition in 1970–2 and a retrospective exhibition of drawings and models at the Tate Gal. in 1976.

Gabo never trained as an artist but came to art by way of his studies of engineering and physical science and was one of the first artists to embody in his work modern concepts of the nature of space. As one of the founders of Constructivism his ideas were set forth in his *Realistic Manifesto* and his aesthetics was further expounded in relation to the older Russian tradition in his A. W.

Mellon Lectures of 1959, published as *Of Divers Arts*. In his work he developed a number of themes over years and decades, such as *Spheric Theme, Spiral Theme, Column, Torsion*, etc. He was one of the earliest to experiment with KINETIC sculpture and to make extensive and serious use of semi-transparent materials for a type of abstract sculpture which with apparent weightlessness incorporates space as a positive element rather than displacing space or enclosing it. He was throughout his life an advocate of the Constructivist idea not merely as an artistic movement but as the ideology of a life style.

GAGNON, CLARENCE. See CANADA.

GAÏTIS, YANNIS (1923–). Greek painter born and studied in Athens. From 1954 he spent most of his time in Paris. He was influenced by the TACHISM of the ÉCOLE DE PARIS and painted in a manner of expressive abstraction incorporating occasional childlike caricatures of the human figure.

GALLARD, MICHEL DE. See HOMME-TÉMOIN.

GALLÉN-KALLELA, AKSEL (1865–1931). Finnish painter and graphic artist born at Pori. After studying in Helsinki he worked in Paris under Bouguereau and Bastien-Lepage, 1884–90, and he was for a time associated with the EXPRESSIONIST group, the BRÜCKE. His style developed through French Symbolism and ART NOUVEAU to a distinctive manner of expressive naturalism. He is chiefly known for his romantic illustrations, done in the 1920s, for the Finnish national epic *Kalevala*. He also painted a number of murals for public buildings and his designs for stained glass, fabrics and jewellery gave an important stimulus to the development of Finnish crafts. In all its ramifications his work manifested strong leanings towards Finnish folklore and nationalism.

GALLÍ, JORDI. See SPAIN.

GALLO, FRANK (1933–). American sculptor, born at Toledo, Ohio, studied at Toledo University and the University of Iowa. From 1960 he taught in the University of Illinois. He had numerous one-man exhibitions from the 1960s and was represented in international exhibitions including 'Young America', Whitney Mus. of American Art, 1965; Toronto International Sculpture Symposium, 1967; Venice Biennale, 1968. He belonged to the category of POP artists and specialized in life-like and often life-size figures or tableaux in coloured epoxy or similar materials. These were based upon shop-window dummies or pin-up girls but were rendered highly sensuous and erotic, the tactile quality of the material being employed to create an illusion of flesh surface and the erotic forms being emphasized by darker incised lines. His work is in a number of public collections,

including The Mus. of Modern Art, New York; Cleveland Mus. of Art; Chicago Art Institute; Los Angeles County Mus. of Art; National Gal., Melbourne, etc.

GARAFULIC, LILI. See LATIN AMERICA.

GARCÍA OCHOA, LUIS (1920–). Spanish painter, born at San Sebastian. He began but did not complete studies in architecture and the fine arts in Madrid. In 1954 he was awarded a prize by the San Sebastian City Council and in 1959 a Gold Medal at Córdoba. In the same year he received scholarships from the French and Spanish states to study in Paris, Milan and London. In 1965 he received a stipend from the Juan March Foundation and won a Grand Prize at the Alexandria Biennale and a Grand Prize for Basque painting. In his early period he was a member of the Madrid school of expressive landscape but later gravitated towards an art of critical realism with overtones of social comment and satire.

GARCÍA ORTEGA, JOSÉ (1921–). Spanish painter, born at Arroba de los Montes, Ciudad Real. He was self-taught as an artist. He was a painter of SOCIAL REALISM and social comment and a key figure in the *Grupos de Estampa Popular* movement, recruiting artists and engravers to adopt in their work an attitude of combative social protest. Owing to his political activities he had to leave Spain and live in France during the 1960s.

GARCÍA RAMOS, PEDRO ANTONIO. See SPAIN.

GARCÍA-ROSSI, HORACIO (1929–). Experimental and OP artist born at Buenos Aires, Argentina, and working in Paris. He was a member of the NOUVELLE TENDANCE amd the GROUPE DE RECHERCHE D'ART VISUEL (GRAV). In his method of approach he adopted a scientific attitude, like that of LE PARC, and tried to eliminate subjective effects. He was best known for *Boîtes Lumineuses à manipuler*, perforated metal cylinders from which light is refracted by translucent plexiglass rods, varying as the box is moved by the viewer.

GARGALLO, PABLO (1881–1934). Spanish sculptor, born at Maella, near Catalonia. He began to model in clay while still a boy and was trained at the Barcelona Academy of Art in the ART NOUVEAU manner. In 1903 he spent six months in Paris after winning a scholarship, but owing to the death of his father was compelled to return to Spain and support his family by working for commercial architects. In 1911 he was again in Paris, where he became an intimate of MODIGLIANI, Juan GRIS and the group of CUBISTS. It was then that he matured the highly original technique which established his importance in the progress of 20th-c. sculpture. Building upon the Spanish traditions of

fine metalcraft, he began to compose masks from thin sheets of iron and copper, hammered, twisted, cut and fitted together, evolving a new mode of plastic expression which had considerable and growing influence in expanding the sculptural idiom of later decades. With extreme economy of means he was able to suggest volume while giving little relief to his thin sheets of metal. He was one of the first to practise the transposition of a convex into a concave surface and he was also, in his later work, one of the first to give positive significance to enclosed space in a sculptural work. In his use of space and in his method of creating an illusion of volume by the subtle interplay of concave and convex surfaces his style has affinities with those of ARCHIPENKO and Julio GONZÁLEZ. Retrospective exhibitions of Gargallo's work were held at the Mus. de Arte Contemporaneo, Madrid, and the Salon d'Automne, Paris, in 1935; at the Petit Palais, Paris, in 1947; and at the Venice Biennale in 1955.

GARRIDO, LUIS. See SPAIN.

GATCH, LEE (1902–68). American painter born at Baltimore, studied at the Maryland Institute and then at the Académie Moderne, Paris, under LHOTE and KISLING. His first one-man show was at J. B. Neumann's New Art Circle, New York, in 1927 and he continued to exhibit both individually and in collective shows until his death. A retrospective exhibition of his work was put on by the Whitney Mus. of American Art in 1960. His commissions included murals for U.S. Post Offices, e.g. at Elizabethtown, Pa. During the 1930s Gatch went his own way and, like Milton AVERY, found a new approach to painting the figure, reducing it to rhythmic patterns of flat colour in a style analogous to the post-FAUVIST period of MATISSE. At this time he often experimented with compositions in different hues of a single colour. Essentially abstractions from nature, Gatch's paintings manifested an interest in symbolism—symbols with a religious connotation became frequent in his later period—and at the same time in formal relations and texture. His formal compositions were often based on sweeping curvilinear shapes contrasted with rectilinear forms placed diagonally on the canvas.

GAUDIER-BRZESKA, HENRI (HENRI GAUDIER, 1891–1915). French sculptor, born at St. Jean de Braye, near Orleans. In 1910 he started to work as a sculptor in Paris and met the Polish-born Sophie Brzeska, with whom he lived from that time, both of them using the hyphenated name. In 1911 they went to London, which Gaudier had visited briefly in 1906 and 1908, and lived for a while in extreme poverty. In 1912 he met Katherine Mansfield and John Middleton Murry through Haldane MacFall. In the following year he made friends with Frank Harris, Horace BRODZKY, Alfred Wolmark, Wyndham LEWIS, and

through them came into contact with Ezra Pound and Jacob EPSTEIN. Through Nina Hammett he met Roger FRY and exhibited five sculptures at the Grafton Group exhibition organized by Fry at the Alpine Club in 1914. In March 1914 he contributed to the first LONDON GROUP exhibition as a founding member and to the 'Twentieth Century Art' exhibition held at the Whitechapel Art Gal. He signed the VORTICIST Manifesto in the first number of BLAST, contributing an essay and illustration to both numbers. He exhibited in the Vorticist exhibition of 1915. In 1914 he enlisted in the French army and was killed at Neuville-Saint-Vaast in 1915. A memorial exhibition was held in 1918 at the Leicester Gals.

Gaudier developed with astonishing rapidity from a modelling style based upon Rodin towards a highly personal manner of carving in which he anticipated formal innovations which were common to Epstein and others. He evolved modes of abstraction which were in advance of his time. In his lifetime his work was appreciated by the few connoisseurs, but since his death it has come to be widely recognized that had he not died when his work was immature and still in the formative stage, he might well have become one of the greatest sculptors of the century. His works may be found in the Tate Gal. (*The Dancer*, 1913; *The Red Stone Dancer*, 1913; *Ornament*, 1914), the Mus. National d'Art Moderne, Paris, The Mus. of Modern Art, New York (*Birds Erect*, 1914), the Mus. of Fine Arts, Boston, the Kunsthalle, Bielefeld, and elsewhere.

GAUL, WINFRED (1928–). German painter, born in Düsseldorf and studied at the Academy of Art, Stuttgart, under Willi BAUMEISTER. In the latter half of the 1950s he painted 'informal' pictures in the TACHIST manner, which he described as 'imaginary landscapes'. He exhibited at the DOCUMENTA exhibition, Kassel, in 1959, and lectured at the Kunstschule, Bremen, in 1964–5. He was also a visiting lecturer at Bath in 1965 and at Hull in 1966. At the beginning of the 1960s he became interested in the traffic sign as a symbol of modern city life and his 'signal' paintings and constructs have been widely exhibited in Europe and America since 1962. He had a large one-man exhibition at the Palais des Beaux-Arts, Brussels, in 1967. In 'The Place of Painting in a Technological Society' he wrote: 'As art has primarily to do with the norm, even if it attacks or exposes it, traffic signs and signals seem to me to be especially suitable for an art which is concerned with communication. Whereas pop art and "happenings" are happy only to imitate reality, to mirror real situations and thus to expose their commercialisation, I penetrate the waste landscapes of the barren cities. My "signals" are the hieroglyphics of a new urban art. They usurp the banality of the jargon of their originals to form a new language of a new, cool and unexploited beauty. Their aesthetic is a new dimension, of harsh colours and gigantic shapes,

an art whose place is amongst skyscrapers and industrial buildings, on the intersections of motorways, flooded by traffic.'

GAŽI, DRAGAN (1930–). Yugoslav naïve painter, born in Hlebine. He showed an interest in drawing and painting from his schooldays and in 1947 was taught perspective by the academic painter Krsto HEGEDUŠIĆ. He retained, however, the characteristics of a naïve artist and was a member of the Hlebine school. (See NAÏVE ART.) He was distinguished by a gift for portraiture, depicting his figures with exaggerated dimensions out of proportion to their surroundings. A fine example of his style is his *Firewood Gatherer* (Frankfurt, 1962). He had his first exhibition in Zagreb in 1952, since when his work has been shown in many European countries including Russia.

GECELLI, JOHANNES (1925–). German painter born at Königsberg. After war service he studied at the Academy of Art, Düsseldorf, from 1947 to 1951. He visited England in 1949 and France in 1955. In 1960 he was awarded the Villa Romana prize, Florence, and in 1963 the Ruhr prize. In 1965 he was appointed to the teaching staff of the Hochschule für Bildende Künste, Berlin. He had one-man exhibitions in a number of German towns, including Cologne, Mannheim, Nuremberg, Heidelberg, and he was represented in a number of important collective exhibitions of German art. His figures and still lifes were executed with extreme simplicity of artistic means, at first in finely modulated monochrome though later he made more use of contrasting colour. Shadowy shapes seem to emerge out of a background from which they are barely distinguishable while at the same time suggesting the dynamic postures of movement.

GEIGER, RUPPRECHT (1908–). German painter born in Munich, where he studied architecture from 1928 to 1932 and practised it until 1939. He began to paint without formal training in 1945 and in 1949 became a member of the ZEN group. His work was exhibited widely in Germany and also in Italy, Paris, Switzerland and Vienna. From 1965 he taught at the Academy of Art, Düsseldorf. He was a COLOUR FIELD painter and was the first artist in Germany to investigate the spatial potentialities of pure colour after the First World War.

GEITLINGER, ERNST (1895–1972). German painter born at Frankfurt. He studied in America, 1913–29, and later at Munich. In 1947 he became a founding member of the Munich *Neue Gruppe* and he taught at the Munich Academy, 1951–64. During the 1940s Geitlinger's paintings had a fairy-tale quality reminiscent of CHAGALL and some aspects of KLEE with something of the

naïvety of children's drawings. In the 1950s he turned to abstract work.

GENERALIĆ, IVAN (1914–). Yugoslav naïve painter, born in the Croatian village of Hlebine (see NAÏVE ART). He displayed an interest in drawing from early childhood and as a boy he used to carry with him paper and pencil while herding pigs in order to make rapid sketches of anything which attracted his attention. In 1930, after contact with the painter Krsto HEGEDUŠIĆ and members of the ZEMLJA group from Zagreb, he took the initiative in forming the Hlebine group of peasant painters, of which he himself remained the central and most important figure. He painted in water-colour, in oils on canvas and most particularly in oils behind glass, a technique which he perfected. His repertory was extremely catholic, his favourite themes being scenes from village life, celebrations, festivals, etc., landscapes, still lifes in a landscape, figures and portraits. While some of his pictures are quiet and almost idyllic depictions of peasant activities, in others there is an element of grotesque fantasy reminiscent of Bruegel or Hieronymus Bosch while still others have a SURREALIST air of the unexpected, such as *The Fish* (oil behind glass, 1963), in which an enormous fish floats hooked in the air above a peaceful landscape featuring an angler with his rod beside a village stream. A number of his pictures feature a flamboyant rooster, which seems to have had a private symbolism for him. Outstanding among his cycle of rooster paintings is *Crucified Rooster* (1964), while the intrusive bird appears even in his great painting *The Death of my Friend Virius* (1959). Generalić had all the identifying marks of a genuine naïve painter and despite his occasional contacts with orthodox and historic art, he always remained so. Of peasant stock, he continued to live the life of a peasant even after the 'painting village' of Hlebine was attracting visitors from all over the world, and after he himself had won world-wide reputation as one of the greatest of naïve painters he continued to paint only in his spare time.

He first exhibited with the *Zemlja* group in 1931 and his first one-man show was in the Salon Ulrich, Zagreb, in 1938. Since the war, as his fame has spread, his pictures have been shown in most of the major countries of the world.

GENERALIĆ, JOSIP (1936–). Yugoslav NAÏVE painter, son of the foregoing. Born in Hlebine, he attended primary and secondary school there from 1943 to 1951, then taught drawing in Virje. He was drawing teacher at the primary school in Hlebine, 1957–9, then studied in Zagreb, training to be a sports teacher, while at the same time taking instruction in painting at the Academy. Taught by his father, Josip remained stylistically a naïve painter and was among the most prominent artists of the second generation in the school of Hlebine. Yet he was no longer a peasant and his attitude to nature was less direct than that of Ivan. He had all

his father's love for minute detail but lacked the occasional fantasy and brooding melancholy which distinguished his father's work; his own work was at once less profound and more decorative. He exhibited at Bilece, Herzegovina, from 1956 and had his first one-man show in Koprivnica in 1959. Since that time his work has become more widely known and he has been exhibited in many countries both with his father and alone.

GENERATIVE ART. A form of geometrical abstraction in which a basic element is made to 'generate' other forms by rotation, etc. of the initial form in such a way as to give rise to an intricate design as the new forms touch each other, overlap, recede or advance with complicated variations. A lecture on 'Generative Art Forms' was given at the Queen's University, Belfast Festival in 1972 by the Romanian sculptor NEAGU, who also founded a Generative Art Group. Generative art was also practised among others by Eduardo MCENTYRE and Miguel Ángel Vidal (1928–) in the Argentine.

GENOVÉS, JUAN (1930–). Spanish painter and graphic artist, born at Valencia. He studied at the School of Fine Arts, Valencia, and afterwards settled in Madrid. He was represented at the Venice Biennale and at the São Paulo Bienale of 1967. He was also exhibited by the Marlborough Gal., London, in 1967. Genovés had a highly individualistic style making use of undetailed silhouettes to depict ant-like crowds of human beings, symbolizing the brutal use of power and the terror of the oppressed fleeing before it. Unusual use of space and perspective give his paintings a suggestive and quasi-metaphysical rather than a crudely realistic character. It has been said that 'Genovés has created a unique expression: a generalised political art'. Typical of his work is the *Silencio, Silencio* portfolio of 1970. He also adapted the photographic image for these effects, using it quite differently from the American and British POP artists. The collections in which his works are represented include The Mus. of Modern Art and the Solomon R. Guggenheim Mus., New York, the Art Institute, Chicago, the National Gal., Rome, the Museums of Modern Art in Barcelona and Rio de Janeiro, the Centre National d'Art Contemporain, Paris.

GENTIL, VICTOR (1919–). Belgian sculptor and experimental artist born at Ilfracombe, England, and studied at the Academy of Art, Antwerp. After passing through an EXPRESSIONIST and a SURREALIST phase he turned to abstraction and took up ASSEMBLAGE in the mid 1950s. He was best known for his assemblages structured from diverse materials and components of furniture, musical instruments, etc. He exhibited at the Tokyo Biennale in 1963 and the Venice Biennale in 1964. He had one-man exhibitions at the Gal. Bonino, New York, the Kunsthalle, Basle, in 1966 and the Hamilton Gal., London, in 1967.

GEOFFREY, IQBAL (1939–). Pakistani painter, born at Chiniot, West Pakistan. He was called to the Bar at the age of 20. In 1960 he settled in England and devoted himself full time to painting. He had a number of one-man exhibitions in London and participated in mixed exhibitions, including 'Commonwealth Art Today', at the Commonwealth Institute in 1962–3. Among other collections his works are represented in those of the Tate Gal. and the Arts Council of Great Britain. In 1962 he was awarded a fellowship at the Huntington Hartford Foundation.

GERMANY. At the beginning of the century German art lacked a coherent and continuous tradition, and perhaps in consequence of this was extremely susceptible to outside influences. The most important of these were the medieval woodcut, ART NOUVEAU in its guise of *Jugendstil*, and French Symbolism, FAUVISM and CUBISM. Some artists were also alive to the exotic appeal of African and Indonesian art. Among individual artists Van Gogh, MUNCH and HODLER made the strongest impact on innovative movements in Germany. Moreover, owing to the protracted political fragmentation, Berlin was not so dominating a cultural centre in Germany as Paris in France and German artistic development proceeded much longer on a regional basis.

In the last decade of the 19th c. the most advanced movement in art was *Naturlyrismus*, the lyrical expression of nature, which combined a typically German mixture of sentimentalism and genuine emotional attachment to nature with stylistic influences from Millet, Böcklin and the Barbizon school. Its main centres were at the villages of Dachau, near Munich, and Worpswede, near Bremen. The artists from both centres exploited the expressive power of colour and line and thus prepared the way for later German EXPRESSIONISM. The one artist of European stature to emerge from this movement was Paula MODERSOHN-BECKER who, after being trained in the aesthetic of Worpswede, came under the influence of the POST-IMPRESSIONISTS Gauguin and Cézanne and developed a personal style of proto-Expressionism.

Impressionism came to Germany *c.* 1900 and fostered by the Berlin SECESSION continued to be the style most accredited by the establishment until the First World War. Its most prominent practitioners were Max LIEBERMANN, Max SLEVOGT and Lovis CORINTH.

Art Nouveau reached Germany about the turn of the century under the name *Jugendstil*, coinciding with a new interest in the industrial arts. Its main centre was in Munich, where it was regarded as the style of the *avant-garde*. It also established itself slightly later in Vienna, where the most prominent exponent was Gustav KLIMT.

The movement most typical of German art in the present century has been Expressionism. Its most important manifestations were the BRÜCKE, which was established at Dresden in 1905, and the

BLAUE REITER, which originated in 1911 under the leadership of the Russian KANDINSKY as a splinter group separating off from the Munich NEUE KÜNSTLERVEREINIGUNG. Although German Expressionism was formally declared to be dead by the early 1920s, the stylistic spirit of the movement survived to influence German art until after the mid century.

The most important rallying point for German art in the years from 1912 was the gallery Der STURM opened in Berlin by Herwarth Walden in association with his magazine of the same name.

During the 1920s the movement which held the stage in Germany was that known as the NEUE SACHLICHKEIT (New Objectivity), a realistic art of social satire and caricature. Its chief exponents were George GROSZ and Otto DIX. Max BECKMANN, who came to prominence at this time and was considered to be the most original representative of the German spirit in art, was loosely associated with the movement.

From 1919 to 1933 the BAUHAUS, founded by GROPIUS, was the nucleus for geometrical abstraction, functionalism, CONSTRUCTIVISM and the machine aesthetic. Among the German artists associated with it were Josef ALBERS, Gerhard MARCKS and Oskar SCHLEMMER. Also among its teachers were the Russian-born Kandinsky, the Swiss-born Paul KLEE, the American-born Lyonel FEININGER and the Hungarian-born MOHOLY-NAGY. After the dissolution of the Bauhaus in 1933 the National Socialist regime proscribed all innovative art in Germany as DEGENERATE and fostered in its place an Academy-type art which did not outlast the regime.

Since the end of the Second World War there has been considerable artistic activity in Germany, much of it politically oriented or tending in the direction of CONCEPTUAL ART, and there have been a number of small associations such as ZERO of Düsseldorf and ZEBRA of Hamburg. But there has been no large-scale artistic movement of German origin.

Throughout the century a number of prominent German artists have lived and worked abroad. Notable among them are Max ERNST among the SURREALISTS, WOLS and Hans HARTUNG among the TACHISTS and Josef Albers among the geometrical abstractionists.

Because of the break in development caused by the National Socialist regime the new start made after 1945 was even more radical in Germany than elsewhere. The link between the post-war generation and the past was furnished by a small number of isolated figures who did not constitute a movement: Willi BAUMEISTER, Ernst Wilhelm NAY, Hans UHLMANN, Theodor WERNER, Fritz WINTER and, most solitary of all, Julius BISSIER, who introduced a link with the Far East. Initially the post-war artists were influenced by ABSTRACT EXPRESSIONISM and ART INFORMEL, particularly the work of Wols and Hartung, and they experimented with the techniques of AUTOMATISM and improvisation.

Prominent among them were Karl Otto GÖTZ and Bernard SCHULTZE. Others working in this style were SONDERBORG, Gerhard HOEHME, Emil SCHUMACHER, Hans TRIER, Peter BRÜNING. The pictorial use of lettering or signs was exploited by such artists as Winfred GAUL, Ferdinand KRIWET and H. A. P. GRIESHABER, and Heinz TRÖKES among others explored the expressive uses of Oriental calligraphy.

KINETICISM and the use of light were the subject of experiment by the Düsseldorf artists who formed the Zero group in 1957. A late revival of SURREALISM was introduced by the work of Paul WUNDERLICH, Richard OELZE, Horst JANSSEN and URSULA, while HUNDERTWASSER has sometimes been thought to show Surrealist affinities, although his style developed rather into a crude and clamant Expressionism. POP ART came late to Germany and did not establish itself there, although there were several artists whose works were sometimes claimed to display affinities with Pop in some of its aspects. Among these were Wolf VOSTELL, Gerd RICHTER, Karl Georg PFAHLER, Konrad KLAPHECK, Arnold LEISSLER, Winfred Gaul, H. P. ALVERMANN. Pfahler and Gaul, as well as Alexei Iljitsch BASCHLAKOW and Lothar QUINTE, developed a mechanical and impersonal facture which had something in common with POST-PAINTERLY ABSTRACTION in America.

In sculpture also German artists went along with the main trends outside and had little concern for continuity. Hans Uhlmann pioneered iron and steel sculpture in Germany, abandoning his earlier suggestions of spider-like figures for mathematically based CONSTRUCTIVIST abstractions. He was followed by Norbert KRICKE, with his sculptures of wire and steel rods, and by Brigitte MEIER-DENNINGHOFF, who after working with Henry MOORE and Antoine PEVSNER began about the mid 1950s to make sculptures of winding vertical planes built up from steel rods. Friedrich WERTHMANN combined rods and strips into open, waving, insect-like structures, Jochen HILTMANN explored the natural formations of cast steel, while Erich HAUSER welded steel plates into expressive constructions. Kinetic sculpture was practised by Harry KRAMER and Günther HAESE as well as by members of the Zero group.

The centre of stone carving was the Symposion europäischer Bildhauer in Berlin, which included Gerston FEHRENBACH, Utz KAMPMANN and Otto Herbert HAJEK. Lothar FISCHER, one of the founding members of the SPUR group, worked mainly in terracotta, while Horst Egon KALINOWSKI invented the leather-covered wood and iron constructions which he called 'caissons'.

In painting and in sculpture German artistic production in the post-war period has been notable for its diversity, as though each artist strove to find some new gadget or gimmick which would be his alone.

GERNEZ, P.-F. See FRANCE.

GERSTL, RICHARD (1883–1908). Austrian painter born in Vienna and studied at the Academy there. His early painting was in the style of the Vienna SECESSION, the Austrian *Jugendstil*, and was influenced by the decorative linearism of KLIMT. By 1905 he had advanced towards a personal style of EXPRESSIONISM and was also doing portraits, including two groups of the Schoenberg family, remarkable for their psychological insight. He committed suicide before his individual style could fully mature and his work remained little known until the 1930s.

GERSTNER, KARL (1930–). Swiss painter and designer, born in Basle. He was trained in advertising art and ran an advertising business there. He continued and developed the CONCRETE art of Max BILL and in 1954 published a book *Kalte Kunst* (see COLD ART) in which he advocated the use of sequential systems with little or no concession to traditional aesthetic notions of balance, harmony, composition, etc. With LOHSE he helped to extend Max Bill's idea of mathematical programming into the realm of colour and in 1964 he published *Programme Entwerfen*, a theoretical study of programmatic art. Among his ideas were the production of *multiple* works and *modular* composition, that is works composed of units capable of being put together in a variety of ways (sometimes called GENERATIVE ART). He was also one of the principal advocates of spectator participation and in the preface to an exhibition of the NOUVELLE TENDANCE group in 1964 he declared: 'Our aim is to make you a partner . . . our art depends on your active participation. What we are trying to achieve is for your joy before the work of art, that it may be no longer that of an admirer but of a partner.'

GERTLER, MARK (1891–1939). British painter born in London of a family of Jewish immigrants from Przemysl, Poland. In 1893 the family returned to Przemysl, where Mark passed his early years. Back in London in 1893, he grew up in the impoverished conditions which prevailed among the Jewish immigrant community of Whitechapel. He was obsessed with drawing and painting from childhood and when in 1906 he determined on the career of painter he knew nothing of art beyond the work of pavement artists and had not been inside a gallery. He studied at the Regent Street Polytechnic and afterwards, with the help of Sir William ROTHENSTEIN and the Jewish Educational Society, at the Slade School of Art, where his outstanding talent was early recognized. There he became a friend of NEVINSON, WADSWORTH and Adrian Allinson. In 1911 his painting *The Apple Woman* was accepted for exhibition by the NEW ENGLISH ART CLUB and he was elected a member of the Club in 1912. In 1912 also he had a joint exhibition with John Currie, a close friend, at the Chenil Gal. and in 1914 he was included in the Whitechapel Art Gal. exhibition 'Twentieth Century Art'. In 1915 he was elected a member of the

LONDON GROUP. Through Currie he met the collector Edward Marsh, who became a friend and patron and for some years helped him financially with a small allowance. Gilbert Cannan, a member of Marsh's circle, became a friend and made him the hero of his popular novel *Mendel*. While staying with Cannan at Cholesbury he got to know Katherine Mansfield and Middleton Murry and Frieda and D. H. Lawrence. Lawrence made him the model for the sculptor Loerke in his novel *Women in Love*. In 1917–18 he attracted the attention of Roger FRY, who encouraged him and helped him to participate in exhibitions he organized. In a letter to Vanessa BELL Fry said: 'Except for Gertler we are fearfully tasteful.'

After showing symptoms of depression and discouragement Gertler collapsed from tuberculosis in 1920, the year of his first one-man show at the Goupil Gal. Although apparently cured of tuberculosis, he continued a constant battle against financial stringency, although from 1921 to 1932 he received a small income first from the Goupil and then from the Leicester Gal. He was obsessed by family difficulties, illness and recurrent attacks of depression and discouragement. He committed suicide in 1939.

From his student days Gertler impressed all who knew him by his talent, his capacity for hard work and his utter devotion to his art. The word 'genius' was frequently applied to him. In a letter to Rupert Brooke Edward Marsh said: 'I've made friends with Gertler and Currie—especially Gertler, who I see a great deal of and think the greatest genius of the age.' During his early period he painted subjects from the Jewish environment of Whitechapel, including many portraits of his mother, Golda, in a style of strong and sensitive naturalism, which is illustrated by *The Artist's Mother* (Tate Gal.), *A Jewish Family* (Tate Gal.), *The Artist's Mother* (Swansea), *The Rabbi and his Grandchild* (Southampton). The pencil portrait of his mother in the Tate Gal. is adequate to explain why he was considered the finest draughtsman since Augustus JOHN. Gertler was in the van of the progressive painting which followed Roger Fry's Post-Impressionist exhibitions in London. But he was suspicious of 'movements' and did not ally himself with the abstractionist tendencies of the VORTICISTS. The nearest he came to this was his controversial painting *The Merry-go-Round* (Ben Uri Gal., 1916), of which D. H. Lawrence wrote: 'It is the best *modern* picture I have ever seen: I think it is great and true. But it is horrible and terrifying . . .' During the 1920s he painted chiefly one-figure compositions and still lifes. Among the loveliest of his pictures of women are *The Servant Girl* (Tate Gal., 1923) and *Young Girlhood—II* (Ashmolean Mus., Oxford, 1925). He loved to collect objects in his studio—Victoriana, baskets of fruit, wooden dolls, etc.—and he built still lifes from them, often using the same objects again and again. Of *The Basket of Fruit* (Tate Gal., 1925) he wrote to T. Balston: 'You have the best Still Life I've done.'

In the 1930s he changed his way of composing his pictures once again, giving more prominence to pattern and structure and making a completely individualistic use of things he had absorbed from DERAIN and MATISSE. Examples from this period are: *The Song* (New Grafton coll., 1932), *The Mandolinist* (Tate Gal., 1934), *The Bride* (1937) and *Spanish Fan* (1938). The pictures of these years, in which Gertler was most distrustful of his own powers, although lacking the spontaneity of his earlier work, are masterpieces in their own right and in them he came nearest to his persistent aim of finding 'the eternal and unchanging' in the world of appearances.

After Gertler's death there were a number of exhibitions of his work, including a large Memorial Exhibition at the Whitechapel Art Gal. in 1939. It was not until the 1960s that the outstanding quality of his achievement began to be generally recognized among museum directors and collectors.

GERZSO, GUNTHER. See LATIN AMERICA.

GESTURAL PAINTING. A near synonym of ACTION PAINTING, but used more generally and not envisaging a specific school of American painting. The term carries an implication not only that a picture is the record of the artist's actions in the process of painting it but that the recorded actions express the artist's emotions just as in other walks of life gestures express a person's feelings. The name 'gestural' is applied particularly to painting in which the visible sweep and manner of applying pigment has been deliberately emphasized. It has sometimes been used as a synonym for ART INFORMEL or TACHISM.

GHEZZI, ANTONIO. See CORRENTE.

GHIKA, NIKOLAS HADJIKYRIAKOS (1906–). Greek painter and graphic artist, born in Athens. In 1922 he enrolled at the Sorbonne to study French and Greek literature but gave most of his time to the study of painting and engraving at the Académie Ransom under BISSIÈRE. He exhibited at the Salon des Indépendants in 1923 and had his first one-man show at the Gal. Percier in 1927. Until *c.* 1937 his work was strongly under the influence of the post-CUBIST work of PICASSO and BRAQUE, but during the 1930s he became interested also in Mediterranean landscape and Greek popular art. From *c.* 1938 onwards he came to be recognized as the most important modern representative of the Greek artistic tradition and the most successful artist in achieving a synthesis between this ancient tradition and contemporary artistic movements. In 1942 he was appointed Professor at the School of Architecture in the National Technical University of Athens and he continued to teach drawing and composition there until his retirement in 1960. He was elected to the Athens Academy in 1974 and to the Committee of

the National Theatre in 1975. Besides painting, Ghika designed for the theatre and ballet and illustrated books by René Char, Cavafy and Kazantzakis. In 1936 he was joint editor of an *avant-garde* monthly review *The Third Eye.* From 1927 he had many one-man exhibitions in Greece, Europe and America and he also participated in many group exhibitions including: 'Greek Art 3000 BC–AD 1945' at the Royal Academy, London, 1946; 'Six Contemporary Greek Artists' organized by the British Council at Greek House, London, 1946; Greek Pavilion, 25th Venice Biennale, 1950; 'Four Painters of 20th Century Greece', Wildenstein Gal., London, 1975. His important personal exhibitions included one organized in Athens by the British Council, 1946; Alexander Iolas Gal., New York, 1958; Whitechapel Art Gal., 1968; retrospective in the National Gal. of Athens, 1973, the first time a living artist had shown there.

GIACOMETTI, ALBERTO (1901–66). Swiss sculptor, born in the Alpine village of Borgonovo, near Stampa, in the Italian-speaking part of Switzerland. His father, Giovanni GIACOMETTI, was a Post-Impressionist painter. The FAUVIST painter Cuno AMIET was his godfather. In his early years he showed gifts for drawing, painting and modelling and he was at first undecided whether to become a painter or a sculptor. In 1919–20 he studied painting at the École des Beaux-Arts, Geneva, under David Estoppey (1862–1952), an exponent of the DIVISIONIST technique of painting, and sculpture at the École des Arts Industriels under Maurice Sarkissoff (1882–1946), a member of ARCHIPENKO's circle. In May 1920 he visited the Venice Biennale with his father, where he saw the sculpture of Archipenko, and remained in Italy studying through 1921, spending nine months in Rome with his father's cousin Antonio Giacometti. At the beginning of 1922 he moved to Paris, enrolling in Antoine BOURDELLE's class at the Académie de la Grande Chaumière. During this period he was interested in primitive African and Polynesian sculpture seen at the Mus. de l'Homme and the Jardin des Plantes. He also knew LAURENS and the work of LIPCHITZ. Bourdelle was one of the vice-presidents of the Salon des Tuileries and despite his lack of sympathy for post-Cubist work he enabled Giacometti to exhibit one *avant-garde* and one traditional work there from 1925. Giacometti's first exhibition in Switzerland was at the Gal. Aktuaryus, Zürich, in 1927 together with paintings by his father.

After passing through a CUBIST period Giacometti first attracted attention as an *avant-garde* sculptor with a series of *Plaques* done in 1927–8. These plaques, with delicately modulated depressions and fine incisions as their only concession to figuration, marked the culmination of a conflict which had obsessed him from his student days between his desire to produce a truthful image of actuality and his interest in abstract sculptural

form. In the process he was struggling towards a new way of perceiving reality. Giacometti himself expressed a doubt whether these plaque sculptures, which were modelled from memory, corresponded to a desire to make something he saw in things or to express the way he felt about them or 'a certain feeling for form that is inside you and that you want to bring outside'. Jean Cocteau said of them in his *Diaries*: 'I know of such powerful, light sculptures by Giacometti that one is led to speak of snow that preserves the footprint of a bird.' An example of this style is the marble *Woman* (1928) in the Kunsthaus, Zürich.

Towards the end of the 1920s and during the early part of the 1930s Giacometti was associated with the SURREALISTS, whom he described as 'the only movement where something interesting was happening'. His first one-man exhibition in Paris was at the Gal. Pierre Colle in 1932 and in the same year Christian Zervos published a profusely illustrated essay on his work in *Cahiers d'art*. He wrote: 'Giacometti is the first young sculptor to profit extensively from the examples of the pioneers (Brancusi, Laurens, Lipchitz). The newness of his work lies in personal expression, in joy at adventure, in the intellectual alertness of the artist, and, above all, in the primordial power that infuses the whole. At present Giacometti is the only young sculptor whose work justifies and continues the new directions in sculpture.' Giacometti's works, particularly the 'erotic-kinetic objects' of 1930–2, were widely shown in Surrealist exhibitions, including the exhibition 'Fantastic Art, Dada, Surrealism' at The Mus. of Modern Art, New York, and in 1934 the Julien Levy Gal., New York, showed twelve of his post-Cubist and Surrealist sculptures. Among the most famous of his works from this period are: *Cage* (wood construction, Moderna Mus., Stockholm, 1931); *Suspended Ball* (iron and plaster, Kunstmus., Basle, 1930); *Caught Hand* (wood and metal, Kunsthaus, Zürich, 1932); and *The Palace at 4 A.M.* (construct of wood, wire, glass and string, The Mus. of Modern Art, New York, 1933). The photographer Brassaï recorded: 'When I photographed the famous *Suspended Ball* or *The Palace at 4 A.M.*, Alberto told me that he had visualised all of these objects in almost final form, that he had executed them without any thought about their significance, and that their meaning was revealed to him only later.'

Giacometti's artistic development continued to be dominated by the conflict between abstract forms, which, he said, 'seemed to me to be true for sculpture', and the representation of the human body as an 'aspect of reality which particularly appealed to me'. About 1934 he became convinced that his imaginary Surrealist constructions were carrying him too far from the world of actuality and in 1935 he broke rather dramatically with the Surrealists, returning to the model and the representation of reality as it is. For the next ten years or so he was concerned with working out a practical phenomenology of perception and—as the Impres-

sionists had done a century earlier in a very different context—he made it his aim to represent reality as it actually appears without the traditional and familiar conventions of perception. This involved new ways of seeing and in a number of published interviews Giacometti has recorded the difficulties which he experienced. In particular he introduced into sculpture the concept of *distance* by making heads and figures small as seen from a distance in relation to a sense of 'absolute size'. These practical investigations into the optical laws governing the appearance of things at a distance went on through the 1940s until *c.* 1947, when he first began to produce the tiny, frontally seen figures such as *Four Women on a Base* (painted bronze, Kunstmus., Basle, 1950) and *The Cage* (*Woman and Head*) (painted bronze, Kunsthaus, Zürich, 1950). Advancing from this, between *c.* 1947 and *c.* 1951, he developed the style of elongated, skeletal figures by which he is best known. In these figures the sculpture is conceived as an aesthetic presence, an aesthetic equivalent of perceived reality. This, his fully mature style on which his fame chiefly depends, was possible only after he had worked through and abandoned his Cubist, Constructivist and Surrealist periods and after the prolonged researches into a new and more direct way of perceiving the world of appearance.

At the beginning of the 1950s Giacometti underwent another artistic crisis as the result of certain visionary experiences and evolved yet another, quasi-mystical conception of art. He then began to think of his work and aims not as the reproduction of appearances but as a magical reduplication of the reality itself which lay behind the appearances. From 1952 to *c.* 1958 was the period of narrow heads set upon exaggeratedly broad and massive shoulders, and Giacometti began again to paint his sculptures 'so that the whole statue succeeds in creating the same magic one feels when confronted with reality'. His aim was the evocation of the mysterious sense of metaphysical 'being', the impact of real presence, in an imaginary space. The physical reality of the art work sank increasingly into abeyance in order to convey the suggestion of an intangible reality behind the appearance. It was in 1954 that Jean-Paul Sartre wrote in an essay 'Les Peintures de Giacometti' that one day Giacometti would 'come nearer than any previous artist to achieving the impossible, when his portraits would affect us with all the force of a corporeal presence'. Something of this took place in the series of portrait heads done during the last years of his life, beginning with the portrait of Professor Isaku Yanaihara on which he was working in 1956. In these it was his aim to create not mere likenesses, but a reality in real space corresponding to the essence of personality. Reinhold Hohl said of them: 'They are the most rudimentary representations of corporeality one can imagine, almost negation of the organic existence of their subjects, but for that all the more deeply pro-

bing, knowing and silent, like the faces of old men ... They are the nuclei of personalities, and they dominate the surrounding space with their silence.'

It has been fashionable to offer 'interpretations' of Giacometti's work in terms of its contemporary relevance. His elongated, stem-like figures, in which optical distance is seen as an inherent quality of the subject, have, for example, been interpreted as symbols of man's spiritual alienation. The encaged figures and constructions have been interpreted as metaphors for human imprisonment within the realm of the ephemeral, and so on. All such interpretations must be regarded as speculative, and despite the abundance of documentation in the form of recorded interviews, etc. Giacometti's meanings and intentions remain enigmatic, for they were enigmatic even to himself. Yet beyond question during his lifetime and afterwards Giacometti was felt to be, among all contemporary sculptors and perhaps all contemporary artists, the one most in tune with the spiritual atmosphere of the age, particularly as this was crystallized in the philosophy of Existentialism. This is attested both through the interest in his works expressed by such writers as J.-P. Sartre, Camus, Genet, etc. and by the wide recognition which they received despite their difficulty. In 1955 he had simultaneous retrospective exhibitions at the Solomon R. Guggenheim Mus., New York, and the Arts Council, London; and again in 1965 at the Tate Gal., London, and The Mus. of Modern Art, New York. In 1954 an exhibition of his work travelled round various towns of Germany. In 1956 he had a retrospective exhibition at the Kunsthalle, Berne, and showed his series of standing figures in the French section of the Venice Biennale. In 1959 he was invited to do a monumental sculpture for the plaza of the Chase Manhattan Bank skyscraper, New York, and began on a project, which remained unfinished at his death, for larger-than-life figures representing the 'totality of life'. From the end of the 1950s Giacometti's reputation as a painter began to increase and in 1964 he received the Guggenheim International Award for painting. In 1961 he was given the Carnegie Sculpture Prize at the International Painting and Sculpture exhibition, Pittsburgh, and in 1962 a personal exhibition and the First Prize for Sculpture at the Venice Biennale.

Giacometti became something of a legend during his lifetime and impressed even those who failed to understand his deeper purposes by the integrity of his thought no less than the virtuosity of his achievement.

GIACOMETTI, AUGUSTO (1887–1947). Swiss painter born at Stampa, near Grisons, a second cousin of the painter Giovanni GIACOMETTI. He studied at the Technical School of Art, Zürich, 1894–7, and under Eugen Grasset from 1897, from whom he learned the ART NOUVEAU style. From 1902 to 1915 he was in Berlin, but lived subsequently in Switzerland. Though little known outside Switzerland, Augusto Giacometti deserves a wider reputation for his pioneering work in near-abstract colour composition. Throughout his life he was dominated by colour and light. In his early, Art Nouveau period, before the turn of the century, he was painting what were virtually abstract colour compositions and his later pictures had the brilliance and luminosity of stained glass windows—an art which he also practised. By luminous compositions of abstract colour he would convey his impression of a landscape, a still life or even a picture by an Old Master. After c. 1920 his pictures were more representational, although his preoccupation with colour and his skill in handling colour combinations remained the predominant feature of his work.

GIACOMETTI, GIOVANNI (1868–1933). Swiss painter, born at Stampa, near Grisons. He was a second cousin of the painter Augusto GIACOMETTI and father of the sculptor Alberto GIACOMETTI. He studied at the Academy of Art, Munich, 1886–7, and in 1889–91 at the Académie Julian, Paris, where he met Cuno AMIET. In 1893 he settled in Stampa, visiting Rome and Italy, and from 1894 he made several visits to Maloja with Giovanni Segantini (1858–99). He was an individualistic and accomplished painter in the Late-Impressionist manner and had certain affinities of style with Amiet and HODLER, with both of whom he maintained close friendships.

GIBSON, LLOYD (1945–). British sculptor, born at Cambridge. He studied at Newcastle University and was awarded the Hatton Scholarship and the Annabella Smiles and Bunzl Travelling Scholarships. He taught in the Fine Art Department of the Newcastle upon Tyne Polytechnic. He belonged to the 'Object' school of sculpture which came to the fore in the later 1960s, akin to NOUVEAU RÉALISME. His constructions, sometimes hanging, were often made of rope, tubing, canvas, cord, and were painted or varnished. He had one-man exhibitions at the Gulbenkian Gal., Newcastle upon Tyne (1969) and the Durham Light Infantry Mus., Durham. His works were represented in several group shows, including 'The Condition of Sculpture' at the Hayward Gal., London (1975).

GIEROWSKI, STEFAN (1925–). Polish painter born at Częstochowa, studied at the Academy of Art in Kraków and taught in the Warsaw Academy. From c. 1965 he worked in a manner akin to COLOUR FIELD painting but his pictures often had a strangely hallucinatory effect which was in some respects analogous to certain manifestations of OP ART.

GILBERT, SIR ALFRED (1854–1934). British sculptor and metal worker, born in London. After beginning to train as a surgeon he studied art at the Royal Academy Schools and the École des

Beaux-Arts, Paris, after which he spent six years in Rome. He returned to England in 1884 and worked on several major projects, the best known of which is his Shaftesbury Memorial Fountain in Piccadilly Circus with its famous figure *Eros* (unveiled in 1899). Its celebrity has overshadowed Gilbert's achievements in metal-work. The epergne in silver, parcel-gilt, which he made for Queen Victoria's Jubilee in 1887, was an anticipation of ART NOUVEAU style. He was elected A.R.A. in 1887 and R.A. in 1892. In 1900 he was appointed Professor of Sculpture at the Royal Academy and despite his resignation in 1908 his influence was extensive. From 1909 he lived in retirement at Bruges, but in 1926 he returned to England at the request of King George V to complete his masterpiece, the *Tomb of Clarence* at St. George's Chapel, Windsor, which he had begun in 1892. He was knighted in 1932. There is a statuette of *Victory* by him in the Diploma Gal. of the Royal Academy and a bust of *G. F. Watts* in the Tate Gal. Gilbert remained outside the main *avant-garde* trends of early 20th-c. art.

GILI, MARCEL (1914–). French sculptor, born at Thuir in the Pyrénées orientales. He was influenced by MAILLOL, whom he knew in 1930, but in went over to abstraction and in 1933 joined the ABSTRACTION-CRÉATION association. In 1935 he abandoned abstraction and destroyed all his work in this mode, concentrating thenceforward on the disposition of volumes and the play of light in the study of the human form. He worked mainly in terracotta but also used bronze and aluminium. His style was austere and restrained but with great plastic power and vigorous rhythmical composition. In 1943 he was a founder member of the Salon de Mai and in 1946 he obtained the Casa Velazquez prize. Among his commissions were a gigantic terracotta for Saint Maur des Fossés and a large wooden sculpture, *Le Technicien*, for the town of Bourges. His *Jeune Garçon* is in the Mus. National d'Art Moderne, Paris.

GILIOLI, ÉMILE (1911–77). French sculptor, born in Paris but brought up in Italy. After working for 6 years at smithery he entered the École des Arts Décoratifs, Nice, in 1928, and then the École des Beaux-Arts, Paris, in 1931. The works of his early period included the *Christ* for the Church of the Sacré-Cœur, Grenoble, 1941, and *Monument des Déportés*, Grenoble, 1950. In 1945 he settled in Paris and for a while occupied himself with religious art, exhibiting at the Salon de Mai. In 1947, however, he turned to abstraction, concentrating on the play of forms with exquisitely wrought and highly simplified asymmetrical constructions. At this time he was one of the circle of abstract artists associated with the Gal. Denise René. He also designed tapestry for Aubusson and in 1957 was awarded the Tapestry Prize at São Paulo.

GILL, ERIC (ARTHUR ERIC ROWTON GILL,

1882–1940). British sculptor, engraver, typographer and writer, born at Brighton, son of a Church of England clergyman. He studied at the Chichester Art School and in 1900 was briefly apprenticed to an architect in London. He then resumed his studies of art and typography at the Central School of Arts and Crafts and studied the craft of carving inscriptions at Westminster Technical Institute. He was a member of the Art Workers' Guild and of the Fabian Society. He began to earn his living as a letter cutter in 1903, began to carve figures in 1910 and exhibited at the Chenil Gal. in 1911. In 1913 he became a convert to Roman Catholicism and was commissioned to make the *Stations of the Cross* at Westminster Cathedral, 14 relief carvings which he did in 1914–18. These and the *Prospero and Ariel* group on Broadcasting House (1929–31) are his best-known carvings. Having been commissioned to do a group of Prospero and Ariel, he made in fact a sculpture of God the Father and God the Son, with the Son (Ariel) bearing the stigmata. He wrote: 'I took it upon me to portray God the Father and God the Son. For even if that were not Shakespeare's meaning, it ought to be the BBC's.' After the war he became a Tertiary of the Order of St. Dominic and founded a Guild of St. Joseph and St. Dominic, which was to be a guild of craftsmen with the object of reviving a religious attitude towards art and craftsmanship in opposition to the social and economic trends of the time. In 1924 Gill began his association with the Golden Cockerel Press of Robert Gibbings, for which he illustrated many books. He also designed the 'Perpetua' and 'Gill Sans-serif' typefaces for the Monotype Corporation.

In sculpture Gill was one of the protagonists in the movement for the revival of direct carving. He was also a major figure in the revival of book design and typography. Among the best known of the books he designed and illustrated are *The Canterbury Tales* (1927) and *The Four Gospels* (1931). Chief among his own writings were *Art* (1934), in which he expounded his own views about the nature of art, claiming to 'debunk' the 'bunk' that is written about it and attacking its commercialization, and his *Autobiography*, written in 1940. In his life, his work and his writing he was a vigorous advocate of a romanticized medievalism. An exhibition at Kettle's Yard, Cambridge, in 1979 and an exhibition at the Whitworth Art Gal., Manchester University, in 1980 show that interest in his work continues.

GILLES, WERNER (1894–1961). German painter, born at Reydt in the Rhineland. In 1914 he joined the Academy of Art at Kassel. After serving in the war he studied at the BAUHAUS, Weimar, under Lyonel FEININGER and then, after a year in Italy, under Oskar SCHLEMMER. In 1930 he obtained the Prix de Rome and spent ten years in Italy, returning thereafter to live in Munich and Ischia. His style was mannered and formalized

without being genuinely abstract. He painted brightly coloured landscapes based on the scenery of Ischia and mythological subjects taken from Greek and biblical legend (e.g. the *Orpheus* and *St. George* cycles).

GILLET, ROGER-EDGAR (1924–). French painter born in Paris, where he studied at the École Boulle, 1939–44, and the École des Arts Décoratifs, 1944–6. From 1946 to 1948 he taught at the Académie Julian. His work belonged to the category of expressive abstraction and from 1952 he participated in a number of exhibitions of ART INFORMEL. He had a one-man show at the Gal. Craven, Paris, in 1953 and exhibited at the Salon de Mai in 1955. His painting at this time consisted of delicate modulations of the picture surface within a restricted range of colours. Later he used stronger, block-like forms in powerful reds, blacks and whites rhythmically combined in a basically ochre composition and set off by thickly impasted, relief-like textures. From the mid 1960s he abandoned the purely abstract and began to paint a fantastic world of hazily indicated grotesque figures, suggestions of limp or swollen bodies, pulpy, half-visible faces, frogs, spiders, women with the heads of rats or toads, etc. Painted in subdued and earthy but none the less sensitive tones, this dim world of shapeless beings was meant to express the tragic disintegration of the soul into madness.

GILMAN, HAROLD (1876–1919). British painter, born at Rode, Somerset. After spending a year (1894) at Brasenose College, Oxford, and a year in Odessa, he entered the Hastings Art School in 1896 and then studied at the Slade School, 1897–1901, where he made a lifelong friend of his fellow-student Spencer GORE. In 1904 he visited Spain and there in the paintings of Velazquez and Goya he may have derived corroboration for the inborn tendency towards Realism which later manifested itself in his work. Back in London he was a member of SICKERT's circle at 19 Fitzroy Street and found congenial Sickert's belief in the 'visual poetry' of the 'near and familiar', the street life and interiors of the more tawdry parts of Camden Town. He was an admirer of Lucien PISSARRO and through him of Impressionist techniques. With Robert BEVAN he formed the small CUMBERLAND MARKET GROUP and he also became a founding member of the CAMDEN TOWN GROUP in 1911. In 1913 he was made first President of the LONDON GROUP.

Gilman's painting and artistic outlook were revolutionized by the impact made on him by the Post-Impressionist exhibitions of Roger FRY and in 1912 he went with GINNER to Paris. As a result of this visit he, with Ginner and Spencer Gore, elaborated the artistic philosophy which they called NEO-REALISM and which was formulated by Ginner in an article which appeared in the magazine *The New Age*. In the name of 'Neo-Realists' he exhibited with Gore in 1913 and with Ginner in

1914. Influenced by Van Gogh and Gauguin he adopted a brighter palette and painted in brilliant patches of pure colour instead of the DIVISIONISM of Neo-Impressionism. It is significant that when he later taught at the Westminster School of Art, and then at a small school which he opened with Ginner in Soho, it seemed to his students that he *saw* nature in the clear, pure colours in which he painted. He was the greatest British exponent of what the French called SYNTHETISM, by which was meant, roughly, the artistic as opposed to the scientific aspects of Neo-Impressionism as modified by Gauguin. At the same time he rejected the ephemeral or 'snapshot' quality which was part of the Impressionists' philosophy and sought to give his works permanence and dignity, while always expressing through them the human aspect of the reality which he painted. In this new style Gilman had achieved the status of a master, as is evidenced by the best known of his works: *The Artist's Mother* (Tate Gal., 1917) and *Mrs. Mounter at the Breakfast Table* (Tate Gal., 1917). In 1918 he was commissioned by the Canadian Government to do a picture of Halifax Harbour for the War Memorial at Ottawa (National Gal. of Canada, Ottawa). His premature death from Spanish influenza in 1919 cut short the career of a painter who had the qualities of a great master. He was given a retrospective exhibition at the Tate Gal. in 1954.

GIMOND, MARCEL (1894–1961). French sculptor born at Tournon, son of a blacksmith, by whom he was trained in smithery. He had a solid classical education and throughout his life was an enthusiastic admirer of the art of antiquity and the Middle Ages. He knew MAILLOL and Renoir, by both of whom he was encouraged to pursue an artistic career. He exhibited first at the Salon d'Automne in 1922, won the Blumenthal prize in 1924 and a prize at the Exposition Universelle of 1937. He was made Professor at the École des Arts Décoratifs in 1944 and taught sculpture at the École des Beaux-Arts from 1946. He won the National Prize for Arts in 1958. Throughout his career he concentrated on the female nude and on portrait busts and did portraits of many prominent personalities. He had a high conception of the spiritual nature of sculpture and used to declare that it was his ambition to make of CUBISM 'something human and not merely decorative'. His influence on his pupils was considerable and he used to teach that 'the surface is merely the result of lines of force coming from within'. He also published various works on sculpture, including *Douze Entretiens sur la sculpture* (1961).

GINNA-CORRADINI, ARNALDO. See FUTURISM.

GINNER, CHARLES (1878–1952). British painter, born at Cannes of English parents. After overcoming the opposition of his family he studied painting and architecture in Paris from 1904 at the

Académie Vitti and the École des Beaux-Arts. In 1908 he began to work on his own, taking the POST-IMPRESSIONISTS, especially Van Gogh and Gauguin, as his guides. In 1909 he went to Buenos Aires and his exhibition there helped to introduce Post-Impressionism into the Argentine. In 1910 he settled in London at the persuasion of his close friends Harold GILMAN and Spencer GORE, with whom he became a member of the informal group of artists who frequented SICKERT's studio in Fitzroy Street. He became a member of the CAMDEN TOWN GROUP in 1911 and of the LONDON GROUP in 1913. In 1914 with Gilman he promoted what the latter named the NEO-REALIST manner of painting in opposition to contemporary interpretations of Impressionism and Neo-Impressionism, claiming that creative art must be founded on the objective translation into paint of the artist's intimate research into nature. His views were expressed in an article 'Neo-Realism' contributed to the journal *The New Age* and subsequently used as a preface to the catalogue of an exhibition which he held with Gilman at the Goupil Gal. in 1914. During the First World War he worked for the Canadian War Records and in the Second World War he was an official War Artist recording harbour scenes and bomb-damaged buildings in London. He joined the NEW ENGLISH ART CLUB in 1920 and was elected A.R.A. in 1942. Ginner was chiefly known for his city and street scenes, in which he chose for preference conventionally unattractive buildings, and while apparently defining every brick yet succeeded at his best in accentuating an interesting pattern and conveying the impression and mood of the scene. An example is *Emergency Water Storage Tank* (Tate Gal., 1941–2). A commemorative exhibition of his work was organized by the Arts Council of Great Britain in 1953. His work is well represented in the Tate Gal.

GIORGI, BRUNO (1905–). Brazilian sculptor born in Mococa, S. P. He began studying sculpture in Rome between 1920 and 1922, then went to Paris where he worked first with MAILLOL then at the Académie Ransom and in 1936 at La Grande Chaumière. In 1939 he returned to Brazil and shared a studio in São Paulo with a fellow sculptor, Joaquim Lopes Figueira, Jr., and between 1943 and 1949 he lived in Rio de Janeiro. In 1949 he returned to São Paulo and, after further trips to Italy in 1954, from 1955 he made his home in Rio. Until 1947 his work was very much influenced by Maillol and the classical tradition. The influence of Henry MOORE also led him to do a series of recumbent figures. From the late 1940s onwards his figures became elongated, more expressionistic, with disproportionately wide shoulders and small heads. He collaborated with Brazilian architects, contributing sculptures to the major architectural complexes. The best known are *Monument to Youth* of the 1940s for the garden of the Ministry of Education and Public Health in Rio, and his two works in Brasilia, the bronze *Warriors* (1961)

for the Plaza of the Three Powers and the Carrara marble *Meteor* for the reflecting pool in front of the Ministry of Foreign Affairs. A smaller bronze version of *Warriors* (1957) is in the collection of the Mus. de Arte Moderna, Rio. Giorgi participated in the first, second and fourth São Paulo Bienales (1951, 1953 and 1957). In 1953 he was awarded a silver medal in the modern division of the National Salon of Fine Arts in Rio. Besides the numerous exhibitions he had in museums and galleries all over Latin America in the 1960s, he participated in the Salon d'Automne exhibitions of 1956, 1957 and 1958 in Paris. In 1948 he was given an individual exhibition at the Municipal Chamber of Rio, in 1950 at the Mus. de Arte Moderna, São Paulo, and he participated in the Venice Biennales of 1950 and 1952. He also executed many portraits, including one of the Portuguese poet Luis de Camoens.

GIRONELLA, ALBERTO. See LATIN AMERICA.

GISCHIA, LÉON (1903–). French painter, born at Dax, Landes. After studying literature, archaeology and the history of art he took up painting in 1923 and studied under Othon FRIESZ and Fernand LÉGER. After travelling to Spain and Italy he went to the U.S.A. for three years in 1927 and abandoned painting. He took it up again, however, in 1936 and in 1937 he was commissioned with LE CORBUSIER and Léger to do the decorations for the Pavilion of Modern Times at the Exposition Universelle in Paris. In 1941 he participated in the exhibition 'Jeunes Peintres de la Tradition Française' and he collaborated in the foundation of the Salon de Mai in 1945. Afterwards he exhibited at the Gal. de France. He did not abandon representation for the abstract but in the manner of Edouard PIGNON and Maurice ESTÈVE he made his still lifes into decorative geometrical patterns with vividly contrasting colours. Typical of his style is *Les Toiles* (Mus. National d'Art Moderne, Paris, 1944). It is a style sometimes described as Neo-Cubism.

Gischia also regularly designed stage sets for the Théâtre Populaire of Jean Vilar.

GLACKENS, WILLIAM JAMES (1870–1938). American painter and draughtsman, born in Philadelphia, trained at the Pennsylvania Academy of the Fine Arts, Philadelphia. In 1891, while working as an artist-reporter on the *Philadelphia Press*, he became a friend and disciple of Robert HENRI and he was persuaded by Henri to take up oil painting in 1894. In 1895 he worked in Paris and exhibited at the Salon. In 1898 he was covering the fighting in Cuba during the Spanish–American war for *McClure's Magazine*. After Henri settled in New York Glackens joined him there, supporting himself as an illustrator on Pulitzer's *New York World* and *The New York Herald* and by book illustrations done in a fresh and realistic manner. He was known as a member of the NEW YORK REALISTS,

who formed the nucleus of the group of The EIGHT and who under the continuing influence of Henri promoted the ASH-CAN school of SOCIAL REALISM. Yet as a painter Glackens's social realism was limited to his preferred holiday scenes of middle-class life and to representing the life of the people as a colourful spectacle, as in *Washington Square* (The Mus. of Modern Art, New York, 1914). As early as 1905 he was painting in a style of high-keyed Impressionism, as in his *Chez Mouquin* (Art Institute of Chicago, 1905), a painting of a restaurant where the New York Realists often resorted, closely inspired by Manet's *Un Bar aux Folies-Bergère*. By the time of the ARMORY SHOW, which he helped to organize and in which he was represented, he was painting in the manner of the early Renoir. In 1912 Glackens was employed as art consultant to Dr. Albert C. Barnes and toured Europe buying up paintings by Renoir, Degas, Cézanne, Van Gogh and others, which formed the nucleus of the famous Barnes Collection at Merion, Philadelphia. A memorial exhibition of Glackens's work was held at the Whitney Mus. of American Art, New York, in 1938.

GLARNER, FRITZ (1899–1972). Swiss-American painter, born in Zürich and studied at the Academy of Fine Arts, Naples. During the 1920s he was in Paris, where his work evolved from Impressionism to CONSTRUCTIVIST abstraction, and in 1933 he was a member of the ABSTRACTION-CRÉATION association. He went to the U.S.A. in 1936 and was an early member of the AMERICAN ABSTRACT ARTISTS. He was a friend of MONDRIAN when the latter came to New York and during the 1940s he was chiefly known for a modification of Mondrian's NEO-PLASTICISM which he called 'Relational Painting'. On the theory that painting involves a two-dimensional equilibrium established through balance of elements in tension he modified Mondrian's strict use of orthogonals, using a trapezoid rectangle and diagonals between perpendiculars. Among the commissions which he executed were a mural for the Time & Life Building and for the Dag Hammarskjold Library, United Nations, New York.

GLASGOW SCHOOL. A loose association of British painters centred in Glasgow during the second half of the 19th c. They were in revolt against the conservatism of the Academy and were advocates of the *plein air* school of painting. They absorbed some of the more romantic elements from the NEW ENGLISH ART CLUB and developed an enclave of the lyrical naturalism—*Naturlyrismus*—which flourished all over Europe at this time. The school had reached its apogee before 1900 and did not outlast the First World War, but it had some influence on the younger painters at the opening of the 20th c.

GLEIZES, ALBERT (1881–1953). French painter born in Paris. After working as an industrial designer he began to paint c. 1900 and became a member of the CUBIST school, exhibiting with them in 1910 and 1911. He was a founding member of the SECTION D'OR in 1912 and with METZINGER he wrote the influential book *Du Cubisme*. Although he was active in publicizing Cubism both in Europe and in America, he made no positive contribution to the style by his own work. He initiated the formation of an artist colony at Moly-Sabata near Vienne and in 1939 became the centre of another group of painters when he settled at Saint Rémy, Provence. In 1941 he returned to Roman Catholicism and in 1950 participated in an exhibition of Sacred Art at the Vatican. A large retrospective exhibition of his work was shown at the Solomon R. Guggenheim Mus., New York, in 1964–5.

GNOLI, DOMENICO (1933–70). Italian painter and draughtsman, born in Rome and self-taught as an artist. He did theatrical designing during the 1950s and worked as a magazine illustrator until 1965. He took up painting in the early 1960s and after passing through a phase of TACHISM he adopted a figurative style under the combined influence of HUNDERTWASSER and American POP ART. He had an exhibition at the Kestner-Gesellschaft, Hanover, in 1968.

GODWIN, TED. See CANADA.

GOERG, ÉDOUARD (1893–1969). French painter and draughtsman, born in Sydney, Australia, of French and Irish parents. After a few years in England he was brought to Paris in 1900 and in 1912 entered the Académie Ransom, where he studied under SÉRUSIER and Maurice DENIS. In 1924 he met PASCIN, GROMAIRE, GRUBER and others at the Gal. Weill but, although his sympathies were with them in opposing the *avant-garde* movements, particularly CUBISM, in favour of a more expressive and humanistic form of art, he belonged to no group or association. He said in 1935: 'What I love in art is man ... I know full well, indeed one is only too much aware of it today to the detriment of emotion, that a picture has its own laws, that it is a flat surface, a combination of volumes ... But that is not enough.' His own style might be described as poetic naturalism. He taught engraving at the École des Beaux-Arts and also did book illustrations, including the *Contes* of Hoffmann, Baudelaire's *Les Fleurs du mal*, *The Divine Comedy* and the *Book of Job*. In 1949 he was awarded the Prix Hallmark.

GOERITZ, MATHIAS (1915–). German-Mexican sculptor, born in Danzig. He first studied medicine, but after a year turned to art and philosophy at the Kunstgewerbeschule of Berlin-Charlottenburg and Berlin University. His early work followed the lines of German EXPRESSIONISM and DADA, influences that remained with him for many years. After travelling through western Europe he

lived in Paris from 1936 to 1938. During those years he formed friendships with Jean ARP and Paul KLEE. With the outbreak of the Second World War he went to Morocco in 1941 and then to Spain, where he founded the School of Altamira which was to contribute to the rise of abstract art in Spain. He also founded the Gal. Palma in Madrid, where he exhibited.

In 1949 he accepted an invitation to teach at the University of Guadalajara in Mexico and remained there until 1953. He then settled permanently in Mexico City, and exhibited at the Proteo Gal. in 1955. During this period he worked as architect, painter and sculptor, making free-form metal and wood constructions, many of which were on biblical themes. Goeritz referred to his own work as 'emotional sculpture' although it frequently had humour also. He was severely criticized by the Muralists RIVERA and SIQUEIROS for infecting Mexico with 'European decadence'. His commissioned works included stained glass windows, as in the cathedral of Cuernavaca, and large-scale monuments. In 1953 an admirer of his work commissioned an experimental museum El Eco, in Mexico City, which fused architecture, sculpture and painted murals, with contributions by Henry MOORE and Carlos MÉRIDA. But after his patron's death the museum was converted into a cabaret and later destroyed. In 1957 and 1958 Goeritz constructed the *Towers Without Function*, a group of five painted concrete towers rising to heights of from 160 to 190 ft (49 m to 58 m) in Satellite City, near the capital, in collaboration with the architect Luis Barragán. In 1968 he built the star-based towers *Big Dipper* near the Olympic Stadium in Mexico City as part of a *Constellations* series. He also directed the 'Route of Friendship' project in conjunction with the 1968 Olympics in Mexico, to which sculptors from many countries contributed large-scale works. Goeritz's work has sometimes been linked to MINIMAL sculpture in spite of his very different intentions. He championed human values in art and denounced what he considered frivolities in contemporary art. On the occasion of the exhibition of Jean TINGUELY's self-destroying machine *Homage to New York* at The Mus. of Modern Art, New York, in 1960 Goeritz distributed pamphlets outside the museum calling for a stop to 'aesthetic, so-called "profound" jokes' and a return to timeless 'static' values. He wrote several other manifestos and statements the same year, including *Los Hartos* (*The Fed-Ups*) accompanying an exhibition at the Gal. Antonio Souza in Mexico City, objecting to and parodying what he considered the vacuity of some modern art. Also in 1960 a manifesto accompanied his exhibition of 'Metachromatic Messages' at the Gal. Antonio Souza and two years later at the Carstairs Gal. in New York, where he also exhibited in 1956 and 1960. Some of the *Messages* series were composed of *clouages* of gilt wood and metal, later including letters instead of nails, arranged in certain orders to form 'concrete poetry'. Goeritz has

had many one-man exhibitions in Guadalajara, Mexico City, Europe and the U.S.A. Besides the Gal. Antonio Souza in Mexico he also exhibited at the Gal. de Arte Mexicano in 1952, 1959 and 1961. In Paris he showed at the Gal. Iris Clert in 1960 and in New York at the Byron Gal. as well as at the Carstairs. His work was included in the 'New Media—New Forms' exhibitions at the Martha Jackson Gal., 1960, The Mus. of Modern Art, New York, 1961 and the Carnegie International, Pittsburgh, 1962. In the late 1970s Goeritz was working on large-scale projects in Mexico, Europe and Israel. Along with TAMAYO, he is considered one of the key figures in the artistic renovation that took place in Mexico in the 1950s. He exerted a great influence, especially on younger sculptors and architects.

GOETZ, KARL OTTO. See GÖTZ, Karl Otto.

GOGUEN, JEAN. See NOUVEAUX PLASTICIENS.

GOITIA, FRANCISCO. See MEXICO.

GOLDBERG, MICHAEL (1924–). American painter born in New York. He studied at the Art Students' League, 1938–42 and 1946 under José de CREEFT, at the City College of New York, 1940–2 and 1946–7, and the HOFMANN School, 1941–2 and 1948–50. His first one-man exhibitions were at the Tibor de Nagy Gal. in 1953 and the Poindexter Gal. in 1956 and 1958, and he showed in many collective exhibitions both in the U.S.A. and internationally. During the 1950s Goldberg developed an ABSTRACT EXPRESSIONIST technique, continuing the exploratory innovations of DE KOONING. He was particularly fond of COLLAGE and sometimes cut up oil paintings to make collages from them.

GOLDEN FLEECE (ZOLOTOE RUNO). Russian art journal edited by the banker and collector Nikolai Riabushinsky and appearing between 1906 and 1909 (last two issues for 1909 appeared early in 1910). It carried on the tradition of MIR ISKUSSTVA and was particularly close to the Russian Symbolist writers and artists, especially the 'Blue Rose' group. It also championed the early *avant-garde*, specifically the Neo-Primitivists led by GONCHAROVA and LARIONOV. In 1908 the *Golden Fleece* organized a large exhibition in Moscow called the 'Salon of the *Golden Fleece*' with French and Russian sections. The French section included paintings by the NABIS (VUILLARD, BONNARD, Maurice DENIS), by the FAUVES and by the POST-IMPRESSIONISTS Van Gogh, Gauguin and Cézanne together with drawings by Renoir and Toulouse-Lautrec. It has been described by A. C. Barr, Jr. as 'the most discriminating general exhibition of French Post-Impressionist painting held anywhere—including France—up to that time'. The Russian section displayed many works of Larionov and Goncharova. In January/February 1909 a second Franco-Russian exhibition

was organized and French and Russian works were hung together. The French were represented mainly by Fauves and included some pre-CUBIST works from the previous year by BRAQUE, DERAIN and LE FAUCONNIER. A third exhibition, held at the end of 1909 and devoted only to Russian works, was dominated by the work of Larionov and Goncharova.

GOLUB, LEON (1922–). American painter born in Chicago, studied at the University of Chicago and then, after serving in the army 1943–6, at the Art Institute, 1946–50. After visiting Italy, 1956–7, he taught at Indiana University from 1957 to 1959, when he moved to Paris. He returned to the U.S.A. in 1964 and became Professor of Art at Livingston College, Rutgers University. From the latter part of the 1950s Golub was dominated by the theme of human corruptibility, creating a galaxy of colossal but tormented human figures, as in his *Gigantomachy* series of the 1960s and his *Fallen Fighter* of 1971. He developed a technique of working on unstretched canvas with thick layers of lacquer which were then roughed and gouged, giving the impression of enormous fleshless figures consisting only of muscles and tendons. It is possible to find an Existentialist spirit in his work. Thus Barry Schwartz said of it in *The New Humanism* (1974): 'Golub has created the epic view of the twentieth century: The dream of universal power and self-possessed stature, the nightmare of the use of power, and the failure to secure well-being are brought together in totemic images of our plight and our hope.'

Golub exhibited at the São Paulo Bienale of 1961 and at DOCUMENTA III, Kassel, in 1964. A retrospective exhibition of his works was held at Temple University, Philadelphia, in 1964. His views on the humanist function of art were expressed in an interview published in the magazine *Arts* for February 1970.

GONCHAROV, ANDREI. See SOCIALIST REALISM.

GONCHAROVA, NATALIA SERGEEVNA (1881–1962). Russian painter born in the province of Tula, south of Moscow. Her paternal grandmother was a daughter of the poet Pushkin and her mother was a member of the influential Belyaev family, which had supported the nationalist trend in Russian music during the 19th c. After studying science at Moscow University she took sculpture lessons from 1898 at the Academy under Pavel Trubetskoi, a member of the MIR ISKUSSTVA group. She began to exhibit in 1900 and subsequently for the completion of her education she travelled widely in Europe, including visits to England, Spain, Switzerland, Italy and Greece. She took up painting in 1904. While a student she met LARIONOV and began a lifelong friendship and artistic collaboration with him. They both contributed to the *Mir Iskusstva* exhibition of 1906 and to the exhibition of Russian art organized by DIAGH-

ILEV at the Salon d'Automne, visiting Paris together. She participated in the GOLDEN FLEECE exhibitions of 1908 and 1909 and in Larionov's KNAVE OF DIAMONDS exhibition of 1910 and DONKEY'S TAIL exhibition of 1912. She was profoundly interested in Russian peasant art and in medieval icon painting and it was under the influence of these interests that she developed a cultivated primitivism in her painting of this time, as is evident in such pictures as *Haycutting* (1910) and *Dancing Peasants* (1911), both of which are illustrated in *The Russian Experiment in Art 1863–1922* (1962) by Camilla Gray. Larionov and also MALEVICH were led to experiment with primitivism in a similar way, using stylizations in the manner of peasant embroideries and popular wood engravings (*lubki*) with bright patterns of flat colour in the manner of folk art. Malevich indeed said: 'Goncharova and I worked more on the peasant level. Every work of ours had a content which although expressed in primitive form revealed a social concern.' In many of her paintings Goncharova managed to achieve a successful combination of this folk-art interest with FAUVIST and CUBIST influences. At the TARGET (*Mishen*) exhibition of 1913 she together with Larionov showed works done under the influence of FUTURISM which inaugurated the RAYONIST style. Typical examples are the paintings *Cats* (Solomon R. Guggenheim Mus., New York), dated 1910, and *Electricity* (1910–11). More in keeping with the Italian Futurist principles was her painting *The Cyclist* (Russian Mus., Leningrad, 1912–13). These and other works of hers and Larionov's were exhibited at the Gal. Paul Guillaume, Paris, in 1914. At the same time she was devoting her attention to stage designing and in 1915, when she settled in Paris with Larionov, she abandoned easel painting in favour of this. She designed settings and costumes for Diaghilev, including *Le Coq d'Or* in 1914, *Les Noces* in 1923 and a revival of *The Firebird* in 1926.

Works of Goncharova and Larionov were exhibited at the Kingore Gal., New York, in 1922. In 1948 she held a retrospective exhibition at the Gal. des Deux-Îles, Paris, and in 1952 her work was shown at the exhibition 'L'Œuvre du XXe siècle' in the Mus. National d'Art Moderne, Paris. She resumed painting in 1956 and in the same year she held a retrospective exhibition of her works from 1907 to 1956 at the Gal. de' l'Institut, Paris. In 1961 the Arts Council of Great Britain organized a retrospective exhibition of her works and those of Larionov with a catalogue containing introductory essays by Camilla Gray and Mary Chamot.

GONZÁLES, JUAN FRANCISCO. See LATIN AMERICA.

GONZÁLEZ, JULIO (1876–1942). Spanish sculptor, born in Barcelona of a family of metal-workers. He learned the techniques of metal-working

in his father's shop as a youth, but like his brother Juan he wanted to become a painter and after studying in Barcelona went to Paris in 1900. There he became a close friend of PICASSO and a member of his circle. It was not until 1927 that he abandoned painting for sculpture and thus found his true vocation. He worked mainly in wrought and welded iron, like GARGALLO adapting to the purposes of sculpture traditional Spanish techniques which had hitherto been devoted to decorative ironwork. He worked in fairly close collaboration with Picasso, initiating him into the traditional Spanish techniques of metal-work and the natural qualities of iron, while Picasso in his turn may have influenced the formal development of González's work. This became increasingly abstract, though retaining figurative suggestions. In 1932 González became a member of CERCLE ET CARRÉ and in 1934 he joined the ABSTRACTION-CRÉATION association. In 1936–7 he made for the Spanish Pavilion at the Paris Exposition Universelle a life-size figure of a peasant woman holding a child in her arms, calling it *La Montserrat* after the mountain outside Barcelona as a symbol of popular resistance and suffering in the Spanish Civil War. It is now in the Stedelijk Mus., Amsterdam. This was the last of a *Montserrat* series begun in 1932.

The earliest metal sculptures of González were masks strongly reminiscent of African sculpture and fairly compact figures in a CUBIST style. His work became increasingly open, abandoning volumetric solidity and *defining* space by an assembly or network of rods and ribbons and narrow bands of metal. The subject is suggested rather than expressed and is implied by gesture or attitude rather than by overt similarity of form. Sometimes, as in his well-known *Cactus Man* (of which he did more than one example), human and vegetable suggestions are conflated. Examples of his mature style are *Angel* (Mus. National d'Art Moderne, Paris, 1933) and *Woman Combing her Hair* (The Mus. of Modern Art, New York, 1936).

González was one of the pioneers of contemporary sculpture in metal. His influence has been very great in the revival of metal sculpture which took place, particularly in America and England, in the decades following the Second World War. His work was a link between Cubism and the CONSTRUCTIVIST sculpture of the post-war decades and had SURREALIST features which influenced, among others, Reg BUTLER. The Mus. of Modern Art, New York, held a retrospective exhibition of his work in 1956. A representative exhibition was staged at the Tate Gal. and the Gal. de France, Paris, in 1970.

GOODE, JOE (1937–). American POP artist born at Oklahoma City and studied in the late 1950s with RUSCHA at the Chouinard Art Institute, Los Angeles. During the 1960s he painted isolated household objects or real objects of a commonplace character, such as milk bottles, set against a uniformly painted background.

GOODNOUGH, ROBERT (1917–). American painter born at Cortland, N.Y. He studied at Syracuse University, New York University, the New School of Social Research, the HOFMANN School and the OZENFANT School of Art, New York. He taught at Cornell and New York universities, was art critic for *Art News*, 1950–7, and secretary for the series *Documents of Modern Art* edited by Robert MOTHERWELL. He exhibited at the Tibor de Nagy Gal. from 1952, at the Dwan Gal., 1959–62, at the Nova Gal., Boston, the Arts Club of Chicago and elsewhere and was represented in a number of collective shows, including the Kootz Gal., New York, 'New Talent', 1950; Sidney Janis Gal., 'Four Younger Americans', 1956; The Mus. of Modern Art, New York, 'The New American Painting and Sculpture', 1969. Goodnough was one of the group of artists, including Al HELD and Raymond PARKER, who in the late 1950s reacted against the formlessness of ACTION PAINTING and sought to create a more coherent structure from more clearly articulated abstract colour masses.

GORDIN, SIDNEY (1918–). Russian-American painter and sculptor born at Chelyabinsk, Siberia, studied at the Cooper Union, 1937–41, and taught at the Pratt Institute, 1953–8, Brooklyn College, 1955–8, New School for Social Research, 1956–8, the University of California at Berkeley from 1958. His first one-man exhibitions were at Bennington College and the Peter Cooper Gal., New York, in 1951. From 1953, besides collective shows, he exhibited mainly at the Grace Borgenicht Gal., New York, and the Dilexi Gal., San Francisco. Starting as a painter, he turned to sculpture in the 1940s. His sculpture was at first geometrical with balanced spatial organization but later tended to develop rather in the direction of organic forms.

GORDON, HORTENSE. See CANADA.

GORE, SPENCER FREDERICK (1878–1914). British painter, born at Epsom, Surrey. After leaving Harrow, he studied at the Slade School, 1896–9, under Frederick BROWN, Wilson STEER and Henry TONKS. He was contemporary at the Slade with Harold GILMAN and the two became lifelong friends. In 1904 he met SICKERT in Dieppe and was brought by him into closer touch with French painting. In 1905 he became a member of Sickert's circle of artists who met in his studio at 19 Fitzroy Street and there made a close friend of Lucien PISSARRO, from whom he acquired a deeper knowledge and understanding of Impressionist and Neo-Impressionist methods. He was a founding member and first President of the CAMDEN TOWN GROUP formed in 1911. He became a member of the NEW ENGLISH ART CLUB in 1909 and joined the LONDON GROUP in 1913.

Up to *c.* 1906 Gore painted landscapes in the tradition set by Corot and Sisley which, although showing personal vision, were the work of a com-

petent student rather than a master. In London, from 1905 to *c.* 1911, he concentrated upon theatre and music-hall themes and produced a number of works which were both personal and masterly, revealing the extent to which he had made Impressionism his own. Wyndham LEWIS in an obituary notice ranked his theatre paintings above those of Degas. Roger FRY's Post-Impressionist exhibitions of 1910 and 1912 stimulated in him a new understanding of structure and the paintings of his last years exploited the lessons he had absorbed from Cézanne and Gauguin. These paintings have been described as the most original of all those produced in London under the influence of Post-Impressionism. Landscapes of Richmond Park done in the last year of his life are thought to embody the best of what he did. A retrospective exhibition was given at the Leicester Gals. in 1928 and a large memorial exhibition was arranged by the Arts Council of Great Britain in 1955.

GORIN, JEAN (1899–). French painter born at Saint-Emilion-Blain, studied at the Académie de la Grande Chaumière, Paris. In 1926 he met MONDRIAN and became a lifelong convert to NEOPLASTICISM, being one of the first to make relief constructions in this style. He was a member of the CERCLE ET CARRÉ group and of ABSTRACTION-CRÉATION, being active in the organization of the latter and editor of the 1936 *Almanac.* In 1946 he was one of the founders of the SALON DES RÉALITÉS NOUVELLES. His constructions, which lie on the border between painting and sculpture, anticipated the post-war type of CONSTRUCTIVIST structures. Gorin continued the horizontal–vertical style of Mondrian, although in his late works he introduced diagonal and circular shapes. A retrospective exhibition of his work was given at the Stedelijk Mus., Amsterdam, in 1967.

GORKY, ARSHILE (VOSDANIG MANOOG ADOIAN, 1905–48). American painter, born at Khorkom Vari in Turkish Armenia. In 1909 he fled from Turkish persecution and worked as a printer and bookbinder in Erivan, the capital of Soviet Armenia. In 1920 he emigrated to the U.S.A. and studied art at Rhode Island School of Design and in Boston. In 1925 he moved to New York, where he first studied and then taught at the Grand Central School of Art. He was among the first to recognize the importance of the abstract work of Stuart DAVIS at this time. He himself owed a debt to PICASSO, seen both in his haunting *The Artist and his Mother* (Whitney Mus. of American Art, 1926–9) and in the CUBIST abstractions which he did at this period. During the 1930s he worked on the FEDERAL ARTS PROJECT and is remembered for the abstract mural he did for the Administration Building at the Newark Airport, a study for which is in The Mus. of Modern Art, New York. Gorky was never at home with geometrical abstraction but preferred to adapt Cubist techniques to his own more painterly and expressive pur-

poses. He came into his own when he became a friend of the circle of European immigrant SURREALISTS who during the early years of the 1940s lived in New York. Under this influence he worked out a style of abstraction using biomorphic forms akin to those of MIRÓ, as may be seen in various versions of *Garden in Sochi* (The Mus. of Modern Art, New York, 1941) and *Mojave* (Los Angeles County Mus. of Art, 1941–2). In 1941 he married for the second time and from 1943 began a series of lyrical abstract drawings based upon the forms of the Virginia landscape. To this phase belong such paintings as *The Plow and the Song* and *Water of the Flowery Mill,* which universalize landscape forms into shapes of general significance. At the peak of his powers, however, Gorky suffered a tragic series of misfortunes. In 1946 a fire in his Connecticut studio destroyed a large proportion of his recent work. In the same year he was operated on for cancer. In 1948 he broke his neck in a motor-car accident and committed suicide shortly afterwards.

Gorky's early works have been described as those of a clever pasticheur. His last works, though still showing the influence of Miró and KANDINSKY, fused Surrealism with biomorphic abstraction and achieved superb power of originality. He has been named both the last of the great Surrealists and the first of the ABSTRACT EXPRESSIONISTS. Both descriptions apply. His work in the 1940s was a potent factor underlying the emergence of a specifically American school of abstract art.

He had a one-man show at the Levy Gal., New York, in 1945, a retrospective exhibition at The Mus. of Modern Art, New York, in 1962 and a retrospective exhibition of drawings at the University of Maryland Fine Arts Center in 1969, and at the Tate Gal. in 1966.

GORMAN, RICHARD. See CANADA.

GORRIS, JOSÉ MARIA. See SPAIN.

GOSTOMSKI, ZBIGNIEV (1932–). Polish painter and experimental artist born at Bydgoszcz. He studied at the Warsaw Academy and afterwards taught there. He was an exponent of postwar CONSTRUCTIVISM and pioneered experiments in Poland into ENVIRONMENT ART, LUMINISM and spatial constructions. He was particularly known for his strange black and white geometrical reliefs which produced an almost hallucinatory effect.

GOTTLIEB, ADOLPH (1903–74). American painter, born in New York. After studying at the Art Students' League, New York, under John SLOAN and Robert HENRI he went to Europe and studied at the Académie de la Grande Chaumière, Paris, in 1921. On his return he studied at the Parsons School of Design, Cooper Union, in 1923. He won the Dudensing National Competition in 1929 and his first one-man show, consisting of EXPRESS-

IONIST landscapes and figures, was at the Dudensing Gal. in 1930. In 1935 he was one of the founding members of the Expressionist group The TEN, with whom he exhibited until 1940. In 1936 he worked for the FEDERAL ARTS PROJECT. During the latter part of the 1930s he began to collect primitive and American Indian art objects, an interest which was manifested in the imagery which characterized his mature work of the 1940s and 1950s. His landscapes at this time reflected overtones of SURREALISM, particularly in the formalization of unreal space—which may also have been influenced by the landscape contours of the Arizona desert, where he lived from 1937. The Surrealist tendency was enhanced by contact with expatriate European Surrealists from 1941 and he also became interested in Freudian psychology and the Surrealist doctrine of the unconscious as a source of artistic material. As a member of the NEW YORK SCHOOL he is best known for his series of *Pictographs* done between 1941 and 1951. These pictures were divided into compartments, each of which was filled with schematic shapes operating as Freudian symbols or abstract mythological concepts endowed with universal significance from unconscious association. A series of *Imaginary Landscapes* in the first half of the 1950s consisted of a zone of astral shapes above loosely pictured foregrounds and was succeeded by a *Burst* series, which carried the artist's style still further in the direction of expressive abstraction but still suggested solar orbs and astral bodies hovering above violently coloured terrestrial explosions. Gottlieb was a highly original member of the ABSTRACT EXPRESSIONIST movement and was widely exhibited throughout the world. He had retrospective exhibitions at Bennington College (1954), the Jewish Mus. (1957), the Whitney Mus. of American Art and the Solomon R. Guggenheim Mus. (1968).

GÖTZ, KARL OTTO (1914–). German painter born at Aachen and studied at the School of Arts and Crafts there, 1931–4. During the 1930s he did photographic montages and made use of a spray technique. After serving in the war he founded the magazine *Meta* in 1948 and in 1949 was in touch with the COBRA group. In 1950 he moved to Frankfurt and became one of the best known of the Frankfurt group of TACHISTS. He experimented after the war years with electronic picture sequences and from the mid 1930s was interested in abstract films.

GRAEVENITZ, GERHARD VON (1934–). German sculptor born at Schilde, Mark Brandenburg. After studying economics at Frankfurt University he studied art at the Munich Academy from 1957 to 1961. He was editor of the periodical *Nota*, director of the gallery Nota in Munich and in 1962 became a member of the association NOUVELLE TENDANCE. Starting with white reliefs, he began in the early 1960s to make KINETIC pictures in which geometrical shapes were given random movement by electric motors. During the 1960s he developed 'light objects' in which movable aluminium parts were made to reflect light in constantly changing patterns. He conceived his artistic programme as an attempt to go beyond CONSTRUCTIVISM in the creation of a new art form and wrote in the catalogue to the exhibition 'Kinetics' at the Hayward Gal., London, in 1970: 'My kinetic objects are visual objects. The elements are simple and geometric (for example ellipses in *Round Objects With Ellipses*, 1970). Kinetic objects are not traditional sculptures set in motion. Motion means the changing of the network of relationships which defines the structure in space and time. Kinetic art is not a new style but a new art in the sense that it establishes a new object–spectator relationship.'

GRAHAM, DAN. See CONCEPTUAL ART.

GRAHAM, JOHN (IVAN DABROWSKY, 1881–1961). Russian-American painter and theorist born at Kiev. It is not certain whether or where he received formal training in art, but it is apparent from his writings that he knew members of the Russian *avant-garde*—GABO, LISSITZKY, David BURLIUK and the poet Mayakovsky—and his early works show the influence of RAYONISM. Like MALEVICH and KANDINSKY he later became involved with the theosophical views of Madame Blavatsky and Rudolf Steiner. He emigrated to the U.S.A. in 1920 and became an American citizen. In New York he studied under John SLOAN at the Art Students' League and he was a friend of David SMITH and knew Stuart DAVIS, Willem DE KOONING, Arshile GORKY and others who later became famous in the history of American art. His influence was strong in the artistic circles of New York, where he established a reputation as the mouthpiece of modernism and a link with the European *avant-garde*. He discussed the AUTOMATISM of the SURREALISTS before this was generally understood in America and he anticipated the doctrines of MINIMALISM. In his *System and Dialectics of Art* (Paris, 1937) he elaborated his doctrines of the occult, his mysticism and his aesthetics of contemporary art. His own painting was a personal variant of synthetic CUBISM. His first one-man exhibitions were at Baltimore Mus. of Art (1926), Gal. Zborowski, Paris (1929) and the Société Anonyme, New York (1931). He had retrospectives at the Gal. Mayer, New York (1960), Arts Club of Chicago (1963), University of Minnesota (1964), Emmerich Gal., New York (1966 and 1968), The Mus. of Modern Art, New York (1968). He is chiefly remembered today for the great influence he had on the evolution of modernism in the U.S.A.

GRAN, ENRIQUE. See SPAIN.

GRANDMA MOSES. See MOSES, GRANDMA.

GRANT, DUNCAN JAMES CORROWR (1885–

1978). British painter and decorator born at The Doune, Inverness-shire. He passed his childhood in India and Burma and was subsequently educated for a military career, for which he had no disposition. From 1902 to 1905 he studied at the Westminster School of Art and then after a visit to Italy, where he copied paintings by Masaccio and Piero della Francesca, he attended Jacques-Émile Blanche's school La Palette in Paris in 1906 and 1907, followed by a summer term at the Slade School in 1908. He exhibited at the NEW ENGLISH ART CLUB from 1909 and at the FRIDAY CLUB from 1910. He first met Vanessa BELL (then Vanessa Stephen) in 1905 at the Friday Club; he was a friend of Roger FRY and Clive BELL and in course of time he came to be recognized as the outstanding artist, with Vanessa Bell, of the BLOOMSBURY GROUP. He exhibited 6 pictures in the English section of the Second Post-Impressionist exhibition in 1912 and in 1913 his decorative talents found one of their earliest outlets in Roger Fry's Omega Workshops. Throughout his life he continued to occupy himself, in addition to painting, with theatrical design and schemes of decoration, often in conjunction with Vanessa Bell.

Grant's painting style evolved from a deep admiration for the Post-Impressionists and the FAUVES. He had his first one-man exhibition at the Carfax Gal. in 1920 and was represented at the Venice Biennale in 1926 and 1932. His own artistic idiom matured during the 1920s, combining decorative gifts with a mastery of formal construction manifested in many of his portraits, such as *Vanessa Bell* (Tate Gal., 1942), and the best of his still lifes and landscapes. While the elements of his style were all present by the end of the 1920s, his painting retained exceptional freshness and vitality through to the 1970s. Although his very high reputation declined with the dissolution of the sensibility represented by Clive Bell and the Bloomsbury Group, he continued to be held in respect and it is likely that, while his stature as a painter was somewhat exaggerated in the Bloomsbury circle, it was underrated subsequently. He had his first retrospective exhibition in 1929 at Paul Guillaume, Brandon Davis Ltd. In 1942 he was elected to the Art Advisory Panel of the Council for the Encouragement of Music and the Arts (C.E.M.A., afterwards the Arts Council). He had a retrospective at the Tate Gal. in 1959 and at the Minories, Colchester, in 1963. In 1964 the Wildenstein Gal. staged an exhibition 'Duncan Grant and his World' and in 1966 the Royal West of England Academy, Bristol, gave a joint exhibition of Duncan Grant and Vanessa Bell. The Arts Council circulated an exhibition of his portraits in 1969 and in 1970 he was the subject of a film by Christopher Mason. In the same year he received an Honorary Doctorate of Letters from the Royal College of Art. He was represented in the exhibition 'British Painting '74' at the Hayward Gal. and exhibitions of his works were given by the Anthony d'Offay Gal. in 1972 and 1975. In 1975 'Nine-

tieth Birthday' exhibitions were given by the National Gal. of Modern Art, Edinburgh, and by the Tate Gal.

GRANT, KEITH (1930–). British painter and sculptor born at Liverpool, studied at the Willesden School of Art, 1952–5, and the Royal College of Art, 1955–8, where he won a Silver Medal for mural painting. In 1958 he was awarded travelling scholarships to France, in 1960 a Norwegian Government scholarship and in 1962 an Icelandic Government scholarship. In 1973 he obtained a Gulbenkian award and in 1976 a grant from the Norwegian Ministry of Culture to visit Norway. Among his commissions were murals for Verulamium Mus., St. Albans, Rhodesia House (1959), the Music Room at Auchenleish, Angus, Scotland (1966), the Middlesex Hospital (1972) and the Charing Cross Hospital (1975–7). He was commissioned to do an outdoor KINETIC construction for the Aldeburgh Festival (1969) and a large construction for the International Exhibition of Kinetic Art at the Hayward Gal., 1970, and in 1971 he did an open-air sculpture outside the Shaw Theatre, Euston Road, London. He taught as Head of Painting at Maidstone College of Art, 1969–71. From 1959 he had regular one-man exhibitions of paintings at the New Art Centre and at the Roland, Browse and Delbanco Gals., London. His painting, mainly of landscape, was expressive and dramatic, verging towards abstraction but without obscuring the subject.

GRASS ROOT ARTISTS. An alternative term sometimes applied to the school of REGIONALISTS who were dominant in American art during the 1930s.

GRATTAGE. Name given to the process devised by Max ERNST for transferring the method of FROTTAGE from drawing to oil painting. The name was also given to a process invented by Esteban FRANCÈS *c.* 1938. A superimposed layer of paint was worked with a razor blade so that unexpected and unplanned shapes from under layers of paint showed through, creating an iridescent brilliance. The method was adopted by the SURREALISTS as a technique for gaining access to the unconscious creativity.

GRAU, ENRIQUE. See LATIN AMERICA.

GRAUBNER, GOTTHARD (1930–). German painter born in Erlbach, Vogtland, studied in Berlin, Dresden and Düsseldorf from 1947 to 1959 and from 1965 taught in the Academy of Art at Hamburg. He first exhibited with the ZERO group but during the 1960s and 1970s his work was shown widely in Germany and in group exhibitions abroad. He belonged to the category of COLOUR FIELD painters and investigated the phenomena of 'colour-space'. To this end he employed unusual technical devices, using transparent

grounds and making monochromatic 'pillow pictures' on a ground of foam rubber and polyester encased in perlon.

GRAVES, MORRIS (1910–). American painter, born at Fox Valley, Oreg. He attended school in the Puget Sound region and from 1928 made trips to the Far East as a seaman with the American Mail Line. These early trips to the Orient made a deep impression and had a lasting influence on his work and outlook. In 1932 he finished schooling at Beaumont, Texas, and first received instruction in painting at the High School there. From 1932 he lived in or near Seattle until 1964, when he moved to Loleta in north-west California. In 1936–7 he worked for the FEDERAL ARTS PROJECT and in 1939 showed four paintings in the Federal Arts Project Group Exhibition at The Mus. of Modern Art, New York. During this period he made friends with John Cage and Mark TOBEY. From 1940 to 1942 he worked on the staff of the Seattle Art Mus. In 1946–7 he was awarded a Guggenheim Fellowship to study in Japan but was refused a military permit to enter Japan as a civilian. He visited Japan again in 1963, and from 1971 to 1973 he travelled in Asia, Africa, South America, Burma and Nepal. In 1947 he was awarded the Norman Wait Harris Medal by the Art Institute of Chicago for his painting *Black Waves*. In 1948–9 he visited Europe on the invitation of the collector Edward James and was awarded the Watson F. Blair Prize for *In the Air* by the Art Institute of Chicago. In 1955 he received the University of Illinois Purchase Prize, in 1956 a grant from the National Institute of Arts and Letters and in 1957 won the first Windsor Award for study in Europe. In 1968 he was elected an Honorary Member of the American Watercolor Society.

From 1936 he had constant one-man exhibitions and was included in very many group shows. A retrospective exhibition arranged by the Art Galleries of the University of California in Los Angeles in 1956 was subsequently shown by a number of institutions. A further retrospective was held at the University of Oregon Mus. of Art, Eugene, Oreg., in 1966. His works are included in most important public collections of the U.S.A. and are in many private collections. The largest single collection of his work—490 studies—is The Morris Graves Archival Collection at the Mus. of Art of the University of Oregon in Eugene.

Morris Graves painted mainly birds and small animals with a keen eye for characteristic attitudes and poses. But he had a highly personal fantasy and an individualized sensibility which caused his work to reflect an inner world owing much to Oriental mysticism. He was one of the most original and imaginative of the American REGIONAL painters. In his *American Art of the 20th Century* Professor Sam Hunter has written of him: 'A deeply religious man and a serious student of Vedanta, Graves has made a tender, lyrical poetry from such images as a pine tree tremulously holding a full moon in its branches, or tiny birds and snakes, images which seem to be secreted rather than painted on canvas or paper. His art is rapt, visionary, hypnotic. Its mystical mood is best caught in the nature poetry which D. H. Lawrence wrote in the New World.' Both in technique and in his imagery Graves owed much to ancient Chinese and Korean painting. He painted for preference on Japanese or Chinese paper and 'found a delight in the fragility, the transiency of the material'. In a completely personal idiom he produced delicate surface modulations with wavy or hatched lines. In the 1960s he turned also to three-dimensional constructions owing to a 'need for the absolute opposite of fragility . . . something related to the magic side of our scientific culture that would endure under any circumstances in nature'.

GREAVES, DERRICK (1927–). British painter born in Sheffield, studied at the Royal College of Art, 1948–52. He was a member of the KITCHEN SINK SCHOOL and was also interested in the *faux naïf* with sophisticated use of child-like imagery and modulation of texture in the manner of DUBUFFET. From *c*. 1960 his painting became non-figurative.

GRECO, EMILIO (1913–). Italian sculptor born at Catania, Sicily. After being apprenticed to a funerary stone-mason he studied briefly at the Palermo Academy of Art while serving in the army and in 1948 obtained a minor teaching post in the Liceo Artistico, Rome. His first one-man show was in Rome in 1946 and brought him to prominence. He worked mainly in bronze, preferably portrait busts and life-size female nudes. The latter were tall and posturing with a Mannerist elegance which often embodied witty parody of classical statues.

GREENE, BALCOMB (1904–). American painter, born at Niagara Falls. After taking a degree in philosophy at Syracuse University in 1926, he studied psychology at Vienna in 1927 and then read for a Master's degree in English at Columbia University. In 1931 he went to Paris with the intention of becoming an artist and studied at the Académie de la Grande Chaumière. On his return to the U.S.A. in 1933 he supported himself by journalism until 1936–9, when he executed murals for the FEDERAL ARTS PROJECT. In 1943 he obtained an M.A. degree in history of art at New York University, and from 1942 to 1959 he taught art history at the Carnegie Institute of Technology, Pittsburgh. During the 1930s he painted geometrical abstracts and was a founder member of the AMERICAN ABSTRACT ARTISTS association. During the 1940s his work became more representational, sometimes with figures fragmented against an abstract background, and during the latter 1950s and the 1960s a new note of humanism, almost of Existentialism, became noticeable in many of his pictures. In *The New Humanism* (1974) by Barry

Schwartz he was classified as a 'metaphysical Humanist', whose images were said to be 'of a monumental humanity eroded by time and progress'. In 1961 a retrospective exhibition of his work was given by the Whitney Mus. of American Art and was circulated by the American Federation of Arts.

GREENE, STEPHEN. See UNITED STATES OF AMERICA.

GREIS, OTTO. See QUADRIGA.

GRIESHABER, H. A. P. (1909–81). German graphic artist, born at Rot in Upper Swabia. After being apprenticed to a typesetter in Reutlingen, he studied painting at Stuttgart and then, 1928–31, in London and Paris. After travelling in Greece, Egypt and Arabia, he worked at Reutlingen from 1933 to 1940 and settled there in 1947 after serving in the war. In 1951 he won the Junger Westen prize, in 1961 the city of Darmstadt prize for art and in 1962 the Cornelius prize of the city of Düsseldorf. From 1955 to 1960 he taught at the Academy of Art, Karlsruhe, where he exercised an important influence on many of the younger German artists who practised figurative abstraction. He began making woodcuts in 1932 and was chiefly known for his elaborations of woodcut technique.

GRILO, SARAH (1921–). Argentine painter born in Buenos Aires. Between 1948 and 1950 she lived in Paris and Madrid and had her first exhibition in 1949 at the Gal. Palma, Madrid. She began as a figurative EXPRESSIONIST but by the early 1950s her work became increasingly abstract. By 1955 she had achieved a balance of form and colour with an informal geometry and flat colours. She was one of the original members of the *Artistas Modernos* group in Buenos Aires. In 1952 she exhibited with Miguel O'Campo and José Antonio Fernandez-Muro at the Gal. Viau in Buenos Aires. In 1959 she participated in the Carnegie International Award exhibition in Pittsburgh, in the Brussels World's Fair exhibition and in 'South American Art Today' at the Dallas Mus. in the U.S.A. Between 1953 and 1961 she showed at the 2nd to the 6th São Paulo Bienales and in the Torcuato di Tella Foundation Award exhibition in 1961. In the 1960s she showed in numerous galleries in Europe and North and South America, including the Gal. Bonino in Buenos Aires (1961) and the Obelisk Gal. in Washington. In 1962 she was awarded a Guggenheim Fellowship and moved to New York, where she remained for almost a decade. Shortly after her arrival, her paintings became freer and sometimes she incorporated letters, numbers and graffiti into her compositions of thin, transparent and luminous colour. *Three Black Zones* and *White and Yellow* were exhibited in 1963 at the Bianchini Gal. in New York. The same year she was included in

'Women in Contemporary Art' at Duke University in Durham, North Carolina, 'Il Arte de America y España' in Madrid and 'L'Art Argentin Actuel' at the Mus. National d'Art Moderne, Paris. In 1966 she participated in 'Art of Latin America Since Independence' at Yale University and in 'The Emergent Decade' at the Solomon R. Guggenheim Mus. in New York. From the early 1970s she lived in Spain.

GRIS, JUAN (JOSÉ VITTORIANO GONZÁLEZ, 1887–1927). Spanish painter, born in Madrid. In 1902 he entered the Escuela de Artes y Manufacturas, Madrid, and contributed drawings to *Blanco y Negro* and *Madrid Comico*. In 1906 he came to Paris, where he lived in the same house as PICASSO at 13 Rue Ravignan and met Guillaume APOLLINAIRE, André Salmon, Max Jacob, etc. For some years he supported himself by doing drawings for periodicals such as *L'Assiette au Beurre*, *Le Charivari* and *Le Cri de Paris*. He began painting seriously in 1910 and in 1912 he exhibited at the Salon des Indépendants, in Barcelona and with the SECTION D'OR. In this year the dealer Daniel-Henri KAHNWEILER made an exclusive contract to buy his work. In 1912 he began to experiment with the technique of PAPIERS COLLÉS which had been initiated by Picasso and BRAQUE and in the ensuing years he matured a personal form of Synthetic CUBISM which has been considered no less important than the work of Picasso and Braque in this mode. In 1914 his contract with Kahnweiler lapsed and in 1917 he made a contract for three years with Léonce Rosenberg. In 1919 he exhibited 50 paintings at Rosenberg's Gal. de l'Effort Moderne and in 1920 he exhibited again at the Section d'Or and the Salon des Indépendants. During the 1920s Gris suffered increasingly from ill health but continued to paint. He had an exhibition at the Flechtheim Gal. in Düsseldorf in 1925, and after his death at the age of 40 years a retrospective exhibition was given at Kahnweiler's Gal. Simon in 1928, a Memorial Exhibition at the Flechtheim Gal., Berlin, in 1930, an exhibition at the Marie Harriman Gal., New York, in 1932 and an exhibition at the Kunsthaus, Zürich, in 1932. A large exhibition was arranged by The Mus. of Modern Art, New York, in 1958.

With Picasso and Braque, Juan Gris is considered to be one of the greatest and most original artists of Cubism.

GROMAIRE, MARCEL (1892–1971). French painter, born at Noyelles-sur-Sambre of a French father and Flemish mother. He had no formal training but from 1910 he frequented the studios of Montparnasse, where he met pupils of MATISSE, and he had advice from LE FAUCONNIER, who was teaching at the Académie de la Palette. Before the outbreak of war he visited the Netherlands, Belgium, Germany and England and made contact both with contemporary EXPRESSIONISM and with

the traditional naturalism of the Low Countries, both of which combined in helping to mould his later style. He fought in the war and was wounded in 1916. After several personal exhibitions he began to show his work at the Salon des Indépendants and the Salon d'Automne in 1921 and at the Salon des Tuileries from 1924. He found a patron in Dr. Girardin, whose collection of his works is at the Petit Palais. In the Exposition Universelle of 1937 he executed a frieze for the Sèvres Pavilion. At this time he did tapestry designs for the Gobelins and collaborated with LURÇAT in reviving the Aubusson tapestry industry. Standing outside the *avant-garde* groups, Gromaire matured a style of expressive naturalism influenced to some degree by LÉGER in the years following the war. He had great decorative gifts, which he held in leash in the interest of formal construction. His interest was primarily in painting the life of the people and he is seen at his best in his well-known painting *La Guerre*, exhibited at the Salon des Indépendants in 1925. He had a large retrospective exhibition at the Maison de la Pensée Française in 1957.

GROOMS, RED (1937–). American sculptor, born at Nashville, Tenn. He studied at Peabody College, the New School for Social Research, the Chicago Art Institute School, and the HOFMANN School, Provincetown. From the end of the 1950s his works were widely shown in individual and group exhibitions and are included in a number of public collections, among them The Mus. of Modern Art, New York, and the Art Institute, Chicago. His work stemmed from POP ART and he did realistic figures and situations in the Pop manner. He was also known for ASSEMBLAGES, ENVIRONMENTS and HAPPENINGS and he was responsible for a number of films during the 1960s.

GROPIUS, WALTER (1883–1969). German architect, designer and teacher, born in Berlin. He studied architecture in the universities of Berlin and Munich and in 1907 went to work in the office of the architect Peter Behrens, whose chief assistant he became. He set up his own office in Berlin in 1910. In 1918 he combined the Grossherzögliche Sächsische Kunstgewerbeschule and the Hochschule für Bildende Kunst at Weimar to form the BAUHAUS, of which he was Principal, first in Weimar and from 1925 in Dessau, until 1928. According to his founding proclamation the purpose of the Bauhaus was to unite all the arts under the primacy of architecture, to ensure that they should be practised as crafts in the sense taught by William Morris and that they should contribute to the *Gesamtkunstwerk*, the total work of art, which was the building and everything in it. In 1923 he added the idea, which became central to Bauhaus doctrine, of the importance of the craftsman-artist-designer for industrial mass-production, and the Bauhaus studios became laboratories where prototype designs for machine manufacture were evolved. The characteristic Bauhaus style was im-

personal, geometrical and severely functional but with a refinement of line and shape that derived from a strict attention to economy of means and a close study of the nature of the materials.

In 1928 Gropius left the Bauhaus and resumed his architectural practice in Berlin. In the same year he was instrumental in the founding of CIMA (Congrès Internationaux d'Architecture Moderne). In 1934, after the National Socialists had come to power, he left Germany for England, where he practised in partnership with the British architect Maxwell Fry. In 1937 he went to the U.S.A., where he had been offered the Chair of Architecture at the Graduate School of Design at Harvard, and he remained President of the Department until 1951. In 1945 he was associated with a group of young architects in founding The Architects' Collaborative (TAC). He remained active until the end of his life and had an exceptional list of notable buildings to his credit.

Although Gropius's practical work was in the field of architecture, by his ideas, his teaching and his personality, through the Bauhaus and afterwards, his influence upon modernist trends in all the visual arts may have been as important as that of any other one man in the present century. Nowhere else have so many major artists of outstanding originality been brought into collaboration as those whom Gropius induced to teach at the Bauhaus. They included ALBERS, BREUER, KLEE, SCHLEMMER, FEININGER, KANDINSKY, MOHOLY-NAGY, ITTEN and Gerhard MARCKS. Both by their teaching at the Bauhaus and through their later work in exile their influence was profound. The personality of Gropius, arid as it was in certain respects—he once described King's College Chapel, Cambridge, to the writer as a 'sow reversed'—was dominant in propagating through all the arts an aesthetic thoroughly in harmony with the machine-awareness of an increasingly technological age.

GROPPER, WILLIAM (1897–1977). American painter and graphic artist, born in New York. He established his reputation as a political cartoonist and during the 1930s worked for the FEDERAL ARTS PROJECT, being a member of the Artists' Congress formed in 1936. He had one-man shows at the A.C.A. Gal., New York, including a retrospective in 1968. Professor Sam Hunter wrote of him: 'In the case of William Gropper's broadly caricatured "capitalists" and virulent lawmakers, the removal of the social target and animus permits us better to appreciate his abrupt and powerful simplicities of design and figuration.' An example is *The Senate* (The Mus. of Modern Art, New York, 1935).

GROSVENOR, ROBERT (1937–). American sculptor born in New York. He studied at the École des Beaux-Arts, Dijon, 1956, the École Nationale des Arts Décoratifs, 1957–9, and at the University of Perugia, 1958. His first one-man exhibition was at the Dwan Gal., New York, in

1966 and in the same year his work was included in the exhibition 'Primary Structures' at the Jewish Mus., New York. In 1968 he was represented in the collective exhibition 'Plus by Minus' at the Albright-Knox Art Gal., Buffalo, and in 'Minimal Art' at The Hague. Robert Grosvenor's work belonged to the category of MINIMAL ART and his enormous cantilevered beams of steel or wood were central in the trend towards a more objective and detachedly impersonal style which succeeded the expressive tendencies of the 1940s and early 1950s. His aesthetic was close to that of Robert MORRIS in the 1960s.

GROSZ, GEORGE (1893–1959). German painter and draughtsman. Born in Berlin, he studied there and in Dresden. He began as a caricaturist with a strong bent for social satire and through his drawings expressed his 'profound disgust with life' and held up to obloquy the depravity of the Prussian military caste. His first books of drawings appeared in 1915–16, showing a calculatedly naïve approach to his subject with a line which owed something to PASCIN and something to KUBIN. From 1917 to 1920 he was prominent among the Berlin DADA group and during the 1920s, while still working on Dadaist montages, he became a leading exponent of the NEUE SACHLICHKEIT. His collections of drawings *The Face of the Ruling Class* (1921) and *Ecce Homo* (1927) earned him an international reputation as a social satirist and an artist of the Left. He had his first one-man show in America at the Weyhe Gal., New York, in 1931. He was invited to the U.S.A. in 1932 by the Art Students' League of New York and settled there in 1933. In America his satirical manner was largely abandoned for more romantic landscapes and still lifes with from time to time apocalyptic visions of a nightmare future. He returned to Berlin in 1959 and died there shortly after his arrival. Grosz was hailed by the literary critic Edmund Wilson as the greatest of the satirical artists, 'at least as great as Hogarth', and by the art historian Hans Hess, in his Introduction to the catalogue for retrospective exhibitions shown in New York and Berlin in 1963, as 'the most powerful political satirist since Goya and Daumier'.

GROUPE DE RECHERCHE D'ART VISUEL (GRAV). An association formed in Paris in 1960 first with eleven artists, then reduced to six: Julio LE PARC, François MORELLET, Francisco SOBRINO, Joel STEIN, YVARAL (Jean-Pierre Vasarely), and Horacio GARCÍA-ROSSI. Formed within the ambit of the NOUVELLE TENDANCE, the main purpose of the association was to research into the aesthetic manipulation of light and movement. The members adopted a scientific approach to the production of art works and investigated the use of modern industrial materials for artistic purposes. In common with other contemporary groups they made it one of their aims to produce works of art which called for closer collaboration on the part of the observer and as well as individual works they collaborated in the production of anonymous group works.

Among others they exhibited at the Gal. Denise René in the 'Art Abstrait Constructif International' of 1961 and again at the same gallery in 1966; at the Contemporaries Gal., New York, in 1962 and 1965; at the Tate Gal. in 1964; and at The Mus. of Modern Art, New York, in 1966. They were represented in the 'Art Today' exhibition at the Albright-Knox Art Gal., Buffalo, in 1965; in DOCUMENTA III at Kassel in 1964; in the 'Licht und Bewegung' exhibition at the Kunsthalle, Berne, in 1965; in the Pittsburgh International Exhibition of Contemporary Painting and Sculpture in 1961; in the exhibition 'The Responsive Eye' of The Mus. of Modern Art, New York, in 1965; in the São Paulo Bienale of 1963 and the Venice Biennale of 1964.

While GRAV was the most important and the most rigidly scientific association in the development of OP ART and KINETIC ART, many individual and collective statements from the group emphasized the close connection between Op art and spectator participation. On various occasions they attempted to bring art into the life of the streets, as in their *Journée dans la Rue* (19 April 1966), and they have also been concerned with 'ludic' art or the art of game.

GROUPE DES VINGT (XX). An association of *avant-garde* artists formed in Brussels in 1883 and dissolved in 1893, being followed by La LIBRE ESTHÉTIQUE. The association existed to promote innovative art, Belgian and foreign, and arranged exhibitions. Among its members were ENSOR and a number of others who were leaders and founders of contemporary art in Belgium. The main organ of propaganda was the magazine *L'Art Moderne*, founded in 1881.

GROUPE ESPACE. An association founded in Paris in 1949 by André BLOC and artists associated with the periodical *Art d'Aujourd'hui*. The members included Nicolas SCHÖFFER, Jean GORIN and Edgard PILLET. Their object particularly was to promote that part of CONSTRUCTIVIST doctrine which formed the subject of the last paragraph of MONDRIAN's essay 'Plastic Art and Pure Plastic Art', namely that Constructivist art, united with architecture, had as its function the creation of a new urban environment appropriate to the new society and the new man which were to emerge in the modern age. They envisaged a 'public art', art as a social and collective, not an individual, phenomenon.

GROUP OF AVANT-GARDE ARTISTS (SKUPINA VÝTVARNÝCH UMĚLCU). A splinter group of progressive artists which broke away from the MÁNES UNION in Prague in 1911. The leading members of the group were FILLA, Beneš, PROCHÁZKA, ČAPEK and GUTFREUND. They endea-

voured to combine CUBISM with Germanic EXPRES-
SIONISM, along with some FUTURIST influence after
1913. They were in touch with the artists of the
BRÜCKE and in 1913 they showed as a group in the
STURM Gal., Berlin. In 1913 and 1914 they arran-
ged exhibitions of Cubist works by PICASSO,
BRAQUE and GRIS in Prague. The Czech artists,
unlike the major Cubists, wanted their works to
express the inner feelings and spiritual exaltations
of man.

GROUP OF SEVEN. A group of Canadian pain-
ters who found their main inspiration in the land-
scape of northern Ontario and made it their ambi-
tion to represent the unique character of Canada
in appropriate pictorial form. In the years follow-
ing 1911 a band of artists with similar views came
together. It comprised J. E. H. MACDONALD,
Lawren HARRIS, Tom THOMSON, A. Y. JACKSON,
among others. The group was officially established
after the war in the spring of 1920 and held its first
exhibition in May 1920 in the Art Gal. of Tor-
onto. Its last exhibition was in December 1931.
(See CANADA.)

A gallery dedicated to the group—the McMich-
ael Canadian Collection—was opened in Klein-
burg, Ontario, in 1966 and in 1970 the National
Gal. of Canada mounted a major exhibition of
their work.

GROUP X. A short-lived and heterogeneous asso-
ciation of British artists, including some former
members of the VORTICIST movement, which was
formed in 1920 and held one exhibition, at the
Mansard Gal. in that year. The members of
the group were: Jessica DISMORR, Frank DOBSON,
Frederick ETCHELLS, Charles GINNER, Cuthbert
HAMILTON, Wyndham LEWIS, McKnight Kauffer,
William ROBERTS, John Turnbull and Edward
WADSWORTH.

GRUBER, FRANCIS (1912–48). French painter,
born at Nancy of an Alsacian father and a Polish
mother. Both his father and his brother were de-
signers of stained glass. Owing to ill health he was
unable to attend art school until late but he re-
ceived private instruction from BRAQUE and BISSI-
ÈRE. In 1928 he entered the Académie Scandinave
and attracted the attention of FRIESZ and DU-
FRESNE. He exhibited at the Salon d'Automne and
the Salon des Tuileries from 1930 and made a
name for himself both by his work and by his per-
sonality. Repudiating CUBISM and SURREALISM he
belonged to the independent French EXPRESS-
IONISTS. He was a craftsman of outstanding tech-
nical proficiency and at the same time his pictures,
even when their theme was derived from everyday
life or familiar objects, were monumental with
expressive vitality. Attacked by tuberculosis, he
painted with frenetic energy. In 1936 he executed a
large mural, *Hommage à Le Nôtre*, for the Lycée
Lakanal. In 1942 he succeeded Bissière for a short
while at the Académie Ransom and in 1947 he re-

ceived the Prix National. Besides Paris, his works
were exhibited in New York, Buenos Aires, Swit-
zerland, Denmark and Spain. In 1949 the Mus.
National d'Art Moderne, Paris, put on a memorial
retrospective exhibition and a retrospective exhibi-
tion was shown at the Tate Gal. in 1959.

GRÜNEWALD, ISAAC (1889–1946). Swedish
painter born in Stockholm. He studied under
MATISSE, 1908–11, and evolved a basically FAUVIST
style which was not well received by the establish-
ment in Sweden. From the 1920s he developed a
more plastic manner of painting in which objects
were solidly defined in heavy impasto. He was
popular for his water-colour landscapes and was
successful in theatrical design and decorative pro-
jects, including the decoration of an auditorium in
the Stockholm Concert Hall. Through his teaching
at the Stockholm College of Art he exerted con-
siderable influence on younger Swedish artists.

GRUPPO DEGLI OTTO PITTORI ITALIANI.
A group of eight Italian painters, organized in
1952 by the critic Lionello Venturi, which exhib-
ited at the Venice Biennale of that year. Six of
them were painters of the abstract who had split
off from the FRONTE NUOVO DELLE ARTI. They
were: BIROLLI, CORPORA, MORLOTTI, SANTOMASO,
TURCATO and VEDOVA. In addition the group in-
cluded AFRO and Mattia Moreni. The movement
was described by Venturi as 'Abstract-Concrete'.

GRUPPO DEI 6. See CHIARISTI.

GRUPPO N. An association of artists founded in
Padua in 1959. The members were Alberto BIASI,
Ennio Chiggio, Giovanni Antonio Costa, Edoardo
N. Landi, and Manfredo Massironi. They were
interested mainly in geometrical abstraction, espe-
cially OP ART, ENVIRONMENT ART and spectator in-
volvement.

GRUPPO T. An association formed in Milan in
1959 by Giovanni Anceschi, Davide BORIANI,
Gianni Colombo and Gabriele de Vecchi, later
joined by Grazia Variso. The group was interested
in exploring KINETIC ART and light environments,
particularly in the 'disappearance of the object' by
the activation of ambiguous space by means of
optical devices. (See LUMINISM.)

GUAYASAMÍN, OSWALDO (1919–). Ecuado-
rian painter born in Quito. Guayasamín was the
oldest of ten children in a poor family. He enrolled
at the Escuela Nacional de Bellas Artes in Quito in
1932 against his father's wishes and studied arch-
itecture and painting until 1941. In the early 1940s
he went to Mexico, where he met OROZCO and
worked with him. Guayasamín's painting focuses
on the plight of the poor Indian in a style fusing
PICASSO with Mexican Muralism, often in violent
colours recalling TAMAYO. Following his first ex-
hibition in Ecuador, he was invited by the U.S.

State Department to show in a travelling exhibition in the U.S.A., where he spent 7 months. As a result of his trips to Peru, Chile, Argentina and Bolivia in 1944–5, he began the series of paintings 'Huacayñan', focusing on life among the poor, exploited and downtrodden Indians and blacks of Latin America. By 1952 this series comprised 103 paintings, and was exhibited successively at the Mus. de Arte Colonial, Quito (1952), the Mus. Nacional de Bellas Artes, Caracas (1953), and the Pan American Union, Washington (1955). In 1956 Guayasamín went to Europe for the first time and exhibited part of the 'Huacayñan' series at the 3rd Hispano-American Bienale in Barcelona, where he was awarded a prize for *The White Coffin* from the series. He won the 'Best South American Painter' award at the São Paulo Bienale in 1957.

Guayasamín also painted murals, two of which are in the Government Palace and the Casa de la Cultura in Quito. He visited Cuba, China, Russia and met and painted many heads of state, including the Chilean president, Salvador Allende. In 1962 he began the series 'La Edad de la Ira' (The Age of Wrath), whose title is said to have been inspired by Malraux's *Le Temps de Mépris*. In this series his colour is muted. Through the 1960s and early 1970s he exhibited extensively in Ecuador, Mexico, Chile, Italy, Spain, France and Czechoslovakia. He dedicated a museum, the Mus. Guayasamín, to the town of Quito.

GUBLER, MAX PAUL (1898–1971). Swiss painter, born in Zürich. His brother EDUARD (1891–1971) was a teacher of painting, his brother ERNST (1895–1958) was a painter and sculptor, and from them he learned painting after having started studying at a Teachers' Training College outside Zürich. Between 1915 and 1918 he frequented DADA circles in Zürich, which included Hugo Ball, Tristan Tzara and Hans RICHTER. In 1918 he chose painting as a career and was helped financially by the Berlin dealer Paul Cassirer and the Swiss collector Hans Coray, while from time to time he worked as a picture restorer. In 1921 he visited HOFER in Berlin. From 1923 to 1927 he lived on the island of Lipari and from *c*. 1930 to 1937 he worked in Paris. He matured into a competent, pleasing and prolific but mediocre artist, painting in a style which varied from Late-Impressionism to Late EXPRESSIONISM (in the 1940s) in the French rather than the German manner with a preference for light pastel colours in both styles. Besides participating in many group exhibitions, including the Venice Biennale in 1952, he had large one-man shows at the Kunstmus., Berne, in 1951 and 1969, at the Kunsthaus, Basle, in 1959, and at the Kunsthaus, Zürich, in 1952. A travelling exhibition of his work visited Schaffhausen, The Hague, Munich, Bremen and elsewhere in Germany in 1962 and a large retrospective exhibition was staged at the Kunsthaus, Zürich, in 1975. In 1953 he did illustrations for Hemingway's *The Old Man and the Sea* and these were exhibited at Chicago, Minneapolis, St. Louis and elsewhere in the U.S.A. in 1955.

GUDNASON, SVAVAR (1909–). Danish painter born at Hafu, Iceland, studied in Copenhagen and in Paris under LÉGER. He was one of the pioneers of abstract painting in Denmark and Iceland.

GUERRA, NOÉMIA (1920–). Brazilian painter born in Rio de Janeiro. She studied under André LHOTE, 1952–3, and from 1958 lived in Paris. From 1960 she had a number of one-man exhibitions, including 6 in London, and participated in collective exhibitions including 'Art Contemporain' at the Grand Palais, Paris, and the São Paulo Bienale in 1963, 1967, 1969 and 1975. Her work belonged to the category of expressive abstraction or near-abstraction and she had an unusual gift for expressing movement by the abstract medium of colour. Much of her painting was based upon concepts of dance.

GUERRERO, JOSÉ (1914–). Spanish painter born in Granada. He studied at the Granada School of Arts and Crafts and then at the San Fernando School of Fine Arts, Madrid. In the 1940s he was a member of the group of painters, including Lara, Lago, Valdivieso, Palazuelo and Bernardo Olmedo, who set themselves to stimulate a revival of Spanish art from Madrid. He spent the years 1945 and 1946 in Paris and from 1949 he lived for a number of years in the U.S.A., where he came into contact with the NEW YORK SCHOOL of ABSTRACT EXPRESSIONISM. In 1958 he was awarded the Graham Foundation scholarship and in 1959 the Art Institute of Chicago prize. On his return to Spain he was painting, in the latter half of the 1960s, in an expressive TACHIST manner with broad patches of colour. The influence of KLINE and MOTHERWELL is apparent in his work done in the 1970s, which was close to Abstract Expressionism in style.

He exhibited widely in Spain and in Europe and the U.S.A. and participated in many international group shows. His work is represented in many leading public collections in Spain and abroad.

GUEVARA, ALVARO (1894–1951). British painter, born in Chile. He studied at the Slade School and showed great promise as a student, being given an exhibition at Roger FRY's Omega Workshops in 1916. He did not live up to his early promise and his later work consisted of café scenes, bathers, dancers, acrobats, etc. in a pastiche of fashionable styles. His *Portrait of Edith Sitwell* stands out as his most accomplished work. A retrospective exhibition of his work was given by the Colnaghi Gal. in 1975.

GUIETTE, RENÉ (1893–1976). Belgian painter born at Antwerp, where he studied at the University, turning to painting in 1919. He first

worked in an EXPRESSIONIST manner but during the 1930s and 1940s he experimented with a number of different styles. In 1950 he began to produce works in the manner of DUBUFFET, scratching or etching a design into the surface of a thick impasto. He also worked in the manner of LYRICAL ABSTRACTION and was associated with the Belgian group JEUNE PEINTURE BELGE.

GUIGNARD, ALBERTO DA VEIGA. See LATIN AMERICA.

GUINOVART, JOSÉ (1927–). Spanish painter, born in Barcelona and studied at the Barcelona School of Arts and Crafts. He was one of the most vigorous EXPRESSIONIST painters of post-war Spain and although he was not a member of the DAU AL SET group, he participated sporadically in its activities. He also did much magazine illustration. In 1958 he changed to abstract painting in a manner akin to ART INFORMEL and he began to incorporate pieces of wood and other materials in his paintings. In 1963 he designed the sets for *Les Noces de Sang*, produced by Cavalcanti. Besides Spain he had one-man shows in Rome, Florence, Milan and Buenos Aires and he was represented in collective exhibitions of *avant-garde* Spanish art. His work is represented in the Mus. de Arte Contemporaneo, Madrid.

GUITET, JAMES (1925–). French painter born at Nantes, where he attended the École des Beaux-Arts. He afterwards taught drawing at Angers. He painted in a style of LYRICAL ABSTRACTION which has been compared to the manner of the Dutch artist Geer van VELDE. He exhibited at the Gal. Arnaud, Paris, and at the SALON DES RÉALITÉS NOUVELLES.

GULBRANSSON, OLAF (1873–1958). Norwegian painter and draughtsman born at Schererhof, Tegernsee. After working as a caricaturist for humorous magazines from the age of 16, he studied at the School of Arts and Crafts, Oslo, and then in 1900 at the Académie Colarossi, Paris. On his return to Norway he did an album of caricatures of 24 famous Norwegians and from 1902 gained an international reputation as a caricaturist for the German humorous magazine *Simplicissimus*. He was elected to the Prussian Academy in 1916 and in 1924 became an honorary member of the Munich Academy, where he was Professor of Painting from 1929. In 1951 he was elected to the Bavarian Academy of Fine Arts. Besides the superb caricatures, in which he stigmatized the foibles of the famous and the middle classes, Gulbransson was a talented portraitist. He had a posthumous retrospective exhibition in Oslo and Munich in 1962.

GUNDERSEN, GUNNAR S. (1921–). Norwegian painter born in Oslo and studied at the School of Arts and Crafts there. Returning to Norway after visiting Paris, Portugal and several Scandinavian countries, he collaborated in 1950 with Ludvig EIKAAS on mural paintings for the Kemiske Factory, Oslo, and other buildings. He taught at the Academy of Art and at the Technical College, Oslo, and in 1956 he was instrumental in founding the *Taerningen* group. His paintings showed fragments of recognizable objects against clearly defined abstract forms rhythmically composed in pure colours.

GURO, ELENA. See MATIUSHIN, Mikhail.

GURVICH, JOSÉ. See LATIN AMERICA.

GUSTON, PHILIP (1913–80). American painter born in Montreal, Canada, and brought to the U.S.A. in 1916. After studying at the Otis Art Institute, Los Angeles, for 3 months in 1930, he travelled to Europe and then in 1934 became acquainted with the Mexican muralists. He did murals for the FEDERAL ARTS PROJECT from 1935 to 1942, which enabled him to bring into play his experience of Mexican murals and at the same time to experiment with figurative abstraction on a large scale. Among his murals were: façade for WPA Building at the New York World's Fair, 1939; the Queensbridge Housing Project, 1940; Social Security Building, Washington, 1942. He taught at the State University of Iowa, 1941–4, and at the universities of Washington, 1945–7, and New York, 1951–9, at the Pratt Institute, 1953–7, and elsewhere for shorter periods. In the early 1940s he was still painting in a figurative manner of fantasy bordering upon SURREALISM and MAGIC REALISM but still his own. Towards the end of the 1940s he began to experiment with abstractions vaguely suggestive of urban landscapes until *c*. 1950 he eliminated the figurative element from his work, adopting an expressive geometrical style which owed something to MONDRIAN but was more romantic and impressionistic than CONSTRUCTIVISM. This manner of his has been described as 'abstract Impressionism' and he was associated with the more lyrical group of ABSTRACT EXPRESSIONISTS such as MARCA-RELLI. From *c*. 1955 his interest in abstract colour divorced from form coincided with the aims of those artists who spoke of 'the shape of colour'. He painted areas of bright and strong colour centralized on a light and fluid background to give the effect of massive and dominant images engaged in interplay within the picture area. In the course of the 1960s shades of grey encroached on the earlier brilliance of colour and vague naturalistic associations crept in, until in the 1970s he introduced a new manner of figuration between satire and Goya-like grotesquerie. Using a comic-strip technique and harsh discordant colours, and painting with a certain deliberate brutality, he depicted scenes of the Ku Klux Klan and fantastic social comment. In 1975 he began a series of paintings in which he returned to the rich impasto of the 1950s and his Klan 'bosses' were

swallowed up in a sea of brilliant red.

Guston was awarded a Carnegie First Prize in 1945, a Guggenheim Fellowship in 1947 renewed in 1968, the Prix de Rome and an American Academy of Arts and Letters grant in 1948, Ford Foundation grants in 1948 and 1959. His first one-man exhibitions were at the Midtown Gal., New York, in 1945 and the Boston Mus. School in 1947. He had retrospectives at the São Paulo Bienale, 1959, the Venice Biennale, 1960, the Solomon R. Guggenheim Mus. in 1962, Brandeis University in 1966. His work was widely exhibited in collective exhibitions of American painting both in the U.S.A. and abroad and he is represented in many public collections, including The Mus. of Modern Art, New York, Solomon R. Guggenheim Mus., The Metropolitan Mus. of Art, New York, Whitney Mus. of American Art, Los Angeles County Mus. of Art, the Tate Gal., etc. Despite the enormous interest of his later work, Guston is often chiefly remembered as one of the romantic and lyrical group of Abstract Expressionists in the NEW YORK SCHOOL. In 1960 he wrote: 'There is something ridiculous and miserly in the myth we inherit from abstract art: That painting is autonomous, pure and for itself, and therefore we habitually analyse its ingredients and define its limits. But painting *is* "impure". It is the adjustment of "impurities" which forces painting's continuity. We are image-makers and image-ridden.'

GUTAI GROUP. A group of Japanese artists founded by Jiro YOSHIHARA at Osaka in the 1950s. The group contained *c.* 20 artists including Atsuko TANAKA, Sadamasa Motonaga, Kazuo Shiraga and Minoru Yoshida. They were chiefly known for their HAPPENINGS in the spirit of DADA.

GÜTERSLOH, ALBERT PARIS (ALBERT KONRAD KIEHTREIBER, 1887–1973). Austrian painter, born in Vienna. He started as an actor and stage designer (using the name ALBERT MATTHÄUS) and later was a journalist. He was self-taught as a painter. His work was shown for the first time at the exhibition of the *Neukunstgruppe*, formed by Anton FAISTAUER, in the Gal. Pisko in 1909. He taught at the Vienna School of Arts and Crafts, 1919–38, bringing new life into the department of tapestry design. From 1945 he was professor at the Vienna Academy of Fine Art. He was a founder member and first President of the Vienna Art Club, formed in 1945, and his teaching was influential in forming some of the young artists who *c.* 1950 initiated the characteristically Austrian movement of FANTASTIC REALISM.

GUTFREUND, OTTO (1889–1927). Czech sculptor born at Dvur Kralové. He was trained at the Prague School of Decorative Arts and worked with BOURDELLE in Paris, 1909–10. He was attracted by CUBISM and was among the first to apply the principles of Cubism to sculpture. On his return to Prague in 1911 he formed one of a small

group of *avant-garde* artists attempting a fusion of Cubism with EXPRESSIONISM. He spent the war years in France and after his return to Prague in 1919 developed a more popular and naturalistic style based upon folk art. A bust from his Cubist period (1912–13) is in the Tate Gal.

GUTHRIE, SIR JAMES. See NEW ENGLISH ART CLUB.

GUTTMANN, ROBERT (1880–1942). Czech NAÏVE painter, born at Susiče. He moved to Prague in 1896 and became an ardent Zionist. In 1900 he attended art school for a short while but he did not take painting seriously until after the First World War. He became a well-known eccentric and traveller. In 1941 he was deported to Łódz, Poland, where he died. Guttmann painted Jewish themes and genre scenes, combining in his work mystical EXPRESSIONISM with the spontaneous directness of naïve painters.

GUTTUSO, RENATO (1912–). Italian painter born at Bagheria, near Palermo, Sicily. After studying law he took up painting in 1931 and for a while worked as a picture restorer in Rome. He was a forceful, vigorous personality and in 1938 became a founder member of the anti-Fascist association CORRENTE. His painting *Flight from Etna* (1938–9) established the reputation of Communist which his subsequent work confirmed. But his art of SOCIAL REALISM was infused with a passionate commitment to human vicissitudes and artistic quality was never subordinated to political propaganda. In 1941 his *Crucifixion* stigmatized Fascism and in 1943–5 he published a series of drawings protesting against the massacres which took place under the German Occupation in Italy. But his *Assassination* pilloried the Mafia and his *Occupation of a Virgin Land* (1950) laid bare the political troubles of his native Sicily. Later pictures such as *Wandzeitung 1968* and *Chile, September 1973* left no doubt where his sympathies lay. Yet his work never came into the category of SOCIALIST REALISM and he remained always the artist before the politician. After the war he was a member of the FRONTE NUOVO and in 1950 he was awarded the Marzotto prize. His interest in the history of art and in artists present and past provided him with a second major theme. He saw in the executions of the Second World War a renewal of the *Execution* of Goya and he introduced visual 'quotations' from PICASSO and other artists into his own paintings. In particular his 'Conversation Pieces' brought past and present together: *La Visite* (1970) pictures Picasso, Dürer and Marlene Dietrich; *Die Unterhaltung mit den Malern* brings together Picasso, Cézanne, Velazquez, Cranach, Rembrandt, Delacroix, Courbet and three female figures from Picasso's paintings; and *Café Greco* (Ludwig Mus., Cologne, 1976), measuring 280 by 330 cm, depicts a scene with CHIRICO in this famous café.

Guttuso was elected a councillor of his native town in 1973 and Italian Senator in 1976. He had a retrospective exhibition at the Kunstverein, Darmstadt, in 1967 and a large retrospective in the Kunsthalle, Cologne, in 1977.

GUZMAN DE ROJAS, CECILIO. See LATIN AMERICA.

GWATHMEY, ROBERT (1903–). American painter born at Richmond, Va., studied at North Carolina State College, 1924–5, the Maryland Institute of Design, Baltimore, 1925–6, and at the Pennsylvania Academy of the Fine Arts, 1926–30, where he obtained Cresson Scholarships enabling him to travel to Europe and the Caribbean. After graduation he taught at Beaver College, Jenkintown, Pa., 1931–7, at the Carnegie Institute of Technology, 1938–52, as Instructor in the Department of Painting and Design and at the Cooper Union, 1942–68. On leaving his post at Beaver College in 1938 he destroyed all his work up to date, declaring 'it takes about ten years to wash yourself of academic doctrine'. As a result of showing his picture *Land of Cotton* in 1939 he was offered an exhibition by the American Contemporary Art Gallery, for which he was not ready until 1941. He worked slowly and exhibited infrequently. He had retrospectives, however, at the Randolph-Macon Women's College in 1967 and at Boston University in 1969. Under the FEDERAL ARTS PROJECT/WPA scheme he executed a mural for the Post Office at Eutaw, Ala., and he won the Government State Mural Competition in 1939. His work had strong social implications, castigating poverty and oppression with occasional satire. But he did not paint realistically, converting his subjects instead into strongly patterned designs of flat unmodulated colour with boldly incisive lines.

H

HAACKE, HANS (1936–). German experimental artist born at Cologne and studied from 1956 to 1960 at the Hochschule für Bildende Künste, Kassel. In 1960 he obtained a scholarship to study with HAYTER at Atelier 17 in Paris. In 1962–3 he had a Fulbright travelling scholarship and from 1963 he taught at Rutgers University, Philadelphia College of Art, the Cooper Union, New York, and elsewhere in the U.S.A. He exhibited widely in Germany, the U.S.A. and elsewhere. His speciality was to enclose water in plexiglass containers and expose these to light so that as the temperature in the box rose and condensation took place drops of water would be deposited on the inner walls and the light reflection would change. He was chiefly interested in movement and light and the theory behind his work was the creation of objects which reacted integrally with their environment. Wind and water played a large role in his work. From about the mid 1960s he became more interested in spectator participation and the social function of art. His *Large Wave* (1965), for example, consisting of two bars filled with coloured liquid, had to be manipulated by the spectator in order to function. He was a pioneer in the use of air, participating in the 'Air Art' exhibition which toured in the U.S.A. in 1968. His *Sky Line* of helium-filled balloons at Central Park was an example of his adaptation of the art work to varying environmental conditions.

HABER, SHAMAI (1922–). Israeli sculptor born at Łódz, Poland, and emigrated in 1935 to Palestine, where he studied at the Academy of Art, Tel Aviv, 1943–7. In 1949 he settled in Paris. His early work was influenced by DESPIAU but *c.* 1953 he turned to abstraction and exhibited at the Salon de la Jeune Sculpture. In 1959 he won the Prix Bourdelle. Although he lived in Paris and his work was abstract, Haber was dominated by the concept of the Israeli landscape, as was evidenced, for example, by his monumental assembly of stones for the atomic-research centre at Newe-Rubin and the monument he did in conjunction with DANTZIGER for the Israel Mus. in Jerusalem.

HADZI, DIMITRI (1921–). American sculptor born in New York. He studied at the Polytechnic Institute, Brooklyn, the Cooper Union, the Polytechneion, Athens, the Mus. Artistico Industriale, Rome, and the Brooklyn Mus. School. Among his awards were a Fulbright Fellowship (Greece), 1950, L. C. Tiffany Grant, 1955, Guggenheim Foundation Fellowship, 1957, National Institute of Arts and Letters grant, 1962. His first one-man exhibition was at the Gal. Schneider, Rome, in 1958 and in America at the Seiferheld Gal., New York, in 1959. He also exhibited at the Gal. Van der Loo, Munich, in 1961 and the Gal. Hella Nebelung, Düsseldorf, in 1962. He participated in a number of collective shows, American and international, including: The Mus. of Modern Art, New York, 'New Talent', 1956 and 'Recent Sculpture USA', 1969; 'International Outdoor Sculpture', Middelheim Park, Antwerp, 1957 and 1959; Claude Bernard, Paris, 'Aspects of American Sculpture', 1960; International Sculpture Exhibition, Battersea Park, London, 1963; New York World's Fair, 1964–5. His commissions included sculpture for the Massachusetts Institute of Technology; Lincoln Center for the Performing Arts, New York; Reynolds Metal Co. Memorial Award; Sun Life Insurance Co., Baltimore; John F. Kennedy Federal Office Building, Boston. Hadzi's motifs were usually taken from classical history and mythology, but from *c.* 1958 he became more abstract with forms derived from shields and helmets somewhat reminiscent of Henry MOORE's *Helmet Heads.* He worked chiefly in bronze although he also did direct carving. His work was massive, rugged and static with heavy slabs resting on slender supports.

HAESE, GÜNTER (1924–). German sculptor born in Kiel, studied at the Academy of Art, Düsseldorf, 1950–8. Besides numerous exhibitions in Germany his work was shown at The Mus. of Modern Art, New York, in 1964 and at the Marlborough Gal., London, in 1965. He made objects from light materials such as brass mesh, parts of watches, feathers, etc., arranging similar forms serially, with the intention that motion should be imparted to them in the manner of MOBILES.

HAESE, REINHOUD D' (1928–). Belgian sculptor born in Grammont, brother of Roel d'HAESE. After training at the École des Arts Décoratifs, Brussels, he worked in an EXPRESSIONIST manner and had contacts with the COBRA group. From 1959 he lived in Paris. He worked first by modelling for plaster and terracotta but later did metal sculpture in an ART INFORMEL style, using sheets of copper and brass.

HAESE, ROEL D' (1921–). Belgian sculptor born in Grammont and studied at the Academy of

Alost and at La Cambre under Oscar JESPERS. During the 1950s he made his name with EXPRESSIONIST sculpture in cast iron and forged steel and became one of the leading sculptors of the ART INFORMEL school, combining exploitation of the natural properties of metal with suggestions of organic form and SURREALIST fantasy. He was one of the earliest sculptors to make ASSEMBLAGES. He was also a fine draughtsman and used drawing as a major means of expression.

HAGENBUND (KÜNSTLERBUND HAGEN). A group of Austrian artists founded in January 1899. It took its name from that of the landlord, Herr Haagen, of an inn, Zum Blauen Freihaus, where the artists used to meet in informal discussion. At first formed as a club within the Künstlerhaus (see AUSTRIA), it soon broke away and became independent. Its professed aim was, like that of the SECESSION, to improve artistic taste by holding exhibitions of *avant-garde* artists and it was held to be intermediary between the extremism of the Secession and the conservatism of the Künstlerhaus. Among the Austrian artists who participated in its exhibitions, the first of which was in 1902, were R. C. ANDERSEN, Anton FAISTAUER, A. P. GÜTERSLOH, Franz WIEGELE, Oskar KOKOSCHKA, Egon SCHIELE, Anton KOLIG, Anton HANAK. Its importance was short-lived, although it remained active until the First World War.

HAINS, RAYMOND (1926–). French photographer and AFFICHISTE born at St. Brieuc. He did abstract photographs in the second half of the 1940s and made films together with Jacques de la VILLEGLÉ. In 1949 they began to use torn posters as an art form, coining the term *affiches lacérées* and calling themselves *affichistes*. They gave a joint exhibition of these torn posters in 1957. Hains used them primarily as a medium for demonstrating the aesthetic bankruptcy of the advertising world and also occasionally for political propaganda. In 1960 he was a founding member of the group NOUVEAUX RÉALISTES.

HAJEK, OTTO HERBERT (1927–). Russian-German sculptor born at Kaltenbach and studied at the Stuttgart Academy, 1947–54. His first one-man exhibition was at the Junges Theater, Stuttgart, in 1951 and since then his work has been extensively exhibited in Germany and elsewhere in Europe. He took part in the first three DOCUMENTA exhibitions at Kassel. After experimenting with pierced and broken surfaces he advanced to a manner of sculpture which he called *Raumknoten* (*Knots in Space*) and *Räumliche Wände* (*Space Walls*). He conceived these as a 'stratification of space', a kind of dialectic between space and plastic volume. In the 1960s he introduced bands of colour which obscured the spatial contours of his works and visually extended them into the surrounding space. These *Farbwege* (*Ways of Colour*), as he called them, disrupted the solid forms and

integrated the sculptures with the surroundings. He said: '*Farbwege* override situations and cause the situation of Man to be understood as an artificial unity.' He often built up his sculptures in modelling cement, which he then covered with wax and cast. Among his commissions were a sculpture for the auditorium of Freiburg University (1959), a *Leitwand* for the Memorial Hall in Frankfurt (1962), a *Way of the Cross* for the parvis of the Church of Regina Martyrum in Berlin-Plötzensee (1961–3).

HALL, DAVID (1937–). British sculptor. First trained as an architect, he later studied at the Royal College of Art. His style conformed with that of the artists introduced by the 'New Generation' exhibition at the Whitechapel Art Gal. in 1965. He made constructions of welded steel and other materials, experimenting in particular with 'space altering' techniques and using, for example, steel plates hovering above the floor level in such a way as to create perspectives which modified and distorted the true perspective of the room. Such works invited attention not so much to themselves as to their spatial effects, the total modified environment in which they were set. He was represented in several group exhibitions of *avant-garde* sculpture, including 'Four Young Artists' at the I.C.A. Gals., London (1964) and the Jewish Mus., New York (1966). He was awarded the Prix des Jeunes Artistes and the Prix de la Ville in Paris in 1965. Among the public collections in which his works are represented are: the Gulbenkian Foundation and Contemporary Art Society and the Arts Council, London; Leicestershire Education Authority; Gemeentemus., The Hague.

HALL, NIGEL (1943–). British sculptor born in Bristol, studied at the West of England College of Art, 1960–4, and the Royal College of Art, 1964–7. He obtained the Harkness Fellowship and travelled in the U.S.A., Canada and Mexico, 1967–9. From 1967 he had one-man shows in Paris, Los Angeles, Hamburg, Cologne, Gothenburg, London, New York, Rome, and his work was represented in a number of group exhibitions, including: 'New British Painting and Sculpture' touring from U.C.L.A. Gals., Los Angeles (1967–9); Salon des Réalités Nouvelles, Paris (1972); 'British Art mid '70s', Jahrhunderthalle, Hoechst (1975); 'The Condition of Sculpture', Hayward Gal., London (1975). His latest works shown consisted of elongated structures of thin painted aluminium strips, free-standing or attached to a wall.

HALLER, HERMANN (1880–1950). Swiss painter and sculptor born at Berne. He studied architecture at Stuttgart and then painting at Munich, 1899–1903. From 1903 he belonged with Karl HOFER to the group of young painters who were promoted by Dr. Theodor Reinhart-Volkart. While in Rome with Hofer he became interested in Etruscan art and turned from painting to sculp-

ture. From 1909 to 1914 he lived in Paris, spending the summers at Cap Ferrat, and on the outbreak of the First World War he settled in Zürich. In 1949 he won the Grand Prix at Zürich. A number of his terracottas, including a portrait of the painter Karl WALSER, are in the Stiftung Oskar Reinhart at Winterthur.

HAMAGUCHI, YOZO (1909–). Japanese graphic artist. After studying sculpture at the Imperial School of Fine Arts, Tokyo, he emigrated to Paris in 1930. Known chiefly for his etchings, landscapes and still lifes, he combined European techniques with Japanese sensitivity and charm. He was awarded the First Prize for prints at the São Paulo Bienale of 1957.

HAMILTON, CUTHBERT (1884–1959). British painter, born in India and studied at the Slade School 1899–1903. He joined the Omega Workshops in 1913 but seceded with Wyndham LEWIS and joined the VORTICIST group, signing the manifesto of BLAST and joining the Rebel Art Centre in 1914. He participated in the LONDON GROUP exhibition of 1914 and contributed near-abstract works to the exhibition of GROUP X at the Mansard Gal. in 1920. He was also interested in pottery and founded the Yeoman Potteries, beginning about the same time to experiment with sculpture.

HAMILTON, RICHARD (1922–). British painter born in London. In 1936–7 he attended evening classes at St. Martin's School of Art while working in the publicity department of an electrical firm and from 1938 to 1940 he studied at the Royal Academy Schools. After working as a jig and tool draughtsman, 1941–5, he was readmitted to the Royal Academy Schools in 1946 but was expelled. He then studied at the Slade School, 1948–51. He taught at the Central School of Arts and Crafts, 1952–3, from 1953 to 1956 was lecturer at King's College in the University of Durham at Newcastle upon Tyne, and from 1957 to 1961 taught at the Royal College of Art, London. His first one-man exhibition was at Gimpel Fils, London, in 1950. In 1951 he devised and designed the exhibition 'Growth and Form' for the I.C.A., London. In 1955 he planned the exhibition 'Man, Machine and Motion' at the Hatton Gal., Newcastle upon Tyne, and the I.C.A., London. In 1956 he collaborated with John McHale and John Voelcker in organizing the 'This is Tomorrow' exhibition at the Whitechapel Art Gal., London, and in 1966 organized the Arts Council's retrospective exhibition of Marcel DUCHAMP at the Tate Gal., for which he reconstructed Duchamp's *Large Glass*. In 1964 his works were shown at the 'Pop Art' exhibition in The Hague, Vienna and Berlin. In 1969 he was awarded jointly with Mary MARTIN First Prize for Painting at the 7th John Moores Liverpool exhibition and in the same year a film of his work was

made for the Arts Council. In 1970 he had a retrospective exhibition at the Tate Gal., the Stedelijk Mus., Eindhoven, and the Kunsthalle, Berne, and in 1973 a retrospective at the Solomon R. Guggenheim Mus., New York, shown also in the Städtische Gal., Munich, and the Kunsthalle, Tübingen.

Hamilton took a major part in promoting the growth of POP ART and the NEW REALISM in Britain and was a founder member of the INDEPENDENT GROUP in the 1950s. He was best known for his montages featuring scenes from the fields of advertisement and contemporary life. These were carefully and deliberately planned to suggest critical and revealing insights into significant trends in contemporary culture and society. He was represented in the exhibition 'Pop Art in England' shown in 1976 at the Kunstverein, Hamburg, the Städtische Gal. im Lenbachhaus, Munich, and the York City Art Gal. Here his well-known *Just what is it that makes today's homes so different, so appealing?* (1956) was described as one of the key works of English Pop art with Peter Blake's *On the Balcony*. Many of Hamilton's most striking works were systematic sequences, among the most important of which were: *Hommage à Chrysler Corp*, inspired by Reyner Banham's investigations into car styling and sex symbolism and designed to 'portray the American automobile as expressed in the mag-ads'; *$he*, also concerned with the social psychology of advertising; *Interior*, inspired by the film *Shockproof* featuring Patricia Knight; *My Marilyn*. The specific character of Hamilton's work within the general category of Pop was admirably summed up in the catalogue of 'Pop Art in England' as follows: 'As an intellectual artist of the 20th century, Hamilton proceeds from the availability of the artistic styles and methods; the choice of pictorial media —painting, collages, processed readymade, trompe l'œil, free use of colour, quotation, etc. is guided by the thematic intention: the idea is given primacy.'

HANAK, ANTON (1873–1934). Austrian sculptor born at Brünn. He went to Vienna at the age of 15 and after being apprenticed to a cabinet maker studied sculpture at the Academy of Art. Here he was 'discovered' by the architect Josef Hoffmann and collaborated with him on settings for various exhibitions in Rome, Stockholm, etc. He was a member of the SECESSION and after teaching at the School of Arts and Crafts was made a professor at the Academy in 1932. Hanak based himself on Michelangelo and Rodin but worked towards an EXPRESSIONIST style of block-like abstraction. In his teaching he emphasized the importance of attention to materials and the techniques of carving. He stands at the head of the modern movement in sculpture in Austria, though the movement matured only with his pupils, particularly WOTRUBA and LEINFELLNER.

HANSEN, EMIL. See NOLDE, Emil.

HANSEN, SINE (1942–). German painter, born in Inowroclaw, Poland. She trained at the Hochschule für Bildende Künste, Braunschweig, from 1961 to 1965 and then had numerous one-man exhibitions in Germany and participated in collective exhibitions of *avant-garde* German art. Working mainly in tempera, she depicted precisely delineated abstract forms with an objectivity and anonymity which had something in common with HARD EDGE painting in America and some affinities with the German school of POP ART.

HANTAI, SIMON (1922–). Hungarian painter born at Bia, studied at the École des Beaux-Arts, Budapest. He went to Paris in 1949, became friendly with André BRETON and joined the SURREALIST movement in 1953. He adopted the Surrealist method of AUTOMATISM and used a delicate calligraphic style of arabesque which has been described as a graphic analogue of ACTION PAINTING. His pictures featured horrific visionary fantasies with men surrounded by animal skulls and ramparts of monstrous entrails in bright colours. He was instrumental in forcing the exclusion of Max ERNST from the Surrealist movement but broke with the movement himself in 1955, when under the influence of MATHIEU he changed to a style of ART INFORMEL. In 1957 he became a Roman Catholic and arranged ceremonies in remembrance of the condemnation of the Averroist Siger of Brabant by the Inquisition in the 13th c.

HAPPENING. The word 'happening', in the sense in which it became current during the 1960s as the name for a new art form, was coined by Allan KAPROW in 1959. It occurred originally in the title of a score he published in the *Anthologist* of Rutgers University, and its very vagueness helped its adoption not only in America but also in Europe and Japan for a diversity of contrived artistic phenomena. The concept of the Happening was closely bound up with Kaprow's deliberate rejection of the traditional principles of craftsmanship and permanence in the arts. He thought of the Happening as a development mainly from the ASSEMBLAGE and the ENVIRONMENT. While both the Assemblage and the Environment were relatively fixed and static, the Assemblage something constructed to be contemplated from outside, to be 'handled or walked around', and the Environment something to be 'walked into', something by which the observer was enveloped and manipulated, the Happening was conceived by contrast as a genuine 'event'. It had close affinities with theatrical and performance art and it was not restricted like the Environment to the confines of a gallery or some other site. In conformity with the theories of the composer John Cage about the importance of chance in artistic creation, Happenings were described as 'spontaneous, plotless theatrical events'. In America the artists chiefly responsible for the development of the Happening in its early stages were, besides Cage and Kaprow, Jim DINE, Claes OLDENBURG, Robert RAUSCHENBERG, Roy LICHTENSTEIN, Red GROOMS, Robert WHITMAN. The idea of the Happening was inextricably linked with the principle of spectator participation, which had taken firm hold not only in America but also in Europe and Japan. Outside America the Happening was widely exploited, by the GUTAI GROUP in Japan and the FLUXUS group and many others in Europe. Although the very notion of the Happening involved the emergence of the artist from the rarefied confines of the galleries and museums into the streets and the market-place, the term was often used to cover staged demonstrations for politico-social propaganda, as for example many of the Happenings by Joseph BEUYS, or demonstrations intended to shock established moralities. At the other pole it was held to be characteristic of the Happening that it should bring into being situations or events in which the elements of everyday life and everyday technology are invested with the strangeness of the poetic and the fantastic. Bazon Brock, Professor of Non-Normative Aesthetics in Hamburg, described the Happening as 'an instrument for the production of contradictions'. Ben Vautier, the chief organizer of Happenings in France, described them as 'a passionate transformation of reality through the aid of various accessories—plastic, figurative, luminous, etc.; a series of unusual events whose basic framework is planned though the details are improvised; a generally amateurish quality in the presentation; and, more often than not, a particular *leitmotif*, a sexual or political symbol'. Over a very wide range of variety Happenings verged towards theatrical spectacle on the one hand and public demonstrations on the other, though always postulating some measure of spectator participation.

In practice and in theory too, very different emphasis was laid upon the importance of spectator participation. In America George Brecht used the word 'event' for Happenings which involved the spectator in total, multi-sensory experiences rather like what was aimed at by some of the practitioners of ARTE PROGRAMMATA in Italy. Rauschenberg aimed at making the spectator 'feel his whole body' but maintained that the artist must initiate and control the whole process. Milan Knizak, although requiring some measure of spectator involvement, called his Happenings 'demonstrations'. At the one extreme it was held that Happenings are not contrived events in which the members of a group are swayed by a common emotion as in religious or crowd hysteria but events in which each member of the group, large or small, ignores the others and each is free to participate or not in what is going on. It was in this that the artistic character of the Happening was believed to lie. Pierre Restany, for example, writing in *L'Avant-garde au XXe siècle*, said: 'The happening may be seen primarily as a mechanism of communication, a language (or series of methods) particularly adapted to this purpose, a technique of collective participation whose practical justifica-

1. Kasimir Malevich: *Suprematist Painting* (*Yellow Rectangle*), 1917–18. Oil on canvas. 106 × 70 cm.

2. Lyubov Popova: *Architechtonic Composition*. 1918. Oil on board mounted on canvas. 45 × 53 cm.

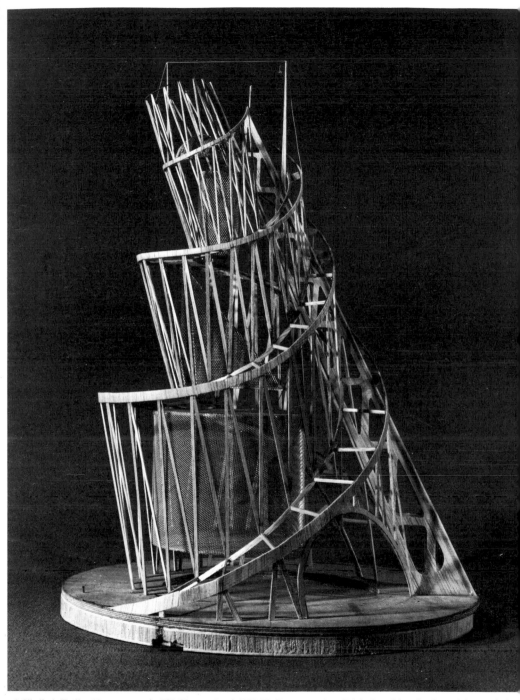

3. Vladimir Tatlin: *Monument to the Third International*, 1919–20. Reconstruction. Original model made of wood, iron and glass.
Proposed height of monument: about 750 metres, i.e. twice the height of the Empire State Building.

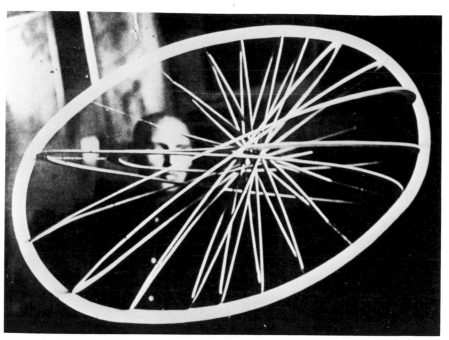

4. Aleksandr Rodchenko: *Hanging Construction*, 1920. Wood. Photographed with the artist.

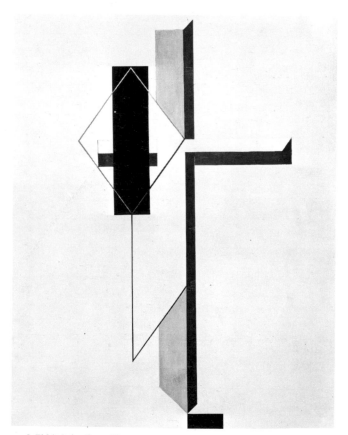

5. El Lissitzky: *Proun Composition*, *c.* 1922. Gouache and ink. 50 × 40 cm.

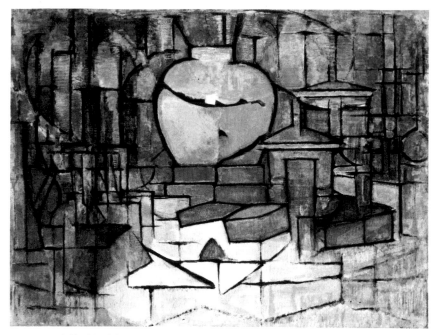

6. Piet Mondrian: *Still Life with Ginger Jar II*, 1911. Oil on canvas. 91 × 120 cm.

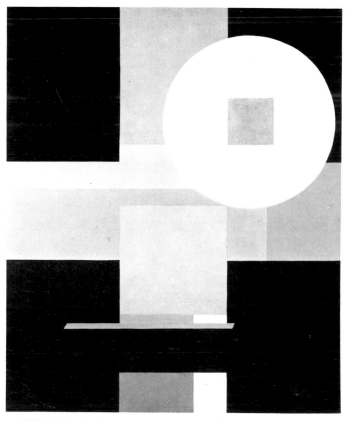

7. Friedrich Vordemberge-Gildewart: *Composition No. 15*, 1925. Oil on canvas.
150 × 125 cm.

8. Theo van Doesburg: *Counter-composition in dissonances XVI*, 1925. Oil on canvas. 100 × 180 cm.

9. Piet Mondrian: *Composition with Red, Yellow and Blue*, 1939–42. Oil on canvas. 73 × 69 cm.

10. Georges Vantongerloo: *No. 98 $\frac{2478\ Red}{135\ Green}$*, 1936. Oil. 57 × 57 cm.

11. Sophie Taeuber-Arp: *Twelve Spaces*, 1939. Oil on canvas. 80 × 106 cm.

12 (*above*). Antoine Pevsner: *Construction in Space*, 1929. Burnt sheet brass and glass. 69 × 84 cm.

13 (*left*). Naum Gabo: *Linear Construction in Space Number 4*, 1958. Plastic and stainless steel. 102 × 53 × 53 cm.

14. Auguste Herbin: *Air, fire*, 1944. Oil on canvas. 60 × 92 cm.

15. Alberto Magnelli: *Opposition No. 1*, 1945. Oil on canvas. 100 × 81 cm.

16. Max Bill: *Four Stabilized White Nuclei*, 1964–71. Oil on canvas.
233 × 283 cm.

17. Richard Lohse: *Fifteen Rows of Colour Merging Vertically*, 1950–67.
Oil on canvas. 120 × 120 cm.

18. Alfred Wols: *Composition*, 1947. Oil on canvas. 81 × 65 cm.

19. Jean Dubuffet: *Head*, 1947. Oil on plaster. 92 × 73 cm.

20. Maria Elena Vieira da Silva: *Paris*, 1951. Oil on canvas. 33 × 48 cm.

21. Jean Atlan: *Warrior of Baal*, 1953. Oil on canvas. 163 × 130 cm.

22. Jean Le Moal: *The Feast of St John, Midsummer Day*, 1955. Oil on canvas. 116 × 89 cm.

23. Willi Baumeister: *Aru 2*, 1955. Oil on board. 100 × 130 cm.

24. Fritz Winter: *Force-Impulses of the Earth*, 1944. Mixed
media on paper. 30 × 21 cm.

25. Nicolas de Staël: *Les Toits*, 1952. Oil on
board. 200 × 150 cm.

26. Serge Poliakoff: *Abstract Composition*, 1954. Oil on canvas.
116 × 89 cm.

27. Jean Riopelle: *Robe of Stars*, 1952. Oil on canvas. 73 × 92 cm.

28. Gustave Singier: *La Nuit de Noël*, 1950. Oil on canvas. 38 × 46 cm.

29. Alfred Manessier: *Crown of Thorns*, 1950. Oil on ~~canvas. 163 × 98 cm.~~

30. Pierre Soulages: *30 November*, 1959. Oil on canvas. 195 × 130 cm.

31. Hans Hartung: *T1963–R6*, 1963. Acrylic on canvas. 180 × 141 cm.

32. Alan Davie: *Entrance for a Red Temple No. 1*, 1960. Oil on canvas. 213 × 173 cm.

33. Bram van Velde: *Gouache*, 1961. 127 × 122 cm.

34. Georges Mathieu: *Dâna*, 1958. Oil on canvas. 65 × 100 cm.

35. Jean Bazaine: *The Sea at Noon*, 1960. Oil on canvas. 40 × 80 cm.

tion is an end in itself: that of arousing among the participants an active sympathy, making them pass from receptivity to action, creating in them and around them the conditions of a possible participation.' But he regarded the spectator's participation always as an expression of individual freedom, not as something imposed upon him, and was prepared to regard non-participation as an ultimate expression of this freedom and therefore as an integral element in the Happening. Jean-Jacques LEBEL, on the other hand, the most committed French theorist of the Happening, described it as a collective effort of 'sacralization' and '*par excellence* an act of participation and revolt in which the creative experience is more important than the end-product, whether saleable or not'. He thought of this process as enforcing the supremacy of instinct over reflection so as to overcome man's conditioning by society and help him become a child again by fusing art with life. The theory of the Happening is as diverse as the practice.

HARD EDGE PAINTING. A term coined by the critic Jules Langsner in 1958 as an alternative to replace the older term 'geometrical abstraction'. It was taken up by Lawrence Alloway, who defined its application as follows in his Introduction to a catalogue of the exhibition 'Systemic Painting' at the Solomon R. Guggenheim Mus. in 1966: 'The purpose of the term, as I used it in 1959–60, was to refer to the new development that combined economy of form and neatness of surface with fullness of color, without continually raising memories of earlier geometric art. It was by way of stressing the wholistic properties of both the big asymmetrical shapes of Smith and Kelly and the symmetrical layouts of Liberman and Martin.'

During the 1960s the term came to have a more general application. It was used to describe the style of non-representational painting which was distinguished from ABSTRACT EXPRESSIONISM both because it used a few large areas of colour separated by crisp, clearly defined edges and by the fact that, unlike the spontaneous and impulsive practice of the Abstract Expressionists, Hard Edge paintings were planned in advance of their execution. In *American Art of the 20th Century* (1973) Sam Hunter wrote: 'The term is descriptive and only partially illuminating, but it must stand for the moment to describe more precisely engineered and calculated painting of immaculate surfaces emerging just before 1960.' Among the main exponents of the style were Ellsworth KELLY, Leon Polk SMITH, Kenneth NOLAND, Sven LUKIN, Charles HINMAN, Paul FEELEY, Gene DAVIS, Tom DOWNING.

HARE, DAVID (1917–). American sculptor, born in New York. He studied experimental photography and edited from 1940 the SURREALIST magazine *VVV*. He was chiefly known, however, for his sculpture, which was extensively exhibited

from the 1940s onwards. This belonged to the welded metal variety which has been regarded as the sculptural analogue of ABSTRACT EXPRESSIONISM in painting and it was marked particularly by SURREALIST or DADAIST elements and an interest in American Indian background. Among the many collective exhibitions in which he was represented were 'Dada, Surrealism and their Heritage' (1968) and 'The New American Painting and Sculpture' (1969) at The Mus. of Modern Art, New York. He had a retrospective exhibition at the Philadelphia Mus. of Art in 1969.

HARRIS, LAWREN STEWART (1885–1970). Canadian painter, born at Brantford, Ont., into a wealthy family, partners in the large farm-implement firm of Massey-Harris. From 1904 he studied in Berlin—principally under Adolf Schlabitz and Franz Skarbina—and after a year and a half of travel in the Middle East and in Minnesota as a magazine illustrator returned to Toronto in 1909. *Houses, Wellington Street* (private coll., 1910) reflects in its dark urban moodiness his training in Berlin. Views of houses and cityscapes remained of interest until 1920, although after meeting J. E. H. MACDONALD in 1911 he turned as well to landscape and the consideration of northern themes. His first major exhibition piece, *The Drive* (National Gal. of Canada, Ottawa, 1912), is vigorous and redolent of the land.

A visit with MacDonald to an exhibition of contemporary Scandinavian painting in Buffalo in 1913 suggested a broad, decorative handling of northern subjects. Harris and MacDonald attracted other painters concerned to explore Canadian themes, and in 1914 a Studio Building of Canadian Art, largely financed by Harris, was opened in Toronto. The war dispersed the painters, but in 1918 Harris discovered Algoma, in northern Ontario, returning there the same year with MacDonald and Frank Johnston. In May 1920 Toronto saw the first exhibition of the GROUP OF SEVEN. The rich lushness of Algoma was suited to the dramatic and colourfully decorative style Harris had developed, and his Algoma canvases— e.g. *Autumn, Algoma* (Victoria University, Toronto, 1920)—are second only to those of MacDonald in imposing grandeur.

Harris was deeply impressed by his first visit to Lake Superior in 1921. The reaching, aspiring forms of his North Shore canvases, such as *Lake Superior* (Art Gal. of Ontario, Toronto, 1924), express a desire for spiritual fulfilment through immersion in the vital forces of overpowering landscape. From 1924 onwards he sought out inspiring landscape, in the Rockies, and even in the Eastern Arctic in 1930. *Maligne Lake, Jasper Park* (National Gal. of Canada, Ottawa, 1924) is a grave, hushed tribute to the spiritualizing force of the country. By the late 1920s Harris's work was the most influential of the Group of Seven.

In 1934 Harris moved to Dartmouth College, Hanover, New Hampshire, as Artist in Residence.

His earliest surviving abstract compositions date from 1936. In 1938 he moved to Santa Fé, New Mexico, where he joined the Transcendental Painting Movement which, influenced by the writings of KANDINSKY, sought 'to carry painting beyond the appearance of the physical world, through new concepts of space, colour, light and design to imaginative realms that are idealistic and spiritual'. His Santa Fé pictures, such as *Abstract Vertical* (Art. Gal. of Hamilton, 1939), with their interlocking circular forms folding in together in a complex almost organic way, suggest the influence of Jay Hambidge's theories of Dynamic Symmetry.

In 1940 Harris returned to Canada, settling in Vancouver where his presence did much to generate an active artistic scene—particularly during the 1940s and 1950s—and was important to a number of younger artists, especially Jock MACDONALD. The first painting he completed upon his return—*Composition I* (Vancouver Art Gal., 1940)—along with the paintings brought from Paris early that same year by Alfred PELLAN, represent the first solid beginnings of abstract art in Canada. Harris in fact became a kind of patriarch of Canadian painting, honoured with a full-scale retrospective at the Art Gal. of Toronto in 1948 which was then circulated round the country by the National Gal. of Canada. Another major retrospective was mounted by the National Gal. in 1963 (also shown in Vancouver). Harris's last, mystical abstractions were produced in 1968, at the age of 83. His writings include 'An Essay on Abstract Painting', which appeared first in the *Journal of the Royal Architectural Institute of Canada* in January 1949 and then as a separate publication (*A Disquisition on Abstract Painting*, Toronto) in 1954.

HARRISON, NEWTON (1932–). American CONCEPTUAL artist, born in New York. He went to Southern California in 1965 and taught at the University of California in San Diego. He began his first major project in 1969 in connection with the 'Art and Technology' programme of the Los Angeles County Mus. of Art and designed in collaboration with the Jet Propulsion Laboratory an environmental piece composed of 12 ft (3·6 m) high plexiglass columns filled with fluctuating gas plasmas. In 1971 he executed *Hog Pasture* for the exhibition 'Earth Air Fire Water: Elements of Art' at the Boston Mus. of Fine Arts and in the same year he designed for the 'Art and Technology' exhibition of the Los Angeles County Mus. of Art four pools filled with salt water solutions of algae and shrimp brine. Harrison had no respect or liking for art as it is traditionally conceived. He said: 'Art has to change. Its whole ground must be redefined. It is sterile; it is a closed system; it is stiflingly cross-referential and its yield per quantum of effort expended is pitifully low.' He became obsessed with the question of ecological survival and for the exhibition '11 Los Angeles Artists' organized for the Hayward Gal. in 1971 he contributed seven 'recipes' for survival systems. Of

Portable Fish Farm he wrote: 'The revolutionary aspect of the work is contained in its possibility for putting into anyone's hands a self-sufficient survival resource. Its presence in a museum gives it a certain contextual meaning which is interesting in itself, though not nearly as important to me as its wider ramifications. In the museum, it becomes more or less witty ... No matter what claims an artist may make for the self-referential quality of his work, that work remains an analogue to some natural process, event or circumstance. Raising catfish and feeding catfish entrails to sustain lobsters (as happens in the present work) has esthetically the same relational meaning as the vibration created by the juxtaposition of red and blue areas in an Ellsworth Kelly painting.' Harrison claimed that his artistic procedures were no more than radical advances on traditional artistic conventions. Others have taken the more plausible view that what he was doing, admirable though it may have been, was wrongly brought within the ambit of fine art.

HARTH, PHILIPP (1887–1968). German sculptor, born at Mainz. After working in his father's stoneyard and studying at the School of Arts and Crafts at Mainz, he was a student at the Academy of Karlsruhe, 1906–7. Then after teaching briefly at the School of Arts and Crafts in Mainz, he settled in Berlin, where his house and studio were destroyed by bombing in 1941. In 1911 he worked briefly in the architectural office of Peter Behrens and Herrmann Muthesius. After the war he worked as a sculptor, concentrating on animals and for the most part carving directly in stone or wood. His first exhibition was at the Wallerstein Gal., Berlin, in 1927. He had subsequently many exhibitions in Germany, including Königsberg (1929), Chemnitz (1930), Mannheim (1957), Folkwang Mus., Essen, and Kunsthalle, Hamburg (1958), Mainz (1962), Munich (1971). His works were also shown in France, Belgium, the Netherlands, Italy, Greece, Switzerland, Canada, Brazil, Mexico, the U.S.A., Japan, etc. In 1936 he was awarded the Villa Romana prize and in 1937 he won a Grand Prix at the Paris Exposition Universelle. He was awarded the Cornelius Prize of the city of Düsseldorf in 1957 and the art prize by the city of Mainz in 1962. His works are represented in a number of important public collections in Germany. He also did book illustration and was the author of theoretical writings on art, including *Aufsätze über bildhauerische Gestaltung* (Berlin, 1939).

HARTIGAN, GRACE (1922–). American painter, born at Newark, N.J. In the 1940s she studied with Isaac Lane Muse, travelled in Europe and lived for a while in Mexico. In 1953 she designed for the Artists' Theater, New York, including sets for Kenneth Koch's *Red Riding Hood*. In the 1950s she came to prominence as one of the second wave of ABSTRACT EXPRESSIONISTS. Her first

one-man exhibition was at the Tibor de Nagy Gal. in 1951. She continued to exhibit through the 1950s and 1960s and was included in a number of important collective exhibitions of contemporary and abstract American art.

HARTLEY, MARSDEN (1877–1943). American painter, born in Lewiston, Maine. He studied at the Cleveland School of Art from 1892 and from 1898 at the Chase School, New York, and the National Academy of Design. His early style was influenced by the Italian DIVISIONIST Segantini (1858–99), from whom he took the 'stitch' technique of brush-stroke, and by the colouring of the American proto-modernist, Albert Pinkham Ryder (1847–1917). His first one-man exhibition was at the 291 Gal. in 1909 and he continued a member of the STIEGLITZ circle of artists. In 1912 he was sent to Europe by Stieglitz, but finding CUBIST Paris little to his taste he went to Munich and Berlin, where the EXPRESSIONISM of KANDINSKY and JAWLENSKY proved more congenial, and he exhibited in 1913 with the BLAUE REITER at the first German Herbstsalon in Berlin. In 1913 he returned to America and exhibited at the ARMORY SHOW. From 1914 to 1916 he was again in Europe, visiting London, Paris, Berlin and Munich. During these years he painted in an abstract manner with Expressionist overtones as in the famous *Painting No. 5* (Whitney Mus. of American Art, 1914–15), a picture painted in rich Expressionist colours and incorporating military emblems and decorations of wartime Germany. The picture represents a remarkable personal synthesis, being more closely structured and objective than German Expressionism yet more freely patterned and highly coloured than French Cubism. Instead of continuing on this path, however, on his return to the U.S.A. in 1916, where he participated in the FORUM Exhibition of *avant-garde* American art held at the Anderson Gal., he began to paint near-CONSTRUCTIVIST abstracts in clear pastel hues. In 1917 he abandoned the abstract and from 1918 to 1920 did dramatic pastels of the New Mexico landscape, upon which in the early 1920s he based equally dramatic though more formalized oils. In 1925 he was represented in the exhibition 'Seven American Painters' shown by Stieglitz at his new Intimate Gal. and he continued to exhibit with Stieglitz. But in the decade up to 1936 he led a wandering, unsettled life, visiting France, Italy, Germany and New Mexico. In 1932–3 he began to paint in a sophisticated 'primitive' manner of the *faux naïf*, with the deliberate awkwardness and expressive *gaucherie* which had been taken over by the early German Expressionists from the NABIS for the symbolization of strong, primitive feeling. Typical of this style, which lasted the rest of his life, is the painting *Fisherman's Last Supper— Nova Scotia* (1940–1).

He was given a retrospective exhibition with Lyonel FEININGER at The Mus. of Modern Art, New York, in 1944.

HARTMAN, MAUNO (1930–). Finnish sculptor and painter, born at Turku. After training as a prison warder, his father's occupation, he studied at the School of Drawing of the Turku Art Association, 1950, and then at the School of the Institute of Applied Art, Helsinki, 1950–4. In 1957 he was awarded a scholarship by the City of Turku as a result of an exhibition of abstract works and with this he was able to study for a year at the Academy of Art, Perugia, and to visit Greece, Egypt, Paris and London. Returning to his home town in 1960, he installed himself in an abandoned pig-sty and used as materials for his work blackened timbers and worn floorboards from a derelict smithy. Descended from a family of carpenters, he found wood-working tools ready to hand. From this time timber was the material of his sculpture and he made it his mission to explore the artistic possibilities latent in the traditions of the northern carpenters. His purpose was to create works which would have a direct meaning for ordinary people in an art which was 'objective' in that it eschewed expression of the artist's personality and sought to present objects which would be comprehensible and familiar. His early works have been described as 'national totem poles', suggestive of Finno-Ugrian mythology and folklore. In 1963 he created a sensation by his *Pregnant Pegasus*, a large abstract sculpture made of wooden boards and plywood on which were inscribed poems by Pentti Ailio. This was followed by the fortress-like *Research Completed* (1964) and a series of very large works constructed from timber baulks, with architectural qualities as the spectators could enter or climb through them. His aim, enhanced by humorous titles, was to eliminate solemnity and encourage the artistically unsophisticated into spontaneous and pleasurable contact with the material.

He continued to make room-like sculptures from timbers taken from demolition sites, carefully and meticulously fitted together without nails or screws, and also smaller works carrying suggestions from folklore or daily life, such as *The Bee-timber* (*Pee-Puu*) and *The Shoe-maker* (both in the Ateneum, Helsinki, 1965).

HARTUNG, HANS (1904–). German-French abstract painter. Born in Leipzig, he studied in the Academies of Leipzig, Dresden and Munich, where he also studied the philosophy and history of art. In Munich he met KANDINSKY and became interested in the work of MARC. He began painting abstracts in 1922 and had his first exhibition at Dresden in 1931. In 1935 he fled from Germany and settled in Paris. He was afterwards imprisoned in Spain and during the war he served in the French Foreign Legion. After the war he returned to Paris, being naturalized in 1946. Hartung was a prominent member of the ÉCOLE DE PARIS. He developed a highly original style of abstract or gestural painting in which thick black lines and blotches predominate in a manner superficially

analogous to calligraphic scribbling. He has been regarded as one of the main precursors of ART IN-FORMEL and of TACHISM.

HARTUNG, KARL (1908–67). German abstract sculptor, born in Hamburg. After studying applied art he spent the years 1929 to 1932 in Paris, where he knew the work of DESPIAU and MAILLOL. After a year in Florence he returned to Hamburg in 1933, where he took up abstract sculpture. He moved to Berlin in 1936. After being taken prisoner during the Second World War, he returned to Berlin in 1945 and in 1951 became instructor at the Berlin Hochschule für Bildende Künste. He began to exhibit his abstract work in 1945 and achieved international recognition, exhibiting in most European countries, in Brazil and in the U.S.A. His style was extremely individualistic, at times using figurative forms reduced to their most primitive elements, at times purely imaginative shapes, and sometimes combining the two. Sometimes his static forms have a monolithic grandeur, drawing the enclosed or intervening space into powerful unity with the sculptured masses.

HASSAM, CHILDE. See UNITED STATES OF AMERICA.

HAUKELAND, ARNOLD (1920–). Norwegian sculptor born at Vaerdal, studied in 1945 at the Académie Colarossi, Paris. His early work was in the tradition of MAILLOL and BOURDELLE. It is exemplified by an equestrian statue which he executed for the town of Sandvika to commemorate the Liberation and with which he made his name. As a result of a visit to Greece and to the Venice Biennale in 1960 he came into contact with modern trends in sculpture and radically altered his style, composing his works from concave and convex metal plates with smooth curves meeting in knife-sharp edges and arcs. These later works combined tension with spatial unity. Examples are Dynamik 1 in forged iron at Oslo Bycs Vel and Air at the University of Blindern. He also executed sculptures for Trondheim Cathedral in 1966.

HAUSER, ERICH (1930–). German sculptor, born 'at Rietheim, Tuttlingen. After learning with a steel engraver at Tuttlingen he attended evening classes in sculpture at the Freie Kunstschule, Stuttgart, from 1949 to 1951. Among the prizes which he won were the Junger Westen and an honorary mention at the Third Biennale for Young Artists, Paris, in 1963, the Burda prize for sculpture in 1966 and a First Prize for Sculpture at the São Paulo Bienale of 1969. He made sculpture from welded steel plates. His works fell within the category of geometrical abstraction but they had a dynamic and monumental character and the contrast between polished and unpolished surfaces imparted to them a liveliness as if of light and dark colour.

HAUSMANN, RAOUL (1886–1971). Austrian painter and photographer, born in Vienna. In the years after the First World War he was one of the leading Berlin DADAISTS, contributing to avant-garde periodicals, issuing Dadaist manifestos and perpetrating typical Dadaist practical jokes. He was an originator of PHOTOMONTAGE, which he called 'an explosive mixture of different points of view and levels', and some of his works in this medium epitomize the period. One of his best-known montages, Tatlin at Home (1920), composed of an anonymous man cut from a magazine with the brain overpasted with complicated mechanical apparatus, seems to honour TATLIN as the originator of 'machine art'. Together with SCHWITTERS he participated in the Dada festival at Prague in 1921 and his 'optophonic poem' may have inspired Schwitters's 'original sonatas'. Hausmann stopped painting in the mid 1920s until c. 1941, when he settled in France. After his death a room at the Mus. National d'Art Moderne, Paris, was devoted to his work.

HAUSNER, RUDOLF (1914–). Austrian painter born in Vienna, studied at the Vienna Academy of Art under GÜTERSLOH, 1931–5. In 1938 he was proscribed as a DEGENERATE painter and forbidden to exhibit. In 1946 he became a founding member of the Vienna Art Club and evolved a personal style of SURREALISM, becoming known as the chief exponent of Surrealism in Austria. In 1965 he was visiting lecturer at the Hamburg College of Fine Art. Hausner was a prominent member of the Austrian school of FANTASTIC REALISM, which emerged in Vienna in the late 1940s. He painted dream-like scenes which combined MAGIC REALISM with strange perspectives reminiscent of METAPHYSICAL painting and he often introduced self-portraits as in his Die Arche des Odysseus (Mus. der Stadt, Vienna, 1956) and his Adam pictures, surrounding them with mannered, DALÍ-like figures which combined naïveté with Freudian implications. His work became known abroad after his participation in DOCUMENTA II at Kassel.

HAYDEN, HENRI (1883–1970). Polish-French painter born in Warsaw. After studying there he went to Paris in 1907 and became a French national in 1924. His style was first influenced by Cézanne and then on meeting LIPCHITZ and Juan GRIS he embraced CUBISM c. 1915. During the 1920s he reverted to a more naturalistic style, alternating between landscapes and still lifes composed from musical instruments. About 1950 he abandoned Cubist stylization and evolved a lyrical and highly decorative mode of abstraction with flowing curves and bright fluorescent colours.

HAYTER, STANLEY WILLIAM (1901–). British painter and engraver, born in Hackney, London. His father, William Harry Hayter, was a painter and among his forefathers were Charles Hayter (1761–1828), who was Professor of Per-

spective to Princess Charlotte, and Charles Hayter's eldest son, George, who was Portrait and History Painter to Queen Victoria. Stanley William began to paint as a hobby in his father's studio at the age of 14 and during his childhood he made the acquaintance of old masters in his father's company at the National Gal. But he did not envisage an artistic career until later. After working in the research laboratory of the Mond Nickel Company he took an honours degree in chemistry at King's College, London, in 1921 and from 1922 worked for the Anglo-Iranian Oil Company at Abadan on the Persian Gulf. In 1926 he took the decision to become an artist, left the Anglo-Iranian Oil Company and settled in Paris, where he studied for three months at the Académie Julian. In 1921, while working for his degree in London, he first evinced an interest in print-making. This interest returned in 1926 and became a lifelong passion for gravure in all its forms. In 1927 he founded Atelier 17 for teaching and research into the techniques of print-making.

Atelier 17 proved to be special among institutions of its kind and soon became famous among artists throughout the world. It was indeed far removed from the general run of art schools or academies for teaching students the rudiments of their craft. It became a recognized centre where artists of stature could meet together not only to improve their mastery of engraving techniques but for collaboration and discussion and above all for joint research into new methods of gravure. Among the prominent artists who worked at Atelier 17 were PICASSO, MIRÓ, DALÍ, ERNST, MATTA, CHAGALL, MASSON, TANGUY, GIACOMETTI, POLLOCK, ROTHKO, DE KOONING. Thus to some extent Atelier 17 revived in the 20th c. the 'workshop' conception of the artist, not as a lone wolf or solitary genius but as a member of a group working at a trade together, pooling their ideas and communicating their discoveries. Hayter's unflagging enthusiasm was a potent factor in the astonishing revival of gravure which took place in the 20th c. and his Atelier 17 was the most important single influence in the movement which guided its recovery from the position of a subordinate and illustrative technique, to which it had sunk in the 18th and 19th centuries, to its establishment as an autonomous medium for creative art with new expressive possibilities and techniques always to be discovered. Hayter's books New Ways of Gravure, 1966 (1949), and About Prints, 1962, became the classics of this movement.

Hayter himself was no mean artist either as painter or as engraver and examples of his work have been acquired by many public and private collections. He was on terms of friendship with many leading SURREALISTS, exhibited with the Surrealists at Paris in 1933 and helped to organize the London Surrealist exhibition of 1936, in which he was also represented. He did not ever wholly identify himself with Surrealism but had affinities also with abstract styles, as for example in Chemine-ments (Mus. d'Art Moderne de la Ville de Paris, 1971–2) and Combat (The Mus. of Modern Art, New York, 1936).

Hayter spent the years 1941 to 1950 in New York, where he established a new Atelier 17, which remained open until 1955. In 1950 he returned to Paris, where he reopened the former Atelier 17. A retrospective exhibition of his work was held at the Whitechapel Art Gal. in 1957 and an exhibition of 150 of his engravings was given at the Victoria and Albert Mus. in 1967 with a smaller exhibition of his paintings at the Grosvenor Gal., London. In 1972 an exhibition of recent paintings was given at the Mus. d'Art Moderne de la Ville de Paris. Hayter received the Légion d'honneur in 1951, the O.B.E. in 1959 and the C.B.E. in 1964.

HEARTFIELD, JOHN (HELMUT HERZ-FELDE, 1891–1968). German journalist and painter, son of the poet Franz Held. With his brother Wieland and George GROSZ he founded the publishing house Malik Verlag and launched the pacifist journal Neue Jugend in 1916. He was one of the founders of the Berlin DADA group and is chiefly remembered for his pioneer work in PHOTO-MONTAGE. He was a confirmed and militant Communist and went to live in East Berlin in 1950.

HECKEL, ERICH (1883–1970). German painter born at Döbeln, Saxony. In 1904 he began to study architecture at the Technical College, Dresden, and in 1905 formed the association Die BRÜCKE in collaboration with his schoolfellow SCHMIDT-ROTTLUFF, an architectural student Bleyl and Ernst Ludwig KIRCHNER. Like the others, Heckel was without formal training as a painter and his talent is sometimes thought to be revealed more fully in his graphic work, particularly his woodcuts, than in his painting. In 1906 his painting style was grounded on German Expressionism and Van Gogh and was notable for his juxtaposition of harsh, unbroken colours in his landscapes, nudes and portraits. His work was, however, somewhat more lyrical than that of the other members of the Brücke and he showed a special concern for depicting sickness and inner anguish. His landscapes too sometimes displayed a decorative quality which was foreign to most German EXPRESSIONISM. In 1911 he settled in Berlin with Kirchner and other members of the Brücke. Here as a result of contacts with FEININGER, MACKE and Franz MARC the formal structure of his painting gained in strength and coherence. But his image of humanity became even more pessimistic, with harshly angular distortions, anguished expressions and rigid, distracted gestures. The mood was reflected in his colours, which were reduced to harsh contrasts of feverish reds against strident yellows and dull blues. From 1914 Heckel served as a medical orderly in Flanders and there came into contact with ENSOR and BECKMANN, by whom he was again influenced. His landscapes became more sombre in

colour, expressing the agony of war through conflict of the elements, and the melancholic and tragic mood of his work was enhanced. After 1920 his work became more conventional. He continued to paint German and Italian landscapes but in a more lyrical mood, with more classical restraint and a breadth of rhythm which had little in common with his earlier *Brücke* style. But the verve of the earlier, Expressionist style was lost. In 1937 his work was proscribed as DEGENERATE art. In 1944 his Berlin studio was destroyed by fire and he retired to Hemmenhofen on Lake Constance. From 1949 to 1955 he taught at the Karlsruhe Academy.

Heckel was one of the most powerful and most interesting artists of the first wave of German Expressionism. As was the case with most of the other artists of the *Brücke*, the vigour and intensity of his work did not survive the First World War.

HEERICH, ERWIN (1922–). German sculptor, born at Kassel. He trained at the Academy of Art, Düsseldorf, 1945–54, and from 1969 taught sculpture there. He worked in the mode of geometrical abstraction, his preferred material of sculpture being carton.

HEERUP, HENRI (1907–). Danish sculptor and painter, born in Copenhagen and studied at the Copenhagen Academy, 1927–32. Influenced by Romanesque sculpture and the sculpture of primitive tribes, he carved monolithic granite figures in simplified forms which he then painted. In his paintings he adopted a similar manner of expressive and often childlike simplifications. An example is *The Bird and Spring* (Gladsaxe Commune, Copenhagen; oil on wood; 1963). He was also a member of the Danish SURREALIST movement. His work was shown at the Venice Biennale of 1962.

HEGEDUŠIĆ, KRSTO (1901–75). Yugoslav painter and graphic artist born in Petrinja and studied first at the Academy of Art, Zagreb, 1920–6, and then in Paris. On his return to Yugoslavia he founded the association ZEMLJA and was its ideological and artistic leader. As a SOCIAL REALIST he inspired the group to an art of revolutionary social protest. Artistically he believed that the effete academicism of the day could be revitalized by direct contact with peasant life and with the genuine folk art of the people. In pursuance of the latter belief he was chiefly responsible for forming the most widely known centre of Yugoslav NAÏVE ART at Hlebine and for bringing out the talent of Ivan GENERALIĆ, the greatest of the Yugoslav naïve painters. After the war he found affinities with the NEUE SACHLICHKEIT of GROSZ and DIX and also with SURREALISM. In works such as *Water Corpses* (Gal. of Modern Art, Zagreb, 1956), *Morning*, etc. the unreal dreamlike space of Surrealism and a certain macabre quality combined to lend a suggestive rather than a directly naturalistic tone to their implications. His main force, however, both in his art and in his teaching at the Zagreb Academy was in the direction of socially committed Realism.

HEILIGER, BERNHARD (1915–). German sculptor, born at Stettin. He studied at Stettin and then at the Berlin Academy, where he taught from 1949. His early work was strongly under the influence of Henry MOORE and in this style he did a number of public commissions such as *Ferryman* at Esslingen and *Figurenbaum* for the German Pavilion at the Brussels International Exhibition of 1958. About 1955 he abandoned figurative work for abstraction and produced expressive works such as *Flamme* (1962) and reliefs for the German Embassy in Paris.

HEIZER, MICHAEL. See CONCEPTUAL ART.

HELD, AL (1928–). American painter born in New York. After studying at the Art Students' League in 1948 he went to Paris in 1949 and studied at the Académie de la Grande Chaumière and the Zadkine School. There he sought to achieve a synthesis between expressive abstraction of the Jackson POLLOCK type and geometrical abstraction in the manner of MONDRIAN. Dissatisfied with the result, he returned to the U.S.A. in 1952 and under the influence of masters of the NEW YORK SCHOOL he painted heavily pigmented canvases in the mode of ABSTRACT EXPRESSIONISM, exhibiting these at the Poindexter Gal. in 1959. Abandoning expressive abstraction c. 1960, he evolved during the 1960s a highly personal style which had affinities both with COLOUR FIELD painting and with HARD EDGE painting. Unlike other Colour Field painters such as Helen FRANKENTHALER and Morris LOUIS, he did not adopt the technique of thinly stained unprimed canvas but maintained a heavy impasto, which he worked up into a massive over-all texture. He used simple, hard-edged geometrical forms often based on letters of the alphabet, e.g. *The Big N; The Yellow X.* About 1967 he began to combine and overlap these geometrical forms into complicated structures of boxes and cubes, layering the surface until the painting acquired almost the solidity of a low relief. He was much concerned with the expressive importance of *scale*. But unlike some Colour Field painters he did not seek by means of scale to absorb and engulf the spectator into the picture, but maintained the objectivity of the painting as an independent reality in itself, emphasizing the physical reality of the pigment. During the 1970s his work increased in stature and power with his well-known linear structures of white lines and a black ground (e.g. the *Flemish* series) and black lines on a white ground. It has been maintained that these perspective, box-like structures are characteristic of a renewed interest among some European and American artists in the architectural

and illusionistic perspective of the Renaissance. About the mid 1970s some of the white paintings used more delicate, curvilinear techniques suggesting a certain transparency of space and these may evince an interest by the artist in space exploration and interplanetary travel, e.g. *Mercury Zone II*, 1975. At the end of the 1970s he was exhibiting acrylic paintings which not only carried the eye outside the area of the picture but embodied the false perspectives and illusionary overlapping and shifting planes of OP ART.

HELDT, WERNER (1904–55). German painter born in Berlin, studied at the Berlin Academy of Art, 1923–30. In 1930 he was in Paris and he spent two years, 1932–4, in Minorca. After the war he settled in West Berlin with frequent visits to Ischia. Heldt is best known as a painter of street scenes and for this reason only he has been called the 'UTRILLO of Berlin'. His streets were often painted at night, with suggestions of distant or 'Metaphysical' perspectives and were usually empty. He also embodied his wartime experiences in pictures of dream cities which bordered on SURREALISM. Towards the end his work became increasingly abstract.

HELIKER, JOHN EDWARD (1909–). American painter born at Yonkers, N.Y. He studied at the Art Students' League, 1927–9, under Thomas Hart BENTON and Kenneth Hayes MILLER. After a visit to Europe, during which he resided for two years in Italy, he taught at Colorado Springs Fine Arts Center and at Columbia University from 1947. Among his awards were First Prize at the Corcoran, 1941; Prix de Rome, 1948; Adolph and Clara Obrig Prize, National Academy of Design, 1948; Guggenheim Foundation Fellowship, 1952; National Institute of Arts and Letters grant, 1957. His first one-man exhibition was at the Maynard Walker Gal., New York, in 1936, where he also exhibited in 1938 and 1941. He had a retrospective at the Whitney Mus. of American Art in 1968. From *c.* 1940, when he moved to New England, he concentrated on still life and landscape, painting with a strong sense of pattern and a dramatic semi-CUBIST emphasis on the shapes of rocks and clouds. In the 1950s he developed a less representational manner with even stronger emphasis on linear pattern and the harmonizing of rectilinear forms. After the mid 1950s his compositions became looser with a more fluid rhythm and sense of movement, added importance being given to colour. During the 1960s his painting, although still strongly linear, became more representational with an architectural emphasis deriving from frequent visits to Italy.

HÉLION, JEAN (1904–). French painter, born at Couterne, Orne. He studied engineering at Lille and then architecture in Paris. In 1926 he was introduced to CUBISM by TORRES-GARCÍA and met MONDRIAN, by whom he was much influenced. He was also associated with Van DOESBURG and signed the latter's manifesto ART CONCRET in 1930. He became a member of the association ABSTRACTION-CRÉATION in 1932. In 1936, when *Abstraction-Création* was dissolved, he went to America but returned in 1940 to join the French army. He was made a prisoner of war but escaped and made his way back to America, where he published an account of his experiences. He returned to Paris in 1946. Hélion is best known for his geometrical abstractions done in the 1930s, broadly patterned compositions with strangely curving planes which may reflect an influence from the mechanistic paintings done by LÉGER in the early 1920s.

HENDERSON, GERARD D'A. See HSING TEH-HSIN.

HENDERSON, NIGEL. See INDEPENDENT GROUP.

HENN, ULRICH (1925–). German sculptor, born in Schwaebisch Hall. During the 1940s he began to work in wood while he was an American prisoner of war in Italy. After his release in 1946 he trained for a short while at Stuttgart and set up as an independent sculptor in 1948, at first doing restoration work for old churches and museums. In the early 1950s he began to model in wax for bronze casting and from that time worked mainly on ecclesiastical commissions—bronze doors, candlesticks, altar pieces, etc. His work had a strong medieval flavour. His first exhibition was at the Roland, Browse and Delbanco Gal., London, in 1974 and consisted of maquettes for larger works. Among other towns his work may be seen at churches in Pforzheim, Kassel, Trier, Münster, Bielefeld, Esslingen. He also did fountains at Ruit and Bonlanden.

HENRI, ROBERT (ROBERT HENRY COZAD, 1865–1929). American painter. He grew up in Nebraska and studied at the Pennsylvania Academy of Art under Thomas Pollock Anschutz (1851–1912), a pupil of Thomas EAKINS of whose realism Henri became an ardent admirer. From 1888 to 1891 he studied at the École des Beaux-Arts, Paris, under the academic painter Adolphe Bouguereau, and became a confirmed admirer of Frans Hals. He was uninfluenced by the Impressionists in general, though he was profoundly interested in the 'Spanish' features of Manet—his realism, his 'dark' palette and his virtuoso brushwork. Henri returned to Philadelphia in 1891 imbued with proselytizing enthusiasm for his belief that art must be made to forsake the ivory tower of academicism and concern itself with everyday subjects of general interest to the people at large. His studio at 806 Walnut Street became a centre where young artists could meet and have discussions. Among his disciples were four young newspaper artist-reporters, William GLACKENS, John SLOAN, George LUKS and Everett SHINN, all working on the *Philadelphia Press*. In the summer of 1893

Henri founded the Charcoal Club, disbanded in 1894, where these artists could sketch from life and where they were persuaded to make their first ventures into oil painting. This was the seed from which grew the ASH-CAN school of American Realism during the first decade of the 20th c.

Following a trip to Europe in 1898, when his painting *Snow* was purchased by the French Government for the Luxembourg Mus. after having been rejected by the *Salon*, and when Henri came to appreciate qualities in the technique of Goya, he returned to settle in New York and became an instructor at the New York School of Art founded by William Merritt Chase. He was soon joined by his friends from Philadelphia, who began to be known as the NEW YORK REALISTS. By 1905 they had all been accepted as members of the Society of American Artists. In 1905 Henri's *Lady in Black* was awarded a prize at the Art Institute of Chicago, and he served on the awards jury of the Carnegie International Exhibition. In 1907 he was appointed to the jury for the Spring exhibition of the National Academy and official recognition seemed to be at hand. But he was unable to secure acceptance for any of the paintings of his group and his own submissions were accorded only second-class rating, whereupon he withdrew them in anger. In reaction from what they regarded as a slight by the Academy, the New York Realists staged their own exhibition in 1908 together with the Impressionist painter Ernest Lawson, the 19th-c. romantic Arthur B. DAVIES and the Neo-Impressionist Maurice Prendergast of Boston. Under the title The EIGHT this heterogeneous exhibition won a *succès d'estime*, although it aroused criticism from the professional reviewers mainly on the ground of subject matter and 'dissonance' of style rather than on artistic or technical grounds. It has been regarded as a landmark in the development of native American painting.

In 1909 Henri established his own school on Broadway near the site of the present Lincoln Center. He was joined there by several of his former pupils at the New York School of Art, including George BELLOWS and Edward HOPPER. Yasuo KUNIYOSHI and Kenneth Hayes MILLER, who later perpetuated Henri's approach in the school of AMERICAN SCENE PAINTING with the Art Students' League, also briefly studied there, as did the SYNCHROMISTS Stanton MACDONALD-WRIGHT and Patrick Henry BRUCE and the modernist Stuart DAVIS. In 1910, together with Rockwell KENT, Henri organized a second group show of Independents without a jury to adjudicate entries. The show, which included The Eight and several of Henri's pupils together with about 200 others, won a resounding popular success despite attacks from the critics.

Henri's importance in the 20th-c. art of the U.S.A. derives from his influence as a teacher and a crusader and he was an innovator in the field of subject matter rather than technique. His book *The Art Spirit* also made an impression on many younger artists. His own work was painted in a bravura style of virtuoso impasto brushstrokes with strong dramatic contrasts of chiaroscuro. It was not only often superficial but now seems less different from that of his conservative contemporaries than it seemed at the time. Examples are: *West 57th Street* (Yale University Art Gal., 1902); *Laughing Child* (Whitney Mus. of American Art, 1907), hung at the entrance to the exhibition of The Eight; *The Masquerade Dress: Portrait of Mrs. Robert Henri* (The Metropolitan Mus. of Art, 1911). In the field of style and technique he was neither radical nor revolutionary. Henri was the first effective apostle of a popularist, democratic American Art.

HEPWORTH, DAME BARBARA (1903–75). British sculptor, born at Wakefield, Yorkshire. She was trained at the Leeds School of Art, 1920, from where she obtained a scholarship to the Royal College of Art, 1921–4. She was in Italy with a West Riding scholarship from 1924 to 1926, living mainly in Florence and Rome, and in Florence she married a fellow student, the sculptor John Skeaping. On their return to London the two held a joint exhibition in their studio in St. John's Wood, at which the collector George Eumorfopoulos—introduced by Richard Bedford, Head of the Department of Sculpture at the Victoria and Albert Mus. and himself a sculptor—bought four of Barbara Hepworth's carvings, including the group *Doves* now in the Manchester City Art Gal. In the following year the couple held a joint exhibition at the Beaux-Arts Gal. and moved to a studio off Parkhill Road, Hampstead. In 1931 Barbara Hepworth met Ben NICHOLSON, who was to become her second husband, and in the same year she joined the SEVEN AND FIVE SOCIETY, which under the influence of Nicholson and MOORE was tending increasingly towards abstraction. In 1932 she went to France with Nicholson and met BRAQUE, BRANCUSI, PICASSO, MONDRIAN and others of the European *avant-garde*. In 1932 also she held a joint exhibition with Nicholson at Tooth's Gal., which attracted the attention of the critics Herbert READ and R. H. Wilenski. In 1933 both she and Nicholson joined the 'advanced' group UNIT ONE, which was formed on the initiative of Paul NASH.

Through the 1930s Barbara Hepworth lived in the Parkhill Road studio, working in close harmony with Ben Nicholson and Henry Moore, who had been her contemporary at the Royal College. With them she formed an enclave which came to be increasingly recognized as the nucleus of the abstract movement in Britain. All three later achieved international fame and they were almost alone among the British artists of that time who remained consistently faithful to abstract principles. In the Unit One exhibition she exhibited carvings which were recognizably organic forms (*Mother and Child, Reclining Figure*, etc.) greatly simplified but without mannered distortions.

From as early as 1934, however, she also made non-organic, geometrical abstract carvings more closely in accordance with CONSTRUCTIVIST principles, e.g. *Discs in Echelon* (The Mus. of Modern Art, New York, 1935); *Two Segments and Sphere*, which was shown at the 'Abstract and Concrete' exhibition organized by Nicolette Gray at the Reid and Lefevre Gal. in 1936; *Pierced Hemisphere 1* (Wakefield City Art Gal., 1937); *Single Form* (Dag Hammarskjöld Mus., Backakra, Sweden, 1937–8); *Forms in Echelon* (Tate Gal., 1938). In her *Pierced Form* of 1931 (destroyed in the war) she first introduced into England the use of the 'hole', which was adopted by Henry Moore in 1932 and which both in her own work and in Moore's turned out to be of crucial importance to their innovations in sculptural form. During the 1930s both she and Moore were devoted advocates of direct carving rather than modelling. A considerable number of her sculptures from this decade were destroyed in the war or have otherwise disappeared.

On the outbreak of war Barbara Hepworth with Ben Nicholson left London and settled in St. Ives, Cornwall, eventually creating there the nucleus of an artistic colony. From 1940 her use of the 'hole' became increasingly subtle and more intricately complex. The holes were generally larger while oval and even spiral forms predominated, rendering the interior shapes more expressive. Sometimes more than one hole was pierced in a sculpture, often with the effect of creating more than one formal centre, e.g. *Bicentric Form* (Tate Gal., 1949). In 1938 she had begun to use strings set across the hole or cavity; but unlike GABO (who was in England in the 1930s), who used strings and similar materials to define open-space or transparent sculpture, the stringed hole in Hepworth's work balanced and contrasted with the solid masses. She also began at this time the serious use of colour, not in such a way as to obscure or suppress the natural appearance of the material but rather to enhance the evocative impression of her forms in a way suggested by Adrian Stokes's book *Colour and Form* in 1937. Examples of these developments are: *Two Figures* (Minnesota University, Minneapolis, 1947–8); *Pelagos* (Tate Gal., 1946). She herself said, as quoted by A. M. Hammacher: 'The colour in the concavities plunges me into the depth of water, caves, of shadows deeper than the carved concavities themselves.' Hepworth had a very strong gift of emotional identification with nature and it is the reflection of this in her sculpture which induced many critics to speak of her work as a continuation of the English Romantic landscape tradition. It is not something that was manifested only, or chiefly, in a distant affinity of some of her carvings with natural pebble or rock forms, or merely in her power to create sculptures for open-air settings, but something at once deeper and more general: a power to create three-dimensional sculptural forms which evoke feelings that are the counterpart of an almost pantheistic emotional identification with nature. As far back as 1934 she wrote in *Unit One*: 'In the contemplation of Nature we are perpetually renewed, our sense of mystery and our imagination is kept alive, and rightly understood, it gives us the power to project into a plastic medium some universal or abstract vision of beauty.' The whole of the rest of her work was a development and enrichment of this sentiment.

In 1950 she went to Venice on the invitation of the British Council, representing Britain at the Biennale. After the dissolution of her marriage with Ben Nicholson in 1951 and the loss of her first son in 1953, she made a visit to Greece in 1954, the strong impact of which, while not in any way changing the direction of her artistic evolution, none the less broadened the scope of feeling and the abstract poetic content of her work. She often gave titles with Greek associations, as *Corinthos* (Tate Gal., 1944–5); *Curved Form (Delphi)* (Ulster Mus., Belfast, 1955). Her work often reached monumental scale, designed either for landscape or for architectural setting: *Figure (Requiem)* (Aberdeen Art Gal., 1957); *Figure (Archaean)* (Rijksmus. Kröller-Müller, Otterlo, Netherlands; Stirling University; Washington University; St. Catherine's College, Oxford); *Meridian* (State House, London, 1958–9); *Sea Form (Porthmeor)* (Tate Gal.; Yale University Mus.; British Council; Gemeentemus., The Hague, 1958); *Single Form* for the Dag Hammarskjöld Memorial, New York (1962–3). The last four of these are in bronze. Although in the 1930s Hepworth had been a convinced advocate of direct carving, she turned in the late 1950s also to the use of bronze, hand-finishing the surface on the plaster cast before casting into bronze. Some of her bronzes were of like conception with her holed carvings in wood or stone, as *Elegy III* (Rijksmus. Kröller-Müller, 1966); *Spring* (Arts Council, 1966). Some were more geometrical and designed for outdoor settings, as *Square Forms with Circles* (Israel Mus., Jerusalem, 1963); Rietveld Pavilion figure (Rijksmus. Kröller-Müller, 1961); *Four-square (Walk through)* (Churchill College, Cambridge, 1966). She also did during the 1960s some works in marble and stone of a more geometrical character reminiscent of the Constructivist style of Ben Nicholson's reliefs: e.g. *Marble with Colour (Crete)* (Boymans-van Beuningen Mus., Rotterdam, 1964).

In 1953 she was awarded second prize in the International Sculpture Competition for a monument to the Unknown Political Prisoner, in 1959 the Grand Prix at the São Paulo Bienale and in 1963 the Foreign Minister's Award at the Biennale, Tokyo. She received honorary doctorates at the universities of Birmingham (1960) and Leeds (1961). She was created C.B.E. in 1958 and Dame of the British Empire in 1965. A retrospective exhibition of her work was held at the Tate Gal. in 1968. Her studio in St. Ives was opened as a public museum in 1976.

HERBIN, AUGUSTE (1882–1960). French pain-

ter, born at Quiévy, near Cambrai. After studying at the École des Beaux-Arts, Lille, 1900–2, he moved to Paris in 1903 and worked in isolation under the influence of the Impressionists and POST-IMPRESSIONISTS, exhibiting at the Salon des Indépendants in 1906. In 1909 he took a studio in the BATEAU-LAVOIR and came under CUBIST influences, combining Cubist structure with expressive landscape. His work became gradually more abstract until he was producing completely abstract compositions c. 1917. Léonce Rosenberg began buying his canvases c. 1910 and he was one of the first to exhibit at Rosenberg's new gallery L'Effort Moderne from 1917. In the early 1920s he reverted to a simplified form of Cubism with geometrical forms interpolated, but from c. 1926 he painted pure abstracts and in 1931 he was a founder member of the ABSTRACTION-CRÉATION association. In 1949 he wrote L'Art non-figuratif et non-objectif, in which he set forth the theory of his later works, making extensive use of Goethe's theory of colour. His post-war works were completely flat compositions juxtaposing basic geometrical shapes in pure, unmodulated colours. He exhibited at the SALON DES RÉALITÉS NOUVELLES, of which he was a director until 1955. A large retrospective exhibition was given at the Kestner-Gesellschaft, Hanover, in 1967. Herbin was one of the few French painters who consistently devoted himself to geometrical abstraction over a length of time and he had considerable influence on young artists.

HERMAN, SALI (1898–). Australian painter, born in Zürich. At the age of 18 he visited Paris and became interested in modern art, admiring particularly the work of UTRILLO. From 1916 to 1918 he studied drawing and composition at the Zürich Technical School and painting at the Max Reinhardt art school. In 1920 he won a Carnegie study grant with Portrait of Youth (1919). He then turned to dealing, specializing in Oriental rugs and paintings. He travelled extensively in Europe, America and Africa before arriving in 1937 in Melbourne, where some members of his family, including his mother, had preceded him. In Australia he attended the George Bell school (see AUSTRALIA) for fourteen months before settling permanently in Sydney in 1938. In both cities he became actively involved in the controversy over modern art.

During the Second World War he served first as a camouflage painter (1941–4) and then as an official War Artist in New Guinea and the Solomons (1945–6). In the years after the war he sought for many of his subjects among the late 19th-c. terraces and cottages of the inner-city suburbs of Sydney such as Paddington and Glebe—then regarded as slums. Independently of his intentions the paintings helped to develop an interest in the architecture and social life of the inner-city areas. Herman also travelled widely throughout Australia, searching the tropics and the interior for subjects. His works possessed a sure sense of form

and a physical enjoyment of colour. Though French in feeling and matière, the best of his paintings recaptured the optimism and sense of visual discovery which animated the masterpieces of the Heidelberg School.

HERMANN, ERNST (1914–). German sculptor born at Münster, trained in Aachen and Düsseldorf. In 1951 he was awarded the Junger Westen Prize and an art prize from the city of Darmstadt, in 1964 the Konrad von Soest Prize and in 1967 the Wilhelm Morgner Prize. His work was exhibited widely in Germany and in 1959 was included in the exhibition 'Deutsche Kunst' shown at the Stedelijk Mus., Amsterdam, and the Kunsthalle, Basle. He worked mainly in steel or light metals. Geometrical shapes, curvilinear or rectilinear, were combined so that the significance lay in the combination rather than the individual forms, as in the work of such artists as HAJEK, HEERICH and Lenk.

HERNÁNDEZ, DANIEL. See LATIN AMERICA.

HERNÁNDEZ, FELICIANO (1936–). Spanish sculptor born at Gallegos de Altamiros, Avila, and studied at the School of Fine Arts, Madrid. He had a one-man show at the São Paulo Bienale of 1967 and in 1972 won the Sculpture Prize at the Ibiza International Bienale. His sculptures were composed from a number of similar blocks of brightly painted iron linked by steel cable. He was a leading representative of Spanish CONSTRUCTIVISM.

HERNÁNDEZ, JOSÉ. see SPAIN.

HERNÁNDEZ, MATEO (1888–1949). Spanish sculptor born in Madrid. After working in Madrid and Salamanca he settled in Paris in 1913 and obtained the Grand Prix for Sculpture at the Paris Exposition Internationale of 1925. He practised direct carving in hard stones—granite, diorite, porphyry—in a style of monumental naturalism. He was known especially for his realistic animal sculptures and was regarded as one of the outstanding animal sculptors of his time. Examples of his work are Black Panther (The Metropolitan Mus. of Art, New York) and Hippopotame (Mus. National d'Art Moderne, Paris).

HERNÁNDEZ MOMPO, MANUEL (1927–). Spanish painter, born in Valencia and trained at the Valencia School of Fine Arts. He received a Fine Arts stipend from the Juan March Foundation in 1958 and was awarded prizes for painting at Madrid in 1963, 1965 and 1966. In 1968 he won the UNESCO prize in the Venice Biennale. Towards the end of the 1960s he was painting in an Impressionist version of ART INFORMEL but had also evolved a more advanced style, akin to that of Cy TWOMBLY, in which small 'written images' and scribbles were dispersed over an empty background. He exhibited widely inside and outside

Spain and his work was included in international group shows. Among the public collections in which he is represented are the museums of Contemporary Art of Madrid and Seville, the museums of Cuenca and Valencia, the Mus. d'Art Moderne de la Ville de Paris, Pembroke College, Oxford, the Fogg Art Mus., Harvard and the Mus. Solidaridad, Santiago de Chile.

HERNÁNDEZ PIJUAN, JUAN (1931–). Spanish painter born in Barcelona, studied at the Barcelona School of Fine Arts. He practised monochrome COLOUR FIELD painting, sometimes grading the shade of colour over the canvas and sometimes adding graphic elements. He was awarded a prize by the Dirección General de Bellas Artes, Alicante, in 1957, the Maribor Prize at the Engraving Biennale, Ljubljana, in 1965 and the Engraving Prize at the Kraków Biennale, 1966. His works are represented in the museums of Contemporary Art of Madrid and Seville and in the museums of Cuenca, Liège, Bologna, Skopje, Ljubljana, Warsaw, Kraków, Vienna, Boston and Houston.

HÉROLD, JACQUES (1910–). Romanian painter and sculptor, born at Piatra. He went to Paris in 1930 and in 1934 joined the SURREALIST movement. His work was dominated by three obsessive themes: a motorcyclist who after a collision was bleeding in thin streams; a pastry-cook crushed against a wall by a runaway tram; and the head of a girl with the skin torn into thin strips. These were painted in a semi-abstract manner always with a crystalline design. Later his work became non-figurative and he created involuntary shapes by AUTOMATIC and unplanned movements of brush or palette knife. In 1951 he left the Surrealist movement.

HERON, PATRICK (1920–). British painter born at Leeds, studied part-time at the Slade School of Art, 1937–9. From 1945 to 1947 he wrote art criticism for the *New English Weekly*, he was art critic to the *New Statesman and Nation* from 1947 to 1950 and was London correspondent to the New York journal *Arts* in 1955–8. From 1947 he exhibited constantly both in one-man shows and in collective exhibitions, in Britain, Europe, Australia and the U.S.A. He was awarded the Grand Prize at the 2nd John Moores Liverpool exhibition in 1959 and a Silver Medal at the São Paulo Bienale in 1965. He had retrospective exhibitions at Wakefield City Art Gal. in 1952, the Demarco Gal., Edinburgh, and the Kunstnernes Hus, Oslo, in 1967, the Mus. of Modern Art, Oxford, in 1968 and the Whitechapel Art Gal. in 1972. His works are represented in many public collections in Britain, Australia, Canada and the U.S.A., including the Tate Gal., the Victoria and Albert Mus. and the British Museum, London, the Albright-Knox Art Gal., Smith College Mus. of Art, Brooklyn Mus. among others in the U.S.A., Toronto Art Gal., Montreal Mus. of Fine Art,

Power coll., Sydney, the Art Gal. of Queensland, Brisbane, Boymans-van Beuningen Mus., Rotterdam. Among his writings are *The Changing Forms of Art* (1955) and 'The Shape of Colour', the Power Lecture for 1972.

Heron painted in an individual style which can be located between TACHISM (in 1956 his exhibition was described by the critics as 'Tachist') and COLOUR FIELD PAINTING. He was concerned to preserve and intensify the pure visual sensation of colour. In his Power Lecture he stated that 'The finished painting should also end in pure sensation of colour . . .' and 'Painting's role in civilisation is that of man's laboratory for the disinterested exploration of visual appearances as such, an exploration carried out uninhibited by any practical demands whatsoever'.

HERRÁN, SATURNINO. See LATIN AMERICA.

HERVIEU, LOUISE (1878–1954). French painter, graphic artist and writer, born at Alençon. She exhibited paintings only once, in 1910, and afterwards turned to pastels, charcoal drawings and graphic work. Among the books which she illustrated was *Les Fleurs du Mal* (1920). Her favoured subjects were intimate interiors and still lifes of flowers, which she endowed with a mysterious and tragic atmosphere of lyrical charm. Her pastels, and still more her charcoal drawings, were highly valued for the finesse of their execution and a number are preserved in the Mus. National d'Art Moderne, Paris. Owing to failure of eyesight in the 1920s she abandoned art and took up literature.

HESSE, EVA. See CONCEPTUAL ART.

HEWARD, PRUDENCE. See CANADA.

HIGGINS, EDWARD (1930–). American sculptor, born at Gaffney, S.C., and studied at the University of North Carolina. His sculpture commissions included work for the Cameron Building, New York (1962) and the Lincoln Center for the Performing Arts (1964). He exhibited during the 1960s at the Leo Castelli and Richard Feigen Gals., New York, and his work was included in important collective exhibitions of the most recent American art. In opposition to the expressive sculpture in welded metal which was popular during the 1950s, Higgins evolved a simpler and more geometrical style in the CONSTRUCTIVIST tradition, combining welded steel with white plaster and linking rectilinear with curvilinear forms. In keeping with the aesthetics of POSTPAINTERLY ABSTRACTION and MINIMAL ART his work eschewed all suggestive or symbolic overtones and was restricted to rigorously optical meaning.

HIGGS, CECIL. See SOUTH AFRICA.

HILL, ANTHONY (1930–). British CON-

STRUCTIVIST artist, born in London. He studied at the St. Martin's School of Art and the Central School of Art and Design, 1947–50. In 1950 he began making abstract paintings, collages and projects for serial production. He visited Paris in 1951, where he met VANTONGERLOO, Sonia DE-LAUNAY, Michel SEUPHOR and members of the SALON DES RÉALITÉS NOUVELLES. He helped to promote some of the first exhibitions of CONCRETE ART in London after the Second World War. In 1971 he was awarded a Leverhulme Research Fellowship to work as Honorary Research Fellow in the Mathematics Department at University College, London. He participated in the exhibitions 'Konkrete Kunst' (Zürich, 1960); 'Art Abstrait Constructive' (Denise René Gal., Paris, 1961); 'Experiments in Construction' (Stedelijk Mus., Amsterdam, 1962); 'Art and Movement' (Tel Aviv Mus., 1965); 'Relief Construction' (Mus. of Contemporary Art, Chicago, 1968); 'Plus by Minus: Today's Half Century' (Albright-Knox Art Gal., Buffalo, 1968); 'Constructivism: Elements and Principles' (1st Nuremberg Biennale, 1969). He showed two mathematically planned painted designs in 'British Painting '74' at the Hayward Gal. Influenced by Charles BIEDERMAN, Hill was one of the leaders of the post-war Constructivist movement in England. He edited an anthology *DATA—Directions in Art, Theory and Aesthetics* (1968), which was described by Stephen Bann as 'by far the most illuminating and comprehensive recent survey of attitudes towards the constructive tradition', and he contributed articles to the Dutch Constructivist magazine *Structure*.

HILLHOUSE, MAY. See SOUTH AFRICA.

HILLIARD, JOHN. See CONCEPTUAL ART.

HILLIER, TRISTRAM (1905–83). British painter, born in Peking of Huguenot stock. He went to school at Downside and seriously considered a monastic career, but instead of this he spent two years (1922–4) at Christ's College, Cambridge, and was then apprenticed to a firm of Chartered Accountants. He began painting seriously while at Cambridge and quickly abandoned accountancy to study at the Slade School under TONKS while attending the Westminster School of Art in the evenings, where he worked under MENINSKY. After eighteen months at the Slade he went to Paris, where he worked under LHOTE. He had his first London exhibition in 1931 at the Reid and Lefevre Gal. In 1933 he became a member of UNIT ONE and contributed to Herbert Read's book of that name. Throughout the 1930s he travelled widely in Europe, conceiving a special affection for Spain and Portugal. During the Second World War he served with the Royal Naval Volunteer Reserve (1940–4) and afterwards settled in Somerset, where he wrote an autobiography, *Leda and the Goose* (1954). He was made A.R.A. in 1957 and R.A. in 1967.

Hillier was influenced by SURREALISM, particularly in the achievement of an impression of strangeness and otherworldliness by the juxtaposition of incongruous objects and the use of unreal perspectives. The outstanding qualities of his painting were sharpness of definition, precision and clarity, which lent even to his most Surrealist works a sense of MAGIC REALISM. He has works in the Tate Gal., the National Gal. of Canada and the National Gal. of New South Wales, among others.

HILTMANN, JOCHEN (1935–). German sculptor born in Hamburg, studied painting in Hamburg and Düsseldorf but had no formal training in sculpture. In 1962 he was awarded the Cornelius Prize of Düsseldorf, in 1964 a scholarship for the Villa Massimo, Rome, and in 1965 the Art Prize for Youth in sculpture. From 1968 he taught at the Hochschule für Bildende Künste, Hamburg. Besides exhibitions in Germany he showed in New York, Rome and Antwerp. Among the collective exhibitions in which he participated were DOCUMENTA III (1964) and the Carnegie International, Pittsburgh, in 1967 and 1970. His early sculpture consisted of metal spheres on which apparently random fungus-like growths were contrasted with smooth surfaces. From *c.* 1966 the spheres were elongated by wormlike growths and protuberances into shapes suggestive of slugs or intestines. These sculptures were intended to be placed, apparently at random, in the open. Hiltmann claimed that in them he was not merely showing a contrast between the organic and the 'technical' or mass-produced object, but was achieving a radical integration between the two.

HILTON, ROGER (1911–75). British painter born in Northwood, Middlesex, studied at the Slade School of Fine Art, 1929–31, and at the Académie Ransom, Paris, 1931–9, where he came under the influence of Roger BISSIÈRE. He was a prisoner of war 1942–5, after which he taught art for a while at Bryanston School. The figurative element gradually disappeared from his work during this period and by 1950 his paintings were completely abstract. In 1953 he visited the Netherlands and was influenced by the work of MONDRIAN, which he saw at The Hague. By 1955, however, he had reverted to a more lyrical type of abstraction, with an improvisatory appearance and a suggestion of the clumsiness which often characterizes child art. He had a liking for simple and dynamically contrasted colours and from this time used colour for the achievement of a highly personal kind of picture-space: instead of creating a 'virtual' recessionary space behind the picture plane, his forms seem to leap forward in the direction of the spectator. In the words of Patrick HERON (*Changing Forms of Art*, 1955): 'Hilton's "flat" colour-patches *advance*, bodily, physically, it seems, from the canvas towards one and out into the room.' From *c.* 1955, while continuing to paint abstracts, he no longer eschewed a figural

clement, though his images were not representational. He himself said in 1961: 'Abstraction in itself is nothing. It is only a step towards a new sort of figuration, that is one which is more true.' From 1954 to 1956 he taught at the Central School of Arts and Crafts, London. In 1964 he was awarded the UNESCO prize at the Venice Biennale. In 1965 he moved to St. Just, Cornwall. An exhibition of paintings and drawings covering the years 1931–73 was arranged by the Arts Council of Great Britain at the Serpentine Gal. in 1974.

HILTUNEN, EILA (1922–). Finnish sculptor, born at Sordavala, Karelia, and studied, 1942–6, at the School of the Academy of Art, Helsinki. She first exhibited in 1944, working competently in a naturalistic and classical style, and made her mark by her war memorials, of which the one at Simpele is considered to be the best. At this time she also did portrait busts of Finnish celebrities such as President Paasikivi and the writer Sillanpaa. About 1958 she discovered the technique of welding and was further inspired when she met ARCHIPENKO during a visit to the U.S.A. with a Ford Foundation scholarship. In the early 1960s she continued to work figuratively but in a style deriving from her new welding technique, sometimes hollow groups in which the enclosed space was given sculptural dimensions and sometimes groups in violent motion. Among the latter the most distinguished is her *Under Water*, in which two figures constructed from welded copper hoops seem to be swimming and gliding weightlessly in the water. Her most famous work of all is the abstract *Sibelius Monument*, consisting of a nest of polished steel tubes which have been likened both to organ pipes and to the pine trunks of the Finnish forests. One writer says: 'The finished work gives those who see it a completely new experience of a craggy coast, of Fingal's cave, of murmuring waters, of the wholly musical feeling that it is possible to walk into the structure, to be surrounded by the rise and fall of its movements, by the meeting and fading of its forms, to lose oneself in its all-embracing beauty.' Even from afar it stands out as the epitome of 'frozen music'.

HINMAN, CHARLES (1932–). American painter, born at Syracuse, N.Y., studied at Syracuse University and at the Art Students' League, 1955–6. At the end of the 1950s he travelled to Europe, India, Japan and round the world. His first one-man exhibition was at the Richard Feigen Gal., New York, in 1964 and he had a retrospective at the Lincoln Center in 1969. He was represented in a number of collective exhibitions of recent and innovative art in America. His work belonged to the general category of POST-PAINTERLY ABSTRACTION but had much in common with MINIMAL ART in its complete repudiation of all non-literal qualities, restricting painting to the optical properties of two-dimensional shape and simple colour. He worked both in SYSTEMIC ART and with the shaped canvas.

HIQUILY, PHILIPPE (1925–). French sculptor born in Paris. He began his training at the École des Beaux-Arts, Orleans, then during the Second World War served in Indo-China. After the war he completed his studies at the École des Beaux-Arts, Paris, 1949–52, and during this time turned towards abstract metal sculpture, working in iron, steel, brass, aluminium, etc. Under the influence of Germaine RICHIER his sculptures displayed a certain air of fantasy, combining massive volumes with slender or pointed shafts, though he remained centrally concerned with the problem of suggesting movement. From 1956 he exhibited at the Salon de Mai and the Salon de la Jeune Sculpture.

HIRSHFIELD, MORRIS (1872–1946). American NAÏVE painter. Born in a small Polish town near the Russian border, he emigrated to the U.S.A. in 1890. He worked first in a women's clothing shop and afterwards owned a firm dealing in bedroom slippers. He began to paint in 1936 after he had retired from business because of illness. He was exhibited in The Mus. of Modern Art, New York, in 1943, in the Sidney Janis Gal. in 1949, in the Kunsthaus, Zürich, and the Gal. Maeght, Paris, in 1951 and in 1958 was represented in the exhibition 'Fifty Years of Modern Art' in Brussels. He worked very slowly, often taking a year or more to do a picture, and his output was consequently small. He painted animals from cheap prints in children's books, transforming the banal originals into fabulous creatures from a fairy-tale world. He also did erotic nudes with vacant faces which have been compared to the work of Tom WESSELMAN, though the nudes of Hirshfield were done without irony or conscious exhibitionism. His *Girl in a Mirror* (1940) is in The Mus. of Modern Art, New York. He painted with meticulous attention to detail and with a strong sense of pattern.

HITCHENS, IVON (1893–1979). British painter born in London, studied at the St. John's Wood School of Art and the Royal Academy Schools. He became a member of the SEVEN AND FIVE SOCIETY in 1922 and of the LONDON GROUP in 1931. In 1934 he was one of the seven artists who exhibited at the Zwemmer Gal. under the title OBJECTIVE ABSTRACTION and he was the only one of the group who remained consistent to this style. It is a form of expressive abstraction which transforms natural appearances into ensembles of coloured shapes which are intended to evoke in the spectator feelings similar to the feelings aroused by the actuality from which the painting originates. Hitchens painted on the borderline between abstraction and depiction. Sometimes hints of his subject are discernible in his painting but usually abstraction was taken beyond the point of subject recognition. Hitchens also retained a fondness for a longitudinal format which compels the eye to scan the picture horizontally and follow the rhythms of his horizontal forms. In 1940 he was bombed in London and moved to Sussex, where his

paintings of the countryside, though not topographical, continued the tradition of English Romantic landscape.

His first retrospective exhibition was at Temple Newsam, Leeds, in 1945. In 1956 he exhibited at the Venice Biennale and subsequently, under the auspices of the British Council, at Vienna, Munich, Paris and Amsterdam. He exhibited at the Waddington Gals., London, from 1962 to 1976, including a retrospective in 1973. He also had retrospectives at the Tate Gal. in 1963 and at the Southampton Art Gal. in 1964. In 1965 he exhibited at the Poindexter Gal., New York. Contrary to what often happens when an artist remains constant in one style over a period of decades, Hitchens's work did not become stereotyped or banal, the only change being an intensification of colour in some of his work in the 1970s. Among the many public collections which possess examples of his work are the Tate Gal., the Mus. National d'Art Moderne, Paris, the National Galleries of Canada, Norway, New Zealand, New South Wales, South Australia, Victoria, Gothenburg Art Mus., Sweden, Seattle Art Gal., Albright-Knox Art Gal., Buffalo, etc. He was created C.B.E. in 1958.

HOCKNEY, DAVID (1937–). British painter and draughtsman born at Bradford. He studied at the Bradford College of Art, 1953–7, and then at the Royal College, 1959–62, where R. B. KITAJ was a fellow student. He won the Royal College of Art Gold Medal, the Guinness Award for Etching, First Prize at the Craven Image Exhibition and the prize in the Junior Section of the John Moores Exhibition, Liverpool, all in 1961. In 1963 he was awarded a prize in the Graphics section of the Paris Biennale and held his first one-man exhibition at the Kasmin Gal. David Hockney represents the unusual phenomenon of an artist who won instant international success while still a student. He first burst upon the public notice internationally with a set of 16 etchings entitled *A Rake's Progress* inspired by a visit to New York in 1961 and exhibited at the Alecto Gal. in 1963. From the time when he began showing in the 'Young Contemporaries' exhibitions at the R.B.A. Gals., London, in 1960 his paintings and drawings and prints were eagerly sought after by connoisseurs and collectors. A painting which was priced at £500 at the Kasmin Gal. in 1966 sold at Sotheby's in 1974 for £25,000. He had a comprehensive retrospective exhibition at the Whitechapel Art Gal. in 1970, shown also in the Kestner-Gesellschaft, Hanover, and the Boymans-van Beuningen Mus., Rotterdam. An exhibition of his works at the Mus. des Arts Décoratifs, Paris, was arranged by the Arts Council in 1974. He was one of the artists figuring in the exhibition 'Pop Art in England' shown in 1976 at the Kunstverein, Hamburg, the Städt. Gal. im Lenbachhaus, Munich, and York City Gal. Hockney taught at Maidstone College of Art in 1962 and from 1963 held teaching posts at

the University of Iowa, the University of Colorado and the University of California. He designed décor and costumes for a performance of Alfred Jarry's *Ubu Roi* at the Royal Court Theatre in 1966 and in 1971 an album of 72 drawings was published.

Hockney has often been classified as a POP artist. In *Movements in Art since 1945* Edward Lucie-Smith wrote: 'Hockney is an artist who has had an interesting if slightly erratic development. He began as the *Wunderkind* of British art. His life-style was instantly famous; his dyed blond hair, owlish glasses, and gold lamé jacket created— or contributed to—a persona which appealed even to people who were not vitally interested in painting. In this sense, he forms part of the general development of British culture which was symbolized by the sudden and enormous fame of the Beatles. But it was also clear that Hockney was precociously gifted. In his early work, he adopted a cartooning, *faux-naïf* style which owed a lot to children's drawings. Often these early pictures have a delightful deadpan irony.' Later his work developed in the direction of increasing perspicuity and realism. John Rothenstein has felicitously described its distinctive character as the 'epitome of expectant stillness'. Hockney himself later declared, 'I am not a pop-painter.' In a review of an exhibition 'Four Young Artists' held at the I.C.A. Gals. in 1973 the *Times* art critic wrote: 'Mr. David Hockney, on the other hand, is … a fantasist with an entrancingly original imagination in which quaintness and caricature are combined. He does not … reflect the outer world so much as project an inner one, the wry poetry of which is translated in a technique which can be extraordinarily exquisite and sensitive. But his performance is as precarious as a tight-rope act: the balance is perfectly held, but pretentiousness and whimsicality seem to yawn on either side, making his achievement much the most interesting but also the most dangerously fragile, of the four artists here.' A superb natural draughtsman, Hockney was distinguished above all by his versatility. His pictorial language was highly diversified, combining figurative representation with verbal allusions and geometrical pattern, often using style as a pictorial theme. He deliberately avoided pictorial illusions of reality and in contrast to the hermeticism of ABSTRACT EXPRESSIONISM aimed at the maximum of readability and clarity, even employing tautological combination of pictorial and written semantics. He acknowledged the influence of both Kitaj and DUBUFFET. Unlike most Pop artists, he did not make advertisement and the mass media his major themes.

HODGINS, ROBERT. See SOUTH AFRICA.

HODGKIN, HOWARD (1932–). British painter born in London, studied at the Camberwell School of Art, 1949–50, and at the Bath Academy of Art, Corsham, 1950–4. He taught at Charterhouse

School, 1954–6, at the Bath Academy of Art, 1956–66, and at the Chelsea School of Art, 1966–72. From 1962 he had one-man exhibitions in London, Bristol, Cologne, New York, a retrospective at the Serpentine Gal. in 1966, and his work was included in important collective exhibitions of contemporary British painting. He was a painter of considerable originality with a personal idiom of abstraction. Among the public collections owning his works are the Tate Gal., the Arts Council of Great Britain, the Victoria and Albert Mus., the art galleries of Kettering, Bristol, Oldham, Swindon, the Peter Stuyvesant Foundation, the Walker Art Center, Minneapolis, the São Paulo Mus.

HODGKINS, FRANCES (1870–1947). British painter, born in Dunedin, New Zealand. She was taught water-colour painting by her father, an amateur painter, but had no formal training. She came to Europe in 1900 and travelled to France, the Netherlands, Italy and Morocco, settling in Paris in 1902. There, after teaching for a year at the Académie Colarossi, she opened her own water-colour school. Returning to New Zealand in 1912, she exhibited her water-colours there and in Australia with resounding success. She did not begin to paint in oils until 1915, while living at St. Ives, Cornwall. In 1919 she returned to France, where she was influenced by MATISSE and DERAIN. From 1922 to 1926 she lived in Manchester, designing for the Calico Printers' Association, and it was presumably during these years that she developed the highly personal style which brought her to prominence among the *avant-garde* of that time. She gained an immediate success with an exhibition at the Claridge Gal., London, in 1928 and was praised for a highly individual style combining unusual resonant colours with an apparently artless orchestration of design which lent a strange poetry to her work. She was welcomed by the younger, *avant-garde* artists and in 1929 was made a member of the SEVEN AND FIVE SOCIETY. She spent the last 15 years of her life in Purbeck, Dorset, where she continued to perfect her assured mastery of the vigorous poetic style upon which her popularity rested. She painted mainly landscapes and still lifes. She was exhibited together with Gwen JOHN and Ethel WALKER at the Tate Gal. in 1952.

HODGSON, TOM. See CANADA.

HODLER, FERDINAND (1853–1918). Swiss painter, born at Berne. He began by painting picturesque views for tourists and then from 1872 studied at the École des Beaux-Arts, Geneva, under Barthélemy Menn, a friend of Corot. During this time he developed an enthusiasm for Holbein and then began to paint rather solemn studies of people at work. About 1880 he experienced a religious crisis, went to Paris in 1881 and associated with the Rosicrucians, with whom he

exhibited his picture *Les Âmes Déçues*. During the 1890s he painted religious pictures under the influence of the Symbolists and also grandiloquent historical works such as his murals for the Historical Mus., Zürich. In 1900 he was awarded a Gold Medal at the Paris Exposition Universelle for his painting *Day* (Kunstmus., Berne). In 1904 he had a one-man exhibition with the Vienna SECESSION and settled in Geneva. Hodler enjoyed a high reputation in his lifetime and for a while was considered to be Switzerland's leading painter at the turn of the century. By the mid century, however, his more pretentious works were considered to lie outside the main trend of development, and highest appreciation was accorded to his Alpine landscapes and his portraits.

HOECH, HANNAH. See PHOTOMONTAGE.

HOEHME, GERHARD (1920–). German painter born at Greppin, near Dessau, studied first at Burg Giebichenstein, near Halle, and then from 1952 at the Academy of Art, Düsseldorf, where he taught from 1960. His painting towards the end of the 1950s was in the manner of expressive abstraction and he became one of the best-known artists working within Germany in the style of ART INFORMEL. In fact, however, his pictures were not impulsively composed but carefully controlled for pictorial ends. Through an interest in serial structures he developed in the early 1960s his *Schriftbilder*, all-over calligraphic compositions in the manner of TWOMBLY with a suggestion of handwriting. From these evolved his plexiglass boxes with nylon threads and cords stretched against a painted background. His works were widely exhibited in Germany.

HOELZEL, ADOLF (1853–1934). German painter, born in Olmütz, Czechoslovakia. After working in lithography and typography Hoelzel entered the Vienna Academy in 1871 and the Munich Academy in 1876. He settled in Dachau in 1888, where he opened a private school of painting and was a co-founder of the New Dachau Circle. In 1906 he became head of the Department of Composition at the Stuttgart Academy, where Willi BAUMEISTER, Oskar SCHLEMMER and Johannes ITTEN were among his pupils. From 1916 until his retirement in 1919 he was director of the Academy.

He made an intensive study of contemporary colour theories and from c. 1895 developed his own colour system, producing work between 1905 and 1917 which was close to non-objective colour abstraction. From 1904 his writings in *Die Kunst für Alle* on the elements of artistic expression were widely read and influential. From 1917 he began compositions on the theme of 'coloured sounds' which exemplified his concept of 'absolute art' and in which his movement away from representation reached its peak. At this time he also began to work in stained glass and in 1923 he began a series of pastels.

HOEYDONCK, PAUL VAN (1925–). Belgian sculptor and experimental artist born at Antwerp, where he studied at the Academy of Art and the Institute of Archaeology. He was co-editor of the magazines *Formes, G. 58 Hessenhuis* and *Art Construit*. In the mid 1950s he became interested in KINETIC ART and produced kinetic shadow pictures and plexiglass reliefs. From this he went on to ASSEMBLAGES of strange science-fiction figures of spacemen, robots, etc. on wooden reliefs which he called 'Archaeology of the Future'.

HOFER, CARL (1878–1956). German painter, born in Karlsruhe. From 1903 to 1908 he worked in Rome and his style was based on the classicism of the German 19th-c. painters who lived in Rome, particularly Hans von Marées. He was in Paris from 1908 to 1913 and his style stiffened structurally under the influence of Cézanne. He made trips to India in 1909 and 1911, bringing back a personal iconography of swooning, lyrical figures. He settled in Berlin in 1913 and in 1914 had a one-man exhibition in the Cassirer Gal. there. But he was trapped in Paris at the outbreak of war and spent three years in an internment camp. On his return to Berlin in 1918 he was appointed a teacher at the Hochschule für Bildende Künste and in 1923 became a member of the Prussian Academy. But the spirit if not the manner of his painting had changed. Except for a brief experiment with ABSTRACT painting in 1930–1, his art was one of disillusionment and pessimism, telling his dark vision of modern life through a small range of obsessively recurrent images. In 1933 he was condemned by the regime as DEGENERATE and removed from his teaching post. In 1943 his studio and most of his work were destroyed by bombing. In 1945 he was reinstated and made director of the Hochschule. Hofer remained throughout his life an individualist, as Werner Haftmann has said of him: 'Here was a man who had begun with a classical vision and a neatly circumscribed version of beauty; and then his encounter with reality shattered the dream. A disillusioned idealism engendered bitter images with which he interpreted the life of his time and supplied the succinct form. Hofer was perfectly right in refusing to be called an Expressionist. He was a classical idealist thwarted by reality.' Nevertheless his influence on many German EXPRESSIONIST artists was far from negligible.

HOFLEHNER, RUDOLF (1916–). Austrian sculptor born at Linz, studied first at the State Technical College of Machine Engineering at Linz and then at the Vienna Academy, 1938–9. He taught at the Linz School of Arts and Crafts, 1945–51, then worked in WOTRUBA's studio until 1954. In 1962 he was appointed Professor at the Stuttgart Academy of Fine Arts. He contributed to the DOCUMENTA II exhibition at Kassel in 1959 and was represented at the Venice Biennale in 1960. In 1963 he had a one-man show in Vienna and subsequently at various towns in Germany and Switzerland and in New York (1965). Hoflehner's work was completely abstract up to 1954, constructed from massive blocks and sheets of iron or steel. Then after spending six months in Greece he began to base his abstractions on the human figure, contrasting brightly polished planes with rougher surfaces. He declared that in addition to their formal qualities his figures symbolically expressed an attitude to the world.

HOFMANN, HANS (1880–1966). German-American artist, born in Weissenberg, Bavaria. From *c.* 1898 he studied art in Munich and was trained in a DIVISIONIST mode of late Neo-Impressionism. He lived in Paris from 1904 to 1914 and knew many of the protagonists of FAUVISM, CUBISM and ORPHISM. The American critic Clement Greenberg was later impressed by his knowledge of the colour principles of MATISSE. In 1915 he founded his own art school in Munich and taught there successfully until 1930. In 1930 and 1931 he gave courses in the University of California at Berkeley and Los Angeles and in 1932–3 he taught at the Art Students' League, New York. He founded his own school in New York in 1934 and gave summer courses in Provincetown, Mass. He acquired American citizenship in 1941.

As a teacher Hofmann had considerable influence on the minority group of American artists who practised abstract painting during the 1930s. Hofmann himself experimented with many styles of *avant-garde* painting. The two most distinctive were: a style consisting of largish over-lapping squares, etc. of comparatively unmodulated pigment laid on with a thick impasto, e.g. *Cathedral* (1959) and *Ignotum per Ignotius* (1963); and a style between ABSTRACT EXPRESSIONISM and a heavyish rendering of TACHISM, e.g. *Effervescence* (Art Mus., University of California at Berkeley, 1944) and *Fragrance* (Honolulu Academy of Arts, 1956). His first exhibition in New York was at the Peggy Guggenheim 'Art of this Century' Gal. in 1944. He had a retrospective exhibition at the Mus. of Modern Art, New York, in 1963. Hofmann was a significant figure in the development of an American art of Abstract Expressionism in the 1940s.

HOLDING, EILEEN. See CIRCLE.

HOLGATE, EDWIN. See CANADA.

HOLISTIC PAINTING. See FIELD PAINTING.

HOLLAND. See NETHERLANDS.

HOLLEGHA, WOLFGANG (1929–). Austrian painter, born at Klagenfurt. He was trained at the Vienna Academy of Art, 1948–54, and was one of the group of young painters who led the trend towards abstraction in the post-war artistic revival (see AUSTRIA). In 1958 he won the Guggenheim Prize for Austria and he was awarded a prize in

Cincinnati in 1961. His work was at first stiffly geometrical in character but developed into a freer, calligraphic form of LYRICAL ABSTRACTION in which loosely associated quasi-organic shapes in brilliant colours stood out against a white background.

HOLMGREN, MARTIN (1921–). Swedish sculptor born at Hallnas. The nature of his work was determined by a persisting interest in the problems arising from movement. His first work was representational, drawings and small statues of ballet subjects. His *Trafikmiljö* of 1953 was an attempt to convey an impression of the movement of traffic. A visit to France in 1952 brought him into contact with contemporary idiom and he developed a style of richly expressive abstraction or near-abstraction in which he sought to convey the human predicament in face of catastrophe and confusion. His *Forms Seeking a Common Centre* (Moderna Mus., Stockholm, 1955–60) is an example of the tension of movement conveyed through expressive forms in bronze.

HOLTY, CARL ROBERT (1900–73). German-American artist, born at Freiburg. He went to the U.S.A. as a child and became an American citizen in 1906. After studying at the National Academy of Design and then at the Academy of Fine Arts and the Hans HOFMANN school, Munich, he worked in a manner of semi-geometrical abstraction and was a member of the ABSTRACTION-CRÉATION association and of AMERICAN ABSTRACT ARTISTS, 1937–43. He was a friend of MONDRIAN in New York and was influenced by NEO-PLASTICISM.

HOLTZMAN, HARRY (1912–). American painter, born in New York and studied at the Art Students' League, 1928–33. He was an early admirer of MONDRIAN and in 1934 went to Paris in order to meet him. He was a founding member of AMERICAN ABSTRACT ARTISTS. In 1940 it was owing to his persuasion and help that Mondrian left London for New York and he was sole beneficiary on Mondrian's death in 1944. At this time he practically abandoned painting and in the 1950s he published the review *Transformation*.

HOMME-TÉMOIN. A group of French artists who were united in their promotion of expressive SOCIAL REALISM in opposition to the current schools of abstraction. They came to public notice in 1948 when Michel de Gallard, Bernard LORJOU, Yvonne Mottet, Paul REBEYROLLE and Michel Thomson exhibited at the Gal. du Bac, Paris. They declared that 'man is an eater of red meat, fried potatoes, fruit and cheese', solidly rooted in the elementary material needs of daily life, and that his need in consequence was for true, authentic and direct pictures. They set the solid common sense of the populace against the refinements of the abstractionists who, engrossed in their purely pictorial problems, had lost contact with ordinary life. The following year they exhibited at the Gal. Claude, augmented by Bernard BUFFET, Charazac, Simone Dat and André MINAUX. Their ambition was to document the ordinary life of their day in as realistic a manner as possible.

HOPPER, EDWARD (1882–1967). American painter, born at Nyack, N.Y. He was trained at the Chase School of Art, New York, under Robert HENRI, 1900–6, and between 1906 and 1910 made three trips to Europe though these had little influence on his realistic painting style. In 1910 he showed at the first Independents exhibition. He was not affected by the modernist movements of the STIEGLITZ circle or the ARMORY SHOW and later disclaimed having been a member of the ASH-CAN school, declaring that his work had no social content whatsoever, whereas the Ash-Can school of Realism had a 'sociological trend' which did not interest him. (These and later quotations from Hopper's own statements are taken from an interview published in Katharine Kuh, *The Artist's Voice*, 1962.) From *c.* 1913 to 1923 he abandoned painting, earning his living by commercial illustration, although in 1920 he had a one-man exhibition of pictures he had painted in Paris. His work since the 1920s has been regarded as a central example of AMERICAN SCENE painting, expressing the loneliness, vacuity and stagnation of town life. Yet Hopper remained always an individualist and in the interview referred to above he said: 'I don't think I ever tried to paint the American scene; I'm trying to paint myself.' Of the 'loneliness and nostalgia' which have been read into his works he said: 'If they are, it isn't at all conscious.' Paintings such as *Early Sunday Morning* (Whitney Mus. of American Art, 1930) and *Nighthawks* (Art Institute of Chicago, 1942) convey a mood of loneliness and desolation by their emptiness or the presence of anonymous, non-communicating figures. Yet again, of the latter Hopper said: 'I didn't see it as particularly lonely . . . Unconsciously, probably, I was painting the loneliness of a large city.'

Deliberately so or not, Hopper soon obtained widespread recognition as a painter of one aspect of the American scene and he was given a retrospective exhibition at The Mus. of Modern Art, New York, in 1933 and a large exhibition at the Whitney Mus. of American Art in 1964. He had a retrospective exhibition at the Boston Mus. of Fine Arts in 1950 and a one-man exhibition at the Venice Biennale of 1952. His works have no overt social propaganda as had those of the SOCIAL REALISTS and none of the blatancy of the German EXPRESSIONISTS. Yet they express a precise mood and their stillness and reserve often exert a psychological impact and a sense of presence as powerful as that of the REGIONALISTS Grant WOOD or Andrew WYETH. It is an impact distantly akin to that made by the METAPHYSICAL painter CHIRICO; but while Chirico's effect was obtained by

making the unreal seem real, Hopper's was rooted in the presentation of the familiar and real.

HOSKING, KNIGHTON (1944–). British painter, born at Sidmouth, Devon. He studied at Exeter College of Art, 1959–63, and the Central School of Art and Design, 1963–6. In 1966 he travelled to the U.S.A. with a Peter Stuyvesant Foundation Fellowship. He was included in the group exhibitions 'The New Generation', Whitechapel Art Gal., 1966, and 'British Painting '74' at the Hayward Gal., among others and had one-man exhibitions at the Serpentine Gal. and elsewhere. His works are in the collections of the Arts Council, the Contemporary Arts Society, the Peter Stuyvesant Foundation, etc. He painted large canvases in black, relieved by the admixture of white pigment, using very heavy impasto in which he sculpted lines and ridges in a style of expressive abstraction.

HOUSTON, JOHN (1930–). British painter, born at Buckhaven. He taught at the Edinburgh College of Art, was elected associate of the Royal Scottish Academy in 1964 and academician in 1972. In 1964 he won the Guthrie award and in 1965 the Cargill prize, Royal Glasgow Institute. He painted landscapes of sea, sky, clouds and headlands simplified to the point of abstraction. Among the exhibitions in which he participated were 'Contemporary Scottish Painting', Toronto, 1961; 'Fourteen Scottish Painters', Commonwealth Institute, 1963; 'Three Centuries of Scottish Painting', National Gal. of Canada, Ottawa, 1968; 'Twelve Scottish Painters', Maine State Commission on the Arts and Humanities, touring the U.S.A. and Canada. He had one-man exhibitions among others at the Mercury Gal., London, and the Cerberus Gal., New York, and a retrospective exhibition in 1974 at the Oban Art Society, Dunfermline. Among the collections which own his works are: the Contemporary Arts Society; the Scottish Arts Council; the Scottish National Gal. of Modern Art and the Royal Scottish Academy; the Department of the Environment; Edinburgh University; the Nuffield Foundation; the Royal Bank of Scotland; the Education Authorities of Edinburgh, Glasgow, Carlisle, Nottingham, Dunbarton; the public galleries of Aberdeen, Liverpool, Bradford, Glasgow, Kirkcaldy, Perth, Portsmouth City.

HOYLAND, JOHN (1934–). British painter, born at Sheffield and studied at the Sheffield College of Art, 1951–6, and at the Royal Academy Schools, 1956–60. He taught at the Croydon School of Art, 1962–3, at the Chelsea School of Art, 1962–70, where he became Principal Lecturer in 1965. He was Charles A. Dana Professor of Fine Art at Colgate University, New York, in 1972 and in 1974 began teaching at St. Martin's School of Art, London. In 1964 he obtained the International Young Artists Award, Tokyo, and

in the same year visited the U.S.A. on a Peter Stuyvesant Foundation Travel Bursary and came into contact with COLOUR FIELD artists such as Morris LOUIS and NOLAND. His work from that time was HARD EDGE with bands of interacting colour. In the 1970s he painted one-colour canvases, the colour heightened in intensity and brilliance by surface treatment and underpainting with a border of contrasting tone which reflected back upon the main area. He showed two paintings of this style in the 'British Painting '74' exhibition at the Hayward Gal. His work has been widely exhibited in Europe and America as well as Britain and is represented in the Tate Gal. and other public collections.

HRDLICKA, ALFRED (1928–). Austrian sculptor and graphic artist, born in Vienna. After beginning to train as a dentist he studied painting under GÜTERSLOH at the Vienna Academy and then sculpture under WOTRUBA, 1953–7. His sculpture was in a vein of expressive naturalism with a suggestion of primitive naïvety and had as its basic theme the expression of human suffering and torment, e.g. *Crucifixion* (Mus. des 20. Jahrhunderts, Vienna, 1959). His important graphic works had a similar theme. In 1963 his work was exhibited at Salzburg when he taught at the Salzburg International Summer Academy of Fine Arts and in 1968 he was awarded the Austrian National Prize for Sculpture.

HSING TEH-HSIN (GERARD D'A. HENDERSON, 1928–). British painter, born in Kuala Lumpur. Trained as a musician, he was largely self-taught as a painter. He worked chiefly in England and Spain, had one-man shows in Singapore, San Francisco and Barcelona and participated in many collective exhibitions, including 'Commonwealth Art Today', at the Commonwealth Institute, London, in 1962–3. He was commissioned to do a large mural in Singapore for the Royal Dutch Airlines, murals for the Raffles Hotel, Singapore, and the Savoy Hotel, London, and stained glass windows for the Church of the Sacred Family, Seu-de-Urgel. He is represented in the Barcelona Mus. of Modern Art and other public collections.

HUBACHER, HERMANN (1885–1976). Swiss sculptor, born in Biel and trained at the Biel Technical College and the École des Beaux-Arts, Geneva. He studied in Vienna, 1906–7, and in Munich, 1909–10. In 1910 he settled in Berne, moving to Zürich in 1916. He worked in a manner of restrained naturalism. A portrait bronze of the art historian Heinrich Wölfflin by him is in the Stiftung Oskar Reinhart, Winterthur.

HUDSON, ROBERT H. (1938–). American sculptor born at Salt Lake City, Utah, studied at San Francisco Art Institute, taught in the University of California at Davis. His first one-man exhibitions were at the Richmond Art Center and

the Batman Gal., San Francisco, in 1961. He continued to exhibit extensively in California and at the Allan Frumkin Gal., Chicago. His work belonged to the advanced California style of the 1960s, lying for the most part between FUNK ART and JUNK ART. Among the group shows in which he was represented were: Whitney Mus. of American Art, 'Young America', 1965; University of California at Berkeley, 'Funk', 1967: Los Angeles County Mus. of Art, 'American Sculpture of the Sixties'. Although he also worked in the manner of Funk art, his work was described by Michael Benedikt as falling within Lucy Lippard's definition of 'Eccentric Abstraction'. He was particularly bold in his three-dimensional use of kaleidoscopic colour.

HUEBLER, DOUGLAS. See CONCEPTUAL ART.

HUELSENBECK, RICHARD. See CABARET VOLTAIRE; DADA; PHOTOMONTAGE.

HUGNET, GEORGES. See SURREALISM.

HULTBERG, JOHN (1922–). American painter born at Berkeley, Calif., studied at Fresno State College, Calif., 1939–43, at the California School of Fine Arts and then at the Art Students' League, 1949–51, under Byron BROWNE. He had his first one-man show at the Contemporary Gal., Sausalito, Calif., in 1949, then moved to New York and had his first New York show in 1953 at the Korman Gal. In 1955 he won First Prize at the Corcoran Gal. of Art, Washington, and First Prize at the Congress for Cultural Freedom, and in 1956 received a Guggenheim Foundation Fellowship. From 1955 he began exhibiting at the Martha Jackson Gal., New York, and started to hold a large number of one-man shows both elsewhere in the U.S.A. and in Europe. He also participated in frequent collective shows both in America and abroad. In the 1950s his work was based on a grid consisting of multiple squares, which was sometimes tilted to convey the impression of deep space or to give a kinaesthetic sense of movement while still retaining the impression of two-dimensional pattern with a visual ambiguity suggestive of OP ART. In the latter 1950s, from c. 1957, he developed a personal style combining free form with HARD EDGE and using geometrical forms vaguely suggestive of natural objects floating freely in monochromatic space. Without being eclectic, his style was a fusion of many manners including, as well as his grid paintings, situational and environmental composition.

HUMBLOT, ROBERT (1907–62). French painter, born at Fontenay-sous-Bois. After studying science at the Sorbonne he turned to painting and was a student at the École des Beaux-Arts, 1931–4. He was one of the small group of friends, including ROHNER and JANNOT, who condemned the current *avant-garde* movements as too precious

and made it their ambition to vivify classical French art by adapting it to present-day needs. They founded the association FORCES NOUVELLES, which wished to restore strict principles of draughtsmanship and good craftsmanship while maintaining a close contact with nature and humanity. Humblot was most successful as a landscape painter and was particularly attracted by port scenes. In 1940 he was made a prisoner of war but escaped in 1941. The Gal. Charpentier gave an exhibition of his landscapes in 1946.

HUMPHREY, JACK. See CANADA.

HUNDERTWASSER, FRITZ (FRIEDRICH STOWASSER, 1928–). Austrian painter, born in Vienna of Jewish descent on his mother's side. He took the name Hundertwasser in 1949, translating the syllable 'sto' (which means 'hundred' in Czech) by the German 'hundert'. From c. 1969 he signed his work FRIEDENSREICH HUNDERT-WASSER, symbolizing by 'Friedensreich' (Kingdom of Peace) his boast that by his painting he would introduce the observer into a new life of peace and happiness, a 'parallel world', access to which had been lost owing to the corruption of the instinct for it by the sicknesses of civilization. He often added 'Regenstag' (Rainy Day) to the name—making it in full FRIEDENSREICH HUN-DERTWASSER REGENSTAG—on the ground that he felt happy on rainy days because colours then began to sparkle and glow. This exaggerated concern with the name was a symptom of the braggadocio and conceit which were apparent in his work as well as his life.

From 1936 when he began to attend the Montessori school in Vienna Hundertwasser showed some natural talent and even sensitivity as a draughtsman and water-colourist. In 1948 he attended the Vienna Academy of Fine Art for three months and acquired a grounding in the traditional 19th-c. water-colour landscape tradition. In the same year he was influenced by the Memorial Exhibition of Egon SCHIELE held in Vienna. In 1949 he travelled in Italy with the Paris painter René Brô and on returning to Paris collaborated with him on murals. At this time he came into contact with expressive abstraction or ART INFOR-MEL and his own style changed radically in the direction of EXPRESSIONISM. His work became increasingly abstract, although symbolic and fanciful figurative elements continued to be present. About 1953 he 'discovered' the spiral and from this time onwards it became an obsessive feature of his style. Hundertwasser declared that the spiral held symbolic significance for him; it was a symbol of creation, life, the circulation of the blood, the unending path which does not close upon itself; the clockwise and anti-clockwise spiral had a different significance; and so on. Such symbolic significance, where it exists, is esoteric in the sense that it is not discernible by an observer to whom it has not been explained, and it is not germane to the

aesthetic aspects of the work. Hundertwasser's spirals have been compared with the curves of KLIMT and may have been derived from Klimt. But in fact there is little likeness between the curvilinear decorative rhythms of the *Jugendstil* and the harsh, tight spiralling scribbles which eventually became increasingly dominant in Hundertwasser's work.

Hundertwasser had a predilection for harsh and acrid colour combinations and for the use of luminous pigments. The delicate sensibility of his early water-colours disappeared from the later work and although the latter has been compared with Oriental, particularly Persian, colour traditions, there was in it none of the refinement and subtlety displayed by the best Oriental work. From *c.* 1954 he evolved a very obscure theory of 'Transautomatism', which was apparently derived from SURREALIST ideas of AUTOMATIC creation but which postulated a series of automatic creative acts on the part of the *observer* rather than a single or uniform response to the art object created by the artist. He also continued to maintain that the artist's creative act was the expression of a religious impulse, opening up to the observer a new paradise of joy and peace.

Hundertwasser travelled much both in Europe and the East, visiting Japan in 1961 and participating in the Sixth International Exhibition at Tokyo. He settled in Rome *c.* 1957, was visiting lecturer at the College of Art in Hamburg in 1959 and during the 1960s made homes in Venice, Vienna and northern France. He visited the U.S.A. in 1968 and in 1969 had a touring exhibition in Berkeley, Santa Barbara, Houston, Chicago, New York and Washington.

In 1951 he became a member of the Art Club, Vienna. In 1962 he had a one-man show in the Austrian Pavilion at the Venice Biennale and in 1964 a one-man touring exhibition at the Kestner-Gesellschaft, Hanover, and at Amsterdam, Berne, The Hague, Stockholm and Vienna. A touring exhibition was shown in 1967 in Paris, London, Geneva and Berlin. In 1970–2 he collaborated in a film *Hundertwassers Regenstag* by Peter Schamoni. In 1971 he designed posters for the Olympic Games at Munich and also began to work on town-planning projects for Vienna and New Zealand. In 1974 he had a touring exhibition in Australia with the title 'Stowasser 1943—Hundertwasser 1974' and in the same year he designed a 'Conservation Week' poster for New Zealand and produced a much advertised series of postage stamps for Austria. A large retrospective exhibition was staged at the Haus der Kunst, Munich, in 1975 and Hundertwasser then announced that he was preparing a worldwide touring exhibition which would be shown in 15 countries and 5 continents with the title 'Österreich zeigt den Kontinenten Hundertwasser'.

Hundertwasser stood outside most contemporary artistic movements though borrowing from many. He had a talent for self-advertisement and built himself up into a picturesque figure given to gnomic utterances about his own significance to the world. He was almost certainly overrated as an artist during his own lifetime.

HUOT, ROBERT (1935–). American painter born at Staten Island, N.Y., studied at Wagner College and Hunter College. After travelling extensively he taught at Hunter College from 1963. From the mid 1960s he became known as one of those who practised SYSTEMIC and MINIMAL painting, and he adopted the aesthetic outlook of these schools. He was represented in an exhibition '8 Young Artists' put on by the Hudson River Mus. in 1964, of which the critic E. C. Goossen wrote, 'None of them employs illusion, realism, or anything that could possibly be described as symbolism', and emphasized their concern with 'conceptual order'. He was also represented in the exhibition 'The Art of the Real' at The Mus. of Modern Art, New York, in 1968.

HURRY, LESLIE (1909–78). British painter, born in London, studied at St. John's Wood Art School and at the Royal Academy Schools. From 1937 he had a number of one-man exhibitions, at the Redfern Gal., Roland, Browse and Delbanco and the Mercury Gal. As a result of his exhibition at the Redfern Gal. in 1941 he was commissioned by Robert Helpmann to design sets for his ballet *Hamlet*. This was the beginning of a long association with the theatre during which he worked for the Royal Shakespeare Company, the Old Vic, Glyndebourne, Sadler's Wells and, in Canada, the Stratford, Ontario Company. His works are in a number of public collections, including the British Mus., the Victoria and Albert Mus., Birmingham Art Gal. and the Melbourne Art Gal.

HUSZÁR, VILMOS (1884–1960). Hungarian painter, born at Budapest, studied at Munich and at the School of Decorative Arts, Budapest. He settled in the Netherlands in 1905 and under the influence of the Dutch MONUMENTALISTS he worked on graphic art and designs for stained glass, veering towards a geometrical, non-figurative style. In 1917 he was one of the associates of Theo van DOESBURG in the formation of De STIJL and he continued his association with the group until 1923.

HUTTER, WOLFGANG (1928–). Austrian painter born in Vienna, studied at the Vienna Academy of Art under GÜTERSLOH until 1948. From 1950 he contributed to various international exhibitions, including the Venice Biennale and Pittsburgh (1950 and 1952). He was one of the Austrian school of FANTASTIC REALISM, painting fairy-like scenes with imaginary figures set amidst jungles, in a story-book world. He also did tapestries and mosaics, and murals for public buildings in Vienna and the Festival Theatre at Salzburg.

HUXLEY, PAUL (1938–). British painter born in London, studied at the Harrow College of Art and the Royal Academy Schools, 1953–60. He worked in New York with a Harkness Fellowship, 1965–7, and was Visiting Professor at the Cooper Union, New York, in 1974. He taught at the Central School of Art and Design, London, and at the Camberwell School of Arts and Crafts. Huxley painted with a simple vocabulary of geometrical elements, chiefly squares and rectangles, in the tradition of De STIJL, but his construction was more flexible than that of MONDRIAN. He worked by eye not by rule, making due allowance for the effects of optical illusion and the optical interaction of shapes upon each other, and he often worked for long periods on the planning of his paintings in series. It has been said that 'the abstract world of Huxley's paintings, at first remote and uncommunicative, becomes a dramatic and emotional transaction'. His work was exhibited widely both in Britain and abroad. A list of exhibitions is contained in the catalogue to the exhibition 'British Painting '74', at the Hayward Gal., in which he was represented.

HYPERREALISM. See PHOTOGRAPHIC REALISM.

HYPPOLITE, HECTOR. See LATIN AMERICA.

I

IBARROLA, AGUSTÍN. See EQUIPO 57.

IGLESIAS Y ACEVEDO, FELICINDO (1898–). Spanish NAÏVE painter, born in Orense, Galicia. In 1933 he emigrated to Cuba, and became an importer of wine and sauces. He was a musician in the church at Havana. He took up painting in 1939 and painted mainly historical scenes such as the discovery of Cuba by Christopher Columbus, using an enamel-like technique reminiscent of medieval altar-pieces. He has exhibited in Latin America, the U.S.A. and Europe.

IKEDA, MASUO (1934–). Japanese graphic artist born at Shenyan, Manchuria, and self-taught as an artist. He was prominent in the School of Grotesque Art which dominated the Tokyo scene in the 1950s. (See JAPAN.) He won international recognition at the Tokyo International Prints Exhibition of 1960 and he was given a one-man show at The Mus. of Modern Art, New York, in 1965. His work was erotic and ironic in character, combining the female figure with patterned abstraction.

IMAGIST. Term proposed by H. H. Arnason in connection with an exhibition 'American Abstract Expressionists and Imagists' held at the Solomon R. Guggenheim Mus. in 1961. He applied it to those American contemporaries of ABSTRACT EXPRESSIONISM whose work was not primarily expressionist, including Al HELD, Ellsworth KELLY, Kenneth NOLAND, Leon SMITH, Frank STELLA, Jack YOUNGERMAN. The term HARD EDGE is more generally used of their work.

IMAI, TOSHIMITSU (1928–). Japanese painter born in Kyoto. After studying in Tokyo he emigrated to Paris in 1952 and adopted the TACHIST manner of lyrical abstraction then current in the ÉCOLE DE PARIS. He exhibited in Paris, Rome and Turin and contributed to the Salon d'Art Sacré.

IMKAMP, WILHELM (1906–). German painter born at Münster, studied at the BAUHAUS under KLEE, KANDINSKY and FEININGER, 1926–9. During the 1930s he lived and painted at Essen, specializing in cosmic landscapes in which the vertical structures and linear perspectives betray the influence of Feininger. After serving in the war he settled in Stuttgart in 1948 and from this time his work became almost completely abstract, with reminiscences of the harsh structural qualities of German EXPRESSIONISM. Besides Germany, his work was exhibited in Switzerland and in Pittsburgh and New York.

IMMACULATES. See PRECISIONISM.

INDEPENDENT GROUP. A small and informal organization operating during the 1950s within the Institute of Contemporary Arts, London. It was first convened in the winter of 1952–3 by Reyner Banham for the purpose of holding exploratory meetings to discuss techniques. It was reconvened in the winter of 1954–5 by John McHale and Lawrence Alloway on the theme of popular culture. With the discovery of a common vernacular culture, the first phase of English POP ART grew out of the Independent Group. Besides Reyner Banham and Lawrence Alloway the nucleus of the group was constituted by the artists Richard HAMILTON, Eduardo PAOLOZZI, William TURNBULL, Nigel Henderson, the architects Peter and Alison Smithson and Colin St. John Wilson, and the critic Tony del Renzio.

INDIANA, ROBERT (ROBERT CLARK, 1928–). American painter, sculptor and graphic artist, born at New Castle, Ind. He attended Saturday classes at the John Heron Art Institute, 1945–6, and classes at Syracuse University while serving in the Army Air Corps, 1946. He then studied at the Munson-Williams-Proctor Institute, Utica, 1947–8, at the Chicago Art Institute School, 1949–53, and at the Edinburgh College of Art, Scotland, 1953–4. He began to do HARD EDGE painting in the mid 1950s, using geometrical patterns often based on the gingko leaf and the avocado, and at the end of the 1950s began to make constructions of weathered iron and junk wood. His first one-man show, of paintings based on the letters L.O.V.E., was at the Stable Gal., New York, in 1962. He was associated with the American POP artists and his works quickly began to be represented in important group exhibitions and to be purchased for leading public collections. Like other Pop artists he chose as his themes banal objects from contemporary life, specializing in lettering and signs. His vivid colours often created an effect of optical ambiguity which was distantly reminiscent of OP ART. In 1964 he collaborated with Andy WARHOL in a film *Eat* and executed a commission for the exterior decoration of the New York State Pavilion at the World's Fair which was a 20 ft (6m) sign EAT. He had a retrospective exhibition in 1968 at the Philadelphia Institute of Contemporary Art.

INFORMALISM. See ART INFORMEL.

INKHUK (INSTITUTE OF ARTISTIC CULTURE). An organization set up in Moscow in May 1920 for the purpose of working out and implementing a programme of artistic experiment. It was established as a section of the Department of Fine Arts, which was formed in 1918 under the Commissariat for People's Enlightenment (IZO NARKOMPROS). At the end of 1921 sections were formed in Petrograd under TATLIN and in Vitebsk under MALEVICH. It was originally intended that the programme of *Inkhuk* be drawn up by KANDINSKY, but his scheme (which later formed the basis of his teaching at the BAUHAUS) was rejected by the Leftist majority of *Inkhuk* artists and Kandinsky left the organization. The sculptor and painter Aleksei Babichev (1887–1963) formulated a new programme, one which was very rational and objective.

Kandinsky's ideas were uncongenial to *Inkhuk*, most of whose members were opposed in principle to 'pure art' designed for contemplation and enjoyment and desired instead a new type of art which should contribute directly to the construction of a new Communist Utopia. 'Art of the proletariat is not a holy shrine where things are lazily regarded, but work, a factory which produces new artistic things.' There were, however, two schools of thought about the form which the new art was to take: it was named 'laboratory art' and 'production art' respectively, though the pronouncements of neither side were particularly clear. Malevich believed that industrial design is not a function of the creative artist but regarded his works such as the *Planits* and *Arkitektonics* as models or ideals from which the practical designer could draw inspiration for a new style in keeping with the contemporary environment. Others regarded what had formerly been 'studio art' or 'pure art' as experimentation in the combination and relation of colours, shapes and masses, or in the practical and aesthetic properties of materials, from which the practical designer could benefit. For example, Lyubov POPOVA said of works she contributed to an exhibition of 'laboratory art' held in Moscow in 1921 under the title '5 × 5 = 25': 'All the given constructions are pictorial and must be considered simply as a series of preparatory experiments towards materialised constructions.' The catalogue of this exhibition announced it as the end of easel painting. In its place was to come 'production art', in which the distinction between artist and engineer was to be eliminated and the artist was to become a designer or craftsman for machine production. It is symptomatic of this ideological development that most of the abstract artists who remained in Russia turned their energies to industrial design. Those who left included Kandinsky, the brothers PEVSNER and, for a time, LISSITZKY. Many of Russia's *avant-garde* artists and critics were associated with *Inkhuk* in one way or another —EXTER, KLIUN, PUNIN, RODCHENKO, the STENBERG brothers, STEPANOVA, to mention but a few.

INNES, JOHN DICKSON. See CAMDEN TOWN GROUP.

INSHAW, DAVID (1943–). British painter, born in Staffordshire. He studied at Beckenham School of Art, 1959–63, and then at the Royal Academy Schools, 1963–6. In 1964 he studied in Paris with a French Government scholarship, and from 1966 he taught painting and printmaking at Bristol Polytechnic. In 1975 he was appointed Fellow Commoner in Creative Art at Trinity College, Cambridge. In 1968 he was represented at the Royal Academy Bicentenary Exhibition and in 1971 in the Arts Council 'Art Spectrum, South-West' exhibition. He exhibited at the Arnolfini Gal., Bristol, in the Festival Gal., Bath, and in a number of London galleries. He painted in a mannered style of sophisticated *faux naïf*.

INSLEY, WILL (1929–). American sculptor born at Indianapolis, Ind. He took a B.A. degree at Amherst College in 1951 and then a B.A. in architecture at Harvard Graduate School. He was Artist in Residence at Oberlin College in 1966, taught at the University of North Carolina, 1967–8, at Cornell University in 1969 and from 1969 at the School of Visual Arts, New York. He obtained a Guggenheim Foundation Fellowship in 1969. His first one-man exhibition was at Amherst College in 1951 and he then exhibited at the Stable Gal., 1965–8. Among the collective exhibitions in which he was represented was 'Systemic Painting' at the Solomon R. Guggenheim Mus. in 1966. Insley belonged to the school of MINIMAL artists and his work often came within that category of Minimal art which has been called SYSTEMIC. At first intending to be a painter, he afterwards turned to sculpture. Owing to his interest in architecture his structures showed a keen concern for questions of *scale*—they were often planned too large for exhibition indoors—and for architectural concepts of space. An interview with him, in which he voices these views, by Elayne Varian, Director of the Contemporary Study Wing of the Finch College Mus. of Art, is printed in Gregory Battcock (ed.), *Minimal Art* (1968).

INSTALLATION. Term which came into vogue during the 1970s for an ASSEMBLAGE or ENVIRONMENT constructed in the gallery specifically for a particular exhibition.

IONESCO, NICOLAS (1919–). Romanian painter, born in Bucarest and studied at the Bucarest School of Art. In 1946 he went to Paris and worked with LÉGER and LHOTE. In 1949 he turned to abstract painting and joined the Atelier d'Art Abstrait founded by Edgard PILLET with DEWASNE and HERBIN. He joined the SALON DES RÉALITÉS NOUVELLES and took part in several group exhibitions. His first one-man show was at the Gal. Arnaud, Paris, in 1952.

IPOUSTÉGUY, JEAN (1920–). French sculptor born at Dau-sur-Meuse. After executing frescoes and stained-glass windows in the late 1940s he settled at Choise in 1949 and turned to sculpture. During the 1950s he did small sculptures both figurative and abstract but in the 1960s he turned to large-scale sculptural situations or scenes, which he called 'sculptural landscapes'. An example is his *Discours sous Mistra* of 1964. In 1964 he won the Bright Award at the Venice Biennale.

IRASCIBLE EIGHTEEN, THE. See UNITED STATES OF AMERICA.

IRWIN, GWYTHER (1931–). British painter born in Cornwall, studied at Goldsmiths' College of Art, 1950–1, and the Central School of Art and Design, 1951–4. He was visiting lecturer at Bath Academy, 1959–63, and at Hornsey College of Art, 1966–8, taught at the Chelsea School of Art, 1967–9, and became Head of the Fine Art Department at Brighton Polytechnic in 1969. From the late 1950s he had one-man exhibitions at the Institute of Contemporary Arts (1958), Gimpel Fils (1959, 1960, 1962, 1967, 1970) and New Art Centre (1973, 1975). He was represented in a number of group exhibitions, including Carnegie Institute, Pittsburgh and The Mus. of Modern Art, New York (1961); 'British Painting in the Sixties', Whitechapel Art Gal. (1963); Venice Biennale (1964); 'Painting and Sculpture of the Decade', Tate Gal. (1964); Carnegie International Biennale (1967); International Kunstmesse, Basle and Düsseldorf (1973). His works are included in a number of public collections, among which are: Tate Gal.; Contemporary Arts Society, London; Calouste Gulbenkian Foundation; British Council; Arts Council of Great Britain; Peggy Guggenheim, Venice; Yale University Art Gal.; The Mus. of Modern Art, New York; Albright-Knox Art Gal., Buffalo; Carnegie Mus., Pittsburgh. Irwin worked in a style of geometrical abstraction sometimes on the fringe of OP ART. His paintings are unassuming and restrained, imposing themselves by familiarity rather than by sudden impact.

IRWIN, ROBERT (1928–). American artist, born at Long Beach, California. Irwin undertook novel scientific research into perceptual psychology and exercised an important influence both as a teacher and as a theorist on the development of American West Coast art in Los Angeles. From 1966 his work was largely concerned with perceptual and 'space altering' manipulations and progressed towards ever increasing simplicity in terms of number and complexity of elements. He was known particularly for the series of 'disc paintings' done in 1968 and 1969. These were subtly inflected and carefully lighted wall-hanging discs, the effect of which was to produce 'free' perceptual colour without precise shape or location. In the early 1970s he produced a series of carefully cut and polished clear prismatic acrylic columns and a 32 ft (10 m) high sculpture for a commission at Northridge, California. He participated in many exhibitions, including: The Mus. of Modern Art, New York, 'The Responsive Eye' (1965); Jewish Mus., New York, with Gene DAVIS and Richard SMITH (1968); Fort Worth Art Center, with Doug WHEELER (1969); Tate Gal., with Larry BELL and Doug Wheeler (1970); University of California Los Angeles Art Gals., 'Transparency, Reflection, Light, Space: Four Artists' (1971); Los Angeles County Mus. of Art, 'Art and Technology' (1971); Hayward Gal., '11 Los Angeles Artists' (1971).

ISKUSSTVO (ART). The monthly art journal of the Ministry of Culture of the U.S.S.R. and the Academy of Arts of the U.S.S.R. Founded in 1933 (suspended publication between July 1941 and December 1946), *Iskusstvo* maintains the Party policy on art appreciation and criticism, relying on a strict interpretation of the principles of Soviet SOCIALIST REALISM. Although devoted primarily to achievements in all the Soviet arts, *Iskusstvo* sometimes runs articles on non-Soviet artists, movements, exhibitions, etc.

ISTRATI, ALEXANDER (1915–). Romanian painter, born at Dorohai. After studying art and law together in Romania, he went to Paris in 1947 with an allowance from the Institut Français at Bucarest. In Paris he studied painting at the École des Beaux-Arts and under LHOTE. He was particularly interested in colour and during the 1950s he exhibited colour abstractions of the ART INFORMEL variety at the Gal. Denise René and the Craven Gal. in Paris. From this he advanced to large-scale monochromes in which the colours seemed to live with a life of their own by subtle gradations and a sparing use of complementaries.

ITALY. In the first two decades of the century the history of progressive art in Italy is summed up in the story of FUTURISM, METAPHYSICAL PAINTING and the work of the independent artists MODIGLIANI and MORANDI and the sculptors MARINI, MARTINI and MANZU.

A general reaction against progressive and innovatory art crystallized with the formation in 1926 of the NOVECENTO whose programme, not uninfluenced by the isolationist chauvinism of the Fascist regime, combined a revival of Italian tradition and a rather affected Neo-Classicism with a deliberately reactionary opposition to the European *avant-garde*. The more prominent members of the *Novecento* were FUNI, TOSI, SIRONI and MARUSSIG. Among the more independent artists working at this time were CASORATI and de PISIS, both of whom lived for the greater time abroad, and the Realists ROSAI and DONGHI. Revolt against the cramping authority of the *Novecento* first made itself successfully felt with the formation of the ROMAN SCHOOL in 1930 by MAFAI and SCIPIONI. Their lively EXPRESSIONISM, based on that of the

ÉCOLE DE PARIS and especially SOUTINE, was carried on by such artists as SCIALOJA, Vespignani and STRADONE. In the 1930s also a number of artists working in isolation were pioneering expressive abstraction in Italy.

In 1938 the association CORRENTE was formed in Milan on the initiative of BIROLLO with no fixed artistic programme except the desire to go further than the Roman School in protest against the imposed provincialism of the *Novecento* and the Fascist authorities. Immediately after the end of the war, in 1946, the *Nova Secessione artistica Italiana* was formed and issued a manifesto signed by eleven artists. Its name was changed and it became the FRONTE NUOVO DELLE ARTI, which brought together all those artists who, in reaction from the enforced isolation of the wartime years, welcomed contact with the *avant-garde* movements outside Italy. But though they were united in this, they were at variance in their artistic aims. Their first exhibition took place in 1947 and at the Venice Biennale of 1948 the association was disrupted by a split between the Neo-Realists and the advocates of expressive abstraction.

In 1952 the GRUPPO DEGLI OTTO PITTORI ITALIANI, most of whom had been members of the *Fronte Nuovo*, was formed under the auspices of the critic and historian Lionello Venturi, who described the movement as 'Abstract-Concrete'. This became the nucleus of a powerful movement in the direction of expressive abstraction, or *Informalismo* as it was called, with Moreni and VEDOVA in the van together with Alfredo CHIGHINE, Emilio SCANAVINO, Sergio ROMITI and in Rome Mario Mafai and Toti Scialoja. In partial opposition to INFORMALISM a group CONTINUITÀ was organized in 1961 whose nucleus was constituted by artists who had been members of the *Forma* group which had been established in Rome in 1947. The aims of this group as explained by their spokesman, the critic Carlo Argan, were to recover continuity with the historical greatness of Italy's painting and to encourage composition in opposition to the fragmentary and unorganized character of ART INFORMEL.

Meanwhile Lucio FONTANA propagated his new version of modernism with his doctrine of SPAZIALISMO, which rejected the traditional idea of easel painting and advocated the free development of colour and form in space. Alberto BURRI exploited the evocative quality of old and torn materials in a manner analogous to TÀPIES in Spain and JUNK ART in California, anticipating ARTE POVERA in Italy.

The 1950s saw the beginning of a reaction against the spontaneous and improvisatory expressive abstraction known as *Art Informel* in France and *Informalismo* in Italy and a revival of interest in Constructivism, KINETIC ART and other forms of geometrical abstraction, known collectively as *Arte Concreta* in Italy (see CONCRETE ART). In 1948 the MOVIMENTO PER L'ARTE CONCRETA (MAC) was founded in Milan by Gillo Dorfles with Bruno

MUNARI and Atanasio SOLDATI and attracted most of the younger experimental artists, becoming the most influential of the Italian *avant-garde* movements. A number of groups were founded for collective research into industrial design, kinetic art, 'programmed' or multiple art, etc. The most important of these were *Gruppo T* in Milan and *Gruppo N* of Padua. In Rome were the groups *Operativo R* and *Sperimentale P*. (The history of Italian art in this century could almost be written in terms of groups and associations.) Lumino-kinetic environments and illusionistic effects of light were investigated by such artists as Munari, Enzo Mari, Giovanni Antonio Costa, Getulio Alviani, Umbro Apollonio and many others. HAPPENINGS involving the 'ludic' element or the element of play were designed by Mari, Dadamaino, Munari, Giovanni Belgrado and others. Costa's *Visione Dinamica*, a dark rhomboidal metallic surface set with radially twisted white plastic strips in such a way that the surface changes as the spectator changes position, heralded a wealth of renewed interest in the use of such devices to stimulate movement on the part of the viewer. Gianni Colombo, Giovanni Anceschi and Davide BORIANI were only a few of the many who studied and exploited the psychological effects of unusual manipulations of light. Gabriele de Vecchi invented a 'radarscope' in which the atmospheric element was a metal plate and the rotating solid element a thin plate of transparent glass. In general these experiments were moved by a desire to repudiate the old subjectivism of Romantic art and to seek principles of design and response as objective and as universal as those in a scientific laboratory or a laboratory of psychological research.

Alongside this emerged a new figurative art which related to the *Movimento Nucleare* inaugurated by Enrico BAJ, the 'sign' painting of Emilio Scanavino and Giuseppe CAPOGROSSI, and to American POP ART, although the borrowings from the last were modified in characteristic ways. This new 'objectivity' included both a return to representation and the construction of art works from real things. Although the artists responsible for this trend often worked in groups, they were highly individualistic. In Milan there were ARICÒ, ADAMI, Baj and ROMAGNONI. In Naples the *Gruppo 58* was founded by Lucio del Pezzo and Luigi CASTELLANI. Turin had Michelangelo PISTOLETTO. In Rome Mimmo ROTELLA built up works from torn posters; Mario Schifano constructed a new reality in his *Hommages* to the Futurists, using photographs and historical documents; Franco ANGELI used political and social symbols; Mario CEROLI made enlarged images of everyday objects. Others such as Claudio Cintoli, Giosetta Fioroni and Sergio Lambardo also followed the path of significant objectivity.

Two other tendencies require mention. A revival of Surrealism took place both inside and outside the ambit of *Art Informel*. Among the artists con-

cerned were Franco Francese, who was influenced by Francis BACON, and Sergio VACCHI. Finally there was the movement of ARTE POVERA and the use of worthless materials and trash for their evocative potentialities.

ITTEN, JOHANNES (1888–1967). Swiss artist and teacher, born at Südern-Linden, Thun. He studied under Adolf HOELZEL at Stuttgart, 1913–16, and then opened his own school of art in Vienna. From 1919 to 1923 he taught at the BAUHAUS, where he introduced the important 'Preliminary Course' obligatory for all students. From 1923 he had his own art school in Berlin and from 1932 he taught at the Krefeld School of Textile Design. In 1938 he settled in Zürich, where he was appointed Director of the School and Mus. of Arts and Crafts, the Rietberg Mus. and the School of Textile Design. His own work belonged to the category of geometrical colour abstraction, exemplifying his researches into colour. These were evolved from the colour theories of Hoelzel, the ORPHISTS and the CONCRETE ART of Max BILL and his followers, but Itten pursued original researches into the psychology of colour perception. He wrote *Kunst der Farbe* (1961) and he published his Bauhaus course under the title *Mein Vorkurs am Bauhaus. Gestaltungs und Formenlehre* (Ravensburg, 1963). He had retrospective exhibitions at the Stedelijk Mus., Amsterdam, in 1957 and at the Kunsthaus, Zürich, in 1964.

J

JACKSON, ALEXANDER YOUNG (1882–
1974). Canadian painter, born in Montreal. He
began work at the age of 12 with a lithography
firm, where he quickly displayed a talent for draw-
ing. He made sketching trips, and studied in his
spare time under Edmond Dyonnet and William
Brymner. Later he studied part-time at the Art
Institute, Chicago, and for six months under LAU-
RENS at the Académie Julian. In 1908–9 he travel-
led through Italy, Belgium and the Netherlands.
On his return to Montreal he held a small exhibi-
tion, but had to resort again to commercial work.
He was in France again—this time painting, not
studying—from 1911 to 1913. Meanwhile his work
—especially *The Edge of the Maple Wood* (Na-
tional Gal. of Canada, Ottawa, 1910)—had im-
pressed J.E.H. MACDONALD and Lawren HARRIS,
and upon Jackson's return they invited him to
Toronto. After some deliberation, Jackson decided
to settle in Toronto, where he shared space in the
new Studio Building with Tom THOMSON. In 1914
he painted a large canvas from sketches made dur-
ing the summer of the previous year in Georgian
Bay. Boldly aggressive, *Terre Sauvage* (National
Gal. of Canada) became the battle standard of
the new group. When war broke out Jackson en-
listed, and was wounded in France in 1916. He
then worked for the Canadian War Records Pro-
gramme, and prepared some 25 canvases of the
Canadian action in France, now in the collection
of the Canadian War Mus., Ottawa.

In 1919 Jackson returned to Toronto, joining
MacDonald, Harris and Frank Johnston on a
box-car trip into Algoma. This was the first of
several visits to the region, and in 1921 Harris and
Jackson penetrated further, to the north shore of
Lake Superior. However, despite two or three strik-
ing canvases—e.g. *First Snow, Algoma* (McMich-
ael Canadian coll., Kleinburg, Ont., 1919–20)—
Jackson responded less fully to Algoma than he
did to the hilly region of rural Quebec along the
St. Lawrence River. From 1921, he returned there
almost every spring, and the canvases he prepared
from sketches made there are probably his finest
work. *Early Spring, Quebec* and *Laurentian Hills,
Early Spring* (Art Gal. of Ontario, Toronto, 1926
and 1931 respectively) are but two that, with their
easy, rolling rhythms and rich and full colouring
(often limited to tones of brown and grey), had a
far-reaching impact on Canadian landscape paint-
ing.

Jackson's life-style also had a very great influ-
ence on younger Canadian painters. Except for his

field trips, he lived alone in his room in the Studio
Building in Toronto. Especially after Harris left
Toronto in 1934, he seemed the giant figure of
Canadian art, standing for the land as a whole in a
way that no painter has done since. In fact he vis-
ited virtually every region of the country—includ-
ing the High Arctic—during the half century of his
travels. Until the mid 1940s his influence was dis-
cernible in the work of most younger Canadian
painters. He was honoured with major retrospec-
tives at the Art Gal. of Toronto in 1953 (also
shown in Ottawa, Montreal, Winnipeg) and at the
London Art Gal., Ont., in 1960 (also shown in
Hamilton). He wrote his memoirs, *A Painter's
Country* (Toronto and Vancouver, 1958).

JACOBSEN, EGILL (1910–). Danish painter
born in Copenhagen. During the 1930s he painted
in a dramatic style of expressive abstraction with
Danish folk art as his starting point. He was par-
ticularly known for his expressive 'Masks' painted
in brilliant and luminous colours.

JACOBSEN, ROBERT (1912–). Danish sculp-
tor born in Copenhagen. He began his working
life as a sailor and was self-taught as a sculptor,
beginning under the influence of German EX-
PRESSIONISM in 1929. In the early 1940s he was in-
fluenced by SURREALISM and joined the Danish
Surrealist group *HOST*, carving fabulous beasts in
wood. But at the same time he produced abstract
works. During the 1940s he also began to carve in
stone and to paint his sculptures. In 1947 he moved
to Paris and from that time worked in iron and
welded steel, exhibiting at the Gal. Denise René, at
the Salon de Mai and the Salon de la Jeune Sculp-
ture. His work in sheet iron displayed both virility
and fantasy, as for example *Le Crapaud Amoureux*
(Nationalmus., Stockholm, 1959). He was espe-
cially known for his *Dolls* series, figures construc-
ted from scrap metal, chains, bicycle wheels, etc.
taken from dump heaps. These were striking for
their humour, satiric quality and their felicity in
caricaturing human types.

JACQUET, ALAIN GEORGE FRANK (1939–
). French experimental artist born at Neuilly-
sur-Seine. After having studied architecture and
worked as an actor he began to paint in a POP
idiom. He came to artistic maturity in the decade
following the challenge of NOUVEAU RÉALISME to
abstract painting and to the very concept of pic-
torial art. He was a pioneer of MEC art, having first

applied the word to his *Déjeuner sur l'Herbe* in 1964. He also pioneered the concept of the MUL-TIPLE. The *Déjeuner* was manufactured with 200 examples and subsequent works had equally large editions. In 1963 he raised the question symbolically when members of the public were invited to cut off small pieces from his canvas and take them away as souvenirs at 10 francs a piece. He developed the technique of photographic transfer and at the São Paulo Bienale of 1967 made a holograph transfer by laser light. In 1969 he abruptly abandoned the sophisticated techniques of Mec art for the exaggerated ANTI-FORMAL simplicities of ARTE POVERA, making an exhibition from a few electric wires dangling from the wall, a leaking water pipe dripping from the ceiling and pieces of barbed wire scattered on the floor.

JAENISCH, HANS (1907–). German painter, born in Eisenstadt. He lived in Berlin from 1923, joining the STURM association in 1927 and the *Künstlerbund* in 1950, in which year he was awarded the Art Prize for painting by the City of Berlin. In 1953 he was appointed Professor at the Hochschule für Bildende Künste, Berlin. His style was a combination of abstract art and ART BRUT. He made much use of *haute-pâte* or relief painting and in 1953 began sculpture in bronze.

JALAVISTO, MIKKO (1937–). Finnish painter, born at Oulu and trained at the School of the Fine Arts Academy of Finland, Helsinki. Besides exhibitions in Finland, he participated in the São Paulo Bienale (1970), a group exhibition at Stockholm and Oslo (1970), 'Kunstszene Finnland' at Düsseldorf (1974) and 'Workaday Finland' at the I.C.A. Gals., London (1974). He received awards at the 40th anniversary of the Finnish Society of Painters (1969) and at the triennale of the Fine Arts Academy of Finland (1971). He worked in a style of virtually hallucinatory realism somewhat like that of the Canadian painter Alex COLVILLE, taking as his subject architectural projects for housing people moving from the country into the towns.

JANČIĆ, DJURO (1934–). Yugoslav NAÏVE painter, born at Plaški in the Velebit Mountains. He showed talent for drawing while at school, but being of a poor family he had to cut short his school years and was unable to continue his art. In the 1950s he moved to Zagreb, where he worked as a chauffeur. In 1962 the desire to paint suddenly returned. He visited exhibitions and began to paint, first using the technique of oil under glass but soon changing to oil on canvas. During the 1960s he rapidly achieved a style of his own, painting scenes from the Velebit in a typically naïve manner, and his work became widely known and admired both in Yugoslavia and elsewhere in Europe.

JANCO, MARCEL (1895–). Romanian-Israeli painter born at Bucarest. He studied architecture at Zürich, 1915–16, and discovered an interest in CUBIST painting. He then became one of the most active members of the Zürich DADA group, while also making abstract painted reliefs which, with his drawings from the same period (1916–19), are considered to be his most interesting work. He also designed costumes and masks for the Dada soirées. In 1919 he went to Paris and joined the Dada group there, exhibiting his work along with other abstract artists. Owing to a quarrel with Tristan Tzara he returned to Bucarest and founded there the paper *Contimporanul*, which ran from 1922 to 1940. In 1940 he went to Israel and settled at Tel Aviv. Janco was something of an idealist. He sought a synthesis between abstract painting and architecture and in 1920, before leaving Switzerland, he founded a group called *Das Neue Leben* (The New Life) to work for a new society in which art and architecture would enjoy their proper place.

JANNOT, HENRI (1905–). French painter born in Paris, studied at the École des Beaux-Arts, 1925–32. After being attracted for a short while by the FAUVES and UTRILLO he made contact with a young group of EXPRESSIONISTS, including ROHNER and HUMBLOT, and with them founded the association FORCES NOUVELLES, giving a joint exhibition with them in 1935. He combined this with a taste for Realism, gained from the exhibition 'Maîtres de la Réalité' in 1934, and from these diverse interests he evolved a personal style of expressive naturalism.

JANSEM, JEAN (1920–). French painter of Armenian origin, born at Seuleize. He went to France in 1931 and studied at the École des Arts Décoratifs. After earning his living by humorous drawings and cinema posters he exhibited with the Salon de la Jeune Peinture from 1950, becoming President in 1956. He was awarded the Prix Populiste in 1951 and the Prix Antral in 1953. During the 1950s he matured a style of realistic depiction, specializing in showing the poor and unfortunate.

JANSSEN, HORST (1929–). German graphic artist born at Hamburg, where he studied at the Landeskunstschule. His prints and drawings showed a taste for the macabre and a penchant for obscenity wittily treated. He was exhibited at the Kestner-Gesellschaft, Hanover, in 1965–6 and at the Venice Biennale in 1968. He was one of the artists who introduced a revival of SURREALISM in Germany after the Second World War.

JANTHUR, RICHARD. See PATHETIKER, DIE.

JAPAN. Japanese art was rapidly assimilating the movements of Western modernism when war broke out in 1939. After the end of the war it took more than a decade before the new international movements became familiar to the younger gener-

ation of Japanese artists. Some artists migrated to Europe or the U.S.A. like OKADA and SUGAI, Key SATO, Toshimitsu IMAI, Hisao DOMOTO, Yase TABUCHI and Kenjiro AZUMA. In the early 1950s the so-called School of Grotesque Art reflected the prevalent attitude of confusion and defeat in ironic and nihilistic fantasy. Of this school the most important members were the etcher Tatsuo IKEDA and the young On KAWARA. During the 1950s also the GUTAI group was formed in Osaka, staging HAPPENINGS in the spirit of DADA. Prominent among them was Atsuko TANAKA. The first direct contact with the West was brought about by the exhibition 'International Art Today' of 1956, which had an effect analogous to that of the ARMORY SHOW in America at an earlier date. *Gutai* was followed by the formation in Tokyo in 1958 of the NEO-DADA ORGANIZERS group, who promoted a form of JUNK ART and destructive Happenings. The movement showed an obsession with ruins and destruction. It was violent, explosive and short-lived. Prominent in it were Shusaku ARAKAWA, Genpei AKASEGAWA, Tomio MIKI, and Shijiro Okamoto.

Abstract painting in post-war Japan was pioneered by Takeo YAMAGUCHI, Yoshishige SAITO and Toshinobu ONOSATO. Among the younger sculptors important innovatory work has been done by Jiro TAKAMATSU, Noriaki FUKUSHIMA and Kazuo YUHARA.

JAWLENSKY, ALEXEI VON (1864–1941). Russian painter, born at Kuslovo. Of an aristocratic family, he was educated at the Cadet School in Moscow and became an officer in the Guards. In 1889 he abandoned a military career for art and studied at the St. Petersburg Academy under the historical painter Ilya Repin (1844–1918). Dissatisfied with historical realism he left Russia in 1896 with Marianne von WEREFKIN for Munich, where he studied at the school of Anton Azbé, at which KANDINSKY was later a pupil. In 1905 he travelled to Brittany and Provence, making contact with painters of the Pont Aven school. During a stay of some months in Paris he became acquainted with the paintings of Gauguin and Van Gogh and worked for a short while with MATISSE. In this artistic environment he found what he needed and evolved the mode of expression suited to his passionate but naïvely religious temperament, painting in flat, strong hues with bold outlines in a manner akin to the FAUVES. Yet his work was in no sense derivative upon the French school but combined these influences with Russian traditions of icon painting and peasant art to form a highly personal style. It has been said that he 'saw Matisse through Russian eyes'. His pictures from this period still produce the impact of a magic and mystical reality which is equalled only by the later work of Kandinsky. In 1909 he became a founder member of the NEUE KÜNSTLERVEREINIGUNG at Munich and after Kandinsky he was certainly the outstanding painter of the group. His synthesis of

Russian and French elements is best seen in the series of heads which he began in 1910. An example is the *Portrait of Alexander Sacharoff* (Städtisches Mus., Wiesbaden, 1913).

From 1914 he lived as a solitary at Saint-Prex, Switzerland, and there he painted a series of 'Variations' on a single theme: objective abstractions upon the view from his window. These have a meditative, religious aura which makes them no less original than his earlier work. Like Kandinsky and others, Jawlensky was obsessed by a belief in the correspondence between colours and musical sounds and he named these small abstract landscapes 'Songs without Words'. In 1917 he began the series of formalized and semi-abstract heads in which his mystical temperament and his synthesis of traditional Russian with modern French elements were most fully expressed. A fine late example is that named *Night* (Städtische Kunstsammlung, Bonn, 1933).

Despite his sympathy with Kandinsky, Jawlensky did not break with the *Neue Künstlervereinigung* when Kandinsky with Gabriele MÜNTER, Franz MARC and Alfred KUBIN formed the BLAUE REITER in 1911. Nor did he ever follow the lead of Kandinsky towards NON-OBJECTIVE art but always grounded his abstractions on a natural subject. In 1924, however, while living in Wiesbaden, he joined with Kandinsky, KLEE and FEININGER to form the BLAUEN VIER and exhibited with them for some years until he became crippled with arthritis and abandoned painting.

JEANNERET, CHARLES-ÉDOUARD. See LE CORBUSIER.

JENKINS, PAUL (1923–). American painter and draughtsman born at Kansas City, studied at Kansas City Art Institute and School of Design, 1938–41, and, after working as an apprentice at a ceramics factory, at the Art Students' League, 1948–51. In 1966 he was awarded the Silver Medal at the Corcoran Biennial and won the Golden Eagle Award for a film *The Ivory Knife*, of which he was the subject. He worked both in Paris and in New York. His first one-man exhibitions were at the Studio Paul Facchetti, Paris, and the Zimmergal. Franck, Frankfurt, in 1954 and his first in the U.S.A. at the Zoé Dusanne Gal., Seattle, in 1955. He has since exhibited regularly at the Martha Jackson Gal., New York, and at the Gal. Stadler, Paris, the Tooth Gal., London, and in most of the major art centres of Europe, Japan, Canada, etc. Among the collective exhibitions in which he was represented were: The Mus. of Modern Art, New York, 'Recent Drawings USA', 1956; Arts Council Gal., London, 'New Trends in Painting', 1957; Whitney Mus. of American Art, 'Young America', 1957, and 'Nature in Abstraction', 1958; Solomon R. Guggenheim Mus., 'Abstract Expressionists and Imagists', 1961; Salon des Réalités Nouvelles, Paris, 1963; Tate Gal., London, 'Painting and Sculpture of a Decade, 1954–64', 1964. His works

are in many public collections including: The Mus. of Modern Art, New York; Tate Gal. and Victoria and Albert Mus., London; Stedelijk Mus., Amsterdam; Bezalel Mus.; National Mus. of Western Art, Tokyo; Mus. National d'Art Moderne, Paris.

From 1953, when he went to live and work in Paris while maintaining his New York residence, he painted in a liquid medium with a jewel-like range of colours reminiscent of his experience with ceramic glazes, combining the impressions of control and chance. After his return to the U.S.A. in 1956 he was influenced by Helen FRANKENTHALER and Morris LOUIS and developed a technique of pouring thinned oil or acrylic paint on to white primed canvas from corner to corner to form flaring or tapering channels with a mysterious suggestiveness.

JENSEN, ALFRED (1903–81). American painter born at Guatemala City, studied at the School of Fine Arts, San Diego, the HOFMANN School, Munich, and the Académie Scandinave, Paris, where he came into contact with Charles DESPIAU, Charles DUFRESNE, Othon FRIESZ, Marcel GROMAIRE and André MASSON. His first one-man shows were at the Heller Gal., 1952, and the Tanager Gal., 1955, New York, and he subsequently exhibited at the Martha Jackson Gal. and others. He had a one-man show at the Stedelijk Mus., Amsterdam, in 1964 and in the same year exhibited with Franz KLINE at the Kunsthalle, Basle. His work was represented in many collective exhibitions of progressive art in the U.S.A. and abroad, including the Venice Biennale of 1964 and DOCUMENTA IV, Kassel, in 1968.

Jensen participated in the 1961 Guggenheim exhibition 'American Abstract Expressionists and Imagists', the 1962 Whitney Mus. of American Art exhibition 'Geometric Abstraction in America' and in the Los Angeles County Mus. of Art exhibition 'Post Painterly Abstraction' of 1964. He painted his geometrical abstracts in pure spectral colours, often basing the composition on mathematical computations and often making use of the devices of visual ambiguity and conflicting illusion which are the stock-in-trade of OP ART.

JEPURE, VIORIKA. See NAÏVE ART.

JÉROME, JEAN-PAUL. See CANADA.

JESPERS, OSCAR (1887–1970). Belgian sculptor born at Antwerp, son of a sculptor. He studied at the Academy and then at the Higher Institute of Fine Arts, Antwerp. His early work was Impressionist, reflecting the influence of Rodin and Rik WOUTERS. Later, as a result of his friendship with the painter Paul JOOSTENS, he moved towards a geometrical simplification of forms in the CUBIST manner. In the 1920s his work tended more and more in the direction of EXPRESSIONISM, a typical example being the carving *Jeune Femme* executed in limba wood from the Congo (Mus. Royaux des Beaux-Arts, Brussels, 1930). After 1937 he began to model and his forms became more supple and classical as in *Femme Accoudée* (bronze, 1949–50), while his direct carving took on a notably monumental character as in the granite *Le Prisonnier* (1949–50). From 1927 to 1952 Jespers taught at the École Nationale Supérieure d'Architecture et des Arts Décoratifs, La Cambre, Brussels. He executed a number of public commissions and was a member of a number of associations, including *Les Neuf* and the *Sélection* circle.

JEUNE PEINTURE BELGE. An *avant-garde* artists' association founded in Brussels in 1945. Although the members of the group were strongly individualistic in their aims and had no common programme, they were basically abstract in their outlook and were influenced most importantly by Flemish EXPRESSIONISM and by the expressive abstraction of the post-war ÉCOLE DE PARIS, particularly by BAZAINE. Among the leading members were the abstract artists Gaston BERTRAND, Anne BONNET, Marc MENDELSON, Louis Van LINT and Antoine MORTIER, while older artists such as René GUIETTE, Pol BURY, Jean MILO and Pierre ALECHINSKY were also associated with the movement, as was the Danish-born painter and sculptor Serge VANDERCAM.

The group was extremely active under its President, Renée Lust, but disintegrated after his death and the formation of the ART ABSTRAIT group in 1952. The memory of it survives in the Prix de la Jeune Peinture Belge, awarded annually for painters under the age of 40.

JOCHIMS, REIMER (1935–). German painter, born at Kiel. He studied philosophy and history of art at Munich University from 1955 to 1956 and from 1967 to 1968, when he was appointed to the teaching staff of the Academy of Art, Munich. He began painting without formal training in 1955 and his work was exhibited widely in Germany. He belonged to the category of COLOUR FIELD painters who investigated the spatial aspects of pure colour. In his *Chromatischen Reliefs* he tried to create the impression of one colour surface lying in front of another.

JOHN, AUGUSTUS EDWIN (1878–1961). British painter, born at Tenby in Pembrokeshire, whose elder sister Gwen JOHN was also a painter of note. He studied at the Slade School, 1894–8, where his natural gifts of draughtsmanship were early recognized. By the age of 20 he had established himself as one of the leading draughtsmen in England and his drawing has been compared with that of Hogarth and Gainsborough. His performance was unequal and as his popularity with the younger generations of artists waned it became fashionable for critics to impugn his drawing. It may therefore be of value to quote the considered assessment of John Rothenstein, written in 1952:

'The best of his student drawings can hang without dishonour in any company ... With John the power of drawing splendidly endured for decades, changing its character, flickering, faltering and slowly sinking, but always present, and even in old age apt to blaze suddenly up.' As a painter his work was that of a brilliant student. He won the first prize at the Slade Summer Composition competition in 1898 with a brilliant pastiche *Moses and the Brazen Serpent* (Slade School of Fine Art). A commissioned portrait of 1899 entitled *Old Lady* (Tate Gal.) has evoked curiously discrepant judgements from critics. John Rothenstein thought that 'In grasp of character as well as in drawing it is far inferior to the best of the drawings he did at the Slade'. Malcolm Easton and Michael Holroyd have said: 'It is sad to read John's almost contemptuous dismissal of the picture in his memoirs, revealing his utter incapacity to distinguish between good and bad in his own work.'

The story is told that a diving accident at Tenby in 1897 resulting in a serious head injury changed both John's personality and the character of his work. Be that as it may, from having at first the reputation of a quiet and diligent student at the Slade, during the first quarter of the century his name became synonymous with all that was most independent and rebellious in English art and he became one of the most talked-of figures of his day, in life the typical buccaneering, swashbuckling Bohemian and in his art the revolutionary individualist.

John had his first exhibition in 1899 and in the same year four drawings were accepted by the NEW ENGLISH ART CLUB, with which he remained a regular exhibitor. His exhibition was a success and was well reviewed by Dugald MacColl, on whose recommendation John obtained the post of instructor at the art school attached to University College, Liverpool. In 1901 he had married Ida Nettleship, whom he had known at the Slade, and he was in need of a regular source of income. It was at Liverpool that the seeds were sown of the enthusiasm for the Romany gipsies which caused him to live a caravan life with his family for recurrent periods until the First World War. Dreading the effects of security and domesticity, he returned to London in 1902 with some hope of making his living as a portait painter. In 1903 he met Dorothy McNeill ('Dorelia'), who became a permanent member of his household late in 1904 and was his lifelong companion after the death of his wife in 1907. She was the model for *The Smiling Woman* (Tate Gal., 1908), the best known of all his portraits. As Burne-Jones created an etiolated type of medieval beauty, so John in the first decade of the century created and made fashionable a robuster type of gipsy beauty, romanticizing the gipsies of north Wales. In 1909 John met the American lawyer and collector John Quinn, who supported and publicized the ARMORY SHOW. Quinn became his patron and made it possible for him to visit Provence. The exhibition of his 50 oil sketches *Provençal Studies* and a group of fine drawings in London in 1910 evoked the same sort of astonished dismay as was aroused in the following year by Roger FRY's Post-Impressionist exhibition. The *Times* reviewer asked: 'What does it all mean? Is there really a widespread demand for these queer, clever, forcible, but ugly and uncanny notes of form and dashes of colour?' In 1911 John met the Welsh painter John Dickson Innes and some of his finest landscape was done in his company during the years 1912–14, e.g. *Llyn Treweryn* (Tate Gal., *c.* 1912). The stature of John's reputation abroad at this time may be gauged from the fact that no less than 38 of his paintings were exhibited at the Armory Show in 1913.

With the First World War a decline set in and the innovative vitality departed from his work. After the war he became a slick and somewhat banal portraitist of the wealthy and famous, his old rumbustious rebelliousness turned to fashionable farouche. Yet his talent sometimes shone forth. His portrait *Madame Guilhermina Suggia* (Tate Gal., 1920–3) is one of the masterpieces of the post-war years and his portraits of George Bernard Shaw (Fitzwilliam Mus., Cambridge, 1915) and of Dylan Thomas (National Mus. of Wales, 1936), once celebrated, have fallen into unjustified neglect.

John became a member of the New English Art Club in 1903, A.R.A. in 1921 and R.A. in 1928. He received the Order of Merit in 1942 and was a Trustee of the Tate Gal. 1933–40. An exhibition of his drawings was shown at the National Gal. in 1940. In 1954 a comprehensive retrospective exhibition at the Diploma Gal. of the Royal Academy revealed the distance that separated John from his younger contemporaries. Reaction from the great reputation which he once enjoyed led to undeserved neglect and a failure to do justice to the qualities of greatness which his best work possesses. But a retrospective exhibition of his paintings and drawings followed by a complementary exhibition of the 'Life and Times' at the National Portrait Gal., London, in 1975, did much to rectify this neglect.

JOHN, GWEN (GWENDOLEN MARY JOHN, 1876–1939). British painter, born at Haverfordwest, and grew up at Tenby, Pembrokeshire She studied at the Slade School, 1895–8, and then briefly at Whistler's Academy in Paris. She settled in Paris in 1904 and earned a meagre living by posing for other artists. She was a devoted friend of Rodin from 1906, a friend of Rilke from *c.* 1908 and a friend of the Roman Catholic theologian and aesthetician Jacques Maritain. From 1913, in which year she was received into the Roman Catholic Church, she lived at Meudon in increasing solitude and retirement. She sought seclusion and throughout her life she was overshadowed (though not artistically) by the more flamboyant personality of her brother Augustus JOHN. Her painting was as reticent and unassuming

as her life, but it was an art of great consistency and unobtrusive originality. Like her brother she was a natural and gifted draughtsman. Her principal subjects were portraits, interiors and young girls. She exhibited irregularly with the NEW ENGLISH ART CLUB from 1900 to 1911, had three paintings in a joint exhibition with her brother at the Carfax Gal. in 1903, was included in the ARMORY SHOW in 1913, in 'Modern English Artists' at the Sculptors' Gal., New York, in 1922 and in 'British Painting since Whistler' at the National Gal., London, in 1940. She exhibited in Paris at the Salon d'Automne and the Salon des Tuileries, 1919–25. Her only one-man show during her lifetime was at the New Chenil Gals., London, in 1926. Her work remained relatively unknown until a Memorial Exhibition at the Mathiesen Gal. in 1946, since when she has been regarded by some competent critics as one of the greatest women painters of her day. A memorial exhibition together with Ethel WALKER and Frances HODGKINS was arranged by the Arts Council at the Tate Gal. in 1952 and an individual retrospective exhibition in 1968. In 1976 to mark the centenary of her birth a retrospective exhibiton was given at the Anthony d'Offay Gal. In the Introduction to the catalogue of this exhibition Mary Taubman wrote: 'Hers is an œuvre of exceptional consistency. For though she was very much a painter of her time, constantly aware of and responsive to the changes taking place in the world of art, she remained aloof from any group or movement and, with dedicated single-mindedness, pursued the expression of her own highly original vision . . .'

JOHNS, JASPER (1930–). American painter and sculptor, born at Augusta, Ga., and brought up in South Carolina. He studied at the University of South Carolina and after attending art school in New York for a short time (1949) was drafted into the army and stationed in Japan. From 1952 he lived in New York, where he worked in a bookshop and did display work for department stores. His series of *Flags*, *Targets* and *Numbers*, which have remained among the best known of his paintings, were done in 1954–5 and were first exhibited at the Leo Castelli Gal., New York, in 1958. In the late 1950s he began his sculptures, using the image of the electric torch and the electric light bulb. In 1960 he did the two *Painted Bronzes*, one consisting of two ale cans and the other of a set of paint brushes in a coffee tin. During the 1960s he did the well-known series *O Through 9* (1961), the large paintings *Diver* (1962), *Watchman* and *Souvenir* (done in Japan, 1964), *According to What* (1964), *Harlem Light* (1967) and *Wallpiece* (1968), among others. From 1961 Johns began to affix real objects to the surface of his canvas, as in the *Devices* series, where he attached measuring instruments with which parts of the pictures had been made. His *Map* (1967–71), based on Buckminster Fuller's Dymaxion projection, was exhibited at The Mus. of Modern Art, New York, in 1971.

Johns and Robert RAUSCHENBERG are regarded as the forerunners of POP ART in America and are sometimes called NEO-DADAISTS. They are often considered to have been largely responsible for the breakthrough from ABSTRACT EXPRESSIONISM to the types of Pop art and MINIMAL ART which succeeded it. Of John's first one-man show, in 1958, the critic Leo Steinberg wrote: 'The pictures of De Kooning and Kline, it seemed to me, were suddenly tossed into one pot with Rembrandt and Giotto. All alike suddenly became painters of illusion.' Johns marked a crucial step, in the rejection of painterly artifice, towards the demand, central to so much of contemporary art, that the work of art should be viewed as a reality in itself. In an interview with the critic David Sylvester, asked why he used such things as flags, targets, maps, numbers and letters as starting points, Johns said: 'They seemed to me pre-formed, conventional, depersonalised, factual, exterior elements . . . The most conventional thing, the most ordinary thing—it seems to me that those things can be dealt with without having to judge them: they seem to me to exist as clear facts, not involving aesthetic hierarchy.' Later in the interview he remarked: 'I like what I see to be real, or to be my idea of what is real. And I think I have a kind of resentment against illusion when I can recognise it. Also, a large part of my work has been involved with the painting as an object, as a real thing in itself.'

Besides numerous exhibitions in America, Europe and Japan, he was represented at the Venice Biennale in 1958 and 1964, in 'Painting and Sculpture of a Decade' (Tate Gal., 1964), 'Pop Art' (Hayward Gal., 1969), 'American Pop Art' (Whitney Mus., New York, 1974), and 'Painting and Sculpture 1940–1970' at The Metropolitan Mus., New York, in 1971. Retrospective exhibitions were held at the Columbia Mus. of Art, South Carolina, in 1960; the Jewish Mus., New York, and the Whitechapel Art Gal., London, in 1964, and the Pasadena Mus., California, in 1965. An exhibition of his drawings was held in 1966 at the Smithsonian Institution National Collection of Fine Arts, Washington D.C., and a large exhibition of over 100 drawings, assembled by the Arts Council of Great Britain, toured a number of galleries in Britain in 1974–5.

Johns was a director of the Foundation for Contemporary Performance Arts from 1963 and collaborated as Artistic Adviser with the Merce Cunningham Dance Company. He was elected a member of the National Institute of Arts and Letters in 1973.

JOHNSON, LESTER (1919–). American painter and graphic artist born at Minneapolis, studied at the Minneapolis Institute School, St. Paul School of Art and Chicago Art Institute School, 1942–7. He taught at the School of Visual Arts, New York, in 1964 and from 1964 at Yale University. His first one-man show was at the Artists' Gal., New York, in 1959 and since then he has

continued to exhibit frequently, including four exhibitions at the Martha Jackson Gal. in the 1960s and an individual exhibition at the Smithsonian in 1968. Among the group exhibitions in which he was represented were: Jewish Mus., New York, 'The New York School, Second Generation', 1957; Institute of Contemporary Arts, Boston, '100 Works on Paper' (circulating to Europe, 1959) and 'Future Classics', 1960; American Federation of Arts, 'Graphics '60', 1960; The Mus. of Modern Art, New York, 'Recent American Painting and Sculpture (circulating in U.S.A. and Canada), 1961–2, and 'Recent Painting USA: The Figure', 1962–3, and 'The 1960s', 1967. His work was representative of the 'conservative modernism' in America during the 1950s and 1960s onwards.

JOHNSON, RAY (1927–). American POP artist and collagist, born in Detroit. He studied at the Art Students' League and at Black Mountain College under ALBERS, MOTHERWELL and ZADKINE. He was a member of the American Abstract Artists, 1949–52, and he founded and operated the New York Correspondence School. His first one-man shows were at the Willard Gal. and the Richard Feigen Gal., New York and Chicago, 1965–8. He participated in a number of collective exhibitions. In the main he did COLLAGES which combined features of SURREALISM with Pop Art sentiment. These included burlesques of famous artists, such as his *Homage to Magritte* (1962), *Bridget Riley's Comb* (1966), *Mondrian* (1967).

JOHNSTON, FRANK. See CANADA.

JOKINEN, LEO (1947–). Finnish painter, born at Turku and studied at the Art Association of Turku Art School. Using photographs as a starting point, he painted subjects from the life of the working classes with PHOTOGRAPHIC REALISM. Besides exhibitions in Finland, he took part in an exhibition of Finnish artists at Stockholm (1972), an exhibition of young Turku artists at Leningrad (1974) and the exhibition 'Workaday Finland' at the I.C.A. Gals., London (1974). In a catalogue note to the last he wrote: 'I have endeavoured to find my motif among the working-class people to whom I feel close and whose milieu I have depicted in my paintings since the fifties and sixties.'

JONAŠ, MARTIN (1924–). Yugoslav naïve painter, born in the Serbian village of Kovačica. A peasant, he painted in his leisure time, after working on the land. He is regarded as the greatest individualist among the groups of peasant painters at Kovačica (see NAïVE ART) and the most original. He painted rustic genre scenes in gay fairy-tale colours with typical attention to detail combined with an unusual gift of pictorial pattern. He liked to show his figures in peasant costume, using this as a decorative element in his compositions, and in his later works he depicted a story in the manner of the comic strip, using a similar technique. Since 1952 he has been exhibited widely in Yugoslavia and more recently in the U.S.A. (New York, Chicago, Washington, Pittsburgh, etc.), in London and Edinburgh, and in a number of European towns (Bratislava, Zürich, Vienna, Prague, etc.).

JONES, ALLEN (1937–). British painter born at Southampton, studied at the Hornsey College of Art, 1958–9, and at the Royal College of Art, 1959–60, from which he was expelled. From 1960 he showed in the 'Young Contemporaries' exhibitions at the R.B.A. Gals., London, and in 1961 and 1963 he exhibited at the Paris Biennale. His first one-man show was at the I.C.A. Gals., London, in 1962. He taught at the Croydon College of Art, 1961–3, and at the Chelsea School of Art, 1964. In 1964–5 he visited the U.S.A., receiving the Tamarind Fellowship for Lithography in 1966. He was Guest Lecturer at the Hochschule für Bildende Künste, Hamburg, 1968–9, and in 1969 taught at the University of South Florida, Tampa. From the 'Young Contemporaries' exhibition of 1961, when POP ART first made its impact on the public, Allen Jones was one of the most successful of British Pop artists. He was represented in many important international exhibitions of Pop art and contemporary British art. He had a retrospective of his graphic works at the Boymans-van Beuningen Mus., Rotterdam, in 1969, a large one-man exhibition at the Marlborough Fine Art Gal., London, in 1972 and he was one of the artists featuring in the exhibition 'Pop Art in England' of 1976. A large retrospective was given in 1980 at the Arts Palace in the Ehrenhof, Düsseldorf, at which two decades of his pictorial work were documented consecutively for the first time.

From his student days at the Royal College of Art, Jones gave priority to the formal aspects of painting and in 1965 he was quoted by Mario Amayo as saying: 'It begins as a formal picture and that leads me to the imagery. The shapes themselves suggest the subject, not the subject the shapes.' He was seeking a way of adapting the formal discoveries of ABSTRACT EXPRESSIONISM to figurative painting. Although like other Pop artists Jones was interested in the mass media, he rarely took the motifs of his pictures from this field, but rather from his own experience and observation. From the painting *3rd Big Red Bus* of 1962 he was interested in the problem of identifying the picture with its subject, painting not a picture *of a* red bus, but a 'red-bus-picture'. From the mid 1960s he began to base his compositions upon the truncated combination and transposition of fetishistic or obsessive objects, often of a sexual character such as the truncated thighs depicted against highly coloured monochromatic backgrounds in his exhibition at the Waddington Gals., London, in 1976 and his use of legs, stockings, shoes, etc. taken from women's fashion magazines.

JONES, ARNE (1914–). Swedish sculptor. He

worked as a stonemason from 1934 to 1944 and studied sculpture at the Stockholm College of Art, 1941–7. His monumental sculpture was architectural in form, integrating with space and with the environment. It was strongly lyrical in tone, often carrying suggestions of organic growth and often offering a strikingly different appearance when seen from different positions. He designed a number of fountains and incorporated the movement of water and artificial lighting as sculptural elements. He also did a number of grotesque terracotta portraits.

JONES, DAVID MICHAEL (1895–1974). British painter, engraver and writer, born at Brockley, Kent, of Welsh extraction on his father's side. Throughout his life he felt a profound attraction towards his Welsh background. From early boyhood drawing meant more to him than formal education. His studies at the Camberwell School of Art, 1909–15, left him, as he said, 'completely muddle-headed as to the function of art in general'. After serving during the war in the Royal Welch Fusiliers he studied for three more years from 1919 at the Westminster School under Walter BAYES and Bernard MENINSKY. In 1921 he became a convert to the Roman Catholic Church and in 1922 met Eric GILL and joined the Guild of St. Joseph and St. Dominic at Ditchling, Sussex, where under the influence of Gill he first achieved a sense of purpose. Gill not only introduced him to the craft of engraving on wood but guided him towards a conception of art which rejected the current concern with formal properties in favour of an art which aspired to reveal universal and symbolic truths behind the appearances of things. By 1926 Jones felt that he had found a 'fairly recognisable direction' in his work and destroyed the greater part of his earlier drawings. From 1925 he illustrated books for the Golden Cockerel Press, including *The Chester Play of the Deluge* and *Gulliver's Travels*. He spent 1924 in London but rejoined Gill at Capel-y-Ffin in the Vale of Ewyas, returning to Brockley in 1927, in which year he became a member of the Society of Wood Engravers. But he abandoned engraving in 1932 because of trouble with his eyesight.

From 1928 to 1933 he was a member of the SEVEN AND FIVE SOCIETY and came to be recognized as a representative of the 'modern' trend. Owing to a breakdown, however, he abandoned painting in 1933 and took to writing. His chief literary works were *In Parenthesis* (completed in 1937), which was declared by T. S. Eliot to be a work of genius and was awarded the Hawthornden Prize, and *The Anathemata* (1952). In 1954 he was awarded the Russell Loines Award for Poetry by the National Institute for Arts and Letters of the U.S.A.

He resumed painting c.1940 and the watercolour sketches he did in the early years of the 1940s are considered to be the masterpieces in his varied output. Chief among these are *Vexilla Regis*

and *Aphrodite in Aulis* and four drawings illustrating the Arthurian legend, two of which, *Guenever* and *The Four Queens*, are in the Tate Gal. Jones's work, both engraving and water-colour, was extremely personal, defying classification or comparison. He had a large and enthusiastic personal following rather than a recognized position in the development of British or European art. Of these later works William Feaver has written: 'They have to be regarded in an interpretative way—the legends cited, the imagery perused. Seen as mere pattern-plays, exercises in a free-style water-colour technique, somewhat deficient in 20th-century-approved plastic values, they can only seem muddled. In David Jones's terms though, and from his viewpoint, a wealth of books behind him, strange tongues and odd runnels of information, the paintings fall in line with the writings and prove coherent.' After the war he retired to Harrow and apart from one or two drawings devoted himself mainly to calligraphic inscriptions in the Welsh language. He was created C.B.E. in 1955.

David Jones exhibited water-colours at the Goupil Gal. in 1927 and 1929, at Chicago in 1933, at the Venice Biennale of 1934 and at the New York World's Fair in 1939. A C.E.M.A. exhibition toured Britain in 1944 and an Arts Council exhibition was shown in Wales, Edinburgh and at the Tate Gal. in 1954. Memorial exhibitions were given at Kettle's Yard, Cambridge, and at the Anthony d'Offay Gal., London, in 1975.

JONK, NIK. See NETHERLANDS.

JOOSTENS, PAUL (1889–1960). Belgian painter, born in Antwerp. After studying with the architect Max Winders he attended the Academy and the Institut Supérieur at Antwerp, where he became interested both in ENSOR and in the Flemish primitives. His own work was at first in a Late-Impressionist style but during the First World War he experimented with EXPRESSIONISM, CUBISM and FUTURISM, culminating in COLLAGES and constructions which had affinities with DADA. Although he was never in fact a member of the Dada movement, the objects and ASSEMBLAGES which he produced in the early 1920s had much in common with the anti-art tendencies of Dada and this, combined with his sarcastic attacks upon traditional aesthetic values, caused him often to be classed with the more extreme exponents of Dada theories. His collages were unlike those of Synthetic Cubism and went much further in the direction of the abstract. His restless and caustic personality made a strong impression in the groups connected with the review *Het Overzicht* and with *Moderne Kunst*. After 1925 he returned to figurative work and created a series of 'Lolitas' and Hollywood stars posing as medieval Madonnas.

JORN, ASGER (ASGER OLUF JØRGENSEN, 1914–73). Danish artist, born at Vejrum in West Jutland. He went to Paris in 1936 and studied with

LÉGER and LE CORBUSIER. He did a large decoration, 54 sq. yards (45m²), for the Palais des Temps Nouveaux at the Exposition Universelle, Paris, in 1937 and ghosted part of Léger's canvas for the *Grand Palais de la Découverte*, Paris. During the war years he was active in Denmark. He founded the COBRA group, 1948–50, in Brussels. In 1951–2 he was in hospital in Silkeborg for 17 months with tuberculosis. During the same period he did the two large paintings on hardboard *On the Silent Myth* (Silkeborg Public Library). In 1953 he moved to Switzerland, where he was active in the International Situationist movement (1957–61). During the 1960s his pictures were increasingly exhibited abroad, including *Luxury Paintings* at the Tooth Gal., London, in 1961 and an exhibition at the Lefevre Gal., New York, in 1962. Deriving from EXPRESSIONISM, Jorn's art of the COBRA period had close affinities with ART INFORMEL. His later work became increasingly violent in its revival of KITSCH and its search for the horrific and the unorthodox.

JOVANOVIĆ, MILOSLAV. See NAÏVE ART.

JOVÉ, ÁNGEL. See SPAIN.

JUDD, DONALD (1928–). American sculptor, born at Excelsior Springs, Mo., studied at the College of William and Mary, 1948–9, Columbia University, 1949–53, and at the Art Students' League. His first one-man show was at the Green Gal., New York, in 1964, at which time he emerged as one of the most prominent and articulate of the MINIMALISTS. He opposed all forms of illusionism and EXPRESSIONISM and advocated 'objective' sculpture consisting of simple, unexpressive forms which he called 'specific objects'. He was opposed to traditional composition based on ideas of relations among the parts in a whole, being one of the most dogmatic advocates of 'holistic' or non-relational art. His own sculpture, which was set on the floor and rarely reached above eye level, consisted of stainless steel or painted iron boxes or similar simple forms set side by side without emotional overtones. His work was represented in many important collective exhibitions of contemporary American art and he had a first retrospective exhibition at the Whitney Mus. of American Art in 1968.

JUGENDSTIL. See ART NOUVEAU.

JUNEAU, DENIS. See NOUVEAUX PLASTICIENS.

JUNG, FRANZ. See DADA.

JUNK ART. Art which, discounting the traditional materials of fine art, is constructed from worthless materials, refuse, rubbish and urban waste. The Junk movement is traced in the U.S.A. to the 'combines' of Robert RAUSCHENBERG, who in the mid 1950s began to affix to his canvases rags and tatters of cloth, torn reproductions and other waste materials. The name 'Junk art' was first applied to these by the critic Lawrence Alloway and was then extended to sculpture made from scrap metal, broken machine parts, used timber and so on by John CHAMBERLAIN, Robert MALLERY, Richard STANKIEWICZ, Mark di SUVERO, Lee BONTECOU, etc.

In so far as Junk art represented a revolt against the traditional doctrine of fine materials and a desire to show that works of art can be constructed from the humblest and most worthless things, it may be plausibly traced back to Kurt SCHWITTERS and the COLLAGES of early Synthetic CUBISM. There was, however, a widespread revival of this attitude during the 1950s and the Junk art of the U.S.A. had its analogies in the work of TÀPIES and others in Spain, BURRI and ARTE POVERA in Italy and similar movements in most European countries and in Japan, where the litter and refuse left over from the war was sometimes converted to artistic use. In the case of Rauschenberg and others the use of Junk material was objective and unemotional, or at most carried a suggestion of the rapidity with which everyday articles such as milk bottles or comic strip cartoons turn into refuse and waste. In other cases, including the Junk sculpture of California and the work of Burri and Tàpies, a nostalgic emotional suggestion was conveyed by the use of discarded machine parts, rotted beams and rusted metal, torn and dirty textile scraps, and the detritus generally of industrialized urban life.

JUNNO, TAPIO (1940–). Finnish sculptor born at Piippola, trained at the Institute of Industrial Design and the School of the Fine Arts Academy of Finland. Besides exhibitions in Finland, he participated in exhibitions at The Hague (1965), Biennale of Young Scandinavian Artists at Copenhagen (1966), São Paulo Bienale (1967), Baltic Biennale at Rostock (1970), a Biennale of Miniature Sculpture at Budapest (1971), International Exhibition at Monaco (1971) and 'Workaday Finland' exhibition in the I.C.A. Gals., London (1974). His sculpture, which was extremely varied, included semi-abstract totem-like figures. In the Introduction to the catalogue of the London exhibition it was said that, like Arvo SIIKAMÄKI, his figures depict 'the individual anguish of people today'.

JÜRGEN-FISCHER, KLAUS (1930–). German painter and writer, born at Krefeld. He studied at the Academy of Art, Düsseldorf, from 1949 to 1951 and then under Willi BAUMEISTER at Stuttgart. In 1955 he published a work of Existentialist philosophy, *Der Unfug des Seins*, and in the same year joined the editorial staff of the journal *Das Kunstwerk*. In 1960 he founded the journal *Vernissage*. In 1963 he published a manifesto *Was ist komplexe Malerei?* which established the theoretical basis of the group SYN, of which he

became a founding member in 1965. He also edited the journal *Syn*, which advocated an 'integral' art based exclusively on 'pictorial principles'. In 1960 he organized an exhibiton 'Avantgarde 60' in Trier, in 1962 the exhibition 'Komplexe Farbe' in Wiesbaden and Hamburg, and in 1963 was joint organizer of the exhibition 'Absolute Farbe—Avantgarde 1963' in Trier. His first one-man show was at Krefeld in 1950, after which he had many shows in Germany and also exhibited in London, Turin and Venice. In his painting Jürgen-Fischer tried to develop a modern classicism based on theoretical principles of colour-layers to form abstract colour space.

K

KAHLER, EUGEN (1882–1911). Czech painter, poet and graphic artist. Born in Prague, he studied at Munich, 1901–5, at the Academy of Art and privately with Hugo Habermann. After travelling to Paris, London, Brussels, etc. he returned to Munich in 1910, where his works were exhibited at the Thannhäuser Moderne Gal. Two of his prints were included in the first exhibition of the BLAUE REITER in December 1911, and an obituary by KANDINSKY was published in *Blaue Reiter Almanach*. His work was mystical and visionary.

KAHLO, FRIDA. See RIVERA, Diego Maria.

KAHNWEILER, DANIEL-HENRI (1884–1976). German-French art dealer and writer, born at Mannheim. In 1907 he opened his gallery in the rue Vignon, Paris, and became interested in the FAUVES—DERAIN and VLAMINCK particularly. He was chiefly known, however, as the friend and promoter of the CUBISTS. From 1907 he was the chief dealer of PICASSO and remained his lifelong friend. In 1908 he exhibited Cubist canvases of BRAQUE which had been rejected by the Salon d'Automne and he was a friend and supporter of Juan GRIS, of whom he wrote a standard biography in 1947. Among his many publications were *L'Enchanteur pourrissant* by APOLLINAIRE with woodcuts by Derain, *Saint Matorel* by Max Jacob with etchings by Picasso, Erik Satie's one-act operetta *Le Piège de Méduse* with coloured wood engravings by Braque. He was the first publisher of Apollinaire, Max Jacob, André MALRAUX and Georges Limbour, among others. After the Second World War his gallery was moved to rue de Monceau and was managed by his sister-in-law, Louise Leiris. In the Introduction to Kahnweiler's autobiographical book *My Galleries and Painters* John Russell wrote: 'Where the old-style dealers did their artists a favour by inviting them to luncheon, Kahnweiler lived with Picasso, Braque, Gris, Derain and Vlaminck on a day-to-day, hour-to-hour basis. The important thing was not so much that they should sell as that they should be free to get on with their work; and Kahnweiler, by making this possible, helped to bring into being what now seems to us that last great flowering of French art.' He became a French citizen in 1937.

KALINOWSKI, HORST EGON (1924–). German sculptor, born at Düsseldorf, where he trained from 1945 to 1948. In 1949–50 he studied mosaic in Venice and Rome and from 1950 to 1952 he studied in Paris under DEWASNE and PILLET. In the 1950s he did abstract paintings and COLLAGES. During the 1960s he produced his most distinctive works, which he called *caissons*. These were abstract frameworks of wood or iron covered in leather. He gave to them suggestive names such as *Torquemada* (1967), *Lobe de Boudha* (1969), *Regard Immuable* (1969), but they were without representational import. He sometimes elongated the *caissons* into *Stelen* and sometimes imparted a pulsating movement to them by electro-magnetic devices. His works were exhibited in Germany, Paris, London and New York. From 1968 he taught at the Academy of Art, Karlsruhe. He also did graphic work, including etchings to illustrate Japanese haiku, and designed theatrical décors and costumes.

KALLOS, PAUL (1928–). Hungarian-French painter, born at Hernadnemeti, Hungary. After spending a year (1944–5) in a German concentration camp, he studied at the School of Fine Arts, Budapest, 1946–9. He then went to Paris and became known as a leading member of the school of young artists painting in the manner of LYRICAL ABSTRACTION. From 1956 he exhibited at the Gal. Pierre.

KALTE KUNST. See COLD ART.

KAMPMANN, UTZ RÜDIGER (1935–). German sculptor, born in Berlin. He studied at the Hochschule für Bildende Künste, Berlin, 1957–63. He won the Villa Romana Prize in 1964 and the Art Prize of the city of Berlin in 1969. His first sculptures were in clay or cement but *c.* 1965 he began to make the boxed assemblages of aluminium, plexiglass etc. for which he became known. These were built from layers of cubes with engine parts, electric light bulbs, batteries, etc. and were named 'Radiators'. He ascribed as much importance to colour as to shape and tried to integrate colour with form, employing also light effects. From 1966 to 1970 he worked in conjunction with the architect W. Poreinke on the colour design of the satellite town of Berlin, Märkisches Viertel. During the same period he designed the colour for two projects in Zürich, Trigondorf Doldertal and the Chemie-Bar E.T.H.

KANDINSKY, WASSILY (1866–1944). Russian painter, born in Moscow. He studied law, economics and politics at Moscow University and in

1893 was appointed lecturer there in the Faculty of Law. He was also an accomplished amateur musician. But the impact made upon him by the first Russian exhibition of French Impressionists in 1895 was so great that, refusing the offer of a lectureship at the University of Dorpat, Estonia, in 1896, he went to Munich in 1897 to study painting, working under Anton Azbé and later under Franz von STUCK, a teacher at the Munich Academy and a founding member of the Munich SECESSION. At this time the prevailing *avant-garde* in Munich was ART NOUVEAU or, as it was called, *Jugendstil*, and Kandinsky familiarized himself with this style, becoming in 1901 one of the founders of the *avant-garde* exhibiting association *Phalanx*. Between 1903 and 1908 he travelled in Italy, the Netherlands and Tunis, spending 1906–7 in Paris, where he exhibited at the Salon d'Automne. He returned to Munich in 1908 and in 1909 became a founding member and first President of the NEUE KÜNSTLERVEREINIGUNG. Meanwhile he was the central figure of an artists' summer colony which met at the house of his mistress, Gabriele MÜNTER, in Murnau, outside Munich, and which included the Russian artists JAWLENSKY and WEREFKIN and the younger German painters Franz MARC and August MACKE. These formed the nucleus of the splinter group which at the end of 1911 seceded from the *Neue Künstlervereinigung* and established the BLAUE REITER. In 1912 he published in the *Blaue Reiter Almanach*, of which he was co-editor, his essay 'Über die Formfrage' ('On the Question of Form'), and also wrote his autobiographical *Rückblicke* (*Reminiscences*), which was published in *Der* STURM in 1913. His longer work, *Über das Geistige in der Kunst, insbesondere in der Malerei*, one of the seminal formulations of the principles of ABSTRACTION, was also published in 1912. A Russian version had been read at the Pan-Russian Congress of Artists at St. Petersburg in December 1911.

After the outbreak of the First World War Kandinsky returned to Russia and although he did little painting there, he found the opportunity under the administration of Lunacharsky to convert his theoretical ideas about the nature of art into practical projects within the general programme of State-controlled cultural education. In 1921 he was a member of IZO NARKOMPROS (the Visual Arts section of the People's Commissariat of Enlightenment). In 1920 he had drawn up a programme for the newly formed INKHUK (Institute of Artistic Culture), which controlled the VKHUTEMAS, but his conception of art as a spiritual process was opposed to the utilitarian artistic doctrines of the CONSTRUCTIVIST group and his programme was turned down. A similar programme which he worked out for the Department of Fine Arts in the Academy of Sciences was also put into abeyance. Out of sympathy with the new ideas which subordinated fine art to industrial design, he left Russia in 1921 to take up a teaching post in the BAUHAUS, where he remained until it was

closed. In 1923 he was made Vice-President of the SOCIÉTÉ ANONYME in New York. In 1924 he joined with KLEE, Jawlensky and FEININGER in forming the BLAUEN VIER. In 1927 he became a German citizen. His most important theoretical work, *Punkt und Linie zu Fläche: Beitrag zur Analyse der malerischen Elemente* was published as a Bauhaus booklet in 1926.

On the closing of the Bauhaus by the National Socialist Government in 1933 Kandinsky left Germany for Paris, where he lived until his death. In 1937 his works were included in the exhibition of DEGENERATE ART organized by the Nazis in Munich. He became a French citizen in 1939.

Kandinsky's paintings at the turn of the century combined features of *art nouveau* with reminiscences of Russian folk art. A fairy-tale element united with dramatic clashes of colour which foretold his later abstractions. His progress towards non-figurative abstraction proceeded alongside the development of his philosophical views about the nature of art as 'non-objective' and culminated in the abstract paintings done at the time of the *Blaue Reiter*. His first entirely non-representational work, a gouache, is traditionally ascribed to 1910 but is put by some historians as late as 1913. The best collection of works from this early period is to be seen at the Städtische Gal. im Lenbachhaus, Munich. The abstractions of his Bauhaus period were as a general rule more deliberately planned and the geometrical boundaries of the forms were more precise, although they still belonged to the category of Expressive rather than geometrical abstraction and the romantic element of the Munich period had not disappeared. Working in proximity, Kandinsky and Klee influenced each other and towards the end of the 1920s Kandinsky's work moved towards a less rigorous and sometimes even a playful character. In his Paris period these earlier experiences coalesced in works of full and balanced maturity which often showed an extraordinary, almost un-European character of form and colour which some critics have attributed to his Mongolian ancestry. Some of the paintings of the late 1930s and early 1940s displayed a serene exuberance combined with a vital energy which gives them the character of genuine masterpieces. It was said in the Introduction to the catalogue of an exhibition organized at the Scottish National Gal. of Modern Art, Edinburgh, in 1975: 'No artist before or since can have controlled such a vast array of perfectly disciplined formal and colouristic powers as Kandinsky in the last paintings.'

Both for the quality and influence of his works and for the influence of his theoretical and pedagogical writings Kandinsky was the most important figure in the development of non-representational abstraction in the first half of the century. He was the pioneer among those artists who made it their aim, not to reproduce the expressive qualities of things and scenes in nature—as was done, for example, by Roger BISSIÈRE, BAZAINE, ESTÈVE—

but to exploit the intrinsic expressive attributes of artistic materials, notably pigments, without reference to natural appearances. From early childhood Kandinsky was unusually sensitive to the emotional associations of colours and had strongly developed powers of synaesthesia. Finding it impossible to reproduce in painting the colours which moved him so profoundly, he reached the conclusion by a kind of intuitive leap rather than by logical thought that art and nature are two separate 'worlds', with different principles and different aims. And from this he came to his belief in the 'autonomy' of art—the belief that a work of art stands or falls by inherent aesthetic principles, not by any resemblance to the outside world. In *Über das Geistige in der Kunst* he wrote eloquently to insist on the primacy of the expressive and compositional aspects of art, although he did not repudiate representation *in toto*. He distinguished between the 'inner' and the 'outer' elements of a work of art, calling the intrinsic expressive aspects 'internal meaning' or 'inner resonance', and he argued that it is only in combination, that is in an aesthetic composition, that they produce a 'spiritual vibration' and that 'it is only as a step towards this spiritual vibration that the physical impression is important'. He held that the 'pure' artist seeks to express only 'inner and essential' feelings and ignores the superficial and fortuitous. As art matures in the course of time the artist attempts to express 'more refined emotions, as yet unnamed'. The final goal is the 'substance which only art can comprise, which only art can clearly express by those means of expression that are proper to it'. It is this unique mode of expressiveness, he thought, which constitutes the common element uniting the art of all ages. His detailed analysis of the pictorial elements—colours, lines, planes, etc.—was conducted on this basis in the belief that to create a fully expressive composition an artist must have complete knowledge of the tools with which he works.

In his own work Kandinsky was a pioneer in developing a new type of picture space no longer based on the traditional quarter-sphere bounded by the plane of the earth's surface and the picture plane, but a complete sphere unlimited in all directions and drawing the observer into the picture like an astronaut in deep space. With the disappearance of geometrical perspective along with the abandonment of representation he organized his picture space by a very precise manipulation of the more recondite sensory properties of colours and shapes. Unless it has abandoned composition altogether, almost all expressive abstraction subsequently has based itself on Kandinsky's new picture space. His other most important contribution was in the creation of virtual movement without the representation of moving things. From c. 1920 he was able to impart virtual movement to his canvases in a manner and to a degree which had not been realized hitherto. Although a forerunner of expressive abstraction, he was a master of com-

position and did not herald the spontaneous, improvisatory, formless ideals of ABSTRACT EXPRESSIONISM and ART INFORMEL.

KANE, JOHN (1860–1934). American NAÏVE painter, born in West Calder, Scotland, and emigrated to Pittsburgh in 1879. He was employed in Pittsburgh as a steelworker and then worked from 1884 to 1890 as a coalminer in Alabama, during which time he first began to sketch. After losing a leg in 1891 he worked as a watchman on the railway. During this time he tinted and painted photographs. His first oil paintings were done c. 1910 when he was working in Ohio as a carpenter and housepainter. He painted portraits—including a *Self-Portrait* (1929) now in The Mus. of Modern Art, New York—landscapes, interiors and cityscapes of industrial Pittsburgh, combining meticulous detail with naïve stylization and imaginative reconstruction. He said: 'When I look at Pittsburgh, I see it both as it is in my memory and as it looks today. And so I see it double: once as God made it, and once as man has changed it.' He came to public notice in 1927 when some of his works were accepted for the Carnegie International Exhibition in Pittsburgh and he was awarded a Carnegie Prize. From that time until his death he was included in every Carnegie International and several of his works have been acquired by the Carnegie Institute Mus. of Art in Pittsburgh. He was represented in the exhibition 'Masters of Popular Painting' at The Mus. of Modern Art, New York, in 1938 and his works have frequently been included in exhibitions of popular art in Europe. Although Kane was the first naïve painter to achieve recognition in the United States, he died in poverty of tuberculosis in a Pittsburgh hospital.

KANERVA, AIMO ILMARI (1909–). Finnish painter. He studied in Helsinki, where he had his first one-man exhibition in 1933. He also exhibited in many European countries and extensively in the U.S.S.R. He was represented at the Venice Biennale of 1960. Kanerva was known both for his portraits and for his landscapes in an extremely personal mode of Finnish EXPRESSIONISM. Critics spoke of their 'restraint and placidity, often sinking into melancholy, so typical of the Finn ...' Many of these landscapes, particularly those representing trees and the remoter districts of northern Finland, verged towards the abstract, and his calligraphic abstracts based upon plant and flower subjects were reminiscent of the Chinese. Kanerva was elected Professor in 1969 and a large retrospective exhibition of his work was staged in Helsinki in 1977.

KANOLDT, ALEXANDER (1881–1939). German painter, born and trained in Karlsruhe. In 1901 he joined the Munich NEUE KÜNSTLERVEREINIGUNG and from 1913 to 1920 he was a member of the Munich SECESSION. He taught at the Breslau

Academy of Art from 1925 and in 1932 was appointed to the Berlin Academy. After the First World War, in conjunction with SCHRIMPF and MENSE, Kanoldt was a leading member of the NEUE SACHLICHKEIT group who under the influence of DERAIN and the VALORI PLASTICI developed, in the words of Werner Haftmann, 'a brittle graphic technique in the service of a mannered realism'. His work lacked the poetic quality of the Italians.

KANTOR, TADEUSZ (1915–). Polish painter, born at Wielopole near Kraków and trained at the Kraków Academy of Art. He was a main pioneer of modern art in Poland after the Second World War. After a SURREALIST period which lasted until the mid 1950s he passed through a TACHIST phase and during the 1960s painted in a more personal idiom, depicting vaguely-suggested objects in bold masses against a monochromatic background. Kantor was also known as a theatre director. During the war he ran an underground experimental theatre which was revived in the 1950s. Both in his theatrical productions and in his paintings Kantor introduced the factor of chance as a constitutive element.

KAPROW, ALLEN (1927–). American painter and creator of HAPPENINGS, born at Atlantic City. He studied at New York University, 1945–9, and at the HOFMANN School, 1947–8, then studied art history under Meyer Schapiro at Columbia University, 1950–2, and music under John Cage, 1956–8. He taught at Rutgers University, 1953–61, at the Pratt Institute, 1960–1, at the State University of New York at Stony Brook, 1961–9, and then at the California Institute of the Arts, Los Angeles. In an article published in 1958 in *Art News* he argued for the abandonment of craftsmanship and permanence in the fine arts and advocated the incorporation of perishable materials. He is considered to be the originator of the Happening. His view was that the ASSEMBLAGE was to be 'handled and walked around', the ENVIRONMENT was to be 'walked into', but the Happening was to be a genuine 'event' involving spectator participation and no longer confined to the museum or gallery. During the 1960s he developed the art of the Happening in the direction of environmental theatre or performance art continuous with everyday life, breaking down the barriers between art and actual experience. From John Cage he took over the idea of chance and indeterminacy in aesthetic organization. His first major exhibition was of a work called '18 Happenings in 6 Parts' at the Reuben Gal. in 1959. His many exhibitions included 'Environments' at the Rijksmus., Amsterdam, and the Moderna Mus., Stockholm, 1961, and 'Happenings' at the Théâtre des Nations, Paris, in 1963, the Institute of Contemporary Art, Boston, and Central Park, New York, in 1966. He had a retrospective exhibition at the Pasadena Art Mus. in 1967.

KARFIOL, BERNARD (1886–1952). American painter born in Budapest of American parents. After studying at the Pratt Institute and the National Academy of Design, he went to Paris in 1901 and studied at the Académie Julian under LAURENS, exhibiting at the Salon d'Automne in 1904. While in Paris he knew Gertrude and Leo Stein and through them met PICASSO. Returning to the U.S.A. in 1906, he exhibited in the ARMORY SHOW and had his first one-man exhibition at the Joseph Brummer Gal., New York, in 1924. From this time he continued to exhibit both in individual and in group shows, including 'Paintings by 19 Living Americans' at The Mus. of Modern Art, New York, in 1929. In the 1920s he painted mannered and emaciated figures in the manner of Picasso's Blue period, turning to heavier and more robustly composed nudes in the early 1930s. By the mid 1930s his work became more academic and lost its earlier vigour.

KATZ, ALEX (1927–). American painter born in New York, studied at the Cooper Union and Skowhegan School, where he taught in 1959. He also taught briefly at Yale University, the Pratt Institute, the School of Visual Arts, New York, and New York Studio School. He designed stage sets and costumes for, among others, the Paul Taylor Dance Company and the Artists' Festival Theater, Southampton. His first one-man exhibitions were at the Roko Gal., New York, in 1954 and 1957. Among the collective exhibitions in which his work was shown were: Whitney Mus. of American Art, 'Young America', 1960; The Mus. of Modern Art, New York, 'American Collages', 1965, 'The Inflated Image', 1968; Rhode Island School of Design, 'Recent Still Life', 1966. Katz has sometimes been classified with POP artists, although his work lacked the characteristic concern with popular culture which Pop art displays. From the late 1950s he found his favourite subject matter in well-known personalities of the art world and his personal friends depicted at cocktail parties, etc. He developed a highly personal style combining PHOTOGRAPHIC REALISM with a mannered and deliberate NAÏVETÉ, eliciting a strange poetry from an apparently mechanized technique.

KAUFFER, MCKNIGHT. See CUMBERLAND MARKET GROUP and GROUP X.

KAUFFMAN, CRAIG (1932–). American experimental artist born at Eagle Rock, Calif., studied at the University of Southern California, 1950–2, and at the University of California in Los Angeles. He taught at the University of California from 1967. His first one-man exhibition was at the Felix Landau Gal., Los Angeles, and he continued to exhibit mainly in Los Angeles and San Francisco. His work was represented in a number of collective exhibitions devoted to the newest styles of the young generation of artists. He was keenly interested in colour for its own sake and in devis-

ing subtly inflected colour continua. Like other West Coast artists, such as Larry BELL, he dispensed with pigment and canvas and experimented with the aesthetic potential of new industrial and synthetic materials. His speciality was a vacuum-forming process for colouring his plastic reliefs.

KAUS, MAX (1891–1977). German painter, born and trained in Berlin. In 1926 he taught at the Meisterschule, Berlin, and in 1945 he was appointed Professor at the Berlin Hochschule für Bildende Künste. Up to 1923 he did mainly graphic work under the influence of HECKEL. Later he adopted an EXPRESSIONIST style of painting derivative from the BRÜCKE. After the Second World War he moved towards abstract painting.

KAWARA, ON (1933–). Japanese painter born at Kariya and self-taught as an artist. He was a leading member of the School of Grotesque Art which dominated the Tokyo scene in the 1950s, coming first to notice in 1952 with his *Bathroom* series, *Yellow Race* and *Events in Storage*. These paintings and drawings depicted disjointed human bodies and corpses in a violently satirical vein. He later devised a method by which he duplicated an original painting in a number of variations which he called 'Original Printed Paintings'. Later he emigrated to the U.S.A. and devoted himself to CONCEPTUAL ART.

KELLY, ELLSWORTH (1923–). American painter and sculptor, born at Newburgh, N.Y. He studied at the Boston Mus. School and then at the Académie des Beaux-Arts, Paris, and remained in France until 1954. On his return to the U.S.A. he found his place primarily and prominently among the HARD EDGE colour painters who succeeded the ABSTRACT EXPRESSIONISTS. Repudiating illusion and artifice, his paintings consisted of flat areas of unmodulated colour separated by sharp boundaries. In the 1960s he did paintings made up of adjacent panels of uninflected colour. He was also among the first to develop the idea of the shaped canvas. During the 1940s he had done low-relief constructions laced with cord and wire, sometimes deriving from natural shapes formalized into abstract patterns and sometimes incorporating biomorphic SURREALIST forms. His later sculpture, which was highly coloured and had close affinities with his own two-dimensional paintings, resulted as a development from a sculptural screen commissioned for the Philadelphia Transport Building in 1956. He also did a sculpture for the New York Pavilion at the World's Fair of 1964–5. Apart from the occasional use of ambiguity between figure and ground, Kelly's painting was the most matter-of-fact and the most objective of all the school of POST-PAINTERLY ABSTRACTION. His first one-man exhibitions in the U.S.A. were at the Betty Parsons Gal., New York, from 1956. After this he was very widely exhibited both in the U.S.A. and abroad and was included in most im-portant group exhibitions of the newer art.

KEMÉNY, ZOLTAN (1907–65). Hungarian-Swiss sculptor, born at Banica, Transylvania. After studying first architecture and then painting in Budapest, he lived from 1930 to 1940 in Paris. He settled in Zürich *c.* 1943 and became a Swiss national in 1957. Kemény made reliefs on the borderline between painting and sculpture, incorporating many different materials in them and creating swirling surface rhythms. In 1951 he began to make translucent reliefs to be set up in front of electric lights and about the mid 1950s he began to do the 'Images en Relief' for which he was chiefly known. These were metal reliefs into which he incorporated curious and unexpected conglomerations of industrial metal products and mass-produced articles. In the 1960s he gave these reliefs symbolical names such as *Vitesse involontaire*, *Jonction de la pensée et du réel*. He was given a retrospective memorial exhibiton at the Mus. National d'Art Moderne, Paris, in 1966.

KEMKO, JOSEF (1887–1960). NAÏVE sculptor, born at Helpa, Czechoslovakia. A railway worker by profession, he began in childhood to carve kitchen utensils and shepherd's tools from wood with a knife. He later made free-standing figures of peasants and animals, robust and vividly lifelike though without knowledge of anatomy. His favourite theme was derived from the legend of the Slovak brigand Jánošik. He was one of the few naïve sculptors who was not also a painter and was relatively uninfluenced by folk art or popular religious art. He was represented in the exhibitions 'Lay Art of Slovakia', Prague, 1962, and 'Naïve Art in Czechoslovakia', Prague, Brno, Bratislava, 1963–4.

KENNINGTON, ERIC (1888–1960). British painter, sculptor and graphic artist born in London and studied at the Lambeth School of Art, 1905–7. He was an official War Artist in the First and Second World Wars and was chiefly known for his studies of the daily life of ordinary soldiers and the R.A.F. in the Second World War. Between the wars he worked mainly as a portraitist but also did book illustration, including illustrations to T. E. Lawrence's *Seven Pillars of Wisdom*. His sculptures included the *Monument to the 24th Division* in Battersea Park (1924) and sculptures for the Shakespeare Memorial Theatre, Stratford (1930). He became a member of the Royal Academy in 1959.

KENT, ROCKWELL (1882–1971). American painter and graphic artist, born at Tarrytown Heights, N.Y. He studied architecture at Columbia University, 1906–10, and was a pupil of Robert HENRI. He was associated with Henri in organizing the first Independents show in 1910. His work at this time was mainly landscape and marine painting with affinities to the work of Winslow Homer but with more broadly organized

planes and a palette akin to that of The EIGHT, notable for its solid forms and striking contrasts of light and shade. Among his commissions were murals for the U.S. Post Office and the Federal Building, Washington. He was a member of the National Institute of Arts and Letters and in 1962 was made an honorary member of the Academy of Art, U.S.S.R. He wrote three autobiographical works: *Rockwellkentiana* and *Rockwell Kent* in 1945 and *It's Me O Lord* in 1955.

KEPES, GYORGY (1906–). Hungarian-American painter, born at Selyp, Hungary, and studied at the Budapest Academy of Fine Arts. He taught at the New Bauhaus, Chicago, 1937–43, and collaborated with MOHOLY-NAGY in founding the Chicago Institute of Design. His first one-man show was at the Katharine Kuh Gal., Chicago, in 1939. Among other commissions he did murals for the Harvard University Graduate Center and the Royal Dutch Airlines, New York. He wrote *Language of Vision* (Chicago, 1944) and *The New Landscape in Art and Science* (Chicago, 1956) and edited *The Visual Arts Today* (Wesleyan U.P., Middletown, Conn.).

KERÁK, JOZEF (1891–1945). Czech NAÏVE sculptor, born at Velké Rovno. A tinker by trade, he hiked across most of central Europe carrying his workshop on his back. With extraordinary technical skill he fashioned figures from thickly entwined spirals of wire, both fairy-tale figures, witches and princesses, and figures from daily life. Despite the intractability of his medium all his figures had a singular spontaneity and lifelikeness, particularly in posture and gesture. His work was included in the exhibitions 'Lay Art of Slovakia', Prague, 1962, and 'Naïve Art in Czechoslovakia', 1963–4.

KERMADEC, EUGÈNE (1899–). French painter, born in Paris. He passed his youth on the island of Guadeloupe, Antilles, returning to Paris in 1920. After some experimentation with CUBIST stylizations he evolved a personal style in the late 1920s and enjoyed a considerable reputation during the 1930s as a 'minor master', particularly for his landscapes and figure compositions, which retained reminiscences of his early years. After the Second World War he was caught up in the vogue for expressive abstraction and from 1956 painted abstracts. He had a retrospective exhibition at the Kunsthalle, Basle, in 1958.

KESSANIS, NIKOS. See NIKOS.

KIENHOLZ, EDWARD (1927–). American maker of tableaux, born at Fairfield, Washington. After studying at Eastern Washington College of Education he founded the Now Gal. and the Ferus Gal. in Los Angeles. He belonged to the California school of FUNK ART, using the bizarre and shoddy detritus of contemporary life and creating situations of a horrific and shockingly gruesome character, in which human bodies or corpses were set in environments constructed from real objects. He was included in The Mus. of Modern Art, New York, exhibition 'The Art of Assemblage' in 1967 and among his many one-man shows was one at the Washington Gal. of Modern Art in 1967 and an exhibition which toured major European centres in 1974. His brutal images of murder, sex, death and decay have both attracted and repelled the imagination. A typical example of his work is *The State Hospital* (Moderna Mus., Stockholm, 1964–6). In 1975 Kienholz began to work in Berlin and his work took on more precise social implications. In 1977 he staged exhibitions consisting of pseudo radio-receiving apparatus in a poor or decrepit state, which when activated played raucous music from Wagner, supposedly recalling the National Socialist spirit.

KIESLER, FREDERICK (1896–1965). Austrian-American architect and sculptor born at Vienna. He went to the U.S.A. in 1926, became a citizen and from 1933 to 1957 was Scenic Director at the Juilliard School of Music, New York. He designed the Art of this Century Gal. (1940), the World House Gals. (1957) and the Kamer Gal. (1959) in New York and the Gal. Maeght, Paris, in 1947. He had an exhibition of sculpture at The Mus. of Modern Art, New York, in 1951, and exhibited his 'Endless House' there in 1960; in 1960 also he had an exhibition of Architectural Plans at Houston University and in 1964 an exhibition 'Environmental Sculptures' at the Solomon R. Guggenheim Mus. Kiesler belonged to the group of pioneer European artists who transplanted European modernism to the U.S.A. About 1923 he became associated with the De STIJL group and in the 1940s with the SURREALISTS. Yet his ideas were strongly independent, centring around what he called 'Corealism', which embodies both the continuity of time and space and the idea that a work of art cannot exist without an environmental context. One of his dominant concerns both in his sculpture and in his architectural plans was the expression of infinite continuity or 'endlessness', which occupied him from his 'Endless House', designed as a Space Theater in 1923 and exhibited in 1960 in a more sculptural form, to the landscape series of 1961–4. His art was a fusion of sculpture, painting, architecture and theatre, strongly romantic in character, and he believed that art must result from intuitive and spontaneous creative inspiration.

KIKOÏNE, MICHEL (1892–1968). Russian painter born at Gomel. After studying at Wilno he went to Paris and trained at the École des Beaux-Arts there, having his first exhibition in 1919. In style he was one of the EXPRESSIONISTS of the ÉCOLE DE PARIS, painting landscapes, still lifes and figure studies. His Expressionism was more restrained than that of SOUTINE, with whom he was on terms

of friendship, employing delicate and subtly modulated tones, pastel shades in a rich impasto.

KINETIC ART, KINETICISM. From about the middle of the 19th c. the word 'kinetics' entered the vocabulary of science to denote the branch of dynamics which investigates the relations between the motions of bodies and the forces acting upon them, in contrast to 'statics', which is concerned with bodies in equilibrium. In 1891 the word acquired a new application when as a result of researches by Muybridge it became possible to take a rapid succession of photographs of a continuous process or movement and a machine was invented, called the kinetoscope, for projecting the photographs so as to create an illusion of movement on the principle of the magic lantern or the later cinematograph projector. 'Kinetic' was first used in connection with fine art by GABO and PEVSNER in their *Realistic Manifesto* of 1920. But 'dynamic' continued to be the term in most general use to denote the impression or illusion of movement in the arts of painting and sculpture, as well as for the impression of internal tension or stress among the planes and masses of a work, and it was not until the 1950s that the term 'Kinetic Art' became established as a recognized addition to critical classification.

Since then the term has been extended to cover a pretty wide spectrum of styles and techniques. In a collection of papers from the magazine *Leonardo*, published in 1974 under the title *Kinetic Art: Theory and Practice*, the editor, Frank J. Malina, defined the scope of Kinetic Art as follows: 'Kinetic art includes visual artifacts of three-dimensional or constructional type with mechanical motion of solid bodies, such as animated clockwork systems (which can be found on clocktowers in many cities of Europe) and Calder mobiles driven by air currents. The second major domain of kinetic art comprises the use of cinema equipment to create pictures of changing composition and colour projected on to a framed area (the screen) ... Finally, there is the whole range of the less familiar kinetic "painting" systems, utilising a translucent screen.' The following categories and techniques have commonly been included under Kinetic Art.

1. Painting which exploits optical illusions and visual ambiguity in order to produce in the spectator a calculated and often uncomfortable sensation of optical instability and movement. The term *cinétisme* was applied to this kind of painting by VASARELY, one of its originators, and critics thereafter classified it as Kinetic Art (e.g. Frank Popper in *Origins and Development of Kinetic Art*, 1968). It is more commonly known as OP ART.

Two other categories involving apparent rather than real movement have been classified as Kinetic Art. They are:

2. Works constructed so that their appearance changes drastically and unexpectedly as the spectator changes his position in relation to them. Perhaps the first to use this device was LISSITZKY in the wall of the 'Abstract Gallery' which he designed at Hanover in 1928. Since the mid century the method of creating apparent movement in the art object by taking advantage of the observer's movements has been explored particularly by the Venezuelan Jésus Raphael SOTO and by the Israeli artist Yaacov AGAM. Agam adopted the term 'kinetic' to describe his work *c*. 1952–3. This technique was also explored by members of the GROUPE DE RECHERCHE D'ART VISUEL (GRAV).

3. The creation of apparent movement by the serial lighting of parts of the work on the analogy of those neon advertisements which bring about the illusion of movement by lighting up the letters of a legend or the parts of a design in serial order. Techniques of this kind are commonly classified under the heading LUMIA.

4. The simplest type of construct involving real movement is the unpowered mobile, which was introduced by Alexander CALDER in the early 1930s (although experiments with unpowered moving constructs had been made in Russia by RODCHENKO in 1920). The principle of the unpowered mobile is a built-in tendency to casual movement dependent on the structure, for example a plaque or ball supported on a thin, wire-like rod, and such constructs became so popular that by the 1960s 'mobiles' were sold in novelty shops as gadgets for interior decoration. They are discussed more fully under MOBILE.

5. Three-dimensional constructs with mechanically moving parts as a feature of major importance constitute the bulk of what is usually meant by 'Kinetic Art'. These are of very great diversity and have been subject to continual experiment and change since the mid century. The only feature they all have in common is that they are made to serve no practical purpose.

There were surprisingly few anticipations of the incorporation of real movement in painting or sculpture until after the 1930s. For all their emphasis upon dynamic movement the FUTURISTS made few if any experiments with actual movement apart from the cinema. In their manifesto *Futurist Reconstruction of the Universe* (1915) BALLA and DEPERO spoke of plastic constructions 'which rotate, decompose, transform, appear and disappear'. But they did not carry these suggestions further than movable figures for their 'mechanical theatre'. ARCHIPENKO's *Medrano 1* and *Medrano 11* (1914) were constructs made of wood, glass, wire and metal with some movable parts. But neither these nor the 'detachable' sculptures of LAURENS, made about the same time, incorporated real movement as an aesthetic element. It was not until 1922 that Archipenko invented his *Archipentura*, an electrically driven machine for creating the illusion of pictorial movement on the magic lantern principle. Probably the earliest work incorporating real movement was DUCHAMP's *33 West 67th Street*, a bicycle wheel mounted on a stool; but this, significantly, was one of his READY-

MADES intended to illustrate the principle of ANTI-ART. In the early 1920s Duchamp also made *Roto-reliefs* and *Rotative Demi-Spheres*, which when made to revolve created the illusion of *volume* (rising and falling spirals, etc.). Similarly Robert DELAUNAY's revolving colour discs had other purposes than to employ movement aesthetically. Another instance where movement was not intended to be seen as movement but was used to create an illusion of volume was Gabo's *Kinetic Construction No. 1* of 1920, a thin strip of steel which when made to vibrate produced an appearance of volume as it was forced out of the vertical. Gabo also produced a drawing for a kinetic construction involving real movement in 1922 and a design for a fountain to be moved by water-power in 1929. In 1920 TATLIN designed a revolving movement in his project for a *Monument to the Third International*, but this was not realized and was perhaps incapable of realization. MOHOLY-NAGY's *Lichtrequisit* of the 1920s was an elaborate electrical machine using movement primarily for the production of light effects. This, apart from the powered and unpowered mobiles introduced by Calder in the 1930s and preceded by Rodchenko's hanging *Constructions* of the early 1920s, is the sum of what was done before the 1940s.

From the 1920s there was discontent in some quarters with the progress made in the representation of movement in painting and sculpture. Gabo, for instance, said in his *Realistic Manifesto*: 'Futurism has not gone further than the effort to fix on canvas a purely optical reflex . . . It is obvious now to every one of us that by the simple graphic registration of a row of momentarily arrested movements one cannot recreate movement itself.' There were vague projects for the harnessing of real movement but experiment with movement for movement's sake as an aesthetic and expressive element did not begin seriously until after the 1940s. The artists who were in the van belong by and large to two groups, those who came to Kinetic Art by way of DADA and SURREALISM, and those who developed it from the standpoint of CONSTRUCTIVISM.

The Italian MUNARI, who from 1933 worked on mobiles which he called 'useless machines' (*macchine inutili*), wrote a manifesto of '*macchinismo*' in 1938. In the 1940s he constructed a number of kinetic objects such as *L'Ora X*, in which hands were driven by clockwork round a timeless clock face. He also experimented with kinetic constructs producing unstable images on screens in the manner of non-objective cinema. About 1959, after prolonged experimentation with his *plans mobiles* (mobile planes) and *multiplans* (multiplanes), the French artist Pol BURY began to make more complicated three-dimensional structures in which movement was designed for expressive purposes. In the 1950s the Swiss Jean TINGUELY made reliefs composed of layers of movable rods and during the 1960s more complicated kinetic constructs some of which were intended to be ironic

satires on the machine. The Greek sculptor TAKIS made mobiles which he called *Signals* during the 1950s and from 1959 experimented with the use of magnetic force in kinetic objects. The New Zealander Len Lye, a pioneer in cinematograph animation, afterwards made 'animated steel' sculptures intended to display fundamental patterns of movement, often combining movement with noise and light effects.

Some indication of the rapid expansion of Kinetic Art and the interest in it may be gathered from the main exhibitions which during this time were devoted to it, sometimes in conjunction with Op art. In 1955 the Gal. Denise René, Paris, one of the most important commercial galleries for the exhibition of experimental art, staged an exhibition 'Mouvement' in which eight artists were represented: Calder, Agam, Bury, Duchamp, Robert JACOBSEN, Soto, Tinguely and Vasarely. A second exhibition 'Mouvement Deux' was held in 1964. In 1955 the Mus. Cantonal des Beaux-Arts, Lausanne, led the way among public galleries with an exhibition entitled 'Le Mouvement dans l'Art Contemporain', which showed the progress in representing virtual movement from the Futurists to the abstract artists. By 1971 there were 75 artists represented at an international exhibition 'Movement in Art' shown at the Stedelijk Mus., Amsterdam, the Moderna Mus., Stockholm, and the Louisiana Mus., Copenhagen. The catalogue contained a lexicon of kinetic artists and a historical survey by K. G. Hultén. In 1962 an exhibition organized by Bruno Munari and circulated to Milan, Rome and Venice included a section devoted to 'Arte Cinetica' together with 'Arte Programmata', etc. In 1965 an exhibition 'The Responsive Eye' at The Mus. of Modern Art, New York, leaned towards Op art. But three-dimensional real movement was well represented (84 exhibits) in an exhibition 'Kinetic and Optic Art Today' at the Albright-Knox Art Gal., Buffalo. Other exhibitions in the same year were 'Kinetische Kunst' at the Gemeentemus., The Hague, and at Eindhoven; 'Licht und Bewegung' at the Kunsthalle, Berne; 'Kinetic und Objekte' at the Staatsgal., Stuttgart; 'Art et Mouvement: Art Optique et Cinétique' at the Tel Aviv Mus.; and 'Art and Movement' at the Royal Scottish Academy, Edinburgh. In 1966 the Arts Council of Great Britain organized an exhibition 'In Motion' and the University Art Gal., Berkeley, an exhibition of Kinetic Sculpture with biographies, chronology and bibliography, while an exhibition 'Licht und Bewegung—Kinetische Kunst' at the Kunsthalle, Düsseldorf, was also accompanied by biographical notes and a chronology of Kinetic Art. Since then exhibitions both large and small have multiplied.

By the end of the 1960s a very large number of artists indeed were making three-dimensional constructs exploiting real movement for a diversity of aesthetic purposes. The variety of objects being produced and the diversity of techniques and materials had expanded almost beyond the possi-

bility of classification and was continuously being added to. Kinetic sculpture was combined with auditory and light effects, computers were being pressed into service and the *Leonardo* anthology even had articles on 'The Chromatic Abstracto-scope: An Application of Polarized Light' and 'On Producing Illusions by Photic-stimulation of Alpha Brain Waves with Flashing Lights'. Almost every conceivable type of motive power was being exploited for moving constructs – the muscular exertion of the spectator, clockwork, springs, water-power, motors, electricity, magnetism, etc. In some cases the movement was so slow as to be scarcely discernible and in other cases it might be too fast for the eye to follow. Sometimes movement was regular, sometimes purely haphazard and sometimes a fortuitous factor was built into a systematic movement process.

In the 1970s almost all the work was experimental and no clear aesthetic aim had emerged, although it was widely accepted that Kinetic Art had established itself as a new art form and that a new aesthetics of movement must come. Since the 1920s there had been vague and quasi-metaphysical talk about movement involving the introduction of a 'fourth dimension', the dimension of time, into plastic art. Such talk, of course, mystificatory as it is, does not go beyond the banal truism that real movement is, necessarily, movement in time and it has not proved useful towards the definition of a new aesthetics. Yet a better understanding of the aesthetics of movement was generally felt to be necessary as a basis for discriminating between what had genuine artistic value and the vast mass of what could only be regarded as artistic lumber whatever the ingenuity involved.

Among the many there were some artists engaged in exploring the aesthetic qualities of movement itself—movement may be graceful, smooth, rhythmical, clumsy, jerky, repetitive, monotonous, and so on—as a basis for a new art of movement. Some were interested in the movements of living creatures, some in the movements of machines, some in natural movements such as those of the stars, the sea, wind, etc. Some artists attempted, as a basis for an aesthetics of movement, to fixate these qualities and types of movement, to reproduce and combine or suggest them, without naturalistic reproduction of the moving object. In *Les Catégories Esthétiques* of 1956 the veteran French aesthetician Étienne Souriau distinguished a class of 'agogic' aesthetic categories concerned with *tempo* and differentiated two types of response: those concerned with appeasement and calm on the one hand and on the other those connected with excitement and incitation. From a survey of the work being done one might add the contrasting responses of hypnotic acceptance of a regularly repeated stimulus on the one hand (exploited among others by MORELLET of the *Groupe de Recherche d'Art Visuel* and by several artists of the NOUVELLE TENDANCE) and on the other hand sur-prise and shock in face of the unexpected. 'Perhaps too one might add the 'ludic' reaction of amusement to suggested rhythms of childhood play or adult sport. But in the 1970s understanding of the new aesthetic principles involved was still in its infancy.

KING, PHILLIP (1934–). British sculptor, born in Tunis. After reading languages at Cambridge University he studied at the St. Martin's School of Art, 1957–8, and was assistant to Henry MOORE, 1958–60. He was a Trustee of the Tate Gal. and he taught at the St. Martin's School of Art. A pupil of Anthony CARO, King was prominent among the British *avant-garde* sculptors who came to artistic maturity in the mid 1960s. He worked for preference in man-made materials such as brightly coloured fibreglass but also used painted steel and mesh as in *Open (Red-Blue) Bound*, shown in 'The Condition of Sculpture' exhibition at the Hayward Gal., London, in 1975. King aimed at the ambiguous and enigmatic in his constructions, juggling with the sense of balance and proportion. Alan Bowness wrote of his works exhibited at the Venice Biennale of 1968: 'The enigmatic character of King's work springs from a built-in, subliminal effect of paradox. Each sculpture is so very much more remarkable than its bare factual existence as a physical object in space ... each sculpture will shift suddenly into a different identity whilst its structure is examined.' He exhibited at the Rowan Gal., London, and at the Whitechapel Art Gal. (1968). An exhibition of his work made a tour of European museums in 1974–5. Among the group exhibitions in which he was represented are: Fifth Guggenheim International Exhibition, New York (1967); Venice Biennale (1968); 'International Sculptors Symposium for Expo '70', Osaka, Japan (1972); 'British Sculpture of the Sixties', I.C.A. Gals., London (1972); 'Henry Moore to Gilbert and George—Modern British Art from the Tate Gallery', Palais des Beaux-Arts, Brussels (1973); 'The Condition of Sculpture', Hayward Gal., London (1975).

KING, WILLIAM DICKEY (1925–). American sculptor, born at Jacksonville, Fla. He studied at the University of Florida, the Cooper Union, Brooklyn Mus. School, and the Central School of Arts and Crafts, London. From 1953 to 1960 he taught at Brooklyn Mus. School. He won the Cooper Union Sculpture Prize in 1948 and a Fulbright Fellowship in 1949. From the mid 1950s his work was widely exhibited in both individual and collective shows. It was related to POP ART principles and consisted of groups and ASSEMBLAGES of figures, often displaying an element of caricature, in vinyl and similar materials.

KINLEY, PETER (1926–). British painter, who studied at St. Martin's School of Art, London, and taught there 1955–64, then at the Wimbledon School of Art, 1964–70, and at the Bath Academy

of Art, Corsham, from 1971. He participated in group exhibitions in England, America and many European countries, including: Pittsburgh International Exhibition, 1961; the Contemporary Arts Society exhibition 'British Painting in the Sixties'; San Francisco Mus. of Art exhibition 'British Art Today'; the Tokyo International Biennale 'New Image in Painting', 1974; and 'British Painting '74' at the Hayward Gal., London. He was a prize winner at the John Moores Seventh Biennial of Modern Art, Liverpool, in 1969 and he had one-man shows from 1954 at Arthur Tooth & Sons and Gimpel Fils, London, at Paul Rosenberg & Co., New York and at the Bluecoat Society of Arts, Liverpool, in 1970. He has works in the Tate Gal. and the Arts Council coll., Great Britain, the Albright-Knox Art Gal., Buffalo, the Gal. of New South Wales, Sydney, Australia, and São Paulo, Brazil. His paintings were composed from stylized abstract shapes suggestive of a child's drawing of a human figure, a dog, a motor car, etc. against highly coloured monochromatic and uninflected backgrounds.

KIRCHNER, ERNST LUDWIG (1880–1938). German EXPRESSIONIST painter and the dominant figure in the BRÜCKE group, which he founded with Erich HECKEL, Fritz Bleyl and Karl SCHMIDT-ROTTLUFF in 1905. From 1901 to 1905 he studied architecture at the Technische Hochschule, Dresden, with an interlude in 1903–4 when he studied painting at Munich. In his early woodcuts a reflection of the mannered linearism of the *Jugendstil*, the German version of ART NOUVEAU, was soon displaced by the harsh contrast of planes and the abrupt angularity which he derived from his admiration for late Gothic German woodcuts and which became characteristic of the style of the *Brücke*.

He was the first of the group to discover an enthusiasm for Polynesian and other primitive art, which he admired in the ethnographical department of the Zwingler Mus. at Dresden, but this had less apparent effect on his own painting or sculpture than on the work of other members of the *Brücke*. In painting he was first influenced by the Post-Impressionists, whom he saw exhibited at Munich, and particularly by Gauguin and Van Gogh. But under the influence chiefly of MUNCH he developed a style similar to that of the FAUVES with simplified drawing and boldly contrasting colours. By 1907–10 he had matured a manner of painting superficially similar to that achieved by MATISSE and his colleagues in 1905. But he was more impetuous and direct in his approach to his subjects, less concerned with pictorial values, than the Fauves. He was more committed to theme than they and attempted to express in paint the emotional atmosphere distilled by the life of the circus and the music-hall, the gaiety and the sadness with its overtones of sexuality in the human detritus of the urban scene. As he himself later put it, it was his concern to distil directly from nature what he referred to as primordial signs and hieroglyphs and to use these harshly simplified and often distorted forms to express contemporary states of mind.

In 1911 he went to Berlin and during 1912 and 1913 created the series of street scenes which are regarded as the most extreme and most mature manifestation of German Expressionism. In a style which had become more frenzied, with more ruthless fragmentation of the object, he gave visible expression to the pace, the morbidity, the glare and the exhibitionist eroticism of megapolitan man as represented by the Kurfürstendamm in the years immediately preceding the First World War. These were years of mental crisis for him and in 1914, soon after his mobilization, he suffered a severe physical and nervous breakdown. After some while in a sanatorium at Taunus he was sent in 1917 to Davos, Switzerland, where he continued to live until he committed suicide in 1938 as a result of mental disturbance caused by political events in Germany and the condemnation of his own art. During the period of his earlier mental breakdown, in 1916, he did illustrations to Chamisso's *Peter Schlemihl* which, with the illustrations done in 1924 to Georg Heym's *Umbra vitae*, are regarded as outstanding masterpieces of Expressionist graphic art.

Living in solitude among the Swiss mountains near Davos, Kirchner began to paint again. From 1921 to 1925 he did monumental mountain landscapes and scenes from the life of mountain peasants. 'It has always been my aim', he wrote, 'to express emotion and experience in large simple forms and clear colours, and that is still my goal. I want to express the richness and joy of life, to paint men in their work and play, their reactions and counter-reactions, to express both love and hate.' In the new environment the tortured quality of his earlier work gained in a new serenity what it lost in vigour. From 1928 his style underwent another change. It became more abstract as he painted less directly from nature, using his 'hieroglyphic' forms as a kind of picture-writing in which direct representation played a smaller part. 'The hieroglyph,' he said, 'this non-naturalistic formation of the inner image of the visible world, broadens and takes shape according to optical laws that had not hitherto been used in this way in art—the laws, for example, of reflection, interference, polarisation, etc.' It was a conception which had something in common with the doctrine expressed by KANDINSKY in 1912. But there seems little doubt, although he himself would not admit it, that Kirchner's new manner was influenced by experimental ideas of PICASSO in the working out of a sort of abstract pictorial script for the visual expression of experience.

A comprehensive Centenary retrospective exhibition was circulated to Berlin, Munich, Frankfurt, Zürich, Basle, etc. in 1979–80. An exhibition of water-colours, drawings and graphics, also in commemoration of his centenary, was staged by

the Städelsches Kunstinstitut, Frankfurt-on-Main, in 1980.

KISLING, MOÏSE (1891–1953). Polish-French painter and draughtsman, born at Kraków. He studied at the Academy of Art in Kraków under Josef Pankiewicz, by whom he was introduced to the Impressionists, particularly BONNARD and VUILLARD. In 1910 he established himself in Montparnasse, where he became a well-known figure and a friend particularly of MODIGLIANI and CHAGALL. In 1911–12 he was one of the group of artists at Céret which included PICASSO, BRAQUE, Juan GRIS and the poet Max Jacob. At this time he underwent some influence from CUBISM and particularly from DERAIN. During the war he volunteered for the Foreign Legion and thus obtained French citizenship. He was wounded in 1914 and invalided out. After the war he consolidated the various influences into a personal style which was no longer derivative and he became known to a wider public through an exhibition in 1919 at the Gal. Druet. His mature style was marked by polished and elegant draughtsmanship and delicately modulated colours, and he achieved considerable success as a portraitist. He passed the Second World War in the U.S.A. and in 1945 had an exhibition of recent works at the Gal. Guénégaud. He returned to Paris in 1946.

KITAJ, R. B. (1932–). American painter born in Cleveland, Ohio, studied at the Cooper Union, New York, 1950, and at the Akademie der Bildenden Künste, Vienna, 1951. After working as a seaman, 1952–3, and serving in the American army in Germany, 1955–7, he went to England with a G.I. scholarship, 1958–61, and studied at the Ruskin School of Drawing and Fine Arts, Oxford, and at the Royal College of Art. From 1961 to 1967 he taught at the Ealing School of Art, the Camberwell School of Art and the Slade School. In 1967 he was guest teacher at the University of California in Berkeley. He showed in the 'Young Contemporaries' exhibitions at the R.B.A. Gals., London, from 1960 and had his first one-man show at the Marlborough Gal. in 1963. He had retrospectives at the Los Angeles County Mus. of Art in 1965 and at the Kestner-Gesellschaft, Hanover, and the Boymans-van Beuningen Mus., Rotterdam, in 1970. Although American born, he was regarded as a leader among British POP artists and he was represented in the exhibition 'Pop Art in England' shown at Hamburg, Munich and York in 1976. In 1976 also he was purchased for the Arts Council pictures exhibited at the Hayward Gal. under the title 'The Human Clay'.

Kitaj was a contemporary of David HOCKNEY and Allen JONES at the Royal College, influencing them and being influenced by them. He admired PAOLOZZI and was a friend of Richard HAMILTON. He described his own work as a 'clear continuation' of ABSTRACT EXPRESSIONISM. Unlike the majority of Pop artists who drew their inspiration from the popular culture of the mass media, Kitaj had little interest in this but found significance in the figurative art of HOPPER, Ben SHAHN, Francis BACON and the historical sources of the 20th c., declaring that he was *not* a Pop artist. Kitaj was essentially an intellectual artist and evolved a multi-evocative pictorial language. His pictures were composite of elements derived from a wide range of sources and no one picture contained a clear and specific message. In the catalogue to the 'Pop Art in England' exhibition it was said: 'The ambiguity is intentional, but also intentional is the conveyance of the fact that all assertions are conditional and complex, i.e. can only be decoded if the receiver is in possession of sufficient previous information and of sufficient knowledge of the context referred to to be able to understand the coded information.' An exhibition at the Marlborough Gal., London and Zürich, in 1977 obtained a *succès de scandale* owing to the inclusion of obscene drawings among the exhibits. His painting *The Orientalists* was described by a reviewer in the *Burlington Magazine* as 'among the most beautiful pictures painted anywhere since the war'.

KITCHEN SINK SCHOOL. A group of British SOCIAL REALIST painters who were active in the years immediately following the Second World War and in the early 1950s. Prominent among them were John BRATBY, Jack SMITH, Edward MIDDLEDITCH and Derrick GREAVES. By their choice of drab and sordid themes and their violently aggressive technique they expressed the postwar mood of the 'angry young men'. The mood did not last and the group, never tightly organized, ceased to cohere after a few years.

KITSCH. An adjective originally current in southern Germany and applied particularly to Neo-Gothic or Neo-Classical architecture with the implication 'false' or 'unauthentic'. In this signification it has been likened to the French adjective *toc*. The word later achieved an international vogue with the sense 'in bad taste' and in this sense came to be applied to a great variety of art objects in many different styles. This usage was discussed and analysed by G. Dorflès in his books *Le oscillazioni del gusto* (1958) and *Kitsch, una antologia del cativo gusto*. Attempts to equate Kitsch with certain aspects of Mannerism and to elevate it into an independent artistic style have not been successful. At the other extreme Kitsch was associated with a tendency, reminiscent of DADA, to take pleasure in bad taste as such and in revolt from traditional standards to exalt whatever was formerly condemned for tastelessness. This tendency is apparent in such works as *Les chefs-d'œuvre du Kitsch* (1972) by J. Sternberg and *Psychologie du Kitsch, l'art du bonheur* (1971) by A. Moles. Kitsch has nothing in common with NAÏVE ART, for the latter stands outside the aesthetic

tradition whereas in all its various interpretations Kitsch implies the exaltation of something which is, or has been, disapproved of within traditional standards of good taste.

KIYOOKA, ROY. See CANADA.

KLAPHECK, KONRAD (1935–). German painter, born at Düsseldorf and studied at the Academy of Art there from 1954 to 1958, spending 5 months in Paris in 1956–7. From 1959 he had one-man exhibitions in many towns of Germany and at the Robert Fraser Gal., London (1964), the Palais des Beaux-Arts, Brussels (1965), the Sidney Janis Gal., New York (1969). He took part in a number of international and collective exhibitions, including DOCUMENTA III, Kassel (1964), 'Salon de la Jeune Peinture' and '11th Exposition Internationale du Surréalisme', Paris (1965), Documenta IV (1968). In reaction from ART INFORMEL and expressive abstraction he painted prosaically realistic representations of utility objects such as typewriters, sewing machines, telephones, water taps, shoe trees, bicycle bells, often using advertisements as his copy and declaring that each of these objects lent a specific character to the pictures made from it. He was a leader of the campaign to produce an art of 'prosaic super-objectivity'.

KLEE, PAUL (1879–1940). Swiss painter, born at Münchenbuchsee, near Berne. He trained at the Academy of Fine Art, Munich, 1898–1901, and after travelling in Italy, 1901–2, and visiting Paris in 1905 with Louis MOILLIET he settled in Munich in 1906, marrying the pianist Lily Stumpf. At this time he was painting on glass and was exhibiting in Munich and Berlin. By 1910 he was sufficiently well known to have an exhibition of 56 works at the museum of Berne, followed by exhibitions at Zürich, Basle and Winterthur. From 1911 he made contact with the BLAUE REITER group at Munich and in the following year took part in the second *Blaue Reiter* exhibition. In 1914 he travelled with Louis Moilliet and August MACKE to Tunisia, a journey which awakened him to a new sense of colour and was the source of some of his most characteristic abstractions. During the war he served in the German army, being engaged for part of the time on painting aeroplane wings. After the war he entered into an agreement with the Munich dealer Goltz, who in 1919 staged an exhibition listing 362 works which made Klee internationally famous. Invited by GROPIUS to teach painting at the BAUHAUS, he moved to Weimar in 1921 and followed the Bauhaus to Dessau in 1926. In 1924 he had his first American exhibition in New York and in 1925 he took part in the great Paris SURREALIST exhibition. In 1929, to celebrate his 50th birthday, the Flechtheim Gal. in Berlin staged a large exhibition, which was shown the following year by The Mus. of Modern Art, New York. His first exhibition in England

was at the Mayor Gal., in 1934. In 1931 he left the Bauhaus to take up an appointment at the Düsseldorf Academy but he was forced to abandon this in 1933 by the Nazi administration and left Germany for Berne. His works were included in the notorious exhibition of DEGENERATE ART in the Hofgarten, Munich, in 1937.

Although Klee was not politically inclined, there is no doubt that during his last years in Berne his mood was one of profound disappointment, perhaps bordering on acute depression. In 1935 he suffered the first symptoms of the illness which caused his death in 1940. Although he remained actively productive until the end, the predominance of a darker scale of colour in the paintings of the last seven years, their preoccupation with malign and malevolent forces and themes of corruption, the appearance of a bitterer form of satire instead of his earlier playfulness, and such pictures as the now famous self-portrait *Von der Liste grestrichen* (1933) and the ultimate *Tod und Feuer* and *Stilleben* of 1940 all attest to the mental stress under which he lived during these years. Yet his technical and formal mastery remained unaffected and some critics have thought that the work of these last years was among the finest of his whole career. In the catalogue to an exhibition 'Paul Klee. The Last Years' consisting of paintings from the collection of his son, Felix Klee, arranged by the Arts Council of Great Britain at the Scottish National Gal. of Modern Art and the Hayward Gal. in 1974 and 1975, Douglas Hall wrote: 'The late work of Paul Klee, besides its enormous psychic interest, was of high importance for the future development of modern art. His disjunctive method of composition, his abnegation of the necessity to focus on a point or an episode of a painting, represent one of the very few new inventions in painting since cubism.'

Klee was one of the most inventive and prolific of the modern masters. His complete output has been estimated at some 8,000 works. He worked in a dozen different styles, each of which he made uniquely his own so that a work from his brush is unmistakable in any style. He combined unrivalled imaginative gifts with supreme technical and formal proficiency. Both by his teaching and by his example he had an influence on the innovative art of this century that has been surpassed by no other artist. His works are contained in the most important public collections throughout the world, the largest single group being at the Paul Klee Stiftung in the Kunstmus., Berne.

An exhibition 'Paul Klee. Das Frühwerk, 1883–1922', staged by the Stadt. Gal. im Lenbachhaus, Munich, in 1979–80 to celebrate the 100th anniversary of Klee's birth, was said to reveal the origins of much of his later iconography. The exhibition was astonishing in its revelation of how little in the earlier work predicted the imaginative mastery that was to come and the crucial influence which the journey to Tunisia exercised upon the artist's later development.

Of Klee's own writings the most important are: *On Modern Art* (1948), English translation of a lecture delivered in 1924 at Jena and published in 1945; and *Pedagogical Sketchbook* (1953), English translation of *Pädagogisches Skizzenbuch* published in 1925 as the second of the Bauhaus Books.

KLEIN, CÉSAR (1876–1954). German painter and theatrical designer born at Hamburg, trained at Hamburg, Düsseldorf and Berlin and in 1918 became Director of the Werkbund. In the same year he founded the NOVEMBERGRUPPE together with Max PECHSTEIN. From 1919 to 1933 he taught at the Mus. of Arts and Crafts, Berlin. He was one of the early EXPRESSIONIST and decorative artists, then after passing through phases of CUBISM and SURREALISM, he practised geometrical abstraction.

KLEIN, WILLIAM (1928–). American painter, photographer and film director, born in New York but lived in Paris from 1948. He worked with Fernand LÉGER and did a number of murals for French and Italian architects. He was best known for his work in photography and the cinema. He obtained the Prix Nadar for his album of photographs of New York in 1957 and at the Photokina Exhibition of 1963 he was voted one of the 30 most important artists in the history of photography. His film *Qui êtes-vous, Polly Magoo?* was awarded the Prix Jean Vigo in 1967. He had a retrospective exhibition at the Stedelijk Mus., Amsterdam, in 1967.

KLEIN, YVES (1928–62). French artist, born at Nice. Among other things he was a jazz musician and in 1952–3 he lived in Japan, where he obtained the Black Belt for judo and wrote a standard text-book on the subject. He was one of the leaders of the European NEO-DADA movement, being a founder with the critic Pierre Restany of the movement NOUVEAUX RÉALISTES. In 1946 Klein began working on his 'monochromes', non-objective paintings in which a canvas was uniformly painted a single colour. According to his catalogue statements these were first exhibited privately in London in 1950. They were exhibited at Paris first in 1956 at the Gal. Colette Allendy, having been refused by the SALON DES RÉALITÉS NOUVELLES in 1955. About this time Klein began his 'Blue period' using a distinctive blue, which he called 'International Klein Blue', for monochrome paintings, sculptured figures, reliefs of sponges on canvas, etc. In a lecture given at the Sorbonne in 1959, an extract from which was reprinted in the catalogue of the retrospective exhibition given by Gimpel Fils in 1973, Klein explained his theory of monochrome painting as an attempt to depersonalize colour by ridding it of subjective emotion and so to give it a metaphysical quality. ('And without doubt it is through colour that I have little by little become acquainted with the immaterial.') His preference for blue was explained as follows: 'Blue has no dimensions, it is beyond dimensions, where-

as other colours are not. They are pre-psychological expanses, red, for example, presupposing a site radiating heat. All colours arouse specific associative ideas, psychologically material or tangible, while blue suggests at most the sea and sky, and they, after all, are in actual, visible nature what is most abstract.' In 1947 Klein composed his *Symphonie monotone*, a single note sustained for ten minutes and alternating with ten minutes' silence. He also made pictures by a variety of unorthodox methods, including the action of rain on a prepared paper (these he called *Cosmogonies*), the use of a flame-thrower (*Peintures de Feu*) or imprints of the human body (*Anthropométries*). In 1958 he created a sensation in Paris by an 'exhibition of emptiness'—an empty gallery painted white. In 1960 he gave his first public exhibition of the *Anthropométries*: girls smeared with blue pigment were dragged over canvas laid on the floor to the accompaniment of his *Symphonie monotone*.

From the time of his death his work has been widely exhibited in leading galleries throughout the world and it came to be considered a significant harbinger of things to come by important sections of the post-1945 *avant-garde*. Its nature was well summed up by Edward Lucie-Smith, who wrote in his *Movements in Art since 1945* (1969): 'The major personality among these European neo-dadaists was undoubtedly the late Yves Klein. Klein is an example of an artist who was important for what he did—the symbolic value of his actions—rather than for what he made. One sees in him an example of the increasing tendency for the personality of the artist to be his one true and complete creation.' In an article 'Defining Art', printed in the *New Yorker*, 25 February 1967, the critic Harold Rosenberg said of him: 'A highly decorative showman, he used art, art ideas, and vanguard-audience attitudes to build a career in painting and sculpture as spectacular as one in Hollywood or the Via Veneto . . . Klein's talent lay neither in his works nor in the originality of his ideas but in his way of staging them and himself.'

KLIMT, GUSTAV (1862–1918). Austrian painter and graphic artist born in Vienna and studied at the Vienna School of Arts and Crafts, where he came under the influence of the historical painter Hans Makart (1840–84), who combined superb decorative and technical skill with poverty of ideas. From 1883 he worked with his brother Ernst and Franz Matsch in an artist-decorators business, executing among other commissions decorations for the Burgtheater (1888) and the Mus. of the History of Art (1891). The business broke up with the death of Ernst in 1892 and Klimt ceased painting for some years until in 1897 he was one of the founders of the Vienna SECESSION, of which he became the first President. From this time he began to mature a style of his own, based very largely upon ART NOUVEAU. His work in this mode was not understood and his murals for Vienna University (1900–3) caused violent contro-

versy and were rejected. His Beethoven frieze for the Klinger exhibition of 1902 was also rejected. None the less he exhibited 80 works in the Secession in 1903 and had a full-scale retrospective in the 18th Secession Exhibition of 1904. He was becoming more and more isolated, however, and tension between his supporters and those of Josef Engelhart caused a split in the Secession in 1905. It was between 1905 and 1909 that he designed murals, executed 1909–11, for the Palais Stoclet in Brussels, which had been designed by the architect Josef Hoffmann, also an original member of the Secession.

Klimt's work now seems dated and his importance is sometimes thought to lie in the influence he had upon younger Austrian artists such as KOKOSCHKA and SCHIELE. But his ornamental figure paintings with their shallow picture space, the mosaic-like landscapes which he did after 1903 and above all his superb drawings and graphic work have a permanent value in the history of decorative art.

KLINE, FRANZ (1910–62). American painter, born at Wilkes-Barre, Pa. After attending Boston University, 1931–5, he studied at Heatherley School of Art, London, 1937–8, returning to America in 1939. At this time his work was traditional in style and through the 1940s he painted urban landscapes which revealed a fine sensibility for the monumentality of the silhouettes and structures of Manhattan. From c. 1950 he developed an extremely original style of expressive abstraction, converting the brush strokes of these drawings into independent ideograms and using bold black patterns on a white ground reminiscent of Oriental calligraphy although different in origin. Towards the end of his life he sometimes incorporated vivid colours but for the most part remained constant in the black–white style perfected in the 1950s. It was a feature of this style that unlike calligraphy the black forms were not seen as patterns on an amorphous ground but the white areas had the force of independent images. To add to this effect they were sometimes smudged with black and the black patterns were sometimes modulated by traces of white paint.

Kline had his first one-man show at the Charles Egan Gal., New York, in 1950 and made a strong impression particularly with his painting *Chief* (The Mus. of Modern Art, New York), followed in 1951 by *Ninth Street*. During the 1950s he taught at Black Mountain College, the Pratt Institute and Philadelphia Mus. School. He had retrospective exhibitions at the Washington Gal. of Modern Art, 1962, the Whitechapel Art Gal., London, and the Mus. d'Art Moderne de la Ville de Paris, 1964, and the Whitney Mus. of American Art, 1968.

KLINGER, MAX (1857–1920). German painter, sculptor and graphic artist, born at Leipzig. He studied at Karlsruhe and Berlin, then spent the years 1883–6 in Paris, 1886–8 in Berlin and 1888–93 in Rome. On his return to Germany he settled in Leipzig, 1893. His style displayed ART NOUVEAU features upon a basis of conventional classicism and he is usually ranked among the German *Jugendstil* artists. He is known for his very large painting *The Judgement of Paris* and for his monumental sculpture *Beethoven* (Mus. der Bildenden Künste, Leipzig, 1899–1902) in white and coloured marbles, bronze, alabaster and ivory. The latter was exhibited as the centre piece of the 14th exhibition of the Vienna SECESSION and afterwards at Düsseldorf and Berlin. There is also at the Leipzig Mus. his half-length sculpture *Salome*, also in coloured marbles. Klinger was perhaps best known for his etchings, which reveal a world of fantasy akin to that of Boecklin (1827–1901), forerunners of the fantasy element in SURREALISM. Best known among these are his 'illustrations' to Brahms's *Fantasias*.

KLIPPEL, ROBERT (1920–). Australian sculptor born in Sydney. During the Second World War he made model aeroplanes and ships and served in the Royal Australian Navy. After the war he studied sculpture—chiefly wood carving—under Lyndon Dadswell at East Sydney Technical College. In 1947 he went to London and studied for a short period at the Slade, residing at the Abbey, New Barnet, where studios for artists were established by the sculptor and art dealer, William Ohley. Here other Australian artists, including James Gleeson (with whom he exhibited at the London Gal. in 1948), Noel COUNIHAN, Leonard FRENCH and Graham King, resided in the later 1940s. In 1949 Klippel held his first one-man show at the Gal. Nina Dausset, Paris. He met RIOPELLE and developed an interest in ABSTRACT EXPRESSIONISM, which he discussed with Australian artists on his return to Sydney in 1951, being one of the first to do so. He became associated with the Society of Sculptors and Associates established in Sydney by Anita Aarons (1951) and began to study metal sculpture. Klippel exhibited with Ralph Balson at the Macquarie Gals., Sydney, in 1952, and with Direction One in 1956. In 1957 he visited New York and became an instructor in sculpture at the Minneapolis School of Arts, 1958–62. There he turned increasingly to metal welding, developing finely-wrought, tensile structures of great elegance from steel-plate, copper and odd pieces of industrial junk. His sculpture was well received on his return to Sydney in 1963. He held exhibitions at the Terry Clune Gal., Sydney, in 1962 and the Australian Gals., Melbourne, in 1963, where he first showed JUNK sculpture. These 1963 exhibits made extensive use of small precision-made elements such as pieces from typewriters and adding machines. Unlike many sculptors working with junk metal, Klippel did not seek to create a metamorphic imagery. He sought rather to create purely abstract constructions in metallic forms that were self-sufficient, lyrical and elegant.

KLIUN (or **KLIUNKOV**), IVAN VASILIEVICH (1870–1942). Russian painter, born at Kiev, studied in Kiev, Moscow and Warsaw. In 1910 he made contact with the UNION OF YOUTH and befriended MALEVICH, MATIUSHIN and others and in 1915 he supported SUPREMATISM. In 1916 he joined the KNAVE OF DIAMONDS group, and from 1915 to 1917 contributed to many *avant-garde* exhibitions, including Tramway V, 0.10., The Shop, Knave of Diamonds. He was professor at Svomas/VKHU-TEMAS, 1918–21 and in 1922 a member of INKHUK. In 1925 he was a member of the Moscow group Four Arts. Through the 1930s he continued to exhibit, although he painted in a figurative manner again.

KLUTH, KARL (1898–1972). German painter born at Halle on Saale, studied in Karlsruhe and in 1952 was made Professor at the Landeskunstschule, Hamburg. He painted in an EXPRESSIONIST style which betrayed the influence of KIRCHNER, giving in his works an impression of intense but undirected movement.

KNAJZOVIĆ, JANO (1925–). Yugoslav naïve painter, born in the Serbian village of Kovačica. Working as a peasant on the land, he began to paint in his spare time in 1946 and he is regarded as among the most talented painters of the Kovačica group (see NAÏVE ART). He painted village genre scenes with gaiety and a sense of humour. Without obsessive attention to detail his figures are clearly delineated and his pictures show a natural gift for decorative rhythm and composition. From 1952 he was exhibited widely in Yugoslavia and in other European countries, including London, Edinburgh, Paris, Moscow, Leningrad, Rotterdam, Vienna, Basle, Hamburg, Frankfurt, Kassel, Turin.

KNATHS, KARL (1891–1971). American painter born at Eau Claire, Wis., studied at the Chicago Art Institute School. He painted in a style of geometrical abstraction and was one of the original exhibitors with AMERICAN ABSTRACT ARTISTS. During the 1940s he knew MONDRIAN and was influenced by NEO-PLASTICISM. His works were widely exhibited in collective shows but his first one-man show was at the Phillips Gal., Washington, in 1957 and concurrently at the Daniels Gal., New York. In 1949 his work was shown in the exhibition 'Four American Expressionists' at the Whitney Mus. of American Art. In 1955 he was elected to the National Institute of Arts and Letters.

KNAVE OF DIAMONDS (BUBNOVYI VALET). An artists' association and exhibition group which was formed in Moscow in 1910 and for a short time became the most important of the *avant-garde* associations. Its first exhibition, in December 1910, brought together in co-operation with BURLIUK brothers with LARIONOV, GONCHAROVA

and MALEVICH. In addition the core of the first exhibition was formed by four young artists, Aristarkh LENTULOV, Pietr Konchalovsky (1876–1956), Robert FALK and Ilya Mashkov (1884–1944), who had been expelled from the Moscow Academy in 1909 for too extreme devotion to the works of Cézanne, Van Gogh and MATISSE. The French paintings included in the exhibition were chosen by the critic Alexander Mercereau and were restricted to the CUBISTS GLEIZES and LE FAUCONNIER and to Luc-Albert MOREAU: the German EXPRESSIONISTS of the BRÜCKE and the BLAUE REITER, together with the expatriate Russians KANDINSKY and JAWLENSKY, were heavily represented at the invitation of David Burliuk.

In 1911 Larionov, Goncharova and Malevich broke away from the Knave of Diamonds group, accusing it of being too dominated by the 'cheap Orientalism of the Paris School' and the 'Munich decadence', and founded their own association, the DONKEY'S TAIL, to promote an art based upon native Russian inspiration. In fact at this time both Kandinsky and Jawlensky were very much under the influence of Russian peasant art and icon painting, while the inspiration of the FAUVIST and FUTURIST schools remained strong in Russia. The Knave of Diamonds continued to function as an exhibition society until 1918.

KNEALE, BRYAN (1930–). British painter and sculptor, born in the Isle of Man. He studied painting at the Douglas School of Art in 1947 and then at the Royal Academy Schools, 1948–52. In 1948 he won the Rome Prize and spent much time in Italy, where he was influenced by the FUTURISTS and the METAPHYSICAL painters. Returning to London in 1951, he destroyed all the paintings done during his Italian period except two and began to paint with the palette knife in layers. His first exhibition of painting was at the Redfern Gal. in 1954. He stopped painting in 1959 and after learning to weld moved into a forge at Fulham in 1960. From that time he produced abstract sculpture mainly in forged iron and steel, although he also used other materials such as aluminium, perspex, brass, wood, sometimes in conjunction, emphasizing and contrasting the intrinsic qualities of each material. He won the First Prize at the *Daily Express* 'Young Artists' Exhibition' in 1954 and had a retrospective show at the Whitechapel Art Gal. in 1966. His works are in many public collections, including the Tate Gal., the Arts Council of Great Britain, the Contemporary Art Society, London, the National Gal. of South Australia, the National Gal. of Victoria, Melbourne, the Mus. de Arte Moderna, São Paulo, the Bahia Mus., Brazil, the National Gal. of New Zealand. He has also executed a number of public commissions.

KNIGHT, DAME LAURA (*née* JOHNSON, 1877–1970). British painter born at Long Eaton, Derbyshire, studied at Nottingham School of Art and married the painter Harold Knight. She was

elected A.R.A. in 1927, received an honorary degree of LL.D. from St. Andrew's University in 1931, and in 1936 was elected R.A. and asked to serve on the Council. Although she painted many other subjects, she was very widely known as a painter of circus life and ballet scenes. In 1931 the Cleveland Art Institute, Chicago, held an exhibition of her works which was also shown in Pittsburgh and at the Howard Young Gal., New York. In 1939 she had an important exhibition at the Leicester Gals. and was commissioned by the War Artists' Advisory Committee to paint portraits and by the Air Ministry to paint balloon fabric workers. After the war ended she was sent as an official artist to paint portraits at the War Criminals' Trials in Nuremberg. In 1965 she had a retrospective exhibition at the Diploma Gal. of the Royal Academy, the first woman to be so honoured. In 1969 a retrospective exhibition covering 75 years of her painting was put on by the Upper Grosvenor Gals. and in 1970 an exhibition was staged at Nottingham Castle Mus. as part of the Nottingham Festival.

In the Foreword to her book *Laura Knight* (1975) Janet Dunbar notes that Laura Knight 'was one of the most publicized artists of the first half of the century, reaching the height of her fame in the '20s, '30s and '40s. Her paintings hang in public galleries and in private collections all over the world, and many of them are familiar through reproductions. ... Yet today, in the '70s, she is not even a name in the main-line histories of twentieth-century painting.' In his Appendix to the book David Phillips, Director of the Castle Mus. and Art Gal., Nottingham, says: 'Dame Laura never abandoned her more down to earth subjects, and the later circus and gipsy paintings of her maturity depended on a straightforward reportage of the personalities and details of daily life. The aesthetic qualities of her more ambitious flights were frankly corny—a prodigious technical competence brandishing styles and effects, but without any real visual thinking running through them. She simply did not have the kind of imagination to concern herself with the exploration of the possibilities of expression through pure colour, or abstraction, or representative painting outside the conventions of perspective.'

KNIZAK, MILAN. See HAPPENING.

KOBRO, KATARZYNA (1898–1950). Polish sculptor, wife of Władysław STRZEMINSKI. She was trained in Moscow and was a member of the Russian *avant-garde*. In 1922 she acquired Polish citizenship on moving to Kiev and subsequently settled in Lwów. She was a founding member of the CONSTRUCTIVIST group BLOK in 1924 and continued actively to pioneer geometrical abstraction in Poland. She herself worked in a SUPREMATIST manner until the late 1920s, when she made brightly coloured spatial constructions of curved sheets of metal according to precise mathematical calculations. A retrospective exhibition of her works was given in Warsaw and Łódz in 1956–7.

KOBZDEJ, ALEXANDER (1920–). Polish painter and experimental artist born at Olesko and studied at the Polytechnic in Lwów and the Academy of Fine Arts, Kraków. He taught in the Warsaw Academy of Arts and was visiting Professor at the Hamburg College of Fine Arts, 1965–6. From c. 1955 he painted in a manner of expressive abstraction akin to the ART INFORMEL of the ÉCOLE DE PARIS, incorporating with this elements from Polish folk art and macabre fantasy. He often divided his pictures vertically into polyptychs. From the late 1960s he experimented with three-dimensional constructions, often painting these in striking colours and making them with movable parts. He obtained a prize at the São Paulo Bienale and in 1968 had a retrospective exhibition at the National Mus., Poznań.

KOENIG, FRITZ (1924–). German sculptor born in Würzburg, studied at the Munich Academy, 1946–52, and from 1964 taught at the Technical College, Munich. In his early work he made figures and groups with flat, stylized forms but during the 1960s he did abstract symbolic works such as the set of *Caryatids* and his bronze *Domus*.

KOHN, GABRIEL (1910–75). American sculptor born at Philadelphia, Pa., studied at the Cooper Union, the Beaux-Arts Institute of Design, New York, and the Zadkine School of Sculpture, Paris. Among his awards were one for the International Unknown Political Prisoner Competition at the Tate Gal., London, in 1954 and a Ford Foundation Grant in 1960. He had one-man exhibitions from the 1950s and was represented in important collective exhibitions of recent art both in the U.S.A. and in Europe. His work was abstract in the CONSTRUCTIVIST tradition and eschewed symbolic or expressive appeal, concentrating on purely optical and objective impression in accordance with the doctrines later propounded by MINIMAL artists. He worked in laminated wood, constructing his delicately modulated forms with exquisite craftsmanship, and he has been called 'the most original wood sculptor in America'. His sculptures, sometimes single forms cloaking subtle complication under apparent simplicity, usually dispensed with a stand and exploited to the full the optical effect of the carpentry involved.

KOKOSCHKA, OSKAR (1886–1980). Austrian-British painter, born at Pöchlarm. He studied under CIŽEK at the Vienna School of Arts and Crafts, 1904–9, and there came under the influence of Gustav KLIMT and the prevailing ART NOUVEAU style, which had come belatedly to Vienna from the *Jugendstil* of Munich and from British sources. His coloured lithographs *Die träumenden Knaben* (*The Dreaming Boys*), published by the *Wiener Werkstätte* in 1908, were a typically mannered

conflation of Art Nouveau and late Symbolist styles. They contained something of Klimt, something of Beardsley, with an angularity which was distantly reminiscent of the work of the BRÜCKE. The reaction to this and to his exhibits at the first *Kunstschau* (1908) was such that he was compelled to leave the School of Arts and Crafts. In the *Kunstschau* of 1909 reaction to his two blood-and-thunder plays *Sphinx und Strohmann* (*Sphinx and Strawman*) and *Mörder, Hoffnung der Frauen* (*Murderer, Hope of Women*) induced him to leave Vienna for Switzerland, where he did landscape painting for the first time. From 1906 Kokoschka had painted still lifes and a series of portraits which have remained famous for their psychological insight, their power to reveal what he referred to as the 'closed personalities, so full of tension' of the sitters. Other critics have taken the view that 'what is essential in the portraits is not any particular outward resemblance nor even the disclosure of a psychological truth ... The essence of such portraiture is the "inner face" that Kokoschka projects into them, a poetic *possibility* read into them by the painter, a reflection of his own being' (Werner Haftmann). In 1910 he was in Berlin, in contact with the STURM group. His portraits were published by Herwarth Walden in *Der Sturm* and an exhibition of his painting was given in the Folkwang Mus. Besides painting, Kokoschka did a number of graphic illustrations during the years 1910 to 1914, whose visionary quality and nervous technique, a quality which—as much of his work—verges on exhibitionism, exemplifies the culmination of one trend in Germanic EXPRESSIONISM. Among the works he illustrated in these years were Ehrenstein's *Tubutsch* and *The Chinese Wall* by Karl Kraus and he also did illustrations conveying his impressions of Bach's cantata *O Ewigkeit—Du Donnerwort*. In 1914 he executed the first of his large allegorical paintings, *The Tempest* or *The Bride of the Wind* (Kunstmus., Basle), symbolizing his relationship with Alma Mahler.

After being wounded in the First World War Kokoschka went to recuperate in Berlin, where Herwarth Walden arranged a large exhibition of his works in 1916, and in 1917 moved to Dresden. Here his behaviour became markedly eccentric, culminating in arrangements for the construction of a life-size female figure (represented in the painting *Woman in Blue*, Stuttgart, 1919) with whom he proposed to live the artist's life. With characteristic exhibitionism he later authorized the publication of his correspondence with the dressmaker whom he employed for the job. In 1920 he was appointed Professor at the Dresden Academy and taught there until 1924, when he left without notice. The next seven years were spent travelling in Switzerland, France, Spain, Italy and North Africa with a visit to London in 1926. He was in Vienna, 1931–4, and in Prague, 1934–8. During these years he painted largely landscapes in an Expressionist manner and perfected a personal

kind of 'portrait' picture of town scenes from a high viewpoint. In 1937 his work was condemned by the National Socialist regime in Germany and he painted the defiant *Self Portrait of a Degenerate Artist*. He fled to London in 1938 and obtained British nationality in 1947. In 1953 he left England and settled at Villeneuve, near Geneva. His most important works during this latter period were the *Prometheus* ceiling (1950) for Count Seilern's house in London and the *Thermopylae* triptych (1954) for the university of Hamburg. Important exhibitions of his work were held at Munich and Vienna in 1948, and a retrospective of his graphic work at the Haus der Kunst, Munich, in 1976. In 1962 the Arts Council of Great Britain organized a comprehensive retrospective exhibition at the Tate Gal., which was afterwards shown in Hamburg.

Kokoschka remained steadfastly unaffected by modern movements and techniques such as FUTURISM, CUBISM, SURREALISM and the many which followed them. Throughout his long life he was content to continue, often with an imaginative quality verging on greatness, his highly personal version of pre-1914 Expressionism. The large retrospective exhibitions have emphasized, however, that his work underwent no real development in artistic depth since the early years.

KOLBE, GEORG (1877–1947). German sculptor born at Waldheim, studied at Dresden, Munich and at the Académie Julian, Paris. He specialized in graceful and rhythmical nude figures, which had considerable popularity during the 1920s. In 1929 his nude *Dancer* was chosen for the German Pavilion at the Barcelona International Exhibition. During the 1930s his work found favour with the National Socialist regime and he began to produce stereotyped figures in furtherance of the 'strength through joy' philosophy and the ideal of a master race.

KOLIG, ANTON (1886–1950). Austrian painter born in Neutitschein, Moravia, studied at the Academy of Art and the School of Arts and Crafts, Vienna, 1904–12, and exhibited with the HAGEN-BUND in 1911. Financed by KLIMT, he went to Paris and the south of France in 1912–13 and in 1914 settled in Nötsch, where he lived in friendship with WIEGELE, whose sister he had married. From 1928 to 1943 he taught at the Stuttgart Academy. Apart from painting he did textile designs, tapestries, murals and a large volume of graphic work. He was given an exhibition, together with HANAK, at the Künstlerhaus, Vienna, in 1963.

KOLLWITZ, KÄTHE (*née* SCHMIDT, 1867–1945). German graphic artist and sculptor. She married a doctor, Karl Kollwitz, in 1891 and lived in the poorer quarters of northern Berlin. She was a woman of strong social convictions and her work is permeated with sympathy for the poor and oppressed. Much of her work was intended as a social protest against the working conditions of

the day, and so interpreted her series *Weavers' Revolt* (1897–8), inspired by Hauptmann's play *The Weavers*, and *Peasants' War* (1902–8) brought her notoriety. She concentrated on the great tragic themes of life, many of her best works were devoted to the Mother and Child theme, and many of the later ones were pacifist in intention. Her social views were left-wing in character and in 1927 she visited Russia, but was subsequently disillusioned with Soviet Communism. In 1929 she was made the first woman member of the Prussian Academy in Berlin, but in 1933 she was expelled and her work was officially frowned upon. Subsequently during the 1930s she made her most moving series of eight lithographs on the theme of Death. She also made some bronzes, including a war memorial at Dixmuiden, Flanders, completed in 1932. In its elimination of the accidental and instinctive grasp of the tragic essential her work was in line with modern German EXPRESSIONISM and she represents in its purest form the element of social protest which has been prominent in much German Expressionist art.

KONCHALOVSKY, PIETR. See KNAVE OF DIAMONDS.

KONKRETE KUNST. A development by Max BILL of Theo van DOESBURG's concept of *art concret*. See CONCRETE ART and MOVIMENTO PER L'ARTE CONCRET.

KONTOGLOU(S), FOTIS (FOTIS APOSTOTELIS, 1896–1965). Greek painter born in Asia Minor. He studied at the National School of Fine Arts, Athens, and in 1915 went to Paris, where he worked until 1919 as illustrator for the magazine *Illustration*. After travelling in Scandinavia, Spain, Belgium and the U.S.A. he returned to Asia Minor and in 1920 published his book *Pedro Cazas*. In 1922 he went to Athens as a war refugee from Asia Minor and in 1925 with the architect Pikionis and the poet Varnalis he edited a literary periodical called *Philiki Etairia*. In the 1930s he worked as a restorer for the Byzantine Mus. of Athens and for the Coptic Art Mus., Cairo, and restored frescoes at Mistra. He also painted murals in the Athens Town Hall with figures from ancient Greek history and mythology side by side with famous Byzantine personalities and heroes of the 1821 Revolution. Up to *c.* 1945 he was regarded as the most important and original modern exponent of the Graeco-Byzantine artistic tradition. After the Second World War he abandoned secular painting and devoted himself to icons and murals in more sterile imitation of Byzantine models. He was represented in the exhibition 'Greek Art 3000 BC–AD 1945' at the Royal Academy, London, in 1946 and in the exhibition 'Four Painters of 20th Century Greece', at the Wildenstein Gal., London, on the occasion of the Greek Month in 1975.

KOONING, WILLEM DE. See DE KOONING, Willem.

KOROŠEK, ŽLJELKO. See NAÏVE ART.

KOSICE, GYULA (1924–). Argentine sculptor and experimental artist born in Czechoslovakia on the border of Hungary. Kosice was brought to Buenos Aires in 1928 and he became an Argentine citizen. From 1939 to 1940 he studied drawing and sculpture in the Academia de Buenos Aires and during this period he worked in wood and metal in a CONSTRUCTIVIST style. He was one of the founders of the modern art movement of the mid 1940s in Argentina. In 1944 he co-founded the review *Arturo* in collaboration with Carmelo Arden Quin, a Uruguayan, and Tomas MALDONADO. The following year he co-founded the *Arte Concreto-Invención* group which re-emerged later as the *Arte Concreto* group. In 1946 he founded the *Arte Madi* movement with Arden Quin and Martin Blaszko, followed by a manifesto and an exhibition at the Instituto Francès de Estudios Superiores at the Gal. Van Riel in Buenos Aires. The manifesto called for 'an art of mathematical spirit, cold, dynamic, cerebral, dialectic' somewhat similar to the Inventionist-Concrete manifesto, which stood for a scientific aesthetic opposed to the SURREALIST psychological search for creativity. Thus the word 'creation' was replaced by 'invention'. Both groups believed in a constructive use of contemporary and industrial materials. Although the *Madi* disbanded in 1947, several *Madi* exhibitions took place in Argentina and France well into the 1950s and Kosice published the review *Arte Madi*, of which 8 issues appeared between 1947 and 1954. However, he abandoned the original *Madi* group, setting out in a new direction under the name *Madinensor*.

Kosice subsequently became primarily known for his hydraulic sculpture, which he began in Paris in 1957. He introduced water as an element of instability into kinetic aluminium and transparent plexiglass constructions to which he added electric lights. His hydraulic innovations were first shown at the Gal. Denise René in Paris between 1958 and 1960 and he wrote a manifesto, *La Arquitectura del Agua en la Escultura* (*The Architecture of Water in Sculpture*), for which he was awarded a literary prize in 1960 and which was later incorporated into a collection of essays, word definitions, poems, manifestos and writings on *Madi* and *Arturo* under the title of *Arte Hidrocinetico. Movimiento Luz Agua* (*Hydrokinetic Art. Movement Light Water*) published in Buenos Aires in 1968. He continued to participate in *Madi* exhibitions, in 1955 at the Gal. Numero in Florence, in 1956 at the Venice Biennale, at the Gal. Bonino ('Arte Madi Internacional') and at the Mus. de Arte Moderno in Buenos Aires ('15 anos de Arte Madi'). He had one-man exhibitions in Paris at the SALON DES RÉALITÉS NOUVELLES in 1948, the Gal. l'Œil in 1963 and the Gal. La Hune in 1964. In New York, he showed at the Terry Dintenfass in 1965 and the Gal. Bonino in 1967. In 1968 he had a retrospective '100 Obras de Kosice, un Pre-

cursor' in two places at once, the Instituto Tor-
cuato di Tella and the Gal. Bonino in Buenos
Aires. He also exhibited in London, Caracas and
Lima, and his hydrokinetic work was shown ex-
tensively in the 1960s. In 1966 he constructed a
Mobile Hydromural relief with plexiglass, water
and light at the Gal. Embassy in Buenos Aires and
in 1971 a project for a suspended cosmic habitat
composed of hemispherical plexiglass structures
La Ciudad Hidroespacial, at the Gal. Bonino,
Buenos Aires. His work has also been included in
numerous group exhibitions. In the U.S.A. he par-
ticipated in 'New Art of Argentina' at the Walker
Art Center, Minneapolis, in 1964 and 'Light as a
Creative Medium' at Harvard in 1965. He was in-
cluded in the 1961 exhibition 'Argentine Painting
and Sculpture' at the National Gal. of Modern
Art, Edinburgh, as well as in London and Stock-
holm. He was awarded a bronze medal at the 1958
International Exhibition in Brussels, the 1962
National Award at the international sculpture
exhibition at the Instituto Torcuato di Tella and
the 1968 Torcuato di Tella award for visual ex-
periments, in Buenos Aires. Kosice also made
water and plexiglass jewellery. His work is in pri-
vate and museum collections in Argentina, Uru-
guay, Sweden, Colombia and the U.S.A.

KOSKINEN, HARRO (1945–). Finnish painter,
born at Turku and trained at the Art Association
of Turku Art School. He painted with PHOTOGRA-
PHIC REALISM scenes from the life of the working
classes. Besides exhibitions in Finland he took part
in the Paris Biennale of 1971, an exhibition of the
Nordic Graphic Union at Reykjavik (1972), a
joint exhibition at Stockholm arranged by the
Artists' Association of Finland (1973), an exhibi-
tion of Finnish graphic art at the Swiss Cottage
Library, London (1973), an exhibition at the
Youth Festival, Berlin (1973), and the 'Workaday
Finland' exhibition at the I.C.A. Gals., London
(1974). In a catalogue note to the last he stated
that he was dissatisfied with the pictures he had
done so far because 'they show the employer's
notion of the worker's life. When I can manage to,
I also intend showing the worker's own idea of his
life.'

KOSUTH, JOSEPH (1945–). American experi-
mental artist who about the mid 1960s came to the
fore as one of the chief pioneers of CONCEPTUAL
ART and as an influential exponent of the principles
of Conceptualism. In his two essays 'Art After
Philosophy' (*Studio International*, October and
November 1969) he cited the READY-MADES of
Marcel DUCHAMP as constituting the revolution
from 'appearance' to 'concept' and therefore 'the
beginning of "modern art" and the beginning of
Conceptual Art'. He endeavoured to isolate true
art both from the aesthetics of formal qualities and
from the reproduction of observed reality. 'Actual
works of art', he said, 'are little more than histori-
cal curiosities.' He enunciated the principle that the
work of art is a tautology, implying that artistic
activities are a verification of art itself and are
therefore self-verifying in the way that a math-
ematical equation is self-verifying. This principle is
said to have been illustrated in his picture *One and
Three Chairs* (The Mus. of Modern Art, New
York, 1965), presenting an actual chair alongside a
full-scale photograph of a chair and an enlarged
photograph of a dictionary definition of a chair.
Later Kosuth joined the Art and Language Group,
which investigates current concepts of art by means
of linguistic analysis.

KOVAČIC, MIJO. See NAÏVE ART.

KRAMER, HARRY (1925–). German sculptor
born at Lingen. Trained as a dancer and choreo-
grapher, he began to make movable puppets and
marionettes in 1952 and drew up plans for a mech-
anical theatre. From this he went on to KINETIC
constructions from wood and metal with a drive
mechanism, calling them *sculptures automobiles*.
During the 1960s he made wire sculptures in the
form of towers, columns and spheres which made
sounds like clocks and bells or the twittering of
birds. During the 1960s he visited Las Vegas and
devised a plan for making sculptures industrially.
He also produced architectural sculptures for in-
corporation into building projects. Besides sculp-
ture Kramer produced a number of films.

KRASNER, LEE (1911–). American painter,
born in Brooklyn, N.Y. She studied at the Cooper
Union, the National Academy of Design and the
HOFMANN School of Fine Arts. In 1942 she exhib-
ited with Jackson POLLOCK, whom she married in
1944, at the MacMillin Gal., New York. Her first
one-man exhibition was at the Betty Parsons Gal.
in 1950, after which she had regular exhibitions
through the 1950s and 1960s, including one-man
shows at the Whitechapel Art Gal., London, 1965,
and the Arts Council Gal., 1966. In 1969 she was
represented in The Mus. of Modern Art, New
York, exhibition 'The New American Painting and
Sculpture'. She did an 86 ft (26 m) mural for Broad-
way Building, New York.

KREČA, DJORDJE (1934–). Yugoslav NAÏVE
sculptor, born at Budimlić Japra in Bosnia.
During the war he saw his father put to death
before his eyes and after wandering homeless was
put in a school for war orphans. He studied
forestry at Split and worked for a time as a for-
ester. He began to paint in 1964 and the following
year took up sculpture in wood. His figures, with a
strong sense for sculptural form, have the heavy,
brooding solidity of idols with an occasional turn
of fantasy. He has done figures of Icarus, Joan of
Arc and the legendary nun Jefimija, depicted
naked beneath her cloak and crowned with an
eagle. The cutting of the face is reminiscent of
African carving from the Ivory Coast. His first
one-man show was at Zagreb and Split in 1967.

He has also shown in Amsterdam, Mexico City, Bremen and Milan (1968), Bratislava (1969) and elsewhere.

KRESTENEN, TOM (1927–). Swedish painter, born and brought up in Denmark. His work was EXPRESSIONIST, rich though luminous in subdued colours as in *Tragic Landscape* (1974). His most distinctive paintings were made up of three or five vertical panels like medieval triptychs or pentatychs but portraying instead of saints on each panel a tortured and suffering human body. They have been said to be 'related in their blackness to the nightmares of Goya and to the war victims seen in press photographs'. He himself said: 'I should like to use the language of the Renaissance, and be on Goya's side.' He had numerous individual and group exhibitions in Scandinavia, Berlin, the U.S.A., etc. and he was represented in the exhibition 'Five Swedish Artists' at the Serpentine Gal., London, in 1975.

KRETZ, LÉOPOLD (1907–). Polish-French sculptor born at Lwów. After studying at the École des Beaux-Arts, Kraków, while working as a stonemason, he went to Paris in 1931 and studied at the École des Beaux-Arts there. In 1951 he became Professor at the École des Beaux-Arts, Reims. His sculpture was in a style of sensitive and refined naturalism, examples being the *Victoire* (Mus. d'Art Moderne de la Ville de Paris) and *Vénus debout* (Mus. National d'Art Moderne, Paris, 1937). After the war he abandoned stone-carving for bronze.

KRICKE, NORBERT (1922–). German sculptor born at Düsseldorf, where he taught in the Academy after having studied at the Berlin College of Fine Arts, 1946–7. In 1958 he was awarded a prize from the Graham Foundation for Advanced Studies in the Fine Arts, Chicago, and in 1962 he visited Harvard University at the invitation of GROPIUS to work on designs for industrial sculpture. From c. 1950 he made abstract metal sculpture from steel rods and tubes combined with wires bent into acute shapes. These gave a light and airy impression like drawings in space. He also did a number of plexiglass fountains, which he called *Wasserwälder*, and made sculptures to stand in front of the Mannesmann Building, Düsseldorf.

KRIEG, DIETER (1937–). German painter, born in Lindau. From 1958 to 1962 he studied at the Academy of Art, Karlsruhe, under H. A. P. GRIESHABER. In 1966 he was awarded the German art prize for young painters, in 1969 a prize at the Bratislava Biennale and in 1969 an art prize from the city of Bremen. He had one-man shows in a number of German towns and participated in many collective exhibitions, including the 5th Paris Biennale, 'German Painters of Today' at Melbourne and Adelaide, a touring exhibition 'Young

German Art' in the U.S.A. and an exhibition '40 Germans under 40' which toured Finland and Norway in 1969. He painted parts of the human body (hands or feet), parts of trousers or accessories such as coat-hangers or trouser presses, with detailed realism but in a reduced colour range against a featureless background. In order to increase the sense of objectivity and to eliminate all expressiveness he latterly worked with a spray-gun.

KRIMS, LES. See PHOTOMONTAGE.

KRIWET, FERDINAND (1942–). German artist, born in Düsseldorf. He first came to the fore c. 1967 with mixed media demonstrations, 'auditory texts' (*hörtexte*), 'visual and concrete poetry' and various publications called *Leserattenfänge*. He was a letterist but put together letters as symbols in a design without attention to meaning. For some years after the late 1960s he propagated his ideas widely in exhibitions within Germany, in England, America and elsewhere.

KROLL, LEON (1884–1974). American painter and draughtsman, born in New York. From 1900 to 1902 he studied at the Art Students' League under J. H. Twachtman while earning his own living and then studied at the National Academy of Design and at the Académie Julian, Paris, under LAURENS. He taught at the National Academy of Design and the Art Students' League from 1911, at Maryland Institute, 1919–21, and at Chicago Art Institute School, 1924–5. His first one-man show was at the National Academy of Design in 1910 and he was included in the ARMORY SHOW of 1913. His early works had affinities with the ASH CAN school and his early portraits were infused with humanity and warmth. As time went on, however, his work became drier and more academic and his name is chiefly associated with academic nudes and landscapes under the influence of Poussin, for whom he conceived an admiration during his studies in Paris. He was also active as a muralist, among his commissions being murals for the U.S. Justice Department, Washington (1936–7), Worcester War Memorial Building, Mass. (1938–41), Johns Hopkins University (completed in 1956), the U.S. Military Cemetery, Omaha Beach, France. After enjoying great popularity, he failed to keep up with progressive trends and in the 1950s was active mainly in book illustration.

KRUSHENICK, NICHOLAS (1929–). American painter, born in New York. He studied at the Art Students' League and at the HOFMANN School, New York. In 1967 he obtained a Guggenheim Foundation Fellowship. Krushenick was known and exhibited from the mid 1950s among those who practised the more experimental forms of POST-PAINTERLY ABSTRACTION and MINIMAL ART. He was one of the few in America who developed from geometrical abstraction in the direction of

the hallucinatory effects cultivated by OP ART.

KRUYDER, HERMANN JUSTUS (1881–1935). Dutch painter, born at Lage Vuursche. About 1900 he learned the technique of painting at the School of Arts and Crafts, Haarlem, and then worked as a glass painter at Delft. In 1910 he returned to Haarlem and decided to become a painter, but it was not until 1916 that he found his artistic style. From then he lived in various villages around Haarlem and painted scenes and objects from rustic life. It was a mark of his style that he would paint animals and human beings disproportionately small so that they looked like toys, and their clumsily stylized shapes were in contrast with the meticulous precision of a professional glasspainter's colours. Their large, staring eyes made an uncanny impression and the general appearance of his works was reminiscent of the painting on folk pottery. His style lay midway between EXPRESSIONISM and the NAÏVE.

KRYLOV, PORFIRII. See KUKRYNIKSY.

KUBIN, ALFRED (1877–1959). Austrian graphic artist. Born at Leitmeritz, Bohemia, he passed his childhood in Salzburg and in 1892 worked as a photographer's assistant in Klagenfurt. In 1898 he went to a private art school in Munich and he had his first exhibition at the Cassirer Gal., Berlin, in 1902. Hans von Weber published the first folio of his drawings in 1903. He travelled to Paris and Italy in the years following 1905 and in 1906 he bought a country house at Zwickledt in Upper Austria, where he lived in seclusion for much of his life. In 1910 he became a member of KANDINSKY's circle at Munich and in 1911 joined the BLAUE REITER, exhibiting with them in the STURM show of 1913. In 1924 he became a member of the Prussian Akademie der Künste, Berlin, and Professor in 1937. He had an exhibition at the Albertina, Vienna, in 1937 and one at the Bavarian Academy of Fine Arts, Munich, in 1949.

Kubin had a taste for the morbid and fantastic, which he combined with pessimistic social satire and allegory. In his earlier work elements from the macabre etchings of Goya, the erotic obsessions of Felicien Rops and the tainted beauties of Beardsley coalesced in the murky twilight space of Redon, whom he met in 1905. He was one of the few great neurotic artists, who expressed his neuroses through the images of his art. In 1896 he attempted suicide on his mother's grave and in 1903 he underwent a mental breakdown after the death of his fiancée. His works reveal an obsession with the theme of death and with female sexuality as a symbol of death. Primarily an illustrator, he created a haunted, nightmare, unhealthy world, many of the images in which acquired a historical importance as sources of later SURREALIST imagery. In 1909 he wrote a Kafkaesque novel Die andere Seite. He had memorial exhibitions at the Bavarian Academy of Fine Arts, Munich, in 1964 and

1977. Among the 'themes' under which his works were catalogued in the latter exhibition were: 'Die Welt als Hölle', 'Mythen des Weibes als Zerstörerin', 'Dämonische Herrschaft und Groteske Götzenkulte', 'Gigantische und Dunkle Seelenkräfte'.

KUBISTA, BOHUMIL (1884–1918). Czech painter. He was one of the avant-garde artists in Prague at the turn of the century and in 1907 founded the progressive group The EIGHT with FILLA and PROCHÁZKA. About the same time he was invited to join the advanced German group Die BRÜCKE. About 1909 he became interested in CUBISM as a result of a visit to Paris and like many Czech artists at this time he evolved a style which attempted to combine Cubistic formal analysis with Germanic EXPRESSIONISM. He was later also influenced by FUTURISM.

KUBOTTA, ARTURO. See LATIN AMERICA.

KUDLA, LEON (1879–1964). Polish NAÏVE sculptor, born at Swierze Gorne. After serving for six years in the Russian army he was a shop-keeper and later a postman in Warsaw. He started carving in wood c. 1930, producing figures which had an affinity with the folk art of Poland. His work was included in post-war exhibitions of naïve art in Poland and Bratislava and a documentary film about him entitled Cantata in Wood was made by Makarczynski.

KUHN, WALT (1877–1949). American painter born at Brooklyn, N.Y. He studied at the Académie Colarossi, Paris, and the Academy of Fine Arts, Munich, and taught at the New York School of Art, 1908–9. In the first decade of the century he was a Realist painter of the circle of Robert HENRI. He was active in organizing the ASSOCIATION OF AMERICAN PAINTERS AND SCULPTORS and was Executive Secretary of the Association. He took a major part in the planning and organization of the ARMORY SHOW and in 1912 he went to Europe with Arthur B. DAVIES in order to select and plan the contributions. He was also largely responsible for the publicity of the show and in December 1912 he wrote to Walter Pach, the European agent of the Association: 'We want this old show of ours to mark the starting point of the new spirit in art, at least as far as America is concerned.' Kuhn had his first one-man show in 1910 at the Madison Gal., New York, where he also exhibited in 1911 with a group who called themselves The Pastellists. In 1917 he founded the Penguin Club. During the 1920s he designed sets for revue skits on Broadway. Retrospective exhibitions of his works were staged by the American Federation of Arts in 1951, the Albany Institute of History and Art in 1958, Cincinnati Art Mus. in 1960, Fort Worth Art Center in 1964 and the University of Arizona in 1966. Kuhn's favourite subjects were clowns and circus figures, in which the influence of

PICASSO and DERAIN is apparent. During the 1930s he also did landscapes, still lifes and flower pieces, often using the bright colours and distortions of MATISSE. During the 1940s a friendship with PASCIN resulted in a volume of characteristic graphic work.

KUKRYNIKSY. A collective pseudonym of three Soviet artists who always worked in concert: Mikhail *Ku*priianov (1903–), Porfirii *Kry*lov (1902–) and *Nik*olai Sokolov (1903–). The collective was famous for its political and social caricatures in *Pravda*, *Krokodil* and many other newspapers and periodicals. In 1925 they began their work as a group; in 1929 they began to make joint contributions to exhibitions; in 1933 they joined the permanent staff of *Pravda*. In the late 1930s and during the war they did many biting caricatures of Mussolini and Hitler. After the war they continued as political caricaturists and also gave particular attention to book illustration (1950 edition of Gorky's *Mother* and 1958 edition of Chekhov's *Lady with a Dog*). In 1965 they were Laureates of the Lenin Prize.

KULMALA, MATTI (1946–). Finnish graphic artist, born in Tampere and studied at the Institute of Industrial Arts. Besides exhibitions in Finland he was represented in collective exhibitions of Finnish graphic art in Paris, Bucarest, Sweden, Essen, Bremerhaven, Sâo Paulo, Oslo, Kraków, Rio de Janeiro. He also participated in the British International Print Biennale at Bradford (1972), in 1974 in the Fifth Biennale Internationale de la Gravure in Kraków, where he was awarded a state art prize and medal 'Kunstszene Finnland', and in 'Workaday Finland' at the I.C.A. Gals., London. Besides public and private collections in Finland, he is represented in the Mus. de Arte Contemporanea of the University of Sâo Paulo, the city of Essen, the National Mus. at Warsaw. He depicted objects from the ordinary environment of everyday life in a style of PHOTOGRAPHIC REALISM.

KUMALO, SYDNEY. See SOUTH AFRICA.

KUNIYOSHI, YASUO (1893–1953). Japanese-American painter, born at Okayama. He went to the U.S.A. in 1906 and apart from some previous study in the Dyeing and Weaving Department of the Okayama Industrial Arts High School in 1904, his artistic training was entirely Western. He attended evening classes at the Los Angeles School of Art for three years and then continued at the National Academy of Design, at the Robert HENRI School, 1910, and at the Art Students' League, 1916–20. In 1916 he met Jules PASCIN, whose friendship made a considerable impression upon him. In 1917 he exhibited with the New Society of Independent Artists and enjoyed the patronage of Hamilton Easter Field until the latter's death in 1922. During the 1920s he continued to paint

while supporting himself by photography. His work was decorative in a highly personal style. His figures of women and children and a ubiquitous cow were reduced to symbolic forms and his uptilted planes and reverse perspectives were reminiscent of some NAÏVE art. He began to achieve recognition during the 1930s after being included in the 'Modern American Artists' exhibition at The Mus. of Modern Art, New York, in 1929. He taught at the Art Students' League, 1933–53, and at the New School for Social Research, 1936–53. He was a member of Salons of America, 1922–38, and was first President of the Artists' Equity Association, 1947–50. During the war he worked on the staff of the Wartime Intelligence Agency and was active in designing posters against Japan. He became a member of the Society of Japanese-American artists founded in 1944. He had retrospective exhibitions at the Downtown Gal. in 1942 for the benefit of United China Relief, at the Whitney Mus. of American Art in 1948, at Boston University in 1961 and at the National Mus. of Modern Art, Tokyo, in 1954. While to the American world his work seemed vaguely Oriental or naïve, in Japan critics found it something quite outside the Japanese traditions. In the 1960s, however, Japanese interest in his work underwent a boom and a large travelling exhibition was organized in 1975 by the Bridgestone Mus. of Art, Tokyo, in conjunction with the Tokyo Shimbun and the Chunichi Shimbun.

KUPKA, FRANTIŠEK (FRANK, FRANÇOIS, 1871–1957). Czech painter, born at Opočno in eastern Bohemia. As a boy he was apprenticed to a saddler, who was known locally as a spiritualist and head of a secret sect. At this time Kupka first showed his power as a medium and began the interest in spiritualism and the occult, later in theosophy, which persisted throughout his life. His interest in folk art also dated from his early youth, when he travelled in southern Bohemia as a journeyman saddler. In 1888 he began his artistic training at the Kunstgewerbeschule at Jaromer under Alois Studnička (1842–1927) and in the following year was able to enter the Academy at Prague. Studnička was an admirer of the Czech painters of the Nazarene school and from him Kupka derived his lifelong interest in the expressive force of colours in decorative and abstract art and his admiration for the Czech artists Josef Mánes (1820–71) and Mikuláš Aleš (1852–1913), both of whom were inspired by the doctrines of Nazarenism and interested in folk art and in the relations between abstract decoration and music. At Prague Kupka studied under the Nazarene religious painter František Sequens (1836–96) and was further confirmed in the Nazarene doctrine of the spiritual symbolism of art. In 1892 he went to Vienna, where he studied under the Nazarene fresco painter A. Eisenmenger (1830–1907). This was a decade of cultural and intellectual ferment in Vienna and during the years he spent there

Kupka was confirmed in his belief that 'it is necessary for an artist to seek and find a means by which he may express the material likeness of all movements and states of his inner life and through which he may capture all abstractions'. In particular his interest in theosophy and esoterica brought him into contact with the controversial Nazarene painter and philosopher Karl Diefenbach and the critic Arthur Roessler. He came to the realization that a painting need not have a 'subject' and laid the roots of his ambition to create paintings whose linear rhythms and colour schemes would produce effects similar to those of music, signing himself 'colour symphonist' in his letters to Roessler.

In 1896 Kupka settled in Paris, where he made a name for himself as an illustrator and a painter of imaginary landscapes, while continuing his interest in spiritualism and the occult. He also became interested in the depiction of movement, the chronophotographic techniques of Etienne-Jules Marey and the praxinoscope, and he himself began to experiment with ways of suggesting movement by non-representational abstract forms, producing in 1909 a series of pastels and drawings depicting progression and movement according to musical laws.

In 1904 he went to live at Puteaux, a neighbour of Jacques VILLON and Raymond DUCHAMP-VILLON, becoming later a member of the PUTEAUX GROUP. Although he associated with the CUBISTS, his inspiration and motivation were different from theirs and he always emphasized this difference. Like KANDINSKY in Germany he was a pioneer in the development of non-representational abstraction, one of the earliest in Europe to investigate and exploit the spiritual symbolism inherent in abstract colour and shape and one of the first successfully to create works of visual art on the analogy of music. The ideas which for many years he had been maturing and working out in preliminary studies found concrete expression in his *Amorpha: Fugue à deux couleurs*, which created something of a sensation when exhibited together with his *Chromatique chaude* at the Salon d'Automne in 1912. These pictures, sometimes described as the first deliberately non-representational abstract paintings in European art, were cited by APOLLINAIRE together with canvases by DELAUNAY and PICABIA when he invented the term ORPHISM. They were followed by *Plans verticaux bleus et rouges*, exhibited at the Salon des Indépendants in 1913. His *Newton-Disques* (1912), abstract compositions of interpenetrating circles divided into spectrum hues, were in line with Delaunay's experiments into the abstract properties of contrasting colours. Studies such as his *Localisations de mobiles graphiques* show his continuing interest in the abstract depiction of movement, though along a path different from that pursued by the FUTURISTS.

During the First World War Kupka enlisted in the Czech Legion together with Blaise Cendrars, who described their experiences in *La Main coupée*.

After the war he taught at the Prague Academy as Visiting Professor, 1918–20, while continuing to do book illustrations and to work in abstract art. In 1923 his theoretical work *Tvoreni v Umeni výtvarném* (*Creation in Plastic Art*) was published in Prague and in 1924 he exhibited *Diagrammes* and *Arabesques tournoyantes* at the Gal. La Boétie, Paris. He joined the ABSTRACTION-CRÉATION group in 1931 and in 1936 exhibited a panorama of abstracts together with Alphonse MUCHA at the Mus. des Écoles Étrangères Contemporaines, Jeu de Paume des Tuileries, Paris. He was later made Honorary Chairman of the SALON DES RÉALITÉS NOUVELLES.

In 1946 a large retrospective exhibition of his work was given in Prague and 50 paintings were bought for a Kupka Mus. This was followed by a retrospective at the Louis Carré Gal., New York, in 1951. In 1956 Alfred Barr bought a group of his major works for The Mus. of Modern Art, New York, and Kupka presented to the museum a collection of his studies and sketches. Nevertheless, although his fame as a major European artist was firmly established, owing to the difference in spirit between his works and those of the main Paris schools his importance as an innovator and a precursor of modern abstraction was hardly realized before the 1960s. Among the many memorial exhibitions were those at the Mus. National d'Art Moderne, Paris, 1966; Kestner-Gesellschaft, Hanover, 1966; Kunstverein, Cologne, 1967–8; Mus. des 20. Jahrhunderts, Vienna, 1967; Stedelijk Mus., Amsterdam, 1968; Solomon R. Guggenheim Mus., New York, and Kunsthaus, Zürich, 1976.

KUPRIIANOV, MIKHAIL. See KUKRYNIKSY.

KUTTER, JOSEPH (1894–1941). Luxembourg painter, born in the city of Luxembourg. In 1917–18 he studied at the Academy in Munich, where he came into contact with German EXPRESSIONISM, and returning to Luxembourg in 1924 he evolved a less restless form of personal Expressionism free from the shrill colour dissonances and harsh angularities so characteristic of the Germanic variety. In its careful attention to composition his style was closer to that of the French Expressionists, though he worked slowly and meticulously rather than impulsively. His figures had something of the monumentality of PERMEKE but their almost sleepy calm was far removed from the dramatic and anguished vigour typical of much Flemish Expressionism. In the 1930s and particularly in the series of clowns painted between 1936 and 1938—sometimes described as self-portraits—his manner changed and his figures displayed the ravages of spiritual and mental illness and a deep-seated terror before the unknown. They were nevertheless carefully painted, with strongly composed forms in bright colours standing out from a sombre background. His landscapes also, painted in Venice, Saint-Tropez, Calvi and Corsica between 1927 and 1933 and in Luxembourg, the Netherlands and

Germany from 1934, had a sombre and desolate charm which reflected the artist's obsessional anxiety in face of the objective world. Kutter was a colourist of sensitivity and distinction and an Expressionist of a very personal kind both in his figural studies and in his landscapes. He was described by Jean Cassou as 'indubitably the finest representative of the art of his small country and an artist of European stature'.

L

LABORATORY ART. When KANDINSKY's programme for INKHUK was rejected in 1920 (see RUSSIA AND THE U.S.S.R.) there was adopted instead a programme of 'Laboratory Art'. This derived from the belief that 'pure art'—that is non-utilitarian art such as easel painting—had had its day and was no longer justified. Instead, art should be directed to socially useful ends and the distinction between fine art and industrial design should be abolished. This ideology was known as 'Objectism'. All 'art' was directed towards the production of an 'object', which might equally well be a utilitarian object such as a house or a pair of shoes, or a poem. The artistic activity consisted in investigating the properties of the material—aesthetic as well as physical and functional—and adapting the material for a practical purpose. Some artists continued to work in traditional materials, though in a modified way. Others abandoned traditional art altogether for industrial design. The latter, with TATLIN in the lead, took the name of CONSTRUCTIVISTS.

The $5 \times 5 = 25$ exhibition of 1921 summed up the achievement of the laboratory art group for the year. It was followed by a 'Counter-Object' movement, which repudiated Objectism as applied to traditional art production, and from this time Constructivism in the Russian sense of the term became the official doctrine of *Inkhuk*.

LABRA, JOSÉ MARIA DE. See SPAIN.

LACASSE, JOSEPH (1894–1975). Belgian painter, born at Tournai. From 1905 he worked as a quarryman at the Tournai stone quarries and while so employed attended evening classes in drawing from 1909 to 1911, learning to imitate marble and wood in paint. At this time he painted decorative abstractions, often using the materials of his work as subjects, and was ridiculed by his fellow students as the 'mosaicist'. An example of this 'unconscious Cubism' is his painting *Les Oiseaux* (Mus. Royaux des Beaux-Arts, Brussels, 1910). In 1911 he attended the École des Beaux-Arts, Tournai, and learned to do figurative compositions. After the war, during which he was made a prisoner and escaped, he continued his studies at the Academy of Fine Arts, Brussels, 1919–20. In 1925 he settled in Paris and for some years enjoyed a reputation as a religious painter. Then in 1931 he met DELAUNAY and turned more deliberately to abstraction, founding the group *L'Equipe* in Paris. With the 'elimination of the

visual object' and concentration upon the experiencing of pure colour he found his true style. He spent the Second World War in England, where he was Director of the Rehabilitation Centre for wounded soldiers at Stoke-on-Trent. Returning to Paris after the war, he became one of the pioneers of expressive abstraction and is said to have influenced the development of POLIAKOFF. His later style consisted of flat interlocking forms in rich colours or of virtually monochromatic canvases designed to emphasize the intensity of the colour experience. He took part in the main Belgian and Paris Salons and the São Paulo Bienale and had many one-man exhibitions in Paris and Belgium, at the Rose Fried Gal., New York, in 1955, and a retrospective at the Drian Gal., London, in 1962, which brought him belated recognition as one of those in the van of the abstract movement.

LACEY, BRUCE (1927–). British experimental artist born at Catford, London. He began to study art in 1948 and made a speciality of animated robots. The best known of these was an erotic robot included in the exhibition 'Cybernetic Serendipity' organized by Jasia Reichardt at the I.C.A. Gals. in 1968.

LACHAISE, GASTON (1882–1935). French-American sculptor, born in Paris, son of a cabinet maker. He trained at the École Bernard Palissy, 1895, and then at the Académie des Beaux-Arts, 1898–1904. He emigrated to the U.S.A. in 1906, becoming one of the pioneers of modern sculpture in America and helping to reintroduce the method of direct carving. He settled first in Boston, where he worked for René Lalique and then for Henry Hudson Kitson, accompanying the latter to New York in 1912. There, however, he left Kitson and became assistant to Paul MANSHIP. His personal style matured in the following years and he had his first one-man show at the Bourgeois Gal., New York, in 1918 and an exhibition at the STIEGLITZ Intimate Gal. in 1927. He did a number of portrait busts remarkable for their psychological insight, including one of the poet E. E. Cummings and a coloured plaster of the painter John MARIN. He was chiefly known, however, for his female nudes, which were massive and voluminous without being academic, maintaining a fluid rhythmical movement with masterly surface articulation, and had an overt femininity which has been compared to that of Renoir. The best-known example is *Standing Woman* (Whitney Mus. of American Art, 1912–

27). He had retrospective exhibitions at The Mus. of Modern Art, New York, in 1935; Los Angeles County Mus. of Art, 1963; San Francisco Mus. of Art, 1967. He also executed commissions for sculpture on the Electricity Building, Chicago, the Rockefeller Center, New York, and Fairmount Park, Philadelphia.

LACKOWIĆ, IVAN (1932–). Yugoslav naïve painter, born in the Croatian village of Batinska in the department of Kovprivnica. He was fond of drawing and painting at school but being the eldest of four brothers in a peasant family, he had to cut short his school years and from 1943 to 1952 worked as a forester and gardener. During this time he continued to paint and, according to his own statement, lacking paper he painted his pictures on the walls of his own house and those of his neighbours, making his own pigments which he mixed with milk and applied with the hairy spikes of maize cobs. The subjects of these pictures were mainly flowers, houses and fields. He did his military service from 1952 to 1954, during which time he first came to know charcoal and ink, drawing posters and placards. In 1957 he made contact with the Gal. of Primitive Art at Zagreb through the help of Professor Dragutin Ančić and in 1958 he moved to Zagreb and obtained employment in the Post Office. In 1961 he met a journalist, Gerhard Ledić, who encouraged him and brought him into contact with Professor HEGEDUŠIĆ, and in 1962 he was introduced by the latter to the technique of painting under glass. He painted scenes remembered from his native village, peasants trudging homewards through the snow or gathering firewood. His outlines were soft and his pictures expressive with a fine sense of space, equal to the best of the Hlebine school (see NAÏVE ART). He said himself of his paintings that they were often bitter and sad, often cheerful and gay. They were exhibited widely in Yugoslavia, both in collective exhibitions and in one-man shows. Outside Yugoslavia his work was exhibited in London, Frankfurt and other European cities.

LAERMANS, EUGÈNE (1864–1940). Belgian painter, born in Brussels. At the age of eleven he became a deaf-mute as a consequence of meningitis and studied painting for ten years at the Academy of Fine Arts and the Free Academy of La Patte de Dindon. Laermans depicted the wretched conditions of the working classes and the agricultural population in paintings which, without laboured sentimentality, emphasized the individual character of the peasant and worker. By the end of the century he had established his position as a pioneer of SOCIAL REALISM and of that aspect of Flemish EXPRESSIONISM which concentrated on the theme of the working man. He took part in exhibitions of the Société des Beaux-Arts and La Libre Esthétique and his fame was consolidated by a retrospective exhibition of his works in 1899. His eyesight began to fail in 1909 and in 1924 he became blind and ceased to paint. He was made Baron in 1927 and his work was honoured by the *avant-garde* circle of *Le Centaure*. His masterpiece is considered to be *Le Mort* (Mus. Royaux des Beaux-Arts, Brussels, 1904), which exemplifies his favourite theme of a long white wall and an insistent, orange sky.

LAETHEM-SAINT-MARTIN. A Belgian village not far from Ghent, where *c.* 1900 a small group of artists settled under the aegis of the poet Karel van de Woestijne in order to enjoy the simple life in communion with nature. They were the sculptor George MINNE, the Symbolist painter Gustave van de WOESTIJNE, brother of the poet, Valerius de SAEDELEER and Albert SERVAES. They are known as the First Laethem Group. Their work, of a meditative and somewhat melancholy character, to some extent influenced by Pre-Raphaelitism, consisted of simple peasant scenes and landscapes in reaction from the historicism of academic art and from the at that time more advanced ART NOUVEAU of Brussels.

About 1910 a second group settled there consisting of the brothers Gustave and Léon de SMET and Frits van den BERGHE. During the First World War, from 1914 to 1918, they were interned in the Netherlands. Returning in 1918, they were joined by PERMEKE and constituted the Second Laethem Group. They were chiefly responsible for the promotion of EXPRESSIONISM in Belgium.

LAFFON, CARMEN (1934–). Spanish painter, born in Seville, studied at Seville and Madrid. She was an *intimiste* painter and stood outside the wave of abstraction which swept Spain in the late 1950s and 1960s, painting figures and interiors in a Late-Impressionist style with sensitive feeling for delicate blending of shades and colours.

LA FRESNAYE, ROGER DE (1885–1925). French painter, born at Le Mans of an old Normandy family. After a good general education he joined the Académie Julian in 1903 and there knew DUNOYER DE SEGONZAC, L.-A. MOREAU and BOUSSINGAULT. In 1904 he went to the École des Beaux-Arts and then, after doing his military service in 1905, entered the Académie Ransom in 1908. There he worked under DENIS and SÉRUSIER and learned the NABI doctrine that far from being a mere reproduction of natural appearances, painting is a concrete image of a man's inner life, the outcome of intelligence and discipline. He himself said: 'Dans la peinture il y a deux choses, l'œil et le cerveau. Il faut travailler à leur développement mutuel, à l'œil par la vision sur nature, au cerveau par la logique des sensations organisées qui donnent les moyens d'expression.' ('In painting there are two things, the eye and the brain. One must work for their mutual development, the eye by the vision of nature and the brain by the logic of organized sensations which afford the means of expression.') From 1910, under the influence of

Cézanne, he began to reduce the importance of colour and increase that of formal structure in his works. About 1912 he met BRAQUE and came into contact with the CUBIST group, being particularly interested in the work of Robert DELAUNAY. He was never fully a Cubist, however. From *c.* 1913 he produced a number of still lifes and figure studies which were Cubistic in their geometrical analysis of planes but not in their colour or their expressive character. His approach was at once more intellectual and more humanistic than that of Braque at this time and he was interested in the Cubist devices as a technique to be applied to the aims of Expressive Realism.

From 1914 to 1917 he served in the army and was discharged with tuberculosis, from which he did not recover. Though he continued to paint and in 1920 began to write for L'ESPRIT NOUVEAU, he never again had the physical energy for sustained work and the best part of his output was concluded by 1918. He exhibited at the Salon des Indépendants and at the Salon d'Automne before the war and in 1913 was elected to the jury of the Salon d'Automne. In 1923 he had a large exhibition at the Salon des Tuileries. After the war he abandoned Cubist spatial analysis for a more linear and decorative realism.

James Thrall Soby has said: 'Roger de La Fresnaye's estimable function was to combine the angular structure of cubism with traditional French relish in color, as though he kept Delacroix in mind as well as Cézanne.'

LAGRU, DOMINIQUE (1873–1960). French NAÏVE painter, born in Perresy-les-Forges, Saône et Loire. He was a shepherd and a miner and did not begin to paint until he was 76. He then painted imaginary landscapes peopled by prehistoric reptiles and imaginary fauna which he derived from zoological texts. He first exhibited in the Gal. Romi, Paris, in 1951 and was represented in many international exhibitions of naïve art.

LAGUNAS, SANTIAGO. See SPAIN.

LAI MING (1929–). British painter born in Macau and brought up in Hong Kong, where he was taught by Ko Chien-fu, the founder of the Lingnan School. He was a member of the Chun Sui Art Institute and graduated at the South China Art Academy, Canton, in 1948. He became Director of the Hong Kong Buddhist Art and Culture Association and through his teaching exercised an important influence on younger artists. He was represented in the exhibition 'Commonwealth Art Today', 1962–3, at the Commonwealth Institute, London, by his painting *Vulture* executed in Chinese style.

LALIBERTÉ, ALFRED. See CANADA.

LAM, WIFREDO (1902–82). Cuban painter born at Sagua la Grande of an Afro-Indian mother and a Chinese businessman, who died in 1926 at the age of 108. After studying painting at the San Alejandro Academy in La Havana he left for Madrid in 1923 to study at the San Fernando Academy, but soon became dissatisfied with the academic style and branched out on his own. He had his first individual exhibition in the Vilches Gal. in Madrid in 1928 and the following year in Barcelona. In 1938 he left for Paris, where he contacted PICASSO at the suggestion of the Catalan sculptor Manolo Hughet. The two became close friends and Picasso introduced him to the Paris art world. In 1939 Lam had his first Paris exhibition at the Gal. Pierre Loeb and worked in Picasso's studio, where he came under the influence of the latter's post-*Guernica* work. He met André BRETON, whose book *Fata Morgana* he illustrated in 1940, and joined the SURREALIST association. He followed the group to Marseilles and in 1941 sailed for Martinique on the same ship as MASSON, Breton and the French anthropologist, Claude Lévi-Strauss. In 1942 he had an exhibition at the Gal. Pierre Matisse in New York. After his return to Cuba he came increasingly under the spell of African and Oceanic sculpture and translated these images into irrational, biomorphic configurations which fused human, animal and vegetable elements in totemic compositions, as in *The Jungle* of 1943. Following a visit to Haiti in 1946 he also began incorporating images of Voodoo gods and rites in his work. In 1951 he returned to Paris and for the next thirteen years travelled back and forth to New York and Italy. He moved to Albisola Mare, near Genoa, in 1964 and from 1974 divided his time between Paris and Albisola. He won many prizes, including the Guggenheim International Award in New York and the Marzotto Prize in Valdagno, Italy, in 1964. In the 1970s he began making bronze sculpture.

Lam is considered to be among the most talented of those who have reconciled the artistic vigour of Latin America with the European *avant-garde* and with the powerful mystique of African and Oceanic tradition. His works have been very widely exhibited and are contained in many leading public and private collections.

LAMB, HENRY (1883–1960). British painter, born in Australia and brought up in Manchester, where his father was Professor of Mathematics. Under parental pressure he studied medicine in Manchester but in 1907 he came to London with Nina Forrest and studied under Sir William Orpen and Augustus JOHN at the Chelsea School of Art. He also studied in Paris and painted in Brittany. In 1911–12 he was a member of the CAMDEN TOWN GROUP and in 1912 he exhibited a portrait of Lytton Strachey at the first POST-IMPRESSIONIST exhibition, organized by Roger FRY. Lamb was a recognized member of the BLOOMSBURY GROUP and a friend of Vanessa BELL. He was known chiefly for his clever and sensitive portraits, which included Vanessa Bell, Lytton Strachey, Roger Fry,

Lady Ottoline Morrell and others. In 1916 he joined the forces as a medical officer and served in Macedonia and the Near East. His painting *Bombardment in the Judaean Hills* is in the Imperial War Museum. He was an official War Artist again from 1940 to 1945. In 1949 he was made a member of the Royal Academy.

LAMBARDO, SERGIO. See ITALY.

LAMBÈRECHTS, FRANS (1909–). Belgian sculptor and experimental artist born in Brussels. He first trained as a stonemason and then studied at the Brussels Academy, 1930–3. From *c.* 1950 he turned to abstraction and explored the possibilities of polyester, using polyester constructions as part of total ENVIRONMENTS and spectacles which also involved music and light effects.

LAMBERT, GEORGE. See AUSTRALIA.

LANDAU, JACOB (1917–). American painter and graphic artist, born in Philadelphia. Landau's work expressed the existential predicament of modern man in an age of crisis and uncertainty as to his future. In such sequences as *The Holocaust Suite* (1968) and *Urbanology Triptych* (1969) he developed a personal technique of multiple allegorical images symbolizing conflicting passions of love and hate, hope, despair and futility. He also did large stained-glass windows of Old Testament prophets and illustrations for *The Divine Comedy* and *The Revelation of St. John*. His work was exhibited widely in the U.S.A. and is represented in many collections, including The Mus. of Modern Art, New York, The Metropolitan Mus. of Art, the Whitney Mus. of American Art, the National Collection, Washington, and the Los Angeles County Mus.

LANDI, EDOARDO N. See GRUPPO N.

LANDUYT, OCTAVE (1922–). Belgian painter and designer born at Ghent, studied at the Academy of Art, Courtrai, and then taught at the École Normale, Ghent, and was head of the Bureau of Design in Courtrai. He won a Guggenheim prize 1958. Landuyt became an important figure in the Belgian revival of SURREALISM in the 1950s, concentrating on images of madness and macabre scenes. In the 1960s his Surrealism became more abstract.

LANSKOY, ANDRÉ (1902–76). Russian-French painter, born in Moscow. In 1919 he fled to Kiev and fought with the White Army. He went to Paris in 1921 and studied at the Académie de la Grande Chaumière. In 1923 he exhibited in a group show at the Gal. La Licorne and was noticed by Roger Dutilleul and Wilhelm UHDE. His first one-man show was at the Gal. Bing in 1925. At this time he was painting still lifes, portraits and landscapes, often fantastic in character, in a manner of Ex-

pressive Realism. He had a travelling exhibition in the Netherlands in 1938. About this time, partly under the influence of KANDINSKY, he turned towards non-figurative art. His first non-figurative gouaches were done in 1939 and his first non-figurative oil paintings in 1944, in which year he entered into an arrangement with the Gal. Carré. He evolved a highly individual mode of abstraction, consisting of pseudo-hieroglyphic and apparently random shapes in bright colours executed upon a dark, usually black, monochrome background. His work belonged to the general category of TACHISM or expressive abstraction. It was not abstracted from nature as was often that of BAZAINE and de STAËL, but it was more tightly organized than the ART INFORMEL of WOLS and SCHNEIDER. He had a retrospective exhibition at the Mus. Galliera in 1966.

LANYON, PETER (1918–64). British painter, born at St. Ives, Cornwall, studied at the Euston Road Art School in 1938 and then under Ben NICHOLSON and Naum GABO at St. Ives. From 1940 to 1946 he served in the Royal Air Force and from 1950 to 1957 taught at the Bath Academy of Art, Corsham. He was Visiting Painter at San Antonio Art Institute, Texas, in 1963 and in 1964 he lectured for the British Council in Czechoslovakia. Besides one-man shows in London, he was represented in collective exhibitions, including: Salon des Réalités Nouvelles, Paris, 1947–9; Pittsburgh International, 1955, 1958, 1961, 1964; DOCUMENTA II, Kassel, 1959; 'British Paintings 1720–1960', Pushkin Mus., Moscow and Hermitage, Leningrad, 1960; 'Painting and Sculpture of a Decade', Tate Gal., 1964. Among the public collections owning his works are: Gulbenkian Foundation, Tate Gal., Cleveland Mus. of Art, Carnegie Institute, the Universities of Princeton and Yale, National Gal. of Canada, Toronto Art Gal. and the galleries of South Australia, Western Australia and Victoria.

Lanyon was one of the St. Ives group of painters. He began by painting the Cornish landscape in the lyrical manner of the 1920s but later turned to lyrical and expressive abstraction. His paintings were evocative of the sea and sky and the green countryside, reduced to flat abstract pattern. His ASSEMBLAGES, many of which were intended as preparatory ideas for paintings, were built up from found objects such as driftwood, pieces of glass, rope, etc., sometimes free-standing and sometimes boxed, and in the post-war period, after Lanyon had undergone the influence of GABO, were often brightly painted in a decorative, non-representational manner. In 1968 the Arts Council arranged a retrospective exhibition of his works which was shown at the Tate Gal. and other major galleries in Britain. Since that time there have been periodic exhibitions.

LA PATELLIÈRE, AMÉDÉE DUBOIS DE (1890–1932). French painter, born at Bois-Benoît,

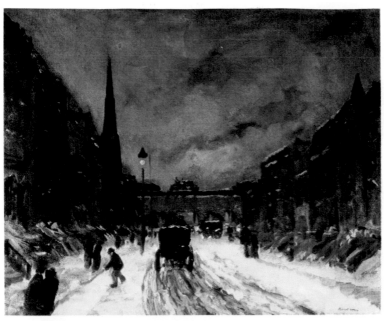

1. Robert Henri: *West 57th Street, New York*, 1902. Oil on canvas. 66 × 81 cm.

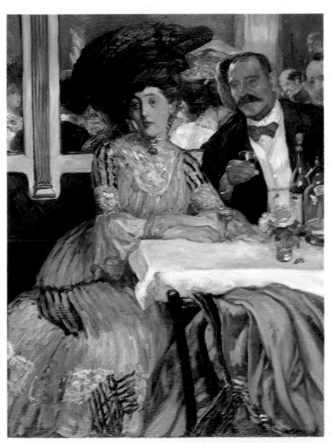

2. William Glackens: *Chez Mouquin*, 1905. Oil on canvas. 122 × 92 cm.

3. Everett Shinn: *Revue*, 1908. Oil on canvas. 46 × 61 cm.

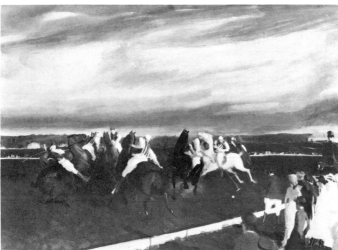

4. George Bellows: *Polo at Lakewood*, 1910. Oil on canvas. 114 × 160 cm.

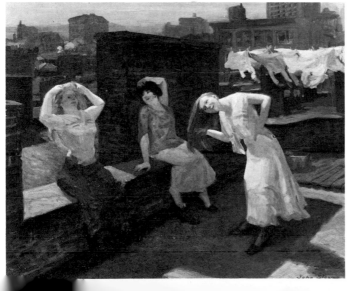

5. John Sloan: *Sunday, Women Drying their Hair*, 1912. Oil on canvas. 65 × 80 cm.

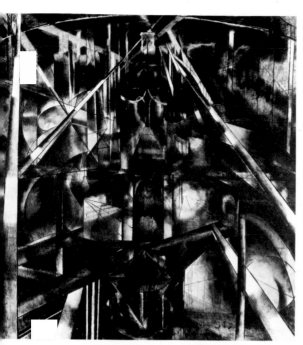

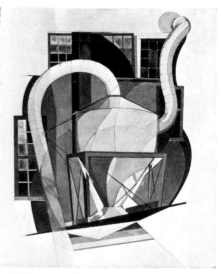

6 (*left*). Joseph Stella: *Brooklyn Bridge*, 1917–18. Oil on canvas. 213 × 193 cm.

7 (*above*). Charles Demuth: *Machinery*, 1920. Tempera and pencil on cardboard. 61 × 50 cm.

8. John Marin: *Lower Manhattan* (*Composing Derived from Top of Woolworth*), 1922. Watercolour and charcoal with paper cutout attached with thread. 55 × 68 cm.

9. Marsden Hartley: *Painting No. 5*, 1914–15. Oil on canvas. 100 × 81 cm.

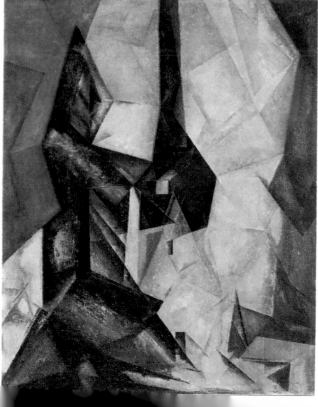

10. Lyonel Feininger: *Gelmeroda IV*, 1915. Oil on canvas. 99 × 79 cm.

11. Arthur Dove: *Fog Horns*, 1929. Oil on canvas. 48 × 66 cm.

12. Georgia O'Keeffe: *Stables*, 1932. Watercolour. 30 × 81 cm.

13. Edward Hopper: *Early Sunday Morning*, 1930. Oil on canvas. 89 × 152 cm.

14. Reginald Marsh: *The Bowery*, 1932. Tempera on masonite. 122 × 91 cm.

15. Charles Sheeler: *American Interior*, 1934. Oil on canvas. 83 × 76 cm.

16. Thomas Hart Benton:
City Scenes: Steel, 1930–1.
Mural in tempera.

17. Jack Levine: *The Feast of
Pure Reason*, 1937. Oil on
canvas. 107 × 122 cm.

18. Ben Shahn: *Welders*, 1943.
Tempera on cardboard
mounted on composition
board. 56 × 100 cm.

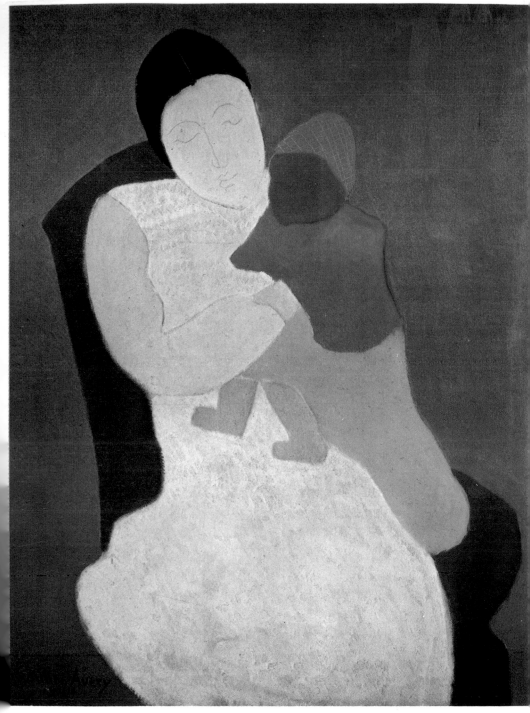

19. Milton Avery: *Mother and Child*, 1944. Oil on canvas. 102 × 76 cm.

20. Morris Graves: *Bird in the Spirit*, *c.* 1940–1. Gouache on paper. 55 × 107 cm.

21. Loren MacIver: *Venice*, 1949. Oil on canvas. 150 × 236 cm.

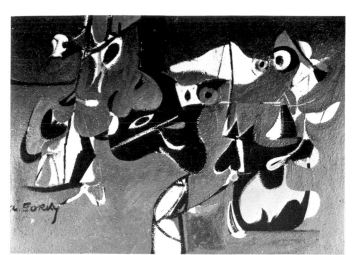

22. Arshile Gorky: *Garden in Sochi*, 1941. Oil on canvas. 112 × 158 cm.

23. Robert Motherwell: *Pancho Villa, Dead and Alive*, 1943. Gouache and oil with collage on cardboard. 71 × 91 cm.

24. Franz Kline: *Chief*, 1950. Oil on canvas. 148 × 187 cm.

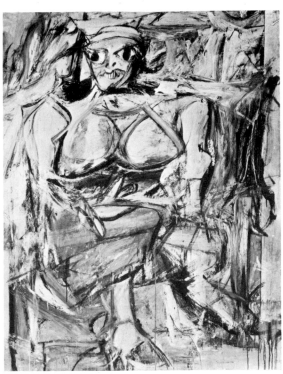

25. Hans Hofmann: *Effervescence*, 1914. Oil, indian ink, asein, enamel on plywood panel. 138 × 91 cm.

26. Willem de Kooning: *Woman I*, 1950–2. Oil on canvas. 193 × 147 cm.

27. Jackson Pollock: *Echo* (*Number 25, 1951*), 1951. Enamel paint on canvas. 233 × 218 cm.

28. Bradley Walker Tomlin: *Number 20*, 1949. Oil on canvas. 218 × 203 cm.

29. Clyfford Still: *Untitled*, 1945. Oil on canvas.
108 × 84 cm.

30. Philip Guston: *The Clock*, 1951. Oil on canvas.
193 × 163 cm.

31. Adolph Gottlieb: *The Frozen Sounds, Number 1*, 1951. Oil on canvas. 91 × 122 cm.

32. William Baziotes: *White Bird*, 1957. Oil on canvas. 152 × 122 cm.

33. Mark Tobey: *New Life* (*Resurrection*), 1957. Tempera on cardboard. 110 × 69 cm.

34 (*above left*). Seymour Lipton: *Imprisoned Figure*, 1948. Wood and sheet-lead construction. 215 × 78 × 60 cm. (including wood base).

35 (*above right*). David Hare: *Juggler*, 1950–1. Steel. Height 204 cm.

36 (*left*). Herbert Ferber: *Sun Wheel*, 1956. Brass, copper and stainless steel. Height 143 cm.

37. Isamu Noguchi: *Even the Centipede*, 1952. Kasama ware in eleven pieces, each approximately 46 cm. wide, mounted on wood pole 427 cm. high.

38. Larry Rivers: *Washington Crossing the Delaware*, 1953. Oil on canvas. 207 × 283 cm.

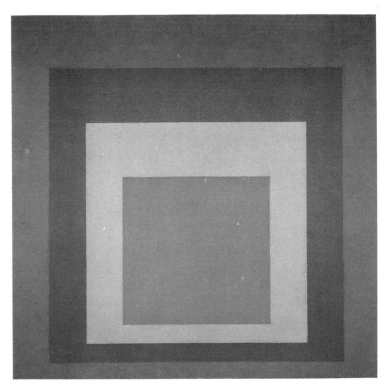

39. Josef Albers: *Homage to the Square: 'Ascending'*, 1953. Oil on composition board 110 × 110 cm.

40. Stuart Davis: *The Paris Bit*, 1959. Oil on canvas. 102 × 152 cm.

near Nantes. After beginning the study of law at Nantes, he left for Paris in 1912 and enrolled at the Académie Julian. He was wounded twice in the war with lasting effects on his health. He had his studio in Paris while spending much time in Brittany, the valley of Chevreuse, where he painted most of his landscapes, and Provence. La Patellière held aloof from CUBIST mannerisms although his still lifes and interiors were strictly constructed. In a quiet and unemphatic way he represented objects in full perspective while at the same time preserving the picture plane, and he was skilled in the use of light to emphasize the rhythm and construction of his compositions rather than to modify his usually sombre colours. In these ways he was often nearer to the true principles of the original Cubists than the mannered formulas of their followers. Perhaps his artistic nature was most fully evidenced in the lyrical and expressive landscapes in which he depicted the life of the peasants and the countryside. From 1922 he exhibited regularly at the Salon des Indépendants and in 1934 the Salon d'Automne gave a retrospective exhibition of his works. A large memorial retrospective arranged by the Mus. National d'Art Moderne, Paris, in 1945 was shown also in Liège and Brussels.

LAPICQUE, CHARLES (1898–). French painter, born at Theizé. He obtained a degree in civil engineering at Lisieux in 1924 and in 1939 became a Doctor of Science with a dissertation on Optics and the Perception of Contours. He took up painting as a hobby in 1925 and during the 1930s exhibited in the main Paris Salons. In 1937 he was commissioned to do 5 paintings for the Palais de la Découverte at the Paris Exposition Universelle. Towards the end of the 1930s he was associated with BAZAINE, MANESSIER and VILLON and in 1941 was one of the group of *Jeunes Peintres de la Tradition Française*. Like many of the *avant-garde* in the ÉCOLE DE PARIS during the 1940s he developed a mode of abstraction based on natural appearances. From the scene before him—a landscape, regatta, etc.—he evolved a network of heavy crisscross lines, the intervals between which were filled with colour as if seen behind a lattice. His style was later influenced by DUFY and to some extent modified by Tiepolo and Tintoretto after a visit to Venice.

LAPOUJADE, ROBERT (1921–). French painter, born at Montauban. After leaving school at the age of fourteen he held a variety of jobs—butcher's boy, riveter, roofer—and at the age of twenty he was connected with a school of dramatic art at Arth-sur-Meurthe. In 1941 he fled to the Hautes-Alpes and lived for fifteen months in a cave. He was self-taught as an artist. After the Liberation he went to Paris and had his first exhibition in 1947 at the Gal. Jeanne Castel. In 1949 he had an exhibition at the Gal. Chardin of fifty silverpoint portraits of literary celebrities. The fol-

lowing year he turned to non-figurative art and wrote a book on the problem of form, *Le Mal à Voir*. His abstract method was highly individual: he covered the canvas with a thick layer of green paint and then meticulously worked his designs into it. In 1952 he had one-man shows at the Gal. de Babylone and the Gal. Arnaud, Paris. He also exhibited at the Salon de Mai and at the SALON DES RÉALITÉS NOUVELLES. In 1953 he travelled and exhibited in Italy and Germany and in 1954 visited Spain. In 1955 he published a second theoretical work, *Les Mécanismes de la Fascination*. He taught painting at the École Alsacienne. Lapoujade often derived the idea of his abstracts from natural appearances, e.g. an old decayed wall, and he believed that non-figurative art could have a social reference, which he indicated by the title. He called this non-figurative presentation of a theme 'allusive ambiguity'.

LAPRADE, PIERRE (1875–1931). French painter born at Narbonne, studied under BOURDELLE in Montauban and then at the Académie Carrière in Paris, where he met MATISSE, DERAIN and PUY. He joined with them in forming the FAUVIST movement and in founding the SALON D'AUTOMNE. Laprade was little influenced, however, by the Fauvist style and his association with the group was brief. He was essentially a Late Impressionist, an *intimiste* in the manner of VUILLARD, and he is best known for his intimate interiors and his delicate Italianate landscapes in silvery tones. He exhibited first at the Salon des Indépendants in 1901 and afterwards at the Salon d'Automne, the Salon des Tuileries and the Gal. Drouet. His style was eminently adapted to water-colour and from his youth he excelled in this medium. During the 1920s he did stage designing for the Ballets Suédois and the Théâtre des Arts and he also did a considerable volume of book illustration.

LARDERA, BERTO (1911–). Italian-French sculptor born at La Spezia. After studying at the University of Florence and then taking classes in drawing, Lardera taught himself sculpture. He settled in Paris in 1947 and in 1950 did sculpture for the Haus Lange of Mies van der Rohe at Krefeld and in 1968 for the Île de France. Beginning with two-dimensional works from metal sheets, he went on to three-dimensional constructions in a style of poetic but geometrical abstraction. Working mainly in welded sheet iron, sometimes part-coloured in restrained red, etc., he created quasi-figures to which he gave expressive names such as *Sláncio temerario* (*Rash Impetus*; 1958).

LARIONOV, MIKHAIL FEDOROVICH (1882–1964). Russian painter born at Tiraspol, near Odessa, in the Ukraine, and trained at the Moscow Institute of Painting, Sculpture and Architecture, where he continued until he was called up for military service in 1908. He was a prolific worker and had a strong personality. Under the

influence of BONNARD, VUILLARD and the FAUVES his work in these early years represented a Russian version of POST-IMPRESSIONISM which dominated the exhibitions of the GOLDEN FLEECE. Together with his friend, artistic associate and, later, his wife GONCHAROVA, however, he developed a form of cultivated Primivitism—his style more aggressive than hers—based upon an interest in Russian folk-art. This tendency was already evident at the first Golden Fleece exhibition of April–June 1908. Shortly afterwards he broke completely with the followers of French styles and arranged a series of exhibitions on his own. These were: the KNAVE OF DIAMONDS exhibition (*Bubnovyi Valet*) of 1910 in conjunction with the BURLIUK brothers; the DONKEY'S TAIL (*Oslinyi Khvost*) of 1912 after he and Goncharova had broken with the Knave of Diamonds group; and the TARGET (*Mishen*) exhibition of 1913. In a series of 'Soldier' and 'Prostitute' pictures done in 1908–13 this Primitivism was exaggerated into crude distortions and a deliberate flouting of conventional good taste. At the same time, and also in conjunction with Goncharova, Larionov was developing his own counterpart to Italian FUTURISM, which he formulated in 1912, i.e. RAYONISM. The 'movement', if such it may be called, was launched at the *Mishen* exhibition of 1913, for which Larionov issued a somewhat hysterical manifesto in the manner of the manifestos of MARINETTI and the Italian Futurists. In 1914 he and Goncharova held a large retrospective exhibition of their works at the Gal. Paul Guillaume, Paris. He returned to Russia at the outbreak of war, but went back to Paris with Goncharova in 1915 and settled there. From this time he practically abandoned easel painting and concentrated on theatrical designing for the Ballets Russes of DIAGHILEV. Among others he did the décor and costumes for *Soleil de nuit* (1915), *Contes russes* (1917) and *Renard* (1922). His works were exhibited together with those of Goncharova at a retrospective exhibition of Rayonism in Rome in 1917, at the Kingore Gal., New York, in 1922, at the Gal des Deux-Îles, Paris, in 1948, the Gal. Maeght in 1949, and at the exhibition 'L'Œuvre du XXe siècle' in the Mus. National d'Art Moderne in 1952. He had 40 paintings at a retrospective exhibition with Goncharova in the Gal. de l'Institut, Paris, in 1956 and in 1961 the Arts Council of Great Britain organized a retrospective exhibition of their works.

LASANSKY, MAURICIO (1914–). American painter and graphic artist born in Buenos Aires. In 1943 he was awarded a Guggenheim Fellowship to study in the U.S.A. and afterwards became Professor of Art in the State University of Iowa. In 1960 the Ford Foundation organized a travelling retrospective exhibition of his work. His works expressed the existential character of modern humanism, symbolizing the spiritual isolation of contemporary man. He made his name with his *Nazi Drawings* (1961–6), which were exhibited among other places at the Whitney Mus. of American Art, the Philadelphia Mus. of Art, the Des Moines Art Center and the Palace of Fine Arts, Mexico City. These life-size drawings have been described as one of the most powerful allegories of the brutalities of Fascism and as a major contribution to humanist art. Lasansky is chiefly known as an etcher and engraver.

LASSAW, IBRAM (1913–). Egyptian-American sculptor born at Alexandria. He went to the U.S.A. in 1921 and acquired citizenship in 1928. He studied at City College and the Beaux-Arts Institute of Design, New York, and in 1933 was among the earliest American artists to produce abstract sculpture, working in welded iron wire and bronze. He was a founder member of the AMERICAN ABSTRACT ARTISTS and President, 1946–9, becoming a charter member of the Artists' Club in 1949. He did not mature his personal style until c. 1950 and he had his first one-man exhibition at the Kootz Gal. in 1951. From then he exhibited frequently both individually and in group exhibitions in America and abroad. Although he continued to produce open forms in welded bronze and steel, the grid-like structures of his earlier period gave place to a more expressive idiom, which during the 1960s sometimes took on a suggestion of natural forms. He was a serious student of Zen and his later work has sometimes been held to be expressive of the serenity and sense of cosmic oneness inherent in that philosophy. He had a retrospective exhibition at the Massachusetts Institute of Technology in 1957. Lassaw was one of the group of sculptors, including ROSZAK and FERBER, whose work paralleled that of the ABSTRACT EXPRESSIONIST painters.

LATASTER, GER (1920–). Dutch painter born at Schaesberg, Limburg, studied at the School of Arts and Crafts, Maestricht, and the Academy of Art, Amsterdam. He was one of the group of painters who revived a quieter form of EXPRESSIONISM after the EXPERIMENTAL GROUP. But he settled in Paris during the 1950s and there developed a style akin to ACTION PAINTING, abandoning representation for large-format abstraction.

LATIN AMERICA. SPANISH MODERNISM, IMPRESSIONISM, POST-IMPRESSIONISM AND CUBISM. During the first two decades of the 20th c. Latin American art absorbed the combined influences of Spanish Modernism (ZULOAGA and Sorolla), Symbolism, French Impressionism and, later, POST-IMPRESSIONISM. *Plein air* painting replaced the academies, which had dominated 19th-c. art all over Latin America. In Mexico Saturnino Herrán (1887–1918), a pupil of the Spanish painter Antonio Fabrés, painted Mexican Indians as non-idealized people, and Joachim Clausell (1866–1935) applied Impressionist techniques to Mexican landscape. The Brazilian Elyseu Visconti (1866–1944) changed from Symbolism to Impressionism in the 1930s and the Uruguayan Pedro Blanes-Viale

(1879–1926) launched a 'luminist' form of Impressionism with sun-drenched landscapes. Many artists retained the solidity of form popular in Spanish and German Impressionism. In Argentina Martín Malharro (1865–1911) introduced Impressionism after 1901, and the German-trained Fernando Fader (1882–1935) founded the Impressionist *Nexus* group in 1907. The Chilean Juan Francisco Gonzáles (1853–1933), who specialized in flower painting, and the Peruvians Daniel Hernández (1856–1932) and Carlos Baca-Flor (1867–1941), the latter also a successful portrait painter, were the main exponents in their respective countries. In Venezuela Impressionism had made its appearance in the late 19th c. and continued to be practised well into the 20th c. It was reinforced by the founding in 1912 of the anti-academic *Circulo de Bellas Artes*. Impressionism had numerous adherents there, including Emilio Boggio (1857–1920), Rafael Monasterios (1884–1961) and Manuel Cabré (1890–), and it was carried to an original conclusion by Armando REVERÓN, who painted 'white' coastal scenes in which he reconverted the spectrum colours back into white light.

Post-Impressionism and EXPRESSIONISM had a large following. The best-known artists were the Colombian Andrés de Santa Maria (1860–1945), who explored the properties of distortion and artificial light in his interior scenes, and the Uruguayan Pedro FIGARI, an essayist, diplomat and lawyer, who painted scenes of bourgeois salon life in Buenos Aires and the Afro-American ritual dances known in Uruguay as the *Candombe*, rendered in bright flat colours.

CUBISM in its strict sense had few followers in Latin America. Diego RIVERA was a Cubist between 1913 and 1917. In Argentina Emilio PETTORUTI, a painter, developed a personal version of Synthetic Cubism with delicately orchestrated colours, and Pablo CURATELLA MANES, a sculptor, worked in a style related to that of LIPCHITZ and ARCHIPENKO. Yet Cubism with FUTURISM exerted a great influence all over Latin America as a basis for the innovations of the 1920s and after, including those of the Muralists of MEXICO. Even more than Cubism Picasso was imitated in all his stages, especially in the western and more insular countries such as Ecuador, Bolivia and Paraguay.

THE 1920s IN THE EASTERN COUNTRIES, CUBA AND CHILE. In the 1920s artists began to affirm their regional identities by applying a mixture of Cubism, Futurism, German Expressionism and FAUVISM to local themes. Contemporary with the Mexican Muralist movement of 1922 was the emergence of *avant-garde* groups in Cuba, Argentina, Chile and Brazil. In 1924 the Cuban painter Victor Manuel (1897–) introduced modern art in Cuba and organized a rebellion against the San Alejandro Academy in Havana. He was supported by the poet Jorge Mañach, who founded the *avant-garde Revista de Avance* in 1927. In Argentina poets and painters also banded together and in 1924 founded the review *Martín Fierro* (named

after the famous 19th-c. hero of the gaucho epic by José Hernández). The *Martinfierristas* included the painters Juan DEL PRETE, XUL SOLAR and Pettoruti, and the sculptor Curatella Manes. In Chile a more Francophile revolt took place with the founding in 1928 of the *Grupo Montparnasse* (Montparnassians) by several artists including the semi-abstract painter Camilo MORI, with the support and subsequent leadership of Pablo E. Burchard (1873–1960), whose son Pablo A. Burchard (1919–) was also a painter. The most revolutionary movement of the 1920s occurred in Brazil when the *Semana de Arte Moderna* (Modern Art Week)—a composite of dance spectacles, poetry readings and an art exhibition—was organized by the painter Emiliano di CAVALCANTI and several poets in São Paulo. The exhibition included Cubist and Expressionist paintings by Vicente do Rego Monteiro (1899–1970) and Annita MALFATTI, and sculpture by Victor Brecheret (1894–1955). German Expressionism was first introduced in Brazil in 1913 by the Lithuanian-born Lasar SEGALL and again in 1917 by Annita Malfatti after she returned from Germany and the U.S.A., where she had studied. In the same spirit of renovation, the architect Gregorio Warchavchik issued a *Manifesto of Functional Architecture* in 1925 patterned on Le Corbusier's theories, and the sociologist Gilberto Freyre issued a *Regionalist Manifesto* in Recife in 1926. The same year, the *Verde-Amarelo* literary group (named for the colours of the Brazilian flag) was formed in São Paulo. Among the greatest innovators of the 1920s in Brazil was Tarsila do AMARAL, who applied her Paris training (with André LHOTE and Fernand LÉGER in 1923) to a colourful and original Regionalism inspired by childhood memories and a trip she took to the gold-mining state of Minas Gerais with her husband, the poet Oswald de Andrade, and the Swiss-French poet Blaise Cendrars. With Oswald, Tarsila also created the *Pau-Brasil* (Brazilwood) movement in 1924, and an Anthropophagist movement in 1928, in which she painted and he wrote corresponding poems with Brazilian imagery that fused modern industry with Primitivism.

THE 1920s IN THE ANDEAN COUNTRIES. In countries where a large Indian and mestizo population exists *avant-garde* painting and sculpture came later. Instead indigenous schools of painting, patterned after the work of the Mexicans, arose in the 1920s. In Peru José SABOGÁL initiated the indigenist school after returning from Mexico in 1923. Other artists followed, such as Julia CODESIDO, Camilo Blas (1903–), Enrique Camino Brent (1875–1960), Jorge Vinatea Reinoso (1900–31) and Mario Urteaga (1875–1959), the last a self-taught painter. In La Paz, Bolivia, the first National Academy of Fine Arts was founded in 1926 and later directed by Cecilio Guzman de Rojas (1900–50), a Spanish-trained Bolivian who painted Indians in a Symbolist style. One of Bolivia's most unusual personalities was the self-taught painter and essayist Arturo BORDA, who sometimes incorporated

ancient Bolivian myths into his landscapes (a mountain takes the shape of the great Earth Mother) and is best known for a double portrait of his parents, *Leonor Gonzáles y José Borda*, which was included in the exhibition 'Art of Latin America Since Independence' at Yale University in 1966. In Ecuador prior to the 1930s, painters still did landscapes and figure compositions in a Symbolist style.

NATIONALISM AND SOCIAL REALISM IN THE 1930s AND 1940s. The influence of the Mexican Muralists which prevailed in the 1920s accelerated in the 1930s and early 1940s and spread to all Latin America. Indigenism was officially inaugurated in Ecuador when a rebellion erupted in 1939 and artists founded the 'May Salon of the Syndicate of Ecuadorian Artists and Writers' patterned after the earlier Mexican 'Syndicate of Technical Workers, Painters and Sculptors'. Indigenism and Muralism with a Picassoesque touch were practised by Eduardo Kingman Riofrio (1913–), Diógenes Paredes (1910–) and Oswaldo GUAYASAMÍN. Muralism was not new in Bolivia but a Mexicanized version was introduced there by Roberto Berdecio (1910–) in the 1940s after he returned from Mexico. In Peru Muralism persisted into the 1960s under the leadership of the painter and art historian Juan Manuel Ugarte Elespuru (1911–), whose murals are in many public buildings in Lima. Socially conscious and indigenist movements also sprang up in Argentina, Chile, Brazil, Colombia and Venezuela in the 1930s and 1940s. SIQUEIROS travelled to Argentina in 1933, where the Argentine painters Lino Eneas SPILIMBERGO, Juan Carlos Castagnino (1908–71) and Antonio BERNI collaborated with him on a mural, *Plastic Exercise*, near Buenos Aires. Berni later became famous for his COLLAGES made out of diverse materials salvaged from refuse and for his two characters, Juanito Laguna, a poor slum boy, and Ramona Montiel, a courtesan, through whose experiences Berni expressed his social and political concerns. Muralism sprang up in Chile after Siqueiros went to Chillán in 1941 and painted murals there. A more popular and collective form of Muralism emerged in Chile in the late 1960s and early 1970s led by brigades of young members of the Popular Front under Allende. In Venezuela Cesar Rengifo (1915–) and especially Gabriel Bracho (1915–) also followed the tradition of Siqueiros. In Brazil nationalism and Muralism were dominated by Cándido PORTINARI, who painted scenes of Brazilian customs and life among the poor. He collaborated with the architects Lucio Costa and Oscar Niemeyer notably in Rio de Janeiro and the state of Minas Gerais, where he did frescoes and ceramic tile murals. His work had become more Expressionistic by the mid 1940s.

THE DEVELOPMENT OF NEW AVANT-GARDE GROUPS IN THE 1930s AND 1940s IN BRAZIL AND URUGUAY. Alongside SOCIAL REALISM, new *avant-garde* groups emerged in Brazil such as the Club of Modern Artists founded in 1932 in São Paulo, and an experimental theatre founded in 1933 by Flavio de Rezende Carvalho (1899–), sculptor, architect, social psychologist, playwright, civil engineer and essayist besides painter of garishly coloured Expressionistic portraits. The same year the *SPAM* (*Sociedad Pro-Arte Moderna*) dedicated itself to exhibitions, annual dances and spectacles. In 1937 the first 'Annual May Salon' was initiated with a corresponding review *RASM* (*Revista Anual do Salão de Maio*). The Uruguayan painter Joaquín TORRES-GARCÍA, whose Catalonian-born father had taken him to Spain from Uruguay at the age of 17, returned to Montevideo in 1934 and founded the *Asociación Arte Constructivo* the following year and in 1944 his workshop, the *Taller Torres-García*, which attracted numerous followers. These included Julio Alpuy (1919–), José Gurvich (1927–75), Gonzalo Fonseca (1922–) and Torres-García's two sons, Augusto (1913–) and Horacio Torres (1924–76). Many of these artists both painted and sculpted. Fonseca turned to sculpture.

SURREALISM IN THE 1930s AND 1940s. Although a touch of the fantastic had existed in Mexico in the 1920s in the painting of Frida Kahlo (1910–54) and Juan O'GORMAN, SURREALISM was officially introduced in Latin America after the mid 1930s. André BRETON visited Mexico in 1938 and the Surrealists Wolfgang PAALEN, Remedios Varo (1913–63) and Leonora CARRINGTON sought refuge there from the war between 1939 and 1941. In the mid 1930s the Spanish-born Argentinian Juan BATLLE-PLANAS exhibited his *Radiografias Paranoicas* in Buenos Aires. In 1939 the *Grupo Orión*, whose members were sometimes referred to as 'Superrealist' because of their affinities with the Italian METAPHYSICAL school, emerged with Luis Barragán (1914–), Vicente Forte (1912–), Leopoldo PRESAS and others. Another painter, Raquel FORNER, also went through a Surrealist phase before devoting herself to themes of alienation, the Spanish Civil War, the Second World War, women and, later, space travel, in a vivid Expressionist style. In the 1940s Surrealist tendencies even appeared in the work of such non-Surrealists as Diego Rivera, Tarsila do Amaral and Portinari. The Cubans Wifredo LAM and Mario Carreño (1913–) had affinities with Surrealism. Carreño, who painted in a geometrical style related to that of the Guatemalan Carlos MÉRIDA, returned to Surrealism after his arrival in Chile in the 1950s. The Chileans Roberto MATTA Echaurren and Nemesio Antúnez (1918–), later resident in Europe, both studied architecture. Antúnez worked in HAYTER's *Atelier 17* in New York and Paris in the 1940s, and later founded his own workshop, the *Taller 99*, in Santiago, Chile. His subjects varied between watery Andean landscapes, undulating chequered patterns and penumbral metaphysical football games and ball courts. Surrealism had many adherents in Chile, including

Rodolfo Opazo (1935–), Juan Gomez Quirós (1939–), Ricardo Yrrarázaval (1931–), Guillermo Nuñez (1930–), who practised it for varying periods in their careers, Nuñez in the early 1960s, Yrrarázaval in the 1970s after a period of totemic painting involving ancestral images.

NATIVISM IN THE 1940S. Nativism re-emerged in the 1940s in Haiti and Brazil in a vividly coloured form of exotic imagery sometimes incorporating themes of African religion. In 1944 a North American painter DeWitt Peters organized the Centre d'Art Gal. in Port-au-Prince, Haiti, to encourage a growing Haitian tradition of NAÏVE painting with Hector Hyppolite (1889–1948), Wilson Bigaud (1931–), Préfète Duffaud (1923–), Castera Bazile (1923–65) and others. In Brazil Heiter Dos Prazeres (1898–1966), Alberto da Veiga Guignard (1896–1962) and Djanira (1914–) depicted popular scenes, colonial churches and folklore subjects.

ART AFTER 1945: THE 1940S AND 1950S IN THE EAST. After the mid 1940s abstract art took a firm hold with geometrical tendencies becoming more prevalent in the east and informalist ones in the west. Modern art was promoted in Argentina and Brazil with the founding of new museums and galleries: in São Paulo the Mus. de Arte de São Paulo (1947) and the Mus. de Arte Moderna (1948); in Rio the Mus. de Arte Moderna (1949); in Buenos Aires the Ver y Estimar (1948), an exhibition and lecture centre, and the Gal Bonino. in the 1950s. In 1944 the Czechoslovakian-born Argentinian sculptor Gyula KOSICE, the Uruguayan Carmelo Arden Quin (1913–) and others contributed to the publication of an issue of the avant-garde review Arturo (1944) and founded the Madi group in 1945 (disbanded in 1947) based on Torres-García's CONSTRUCTIVIST theories. The same year the Arte Concreto-Invención movement, which later became the Arte Concreto, emerged, headed by Tomás MALDONADO, who had known the Swiss CONCRETE artist Max BILL at the School of Design in Ulm, Germany. An 'Inventionist-Concrete' manifesto stated that 'the scientific aesthetic will replace the thousand-year-old speculative and idealist aesthetic'. The Madi group made a similar statement calling for unromantic and non-representational art. Kosice later developed 'hydraulic' sculpture using plexiglass, light and water as an element of instability. Contemporary with the Madi and the Concrete Art movement was Lucio FONTANA's 'White Manifesto' of 1946, which proposed 'the development of an art based on the unity of time and space'. In Brazil a Concrete movement developed in art and poetry following the first São Paulo Bienale in 1951. The artists included Hermelindo Fiaminghi (1920–), Waldemar Cordeiro (1925–), Lothar Charoux (1912–) in São Paulo; Ivan Serpa (1923–73), Lygia CLARK, Almir MAVIGNER—the last also associated with Tomás Maldonado and Max Bill—in Rio. By 1959 several artists from the Rio group had broken away from the rigours of Concrete art

to found a Neo-Concrete movement. These included Lygia Clark, Amilcar de Castro (1920–), Helio Oiticica (1937–80), all sculptors, and Ferreira Gullar (1930–), a critic and poet. This deformalizing trend became widespread and many other artists who had belonged to Formalist groups in the late 1940s and early 1950s became Informalists in the 1950s in Argentina, Uruguay and Brazil—a trend which corresponded to similar ones in Europe and the U.S.A.: TACHISM and ABSTRACT EXPRESSIONISM. Artists who had belonged to the Arte Concreto group in Buenos Aires reallied themselves with the less formalist theories of the Artistas Modernos in 1952 and the Asociación Arte Nuevo in 1955. The Argentinian Informalists included Sarah GRILO, José Antonio FERNÁNDEZ-MURO, Clorindo Testa (1923–), Mario Pucciarelli (1928–), Kazuya Sakai (1927–), Miguel O'Campo (1922–) and Marta Peluffo (1931–). In Uruguay the Informalists included the brothers Jorge (1922–) and Carlos (1923–) Paez Vilaró, who later became more figurative. In Brazil the principal exponent of Informalism was Manabu MABE.

THE 1940S AND 1950S IN CENTRAL AMERICA, THE CARIBBEAN AND THE WEST. A number of artists emerged in Central America, Cuba, Colombia, Ecuador, Bolivia and Peru who developed abstract styles sometimes inspired by their regional and pre-Hispanic heritage. In Central America the Nicaraguan Armando MORALES painted flat black and white abstractions suggesting architecture and ranging in texture from smooth shiny surfaces to thicker, rougher ones. He later turned to a more figurative style. The Cuban painter Amelia Pelaez (1897–) and the Colombians Alejandro OBREGÓN and David Manzur (1929–) developed styles deriving from Picasso rather than the later Informalism. Pelaez turned to a more figurative expression with jewel-like colours in her canvases and murals while Obregón, who was born in Spain, explored a repertory of subjects ranging from Caribbean flora, volcanoes and condors in abstract configurations to political themes inspired by Colombia's uprisings of the late 1940s and early 1950s. In Ecuador, Manuel Rendón (1894–) initiated abstract painting. Anibal VILLACÍS and Enrique Tábara (1930–), the latter having worked for several years with Informalists in Spain, incorporated references to pre-Hispanic themes into heavily impastoed abstractions. The Bolivian Maria Luisa PACHECO conjured up jagged Andean peaks in glowing textile colours or translucent whites and blacks, and the Peruvian Fernando de SZYSZLO painted abstractions in luminous glazes inspired by Inca poetry and religion. Other Peruvians such as Sabino Springuett (1914–) and Arturo Kubotta (1932–) evoked textile designs through thick impastos.

SCULPTURE IN THE 1940S AND 1950S IN SOUTH AMERICA. The Informalist tendency spread to sculpture in the 1940s and 1950s. In Argentina

Alicia PENALBA created dynamic abstractions from biomorphic floral shapes and Libero Badii (1916–) a variety of organic compositions ranging from monumental to minuscule. In Chile Lili Garafulic (1914–) and Marta COLVIN exploited the intrinsic qualities of their materials. Colvin incorporated themes related to pre-Hispanic cultures as in *Gate of the Sun* (1964). In Brazil two essentially figurative sculptors, Alfredo Ceschiatti (1918–) and Bruno GIORGI, and the Surrealist Maria MARTINS came to prominence during the architectural expansion of the 1950s and early 1960s for their contributions to the new capital, Brasilia— Bruno Giorgi with a tall figurative work, *The Warriors*, at the Civic Centre as well as a graceful white abstraction that appears to float on the surface of a reflecting pool at the Ministry of Foreign Affairs, Ceschiatti with the statue *Blind Justice* at the Civic Centre.

PAINTING AND SCULPTURE IN MEXICO IN THE 1950s. In Mexico two artists paved the way for abstraction in the 1950s, breaking the spell of institutionalized Muralism: Rufino TAMAYO and the German-born sculptor Mathias GOERITZ. Tamayo, recognized by many younger artists as the liberator of form and colour, had lived in New York and Europe and was not appreciated in his own country until the 1950s, when his aggressive animals and gesticulating figures in violent colours, sometimes inspired by Mexican pre-Hispanic and folk art, made many converts in Mexico. Goeritz went to Mexico in 1949 (he had lived in Spain and North Africa before) to teach at the University of Guadalajara. With his organic wood and metal constructions he did for sculpture what Tamayo did for painting. His monumental concrete sculpture launched a tradition in Mexico that has become popular among younger sculptors. Goeritz's best-known work in this category, executed in collaboration with the Mexican architect Luis Barragán, is *Towers Without Function* (1957–8), a complex of five towers from 160 (49 m) to 190 (58 m) feet high, in Satellite City near Mexico's capital.

THE 1960s: PAINTING, SCULPTURE AND MIXED MEDIA. The spreading of new galleries, the addition of two important Bienales—in Córdoba, Argentina (1962–8) and Medellin, Colombia (1968–72)—and the renewed interest shown in North America for Latin American art through exhibitions—several at the Walker Art Center in Minneapolis, 'Art of Latin America Since Independence' at Yale University (1966), 'The Emergent Decade' at the Solomon R. Guggenheim Mus., New York (1966), and many others—accelerated communication and diffusion between the western countries. Formalist and Informalist tendencies coexisted with diverse neo-figurative styles. In Mexico artists carried on the tradition of Goya in new ways, Rafael Coronel (1932–) with an unsettling world of alienated people, Alberto Gironella (1929–) with variations on Velazquez's paintings. The best-known neo-figurative painter was José Luis CUEVAS, whose work was introduced into the United States in 1954 when it was shown at the Pan American Union in Washington in an exhibition organized by the Cuban critic José Gomez Sicre. Cuevas's Kafkaesque world of grotesque creatures influenced others in Mexico. In 1962 a group called *Nueva Presencia* (translated as 'New Imagists' when shown in an exhibition of its members at the Cober Gal. in New York the same year) was formed with the objective of creating a new humanist art committed to universal and not just local issues.

In Colombia neo-figurative painting developed in an original way with a tendency to amplify the human proportions. In the work of Enrique Grau (1920–) happy-looking ordinary types in situations from everyday life occupy most of the canvas with their large bodies and faces. The best known for this tendency is Fernando BOTERO, who painted blown-up figures satirizing Colombian society— bishops bathing, the Colombian Presidential family, Colonial retables, houses of prostitution, 'family' pictures. In Venezuela, Jacopo Borgés (1931–) in the 1960s painted vividly coloured dynamic figures swirling through pictorial space, and Hector Poleo (1918–) depicted a more poetic oneiric world of faces and flowers in an Informal Symbolist style. In sculpture the Venezuelan MARISOL Escobar, well known for her participation in the POP ART movement of the U.S.A., produced numerous works satirizing bourgeois society. In Argentina the four painters Luis Felipe Noé (1933–), Ernesto Deira (1928–), Romulo Macció (1931–) and Jorge de la Vega (1933–73), under the collective name of *Otra Figuración*, specialized in an Expressionist colourful drip technique with faces and monstrous creatures reminiscent of the COBRA painters ALECHINSKY, APPEL, etc. A group of artists who represented the Argentinian counterpart of North American Pop Art, but with more fantasy and social meaning, emerged in the mid 1960s in Buenos Aires. Their activities were largely sponsored by the Instituto Torcuato di Tella, a visual art and experimental centre founded in 1958 (closed in the 1970s), and championed by the critic Jorge Romero Brest. Among these Dalila Puzzovio (1942–) painted a large billboard of a reclining figure with her own face (exhibited on a building in the centre of Buenos Aires), and Susana Salgado (1935–) made oversized plastic flowers and other objects. The best known was Marta Minujin (1941–), who made imaginative biomorphic objects out of mattress ticking. In 1965 she presented a half-block-long ENVIRONMENT in Buenos Aires and the following year a similar but smaller one, *El Batacazo* (*The Long Shot*), at the Bianchini Gal. in New York. An admirer of McLuhan, she also organized many media-related events in North and South America. The Graphic Bienales of Cali, Colombia, and Puerto Rico have since the late 1960s stimulated the development of the graphic media in Latin America as a major means of expression and a

way to original and autonomous forms of figuration.

INDEPENDENT ARTISTS WORKING IN THE 1960s. Some artists have evolved personal styles with or without recognizable subject matter. The Mexicans Gunther Gerzso (1915–) and two younger artists, Vicente Rojo (1932–) and Manuel Felguerez (1928–), all worked abstractly, the latter two by using semaphoric shapes in HARD EDGE compositions. Others, such as Francisco Toledo (1940–), used playful imagery in varying degrees of figuration or abstraction. The Guatemalan Rodolfo Abularach (1933–) turned the human eye into a cosmic icon, and the Brazilian Alfredo VOLPI turned flat colours and geometric planes into festive patterns with an indigenous flair. Several Ecuadorians and Argentinians worked with shaped canvas, often extended into three-dimensional volume. The Ecuadorian Luis Molinari Flores (1929–), who had belonged to the *Grupo Van* with Villacís, Tabara and others in 1960, turned to shaped canvases in the 1960s. The Argentinian Marcelo Bonevardi (1929–) embedded polished wooden constructions in flatly painted 'Metaphysical' compositions on canvas echoing Torres-García's theories. The Brazilian sculptor Sergio de Camargo (1930–) used white as a basic colour (as did many painters and sculptors in Latin America) and created sculpture with proliferations of truncated cylinders and sections of a square in painted wood or marble.

CONSTRUCTIVIST AND GEOMETRIC ART IN THE 1960s: COLOMBIA. Geometry formed the basis of the work of many Colombian painters and sculptors. The sculptors Eduardo RAMIREZ VILLAMIZAR and Carlos Rojas (1933–) made austere monumental forms. Rojas sometimes combined painting with sculpture. He also made exterior linear structures with black rods that seem to frame the landscape. Ramirez made large-scale monuments, including one for the John F. Kennedy Center in Washington. Edgar NEGRET made graceful metal constructions from nuts and bolts that suggest machinery as well as primeval creatures within a geometrical framework. All these artists restricted their colours mainly to black, white, red or neutral tones. Omar Rayo (1928–) painted black and white patterns resembling folded napkins and created intaglios of daily objects, clothes, can openers, shoes, in highly stylized formal designs. Santiago Cárdenas (1937–) also painted ordinary objects such as chairs, umbrellas, electric outlets and plugs in sparse, precise compositions.

OPTICAL AND KINETIC ART: VENEZUELA AND ARGENTINA. The major Optical (see OP ART) and KINETIC artists have been Venezuelans and Argentinians. In Venezuela Kinetic Art was popularized and promoted from the mid 1950s when the architect Raul Villanueva built the core of University City in Caracas and incorporated sculpture and murals by CALDER, Léger, VASARELY and several Venezuelans. Alejandro OTERO, Jesús Rafael SOTO and Carlos CRUZ-DIEZ are among the best known.

Otero, who lived in Paris, painted a series of *Coffee-pots* in the 1940s which became increasingly abstract as the reflections of light on metal came to replace the objects themselves. In the 1950s he began the *Colour-rhythms*, which consist of superimposed vertical bands painted in bright optical Duco colours. Soto, also in Paris for several years, was included in the exhibition 'Le Mouvement' (1955) at the Denise René Gal. there. His delicately orchestrated *Vibrations* were made by suspending thin wires or attaching squares over a thinly striped surface, creating a rippling effect. The *Penetrables* were environments of densely packed translucent nylon tubes through which people could walk. Cruz-Diez created dematerialized images of shifting and vanishing geometrical patterns, which he called *Fisicromias*, by painting along perpendicular vertical strips attached to a flat surface instead of the surface itself.

Argentinians have variously explored plastic, metal, light, glass and other materials. Rogelio POLESELLO arranged brightly patterned paintings behind, or near, plastic panels embedded with magnifying lenses to create multiple psychedelic images. He used coloured plastics in diverse illusory ways. The best-known Argentinian Kineticist was Julio LE PARC, who was a founder of the GROUPE DE RECHERCHE D'ART VISUEL (GRAV) in 1960. He painted retinal images with high-keyed spectrum colours and created numerous environmental works such as his installation in 1966 at the Howard Wise Gal. using suspended metal elements, lights and distorting mirrors. Other Argentinians, Marta Boto (1925–) and Hugo Demarco (1932–), animated their works with motors. In the late 1960s three artists in Buenos Aires started what they called GENERATIVE painting, i.e. painting in which one form generates another. They were Eduardo MCENTYRE, Miguel Ángel Vidal (1928–) and Ary Brizzi (1920–), the last also a sculptor. In their painting they created illusions of three-dimensional space with curved or straight lines that combined to form volumes. Light and colour were at their densest at the linear intersections.

In the 1970s neo-figuration increased in many countries, and in Argentina and Chile Surrealism continued to be practised.

LATTANZI, LUCIANO (1925–). Italian artist and writer on art theory, born at Carrara. He studied philology at Naples and then took up art in 1956. His paintings were decorative abstractions in which he made extensive use of a repertory of 'semantic signs': squares, circles, crosses, zigzags, ciphers, etc., which were interwoven and superimposed to form patterns but had no logical semantic significance. He called this 'Semantic Art' and in 1961 issued a manifesto 'On the Semantic Picture' jointly with the German Werner SCHREIB, followed in 1962 by a book *Semantic Painting*.

LAUBSSER, ERIC. See SOUTH AFRICA.

LAUBSSER, MAGGIE. See SOUTH AFRICA.

LAUKO, JURAJ (1894–). Czech NAÏVE painter, born at Szarvas, Hungary. He began painting in 1928. He was represented in an exhibition of Slovak Amateur Art in Prague (1962), in the exhibition 'Naïve Art in Czechoslovakia' at Brno, Bratislava, Prague, Ostrava (1963–4), and in exhibitions of naïve art at Salzburg, Graz and Linz (1964). His cycle 'A Year in a Slovak Village' was exhibited in Bratislava in 1965. Using warm, clear colours, he painted scenes from village life with great freshness and spontaneity, managing well the distribution of groups and crowds of figures. His best-known sequence is the cycle of episodes 'A Year in the Country'.

LAUNOIS, JEAN (1898–1942). French painter, born at Les Sables-d'Olonne. He was a friend of André Gide and Albert MARQUET and was ranked among the *peintres maudits*. He travelled in Algeria and Indo-China and was known chiefly for his lively water-colours and illustrations, which expressed a mood of disenchantment with his experiences there.

LAURENCIN, MARIE (1885–1956). French painter born in Paris. Apart from evening classes in drawing she was self-taught as an artist. In 1907 she was introduced by the picture dealer Clovis Sagot to APOLLINAIRE, PICASSO and their circle and from this time until the outbreak of the First World War she lived with Apollinaire and was an exhibiting member of the CUBIST group. Her own work, however, was entirely peripheral to the Cubist movement. She painted delicately decorative portraits of young girls in pastel colours and although she borrowed a few tricks of stylization from her Cubist friends, her own lyrically charming or even sometimes saccharine style remained basically unchanged throughout. Her personality was stronger than her works. From 1913 to 1940 she was exhibited under contract by Paul Rosenberg. In addition to painting she designed sets for Poulenc's *Biches* for the Ballets Russes in 1924 and in 1928 the décors for *À quoi Rêvent les Jeunes Filles* for the Comédie Française. She illustrated some 30 books, including *Alice's Adventures in Wonderland* and *La Tentative Amoureuse* by André Gide.

LAURENS, HENRI (1885–1954). French sculptor, born in Paris of a working-class family. He received his early training with a decorator from 1899 and in 1902 moved to Montmartre and practised sculpture. At first influenced by Rodin, he gradually developed a more formalized style which in some ways foreshadowed CUBISM. In 1911 he met BRAQUE and through him became a convert to the Cubist movement. Translating into sculptural terms the Cubist painters' emphasis on geometrical analysis of forms, he built up solid figures whose interest lay in the interplay of rectilinear planes rather than the suggestion of volume and in which curvilinear profiles were reduced to a minimum. Examples of this style are the stone *Man with a Pipe* (Fine Arts Associates, New York, 1919) and a *Head* in painted wood (The Mus. of Modern Art, New York, 1915–18). He also produced a large number of polychrome constructions in metal, wood, paper, plaster, etc. which often closely resembled Cubist still-life paintings with the suggestion of multiple viewpoints and subtle interplay of planes. He developed a certain originality of idiom in these constructions and in COLLAGES and was introduced by PICASSO to Léonce Rosenberg, who supported him and gave him exhibitions in 1917 and 1918. Of his Cubist work D.-H. KAHNWEILER wrote: 'I have often stated how important Henri Laurens' work seemed to me. His place in the "great phase" of Cubism cannot be too highly estimated. With his coloured reliefs he contributed to the solution of the problem of creating form without recourse to modelling. I once described his collages as the "flowering of Cubism".'

In the 1920s Laurens abandoned the geometrical form of Cubism and reintroduced curvilinear shapes into his work. During the financially stringent period of the Depression he worked mainly in terracotta, gradually evolving the mannered and highly personal style of organic distortion which came to maturity in the later 1930s. In 1935 the award of the Helena Rubinstein prize brought him to public notice and in 1936–7 he did a number of works in his new style for the Sèvres Pavilion and the Palais de la Découverte at the Paris Exposition Universelle. With his escape from the rigours of Cubism Laurens also became interested in mythological figures such as his *Sirens* and his *Oceanides* and *Ondines*, which often acquired a symbolic significance. His *Caryatid* was bought by the State in 1938 and in 1946 the Mus. Nationaux purchased his *Large Siren* and the Direction Générale des Arts et Lettres his *Adieu* (1941). The latter, according to Carola Giedion-Welcker, 'made during the dark days of the fall of France, is a powerfully dramatic symbol of the collapse'. Others have interpreted it more widely as a metaphor of the human life cycle.

In 1947 Laurens was exhibited at the Buchholz Gal., New York. In 1948 he represented French sculpture at the Venice Biennale and in 1948 a major retrospective exhibition, for which D.-H. Kahnweiler wrote an Introduction, was put on by the Palais des Beaux-Arts, Brussels, and the Kunstforeningen, Copenhagen. A still larger retrospective, the largest Laurens exhibition to that date, was organized in 1951 at the Mus. National d'Art Moderne, Paris, with a catalogue by Jean Cassou, and in the same year a smaller exhibition was given by the Arcade Gal., London. In 1952 the monumental version of his *Amphion*, a bronze 13 ft 3 ins (4 m) high, was commissioned for the University of Caracas and in 1953 Laurens was awarded First Prize at the São Paulo Bienale.

Laurens was considered by the French *avant-garde* to be the greatest French sculptor of his age (though, as Werner Haftmann remarked, if one excludes painter-sculptors and foreigners working in France, there is no one left who could be measured against him). He was admired by Picasso, Braque and Juan GRIS, and when he failed to obtain the prize at the Venice Biennale MATISSE in protest shared his prize for painting with him. After his death his international reputation spread more widely despite the rather mannered style and obscure symbolism of his later work. Posthumous exhibitions included the Marlborough Fine Arts Gal., London (1954 and 1957) and the Marlborough-Gerson Gal., New York (1966); a travelling exhibition shown in Cologne, Krefeld, Hamburg, Berlin and Basle (1956); The Fine Arts Associates Gal., New York (1958); Kunsthaus, Zürich (1961); Stedelijk Mus., Amsterdam (1962); Malmö Mus. (1965); Grand Palais, Paris (1967).

LAUSEN, JENS (1937–). German painter, born in Hamburg. After apprenticeship in a workshop of graphic art, he trained at the Hochschule für Bildende Künste, Hamburg, from 1957 to 1961, and then worked as an industrial designer. Combining an enthusiasm for German Romantic landscape with an interest in the German school of POP ART, he evolved an original style of fantastic landscape. Watch towers, signal lights, transmission stations stand like statues in the foreground of his pictures with idealized cosmic landscapes indicated behind. Besides exhibitions in Germany he had a one-man show at the Marlborough Fine Arts Gal., London, in 1969; among the collective exhibitions in which he was represented were the 9th Biennale, Tokyo, '6 Deutsche Maler' at the Gal. Claude Bernard, Paris, in 1967 and 'German Painters of Today' in Melbourne, Adelaide and Karachi in 1968.

LAVAL, CHARLES. See SYNTHETISM.

LAVERY, SIR JOHN (1856–1941). British painter born in Belfast, studied at Glasgow and subsequently in Paris, at the Académie Julian and the Académie Colarossi. He was a member of the GLASGOW SCHOOL and later worked in London. His first one-man exhibition was at the Goupil Gal. in 1891. His early work was influenced by Whistler, the Impressionists and the *plein air* school. It held considerable promise, which was not fulfilled as later in life he succumbed to the facile lures of a popular portrait painter. He was knighted in 1918 and was made an R.A. in 1921. In 1941 a memorial exhibition of his work was held at the Leicester Gals.

LAVONEN, AHTI (1928–70). Finnish painter and graphic artist, studied at the Free Art School, Helsinki. His first one-man exhibition in Finland was in 1949. He also exhibited in Paris, Milan and the U.S.A. and was represented at the Venice Biennale

in 1962 and 1968. During the latter 1950s he painted geometrical abstractions reminiscent of the work of CARLSTADT, but early in the 1960s he turned to INFORMAL and expressive abstraction in a more individual manner. From this he developed in the direction of MATTERISM with exaggerated emphasis on the material substance of the painting and on surface texture until his built-up surfaces reached the point of actual reliefs. At the end of the 1960s his style changed once more as in his *Small Plastic Aluminium Relief* (1969), where painted and metallic surfaces are contrasted and the play of light on smooth surfaces is exploited.

LAWRENCE, JACOB (1917–). Black American painter, born in Atlantic City, moved to Harlem and began to paint *c.* 1930. He depicted life in the tenements of Harlem and documented the predicament of black people. He belonged to the school of SOCIAL REALISM, using his art as an instrument of social protest. He was also interested in Negro history and did series of paintings depicting incidents from it.

LAWSON, ERNEST. See EIGHT, THE.

LEBEL, JEAN-JACQUES (1936–). French painter, experimental artist and art theorist. Brought up in New York, Lebel studied painting at Florence. He was the founder of *Workshop de la libre Expression*, Paris, 1964, and during the 1960s he became the chief theorist of HAPPENINGS in France. He made COLLAGES which often took on a political slant, and in his theory of Happenings he emphasized total audience commitment and regarded the Happening as an instrument of man's rebellion in search of freedom from social conditioning.

LEBENSZTEIN (LEBENSTEIN), JAN (1930–). Polish painter born at Brest Litovsk, studied at the Academy of Art, Kraków, settled in Paris in 1959. Lebensztein was a painter of the imagination who depicted fantasy figures with a richly EXPRESSIONIST technique. His 'axial figures' of the 1950s gave place during the 1960s to vaguely biological allusions and allegorical compositions. He was awarded a prize at the Paris Biennale des Jeunes and in 1961 he had a one-man exhibition at the Mus. National d'Art Moderne, Paris.

LEBLANC, WALTER (1932–). Belgian sculptor and experimental artist born at Antwerp and studied at the Academy there. He was prominent in the development of CONSTRUCTIVISM in Belgium and he experimented with effects of movement and light. He exhibited with the NOUVEAUX RÉALISTES at the *Nouvelle Tendance* and some of his works reached environmental scale. He was particularly known for his *Torsions* and his *Mobilo-Statiques*. The former subjected serial colour notations to a 'torsion' or twisting effect from which the work acquired dynamism. The *Mobilo-Statiques* used

parallel spiral strips of white plastic which reflected and absorbed light to create a plane made up of spaces. A vibratory effect was produced.

LEBRUN, RICO (1900–64). American painter and graphic artist, born in Naples. He studied at the National Technical Institute and the Industrial Institute, Naples, while attending classes also at the Naples Academy of Fine Arts. After serving in the First World War he worked as a designer of stained-glass windows until 1925, when he moved to New York and supported himself as an advertisement artist. From 1930 to 1933 he studied fresco techniques in Italy and on his return to the U.S.A. he executed a mural for the Fogg Art Mus., Cambridge, Mass. After winning a Guggenheim Fellowship he taught at the Art Students' League, 1934–5, and then collaborated on a FEDERAL ARTS PROJECT for a mural for the Pennsylvania Station Post Office Annex, New York. He held his first one-man show at the Julien Levy Gal., New York, in 1944. In 1951 he became director of the Jepson Art Institute, Los Angeles, where he had been teaching since 1947, and during the same period he was working on a series of Crucifixions which culminated in the *Crucifixion Triptych* (Syracuse University, 1950). His work during the 1950s displayed an increasing tendency towards baroque frightfulness which has, perhaps inevitably, elicited comparisons with Goya. From 1950 to 1961 he worked on a mural commissioned by Pomona College, Claremont, California, and in the early 1960s did a series of illustrations for Dante's *Inferno*. A retrospective exhibition of his work was held at the Los Angeles County Mus. of Art in 1967. In *The New Humanism* (1974) he was described by Barry Schwartz as 'the most influential metaphysical Humanist of the century'.

LECK, BARTH (BART) ANTHONY VAN DER (1876–1958). Dutch painter born at Utrecht, studied at the State School for Decorative Arts there and at the Academy, Amsterdam. His early landscape work fell within the ambit of the HAGUE SCHOOL, but he then joined the Dutch Monumentalist group and from 1908 developed a highly personal style of simplification and stylization. While his work remained representational, he eliminated three-dimensional perspective and on a flat plane reduced his figures to sharply delineated geometrical forms in primary colours. In 1917 he joined the De STIJL group and began to paint abstract compositions consisting of fragmentary lines and coloured rectangles into which figural scenes had been broken down. They were very similar to the paintings which MONDRIAN was producing at this time and for a while the two artists worked closely together. But whereas Mondrian went on to 'pure' abstraction with no underlying figural source, Van der Leck reverted to figural subjects though employing the same restricted and geometrical elements. In 1918 he designed the interior of the Bruynzeel stand at the Utrecht Fair. During the 1920s he became interested in textile design and during the 1930s and 1940s he extended his interests to ceramics and interior decoration, experimenting with the effects of colour on the sense of space.

Paintings by Van der Leck may be seen at the Rijksmus. Kröller-Müller, Otterlo.

LE CORBUSIER (CHARLES-ÉDOUARD JEANNERET, 1887–1965). Swiss-French architect and painter, born at Chaux-de-Fonds, where he studied at the local art school and trained as an engraver. He began the study of architecture in 1905 and became one of the most influential figures of his generation in the development of modern architecture. Although his achievement in painting and the graphic arts was smaller, it was not without importance. He became deeply involved with the experiments of the CUBIST school; then, believing that Synthetic Cubism was degenerating into an art of empty decoration, he met OZENFANT in 1918 and in collaboration with him published the book *Après le Cubisme* setting forth these views. In the same year he exhibited paintings and drawings jointly with Ozenfant at the Gal. Thomas. At this time he was still signing his work 'Jeanneret'. In 1920 he collaborated with Ozenfant in founding the journal *L'Esprit Nouveau*, which gave admirable expression to the new aesthetic spirit of the 1920s and gave birth to the movement of PURISM with its doctrine of a machine aesthetic. He wrote, 'A great epoch has begun, animated by a new spirit: a spirit of construction and synthesis, guided by a clear conception.' Up to 1929 he painted only still life, but from that time the human figure was occasionally introduced into his compositions. Although he retained the Purist dislike of ornament for its own sake, his work became more dynamic and his manipulation of volumes more suggestive of fresco. In 1936 he did tapestry designs for Aubusson. In these years his painting grew more imaginative and lyrical though still restrained by his horror of any form of excess. He became a French citizen in 1930. His subsequent honours and fame owed more to his achievements in architecture than painting.

LE-DANTIGU, MIKHAIL. See RAYONISM.

LEDUC, FERNAND. See CANADA.

LEE-NOVA, GARY. See CANADA.

LEF. The main periodical of Soviet CONSTRUCTIVISM. It was founded and edited by the poets Vladimir Mayakovsky and Pavel Tretyakov. It ran from 1923 to 1925 and under the title *Novyi Lef* in 1927–8.

LE FAUCONNIER, HENRI (1881–1946). French painter, born at Hesdin, Pas-de-Calais. He moved to Paris in 1901 and in 1906 began to study at the Académie Julian, where DUNOYER DE SEGONZAC,

BOUSSINGAULT and LA FRESNAYE were fellow students. From 1906 he made repeated visits to Brittany, where he painted solidly constructed landscapes and peasants in local costume in a style which owed much to Cézanne. From *c*. 1910 he was in close contact with artists of the CUBIST school and exhibited with them in 1911. He also became a member of the NEUE KÜNSTLERVEREINI-GUNG at Munich in 1910 on the invitation of KANDINSKY, and his *L'Abondance* (Gemeentemus., The Hague), which he had exhibited at the Salon des Indépendants in 1911, was reproduced in the BLAUE REITER *Almanach* and shown in the KNAVE OF DIAMONDS exhibition in Moscow. He had a one-man exhibition at the Folkwang Mus., Hagen, in 1912—one of a number of exhibitions in Germany during the years before the outbreak of war. In 1912 he began to teach at the Académie de la Palette, where Marcel GROMAIRE was among his pupils, and within the next couple of years left Cubism for a variety of EXPRESSIONISM, although he still retained in his work structural features derived from Cubism but adapted to expressive purposes. He passed the war years in the Netherlands, where he laid the basis of an important European reputation and exercised considerable influence on the development of northern Expressionism as well as spreading the mannerisms of the Cubist school. After his return to Paris in 1920 he gradually abandoned his Expressionist manner for a more restrained and austere style. The J. B. Neumann Gal. in New York gave a retrospective exhibition of his works in 1949 and the Stedelijk Mus., Amsterdam, in 1959. G. H. Hamilton has said that 'Le Fauconnier's influence was greater than his talents' and that 'he was so skilful an expositor that he, rather than a more creative artist, was a principal agent for the dissemination of the new idea' (i.e. Cubism). His painting *L'Abondance* (1910–11) has been described as 'one of the most exhibited paintings in Europe before the First World War'.

LEFRANC, JULES (1887–). French NAÏVE painter born, like Henri ROUSSEAU, at Laval on the Mayenne. He worked in his parents' hardware store devoting his spare time to painting, at which he was encouraged by Monet in 1902. In 1911 he bought a wholesale hardware business. After serving in the First World War he met Louis Aragon in 1920 and in 1928 he retired from his business in order to devote himself to painting. He worked with minute and detailed precision, often using ruler and set-square, yet with a feeling for mass, and his brilliant colours have the smoothness of enamel. He transposed the mechanism of the industrial world into a still life of mechanical things. His first one-man show was in 1938 at the Gal. Carrefour, Paris, introduced by Jean Cassou. He was included in many international exhibitions of naïve art and in 1953 his picture *Le Château et son miroir d'eau*, shown at the Gal. de Berri, was acquired by the Mus. National d'Art Moderne. In 1956

he had an exhibition at the Gal. Berri-Lardy, Paris.

LÉGER, FERNAND (1881–1955). French painter, born at Argentan, Normandy. He was apprenticed to an architect in Caen, 1897–9, and then worked as a draughtsman in an architect's office in Paris, 1900–2, and as a photographic retoucher, 1903–4. In 1903 he failed the entrance examination for the École des Beaux-Arts, Paris, and studied at the École des Arts Décoratifs and the Académie Julian. From *c*. 1909 he was associated with the CUBISTS and from 1911 was a member of the informal PUTEAUX group. In 1913 he signed a contract with D.-H. KAHNWEILER. During his Cubist period his tubular and curvilinear abstractions contrasted with the rectilinear forms preferred by PICASSO and BRAQUE and *c*. 1911 he was the first of the Cubists to experiment with non-figurative abstraction. After having been gassed in the war he was discharged in 1917 and formed a friendship with LE CORBUSIER and OZENFANT. He collaborated with Ozenfant in the *atelier libre* and in 1925 he exhibited at Le Corbusier's Pavillon de l'Esprit Nouveau. In 1925 also he did mural decorations in collaboration with DELAUNAY for the entry hall of the exhibition 'Les Arts Décoratifs'. During this period of his association with the leaders of the PURIST movement his work exemplified the 'machine aesthetic' which Purism stood for. His paintings were static, with the precise and polished facture of machinery, and he had a fondness for including representations of mechanical parts. During the late 1920s and 1930s he also painted single objects isolated in space and sometimes blown up to gigantic size. He also busied himself with theatrical décors, especially for the Ballets Suédois, and with the cinema. His *Ballet mécanique* (1924) was the first film without scenario. During the Second World War he lived in the U.S.A., teaching at Yale University together with Henri Focillon, André Maurois and Darius Milhaud, and at Mills College, California. His painting at this time consisted of compositions featuring mainly acrobats and cyclists. From his return to France in 1945 his painting reflected more prominently his political interest in the working classes. But its static, monumental style remained, with flat, unmodulated colours, heavy black contours and a continuing concern with the contrast between cylindrical and rectilinear forms. In 1949 he opened a studio for ceramics with his former pupil Robert Brice and made there his glass mosaic for the University of Caracas (1954). At the same time he was working on the windows and tapestries for the church at Audincourt (1951). A Léger Museum was founded in his honour at Biot, with large ceramic panels designed by him. Memorial retrospective exhibitions were given at the Mus. des Arts Décoratifs, Paris, in 1956 and at the Haus der Kunst, Munich, in 1957.

Although in his Cubist years Léger started with the concept of art as an autonomous activity, during his war years his contact with men of dif-

ferent social classes and different walks of life came as a revelation to him. 'I was abruptly thrust into a reality which was both blinding and new,' he said. Henceforward he made it his ambition to create an art which should be accessible to all ranks of modern society. He saw the poetic value that lies in the clear delineation of everyday objects, the intrinsic beauty of modern machinery and the things which are mass produced by machinery, and he favoured proletarian subjects, depicting them with the same clarity and precision as the themes taken from machine culture. His views were best expressed in a lecture delivered in 1923 at the Collège de France: 'The Aesthetics of the Machine: Manufactured Objects, Artisan and Artist'. His influence on the artists of his day was far-reaching and very diversified.

LEGUEULT, RAYMOND (1898–). French painter born at Paris and studied at the École Nationale des Arts Décoratifs, where he taught from 1925 after making a visit to Spain in 1922. From 1952 he was *chef d'atelier* at the École des Beaux-Arts. Legueult was one of the leading painters of 'poetic reality' using a refined and sophisticated style of Late Impressionism deriving from BONNARD. He had frequent one-man exhibitions in Paris and in 1958 an individual room at the Venice Biennale. In the 1920s he collaborated with Maurice BRIANCHON on theatrical designs for the ballet.

LE HAVRE GROUP. A name sometimes applied to DUFY, FRIESZ and BRAQUE, who had all attended the École Municipale des Beaux-Arts in Le Havre. They later became members of the FAUVES group.

LEHMBRUCK, WILHELM (1881–1919). German sculptor, born near Duisburg, son of a miner. He studied first at the School of Applied Art, 1895–9, and then at the Academy of Art, Düsseldorf, 1901–7, and in 1905 travelled to Italy on prizes which he won for sculpture. He was in Paris from 1910 to 1914 and there came into contact with ARCHIPENKO, MODIGLIANI and others of the ÉCOLE DE PARIS. Lehmbruck's early work was in the tradition of classical naturalism and stood in succession to that of Rodin and MAILLOL. He found his personal style during his stay in Paris and his *Kneeling Woman* of 1911, shown at the Cologne *Sonderbund* exhibition of 1912, was hailed by critics as the culmination of German EXPRESSIONISM while Lehmbruck himself was praised by Meier-Graefe and others as the outstanding German sculptor. Adverse criticism of his work centred around the *Dying Warrior*, conceived as a tribute to those who fell in the First World War. This was exhibited at the Berlin SECESSION in 1916 and aroused hostility by its failure to conform to the public idea of the heroic war memorial. It is a semi-prostrate nude warrior grasping the hilt of a broken sword. In 1917–18 Lehmbruck was working in Zürich. He returned to Berlin in 1919 and committed suicide there.

Lehmbruck often worked in marble, but he was by temperament a modeller rather than a carver, working in clay over a spindly armature, and several of his works were cast in artificial stone to preserve the texture of the clay. With BARLACH he has been represented as the outstanding exponent in sculpture of modern German Expressionism. But the spirit of his work is very different from that of Barlach. Seen in historical perspective, his figures with their elongated tubular limbs and bodies now seem more mannered than monumental. Lehmbruck also did etchings and lithographs. He left some 75 plates, which include illustrations to the Bible and to Shakespeare.

LEHMDEN, ANTON (1929–). Painter, born at Nitra, Czechoslovakia, lived in Vienna from 1945 and studied at the Vienna Academy of Art under R. C. ANDERSEN and GÜTERSLOH. From his student days he studied the paintings of Altdorfer, Bruegel and the 15th-c. Italian masters in the Kunsthistorisches Mus., Vienna, and emerged to public notice as a member of the Austrian school of FANTASTIC REALISM which arose in Vienna in the 1940s. With FUCHS, HAUSNER and HUTTER he exhibited at Turin (1949), Venice (1951), Amsterdam (1956) and Istanbul (1962). He contributed to the Venice Biennale in 1950 and 1954. His paintings based on fantasized memories of wartime scenes against desolate backgrounds, executed in a classical technique derived from Altdorfer and Bruegel. He also painted allegorical townscapes and was a master of etching techniques.

LEINFELLNER, HEINZ (1911–74). Austrian sculptor born at Steinbrück, Styria, studied at the School of Arts and Crafts, Graz, and afterwards, 1932–3, at the Vienna Academy, where he was a pupil of HANAK. Later he worked as assistant to WOTRUBA, 1947–51, and was appointed Professor at the Vienna Academy of Applied Arts in 1959. He was represented in the DOCUMENTA II exhibition at Kassel in 1959 and had a retrospective exhibition at the Kunsthalle, Baden-Baden. In 1961 he was made an honorary member of the Belgian Royal Academy. After passing through a CUBISTIC phase he gradually evolved a personal style of heavy rectilinear forms and flat planes, often planning his sculptures to fit as an integral element into building projects. His latest style, however, exploited moulded shapes and rounded contours adapted more subtly to suggestions of the human figure.

LEISSLER, ARNOLD (1939–). German painter born at Hanover, studied at the Werkkunstschule there and at the Academy in Nuremberg. In 1961 he was awarded a scholarship from the Gropius Foundation, Hanover, to visit Florence, in 1965 he won the prize for art at Wolfsburg and in 1967 a scholarship to the Villa Massimo, Rome. In the 1960s he was one of the few German artists to introduce the use of POP ART imagery, developing

from this in the direction of abstraction with a meticulous, impersonal facture reminiscent of POST-PAINTERLY ABSTRACTION in America. His work was extensively exhibited in Germany from the mid 1960s.

LE MOAL, JEAN-LOUIS (1909–). French painter, born at Authon-de-Perche of Breton stock. He studied at the École des Beaux-Arts, Lyons, and then at the Académie Ransom, Paris, where he was influenced by BISSIÈRE, 1934–8. During this time his work, in contact with MANESSIER and BERTHOLLE, became increasingly abstract. His first exhibition was in 1938 at the Gal. Breteau. In 1939 he collaborated on an enormous abstract ceiling painting for the International Exhibition of New York. Returning to Lyons and Paris he joined the group *Témoinages* and was a founder member of *Les Jeunes Peintres de la Tradition Française.* During the 1940s he exhibited at the Gal. de France, the Gal. René Drouin and the Salon de Mai and in 1956 had an important one-man show at the Gal. de France. In 1953 he won the Prix de la Critique. He belonged to the school of LYRICAL ABSTRACTION which dominated the ÉCOLE DE PARIS in the late 1940s and 1950s and like BAZAINE, ESTÈVE, Manessier and SINGIER he evolved his abstractions from impressions made by natural appearances. His personal style within the category of lyrical abstraction was characterized by linear arabesque interspersed with spots and flecks of colour.

From c. 1939 he did much stage design and he was also expert in stained glass.

LE MOLT, PHILIPPE. See FRANCE.

LENTULOV, ARISTARKH VASILIEVICH (1882–1943). Russian painter and designer born in the Penza region. He studied at the Penza School of Drawing, 1898–1900; in Kiev, 1900–5; and in 1906 entered the St. Petersburg Academy of Fine Arts, where he worked under Dmitrii Kardovsky. In 1908 he contributed to the Wreath exhibition in St. Petersburg, the first of many involvements with the *avant-garde,* and in 1910, with FALK, Konchalovsky, LARIONOV, Mashkov, etc., he formed the nucleus of the KNAVE OF DIAMONDS. In 1911 he travelled to Italy and France, where he was influenced by LE FAUCONNIER, GLEIZES and METZINGER, and in 1912 he exhibited his first CUBISTIC works. In 1913 he painted *St. Basil's Cathedral, Red Square,* one of his most important works. He was Director of the Studio of Theatre Design in the VKHUTEMAS from 1919 to 1926 and in 1925 was co-organizer of the Cézannist group called Moscow Painters. He joined AKHRR in 1926 and in the late 1920s changed from his more experimental and innovative style to a more naturalistic and conventional manner, continuing to paint landscapes and portraits until his death.

LEONCILLO, LEONARDO (1915–68). Italian sculptor and potter born at Spoleto and trained at the Art Institute in Perugia. After managing a pottery workshop in Umbria he settled in Rome in 1942 and became a member of the FRONTE NUOVO in 1946. From CUBISTIC and EXPRESSIONIST stylizations his work developed towards geometrical abstraction without any basis in natural appearances but always with a sensibility for the expressive qualities of his materials.

LE PARC, JULIO (1928–). Argentinian experimental artist born at Mendoza and trained in Buenos Aires. He went to Paris in 1958 and after working for a while with Victor VASARELY became a founder member of the GROUPE DE RECHERCHE D'ART VISUEL (GRAV). He was prominent in exploring certain forms of OP ART, KINETIC ART and the utilization of light for artistic purposes (LUMIA). Le Parc professed to adopt a rational and objective attitude to his work, repudiating the idea of artistic creativity and working according to scientific principles. With other members of GRAV he favoured collective composition. He also wished to eliminate subjective response on the part of the spectator, looking for an objective and predictable perceptual response to a planned stimulus. The idea that a work of art should carry symbolic or subjective meaning for the spectator was foreign to his method of approach. He did, however, develop in certain ways the notion of observer participation. He began with the exploration of surface patterns of which one or more parameters were modified according to a regular sequence in such a way as to produce unstable or ambiguous visual structures on the periphery of perception. About 1960 his interest in colour and light led him to explore the possibilities of MOBILES with the use of perspex prisms and cubes to produce calculated effects of transparency and reflected light. He also made reliefs of different substances which rotated at different speeds and he exploited the textural qualities of various materials for the reflection of light. His *Ensembles* of 1962 enveloped the spectator in a changing rhythm of reflected light and his *Continuels-lumière,* demonstrated at the exhibition 'Kunst-Licht-Kunst', Eindhoven, in 1966, refined his techniques for combining reflected light with movement. This was also the principle of his *Labyrinthe* made for the Paris Biennale of 1963. His *Continuel-mobile, Continuel-lumière* of 1963 is in the Tate Gal., London. Spectator participation was invited by constructs with adjustable parts whose manipulation caused a sudden production of light or modified the movement of reflected light. Le Parc also experimented with various means of affecting the spectator by sudden or unexpected stimuli, such as distorting spectacles or a collapsible chair, which can only by a stretch of imagination be considered relevant to artistic concerns. Edward Lucie-Smith said of him in *Movements in Art since 1945* (1969): 'Le Parc creates devices which belong partly to the laboratory, partly to the funfair. They are experiments with mechanisms and also experiments

upon the psychology of the spectator.' He did, however, take a prominent part in the complicated experimentation which took place during the 1960s in Op and Kinetic art.

In the course of the 1960s he exhibited with numerous groups other than GRAV, including the NOUVELLE TENDANCE, and he shared several collective awards with GRAV colleagues. In 1966 he invited controversy when he was awarded the Painting Prize at the Venice Biennale. His work became widely known in collective exhibitions of experimental art in North and South America, Europe and Japan. In 1966 and 1967 he exhibited at the Howard Wise Gal., New York, and the Gal. Denise René, Paris. From 1968 his works began to assume a rather blatant political tone. In works exhibited, for example, at the 2nd Coltejer-Medellín Bienale (1970) and at the Kunsthalle, Düsseldorf (1972), spectators were invited to shoot arrows at caricature cut-outs personifying Imperialists, Capitalists, the Military and the Police. He later reverted to more conventional modes of expression.

LEPLAE, CHARLES (1903–61). Belgian sculptor born at Louvain, son of a university professor. He spent the years 1914–18 at Oxford and was destined for a university career, but in the 1920s he was attracted to sculpture and became intimate with EXPRESSIONIST artists. He studied sculpture in Paris under Charles DESPIAU and was influenced by the work of MAILLOL. In 1932 he settled in Brussels and took part from then onwards in exhibitions of the *Centaure* group and *L'Epoque*. In the 1940s he experimented with the use of polychrome and combining bronze with ceramics or with terracotta as in his *Torse d'Homme* (Mus. Royaux des Beaux-Arts, Brussels, 1947). He taught at the École Nationale Supérieure d'Architecture et des Arts Décoratifs (La Cambre) and he was founder of the National Belgian Council of the Plastic Arts.

LESLIE, ALFRED (1927–). American painter born in New York. He studied with Tony SMITH, William BAZIOTES and others at New York University, 1956–7. His first one-man exhibition was at the Tibor de Nagy Gal., New York, in 1951 and he continued to exhibit there during the 1950s. From about the mid 1950s Leslie was one of the group of artists who constituted the second generation of ABSTRACT EXPRESSIONISTS, following the path inaugurated by DE KOONING. From the mid 1960s he switched to a style within the ambit of the NEW REALISM and specialized in more-than-life-size portraits which overwhelmed the spectator by their size. An example is his self-portrait *Alfred Leslie* (Whitney Mus. of American Art, 1966–7), which measures 9 ft by 6 ft (2·7 m by 1·8 m). He was co-director of a film, *Pull My Daisy*, in 1960.

LES VINGT. See GROUPE DES VINGT.

LEVEDAG, FRITZ (1899–1951). German painter born in Münster, studied at Düsseldorf and from 1926 to 1929 at the BAUHAUS, Dessau, under KLEE and KANDINSKY. He painted in a style between geometrical abstraction with softened outlines and TACHISM, or sometimes did still lifes in a manner reminiscent of the PURIST school of OZENFANT and LHOTE.

LEVINE, JACK (1915–). American painter and draughtsman, born in Boston and trained at the Boston Mus. School. His style was based upon that of EXPRESSIONISTS of the ÉCOLE DE PARIS such as SOUTINE and ROUAULT but the subject matter of his art was social satire and he belonged to the school of American SOCIAL REALISTS. The pictures which are most usually reproduced are *The Feast of Pure Reason* (The Mus. of Modern Art, New York, 1937) and *Gangster Funeral* (Whitney Mus. of American Art, 1953). He had retrospective exhibitions at the Boston Institute of Contemporary Art in 1952 and at the Whitney Mus. of American Art in 1955.

LEVY, RUDOLF (1875–c. 1944). German painter born at Stettin, trained in arts and crafts at Karlsruhe and afterwards studied painting in Munich. From 1933 he lived in Paris and was a member of the group of artists centred on the Café du Dôme which included Hans PURRMANN and Oskar MOLL. From 1907 he worked with MATISSE in his studio for some years. After returning briefly to Berlin in 1931 he emigrated to Italy in 1937. He was seized by the Gestapo in Rome in 1943 and died in a concentration camp. Levy was among the most interesting of the German followers of Matisse.

LEWIS, GLEN. See CANADA.

LEWIS, PERCY WYNDHAM (1882–1957). British painter, novelist and critic. Some uncertainty has attached to the date and place of his birth. According to most recent accounts he was born on his father's yacht off Amherst, Nova Scotia. His father was American, his mother British, of Scottish-Irish descent. He studied at the Slade School, 1898–1901, and afterwards travelled to Munich, the Netherlands, Spain and Paris, working for six months during this period at the Heimann Academy, Munich. He settled in England in 1909, became a founding member of the CAMDEN TOWN GROUP in 1911 and showed in its first three exhibitions. At the 'Second POST-IMPRESSIONIST Exhibition' in 1912–13 he showed drawings from his *Timon of Athens* portfolio, which included some of the earliest non-representational abstracts in Europe. These designs foreshadowed the typical style of his Vorticist period. He contributed to the Allied Artists' Association Salon in July 1913 and at the same time joined Roger FRY's group of artists at the Omega Workshops. But in October of the same year, following a quarrel with Fry, he

broke with Omega and wrote a provocative preface to a catalogue for the 'Cubist Room' at the 'Camden Town Group and Others' exhibition arranged by Percy Rutter at Brighton, the germ from which the LONDON GROUP came into being. He exhibited as a founder member at the London Group show in March 1914 and at the same time founded the Rebel Art Centre, from which the Vorticist movement sprang (see VORTICISM). He edited the two numbers of the Vorticist periodical BLAST and exhibited in the Vorticist exhibitions of 1915 and 1917 (in New York). In the same year he decorated a 'Vorticist Room' in the Restaurant de la Tour Eiffel.

In 1916 Lewis enlisted as a gunner and in 1917 he was seconded as a war artist to the Canadian War Memorials scheme. In 1919 he had an exhibition 'Guns' at the Goupil Gal. consisting of pictures of war subjects. Among the best known of his wartime pictures are *A Canadian Gun Pit* (National Gal. of Canada) and *A Battery Shelled* (Imperial War Mus., London). In 1919 he founded the short-lived GROUP X, which exhibited in 1920 at the Mansard Gal. but failed to establish itself as a successor to the Vorticist movement. In 1921 he held his second one-man exhibition 'Tyros and Portraits' at the Leicester Gals. and founded the art review *The Tyro*, which ran to two numbers, followed in 1927–9 by *The Enemy*, of which three numbers appeared. During the 1920s he was writing some of his major books. In the sphere of art he was doing what he called 'experimental drawings', exercises in abstraction from the nude, and began the portraits which in the opinion of posterity contribute no less than the Vorticist and abstract works to his artistic stature. In 1932 he published a portfolio *Thirty Personalities and a Self-portrait*, the drawings for which were exhibited at the Lefevre Gal. In 1938 Augustus JOHN resigned from the Royal Academy as a protest against the rejection of Lewis's portrait of T. S. Eliot (now in Durban Municipal Art Gal.). In 1939 he published *Wyndham Lewis the Artist*, which reprinted his writings on art with a survey of his artistic career up to date and a reproduction of the T. S. Eliot portrait as its frontispiece.

From 1939 to 1940 he was in Buffalo and New York and from 1940 to 1945 in Toronto. He returned to England in 1945 and was art critic to *The Listener*, 1946–50. He became blind in 1950. In 1949 a retrospective exhibition was held at the Redfern Gal. and in 1956 the Arts Council organized an exhibition 'Wyndham Lewis and Vorticism' at the Tate Gal., for which Lewis wrote an Introduction to the catalogue containing the provocative statement: 'Vorticism, in fact, was what I, personally, did and said at a certain period.'

Lewis was the most original and idiosyncratic of the major British artists working through the first decades of the century. He was among the first artists in Europe to produce non-representational abstract paintings and drawings. These do not belong to the genre of 'expressive abstractions'

which was the ideal of KANDINSKY and the BLAUE REITER but have a vital vigour and energy that is lacking in Russian SUPREMATISM. Lewis took from both CUBISM and FUTURISM features from which he built his personal style, but without accepting either. He accused Cubism of failure to 'synthesize the quality of LIFE with the significance or spiritual weight that is the mark of all the greatest art' and of being mere acrobatics of visual intelligence. The Futurists, he wrote, had the vivacity and the quality of life which the Cubists lacked but they themselves lacked the grandness and the 'great plastic qualities' which Cubism achieved. In *Blast* No. 2 he wrote: 'In Vorticism the direct and hot impressions of *life* are mated with abstraction or the combinations of the *Will*.' His own work was 'electric with a mastered and vivid vitality'. He created a style. Had it not been for the intervention of the war, the dissipation of his energies in controversy and propaganda, and had he not proved as great in literature as in art, he would have been one of the supreme and most influential artistic personalities of the century. Among the best known of his literary works are: *Tarr* (1918), his first novel, *The Childermass* (1928), the first book of a projected trilogy 'The Human Age', of which the second and third books, *Monstre Gai* and *Malign Fiesta*, were published in 1955, *The Apes of God* (1930). Among his books of essays and criticism are: *Time and Western Man* (1927) and *The Writer and the Absolute* (1952). *Blasting and Bombardiering* (1937), *Wyndham Lewis the Artist* (1939) and *Rude Assignment* (1950) were autobiographical.

LEWITT, SOL (1928–). American sculptor born at Hartford, Conn., and studied at Syracuse University, 1945–9. His first one-man show was at the Daniel Gal., New York, 1965, and in the following year he was represented in the Whitney Annual and in the exhibition 'The Ten' at the Dwan Gal. His open-frame, glassless, multicompartmental structures of baked enamel on aluminium girders put him with Donald JUDD and Robert MORRIS in the foremost rank of MINIMAL artists and represented at the same time one of the most interesting developments of SERIAL ART. Yet his works were not based on mathematical formulae like CONCRETE ART. Mel Bochner wrote of them in *Minimal Art*: 'His complex, multipart structures are the consequence of a rigid system of logic that excludes individual personality factors as much as possible. As a system it serves to enforce the boundaries of his work as "things-in-the-world" separate both from maker and observer. . . . When one encounters a LeWitt, although an order is immediately intuited, how to apprehend or penetrate it is nowhere revealed. Instead one is overwhelmed with a mass of data—lines, joints, angles. By controlling so rigidly the conception of the work and never adjusting it to any predetermined ideas of how a work of art should look, LeWitt arrives at a unique perceptual breakdown of conceptual order into visual chaos. The pieces situate in centers

usurping most of the common space, yet their total volume (the volume of the bar itself) is negligible. Their immediate presence in reality as separate and unrelated things is asserted by the demand that we go around them. What is most remarkable is that they are seen moment to moment (due to a mental tabulation of other views), yet do not cease at every moment to be flat.' In the 1970s LeWitt also experimented with CONCEPTUAL ART and the elimination of the object. As early as 1968 he fabricated a metal cube and buried it in the ground at Visser House, Bergeyk, Netherlands, documenting photographically the visual disappearance of this object.

LEYGUE, LOUIS (1905–). French sculptor born at Bourg-en-Bresse, studied under Robert WLÉRICK and at the École des Arts Décoratifs and the École des Beaux-Arts, Paris, and in 1931 won the Grand Prix de Rome. In 1945 he became *Chef d'atelier* at the Ecole des Beaux-Arts. He made his name by his *Monument to the Unknown Political Prisoner* in 1953, a work of great originality in virtue of the silhouette formed by the edges of a void within the angle of the block of stone. He also did monumental sculpture in Canada in 1938, wood sculptures for the Palais de Justice and Hôtel de Ville, Abidjan, and monumental bronzes for Caen, Lisbon, Reims, Casablanca. Leygue combined lyrical and baroque feeling with modernistic design.

LHERMITE, LÉON (1844–1925). French painter, studied under Lecoq de Boisbaudran. His work enjoyed great popularity at the turn of the century and in 1905 he was made a member of the Académie des Beaux-Arts. He painted rustic scenes in a manner of sentimental naturalism which is no longer in vogue (e.g. *L'Ami des Humbles*, Boston Mus. of Fine Arts). His pastels and charcoal drawings were energetic and have lasted better.

LHOTE, ANDRÉ (1885–1962). French painter born at Bordeaux. After working for ten years with a commercial wood-carver, he was overwhelmed *c.* 1906 by works of NEGRO SCULPTURE and by the painting of Gauguin. From this time he began to paint without formal training, went to Paris in 1906 and exhibited at the Salon des Indépendants and the Salon d'Automne. In 1909 he became intimate with DUFY and Jean MARCHAND and had his first one-man exhibition in 1910 at the Gal. Druet. His work was noticed by critics such as André Salmon, Guillaume APOLLINAIRE and Jacques Rivière and his position in the art-world of Paris was thus established. In 1911 he made contact with the CUBISTS and applied the stylistic mannerisms of the Cubist school to the depiction of everyday objects and scenes, particularly port scenes and sporting events, analysing his subject into quasi-geometrical planes defined by careful contours and pure colours as in his *Rugby* (Mus. National d'Art Moderne, Paris, 1917). From 1917

to 1940 he contributed criticism and articles expounding his aesthetic views to *La Nouvelle Revue Française* and he had ambitions as a writer, publishing a number of books on art from 1923 to 1950. He was active in defence of the 'moderns' and made a sensation in 1935 by a lecture 'Faut-il brûler le Louvre?' He was a gifted teacher and exercised an extensive influence on younger artists both French and foreign through his own academy of art, the Académie Montparnasse, which he opened in 1922, founding a South American branch on his visit to Rio de Janeiro in 1952. In 1937 he executed the mural *Gaz* for the Palais de la Découverte at the Paris Exposition Universelle and in 1938 he founded an active artistic centre in the town of Gordes. In 1951 he visited Egypt and developed an enthusiasm for ancient Egyptian painting and in 1955 he executed three large panels, *Gloire de Bordeaux*, for the Faculty of Medicine at Bordeaux and was awarded the Prix National des Arts.

Lhote's production was extremely varied in subject, including landscapes, still lifes, interiors, mythological scenes, portraits. All were deliberately composed in complicated systems of interacting planes and semi-geometrical forms precisely articulated and defined by clear, unmodulated colours. His designs and rhythms were usually intellectualized rather than spontaneous, though some of his still lifes had a quiet charm not unlike the work of the PURISTS. He had restrospective memorial exhibitions at the Mus. Toulouse-Lautrec, Albi, in 1962 and the Mus. Lyon in 1966. Among his writings were studies of artists (Seurat, Bonnard, etc.) and didactic treatises such as *Traité du paysage* (1939), *Peinture d'abord* (1942) and *Traité de la figure* (1950).

LIAUTAUD, GEORGES. See NAÏVE ART.

LIBRE ESTHÉTIQUE, LA. An association of artists formed in Brussels in 1884 to carry on the work of the GROUPE DES VINGT (XX). It continued until 1914 and included most of the *avant-garde* Belgian artists of the period. It arranged exhibitions of foreign innovative art and provided opportunities for Belgian artists to exhibit.

LICHTENSTEIN, ROY (1923–). American painter, sculptor and graphic artist, born in New York. He studied at the Art Students' League under Reginald MARSH in 1939–40 and at the Ohio State University, 1940–3. After working in Cleveland, Ohio, as a commercial artist and free-lance designer, 1951–7, he taught at the New York State College of Education, Oswego, 1957–60, and at Rutgers University, 1960–3. After passing through an ABSTRACT EXPRESSIONIST phase he changed to POP ART *c.* 1957, influenced in his choice of subject matter partly by the HAPPENINGS then being introduced by Claes OLDENBURG and Allan KAPROW, his colleague at Rutgers. His first one-man exhibition of work in this style was at the Leo Castelli

Gal. in 1962 when Pop art first burst upon an astonished public. In common with other Pop artists Lichtenstein adopted the vulgar and debased images of popular commercial art, comic-strip characters, advertisements and wrappings for bubble-gum, ice-cream soda, etc. (*Whaam!*, Tate Gal., London, 1963). He also parodied PICASSO, MONDRIAN, etc. and with dead-pan irony made pictures from blown-up and precisely executed brush strokes such as those of the ACTION PAINTERS (e.g. *Little Big Painting*, Whitney Mus. of American Art, 1965). Despite his use of popular KITSCH, his paintings had high formal quality and he became recognized as one of the most eminent among the Pop artists. His *Dinnerware Objects* and other ceramics of the 1960s and his enamel on steel *Explosions* of 1965 were forerunners of the *Sculptures* of 1977 exhibited at the Leo Castelli Gal., New York, and the Mayor Gal., London. These were open-work silhouettes cast in bronze and part painted in vivid yellows and blues representing again banal objects of everyday life—teapot on stand, cup and saucer, lamp, dressing-table mirror, etc. The representations were entirely without irony or social comment but neither flattered nor concealed the tawdry insensitivity of some of their shapes. But the sculptures combined a masterly sense of form with unsurpassed technical virtuosity, suggesting in this intractable material even the light from a lamp, reflections in a mirror and hot steam rising from a cup.

Lichtenstein had retrospectives at the Pasadena Art Mus. and the Stedelijk Mus., Amsterdam, in 1967, at the Tate Gal. in 1968 and at the Solomon R. Guggenheim Mus., New York, in 1969.

LICINI, OSVALDO (1894–1958). Italian painter born at Monte Vidon Corrado, Ascoli Piceno, and studied at Bologna, where he was friendly with MORANDI. After painting naturalistic portraits and figure studies he went over to abstraction *c.* 1930 and in 1935 exhibited CONSTRUCTIVIST paintings in the manner of KUPKA at the Quadriennale in Rome together with MAGNELLI and SOLDATI. He continued this manner of painting until *c.* 1950, when he changed to a style of SURREALIST AUTOMATISM. His Constructivist work was exhibited at the Venice Biennale in 1950 and in the 1958 Biennale he received the Italian prize for painting. A posthumous exhibition of his work was given at Leghorn in 1959.

LIČKOVÁ, ANNA (1895–). Czech NAÏVE painter, born at Tešín. She began painting in 1953 and her work was included in exhibitions of 'Folk Art in Slovakia' (Bratislava, 1957), 'Slovak Amateur Art' (Bratislava, 1960; Prague, 1962), 'Naïve Art in Czechoslovakia' (Brno, Bratislava, Prague, Ostrava, 1963–4) and exhibitions of naïve art at Salzburg, Graz, Linz (1964). In 1964 she participated in an exhibition 'Women as Artists', Paris, and had a one-man show at Žilina. She painted lively and expressive scenes embodying her memories of

country life. The individual figures and details were spontaneous and closely observed, though naïvely drawn, and stood out emphatically in the absence of logical over-all design.

LIEBERMANN, MAX (1847–1935). German painter and graphic artist born in Berlin and studied at Berlin University, 1866–8, and at the Weimar Academy of Art, 1868–73. He was influenced by MUNKÁCSY, whom he met at Düsseldorf in 1871, and by Frans Hals and Dutch *plein air* painting, which he saw on visits to the Netherlands in 1871 and 1872, finding especial affinities with the works of Israels (1824–1911). His importance in his day lay in his openness to foreign influences. He was one of the first to overcome the parochiality of the German naturalistic tradition and to broaden the outlook of German painters to newer trends. During his visit to France in 1874 he found himself more in sympathy with Courbet, Millet and the Barbizon school than with Manet or Renoir; but after his return to Germany in 1878 he came to be considered the leading German Impressionist painter together with CORINTH and SLEVOGT. In 1899 he founded the Berlin SECESSION and became its President. In his later years he developed his gifts for portraiture, and his portraits of the composer Richard Strauss are especially remembered today. He was unable, however, to keep abreast of developments and in 20th-c. art history he stands as the supporter of that old-fashioned traditionalism against which NOLDE, the members of the BRÜCKE and other German EXPRESSIONISTS were in revolt. A comprehensive exhibition 'Max Liebermann und sein Zeit', staged by the Haus der Kunst, Munich, in 1980, gave an excellent impression of what he stood for in German painting at the opening of the century.

LIGHT ART. The attempt to use light as an artistic medium on its own account and as an instrument of major importance in the creation of total ENVIRONMENTS was one of the dominating ideas in experimental art during the second half of the century. It is discussed under LUMINISM, LUMIA.

LIGHTFOOT, M. G. See CAMDEN TOWN GROUP.

LILLIESTRÖM, PER (1932–). Swedish painter and graphic artist, born in Björnlunda. He studied at the Stockholm School of Arts, Crafts and Design, 1950–3, at the Académie Julian, Paris, and under André LHOTE, 1953–6. From 1956 he lived in Tenerife, Canary Islands, where in 1973 he formed the Estudio Azul, an international workshop for experiment in the graphic arts. He was a member of the *Association Internationale des Arts Plastiques*. Besides Tenerife he had one-man shows in Paris, Stockholm, Helsinki, Copenhagen, Madrid, Tokyo, Buenos Aires and at the Drian Gal., London. His paintings were abstract in a manner deriving from ART INFORMEL.

LIMOUSE, ROGER (1894–). French painter born at Collo, Algeria. He went to Paris in 1919 and studied at the Académie Julian and the École des Beaux-Arts. From 1924 he taught in art schools of the Ville de Paris and in 1948 was appointed to the teaching staff of the École des Beaux-Arts. In 1933 he won the Prix des Vikings and in 1951 the Grand Prix at the Menton Biennale. After passing through a Late-Impressionist phase in which he was influenced particularly by BONNARD, he evolved a style of simplified and expressive realism, painting canvases of large format in bold and sensuous colours, which he applied with a thick impasto in a broad and generous technique. Besides still lifes and figure studies he was known for his scenes from the native life of Algeria and Morocco. In 1956 he exhibited at the Gal. Romanet with the *Peintres de la Réalité poétique*.

LIN, RICHARD (LIN SHOW YU, 1933–). Chinese-British sculptor born in Formosa. After studying architecture in London, 1954–7, he began to make strictly formal CONSTRUCTIVIST reliefs in bronze or aluminium in a style deriving from the NEO-PLASTICISM of MONDRIAN. He achieved unusual refinement with meticulous finish and the subtle interplay of sensitively varying surface textures.

LINDELL, LAGE (1920–). Swedish painter born at Stockholm and studied at the Stockholm College of Art, 1941–6, where he was a pupil of Isaac GRÜNEWALD. From 1947 he painted townscapes and genre scenes in a mode of CUBIST abstraction such as his *Vär i Hagalund* (Nasjonalgal., Oslo, 1947). Later he turned to lyrical abstraction with strong feeling for romantic landscape in the Swedish tradition, being inspired particularly by the island of Ven. In the 1960s he adopted a more rigorous style of concise, clearly articulated forms, sometimes derived from natural appearances, in black and white with occasional spots of primary colour. Typical of this style is *Figure Composition* (Moderna Mus., Stockholm, 1964). In 1965 he did decorations for the Astra factory at Södertalje.

LINDNER, RICHARD (1901–78). German-American painter, born at Hamburg. After training as a concert pianist he took up painting in 1922 and studied in Nuremberg and Munich. In 1933 he fled from the Nazi regime and settled in Paris. He went to the U.S.A. in 1941 and worked there as an illustrator of magazines and books, obtaining citizenship in 1948. He began teaching at the Pratt Institute in 1951, abandoned illustration and reverted to easel painting. His first one-man exhibition was at the Betty Parsons Gal., New York, in 1954, where he attracted attention by his precise and cruel images of children. During the 1950s and 1960s his imagery, taken from the most vulgar and sordid life of the New York streets, gradually became less naturalistic, with harsh colours and hard outlines which brought it

into the ambit of POP ART. His style was distinguished by its overtly sexual and erotic symbolism lacking sensitivity or expressive appeal. His work was exhibited mainly in Germany and the U.S.A. and was included in important international exhibitions.

LINDSTRÖM, BENGT (1925–). Swedish painter born at Storsjöapell. He studied in Stockholm under GRÜNEWALD, in Copenhagen under Aksel Jörgensen and briefly at the Art Institute School, Chicago, then settled in Paris in 1947 and studied under LÉGER and LHOTE. From the end of the 1950s he became known for his macabre and demonic scenes painted in vivid and violent colours.

LINT, LOUIS VAN (1909–). Belgian painter born at Brussels of a Flemish father and a French mother, studied at the Academy of Saint-Josseten-Noode. In 1939 he founded the association *La Route Libre* together with Anne BONNET and Gaston BERTRAND. His first one-man exhibition was at the Palais des Beaux-Arts, Brussels, in 1941. In 1945 he was active in helping to found the association JEUNE PEINTURE BELGE, with which he exhibited in a number of countries. During the 1940s his figurative painting was EXPRESSIONIST in the manner of the COBRA group, of which he was a member. He began to paint abstracts c. 1950, and matured a style of expressive abstraction which combined the qualities of draughtsmanship and composition which had characterized his figurative work with influences from the lyrical abstraction of the post-war ÉCOLE DE PARIS, especially BAZAINE. His works were exhibited widely not only in Belgium but in the Netherlands, Switzerland, Italy, Paris and the U.S.A. In the 1960s he reverted to figurative painting though with a new compactness and solidity deriving from his abstract period. In 1958 he won the Grand Prix de la Critique at Charleroi.

LIPCHITZ, JACQUES (CHAIM JACOB LIPCHITZ, 1891–1973). Sculptor, born at Druskieniki in Lithuania, became a French citizen in 1925, settled in the U.S.A. in 1941. The eldest son of a well-to-do Jewish building contractor, he displayed a bent for drawing and modelling while still at school in Bialystok and later in Vilna, where his models were seen and commended by Professor Ginsberg. Against the wishes of his father, who wanted him to train as an engineer, he was helped by his mother and an uncle to travel to Paris in 1909. There he took classes in stone carving and anatomy at the École des Beaux-Arts and also attended the Académie Julian and the Académie Colarossi. But it is probable that his interest in art history, particularly ancient Egyptian, Archaic Greek and Gothic art, and his passion for collecting African, Oceanic and exotic art objects, had a more important bearing on his future development than his formal art studies. He began exhibiting with other young Russian *émigré* artists

in 1911 at the Gals. Malesherbes and in 1912 at the Salon National des Beaux-Arts and the Salon d'Automne. In 1911 he contracted tuberculosis and recuperated in Belgium. In 1912 he was re-called to Russia for military service but was dis-charged on medical grounds and returned to Paris. In 1913 he met and made friends with Max Jacob and MODIGLIANI. He also knew SOUTINE, whom he introduced to Modigliani in 1915. In 1914 he tra-velled with Diego RIVERA to Majorca and then to Madrid, where in the Prado the works of Tin-toretto, Goya, Hieronymus Bosch and especially El Greco had upon him the impact of a revelation. Through Diego Rivera he also met PICASSO and other artists of the CUBIST circle. Thus coming to Paris as he did entirely without artistic back-ground, he was subjected in a short period of years to an astonishing variety of formative influences.

It was in the years 1913 and 1914 that Lipchitz emerged as a sculptor with a distinctive personal style, exemplified by the bronzes *Woman with Ser-pent* (Philadelphia Mus. of Art), *Acrobat on Horse-back* (Otto Gerson Gal., New York), the lead group *The Meeting*, and the bronze *Mother and Children*, which achieves a surprisingly felicitous fusion of African with medieval Gothic stylistic traits. His work in these years was both vital and mannered, making effective use of openwork and realizing a rhythmical counterpoint between sharply defined planes and curved surfaces. Both the works mentioned and more compact figures such as the bronzes *Horseman with Fan* and *Sailor with Guitar* (Mus. National d'Art Moderne, Paris) contained many suggestions which were further developed during the 1920s and 1930s after Lip-chitz had passed through his Cubist period. For it was not until 1915–16 that, largely under the influ-ence of Juan GRIS, he subordinated his natural exuberance fully to the stringencies of the Cubist aesthetic.

For the ten years from c. 1916 to the mid 1920s Lipchitz worked in a Cubist manner, making im-portant contributions to the aesthetics of Cubist sculpture. Many of the devices which were ex-plored by Cubist painters—such as the multiple viewpoint, the use of overlapping and intersecting planes with severe reduction of spatial depth—cannot be translated directly into sculpture in the round, and the small group of original sculptors within the Cubist ambit—ARCHIPENKO, LAURENS, Lipchitz—each applied Cubism in an individual way. The severely rectilinear figures of Lipchitz, in which the part played by curvilinear profiles is reduced to a minimum, created little impression of volume. During his Cubist period he used the sub-ject simply as a basis upon which to build a con-struction of geometrical 'crystalline' forms (the metaphor of the crystal was much in vogue at the time) and, as some critics think, he may have been influenced in his method by the drawings of Vil-lard d'Honnecourt, in whom he had been inter-ested. In 1915 and 1916 he made figures which could be disassembled, constructing them from

sheets and strips of wood or metal and aiming at a counterpoint of interacting planes rather than the enclosure of volume. In 1916 he created a sensa-tion by boring a hole through his stone *Man with a Guitar* (The Mus. of Modern Art, New York) for purely formal reasons—a device for bringing space *within* the body of the sculpture which was de-veloped by Henry MOORE and Barbara HEPWORTH during the 1930s. In general he adopted during these years the Cubist preference for non-commit-tal subjects such as harlequins and musicians, musical instruments, etc., particularly in a number of relief plaques of still lifes reminiscent of Cubist paintings. But neither the formal disciplines of the Cubists nor their disregard for the symbolic and psychological aspects of subject matter accorded well with Lipchitz's temperament and after 1925 he reverted to more fluid, rounded forms as in the *Joie de Vivre* of 1927 (perhaps the earliest sculp-ture made to revolve on a turntable before the spectator), returning to the mannerist style of his pre-Cubist period but with the added strength and vigour of a decade's research into formal struc-ture. This was the period of his 'transparent sculp-tures', openwork compositions of strips and bands of metal which give the impression of being a lyri-cal calligraphy in space. Carola Giedion-Welcker described them in *Contemporary Sculpture* (1961) as 'a mobile pattern of lines in which nothing re-mains but shapes of air bounded by ropy strands of bronze'. His sculptures were now no longer simply controlled exercises in formal construction and analysis but bore such titles as *Mother and Child* (Cleveland Mus. of Art, 1930), *Return of the Prodigal Son* (1931) or carried the significance of a profound visual symbolism which cannot be trans-lated into words, as in *The Couple* (Rijksmus. Kröl-ler-Müller, Otterlo; 1929). This trend in his work culminated in the 'tumultuous labyrinth of curving lines', the famous *Song of the Vowels* (bronzes in the Kunsthaus, Zürich, the Mus. National d'Art Moderne, Paris, and the Nelson A. Rockefeller coll., New York), done in 1931–2. In 1932 he did an openwork *Head* (Stedelijk Mus., Amsterdam) which is the prototype of Henry Moore's *Helmets* of the 1940s.

During the 1930s he continued his interest in mythological themes and under the stress of Euro-pean events he became obsessed with the mythical monster and with themes of struggle such as the *Rape of Europa* and the *Theseus* cycle. His *Pro-metheus* wrestling with the vulture of Zeus was begun in 1936 for the Paris Exposition Universelle of 1937. In 1944 he was commissioned to do an-other version, *Prometheus Strangling the Vulture*, for the Ministry of Education and Health at Rio de Janeiro. The motif of struggle and baroque vio-lence dominated the work of this period.

In 1941 Lipchitz emigrated to New York and after an initial period of hardship won recognition as one of America's foremost sculptors. In the early 1940s he produced a number of extremely elaborate bronzes continuing the manner of his

'transparent sculptures' of the 1920s, but more mature and richer in suggested symbolism. These included *Blossoming* (The Mus. of Modern Art, New York) and *Barbara* (Smith College Mus. of Art, Northampton, Mass.). Following a large exhibition at the Gal. Maeght, Paris, in 1946 he obtained a commission for a figure of *Nôtre-Dame de Liesse* for the church at Assy in Haute-Savoie. He worked for many years upon this project, a large model for it being lost in a fire which destroyed his studio in 1952. A cast has been erected in New Harmony, Indiana, as a memorial to Robert Owen. During the 1950s he was also working on a large relief *The Birth of the Muses* for Mrs. John D. Rockefeller and on an important project *The Spirit of Enterprise* commissioned for the city of Philadelphia. A bronze sketch for this may be seen in the Tate Gal., London. In 1955–6 he did 33 'semi-automatics', bronzes which he called by this name because they were modelled in the first instance by touch without recourse to sight. From 1948 he worked also on the *Hagar* theme (Art Gal. of Toronto), in which he developed the earlier 'mother and child' concept. In 1959 he began a series of fantastic bronzes incorporating small objects, which extended the art of *cire-perdue* casting to its limits. The series was exhibited by the Fine Arts Associates, New York, under the title *A la limite du possible*.

Lipchitz had his first one-man exhibition at the gallery of Léonce Rosenberg, Paris, in 1920. In 1930 a retrospective exhibition of 100 sculptures was organized by Jeanne Bucher at the Gal. de la Renaissance, Paris, and in 1937 a room was given over to 36 of his works at the Petit Palais exhibition 'Les Maîtres de l'Art Indépendant'. In 1935 a large exhibition of his work was given at the Brummer Gal., New York, with a catalogue written by Élie Faure. After he had emigrated to America exhibitions were arranged by Curt Valentin at the Buchholz Gal., New York, in 1942, 1943, 1946, 1948 and 1951. In 1950 an exhibition of his work was made by the Art Mus. of Portland, Oregon, and this was also shown at San Francisco and Cincinnati. In 1951 The Mus. of Modern Art, New York, circulated an exhibition of *The Birth of the Muses* and the same museum in 1954 made a large retrospective exhibition, shown also at the Walker Art Center, Minneapolis, and the Cleveland Mus. of Art, with a catalogue by Henry R. Hope. In 1958 an exhibition of 116 works ranging from 1911 to 1957 and selected by Lipchitz himself was arranged by the Stedelijk Mus., Amsterdam, and subsequently shown at Otterlo, Basle, Dortmund, Brussels, Paris and London.

Lipchitz remained always abreast of the formal developments in sculptural expression during his lifetime, often indeed taking the lead in experimentation and innovation. In his own way he explored to the full the emotional symbolism of sculptural form. Yet he never pursued abstraction for its own sake but remained firmly within the great tradition which regards art as a symbolic expression of basic human predicaments and of those deepest psychological stirrings which cannot be expressed otherwise than in the language of metaphor. He was an admirer of Rodin, of whom he said in an introduction to the catalogue of a Rodin exhibition at the Curt Valentin Gal., New York, in 1954: 'The names of Cézanne and Rodin will live forever in the glory of the eternal light as the two geniuses to whom we owe our completely renewed vision.' G. H. Hamilton has said of Lipchitz: 'In technique as well as in content, in his preference for modelling (his use of plasticine instead of clay may account for his sometimes lumpy surfaces) and for symbolic themes presented with maximum expressive intensity, Lipchitz is Rodin's successor.' But Lipchitz is more versatile. It is in the spirit rather than in techniques that he carried on the great Romantic tradition. His own statement in a conversation with the critic Cranston Jones, broadcast in 1958 and quoted by A. M. Hammacher, is perhaps the best summary. 'You see, I'm now for almost fifty years a professional sculptor—half a century. And I always was asking myself: what is art? It's such a powerful drive. What makes me drive? What gives me the impulse to make art? And I found out. I don't know if it is the real answer, but for me it is the real answer. It's a kind of desire to fight against death. Love is that, too. But art is a human way. Procreation—the animals have procreation, and they are driven by this powerful thing which pushes them to make the species survive. But human beings have art and that differentiates them from the animal. And there comes a time when you feel this continuity, this immortality of art . . .'

LIPKIN, AILEEN. See SOUTH AFRICA.

LIPPOLD, RICHARD (1915–). American sculptor born at Milwaukee, Wis. Son of a mechanical engineer, he studied industrial design at the University and Art Institute of Chicago, 1933–7. He became interested in wire sculpture while teaching at the University of Michigan, 1940–1, and was largely self-taught as a sculptor. Deriving from his own engineering knowledge and from CONSTRUCTIVISM of the type fostered by GABO, his work belonged to the new school of sculpture which, instead of occupying space or enclosing space, incorporates space as an active and positive element. His sculptures were constructed from metal wires and rods in tension to give an impression of weightlessness and depended much on the use of light and KINETICISM, exploiting in particular the apparent movement which arises from the movements of the spectator. His first one-man show was at the Willard Gal., New York, in 1947, after which he continued to exhibit in the U.S.A. and was represented in important group shows in the U.S.A. and Europe. Among his important commissions were: an out-of-doors construction for Harvard University Graduate Law School (1950), *Variation within a Sphere, No. 10: the Sun*

for The Metropolitan Mus. of Art, New York (1953–6); *Flight* for the Pan American Building, New York (1962).

LIPSHITZ, LIPPY. See SOUTH AFRICA.

LIPSI, MORICE (1898–). Polish-French sculptor born at Łódz. He went to Paris in 1912 and studied at the École des Beaux-Arts, concentrating on the techniques of wood carving and ivory carving. In 1922 he exhibited ivory carvings somewhat CUBISTIC in style and then went on to work in stone and terracotta, making garden sculpture for a living. He obtained French citizenship in 1933. In 1942 he left Paris for the south of France and then Switzerland, returning to France in 1945. While in Geneva he made a series of works in which natural forms—snails and leaves—were incorporated, but he gradually developed in the direction of purely abstract art. From the mid 1950s he executed a number of monumental works in stone, some of them done from lava, and in the 1960s produced elementary block-like forms with coarsely textured surfaces.

LIPTON, SEYMOUR (1903–). American sculptor born in New York. He studied dental surgery at Columbia University, 1923–7, and took up sculpture without formal training in 1932 while practising as a dentist. Until the mid 1940s he carved in wood and stone, using violent distortions to express his sense of social struggle and anguish. His first one-man show was at the American Contemporary Artists' Gal. in 1938. He abandoned wood for metal casting *c.* 1942 and leaving the human figure, he 'began using skeletal forms, horns, pelvis . . . to convey the basic struggles in nature on a broader biological level'. About 1945 he initiated the techniques of expressive abstraction which brought him into the group of sculptors (LASSAW, ROSZAK, FERBER, etc.) whose work paralleled that of the ABSTRACT EXPRESSIONIST painters. His first one-man exhibition of metal sculpture was at the Betty Parsons Gal. in 1948. In the 1950s his violently expressive abstractions began to give way to more controlled and lyrical forms fashioned from curving shells of Monel metal welded together at the edges and covered with nickel-silver or bronze. Towards the end of the 1950s he once again introduced forms suggestive of the human figure, as in *Sentinel* (Yale Art Gal., 1959). He executed many important sculptural commissions, including among others: Temple Israel, Tulsa, Oklahoma; Temple Beth-El, Gary, Indiana; Inland Steel Building, Chicago; International Business Machines Corp., New York; Dulles International Airport, Washington; Golden Gateway Redevelopment Project, San Francisco; and the famous *Archangel* for Philharmonic Hall, Lincoln Center, New York. His work was widely exhibited in the U.S.A. and was included in many important group exhibitions in the U.S.A. and abroad.

LISMER, ARTHUR. See CANADA.

LISMONDE, JULES (1908–). Belgian painter and draughtsman born at Anderlecht, near Brussels, studied at the Académie des Beaux-Arts, Brussels, and at Saint-Josse. During the 1940s he concentrated on drawings and 'psychological portraits'. In 1946 he became a member of JEUNE PEINTURE BELGE and his work became increasingly abstract. He was chiefly known for delicate landscape drawings which, though they were abstract linear designs, originated from impressions of landscape and were usually recognizable as such.

LISSITZKY, EL (ELIEZER MARKOWICH, 1890–1947). Russian painter, sculptor and graphic artist, born at Smolensk. After studying engineering at Darmstadt from 1909 to 1914 he returned to Russia at the outbreak of war and studied architecture in Moscow. He collaborated with CHAGALL on the illustration of Jewish books, working in a manner which combined the CUBO-FUTURIST style with peasant woodcut (*lubok*) tradition, and in 1918, when Chagall was appointed head of the art school at Vitebsk, he joined him as Professor of Architecture and Graphic Art. He met MALEVICH at Vitebsk in 1919 and became one of the leading figures in Russian CONSTRUCTIVISM. After seeing the 'X State Exhibition. Non-Objective Creation and Suprematism' in Moscow in 1919 he began his famous series of Constructivist paintings which he called *Proun*. At the same time he was interested in typographical design and during 1920 he designed his 10-page book *The Story of Two Squares* (Berlin, 1922), which has been regarded as a landmark in modern typography and book design. In 1920 Lissitzky left Vitebsk and taught in the VKHUTEMAS at Moscow. In 1922 he went to Berlin, where he arranged and designed the important exhibition of abstract art at the Van Diemen Gal. (later shown also in Amsterdam) which first comprehensively presented the modern movement in Russia to the West. While in Berlin he collaborated with Ilya Ehrenburg in editing a Constructivist magazine entitled VESHCH/GEGENSTAND/OBJET, made contact with Van DOESBURG and members of De STIJL and with Hans RICHTER and MOHOLY-NAGY was one of the founders of the Constructivist group and magazine G. In 1923 he went with GABO to a BAUHAUS exhibition at Weimar and there met GROPIUS. From 1923 to 1925 he was in Switzerland, where he organized the ABC group and collaborated on a magazine of the same name. In 1926 he was invited to Hanover by the Kestner-Gesellschaft, remaining there until 1928. Here he designed for the Provinzial Mus. an 'Abstract Gallery' in which two of the walls were constructed of metal strips projecting from the surface and painted black on one side, white on the other, so that the wall changed colour as the spectator approached. This was perhaps the earliest use of a quasi-moiré effect in structural design. Lissitzky returned to Russia in 1928 and devoted

himself mainly to typography and industrial design. In 1939 he designed the Soviet Pavilion of the World's Fair in New York.

For a considerable time Lissitzky was the best known of the Russian abstract artists in the West. In his mature work he achieved a fusion between the SUPREMATISM of Malevich (often using his diagonal axis), the Constructivism of TATLIN and RODCHENKO and features of the Dutch NEO-PLASTICISM of MONDRIAN.

LIUKKO, RAUNI (1940–). Finnish sculptor born at Vehmaa and studied at the Institute of Industrial Arts, 1960–3. Besides exhibitions in Finland, she participated in the 'Barnslightter' exhibition which toured Sweden in 1971, the exhibition 'Satire at Peace Work' in Moscow, at which she received a diploma (1973), the Nordic Section of the Milan Triennale, at which she was awarded a Grand Prix (1973), the 'Kunstszene Finnland' exhibition, Düsseldorf (1974) and the 'Workaday Finland' exhibition at the I.C.A. Gals., London (1974). She made groups of life-size figures usually from fibreglass and styrox or fibreglass and gypsum. Her *Joint Life-belt* (1972), which was among those exhibited in London, consisted of nine life-size figures of children with the ungainly postures of achondroplastics. In a note she explained that as a teacher she saw how school 're-flecting society, represses its pupils', and that she wished through her work to 'make society more human'. 'There was no sense in producing sculpture for a tiny, cultivated public of gallery-goers. I wanted to make sculptures for the man in the street who never visits an art gallery.' She added: 'My aim was that nobody could deny the reality of these sculptures, that they would sink into the consciousness of the onlooker—even though he would not like what he saw.'

LOCKHEAD, KENNETH. See CANADA.

LOHSE, RICHARD PAUL (1902–). Swiss painter and graphic artist born at Zürich and trained at the Zürich School of Arts and Crafts. In 1927 he became a founding member of the Swiss association of *avant-garde* painters *Allianz*. He worked consistently to develop the ideas of Max BILL about CONCRETE ART, or COLD ART, which seeks to generate compositions from modular or nuclear elements by systematic or serial operations based upon mathematically expressible formulae. Like Karl GERSTNER he worked at extending these serial systems into the sphere of colour combination. From 1948 to 1955 he edited the journal *Bauen und Wohnen* and from 1959 he was joint editor of *Neue Grafik*. A large retrospective exhibition of his works at the Kunsthaus, Zürich, in 1976 contained a section illustrating the historical development of his modular and serial systems and an analytical section showing how the shapes and colours of his compositions were mathemati-cally generated by his formulae. Lohse believed that the 'creative' element in art is restricted to the choice of elements and the formulae of development from them, the rest depending on ingenuity and skill.

LONDON GROUP. An exhibiting association of English artists which in 1913–14 gathered under its wing most of the prominent small groups of younger artists outside the Academy and the NEW ENGLISH ART CLUB—the CAMDEN TOWN GROUP, the Fitzroy Street group, the CUMBERLAND MARKET GROUP together with various artists who had shown in the Allied Artists' Exhibitions organized by Frank Rutter from 1908. After a mixed exhibition held at Brighton, December 1913 to January 1914, under the name 'The Camden Town Group and Others', the London Group held its first exhibition under that name at the Goupil Gal. in March 1914. The Group was not associated with any particular aesthetic doctrine apart from a generally shared impatience with the conservatism of the Academy and the New English Art Club, but it was broadly representative of the various trends of painting at the time from the more cautious English Impressionist schools to the most advanced movement represented by Wyndham LEWIS and Edward WADSWORTH. The members included Paul and John NASH, Mark GERTLER, NEVINSON and others. The first President was Harold GILMAN. SICKERT, the father figure, did not actually join until 1916. Roger FRY became a member in 1917 with Nina Hamnett. Duncan GRANT and Vanessa BELL were elected in 1919. The exhibitions attracted the favourable attention of advanced critics like Frank Rutter and T. E. Hulme, though the strong interest in POST-IMPRESSIONISM was de-precated by TONKS, who said: 'The leaders of the London Group have nearly all come from me. What an unholy brood I have raised.' Thus was signalized an opposition between 'advanced' art and the semi-academicism of the Slade School.

The London Group continued its 'pleasant and restrained' exhibitions, originally biennial but later annual, through the 1920s and 1930s, giving them a comprehensive character which embraced most of the non-academic British artists of the time and avoided identification with particular aesthetic trends and schools. Unlike so many associations it survived opposition and was revived after the Second World War, coming to be regarded as something of an institution. But while acquiring the dignity of an institution it lost much of its early sense of mission and by 1950 it would not have been easy to say what were the artistic princi-ples for which it stood. Through to the 1980s membership of the London Group conferred something of a cachet on a young artist.

LONDOT, J. M. See MATTERISM.

LONG, RICHARD. See CONCEPTUAL ART.

LÓPEZ, FRANCISCO (1932–). Spanish sculp-tor and draughtsman born in Madrid and studied

at the Escuela de Artes y Oficios there, 1951–5. In 1956 he was awarded a scholarship by the Ministry of National Education which enabled him to visit Italy and Greece. His father was a well-known goldsmith and engraver of Madrid and from him López may have derived his graphic technique. From student days he was a close friend of Antonio LÓPEZ GARCÍA, both of whom were prominent in the new school of Realism. Besides exhibitions in Spain he was represented in many international exhibitions of Spanish Realism, including: 'Magischer Realismus in Spanien heute', Frankfurt and Munich, 1970; 'Contemporary Spanish Realists', Marlborough Gal., London, 1973; 'Kunst nach Wirklichkeit— Ein neuer Realismus in Amerika und Europa', Hanover, Paris, Munich, Rotterdam, Milan, 1974; 'Realismus + Realität', Darmstadt, 1975; and 'Spanische Realisten', Leverkusen, 1974 and Zürich, 1975. He was married to Isabel QUINTANILLA.

LÓPEZ GARCÍA, ANTONIO (1936–). Spanish painter, born at Tomelloso, Ciudad Real, nephew of Antonio LÓPEZ TORRES. He studied at the San Fernando School of Fine Arts, Madrid, 1950–5 and in 1955 obtained a grant from the Ministry of National Education for a visit to Italy. Besides exhibitions in Spain he showed at the Carnegie International, Pittsburgh, in 1965 and 1967 and at the Staempfli Gal., New York, in 1965 and 1968. Among the collective exhibitions in which he participated were 'Spanische Kunst der Gegenwart', Berlin, Nuremberg, Rotterdam, Copenhagen, 1975; 'Magischer Realismus in Spanien heute', Frankfurt and Munich, 1970; 'Contemporary Spanish Realists', Marlborough Gal., London, 1973; 'Kunst nach Wirklichkeit—Ein neuer Realismus in Amerika und Europa', Hanover, Paris, Munich, Rotterdam, Milan, 1974; 'Realismus + Realität', Darmstadt, 1975, where he was awarded the prize for art by the City of Darmstadt; and 'Spanische Realisten', Leverkusen, 1974 and Zürich, 1975. From 1964 to 1969 he taught Colour Preparation (*Preparatorio de Colorido*) at the San Fernando School of Fine Arts, Madrid. He worked with a masterly technique in a style of sensitive and unassuming realism. His work is represented in The Mus. of Modern Art, New York.

LÓPEZ TORRES, ANTONIO (1902–). Spanish painter, born at Tomelloso, Ciudad Real, and trained at the San Fernando School of Fine Arts, Madrid, 1926–31. His first exhibition was in 1935 at the Circulo de Bellas Artes, Madrid, where he had a retrospective in 1947 and exhibited again in 1959. In 1941 he was awarded a grant from the Royal Academy of Fine Arts of San Fernando, Madrid, for a visit to Italy. In 1957 he had an exhibition at the Mus. de Arte Contemporaneo, Madrid, in 1970 he was represented in the collective exhibition 'Magischer Realismus in Spanien heute' at Frankfurt and Munich and in 1973 he had a one-man show at the Mus. de Arte Contem-

poraneo, Madrid. For many years he was Professor at the Escuela de Artes y Oficios, Madrid, and on his retirement a museum was founded in his name, where most of his works are collected. He worked with exquisite technique in a style of quiet and unassuming realism.

LORING, FRANCES. See CANADA.

LORJOU, BERNARD (1908–). French painter, born at Blois, Loir-et-Cher. He painted from childhood and without formal training. In 1931 he travelled to Spain and was profoundly impressed by Spanish painting, particularly Velazquez and Goya. After the Second World War he emerged as a leader of the SOCIAL REALIST reaction from the current tendencies to abstraction and he was a member of the Social Realist group HOMME-TÉMOIN, exhibiting with them in 1948 and 1949. In 1948 he was awarded the Prix de la Critique together with Bernard BUFFET. He exhibited at the Salon des Indépendants and the Salon d'Automne, and had one-man shows at the Gal. Charpentier, Paris, in 1954 and at the Wildenstein Gal., London, in 1958. He later developed a violently expressive style in which strong black outlines stood out from a lighter background and contrasted with decorative elements whose facile aping of the falsely idyllic is reminiscent both of the world of the Hippies and the psychedelic.

LOTH, WILHELM (1920–). German sculptor born in Darmstadt, where he studied at the Werkkunstschule after having been induced to take up sculpture by Käthe KOLLWITZ. He taught from 1948 to 1958 at the Technische Hochschule, Darmstadt, and in 1960 obtained a Professorship at the Academy of Karlsruhe. His works were mainly in bronze, based on the human figure, but towards the end of the 1960s he was making non-representational works, often in aluminium, whose main feature was the polarity between organic and geometrical shapes. Loth was exhibited widely throughout Germany and also in Paris, Italy and Scandinavia.

LOUIS, MORRIS (MORRIS LOUIS BERN-STEIN, 1912–62). American painter, born at Baltimore, Maryland, his father being an émigré from Russia. He adopted the name 'Louis' for professional purposes c. 1939. He studied at the Baltimore Institute of Fine and Applied Arts, 1929–33, moved to New York in 1936 and participated in the FEDERAL ARTS PROJECT/WPA easel painting project and joined SIQUEIROS and others in a studio experimenting in the technique of Duco enamel paint. In 1940 he returned to Baltimore, where he taught privately, and in 1948 he began the use of Magna acrylic paints. He exhibited annually with the Maryland Artists group at the Baltimore Mus. of Art from 1948 to 1952, when he moved to Washington and became an instructor at the Washington Workshop Center. Here he met Ken-

neth NOLAND, with whom he collaborated in working out new ideas, and in 1954 they held a joint exhibition at the Kootz Gal., New York. At this time also the critic Clement Greenberg became interested in his work. In 1959 he exhibited 23 *Veils* at French & Co., New York. As a result of this exhibition he made a contract with Lawrence Rubin for exhibitions at the Gal. Neufville, Paris, in 1961 and at the Gal. Lawrence in 1962 and 1964. In 1960 he exhibited at the I.C.A., London, and at the Gal. dell' Ariete, Milan. He moved to the André Emmerich Gal., New York, in 1961, and had a one-man show there. In the same year he exhibited in group shows at the American Embassy and the Marlborough Fine Art Gal., London. He died in Washington in 1962 after an operation for lung cancer.

A posthumous exhibition was staged by the Emmerich Gal. in the autumn of 1962 and the gallery continued to hold exhibitions in 1964, 1965, 1966, 1967, 1968, 1969, 1970 and 1972. A memorial exhibition of 17 paintings was given at the Solomon R. Guggenheim Mus. in 1963 and in 1965 retrospective exhibitions were shown at the Stedelijk Mus., Amsterdam, the Staatliche Kunsthalle, Baden-Baden and the Whitechapel Art Gal., London. In 1967 a major retrospective was shown at the Los Angeles Mus. of Art, the Mus. of Fine Arts, Boston, and the City Art Mus., St. Louis. In 1974 an important exhibition organized by the Arts Council of Great Britain was shown at the Hayward Gal., London, and subsequently at the Kunsthalle, Düsseldorf, the Mus. des 20. Jahrhunderts, Vienna, and the Palais des Beaux-Arts, Brussels.

Louis is considered to have been the main pioneer of the movement beyond ABSTRACT EXPRESSIONISM in the direction of COLOUR FIELD painting. John Elderfield began his Introduction to the catalogue of the Arts Council exhibition of 1974 with the words: 'Morris Louis is one of the very few artists whose work has really changed the course of painting. Recognition of this fact has been slow coming, and it is still not orthodox opinion. With Louis, however, fully autonomous abstract painting came into its own for really the first time, and did so in paintings of a quality that matches the level of their innovation.' And he concluded: 'In less than a decade, Louis transformed not only his own art, but the practice of painting itself—if only, like anything truly radical, to return to its fundamental roots.' The breakthrough for Louis came in 1954 when his manner of painting fundamentally changed, apparently as a result of a visit to the studio of Helen FRANKENTHALER, where he was impressed by her painting *Mountains and Sea*. From this time he used thinned-out acrylic paint which, when poured on to unprimed or sometimes partially sized cottonduck canvas, acted as a stain and not as an overlaid surface of pigment. The flow of the pigment was controlled by moving the canvas or the scaffolding to which it was loosely stapled. In his

series of *Veils* done in 1954, and again in 1957–60, the paint was poured down the canvas in striated patterns of partially overlapping areas of translucent dyes. The technique of pouring enabled Louis to achieve an impersonal quality and to eliminate the 'gestural' quality of ACTION PAINTING. It also enabled him to eliminate the last relics of figuration with the abandoning of the 'abstract image'. And the staining technique, finally, excluded the tactile quality which is inherent in a painterly surface of overlaid pigment, and so isolated the purely visual qualities of colour. The technique is particularly exacting, allowing no possibilities for subsequent alteration or modification. For this reason, perhaps, Louis destroyed most of the work done in 1955 and most of the paintings which were unsold at his one-man exhibition at the Martha Jackson Gal., New York, in 1957.

Louis painted the last of his *Veils* in the winter of 1959/60. But from the summer of 1959 he was experimenting—though still with the same technique—in a number of directions at once. These series of paintings are conventionally known as *Florals, Alephs, Columns, Omegas* and *Japanese Banners*. (Louis himself was disinclined to name his works and few of the titles originated with him.) In the *Florals* the verticality of the *Veils* is abandoned and instead of flowing downwards with the force of gravity the partially overlapping areas of stain pour inwards towards a common centre. In the *Aleph* series the centre is overlaid by a large oval of darker stain, and the areas of clearer pigment seem to radiate outwards from it in all directions with the impression of a sunburst. The common feature of *Columns, Omegas* and *Japanese Banners* is that large areas of canvas are left empty and unstained. In the *Columns* vertical stripes of colour (usually two, sometimes one) are balanced by large areas of untreated canvas. The stripes may be virtually monochromatic or they may be composed of twined ribbons of partially overlapping colour as if cut from one of the *Veils*. When monochromatic the stripes are sometimes supported by finer strips of contrasting colour running vertically beside them. In the *Omega* series horizontal fingers of different colours reach inwards from the left and the right towards the centre. The series known as *Japanese Banners* is composed of diagonal stripes of colour, often broken and always irregular, restricted to the left and right sides of the pictures, leaving a large empty centre or building up in the form of rough pyramids. Sometimes diagonally continuous stripes are cut by an empty central column.

These experiments led on to the series of *Unfurleds*, of which Louis painted 120 between the summer of 1960 and the spring of 1961. In these pictures the large central area of unpigmented canvas is given a curious positive quality by diagonal stripes of colour on the left and right in the form of half pyramids the other half of which lies outside the picture. In these *Unfurleds* the edges of the stripes are more sharply defined and the

colours are pure without overlapping. It has been claimed that they reveal in Louis a sensitivity to colour contrast and harmony which has not been equalled except by MATISSE in his later work. Examples of *Unfurleds* are *Delta Gamma* (Mus. of Fine Arts, Boston, 1960) and *Beta Upsilon* (National Collection of Fine Arts, Smithsonian Institution, 1960). Like the majority of Louis's paintings most of these are of very large size.

In the spring of 1961 Louis stopped painting *Unfurleds* and began what was to be the last of his series—the *Stripes*. In these paintings bunched straight vertical bands of colour are surrounded by empty canvas. There is little or no overlapping and the vertical stripes of almost pure pigment have clearly defined edges with only slight bleeding as demanded by the balance and contrast of colour. The width of the stripes is also varied in accordance with the intrinsic prominence or saturation of the colours. Towards the end Louis cropped some of these *Stripes* paintings and turned them into the horizontal plane, causing them as it were to float unanchored by gravity. It has been claimed by critics that in this final phase of Louis's painting figuration and structure had been fined down to the ultimate minimum and a pure presentation of colour without extraneous features had been achieved. The impact made by these works on the development of Colour Field painting was immense.

LOUTREUIL, MAURICE (1885–1925). French painter who lived the life of a Bohemian and anarchist, forming with CAILLARD and the writer Eugène Dabit the group *Pré-Saint-Gervais*. He painted landscapes, interiors and nudes in a vigorous and seemingly careless style with violent but effective contrasts of colour. Neglected in his lifetime, his work has come to seem more important after his death and beneath the impetuosity of his technique an austerity and refinement have been discerned which are essentially modern in spirit. After travelling in Africa, Loutreuil died in a Paris poorhouse.

LOVAK, BRANKO. See NAÏVE ART.

LOWRY, LAURENCE STEPHEN (1887–1976). British painter born in Rusholme, a suburb of Manchester, and studied intermittently at art schools in Manchester and Salford from 1905 to 1925. It was during this period that he evolved the theme and style for which he is best known: firmly drawn backgrounds of industrial buildings bathed in a white haze which is typical of these areas, against which groups or crowds of figures move about their affairs isolated in an intensely individual, personal life. Although his works have superficially many of the features of NAÏVE painting, this is belied by the expressive strength of his composition and the skill of his draughtsmanship. His pictures embodied a consistent but disquieting vision, combining penetration and compassion,

revealing the alienation of the lonely and man's inconsequence against the juggernaut of industrialism. Although he achieved national recognition with an exhibition at the Reid and Lefevre Gal. in 1919, he remained an elusive and underrated figure until the large retrospective exhibition arranged by the Arts Council in 1966. He became a member of the Royal Society of British Artists in 1934 and of the LONDON GROUP in 1948, was elected A.R.A. in 1955 and R.A. in 1962. An exhibition at the Crane Kalman Gal. in 1975 was designed to show how Lowry came to occupy his unique position as a painter of the industrial scene and a monumental retrospective was staged by the Royal Academy in 1976. This exhibition brought into prominence considerable divergence of opinion among critics. Some thought of him as a great artist with an important original vision. Others represented him as a very minor, or at best competent, artist but interesting as a social commentator in the visual field.

LUBARDA, PETAR (1907–). Yugoslav painter born at Ljubotinje. He studied very briefly in Belgrade and briefly also at the École des Beaux-Arts, Paris, but was mainly self-taught as an artist. He remained in Paris from 1926 to 1932, exhibiting at the Salon des Indépendants. On returning to Yugoslavia he founded his own art school at Cetinje. Lubarda's painting derived its inspiration from the landscape of his native Montenegro, a harsh country of mountains and rocks against the deep blue of sea and sky. Starting from a dramatic EXPRESSIONISM, he evolved in the direction of expressive abstraction and after the war painted in a highly personal way, with large surfaces and sharp accents uniting the primitive and primordial with contemporary idiom. He had a retrospective exhibition in the Mus. of Contemporary Art, Belgrade, in 1956.

LUCE, MAXIMILIEN (1858–1941). French painter and graphic artist, a pupil of Carolus Duran. After working for the *Graphic* in London, he became friends with Pissarro, Signac and Seurat and adopted the DIVISIONIST style of Neo-Impressionism. From 1888 he exhibited at the Salon des Indépendants and became President of the Society in 1935. As a result of a visit to Belgium c. 1896, in the course of which he became a member of the Brussels GROUPE DES VINGT (XX), he began to paint scenes from the life of factory workers and miners. Later, however, he reverted to a more luminous version of Neo-Impressionism and did much to popularize Divisionism outside France.

LUCHIAN, STEFAN (1868–1916). Romanian painter, born in Stefanesti, studied in Bucarest and Paris. He was a founder of the Salon of Independent Artists in 1896 and of the Association of Young Artists in 1902. In that year he became partially paralysed.

LUCHISM. See RAYONISM.

LU CHON MIN (1933–). British painter, born in Johore, Malaysia, and trained at the École des Beaux-Arts, Paris. He exhibited in the main Paris Salons, had a one-man exhibition in Singapore in 1954 and one in Paris in 1959. During the 1960s he exhibited regularly in Malaysia and taught at a Chinese school in Johore. He has works in the Mus. Cernuschi, Paris, and in the National Art Gal., Kuala Lumpur.

LUCIO (LUCIO MUÑOZ, 1929–). Spanish painter, born in Madrid and studied at the San Fernando School of Fine Arts. In 1955–6 he held a scholarship from the French State. From early in his career he painted in an abstract idiom with great feeling for the sensuous qualities of his materials and a sensitive appreciation for subtle blendings and contrasts in shades of colour. In 1957 he began to use a personal technique, cutting and scratching wood for the sake of cast shadows in delicately modulated abstract compositions with affinities to ART INFORMEL. His most important work in this technique was a large mural above the High Altar in the Basilica at Aránzazu, done in 1962. Besides Spain Lucio exhibited in Frankfurt, Munich, Lisbon, New York, Chicago, Buenos Aires, Havana, and his work was included in many collective international exhibitions. It is represented in a number of public collections in Spain and abroad, including the Tate Gal., the Gemeentemus., The Hague, and the museums of Amsterdam, Oslo, Gothenburg, Vienna, New Orleans, Buenos Aires, Havana, Santiago de Chile and Dortmund.

LUKE, ALEXANDRA. See CANADA.

LUKIN, SVEN (1934–). American painter born at Riga, Latvia, studied at the University of Pennsylvania. His first one-man exhibition was at the Nexus Gal., Boston, after which he exhibited frequently and was included in collective exhibitions of innovative American art. His work belonged to the style of POST-PAINTERLY ABSTRACTION and he specialized particularly in the use of the shaped canvas, carrying it as a mannerism far in the direction of the abstract three-dimensional construction. Among others he was represented at the exhibitions 'The Shaped Canvas', Solomon R. Guggenheim Mus., 1964; 'New Shapes of Colour', Stedelijk Mus., Amsterdam, 1966; 'Painting: Out from the Wall', Des Moines, 1968.

LUKS, GEORGE BENJAMIN (1867–1933). American painter and draughtsman born at Williamsport, Pennsylvania, and brought up among the Pennsylvania miners. After attending the Pennsylvania Academy of the Fine Arts in Philadelphia, he spent ten years in Europe, living a Bohemian life mainly in Paris and Düsseldorf. On his return he was employed as an artist-reporter by the *Philadelphia Press*, became a member of the group, including GLACKENS, SHINN and SLOAN, who became friends and disciples of Robert HENRI, and was persuaded by Glackens to turn his hand to pastels and oils. In 1898 he was employed as an illustrator by the *Evening Bulletin* to record the fighting in Cuba during the Spanish–American war. He then moved to New York, where he earned a living by doing a comic strip for the *New York World*. Continuing to paint and maintaining his association with Robert Henri, he was one of the so-called NEW YORK REALISTS who promoted the ASH-CAN school of SOCIAL REALISM and in 1908 he exhibited at the Macbeth Gal. as a member of The EIGHT. In his early work at the turn of the century Luks depicted the miners whom he had known in his childhood. Later his favourite themes were taken from the street life of New York. Typical examples of his work are *The Spielers* (Addison Gal., Andover, Mass., 1905), *Hester Street* and *The Wrestlers* (Mus. of Fine Arts, Boston, 1905). Luks was an ebullient personality and an obsessive fantasist. His vitality and verve were a potent factor in the campaign of the Ash-Can school against effete and bloodless academicism in favour of a new popularist and democratic American art.

LUMINISM, LUMIA. The word 'Luminism' was first used by Willoughby Sharp in the catalogue of an exhibition 'Light, Motion, Space' at the Walker Art Center, Minneapolis, in 1967. 'Lumia' was first used by Thomas WILFRED for his light constructions early in the century. (See 'Composing in the art of Lumia', *Journal of Aesthetics and Art Criticism*, December 1948.)

The idea of the 'Colour Organ', which would produce moving structures of coloured light either interpreting musical compositions or independently on the analogy of musical sounds, goes back to the 18th c. The first Colour Organ, the 'Clevessin Oculaire', was demonstrated in 1734 by the Jesuit mathematician Louis Bertram Castel (1688–1757). The attempts to synchronize and relate music with moving patterns of coloured light culminated with the Russian composer Alexander Scriabin (1872–1915), who attempted to create a composite spectacle–sound environment for the performance of his *Prometheus* at Carnegie Hall, New York, in 1915, and the 'colour piano' of the abstract painter Vladimir BARANOFF-ROSSINÉ. The idea that non-representational colour could be structured into non-representational art works on the analogy of musical sounds was from before the turn of the century one of the main impulses which led on to expressive abstraction (see ABSTRACTION). It was a trend which culminated in the works of KUPKA.

These were important precursors of the emergence of abstract painting. But the exploitation of light itself as an independent artistic medium came only later in the 20th c. Two conditions were necessary before it could be possible: (1) the accep-

tance of non-representational abstraction and KINETICISM; and (2) the advanced technology in the control of light and light sources upon which modern Lumia artists rely. Thomas Wilfred is usually credited with being the pioneer of 'light painting', i.e. the projection of moving light as an independent artistic medium without reference to music. Starting in 1905 with an incandescent lamp and pieces of glass in a cigar box, he built his *Lumia c.* 1920 and in 1930 founded an Art Institute of Light. MOHOLY-NAGY started building his 'Light Modulators' in the 1920s and constructed his *Light Display Machine*, which has been described as a 'programmed light robot' and was used in his film *Light display, black, white and grey* (1925–30). Hans RICHTER with W. Eggeling made use of light projection for his first abstract film *Rhythm 21* in 1921. The New Zealander Len Lye in 1935 was the first to introduce the technique of painting designs directly on to film. The ideas of Moholy-Nagy meanwhile were being researched and developed in the BAUHAUS, notably by Ludwig Hirschfeld MACK, who devised a construction for projecting rheostat-controlled coloured shapes on to a transparent screen. Since the end of the Second World War light projection machines have multiplied in variety and complexity. Julio LE PARC, Richard LIPPOLD, Gerhard von GRAEVE-NITZ, Henk PEETERS, Alberto BIASI are but a few among the many who have shown ingenuity in the use of rotating or curved mirrors and reflectors, polarized light, controlled refraction by lenses and prisms, coffered relief surfaces, etc. for light projection. Some, such as Nicolas SCHÖFFER and Frank MALINA, have reintroduced the element of sound.

A different mode for the aesthetic use of light is the light *spectacle*, which merges into the light ENVIRONMENT. The prototype for this was GABO's *Light Festival* in 1929, a proposal to light up a Berlin architectural site. Although this was not carried out, the idea was utilized in the 'Light Cathedral' of 1938 by the Nazi architect Albert Speer. It was the origin of the modern *Son et Lumière* spectacles. After the war light environments and light spectacles appealed to the imagination and ingenuity of experimental artists everywhere: Japan, Europe and America. In Italy FONTANA and MUNARI prepared the ground for a large number of younger artists. In Germany the artists of the ZERO group led the way in light research, particularly Otto PIENE, Heinz MACK and Günther UECKER. In Paris the international GROUPE DE RECHERCHE D'ART VISUEL included light structures and environments in its programme.

The number of experimental artists who have been using light for the formation of art objects is so large and the techniques they have devised are so diverse that they defy classification. One may instance the use of fire by Yves KLEIN and of fireworks by TAKIS, both in 1957; Frank Malina's 'lumidyne' system; AGAM's coloured discs; Dan FLAVIN's 'icons' from factory-made fluorescent lights; the use of neon light by CHRYSSA, Martial RAYSSE and others; ALVIANI's reflected light from directionally machined aluminium surfaces; LIPPOLD's lines of light reflected in space from wires; Piene's incandescent lamps which establish volumes in space; the mirror rooms of SAMARAS; the IMOOS of Bryan WYNTER; and many more. Light as an artistic medium is a new thing in this century and the fantasy and inventiveness with which it has been pursued defy description. Some of those who have been most deeply involved in the novelty of research have been at least as much interested in new methods and devices as in the aesthetic quality of what they had invented.

Among important collective exhibitions of Luminist art in the 1960s are the following: 'Kunst-Licht-Kunst', Eindhoven, 1966; 'Lumière et Mouvement', Mus. d'Art Moderne de la Ville de Paris, 1967; 'Light, Motion, Space', Walker Art Center, Minneapolis, 1967; 'Focus on Light', New Jersey State Mus., Trenton, 1967; 'Light and Motion', Worcester Art Mus., 1968.

LUNDQVIST, EVERT (1904–). Swedish painter, who studied at the Academy of Art, Stockholm, and taught there from 1960. He visited France and Germany from 1925 to 1931, during which time he obtained a thorough grounding in the classical tradition of Chardin, Daumier, Corot, Ingres. At the same time he was an EXPRESSIONIST by temperament and developed a style which combined a classical sense of form with emotional expression. He painted with a heavy impasto in rich and expressive colours, imparting a luminous and glowing quality to his dynamic forms. During the 1950s he became one of the protagonists of the Neo-Expressionism which competed in Sweden with Geometrical Abstraction, maintaining always a classical restraint and a powerful feeling for composition.

LURÇAT, JEAN (1892–1966). French painter and designer, born at Bruyères, Vosges. After taking a course in medicine at Nancy he studied painting under Victor Prouvé, who was director of the Nancy École des Beaux-Arts and succeeded Émile Gallé as President of the Nancy group of designers. In 1912 he went to Paris, where he studied under the graphic artist Bernard Naudin (1876–1946) at the Académie Colarossi. He frequented the circle of PICASSO and MARCOUSSIS and for a time his work came under the influence of CUBISM. After being wounded in the First World War he was discharged in 1917. The most important and lasting influence on his work came from his extensive travels during the 1920s, in Spain in 1923 and from 1924 to 1929 in the Middle East, North Africa and the Sahara. His painting was dominated by impressions of desert landscape, reminiscences of Spanish and Greek architecture and a fantasy of incongruous unreality which caused him to join the SURREALIST movement for a short period in the 1930s.

Lurçat is chiefly remembered, however, by his work for the revival of the art of tapestry in both design and technique. His designs were based on fantastic representations of the vegetable and insect worlds combined with exalted themes from human history, and he succeeded in combining the stylizations of medieval religious tapestry with modern modes of abstraction and simplification to form the basis of a new mode of design. His first design, *Illusions d'Icare*, was woven at the Gobelins in 1936. In 1939 he was appointed designer to Aubusson and together with GROMAIRE brought about a renaissance in their work. His most important designs were: *The Apocalypse* (56 m²) for the church of Assy (1948); tapestries for the Palais de l'Europe at Strasbourg (1951–4); *Hommage aux morts de la Résistance et de la Déportation* (Mus. d'Art Moderne de la Ville de Paris, 1954); *Chant du Monde* (a set of tapestries 500 m²), 1957–63.

In the 1960s he renewed his painting activities with a number of highly original gouaches. From 1930 onwards he also did a number of coloured lithographs, stage designs and book illustrations.

LYE, LEN. See KINETIC ART and LUMINISM.

LYMAN, JOHN GOODWIN (1886–1967). Canadian painter, born in Biddeford, Maine, but grew up in Montreal. He studied art in Paris, under LAURENS at the Académie Julian. In 1908 he became a friend of James Wilson MORRICE, who directed him towards experimental painting. He met Matthew SMITH at Étaples in 1909, and the two enrolled in the school recently opened in Paris by Henri MATISSE, although illness forced Lyman's withdrawal after only six months. Matisse's work, however, continued to be his principal inspiration; Morrice and Smith, too, remained his mentors throughout his life.

In 1910 Lyman and Smith painted together at Pont Aven. After Lyman's marriage, he and his wife spent two years travelling around France and to Bermuda, returning to Montreal in 1913. Here an ambitious one-man show at the Art Association of Montreal was crudely attacked by the local press, and the Lymans immediately returned to France. For the next eighteen years they lived abroad—chiefly in France, Spain and North Africa but also in Bermuda and for one winter in Los Angeles. The Depression brought Lyman back to Montreal in 1931. He had held a second one-man show there in 1927 and a third in February 1931. His work was by then less concerned with FAUVE-like colour and more with clear modelling and classical, rather studied compositions, and the critics were prepared to commend it. In the autumn of 1931 Lyman and two or three others opened an art school, The Atelier, modelled on a Parisian academy. It lasted only one year, but

he and his co-instructors held two exhibitions of their work (1932, 1933) which they in part intended to demonstrate the value of 'pure' painting on the French model to counteract the inordinate influence then enjoyed by the GROUP OF SEVEN. To promote the ideal of the ÉCOLE DE PARIS became Lyman's consuming concern during the 1930s. To this end he wrote art criticism and organized exhibitions. These years were also his own most productive period. His mature work—like *Lady with a White Collar* (National Gal. of Canada, Ottawa, 1936)—is strongly modelled, sensitively though austerely coloured, and highly formal, almost stiff, in mood. In 1939 he founded the Contemporary Art Society, which aimed at fostering a living, modern art, free of nationalistic ideology. From 1948—the year which also marked the demise of the Contemporary Art Society—until 1957, when he retired, Lyman taught in the Department of Fine Arts at McGill University. He continued to paint, holding one-man shows at the Dominion Gal., Montreal (1947, 1955), and the Studio of Jacques and Guy Viau, Montreal (1949). A major retrospective exhibition was given at the Montreal Mus. of Fine Arts in 1963 (also shown in Ottawa and Hamilton), and another was staged by the Mus. du Québec in Quebec City in 1966, which subsequently toured nationally.

LYRICAL ABSTRACTION. A term which is used differently by different writers. Bernard Dorival in his *Les Peintres du XXe Siècle* (1957) restricts it to the expressive abstraction of artists such as Robert LAPOUJADE and Bernard DUFOUR whose works do not derive from or suggest natural appearances and to the younger artists such as Paul KALLOS and Serge REZVANI who were more concerned with formal structure in their works than had been the initiators of ART INFORMEL such as WOLS and HARTUNG. Pierre Cabanne and Pierre Restany, however, in *L'Avant-garde au XXe Siècle* (1969) applied the term to the whole school of Expressive Abstraction, sometimes called TACHISM, which was initiated in reaction from geometrical abstraction by Wols, MATHIEU, Hartung, ATLAN and DUBUFFET, and regarded BRYEN and FAUTRIER as its forerunners. They wrote: 'Fautrier, Bryen, Wols, Hartung lead us to the very heart of the lyrical adventure, which the peremptory brilliance of Mathieu traverses like a flash of lightning.... The revelation of the American school, which made itself felt from 1952, appeared as an additional argument in favour of lyrical abstraction.' They recognized a second wave of lyrical abstraction from the mid 1950s, with TAL COAT as its most important representative, which owed something to the American ALL-OVER style and to the mysticism of Sam FRANCIS. Mathieu applied the term 'lyrical abstraction' to his own work.

M

MAAS, PAUL (1890–1962). Belgian painter, born at Brussels of a well-to-do middle-class family. After studying literature at the Free University of Brussels, he was wounded in the war and invalided out in 1914. At the end of the war he met Rik WOUTERS in Amsterdam and was encouraged by him to take up painting. Then on his return to Brussels he became a friend of Henri-François RAMAH and joined the group of EXPRESSIONIST artists led by De SAEDELEER. In his early period Maas used carefully constructed geometrical forms painted in smooth colours with subdued tonal changes. Between 1938 and 1940 he changed his style to a mode of Expressionism akin to that of SOUTINE, using a vigorously expressive technique characterized by the subtle richness of its impasto. In certain of his pictures there were traces of FAUVIST colouring. He painted still lifes, portraits, figure studies and crowd scenes, often with a somewhat pessimistic and derogatory outlook as in *Albert-plage* (Mus. Royaux des Beaux-Arts, 1960–2). His method of portraiture is illustrated by the *Portrait de Zadkine* (Mus. Royaux des Beaux-Arts, 1947), in which he constructs the portrait by means of simplified planes of colour, achieving the likeness by posture, outline and the suggestion of a few characteristic traits.

MABE, MANABU (1924–). Brazilian painter born in Kumamoto, Japan, and moved to Brazil with his family in 1934. He first worked as a farm hand on coffee plantations near São Paulo and sold hand-painted ties for a living. He began painting professionally in 1946 with no formal training and started exhibiting in Salon groups in 1951. His abstractions bore close affinities with ACTION PAINTING. He particularly admired the painting of the French artist Georges MATHIEU, who visited Brazil in 1959 to exhibit and lecture. Mabe's gestural INFORMALISM was enhanced by brilliant and tasteful colour sometimes combining drip techniques with generous brushwork and contrasting broad flat areas with delicately detailed calligraphic passages. He often entitled the work after the image had emerged. His titles are based on Oriental mysticism, as for instance *The Infinite, The Voice of Heaven* (1963), moods and states such as *Ecstatic* (1966), *Innocent* (1963), nature as in *Primavera* (1965), topical events as in *Poem of Hiroshima* (1960) and sometimes on the formal aspect of the work as *Conquest of the Circle* (1963). He never lost, however, his sense of art as a mystical manifestation. In 1959 he participated in the First Biennale of Young Artists in Paris and had his first individual exhibition at the Gal. Barcinsky in Rio de Janeiro. In 1960 he exhibited at the Mus. de Arte Moderna in Rio and in 1961 at the Gal. La Cloche, Paris. From 1953 on he was regularly represented in the São Paulo Bienale and in the National Salon of Modern Art, Rio (1952–60). As a member of a large community of Japanese-Brazilian artists his work was included in 'Artistas Nipo-Brazileiros' at the Mus. de Arte Contemporanea, São Paulo, in 1966. Mabe received numerous awards, including the gold medal at the São Paulo Salon of Modern Art (1957), a first prize at the Venice Biennale (1959) and an acquisition prize in 'South American Art Today' at the Dallas Mus. of Fine Arts (1959). He also received various fellowships. In 1972 he participated in the 3rd Coltejer-Medellín Bienale in Colombia and in 1975 had a retrospective at the São Paulo Mus. of Art.

MAC. See MOVIMENTO PER L'ARTE CONCRETA.

MAC'AVOY, EDOUARD (1905–). French painter born in Bordeaux. He went to Paris in 1929 and studied at the Académie Julian. His first exhibition was in 1937 at the Gal. Charpentier, from which time he made a reputation as a portraitist. His portraits were outstanding for their dramatic intensity and psychological insight. Portraits of Jean Cocteau, Marie Nöel, André Gide and Pablo PICASSO are in the Mus. National d'Art Moderne, Paris, his portrait of Pope John XXIII is in the Vatican and a portrait of François Mauriac is in the Mus. of Art, Boston.

MACBRIDE, ROBERT. See MACBRYDE, Robert.

MACBRYDE, ROBERT (ROBERT MACBRIDE, 1913–66). British painter, born at Maybole, Ayrshire. After working for five years as an engineer in a factory he began to study art at the Glasgow School of Art in 1932. He there became a close and lifelong friend of Robert COLQUHOUN, with whom he lived and worked until the latter's death in 1962. While Colquhoun was probably the better draughtsman and the more imaginative artist, MacBryde may have had the finer sense of colour. He himself consistently maintained Colquhoun's artistic leadership and the association may have led to his own neglect in critical appreciation. His work was influenced by SURREALISM and by Jankel ADLER.

MACCÍO, ROMULO. See LATIN AMERICA.

MACCOLL, DUGALD SUTHERLAND (1859–1948). British painter and critic, born in Glasgow. He studied under Frederick BROWN and was a member of the NEW ENGLISH ART CLUB. He was art critic of the *Spectator* (1890–6), the *Saturday Review* (1896–1906 and again 1921–30) and of the *Weekend Review*. He was Keeper of the Tate Gal. (1906–11) and of the Wallace Collection (1911–24). MacColl was an influential fighting critic and made a notable though unsuccessful stand against the London County Council for the preservation of John Rennie's (1761–1821) Waterloo Bridge. His books include *Nineteenth Century Art* (1902), one of the first British assessments of French Impressionist painting, *Confessions of a Keeper* and *Philip Wilson Steer* (1945).

MACDONALD, JAMES EDWARD HERVEY (1873–1932). Canadian painter and graphic artist, born in Durham, England, but moved to Hamilton, Ont., at the age of 14. Here he enrolled in night classes at the Hamilton Art School. He began his career as a commercial artist, but he pursued his interest in painting, spending vacations sketching and also studying part-time, after moving to Toronto, at the Central Ontario School of Art and Design. He lived in England for a few years, working for Carlton Studios in London. In 1907 he returned to Toronto, and the following year began to exhibit his landscape paintings. The next summer his search for subjects led him to explore the semi-wilderness region north of Lake Ontario. Elemental works like *By the River, Early Spring* (Hamilton Teachers' College, 1911) excited a great deal of interest when they were shown in a small exhibition at the Arts and Letters Club, Toronto, in 1911. As a result of this show, MacDonald met Lawren HARRIS and was persuaded to devote all his time to landscape painting. He and Harris began working together, inspired by the dream of an approach to painting that would be uniquely Canadian. Their enthusiasm culminated in the formation, in 1920, of the GROUP OF SEVEN. During the years before the war MacDonald, often with Harris, sketched in the country north of Lake Ontario, in the Laurentians north of Montreal, and among the wild rocky islands of Georgian Bay. They knew they had their subject. What they lacked was a meaningful approach, a compatible technique. A visit to an exhibition of contemporary Scandinavian painting in 1913 set their direction in this respect and they began to experiment with bolder colours and more generalized forms. To express the vitality of the north became their aim.

During the war MacDonald suffered difficulties. His experimental work—particularly *Tangled Garden* (National Gal. of Canada, Ottawa, 1916)—often drew abuse from critics. His close friend Tom THOMSON was drowned in 1917, and later that year MacDonald suffered a physical collapse. In September 1918, however, he made the first of several sketching trips to the Algoma region of Ontario, with Harris and Frank Johnston. In May 1920 Toronto saw the first exhibition of the Group of Seven. MacDonald's trips to Algoma resulted in his largest, most important canvases, culminating in *The Solemn Land* and *Autumn in Algoma* (National Gal. of Canada, Ottawa, 1921 and 1922 respectively). They are among the finest works produced by the Group, richly decorative and profound with the blown fullness of late autumn.

From 1921 MacDonald taught at the Ontario College of Art as Instructor in Decorative and Commercial Design, but kept up his regular sketching trips. He frequently visited the Rocky Mountains, where he produced sketches of great beauty. During the 1920s he was also engaged in a number of decorative mural programmes in Toronto, e.g. St. Anne's Church (1923), the Claridge Apartments (1928) and the Concourse Building (1929). He became Principal of the Ontario College of Art in 1929 but suffered a stroke in 1931 and travelled to Barbados to recuperate. Here, shortly before his death, he produced a few brilliant sketches of beach and surf, among the most elemental of his works.

Retrospective exhibitions include: Art Gal. of Toronto, and in Ottawa (1933); Mellors Gal., Toronto (1937); Dominion Gal., Montreal (1947); Art Gal. of Hamilton (1957); Art Gal. of Toronto, and in Ottawa (1965).

MACDONALD, JOCK (JAMES WILLIAMSON GALLOWAY, 1897–1960). Canadian painter, born in Thurso, Scotland, son of an architect, educated there and in Edinburgh. He worked as an architectural draughtsman, then served in the First World War. After the war he studied commercial design at Edinburgh College of Art (1919–22). He worked briefly as a designer with a textile firm, then became Head of Design at the Lincoln School of Art in 1925. In 1926 he emigrated to Canada, to teach at the new Vancouver School of Decorative and Applied Arts. Here he made friends with Fred Varley, a member of the GROUP OF SEVEN, who encouraged him to paint and accompanied him on sketching trips. The first canvas he exhibited, *Lytton Church, British Columbia* (National Gal. of Canada, Ottawa, 1930), was firmly in the Group of Seven tradition. The Depression caused severe salary cuts at the Vancouver School, so Varley and Macdonald left and with some friends founded the British Columbia College of Arts in 1934. The move stimulated experimentation in Macdonald and also in 1934 he painted his first abstract or AUTOMATIC work, *Formative Colour Activity* (National Gal. of Canada). During the next few years he suffered hardship. After the College collapsed in 1935 he lived with his family in isolation on the west coast of Vancouver Island. Because of poor health and lack of money he returned to Vancouver in 1936 and at

last, in 1938, got a job as a high-school art teacher. In Vancouver he tried a new series of abstractions which he called 'modalities', geometric designs partly based on his earlier textile work. He became a friend of Emily CARR, and in 1940 of Lawren HARRIS, who encouraged him in his abstract experiments. During the 1940s he successfully developed a SURREALISTIC style, which was well illustrated in two shows, at the Vancouver Art Gal. and at the San Francisco Mus. of Art, of automatic paintings in water-colour. In 1946 he was appointed director of the Art Department of the Provincial Institute of Technology and Art, Calgary, Alberta, but the following year he moved to Toronto to teach at the Ontario College of Art. He spent two summers (1948-9) at the Hans HOFMANN School and also made short trips to the Netherlands and France (1949, 1950). He continued to work mainly in water-colour, in the early 1950s introducing a wax-resist technique. Two influences inspired him to work more ambitiously in oils. The first was a meeting with Jean DUBUFFET during a year spent in Europe (1954-5). The second was his association with the abstract group PAINTERS ELEVEN, who, through a joint exhibition with AMERICAN ABSTRACT ARTISTS in New York in 1956, were also closely in touch with current New York painting. During the last five years of his life Macdonald's output was prodigious, as he threw himself into experimenting with various techniques and media. In 1957 he was greatly encouraged by the comments of the American critic Clement Greenberg, and from this point large-format paintings—usually painted with lucite—dominated his production. Works of forceful quality, they proved a moulding influence upon the younger painters of Toronto (*Contemplation*, Art Gal. of Greater Victoria, 1958; *Fleeting Breath*, Art Gal. of Ontario, Toronto, 1959). Macdonald also returned to exhibiting: at Hart House, University of Toronto, November 1957; Park Gal., Toronto, April 1958; Arts and Letters Club, Toronto, March 1959; Westdale Gal., Hamilton, November 1959; Here and Now Gal., Toronto, January 1960. The Art Gal. of Toronto arranged a full retrospective in May 1960, a singular honour. Until his death he continued to work feverishly, following one image and colour harmony through a series of paintings. A scholarly retrospective exhibition of his work was circulated by the National Gal. of Canada in 1969-70.

MACDONALD-WRIGHT, STANTON (1890-1973). American painter born at Charlottesville, Va., brother of the critic Willard Huntington Wright. In 1907 he went to Paris and after working for a year and a half at the Sorbonne studied art at the École des Beaux-Arts and the Académie Julian. Together with Morgan RUSSELL he studied colour theory and c. 1912 they evolved a theory of painting based upon the scientific deployment of colour. Their theory, which was parallel to the ORPHISM of Robert DELAUNAY and which they

called SYNCHROMISM, was put forward in statements made at a joint exhibition held first at the Neue Kunstsalon, Munich, and then at the Gal. Bernheim-Jeune, Paris, in 1913. Macdonald-Wright exhibited at the ARMORY SHOW in 1913 and later in the same year had a joint exhibition with Morgan Russell of Synchromist works at the Carroll Gal., New York. They claimed that they and not Delaunay and KUPKA were the originators of the new style of abstract colour painting. In 1916 both Macdonald-Wright and Russell participated in the FORUM EXHIBITION organized by Willard Huntington Wright. After spending part of 1914–16 in London with his brother, Macdonald-Wright returned to the U.S.A. in 1916 and in 1917 held a one-man show at the 291 Gallery of Alfred STIEGLITZ. Among his Synchromist paintings are: '*Conception*' *Synchromy* (Whitney Mus. of American Art, 1915) and *Synchromy* (The Mus. of Modern Art, New York, 1917).

In 1919 he moved to California, where he abandoned Synchromist painting and began working on a 'kinetic' machine for colour cinema. He was director of the Los Angeles branch of the Art Students' League, 1922-30, and was affiliated with the FEDERAL ARTS PROJECT/WPA, 1935-42. From 1933 to 1935 he worked on a large mural (now in the Smithsonian Institution, Washington) for the Santa Monica Library, California. As a result of this he became interested in architectural decoration, invented a material which he called *Petrachrome* for the decoration of walls and collaborated in a book on the history of mosaic. After visiting Japan in 1937 he taught Oriental and modern art at the University of California in Los Angeles, 1942-52. After a second visit to Japan, 1952-3, he gave up teaching and reverted to abstract painting. From 1958 he spent part of every year in a Zen monastery in Japan.

Retrospective exhibitions of his works were given at the Los Angeles County Mus. of Art in 1956 and at the Smithsonian Institution in 1967.

MCENTYRE, EDUARDO (1929-). Argentine painter, born in Buenos Aires. McEntyre practised geometrical abstraction in the manner which was called GENERATIVE ART. In this style a basic element (with McEntyre usually a circle) is made to 'generate' new forms and to create intricate designs by rotation of the initial form and by making the new forms touch or cut each other, overlap, recede, etc. By different intensities of colour he created great chromatic richness and gave an almost mystical quality to his paintings, sometimes with affinities to OP ART. He exhibited in most of the important art centres of South America and also in New York, Munich, Berlin and Cologne. As well as the Argentine his works were included in many group shows in the United Kingdom, Mexico, Spain, Brazil, Uruguay, Peru, Venezuela, the U.S.A., Israel, Switzerland, Italy and France. He was awarded First Prize at the Second Latin-American Engraving Bienale at Puerto Rico in 1972.

MCEVOY, ARTHUR AMBROSE (1878–1927). British painter, born at Crudwell, Wiltshire. Encouraged by Whistler, he studied at the Slade School, 1893–6. For some years after leaving the Slade he devoted himself to making a meticulous study of the methods of the Old Masters, while he himself painted intimate studies of figures in interiors, low-toned, unassuming and quiet in mood. One of the best of these is *The Ear-ring* (Tate Gal., 1911). Yet he had versatility and a story is told that at the annual exhibition of the NEW ENGLISH ART CLUB in 1909 one of his paintings was mistaken for SICKERT'S. About 1913 a radical change took place in his work and he came to the fore as a popular portrait painter. He painted for preference beautiful women and often in water-colour. His work in this genre was unequal; while some of his portraits were flashy with a spurious glamour, the best of them had a sensitiveness and distinction that were unsurpassed in their day. The critic R. H. Wilenski went so far as to claim that he had brought back into English portrait painting Gainsborough's romantic air of refinement while surpassing Gainsborough in his ability to suggest gracefulness of attitude.

In 1902 he became a member of the New English Art Club. During the First World War he served in the Royal Naval Division and some of the portraits he did at this time are in the Imperial War Museum. In 1933 he participated in a memorial exhibition at Manchester together with Sir William Orpen and Charles Ricketts.

MCFEE, HENRY. See FORUM EXHIBITION.

MACIVER, LOREN (1909–). American painter born in New York. Apart from intermittent lessons at the Art Students' League in 1919–20 she was self-taught as an artist. During the 1930s she worked for the FEDERAL ARTS PROJECT and she had her first one-man exhibition at the East River Gal., New York, in 1938. In the 1940s she turned to decorative abstraction and became one of America's best-known women painters. She has been called an 'imagist poet in paint', capturing in her work the fleeting impression of the commonplace—a bunch of flowers on a garbage tip, the rainbow colours in an oil slick—and lending a magic charm to remembered moments. Her paintings displayed at the same time a lapidary instinct for abstract pattern with which to carry the sense of wonder she imparts. She also did murals for ships of the Moore-McCormack Lines and American Export Lines and was known for her book illustrations, magazine covers and posters. In 1957 she received First Prize at the biennial of the Corcoran Gal. and in 1960 a Ford Foundation Grant. She had retrospective exhibitions at the Whitney Mus. of American Art in 1953 and at the Mus. d'Art Moderne de la Ville de Paris in 1968.

MACK, HEINZ (1931–). German sculptor born at Lollar, Hesse, and studied at the Academy in Düsseldorf from 1950 to 1953, after which he took a degree in philosophy at Cologne University. In 1958 he founded the group ZERO with Otto PIENE and Günther UECKER and was co-editor of the magazine *Zero*. He won the Marzotto Prize in 1965 and a First Prize at the Paris Biennale in 1966. He made 'light' objects, which he called 'Dynamic Structures', consisting of polished metal plates behind plexiglass or curved sheets of glass; irregular movements were imparted to them by an electric motor so as to cause constantly changing light reflections. In 1968 he began his 'Sahara Project', in which 'light' objects reflected the blinding sunlight in such a way as to take on an unreal appearance. Among other things he erected a 'light column' 11 m high for a television film. See also LUMINISM.

MACK, LUDWIG HIRSCHFELD (1893–1965). German-Australian artist and teacher, born in Frankfurt-on-Main. He studied painting at the Wilhelm Debschtiz Art School in Munich and art history under Heinrich Wölfflin at Munich University. After service during the First World War he studied at the Stuttgart Academy under Adolf HOELZEL, from whom he derived an interest in colour theory. In 1919 he enrolled in Johannes ITTEN's preliminary classes at the Weimar BAUHAUS and became an apprentice in the printing workshop under Lyonel FEININGER. Working chiefly in lithography, he participated in the printing of cover designs for the Bauhaus 'portfolios' as well as producing his own work (e.g. *Reaching the Stars*, Art Gal. of N.S.W., 1922), which reflected the influence of Paul KLEE. His best-known achievements at the Bauhaus were his 'Colour Light Plays' developed from 1922 onwards. After the removal of the Bauhaus to Dessau in 1925, Mack taught art for four years at the Freie Schulgemeinde at Wickersdorf. This was followed by a further period of art teaching, in the preliminary course for young architects at Weimar (1929–30), and later as Professor of Art and Craft at the Paedagogische Hochschule at Frankfurt-on-Oder. Owing to pressure from the Nazis he left Germany for London in 1936 and worked at various jobs in England and Wales before being interned at the onset of the Second World War. He was sent to Austalia in 1940.

On being released from internment in 1942 he became art master at the Geelong Grammar School in Victoria, where he remained until his retirement in 1957. During these years he introduced Bauhaus teaching methods, which came to exercise a considerable influence on art teaching in Victoria. In Australia he continued to paint and draw, producing works which continued the colour researches of his Bauhaus days (e.g. *Composition*, Art Gal. of N.S.W., 1946). He held three exhibitions at private galleries in Melbourne—Peter Bray (1954), Gal. A (1960, 1965)—and was author of *The Bauhaus: an Introductory Survey* (1963). A retrospective exhibition of his work was held in the Art Gal. of N.S.W. in 1974.

MACKE, AUGUST (1887–1914). German painter born at Meschede, Westphalia, and studied at the Academy in Düsseldorf, 1904–6. He passed his youth, however, mainly in Bonn and Cologne and seems to have absorbed the light-hearted visual sense of the Rhineland. He visited Paris in 1907 and found himself at home with the ways of painting then in vogue there—French Late-Impressionism and particularly FAUVISM. On a further visit in 1912 he was deeply impressed by DELAUNAY's experimental developments in the 'simultaneous contrast' of colours and with the CUBIST analysis of forms. In his own work he evolved a gay and extremely personal synthesis of Impressionism, Fauvism and ORPHISM with which to display a basically EXPRESSIONIST attitude. In 1909–10 he met KANDINSKY and Franz MARC in Munich and joined them in the formation of the BLAUE REITER, with whom he exhibited. Apart from a few experiments in non-figurative abstraction in 1913, his work was representational. In style it came closer to the spirit of French art than that of any other German painter of the time. Early in 1914, in which year he was killed in action, he made a trip with Paul KLEE and Louis MOILLIET to Tunisia. The water-colours he did on this trip are considered to be his most personal achievement and represent a highly individual adaptation of Delaunay's use of colour for expressive purposes; the starting point for further development by Klee.

MCKEAN, MARGARET. See SOUTH AFRICA.

MACKENSEN, FRITZ. See WORPSWEDE.

MCLAUGHLIN, JOHN (1898–1976). American painter, born at Sharon, Mass., and resided at Laguna Beach, California. He travelled to the Far East in 1935 and spent several years in Japan, beginning to paint in 1938 without formal training. He was one of the four West Coast artists in connection with whose work the critic Jules Langsner coined the term HARD EDGE in 1958 and he made important contributions to the West Coast developments which succeeded ABSTRACT EXPRESSIONISM. His works have been widely exhibited, including retrospectives at the Pasadena Art Mus. in 1956 and 1963 and at the Corcoran Gal. of Art, Washington, in 1968–9. He was also represented in many collective exhibitions of American painting and West Coast painting in the styles of Hard Edge and geometrical abstraction, including 'West Coast Hard-Edge' at the Institute of Contemporary Arts, London, in 1960 and '11 Los Angeles Artists' at the Hayward Gal., London, in 1971.

MCLEAN, BRUCE. See CONCEPTUAL ART.

MCNEIL, GEORGE (1908–). American painter, born in New York, studied at the Pratt Institute, the Art Students' League, the HOFMANN School and Columbia University. During the 1930s he designed abstract murals for the FEDERAL ARTS PROJECT and he was one of the original members of AMERICAN ABSTRACT ARTISTS. His work was widely exhibited in America, including 'New Horizons in American Art' (1936), 'Abstract Painting and Sculpture in America' (1951) and 'The New American Painting and Sculpture' (1969) at The Mus. of Modern Art, New York.

MAES, KAREL (1900–). Belgian painter born at Mol. After passing through a CUBIST phase he began painting abstract pictures c. 1918 and he was one of the few who practised abstraction in Belgium during the 1930s. He was an editor of the journal *Sept Arts*.

MAFAI, MARIO (1902–65). Italian painter, born in Rome. With SCIPIONE he founded the ROMAN SCHOOL of Neo-Romanticism and poetic expressiveness in opposition to the stereotyped Neo-Classicism of the NOVECENTO. The movement was strongly influenced by the EXPRESSIONISM of SOUTINE and the ÉCOLE DE PARIS. Though less imaginative, less visionary than those of Scipione, his pictures were more painterly in construction and his still lifes and town scenes were touched with a fine poetic sensibility. Of the former J. T. Soby and A. H. Barr, Jr. said (Catalogue of exhibition 'Twentieth-Century Italian Art' at The Mus. of Modern Art, New York, 1949): 'Indeed, the younger generation in Italy has produced few images which can compare in sheer sensibility to the best of Mafai's still lifes of 1930–35.' During the Second World War he painted a series of *Fantasies* conceived as a sort of Passion Play enacted by the oppressors and the oppressed. Of the contrast between Mafai and Scipione, the two leaders of the Roman School, Werner Haftmann said: 'While in Scipione the picture as a whole is born of an hallucinated Baroque imagination, Mafai takes more account of real objects. His poetic vision discovers rich beauty in poor, forlorn, forgotten things—a bunch of flowers, a deserted house, a desolate landscape. It is a subtle, peculiar beauty—reality is cloaked in precious colour and even a heap of rubble takes its place in a delicate, rich ensemble. It is this precious quality in his colour that gives each of Mafai's visual experiences its melancholy tone, for behind the radiance we discern graphic signs of decay, which lend the ephemeral beauty a moving poetic accent—trees with branches flowing like hair in the wind, bushes like twining snakes, houses which stagger beneath impending ruin.' This concern for the simple, the weak and the ephemeral was a direct contrast to the epic grandiloquence of the official art in 'Fascism's thunderous springtime'. Among the younger painters the influence of Mafai was most clearly apparent in SCIALOJA and Tamburi.

MAGIC(AL) REALISM. Term introduced by Franz Roh in a book on Post-Impressionism in 1925, and adopted by later criticism, to distinguish the Verism of the German NEUE SACHLICHKEIT

iantic naturalism of painters such as ɔl and Hans Thoma. The term has, :n more often used of the suggestion native or dream reality other than the reality everyday life which, with a strong impression of 'presence', is conveyed by some NAÏVE art, some METAPHYSICAL PAINTING and some SURREALISM.

MAGNELLI, ALBERTO (1888–1971). Italian painter, born in Florence. He began to paint *c.* 1911 without previous training when he made contact with the Florentine FUTURISTS, although he did not formally join their movement. He was in Paris in 1913–14 and met MATISSE, PICASSO and members of the CUBIST circle. Returning to Italy in 1915, he painted brightly coloured abstracts for a short while but reverted to figurative painting and concentrated mainly on formalized landscapes under the influence of the Italian METAPHYSICAL school. On a visit to the marble quarries at Carrara in 1931 he was impressed by the shapes of the blocks and did a series of near-abstract paintings which he called *Broken Stones*. He went to Paris in 1933, became a member of the ABSTRACTION-CRÉATION association and went back to completely abstract painting. During the German occupation he worked at Grasse together with Sonia DELAUNAY, Sophie TAEUBER-ARP and Jean ARP. Immediately after the war he enjoyed a wave of popularity, culminating in a memorable exhibition at the Gal. Drouin, Paris, in 1947, and at this time he was considered to be the most important abstract artist working in Paris, the successor to KANDINSKY (by whom he had been considerably influenced at an earlier stage in his career). But Magnelli did not conform to the type of ART INFORMEL or expressive abstraction. His abstract compositions were composed of firmly outlined geometrical or near-geometrical shapes built into structures in a manner akin to that of the CONSTRUCTIVISTS. Only his colours were highly expressive. He was also notable for an extremely personal manner of outlining his forms, of which Michel SEUPHOR said: 'One of his most successful discoveries is the multi-coloured line which acts as a kind of transparent skin, surrounding or even sectioning his forms and subtly changing whatever area it penetrates while respecting the values it finds there.'

He had a one-man show at the Venice Biennale in 1950 and important shows at the Palais des Beaux-Arts, Brussels, in 1954, at the Kunsthaus, Zürich, in 1963 and at the Mus. National d'Art Moderne, Paris, in 1968.

MAGRITTE, RENÉ-FRANÇOIS-GHISLAIN (1898–1967). Belgian painter, born at Lessines, Hainaut. In 1910 the family moved to Châtelet, where Magritte learnt painting and drawing with the local children. In 1913 he moved to Charleroi with his father and two brothers, his mother having committed suicide the year before. From 1916 he attended the Académie des Beaux-Arts,

Brussels, intermittently until 1918, when the family settled there. Here he associated with an *avant-garde* group which included Pierre-Louis FLOUQUET and E. L. T. MESENS. In 1922 he married Georgette Berger and worked for a short time in a wall-paper factory where he met Victor SERVRANCKX. A turning point in his artistic career occurred when he saw a reproduction of CHIRICO's painting *Le Chant d'Amour* and in 1924 he published with Mesens the review *Oesophage*, from which sprang an association with activities similar to those of the French SURREALISTS. A contract with the gallery CENTAURE in 1925 enabled him to devote himself full time to painting. An exhibition at the same gallery in 1927 was not well received by the critics and he moved to Paris, where he associated with André BRETON, Paul ÉLUARD and their group. From this time his reputation spread internationally and his works were widely exhibited both in Europe and in America.

He returned to Belgium in 1930 and resumed his contacts with *avant-garde* artists and writers in Brussels. His first one-man show in America was at the Julien Levy Gallery, New York, in 1936. During the 1930s his works were included in all important international Surrealist exhibitions. In 1953 he was commissioned to design eight murals for the grand salon of the Casino of Knokke-Le Zoute, in 1957 he designed the mural *La Fée Ignorante* for the Palais des Beaux-Arts, Charleroi, and in 1961 the mural *Les Barricades Mystérieuses* for the Palais des Congrès, Brussels. His first retrospective exhibition in the U.S.A. was at the Mus. of Contemporary Arts, Dallas, in 1960. A major exhibition was staged by The Mus. of Modern Art, New York, with sponsorship of the Belgian Government in 1965 and a retrospective loan exhibition was given by the Marlborough Fine Art Gal., London, in 1973.

Except for three years in the early 1940s when he experimented not very successfully with Late-Impressionist techniques, Magritte painted in a highly realistic style with careful and precise definition of his subjects and a hard finish rather than tonal subtleties. The Belgian critic E. Langui said of him: 'In style and imagery, form and content, sense and signification, Magritte instinctively goes to the heart of the problem, which is not a question of aesthetics or a style of painting but a mode of existence, namely the behaviour of human beings freed from the constraints of reason, morality, religion and society. The important thing is what one is saying, not how one says it, and so the artist adopts a simple, direct and popular style for the most improbable stories, mysterious situations and unexpected encounters.' But in his almost hallucinatory MAGIC REALISM he showed himself an accomplished technician.

Magritte recalled that from his cradle he saw 'helmeted men wearing the shroud of a stranded balloon on the roof of their family residence'. Once he had found his way he was a natural and spontaneous Surrealist with all the Surrealist's gift

for the juxtaposition of incongruities with a haunting significance incapable of verbal formulation and for manipulating ambiguities of perspective with the talent to create purely visual shock. He could confer specious reality on the spatial unrealities of dream. Iconographically he had a repertoire of obsessive images which appeared again and again in ordinary but incongruous surroundings. He exploited repeatedly the ambiguity between picture and landscape, inside and out-of-doors, day and night. In a number of paintings, for example, he depicted a night scene, or a city street lit only by artificial light, below a clear sunlit sky. He made Surrealist analogues of a number of famous paintings, for example David's *Madame Récamier* and Manet's *The Balcony*. For the fertility of his imagery and the unforced spontaneity of his effects Magritte was one of the very few natural and inspired Surrealist painters. J. T. Soby summed this up felicitously when he wrote: 'In viewing Magritte's paintings it is always well to remember that everything seems proper. And then abruptly the rape of commonsense occurs, usually in broad daylight.'

MAILLOL, ARISTIDE (1861–1944). French sculptor. He was born at Banyuls in the Pyrénées orientales and the Virgilian quality of this idyllic Catalan countryside left a permanent impression upon him. He went to Paris in 1882 and studied at the École des Beaux-Arts first under Jean-Léon Gérôme, and then under Alexandre Cabanel (1823–89). In 1883 he became a friend of BOURDELLE and met Gauguin, whose influence was expressed in his tapestry designs; in 1886 he started a small tapestry manufacture at Banyuls. In 1893 he came into contact with the NABIS and exhibited with them until 1903. It was not until the turn of the century, when he was approaching 40, that Maillol turned to sculpture. He restricted himself to the female nude, expressing his whole philosophy of form through this medium. Commissioned in 1905 to make a monument to the tribune Louis-Auguste Blanqui, he was asked by the committee, which included Clemenceau and Mirbeau, what form he proposed to give it. He replied: 'Eh! une femme nue.' A torso for the monument, *L'Action enchaînée*, is in the Tate Gal., London. In 1908 he visited Greece with the German collector Kessler and the influence of this contact with the Greek countryside may be seen in his illustrations done in 1926 for Virgil's *Eclogues* and in 1937 for the *Daphnis and Chloë* of Longus. Maillol had a retrospective exhibition at the Kunsthalle, Basle, in 1935 and at the Petit Palais, Paris, in 1937. A retrospective exhibition of 170 works was given at the Solomon R. Guggenheim Mus., New York, in 1976.

Maillol was the most distinguished figure of the transition from Rodin to the moderns. He tempered the emotive Romanticism of Rodin with classical restraint and sensibility. More than any artist before him he brought to conscious realization the concept of sculpture in the round as an independent art form stripped of literary associations and architectural context. After his return from Greece he worked for 25 years with the female nude to construct an infinitely subtle art of three-dimensional plastic forms, seeking unification without loss of plenitude, and he was pre-eminent in giving to his figures that sculptural 'fourth dimension' consisting of a controlled tension of centripetal against outward pulsating forces. This last aspect of his work was carried further, though not always without flabbiness, by the English sculptor Frank DOBSON.

MAINSSIEUX, LUCIEN (1885–1958). French painter, born at Voiron. He was a pupil of Jules FLANDRIN and was known chiefly for his landscapes of Provence, Italy and North Africa and for his water-colours painted in a delicate and classical style. He was also music critic of the periodical *Le Crapouillot*.

MAISTRE, ROY DE (1894–1968). Australian painter born in New South Wales, studied at Sydney Art School and the Royal Art Society, Sydney. He lived much of his time in Britain and Europe, however, coming to London in 1923 and then spending two years in France on a travelling scholarship. He returned to Australia in 1926 but spent the years 1930 to 1938 in France and London. After working in a manner akin to that of the CAMDEN TOWN GROUP, he became interested in the POST-IMPRESSIONISTS and then adopted a CUBIST idiom. He was, however, keenly interested from his student days in the expressive values of colours, the analogy between colour combinations and musical harmony, and the function of colour for the articulation of structure. Much of his work was an exemplification of these interests. Among his best-known works are the *Stations of the Cross* at Westminster Cathedral.

MÄKILÄ, OTTO FREDRIK (1906–55). Finnish painter and graphic artist, studied at the Drawing School of the Turku Art Association, of which he was later Principal, 1950–5, and at the Académies de la Grande Chaumière and Colarossi, Paris. Mäkilä was the chief representative of international SURREALISM in Finland. His first exhibition was in 1926. In 1957 a large memorial exhibition of his works was given in Helsinki.

MAKOVETS (also called ART-LIFE). A society of artists and writers founded in Moscow at the end of 1921. It organized one exhibition (Moscow, 1922) and published its own journal (two issues, Moscow, 1922). The members included Chernyshev, Chekrygin, SHEVCHENKO, Zhegin. Many of them supported the Neo-Romantic tendency in early Soviet art, favouring lyrical, even EXPRESSIONIST landscapes and portraits. The society was named after the hill on which Sergei Radonezhsky built the Troitse-Sergiev Lavra (now the Zagorsk

monastery and museum complex) in the 14th c.—a gesture which betrayed its members' emphasis on the spiritual and religious quality of art.

MAKOWSKI, ZBIGNIEV (1930–). Polish painter born in Warsaw and studied at the Academy of Fine Arts there. Makowski matured his personal style slowly, starting from the 'Unism' of STRZE-MINSKI. He combined this with the automatic script writing of the SURREALISTS and with the expressive abstraction of ART INFORMEL into a personal idiom of cryptic signs and symbols, mysterious ciphers and hieroglyphs, which are sometimes isolated in a chequerboard pattern. The complete pictures are said to suggest the hermetic ambiguity of ancient scripts and the inherent ambiguity of conceptual communication.

MALDONADO, TOMAS (1922–). Argentine painter, graphic artist, theorist and industrial designer born in Buenos Aires. In 1944 he illustrated and wrote articles for the *avante-garde* review *Arturo* and in 1945 headed the *Arte Concreto-Invención* group and contributed to its review. He later became a member of the *Artistas Modernos*. He was mainly responsible for introducing CON-CRETE ART into Argentina. In 1951 he founded the review *Nueva Vision*, which later became a publishing firm. The ideas expressed in *Nueva Vision* were based on the theories of Max BILL, whom Maldonado had admired for many years and met in Europe in 1949. Other artists, such as Lidy Prati, Alfredo Hlito and Claudio Girola, collaborated on the review, which featured articles and reproductions of the work of the De STIJL group, VANTONGERLOO, Van DOESBURG, VORDEMBERGE-GILDEWART, MONDRIAN, as well as the emerging Argentine abstract artists Sarah GRILO, FERNANDEZ-MURO and O'Campo. In 1954 Maldonado left for Germany, where he taught at the Hochschule für Gestaltung directed by Max Bill in Ulm. After Bill's resignation in 1956 he took over the direction of the school, giving up the practice of art and devoting himself to teaching and theory. Besides his numerous articles he was also the author of several books, including *Max Bill* (Buenos Aires, 1955) and *Design, Nature and Revolution;Toward a Critical Ecology* (1972). Few of his paintings are in circulation but the painting *From a Sector* was included in the exhibition 'Art of Latin America Since Independence' at Yale University and other locations in the U.S.A.

MALEVICH, KASIMIR SEVERINOVICH (1878–1935). Russian painter, born and trained near Kiev. When he went to Moscow in 1905 he was already an accomplished painter in what has been called the 'Russian Impressionist' style. In Moscow he saw works of the French POST-IM-PRESSIONISTS and FAUVES either in reproduction or in the SHCHUKIN and MOROZOV collections, including works by BONNARD, VUILLARD, Cézanne and LÉGER. His *Flower Girl* (Russian Mus., Leningrad,

1904–5) was a sensitive and sophisticated work proving that he had fully assimilated the lessons of the French masters. From *c.* 1908, however, his friendship with GONCHAROVA and LARIONOV brought about a radical change in his style. He became acutely conscious of the social significance of his work and began to paint rural peasant subjects, while a deliberate Primitivism took the place of his former sophisticated refinement (*Woman with Buckets and a Child* and *Peasants in Church*, both in Stedelijk Mus., Amsterdam, 1910–11). But he was at the same time deeply engrossed in CUBIST methods and in many of his peasant scenes the figures were formalized into tubular shapes reminiscent of Léger while figures and background were broken up into a system of planes with little recession but articulated in contrasting areas of flat colour. Such are *Taking in the Harvest* (Stedelijk Mus., Amsterdam, 1911) and *Haymaking* (Tretyakov State Gal., Moscow, 1911). Pursuing this path, with the organization of planes and volumes becoming more prominent and systematic while the importance of the subject diminished pictorially, Malevich achieved the personal interpretation of Analytical Cubism, with some suggestions of FUTURISM, which he called CUBO-FUTURISM. The first picture in which he fully realized this union of styles was *The Woodcutter* (Stedelijk Mus., Amsterdam, 1912), which was first shown in the 1912–13 exhibition of the UNION OF YOUTH in St. Petersburg. Other Cubo-Futurist paintings, in which abstraction is taken still further, are: *Woman with Buckets* (The Mus. of Modern Art, New York, 1912), *The Knife Grinder* (Yale Art Gal., 1912) and *Head of a Peasant Girl* (Stedelijk Mus., Amsterdam, 1913). With another fairly abrupt change of style Cubo-Futurism was followed in 1913 and 1914 by pictures built up from a conglomeration of realistically rendered details or COLLAGES in the manner of the Synthetic Cubism of PICASSO and BRAQUE. Pictures done in this manner are *The Guardsman* (Stedelijk Mus., Amsterdam, 1912–13), *Woman and Advertisement Pillar* and *An Englishman in Moscow* (both in Stedelijk Mus., Amsterdam, 1913 and 1914). What Malevich called the 'non-sense realism' or 'alogicality' of these pictures was a pictorial analogue of the contemporary ideas in poetry formulated by Khlebnikov and Kruchenykh. In 1913 Malevich designed stage sets and costumes for Kruchenykh's Futurist opera *Victory over the Sun*, produced in St. Petersburg under the auspices of the Union of Youth (music by Matiushin).

Following his 'non-sense realist' or 'alogical' paintings and collages Malevich began to work on non-objective paintings which he exhibited in December 1915 as SUPREMATIST. Suprematism was certainly not a direct development of Analytical or Synthetic Cubism. While Cubism analysed natural appearances into geometrical or quasi-geometrical forms, as Cézanne had recommended, Suprematism was a form of CONSTRUCTIVISM, building up or *constructing* pictures from abstract geometrical

shapes without reference to observed reality. In the essay 'Suprematism' contained in his book *The Non-Objective World* Malevich wrote: 'The Suprematists have deliberately given up the objective representation of their surroundings in order to reach the summit of the true "unmasked" art and from this vantage point to view life through the prism of pure artistic feeling.' He described Suprematism as an art without social, political or other usefulness, a pure expression of what would now be called 'aesthetic feeling'. The elements from which Suprematist pictures were constructed were the rectangle, the circle, the triangle and the cross. Malevich believed that the 'purest' was the square. This painting of 'pure feeling' culminated in the famous 'white on white' series in 1917–18 (*Suprematist Composition: White on White*, The Mus. of Modern Art, New York). Some of these works—e.g. *Yellow Quadrilateral on White* (Stedelijk Mus., Amsterdam, 1916–17)—appear surprising anticipations of some MINIMAL ART of the 1960s.

In the controversy within INKHUK Malevich sympathized with KANDINSKY and the PEVSNER brothers in opposing the view of the PRODUCTIVIST group that all art must necessarily be utilitarian, maintaining rather that industrial art is dependent upon new ideas derived from autonomous creative art. In fact he never felt drawn to the world of design despite his desultory attempts at porcelain design in the 1920s and a book cover for PUNIN in 1920; even his so-called *Planits* and *Arkitektonics* of the early 1920s were experiments in volumetrical Suprematism and not part of an essentially functional design. Malevich taught at the Vitebsk art school, where he ousted CHAGALL, and exerted a profound influence there on LISSITZKY. In 1922 he joined the Petrograd branch of *Inkhuk*. In 1927 he travelled to Warsaw and to the Bauhaus, where he met ARP, SCHWITTERS and others. In the late 1920s, in Leningrad, he returned to a more figurative kind of painting, and in the early 1930s did a series of remarkable portraits of friends and members of his family.

In *Cubism and Abstract Art* (1936) A. H. Barr, Jr. gives the following estimate of Malevich's importance in the history of 20th-c. art. 'In the history of abstract art Malevich is a figure of fundamental importance. As a pioneer, a theorist and an artist he influenced not only a large following in Russia but also, through Lissitzky and Moholy-Nagy, the course of abstract art in Central Europe. He stands at the heart of the movement which swept westward from Russia after the War and, mingling with the eastward moving influence of the Dutch Stijl group, transformed the architecture, furniture, typography and commercial art of Germany and much of the rest of Europe.' One should add that he is to be regarded as the 'father' of the Constructivist art which came to the fore in Europe after the Second World War.

An exhibition of works loaned by the Tretyakov State Gal., Moscow, and the Russian Mus., Leningrad, including works hitherto unknown in the West, was shown at the Centre Georges-POMPIDOU, Paris, and at Düsseldorf, 1979–80.

MALFATTI, ANNITA* (1896–1964). Brazilian painter born in São Paulo. After a period of study at Mackenzie College in São Paulo, she travelled to Germany. She first went to Dresden, then to Berlin, where she studied at the Royal Academy with Bruger, Bischoff Culn and Lovis CORINTH. She saw an exhibition of POST-IMPRESSIONISTS during a visit to Southern Germany and their work along with Corinth's made a great impact on her own painting. She began making a bold use of colour and form. Her style at that time combined German EXPRESSIONISM with CUBISM. After 1914 Malfatti went to the U.S.A., where she studied first at the Art Students' League in New York and later, following dissatisfaction with that institution, with the more progressive painter Homer Boss of the Fifteen Group. In New York she met Marcel DUCHAMP, 'who painted on enormous plates of glass', and also Isadora Duncan and Maxim Gorky. She also did illustrations for the magazines *Vogue* and *Vanity Fair*. In 1916 she returned to Brazil and a year later shocked the Brazilian public when she exhibited 53 of her works in São Paulo. The critic Monteiro Lobato called her a paranoiac and mystifier in the newspaper *O Estado de São Paulo*. But Malfatti won the support of the modernist poets and painters, whom she joined in the 'Week of Modern Art' at the São Paulo exhibition in 1922 with such works as *Russian Student, The Yellow Man, The Japanese, Woman with Green Hair*. After further travel abroad she returned to Brazil and from 1930 onwards had several exhibitions in São Paulo. But her work of this period—which included many landscapes and regional subjects—had lost some of its earlier vigour. She participated in the activities of the *Sociedad Pro-Arte Moderna* of São Paulo (*SPAM*) in 1933 and in the 'Third May Salon' exhibition in 1939. In 1951 she was represented in the First São Paulo Bienale, and in the Seventh in 1963 was given an exhibition room to herself. In 1957 she exhibited widely in Argentina, Chile and Peru, and participated in the 1960 exhibition 'Contributions of Women to the Plastic Arts of the Country' at the Mus. de Arte Moderna, São Paulo. Her 1922 portrait of the poet *Mario de Andrade* was included in 'Art of Latin America Since Independence' at Yale, the University of Texas and other centres in the U.S.A. in 1966.

* The spelling 'Annita' seems to have been preferred by the artist, who signed her name that way.

MALFRAY, CHARLES (1887–1940). French sculptor, born at Orleans. He went to Paris in 1904 and studied at the École des Arts Décoratifs and the École des Beaux-Arts. After being gassed in the First World War he resumed work in Paris and obtained the Blumenthal prize and the Rome prize in 1920. He succeeded MAILLOL at the Académie Ransom. His work was noted for its power-

ful modelling and its dramatic expressiveness. His output was not large and most of it is to be found in the courtyard of the Petit Palais and the museum of Orleans.

MALHARRO, MARTIN. See LATIN AMERICA.

MALINA, FRANK JOSEPH (1912–81). American experimental artist born at Brenham, Texas. He was trained in jet propulsion and astronautical science but from the early 1950s devoted himself to KINETIC ART and LUMINISM. He originated the 'Lumidyne' system of producing kinetic painting by electric light transmitted through a painted transparent element in motion and through a static painted transparent element on to a translucent screen. He worked for a synthesis of art and science, editing the periodical *Leonardo*. He also edited *Kinetic Art: Theory and Practice* (1974), a selection of papers from *Leonardo*.

MALLARY, ROBERT (1917–). American sculptor, born at Toledo, Ohio, and studied at La Escuela de las Artes del Libro, Mexico City. He came to the fore during the 1960s as an exponent of the school of JUNK ART, making abstract constructions from worthless materials which often had comic implications reminiscent of the satirical aspects of POP ART. He was awarded a Guggenheim Foundation Fellowship in 1964 and in 1969 had a retrospective exhibition at the State University of New York at Potsdam.

MALLORY, ROBERT. See COMPUTER ART.

MALOBA, GREGORY (1922–). African sculptor, born in Kenya and trained at the School of Fine Art, Makerere University College, then later at the Bath Academy of Art and the Camberwell School of Art. He was Senior Lecturer at the School of Fine Art, Makerere. His bronze *Compassion* was presented to H.R.H. Princess Margaret on her marriage by the Government of Uganda and was included in the exhibition 'Commonwealth Art Today' at the Commonwealth Institute, London, in 1972–3. He also executed a large relief sculpture for the New Bank of India, Kampala.

MALRAUX, GEORGES ANDRÉ (1901–76). French critic and theorist of art, born in Paris of Flemish descent on his father's side. After archaeological and Oriental studies at the Mus. Guimet and the Louvre school, he worked at journalism and spent some years in Cambodia and Indo-China. In 1933 he received the Prix Goncourt for his novel *La Condition humaine*, about Communism in China. In 1934 he presided over a world committee for the liberation of Dimitrov and Thaelmann and was a founder of the International League against Anti-Semitism. He was active in the Spanish Civil War, creating the España squadron, and in 1937 published a documentary novel,

L'Espoir, about the war. During the Second World War he served in the Tank Corps and afterwards was active in the Maquis. In 1945 he met De Gaulle and was appointed Minister of Information, resigning in 1946. He was Minister of Cultural Affairs from 1959 until his retirement in 1969.

Malraux began working in 1935 on his *Psychologie de l'Art*, which was published in three volumes: *Le Musée imaginaire* (1947), English trans. *Museum without Walls* (1949); *La Création artistique* (1948), English trans. *The Creative Act* (1949); and *Les Voix du silence* (1951), English trans. *The Voices of Silence* (1954). He wrote a companion work, also in three volumes, *Musée imaginaire de la sculpture mondiale* (1952 and 1954). His other most important work on art was *La Métamorphose des Dieux* (1957), English trans. *The Metamorphosis of the Gods* (1960). These works are outstanding among modern writing on art and aesthetics. Malraux was the most important advocate of the typically 20th-c. doctrine of the 'autonomy of art', that is the aesthetic and critical doctrine that works of art are to be appraised solely by intrinsic aesthetic standards, all other functions being secondary. He was most widely known for his brilliant concept of the 'museum without walls', that is an assemblage of art objects from all peoples and all ages brought together and compared for their aesthetic qualities alone. The concept implies that there exist universal aesthetic standards inherent to human nature as such and independent of race and time. Malraux more than any other writer gave expression to the broadening of aesthetic outlook and the heightening of aesthetic self-consciousness which were consequent upon increased possibilities in the 20th c. to become familiar with the art products of the whole world through the complete course of human history.

MAMBOUR, AUGUSTE (1896–1958). Belgian painter born at Liège and studied at the Liège Academy of Art, where he obtained the Rome Prize and was in consequence able to spend six months in the Congo. He brought back a number of sketches from which he executed a series of paintings on the theme of *The Black Man*. From these he strictly excluded any suggestion of the anecdotal or picturesque, rigorously simplifying the forms and working with a smooth impasto in a restricted palette of sombre blue and shades of green. These unusual works brought him into contact with the *avant-garde* groups of SÉLECTION and Le CENTAURE. From the mid 1920s Mambour turned to an original version of SURREALISM and became known as one of the group of Belgian Surrealists.

MAMPASO, MANUEL (1924–). Spanish painter, born at Corunna and studied at the School of Fine Arts, Madrid. He was by temperament an EXPRESSIONIST and in the early years he did a

number of large Expressionist paintings intended to explore an aesthetic for communication with the masses. These belonged to the category of SOCIAL REALISM, a genre which made no great impact in Spain. From Expressionism he moved to expressive abstraction and his painting *Verdes y redes* (*Greens and Nets*) exhibited at the Madrid Bienale of 1951 provoked some of the earliest discussion in Spain about the nature and justification of abstract painting. During the 1950s he matured a vigorously expressive style of calligraphic abstraction which caused him to be heralded as the Spanish representative of ACTION PAINTING.

MANÉ-KATZ (1894–1962). Russian-French painter, born at Kremenchug in the Ukraine. After studying in Vilna and Kiev he went to France in 1913 and entered the École des Beaux-Arts. He returned to Russia in 1914 on the outbreak of war but settled in Paris in 1921 and was naturalized in 1928. He exhibited in the main Salons and in a number of private galleries in Paris, the U.S.A. and Israel, which he visited between 1927 and 1937. He painted still lifes and landscapes, but he was chiefly known for his ghetto scenes and pictures of Jewish history and folklore. These were simple and child-like in a manner reminiscent of CHAGALL but were at once more classical and more brilliantly coloured than Chagall's paintings. Mané-Katz's works are represented in public collections at New York, Chicago, Amsterdam, São Paulo and Tel Aviv.

MANESSIER, ALFRED (1911–). French painter born at Saint-Ouen, Somme. After studying architecture at the École des Beaux-Arts, Amiens, he went to Paris in 1929 and studied painting by copying Old Masters in the Louvre and attending the art schools of Montparnasse informally. He exhibited at the Salon des Indépendants in 1933 and then at the Salon d'Automne and the Salon des Tuileries. During the 1930s he was attracted towards SURREALISM and in 1937 he collaborated on decorations for the Pavillon des Chemins de Fer et de l'Air at the Exposition Universelle. In 1941 he participated with BAZAINE, ESTÈVE, LAPICQUE and LE MOAL in the exhibition 'Jeunes Peintres de la Tradition Française' and became one of the outstanding exponents of expressive abstraction in the post-war ÉCOLE DE PARIS. He had been a pupil of Roger BISSIÈRE and followed him in deriving his abstractions from the expressive qualities of natural appearances. He was particularly interested in stained glass and the play of light, basing many of his abstractions upon it, and he designed stained glass windows for many churches. He had comprehensive exhibitions at Paris in 1949, Brussels in 1951 and in 1953 he was awarded the Prize for Painting at the São Paulo Bienale. After a visit to La Trappe in 1943 his art became increasingly religious in character although still abstract. Besides windows for churches he did a well-known series of lithographs on the subject of Easter in 1949.

Manessier was extremely influential among the artists of the TACHIST school.

MÁNES UNION OF ARTISTS. An association of artists in Prague, analogous to the Salon d'Automne in Paris, which was largely responsible for introducing progressive trends to Czech artists. An exhibition of works by Edvard MUNCH in 1905 was followed by an exhibition of French Impressionist and POST-IMPRESSIONIST painting in 1907. In 1910 the Union showed works by French artists from the Salon des Indépendants including examples of the FAUVES and in 1914 an exhibition of the CUBIST school but without PICASSO, BRAQUE or GRIS.

MANGUIN, HENRI CHARLES (1874–1949). French painter, born in Paris. He joined the school of Gustave MOREAU in 1896 and there made friends with MATISSE, MARQUET and CAMOIN. He was one of the less revolutionary members of the FAUVISTS, exhibiting at the Salon d'Automne from 1904. Manguin was a minor talent, but whether he painted nudes, still lifes or scenes from the south coast of France he showed himself a facile and exuberant painter with a natural gift for bright colours. He lived and worked mainly in Saint-Tropez and throughout his life he followed his natural bent, holding aloof from the more revolutionary and experimental movements of the time.

MANLEY, EDNA (1900–1977). British sculptor, born in Hampshire and trained at the St. Martin's School of Art, London. She had a number of one-man exhibitions in London and was a member of the LONDON GROUP. She devoted her life to teaching and encouraging the arts in Jamaica, where she was regarded as the leading sculptor of her day.

MANNUCCI, EDGARDO (1904–). Italian sculptor born at Fabriano. From *c.* 1930 he worked in Rome, where he taught at the Academy of Art. About 1950 he came under the influence of BURRI and changed his manner of expressive naturalism to an individualistic mode of abstraction for which he used silver and bronze wire together with luminous materials with highly polished surfaces.

MAN RAY (1890–1977). American painter, draughtsman, sculptor and photographer, born at Philadelphia. He studied painting in New York at the Ferrer Center and other schools while working in an advertising agency and later as an engineering draughtsman. Through his friendship with Alfred STIEGLITZ he became interested in photography, which he took up *c.* 1915, and developed an enthusiasm for European *avant-garde* art, which was further enhanced by the ARMORY SHOW. In 1915 he began a lifelong friendship with Marcel DUCHAMP, collaborating with him and PICABIA in founding the New York DADA movement. He also collaborated with Duchamp and Katherine DREIER

in forming the SOCIÉTÉ ANONYME. In 1921 he went to Paris and became a member of the European Dada group and then of the SURREALIST movement. He was one of the pioneers of the photogram, for which he used the name 'rayograph', and during the 1920s he developed these and also pioneered spraygun paintings, which he called 'aerographs'. He also turned his energies to making abstract and Surrealist films, including *Le Retour de la Raison* (1923), *L'Étoile de Mer* (1928) and *Les Mystères du Château de Des* (1929). During the 1930s he continued to paint in a Surrealist manner and published several volumes of photographs and rayographs. In 1940 he went back to America to escape the Nazi occupation of Paris and settled in Hollywood, returning to Paris in 1950.

Man Ray is regarded as one of the most important photographers of his time, particularly for his pioneering of the rayograph, a photograph produced without a camera by placing objects directly on sensitized paper and exposing them to light, and for his development of the technique of edge reversal or 'solarization' during the 1930s. He gained an international reputation as one of the most prominent figures in the Dada and Surrealist movements, and several of his constructions have become famous as paradigms of Dada. Later critics, however, have spoken of his 'jackdaw eclecticism' and have accused his painting of being technically poor. A large retrospective exhibition arranged by the New York Cultural Center to coincide with his 85th birthday was shown in New York in 1974 and at the I.C.A. Gals., London, in 1976. While this exhibition proved the enormous ingenuity and versatility of Man Ray, the general reaction among critics was that it set the seal upon the poverty of Dada once the shock of novelty had worn off.

MANSHIP, PAUL (1885–1966). American sculptor, born at St. Paul, Minn., and studied at the St. Paul School of Art, 1892–1903, the Art Students' League, 1905, the Pennsylvania Academy of the Fine Arts, 1906–8, and the American Academy, Rome, 1909–12. His first one-man exhibition was with the Architectural League of New York in 1912 and he had a retrospective exhibition at the Smithsonian Institution in 1958. He was mainly known for portraits and mythological groups executed in a highly competent academic style. He was President of the Federal Commission of Fine Arts, 1937–41, President of the National Sculpture Society, 1939–42, and President of the American Academy of Arts and Letters, 1948–53. In 1927 he designed coinage for the Irish Free State.

MANSON, J. B. See CAMDEN TOWN GROUP.

MANUEL, VICTOR. See LATIN AMERICA.

MANZONI, PIERO (1933–63). Italian experimental artist, born at Soncino. Influenced by the SPAZIALISMO of Lucio FONTANA, he was one of the forerunners of ARTE POVERA. From 1957 he began to exhibit *Acromes*, which were white monochromes produced by dipping his canvas in kaolin. He also experimented with materials such as glass wool and polystrol. In 1959 he became a founding member of the Gal. Azimuth in Milan.

MANZÙ, GIACOMO (1908–). Italian sculptor, born at Bergamo, son of a cobbler and part-time sexton in straitened circumstances. Although he was brought up with no background of artistic culture, he gave evidence even as a boy of a passion for drawing and modelling in clay. From the age of eleven he worked successively for a carpenter, a woodcarver, a gilder and a worker in stucco, mastering the elements of several crafts. At the same time he painted and modelled in his spare time and attended evening courses at the Fantoni Trade School. In the early 1920s, *c.* 1923, he became familiar through illustrated books with the works of MAILLOL, with Greek sculpture and with Donatello and Michelangelo. It was not until later that he knew the work of the Italian sculptor Medardo ROSSO or the FUTURISTS. Thus by his own natural and undirected taste he found his path in the great classical tradition of sculpture. In 1927 he left Bergamo for the first time, being conscripted for military service in Verona. There he was impressed by the Romanesque bronze doors of San Zeno Maggiore and by the equestrian statue of the Can Grande della Scala. He also from time to time attended the Accademia Cignaroli. In 1928, when his period of military service was ended, he went to Paris with the intention of studying sculpture and in the hope of meeting Maillol. But being without means, after three weeks he collapsed from hunger and was deported as an undesirable alien. His passport was confiscated on his return to Italy, and he settled in Milan.

In 1930 Manzù obtained a commission for decorative work and figures of saints at the Catholic University of Milan and was thus able to devote himself seriously to sculpture. Reliefs, such as *Annunciation* (polychrome stucco, 1931), *Circus Scene* (wrought copper, 1932) and *Entombment* (wrought silver, 1932) evidence both the attachment to biblical and religious themes, which doubtless stemmed from his boyhood upbringing and was to last through his life, and also his interest in the technique of relief sculpture. From *c.* 1933 his growing interest in Medardo Rosso revealed itself in a series of female heads and busts which already displayed the unemphatic naturalism and the power to grasp an essential likeness without rhetoric or sentimentality which eventually brought him recognition as one of the finest portraitists of his age. The culmination of his many portrait busts is perhaps *Pope John XXIII* (Vatican coll., 1963), commissioned in 1958.

During the 1930s Manzù slowly matured his own style and gradually won recognition. He par-

ticipated in a group exhibition in Milan in 1930 and again, at the Gal. del Millione, in 1932 and at Bergamo in 1933. His works were first shown abroad in St. Gallen in 1934, and he was represented in a collective exhibition of old and modern Italian art in Paris in 1935 and in a collective exhibition of contemporary Italian works at Bucarest in 1936. During a short visit to Paris in 1936 he did not come into contact with the artists of the *avant-garde* although he was interested by the sculptures of BRANCUSI. The Greek and Egyptian sculpture of the Louvre made a deep impression on him, as also did the small studies of Rodin which he saw in the Rodin Mus. In 1936 he also exhibited for the first time at the Venice Biennale. His first real success was a one-man exhibition at the Gal. Cometa, Rome, for which Carlo CARRÀ wrote an introduction, in 1937. This was followed by a success in the Venice Biennale of 1938. In 1940 he was appointed Professor of Sculpture at the Brera, Milan, and taught concurrently at the Academy in Turin. In 1941 he exhibited at the Gal. Barbaroux in Milan the first group of his reliefs on the theme of the Crucifixion, *Cristo nella Nostra Umanità*, which were susceptible of a secondary interpretation as a castigation of Fascist and Nazi excesses. It was a bold act which raised a storm of abuse and caused him to be branded as an enemy of the regime. In the Rome Quadrennale of 1942 he caused a stir with his bronze of the young Francesca, daughter of Baroness Blanc, and was awarded the Grand Prix. In 1947 he had a large one-man show at the Palazzo Reale, Milan, for which Lionello Venturi wrote the Introduction, and in the same year he put in for an international competition for a new portal of St. Peter's dedicated to 'The Triumph of the Saints and Martyrs of the Church'. This was finally commissioned in 1952 and the portal was inaugurated in 1964, after the theme had been changed in 1961 to a 'Portal of Death'. Thus by the early 1950s Manzù's position of pre-eminence was established in Italy.

In 1953 his first one-man exhibition outside Italy took place at the Hanover Gal., London. In 1954 he resigned his teaching post at the Brera in protest because his project for an international school of art was turned down by the Ministry of Culture and in the same year he was appointed by Friedrich Welz to the International Summer Academy at Salzburg, where he continued to teach until 1960. In 1955 he was asked to submit designs for the doors of the cathedral at Salzburg. These were commissioned in 1957 and inaugurated in 1958. In 1959 Glauco Pelligrini began a documentary film of Manzù's work on the portal of St. Peter's, which attracted widespread attention. In the same year Welz arranged a large travelling exhibition of Manzù's work which went from the Haus der Kunst at Munich to the Historische Mus. at Frankfurt and in 1960 to the Nationalgal., Berlin, the Ateneum at Helsinki, and was shown in an extended form at the Zwerglgarten in Salzburg and at the Tate Gal., London. In 1961 Manzù

visited New York and spent a few days in Detroit, where he obtained commissions for two fountains from the architect Yamasaki. A standing figure of a dancer, one of the 'Dance Step' series 134 in. (3·4 m) high, was completed in 1964 and installed in front of the Gas Company Building, Detroit. In 1966 he received the International Lenin Peace Prize and in the same year signed a contract for a portal for the Sankt-Laurents church, Rotterdam.

Manzù was an artist who would allow a visual idea to germinate in his mind over the years, bringing it to the fore at intervals and executing it in a number of variants. The idea of the 'Girl with a Chair' seems to have originated with drawings done in 1931 and 1932 of a young girl together with a kitchen chair which Manzù brought from his childhood home in Bergamo and treasured throughout his life. A first version, life-size in chased copper, of a naked sitting girl (originally with a chair, which was later removed by Manzù) was done in 1933 and four years later, in 1937, another version, 20 in. (0·5 m) high, was cast in lead. After ten years, in 1947, he again did a life-size version of the same theme, with the figure cast in lead and the chair in bronze (Mus. of Modern Art, Turin). In 1949 he did another, 'improved' version, also life-sized, variants of which are in the Mattioli coll., Milan, and the Mus. de Arte Contemporaneo, Madrid. In 1955 a final version appeared, variants of which are in the National Mus., Toronto, the Nasjonalgal., Oslo, and a private collection in New York. Of this work John Rewald has said in his book on Manzù: 'Apart from Degas' famous fourteen-year-old dancer with the real muslin tutu there is probably no work of modern sculpture which is so unusual, and yet appears so natural, as Manzù's "Girl on a Chair". The great assurance with which they depart from anything created previously is common to both works, but their inventiveness has not become an end in itself. On the contrary, there is no experimentation with surprising elements—as is so often the case with modern sculpture—for the originality is here inseparable from the concept of the work.' Unlike most sculptors Manzù, with a few exceptions, allowed only one bronze to be cast of each of his figures. He did, however, often produce variant versions of the same figure with one cast of each version.

The well-known series of 'Cardinals', in which the pyramidical shape of the mitre is made to echo the triangular form of the robes, derived from the deep impression made upon Manzù by the sight of the Pope between two seated cardinals when he visited St. Peter's in 1934. Yet his first sculpture of a cardinal, cast in lead and subsequently destroyed, was not made until 1936. A small bronze, now in the Gal. Nazionale d'Arte Moderna, Rome, was made in 1937. He was occupied with the theme intermittently from 1945 and the first large statue of a cardinal was made in 1949. Small bronzes in the Tate Gal., London, the Nasjonalgal., Oslo, and the Mus. de Arte Moderna, São

Paulo, date from 1948, 1950 and 1951 respectively. Large 'Cardinals' are in the Wallraf-Richartz Mus., Cologne (1954), the Gal. Internazionale d'Arte Moderna, Venice (1955), the Civica Gal. d'Arte Moderna, Milan (1965), Middelheim Park, Antwerp (1952) and the Municipality of Tilburg, Netherlands (1954). Altogether Manzù made more than fifty sculptures of cardinals besides numerous drawings, and figures of cardinals appeared in some of his reliefs, including the relief of the Inauguration of the Second Vatican Council on the inner side of the Door of Death at St. Peter's, Rome. These cardinals have been variously interpreted as expressions of an anti-clerical attitude or as glorifications of the dignity of the Church. Manzù himself always said that he regarded them as still lifes with no deeper significance than a plate of apples, representing 'not the majesty of the church but the majesty of form'. Only one is a portrait, that of Cardinal Giacomo Lercaro, an 8 ft (2·4 m) statue now in the Basilica of San Petronio, Bologna, commissioned in 1953.

Almost alone in the 20th c. Manzù revived the technique of relief sculpture, continuing the classical tradition of Donatello, Agostino di Duccio and the ancients, working both in low and in high relief. He himself said that low relief interested him because it at once offers opportunities akin to painting and also demands a special sort of spatial organization in the representation of forms in planes of reduced depth. He had a natural and spontaneous gift for relief as for drawing and modelling in clay.

Manzù was virtually self-taught as a sculptor and as an artist. Throughout his life he held aloof from the *avant-garde* movements and controversies which surrounded him and in spite of the artificial artistic isolation imposed by the Fascist regime in Italy he made himself the outstanding representative in his time of the great classical tradition of Western sculpture. Yet his work was always contemporary in spirit and at no time did it contain traces of academicism. Although his recognition outside Italy was somewhat tardy, he will no doubt be remembered as the greatest religious sculptor and one of the greatest all-round artists of the century.

Among his graphic works were 20 etchings for Virgil's *Georgics* (Milan, 1947) and lithographs and etchings to illustrate Salvatore Quasimodo's *Il Falso e Vero Verde* (Milan, 1954).

MANZUR, DAVID. See LATIN AMERICA.

MAQHUBELA, LOUIS. See SOUTH AFRICA.

MARA, POL (1920–). Belgian painter born and trained in Antwerp. He evolved a SURREALIST style notable for its subtle and swirling colour and created a fantasy world of fabulous beings. About 1960 his work became more abstract, a tendency which was accentuated by a visit to Greece. Towards the end of the 1960s he adopted POP ART iconography, introducing into his work imagery from the mass media often with a strongly erotic flavour.

MARAN, ANUICA (1918–). Yugoslav NAÏVE painter, born in the village of Uzdin in the Yugoslav Banat. A peasant and a housewife, she used to weave and embroider folk costumes. In 1961 she bought some tubes of oil paint in the neighbouring town and was shown how to use them by the village school-teacher, Adam Doclean, on whose suggestion she gathered around her a group of five other women to paint. This was the origin of the Uzdin school of women painters, who became widely known in Yugoslavia and abroad. Their work was in the main decorative and two-dimensional in the manner of embroidery. Along with the decorative design, however, Maran had a strange gift for simple and expressive realism.

MARC, FRANZ (1880–1916). German painter, one of the founders of the BLAUE REITER group. Son of a Munich painter, he began to study at the Munich Academy in 1900. Visits to Paris in 1903 and again in 1907 brought him into contact with Impressionism and the POST-IMPRESSIONISTS, among whom he found the closest affinity with Van Gogh. Of a deeply religious disposition (he visited Mt. Athos in 1906), he was troubled by a profound spiritual *malaise* and sought through painting to achieve a mystical union with the ultimate realities behind the ephemeral appearances of things. From the academic naturalism of his earliest works he advanced towards a more EXPRESSIONIST style with the use of simplified forms. In 1910 he entered into a close friendship with MACKE, who introduced him to the Expressionist use of colour. Through Macke he joined the NEUE KÜNSTLERVEREINIGUNG at Munich and found in KANDINSKY and JAWLENSKY men of congenial artistic views. At this time he began his well-known series of animal paintings in which colour was used symbolically rather than naturalistically (*Red Horses* and *Blue Horses* of 1911). Believing that animals were both more beautiful and more spiritual than men, he sought by a symbolic use of colour and by simplified, rhythmically constructed shapes to represent animals and the world as they would appear to the spiritual eyes of animals themselves. In 1912 he met DELAUNAY in Paris and was influenced still further in this direction by the ORPHIST experiments in the abstract use of colour. The culminating work of this period was the *Tierschicksale* (*Animal Destinies*) (Basle, 1913). Under the influence partly of CUBISM, through 1914 his paintings became still more abstract, losing almost entirely any representational content (*Tyrol*, Munich, 1913–14; *Fighting Forms*, Munich, 1914). These last paintings are considered the culmination of that stream of German Expressionism which, free from social and didactic preoccupations, moved in the direction of expressive abstraction.

Marc's writings have been published under the

titles *Aufzeichnungen und Aphorismen* (Munich, 1946) and *Briefwecksel mit August Macke* (Cologne, 1964). He also contributed to the *Almanach* of the *Blaue Reiter*.

MARCA-RELLI, CONRAD (1913–). American painter, born at Boston, Mass. He studied one year at the Cooper Union but was mostly self-taught as an artist. After serving in the American army until 1945 and then travelling in Europe and Mexico, he came to prominence in the 1950s as one of the second wave of ABSTRACT EXPRESSIONISTS, developing a highly original and dramatic technique of COLLAGE painting. Cut-out shapes of painted canvas were attached to a canvas ground in expressive combinations with a black glue which served to outline their forms. During the 1960s he experimented with novel forms of relief painting and constructions which had much in common with the more objective and reserved manner of POST-PAINTERLY ABSTRACTION. He had a retrospective exhibition at the Whitney Mus. of American Art in 1967.

MARCHAND, ANDRÉ (1907–). French painter born at Aix-en-Provence. He went to Paris in 1929 and exhibited at the Salon d'Automne in 1932 and the Salon des Indépendants in 1933. In 1937 he obtained the Prix Paul-Guillaume for a painting done in Algeria, *La Jeune Fille et le Paralytique*. In 1941 he participated in the exhibition 'Jeunes Peintres de la Tradition Française' and he became friends with TAL COAT and GRUBER. By the end of the 1940s his painting was verging on abstraction, but he believed that painting should not be devoid of social comment and did not entirely abandon figuration. His own style was extremely mannered, with elongated, hieratic figures. He also did tapestry design, designed the décor for ballets and executed a considerable volume of graphic works including illustrations for *Les Nourritures terrestres* by André Gide and *Le Visionnaire* by Julien Green.

MARCHAND, JEAN (1882–1941). French painter born in Paris and studied part-time at the École des Beaux-Arts there, 1902–9. He exhibited at the Salon des Indépendants from 1908 and also at the Salons d'Automne and Tuileries. His first paintings were of landscapes and tramps sleeping out of doors. This work shows a reconciliation between the formal simplifications of Cézanne and the colour simplifications of Gauguin. There was also some affinity with the work of BRAQUE and DUFY in their immediately post-FAUVIST period. In 1910 he also experimented with CUBISM, but in the 1920s he developed a style of vigorous naturalism akin to that of DERAIN. When some of his work was shown in a collective exhibition at the Carfax Gal., London, in 1915, Clive BELL wrote: 'No living painter is more purely concerned with the creation of form and the emotional significance of shapes and colours than Marchand.' His first one-

man show was at the Carfax Gal. in 1919, after which he exhibited frequently in Paris and internationally, including a large exhibition at the Gal. Georges Giroux, Brussels, in 1930. Among his murals was one for the Residence at Beirut done in 1928. He also did an important volume of graphic work including illustrations for *Le Cimetière marin* by Paul Valéry and *Chemin de Croix* by Claudel. He had a posthumous exhibition at the Redfern Gal., London, in 1955, followed by retrospectives in Paris, Basle, Milan, Rome, in 1956 and at the Gal. del Cavallino, Venice, in 1957. Paintings by Jean Marchand are in the Mus. National d'Art Moderne, Paris, the Tate Gal., the Courtauld Gal., the Albertina, Vienna, the Mus. du Luxembourg, the Walker Art Gal., Liverpool, and also in New York, Chicago, Tokyo, Johannesburg and elsewhere.

MARCKS, GERHARD (1889–1981). German sculptor born in Berlin and self-taught as an artist. After teaching for a year at the Berlin School of Arts and Crafts he joined the BAUHAUS in 1919 and taught in the pottery school at Weimar. At this time he did woodcuts which had affinities with Cubist-influenced work of contemporary German EXPRESSIONIST painters. Marcks has been called the 'last of the original German expressionist sculptors'. He first studied drawing in the studio of Richard Scheibe from 1907 and turned increasingly to sculpture from the late 1920s onwards. Deriving from German Expressionism, his sculpture was notably in the classical vein, influenced by MAILLOL and also by the Romanesque. After the Second World War he taught at the State School of Art in Hamburg and from 1950 lived in Cologne.

MARCOUSSIS (LUDWIG MARKUS, LOUIS MARKOUS, 1883–1941). Polish-French painter born in Warsaw and studied at the Academy of Art, Kraków. He went to Paris in 1903 and studied at the Académie Julian, where he met LA FRESNAYE. After working as a cartoonist for some years he met BRAQUE in 1910, then PICASSO and APOLLINAIRE and afterwards others of the CUBIST school. In 1912 he exhibited with the SECTION D'OR, and again after the war in 1920. He was one of the most perceptive of the minor Cubist artists and never turned the Cubist techniques into a mannerism but combined clarity and simplicity of structure with poetic realism and a feeling for nature. Jean Cassou has called him a 'representative of the pure form of Cubism' and adds that 'his Cubist discipline, which achieves grandeur in some of his still lifes, is often lightened with subtle taste and genuine musicality'. In 1913 and again after the war he experimented in the manner of Synthetic Cubism, but his evocative representations of nature are more typical. In 1920 he exhibited at the STURM Gal., Berlin, and in 1933 he visited the U.S.A. for an exhibition in Chicago. Max Jacob spoke of his superstitious nature and

in 1941 he did a set of drypoints which he called *Devins*. He also illustrated a number of books, including two by Tristan Tzara.

MARI, ENZO (1932–). Italian experimental artist born in Milan and studied at the Accademia di Brera there. He first exhibited at the Gal. San Fedele, Milan, in 1955. Besides many one-man shows he participated in 'Licht und Bewegung', Kunsthalle, Berne, 1965; the third NOUVELLE TENDANCE exhibition, Zagreb, 1965; and 'The Responsive Eye', The Mus. of Modern Art, New York, 1965. He experimented with OP ART, KINETIC ART and LUMIA with particular interest in light as an artistic medium and in spectator participation. He devised games for children demanding direct participation as in *Animal Compositions*, *Fables Game*, *Big Stone Game*, etc., while his *Modulo 856* was for adults. Mari believed that in infancy we discover the external world and hence form our personal attitudes; therefore intervention necessarily involves conditioning and for that reason the children's game is one of the few opportunities open to the designer to intervene effectively for the renewal of society. The temptation to classify as fine art such socially oriented intervention as the planning of children's games is symptomatic of one tendency in modern art since the 1950s.

MARIN, JOHN (1870–1953). American painter, born at Rutherford, N.J. After beginning as an architect he studied painting at the Pennsylvania Academy of Fine Art, Philadelphia, 1899–1901, and then at the Art Students' League, New York, 1901–3. He spent the years 1905 to 1909 in Europe, where he lived in Paris, travelling to the Netherlands, Belgium and Italy. He was relatively untouched by the European *avant-garde* movements but developed a delicate, tonal style of landscape based upon Whistler and the Chinese. Through a meeting with Edward Steichen, the European 'contact' of Alfred STIEGLITZ, he was brought to the latter's notice and returned to New York in 1909 for an exhibition at the 291 Gal. It was here, as a member of the Stieglitz circle of artists, that he came into contact with *avant-garde* ideas. He went to Europe again in 1910, returning to New York in 1911 with a different vision. Although his painting remained allusive and fragmentary, it was tautened by his contact with CUBISM and FUTURISM without losing its spaciousness and airiness. Unlike the Cubists he was interested in capturing atmospheric effects, his use of space depended on tension and balance and his image was never static but expressive of a restless world of flux. He became obsessed with New York and the Maine coast, seeing them with new eyes. In 1913 he wrote: 'Shall we consider the life of a great city as confined simply to the people and the animals on its streets and in its buildings? Are the buildings in themselves dead? . . . You cannot create a great work of art unless the things you behold respond to something within you. . . . the whole city is alive; buildings, people, all are alive; and the more they move me, the more I feel them to be alive. It is this "moving of me" that I try to express . . .' Examples of his work are; *Brooklyn Bridge* (The Mus. of Modern Art, New York, 1910); *Lower Manhattan* (The Mus. of Modern Art, New York, 1922); *Region of Brooklyn Bridge Fantasy* (Whitney Mus. of American Art, 1932).

By 1913–15 Marin's style was matured and it underwent no further major changes. He was represented in the ARMORY SHOW and in the FORUM exhibition held at the Anderson Gal. in 1916. He had retrospective exhibitions at The Mus. of Modern Art, New York, in 1936; the Institute of Modern Art, Boston, in 1947; the Mus. of Fine Art, Houston, in 1953; American Academy of Arts and Letters, 1954; the University of California at Los Angeles in 1955.

MARINETTI, FILIPPO TOMMASO (1876–1944). Italian poet and writer who is chiefly remembered today as the founder and guiding spirit of FUTURISM. He was born at Alexandria, Egypt, of Italian parents, studied at the Sorbonne and subsequently, in 1899, took a doctorate in jurisprudence at Genoa. From the time of his arrival in Paris in 1893 Marinetti moved among the literary *avant-garde* and he was associated with the *naturiste* reaction from Symbolism. His own verse was written almost exclusively in French until *c*. 1912. In 1905 he founded the literary journal *Poesia* with its headquarters in Milan. The journal stood for artistic liberty, formal innovation and an aggressive repudiation of tradition. His own poems published in it, particularly 'Le Démon de la vitesse' and 'A l'automobile', anticipated the main elements of Futurism—the exaltation of modernity and intoxication with speed as exemplified by the motor car. Futurism was launched by his manifesto published in *Le Figaro* on 20 February 1909. By this and by his subsequent leadership of the movement which resulted from it Marinetti showed himself a born entrepreneur of ideas. The manifesto was couched in deliberately provocative language, its aim was to shock, and it was from this rather than from the originality of its ideas that its great vitality derived. Its main themes, which remained throughout the themes of the Futurist movement, were an aggressive campaign for the destruction of traditional values, social and artistic, repudiation of the past and an obsessive enthusiasm for modernity as exemplified in speed, dynamism and the machine. There was considerable debt to Nietzsche and to Bergson and many of the ideas had been anticipated, although less forcefully, by the Italian philosopher Papini, who was the moving spirit behind the Florentine periodicals *La Voce* and *Lacerba*. It was, however, Marinetti's manifesto which brought into being and inspired the Italian movement of Futurism.

Marinetti was an indefatigable traveller and lecturer and by his personal visits carried Futurist ideas and enthusiasms as far afield as Moscow and

London. He was one of Mussolini's earliest followers and in 1916, after the dissolution of the first phase of Futurism, he re-formed the movement with a younger group of artists in Italy and with BALLA in the lead. This second phase of Futurism lacked the creative energies of the first and lacked the conditions for them. Artists were under strong pressure to favour themes dealing with the glorification of Fascism, nationalism and war and it was perhaps largely due to the continued favour in which Marinetti stood with the regime that they escaped the complete regimentation of Italian art. In 1929 Marinetti accepted membership of Mussolini's restored *Accademia Italiana* but during the 1930s he became disillusioned with the regime.

MARINI, MARINO (1901–80). Italian sculptor and painter, born at Pistoia. He studied painting and sculpture at the Academy of Fine Arts, Florence, under Domenico Trentacoste (1859–1933) and until *c.* 1928 applied himself mainly to the graphic arts. In 1929 he succeeded Arturo MARTINI as teacher at the Scuola d'Arte di Villa Reale, Monza, and taught there until 1940, when he became Professor of Sculpture at the Accademia di Brera, Milan. During the 1930s he travelled frequently in Europe and also visited the U.S.A. But he did not ally himself either with the FUTURIST tradition in Italy or with any of the *avant-garde* movements elsewhere in Europe, remaining essentially isolated in his artistic aims. In 1935 he was awarded the First Prize for Sculpture at the Rome Quadriennale and in 1937 obtained a prize for sculpture at the Exposition Universelle, Paris. From 1942 to 1946 he lived in the Ticino, Switzerland, and afterwards mainly in Milan. He obtained a prize in 1952 at the Venice Biennale and in 1954 the Grand Prize at the Accademia dei Lincei, Rome. His work was represented at the Brussels Fair of 1958 and at DOCUMENTA II, Kassel, in 1959.

Marini assimilated the archaic and combined a suggestion of the primitive with a dynamic vitality which has been hailed as an essential feature of the present age. His favourite theme, and that for which he is most widely known, was the horse and rider, which he represented not in motion but imbued with inner energy. These equestrian statues, with their realistic grasp of essential form and attitude, have been interpreted as carrying an obscure tragic symbolism, which Marini himself has described as a kind of 'Twilight of Mankind'. Examples of his *Horse and Rider* compositions are in the Nationalmus., Stockholm (1937), the Kunstmus., Gothenburg (1945), the Kunstmus., Düsseldorf (1949), the Rijksmus. Kröller-Müller, Otterlo, and in many private collections. *The Miracle*, versions of which are in Middelheim Park, Antwerp, the Kunsthalle, Mannheim, and the Kunstmus., Winterthur, carries to the extreme of sculptural possibility the dramatic situation of a rider on the point of falling from his rearing horse. In the *Monumental Rider* (1957–8), commissioned

for the Bouwgelust estate at The Hague, Marini converted the theme to a dramatic interplay of block-like abstract shapes. A bronze study for this monumental figure is at the Shell Building, London.

Marini also represented the female figure with the strength and vigour of a *Magna Mater* or with the hieratic intensity of a temple priestess. The former is exemplified by his *Pomona*, versions of which are in the Gemeentemus., The Hague, and in several private collections; the latter by the fine *Dancer* (1953) in the Albright-Knox Art Gal., Buffalo. Marini has also been recognized, with his fellow national MANZÙ, as one of the more sensitive portraitists since DESPIAU. Outstanding among his portraits are *Curt Valentin* (Kunsthalle, Hamburg, 1954) and particularly *Igor Stravinsky* (Institute of Art, Minneapolis, 1951).

Like many contemporary sculptors Marini interested himself in polychrome, recognizing no essential difference between painting and sculpture in this regard. He would combine several sculptural techniques in one figure and would often work on a bronze cast with chisel or corrosive dyes, as in the polychrome bronze *Dancer* (1949–54) in the Städt. Mus., Duisburg, and the bronze *Bull* (1953) in the Mus., de Arte Moderna, Rio de Janeiro.

Although, like Manzù, Marini held himself aloof from contemporary groups and movements, since the Second World War he has been widely recognized internationally as one of the outstanding creative figures in contemporary sculpture.

MARINKOVIĆ, MIROSLAV (1928–). Yugoslav naïve painter, born in the Serbian village of Oparić. He was a peasant and worked on the family holding. After doing his military service in 1948 he began to draw in secret and in 1956 was encouraged to paint by Janko BRAŠIĆ and taught by him the technique of oil paints. His painting caused a breach with his father and the family holding was divided between them. His output was small but had the genuine characteristics of NAÏVE painting and from the 1960s he exhibited in Yugoslavia and abroad. A picture of harvest and sheep herding is in the Frankfurt museum.

MARISOL (MARISOL ESCOBAR, 1930–). American sculptor born in Paris of Venezuelan parents. She passed much of her childhood in Los Angeles but in 1949 studied at the École des Beaux-Arts and the Académie Julian, Paris. In 1950 she went to New York and studied there at the Art Students' League under Yasuo KUNIYOSHI, then at the HOFMANN School, and the New School for Social Research, 1951–4. About 1953–4, after seeing an exhibition of pre-Hispanic American art, she turned her attention primarily to sculpture, at first making small playful and erotic terracottas. From about 1955, perhaps influenced by the humorous figures of William Dickey King, she began to carve life-size figures from wood. Her subjects

included family groups, such as *Family* (1956), and parodies of social life and the middle classes, such as *Woman and Dog* (1964) and *The Party* (1965–6). These figures combined block-like wooden torsos with plaster faces, hands or legs often cast from Marisol's own face or limbs. She used to unite her figures with a variety of accessories such as necklaces, television sets, mirrors, pots of flowers, umbrellas, etc., so that they sometimes verged upon being ASSEMBLAGES. Her works were exhibited widely in the U.S.A., South America and Europe and by the mid 1960s her reputation was established in New York. This was the heyday of POP ART and her work had some affinities with Pop. Yet in the combination of humour, social satire and caricature she remained uniquely herself. In her life-size portrait figures—which included Lyndon B. Johnson, Queen Elizabeth II and the comedian Bob Hope—she had the gift of conveying the commonplace character of famous people. But apart from the humorous and comic aspects of her work, it had both solidity and power. In the 1970s she did a series of 'Fishes' and executed works of a more 'folklorist' type for industrial centres in Venezuela.

MARKLE, ROBERT. See CANADA.

MARQUET, ALBERT (1875–1947). French painter born at Bordeaux, studied at the École des Arts Décoratifs in Paris from 1890 and there met MATISSE in 1892. In 1897 he entered the studio of Gustave MOREAU and joined the group formed by Matisse, CAMOIN and MANGUIN. In 1900 he worked with Matisse on decorations for the Exposition Universelle at the Grand Palais. He first exhibited at the Salon des Indépendants in 1901 and subsequently at the Salon d'Automne. Marquet claimed that he and Matisse were painting in the FAUVIST manner before the turn of the century and he became an acknowledged member of the Fauves group. Subsequently, however, he abandoned the Fauvist style and turned to naturalistic landscape. In 1912 he travelled widely, visiting particularly the ports, and in 1913 he went to Morocco with Matisse and Camoin. In the 1920s and 1930s he also spent much time travelling, and from 1925 he painted largely in water-colour. Marquet was a superb draughtsman, in the judgement of Jean Cassou 'one of the best there has been'. Matisse called him 'our Hokusai'. In his paintings he achieved a lucid simplicity which gives them a poetic quality of their own and he is now remembered, apart from his drawings, chiefly for his port scenes and his paintings of the bridges and quays of Paris.

MARSH, REGINALD (1898–1954). American painter born in Paris of American parents, both of whom were artists. He drew from childhood. After attending Yale University he worked as an illustrator on *Harper's Bazaar* and the *New York Daily News* and in 1925 became one of the original staff members of the *New Yorker*. He went to Europe in 1925 and studied the work of Rubens, upon whom he based his style. During the 1930s Marsh came to the fore as one of the leading painters of the shabbiness and tawdriness of city life. His favourite subjects were Coney Island, the amusement arcades of Times Square, the Bowery and the poorer aspects of the street life of New York. He was also capable of bitter satire against the smug complacency of the wealthy. His pictures therefore belong both to the realist painters of the AMERICAN SCENE and to the SOCIAL REALISTS who used their art as an instrument of social protest. Among the best known of his paintings are: *The Park Bench* (University of Nebraska, 1933); *The Bowery* (The Metropolitan Mus., of Art, New York, 1930); *Bowery and Pell Street—Looking North* (1944); and *The Death of Dillinger* commissioned by *Life* magazine in 1940. Marsh had retrospective exhibitions at the Whitney Mus., of American Art in 1955 and at the University of Arizona Art Gal., Tucson, in 1969.

MARTIN, KENNETH (1905–). British painter and sculptor, born at Sheffield. From 1921 to 1929 he attended the Sheffield Art School while supporting himself as a free-lance graphic artist, and from 1929 to 1932 he studied at the Royal College of Art. While at the Royal College he married Mary Balmford, whose artistic development as Mary MARTIN had very close affinities with his own. During the 1930s he painted in a naturalistic style and was in close touch with artists of the EUSTON ROAD SCHOOL. During the 1940s the representational character of his work receded while the element of structure and design became progressively more prominent until in 1948–9 both he and Mary Martin made their first completely abstract paintings. Together with Anthony HILL, Victor PASMORE and Adrian Heath, the Martins became the leaders of a new CONSTRUCTIVIST movement which burgeoned both in England and in America with the writings of Charles BIEDERMAN and the Belgian magazine *Structure* as its theoretical basis. In 1951, in conjunction with an exhibition 'Abstract Art' at the A.I.A. Gal., London, Kenneth Martin published his *Broadsheet No. 1*, in which he concisely reformulated the essential views of the pre-war Constructivists. He and Mary Martin made their first constructions at the beginning of the 1950s. Thereafter with great versatility he pioneered in England a number of different forms of geometrical abstraction. Of his conversion to geometrical abstraction he said: 'The moment I became a purely abstract artist I began to realise what I'd been missing. . . . That I'd really missed the whole of the modern movement.'

The main forms of geometrical abstraction which Martin developed were the following:

1. Paintings, drawings and prints. From the early 1950s Martin developed types of linear construction, initiated by Max BILL in the 1930s, evolved from mathematical formulae or upon which

mathematically formulated systems of proportion imposed limiting conditions. He began with drawings and graphic works featuring mathematically expressible proportional systems and the displacement of forms upon an underlying grid. A later series was concerned with the progressive modulation of linear configurations according to combinatorial systems of varying degrees of complication such as the Fibonacci series. From 1969 he worked mainly on series of paintings and drawings which he called *Chance and Order* and *Metamorphoses*. In these the element of chance was made to determine the direction of lines plotted on a predetermined grid or grids. By this method the final work is partly generated by chance, but the chance procedures and the means by which they are translated into the art work are combined with a series of arbitrary but rational rules imposed by the artist. It has been claimed for work of this kind that it is a manifestation of a modern world-wide tendency to deflect attention from the finished art work towards the process by which it was brought into being. Yet it is patent that, at least without explanation from the artist, the mathematical basis of these works, or the rules which are arbitrarily combined with chance, are not obvious to or discoverable by the ordinary, non-mathematical observer or even perhaps by a trained mathematician in so far as chance arbitrarily enters in. The process is not apparent in the product.

2. Mobiles. Martin's mobiles had very little in common with those initiated by Alexander CALDER. His earliest series, called *Reflectors*, explored the uses of reflected light and colour as the reflecting lower surface of a disc moved above the upper surface of another. From these developed the *Linkages*, systems of rotating discs and ovoids linked by connecting rods and struts. The connecting links were sometimes covered with fluorescent paint and lit by ultra-violet light. The largest and most original series were the *Screw Mobiles*. Suspended on nylon threads, these were perpendicular rods of brass from which thin struts and linkages welded to rectangular plates were cantilevered out. As the structure turned slowly on a central axis new movements were continuously generated and the profiles expanded and contracted. From these evolved the *Oscillations*—stepped, tower-like constructions with lateral bars moving according to complex predetermined rhythms—and groups of hanging constructions which he called *Tunnels* and *Transformables*.

3. Martin also made a large variety of small standing constructions, usually of brass. In these, as in the mobiles, his method of construction was to evolve complex configurations from relatively few basic elements according to simple and uniform systems of structuring. The simplicity of the basic forms and systems of combination produced complex rhythms and configurations. In an article on 'The Development of the Mobile' he formulated his method in the following words, which apply also to the standing constructions: 'In all

these instances I have attempted to achieve a form from the simplest basic principles. I believe that this is fundamental to the constructivist idea. The work is the product of the simplest actions. It is not a reduction to the simplest form of the complex scene before us. It is the building by simple events of an expressive whole.'

4. Martin also did the following larger constructions on commission: 'Twin Screws' for the Congress Building of the International Union of Architects, South Bank, London (1961); Stainless Steel Fountain for Brixton College of Further Education (1961); Construction for the Nuffield Institute of Comparative Medicine at the London Zoo (1961-7); Aluminium Construction for the Engineering Laboratory, Cambridge (1967).

Kenneth Martin has exhibited widely both in one-man shows and in group shows of Constructivist and KINETIC ART. He is represented in a number of public collections, including the Tate Gal., the Victoria and Albert Mus., the British Council, the Arts Council of Great Britain, the Contemporary Art Society, the Delgado Mus., New Orleans, the Peter Stuyvesant Foundation, etc. In 1970-1 the Arts Council arranged a travelling exhibition of Mary and Kenneth Martin which included their two joint works which were actually executed. They were: *Structure in Collaboration* (1960) and *Environment*, designed in collaboration with the architect John Weeks for the 'This is Tomorrow' exhibition at the Whitechapel Art Gal. in 1956. In 1975 a retrospective exhibition of the works of Kenneth Martin was shown at the Tate Gal., London. The large two-volume catalogue issued for this exhibition is the best introduction to the artist and the Constructivist ideas he stood for.

MARTIN, MARY (*née* BALMFORD, 1907-69). British painter and sculptor born at Folkestone. She studied at Goldsmiths' School of Art and the Royal College of Art, 1925-32. In 1930 she married Kenneth MARTIN, who was also studying at the Royal College. She painted landscapes and still lifes, but during the 1940s her work moved towards geometrical abstraction and she and her husband made their first completely abstract paintings in 1948-9. With Kenneth Martin, Anthony HILL and Victor PASMORE she belonged to the group of post-war CONSTRUCTIVISTS which continued the tradition of geometrical abstraction in England, and her work was shown in many exhibitions of international Constructivist art. Her first construction, *Columbarium*, a bronze, was done in 1951. The standard elements in her later constructions, already present in this first example though cut in reverse, were the square, the rectangle, the cube and the triangular wedge. Her more important commissions included a Screen for Musgrave Park Hospital, Belfast (1957); six reliefs for S.S. *Oriana* (1960); Wall Construction for Congress Building of the International Union of Architects, South Bank, London (1961); Wall Construction

for the University of Stirling (1969). In 1969 she won joint First Prize with Richard HAMILTON at the John Moores Liverpool exhibition. In 1970-1 the Arts Council of Great Britain arranged a joint travelling exhibition of her works with those of her husband.

MARTINA, PIERO. See CORRENTE.

MARTÍNEZ, ARTURO. See SPAIN.

MARTINFIERRISTAS. See LATIN AMERICA; PETTORUTI, Emilio.

MARTINI, ARTURO (1889-1947). Italian sculptor born at Treviso, where he was employed as an apprentice in a ceramics workshop and afterwards studied sculpture. About 1920 he was connected with VALORI PLASTICI, and some of his works were reproduced in their magazine. During the 1930s he worked mainly in Milan, but later taught sculpture at the Academy of Fine Arts, Venice, and in 1948 he was given a memorial exhibition at the Venice Biennale. In his work vigorous EXPRESSIONISM alternated with an excessive mannerism, particularly in his terracottas. In *A Concise History of Modern Sculpture* Herbert Read attributes this mannerism to the influence of Adolf Hildebrand (1847-1921), under whom he studied in Munich in 1909. Martini was interested in the sculpture of the past, particularly Etruscan and Renaissance Baroque; he accepted features from CUBISM and other contemporary movements but did not identify himself with any of them. In 1945 he decided to abandon sculpture and become a painter, justifying this determination by a pamphlet entitled *Scultura—lingua morta*.

MARTINS, MARIA (MARTINS PEREIRA E SOUZA, MARIA DE LOURDES, 1900-73). Brazilian sculptor born in Campanha, Minas Gerais. She began as a painter and engraver and first took up sculpture in 1926, working in terracotta, then marble and later in bronze. As the wife of a diplomat she travelled widely from 1936 to 1939, first to Tokyo, where she learnt ceramic techniques, then to Brussels in 1939, where she studied with the sculptor Oscar JESPERS. She rejected the Graeco-Roman tradition in favour of a freer rendition of memories of the wild tropical vegetation of Brazil, into which she sometimes incorporated figures from erotic and SURREALIST fantasies. Her first individual exhibition took place in 1941 at the Corcoran Art Gal. in Washington, followed by exhibitions at the Valentine Gal. in New York (1942, 1943, 1944 and 1946), the Julien Levy Gal. in New York (1947), the Gal. Drouin in Paris (1949), the Mus. de Arte Moderna in São Paulo (1950) and in Rio de Janeiro (1956). She executed a bronze sculpture for the gardens of the Presidential Palace of the Alvorada in Brasilia in the early 1960s. She participated in numerous group exhibitions, including 'Religious Art of Today',

Ohio, 1944; 'Origins of Modern Sculpture', St. Louis, 1946; the Surrealist exhibition in Paris at the Gal. Maeght, 1947; 'From Rodin to Our Days' at the Maison de la Culture Française, Paris, 1949; and in several São Paulo Bienales, in which she was awarded prizes including one for the best national sculptor. Her work is in the collections of the Mus. de Arte Moderna, Rio, the Art Institute of Chicago, The Metropolitan Mus., New York, and the Philadelphia Mus.

MARUSSIG, PIERO (1879-1937). Italian painter born at Trieste. After studying in Vienna, Munich and Paris he joined the NOVECENTO ITALIANO group in 1922, which was formed with the object of reviving the large-scale figurative style of the classical period of Italian art. Marussig himself sought a compromise between the ideals of the *Novecento* and the formal interests of post-CUBIST trends in France. His later work relied increasingly on luminous colour composition.

MARYAN, MARYAN S. (PINCHAS BURSTEIN, 1927-). Painter and graphic artist, born at Nowy Sacz, Poland. He was confined in Nazi concentration camps between 1939 and 1945, lived in Israel from 1947 to 1950 and studied at the École Nationale des Beaux-Arts, Paris, from 1950 to 1953. He settled in New York in 1962, His painting, described by Barry Schwartz as 'one of the most ambitious representational arts of our time', had a SURREALIST quality of the remembered macabre. He attacked the concept of authority in gruesome images of figures choking on their own internal organs. 'In each progressive painting', says Schwartz, 'we see power ridiculed by gestures of infantilism, sickness, foolishness, absurdity and pathological collapse.' Borrowing both from PICASSO and CHAGALL, he evolved a personal style by which to express his horror of a world in which madness and sadism reign.

MASHKOV, ILYA. See KNAVE OF DIAMONDS.

MASON, JUDITH. See SOUTH AFRICA.

MASSIRONI, MANFREDO. See GRUPPO N.

MASSON, ANDRÉ (1896-). French painter, born at Balagny, Oise. After studying painting at the Académie des Beaux-Arts, Brussels, he went to Paris in 1912 on the advice of Émile Verhaeren and entered the École des Beaux-Arts there. He served in the war and was severely wounded. His wartime experience affected him deeply and left him with a profound and troubled curiosity about the nature and destiny of man and an obscure belief in the symbolic unity of all things which, lacking the intellectual training to formulate into a philosophy, he devoted the whole of his artistic activity to penetrate and express. In *Le Plaisir de peindre*, written in 1950, he said; 'Does this mean that one must give precedence to reflection before

instinct or to intelligence over what it is customary to call inspiration? By no means. The fusion of heterogeneous elements brought into play by the painter-poet is accomplished with the rapidity of a lightning flash. The unconscious and the conscious, intuition and understanding, must operate their transmutation in the super-conscious, in the radiant unity.'

He returned to Paris in 1919 and in 1922 met Daniel-Henri KAHNWEILER, who made it possible for him to devote himself wholly to painting and organized his first exhibition, at the Gal. Simon. At this time his work showed the influence of CUBISM, particularly Juan GRIS, and of DERAIN. From 1922 he also began to associate with some of the founders of the SURREALIST movement, MIRÓ, ERNST and the poets Michel Leiris and Georges Limbour, the latter of whom wrote the Preface to his exhibition catalogue. His painting Les Quatre Éléments, which already expressed his obsession with universal rhythms and cosmic unity, attracted the attention of André BRETON and in 1924 Masson joined the Surrealist association. He was particularly impressed by the Surrealist practice of AUTOMATISM, which he regarded as an 'investigation into the powers of the unconscious', and he practised this method of composition until 1928, when he left the movement after a quarrel with Breton. His method of automatic painting was to draw automatically on canvas with adhesive and then add colour by spreading coloured sands. Although he exhibited with the Surrealists from 1924 to 1928, and had a second Surrealist period c. 1937, he never courted the MAGICAL REALISM of the Surrealists; his work was spontaneous, suggestive and symbolic.

In 1929–32 he travelled in Germany and the Netherlands and in 1933 he exhibited with Miró in New York and did the décor for Massine's ballet Les Presages. From 1934 to 1937, during the Spanish Civil War, he lived at Tosca in Catalonia and did several series symbolizing violence and carnage—Massacres, Sacrifices, Tauromachies—usually transfusing them with an erotic significance as was his general practice. During this time he also did the décor for J.-L. Barrault's stage setting of the Numance of Cervantes. After his return to France in 1937 he designed stage settings and décor for La Faim by Knut Hamsun and the Médée of Darius Milhaud.

In 1940 he went to America, where among the New York group of émigré Surrealists his influence on the early stages of ABSTRACT EXPRESSIONISM was considerable, particularly with Arshile GORKY. Analogies have been drawn between the automatism of his method of sand painting and American ACTION PAINTING as practised for example by Jackson POLLOCK. In 1946 he returned to France and settled the following year in Aix-en-Provence. Here he did a number of landscapes of Provence, designed the sets for a production of Hamlet, did illustrations for L'Espoire and Les Conquérants of MALRAUX and executed series of lithographs and drawings for his portfolios Bestiaire and Mythologies. In 1950 he had a large retrospective exhibition with GIACOMETTI at Basle and in 1955 he was awarded the Grand Prix National. His most important retrospective was staged by The Mus. of Modern Art, New York, in 1976. In 1963 he did stage designs for a production of Berg's Wozzeck.

In his book Le Plaisir de peindre he wrote: 'The true power of a work of imagination, the effect of surprise annulled, will be the result of the three following conditions: (1) The intensity of the preliminary meditation. (2) The freshness of the vision of the external world. (3) The necessity of knowing the pictorial means appropriate to the art of this time.' Masson combined in his own work great technical proficiency with a personal if sometimes obscure inner vision and a keen eye for external appearances.

MASTROIANNI, UMBERTO (1910–). Italian sculptor born at Fontana Liri, near Rome. After the war he worked in Turin, where he taught at the Academy. He executed a monument at Turin to the Italian partisans and did a sculpture for the Rotterdam railway station. After a FUTURIST phase he turned to abstraction and was regarded as the most important member of the INFORMAL school working in Turin. His structures were often immense, like the Battaglia in the Gal. Nazionale d'Arte Moderna at Rome, and they have been likened to 'geological formations with a new anthropomorphic sense'.

MATEOS, FRANCISCO. See SPAIN.

MATHIEU, GEORGES (1921–). French painter, born at Boulogne-sur-Mer, Pas-de-Calais. After studying philosophy and law he began to paint in 1942 and by 1944 had worked his way towards non-figurative abstraction. He was, however, opposed to the geometrical abstraction then in vogue and became one of the originators of the Paris school of expressive abstraction. In 1947 he settled in Paris and his work was confirmed by the example of WOLS in the direction of ART INFORMEL. He also found affinities with the American ABSTRACT EXPRESSIONISTS. He worked at great speed without a preconceived plan, using a kind of inspired calligraphy. With Camille BRYEN he organized a number of exhibitions of expressive abstraction, including one in 1950 at the Gal. Montparnasse combining French and American painters. He exhibited at the SALON DES RÉALITÉS NOUVELLES and the Salon des Surindépendants. His first one-man exhibition was at the Gal. Drouin, Paris, and in America at the Stable Gal., New York, in 1952. His reputation rapidly became international and his work was very widely exhibited as the vogue for expressive abstraction and GESTURAL painting grew. He exhibited at the Institute of Contemporary Arts, London, in 1956 and visited Tokyo and the U.S.A. in 1957. He painted many large-format

pictures in which he rapidly recorded his 'psychic impressions' on a monochromatic background. In 1956 he did a painting 12 ft (3·6 m) high on the stage of the Théâtre Sarah Bernhardt entitled *Hommages aux poètes du monde entier*. Among his writings were: *Anagogie de la non-figuration* (1952); *D'Aristote à l'abstraction lyrique* (1959); *De la dissolution des formes* (1960); *Au-delà du tachisme* (1963). He had a retrospective exhibition at the Mus. d'Art Moderne de la Ville de Paris in 1963.

MATINA, MARIJA. See NAÏVE ART.

MATISSE, HENRI ÉMILE BENOÎT (1869–1954). French painter. Born at the home of his grandparents in La Cateau-Cambrésis, he spent his childhood in the family home at Bohain-en-Vermandois and received a classical education at the Lycée de St. Quentin. After qualifying in law at Paris, 1887–8, he became a clerk in a law office at St. Quentin but in 1890 he began painting and the following year abandoned law for the study of art. He first studied under the academic painter Bouguereau at the Académie Julian but in 1892 changed to the more congenial teaching of Gustave MOREAU at the École des Beaux-Arts, where MARQUET, MANGUIN, CAMOIN and ROUAULT were among his fellow students. In 1896 he exhibited four pictures at the Salon de la Nationale. They were competent, sober and unadventurous, influenced by Chardin and Corot, and they were well received. In the following year he was elected associate member of the Société Nationale.

His first acquaintance with Impressionism probably dates from the exhibition of pictures from the Caillebotte Bequest at the Luxembourg in 1897 and in 1898 he exhibited at the Nationale his large painting *La Desserte* (*Dinner Table*), which might have been from the Impressionist school. From this time colour became of prime importance in Matisse's painting and through contact with the work of Gauguin, Van Gogh and Cézanne he began to evolve a personal style of his own. In 1899 he visited London and studied Turner on Pissarro's advice. In 1900 he was living in a situation of financial stringency, doing hack work and supporting his family by painting decorations at the Grand Palais at so much a metre; yet he had already bought two drawings by Van Gogh, *Head of a Boy* by Gauguin and Cézanne's *Three Bathers* (presented to the Mus. d'Art Moderne de la Ville de Paris in 1936). While working at the Académie Carrière in 1899 he had met DERAIN, who introduced him to VLAMINCK in 1901. Already regarded as a leader among the group of young artists later named FAUVES, he was one of the founders of the Salon d'Automne in 1903 and with the other Fauves created a sensation at the exhibition of 1905. Meanwhile in 1904 he had his first one-man exhibition with Ambroise VOLLARD. Matisse was never touched more than superficially by the CUBIST exercises of PICASSO and BRAQUE but in the first years of the century he matured his own style

of decorative and expressive abstraction, developing the rhythmical linear patterns of Gauguin and the SYNTHETISTS and their flat areas of uniform colour into a personal manner of expressive composition. This culminated in two outstanding paintings, both landmarks in the story of contemporary art, *Luxe, calme et volupé* exhibited at the Salon des Indépendants in 1905 and bought by Signac, and *Bonheur de vivre* exhibited in 1906 and bought by Leo Stein. These were followed by the stylistically no less important *La Dance* and *La Musique* in 1909–10. Matisse's own artistic principles, which matured with time but underwent no radical change throughout his life, were set forth in 'Notes d'un peintre' published in *La Grande Revue* in 1908. By the outbreak of the First World War his position was established among connoisseurs, artists and the public alike as one of the most important *avant-garde* artists of his day. His pictures were bought by the Steins and the Russian collectors SHCHUKIN and Morosov. He had a large exhibition at the Gal. Bernheim-Jeune in 1910 and was well represented both in the Post-Impressionist exhibitions arranged by Roger FRY in London and in the ARMORY SHOW at New York.

For the rest of his long life Matisse continued to mature and perfect his style of decorative abstraction, augmenting his world-wide reputation as one of the leading painters of his day, influencing many but not founding a school. In 1923 the Shchukin and Morosov collections of nearly 50 of his works were combined in the Mus. of Modern Western Art, Moscow. In 1927 he was awarded First Prize at the Carnegie International at Pittsburgh. In 1925 he was made Chevalier de la Légion d'honneur and in 1947 was elevated to Commandeur. From the 1920s he divided his time between Paris and Nice and in 1943 he settled at Vence. His most important commissions were the *Dance* murals for the Barnes Foundation, Pennsylvania (1930–2), and his decorations of the Chapelle du Rosaire, Vence, begun in 1948 and completed in 1951. In 1947 the Mus. National d'Art Moderne began to assemble a representative group of his works and in 1952 the Mus. Matisse was inaugurated at Le Cateau-Cambrésis. Among his most important retrospective exhibitions were: exhibition at the Salon d'Automne in his honour, 1945; at Nice and at the Maison de la Pensée, Paris, 1950; The Mus. of Modern Art, New York, 1951. Posthumous retrospectives were shown in Paris (1956, 1970), Los Angeles (1966), London (1968).

Matisse began to study sculpture in 1900 and continued to make sculptures at intervals throughout his career. Perhaps the most famous are the four versions of the relief *The Back* (Tate Gal., 1909–29). Exhibitions of his sculpture took place in London and New York in 1953. He designed sets and costumes for Diaghilev's *Le Chant du Rossignol* in 1919 and for *Rouge et Noir* in 1937. Among the works he illustrated were: *Poésies de Stéphane Mallarmé* (1932), the *Ulysses* of James

Joyce (1935), *Jazz* (1947), *Poèmes de Charles d'Orléans* (1950). From 1948 he worked at his *gouaches découpées*, non-representational abstracts which are among the most successful colour abstractions ever created (*L'Escargot*, Tate Gal., 1953).

After completing his work for the Chapelle du Rosaire, Vence, Matisse wrote an introduction to the picture book of the Chapel in which he described it as 'the culmination of a life of work and the coming into flower of an enormous, sincere and difficult effort'. The introduction began as follows, with what is to all intents and purposes a summary of his artistic credo: 'All my life I have been influenced by the opinion current at the time I first began to paint when it was permissible only to render observations made from nature, when all that derived from the imagination or memory was called bogus and worthless for the construction of a plastic work. The teachers at the Beaux-Arts used to say to their pupils, "Copy nature stupidly." Throughout my career I have reacted against this attitude to which I could not submit; and this struggle has been the source of the different stages along my route, in the course of which I have searched for means of expression beyond the literal copy—such as Divisionism and Fauvism. These rebellions led me to study separately each element of construction; drawing, colour, values, composition; to explore how these elements could be combined into a synthesis without diminishing the eloquence of any one of them by the presence of the others, and to make constructions from these elements with their intrinsic qualities undiminished in combination; in other words to respect the purity of the means.'

MATIUSHIN, MIKHAIL (1861–1934). Russian musician and painter. In 1913 he wrote the music for the FUTURIST opera *Victory over the Sun*, which was produced by the UNION OF YOUTH with nonsense libretto by Kruchenykh and costumes and décor by MALEVICH. Matiushin began to paint *c.* 1908 under the influence of the BURLIUK brothers. He was a close friend of Malevich and his wife was the poet-painter Elena Guro.

MATTA (ROBERTO SEBASTIÁN MATTA ECHAURREN, 1911–). Chilean-French painter, born in Santiago. After completing his studies in architecture at the Catholic University, Santiago, in 1931 he left for Paris in 1933 and worked for two years intermittently as draughtsman in the studio of LE CORBUSIER. He travelled to Italy, Russia and Spain, where in 1936 he met the poet Federico García Lorca, who put him in touch with Salvador DALÍ. Through Dalí he met André BRETON in Paris, joined the SURREALIST group and with Yves TANGUY and ONSLOW-FORD became one of the leading practitioners of the Surrealist doctrine of AUTOMATIC composition. In 1937 he exhibited his first drawings in a Surrealist exhibition. In 1938 he began to paint and also published an article 'Sensitive Mathematics—Architecture of

Time' in *Minotaure* proposing an adaptable architecture based on a Freudian interpretation of human needs. Matta lived in New York between 1939 and 1948 and exercised an important influence on American Surrealism, particularly on that of GORKY, until he severed his connection with the movement in 1948. He exhibited at the Julien Levy Gal. in 1940, the Pierre Matisse Gal. in 1941 and the Sidney Janis Gal. in 1945. On his return to Europe he lived in Rome from 1950 to 1954, then in Paris, exhibiting at the Salon de Mai in 1955.

Matta's early Surrealist paintings, which he called 'Psychological Morphologies' or 'Inscapes', were concerned with depicting imagery of the unconscious mind by techniques of automatic composition and consisted of strange, agitated, amoeba-like or insect-like forms often composing a kind of script. He had illustrated Lautréamont's *Les Chants de Maldoror* in Paris and through Lautréamont came to full awareness of the 'untameable nature' of the New World. He realized this awareness after a trip to Mexico in 1941 and painted *Listen to Living* (1941) and *The Earth is a Man* (1942), where telluric, erotic and cosmic forces explode in cataclysmic encounters. In the early years of the 1940s his compositions became increasingly dynamic with organic and mechanistic shapes floating and colliding in a splendid cosmic space which was nevertheless fraught with violent and agitated movement and symbolized his mystical belief in the cosmic unity of all things. From 1944 his work underwent a profound change. In that year he met DUCHAMP in New York. He had already paid homage to Duchamp's *The Bride Stripped Bare by her Bachelors, Even* when in 1943 he painted *The Bachelors Twenty Years Later*. After 1944 his paintings, such as *To Escape the Absolute*, included vitreous floating geometrical planes which Nicolas Calas referred to as his 'transparent Cubism'. Basing himself on a study of pre-Conquest Mexican iconography, he adapted it for the purposes of a new pictorial imagery of the machine age, expressing the isolation and anxiety of modern man in the grip of a technological culture. He also began using puns in his titles: *Le Vertige d'Eros* in French doubles for *Le Vert Tige des Roses* (*The Green Stem of the Roses*). After the mid 1940s his organic and mechanistic figures took on a comic-strip appearance. He reintroduced the human figure into his compositions, but human beings existing in a symbiotic relationship with machines, and parts of machines or electrical components were represented with the frenzied but undirected activity of mindless insects. Man and machine were identified but their roles were reversed. In the late 1940s and 1950s his work became more Expressionistic and delicate in tone, as in *The Birth of America* (1957). In the 1950s and 1960s open-armed lovers, crucified victims and astronauts made their appearance. His work of the 1960s tended to be more political in intention and in 1962 he was awarded the Marzotto Prize for *La Question Djamila* inspired by

the Spanish Civil War. He also did canvases of mural size on such themes as Vietnam, Santo Domingo and Alabama, which were exhibited at the Iolas Gal., New York, in 1968. His political murals included *Three Constellation Beings Facing the Fire* at the UNESCO Building, Paris, in 1956, murals for the University of Santiago, Chile, in 1962–3 and murals painted in Santiago in 1971 for the Popular Front Muralist brigades, in which he used a popular comic-strip technique with slogans.

Matta lived in Paris from 1955 to 1969, becoming a French citizen. In 1957 he was given a retrospective exhibition at The Mus. of Modern Art, New York, in 1958 at the Mus. of Modern Art, Stockholm, and in 1963–4 at the Palais des Beaux-Arts, Brussels, and the Mus. Civico, Bologna. During the 1960s he travelled to several Latin American countries and from 1969 lived near Rome with frequent visits to Paris.

Matta's cosmic and apocalyptic paintings continued during the 1970s. In 1970 he held a retrospective exhibition in the Nationalgal., Berlin, at which six 10 m canvases were shown together for the first time. In 1971 the Peugeot workers organized a retrospective in the town hall of Sochau (Doubs). In 1975 a travelling exhibition 'El Gran Burundún-Burunda ha muerto' was shown in the Mus. de Arte Moderno, Mexico City, as a supporting manifestation to the Russell tribunal on the crimes of the Chilean Junta. In 1977 Matta had retrospective exhibitions at Viterbo and in the Hayward Gal., London. The latter exhibition was entitled 'Coïgitum' after the painting done in 1972–3, of which he said: '*Coïgitum* is an attempt to represent living man as a solar system with several suns (sex, intelligence, love, spirit, karma) all of which at different moments of life change or transfer the central light to each other.'

MATTERISM. Name given in the Netherlands and Belgium to a style of painting which exploits the evocative powers of materials, using a heavy impasto in the manner of DUBUFFET and embedding in it materials such as shells, sand, slate, iron filings, etc. for the sake of their expressive force. Painters who used this technique were WAGEMAKER and Bram BOGART in the Netherlands, Bert de Leeuw, J. M. Londot, René GUIETTE and Marc MENDELSON in Belgium.

MATULKA, JAN (1890–1972). Czech-American painter born in Prague. He studied at the National Academy of Design and taught at the Art Students' League, where David SMITH was one of his pupils. His first one-man shows were at the Modern Gal., New York, in 1927 and 1930. Matulka was one of the European-born artists who transmitted the principles of European *avant-garde* art to the U.S.A. and helped the assimilation of CUBISM and other forms of ABSTRACTION by the younger American artists. His works are contained in many leading American collections, including The Metropolitan Mus. of Art, New York; the Whitney Mus.

of American Art; the Solomon R. Guggenheim Mus.; the Brooklyn Mus.; the Art Institute of Chicago.

MAURER, ALFRED H. (1868–1932). American painter born in New York, son of Louis Maurer, a Currier and Ives lithographer. Maurer was one of the first of the modern American artists to move to Paris, entering the Académie Julian in 1897, and apart from short trips he remained there until 1914. He won a gold medal at the Carnegie International Exhibition of 1901. His early style was based upon that of Whistler but influenced also by Sargent. He was one of the circle of artists who frequented the Paris home of Gertrude Stein; she introduced him to the FAUVES *c.* 1907 and in consequence of this his work underwent an abrupt change to a modernist idiom. His work in the Fauvist style was introduced to America by STIEGLITZ in a joint exhibition with John MARIN at the 291 Gal. in 1909 and he was included in the Stieglitz exhibition of Younger American Artists in 1910. When Arthur B. DAVIES and Walt Kuhn visited Paris in 1912 to prepare for the ARMORY SHOW they were helped by Maurer with introductions to the POST-IMPRESSIONIST dealer Ambroise VOLLARD. Maurer exhibited in the Armory Show, in the FORUM Exhibition which followed it in 1916 and in the first exhibition of the SOCIETY OF AMERICAN ARTISTS in 1917.

Through his life there was tension between Maurer and his father, who was not in sympathy with modernist styles of painting, and this was exacerbated when in 1914 he was compelled to return to the U.S.A. and take up residence with his father. During the 1920s he reverted to a style of expressive naturalism, and an air of melancholia has been noted in his works, as if they spoke of sadness for promise unfulfilled. Sherwood Anderson wrote of them: 'The young girls are like desert flowers, flashing into quick beauty just caught.' Maurer was exhibited by the dealer E. Weyhe in the later 1920s but no longer took an active part in American *avant-garde* activities. In the early 1930s he painted some pictures reminiscent of later CUBIST mannerisms, such as *Still Life with Doily* (Brandeis University Art coll., 1930–1), and double interpenetrating heads, such as *Twin Heads* (Whitney Mus. of American Art, *c.* 1930). The final loss of confidence in his own work seems to have been caused by the success of his father's first one-man exhibition of his popular renderings of the American West. He committed suicide in 1932 a month after his father died at the age of 100. Maurer is a tragic example of an American artist of undoubted talent who was prevented by conditions from developing his potential to the full.

MAVIGNIER, ALMIR (1925–). Brazilian-German painter, born in Rio de Janeiro. From 1945 he studied painting with Arpad SZENÈS and was a member of abstract groups in Brazil. He

came to Europe in 1951 and from 1953 to 1958 studied at the Hochschule für Gestaltung in Ulm. After working as a commercial artist in Ulm he was appointed in .1965 to the staff of the Hochschule für Bildende Künste, Hamburg. In 1968 he obtained a prize from the Mus. of Modern Art, Kyoto, at the 6th Biennale of Graphic Art, Tokyo. He exhibited widely in Germany, Brazil and elsewhere and participated in many collective exhibitions, including the São Paulo Bienale, the Venice Biennale, the SALON DES RÉALITÉS NOUVELLES, 'The Responsive Eye' (1965) and 'Word and Image' (1968), The Mus. of Modern Art, New York. He devoted himself to the visual problems of Max BILL and Josef ALBERS, by both of whom his work was influenced. His own work, usually in near-monochrome, was on the fringe of OP ART, often using a grid of dots to emphasize the impression of luminosity.

MEAD, RAY. See CANADA.

MEADOWS, BERNARD (1915–). British sculptor, born at Norwich. After studying at the Norwich School of Art, 1934–6, he was studio assistant to Henry MOORE, 1936–40, and attended the Royal College of Art, 1938–40. After serving in the war he returned to the Royal College of Art in 1946 for two years, later becoming Professor of Sculpture there. He was represented in the British Pavilion at the Venice Biennale of 1952 and his sculpture was shown in open-air exhibitions at Battersea (1952), Middelheim (1953) and Holland Park (1958). He participated in a number of important international exhibitions and represented Britain at the Venice Biennale of 1964. He had one-man shows at Gimpel Fils, London, and at the Paul Rosenberg Gal., New York, and was represented in the exhibition 'Painting and Sculpture of a Decade' at the Tate Gal. in 1964. An exhibition of his sculptural drawings was given by the Taranman Gal., London, in 1975. He worked mainly in bronze and his sculptures, though abstract, often suggested organic forms, particularly fruits; indeed during the 1960s he sometimes used actual fruits in his casting.

MÉCANO. A review founded by Van DOESBURG in 1922 and edited by him under the pseudonym I. K. Bonset. It ran to four numbers. The contributors included DADAISTS such as HAUSMANN, ARP, PICABIA, SCHWITTERS and Tzara and made fun of the Bauhaus for its solemn sense of dedication. In this review Van Doesburg also attempted to extend the principles of CONSTRUCTIVISM to poetry.

MEC ART. Abbreviation of 'mechanical art', the term was perhaps first used by JACQUET in 1964 of his Déjeuner sur l'herbe with a pun on the sense of 'mec' in Paris argot. It was then adopted for an exhibition of works by Béguier, BERTINI, Pol BURY, Alain Jacquet, NIKOS and Mimmo ROTELLA at Gal. J, Paris, in 1965 and in Brussels the following year

with the title 'Hommages à Nicéphore Niepce'. All these artists used photographic techniques for the mechanical production of a new, synthetic image.

In 1962 Andy WARHOL had adopted the technique of photographic transfer on to canvas, on the analogy of serigraphic techniques, in order to incorporate photographic images into his paintings. RAUSCHENBERG adopted a similar technique in his 'combine-painting'. Both of them used the photographic transfer unadapted in the manner of an objet trouvé to be incorporated into their paintings. The European artists on the contrary, each in his own way, employed photographic techniques in order to modify or restructure the photographic image, creating a new, synthetic image by means of these mechanical procedures. Bertini incorporated COLLAGES from journals and documents or typographical elements into his TACHIST paintings and then used photography to unify the image and abolish the difference between the collage and the painted portions. Pol Bury adopted a very similar technique in his Cinétisations, in which photographic collages were subjected to imperceptible movement about an axis. In his Fantasmagories Nikos photographed people behind a screen with variable luminosities, thus producing a large range of conflicting shadows and superimposed contours. The portrait thus obtained was enlarged for transfer on an emulsified canvas. Jacquet used a method of printing in large series by means of screens which ensured a selection of colours from a diapositive original. Rotella combined the technique of photographic transfer with his affiches déchirées, detaching selected elements for photographing on to the canvas. Other artists also experimented with these techniques and Mec art made an impressive showing at the 1967 Paris Biennale.

MECHANOFAKTUR. See BERLEWI, Henryk.

MEDLEY, ROBERT (1905–). British painter, born in London. He studied at the Byam Shaw School, London, from 1921 to 1923 and then until 1925 at the Slade School, where he knew Roger FRY, Duncan GRANT and others of the BLOOMSBURY GROUP. In 1926–7 he studied at the Académie Moderne, Paris, under Jean MARCHAND. He became a member of the LONDON GROUP in 1920 and in 1932 his work was exhibited at the London Artists' Association. From 1933 to 1939 he worked at the Group Theatre designing sets and costumes for plays by Eliot, Auden, Isherwood, MacNeice, etc. During this period he became interested in SURREALISM and he exhibited in the London Surrealist exhibition of 1937. After the war period, during which he was a War Artist for the A.R.P., he taught briefly at the Chelsea School of Art and then from 1951 to 1958 taught stage design at the Slade School. From 1958 to 1965 he was head of the Department of Fine Art at the Camberwell School of Arts and Crafts. During the 1940s his painting remained fundamentally repres-

entational though dominated by a concern for form and structure. In the 1950s, under the influence of current American painting, he became more interested in displaying the abstract qualities of pigment colour. From 1945 he had one-man shows at a number of London galleries, including the Lefevre, the Leicester and the Hanover, and he had a retrospective exhibition at the Whitechapel Art Gal. in 1963 and was represented in the exhibition 'British Painting 1974' at the Hayward Gal. Besides various municipal galleries his works are included in the collections of the Tate Gal., the Arts Council of Great Britain and the National Gal. of Canada at Toronto.

MEDUNETSKY, KASIMIR. Russian CON-STRUCTIVIST artist, a pupil of TATLIN in the VKHUTEMAS. In 1920 he exhibited constructions in the exhibition of the Society of Young Artists (OBMOKHU) and in 1921 had a three-man show with the brothers STENBERG also in the Vkhutemas. Joining the Constructivist group, he signed a manifesto in 1922 condemning non-useful art as a 'speculative activity' and thenceforth devoted himself mainly to designing for Meyerhold's Kamerny theatre in Moscow. One of Medunetsky's constructions, from 1919, was illustrated in CIRCLE, published in London in 1937.

MEHKEK, MARTIN (1936–). Yugoslav naïve painter, born in the Croatian village of Novačka, near Gola and Hlebine. He began to paint and draw as a boy but on leaving school he was compelled to abandon the interest owing to the strenuous demands of work on the land. He began to paint again c. 1953, specializing in scenes from the life of the gipsies and pictures of men at work. He was a member of the Hlebine school of peasant painters (see NAÏVE ART). He had a special talent for portraiture, not so much depicting the individual as caricaturing the type. An outstanding example of this style is his glass painting *The Boss* (Frankfurt, 1965). From 1955 he exhibited in the chief towns of Yugoslavia and in many European towns including Edinburgh (1962), Moscow, Leningrad, Budapest, Vienna (1962–3), Klagenfurt (1964), London (1965) and Frankfurt (1966).

MEHRING, HOWARD (1931–). American painter born in Washington, D.C., and studied education at Wilson College. He had one-man exhibitions at the Sculptors Studio (1957) and the Origo Gal. (1959), Washington, and then travelled extensively in Europe and England, 1962–6. He was shown in the Los Angeles County Mus. of Art 'Post-Painterly Abstraction' exhibition (1964) and in the 'Washington Color Painters' exhibition (1965) at the Washington Gal. of Modern Art. He was also included in the exhibition 'Systemic Painting' at the Solomon R. Guggenheim Gal. in 1966. Mehring belonged to the Washington group of Colour Painters who followed NOLAND in structuring colour as a purely optical phenomenon, developing a HARD EDGE style.

MEIDNER, LUDWIG (1884–1966). German painter and writer, born at Bernstadt, Silesia. He studied at the Breslau Academy 1903–5 and eked out a living as a fashion artist in Berlin in 1905–6. In 1906–7 he was in Paris, studying at the Académie Julian. He was unaffected by *avant-garde* artistic movements there although he made friends with MODIGLIANI, who did several portraits of him. About 1912 he began to paint visionary and apocalyptic landscape scenes which brought him within the more ecstatic school of German EX-PRESSIONISM. An example is *Apocalyptic Landscape* (Nationalgal., Berlin, c. 1913). Expressionistic also, in a different manner, is the pencil *Self-Portrait* (Staatsgal. Moderner Kunst, Munich, 1915). At the same time he began a period of prolific and equally ecstatic literary work. The period came to an end abruptly c. 1922 and in 1923 he wrote: 'It is only with the deepest blushes that I can read my youthful work.' In 1912 he participated in the exhibition at the STURM Gal. of the group *Die Pathetiker*, of which he was a founder. In 1924–5 he taught at the Studienateliers (Study Workshops) for painting and sculpture in Berlin. From 1935 to 1939 he was drawing master at the Jewish Hochschule in Cologne. In 1939 he fled to England, where he was interned 1940–1. He returned to Germany in 1953, settled in Frankfurt and later moved to Darmstadt. In respect of the Jewish character of his Expressionism he has been compared by Werner Haftmann with CHAGALL, SOUTINE, PASCIN and SCIPIONE. Haftmann also described him as 'a visionary and prophet of high stature endowed with keen feeling for the soul of his time, yet utterly unable to draw'.

MEIER-DENNINGHOF, BRIGITTE (1923–). German sculptor born in Berlin and studied at the Academies of Berlin and Munich. She was an assistant of Henry MOORE in 1948 and worked with Antoine PEVSNER in 1949–50, and her early work was influenced by both. From about 1955 she devoted herself to metal sculpture formed from vertical rods welded together to form winding or curving walls or bunched groups of rods and pipes. In 1960 she settled in Paris. She had a retrospective exhibition at the Kestner-Gesellschaft, Hanover, in 1966.

MEISSNER, PAUL (1907–83). Austrian painter born in Vienna, where he studied at the Academy under Ferdinand Andri (1871–1956) and then, 1932–4, at Milan. He was President of the SECESSION from 1954. From naturalist beginnings he passed to a style of expressive abstraction in paintings, dominated by shades of grey, which endeavoured to express the antithesis between life and death and the creation of order out of chaos.

MEISTERMANN, GEORG (1911–). German painter born in Solingen, studied at the Academy of Art in Düsseldorf, 1929–33. He taught from 1953 at the Städtische Kunstschule, Frankfurt,

was appointed to the Düsseldorf Academy in 1955 and in 1960 to the Academy in Karlsruhe. In the post-war years he painted pictorial abstracts based on natural scenes and symbolic pictures which betrayed the influence of LÉGER. Towards the end of the 1950s he did two-dimensional monochromatic works deriving from the style of ROTHKO. From the late 1930s he interested himself in stained glass and among others did the windows for the Rundfunkhaus, Cologne, and the church of St. Kilian, Schweinfurth.

MELDRUM, MAX (1875–1955). Australian painter, born in Edinburgh. Meldrum arrived in Melbourne in 1889 and studied painting at the National Art Gal. School of Victoria under Bernard Hall, who played a significant role in determining his lifelong preoccupation with tonal values. In 1889 he won the travelling scholarship of the School and then lived and studied in France for 13 years. He returned to Melbourne in 1911 and in 1917 established a school to disseminate the ideas expressed in *Max Meldrum: His Art and Views*, which was published the same year. He based his ideas on his study of the Old Masters. 'The careful study of undisputed art strongly leads me', he wrote, 'to the conviction that the art of painting is a pure science.' For Meldrum painting was a wholly objective exercise in defining and translating optical impressions in a rationally ordered way, using a predetermined formula for establishing tone. Modern art, he claimed, with its emphasis on colour, composition and individual expression spelt social decadence. Meldrum's doctrine gained many adherents in Melbourne and Sydney between the wars. The first comprehensive theory of painting developed in Australia, it provided rules and procedures but discounted the importance of creative imagination.

Meldrum was a powerful personality and dedicated to his convictions. These often brought him into public conflict, particularly during eight stormy years (1937–45) as a trustee of the National Gal. of Victoria. His own paintings, such as *Picherit's Farm* (1910) and *Portrait of the Artist's Mother* (1913) (both in the National Art Gal. of Victoria), though competently handled, lacked inspiration. His method became particularly popular among portrait painters but tends to be repetitive, the work of his disciples being difficult to distinguish from that of their master.

MELLI, ROBERTO (1885–1958). Italian sculptor and painter born at Ferrara. He worked as a sculptor in Rome until 1914, when he abandoned sculpture for painting. He was subsequently lionized by the VALORI PLASTICI group.

MENDELSON, MARC (1915–). Belgian painter, born in London of a Belgian father and an English mother. He was a founding member of the Belgian association JEUNE PEINTURE BELGE in 1945. After an early period of *intimiste* work he turned to abstraction c. 1948 and exhibited with the group. He executed large abstract decorations for the Kursaal, Ostend, and for a restaurant in Brussels. He had a one-man show at the Palais des Beaux-Arts, Brussels, in 1955 and participated in the Venice Biennale of 1956. In the late 1960s he reverted to figurative work of an extremely imaginative character.

MÉNDEZ, LEOPOLDO. See MEXICO.

MENINSKY, BERNARD (1891–1950). British painter and draughtsman. Born in the Ukraine, he was brought to England when six weeks old and passed his childhood in Liverpool. In 1906 he began to study at the Liverpool School of Art, where he won various scholarships and the King's medal. After working for three months in 1910 at the Académie Julian in Paris, he joined the Slade School in 1912. After a year there he joined Gordon Craig's newly formed theatre school, the Arena Goldius, in Florence as teacher of drawing and stage design. In 1913 he returned to London, began to teach drawing at the Central School of Arts and Crafts and exhibited with the LONDON GROUP, of which he remained a lifelong member. From 1914 to 1918 he worked as an official War Artist. In 1920 he succeeded SICKERT as teacher of life-drawing at the Westminster School of Art, also resuming his part-time teaching at the Central School. He held both these posts until 1939 while continuing to exhibit in London, the U.S.A. and elsewhere. During the Second World War he taught until 1945 at the City of Oxford Art School. During this period he produced a series of gouaches depicting lyrical figures in landscape which formed the basis for the powerful oil paintings of his last years. Meninsky won international renown as a brilliant teacher. His stature as an artist has probably been underestimated in his lifetime and since. He was given a retrospective memorial exhibition at the Blond Fine Art Gal., London, in 1978.

MENSE, CARLO (1889–1965). German painter born at Rheine, studied at Düsseldorf and then in Berlin under CORINTH. After a period of EXPRESSIONISM he became one of the leaders, with KANOLDT and SCHRIMPF, of that strand of the NEUE SACHLICHKEIT which under the influence of the VALORI PLASTICI practised a harshly mannered and sculpturesque way of depicting the objective world. From 1925 to 1932 he taught at the Breslau Academy of Art. His latest work consisted of flat unmodulated quasi-abstract compositions which still retained figurative associations.

MERCEREAU, ALEXANDRE (1884–). French writer and European traveller who contributed largely to the expansion of CUBISM outside France. He was in Russia in 1906 and edited the French section of the review *La Toison d'Or*. It was at his house in Paris that members of the future Cubist

school (GLEIZES, LÉGER, LE FAUCONNIER, MET-
ZINGER, DELAUNAY) met in 1909–10 and he was
responsible for introducing their works at the
KNAVE OF DIAMONDS exhibitions of 1910 and 1911
in Moscow. He organized an exhibition of *avant-
garde* French art at Budapest in 1913 and in 1914
organized the large Cubist exhibition of the MÁNES
Society in Prague, for which he wrote an introduc-
tion to the catalogue. In 1912 he wrote *La Littéra-
ture et les idées nouvelles* and in 1921 he published
a monograph on LHOTE.

MEREDITH, JOHN. See CANADA.

MÉRIDA, CARLOS (1891–). Guatemalan
painter, born in Guatemala City (or according to
some accounts in Quetzaltenango), of Maya-
Quiché origin. He began studying painting at the
Institute of Arts and Crafts in Guatemala City
and with Santiago Vichi in Quetzaltenango, where
his family moved in 1907. When he returned to
Guatemala City in 1909 he worked with a group
of *avant-garde* artists led by Carlos Valenti and
Jaime Sabartés. In 1910 he went to Europe with
Valenti and in Paris studied with Van DONGEN and
MODIGLIANI. There he also met the Mexicans
Diego RIVERA, Montenegro, Jorge Enciso and
others. He first returned to Guatemala in 1914 and
discovered his country's folklore. Then after a
short trip to the U.S.A. he went to live in Mexico,
where he remained from 1919. In 1922 he joined
the Muralists and worked with Rivera on his
Escuela Preparatoria murals. In 1923 he helped to
found the Syndicate of Technical Workers, Pain-
ters and Sculptors with the other Muralists.
During the 1920s he painted canvases and murals
of figures in a Post-Impressionist style, but after
his return to Paris in 1927 he began to use more
abstract, biomorphic forms. He had his first ex-
hibition in New York at the Valentin-Dudensing
Gal. in 1926 and in 1927 he exhibited at the Gal.
des Quatre Chemins in Paris. After 1927 he aban-
doned folkloric themes in favour of more romantic
and SURREALIST imagery and in the 1930s incor-
porated themes of dance into his paintings. After
his return to Mexico in 1929 he founded the gal-
lery of the Palacio de Bellas Artes with the painter
Carlos Orozco Romero and the School of Ballet of
the Ministry of Public Education in 1931, which
he was to direct for the next three years. In 1941
he taught in the U.S.A. at the North Texas State
Teachers' College in Denton. During a stay in
New York in the 1940s he formed friendships with
GLEIZES, ALBERS, BRETON, DUCHAMP, CALDER, ZAD-
KINE, ERNST, LÉGER and HARE. His work has been
compared in turn to that of KLEE, MONDRIAN and
Albers. After his return to Mexico in 1949 he
became interested in the integration of architecture
with painting, a preoccupation of many Latin
Americans in the 1950s, and collaborated with the
architects Mario Pani and del Moral on the
'Juarez' housing project in 1952 in Mexico City.
Mérida returned to using the figure in the late

1940s after a period of pure abstraction and after
1951 he incorporated it into carefully structured
geometrical designs. He also introduced themes of
Maya culture such as in his glass mosaic mural
The Mestizo Race of Guatemala (1956) at the
Municipal Building in Guatemala City's Civic
Centre. (He had studied the technique of Venetian
mosaic during a trip to Italy in 1950.) He con-
tinued to do murals in Mexico and Guatemala
through the 1950s and 1960s and in 1968 decor-
ated the Convention Center in San Antonio,
Texas, with glass mosaic murals. He exhibited
widely in France, Italy, Venezuela, the U.S.A. and
Mexico. In 1935 he showed at the Katherine Kuh
Gal. in Chicago and in 1945 at the Curt Valentin
Gal. in New York, in 1954 and again in 1964 he
exhibited at the Gal. de Arte Mexicano in Mexico,
D.F. He won an acquisition prize at the São Paulo
Bienale in 1957. In the 1960s he showed widely in
Mexico, and in Texas and Arizona in the U.S.A.
He participated in the 1964–5 New York World's
Fair exhibition and in 'Art of Latin America Since
Independence' at Yale and the University of Texas
at Austin in 1966 and the same year had an exhibi-
tion at the Martha Jackson Gal. in New York. His
work is in numerous private and public collections
in Mexico and North and South America.

MERIOOLA GROUP. An association of medi-
evalizing artists established in Sydney in 1945. See
AUSTRALIA.

MERKEL, GEORG (1881–1976). Austrian painter,
born in Lemberg. He studied in Kraków in 1903
and from 1903 to 1914 was in Paris, where he
modelled himself on Poussin, Claude Lorrain and
Puvis de Chavannes. In 1938 he emigrated to
France. He painted idyllic Arcadian scenes of a
Golden Age.

MERTZ, ALBERT (1920–). Danish painter
born in Copenhagen. He combined many tech-
niques—photocollages, films, MOBILES, photo-
grams with painting and linocuts—and created an
imbroglio of many styles, uniting DADA, POP,
SURREALISM with abstraction. His works created a
curious impression combining realism with fan-
tasy, the idyllic with the horrific and caricature
with EXPRESSIONISM. He emigrated to France in
1963. He was particularly known for his genre
scenes from working-class life presented with a
Surrealist nightmare quality of unreal naïvety.

MERZ, MERZBAU. See SCHWITTERS, Kurt.

MESENS, E. L. T. (1903–71). Belgian musician,
poet and painter born in Brussels. Until *c.* 1923 he
worked as a poet and composer. In 1924 he de-
veloped an interest in plastic art under the influ-
ence of DUCHAMP and PICABIA, whom he met in
Paris in 1921, and was influenced towards SUR-
REALISM by the paintings of CHIRICO. In 1925 he
collaborated with MAGRITTE in founding the re-

views *Oesophage* and afterwards *Marie* and he helped to form the Belgian group of Surrealists. In 1928 he began to contribute to the Belgian Surrealist magazine *Variétés*. He helped to organize a number of international exhibitions which brought the various Surrealist groups in touch with one another and in 1938 he settled in London, where he became a director of the London Gal. Mesens was chiefly known for his highly original COLLAGES, which he created from an eccentric assortment of materials—tickets, ribbons, pieces of paper and print, etc. He made extensive use of printed words to create disconcerting or amusing ambiguities and suggested meanings, some of which might almost be regarded as anticipations of the CONCEPTUAL ART of the 1960s. One such is *Variations for the Milkman* (Mus. Royaux des Beaux-Arts, 1970), a collage of 12 notes to the milkman written in coloured crayons. Like Paul JOOSTENS, his influence derived as much from his personality as from his *œuvre*.

MESSAGIER, JEAN (1920–). French painter born in Paris and studied at the École des Arts Décoratifs there from 1942. In the early 1950s he abandoned a style of firmly constructed forms for a freer mode of expressive abstraction linked to his love for the countryside around Montbéliard. About 1960 he found his personal manner of LYRICAL ABSTRACTION which, in keeping with a near-mystical outlook which he shared with TAL COAT and DEGOTTEX, was intended to induce an attitude of contemplation in the observer.

MEŠTROVIĆ, IVAN (1883–1962). Sculptor, born at Vrpolje, Yugoslavia, of peasant stock. After being apprenticed to a stonemason in Split, he studied sculpture at the Academy in Vienna, 1900–4. He exhibited with the Vienna SECESSION from 1902, showing some 50 pieces in the 1909 exhibition. In 1907–8 he was in Paris, where he made contact with Rodin and BOURDELLE. Returning to Yugoslavia, he began to make his name as a monumental sculptor, working in a variety of classicist styles furbished with a superficial air of modernity. He passed the First World War in Rome, Geneva, Paris and London, where a large exhibition of his works was held at the Victoria and Albert Mus. In 1919 he returned to Yugoslavia, where he received many public commissions and built up his fame internationally as a monumental sculptor. In 1933 a large show toured Prague, Munich, Vienna, Berlin and Graz. In 1934 he executed an enormous mausoleum outside Belgrade in commemoration of the Unknown Soldier. During the Second World War he obtained several commissions from the Vatican and after living in Switzerland from 1943 to 1946 he went to the U.S.A. There he obtained the post of Professor of Sculpture at Syracuse University and from 1955 was Professor of Sculpture at the University of Notre Dame, Indiana. He executed a number of monuments in the U.S.A.

Meštrović worked both in bronze and in marble, preferably though not always on a colossal scale. He was an ardent patriot and was always concerned to emphasize the symbolic significance of his subject. Although he contributed nothing to the progress of *avant-garde* movements in sculpture, his work was not without importance in the context of public and monumental sculpture. He is praised for his depiction of 'energy' by Herbert Maryon in *Modern Sculpture* (1933) and Maryon said of his equestrian monument to the national hero Marko Kraljević: 'Here is an attempt to suggest the utmost strength that could be enshrined within the human or equine body: the figures are literally bursting with energy. They have a barbaric power which is unequalled in intensity by any others known to me. Horse and man belong to another world, to that dim, legendary past in which roamed heroic figures, semi-human or divine.' In *Painting and Sculpture in Europe, 1880 to 1940* G. H. Hamilton wrote: 'But so much storm and fury yielded little in the way of original sculptural form, once the novelty of his technique had worn off. Like Milles, and the host of sculptors who followed where they led, he failed to realise that artistic symbols are only meaningful when they acquire expressive artistic form.'

METAPHYSICAL PAINTING. *Scuola Metafisica* (Metaphysical School) was the name given by CHIRICO and CARRÀ to the painting which resulted from their meeting early in 1917 at the military hospital of Ferrara, where both were recovering from mental disorders. It was not a school in the strict sense of the word but has been described rather as a 'new way of seeing'. The Metaphysical School started with no inaugural programme, as had been the case with FUTURISM, although attempts were later made to define a 'metaphysical aesthetic' in the periodical VALORI PLASTICI. Although its European reputation has been high and its influence—particularly on SURREALIST art—was important, the association was both restricted and short-lived. In the summer of 1917 Carrà left Ferrara for Milan on convalescent leave and organized an exhibition of his pictures there. In 1919 he published his book *Pittura Metafisica*. This was adversely reviewed by Chirico and the friendship between the two artists deteriorated. By the end of 1919 Chirico had modified his 'Metaphysical' style and Carrà did not continue in it after 1921. Filippo de PISIS was also at the military hospital of Ferrara in 1917, but at this time he was only 21 and had done little painting. His 'Metaphysical' paintings appear to have been antedated in the main from the 1920s. The movement was joined by Giorgio MORANDI in 1918 but was deserted by him at the end of 1920. The periodical *Valori Plastici* ran from 1918 to 1921. Certain other Italian painters, such as for example Massimo CAMPIGLI and Mario SIRONI, were from time to time influenced by the 'Metaphysical' manner, but they were in no sense adherents to the group.

The meaning attached to the term 'metaphysical', which occurs in the titles of several pictures painted at this period, was never precisely formulated. Chirico's brother, the poet and musician Alberto Savinio (1891–1952), said that it involved 'the total representation of spiritual necessities within plastic limits—power to express the spectral side of things—irony'. But this and other such generalized statements are insufficient to differentiate the special characteristics of 'Metaphysical' painting from those of other schools. Although 'Metaphysical' painting in most of its various forms is not difficult to recognize in practice, its differentiating qualities defy verbal definition. Perhaps the most striking feature is the powerful suggestions which these pictures make of a mysterious reality beyond the reality of their painted subjects. It was this search for the mystery of a reality beyond the visible which chiefly differentiated the 'Metaphysical' school from Impressionism and the traditions which derived from it. The air of mystery was partly conveyed by unreal perspectives and lighting, partly by the adoption of a strange iconography such as the use of the tailor's dummy, still more perhaps by an incongruous and dreamlike juxtaposition of veristically depicted objects in a manner later taken over by some of the Surrealists. But the oneiric quality of the 'Metaphysical' paintings differed from that of the Surrealists because of their concern with pictorial structure and a strongly architectural sense of repose deriving from Italian 15th-c. tradition. This static repose and the suggestion of a mysterious 'other' reality also differentiated 'Metaphysical' art from Futurism, from which Carrà was a convert; it had none of the Futurist interest in depicting the movement and bustle of this world. Something of this quality, and the fundamental difference in aim between 'Metaphysical' painting and both Impressionism and Futurism, was suggested in a statement made by Chirico in an essay on Courbet published in 1925. After referring to the 'disturbing' connection which exists between perspective and 'metaphysics', he said: 'The work of art should tell something beyond the limits of its volume. The object and the figures represented must also tell poetically what their volumes hide materially.' Elsewhere he suggested what became the main implications of this painting for Surrealism when he wrote: 'One must not forget that a picture should always be the reflection of a profound sensation, and that profound signifies strange, and strange signifies little known or entirely unknown. . . . To be truly immortal a work of art must stand completely outside human limitations; logic and common sense are detrimental to it. Thus it approximates dream and infantile mentality. . . . One of the strongest sensations left to us by prehistory is that of presage. It will always be with us. It is as it were an eternal proof of the nonsense of the universe.' No doubt this suggestion of presage is the most prominent differentiating characteristic of Chirico's 'Metaphysical' paintings. Its presence is somewhat less strongly felt in the 'Metaphysical' paintings of Carrà, but is not absent from them.

The peculiar idiom of the Metaphysical School was the creation of Chirico. While he was working in Paris (1911–15) he was already painting those strangely evocative city squares which evoked the admiration of Guillaume APOLLINAIRE, and in the latter part of the period he was locating in the foreground of his pictures some incongruous object—monstrous artichokes, a classical statue which wavers between being marble or flesh-like, 'things fallen from another planet', in the words of Italo Faldi. In the same period also he began the use of the tailor's dummy, as in such well-known paintings as *The Philosopher and the Poet* (1914), *The Seer* (1915), *Hector* (1916). This image was derived from his brother Savinio's play *La Chanson de la Mi-Mort*, which was published by Apollinaire in the *Soirées de Paris* in 1913. But the evocative use made of it by Chirico remains entirely his own and with it he created a purely visual metaphor with hallucinatory intimations of ontological mystery, or sometimes (as in the *Hector* of 1914 or *Il Trovatore* and *Hector and Andromaque* of 1917) combined it with suggestions of medieval armour and draughtsman's instruments. The persistence of this image may be seen in the blank oval faces of the figures in a painting as late as *The Archaeologists* of 1927. It was in these years that Chirico also began the use of the draughtsman's instruments as paraphernalia in the construction of his pictures. The pictures he painted during these years in Paris were 'Metaphysical' in all but the name and by 1916 the iconography which characterized the Metaphysical School had been fully worked out. In his painting in the hospital at Ferrara it remained only to combine the various types of imagery more freely for the production of such 'Metaphysical' masterpieces as *Grand Metaphysician*, the famous *Muse Inquietanti* (*Disquieting Muses*) of 1917, and the 'Metaphysical Interiors', in which incongruous objects are set with *trompe l'œil* verism amidst a scaffolding of carpenter's T-squares.

Carrà approached 'Metaphysical' painting by a different path. By 1915 he had become an enthusiastic student of the school of Giotto and Uccello, later of Masaccio and Piero della Francesca, attempting to bring to his own painting the monumental quality of their work. He came to believe that by structural or purely painterly means ordinary everyday objects could be given the force of artistic revelation so that one might say 'in this way we rise from the depths to the surface like a flying fish'. His *Composizione con TA* (*Composition with TA*) and his *Gentiluomo Ubriaco* (*Drunken Gentleman*), both painted in 1916, already carry something of the sense of mystery and revelation which was to become characteristic of 'Metaphysical' painting. After the meeting with Chirico in 1917 Carrà adopted the latter's imagery of the tailor's dummy or lay figure and

the carpenter's set square, compasses, etc. But although he took over Chirico's iconographical vocabulary, his painting was less dependent on that of Chirico than has sometimes been supposed. His tender and idyllic colour contrasts with the more sombre tones of Chirico, his incandescent or translucent treatment of light contrasts with Chirico's suggestion of theatrical spotlighting and his texture, built up slowly and with constant revisions, contrasts by its tactile appeal with that of Chirico. All his works in this manner are remarkable for their simplicity and purity of style. Carrà painted some 15 'Metaphysical' pictures in all, the last being *The Engineer's Mistress* of 1921 (The Gianni Mattioli Foundation, Milan, Feroldi coll.). Although these works have been somewhat overshadowed by those of Chirico, they are among the best that Carrà painted and of *L'Idolo Ermafrodito* (*The Hermaphroditic Idol*) and *Penelope* Guido Ballo says, not unjustly, that they 'could be ranked among the best paintings of our time'.

The few paintings done by Morandi in the 'metaphysical' manner were more peripheral to the style than those of Chirico or Carrà. His still lifes were not fraught with the mysterious menace of Chirico's paintings and he made less use of Chirico's vocabulary of imagery than did Carrà.

METELLI, ORNEORE (1872–1938). The most highly considered NAÏVE painter of Italy, he was born in Terni and was a master-shoemaker there. He played the trumpet in the town orchestra and his portrait of himself in musician's regalia is among his best-known paintings. He began painting at the age of 50 and worked enthusiastically far into the night and early in the mornings. His main subjects besides portraits were city scenes and architectural compositions from Terni. His reputation as a naïve painter grew to be very high among critics and his pictures were widely exhibited. They were painted with strong colours, assured line and a forthright though quite unsophisticated strength.

METZEI, LESLIE. See COMPUTER ART.

METZGER, GUSTAV (1926–). Born in Nuremberg of Polish Jewish parents, he emigrated to England in 1939 and became stateless. After studying cabinet making and working at joinery and farming, 1941–4, he studied art in Cambridge, then in London under BOMBERG and at Antwerp. From 1960 he promulgated and demonstrated AUTO-DESTRUCTIVE ART and arranged 'events'. In 1966 he organized a 'Destruction in Art' symposium and from 1969 to 1972 he was editor of PAGE, the Bulletin of the Computer Art Society. He was one of the 'Seven German Artists' represented at the 'Art into Society/Society into Art' exhibition staged by the Institute of Contemporary Arts, London, in 1974. In the catalogue to this exhibition he advocated a three-year strike by

artists, claiming that if they ceased all production and all artistic activities from 1977 to 1980, this would cripple the social mechanisms for the production, distribution and consumption of art.

METZINGER, JEAN (1883–1957). French painter born at Nantes. He went to Paris in 1903 and his painting was influenced by Neo-Impressionism and then by FAUVISM. He became a member of the CUBIST school, exhibiting with them in 1910 and 1911, and was a founding member of the SECTION D'OR. In 1913 he was represented in the STURM exhibition at Berlin. After the war his style became more realistic with affinities to the NEUE SACHLICHKEIT. He was active in the dissemination of Cubist ideas and is now chiefly remembered for the book *Du Cubisme* (1912) which he wrote in collaboration with GLEIZES.

MEUNIER, CONSTANTIN (1831–1904). Belgian sculptor and painter who worked in the spirit of SOCIAL REALISM, glorifying the nobility of labour. He found his subjects mainly among miners, factory workers and stevedores: e.g. *Dock Labourer* (bronze, Antwerp). The Belgian Government commissioned him in 1896 to do a *Monument to Labour*, which he was unable to complete before his death. The pieces he executed for it are on view in Brussels. He worked in a romantic academic style but nevertheless had considerable influence on younger sculptors in the early decades of the 20th c., particularly those interested in Social Realism and including MINNE in his post-Symbolist period.

MEXICO. Mexican art has been unusually closely tied in with the social and political situation and its sociological condition has not been paralleled in any contemporary culture. It has been ideological, educational and deliberately subserving the propagation of the ideals and aspirations of the revolutionary state. After the Revolution of 1910 official patronage, both federal and national, went further than in any other country and brought about an almost total commitment of artists to their social responsibilities within the new cultural orbit. Even the most prominent and individual artists, OROZCO, SIQUEIROS, RIVERA, whose names have transcended the national boundaries, devoted their talents to furthering the revolutionary ideals and furnishing for the new cultural ideas firm roots in native tradition. The position of art in the state as the chief cultural manifestation of the Revolution determined both its iconology and its genre. Over most of the period until the Second World War mural painting and graphic art preponderated. Mexican art was figurative with a strong element of caricature and social symbolism, some admixture of lyrical primitivism and inevitably a prominent didactic motive. After the Second World War easel and ABSTRACT painting began to come to the fore in the work of TAMAYO and a group of younger artists, some of whom were known in

international exhibitions by the 1960s.

The revolution in its first decade had no clearly expressed positive programme. It was, however, in violent opposition to foreign domination, the power of the Church, special privilege, large estates with the exploitation of the peasant population, the concentration of wealth and the tyranny of office. These attitudes formed the dynamic inspiration of Mexican artists, many of whom had been actively involved in the revolutionary wars, and to them they added the ideals of bringing enlightenment to the masses and constructing a popular art based on national Mexican traditions. During the first revolutionary decade the most significant work was that of Francisco Goitia (1884–), who painted scenes of Indian peasant life with emphasis on its tragic aspect (*Viejo del Muladar*, Mus. Nacional de Artes Plásticas, Mexico, 1916; *Tata Jesucristo*, Philadelphia Mus. of Art). Important too was José Guadalupe Posada, whose violently propagandist broadsheets (*calaveras*) were a genuine manifestation of popular art. In these artists appeared two features which were profoundly characteristic of Mexican art: a preoccupation with death and a gift for caricature. During this period also Orozco was producing a series of caricatures and revolutionary drawings depicting the horrors of civil war in Mexico.

A powerful impetus to the development of a 'Mexican renaissance' in art was given during the administration of Alvaro Obregón (1920–4) by the cultural ideals of the Minister of Education, José Vasconcelos, who took over and actively extended the policy of government patronage of artists and laid the real basis of the characteristically Mexican system of open-air rural art schools as a central feature of his programme of popular education. Dr. Atl (Gerardo Murillo, 1875–1964), one of the most active and stimulating personalities of the Revolution, a combination of scholarly intellect and violent artistic temperament, became the pivot around which congregated a group of artists activated by creative fervour and social idealism rather than any precisely formulated aesthetic programme. Orozco, who had been in the U.S.A. from 1917 to 1919, returned to join the movement; it was strengthened by the arrival of Diego Rivera and Siqueiros from Europe in 1921 and 1922 respectively, and the stage was set for much of the future development of Mexican art. In 1921 Siqueiros published a famous manifesto in which he advocated the abandonment of easel painting in favour of mural and propounded the principle that the theme and doctrine of a picture are as important as style and execution. He put forward the ideal of 'a monumental and heroic art, a human and public art, with the direct and living example of our great masters and the extraordinary cultures of pre-Hispanic America'. Mexican art has above all been a public art.

With the coming of the Calles regime Orozco and others were dismissed from government employment, the Syndicate of Technical Workers, Painters and Sculptors, which had been the hub of the movement, was disbanded and the progress of a national art in Mexico suffered a setback. It was not until the appointment of the liberal Minister of Education, Narciso Bassols, in 1933 that revolutionary art began once again to flourish. From this time it became the fixed policy for all new Federal schools to be decorated with murals. During the intervening period the lack of government patronage and the generally reactionary attitude brought about an escapist turning away from the current social problems and the most important works of Mexican painters were done abroad. In Mexico itself a group of easel painters were more open to the influences of current European movements, combining the classicism of PICASSO and BRAQUE with a characteristic monumentalism and an interest in Mexican popular art rather than in retrospective folklorism. This monumental classicism was particularly evident in the work of Manuel Rodríguez Lozano (1896–) and his influential follower Julio Castellanos (1905–47), whose work achieved a typically Mexican quality without recourse to picturesque folk types (*The Dialogue*, Philadelphia Mus. of Art; *La Manteada* fresco, Melchior Ocampo School, Coyoacán). The Guatemalan Carlos MÉRIDA, known chiefly for his water-colours, changed from a lyrically nativist style to increasingly abstract still life compositions. Rufino TAMAYO held his first one-man exhibition in Mexico City in 1926, showing still lifes and simple everyday themes in techniques derived from the ÉCOLE DE PARIS. His statement of his aesthetic aims is diametrically opposed to that of Siqueiros previously quoted: 'to pretend that the value of painting is derived from other elements, particularly from ideological content which is not otherwise related to plastic content, cannot but be considered a fallacy . . .'

The election of Lázaro Cárdenas in 1934 inaugurated a new era of liberal reform favourable to progressive socialistic art. The L.E.A.R. (League of Revolutionary Writers and Artists) and the Workshop of Popular Graphic Art (*Taller de Gráfica Popular*) were formed to support the reform programme and through the L.E.A.R. was planned a new art movement for the masses whose first expression was an enthusiastic, though not strikingly successful, project of co-operative mural painting in the Abelardo Rodríguez market.

The *Taller* was formed in 1937 under the leadership of Leopoldo Méndez (1903–) and the artist Pablo O'Higgins (1904–), who was born in the U.S.A. It favoured communal activity and group projects of a propagandist nature and set more store on the dramatic impact of a picture's message than on formal aesthetic qualities. Among the members were Antonio Pujol (1914–), a pupil of Tamayo and Mérida, Alfredo Zalce (1908–), known for his cement murals at the Ayotla School, Tlaxcala, and for his fine series of *Estampas de Yucatán* (1945), and the Bolivian Roberto Berdecio (1910–). During the 1930s and on into

the 1940s many collective murals were executed by O'Higgins, Méndez and other members of the group in a style which became increasingly derivative from the decorativeness of Rivera combined in varying proportions with the more vigorous style of Orozco. Except with a few artists such as Zalce it showed a growing tendency to rhetoric and bombast. More individual in style, though tending to the pedantic, was the work of the architect-painter Juan O'Gorman, whose anti-Fascist and anti-Church frescoes at Mexico City airport were destroyed in 1939 during a political swing to the right. His enormous mural (15 m by 12·5 m) in the Gertrudis Bocanegra Library at Pátzcuaro, portraying in narrative 1,000 years of the history of the state of Michoacán, is one of the most elaborate murals ever painted. In 1952 he did decorations for the Library Building at the new University City. As head of the Department of Construction in the Ministry of Public Instruction he was in charge of the building of 30 new schools (1932–5) and he became one of the leaders of modern Mexican architecture.

The rapid industrialization of Mexico from the mid 1940s was reflected in such works as the machine-art mural by Orozco at the National School for Teachers (1947), the Siqueiros mural in the National Polytechnical Institute (1952) and a number of murals by Jorge González Camarena for industrial and commercial buildings. An active era of building gave rise to a new school of Mexican architecture which attracted attention abroad. The emergence of a moneyed middle class led to the appearance of private galleries and created a public for the easel painter. In 1950 the Government organized a Salón de Plástica Mexicana where independent artists could exhibit without charge and sell their works without commission. A department for technical research in plastics set up in the National Polytechnical Institute brought to light new materials for the painter such as vinylites and pyroxilins. Vinylite was used by Camarena for his large mural on the Social Security Administration building depicting the growth of the new Mexico City. Camarena, perhaps the best of the mural painters at the mid century, developed an original style with a rather self-consciously poetic and mannered symbolism reminiscent of the latter-day ART NOUVEAU. Outstanding among the easel painters of the 1950s were Tamayo and Martínez de Hoyos. The latter became known for an original treatment of formalized spatial organization which makes a mystical, symbolic impact somewhat akin to that of CHIRICO. Tamayo had matured the formal quality of his work and enriched it with a disturbing symbolism sometimes akin to that of Francis BACON and achieved a stature which gave him prominence on an international scale (*Singing Bird*, Venice). His experiments in abstract murals (Palacio de Bellas Artes, Mexico City, 1952–3) have been somewhat less regarded outside Mexico.

From 1910 until well into the 1950s Mexican painting was socially committed to a degree unequalled in any other country without, as in the U.S.S.R., being dominated by an ideology imposed from above. The artists were, on the whole, among the most important proponents of the ideologies they fostered.

MEYER-AMDEN, OTTO (1885–1933). Swiss painter, admitted in 1892 to an orphanage in Berne. After being apprenticed to lithographic workshops at Berne and Zürich he studied at the Kunstgewerbeschule, Zürich, where he entered into a lasting friendship with the painter Eugen Zeller (1889–1974). After studying painting at Munich and for a few months in Paris, he worked under Adolf HOELZEL in Stuttgart from 1907 to 1912. There he formed an artists' colony which included BAUMEISTER, ITTEN, SCHLEMMER. From 1928 he taught at the Kunstgewerbeschule, Zürich. His style of painting, formed in reaction from FAUVISM, was something of a pastiche between early CUBISM and SURREALISM. Werner Haftmann has said of him: 'Otto Meyer, a thorough-going mystic, convinced of man's spiritual mission, regarded artistic production as the reflection of an "inner movement" in which the human spirit responds to the world with ideas and signs. He believed the numbers and geometries hidden in nature to be mystical signs by means of which such ideas could be represented. In his Stuttgart years Meyer-Amden painted abstractions from nature as well as meditative exercises in abstract, geometrical forms. His aim was to create a single, spiritual order embracing both organic life and the geometrical ideal. Man, in his system, was the point of intersection between the natural and spiritual orders.' Memorial exhibitions of his work were held in Zürich (1933, 1935), Basle (1952) and Karlsruhe (1953).

MICHAUX, HENRI (1899–). Belgian-French poet and painter, born in Namur. He attended the Jesuit school in Brussels, 1911–19, under the German Occupation, was notably introverted and remained deeply religious throughout his life. After beginning and abandoning the study of medicine he went to sea in the Merchant Marine in 1920 but was put out of work by a general stoppage of shipping. He began to write in 1922, made a name for himself in literary circles and went to Paris in 1924. He did his first paintings and drawings in 1926 and 1927. During the decade 1927 to 1937 he travelled to Turkey, Italy, Portugal and South America, writing much but doing little drawing. It was between 1937 and 1940 that he took up painting seriously, evolving a personal style of gouaches on a black ground to which he gave the name *Phantomisme*. These lyrical, dreamlike abstracts, done by the method of AUTOMATISM favoured by the SURREALISTS, created 'an ambiguous world of psychic images, myths and phantoms'. Later, in the catalogue to his exhibition at the Gal. Cordier, Paris, in 1959, Michaux disclaimed

TACHISM, saying: 'If I am a tachist, I am one who cannot bear blots. . . . Blots as such revolt me, and are simply blots, which do not mean a thing to me.' Yet indubitably these early gouaches were one of the predecessors of that form of expressive abstraction which under the name of ART IN-FORMEL treated painting as an art of psychic improvisation. He had exhibitions at the Librairie-Gal. de la Pléiade in 1937 and at the Gal. Pierre Loeb in 1938. During the years 1937 to 1939 he was also co-editor of a mystical periodical *Hermès* (*Mystique—Poésie—Philosophie*). After the war he had exhibitions at the Gal. Rive Gauche in 1944 and 1946 and at the Gal. Drouin in 1948 and 1949. In 1948, as a visionary expression of his spiritual shock at the death of his wife in an accident, he did several hundred pen and water-colour drawings in a few weeks and a set of twelve lithographs, which he named *Meidosems*.

About 1950 his style changed radically and the new manner was seen in sets of ink drawings which he named *Mouvements* (1951) and *Mêlées, Foules, Préhistoire* (1952–3) and described as 'seconde écriture', 'a new speech which turns its back on the verbal'. These were described by Kurt Leonhard as follows: 'The black and white drawings in Indian ink (since 1950) are altogether different. In the opposition of black and white a brusque hardness is revealed which can hardly be reconciled with the lyrical passivity of the water-colours . . . the one theme which finds its thousands of variations in these paintings is the movement, accumulated speed, storm and flight, the airborne and earthborne battles of the heavenly and earthly hosts, of somersaulting gremlins and of chasing ghosts. If the key word for the water-colours is "phantom", the word which best sums up the basic mood of the ink drawings is "panic" . . .' In 1955, the year in which he took French citizenship, Michaux began to draw under the influence of mescalin. The drawings done while under the influence of the drug reveal a difference in technique and a change of psychic condition. The technique is pen drawing and the drawings are done in meticulously fine detail in an ALL-OVER style which spreads over the whole picture without distinct centres of interest within the area. In this respect one might draw an analogy with the all-over style of Jackson POLLOCK and, later, Cy TWOMBLY. These have been described, rather imaginatively, by Leonhard as 'pictures without an object, or better, representations of an objectless world'. This courageous attempt to experiment for artistic purposes with the revelatory drug celebrated by Huxley in his *The Doors of Perception* was unique. Michaux described the hypersensitive mescalin state as follows: 'un soulève-ment par-dessus soi, par-dessus tout, un soulève-ment miraculeux qui est en même temps un acquiescement, un acquiescement sans borne, apaisant et excitant, un débordement et un libéra-tion, une contemplation . . . joie abondante dont en ne sait si on la reçoit ou si on la donne . . . hors de soi dans une rénovation qui dilate, qui délate ineffablement, de plus en plus . . .' If these drawings done under its influence are regarded as a concrete documentation of the mescalin state, they are failures. They do not communicate the state and by artistic standards they lack the impact of a revelation. During the 1960s, while not entirely abandoning the mescalin drawings, Michaux did works in mixed media, combining gouache with coloured crayon and Indian ink, which in opposition to the aggressive formlessness of *art informel* were more coherently composed and even embodied figurative suggestions and allusions. The mescalin experiences too were used as a basis for compositions done while not actually under the influence of the drug.

Michaux continued to be exhibited in many countries during the 1960s, including the Palais des Beaux-Arts, Brussels (1957 and 1961); the Cordier-Warren Gal., New York (1961); the Venice Biennale (1960), at which he was awarded the Einaudi Prize; Gal. One (1957) and the Robert Fraser Gal. (1963), London. He had retrospectives at the Gal. Daniel Cordier, Frankfurt (1959); the Stedelijk Mus., Amsterdam, and the Gal. Motte, Geneva (1964); the Mus. National d'Art Moderne, Paris (1965). In 1965 he declined the Grand Prix National des Lettres for his poetic works.

MICUS, EDUARD (1925–). German painter, born at Höxter, Westphalia. He took up painting in 1943 as a result of a friendship with Reinhard Schmidthagen and the circle of the theorist R. Haman in Marburg, although he also worked as a typesetter. From 1948 to 1952 he studied under Willi BAUMEISTER at the Academy of Art in Stuttgart. In 1965 he became a founding member of the group SYN, with whom he exhibited. His pictures, which he called *Coudrages*, fell into the general category of expressive abstraction but were quite distinctive in style. Each picture was made up of two or more different canvas grounds stitched together so as to form a contrast with each other and abstract images were either painted on in acrylic or cut from contrasting materials and fastened on. In the late 1960s he began to introduce representational elements into his works while still maintaining the basic theme of contrasting materials.

MIDDLEDITCH, EDWARD (1923–). British painter born at Chelmsford, studied at the Regent Street Polytechnic and the Royal College of Art. In the 1950s he painted still lifes and landscapes and for a while belonged to the group of SOCIAL REALISTS known as the KITCHEN SINK SCHOOL. During the 1960s his work became increasingly abstract without completely abandoning subject matter.

MIGNECO, GIUSEPPE. See CORRENTE.

MIHELIĆ, FRANCE (1907–). Yugoslav painter and graphic artist, born at Virmase, Slovenia, and studied at the Academy of Art, Zagreb. After the Second World War, during which he was active in the Resistance Movement, he became Professor at the Academy of Art, Ljubljana. His work combined SURREALISM with strong influences from folk art and depicted themes from peasant life in a fantastic and sometimes macabre fashion. In 1958 he executed a number of panel decorations for the Slovene Parliament Building in Ljubljana. He had important exhibitions at Rome in 1958 and Belgrade in 1967.

MIKI, TOMIO (1937–). Japanese painter and sculptor born in Tokyo. He was prominent as a member of the NEO-DADA ORGANIZERS group, making JUNK sculptures from old automobile parts. During the 1960s he became known for his *Ears*. These were realistic replicas of human ears, sometimes blown up to 3 m in height, cast in aluminium or plexiglass. These 'metaphysical objects' were supposed to symbolize a neutral region between hearing and non-hearing. He later made large abstract constructions of painted wood derived from the structure of the ear. At the Osaka 'Expo '70' exhibition he designed a huge 'Ear Plaza'.

MIKL, JOSEF (1929–). Austrian painter born in Vienna, studied at the Vienna Academy of Fine Art, 1949–56, and from 1951 to 1955 was a member of the Vienna Art Club. He was one of the group of young abstract artists who emerged in AUSTRIA during the 1950s and 1960s. As a student he concentrated upon the study of the human body. Then after a period of geometrical abstraction, influenced by De STIJL, in which he was concerned mainly with the problem of colour, he developed a freer, semi-figurative, TACHIST manner, incorporating block-like elements which sometimes assumed the character of an icon. He designed stained glass windows for the Church of Peace at Hiroshima. In 1964 he was given a one-man exhibition at the Mus. des 20. Jahrhunderts, Vienna.

MIKULSKI, KAZIMIERZ (1918–). Polish painter and poet born at Kraków and studied at the Kraków Academy. He worked for a while as a scene painter in Kraków and was instrumental in founding the theatre *Cricot 2*, which revived the experimental theatre run by Tadeusz KANTOR during the Occupation. After passing through a SURREALIST period, Mikulski began from *c.* 1965 to combine POP ART images with a background structure of geometrical forms, seeking to present stereotypes of modern man within a cool modernistic framework.

MILLARES, MANUEL (1926–72). Spanish painter born at Las Palmas. He was self-taught as an artist, graduating from figurative painting to SURREALISM. His *Canary Island Pictographs* reveal the importance of MIRÓ as a formative influence during the early stages of his artistic career. In 1950 he founded the association *Planas de Poesía* and became editor of the series of art monographs 'Arqueros'. During the 1950s his style changed in the direction of ART INFORMEL and in 1956 he was one of the organizers of the Valencia Salón de Arte Abstracto, in 1957 a founding member of the association of abstract artists EL PASO. His manner had some affinities with ARTE POVERA, combining COLLAGE with inspired scribbles. In 1969 he began a series entitled *Antropofaunas* in which he used red painted rags and rough textiles with drawn threads, dramatic smudges of paint and loosely organized scribbled forms. His work was exhibited widely outside Spain and was included in many international group shows. Besides Spanish collections it is represented in The Mus. of Modern Art, New York, the Tate Gal. and the British Mus., London, the Minneapolis Mus., the Gemeentemus. at The Hague, the Gal. Nazionale d'Arte Moderna, Rome and the museums of Warsaw, Stockholm, Nuremberg, Rotterdam, Buenos Aires and São Paulo.

MILLER, GODFREY (1893–1964). New Zealand painter, born in Wellington, New Zealand. He spent his childhood at Hawera, Taranaki, where the great cone of Mount Egmont made a lasting impression upon him. 'So in spirit like Cézanne's Mt. St. Victoire,' he recalled later in life. In 1907 the family moved to Dunedin. In youth he read Ruskin, Shakespeare and Francis Thompson and became interested in photography. After the outbreak of the First World War he joined the New Zealand Light-Horse, which trained in Egypt. He was wounded at Gallipoli and repatriated to convalesce at Rotorua. His war experience deeply affected him and he became convinced that war represented a failure in thinking—particularly Western thinking. In 1917 he completed his studies in architecture at Dunedin, but turned to painting in consequence of the encouragement given him by A. H. O'Keefe, a Dunedin artist. In 1919 he visited the Philippines, China and Japan and this contact with Asia permanently influenced his outlook and his art.

In 1920 he left Dunedin for Melbourne and lived for ten years at Warrandyte. Because of an annuity, bequeathed by his mother, he was able to devote himself entirely to painting. At this time he painted small, well-constructed, tonally-resonant landscapes. In 1929 he went to London and studied sculpture at the Slade School, where Henry TONKS taught him drawing. 'I was the only student who stood at his grave when they buried him,' he recalled some years later. Miller's early work was in the manner of Turner's *Liber Studiorum* landscapes and Cuyp's studies of cattle had also influenced him; but in London the work of Seurat and the POST-IMPRESSIONISTS became important factors in the development of his style. The works of Claude, he said, 'taught me to arrange masses in

space'. Returning to Melbourne in 1931, he continued to paint landscapes, but his work became increasingly conceptual. 'He who can envisage ideas of truth and put them out in any form whatever is an artist,' he declared. In 1933 he revisited London, where his father died the following year. He then visited France, Italy and Spain. In 1935 the Chinese Exhibition at Burlington House greatly impressed him and a year later he began to come to terms with CUBIST and abstract art, and read Valéry and Matila Ghyka on the hidden geometry of art. It was at this time that he began his *Triptych* (Tate Gal.). In 1939 he embarked on a Mediterranean cruise and then settled in Sydney, where he turned his attention increasingly to the study of the nude.

In 1940 he made the first of his visits to Central Australia. By this time he was master of the style by which he has become known. Appearances, never entirely eradicated from the canvas, are held within intricate and interpenetrating grids. Though his paintings bear some affinity with those of Seurat, their emotional effect is different. Miller seeks to impose classical principles of form upon a pictorial universe which is being created and destroyed continuously by energy and light. He was fond of quoting Francis Thompson: 'That thou canst not stir a flower/Without troubling of a star.' In 1945 he was invited to teach drawing at the East Sydney Technical College and there he deeply influenced a generation of students. In 1952 he exhibited with the SYDNEY GROUP (from which the Art Gal. of New South Wales bought *Unity in Blue*) and visited Switzerland. He profited from reading Goethe's *Farbenlehre*, was a lifelong student of Rudolph Steiner, and practised eurhythmics. In 1957 he held his first one-man show, at the Macquarie Gals., Sydney. Two years later the National Gal. of Victoria held a retrospective exhibition of his work. He died at Paddington, Sydney. A memorial exhibition of his work was held at the Darlinghurst Gals., Sydney, in 1965.

MILLER, KENNETH HAYES (1878–1952). American painter born at Oneida, N.Y., studied at the Art Students' League with Kenyon Cox. He taught at the New York School of Art, 1899–1911, and at the Art Students' League, 1911–35, 1937–43 and 1945–52. He was represented at the ARMORY SHOW in 1913, his first one-man show being at the Montross Gal., New York, in 1922. Subsequently his work was widely known in group and individual exhibitions. During the 1930s he was prominent in the school of AMERICAN SCENE PAINTING as a practitioner of social and urban Realism.

MILNE, DAVID BROWN (1882–1953). Canadian painter and print-maker, born near Paisley, Ont. He studied at the Arcade School, New York, and then part-time at the Art Students' League. In 1913 he exhibited in the ARMORY SHOW. In 1915 Milne and his wife left New York, to settle at Boston Corners in the lower Berkshires. His painting developed in a slow but steady and internally logical way.

Milne's New York paintings—e.g. *Billboard* (National Gal. of Canada, Ottawa, 1912)—are almost FAUVE in colour, but also exhibit a concern for regular patterning in the brush-work which resembles the work of Maurice Prendergast. This patterning became more organic at Boston Corners, more suited to landscape forms. *The Boulder* (Winnipeg Art. Gal., 1916) shows as well the harmonious, closely valued hues typical of this period.

In 1918 Milne enlisted in the Canadian army, and worked as an official War Artist in Britain, France and Belgium, producing 109 works, all but two of which are now in the National Gal. of Canada. Mainly dry-brush water-colours, they are almost Oriental in their delicate treatment of space. In 1919 Milne returned to Boston Corners. In 1923 he left New York State for Ottawa, where he hoped to establish himself. He had some success— some of his works were bought by the National Gal. of Canada, he contributed to the Canadian section of the British Empire Exhibition at Wembley, and a small one-man show of water-colours was held at the Art Association of Montreal in 1924 (his first one-man show had been at Cornell University, Utica, N.Y., in 1922)—but he failed to support himself by painting and returned to the U.S.A. In the spring of 1929 he was back in Canada, and spent the summer at Temagami, north-west of Ottawa, in the seclusion he seemed to need, with everything organized to the single end of painting. His highly personal style, a combination of delicate line with vigorous composition, is evident in *Water Lilies, Temagami* (Hart House, University of Toronto, 1929). While living near Toronto in the early 1930s, Milne was able to establish an arrangement with Vincent Massey—a diplomat and one of Canada's more prominent patrons—whereby the Masseys purchased a large number of his works and arranged for shows at Toronto's Mellors Gal. Exhibitions were held there from 1934 to 1938. In May 1933 Milne returned to the bush, to Six Mile Lake near Georgian Bay, seeking near-solitude. His works—e.g. *Poplars among Driftwood* (National Gal. of Canada, Ottawa, 1937)—had become greatly simplified, almost abstract studies in form. During the summer of 1937 he returned to water-colours after a period of almost twelve years of exclusive use of oil. From 1926 he also produced colour dry-points with some regularity. After the Massey–Mellors arrangement ended in 1938, Douglas Duncan, who had been impressed by the first Mellors exhibition, became Milne's dealer and organized annual shows until the artist's death. Milne's works of the 1940s—mainly water-colour washes—are quite distinct from his earlier work. Seldom does one see the earlier dry line or aggressive form; rather soft suffusions of colour. It was a period of numerous fantasy pictures as well, many of a whimsically religious nature.

1. David Smith: *Hudson River Landscape*, 1951. Steel. 258 × 84 × 52 cm.

2. David Smith: *Cubi XIX*, 1964.
Stainless steel. 287 × 156 × 105 cm

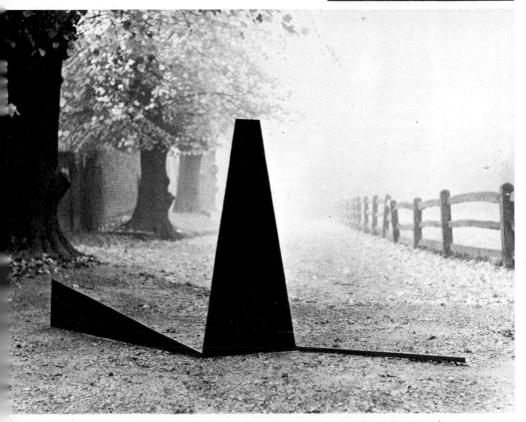

3. Anthony Caro: *Slow Movement*, 1965. Painted steel. 145 × 300 × 61 cm.

4. Barnett Newman: *Adam*, 1951–2. Oil on canvas. 243 × 203 cm.

5. Ad Reinhardt: *Red Painting*, 1952. Oil on canvas. 198 × 366 cm.

6. Mark Rothko: *Light Red over Black*, 1957. Oil on canvas. 233 × 153 cm.

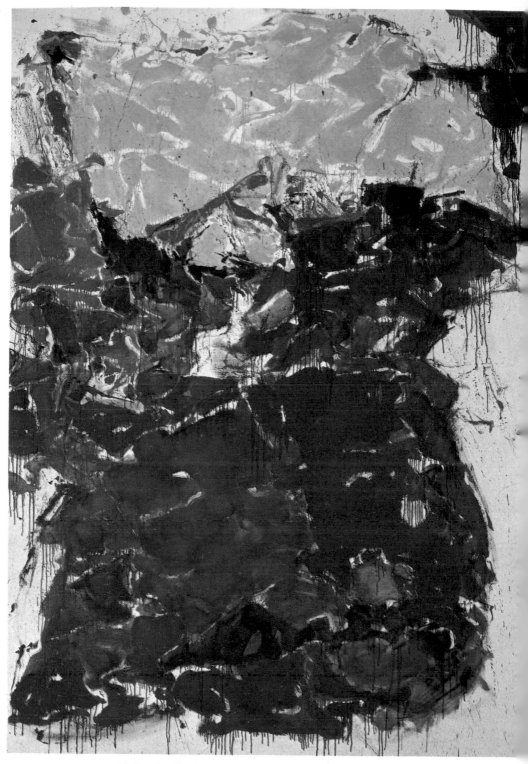

7. Sam Francis: *The Over Yellow*, 1957–8. Oil on canvas. 290 × 200 cm.

8. Morris Louis: *Delta Nu*, 1961.
Acrylic on canvas. 262 × 432 cm.

9. Helen Frankenthaler: *Rapunzel*,
1974. Acrylic on canvas.
274 × 206 cm.

10 (*above left*). Larry Poons: *Untitled, No. 3*, 1970. Acrylic on canvas. 290 × 105 cm.

11 (*above*). Kenneth Noland: *Untitled* (*Chevron*). Acrylic on canvas. 257 × 63 cm.

12 (*left*). Jules Olitski: *Bronze Emperor 7*, 1974. Acrylic on canvas. 229 × 119 cm.

13. Ellsworth Kelly: *Blue, Green, Yellow, Orange, Red*, 1960. Oil on canvas. Five parts, each 132 × 122 cm.

14. Frank Stella: *Jardim Botanico I*, 1975. Lacquer and oil on aluminium. 244 × 330 cm.

15. Robert Morris: *Untitled*, 1961. Reinforced fibreglass and polyester resin. 91 × 122 × 228 cm.

16. Sol LeWitt: *Two Open Modular Cubes/half off*, 1970. Sculpture in enamel and monochrome. 160 × 306 × 233 cm.

17. Donald Judd: *Installation Exhibition* in the National Gallery of Canada, 1975.

18. Dan Flavin: *Monument 7 for V. Tatlin*, 1964–5. Fluorescent tubes. 300 × 100 cm.

19. Chryssa: *Study for the Gates Series. No. 2*, 1966. Neon and coloured plexiglass. 109 × 86 × 69 cm.

20. Naum Gabo: *Kinetic Construction*, 1920. Metal rod vibrating by means of a motor. Height 46 cm.

21. Laszlo Moholy-Nagy: *Space Modulator*, 1942. Oil on incised and moulded plexiglass mounted with chromium clamps 5 cm. from white plywood backing. Plexiglass: 45 × 30 cm.

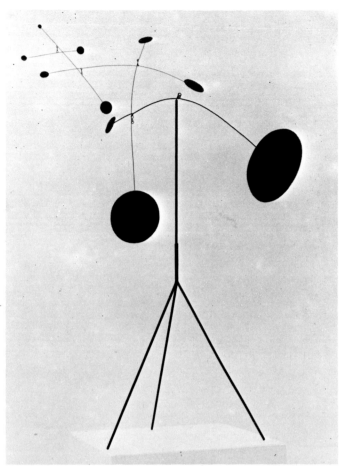

22. Alexander Calder: *Black Mobile*, *c*. 1948. Sheet metal, metal rods and wire. 93 × 75 cm.

23. Julio Le Parc: *Continual Mobile, Continual Light*, 1963. Mobile in mixed media. 160 × 160 × 21 cm.

24. Pol Bury: *The Staircase*, 1965. Wood with motor. 200 × 69 × 41 cm.

25. Jesús Rafael Soto: *Relationships of Contrasting Elements*, 1965. Relief in mixed media. 159 × 107 × 15 cm.

26. Jean Tinguely: *Baluba No. 3*, 1959. Wood, metal, electric light and motor. Height 144 cm.

27. Yaacov Agam: *Double Metamorphosis*, 1968–9. Oil on aluminium. 127 × 188 cm.

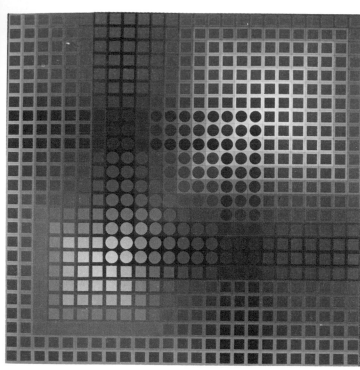

28. Victor Vasarely: *Arny – C*, 1967–9. 140 × 140 cm.

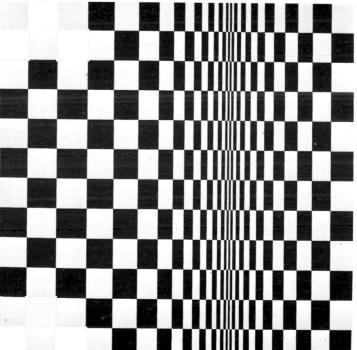

29. Bridget Riley: *Movements in Squares*, 1962. Tempera on board. 123 × 121 cm.

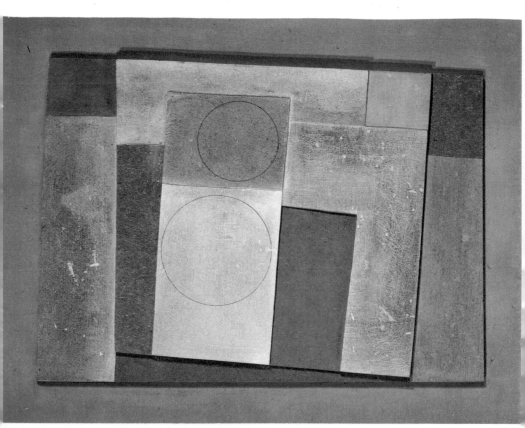

30. Ben Nicholson: *Blue Rock*, 1961. Relief. 35 × 43 cm.

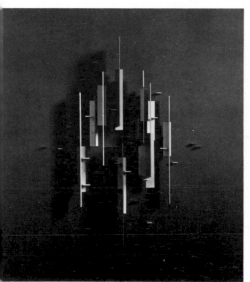

31. Charles Biederman: *Structuralist Relief, Red Wing No. 20*, 1964–5. Relief in oil and metal. 105 × 91 × 15 cm.

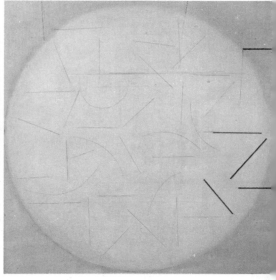

32. Victor Pasmore: *Line and Space No. 21*, 1964. Oil on gravure/board. 123 × 123 cm.

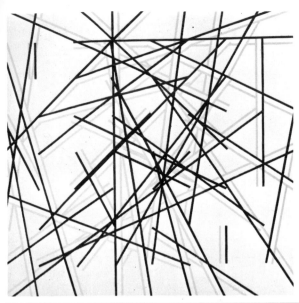

33. Kenneth Martin: *Chance and Order 19* (*Black and Red*), 1975. Oil on canvas. 91 × 91 cm.

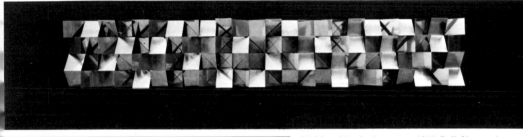

34. Mary Martin: *Inversions*, 1966. Relief in metal, oil and wood. 183 × 731 × 28 cm.

35. Anthony Hill: *Relief Construction*, 1963. Vinyl laminate and aluminium. 110 × 91 × 5 cm.

Milne was one of four painters to represent Canada in the 1952 Venice Biennale, and in 1955–6 the National Gal. of Canada organized a comprehensive retrospective. In 1967 a retrospective was organized by the Agnes Etherington Art Centre in Kingston, Ont., which travelled to seven other cities in Canada. Other exhibitions have been held in Montreal, Gal. Godard Lefort (1971); Toronto, Marlborough Godard, works of the New York period (1972), and works of the year in Toronto (1976). The National Gal. of Canada has also circulated exhibitions of some of the war paintings (1968–9) and a broader selection of water-colours (1973–4).

MILO, JEAN (ÉMILE VAN GINDERTAEL, 1906–). Belgian painter, born in Brussels and studied at the Académie des Beaux-Arts, Brusssels. His early work was EXPRESSIONIST in character and for a time he joined the Etikhove group of Flemish painters. He travelled extensively to London, Paris and the Netherlands and had numerous one-man shows both in Belgium and elsewhere in Europe. He changed from figurative painting to expressive abstraction c. 1950 and was a member of the JEUNE PEINTURE BELGE group. In 1952 he was associated with the ART ABSTRAIT group with interests in geometrical abstraction and exhibited with the SALON DES RÉALITÉS NOUVELLES. He was a brother of the Parisian art critic R. van Gindertael.

MILOW, KEITH (1945–). British painter and draughtsman born in London, studied at the Camberwell School of Art, 1962–7, and at the Royal College of Art, 1967–8. He taught at the Ealing School of Art, 1968–70, and was awarded a Gregory Fellowship at Leeds University in 1970. In 1972–4 he worked in New York with a Harkness Fellowship. Besides one-man exhibitions including the I.C.A. in 1971, King's College, Cambridge, and Leeds City Art Gal. in 1972, his work was included in a number of group shows, including: Richard Feigen Gal., New York, in 1969 and 1970; 'Six at Hayward' at the Hayward Gal., 'Works on Paper' at The Mus. of Modern Art, New York, and 'Multiples' at the Whitechapel Art Gal., London, in 1970; 'The New Art' at the Hayward Gal. in 1972; 'Homers' at The Mus. of Modern Art, New York, in 1973; 'British Painting '74' at the Hayward Gal. and a touring exhibition 'Art as Thought Process' organized by the Arts Council of Great Britain in 1974. Milow was one of the protagonists of CONCEPTUAL ART.

MINASSIAN, LEONE (1905–). Italian painter born in Constantinople and studied at Naples. At the end of the 1940s he painted semi-abstract pictures which had affinities both with SURREALISM and with Italian METAPHYSICAL painting. In the 1950s he abandoned representation for expressive abstraction. He was also prolific as a graphic artist and as a copyist.

MINAUX, ANDRÉ (1923–). French painter, born in Paris. He painted from childhood in a lyrical and romantic figurative style and at the École des Arts Décoratifs, where he studied from 1941 to 1945, he attracted the attention of BRIANCHON. His mature style was an extremely expressive form of SOCIAL REALISM. He exhibited at the Salon des Indépendants from 1944 and at the Salon de Mai and the Salon d'Automne from 1948. In 1949 he participated in the second exhibition of the Social Realist group HOMME-TÉMOIN. He afterwards had one-man shows at the Gal. Saint-Placide.

MINGUZZI, LUCIANO (1911–). Italian sculptor, born in Bologna and studied at the Bologna Academy of Art. He first exhibited in 1943 at the Rome Quadriennale, where he was awarded a prize. He won the Angelicum Prize in 1946 and in 1950 tied for First Sculpture Prize at the Venice Biennale. In the same year he was commissioned to do a portal for the cathedral at Milan, moved to Milan and was appointed Professor of Sculpture at the Accademia di Brera there. In 1951 he obtained a prize at the São Paulo Bienale and in 1952 the first subsidiary prize for a one-man exhibition at the Venice Biennale. In 1953 he was awarded Third Prize in the competition for a Monument to the Unknown Political Prisoner and in 1955 obtained the Rome Prize for Sculpture at the Rome Biennale. He was represented in the 'New Decade' exhibition at The Mus. of Modern Art, New York, in 1955 and at DOCUMENTA II at Kassel in 1959. His works are represented in many public collections, including the Tate Gal., the Brooklyn Mus., New York, São Paulo, The Hague, Stockholm and Helsinki. He is represented in the Open Air Sculpture Mus. at Middelheim Park, Antwerp, by his characteristic *Six Personages* (1957).

During the 1950s and 1960s Minguzzi experimented with and gradually matured the then most recent style of sculpture, in which volume is discarded and space is defined, organized and concentrated by an openwork scaffolding of rods and bands so as to create an impression of rhythmic weightlessness. It is a style which was also pursued, each in an entirely original way, by such sculptors as Robert COUTURIER, David SMITH and MIRKO Basaldella. In the model for *Monument to the Unknown Political Prisoner, Memory of the Man of the Concentration Camp* and some versions of the theme *Shadows in the Forest* a central form lightly indicated in twisted sheet metal was enclosed in an open network of contorted strips and bars which as it were shut in the space around. An even more ethereal structure was achieved in *The Eagles* (1958), *Lights in the Forest* (1959) and *Wind Amongst the Reeds* (1961).

MINIMAL ART. Term used to describe a complex trend in art which arose during the 1950s, chiefly but not exclusively in the U.S.A. and largely in reaction from ACTION PAINTING and some aspects of ABSTRACT EXPRESSIONISM. The term and

idea were anticipated by John GRAHAM when he spoke of 'Minimalism' in *System and Dialectics of Art* (1937) and before that by David BURLIUK in an introduction to a catalogue of Graham's exhibition at the Dudensing Gal. in 1929. Here he said: 'Minimalism derives its name from the minimum of operating means ... Minimalist painting is purely realistic—the subject being the painting itself.' And of Graham himself he said: 'His latest period, Minimalism, is an important discovery that opens to painting unlimited possibilities.'

Like many other terms which came into use in the context of modern art movements, 'Minimal art' was given a very wide range of application. This point was emphasized by the English critic Edward Lucie-Smith in an article 'Minimal Art' contributed to the book *Concepts of Modern Art* (1974), where he wrote: 'Of all the art movements discussed here, this has probably the least coherence, the least independent existence of its own. Yet few topics have greater relevance to the development of modern art as a whole.' In fact it combined two concepts: (1) art works which had an unusually low degree of differentiation (e.g. uniformly painted monochromatic canvases) and therefore a minimal amount of 'art-work' on the part of the artist; and (2) art works which, although they might be highly differentiated, had a minimal amount of 'art-work' contributed by the artist because their components were identical or near-identical with everyday mass-produced objects. In January 1965 Richard Wollheim, Grote Professor of Philosophy of Mind and Logic in the University of London, contributed an article entitled 'Minimal Art' to *Arts Magazine*. The article opened as follows: 'If we survey the art situation of recent times, as it has come to take shape over, let us say, the last fifty years, we find that increasingly acceptance has been afforded to a class of objects that, though disparate in many ways—in looks, in intention, in moral impact—have also an identifiable feature or aspect in common. And this might be expressed by saying that they have a minimal art-content: in that either they are to an extreme degree undifferentiated in themselves and therefore possess a very low content of any kind, or else that the differentiation that they do exhibit, which may in some cases be very considerable, comes not from the artist but from a nonartistic source, like nature or the factory. Examples of the kind of thing I have in mind would be canvases by Reinhardt or (from the other end of the scale) certain combines by Rauschenberg or, better, the non-"assisted" ready-mades of Marcel Duchamp.' Gregory Battcock, who reprinted the article in *Minimal Art. A Critical Anthology* (1968), stated: 'The author may well have been the first critic to apply the label "Minimal" to recent art.'

Gregory Battcock's *Anthology* is evidence of the very great diversity of artistic styles and concepts which were by the end of the 1960s associated with the term 'Minimal art'. On the one hand it included certain aspects of POP ART such as works by Andy WARHOL, Tom WESSELMANN, Claes OLDENBURG etc.; FUNK art tableaux such as those by Edward KIENHOLZ; KINETIC and LUMINIST art such as that of CHRYSSA, Julio LE PARC and members of the ZERO group. All these had their several and separate 'ancestries'. On the other hand it covered works which were highly undifferentiated in themselves, such as the PRIMARY STRUCTURES of Robert MORRIS and Donald JUDD, AND SERIAL art consisting of a set of such 'unitary objects' arranged according to some readily recognizable principle. It is a characteristic of both these groups of Minimal art that many of the art objects of both kinds would not ordinarily before the 1950s have been classified without protest as fine art by most critics or connoisseurs or by the general public. It is a symptom of the radical change in sensibility which made itself felt in the 1950s that from that time such objects were readily accepted as art at least by the sophisticated 'art world'.

The term 'Minimal art' was taken up by the critic Barbara Rose in an article entitled 'A B C Art' contributed to *Art in America*, October/November 1965. With an eye mainly to the kind of Minimal art which eschewed any but the simplest degree of internal differentiation, she spoke of a shift towards a new sensibility occurring in the 1950s and of an art 'whose blank, neutral, mechanical impersonality contrasts so violently with the romantic, biographical Abstract-Expressionist · style which preceded it that spectators are chilled by its apparent lack of feeling or content'. She pointed out that this new kind of art deliberately abrogated the traditional requirements of uniqueness, emotional or expressive content, and complexity.

By his exhibition of a set of all white followed by a set of all black canvases in 1952 Robert RAUSCHENBERG anticipated the monochromatic canvases exhibited by Yves KLEIN in 1956. This exemplified certain of the principles of Minimal art. The term was also applied more widely to any *reduction of artifice*, any repudiation of traditional artistic devices. Thus Morris LOUIS was sometimes said to be a forerunner of Minimalism because he repudiated the 'painterly' use of pigment when he adopted the technique of staining unprimed canvas which had been taken over by Helen FRANKENTHALER from late works of Jackson POLLOCK. Barnett NEWMAN too was called a forerunner of Minimalism because he anticipated the 'holistic' doctrine, which repudiates internal relations among the parts of a composition. Because of their repudiation of 'virtual' qualities the HARD EDGE paintings of Al HELD, Jack YOUNGERMAN and others have also sometimes been brought within the ambit of Minimal art. The term has, however, been applied in a more precise and particular way, recognized by most critics, to the highly undifferentiated works of such sculptors as Tony SMITH, Carl ANDRE, Robert Morris, Donald Judd, etc. The theory behind the exhibition of such works as 'art' seems to have been embodied in the claim that by eschewing all 'virtual' qualities

and maintaining a maximum degree of visual simplicity they made a unified total impression on the observer with the negation of all ambiguity. Although in these typical manifestations Minimal art carried simplification to an extreme, its appeal was to a highly sophisticated public and its appreciation, of necessity primarily intellectual, was learned rather than spontaneous.

MINNE, GEORG (1866–1941). Belgian sculptor, painter and graphic artist, born at Ghent, son of an architect. He first studied architecture at the Ghent Academy, then transferred to painting and sculpture. Working first in a style of academic naturalism, he was influenced in the latter half of the 1880s by the Symbolists, whose poems he illustrated in a manner drawn from late Gothic and Pre-Raphaelite medievalism. Turning his attention increasingly to sculpture, he tried to find a sculptural analogue of Symbolism. In 1898 he settled among the Symbolist colony of artists at LAETHEM-SAINT-MARTIN. At this time his sculpture, which was mainly religious with both Gothic and ART NOUVEAU features, had considerable influence on younger sculptors, including LEHMBRUCK. The works which best embody the mood of this period are his *Petit Porteur de Reliques* (1897; second version in 1929) and his *Kneeling Youth* (1896; second version in The Mus. of Modern Art, New York, 1898). The image of the kneeling youth was used in his *La Fontaine aux Agenouilles*, in which five marble versions of this figure are set around the rim of a simple basin (Folkwang Mus., Essen, 1906; bronze replicas in Ghent and Brussels). It has been suggested that the idea of repeating the same figure so that the spectator sees it from different angles appealed to Minne as an analogy of the Symbolist idea of turning over the same thought from different points of view. From *c.* 1908, by which time the Symbolist outlook was no longer viable, Minne turned to a more naturalistic and socially oriented style in the manner of his countryman Constantin MEUNIER. He spent the war years in England. In the 1920s, by which time his reputation was high, he did little more than return to his earlier motifs, carving in a monumental, block-like manner. In the representations of mother and child from the late 1920s, however, there is a note of sensuality in an *œuvre* which was otherwise deliberately ascetic.

MINTCHINE, ISAAC (1900–41). Born at Kiev, poet and artist, Mintchine passed his working life in Paris but living in seclusion and avoiding contact with other *émigrés* of the ÉCOLE DE PARIS. Like the early KANDINSKY, CHAGALL and RYBACK his painting combined memories of Russian folk art and the icon.

MINUJIN, MARTA. See LATIN AMERICA.

MIR ISKUSSTVA (THE WORLD OF ART). A movement centred in St. Petersburg which during the 1890s represented the artistic *avant-garde* in Russia and during the early years of the 20th c. had considerable influence in bringing Russian art to the knowledge of western Europe. The group included such well-known figures as Alexandre BENOIS, Léon BAKST and Sergei DIAGHILEV, and among its associates were Valentin Serov (1865–1911) and Mikhail VRUBEL. The aim of the group was to bring about a revival of Russian culture both by stimulating interest in the national heritage and by renewing contact with German, English and French ideas; in this way they hoped to create in Russia an international centre which would contribute to the main stream of European art and culture. The society published a journal with the same name, *Mir Iskusstva*, from 1898 to 1905, with the avowed intention of combating the provincialism of Russian art and awakening interest in current trends outside. The early numbers were mainly interested in the ART NOUVEAU artists and the ideas of the Symbolists. The last numbers, in 1904 (the last two appeared in early 1905), were concerned more with the French Neo-Impressionists and Cézanne. With the same object the society organized exhibitions (1899–1906) which were at first intended to be international in scope but from 1900 represented only the St. Petersburg and Moscow schools. A second cycle of *Mir Iskusstva* exhibitions started in 1910, although with the absence of Diaghilev they did not have the sense of direction which characterized the first series. Many of the *avant-garde*, including ALTMAN, LISSITZKY and TATLIN, were represented at the later exhibitions, which took place regularly until 1924. The importance of *Mir Iskusstva* as a promoter of modern artistic trends dwindled after 1904, although it continued its traditions of graphic finesse and decoration in book illustration and portraits and its influence as a society was powerfully felt in the introduction of Russian art to western Europe.

MIRKO (MIRKO BASALDELLA, 1910–69). Italian sculptor, born at Udine, near Venice, brother of the painter AFRO. He was trained at Venice, Florence and Monza, and in 1932 was a pupil of Arturo MARTINI. He worked in Rome from 1934 and exhibited there in 1935, at Turin in 1936 and in 1940 at the Gal. Nazionale d'Arte Moderna and the Gal. Roma in Rome. He also took up painting and first exhibited his paintings in Rome in 1947. His paintings and sculptures were exhibited at the Knoedler Gal., New York, in 1947 and 1948 and he had a one-man show in the Viviano Gal., New York, in 1950. In 1950 he did bronze gates and balustrades for the Mausoleo delle Fosse Ardeatine, Rome, a memorial to the 320 Italians executed by the Germans in reprisal for the death of 32 Germans in 1944. In 1951 he decorated the ceiling and did murals and mosaics for the Food and Agriculture Organization Building, Rome. He exhibited at the Venice Biennale in 1952, 1954 and 1960 and in 1953 he won a second prize in the

international competition for the Monument to the Unknown Political Prisoner. In 1955 he was represented in 'The New Decade' exhibition at The Mus. of Modern Art, New York. He taught at the Graduate School of Design at Harvard University. In *A Concise History of Modern Sculpture* (1964) Herbert Read brings Mirko within his general formulation: 'To create an *icon*, a plastic symbol of the artist's inner sense of numinosity or mystery, or perhaps merely of the unknown dimensions of feeling and sensation, is the purpose of the great majority of modern sculptors...' Mirko himself has said: 'The realization of recent scientific achievements gives a special character to the poetry of our time; it sheds light upon unknown worlds and paves the way for new investigations. Contemporary artistic movements appear "modern" thanks to their specialized techniques, but their poetic expressiveness is something quite separate, for it depends on deep and remote motivations, in fact on primordial and subconscious impulses.' Mirko worked in many different materials, ever searching for fresh and more expressive techniques. Like other sculptors of his generation he experimented with 'open' sculpture which sacrifices volume for enclosed space. His *Bull* (1948) has a dynamic energy akin to that of the *Horse* of DUCHAMP-VILLON, yet consists entirely of enclosed spaces defined and energized by a complicated scaffolding of contorted bronze struts.

MIRÓ, JOAN (1893–1983). Spanish painter, born at Barcelona. From 1912 he studied at the Barcelona École des Beaux-Arts and the Académie Gali, where he learnt to draw objects which he knew only by touch. At his first exhibition, in the Dalmau Gal. in 1918, he showed pictures which combined suggestions of Catalan folklore with a FAUVIST technique. In 1919 he visited Paris, became a friend of PICASSO and was for a while influenced by CUBISM, combining it with a sophisticated Primitivism. On a second visit to Paris in 1920 he made contact with *avant-garde* writers and with the Paris DADAISTS, but in the split which occurred he went along with the SURREALISTS, signed their manifesto in 1924 and joined the movement in 1925. His picture *Terre labourée*, completed in 1924, inaugurated his genuinely personal style. In it angular and spiky forms, still figurative, emerge from a smooth background and create the hallucinatory impression of a strange but undisturbing dream. Throughout his life, whether his work was purely abstract or whether it retained figurative suggestions, Miró remained true to the basic Surrealistic principle of releasing the creative forces of the unconscious mind from control by logic and reason, rejecting traditional devices of pictorial representation and composition, and fusing the spontaneous expressions of a-logical fantasy with the reality of experience into a higher reality of pictorial creation. In his mature work he used none of the superficial devices beloved by the Surrealists and he stood apart from the several

stylistic categories of Surrealism; yet he was the greatest of all Surrealist abstract artists and can be compared in stature only to KANDINSKY among the forerunners of expressive abstraction.

A visit to the Netherlands in 1928 inspired his well-known series of *Intérieurs hollandais*, followed in 1929 by *Portraits imaginaires* with the visionary quality of dream. He then turned to lithography and *papiers collés*, which he exhibited at the Gal. Goemans in 1930, heralding a more abstract, less figurative style. In 1932 he did sets and costumes for *Jeux d'enfant* at the Monte Carlo Ballet. In 1934 a number of *Cahiers d'art* was devoted to his work and in 1937 he was commissioned to do a large mural for the Spanish Pavilion at the Paris Exposition Universelle.

In 1940 he returned to Spain to avoid the German invasion and remained in Spain until 1948. His late period was inaugurated by the series of *Constellations*, luminous gouaches with small forms scattered in a magical space creating a dreamlike image of the earth and the cosmos. From 1944 he turned to ceramics in collaboration with the potter Llorens Artigas and also took up terracotta, which absorbed the major part of his energies in the 1950s. He visited the U.S.A. in 1947 and did a mural at Cincinnati, followed by a large mural for Harvard University in 1950. From then until 1958 he worked on two immense ceramic wall decorations, *Mur du Soleil* and *Mur de la Lune*, for the UNESCO building, Paris. During this time he was also very actively engaged on etchings and lithographs and in 1954 received the Grand Prix for graphic art at the Venice Biennale.

Although it had its source in the attitudes encouraged by the Surrealist movement, Miró's work was of a stature which precluded its being brought within the classification of Surrealism. It contains elements of Primitivism, a personal mythology and magic and innovations in the field of abstraction which take it outside all classification. His fame was world-wide. Among his retrospective exhibitions were: The Mus. of Modern Art, New York, 1941 and 1959; Barcelona and Berne, 1949; Mus. National d'Art Moderne, Paris, 1962; the Arts Council of Great Britain, 1964. The Foundation Joan Miró was opened in 1975 on the heights of Montjuic overlooking Barcelona. Built by José Luis Sert, it is designed both as a memorial museum housing the collection of Miró's works and as a centre of artistic activity. In 1978 a comprehensive retrospective exhibition was staged at the Mus. de Arte Contemporaneo, Madrid.

MITCHELL, JOAN (1926–). American painter born at Chicago. She studied at Smith College, Columbia University, the Art Institute of Chicago School, 1944–7, and New York University. During the 1950s and 1960s she exhibited at the Stable Gal. and elsewhere in the U.S.A. and also in Paris, where she resided. Her work was internationally known and was represented in a number of collec-

tive exhibitions, including The Mus. of Modern Art, New York, 'Two Decades of American Painting', 1967, circulated to Japan, India, Australia. During the latter half of the 1950s she formed one of the group of younger artists who developed the brand of late ABSTRACT EXPRESSIONISM which followed the path traced out by DE KOONING.

MOBILE. Name first used by Marcel DUCHAMP to designate a group of hand- and motor-driven kinetic sculptures exhibited by Alexander CALDER at the Gal. Vignon in 1932. During the 1930s Calder created motor-driven sculptures both as reliefs with parts moving within a frame and as freestanding works with moving elements. His most characteristic works of the 1930s and 1940s, however, were free-standing constructions consisting of metal parts suspended on wires and moved by a combination of air currents and their own structural tension. It is with constructions of this type that the word 'mobile' is most generally, though not exclusively, associated.

Although the name of Calder is most closely associated with the Mobile, many other sculptors have experimented with the genre and since the mid century it has even become a popular article of interior decoration sold in novelty shops, etc. The Mobile remains, however, a genuine sculptural form, in which Calder has probably not been surpassed. See also KINETIC ART.

MODERSOHN, OTTO. See WORPSWEDE.

MODERSOHN-BECKER, PAULA (1876–1907). Born in Dresden, Paula Becker moved to Bremen in 1888. She studied drawing in London in 1892 and travelled in Norway and Switzerland. In 1896–7 she studied in Berlin and in 1898 joined the artist community which had been founded at WORPSWEDE by the landscape painter Fritz Mackensen (1866–1953). In 1901 she married Otto Modersohn (1865–1943), another member of the group. She shared in a high degree the poetic sensibility for nature which was cultivated by the Worpswede school and she was a friend of the poet Rilke. But she was dissatisfied with the sentimentalized idealization of the Worpswede manner, which she found too 'genre-like', and made it her object to express by means of the utmost simplicity and economy of form 'the unconscious feeling that often murmurs so softly and sweetly within me'. In 1902 she wrote in her journal that 'one should not think so much about Nature in relation to painting, at least not during the conception of the picture. The colour sketches should be made just as one has perceived something in Nature. But the principal thing is my personal feeling.' In 1901 and subsequently until her early death in 1907 she visited Paris, and in the last years of her life, under the influence of Gauguin, Cézanne and the Pont Aven painters, she found the 'great simplicity of form' for which she had been searching and came to regard painting as a

kind of 'Runic script' for the expression of innermost emotion. She is significant for contemporary art as one of the first to have grasped the spirit of EXPRESSIONISM in its German form, and as one of the typical exponents of German Expressionism. Among her best-known works are her portrait *Rainer Maria Rilke*, self-portraits with wide, staring eyes and *Old Woman by the Poorhouse Duckpond* (Roselinhaus, Bremen, *c.* 1906). Her writings were published as *Briefe und Tagebuchblätter* at Munich in 1921. The Kunsthalle, Bremen, is custodian of the Paula Modersohn-Becker Stiftung, comprising 114 drawings together with press material and photographs.

MODIGLIANI, AMEDEO (1884—1920). Italian painter, sculptor and draughtsman born at Leghorn of a once wealthy Jewish banking family living in reduced circumstances. In 1895, while still at school, he suffered a severe attack of pleurisy, a forerunner of the tuberculosis which brought his brief life to a close. After studying painting with Guglielmo Micheli, a late follower of the *plein air* school, and then briefly at Florence and Venice, he made his way to Paris in 1906 and passed the rest of his life there. Here he immersed himself in the café and night life of the artistic quarter, joining in the gatherings of artists at the BATEAU-LAVOIR and other studios but living apparently in conditions of extreme poverty. He made friends chiefly with SOUTINE, KISLING and other expatriate EXPRESSIONISTS of the French school. His painting *The Cellist* (1909) brought him some recognition when exhibited at the Salon des Indépendants in 1910, but he exhibited little in his lifetime. Apart from this exhibition and seven sculptures shown at the Salon d'Automne in 1912, his only exhibition of note was in London, at Heal's, in 1919, organized by Sacheverell and Osbert Sitwell. Lacking other sources of income, he was supported by two patrons who bought most of his output: Dr. Paul Alexandre from 1908 until the outbreak of war in 1914 and the collector Leopold Zborowski (together with Paul Guillaume) from 1916 until his death. He met BRANCUSI *c.* 1909 and although documentation is lacking, it seems to have been due largely to his influence that Modigliani took a more active interest in sculpture from that time.

Owing to the paucity of reliable documentation and the mass of legend that has accumulated representing Modigliani as the typical romantic genius, starving in a garret, the victim of drugs, alcohol and tuberculosis, but painting and carving obsessively, it is still difficult to assess the man or his work objectively. G. H. Hamilton has said: 'Modigliani's brief life was so spectacular a story of the self-destruction of a talent that for many years it prevented a just evaluation of his work.' The difficulty is enhanced by the individualistic, mannered and eclectic character of his work both in painting and in sculpture. Despite his immersion in the artistic life of Paris during the first two decades of the century, his style had no more than a

superficial connection with the artistic movements of his time. H. H. Arnasson goes so far as to say: 'Modigliani was not really an artist of the twentieth century, despite his connections with the School of Paris. He would have been at home in the Florence of Uccello or Botticelli.' Moreover his work is now seen to have been uneven as well as mannered. But despite everything his position still stands assured as one of the outstanding original talents of his day.

Like many others, Modigliani was tremendously impressed by the retrospective exhibition of Cézanne in 1907. He owed to Cézanne the firmer composition and the broken planes of his later portraits, but it can now be seen that the debt was superficial. He had no real interest in the principles of CUBISM, which were directly descended from certain aspects of Cézanne's work, and he never mastered Cézanne's power of integrating the figure into its environment. Instead he represented face or figure in the manner of sculptural relief detached from the background and both his portraits and his nudes drew their appeal from expressive contour drawing. His mannered elongations are quite distinctive both in painting and in sculpture. But despite his mannerism he had an uncanny gift for rendering the idiosyncrasies of character, as may be seen for instance in his portraits of Max Jacob, Soutine, Jean Cocteau, Jacques Lipchitz, etc.

In art as in life Modigliani was an eclectic and an individualist. Through his mannered eccentricity the flame of a great though not fully developed talent shines forth.

MOHOLY-NAGY, LÁSZLÓ (1895–1946). Hungarian-American painter and sculptor, born at Bacsbarsod, Hungary. After qualifying in law at Budapest University and serving in the war, he was co-founder of an *avant-garde* group of painters MA (Today) at Budapest in 1918. In 1919 he went to Vienna and came under the influence of MALEVICH, LISSITZKY and GABO. He moved to Berlin in 1921, experimented with COLLAGE and PHOTOMONTAGE and exhibited at the STURM Gal. in 1922. From 1923 to 1928 he taught at the BAUHAUS while showing unusual versatility in experimental films, theatre, industrial design, photography and typography as well as painting and sculpture. He was also co-editor of the Bauhaus series of publications. The substance of his teaching was summed up in the work *Von Material zu Architektur* (1929), translated as *The New Vision, from Material to Architecture* (New York, 1932). On resigning from the Bauhaus together with GROPIUS in 1928 he worked for some years in Berlin chiefly on stage design and experimental film. In 1934 he emigrated to Amsterdam and in 1935 moved to London, where he was a member of the CONSTRUCTIVIST group represented by the publication CIRCLE, to which he contributed an article on Light Painting. In London he also began the constructions which he named 'Space Modulators'. In 1937 he emigrated to Chicago, where he became Director of the New Bauhaus and founded the Institute of Design with Gyorgy KEPES. He exhibited extensively both in Europe and in the U.S.A. and had retrospective exhibitions at the Solomon R. Guggenheim Mus. in 1947, the Chicago Art Institute and the Stedelijk van Abbe Mus., Eindhoven, in 1967 and at the Chicago Mus. of Contemporary Art in 1969. A travelling exhibition toured the U.S.A. in 1964.

Moholy-Nagy was one of the most experimental and versatile artists in the Constructivist school, pioneering especially in the artistic uses of light, movement, photography, film and plastic materials. He was one of the most emphatic advocates of the Constructivist doctrine that so-called fine art must be integrated with the total environment. His views were most fully expressed in his posthumously published book *The New Vision and Abstract of an Artist* (1947).

MOILLIET, LOUIS (1880–1962). Swiss painter, born in Berne. He studied under Fritz Mackensen at WORPSWEDE, 1900–3, then at Weimar and under Leopold Graf Kalckreuth at Stuttgart, absorbing the manner of German *Naturlyrismus*, the lyrical expression of a feeling for nature. In 1910 he settled at Gunten on the Thuner See, where he formed a friendship with August MACKE. From this time he began an association with the painters of the BLAUE REITER group and indeed was responsible for introducing to the group Paul KLEE, whom he had known from early years. In 1912 he showed at the *Sonderbund* exhibition in Cologne and in 1914 he accompanied Macke and Klee to Tunisia on a journey whose repercussions on the development of expressive abstraction have become famous in the history of 20th-c. art. He passed the war years in Switzerland and then in 1919 began extensive travels, after which he lived in seclusion at La Tour de Peiltz on Lake Geneva.

Moilliet was particularly strong as a watercolourist. Taking his geometrical structure from CUBISM and an intensification of colour contrast from ORPHISM, he achieved a quite personal synthesis with the brilliant transparency of colour and light in his landscapes of the 1920s. He designed windows for the Lukaskirche at Lucerne in 1934–6 and for the Zwinglikirche at Winterthur in 1943–4. Retrospective exhibitions of his work were given at the Kunsthalle, Berne, in 1951 and 1963.

MOKRY-MÉSZÁROS, DESZÖ (1881–1970). Hungarian NAÏVE painter, born in Sajóecseg. He was trained in agriculture but travelled widely in Asia, Europe and Africa as an amateur archaeologist and zoologist. He painted scenes from his travels in a typically decorative and naïve way but with a unique touch of fantasy. He exhibited in Budapest (1910, 1913, 1930), Bratislava (1966) and after his death his work was shown in Zagreb (1973) and included in the exhibition 'Die Kunst der Naiven' (Munich, 1974, Zürich, 1975). Pictures

by him are in the Hungarian National Gal., Budapest, and the Municipal Gal., Miskolc.

MOLINARI, GUIDO (1933–). Canadian painter, born in Montreal, studied at the École des Beaux-Arts, Montreal, and at the Montreal Mus. of Fine Arts School. He quickly became involved in the Montreal *avant-garde* scene, and experimented with AUTOMATIC composition. A number of MASSON-like ink drawings made up his first one-man show, held in a restaurant in 1954. He first visited New York the following year. From 1955 to 1957 he ran his own gallery in Montreal, L'Actuelle. His first one-man show of paintings, in 1956, displayed simple arrangements of black straight-edged forms on white (*Angle noir*, National Gal. of Canada, Ottawa). After working mainly with gouache for two years he returned to painting on canvas in 1958, at first still in black and white but later in the year he juxtaposed rectangles of different sizes and colours (*Poly-Relational*, National Gal. of Canada, Ottawa). He took part in a two-man show with Claude Tousignant at the Montreal Mus. of Fine Arts in 1961 and in 'Geometric Abstraction in Canada' at the Camino Gal., New York, in 1962. He first came close to abandoning the composition of geometrical elements in *Hommage à Jauran* (Vancouver Art Gal., 1961), a canvas made up only of vertical bars of colour. But it was not until 1963 that he consistently made the bars of uniform width. This removed completely any need to devise an 'image' from variable forms and placed the emphasis solely on colour structure, making possible through the interaction of colour what he called 'the continuous perceptive restructuring of the painting'. Over the next few years he refined this technique, making the 'stripe' format his own. He then began to experiment with geometrical divisions of his canvas (*Hommage à Barnett Newman*, private coll., 1970), most recently employing a kind of chequer-board pattern.

Molinari's theoretical views were expressed, among other places, in the magazine *Situations* which he helped to found in 1959. He participated in 'The Responsive Eye' exhibition at The Mus. of Modern Art, New York, in 1965, and represented Canada at the 1968 Venice Biennale. In 1976 the National Gal. of Canada organized a major retrospective which was shown in Ottawa, Montreal, Toronto and Vancouver.

MOLL, OSKAR (1875–1947). German painter, born in Brieg and trained in Berlin under Lovis CORINTH. He went to Paris in 1908 and was one of the group of German artists who gathered in the Café du Dôme. He was a founding member of the Berlin NOVEMBERGRUPPE in 1918 and joined the staff of the Breslau Academy of Art, of which he was made Director in 1934, but was dismissed as a DEGENERATE artist under the National Socialist regime. In 1967 he was given a retrospective exhibition at the Wilhelm Lehmbruck Mus., Duisburg. Moll was one of the German followers of MATISSE, painting lyrical landscapes in the FAUVIST manner.

MONASTERIOS, RAFAEL. See LATIN AMERICA.

MONDRIAN, PIET (1872–1944). Dutch painter, born at Amersfoort of Calvinist parents. He studied at the Academy in Amsterdam and began by painting landscapes after the manner of The Hague school in delicately subdued greys and greens. It was during this period, *c.* 1903, that he began the interest in theosophy which was to colour his later thinking. In 1908 his palette changed abruptly to the lighter and more resonant colours of the Dutch Luminists and for a time he was painting in a Neo-Impressionist technique. In 1911 he went to Paris, where he occupied the studio of the Dutch painter-critic Conrad Kikkert. There he met TOOROP and together with Van der LECK passed through a SYMBOLIST phase. His chief interest at this time, however, was in CUBISM and until 1914 he endeavoured to carry the Cubist principles further in the direction of abstraction than had been done by the Cubist painters themselves. He said: 'Cubism did not accept the logical consequences of its own discoveries; it was not developing towards its own goal, the expression of pure plastics.' In fact, however, his concepts and aims were different from those of the Cubists and he was actuated by an aesthetic asceticism and a love of abstraction for its own sake which were foreign to Cubism. In 1914 he returned to the Netherlands and remained there during the First World War, painting for the most part sea scenes of increasing abstraction. In 1917 he formed with Theo van DOESBURG the group De STIJL, of which he became the most prestigious member. During the period from 1914 he was working towards compositions of lines and rectangles which were genuine abstractions from naturalistic scenes, but from which in the last resort all figurative likeness had been eliminated. These compositions were more radical than those of the Cubist school in that he restricted himself to a few primary colours, banished all suggestion of a third dimension and as far as possible did away with curves and slanting lines, limiting himself more and more to the vertical and the horizontal. The process of development may be seen in the famous series *Arbres* from the Paris period and the later sea scenes. But by 1917 he had developed the style of composition for which he is best known and to which he gave the name NEO-PLASTICISM. These were no longer abstractions from naturalistic images but were constructed of vertical and horizontal lines breaking the picture area into rectangles. It was in accordance with the philosophy of Neo-Plasticism that he aimed at a machine-like precision in these compositions and eliminated from them all signs of brush stroke or individualized technique.

In 1919 Mondrian returned to Paris and continued to paint in semi-retirement according to the

rigid formula he had evolved. Often his compositions fell into series of virtually identical paintings with slight variations only. His aim was the pursuit of 'pure plastic' (Dutch *beelden* in the sense of 'form') by the ever stricter limitation of expressive means. He disapproved of Van Doesburg's 'Counter-compositions', which departed from the strict vertical and horizontal, and from 1924 ceased active collaboration with De Stijl.

In 1938 he moved to London, where his essay 'Plastic Art and Pure Plastic Art' was published in *Circle* (1937). In 1940 he left London for New York, after his studio in London had been destroyed by bombing, and there he painted his *Boogie-Woogie* compositions expressive of the syncopated rhythms of city life. These were more colourful and more restless in rhythm than the compositions of the earlier periods. The lines themselves were often coloured or made up of small squares of bright colour and the interstices were left white.

Mondrian's work has come to be recognized as supreme in its own field and his influence has been important in many areas of abstract and non-figurative art. In a more superficial way his own painting and that of Neo-Plasticism generally have had a profound influence on the style of much industrial, decorative and advertisement art from the 1930s onwards.

Besides important theoretical articles in *De Stijl* Mondrian wrote *Néo-plasticisme* (Paris, 1920), which was published by the BAUHAUS in German translation under the title *Neue Gestaltung* (1924), and the essay 'Plastic Art and Pure Plastic Art' published in *Circle* (1937). His collected essays were published in New York under the title *Piet Mondrian: Plastic art and pure plastic art* (1947). Among the many retrospective exhibitions of his work were: The Mus. of Modern Art, New York, 1945; Stedelijk Mus., Amsterdam, 1946; Städtische Mus., The Hague, Kunsthaus, Zürich, and Whitechapel Art Gal., London, 1955; Venice Biennale, 1956.

MONTEFIORE (ULRICO SCHETTINI, 1932–). Italian painter, born at Castrovillari, Cosenza. After studying at Pesaro, Paris and Rome, he settled in England in 1958. He lectured at the College of Art and Crafts, Hull (1967–8), at the Central School of Art and Hornsey College of Art, London, and the College of Art and Design, Carlisle (1968), at the City Literary Institute (1971–2) and at King's College, London (1972). He worked in New York in 1964 and lectured in America under the auspices of the Association of American Colleges annually from 1966 to 1971. He had his first retrospective exhibition at the municipal Art Gal., Hull, which attracted international attention, and shortly afterwards ceased painting for a while and destroyed many of his works. About this time he took 'Montefiore' as his professional name. A large exhibition of his work was given at the Café Royal, London, in 1972 and a still more important

exhibition at the Palazzo della Permanente, Milan, in 1974.

MOORE, HENRY (1898–1986). British sculptor. Son of a Yorkshire mining engineer, he was trained in art, after service in the British Armed Forces, at Leeds School of Art and from there obtained a scholarship to the Royal College of Art (1919–23). He taught at the Royal College 1923–32 and at Chelsea School of Art 1932–9. During the 1930s he lived in Hampstead in the same area as Ben NICHOLSON, Barbara HEPWORTH, the critic Herbert Read and others of the *avant-garde*. In 1940, after the bombing of his studio, he moved to Much Hadham in Hertfordshire. From *c.* 1930 he was one of the most important figures in British art. His international reputation became established in the 1940s, helped partly by an illustrated record of his work published in 1944. In 1946–7 he had one-man shows in The Mus. of Modern Art, New York, the Philips Memorial Gal., Washington, the Art Institute, Chicago, the Mus. of Modern Art, San Francisco; and an exhibition toured Australia in 1947. Since that time his works have been continuously exhibited in most major countries. He represented Britain at the Venice Biennale in 1948 and took the International Sculpture Prize. He also won the International Sculpture Prize at the São Paulo Bienale in 1953 and at Tokyo in 1959, the Sculpture Prize of the Carnegie Institute of Pittsburgh in 1958 and the Feltrinelli Prize, Rome, in 1963. He was made a Companion of Honour in 1953 and received the Order of Merit in 1963. Moore's public commissions included: the figure of *North Wind* on the London Underground Railway Headquarters at St. James's, London (1928); *Madonna and Child* for the church of St. Matthew, Northampton (1943–4); *Three Standing Figures* for Battersea Park, London (1947–8); *Madonna and Child* for Claydon church, Suffolk (1949); *Reclining Figure* commissioned by the Arts Council for the Festival of Britain in 1951 (now at Temple Newsam Gal., Leeds); *Screening Wall* and *Draped Reclining Figure* for the *Time–Life* building, London (1952–3); *Reclining Figure* for the UNESCO building, Paris (1957–8).

Moore brought a new impulse into British sculpture. His primary interest was always research into three-dimensional spatial construction. But with this he combined a sensitive feeling for the material, bringing back the tradition of direct carving so long lost and a romantic sensibility which imparts a moving and telluric character to his figures. Although he produced pure abstract sculptures, unlike Barbara Hepworth he never made the abstract his major concern but throughout his career produced figural sculptures with the emotional impact of natural conformations. Early in his career Moore rejected the classical and Renaissance conception of beauty and put in its place an ideal of vital force and formal vigour which he found exemplified in much ancient sculpture

(Mexican, Sumerian, etc.) which he studied at the British Museum. In his contribution to UNIT ONE he wrote in 1934: 'For me a work must first have a vitality of its own. I do not mean a reflection of the vitality of life, of movement, physical action, frisking, dancing figures, and so on, but that a work can have in it a pent-up energy, an intense life of its own, independent of the object it may represent. When a work has this powerful vitality we do not connect the word Beauty with it. Beauty, in the later Greek or Renaissance sense, is not the aim of my sculpture.' He was conscious that the vitality at which he aimed is to be found in much sculpture of different peoples and different ages, constituting a unifying force independent of the Graeco-Renaissance tradition. In 1941 he said: 'The same shapes and form-relationships are able to express similar ideas at widely different places and periods in history, so that the same form-vision may be seen in a Negro and a Viking carving, in a Cycladic stone figure and a Nukuoro wooden statuette.'

Moore was also an outstanding sculptural draughtsman with a style recognizably his own. His drawings done as an official War Artist (1940–2) of the London Tube shelters are among the most poignant records that exist of the effects of a bombing war on the civilian population.

MOOY, JAAP (1915–). Dutch painter and sculptor, born at Bergen, Netherlands. After travelling extensively as a ship's engineer he began to paint in 1939 without formal training but under the influence of Charley TOOROP. From expressive his painting became in the 1960s geometrical HARD EDGE. He began PHOTOMONTAGE c. 1950 and sculpture c. 1955. His sculptures, for which he was best known, were made from machine parts, nuts and bolts and scrap metal and the fantastic forms into which he built them are reminiscent of the ABSTRACT EXPRESSIONIST mode of JUNK sculpture practised in California.

MORALES, ARMANDO (1927–). Nicaraguan painter born in Granada. After attending classes at the School of Fine Arts, in Managua, he travelled to Brazil and Peru, where he had his first individual exhibition at the Institute of Contemporary Art, Lima, in 1959. He went to the U.S.A. in 1960 on a Guggenheim Fellowship. In New York he studied print-making at the Pratt Graphic Art Center. Between 1962 and 1966 he travelled to Panama, Nicaragua, Venezuela, Colombia, France, Spain, England, Italy and Germany, where he made a series of lithographs. In 1966 he returned to live in New York with occasional trips to Venezuela, Nicaragua and Mexico. His work of the 1960s was related to Spanish INFORMALISM. He used COLLAGES of canvas over which he painted in muted colours, off-white and black with a variety of textures from rough to mirror-smooth. The shapes were based on architectural elements such as arches, walls, windows, which he transposed into non-objective structures combining broad areas of flat colour with lines composed of small dashes. After 1968 he returned to the figure, at first in a loosely painted EXPRESSIONIST style with faceless mannikin-like female nudes in simplified METAPHYSICAL landscapes. He also painted pears and apples. Gradually he introduced more colour and delineated some features in the faces. Some of his paintings of the 1970s recall Goya and other Spanish masters. In the 1970s he was appointed Cultural Attaché to the Nicaraguan consulate and began teaching at the Cooper Union. Throughout the 1960s and 1970s Morales exhibited widely in New York, Panama City, Bogotá, Detroit, Caracas, Mexico City. He won several awards and participated in the 2nd, 3rd and 5th São Paulo Bienales (1953, 1955 and 1959), winning an award in 1959. He also received the purchase award at the 1964 Carnegie International, Pittsburgh. In 1966 he participated in 'The Emergent Decade' exhibition at the Solomon R. Guggenheim Mus. in New York and in 'Art of Latin America Since Independence' organized at Yale University.

MORALIS, YANNIS (1916–). Greek painter born at Arta and studied in Athens and Paris. He was Professor at the School of Fine Arts, Athens, and with GHIKA, TSAROUCHIS and ENGONOPOULOS he belonged to the older generation of painters whose influence was decisive in directing the recovery of Greek art after the war. He was deeply immersed in European movements such as FAUVISM and CUBISM, combining this with an interest in Greek vase painting and Byzantine folk art. In his latest period he showed a preference for geometrical modes of abstraction.

MORANDI, GIORGIO (1890–1964). Italian painter born at Bologna, where he studied at the Academy of Fine Arts. In 1914 he met BOCCIONI and CARRÀ and for a while was loosely associated with the FUTURISTS. In 1918–20 he joined the *Scuola Metafisica* (see METAPHYSICAL PAINTING) and was loosely associated with VALORI PLASTICI. But Morandi's painting remained individualist, and was remarkably little affected by any of the various groups. From 1914 he gave drawing classes in Bologna and in 1930 became Professor of Graphic Art at the Bologna Academy of Fine Arts. In 1948 he was made a member of the Accademia di San Luca, Rome, and received the Grand Prix for Painting at the Venice Biennale. In 1952 he was made a member of the Swedish Academy and in 1963 he was awarded the Archiginnasio d'Oro at Bologna. Morandi's painting was concerned exclusively with objects. Apart from some landscapes empty of human figures he painted only still lifes. He built these up meticulously from ordinary objects—bottles, etc.—without expressive appeal and the effect of his paintings depended wholly on his mastery of architectonic form and the clarity of pictorial definition. He combined the classical Italian tradition with intuitive under-

standing of Cézanne, the Impressionists, CUBISM and METAPHYSICAL painting, fusing his knowledge into an entirely personal style. Morandi is recognized as one of the great still-life painters of all time, alongside Chardin and Cézanne.

Morandi's connection with the Metaphysical School between 1918 and 1920 was peripheral. But his bottles and jugs were not painted merely for their suggestion of the everyday things of life. In his ascetic and unrhetorical emphasis upon formal essence, and his almost Oriental sense of circumambient space, he came closer than any other artist has come to Schopenhauer's ideal of painting which makes visible the Platonic ideas of things. It is this which gives to his pictures their inexplicable suggestion of a reality and a presence behind the visible representation.

MOREAU, GUSTAVE (1826–98). French painter who, like certain of the Parnassian poets, exploited the romantic possibilities of long-dead civilizations and mythologies, creating fantasies of the false antique. He used a meticulous and ornate style reminiscent of certain 15th-c. Italian masters. He was a painter of the literary idea rather than the visual image and his pictures appealed to the imagination of certain contemporary authors. Long descriptions of them were introduced by J. K. Huysmans in *A rebours* and by Jean Lorrain in *Monsieur de Phocas*. In 1891 he succeeded Élie Delaunay as professor at the École des Beaux-Arts.

His influence on artists of the 20th c. cannot be discounted, though it was the influence of a teacher in spite of and not through his own painting. Jean Cassou said of him in *Panorama des Arts Plastiques Contemporains* (1960): 'A man of sure taste and rare intellectual and moral quality, he made no mistakes and some of the best artists of our time have come from his studio and have all retained a deep gratitude for his beneficent influence.' Writing of his *St. George and the Dragon* (National Gal., London), Lawrence Gowing has said: 'Moreau cherished an idea of painting as a sensual dream, a mood of abandonment to what was precious and rapturous in the myths of *décadence*, snaky, epicene rhythms that passed for life-drawing, and the emotional transports that luscious and lurid colour could produce in itself. It was this mood that started people like Matisse and Rouault on their way.' Among others MATISSE, MARQUET, MANGUIN and CAMOIN, leading painters of the FAUVISTS, worked in his studio. Throughout his life Matisse acknowledged his debt to Moreau and to Pierre Courthion he said: 'Moreau gave us no fixed line to follow. His teaching troubled us profoundly. With him one was able to discover the sort of work most suited to one's temperament. In the minds of the young he created desires which, it must be admitted, were not always suited to their capabilities.' ROUAULT also was a pupil of Moreau.

MOREAU, LUC-ALBERT (1882–1948). French painter born at Paris. He studied at the Académie Julian, where he met DUNOYER DE SEGONZAC, and then at the Académie de la Palette. In 1907 he worked with Segonzac and BOUSSINGAULT at a villa in Saint-Tropez which they rented from Signac. About 1911 he began to toy with the CUBIST ideas which were much in the air at that time, but from 1914 he reverted to Realism and during the war he was a member of *Bande Noire* organized by Segonzac together with LA FRESNAYE and Jean MARCHAND. From 1920 to 1925 he was President of the Société des Artistes Indépendants and painted pictures, many of them reminiscences of the war, which although retaining some influences of Cubistic stylization, brought him within the current of Expressive Realism. In 1925 he went to live at Saint-Tropez and extended his repertory to interiors and still lifes, landscapes, female portraits and—a special favourite—boxing scenes.

Moreau is remembered as a draughtsman and graphic artist even more than for his painting, and his output of lithographs was very large. Among the books which he illustrated were: Carco, *Chansons Aigres-Douces* (1913), Maurras, *Le Mystère d'Ulysse* (1923) and Colette, *La Naissance du Jour* (1931).

MORELLET, FRANÇOIS (1926–). French artist, born at Cholet, Maine-et-Loire, and a pioneer in certain areas of OP ART. He was a founder member of the GROUPE DE RECHERCHE D'ART VISUEL (GRAV) and exhibited with that group and with the NOUVELLE TENDANCE. He is best known for his *Sphères-trames*, which were cellular spheres built up of small metal rods or tubes set at right angles to each other. Some of them were as much as 6 ft (1·8 m) in diameter. They hung as MOBILES and had curious properties in regard to the reflection of light. He also constructed *Grillages* by setting metal meshes one upon another with different axes. Morellet also exploited the element of chance in painting by distributing coloured squares according to chance arrangements of figures (see STOCHASTICISM).

MORENI, MATTIA. See GRUPPO DEGLI OTTO PITTORI ITALIANI.

MORENO, LUIS GUEVARA. See OTERO, Alejandro.

MORENO, MARIA (1933–). Spanish painter and draughtsman born in Madrid, where she studied at the San Fernando School of Fine Arts and from 1959 to 1971 taught drawing at various schools. She was married to Antonio LÓPEZ GARCÍA, but her style of candid and poetic Realism was very much her own both in her landscapes and in her interiors. Besides exhibitions in Spain she participated in international collective exhibitions including 'Magischer Realismus in Spanien heute', Frankfurt and Munich, 1970; 'Contemporary Spanish Realists', Marlborough Gal., London, 1971; 'Spanischen Realisten', Leverkusen, 1974,

and Zürich, 1975; 'Ars '74', Helsinki, 1974; 'Realismus + Realität', Darmstadt, 1975.

MORENO, RAFAEL (1887–1955). Spanish NAÏVE painter, born in Huelva. He worked as a bricklayer, a farmer and a bullfighter and owned at various times a general store, a fruit shop and a shooting gallery. He moved to Cuba and in 1930 began to paint murals in bars and cabarets of the Havana suburb La Playa. He exhibited in Havana, The Mus. of Modern Art, New York, which owns his picture *On the Farm* (1943), Port-au-Prince, Kansas City, the Gal. Pierre Loeb, Paris, and two of his works were included in the exhibition 'Die Kunst der Naiven' (Munich 1974, Zürich 1975).

MORGENTHALER, ERNST (1887–1962). Swiss painter, born in Kleindietwil, near Huttwil. He studied in Zürich under Eduard Stiefel and in Berlin under Fritz Burger. From 1914 to 1920 he worked from time to time with Cuno AMIET, Paul KLEE and at the school of Heinrich Knirr in Munich. From 1928 to 1931 he was in Paris and then settled in Zürich. Morgenthaler was among the more influential artists in *avant-garde* circles of Switzerland although he himself remained independent of any particular movement. His own painting of landscapes and portraits was delicate, sensitive and showed the accomplishment of a genuinely gifted artist though not an initiator of new ideas.

MORGNER, WILHELM (1891–1917). German painter born at Soest, Westphalia, and studied at WORPSWEDE. In 1911 he joined the Berlin SECESSION. At first he painted in an EXPRESSIONIST manner influenced by Van Gogh but later came under the influence of KANDINSKY and the BLAUE REITER group. He was represented in the exhibition of German Expressionist painters held at the Landesmus. für Kunst und Kulturgeschichte, Münster, in 1974.

MORLOTTI, ENNIO (1910–). Italian painter born in Lecco, Lombardy, trained in Florence and at the Accademia di Brera in Milan. He was associated with the CORRENTE group in 1938 and after the war he was a member of the FRONTE NUOVO and of the splinter GRUPPO DEGLI OTTO PITTORI ITALIANI. Morlotti was above all a painter of the southern Italian landscape. During the 1950s his work became more abstract and he adopted the style of ART INFORMEL although the expressive features of the landscape which had inspired his early work were still in evidence. In 1952 he exhibited at the Venice Biennale.

MOROZOV, IVAN ABRAMOVICH (1871–1921). Russian collector and connoisseur, born in Moscow. He was a wealthy businessman, owner of a complex of textile mills. His collection of western European modern masters was world famous. In 1903 he began to collect French Impressionists

and POST-IMPRESSIONISTS, which he housed in his Moscow mansion (BONNARD, Denis, Gauguin, MATISSE, Monet, etc.), and by 1917 he owned 250 works by such artists. He also collected Russian moderns, especially of the Blue Rose and Neo-Primitivist groups. In 1918 his collection was nationalized and was later amalgamated with the SHCHUKIN collection. It is now divided between the Hermitage, Leningrad, and the Pushkin Mus., Moscow.

MORREN, GEORGE (1868–1941). Belgian painter, born at Hoogboom-lez-Antwerp. He studied at the Academy of Fine Arts, Antwerp, and then from 1881 to 1891 with Carrière and Puvis de Chavannes in Paris. From 1892 he took a leading role in Belgian *avant-garde* movements. He exhibited with La LIBRE ESTHÉTIQUE and in 1904 he was a founder of *Vie et Lumière*. From 1910 his property at Saint-Germain-en-Laye was a meeting place for French and Belgian artists and writers. His painting was Late-Impressionist in style with affinities to that of Renoir. He also did sculpture, decoration and design.

MORRICE, JAMES WILSON (1865–1924). Canadian painter, born in Montreal. His father was an art collector and benefactor and encouraged his early interest in painting. He studied law in Toronto (1882–9) and then travelled to Paris, where he enrolled in the Académie Julian. He was drawn into the Anglo-American circle around Whistler, whose influence is evident in much of his work before the turn of the century. In 1895 he met William GLACKENS and Robert HENRI, the future founders of the New York ASHCAN school. Through his association with them his painting lost its earlier wash-like effect and began to display a more textured, painterly quality (*Return from School*, Art Gal. of Ontario, Toronto, c. 1900). During the early years of the new century Morrice fraternized with a group which included Arnold Bennett and Somerset Maugham, Clive BELL, the occultist Aleister Crowley, and the Irish painter Roderic O'Conor. His sensitive, personal style matured, as is shown in his paintings of views from his studio in the Quai des Grands-Augustins. His *The Ferry, Quebec* (National Gal. of Canada, Ottawa, 1909) is one of the greatest Canadian paintings. Still to some degree 'painterly' in that it is loose and open in handling, it is at the same time concerned with mood and atmosphere in a rigorous, almost formal manner.

Until 1915 Morrice revisited Canada nearly every winter, painting along the north shore of the St. Lawrence River or in Montreal. He exhibited frequently with the Royal Canadian Academy of Arts (of which he was elected an honorary non-resident member in 1913) and was a founder member of the Canadian Art Club. However, from 1905 his main forum was in Paris, where he showed annually at the Salon d'Automne. At about this time too he started to associate with

French artists, principally the FAUVE, Albert MARQUET. By 1909 he had met MATISSE, with whom he painted in Tangier in the winter of 1912–13. Between 1914 and 1921 he travelled to Cuba and the West Indies as well as to North Africa and the south of France, and his palette became lighter. Shortly after the war he began to suffer from the effects of alcoholism. Throughout the last decade of his life he was mainly preoccupied with the challenge presented by the work of Matisse. Although it reflects Matisse's colour and to some degree his drawing, *Village Street, West Indies* (Montreal Mus. of Fine Arts, 1921), like most of his late work, shows that he successfully integrated this massive influence with his own sense of just balance, his own special view of pictorial space. He worked with Marquet in Algiers early in 1922, but that summer he stopped painting. He died in Tunis in 1924 and in the same year the Salon d'Automne held a memorial exhibition.

A sequence of retrospective exhibitions kept Morrice's memory alive, in Canada and elsewhere. They included: Art Association of Montreal (1925); French Gals., London (1925); Gal. Simonson, Paris (1926); Jeu de Paume, Paris (1927); W. Scott and Sons, Montreal, and in Toronto (1932); National Gal. of Canada, Ottawa, and in Montreal and Toronto (1937–8); Royal Canadian Academy, Toronto (1953); Venice Biennale (1958); Montreal Mus. of Fine Arts, and in Quebec and Ottawa (1965–6); Holburne of Menstrie Mus., Bath, and in London, Bordeaux and Paris (1968).

MORRIS, EDMUND. See CANADA.

MORRIS, GEORGE L. K. (1905–75). American writer, critic and painter born in New York. After taking a B.A. degree at Yale University in 1928, he studied at the Art Students' League under John SLOAN and Kenneth Hayes MILLER and at the Académie Moderne, Paris, under LÉGER and OZENFANT. He is known primarily as a writer and critic, in which latter capacity his judgement was sound and influential. He was co-editor with ARP of the Paris magazine *Plastique* and editor of the New York journal *Partisan Review*. He was a founding member of the AMERICAN ABSTRACT ARTISTS ASSOCIATION and President, 1948–50. In 1946 he wrote an account of the Association with documentation of members (*American Abstract Artists*, 1946). He was also a member of the Federation of Modern Painters and Sculptors. In 1952 he lectured in Europe on American art and was U.S. delegate at the UNESCO conference in Venice. He exhibited frequently during the 1930s and 1940s and had a retrospective at the Institute of Contemporary Art, Washington, in 1958. Besides the American Abstract Artists and the Federation of Modern Painters and Sculptors he exhibited at the SALON DES RÉALITÉS NOUVELLES, Paris. His works are represented in a number of university collections, including the universities of Brandeis, Georgia, Illinois, Michigan, Oklahoma, and in

The Metropolitan Mus. of Art, New York, the Corcoran, the Pennsylvania Academy of the Fine Arts, the Philadelphia Mus. of Art, and others.

MORRIS, MICHAEL. See CANADA.

MORRIS, ROBERT (1931–). American sculptor born in Kansas City, Mo., trained at Kansas City University and Art Institute and at San Francisco Art Institute, 1948–51. He studied at Reed College, Oregon, 1953–5 and obtained an M.A. degree at Hunter College in 1966. His first one-man show was at the Dilexi Gal., San Francisco, in 1957 and in 1966 he was represented in the exhibition 'Primary Structures' at the Jewish Mus., New York. Morris was one of the most prominent and articulate among the exponents of MINIMAL ART, repudiating composition by the relation of parts into a whole and advocating a 'non-relational' or 'holistic' aesthetic. His PRIMARY STRUCTURES exhibited at the Green Gal., New York, in 1965 and afterwards were simple, immediately visualizable objects such as elementary polyhedrons with no parts and no internal structure, repudiating all artifice and carrying intellectual simplification to the extreme. During the 1960s he also experimented with Performance art in conjunction with Walter DE MARIA and others and latterly also with EARTHWORKS, ENVIRONMENT ART and temporary structures of miscellaneous materials such as *Steam Cloud* (1969). He had important one-man exhibitions at Eindhoven, Netherlands, and at the Ileana Sonnabend Gal., Paris, in 1968, the Whitney Mus. of American Art in 1970 and at the Tate Gal. in 1971.

Both as a sculptor and as a theorist Morris was a pioneer of Minimal art and took a leading part in its development. The theory of primary structures, which he also called 'unitary forms', is well expounded in two articles which he published in *Artforum*, February and October 1966 (reprinted in *Minimal Art*, ed. Gregory Battcock, 1968). 'A single, pure sensation cannot be transmissible precisely because one perceives simultaneously more than one property as parts in any given situation: if color, then also dimension; if flatness, then texture, etc. However, certain forms do exist that, if they do not negate the numerous relative sensations of color to texture, scale to mass, etc., do not present clearly separated parts for these kinds of relations to be established in terms of shapes. Such are the simpler forms that create strong gestalt sensations. Their parts are bound together in such a way that they offer the maximum resistance to perceptual separation. In terms of solids, or forms applicable to sculpture, these gestalts are the simpler polyhedrons. . . . The simpler regular and irregular ones maintain the maximum resistance to being confronted as objects with separate parts. They seem to fail to present lines of fracture by which they could divide for easy part-to-part relationships to be established. I term these simple regular and irregular polyhedrons "unitary"

forms.' Morris deliberately used the most easily perceived and understood shapes, the simpler polyhedrons, partly in reaction from the cult of spontaneity and personality expression favoured by ABSTRACT EXPRESSIONISM, but also in opposition to the traditional doctrine, which he traced to MONDRIAN, that a work of art is a unified system of relations among parts. As modular variations and serial repetitions became more important in his later work, however, the interest of the forms for their own sake diminished. During the 1960s Morris was also a leader, with Carl ANDRE, in breaking down the traditional mentality linking the work of the artist with the studio, and promoted the idea of executing sculptural works *in situ* as situational constructs designed to function outside the confines of studio and gallery. The potential of masses of earth and waste materials as artistic media was exploited in Earthwork exhibitions at the Dwan Gal. and Cornell University in 1968 and 1969. But as early as 1964 Morris had commented, 'Why not put the work outside and further change the terms?'

MORTENSEN, RICHARD (1910–). Danish painter born in Copenhagen and studied at the Royal Academy there, 1931–2. While still a student he was impressed by the work of KANDIN-SKY and during the 1930s he played an important role in introducing international abstraction into Denmark, being a founder of the *Linien* group of artists in 1934. He was a master of line and succeeded in combining spontaneous expression with well-thought-out structure. In 1947 he moved to Paris and became an important figure in the ÉCOLE DE PARIS. In 1960 he had a one-man show in the Danish Pavilion at the Venice Biennale and in 1962 a retrospective exhibition at the Gal. Denise René, Paris.

MORTIER, ANTOINE (1908–). Belgian sculptor and painter, born in Brussels. From his student days he devoted himself to sculpture and drawing and took up painting only at the end of the 1930s. In the mid 1940s he adopted the mode of expressive abstraction and joined the JEUNE PEINTURE BELGE association, with whom he exhibited both in Belgium and abroad. His works generally embodied figurative elements or retained suggestions of natural appearances though in principle they were abstract.

MORTON, DOUGLAS. See CANADA.

MOSER, KOLOMAN (1868–1918). Austrian painter and designer. He was born in Vienna, was a co-founder of the Vienna SECESSION in 1897 and was influential in starting its journal VER SACRUM, for which he did the cover design. With the architect Josef Hoffmann and the painter Fritz Wärndorfer he was instrumental in the creation of the *Wiener Werkstätte*, which promoted ART NOUVEAU (*Jugendstil*) in arts and crafts. He himself was pro-minent in book binding, poster art, furniture design, etc. in this style about the turn of the century. From 1899 he taught at the Vienna School of Arts and Crafts. His painting was influenced by the Impressionists, especially HODLER, and his interest in Japanese woodcuts was apparent in his designs.

MOSER, WILFRID (1914–). Swiss-French painter and graphic artist, born in Zürich. After extensive travel he settled in Paris in 1945 and adopted the abstract style which was then the vogue. He was included in the exhibition 'Six Young Painters of Paris' which was shown in Stockholm and Zürich in 1951 and had a one-man show in Zürich in 1953. In 1952 he exhibited with Louis NALLARD at the Gal. Jeanne Bucher, Paris. He evolved a linear style of perpendicular hatching in a restricted range of subtly blended colours, giving the impression of ALL-OVER surface variation.

MOSES, GRANDMA (ANNA MARY MOSES, *née* ROBERTSON, 1860–1961). American primitive painter, born at Greenwich, N.Y. In 1887 she married Thomas Salmon Moses, with whom she lived and farmed in Virginia until 1905, when they returned to New York State and purchased a dairy farm at Eagle Bridge. On the death of her husband in 1927 she lived for a while with her daughter in Bennington, returning to Eagle Bridge in 1935. Although she had drawn occasionally for a pastime in her childhood, Anna Moses did not begin to paint pictures to be hung until she was in her 70s. Her first attempts were pictures done in brightly coloured worsted yarns while at her daughter's house at Bennington in the early 1930s. These with some painted pictures were 'discovered' in 1938 by the New York collector Louis Caldor exhibited in the window of the drugstore at Hoosick Falls. On the initiative of Caldor three pictures were included in an exhibition 'Contemporary Unknown American Painters' organized by Sidney Janis at The Mus. of Modern Art, New York, in the autumn of 1939. In 1939 also Otto Kallir, who had just opened in New York a branch of the Paris Gal. St. Etienne, became interested in the pictures and put on a one-man show in the autumn of 1940. The exhibition was well received and the name 'Grandma Moses' was first used in a review article by the *New York Herald Tribune*. The exhibition went on from the St. Etienne gallery to Gimbels Department Store for the Thanksgiving Festival and in January 1941 to the Whyte Gal. in Washington, D.C. In an exhibition at the Syracuse Mus. of Fine Arts in May 1941 Grandma Moses took the New York State Prize with her picture *The Old Oaken Bucket*. Through 1942 a one-man show of 32 of her paintings remained on view at the American-British Art Center in New York. By the middle of the decade her name was widely known and her pictures so popular that from 1946 they were reproduced for Christmas cards.

Entirely self-taught, Grandma Moses painted with a spontaneity and colourfulness in which natural primitiveness was only a part, though an integral part. Her early pictures always expressed a personal experience, a scene or incident with which she felt herself identified. During the 1940s her horizon expanded and the figures or incidents began to be features in a wider landscape vista. Sometimes the figures or the subjects were taken from newspaper clippings, old prints or book illustrations, but they were not directly copied; in all cases Grandma Moses endowed them with her own idiosyncratic vision. Her manner has been summed up as follows by Otto Kallir: 'The blending of two distinct components—sensitively felt and beautifully represented nature scenes, painted in an almost Impressionist manner, with primitive though often colorful human figures—into artistic harmony constitutes what has become known and recognized the world over as the Grandma Moses style.'

In 1946 a book was published with the title *Grandma Moses: American Primitive* and in 1950 a documentary film was completed of which Archibald MacLeish wrote and spoke the text. In 1949 Grandma Moses was honoured by the President with an award for 'outstanding accomplishment in Art', the Women's National Press Club Award. Grandma Moses had been taken to the heart of the American public. Her name and fame had also aroused curiosity in Europe and in 1950 a collection of 50 of her pictures was exhibited under the sponsorship of the American Information Centers at Vienna, Munich, Berne, The Hague and Paris. The interest aroused by these exhibitions was undoubtedly a stimulus for a new 'revival' of American NAÏVE art, leading to an exhibition assembled in 1954 by the Smithsonian Institution and sent on tour to Europe under the title 'American Painting: Peintres Naïfs from 1700 to the Present'. Grandma Moses wrote an autobiography *My Life's History*, which was published in America in 1952, and subsequently in England and even in German translation. In 1953 she gave a memorable television interview with Edward R. Murrow as commentator. During the 1950s also she began to do charming paintings on ceramic tiles, of which she completed 85. In 1960 and 1961 Governor Nelson A. Rockefeller proclaimed her birthday 'Grandma Moses Day' in the State of New York.

MOSKOVITZ, SHALOM. See SHALOM VON SAFED.

MOTHERWELL, ROBERT (1915–). American painter born in Aberdeen, Washington, and passed his childhood in San Francisco, California. Awarded a fellowship at the Otis Art Institute, Los Angeles, at the precocious age of eleven, he studied there 1926–9. After studying painting for a short while at the California School of Fine Arts, San Francisco, in 1932 he entered Stanford University and took a degree in philosophy, writing his undergraduate thesis on psychoanalytic theory,

a subject which remained a lifelong interest with him. During a tour of Europe in 1935 he became interested in French literature and wrote on André Gide. In 1937 he enrolled in the Department of Philosophy at Harvard, took courses in aesthetics under Arthur O. Lovejoy and D. W. Prall and began work on a thesis on the aesthetic ideas in Delacroix's *Journals*. After a further visit to Europe, which included the universities of Grenoble and Oxford, he began teaching art at the University of Oregon in the summer of 1939. In 1940 he moved to New York and entered as a graduate student at Columbia University under Professor Meyer Schapiro. From this time he began to broaden his contacts with other artists, particularly the international group of SURREALIST artists in and around New York, and although his own work was more abstract than theirs, he was at this time much interested in Surrealist theories, especially the theories about AUTOMATISM. In the summer of 1941 he visited Mexico with MATTA Echaurren and stayed to paint there with Wolfgang PAALEN. It was probably about this time that he decided to devote himself professionally to painting.

In 1943 he was invited together with POLLOCK and BAZIOTES by Peggy Guggenheim to make COLLAGES for an exhibition at her 'Art of this Century' Gal. and his first one-man exhibition, at this gallery in 1944, contained three important collages: *Pancho Villa, Dead and Alive* (bought by The Mus. of Modern Art, New York), *Joy of Living* (Baltimore Mus. of Art) and *Surprise and Inspiration* (Peggy Guggenheim coll., Venice). The interest in collages, brilliantly coloured, remained a major preoccupation throughout his career. They became increasingly monumental during the 1970s, ranging from austerely classical to violently expressive and automatist.

In 1945 Motherwell became director of the series 'The Documents of Modern Art', for which he edited in 1951 *The Dada Painters and Poets: An Anthology*. In 1948 he collaborated with ROTHKO, Baziotes, Barnett NEWMAN and David HARE in founding the 'Subject of the Artist' school, whose purpose was to emphasize that abstract art has its own subject matter and to offer facilities for artists to address students on this theme. The school was short-lived but from it emerged 'The Club', where artists and writers met weekly for discussion during the 1950s. In 1951 he was appointed Associate Professor at Hunter College in the University of New York and continued there until 1959. In 1958 he married the painter Helen FRANKENTHALER. From 1962 he was Art Director of *Partisan Review*. In 1946 he had an exhibition at the San Francisco Mus. of Art, began exhibiting at the Kootz Gal., New York, and was included in the 'Fourteen Americans' exhibition at The Mus. of Modern Art, New York. Since then he has exhibited continuously and has been represented in virtually every major exhibition of contemporary American art at home and abroad. His first retrospective exhibition was at Bennington College,

Vermont, in 1959. In 1962 he had a retrospective at Pasadena Art Mus. based on the exhibition of his works organized by The Mus. of Modern Art, New York, for the São Paulo Bienale in 1961. In 1965 The Mus. of Modern Art, New York, organized an exhibition 'Robert Motherwell: Works on Paper' for circulation in North and South America and in 1966 a large retrospective, which after being shown at the museum circulated in Europe. His reputation continued to expand in the decade which followed and he is reckoned to be one of the most brilliant and perhaps the most articulate of the artists in the NEW YORK SCHOOL.

Motherwell's paintings and collages of the early 1940s enunciated certain basic abstract images and forms which persisted throughout his career. In 1949 he began his famous series 'Elegy to the Spanish Republic', of which he painted nearly 150 from then until 1976. Inspired by his emotional reaction to the Spanish Civil War, the pictures in stark black and white were constructed with roughly-executed vertical rectilinear bands framing suspended ovoid shapes. Very similar images compose his *At Five in the Afternoon* (1949) and *Irish Elegy* (1965). In these paintings, it has been said, Motherwell 'liberated himself from the tradition of easel painting and formulated his mature concept of painting as a mural, preserving the integrity of the picture plane and capable of infinite lateral expansion'. Except for a series of small paintings *Beside the Sea* executed on paper in the early 1960s, he restricted brilliant colours mainly to his collages. In the late 1960s a second theme emerged, the 'Opens', quasi-geometrical, COLOUR FIELD paintings in saturated colour, which explore the sensuous effects of colour on a large scale. *Open No. 37 in Orange*, an almost monochromatic painting, measures 6 ft 4 in. by 9 ft 6 in. (1·9 m by 2·9 m). At the same time he came to prominence as a print-maker. In the mid 1970s a third major theme emerged, exploiting the expressive vigour and grandeur of certain early phases of ABSTRACT EXPRESSIONISM and based on images taken from his painting *Africa* of the early 1960s.

MOTJUOADI, ANDREW. See SOUTH AFRICA.

MOTONAGA, SADAMASA. See GUTAI GROUP.

MOTOROJESCU, MARIORA. See NAÏVE ART.

MOTTET, YVONNE. See HOMME-TÉMOIN.

MOVIMENTO PER L'ARTE CONCRETA (MAC). A movement founded at Milan in 1948 by Gillo Dorfles, Bruno MUNARI and Atanasio SOLDATI in opposition to the then current INFORMALISM or expressive abstraction. Following the terminology introduced by Max BILL in Switzerland, 'Concrete' was used in Italy at this time (see CONCRETE ART) to cover what had been known as CONSTRUCTIVISM and the movement embraced a wide spectrum of geometrical abstraction. It attracted

many adherents among the experimental artists in Italy. The tendency to geometrical abstraction was solidified by an exhibition 'Arte Astratta e Concreta in Italia' held in 1951 at the Gal. Nazionale d'Arte Moderna, Rome, to which 70 established artists contributed. It got further stimulus from the exhibition of Concrete Art organized by Max Bill in Zürich in 1960 and the 'Monochrome Malerei' exhibition at Leverkusen in the same year.

MOVIMENTO SPAZIALE. A movement formed in Italy in 1948 on the initiative of FONTANA. It included DOVA, CRIPPA and DONATI. See SPAZIALISMO.

MOYNIHAN, RODRIGO (1910–). British painter born at Tenerife, studied painting in Rome, 1928, and then at the Slade School, 1928–31. He was Professor of Painting at the Royal College of Art, 1948–57. Moynihan was a member of the OBJECTIVE ABSTRACTION group in the early 1930s but was later associated with the EUSTON ROAD SCHOOL and painted in the naturalistic manner adopted by that school. From 1957, when he moved to France, his painting approximated to certain aspects of the expressive abstraction which flourished in the ÉCOLE DE PARIS during the 1950s.

MRAZ, FRANJO (1910–). Yugoslav naïve painter, born in the Croatian village of Hlebine of a peasant family. He was interested in drawing from childhood and his first water-colours date from *c*. 1922. In 1930 he became with Ivan GENERALIĆ one of the founders of the Hlebine school (see NAÏVE ART). He exhibited with Generalić in 1931 as a guest of the ZEMLJA group in Zagreb and had his own show there in 1935, exhibiting also with Generalić and VIRIUS at the Zagreb Fair of 1935–6. He participated in the Liberation movement in 1941 and after the war settled in Belgrade as a painter. Before the war he painted mainly scenes from peasant life in the 'oil behind glass' technique. During the war his experiences in the Liberation movement made a great impression on him and they formed a major theme in his post-war painting. He has been exhibited widely both in Yugoslavia and abroad, including the 3rd São Paulo Bienale (1955), Edinburgh (1962), Moscow, Leningrad, Budapest and Vienna (1962–3) and many collective exhibitions of naïve painting.

MUCCHI, GABRIELE. See CORRENTE.

MUCHA, ALPHONSE (1860–1939). Czech painter and designer born at Ivancise and studied at the Académie Julian and the Académie Colarossi, Paris. He achieved prominence with an individual manner of ART NOUVEAU. His paintings included a large cycle on the history of the Slav people. He was even better known, however, as a designer, particularly for his posters, which included the Sarah Bernhardt posters in the 1890s.

After a period of neglect a revival of interest in his work culminated in a large exhibition of paintings, posters, drawings, furniture and jewellery at the Grand Palais, Paris, in 1980.

MUCHE, GEORG (1895–). German painter, born at Querfurt. He was trained at Berlin and Munich, 1912–15, and taught at the STURM Art School in Berlin, 1916–20. He joined the BAUHAUS in 1920, where he was concerned mainly with building plans and the arrangement of exhibitions; but he left it in 1927 when the Bauhaus was forced to move to Dessau and joined ITTEN in the school which the latter had opened in Berlin. From 1931 to 1933 he taught at the Breslau Academy and in 1939 obtained a teaching post at the Krefeld School of Textile Engineering, remaining there until 1958. Muche painted at first in an abstract manner reminiscent of KANDINSKY and KLEE. In the 1920s he moved to a more decorative and figurative style with plant forms standing out against pastel-toned backgrounds in designs which suggested JUGENDSTIL with overtones of SURREALISM.

MÜLLER, JAN (1922–58). German-American painter born at Hamburg. He went to the U.S.A. in 1941 after being interned in Paris as a German refugee and escaping to Spain. In New York he studied at the Hofmann school, 1945–50. In 1952 he was a co-founder of the Hansa Gal., and exhibited there from 1953. He had retrospectives there in 1959 and at the Solomon R. Guggenheim Mus. in 1962. In 1957 he was represented in the exhibition 'The New York School, Second Generation' at the Jewish Mus., New York, and in 1959 in the exhibition 'New Images of Man' at The Mus. of Modern Art, New York. After using in his earlier works the abstract idiom of HOFMANN, Müller belonged to the group of artists who in the late 1950s adapted ABSTRACT EXPRESSIONIST techniques to the representation of the figure. He painted fantastic landscapes peopled with primitive or demonic figures as in his *Jacob's Ladder* (Solomon R. Guggenheim Mus., 1958). He often took his subjects from literary sources—Shakespeare, Cervantes, the Bible—setting his frantically gesticulating ghostly black and white figures in a brightly coloured environment.

MÜLLER, OTTO (1874–1930). German EXPRESSIONIST painter born at Liebau in Silesia. After four years' apprenticeship in lithography at Breslau he studied painting for two years in Dresden, 1896–8. He was befriended by the writers Gerhart and Carl Hauptmann, who were his relations, and after travelling in Switzerland and Italy with Gerhart Hauptmann he was set up in a studio in Dresden in 1898, where he remained until 1908. During these years he made frequent painting trips in the Riesengebirge, came under the influence of Böcklin (1827–1901) and made it his aim to express the unity of man with nature. He was a prolific worker but later destroyed most of his paintings from these years. In 1908 he moved to Berlin and in 1910 was rejected by the Berlin SECESSION. He met members of the BRÜCKE at the exhibition of rejected artists, joined the *Brücke* and in 1911 travelled with KIRCHNER in Bohemia. Under this influence his style became more harsh and angular, with emphatic outlines. He painted nudes in landscape, pure landscape and after 1920 gipsy subjects. His great technical proficiency enabled him to use distemper for a matt finish. The change of style brought about by his contact with the *Brücke* artists may be seen by comparing his *Judgement of Paris* (Gal. des XX Jahrhunderts, Berlin) with *Three Nudes before a Mirror* (Staatsgal. Moderner Kunst, Munich). A good example of his later work is *Gipsy Madonna* (Hessisches Landesmus., Darmstadt, 1927). From 1919 until his death he taught at the Academy in Breslau.

MULTIPLES. While in the past works of graphic art and cast sculptures have commonly been produced in multiple, though usually limited, editions, paintings, carved sculpture and drawings have been valued for their individual uniqueness. From about the mid century the term 'multiples' has come increasingly into use in several schools of art to designate works other than graphic art or cast sculpture which are planned to be produced by a variety of industrial processes in unlimited numbers. In principle they are not industrially produced copies of an original work hand-made by the artist himself. Indeed in some cases the artist produces only a blue-print or instructions for the industrial process.

The concept of the multiple represents a revolution of aesthetic attitude according to which craftsmanship is disvalued and works of art are no longer regarded as rare items for collectors and connoisseurs but as consumer goods for the masses like any other industrial product. According to this new aesthetic their value lies in their ability to transmit images and forms in visual form.

MUNARI, BRUNO (1907–). Italian sculptor and experimental artist born at Milan. He was briefly associated with the FUTURISTS and contributed to the AEROPITTURA exhibition of 1931. But during the 1930s he became known for his abstract constructions and wire MOBILES, which he called *machines inutiles* and which anticipated and influenced TINGUELY, who met Munari in 1954. In 1938 he published the first of his many manifestos on his concept of machine art: *Manifesto del macchinismo*. In 1949 he became a founding member of the MOVIMENTO PER L'ARTE CONCRETA and he pioneered ARTE PROGRAMMATA in Italy, i.e. the art of the MULTIPLE in connection with industrial design. Among the KINETIC objects he constructed during the 1940s was *L'Ora X*, in which hands were driven by clockwork round a clock face without time markings. He also experimented with the factor of

chance (STOCHASTICISM). His experiments with the decomposition of light bore fruit in *Direct Projections of Polarized Light* in 1957. PICASSO had called Munari 'the new Leonardo' and during the 1950s he was certainly the most active and ingenious of Italy's many experimental artists. He held with Gillo Dorfles that industrial design has more influence than handicrafts or fine art 'to educate the public and reawaken it to the genuine values of modern art' and he believed that in this field we can move away from the subjective values glorified by Romantic art and reach a code of objective design values which can be appreciated and understood by people all over the world. He believed that the designer was not to be considered so much an artist in the traditional sense as a visual operator working with a team of experts for the benefit of the community. In 1952 he published a series of manifestos, including: *Macchina-arte macchinismo*; *Arte organica*; *Disintegrismo*; *Arte totale*. In his *Manifesto del macchinismo* he wrote: 'The artists are the only people who can save humanity from the danger (of the multiplication of machines). Artists should take an interest in machines, abandoning the romantic brush and palette and canvas. They must get to know the anatomy of the machine, the language of mechanism, understand the nature of the machines, and distract them by making them work in an irregular manner, create works of art with those machines and with the means they provide.' He participated in the exhibition 'Arte Astratta e Concreta in Italia' at the Gal. Nazionale d'Arte Moderna, Rome, in 1951. His reputation was international and among his many exhibitions were ones at The Mus. of Modern Art, New York, and the Hessenhuis, Antwerp, in 1959 and at the National Mus. of Modern Art, Tokyo, in 1960. During the 1960s Munari also worked at experimental cinema.

MUNCH, EDVARD (1863–1944). Norwegian painter who was considered one of the main modern interpreters of the ancient Nordic spirit and who also became one of the chief sources of German EXPRESSIONISM. After early studies at Oslo he travelled extensively in France, Italy and Germany until 1908, when he suffered a serious mental illness. The remainder of his life was spent in Norway. From the time of his first visit to Paris in 1885 the manner of his work was influenced by the Impressionists and after 1908 by the NABIS and the POST-IMPRESSIONISTS, particularly Van Gogh, Gauguin and Toulouse-Lautrec. But his subjects had an uninhibited and almost neurotic emotionalism which anticipated the later Expressionist movement (*The Sick Girl*, 1886; *Spring*, 1889; *The Day After*, 1886, preserved only in later versions). The violence and hysteria of his work appeared also in woodcuts and engravings. In 1892 he exhibited more than 50 pictures at the Kunstlerverein in Berlin and these made such an impact that the exhibition had to be withdrawn. It was one of the elements which led to the formation of the Berlin SECESSION group.

During the 1880s he was occupied with a series of pictures which he called the 'Frieze of Life'—'a poem of life, love and death'—which had affinities with early ART NOUVEAU but had an intense emotionalism foreign to most manifestations of that style. Twenty-two of these paintings were exhibited in Berlin in 1902. They were executed in deep colours, and were imbued with the anguished and sensual symbolism of the time. Several of the subjects, e.g. *The Kiss* and *The Shriek*, were also translated by Munch into etching, lithography or woodcut—arts in which his summary manner was to be felt as revolutionary. The woodcuts in particular had a wide influence.

After his return to Norway in 1908 his art became more extroverted. In landscapes, portraits and pictures of workmen in the snow his technique grew more and more sketchy and energetic, his palette bright and vigorous. The great achievement of this period was a series of large oil paintings for the University Hall of Oslo (1910–15) exalting the positive forces of nature, science and history. In 1916 he settled at Ekely, Oslo, thenceforth living a solitary life. During the 1920s his art again became strongly emotional, harking back to the symbolism of his earlier days. Indeed his work never lost its violently evocative character, and the passion for visual symbolism expressive of strong emotion may be seen even in the last of his numerous self-portraits, *Between the Clock and the Bed* (Oslo, 1940).

Munch was the most powerful of modern Norwegian artists. His influence was particularly strong in Scandinavia and Germany, where he and Van Gogh are regarded as the two main sources of EXPRESSIONIST art. This influence was much more than stylistic. In the mood of disillusionment with contemporary conditions and the sense of man's alienation which his pictures express; in his desire to paint an iconography of what he called 'modern psychic life' but with emphasis always on conflict, neurosis and tension; and by the intensity with which he symbolized and communicated mental anguish through an unrestrained and violent distortion of colours and forms, he was the embodiment of that spirit which has animated the more tortured exponents of German Expressionism.

MUNKÁCSY, MIHALY VON (LEO LIEB, 1844–1900). Hungarian painter, who took the name of his birthplace. After training in Budapest, Munich and Düsseldorf Munkácsy settled in Paris. His theatrical costume pictures (*Milton and his Daughters*, Lenox Library, New York, 1877–8) were enormously popular in their day, but Munkácsy did more lasting work in genre and landscape. He was much admired by Leibl and LIEBERMANN. In Paris he had little contact with his French colleagues and it seems worthy of note that he despised the Impressionists and abused Manet.

MUÑOZ, LUCIO. See LUCIO.

MÜNTER, GABRIELE (1877–1962). German painter, born in Berlin. She was a pupil of KANDINSKY at the PHALANX school of art in Munich from 1902, travelled with Kandinsky to France in 1906 and settled with him at Murnau in 1908. With Kandinsky and JAWLENSKY she helped to found the NEUE KÜNSTLERVEREINIGUNG, Munich, and she was a member of the BLAUE REITER and later of the Munich *Der Sturm*. After a period in Scandinavia, 1914–20, she returned to Germany and in 1931 settled in Murnau. She adopted the FAUVE techniques and combined them with a somewhat mannered naïvety. A good collection of her paintings, as also paintings of Kandinsky from the period 1906 to 1910, may be seen at the Städt. Gal. im Lenbachhaus, Munich, where she had an important exhibition in 1977.

MURCH, WALTER TANDY (1907–67). Canadian-American painter born at Toronto, became a U.S. citizen in 1948. He studied at the Ontario College of Art, 1924–7, then at the Art Students' League, New York, 1929–30, and with Arshile GORKY, 1930–2. After travelling to Mexico and France he taught at the Pratt Institute, 1952–61, and at Boston University from 1961. His first one-man exhibition was at the Wakefield Gal., New York, in 1949 and from 1947 to 1966 he exhibited frequently at the Betty Parsons Gal. and elsewhere. He had a retrospective at the Rhode Island School of Design in 1966. His work featured in many collective exhibitions of contemporary American painting, including: 'Contemporary American Painting', Tokyo, 1952; 'American Painting', I.C.A., London, 1956; Detroit Institute of Arts, '40 Key Artists of the Mid-20th Century', 1965; Rhode Island School of Design, 'Recent Still Life', 1966. Murch painted still lifes from banal domestic objects, or compositions of geometric blocks, giving them a dramatic quality by means of romantic lighting.

MURRAY, ROBERT (1936–). Canadian sculptor and painter born in Vancouver and grew up in Saskatoon, Saskatchewan. He studied painting at the School of Art, University of Saskatchewan, Regina (1956–8), and at the Institute Allende, San Miguel, Mexico (1958–9). Back on the Prairies he began work on a sculptural fountain commission for the new Saskatoon city hall, which was fabricated from steel to his instructions in 1960. During the summers between 1957 and 1960 he attended the Artists' Workshop at Emma Lake in northern Saskatchewan, studying successively with the American artists Will Barnett, John FERREN, Barnett NEWMAN, and the critic Clement Greenberg. In 1960 he moved to New York and briefly studied painting at the Art Students' League before turning to sculpture again. His first New York pieces, columnar in form, were made of plaster to be cast in bronze (as *Adam and Eve*, National Gal. of Canada, Ottawa, 1962–3). *Pointe-au-Baril I* (now *Ferus*, coll. of the artist, 1963), which was made of wood and iron and then fabricated in steel, was followed by a series of somewhat larger than man-size pieces, usually formed of a conjunction of vertical planes (e.g. *T.O.*, Art. Gal. of Ontario, Toronto, 1963). Then in the summer of 1965 participation in the Long Beach State College sculpture symposium in California gave Murray the chance to work on a grand scale. There he had *Duet* fabricated (Long Beach State College), a piece constructed of huge leaning planes, painted, as were his earlier planar pieces.

Murray taught at Hunter College, New York (1965–9), and the School of Visual Arts, New York (1971–). Examples of his monumental pieces can be seen out of doors at Vancouver International Airport (*Cumbria*, 1966), Fredonia State College, New York (*Megan's Red*, 1968), in Ottawa at the Department of National Defense (*Tundra*, 1972–3) and the Department of External Affairs (*Haida*, 1973), Wayne State University, Detroit (*Dordkyn*, 1973–4), Swarthmore College, Pennsylvania (*Garnet*, 1974), University of Massachusetts, Amherst (*Quinnipiac*, 1974–5). His first one-man show was at the Betty Parsons Gal., New York, in 1965. He exhibited several times at the David Mirvish Gal., Toronto, from 1967, had a one-man show at the Jewish Mus., New York, also in 1967, represented Canada at the 1969 São Paulo Bienale, and was given a major two-man exhibition, with the sculptor Ronald Bladen, at the Vancouver Art Gal. in 1970.

MURTIĆ, EDO (1921–). Yugoslav painter and graphic artist born at Velika Pisanica, Croatia, and studied both at Zagreb and at Belgrade. After the war he produced paintings and graphic work in a style of rhythmical abstraction based upon sketches done while fighting with the partisans and he further developed this semi-abstraction, with some affinities to FEININGER, in a series of townscapes done while visiting New York in 1952. By the end of the 1950s his style had developed still further in the direction of formal arabesque and in the 1960s he went over to a dynamic mode of ART INFORMEL. Murtić also designed posters, worked in ceramics, did theatrical design and designed factory interiors. He illustrated a number of books in collaboration with Zlatko PRICA.

MUXART, JAUME. See DAU AL SET.

MYERS, JEROME. See UNITED STATES OF AMERICA.

N

NABIS. A group of young artists formed in 1888 within the Symbolist movement under the influence chiefly of Gauguin. Paul SÉRUSIER, the founder of the group, had been directly inspired by Gauguin at Pont Aven. Other leading members of the group were Pierre BONNARD, Maurice DENIS and Edouard VUILLARD. Toulouse-Lautrec was associated with them and MAILLOL was a member of the group before he took up sculpture. The name *Nabis* was coined from the Hebrew word for prophet and expressed their attitude towards the new styles of colour DISTORTION as a kind of religious illumination. The group met and exhibited together from 1892 until 1899, after which the members went their several ways and gradually drifted apart. Although the activities of the group itself fall outside the present century, their theories and attitudes—particularly their differentiation between aesthetic or objective 'distortion' and psychological or subjective 'distortion'—had considerable importance for the development of ideas in the early decades of the century.

NADELMAN, ELIE (1882–1946). French-American sculptor, born in Warsaw. After brief studies in Warsaw and six months in Munich he settled in Paris *c.* 1902. His work was based upon that of Rodin and the antique, which he studied at the Louvre, but he developed in the direction of ideal abstraction and he referred to his sculptures executed between 1904 and 1914 as 'Researches in Volumes and Accord of Forms'. He believed that by calculation and analysis of human and animal shapes it was possible to arrive at an ideal of absolute beauty not dependent upon reproducing beautiful forms in nature. In exemplification of these theories he had a sensational first exhibition at the Gal. Drouet in 1909. An *Abstract Head* devoid of facial features, shown at this exhibition, was a forerunner of BRANCUSI's portraits of *Mlle Pogany* and his heads of *Muses*. Nadelman later became victim of the obsession that PICASSO's CUBISM had been stolen from his own researches into the application of geometrical curves in order to achieve that 'accord and opposition' of forms which is identical with ideal beauty. He was known to Gertrude Stein, who wrote a pen portrait of him in *Larus* (Vol. 1, No. 4, July 1927). An exhibition at the Paterson Gal., London, was bought up complete by Helena Rubinstein, who constituted herself his patron. With her help he emigrated to New York in 1914 and obtained American citizenship in 1927. In America Nadelman continued his search for ideal classical proportions though he also did portraits and small figures of kindly caricature. His *Standing Bull* and *Wounded Bull* (both The Mus. of Modern Art, New York, 1915) were more distinctly Cubist in style. His bronze *Man in the Open Air* (also 1915) was described by Albert E. Elsen in his Introduction to the catalogue of the exhibition 'Pioneers of Modern Sculpture' at the Hayward Gal., London, in 1973: 'Nadelman's ideal man is undisturbed by psychic self-search or spiritual tension. He is a bowler-hatted, bow-tied modern Apollo, a paragon of poise. Here is modern man, released and at home with himself, in skin-tight fashion and the out-of-doors.'

Nadelman was exhibited by Alfred STIEGLITZ at the 291 Gal. in 1915 and he subsequently enjoyed a popular demand for portrait busts, though continuing to carve small sophisticated figures in wood without the model and to do female figures of dancers and circus performers. During the 1930s much of his sculpture was destroyed in an accident and he henceforth ceased to exhibit. A memorial exhibition was given at The Mus. of Modern Art, New York, in 1948.

NAGEL, PETER (1942–). German painter born at Kiel, trained at the Academy of Fine Arts, Hamburg. He qualified as an art teacher in 1965 and studied in London in the same year. In 1968–9 he obtained a scholarship to the Villa Massimo, Rome, and in 1969 the Premio Fiorino, a prize from the German Government to paint in Florence. In 1970 he was awarded First Prize at an International Triennale for Graphic Art in Switzerland. In 1965 he was one of the four artists who formed the ZEBRA group. He painted with PHOTOGRAPHIC REALISM approaching *trompe l'œil*, using blown-up shapes, bloated baby figures, motor tyres, etc. against a featureless background. His works sought complete objectivity with the elimination of subjective expression. From 1965 he had one-man exhibitions in Germany and took part in a number of collective exhibitions both with the *Zebra* group and otherwise.

NAÏVE ART. 'Natural' painters who owe little or no debt to traditional techniques and training are not a new thing in this century, though their vogue is new. From the Middle Ages there has existed popular and untutored painting, both amateur and professional, alongside the more sophisticated works of recognized artists within an established tradition. One might instance the murals of Cata-

lonia, now preserved in the Mus. of Catalan Art, Barcelona, called by Sacheverell Sitwell 'the most astonishing collection of primitive painting in the world', or those in the 15th-c. chapel of St. Sebastian in the village of Lanslevillard, Savoie. Some of the first painters of colonial America lacked any orthodox training in traditional techniques and pictorial conventions but are now admired for just those qualities which to previous generations of critics made them seem bungling and incompetent. What is new in the 20th c. is the serious respect which has been accorded to some of these unsophisticated painters by sophisticated connoisseurs and the admiration for those qualities in their work which seem to be furthered by the lack of formal training. The cult—for such it became, with the German critic Wilhelm UHDE as its most active early protagonist—started with the belated recognition accorded between 1908 and 1914 to the Douanier ROUSSEAU, who is now valued most highly among modern naïve artists. Other 'contemporary primitives', as they were also called, discovered or brought to public notice during the 1920s and 1930s included: VIVIN, SÉRAPHINE, BAUCHANT, BOMBOIS, RIMBERT, EVE, PEYRONNET and LEFRANC. Although they were at first an elitist taste, the reputation of the naïves gradually spread more widely. Leading commercial galleries gave individual and collective exhibitions to them and their works began to be acquired by major public and private collections. An important collective exhibition was held at the Gal. des Beaux-Arts, Paris, in 1933 and a still larger exhibition at the Salle Royale in 1937 was shown in 1938 at the Kunsthaus, Zürich, and in 1939 at The Mus. of Modern Art, New York. In 1944 the Mus. National d'Art Moderne, Paris, staged a large exhibition of the Douanier Rousseau to mark the centenary of his birth, in 1948 the Gal. Bing held an important exhibition of Vivin, in 1949 the Gal. Charpentier showed a collection of paintings by Bauchant and in 1951 France contributed a group of paintings by Séraphine to the first São Paulo Bienale. Thus was the cult of the 'modern primitive' established and with its establishment new primitives continued to be discovered. In many cities commercial galleries were set up which specialized in naïve painting.

Naïve painters have been classified under a number of names, chief of which are: Neo-Primitives, Modern or Contemporary Primitives, Maîtres Populaires de la Réalité (exhibition of 1937), Art Remote from History and Style. René Huyghe suggested 'instinctual painters' and Wilhelm Uhde 'Peintres du Cœur Sacré'. The word 'primitive' is inappropriate because it suggests analogy with the arts of primitive peoples, among whom tradition is a very powerful factor, whereas one of the most significant features of naïve painters is their freedom from artistic traditions. Except in France, the term 'naïve art' has come into most general acceptance, although dealers often offer for sale mediocre amateur pictures from previous centuries under the title 'early primitives'.

Naïve art must be distinguished not only from the art of primitives but equally from amateur art ('Sunday afternoon painters'), folk art, children's art, the art of psychotics and of course from academic art. Just as some modern painters have tried to reproduce in their work the freshness and spontaneity of children's art, so there have been sophisticated painters who have deliberately cultivated a 'false naïvety' (faux naïf) attracted by some quality of freshness and directness in the work of naïve artists which seemed to them to have been lost in orthodox traditional art. But this sophisticated naïvety is no more to be confused with the spontaneous quality of the true naïve than is the deliberately childlike work of say PICASSO or KLEE to be confused with genuine children's drawing. Naïve art has a quality of its own which can readily be recognized though in what precisely that quality consists is very difficult to define.

Naïve painters do not constitute a group or school. Usually, though not always, they have worked in isolation both from each other and from the orthodox art production around them. Both in their habits and in their work they are extremely diverse and have relatively few traits in common. Some have manifested an interest in painting from childhood, others have taken it up in middle age or late in life. From necessity or choice many of them have been spare-time artists, painting for their own amusement and pleasure while earning a living in other ways. Their favoured themes and their modes of representation, though highly personal, also differ greatly from one another. Many have been interested primarily to depict scenes and incidents from the daily life with which they were familiar. These have often given great attention to realistic detail, incorporating conceptual as well as visual features in the endeavour with painstaking precision to render each fact as they knew it to be whether or not it could be so seen within the total configuration of the scene they have portrayed. Others, like Séraphine, Caillaud and Ivan VEČENAJ, gave free rein to imagination and fantasy, sometimes with an almost SURREALISTIC effect. The traditional principles of perspective as worked out during the Renaissance usually go by the board, though many naïve artists are capable of rendering distance and depth by their own means. So-called 'psychological' perspective is a prominent feature of very much naïve painting, the relative size of objects and figures being determined by psychological interest without regard to natural proportions. As in the classical case of Rousseau, naïve painters have usually been singled out for admiration on account of qualities in their work of which they themselves were unaware. If it is possible at all to point to any quality which the best naïve work has in common with that of sophisticated artists, it is a power of pictorial construction (lacking almost always in the work of children and psychotics) and a power to

invest the depiction of the commonplace and familiar with a poetic freshness which imparts to it the force of a visual revelation.

Some naïve painters have also carved or modelled figures. In general these have more in common with traditional folk art or popular religious art, but sometimes they make the same sort of impact as the paintings. Naïve sculptors who are not also painters are relatively rare. Interesting examples are KEMKO and KERAK from Czechoslovakia, KREČA, ŽIVKOVIĆ, Petar SMAJIĆ, Dragiša and Milan STANISAVLJEVIĆ from Yugoslavia, Leon KUDLA and Jedrzej WAWRO from Poland, BOEDEKER from Germany and Georges Liautaud from Haiti.

In the U.S.A. amateur painting in the 19th c. was freer from the influence of dominant artistic styles than in most European countries and under the name of 'limners' both self-taught amateurs and unschooled professionals flourished from the Independence until the early years of the 20th c. The difference between these amateurs and true naïve painters was relatively slight and many of them were forerunners of 20th-c. American naïve painting. The most widely publicized of the naïve painters in the 20th c. was Grandma MOSES. But mention should also be made of Morris HIRSCH-FIELD, John KANE and the black painter Horace PIPPIN. In England the best-known naïve painter was Alfred WALLIS, who influenced Christopher WOOD and Ben NICHOLSON at one stage in their artistic careers. The naturalized Pole Andrzej Kuhn must also rank as a naïve. Hungary had CSONTVARY-KOSZTKA, Switzerland the lumberjack Adolf DIETRICH, Italy the shoemaker Orneore METELLI, Poland had NIKIFOR and Teofil Ociepka, Germany Boedeker, Karl Eduard Kazimierczak, Max Raffler and the Lithuanian Friedrich SCHRÖ-DER-SONNENSTERN. Israel had SHALOM, Belgium Micheline BOYADJIAN and Edgar TYTGAT and Spain had Miguel VIVANCOS. Czechoslovakia proved a fertile field for naïve art, which was encouraged and exhibited and is ably catalogued by Arsen Pohribný in Naïve Painters of Czechoslovakia (1967) (see DAŇKO, GUTTMANN, LAUKO, LIČKOVÁ, PROCHÁZKOVÁ, SCHMIDTOVÁ, KEMKO and KERAK).

Of all countries, however, Yugoslavia has proved the most fertile in naïve painting and has produced the largest number of outstanding naïve artists. Writing in 1966, Ernst Winterberg claimed that Yugoslavia had at that time 91 naïve painters, of whom more than 20 enjoyed world-wide fame. Unlike other countries the naïve painting of Yugoslavia was concentrated around four main centres: Hlebine, Kovačica, Oparić and Uzdin.

Hlebine is a village of Croatia close to the Hungarian frontier. In 1929 the academic painter Krsto HEGEDUŠIĆ together with other Croatian painters of Zagreb formed a small group under the name ZEMLJA (Earth) and in pursuance of their aesthetic policy these artists went to Hlebine with the hope of revitalizing the effete official painting by direct contact with 'nature' and the peasant population. There Hegedušić met the 16-year-old peasant Ivan GENERALIĆ, who with Mirko VIRIUS and Franjo MRAZ formed the nucleus of a local school of naïve painting which later achieved world-wide fame. After the Second World War these pioneers were joined by Ivan VEČENAJ from the neighbouring village of Gola and younger naïve painters swelled the total to about 20. They included Franjo Dolenec, Franjo FILIPOVIĆ, Dragan GAŽI, Josip GENERALIĆ, Žljelko Korošek, Mijo Kovačić, Branko Lovak, Marija Matina, Martin MEHKEK, Tereza Posavec, Franjo Radmanić, Stjepan VEČENAJ, Franjo Vujčec. The school revived the medieval techniques of votive painting and brought the technique of painting under glass to a high level of virtuosity.

Kovačica is a village about 40 km east of Belgrade in the province of Vojvodina, with a Slovak peasant population. The surrounding villages of Paluška, Sokol and Bireš were painting since c. 1938 and after the Second World War formed the nucleus of the Kovačica school. The village has its own art gallery in the House of Culture and pictures are permanently on exhibition there. The Kovačica school has no outstanding central figure like Generalić in Hlebine, but Jano KNAJZOVIĆ and Martin JONAŠ stand out for their lively colours and the woman painter Zuzana CHALUPOVA for the charming detail of her naïvely observed conversation pieces. Most artists of the school manifest in their work a love of their native village life and interest in Slovak folklore.

Uzdin is a village in the Yugoslav part of the Banat with a predominantly Romanian population. Its painters are all women and the school began c. 1961 under the impetus of a schoolteacher, Adam Doclean, who discovered the naïve painter Anuica MARAN. Maran gathered other women painters around her: Maria Balan, Anuta Dolama, Mariora Motorojescu, Sofia Doclean, Florika Chet, joined later by Florika Puia, Steluca Caran and Viorika Jepure. These women painters drew their themes from everyday events of village life combined sometimes with folklore and fantasy, using these as the basis for a purely decorative art as two-dimensional as embroidery. They formed their own village gallery where they exhibited and since 1962 their pictures have been frequently exhibited abroad.

Oparić is a Serbian village between Belgrade and Niš, where a group of naïve artists was formed around the central figure of the self-taught painter Janko BRAŠIĆ. Most of the small group were taught by Brašić. They did not use the technique of painting under glass but painted in oils, depicting the events of village life in strong, massive colours but with a certain spontaneity of vision and lyrical interpretation. The group included Milutin Arsić, Miloslav Jovanović and Miroslav MARINKOVIĆ from Oparić, Ljubinko Kamatović, Miroljub Milošević and Budimir Rajković from neighbouring villages.

Besides these centres there have also been inde-

pendent naïve artists of note in Yugoslavia. Prominent among them are Eugen BUKTENICA from the Dalmatian island of Šolta, Emerik FEJEŠ from Novi Sad, Slavko STOLNIK from Slovenia and Ivan RABUZIN from the Croatian hamlet of Kljuc. In Zagreb a small group of naïve painters included Mato Skurjeni, Antun BAHUNEK, Djuro JANČIĆ and—most talented of all—Ivan LACKOWIĆ.

The cult of naïve painting in the present century has obviously a close connection with the interest taken in children's art, folk art, the art of primitive peoples and the art of psychotics. In all these cases the interest seems to be linked with the belief that art should be spontaneous and instinctive, unhampered by intellectual rules embodied in traditions, an affair of the imagination rather than reason. There is also a belief that an untrained artist unfamiliar with historical art and the orthodox art of the day—and with the increasing prevalence of the mass media such unfamiliarity is becoming ever more rare—is likely, if talented, to have a freshness and directness of vision which may be lost through exposure to academic training and sophisticated art production. The justification of this cult is less obvious than the historical reasons that prompted it. It is indeed certain that virtuosity and skill, thorough training and deep intellectual understanding are not sufficient in themselves to ensure the production of great art. This is one of the insights which inspired the various anti-art movements such as DADA. But neither is the abolition of these factors, the absence of traditional training and technique, sufficient in itself to produce a work of art. Not all unsophisticated painting by artists 'remote from history and style' is worthy of the attention of the connoisseur. The true naïve painter has qualities and a talent of his own and is probably as rare as is the true artist among all those who undergo artistic training. When owing to the cult of collection naïve paintings acquire financial value, there is a danger—as happened to some extent in Yugoslavia during the late 1960s—that naïve painters begin to repeat themselves with a consequent loss of spontaneity in their work.

Important exhibitions of naïve art include: 1933, 'Un Siècle de Peinture Naïve', Paris; 1937, 'Les Maîtres Populaires de la Réalité', Paris and Zürich; 1939, 'Masters of Popular Painting', New York and London; 1958, 'La Peinture Naïve du Douanier Rousseau à nos jours', Knokke-Le Zoute; 1961, 'Das naive Bild der Welte', Baden-Baden, Frankfurt, Hanover; 1962, 'Yugoslav Modern Primitives', Edinburgh; 1964, 'De Lusthof der Naiven', Rotterdam; 'Le Monde des Naïfs', Paris; 'Die Welt der naiven Malerei', Salzburg; 'Naive Malerei', Oldenburg; 1966, 'I Triennale der naiven Kunst', Bratislava; 'Rousseau et le Monde des Naïfs', Tokyo; 1969, 'II Triennale der naiven Kunst', Bratislava; 1970, 'Naivi 70', Zagreb; 1971, 'Werk und Werkstatt Naiver Künstlere', Recklinghausen; 1972, 'III Triennale der naiven Kunst', Bratislava; 1973, 'Naivi 73', Zagreb; 'Yugoslav

Naïve Paintings', Acapulco; 1974, 'De Grote Naieven', Amsterdam; 'Die Kunst der Naiven. Themen und Beziehungen', Haus der Kunst, Munich, and (1975) Kunsthaus, Zürich.

NAKAMURA, KAZUO. See CANADA.

NAKE, FRIEDER. See COMPUTER ART.

NAKIAN, REUBEN (1897–). American sculptor born in New York, studied from 1911 at the Robert HENRI School, the Art Students' League and the Beaux-Arts Institute of Design. He was apprenticed to Paul MANSHIP, 1917–20, and worked with Gaston LACHAISE, 1920–3. He obtained a Guggenheim Foundation Fellowship in 1930 and exhibited in New York from c. 1926. He drew his inspiration from the grandeur of European art and often worked on a monumental scale. In the 1930s he was known particularly for his portrait sculpture. During the war years he confined himself almost entirely to drawing but returned to sculpture c. 1947 and became one of the pioneers of the new school of expressive abstraction. He used terracotta, quick-drying plaster and burlap stretched on chicken wire and dipped in plaster or glue. As his style developed he also worked for casting in bronze and used welded steel (*Rape of Lucrece*, The Mus. of Modern Art, New York, 1955–8). His sculptures were usually based on a mythological theme with figurative suggestions but made their impact by their rhythmical and expressive abstract qualities. From 1949 he exhibited at the Charles Egan Gal., New York, and he had one-man shows at São Paulo in 1961 and the Los Angeles County Mus. of Art in 1962. In 1966 he had a retrospective exhibition at The Mus. of Modern Art, New York. In 1961 he executed a commission for sculpture decorating the façade of the Loeb Student Center, New York University.

NALLARD, LOUIS (1918–). French painter, born and studied in Algiers. He began to exhibit in Algiers at an early age in a style of poetic Realism with delicate interplay of colour. In 1945 he changed to expressive abstraction and in 1947 he settled in Paris, but travelled extensively to the Netherlands and Spain. He exhibited frequently both in Paris and abroad and had a one-man show at the Gal. Jeanne Bucher, Paris, in 1953. From 1949 he exhibited at the Salon de Mai and often showed in joint exhibitions with his wife, Maria Manton. His work was in an ALL-OVER style of linear hatchings in a restricted range of colour giving the impression of subtle surface variation.

NANNINGA, JAAP (1904–62). Dutch painter born at Winschoten, studied at Groningen and Amsterdam and then at the Academy of Art, The Hague, 1939–43. He spent much time in the south of France and in Paris, where he came under the influence of Geer van VELDE and matured a style of sensitive and introspective abstraction which

has been compared in some respects with that of CORNEILLE. His colours were subdued and his abstracts reflected the mood of landscape. He was given a retrospective memorial exhibition at the Rotterdam Mus. in 1963.

NARKOMPROS (NKP). Abbreviation of *Narodnyi komissariat prosveshcheniia* (People's Commissariat of Enlightenment) founded shortly after the October Revolution in Soviet Russia. Under the general directorship of Anatolii Lunacharsky, Narkompros was in charge of general cultural and educational policy. It contained a special Visual Arts Section (called IZO Narkompros) headed by Shterenberg (based in Petrograd) and assisted by TATLIN (in Moscow). IZO Narkompros concerned itself with the organization of a cycle of state exhibitions (21 between 1918 and 1921), with the administration of the new art schools (Svomas/ VKHUTEMAS) and research institutes (INKHUK) and with public commissions (such as Lenin's Plan of Monumental Propaganda). Many of the *avant-garde* artists and critics were associated with IZO Narkompros in one way or another. In 1918–19 it published its own journal, *Iskusstvo kommuny* (*Art of the Commune*), to which ALTMAN, MALEVICH, POUGNY (Puni), PUNIN, Shterenberg and others contributed. Narkompros also contained special sections devoted to the theatre (TEO), music (MUSO), literature (LITO) and the cinema (FOTO-KINO). In the early years, partly as a result of Lunacharsky's tolerance and liberalism, Narkompros maintained a fairly independent stance, but by the late 1920s (especially after Lunacharsky's departure in 1929), it became an integral part of the Party apparatus.

NASH, JOHN NORTHCOTE (1893–1977). British painter and draughtsman, born at Earls Court, London. He had no formal training as a painter but was persuaded by his elder brother, Paul, to take up the career of artist, beginning with drawing and water-colour. He started painting in oils *c.* 1914 and began wood engraving *c.* 1920. His reputation rests chiefly on his landscapes, particularly the water-colours, which have the direct vision of the countryman and an unassuming candour combined with poetic insight.

In 1913 he had a successful exhibition together with his brother at the Dorien Leigh Gals. and became a member of the LONDON GROUP. In 1915, as a member of the CUMBERLAND MARKET GROUP, he exhibited with GILMAN, BEVAN and GINNER at the Goupil Gal. His first one-man show was at the Goupil Gal. in 1921. He was an official War Artist in 1918 and again in 1940. He taught at the Ruskin School of Drawing, Oxford, from 1922 to 1927 and at the Royal College of Art 1934–40 and again from 1945. He was made A.R.A. in 1940 and R.A. in 1951. A retrospective exhibition of his work was held at the Leicester Gals. in 1954. Besides his drawings and landscape paintings John Nash illustrated some 26 books, many of them

botanical works. Best known are his illustrations to R. Gathorne-Hardy's *Wild Flowers in Britain* (1938) and *English Garden Flowers* and Gilbert White's *The Natural History of Selborne* (1951).

NASH, KATHERINE. See COMPUTER ART.

NASH, PAUL (1889–1946). British painter and draughtsman, born at Earls Court, London. He received his artistic training at Chelsea Polytechnic, 1907–8, the London County Council school at Bolt Court, Fleet Street, 1908–10, where he attracted the attention of Sir William ROTHENSTEIN with a drawing, *Flumen Mortis*, and the Slade, 1910–12. Among his contemporaries at the Slade were Stanley SPENCER, Mark GERTLER, Edward WADSWORTH and Ben NICHOLSON, with the last of whom he became a close friend. In 1911 he met Sir William Richmond, R.A., and on his advice set himself to become a landscape painter, deliberately suppressing the imaginary element in his work, although he had first embarked upon an artistic career with the idea of earning his living as an illustrator. His first one-man show was at the Carfax Gal. in 1912 and in 1914 he exhibited water-colours together with his brother John at the Dorien Leigh Gals., where he attracted the attention among others of Roger FRY and was invited by him to design for the Omega Workshops. He also became a regular exhibitor at the NEW ENGLISH ART CLUB. There was already a small vogue for 'Nash trees', although at this time his pictures were basically coloured or tinted drawings and to some extent they have always retained this quality. From childhood Nash had had a strong sense of 'place' and his landscape studies derived their originality from their powerful evocation of the personality of the place. It was this which conferred on them a 'poetic' character which, persisting through life, established Nash firmly in the tradition of English landscape painting.

Nash enlisted in the Artists' Rifles in 1914 and saw active service on the Ypres Salient in the spring of 1917. He was invalided home and towards the end of the year returned to the Front as an official War Artist. His war pictures, done from drawings made on the spot, were exhibited at the Goupil Gal. in 1917 and at the Leicester Gals. in 1918. By their directness and immediacy, and their power to convey the true mood of frightfulness in the landscape of war, they created an enormous impression and established Nash as the most important and original of the war artists. Arnold Bennett, in a foreword to the catalogue of the Leicester Gals. exhibition, wrote: 'The interpretative value is, to my mind, immense. Lieutenant Nash has seen the Front simply and largely. He has found the essentials of it—that is to say, disfigurement, danger, desolation, ruin, chaos—the little figures of men creeping devotedly and tragically over the waste.' Herbert READ, writing of the same exhibition, said: 'I have myself just returned from the Front, and it is perhaps worth recording that

my interest in Paul Nash's work dates from this time. I was in no mood for any falsification of this theme; I wanted to see and hear the truth told about our hellish existence in the trenches. . . . I was immediately convinced by the pictures I then saw, because here was someone who could convey, as no other artist, the phantasmagoric atmosphere of No Man's Land.' Nash had begun to paint in oils towards the end of 1917. Among the more important oils in the exhibition were *We are Making a New World* (Imperial War Mus., 1918) and *Void* (National Gal. of Canada, Ottawa, 1918). The large canvas *The Menin Road*, commissioned for the Imperial War Mus., was completed in 1919 and in the same year he began the more ambitious, if rather less directly authentic, *A Night Bombardment* commissioned by the Canadian War Records.

During the 1920s Nash passed through a difficult period both financially and otherwise. He made his home at Dymchurch on the Romney Marsh (1919–24) and then at Iden in Sussex (1925–9). His landscapes became increasingly formalized, though he never went over to abstract construction except in a few wood engravings, and some of his most evocative work, as yet without symbolic import or SURREALIST flavour, dates from this time. Examples are: *The Wall against the Sea* (Carnegie Institute, Pittsburgh, 1922); *The Shore* (Leeds City Art Gal., 1923); *Winter Sea* (York City Art Gal., 1925). In its day *Wood on the Downs* (Aberdeen Art Gal., 1929), widely known through frequent reproduction, was regarded as a paradigm of modernity in British art. In 1922 Nash made seven woodcuts which, illustrated by his own prose poems, were published in a book entitled *Places*. In the following year he was commissioned by the Nonesuch Press to do 12 wood engravings to illustrate the story of Creation in the book of Genesis. These were the most abstract of all his works.

After a successful exhibition at the Leicester Gals. in 1928, as if he were reluctant to rest with a popular image, Nash's work began to change its character, taking on both symbolical and Surrealistic features, a development which continued through the 1930s. *Northern Adventure* (Aberdeen Art Gal., 1929) looks forward to *Glass Forest* (Brighton Art Gal., c. 1930–4) and *Voyages to the Moon* (Tate Gal., 1934–7), in which he used the extended perspectives of the mirror image, and to the unending dream perspectives in such pictures as *The Three Rooms* (Brighton Art Gal., 1936–7) and the use of dual vision as in *Harbour and Room* (Brighton Art Gal., 1931). In 1931–2 Nash did the now famous illustrations for Sir Thomas Browne's *Urn Burial* and *The Garden of Cyrus*, which Herbert Read called 'one of the loveliest achievements of contemporary English art'. In these illustrations he approached most nearly of any of his works to the mystical and many of the designs afforded themes for his later paintings. During this period also he took the lead in developing interest in the

objet trouvé, signalizing the intrinsic character of chance objects such as curiously shaped pebbles or gnarled sections of dead branches by means of photography, by isolating them on stands and pedestals or in other ways. Enlarged, such objects often became Surrealistic monsters in his paintings, such as *Landscape of the Megaliths* (Albright-Knox Art Gal., Buffalo, 1937); *Nest of Wild Stones* (Arts Council of Great Britain, 1937); *Nocturnal Landscape* (Manchester City Art Gal., 1938); *Stone Forest* (Whitworth Art Gal., University of Manchester, 1937).

In 1933 Nash was instrumental in forming the short-lived association UNIT ONE. In the Second World War as an official War Artist once again he worked mainly under the aegis of the Air Ministry and won the reputation of being the most successful, if not the only, artist to represent visually the realities of aerial combat. He emphasized the inhuman mechanization of modern warfare, endowing the aeroplane with a character and personality of its own akin to the Surrealistic personalities which had pervaded paintings of his earlier period. This is apparent both in pictures depicting actual conflict such as *Night Fighter* (National Gal. of Canada, 1940) or *Target Area* (Imperial War Mus., 1945) and in those depicting the wrecked victims of combat such as *Totes Meer* (Tate Gal., 1940–1) and *Under the Cliff* (Ashmolean Mus., 1940). During the closing years of his life Nash suffered from attacks of bronchial asthma, which became chronic. But quite apart from his war pictures, his work took on a new character in this phase. The element of fantasy returned as in *Landscape of the British Museum* (Fitzwilliam Mus., Cambridge, 1944). More important still, what C. Day Lewis called his 'master-habit of metaphor' matured into pictures which, combining his unique feeling for the personality of objects with the Surrealistic quality of MAGIC REALISM, took on a genuinely 'visionary' character. Outstanding examples of this final phase are: *Landscape of the Vernal Equinox* (H.M. The Queen Mother, 1943–4); *Hydra Dandelion* (H.M. The Queen, 1945); *Eclipse of the Sunflower* (examples in Victoria and Albert Mus. and British Council, both 1945); *November Moon* (Fitzwilliam Mus., Cambridge, 1942); *Solstice of the Sunflower* (National Gal. of Canada, 1945).

Paul Nash was called by René MAGRITTE 'the master of the object' and Margot Eates in her study of 1973 uses the sub-title 'The Master of the Image'. For the 'poetic' character of his painting—his power to see and depict trees, scenes and inanimate objects as personalities with a character and presence of their own—he has been accorded a place within the tradition of English landscape painting, though his crispness and definition had nothing in common with the Impressionism either of Constable or Turner. He was little affected by the French Post-Impressionism introduced into Britain by Roger FRY, but going his own way he produced work which established itself as an im-

portant landmark in the development of English art of the 20th c. A Memorial Exhibition was given at the Tate Gal. in 1948.

NATIONAL SOCIALIST ART IN GERMANY. When Hitler came into power in 1933 modern art in Germany was suppressed (see DEGENERATE ART) and a new Government-controlled art was fostered, whose purpose was to glorify the Nazi philosophy of the Nordic superman against the background of his Germanic homeland and to further the Nazi cult of 'Strength through Joy'. In October 1933 a Day of German Art was observed in Munich and the construction of a House of German Art was begun. In April 1935 Goebbels issued a decree bringing all artists under the jurisdiction of the Reichskulturkammer, founded in 1933, and artists were ordered to produce a 'racially conscious' popular art. At the opening of the Reichskultursenat in November 1935 Goebbels declared: 'The freedom of artistic creation must keep within the limits prescribed, not by any artistic idea, but by the political idea.' An exhibition of this art was held in July 1937 at the newly completed House of German Art in Munich. Hitler intervened personally at this exhibition, dismissed the selection committee and put the exhibition under the administration of his court photographer. Within the next few years some 20,000 officially approved paintings were disseminated to the museums throughout the land, where they took the place of the 'degenerate' works which had been purged. They were removed from public view at the end of the war but in 1974 a selection was exhibited at the Kunstverein Mus., Frankfurt.

Perhaps the best description of this Nazi art was contained in an article by William Feaver published in *The Sunday Times*, 5 January 1975, in which he wrote: 'The most obvious characteristic of National Socialist painting, setting aside everything that went with Nazism as a means of expression and way of life, the racial smears and the worship of force, is its gladsome-mindedness. Doubts, questionings and innovations were best left to the perverts and degenerates, the Klees and Ernsts, and banned. The sort of art Hitler and millions of others wanted was heartwarming, encouraging and, wherever possible, discreetly salacious. It was not peculiarly Third Reichian. It belonged to a Salon tradition stretching way back into the mid-19th century. Soviet Five-Year-Plan, Good-Earth art was similar, and the style in general was echoed during the Thirties in the Cleanly-Realist sectors of the Royal Academy, the Paris Salon, and in murals executed in U.S. post offices and other public places as part of Roosevelt's New Deal in art.'

NAUDE, HUGO. See SOUTH AFRICA.

NAUMAN, BRUCE (1941–). American artist born at Fort Wayne, Ind., and lived at Pasadena, California, where he became a prominent member of the West Coast artistic movement. He was an exponent of CONCEPTUAL ART and in particular of BODY ART, after having passed through a phase of FUNK ART. In their note to the catalogue of the exhibition '11 Los Angeles Artists' at the Hayward Gal. in 1971 Maurice Tuchman and Jane Livingston said: 'What is almost consistently true of his work is that it deals with portrayals or extensions of the artist's physical self; or it creates situations in which the observer confronts or uses his own body as an "esthetic" act.' His 'creations' often consisted of annotated sketches which might or might not be realized, as the contributions to the Hayward Gal. exhibition: *Green Light Piece* and *Paralax Room*. Among the collective exhibitions in which he was represented are: San Francisco Mus. of Art, 'New Directions', 1966; Los Angeles County Mus. of Art, 'American Sculpture of the Sixties', 1967; DOCUMENTA IV, Kassel, 1968; Kunsthalle, Berne, 'When Attitudes Become Form', 1969; Solomon R. Guggenheim Mus., New York, '9 Young Artists', 1969; Whitney Mus. of American Art, 'Contemporary American Sculpture', 1970; New York Cultural Center, 'Conceptual Art and Conceptual Artists', 1970.

NAVARRO, PASCAL (1923–). Venezuelan painter, studied at the Academy of Fine Arts, Caracas, 1938–44. He travelled in Italy, Spain, England and Belgium and was in Paris in 1947. He took up abstract painting after seeing the exhibition 'Premiers Maîtres de l'Art Abstrait' at the Gal. Maeght in 1949 and from 1950 to 1952 he was a member of the Atelier d'Art Abstrait founded by PILLET and DEWASNE. He exhibited at the SALON DES RÉALITÉS NOUVELLES and had a one-man show at the Gal. Arnaud, Paris, in 1952.

NAY, ERNST WILHELM (1902–68). German painter, born in Berlin and trained at the Berlin Academy of Art under HOFER. He went to Paris in 1928 and to Rome in 1930. In 1936 he went to Norway on the invitation of MUNCH. In 1951 he joined the Cologne ZEN group and settled in Cologne. In the mid 1930s Nay was painting scenes from Lofoten and the fjords in an EXPRESSIONIST style with heavy brush-strokes and colours based on the FAUVES. Towards the end of the decade he was giving even more emphasis to colours with suggestions of mystical or mythological scenes half emerging from them. By 1950 he was painting in an almost purely abstract manner with straight and curvilinear lines and ellipsoid shapes merging into a decorative harmony. Further emphasis upon colour led him c. 1953 to a form of TACHIST composition. At this time he said: 'I not only give colour precedence over all other plastic media but my formative activity is determined by it.' He had retrospective exhibitions at Düsseldorf in 1959 and at Essen in 1962.

NEAGU, PAUL (1938–). Romanian sculptor and graphic artist, born at Bucharest. In 1969 he had an

exhibition of 'tactile objects' at the Amphora Gal., Bucarest, and went to Edinburgh for an exhibition 'Four Romanian Artists' at the Richard Demarco Gal. He issued a manifesto 'Palpable Art' and gave a demonstration of it at the Edinburgh Festival. From 1970 he lived and worked in London. Between 1971 and 1974 he arranged a series of 'events', including 'Blind's Bite', 'Horizontal Rain', 'Going Tornado', which reappear in his graphic work. In 1972 he lectured on 'Generative Art Forms' at the Queen's University, Belfast, and was one of the founders of the GENERATIVE Art Group. He had a number of one-man exhibitions, including Mus. of Modern Art, Oxford (1975), and Thumb Gal., London (1976), and his work was represented in a number of group shows, including John Moores Exhibition, Liverpool, 1969 and 1974; Serpentine Gal., 1973; 'Condition of Sculpture', Hayward Gal., 1975. Much of his graphic art was based on an extremely personal philosophy or mythology which remained obscure to many people despite lavish explanatory notes included in the drawings themselves and despite the artist's published statements. Some of his drawings were analyses (called 'inquests') of well-known works of art—the *Flying Horse* of Kansu, drawings by Cranach, Michelangelo, etc. These drawings were roughly reproduced and divided into a large number of segments resembling, in a general way, the drawings of DALÍ.

NEGRET, EDGAR (1920–). Colombian sculptor born in Popayán. His first studio was located in the Franciscan convent there, then from 1938 to 1943 he studied at the School of Fine Arts, Cali. He formed a friendship with the Spanish sculptor Jorge de Oteiza when the latter visited Colombia in 1944. At this time Negret was working in a simplified figurative style in stone, as in *Virgin* (1944), and metal, as in *Head of Christ*, but he became increasingly interested in a more modern use of space and volume when Oteiza introduced him to the sculpture of Henry MOORE through illustrations. His first exhibition took place at the Biblioteca Nacional, Bogotá, in 1946. In 1951 he went to Europe and in 1953 visited Spain and Mallorca, where he found several sculptors working in metal and glass. He exhibited at the SALON DES RÉALITÉS NOUVELLES in 1952 and *Divergences* in 1953. From 1955 to 1963 he lived in New York, where he formed friendships with Ellsworth KELLY, Jack YOUNGERMAN, Louise NEVELSON, and Robert INDIANA. He taught for a while at the New School for Social Research and during that time won a UNESCO research grant to study indigenous American art. He began to work exclusively with metal, bending and soldering it into a variety of shapes as in the 'Magic Apparatus', 'Masks' and 'Signals' series, which he exhibited for the first time in 1958 at the Biblioteca Nacional, Bogotá. By the early 1960s his sculpture had simplified and he developed a module which he built into vertical, horizontal or oblique compositions whose units

were assembled with nuts and bolts all of which he painted white, red or black. He deliberately gave his works the appearance of industrial structures such as the 'Bridges' series begun in 1964, and skyscraper skeletons as in his *Edifice* (1968). Many of his titles also alluded to space travel, such as *Navigator* (1972) and *Acoplamiento* (1974), which can be translated either as 'Docking' or 'Coupling'. In *Temple* (1973) he also pays tribute to pre-Hispanic architecture. He exhibited widely in Europe, the U.S.A. and Latin America. In the 1950s he showed at the Peridot Gal. (1955) and at the Pan American Union, Washington (1956). In the 1960s he exhibited at the Mus. of Modern Art, Bogotá (1965), the Mus. of Modern Art, Rio (1966) and the Bonino Gal., New York (1969). He participated in the 1963 Festival of Two Worlds in Spoleto, in the São Paulo Bienales of 1957 to 1965, winning a silver medal at the last, in the Guggenheim International 'Sculpture from Twenty Nations' (1967–8), the 34th Venice Biennale in 1968, winning the David Bricht prize, and in DOCUMENTA IV, Kassel, 1968. He also won an award at the XIXth National Salon, Bogotá, in 1967. In 1973 he was given a retrospective at the Mus. of Fine Arts, Caracas. After his return to Colombia he taught at universities in Bogotá with frequent trips abroad. Negret's modular sculpture greatly influenced the work of younger Colombian sculptors.

NEGRO SCULPTURE, INFLUENCES OF. Art objects from Africa found a place in the *Kunstkammer* and *Cabinet de Curiosités* of Western Europe from the time of the late Renaissance. It is known that the son of André Tiraqueau (1480–1550), the patron of Rabelais, had objects from Guinea in his collection. Collections in the Mus. Archeologico of Madrid, the British Mus., the Mus. of Leyden, the Vatican collections, the Mus. de l'Homme, Paris, and others go back to the beginning of the 16th c. after trade had been opened up with the west coast of Africa. The objects consisted of ivories, bronzes, carved wood and some gold and jewellery. There were weapons and utensils, musical instruments, religious and ceremonial objects, hanging masks, etc. The systematic despoliation of Africa by merchants, missionaries and ethnologists began, however, about the middle of the 19th c., and when in the years following 1870 most of the important cities of Europe formed their ethnological museums the mass of material available was already enormous. By 1885 almost all the regions of Africa were represented in the European museums. According to an estimate of Th. Masui, curator of the Congo Mus. at Tervuren, Belgium, some 20,300 objects had reached European museums from the Congo alone within the space of twenty years. The British punitive expedition against Benin in 1897 resulted in massive additions to the booty of bronzes and ivories, which were subsequently dispersed to the British Mus., the Pitt Rivers Mus., the Mus. für

Volkerkunde, Berlin, and others, including Dresden, Cologne, Vienna, Leningrad, Stuttgart and Leyden. But up to the end of the century interest in these acquisitions was solely ethnological, and not very well informed. There was virtually no aesthetic interest in them and throughout the 19th c. they held little or no appeal for artists. Typical of the attitude taken is a remark made by André Michel (reproducing almost verbatim a statement made by Sir John Lubbock in 1870) in the article on Africa for the *Grande Encyclopédie* edited by C. Augé (1898–): 'Among the Negroes, who like all the tribes of Central and Southern Africa appear to be very backward in everything to do with art, we find idols representing the characteristics of the Negro race with a grotesque fidelity.'

Aesthetic interest, and the interest of artists themselves, in Negro sculpture began in the 20th c. The way was prepared to some extent by Gauguin, who with his passion for Breton folk art, Egyptian and Cambodian art, Japanese woodcuts and the art of the Oceanic islands of Tahiti and Martinique encouraged artists to look with new eyes upon the exotic and the primitive. The trend was continued by MATISSE with his interest in Persian ceramics as well as Japanese prints and Polynesian *tapa* designs. For before Negro sculpture could exert an influence on European art it had to be seen by European artists not as cult objects, fetishes and utensils from peoples at a very low level of artistic development but as autonomous art with an aesthetic of its own differing in specific ways from the European aesthetic tradition. And when the African aesthetic was not only seen but was seen to impinge upon new problems with which European artists were themselves concerned, then the influence became more than casual. This happened during the first decade of the 20th c. In the words of D.-H. KAHNWEILER: 'About 1907 certain painters and their friends began to collect sculptures of black Africa and of Oceania promiscuously. It seems clear that works so distinct from the aesthetic pantheon must have had some relation with the aims put before themselves by the painters who attributed artistic value to these sculptures' (*Confessions Esthétiques*, Paris, 1963). Yet the African art these artists knew was more restricted than is always realized. It was different for the French and the Germans, and what they saw in it was different too. In France African art was a branch of 'l'art colonial' and up to 1914 was to all intents and purposes restricted to the Ivory Coast (Baule and Senufo) and the French Congo (Dahomey and peoples of the Ogowe river). MODIGLIANI borrowed occasionally and casually from Baule, SCHMIDT-ROTTLUFF more systematically from Dan. There were by and large two contrasting—though not mutually exclusive—types of interest. Those who valued Negro art as something spontaneous, primitive, picturesque, exotic, were VLAMINCK, DERAIN, NOLDE, the artists of the BRÜCKE. Those who valued it for profounder structural reasons included Matisse, PICASSO, BRAQUE, GRIS.

There are, inevitably, several variant versions of the 'discovery' of Negro sculpture by the artists of Paris. One of the more picturesque stories has it that Vlaminck acquired a Negro statue for a song in a bistro at Bougival (or three statues in a bistro at Argenteuil) and took it to show Derain, exclaiming enthusiastically: 'It is almost as beautiful as the Venus de Milo.' Derain, equally enthusiastic, replied: 'Quite as beautiful.' They then took it to Picasso, who after reflection pronounced in his heavy Spanish accent: 'It is more beautiful' (*C'est plusss bô*). Others, including Gertrude Stein, have attributed the discovery to Matisse and many (including Max Jacob) have claimed that it was from Picasso's interest in a Negro sculpture that CUBISM was born. Be this as it may, it is certain that in the years 1905 to 1908 a small group of painters were collecting African sculptures, were discussing them and were profoundly excited by them. It was in these years too that Paul Guillaume began the collection which was published in 1917 and acquired an interest which led him in 1926 to write *Primitive Negro Sculpture* in collaboration with Thomas Munro. It seems paradoxical that the painters who took the lead in discovering an enthusiasm for African sculpture were FAUVISTS, whose primary interest at the time was in colour and colour relations. It was these artists, however, who began to value objects imported from Africa and the South Seas for their spontaneity and their emotive power. It was Picasso who first derived a deeper constructive inspiration from African sculpture.

In the spring of 1907 Picasso had painted *The Harvesters*, a picture which both in his desire to create movement and in his use of colour approached most closely to the Fauves. *Les Demoiselles d'Avignon*, painted through 1906 and 1907, had a different aim. The colour was restricted to pinks and blues while the forms were deliberately static and more clearly defined. The three figures on the left of the picture have obvious affinities with nudes painted in the previous year and show the influence of Iberian sculpture. But the two figures on the right, thought to have been painted later, as obviously relate to the African masks from the French Congo. The harsh faces are given relief with bold hatching and have a barbaric violence of appeal. In the years immediately following *Les Demoiselles d'Avignon* Picasso carried further the discoveries he had used in these figures and applied them to the rendering of still life and landscape. These years are therefore known as his 'Negro Period'. The new style may be seen in *Dancer* (1907), *Negro Dancer* (1907), *Bather* (1908), *Fruit Dish* (1908–9), Nos. 9a, 10e, 12b, 12a in the catalogue of the Picasso exhibition at the Tate Gal. in 1960, and others from the same time. One can trace how this style developed into the Cubist manipulation of forms. From African sculpture Picasso derived two things, both very different from simple exotic appeal and emotive strength: on the one hand he began to use DISTOR-

TION more freely than before for expressive purposes as African sculpture exaggerates and distorts the human form in the interest of psychological emphasis; on the other hand he saw in African sculpture a *conceptual* art which depicts what is known rather than what is directly seen. It was these qualities which lay at the basis of the new Cubist interpretation and of much that followed it. In his book *Cubism* (1959) John Golding wrote: 'Salmon quotes Picasso as saying that he admired Negro sculptures because he found them "raisonnables". In stressing the more "reasonable" or rational character of African art, Picasso was underlining the quality that distinguishes it most fundamentally from Western art. As opposed to Western art, Negro art is more conceptual, much less conditioned by visual appearances. The Negro sculptor tends to depict what he knows about his subject rather than what he sees. Or, to put it differently, he tends to express his *idea* of it. This leads inevitably to great simplification or stylization, and, at the same time, to a clarification and accentuation of what are felt to be the significant features or details of the object depicted.' Golding, following Kahnweiler, also emphasized the debt to the non-naturalistic qualities of Wobé art from the Ivory coast in the constructions of Picasso and Braque during the years 1912 and 1913. The non-naturalistic forms in still lifes of this period take on the quality of symbols, from which the spectator can reconstruct the subject. The part may stand for the whole or solids and voids may alternate, and so on.

The attitude of the German Expressionists of the *Brücke* was contrary to this. Their approach was subjective and emotional. They appreciated primitive art, including African, as something exotic, a force of inspiration against the rationalism to which they were themselves opposed, a vigorous affirmation of vitality, and little else. For them it was a new stimulus rather than the source of a new aesthetic.

After Cubism the influence of African sculpture was assured, but the attitude towards it rather curiously changed once again. For many people it was no longer a 'conceptual' art or an 'exotic' source of inspiration, but rather a true representation of our actual perceptions of the world. This view was held in particular by GIACOMETTI and is expressed in the following statement by Jean-Marie Drôt (quoted by Reinhold Hohl, *Giacometti*, p. 248): 'Basically, Western, or, say, Greco-Roman sculpture, which wants to represent the head as it is, is the most abstracted and constructed sculpture there is. The sculpture of Africa or Polynesia, where they made large, flat heads, corresponds much more closely to what we perceive of the world than Greco-Roman sculpture.' It seems to be the case that the interest in African sculpture, or in African sculpture seen through Cubist eyes, induced characteristic changes, at any rate among artists and connoisseurs, in our way of looking at the world of actuality, so that what

seemed barbaric, crude, primitive, or at best vital and exotic at the end of the 19th c. was by the 1920s already beginning to be seen as a true reflection of our actual perceptions. As this modification in the way of looking at things established itself, the influence of Negro sculpture became even more pervasive and more subtle.

NEJAD, MEHMED D. (1923–). Turkish painter, born in Istanbul. After studying at the Academy of Fine Arts, Istanbul, he modelled his style on Byzantine mosaics and Islamic decorative and calligraphic art. He went to Paris in 1945 and changed his manner of painting in the direction of the expressive abstraction later known as TACHISM. His pictures were spontaneously composed rather than calculated and he said: 'In painting I throw the whole of my work into question every time I take up my brush.' His work consisted typically of sets of related expressive forms standing out against a near-monochromatic background in closely related hues. He had a number of one-man shows in Paris during the 1950s and took part in group exhibitions, including the SALON DES RÉALITÉS NOUVELLES and the Salon de Mai. In 1952, discontented with the way in which his works were hung at the Salon de Mai, he founded the Salon d'Octobre for abstract art.

NELE, E.R. (1932–). German sculptor, born in Berlin. She studied from 1950 to 1955 at the Central School of Arts and Crafts, London, and then in Berlin under Hans UHLMANN. In 1956 became known for her jewellery exhibited at the Stedelijk Mus., Amsterdam, and in 1957 won the Gold Medal for Jewellery at the Milan Triennale. She won the Schwabinger Kunstpreis in 1962 and in 1963 the Munich prize for sculpture. From the 1960s her work was exhibited widely in Germany and in 1960 at the Molton Gal., London. She did bronzes cast from steel assemblies and from the late 1960s she made 'elementary forms' of flat columns and cylinders with spheres attached. These stood on the ground and were described as 'playthings' inviting the spectator to participate in the game. The parts were movable and could be rearranged by the spectator.

NELLENS, ROGER (1937–). Belgian painter born at Liège. He began painting *c.* 1960 without formal training on the collapse of his poultry farm at Knokke-Le Zoute. He painted imaginary machines or parts of machines, using as his source diagrams and illustrations of 18th- or 19th-c. machines. 'My machines', he said, 'are useless except as a pretext for painting.' Painted in black and white or in subdued colours against monochromatic backgrounds, they were depicted with razor-sharp precision in flat, two-dimensional patterns and had the clarity of blown-up miniatures. These machine paintings evolved from paintings of railways and signals which began with a commission for a painting of a railway station in 1967. Nellens

exhibited at the Salon de Mai from 1967 and at the Biennale de Paris in 1971. From this time his work began to be more widely known and exhibited, including one-man exhibitions at the Alexander Iolas Gal., New York, in 1974 and at the Marlborough Fine Art Gal., London, in 1976. Among other public collections his works are represented in the Mus. d'Ostende, the Boymans-van Beuningen Mus., Rotterdam, and the Tate Gal., London.

NEO-DADA. See POP ART.

NEO-DADA ORGANIZERS. A group of Japanese artists based in Tokyo and emerging from the Yomiuri Independent Exhibition of 1958. The movement was obsessed with the ideas of ruins and destruction, advocating JUNK ART in rebellion against traditional conceptions of art and organizing violently destructive demonstrations. The urban planner Arata Isozaki wrote: 'The ruins are the symbol of our future city; the future city *is* ruins.' Among the artists prominent in the movement were Shusaku ARAKAWA, Genpei AKASEGAWA, Tomio MIKI and Shijiro Okamoto. The group dispersed in 1963.

NEO-GESTALTISM. See OP ART.

NEO-PLASTICISM. The term was taken by MONDRIAN from M. J. H. Schoenmaeker, by whom he was deeply influenced in his mystical and transcendental ideas about the totality of nature and its expression through the geometrical intersection of lines. Schoenmaeker's phrase *de nieuwe beelding* was rendered by Mondrian as *Néo-Plasticisme* and the mystical philosophy of Schoenmaeker was a major inspiration of Mondrian's first published work, *De Nieuwe Beelding in de Schilderkunst* (*Neo-Plasticism in Pictorial Art*), in which he wrote: 'The new plastic art starts where form and colour are expressed as a unity in the rectangular plane. By this universal means of expression the versatility of nature can be reduced to more plastic expression of definite relations.' It seems likely that it was mainly the influence of Schoenmaeker which directed and fortified Mondrian in his change-over from the abstractions which he made from nature during the years 1908 to *c.* 1915 and strengthened him in his adoption of the rigorously rectilinear manner of geometrical abstraction without a basis in natural appearances which he called Neo-Plasticism. Schoenmaeker, whom Mondrian knew in 1916–17, was a writer of popular books on philosophy and religion and the mystical doctrines of his book *Het Nieuwe Wereldbeeld* (*The New World-Picture*) coalesced with Mondrian's theosophical beliefs. See also De STIJL.

NEO-REALISM. Name of an aesthetic philosophy worked out by Harold GILMAN, Charles GINNER and Spencer GORE in 1913. Gilman and Gore exhibited together under the name 'Neo-

Realists' in 1913 and Gilman and Ginner together in 1914. Their philosophical outlook was formulated in an article by Ginner which appeared in the magazine *The New Age* in 1914 and which was reprinted in the catalogue of the Gilman/Gore exhibition at the Goupil Gal. in the same year.

In Ginner's pamphlet Realism was defined in terms of artistic style rather than subject matter. It involved a direct expression of the artist's experience of nature, his personal interpretation of nature, as against derivative impressions borrowed from elsewhere. 'Each age has its landscape, its atmosphere, its cities, its people. Realism, loving Life, loving its Age, interprets its Epoch by extracting from it the essence of all it contains of great or weak, of beautiful or of sordid, according to the individual temperament.' By this criterion the Impressionists were asserted to be Realists, as also were the Post-Impressionists Cézanne, Gauguin and Van Gogh. The Neo-Impressionists were condemned for having neglected the direct contact with Nature and Life in favour of their scientific interests. The CUBISTS were condemned for analogous reasons. The 'decorative' concept of art inherent in the work of MATISSE was also condemned. The direct contrary of Realism was said to be Academicism, defined as 'the adoption by weaker commercial painters of the creative artist's personal methods of interpreting nature and the consequent creation of a formula', a process which finally ended in the 'débâcle of Bouguereau, Gérôme, of the British Royal Academy'.

The term is also sometimes used as a translation of *Nouveau Réalisme* (see NOUVEAUX RÉALISTES) or as a synonym of NEW REALISM.

NÉO-RÉALISME. Name often given to a movement among French painters of the 1930s in the direction of poetic Naturalism. Without forming a group or association, these artists included among others: Raymond LEGUELT, Maurice BRIANCHON, Jean AUJAME, André DUNOYER DE SEGONZAC, Charles DUFRESNE, Luc-Albert MOREAU.

NESCH, ROLF (1893–1975). German-Norwegian painter and graphic artist born at Oberesslingen, Württemberg. After being trained as a decorative commercial painter he studied at the Stuttgart School of Arts and Crafts, 1909–12, and then at the Dresden Academy, 1913–14. There he knew KIRCHNER and other members of the BRÜCKE. After the war, in which he was taken prisoner, he studied the art of printing and in 1930 went to Hamburg and joined the Hamburg SECESSION. In 1933 he emigrated to Norway and gathered around him a group of young experimental artists to investigate the expressive possibilities of new materials. Still strongly under the influence of German EXPRESSIONISM he devised in 1937 a method of soldering copper wire, or later of affixing pieces of coloured glass, wire mesh, nails, etc. to the surface of the plates he used for printing in a kind of mosaic. These constructs he called

'material pictures'. He acquired Norwegian citizenship in 1946. In 1966 he was given a retrospective exhibition at the Akademie der Künste, Berlin.

NESJAR, CARL (1920–). Norwegian painter, sculptor and graphic artist. From 1927 to 1948 he lived mainly in the U.S.A., where he studied at the Pratt Institute and Columbia University. In the 1950s he spent much time in France, where he knew PICASSO. His painting was originally in a style of expressive naturalism with restrained colours, but became progressively more abstract. He worked out an original method of decorative sculpture by sandblasting concrete and used this technique in decorations for the Government Building, Oslo, and for decorative sculpture done in Barcelona to designs by Picasso. Nesjar also produced abstract photographs from natural forms and made experimental films.

NETHERLANDS (HOLLAND). The highlights of Dutch art in the first half of the century were: the FAUVISM of Kees van DONGEN, who, however, worked mainly in Paris; MONDRIAN, Van DOESBURG and the De STIJL group; and after the Second World War Karel APPEL and the other Dutch adherents of the COBRA group. There was, however, other important work going on inside the Netherlands both before and after the Second World War. While SURREALISM made little impression there, a strong movement in EXPRESSIONISM and expressive Realism continued up to c. 1940. Among the many artists working competently in this manner were Charley TOOROP, Piet OUBORG and H. N. WERKMAN.

In 1946 the association *Vrij Beelden* (Free Creativity) was formed, bringing together younger progressive artists over a wide spectrum of styles. Two years later, in 1948, there arose from it the EXPERIMENTAL GROUP with Appel, CONSTANT and CORNEILLE as the central figures, joined among others by Anton ROOSKENS and Gerrit BENNER. In the journal of the group, *Reflex*, Constant wrote that they held to the belief that improvisation is 'an essential precondition of vital art' and said that although their work was not abstract, they 'refused to accept imitation in any sense whatsoever'. Their work led them 'through every region of the subconscious, ever revealing images hitherto unknown', After the formation of COBRA members of the group were associated with it and the main emphasis moved to Paris when Appel and Corneille settled there in 1950. A rejuvenated and calmer mode of Expressionism then emerged in the Netherlands, closely associated with the ideals of the Dutch poets known as the 'Fiftiers'. Among those who helped to establish it were Pierre van SOEST and Ger LATASTER. Jaap NANNINGA occupied a place somewhat apart, while in the late 1950s Jaap WAGEMAKER represented MATTERIST painting in the manner of DUBUFFET, and Bram BOGART brought a similar mode of ART INFORMEL from his long residence in Paris.

Co WESTERIK was a representative of the new, PHOTOGRAPHIC REALISM and Martin ENGELMANN, working abroad, came to the fore as a Surrealist. In the Netherlands there was a flourishing vogue for the new CONSTRUCTIVISM, KINETIC and experimental art among the younger generation, among whom were numbered Joost BALJEU, Pieter ENGELS, Ad DEKKERS, Willem Theodor SCHIPPERS and Willem de Ridder, the Netherlands representative of FLUXUS. The NUL group was founded in close association with the German ZERO group and with similar aims. Among its members were Johannes Jacobus SCHOONHOVEN, Henk PEETERS and Armando and Herman de VRIES.

Among the Dutch painters who, like Van Dongen, lived and worked abroad were Willem DE KOONING, a leading figure in American ABSTRACT EXPRESSIONISM, Bram and Geer Van VELDE, Lataster and the Surrealist Martin Engelmann.

Sculpture has not been traditionally prominently cultivated in the Netherlands, but after the Second World War a noteworthy revival took place both in sculpture and in the new experimental art of movement, light and total ENVIRONMENTS which border upon the traditional concept of sculpture. Carel VISSER and André VOLTEN stand out for their metal sculpture in the category of the new Constructivism but with its roots in De Stijl. Wessel COUZIJN represented Abstract Expressionism in sculpture before he turned to a more geometrical mode. Jaap MOOY and the American Shinkichi TAJIRI practised a mode of expressive abstraction more akin to the JUNK sculpture of California. Among the younger generation, NOUVEAU RÉALISME was taken up by such artists as Mark BRUSSE, Nic Jonk and Arthur Spronken.

NEUKUNSTGRUPPE. See FAISTAUER, Anton.

NEUE KÜNSTLERVEREINIGUNG (NKV), MUNICH. An association of artists founded in 1909 by KANDINSKY, JAWLENSKY and Gabriele MÜNTER. These artists were at that time imbued with the ideas and techniques of the FAUVES and their association was in opposition to the academic schools of Munich, which was still a centre of the *Jugendstil*, the German version of ART NOUVEAU. The group included the Austrian graphic artist Alfred KUBIN, the American-born Adolf Erbslöh (1881–1947), the German Alexander KANOLDT and for a short time Carl HOFER. The NKV held its first exhibition in 1909, limited to the works of members. But in 1910 it staged a much larger exhibition, European in character, which included works by the Russians David and Vladimir BURLIUK, and works by ROUAULT, PICASSO, LE FAUCONNIER and members of the Fauves (BRAQUE, DERAIN, Van DONGEN, VLAMINCK), some of whom had already advanced towards CUBISM. The theorist of the group was Otto Fischer, who in 1912 wrote: 'Colour is a means of expression which appeals directly to the soul.

Colour is a means of composition. The essence of things is captured not by correct drawing, but by powerful and dynamic, compelling and masterful outline. Things are more than things when they are the expression of the soul.' These words could well stand as a statement of EXPRESSIONISM. But against Kandinsky's abstract, non-representational experiments he wrote: 'A picture does not express the soul directly, but rather the soul as reflected in the object. A picture without an object is meaningless.' The BLAUE REITER came into existence as a splinter group from the NKV.

NEUE SACHLICHKEIT (NEW OBJECTIVITY). A movement of satirical SOCIAL REALISM which developed in German painting during the early 1920s. It continued the interest in social criticism which characterized much of the prevalent EXPRESSIONISM but repudiated the abstract tendencies of the BRÜCKE. The name was coined in 1923 by G. F. Hartlaub, director of the Kunsthalle, Mannheim, in connection with an exhibition, held in 1925, of 'artists who have retained or regained their fidelity to positive, tangible reality'. In its early stages the movement owed something to the cynical destructiveness and the contempt for traditional values which characterized DADA and something to FUTURIST devices such as the simultaneous combination of different views. The two outstanding figures in the movement were Otto DIX and George GROSZ, both of whom used the techniques of verism to portray the face of evil for the purposes of violent social satire. Minor artists in the movement were Heinrich Davringhausen, Georg SCHOLZ and Alexander KANOLDT, formerly a member of the Munich NEUE KÜNSTLERVEREINIGUNG. The movement was dissipated in the 1930s before a State-imposed naturalism for the glorification of the National Socialist myth.

NEVELSON, LOUISE (1899–). Russian-American sculptor born at Kiev. She was taken to the U.S.A. in 1905 and lived at Rockland, Maine, until 1920, when she moved to New York. She began the serious study of art at the Art Students' League in 1929–30 and then studied under Hans HOFMANN at Munich. In 1932–3 she worked with Ben SHAHN as assistant to Diego RIVERA in Mexico City. She began to hold one-man exhibitions in New York from the early 1940s but it was not until c. 1955 that her work achieved general recognition when the Whitney Mus. of American Art bought her *Black Majesty*, The Mus. of Modern Art, New York, her *Sky Cathedral* and the Brooklyn Mus. her *First Personage*. It was towards the end of the 1950s that she began the 'sculptured walls' for which she became internationally famous. These are wall-like reliefs made up of many boxes and compartments into which abstract shapes are assembled together with commonplace objects such as chair legs and slats, bits of balustrades, finials and other 'found objects'.

These constructions were painted a uniform black—or afterwards white or gold—and their formal elegance counteracted the banality of the enclosed forms and contributed to her growing reputation as a leader in both ASSEMBLAGE and ENVIRONMENT sculpture. *An American Tribute to the British People* (1960–5; c. 90 ft by 14 ft: 27 m by 4 m) was acquired by the Tate Gal. In the late 1960s she began to work in a greater variety of materials—lucite, aluminium, plexiglass, epoxy, etc.—and sometimes produced small constructions for reproduction as multiples. Her *Transparent Sculpture VI* (1967–8) in lucite was acquired by the Whitney Mus. of American Art, where she had her first retrospective in 1966. From this time into the 1970s she also began to receive commissions for large open-air and environmental sculptures, which she executed in aluminium or steel—e.g. *Transparent Horizon* (1975) in Cor-ten steel at the Massachusetts Institute of Technology—or interiors such as *Bicentennial Dawn* (1976), clustered pillars of white painted wood in the vestibule of the U.S. Courthouse, Philadelphia.

NEVINSON, CHRISTOPHER RICHARD WYNNE (1889–1946). British painter, born in London, son of the author and journalist H. W. Nevinson. He studied at St. John's Wood School of Art and at the Slade School. In 1912–13 he shared a studio in Paris with MODIGLIANI, was friendly with SEVERINI and through him knew MARINETTI and others of the FUTURISTS. In 1913 he was included in the 'Post-Impressionist and Futurist Exhibition' at the Doré Gal., and exhibited at the Allied Artists Association Salon and the 'Cubist Room' section of the 'Camden Town Group and Others' exhibition at Brighton (see VORTICISM). In 1914 he exhibited with the FRIDAY CLUB, became a founding member of the LONDON GROUP, exhibited in the 'Twentieth Century Art' exhibition at the Whitechapel Art Gal., and joined the Rebel Art Centre. In 1913 he spoke at a reception to welcome Marinetti and in 1914 signed Marinetti's Futurist manifesto *Vital English Art*, which was afterwards repudiated by other members of the Rebel Art Centre on the ground that their signatures had been appended to it without authorization.

Unfit for active service, Nevinson joined the Red Cross in 1914. He showed his first war pictures at the London Group exhibition of 1915, contributed an illustration to BLAST No. 2 and was included in the Futurist section of the Vorticist exhibition of that year. He held successful one-man exhibitions at the Leicester Gals. in 1916 and 1918. The pictures exhibited in 1916, which are considered his best, were records of his wartime experiences and were painted in a harsh Futurist manner suited to the theme (*The Arrival*, Tate Gal., London, 1913–14; *Returning to the Trenches*, National Gal. of Canada, Ottawa, 1914–15). He became an official War Artist in 1917–18, but he renounced Futurism c. 1918 and his later work

was more conventional in manner, less vigorous in its impact.

NEW ENGLISH ART CLUB. During the second half of the 19th c. the standing of the Royal Academy among creative artists in England was lower than at any other time in its history. George Moore expressed the general feeling among them when he wrote in his *Modern Painting* (1898): 'That nearly all artists dislike and despise the Royal Academy is a matter of common knowledge.' The New English Art Club was founded in 1886 by John Singer Sargent, who had returned in 1884 from ten years' study in Paris, and a group of young painters representing the most progressive tendencies in the English art world at the time. Actually these 'progressive tendencies' are now seen to have consisted of little more than a love of naturalistic painting in preference to the romantic idealization of the Academy, a superficial adaptation of new French colour techniques to traditional English landscape and genre painting, and a rather attenuated realism derived from the Barbizon school and Bastien-Lepage. At the time, however, the formation of the Club was felt to be an event of prime significance for the emancipation of English art. Alice Meynell described its aim as 'following, in England, the methods long practised in France—vivid and simple study of nature'. Writing as late as 1937 Mary Chamot spoke of it as 'unquestionably the most vital artistic movement in English painting of the last half century'. Besides Sargent the founders included Sir George CLAUSEN, Wilson STEER, Stanhope Forbes (1857–1948) and Frederick BROWN, who drew up the rules. The first exhibition took place in 1886. Of the early members some subsequently joined a group of painters in Cornish fishing villages known as the Newlyn Group and some drifted into the Academy. A Scottish contingent, including Sir James Guthrie (1859–1930) and Sir John LAVERY, broke away and formed the GLASGOW SCHOOL. In 1889 a rebel group formed itself within the Club around SICKERT, who had become a member in 1888, calling themselves the 'English Impressionists' and held their own exhibition at the Goupil Gal.

From 1886 until 1904 the Club held regular annual exhibitions and from *c.* 1889 until the first Post-Impressionist exhibition in 1910 (neither the First nor the Second Post-Impressionist exhibition was arranged with the co-operation of the New English Art Club) it contained a high proportion of the most progressive painters in England. They received support from the critics when MACCOLL became art critic to the *Spectator* in 1890 and George Moore began writing for the *Speaker*. Among the more prominent painters who made their début with the New English Art Club or who were associated with it have been: James McNeill Whistler, Augustus and Gwen JOHN, Henry TONKS, Sir William ROTHENSTEIN, Sir William Orpen (1878–1931), Charles Edward Conder (1868–

1909), MCEVOY, Roger FRY, Lucien PISSARRO, Spencer GORE, Ethel WALKER, Bernard MENINSKY, Ethelbert White, Paul NASH, Mark GERTLER.

In the first decade of the 20th c. the New English Art Club, which had been formed in protest against the Royal Academy, began itself to be regarded as reactionary while it failed to keep pace with progressive trends, and the critic Frank Rutter, who frequented the circle of artists around Sickert, founded the ALLIED ARTISTS' ASSOCIATION, which held its first exhibition in the Albert Hall in 1908. Then in 1911 the CAMDEN TOWN GROUP was formed with Spencer Gore as President and this in turn gave place to the LONDON GROUP in 1913. From the First World War the Club occupied a position midway between the Academy and the *avant-garde* groups. With the gradual liberalization of the Academy exhibitions its importance progressively diminished.

NEW HORIZONS. A group of Israeli artists formed in 1948 by Yossef ZARITSKY. It brought together the older generation of artists with the younger generation and represented the first deliberately modernist movement in Israel.

NEWMAN, BARNETT (BARUCH NEWMAN, 1905–70). American painter, born at Manhattan, New York, of Polish immigrant parents. He studied at the Art Students' League, 1922–6, and at City College, New York, where he graduated in 1927. He then entered his father's clothing business, which collapsed in the crisis of 1929 and which he kept going with difficulty until 1937. During the 1930s he did occasional work as an art teacher in high schools and was also active in local politics, running for Mayor in 1934. In painting he believed that European CUBISM, CONSTRUCTIVISM and SURREALISM, as also American REGIONALISM and SOCIAL REALISM, had run their course and that a radical change was necessary. In this belief he destroyed almost all the painting he did in the 1930s and early 1940s. Making a new start, he gradually found his own style of mystical abstraction during the second half of the 1940s, achieving a breakthrough with *Onement*, painted in January 1948, a monochromatic canvas of dark cadmium red with a single stripe of light cadmium running down the middle. In 1948 also he collaborated with ROTHKO, BAZIOTES and MOTHERWELL in founding the 'Subject of the Artist' school from which developed in the early 1950s important meetings and discussion of the principles of ABSTRACT EXPRESSIONISM, and he was associate editor of the journal *Tiger's Eye*, which ventilated the ideas of these painters.

Newman was among the most prestigious and most written about artists of the NEW YORK SCHOOL, was an important influence on younger artists such as Larry POONS and Frank STELLA and was the forerunner of styles which succeeded Abstract Expressionism, such as monochromatic COLOUR FIELD painting; holistic or non-relational

painting; certain aspects of Jasper JOHNS and Kenneth NOLAND; and the shaped canvas. He was also among the pioneers of the very large format so that the picture, occupying the whole visual field of the viewer, makes a qualitative impact in virtue of sheer size.

His first one-man exhibitions, at the Betty Parsons Gal. in 1950 and 1951, aroused only hostility and incomprehension and he was not included in the 1952 'Fifteen Americans' exhibition of The Mus. of Modern Art. During the later 1950s, however, his work began to have some influence on artists such as Rothko, REINHARDT and STILL, and in 1958 four of his paintings were included in the Museum's exhibition 'New American Painting', which toured Europe for two years. He had retrospectives at Bennington College in 1958 and at the new Madison Avenue gallery of French & Co. in 1959. As early as 1955 the critic Clement Greenberg had written appreciatively of his work in *Partisan Review*. It was not, however, until the exhibition of his *Stations of the Cross* at the Solomon R. Guggenheim Mus. in 1966 that his true artistic stature began to be generally recognized. During the 1960s, besides the very large painting *Anna's Light* (1968) and the series *Who's Afraid of Red, Yellow & Blue*, he did among others the two triangular paintings *Chartres* (1969) and *Jericho* (1968–9) and the sculpture *Broken Obelisk* (1963–7), which was described by Thomas B. Hess as 'one of the most impressive monumental sculptures of the twentieth century'. In 1963 he exhibited at the Jewish Mus. a model for a synagogue which he had executed in collaboration with the young sculptor Robert MURRAY. His last exhibition, at which he showed works done since 1953, was at the Knoedler Gal. in 1969. Since his death his work has been very widely exhibited, including a large retrospective exhibition which the artist began to plan in 1969 and which was shown at The Mus. of Modern Art, New York, the Stedelijk Mus., Amsterdam, the Tate Gal., London, and in Paris. His complete drawings were shown at The Metropolitan Mus. of Art, New York, in 1980.

NEW REALISM. A descriptive name which in the late 1950s and early 1960s was applied to the currents of reaction from ABSTRACT EXPRESSIONISM which involved the exploitation of trite realistic images from the popular mass media and the use of actual things, usually mass-produced consumer goods of everyday life, in ASSEMBLAGES or attached to the surface of a painting. The term has, however, been very loosely used in art literature to cover also a reaction from Abstract Expressionism and TACHISM in favour of a revival of naturalistic figuration imbued with a new spirit of objectivity exemplified, for example, by PEARLSTEIN, and also for the style better described as PHOTOGRAPHIC REALISM.

The exhibition of English POP ART which circulated to The Hague, Vienna and Berlin in 1964–5 was entitled 'Nieuwe Realisten'. The title had been dropped for the exhibition which was shown in Hamburg, Munich and York in 1976. The latter was simply called 'Pop Art in England'.

NEW YORK REALISTS, THE. Informal name given during the early years of the 20th c. to Robert HENRI and his disciples, George LUKS, William J. GLACKENS, John SLOAN and Everett SHINN. See also The EIGHT.

NEW YORK SCHOOL. Name given to the innovatory painters, mainly abstract and mainly EXPRESSIONIST, who worked in New York during the 1940s and 1950s, achieving stylistic maturity c. 1947–8. An exhibition staged by the Los Angeles County Mus. in 1965 entitled 'New York School—The First Generation Painting of the 1940s and 1950s' included the following 15 artists: William BAZIOTES, Willem DE KOONING, Arshile GORKY, Adolph GOTTLIEB, Philip GUSTON, Hans HOFMANN, Franz KLINE, Robert MOTHERWELL, Barnett NEWMAN, Jackson POLLOCK, Richard POUSETTE-DART, Ad REINHARDT, Mark ROTHKO, Clyfford STILL, Bradley Walker TOMLIN. The catalogue to this exhibition was revised by Maurice Tuchman and reissued in book form in 1971. In his Foreword Tuchman wrote: 'The title of our exhibition and the criteria behind the choice of artists were based on historical considerations: the first generation of New York School painters were those whose activity centred in New York City after 1940 and who had achieved by 1950 a mature and distinctly individual style. The term "New York School" as a geographical indicator is more valid in application to the first generation than in relation to its followers, for the proliferation and dispersal of the achievement and ideas of the earlier group of artists make it impossible to impose such localized restraints on the younger generation.'

An exhibition 'The New American Painting and Sculpture: The First Generation' with catalogue by William S. Rubin and William Agee was organized by The Mus. of Modern Art, New York, in 1969 and an exhibition 'New York Painting and Sculpture 1940–1970' with catalogue by Henry Geldzahler was given at The Metropolitan Mus. of Art, New York, in 1969–70. Tuchman rightly points out that 'Both exhibitions reaffirm the fact that it is against the background of New York artists that all current American art must be viewed'.

Stylistically the work of the New York School is known as ABSTRACT EXPRESSIONISM. Tuchman emphasizes the importance of this stylistic achievement in American art history. 'Virtually every important American artist to have emerged in the last fifteen years looks to the achievement of American abstract expressionism as a point of departure, in the same way that most European artists of the 1920s and 1930s referred in their work to the inventions of cubism.'

NICHOLSON, BEN (1894–1982). British painter

born at Denham, Bucks., eldest son of William NICHOLSON and Mabel Pryde, sister of James PRYDE and herself a painter. Ben Nicholson said: 'I owe a lot to my father, especially to his poetic idea and to his still-life theme.' Apart from a brief period at the Slade School in 1911 he was without formal training in painting and despite contacts with the VORTICISTS during the war years and some work in France and Italy, he did not apply himself seriously to painting until his marriage with Winifred Dacre (Roberts) in 1920. He was in Paris in 1921 and saw works of PICASSO and BRAQUE. During the 1920s he painted still lifes and Cornish and Cumbrian landscapes which revealed a genuine understanding of CUBIST methods of abstraction without in any way subscribing to the superficial mannerisms of the Cubist school. He worked in close collaboration with Winifred Nicholson and was on terms of friendship with Christopher WOOD from 1926 to 1930 and with the Cornish NAÏVE artist Alfred WALLIS. He joined the SEVEN AND FIVE SOCIETY in 1924 and became its Chairman in 1926. About 1930 he began to share a studio with Barbara HEPWORTH, who became his second wife, and turned his attention to geometrical abstracts, particularly the low reliefs of cutout cardboard which have been chiefly associated with his name. His first all-white relief was shown with the Seven and Five Society in 1934. In 1932 he went to France with Barbara Hepworth and made direct contact with Picasso, Braque, BRANCUSI, ARP, and stayed with CALDER at Dieppe. At the instigation of HÉLION they joined the ABSTRACTION-CRÉATION association, remaining members until 1935, and in 1933 they were members of UNIT ONE. During the 1930s Nicholson and Hepworth were active in the group of English avant-garde artists which included Henry MOORE and Paul NASH and in 1937 Nicholson was co-editor with GABO and the architect J. L. Martin of the CONSTRUCTIVIST manifesto CIRCLE. In 1939 he moved to Cornwall, remaining there until 1958, and was prominent among the artists who made their centre at St. Ives. In the post-war period his reputation rapidly grew and quickly reached international proportions. In 1951 he designed a mural for the Festival of Britain, in 1952 he won First Prize at the Carnegie International, in 1956 the First Guggenheim International Prize and in 1957 the International Prize for Painting at the São Paulo Bienale. He had a retrospective exhibition in the British Pavilion at the Venice Biennale of 1954 and major retrospectives at the Tate Gal. in 1955 and 1969. In 1968 the Order of Merit was conferred upon him by the Queen. His marriage with Barbara Hepworth was ended in 1951 and in 1957 he married Felicitas Vogler, moving to the Ticino, Switzerland, in 1958. This was the beginning of one of his most actively productive periods. He was busy with relief projects for free-standing walls, including a relief wall shown at DOCUMENTA III in 1964, and with abstract reliefs, some of them of monumental proportions. Examples of reliefs

from this time are Carnac. Red and Brown (1966) and Tuscan Relief (Tate Gal., 1967).

Although Nicholson never completely abandoned figurative work, he stands out as one of the most original and consistent exponents of geometrical abstraction. His work was always in supremely good taste and had a richness of variety which few abstract artists have equalled. When coloured his work was never superficially painted but the colour permeated the material in which he worked.

NICHOLSON, SIR WILLIAM NEWZAM PRIOR (1872–1949). British painter, wood engraver and theatrical designer. Born at Newark on Trent, he studied art briefly under the immigrant German portrait painter Sir Hubert von Herkomer (1849–1914) and then at the Académie Julian. From 1893 to 1898 he collaborated with James PRYDE, whose sister he had married, in a series of posters for Henry Irving under the name 'The Beggarstaffs'. In the early decades of the century he made a considerable reputation as a painter of elegant portraits, still lifes and landscapes and he has been highly praised in each of these genres. He was without penetrative insight but was caught by the superficial appearances of things and in fact his work was variable. At his best he achieved a perfection within his own limitations which warrants the description 'little master' ascribed to him by John Rothenstein. He was a skilled engraver and illustrated a number of books with woodcuts. He did the original settings for Peter Pan in 1904. He was a founding member of the National Portrait Society in 1911 and was knighted in 1936. He had a retrospective exhibition at Nottingham in 1933 and a joint exhibition with J. B. Yeats at the National Gal. in 1942. Among his most successful paintings are: The Lowestoft Bowl (Tate Gal., 1900) and Mushrooms (Tate Gal., 1940) in still life; Miss Jekyll (National Portrait Gal., 1940), Professor Saintsbury (Merton College, Oxford, 1925) and Mr. and Mrs. Sidney Webb (The London School of Economics, c. 1927) in portraiture.

NIEVA, FRANCISCO. See SPAIN.

NIKIFOR (c. 1895–1968). Polish NAÏVE painter, born in the village of Krynica. His mother was a deaf and dumb beggar, whose name is uncertain (perhaps Maria Derewniak), and Nikifor himself suffered from a speech defect. He also used the names Trifun and Matejko. He lived the life of a tramp, wandering through the villages of Galicia, and made paintings on scraps of paper, the backs of cigarette packages, wrapping paper, etc., selling them for a trifle. He did architectural scenes and city-scapes, mixing reality with fantasy, and was fond of representing himself in various imagined situations. His paintings all have written inscriptions which are meaningless since he never learned to read and write. He was very prolific and some

thousands of his small paintings are in existence. He was 'discovered' as a naïve painter in 1930 and his work was commented on by critics. His first showing was in Warsaw and afterwards at Kraków in 1947. Subsequently he was included in many international exhibitions of naïve art and his work is highly thought of by connoisseurs of naïve painting.

NIKOS (NIKOS KESSANIS, 1930–). Greek painter and experimental artist born at Thessaloniki and studied in Athens. In 1959 he settled in Paris. After having made his mark by vigorous paintings in a TACHIST idiom, he experimented with the photographic techniques of MEC art. He did a series of anamorphosis projections by throwing on to canvas enlarged images of portraits from a diapositive put through an epidiascope.

NIVOLA, CONSTANTINO (1911–). Italian-American painter, sculptor and designer, born at Orani, Sardinia. He studied under Marino MARINI at the Instituto Superiore d'Arte, Monza, Italy, 1930–6, and then from 1936 to 1939, when he went to the U.S.A., he was Art Director for the Olivetti Company. In the U.S.A. he was Art Director for the magazine *Interiors*, 1941–5, Director at the Design Workshop of Harvard University Graduate School, 1953–7, and taught at Columbia University, 1961–3. His first one-man show in the U.S.A. was at the Tibor de Nagy Gal., New York, in 1950, after which he exhibited frequently in both individual and collective shows. Among his many commissions were: mural for Milan Triennial, 1933; Italian Pavilion at Exposition Universelle, Paris, 1937; mural for Olivetti Showroom, New York, 1953–4; façade for Exposition Hall, McCormick Place, Chicago, and murals for Motorola Building, Chicago, 1960; 35 sculptures for Saarinen Dormitories, Yale University, 1962; sculpture for the Mus. de Arte Moderno, Mexico City, on the occasion of the 19th Olympiad, 1968. His works are represented in The Mus. of Modern Art and the Whitney Mus. of American Art, New York, among others.

Although he also did free-standing sculpture, Nivola was mainly known for his sculptural reliefs, which included both monumental architectural reliefs and the more intimate terracotta landscapes and seascapes of the early 1960s. In these he combined natural imagery with figural suggestions in a free and spontaneous style. He was also known for reliefs in reinforced plaster which concentrated emphasis on rich surface texture often brightly coloured.

NOÉ, LUIS FELIPE. See LATIN AMERICA.

NÖFER, WERNER (1937–). German graphic artist, born in Essen. From 1960 he studied at the Hochschule für Bildende Künste, Hamburg, and in 1966 he spent a year in England on a grant. He belonged to the German school of POP ART and made the serigraph his principal medium, often combining realistic scenes with a decorative abstract framework. Besides exhibitions in Germany, he showed at the exhibition 'Contemporary German Printmakers', Pratt Institute, New York, in 1969, and at the 'English Print Biennial', Bradford, and the 'Printmakers' Council Exhibition', Institute of Contemporary Arts, London, in 1969.

NOGUCHI, ISAMU (1904–). American sculptor, born at Los Angeles of an American mother and a Japanese father, the poet Yone Noguchi. He passed his childhood in Japan, returning to the U.S.A. in 1917. In 1921 he worked for a short time with Gutzon BORGLUM, then after pre-medical studies at Columbia University, 1921–4, he was assistant to Onorio Ruotolo, Director of the Leonardo da Vinci Art School, New York. It was at this time that he decided to be a sculptor. In 1927 he obtained a Guggenheim Foundation Fellowship and worked for two years under BRANCUSI in Paris. This was the crucial influence on his development and he later declared that from Brancusi he learnt respect for craftsmanship and materials. It was at this time that he began to do sheet metal abstractions, which he continued into the 1940s. He returned to New York in 1928 and after visiting Japan and China in 1930–1, worked for the FEDERAL ARTS PROJECT/WPA during the 1930s. In 1935–6 he did a large wall sculpture *History of Mexico* in coloured cement at Mexico City and in 1938 won a competition for bronze reliefs for the Associated Press Building, Rockefeller Center, New York. During the 1940s he turned from sheet metal to slate and marble. His *Kouros*, which in his own words 'defies gravity', was shown in The Mus. of Modern Art exhibition 'Fourteen Americans' (1946) and was acquired by the museum. During the 1950s and 1960s his sculpture fell into two groups: heavy, monolithic works which nevertheless often enclosed space as an integral element (e.g. *In Stillness Moving*, 1970) and others which seemed to defy weight, often made of anodized aluminium or, like *Centipede* (The Mus. of Modern Art, New York, 1952), of individual ceramics fastened to an upright.

From 1935 he was interested in theatre and ballet, doing designs for Merce Cunningham, Martha Graham, Sir John Gielgud, etc. His abstract stage designs and environments were lighted so as to become integral parts of the choreography. He also designed furniture and interiors and he had a particular interest in sculptural gardens and playgrounds, including a design for a Play Mountain done in 1933 for the New York City Parks Department, gardens for Connecticut General Life Insurance Co., Chase Manhattan Bank, two gardens for Keyo University, Japan, *Japanese Gardens* for UNESCO, Paris, and a 5-acre sculpture garden for the National Mus. at Jerusalem. Among his notable commissions were bridge sculpture in Peace Park, Hiroshima, and a piazza and sculpture for First National Bank of

Fort Worth, Texas. He had a retrospective exhibition at the Whitney Mus. of American Art in 1968. From the late 1960s into the 1970s he also turned to stainless steel, which he exploited for its expressive potentialities as in *Roof Frame* (1974) and *Intetra* (The Society of the Four Arts Center, Palm Beach, Florida, 1976).

NOLAN, SIDNEY (1917–). Australian painter, born in Melbourne. His father was a tram-driver and both parents were Irish. In youth he was a racing cyclist and athlete but he turned from odd jobs to art after attending night classes at Prahran Technical College and the National Gal. School, Melbourne. Associating with the Bohemian circles then seriously threatening established art values in Melbourne, he became a foundation member of the Contemporary Art Society in 1938, contributing to its early exhibitions. In 1940 his patron John Reed opened his first one-man show. It revealed an interest in COLLAGE, in Rimbaud and in the derangement of figuration. So did his designs for *Icare*, the ballet by Serge Lifar, who was then touring with the de Basil Company's second season in Australia (1939–40). From 1941 to 1945 Nolan served as a private soldier in the Australian army. While stationed in the Wimmera District of Victoria he painted a series of bright, flattish and rudimentary interpretations of the landscape based, as he put it later, on 'Rousseau and sunlight'. They provided the first unmistakable signs of the originality of his vision. At this time also he painted a number of pictures based upon memory and experience, many being associated with the Melbourne suburb of St. Kilda where he lived as a boy. On leaving the army Nolan joined the publishers Reed and Harris, illustrating poetry and fiction and providing editorial assistance for *Angry Penguins* (1941–6) and *Angry Penguins Broadsheet* (1947). In 1946 he travelled in North-Eastern Victoria visiting places associated with the notorious bushranger Ned Kelly, who had become a legendary figure in Australian folk history. From his grandfather Nolan had heard much about Kelly, for he had been a policeman in Victoria in Kelly's time. The series of paintings which followed celebrate Kelly as a folk-hero in a folk-NAÏVE style, and endow him with a kind of semi-comic immortality. It is Nolan's best-known achievement, but his odd mixture of sunlight and colonial legend reached its height in the paintings which flowed from a visit to Fraser Island, Queensland. Here in 1836 a shipwrecked Scottish woman, Eliza Fraser, had lived with a convict, Bracegirdle (whom she later betrayed), among Aborigines. The images of an escaped convict in antipodean landscape first embodied in his Fraser paintings became a recurrent theme in Nolan's art. In 1948 he married Cynthia Reed, novelist and the sister of John Reed. The Kelly paintings were exhibited in Melbourne, the Fraser paintings in Brisbane, and Nolan designed the décor and costumes for Cocteau's *Orphée*, produced by the Sydney University Dramatic Society. In 1949 he completed a series of paintings on glass about the Eureka Stockade, a gold-miners' uprising on the Ballarat diggings in 1854, which possesses legendary significance for Australian labour history. He also began to paint in outback Queensland and in the interior of Australia, relating events in the lives of explorers such as Burke and Wills to the hard, dry beauty of the desert landscape.

Late in 1949 John Reed arranged an exhibition of Nolan's Kelly paintings at UNESCO, Paris. In 1950 Nolan came to London, held a show of his Central Australian work at the Redfern Gal. and spent a few months in Cambridge. Later he visited France, Spain, Portugal and Italy, exhibiting some small Mediterranean studies on his return to Australia in 1951. Next year the *Courier Mail*, Brisbane, commissioned him to make drawings of Central Australia during the severe drought of 1952. The paintings which came from the experience, exhibited in Melbourne, Sydney and later at the Redfern Gal. (October 1952), were more severe than anything he had done before, depicting the twisted cadavers of animals in dead colours and arid spaces. In 1953 Nolan assisted John Heyer in the creation of the film *Back of Beyond*, which won the Grand Prix at the Venice Film Festival in 1954, when Nolan also exhibited in the Venice Biennale and worked in southern Italy. Here again it was folk art which attracted him and provided themes for his work. In 1954 he held a joint exhibition in Rome with Albert TUCKER. Nolan now made London his home but continued to travel widely. In 1955 he painted a second series of Kelly paintings.

Henceforth his paintings transposed and conflated imagery from earlier work with new experiences and new contexts—combining accident, experience and reminiscence in a pictorial process which has been described as 'iconomorphic'. It may be found in most of his subsequent paintings, such as the Gallipoli paintings (1957–8), *Leda and the Swan* (1960) and the African paintings (1962). Elwyn Lynn summed up as follows: 'Nolan is something rare and suspected in modern art; he is a supreme entertainer: a new Nolan is a new performance and if, as the late Godfrey Miller thought, there is something of the showman in him, then it is the showmanship of the choreographer and the performer combined; his later works especially have ballet's calculated unexpectedness, and its combination of wilfulness and whimsy with predestination.'

NOLAND, KENNETH (1924–). American painter, born at Ashville, North Carolina. He studied at Black Mountain College, 1946, and then at the Zadkine School of Sculpture, Paris, 1948–9. His first one-man exhibition was at the Gal. Creuze, Paris, in 1949, after which he was shown widely in the U.S.A. and in international exhibitions. In the early 1950s he was one of the group of artists around Morris LOUIS and Helen FRAN-

KENTHALER who in reaction from ABSTRACT EXPRESSIONISM and ACTION PAINTING developed pure colour painting with the technique of acrylic paint and stained canvas. During the 1950s and 1960s, however, Noland tended to employ more precisely articulated geometrical forms, which brought him within the ambit of HARD EDGE painting. In the late 1950s and early 1960s he used concentric circles on a square canvas. This was followed by a chevron motif, sometimes on a diamond or lozenge shaped canvas, and this again was gradually lengthened into horizontal stripes running across a very long rectangular canvas. Balancing these superficially simple motifs, colour relations were simplified and surface modulation was rejected. Noland was one of the most prominent among those artists who sought to establish a definite relationship between the pictorial image and the shape and size of the canvas. He exhibited with OLITSKI, Frankenthaler and STELLA and was represented in most important collective exhibitions of the schools of painting which succeeded Abstract Expressionism. He had a retrospective exhibition at the Jewish Mus., New York, in 1964.

NOLDE, EMIL (EMIL HANSEN, 1867–1956). German painter. Born at Nolde in Schleswig, he changed his name c. 1904. He studied at Flensburg and Karlsruhe and then taught in the school of industrial design at St. Gall, 1892–8. In 1898–9 he worked at Munich with Adolf HOELZEL, who was interested in investigating the effects of pure colours and forms, and he came under the influence of the Dachau landscape painters. He also worked in Paris and Copenhagen c. 1899 to 1906, when he settled in Berlin. For a short period (1906–8) he was a member of the BRÜCKE, but his temperament was essentially that of a solitary and for the most part he refrained from committing himself to groups or associations. Although Nolde's style of painting evolved from an Impressionist manner towards that of the EXPRESSIONISTS, upon whom he exerted an important influence, he displayed even during the 1890s a personal inclination for grotesque characterization and the invention of a personal mythology, peopling his canvases with imaginary primeval beings intended to display the primitive traits of human passions. About 1908 he came under the influence of MUNCH, ENSOR and Van Gogh. His style became more monumental and he painted at this time a series of large ecstatic and Expressionistic religious pictures, perhaps his most lasting works, followed by a number of paintings of figures done with barbaric sensuality and expressive of a personal mythology. His interest in the primitive led him in 1913–14 to accompany an expedition across Russia to Korea, China and Polynesia organized by the German Colonial Office.

Nolde combined French Impressionist and FAUVIST techniques with the most individualistic and rhapsodic Germanic mythological spirit. He was one of the most important, if most individual, figures in the history of modern German Expressionism. In 1910 he was prominent in the controversy between the newer Expressionistic school and the by that time 'traditional' Impressionism led by LIEBERMANN, a controversy which led to the formation of the *Neue Sezession* in Berlin. In 1941 he was denounced as DEGENERATE by the Nazi regime and was forbidden to paint. He then painted in secret small water-colours, which he called 'unpainted pictures'. More recently many German critics have spoken of Nolde as the 'pioneer of a national German art'.

NON-OBJECTIVE ART. A term which seems to have been first used by the Russian artist RODCHENKO. It was applied by him to certain of his geometrical abstracts—drawings and constructions—which had no representational content. The term was taken over by MALEVICH, who used it in the title of his book *Das Gegenstandlöse Welt* (1927). While the Russians restricted the use of the term in the main to geometrical abstraction, it has become current in the West as a general term for all abstract art, including ABSTRACT EXPRESSIONISM and related movements, which does not depend on the appearances of the visual world as a starting point. In this sense it is a synonym of 'non-figurative' and 'non-representational'. The possibility of an art which relies solely on the relations between colours and abstract forms without any representational significance was foreshadowed by KANDINSKY in his book *Über das Geistige in der Kunst (Concerning the Spiritual in Art)* in 1912. It was this book which gave currency to the term 'non-objective' in the West.

NOUVEAUX PLASTICIENS. A group of Montreal painters formed in 1959 and consisting of Guido MOLINARI, Claude TOUSIGNANT, Jean Goguen (1928–), Denis Juneau (1925–). They painted large canvases in which the image was wholly abandoned, relying on the integration of colour with structure and the imposing effect of large expanses of uniform colour. See CANADA.

NOUVEAUX RÉALISTES. A group founded by the critic Pierre Restany in 1960 with Jean TINGUELY, Yves KLEIN, ARMAN and Martial RAYSSE among its members. The use of the word 'Réaliste' had nothing to do with realism in the traditional sense of veridical representation, for the group repudiated traditional easel painting, including both representational and abstract painting, and advocated instead the use of real materials, existing artefacts and new techniques of light, etc., in the formation of works of art of a novel kind. Restany exhibited in his Gal. J artists such as Tinguely, CÉSAR and CHRISTO, who shared this outlook. In 1960 he put out a manifesto of *Nouveau Réalisme*.

NOUVELLE TENDANCE, NEW TENDENCY.
Terms which began to be used in the early years of
the 1960s to describe the very diverse CON-
STRUCTIVIST tendencies which came to the fore in
most countries of western Europe, and in Japan,
the Argentine, Brazil and Venezuela. Though very
different in their stylistic manifestations, most of
these movements had in common the depersonali-
zation of the art work, the appropriation of new
materials and new techniques borrowed from
industrial science, a cult of group activity and
anonymity, the exploitation of direct stimuli such
as light, sound and real movement, and an icono-
clastic attitude towards traditional aesthetic stan-
dards. Generally the movements were in declared
opposition to expressive abstraction such as ART
INFORMEL, TACHISM and ABSTRACT EXPRESSIONISM.
The two great forerunners of the New Tendency
were recognized to be Piero MANZONI, who died in
1963, and Yves KLEIN, who died in 1962.

The first exhibition inspired by the ideas of the
New Tendency was 'Monochrome Malerei' arran-
ged by Udo Kulterman at the Städtisches Mus. at
Leverkusen in 1960. It was followed by 'Nove
Tendencje' in 1961 at the Gal. Suvremene Umjet-
nosti, Zagreb. Further 'Nove Tendencje' exhi-
bitions were held at Zagreb in 1963, 1965 and
onwards. The GROUPE DE RECHERCHE D'ART VISUEL
(GRAV) held views sympathetic to those of the
New Tendency and under their leadership a large
exhibition was arranged in 1963 at Frankfurt en-
titled 'European Avant-Garde. Arte Programmata,
Neue Tendenzen, Anti-Peinture, Zero'. The term
was introduced into the U.S.A. by George RICKEY
in 1964. In Italy ARTE PROGRAMMATA, in Germany
ZERO and in the Netherlands NUL promoted New
Tendency ideas. In London the Royal College of
Art put on an 'Arte Programmata' exhibition in
1964, which was subsequently shown in the U.S.A.
by the Smithsonian Institution, and in 1964 'New
Tendency' artists achieved recognition at the
Venice Biennale. Since 1965 exhibitions have been
frequent in many countries.

At the meeting organized in Paris by GRAV
artists from many countries agreed to adopt the
name *Nouvelle Tendance, recherche continuelle*
(*NTrc*) for the movement.

NOVECENTO ITALIANO. A movement in
Italian art which was initiated by a group of artists
formed at the Pesaro Gal., Milan, late in 1922 and
consisting of Achille FUNI, Anselmo Bucci (1887–
1955), Piero MARUSSIG, Ubaldo Oppi (1889–1946),
Leonardo Dudreville (1885–) and Mario SIRONI.
The first official meeting of the group was held at
the Pesaro Gal. in the following year and Mus-
solini was among the speakers. The group stood
for a tendency to reject European *avant-garde*
movements and revert to a naturalistic type of art
based upon classical Italian traditions. It was a
tendency which on the one hand had already
found expression in VALORI PLASTICI, supported by
the interest of both CHIRICO and CARRÀ in early

Renaissance Italian art, and on the other hand
coincided sufficiently well with the narrowly chau-
vinistic outlook of the official regime in artistic
matters. The group exhibited at the 14th Venice
Biennale and its objects were declared to be to
work for 'a pure Italian art, drawing inspiration
from the purest sources, determined to cast off all
imported "isms" and influences, which have so
often falsified the clear essential traits of our race'.
In the same year the group disintegrated and in
1925 a new *Comitato direttivo del Novecento Ita-
liano* was formed under the auspices of the critic
Margherita Sarfatti. Although the aims were now
stated less jingoistically, *italianità* with its implica-
tions of naturalism and Italian classicism remained
its guiding principle. As Sarfatti declared: 'The
word Novecento shall resound through the world
as gloriously Italian again as the Quattrocento.'
The *Novecento* had no clear artistic programme
and numbered within its ranks artists of very dif-
ferent styles and temperaments. It was joined by
Carrà, TOSI and CAMPIGLI among others. But it
came more and more to be identified with the
empty formalism and idealized propaganda en-
couraged by the Fascist *Sindicati delle Belle Arti*
and during the 1930s it was the main bulwark of
reaction.

NOVELLI, GASTONE (1925–68). Italian painter
born at Vienna. After studying social sciences at
Florence he began to draw in 1947 under the in-
fluence of Max BILL. He was in Brazil from 1948
to 1955 and taught at the Institute of Art in São
Paulo. In 1955 he settled in Rome and founded
with PERILLI the magazine *L'Esperienza moderna*.
He was a founding member of the CONTINUITÀ
group in 1961. Novelli incorporated words, geo-
metrical shapes and 'signs' in his paintings, which
were a kind of spontaneous calligraphic language
making an ALL-OVER pattern.

NOVEMBER GROUP. An association of Finnish
artists founded in Helsinki in 1917. Successor to
the SEPTEM, the November Group contained the
most important of the younger artists who came
to the fore in the decades 1910 to 1930. Combin-
ing influences from FAUVISM and Continental
EXPRESSIONISM with a sometimes aggressive
nationalism, these artists were responsible for the
emergence of a recognizably Finnish form of
Expressionism.

NOVEMBERGRUPPE. A group of German radi-
cal artists formed in Berlin in November 1918 with
the professed object of renewing national life by
means of a closer relation between progressive
artists and the public. The prime movers in the
formation of the group were Max PECHSTEIN and
César KLEIN, but they were later joined by others,
including Heinrich CAMPENDONK, Rudolf BELLING,
Erich BUCHHOLZ, Otto MÜLLER, Hans PURRMANN.
In 1919 the founders of the association created the
Arbeitsrat für Kunst (Workers' Council for Art),

which issued a questionnaire on the relations between artists and the socialist state, social welfare and the public in general. Artistically the group covered a wide spectrum, from EXPRESSIONISM and CUBISM to geometrical abstraction, CONSTRUCTIVISM and socially critical Realism. By exhibitions staged during the early 1920s the association did much to foster an artistic revival, but they broke up in 1924 with the swing of public opinion towards the right and their aims were eventually incorporated into those of the Weimar BAUHAUS movement.

NOWOSIELSKI, JERZY (1923–). Polish painter born at Kraków. He studied and afterwards taught at the Kraków Academy of Art. He developed a highly individual style based upon an intimate knowledge of Polish icon painters and the Byzantine tradition, which was subsequently combined with aspects of SURREALISM and elements of formal abstraction.

NUL. Dutch group of CONSTRUCTIVIST and experimental artists representing the NOUVELLE TENDANCE in the Netherlands. The group was founded in 1961 by Henk PEETERS, Jan SCHOONHOVEN and Herman de VRIES. Its aims were similar to those of the German group ZERO and the two groups often exhibited together. The *Nul* artists were exhibited at the Stedelijk Mus., Amsterdam, in 1962 and 1965 and at the Gemeentemus., The Hague, in 1964. They exhibited at the Gal. Chalette, New York, and the New Vision Centre, London, and participated in 'Nove Tendencje', Zagreb, in 1963. Henk Peeters and Herman de Vries edited a group periodical *Nul-O*, of which three numbers appeared between 1961 and 1963.

NUÑEZ, GUILLERMO. See LATIN AMERICA.

NUÑEZ DEL PRADO, MARINA (1910–). Bolivian sculptor born in La Paz. She began by studying music and painting following her family's tradition, but turned to sculpture at the Academia Nacional de Bellas Artes in La Paz, where she studied from 1927 to 1929. She later returned there to teach until 1938. She had her first exhibition at the Club de La Paz in 1930, followed by exhibitions all over Latin America, and in the U.S.A., France and Italy. In 1936 she travelled to Argentina, Uruguay and Peru, and in 1940, on a grant from the American Association of University Women, went to the U.S.A., where she remained until 1948. During that period she absorbed the work of ARCHIPENKO, MESTROVIĆ, MOORE, BRANCUSI, ARP and PICASSO. She considered Michel-

angelo her first teacher and many of her early works of Aymara types and social themes were characterized by a great monumentality. Her wood carvings *Dance of the Cholas* (1937), *Huaca-Takori* (a fertility ritual dance, 1937), *Llamas* (1943) are characteristic of this period. In the early 1940s she participated in many travelling exhibitions. In 1946 she won a gold medal for her sculpture *The Miners* at the National Association of Women Artists in New York. The following year she was selected from several artists to execute a marble bust of Leo S. Rowe, the director of the Pan American Union in Washington, D.C., which led to numerous other portrait commissions for government officials. When she returned to Bolivia in 1948 she came under the spell of the Bolivian landscape with its awe-inspiring geological beauty, local lore which she had already used, and pre-Hispanic cultures. Besides bronze she also worked in local materials—granite, basalt, onyx and various woods—using each according to its colour and intrinsic character to enhance her subject.

In 1951 Marina Nuñez organized the Bolivian exhibition at the first São Paulo Bienale and the following year she organized the one at the 26th Venice Biennale, in which Bolivian artists were represented for the first time. After further trips to Europe and North Africa she shared an exhibition with the Peruvian painter Julia CODESIDO and the Brazilian sculptor Irene Hamar at the Petit Palais in Paris in 1953. She went to Cuba and Mexico, where she was the first foreigner to be admitted to the exhibition of the Salon de la Plástica Mexicana in 1954. Upon her return to Bolivia she was awarded the annual grand prize for sculpture by the city of La Paz and decorated by the Bolivian government with the Order of the Condor of the Andes. She received two honorary degrees in the U.S.A., the first at Russell Sage College of Troy, New York, in 1941 together with Eleanor D. Roosevelt, the second at Western College for Women at Oxford, Ohio, in 1955. She also won honourable mention at the São Paulo Bienale in 1955 and the grand prize for sculpture in 1960 at the Second Inter-American Bienale in Mexico. The Mus. Nacional de Bellas Artes in Buenos Aires gave her a retrospective in 1959. Although her style changed from the realistic portraits of local types of the 1940s and early 1950s to a simplified curvilinear and more abstract form, her work remained essentially organic and evocative, as exemplified by her 'Maternal' series (1957–8). She has referred to her work as 'dreams of stone filled with the telluric power of the high Andes'. Its vitality introduced a fresh impetus into Bolivian sculpture in 1949.

O

OBJECTISM. See LABORATORY ART.

OBJECTIVE ABSTRACTION. A term used to describe the work of a group of British painters who in the 1930s experimented with the transformation of natural objects or scenes into patterns of coloured shapes. It was therefore a close relation of the expressive abstraction of the later Monet and his successors such as BAZAINE and MANESSIER, who made it their aim to depict the optical impression without depicting the object. To this principle, however, the British artists added the Romantic aim of transforming their subject into an ensemble of abstract shapes which would evoke the feelings aroused by nature. Historically, they were probably influenced more by the later works of J. M. W. Turner than by Impressionism. The artists in the group included William COLDSTREAM, Graham BELL, Victor PASMORE, Rodrigo MOYNIHAN and Ivon HITCHENS. Of these Hitchens alone remained consistent to this style. In 1934 an exhibition 'Objective Abstraction' was held at the Zwemmer Gal.

OBJET TROUVÉ (FOUND OBJECT). Kurt SCHWITTERS was probably the first to construct COLLAGES and ASSEMBLAGES, artistic structures, from casually found refuse—used tram tickets, pieces of torn newspaper, etc. The *objet trouvé* proper, that is the single object elevated into the status of art work, is usually traced back to Marcel DUCHAMP. Duchamp, however, used it with ironic implications as ANTI-ART rather than 'art' in the traditional sense. The SURREALISTS made considerable play with 'found objects', exploiting incongruity of juxtaposition. Others, such as Paul NASH, seriously conferred the status of art works on found objects such as pebbles, broken branches of trees, etc., 'framing' them for aesthetic contemplation by setting them on pedestals or plinths. Since that time the nostalgic and expressive character of ordinary things, particularly used and useless things, worn out, rusted or broken, has been exploited by many schools of art from JUNK sculpture to POP ART and ARTE POVERA.

OBJETS TYPES. See PURISM.

OBMOKHU (SOCIETY OF YOUNG ARTISTS). A group, mainly pupils of TATLIN and RODCHENKO in the VKHUTEMAS at Moscow, who experimented on spatial constructions and the properties of industrial materials. In 1920 *Obmokhu* held an exhibition of constructions by thirteen students of the Vkhutemas. These were not socially useful designs but open spatial constructions making dynamic use of the spiral form. A year later most of these associated themselves with the CONSTRUCTIVISTS, signed a manifesto condemning non-useful, i.e. 'fine', art as a 'speculative activity' and occupied themselves in designing for the theatre or in industrial design. Prominent among them was Kasimir MEDUNETSKY.

O'BRADY (GERTRUDE MACBRADY, 1901–). French-American NAÏVE painter, born in Chicago. She began to paint in 1939 while living in France. During the Second World War she was in a concentration camp from 1941 to 1945. She was included in an exhibition 'American Portraits' at the Gal. Georges Moratier, Paris, in 1945 and at the Gal. Maeght in 1946. She stopped painting soon after this. One of her best-known pictures is *Anatole and Minou* (1939), a portrait of Anatole Jakovsky, the patron of naïve artists, who is depicted lying on a sofa in an alcove elaborately hung with pictures. The painting is highly decorative, flat and without perspective, but vivid in a genuinely naïve manner.

OBREGÓN, ALEJANDRO (1920–). Colombian painter born in Barcelona, Spain. He was raised in the Colombian coastal town of Barranquilla, then after travelling to England he attended the School of Fine Arts, Boston, in 1939. After this he returned to live in Barcelona as Vice Consul for Colombia, studying painting briefly at the Lotja. After his return to Bogotá in 1944 he taught at the School of Fine Arts and in 1948 was Director for a year. In 1943 he had his first individual exhibition at the Biblioteca Nacional and participated in the 5th Salon of Colombian Artists. The following year he was awarded First Prize at the 1st 'Salon de Artistas Costeños' in Barranquilla. Between 1949 and 1954 he lived in France, where he exhibited extensively. In 1955, on his way back to Colombia, he stopped in Washington to show his work at the Pan American Union. In 1956 he settled in Barranquilla, making frequent trips to France and Bogotá. Obregón's early paintings of figures and still lifes reflected the influence of Gauguin but later he absorbed the styles of PICASSO and TAMAYO. By the mid 1950s he had developed a semi-abstract colouristic style related to Spanish INFORMALISM and the ABSTRACT EXPRESSIONISM of the U.S.A., which he gradually

transformed into an original expression with high-keyed but carefully orchestrated colours. His paintings focused on American subjects such as condors (*The Last Condor*, 1965), bulls, cocks, doves, volcanoes (*Galerazamba Volcano*, 1966), barracudas, Andean and tropical coastal vegetation (*Jungle Flower*, 1962). After 1968 he added falling Icarus themes, 'Paisajes para Angeles' and 'Sortilegios' (Sorceries). Some paintings of the 1960s also reflected political concerns as in *Violence: Detail of a Genocide* (1962), symbolizing the period of political unrest called *la violencia* which plagued Colombia between 1948 and the mid 1950s. Obregón was awarded a prize for one of this series at the 1962 National Salon in Bogotá. He exhibited extensively all over Latin America, and in the U.S.A. and Europe. He participated in the São Paulo Bienales of 1957 and 1959 and was awarded First Prize at the Guggenheim International exhibition in New York for his painting *Velorio (The Wake)* in 1956. In the 1960s he was represented in numerous collective exhibitions in the U.S.A., including 'Latin America: New Departures' at the Institute of Contemporary Art, Boston (1961), 'The Emergent Decade' at the Solomon R. Guggenheim Mus., New York, and 'Art of Latin America Since Independence', Yale University. He had an important retrospective at the Mus. of Modern Art, Bogotá, in 1974. Obregón also painted numerous murals, including *Symbology of Barranquilla* (1956) for the Banco Popular in that city. The critic Marta Traba referred to his mural on the theme of a condor at the Biblioteca Luis Angel Arango, Bogotá (1959), as marking the birth of Colombian Muralism. He moved to Cartagena in the early 1970s.

O'CAMPO, MIGUEL. See LATIN AMERICA.

OCIEPKA, TEOFIL. See NAÏVE ART.

O'CONNER, PATRICK. See SOUTH AFRICA.

OELZE, RICHARD (1900–). German painter born at Magdeburg, studied at the BAUHAUS, 1921–5, and then in Dresden and Berlin. He spent the years 1932 to 1936 in Paris and was associated with the SURREALIST group. From 1937 to 1939 he was in Switzerland and Italy. After serving in the war he spent the years 1946 to 1962 at WORPSWEDE. Using the techniques of AUTOMATISM popularized by Max ERNST, he painted strange other-worldly landscapes from which vague anthropomorphic shapes emerged. He participated in the International Surrealist exhibition at London in 1936 and in The Mus. of Modern Art, New York, exhibition 'Fantastic Art, Dada, Surrealism'. From that time he was little heard of until *c.* 1960. In 1964 he won the Osthaus prize of the city of Hagen and in 1968 exhibited at the Venice Biennale.

OF, GEORGE. See FORUM EXHIBITION.

O'GORMAN, JUAN. See MEXICO.

O'HIGGINS, PABLO. See MEXICO.

OITICICA, HELIO. See LATIN AMERICA.

OKADA, KENZO (1902–). Japanese-American painter, born in Yokohama. He studied at the Meijigakuin Middle School and at Tokyo University of Arts and then in Paris under FOUJITA, 1924–7. He returned to Japan in 1927 and taught at the Nippon Art College, 1940–2, the Musashino Art Institute, 1947–50, and the Tama College of Fine Arts, Tokyo, 1949–50. In 1950 he emigrated to the U.S.A. and became an American citizen in 1960. His first one-man show in Japan was at the Nichido Gal., Tokyo, in 1929 and in America at the Betty Parsons Gal. in 1953. He had a retrospective exhibition circulating in Japan and at San Francisco and Austin, Texas, 1966–7. Among many collective exhibitions he participated in the São Paulo Bienale of 1955 and the Venice Biennale of 1958. He painted delicate and hazy abstractions, though in his later works the forms became sharper and more precise.

OKAMOTO, SHIJIRO. See NEO-DADA ORGANIZERS.

O'KEEFFE, GEORGIA (1887–1986). American painter born at Sun Prairie, Wis. She studied at the Chatham Episcopal Institute, Va., in 1901, at the Art Institute, Chicago, 1904–5, and at the Art Students' League, New York, 1907–8. After working briefly as a commercial artist she taught in the University of Virginia and was Supervisor of Art in public schools at Amarillo, Tex., between 1912 and 1916. In 1916 she did further study, at Columbia University with Arthur Dow and Alan Bement, and she subsequently taught at Columbia College and West Texas State Normal College, Canyon. Her work was exhibited at the 291 Gal. of Alfred STIEGLITZ in 1916 and again in 1917 and 1926. In 1918 she gave up teaching and devoted herself full time to her art, becoming a member of the circle associated with Stieglitz and the 291 Gal. She had her first one-man show at the Anderson Gal., New York, in 1923 and in 1924 she became the wife of Alfred Stieglitz. O'Keeffe's quality as an artist ahead of her time was recognized and over the years her reputation has been established as one of the great pioneers of modernism in America. Her work was very widely exhibited both in individual shows and in important collective exhibitions of American art. Among her retrospectives were: Art Institute of Chicago, 1943; The Mus. of Modern Art, New York, 1946; Dallas Mus. of Fine Art, 1953; Worcester Art Mus., 1960; Whitney Mus. of American Art, 1970.

O'Keeffe was known chiefly for her abstractions based on enlargements of flower and plant forms and for her works in the CUBO-REALIST manner of

the PRECISIONIST school, of which she was one of the precursors. Her work did not belong to the geometrical abstraction of the CONSTRUCTIVIST school and neither could it be classed with the sort of abstraction which relies on the spontaneous or automatic expression of emotion through formal means. It was always based closely upon natural appearances. Indeed from her own point of view she did not so much deliberately 'abstract' as paint realistically aspects of nature which fascinated and intrigued her, and what fascinated her were those aspects of things which display the kind of formal properties by which abstract artists are excited. This is clear in some of her Cubo-Realist paintings such as: *White Canadian Barn No. 2* (The Metropolitan Mus. of Art, New York, 1932); *Stables* (Detroit Institute of Arts, 1932); and *Patio with Clouds* (Milwaukee Art Center, 1956). Of the last of these she said: 'The painting is not abstract. It's quite realistic.' She meant it was a realistic representation of those abstract features of the scene which excited her. Her biomorphic paintings, which demonstrate her interest to emphasize and display the formal qualities she discerned in organic things, continued throughout her career. They were based upon enlarged, close-up views of parts of flowers, plants, etc. Examples are: *Abstraction, White Rose* (1927) and *Black Iris* (The Metropolitan Mus. of Art, New York, 1949). In the 1940s she tended to become more abstract in the sense that a single detail was enlarged to constitute the whole painting and the subject of the painting became less readily discernible. She often painted in series, as the *Pelvis Series* of the 1940s, which were based upon pelvis bones. Of this series she said in an interview with Katharine Kuh: 'When I started painting the pelvis bones I was most interested in the holes in the bones—what I saw through them—particularly the blue from holding them up in the sun against the sky.'

O'Keeffe was a natural and intuitive artist of abstraction in the sense that she had a gift for seeing and an interest in painting the abstract forms of visible things. Her great influence in American art derived very largely from this. She was made a member of the National Institute of Arts and Letters in 1947.

OLDENBURG, CLAES THURE (1929–). American sculptor and draughtsman, born in Stockholm. He spent his early years in New York and Oslo and then lived in Chicago from 1937 to 1952, when he settled in New York. He graduated from Yale University in English literature and art in 1950 and in 1953 he was naturalized as an American citizen. He decided to become an artist in 1952 and attended the Chicago Art Institute while earning his living with part-time jobs as a reporter and illustrator. In New York he came into contact with a group of young artists, including Allan KAPROW, George SEGAL and Jim DINE, who were in revolt against ABSTRACT EXPRESSIONISM and from *c.* 1958 onwards he became interested in arranging HAPPENINGS, ensembles, ENVIRONMENTS, 'situations', etc. He had his first one-man show at the Judson Gal., New York, in 1959. His 'metamorphic mural' *The Street* and his 'ray gun', an invincible weapon adapted from the comic strips, made their first appearance in 1960. In 1961 he opened 'The Store', at which he sold painted plaster replicas of foods and other domestic objects. His theme of *The Home* was initiated in 1963 with his *Bedroom Ensemble*, and was followed by the *Airflow* theme begun in 1965.

Oldenburg was prominent among the American POP artists but had a number of original lines, as for instance objects made from muslin or burlap soaked in plaster and painted with enamel and his 'giant objects' made of canvas filled with foam rubber or muslin soaked in plaster over a wire frame, e.g. *Giant Ice-Cream Cone* (1962); *Giant Hamburger* (1962); *Giant Wedge of Pecan Pie* (1963). He became very well known for his 'soft sculptures', begun in 1961–2, among the most famous of which were his *Soft Typewriter* (1963) and *Soft Engine for Airflow with Fan and Transmission* (1966). He was an originator of what in the late 1970s began to be called SOFT ART.

Famous also were his 'projects for colossal monuments', the first drawings for which were exhibited in 1965 at the Sidney Janis Gal., New York, and the first three-dimensional models made in 1966. In 1967 a one-man show was held of monumental proposals for the opening of the Mus. of Contemporary Art, Chicago. In 1967 he did a *Proposed Colossal Monument for Thames River: Thames Ball*, in 1969 a *Proposal for a Skyscraper in the Form of a Chicago Fireplug*. He also did 'feasible' monuments, including *Feasible Monument for a City Square: Hats Blowing in the Wind* in 1969. *Lipstick*, the first of these 'feasible monuments' to be executed, was presented to Yale University in 1969 by Colossal Keepsake Company. Oldenburg himself stated: 'I have always been fascinated by the values attached to size.' As a brief general summary of the concept underlying his work the following statement is as good as any. 'My art shows the following: The source. For example, a pie or a hamburger. Dishwashing got me used to sensual effects I later wanted to re-live, I preferred touching the food to eating it. Exaggeration of the elements I desired to re-experience. Like caricature, a simplification and intensification of only certain effects appealing to my specific appetites. But not caricature. Rationalisation of the result. A confessed exhibitioner, I cannot hide the outcome of my pleasure. I must explain. Beastly desire precedes beauty. Beauty is weak without its origin in beastly desire. How can I explain this satisfying result to others? Guilt leads to reasoning.'

In 1970 a large retrospective exhibition was arranged by The Mus. of Modern Art, New York, and by the Arts Council of Great Britain in the Tate Gal.

OLEFFE, AUGUSTE (1867–1931). Belgian painter, born at Saint-Josse-ten-Noode, near Brussels. He was a lithographer by profession and studied painting in the evenings at the Academy of Saint-Josse-ten-Noode. He visited Paris in 1890 and from 1895 to 1902 lived at Nieuwpoort, where he painted seascapes and pictures of the fishing population. In 1905 he became a founding member of *L'Art Contemporain* in Antwerp. In the same year he settled at Auderghem, near Brussels. His painting was Late-Impressionist in style, with lively and brilliant colour and emphatic contrasts of blacks and whites.

OLITSKI, JULES (1922–). American painter and sculptor, born at Gomel, Russia. He studied at the National Academy of Design, 1939–42, and at the Beaux-Arts Institute of Design, New York, 1940–7, then at the Zadkine School of Sculpture and the Académie de la Grande Chaumière, Paris, 1949–50. He obtained a degree in art education at New York University in 1954, then taught at Post College, Long Island, 1956–63, and at Bennington College, 1963–7. His first one-man exhibitions were at the Gal. Huit, Paris, in 1951 and the Alexander Iolas Gal., New York, in 1958. In reaction from ABSTRACT EXPRESSIONISM Olitski took up and developed the stained canvas technique initiated by Helen FRANKENTHALER and Morris LOUIS. His so-called 'core' pictures of the early 1960s combined the concentricity of NOLAND with a weighted contour which has been compared with the *Unfurleds* of Louis. In 1964 he began the ALL-OVER sprayed paintings, which did away with contour drawing and prepared the way for the monochromatic sprayed COLOUR FIELD paintings of the second half of the 1960s, for which he became chiefly known. In these paintings he made it his aim to create a purely optical field of atmospheric colour divorced from shape and from the physical impact of pigment. Combining the techniques of dyeing with successive sprayings he produced ever more brilliant and dazzling effects of atmospheric, 'non-attached' colour haze with contrasts of extreme delicacy between bands of colour closely related in tone. In this way he created an illusory space in terms of sheer colour without the adjuncts of shape or perspective. During the 1970s his colours were reduced to delicately vibrant modulations of greys and browns, often in water-based acrylic, and an expressive modelling of surface texture introduced a new note into his work. Among near-monochromatic Colour Field painters he evolved a highly personal manner.

Olitski took up sculpture seriously in 1968 with 20 very large works done at St. Neots, England, in the brief time of seven weeks and exhibited in 1969 at The Metropolitan Mus. of Art, New York. They were constructed from sheets of aluminium, sprayed with acrylic lacquer, and combining circular and elliptical shapes, concave and convex. Many of these sculptures had a 'landscape' effect reminiscent of Anthony CARO. About 1970 they were succeeded by the concentric 'ring' sculptures usually of mild steel or Cor-ten steel lying low on the ground. In an article contributed to *Art International*, Vol. XXII, No. 3 (1978), Kenworth Moffett said of these: 'A variety of shifting and concentric levels now occurs *inside* the sculpture while the sculpture as a *whole* seems to emerge from or sink into the ground.' From about 1973 the 'ring' sculptures became tall and tub-like, developing vertically in a series of concentric scalloped 'walls'. Then with the *Greenberg Variations* in 1974 began a new series of 'stacked' sculptures in which tiers of sheets are stacked or piled on top of each other in successive 'storeys'. Latterly sheets were stacked with the broad sides horizontal rather than vertical and tiers of curved alternated with straight or corrugated sheets. Of these works Moffett said: 'All these works unfold and fold, open and close from level to level as one proceeds around them. Rude and simple, they are also complex, evocative . . .'

OLIVEIRA, NATHAN (1928–). American painter and graphic artist born at Oakland, Calif., studied at Mills College and California College of Arts and Crafts, where he taught, 1955–6. He also taught at the University of Illinois and at the University of California in Los Angeles. He exhibited from 1958 at the Alan Gal., New York, the Paul Kantor Gal., Beverly Hills, and elsewhere. He had a retrospective at the University of California in Los Angeles in 1963. The group exhibitions in which he participated included The Mus. of Modern Art, New York, 'New Images of Man', 1959 and 'Recent Painting USA.: The Figure', 1962–3. Oliveira used the techniques and brushwork of ACTION PAINTING, adapting them to figurative purposes, particularly the human figure. In the late 1950s he painted figures reminiscent of the painted figures of GIACOMETTI, small in relation to the canvas area and set in a vague, non-specific space. During the 1960s the figures were executed with greater detail and were set in a realistic space. From the end of the 1960s the expressive and painterly use of pigment which he had derived from ABSTRACT EXPRESSIONISM had disappeared and the figures were reduced in importance, all emphasis being placed on a stage or empty theatre.

OLSEN, JOHN (1928–). Australian painter, born in Newcastle, N.S.W. He studied at Julian Ashton's art school under John Passmore and briefly with Desiderius Orban. From Passmore he gained an interest in painting as a process by which it was possible to evoke moods and sensations of place. Discussions with friends—William Rose and Eric Smith and Robert KLIPPEL the sculptor (who had met RIOPELLE in Paris)—during the early years of the 1950s, together with the impact of the exhibition 'French Painting Today' at Sydney in 1953 (particularly the works of HARTUNG, VIEIRA DA SILVA, and SOULAGES), aroused his interest in an informal abstract style (see ART IN-

FORMEL). 'The Bicycle Boys' group of paintings shown in his first one-man exhibition at the Macquarie Gals., Sydney, February 1955, typified his early manner and revealed the influence both of Passmore's teaching and of these discussions.

During 1955 Olsen lived in Melbourne, where contact with such artists as Donald Laycock strengthened his growing interest in ABSTRACT EXPRESSIONISM. His *View of the Western World* (1956), shown in the Pacific Loan Collection of 'Contemporary Australian Painting', was the culmination of a series of paintings inspired by Sydney as a seaport. He was seeking to remove from his paintings any vestige of perspective or a single point of view and replace them by a total and generalized experience. Dylan Thomas's *Under Milk Wood* was an inspiration in this. In December 1956 Olsen and his friends Klippel, Passmore, Rose and Smith devised the exhibition 'Direction I'. Its intention was to declare the emergence of what came to be a particular variety of Abstract Expressionism in Australia. It was attuned more to French than to American models, and put a special emphasis upon the evocation of a sense of place. After the exhibition Olsen, with the help of a private sponsor, left Sydney to study in Europe. He worked briefly in London, then at HAYTER'S studio in Paris, and later in Majorca and Spain. The art of Alan DAVIE, the COBRA Group and TÀPIES impressed him. Works such as *Spanish Encounter* (Art Gal. of New South Wales, 1960) reveal his intense desire to 'inhabit a landscape'. The line is no longer rhythmic but free, open and broken upon thick but light-coloured grounds.

On his return to Sydney Olsen and his friends formed, late in 1960, a group known as 'Sydney 9', by which they sought to introduce European methods of exhibition and sale and a more discriminating criticism of non-figurative art. The group exhibited in Sydney and Melbourne in 1961. These exhibitions, in part a reply to the Melbourne ANTIPODEANS, increased the audience for Abstract Expressionist painting in Australia. While in Europe, however, Olsen had felt that his art was threatened by international styles, and he began there to explore in imagination the Australian outback: 'What is it like to get a totality of the Riverina . . . to travel through, to feel the rise and fall of hill and plain, to circumvent, to come back where I have gone before?' Such paintings as *Journey into You Beaut Country* (National Art Gal. of Victoria, 1961) sought to apply this new approach to the bush landscape. They exercised a major influence upon painting in Australia during the early 1960s. In 1972 Olsen was commissioned to paint a mural for the Sydney Opera House. Inspired by Kenneth Slessor's poem 'Five Bells', it brings the approach to Australian landscape painting which he pioneered to the special problem of creating a 'total' sensation of Sydney Harbour by night.

ONOSATO, TOSHINOBU (1912–). Japanese painter born at Nagano. He was a prisoner of war in Siberia, returning to Japan in 1949. He then became a pioneer of abstraction in Japan and one of the best-known Japanese artists of his generation. Working first in a mode of TACHIST or expressive abstraction, he evolved his unique style of geometrically arranged circles in 1955, restricting himself in the main to red, yellow and blue. The circles were overlaid by a geometrical mosaic of different sized squares and the total effect resembled an over-all geometrical design. He had an exhibition at the Miami Gal. in 1962 and was represented at the Venice Biennale in 1964 and 1966.

ONSLOW-FORD, GORDON (1912–). British-American painter, born at Wendover. He studied at the Naval Colleges of Dartmouth and Greenwich and spent ten years in the Royal Navy. He was self-taught as an artist although he spent much time in the studios of LÉGER and LHOTE while living in Paris, 1936–9. In 1938 he was a member of the SURREALIST group. He emigrated to the U.S.A. in 1940 but spent the years 1941–7 in an isolated village in Mexico. His style was influenced by Surrealism, particularly that of MATTA, and he painted amoeba-like forms floating in space, sometimes with violent FUTURIST accents. His first one-man show was at the Karl Nierendorf Gal., New York, in 1940 and he also exhibited in the San Francisco Mus. of Art. In 1951 he collaborated with Wolfgang PAALEN in organizing the 'Dynaton' exhibition at the San Francisco Mus. of Art. Subsequently his work lost its pronounced Surrealist character and developed a lyrical calligraphic style. His theories of painting were expressed in *Towards a New Subject in Painting* published by the San Francisco Mus. of Art in connection with an exhibition in 1948.

OP ART (abbreviation of OPTICAL ART on the analogy of POP ART). A term which came into use at the time of the exhibition 'The Responsive Eye' at The Mus. of Modern Art., New York, in 1965. It was loosely used to refer to a class of geometrical abstraction which exploits perceptual ambiguities and other marginal optical devices in order to shock and disrupt vision, causing the work to seem to vibrate, pulsate or flicker and sometimes creating a hallucinatory appearance of movement. The borderline between artistic research into such perceptual anomalies and scientific research into the psychology of perception is slight. The purpose of optical art in the most general terms is to activate vision by imparting the strongest possible retinal experiences and this is done by exploiting visual ambiguities, the simultaneous presentation of incompatible perceptual illusions, etc., so that as the visual system is fatigued the eye fluctuates in an attempt to evoke and maintain a consistent image. For this purpose the distracting feature of representational subject matter is eliminated and the maximum geometrical clarity is sought, to ensure machine-like precision in the control of surfaces and edges in order to evoke an exactly

prescribed visual sensation.

Many of the devices employed by practitioners of Op art are elaborations upon the well-known visual illusions to be found in standard text-books of perceptual psychology. Among the more important are: reversible and equivocal geometrical figures such as 'Schröder's staircase' and 'Thiery's figure'; apparent changes of curvature, etc. due to variation of size; apparent distortion of a foreground figure set against a background with strong directional forces, such as Hering's illusion of direction and the Frazer spiral; irradiation effects causing apparent changes of size and illusory changes of brightness in a homogeneous figure set against backgrounds of contrasting brightness; negative after-images such as illusory grey spots appearing at the points of intersection of a black and white grid; apparent changes of thickness and direction in a diagonal seen against a grid of horizontal lines and, arising from this, the moiré pattern produced when a periodic structure is superimposed on itself at a slight angle; figure–ground ambiguities and a wide diversity of three-dimensional illusions in a flat geometrical pattern, such as confusion of convex and concave form produced by lighting reversal. Somewhat more complicated effects are exploited by many Op artists who devise systematic variations in the size, shape, direction, value or numbers of serialized units to produce the illusion of warping or pulsating surfaces and the systematic enlarging or reducing of elements in periodic pattern systems in order to cause illusions of surface swelling, magnification, etc. These and other extremely subtle and complicated manipulations of patterns are exploited with the express purpose of causing ambiguous or conflicting optical illusions from which arise illusions of movement. In an over-all patterned surface apparent shapes seem to flicker, disappear and reappear. Sometimes the illusion of an infinite regress is created and sometimes an 'imaginary' unreal space which is neither two-dimensional nor three-dimensional.

The most widely known pioneer of Op art was Victor VASARELY, who made it his main preoccupation from c. 1935 and put out a number of manifestos in the 1950s. Because many of his productions created the illusion of movement or flicker, he coined the term 'cinétisme' and cinétisme or art cinétique became current as the French equivalent of 'Op art'. Other pioneers of Op art were the Israeli artist AGAM with his 'transformable reliefs', the Venezuelan Jesús Rafael SOTO with his vibratory screens, Bridget RILEY in England and in France YVARAL, son of Vasarely, and François MORELLET. In the U.S.A. Josef ALBERS demonstrated what he called 'the discrepancy between physical fact and psychic effect' by his Interiors of the 1940s and his Structural Constellations of the 1950s. The most prominent among Op artists there was Richard ANUSZKIEWICZ. Certain effects such as the exploitation of the after-image and irradiation along the arris between adjacent colour sur-

faces, which are closely allied to Op art, were developed by HARD EDGE painters. The chief organization for research into the principles of Op art was the GROUPE DE RECHERCHE D'ART VISUEL (GRAV), founded in Paris in 1961 under the auspices of Denise René. Similar work was done in Spain by EQUIPO 57. In Italy Op art was practised collectively by GRUPPO N of Padua, but interest in it was fairly widely disseminated under the category of ARTE PROGRAMMATA, called by the critic Argan 'Neo-Gestaltism'.

Since the 1960s the term 'optical art' has also been used in the language of criticism, notably by Clement Greenberg, to describe painting in the category of POST-PAINTERLY ABSTRACTION when a painting aims at creating a purely visual, non-tactile sense of colour-space without 'expressive' nuances. In both COLOUR FIELD painting and Op art scale is usually all-important and the impact of a work can seldom survive reduction of size in a reproduction.

OPAZO, RODOLFO. See LATIN AMERICA.

OPPENHEIM, DENIS. See CONCEPTUAL ART.

OPPENHEIM, MERET (1913–). German-Swiss artist, born in Britain. She was introduced to the SURREALIST group by GIACOMETTI, was for a time the model and the disciple of MAN RAY and was celebrated among the Paris Surrealists as the 'fairy woman' whom all men desire. About 1936 she became known for her Surrealist 'objects', mainly everyday utensils made of fur, leather, etc. Her Tasse à thé en fourrure (Fur Tea Cup) of 1936 is in The Mus. of Modern Art, New York.

OPPERMANN, WOLFGANG (1937–). German painter and graphic artist born in Hamburg and studied at the Hamburg Hochschule für Bildende Künste from 1959. From 1962 he taught graphic art there as assistant to Paul WUNDERLICH. In 1966 he won a scholarship to the Villa Massimo, Rome. From 1965 he had one-man shows in many of the main German centres and participated in collective exhibitions, including the Paris Biennale for Young Artists of 1967 and the exhibition '14 × 14' at the Kunsthalle, Baden-Baden, 1968. His works were constructed from geometrically precise machine-like parts, which he built up into the semblance of robot figures, thus combining elements of CONSTRUCTIVISM and SURREALISM. He was one of the few younger German artists who specialized in lithography and etching for pictorial purposes.

OPPI, UBALDO. See NOVECENTO ITALIANO.

ORCAJE, ÁNGEL. See SPAIN.

ORELLANA, GASTON (1933–). Humanist painter whose enormous canvases are said to present a visual allegory of the existentialist

predicament of contemporary man. Born at Valparaiso, Chile, he took Spanish nationality in 1951 and made his residence in Madrid and Milan. His devitalized figures and the atmosphere of death and abandonment which permeates his compositions mirror his obsession with the horrors of war and aggression. He said: 'It is the aim of my work to be the mirror where desolation and disconsolation bloom and decline: life without death: premature deaths: persecutions and judgements.' Public collections in which his works are represented include those of The Metropolitan Mus. of Art, New York, the Mus. de Arte Moderna, Barcelona, the Mus. Nacional de Bellas Artes, Santiago, the Mus. de Arte Moderna, São Paulo, and the Mus. of Fine Arts, Phoenix, Arizona.

ORLOFF, CHANA (1888–1968). Russian-French sculptor born at Konstantinovka in the Ukraine. She went to Palestine in 1904 and to Paris in 1911, becoming a French citizen in 1925. In Paris she knew APOLLINAIRE and artists of the CUBIST school. Working at that time mainly in wood, she did lively figures in modern dress, naturalistic in style though with fashionable Cubistic stylizations. An example of her work is *Lucien Vogel* (Mus. National d'Art Moderne, Paris, 1922). Her studio was looted during the German Occupation in 1942 and on her return to Paris in 1945 she worked mainly in bronze with graceful and elegantly elongated forms.

OROZCO, JOSÉ CLEMENTE (1883–1949). Mexican painter born at Zapotlán, Jalisco. Orozco received his education at the School of Agriculture in San Jacinto and the National University of Mexico. He learned architectural drawing in the School of Fine Arts, Mexico City, where his family moved in 1890. During his school years he lost the sight of one eye and his left hand in a chemical accident. Later he spasmodically attended art classes at the San Carlos Academy but was largely self-taught as a painter. He had heard about Michelangelo from Dr. Atl and was a fervent admirer of the engraver and cartoonist José Guadalupe Posada. Orozco himself began as a cartoonist, contributing to several journals. In 1915 he worked in Orizaba on the publication *La Vanguardia* with Dr. Atl. He travelled to the U.S.A. between 1917 and 1919, and again from 1927 to 1934. His only trip to Europe was in 1934, when he visited England, France, Italy, Spain and saw the works Dr. Atl had told him about. Orozco's early paintings of prostitutes and schoolgirls were in a POST-IMPRESSIONIST style popular in Catalonia at the turn of the century. His first murals at the National Preparatory School in Mexico City in 1923 reflected his love for the great masters of the Italian Renaissance. In the U.S.A. his fresco *Prometheus* (1939) at Pomona College in Claremont, California, shows the evolution of his mature style with its Nietzschean gigantism. In New York he frequented the salon of the widow of the Greek poet Sikelianos, where he met an international group. His frescoes at the New School for Social Research of 1931 with their portrayals of Lenin and Gandhi reflect Orozco's new awareness of world concerns. The same year he painted *Zapatistas* (The Mus. of Modern Art, New York). *An Epic of American Civilization* (1932–4) at the Baker Library, Dartmouth College, Hanover, New Hampshire, is the most striking of his murals in the U.S.A.

After his return to Mexico in 1934 he was at the height of his powers. He painted his best murals in Guadalajara between 1936 and 1939 at the University of Guadalajara, the Government Palace and the Hospicio Cabañas, in which he depicted the pre-Hispanic world, the Conquest and the founding of Guadalajara on wall panels, vaults and dome pendentives. Orozco expressed the physical and mystical conflicts of humanity rather than a personal judgement of good and evil. His ideals are embodied in his fresco *Man of Fire* in the dome of the Hospicio Cabañas, in which a swirling burning man is purified through fire. He had his first exhibition in Paris in 1925 at the Gal. Bernheim-Jeune and in 1930 he exhibited in New York City at the Delphic Studios, a gallery run by Alma Reed, who was instrumental in launching the work of the Mexicans. In 1940 he painted *Threat of the Dive Bomber* on six movable panels for the exhibition 'Twenty Centuries of Mexican Art' at The Mus. of Modern Art, New York. In 1947 he was honoured with a large retrospective at the Palacio de Bellas Artes in Mexico City and with six exhibitions at the Colegio Nacional between 1943 and 1947. In his last years he divided his time between Mexico City and Guadalajara, where his studio was turned into a museum after his death and a commemorative statue of him was placed in the park facing it.

ORPEN, Sir WILLIAM. See NEW ENGLISH ART CLUB.

ORPHISM. A name coined by Guillaume APOLLINAIRE to describe the art of Robert DELAUNAY exhibited at the SECTION D'OR in 1912 and at the STURM Gal., Berlin, in 1913. He understood by it non-representational colour abstraction and in his book *Les Peintres cubistes* (1913) he described it as 'the art of painting new structures out of elements which have not been borrowed from the visual sphere but have been created entirely by the artist'. He conceived Orphism as a 'movement' within the ambit of CUBISM and associated with it other artists such as Sonia DELAUNAY-TERK, PICABIA, DUCHAMP, LÉGER and KUPKA. The word *orphique* had previously been used by the Symbolists and in reviving it Apollinaire gave to it a romantic significance implying the injection of a more lyrical attitude towards colour into the austerity of Cubism and an interest in the analogy between pure colour abstraction and music—the latter was, of course, a main preoccupation of Kupka. It was

these romanticized associations that gave to Orphism its main appeal to German EXPRESSIONISTS such as MACKE.

Delaunay, however, was at this time interested primarily in investigating the principles of colour combination according to the laws of 'simultaneous contrast' enunciated by Eugène Chevreul, who had also influenced Seurat. In 1912 Delaunay began his series of abstract *Simultaneous Discs* and *Circular Rhythms* showing interpenetrating and revolving areas of pure colour which constituted colour structures existing in their own right. He wrote: 'Colour alone is form and subject. So long as art does not free itself from the object, it remains descriptive, literature, degrading itself by using defective means of expression, dooming itself to servitude and imitation. This is true even when it emphasizes the light playing on an object or the light resulting from relationships among several objects, so long as it fails to give light pictorial independence.' Short-lived as it was, this was the earliest overt movement devoted explicitly to non-representational colour abstraction. In his later writings (*Du Cubisme à l'art abstrait*, 1957) Delaunay restricted the term 'Orphism' more narrowly to these colour exercises, to similar exercises by Kupka, and to the work of the American SYNCHROMATISTS Stanton MACDONALD-WRIGHT and Morgan RUSSELL. He found the origins of Orphism thus conceived to lie in Impressionism and the Neo-Impressionism of Seurat rather than in Cubism. See also SIMULTANISM.

ORR, CHRIS (1943–). British painter and graphic artist born in London, studied at Ravensbourne College of Art, 1959–63, Hornsey College of Art, 1963–4, and the Royal College of Art, 1964–7. He later taught at the Royal College of Art. From 1969 he had one-man exhibitions at, among others, the Serpentine Gal., the Gal. La Citta, Verona, Bear Lane Gal., Oxford, Gal. Grafica, Tokyo, Kalamazoo Institute of Arts, U.S.A. He was represented in group exhibitions, including: 12th São Paulo Bienale; 10th International Print Biennale, Ljubljana; 'Image Reality—Super Reality', British Council touring exhibition, 1973; 'New British Graphics', Brooklyn Mus., New York, 1974; 'Body and Soul', Walker Art Gal., Liverpool., 1975. In his taste for yesterday's kitsch he had affinities with POP ART, but this was seasoned by a rich fantasy, a touch of *faux naïf* and a gift for burlesque.

ORTEGA MUÑOZ, GODOFREDO (1905–). Spanish painter, born at San Vicente de Alcántara, Badajoz. He was one of the foremost EXPRESSIONIST painters of post-war Spain, known particularly for his bleak landscapes of Estremadura. He was awarded a Grand Prize at the Hispano-American Bienale at Havana in 1954 and he participated in the Hispano-American Bienale of Barcelona in 1956 and the Venice Biennale of 1958. During the 1960s his landscapes became increasingly formalized, usually combining relatively few tones of ochres, browns, pinks and yellows. He was represented in the exhibition 'Arte '73' arranged by the Juan March Foundation in London.

ORTIZ VALIENTE, MANUEL. See SPAIN.

ORTMAN, GEORGE (1926–). American painter and graphic artist, born at Oakland, Calif. He studied at the California College of Arts and Crafts, 1947–8, S. W. HAYTER's Atelier 17, New York, 1949, under André LHOTE in Paris, 1950, and at the Hans HOFMANN School of Fine Arts, New York, 1950–1. He taught at the School of Visual Arts, New York, 1960–5, New York University, 1963–5, and Princeton University, 1966–9. His first one-man show was at the Tanager Gal., New York, in 1953 and from then he exhibited regularly in many towns of the U.S.A. and participated in group shows both in the U.S.A. and abroad. He had retrospective exhibitions at Farleigh Dickinson University, 1963, the Walker Art Center, Minneapolis, 1965, and Princeton University, 1967. After passing through an ABSTRACT EXPRESSIONIST phase in his student days he settled on a style of geometrical abstraction using simple geometrical forms such as circles, squares, lozenges, arrows and crosses, done in unmodulated primary colours.

OSSORIO, ALFONSO (1916–). American painter, born at Manila, Philippines. He studied in England in 1924, went to the U.S.A. in 1929, graduated at Harvard in 1938 and then attended the Rhode Island School of Design, 1938–9. His first one-man show was at the Wakefield Gal., New York, in 1941. During the 1950s, when he exhibited mainly at the Betty Parsons Gal., New York, he worked in the style of ACTION PAINTING, using the drip technique but gradually introducing elements of fantasy. In the late 1950s and through the 1960s he used a technique of heavy impasto into which he introduced a variety of materials such as shells, feathers, rope, imitation eyes, etc., giving his works the quality of jewelled mosaics. He was represented in a number of important group exhibitions, including 'The Art of Assemblage' and 'Dada, Surrealism and their Heritage', The Mus. of Modern Art, New York.

OTERO, ALEJANDRO (1921–). Venezuelan painter and sculptor born at El Manteco, Bolivar State. He studied (and later taught) painting and stained glass at the Escuela de Artes Plásticas, Caracas, 1939–45, and from 1941 exhibited regularly in the Salon Oficial de Artes Plásticas. He was first influenced by PICASSO, then in 1945 he went to Paris on a Government grant and embarked on a 'Cafetera' (Coffee-pot) series made up of fractured planes of intersecting lines which suggested reflections in the pots rather than the objects themselves. By 1946 these had become completely abstract and he exhibited them at the

Salon des Surindépendants in 1948. When in 1949 they were first exhibited in Caracas, at the Mus. de Bellas Artes, they caused a public scandal and together with other *avant-garde* artists (Luis Guevara Moreno, Mateo Manaure, Francisco Narvaez) and writers Otero formed a group which the critic Gaston Diehl, then French Cultural Attaché in Caracas, labelled 'The Dissidents'. After Otero's return to Paris with Moreno and the Venezuelan writer J. R. Guillent Perez in 1949, the group published 5 issues of the *Revista Los Disidentes* (1950) in which they attacked the conservative artistic atmosphere of Venezuela. Otero then became interested in the work of MONDRIAN, joined the Denise René group and met a fellow Venezuelan artist Jesús SOTO and the North American painters Ellsworth KELLY and Jack YOUNGERMAN. In 1950 he began a series of white canvases with coloured lines. From 1951 onwards he did a series entitled 'Modular Vibrations' in which horizontal and vertical bands of colour created optical effects. In 1954 he began a series of paintings with rhythmically organized vertical bands of bright colour, which in 1955 emerged as the *Coloritmos* (*Colour-rhythms*). After his return to Caracas in 1952 he worked on projects for the integration of art and architecture, contributing to the exterior design of the School of Architecture at University City (built by Carlos Paul Villanueva, 1952-4). In 1955 he began a series of 75 *Coloritmos* with Duco colours applied with an airbrush and continued to do them intermittently from that time. After his return to Paris in 1960 he did a series of textured COLLAGES using old manuscripts and brightly coloured materials, and also made ghostly white ASSEMBLAGES with 'found objects', such as *White Saw* (1963). During the 1960s he exhibited regularly in Caracas, Bogotá, Austin (Texas), London and Mexico City. He participated in several São Paulo Bienales (1956-75), winning an award in 1959, in the Venice Biennales, 1956-66, and in 'South American Art Today' at the Dallas Mus., Texas (1959). He was included in the Guggenheim International exhibition in New York (1964), in the 2nd Córdoba Bienale in Argentina and 'Art of Latin America Since Independence' at Yale University in 1966. From 1967 on he executed a number of large out-of-doors KINETIC works such as *Vertical Vibrante*, a metal structure for the entrance of the city of Maracay. One of several versions of *Integral Vibrante* is located in Ciudad Guayana in the south-east. It is a cubic work containing formations of propeller-like aluminium elements whose movement and colour depend on nature. Besides executing many murals and sculptures for industrial firms and schools, Otero was active as a writer and lecturer. He co-ordinated reforms at the Escuela de Artes Plásticas in Caracas, and after his return from Paris in 1964 he was appointed Vice-President at the National Institute of Culture and Fine Arts.

OTRA FIGURACIÓN. See LATIN AMERICA.

OUBORG, PIET (1893-1956). Dutch painter and draughtsman born at Dordrecht. He taught drawing in the Dutch East Indies from 1916 to 1938 and during this time matured a personal style of SURREALISM based mainly upon TANGUY and MAGRITTE. After returning to the Netherlands in 1938 he settled at The Hague and developed a style of expressive abstraction and AUTOMATIC drawings which have been likened to those of Henri MICHAUX. He had a retrospective exhibition at the Stedelik Mus., Eindhoven, in 1965.

OUDOT, GEORGES (1928-). French sculptor born at Chaumont, studied at the École des Beaux-Arts, Paris, 1946-50. In 1952 he retired to Besançon but continued to exhibit at the Salon de la Jeune Sculpture. In 1955 he was awarded the Prix Fénéon. His work was naturalistic, animated and with well-defined volumes. He executed a monument to the sociologist Proudhon at Besançon in 1956.

OUDOT, ROLAND (1897-). French painter, born in Paris. After studying from 1912 to 1916 at the École des Arts Décoratifs he collaborated with Léon BAKST on décor for the Russian Ballet until the death of the latter in 1924. At the same time he did textile and furniture designing. He worked in many different genres, including mural decorations for the Palais de Chaillot and tapestry designs for Aubusson and the Gobelins. He experimented also with different styles, including FAUVISM and CUBISM. But in his mature style he is best known for his landscapes and portraits done in a manner of poetic Realism owing much to BONNARD and he is classified with the school of NÉO-RÉALISME to which LEGUEULT, BRIANCHON and AUJAME also belonged. His work combined classical restraint and lucidity with imaginative power. He exhibited first in 1919 at the Salon d'Automne with Brianchon and Legueult. In the 1950s he exhibited regularly at the Salon des Tuileries and was included in collective exhibitions in the Netherlands, Zürich and the U.S.A. He had a large exhibition at the Gal. Romanet, Paris, in 1956 and a retrospective at the Mus. des Beaux-Arts, Neuchâtel, in 1963. He also illustrated books by François Mauriac, Jean Giraudoux and Gérard de Nerval.

OZENFANT, AMÉDÉE (1886-1966). French painter, born at Saint-Quentin, Aisne. He went to school in Spain and then studied drawing at the Saint-Quentin School of Art. From there he went on to study at the Académie de la Palette, where DUNOYER DE SEGONZAC and LA FRESNAYE were among his fellow pupils. He exhibited at the Salon de la Nationale in 1908, at the Salon d'Automne in 1910 and at the Salon des Indépendants in 1911. At this time he was interested in CUBISM though not a member of the Cubist group. According to his own account he came to realize after 1915 that Cubism had entered into a blind alley and had

degenerated towards decorative abstraction. These views he publicized in the review *L'Élan*, which he edited from 1915 to 1917. In 1917 he entered into an association with the Swiss painter and architect Charles-Édouard Jeanneret, known from 1921 as LE CORBUSIER, and collaborated with him in 1918 in a book *Après le Cubisme*, which launched the doctrines of PURISM. In 1920 he founded with Jeanneret the periodical L'ESPRIT NOUVEAU, which was the main forum of Purist and 'machine' aesthetics until 1925. In 1924 he wrote with Jeanneret *La Peinture Moderne*, which he later described as a 'résumé of the *L'Esprit Nouveau* campaigns'. In 1925 he turned to mural painting and between then and 1928 executed a vast mural *Les Quatre Races* in the Mus. National d'Art Moderne, Paris. In 1928 he published his most important book, *Art*, an English version of which appeared in London in 1931 entitled *Foundations of Modern Art* (later edition New York, 1952). From 1931 to c. 1938 he worked on an enormous composition

Vie, in which more than 100 figures, treated in a Purist manner, are lyrically singing to the solidarity of mankind. From 1935 to 1938 he lived in London, where he founded a school, and in 1939 he published an autobiographical work *Journey through Life* covering the years 1931 to 1934.

In 1938 Ozenfant moved to New York, where he founded the Ozenfant School of Fine Arts. During the years that followed he developed his theory of 'preformation', according to which the world's great masterpieces of art exist always in the subconscious of mankind, awaiting an 'inventor' to discover them and bring them to life. During his Purist period and the 1930s Ozenfant's work was governed by the idea of economy—to say the maximum possible with the most economic means. After 1950 he seems to have taken as his maxim 'to say the most possible'. His later works give a first impression of simplicity but the nearer one approaches them the more detail appears.

P

PAALEN, WOLFGANG (1907–59). Austrian-Mexican painter, born in Vienna. After studying in France, Germany and Italy he lived in Paris from the late 1920s until 1939, when he emigrated to Mexico, becoming a Mexican citizen in 1945. He was a member of the ABSTRACTION-CRÉATION group, 1932–5, and then joined the SURREALIST group, 1936–40. He participated in Surrealist exhibitions, including the London Surrealist exhibition of 1936, and in 1940 he collaborated with André BRETON in arranging the international Surrealist exhibition in Mexico City. He abandoned Surrealism, however, in the following year and founded the review *Dyn*. In 1951 he collaborated with ONSLOW-FORD in arranging the 'Dynaton' exhibition at the San Francisco Mus. of Art.

Paalen is chiefly remembered for his Surrealist paintings. He cultivated the method of AUTO-MATISM and invented the technique of FUMAGE. His pictures often depicted strange, clawed figures which he called 'Saturnine Princes', looming from a semi-transparent surface. After his arrival in Mexico he began to incorporate in his paintings meteor-like streaks, which he later interpreted as the lineaments of hidden gods. He made a thorough study of the pre-Hispanic art of Central America and the North-West Coast and developed a new style in the 1950s, abandoning figuration and suggesting a violent and tragic space with vibrant lines and a few patches of brilliant colour. This developed until his pictures in 1958 were likened to flowering shrubs. In 1967 the Mus. de Arte Moderno, Mexico City , held an exhibition in his honour.

PACHECO, JOAQUÍN. See SPAIN.

PACHECO, MARIA LUISA (1919–82). Bolivian painter born in La Paz. Pacheco studied painting at the Academy of Fine Arts of the University of San Andres, La Paz, where she was to return later to teach. From 1946 to 1951 she illustrated the La Paz daily newspaper *La Razón*. In 1951 and 1952, with a fellowship from the Spanish government, she studied in Madrid at the Academia Real of San Fernando and the private academy of Daniel Vázquez Díaz. Until 1952 her painting dealt with the social realities of Bolivia, focusing on subjects like Indians and tin miners. But her trip to Spain brought her under the influence of the Spanish painters Villares, CANOGAR and TÀPIES as well as Vázquez Díaz and she turned to abstraction. After her return to Bolivia she acted as president of the Hispano-Bolivian Cultural Institute from 1954 to 1955 and was co-founder of the group '8 Contemporary Painters' in 1955 in La Paz.

In 1956 she went to the U.S.A., settling in New York, and subsequently became a United States citizen. In her first years there she absorbed ABSTRACT EXPRESSIONISM and especially admired the work of DE KOONING. Her paintings *Colonial Town* (1955), *Idols* (1956), *White Figure* (1959) also show CUBIST influences. But Pacheco developed an individual form of abstraction with COLLAGES of corrugated board, thin sheets of plywood, canvas and sand in glowing colours that reflect the shapes and luminosity of the Andean landscape. In the 1960s she painted the 'Tihuanacu' series paying homage to Bolivia's great pre-Hispanic culture. She won Guggenheim Fellowships during three successive years, 1958, 1959 and 1960. Other awards include a prize for painting at the São Paulo Bienale in 1959, First Prize at the National Painting Contest in La Paz in 1954, and acquisition prizes at the Pan American Union in Washington in 1959 and the Dallas Mus. of Art, Texas, in 1969. She had individual exhibitions in La Paz, Buenos Aires, Santiago de Chile, Lima, New York and Washington. She also participated in group exhibitions at the Art Institute of Chicago (1958), the University of Illinois (1962), the Gal. Profili, Milan (1962), the 'Festival of Two Worlds', Spoleto (1963), and also showed in Belgrade, Bonn, Madrid and Barcelona.

PAEZ VILARÓ, JORGE and CARLOS. See LATIN AMERICA.

PAGE, FRED. See SOUTH AFRICA.

PAINTERS ELEVEN. A group of Toronto abstract painters active during the 1950s. The group was formed and the name taken at a meeting in 1953, which arranged for a co-operatively financed exhibition to be held at the Roberts Gal. in February 1954. The nucleus of the group were six painters who had been brought together by William RONALD in an exhibition 'Abstracts at Home' arranged by him at the Toronto department store Robert Simpson Co. They were: Kazuo Nakamura (1926–), Alexandra Luke (1901–67), Ray Mead (1921–), Oscar Cahén (1916–56), Jack BUSH, Tom Hodgson (1924–). In addition Ronald brought to the meeting his former teacher Jock MACDONALD, Ray Mead brought in Hortense Gordon (1887–1961), who taught design at the

Hamilton Technical School, and Oscar Cahén brought two graduates of the Toronto Western Technical School, Walter Yarwood (1917–) and Harold Town (1924–). Apart from working in the abstract these painters had little in common and for this reason the non-committal name of the group was deliberately chosen. In the spring of 1956 Painters Eleven were guest exhibitors of the newly formed AMERICAN ABSTRACT ARTISTS Association at the Riverside Mus., New York. A show (without Ronald) was held at the new Park Gal., Toronto, in 1957 and was exhibited also in Montreal in 1958. A selection was then circulated across Canada by the National Gal. of Canada (1958–9). The last Toronto show was held at the Park Gal. in November 1958 and the group was formally disbanded in October 1960. A short *History of Painters Eleven* by Kathryn Reid Woods was published by the Robert McLaughlin Gal., Oshawa, Ont., in 1971.

PALACIOS TÁRDEZ, PASCUAL. See SPAIN.

PALAZUELO, PABLO. See SPAIN.

PALENCIA, BENJAMIN (1902–). Spanish painter, born at Barrax, Albacete. He was primarily a landscape painter, an EXPRESSIONIST with a strong sense of colour, who was a central figure of the Madrid school.

PAOLOZZI, EDUARDO (1924–). British sculptor, born at Edinburgh of Italian parents, studied at the Edinburgh College of Art, 1943, and at the Slade School, 1944–7. After a one-man exhibition at the Mayor Gal., London, in 1947 he worked in Paris, 1947–9, and then taught at the Central School of Art and Design, 1949–55, at St. Martin's School of Art, 1955–8, was a guest teacher at the Hochschule für Bildende Künste, Hamburg, 1960–2, and at the University of California at Berkeley, 1968. He taught at the Royal College of Art, London, from 1968 and in Berlin during the early 1970s. His first major sculptural commission was a fountain for the Festival of Britain in 1951. In 1952 he showed at the Venice Biennale. He was represented in the Pop Art exhibition shown at The Hague, Vienna and Berlin in 1964 and in 'Pop Art in England' shown at Hamburg, Munich and York in 1976. He had retrospectives at the Stedelijk Mus., Amsterdam, and the Kunsthalle, Düsseldorf, in 1968–9, at the Tate Gal. in 1971 and at the Kestner-Gesellschaft, Hanover, and the Nationalgal., Berlin, in 1974–5.

From the mid 1940s Paolozzi became interested in the works of CHIRICO, DADA and SURREALISM, evincing a special interest in the kind of COLLAGE defined by Max ERNST as 'The systematic exploitation of the chance or artificially provoked encounter of two or more substantially alien realities on a seemingly unsuitable level'. From 1947 he made collages embodying the Surrealist conception of the juxtaposition of incongruities and em-

bodying the principle of the combination and modification of existing reality and existing picture material. Making no attempt to produce a homogeneous picture, he used cuttings from old American magazines, advertising prospectuses, technological journals, etc. for his series of collages and 'scrapbooks'. Paolozzi regarded these collages as 'ready-made metaphors' representing the popular dreams of the masses, a 'universe of pictures' representing the real world as the media reproduce it. Through these works he was recognized as one of the leaders in the first generation of English POP ART.

During the 1950s Paolozzi showed heavy roughcast figures in bronze and square, box-like forms with mechanistic overtones which looked forward towards the 'mechanical men' of the 1960s—large totem-like figures made up from casts of pieces of machinery and often brightly painted. He was represented in the 'This is Tomorrow' exhibition at the Whitechapel Art Gal. in 1956 and had his first one-man show of sculpture at the Mayor Gal. in 1967. An exhibition at the Marlborough Gal. in 1976 showed his work of the 1970s. This comprised work of two kinds: 1. Heavy, solemn pseudo-machines, casts which gave the general impression of being machines although they resembled no particular kind of machine. They were free-standing and set on the floor. 2. Box-like low reliefs, both small and large, in wood or bronze, sometimes made to hang on the wall, compartmented and filled with small carved items. The latter were sharply and precisely cut and had a general resemblance to the work of Louise NEVELSON except that representational likeness was more completely banished from the elements of which they were composed.

PAPIERS COLLÉS. A variety of COLLAGE which consists specifically of incorporating pieces of decorative paper in a picture. The technique was invented by BRAQUE in 1913 when he used in a still life pieces of wall-paper simulating wood graining which he had seen in a shop in Avignon. In his book *Cubism* (1959) John Golding wrote of Braque's *Still Life with Guitar*: 'the fragments of *papier collé* here can be said to exist on three levels. They are flat, coloured, pictorial shapes. They represent or suggest certain objects in the picture by analogies of colour and texture or by the addition of keys or clues. Thirdly, and this is the aspect of *papier collé* that most relates it to other forms of Cubist *collage*, the pieces of paper exist as themselves, that is to say one is always conscious of them as solid, tactile pieces of extraneous matter incorporated into the picture and emphasizing its material existence.' The technique was almost immediately adopted by PICASSO and it has remained an accepted method in various schools of advanced contemporary art.

PAPS (DR. WALDEMAR RUSCHE, 1882–1965). German NAÏVE painter, born at Naumburg. He was a well-known eye surgeon and head of the

eye clinic in the hospital of St. Josef Stift in Bremen. He began to paint after retiring at the age of 70, painting mainly scenes remembered from his travels as a young ship's doctor but also flower pieces and harbour scenes. He was exhibited in Bremen (1959, 1965), Stuttgart (1960), Constance (1961), Munich (1963, 1965), Zagreb (1965), at the Goethe Institute, Paris (1970), Recklinghausen (1971), and Bratislava (1972). A picture of his was included in the exhibition 'Die Kunst der Naiven' (Munich, 1974; Zürich, 1975).

PAREDES, DIÓGENES. See LATIN AMERICA.

PAREDES JARDIEL, JOSÉ. See SPAIN.

PARIS, HAROLD P. (1925–79). American sculptor born at Edgemere, N.Y., studied at Atelier 17 and the Creative Graphic Workshop, New York, 1949–52. He then studied at the Academy of Fine Arts, Munich, from 1953 to 1956, when he moved to Paris. He obtained a Guggenheim Foundation Fellowship and a Fulbright Fellowship (Germany) in 1953 and a University of California Creative Arts Award and Institute Fellowship, 1967–8. His first one-man exhibitions were at the Argent Gal., New York, and the Philadelphia Art Alliance in 1951 and the Village Art Center, New York, in 1952. He continued to exhibit frequently both in individual and in collective shows, in the U.S.A. and abroad. He settled on the West Coast and was known for the great versatility of his constructions in multiple materials and his experiments in mixed media. He was one of the group of artists who followed the path indicated by the work of Peter VOULKOS.

PARIS, SCHOOL OF. See ÉCOLE DE PARIS.

PARKER, RAYMOND (1922–). American painter born at Beresford, S.D., studied at the State University of Iowa. He taught at Hunter College from 1955, and in 1967 he was a member of the National Council on the Arts and received a Guggenheim Fellowship. His first one-man show was at the Walker Art Center in 1950, after which his work was exhibited frequently in both individual and group shows of progressive American art. He had retrospectives at the Dayton Art Institute, Ohio, in 1965, at Washington Gal. of Modern Art in 1966 and at San Francisco Mus. of Art in 1967. Parker painted in a style of POST-PAINTERLY ABSTRACTION in vividly contrasting colours and clearly defined but not fully geometricized forms.

PASCAL, SUSANNE (1914–). American sculptor in glass, born in Montana, daughter of a French painter, Charles Pascal. Owing to deafness she used drawing as a means of communication from an early age. She went to Italy at the age of 11 to study sculpture under Professor Julius Attilio and later studied painting in Paris for ten years, but subsequently reverted to sculpture. She began glass sculpture in 1952 but it was not until 1964 that she discovered, in an abandoned glass factory at Dunbar, Pennsylvania, cullet sufficiently hardened by weathering to stand up to carving with hammer and chisel. She had one-man shows in Zürich (1966), New York (1966, 1972), Los Angeles (1967), the American Cultural Center, Tokyo (1968), Paris (1970) and at the O'Hana Gal., London (1974). Her works are represented in, among others, the Los Angeles County Mus. of Art, the Petit Palais Mus., Geneva and the permanent collections of the American Embassies in London and Tokyo.

PASCALI, PINO (1935–68). Italian experimental artist born at Bari and active in Rome. After passing through a phase of expressive abstraction he made 'play pieces' in the category of ANTI-FORMAL art such as his *Fictitious Sculptures* of 1966 and his *Water Pieces* of 1967, the latter being aluminium basins filled with water dyed to imitate sea-water. He died prematurely in 1968 and received posthumously in the same year a Grand Prix at the Venice Biennale. In 1969 he had a memorial exhibition at the Gal. d'Arte Moderna, Rome.

PASCIN, JULES (JULIUS PINCAS, 1885–1930). Bulgarian-American painter and draughtsman, born at Vidin, Bulgaria. His father was a Spanish Jew and his mother Italian. He studied in Vienna and then at Munich, 1900–3, where he contributed drawings to *Simplicissimus*, Lustige Blätter and other journals. He had already made a name when he went to Paris in 1905 and continued to work for journals there. At the outbreak of the First World War he was in England and from there he made his way to New York, where he acquired American citizenship. He returned to Paris in 1920, where he joined the circle of artists at Montmartre who gravitated around SOUTINE, MODIGLIANI and CHAGALL. He did portraits of his friends and began a number of large paintings with biblical themes. He committed suicide in 1930 on the day of the opening of his exhibition at the Gal. Georges Petit. Pascin was a natural and compulsive draughtsman. Both for his technical brilliance and for his themes he has been likened to Toulouse-Lautrec, while the touch of apocalyptic fantasy in some of his work has inspired a comparison with Soutine. A large retrospective exhibition of his work was given at the Haus der Kunst, Munich, in 1969.

PASMORE, EDWIN JOHN VICTOR (1908–). British painter, born at Warlingham, Surrey. While at school at Harrow he displayed a talent for painting, but owing to the death of his father in 1926 he was unable to go to art school and worked from 1927 to 1938 as a clerk with the London County Council. During this time he attended evening classes at the Central School of Arts and Crafts. In 1933 he became a member of The London Artists' Association and had his first

exhibition, at the Cooling Gals. In 1934 he was elected to the LONDON GROUP and contributed to the 'OBJECTIVE ABSTRACTION' exhibition at the Zwemmer Gal. At this time he was experimenting with abstraction; but like many English artists during the second half of the 1930s he reverted to naturalistic painting and in 1937 he joined with William COLDSTREAM and Claude ROGERS in founding the EUSTON ROAD SCHOOL. At this time and in the early 1940s he was painting lyrically sensitive but perceptive Thames-side landscapes which have been likened to those of Whistler. A typical example of this style is *Chiswick Reach* (National Gal. of Canada, Ottawa, 1943). In 1947 he underwent a dramatic conversion to pure abstract art, making a profound study of its principles as well as practising it, and by the early 1950s he had matured a personal style of geometrical abstraction. At the same time he made abstract reliefs partly under the influence of Ben NICHOLSON and partly under that of Charles BIEDERMAN's book *Art as the Evolution of Visual Knowledge*, lent to him in 1951 by Ceri RICHARDS. His earlier reliefs had a hand-made quality but later, through the introduction of transparent perspex, he gave them the impersonal precision and finish of machine products. Some of these reliefs were done as elements in architectural projects. Through work in this style he came to be regarded as one of the leaders of the CONSTRUCTIVIST revival in Britain.

In 1950 and 1951 he visited Ben Nicholson and Barbara HEPWORTH at St. Ives and exhibited with them in the first entirely abstract exhibition in Britain since the war, organized by the Penwith Society. In 1950 also he executed a mural relief for the Kingston Bus Drivers' canteen, a first experiment in his idea of bringing abstract art to the general public. In 1955 he was appointed Consulting Director of Architectural Design for Peterlee New Town, Durham, a project for housing the Durham miners during the Depression, and designed an urban centre in the form of a Pavilion which integrated architectural design with abstract relief painting. From 1949 to 1953 he taught at the Central School of Art and Design and in 1955 he was appointed Master of Painting in Durham University. In this post, which he retained until 1961, he introduced a pedagogical method which under the name 'basic design' spread widely among British art schools and teaching institutions.

Pasmore has been exhibited widely in Europe and America as well as Britain. An important retrospective exhibition was given at the Tate Gal. in 1965 and a travelling retrospective was organized by the Arts Council in 1980. He was awarded the C.B.E. in 1959.

PASSOW, CORD. See COMPUTER ART.

PATHETIKER, DIE. An EXPRESSIONIST group formed in Berlin by Ludwig MEIDNER together with Jakob Steinhardt and Richard Janthur in 1912.

They were shown at the 8th exhibition of the STURM Gal. in the same year.

PEAKE, FABIAN (1942–). British painter and graphic artist born at Rustington, Sussex, studied at the Chelsea School of Art, 1958–63, and at the Royal College of Art, 1963–6. He taught at Luton School of Art, 1967–71, Berkshire College of Art, Reading, 1971–2 and Wolverhampton Polytechnic, 1971–4. He exhibited with the LONDON GROUP in 1965, in the 'Young Contemporaries' exhibition of 1964, at the 8th John Moores Exhibition, Liverpool, in 1972, at Gallery 21, London, in 1975, and elsewhere. His style combined geometrical abstraction with self-consciously fanciful realistic elements.

PEAKE, MERVYN (1911–68). British illustrator and caricaturist, born at Kuling in central China and educated as a boy at Tientsin Grammar School. He came to England at the age of 11 and in 1930 entered the Royal Academy Schools. In 1934 he joined a group of artists working on the island of Sark but two years later took a teaching post at Westminster School of Art. Peake continued the English tradition of caricature and he is best known for his illustrations of his own trilogy *Gormenghast*, particularly the first volume, *Titus Groan*, which appeared in 1946, and for his illustrations to *The Rime of the Ancient Mariner*. His drawings began to appear in the *London Mercury* in 1937 and he had his first one-man exhibition in 1938 at the Crane Kalman Gal. In 1947 he was commissioned by the Ministry of Information to make drawings of persons liberated from Belsen Concentration Camp. He began to teach at the Central School of Art and Design in 1950. His drawings of 1946 to illustrate poems by Oscar Wilde were published in 1980.

PEARLSTEIN, PHILIP (1924–). American painter, born in Pittsburgh, lived and worked in New York City. He belonged to the school of NEW REALISTS who in the early 1960s inaugurated a 'return to the human figure' in reaction from ABSTRACT EXPRESSIONISM. But his interest in pictorial construction differentiated him from the 'Radical Realists'. In the words of Barry Schwartz in *The New Humanism* (1974): 'This new figuration claims to take nature as it is. The artist's stance is conspicuously cool, detached and uncommitted. Realists like Philip Pearlstein insist that their art makes no judgements, offers no human involvement beyond the eye itself. In his wish to dissociate himself from any implications beyond the purely visual, Pearlstein turns the human subject or human presence into an anatomical object under the scrutiny of visual perception. He has argued that his model is of no more interest than the furniture she sits on.' In an introductory statement to the catalogue of an exhibition at the Gimpel Fils Gal., London, in 1975, Pearlstein said: 'I have made a contribution to humanism in 20th century

painting—I rescued the human figure from its tormented, agonized condition given it by the expressionistic artists, and the cubist dissectors and distortors [*sic*] of the figure, and at the other extreme I have rescued it from the pornographers, and their easy exploitations of the figure for its sexual implications. I have presented the figure for itself, allowed it its own dignity as a form among other forms in nature.' Pearlstein painted without artifice except for a trick of cutting off the lower extremities and the upper part of the face, thus imparting to his figures an impression of monumentality as if they exceeded the confines of the canvas.

Pearlstein had a number of one-man shows in the U.S.A., including Kansas City Art Institute (1962), the Carnegie-Mellon Institute (1968) and a retrospective touring exhibition (1970–1). In Europe he had one-man shows in Cologne, Berlin, Hamburg, Zürich, Malmo and London. Among other public collections his works are represented in The Mus. of Modern Art, New York, the Whitney Mus. of American Art, New York, the Art Institute of Chicago and the Philadelphia Mus. of Art.

PECHSTEIN, MAX (1881–1955). German painter and graphic artist, born at Zwickau, studied in Dresden and in 1906 became a member of the BRÜCKE. In 1908 he moved to Berlin and was active in the controversies for 'modern' art against old-fashioned Impressionism, becoming one of the founders of the *Neue* SEZESSION. In 1912 he was expelled from the *Brücke* because of his refusal to leave the *Neue Sezession*. Pechstein had a facile gift for reproducing the superficial features of the French FAUVISTS, MATISSE in particular. His love of the exotic, shared by other members of the *Brücke*, led him to make a visit in 1913–14 to the Palau Islands in the Pacific and he painted gay and lively anecdotal pictures depicting the paradisal life of the island fishermen in a near-Fauvist manner. For these reasons, perhaps, Pechstein was the first member of the *Brücke* to achieve popularity and win general recognition. He was also known for his portraits and his opulent flower pieces. In 1918 he was one of the founders of the NOVEMBER-GRUPPE and he taught in the Berlin Academy from 1923, from which he was dismissed in 1933 and reinstated in 1945. Pechstein's early popularity as a representative of German EXPRESSIONISM did not stand up to the verdict of time.

PEDERSEN, CARL HENNING (1913–). Danish painter, born in Copenhagen and self-taught as a painter. He started as an abstract artist but moved during the 1940s towards Danish EXPRESSIONISM and became a member of the COBRA group in 1948. In lyrically expressionist compositions with colour varying from ecstatically flaming to ascetic refinement he portrayed a fantastic world of horses and dwarfs, palaces and princesses, demons and ghosts. He won a Guggenheim prize in 1958 and exhibited at the Venice Biennale

in 1962. In 1967 he was exhibited with Henry HEERUP at the Moderna Mus., Stockholm.

PEETERS, HENK (1925–). Dutch experimental artist born at The Hague and studied at the Royal Academy of Art there. He was a member of the NUL group. He was awarded the Swiss prize for abstract painting in 1960. His works were exhibited at the New Vision Centre, London, the Køpcke Gal., Copenhagen, the De Cordova Mus., Lincoln, Mass., etc., and were represented in exhibitions of the NOUVELLE TENDANCE, Zagreb, and other international shows of *avant-garde* art. Peeters made COLLAGES and structures from commonplace materials, often in white, e.g. a panel of cottonwool balls behind transparent nylon, and he also exploited the effects of light and water, e.g. his *Water-Ceiling* shown at Halfmannshof, Gelsenkirchen in 1965. Among other methods of making light an independent aesthetic medium he experimented with the refraction of light controlled by prisms and lenses.

PEETERS, JOZEF (1895–1960). Belgian painter, born at Antwerp. In 1913 he began to study at the Academy of Fine Arts, Antwerp, where he came into contact with FUTURIST works and in 1918 he founded the *Moderne Kunst* association and began to produce dynamic works in a Futurist manner under the influence of MARINETTI. From 1920 he was in close touch with the Dutch De STIJL group and began to work in a CONSTRUCTIVIST manner of geometrical abstraction. In 1920 he helped to organize the First Congress of Modern Art in Antwerp and in 1922 he collaborated with Michel SEUPHOR in founding the Constructivist review *Het Overzicht*. In 1925, when *Het Overzicht* ceased publication, he founded the review *De Driehoek* in support of Constructivist art. In 1927 he abandoned painting, taking it up again only in 1956, at first with figurative work but later reverting to his earlier Constructivist style. In 1960 a large retrospective exhibition of his work was given in Antwerp as an act of homage from the younger generation to an artist who had come to be regarded as a pioneer of Belgian abstraction.

PEINTRES MAUDITS. See ÉCOLE DE PARIS.

PELAEZ, AMELIA. See LATIN AMERICA.

PELLAN, ALFRED (1906–). Canadian painter, born in Quebec. Precociously talented, he entered the École des Beaux-Arts there at the age of 14. In 1926 he won a Quebec Province scholarship to Paris, where he studied in Lucien Simon's atelier at the École Supérieure des Beaux-Arts. Apart from a brief return to Quebec in 1936, he lived in Paris until the German invasion, exhibiting with the Surindépendants in 1937 and again in 1938 and 1939, and in the latter year also holding a one-man show at the Gal. Jeanne Boucher.

When he returned to Quebec, Pellan was greeted with great acclaim, which centred on a large exhibition of his Parisian paintings held at the Mus. du Québec in June 1940 and in Montreal in October. Particularly in Montreal his abstract work seemed to touch a chord, bearing evidence as it did of the force of modern French painting. In 1941 Pellan settled in Montreal and began to exhibit with the Contemporary Art Society. In an apparently self-conscious demonstration of the range of his talent, that summer he painted a number of portraits and landscapes in Charlevoix county. In 1943 he began teaching at the École des Beaux-Arts de Montréal, and over the following few years assumed a role somewhat in competition with that of BORDUAS at the École du Meuble. In 1948 he in fact assisted in the formation of the *Prisme d'yeux* group in opposition to the growing force of the AUTOMATISTES. This conflict with Borduas came to a head late in 1948, resulting in the collapse of the Contemporary Art Society. Pellan's painting during the mid 1940s settled on a kind of abstracted figuration—e.g. *Quatre Femmes* (Mus. d'Art Contemporain, Montreal, 1945)—inspired somewhat by the work of Fernand LÉGER, who visited Pellan in Montreal in 1945.

From 1952 to 1955 Pellan lived again in France, where his work evolved into a highly coloured and tightly worked personal SURREALISM, usually rich—as in *La Chouette* (Mus. National d'Art Moderne, Paris, 1954)—with drawn detail and allusive reference. In 1955 he was honoured with a major retrospective at the Mus. National d'Art Moderne. His return to Canada was marked with another large retrospective at the Hall of Honour in Montreal (1956). Further retrospective exhibitions included: National Gal. of Canada, Ottawa, and Montreal, Quebec and Toronto (1960–1); Kitchener-Waterloo Art Gal., Ontario (1964); Winnipeg Art Gal. (1968); Mus. d'Art Contemporain, Montreal (1969); Montreal Mus. of Fine Arts, and Quebec and Ottawa (1972–3). He also produced many public murals and decorative pieces, e.g. for the Winnipeg International Airport (1963) and for the National Library of Canada, Ottawa (1968).

PELUFFO, MARTA. See LATIN AMERICA.

PENALBA, ALICIA (1918–). Argentine sculptor born in Buenos Aires. She initially studied drawing and painting at the Academia Nacional de Bellas Artes, Buenos Aires. She turned to sculpture in Paris, where she went in 1948 on a fellowship and studied with ZADKINE. Even more than by Zadkine she was impressed by the work of ARP and BRANCUSI. From 1952 onwards she participated in the exhibitions of the Salon de la Jeune Sculpture and after 1955 in those of the SALON DES RÉALITÉS NOUVELLES. She had her first individual exhibition in Paris at the Gal. du Dragon. In 1960 she exhibited at the Gal. Claude Bernand, Paris, and the Otto Gerson Gal., New York. She was awarded the International Prize for Sculpture at the São Paulo Bienale in 1961. Her work of 1960 to 1965 was shown at the Gal. Bonino, New York, in 1966 and she participated in exhibitions in Antwerp, Tokyo, Kassel, Vienna, Pittsburgh, Paris and other cities. Her work prior to 1952 is known as 'totemic' with evocations of exotic petrified vegetable forms. Her bronze *Chrysalide* of 1956 is a vertical concretion of static elements whereas her 1961 version of the same subject is symbolic of movement and transformation, evoking flight rather than the concrete presence of the object. Penalba says of her totemic period that this phase of her work was 'moved by a need to spiritualize the symbols of eroticism which is the source of all creation and the purest and most sacred state in the life of man . . . suggesting as much the idealization of the flesh as its birth'. She is concerned with the rhythmic and abstract concept of the act of procreation. Her works of the 1960s are asymmetrical weightless forms with dynamic shapes stacked precariously as if ready for take-off. She chose to work in clay because of its malleability and has made many bronze casts. Some of the vegetable and animal forms that characterized her totemic period were inspired by the pre-Hispanic cultures of America, as was the work of many artists in the late 1940s and 1950s. While the balance of mass and space in such works as *Sea Fruit* and *Magic Forest* of the early 1960s retains overt erotic evocations, *Small Winged Object* (1965), *Sorcery on the Wall* (1960), *Orolirio* (1962) are examples of her more dematerialized 'flight' themes. Penalba also executed large-scale works such as the polyester relief composed of separate units on the park wall of the Kröller-Müller Mus. at Otterlo, Netherlands (1960), and *Winged Field* at St. Gall University, Switzerland (1963). Her work is in several public collections in Belgium, France, the Netherlands, Germany, the U.S.A. and Brazil.

PEPLOE, S. J. See FERGUSSON, John Duncan.

PERCEPTUAL ABSTRACTION. Term sometimes used to cover several schools of abstract art which succeeded ABSTRACT EXPRESSIONISM, such as COLOUR FIELD painting, HARD EDGE painting, MINIMAL ART and some forms of OP ART. The term indicated the switch which had taken place from emphasis upon expressive and painterly qualities to perceptual clarity and precision with emotionally neutralized content.

PERCEVAL, JOHN (1923–). Australian painter, born at Bruce Rock, Western Australia. His parents separated shortly after his birth and after 12 unhappy years with his father he rejoined his mother in Melbourne, where she and the artist Arnold Shore encouraged his interest in art. At the age of 15 he was bedridden for 18 months as the result of an attack of poliomyelitis, but was able to paint incessantly during this time. During the 1930s he was employed on a dairy farm and later

as a window dresser at a city store in Melbourne. In 1939 he enlisted, but being unfit for active service was assigned to the cartographic section of the Australian Army Survey Corps. Here he met Arthur BOYD and his brother Guy and was received into the Boyd household. He later married Mary Boyd. In 1944 Arthur Boyd, Peter Herbst and John Perceval began a pottery for the manufacture of utility wares (in order to meet wartime shortages) at the Boyd family home at Murrumbeena, Melbourne. Later they branched into the production of decorative wares.

As a painter Perceval had little formal training. He attended the National Gal. School, Melbourne, briefly and first exhibited in the Anti-Fascist exhibition organized by the CONTEMPORARY ART SOCIETY in 1942, and then at the annual exhibitions of the Society from 1942 to 1944. His early works such as *Survival* combined SOCIAL REALIST themes with an EXPRESSIONIST vigour. In 1943, however, his paintings became more personal. They sought to express the innocence, fantasies and fears of childhood. During 1947 and 1948, working closely with his friend Arthur Boyd, he turned to crowd scenes and biblical subjects in paintings which owed much to Bruegel and Bosch and something to Rembrandt. From 1949 to 1954 he concentrated upon developing his pottery techniques and made experiments in firing and glazing. In 1953 he returned to painting and completed a series of landscapes of the port of Williamstown and of the old mining village at Gaffney's Creek, Victoria. They were rendered in full colour and with a broad, folk-naïve technique, as in *Wild Goats at Gaffneys Creek* (1956). In 1957 he exhibited his first series of ceramic angels at the Mus. of Modern Art, Melbourne. In such pieces as *Angel with Lute* (Queensland Art Gal., 1957) he revealed his new-found mastery of *sang-de-bœuf* glaze. During the later 1950s his landscape paintings were done in a highly vigorous *alla prima* technique which became increasingly tactile, calligraphic and abstract, though they were still determined by the experience of a particular setting and environment, e.g. *Homage to Buvelot* (Ballarat Art Gal., 1960).

In 1961 Perceval received a commission from the University of Monash, Victoria, for the Lawrence Hargreaves Library of Science and Technology. In this work his ceramic angels became the victims of an aviator's 'atomic' world. From 1963 to 1965 he lived in London, holding an exhibition at the Zwemmer Gal. in 1964. In 1965 he returned to Australia and accepted an invitation to a Creative Fellowship at the National University, Canberra, the first to be established in Australia.

PEREIRA, I. RICE (1901–71). American painter, born at Boston, Mass. After studying at the Art Students' League she travelled in Europe and North Africa, returning to America *c*. 1933. She was among the earliest in America to paint in a style of geometrical abstraction and was a member of AMERICAN ABSTRACT ARTISTS. Her work was much exhibited both in one-man shows and in collective exhibitions of advanced American art. She had a retrospective exhibition circulating from the Whitney Mus. of American Art in 1953.

PERI, LASZLO (1889–). Hungarian-German artist, born in Budapest. After working as a bricklayer he did EXPRESSIONIST drawings, but in 1921 he joined the CONSTRUCTIVIST group in Berlin, continuing Constructivist work through the 1920s, contributing to a number of magazines and working between 1924 and 1928 as architect for the Berlin Municipal Council. He abandoned abstract painting in 1928 and in 1933 he settled in London.

PERILLI, ACHILLE (1927–). Italian painter born in Rome. He was a member of the *Forma* group set up in Rome in 1947 and of the CONTINUITÀ group of 1961. He was co-founder of the magazines *Arti visive* (1952), *L'Esperienza moderna* (1957) and *Grammatica* (1964). His paintings were derived from gestures and 'signs', which he later built up into 'Picture-Stories' with small figures in series against a monochromatic background in imitation of comic strip cartoons. He also made mobile sculptures for the theatre.

PERMEKE, CONSTANT (1886–1952). Belgian artist born at Antwerp, son of a marine painter. After studying at the Academies of Bruges and Ghent, where he was a friend of the painters Gustave de SMET and Frits van den BERGHE, he settled at LAETHEM-SAINT-MARTIN from 1909 to 1912 and later was a member of the Second Laethem Group of Flemish EXPRESSIONISTS. From 1912 to 1914 he lived at Ostend. Seriously wounded in the First World War, he was evacuated to England and there, from 1916, painted his first major Expressionist works. An example is *L'Étranger* (Mus. Royaux des Beaux-Arts, Brussels, 1916), which is regarded as the major work of his early period. Returning to Belgium in 1918, he lived first at Antwerp and then at Ostend, where sailors and fishermen replaced peasants as his subjects. In 1929 he built himself a house at Jabbeke, near Bruges, which he named *De Vier Winden* (The Four Winds) and which from 1959 was converted into the Permeke Mus. In 1935 he took up sculpture, but his heavy and Expressionist figures were less innovative than his paintings.

Permeke was a dominant figure in Belgian Expressionism and won international recognition as one of the world's greatest Expressionist artists. Devoid of social criticism his massive figures of peasants, fishermen and circus artistes had an elemental force and solidity which emphasized the pathos of the human condition. His landscapes achieved a similar monumental magnificence. Among painters he was obsessed more than most by the ponderous plasticity of sculptural form. His charcoal drawings were also outstanding for their monumental expressive realism. He was given a

large retrospective exhibition at the Koninklijk Mus., Antwerp, in 1959.

PETTIBONE, RICHARD. See POP ART.

PETTORUTI, EMILIO (1892–1971). Argentine painter born in La Plata. After a short period of study in La Plata, the province of Buenos Aires granted Pettoruti a scholarship for European study in 1913. He went to Italy, where he lived for the next eleven years dividing his time between Florence, where he had his first exhibition at the Gal. Gonelli in 1916, Rome and Milan. He participated in the boisterous meetings of the FUTURISTS in Milan and Florence, where he frequented the Caffé delle Giubbe Rosse (Red Shirts), a Futurist meeting place. His painting of 1913–19 echoed the Futurist theories of 'dynamism', but unlike the Futurists, he also sought Italy's cultural past and studied the frescoes and mosaics of the Italian *quattrocento*, especially those of Piero della Francesca. His first exposure to CUBISM occurred in Berlin and Paris, where he travelled in 1923, and he formed a friendship with Juan GRIS. He was especially drawn to the painting of BRAQUE. In 1923 35 of Pettoruti's works were exhibited at the STURM Gal. in Berlin. His work of this period combined Synthetic Cubism with flat translucent colour in compositions that did not entirely eliminate three-dimensionality. In the 1920s and 1930s he painted a series of musicians and harlequins which, unlike PICASSO's, have considerable tonal variety and subtlety as in *Quintet* (1927). In 1924 Pettoruti returned to Argentina, where he remained until 1952. Shortly after his return he joined the *Martinfierristas*, a group of *avant-garde* painters and poets founded in 1924, who sought to synthesize international contemporary art forms with the Argentine cultural heritage. A manifesto stating these facts was published in the fourth issue of the group's review *Martin Fierro*, whose name derives from the famous 19th-c. gaucho epic by José Hernández. Pettoruti's first exhibition of Cubist paintings at the Gal. Witcomb in Buenos Aires in 1924 created considerable controversy and his meetings with the *Martinfierristas* in the Café La Perla in Buenos Aires usually ended in violent encounters with more conventional artists. Although Pettoruti gained a following among artists and intellectuals in Argentina, he continued to be frowned on by officials and his two terms as director of the Mus. of Fine Arts in La Plata were both terminated after a short while, on the second occasion by the Perón government in 1947. He exhibited in many Argentine cities, in 1926 and 1940 at the Asociación Amigos del Arte in Buenos Aires, in 1927 at the Municipal Mus. of Fine Arts in Rosario, in 1936 in the Salons of the newspaper *El Argentino* in La Plata. In 1939 he exhibited in the National Salon of Fine Arts in Montevideo and in the U.S.A. he showed at the San Francisco Mus. of Art in 1942 and 1944, the New York National Academy of Design in 1943 and the Seattle Art Mus. in 1944. He returned to Italy in 1952 and the following year to Paris, where he lived until 1958. During the 1950s his work became more poetic with themes of landscapes and light at particular times of the day simplified into abstract patterns as in *The Last Hour of the Day* and *Summer Night*, both of 1955. During this period his work was shown in Rio de Janeiro and São Paulo (1949), Milan (1952), Florence (1952 and 1959), Rome (1953), Paris (1958) and London (1960). In 1956 he was awarded the Continental Guggenheim Prize of the Americas at the First Guggenheim International in New York. This won him favour in Argentina and in 1962 he was given a retrospective to honour 50 years of his work at the National Mus. of Fine Arts in Buenos Aires. He was represented in 'Art of Latin America Since Independence' in 1966 at Yale, the University of Texas and other centres with *Quintet* and *Man With Yellow Flower* (1932).

PEVSNER, ANTOINE (1886–1962). Russian-French sculptor born at Orel, brother of Naum GABO. After studying at the Academy of Art in Kiev, 1902–9, he entered for the Academy at St. Petersburg but after a trial period was not accepted. At this time he was interested in early Russian folk painting and medieval icons. In 1913 he came into contact with the Paris CUBISTS through ARCHIPENKO and MODIGLIANI and also saw FUTURIST constructions by BOCCIONI. Under the impact of these works he turned in the direction of abstract painting. In 1915 he joined Gabo at Oslo, took up sculpture and worked together with him on CONSTRUCTIVIST principles. In 1917 he returned to Russia with Gabo and was appointed Professor at the Academy of Art in Moscow together with MALEVICH and KANDINSKY. In 1919 he subscribed to Gabo's *Realistic Manifesto* and exhibited some of his non-figurative works in the Tverskoi gardens. Leaving Russia in 1922, he helped organize the first exhibition of Russian painting in Berlin, meeting there Marcel DUCHAMP and Katherine DREIER. In 1923 he settled in Paris, becoming a French national in 1930, and in 1931 he joined the ABSTRACTION-CRÉATION association. He moved to London at the end of the 1930s but returned to Paris, where he followed an individualistic path with constructions which imparted a mysterious energy to space captured and enfolded by subtly curving planes. He was a founding member of the SALON DES RÉALITÉS NOUVELLES in 1947, by which time his reputation was international and he was recognized as one of the most important pioneers of the Constructivist movement. He had a retrospective exhibition at the Mus. National d'Art Moderne, Paris, in 1956, a one-man exhibition at the Venice Biennale of 1958 and after his death a permanent room at the Mus. National d'Art Moderne.

PEYRONNET, DOMINIQUE (1872–1943). Born in a suburb of Bordeaux, he was a working printer

who did not take up painting until the age of fifty. He painted with the precision of an artisan and may be regarded as the typical unsophisticated or NAÏVE painter in his ambition to achieve exact realism of representation by meticulous attention to detail rather than by the Impressionists' method of transferring to canvas what the eye perceives. He painted for preference woodland scenes and sea pieces and took a naïve pride in the belief that no artist had pictured the sea as faithfully as he. Despite the banality of his aims he often infused commonplace subjects with a poetic quality which caused his works to be admired among popular and unsophisticated painting. In 1932 he exhibited at the Salon des Indépendants and the Salon de l'École Française. He worked slowly and only some 30 pictures by him are known to exist. His standing is nevertheless high among the naïve painters of France. He was included in the international exhibition of naïve art which was shown in 1964 at Rotterdam, Paris and Salzburg and in the 1975 exhibition at Zürich.

PEZZO, LUCIO DEL. See ITALY.

PFAHLER, KARL GEORG (1926–). German painter and sculptor, born in Weissenburg, Bavaria. From 1950 to 1954 he studied at the Academy of Art, Stuttgart, and in 1955 he founded *Gruppe 11.* In 1957 he was awarded the Kunstpreis der Jugend at Baden-Württemberg. He painted clearly defined geometrical shapes in a manner derived from CONSTRUCTIVISM but exploiting spatial distortions arising from the colours. In the late 1960s he turned to three-dimensional structures in the attempt to create apparent movement among coloured surfaces. His work was widely exhibited in Germany and was represented in a number of collective exhibitions abroad, including 'Les Jeunes Contemporains en Allemagne', Mus. National d'Art Moderne, Paris, 1964; 'Signale', Kunsthalle, Basle, 1964; 'Sculpture from Twenty Nations', New York, Toronto, Ottawa, Montreal, 1967; 'Painting and Sculpture from Europe', Jewish Mus. of New York, 1968.

PHALANX. A group of artists organized in Munich by KANDINSKY in 1901 in opposition to the Academy and the conservative views of the SECESSION. The *Phalanx* organized exhibitions of Monet in 1903 and of the Neo-Impressionists Seurat, Signac and Luce in 1904, which was seen by KIRCHNER and had an important effect on his artistic development. The *Phalanx* had its own art school, at which Gabriele MÜNTER was a pupil of Kandinsky.

PHILIPSON, ROBIN (1916–). British artist, trained at the Edinburgh College of Art, where he was Head of the School of Painting from 1960. In 1963 he was Visiting Professor at the University of Colorado, in 1965 he obtained a Leverhulme Travel Award and in 1967 the Cargill Award from the Glasgow Institute of Fine Arts. In 1969 he was elected a member of the Council of the Edinburgh Festival Society. He was made a Royal Scottish Academician in 1962 and President of the Royal Scottish Academy in 1974. From 1954 he had one-man exhibitions in London and Edinburgh. His works are represented in many public collections throughout Great Britain and also at the University of Colorado and the North Carolina Art Gal. in the U.S.A. He painted architectural interiors, landscapes, cock-fights, etc. in a decorative Late-Impressionist style.

PHILLIPS, PETER (1939–). British painter born in Birmingham, studied at the Birmingham College of Art, 1955–9, and at the Royal College of Art, 1959–62. In 1962–3 he taught at the Coventry and Birmingham Colleges of Art and in 1968–9 he was a guest teacher at the Hochschule für Bildende Künste, Hamburg. From 1959 he showed in the 'Young Contemporaries' exhibitions at the R.B.A. Gals., London, in 1963 in the Paris Biennale and in 1964 at the 'Pop Art' exhibition shown in The Hague, Vienna and Berlin. In 1964 also he worked on the Shakespeare Memorial Exhibition. He spent two years in New York, 1964–6, and had his first one-man exhibition at the Kornblee Gal., New York, in 1965. In 1972 he had a retrospective exhibition at the Westfälischer Kunstverein, Münster, and in 1976 a one-man exhibition at the Waddington Gals., London, a retrospective exhibition of graphic work at the Tate Gal., and was represented in the exhibition 'Pop Art in England' shown at Hamburg, Munich and York.

Phillips was one of the leading British POP artists and after PAOLOZZI was the one most specifically aligned to American popular culture. He worked by adoption or direct reproduction of existing figurative symbols taken from show business, automatic amusement machines, juke boxes or general advertisements, sometimes incorporating abstract symbols related to the design of automatic amusement machines. These motifs were fitted into a geometrical grid and were subjected to strict formalization, their banal character emphasized by repetition and isolation. During the 1960s the formalization became more marked and an element of abstraction in the organization of his pictures conflicted with the hyperrealism of their elements. From his student days at the Royal College Phillips was impressed by Jasper JOHNS and the 'combine pictures' of Robert RAUSCHENBERG. The technical anonymity of his work, enhanced by his use of the spray gun, and the objectivity of his attitude are symptoms of reaction against the subjectivity of ABSTRACT EXPRESSIONISM.

PHILLIPS, TOM (1937–). British painter and musician, educated at St. Catherine's College, Oxford, and studied painting at the Camberwell School of Arts and Crafts. In 1966 he published *A Humument,* which he described as 'a treated ver-

sion of a Victorian novel (*A Human Document* by W. H. Mallock, 1892) which, in that it comprises visual material, stories, scores, poems, etc., is an attempt to make a Gesamtkunstwerk in small format'. As a musician he performed from 1968 at the Bordeaux Festival, the York Festival of New Music, Cheltenham Festival, and Assonanza Nuova, Rome, among others. He was represented at the 'Young Contemporaries' exhibition of 1964 and '4 English Painters' at Chicago in 1967, was a prizewinner at the 7th John Moores Liverpool exhibition and showed in the exhibition 'Multiples' at the Whitechapel Art Gal. in 1970. In 1973 he participated in 'La Peinture Anglaise d'Aujourd'hui' at the Mus. National d'Art Moderne, Paris; and in 1974 in the Tokyo International Biennale and in the 'British Painting '74' exhibition at the Hayward Gal. He also had one-man shows, including the Welsh Arts Council Gal., Cardiff, in 1972, the Gal. Rudolph Zwirner, Cologne, and in 1974 at Gal. 101, Johannesburg, and the Marlborough Gal., New York.

PHOTOGRAPHIC REALISM. A style of realistic painting, also called Hyperrealism and Superrealism, which came into vogue in the late 1960s. A painting was made to resemble the impression of a sharply focused photograph, the sharpness and precision of detail being evenly distributed over the whole with no subordination in deference to variations of psychological interest. See also John SALT and the ZEBRA group.

PHOTOMONTAGE. A technique developed from the COLLAGES of the CUBISTS by the Zürich DADAISTS, in particular Richard Huelsenbeck and Raoul HAUSMANN, though it was also practised by John HEARTFIELD, Johannes Baader, Hannah Hoech, George GROSZ and others. The technique consisted of cutting up photographs and mounting them together with pieces of newspaper, drawings, etc. in an illogical way which was called the 'alienation' (*Verfremdung*) of photography. Hans RICHTER described the technique as follows: 'They cut up photographs, stuck them together in provocative ways, added drawings, cut these up too, pasted in bits of newspaper, or old letters, or whatever happened to be lying around—to confront a crazy world with its own image.' The method was used for political propaganda, social criticism and generally to assist the shock tactics in which the Dadaists indulged.

Hausmann, who claimed to have been its inventor, wrote: 'Photomontage in its earliest form was an explosive mixture of different points of view and levels ... with its contrasts of structure and dimension, rough against smooth, aerial photograph against close-up, perspective against flat surface, the utmost technical flexibility and the most lucid formal dialects are equally possible.' He gave the following explanation of the use of the term 'photomontage' for this technique: 'We called this process photomontage because it embodied our refusal to play the part of artist. We regarded ourselves as engineers, and our work as construction: we *assembled* our work like a fitter.'

Grosz also claimed to have invented the process conjointly with Heartfield. He said: 'On a piece of cardboard we pasted a mischmasch of advertisements for hernia belts, student song-books and dog foods, labels from schnaps- and wine-bottles and photographs from picture papers, cut up at will in such a way as to say, in pictures, what would have been banned by the censors if we had said it in words. In this way we made postcards supposed to have been sent home from the Front, or from home to the Front. This led some of our friends, Tretjakoff among them, to create the legend that photomontage was an invention of the "anonymous masses". What did happen was that Heartfield was moved to develop what started as an inflammatory political joke into a conscious artistic technique.'

Photomontage was developed into a SURREALIST technique by Max ERNST, who helped to introduce it to the Paris Surrealists. It was practised by a number of Surrealist artists during the 1920s and 1930s, including Willi BAUMEISTER and Herbert BAYER. It was also used by LISSITZKY and RODCHENKO in Russia.

The technique was revived in a manner between the Dadaist and the Surrealist practice by the NEW REALISTS of the 1960s, such as Saul STEINBERG and Les Krims.

PICABIA, FRANCIS (1879–1953). French painter, born in Paris of a Cuban father and French mother. He studied at the École des Beaux-Arts, the École des Arts Décoratifs and under Pissarro. He acquired a considerable reputation for Impressionist paintings in the style of Pissarro and Sisley, exhibiting in 1903 at the Salon des Indépendants and having his first one-man show in 1905. From 1909 to 1911 he was associated with the CUBIST school, a member of the PUTEAUX circle, where he knew the DUCHAMP brothers, and in 1911 a founder member of the SECTION D'OR. His *Caoutchouc* of 1909 was one of the earliest non-figurative abstractions. He showed himself adept during these years in the Cubist style and in 1912 he produced work in the manner of DELAUNAY'S ORPHISM. In 1913 he went to the U.S.A. for the ARMORY SHOW, in which he was represented. There he met the photographer Alfred STIEGLITZ and contributed to the review *291*. He also renewed his friendship with Marcel Duchamp and with him founded American DADA. It was during this period that he produced his post-Cubist abstractions such as *Udnie* (Mus. National d'Art Moderne, Paris, 1913) and began his mechanistic fantasies and functionless machines.

In 1916 he was in Barcelona, where he published the first number of his Dada review *391*, and with this as his introduction he joined forces with the Zürich Dada group in 1918. Shortly afterwards he returned to Paris, where he took part in provoca-

tive Dada demonstrations, showed his *Machines Ironiques* and published a number of mystificatory and sarcastic tracts. After the collapse of the Paris Dada movement he joined the SURREALISTS and continued to exhibit with them, though less actively, during the 1930s. In 1924 he had collaborated with Erik Satie in a ballet *Relâche* and in 1925 with René Clair in a film, *Entr'acte*. He illustrated *Le Peseur d'Âmes* by André Maurois. During the 1920s and 1930s he also produced his *Transparencies*, delicately lyrical collages made from cellophane sheets with colour wash.

During the Second World War he painted classical nudes, but in 1945 returned to Paris and reverted to abstract or 'Sur-Irréaliste' paintings, to which he gave mystificatory titles such as *Je ne veux plus peindre, Quel est le titre?*

Picabia was the most versatile of 20th-c. artists, proving himself adept in a number of successive styles. He courted absurdity and aggressive unconventionality but he was always in the forefront of ideas and despite his mystificatory bent, was himself fertile of new ideas. He had a retrospective exhibition at the Gal. Drouin, Paris, in 1949, on which occasion he published the pamphlet *491*, a retrospective at the Gal. Furstemberg, Paris, in 1956 and one at the Institute of Contemporary Arts, London, in 1964. Much of Picabia's later work was inferior and little of his best work was available so that his reputation declined and he was spoken of as a brilliant but too facile campfollower. A large retrospective exhibition at the Grand Palais, Paris, in 1975 made it possible to rectify this impression. Picabia displayed in an extreme form the restlessness which has pervaded much of contemporary art and the pursuit of the new for its own sake.

PICASSO, PABLO (1881–1973). Spanish artist and leader of the ÉCOLE DE PARIS, son of José Ruiz Blasco, a drawing-master of Malaga, and Maria Picasso. Until 1898 Picasso always included his father's name, Ruiz, as well as his mother's when signing his pictures, but from *c.* 1900 he dropped the name Ruiz from his signature.

Picasso's personality dominated the development of the visual arts during most of the first half of the 20th c. His versatility, technical brilliance and imaginative depth have not been surpassed in this or probably in any other age, and he provided the incentive for most of the revolutionary changes during the half century. His superb draughtsmanship, visual originality and power of construction have come to be universally admitted. While he was supreme master of the classical tradition, his most important influence during his lifetime has been to strengthen the conception of art as an emotional medium and to swing the emphasis of taste towards dynamic power and vitality rather than formal or abstract perfection.

Picasso painted at Corunna (1891–5) and then mainly at Barcelona (1895–1904). He visited Paris first in 1900 and alternated between Paris and Bar-

celona until 1904. His precocious talent matured unusually early and some of his work done before the age of 14 reveals the qualities of a master (*Girl with Bare Feet*, 1895). On his first introduction to the artistic milieu of Paris he was influenced by the drawings of Théophile-Alexandre Steinlen (1859–1923) and Toulouse-Lautrec (*Le Moulin de la Galette*, Thannhäuser coll., New York, 1900). But his work during 1901 to 1904, known as his Blue Period, in the main combined an interest in plastic representational form with emotional subject matter in the Spanish tradition and showed little concern for the atmospheric effects of Impressionism. His subjects were mainly drawn from poverty and the social outcasts and the predominant mood was one of slightly sentimentalized melancholy. His paintings were dominated by cold ethereal blue tones (*La Vie*, Cleveland Mus. of Art, 1903; *Child Holding a Dove*, Courtauld coll., London). He also did a number of extraordinarily powerful engravings in a similar vein (*Célestine*, 1903; *Le Vieux Guitariste*, 1903; *The Frugal Repast*, 1904).

In 1904 Picasso took a studio in the BATEAU-LAVOIR and became the centre of an *avant-garde* circle which included Max Jacob, Guillaume APOLLINAIRE, André Salmon and Marie LAURENCIN. He had begun to attract the notice of connoisseurs such as the Russian SHCHUKIN and Leo and Gertrude Stein; and *c.* 1907 he was taken up by the dealer D.-H. KAHNWEILER. The two or three years from 1905 are known as his Rose Period. The predominant blue tones of his earlier work gave way to pinks and greys and the mood became less austere. His favourite subjects were acrobats and dancers, particularly the figure of the harlequin. During these years he produced his first sculptures and some of his painted nudes took on a sculptural solidity which foreshadowed the majestic nudes of the early 1920s. In 1906 he met MATISSE, but though he seems to have admired the work being done by the FAUVES, he did not himself follow their method in the decorative and expressive use of colour. During the years 1907 to 1909, called his Negro Period, he pursued an independent path, concentrating on the analysis and simplification of form and taking his direction from his studies of Cézanne and NEGRO SCULPTURE. The researches of these years culminated in the painting later named by André Salmon *Les Demoiselles d'Avignon* (The Mus. of Modern Art, New York, 1906–7), which in its treatment of form was as violent a revolt against traditional Impressionism as the paintings of the Fauves were in the realm of colour. At the time the picture was incomprehensible to artists, including Matisse and DERAIN, and it was not publicly exhibited until 1937. It is now seen by art critics not only as a crucial achievement in Picasso's personal development but as the most important single landmark in the development of contemporary painting and as the herald of CUBISM.

During the years 1910 to 1916 Picasso worked

in close association with BRAQUE and later with Juan GRIS for the development of Cubism, first Analytical Cubism and from *c.* 1912 Synthetic Cubism, introducing incidentally such techniques as COLLAGE, PAPIER COLLÉ, and the incorporation of real elements into the structure of a picture. Cubism represents the most rigorous exploration of a conceptual art at the opposite pole both from Romantic emotionalism and from Impressionist techniques aiming at an exact reproduction of the visual image. Although the austerity of the restrictions imposed during the first formative years was not maintained, Picasso himself never ceased to explore further the discoveries which were made and Cubism has been rightly regarded as the most widely influential aesthetic movement of the 20th c. One of its most important results was to establish firmly the idea that the work of art exists as an object in its own right and not merely as an image or a reflection of a reality outside itself.

In 1917 Picasso went with Jean Cocteau to Rome to design costumes and scenery for the ballet *Parade* and during the next few years after his return to Paris he was painting further pictures in an obviously Cubist manner and also monumental classical nudes (*Three Musicians*, 1921; *Seated Women*, 1920, both in The Mus. of Modern Art, New York). He was hailed by André BRETON as one of the initiators of SURREALISM (*Le Surréalisme et la Peinture*, 1928). His works were shown in Surrealist exhibitions, illustrated in the Surrealist periodical *Minotaure*, etc. But his predominant interest in the analysis and synthesis of forms and his conviction that painting should be conceptual rather than purely visual were at bottom opposed to the irrationalist elements of Surrealism, their exaltation of chance, and equally to the direct realistic reproduction of dream or subconscious material. From the latter part of the 1920s, however, Picasso's work became increasingly fraught with a new and mounting emotional tenseness, a mood of foreboding and an almost clinical preoccupation with anguish and despair. He was concerned with the mythological image of the Minotaur and the images of the Dying Horse and the Weeping Woman. It was a period which culminated in his second pivotal painting, *Guernica* (the first being *Les Demoiselles d'Avignon*), produced for the Spanish Pavilion at the Paris Exposition Universelle of 1937 to express universal horror and indignation at the destruction by bombing of the Basque capital Guernica. It was followed by a number of other great paintings, from *Night Fishing at Antibes* (The Mus. of Modern Art, New York, 1939) to *The Charnel House* (Chrysler coll., 1945), expressing his horror at the cruelty and destructiveness of war. In treating such themes Picasso universalized the emotional content by an elaboration of the techniques of expression which had been developed through his researches into Cubism.

After the Second World War Picasso settled first at Antibes (1946) and then at Vallauris, where he added pottery to his many activities. In 1955 he moved to Cannes and in 1958 bought the Château de Vauvenargues. His painting remained vigorous, varied and continuously inventive of new modes for the solution of new problems. Particularly interesting were a series of 15 variations on *Les Femmes d'Alger* by Delacroix (1954–5) and 58 paintings done in 1957, of which 44 were variations on *Las Meninas* of Velazquez, which Picasso had seen at the age of 15, and the remainder views over the bay from the window of his studio. His enormous mural for the UNESCO building in Paris, painted at Vallauris, was hailed by LE CORBUSIER as a masterpiece but in the 20 years following its completion it has not been generally regarded as one of Picasso's successes. Notable among his early works at Vauvenargues were his illustrations for the book *Toros y toreros*, produced in collaboration with the bull-fighter Luis Miguel Dominguin. Among these drawings are the representations of bull-fights in which the figure of Christ appears.

During the 1960s Picasso took up flat and folded metal sculpture while continuing to work in ceramics and developed the technique of linocut. His most prestigious work in painting was the series of *Déjeuners*, whose ultimate source was Manet's *Déjeuner sur l'herbe*. Outstanding also were his series of *Rapes* reminiscent of Delacroix and later of Poussin's *Massacre of the Innocents* and David's *Sabine Women*. During 1963 he also began the series of paintings and drawings on the theme of the artist and model.

After an illness and operation for prostate in 1966, Picasso resumed painting in 1967. During these and the following years he devoted himself particularly to drawing and etching, including a famous series of 347 etchings many of which included erotic themes. In January 1969 he began to paint again and within the year he produced 165 extraordinary canvases. They were exuberant in colour, hasty in execution with a deliberate repudiation of technique, but with all the panache of a supremely creative mind. He died of heart failure during an attack of influenza on 8 April 1973, his mind full of plans for further work and exhibition.

Picasso's output has been more splendid than that of any contemporary artist and divisions into periods are to some extent arbitrary since he was at all times working on a wealth of themes and in a variety of styles. As few other artists, he had the power to concentrate the impress of his genius even in the smallest and slightest of his works.

PICELJ, IVAN (1924–). Yugoslav painter and graphic artist born at Okučani, Croatia, studied at the Academy, Zagreb, 1943–6. In 1948 he collaborated with the architect V. Richter and the painter Alexander Srnec in forming a group which arranged a number of exhibitions of Yugoslav work both in Yugoslavia and abroad. In 1951 he collaborated in founding the group *Exact 51* (Experimental Atelier 51), which was the first associa-

tion of abstract artists in Yugoslavia. It was in that year that his work became completely abstract in a manner combining CONSTRUCTIVISM with HARD EDGE. Both his paintings and his silkscreen prints were composed from carefully balanced geometrical shapes with a meticulous surface finish. An example of this style is *Composition XWY 2* (Mus. of Modern Art, Ljubljana, 1960). From 1952 he exhibited at the SALON DES RÉALITÉS NOUVELLES, Paris.

PIENE, OTTO (1928–). German painter, sculptor and experimental artist born in Laasphe, Westphalia. He studied at the Academies of Munich and Düsseldorf from 1948 to 1953 and then studied philosophy from 1953 to 1957 at Cologne University. From 1965 he taught in various universities of America while continuing to work in Düsseldorf. His work was widely exhibited in Germany and America and was also shown in London and Paris, including the exhibitions 'Painting and Sculpture of a Decade' at the Tate Gal. (1964) and 'Art Today' at the Albright-Knox Art Gal., Buffalo (1965). With Heinz MACK and Günther UECKER he founded the ZERO group. His paintings were mainly in monochrome but by an articulation of light achieved through screen processing he gave to the surface a semblance of an irregular pile or nap. In all his work he exploited an interest in light, using reflectors, heliographs, etc. From *c.* 1959 he produced his 'Shadow Drawings' and 'Shadow Pictures', for which he exploited the patterns deposited by candle black. At the same time he made his Light Ballet, in which machines instead of dancers cast shadows. He wrote of this in 1961: 'I think of an enormous, half-spherical space on the walls of which light is projected in continuous transformation; spectators can come and go when they will.' He also engineered large out-of-doors light projects such as *Luftprojekt* at Karlsruhe and *Lichtlinie* at the Institute of Technology, Cambridge, Mass., both in 1968, and from the end of the 1960s he made objects of plexiglass and electric light which he called *Heliumplastik* and also experimented with KINETIC 'light-spheres'. Piene was in the van of experiments in LUMINISM and multisensory ENVIRONMENTS.

PIERIS, JUSTIN. See DARANIYAGALA, Justin Pieris.

PIGNON, EDOUARD (1905–). French painter, born at Bully-les Mines, Pas-de-Calais. After working for 15 years in the mines he went to Paris in 1927 and kept himself by a variety of occupations while painting in his spare time and attending evening classes in sculpture. In 1936 he opted for painting on the advice of PICASSO, but it was not until 1943 that he was able to devote himself entirely to art. From 1932 he exhibited in the main Salons, the Indépendants, Surindépendants and Tuileries, and in 1941 he was a member of the group *Jeunes Peintres de la Tradition Française*.

During the 1930s, in a style influenced by Picasso and LÉGER, he painted large canvases of the life of the working people. During the 1940s his style developed into a more painterly synthesis of the post-CUBIST structure of Picasso and Léger with the decorative colour of MATISSE. In 1946 he had a one-man show at the Gal. de France and in the following year an exhibition of views of Ostend with compositions of masts, sails, rigging, etc. His still lifes and *Maternités* of the late 1940s showed the progress of his work in structural vigour. Through the 1950s he achieved a new expressiveness in the striking *Le Mineur Mort* (1952), which returned to a theme already painted in 1936, and a new expansiveness in his series of *Olive Trees* and nudes in landscapes. In his *Battles* of the 1960s he showed his ability to depict tension and movement.

Pignon also designed settings for the Théâtre National Populaire, including settings for Brecht's *Mother Courage*, and illustrated the poems of Prévert.

PILLET, EDGARD (1912–). French sculptor and painter, born at Saint-Christoly-de-Médoc in the Gironde. He studied sculpture at the École des Beaux-Arts, Bordeaux, from 1927 to 1930, then went to Paris and became a student at the École des Beaux-Arts there. In 1934 he came under the influence of DESPIAU and developed a restrained classical manner of modelling portrait busts until 1939, when he went to Algeria with the Abd-el-Tif prize. In Algeria he gave up sculpture and turned to painting, in which he had always been interested. During the war he served in Tunis, returning to Abd-el-Tif in 1942. He left Algeria for Paris in 1945 and joined the new ÉCOLE DE PARIS with PIGNON, ESTÈVE, FOUGERON and GISCHIA, obtaining in 1948 the Prix de la Jeune Peinture. During the latter half of the 1940s geometrical abstraction was establishing itself in Paris alongside the more familiar LYRICAL ABSTRACTION and Pillet abandoned figurative painting for CONSTRUCTIVIST abstraction, becoming in 1949 Secretary General of the magazine *Art d'Aujourd'hui*, the first journal to be devoted specifically to abstract art. In 1950 together with Jean DEWASNE he founded the Atelier d'Art Abstrait, where he was later joined by HERBIN, DOMELA, VASARELY and DEYROLLE. For the next two years, until the Atelier was closed in 1952, he taught and wrote for the promotion of 'hard' or geometrical abstraction. In 1951 he made an abstract film *Genesis* constructed from the strict play of geometrical forms and so differing from the type of abstract film with which the DADAIST Hans RICHTER and others had experimented in the 1920s. He made films of LAURENS and MAGNELLI in 1952. In 1952 also he did colour murals for the printing works Mame at Tours, built by the architect Bernard Zehrfuss, and in connection with this made a study of the function of colour in connection with industrial architecture. Writing in *L'Œil* in 1959 Françoise Choay

said that this was one of the first French experiments in the use of colour for the 'aménagement de climat intérieur', and that it still remained exemplary. About 1953 Pillet's painting changed its character: instead of being built up from relatively discrete geometrical elements, his pictures were now becoming a calligraphic orchestration of heavy curvilinear and straight lines upon a neutral or recessive background. He himself wrote: 'I have always been concerned with clarity and logic. At the beginning this was expressed in extreme simplicity and a certain static quality ... but from 1952 the need for liberty impelled me to use freer forms with curvilinear forms predominant. This provoked a dynamism in terms capable of creating movement on the surface of the canvas, using solid colours instead of the flat colours I had used hitherto.' The first half of the 1950s were years in which Pillet's work became widely known through his participation in exhibitions. Besides many group exhibitions he had one-man shows in Paris (Gal. Denise René, 1951; Gal. Arnaud, 1955), Helsinki (1952), Brussels and Lisbon (1953), Metz (1954), Milan (1955).

In 1955 Pillet went to the U.S.A. to teach painting at the university of Louisville, Kentucky, and in 1956 he taught at the Art Institute, Chicago. On visits to New York he met Jackson POLLOCK and other ABSTRACT EXPRESSIONISTS. After his return to Europe in 1957 his painting lost its geometrical character, heavy contour lines no longer formed a pattern against a neutral background but the surface itself was patterned in a freer type of abstraction reminiscent of BISSIÈRE or VIEIRA DA SILVA. In the 1960s he developed his since famous *creusets* (crucibles or dug-outs). These were depressions, usually oval, in a composition ground, giving a curved instead of a flat painting surface. The surround was sometimes decorated with patterns of nails which cast shadows according to the incidence of the light. The *creusets* varied in size from an ordinary easel painting to very large murals. Until 1963–4 they often took the form of masks. Later they were decorated with inscribed patterns like Mexican hieroglyphics or like engraved or embossed metalwork. In 1964 and 1965 Pillet decorated the Palais de la Présidence and the Assemblée Nationale at Abidjan, Ivory Coast, with murals done in this way.

In 1952 and 1954 Pillet published albums of *Idéogrammes*, which were serigraphs based upon preliminary sketches done for his abstract paintings or colour compositions. They were described by Dorflès as 'une sorte de bréviaire de poche' ('a kind of pocket breviary').

Pillet's works are in many collections, public and private, including the Mus. National d'Art Moderne and the Mus. de la Ville de Paris; The Mus. of Modern Art, New York; the National Mus. Ateneum, Helsinki; the Bielefeld Mus., Germany; the National Mus., Algiers; and the National Mus. of Djakarta, Indonesia.

PILLHOFER, JOSEF (1921–). Austrian sculptor born in Vienna, studied at Graz and then at the Vienna Academy under WOTRUBA. In 1950–1 he studied in Paris and came into contact with LAURENS, BRANCUSI and GIACOMETTI. He was one of the more talented of the younger generation of Austrian sculptors who followed Wotruba. His work was based on the human figure, sometimes in a stylized naturalism and sometimes in a highly simplified abstraction. He exhibited both inside Austria and abroad, including the Venice Biennales of 1954 and 1956.

PIMENOV, YURII. See SOCIALIST REALISM.

PINCHAS, JULIUS. See PASCIN, Jules.

PIPER, JOHN EGERTON CHRISTMAS (1903–). British painter and designer, born at Epsom, Surrey. Despite artistic leanings he was articled to his father's law firm in 1922, where he remained until 1926. He obtained his artistic training at the Richmond School of Art under Raymond Coxon and then at the Royal College, where Henry MOORE was a teacher. From 1928 he wrote reviews for the *Listener* and the *Nation*. He showed himself a discerning critic, being among the first to recognize such contemporaries as Ivon HITCHENS, William COLDSTREAM, Ceri RICHARDS and Victor PASMORE. In the early 1930s he became absorbed in the abstract movement of which Ben NICHOLSON and Barbara HEPWORTH were leaders, and was strengthened in this direction by a visit to Paris in 1933, when he met BRAQUE, BRANCUSI, LÉGER and HÉLION. He was also associated with the pioneer review of abstract art *Axis* edited by Myfanwy Evans, whom he married in 1935. His abstract paintings during this period, done in subdued greys, blues and black heightened with touches of red, were praised by Hugh Gordon Porteus for 'a beauty, a purity and an honesty which must compel admiration'. But he did not cease topographical drawing and painting, delighting particularly in coastal scenes and old chapels in their rural setting, continuing also his interest in stained glass tracings. During the latter part of the 1930s he more and more abandoned the abstract, reverting to representational landscape. John Betjeman says: 'From 1938 until the war he made regular tours to various parts of England and Wales, looking for stained glass, churches with box-pews in a Cotman state of picturesque decay, ruins, early industrial scenery, Welsh lakes and waterfalls, country houses, Yorkshire caves. He came back with hundreds of water-colours and material for later oils.' His romantic fantasies on great houses and churches in decay earned him a comparison with Piranesi.

His paintings of bomb-devastated buildings during the war won high praise. Among them are: *Council Chamber, House of Commons* (Imperial War Mus., 1941), *St. Mary le Port, Bristol* (Tate Gal., 1940), *Somerset Place, Bath* and *All Saints*

Chapel, Bath (both Tate Gal., 1942). In 1941 he was commissioned by H.M. Queen Elizabeth to do two series of water-colours of Windsor Castle and by Sir Osbert Sitwell to do paintings and water-colours of Renishaw Hall. He continued after the war to paint a wide variety of buildings, and in the words of John Rothenstein: 'The result has been the most various and by far the most extensive record of the buildings of Britain by any artist of this century.' In 1942 Piper wrote *British Romantic Artists*, tracing the Romantic impulse in British art, a book which clearly reflected his concept of his own artistic purpose.

Piper has been called 'the most versatile visual man of his generation'. He has done book illustration, theatrical design, designed pottery, stained glass windows, textiles, and has written on the arts and on the countryside. In collaboration with John Betjeman he has produced and illustrated architectural guides to Buckinghamshire, Berkshire, Shropshire and Oxfordshire. In 1939 he published a book entitled *Brighton Aquatints*, which won the praise of Lord Alfred Douglas. His first stage designs were done in 1937 for Stephen Spender's *Trial of a Judge*. He did designs for Benjamin Britten's operas, including *Death in Venice* of 1973. His work for the ballet *Job* at Covent Garden with music by Vaughan Williams led to many commissions for stage designs in the 1950s at Glyndebourne and elsewhere. He designed stained glass windows for Eton College Chapel in 1958, for Nuffield College Chapel, Oxford, in 1961, for Llandaff and Coventry cathedrals in 1962. He worked with Osbert Lancaster on the spectacular main vista of the Festival Gardens and designed a large decoration for the Homes and Gardens pavilion at the Festival of Britain. His first London one-man exhibition was at the London Gal. in 1938 and his first New York exhibition at the Curt Valentin Gal. in 1948. A retrospective exhibition was given by the Marlborough Gal. of Fine Art in 1964. He has been exhibited very frequently in Britain, on the Continent and in America and his works are represented in many major public collections. He was made a Companion of Honour in 1972.

PIPPIN, HORACE (1888–1947). Black American NAÏVE painter, born at West Chester, Pa., and brought up in Goshen, N.Y. He began to draw in infancy and painted religious pictures from the age of ten. Leaving school at the age of 15, he worked successively as a bellboy, foundryman and junk dealer. He was seriously wounded in France during the First World War and on his return to the U.S.A. he devoted himself chiefly to painting. His main themes were scenes from Negro life, religious scenes and memories of the war. He began to paint in oils *c.* 1930. He was 'discovered' in 1937 by Christian Brinton and several of his paintings were shown by The Mus. of Modern Art, New York, in 1938. General recognition did not arrive until the 1940s but in the years before his death his work was reproduced in the leading magazines and was bought both by private collectors and for museums. His best-known works are his trilogy on John Brown, who espoused the cause of slave emancipation, and his picture of *Uncle Tom*.

PIROSMANASHVILI, NIKO (NIKOLAI ASLANOVICH, 1863–1918). NAÏVE painter, born in the Georgian village of Mirzani in Kachetia, now part of the Soviet Union. His parents were peasants and died when he was a boy. He was brought up in Tiflis, where he worked as a shepherd, a house servant and a labourer on the trans-Caucasian railway. For a time he ran a dairy and a small paint shop but these enterprises failed and he supported himself as an itinerant sign-painter. His work was noticed by Georgian professional painters in 1916 but he was too proud to accept their aid and in 1918 he died in obscurity. Interest in his work revived with the growing cult for naïve painting, his pictures began to be collected and many of them are now a valued possession of the national museum of Tiflis. He painted scenes from the daily life of the Georgian people, delighting particularly in festivals, ceremonies and carousing. His monumental still lifes, composed particularly of luscious fruits, fish and *shashliks*, are a Utopian dream endowed with reality. He also painted the river Emut and the landscape of the port Bahumi. He was an ardent student of Georgian poetry and often included in his paintings episodes from the Georgian heroic sagas. His paintings combine realism with poetic fantasy and his palette owes much to the traditional colours of Georgian folk art.

PISIS, FILIPPO TIBERTELLI DE (1896–1956). Italian painter, born at Ferrara. He took up painting after having studied literature at Bologna university. In 1917 he came into contact with CHIRICO and CARRÀ at the military hospital of Ferrara, but at this time he had done little painting and the influence of METAPHYSICAL PAINTING upon his work was slight, although he was claimed by the Metaphysical school. He himself wrote: 'Some pictures done in 1926 and 1927—fishes hanging in the sun outside a window, melancholy red wine in an old carafe set on a pensive table within the empty parallelopiped of a macabre room—are works that could be called *metaphysical* even in the ordinary historical sense.' Yet beyond a lucid precision of feeling and a certain suggestion of spiritual tension none of his works was more than peripherally in the Metaphysical style. In 1920 de Pisis decided to devote himself wholly to painting and from that year until 1940 he worked in Paris, though with frequent visits to Italy. As a painter he was exceptionally versatile and his output was both prolific and varied. He excelled at the rapid, unpremeditated sketch rather than the elaborately planned composition. His forte lay in his facility and graciousness. Despite his residence in Paris he did not

become involved in the current artistic movements but developed a style which can best be described as lyrical Impressionism. The influences of Manet, Degas and Cézanne have been traced in his work by Guiseppe Raimondi. Others have seen the influences of Tintoretto, Guercino and above all, Guardi. The quality of his work varied; at its best it could be compared with that of Pissarro, Sisley or UTRILLO. As might be seen from comprehensive exhibitions of his work given at Ferrara and Milan in 1951, he succeeded better than perhaps any other artist in bringing about a *rapprochement* between French Impressionist and 18th-c. Venetian traditions within a modern idiom.

PISSARRO, LUCIEN (1863–1944). French-British painter, born in Paris, eldest son of Camille Pissarro. His four brothers all became painters. Lucien was taught and continuously coached by his father, and Camille Pissarro's letters to his son are a valuable document to students seeking insight into 19th-c. Impressionism and its successors. In 1883 Lucien came briefly to London and worked for music publishers, but returning to France for family reasons he worked in Paris for a firm of lithographers with whom he learnt the techniques of colour reproduction while continuing to paint. In 1886 he and his father came into close contact with the Neo-Impressionists Seurat and Signac and both of them participated in the eighth and last Impressionist exhibition of 1886. In 1890 he settled permanently in England and became a British subject in 1916.

In England Pissarro became a friend of Charles RICKETTS and in 1894 he founded the Eragny Press, one of the most distinguished of the private presses, noted particularly for its successful use of colour. He continued to be occupied with this until 1914, although he never abandoned painting. From 1905 he was a member of the circle of artists who gathered around SICKERT and met at 19 Fitzroy Street. He became a member of the NEW ENGLISH ART CLUB in 1906 and of the CAMDEN TOWN GROUP in 1911. His first one-man show was at the Carfax Gal. in 1913. From 1934 he exhibited at the Royal Academy.

Lucien Pissarro was modest and unassuming in character and compared with his more famous father his talent was a minor one. He had sensitivity, delicacy and distinction but was a less creative figure. In English art he is notable particularly as a contact with French Impressionism and Neo-Impressionism and a protagonist of the Continental DIVISIONIST technique which arose from them and of the *plein air* school of painting.

PISSARRO, OROVIDA CAMILLE (1893–1968). British painter, daughter of Lucien PISSARRO. Her devotion to Oriental art was reflected in her prints and in her stylized paintings of tigers and horses. When her sight failed she turned from etching to oil painting. At this time too she turned away from Oriental subjects towards domestic scenes and animals. A Memorial Exhibition of her work was given at the Ashmolean Mus., Oxford, in 1969. An exhibition 'Orovida Pissarro and her Ancestors—Lucien and Camille' was staged by the New Grafton Gal., London, in 1977.

PISTOLETTO, MICHELANGELO (1933–). Italian painter, born in Biella. After studying in Turin he worked until 1957 as an assistant to his father, a picture restorer. He was an experimental painter in the style of the NEW REALISM and is best known for his 'mirror paintings', begun in 1962. Using life-size photographs, usually of figures in arrested action, he traced these on onion-skin paper, cut out the figures as silhouettes and pasted them on to thin sheets of polished steel. The pictures were then finished in a range of sombre colours and the steel sheets were placed so that they reflected the image of the spectator in the areas surrounding the figure. This was an attempt to involve the spectator in the picture by incorporating his own moving image alongside the photographic image. Pistoletto stated that he was concerned with creating a system dealing with two levels of perception: the continually changing reflection in the metal surface and the static painted figure. He had exhibitions at the Gal. Sperone, Turin, and the Gal. Sonnabend, Paris (1966). He was also one of the initiators of ARTE POVERA.

PITTURA METAFISICA. See METAPHYSICAL PAINTING.

PIZZINATO, ARMANDO (1910–). Italian painter born at Maniago, Udine. He was a member of the FRONTE NUOVO in 1946, when he painted in a naturalistic style with some influence from FUTURISM. In the 1950s, however, he turned to propaganda painting based upon a poster technique.

PLANSON, ANDRÉ (1898–). French painter, born at La Ferté-sous-Jouarre, Seine-et-Marne. He studied at the Académie Ransom and obtained the Prix Blumenthal in 1932. He had a large one-man exhibition in 1954 at the Gal. Durand-Ruel. Planson belonged to the school of poetic Realists who came to the fore in the 1930s. In the tradition of Courbet, though more brightly coloured, his painting was redolent of earthy good humour and love of the soil.

PLASTICIENS, LES. A group of four Montreal painters who exhibited first in 1955. They were Louis Belzile (1929–), Jean-Paul Jérôme (1928–), Fernand Toupin (1930–) and Rodolphe de Repentigny (1926–59), who was also a mathematician at the Université de Montréal and the Sorbonne and art critic for *La Presse*. The group was joined by Fernand Leduc (1916–) in 1954. The name was taken from the signature to a manifesto in which they opposed the method of spontaneous expression favoured by the AUTO-

MATISTES and advocated instead the deliberate organization of plastic elements, mainly geometrical and without associative meanings, in a manner akin to CONSTRUCTIVISM. In January 1959 Guido MOLINARI and Claude TOUSIGNANT exhibited with the *Plasticiens* in a show 'Art Abstrait' at the École des Beaux-Arts in Montreal and later, with Jean Goguen (1928–) and Denis Juneau (1925–), formed the NOUVEAUX PLASTICIENS group. See CANADA.

PLAZA, JULIO. See SPAIN.

POHL, ULLI (1935–). German sculptor and experimental artist born in Munich and trained at the Munich Academy. He was associated with the ZERO group and participated in exhibitions both in Germany and abroad during the 1960s and 1970s. His interest was in light and movement and he made 'light objects' of transparent plastic, usually lozenge shaped, which could be controlled to conduct light through apertures which could be opened or closed. Pohl exploited the properties of plexiglass and Perspex for transmitting, reflecting and refracting light in order to delineate the edges of geometrical forms.

POLEO, HECTOR. See LATIN AMERICA.

POLESELLO, ROGELIO (1939–). Argentine painter, born in Buenos Aires and studied at the National School of Plastic Arts. From 1959 he had one-man shows in the Argentine, Venezuela, Peru, Colombia, Brazil, Puerto Rico, Mexico and the U.S.A. and participated in international group shows both in America and in Europe. In his paintings he investigated recondite perceptual experiences, converting unusual optical effects into visual poetry by repetition combined with abstraction. He worked in cut acrylic and did sequences of geometrical paintings which bordered on OP ART without exploiting the usual Op art illusions. He was awarded First Prize at the Esso Salon of Young Latin-American Artists at Washington in 1965 and several prizes in Buenos Aires, including the Georges Braque Prize (1968), the First Paolini Prize (1971) and the First Prize at the 5th Paolini Salon (1974). He was represented in the 'Art in the Argentine' exhibition shown at the Wildenstein Gal., London, in 1975.

POLIAKOFF, SERGE (1906–69). Russian-French painter, born in Moscow. He settled in Paris in 1923 and in 1930 began to study painting, working at the Grande Chaumière under Othon FRIESZ while playing the guitar at night for a living. From 1935 to 1937 he was in London, studying first at the Chelsea School of Art and then at the Slade School. During this time he began to find his own style and he exhibited his first abstract painting at the Gal. de la Niveau in 1938. From then until 1945 he exhibited yearly at the Salon des Indépendants. He had his first one-man show at the Gal. l'Esquisse in 1945 and from 1946 to 1962 exhibited regularly at the Salon de Mai. In 1947 he received the Kandinsky prize. From this time he had frequent one-man shows and was included in important group shows both in Paris and abroad, including the exhibition 'L'École de Paris' at the Royal Academy, London, in 1951. From c. 1950 Poliakoff had matured his style of abstract painting, begun in 1937 on his meeting with KANDINSKY, and his position was established as one of the most important painters in the French school of expressive abstraction. He adopted an almost religious attitude towards painting, saying: 'You've got to have the feeling of God in the picture if you want to get the big music in.' He had retrospective exhibitions at the Kunsthalle, Berne, in 1960 and at the Whitechapel Art Gal., London, in 1963 and 1969.

POLLOCK, JACKSON (1912–56). American painter, born at Cody, Wyo. After a passing interest in sculpture while living in southern California from 1925, he began to study painting in 1929 at the Art Students' League, New York, under the REGIONALIST painter Thomas Hart BENTON. During the 1930s he worked in the manner of the Regionalists, being influenced also by the Mexican Muralist painters and by certain aspects of SURREALISM. From 1938 to 1942 he worked for the FEDERAL ARTS PROJECT. He first exhibited in 1940, at the McMillan Gal. together with Willem DE KOONING and Lee KRASNER, and he had his first one-man show in 1943 at the Art of this Century Gal., where he soon became a star exhibitor. By the mid 1940s he was painting in two distinct styles, a linear style of somewhat mannered elegance and a more romantic style of rich impasto. The 'drip and splash' style for which he is best known, and which caused him to be recognized as the leader of the ABSTRACT EXPRESSIONIST movement and the most important innovative artist of his time, emerged with some abruptness c. 1947. Instead of using the traditional easel he affixed his canvas to the floor or the wall and against this rigid surface poured and dripped his paint from a can and instead of brushes manipulated it with 'sticks, trowels or knives' (to use his own words), sometimes obtaining a heavy impasto by an admixture of 'sand, broken glass or other foreign matter'. This manner of painting had in common with Surrealist theories of AUTOMATISM that it was supposed by artists and critics alike to result in a direct expression or revelation of the unconscious moods of the artist. For this reason it was referred to as 'gestural' painting and in the U.S.A. the term ACTION PAINTING was coined for it. Pollock's name is also associated with the introduction of the ALL-OVER style of painting which avoids any points of emphasis or identifiable parts within the whole canvas and therefore abandons the traditional idea of composition in terms of relations among parts. The design of his painting had no relation to the shape or size of the

canvas—indeed in the finished work the canvas was sometimes docked or trimmed to suit the image. This method of painting was no doubt partly responsible for the very great emphasis placed by the POST-PAINTERLY ABSTRACTION school in reaction from it on the identification of the pictorial image with the shape of the canvas. Pollock also introduced a novel form of picture space, the calligraphic or scribbled paint marks seeming to lie a very little way behind the picture surface and movement being set up not into the canvas in depth but laterally across the canvas towards a centre. All these characteristics were important for the new American painting which matured in the late 1940s and early 1950s.

During the 1950s Pollock continued to produce figurative or quasi-figurative black and white works and delicately modulated paintings in rich impasto as well as the paintings in the new all-over style. He was strongly supported by advanced critics, particularly Harold Rosenberg, but was also subject to much criticism as the leader of a still little comprehended style. By the 1960s he was generally recognized as the most important figure in the most important movement of this century in American painting, but a movement from which artists were already in reaction. He was perhaps the most often and most widely exhibited of all the members of the NEW YORK SCHOOL. His first one-man exhibitions in Europe were at the Mus. Civico Correr, Venice, and the Gal. d'Arte del Naviglio, Milan, in 1950. He had his first retrospectives at The Mus. of Modern Art, New York, in 1956 and 1967.

POMODORO, ARNALDO (1926–). Italian sculptor born at Morciano di Romagna. He took up sculpture only after having studied architecture and stage design and after having served an apprenticeship in goldsmithery. He settled in Milan in 1954 and had his first exhibition there in 1955. In his earlier period he was associated with expressive abstraction or INFORMALISM but he later became interested in the form of CONCRETE ART which was oriented towards machinery. He constructed his works from wheels and sprockets, bronze bars and cubes, parts of machines and moving mechanisms, etc. The forms so built were sometimes organic in suggestion and did not follow any fixed rule. Typical of his work is a large relief *Grande Omaggio alla Civiltà Tecnologica* executed for the College of Further Education, Cologne. Some of his works were constructed from parts which could be arranged at will by the spectator. In 1963 he was awarded the Sculpture Prize at the São Paulo Bienale and in 1964 he won the Prize for Italian Sculpture at the Venice Biennale.

POMODORO, GIÒ (1930–). Italian sculptor born at Orciano di Pesaro. Brother of the foregoing, he was self-taught as a sculptor. He settled in Milan in 1953 and had his first exhibition in Florence in 1954. In 1959 he won the Sculpture Prize at the Paris Biennale. His work consisted mainly of reliefs in cast bronze and later porcelain. Rather than conventional reliefs these were sculptures with one dimension truncated, the aim being to integrate the surface with surrounding space and to give an impression of movement in a non-Euclidean space.

POMPIDOU, LE CENTRE NATIONAL D'ART ET DE CULTURE GEORGES-. In 1969 President Georges Pompidou declared: 'Je voudrais passionément que Paris possède un centre culturel qui soit à la fois un musée et un centre de création, où les arts plastiques voisineraient avec la musique, le cinéma, les livres, la recherche audio-visuelle, etc.' ('I passionately wish that Paris could have a cultural centre that would be both a museum and a centre for creativity—a place where the plastic arts, music, cinema, literature, audio-visual research, etc. would find a common ground.') On 3 January 1975 the Centre National d'Art et de Culture Georges-Pompidou was created by law as a public establishment under the authority of the Secrétaire d'Etat à la Culture to encourage artistic and spiritual expression. The Centre is composed of two departments, the National Mus. of Modern Art and the Centre for Industrial Creation. Associated with it are the Bibliothèque Publique d'Information and the Institut de Recherche et de Coordination Acoustique/Musique. It was described by its President, Robert Bordaz, as 'the instrument of a new Renaissance, reinserting art and culture into daily life', with the aim 'to rediscover the fundamental unity behind the multiple aspects of current manifestations'.

The Centre was inaugurated in January 1977 and was a *succès de scandale*, arousing a storm of controversy. It was described as follows in the *Burlington Magazine* (April 1977): 'The building consists of a concrete substructure (166 m by 122 m) and a superstructure of steel girders (166 m by 70·45 m) and five huge platforms (7,500 m² each) are superimposed; their vertical load-bearing structures are entirely exterior to the building—an audacious decision marking the latest conquests in the practice of iron architecture. But while this technological feat is obviously within the possibilities of modern construction, it is its aesthetic aspect that is resolutely new. The building is no more a strictly geometrical form in steel and glass distinctly separated from the environment through its plane surfaces and cubic volumes. Not only the load-bearing structures but the main technical equipment—lifts, escalators, ducts for air and fluids, corridors—are on the outside of the building, creating a complex yet consistent game of pipe-shaped surfaces protruding into the surrounding space and combining with it. It is for the first time that this principle of interaction of the building with the external space has been applied to a construction of such enormous dimensions with an aesthetic purpose in view.' The new Mus. of Modern Art incorporated into the Centre, occupying

17,000 m², is the largest centre for contemporary art in the world. It was inaugurated with a retrospective exhibition of Marcel DUCHAMP.

POMPON, FRANÇOIS (1855–1923). French sculptor, born at Saulieu. He learned the techniques of wood-carving in the studio of his father, who was a cabinet-maker, and of stone-carving with a neighbouring stonemason. In 1894, after studying briefly at the École des Beaux-Arts, Dijon, he went to Paris and worked for 15 years as an anonymous craftsman for Rodin. Encouraged by Rodin, he devoted himself in 1914 to sculpture on his own account and made his name with his *Ours Blanc* (Mus. National d'Art Moderne, Paris) exhibited at the Salon d'Automne in 1922. He was known chiefly for his animal sculpture and was considered to be the greatest animal sculptor since Antoine Barye (1796–1875). His sculpture was distinguished both for the excellence of his craftsmanship and for his skill in rendering the essential form with the utmost economy of means. He was a modern master of generic abstraction (see ABSTRACTION). On his death he bequeathed more than 300 pieces to the Mus. d'Histoire Naturelle, which founded a museum in his name, later transferred to Dijon, where his studio was turned into a museum. He also did some monumental works, including *Le Taureau* commissioned by the Ville de Paris and erected in the Place de Saulieu.

PONÇ, JUAN (1927–). Spanish painter and graphic artist born at Barcelona and studied under the Barcelona painter Ramón Rogent. He was a founding member of the DAU AL SET group and contributed to its journal. At this time his work was SURREALIST in flavour, peopling a world of fantastic landscape with a galaxy of imaginary monsters. In 1949 he was chosen by the critic and historian Eugenio d'Ors for the Salón de los Once, Madrid. In 1955 he was granted a scholarship by the President of the São Paulo Bienale and left Spain for Brazil. In 1966 he did a set of 30 etchings to illustrate Kafka's *Metamorphosis* and in 1969–70 published a set of lithographs entitled *Las Manos de Fanafa*. In 1972 he did a series of 25 etchings at the Ateliers Rigal, Paris, was represented at the International Book Fair in Switzerland and Germany and was awarded a prize by the art critics of Barcelona. During the 1960s his painting became more abstract and less illustrative but still retained vague Surrealistic overtones. Outside Spain he exhibited in Frankfurt, Bonn, New York, São Paulo and Rio de Janeiro. He was represented in the exhibition 'Arte 73' organized by the Juan March Foundation. His work is represented in the Mus. d'Arts Graphiques, Paris, the Mus. de Arte Moderna, São Paulo, and at the Berne Mus.

PONCELET, GEORGES. See FRANCE.

POONS, LARRY (1937–). American painter, born in Tokyo. After studying at the New England Conservatory of Music and under John Cage at the New School for Social Research, New York, he studied painting at the Boston Mus. School in 1958. His first exhibitions were at the Green Gal., New York, in 1963, 1964 and 1965, after which he exhibited frequently and participated in important collective exhibitions. He was known as one of the more prominent figures of the COLOUR FIELD school of painting initiated by Helen FRANKENTHALER and Morris LOUIS. His personal style, however, set him apart. Against a background of intensely saturated colour he painted optically active ovoid dots which seem to spin and recede, creating strange after-images and giving rise to a unique visual experience which caused him at one time to be assimilated to the OP ART painters. The lack of any points of emphasis in his canvases was reminiscent of the ALL-OVER style initiated by Jackson POLLOCK. By the end of the 1960s his work had become more painterly, the colour more austere and the dots extended to streaks which have been likened to 'enlarged microscope slides of slipper bacilli'. At the same time the paintings gained in depth and atmospheric quality, but his interest remained primarily in the visual experience of colour. Among others his work is represented in The Mus. of Modern Art, New York, and the Albright-Knox Art Gal., Buffalo.

POP ART. 1. BRITAIN. The theory of British Pop art was worked out between 1952 and 1955 in the INDEPENDENT GROUP meeting at the Institute of Contemporary Arts, London. Members of the group included the architect Reyner Banham, the critic Lawrence Alloway, artists Richard HAMILTON, Eduardo PAOLOZZI and William TURNBULL. In the words of Alloway: 'We discovered that we had in common a vernacular culture that persisted beyond any special interests or skills in art, architecture, design, or art-criticism that any of us might possess. The area of contact was mass-produced urban culture: movies, advertising, science fiction. We felt none of the dislike of commercial culture standard among most intellectuals, but accepted it as fact, discussed it in detail, and consumed it enthusiastically.' The word 'Pop' was coined by Alloway to apply to this popular culture and imagery, which was expected to appeal to the unspecialized man-in-the-street and to the young. It later came to be applied to the new type of figurative art which evolved from this interest. An exhibition 'This is Tomorrow' initiated at the Whitechapel Art Gal. in 1956 by Richard Hamilton—who made for it his COLLAGE *Just what is it that makes today's homes so different, so appealing?*—foreshadowed the path which the movement was to take. In 1957 Peter BLAKE's *On the Balcony* was completed, described as 'the first major work of the new English figuration'. In 1959 or 1960 the younger generation of Pop artists, KITAJ (who came to England in 1958), BOSHIER, HOCKNEY, Allen JONES, Peter PHILLIPS, began exhibiting in

'The Young Contemporaries' at the R.B.A. galleries. It was here and in 'The New Generation' exhibition at the Whitechapel Art Gal. in 1964 that Pop art made its first big impact on the British public. In 1963 Britain was represented among others by Blake, Hockney, Jones and Phillips at the Paris Biennale for Young Artists and in 1964 British Pop art was shown at The Hague, Vienna and Berlin in an exhibition entitled 'Nieuwe Realisten'. In 1976 an exhibition 'Pop Art in England', organized by the Arts Council, was shown at the Kunstverein in Hamburg, the Städtische Gal. im Lenbachhaus, Munich, and York City Gal. It was divided into two sections: (1) the pioneers, Paolozzi, Hamilton, Blake, TILSON; and (2) the successors, Hockney, Kitaj, Boshier, Richard SMITH, Allen Jones, Peter Phillips.

The main practitioners of Pop art in England were extremely individualistic in attitude and style. They had in common an interest in the imagery of the mass media, advertisements of everyday consumer goods, etc., although the uses they made of this imagery were different. In the beginning, and particularly in the cases of Paolozzi and Phillips, this was allied with an interest in the popular imagery of American mass culture, which appealed as a symbol of a romantic and nostalgic, though second-hand, admiration for American prosperity and technological progress. The attitude which inspired the new art embraced far more than a purely artistic revolution. It involved rejection of traditional art and the art favoured by the Establishment, but this was linked with a desire to break down the barriers between so-called 'high' culture and the popular 'sub-culture' by absorbing the imagery of the latter without despising its triviality and banality and without condemning it as trash by accepted aesthetic standards. The repudiation of Establishment art was felt to be in line with the widespread revolt of the younger generation symbolized by Hollywood films, science fiction, comic strip cartoons and the Teddy-boy culture. But besides these primarily sociological interests the Pop artists, who were genuine artists with a professional knowledge of earlier artistic achievements, were concerned with purely pictorial problems as to the nature of pictorial representation and semantic problems as to communication by visual symbolization. In one way or another they all had these problems in view and in course of time these came to preponderate over the sociological interests in which Pop art had originated. In the catalogue of the exhibition 'Pop Art in England' it is penetratingly said: 'Pop art not only enquires into the pictorial appearance of an object but also asks, "How many types of symbols and meanings can a work of art contain at the same time?" (Lawrence Alloway) and "How far can symbols be reduced without losing their information value?" The multi-evocative pictorial language of Paolozzi is the answer to the first question, and Hamilton's pictorial world of investigation into the media to the second question,

both answers given not in a systematic, scientific but in an artistic form. This reflection on pictures and their effects is also an important component of the works of other English Pop artists. With his pictures within a picture Blake draws attention to the dominance of reproductions; Hockney introduces tautologies to reduce the loss of information and to simplify legibility and interpretation; in *Play within a Play* he is concerned with reality levels and pictorial illusions; Tilson combines slightly diverging pictures and words to convey almost identical items of information through the use of different symbols; Jones and Phillips, each in his own manner, try to integrate the picture with the object presented, i.e. the illustration with the illustrated (in principle a semantic problem); Kitaj makes difficulties of communication the theme of his pictures.'

2. AMERICA. In America Pop art began to emerge in the mid 1950s as one strand in a general reaction from ABSTRACT EXPRESSIONISM, though with some influence from DE KOONING. Its forerunners are considered to have been Jasper JOHNS and Robert RAUSCHENBERG, both of whom used commonplace imagery and popular KITSCH but combined it with a superb though unobtrusive technical brilliance which removed their work wholly from the realm of Kitsch. American Pop art had its roots in DADA and was sometimes known as 'Neo-Dada'. There was also a link with American Indian art and with the American primitives, so that sometimes Pop art was regarded as a new flowering of national tradition. Thus in 1965 the Milwaukee Art Center staged an exhibition with the title 'Pop Art and the American Tradition'.

Prominent among American Pop artists were Andy WARHOL (who applied his fine gifts of draughtsmanship to deliberately frivolous subjects), Jim DINE, Roy LICHTENSTEIN, Claes OLDENBERG, Tom WESSELMANN, James ROSENQUIST, Robert INDIANA. Richard SMITH and Larry RIVERS also worked in a manner which brings them within the group, as also the sculptors George SEGAL and MARISOL. California was the seat of a particularly active efflorescence of Pop art with Mel RAMOS, Edward RUSCHA, Wayne THIEBAUD, Joe GOODE, Robert O'Dowd, the tableaux of Edward KIENHOLZ and the ASSEMBLAGES of Richard Pettibone. What these artists had chiefly in common was a consuming interest in contemporary megalopolitan culture dominated by the mass media and the mass production of consumer goods, with a brashness arising from the need to make an immediate impact on minds stupefied by commercial advertising and packaging. Among the offshoots of American Pop were the art of the assemblage and the art of the HAPPENING.

Pop art spread, chiefly through the influence of America, to other European countries, Latin America and Japan, though no important Pop art movements struck root except in Britain and the U.S.A. The work of some individual artists came

within the category of Pop—FAHLSTROM in Sweden, Alain JACQUET in France, Valerio ADAMI in Italy, ARMAN of the NOUVEAUX RÉALISTES and some few in Germany. But as a coherent movement Pop belonged to the U.S.A. and Britain.

POPOVA, LYUBOV SERGEEVNA (1889–1924). Russian painter, born near Moscow. After studying with Stanislav Zhukovsky and Konstantin Yuon, 1907–8, she worked in Paris, 1912–13, frequenting the studios of LE FAUCONNIER and METZINGER. After her return to Russia in 1913 she was in close contact with TATLIN and Aleksandr VESNIN. She contributed to the KNAVE OF DIAMONDS, Tramway V, 0.10, The Shop and 5 x 5 = 25 exhibitions. In 1918 she was professor at Svomas/VKHUTEMAS and in 1920 she was a member of INKHUK. She designed sets and costumes for Meyerhold's production of Crommelynck's *The Magnanimous Cuckold* in 1922 and for Sergei Tretyakov's *Earth on End* in 1923. In 1923–4 she worked on textile design for the First State Textile Print Factory, Moscow. She was given a retrospective memorial exhibition in Moscow in 1924.

Popova was one of the foremost members of the Russian *avant-garde* although she died prematurely, at the height of her creative career. She deserves particular attention in the context of colour and space: she was profoundly interested in what she termed the architectonic value of a picture, formulated by her as 'Energetics = direction of volumes + planes and lines or their vestiges + all colours'—to which end she often relied on a rotational sequence of tones, and she introduced her new spectral and spatial interpretations to stage and industrial design, so making a formative contribution to the development of utilitarian CONSTRUCTIVISM. Her experimental works, the so-called 'painterly architectonics' of 1916–20, displayed a very flexible, very sensitive response to colour, but one which differed considerably from MALEVICH's approach. Whereas Malevich tended to juxtapose yellow, red, black, white in separate units with extreme tension and abruptness, Popova envisaged a softer interaction, resorting to subtler gradations of colour and more gradual intersections of planes, often creating a circular or at least mobile effect. Moreover, Popova tended to reject the perspectival attribute of colour so that in many of her architectonic paintings the colour of the frontal planes is not consistently lighter or darker than those behind. The two qualities displayed by her abstract works, i.e. her concentration on a dynamic, often rotational scheme and her deliberate neglect of perspective, pointed to her conception of painting as a surface art removed from the three-dimensional and hence illusionist role normally imposed on colour and form. Like Aleksandr Drevin, KLIUN and ROZANOVA, Popova felt that painting had to return to its two-dimensional basis and to dismiss perspective, space and volume as relevant only to the relief and material construction.

PORTA, ALBERTO. See SPAIN.

PORTER, FAIRFIELD (1907–75). American painter and critic born at Winnetka, Ill., studied at Harvard University and at the Art Students' League. He was Editorial Associate of the magazine *Art News* from 1951 to 1958, when he became Art Critic to *The Nation*, and he was a member of the International Association of Art Critics. He exhibited at the Tibor de Nagy Gal. annually from 1951 and elsewhere and had a retrospective at the Cleveland Mus. of Art in 1966. Relatively uninfluenced by ABSTRACT EXPRESSIONISM, Porter painted carefully constructed pictures with the emphasis on pattern rather than modelling. His early works often contained social commentary but after the mid 1940s he painted everyday scenes notable chiefly for the excellence of his technique.

PORTINARI, CÁNDIDO (1903–62). Brazilian painter born at Brodósqui of Italian immigrants. His first contact with painting was at the age of 9 when some itinerant painters allowed him to help them decorate a church in his home town near São Paulo. In 1918 he left for Rio de Janeiro, where he studied at the National School of Fine Arts under Lucilio de Albuquerque and Rodolfo Amoedo. In the 1920s he supported himself by doing portraits. He exhibited for the first time in 1922 at the National Salon of Fine Arts in Rio and in the following years won several awards. In 1928 he was awarded a travel prize for his portrait of the poet Olegário Mariano and lived in Paris until 1931. He also travelled to Italy, Spain and England. After his return to Rio he abandoned his academic manner and began painting scenes of Brazilian life in a style that combined Mexican Muralism, CUBISM and EXPRESSIONISM. In the 1940s his work also took on SURREALIST overtones. His subjects were scenes of his childhood in Brodósqui, coffee plantations, scarecrows, children's football games (he himself had injured a leg playing football as a boy). His painting *El Morro* (*The Hill*) of 1933 represents a slum section near Rio dominated by the red Brazilian soil. In 1935 he won the second honourable mention at the Carnegie International in Pittsburgh for his painting *Coffee*. He also painted folklore subjects and different ethnic types, whites, blacks and mulattoes shown together in close bonds of friendship. During the 1940s his social subjects acquired greater pathos, e.g. his 'Emigrant' series depicting the poor of the northeast region of Brazil in the aftermath of a severe drought. During this period he also turned to biblical subjects and murals, including scenes of the prophets for a radio station in São Paulo in 1943. His murals also included frescoes and tile panels for the Ministry of Public Education and Health in Rio (begun in 1936), three panels for the Brazilian pavilion at the New York World's Fair (1939), frescoes on the theme of the discovery and colonization of Hispano-America for the Hispanic Foundation of the Library of Congress in Washington, D.C. (1942) and frescoes and ceramic tile

murals on the life of St. Francis of Assisi for the church of Pampulha near Belo Horizonte (1944). In 1957 he also painted murals on the theme of 'War and Peace' for the United Nations in New York. Between 1937 and 1939 he taught painting at the University of the Federal District in Rio. His exhibition at the National Mus. of Fine Arts there in 1939 established his reputation as one of Brazil's foremost painters. In 1940 he had individual exhibitions in the U.S.A. at the Detroit Institute of Arts and at The Mus. of Modern Art, New York. He returned to Paris on several occasions and exhibited there in 1946 at the Gal. Charpentier. In 1950 he was represented at the Venice Biennale and two years later was included in the exhibition 'A Century of Brazilian Painting' in São Paulo. He won several prizes abroad, including the Guggenheim, the Hallmark and in 1955 the International Fine Arts Council prize as 'best painter of the year'. In 1960 he was on the jury of the Second Interamerican Bienale in Mexico. During the last decade of his life he exhibited widely in Europe and the Americas. After his death his work continued to be in demand and in 1966 he was included in the exhibition 'Art of Latin America Since Independence' at Yale University.

PORTWAY, DOUGLAS. See SOUTH AFRICA.

POSADA, JOSÉ GUADALUPE. See MEXICO.

POSAVEC, TEREZA. See NAÏVE ART.

POST-IMPRESSIONISM. The term is not to be confused with the Neo-Impressionism of Seurat, Signac, Pissarro, etc., which survived in the method of DIVISIONISM for the optical admixture of colours. The term 'Post-Impressionism', as coined by Roger Fry, referred to a diverse group of artists with little stylistic uniformity, of which Cézanne, Gauguin, Van Gogh and MATISSE formed the nucleus. See Roger FRY.

POST-PAINTERLY ABSTRACTION. Term introduced by the American critic Clement Greenberg in his catalogue to an exhibition of contemporary painting which he arranged at the Los Angeles County Mus. in 1964 under the title 'Post-Painterly Abstraction'. He used the term to cover a generation of artists who, despite a wide variety of individual styles, represented a breakaway from ABSTRACT EXPRESSIONISM without reverting to figural painting. Among the most prominent representatives of this new trend, which began about the mid 1950s, were Morris LOUIS, Kenneth NOLAND, Jack YOUNGERMAN, Leon Polk SMITH, Frank STELLA, Ellsworth KELLY, Larry POONS, Al HELD, Jules OLITSKI. They had in common the repudiation of 'painterly' qualities such as the expressive brush-stroke and personalized facture, and for the spontaneous and impulsive method of ACTION PAINTING they substituted coolly planned and clearly defined areas of unmodulated colour. They suppressed tactile and other illusionistic qualities, emphasizing the actuality of the artistic materials,

and they aimed at an art of purely optical colour, identifying the physical art work with the picture image and eliminating associative appeal.

POUGNY, JEAN (IVAN ALBERTOVICH PUNI, 1894–1956). Russian-French painter of Italian descent. He was born at Kuokalla, near St. Petersburg, and was encouraged by the painter Ilya Repin (1844–1930) to become an artist. After studying painting from 1910 at the Académie Julian and elsewhere in Paris, he returned to St. Petersburg in 1912 and frequented the avant-garde circles of the UNION OF YOUTH, which included MALEVICH, TATLIN, LARIONOV, etc. After a further visit to Paris in 1914, when he exhibited at the Salon des Indépendants, he returned to St. Petersburg in 1915. Having broken with the Union of Youth, he and his wife, Kseniia Boguslavskaia, organized the 'Tramway V' exhibition (Petrograd, 1915) and '0.10. The Last Futurist Exhibition' (Petrograd, 1915–16). At the latter he and his wife issued a SUPREMATIST manifesto. At this time he was himself painting in the CUBIST manner and simultaneously producing paintings and constructions in the Suprematist style of geometrical abstraction. After the Revolution he was given a teaching position at the reorganized Academy of Fine Arts in Petrograd in 1918. With Boguslavskaia, the Cubist Natan ALTMAN and many other avant-garde artists he staged a realistic enactment of the storming of the Winter Palace.

By 1920, however, he left Russia and went to Berlin, where he exhibited at the STURM Gal. and with the NOVEMBERGRUPPE. In 1923 he published a book entitled L'Art Contemporain (also in Russian). In that year he settled in Paris and quickly found his place among avant-garde circles there, exhibiting regularly at the Salon des Tuileries. Abandoning his earlier abstract and Cubist styles, from this time he painted mainly still lifes and interiors in a Late-Impressionist manner not unlike that of VUILLARD. In this style he established for himself a recognized position in contemporary French painting and was included in a number of group shows such as the exhibition of Modern French Art at Moscow in 1928, the exhibition 'Art Vivant' in the Palais des Beaux-Arts, Brussels, in 1930, the UNESCO exhibition in the Mus. National d'Art Moderne, Paris, in 1946, 'Fifty Years of French Painting' at the National Gal., London, in 1951, and many others. His many one-man shows included those at the Knoedler Gal., New York in 1949 and 1952, and at the Adams Gal., London, in 1950. He obtained French citizenship in 1946 and was made Chevalier de la Légion d'honneur in 1947.

Retrospective memorial exhibitions were held in 1958 at the Mus. National d'Art Moderne, Paris, the Mus. Toulouse-Lautrec, Albi, and the Mus. d'Art et d'Industrie, Saint-Étienne, and rètrospectives were staged at the Academie der Künste, Berlin, and the Kunsthaus, Zürich, in 1975. His *Suprematist Construction*, a still life relief con-

struction of 1915, was included in the 'Pioneers of Modern Sculpture' exhibition organized by the Arts Council of Great Britain at the Hayward Gal. in 1973.

POUSETTE-DART, RICHARD (1916–). American painter, born at St. Paul, Minn., son of the painter and writer Nathaniel Pousette-Dart. He studied at Bard College, 1936, but soon abandoned academic study for the practice of painting. He painted from the first in an abstract idiom with certain SURREALIST overtones. In the early 1940s he developed a style suggestive of Oriental calligraphy with thick impasto and totemic elements which in the 1950s matured into an ALL-OVER style in rich tapestry-like colours. He belonged to the NEW YORK SCHOOL of ABSTRACT EXPRESSIONISTS in the 1940s, although his work retained a lyrical character of its own. In the 1970s his all-over painting took on a distinctive style of minutely meticulous texturing. His first one-man exhibition was at the Artists' Gal., New York, in 1941. He was included in the exhibition of the NEW YORK SCHOOL staged by the Los Angeles County Mus. of Art in 1965 and in other important collective exhibitions of innovative American art. He had a retrospective exhibition at the Whitney Mus. of American Art in 1963.

POWER, JOHN. See AUSTRALIA.

PRACHENSKY, MARKUS (1932–). Austrian painter born at Innsbruck. He studied architecture but turned to painting and c. 1945 became one of the leaders in the post-war trend towards abstraction. He painted in a TACHIST manner and in a restricted range of flat colours, sometimes using 'signs' suggestive of script.

PRAMPOLINI, ENRICO (1894–1956). Italian painter, born in Modena and studied in Rome. He joined the FUTURIST movement in 1912 and was one of the few members of the second Futurist phase to keep in touch with artistic events outside Italy. He was a signatory to the Futurist manifesto of AEROPITTURA in 1929. But he had been associated with the DADA movement in Zürich and joined the Berlin NOVEMBERGRUPPE in 1919. He was a member of the SECTION D'OR in 1922 and of ABSTRACTION-CRÉATION in 1931. From 1925 to 1937 he lived in Paris. He was one of the few Futurist artists who advanced towards non-figurative abstraction and he is regarded with MAGNELLI as one of the pioneers of abstract art in Italy. He was chiefly known for his 'polymaterial' compositions (*arte polimaterica*) on which he worked from 1914. These were built up from a variety of materials—cork, sponges, tin foil, etc.—and were termed *Interviste con la Materia*. He was in contact with MONDRIAN, VANTONGERLOO and others of the CONSTRUCTIVIST movement and after the end of the First World War he participated regularly in international exhibitions of abstract art.

PRANTL, KARL (1924–). Austrian sculptor born at Pöttsching, Burgenland. After studying painting at the Vienna Academy under GÜTERSLOH, he took up sculpture without formal training. In collaboration with Friedrich Czagan he founded the Symposium of European Sculptors at St. Margarethe, Burgenland. His own sculpture consisted of monolithic menhir-like stone structures and smaller bronzes, which were conceived in the abstract without derivation from the human figure. Some of the larger pieces were also cast in iron, some carved in polished granite often relieved by a pattern of indentations. The sculptures, which he called *Stones of Meditation*, were supposed to invite contemplation.

PRASSINOS, MARIO (1916–). Greek-French painter born in Constantinople of Greek parentage. He studied languages at the Sorbonne, 1932–6, and acquired French nationality in 1940. He made contact with the French SURREALISTS and exhibited Surrealist paintings in Paris from 1937. After the war he painted expressive abstractions in the TACHIST manner and exhibited regularly at the Salon de Mai. His works were also exhibited in Brussels, Antwerp, Amsterdam, Turin, New York and elsewhere. He did designs for theatre and ballet, including Paul Claudel's *Toby et Sarah*, and he illustrated a number of books including *Le Bestiaire* by APOLLINAIRE, *Le Mur* by Sartre and *Journal d'un Fou* by Gogol.

PRATT, CHRISTOPHER. See CANADA.

PRAZERES, HEITOR DOS (1893–). Brazilian NAÏVE painter, born in Rio de Janeiro. A writer of popular Negro music, he began to paint in 1937 though continuing to write music. He participated in a number of group shows and in 1959 and 1961 had one-man shows at the Mus. de Arte Moderna, Rio de Janeiro. He was awarded a prize at the first São Paulo Bienale. His picture *St. John's Day* (The Mus. of Modern Art, New York, 1942) was included in the exhibition 'Die Kunst der Naiven' (Munich, 1974; Zürich, 1975).

PRECISIONISM. A movement in the art of the U.S.A. from c. 1915 whose distinguishing feature was the application of quasi-CUBIST techniques of abstraction to the depiction of everyday and preferably industrial subjects. For this reason the movement was also known as Cubist-Realism. And because of the sharp lucidity of treatment adopted by most of the artists, in many ways akin to that of WADSWORTH and NASH in England, their hard outlines, solid shadows and slick, impersonal surfaces, they were also known as Immaculates. The style involved a fairly advanced degree of 'dehumanization' in favour of the attempt to endow commonplace and industrial subjects with epic or heroic character.

Examples of the exaltation of the commonplace are *Barn Abstraction* (Philadelphia Mus. of Art, 1918) and *American Interior* (Yale University Art

Gal., 1934), both by Charles SHEELER. In the latter he makes use of the plain functional design and fineness of finish of Shaker furniture. From early in the movement the machine and machine-part were favourite themes and pictures such as *Machine* (Yale University Art Gal., 1916) by Morton SCHAMBERG and *Machinery* (The Metropolitan Mus. of Art, New York, 1920) by Charles DEMUTH may have been influenced in part by the imaginary, functionless machines of DUCHAMP. Later the factory and industrial scene were treated in a similar way, as in *Incense of a New Church* (Columbus Gal. of Fine Arts, 1921) by Charles Demuth, *Grain Elevators from the Bridge* (Whitney Mus. of American Art, New York, 1942) by Ralston CRAWFORD, *Erie Underpass* (The Metropolitan Mus. of Art, New York, 1949) by Niles Spencer. Pictorially the aim of the artists in this movement was to achieve a unified abstract design based on Cubist precedents without losing the recognizability of the subject; the deeper motive was to utilize modern techniques to endow the contemporary American industrial and technological scene with an air of epic grandeur.

PREGARTBAUER, LOIS (1899–1971). Austrian painter born at Misselsdorf, Styria. He worked as an engineer and stage designer until 1950, when he turned to painting and joined the Vienna SECESSION. He specialized in townscapes, depicting in an abstract Impressionist way the megalopolitan scene.

PREGELJ, MARIJ (1913–67). Yugoslav painter and graphic artist born at Kranj, Slovenia, and studied at the Academy of Art, Zagreb. He taught at the Gymnasium, Ljubljana, from 1938 to 1946, with a break of two years when he was a prisoner of war, then at the School of Arts and Crafts until 1948 and from 1948 at the Academy of Art. His painting was representational, at first within the mode of SOCIAL REALISM but later taking on a visionary and symbolic character. His work had a monumental nature and the stiff, hieratic poses of his figures recalled the Byzantine. Besides easel paintings he executed a number of murals in and around Ljubljana, often conceived in series. His graphic work, mainly woodcuts and lithographs, included illustrations for the *Iliad* and *Odyssey*, Hemingway and his father's works.

PRELLER, ALEXIS (1911–75). South African painter, born and educated in Pretoria. He had no continuous formal training, though he was for a while (1934) at the Westminster School in London and a few years later (1937) at the Grande Chaumière in Paris. His first exhibition was held in Pretoria in 1935. In 1939 he visited the Congo, which he found very stimulating and which seems to have oriented him to his African setting. He served in a Field Ambulance Corps from 1940 to 1943, when he became a prisoner of war in Italy. After the war he settled near Pretoria.

He was regarded as one of South Africa's two or three foremost painters, using a personal version of the African image with SURREALIST overtones. His technique was polished and precise, sometimes approaching PHOTOGRAPHIC REALISM, yet he also produced his own version of ABSTRACT EXPRESSIONISM. The images he most often used were based not directly on the forms and patterns used by tribal Africans in South Africa (though these do emerge), but on a view of the tribal or hieratic personage regarded as a symbol in his formally conceived setting. Visually his themes referred especially to the decorative patterns evolved in the villages and kraals of the Mapogga people, an offshoot originally of the Zulu, who settled in the Transvaal and are known to the white communities for their strikingly painted huts and hard walls and for the elaborate personal decorations which the women continue frequently to wear. Surrounded as he was at his country dwelling by groups of these people, Preller for many years allowed the colour and pattern of their outward show to invade his paintings. Even in paintings which have no direct representation, there seems to be an evocative reference to ancient or ingrained sensibility.

Preller exhibited in the Venice Biennale and in London. The controversial climate in which he spent most of his professional life had by the 1970s largely given way to general appreciation of his great quality.

PRENDERGAST, MAURICE. See EIGHT, THE.

PRÉ-SAINT-GERVAIS GROUP. See CAILLARD, Christian.

PRESAS, LEOPOLDO (1915–). Argentine painter born at Buenos Aires, studied at the National School of Fine Arts there and the Argentine Institute for Graphic Arts. He was a founding member of the Orion Group, which introduced SURREALISM to the Argentine in the 1930s and arranged exhibitions. His works were shown by the Group in 1939 and 1950. From 1946 he participated regularly in the official Salons and had one-man shows in the main centres of the Argentine as well as New York (1956), Rio de Janeiro (1961) and elsewhere. In 1967 he was invited to participate in the exhibition of Sacred Art at the Mus. National d'Art Moderne, Paris, and had a retrospective exhibition in New York. Among other awards he received the Grand Prix d'honneur at the National and Metropolitan Salons, Buenos Aires, in 1959 and the Augusto Palanza Prize in 1963. His early work was influenced by Surrealism but during the 1950s his style tended towards expressive and decorative colour abstraction.

PRESTON, MARGARET (1893–1963). Australian painter, print-maker and wood engraver, born in Adelaide and studied first at the School of Design there, then at the Melbourne National Art

Gal. School under Bernard Hall, and later in Munich and Paris. Her early work, which was tonal and realistic, was exhibited at the Royal Academy, the New Salon and the NEW ENGLISH ART CLUB. Settling in Sydney after the First World War, she became interested in modern art. Discarding tonalism she devoted herself to a style based on schematic design and strongly contrasted colours. Her advocacy of a distinctive national art is reflected in her bush landscapes and still life paintings of native flora, such as *Australian Gum Blossoms* (Art Gal. of N.S.W., 1968). During the 1940s she became aware of the beauty of Aboriginal art and was probably the first artist of European origin actively to champion it as an independent art form worthy of emulation. Its influence permeates many of her works of the 1940s. Her adoption of earth colours for prints and paintings developed from this interest.

PREVIATI, GAETANO (1852–1920). One of the leading artists of the Milan DIVISIONIST school of painting which was introduced and supported by the brothers Vittore and Alberto Grubicy de Dragon. Previati believed that scientific theories of colour, such as those with which Seurat and Signac had worked, were essential to the modern painter and 'most suitable to express the thoughts and sentiments of modern men'. He wrote a treatise on painting for the guidance of modern artists, the first two volumes of which, *La Tecnica della pittura* and *I Principii scientifici del divisionismo*, appeared in 1905 and 1906 and the third volume, *Della Pittura: tecnica e arte*, in 1913. Both Previati and Giovanni Segantini (1858–99), the other outstanding artist of the Milan Divisionist school, were admired by the FUTURISTS for the expressive qualities of their painting and their aspirations towards modernity and Previati was hailed by BOCCIONI as 'the greatest artist which Italy has had from Tiepolo until today . . .' Works by him may be seen in the Civica Gal. d'Arte Moderna, Milan.

PRICA, ZLATKO (1916–). Yugoslav painter and graphic artist born at Pečuh, Hungary, and studied at the Academy, Zagreb. He drew his artistic inspiration both from folk art and from Indian art and worked out a highly original combination of abstract and figurative design. He used primary colours in clashing combinations and showed figures behind a veil, as if seen through a window, in rhythmically abstract structures. He did a number of murals and also illustrated books in collaboration with Edo MURTIĆ.

PRICE, KENNETH (1935–). American sculptor, born at Los Angeles. Price was prominent among a group of artists who developed the southern California craft tradition of ceramics into an independent sculptural form. From 1958 he produced small fired biomorphic clay pieces coloured with lacquers rather than glazes. These were irregular ovoid and dome-shaped works. He also did many series of cups, which often incorporated small animal figures. From the late 1960s his preliminary drawings began to assume an autonomous importance of their own. During the 1960s and early 1970s he exhibited at the Ferus and Mizuno Gals., Los Angeles, the Kasmin Gal., London, and the Neuendorf Gal., Cologne. His work was included in a number of collective exhibitions featuring the most recent tendencies in American art.

PRIMARY STRUCTURES. Name given to a style of sculpture which came to prominence in the mid 1960s. It first obtained public recognition at an exhibition 'Primary Structures' organized by Kynaston McShine at the Jewish Mus., New York, in 1966. The style was distinguished by its preference for regular polyhedrons and drastically simplified geometrical structures and its frequent use of industrially fabricated elements. Among those who worked in this style were artists such as Tony SMITH, Don JUDD, Ronald Bladen, Robert MORRIS, Carl ANDRE, Dan FLAVIN, Sol LEWITT. The movement was included within the scope of MINIMAL ART and indeed the term 'Primary Structures' was sometimes used as a synonym of 'Minimal Art'.

PROCHÁZKA, ANTONÍN (1882–1945). Czech painter who *c.* 1908 became a member of the Czech group *Osma* (The Eight), whose object was to renovate Czech art in a direction combining Impressionist and Expressionist elements. Influenced subsequently by CUBISM, he was a member of the *avant-garde* group, including FILLA and ŠPÁLA, which *c.* 1911 wished to initiate a new Czech art combining features of Cubism with German EXPRESSIONISM.

PROCHÁZKOVA, LUDMILLA (1903–). Czech NAÏVE painter, born at Herspice, near Slavkov. She began painting in 1945 and her work was exhibited at the Mánes Artists' Club, Prague, in the 'Naïve Art in Czechoslovakia' exhibition at Brno, Bratislava, Prague, Ostrava, and in exhibitions of naïve art at Salzburg, Graz, Linz. Her pictures show occupations (threshing, baking, etc.), customs (birth, marriage, etc.) and festivals of old Moravia.

PROCTOR, THEA. See AUSTRALIA.

PRODUCTIVIST. A group of NON-OBJECTIVE artists who after the 1917 Revolution in Russia rejected 'pure art' and LABORATORY ART in favour of 'production art'. Their views were expressed in a manifesto by TATLIN in 1920 issued as a reply to GABO's *Realistic Manifesto*. Their aims and ideology were later given the name 'Constructivism' and are described under the heading 'Soviet Constructivism' in the article CONSTRUCTIVISM. See also INKHUK.

PROGRAMMED ART. See ARTE PROGRAMMATA.

PROTIĆ, MIODRAG (1922–). Yugoslav painter, critic and Director of the Mus. of Modern Art, Belgrade. His early painting done in saturated colour and solid contours was under the influence of LHOTE. In his later work he investigated problems connected with the relation of the picture surface to the image and to the representation of light. He matured a mode of lyrical abstraction.

PROUN. Abbreviation of the Russian words *Proekt utverzhdeniia novogo* (Project for the Affirmation of the New). *Proun* was the name given by LISSITZKY to a series of two-dimensional experiments which he created between 1919 and *c*. 1924. According to his definition a *Proun* was 'the creation of form (control of space) by means of the economic construction of material to which a new value is assigned'. Influenced by MALEVICH's SUPREMATISM and first conceived while Lissitzky was working at Vitebsk, the *Prouns* were compositional arrangements in mass, force, tension, and as such anticipated much of Lissitzky's architectural and interior design work of the 1920s. They were to some extent an attempted synthesis of Suprematist and CONSTRUCTIVIST principles.

PRYDE, JAMES FERRIER (1866–1941). British painter born in Edinburgh. He studied desultorily at the Royal Scottish Academy and then briefly at the Académie Julian, Paris. In 1893 he visited William NICHOLSON, who had just married his sister, for a weekend and stayed for two years. During this time and until *c*. 1898 he collaborated with Nicholson under the name of 'The Beggarstaffs' in a series of posters for Henry Irving which stand high in the history of poster art. As a painter Pryde came to maturity *c*. 1905 and his most fruitful period was from then until 1925. But he lived a Bohemian life in London and his output was small. He painted little after 1925, although he designed costumes and sets for *Othello* in 1930. Pryde was an imaginative painter and his pictures, which were mainly architectural compositions and interiors, made their impact by the strange and dramatic grandeur of his vision: as paintings they have been judged too theatrical. John Rothenstein quotes Augustus JOHN, who said after a visit: 'This studio had the lofty, dignified and slightly sinister distinction of his own compositions. Upon the easel stood the carefully unfinished and perennial masterpiece, displaying under an ominous green sky the dilapidated architectural grandeur of a building, haunted rather than tenanted by the unclassified tatterdemalions of Jimmy's dreams. With figures dwarfed by their surroundings the paintings express the insignificance of man set amid dramatic voids.' A memorial exhibition organized by the Arts Council in 1949 was shown in Scotland, Brighton and at the Tate Gal.

PUCCIARELLI, MARIO. See LATIN AMERICA.

PUIA, FLORIKA. See NAÏVE ART.

PUJOL, ANTONIO. See MEXICO.

PULLINEN, LAILA (1933–). Finnish sculptor born at Zelenogorsk, Karelia. After studying at the School of the Academy of Art, Helsinki, 1953–6, she held an exhibition of small traditional, though powerful, female figures at the Artek Gal. She then studied at the Academy of Art, Perugia, in 1958 and at the Accademia dei Belle Arti, Rome, 1961–2. After experimenting with various modern styles and techniques, such as sculpture from scrap, abstract iron sculpture, etc., she found her own style by combining dynamically moulded cast bronze shells in one work with massive lumps of marble, basalt or ebony. Works in this manner are *Marilyn Monroe—In Memoriam* (1964), *Sibyl* (1963) and *Dolce Vita* (1966). With works of this kind she represented Finland in the Venice Biennale of 1964 and won recognition as one of Finland's leading sculptors. One of her greatest works was the sculpture executed in 1965 for the Helsinki Town Hall. Commissioned to execute a huge relief for the Finnish Pavilion at 'Expo '67', Montreal, illustrating copper as a basic industrial material of Finland, she devised a new and original technique. Selecting the thickest available copper plate she worked it by means of a controlled use of explosives.

PULSA. A group of seven artists from New Haven, Conn., formed to collaborate in producing 'light environments' which depended on chance stimuli in the environment acting reciprocally with computer programming and weather conditions to create zones of pulsating light, sound and heat. They took part in the 'Spaces' exhibition organized by The Mus. of Modern Art, New York, in 1969.

PUNI, IVAN ALBERTOVICH. See POUGNY, Jean.

PUNIN, NIKOLAI NIKOLAEVICH (1888–1953). Russian art critic born in St. Petersburg. From 1912 he was close to the *Apollon* circle in St. Petersburg and contributed to the journal. In 1918 he was a member of IZO NARKOMPROS, in 1919 a leading member of the Communist FUTURIST (*Komfut*) group, in 1921–2 a founder member of INKHUK. From 1918 to 1930 he lectured and wrote on modern art. In 1933 he was arrested but freed on the intercession of Boris Pasternak. In 1935 he was arrested again and deported to Siberia.

Punin is remembered above all for his contribution to the new Soviet criticism of the 1920s and was essentially a member of the Formalist school of criticism. His assertion that modern art criticism should be scientific expresses his own aim. In the Formalist spirit Punin even succeeded in reducing the creative process to a mathematical formula: $S(Pi + Pii + Piii + \ldots . P)Y = T$, where S equals the sum of the principles (P), Y equals intuition and T equals artistic creation. In this re-

spect it is logical that Punin should have preferred the 'engineer' TATLIN to the artist MALEVICH, concluding that Malevich was too subjective to examine material in a scientific and impartial manner. Even so Punin was a keen supporter of many different members of the Russian *avant-garde*, including Malevich and Mansurov.

PURISM. A movement linked with the new aesthetic of 'machine art' which established itself in Paris from *c*. 1918 to *c*. 1925. Its founders and protagonists were Amédée OZENFANT and the Swiss painter and architect Charles-Édouard Jeanneret (see LE CORBUSIER). In 1917 Ozenfant came to the conclusion that CUBISM had missed its path and was degenerating into an art of decoration. These views he publicized in his review *L'Élan*, which appeared from 1915 to 1917. In 1918 he collaborated with Jeanneret in a book *Après le Cubisme*, in which they laid down the foundations of Purism. They collaborated also in a journal L'ESPRIT NOUVEAU, which ran from 1920 to 1925, and in 1924 they published a joint work *La Peinture Moderne*, which Ozenfant later described as a 'résumé of the *L'Esprit Nouveau* campaigns'.

They regarded their association as 'a campaign for the reconstitution of a healthy art', their object being to 'inoculate artists with the spirit of the age'. They set great store by 'the lessons inherent in the precision of machinery' and they were at one with that form of Functionalism which advocates the adaptation of form to function. They held that painting should by cool abstraction emphasize the fundamental shapes of basic tools and utensils which, they claimed, had in the course of evolution acquired the ideal forms adapted to their function and the requirements of the human body. These they called *objets types*. Emotion and expressiveness should be strictly excluded apart from the 'mathematical lyricism' which is the proper response to a well-composed picture.

Despite the anti-emotionalism of this Functionalist doctrine, it was advocated by Ozenfant with passionate missionary fervour. It won a considerable measure of support from artists and writers of widely different persuasions but Purism did not establish a continuing school of painting. Its main sequel is to be found in the architectural theories and achievements of Le Corbusier. The Purist paintings of Ozenfant and Jeanneret were in themselves neither mediocre nor outstanding. Their main outlet was through the gallery of Léonce Rosenberg, who acted as their patron and himself founded a review *L'Effort Moderne* in 1924. The main merit of Purism was that for its time it was thoroughly in the swim and it gave expression to aesthetic ideas which were becoming dominant elsewhere (e.g. in NEO-PLASTICISM, European CONSTRUCTIVISM and the BAUHAUS) but had otherwise little support in Paris.

PURRMANN, HANS (1880–1966). German painter born in Speyer and trained at Karlsruhe. After moving to Berlin and joining the Berlin SECESSION, he spent the years from 1906 until *c*. 1914 in Paris, where he was prominent among the German disciples of MATISSE and FAUVISM. Under the National Socialist regime his work was declared DEGENERATE and he remained outside Germany as head of the Villa Romana in Florence until settling in Switzerland in 1944. In his later years he moved from the rather brash colours of his Fauvist period to a more subtle and vibrant form of Late-Impressionism. He died in Basle.

PUTEAUX GROUP. A group of artists, affiliated with the Cubists, who between 1911 and 1913 met at the studio of Jacques VILLON in the suburbs of Paris. Besides Marcel DUCHAMP and Raymond DUCHAMP-VILLON the circle included GLEIZES, METZINGER, GRIS, LÉGER, ARCHIPENKO and the Czech artist František KUPKA. The group produced a rather uninspired 'Cubist House' at the Salon d'Automne of 1912 and in October 1912 organized a SECTION D'OR exhibition.

They criticized Analytical CUBISM on the ground that it lacked human interest and they reintroduced an interest in colour which led on in 1912 to ORPHISM.

PUVREZ, HENRI (1893–1971). Belgian sculptor born in Brussels. Almost completely self-taught, he passed at an early stage from representational work to abstraction, using the techniques of direct carving. From 1925, influenced by his friend Oscar JESPERS and by ZADKINE and NEGRO art, he worked in an EXPRESSIONIST manner. During the 1930s he cultivated more rounded and classical forms in the tradition of Rodin, MAILLOL and Frank DOBSON, although still monumentally expressive. An example of his mature style is his *Maternité IV* (Mus. Royaux des Beaux-Arts, Brussels, 1935). Although he usually worked without a model, during the 1940s he did a series of portraits, often of artist friends, outstanding among which is his *Constant Permeke* (bronze, 1942).

PUY, JEAN (1876–1960). French painter born at Roanne, trained at the École des Beaux-Arts, Lyons, 1895–8, and in Paris at the Académie Julian, 1898, and the Académie Carrière, 1899, where he met MATISSE. He began to exhibit at the Salon des Indépendants in 1901 and became one of the more moderate members of the FAUVIST group. He painted landscapes, nudes, interiors, flowers, etc. but although he was an artist of distinction, natural and spontaneous in style, he was in no sense an innovator and belonged to none of the great revolutionary movements of his time. In 1923 he illustrated Ambroise VOLLARD's *Le Père Ubu à la guerre*.

PUZZOVIO, DALILA. See LATIN AMERICA.

Q

QADRI, SOHAN (1932–). Indian painter born in the Punjab and studied at Punjab University, where he took a diploma in art, afterwards teaching art in a postgraduate college and practising as a photographer. He spent long periods in silence and meditation, visiting remote temples in the Himalayas, and he experienced illumination while living among Sadhus and mountain peoples. He travelled extensively outside India and held one-man shows among other places at Nairobi, Brussels, Copenhagen, Zürich, Basle, Vienna, Hollywood, Munich, Toronto, in the Commonwealth Institute, London, and in Poland. His paintings, which were non-representational abstractions, have been said to echo his mystical experiences. Strange but arresting abstract shapes emerge from monochromatic areas.

QUADRIGA. A group of TACHIST painters formed in Frankfurt in 1952. The group consisted of Karl Otto GÖTZ, who from 1948 edited the magazine *Meta*, SCHULTZE, Kreutz and Otto Greis. They were later joined by Emil SCHUMACHER. Their work was most closely aligned with the LYRICAL ABSTRACTION which drew its inspiration from RIOPELLE and WOLS but influences from ABSTRACT EXPRESSIONISM, in particular POLLOCK, and from the COBRA group were also apparent. The group gave their first exhibition with the title 'Neo-Expressionists' in December 1952 at the Gal. Franck in Frankfurt. They represent the German variant of ART INFORMEL.

QUIN, CARMELO ARDEN. See LATIN AMERICA.

QUINTANILLA, ISABEL (1938–). Spanish painter and draughtsman, born in Madrid. After attending a private art school she studied at the San Fernando School of Fine Arts, Madrid, from 1954 to 1959. She was in Rome from 1961 to 1964. Her landscapes, still lifes and interiors belonged to the school of Spanish Realism and were distinguished by meticulous technique and a poetic and unassuming naturalism. She was married to Francisco LÓPEZ. Besides exhibitions in Spain she contributed to the main international exhibitions of contemporary Realism and was represented in the exhibition 'Spanische Realisten', Leverkusen, 1974 and Zürich, 1975.

QUINTE, LOTHAR (1923–). German painter born at Neisse and trained at Bernstein. During the 1950s he worked in Reutlingen, interesting himself in shadow plays and film as well as painting. From 1957 to 1959 he worked in Lauterbourg, France. In 1954 he won the Art Prize for Youth and in 1965 the Burda Prize for painting. From 1959 to 1960 he taught at the Werkkunstschule, Krefeld. His work was widely exhibited in Germany and was represented in collective exhibitions abroad, including 'Six German Painters', at the Institute of Contemporary Arts, London, 1964, 'Recent Acquisitions', The Mus. of Modern Art, New York, 1966, and 'Formen der Farbe' at the Kunsthalle, Berne. He began with COLOUR FIELD painting, demonstrating the spatial aspects of pure colour, and in the later 1960s painted bands and streaks of luminous colour against a monochromatic background, usually dark. His later works belonged to the genre of what was then called 'Signal' painting.

QUIRÓS, JUAN GOMEZ. See LATIN AMERICA.

R

RABIN, OSKAR YAKOVLEVICH (1928–). Russian painter. Not a member of the Artists' Union, he was the only unofficial artist among the representatives of SOCIALIST REALISM in the exhibition of contemporary Soviet art at the Grosvenor Gal., London, in 1964. In a review of this exhibition the art critic of *Time* magazine wrote: 'The only Russian painter who might be at home in any Western city's art museum is Oskar Rabin, an outcast.' In 1965 he had a one-man show at the Grosvenor Gal. and the Arleigh Gal., San Francisco. He was then described by the reviewer Terence Mullaly as a 'major talent' and by John Russell as 'a genuine painter who keeps well above the level of the tourist trade'. Rabin was married to Valentina-Vida, also a painter and daughter of the artist Yevgeny Kropivnitsky. He was a leading spirit in the open-air exhibition of unofficial art in Moscow which was broken up by the authorities on 15 September 1974, but allowed to take place later in the month. Although he first enjoyed official tolerance, his passport was later withdrawn by the authorities and he moved to Paris.

Rabin painted in thick impasto mainly with a palette knife and generally in subdued ochre and umber tones. His favourite themes were fantastic cityscapes juxtaposed with incongruous objects, such as a Titian nude, a torn vodka label, samovars, trains, etc. For many years he worked as a railway porter and engine driver, painting in his spare time, and he made use of themes taken from the context of the railway.

RABUZIN, IVAN (1919–). Yugoslav NAÏVE painter, born in the Croatian village of Kljuc. A carpenter by trade, he worked as a furniture maker while attending evening classes in drawing at Zagreb. From 1950 to 1961 he worked in the furniture factory of the village of Novi Marof. In 1958 he came to the notice of the Gal. of Primitive Art in Zagreb and from 1962 worked as a full time professional painter. In 1969 he was awarded the Henri Rousseau prize in Bratislava. Outside Yugoslavia he has exhibited in Moscow, Leningrad, London, Paris, Frankfurt, Hamburg, Vienna, Rio de Janeiro, São Paulo and Budapest.

RADMANIĆ, FRANJO. See NAÏVE ART.

RADICE, MARIO (1900–). Italian painter born in Como and self-taught as an artist. He was one of the pioneers of abstract art in Italy during the 1930s and participated in exhibitions of abstract art in Italy and Scandinavia. He worked closely with architects and his cool, severe abstracts had an architectural quality. They were in the tradition of De STIJL and Van DOESBURG, but complex with deliberate spatial ambiguities. He was an editor of the journals *Quadrante* and *Valori Primordiali*.

RAFFLER, MAX. See NAÏVE ART.

RAFOLS CASAMADA, ALBERTO (1923–). Spanish painter born in Barcelona and studied at the Academy of Fine Arts there. From a FAUVIST style he progressed through volume analysis in a manner suggestive of CUBISM to abstraction, although he was never integrated into the Spanish ART INFORMEL *avant-garde*. In his latest work he used COLLAGE in a manner suggestive of POP ART.

RAINER, ARNULF (1929–). Austrian painter born at Baden, near Vienna, studied at the Academy, Vienna. He was one of the leaders of the abstractionist movement in the artistic revival which began *c.* 1945. After passing through a phase of AUTOMATISM he began to paint black monochromes in a TACHIST manner *c.* 1953. These were followed, from *c.* 1959, by his 'overpaintings', in which four-fifths of the painting was veiled with impenetrable dark or black terminating in a sensitive mass of fine, linear bristles. These works invited contemplation and carried suggestions of the void. Besides exhibitions in Austria he exhibited in London and Brussels in 1961 and he was represented at DOCUMENTA II, Kassel, in 1959. In 1959 he began to publish *Pintorarium* in collaboration with HUNDERTWASSER and Ernst FUCHS.

RAJKOVIĆ, BUDIMIR. See NAÏVE ART.

RAMAH, HENRI-FRANÇOIS (DE RAEMAEKER, 1887–1947). Belgian painter, born at Saint-Josse-ten-Noode, Brussels. Although he briefly attended the School of Arts and Design at Saint-Josse-ten-Noode, he is generally considered to have been a self-taught artist. He made his début as an engraver in 1909 and first exhibited as a painter at the Giroux Gal. in 1912. Starting in an Impressionist manner, he adopted the flamboyant colouring of the FAUVES, which he afterwards channelled to EXPRESSIONIST ends. About 1920 he was painting with a severely controlled stylization of forms in a camaieu palette of greys and beige. One of his finest works in this mature style was his

Portrait of Madame Ramah (Mus. Royaux des Beaux-Arts, Brussels, 1921). In 1926 he became a member of the *avant-garde* group *Les IX*. With his friend Paul MAAS he then joined the circle of Expressionist artists led by De SAEDELEER and during the 1930s and 1940s moved towards an extreme form of Expressionism which sometimes verged upon expressive abstraction and sometimes had psychological features in common with Germanic Expressionism, as in his fine gouache *Self-Portrait* of 1946 in the Mus. Royaux des Beaux-Arts.

RAMIREZ VILLAMIZAR, EDUARDO (1923–). Colombian painter and sculptor born in Pamplona. He studied architecture from 1940 to 1943 and art and design until 1945 at the National University of Bogotá. He began as a painter, gravitating early to geometrical forms. In 1946 he had his first one-man exhibition at the Colombian Society of Engineers, Bogotá, and the same year was awarded a prize at the VIIth Salon of Colombian Artists. In 1950 he visited New York, where he showed at the New School for Social Research along with other Colombians, the sculptor Edgar NEGRET and the painter Enrique Grau. From 1950 to 1952 he studied and worked in Paris, exhibiting at the Arnaud Gal. After a two-year stay in Colombia he returned to Paris and the U.S.A., 1954–6, where he exhibited at the Pan American Union, Washington, 1956, and in New York and Houston. In the 1950s he painted geometrical abstractions with shifting planes of black, white and very little colour. He began sculpture after an intermediate period of relief wall panels. In 1955 he painted his first mural for the Bavarian Brewery in Bogotá and in 1958 executed a relief mural for the Bank of Bogotá. He lived and worked in New York again between 1963 and 1973 with trips to Colombia, where he taught at the School of Fine Arts, Bogotá, 1964–5. He had taught there in 1957 for two years. In New York Ramirez developed an individual style with sheets of black, white or red plastic which he constructed into interlocking geometrical shapes that interconnected interior and exterior forms. He also worked in metal as in *Salute to the Astronaut* (1966), a vertical structure. His work was in the CONSTRUCTIVIST tradition (*Suspended Construction*, 1969; *Modular Construction*, 1973). In the 1960s and 1970s he executed a number of exterior projects and relief murals in the U.S.A. and Colombia. In 1965 he did a wood relief mural for the Biblioteca Luis Angel Arango in Bogotá. In the U.S.A. he worked on a collective sculptural project in the state of Vermont and in 1972 he contributed a tall structure composed of continuous vertical modules for Fort Tryon park, New York, similar to a concrete structure which he did the following year (1973) on a hill overlooking Bogotá. In 1973 he also completed a modular metal sculpture for the Kennedy Center for the Performing Arts in Washington. Ramirez's sculpture is closely linked to the monochromatic geometric work of other Colombians and his

earlier work bore affinities to the work of the Spanish sculptor Jorge de Oteiza (who had visited Colombia in 1944), rather than to North American MINIMAL sculpture. His monumental sculpture is complex and dynamic. He exhibited extensively in the U.S.A., Europe and Latin America. In 1963 he was included in 'Geometrics and Hard-Edge' at The Mus. of Modern Art, New York, and in 1964 he had a retrospective at the Mus. of Modern Art, Bogotá. In 1958 he won an award at the International Guggenheim exhibition, New York, in 1959 at the Salon of Colombian Artists of Bogotá, and First Prize at the National Exhibition of Colombian Artists in Bogotá and Cali. He participated in the 9th and 10th São Paulo Bienales, winning an award at the latter.

RAMOS, MEL (1935–). American POP artist, born at Sacramento, Calif., and studied at San José State College and Sacramento State College. With a brash manner and a delight in the vulgar, he painted the heroes and heroines of comic books and girlie magazines, often depicting them in a realistic three-dimensional technique against a flat background or making them emerge coyly from branded products. Like THIEBAUD he used a thick oleaginous pigment. His work was included in the main collective exhibitions of Pop and related styles of art and was shown in individual exhibitions from the mid 1960s. His first one-man shows were at the Bianchini Gal., New York, in 1964 and 1965. In 1963 he was represented in 'Mixed Media and Pop Art' at the Albright-Knox Art Gal., Buffalo, and in 'The Popular Image' at the I.C.A. Gals., London.

RANTANEN, ULLA (1938–). Finnish draughtsman and graphic artist, born at Keitele and trained at the School of the Fine Arts Academy of Finland. Besides exhibitions in Finland, she participated in international group exhibitions at Ljubljana, Rostock, Copenhagen, Lugano, Kraków, Tokyo, Buenos Aires, São Paulo, Düsseldorf, etc. She participated in overseas exhibitions of Finnish graphic art in Weimar (1965), in Poland, Hungary and the U.S.A. (1967), and in Belgium (1970). She drew ordinary objects from the environment of everyday life in a style of meticulous realism and without overt socio-political bias.

RAŠIĆ, MILAN (1931–). Yugoslav NAÏVE painter, born at Donje Stiplje near the Serbian town of Svetozarevo. He worked on the land and was for a time employed on the construction of the Zagreb–Belgrade highway. He began painting after 1960. His pictures were gaily coloured, minutely detailed scenes from village life, to which he lent a childlike, fairy-tale charm. They were two-dimensional like a tapestry and indicated recession by vertical perspective, the more distant item being depicted above the nearer one. He was first exhibited in 1961 and was subsequently represented at

exhibitions in Belgrade (1966), Bratislava (1966 and 1969), Berlin (1967), Zagreb, West Germany, Amsterdam and Mexico (1968), U.S.A. (1969–70), Venice (1970).

RATCLIFFE, WILLIAM. See CAMDEN TOWN GROUP.

RAUSCHENBERG, ROBERT (1925–). American painter born in Port Arthur, Texas. After studying pharmacy at the University of Texas and serving in the Second World War, Rauschenberg began his study of painting at the Kansas City Art Institute, 1946–7. In 1947 he attended the Académie Julian, Paris, and in 1948–9 studied at Black Mountain College, North Carolina, under Josef ALBERS. He completed his training at the Art Students' League, New York, 1949–50, and in 1952–3 travelled in Italy and North Africa. In 1951 he exhibited at the Betty Parsons Gal., New York, showing all-white paintings with black numbers or figurative symbols—paintings in which the only image was the shadow cast by the spectator. These were followed by a series of all-black paintings in which torn and crushed newspapers pasted down and coated with black enamel created an irregular surface. From this beginning with 'minimality' Rauschenberg advanced towards 'combine' paintings, that is paintings in which real objects, including photographs, were affixed to or combined with the painted surface. An intermediate stage was constituted by the predominantly red COLLAGE constructions in which real objects such as pieces of newspaper, string, photographs, rusty nails, etc. were combined with splashed paint to form a picture surface. Among the best known of the 'combine' paintings are: *Charlene* (1954), *Rebus* (1955), *Odalisk* (1955–8), *Ace* (Albright-Knox Art Gal., Buffalo, 1962). Part of the artist's purpose in using real, three-dimensional objects as elements of his paintings was to break away from the illusionary space which had been retained by ABSTRACT EXPRESSIONISM and, in his own words, 'to act in the gap between' art and life. In the late 1950s he evolved a technique of FROTTAGE to transfer magazine or newspaper pictures and used this for his famous 34 drawings (in water-colour, pencil, chalk and transferred photographs) to illustrate the 34 cantos of Dante's *Inferno* (The Mus. of Modern Art, New York, 1959–60). He also adapted to his own purposes a process of silk-screen stencilling, first tried by Andy WARHOL, and used it in a manner similar to his earlier *frottages*. The technique was used in his enormous *Barge* (1963), 80 in. by 389 in. (2 m by 10 m), in *Axle* (1964), which was shown at the DOCUMENTA III exhibition at Kassel in that year, and in *Tracer* (1964) exhibited in the London retrospective of 1964. Later the process was enriched by the use of colour filtering. During the 1960s he also made three-dimensional constructions of real objects which were self-sufficient and complete in themselves. From 1955 Rauschenberg also designed and

executed stage sets and costumes, and occasionally designed lighting and choreography, for the Merce Cunningham Dance Company.

Rauschenberg has been classified with the Neo-Dada or POP movement. Because of the impetus he imparted to the movement away from Abstract Impressionism this classification is justifiable. Yet he was one of the most individual of artists; despite superficial resemblances his motives and his methods were different from those of most Pop artists. In his desire to 'act in the gap' between painting and life Rauschenberg was at one with the philosophy of the composer John Cage. With Cage also he shared the desire to 'unfocus' the spectator by images of simultaneous and multivalent suggestibility. Of all the artists of his generation Rauschenberg has had probably the widest appeal to the young. As Bryan Robertson wrote of him in 1964: 'Robert Rauschenberg's work has been of key significance for young artists in Europe and America during the past decade. For young artists especially, because they are on his wave-length, they speak his language, and although they do not always share his American experience they understand his references. And the point of view which animates and gives fresh meaning to this experience is universal. Rauschenberg has in fact evolved a new vocabulary, a new sentence construction even, that has permanently enriched our language. But it is probably only now, in the early sixties, that the general public is beginning to appreciate his contribution to recent art. And to see that when one has looked beyond the stuffed goat and the tyre, the winking light bulbs and the built-in radio sets, Rauschenberg is in fact a classical artist with a fastidious sense of structure and a hypersensitive understanding of space. His combines and paintings are part of a tradition accelerated and expanded by Cubism, and his object-sculptures and collages continue a path set by the early sculptures of Picasso and the work of the Dadaists, Duchamp and Kurt Schwitters.'

The retrospective exhibition of Rauschenberg in the Jewish Mus. in 1963 has been called 'the most impressive one-man show of the year in a New York gallery or museum'. A retrospective given in the Whitechapel Art Gal., London, in the spring of 1964 made a no less important impact.

RAVEEL, ROGER (1921–). Belgian painter born at Machelen-à-Leie, studied at the Academies of Deinze and Ghent. During the 1960s he made structures consisting of silhouette-like life-size figures containing apertures through which real landscape was seen. The seen landscape was made the positive constituent of the work, and the figures a 'negative' containing and 'framing' the primary shapes of real life. Some of his later works were composed of groups of figures together with structures which contained mirrors reflecting fragments both of the figures and the landscape, often with illusionistic perspectives. Raveel spoke of this

as a 'new vision' bridging the gap between art and real life. He had one-man shows in Belgium, the Netherlands, France, Italy and Switzerland. His work was represented in group shows, including 'International Art Exhibition', Tokyo (1965); DOCUMENTA IV, Kassel (1968); Venice Biennale (1968). He was a member of a group of four Belgian artists who created permanent ENVIRONMENTS at Beervelde Castle, Ghent, and at the Dulcia factories, Zottegem.

RAYNER, GORDON. See CANADA.

RAYO, OMAR. See LATIN AMERICA.

RAYONISM, RAYONNISM, RAYISM, LUCH-ISM. A painting style practised by the Russian artists GONCHAROVA and LARIONOV in the years 1912 to 1914 and representing their own adaptation of FUTURISM. The movement was launched with a manifesto thought to have been written by Larionov and forming part of a Miscellany issued at the TARGET exhibition held in Moscow in 1913. The manifesto stated: 'Rayonism is a synthesis of Cubism, Futurism and Orphism.' The style was bound up with a very unclear theory of invisible rays, in some ways analogous to the 'lines of force' which were postulated by Italian Futurist theory, emitted by objects and intercepted by other objects in the vicinity: the artist, it was said, must manipulate these rays to create form for his own aesthetic purposes. 'The rays which emanate from the objects and cross over one another give rise to rayonist forms. The artist transfigures these forms by bending them and submitting them to his desire for aesthetic expression.' Many Rayonist paintings are very similar in style to those of the Futurists with particular emphasis on breaking up the subject into bundles of slanting lines. Such are *Forest Pool* (1911) and *Green and Yellow Forest* (1912) by Goncharova, *Rayonist Landscape* (Russian Mus., Leningrad, 1912) and *Sea Beach* (1913) by Larionov. In other works the subject virtually or completely disappears, as for example in *Rayonist Composition* (1913, exhibited under the title *Study* at the Target exhibition) and *Glass* (Solomon R. Guggenheim Mus., New York, 1912–13) by Larionov and *Cats* (Solomon R. Guggenheim Mus., New York, 1911–12) and *Rayonism II* (c. 1912) by Goncharova.

The movement was short-lived as both Goncharova and Larionov virtually abandoned easel painting after 1914 and they founded no school. Some Rayonist pictures continued, however, to be painted during 1913 and 1914 by colleagues of theirs such as Mikhail Le-Dantiju (1891–1917), Sergei Romanovich (1894–1968) and SHEVCHENKO.

RAYSSE, MARTIAL (1938–). French painter and experimental artist born at Golfe Juan, Nice. He was a member of the NOUVEAUX RÉALISTES and he exhibited ASSEMBLAGES of commonplace objects, toys, cheap articles from general stores, etc. in a manner akin to POP ART. He also experimented with the use of neon lighting and wrote: 'To track life down in the realm of colour, I tried using plastics, fluorescence, relationships that were untrue, out of key or paintings with errors . . . flawed and faulty . . . or in bad taste . . . the hideous and the horrible. And now, especially, I see in transcendental colour a substitute for life. Neon also favours movement that is without agitation. It conveys the idea of suppressed action or impetus.' He also made use of mirrors, as for instance in a project at the 'Twelve Environments' exhibition in the Kunsthalle, Berne, in 1968. Raysse combined an interest in the display of common objects with an interest in the creation of ENVIRONMENTS demanding spectator involvement. He worked much in the U.S.A. and had an important exhibition at the Dwan Gal., Los Angeles, in 1967.

READ, SIR HERBERT (1893–1968). British poet and art critic, born in Yorkshire. He was educated at Leeds University and served in the British Army, 1915–18, being awarded the Distinguished Service Medal and the Military Cross. After the war he joined the Ceramics Department of the Victoria and Albert Mus., was Clark Lecturer at Trinity College, Cambridge, 1929–30, Professor of Fine Arts at Edinburgh University in 1931 and Sydney Jones Lecturer in Art at the University of Liverpool. He edited the series *English Master Painters* for the publishers Routledge and Kegan Paul and from 1933 to 1939 he was editor of the *Burlington Magazine*. During the 1930s Read was a close friend of the group of artists around Henry MOORE, Barbara HEPWORTH and Ben NICHOLSON and acted as their public mouthpiece. He was associated with UNIT ONE and edited the book *Unit One. The Modern Movement in English Architecture, Painting and Sculpture* (1934). He was also concerned with the organization of the London SURREALIST Exhibition in 1936. With Roland Penrose he was joint founder of the Institute of Contemporary Arts in 1947 and from 1960 he was a founding member and President of the British Society of Aesthetics and a member of the International Committee for Aesthetics.

Through the 1930s and afterwards Read was a prolific writer of literary and art criticism, and came to be regarded as the interpreter *par excellence* of *avant-garde* art to the general public. In his *Times* obituary (12 June 1968) it was stated that 'arguably it was in his literary criticism that Read reached his highest level; but the fact that the subject was more "in the news" made him more widely known as a writer on modern art and a champion of its most extreme and controversial forms'. Among his best-known books were: *The Meaning of Art* (1931), *Art Now* (1933), *Art and Industry* (1934), *Art and Society* (1936), *Surrealism* (1936). It is considered by some that his most influential work was *Education through Art* (1943). His personal philosophy of art was expressed most consistently in *Icon and Idea* (1958) and *The Forms*

of Things Unknown (1960). He wrote *A Concise History of Modern Painting* in 1959 and *Modern Sculpture* in 1964.

In *Poetry and Anarchism* (1938) he wrote: 'In spite of my intellectual pretensions I am by birth and tradition a peasant. I despise the whole industrial epoch—not only for the plutocracy which it has raised to power but also the industrial proletariat which it has drained from the land. The only class in the community for which I feel any real sympathy is the agricultural class, including the genuine remnants of the landed aristocracy.' It has been considered by some that these sentiments and attitudes precluded Read from a real understanding of those aspects and regions of contemporary art which were most closely committed to modern technocracy. He had little to do at any time with CONSTRUCTIVISM and he was little in sympathy with the developments which in America followed ABSTRACT EXPRESSIONISM. In 1967 he wrote of the 'anti-art' manifestations of TINGUELY, RAUSCHENBERG, Jasper JOHNS, WARHOL and OLDENBURG that they were a 'confused but comprehensible form of Nihilism' and that 'behind them is a deep despair, a denial of the meaningfulness of life'.

READY-MADE. A name given by Marcel DUCHAMP to a mass-produced article selected at random which he would set upon a pedestal and exhibit as 'art'. Such an article isolated from its environment, meaninglessly separated from the many indistinguishable mass-produced articles of the same kind, and shorn of its function, acquires a sort of existentialist individuality, a fetishistic quality and a disturbing dignity of its own. In the words of Werner Haftmann, 'our object will acquire a disquieting dignity, an adventurous forlornness so startling that we can only react with fear, rage or laughter'. Duchamp's first 'ready-mades', which he exhibited with a certain ironical provocativeness, were a bicycle wheel and a bottle opener in 1913 and 1914.

The term has since been expanded to cover machine-produced objects and parts of disused machines used by some POP artists and NOUVEAUX RÉALISTES for the construction of complex works of art or ASSEMBLAGES. The principle, however, was different. The impact made by Duchamp's original 'ready-mades' derived precisely from their isolation and from the complete functionlessness of an object made to be functional.

Duchamp himself distinguished the 'ready-made' from the OBJET TROUVÉ (found object), pointing out that whereas the *objet trouvé* is discovered and chosen out because of its interesting aesthetic qualities, its beauty and uniqueness, the 'ready-made' is one—any one—of a large number of indistinguishable mass-produced objects without individuality or uniqueness. Therefore the *objet trouvé* implies the exercise of taste in its selection, but the 'ready-made' does not.

REAL, ART OF THE. See ART OF THE REAL.

REALISM. The term 'Realism' and its cognates are commonly used in their historical sense of veridical depiction or the representation of things precisely as they are seen to be without imaginative idealization or any kind of 'interpretation'. There is often implied an emphasis upon detail rather than general impression.

The terms PHOTOGRAPHIC REALISM (or 'Photo-realism'), 'Hyperrealism', 'Superrealism' indicate extreme forms of Realism in this sense, usually with exaggerated attention to detail. MAGICAL REALISM carries similar implications.

Since the 1950s, however, the terms have also been used in a contrasting sense, of art which eschews representation and depiction altogether and avoids all forms of illusionism, including the creation of 'virtual' picture space. In this sense art is called 'Realist' when the materials or objects from which the work is constructed are presented for exactly what they are and are known to be.

RÉALITÉS NOUVELLES. See SALON DES RÉALITÉS NOUVELLES.

REBEL ART CENTRE. See BRITAIN; LEWIS, Percy Wyndham; NEVINSON, Christopher Richard Wynne; VORTICISM.

REBEYROLLE, PAUL (1926–). French painter, born at Eymoutiers, Haute-Vienne. He practised painting from childhood and went to Paris in 1945 to take it up as a profession. His inclination for SOCIAL REALISM was strengthened by his taste for Spanish painting, and his favourite subjects were robust peasants from his native countryside, dead animals, etc. He joined the Social Realist group HOMME-TÉMOIN and exhibited with them in 1948 and 1949, obtaining the Prix de la Jeune Peinture in 1950 and the Prix Fénéon in 1951. He was later a member of the Selection Committee of the Salon des Jeunes Peintres. He exhibited at the Salon des Indépendants, the Salon d'Automne and the Salon des Tuileries and in 1957 was elected to the Committee of the Salon de Mai. He was recognized as a leader of the post-war Realist reaction and in 1956 the Maison de la Pensée Française staged a large retrospective exhibition of his works.

REDER, BERNARD (1897–1963). Sculptor and graphic artist, born at Czernowitz, Romania. He studied first graphic art and then sculpture at Prague. Returning to Czernowitz he worked there as a stonemason for seven years during the 1920s. He went back to Prague in 1930 and in 1938 held a one-man exhibition at the Mánes Gal. there which attracted favourable notice in the press. In 1940 he went to Paris and took part in a show of Czechoslovakian art at the Wildenstein Gals. for which Jean Cassou wrote the Introduction to the catalogue. He knew and was encouraged by MAILLOL. On the outbreak of war he moved to Havana and in 1943 went to the U.S.A., eventually acquiring

American citizenship. In 1949 he took part in the 'Third Sculpture International' exhibition of the Philadelphia Mus. of Art, where his stone group *Wounded Women* was described by the magazine *Life* as 'the sensation of the show'. He was represented in 1949 and 1951 in collective exhibitions of woodcuts at The Mus. of Modern Art, New York, and in a collective exhibition of sculpture there in 1953. In 1954 he left the U.S.A. for Rome and in 1956 he settled in Florence, where his sculptures, woodcuts and drawings were on exhibition at the Palazzo Torrigiani.

Both Reder's sculpture and his graphic work are distinguished by an element of personal fantasy. As a sculptor he delighted in baroque groups with strange, often ambiguous creatures or women with bizarre instruments and appurtenances. In his graphic work he invented an intricate process, which he called 'colour woodcut monotypes', which depends upon special effects of inking and allows only a single print to be pulled. Examples of his woodcuts are in a number of American public collections, among which are the print collections at The Mus. of Modern Art, New York; the Art Institute, Chicago; Baltimore Mus. of Fine Arts; The Metropolitan Mus. of Art, New York; National Gal. of Art, Washington; Philadelphia Mus. of Art; the Mus. of São Paulo.

REDPATH, ANNE (1895–1965). British painter born at Galashiels, studied at Edinburgh School of Art. In 1920 she married James Beattie Michie and took up residence in France. Returning to Scotland in 1934 she was elected a member of the Society of Scottish Artists, in 1947 became an Associate of the Royal Scottish Academy and an Academician in 1952. She became an Associate of the Royal Academy in 1960. In 1955 she was awarded an honorary degree of Doctor of Laws at Edinburgh University and the O.B.E. A Memorial Exhibition was held in 1965 and a small retrospective exhibition was given at the Mercury Gal., London, in 1975. Anne Redpath was one of the initiators of the modern school of Scottish painting which centred on Edinburgh, where she worked from 1949.

REEVE, JAMES (1939–). British painter, who studied at the School of Fine Arts, Madrid, and worked in Italy, Spain, Uganda and Haiti. His first one-man exhibition in Britain was at the Tooth Gal. in 1975. He painted mainly landscape in a style of meticulous Realism with an occasional suggestion of the *faux-naïf* and without modulating the sharpness and precision of detail between the foreground and the background distance.

REFUS GLOBAL. An important manifesto published by Paul-Émile Borduas and his disciples in 1948, preaching liberation from all cultural restraints and complete freedom for the creative impulse. The manifesto attacked the social, religious and cultural establishments and created such a furore, signalizing a breach with recognized conventions in all spheres of life, that it has been called the 'beginning of modern French Canada'. See also BORDUAS.

REGGIANI, MAURO (1897–). Italian painter born at Nonantola, Modena, and studied at Florence. In 1925 he settled in Milan. He was one of the earliest to practise abstract painting in Italy and exhibited abstract works at the Gal. del Millione in 1934. About 1940 he painted representational landscapes and still lifes under the influence of MORANDI but he went back to abstraction and he is chiefly known for his work in this manner.

REGINA FIVE. See CANADA.

REGIONALISM. Within the wider category of Painters of the AMERICAN SCENE the name 'Regionalists' was given specifically to a group of artists, prominent during the 1930s and early 1940s, who concentrated on realistic depiction of scenes and types from the American Midwest and deep South. Their motivation, like that of all the American Scene painters, derived from a patriotic desire to establish a genuinely American art by the utilization of American subject matter and the repudiation of innovative artistic styles which had been introduced into America by the STIEGLITZ circle and the ARMORY SHOW. In addition they were moved by a nostalgic desire to glorify, or at the least to record, rural and small-town America as distinct from the new industrial urbanization, and it was from this that their widespread popularity drew its sustenance. Thomas Hart BENTON was the vociferous mouthpiece of the group and prominent among them were Grant WOOD, Andrew WYETH, Edward HOPPER and John Steuart CURRY with Charles BURCHFIELD and Ben SHAHN on the fringes. Hopper was more interested in showing the psychological aspects of loneliness and drabness that characterized some aspects of American life than in the grandiose melodramatic idealization of Benton. In the work of Burchfield there ran a streak of fantasy which was absent from the others; Ben Shahn was driven by the spirit of social protest.

REGO MONTEIRO, VICENTE DO. See LATIN AMERICA.

REINHARDT, AD (1913–67). American painter born at Buffalo, N.Y. He studied at Columbia University under the art historian Meyer Schapiro, 1931–5, at the National Academy of Design and the American Artists' School, 1936–7, and later at the Institute of Fine Arts, New York University, under the Orientalist Alfred Salmony, 1945–51. He worked as U.S. Navy photographer during the war, 1944–5, and as critic and cartoonist for the New York newspaper *PM*, 1944–7. He was a member of the AMERICAN ABSTRACT ARTISTS group

1937–47. From the beginning his painting was abstract although it changed radically in style over the years. Through the 1930s he used a crisp, boldly contoured geometrical style which owed something both to CUBISM and to the NEOPLASTICISM of MONDRIAN. In the 1940s he passed through a phase of ALL-OVER painting which has been likened to that of Mark TOBEY, and in the late 1940s he was close to certain of the ABSTRACT EXPRESSIONISTS, particularly MOTHERWELL, with whom he jointly edited *Modern Artists in America* (1950). Reinhardt's mature style of the 1950s developed from his insistent belief in the complete separation between art and life. His austere and uncompromising pursuit of his faith in the refinement of blank form, vacuity and repetition looked forward to the art of the MINIMALISTS in a future decade. During the 1950s he began to darken his colours and subdue contrasts, often producing near-monochromes with geometrical designs of squares or oblongs done in only slightly different value from the background colour. He began his symmetrically trisected paintings *c.* 1952 and from these developed an 'all black' style in which the trisection was barely distinguishable. He taught at Brooklyn College, 1947–67; Hunter College, 1959–67; and also for shorter periods at California School of Fine Arts, University of Wyoming, Yale University and Syracuse University. He wrote frequently, putting forward dogmatically the intellectual basis of his own stylistic development. He had his first one man exhibition at Columbia University in 1943 and from 1946 exhibited at the Betty Parsons Gal., New York. He had a retrospective at the Jewish Mus. in 1967, and 34 paintings, 1950–67, were exhibited at the Solomon R. Guggenheim Mus., New York, in 1980.

REINOSO, JORGE VINETEA. See LATIN AMERICA.

REIS, GUNTHER VAN DER. See SOUTH AFRICA.

RENDÓN, MARIA. See LATIN AMERICA.

RENGIFO, CESAR. See LATIN AMERICA.

RENQVIST, TORSTEN (1924–). Swedish painter, sculptor and graphic artist, born at Saltsjö-Boo, outside Stockholm. Visiting England in the early 1950s, he came into contact with the work of Paul NASH, SUTHERLAND, BACON and MOORE. By his vigorously expressive painting with its harshly contrasting colours, and also by his writings in Swedish art journals, he became the recognized protagonist of Neo-Expressionism in the controversy with geometrical abstraction in Sweden during the 1950s. From 1955 his work expressed the bare grandeur and desolation of the Lofoten Islands. About the mid 1960s he began to make sculpture, working with metal and carving wood in a deliberately crude style verging towards

abstraction in some cases. In this aspect of his work, influenced as it was by folk art, he was regarded as one of the main forerunners of the new 'archaism'. His graphic work, both woodcuts and etchings, showed at once a close attachment to nature and a feeling of social commitment, as in his series of etchings *Upplopp* (*Insurrection*) inspired by the Hungarian crisis (1957). Besides other exhibitions in Sweden, he represented Sweden at the Venice Biennale of 1964 and had a major retrospective at the Moderna Mus., Stockholm, in 1974. He was represented in the exhibition 'Five Swedish Artists' at the Serpentine Gal., London, in 1975. Among his monumental works are: *Scarecrow* (City Library, Gothenburg, 1971); *The Word* (Swedish Seamen's Church, Port of Antwerp, 1971); *Far-away Bird* (Stockholm Underground, 1974).

REPENTIGNY, RODOLPHE DE. See CANADA.

RESENDE CARVALHO, FLAVIO DE. See LATIN AMERICA.

RESNICK, MILTON (1917–). Russian-American painter and graphic artist who was born at Bratslov and went to the U.S.A. after living in Paris, 1946–8. His first one-man exhibition was at the Poindexter Gal., New York, in 1955, after which he continued to exhibit frequently in the U.S.A. He had a major retrospective at the Madison Art Center in 1967. Among the group shows in which he was represented were: Walker Art Center, Minneapolis, '60 American Painters', 1960; Solomon R. Guggenheim Mus., New York, 'Abstract Expressionists and Imagists', 1961; United States Information Agency, 'Contemporary American Prints', circulated in Latin America, 1961–2; The Mus. of Modern Art, New York, 'The New American Painting and Sculpture', 1969. Resnick was chiefly known for his paintings done under the influence of the mistily intimate image and controlled brushwork of Philip GUSTON. He worked with a very large format, applying squiggles of pigment on patches of flat colour.

RETH, ALFRED (1884–1966). Hungarian-French painter, born in Budapest. He settled in Paris in 1905 and became a French citizen. He was a pupil of the academic painter Jacques Émile BLANCHE, but was attracted to painters of the CUBIST school and exhibited with them from 1910 onwards. In 1913 he had an exhibition at the STURM Gal. and in 1926 he contributed 10 works to the Cubist retrospective at the Salon des Indépendants. He was known especially for his experiments with the incorporation of various materials such as sand, cement, egg-shells, plaster, pebbles, in his pigment, achieving exceptional mastery over various techniques. During the 1930s he also made constructions in wood and metal, calling them *Formes dans l'espace*. He was a member of the ABSTRACTION-CRÉATION association from 1932 and participated

in the SALON DES RÉALITÉS NOUVELLES from 1946. He had a retrospective exhibition at the Gal. de l'Institut, Paris, in 1955.

REUTERSWÄRD, CARL FREDERIK (1934–). Swedish painter and poet, who sought to perpetuate the more extreme vagaries of DADA and NEO-DADA. He was responsible for a number of HAPPENINGS, typical of which was *Der Hecht* (*The Pike*), at the Moderna Mus., Stockholm, in 1962. In 1960 he had cast in bronze a life-size tailor's dummy fully clothed and roped to a chair, which he named *Mascot for 'Movement in Art'*. He wrote and published his own speech as a Nobel Prize winner, the 'speech' consisting only of punctuation marks, and in 1963 he published an advertisement in the *New York Herald Tribune:* 'Carl Frederick Reuterswärd. Closed for holidays 1963–1972.' From 1965 he taught at the Academy of Art, Stockholm. In 1968 he mounted a retrospective exhibition at the Mus. des Arts Décoratifs, Paris. His earlier paintings, mainly in black and white, exemplified the principle of AUTOMATISM and, like his writings, aimed at significant or sensational nonsense. In the early 1970s he experimented with KINETIC effects, using in his *Kilroy* group of objects a laser beam in a darkened room. He was one of the pioneers among artists who experimented with the use of laser light for aesthetic ends, remarking that 'if nobody is in view, no source and no rays, the public will very soon come to the conclusion that the effect is magic'.

REVERÓN, ARMANDO (1889–1956). Venezuelan painter born in Caracas. Reverón was raised in a foster home in Valencia, where his mother had taken him when her marriage proved unsuccessful. Following an attack of typhoid fever in his childhood, he became melancholic, irascible and retreated into a private fantasy world for which he found an outlet through his art. In 1908 he studied painting at the Academy of Fine Arts, Caracas, where he met the Venezuelan painters Monasterios, Monsanto and Cabré. The following year he participated in a student strike against the Academy's conservative director Herrera Toro. In 1910 he exhibited at the Academy with Rafael Monasterios, who shared with him a growing interest in light and atmospheric effects. In 1911 he went to Spain, where he first studied at the School of Fine Arts, Barcelona, and in 1912 at the Academia de San Fernando, Madrid. After a trip to Paris in 1915, he returned to Caracas, where he joined the *Circulo de Bellas Artes*, an *avant-garde* group founded in 1912 by Cabré, Monsanto and others. He later formed a friendship with the Venezuelan-French Impressionist Emilio Boggio, the Romanian painter Sammy Mützner and the Russian decorator, set designer and water-colourist Nicolas Ferdinandov, who had arrived in Venezuela in 1916.

Reverón's early work shows the influence of the Spanish Modernists, ZULOAGA, Chicharro, Re-

goyos, Rusiñol, and he was also fascinated by Goya's *Majas* and paradoxically with the latter's 'Black' period. His production has been divided into three distinct periods: the 'Blue period' from 1918 to 1924, exemplified by *La Cueva* (*The Cave*, 1919) whose two reclining figures suggest Goya's *Majas*; the 'White period' from 1925 to 1935; and the 'Sepia' from 1935 to 1949. Reverón moved to the coastal town of Macuto in 1921 with his wife and model, Juanita, and a monkey, and built a home and studio of wood, palm leaves and thatch, where he lived and worked in primitive seclusion. He became increasingly obsessed with blinding tropical light and he gradually translated the colours of the spectrum back into white light, as in *White Landscape* (1943). He also painted reclining figures in the same manner. Besides Juanita and local types Reverón used as models the life-sized rag dolls which he had made, and posed them as if they were real people. Sometimes he included himself in the painting as in *Self Portrait with Dolls* (1948). During his last period he continued to use white paint as in *Maja Criolla* (1939), allowing a sepia underpainting to show through. At the height of his production he practised a form of ACTION PAINTING, sometimes attacking his canvas with such violence that he perforated it. His work was widely exhibited in France, Venezuela and the U.S.A., at the Gal. Katia Granof in Paris and at the Ateneo de Caracas in 1933, at the Taller Libre de Arte in Caracas in 1949, and in 1955 he had a major retrospective at the Caracas Mus. of Fine Arts. He won several medals, including one at the Paris Exposition Universelle in 1937 and the John Boulton Award at the Official Salon, Caracas, in 1951. His painting is in the collection of the Caracas Mus. of Fine Arts as well as in private collections in Caracas.

REZVANI, SERGE (1928–). Persian-French painter, born at Tehran. He went to Paris in 1931 and studied at the Académie de la Grande Chaumière under Othon FRIESZ. In the mid 1940s he was working in the manner of LYRICAL ABSTRACTION along with such painters as Pierre DMITRIENKO and François ARNAL and he exhibited his first abstract canvases in 1947. He took part in the Salon de Mai and the SALON DES RÉALITÉS NOUVELLES. Michel Seuphor has said of his work that it was 'completely oriental in its warmth but bathed in a sensibility born of the atmosphere of Paris'. Rezvani also did lithography and illustrated poems by Paul Éluard.

RIABUSHINSKY, NIKOLAI PAVLOVICH (1876–1951). Russian collector, patron, painter and poet, member of the powerful Riabushinsky family of bankers and investors in Moscow. From 1906 to 1909 he financed and edited the Symbolist journal GOLDEN FLEECE (*Zolotoe runo*), the last issue of which appeared early in 1910. In 1907 he financed and contributed to the Blue Rose ex-

hibition in Moscow and in 1908–10 sponsored three 'Golden Fleece' exhibitions devoted to the new Russian art (the first two also presented western European moderns). In 1914 he opened an antique shop in Paris and in 1918 he emigrated to Paris, where he opened his Gal. à la Rose Bleue.

RICHARDS, CERI (1903–71). British painter born at Dunvant, near Swansea, of a Welsh-speaking family. He received his artistic training at the Swansea School of Art, 1921–4, and at the Royal College of Art, 1924–7, while at the same time taking classes in life-drawing under Bernard MENINSKY at the Westminster School of Art in the evenings. Richards was a fine natural draughts-man, his earliest ambition having been to become an engineering draughtsman, and he was described by Henry MOORE as 'the finest draughtsman of his generation (of students)'. His first exhibition was at the Glynn Vivian Gal., Swansea, in 1930 and his first London exhibition at the Leger Gal. in 1932. There have been 27 one-man exhibitions of his work, including nine at the Redfern Gal. from 1944 to 1957, a retrospective at the Whitechapel Art Gal. in 1960, a retrospective at the Marlborough New London Gal. in 1965 and in 1972 an exhibition 'Homage to Ceri Richards 1903–71' at the Fischer Fine Art Gal., London.

Richards was an artist of great versatility, able to absorb influences without sacrificing his originality. From 1933, under the influence of PICASSO, he worked on a series of relief constructions and ASSEMBLAGES which were described by John ROTH-ENSTEIN as 'original creations of a rare order, and unlike anything else done in Britain at the time'. He was influenced by the London SURREALIST Exhibition of 1936, which in his own words 'helped me to be aware of the mystery, even the "unreality", of ordinary things'. Among several examples of his work from this period in the Tate Gal. is *Two Females* (1937–8). After the Second World War his painting drew inspiration from the large exhibition of Picasso and MATISSE at the Victoria and Albert Mus. His love of music showed itself in the many pictures with musical themes done during this time—e.g. *Cold Light. Deep Shadow* (Tate Gal., 1950)—culminating in his *Cathédrale engloutie* series illustrating Debussy's music on this theme. He was also inspired by the poetry of Dylan Thomas and one of his finest paintings is entitled *Do not go gentle into that Good Night* (Tate Gal., 1956). In 1962 he was awarded the Einaudi Prize at the Venice Biennale.

In 1943 he was commissioned to do a Madonna and Child for St. Matthew's Church, Northampton. In 1958 he painted an altar frontal for the chapel of St. Edmund Hall, Oxford, and also designed the tabernacle, reredos and two stained glass windows for the Roman Catholic Cathedral, Liverpool, which was consecrated in 1967. Besides these ecclesiastical commissions and his paintings and constructions, he made murals for ships of the Orient Line in 1937 and 1954, designed the drop-cloth for a memorial reading 'Homage to Dylan Thomas' at the Globe Theatre in 1954, designed décor and costumes for Lennox Berkeley's opera *Ruth* (1956) and for Benjamin Britten's *Noyes Fludde* (1958) and did murals for the Shakespeare Exhibition at Stratford in 1964.

Summing up the position of Richards in the art of his time, John Rothenstein wrote: 'The work of Richards, in its remoteness from both realism and from the academic tradition, has long been accorded an honoured place among that of the avant-garde but it is nevertheless, in spite of its profusion of features drawn from or suggested by that of other pioneering artists, independent of any movement. . . . It is the strange combination of ebullience, sparkle, animation and profuse complexity with obliqueness and metaphor, often obscure though never illegible, that makes the art of Richards one of the most elusive but one of the most fascinating of our time.'

RICHARDS, FRANCES (*née* CLAYTON, 1903–). British painter, born at Burslem, Stoke-on-Trent. After studying at the Burslem School of Art she won a scholarship to the Royal College of Art. In 1929 she married Ceri RICHARDS. She taught at the Camberwell School of Art, 1928–39, and at the Chelsea School of Art, 1947–59. From 1945 she exhibited regularly in London and in 1968 had a one-man show at the Royal Scottish Academy. Her illustrations included: *Acts of the Apostles* (edited by Stanley Morison for Cambridge University Press, 1930), *Book of Revelation* (1931), *Book of Lamentations* (Oxford University Press, 1969) and a suite of lithographs illustrating Rimbaud's *Les Illuminations* (1975). Her paintings were, typically, precise but poetic flower pieces done in Cryla on board. In 1958 she designed and executed an altar frontal which toured the U.S.A. in an exhibition of ecclesiastical art.

RICHIER, GERMAINE (1904–59). French sculptor, born at Grans, Bouches-de-Rhône. After studying sculpture (1922–5) at the École des Beaux-Arts, Montpelier, under Louis-Jacques Guiges who had been a carver working for Rodin, she went to Paris in 1925 and worked under BOURDELLE until 1929, when she married the sculptor Otto BAENNINGER. Her first exhibition was at the Gal. Max Kaganovitch, Paris, in 1934 and in 1936 she won the Blumenthal Prize for Sculpture, exhibited at the Petit Palais, Paris, and the Blumenthal Foundation, New York. She spent the war years mainly in Switzerland and Provence, returning to Paris in 1945. In 1944 she exhibited at the Kunstmus., Basle, with MARINI and WOTRUBA and in 1947 she was invited to show in London by the Anglo-French Art Centre. Her international prestige grew steadily in the post-war years, and her work was very extensively exhibited. She was awarded the Sculpture Prize at the São Paulo Bienale in 1951.

Since her death exhibitions of her work included: Kunstmus., Berne, and Hirshhorn coll., Detroit (1959); Solomon R. Guggenheim Mus., New York (1962); Kunsthaus, Zürich (1963); DOCUMENTA III, Kassel, and Tate Gal., London (1964); 'Hommage à Germaine Richier' at the Rodin Mus., Paris (1968); Gimpel Fils, London, retrospective (1973). Her works are represented in the following public collections among others: Amsterdam, Antwerp, Baltimore, Basle, Boston, Brussels, Chicago, Curaçao, Hamburg, Hanover, Helsinki, Minneapolis, Paris, Rio de Janeiro, São Paolo, Vienna, Winterthur.

Richier combined technical proficiency with highly individualistic fantasy. As her style matured her compositions became more open and often had slender, elongated limbs or fibrils suggestive of insect life, while her figures seemed half animal or half insect, as is indicated by such titles as *Le Crapaud* (*The Toad*, 1942), *La Sauterelle* (*The Grasshopper*, 1945), *La Mante* (*The Mantis*, 1946), *L'Araignée* (*The Spider*, 1946), *La Fourmi* (*The Ant*, 1953). These insect-like reminiscences were not used in a sensational way but rather to build an open construction where space is enclosed by thin rods or filaments of material. Of the well-known *Chauve-Souris* (*Bat*) of 1952 Carola Giedion-Welcker wrote in *Contemporary Sculpture* (1961): 'The disintegration and fraying out of the compact mass give rise to new and expressive structural life with a demonic undertone. *The Bat* shows a strange transmutation of animal into vegetable life, of the animal's body and wings into a significant and ambiguous ramification.' Tempting as it is to emphasize this aspect of her work, it is not to be forgotten that Richier was one of the pioneers of an open form of sculpture in which enclosed space becomes as important and alive as the solid material. Richier also practised a disruption of the surface of the work, giving it on the one hand a tattered and lacerated effect and on the other hand converting it into a structural element instead of a mere enclosing skin. It was the former aspect rather than the sculptural significance which impressed Herbert Read when he wrote in *A Concise History of Modern Sculpture* (1964): 'Richier explored the processes of decomposition.' It would be equally true and perhaps more important to say that the opening up of the surface served to convert it into a positive sculptural element.

RICHTER, GERD (1932–). German painter, born in Waltersdorf, Oberlausitz. After working as an advertisement and stage painter he studied at the Academy of Fine Arts, Dresden, 1953–7. In 1960 he moved to West Germany and studied at the Academy of Fine Art, Düsseldorf, 1961–3. In 1967 he won the Junger Westen prize. In 1963 together with Konrad Fischer-Lueg and Sigmar Polke he organized an exhibition in Düsseldorf entitled 'Demonstration für den kapitalistischen Realismus'. From that time he had one-man exhibitions in German centres and also in Rome,

Zürich and Venice, and he was represented in a number of collective shows. His work belonged to the school of PHOTOGRAPHIC REALISM, eliminating expressiveness from the facture and seeking the objectivity of photographic reportage. By a blurring of detail he would sometimes give the impression of an out-of-focus snapshot. Towards the end of the 1960s he sometimes painted landscapes as if seen from above, using his own photographs as models. He also used abstract motifs.

RICHTER, HANS (1888–1976). German artist, born in Berlin. He first came into contact with modern art movements through the BLAUE REITER and the STURM exhibitions in Berlin and he had a one-man exhibition at Munich in 1916. After being discharged from military service he went to Zürich in 1917 and became an active member of the Zürich DADA group. From this time he began abstract work, though he still continued to do woodcuts and linocuts of an EXPRESSIONIST character. In 1918 he began a long association with the Swedish abstract painter EGGELING and together they worked on abstract 'scroll' drawings based on musical rhythms and counterpoint. In 1920 he came into contact with NEO-PLASTICISM and CONSTRUCTIVISM and from 1921 was active as a pioneer in the development of abstract films. From 1923 to 1926 he worked on the Constructivist periodical G (*Gestaltung*), which he had founded with the architect Mies van der Rohe and the critic Werner Graeff. He moved to Paris in 1933 and in 1941 went to the U.S.A., where he taught at the City College of New York. In his latest work, mainly in shades of black, white and grey, he experimented with rhythmic effects of movement over large canvases. He had a one-man show of paintings and 'scroll' drawings at the Gal. des Deux-Îles, Paris, and at Basle in 1950 and further one-man shows in 1952 at the Stedelijk Mus., Amsterdam, and the Gal. Mai in Paris.

RICKEY, GEORGE (1907–). American painter, sculptor and art historian, born at South Bend, Ind. He passed his youth in Scotland, took his degree in art history at Balliol College, Oxford, and studied art at the Ruskin School, Oxford, under LHOTE in Paris, at the University of New York, the State University of Iowa and the Institute of Design, Chicago. From 1930 he taught in various institutions in America, including the universities of Washington, Indiana, Tulane, California. Until *c.* 1950 he devoted most of his time to painting, including murals for Olivet College, the U.S. Post Office at Selinsgrove, Pa., Knox College. He had his first one-man exhibition of paintings at the Caz-Delbo Gal., New York, in 1933. He started making mobiles *c.* 1945 and from 1950 devoted most of his energies to KINETIC sculpture. His first one-man exhibition of sculpture was at the Stable Gal., New York, in 1954. From this time his works were represented in many important group exhibitions of American *avant-garde*

work and he fulfilled a number of sculptural commissions in America, Germany and elsewhere. His kinetic sculptures were for the most part designed to be situated out of doors and generally relied upon air power for their motive force. He had a retrospective exhibition at the Corcoran Gal. of Art, Washington, in 1969.

In 1967 he published *Constructivism: Origins and Evolution*, which is a standard work on the history of CONSTRUCTIVISM covering also OP ART, kinetic art and LUMINISM.

RIDDER, WILLEM DE. See NETHERLANDS.

RIEDL, FRITZ (1923–). Austrian artist, born in Vienna. He devoted himself mainly to tapestry and for a while worked with LURÇAT at Aubusson. From *c.* 1950 he began weaving, composing at the loom without making a preliminary drawing or cartoon. His works were exhibited at Stuttgart, Frankfurt and Hamburg in 1953, at the Venice Biennale in 1954, in Chicago and Boston in 1955, in New York in 1956 and in 1959 at the DOCUMENTA II exhibition at Kassel. In 1954 he did a large tapestry for the Klingspor Mus. at Offenbach.

RIJ-ROUSSEAU, JEANNE (1870–1956). French painter, born at Candé. She was a member of the NABI circle and a friend of Signac. Later she was associated with the CUBISTS, particularly Juan GRIS. Like the Cubists she reduced her subjects to broad flat planes, but unlike them she used bright colours and courted light effects. She was known especially for her theory of *vibrisme*, connecting colours and sounds and instituting an analogy between their psychological effects.

RILEY, BRIDGET LOUISE (1931–). British painter born in London. She studied at Goldsmith's College, 1949–53, where she concentrated on drawing under Sam Rabin, and then at the Royal College of Art, where she learned the techniques of painting, 1952–5. In 1959 she formed a friendship with the painter and teacher Maurice de Sausmarez which lasted until the latter's death in 1970. She painted in Spain and France in the summer of 1959 and later initiated the Basic Art Course at Loughborough. In 1960 she visited Italy with de Sausmarez and was impressed by FUTURIST work which she saw there. It was not until the early 1960s, however, that she found her own path.

Riley's work belonged to the category of OP ART and in general conception had analogies with that of VASARELY, though with characteristic differences in style and performance. She was a master of most of the devices exploited by Op artists, particularly subtle variations in size, shape or placement of serialized units in an all-over pattern, and she aimed at the sort of retinal effects which are characteristic of Op art. The latter may be divided into two main types, although these were some-

times combined within one picture. One was the hallucinatory illusion of movement, as in *Movement in Squares* (Arts Council, 1961), her first work in this genre, and *Fall* (Tate Gal., 1963). The other derived from visual ambiguity at the retinal level. The latter effect depended upon inducing the eye to isolate a relatively small area with a temporary sense of stability and order, but as optical fatigue rapidly set in secondary shapes and conflicting patterns would emerge and overlap in such a way as to render stable, interpretable perception impossible. Riley started her Op art pictures in black and white, in which she was perhaps most successful, and through graded greys she advanced by 1965 to colour compositions which aimed at similar effects. Her work had the precision and inevitability of a scientific diagram, and her pictures were in fact often done by assistants working from detailed drawings and instructions demanding all the accuracy and precision of a scientific chart. It was from such precision that her patterns were able to create vibration and dazzle in the observer's eye.

Riley's first one-man shows were at Gal. One, London, in 1962 and 1963. From that time her work rapidly achieved international acclaim. One of her paintings was used for the cover to the catalogue of the Op Art exhibition 'The Responsive Eye' at The Mus. of Modern Art, New York, in 1964. She has been exhibited very widely at home and abroad, including two important retrospectives, at the Hayward Gal. in 1971 and a touring exhibition arranged by the Arts Council in 1973.

RIMBERT, RENÉ (1896–). French NAÏVE painter, born in Paris. Son of a Parisian framer, he worked as a postman from the age of 13 until his retirement in 1956, painting in his spare time. He was encouraged by Marcel GROMAIRE and was a friend of Max Jacob, who wrote the introduction for his first one-man exhibition, at the Gal. Percier in 1927. He exhibited at the Salon des Indépendants from 1920 to 1928 and at the Salon d'Automne in 1924. He was represented in the Paris–Zürich exhibition of naïve painting in 1937 and was included in most subsequent international exhibitions of naïve art. In 1956 he had an exhibition at the Gal. Montmorency, Paris, to which Maximilien Gauthier wrote the Introduction. Rimbert painted street scenes, squares and façades, transforming the ramshackle and ordinary to poetic beauty by his sensitive colour and imparting to every scene a magical and brooding stillness. Human beings or animals are present in his pictures but are always invisible, being indicated only by a fragment or obscured by distance. In his well-known *The Window of the Douanier* (1957) half the face of Rousseau can be seen staring with startled eye as in his own self-portraits.

RINKE, KLAUS. See CONCEPTUAL ART.

RIOFRIO, EDUARDO KINGMAN. See LATIN AMERICA.

RIOPELLE, JEAN-PAUL (1923–). Canadian artist, born in Montreal. From the age of 6 he was given art lessons by Henri Bisson, and in 1943 he enrolled in the École du Meuble. Here he became a member of BORDUAS's group, and participated in their first exhibition, in New York in 1946. In 1946 he travelled to Paris, where in 1947 he and Fernand Leduc staged an AUTOMATISTE group show at the Gal. du Luxembourg. Although Riopelle returned to Montreal later that year, and contributed the cover design for REFUS GLOBAL the following summer, and although he always maintained strong links with Canada, he afterwards lived and worked almost exclusively in France. His earliest oils were similar in technique to the splashed and drawn pictures of most of his *Automatiste* colleagues, but by 1947 he had developed a rich, multi-coloured image of jammed, shard-like forms, painted with thin, dripping medium (e.g. *Hochelaga*). By 1949–50 he was using thicker medium—usually oil out of the tube—to form smaller jammed shapes, interconnected not by drips but by skein-like strings of paint. These looping lines then became tauter, forming a dense screen cutting across the surface in all directions. During 1952 and 1953 they again diminished in number, and became integrated with facets of paint applied with the palette-knife that, thickly built up, completely covered the canvas. It was these paintings—such as the huge triptych *Pavane* (National Gal. of Canada, 1954)—that first drew international attention to his work. His artistic development continued throughout the 1960s and 1970s, although he consistently used the basic elements of thick medium applied in fractured forms, held together by energetic drawn lines. He was prolific, and renowned for his use of various media, from the late 1940s working interchangeably in water-colour, ink, oil, crayon or chalk, making etchings or lithographs or modelling sculpture. In 1967 he produced huge COLLAGE murals.

Riopelle participated in the large Exposition Internationale du Surréalisme at the Gal. Maeght in 1947. He exhibited frequently in Paris and New York (Pierre Matisse Gal.) as well as in Toronto and Montreal, and held commercial shows in most European centres: Cologne, London, Stockholm, Milan, Geneva, Lausanne, Basle, Zürich. In 1962 he alone represented Canada at the Venice Biennale. In 1963 a retrospective organized by the National Gal. of Canada was shown in Ottawa, Toronto and Montreal; in 1967 another major retrospective was staged by the Mus. du Québec. In 1972 the Centre Cultural Canadien and the Mus. d'Art Moderne de la Ville de Paris joined to present an important exhibition of new paintings and sculpture.

RISSANEN, JUHO VILHO (1873–1950). Finnish painter and graphic artist, studied at the Finnish Central School of Applied Art and the Drawing School of the Finnish Arts Association, Helsinki, and at the St. Petersburg Academy under I. Repin. After 1918 he lived in Denmark and France and in 1939 emigrated to the U.S.A. His first one-man exhibition was in 1897, after which he exhibited extensively both in Finland, where he was a member of the SEPTEM and NOVEMBER groups, and in Europe, being awarded a bronze medal at the Paris World Fair of 1900. Until *c.* 1908 Rissanen was chiefly known for the vigour and expressive power of his paintings based upon Finnish peasant subjects such as *The Fortune-Teller* (Ateneum, Helsinki, 1895). Subsequently under a variety of international influences his work lost in force and originality what it gained in urbanity. Among his public works were murals for Helsinki City Library (1909), the National Theatre (1910) and the Kuopio Mus. (1928).

RITSCHL, OTTO (1885–1976). German painter, born at Erfurt. He started work as a writer, beginning to paint, self-taught, only in 1918. From 1908 he lived in Wiesbaden, where he was associated with JAWLENSKY. His paintings were abstract, not geometrical but with a clear-cut precision of forms. He had a major retrospective exhibition in Wiesbaden in 1955 and was widely exhibited in Germany.

RIVERA, ANTONIO LAGO. See SPAIN.

RIVERA, DIEGO MARIA (1886–1957). Mexican painter, a pioneer of the modern MEXICAN Muralist school, born at Guanajuato. A precocious boy, Rivera enrolled at the age of 10 in the San Carlos Academy under Santiago Rebull, a 19th-c. eclectic academic painter, and José Maria Velasco, one of Mexico's greatest landscape painters. During his student period he came to know the cartoons and engravings of José Guadalupe Posada, which were circulated on broadsheets and sold at street corners. Rivera was given a stipend to study in Europe by the governor of Vera Cruz as a result of his first exhibition in that city in 1907. Between 1908 and 1909 he studied with Chicharro in Spain and from 1911 to 1921 he lived in Paris, where he was friendly with MODIGLIANI and frequented CUBIST circles. Without wholly adopting the Cubist aesthetic, he nevertheless freed himself from any vestiges of academicism, working in the manner of the Cubist school between 1913 and 1917. He also mastered features of formal construction taken over from Cézanne. While in Europe he travelled to Belgium, the Netherlands, England and Italy, where he absorbed the lessons of the muralists of the Italian Renaissance. In 1919 he met SIQUEIROS in Paris and discussed with him the need to transform Mexican art and create a national popular movement. He returned to Mexico in 1921 and in 1922 executed his first encaustic mural at the Amphitheatre Bolivar of the National Preparatory School in Mexico City and joined the Communist

party. Surviving the overthrow of the Obregón regime, he continued to do murals for the Ministry of Education (1923–9), the Agricultural School, Chapingo (1923–7), the National Palace (1929–35), the Ministry of Health (1929), the Palace of Cortez at Cuernavaca (1929–30) and the National Palace of Fine Arts, Mexico City (1934). These murals depicted the social and political history of Mexico in a style of flat, simplified and decorative forms which initiated SOCIALIST REALISM in Mexico and made a considerable impression in the U.S.A. In 1927 he travelled to the Soviet Union on the invitation of the Commission of Public Education there and made a series of drawings of May Day activities. In 1930 he went to the U.S.A., where he exhibited in the California Palace of the Legion of Honor in San Francisco and painted a mural for the San Francisco Stock Exchange. In 1932 he did murals for the Detroit Institute of Arts showing industrial scenes, the making of an automobile, medical research and transportation. In 1933 he began a mural for the Rockefeller Center in New York which was destroyed before completion because of the inclusion of a portrait of Lenin. Before returning to Mexico he did a series of 21 panels for the New Workers' School in New York showing the history of the U.S.A. interpreted through Rivera's Marxist ideas. These panels are described in detail in the book *Portrait of America* of which Rivera was co-author with his biographer, Bertram Wolfe.

Returning to Mexico City in 1934, he painted *Man at the Crossroads*, a replica of his Rockefeller Center murals, at the Palacio de Bellas Artes and the following year he completed work in the stairwell of the National Palace with a portrait of Marx as the new Messiah. In 1937 he published together with Bertram Wolfe his *Portrait of Mexico*, in which he described these murals as well as those of 1929 in the Palace of Cortes, Cuernavaca. After 1944 he painted a second cycle in the National Palace showing the different pre-Spanish cultures and in 1948–9 he created a scandal with his mural *Dream of a Sunday Afternoon in the Central Alameda* for the dining-room of the Hotel del Prado in Mexico City because he had included the words 'God Does Not Exist'. In 1952 he did a mosaic mural for the Insurgentes theatre and began a mural for the Olympic Stadium at University City. He also completed a mural on canvas 50 m² entitled *The Nightmare of War and the Dream of Peace*. Intended for a large exhibition arranged by the Mexican Government for the Mus. National d'Art Moderne, Paris, and the Moderna Mus., Stockholm, it was withheld because of its tendentious character.

In 1954 Rivera was readmitted into the Mexican Communist party and in 1955 he made another trip to the Soviet Union. In his last years, following the death of his painter wife, Frida Kahlo, whom he had married in 1928, he donated the house where she had grown up to the City of Mexico as the Frida Kahlo Mus., and the studio

he built for himself in 1948 was also inaugurated as a museum, the Anahuacalli, and houses Rivera's extensive collection of pre-Hispanic sculptures.

Rivera's earlier works are considered superior to his later ones. They include those at the School of Agriculture in Chapingo and the Ministry of Public Education. At the Social Security Hospital of Zone 1 he explored the subject of pre-Spanish and modern medicine. His work has been greatly acclaimed, and also criticized as being no more than folklore, by his colleagues. His influence both in Mexico and in the U.S.A. was outstanding. He was a complex and sophisticated artist who deliberately put on one side the innovative techniques and styles which he had learnt in Europe in order to found an art of the people suited to the political situation in post-revolutionary Mexico. The decorative and expository character of his narrative murals, his large, simple and monumental forms and bold areas of colour which contributed to his widespread popularity, lack the EXPRESSIONIST character of OROZCO and the dynamic force of Siqueiros. His work was more consciously didactic, less forcefully creative, than that of the other two outstanding Muralist painters of Mexico.

RIVERA, JOSÉ DE (1904–). American sculptor, born at West Baton Rouge, La., and studied at Studio School, Chicago. His commissions included work for Newark Airport (1938), the Soviet Pavilion at New York World's Fair (1939) and the Cavalry Monument, El Paso (1938–40). In 1945 he exhibited with Burgoyne DILLER at Harvard University and during the 1950s at the Grace Borgenicht Gal., New York. He had a retrospective exhibition in 1961 circulating under the auspices of the American Federation of Arts and he was represented in collective exhibitions of progressive American art. In opposition to the welded metal sculpture which was regarded as an analogue of ABSTRACT EXPRESSIONISM, the sculpture of De Rivera consisted of simple and easily apprehensible geometrical forms, often industrially manufactured, which looked forward to the principles of MINIMAL ART.

RIVERA, MANUEL (1927–). Spanish painter born in Granada, studied at the School of Arts and Trades, Granada, and the School of Fine Arts, Seville. After passing through a figurative period he turned to expressive abstraction c. 1953 and in 1957 joined the EL PASO association and became a member of the Royal Academy of Fine Arts, Granada, in 1958. In the same year he had a one-man show at the Venice Biennale. He exhibited at the Matisse Gal., New York, in 1961 and he was represented in the 'Arte '73' exhibition organized by the Juan March Foundation. Following his period of expressive abstraction he developed a highly individual style, using abstract shapes of coloured metallic mesh suspended by threads on large nails over a coloured background,

sometimes giving a moiré effect. These works he called *Espejos* (*Mirrors*). He is represented at The Mus. of Modern Art, New York, the Carnegie Institute, Pittsburgh, the Tate Gal., London, the Kunsthaus, Zürich, among other public collections.

RIVERS, LARRY (1923–). American painter and sculptor. He was a professional saxophonist in the early 1940s and studied at the Julliard School of Music, 1944–5. He began painting in 1945 and studied at the Hans HOFMANN School, 1947–8, and at New York University under BAZIOTES in 1948. His first one-man exhibition was at the Jane Street Gal. in 1949. In 1953 he took up sculpture. He had a retrospective exhibition at the Jewish Mus., New York, in 1965. In his style he carried on and developed the figural aspects of DE KOONING's painting and devoted particular attention to the handling of paint. His attitude to subject matter earned him a special place in the first generation of American POP artists. He gave new life to the contemporary banal and infused fresh vitality into the patriotic themes which had become the clichés of the academies. Typical of this is his important painting *Washington Crossing the Delaware* (The Mus. of Modern Art, New York, 1953). Some critics have seen an element of nostalgia in his work. Edward Lucie-Smith, for example, wrote: 'And here, I think, is where the nostalgia comes in. Rivers turns, not towards objects which conjure up the past, but towards a whole past way of seeing. He tries to take the vision of a Manet, and to transport it entire into the twentieth century.' There is, however, a unity in his work whether he is using a banal historical theme or banal objects of contemporary life and the transmutation which he effects could not have been possible without the painterly techniques of ACTION PAINTING. From the mid 1960s he broadened his method to embrace constructions, including painted sculptures and shaped canvases, COLLAGES and prints. His dexterity with the use of the air brush, often with superimposed montage, gave a smooth and sophisticated finish to his work of the 1970s, which often carried social implications as in *Bad Witch* (1971), referring to the evils of drug abuse. He has been recognized as one of the more versatile and original personalities in the American figurative art which succeeded ABSTRACT EXPRESSIONISM.

ROBERTS, GOODRIDGE. See CANADA.

ROBERTS, WILLIAM (1895–1980). British painter born in London. In 1909 he was apprenticed to the advertising firm Sir Joseph Causton Ltd. to learn commercial art, attending classes at St. Martin's School of Art in the evening. He obtained an L.C.C. scholarship and studied at the Slade School, 1910–13, winning a Slade Scholarship in 1912. After travelling in France and Italy he joined the Omega Workshops in 1913 after Wyndham

LEWIS and his friends had seceded, and exhibited at the NEW ENGLISH ART CLUB in December of that year. Although he did not join the Rebel Art Centre, he was closely associated with Lewis and the VORTICIST movement, signing the manifesto in the first number of BLAST. He contributed to the 'Twentieth Century Art' exhibition at the Whitechapel Art Gal. in 1914 and to the London Vorticist exhibition of 1915 and the New York exhibition of 1917. He was represented at the LONDON GROUP exhibition of 1915. He joined the Royal Field Artillery in 1917 and on his demobilization in 1919 did three paintings for the Restaurant de la Tour Eiffel and exhibited with GROUP X at the Mansard Gal. in 1920. In 1922 he did illustrations for Lawrence's *Seven Pillars of Wisdom* and he held his first one-man show at the Chenil Gal. in 1923. Outstanding among his works of this period are *Leadenhall Market* (1913), *Study for the Return of Ulysses* (1913), and in 1961–2 he painted *The Vorticists at the Restaurant de la Tour Eiffel*: all in the Tate Gal., London.

During the 1920s Roberts painted groups of stiff and stylized figures. In the 1970s he was still exhibiting pictures recognizably in the same style. He was given a retrospective exhibition at the Tate Gal. in 1965 and in 1966 was elected R.A. From 1959 he issued a number of privately printed pamphlets on his early works in refutation of the claim made by Wyndham Lewis in the latter's Introduction to the catalogue of the retrospective Vorticist exhibition arranged at the Tate Gal. in 1956 that 'Vorticism, in fact, was what I, personally, did, and said, at a certain period'. He had a retrospective at the Maclean Gal. in 1980.

ROCA REY, JOACHIN (1923–). Peruvian sculptor born in Lima. He studied at the Academia de Bellas Artes in Lima and taught there and at the Escuela de Artes Plásticas of the Catholic University of Lima from 1957 to 1963. He was first introduced to sculpture at the Academia by the Spanish artist Victorio Macho. Roca Rey had his first exhibition at the Gal. de Lima in 1948, then travelled to France, Belgium, Portugal, Spain and Italy, where he settled until 1952 and returned again later. He was awarded a prize at the Ibero-American Salon in Madrid in 1950 and the following year he exhibited at the Gal. Biosca (Madrid), the Breteau (Paris), the Zodiaco (Rome) and the Numero (Florence). He had individual exhibitions at the Tate Gal. in London (1954), the Instituto de Arte Contemporaneo in Lima (1954 and 1959), the Mus. de Arte Moderna in Rio de Janeiro (1956) and São Paulo the following year, the Pan American Union in Washington (1959), the Philadelphia Mus. (1966) and the Mus. de Bellas Artes in Caracas (1970). In 1966 he was included in an exhibition of Peruvian art at the Corcoran Gal. in Washington. He participated in the biennial exhibitions of São Paulo, Mexico, Carrara, Venice, Rome and Madrid and was awarded several prizes, including one at the IVth Centenary Ex-

hibition at the Universidad Mayor de San Marcos in Lima (1951). Roca Rey also executed monuments in Lima, Panama, Caracas and Rome. His *Project for a Monument for the Unknown Political Prisoner* (1953), now in the permanent collection of the Pan American Union, served as a model for his 1956 *Monument to José Ramón Cantera*, the Panamanian president who was assassinated the year before in Panama City. Roca Rey's work has been praised by the historian Lionello Venturi, who admired his courage in transcending the stylistic limits of the time. His early work was naturalistic but it became increasingly abstract after he saw and admired the sculpture of Henry MOORE and Jean ARP. His themes have included totemic compositions relating to magic and myth, symbols of Andean pre-Hispanic cultures, and mystical concepts of eroticism. He began by using stone, wood and clay but later also worked in steel and bronze, creating soldered open compositions of great lightness. In the 1950s he modified his forms from delicate and graceful compositions such as *Butterfly Hunter* to more massive ones such as *Maternity*, both in aluminium. In the 1960s he returned to open, weightless metal forms with the addition of colour and texture. His sculpture is represented in galleries and museums in Lima, the U.S.A. and Europe, and in private collections in South America.

RODCHENKO, ALEKSANDR MIKHAILO-VICH (1891–1956). Russian painter, sculptor, industrial designer and photographer, born at St. Petersburg. He studied at the Kazan Art School, 1910–14, mainly under Nikolai Feshin and Georgii Medvedev, then moved to the Stroganov Art School, Moscow. In 1916 he contributed 10 works to TATLIN's 'Shop' exhibition, six of them works executed with ruler and compass. In 1917 with Tatlin and YACULOV he was a member of the team of artists who designed the famous interior of the Café Pittoresque, Moscow. From 1918 onwards he worked at various levels in IZO NARKOMPROS. With ROZANOVA he was in charge of the Art-Industrial Sub-section of IZO and he was head of the purchasing committee for the Museum of Painterly Culture. From 1918 to 1926 he taught at the Moscow Proletkult School; in 1919–20 he was a member of *Zhivskulptarkh* (Paint-sculptarch) with Vladimir Krinsky, Aleksandr SHEVCHENKO and others; and in 1920 he became a member of INKHUK. From 1918 to 1921 he was working on his 'spatial constructions' and in 1921 he contributed to the 3rd *Obmokhu* (Society of Young Artists) exhibition and to the '5 × 5 = 25' exhibition in Moscow. From 1920 to 1930 he was professor at VKHUTEMAS/Vkhutein. In 1923 he designed 17 costumes for Aleksei Gan's unrealized spectacle *My* (*We*). From 1923 to 1928 he was closely associated with the magazines *Lef* and *Novyi Lef*, which published some of his articles and photographs. In 1925 he designed a Workers' Club and exhibited in the Soviet Pavilion at the Exposition Inter-

nationale des Arts Décoratifs et Industriels Modernes, Paris. In 1926 he collaborated in Lev Kuleshov's film *Zhurnalistika* (*Journalism*), one of several experiments in film designing. In 1930 he joined the *Oktyabr* (October) Group.

Rodchenko's production was prolific and his artistic evolution was rapid, from his Impressionistic paintings shown in the 'II Periodic Exhibition' at the Kazan Art School in 1913 to his technical graphics at 'The Shop', his painted and unpainted non-figurative sculpture at the 'X State Exhibition. Non-Objective Creation and Suprematism' (1919) and his three monochrome canvases exhibited at the '5 × 5 = 25' exhibition. While his easel painting was radical, it derived a main impetus in its non-figurative phase from the SUPREMATISM of MALEVICH: his *Black on Black* square of 1918 was an obvious gesture to Malevich's original *White on White* square of 1915. POPOVA's architectonic painting also exerted an appreciable influence on his work, as is evident in his series of non-figurative compositions of 1917 onwards such as *Transformation of a Plane by Factural Processing*. His three-dimensional work, however, was a truly original innovation, a brilliant culmination to Tatlin's relief tradition, and his 'spatial constructions' were genuine anticipations of modern CONSTRUCTIVIST abstraction.

During the 1920s Rodchenko devoted his energies mainly to industrial and topographical design, typography, film and stage design, propaganda posters and photography. It was perhaps in his photography that his originality was most evident. In sharp reaction from the graphic and plastic work of his earlier period his photography was geared towards reportage and the creation of a pictorial record of the new Russia, the Five Year Plan (1928–32), the Weissmeer canal, etc. But much of this work was outstanding for its exploitation of unusual perspectives and new angles of vision—'Rodchenko perspective' and 'Rodchenko foreshortening' became current terms in the 1920s—and there is no doubt that his innovative use of light and shadow exerted a certain influence on Sergei Eisenstein, Kuleshov and Dziga Vertov. An exhibition of his photographs from the years 1920 to 1938 was shown in 1978 at the Kunsthaus, Zürich, and the Mus. Ludwig, Cologne, and the well-documented and fully illustrated catalogue edited by Evelyn Weiss offers the best background to this aspect of Rodchenko's work.

Rodchenko returned to easel painting in the mid 1930s and produced a series of ABSTRACT EXPRESSIONIST canvases in the early 1940s.

RODHE, LENNART (1916–). Swedish painter, born in Stockholm. After painting in a CUBIST manner under the influence of PICASSO, he turned to geometrical abstraction after the end of the Second World War and, teaching at the Stockholm Academy, he was one of the most influential of the Swedish CONCRETISTS in the post-war

period. Among his public commissions in this style are a mural done in tempera for a new elementary school in Stockholm, a stained glass window for the Swedish Commercial Bank, Stockholm, and a tile decoration for the Östersund Post Office. In the 1960s he adopted a freer and less rigid style of geometrical abstraction exemplified by a painting done for the Limnological Institute of Uppsala University. He also did designs for tapestry, stage designs and a large volume of graphic works.

RODRÍGUEZ LOZANO, MANUEL. See MEXICO.

ROGERS, CLAUDE (1907–79). British painter born in London, studied at the Slade Art School, where he was a contemporary of William COLD-STREAM and Rodrigo MOYNIHAN. He exhibited with the LONDON GROUP in 1931 and became a member in 1938. With Coldstream and Victor PASMORE he was a founding member of the EUSTON ROAD SCHOOL in 1937. From 1945 to 1948 he taught at the Camberwell School of Arts and Crafts and from 1948 to 1963 lectured at the Slade School. He was President of the London Group 1952–65, member of the Art Panel of the Arts Council of Great Britain 1955–63, member of the National Council for Diplomas in Art and Design and Chairman of the Fine Arts Panel, 1961–8. He was Professor of Fine Art in the University of Reading, 1963–72, and in 1965 was made Fellow of University College, London. He was created O.B.E. in 1959. Through the 1930s he was a confirmed Realist and he continued to paint landscapes and genre scenes in a style derived from the Euston Road School. His painting, however, became with time more at home with newer movements in the direction of abstraction and *B.E. Flight 539*, shown at the Hayward Gal. in the exhibition 'British Painting 74', although representing part of the wing of an aeroplane in a large expanse of open sky, had at the same time the quality of an abstract design. He had retrospective exhibitions in 1955 at King's College, Newcastle, and at Manchester, Bristol, Leicester; and in 1973 at the Whitechapel Art Gal., London, and at Birmingham, Reading, Southampton, Bradford, Sheffield and Newcastle.

ROHLFS, CHRISTIAN (1849–1938). German painter born at Niendorf. From 1874 he was a student at the Weimar Art School and afterwards taught there. In 1901 he was appointed to the Folkwang School at Hagen. In 1906 he met NOLDE at Soest and from that time painted in a manner analogous to that of the EXPRESSIONISTS of Dresden, though he was never a member of the BRÜCKE. He was in Munich from 1910 to 1912, returned to Hagen in 1912 and in 1927 moved to Ascona. His painting had affinities with that of Nolde though he was more lyrical and visionary in his interpretation of nature.

ROHNER, GEORGES (1913–). French painter born in Paris of Swiss descent. He studied at the École des Beaux-Arts, 1929–33, and in his early years was influenced to some extent by the CUBIST school of PICASSO, DERAIN and LA FRESNAYE. But he stayed uncommitted to Cubism or any other *avant-garde* movement and joined the group of young artists, including HUMBLOT, JANNOT, GRUBER, DESPIERRE, whose ambition it was to base an art of expressive and poetic naturalism upon the great painting of the past. In 1934 and 1935 he did military service in the Antilles and executed large paintings for the Hôtel de Ville in Basse-Terre and the Banque de Guadeloupe at Point-à-Pitre. At the same time he joined the group FORCES NOUVELLES and exhibited with them in 1935. He exhibited at the Mus. de France d'Outre-Mer in 1937 and at the Gal. Berri in 1939. While a prisoner of war during the Second World War he painted a large picture, *Le Christ et les Prisonniers*, in 1941 for the chapel of Stalag XII D at Trèves. In this and other works he belonged to the tradition of French EXPRESSIONISM. But he also painted strongly constructed and firmly modelled still lifes. In addition to this he designed tapestries for the Aubusson works.

ROJAS, CARLOS. See LATIN AMERICA.

ROJO, VICENTE. See LATIN AMERICA.

ROMAGNONI, GIUSEPPE (1930–64). Italian painter born and studied in Milan. He painted in a style of fantastic Realism, often using PHOTO-MONTAGE. His pictures were replete with disconnected objects and parts of objects realistically portrayed against a visionary background.

ROMANI, ROMOLO. See FUTURISM.

ROMANOVICH, SERGEI. See RAYONISM.

ROMAN SCHOOL. A movement in Italian art initiated by the artists SCIPIONE and MAFAI in opposition to the authoritative classicism of the NOVECENTO. The new movement first came to notice at an exhibition in the Doria Gal. in 1928. This was followed by a larger exhibition in November 1930 at the Gal. de Roma. Although different in temperament and methods, the two artists were close friends and united in the desire to substitute a new Romantic EXPRESSIONISM inspired by such artists as SOUTINE for the empty rhetoric of official Italian art. In their catalogue of the exhibition 'Twentieth-Century Italian Art' at The Mus. of Modern Art, New York, J. T. Soby and A. H. Barr, Jr. said of the movement: 'To the ponderous classicism of the *Novecento* the two young painters opposed an impulsive neo-romanticism, finding their subjects not in the perorations resounding from the Fascist Olympus, but in the a-political and human sound of the city. Whereas many artists of the older generation had adopted a

life of professorial when not of official pomp, the "Roman School" created a vigorous little Bohemia in which idiosyncratic values of spirit could be preserved and directly expressed. Its members were determined to paint only what they themselves felt deeply, and resisted the government's attempt to revive by edict Italy's cultural supremacy. Their decision might seem inevitable to artists working under a democratic regime; in the Italy of 1930 it was difficult and courageous.' The influence of the movement survived the mid century and was carried on by such young artists as Giovanni STRADONE, Toti SCIALOJA and Renzo Vespignani.

ROMITI, SERGIO (1928–). Italian painter born in Bologna. He studied under MORANDI and although in the 1940s he moved towards abstraction, his painting retained much of the classical and lyrical quality of his teacher. The large colour compositions of his later period had much in common with COLOUR FIELD painting.

RONALD, WILLIAM (WILLIAM RONALD SMITH, 1926–). Canadian painter and performer, born in Stratford, Ont., and brought up at Fergus, near Toronto, son of a market gardener. He studied at the Ontario College of Art, Toronto, where he was encouraged by Jock MACDONALD, and for six weeks with Hans HOFMANN in New York in 1952. He greatly admired the energy of the work of the New York ABSTRACT EXPRESSIONISTS, as is shown in *In Dawn the Heart* (Art Gal. of Ontario, Toronto, 1954). In 1954 he was a founding member of PAINTERS ELEVEN. He held his first one-man show at Hart House, University of Toronto, in 1955; later that year he moved to New York. Here he met artists associated with the American Abstract Artists group, and as a result Painters Eleven exhibited with the group in New York in 1956. The exhibition featured Ronald's New York work, notably *Central Black* (Robert McLaughlin Gal., Oshawa, Ont., 1955–6), a huge black shape reminiscent of Franz KLINE, crudely centred on the canvas. The show led to a meeting with Samuel Kootz, who gave Ronald regular exhibitions until 1963. He enjoyed considerable success in New York, being ranked among the second generation of Abstract Expressionists. Although he continued to live in the U.S.A., becoming an American citizen in 1963, he retained a large following in Toronto and with works like *Gypsy* (1959), with the dramatic central format which he had made his own, he exerted a widespread influence on Toronto painters. However, with the decline of Abstract Expressionism his popularity waned: a show at the David Mirvish Gal. in Toronto in 1965 was interpreted as an attention-seeking gimmick (movable painted panels allowed the viewer to recompose the picture). He stopped easel painting for a time and became a television and radio celebrity. In 1968–9 he completed a huge, brilliantly bold mural, *Homage to*

Robert F. Kennedy, for the National Arts Centre in Ottawa. In lieu of commercial shows he developed a kind of road-show performance in which, dressed in immaculate white, he painted on stage before an audience large works of impressive energy and coherence to the music of a rock-and-roll band and the inspiring gyrations of a go-go dancer. In 1975–6 the Robert McLaughlin Gal. in Oshawa organized a major retrospective that travelled to seven other Canadian centres.

ROOSKENS, ANTON (1906–). Dutch painter born in Limburg, self-taught as an artist. Up to 1939 he worked in continuance of the Flemish EXPRESSIONIST tradition of PERMEKE, but later his work became more abstract and in 1948 he joined the Dutch EXPERIMENTAL GROUP and COBRA.

ROSAI, OTTONE (1895–1957). Italian painter, born at Florence. After studying briefly at the Institute of Decorative Arts and the Academy of Fine Arts he had his first exhibition of graphic work at Pistoia in 1911 and an exhibition of paintings at Florence in 1912. In 1913 he met SOFFICI and under his influence was associated with the FUTURISTS. But *c.* 1919 he abandoned the Futurist style for a highly personal NAÏVE manner of succinct realism. His painting in this manner has been described as follows by Werner Haftmann. 'One day painting began all over again for him, as though painters had not been at work for thousands of years and the painting of the past had never existed. His relation to his art was that of a child or primitive. Feeling that his poetic purpose could not be achieved by traditional methods, he developed a radically simplified style of naïve, folklore-like realism. The subject matter is working-class Florence; ancient poverty-stricken streets, hillsides covered with grey olive trees, the poor people eking out their existence in the nooks and crannies of the grey city. These simple pictures have the profound, painstaking charm of non-professional art and convey a forlorn note, rendered more poignant by the refusal of poetic effects.' During the 1930s he painted large landscapes and townscapes in which objects were portrayed with CUBISTIC simplification and the mood was established by a sensitive and poetical use of colour.

ROSATI, JAMES (1912–). American sculptor, born at Washington, Pa. He first worked as violinist with the Pittsburgh Symphony Orchestra and then turned to sculpture. He was included in the 'Ninth Street Show' organized by the 'Irascible Eighteen' in 1951 and his first one-man show was at the Peridot Gal., New York, in 1954. He worked in many media and during the 1950s and 1960s was prominent in the American *avant-garde*, having close affinities with David SMITH. In the 1960s he taught at the Cooper Union, the Pratt Institute and the university of Yale. He was awarded a Guggenheim Foundation Fellowship in 1964. Among the collective exhibitions in which he

was represented were: American Federation of Arts, 'Contemporary Sculpture', 1960; Kröller-Müller Mus., Otterlo, 'International Outdoor Sculpture Exhibition', 1961; Whitney Mus. of American Art, 'First Five Years', 1962; Battersea Park, London, 'International Sculpture Exhibition', 1963; New York World's Fair, 1964–5; Mus of Contemporary Crafts, 1967–8. He did heavy, block-like abstractions which were relieved by surface modelling giving the impression of wet clay.

ROSENQUIST, JAMES (1933–). American POP artist born in Grand Forks, N.D., and brought up in Minneapolis. During the early 1950s he earned his living as an industrial billboard painter in Minnesota and the Midwest. In 1955 he obtained a scholarship to study art at the Art Students' League, New York, and there met RAUSCHENBERG, JOHNS and other Pop artists. He again painted billboards, for the Artcraft Strauss Sign Corporation, from 1958 to 1960. His first one-man show, at the Green Gal., New York, in 1962, was sold out and in 1963 he obtained a commission for a large mural for the New York World's Fair. From 1965 he showed at the Leo Castelli Gal., New York, and his work was exhibited widely both in America and in Europe. One-man shows included Moderna Mus., Stockholm, Stedelijk Mus., Amsterdam, Kunsthalle, Basle, Louisiana Mus., Copenhagen (1966); National Gal. of Canada, Ottawa (1968); Kunsthalle, Cologne, Whitney Mus. of American Art, New York, Mus. of Contemporary Art, Chicago (1972); Portland Center for the Visual Arts (1973); Mayor Gal., London (1975).

From the late 1950s Rosenquist began to use techniques derived from commercial painting in his own work. His iconography was drawn from contemporary industrial culture and the more brash imagery of poster advertisement. He was known for the very large scale of his pictures, which combined fragmented incongruous images blown up in a manner reminiscent of photographic enlargement and given a suave finish. Like other Pop artists he fragmented common and banal images and dislocated them from their environment. But his work had a certain bland indefiniteness which lacked the bite of WARHOL and Rauschenberg.

ROSENTHAL, BERNARD (1914–). American sculptor born at Highland Park, Ill. He took a B.A. degree at the University of Michigan, then studied at Chicago Art Institute School and the Cranbrook Academy of Art. He obtained the San Francisco Mus. of Art Sculpture Award in 1950, the Sculpture Prize at the Los Angeles All-City Show, 1951, the Los Angeles County Mus. of Art Sculpture Award in 1957, the American Institute of Architects Southern California Chapter Honor Award in 1959, a Tamarind Fellowship in 1964, the Carborundum Major Abrasive Marketing

Award in 1969. His first one-man exhibitions were at the Pat Wall Gal., Monterey, and the A.A.A. Gal., Chicago, in 1947. He continued to exhibit both individually and in collective shows, but he concentrated on architectural sculpture, working in a style within the ambit of ABSTRACT EXPRESSIONISM and often reminiscent of the 'walls' of TÀPIES. Among his many commissions were: Elgin Watch Building, New York World's Fair, 1939; Mus. of Science and Industry, Chicago, 1941; General Petroleum Building, Los Angeles, 1949; reliefs three storeys high for 260 Beverly Drive, Beverly Hills, 1950; Capril Theatre, San Diego, 1954; Beverly Hilton Hotel, Beverly Hills, 1955.

ROSSO, MEDARDO (1858–1928). Italian sculptor born in Turin. After a few months' training at the Academy in Milan he went to Paris in 1884, where he worked in the studio of the naturalistic sculptor Jules Dalou and knew Rodin. He rapidly won recognition for the portraits and genre pieces which he exhibited at the Exposition Universelle of 1889 and at the Salon. In reaction from the Italian Renaissance tradition of ideal three-dimensional tactile objectivity and from traditions of naturalistic representation, Rosso applied to sculpture the Impressionist aesthetic of reproducing the immediate impact and freshness of direct vision in which atmospheric effects and transitory conditions of light break up the permanent identity of the object. He was essentially a modeller rather than a carver and he deliberately subordinated his use of materials to this end, as is apparent for example in his *Impressione d'omnibus* (*Impressions of an Omnibus*), done in 1884 and destroyed in his lifetime, and his *Uomo che legge il giornale* (*Man reading the Newspaper*) (The Mus. of Modern Art, New York, 1894). He anticipated important recent trends by his interest in 'environmental' conditions, and he is said to have remarked: 'We are mere consequences of the objects which surround us'. He therefore attempted to explore sculpturally the psychological unity of the human figure with its environment as in *Bacio sobre il lampione* (*Kiss under the Lamp-post*) of 1882. He also anticipated later trends by his occasional incorporation of real things in a sculptural work, such as a miniature light in the *Bacio* and a miniature holy-water bowl in *Il Scaccino*. He experimented with the unusual medium of wax over plaster and often used it with striking success for expressive and psychological effects, as in *Conversazione in giardino* (*Conversation in a Garden*) of 1893 and his portrait head of the singer Yvette Guilbert (Gal. Nazionale d'Arte Moderna, Rome, 1894).

At the turn of the century Rosso enjoyed an international reputation second only to that of Rodin. Then after a period of obscurity he was 'rediscovered' by the FUTURISTS, who took over and developed many of his ideas. In his 1912 manifesto of Futurist sculpture BOCCIONI called him 'the only great modern sculptor who has

attempted to open up a larger field to sculpture, rendering plastically the influences of an ambiance and the atmospheric ties which bind it to the subject'. This followed the publication by Ardengo SOFFICI in 1909 of *Il Caso Medardo Rosso*, in which Rosso's ideas were elaborated and he was said to have claimed that a piece of sculpture should be conceived as a part of the life surrounding it rather than as 'solely beautiful forms isolated in space and enclosed by definite, static, certain lines; forms are thus imprisoned in a profile of immobility, shaved off from the whirling centre of universal life, remaining there stiff and still to be examined from all sides by curious spectators'. Instead 'the movements of a figure must not stop at the lines of the contour . . . but the intensity of the play of values and the protrusions and lines of the work should impel it into space, spreading out to infinity the way an electric wave emitted by a well-constructed machine flies out to rejoin the eternal force of the universe'. Today Rosso is regarded as one of the precursors of the modern movement in art because of the emphasis he gave to the direct representation of visual experience, because of his interest in psychological expression and because of his realization that the ordinary and commonplace event may have visual expressiveness. He was not a prolific worker, but replicas of many of his works may be seen with his drawings in the Mus. Medardo Rosso at Barzio, Italy.

ROSZAK, THEODORE (1907–81). American painter and sculptor, born at Poznań, Poland, and came to the U.S.A. in 1909. He studied at the Chicago Art Institute, 1922–4, and at the National Academy of Design, New York, 1925–6, returning to Chicago in 1927, where he was a part-time instructor at the Art Institute, 1927–9. In 1929 he went to Europe and worked in Prague, where he came under the influence of CHIRICO and the SUR-REALISTS. After his return to the U.S.A. he had his first one-man show of painting at the Nicholas Roerich Mus. in 1935, but from 1931 an interest in sculpture gradually gained prominence. From 1938 to 1940 he taught at the Design Laboratory, New York, under the direction of MOHOLY-NAGY and developed an interest in geometrical abstraction of the CONSTRUCTIVIST type which lasted until the mid 1940s. But from *c.* 1946 onwards, while continuing to work in welded steel and bronze, he matured a style of expressive abstraction involving quasi-organic forms which brought him within the group of sculptors, including LASSAW and FERBER, whose work paralleled that of the ABSTRACT EX-PRESSIONIST painters. Best known examples of his work in this mode are *Whaler of Nantucket* (Art Institute of Chicago, 1952) and *Sea Sentinel* (Whitney Mus. of American Art, 1956). He had a retrospective exhibition circulating from the Whitney Mus. of American Art in 1956, a circulating exhibition from the Boston Institute of Contemporary Art in 1959, and a one-man show at the Venice Biennale of 1960. He was a member of the Commission of Fine Arts, Washington, and the U.S. State Department National Council on Art and Government, 1963–7.

ROT, DITER (1930–). German painter and commercial designer, born in Hanover. Besides painting, he worked in graphic design, including typography, and furniture, textile and book design. He lived in Switzerland, 1943–55, Denmark, 1955–7, and settled in Iceland in 1957. During the 1960s he moved continuously between the art centres of Europe and the U.S.A., combining teaching with graphic work, and retiring from time to time to his home near Reykjavik. He had many exhibitions in the U.S.A., Germany and England, including a one-man show in 1971 at the I.C.A. Gals., London. In the late 1960s he produced collective prints with Richard HAMILTON. Like Wolf VOSTELL, with whom he collaborated in DADA-like HAPPENINGS, Rot employed the technique of *décollage* to display consumer goods divorced from their practical context as visual objects in their own right.

ROTELLA, MIMMO (1918–). Italian painter and experimental artist born at Catanzaro, Calabria, studied at the Academy of Art, Naples, and at the University of Kansas. He was a pioneer of the NEW REALISM in Italy and in 1960 joined the NOUVEAUX RÉALISTES group. From 1954 he exhibited COLLAGES made up of fragments of posters torn from the walls, calling them *Manifesti lacerati*, and he wrote: 'Tearing posters down from the walls is the only recourse, the only protest against a society that has lost its taste for change and shocking transformations.' During the 1960s he also experimented with photo-reportage on canvas. See AFFICHISTE.

ROTHENSTEIN, SIR WILLIAM (1872–1945). British painter, draughtsman and teacher. He was born at Bradford, Yorkshire, and studied for a year at the Slade School under Alphonse Legros (1837–1911) and afterwards at the Académie Julian, Paris. There he became a close friend of Whistler and was encouraged by Degas and Pissarro. From about 1898 he specialized in portraits of the celebrated and those who later became celebrated. He was a member of the NEW ENGLISH ART CLUB from 1894. His first exhibition in America was at the Art Institute, Chicago, in 1912. He was Professor of Civic Art at Sheffield, 1917–26, and Principal of the Royal College of Art, 1920–35. In the latter position he exercised an influence second only to that of TONKS at the Slade School in earlier decades. He was a Trustee of the Tate Gal., 1927–33, and was knighted in 1931. A special exhibition of his work was given in the British Pavilion at the Venice Biennale of 1930 and in a Memorial Exhibition at the Tate Gal. in 1950.

ROTHKO, MARK (1903–70). Russian-American painter born at Dvinsk (now Daugavpils), Latvia.

1. Eduardo Paolozzi: *I Was a Rich Man's Plaything*, 1947.
Mixed media. 36 × 23 cm.

2. Richard Hamilton: *Interior II*, 1964. Oil, acrylic, and mixed media on wood. 122 × 163 cm.

3. Allen Jones: *Hermaphrodite*, 1963. Oil on canvas. 213 × 122 cm.

4. David Hockney: *Portrait of Sir David Webster*, 1971. Acrylic on canvas. 147 × 178 cm.

5. Richard Smith: *Piano*, 1963. Oil on canvas. 182 × 277 × 114 cm.

6. Joe Tilson: *Air Mantra*, 1971. Oil on wood relief. 201 × 201 cm.

7. Peter Blake: *Got a Girl*, 1960–1. Oil on hardboard and wood, photo-collage and gramophone record. 92 × 152 cm.

8. Patrick Caulfield: *Still Life – Spring Fashion*, 1978. Acrylic on canvas. 61 × 76 cm.

9. Joseph Cornell: *The Caliph of Bagdad*, 1954.
Construction. 52 × 35 × 11 cm.

10. Arman: *Poubelles I*, 1960. Assembled items.
65 × 40 × 10 cm.

11. Yves Klein: *I. K. B. 79*, 1959. Acrylic on fabric on wood.
140 × 120 × 3 cm.

12. Jasper Johns: *Zero Through Nine*, 1961. Oil on canvas.
137 × 105 cm. ·

13. R. B. Kitaj: *London by Night*, 1964. Oil on canvas. 135 × 185 cm.

15. Larry Rivers: *Parts of the Face* (*The Vocabulary Lesson*), 1961. Oil on canvas. 75 × 75 cm.

14. Robert Rauschenberg: *Almanac*, 1962. Oil and mixed media on canvas. 244 × 152 cm.

16. James Rosenquist: *Marilyn Monroe, I*, 1962. Oil and spray enamel on canvas. 236 × 184 cm.

17. Claes Oldenburg: *Soft Drainpipe – Blue* (*Cool*) *Version*, 1967. Acrylic on canvas and metal. 259 × 188 cm.

18. Andy Warhol: *Green Coca Cola Bottles*, 1962. Oil on canvas.
208 × 145 cm.

19. Roy Lichtenstein: *Whaam!*, 1963. Acrylic on canvas. 173 × 406 cm.

20. Richard Lindner· *119th Division*, 1963. Oil on canvas. 204 × 128 cm.

21. Tom Wesselmann: *Great American Nude, No. 99*, 1968. Oil on canvas. 152 × 203 cm.

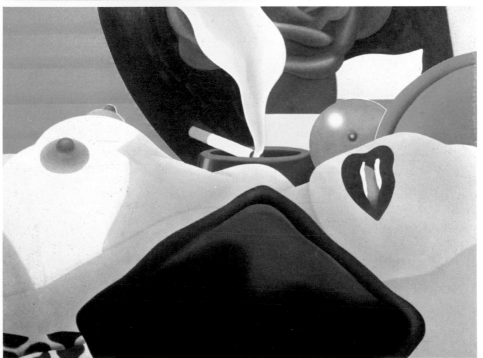

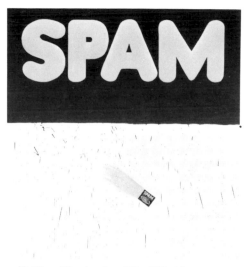

22. Edward Ruscha: *Actual Size*, 1962. Oil on canvas.
183 × 170 cm.

23. Robert Indiana: *The Red Diamond Die*, 1962. Oil on canvas.
216 × 216 cm. on diagonal.

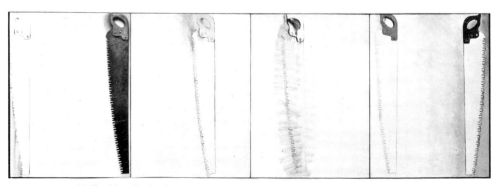

24. Jim Dine: *Six Big Saws*, 1962. Oil, saw, nails on canvas in four parts. 122 × 368 cm.

25. César: *The Yellow Buick*, 1961. Compressed automobile. 151 × 78 × 63 cm.

26. Mark di Suvero: *New York Dawn (for Lorca)*, 1965. Iron, steel and wood. 198 × 188 × 127 cm.

27. John Chamberlain: *Sweet William*, 1962. Welded and painted metal on hardwood base. 172 × 117 × 157 cm.

28. Marisol: *Women and Dog*, 1964. Fur, leather, plaster, synthetic polymer and wood. 183 × 208 cm.

29. Edward Kienholz: *The State Hospital*, 1966. Mixed media. 244 × 366 × 294 cm.

30. George Segal: *Cinema*, 1963. Metal sign, plaster statue, and illuminated plexiglass. 300 × 244 × 99 cm.

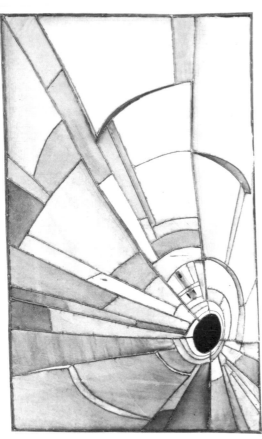

31. Lee Bontecou: *Untitled*, 1959. Canvas on a frame of welded steel. 251 × 148 × 80 cm.

32. Louise Nevelson: *An American Tribute to the British People* (*Gold Wall*), 1959. Sculpture in wood. 310 × 434 × 117 cm.

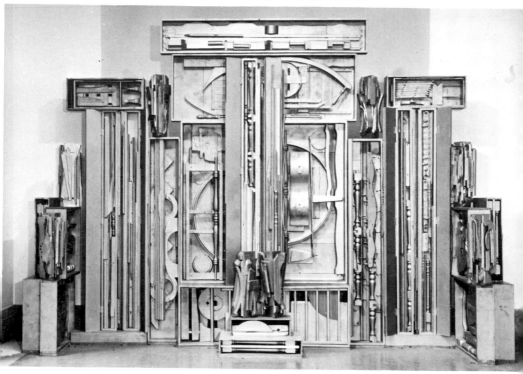

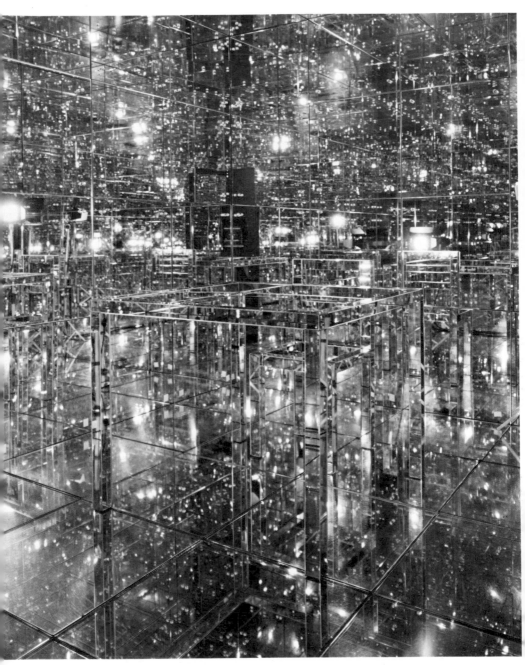

33. Lucas Samaras: *Mirrored Room*, 1966. Mirrors. 244 × 244 × 305 cm.

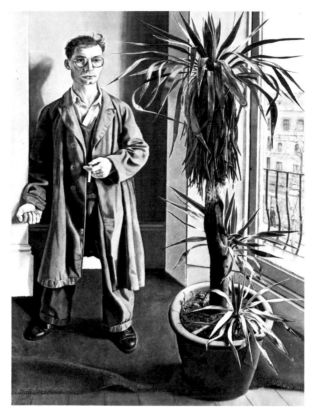

34. Lucian Freud: *Interior near Paddington*, 1951. Oil on canvas.
152 × 114 cm.

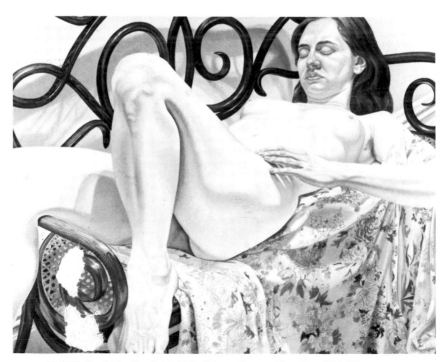

35. Philip Pearlstein: *Female Model Reclining on Bentwood Love Seat*, 1974. Oil on canvas.
122 × 152 cm.

He went to the U.S.A. in 1913 and studied at Yale University, 1921–3. He began to paint in 1925, but apart from a short period of study at the Art Students' League under Max WEBER he was largely self-taught as an artist. He began exhibiting in 1929 and held his first one-man show at the Contemporary Arts Gal., New York, in 1933. In 1935 he was one of the founders of the Expressionist group The TEN. In the early 1940s he was painting in a manner akin to abstract SURREALISM, incorporating biomorphic and organic forms as was done by MIRÓ and in the U.S.A. by GORKY and BAZIOTES. Typical of his work in this style is the water-colour *Baptismal Scene* (Whitney Mus. of American Art), which was included in his one-man exhibition at Peggy Guggenheim's Art of this Century Gal. in 1945. In 1943 he said in a broadcast: 'If our titles recall the known myths of antiquity, we have used them again because they are the eternal symbols upon which we must fall back to express basic psychological ideas. They are the symbols of man's primitive fears and motivations, no matter in which land or what time.... And modern psychology finds them persisting still in our dreams, our vernacular, and our art, for all the changes in the outward conditions of life.' From the mid 1940s, however, the Surrealist flavour of his work receded and from c. 1947 he began to evolve his mature style. In 1948 he was a founder of the 'Subject of the Artist' school together with Baziotes, Barnett NEWMAN and Robert MOTHERWELL. His style in the late 1940s and 1950s consisted typically of large expanses of thinly washed but intense colour divided into two or sometimes three rectangles echoing the format of the frame while upon these floated smaller, vaguely outlined, vaguely rectangular masses of colour with loose, undefined edges. These cloud-like shapes were gradually simplified and refined into larger rectangles floating on a sea of unattached colour. Rothko's colour achieved not only unusual brilliance but a luminosity as if transfused with inner light, an effect which owed much to the sensitive interaction at the edges where fields of adjacent hues were made to meet. He often painted on a huge scale so that the spectator was wholly immersed in a total colour experience. In 1958 he said, in statements quoted by Dore Ashton: 'It was with the utmost reluctance that I found the figure could not serve my purpose—But a time came when none of us could use the figure without mutilating it.' 'Neither Gottlieb's painting nor mine should be considered abstract paintings. It is not their intention either to create or to emphasize a formal color-space arrangement. They depart from natural representation only to intensify the expression of the subject implied in the title—not to dilute or efface it.' 'I paint large pictures because I want to create a state of intimacy. A large picture is an immediate transaction; it takes you into it.' From the end of the 1950s and through the 1960s Rothko's colours became more sombre, with less modulation and less vivid interaction, reflecting

perhaps a period of psychological depression. This last manner was exemplified by wall paintings executed for Harvard University and panels for a chapel at St. Thomas University, Houston, the latter on an enormous scale and consisting of almost uniform red-brown colour. At the end of the 1960s, just before his death, he was experimenting with a new manner in which the picture was divided geometrically into two unequal rectangular areas of uniformly luminous colour.

Both in the U.S.A. and abroad Rothko's work has been among the most widely exhibited of any of the NEW YORK SCHOOL. Exhibitions included retrospectives at The Mus. of Modern Art, New York, the Whitechapel Art Gal., London, the Stedelijk Mus., Amsterdam, in 1961 and the Palais des Beaux-Arts, Brussels, the Kunsthalle, Basle, and the Marlborough Gal., London, in 1962.

ROUAULT, GEORGES (1871–1958). French artist, born in Paris of a Breton cabinet maker and a Parisian mother. From 1885 to 1890 he was apprenticed to a glass painter and worked on the restoration of medieval stained glass while attending courses at the École des Arts Décoratifs in the evenings. In 1891 he entered the École Nationale des Beaux-Arts, where he studied first under Élie Delaunay and from 1892 under Gustave MOREAU. He painted religious pictures, unsuccessfully submitting for the Prix de Rome *Samson tournant la meule* in 1893 and in 1895 *Le Christ mort pleuré par les Saintes Femmes*. But in 1894 he was awarded the Prix Chenavard. From 1895 to 1901, except in 1897 and 1898, he exhibited at the Salon des Artistes Français. On the death of Gustave Moreau in 1898 his studio was turned into a museum of which Rouault was curator. In the same year he underwent a psychological crisis and the character of his work changed. He painted country and suburban landscapes in heavy and gloomy colours. From the inauguration of the Salon d'Automne in 1903 he exhibited there until 1908 and from 1905 to 1912 at the Salon des Indépendants. He continued to associate with the group of artists in the circle of MATISSE and MARQUET, who afterwards were known as FAUVES and who had been fellow students at the École Nationale des Beaux-Arts. But his connection with the Fauve aesthetic was never more than peripheral. He painted clowns, prostitutes, outcasts, and later judges, in sombre but glowing tones with emphatic outlines. These pictures, depicting the ugliness and degradation of humanity with a vigorous and passionate realism reminiscent of a modern Rembrandt, disturbed the public, and even Léon Bloy, with whom Rouault had formed a close friendship in 1904, wrote in the *Mercure de France* in 1909: 'I try in vain to understand how it can be that an artist who is quite the opposite of an ignoramus or vile, the only one who still puts one a little in mind of Rembrandt, can devote himself to this abominable caricature in which the most virile painting of our time is mortally de-

graded in his person.'

Rouault took up the painting of ceramics in 1906 and through the potter Metthey met Ambroise VOLLARD, who later became his exclusive dealer and for whom during the years 1914 to 1920 he engraved illustrations to a number of books (*Les Réincarnations du Père UBU, Cirque de l'étoile filante, Les Fleurs du Mal, Miserere et Guerre*). His first individual exhibition was at the Gal. Druet in 1910 and the same gallery made a large retrospective exhibition of his works in 1924. In 1929 he did the décor for DIAGHILEV's ballet *Le Fils Prodigue*, the music for which was written by Prokofiev. During the 1930s his reputation spread abroad and exhibitions were given in London, Munich, New York and Chicago. He had 42 canvases at the exhibition 'Maîtres de l'Art Indépendant' held at the Petit Palais in 1937 and in 1938 an exhibition of his engravings was given by The Mus. of Modern Art, New York. From about 1940 he devoted himself to religious painting. In 1945 a retrospective exhibition of his work was given in the Kunsthaus, Zürich, and another at The Mus. of Modern Art, New York, included stained glass windows which he had designed for the church at Assy. After the death of Vollard in 1939 many of Rouault's canvases were impounded owing to a legal dispute with Vollard's heirs. On obtaining their release in 1948 he burned 315, which he judged to be not up to standard.

Rouault also did cartoons for tapestry in 1933 and from 1949 designs for enamels. In 1951 in honour of his 80th birthday a celebration was arranged by the Centre of Catholic Intellectuals at Chaillot in which a film was projected on the theme of the *Miserere*. In 1952 a major retrospective was given at the Mus. National d'Art Moderne, Paris.

Rouault's very personal style has been thought to be reminiscent in its glowing colours and strong outlines of the stained glass on which he worked as a youth and his eye for all aspects of human frailty has been compared to Rembrandt, whom he admired. He was the most individual and perhaps the most powerful artist of French EXPRESSIONISM and one of the strongest religious painters of the century.

ROUSSEAU, LE DOUANIER (HENRI ROUSSEAU, 1844–1910).

Born of a tinsmith at Laval, Mayenne, he had little or no formal education. At the age of 18 he entered military service as a saxophonist in the band of the 52nd Infantry Regiment. His claim to have participated in the Mexican campaign is discounted by most historians and it is thought that the exotic elements in many of his paintings were derived from visits to the Jardin d'Acclimatation. After taking part in the 1870 campaign against Germany he left the army in 1871 and obtained a post in the *octroi* department of Customs and Excise. In 1885 he retired from the Customs with a small pension, which he supplemented by giving violin lessons locally. It was at this time too that he set up as an amateur painter, doing portraits and commissions for the local small businessmen. In 1886 he was introduced by Signac and Maximilien LUCE to the Société des Artists Indépendants and exhibited at the Salon des Indépendants regularly from that time until 1898 and again from 1901 to 1910. From 1905 he exhibited at the Salon d'Automne. During the 1890s he made the acquaintance of Seurat, Pissarro, Gauguin and Odilon Redon, though it is not suggested that his own painting was significantly influenced by any of their works. He met Alfred Jarry, also from Laval, and painted his portrait in 1894. By Jarry he was introduced to Rémy de Gourmont, who in 1895 published in the journal *L'Imagier* Rousseau's lithograph *La Guerre*, based upon a picture of the same title exhibited the previous year.

At the turn of the century NAÏVE painting was not appreciated but was confused with the tasteless banalities of the lower middle classes and was always liable to ridicule. Canvases by Rousseau were included in the 'museum of horrors' of Courteline (Georges Moinaux) and it is doubtful whether even artists such as Renoir and Toulouse-Lautrec, to whose attention his works had come, took them very seriously. The cult which made some naïve painting reputable began with the enthusiasm with which an *avant-garde* group in Paris between *c.* 1906 and 1914 hailed Rousseau as a great painter despite his uncultivated naïvety and lack of sophisticated technique. This group consisted of writers such as Alfred Jarry, Max Jacob, Maurice Raynal, Guillaume APOLLINAIRE, André Salmon and artists in PICASSO's circle, including DELAUNAY and VLAMINCK. In 1907 Rousseau met Wilhelm UHDE, who wrote the first monograph on him in 1911 and organized a retrospective exhibition of his work at the Salon des Indépendants. Rousseau was a man of naïve and unworldly character with a frank and simple pride in his own greatness as a painter which, however justified it may seem in the light of later critical judgement, could only appear preposterous to his contemporaries. In 1908 a now famous banquet was organized in his honour at Picasso's studio in the BATEAU-LAVOIR, which although probably serious in intention ended in burlesque. Nevertheless the extraordinary appeal of his paintings continued to be recognized by artists and connoisseurs. By 1910 his reputation was such that an exhibition of his work was given in the 291 Gal., New York. A successful exhibition at the Gal. Bernheim-Jeune in 1912 was followed in 1913 by a special number of the *Soirées de Paris* devoted to him. Among those who bought his paintings were Ambroise VOLLARD, Wilhelm Uhde, Robert Delaunay, Serge FÉRAT (Jastrebzoff), Roch Grey and the FUTURIST, Ardengo SOFFICI. They eventually found their place in the leading collections of the world. During the 1920s began the long series of monographs which have established his position, notably monographs in 1922 by Roch Grey and by Hermann Kolle, in 1927 by Philippe Soupault, André

Salmon, Adolph Basler and Christian Zervos. When visited by Picasso, Rousseau is recorded to have said to him: 'We are the two greatest artists of our age—you in the Egyptian manner, I in the modern.' It was his ambition to paint in the academic way and he admired the works of such traditionalist painters as Adolphe William Bouguereau (1825–1905) and Jean-Léon Gérôme (1824–1904). He has been admired for the extent to which he unknowingly failed to realize this ambition: indeed he is reported himself to have said: 'It is not I who paint, but another who holds me by the hand.' His works had the meticulous attention to detail which is characteristic of most unsophisticated and untutored painters—'modern primitives', as they have been called. He has won the reputation of being not only the greatest of these naïve painters but one of the greatest of all painters in this century owing to the directness of vision, the freshness and spontaneity of conception, a masterly sense of pictorial quality and an unconscious gift of poetic presentation which no critics have succeeded in defining. His painting was particularly versatile in theme. The subjects which he used have been classified under six heads: 1, scenes from daily life, portraits, self-portraits, etc. (portrait of Jarry, imaginary portrait of Pierre Loti, *La Cabriole du Père Juniet*, *La Noce*, etc.); 2, scenes from Paris and its suburbs (*L'Octroi*, *Vu du quai Henry IV*, etc.); 3, military and sporting scenes (*La Guerre*, *Les Joueurs de Football*, etc.); 4, exotic scenes (*Le Lion dévorant l'Antilope*, *Joyeux farceurs*, *les Singes*, *La Charmeuse de Serpents*, etc.); 5, symbolic scenes, in which the allegory is purely visual (*La Muse et le Poète*, *Le Rêve*, *La Bohémienne endormie*, etc.); 6, flower pieces. While he may present the details of flowers and foliage, etc. with a minuteness as if they were seen under a magnifying glass, his compositions large and small have an assurance and impressiveness which make them masterpieces.

Rousseau died of pneumonia in the Necker hospital. He is buried in the cemetery of Baigneux, where in 1912 Guillaume Apollinaire wrote on the tombstone a poetical epitaph which was subsequently engraved by BRANCUSI.

ROUSSEL, KER-XAVIER (1867–1944). French painter, born at Lorry-lès-Metz. He was a friend of VUILLARD and DENIS from schooldays and of BONNARD from his studies at the Académie Julian. Thus he was one of the NABIS group. By the turn of the century he was painting landscapes and portraits in a competent but unoriginal Late-Impressionist manner. He then turned to subjects taken from pagan antiquity and gave rein to the taste for decoration which was a characteristic of the *Nabis*. Among his commissions were a curtain for the theatre of the Champs-Élysées, a mural *La Danse* for the theatre of Chaillot and a mural entitled *Pax Nutrix* for the Palais des Nations at Geneva.

ROY, PIERRE (1880–1950). French painter, born at Nantes. His family was connected with that of Jules Verne, whose stories made a great impression on him as a boy and may have had some influence on the direction which his art took in later life. After working in an architect's office, where he learned precise draughtsmanship, he went to Paris in 1904 and studied at the École des Beaux-Arts, the Académie Julian and the École des Arts Décoratifs. He also travelled to England, the Netherlands, Germany and Italy. In 1910 he made contact with the FAUVES and with the circle of writers Max Jacob, Guillaume APOLLINAIRE and André Salmon. He exhibited at the Société Nationale and the Salon des Indépendants. About 1920 he came under the influence of CHIRICO and moved towards SURREALISM, joining the association and exhibiting with them in 1925 and again in 1933. During the 1930s he made frequent visits to the U.S.A., exhibiting in New York in 1932 and San Francisco in 1938. In 1930 he was a member of the jury at the International Carnegie Exhibition in Pittsburgh. He also designed settings for the Ballets Suédois of Rolf de Maré. Roy's paintings were drawn with meticulous precision, sometimes with *trompe l'œil* realism. The Surrealist effect was obtained by incongruous juxtaposition—e.g. *Les Dangers de l'Escalier* (The Mus. of Modern Art, New York, 1928) with a large snake gliding down a domestic staircase—or incongruous scale and perspective—e.g. *L'Été de la Saint-Michel* (Mus. National d'Art Moderne, Paris, *c.* 1932) with a large wineglass in the foreground set against a much smaller fortress behind. A retrospective exhibition was given by the Kestner-Gesellschaft, Hanover, in 1967.

ROZANOVA, OLGA VLADIMIROVNA (1886–1918). Russian painter, born in Vladimir Province. She attended the Bolshakov Art College and the Stroganov Art School in Moscow, 1904–10. In 1911 she made contact with the UNION OF YOUTH group and in 1912–13 attended Zvantseva's Art School. She contributed to Union of Youth, Tramway V, 0.10, KNAVE OF DIAMONDS and other exhibitions, 1911–17. From 1912 onwards she illustrated FUTURIST booklets and *c.* 1915 executed series of fashion and embroidery designs. In 1916 with MALEVICH, MATIUSHIN, the composer Nikolai Roslavets and others she worked on the first numbers of the SUPREMATIST journal 'Supremus' (not published). In 1918 she was a member of IZO NARKOMPROS and of Proletkult; with RODCHENKO she was in charge of the Art-Industrial Sub-section of IZO and she helped to organize Svomas in several provincial towns. In 1919 a Posthumous Exhibition of her works was given in Moscow and in 1922 she was represented at the 'Erste Russische Kunstausstellung', Berlin.

Rozanova was among the first of the Russian avant-garde to advocate non-representational art. In her theoretical tract *Osnovy novego tvorchestva i prichinyego neponimaniya* (*The Bases of the New Creation and the Reasons Why It Is Mis-*

understood), published in 1913, she declared that 'Only modern Art has advocated the full and serious importance of such principles as pictorial dynamism, volume and equilibrium, weight and weightlessness, linear and plane displacement, rhythm as a legitimate division of space, design, plane and surface dimension, texture, colour correlation and others. Suffice it to enumerate these principles ... to be convinced that they are the qualitative ... New Basis which proves the "Self-sufficient" significance of the New Art. They are principles, hitherto unknown, which signify the rise of a new era in creation—an era of purely artistic achievements.' As a member of the Union of Youth Rozanova was a colleague of Vladimir Markov (Waldemars Matvejs) and Matiushin, whose ideas, especially in the context of concepts such as 'intuition' and 'chance', obviously impressed her. In turn some of her images and metaphors, e.g. the conventional artist as a slave of nature, intuitive reason, were echoed by Malevich in his own writings. Although Rozanova reached a Suprematist conclusion in her own painting, hers was a more formal interpretation and did not share Malevich's cosmic dimensions; and some of those works of 1915–16 which she sub-titled 'Suprematist' were still very figurative, e.g. *Metronome, Oil-stove, Work-box.* Like POPOVA, Rozanova regarded painting above all as a planar or surface art and used dynamic juxtapositions of sections of colour without necessarily referring to the conventional perspectival role of form and colour. This method was also evident in her textile designs and in her Futurist booklet designs. Her interest in planar contrast was manifest in the famous albums *Voina* (*War*) of 1916, in which she skilfully combined coloured COLLAGES and linocuts, and *Vselenskaya Voina* (*Universal War*, Petrograd, 1916), in which she and Kruchenykh composed a series of non-figurative illustrations using coloured paper. Like Kruchenykh, Rozanova also wrote 'transrational' poetry. As KLIUN wrote in 1919: 'Her ever searching soul, her exceptionally developed sense of intuition could never compromise with the old forms and always protested against all repetition whether in everyday life or in art.'

RUCHE, LA. A rotunda-like building put up *c.* 1900 by an old sculptor known as 'le père Dubois' in the rue Dantzig near the Vaugirard abattoirs with the idea of founding an artistic community (phalanstery) there. From *c.* 1905 cheap studios were hired there, badly built and without conveniences such as water and gas. Many expatriate artists found a home there on first coming to Paris, among them MODIGLIANI, CHAGALL, SOUTINE, ARCHIPENKO, LIPCHITZ. Some French artists also had studios there for a time (LÉGER, DELAUNAY, LAURENS) and some poets and writers (Blaise Cendrars, Guillaume APOLLINAIRE, Max Jacob). Political refugees also found shelter there.

RUEDA, GERARDO (1926–). Spanish painter and sculptor, born in Madrid. In 1954 he abandoned his university studies to devote himself to painting and soon rose to prominence as one of Spain's leading exponents of geometrical abstraction both in painting and painted reliefs and in sculptural constructions. In 1963 he collaborated with ZOBEL and TORNER in founding the Cuenca Mus. of Spanish Abstract Art. His work is represented in the museums of contemporary art at Madrid, Seville, Barcelona, Cuenca and in the Biblioteca Nacional, Madrid. Outside Spain the public collections which possess his works include the British Mus., the Mus. National d'Art Moderne, Paris, the Gothenburg Mus., the Brooklyn Mus., New York, the Memorial Art Mus., Rochester, the Fogg Mus., Harvard, the Aschenbach Foundation, San Francisco, the National Mus. of the Philippines, Manila.

RUIZ PERNIAS, JOSÉ. See SPAIN.

RUSCHA, EDWARD (1937–). American POP artist, born at Omaha, Nebr. He studied at the Chouinard Art Institute, Los Angeles, in the later 1950s. His favourite themes were commercial signs and marks reproduced in meticulous lettering borrowed from advertisement technique, sometimes with a small image of the product in the background, or deadpan paintings of petrol stations executed with machine-like precision. He deliberately eschewed all painterly gesture in the interest of stark simplification. Some of his drawings consisted entirely of a single word such as: DIMPLE: JELLY: BUSINESS. He had one-man shows at the Ferus Gal., Los Angeles, from 1963 and at the Alexander Iolas Gal., New York, from 1967. He was also claimed as a CONCEPTUAL artist. He produced books of near-identical photographs without text, e.g. *Twenty-Six Gasoline Stations.* Of these he said: 'Nor am I really interested in books as such, but I am interested in unusual kinds of publications. . . . Above all, the photographs I use are not "arty" in any sense of the word. I think photography is dead as fine art; its only place is in the commercial world, for technical or information purposes. . . . Thus, it is not a book to house a collection of art photographs—they are technical data like industrial photography. . . . I have eliminated all text from my books—I want absolutely neutral material. My pictures are not that interesting, nor the subject matter. They are simply a collection of "facts"; my book is more like a collection of Ready-mades.'

RUSCHE, DR. WALDEMAR. See PAPS.

RUSSELL, MORGAN (1886–1953). American painter born in New York. After studying art under Robert HENRI he went to Paris in 1906 and was for a short while a pupil of MATISSE. In Paris he became a friend of Stanton MACDONALD-WRIGHT, with him studied the colour theories of Chevreul and invented a method of pure colour

painting akin to the ORPHISM of Robert DELAUNAY. The theory of this new method, which they called SYNCHROMISM, was put forward in statements made at a joint exhibition held in 1913 at the Neue Kunstsalon, Munich, and at the Gal. Bernheim-Jeune, Paris. According to a statement made by Frank J. Mather, Jr. in *The Independent*, LXXIV (March 1913, p. 512), quoted by Margaret Rose (in *American Art since 1900*), Russell was considering painting 'solely by means of colour and the way it is put down, in showers and broad patches, distinct from each other or blended, but with force and clearness, and with large geometrical patterns, with the effect of the whole as being constructed with volumes of colour'. Nevertheless the majority of the pictures at the Paris exhibition were figurative. The abstract style of colour painting for which Synchromism chiefly stood came somewhat later, e.g. *Four Part Synchromy No. 7* (Whitney Mus. of American Art, 1914–15); *Synchromy in Orange* (Albright-Knox Art Gal., Buffalo, 1913–14). From *c.* 1920 Russell reverted to figural painting. In the 1930s he went to live in France, where he painted large religious pictures, returning to the U.S.A. in 1946. He was represented in the exhibition 'Abstract Painting and Sculpture of America' at The Mus. of Modern Art, New York, in 1951.

RUSSIA AND THE U.S.S.R. During the first two decades of the 20th c. there was evidence of true creative vitality among *avant-garde* artists in Russia and of unusual fecundity for absorbing and adapting new ideas. Without losing sight of their own folk-art traditions they were in touch with innovative movements in France and Germany, modifying these for the formation of such regional styles as CUBO-FUTURISM and RAYONISM. SUPREMATISM was the earliest manifestation of geometrical abstraction in Europe and CONSTRUCTIVISM made its first tentative appearance on the international stage with the *Realistic Manifesto* of GABO and PEVSNER. This creative period lasted until *c.* 1920, when the enthusiasm for diverting artistic production to the needs of social reconstruction following the Bolshevik Revolution led to a subordination of fine art to industrial design. Increasing regimentation during the 1920s culminated with the introduction in 1928 of SOCIALIST REALISM as the only officially authorized artistic style.

Details of what occurred are given in the articles on individual artists, associations and movements. The following chronological summary is intended to bring the whole period into perspective and to serve as a guide to relevant articles.

1898. MIR ISKUSSTVA (The World of Art) was formed in St. Petersburg. The journal under the editorship of DIAGHILEV continued until 1904. Exhibitions, at first international in character, continued until 1906. In 1910 a new World of Art society was organized and this held regular exhibitions of contemporary Russian art until 1924.

1903. The Union of Russian Artists, an exhibiting society which partly replaced *Mir Iskusstva*, was formed in Moscow.

1906. A Russian section of the Paris Salon d'Automne was organized by Diaghilev, the décor for which was designed by BAKST, in the Grand Palais. The Blue Rose group was formed to organize exhibitions by the younger *avant-garde* artists. The GOLDEN FLEECE exhibition society with its own periodical was formed in close association with the Blue Rose. LARIONOV and GONCHAROVA made their début at the 1906 *Mir Iskusstva* exhibition and joined the Blue Rose group.

1907. An exhibition by the Blue Rose was staged at the house of Pavel Kusnetsov, a leading painter of the group. 'Wreath' exhibitions were organized in the provinces by the BURLIUK brothers.

1908. The first of the three 'Golden Fleece' exhibitions was staged with the French POST-IMPRESSIONISTS strongly represented. The Russian section of the exhibition was dominated by 20 canvases by Larionov.

1909. The second Franco-Russian exhibition was organized by the 'Golden Fleece' in January and the third 'Golden Fleece' exhibition took place in December with a preponderance of works by Larionov and Goncharova in their 'primitivist' style. MARINETTI's Futurist Manifesto was published in Russian, beginning the FUTURIST influence on Russian painting.

1910. The UNION OF YOUTH exhibiting society was formed in St. Petersburg with strong Futurist leanings. The KNAVE OF DIAMONDS exhibition was organized in Moscow in December by the Burliuk brothers, bringing together for the first time the many local groups of *avant-garde* artists.

1911. The Russian Futurist poetry movement was founded and was joined among others by MALEVICH and the Burliuk brothers. Larionov and Goncharova began their Rayonist paintings, a Russian version of Futurism.

1912. Larionov, together with Goncharova, Malevich and TATLIN, rejected the 'Western' influences (i.e. FAUVIST and EXPRESSIONIST) encouraged by the Knave of Diamonds association and formed their own splinter group with the DONKEY'S TAIL exhibition. Malevich used the term 'Cubo-Futurist' of the pictures he sent to this exhibition. 1913 saw the TARGET exhibition of all-Russian work, at which Larionov issued his Rayonist Manifesto and launched his Rayonist works. Malevich exhibited Cubo-Futurist canvases. The last 'Union of Youth' exhibition was held in November. Kruchenykh's Futurist opera *Victory over the Sun* was produced in St. Petersburg with décor by Malevich, who traced the origin of Suprematism to these designs. In 1913–14 Tatlin made his first 'Painted Reliefs', followed by his 'Relief Constructions' in 1914–15 and his 'Corner Reliefs' of 1915–16. These were the earliest manifestation of that principle of CONCRETE ART which repudiates the illusion of three-dimensional picture space.

1915. The 'Tramway V' exhibition, called 'The First Futurist Exhibition', was held in Petrograd

in February. Here Malevich and Tatlin emerged as the leaders of two opposed trends in *avant-garde* art, Suprematism and PRODUCTIVISM (which later assumed the name 'Constructivism'). Tatlin first exhibited here his 'Painted Reliefs'. Cubo-Futurist works were exhibited by Malevich, POPOVA, EXTER, PUNI and other members of the *avant-garde*. '0.10. The Last Futurist Exhibition' was held in Petrograd in the winter of 1915–16, at which Malevich's Suprematist paintings were first publicly shown. Tatlin derided these as unprofessional and exhibited his own 'Corner Reliefs'. This personal clash split the *avant-garde* into two rival groups—Puni, Menkov and KLIUN followed Malevich while UDALTSOVA and Popova ranged themselves behind Tatlin. The Productivist ideas of Tatlin's group represented the emergence of the principle that artistic activity must be channelled to socially useful ends such as industrial design. Larionov and Goncharova joined Diaghilev in Paris, where they virtually abandoned easel painting.

1916. Tatlin organized 'The Shop' exhibition at which RODCHENKO made his début. Malevich published the manifesto *From Cubism and Futurism to Suprematism* in Petrograd.

The period immediately following the Bolshevik Revolution of February 1917 was distinguished not only by a significant move from studio art to industrial design, book and poster art, etc., but also by a revival of figurative art and the formation of a number of Realist groups. By 1922, the year which marked the final flowering of Russian Constructivism, a distinct and often voluntary return to figurative art as an authentic creative force was evident. This reaction against the legacy of Suprematism culminated in the establishment of the first important Realist organization, AKhRR (Association of Artists of Revolutionary Russia), in May 1922. The theory and practice of AKhRR made an essential contribution to the later development of Soviet art: its members rejected abstract art, advocated a new Realism and anticipated the basic principles of Socialist Realism. 'The great October Revolution ... has aroused the consciousness of the masses and the artists.... Our civic duty before mankind is to set down, artistically and documentarily, this great moment of history in its revolutionary impulse.... We will provide a true picture of events and not abstract concoctions discrediting our Revolution in the face of the international proletariat.... We must reveal our artistic experiences in the monumental forms of Heroic Realism.' AKhRR with its keen social awareness, its close contact with the political hierarchy and its own publishing house served as a powerful stimulus for the trend back towards figurative art, emphasized the new propaganda and didactic aims and answered the needs of a new and widened art market.

The following chronological summary indicates the main events in the emergence and development of a distinctive State-controlled Soviet art.

1917. Artists of all persuasions enthusiastically embraced the idea of a popular art which would participate actively in the social reconstruction envisaged by the Revolution. There was a general move among artists to form large associations, often with definite political bias. Malevich joined the Federation of Leftist Artists. Many Leftist artists took up administrative and pedagogical positions in Lunacharsky's People's Commissariat of Enlightenment (NARKOMPROS).

Tatlin and Rodchenko with YACULOV designed a Constructivist interior for the Café Pittoresque in Moscow.

In the autumn Gabo, Pevsner, STENBERG, BARANOFF-ROSSINÉ and other artists returned to Russia from the West.

1918. The Department of Fine Arts (IZO) was created under Narkompros with Stenberg at the head and Tatlin head of the Moscow Division. Rodchenko became Director of the Bureau of Museums and Malevich worked as designer in the State Porcelain Factory. The Petrograd Academy of Art and the Moscow Institute of Painting, Sculpture and Architecture were closed and reorganized under IZO as the Free Studios (Svomas) in Petrograd and the VKHUTEMAS in Moscow. A special sub-section of IZO, headed by ROZANOVA, was created for organizing industrial art in the provinces.

Many leading artists collaborated in designing posters and agit-decorations for the May-Day celebrations and for the first anniversary of the October revolution. Rozanova's death was commemorated by a State-organized retrospective exhibition of her work in Moscow. In December the Fifth State Exhibition of Pictures opened in Moscow with works by KANDINSKY, Popova, Rozanova, Rodchenko, etc.

1919. INKHUK staged the 'X State Exhibition. Non-Objective Creation and Suprematism', which was the culmination of abstract art in Russia and the last group exhibition of so-called LABORATORY art (i.e. art not directed to industrial design or social indoctrination). Malevich showed his now famous *White on White*, which was answered by Rodchenko with his *Black on Black*. Besides works by Popova, Rozanova, STEPANOVA, VESNIN, Kliun, etc., there were contributions by Kandinsky and by Pevsner. In April–June the First State Free Exhibition of Works of Art in Petrograd presented works by Altman, Mansurov, Rozanova, etc. In May the first OBMOKHU exhibition opened in Moscow with works by LENTULOV, MEDUNETSKY, the Stenbergs, Yaculov, etc. In December the 'XVI State Exhibition. K. S. Malevich' showed 153 works by Malevich representing his progress from Impressionism to Suprematism. Malevich announced the demise of Suprematism as a movement in art. In this year also Malevich ousted CHAGALL from the Vitebsk School of Art and with himself as Director renamed the school Unovis (College of the New Art). It was in Vitebsk that El LISSITZKY, who had been working there with Chagall, came into contact with Malevich and began his PROUN

series. In this year also Tatlin was commissioned by the Department of Fine Arts to design his famous *Monument to the Third International*.

1920. The organization of *Inkhuk* was finalized in Moscow and affiliations were set up in Petrograd and Vitebsk. Kandinsky's educational programme for *Inkhuk* was rejected in favour of one by Babichev. The second *Obmokhu* exhibition was opened in Moscow with 'colour constructions' and industrial patterns predominating. In August Gabo and Pevsner issued their *Realistic Manifesto*. In November–December Tatlin's model for his *Monument to the Third International* was on show at the Academy of Arts, Petrograd. The Red Square was decorated by Rodchenko, Popova and Vesnin to celebrate the Third Comintern Congress. Rodchenko, Exeter and others designed décors for plays by Mayakovsky and Tairov. The first MOBILES were shown by Rodchenko.

1921. Gabo, Pevsner, Chagall and Kandinsky left Russia to work in the West.

In September the '5 × 5 = 25' exhibition was organized in Moscow. The Productivist group, who had taken the name of 'Constructivists', issued a Manifesto condemning easel painting and non-utilitarian art in general. In November a group of artists including Popova, Rodchenko and Vesnin left *Inkhuk* in order to devote themselves exclusively to utilitarian and propaganda art and industrial design. In October the Russian Academy of Artistic Sciences (RAKhN) was set up.

1922. The Association of Artists of Revolutionary Russia (AKhRR) was organized in May in Moscow, encouraging the return to figurative painting and Realism. In June the Petrograd *Inkhuk* organized the exhibition 'Survey of New Tendencies in Art', presenting works by Malevich, Mansurov, MATIUSHIN, Tatlin, etc. (Tatlin showed a monochrome pink painting.) In October the 'Erste Russische Kunstausstellung' was organized by Stenberg at the Van Diemen Gal., Berlin, introducing Russian *avant-garde* art to the West.

1923. The first number of the journal *Lef* appeared in March. It lasted until 1925. In the spring Popova and Stepanova were active as designers for the First State Textile Print Factory, Moscow. In October the fourth and last *Obmokhu* exhibition was held in Moscow.

1924–6. In May the first Discussional Exhibition of Associations of Active Revolutionary Art opened in Moscow with the Constructivists well to the fore. A posthumous exhibition was held for Popova in Moscow.

1927. Malevich was allowed to visit Poland and Germany. A Soviet Pavilion at the Paris International Exhibition was designed on Constructivist principles.

1928–32. A revival of interest in the applied arts and photography was encouraged by the group *Oktyabr* (October). Gan, Senkind, the Vesnins, etc. were members.

1929–30. A large retrospective exhibition of FILONOV's works was organized at the Russian Mus., Leningrad, but was not opened.

1932. By decree of the Central Committee of the All-Union Communist Party in April all literary and artistic organizations were disbanded; a single Union of Writers was set up. An analogous arrangement was proposed for the arts but it was not established until 1957. In November the Jubilee Exhibition 'Artists of the RSFSR over the Last 15 Years' opened in Leningrad, among those represented being Malevich, Altman, Suetin, Kliun, Tatlin.

1934. Socialist Realism was presented as the only viable artistic doctrine at the First All-Union Congress of Soviet Writers.

RUSSO, RAUL (1912–). Argentine painter and graphic artist, born at Buenos Aires. He graduated at the Manuel Belgrano National School of Fine Arts in 1931 and then studied at the Ernesto de la Cárcova School of Fine Arts. His first one-man show was in 1936. He had regular one-man shows in the Argentine, from 1961 at the Wildenstein Gal., Buenos Aires, and participated in group shows in many centres of South America, the U.S.A., Europe and Britain. In 1968 he became a member of the National Academy of Fine Arts. He taught in the School of Architecture and Urban Science of the National University, Buenos Aires, and afterwards was Professor of Painting at the Ernesto de la Cárcova School. Among his many awards were the Grand Prix d'honneur at the Buenos Aires Metropolitan Salon in 1958, the Augusto Palanza Prize in 1961 and the Silver Laurel from the Buenos Aires Rotary Club in 1969. Besides painting he was known for his illustrations for prominent Argentinian authors.

RUSSOLO, LUIGI (1885–1947). Italian painter, born at Portogruaro in the province of Venezia. His father was a musician and although he did not study music at the Milan Conservatory like his two brothers, he was brought up in a musical milieu. He moved to Milan with his family and there met CARRÀ, Romolo Romani (1885–1916) and Aroldo Bonzagni (1887–1918), although he seems not to have been formally enrolled as a student of painting at the Accademia di Brera. He was a member of MARINETTI's *Poesia* circle and in 1910 he signed the FUTURIST painters' manifestos. None of his paintings before 1910 can be identified, although he exhibited etchings at the Famiglia Artistica in 1909. His *Lampi* (Gal. Nazionale d'Arte Moderna, Rome, 1910), a nocturnal city scene such as several of the Futurist painters were doing at this time, shows that he was already proficient in the DIVISIONIST technique. He was interested in the problem of representing non-visual sensations by painting and in the problem of synthesizing memories in a single picture. The former is illustrated by his *Profumo* (*Perfume*) of 1910 and *La Musica* (*Music*) of 1911–12; the latter by *Ricordi di una notte* (*Memories of a Night*) of 1911, which, inspired perhaps by Bergson's idea of 'psy-

chic duration', brings together in one composition interpenetrating memory-images of contrasting emotional import. His *Treno in velocità* (*Speeding Train*), done in 1911, was the first Futurist painting to use a speeding machine as its theme. His *La Rivolta* (*The Revolt*), also of 1911, belongs to the class of Unanimist pictures, which endeavour to convey the sensation of mass movement and emotion. In the London exhibition at the Sackville Gal. it was described in the catalogue as: 'The collision of two forces, that of the revolutionary element made up of enthusiasm and red lyricism against the force and inertia and reactionary resistance of tradition.' Russolo was less influenced by CUBISM than his Futurist colleagues Carrà and BOCCIONI and during 1912 and 1913 he was painting canvases in which he explored the typical Futurist preoccupation with the representation of motion in such a way as to bring the spectator empathically into the movement of the picture. From these years come his *Riassunto dei movimenti di una dama* (*Synopsis of a Woman's Movements*, Mus. des Beaux-Arts, Grenoble), *Linee forze della folgore* (*Lines of Force of the Thunderbolt*, destroyed) and *Automobile in corsa* (*Speeding Automobile*, Mus. National d'Art Moderne, Paris); while his *Solidità della nebbia* (*Solidity of Fog*) and *Le Case continuano in cielo* (*The Houses continue into the Sky*, Kunstmus., Basle) express movements of a different kind.

Russolo has suffered unjust neglect and was not represented in the Futurist retrospective exhibition held at Rome in 1955–6, although three of his canvases were included in the anniversary exhibition of 1959 and he was represented by two canvases and an etching in the exhibition of Italian Futurism held at the Royal Academy, London, in 1973. However, important as the works mentioned above were in the development of Futurist painting, Russolo was no doubt most active in connection with his theories of a 'music of noise', which anticipated what was later done by Stockhausen and John Cage. In 1913 he published his manifesto *L'arte dei rumori* (*The Art of Noises*), in which he advocated a music based on sounds of no definite pitch but related to, though not simply imitative of, natural noises. He invented a number of *intonarumori* or 'noise instruments' and 'noise organs',

demonstrated them and wrote music for them. His 'Bruitism', as it came to be called, was taken up by DADA. After the war Russolo settled in Paris and continued to paint in a figurative manner but without contributing further to progressive movements.

RYBACK, ISSACHAR (1897–1934). Russian painter, born at Elisabethgrad of Jewish parentage. He was trained at Kiev, 1911–16, after which he did decorative work while studying at Moscow, 1918–19. He went to Berlin in 1921, where he exhibited with the Berlin SECESSION and was a member of the NOVEMBERGRUPPE. After a year in Russia (1925) he finally settled in Paris in 1926. Ryback was a sensitive and lyrical painter of flower pieces, animals and portraits. A background of Hasidic mysticism pervaded his work and like his fellow-countryman CHAGALL the sustenance of his painting derived from memories of the Jewish-Lithuanian environment in which he spent his early years. In 1932 he published an album of drypoints of Jewish subjects (which were also used as subjects of paintings) and he did ceramic figures of Jewish subjects which were exhibited in 1935 at the Mus. National Céramique de Sèvres. The critic Waldemar George called him 'a visionary of the Ghetto who transforms rags and tatters into brocades'. Ryback visited England in 1933 and held an exhibition of his paintings sponsored by the Cambridge University Arts Society. He was already suffering from the spinal disease which carried him off prematurely two years later. In 1964 a Ryback Museum was opened in Tel Aviv to house his remaining works donated by his widow.

RYSSELBERGHE, THÉO VAN (1862–1926). Belgian painter, born in Ghent. He was a founder of the *avant-garde* GROUPE DES VINGT (XX) formed in 1883 to encourage interest in innovative art and he was considered in his time to be the leading Belgian artist of the Neo-Impressionist school, playing a particularly important role in the field of portraiture. He knew Seurat and adopted his system of DIVISIONISM. In 1898 he moved to Paris and was associated with the Symbolist circle of writers and artists. Later he settled in Provence.

S

SABOGAL, JOSÉ (1888–1956). Peruvian painter born in Cajabamba. Between 1909 and 1912 he travelled to France, North Africa and Spain, where he was influenced by the robust painting of Anglada Camarasa and the symbolism of Ignacio Zuliaga. When he returned to South America he first went to Buenos Aires, where he studied at the Escuela de Bellas Artes, then settled in the northern Argentinian town of Jujuy, where he taught art until his return to Peru in 1918. He visited the Inca capital of Cuzco and its environs, then settled in Lima. His first exhibition in Lima in 1919 astounded an unprepared Peruvian public with the boldness of subject, form and colour and the simplified structure of his paintings. In 1920 Sabogal was named Professor of Lima's Escuela de Bellas Artes, which he also directed from 1933 to 1943, exerting a wide influence on other artists. In the course of a trip to Mexico in 1922 he met RIVERA and OROZCO, an experience that reinforced his already incipient interest in the regional and national subjects of his own country. He came to be known as the father of Peruvian indigenism. As Professor at the Escuela de Bellas Artes he gained a large following, which included Julia CODESIDO, Camilo Blas, Enrique Camino Brent, Teresa Carvallo and Jorge Vinatea Reinoso, around whom an 'indigenist' group was formed. This movement was further popularized by the social writer and journalist, José Carlos Mariátegui, originally a member of and spokesman for the APRA (Alianza Popular Revolucionaria Americana) party. In 1934, Sabogal illustrated Carleton Beals's book about the APRA party, *Fire on the Andes*. Although Sabogal's technical abilities as a painter have sometimes been questioned and his work thought too folkloristic, he was responsible for awakening in the artists of his country an interest in the native arts and crafts as a source of inspiration. After 1940 he developed a manner of painting referred to as his 'adobe style' inspired by popular ceramic and textile work. He also painted murals, did woodcuts and wrote essays on Peruvian lore. In his later years he developed an interest in the costumes of Peruvian Indians as subject matter in contrast to his earlier focus on landscape and traditional local scenes.

SAEDELEER, VALERIUS DE (1867–1941). Belgian painter, born at Alost. He studied weaving at the Industrial School of Ghent and then attended the academies at Alost and Ghent and in 1887 was a pupil of Courtens in Brussels. In 1883 he settled in LAETHEM-SAINT-MARTIN and with George MINNE and Gustave van de WOESTIJNE formed the core of the First Laethem Group, which had so important a bearing on the future direction of Flemish art. Forsaking the spirit of Impressionism, his landscapes were composed in the studio from sketches drawn from nature and expressed the serene tranquillity of the Lys countryside. They were often strongly reminiscent of Bruegel, as in the fine *L'Hiver en Flandre* (Mus. Royaux des Beaux-Arts, Brussels, 1927). The religious atmosphere of the Flemish Primitives, whom he saw exhibited in Bruges in 1902, made a powerful impression on him and from this time his landscapes were imbued with the quiet mystical fervour which was the keynote of the group. Although his work was at this time opposed to the more unrestrained forms of EXPRESSIONISM represented by ENSOR, it was the forerunner of the later development of a calmer and more profound school of expressive representation and De Saedeleer was afterwards recognized as a leader of an Expressionist school which attracted such artists as Paul MAAS and Henri-François RAMAH.

SÁEZ DIEZ, LUIS (1925–). Spanish painter, born in Mazuelo de Muñó, near Burgos, and trained at the San Fernando School of Fine Arts, Madrid. His painting was intensely EXPRESSIONIST in the Spanish manner, either abstract or verging upon abstraction. He had one-man exhibitions in the major Spanish centres from 1951 onwards and also in Frankfurt and Munich and he was represented in many important collective exhibitions both in Spain and abroad. His works are represented in public or private collections in many countries, including Spain, Germany, Britain, the U.S.A., France, Switzerland, Sweden.

SAGE, KAY (1898–1963). American painter, born at Albany, N.Y., and self-taught as a painter. She lived in Italy, 1900–14 and 1919–37, and there painted pictures under the influence of CHIRICO, having her first one-man exhibition at the Gal. del Millione, Milan, in 1936. She went to Paris in 1937 and associated with the SURREALIST group, exhibiting at the Salon des Surindépendants in 1938. In 1940 she returned to the U.S.A. with Yves TANGUY, whom she married. She exhibited at the Pierre Matisse Gal., New York, in 1940 and participated in the International Surrealist Exhibition, New York, in 1942. She continued to exhibit through the 1950s and had a retrospective at the

Catherine Viviano Gal. in 1960. From the time of her return to America architectural motifs became more prominent in her work—strange steel structures depicted in sharp detail against vistas of unreal space—and she incorporated draperies from which faces and figures sometimes mistily emerged. An example of her work in this manner is *Tomorrow is Never* (The Metropolitan Mus. of Art, New York, 1955).

ST. IVES PAINTERS. Name given to a group of painters who concentrated their activities on St. Ives, Cornwall. The group originated when Barbara HEPWORTH and Ben NICHOLSON moved to St. Ives in the early years of the Second World War and 'discovered' there the native painter Peter LANYON. They later formed a nucleus around which congregated a number of painters, including Terry FROST, Patrick HERON and Bryan WYNTER. The St. Ives group were all highly individual with little in common stylistically apart from a general interest in rendering impressions of landscape in terms of a greater or less degree of GESTURAL abstraction.

SAINT PHALLE, NIKI DE (1930–). French sculptor born at Neuilly. She came to prominence during the 1960s chiefly for her ASSEMBLAGES and for sculptures which incorporated containers of paint intended to be burst and spattered when shot with a pistol. She was also known for grotesque and brightly painted female figures which she called *Nanas*. She collaborated with TINGUELY, whom she married, in the enormous sculpture *Hon* (*She*) erected at the Moderna Mus., Stockholm. It was in the form of a reclining woman whose interior was a giant 'environment' reminiscent of a fun-fair. A retrospective of her works was given at the Centre Georges-POMPIDOU, Paris, in 1980.

SAITO, YOSHISHIGE (1904–). Japanese painter born in Tokyo. He was self-taught as an artist and after an interval of writing painted in a SURREALIST style from 1933. After the war he remained withdrawn from current art movements until he came to prominence in 1956 with his series of *Oni* pictures featuring Japanese demons. His first one-man show was at the Tokyo Gal. in 1958, and from this time he was recognized as one of the most important figures in Japanese abstract art. From expressive and LYRICAL ABSTRACTION he turned to a non-expressive mode, abandoning brushes and canvas and working with an electric drill on plywood covered with uniform monochromatic colour. These works made him known internationally and among many other awards he received the Grand Prix at the Tokyo Biennale, the International Painting Prize at the São Paulo Bienale, the prize of the Association International des Critiques d'Art and the painting prize at the Guggenheim International Exhibition.

SAKAI, KAZUYA. See LATIN AMERICA.

SALAMANCA, MANUEL. See SPAIN.

SALGADO, SUSANA. See LATIN AMERICA.

SALLINEN, TYKO KONSTANTIN (1879–1955). Finnish painter born at Narmes. He was the son of a tailor belonging to the strict puritan and fundamentalist religious sect of the Hihhulit, which constituted the background of his early years. After spending several years as an itinerant jobbing tailor in Sweden, he studied art in Helsinki and in 1909 went to Paris. There he was influenced by the FAUVES, particularly Van DONGEN, and by the structural innovations of Cézanne and the POST-IMPRESSIONISTS Van Gogh and Gauguin. His favourite subjects were the harsh Karelian landscapes and simple, unsophisticated peasant people of Finland, whom he painted in strongly brilliant but firmly organized colours. He was a member of the NOVEMBER GROUP and he came to be regarded as the nationalist Finnish painter *par excellence*. Among his masterpieces are *Washerwomen* (Ateneum, Helsinki, 1911) and *The Hihhulit* (Ateneum, Helsinki, 1918), the latter of which combines a harshly mannered medievalism with modern EXPRESSIONISM. His fame was international and he exhibited much both in Finland and abroad. He had memorial exhibitions in Stockholm and Helsinki in 1956.

SALON D'AUTOMNE. A recurrent exhibition founded in 1903 by the FAUVES together with artists from the Salon de la Nationale. BONNARD, ROUAULT, MATISSE and MARQUET were foundation members. The first Salon d'Automne included a Memorial Exhibition of Gauguin and the second a one-man show of 42 paintings by Cézanne, both of which made a deep impression on younger artists.

SALON DE LA NATIONALE. Founded as the Société Nationale des Beaux-Arts (often called the Salon du Champ de Mars) by Puvis de Chavannes, Eugène Carrière and Auguste Rodin in 1890 together with others who seceded from the official Salon des Artistes Français.

SALON DE MAI. A gallery founded in Paris in 1949 by the art historian and critic Gaston Diehl for the purpose of encouraging and exhibiting the younger abstract artists. With Gérard SCHNEIDER on the committee, the gallery did much to promote interest in abstract art during the 1950s.

SALON DES INDÉPENDANTS. In 1884 a Société des Artistes Indépendants was formed by a group of artists which included Seurat, Signac, Odilon Redon, Guillaumin and others. Its purpose was to organize exhibitions and by its constitution, which remained unchanged until the First World War, any artist had the right to exhibit on payment of a fee without a selection committee.

SALON DES RÉALITÉS NOUVELLES. Borrowing a phrase much used by Robert DELAUNAY, the antique dealer Fredo Sidès used 'Réalités Nouvelles' as the title of a CONSTRUCTIVIST exhibition which he organized with the collaboration of Madame van Doesburg at the Gal. Charpentier, Paris, in 1939. In 1946 Sidès opened the Salon des Réalités Nouvelles, which became the leading exhibition centre in Paris for geometrical abstraction.

SALT, JOHN (1937–). British-American painter born in Birmingham, England, studied first at the Birmingham College of Art and later at the Slade School, London. In 1968 he moved to New York and at once changed his style from a precise, mechanical type of abstraction to representational imagery in the tradition of PHOTOGRAPHIC REALISM. By the mid 1970s Salt had become one of the most popular and widely known of the American exponents of sharp-focus Realism. He had had exhibitions in most major cities of the United States, in Canada, Germany, France, Belgium, Italy, the Netherlands, Sweden and in England at the Ikon Gal., Birmingham, in 1965 and 1975.

Salt's principal theme was the automobile and the predominant subjects of his work were wrecked shells of cars, cars abandoned and left to rust in vacant lots or in the countryside. The images are precisely drawn in the meticulously detailed manner of a sharp-focus photograph and landscape elements—grass, trees, foliage—are presented in an equally detailed manner though always as a background to the image of the car. His theme is the feeling of waste and ruin resulting from material and technological prosperity. Like other photorealists his aim was to free his subject from romantic and subjective interpretation and to present his images with the perceptual and conceptual anonymity of a documentary photograph. His method of painting with an airbrush enabled him to achieve an evenness of treatment which gives to his work a corresponding impersonality.

SAMANT, MOHAN B. (1926–). Indian painter, born in Bombay and studied at the Bombay School of Art. In 1955 he received the Calcutta Art Society Gold Medal and in 1956 the Bombay Art Society Gold Medal and a Government of India prize. In 1957–8 he painted in Italy with a scholarship from the Italian Government. After travelling extensively in Europe he settled in New York. He had frequent one-man shows and took part in collective exhibitions in Bombay, New Delhi, Calcutta, Rome, Venice, Zürich, Munich, Hamburg, London and New York. He exhibited at the Venice Biennale in 1955 and 1957, at the São Paulo Bienale in 1957 and at the Carnegie Institute, Pittsburgh, in 1962. His work was included in the exhibition 'Commonwealth Art Today', at the Commonwealth Institute, London, in 1962–3.

SAMARAS, LUCAS (1936–). Greek-American sculptor and experimental artist, born at Kastoria. He obtained U.S. citizenship in 1955, studied at Rutgers University, 1955–9, and at the Columbia Graduate School of Art History, 1959–62. He taught at Yale University and at Brooklyn College. He had his first one-man show at Rutgers in 1955, exhibited in several New York galleries from 1959, at the Mus. of Contemporary Art, Chicago, in 1971, had a retrospective exhibition at the Whitney Mus. of American Art in 1972 and showed 'Pastels' at The Mus. of Modern Art, New York, in 1975. He was included in the exhibition 'The Condition of Sculpture' at the Hayward Gal., London, in 1975. At the end of the 1950s he was making figures from rags dipped in plaster and also did pastels combining SURREALIST fantasy and POP ART iconography. During the 1960s he developed an original style in the use of mixed media, employing thousands of pins, yarns, nails, etc., and he also experimented with ASSEMBLAGES of diverse objects. One of his 'boxes' was compared by the critic Michael Benedikt to the work of Joseph CORNELL, though 'inventive enough . . . to be striking in its own right'. He also experimented with light and reflection in his *Mirrored Room* (1966), a man-high room walled with mirrors in which the spectator was reflected endlessly. Surfaces disappeared and only corners and edges could be detected while spaces repeated endlessly, punctuated only by a three-dimensional lattice of illuminated edges. Samaras exemplified one aspect of Pop sensibility and was alert to the movement towards spectator participation. His main formal concern has been described as 'the enlargement of internal space through fragmentation'. He also achieved notoriety by his 'Autopolaroids' (which were photographs of the most intimate parts of the artist's own body), which he exhibited at the DOCUMENTA.

SANTA MARIA, ANDRÉS DE. See LATIN AMERICA.

SANTOMASO, GIUSEPPE (1907–). Italian painter, born in Venice and studied at the Venice Academy of Fine Arts. From 1937 he spent some time in the Netherlands and Paris and was influenced both by the EXPRESSIONISM of Van Gogh and by the CUBISTS, particularly LÉGER and BRAQUE. He also made a study of Byzantine mosaics. He illustrated Paul ÉLUARD's *Grand Air* with 27 drawings, which were exhibited at the Gal. Santa Radegonda, Milan, in 1945. In 1938 he joined the CORRENTE group, in 1946 he became a founding member of the FRONTE NUOVO DELLE ARTI, and in 1952 he was a member of the GRUPPO DEGLI OTTO PITTORI ITALIANI. His work developed in the direction of abstraction and in the 1950s he achieved a personal and poetic interpretation of the improvisatory manner of ART INFORMEL, influenced chiefly by HARTUNG. G. Marchiori wrote of this phase in his work: 'His personality is best expressed in the

invention of a coloured atmosphere in which each form strives towards a visual incantation, a harmony where painting and music truly blend.' From 1940 he had numerous one-man exhibitions in Italy, Paris and at the Hanover Gal., London (1943). In 1954 he was awarded First Prize for Italian Painting at the Venice Biennale.

SANZ, EDUARDO. See SPAIN.

SASH, CECILY (1925–). South African painter, born in Delmas, a small town in the Transvaal, and trained as an art teacher at the Witwatersrand Technical College Art School in Johannesburg (1943–6). She had a year of study in London and on the Continent (1948–9), and later took a degree in Fine Art at the University of the Witwatersrand, Johannesburg (1952–4). After teaching for some years at a girls' school she made herself known throughout South Africa as an advanced and dynamic teacher and educationist at the University of the Witwatersrand, where she was Senior Lecturer in charge of Design. In 1965 she received an Oppenheimer grant and spent a year on the study of attitudes to art education in England and the U.S.A. In South Africa she was much consulted on matters to do with art education.

Her painting style showed a restless search for a valid personal expression, changing over the years but remaining her own and never losing a brittle piquancy of observation and an ever more brilliant and fastidious quality of draughtsmanship. Seen in retrospect her canvases, in spite of periods of both expressive and formal abstraction, seem to reflect her environmental preoccupations, especially with plants, birds and other creatures. She believed that there is a conscious awareness of the African background in all sensitive South African artists. For many years she worked as a muralist, especially in mosaic, a medium in which her manner took on a dry glitter, and she latterly designed tapestries woven in Aubusson and South Africa. Neither of these media was allowed to obscure the linear character of her technique. In the 1970s she experimented with spatial ambiguity of a somewhat unusual kind, achieved by a combination of linear and modelled forms, usually with very brilliant colour. Her palette varied greatly over the years, approaching almost pure monochrome in the 1950s.

SASSU, ALIGI (1912–). Italian painter, born in Milan. He was a founding member of the COR-RENTE association formed in 1938 to combat the Fascist suppression of innovative art, and was a member of the Milanese *avant-garde*. After passing through a FUTURIST phase Sassu matured a style of imaginative EXPRESSIONISM with evocative brushwork and strong colours.

SATO, KEY (1906–). Japanese painter born in Ōita. After painting in a representational style in Japan he emigrated to Paris after the Second World War, became a member of the ÉCOLE DE PARIS and adopted the TACHIST style of LYRICAL ABSTRACTION. He used subdued colours and mineral forms.

SAURA, ANTONIO (1930–). Spanish painter, born in Huesca. He was self-taught and began painting during a long illness in 1947. During two years in Paris, 1953–5, he made contact with members of the SURREALIST movement, including André BRETON. After his return to Spain, however, he quickly abandoned Surrealism and worked in the direction of expressive abstraction. In 1957 he became a founding member of the EL PASO group in Madrid and during the following years he was among the most active of its members in signalling protest against the Franco regime. The expressiveness of his work became increasingly violent and he was known as perhaps the most powerful exponent of TACHISM in Spain. It has been said that his stormy paintings in blacks and greys on white suggest 'an image of sorrow and revolt with a marked social intention'. His *Great Crucifixion* (Boymans-van Beuningen Mus., Rotterdam, 1963) is an extraordinarily impressive work in this style. He obtained a Guggenheim prize in 1960, a Carnegie prize in 1964, the Grand Prize at the White and Black Biennale, Lugano, in 1966 and First Prize at the Menton Biennale in 1968. He exhibited in many places outside Spain, including Paris, London, New York, Buenos Aires, Rio de Janeiro, Munich, Stockholm, Milan, Brussels, Amsterdam, Rome, and his work was included in many of the more important international exhibitions during the 1960s and 1970s. Among other public collections he is represented at The Mus. of Modern Art and the Guggenheim Foundation, New York, the Fogg Art Mus., Harvard, the Carnegie Institute, Pittsburgh, at the Tate Gal. and the British Mus., London, the Bibliothèque Nationale, Paris, and in the museums of modern art at Caracas, Buenos Aires and Rio de Janeiro.

SAVINIO, ALBERTO (1891–1952). Italian musician, writer and painter, brother of Giorgio de CHIRICO, born in Athens. He was prolific as a composer and during a stay in Paris from 1911 to 1915 he was a member of the Soirées de Paris organized by APOLLINAIRE. He was active as theorist and writer in the METAPHYSICAL School. He began to paint in 1927 and was considered one of the leaders of SURREALISM in Italy. A retrospective exhibition of his work was given at the Gissi Gal. d'Arte, Turin, in 1967.

SCANAVINO, EMILIO (1922–). Italian painter and sculptor born at Genoa and studied at the Liceo Artistico there. He was associated with the SPAZIALISMO movement introduced by Lucio FON-TANA after the Second World War and during the 1950s he was one of the leading proponents of Italian INFORMALISM. He was also associated with the Phases group. After turning his hand briefly to

pottery and sculpture he settled in Milan in 1958. In 1960 he had a one-man exhibition at the Venice Biennale.

SCHAEFER, CARL. See CANADA.

SCHAMBERG, MORTON LIVINGSTONE (1881–1918). American painter born in Philadelphia, where he first studied, afterwards going to Paris in 1906. He was a member of the New York DADA group and exhibited at the 1917 exhibition arranged by the SOCIETY OF INDEPENDENT ARTISTS. He was perhaps the first to use the machine image as the basis for the clear-cut geometrical art of PRECISIONISM, in all probability elaborating this idea from the 'functionless' machines of PICABIA. Examples of his work are *Mechanical Abstraction* (Philadelphia Mus. of Art, 1916) and *Machine* (Yale University Art Gal., 1916). His death in 1918 cut short what promised to be an important contribution to the development of a specifically American school of CUBISM.

SCHAPIRO, MIRIAM (1923–). Canadian-American painter born at Toronto, studied at the State University of Iowa, 1944–9. She obtained a Tamarind Fellowship in 1963. Her first one-man show was at the University of Missouri in 1950; from 1958 she exhibited regularly at the Andre Emmerich Gal., New York, and in 1969 she had retrospectives at Newport Harbor Art Mus., Balboa, California and (with P. Brach, to whom she was married) at La Jolla Mus. of Art. Among the collective shows in which she was represented were: University of Nottingham, England, 'Abstract Impressionists', 1958; The Mus. of Modern Art, New York, 'New Talent, 1958', and 'Abstract American Drawings and Watercolors', circulated to Latin America, 1961–3; San Francisco Mus. of Art, 'Directions—Painting USA'.

SCHEIBE, RICHARD (1879–1964). German sculptor born at Chemnitz. He studied painting at Munich and became a close friend of KOLBE at Rome. He took up sculpture in 1907 and worked under the influence of MAILLOL. He taught at the Städelschule, Frankfurt, from 1925 to 1933 and in 1936 joined the staff of the Berlin Academy. Under the Nazi regime he produced a number of public monuments in the style favoured by the National Socialists.

SCHETTINI, ULRICO. See MONTEFIORE.

SCHIELE, EGON (1890–1918). Austrian painter, born at Tulln on the Danube. From 1906 he studied at the Vienna Academy of Art under Christian Griepenkerl (1839–1916), then joined the *Wiener Werkstätte* and in 1909 left the Academy and participated in the HAGENBUND exhibitions with the *Neukunstgruppe*. At this time his work was under the influence of KLIMT. Between 1909 and 1913 he had matured his own style, which was EXPRESSIONIST in character although Schiele was not formally within the Expressionist movement, and by 1914 he was painting in a flat, highly individual and somewhat mannered style. During the war years he was employed as a War Artist. In 1918 he showed at the 49th exhibition of the Vienna SECESSION and for the first time achieved international acclaim, dying a few months afterwards of Spanish influenza.

A large retrospective exhibition of Schiele's work was staged at the Haus der Kunst, Munich, in 1975 and revealed to critics the outstanding quality of his draughtsmanship and his sensitive gift for portraiture—aspects of his talent which had earlier sometimes been overshadowed by the preciosity which he often cultivated. As stated in an appreciation by Michael Ratcliffe: 'In a mere eight years of activity he had established himself as one of the most spontaneously gifted draughtsmen of all time—he drew with the speed of a man writing a letter full of news—and he left behind a body of paintings, drawings and water-colours which, though informed by the obsessive self-regard of the first Freudian age, is wholly individual and could never be mistaken for that of anyone else.' During the 1970s Schiele's work came to be more and more highly valued both for its confident mastery and economy of line and for the compassion which infuses his repulsive images of humanity.

SCHIFANO, MARIO. See ITALY.

SCHIPPERS, WILLEM THEODOR (1942–). Dutch graphic and experimental artist born at Groningen and trained at the Institute of Arts and Crafts, Amsterdam. He is chiefly known for the soft and loathsome blown-up *Lilac Chair* set up for him in 1965 in the Vondel Park, Amsterdam, and for a television programme entitled *Hoepla*.

SCHIRREN, FERDINAND (1872–1944). Belgian sculptor and painter, born at Antwerp. He trained as a sculptor at the Académie des Beaux-Arts, Brussels, and as a sculptor joined the association *La Labeur* in 1899. He worked in broad expressive planes and masses, as in the bronze *La Servante* of 1910, sometimes in his portraits breaking up the surface so as to cause the subject to be animated by falling light in a manner which foreshadowed the romantic portraits of EPSTEIN. He began painting in 1905 without formal training but taking his inspiration from FAUVISM and he was a leading figure of the Brabant Fauvists, with whom he exhibited in 1912. From 1919 to 1922 he worked in Paris and Nice, settling in Brussels in 1923. During this period his painting style underwent the influence of CUBIST simplifications and he endeavoured to construct his compositions from geometrically simplified planes and masses indicated by pure colour. An example of this phase of his work is *La Femme en Bleu* (Mus. Royaux des Beaux-Arts, Brussels) painted at Nice in 1921. From the 1920s

he painted chiefly in water-colour, applying the resources of rich Fauvist colours to Impressionist elegance.

SCHJERFBECK, HELENE (1862–1946). Finnish painter, born in Helsinki. After studying at Helsinki she worked in Paris under Bastien-Lepage and Puvis de Chavannes. She first attracted attention with her *plein air* landscapes of the 1880s, which were remarkable for the freshness of their colouring. From *c.* 1900 she lived in retirement owing to ill health and gradually evolved a highly personal style of simplified abstraction with sophisticated colouring in virtue of which she was later recognized as one of the most important pioneers of modern art in Finland. Recognition came late and these works were not exhibited until 1937. She was described by John Boulton-Smith in his book *Modern Finnish Painting and Graphic Art* (1970) as 'a genuine, small, highly-civilized master, and no painter in Scandinavia made a more intelligent and original contribution to the early modern movement, save only Munch'. A large memorial exhibition of her work was staged in Helsinki in 1954.

SCHLEMMER, OSKAR (1888–1943). German painter, stage designer and sculptor. He was trained at the Stuttgart Academy under Adolf HOELZEL, who was at that time the leader of the *avant-garde*. During his student days he made a lifelong friend of Willi BAUMEISTER and met other artists in the circle formed around the Swiss artist Otto MEYER-AMDEN. In 1914 he designed mural decorations for the German Werkbund Exhibition at Cologne. He was wounded in 1915 during military service and in 1917–18 was military cartographer at Colmar. In 1919 he exhibited at the STURM Gal., Berlin, and in the same year produced his first abstract relief sculpture of a human figure reduced to a commingling of geometrical and organic shapes. He continued to explore the rhythmic interplay of convex and concave shapes and in 1921 produced abstract free-standing sculpture. From 1920 to 1929 he taught at the BAUHAUS, both stone-carving and then also as head of the department of theatrical design. He did much work for the theatre including designs for the CON-STRUCTIVIST *Triadic Ballet* to music by Hindemith (1922), productions of *Hamlet* and *Don Juan* in Berlin and De Falla's *La Vida Breve* in Magdeburg. He was appointed Professor at the Academy of Breslau in 1929 and in the same year he painted murals for the Hall of Fountains at the Folkwang Mus., Essen (destroyed in 1933). In the early 1930s he was experimenting with wire constructions and constructional reliefs. In 1937 his works were included in the Munich exhibition of DEGENERATE ART. His latest paintings, *c.* 1940, were small water-colours, variations of the view of lighted windows by night, done at Wuppertal where he worked in a paint laboratory.

Schlemmer displayed a mystical temperament from his early years. He made it his aim through extreme simplification of shapes to achieve the 'inner vision granted by intercourse with nature'. In painting he tried to translate the fugitive movements of dance into a static medium and by his grouping of forms to create an irrational space reflecting existential states rather than the emotional moods of men. Thus he was in reaction from EX-PRESSIONISM and he shared something with the French PURISTS and something with the Constructivists. His conception of art is expressed in his own aphorism: 'Dionysian in origin, Apollonian in manifestation, symbol of a unity of nature and spirit.'

SCHMALZIGAUG, JULES (1882–1917). Belgian painter born at Antwerp. Brought up in Antwerp, he went to Germany in 1900 and to Rome in 1905. He was Secretary of *L'Art Contemporain* in Antwerp. In his early period he worked in the manner of Flemish EXPRESSIONISM but he was converted to a new path as a result of the strong impact made upon him by the FUTURIST exhibition at Paris in 1912. He settled in Venice and in 1914 he exhibited with the Futurists in Rome. He was less concerned with the Futurists' ideas about the representation of movement than with the expressive aspects of their work and he was influenced chiefly by SEVERINI's applications of DIVISIONISM and by the expressive abstraction of BOCCIONI's *Stati d'animo*. In his own work he was particularly interested in investigating the problems of light and he studied the use of white for the purpose of defining the space around represented figures. Outstanding examples of this aspect of his work are the portraits done at the end of his life, *Baron Francis Delbreke* and *Mme Nelly Hurrelbrink* (Mus. Royaux des Beaux-Arts, Brussels, 1917). He passed the First World War in the Netherlands, where he worked out his theories of colour and formalized them in a treatise *La Panchromie*. In this he distinguished between the representational or 'narrative' function of colour and the use of colour to express a state of mind. He also developed theories of the simultaneous contrast of 'colour-light' which differed from those of Chevreul mainly by the emphasis which he placed upon light and by his special theory of what he called 'colour padding'. Schmalzigaug is regarded as the leading representative of Futurism in Belgium.

SCHMIDTOVÁ, NATALIA (1895–). Czech NAÏVE painter, born at Dobrinka in the Tambov, Russia. She worked as a governess and a farm labourer while living at Prokurovka, 1915–18, where she married an Austrian prisoner of war, Hugo Schmidt, and began painting in 1944 while living in Zlín. She exhibited in Prague in 1964 and at the Pierre Gal., Paris, in 1957. She was represented in the 'Self-Taught and Folk Artists' exhibition at the Mánes Artists' Club, Prague, in 1963 and at an exhibition of 'Naïve Art' in Czechoslovakia which toured Brno, Bratislava, Prague, Ostrava, 1963–4.

She was also shown in exhibitions of naïve art at Salzburg, Graz, Linz. In an exceedingly lively but unsophisticated disposition of figures she depicted village scenes and festivals, scenes remembered from childhood. Her pictures had the rhythm and spontaneity of children's drawing rather than the minute attention to detail which characterizes the work of naïve artists such as VIVIN.

SCHMIDT-ROTTLUFF, KARL (*né* SCHMIDT, 1884–1976). German painter, born at Rottluff near Chemnitz, studied architecture at the Technische Hochschule, Dresden, and in 1905 became one of the founders of the BRÜCKE. His style was more vigorous and harsher than that of the other members of the *Brücke*. It was particularly forceful in his woodcuts, whose abrupt manner was reflected in his paintings with their flat ungraduated planes of contrasting colours. In 1906 he stayed with NOLDE on the island of Alsen and derived from him the 'monumental Impressionism' which was exemplified in landscapes painted at Dangaster, which he visited with HECKEL in 1907. In 1911 he moved to Berlin, where his manner of monumental painting in harsh simplified forms with crudely contrasting, unmodulated colours was intensified by an interest in NEGRO SCULPTURE. Later, perhaps under the influence of KIRCHNER or a trip to Paris in 1924 and a longer stay in Italy in 1930, he modified his crude planar forms by the introduction of perspective and graded colouring. In 1931 he became a member of the Prussian Academy in Berlin. He was dismissed from it in 1933 and forbidden to paint in 1941. From 1947 he taught in the Berlin Hochschule für Bildende Künste.

SCHNEIDER, GÉRARD (1896–). Swiss-French painter born at Sainte-Croix, Vaud, Switzerland. After studying at the Academy of Neuchâtel he went to Paris in 1916 and worked at the École des Beaux-Arts, 1918–20. He was in Switzerland from 1920 to 1924, when he returned to Paris and took up the profession of picture restorer. After experimenting successively with POST-IMPRESSIONISM, CUBISM, SURREALISM and expressive Realism, he turned to expressive abstraction in 1944 and became one of the leaders of ART INFORMEL. Working in a thick impasto, he regarded his painting as a form of visual music and he was reluctant to give his pictures a title because he believed that they expressed a psychic state which could not otherwise be described. He claimed that abstraction was not a break with the past but a logical outcome of what had all along been inherent in artistic development. He exhibited at the Salon d'Automne in 1926, at the Salon des Surindépendants from 1935 to 1940 and from 1945 to 1946, at the SALON DES RÉALITÉS NOUVELLES from 1947 to 1949 and at the Salon de Mai from 1949. He had one-man shows both in Paris and abroad, including a large exhibition at the Kootz Gal., New York, in 1958 and one at the Gal. Arnaud, Paris

in 1967. He became a French citizen in 1948.

SCHÖFFER, NICOLAS (1912–). Hungarian-French sculptor and experimental artist born at Kolocsa, studied at the Academy of Art, Budapest, and at the École des Beaux-Arts, Paris. He settled in Paris in 1937 and took French nationality. He started with sculpture in the CONSTRUCTIVIST tradition inaugurated by GABO and MOHOLY-NAGY, using space as a sculptural element, but in 1948 he began his 'spatiodynamic' constructions, which were open vertical towers constructed of plexiglass or thin metal plates from which light was reflected. To these he added movement in 1950 and sound in 1954. This was expanded into an audio-visual, spatiodynamic spectacle when at Liège in 1961 he built a luminous, sounding and moving tower 52 m high. Schöffer was among the most ingenious and inventive of the many experimental artists who exploited space, movement, light and sound in the service of artistic experience. Financed by the firm Philips and helped by the collaboration of their technicians he created his first 'cybernetic' sculpture in 1956. This was a robot, *CYSP 1*, which responded to colours and sounds. It was made to perform at a *Nuit de la Poésie* at the Sarah Bernhardt theatre and at the Académie des Beaux-Arts, Amsterdam. In 1957 he gave a 'luminodynamic' spectacle at the Grand Central Station, New York, and in 1966 he had his first one-man exhibition in the U.S.A., at Washington Gal. of Modern Art and subsequently at Minneapolis, Pittsburgh and Seattle. He planned cities of leisure raised on pylons above the ground and other grandiose projects involving the conditioning of living-space by the most sophisticated technological means. He was a confirmed believer in the multiple and many of his smaller inventions were intended to be mass-produced and offered for sale at moderate prices. He was awarded the Grand Prix at the Venice Biennale of 1968.

SCHOLZ, GEORG (1890–1945). German painter, born in Wolfenbüttel. He studied art in Berlin under CORINTH, joined the Berlin NOVEMBERGRUPPE and subsequently taught at the Karlsruhe Academy of Art until 1933. His work belonged to the NEUE SACHLICHKEIT school of social criticism, depicting urban man at the mercy of the machine. Although not in the first rank of artists, he popularized the realist manner of GROSZ and DIX.

SCHOLZ, WERNER (1898–). German painter born in Berlin, where he studied art after the First World War. Under the National Socialist regime his work was declared DEGENERATE and during the Second World War his studio was destroyed in an air raid. Scholz belonged to the second-generation EXPRESSIONISTS, influenced by the artists of the BRÜCKE and in particular by NOLDE, and was highly regarded among the Expressionists of his day. His work had vigour without sensitivity and

depended to a large extent on emphatic black and white contrasts. In substance his painting of this period expressed sadness and sympathy for the rigours of city life. After the Second World War he turned to religious themes, visionary portraits and large pastels on Old Testament subjects.

SCHOOL OF PARIS. See ÉCOLE DE PARIS.

SCHOONHOVEN, JAN (1914–). Dutch painter, sculptor and experimental artist born at Delft and studied at the Academy of Art, The Hague. He was a member of the NUL group. He exhibited among other places at the Gunar Gal., Düsseldorf (1959), the Køpcke Gal., Copenhagen (1960), the New Vision Centre, London (1960), the Denise René Gal., Paris (1963), and he was represented in a number of international exhibitions including the São Paulo Bienale in 1967. He was known chiefly for his white panel reliefs and constructions made of papier mâché.

SCHREIB, WERNER (1925–1969). German artist born in Berlin. After training as an engineer and attending technical schools at Kiel and Wiesbaden he travelled in England, France, Spain and North Africa during the 1950s and in 1959 studied at the Académie Ransom, Paris, and HAYTER's Atelier 17. In 1959 he won the Grand Prix Internationale de Gravure at the First Paris Biennale. He worked by a method which he called *Cachetage*, i.e. casual odds and ends such as nails, screws, bottle caps, studs, buttons, coins, etc. were sealed into a built-up ground of a resinous substance such as bakelite, the surface of which had been gouged and etched into decorative patterns. He also used quasi-semantic signs such as circles and crosses and horizontal lines which gave a superficial impression of newsprint. In 1961 he issued with the Italian painter Luciano LATTANZI a joint manifesto entitled 'On the Semantic Picture', and in 1967 he published a manifesto 'On Semi-Mechanical Production'. His work was on the borders of expressive abstraction but had affinities with both ARTE POVERA and SEMANTIC ART.

SCHRIMPF, GEORG (1889–1938). German painter, born in Munich. He was self-taught, beginning to paint while working as a labourer in Berlin. His first paintings, which were done in a crude EXPRESSIONIST manner, were exhibited at the STURM Gal. In 1920 he visited Switzerland and Italy and was influenced by the ideas of the VALORI PLASTICI. From 1926 to 1933 he taught at the School of Applied Art, Munich, and later at the Schöneberg Academy, Berlin. He belonged to the more romantic strands of NEUE SACHLICHKEIT represented also by KANOLDT, but his work always retained something of the naïvety of the amateur or primitive painter.

SCHRÖDER-SONNENSTERN, FRIEDRICH (1892–). German NAÏVE painter, born in Lithua-nia. After a childhood of extreme poverty he was put in a home for adolescents in 1906 and worked as a labourer for a circus in 1910, subsequently travelling as a preacher, magnetist, singer, prophet, etc. and finding a living as smuggler, postman, gardener's helper and other casual occupations. He served in both World Wars. In the Second World War he deserted, was imprisoned, transferred to a lunatic asylum and with a paralysed leg lived in the ruins of Berlin. He began to draw and paint in 1949 and attracted the interest of Professor Kubiczek. His work was exhibited in Berlin, Paris, Hamburg, Basle and elsewhere and was bought, among others, by Henry Miller, André BRETON, Jean DUBUFFET and Hans BELLMER. His pictures had a crude and grotesque symbolism reminiscent of Hieronymus Bosch and bordering on the schizophrenic, often combined with the pornographic voyeurism of an adolescent. It has been said: 'Sonnenstern's pictures, which prove shocking to any Philistine taste, seem to me not only obscene, but also quite enlightening. They are expressions of madness in an artistic medium, mannered and yet naïve, contradictory in themselves and yet unified in their succinct presentation of archaic and demonic concepts. They are up-to-date and singular manifestations of the subconscious.' Some of the pictures, such as *The Magic Ship of State* (1956) and *Diplomatic Courtship* (1959), carry social and political satire beneath their grotesquerie.

SCHUFFENECKER, ÉMILE. See SYNTHETISM.

SCHULTZE, BERNHARD (1915–). German painter born in Schneidemühl, West Prussia, and studied at Berlin and Düsseldorf, 1934–9. After military service in the war he settled at Frankfurt in 1947, frequently visiting both Paris and New York. In 1967 he won the Art Prize of Darmstadt and in 1970 that of Cologne. His works were exhibited widely in Germany and also in New York, California, Paris and Rome. His early works were SURREALIST and fantastic. Gradually abstract forms encroached upon his figurative themes until at the beginning of the 1950s he was painting expressive abstractions resembling the spontaneous TACHISM of WOLS and LANSKOY but with distinctively morbid and glaring colours. He was at this time a member of the group of Frankfurt Tachists who named themselves QUADRIGA. About the mid 1950s he began to give his paintings genuine relief by the use of strings, straws, etc., garishly coloured, which he called 'tentacles'. In the 1960s he produced more fully three-dimensional works, which he called *Migofs*, using wire mesh and padding encased in cloth and canvas impregnated with resin. Under the influence of POP ART he later began to incorporate coloured photographs and KINETIC elements into these works.

SCHULZ, KONRAD (1940–). German sculptor born in Elbing, studied from 1961 to 1966 at

the Hochschule für Bildende Künste, Hamburg, where Eduardo PAOLOZZI was among his teachers, and in 1967 won a scholarship to the Royal College of Art, London. His work was exhibited widely in Germany and he participated in many collective exhibitions. It was distinguished by his exploitation of 'ring forms' vaguely suggestive of car tyres. He used iron, aluminium, tyres, foam rubber, plexiglass and fibreglass.

SCHULZ SOLARI, OSCAR AGUSTÍN ALEJANDRO. See XUL SOLAR.

SCHUMACHER, EMIL (1912–). German painter, born in Hagen and trained at the Dortmund School of Arts and Crafts, 1923–5. He joined the ZEN group and in 1958 the ZERO group. He taught at the Hamburg Academy of Art from 1958 to 1960, and in 1966 at the Karlsruhe Academy. About 1953 he turned to LYRICAL ABSTRACTION and painted in the manner of the Frankfurt group QUADRIGA. Later in the decade he began to use *haute-pâte* and to make relief paintings, which he called 'tactile objects'. They were like old weathered walls full of cracks somewhat in the manner of TÀPIES. He had a major exhibition at the Westfälischer Kunstverein, Münster, in 1962.

SCHUMACHER, ERNST (1905–63). German painter born at München-Gladbach and trained in Düsseldorf. From 1933 he lived in Berlin and in 1947 was appointed Professor at the Berlin Hochschule für Bildende Künste. He painted townscapes and architectural pictures with the colours of the FAUVES but with a solider, more geometrical structure. Later the tendency to severer structure and interlocking colour-planes dominated his work.

SCHWITTERS, KURT (1887–1948). German DADAIST artist. He studied at the Dresden Academy and his early work was EXPRESSIONIST in manner, although he later repudiated expression as a main purpose of art. He came under the influence of KANDINSKY and in 1918 exhibited at the STURM Gal., Berlin. After the end of the war he settled in Hanover, where he invented a kind of Dada which he called by the invented name 'Merz' and from 1923 to 1932 edited the magazine *Merz*. The name 'Merz' was meaningless and was reached by chance when fitting the letterhead of the Commerz- und Privatbank into a collage. In an attempt to free art from traditional materials and techniques, and equally from an idealistic or socially motivated striving for 'expression', he constructed a new and individualistic form of COLLAGES from the detritus of urban civilization, obsessively collecting refuse such as used bus-tickets, stamps, nails, hair, old catalogues, etc. and building them up into pictorial compositions. In 1922 he went with Van DOESBURG on a Dada lecturing tour through the Netherlands. In 1932 he was a member of the ABSTRACTION-CRÉATION group. He

emigrated to Norway in 1937 and in 1940, after the German conquest of Norway, fled to England. While he lived in Hanover Schwitters was comfortably off, drawing an income from four houses he inherited, working as graphic consultant to the municipality and owning his own advertising studio, Merz-Werbezentrale. But his work had been declared DEGENERATE by the National Socialist regime, his pictures had been removed from German museums, his publications burnt and he had been forbidden to seek employment. He was only able to take work from Germany to Norway because the Customs had declared it worthless. On arrival in England he was at first interned with other German refugees but was released in 1941 and joined Max ERNST in London. In 1944 he was given an exhibition in the Modern Art Gal., to which Herbert READ wrote the Introduction to the catalogue, describing Schwitters as 'one of the most genuine artists in the modern movement', 'the supreme master of collage', and 'a poet parallel to James Joyce'. In 1945 he settled at Ambleside in the Lake District and made a living doing portraits and saleable landscapes, while continuing to do collages in the 'Merz' manner.

From 1919 to 1924 he published articles and poems in the periodical *Der Sturm* and he published poems dedicated to an imaginary mistress, Anna Blume, at Hanover in 1922. His *Sonate in Urlauten*, an experiment in meaningless linguistic sounds, was recited at the BAUHAUS in 1924 and published in 1932.

Schwitters also made a type of CONSTRUCTIVIST sculpture from casual refuse and discarded junk, calling it *Merzbau*. The first construction, at Hanover, was destroyed by bombing in 1943; a second, in Norway, was left unfinished when he fled to England and was destroyed by fire in 1951; a third, begun at Ambleside, England, with funds supplied by The Mus. of Modern Art, New York, was unfinished at the time of his death.

SCIALOJA, TOTI (1914–). Italian artist born at Rome, where he was editor of the magazine *L'Immagine* and wrote on the new tendencies in Italian art. He began painting c. 1940, working in the EXPRESSIONIST tradition of SOUTINE which had inspired SCIPIONE. After experiments in the post-CUBIST manner, he returned to an expressive use of colour and is considered one of the more important artists in the younger generation of the ROMAN SCHOOL. After a visit to New York in 1959–60 he was influenced by American HARD EDGE painting and his painting evolved in this direction. With muted grey rectangles creating advancing and receding planes he built curious spatial ambiguities. From 1953 he taught at the Academy in Rome.

SCIPIONE (GINO BONICHI, 1904–33). Italian painter born at Macerata near San Marino and studied at the Academy of Art, Rome. His artistic career began c. 1927 when he exhibited with MAFAI and virtually ended in 1931, when he was com-

pelled to enter a sanatorium suffering from tuberculosis, which brought about his premature death. Although his production was concentrated within so short a period, his influence persisted and to him is chiefly attributed the effective introduction of romantic EXPRESSIONISM into Italy and with Mafai he is regarded as the founder of the ROMAN SCHOOL in 1928. Comprehensive exhibitions of his work were held posthumously at the Venice Biennale of 1948 and in the Gal. of Modern Art, Rome, in 1954. Influenced by El Greco and Goya, and among the moderns chiefly by SOUTINE and PASCIN, his pictures had a strong element of fantasy and at times displayed a visionary character.

SCOTT, TIM (1937–). British sculptor born in London. After training at the Architectural Association he studied at the St. Martin's School of Art under Anthony CARO and from 1959 to 1961 worked at the Le Corbusier–Wogenscky studio, Paris. Scott was one of the new school of British sculptors who came to public notice with the 'New Generation' exhibition at the Whitechapel Art Gal. in 1965. His work during the 1960s consisted mainly of highly simplified non-representational constructions composed of thick blocks and slabs of perspex, acrylic and forged steel. He had one-man exhibitions at the Waddington Gals., London (1966, 1969, 1971, 1974, 1975), at the Whitechapel Art Gal. (1967), the Mus. of Modern Art, Oxford (1969), the Lawrence Rubin Gal., New York (1969, 1971, 1974), the Mus. of Fine Arts, Boston, and the Corcoran Gal. of Art, Washington (1973). Among the group shows in which he was represented were 'Primary Structures' at the Jewish Mus., New York (1966) and 'The Condition of Sculpture' at the Hayward Gal., London (1975). His works shown at the Waddington Gals. in 1975 and 1977 were made of rusted or painted steel bars and girders bolted or riveted into more flowing and flexible, less chunky forms than formerly.

SCOTT, WILLIAM (1913–). British painter of mixed Scottish and Irish descent, born at Greenock on the Firth of Clyde. He was trained at the Belfast College of Art, 1928–31, and from 1931 to 1934 at the Academy Schools, London, where he won prizes for both painting and sculpture. His early painting consisted mainly of figural work under the influence of Cézanne and BONNARD. After an interval during the war years he concentrated in the latter 1940s chiefly on still life, favouring kitchen objects. Examples from this period are: *Mackerel on a Plate* (Tate Gal., 1951–2); *Frying Pan and Eggs* (National Gal. of New South Wales, 1949); *The Frying Pan* (Arts Council of Great Britain, 1946). He himself said of his painting at this time: 'I picked up from the tradition of painting in France that I felt most kinship with— the still life tradition of Chardin and Braque, leading to a certain kind of abstraction which comes directly from that tradition.' His work continued to be mainly based on still life with increasing abstraction, though a new conception of space entered in from *c.* 1951, until the late 1950s, when he was painting pure abstractions with titles such as *Blue Painting* (Albright-Knox Art Gal., Buffalo, 1960); *White and Sand Colour* (Gal. des 20. Jahrhunderts, Berlin, 1960); *Nearing Circles* (Edinburgh Weavers, Carlisle, 1961). Although these pictures were composed of circles, squares, etc., they were not geometrically exact but bounded by sensitive, painterly lines. He remained within the field of the painterly and did not graduate towards the machine-like type of abstraction.

Scott was elected a member of the LONDON GROUP in 1949, was invited in 1951 by the Arts Council to do a large painting for the Festival of Britain and in 1958 had a retrospective exhibition at the Venice Biennale. He was awarded First Prize in the British Painting section of the 2nd John Moores Exhibition at Liverpool and the International Critics' Purchase Prize at the 6th São Paulo Bienale. He was Ford Foundation artist in residence in Berlin, 1963–5. In 1955 he wrote: 'I should like to combine a sensual eroticism with a starkness which will be instinctive and uncontrived.' In the late 1960s and 1970s his paintings became more austere. He juxtaposed abstract shapes based remotely on frying pans, saucepans, plates, jugs, etc. against a white or flat monochrome background. A retrospective exhibition of his paintings, drawings and gouaches was given at the Tate Gal. in 1972 and a smaller exhibition was given by Gimpel Fils in Zürich and London in 1974. He was created C.B.E. in 1966.

SCOTTISH COLOURISTS. See FERGUSSON, John Duncan.

SCULLY, LARRY. See SOUTH AFRICA.

SEAGO, EDWARD (1910–74). British painter, born at Norwich. He had his first one-man exhibition in London in 1929 without previous artistic education. During the early 1930s he spent much time with travelling circuses in Britain and on the Continent and from 1937 became interested in the ballet as a subject for painting. During the Second World War he served with the Royal Engineers and designed the Insignia and Colours for the Airborne Forces. In 1944 he was invited by Field-Marshal Alexander to paint in Italy during the Italian campaign and the work he then did was exhibited in 1945 at the Colnaghi Gal., London, where he continued to exhibit annually until 1967. In 1953 he was appointed an official Coronation artist and in 1956–7 he accompanied the Duke of Edinburgh on his world tour. An exhibition of the pictures he painted during the tour was held at St. James's Palace in 1957.

Outside Great Britain his work was exhibited in New York (1938, 1952, 1956), Chicago, Los Angeles, San Francisco, Toronto, Tokyo, Johannesburg, Zürich, Brussels, Oslo and Bergen. A retrospective loan exhibition was given in 1962 at

the Castle Mus., Norwich, and a Memorial Exhibition was held in December 1974 at the Marlborough Fine Art Gal., London. Seago was primarily a landscape painter and remained consistent to his own Impressionist idiom. He was an intensive student of the works of Constable, Turner and Boudin, and in the opinion of some critics he was one of the most successful in adapting Impressionist technique to the English landscape tradition. In his Introduction to the catalogue of the 1974 Memorial Exhibition Laurens van der Post attributed his great appeal for 'all layers of society from working classes to royalty' to 'the fact that his most significant work was a celebration of the beauty and wonder of the natural world from which modern man is so profoundly separated in the dark, satanic atmosphere of the cast-iron surround of his increasingly metropolitan life'.

SEARLE, RONALD (1920–). British graphic artist, born at Cambridge and trained at the Cambridge School of Art. His first humorous drawings were published in the *Cambridge Daily News* when he was fifteen. During the Second World War he was captured by the Japanese. After his release in 1946 he worked in England, on the Continent and later in America as a special feature artist for *Holiday Magazine* and *Life*. Four films have been based on his characters. In 1956 he joined the staff of *Punch*. He has published albums of his drawings and has illustrated more than 40 books.

SECESSION (SEZESSION). During the last decade of the 19th c. progressive artists in many German and Austrian towns found themselves out of sympathy with the official establishment or unable to exhibit their works freely with the traditional organizations. They therefore 'seceded' by founding their own organizations and exhibition societies. The name given to such a breakaway group was *Sezession*. The first of these associations was formed in Munich in 1892, its leading members being Franz von Stuck (1863–1928)—later a teacher of KANDINSKY—and Wilhelm Trübner (1851–1917). The Vienna Secession was formed in 1897 with Gustav KLIMT as its first President and issued the magazine VER SACRUM. The *Berliner Sezession*, founded in 1899, was led by Max LIEBERMANN, the protagonist of German Impressionism. When in 1910 a number of younger painters had their works rejected by the *Sezession*—including members of the BRÜCKE—they formed their own *Sezession*, the *Neue Sezession*, under the leadership of Max PECHSTEIN. The older *Sezession* was again split in 1913 by the breakaway of the *Freie Sezession* with Max BECKMANN and Ernst BARLACH in the lead.

SECTION D'OR. The 'Golden Section' was the name given in the 19th c. to the division of a line into two lengths, a and b, so that $a:b = b:a+b$. Euclid called this 'extreme and mean ratio'. It is the only ratio (i.e. quantitative relation between two magnitudes) which is also a proportion (i.e. similarity between ratios). For while a proportion requires three terms, in the Golden Section the third term is the sum of the first and the second. Interest in the Golden Section proportion goes back to the Pythagoreans, who adopted the pentagram—which makes multiple use of the Section—as a symbol of recognition. Interest was revived from the beginning of the 15th c. and mystical properties began to be ascribed to the 'divine proportion', as it was called in Luca Pacioli's book *Divina Proportione* (1509). From this time also the Golden Section was believed to enshroud a basic aesthetic principle underlying natural and organic beauty and the beauties of art and architecture.

When the ORPHIC group was formed in 1912, in addition to the theories of colour in which Robert DELAUNAY and František KUPKA took the lead, these artists also revived the NABI interest in a mathematical system of proportion akin to the Golden Section. They held an exhibition under the name 'Section d'Or' at the Gal. La Boétie in 1912 and founded a periodical with the same name. Interest in the Golden Section has remained continual, if sporadic, among both artists and theorists who have hoped to find in it sometimes a practical guide to composition and sometimes an aesthetic principle exemplified in the art and architecture of ancient and modern times. Examples of books along these lines are: Fredrik Macody Lund, *Ad Quadratum* (1921); Jay Hambidge, *Dynamic Symmetry* (1920); M. C. Ghyka, *Esthétique des proportions dans la nature et dans les arts* (1929); J. W. Power, *Éléments de la construction picturale* (n.d.).

SEGAL, GEORGE (1924–). American sculptor born in New York, studied at Rutgers University, 1941-6, where he received an M.F.A. degree in 1963, and after a year at the Pratt Institute worked at the New York University from 1948 to 1950. He had his first exhibition, of realistic paintings, in 1956 at the Hansa Gal., New York. Before the end of the 1950s he transferred his interest to sculpture, experimenting in plaster on wire mesh and burlap. His most characteristic work consisted of unpainted plaster casts taken from life, sometimes a single figure and sometimes a group, set in a context. Examples are: *The Gas Station* (National Gal. of Canada, Ottawa, 1963); *Cinema* (Albright-Knox Art Gal., Buffalo, 1963); *The Restaurant Window* (Wallraf-Richartz Mus., Cologne, 1967). Segal is classified with POP ART and with ENVIRONMENT and SITUATION ART. More than any other artist of the century his figures and groups capture the spiritual isolation of modern man and the sense of alienation which constitute the central theme of existentialist philosophy.

SEGALL, LASAR (1891–1957). Brazilian painter born in Vilna, Lithuania. In 1906 Segall left Vilna for Berlin, where he attended the Academy of Fine Arts until 1909. After receiving the Liebermann Prize he left Berlin for Dresden, where he worked

at the Academy of Fine Arts as a student-teacher. His style became freer, combining the naturalism of Max LIEBERMANN and the colour of Lovis CORINTH. After his first individual exhibition at the Gurlitt Gal. in Dresden, Segall travelled to the Netherlands and to Brazil for the first time in late 1912. In 1913 he exhibited his works—the first EXPRESSIONIST works to be seen in Brazil—in São Paulo and Campinas. He returned to Dresden in 1914, where he lived until 1923 except for a period when he was transferred to Meissen as a Russian prisoner of the Germans during the war. In Dresden he exhibited and began a series of etchings and lithographs which included *Souvenirs of Vilna* (1919), a book of five etchings. In 1923 he returned to Brazil, became a citizen of that country and joined the modernist movement that was initiated in 1922 with the 'Week of Modern Art' of São Paulo. Between 1926 and 1928 he exhibited his Brazilian works in Berlin, Dresden and Stuttgart as well as in São Paulo and Rio de Janeiro. After another trip to Europe he returned to São Paulo in 1930 and three years later helped to found the *Sociedad Pro-Arte Moderna de São Paulo* (*SPAM*) with a group of friends. In 1935 he began the series *Portraits of Lucy*, of the painter Lucy Citti Ferreira. He also continued to express his concern with the suffering of Europe's Jews, the persecuted and downtrodden, in his paintings. Between 1935 and 1950 he executed the 'Pogrom' series, *Immigrants' Ship, Concentration Camp, War, The Condemned* and *Exodus*. He continued to exhibit in Europe, and in North and South America he exhibited at the Mus. of Fine Arts in Rio de Janeiro (1943), the Associated American Artists in New York and the Pan American Union in Washington (1948), and had a retrospective at the Mus. de Arte de São Paulo in 1951. He participated in the São Paulo Bienales in 1951 and 1955. His Brazilian works included the series *Mangue* (Mangrove), an album of lithographs and xilographs on the subject of Rio's slums and bordellos based on texts by Jorge de Lima, Mario de Andrade and Manuel Bandeira, the *Forest* series (1951) and *Wandering Women* (finished in 1957). After his death in 1957 his work was exhibited at the São Paulo Bienale in 1957, the Mus. de Arte Contemporaneo in Madrid (1958), the Mus. National d'Art Moderne in Paris (1959) and in 'Art of Latin America Since Independence' at Yale, the University of Texas and other centres in 1966. There are two films on Segall's work. His home and studio in São Paulo were converted into a museum after his death.

SEKOTO, GERARD. See SOUTH AFRICA.

SÉLECTION. An *avant-garde* art shop and exhibition gallery opened in Brussels by A. De Ridder and P. G. Van Hecke in 1920 and operative until 1931. Their bulletin, also named *Sélection*, developed into the most important *avant-garde* art magazine of Belgium and the last 12 numbers, between 1928 and 1931, took the form of monographs. From 1927 to 1931 most of the leading Belgian EXPRESSIONISTS, including De SMET, Van den BERGHE and TYTGAT, were under contract to submit half their output to Sélection.

SELIGMANN, KURT (1900–62). Swiss-American painter and graphic artist, born at Basle, studied at the École des Beaux-Arts, Geneva, 1920, and in Florence, 1927. He lived in Paris 1929–38 and became a member of the SURREALIST movement in 1934. His paintings had a magical and apocalyptic character with hazy shapes and swirling draperies indistinguishable from the landscape. He was also known for his Surrealist 'objects'. In 1939 he went to the U.S.A. and became an American citizen. Here he painted a series of visionary works which he called 'Cyclonic Forms' and which purported to express his reactions to the American landscape. He had one-man exhibitions at the Jean Boucher Gal., Paris, in 1932 and 1935, at the Zwemmer Gal., London, in 1933, and exhibited frequently in the U.S.A. He made a serious study of magic and published *The Mirror of Magic* (New York, 1948).

SEMANTIC ART. A branch of expressive abstraction in which 'semantic signs'—crosses, circles, digits, ciphers, horizontals, etc.—are systematically used for constructing decorative compositions in which their semantic significance is not normally exploited. The chief exponents of this mode of abstraction were Luciano LATTANZI and Werner SCHREIB. Many other artists have made incidental use of semantic symbols, often exploiting residual suggestions of their ordinary semantic meaning. CAPOGROSSI in Italy led the way in this direction.

SEMPERE, EUSEBIO (1924–). Spanish sculptor born at Onil, Alicante, and studied at the School of Fine Arts, Valencia. He first exhibited abstract works at the Sala Mateu, Valencia, in 1950. In 1955 he received a scholarship from the French State and one from the Ford Foundation. In the same year he issued a manifesto on the use of light in sculpture and made his first luminous reliefs. After a period in Paris, where he knew VASARELY and HERBIN, he became one of the most important inaugurators of CONSTRUCTIVIST abstraction in Spain. He is chiefly known for his experiments with the use of light and for his abstract sculptures in chrome steel. In Spain he is represented in the Mus. de Arte Contemporaneo and Mus. de la Castellana al Aire Libro, Madrid, and in the museums of Cuenca, Barcelona, Bilbao, Valencia and Seville; outside Spain in The Mus. of Modern Art and the Brooklyn Mus., New York, the Fogg Mus., Harvard, the Mus. of Modern Art, Atlanta, the Aschenbach Foundation, San Francisco, the Baltimore Mus., the British Mus., London, the Stadtmus., Hamburg, the Mus. de Arte Contemporaneo, Santiago de Chile.

SEOANE, LUIS (1910–). Argentine painter and graphic artist, born at Buenos Aires. He spent his youth in Spain, where he first studied law and then drawing and engraving. He returned to the Argentine in 1936, set up his own presses and entered upon a career as painter, illustrator and writer. He did a number of murals, the most famous of which was a gigantic wall painting three storeys high at the San Martín Theatre done in synthetic resins in 1957. His paintings were mainly figures and still lifes, which he executed in stylized outlines drawn upon large areas of unmodulated colour. Among the books which he illustrated were the poems of Rafael Alberti, García Lorca and Pablo Neruda. He had one-man exhibitions both in the Argentine and in Montevideo, New York and London and he participated in a number of group exhibitions of Argentine art.

SEPTEM. Finnish association of painters formed in 1910. Inspired by an exhibition of Franco-Belgian Impressionist and Neo-Impressionist painting held in Helsinki in 1904, they made it their aim to transform Finnish painting in the direction of the colouristic innovations associated with Renoir, BONNARD, ROUSSEL, and the more conservative among the POST-IMPRESSIONISTS. The group exhibited first in 1912 and were active until the end of the 1920s. Under the leadership of A. W. FINCH and Knut Magnus Enckell (1870–1925) they succeeded in radically influencing the course of Finnish art and also offered encouragement to the younger generation of painters who later founded the NOVEMBER GROUP.

SÉRAPHINE or **SÉRAPHINE DE SENLIS** (SÉRAPHINE LOUIS, 1864–1934). French NAÏVE painter born at Assy, Oise. She passed her youth as a farm-hand and later entered domestic service in Senlis. 'Discovered' by Wilhelm UHDE in 1912, she won recognition as one of the most interesting of the French naïve painters. From 1927 her works were exhibited by many of the leading galleries and in 1951 the French authorities sponsored a group of her paintings for exhibition at the first São Paulo Bienale. She painted fantastic compositions of fruit and leaves and flowers worked with minute accuracy of detail into a visionary world of imagination. Towards 1930 her reason failed and she became obsessed with visions of the end of the world. She died in a home for the aged at Clermont.

SERIAL ART. A branch of SYSTEMIC ART, which in turn comes within the wider category of MINIMAL ART. In serial art simple, uniform elements, which may be commercially available objects such as bricks, cement blocks, ceramic magnets, etc., are assembled in accordance with a strict modular principle as opposed to the traditional use of adjustable parts made to fit into a finished work whose precise nature is not known beforehand. In an article 'Serial Art, Systems, Solipsism' published in *Arts Magazine* for Summer 1967, and reprinted in a revised form by Gregory Battcock in *Minimal Art. A Critical Anthology* (1968), Mel Bochner wrote: 'Seriality is premised on the idea that the succession of terms (divisions) within a single work is based on a numerical or otherwise predetermined derivation . . . from one or more of the preceding terms in that piece. Furthermore the idea is carried out to its logical conclusion, which, without adjustments based on taste or chance, is the work.' Lawrence Alloway said that the word serial 'can be used to refer to the internal parts of a work when they are seen in uninterrupted succession'. Among the American artists who have used a serialist methodology are Carl ANDRE, Sol LEWITT, Dan FLAVIN, Mel Bochner. A typical example of serial art was Carl Andre's *Lever*, exhibited at the 'Primary Structures' exhibition in the Jewish Mus., New York, in 1966. It was a single line of 139 unjoined firebricks running 34 ft (10·3 m) across the middle of the gallery floor. The term has also been used in the context of CONCRETE ART in Switzerland.

SEROV, VALENTIN. See MIR ISKUSSTVA.

SERPA, IVAN. See LATIN AMERICA.

SERRA, RICHARD (1939–). American sculptor born in San Francisco and studied at the University of California and at Yale University. He was one of the West Coast 'anti-form' group, including also Robert MORRIS, Keith SONNIER and Bruce NAUMAN, who gave prominence to unusual techniques and eccentric processes and he was represented in the exhibition arranged by Robert Morris at the Leo Castelli warehouse, New York, in 1968. Other group shows in which he was represented include: 'Square Pegs in Round Holes', Stedelijk Mus., Amsterdam (1969); 'When Attitude becomes Form', Kunsthalle, Berne, and I.C.A., London (1971); 'Art and Technology', Los Angeles County Mus. (1971); 'The Condition of Sculpture', Hayward Gal., London (1975). He had one-man shows in the U.S.A. and also at the Gal. La Salita, Rome, and the Gal. Ricke, Cologne. He worked in a variety of materials, from rough lead strips to 16 mm film strip to hot-rolled steel and his work had little unity of style apart from its 'anti-form' orientation.

SERRANO, JUAN. See EQUIPO 57.

SERRANO, PABLO (1910–). Spanish sculptor, born at Crivillén, Teruel, and studied in Saragossa and Barcelona. In 1930 he moved to Montevideo, Uruguay. Returning to Spain in 1954, he obtained the Grand Prize for Sculpture in the Hispano-American Bienale at Barcelona. In 1957 he was a founding member of the association EL PASO. In 1959 he was granted a stipend from the Juan March Foundation and in 1962 was an honorary guest at the Venice Biennale. In 1971 he was made

a member of the Royal Academy of Arts and Letters, Flanders, and was awarded the Grand Prize at the International Sculpture Exhibition, Budapest. His work was abstract and highly expressive in character. He executed monuments to Miguel de Unamuno, Salamanca (1968), to Pérez Galdós, Las Palmas (1969), and to D. Gregorio Marañon, Madrid (1970). Among the public collections in which his work is represented are the Museums of Modern Art at Bilbao, Seville, Cuenca, Rome, Venice, the Mus. National d'Art Moderne, Paris, the Mus. Municipal de Bellas Artes, Montevideo, The Mus. of Modern Art and the Solomon R. Guggenheim Mus., New York.

SÉRUSIER, PAUL (1863–1927). French painter born in Paris where, after studying philosophy, he entered the Académie Julian. In 1888 he met Gauguin and Émile BERNARD at Pont Aven, was converted to their Symbolist views and founded the NABI movement with DENIS, BONNARD, VUILLARD and others. In the 1890s he visited the Beuron School at the Benedictine monastery where his friend, the painter Verkade, had taken vows. He translated *Esthétique de Beuron* (1905) by Father Didier Lenz. From 1908 he taught at the Académie Ransom and in 1921 he published his influential *ABC de la Peinture*.

Sérusier's own painting favoured decorative arabesque with clear, flat colours.

SERVAES, ALBERT (1883–1966). Belgian painter born at Ghent, and studied at the Ghent Academy, where Frits van den BERGHE and Gustave van de WOESTIJNE were among his fellow students. In 1905 he joined the artists' community at LAETHEM-SAINT-MARTIN and was associated with MINNE, De SAEDELEER and artists of the First Laethem Group. In consequence of a religious crisis he found the mystical fervour of the Group congenial to his outlook and his painting changed from a rather brash Impressionist manner to scenes of rustic life and biblical scenes in which the heavy figures were painted in sombre earth colours. In virtue of these paintings he has come to be regarded as one of the founders of Flemish EXPRESSIONISM. During the First World War he remained alone at Laethem-Saint-Martin and the tragic bitterness of his religious paintings drew down upon him the hostility of the religious authorities, by whom he was regarded as an extremist. The inspiration of his *Stages of the Cross* and *Pietàs*, with their tortured figures, skeletons and dramatic chiaroscuro, was drawn rather from Grünewald and the German Primitives than from the spirit of the Flemish Primitives. The expressive power of these paintings is exceptional and with perhaps pardonable exaggeration he was described by the critic W. Vanbeselaere as 'the only irreplaceable religious painter in modern Europe'. After his removal to Switzerland in 1945 his work seldom reached the expressive intensity of his maturity.

SERVRANCKX, VICTOR (1897–1965). Belgian painter born at Diegem and studied at the Académie des Beaux-Arts, Brussels, where MAGRITTE and FLOUQUET were among his fellow students. Afterwards he worked in a wallpaper factory, where Magritte also was employed, and there familiarized himself with the technical properties of colours. He was regarded as the leading pioneer of abstract art in Belgium and, like Flouquet, his abstractions often carried a suggestion of the machine, e.g. *L'Amour de la machine* (1923) and *Exaltation du machinisme. Opus 47* (1923), both in the Mus. Royaux des Beaux-Arts, Brussels. His first abstracts were exhibited at the Giroux Gal., Brussels, in 1917 and in 1918 he was associated with *L'Effort Moderne* movement in Paris. In 1922 he participated in the exhibition organized at the Second Modern Art Congress, Antwerp. In 1926 he was introduced to the U.S.A. by Marcel DUCHAMP and was exhibited by the SOCIÉTÉ ANONYME. He was offered a teaching post at the Chicago Bauhaus by MOHOLY-NAGY, but declined. After the First World War he was an active member of the groups associated with the reviews *Sept Arts* and *Opbouwen*. About 1927 his work changed under the influence of supernatural visionary experiences and he celebrated the essential cosmic unity of life by the use of sinuous and fluctuating curves.

During the 1920s Servranckx also produced abstract sculptures and worked as a designer of carpets and furniture and as an interior decorator. In 1932 he joined the staff of the School of Arts and Crafts at Ixelles. In 1945 he joined the SALON DES RÉALITÉS NOUVELLES association. He was given a retrospective exhibition at the Mus. d'Ixelles, Brussels, in 1965.

SEUPHOR, MICHEL (1901–). Belgian painter, graphic artist and critic, born at Antwerp. He was active in the formation of the associations CERCLE ET CARRÉ and ABSTRACTION-CRÉATION and he edited the periodical *Cercle et Carré*. He wrote what became a standard work on abstract art: *L'Art abstrait. Ses origines, ses premiers maîtres* (1949), and *La Sculpture de ce Siècle* in 1959. In 1957 he wrote a *Dictionnaire de la Peinture Abstraite* which contains also a 'History of Abstract Painting' and in the same year a monograph on Piet MONDRIAN.

Seuphor himself worked in the manner of geometrical abstraction, using chiefly a variety of graphic techniques.

SEVEN AND FIVE SOCIETY. An association of British artists, seven painters and five sculptors, formed in 1919 to encourage a more forceful style of painting than that favoured by Roger FRY and his BLOOMSBURY GROUP of artists. At first the Society was oriented towards a poetical and lyrical naturalism in landscape, still life and figure, but without academicism. In order to ensure flexibility the rules of the Society required members to

be re-elected each year and towards the end of the 1920s and the beginning of the 1930s the bias turned increasingly in the direction of abstraction under the combined influence of Christopher WOOD, Ben NICHOLSON (who joined in 1923), Henry MOORE (who joined in 1930), and Barbara HEPWORTH (who joined in 1931). At this time other members such as Paul NASH, John PIPER and Ivon HITCHENS had also turned towards abstraction and by 1935 the Society had become wholly abstract. The name was changed to Seven and Five Abstract Group and in 1935 the Group held the first completely abstract exhibition in England. Its fourteenth and last exhibition was held in 1936. A comprehensive memorial exhibition was arranged by the Newlyn-Orion Gal., Penzance, in 1980.

SEVEN-SEVEN, TWINS (*c*. 1944–). Nigerian painter who was one of the best-known artists to emerge from the Oshogbo workshop. In this Nigerian 'art school' untrained persons with no preconceived notions about art were simply given paints and materials. No art instruction whatsoever was provided. Several students, and in particular Twins, produced highly original works in which a rich decorativeness and subjective fantasy predominate. Twins exhibited not only in Africa but in London, Edinburgh, Munich and New York.

SEVERINI, GINO (1883–1966). Italian painter born at Cortona. In 1901 he went to Rome, where he studied with BALLA and met BOCCIONI. In 1906 he went to Paris, in the same year as MODIGLIANI, and worked in proximity with BRAQUE, DUFY, VALADON and UTRILLO. At this time his chief interest was in Neo-Impressionism and in particular the DIVISIONISM of Seurat. In a Preface to the catalogue of his retrospective exhibition at the Gal. Berggruen, Paris, in 1956 Severini wrote of these early days: 'In the time of our youth, when Modigliani and I came to Paris, in 1906, nobody's ideas were very clear. Yet without knowing it we knew pretty well things of which we only became aware later on. It is in the early years that one recognizes that dualism which is in the depths of each one of us, where another person, unknown to ourselves, tends at the moment of the act of creation to supplant the person we believed or hoped ourselves to be. It is difficult to reconcile these two individualities, yet it is on such reconciliation that the development of personality largely depends. My first contact with the art of Seurat, whom I adopted for always as my master, helped me greatly to express myself in accordance with the two simultaneous and often opposed aspirations.' It is significant that for the next ten or fifteen years, his formative years, Severini was attempting to reconcile the in many ways conflicting aims of FUTURISM and CUBISM. In the same Preface he wrote: 'In its early days the method of the Cubists of apprehending an object consisted in moving around it; the Futurists claimed that one must get

inside it. To my idea the two points of view can be reconciled in a poetic knowledge of the world. But by the very fact of appealing to the creative depths of the painter by awaking hidden, intuitive and life-giving forces in him, Futurist theories, better than the Cubist principles, have opened unexplored and unlimited horizons. Yet the intellectual abstraction of the second period of Cubism had a great importance. By its aspiration to the eternal and its "notion of measure inspired by the classics" it restored in many painters the sense of craftsmanship (*métier*). And this coincided with another of my ambitions consisting of making, by means of painting, an object with the same perfection of craftsmanship (*métier*) as a cabinet maker when making furniture.' About 1909 Severini got to know PICASSO, Max Jacob and APOLLINAIRE and was attracted to the current theories of Cubism. In 1910 he signed the Futurist Painters' manifesto and when Boccioni, CARRÀ and RUSSOLO visited Paris he brought them into contact with Apollinaire and the Cubists. His *Pan Pan Dance at the Monico* made a sensation at the Futurist exhibition and his *Dynamic Hieroglyphic of the Bal Tabarin* (The Mus. of Modern Art, New York, 1912) remains one of the most successful combinations of Cubist idioms with the Futurist dynamism. The slightly earlier painting *Le Boulevard* (Estorick coll., London), still carrying suggestions of Seurat, combines with its high angle of vision the multiple perspectives of the Cubists with the suggestion of restless movement beloved by the Futurists. This painting was among those which influenced many of the Cubists to abandon their sombre colour scheme and to explore the possibilities of colour. From this time, however, Severini drew closer to Cubism, being distinguished from other Cubists by his decorative gift on the one hand and on the other hand by his rigorous attention to the almost mathematical relationship of forms. He was in contact with METZINGER and GLEIZES and joined the *Effort Moderne* group. His *Composizione* (Jucker coll., 1918) is an outstanding example of this trend in his work.

In 1914 and 1915 Severini under the influence of MARINETTI painted pictures concerned with the idea of war. But although he did not abandon the Futurist idiom entirely, as witness *Cróllo* (*Collapse*) and *Treno Blindato* (*Armoured Train*), of 1915, he was coming to realize that naturalistic representation, even if inspired by machinery and movement, has less value than the symbol expressed through colour and rhythm of form. He wrote that 'modern plastic painting can express not only the idea of the object and its continuity, but also a kind of plastic ideogram or synthesis of general idea. For instance I have tried to express the idea of war by means of a plastic whole composed of cannon, workshop, flag, order of mobilization, aeroplane, anchor. According to our conception of idea-relation no naturalistic description of a battlefield or slaughter can give the synthesis of the idea—War—better than these objects which are the symbol of it.'

In the 1920s Severini reverted to a more naturalistic style and exploited the decorative possibilities of Cubism. He also became interested in mural painting, doing frescoes at Montegufoni, outside Florence, and for churches at Fribourg, Lausanne and elsewhere in Switzerland. During the 1930s he continued his exploitation of the decorative aspects of Cubism in his painting. In the Preface quoted above he wrote: 'People have often passed a negative judgement on the decorative and ornamental possibilities suggested by Cubism. This is a grave error. From Cubism can derive an art of mural and an applied art of great artistic and historical importance. Several artists, including myself, have proved it.' During the 1950s Severini devoted some attention to non-figurative abstract work, such as his *Rythme d'une Danseuse au Tutu Violet* (Schettini coll., Milan, 1953). He had some connection with CONCRETE ART but did not pursue this path far.

Severini was a lucid thinker and what he wrote about his own work and that of others was usually illuminating.

SEZESSION. See SECESSION.

SHADBOLT, JACK. See CANADA.

SHAHN, BEN (1898–1969). American painter and graphic artist, born at Kovno, Lithuania. He came to the U.S.A. in 1906 and was apprenticed to a Brooklyn lithographer, at which trade he worked until 1930. He studied at New York University and the City College of New York from 1919 to 1922, in which year he enrolled at the National Academy of Design. Between 1925 and 1927 he travelled in Italy, Africa and France, where he was attracted by the paintings of DUFY and ROUAULT. His first one-man show was at the Downtown Gal. in 1930. During the Depression he was employed as a photographer on the FEDERAL ARTS PROJECT/ WPA and in the early 1930s he attracted attention by series of gouaches illustrating first the Dreyfus case and then the (1931–2) the Sacco and Vanzetti trials. From this time his work manifested a pronounced leaning towards social criticism, as was exemplified by a series of gouaches and tempera panels concerned with the Tom Mooney case (1932–3). In 1933 he was engaged as assistant to Diego RIVERA on the latter's murals for the Rockefeller Center, New York, and subsequently undertook a number of commissions for murals, including the Bronx Post Office, New York (1938–9), and the Social Security Building, Washington (1940– 1). After the war his interest turned to easel painting and poster design, though he still concerned himself with political and social issues. In the 1960s he gave more time to lecturing and teaching, being Charles Eliot Norton Professor in 1967–8 at Harvard University, which published a book of his essays under the title *The Shape of Content*. He illustrated a number of books, mainly books on Jewish festivals and Hebrew script. He represented America at the São Paulo Bienale of 1953 and the Venice Biennale of 1954 and he had an important exhibition of graphics at the Leicester Gals., London, in 1959.

SHALOM VON SAFED (SHALOM MOSKOVITZ, *c.* 1885–). Israeli NAÏVE painter, born at Safed, Galilee, Israel. A clock-maker and silversmith by trade and a member of the Hasidic faith, he began to paint only in 1957. His pictures illustrated the history of the Jewish people, making no distinction between past and present. He himself said: 'I paint no picture but relate the story of the Bible in lines and colours. All that I do comes from the Holy Book.' His stylized figures were repeated monotonously in the manner of hieroglyphics and arranged in parallel rows one above the other to be read from the bottom upwards in the Oriental way. He had one-man shows at the Jewish Mus., New York (1961, 1964), the Stedelijk Mus., Amsterdam (1967), the Moderna Mus., Stockholm (1967), the Kunsthaus, Zürich (1968), the Palais des Beaux-Arts, Brussels (1968), the Whitechapel Art Gal., London (1969), the Detroit Institute of Arts and the Pennsylvania Academy of the Fine Arts (1971). He is represented in The Mus. of Modern Art, New York, the Mus. National d'Art Moderne, Paris, and the Philadelphia Mus. of Art, among others. A 30-minute documentary film was made about him by Daniel Doron and Arnold Eagle.

SHANNON, CHARLES HAZLEWOOD (1863– 1937). British painter, illustrator and collector. Born in Quarrington, Lincolnshire, he studied at the Lambeth School of Art. Here he met Charles RICKETTS, with whom he collaborated in the Vale Press from 1896 and the magazine *Dial*, for which Lucien PISSARRO did illustrations. Shannon painted figure subjects and portraits in a traditional manner. He was made A.R.A. in 1911 and R.A. in 1920. He was also a member of the NEW ENGLISH ART CLUB. His first exhibition was at the Leicester Gals. in 1907.

SHCHUKIN, SERGEI IVANOVICH (1854– 1937). Russian collector and connoisseur, born in Moscow. He was a member of a large Moscow merchant family with diverse business and collecting interests and was famous for his collection of French Impressionists and Post-Impressionists. In 1897 while in Paris he purchased Monet's *Lilas d'Argenteuil*, the beginning of his collection, and by the early 1900s he owned examples of Degas, Monet, Renoir, etc. The most valuable items of his collection were the works by Gauguin and MATISSE. In the late 1900s he began to buy PICASSO, BRAQUE, DERAIN, LE FAUCONNIER, etc. and in 1910 he commissioned Matisse to paint *La Danse* for the stairwell of his Moscow mansion. In 1918 his collection was nationalized and later it was amalgamated with the MOROZOV collection. It is now

divided between the Hermitage, Leningrad, and the Pushkin Mus., Moscow.

SHEELER, CHARLES R. (1883–1965). American painter, born in Philadelphia. He was trained first at the Philadelphia School of Industrial Design, 1900–3, and then at the Pennsylvania Academy of the Fine Arts, Philadelphia, 1903–6. He travelled to London, the Netherlands and Spain and spent the years 1908–9 in Italy and Paris, where he came in touch with Analytical CUBISM. He returned to the U.S.A. in 1912 and took up commercial photography for a living while continuing to paint. He exhibited at the ARMORY SHOW, at the FORUM EXHIBITION in 1916 and with the SOCIETY OF INDEPENDENT ARTISTS in 1910. Together with Morton SCHAMBERG, with whom he had formerly shared a studio, and Charles DEMUTH he developed the form of native American Cubism which came to be known as PRECISIONISM. His method was to reduce his subject to its barest elements of geometrical structure consistent with recognition. Some of his earliest essays in this direction were *Barns* (Albright-Knox Art Gal., Buffalo, 1917) and *Barn Abstraction* (Philadelphia Mus. of Art, 1918). He himself said, as quoted by Lillian Dochterman: 'In these paintings I sought to reduce natural forms to the borderline of abstraction, retaining only those forms which I believed to be indispensable to the design of the picture.' While their source in Cézanne is clear, their relation to Analytical Cubism is more tenuous. On this Margaret Rose said: 'Beginning in 1917 with *Barns* Sheeler reconstructed his flattened masses into a solidly integrated composition, in which color and texture were arbitrarily added. His analysis consisted mainly of diagramming structure rather than disintegrating it; these reconstructions idealize reality rather than reformulate it through distortion.' About this time Sheeler began to explore the artistic possibilities of photography and he would often use his photographs as a basis for pictorial compositions. His first exhibition of photographs was at the Modern Gal., New York, in 1918. In 1920 he helped to make the film *Manahatta*, from 1923 he worked as a photographer for *Vogue* and *Vanity Fair* and in 1927 photographs he took of the Ford plant at River Rouge gained international acclaim. From *c.* 1918, when he settled in New York, Sheeler's interest turned to cityscapes and architectural subjects and he became fascinated with the skyscraper. He held his first one-man show in 1920 at the De Zayas Gal., New York, where he was a member of the staff.

During the 1930s and through the 1940s Sheeler's interest turned in the direction of country scenes and interiors and he had this in common with the American REGIONALIST painters, although his style remained Precisionist in essence. An example is *American Interior* (Yale University Art Gal., 1934). While retaining this interest in regional themes, he recovered during the 1940s and 1950s his interest in industrial architecture, machinery and urban scenes, as is illustrated by his *New York No. 2,* a rendering of the United Nations complex (Munson-Williams-Proctor Institute, Utica, 1951). In 1959 he suffered a stroke and had to abandon painting and photography. He had retrospectives at The Mus. of Modern Art, New York, in 1939, the University of California at Los Angeles in 1954, the Massachusetts Institute of Technology in 1959 and the National Collection of Fine Arts, Washington, in 1968.

SHER-GIL, AMRITA (1913–41). Indian painter, born in Budapest. Her father, Sardar Umrao Singh Sher-Gil, belonged to an aristocratic Sikh family and was himself a Persian and Sanskrit scholar and a student of philosophy and religion. Her mother, Marie Antoinette Gottesman, from a cultured Hungarian professional family, went to India with the Princess Bamba, granddaughter of the Maharaja Ranjit Singh, and met Umrao Singh in Simla. After their marriage they visited Budapest and were prevented by the outbreak of the First World War and its aftermath in Hungary from returning to India until 1921. From 1921 to 1929 Amrita Sher-Gil lived in Simla. She had shown an unusual talent for drawing from the age of 5 and her interest in drawing and painting continued as she grew up in India. From 1929 to 1934 she studied painting in Paris, first at La Grande Chaumière and then at the École des Beaux-Arts, immersing herself at the same time in the café life of Bohemian Paris. She did not identify herself with the *avant-garde* movements of the day but developed a romantic love for India, where she returned at the end of 1934 declaring: 'Europe belongs to Picasso, Matisse and many others, India belongs only to me.' Apart from a year in Hungary, 1938–9, when she married her cousin, Dr. Victor Egan, the rest of her short life was spent in India.

Amrita Sher-Gil declared that it was her artistic mission 'to interpret the life of Indians and particularly the poor Indians, pictorially'. But the spirit of SOCIAL REALISM was completely absent from her work. Her interest in the poverty and pathos of India was purely aesthetic and she produced sentimentalized images of the suffering masses as aesthetic objects 'strangely beautiful in their ugliness'. Her importance lay in her artist's ability to interpret contemporary India in the idiom of ancient Indian art. Her work was uneven but at its best—as in her South Indian Trilogy: *The Bride's Toilet, The Brahmacharis* and *South Indian Villagers going to Market,* in *Hill Men, Fruit Vendors, Ancient Story Teller* and *Elephant Promenade*—she resuscitated with a touch of genius the pictorial tradition of Ajanta and Ellora and of the Rajput and Basohli miniaturists.

SHEVCHENKO, ALEKSANDR VASILIEVICH (1882–1948). Russian painter born at Kharkov. He studied in Paris, 1905–6, and at the Stroganov Art School and the Moscow Institute of Painting,

Sculpture and Architecture, 1906–9, and evolved a style which combined influences from both Russian peasant art and French CUBISM. He contributed to many *avant-garde* exhibitions in Russia, including DONKEY'S TAIL and TARGET—at which time he was in close relations with LARIONOV and GONCHAROVA. In line with his twofold interest he wrote two theoretical tracts both published in Moscow in 1913: *Neo-Primitivizm. Ego teoriia. Ego vozmozhnosti. Ego dostizheniia* (*Neo-Primitivism. Its Theory. Its Possibilities. Its Achievements*) and *Printsipy kubizma i drugikh sovremennykh techenii zhivopisi vsekh vremen i narodov* (*The Principles of Cubism and Other Modern Trends in Painting of All Times and Peoples*). After his military service he was a professor at VKHUTEMAS from 1918 to 1930. In 1918 he organized the group Colour-Dynamics and Tectonic Primitivism with Aleksei Grishchenko and in 1919–20 was a member of the group *Zhivskulptarkh*. He continued to paint and exhibit throughout the 1930s and until his death.

SHINN, EVERETT (1876–1953). American painter born at Woodstown, N.J., studied at the Pennsylvania Academy of the Fine Arts, Philadelphia. While employed as an illustrator on the *Philadelphia Press* he became a member of the group of friends who were inspired by Robert HENRI. He went to New York in 1896 and there worked on the *New York World* and other newspapers as well as doing illustrations for several magazines, including *Harper's Magazine* and *Everybody's Magazine*. He also illustrated *The Christmas Carol, Rip Van Winkle* and various children's books. When Robert Henri settled in New York he continued the association and was one of the so-called NEW YORK REALISTS who promoted the ASH-CAN school of SOCIAL REALISM in opposition to the effete and bloodless Academicism of the day. He exhibited in 1908 at the Macbeth Gal. as a member of The EIGHT. Unlike the other Social Realists, Shinn preferred fashionable subjects and scenes from theatre and music-hall. Typical of his work are *A Winter's Night on Broadway*, showing the Metropolitan Opera House in a snowstorm, which was bought by *Harper's Weekly* in 1908, and *London Hippodrome* (Chicago Art Institute), exhibited with The Eight in 1908. As a result of the publicity attending the former of these, and of the success of a one-man exhibition in 1902, he obtained a number of commissions for fashionable portraits. He was commissioned in 1911 to do murals for Trenton City Hall, New Jersey, and these were the earliest use of Social Realist themes in public mural decoration. He also did decorations for the interior of the Belasco Theatre, New York.

Shinn's style was a derivative Impressionism, as may be seen in the *Harper's Weekly* pastel or in *Revue* (Whitney Mus. of American Art, New York, 1908).

SHIRAGA, KAZUO. See GUTAI GROUP.

SICKERT, WALTER RICHARD (1860–1942). British painter born in Munich. His father, Oswald Adelbert Sickert, had been a pupil of the French historical and portrait painter Thomas Couture (1815–79) and was of Danish stock but became German as a result of the German seizure of Schleswig-Holstein, then settled in England in 1868 and acquired British nationality. His grandfather, Johann Jurgen Sickert, was also a painter and head of a firm of interior decorators employed at the Royal Palace. After laying the basis of a classical education at King's College, London, and then spending three years on the stage, Walter Sickert studied painting at the Slade School under Alphonse Legros for a short while in 1881 and afterwards worked as assistant to Whistler. In 1883 he worked with Degas in Paris, and Whistler and Degas were the important formative influences on his style. Although he later repudiated some aspects of Whistler's work and differed from him notably in temperament, Whistler's influence on the subtle blendings and gradations among a narrow range of low-keyed tones remained a source of strength to him throughout. Degas stood out as his ideal and undoubtedly fostered his keen eye for the accidental and casual scene while at the same time confirming his conviction that a picture should not be painted direct from life but composed from drawings done on the spot.

In 1888 Sickert joined the NEW ENGLISH ART CLUB and with Wilson STEER became the leader of a 'rebel' group who in 1889 put on their own exhibition 'The London Impressionists' at the Goupil Gal. He was in the vanguard of English painters who appreciated the methods of the French Impressionists and their successors. From 1899 to 1905 he lived mainly in Dieppe with visits to Venice. His paintings of Dieppe churches and Venice canals are among his most admired work. Done in subdued tones with paint lightly applied and with emphatic outlines, they have been described as 'essentially drawings in paint'. Examples are *La Rue Pecquet, Dieppe* (City Mus. and Art Gal., Birmingham, *c.* 1900); *Statue of Duquesne, Dieppe* (City Art Gal., Manchester, *c.* 1900); *Rue Nôtre-Dame, Dieppe* (National Gal. of Canada, Ottawa, 1902).

In 1905 Sickert settled in London and from that time until *c.* 1912 he was the main link between the French *avant-garde* and progressive English art. He became the centre of a circle of artists who forgathered in his studio at 19 Fitzroy Street and later formed the nucleus of the CAMDEN TOWN GROUP (1911) and the LONDON GROUP (1913). They included Lucien PISSARRO, Harold GILMAN, Spencer GORE, Walter BAYES, Henry Lamb, Robert BEVAN, Augustus JOHN, and later Charles GINNER and the critic Frank Rutter. From *c.* 1905 Sickert was the acknowledged leader and the chief inspiration of the group of urban realist painters who sought poetry in the dingy streets and interiors of the Camden Town district. His early interest in

theatre and vaudeville gave him an important theme for his painting at this time. In these years his pictures became more thickly painted, more massively constructed and more compact in design. The majority of the masterpieces on which his fame chiefly rests date from the period 1905 to 1925. Examples are: *Ennui* (Tate Gal., *c.* 1913); *Portrait of Victor Lecour* (City Art Gal., Manchester, 1922); *The Mantelpiece* (Southampton Art Gal., *c.* 1907). In the paintings of this period he used his mastery of French technical and compositional methods for the expression of a peculiarly English vision. There was some decline after *c.* 1925, which showed itself in greater unevenness in his output, although his later paintings such as those of Bath are essential to a complete appreciation of his *œuvre*. He lived and painted in Bath from 1916 to 1919 and again after 1938. Sickert was made A.R.A. in 1924 and R.A. in 1934, but resigned in 1935. He was President of the Royal Society of British Artists in 1928.

As a personality Sickert's primacy was unchallenged among English artists through the first three decades of the century. It has been said that were he famous for no other reason, he would be famous as a teacher. He first opened his own school in 1893. Except for a short interval after the outbreak of the First World War, when his class was taken over by Gilman, he taught at the Westminster Art School until 1918. But most of his teaching was done privately and among his most illustrious pupils was Sir Winston Churchill. He was a highly articulate artist, though not systematic in the expression of his views, and much of his writing was edited by Sir Osbert Sitwell and published posthumously in *A Free House!* (1947).

Sickert took the elements of his style from many sources but moulded them into a completely personal *œuvre* unsurpassed among Britain's artists of his day. From Whistler he derived his characteristic method of painting with subtle gradations among a narrow range of low-keyed tones, relying on vivacious brushwork for vigour and luminosity; but in place of Whistler's delicacy of taste (which Sickert always eschewed) he sought to achieve a special effect of richness and solidity. Within this self-imposed limitation he painted a wealth of colour into drab and dingy subjects and brought dignity and beauty to vulgarly tawdry scenes. At various periods he experimented with the Impressionist palette and techniques and he shared with the Neo-Impressionists their concern for structure and their gift for design. But his attitude was more personal and intimate, representing what he painted as if caught 'through the keyhole' in unsuspecting privacy. He avoided fashionable good taste and the conventionally picturesque, revealing, with no trace of idealization, a rare beauty in the sordid and lending enchantment to the commonplace and dull. In his engravings he continued the tradition of Hogarth, Rowlandson, Cruikshank and Keene, seizing on all that was most characteristic in the quotidian scene and depicting

the pathetic and ridiculous with a penetrating but unmalicious eye. In *British Painting* (1933) R. H. Wilenski called Sickert 'a painter of light' and a 'modern artist concerned with architectural form', and spoke of his 'brilliant Impressionism and caricature-comment at one and the same time'. This admirably sums up the several aspects of Sickert's work.

SIIKAMÄKI, ARVO (1943–). Finnish sculptor born at Saarijärvi, studied at the Finnish Institute of Industrial Arts. Besides exhibitions in Finland his works have been shown in a number of international exhibitions of Finnish art, including the Louisiana Mus., Copenhagen (1969), Warsaw (1973), 'Workaday Finland', I.C.A. Gals., London (1974). Usually in aluminium and sometimes showing groups or tableaux, his works belong to the category of SOCIAL REALISM and it was stated that, like those of Tapio JUNNO, they 'depict the individual anguish of the people today'.

SIMULTANISM (SIMULTANISME). A term coined by Robert DELAUNAY for his use of colour as a means to create virtual space and form in a picture. He took the term from Michel-Eugène Chevreul, whose book *De la loi du contraste simultané des couleurs et de l'assortiment des objets colorés* (1839; English trans., *The Principles of Harmony and Contrast of Colours* by Charles Martel, 1872) was a major influence on the colour theories of Seurat and the Neo-Impressionists. Delaunay himself wrote: 'Around 1912–13 I had the idea of a type of painting which would be technically dependent on colour alone, and on colour contrast, but would develop in time and offer itself to simultaneous perception all at once. I used Chevreul's scientific term of *simultaneous contrasts* to describe this.' But whereas in Chevreul the term had a purely scientific connotation, describing the optical effect of two adjacent colours in enhancing mutually those qualities of each in which they are contrasted, Delaunay's use of the term was both less precise and more dubious. He intended it to signify his theory that colour could become the sole, or at least the major, means by which pictorial form and even the illusion of movement could be created in abstract painting. Delaunay's theory and practice represent the culmination of a tendency which prevailed in European painting from *c.* 1900 to regard colour not merely as a decorative adjunct to drawing but as a major constituent in the creation of form.

In 1913 Delaunay was in controversy with BOCCIONI, who wished to use the word 'simultaneity' for the fusion of memory with direct vision which had been used by some FUTURISTS in the attempt to convey in their pictures a sense of psychic duration, as in SEVERINI's *Souvenirs de voyage* (1910–11) and RUSSOLO's *Ricordi di una notte* (1911).

The term was taken up and generalized by Guillaume APOLLINAIRE, who used it to describe the

basis of his 'Calligramme' poems and to denote an artistic principle then in vogue, according to which unrelated or contrasting items are juxtaposed in a gratuitous and arbitrary way so that the parts of a composition interact through conflict and contrast rather than by logic or conventional modes of discursive construction.

In this sense the concept of 'simultaneity' was one of the most discussed ideas in literature, music and the plastic arts in the years immediately preceding the First World War. It meant the expression of multiple awareness, the immediate intuition of things happening in different places at the same time or the momentary, unextended intuition of sequences of events extended in time. It was the amplification in art and literature of the psychological notion of the 'continuous present'. In the catalogue of their first Paris exhibition in 1912 the Futurists declared: 'The simultaneousness of the states of mind in the work of art: that is the intoxicating aim of our art.' Bergson had written in his *Introduction to Metaphysics*, a book much read by the Futurists: 'No image can replace the intuition of duration, but many diverse images, borrowed from many different orders of things, may, by the convergence of their action, direct the consciousness to the precise point where there is a certain intuition to be seized. By choosing images as dissimilar as possible, we shall prevent any one of them from usurping the place of the intuition it is intended to call up.' Apollinaire also found the idea of simultaneity exemplified in the multiple viewpoints of CUBIST painting. Besides forming the basis of his own *Calligrammes*, it was manifested in the writings of Cendrars, Reverdy, Gertrude Stein and the music of Satie. In *The Banquet Years* (p. 256) Roger Shattuck, who gives one of the most penetrating accounts of simultanism, wrote: 'Be it a Gris still life, a poem by Apollinaire, a passage from Proust, or even a polytonal composition, a work of art began to coordinate as equally present a variety of times and places and states of consciousness.' In March 1976 an exhibition 'Time and Space Died Yesterday' was staged at Kettle's Yard, Cambridge, to document the idea of simultanism as it was understood by writers and artists in the years before the First World War.

SINGIER, GUSTAVE (1909–). Belgian-French painter born at Warneton. He went to Paris in 1919 and was naturalized a French citizen. After attending the École Boulle he worked until 1936 as a commercial decorator and designer, painting in his spare time and taking evening courses at various academies of Montparnasse. In 1936 as a result of a friendship with Charles WALCH he took up painting as a career and exhibited from 1937 at the Salon des Indépendants and the Salon d'Automne, from 1943 at the Salon des Tuileries and from 1945 at the Salon de Mai. In 1941 he was one of the founders of *Les Jeunes Peintres de la Tradition Française*. In 1946 he exhibited with LE MOAL and MANESSIER at the Gal. Drouin and he had one-man shows in 1949 and 1950 at the Gal. Billet-Caputo and in 1952 and 1955 at the Gal. de France. His work belonged to the category of LYRICAL ABSTRACTION based upon natural appearances, though somewhat more geometrical than that of TAL-COAT, Le Moal, BAZAINE and Manessier. Typical of his style is *La Nuit de Noël* (Mus. National d'Art Moderne, Paris, 1950). He also did murals and stained glass for Dominican monasteries and designed tapestries for the Mobilier National.

SIQUEIROS, DAVID ALFARO (1896–1974). Mexican painter born at Chihuahua. He studied at the Academy of San Carlos and the Escuela al Aire Libre of Santa Anita. In 1914 he enlisted in General Venustiano Carranza's revolutionary faction and later joined the forces of General Manuel Diegez, in which he became a captain. He collaborated with Dr. Atl on the Carranzista journal *La Vanguardia* in 1914 and 1915, and in 1919 he was sent to Europe for diplomatic and artistic activities under Carranza and met Diego RIVERA in Paris, where they discussed the need for a new monumental art that would reflect Mexico's current situation. In Barcelona he published an issue of the review *Vida Americana* which included three appeals directed to the artists of America. He returned to Mexico in 1922 to join the Communist party and organize the Syndicate of Technical Workers, Painters and Sculptors. He also formulated a new Muralist manifesto defining the revolutionary ideology of the artists who initiated the Muralist movement. His first mural was an encaustic called *The Elements* painted in a stairwell in the National Preparatory School in Mexico City in 1923. With a new shift in government the mural remained unfinished and he left Mexico City to devote himself to syndical and committee activities, organizing labour unions in Guadalajara and travelling between 1925 and 1930. In 1930 he was given one of many prison terms for political activities and he remained under house arrest in Taxco in 1931. During this period he met the film director Sergei Eisenstein. As a result of conversations Siqueiros began developing his mural theories on the use of PHOTOMONTAGE and illusory devices through distortion and corrective multiple perspectives that would take into account several angles of vision in order to dramatize ideological meanings and increase the impact of the message. These techniques culminated in his mural of 1939, *Portrait of the Bourgeoisie*, at the Electrical Workers' Union in Mexico City. He did two murals in Los Angeles in 1932 at the Chouinard School of Art and the Plaza Art Center, which were destroyed for political reasons and recently restored. In 1933 he travelled to Uruguay and Argentina, where he lectured and painted a mural, *Plastic Exercise*, near Buenos Aires with the collaboration of Argentine artists. In 1935–6 he opened an Experimental Workshop in New York, where he demonstrated the use of new synthetic and industrial

materials, photomontage and drip techniques. Jackson POLLOCK was a member of the workshop. In 1937 he went to Spain to join the Spanish Republican army and was made a Colonel. His painting *El Coronelazo* (*The Great Colonel*) of 1945 celebrates this episode. In 1940, because of his implication in the Trotsky assassination, he left Mexico and went to Chillán, Chile, where in 1941 he painted *Death to the Invader* at the Escuela Mexico with another Mexican painter, Xavier Guerrero. The mural represented the liberation of Chile and Mexico. It has since been destroyed by the military Junta. Siqueiros painted murals of ever increasing size with the help of assistants, using multiple points of view which sometimes created vertiginous vistas. One of these is the mural in the vestibule of the Hospital of the Mexican Institute of Social Security of Zone 1 in Mexico City. He contributed cement and mosaic murals to University City between 1952 and 1956 and painted a continuous mural at the Mus. of National History, *Del Porfirismo a la Revolución*, depicting the events that led to the overthrow of Porfirio Diaz. His most ambitious work was *March of Humanity in Latin America* in the Parque de la Lama in Mexico City, begun in 1965 and completed in 1969, where he covered over 49,000 sq. ft (4552 m^2) of wall space with paint and sculptured forms. The dodecagonal structure which encloses it, caller the Poliforum Cultural Siqueiros, is also painted on its exterior surface.

Although Siqueiros himself insisted that his easel paintings were subordinate to his murals, they and his woodcuts proved a major factor contributing to his international fame as an artist. Their monumental tragedy summed up the sorrow of the Mexican peasantry at a new level of artistic simplicity. From the 1930s he enjoyed constantly increasing recognition as a master and by the 1950s he was the acknowledged leader of the artistic Left in Mexico and his country's most illustrious artist both as a muralist and as an easel painter. He was the most individual of the Mexican muralists and the most spectacular personality of the movement. In contrast with the sense of disillusionment and foreboding which was sometimes apparent in OROZCO's work, that of Siqueiros always expressed the dynamic urge to struggle. If it showed less profundity than Orozco's philosophical conceptions, it surpassed him in fiery impetuosity. The seal was set on his international standing at the Venice Biennale of 1950, where he was awarded the prize donated by the Mus. of São Paulo, the leading honours going to the veteran MATISSE.

Siqueiros was also a prolific writer and published essays explaining his political and technical theories. The best known are *No Hay Mas Ruta que la Nuestra* (*There is no Way but Ours*) of 1945 and *Como Se Pinta Un Mural* (*How One Paints a Mural*) of 1951. His influence on mural painting in the Americas was great and in Mexico his followers continue to work.

SIRONI, MARIO (1885–1961). Painter, born at Sassari in Sardinia of Italian parents. He abandoned the study of engineering in Rome in order to become a painter and frequented the studio of BALLA. His contact with the FUTURISTS, whom he did not join until 1914, was a loose one and is chiefly manifested in his predilection for urban and factory subjects as in such paintings as *The Cyclist* (1915), *The Lorry* (1915) and *Studio of Marvels* (1918). About 1920 he was attracted to the idiom of METAPHYSICAL PAINTING, as may be seen in such works as *Factories and Lorry* (1920) and the later *Eclipse* (1944). But this influence did not go deep and in 1920 he also began the series of townscapes for which he is best known. In 1922 he became a founder member of the Milanese group which met at the Pesaro Gal., Milan, and later gave rise to the NOVECENTO movement. To this movement he contributed a highly original Romantic EXPRESSIONISM which seems to have derived from his earlier interest in PERMEKE and northern Expressionist art. In the 1930s a contrasting gift for monumentalism and grandiloquence was displayed in a number of commissioned murals, including *Italy between the Arts and Sciences* (1935) for the University of Rome and *Law between Justice and Strength* (1936) for the Palace of Justice, Milan. His most characteristic production, however, is in the smaller and less declamatory works. But after his occupation with the murals his series of 'Multiple Compositions' became rather more rigid and stereotyped, though enlivened by richness of colour. Nevertheless a few of the later works, as for example a gouache *House and Trees* (1948), reveal a new and refreshing style of primitivist construction.

SISTIAGA, JOSÉ ANTONIO. See SPAIN.

SITHOLE, LUCAS. See SOUTH AFRICA.

SITNIKOV, VASILY YAKOVLEVICH (*c.* 1920–). Soviet Russian unofficial artist. He was arrested in the wake of the Yezhov purges shortly before the outbreak of the Second World War and passed the war years in a lunatic asylum near Moscow. After the war he was sent for rehabilitation to the Kazan forests. The hardships which he endured during these years left a permanent impression upon him. During the 1950s, back in Moscow, he invented a technique using shoe polish and shoe brushes because of the difficulty of obtaining art materials. In this technique, which continued to influence his use of oils during the 1960s, he did fantastic scenes, delicate erotic nudes and sensitive landscapes. An oil and crayon, *Song of the Lark* (1960), and a crayon, *Plowed Field* (1962), are in the collection of The Mus. of Modern Art, New York.

SITTER, INGER (1929–). Norwegian painter born at Trondheim, studied in Paris under André

LHOTE and at Atelier 17 with HAYTER. She began with naturalistic representation but later turned to expressive abstraction. Her lyrical abstracts in delicate colours convey the moods of sky and sea in which she was always interested. Her work also included abstract COLLAGES and graphics.

SITUATION. A group of English artists who took their name from the exhibition 'Situation' held in the R.B.A. Gals., London, in 1960. The exhibition was organized by the artists and one of the conditions of eligibility was that the picture should be wholly abstract and at least 30 square ft (9·1 m²). The eighteen artists who participated included Harold and Bernard COHEN, Robyn DENNY, John HOYLAND, Gillian AYRES, Richard SMITH and William TURNBULL. Largely under the influence of American COLOUR FIELD painting they held the view that an abstract or monochromatic painting which occupied the whole field of vision would involve the spectator in an 'event' or 'situation'. He would cease to be a mere external observer and would participate in the aesthetic 'situation' which was brought into being. This idea of 'situation' involving the spectator as participant was subsequently taken up internationally.

With no reference to the foregoing the term 'situational sculpture' has been used where sculpture is defined as place or site. Examples are Carl ANDRE's 34 ft (10·3 m) of unattached firebricks laid end to end on the floor of the Jewish Mus., New York, and his 184 bales of hay laid across 500 ft (152·4 m) of open field.

SKOTNES, CECIL EDWIN FRANS (1926–). South African painter and graphic artist, born at East London, Cape Province. After war service with the South African forces in Italy (1944–6) he studied for a year at the Witwatersrand Technical College Art School, and then went on to take a degree in Fine Arts at the University of Witwatersrand (1947–50). In 1952 he was appointed Cultural Officer in charge of the Polly Street Art Centre, Johannesburg, where he helped many young Africans in their technical studies. Many of the leading black artists of the Transvaal owed their start to his help and sympathy. In his own work he began to specialize in woodcuts, which led to a very personal use of the medium, ultimately producing the block rather than prints as the final work. The effect, as he used primitive or Africa-oriented shapes and figures, was often totemic. The colours tended to be reds and ochres with black and white, and he refined and developed his treatment of the surface of the wood. Apart from these often large-scale panels and sometimes posts, he produced paintings, both easel and mural, in which similar conventions were used, though inevitably with more extended figure groups and series. He continued to make graphic prints, usually in black and white, one series of which was a depiction of the Shaka history and legend of the Zulus: *The Assassination of Shaka.*

He travelled often to Europe, represented South Africa several times in the biennial exhibitions of Venice and São Paulo, and apart from his many exhibitions in South Africa showed his work in London, New York, Canada, Lisbon, Italy and Yugoslavia. He represented the artists of South Africa as President of the Council of Artists, and was generally regarded as their spokesman.

SKÚLASON, THORVALDUR (1906–). Icelandic painter born at Bordeyri. After studying in Oslo, he went to Paris and worked under GROMAIRE, 1931–3. His work in the 1930s consisted of figures and still lifes in sombre colours and monumentally solid forms which reveal the teaching of Gromaire. In the mid 1940s, however, he began to paint with geometrically simplified shapes and vivid colours and he is regarded as one of the leading pioneers of abstract art in Iceland.

SKURJENI, MATO. See NAÏVE ART.

SLEVOGT, MAX (1868–1932). German painter and graphic artist born at Landshut, Bavaria, studied at the Academy, Munich, 1885–9, and at the Académie Julian, Paris, in 1889. His paintings were at first in a sombre naturalistic style akin to that of Wilhelm Leibl (1844–1900) but from 1900 onwards they became increasingly colourful and dramatic and he is regarded as one of the leaders of German Impressionism with CORINTH and LIEBERMANN. His later work, especially the large decorative schemes at Cladow (1912), Neukastel (1924 and 1929), Bremen (1927) and Ludwigshafen (1932), was characterized by loose handling of paint, bold effects of light and restless movement of forms. He lived and taught in Berlin from 1901, was made a member of the Dresden Academy of Fine Art in 1915 and head of the 'Masters' Atelier' at the Academy of Fine Art, Berlin, in 1917. Slevogt did graphic work for *Simplicissimus* and *Jugend* from 1896 and many of his book illustrations were famous, including *Ali Baba and the Forty Thieves* (1903), *The Iliad* (1907), Fenimore Cooper's *Moccasin Hunters* (1909), *Benvenuto Cellini* (1913) and marginal illustrations for Mozart's *Die Zauberflöte* (1920). While he used a typical Late-Impressionist technique, with reminiscences of the *plein air* school of painting, there were also anticipations of EXPRESSIONISM in his work, particularly in some of the illustrations.

SLOAN, JOHN (1871–1951). American painter and draughtsman, born at Lock Haven, Philadelphia, trained at the Pennsylvania Academy of the Fine Arts, Philadelphia. He worked as an artist-reporter on the *Philadelphia Press*, 1892–5, and the *Philadelphia Enquiry*, 1895–1903. Like his colleague GLACKENS he had a quick pencil, an observant eye and an almost photographic memory. He became a close friend and disciple of Robert HENRI, by whom he was persuaded to take up painting seriously though for some years he regarded painting

as secondary and illustration as his true vocation. In 1903 he joined Henri in New York, supporting himself by magazine illustration while painting as a member of the so-called NEW YORK REALISTS who promoted the ASH-CAN school of SOCIAL REALISM. He was a member of The EIGHT, whose exhibition in 1908 was a landmark in securing public recognition for the Social Realist school of American painting, and he exhibited with the Independents show organized by Henri and Rockwell KENT in 1910. He was president of the SOCIETY OF INDEPENDENT ARTISTS from 1918 to 1944.

Sloan painted genre scenes observed from his studio window, such as *Sunday. Women Drying their Hair* (Addison Gal. of American Art, Phillips Academy, Andover, Mass., 1912). He was interested in typical genre scenes from Coney Island, Union Square and the Bowery and, like Henri, he tried to represent the grim drabness of the riverside and the dramatic dynamism of the New York skyline. But Sloan's Social Realism was always objectively descriptive and not critical or propagandist. In 1916 he resigned from *The Masses*, of which he had been art editor since 1911, on this issue, declaring: 'They may say that I am now fiddling while Rome burns, but I question whether social propaganda is necessary to the life of a work of art.' He had his first one-man show in 1916, at the Whitney Studio Club, New York. He was elected President of the Art Students' League, the stronghold of AMERICAN SCENE painting, in 1931 and continued to promote the doctrines of the Ash-Can school. He also taught at the George Luks School and the Archipenko School of Art. In 1939 he published *The Gist of Art*, which he wrote with Helen Farr—later to become his second wife—on the basis of his teaching experience.

Sloan was a slow and thoughtful painter who repudiated the artistically brilliant but often superficial virtuosity and bravura cultivated by Robert Henri. Early in his career he tried with no conspicuous success to come to terms with the new concepts of space and pattern design introduced by the Neo-Impressionists. After the ARMORY SHOW he ceased painting from direct observation and adopted a more conceptual approach in search of a timeless solidarity. During the 1930s he applied this new method primarily to the female nude, using a complicated technique of underpainting and glazing with graphic cross-hatching to give solid sculptural forms. But Sloan was at his best when presenting the pathos and the drama of the American scene as an anecdotal or genre artist of Social Realism. An important retrospective exhibition was given by the Whitney Mus. of American Art in 1980.

SLODKI, MARCEL. See DADA.

SLUYTERS, JAN (JOHANNES CAROLUS BERNARDUS, 1881–1957). Dutch painter, born in Hertogenbosch. He studied at the Teachers' Training College (1897–1900) and the Academy of Art (1901–4), Amsterdam, won the Prix de Rome in 1904 and travelled to Italy, Spain, Portugal and Paris. About 1906 he came under the influence of FAUVISM and in 1913, through LE FAUCONNIER, he began to affect the stylistic simplifications of the CUBIST school. At this time he was working among the Calvinist peasantry in the village of Staphorst near Amsterdam, and he evolved a method of EXPRESSIONISM by which to portray the puritanical austerities of their lives in sombre colours and rigid forms. From 1916, when he was working in Amsterdam, he was in contact with the Belgian Expressionists Gustave de SMET and Frits van den BERGHE and reverting to his earlier more lively palette he matured a personal method of Expressionism which he called 'Colourism' and which in the inter-war years made him one of the best-known painters in the Netherlands.

SMAJIĆ, PETAR (1910–). Yugoslav NAÏVE sculptor, born at Donji Dolac, near Split. Of Dalmatian peasant stock, he worked as a cartwright and in the early 1930s began to carve heads for the one-stringed shepherds' instruments, *gusle*, which he made in his spare time. He was encouraged by critics and from *c.* 1935 began to practise sculpture more seriously. His heads had an archaic simplicity through which gleams the direct expressiveness that is characteristic of the naïve artist. A selection of his work was shown at the Yugoslav Pavilion in the Brussels World Fair of 1970.

SMET, GUSTAVE DE (1877–1943). Belgian painter, born in Ghent, son of a decorator, trained at the Ghent Academy. In 1901 he settled at LAETHEM-SAINT-MARTIN and with his brother Léon, Frits van den BERGHE and Constant PERMEKE he formed the Second Laethem Group. He integrated himself into the peasant way of life, became infatuated with nature and changed his style of painting from Impressionism to a manner which has caused him to be regarded as a major figure in Flemish EXPRESSIONISM. During the First World War he was in the Netherlands, for much of the time in the company of Frits van den Berghe, and here he came into contact with German Expressionism and with the former CUBIST painter LE FAUCONNIER, who exercised an important influence on his work, as may be seen in *La Loge* of 1928 (Mus. Royaux des Beaux-Arts, Brussels). In 1922 he returned to the Lys country after a brief stay with Permeke at Ostend and continued to work in an Expressionist manner. He was a main supporter of the gallery and review SÉLECTION founded in Brussels by A. De Ridder and P. G. Van Hecke in 1920, and from 1927 to 1931 was under contract to the gallery, painting circus subjects and pastoral themes. After his major retrospective exhibition at Brussels in 1936 he abandoned his restrained approach for a more spontaneous and violent form of Expressionism. He had retrospective exhibitions at the Palais des Beaux-Arts, Brussels, in 1936 and 1950, at Charleroi in 1953 and at Antwerp in 1961.

He was included in the exhibition 'Ensor to Permeke' at the Royal Academy, London, in 1971 and the exhibition 'Ensor-Magritte' at the Palais des Beaux-Arts, Brussels, in 1975.

SMITH, DAVID (1906–65). American sculptor born at Decatur, Ind. He began the study of art at Ohio University in 1924 and in the summer of 1925 worked at the Studebaker plant at South Bend, Indiana, where he acquired the skills in metalwork which stood him in good stead through his later career. From 1926 to 1930 he studied painting at the Art Students' League, New York, while supporting himself by a variety of jobs. Among his associates were Arshile GORKY and Willem DE KOONING and he was introduced by Jan Matulka, under whom he studied, to *avant-garde* European movements. He turned to sculpture in the early 1930s, making his first welded iron sculpture in 1933, although he always maintained that there was no essential difference between painting and sculpture and that although he owed his 'technical liberation' to Julio GONZÁLEZ, his aesthetic outlook was more influenced by KANDINSKY, MONDRIAN and CUBISM. During the 1930s he was already doing sculpture of considerable originality, constructing compositions from steel and 'found' scrap, parts of agricultural machinery, etc., in a manner which has been thought to anticipate that of STANKIEWICZ. His first one-man exhibition was at the East River Gal., New York, in 1938 and two years later he exhibited a set of 15 bronze relief plaques entitled *Medals of Dishonour* stigmatizing the prevalence of violence and greed throughout the world.

After being employed as a welder on defence work, he returned to sculpture c. 1945. His sculpture during the 1940s and 1950s was open and linear, radiating from a centre like three-dimensional metal calligraphy. Perhaps the most noted work in this style is *Hudson River Landscape* (Whitney Mus. of American Art, 1951). Towards the end of the 1950s and up to his death in a car accident he did the more monumental and massive work for which he is best known, often working in series such as *Zig, Tank Totem, Agricola, Cubi, Voltri*. Although monumental and intended to be seen in the open, these last works were not heavy but had an unstable, dynamic quality which contradicted density. It was these works which initiated a new era in American sculpture. In virtue of them Smith's innovatory influence has been compared with that of CARO in England and Jackson POLLOCK in American painting. But his work was not expressive in the manner of Henry MOORE, who conjured up associations with nature and the material. With his painted or polished metal and often apparently provisional or haphazard arrangement of shapes Smith ushered into sculpture the sort of objectivity which characterized POST-PAINTERLY ABSTRACTION.

Among his many exhibitions were important retrospectives at The Mus. of Modern Art, New York, in 1957, the Tate Gal., London, in 1966 and the Solomon R. Guggenheim Mus. in 1968.

SMITH, GORDON. See CANADA.

SMITH, GRACE COSSINGTON (1892–). Australian painter, born in Sydney. In 1910 she began taking drawing lessons at Dattilo Rubbo's art school (see AUSTRALIA). During 1912–14 she visited England (attending briefly the Winchester Art School) and Germany. She remained virtually unaware of POST-IMPRESSIONIST art until she returned to Sydney in 1914 and met Norah Simpson and the small group of artists interested in Post-Impressionism enrolled in Rubbo's painting classes at the Royal Art Society, N.S.W. Grace Cossington Smith's *The Sock Knitter* (Art Gal. of N.S.W.), exhibited in 1915, reflects the enthusiasm with which she absorbed Norah Simpson's ideas. Its broad treatment, FAUVE-like colours and flattened space suggest that it was the first 'modern' work painted and exhibited in Australia. Like many Sydney artists Grace Cossington Smith was influenced briefly during the early 1920s by Max MELDRUM's tonal theory of painting. Later she returned to more substantial colour and to the application of paint in crisp, juxtaposed strokes— aspects of her work that were to remain constant throughout her career. The influence of MATISSE and Van Gogh is evident in her early work. In the 1930s the influence of Cézanne (e.g. her *Landscape at Pentecost, c.* 1929; *Poinsettias, c.* 1931, National Gal. of Victoria) is more marked.

Grace Cossington Smith never regarded herself as a particularly radical or innovatory artist. Her interest in modernism was inspired not by its intellectual or aesthetic prescriptions, but because for her it constituted a more honest and lively approach to painting. During the 1930s her work became more intimate. She turned increasingly to the light-filled interiors of her home. In such typical paintings as *Door into the Garden* (Bendigo Art Gal., 1959) colour is applied in mosaic-like strokes by means of divided brush-strokes. In 1973 a retrospective exhibition of her painting was held at the Art Gal. of N.S.W.

SMITH, JACK (1928–). British painter born at Sheffield, trained at the Sheffield College of Art, 1944–6, St. Martin's School of Art, 1948–50, and the Royal College of Art, 1950–3. In the mid 1950s he was associated with the realists of the KITCHEN SINK SCHOOL, although even then he attached more importance to formal qualities than to the nature of the subject matter. His still lifes became increasingly abstract with emphasis upon the patterns of cast shadows and by the 1960s he was using a thick impasto with actual relief. By the end of the 1960s he had adopted HARD EDGE patterns of symbolic shapes against a plain ground.

SMITH, LEON POLK (1906–). American painter born at Chickasha, Okla., studied at East

Central State College and at Columbia University. He taught in Oklahoma public schools, was State Supervisor, Delaware, 1941–3, taught at Rollins College, Mills College of Education, and was Artist in Residence at Brandeis University. His first one-man exhibition was at the Uptown Gal., New York, in 1940. He was awarded a Guggenheim Foundation Fellowship, 1944, a Longview Foundation Grant, 1959, and a Tamarind Fellowship. He was best known for his painting during the late 1950s and 1960s in the HARD EDGE style of precisely contoured shapes (often leading the eye outside the area of the canvas) and immaculate unmodulated colours, and he was also a pioneer in experiments with the shaped canvas within the school of POST-PAINTERLY ABSTRACTION. His works were included in exhibitions at the Whitney Mus. of American Art (1959 and 1962) including 'Geometrical Abstraction in America', the Solomon R. Guggenheim Mus., 'Abstract Expressionists and Imagists', and others.

SMITH, SIR MATTHEW ARNOLD BRACY (1879–1959). British painter, born in Halifax, Yorkshire, son of a northern businessman and collector of violins and popular academic paintings. From childhood Matthew Smith's constant preoccupation with painting and his incapacity for business led to family friction and a sense of psychological isolation which followed him through most of his life. From 1900 to 1904 he studied industrial design at Manchester School of Art but showed no aptitude for it. He studied at the Slade School, 1905–7, but was pronounced by TONKS to be lacking in talent and left when his health broke down. He went to Pont Aven in Brittany in 1908, then to Étaples and at the beginning of 1910 to Paris. Here he attended MATISSE's school during its last few weeks, but contrary to the assumption of many who speak of him as the typical English FAUVE his personal contact with Matisse was slight. Returned to London in 1913, his painting underwent a dramatic change. From being diffident and tentative, he began to paint in strident and aggressive FAUVIST colours with firmly constructed draughtsmanship. The three outstanding pictures from this time are *Lilies* (Tate Gal.) and two nudes entitled *Fitzroy Street I* (British Council) and *Fitzroy Street II*. They were rejected by the LONDON GROUP but won the praise of SICKERT. After serving in the war and being demobilized in 1919 he underwent another period of psychological restlessness and loss of self-confidence culminating in a serious attack of melancholic depression. He nevertheless painted his fine *Apples on a Dish* (Tate Gal.) in 1919 and during part of 1920 a series of sombre but expressive Cornish landscapes; but for two years or more he was practically unable to work.

Between the years 1922 and 1926 Smith matured the idiosyncratic vision and painting style which is particularly his own and which with certain increases in assurance and strengthening of design remained remarkably consistent throughout the remainder of his career. His mature style was that of an emotional and intuitive rather than an intellectual painter. It was quite distinctive for its high, luscious Fauvist colours, its thick impasto and expressive brush-strokes, and its emphasis on expressive linear rhythms. His subjects are chiefly nudes, still lifes and flower-pieces, all united by his individualistic colour and the impression of spontaneity rather than planned composition. Matthew Smith was one of the great individualists of British painting in the first half of the century. Slow to establish himself, his reputation consistently grew until, writing in 1952, John Rothenstein said: 'At the present moment Matthew Smith is probably the most admired painter in England, more especially among his fellow artists . . .'

He spent much of the 1920s and 1930s in France, out of contact with the main artistic developments in England. In 1926 he had a small one-man show at the Tooth Gal., London, and a second show in the following year at the Reid and Lefevre Gal. The former was well reviewed by Roger FRY, who remarked that 'it is upon colour that he lays the task of situating his planes in the spatial and plastic construction. Upon colour, too, he relies to achieve the suggestion of chiaroscuro. In all this he is pushing to the furthest limits the essentially modern view of the functional as opposed to the ornamental role played by colour in pictorial design.' There were retrospective exhibitions of his works at the Venice Biennale in 1938 and 1950, at Temple Newsam, Leeds, in 1949, and a large retrospective was held at the Tate Gal. in 1953. In a note to the Tate Gal. exhibition Francis BACON said: 'He seems to me to be one of the very few English painters since Constable and Turner to be concerned with painting—that is, with attempting to make idea and technique inseparable. Painting in this sense tends towards a complete interlocking of image and paint, so that the image is the paint and vice versa. Here the brushstroke creates the form and does not merely fill it in.' A retrospective was staged in 1976 by the Tooth Gal. and Roland, Browse and Delbanco jointly. Matthew Smith obtained the C.B.E. in 1949 and was knighted in 1954.

SMITH, RICHARD (1931–). British painter born at Letchworth, Hertfordshire. He studied at the Luton School of Art, 1948–50, and after doing National Service in Hong Kong, at St. Albans School of Art, 1952–4, and at the Royal College of Art, 1954–7. He began showing his works in the 'Young Contemporaries' exhibitions at the R.B.A. Gals. in 1954. He was a member of the INDEPENDENT GROUP and belonged to the 'middle generation' of British POP ART. In 1957 he visited Italy with a Royal College of Art Travelling Scholarship and then taught mural painting at Hammersmith College of Art until 1959, when he visited the U.S.A. on a Harkness Fellowship for two years—one of the first of the British Pop artists

to do so. Until this time he had been interested chiefly in ROTHKO and Sam FRANCIS, but his interest now turned towards Ellsworth KELLY, Kenneth NOLAND and the COLOUR FIELD painters. His first one-man show was at the Green Gal., New York, in 1961. Returning to England in that year, he had a show at the I.C.A. Gals. in 1962 and taught at St. Martin's School of Art until 1963. In 1966 he was included in the British representation at the Venice Biennale and received the Robert C. Scull Award. In the same year he had his first retrospective exhibition, at the Whitechapel Art Gal. In the following year he was Artist in Residence at the University of Virginia in Charlottesville and was awarded the Grand Prix at the São Paulo Bienale. In 1968 he taught at the University of California and after his return to England represented Britain at the Venice Biennale of 1970 with a one-man show in the British Pavilion. He was awarded the C.B.E. in 1971. In the autumn of 1975 a large exhibition was staged by the Tate Gal. which he preferred not to describe as a retrospective. It was in fact a reconstruction of seven previous exhibitions for each of which all the exhibits were made specifically for the space they occupied. In the catalogue to the Tate exhibition he was described as 'one of the most important and widely exhibited British painters of the generation which came to prominence towards the end of the fifties' and as 'one of the most verbally fluent and intellectually capable artists of his generation'. In 1976 he was represented in the 'Pop Art in England' exhibition organized by the Arts Council for showing in Hamburg, Munich and York. In the catalogue to the latter exhibition it was stated that Smith 'transformed the abstract painting into a visible reflection on urban American civilisation'. In 1980 a large exhibition of his work was given at Fort Worth Mus. of Art and an exhibition of recent work on paper at the Knoedler Gal., London.

Smith's main interest was in the packaging of consumer goods and he organized his abstract forms in accordance with the principles of packaging, his major theme. In the catalogue to his 1966 exhibition at the Whitechapel Art Gal. he said: 'The kind of images I was using then were based on cartons or boxes. The carton is an incessant theme in present-day civilisation: shops are full of boxes and you see these before you see the goods; they practically stand for the goods. . . . In painting these box images, the box was an idiogrammatic two-dimensional representation of a box. Representation in a precise sense. There was no suggestion, ever, of a replica, as in Warhol. I have tried to keep close to the sensibility, ethos almost, of objects and themes in present-day life (like boxes) rather than reconstructing the objects themselves.' From c. 1963 Smith began to experiment with the shaped canvas and by bringing the canvas out from the wall to turn the picture into a three-dimensional object. His later stretched canvases over shaped and projecting stretchers were still a development of the packaging theme and he probably took the concept of the shaped, projecting and hanging canvas further than anyone else.

SMITH, TONY (1912–80). American sculptor, born at South Orange, N.J. After studying at the Art Students' League, 1933–6, and the New Bauhaus, Chicago, 1937–8, he served his apprenticeship in architecture as clerk of works to Frank Lloyd Wright and practised as an architect from 1940 to 1960. He began to interest himself in sculpture c. 1940 and emerged in the early 1960s as one of the forerunners of MINIMAL sculpture. His work was large in scale and composed of simple geometrical shapes to be made in steel, sometimes painted. His sculptures were sometimes composed of modular units or rectangular boxes fitted together. They exemplified more rigorously than most contemporary work the Minimalist aesthetic which eschewed expressiveness and illusion and sought to present the art work as an 'object' in its own right. His first one-man show was at the Wadsworth Atheneum, Hartford, Connecticut. His influence derived not only from his frequently exhibited works but also from his teaching at the Cooper Union, Pratt Institute, Bennington College, etc.

SMITH, WILLIAM RONALD. See RONALD, William.

SMITHSON, ROBERT (1938–73). American sculptor and experimental artist born at Passaic, N.J., and studied at the Art Students' League. His first one-man exhibition was at the Artists' Gal., New York, and he later exhibited at the Dwan Gal. His work belonged to the category of MINIMAL ART and was included in such exhibitions as 'Primary Structures', Jewish Mus., New York (1966), 'Minimal Art', The Hague (1968), 'The Art of the Real', The Mus. of Modern Art, New York (1968). He experimented particularly with reflection and the mirror image and exhibited, for example, krylon-sprayed metal frames containing nothing but mirrorized plastic. His *Ziggurat Mirror* was constructed of a series of sections of ordinary reflecting mirror glass rising one above the other. His views on mathematical impersonality were expounded in an article published by *Arts* in November 1966.

From the late 1960s he turned to EARTHWORKS art, visiting the abandoned quarries and old mine trailings of Pennsylvania and New Jersey, collecting rock fragments, gravel and geological refuse, which he arranged into random heaps or in metal or wood bins. With these and mirrors, combined with site plans, geological maps and Instamatic colour photographs, he built up his well-known 'Non-sites', using natural waste for artistic purposes in a manner similar to that in which JUNK artists had previously used urban waste. His later work was verging towards CONCEPTUAL ART. Among his best-known *in situ* structures was

Spiral Jetty (1970), a spiral road running out into Great Salt Lake, Utah. It was subject to erosion by the action of the water. In 1971 he did *Spiral Hill* at Emmen, Netherlands. Smithson was killed in an aeroplane crash before these new ideas achieved maturity.

SMITS, JAKOB (1856–1928). Dutch-Belgian painter, born at Rotterdam. After being trained as a decorator he studied painting at the academies of Rotterdam, Brussels, Munich, Vienna and Rome. He returned to the Netherlands in 1880 and in 1888 settled at Achterbos, near Antwerp, being naturalized in 1900. Living in solitude he tried to express through his paintings the poetry of his inner vision and the mystical and symbolic qualities of light. He painted landscapes and interiors, religious scenes and portraits remarkable for their psychological insight. In this field he was influenced particularly by Rembrandt as may be seen in the portrait of his second wife *Malvina* (Mus. Royaux des Beaux-Arts, Brussels, 1912). In 1914 *L'Art Contemporain* organized an exhibition in his honour at Antwerp. During the First World War he ceased painting in order to devote himself to charitable work. Resuming after the war, he reworked some of his earlier paintings with the idea of integrating light and subject matter more closely, as in *L'Aube d'Or* of 1924. In the new works of this period the colours were lighter and the heavy outline was replaced by a more rapid and sketchy line.

SNELSON, KENNETH (1927–). American sculptor and experimental artist born at Pendleton, Oreg. He studied at the University of Oregon, Black Mountain College under ALBERS and DE KOONING, and the Académie Montmartre, Paris, under LÉGER. He taught at the Cooper Union, the Pratt Institute, the School of Visual Arts, New York, and the universities of Southern Illinois and Yale. His first one-man exhibition was at the Pratt Institute in 1963, after which he exhibited at the Dwan Gal., New York, and Los Angeles. Outside the U.S.A. he had exhibitions at the Rijksmus. Kröller-Müller, Otterlo, Netherlands, and the Stadtische Kunsthalle, Düsseldorf, both in 1969. He contributed to collective exhibitions both in the U.S.A. and internationally. His work indicated an interest in modern technology and engineering and his constructions, often of aluminium and steel rods linked by strings or wires, belonged to the new category of 'open' sculpture in which space is not enclosed but modulated as a sculptural element.

SNOW, MICHAEL (1929–). Canadian musician, painter, sculptor and film-maker, born in Toronto. He studied design at the Ontario College of Art, Toronto, and in 1953 travelled in Europe, working as a jazz musician. Back in Toronto he worked as an animator with a small film company, Graphic Associates. Here he met his wife, Joyce WIELAND, and became interested in making experimental films. He held his first one-man exhibition of paintings in 1956 at the newly opened Greenwich Gal. (now the Isaacs Gal.), where all his subsequent Toronto shows have been held. The next of these, in 1960, featured paintings derived to some degree from ABSTRACT EXPRESSIONISM. However, he sought to reduce the consequences of chance, and the following year simpler, bolder pictures were shown, the most remarkable being *Lac Clair* (National Gal. of Canada, Ottawa), a large square canvas completely and evenly covered with generous blue strokes, with brown paper tape pasted a little less than half-way along the edge of each side, starting in the lower right corner. His 1962 exhibition at Isaacs was the first devoted to his 'Walking Woman', a generalized silhouette of a young woman caught in mid stride, presented in an increasingly varied number of styles and other altering situations. Further 'Walking Woman' shows followed, including one at the Poindexter Gal., New York, in 1964 and a 'Walking Woman Retrospective' at the Vancouver Art Gal. in 1967. The series grandly culminated in a group of nine Walking Woman sculptures executed in stainless steel, dispersed about the Ontario pavilion at 'Expo '67' in Montreal (Art Gal. of Ontario, Toronto).

Early in 1964 Snow and his wife had moved to New York, where they became further involved in making experimental films. *New York Eye and Ear Control* (1964) was followed by *Short Shave* (1965). In 1967 Snow was included in 'The Painter as Film-Maker' at the Jewish Mus., New York, and here his important film *Wavelength* was premiered. He showed new sculptural works at the Poindexter Gal., New York, in 1968 and at the Isaacs Gal. in 1969, and in 1970 the Art Gal. of Ontario staged a retrospective including all his films and a large sampling of his work in other media. For some years he had been taking still photographs, and these works were featured in the 1970 Venice Biennale, at which he represented Canada. Selections of camera works were shown in several subsequent exhibitions, including The Mus. of Modern Art, New York, 1976, where they were complemented by a retrospective of his films.

It is for his film-making that Snow continues to be widely known. Early in 1971 he released *La Région centrale*, shot in northern Quebec from a camera mounted on a programmed machine that allowed almost complete freedom of mobility. A retrospective of his films was presented at Pesaro, Italy, in 1973. Snow and his wife moved back to Toronto in the early 1970s and he again played music regularly, making several records including his first solo album, 'Musics for Piano, Whistling, microphone and tape recorder' (Chatham Square, 1975). Most of his concerns are found in his double-projection sound sculpture, *Two Sides to Every Story* (National Gal. of Canada, 1974). In 1975 he published a photographic book, *Cover to Cover*. The Mus. National d'Art Moderne, Paris, circulated an exhibition of his work, 'Sept Films et

plus tard', in 1978, and in December that year a large one-man show was held at the Centre Georges-POMPIDOU, Paris.

SOBRINO, FRANCISCO (1932–). Spanish painter and sculptor born at Guadalajara. He emigrated to the Argentine early in life and studied at the School of Fine Arts, Buenos Aires. Here he came into contact with Argentinian CONCRETE ART and began to work in a CONSTRUCTIVIST manner. Returning to Paris, he became a founding member of the GROUPE DE RECHERCHE D'ART VISUEL (GRAV) in 1960. He was known chiefly for his complex geometrical constructs in coloured plexiglass made from identical reflecting units, which he called 'Unstable Transformations'. These created unstable, that is ambiguous and changing, visual effects which were constantly transformed with the movements of the observer.

SOCIALIST REALISM. The accepted name for officially sponsored Marxist art and aesthetics in Communist countries. In the 1934 Statute of the Union of Soviet Writers it was said: 'Socialist Realism is the basic method of Soviet literature and literary criticism. It demands of the artist the truthful, historically concrete portrayal of reality in its revolutionary development. The truthfulness and historical concreteness of the artistic portrayal must be in harmony with the objective of the ideological alteration and education of the workers in the spirit of socialism.' Similar formulations of Socialist Realism have been given in relation to the visual arts. Socialist Realism is, therefore, claimed to be art which (*a*) veridically depicts phenomena significant to the development of Marxist socialism; and (*b*) serves a propaganda function of promoting progress towards the classless society. A similar conflation of the two concepts of objective truthfulness and socialist propaganda is implicit in the definition of Socialist Realism given in the *Dictionary of Philosophy* edited by M. Rosenthal and P. Yudin (Moscow, 1967), where its essence is said to be 'fidelity to the truth of life, no matter how stern it may be, this being expressed in artistic images from the communist angle'. In the 1930s Socialist Realism achieved some interesting results in Soviet art, particularly in the work of DEINEKA who, like his colleagues Andrei Goncharov (1903–) and Yurii Pimenov (1903–), brought a lyrical, often EXPRESSIONIST experience to his understanding of the new realism. Although founded on the programmatic principles of 'typicality' and 'optimism', early Socialist Realism possessed a rhapsodical, fantastic quality which sometimes brings it curiously near to SURREALISM. Unfortunately, as time progressed, Socialist Realism lost its initial sense of conviction and purpose and degenerated into naturalistic idealization. But however eclectic it became, Socialist Realism remained the exclusive and official artistic style for the Soviet Union. See also RUSSIA AND THE U.S.S.R.

SOCIAL REALISM. Name properly given to any school of art which depicts scenes, events or things of social import in a naturalistic manner. Thus the name is properly applied to the American ASH-CAN school of painting and also to those painters of the AMERICAN SCENE who were interested in depicting objectively scenes from urban life and industry. It was also sometimes applied more specifically to those artists, such as Ben SHAHN, Jack LEVINE, Philip EVERGOOD and Jacob LAWRENCE, who used their art as a medium for social protest or propaganda in the interest of social reform.

The term Social Realism must be distinguished from SOCIALIST REALISM, the latter being reserved by convention for art controlled by the wish to glorify social conditions prevailing within a Marxist state.

SOCIEDAD PRO-ARTE MODERNA (SPAM). See LATIN AMERICA and MALFATTI, Annita.

SOCIÉTÉ ANONYME, INC. or **A MUSEUM OF MODERN ART.** An association formed in 1920 by Katherine DREIER together with Marcel DUCHAMP and MAN RAY for the promotion of contemporary art in America by lectures, publications and travelling exhibitions. It had the first museum in the U.S.A., and one of the earliest anywhere, to be devoted entirely to modern art. The Société arranged more than 80 exhibitions between 1920 and 1940, the largest being at the Brooklyn Mus. in 1926. The emphasis was upon *avant-garde* and abstract art and it was through the efforts of the Société that such artists as KLEE, MIRÓ, MALEVICH, SCHWITTERS, BAUMEISTER, VANTONGERLOO were first exhibited in America. To some extent, therefore, the Société carried on the tradition which had been started by the 291 Gal. of STIEGLITZ in the years before the ARMORY SHOW. It also built up a permanent collection of modern painting and sculpture, the greater part of which passed to Yale University Art Gal. in 1941. The Société came to an end in 1950.

SOCIETY OF INDEPENDENT ARTISTS. An American association formed in 1916 to succeed the Association of American Painters and Sculptors, which was dissolved after the ARMORY SHOW. Its object was to hold annual exhibitions in rivalry with the National Academy of Design and to afford progressive artists an opportunity to show their works. It was organized on the model of the French Salon des Indépendants without jury or prizes, giving anyone the right to exhibit on payment of a modest fee. The first President was William GLACKENS, followed by John SLOAN, and Marcel DUCHAMP was one of the first Directors. The first exhibition, in the spring of 1916, comprised more than 2,000 exhibits and included both American and European artists. Although the Society continued to arrange exhibitions until the mid 1940s, subsequent exhibitions were smaller and inferior in quality and its importance dim-

inished. In 1917 Duchamp resigned after the refusal to exhibit his READY-MADE in the form of a urinal entitled *Fountain by R. Mutt*. Although much recondite aesthetic theory has been read into this gesture, it is likely that the main purpose of it was to demonstrate the artistic incongruity of a Society with the professed purpose of allowing anyone to exhibit anything.

SOCIETY OF SCULPTORS AND ASSOCIATES, THE. An association formed in Sydney in 1950 with the help of Lyndon Dadswell (1908–) for the furtherance of innovative trends in Australian sculpture.

SOEST, PIERRE GERARDUS CORNELIS VAN (1930–). Dutch painter and graphic artist born at Venlo and studied at the Academy of Art, Amsterdam. He was a member of the Dutch EXPERIMENTAL GROUP and of the COBRA Group. He painted in a manner of violent EXPRESSIONISM, half-abstract half-SURREALIST, incorporating fragments of human bodies, insects, etc. in powerful but sometimes repellent compositions.

SOFFICI, ARDENGO (1879–1964). Italian critic and painter, born at Rignano in Tuscany and studied at the Academy in Florence. His formative years, 1900–7, were spent in Paris, where he knew writers and painters such as APOLLINAIRE, Max Jacob, PICASSO, BRAQUE, MODIGLIANI and wrote in *avant-garde* periodicals. Returning in 1907, he contributed to Prezzolini's periodical *Leonardo* and was the chief art critic of its successor *La Voce*. His essay 'Picasso e Braque', which appeared in *La Voce* on 24 August 1911, was the first discussion of CUBISM in Italian and may have served to introduce the Milanese FUTURISTS, BOCCIONI, CARRÀ and RUSSOLO, to the aesthetic aims of Cubism. In 1912 he associated himself with the philosopher Papini when the latter seceded from *La Voce* and together they founded the journal *Lacerba*, which then proceeded to join forces with the Milanese Futurists. In 1913 Soffici also published in book form his three articles on Cubism, *Cubismo e oltre*. In these he emphasized his view of Cubism as a static representation of reality complementing the Impressionist revolution, represented Cézanne as the forerunner of Cubism and gave prominence to the concept of Cubism as a search for 'pure pictorial values' in contrast to the Futurist aim of empathy with the dynamic object. Under the influence of Boccioni and Carrà, however, he became converted to Futurism in the course of 1913, and in 1914 a second edition of his book was published with the title *Cubismo e Futurismo* and amplified by his two *Lacerba* articles on Futurism, in which he described Futurism as a Hegelian synthesis of the two apparently irreconcilable ideals of Impressionism and Cubism.

Soffici had already made a name for himself as a painter and in 1908 he exhibited with DELAUNAY at the STURM Gal. in Berlin. In 1913 in an article in *Der Sturm* he described himself as a Cubist. His *Scomposizione dei piani di un lume (Decomposition of the Planes of a Lamp)* of 1912 was a typically Cubist work. The *Linee e volumi di una strada (Lines and Volumes of a Street)*, *Sintesi di un paesaggio autumnale (Synthesis of an Autumnal Landscape)* and the destroyed *Ballo dei pederasti: dinamismo plastico (Ball of the Pederasts: Plastic Dynamism)*, all of 1913, attest his conversion to the Futurist interest in the synthesis of movement but lack the dynamic expressiveness and empathy of the best Futurist paintings. In 1914 he joined with Carrà in experimenting with COLLAGE and his *Cocomero, fruttiera, bottiglia (Watermelon, Fruit Dish, Bottle)*, a work of Synthetic Cubism, marks his break with Futurism, which was later made explicit by attacks in *Lacerba*. From this time Soffici looked increasingly to the narrow Italian tradition in painting and in 1918 he associated himself with the attacks on Cubism and Futurism made by CHIRICO and Carrà in their journal *Valori Plastici*. Soffici's article 'Periplo dell' Arte' was a chauvinistic attack on all forms of modernism in the name of a parochial nationalism.

SOFT ART. Since about the time of the DADA movement an outstanding feature of the art world has been the increasing use of novel and unconventional materials in sculpture. The vogue for non-rigid materials belongs particularly to the 1960s and lasted through the 1970s; from about 1978 'Soft Art' came to the fore as a new catchword. The materials employed have been very diverse—rope, cloth, rubber, leather, paper, canvas, vinyl, kapok, anything in fact which offers a certain persistence but lacks permanent shape or rigidity.

Perhaps the earliest example of 'Soft Art' in this century was the typewriter cover which Marcel DUCHAMP mounted on a stand and exhibited in 1916. But this belongs rather to the category of READY-MADES, which he introduced. The 'Soft Art' movement is therefore usually traced to Claes OLDENBURG's giant replicas of foodstuffs (ice-cream sundaes, hamburgers, pieces of cake, etc.) made from vinyl and canvas stuffed with kapok in the early 1960s. In the mid 1960s he also made 'soft' versions of hard and rigid objects (*Soft Toilet*, 1966; *Soft Giant Drum Set*, 1967). Since then the artists who have experimented with soft materials have been many and diverse, from many different movements: POP ART, SURREALISM, ARTE POVERA, etc. They include among others: Robert RAUSCHENBERG, CHRISTO, ARMAN, Robert MORRIS, Richard SERRA, Antoni TÀPIES. The movement—if such it can be called—has certain affinities with the NEW REALISM, since in general, although the work may be representative of something else, the materials are not concealed and make no pretence to be other than what they are.

From 1978 'Soft Art' gained new publicity on both sides of the Atlantic. A pioneer exhibition, in which some 60 artists were represented, was staged in Munich and Zürich, 1979–80. The catalogue

to this exhibition gives some idea of the extent and ramifications of the movement.

SOKOLOV, NIKOLAI. See KUKRYNIKSY.

SOLANA, JOSÉ GUTIÉRREZ (1885–1945). Spanish painter born in Madrid. He came of a poor family and was untaught as a painter. He painted mainly city and street scenes of Madrid and the surrounding districts and also did conversation pieces of city notables. Solana is considered to have been the greatest of the Spanish EXPRESSIONISTS painters in this century. His work depicted the life of the people in heavy impasto with dramatic chiaroscuro but in a style of unaffected naturalism.

SOLAR, XUL. See XUL SOLAR.

SOLDATI, ATANASIO (1896–1953). Italian painter born at Parma. After studying architecture and obtaining a diploma in 1920, he began to paint in 1922 without formal training. Until the mid 1930s he painted mainly still lifes influenced first by CUBISM and then by the METAPHYSICAL SCHOOL. In the latter part of the 1930s he turned to CONSTRUCTIVISM and in 1946 he became a founding member of the MOVIMENTO PER L'ARTE CONCRETA. Until 1950 he was prominent as a pioneer of geometrical abstraction in Italy.

SOLDI, RAÚL (1905–). Argentine painter, born in Buenos Aires. He studied at the Accademia di Brera, Milan, where he was a member of the artistic *avant-garde* and joined the *Chiaristi* group which exhibited at the Gal. del Millione. He exhibited at Rome, Turin and Milan and in 1929 obtained the First Prize at Trieste. Returning to the Argentine in 1933, he exhibited with the Amigos del Arte Institution and when his works were rejected by the National Salon he exhibited in provincial centres and took part in group exhibitions of Argentine artists in Rome, Paris, New York and Santiago, and at the biennials of Venice and São Paulo. In 1942 he obtained a scholarship from the Argentine National Committee for Culture which enabled him to live for a while in the U.S.A. There he studied stage design. On his return to Buenos Aires he designed settings for Argentine film productions and for the Buenos Aires Opera House and the San Martín Theatre. He also executed murals, including some on religious subjects, and did book illustration. His painting consisted mainly of figure studies and still lifes executed in a Late-Impressionist manner. In 1960 he was a Guest of Honour at the Second Mexico Bienale and in the same year had a retrospective exhibition at the Wildenstein Gal., Paris.

SOLVES, RAFAEL. See EQUIPO CRÓNICA.

SONDERBORG (KURT R. HOFFMANN, 1923–). Painter born in Sonderborg, Denmark, son of a German jazz musician. He grew up in Hamburg and studied art at the Landeskunstschule there, 1947–9, after which he joined the Hamburg group of CONCRETE artists and was for a short time a member of the ZEN group. In the early 1950s he came under the influence of Julius BISSIER and studied graphic techniques under HAYTER in Paris. In 1966 he settled in Stuttgart and taught at the Stuttgart Academy of Art. Sonderborg did calligraphic paintings in a manner akin to that of HARTUNG or KLINE. His method was to apply black paint or ink by 'automatic' techniques and then to make scratches and graffiti in the design which it formed. Writing in 1965, Werner Haftmann described Sonderborg as 'the most important of the younger German painters'.

SONNIER, KEITH. See CONCEPTUAL ART.

SORIA, SALVADOR. See SPAIN.

SOTO, JESÚS RAFAEL (1923–). Venezuelan painter, sculptor and experimental artist born at Ciudad Bolivar. He studied at the Escuela de Artes Plasticas y Aplicadas, Caracas, 1942–7, and from 1947 to 1950 was director of the School of Fine Arts, Maracaibo. In 1950 he went to Paris and lived there intermittently from that time, maintaining studios both there and in Venezuela. His first one-man show was at the Taller Libre de Arte, Caracas, in 1949. He first painted in a POST-IMPRESSIONIST manner, then became interested in CUBISM. Before going to Paris he had seen reproductions of MALEVICH and later, after seeing works by MONDRIAN and the CONSTRUCTIVISTS, he began to experiment with optical phenomena and OP ART. In the early 1950s he experimented with SERIAL ART in such series as 'Progressions', 'Repetitions' and 'Serials'. In his *Displacement of a Transparent Square* (1953–4) he created a spatial effect on a flat surface, which he subsequently developed three-dimensionally by overlapping two or more sheets of transparent plexiglass painted with rectilinear or curved designs. These changed their appearance with the movements of the spectator, thus inviting spectator participation. *Spiral* (1955) was one of the first in which contrapuntal curved patterns on two sheets of plexiglass produced the illusion of a moving spiral. In 1955 Soto was included in the Denise René KINETIC exhibition 'Le Mouvement' with VASARELY, BURY, DUCHAMP, CALDER, TINGUELY, AGAM and Robert JACOBSEN. In 1961 he turned his attention to textural effects and made a series of textured works using materials like rubber studded with nails and pieces of wood. In 1963 he began a series of 'Writings', in which thin curved wires suspended over a flat vertically lined surface created a subtle vibration. The 'Vibration' series was begun about the same time. Some of these consisted of rods suspended in front of a lined panel as in the 'Writings', while others obtained their effect by regularly spaced squares attached to the back panel as in *Vibration* (1965),

which was shown in 'The Emergent Decade' exhibition at the Solomon R. Guggenheim Mus., New York, in 1966. His interest in spectator participation was evidenced by a series of environmental works done in the late 1960s. These, called 'Penetrables', consisted of proliferations of thin suspended nylon tubes forming a tunnel through which spectators walked. One of these was exhibited in 1967 at the Mus. National d'Art Moderne, Paris. In 1971 he made a sonorous 'Penetrable' whose aluminium tubes clanged as spectators walked through it. He also executed a number of murals, including murals for the University of Caracas in 1957, the University of Rennes in 1968, for the Bundesbank, Frankfurt, in 1971 and for the Central Bank of Venezuela, Caracas, in 1973. Soto exhibited extensively in Europe, South America and the U.S.A. He participated in the 1957 and 1959 São Paulo Bienales and in the 1958 and 1960 Venice Biennales and was awarded the David Bright Prize at Venice and the Grand Prix at the Second Córdoba Bienale in 1964. In 1960 he was included in 'Art Concret—50 Ans d'Evolution' at the Helmhaus, Zürich, and in 1964 in 'Pilot Show of Kinetic Art' at the Signals Gal., London. In 1968 he participated in 'L'Art Vivant' at the Maeght Foundation, Saint-Paul-de-Vence, and in 1974 he had a retrospective at the Solomon R. Guggenheim Mus., New York. His Jesús Soto Mus. of Modern Art was inaugurated in 1973 in his home town, Ciudad Bolivar. Several films have been made about his work. He was one of the most widely acclaimed of *avant-garde* artists experimenting in kinetic art, Op art and combined light and sound environments.

SOULAGES, PIERRE (1919–). French painter born at Rodez, Aveyron. He attended briefly the École des Beaux-Arts, Montpellier, but was more interested in the Romanesque sculpture and the engraved menhirs of the district and decided not to attend art school in Paris. After serving in the war and working as a farm labourer near Montpellier he settled in Paris in 1946 and exhibited at the Salon de Mai and the Salon des Surindépendants. In 1953 he won a prize at the São Paulo Bienale, in 1957 a prize from the Japanese Ministry of Education at the International Exhibition at Tokyo, and in 1959 the Grand Prix for Graphic Art at the Ljubljana Biennale. His paintings, often of large format, consisted of black 'signs' which looked like blown-up hieroglyphs or Chinese characters. His work achieved international recognition and he was regarded as one of the most important, as well as one of the most individualistic, artists of the post-war ÉCOLE DE PARIS.

SOUTH AFRICA. Since 1945 it has no longer been possible to divide the arts in South Africa into a section representing the white population and a section representing the black. The social and economic segregation of blacks is less apparent in the arts than elsewhere. Where it chiefly makes itself felt is in the lack of opportunities for training, both because the young black artist is usually under strong family pressure to contribute financially from an early age and also because art is not usually included in his ordinary school curriculum and is not normally regarded as a desirable discipline at universities open to the black student (although most teacher training colleges offer art as part of their curriculum). Although they are more fortunately placed as regards availability of training, the Coloured (i.e. 'Cape Coloured' or descendants of originally mixed stock) and Asian sections of the population have made comparatively little mark on the arts in South Africa. By contrast, where the black (i.e. African) artists have emerged, often through a measure of private sponsorship, they have made a strong impact.

There is little or no tradition of 'high' art among the indigenous peoples within the confines of the Republic of South Africa—or indeed anywhere south of the Congo River. The arts and crafts sponsored by officialdom for the tourist trade are not the concern of this article, being a kind of folk art produced chiefly by women and not to be confused with traditional African art. In South Africa the young black or Coloured artist is heir to no tribal tradition in art any more than is the black artist in America who has never been exposed to the traditional art of his ancestors, but today stands, like him, exactly where his white fellow-artist does.

In the 1940s professional artists in South Africa were drawn almost exclusively from the white population, at that time numbering just over two million. Formal training in art was confined to three university schools: Cape Town, Natal (first at Durban and later at Pietermaritzburg) and Rhodes (at Grahamstown), both the latter then being colleges of the University of South Africa. All used the English language and therefore drew the majority of their students from the English-speaking sector. The only other schools of art offering diplomas were those attached to technical colleges, notably those of Pretoria, Durban and Johannesburg, together with the Michaelis School in Cape Town, which had come under the auspices of the University. There was a handful of private studios which offered a semi-formal training though without any qualifying certificates. Those young people whose families could afford it spent some time in London or Paris, or in the Netherlands or Italy. A small and dwindling number struggled into the professional art world with no training or under the guidance of private teachers. This applied also to the few non-white artists who became known, among them Gerard Sekoto, a painter of lively genre scenes who later disappeared into obscurity in Paris. This kind of subject, usually figuring urban African life, became the stock-in-trade of the black painter.

The three university art schools and most of the schools attached to technical colleges were staffed

almost entirely in pre-war years by teachers who had been trained in England or elsewhere in Europe. The tradition derived from the Royal College of Art. The style of the artist-teachers themselves was based on Augustus JOHN and the NEW ENGLISH ART CLUB. Set against this, particularly among the Afrikaans-speaking groups, was an older tradition of Dutch genre and The Hague School. In addition some after-glow of Impressionism had penetrated to South Africa and through such older painters as Hugo Naudé (1869–1941) had suffused a whole generation of landscape painters, particularly at the Cape but also in the Transvaal. In the 1930s German EXPRESSIONISM exerted a strong influence on many artists. The war broke into a scene in which the eddies of all the important contemporary European movements swirled together without chronological meaning. The flotsam of Impressionism continued to complicate any possible resolution of formal and expressive elements. A bewildered Academicism on the one hand and a continuing compulsion towards description on the other blocked any sweeping victories by advanced fashions from Europe.

When the Second World War was over the painters of standing included Cecil Higgs (1906–) and Maud Sumner (1902–), two women whose *intimiste* POST-IMPRESSIONISM had developed, one into a surface-identifying and expressive *matière*, notably rock pools and flowers, and the other to a simplified CUBISTIC description, chiefly of landscape. Irma Stern (1894–1966) and Maggie Laubser (1886–1973), both trained in Germany, represented the Expressionist influence, which lent itself easily to the harsh and bizarre aspects of African light, environment and native tribal life. These four women were all born in South Africa, as were important younger painters such as Alexis PRELLER, Walter BATTISS, May Hillhouse (1908–). Maurice van Essche (1906–77), Belgian born and trained, was also a significant influence at this time, as was Jean Welz (1900–75), born in Salzburg, who had turned dramatically from architecture to abstract painting before the war. After the war he established himself as one of the country's foremost painters in a Post-Impressionist manner involving a fastidious use of brush and pigment and a delicate draughtsmanship. Battiss and Preller were emerging at about the same time and shared the leading place in South African painting. The work of both reflected African influence in style and theme. Walter Battiss, stimulated by an early enthusiasm for prehistoric rock-drawings, developed his own brand of narrative and calligraphic painting with a brilliant and varied palette; Preller sought his inspiration from more formal and ritualistic references to tribal Africa and its monumental patterns. Both these painters, invoking as they did ancient systems of magic, went their individual ways beside the changing fashions of art generally, within current formal and SURREALIST traditions. Though each of them from

time to time reflected abstract and Expressionist moods, they both affirmed their standing as considerable South African artists in a continuous development. Of the other two artists referred to above, Van Essche retained his own version of French Expressionism, and May Hillhouse ranged widely within an elastic field of Post-Impressionist description.

These, however, were soon superseded by a younger generation, who were for the most part South-African born and trained though many seized the opportunity after the war to spend some time working in London or Paris. Here they found that TACHISM and other forms of expressive abstraction were the vogue. The South Africans went back—those who did go back—in a thoughtful mood. As they had never really espoused Cubism, there could be no real reaction from it. The only forms of Expressionism which had been known in the country were the type of the German BRÜCKE, filtered through local artists like Irma Stern and Maggie Laubser, and that of the Belgian Maurice van Essche, who became Professor of Fine Art at the Michaelis School in 1963. For some years Expressionist techniques remained the most advanced, controversial issues being restricted to subject rather than style. What was produced by the few who 'went abstract' (though most painters experimented with abstraction for a while or from time to time) was something nearer to Tachism than American ACTION PAINTING. Open as ABSTRACT EXPRESSIONISM became to meretricious pastiche, it was probably never more dismally unsuccessful than in its South African version. It was not that its *raison d'être* was misunderstood, at least not by the more alert of its practitioners, but that there were just not enough of them to give it standing as a legitimate genre. The paintings were far too small (for you cannot have a small shout) and the charlatans who eagerly attached themselves to the nucleus of trained painters could not easily be distinguished from them by the bewildered spectator, and were allowed too long to cloud critical standards.

The painter in South Africa has always been strongly moved to depict his environment and even after the war South African painters were still struggling to find a valid expression for the landscape which they had come to know as an extension of themselves and not merely an exotic phenomenon to be described for a distant homeland.

The establishment of South Africa as a Republic outside the British Commonwealth may or may not have accentuated nationalist sentiments among individual artists, but there were certain inevitable material consequences. One was a pronounced and rapid development of local technological expertise. Another was the moving of art education into another phase, where teachers of art were more and more drawn from the local population, with the consequent emergence of professional artists who had either not gone over-

seas for their education or had done so only after preliminary training in South Africa. Most of them in fact, unless they had been awarded some sort of scholarship especially for overseas study, betook themselves to England and the Continent, or further afield, simply as visitors. There were very few South African artists who had not travelled to other countries. The outlook was further broadened by German, Italian and other settlers after the war. It was not until the late 1950s, however, that the next generation of painters began to make itself felt. The older artists referred to above had surged forward strongly after the end of the war, and were too robust themselves and had become too aware of what was going on in other places to yield easily to the younger men and women. Of these several tried to carry forward in a contemporary idiom the South African tradition of landscape. Gordon Vorster (1924–) abbreviated a Post-Impressionist manner to combine recognition with association in a number of canvases devoted to the stony countryside of bushveld and desert, some including animals, many coming off with considerable brilliance. Erik Laubscher (1927–), painting at the Cape, persevered in the perhaps more difficult aim of achieving a strongly formal near-abstract simplification with the landscape little more than a starting point. Cecily SASH began to develop an abstract linear description of more particular aspects of landscape such as grass and plants, usually peopled with birds and insects. Giuseppe Cattaneo (1929–), starting with a biting Post-Impressionist technique, proceeded to develop an affirmative abstraction which swung to direct reference with accomplished ease. Even more non-representational was the work of Gunther van der Reis (1927–).

If Abstract Expressionism was untimely in the gentle exploratory attempts of South African painting to find a path of its own, the movements of the 1960s and early 1970s in Europe and America were even more so. The small congregation of painters in South Africa was not on the whole ready for such innovatory movements as OP ART, KINETIC ART, COLOUR FIELD PAINTING, the slashed canvas, ARTE POVERA, etc., though individual artists did come up with experiments in all these styles. Still less were they situated favourably for the reception of POP ART.

Artists living in South Africa, not only distant from the older world of art but thinly spread over their own terrain, have always entertained a wistful picture of artistic communities in other parts of the world with their constant and febrile interchange of ideas. What in fact is noteworthy is the close contact kept by South African artists with each other, most of the established artists knowing each other fairly well, and the closely knit fabric of the art society. Of course there are in-groups and others. But there is no Establishment of the National Academy or Salon type, holding a position of privilege that tends to exclude the younger *avant-garde* and keep them on the perimeter. The only

body advising the Government on matters relating to the Fine Arts is the Advisory Committee on the Plastic Arts, which reports through the Cultural Council to the Department of National Education. Membership of this Committee is determined by the Minister and is not representative of the artistic community. The South African Association of Arts, which has provincial committees, receives a small subsidy from the Department of National Education, as a result of which it is seen by the Department as a semi-official body, and a member of the S.A.A.A. is usually appointed to the Advisory Committee on the Plastic Arts. The largely amateur direction of the S.A.A.A., however, has tended to the dissatisfaction of professional artists. The laws relating to racial segregation do not extend to this domain, and all artists can show or work or meet with each other as they wish. (There is also no segregation or exclusion in art galleries, or at lectures or public meetings provided they are held, as they invariably are, under private or semi-private auspices such as galleries, universities, colleges or clubs.)

Painting is not a part of the tradition of African peoples, and there is no indication that those tribes which penetrated south beyond the Limpopo were influenced by the rock-paintings that had been produced by the earlier inhabitants of these regions. Apart from the characteristic crafts of a people not yet developed in technology, such as the making and decoration of pottery and personal adornments like beadwork (the beads themselves imported through barter in the early days), the tribes settled in Southern Africa seem not to have been artists, perhaps because of the continuing demand that the men be warriors and hunters. The crafts, like the husbandry, were the province of the women. As has been said, art lessons, especially drawing and painting, are not always available as part of the curriculum offered in schools attended by African children. Schools for Coloured children in the Cape and schools for Indian children in the urban areas of Natal do provide such classes. These lessons terminate, as they do in white children's schools, at the secondary level. The difference is that where the talented or interested white child may elect to take Art as a matriculation or high school subject, or take it as a privately arranged 'extra', the same facilities are not readily available to non-white children, who in any case rarely continue schooling to the matriculation level. They are part of the Provincial Education programme, but their actual provision is a matter for decision by individual schools. If children do remain long enough to qualify for tertiary-level training, it is usually in some field economically or socially more urgent than art studies are felt to be, though handicrafts do tend to be encouraged. This means that when an African youth (for there are almost no black women artists in South Africa) does have the interest and stamina for part-time training in art, he is an exceptional individual who has almost certainly come

under the influence of white artists or teachers, and is introduced to the excitements and possibilities of creative art from a modern and western European point of view. In other words, although his training is far more difficult to acquire and he has to be sufficiently gifted to leap many hurdles, it places him ultimately almost exactly where his white colleagues stand. He may, if he is able, take a degree in Fine Art through the University of South Africa, the only university in the country permitted to enrol students from all ethnic groups; but this is an extra-mural institution teaching almost entirely by correspondence, a difficult enough way to study painting or sculpture but particularly so for students who can count on no help from their home environment. In Eastern Cape the University of Fort Hare, Alice, has a Fine Art department for black students. In Cape Town the Michaelis School of Art remained open to Coloureds but was not easily available to black Africans, who were concentrated in other parts of the country.

Black artists rarely aspire to formal training or diplomas in South Africa but rely rather on private teaching and encouragement. The conditions for success are the same for them as for others: they must find a gallery which considers their work economically viable, first being included in collective exhibitions and then perhaps obtaining a one-man show. They are, however, liable to the additional hazard that they may be overwhelmed by exaggerated and uncritical praise from collectors or critics aware only of the difficulties which beset a black artist, and they may be unable to live up to it.

Although it has been said that the black artist in South Africa can look to no traditional art for the mainspring of his development, and although to all intents and purposes his influences are precisely the same as those of his white colleagues, it has so happened that his work has tended to differ from that of white artists. First of all it has usually taken the form of sculpture rather than painting, an interesting phenomenon in view of the fact that he has on the whole no access to traditional African carving (which in any case is not his own tradition) and that drawings and paintings are so much more readily available and more easily imitated than sculpture. Most educated Africans tend not to be interested at all in the tribal heritage, and are much more likely to be inspired by contemporary examples. Sydney Kumalo, one of the leading African sculptors to emerge in Johannesburg since the mid century, drew in a sophisticated manner though he disclaimed any specific influence; but his bronze sculpture was animistic, consisting of figurines, animals and near-monsters. Lucas Sithole, another young Johannesburg sculptor, like most black (and many white) sculptors in South Africa, worked notably in wood, adapting the natural growth of the tree to infuse vitality into a crouching pregnant woman or tense prowling animal. Abstraction, particularly of a geometrical kind, does not seem to come naturally to this generation of African artists.

Reference has been made to the emphasis on caricature in so much of the drawing and painting of black and Coloured artists. This, though occasionally poignant, emphasized the linear features and prevented a painterly development of any depth. One might mention Louis Maqhubela, who showed painterly qualities, while Mslaba Dumile and Andrew Motjuoadi produced work of striking graphic individuality. Azaria Mbatha, with some mission training, produced a fair amount of work in woodcut which could reach other media. These young artists had not yet reached maturity by the mid 1970s but were already interesting for the essential vitality or animism inherent in so much of their drawing and carving.

Although South African art has not in general been notable for stylistic innovation, it has some qualities that should be recorded. First the paintings are generally smaller than they tend to be in Europe or America, though since the mid century much larger canvases have been produced. Even so, South African painters have always tended to work to a smaller scale than, say, the French or the Americans, and this may in part be due to the fact that they know contemporary works chiefly in reproduction, and in part because of the Dutch background. Both these factors may well have contributed to another characteristic of South African painting, which is the meticulous application of paint. The bravura and the impulsive character of much contemporary painting have not evoked much response in South Africa, which therefore often seems bathed in an almost provincial twilight. Yet it is not quite provincial. From it emerges a handful of talented artists whose character is almost entirely that of sensitivity and control. In the mid 1970s Alexis Preller and Walter Battiss were still regarded as the leading elder exponents, each in his way reflecting the persistent pressures of a specific and unique background. This background, the audible breathing of the African bush, seems always waiting and imminent, and is certainly as relevant as the neon lights and plastic obscenities of American cities, or the crowded humanity of London, Paris or Milan.

There is little else to say about sculpture. More than painting it has clung to monumental portraiture, academic portraiture, bronze portraiture that has in its antecedents something of both Rodin and EPSTEIN, academic studies of animals and African peoples. Some young artists struggled with CONSTRUCTIVISM, never getting a commission big enough to put it to the test but serious nevertheless. Mechanism (Eduardo VILLA) stood incongruously alongside the tense wood of the more vitalist artists (Kumalo, Sithole): the intellectual West confronting Africa.

The difficulty of resolution between the strident voice of the modern world and the quieter but perhaps more penetrating persistence of Africa has led, among other pressures, to the emigration,

temporary or permanent, of several artists reared in South Africa, among them some of high quality. Christo Coetzee (1929–) and Douglas Portway (1922–) had their headquarters in Spain, returning from time to time to sojourn or show paintings in South Africa. The former, who graduated a few years after the end of the war, remained ever afterwards an impatient intellectual wrestling with the flippant immediacy of materials; the latter consistently developed a lyrical non-objective preoccupation with fluid pigment, tending latterly towards environmental colour relations. Also of this generation Cecily Sash left South Africa to work in England.

In South Africa itself a younger generation was emerging in the 1970s with an interesting mystique, not quite African, not quite cosmopolitan. It included two painters of interest in Durban, Patrick O'Connor (1940–), with his involuted erotic fantasies, and Andrew Verster (1937–), with his nightmarish caricatures of life-states. In Johannesburg Judith Mason (1938–) worked with cerebral and fastidious delicacy, evolving a personal Christian mythology in which the word and image combine. Others of the younger artists were preoccupied with formal problems. In the Cape Kenneth Bakker (1926–) emerged with evocative non-representational compositions, not always in paint, and Transvaal painters like Bettie Cilliers-Barnard (1914–), Larry Scully (1922–) and George Boys (1930–) worked mainly in abstraction. Totally non-figurative too was the work of younger painters like Aileen Lipkin (1933–) and Lionel Abrams (1931–). More figurative work came from Cecil Skotnes, who allowed a nostalgia of the African fetish to dominate his angular and linearly harsh panels. Margaret McKean (1936–), not yet widely known to the public, has for some years painted monumental yet partly linear near-abstract female figures which later began to be invaded by Surrealist elements. Robert Hodgins (1920–), lost to painting for some years for journalistic criticism, returned to defend the human figure as formal subject and symbol. The Surrealist black and white spaces of Fred Page (1908–) and the immaculate billboard panels of Helmut Starcke (1935–) and Kevin Atkinson (1939–) move across to the canvases of the younger painters, into Andrew Verster's Pop horror of the everyday, the mythology of Patrick O'Connor's bleeding Oedipus and bound erotic dreams, to meet Judith Mason's poetic Gospel starkness, her thorny Christ and abandoned bones, and the baffled and frightened birds of Cecily Sash.

Some younger sculptors like Janet Fraser (1944–) also dabbled in Surrealism, but sculpture for the most part continued its outward-looking objective interest (commemoration, portraiture) or cultivated the tectonic and abstract. Sculpture is often placed out of doors in South Africa, and the exploratory and intimate are not encouraged by this. Eduardo Villa, of Italian origin, was perhaps the most substantial sculptor after the mid century, working chiefly in metal and producing massive, mechanistic standing and reclining figures and also more delicate and polished smaller ones. Of an earlier tradition of symbol and sentiment, emerging from the welter of brassy portraiture and near-abstraction of commonplace sculpture, Lippy Lipshitz (1903–80) remained the only considerable older artist.

SOUTINE, CHAÏM (1894–1943). Russian-born painter, who settled in Paris and became one of the most radical and most inspired EXPRESSIONISTS within the ÉCOLE DE PARIS. The tenth child of a poor Jewish family of Smilovich, near Minsk, he ran away from home at the age of 13 to avoid being apprenticed as a shoemaker and took drawing lessons in Minsk. In 1910 he began to study at the École des Beaux-Arts in Vilna while maintaining himself by working in a photographic establishment. In 1913 he was able to move to Paris through the help of a patron and there he took a studio at La RUCHE and studied at the Cormon studio in the École des Beaux-Arts. In Paris he became one of the group of uprooted artists who by their way of life and the expression of anguish in their works earned themselves the title *peintres maudits*, making friends particularly with CHAGALL and MODIGLIANI. The latter's portrait of him, done in 1917, is one of the most expressive of that artist's works (Chester Dale coll., Washington). By Modigliani he was introduced to the dealer Léopold Zborowski, who made it possible for him to paint for three years (1919–22) at Céret in Provence. Here he worked feverishly on visionary landscapes in a turbulently emotional idiom more extreme even than the latest works of Van Gogh. These canvases, some 200 in number, were not appreciated by Zborowski, but in 1923 they were discovered by the American critic A. C. Barnes, who bought 100 of them and set up Soutine in a studio near the park of Montsouris. After a short stay in Cagnes and visits to the Netherlands, where he came under the influence of the later works of Rembrandt, he returned to Paris in 1926 and began his paintings of flayed carcases, in which it has been said 'he transcribed the luminosity of putrescence with dazzling visual truth'. Among the most striking of these are *Le Bœuf Écorché* (*Flayed Ox*; Mus. de Grenoble, 1926) and *Chicken* (Kunstmus., Berne, 1925–6). During the 1920s he painted a number of grotesque and exaggerated distorted figures expressive of psychological abnormalities and also a series of unexpectedly tender renderings of choir-boys, page-boys, pastry-cooks, etc. An example is *Pageboy at Maxim's* (Albright-Knox Art Gal., Buffalo, N.Y., 1927). In 1929 Soutine found a refuge at Châtel-Guyon with M. and Mme Castaing, who owned many of his works. After the occupation of France in 1940 he refused an opportunity to go to the U.S.A. and continued unmolested to paint landscapes in the village of Champigny-sur-Veude,

Touraine. He died after an operation for perforated ulcer.

Extreme as it was, the Expressionism of Soutine had little or nothing in common with the main preoccupations of German Expressionism. His affinities with KOKOSCHKA and NOLDE have been exaggerated. Of German Expressionists it could not be said, as it has been said of Soutine, that his 'present reputation rests as much on the form as on the feeling in his work'. His Expressionism was the irrepressible ebullience of that tragic and apocalyptic Jewish temperament which he shared with so many of his exiled compatriots. In character he suffered from periodic depressions and from a persistent lack of confidence in his own work. He was not satisfied with what he produced and would destroy earlier canvases. The same lack of confidence made him reluctant to exhibit. It was for this reason that he remained relatively unknown to the general public in his lifetime. His work, however, had an important influence on the Italian artist SCIPIONE and others of the ROMAN SCHOOL.

SOUVERBIE, JEAN (1891–). French painter born at Boulogne. In 1908 a meeting with Maurice DENIS and Paul SÉRUSIER influenced him to take up an artistic career and from 1916 he studied at the Académie Ransom. CUBIST tendencies were apparent in his work during the 1920s as a result of his interest in BRAQUE and during the 1930s he became known for his monumental murals. These included a fresco for the Mus. des Travaux Publics (1936) and a very large group *La Musique* for the Palais de Chaillot (1937). In 1945 he became Professor at the École des Beaux-Arts and in 1948 an atelier of monumental painting was created there for him. In his still lifes and murals he exploited the stylistic innovations of Cubism for decorative purposes.

SOUZA, F. N. (1924–). Indian painter, born in Goa. He studied at the Sir J.J. School of Art, Bombay, 1940–5, and in 1947 was a founding member of the Progressive Artists' Group and received a prize at the Annual Exhibition of the Bombay Art Society. In 1948 he was represented in the Exhibition of Indian Art at Burlington House, London, and he settled in England in 1949. From 1951 he had one-man shows and participated in collective exhibitions in London, Paris, New York, Zürich, Venice, Rome and elsewhere. In 1957 he obtained a prize at the John Moores Exhibition, Liverpool, and in 1958 he received a Guggenheim Painting Award. In 1960 he was awarded an Italian Government Scholarship and in 1962–3 he was represented in the exhibition 'Commonwealth Art Today' at the Commonwealth Institute, London.

SOVÁK, PRAVOSLAV (1926–). Czech painter and graphic artist born in Bohemia. After studying at Prague University and the Palacky University of Olomouc (Olmütz) he travelled extensively in Europe and America and settled in Switzerland. In 1966 he won the Folkwang Prize and in 1967 First Prize in the Coloured Graphics Triennale, Grenchen, Switzerland. His graphic work was exhibited widely in Europe and in America, including important exhibitions at the Kölnischer Kunstverein and the I.C.A. Gals., London, in 1972. In 1976 he was appointed Professor at the Cologne Academy of Art. He was particularly known for his *Graphisches Tagebuch* and for the series which he called *Indirect Messages*, in which a graphic image was supposed indirectly to convey the artist's outlook on contemporary life and its problems. Examples of his work are in many public collections, including The Mus. of Modern Art, New York, the Stedelijk Mus., Amsterdam, the Boymans-van Beuningen Mus., Rotterdam, the National Gal., Prague, the Kunsthalle, Hamburg, the Folkwang Mus., Essen.

SOVIET ART. See RUSSIA AND THE U.S.S.R.

SOYER, MOSES (1899–1974) and **RAPHAEL** (1899–). Russian-American painters, twins, born at Tombov, Russia. Moses went to America in 1913, became a citizen in 1925, and studied at the Cooper Union, the National Academy of Design, and with Robert HENRI and George BELLOWS. Raphael went to America in 1912, and studied at the Cooper Union, the National Academy of Design, and at the Art Students' League with Guy Du Bois. During the 1930s their work was typical of the SOCIAL REALISM practised by the AMERICAN SCENE painters such as Reginald MARSH and Isabel BISHOP, as in *Office Girls* (1936) by Raphael Soyer (Whitney Mus. of American Art). Their painting, in a style of careful and unemphatic Realism, expressed the spirit of vacuity, hopelessness and despair which dominated the social scene during the Depression. A retrospective exhibition of the works of Raphael Soyer was given by the Whitney Mus. of American Art in 1967.

SPAIN. Spain, like Russia, contributed a number of great personalities who worked outside their native land and some who dominated the artistic movements of the first three decades of the 20th c. Among these were: PICASSO and GRIS in CUBISM; MIRÓ, DALÍ and Oscar DOMINGUEZ in SURREALISM; the individualist BORÈS; and the sculptors Julio GONZÁLEZ, Pablo GARGALLO, Eduardo CHILLIDA and Apelles FENOSA. In Spain itself a tradition of expressive naturalism was solidly rooted by the self-taught painter José Gutierrez SOLANA with his conversation pieces and genre scenes of city and country life and by Godofredo ORTEGA MUÑOZ with his landscapes of bleak Estremadura, while Benjamin PALENCIA with his more softly urbane and poetic landscapes became a central figure in the Madrid school. But the Civil War of the 1930s created an artistic vacuum in the country which endured until after the end of the Second World War. In the early 1940s a group of *avant-garde* painters in Madrid attempted to initiate a revival

in the direction of EXPRESSIONISM. They included José GUERRERO, who later painted in an Informalist manner, Antonio Lago Rivera and Pablo Palazuelo, who later went on to paint with simplified areas of flat colours in a TACHIST manner. But the first effective breakthrough towards modernism came with the formation of the DAU AL SET group at Barcelona, the second most important cultural centre of Spain, and the opening of the Salon d'Octubre there as a centre for young artists, both in 1948. The painter members of the *Dau al Set* group, which represented a phase of Surrealism, were Joan PONÇ, Modesto CUIXART, Joan José THARRATS and Antoni TÀPIES. All of them later went over to expressive abstraction, Tàpies, the greatest individualist of them all, becoming also the leader of ARTE POVERA in Spain. Apart from these the main Surrealists and painters of fantasy at this time in Spain were José CABALLERO, Antonio SAURA and the young Manuel MILLARES.

Expressive abstraction or INFORMALISM made its first appearance when artists of the *Pórtico* group of Saragossa were exhibited by the Buchholz Gal., Madrid, in 1949. They were Fermin Aguayo, Santiago Lagunas and Laguardia. Tàpies had already exhibited mature work in this style at Barcelona in 1954 and in 1956 an exhibition of international expressive abstraction was put on by the Negra Gal., Madrid, under the name 'Arte Otro', a translation of the term ART AUTRE which had been coined by the French critic Michel Tapié. But Informalism was first established as a major Spanish idiom by the inauguration in 1957 of the EL PASO association in Madrid. The four artist members at the foundation of the association were Saura, Millares, Rafael CANOGAR and Luis FEITÓ. They were joined the following year by the painters Manuel VIOLA and Manuel RIVERA and by the sculptor Martín CHIRINO. About the same time Alberto RAFOLS CASAMADA abandoned his post-Cubist manner for Informalist arabesque and José GUINOVART went over to Informalism from SOCIAL REALISM.

The *El Paso* group were opposed to the Franco regime and made their hostility felt by exhibitions and a review, which continued until 1960. This motivation was particularly strong in the work of Saura and Canogar. Outside the group expressive abstraction was practised by a large number of independent artists, many of whom were associated with the Juana Mordó Gal., Madrid. In one form or another ART INFORMEL, Tachism or LYRICAL ABSTRACTION swept over Spain and became the dominant style in the second half of the 1950s and the 1960s. Among the artists who went over to abstraction in the 1950s were: Manuel MAMPASO, Juana FRANCÈS, Francisco FARRERAS, LUCIO Muñoz, Fernando ZOBEL, Gustavo TORNER, Juan HERNÁNDEZ PIJUAN, Alberto Rafols Casamada. Luis SÁEZ and Antonio SUAREZ were among those who practised a more restrained and formal mode of abstraction based on natural appearances. In the second half of the 1960s a maturer and more

assured form of expressive abstraction emerged, betraying certain influences from the New York school of ABSTRACT EXPRESSIONISM. Among the main exponents were: José Guerrero, Manuel HERNÁNDEZ MOMPO, Alfonso Fraile (1930–), Enrique Gran (1928–), Gonzalo Chillida (1926–), brother of the sculptor Eduardo Chillida, José Antonio Sistiaga (1932–) and Salvador VICTORIA.

Although the popularity of expressive abstraction seemed to indicate that it represented the prevailing sensibility of the 1950s and 1960s, there were nevertheless artists who practised a geometrical mode of abstraction rather than the impulsive expressiveness of Informalism. In 1954 the *Grupo Espacio* was formed at Córdoba under the influence of the architect Jorge Oteiza with the object of 'plastic research into space', and this in turn gave rise to EQUIPO 57, formed in 1957 by five Córdoba artists professing CONSTRUCTIVIST principles. *Equipo 57* was mainly active outside Spain, concentrating on collective team work and research into materials and industrial processes. Inside the country a similar course was followed by the self-taught artist Manuel Calvo (1934–), by Pablo Palazuelo (1916–), who developed an individualistic HARD EDGE version of Tachism, and by the linear Constructivist José Maria de Labra (1925–). Labra settled in New York in the 1960s. Francisco SOBRINO, born at Guadalajara in 1932, passed his formative period in the Argentine, where he came into contact with Argentinian CONCRETE ART, and in 1960 became a founding member of the GROUPE DE RECHERCHE D'ART VISUEL in Paris. Mention should be made of Salvador Soria (1915–), who settled in Paris after the Spanish Civil War, returning to Spain in 1953. About 1956 he began to 'paint' with iron, utilizing natural rust and metallic oxides as colourants. Also Francisco Nieva (1927–), who besides formal abstract painting was prominent as a stage designer and critic; Joan Claret (1929–), trained as an architect, who painted complex formal patterns in subdued colours like shadows and reflections on glass; Joan Vilacasas (1920–), who passed from expressive abstraction of the *art informel* type to more formal and organized abstractions in delicate shades of colour, which he called 'Planimetries'. Gustavo Torner also passed from lyrical abstraction to virtually monochromatic painting and to geometrical constructs in metal. Néstor Basterrechea (1924–) went to Buenos Aires after the Spanish Civil War and studied under the artist Emilio PETTORUTI. After passing through a figurative and Expressionist stage, in which he was influenced by the Mexican mural painters, he returned to Spain in 1953 and became a leader in geometrical abstraction, taking an interest also in industrial design. Prominent among those who were in the van of experimentation in Constructivism, Optical painting and LIGHT sculpture were Gerardo RUEDA and Eusebio SEMPERE, while Amadeo Gabino's sculptures in iron and

stainless steel combined abstraction with an evocation of the mysterious and the poetical. Constructivist associations were *Grupo Parpalló* and after 1958 the *Art Actuel de la Méditerranée*. OP ART made little impact on Spain. But a generation of younger artists who matured in the 1960s initiated a new style of simplified or MINIMAL ART in both paintings and constructs. Among them were Lola Bossnard, born at Valencia of Swiss nationality, Juan Antonio Aguirre (1945–), María Cruz Díaz, Pedro Antonio García Ramos (1942–), José María Yturralde (1942–), Jorge Teixidor (1941–). With these stand the older artists Valcarcel Medina of Murcia (1937–), who took something from both MALEVICH and MONDRIAN, Julio Plaza of Madrid (1938–), who experimented with modulating and mobile units, and José María Gorris of Valencia (1937–), who explored positive–negative relations in this style of art. Eduardo Sanz (1928–) made use of mirrors to give an impression of dynamism and movement as the observer moved in relation to the work. José Luis Zumeta (1933–) painted abstracts in bright and saturated colours organized into complicated series of shapes which exploited the intimate relation between colour and form.

Simultaneously with these movements in abstraction there also flourished an art of SOCIAL REALISM in the decades following the Civil War. José GARCÍA ORTEGA was the key figure behind the *Grupos de Estampa Popular* (Popular Print Groups) which were formed in several towns for the purpose of disseminating to all classes of society an art of social criticism and protest through the medium of prints and lithographs. In addition to García Ortega himself, the Madrid group was supported by his two followers, José Ruiz Pernias and Pascual Palacios Tárdez, by Antonio R. Valdivieso, Luis Garrido, Javier Clavo, Francisco Mateos, Antonio Saura, Adán Ferrer, Arturo Martínez, Manuel Calvo and the engravers Manuel Ortiz Valiente, Ricardo Zamorano and Francisco Alvarez together with the Greek Dimitri Papageorgiu, who played an important role in furthering the development of engraving in Spain. Other groups were formed in Seville, Bilbao, Córdoba and Barcelona. A number of prominent artists were associated with the groups, including José Duarte of the Córdoba group and Agustín Ibarrola of the Bilbao group, both formerly members of *Equipo 57*, and José Guinovart and Alberto Rafols Casamada of the Barcelona group. Other artists, although not formally associated with the *Grupos*, were doing work with implicit social comment which brought them into line with the movement. Such, for example, were Luis GARCÍA OCHOA and Amalia Avia of Toledo, whose paintings of street scenes from the poorer quarters gave an impression of dinginess and frustration.

In contrast to the ruthlessly detailed, almost MAGIC REALISM of Francisco Cortijo (1936–), Joaquín Pacheco (1934–) shared with Luis García Ochoa a disposition for satire, almost for caricature. Monjales (José Soler Vidal, 1932–) on the other hand, after passing through a phase of expressive abstraction, turned to a neutral documentary realism, although he did not join the 'Chronicling of Reality' groups which were set up in Valencia. What is sometimes known as the 'Valencia School' worked with the idea of an art which should function as a chronicle of reality and shared the cynical vision and moral disengagement which are characteristic of much POP ART. EQUIPO CRÓNICA was formed by Rafael Solves (1940–) and Manuel Valdés (1942–) supported by Alejandro Toledo and the writer Tomás Llorens. Solves and Valdés collaborated on pictures which aspired to be 'chronicles' of current situations or events in a style of tendentious and sarcastic realism. EQUIPO REALIDAD, also in Valencia, was formed by Jorge Ballester (1941–) and Juan Cardella (1948–). They shared the 'documentary' idea of *Equipo Crónica* though with a more aggressively anti-aesthetic attitude, and they sought their material for preference in the world of the comic strip and the plebeian circus poster. The most original and the most widely known of the Valencia Realists, however, was Juan GENOVÉS. Prominent among the older Realists outside Valencia were Eduardo Urculo (1938–) of Santurce, Vizcaya, whose cynical and aggressive realism combined elements of Pop art with reminiscences of Surrealism, and Ángel Orcaje (1934–) of Madrid, who painted brightly coloured geometrical constructions associated with wide open spaces symbolizing the solitude of urban industrialism.

There were other artists also who continued to paint in a manner of Expressive Realism without implications of social comment. José Vento (1925–) of Valencia became increasingly expressive as time went on, but never abandoned representation. Juan Ignacio Cárdenas (1928–) of Madrid, known as Chinorris, was catholic in his choice of subject matter, often painting in series and always with *joie de vivre*. Joaquín Vaquero Turcios (1933–) of Madrid, son of a painter of the same name, studied architecture in Rome and travelled widely in America. He matured an individualistic style of Expressive Realism which he often used for religious works and among other awards he obtained a Gold Medal at the Salzburg Exhibition of Religious Art. Finally, among the artists who continued to paint representationally in a Late-Impressionist manner but entirely without implications of Social Realism were Antonio LÓPEZ GARCÍA and Carmen LAFFON.

The use of figuration for what in America has been called the New Humanism, as distinct from Social Realism, was also a feature of the 1960s. José Paredes Jardiel in the late 1960s gave vivid expression to the horrific effects of the evils of contemporary life—war, genocide, racial discrimination—and the evils of indifference to evil. José Hernández (1944–) pursued a similar aim by the use of horrific images from the unconsci-

ous. Rafael Canogar and Juan Barjola (1920–) also turned from abstraction and painted figurative pictures of this type in the late 1960s. Experimental art and the NEW REALISM also found some manifestations in Spain during the 1960s. The *Gallots* group, formed in Sabadell, staged HAPPENINGS in public places and anticipated Yves KLEIN by the use of hens dipped in dyes as living paint brushes. Jordi Gallí in Barcelona and others in Valencia exploited photographic images and torn posters in a way reminiscent of RAUSCHENBERG in his 'combine pictures', the European MEC art and the AFFICHISTES such as HAINS. Others again made box ASSEMBLAGES, developed ARTE POVERA for the purposes of social criticism and found new ways of using the COLLAGE technique for the same purpose. Such were Ángel Jové of Lerida, Manuel Salamanca, José Villaubí and Alberto Porta.

SPANISH REALISTS. Name given to an interrelated group of five Spanish artists all of whom worked in a style of unpretentious and unemphatic Realism with masterly craftsmanship always subordinated to the purposes of depiction. The artists were: Antonio LÓPEZ TORRES, Antonio LÓPEZ GARCÍA, Francisco LÓPEZ, Maria MORENO, Isabel QUINTANILLA.

ŠPÁLA, VÁCLAV (1885–1946). Czech painter who *c.* 1911 developed an EXPRESSIONIST form of CUBISM and together with FILLA and PROCHÁZKA formed an *avant-garde* group of artists who proposed to renovate Czech art in a direction which combined Cubist and Expressionist elements.

SPAZIALISMO. A movement founded by Lucio FONTANA in Milan *c.* 1947. The main ideas of the movement were anticipated in his *Manifesto Blanco* published in Buenos Aires in 1946. In it he spoke of a new 'spatial' art in keeping with the spirit of the post-war age. On the negative side it repudiated the illusory or 'virtual' space of traditional easel painting and on the positive side it was to project colour and form into real space by the use of up-to-date techniques such as neon lighting and television. The new art of Spatialism would 'transcend the area of the canvas, or the volume of the statue, to assume further dimensions and become . . . an integral part of architecture, transmitted into the surrounding space and using new discoveries in science and technology'. In 1947, 1948, 1949, 1950 and 1952 Fontana issued manifestos of Spazialismo in Milan and in 1951 a *Manifesto Tecnico dello Spazialismo*. These were more specific in their negative than their positive aspects and carried the concept of Spazialismo little further than the statement that its essence consisted in 'plastic emotions and emotions of colour projected upon space'. In 1947 Fontana created a 'Black Spatial Environment', a room painted black, which was considered to have foreshadowed ENVIRONMENT ART and which was reproduced at an

exhibition in the Palazzo Trinci, Foligno, in 1966 and in the exhibition 'Lines of Research from Art Informel to Today' at the 1968 Venice Biennale. Fontana's holed and slashed canvases, called *Concetti Spaziali*, were also considered to have exemplified Spazialismo.

SPAZZAPAN, LUIGI (1890–1958). Italian painter born at Gradisca, Friuli. He studied in Vienna and Paris and settled at Turin in 1928. From 1925 he was one of the leaders of the *avant-garde* in the Turin school with MASTROIANNI. He was best known for the landscapes of this later period, which are notable for their harmonious colour and their rhythms verging on abstraction.

SPENCER, GILBERT (1892–1979). British painter, born at Cookham, Berkshire. He began as a toy-maker but was persuaded by his elder brother Stanley to go in for painting. He studied painting at the Camberwell School of Art in 1912 and at the Slade School, 1913–15 and 1919–20. His picture *The Seven Ages of Man*, done in 1913, was bought by Lady Ottoline Morrell for the Contemporary Arts Society. He had his first one-man show at the Goupil Gal. in 1923. In 1934–6 he painted two large murals at Holywell Manor, Oxford, illustrating the Foundation Legend of Balliol College. He was Professor of Painting at the Royal College of Art, 1932–48, being an official War Artist 1940–3. From 1948 to 1950 he was Head of the Department of Painting at Glasgow School of Art and in 1950 at the Camberwell School of Art. He is chiefly known for his landscapes of the Thames Valley, Berkshire and Oxfordshire villages. Among the finest are *Little Milton* (City Art Gal., Belfast, 1933) and *Cotswold Farm* (Tate Gal., 1930–1).

SPENCER, NILES. See PRECISIONISM.

SPENCER, STANLEY (1891–1959). British painter, born in the village of Cookham, Berkshire. He studied at the Slade School, 1908–12, obtaining the Melville Nettleship Prize and the Composition Prize in 1912. In the same year he exhibited at the Second POST-IMPRESSIONIST Exhibition organized by Roger FRY. During the First World War he served as an orderly in the Royal Medical Corps and then with the Royal Berkshire infantry in Macedonia. He was a member of the NEW ENGLISH ART CLUB, 1919–27, and had his first one-man show at the Goupil Gal. in 1927. During the 1920s he did a series of pictures best described as visionary transfigurations of his war experiences, culminating in the very large *Resurrection, Cookham* (Tate Gal.), which was painted in Henry Lamb's studio. It was described by John Rothenstein as 'one of the great pictures of this century'. From 1927 to 1932 he painted the series of religious murals for the Oratory of All Souls in the Berkshire village of Burghclere for which he became most widely known. He was made A.R.A. in 1932

and R.A. in 1950, when he was also created C.B.E. In 1932 and 1938 he was represented at the Venice Biennale and in 1933 he was awarded an Honourable Mention at the Carnegie Institute, Pittsburgh. During the Second World War he was commissioned to paint pictures of the shipyards in Glasgow. A retrospective exhibition was held at Temple Newsam, Leeds, in 1947 and a retrospective exhibition of drawings arranged by the Arts Council went on tour 1954–5, being exhibited in the Arts Council galléries, London, in 1955 at the same time as a retrospective exhibition of his paintings in the Tate.

Stanley Spencer was one of the great originals of contemporary British painting. For him the Christian religion was a living and present reality and his visionary attitude has been compared to that of William Blake. The spirit of his painting was drawn from the transfiguration of his native Cookham into the Celestial City, the 'holy suburb of Heaven', and despite a superficial mannerism in his depiction of figures with their occasional reminiscences of the *faux naïf*, the representation of New Testament scenes in modern Cookham was not a trick intended to titillate but the visual expression of a mystical habit of experience. His *Resurrection of Soldiers* at Burghclere is not only an overwhelming interpretation of the Last Day but the culmination of an intuitively developing style with its stable design structure based upon massed crosses and the unstable perspective which carries the eye throughout the picture to various levels of depth and by angles subtly interwoven. Spencer stands alone among artists of his day for the power and the simplicity of his exaltation of religious faith. After the completion of his work at Burghclere he painted Cookham landscapes which have a compulsive power in their simplicity and directness. During these later years too his work displayed an obsessive concern with unusual sexual experiences, in particular with relations between the ugly, the sick and the aged. A series of drawings done between 1939 and 1949 and now in the Astor coll. contain ideas to be worked out in his paintings and illustrate his visionary attitude towards scenes of everyday life. A travelling exhibition of his work was arranged by the Arts Council in 1976 and a major retrospective was staged by the Royal Academy in 1980.

SPHINX, DE. A short-lived group founded in 1916 by Theo van DOESBURG with the architect Jacobus Johannes Pieter Oud (1890–1963) at Leyden.

SPILIMBERGO, LINO ENEAS (1896–1964). Argentine painter born in Buenos Aires, where he studied at the Academia de Bellas Artes. Between 1925 and 1928 he travelled to Italy and France. In Italy he came under the spell of the classicism of the Italian Renaissance and of the METAPHYSICAL painter Massimo CAMPIGLI. In France he worked at La Grande Chaumière and with André LHOTE.

In spite of his exposure to French CUBISM Spilimbergo retained a figurative approach, imbuing his figure compositions with great solidity and simplicity in a Mediterranean classical tradition. He reached the height of his production in the 1930s with women and children as frequent subjects. His work sometimes had a poetic touch which linked him to MAGIC REALISM. He sometimes introduced Metaphysical elements reminiscent of CHIRICO, as in *Terraza con Figuras* (1932). He also painted biblical subjects as well as humble types from suburban Buenos Aires, such as *Arrabal de Buenos Aires* (1933). When the Mexican Muralist SIQUEIROS went to Argentina in 1933 Spilimbergo worked with him on the mural *Plastic Exercise* near Buenos Aires. Spilimbergo was especially noted for his graphic work. He illustrated many books, including Oliverio Girondo's *Interlunio* in 1937. Some of his monotypes suggest the AUTOMATISM of the SURREALISTS. He was especially influential as a teacher. He taught at the Academia Nacional in Buenos Aires, at the Instituto Superior de Bellas Artes in La Plata and at the Instituto Superior de Artes de la Universidad Nacional de Tucumán. In 1956 he was made a member of the Academia Nacional de Bellas Artes. He exhibited widely in Italy, Spain, the U.S.A. and South America. In the U.S.A. he participated in the 1935 Carnegie International, Pittsburgh, and exhibited in Cleveland, Toledo, San Francisco and New York. In 1949 he had retrospective exhibitions in the Argentine provinces at Tucumán, Salta and Santiago del Estero. His work was included in exhibitions of the Fundación Lorenzutti in 1969 and 1970, and in 'A Panorama of Argentine Painting' at Buenos Aires as well as in 'Art of Latin America Since Independence' at Yale and the University of Texas at Austin in 1966. He received many awards in Argentina and in 1937 he won awards for painting and etching at the Paris Exposition Universelle. His work is in many collections in Argentina, Uruguay, France and the U.S.A. His water-colour *Seated Woman* (1932) and monotype *Head of an Indian* (1933) are in The Mus. of Modern Art, New York.

SPILLIAERT, LÉON (1881–1946). Belgian painter born at Ostend, son of a perfume dealer. He was self-taught as a painter, and preferred watercolour and gouache to oil techniques. After passing through a Symbolist period he adopted aspects of ART NOUVEAU to express a completely personal vision, e.g. *Girl Bathing* (Mus. Royaux des Beaux-Arts, Brussels, 1910). Although contemporary with them, he stands apart from the main Flemish EXPRESSIONISTS. W. Vanbeselaere has said of him: 'He feels drawn to the infinity of the sea, the loneliness of beach and dyke and a woman in distress. They mirror his own nameless fear, lonely and thrown back upon himself. When he illustrates imaginary themes his lines and colours acquire immediate expressiveness because, to the man behind them, night and death and the unnameable

are not empty words but haunting realities.' Although Spilliaert remained a lonely figure in Belgian art, both Expressionists and SURREALISTS drew something from the hallucinatory world which he created. Among his best-known pictures are *Gust of Wind*, showing a girl in a billowing gown standing on top of a sea wall and confronting the open sea (Municipal Mus., Ostend, 1904), and *Girls with White Stockings* (Municipal Mus., Ostend, 1912).

After 1904 Spilliaert was often in Paris and was introduced to Symbolist circles there by Verhaeren. He took part in a number of exhibitions, including the Salon des Indépendants in 1911. On his marriage in 1916 he settled in Brussels and did a series of water-colours and lithographs dedicated to Maeterlinck. In 1920 he signed a contract with the gallery SÉLECTION. From 1922 he lived in Ostend until 1935, when he settled again in Brussels. From 1937, when he discovered the region of the Fagnes, a new imagery appeared in his work and it took on a monumental character of formal simplicity illustrated by *Troncs de Hêtres* (Mus. Royaux des Beaux-Arts, Brussels, 1945). A large exhibition was dedicated to him at the Palais des Beaux-Arts, Brussels, in 1944. Throughout his career his draughtsmanship was characterized by extreme economy and sparseness of form, bringing him into an intermediary position between Symbolism and Expressionism.

SPOERRI, DANIEL (1930–). Swiss sculptor, born at Galati, Romania. He settled in Switzerland in 1942, trained as a ballet dancer and danced for the State Opera Company, Berne, 1954–7. From 1955 to 1961 he published *Matérial*, a magazine for concrete poetry. In 1959 he settled in Paris and published *MAT* (*Multiplication d'Art Transformable*), a revised edition of which appeared in 1964. This advocated works of art which could be modified by the transformation or rearrangement of parts. He also made what he called *tableaux pièges* (snare pictures), which consisted of common consumer goods glued to chairs or tables which were then turned on their sides and hung on the wall. During the 1960s Spoerri was active in the NOUVEAUX RÉALISTES movement founded by Pierre Restany, and was one of those who developed the three-dimensional COLLAGE or ASSEMBLAGE. His importance derived as much from his personality as from enduring artistic achievements.

SPRINGUETT, SABINO. See LATIN AMERICA.

SPRONKEN, ARTHUR. See NETHERLANDS.

SPUR. A group of German artists founded in Munich in 1957 by the sculptor Lothar FISCHER and the painters Heimrad Prem, Helmut Sturm and Hans-Peter Zimmer. The group published a magazine *Spur*. After being influenced by Asgar JORN and by the SITUATIONISTS, members of the group turned towards ART BRUT and POP ART.

SPYROPOULOS, JANNIS (1912–). Greek painter, born at Pylos and trained, 1933–8, at the Academy of Fine Arts, Athens. He went to Paris with a scholarship in 1938, studied at the École des Beaux-Arts there and at several independent academies. He returned to Athens in 1940 and spent the war years there. His first one-man show was at the Gal. Parnassos, Athens, in 1950, after which he was represented in several foreign exhibitions of Greek art—Rome (1953), Belgrade (1954), Stockholm, Malmö, Gothenburg (1955). He showed at the São Paulo Bienale in 1957 and in the same year signed a contract with the World House Gal., New York, where he had one-man shows in 1959 and 1961. In 1960 he received the UNESCO prize at the Venice Biennale. He was represented in a travelling exhibition of 8 Greek painters organized by the Smithsonian Institution in 1959, in an International Exhibition organized by the Carnegie Institute at Pittsburgh in 1961 and at Cincinnati in 1962.

About 1955 his style changed from naturalistic representation towards abstraction with suppression of the horizon, two-dimensional pattern and geometrization of forms. In the 1960s he changed again from abstraction based upon natural forms to non-objective abstraction. His later paintings emphasized the lyrical and poetic manipulation of surface and texture without representational implications. He is represented in a number of public collections, including the Royal Palace and the Ministry of Education, Greece, the National Gal., Toronto, the National Gals., Auckland, Bazalel Mus., Jerusalem, the National Gals. of Cyprus and Rhodes, the Roswell Mus. and Art Center, New Mexico, and museums at Ostend, Belgrade, Cincinnati, Dallas.

SREENIVASALU, K. (1923–). Indian painter, born in the Chittor District of Andhra State. He studied at the Government School of Arts and Crafts, Madras, where he later taught. He took part in numerous national exhibitions and was included in travelling exhibitions to China, Japan, the U.S.S.R., the U.S.A. and Eastern Europe. He did mural painting in Parliament House, New Delhi, and other important public buildings.

STABILE. see CALDER, Alexander.

STAEL, NICOLAS DE (1914–55). Russian-French painter, born at St. Petersburg, son of Baron Vladimir Ivanovich de Staël-Holstein. In 1919 he emigrated with his family to Poland and in 1922, on the death of his parents, was sent to school in Brussels. In 1932 he began to study at the Académie des Beaux-Arts there, winning a first prize, but left for the Netherlands, where he discovered Rembrandt, Vermeer and others of the Dutch school. After travelling in Spain, Italy and North Africa he went to Paris in 1938 and joined

the Foreign Legion on the outbreak of war. In 1943 he settled in Paris, where he knew BRAQUE and studied under LÉGER. His work became abstract and his reputation rapidly grew, particularly in the U.S.A., and he was considered one of the outstanding figures in the TACHIST manner of the ÉCOLE DE PARIS. Although the subjects of his abstract paintings were not recognizable, they were usually derived from natural appearances as, for example, *Les Toits* (Mus. National d'Art Moderne, Paris, 1952). From 1953 he reverted to figurative painting although not in a realistic style. In his *Footballers* series and subsequent landscapes, such as *Agrigente* (1954), and his still lifes the subject was extremely simplified into patches of contrasting colour although it remained recognizable. He had a large retrospective exhibition at the Mus. National d'Art Moderne in 1956 after taking his own life in 1955.

STAMOS, THEODOROS (1922–). American painter, born in New York of immigrant Greek parents. He studied sculpture at the American Artists' School, New York, but took up painting in his own time from 1937. His first one-man show, of oils and pastels, was at the Wakefield Gal., New York, in 1940. He developed a manner of LYRICAL ABSTRACTION influenced by the painterly technique of Milton AVERY and was a member of the NEW YORK SCHOOL of ABSTRACT EXPRESSIONISTS. His abstractions were based on sea shells, driftwood, etc. in a sophisticated manner of *faux naïf* suggesting geological formations and biomorphic forms. After a visit to Europe, including Greece, in 1948–9 his style became more abstract, combining mystical meditation on the cosmic infinite with an interest in the universal significance of ancient mythological symbols. He had a retrospective exhibition at the Corcoran Gal., Washington, in 1959.

STANČIĆ, MILJENKO (1926–). Yugoslav painter and graphic artist born at Varaždin, Croatia, studied at the Academy of Art, Zagreb, and subsequently taught there. He painted in a mode of lyrical SURREALISM combining a dreamlike atmosphere with hallucinatory effects.

STANISAVLJEVIĆ, DRAGIŠA (1921–) and MILAN (1944–). Yugoslav NAÏVE sculptor, born at Jabučje, near Lajkovac. A farmer by trade, he began to do sculpture in wood *c.* 1958. His work has been widely exhibited in Yugoslavia together with that of his son, Milan, who began carving *c.* 1960. A relief carving by Dragiša, done in 1967 and entitled *Cosmonauts*, illustrates the stages of a flight to the moon in six successive bands one above the other. The work of Milan, often resembling totem poles, is more violent and complex. A typical example is *Wedding Dirge* (1967), illustrated in *Modern Primitives* by O. Bihalji-Merin.

STANKIEWICZ, RICHARD P. (1922–83). Ameri-
can painter and sculptor born in New York. He studied at the Hans HOFMANN School, New York, 1948, and then in Paris at the Atelier Fernand LÉGER and the ZADKINE School of Sculpture, where he turned from painting to sculpture, 1950–1. He specialized in welded metal sculpture and on his return to New York in the early 1950s he was one of the first to make sculpture from pieces of scrap metal, old and rusty machinery, etc. in a manner which came later to be mainly associated with the JUNK school of California. Some of his sculptures embodied naturalistic suggestions which often involved wit and parody, as in *The Secretary* and *Kabuki Dancer* (Whitney Mus. of American Art, 1956), but later they were usually purely abstract compositions becoming increasingly light and lyrical during the 1960s. In the 1970s his style again evolved and he turned to abstract compositions of interlocking circles and squares hammered out of steel. His first one-man exhibition was at the Hansa Gal., New York, in 1953 and following this his work was much exhibited and was included in many important collective shows both in the U.S.A. and abroad. He had a large exhibition at the Jewish Mus., New York, in 1964.

STARCKE, HELMUT. See SOUTH AFRICA.

STAŻEWSKI, HENRYK (1894–). Polish painter and experimental artist, born in Warsaw and studied at the Academy there, 1914–19. He was a founder member of the group BLOK and was one of the leading exponents of CONSTRUCTIVISM in Poland. He went to Paris in 1930 and became a member of CERCLE ET CARRÉ and subsequently of the ABSTRACTION-CRÉATION association. Towards the end of the 1950s he interested himself in KINETIC ART and made constructions of geometrical reliefs in which colours were graded in series. See also STRZEMINSKI, Władysław.

STEER, PHILIP WILSON (1890–1942), British painter born at Birkenhead, Cheshire. In 1882 he was rejected as a candidate for the Royal Academy Schools and instead studied in Paris, 1882–3, first under Bouguereau at the Académie Julian and then under Cabanel at the École des Beaux-Arts. Both these were conservative artists painting mythological pictures in a derivative Neo-Classical style for popular consumption. He returned to England in 1884 and in 1886 became a founding member of the NEW ENGLISH ART CLUB. In the late 1880s his style was revolutionized by his discovery of the Impressionists, particularly Monet, four of whose paintings were exhibited in 1887–8 by the Society of British Artists. Steer was not only a personal friend of SICKERT but worked closely with him until *c.* 1900, when artistically they began to drift apart. Steer became best known for his portraits and his landscapes, which carried on the tradition of Constable though enlivened by Impressionist colour. But he also did numerous studio studies and 'decorously erotic' nudes. His many

water-colours fall into two groups: monochrome composition studies and more freely painted impressions, which were described by D. S. MacColl as 'water-colour wash-drawings'. Steer's greatest period was *c*. 1907 to *c*. 1910, after which, although his output remained prolific, there was a certain loss of verve. In his lifetime his reputation was high: MacColl described him as 'the greatest colourist and most absolutely born-painter the English School now possesses'. It has since declined as it has become clear that Steer stood outside the main streams of 20th-c. artistic progress.

STEIN, JOEL (1926–). French OP artist born at Boulogne and worked in Paris. He was a founder member of the GROUPE DE RECHERCHE D'ART VISUEL (GRAV), and he explored the optical effects of surfaces made up from metal ribs and strings which change their appearance according to the position of the light source and the movements of the spectator.

STEINBERG, SAUL (1914–). American painter and draughtsman, born at Râmnicul-Sarat in Romania. He studied architecture in Milan, taking a doctorate in architecture at the Reggio Politecnico in 1940. He made his way to New York in 1942 and held his first one-man show at the Wakefield Gal. there in 1943. He made his name as a cartoonist, creating a personal world of the childlike, the irrational and the absurd. He has been called the 'visual lexicographer of absurd terrain', a quality exemplified in *Il Gabinetto del Proprio Niente* (1966). His drawings have been published in *All in Line* (1945), *The Art of Living* (1949), *The Labyrinth* (1959) and *The New World* (1965). He was most widely known for his cartoons published regularly in the *New Yorker* and other magazines. Public collections in which he is represented include The Mus. of Modern Art and The Metropolitan Mus. of Art, New York, the Victoria and Albert Mus., London, Harvard University coll., the Institute of Art, Detroit, the Albright-Knox Art Gal., Buffalo.

STEINER, MICHAEL (1945–). American sculptor born in New York. Steiner belonged to the *avant-garde* of the 1960s, being ranked as a MINIMALIST. Of his exhibits shown at the Dwan Gal. in 1966 the critic Michael Benedikt wrote, contrasting the American PRIMARY STRUCTURES with their British counterparts: 'The shapes of Steiner's pieces are abrupt and machine-like . . . but the proportions are so plump, so softly echoing as to deserve characterisation as soporific. One was in an environment that soothed; one felt, finally, that there was the presence of a new ideal of elegance.' During the latter part of the 1960s and in the 1970s Steiner had frequent exhibitions in New York, Philadelphia, Toronto, etc. and at the Mus. of Fine Arts, Boston (1974). Among the group shows in which he was represented were: 'Minimal Art', Gemeentemus., The Hague (1968);

'11 Americans', Mus. of Contemporary Art, Montreal (1973–4); 'The Condition of Sculpture', Hayward Gal., London (1975).

STEINHARDT, JAKOB. See PATHETIKER, DIE.

STEINLEN, THÉOPHILE-ALEXANDRE (1859–1923). Swiss-French painter and graphic artist, born at Lausanne. He went to Paris in 1882 and made his living doing satirical illustrations and lithographs for the journals. He was a brilliant draughtsman and depicted the life of the poor and down-and-out with sympathy and feeling. He also illustrated a number of books, including engravings for *Gil Blas*. His painting was for the most part in sombre colours and has been compared with that of Daumier, but it was as a graphic artist that he excelled.

STELLA, FRANK (1936–). American painter born at Malden, Mass., studied at the Phillips Academy, Andover, Mass., under Patrick Morgan and at Princeton University under William C. Seitz and Stephen Greene. From 1958 he lived and worked in New York. During the 1960s he came to the fore as one of the most inventive of the new school of POST-PAINTERLY ABSTRACTION in reaction from ABSTRACT EXPRESSIONISM and he was exhibited widely in New York (Leo Castelli Gal.), Los Angeles (Ferus Gal. and Irving Blum Gal.), Pasadena, Seattle, Washington, Toronto, Vancouver, Paris, London, Zürich and elsewhere. In 1970 a retrospective exhibition was circulated under the auspices of the International Council of The Mus. of Modern Art, New York, and was shown among other places at the Hayward Gal., London.

Stella's point of departure in 1958 for his new approach to abstraction was the flag paintings of Jasper JOHNS. By various devices he emphasized the flatness of the painting pattern, abolishing the three-dimensional picture image, and he was uncompromising in his refusal to permit the introduction of deep recession behind the picture plane. The figure–ground relationship was almost completely eliminated and the stripes and orthogonals which constituted the picture echoed the contours of the format. In order to achieve this more effectively he often used notched or shaped canvases. In a style which came to be known as 'non-relational' painting he made the forms coextensive with the painting as a whole and eliminated discrete contained shapes and with them internal relations among the parts. In this respect his work had obvious affinities with the PRIMARY STRUCTURES of some MINIMAL artists and with the ALL-OVER style of painting, in which attention is evenly diffused over the whole canvas and there are no outstanding points of interest brought together by balance, harmony, rhythm, etc. About 1967 he began to use curved and cartwheeling bands on rectangular formats. In these more complicated designs he still maintained tension evenly inflected across the surface and reduced recession to a minimum.

In the effort no doubt to eliminate painterly and expressive character of the facture, he used mainly enamel or metallic paints, fluorescent alkyd or polymer. His paintings were usually so large as to occupy the whole visual field of an observer at normal gallery distance from them.

STELLA, JOSEPH (1877–1946). American painter, born at Muro Lucano, near Naples, Italy. He emigrated to the U.S.A. in 1902 and studied art at the Art Students' League, New York, and the New York School of Art. For some years he earned a living as an illustrator, including drawings of the Pittsburgh steel mills for the *Survey Graphic*. He spent the years 1909–12 in Italy and France, where he was in contact with leading FUTURISTS. He exhibited at the ARMORY SHOW and from 1920 was exhibited by the SOCIÉTÉ ANONYME, of which he was a member. Stella was known as America's leading Futurist, together with Max WEBER. Examples of Futurist paintings, showing affinities with SEVERINI, are: *Battle of Light: Coney Island* and *Spring* (both Yale University Art Gal., 1914). Using his own brand of Futurist technique, Stella exerted himself to give a romanticized image of the industrial townscape of New York, which he regarded as the spirit of the new civilization that was America. In particular he was obsessed with Brooklyn Bridge, which he described as 'the shrine containing all the efforts of the new civilisation, *America*—the eloquent meeting point of all the forces arising in a superb assertion of their powers, an Apotheosis'. Typical of this outlook is *Brooklyn Bridge* (Yale University Art Gal., 1917–18). During the 1920s Stella also painted pictures in the pared-down, more matter-of-fact style of the PRECISIONISTS.

STENBERG, VLADIMIR AVGUSTOVICH (1899–) and GEORGII AVGUSTOVICH (1900–33). Russian painters and designers, brothers, born in Moscow. They studied at the Stroganov Art School, Moscow, 1912–17, and from 1917 to 1920 at Svomas, where they were enrolled in the so-called Studio without a Supervisor. Together with Nikolai Denisovsky, Vasilii Komardenkov, Kasimir MEDUNETSKY, Nikolai Prusakov and Sergei Svetlov they were among the first graduates of Svomas. In 1918 they contributed to the May Day agit-decorations in Moscow, working out designs for the cinema Napoleon and the Railway Workers' Club, and they also worked on agit-decorations for the first anniversary of the October Revolution. They were members of OBMOKHU, 1919–21, and in 1920 members of INKHUK and with Medunetsky they organized an exhibition of constructions there. In 1921 with Aleksei Gan, RODCHENKO, STEPANOVA and others they stood out in opposition to the *veshch* (object) group at *Inkhuk*, rejecting 'pure' art for industrial CON-STRUCTIVISM. In 1922 Vladimir alone contributed to the 'Erste Russische Kunstausstellung' at Berlin. In 1923 they began to work on film posters and

with EXTER, Ignatii Nivinsky, Vera Mukhina and others they worked on the design and decoration of the 'First Agricultural and Handicraft Industrial Exhibition' at Moscow. From then until 1925 they were closely associated with the magazine *Lef* and in 1924 they contributed with Medunetsky under the title 'Constructivists' to the 'First Discussional Exhibition of Associations of Active Revolutionary Art' in Moscow. From then until 1931 they worked on designs for sets and costumes for Aleksandr Tairov's Chamber Theatre, including productions of Ostrovsky's *Groza* (*Storm*), Shaw's *Saint Joan* and Brecht's *Beggars' Opera*. In 1925 they received a Gold Medal for their contribution to the 'Exposition Internationale des Arts Décoratifs et Industriels Modernes' in Paris, and thereafter they contributed stage designs and film posters to many exhibitions both in the Soviet Union and abroad. From 1929 to 1932 they taught at the Architecture-Construction Institute, Moscow. After Georgii's death Vladimir continued to work on poster design.

STENVERT, CARL (KURT STEINWEND-NER, 1920–). Austrian painter, sculptor and film-maker, born in Vienna. He studied at the Vienna Academy of Art under GÜTERSLOH and WOTRUBA, 1945–9. He exhibited widely in and outside Austria, including Basle, Rome and Prague. In 1951 he abandoned painting and sculpture to make documentary and experimental films but in 1963 he returned to plastic art with an exhibition of montages in the Künstlerhaus, Vienna. After this he did montages and ASSEMBLAGES, the latter consisting of conglomerations of various kinds of objects in a container made by the artist as an integral part of the work. These assemblages were meant to portray 'human situations' and had an affinity with POP ART. But a strangeness in the conjunction of objects gave them a macabre quality of their own. In 1964 he participated in an exhibition of Pop Art at the Mus. des 20. Jahrhunderts, Vienna.

STEPANOVA, VARVARA FEDOROVNA, or **AGRARYKH** or **VARST** (1894–1958). Russian painter born at Kovno, studied in 1911 at the Art School, Kazan, where she met RODCHENKO. In 1912 she moved to Moscow, where she studied under Ilya Mashkov and Konstantin Yuon and attended the Stroganov Art School, 1913–14. In 1914 she contributed to the Moscow Salon. From 1918 onwards she was closely involved with IZO NARKOMPROS and in 1919 she contributed to the 'X State Exhibition. Non-Objective Creation and Suprematism'. In 1920 she became a member of INKHUK and in 1921 contributed to the '5 × 5 = 25' exhibition. In 1922 she designed sets for Meyerhold's production of Aleksandr Sukhovo-Kobylin's *Death of Tarelkin*. In 1923 with POPOVA and Rodchenko she worked at the First State Textile Print Factory as a designer and from 1923 to 1928 she was closely associated with

the *Lef* and *Novyi Lef* magazines. She was Professor in the Textile Faculty at VKHUTEMAS, 1924–5, and from the mid 1920s onwards she worked mainly on typography and poster and stage design.

Until 1921 Stepanova was concerned primarily with easel painting and graphics and was a fervent supporter of non-objective art (and of transrational poetry), as she demonstrated in her statement in the catalogue to the X State Exhibition: 'Non-objective creation is still only the beginning of a great new epoch, of an unprecedented Great Creation, which is destined to open the doors to mysteries more profound than science and technology.' Of all the leading members of the *avantgarde* who switched to industrial design in the early 1920s Stepanova was the only one who had received professional training in the applied arts. She drew particular benefit from this while working on her textile designs at the First State Textile Print Factory. It was there that Stepanova, like Popova, tried to eradicate 'the ingrown view of the ideal artistic drawing as the imitating and copying of nature. To grapple with the organic design and to orient it towards the geometrization of forms. To propagate the productional tasks of Constructivism.' Perhaps the most remarkable products of her theory were her several designs for sports clothes, in which she combined an economy of material with loud contrasts in colour (for the purposes of identification on the sports-field) while rejecting as superfluous all ornamental or 'aesthetic' elements.

Stepanova also wrote and illustrated 'transrational' poetry, some of which was shown at the X State Exhibition, 1919. Her ideas were expressed in articles contributed under the name 'Varst' to *Lef*: 'O rabotakh konstruktivistskoi molodezhi' (1923, No. 3, pp. 53–6) and 'Kostyum segodnyashnego dnya—prozodezhda' (1923, No. 2, pp. 65–8).

STEPHENSON, JOHN. See CIRCLE.

STERN, IRMA. See SOUTH AFRICA.

STERNE, HEDDA (1916–). Romanian-American painter, born in Bucarest. After studying at Bucarest University, the Kunsthistorisches Institut of the University of Vienna and at art schools in Paris, she went to the U.S.A. in 1941. Her first one-man exhibition was at the Wakefield Gal., New York, in 1943. In the early 1950s she achieved prominence as one of the second wave of ABSTRACT EXPRESSIONISTS and in 1963 she was awarded a Fulbright Fellowship. Her works were included in a number of collective exhibitions of current American art, among them 'The New Decade', Whitney Mus. of American Art, 1954, and 'American Painting', Virginia Mus. of Fine Arts, 1958.

STIEGLITZ, ALFRED (1864–1946). American photographer and art dealer who was mainly responsible for bringing the works of the European *avant-garde* before the American public during the first two decades of the 20th c. As director of the Council of the informal society Photo-Secession he managed the 'Photo-Secession Gallery' or 'Little Galleries of the Photo-Secession' which was opened at 291 Fifth Avenue, New York, for the exhibition of modernist photographs and in 1907 extended its scope to include 'such other art production ... as the Council will from time to time secure'. His aim was not only to introduce the best of European *avant-garde* art to America but also to provide a centre for those American progressive artists who had hitherto worked mainly abroad. Under his direction the 291 Gallery, as it came to be known, presented the first American exhibitions of MATISSE (1908), Toulouse-Lautrec (1909), the Douanier ROUSSEAU (1910), PICABIA (1913), SEVERINI (1917) and the first one-man exhibition of BRANCUSI anywhere (1914). In 1911 it put on an exhibition of PICASSO's drawings and water-colours showing his evolution through Cubism, and it also gave the first exhibition of children's art and the first major exhibition of NEGRO art in America. Among the American painters introduced by Stieglitz were John MARIN and Alfred MAURER (1909); Marsden HARTLEY, Max WEBER, Arthur DOVE, and Arthur B. CARLES (1910); the sculptor Elie NADELMAN (1915); Georgia O'KEEFFE (1916); and Stanton MACDONALD-WRIGHT (1917).

From 1903 to 1917 Stieglitz edited the journal *Camera Work*, which he published from the 291 Gallery. At first devoted to photography, it was later extended to cover all the visual arts, including reviews and criticisms, and opened its pages to *avant-garde* American writers. In *Camera Work* Stieglitz voiced his opposition to the 'democratic' concept of Robert HENRI, as when in his review of the first exhibition of the Independents, in 1910, he declared: 'You'll never beat the Academy at its own stupid game by substituting quantity for quality.' In 1915 and 1916 he edited a journal *291*, which was the mouthpiece of the New York DADA movement.

The 291 Gallery was closed in 1917 when the building was pulled down. But Stieglitz continued his work with the Intimate Gallery (1925–9) and An American Place (1929–46), both of which promoted American artists of what had come to be known as the Stieglitz group. But the main pioneering work had been done when with the ARMORY SHOW European modernist art burst upon the American scene and experiments in abstraction and other innovative styles began to take root on American soil.

Stieglitz was a brilliant innovative artist in his own medium of photography. Learning from the *avant-garde* paintings which he exhibited, he experimented with various modes of abstraction in photography and his work went a long way to revolutionize the concept of the photographic image and to establish photography as an independent art form.

STIJL, DE. Dutch magazine of aesthetics and art theory edited and financed by Theo van DOESBURG from 1917 to 1928. A final number was produced by Van Doesburg's widow in 1932. It was the organ of an *avant-garde* group of artists, also known as 'De Stijl', founded by Van Doesburg at Leyden in 1917. Besides Van Doesburg himself the original members of the group comprised the painters Piet MONDRIAN and Vilmos HUSZÁR, the poet Antony Kok and the architect Jacobus Johannes Pieter Oud (1890–1963). Collaborators from the beginning were the painter Barth Van der LECK, the Belgian sculptor George VANTONGERLOO and the architects Jan Wils and Robert van t'Hoff. The Italian FUTURIST artist Gino SEVERINI contributed to the first two numbers of *De Stijl* and the furniture designer and architect Gerrit Thomas Rietveld (1888–1964) was associated with the group from 1918.

The periodical *De Stijl* was inspired by Van Doesburg's belief, shared by his collaborators, that the art most representative of the modern world is both revolutionary and self-conscious, involving a new aesthetic creed in which the general public needs to be educated. The purpose of the periodical was to provide a forum for the exposition of this new aesthetic and by doing so to stimulate a new awareness of the sort of beauty which was being aimed at. In explanation of this aim Van Doesburg wrote in the first number of *De Stijl*: 'This periodical hopes to make a contribution to the development of a new awareness of beauty. It wishes to make modern man receptive to what is new in the visual arts . . . The Editors will try to achieve the aim described above by providing a mouthpiece for the truly modern artist, who has a contribution to make to the reshaping of the aesthetic concept and the awareness of the visual arts. Since the public is not yet able to appreciate the beauty in the new plasticism, it is the task of the professional to awaken the layman's sense of beauty. The truly modern—i.e. conscious—artist has a double vocation: in the first place, to produce the purely plastic work of art, in the second place to prepare the public's mind for this purely plastic art.'

The aesthetic creed of the group and the art style which it promulgated were known as the new plasticism or NEO-PLASTICISM. It was characterized by extreme aesthetic austerity, for it involved not only the total rejection of representation but strict limitation of the expressive elements of painting to the straight line, the right angle and the three primary colours, red, yellow and blue, together with the 'non-colours', white, black and grey. This rigid artistic asceticism was imposed in the context of a somewhat mystically conceived general and aesthetic philosophy. The general philosophy was evolved against the background of the First World War. It was believed that the troubles of the time were the effects of rampant individualism, the antidote to which was to be found in an extension of collectivization and depersonalization into all walks of life. Hence machine technology with its abstract ideal of perfectionist precisionism was exalted above craftsmanship and subjective expression was to be abolished from art. On the ethical side Mondrian taught that manifestations of subjective individualism are to be subordinated at all levels to an abstract ideal of universal harmony. He thought that by giving clear and concrete expression to this universal harmony the visual arts could take the lead and point the way to the Utopian life of the future. In accordance with these ideas the narrower philosophy of art proper maintained by the adherents of De Stijl took the line that the elimination of the figurative element from art and the aesthetic asceticism of Neo-Plasticism would have the effect of releasing the visual arts both from dependence on subjective emotion and from extraneous systems of value inherent in the representation of natural objects, and so restore to art the freedom to follow its own laws. This was regarded as a purification of art in line with a historical process which showed a gradual movement away from the representation of natural objects towards the presentation of the essential principles of abstract truth. The culmination was to be an art of pure relationships in which the principles of universal harmony would be embodied in visual form freed from all taint of the accidental and subjective. In effect during the early years of the movement the works of the principal artists were almost as closely similar as those of PICASSO and BRAQUE during the first years of the CUBIST movement.

During the 1920s the movement was to some extent broadened and lost some of its early rigour. While Mondrian was beset by the prophetic vision of the Utopian function of Neo-Plastic painting for the reformation of human mentality, Van Doesburg became increasingly concerned to bring about practical reformation through the medium of architecture, applying himself to architectural projects in collaboration with such architects as Rietberg, Cornelis van Eesteren and the Austrian Friedrich Kiesler. It was chiefly owing to his versatility of interest that such diverse figures as El LISSITZKY, Jean ARP, César DOMELA NIEUWENHUIS, Hans RICHTER, the DADA poet Hugo Ball and the musician George Antheil became associated with the movement. From *c.* 1921 Van Doesburg came under the influence of Dada and in 1922 published a Dada supplement to *De Stijl* with the title *Mecano*. From 1924 he began to modify the early principles of Neo-Plasticism and in the issue of *De Stijl* for 1926 he published a 'Manifesto of Elementarism', as he named this new aesthetic, declaring that Elementarism was a modification of the too dogmatic application of Neo-Plasticism and a logical development of it. In effect, while retaining the strict limitation to the straight line and the right angle, he now made room for greater dynamism by rejecting the 'vertical and horizontal'

and allowing lines in other planes. He was followed in this by Domela and by VORDEMBERGE-GIL-DEWART, who had joined the group in 1924. But in the final, memorial number of *De Stijl* a formulation by Van Doesburg was published in which the main philosophical tenets of Neo-Plasticism were reiterated. A genuine work of art can be created only by those who do not hesitate to distrust and disregard their visual impressions. Composition is the transition towards universal form. The perfect work is created beyond our personality, and personality must be suppressed. The method of spontaneity has never given rise to a work of solid cultural value. And so forth.

De Stijl was the most influential of all the *avant-garde* journals which were started up in the years following the First World War. The ideas it expressed spread outside the Netherlands and the movement which it represented was influential both in the fine and in the practical arts of many European countries, Britain and America, where it had affinities with CONSTRUCTIVISM. The high artistic reputation of Mondrian, who went to New York in 1940, was an important factor in disseminating this influence. In architecture the principles of De Stijl in Europe together with those of Frank Lloyd Wright from America were among the most important formative influences in the emergence of the modern style.

Exhibitions of De Stijl were given by Léonce Rosenberg at the Gal. de L'Effort Moderne, Paris, in 1923, at Hanover in 1924, at the Stedelijk Mus., Amsterdam, in 1951.

STILL, CLYFFORD (1904–80). American painter, born at Grandin, N.D., studied at Spokane University and then at Washington State College, where he remained as a teacher, 1935–41. After working in war industry, 1941–3, he taught at the California School of Fine Arts, 1946–50, and then lived and taught in New York, 1951–60. From 1963 he lived in retirement at Westminster, Maryland. After experimenting in a number of styles he found his own place among the ABSTRACT EXPRESSIONISTS, exhibiting at the Art of this Century Gal. in 1946. From the vaguely SURREAL-IST forms of his painting *Jamais*, shown in this exhibition, he became one of the pioneers of the very large, virtually monochromatic painting. But unlike the thin unmodulated pigment of NEWMAN and ROTHKO, he used heavily loaded, expressively modulated impasto from which sharp, flamelike abstract forms reached out across the canvas. His work was included in many important collective exhibitions both in America and abroad and he had his first retrospective exhibition at the Albright-Knox Art Gal., Buffalo, in 1959, followed by a major one-man show at the Institute of Contemporary Art, University of Pennsylvania, in 1963 and an exhibition of 33 paintings at the Albright-Knox Gal., in 1966.

STOCHASTICISM. (Ancient Greek *stochastikos* from the verb *stochazesthai*: 'to aim' with the subsidiary meaning 'to guess' or 'conjecture'. *Stochasticos* as an adjective meant either 'skilful at aiming' or 'proceeding by conjecture'.) The word 'stochastic' was introduced into mathematics by Jacob Bernouilli in his great treatise on the theory of probability, *Ars Conjectandi* (1713), and it has come into general use as a technical term for describing situations governed by probabilities. The English word 'stochastic', described by *The Oxford English Dictionary* as 'rare or obsolete', meant 'pertaining to conjecture'. It was adopted about the middle of the 20th c. as a technical term in music and the visual arts to describe new styles of composition which involve an element of randomness, depending on chance or aleatoric procedures either in the creation or in the performance or in the behaviour of the finished work. For example some KINETIC works embody a chance element within predetermined sequences of movement, some non-kinetic works make use of moiré or other effects to cause striking changes of appearance according to chance changes in the position of the spectator in relation to the work.

The theoretical justification for the introduction of chance into aesthetic structures has not been worked out, but its use seems to have been a symptom of a pretty general, though not clearly formulated, change in the concept of aesthetic order which took place in the decades following the Second World War. The concept of 'structure' carries with it the ideas of uniformity, stasis and invariability. It involves coherence and the mutual dependence or interrelation of the parts within a whole. In this sense structure is a prerequisite of any organizational activity, any continuity of thought and any perceptual process, for the complete absence of structure would reduce any object of thought or sensation to an incomprehensible aggregate of unconnected elements. In the visual arts 'structure' denotes a principle of formal organization underlying the purely optical phenomena and making the presented whole visually accessible as a system of relations among heterogeneous parts. It is structure in this sense—often called 'form'—which enables a work to be 'perceived' as an aesthetic entity rather than as an assemblage of theoretically related elements, and it is generally accepted that aesthetic form, so understood, can be perceived to an extent beyond what is theoretically demonstrable. The opposite of structural order is 'randomness' or 'chaos', and it used to be taken for granted that any weakening of structural order by the introduction of random features was an aesthetic demerit. The new attitude considers structural order and complete randomness as limiting cases on a sliding scale of 'orderliness', so that an aesthetic structure must necessarily be regarded as a system with a determinable position on the scale. Therefore, it may be argued, it is possible, and may be desirable, to introduce features of controlled disorder, controlled aleatoric or chance processes, within the aesthetic structure.

One of the oldest aesthetic theories maintained that the excellence or 'beauty' of any aesthetic structure may be regarded as a function of 'unity' and 'variety'. It might be argued that the introduction into aesthetic structures of random processes controlled according to principles of probability falls within this ancient formula. But the theoretical arguments for aesthetic randomness, for the use of aleatoric methods, and for stochasticism in general, remain still to be worked out. Some artists have for many years insisted upon the psychological importance of chance in the creation of works of art. But the incorporation of chance elements in performance or behaviour of works of art remains a novelty and a challenge which will doubtless have to justify itself further in practice before a sound aesthetic basis is likely to emerge.

The term 'aleatory' is also used of chance or random elements (Latin: *aleatorius*, depending on the throw of a die).

The early CONSTRUCTIVISTS repudiated the element of chance, wishing to exercise complete control over their works. But the MOBILE, from CALDER to Julio LE PARC, which relies on air currents for its motive force is obviously dependent on chance. Since the development of kinetic art chance has often been incorporated within a system of programmed movement. ARP was one of the first to bring in chance as a major element in the construction of abstract works of art, letting scraps of paper fall at random on a surface and making a COLLAGE by gluing them down where they fell.

Since the 1950s there have been several motives which have encouraged a more serious attention to chance in the formation of art works. The reaction from ABSTRACT EXPRESSIONISM, ACTION PAINTING and TACHISM brought with it an attitude of objectivity and a desire for the 'depersonalization' of the art work. Chance, it was felt, meant the complete abrogation of the artist's authority and the ultimate in 'objectivity'. Largely for these reasons chance has featured importantly in the ARTE PROGRAMMATA of Italy. Furthermore, where spectator participation becomes a main purpose of the art work, some element of chance is obviously to be desired, since if the reaction of the spectator is completely controlled, he no longer 'participates'. In CONCRETE ART, however, where the work is constructed according to, or by means of, a mathematical formula, the introduction of random elements, though practised, seems to be out of place. For the object of such works is the elimination of ambiguity and a full intellectual understanding of the principle according to which the work is constructed. But chance features interrupt or render impossible such understanding and conflict with the basic principle of Concrete art.

STOLNIK, SLAVKO (1929–). Yugoslav NAÏVE painter, born in the village of Voća Donja outside Varaždin. He showed a talent for drawing from early childhood and revived the ambition to become a painter while working as a labourer on the Zagreb–Belgrade highway. In 1954 he received some instruction and encouragement from the academic painter Krsto HEGEDUŠIĆ. He painted for preference in oils under glass and did brightly coloured genre scenes from remembered incidents in his life. From 1955 he was widely exhibited in Yugoslavia and also acquired a reputation in France.

STÖRTENBECKER, NIKOLAUS (1940–). German painter, born in Hamburg and trained at the Academy of Fine Arts there, 1960–5. He held a scholarship to London from the German Academic Exchange Service in 1965–6, a scholarship from the Kulturkreis im Bundesverband der Deutschen Industrie in 1971 and a scholarship to the Villa Massimo, Rome, in 1973–4. He was one of the four artists who formed the ZEBRA group in 1965. From 1965 he exhibited widely in Germany both with the *Zebra* group and in other collective exhibitions. Störtenbecker worked with a minute and detailed Realism and an entirely objective approach so that his paintings gave the impression of being photographs rather than pictures of the subject.

STOWASSER, FRIEDRICH. See HUNDERTWASSER.

STRADONE, GIOVANNI (1911–). Italian artist born at Nola and working in Rome. He was among the younger generation of the ROMAN SCHOOL who continued SCIPIONE's interpretation of the EXPRESSIONISM of SOUTINE. Stradone attempted to find a reconciliation between this and CUBISM.

STREU-KOMPOSITION. See ALL-OVER PAINTING and TWOMBLY, Cy.

STRZEMIŃSKI, WŁADYSŁAW (1893–1952). Polish abstract painter. Following a visit to Warsaw by MALEVICH in 1924, in the course of which he lectured on the principles of SUPREMATISM, Strzemiński formed a group of Polish non-objective artists, who published the periodical *Blok*. Other members of the group were Strzemiński's friend Henryk STAŻEWSKI, who in 1930 became a member of the Paris group CERCLE ET CARRÉ, and Henryk BERLEWI, who had been in touch with Van DOESBURG and the ideas of NEO-PLASTICISM in 1922. Strzemiński and Stażewski originated a new system which they called 'Unism' and which Strzemiński expounded in the first number of the journal *Abstraction-Création* in 1932. He claimed that in order to be seen as an optical unity a canvas should not be divided into sections by lines or opposed masses or rhythms but the picture should consist of an ALL-OVER pattern. 'Line divides—the purpose ought to be not the division of the picture, but its unity, presented in a direct way: optically.' Therefore the painter must renounce the line, rhythm ('because it exists only in

the relations of independent parts'), oppositions and contrasts, and division ('because it concentrates and intensifies the forms around the contour, and cuts the picture into sections'). He claimed that in his system of Unism he had gone beyond Malevich in abstraction because not only were his pictures 'non-objective' in the sense of having no subject but they had no images either (i.e. he had banished Malevich's squares and triangles). In fact the work of the Unists anticipated some of the styles of later artists such as Piero DORAZIO and Jasper JOHNS and their ideas have surprisingly much in common with those of the MINIMALISTS who advocated holistic or non-relational art. Works by Strzeminski and Stażewski are in the Mus. Sztuki, Łódz, Poland.

STUCK, FRANZ VON (1863–1928). German painter, sculptor and graphic artist, born at Tettenweis, Bavaria. He studied at Munich and in 1893 was a founding member of the Munich SECESSION. In 1895 he obtained a teaching post at the Munich Academy, where KANDINSKY and KLEE were among his pupils. He was also an honorary member of the Berlin, Dresden, Stockholm and Milan Academies. At the turn of the century he was one of the promoters of the ART NOUVEAU or *Jugendstil* movement and in his Munich house he tried to realize the *Jugendstil* ideal of the *Gesamtkunstwerk* or 'total work of art'. His decorative use of flat colour to control the mood of a picture to some extent anticipated later developments. Although now forgotten, Stuck enjoyed a very high reputation in his lifetime.

STUPICA, GABRIJEL (1913–). Yugoslav painter and draughtsman, born at Drazgoše, Slovenia, studied at the Academy in Zagreb and taught from 1946 at the Academy of Art, Ljubljana. His manner of painting evolved from EXPRESSIONISM through realistic representation to a method of flat linear ALL-OVER composition which relied heavily on children's drawing and self-sufficient 'symbols' with a psychological import. He was particularly active in portraiture and his work in this field evolved from the psychological portrait through a more classical concept where facial expression and characteristic gesture are paramount to a more suggestive style in which objects and 'signs' create a psychological 'aura' of personality. In his later style he made use of COLLAGE and as it were phantom images of banal objects to create an over-all impression which combined precision with unreality.

STURM, DER (THE STORM). Name of an art journal founded by Herwarth Walden (1878–1941) in Berlin in 1910 and of an art gallery opened in 1912. The gallery ran until 1924 and the journal until 1932. Walden was an enthusiastic supporter of the *avant-garde* and both the magazine and the gallery soon established themselves as the leading organs of *avant-garde* art in Germany. Walden

supported and promoted German EXPRESSIONISM, publishing reproductions of the works of the BRÜCKE and the BLAUE REITER, while KANDINSKY and MARC were advisory editors of the journal. He helped to introduce FUTURISM to Germany, publishing translations of the Futurist manifestos. He also introduced CUBISM and included in the journal a statement by DELAUNAY of his ORPHIST theories and five essays by the modernist architect Adolf Loos. His gallery introduced the works of many of the leading foreign artists to Germany and in 1913 he arranged the first German *Herbstsalon* (SALON D'AUTOMNE).

STURM, HELMUT. See SPUR.

SUAREZ, ANTONIO (1923–). Spanish painter, born at Gijón, Asturias. He had no formal training as a painter but studied the craft practically in Spain and for several years from 1949 in Paris. He also lived in Mexico and the U.S.A. From figurative painting he passed to abstraction. But his abstract style differed from the prevailing ART INFORMEL and TACHISM, being for the most part based upon natural forms, landscapes, trees, etc., and organized rather than incoherent. Painting in a thick impasto, he was a sensitive colourist and an artist of fine natural talent.

SUBJECT OF THE ARTIST SCHOOL. See MOTHERWELL, Robert; NEWMAN, Barnett; ROTHKO, Mark; UNITED STATES OF AMERICA.

SUGAÏ, KUMI (1919–). Japanese painter born at Kobe, studied at the Academy of Art in Osaka. He worked in Kobe until 1952, when he emigrated to Paris. His first one-man show there was at the Gal. Craven in 1953 and he subsequently participated in a number of group shows in Paris, London, Brussels and the U.S.A. After a short SURREALIST period and a phase of ART INFORMEL he evolved an extremely personal style in which geometrical shapes and spirals served as a basis for sophisticated colour harmonies. His work combined traditional Japanese charm with a Western sense of order and invited meditation in accordance with his leanings towards Zen Buddhism. It also manifested a characteristic erotic flavour. He had a major exhibition at the Kestner-Gesellschaft, Hanover, in 1963.

SUGARMAN, GEORGE (1912–). American sculptor, born in New York and studied at the Zadkine School of Sculpture, Paris. He taught at Hunter College from 1960. His work in the 1960s was in reaction against the Expressionist metal sculpture of FERBER, LASSAW, LIPTON, ROSZAK and the JUNK sculptors such as CHAMBERLAIN and Mark di SUVERO who followed them. But it was also in opposition to the 'unitary objects' cultivated by the MINIMALIST sculptors such as Robert MORRIS and Donald JUDD. Like David WEINRIB and Tom DOYLE he constructed ensembles of juxta-

posed but disassociated structures with a large variety of forms, organic as well as geometrical, differentiated by contrasting colours. Like the work of such Minimalists as Dan FLAVIN and Ronald Bladen, these ensembles not only occupied the space in which they were set but modified it visually even to the point of distortion or hallucination. His work was included in American and international group exhibitions of the sculpture of the 1960s and in 1969 he had a retrospective exhibition circulating from the Kunsthalle, Basle, to Amsterdam and West Germany.

SÜLI, ANDRÁS (1897–1969). Hungarian NAÏVE painter, born in Algyö. He worked as a farm labourer and after serving in the First World War returned to Algyö. He began to paint in 1933 but in 1938, disappointed at lack of recognition, he burned most of his pictures and abandoned painting. He was forgotten until the 1960s, when his works were rediscovered and exhibited at the First Triennial Exhibition of Naïve Art in Bratislava. Since then he has been included in a number of international exhibitions of naïve art. Although only 33 of his paintings are known to exist, he is regarded as the most important naïve artist of Hungary. His style has the flat decorative quality of tapestry or a child's sampler, yet at the same time contrives to give a curious suggestion of space and the personality of the objects which he depicts. He had a natural feeling for formal design and pictorial construction. Pictures by him are in the Hungarian National Gal., Budapest.

SUMNER, MAUD. See SOUTH AFRICA.

SUPERREALISM. See PHOTOGRAPHIC REALISM.

SUPREMATISM. A method and philosophy of abstract painting launched by the Russian artist Kasimir MALEVICH in 1915, Suprematism was the earliest of the movements which jointly contributed to the emergence of European CONSTRUCTIVISM. Malevich's somewhat loosely written essay 'Suprematism' in his book The Non-Objective World (English trans. 1959) made the following points about Suprematism. (1) It eschews representation of natural appearances and idealizations of them. (2) It is the expression of pure artistic feeling or 'non-objective sensation'. ('No more "likeness of reality", no idealistic images—nothing but a desert! But this desert is filled with the spirit of non-objective sensation which pervades everything.' (3) Suprematist art serves no ulterior purpose nor is it 'expressive' of the emotions and attitudes of the artist other than the pure artistic feeling. It has no other 'usefulness'. ('Art no longer cares to serve state and religion, it no longer wishes to illustrate the history of manners, it wants to have nothing further to do with the object as such. . . .') (4) The expression of pure

artistic feeling is all that is of value in art, past and present. ('Suprematism is the rediscovery of pure art which, in the course of time, had become obscured by the accumulation of "things".') (5) Suprematism is art constructed from elementary geometrical shapes, specifically the rectangle, the circle, the cross and the triangle. The most perfect or 'purest' of these is the square.

Although Malevich himself speaks of his debts to CUBISM and FUTURISM, it should be understood that Suprematism is not a logical development from any form of abstract art which proceeds by analysing and breaking down natural appearances into more geometrically simple shapes to be organized into structures on the picture plane. Furthermore, Suprematism does not belong with those kinds of abstraction which, while not deriving from natural appearances, have as their purpose the expression or evocation of emotions—such, for example, as ABSTRACT EXPRESSIONISM in America or the various forms of post-war expressive abstraction in Europe such as TACHISM. Like Dutch NEO-PLASTICISM, Suprematism builds up or constructs from non-naturalistic geometrical elements and is therefore to be classed with the form of abstraction which is most properly named Constructivism.

Malevich claims that he began Suprematist compositions in 1913, at the time when he is known to have been producing pictures and COLLAGES in the manner of the Synthetic Cubism of PICASSO and BRAQUE. In this year he produced a backcloth for Kruchenykh's Futurist opera Victory over the Sun consisting of a single square divided diagonally into white and black on a white background. Some canvases in the Russian Mus., Leningrad, consisting of a single square, cross or circle, are dated, provisionally, 1913. It was in 1915, however, that he first publicly launched Suprematism with a Manifesto and canvases shown at '0.10. The Last Futurist Exhibition' in Petrograd. His most extreme expression of his Suprematist ideas was reached in 1918–19 in the White on White series, in which the white square on a white ground is detectable only by a variation of visual texture produced by a difference in brush-stroke. Malevich had a considerable influence on other Russian painters such as POPOVA, RODCHENKO and El LISSITZKY and when Naum GABO returned to Russia in 1917 he found Suprematism dominant among avant-garde artists there. These artists developed other forms of Suprematism and some began to 'apply' it indiscriminately to all kinds of functional designs (textiles, porcelain, theatre sets). The importance of Suprematism in the history of European Constructivism can hardly be exaggerated.

SURREALISM. Surrealism was the most highly organized and tightly controlled of all the artistic movements of the 20th c. Its moral and executive leader was André BRETON, who was given the unofficial title 'the Pope of Surrealism'. More than

an artistic and literary movement, Surrealism was also a life-style and the expression of a philosophical outlook. It has been regarded by some critics and historians as the most significant or the most characteristic expression of the spirit which prevailed in the period between the two world wars. At the heart of Surrealism lay the belief that 'objective chance'—by which was meant inexplicable coincidence—is central to reality, which is not an orderly system of events apprehensible by logical thought. Hence, it was believed, knowledge of true reality can be gained only through a-logical insights of the unconscious mind and these insights can be achieved only by certain (a-logical) AUTOMATIC procedures. The word *surréaliste* was taken over from Guillaume APOLLINAIRE, who had used it in 1917, and it was defined by Breton in his first *Manifesto* as follows: 'SURREALISM, n. masc. Pure psychic automatism, by which it is intended to express, verbally, in writing, or by other means, the real process of thought. Thought's dictation, in the absence of all control exercised by the reason and outside all aesthetic or moral preoccupations. ENCYCL. *Philos.* Surrealism rests in the belief in the superior reality of certain forms of association neglected heretofore; in the omnipotence of the dream and in the disinterested play of thought. It tends definitely to do away with all other psychic mechanisms and to substitute itself for them in the solution of the principal problems of life.'

The immediate predecessors of Surrealism in art were DADA and the early paintings of CHIRICO, in literature Lautréamont, Rimbaud and Jarry. In 1922 Breton, ÉLUARD, Aragon and Péret broke definitively with Dada and continued their experiments with various techniques of automatic writing, trance and the cultivation of dream imagery with the idea of exploring the 'Surreal' world of a-logical reality. The association was founded in 1924 when the 'Bureau de Recherches surréalistes' was opened, the periodical *La Révolution surréaliste* founded and Breton's first *Manifesto* was published.

In 1925 MIRÓ had his first one-man show of fully Surrealist pictures and the first exhibition of the Surrealists as a group took place in the Gal. Pierre, Paris. In 1926 the Gal. Surréaliste opened with an exhibition of MAN RAY and a Belgian Surrealist group was founded. In 1927 TANGUY, ERNST and ARP had one-man shows in Paris and MAGRITTE in Brussels. In 1929 MASSON left the movement and GIACOMETTI and DALÍ joined. Dalí had a one-man exhibition. In 1930 the name of the review changed to *Le Surréalisme au service de la Révolution*, and in the same year Breton published his second manifesto of Surrealism. The emphasis in the first manifesto had been on automatic methods of reaching the unconscious as a way of achieving knowledge of reality. In the second he underlined the dangers which threatened Surrealism from its concerns with revolution and changed his philosophical position, defining 'Surreality' as the reconciliation of dream reality with everyday waking reality in a higher synthesis.

In practice the Surrealists combined two probably incompatible aims: to explore and liberate the creative unconscious and to formulate a policy of practical action for the amelioration of society. From *c.* 1925 the question of political activity for social improvement was a main source of disputes within the movement. Between *c.* 1927 and 1935 there reigned an uneasy period of collaboration with the French Communist Party, during which Breton was unwilling to allow any such radical association as would deprive the Surrealists of independence of action while the Party found their intransigence unsuitable for full incorporation.

Despite the tight organization and the general importance attached to the doctrine of automatism, no single Surrealist style emerged. There were, rather, three main trends, though two or even three of these were often apparent in the same artist. They were: (1) Genuine automatic imagery on the analogy of the 'automatic writing' of mediumistic seances or chance imagery such as the FROTTAGES of Ernst, the FUMAGES of PAALEN and the DÉCALCOMANIES of DOMINGUEZ. Examples of imagery from the unconscious are the forms used by Masson, MATTA, the amoeba-like forms of Miró and those of Arshile GORKY. To this category belongs also the spontaneous calligraphy of HANTAI, which in a sense that transcended Surrealism developed into the improvisatory ALL-OVER 'writing' of Jackson POLLOCK and Mark TOBEY. (2) In Dalí, Magritte, Tanguy, etc. we find an almost opposite style of hallucinatory realism—sometimes called MAGIC REALISM—with careful and precise delineation of detail, yet a realism which does not depict an external reality since the subjects realistically depicted belong to the realm of dream or fantasy. With this is often combined the depiction of a hallucinatory dream-space which goes back to Chirico. (3) Finally, in Surrealist constructions and ASSEMBLAGES as well as paintings the unexpected and startling juxtaposition of unrelated objects was used to create a sense not so much of unreality as of a fantastic but compelling reality outside the everyday world. The text quoted to justify this search for the unexpected combination of incompatibles was a sentence from Lautréamont: 'Beautiful as the chance encounter of a sewing machine and an umbrella on an operating table.'

Although this was not central to Surrealism, some Surrealist artists exploited for their own purposes the tradition of visual conundrums and ambiguities which goes back to the hidden faces and ambiguous figures of Arcimboldo and the self-contradictory perspectives of Hogarth (developed also by M. C. ESCHER). The artists who made most specific use of such devices were Magritte and Dalí. In Magritte's picture *Les Promenades d'Euclide* (1955) the roof of the right-hand tower seen through a window functions both as a solid conical roof and as the flat plane of a road seen in perspective, forcing the viewer to suspend belief in

the visual logic of the picture. In *La Cascade* (1961) and other paintings the depicted painting is perceived incompatibly both as a painting of a landscape and as a window through which a real landscape is seen. In *Le Chœur des Sphynges* (1964) the shapes above the trees are seen both as superimposed forms and as openings in the sky. In several of his pictures there is an ambiguity between day and night. And so on. Dalí makes subtle use of the concealed shape, as in *Slave Market with Disappearing Bust of Voltaire* (1940), where perception of the head of Voltaire depends upon the depiction of the two coifed nuns, and *Skull of Zurbaran* (1956). Dalí's 'paranoiac-critical' method involved the use of images within images with intricately interlinked associations as in *The Three Ages* (1940).

Although it had its birth in Paris and Paris remained its main centre until the Second World War, Surrealism rapidly became an international movement. In the Paris exhibition of 1938, 14 nations were represented. The following list of important international exhibitions is ample evidence of this universal character: 1931 U.S.A.; 1935 Copenhagen, Prague, Santa Cruz de Tenerife; 1936 London; 1937 Tokyo, Osaka and elsewhere in Japan; 1938 Paris and Amsterdam; 1940 Mexico City; 1942 New York; 1947 Paris; 1948 Prague and Santiago de Chile; 1959–60 Paris; 1960 New York; 1961 Milan; 1965–6 Paris; 1967 São Paulo; 1968 Prague.

U.S.A. A colony of *émigré* European Surrealists settled in New York and centred on the Art of this Century gallery of Peggy Guggenheim and the Julian Levy Gal. during the early years of the war. They included Tanguy, Ernst, Matta, CHAGALL, Breton, Masson, TCHELITCHEW, Kurt SELIGMANN. They had contacts with a number of American artists who had already been influenced in various ways and to various degrees by Surrealism, sometimes in conjunction with an interest in pre-Conquest Amerindian art of Central and North America. Among these were Arshile Gorky, Hans HOFMANN (who had opened a school in New York), Adolph GOTTLIEB, William BAZIOTES. It was chiefly the principle of AUTOMATISM, or unplanned and impromptu composition as psychic revelation, which was taken over and transformed in ABSTRACT EXPRESSIONISM. Robert MOTHERWELL gave the name 'Abstract Surrealism' to that stream of Abstract Expressionism which had a strongly lyrical element and which most fully exemplified the doctrine of improvisatory composition.

CANADA. In Canada Surrealism was adopted by the group of AUTOMATISTES centred around Paul-Émile BORDUAS. Of the group RIOPELLE worked in Paris 1947–50 and Borduas himself abandoned Surrealism *c.* 1953.

ENGLAND. In England the International Surrealist Exhibition of 1936 came upon the backwater of the 1930s like a bombshell. Chief organizers were the painter Roland Penrose and the critic Herbert READ, who in the same year edited a

volume *Surrealism* with contributions by Breton, Éluard, Georges Hugnet and Hugh Sykes Davies. David Gascoigne had published his *Short Survey of Surrealism* in the previous year. Many artists were excited by the exhibition. Some went through a Surrealist phase—e.g. Paul NASH. Henry MOORE was implausibly claimed for the movement. But Surrealism did not acclimatize itself in Great Britain as a main stream in the country's artistic development.

BELGIUM. The Belgian Surrealist movement came into being with the merger in 1925 of the group and periodical *Correspondance*, founded by Camille Goemans, Marcel Lecomte and Paul Nougé, and the paper *Oesophage* founded by Magritte and MESENS. Magritte was the outstanding figure of the group, while DELVAUX stood somewhat apart from its activities. Among others were the poets and writers Louis Scrutenaire, Paul Colinet and André Souris. Goemans was director of the Surrealist gallery in Paris. The Brussels Surrealists were notable for the modesty of their claims and for their lack of exhibitionism.

DENMARK. The Surrealist movement in Denmark extended from the Cubist–Surrealist exhibition of 1935 until the Surrealist exhibition of 1940. Its paper was *Konkretion*, its founder the painter Vilhelm Bjerke-Petersen (1909–57). The sculptor Henri HEERUP was also a member of the group.

GERMANY. Surrealism did not take root in Germany. Richard OELZE worked with the automatic techniques of Ernst. A few other artists painted in a Surrealist manner at least for a period: Mac ZIMMERMANN, Edgar ENDE, Heinz TRÖKES, and Rudolf HAUSNER in Austria. But there was no Surrealist movement as such.

Surrealism was both a literary movement and a movement in the visual arts. Although it broke up as an organized movement with the Second World War and its main force was spent by the conclusion of the War, the findings and methods of Surrealism and many of the artistic styles evolved continued to influence individual artists in many countries.

SURVAGE, LEOPOLD (1879–1968). Painter born in Moscow of a Finnish mother and Danish father. After beginning a course of architecture at the Moscow School of Art, he went to Paris in 1908 to study painting with MATISSE. He was attracted, however, by the CUBISTS and exhibited with them at the Salon des Indépendants in 1911. In 1919 he was associated with GLEIZES and ARCHIPENKO in the SECTION D'OR. He had several one-man shows at the Gal. Léonce Rosenberg during the 1920s and exhibited also in New York and Chicago. He had a gift for large-scale decoration and was commissioned by DIAGHILEV to design décor for the ballet *Mavra*. In the Exposition Universelle of 1937 he executed three panels 20 m long for the Railway Pavilion, for which he was awarded a Gold Medal.

Though an adherent of Cubism, Survage re-

tained unusual originality in his interpretation of Cubist principles. He preferred townscapes to the more usual Cubist still lifes and he was dominated by a curious spatial sense which lent to his work a suggestion of haunting mystery foreign to the more orthodox Cubist work.

ŠUTEJ, MIROSLAV (1936–). Yugoslav painter and graphic artist born at Duga' Resa, Croatia, and studied at the Academy of Art, Zagreb. His work spanned geometrical abstraction and OP ART and made frequent use of the circle as an iconic symbol.

SUTHERLAND, GRAHAM VIVIAN (1903–80). British painter, born in London. In 1919 he was apprenticed in the engineering department of the Midland Railway Works at Derby, but after a year he returned to London and became a student at the Goldsmiths' School of Art, 1921–6. Here he concentrated upon engraving and by 1930 he had achieved a considerable reputation as an etcher of landscape. From 1927 he taught at the Chelsea School of Art. The boom in etchings came to an end at the close of the 1920s and c. 1932 Sutherland took up painting, developing almost from the first a highly individual style of landscape. The influence of Samuel Palmer, which had been strong in his etchings, was gradually overcome as his personal vision matured. Sutherland drew his inspiration not from the familiar but from the elements of strangeness in nature, finding his motifs in Pembrokeshire, the westerly part of Wales, and Cornwall. He had a vivid and ubiquitous gift of visual metaphor and would paint as it were 'portraits' of fantastically formed trees or hills or boulders in a manner reminiscent of the OBJETS TROUVÉS of Paul NASH. Renouncing perspective in favour of a 'non-scenic' vision of landscape, he turned his paintings into semi-abstract patterns of haunting and monstrous shapes. Examples of this phase of his work are: *Entrance to Lane* (Tate Gal., 1939); *Green Tree Form* (Tate Gal., 1940); *Fallen Tree with Sunset* (Contemporary Art Society, 1940). In 1940 he did costumes and décor for the ballet *The Wanderer* in an analogous style. By the end of the 1930s Sutherland had won considerable recognition both in his own country and on the Continent. Writing in 1943 Edward Sackville-West was expressing an accepted view when he linked Sutherland with Henry MOORE as 'two of the most significant artists of our time'.

From 1941 to 1944 Sutherland worked as an official War Artist. His paintings of bomb devastation, work in mines and foundries, continued his former technique. The human element was either absent or unobtrusive. But his gift for visual metaphor and for the powerful presentation of the horrific in the realm of form stood him in good stead and these wartime paintings (many of which were acquired by the War Artists' Committee) gained a tautness and an impact which he had rarely mastered in his earlier period. They achieved dramatic power and had, in the words of Eric Newton, 'a bold, crucified poignancy that gives the war a new meaning'.

After the end of the war his painting suffered a certain loss of direction and became more diffuse. The exceptions were paintings and drawings of thorn trees infused with a strong sense of visual metaphor. From 1947, when he visited the Picasso Mus. at Antibes, he spent a large part of each year in the south of France and settled there in 1956. In 1944 he painted a *Crucifixion* for St. Matthew's Church, Northampton, and between 1954 and 1957 he designed the immense tapestry representing 'Christ in Glory in the Tetramorph' for the new Coventry Cathedral. The latter became famous among tourists from most parts of the world. It was followed in 1960 by a *Crucifixion* for the church of St. Aidan, East Acton. Among his portraits were those of Somerset Maugham (Tate Gal., 1949), Lord Beaverbrook, the Hon. Edward Sackville-West (a smaller version of which is in the City Art Gal., Birmingham), Winston Churchill (1954) and Madame Rubinstein (1957).

He was a Trustee of the Tate Gal. 1948–54 and was awarded the Order of Merit in 1960. He had retrospective exhibitions at the Venice Biennale and at the Mus. National d'Art Moderne, Paris, in 1952, at the Tate Gal. in 1953 and at Amsterdam, Zürich and Boston.

SUVERO, MARK DI (1933–). American sculptor born at Shanghai. He migrated with his family to California in 1941 and majored in philosophy in the University of California at Berkeley, also studying at the California School of Fine Arts. In 1957 he moved to New York and had his first one-man show at the Green Gal. there in 1957. His early work was vigorously EXPRESSIONIST but during the 1960s he became one of the forerunners of JUNK ART, making monumental assemblages of beams, tyres, chairs, chains and other scrap from demolished buildings and junkyards. Poised asymmetrically in precarious balance around huge beams and rough-hewn planks, these constructions sometimes contained makeshift seats inviting the spectator to participate in the space and tension of the work. In 1971 he moved to Venice in protest against America's involvement in the Vietnam war and exhibited gigantic outdoor sculptures in Italy. He was represented in a number of collective exhibitions, including Los Angeles County Mus. of Art, 'American Sculpture of the Sixties', 1967; Hayward Gal., London, 'The Condition of Sculpture', 1975. Outside America he had one-man exhibitions at Duisburg and Eindhoven and he had an important one-man exhibition at the Whitney Mus. of American Art, New York, in 1975. In 1975 also he created a series of outdoor, environmental sculptures for five New York boroughs. In *A History of Modern Art* (1977) H. H. Arnason wrote of him: 'Di Suvero's unlimited imagination and originality, as well as the increasing scale and power of his works, have resulted in his emergence

in the 1970s as one of the foremost monumental sculptors. . . . More than any other American sculptor Di Suvero, in his imaginative use of gigantic scale, is the heir of and successor to the late David Smith.'

SUZOR-COTE, MARC-AURÈLE DE FOY. See CANADA.

SYDNEY GROUP. One of the most important associations of Australian artists in the years following the end of the Second World War. It was established in 1945.

SYDNEY 9. A group founded by John OLSEN and his friends in 1960 with the object of introducing into Australia European methods of exhibition and a better understanding of non-representational art.

SYED AHMAD JAMAL (1929–). British painter, born in Johore. He trained at the Chelsea Art School, London, exhibited in London, Manila, Singapore and India, and afterwards regularly in Malaysia. He is represented in the Malayan National Art Gal. and was Senior Lecturer in Art at the Special Teachers' Training Institute, Kuala Lumpur. He painted in a manner of expressive abstraction akin to rhythmical ART INFORMEL.

SYN. A group formed in 1965 by the German artists Bernd BERNER, Erwin BECHTOLD, Klaus JÜRGEN-FISCHER and Eduard MICUS. Its purpose was to formulate and define the artistic elements and means with a view to the controlled use of the more extreme techniques. The group was not closed but was joined from time to time by other artists, e.g. the sculptors Wilhelm LOTH and Dieter Boers and the Japanese Kumi SUGAÏ. Its purpose and principles were set forth in 12 points in the catalogue of an exhibition held at Wiesbaden in 1967.

SYNCHROMISM. A movement whose main import was the reliance upon colour alone to provide both the form and the content of painting. It was developed in parallel with the ORPHISM of Robert DELAUNAY by two American artists, Stanton MACDONALD-WRIGHT and Morgan RUSSELL, working in Paris. They ventilated their theories of colour in statements put forward at joint exhibitions held in 1913 at the Neue Kunstsalon, Munich, and later at the Gal. Bernheim-Jeune, Paris. These theories were extensions of those which Seurat, Signac and others of the Neo-Impressionists had derived from such scientific studies of colour as Chevreul's *De la loi du contraste simultané des couleurs* and O. N. Rood's *Modern Chromatics*. It seems likely that they were influenced towards abstraction after 1913 by the colour discs of Delaunay and KUPKA.

As well as the originators of the movement two other expatriate American artists were known as

Synchromists: Arthur Burdett Frost and Patrick Henry BRUCE, both of whom were friends of Delaunay and former students of MATISSE. Frost returned to New York in 1914 and there helped to disseminate an interest in Synchromism which was aroused by an exhibition of works by Russell and Macdonald-Wright at the Carroll Gal. Among artists who were influenced by this to experiment with various forms of abstract colour painting were: Thomas Hart BENTON, Andrew DASBURG (both of whom showed Synchromist abstract paintings at the FORUM exhibition of 1916), Morton Livingstone SCHAMBERG, Joseph STELLA and Arthur B. DAVIES.

SYNTHETISM. As early as 1876 the term 'synthetism' was in use to distinguish the artistic aspects of Impressionism from the scientific aspects which were developed by the Neo-Impressionists Seurat and Signac. It was used by the Pont Aven artists in a different sense associated particularly with Émile BERNARD, who claimed to have introduced Gauguin to his '*cloisonniste*' and 'Synthetist' manner in 1888. Bernard believed that form and colour must be simplified for the sake of more forceful expression. 'Anything that overloads a spectacle . . . occupies our eyes to the detriment of our minds. We must simplify in order to disclose its [i.e. Nature's] meaning . . . reducing its lines to eloquent contrasts, its shades to the seven fundamental colours of the prism.' Gauguin too spoke much of 'synthesis', by which he meant an intensification and concentration of our primary impressions of nature, and he advised his disciples to 'paint by heart' because in memory coloured by emotion natural forms become more integrated and meaningful. The term *Synthétisme* became a catchword of the Pont Aven artists. At the Exposition Universelle of 1889 they organized an exhibition under this title at the Café Volpini in opposition to current Impressionism, emphasizing the simplification of forms into large-scale patterns, the elliptical style of drawing and the expressive purification of colours. In 1891 a *Groupe Synthétiste* was formed, including besides Gauguin and Bernard, Charles Laval (1862–94), Louis Anquetin (1861–1932), Émile Schuffenecker (1851–1934) and Daniel de Monfried (1856–1929). Some 20th-c. writers renewed these concepts and applied the term to British or American art of the early decades of the century which was derived from the simplified drawing and flat colours of Gauguin in contrast to the DIVISIONISM descended from the Neo-Impressionists.

SYSTEMIC ART. Term originated by Lawrence Alloway in 1966 when he organized an exhibition 'Systemic Painting' at the Solomon R. Guggenheim Mus., New York. Systemic painting, which is a branch of MINIMAL ART, was described and elucidated by Alloway in an introductory essay to the catalogue of the exhibition. The essay was reprinted in *Minimal Art. A Critical Anthology* (1968)

edited by Gregory Battcock. Central to the idea of systemic art is the use of very simple standardized forms, non-representational and usually of a geometrical character, either in a single concentrated image-configuration or repeated in a configurational system according to a clearly visible principle of organization. Alloway suggested the term 'One-Image art' for work of this kind and wrote: 'In style analysis we look for unity within variety; in One-Image art we look for variety within conspicuous unity. The run of the image constitutes a system, with limits set up by the artist himself, which we learn empirically by seeing enough of his work. Thus the system is the means by which we approach the work of art.' He extends the term 'systemic art', however, to include COLOUR FIELD painting and SERIAL painting based on a modular system and painting using uniform or unmodulated grids. The feature which these types of painting had in common was, he claimed, that the organization was patent and visible, not an 'underlying composition' but a 'factual display'. Also 'the end-state of the painting is known prior to completion (unlike the theory of ABSTRACT EXPRESSIONISM)'. He furthermore claimed a similarity between these features of abstract systemic art and the repetitive imagery of some POP ART and its lack of interest in 'gestural handling'.

As examples of 'one-image' systemic art Alloway mentioned the chevrons of NOLAND, the crosses of REINHARDT, the grids of DOWNING and the quatrefoils of FEELEY.

SZENÈS, ARPAD (1900–). Hungarian-French painter, born in Budapest. He went to Paris in 1925 and studied with LÉGER, LHOTE and BISSIÈRE. In 1930 he married VIEIRA DA SILVA, with whom he spent the years 1940 to 1947 in Brazil. He painted in the manner of expressive abstraction, using a restricted palette of lyrically blended whites and greys and basing his pictures on landscape impressions in the manner of Bissière.

SZYMANSKI, ROLF (1928–). German sculptor born in Leipzig. He studied at the School of Arts and Crafts there and subsequently at the Berlin Academy of Fine Art under SCHEIBE and HEILIGER. His style was abstract with expressive and symbolic overtones and occasional suggestions of organic forms.

SZYSZLO, FERNANDO DE (1925–). Peruvian painter born in Lima. After studying architecture for a short time Szyszlo turned to painting and studied under the Austrian-born painter Adolfo Winternitz from 1944 to 1946 at the Escuela de Arte de la Universidad Católica of Lima, where he later returned to teach painting. From 1948 to 1955 he lived first in Paris then in Florence and from 1958 to 1960 in Washington,

where he was consultant in the Visual Art Division of the Pan American Union. In 1962 he was visiting professor of art at Cornell University in Ithaca, N.Y., and in 1965, after a return trip to Peru, visiting lecturer at Yale University. Szyszlo's early work was figurative but after his return from Europe he turned to abstraction. His first three exhibitions in Lima at the Instituto Cultural Peruano Norteamericano in 1947 and the Gal. de Lima in 1948 and 1949 were figurative. When he first exhibited his abstract paintings in Lima in 1951 he met with considerable hostility from the public, who found his work 'decadent', 'un-Peruvian' and 'immoral'. From the 1950s he sought to integrate abstract principles with his country's native culture. He visited pre-Hispanic sites, notably the Inca city of Machu Picchu, and found in the ceramics, textiles, adobe and stone structures of ancient cultures a technical and spiritual power which fulfilled his belief that 'art is the encounter of the sacred with the material'. He incorporated ideas from Quechua poetry and symbols of Inca culture and religion in his work by means of informal, balanced abstract shapes and overlays of luminous, resonant colours. He used black dramatically contrasted with other colours as in *Black Sun* (1959). The Quechua elegy on the death of the last Inca ruler inspired him to do a series of 13 canvases under the Quechua title of 'Apu Inca Atawallpaman'. Other Inca and Quechua series include the 'Execution of Tupac Amaru', 'Puka Wamani', 'The Myth of Incarri', 'Machu Picchu' and 'Waman Wasi' (House of the Falcon). The 'Traviesa' series of 1973 shows SURREALIST elements which he later abandoned to return to a flatter, more colouristic treatment of spatial relationships.

Szyszlo exhibited regularly in Lima, Mexico, Buenos Aires, Bogotá, Caracas, La Habana, Medellín, San Salvador, Guatemala City, São Paulo, Washington, Ithaca, New York, Paris and Madrid, and participated in numerous group exhibitions, including 'The U.S. Collects Pan American Art' at the Art Institute, Chicago (1959); 'Latin America New Departures' at the Institute of Contemporary Arts, Boston (1961); 'Art of Latin America Since Independence' at Yale University (1966); 'The Emergent Decade' at the Solomon R. Guggenheim Mus., New York (1966) and 'Twelve Latin American Artists' at the University Art Mus., Austin, Texas (1975). He also participated in the São Paulo Bienales in 1957 and 1959, the Carnegie International in Pittsburgh and the Venice Biennale in 1958, and the Guggenheim International in 1963. His work is in many major public and private collections in North and South America, including the Mus. de Arte Moderna de São Paulo and the Solomon R. Guggenheim Mus., New York.

T

TÁBARA, ENRIQUE. See LATIN AMERICA.

TABLEAUX-OBJETS. Name given by PICASSO and BRAQUE to the PAPIERS COLLÉS they began in 1912 and to constructions which they made with cardboard, scraps of wood and metal, string, etc. The implication of the phrase was intended to be that a work of representational art is not to be regarded as primarily or only a reflection imaging something in the perceptual world but also as a thing created to exist in its own right, a reality of its own added to the world of appearances.

TABUCHI, YASE (1921–). Japanese painter, studied at the University of Tokyo and emigrated to Paris after the war. From SURREALISM he changed his style in Paris to a mode of LYRICAL ABSTRACTION which combined linear forms with restrained and expressive colour harmonies.

TACHISM. Term introduced in 1954 by the French critic Charles Estienne to designate post-war European lyrical and expressive, as distinct from geometrical, abstraction which ran parallel to the work of such American ABSTRACT EXPRESSIONISTS as Jackson POLLOCK and Sam FRANCIS. The concept of Tachism is very close to that of ART INFORMEL and the two have seldom been kept distinct. The proponents of both terms reckoned WOLS and Hans HARTUNG among the pioneers of the movement and both regarded Henri MICHAUX as typical. Both attached importance to spontaneous and unplanned creation. Tachism laid more emphasis on the spontaneous interplay of blots or patches of colour (rather than conscious organization of colour harmonies) as 'signs' or 'gestures' expressing the emotional condition of the artist. *Art Informel* on the other hand tended to look on abstraction as a form of unconscious calligraphy. In the strictest sense 'Tachism' is the application of spots of colour for their own sake irrespective of subject or theme.

The term was, however, used differently in the 19th c., being applied to the Impressionists in contrast to Neo-Impressionism and the SYNTHETISM of Gauguin. Thus in a review of the 'Impressionist and Synthetist' exhibition at the Paris World's Fair of 1899 the critic Félix Fénéon wrote: 'The means of the *tachistes* [Impressionists], so appropriate to the representation of fleeting visions, were abandoned about 1886 by several painters concerned about an art of synthesis and premeditation.' 'Tachism' was also sometimes used in a pejorative sense of DIVISIONISM, and in Italy it was used of the 19th-c. *Macchiaioli* of Ferrara.

TAEUBER-ARP, SOPHIE (*née* TAEUBER, 1889–1943). Born at Davos, Switzerland, she studied applied art at Munich and Hamburg and from 1916 to 1929 taught at the School of Arts and Crafts in Zürich. She met Jean ARP at Zürich in 1915 and married him in 1922. From 1916 they worked in close collaboration with the Zürich DADA group and also collaborated in joint paintings and compositions of a distinctive CONSTRUCTIVIST type. From 1927 to 1940 they lived at Meudon, near Paris. In 1928 with Arp and Van DOESBURG she did the Constructivist decorations for the café L'Aubette at Strasbourg. With Arp she joined CERCLE ET CARRÉ in 1930 and ABSTRACTION-CRÉATION in 1932, continuing to exhibit her lively and very personal Constructivist abstracts. From Meudon she founded and edited a periodical of abstract art, *Plastique*, of which five numbers appeared between 1937 and 1939, in French, German and English. The first number was devoted to MALEVICH and the third was an American number with an article on the development of abstract art in America. From 1941 to 1943 she lived with Arp at Grasse, forming the centre of a small group of artists which included Sonia DELAUNAY and Alberto MAGNELLI. She died in 1943 from an accident with a leaking stove during a clandestine visit to Switzerland. She left a large number of abstract works which for their liveliness and their rhythmic quality have been considered among the most talented that have been produced in this style.

TAJIRI, SHINKICHI (1923–). American sculptor of Japanese descent. He studied at the Art Institute, Chicago, and then in Paris under ZADKINE, and LÉGER. After being connected with the COBRA group he settled in Amsterdam in 1956, and contributed to the Dutch post-war sculptural revival. He made sculpture from scrap metal and old machine parts during the 1950s in the expressive manner of Californian JUNK sculpture, but during the 1960s employed various kinds of technical apparatus in a severer style. He had a one-man exhibition at the Venice Biennale in 1968.

TAKAMATSU, JIRO (1936–). Japanese sculptor and painter born in Tokyo and studied at the Tokyo University of Arts. He was obsessed with

the problem of perspective and distance and what he called 'solidified perspective'. In a series of *Shadow* paintings begun in 1964 he experimented with the extension of objects through their own shadow. In 1966 he began to construct solid objects which when seen from an appropriate distance appear to represent their subject correctly but when seen from closer at hand appear distorted. In 1969 he showed a series of *Nets* and *Wrinkles* at the Paris Biennale constructed from large sheets of woven cloth. He also designed a *Mirror Plaza* for the Osaka 'Expo '70'.

TAKIS (1925–). Greek sculptor and experimental artist born in Athens. He began sculpture in 1946 without formal training and went abroad in 1954, living in London and Paris. He exhibited at the Hanover Gal., London, in 1955, at the Iris Clert Gal., Paris, in 1959 and at the Iolas Gal., New York, in 1960. In London he was associated with the experimental 'Signals' Gal., which took its name from the 'Signals' which he made between 1954 and 1958. These were abstract KINETIC sculptures made from steel wire and were either weighted at the top in order to put them into constant motion or else used springs as a source of energy for movement, as in *Signal Rocket* (The Mus. of Modern Art, New York, 1955). During the 1960s, however, he explored the field of electro-magnetism, and in his *Magnetic Ballets* and other such works he created objects to move in controlled magnetic fields which existed less for the sake of their intrinsic form than to reveal the operation of a natural force. In particular his iron filings used in association with powerful magnets carried the 'dematerialization of the object' to an extreme, focusing attention not on the presence of the object but on a mysterious and apparently inexplicable manifestation of natural energy. With his kinetic works he sometimes combined light effects and musical sound. In 1972 a major retrospective exhibition at the Centre National d'Art Contemporain, Paris, showed the great variety of his work over the past 20 years. In 1975 he exhibited musically resonant moving discs with combined electro-magnetic effects at the I.C.A. Gals., in connection with the Greek Month in London.

TAL-COAT, PIERRE (1905–). French painter, born at Clohars-Carnoët, Brittany, of a family of fishermen. He showed a talent for drawing and painting from early years and although he had no formal training, he picked up a good deal from visiting artists. After working in a pottery factory at Quimper he spent the years 1924 to 1926 in Paris on military service and then settled at Doélan, near Pouldu. Returning to Paris in 1931, he was associated with the FORCES NOUVELLES group of Expressive Realists and during the latter part of the 1930s did a series of powerfully expressive works, which he called *Massacres*, based upon incidents in the Spanish Civil War. In 1943 he retired to Aix-en-Provence and developed the manner of painting for which he was best known: starting from the impression of a natural scene he took this to the limits of abstraction until precise subject recognition was lost. In 1947 he was introduced by André MASSON to Chinese landscape painting and this influenced his abstractions from that time onwards. Tal-Coat was prominent in the school of LYRICAL ABSTRACTION which dominated the ÉCOLE DE PARIS in the latter 1940s and 1950s. From *c.* 1951 his works took on a mystical and cosmic character best exemplified in his *Terres* and *Herbes* of 1966–7. At the same time he was concerned with the technical problem of suggesting the interplay of light and movement without specific representation.

TAMAYO, RUFINO (1899–). Mexican painter born at Oaxaca. After the death of his parents, who were Zapotec Indians, he moved to Mexico City to live with an aunt and help her with her fruit market. At the age of 17, while attending commercial school to learn business management he secretly studied drawing at night. In 1917 he enrolled at the Academy of San Carlos, but after a while was disappointed with the conservative programme and in 1921 left to paint alone. The same year he was appointed head of the Department of Ethnographic Drawing at the National Mus. of Archaeology in Mexico City and later taught at a primary school in Mexico City and in the open-air rural school programme established by the Minister of Education, José Vasconcelos. This brought him into contact with the folk art traditions of the indigenous Mexican Indians. Tamayo's first one-man show in Mexico City was held in 1926 in a shop and the same year he exhibited for the first time in New York at the Weyhe Gal. He moved to New York in 1936 and lived there intermittently for over 18 years. During that time he taught painting at the Dalton School and the Brooklyn Mus. Art School. He did not go to Europe until 1949, but he was fully acquainted with POST-IMPRESSIONIST and CUBIST painting, which he had seen in New York.

Although Tamayo did many murals, he rejected the SOCIALIST REALISM and the historical narrative style of the Muralists and chose instead to express himself through more symbolic and plastic means, letting colour and form convey emotion. Early in his career he did paint a few works with national revolutionary themes but soon gravitated to broader subjects, figures, animals, still lifes and portraits, many of which were of his pianist wife, Olga. His murals include two at the National Mus. of Anthropology in Mexico City, one of which is *Duality*, and *The Birth of Nationality* at the Palacio de Bellas Artes, where RIVERA, OROZCO and SIQUEIROS also painted murals. In the U.S.A. he painted murals for the Hyllier Art Library at Smith College, Northampton, Mass. and for the Bank of the Southwest in Houston, Texas. His paintings have been shown in numerous exhibitions in Paris and New York. In Mexico he had only three exhibi-

tions prior to 1947. But in 1948 he was honoured with a retrospective at the Palacio de Bellas Artes and subsequently enjoyed success in his own country. He won several prizes, including ones at the 1953 São Paulo Bienale and the 1955 Carnegie International at Pittsburgh, and he was awarded a National Prize by the President of Mexico in 1964. He was given a one-man show at the Venice Biennale in 1950.

Leopoldo Castedo in *A History of Latin American Art and Architecture* (p. 236) has divided Tamayo's painting into five periods, beginning with 1926 when he fled from 'the grandiloquent use of blacks' and used violent siennas, blues, reds, yellows. 'Two years later (his second period) his figures were distinctively Mexican, and in his still lifes (his third period), he increasingly employed abstract forms. His fourth period was signaled by gloomy ideas about humanity and his fifth by a continuity with its predecessor, but now Tamayo permitted himself a peculiar surrender to the visual delights of color.' Tamayo's paintings of animals, such as *Animals* (The Mus. of Modern Art, New York, 1941), were inspired by the pre-Hispanic ceramics of *techichis* (dogs) from the western state of Colima. His vivid colours, particularly the magentas which he used a great deal in his water-melon pictures, come from Mexican folk art. Tamayo's work had a power and a fervour which puts it outside all the usual classifications. He owned a sizeable collection of pre-Hispanic art, which he donated to the city of Oaxaca in 1974 when the Tamayo Mus. of Pre-Spanish Mexican Art was inaugurated.

TANABE, TAKAO. See CANADA.

TANAKA, ATSUKO (1931–). Japanese artist born in Osaka and studied at Kyoto University of Arts. She was a member of the Osaka GUTAI GROUP, which staged HAPPENINGS of the DADA type. She hung pieces of yellow and pink cloth in a pine forest to be fluttered by the wind, hung bells in an exhibition room and decorated panels and dolls with coloured electric lights. She began abstract painting in 1958 and became known for her lyrical abstracts of circles or target-like shapes overlaid with linear dancing patterns in brightly contrasting colours. She was included in the Guggenheim International Award exhibitions of 1960 and 1963 and in the exhibition 'New Japanese Painting and Sculpture' at The Mus. of Modern Art, New York, in 1966.

TANCREDI, PARMEGGIANI. See CONTINUITÀ.

TANDBERG, ODD (1924–). Norwegian painter and sculptor born and trained in Oslo. Both his paintings and his sculptures were in the style of geometrical abstraction. He decorated a number of buildings, including the Government Building, Oslo, with wall panels of sand-blasted concrete combined in a kind of large mosaic with coloured concrete and natural stone. He also made free-standing sculptures by the same method and others of cast concrete or sawn blocks decorated with coloured stones.

TANGUY, YVES (1900–55). French painter, born in Paris of a Breton family. After spending two years in the merchant navy, he met the poet Jacques Prévert while doing military service and in 1922 began a Bohemian existence in his company in Paris. At this time Tanguy did his first drawings, entirely without formal training as an artist. In 1923 a painting by CHIRICO which he saw in the gallery of Paul Guillaume made such an impression on him that he decided to take up painting as a career. In 1925 he became a close friend of André BRETON and joined the SURREALIST movement together with Prévert, participating in subsequent Surrealist exhibitions and signing the Surrealist manifestos. In 1939 he met the American painter Kay SAGE, also an admirer of Chirico, and emigrated with her to the U.S.A. In 1946 he bought a farm and settled in Woodbury, Conn., and in 1948 he obtained American citizenship. A retrospective exhibition of his works was given at The Mus. of Modern Art, New York, in 1955.

Tanguy's paintings were entirely individualistic. They consisted, typically, of unidentifiable objects between marine monsters and menhirs or rock formations scattered on a beach in a landscape of unreal, dream perspectives, and in these paintings he succeeded more than any other Surrealist painter in imparting the inexplicable impact of reality which transfuses the unreal atmosphere of dream. In these silent, timeless dream landscapes without symbolism or psychological trappings Tanguy was the greatest, as he was the most spontaneous, master of the oneiric aspect of Surrealism. After his emigration to America, however, although he continued to paint, his pictures lost much of their poetic charm and strangeness, being composed of large disjointed forms in cool metallic colours.

TANNING, DOROTHEA (1910–). American painter, born at Galesburg, Ill. Except for two weeks at the Chicago Academy of Art she was self-taught in art. She was impressed by the exhibition 'Fantastic Art, Dada, Surrealism' at The Mus. of Modern Art, New York, in 1937, and after a visit to Paris and Stockholm, 1939–41, she began to paint fantastic pictures featuring in the main the erotic fancies of teenage girls in an atmosphere of the Gothic novel. These combined hyper-realistic detail with fantastic, horrific and oneiric themes. Her first one-man exhibition was at the Julien Levy Gal., New York, in 1944. From this time she designed a number of costumes and stage sets for ballets. In 1942 she met Max ERNST in New York, became his wife and returned to France with him in 1949. About 1969 she began to make strange, ambiguous SURREALIST objects from textile materials.

TÀPIES, ANTONI (1923–). Spanish painter born at Barcelona. He early showed an interest in painting and drawing and the tragic events of the Civil War years, which he passed in Barcelona, had a lasting effect upon his work. Writing in 1969 he said: 'The dramatic sufferings of adults and all the cruel fantasies of those of my own age, who seemed abandoned to their own impulses in the midst of so many catastrophes, appeared to inscribe themselves on the walls around me. ... my first works of 1945 already had something of the graffiti of the streets and a whole world of protest—repressed, clandestine, but full of life—a life which was also found on the walls of my country.' From c. 1938 began a lifelong interest, which deepened with time, in the art and thought of the Far East. He studied law at Barcelona University from 1943 to 1946, then devoted himself entirely to painting. From 1948 to 1951 he was a founder member of the DAU AL SET group, which was associated with the magazine of the same name. After his first one-man show, at the Gal. Layetanas, Barcelona, he was able to spend a year in Paris on a French Government scholarship and during this time he visited PICASSO and travelled in Belgium and the Netherlands. In 1953 he visited New York on the occasion of his first American exhibition, at the Martha Jackson Gal., with which he signed a contract leading to numerous exhibitions throughout the U.S.A. He visited the States again in 1959, 1961, 1962 and in 1962 he visited England on the occasion of the exhibition of Spanish artists at the Tate Gal.

From the SURREALIST phase of the *Dau al Set* Tàpies c. 1954 first encompassed his personal style, in which COLLAGE, *haute-pâte*, untreated and common materials, graffiti and apparently random elements were prominent. After a period of intense experimental activity in 1952–3 he evolved a personal style of ARTE POVERA and consistently matured it. He constructed his compositions from commonplace and discarded materials: torn canvases, paper, straw, string, rags, scraps, old stockings, etc. They were splashed with apparently haphazard blots and dribbles, taking on the appearance of damaged or ruined walls whose surfaces were decayed and scrawled over with casual graffiti. While he had something in common with many INFORMAL artists, the high seriousness of his attitude towards his work brings him closest to Alberto BURRI. In 1970 he wrote: 'Our senses lose their sharpness in the excess of bustle, garish colours, and noise by which we are always surrounded. We must conquer and learn the most important sense of all: being able and knowing how to look, being able and knowing how to concentrate on what we do, having time to meditate, having a minimum of decency and freedom in our lives, with sufficient hours of repose in which to realise this way of living ... Despite our Western vulgarity, and the clumsiness of our hurried contemplation, some of us have learnt intuitively to

enter into that state of receptivity that is needed before we can receive the shock and all the release of associations of ideas that constitute artistic emotion. But what is—or was—comparatively common in the East is in our world a phenomenon which seems to be reserved almost exclusively for privileged persons.'

In 1957 Tàpies was a founding member of the Informalist group EL PASO, although he had exhibited work in this style as early as the Barcelona Bienale of 1954. He later reintroduced figurative elements into his work although when he did so he abstracted from the expressive character of whatever was represented, transforming it into a symbol. In the words of José Maria Moreno Galvan: 'The result was that groups of chairs, a reclining woman or an upturned hat took on a weird, ghostly appearance. What has happened is that they have been turned into myths, in the sense that a myth is simply the illumination of a reality—not figured reality but reality adorned with meaning. The meaning in this case is not that of a few chairs, of a reclining woman or of an upturned hat; it is their strange reincarnation, their alienation.'

Among the many prizes and awards of his artistic career were: UNESCO and David Bright Foundation prizes at the Venice Biennale (1958); prize at International Exhibition of Graphic Art, Tokyo (1960); prize of Guggenheim Foundation, New York (1964); Gold Medal at International Congress of Artists, Critics and Art Historians, Rimini (1966); Grand Prix at Seventh International Biennale of Graphic Art, Ljubljana (1967). Among his more important exhibitions have been: retrospective exhibitions at Kestner-Gesellschaft, Hanover, Kunsthaus, Zürich, and Solomon R. Guggenheim Mus., New York (1962); Institute of Contemporary Arts, London (1965); Mus. des 20. Jahrhunderts, Vienna, Kunstverein, Hamburg, and Kölnischer Kunstverein, Cologne (1968); Mus. d'Art Moderne de la Ville de Paris (1973); Nationalgal., Berlin, Hayward Gal., London, and the Glynn Vivian Art Gal., Swansea (1974).

TAPPER, KAIN (1930–). Finnish sculptor born at Saarijärvi of a family of woodcutters and smallholders. He trained at the School of the Institute of Applied Art, Helsinki, 1952–4 and at the School of the Academy of Art in 1955. He first worked on traditional figurative lines but from the late 1950s began to reduce natural forms to their bare essentials in a manner of abstraction which has been compared to that of BRANCUSI. His first masterpiece in this style was *The Shuttle*, a large fountain sculpture outside the cotton mill at Pori, in 1958. He also worked naturalistically, however, as in his commemorative statue of Sibelius at Hämeenlinna, which was unveiled in 1964. His later works, in wood, stone and metal, were non-objective abstractions not reductions from natural appearances. But they were analogues in visual form for lyrical natural experiences and were intended to

evoke and further men's meditative communion with nature in a manner which has been compared to the meditative attitude inspired by Zen Buddhism. Outstanding works in this vein are *Night* (1960), *Tree*, earlier named *Dark Kiln*, and *Beating to Windward* (Moderna Mus., Stockholm, 1962–6) and *Spring Brook* (1967). His most famous work is the abstract wooden relief panel *Golgotha*, which he did as an altarpiece for the church of Orivesi in 1960. Tapper represented Finland at the Venice Biennale of 1962.

TARGET EXHIBITION. An exhibition organized in Moscow by LARIONOV, GONCHAROVA and MALEVICH in March 1913. It was at this exhibition that RAYONISM was launched by Larionov and the first Rayonist pictures were exhibited. Malevich also showed his works in the CUBO-FUTURIST style at the exhibition.

TATLIN, VLADIMIR EVGRAFOVICH (1885–1953). Russian painter, designer and architect born in Moscow, brought up at Kharkov. He is regarded as the founder of Soviet CONSTRUCTIVISM. He ran away to sea at the age of 18 and many of his earlier pictures are of maritime subjects: *The Sailor* (Russian Mus., Leningrad, 1911–12), a self-portrait. After studying at the local art school in Penza, he went to Moscow in 1910 and shared a studio with Aleksandr VESNIN. Before his journey to Berlin and Paris in the autumn of 1913 he exhibited at several *avant-garde* exhibitions in Russia and worked in close association with GONCHAROVA and LARIONOV, who had known him as a boy. The curving lines and flat planes of his *Composition from a Nude* (Tretyakov State Gal., Moscow, 1913) show the influence of Russian icon-painting. He also did stage and costume designs for *The Emperor Maximilian and His Son Adolf* and for Glinka's opera *Ivan Susanin*.

During his journey abroad Tatlin visited PICASSO and it was this which inspired his revolutionary 'Painted Reliefs', 'Relief Constructions' and 'Corner Reliefs' of 1913 onwards. Only one or two of these survive and most are known only from photographs preserved in Soviet archives. It appears that he used a variety of real materials—tin, glass, wood, plaster, etc.—with the object of doing away with pictorial illusion, and used three-dimensional relief instead of illusory picture-space. In *The Great Experiment: Russian Art 1863–1922* (1962) Camilla Gray said of these: 'For the first time in Tatlin's constructions we find real space introduced as a pictorial factor; for the first time inter-relationships of a number of different materials were examined and co-ordinated.' These constructions may therefore be regarded as the earliest exemplifications of the concept of CONCRETE ART. While the earlier constructions were conceived as reliefs standing out from a frame or background, the 'Corner Reliefs' of 1915–16 were fully three-dimensional, being attached to the wall only by wires. At 'The First Futurist Exhibition' ('Tram-

way V') of 1915 Tatlin exhibited some of his 'Painted Reliefs' and with his doctrine of the 'Culture of Materials' he emerged as the leader of a PRODUCTIVIST school of art (later called 'Constructivist') in opposition to the SUPREMATISM of MALEVICH. The rivalry between the two artists came to a head in a second exhibition organized in December 1915 under the name '0.10. The Last Futurist Exhibition'. In 1916 Tatlin organized his own exhibition, 'The Shop', in Moscow, and the following year he assisted in the interior design of the famous Café Pittoresque, Moscow, in collaboration with RODCHENKO and others under the supervision of Georgii YACULOV.

After the October Revolution of 1917 Tatlin's constructions from real materials in real space were felt to be in accordance with the new doctrines and he threw himself whole-heartedly into support of the demand for socially oriented art, declaring: 'The events of 1917 in the social field were already brought about in our art in 1914 when material, volume and construction were laid as its basis.' In 1919 Tatlin was commissioned by the Department of Fine Arts to design the *Monument to the Third International* to be set up in the centre of Moscow. The monument as Tatlin projected it was to be in glass and iron, twice the height of the Empire State Building, and the central glass cylinder was to revolve. It was described by Tatlin as: 'A union of purely plastic forms (painting, sculpture and architecture) for a utilitarian purpose.' A model was exhibited in December 1920 at the exhibition of the VIIIth Congress of the Soviets. The design was condemned by GABO as impracticable and in fact it was never executed. It has later been recognized as the outstanding symbol of Soviet Constructivism. In an introductory essay to the catalogue of the exhibition 'Art in Revolution' organized by the Arts Council of Great Britain in 1971 Kenneth Frampton wrote: 'Tatlin's tower was the initial symbolic crystallisation of a Constructivist aesthetic which on subsequent occasions would occur as the direct expression of a utilitarian rationale. The use of industrial materials, the expression of literal movement, the emphasis on dynamic form, the exhibition of both structure and function, combined with direct incorporation of information and propaganda to reflect the ethos of a secular era, dedicated rationalisation of human life through organised industrialisation.' Of its influence he claimed: 'Few projects in the history of contemporary architecture can compare in impact or influence to Vladimir Tatlin's 1920 design for a monument to the Third International. In Russian avant-garde culture of this century it occupies a position as a work of "architecture" comparable to that held in painting by Malevich's 1913 designs for Kruchenykh's Futurist play *Victory over the Sun*, out of which Suprematism immediately emerged.' In the same year, 1920, Tatlin issued his *Programme of the Productivist Group* setting out the principles of the officially recognized Constructivism.

The *Monument* was the culmination of Tatlin's artistic career. He continued to teach, being appointed to the Higher Technical Institute in 1927, and he was active in the Soviet programme for the organization of museums, schools, etc. for the propagation of modern artistic culture. He himself worked mainly on applied art, designing furniture, workers' clothes, etc. In this field, in opposition to the 'study-constructions' based on geometrical principles of proportion, Tatlin evolved a functional system, which he called 'New Way of Life', based upon organic forms. In the late 1920s and early 1930s he devoted his energies to designing a glider, which he called *Letatlin*. He seems to have been more concerned with aesthetic qualities than with practicality, for the machine did not in fact fly. He wrote of it: 'My machine is built on the principle of life, organic forms. Through the observation of these forms I came to the conclusion that the most aesthetic forms are the most economical. Work on the formation of material is art.' From the point of view of art history it is to be lamented that an artist of Tatlin's stature should have spent what might have been the most productive years of his life in trying to substantiate sociologically oriented theories by working on a machine which did not operate. An important exhibition, ranging over most periods of his work, was staged at the Central House of Writers, Moscow, in the spring of 1977.

TCHELITCHEW, PAVEL (1898–1957). Russian-American painter, born at Kaluga near Moscow. In 1918 he fled with his family to Kiev and there attended the Kiev Academy, where his artistic talent was noticed by Aleksandra EXTER. In 1921 he was in Berlin and in 1923 settled in Paris. He did theatrical designs, circus pictures, landscapes and portraits, Edith Sitwell being one of his subjects. He went to the U.S.A. in 1934 and became an American citizen in 1952. During the 1930s he exhibited at the Tooth Gal., London, the Julien Levy Gal., New York, and the Arts Club of Chicago. He had a retrospective exhibition at The Mus. of Modern Art, New York, in 1964. His interest in theatrical and ballet design was reflected in a certain decorative and mannered quality of his painting with traits of a superficial SUR-REALISM. Among his best-known works were *Phenomena* (Tretyakov State Gal., Moscow, 1938) and *Leaf Children* (1939) and *Hide and Seek* (1942), both in The Mus. of Modern Art, New York.

TEANA, MARINO DI. See EQUIPO 57.

TEIXIDOR, JORGE. See SPAIN.

TEN, THE. A group of American artists founded in 1935 which continued to exhibit until 1940. The artists in the group, who included ROTHKO and GOTTLIEB, worked in an EXPRESSIONIST manner tending towards abstraction. This group is not to be confused with the Impressionist group of the same name organized by John Twachtman in 1898.

TERECHKOVITCH, KONSTANTIN (1902–). Russian-French painter born in Moscow. After studying at the Academy of Fine Art, Moscow, in 1917, he settled in Paris in 1920, acquiring French citizenship in 1943. He exhibited first at the Salon d'Automne in 1925 and had his first one-man show in 1926, where he made an impression with his painting *Facteur d'Avalon*. With Maurice BRIANCHON and Christian CAILLARD he belonged to the school of poetic naturalism. He was a friend of SOUTINE, whose portrait he painted in 1932, and later of BONNARD. From about 1938 he became known for a series of portraits he did of his painter friends. His painting was distinguished for the lyrical freshness of his colours, the vivacity of his brush-work and for a certain magical or fairy-like quality. He also designed sets and costumes for the Monte Carlo ballets and did tapestry designs for Aubusson. Among the books he illustrated were Nathaniel Hawthorne's *Contes du Minotaure* and Tolstoy's *Hadji-Murad*.

TESTA, CLORINDO. See LATIN AMERICA.

THARRATS, JOAN JOSÉ (1918–). Spanish painter and critic born at Gerona. He was a founder member of the association DAU AL SET and was responsible for the printing and designing of its magazine of the same name. He also worked as an art critic for the Barcelona paper *Revista*. Tharrats took up painting *c.* 1950 with imaginary landscapes which had affinities with the METAPHYSICAL school. About 1956, however, he went over to expressive abstraction and developed a richly colourful manner of ART INFORMEL, describing his paintings as *maculaturas* or 'smudges'.

THEK, PAUL (1933–). American sculptor born at Brooklyn, studied at the Cooper Union, the Art Students' League and the Pratt Institute, 1951–4. He was awarded a Fulbright Fellowship in 1967. His first one-man show was at the Mirell Gal., Miami. He also had one-man shows in Rome, Essen, the Stedelijk Mus., Amsterdam, and the Nationalmus., Stockholm. He was represented in the exhibition 'The Obsessive Image' at the I.C.A. Gals., London. He is chiefly known for his horrific tableaux within the ambit of FUNK ART.

THELANDER, PÄR GUNNAR (1936–). Swedish painter and graphic artist. His work had affinities with POP ART and he liked to use as the subject of his pictures the kind of playthings which children make. An example is his *Rider* (1973), representing an equestrian statue made from one potato on top of another with matches to represent legs and arms. The subjects in such paintings were enlarged (the painting in question is 250 × 190 cm) and Thelander said: 'I have been curious as to the expression things assume when

they are magnified and become excessively tangible.' Despite their apparent childishness (Thelander pays a tribute to Jean DUBUFFET), these works were intended to carry ironic symbolization in connection with such problems as power, the significance of man (several of his paintings and etchings were entitled *Man*) and woman as housewife and employee. The intended symbolization was often far from clear to the uninitiated spectator. Thelander had both individual and group exhibitions in Sweden and in Japan, Senegal, South America and the U.S.A. He represented Sweden at the Biennale for Young Artists, Paris, in 1967 and he was included in the exhibition 'Five Swedish Artists' at the Serpentine Gal., London, in 1975.

THEOPHILOS, HADJIMICHALIS (between 1866 and 1873–1934). Greek painter, son of a cobbler from the island of Mytilene. He lived as an itinerant craftsman, travelling from village to village decorating the houses and shops of tradesmen. He took his subjects mainly from ancient Greek history, the War of Independence against Turkey and idealized representations of Greek soldiers, peasant women, etc. His paintings had the quality of the untutored NAÏVE artist and he was 'discovered' in 1928 in consequence of the vogue for naïve painting which was then at its height. From 1929 he worked for the collector and publisher Tériade, producing panel paintings instead of popular murals. During the 1930s his work was exalted not merely as naïve art but as the model of authentic Greekness. The first monograph was written by Kitsos Makris in 1939 and an exhibition of 53 of his paintings was staged at the British Institute, Athens, in 1947. A special number of the review *Anglo-Elliniki Epitheorisi* was dedicated to the exhibition. Exhibitions were held at the Kunsthalle, Berne, in 1960 and at the Mus. des Arts Décoratifs, Paris, in 1961. There is a Theophilos Museum in Mytilene.

THÉVENET, LOUIS (1874–1930). Belgian painter, born at Bruges. At the free Academy 'L'Effort' he met Auguste OLEFFE, by whom he was befriended. They lived at Nieuwpoort from 1895 until 1902, when they returned to Brussels and exhibited together with the group *Le Labeur*, in which Oleffe had been active since its formation in 1898. They also exhibited with the Brabant FAUVISTS at the Giroux Gal. In 1914 Thévenet moved to Hals, where he lived the life of a recluse. He painted unassumingly realistic interiors and scenes from common life in bright and luminous colours which had nothing in common with the Impressionist palette of an *intimiste* such as VUILLARD. He painted ordinary objects with candour and affection and with a technical virtuosity which concealed itself behind the mask of simplicity.

THIEBAUD, WAYNE (1920–). American POP artist. Born at Mesa, Arizona, he first worked as cartoonist and advertisement designer in New York and Hollywood. After serving in the U.S. Army Air Force, 1942–6, he took degrees at San José State College and Sacramento State College before teaching in the Art Department of Sacramento City College and subsequently as Associate Professor of Art in the University of California at Davis. He is best known for his still lifes of cafeteria foodstuffs—cakes, pies, pastries, ice-cream cones, banana splits, etc.—which he painted with advertisement realism against an empty background, emphasizing by monotonous repetitiveness their synthetic quality and assembly-line characterlessness. His figure paintings have a similar appearance of mass-produced anonymity, which gives them the air of stupidity that goes with a complete lack of personality. His first one-man show was in 1961 at the Cooperative Gal., Sacramento, after which he had a number of one-man shows and was represented in important group exhibitions, including 'Mixed Media and Pop Art' at the Albright-Knox Gal., Buffalo, in 1963 and the São Paulo Bienale in 1967. He used a thick, oleaginous pigment, with the bright colours, strong outlines and well-defined shadows of advertisement and poster art, setting his subjects for preference against an unmodulated white background.

THOMSON, MICHEL. See HOMME-TÉMOIN.

THOMSON, THOMAS JOHN (1877–1917). Canadian painter, born in Claremont, Ont., grew up at Leith, near Owen Sound. He briefly studied commercial design in Seattle and then worked as a designer for photo-engraving firms. After moving to Toronto in 1904 he continued to be employed as a commercial artist, studying painting in the evenings, probably with William Cruikshank (1905–6). About 1908 he joined Grip Ltd. as a designer, and there he met J. E. H. MACDONALD, who encouraged his interest in painting. By 1910 he was making periodic sketching trips, and in 1912 he first visited Algonquin Park. In Toronto his friends encouraged him to try a canvas, and he painted *Northern Lake* (Art Gal. of Ontario, Toronto, 1912–13), which was shown in the Ontario Society of Artists exhibition and purchased by the Provincial Government. He spent most of 1913 sketching in Algonquin Park. When he came back to Toronto he found himself in the midst of the excitement stimulated by the construction of the Studio Building and the dreams of Lawren HARRIS and J. E. H. MacDonald for an indigenous Canadian art. He became a close friend of A. Y. JACKSON, sharing studio space with him in the new building and learning from Jackson's European experience (see especially *Moonlight, Early Evening*, National Gal. of Canada, Ottawa, 1913–14). In 1914 he travelled again to Algonquin, and to Georgian Bay. He worked closely with Jackson for part of the time, and his sketches rose dramatically in colour intensity, becoming looser, more spon-

taneous. Back in Toronto he painted his largest canvas to date, *Northern River* (National Gal. of Canada, Ottawa, 1914–15). Early in April 1915 he returned to Algonquin. He worked intermittently as a guide and travelled by canoe all over the Park, producing about 100 oil sketches, the first of those characteristic, spontaneous works of brilliant colour now valued so highly. Many of the canvases he produced that winter in Toronto were ambitiously experimental, and with works like *In the Northland* (Montreal Mus. of Fine Arts, 1915) and *The Pool* (National Gal. of Canada, 1915) he was for the first time working on a level at least equal to that of his colleagues. The work he brought back from his stay in Algonquin in 1916 was among his finest, and that winter he painted his best-known canvases. *The West Wind* (Art Gal. of Ontario, Toronto, 1916–17) and even more *The Jack Pine* (National Gal. of Canada, 1916–17) have become symbols of the creative force in Canadian life. The latter picture in particular, with its stark, lean form silhouetted against a brilliant evening sky, is for many Canadians the image of Thomson himself, imprinted on their vision of the land. The following March Thomson was back in Algonquin, hoping to chronicle systematically the arrival of spring. On 8 July he set out alone on a fishing trip; eight days later his body was recovered from the water. The circumstances of his death remain mysterious (see William T. Little, *The Tom Thomson Mystery*, Toronto, 1970).

The loss was felt deeply by Thomson's friends, but after the war his life and work became an inspiration to the GROUP OF SEVEN, and in a series of memorial exhibitions—Arts Club of Montreal, 1919; Art Gal. of Toronto, 1920; Women's Art Association, Toronto, 1921; National Gal. of Canada, Ottawa, and in Owen Sound, 1922—his reputation was firmly established as the archetype of the Canadian artist, living simply in the northern bush, responding directly to the force of nature. He has remained the most famous Canadian painter, commemorated in numerous exhibitions, including: National Gal. of Canada, Ottawa, 1932; Mellors Gals., Toronto, 1937; Art Gal. of Toronto, 1941; Kitchener-Waterloo Art Gal., 1956; London Art Gal. and at Windsor, 1957; The Tom Thomson Memorial Gal., Owen Sound, 1969; Art Gal. of Ontario, Toronto, and in Regina, Winnipeg, Montreal and Charlottetown, 1971–2.

THÖNY, WILHELM (1888–1949). Austrian painter born in Graz. Originally trained as a singer and pianist, he studied painting in Munich, 1909–12, and was among the founders of the Munich *Neue Sezession*. In 1923 he was among the founders of the SECESSION at Graz. He worked in Paris from 1931 to 1938, when he emigrated to New York. In 1948 the major part of his life's work was destroyed in a fire. His style was individualistic, combining Impressionist and EXPRESSIONIST features, and in Austria he constituted a link between

19th-c. and the early 20th-c. styles. He had a fine gift for draughtsmanship and a gay and lively colour sense which has been compared with that of DUFY. A retrospective exhibition of extant works was given at the Welz Gal., Salzburg, in 1961.

391. A DADA periodical founded by PICABIA, which appeared first in Barcelona in 1917 and afterwards in New York. The name was no doubt meant to recall Alfred STIEGLITZ's periodical *291*, to which Picabia had earlier contributed. The matter of *391* was mainly literary but it contained 'machine drawings' by Picabia similar to those which he exhibited at the Dada show in the Gal. Wolfsberg, Zürich, in 1918.

TICHO, ANNA (1886–1980). Israeli painter and draughtsman born in Brünn and trained in Vienna where she knew Egon SCHIELE, whose influence was apparent in her nudes and landscape drawings. From 1914 she lived in Jerusalem, drawing and painting the ancient city and the life of the surrounding Arab villages. Her work remained individualistic to the end, belonging to no modern school. She drew like an Old Master of the 20th c. She exhibited little and was not widely known outside Israel, although her work was shown in New York, Chicago, Oxford, Amsterdam and Rotterdam. Her drawings were left to the Israeli Mus. and her house, with its collection of old seven-armed candlesticks and other works of art, was made open to the public.

TILSON, JOE (1928–). British sculptor born in London. After working as a carpenter and cabinet maker, 1944–6, and serving with the R.A.F., 1946–9, he studied at St. Martin's School of Art, 1949–52, and at the Royal College of Art, 1952–5. He taught at St. Martin's School of Art, 1958–63, was Guest Lecturer at the Slade School and at King's College in the University of Durham, Newcastle upon Tyne, 1962–3, lectured at the School of Visual Arts, New York, 1966, and was Guest Teacher at the Hochschule für Bildende Künste, Hamburg, 1971–2. He participated in the 'Young Contemporaries' exhibitions at the R.B.A. Gals., London, from 1950 and showed at the Paris Biennale of 1961. His first one-man exhibition was in the Marlborough Gal., London, in 1962. He had retrospectives at the Boymans-van Beuningen Mus., Rotterdam, in 1973–4, and at the Istituto di Storia dell'Arte, Parma, in 1975, and he was represented in the exhibition 'Pop Art in England' organized by the Arts Council and shown at Hamburg, Munich and York in 1976.

Tilson belonged to the older generation of British POP artists. During the 1960s he was interested particularly in slot-machines, advertisements and the inclusion of written words among his pictorial symbols. His use of the last was ambivalent since they had the character both of semantic symbols and of plastic forms existing in their own right. In

1963 he made the 'combination' picture *9 Elements* in which individual symbols were enclosed in boxes resembling the learning games of children. This idea was extended in his *A–Z A Contributive Picture*, to which a number of friends and fellow artists contributed the individual symbols. In the catalogue to 'Pop Art in England' it was said that 'Tilson's primary interest lies not in the artistic style, which submits his objects to a subjective transformation, but in the basic possibilities of a visual communication as practised in art and, particularly, in the mass media'. His declared purpose was to create a popular art for young people in rebellion.

TINGUELY, JEAN (1925–). Swiss sculptor and experimental artist born at Fribourg but brought up in Basle. He studied at the Basle Kunstgewerbeschule, 1941–5, and there became interested in movement as an artistic medium, continuing experiments begun in 1939 with 'meta-mechanical' water-wheels producing sound effects. During the war and in the years immediately following he continued his interest in unconventional artistic media and in 1953 he worked with Daniel SPOERRI in the studio of Jean LURÇAT on a project for 'auto-theatre'. In 1953 he moved to Paris, where he worked on spatial constructions made from soldered steel wire in the form of mural reliefs as well as free-standing sculptures. To these he imparted movement operated by a small crank-handle and he began deliberately to introduce an element of chance into the movements. In 1953 he exhibited these constructions, some of which were driven by a small motor, at the Gal. Arnaud and in 1954 he exhibited at Milan, making all the works on the spot. In Milan he met MUNARI, whose 'useless machines' had an obvious affinity with his, and at this time he adopted the term 'meta-mechanical' for his own works. In 1955 he participated in an exhibition 'Le Mouvement' at the Gal. Denise René, showing two 'drawing machines', which were the precursors of a series of 'meta-matics'. These machines made continuous abstract drawing patterns and while drawing produced *musique concrète*. They were intended to illustrate the doctrine that a work of art is not something fixed and final but is itself creative and continuous within the potentialities conferred upon it. Through the 1950s Tinguely developed the idea of moving constructions which produced sound effects by striking objects such as saucepans, wine glasses, etc. From 1956 he collaborated with Yves KLEIN, holding a joint exhibition with him in 1958 at the Gal. Iris Clert. His drawing machine *Metamatic No. 17* was demonstrated in the courtyard of the Mus. National d'Art Moderne at the first Paris Biennale in 1959 and on a memorable evening at the I.C.A., London, when the audience was enveloped in a mile of paper from a machine operated by cyclists.

About this time Tinguely became obsessed with the idea of destruction in connection with the 'dematerialization' of the work of art and the idea that a machine programmed to destroy itself would turn KINETIC ART into 'performance' art. He created a sensation in 1960 with his first auto-destructive work, *Homage to New York*, which was built and demonstrated at The Mus. of Modern Art, New York, but failed to destroy itself as programmed and caused a fire. A more successful performance was given by his *Study for an End of the World* at the Louisiana Mus., Copenhagen, in 1961 and at Las Vegas in 1962.

In 1960 Tinguely became a founding member of the NOUVEAUX RÉALISTES group formed by Pierre Restany. In the same year he set on wheels his constructions for exhibition at the Gal. des 4 Saisons and took them through the streets to the gallery—one of the earliest manifestations of the attempt to involve the street public in artistic activity, which in 1970 was taken up by the *Nouveaux Réalistes* in Milan and by the London Arts Lab in both London and Paris. He also at this time took up the idea of the MULTIPLE. The catalogue of his exhibition at the Mus. Haus Lange, Krefeld, contained instructions for making a 'meta-mechanical relief' and Tinguely wrote: 'I invite you to use this plan to construct this picture, or to have someone construct it for you, and I acknowledge the result, if accurately executed, as an original work of my own.' During the 1960s he was very prolific, building from junk constructions which combined the principles of kineticism with those of the California JUNK school, being particularly impressed by the work of STANKIEWICZ. Notable among his works at this period were the *Baluba* series and the set of machines entitled *Paradise* constructed on the roof of the French Pavilion at 'Expo '67', the World's Fair, Montreal, and later set up in Central Park, New York.

Tinguely has been regarded as a romantic in view of his sense of the poetic and his feeling for the beauty inherent in the machine and the evocative potentialities of junk. He was capable of incorporating a boisterous humour into his works. His auto-destructive works and functionless machines—which he designated *l'art fonctionnel*—also contained a profound satire upon the irrationality of a technological civilization in the grip of machines which are operated for over-production. He was an innovator not only in his combination of kineticism with the Expressionism of junk sculpture but also in the impetus he gave to the principle of spectator participation as in his *Cyclograveur*, in which the spectator mounts the saddle and pedals the bicycle, causing a steel nail to strike against a vertically mounted flat surface, and the *Rotozazas*, in which the spectator plays ball with the machine. Such works might be interpreted as an ironic ridicule of the practical functions of machines.

TIRRONEN, ESKO AULIS (1934–). Finnish painter and graphic artist, studied at the School of Fine Arts of the Finnish Academy. His first exhibition in Finland was in 1959 and subsequently

his work was shown in Europe, the U.S.A. and in Brazil at the São Paulo Bienale. His earlier work moved from expressive landscape to urban realism, in which by adept use of abstraction and the truncation of forms he achieved what have been aptly described as 'dramas of the ordinary'. He was one of the first to introduce contemporary idioms into Finland after the Second World War, sometimes working during the 1950s with a spray gun in the manner of ART INFORMEL. During the 1960s he also introduced characteristic POP ART elements into his work as in his *Super-Girl* (Ateneum, Helsinki, 1965). In this too he was an innovator in Finland.

TOBEY, MARK (1890–1976). American painter, born at Centerville and grew up in Trempealeau, Wis. He had his first one-man show at the Knoedler Gal., New York, in 1917. He taught at the Cornish School, Seattle in 1922 and from 1925 to 1927 travelled in Europe and the Near East. In 1931 he was resident artist at Dartington Hall, Devonshire, England. He then studied Chinese calligraphy in Shanghai and brushwork in a Zen monastery. On his return to Devonshire he began to do his so-called 'white writing' pictures, calligraphic ALL-OVER designs not constructed from segregable parts as in traditional pictorial composition. He was a pioneer in this sort of over-all construction, anticipating POLLOCK. One of the earliest examples is *Broadway* (The Metropolitan Mus. of Art, New York, 1937). In 1951 he had a retrospective exhibition in San Francisco, Santa Barbara, Washington University and the Whitney Mus. of American Art. In 1955 he had exhibitions in Berne, Paris, the I.C.A., London, and the Art Institute, Chicago. In 1958 he was elected a member of the National Institute of Arts and Letters, awarded the Fine Arts' Medal at the American Institute of Architects and a National Award at the International Guggenheim Exhibition. In 1958 he had a one-man show and was awarded an International Prize at the Venice Biennale, and in 1961 the First Prize at the Carnegie International Exhibition, Pittsburgh. He had a retrospective exhibition at the Seattle Art Mus. in 1959, at the Mus. des Arts Décoratifs, Paris, in 1961, and at the Smithsonian Institution in 1967. About 1958 he settled in Basle, where he died.

Tobey was concerned at the 'growing impersonalism' of America, which he put down to over-industrialization and a spirit of materialism. He said that by his 'white writing' technique 'I found I could paint the frenetic rhythms of the modern city, something I couldn't even approach with Renaissance techniques.' Against the ACTION PAINTERS he believed that 'painting should come through the avenues of meditation rather than the canals of action'. He exercised an important influence on French TACHISM in the 1950s.

Tobey used to declare that his work was influenced by the Baha'i religion, which teaches that science and religion are the two great forces whereby man will gradually come to understand the unity of the world and the oneness of mankind. 'I've tried to decentralize and interpenetrate so that all parts of a painting are of related value. Perhaps I've hoped even to penetrate perspective and bring the far near.' In a letter to Katharine Kuh dated 28 October 1954 (quoted in her book *The Artist's Voice*) he wrote of his artistic development as follows: 'Already in New York in 1919 I began to react to the Renaissance sense of space and order. I felt keenly that space should be freer. I remember, I really wanted to smash form, to melt it in a more moving and dynamic way . . . In 1922 I went to Seattle for the first time . . . It was here I finally realized I could penetrate forms. In 1934, while living in England at Dartington Hall, Devonshire, I made a trip to China and Japan, where I studied brushwork and acquainted myself with some of the Oriental masters. But it was always with a detached interest—never with a conscious idea of imitating. In the early twenties I had studied brushwork in Seattle with Teng Kisei, a student at the University of Washington, and found that one could experience a tree in dynamic line as well as in mass and light. It was however only after returning to England in 1936 that I began the style called "white writing" with the painting *Broadway*—now owned by the Metropolitan Museum. After my return to Seattle in 1939 I gradually got down to expressing myself in this style, and in the forties brought it to its highest peak in a painting called *New York*, a composition of great luminosity. Line became dominant instead of mass but I still attempted to penetrate it with spatial existence. "Writing" the painting, whether in colour or neutral tones, became a necessity for me. I often thought of this way of working as a performance, since it had to be achieved all at once or not at all—the very opposite of building up as I had previously done.'

TOLEDO, FRANCISCO. See LATIN AMERICA.

TOMASELLO, LUIS (1915–). Argentine painter born in La Plata, studied at the Prilidiano Pueyrredón National School of Fine Arts and at the Ernesto de la Carcova School of Painting, Buenos Aires. In 1951 he went to Europe and in 1957 joined the group of Argentine artists working in Paris. In 1953 he was a founder member of the *Asociación Arte Nuevo* in Buenos Aires. From 1958 on he became a member of the Denise René group in Paris and began his KINETIC 'chromoplastic' series which he entitled *Atmosphère Chromoplastique*. The works consist of small white prisms in wood or polyester arranged over a flat white surface in geometric formations, tilted at various angles and painted with a brighter colour on their invisible undersides. The colour glow created by the prisms and their shadows forms delicately dematerialized geometrical designs. Tomasello's work has been exhibited in Europe, the U.S.A. and Latin America. He exhibited at the SALON DES

REALITÉS NOUVELLES, in Paris, between 1959 and 1964 and was included in 'New Argentine Art' at the Walker Art Center, Minneapolis, in 1964. He participated in numerous kinetic exhibitions including 'Lumière et Mouvement' at the Mus. d'Art Moderne de la Ville de Paris in 1967. In 1970 he was awarded First Prize at the Coltejer-Medellin Bienale in Colombia and in 1971 Second Prize at the Biennale at Menton. In the early 1970s he contributed a 'Chromoplastic Atmosphere' mural to the façade of a building in Guadalajara, Mexico, in collaboration with the architect Fernando Gonzalez Gortazar.

TOMEA, FIORENZO. See CORRENTE.

TOMLIN, BRADLEY WALKER (1899–1953). American painter born at Syracuse, N.Y. After attending Syracuse University, 1917–21, he studied at the Académies Colarossi and La Grande Chaumière, Paris. After painting CUBIST still lifes with occasional SURREALIST figurative elements, he turned towards ABSTRACT EXPRESSIONISM in the 1940s, being introduced to AUTOMATISM by MOTHERWELL. By the end of the 1940s he had evolved an original style of composition utilizing ideograms based upon brush strokes which were regularized with a certain classical restraint into quasi-geometrical forms. These were freely combined and decoratively patterned upon an underlying grid formation. He had a retrospective exhibition circulating from the Whitney Mus. of American Art in 1957 and his work was represented in several collective exhibitions of innovative American painting.

TONKS, HENRY (1862–1937). British painter, draughtsman and teacher, born at Solihull, near Birmingham. He studied medicine and became a Fellow of the Royal College of Surgeons. He was interested in drawing as a hobby and in 1888 while Senior Resident Medical Officer at the Royal Free Hospital he attended evening classes under Frederick BROWN at the L.C.C. Technical Institute, Westminster. In 1892 Brown, recently appointed Slade Professor, offered Tonks the post of his Assistant at the Slade School, whereupon Tonks abandoned medicine and devoted himself to the practice and teaching of art. He succeeded Brown as Slade Professor in 1918. As a teacher Tonks had a very considerable influence. He contributed to making the Slade the dominant teaching institution in Britain, the main channel through which the ideas of the NEW ENGLISH ART CLUB were disseminated to students, and to the creation of the 'Slade style', to which the majority of young artists were exposed until the 1930s. He was himself a member of the New English Art Club from 1895 and remained closely associated with it. As a man Tonks was secretive, touchy, suspicious and resentful of criticism, though capable of close friendship with Wilson STEER, George Moore and D. S. MacColl. As a teacher, though notorious for his

sarcasm and abruptness, he got on well with his students. But he had not the gift of recognizing talent easily, as witness his attitude towards Augustus JOHN, Matthew SMITH and Harold GILMAN. He was unable to move with the times, and after the POST-IMPRESSIONIST exhibitions of Roger FRY, which he roundly condemned, he was looked upon as a back number by the more progressive artists and students.

As a painter he was an academic in the sense that he deliberately based himself upon traditional canons. He was not a strong natural draughtsman and many of his works were weak in drawing. He made a fetish of 'the poetic' in painting , which he thought must be spontaneous, and in many of his paintings, such as *Spring Days* (Tate Gal., 1928–9), he was too laboriously in pursuit of the poetic. He was at his best in his conversation pieces—e.g. *Saturday Night in the Vale* (Tate Gal., 1928–9)—and his slighter satirical works. An exhibition of his work was given in the Tate Gal. in 1936.

TOOKER, GEORGE (1920–). American painter born at Brooklyn, New York. After taking a degree in literature at Harvard he studied art at the Art Students' League and privately with Paul CADMUS. He worked, preferably in egg tempera, with a precise and polished surface in a style of exact but unemphatic realism. His subjects, however, expressed the dehumanized and communal hopelessness of modern institutional man and a particularly poignant tension was set up between the superficial facility of the presentation and the profound existentialist message of the subject. His *Government Bureau* (The Metropolitan Mus. of Art, New York, 1956) expresses the stereotyped banality of modern bureaucracy and *The Ward* shows the American flag in a hospital room where the aged are 'alone and forgotten, waiting for death'. His works are also represented in The Mus. of Modern Art and the Whitney Mus. of American Art, New York.

TOOROP, CHARLEY (1891–1955). Dutch painter born at Katwijk, daughter of Jan TOOROP. Trained as a musician, she began to paint *c.* 1914 under the tuition of her father. She was strongly influenced by Van Gogh in the direction of EXPRESSIONISM. During the 1930s she painted figurative compositions in a style of expressive Realism with social implications and sometimes with SURREALIST overtones. During the 1940s the formal structure of her work was strengthened by CUBIST stylizations. She had an exhibition at the Hammer Gal., New York, in 1952.

TOOROP, JAN (1858–1928). Dutch artist born at Poerworedjo, Java, studied in Amsterdam and Brussels. His early work was mannered in a curvilinear, calligraphic style reminiscent of Aubrey Beardsley and may have owed something to the traditional puppet figures of his native land. This work was known to Charles Rennie Mackintosh

and the GLASGOW SCHOOL and may have had an influence in the formation of ART NOUVEAU style. In the 1890s he became a friend of Maurice Maeterlinck (1862–1949) and Émile Verhaeren (1855–1916) and turned to Symbolism, in which direction he influenced MONDRIAN and Van der LECK, 1907–10. In 1905 he was converted to Catholicism and his later painting was religious in character. His influence in Dutch art at the turn of the century was considerable.

TOPOLSKI, FELIKS (1907–). British painter and draughtsman, born in Poland and studied at the Warsaw Academy of Art. He settled in England in 1935 and became a British subject in 1947. He was a War Artist 1940–5 and made an unusually prolific draughtsman's record both on the home front and abroad, with the Royal Navy in the Arctic and Mediterranean and also in the Middle East, China, Burma, Italy and Germany. His large painting *The East*, done soon after the war, is in the national collection of India at New Delhi. *Cavalcade of the Commonwealth*, 60 ft by 20 ft (18·3 × 6 m), was commissioned in 1951 for the Festival of Britain and later placed in the Victoria Memorial Hall, Singapore. His mural *The Coronation of Elizabeth II*, 100 ft by 4 ft (30·5 × 1·2 m), is in Buckingham Palace. He has devoted himself to portraiture in an original style and a series of 20 portraits of English writers was commissioned for the University of Texas, 1961–2. From 1953 he published *Topolski's Chronicle*, a draughtsman's impressions of contemporary incident in many countries and he has used these drawings made in the course of constant travels as the basis for large-scale paintings. He belongs to no school, but developed a vigorous personal style of swirling line and grandiose conception. He stands out among 20th-c. artists for his virtuosity as a draughtsman and his panoramic vision, consistently exploiting the recording function of the artist-draughtsman.

TORNER, GUSTAVO (1925–). Spanish painter and sculptor, born at Cuenca. He was self-taught in art, taking it up *c*. 1947 after having studied forestry engineering. In 1963 he collaborated with ZOBEL and RUEDA in founding the Cuenca Mus. of Spanish Abstract Art and in 1966 he received a stipend from the Juan March Foundation. He first worked in a style of LYRICAL ABSTRACTION emphasizing contrasts between smooth surfaces and coarse materials. Later he turned to geometrical abstraction and as well as painting he made constructions of stainless steel combined with wood, etc. In addition to the Mus. de Arte Contemporaneo, Madrid, he is represented in the museums of Bilbao, Cuenca, Cologne, Liège and Prague and at the Solomon R. Guggenheim Mus., New York.

TORRES-GARCÍA, AUGUSTO and HORACIO. See LATIN AMERICA and TORRES-GARCÍA, Joaquín.

TORRES-GARCÍA, JOAQUÍN (1874–1949). Uruguayan painter born in Montevideo of a Catalan father and a Uruguayan mother. In 1891 he went with his family to his father's home town of Mataró, near Barcelona, and there studied drawing and painting with Josep Vinardell. Between 1892 and 1895 he studied at the School of Fine Arts and the Baixas Academy in Barcelona, where Nonell, Mir and Sunyer were among his fellow students. In 1894 he joined the group of painters called the Circle of Sant Lluc and met the sculptor Julio GONZÁLEZ, in whose studio he drew from live models. He had his first individual exhibition in 1900 at the Salon of 'La Vanguardia'. During this Catalonian period Torres-García also studied mural painting and executed a number of commissions for murals. Between 1903 and 1907 he painted panels in the church of Sagrada Familia, Barcelona, and designed stained glass windows for the Cathedral of Palma de Mallorca at the request of the architect Antonio Gaudí. Between 1909 and 1910 he painted two panels for the Uruguayan Pavilion at the Brussels International Exhibition. He also did murals in the church of San Agustín and in 1913 began work for the Salon de San Jorge in the Provincial Council of Barcelona. But upon the death of the Council's patron the latter murals were replaced by more academic ones at the instigation of the conservative local government. Torres-García's interest in Greek classicism and harmonious proportion was reinforced at this time when he saw the work of Puvis de Chavannes during a trip to Paris. In 1920 he moved to New York with his young wife and children and in 1921 he shared an exhibition with Stuart DAVIS at the Whitney Studio Club.

In 1918 he had begun making wooden toys which bore some similarities to his later CONSTRUCTIVIST work and in spite of a disastrous fire in the New York warehouse where he had stored them before returning to Europe in 1922, he continued making them. He was in Paris from 1924 to 1932 and had his first exhibition there in 1926 at the Gal. A. G. Fabre. Between 1928 and 1929 he met Theo van DOESBURG and Piet MONDRIAN and began to work in his Constructivist style. He then developed his theories of Universal Constructivism based on the fusion of a grid with universal symbols derived from ancient and modern cultures all over the world, including pre-Hispanic America. In 1929, together with Michel SEUPHOR, he was instrumental in founding the Constructivist association and periodical CERCLE ET CARRÉ and in 1930 helped to organize a large and revolutionary international exhibition of the same name in which over 80 leading abstract artists were represented. He also organized the first Latin-American exhibition in Paris, featuring the work of the Mexican Muralists OROZCO and de RIVERA, the Mexican sculptor Cueto, the Argentinian painters DEL PRETE and FORNER, the Uruguayan painter and essayist FIGARI and himself.

In 1933, before returning to Uruguay, he was

instrumental in bringing the Constructivist idea to Spain and in 1934 in Montevideo issued three small pamphlets *Manifestos del Grupo Arte Constructivo*, which had been foreshadowed in the Spanish pamphlets, *Guiones*. In 1934 he founded in Montevideo the *Asociación Arte Constructivo*, whose initials AAC figure in many of his paintings, opened an art school which exerted an important influence on the younger generation of South American artists and founded a Constructivist review *Circulo y Cuadrado*, of which 10 numbers appeared irregularly between 1936 and 1943. It was followed by *Renovador*, a journal (26 issues) inaugurated by Torres-García late in 1944. In 1938 he completed a wall-like monument, *Monumento Cosmico*, in the Parque Rodó, Montevideo, with low relief designs in the style of his paintings. In 1944 he founded the *Taller Torres-García* (Torres-García Workshop), where his many followers included his sons Augusto and Horacio. Besides many articles and lectures his writings included *Raison et Nature* (1932) and *Historia de mi Vida* (1939). His most ambitious book, *Constructive Universalism*, a volume of more than 1,000 pages, was published in Montevideo in 1944. In 1946 he published a manifesto 'The Abstract Rule', in which he envisaged the emergence of a powerful virgin art in the New World away from the 'babel of Europe'. By his example and teaching he did much to promote the development of Constructivist and KINETIC art in post-war Argentina and Brazil; he influenced the progress of the abstract movements of the mid 1940s and artists all over Latin America were inspired by his philosophy of Universalism if not by his individual style. After his return to Uruguay he developed his idiosyncratic style of ideographic images within a grid system to which critics have often likened the later *Pictographs* of Adolph GOTTLIEB. He was included in the 'Art of Latin America Since Independence' exhibition at Yale in 1966. In New York he exhibited at the Sidney Janis and André Emmerich Gals. and in 1970 a retrospective exhibition of his work was staged at the Solomon R. Guggenheim Mus. A representative collection of his work may be seen at the Torres-García Mus. in Montevideo.

TOSI, ARTURO (1871–1956). Italian painter born at Busto Arsizio, near Milan. He was trained in the Milan tradition of Lombard landscape and, after an early phase of Realism in the manner of Courbet, throughout his life he concentrated only on landscape and still life. He has been called a 'natural' or 'instinctive' painter and his work shows a spontaneous feeling for the poetical interpretation of nature uncomplicated by intellectual theories. Between 1909 and 1912 he did a series of pastel drawings at Rovetta in which his sense of limpid colour and his feeling for atmosphere are apparent. He was to some extent influenced by the Impressionists and Cézanne, by the brushwork of the French EXPRESSIONISTS and later perhaps by the

FAUVES; but his work retained its freshness and spontaneity. In 1926 he joined the NOVECENTO ITALIANO.

TOUPIN, FERNAND. See CANADA.

TOUSIGNANT, CLAUDE (1932–). Canadian painter born at Montreal, where he studied at the Montreal Mus. of Fine Arts School and was introduced to geometrical abstraction from the outset. In 1952 he went to Paris but was not impressed by current French painting and returned the following year. Tousignant was a colour painter *par excellence*. He began with monochromatic panels painted with shiny automobile paint. During the 1950s he employed clear, intense colours laid on in long, closely-packed, asparagus-like forms with the object of creating an over-all effect of dynamic colour. On a visit to New York in 1962 he was impressed by the work of Barnett NEWMAN and in pursuit of his aim 'to say as much as possible with as few elements as possible' he adopted the circular canvas and the 'target' image. Free from any associative image and without compositional tension these pictures attempted to realize pure colour sensation. *Œil de bœuf* (National Gal. of Canada, Ottawa, 1964) is typical of this style.

TOWN, HAROLD. See CANADA.

TRAP PICTURES (TABLEAUX PIÈGES; FALLENBILDEN). A device first practised by SPOERRI and later taken up by others of the NOUVEAUX RÉALISTES. Chance remains of an actual event, e.g. a meal, were glued to a board and then hung as a picture. The 'trap picture' was claimed to be a 'frozen document' or continued remembrance of the actual occurrence.

TRECCANI, ERNESTO. See CORRENTE.

TREMLETT, DAVID. See CONCEPTUAL ART.

TREVELYAN, JULIAN (1910–). British painter and graphic artist, born in London and studied in Paris under S. W. HAYTER. He taught at the Chelsea School of Art from 1950 to 1960 and taught etching at the Royal College of Art from 1955. He became a member of the English SURREALIST group in 1935 and from that year he had numerous one-man exhibitions at the Lefevre Gal., Gimpel Fils, the Redfern Gal., the Zwemmer Gal. and a retrospective at the New Grafton Gal. in 1977. He wrote *Indigo Days* (1957), *The Artist and his World* (1960), *Etching* (1963) and *A Place, a State* (1975).

TRIER, HANS (1915–). German painter born in Düsseldorf and studied at the Düsseldorf Academy of Art, 1934–8. After serving in the German forces, 1939–41, and as a technical draughtsman in Berlin, 1941–4, he settled in Bonn in 1946. In 1952 he emigrated to Colombia but returned to Ger-

many after three years. He was visiting lecturer at the Hamburg College of Art, 1955–60, and was appointed to the staff of the Academy of Fine Art, Berlin, in 1957. Trier developed a breathless, calligraphic style and often named his pictures for some chance suggestion or illustrative reference (*Schnellbahn*, 1951; *Nähmaschine*, 1952; *In den Wind geschrieben*, 1953).

TRILLHAASE, ADALBERT (1859–1936). German NAÏVE painter, born at Erfurt. He was trained for a business career but failed in successive business ventures and took up painting in 1918. His paintings were mainly fantasies on biblical themes. Artistically awkward and crude, they blended religious faith with demonological superstition in a hallucinatory world of imagination. He had one-man shows in the Gesolei at Düsseldorf in 1924 and at the Gal. G. Maratier, Paris, in 1939 and was represented in a number of international exhibitions of naïve painting.

TRÖKES, HEINZ (1913–). German painter, born in Duisburg-Hamborn. After a brief period at the Krefeld School of Applied Art he studied under ITTEN, 1933–6, in Berlin and briefly in 1940 under MUCHE at Krefeld. He lived in Berlin from 1940 to 1950 and in 1952 came to know WOLS in Paris. He settled in Ibiza in 1952 and apart from a short period of teaching at the Hamburg Academy of Art, 1956–8, he remained at Ibiza until 1961. In 1961 he joined the staff of the Academy at Stuttgart and in 1966 transferred to Berlin. Trökes painted in a poetic, sometimes calligraphic style which often bordered closely on abstract SURREALISM, translating reminiscences of his travels into fantastically organized optical symbols.

TROVA, ERNEST (1927–). American sculptor, born at St. Louis, Mo. He was self-taught in art. He had his first one-man show at the Image Gal., St. Louis, in 1959, after which he had frequent one-man shows in the U.S.A. and was represented in collective exhibitions of *avant-garde* and fantastic art, including 'Sculpture International', Solomon R. Guggenheim Mus., 1967; 'Dada, Surrealism and their Heritage', The Mus. of Modern Art, New York, 1968; DOCUMENTA IV, Kassel, 1968. He made machine-like constructions incorporating the human form and symbolic of the relation between modern man and the machine or man and the computer. He often worked in series, e.g. *Falling Man Study* (Whitney Mus. of American Art, 1966).

TROYER, PROSPER DE (1886–1961). Belgian painter, born at Destelbergen. After studying at the École de Saint-Luc, Oostakker, and at the Academy of Mechelen he joined the artistic communities of Brussels and Antwerp, where he displayed unusual versatility in assimilating successively the styles of Neo-Impressionism, FAUVISM and CUBISM before discovering FUTURISM. He

exchanged correspondence with MARINETTI and *c.* 1920 executed works which rank high among Belgian Futurist painting. Among them is *La Couseuse* (Mus. Royaux des Beaux-Arts, Brussels, 1920). In 1920 he began to paint CONSTRUCTIVIST works under the influence of MALEVICH and in 1921 joined the Constructivist circle founded by Jozef PEETERS. In the following year, however, he reverted to figurative EXPRESSIONISM.

TRŠAR, DRAGO (1927–). Yugoslav sculptor born at Planina, Slovenia, and studied at the Academy, Ljubljana, where he subsequently taught. He did both figurative and abstract sculpture and was particularly known for his group sculptures simultaneously suggesting rhythmic movement and mass formations of stalactites.

TSAROUCHIS, YANNIS (1910–). Greek painter born in the Piraeus. From 1929 to 1934 he studied at the School of Fine Arts, Athens, and also worked under KONTOGLOU, who had a strong influence upon him. He spent a year in Paris, 1935–6. During the 1930s he was hailed as the outstanding painter of 'Greekness' and the modern 'discoverer of the Greek tradition'. He had his first one-man exhibition in Athens in 1938. In 1951 he exhibited at the Gal. d'Art du Faubourg, Paris, and at the Redfern Gal., London. In 1952 an exhibition of his work was arranged by the British Council in Athens and in 1958 it was included in the Greek Pavilion at the Venice Biennale. In 1961 he had an exhibition at the Iolas Gal., New York. He was one of the four artists in the exhibition 'Four Painters of 20th Century Greece' organized at the Wildenstein Gal. on the occasion of the Greek Month in London in 1975. From 1919 onwards Tsarouchis did important work in costume design and theatrical settings.

TSCHARNER, JOHANN VON (1886–1946). Swiss painter, born in Lwów, Poland, of Russian stock. He was brought up in Switzerland and studied philosophy and painting at Kraków. He studied in Munich in 1907 and from 1908 to 1914 worked in Paris, spending the summers in the Hungarian Carpathians or in Russia. He returned to Switzerland in 1914 and from 1916 lived in Zürich, where he was a friend of MORGENTHALER. From his philosophical studies he inherited the obsession, not unusual among painters, to paint not the appearances but the 'essence' of things. He did not, however, abandon representational painting for CONSTRUCTIVIST abstraction.

TUCKER, ALBERT (1914–). Australian artist, who studied at the Victorian Artists' Society evening classes and briefly with George Bell in 1936. He was influenced by the work of VASSILIEFF, and the German EXPRESSIONISTS, whose work he studied in books in the Public Library of Victoria. Tucker played an active part in controversies which dominated the early years of the CONTEMPORARY ART

SOCIETY OF AUSTRALIA and became widely known after exhibiting *The Futile City* in the Annual Exhibition of the Society in 1940. He was closely associated with John Reed and Max Harris in their publication of the periodical *Angry Penguins* (1941–6; see AUSTRALIA). He contributed some important articles on Realism and politics in opposition to the artists associated with COUNIHAN. In 1943 he painted his *Images of Modern Evil* series, in which a personal style emerged, derived from his study of SURREALISM and Expressionism. In 1947 he visited Japan, where he worked briefly as an official artist (in company with the American writer Harry Roskelenko) to the Allied Occupation Forces. Later that year he left for Europe to live in London (1947–8), France (1949–50), Germany (1951) and Italy (1952–6). He held a one-man show at the Kunstvaal van Lier, Amsterdam, and another at the Gal. di Quatro Venti in Rome in 1953. In 1956 he was invited to exhibit at the Venice Biennale.

Tucker's early work is marked by a highly personal interpretation of social, political and psychological concerns. In 1952 at Noli in Italy he painted a series of pictures based on religious themes. In 1954 he turned for the first time to themes of the Australian frontier: bushranging, exploration and the desert. Tough-minded, residual and humourless, they revealed the impact of ART BRUT and the textural paintings of TÀPIES and BURRI. In 1956 he returned to London and during the next three years his work became fairly well known in London and New York. In 1957 The Mus. of Modern Art, New York, purchased *Lunar Landscape*. In 1960 he returned to Melbourne. Antipodean imagery became a major preoccupation of his work during the 1960s, exemplified in *Gamblers and Parrots* and the *Bush* series of paintings.

TUCKER, WILLIAM (1935–). British sculptor, born at Cairo and studied at the Central School of Art and Design and the St. Martin's School of Art, London. Subsequently he taught at the St. Martin's School. He was among the pupils of Anthony CARO, who created a new British sculptural *avant-garde* in the latter half of the 1960s. He exhibited at the Venice Biennale of 1972, at the Serpentine Gal. under the auspices of the Arts Council in 1973 and in 1975 he was included in 'The Condition of Art' exhibition at the Hayward Gal. He used fibreglass, iron and laminated wood in his constructions.

ŢUCULESCU, ION (1910–62). Romanian painter, born at Craiova. He studied Natural Sciences and Medicine in Bucarest and occupied himself with scientific research until the end of his life. He was senior lecturer at the Brîncoveanu Hospital from 1951 to 1954. Without formal training he began to paint at an early age and exhibited in his native town from 1925. It was only from 1935, however, that he embarked on the career of artist seriously, and his first one-man show at the Athe-

naeum Hall, Bucarest, was in 1938. He continued to exhibit there and at the official Salon, participating in official exhibitions of 'Artistic Youth' and 'Contemporary Romanian Painting'. In 1942 he showed two works at the Venice Biennale, in 1943 he participated in exhibitions at Berne and Stockholm and in 1947 he was represented in an exhibition 'Fine Arts in Romania' organized in Budapest. It was only after his death, however, that his work became widely known internationally.

In 1965 the State Committee for Culture and Arts organized a retrospective exhibition of 278 of his works in Bucarest and similar retrospectives were held in other towns of Romania. In 1966 Romania participated in the 33rd Venice Biennale with 80 of his works. A Ţuculescu exhibition was held in Paris, Le Havre and Copenhagen in 1967. A similar exhibition toured the U.S.A. and was shown in Brussels in 1968 and in 1969 Ţuculescu exhibitions were held in Belgrade, Oslo, Stockholm and Warsaw. In 1970 an exhibition was given in Vienna and memorial exhibitions were arranged in Romania to commemorate his 60th anniversary. An illustrated monograph was published in Bucarest in 1967 and an English translation appeared in 1973.

Ţuculescu's work developed from a Late-Impressionist style in the early years to ART INFORMEL or TACHIST abstraction. He was influenced throughout by the spirit of Romanian folk art and in particular by the patterns of peasant carpets and rugs.

TUMARKIN, YGAEL (1933–). Israeli sculptor, painter and theatrical designer, born at Dresden but taken to Palestine in 1935. His sculpture was abstract and geometrical, constructed in a variety of materials—iron, polyester, reinforced concrete—and made to fit into the open country or as monuments for public buildings. He has sculptures at the Israel Mus., Jerusalem, and the Yad Mordechai Mus., Atlit. He also designed for the Brecht Theatre in East Berlin.

TUNNARD, JOHN (1900–71). British painter and designer born at Caesar's Camp, Sandy, Bedfordshire. After studying design at the Royal College of Art, 1919–23, he worked as a commercial designer until 1929, when he gave up commercial work and started painting. At the same time he became a part-time teacher of design at the Central School of Arts and Crafts. His first one-man show was at the Redfern Gal. in 1933 and in 1934 he became a member of the LONDON GROUP. From 1935 his work became less representational and was influenced by KLEE and MIRÓ. In the 1940s he participated in a number of collective exhibitions, including exhibitions arranged by C.E.M.A. and later by the ARTS COUNCIL. He had one-man exhibitions in Germany, Italy, New York, etc. In 1967 he was elected A.R.A. In 1977 a retrospective exhibition arranged by the Arts Council was shown at the Royal Academy and elsewhere in Britain.

TURCATO, GIULIO (1912–). Italian painter born at Mantua and studied at Venice. He was active in the formation of the *Forma* association at Rome in 1947, joined the FRONTE NUOVO and was a founding member of the GRUPPO DEGLI OTTO PITTORI ITALIANI in 1952 and CONTINUITÀ in 1961. He was influenced successively by French EXPRESSIONISM, CUBISM, FUTURISM and the geometrical abstraction of MAGNELLI. About 1950 he abandoned the expressive abstraction of Italian INFORMALISM and developed a style of geometrical abstraction which led on to two-dimensional linear compositions on monochromatic grounds.

TURNBULL, JOHN. See GROUP X.

TURNBULL, WILLIAM (1922–). British painter and sculptor, born at Dundee. After working in commercial illustration and serving in the R.A.F. during the Second World War, he studied at the Slade School of Art, 1946–8, and then lived in Paris, 1948–50. He visited the U.S.A. in 1957 and Japan and the Far East in 1962. He was represented in the British Pavilion at the Venice Biennale of 1952, at the Carnegie International, Pittsburgh, 1958, in the 'Situation' exhibition at the R.B.A. Gals., 1960, in the 'Sculpture from the Hirshhorn Collection' exhibition at the Solomon R. Guggenheim Mus., New York, 1962, in the 'New Shapes and Forms of Colour' exhibition in the Stedelijk Mus., Amsterdam, 1966, in the Guggenheim International of 1967 and in DOCUMENTA IV, Kassel, 1968. He had one-man shows at the Marlborough Gerson Gal., New York, and at the Art Institute, Detroit, in 1963, at the São Paulo Bienale of 1967 and at the Hayward Gal. in 1968. He had a retrospective exhibition at the Tate Gal. in 1973 and an exhibition of recent works at the Scottish Arts Council Gal., Edinburgh, in 1974.

Turnbull was one of the first British painters to work in the manner of the American COLOUR FIELD painters. During the 1960s he became increasingly interested in the physical presence of the surface and the substance of the pigment, often painting what were virtually monochromes with little colour inflection. From early quasi-figurative sculpture he went over to totem-like abstracts in the early 1960s. Later he worked with painted steel geometrical forms in the manner of Anthony CARO and the PRIMARY STRUCTURES of the American MINIMALISTS. His compositions of the late 1960s were often made up of relatively independent, repeating geometrical elements with no set order so that the installer could dispose of them at his will. In an introductory essay to the catalogue of his 1974 Scottish exhibition Richard Morphet wrote: 'Turnbull's work flatters, makes visible, brings to life, any setting in which it is placed. But its ability so strongly to act as a catalyst in the spectator's awareness of his environment, and also to reflect so wide a range of experience, functions only because the undramatic, "everyday" forms of Turnbull's work are the product of the acts of concentration, choice and affirmation of a richly human imagination.' Like Caro, Turnbull did not exhibit his sculptures on a pedestal but planned them to stand on the ground in more intimate contact with the spectator.

TURNER, J. DOMAN. See CAMDEN TOWN GROUP.

TWACHTMAN, J. H. See UNITED STATES OF AMERICA.

TWOMBLY, CY (1928–). American painter and draughtsman, born at Lexington, Va., and trained at the Boston Mus. School, the Art Students' League, New York, and at Black Mountain College, where he was influenced by Franz KLINE. He began exhibiting in 1951. In 1957 he took up his residence in Rome, but from 1964 exhibited at the Leo Castelli Gal., New York. Among his more important one-man shows were: Palais des Beaux-Arts, Brussels (1965); Stedelijk Mus., Amsterdam (1966); Milwaukee Art Center (1968); Kunsthalle, Berne (1973); Lenbachhaus, Munich (1973); Kunstmus., Basle (1973). From 1967 he was represented at the Annual Exhibitions of the Whitney Mus. of American Art, New York. Among the group shows in which he was included were: the Venice Biennale of 1964; Exhibition of Contemporary Drawings at the Solomon R. Guggenheim Mus., New York (1964); Exhibition of 'Painting and Sculpture Today' at the Indianapolis Mus. of Art (1969) and 'American Painting: The 1960s' at the American Federation of Art (1969).

Twombly belonged to the artistic generation of Jasper JOHNS and Robert RAUSCHENBERG, which from roughly the mid 1950s initiated the series of artistic movements known by the general term POST-PAINTERLY ABSTRACTION as a breakaway from ABSTRACT EXPRESSIONISM. Starting from Abstract Expressionism, Twombly developed a highly original style of 'written images', to use the words of Gillo Dorfles, which has superficial affinities with scribbling, doodling or graffiti. He rejected traditional ideas of composition, inclining rather to the ALL-OVER (German: *Streu-Komposition*) style initiated by Jackson POLLOCK, though his work was looser and more disorganized than that of Pollock and sometimes large areas of barely modulated surface, which might or might not be divided by a central line, were punctuated by relatively small scribbled patches. His work has been compared with the art of 'de-differentiation' about which some psychologists speak.

291 GALLERY. See STIEGLITZ, Alfred.

TWORKOV, JACK (1900–82). American painter, born at Biala, Poland. He came to the U.S.A. in 1913 and studied through the early 1920s at Columbia College, the National Academy of Design and the Art Students' League. From 1931

and 1935 he exhibited at the Dudensing Gal., New York, and from 1947 at the Egan Gal. During the Depression he worked for the Public Works Art Project (1934) and the WPA (1937–41). He met Willem DE KOONING in 1934 and later, abandoning his figurative style, joined with de Kooning in association with the NEW YORK SCHOOL of ABSTRACT EXPRESSIONISM. After the Second World War he lectured and taught in a number of institutions, including the American University in Washington, Black Mountain College, Queens College and the Pratt Institute, New York. At the end of the 1950s, however, a change came over his work. No longer content with the spontaneous and almost AUTOMATIC techniques of Abstract Expressionism, he sought a more disciplined and intellectual framework for his painting. He described this change as follows in an article contributed to the journal *Leonardo* (Vol. 7, No. 2, Spring 1974): 'But by the end of the fifties I felt that the automatic aspect of abstract-expressionist painting of the gestural variety, to which my painting was related, had reached a stage where its forms had become predictable and automatically repetitive. Besides, the exuberance that was a condition of the birth of this painting could not be maintained without pretense forever. At the end of the fifties I began to look around for more disciplined and contemplative forms ... in 1965 I began to study elementary geometry and some aspects of the number system.... From then on all my paintings began with carefully worked out drawings and measurements that I could repeat at will. But the actual painting I left to varieties of spontaneous brushing. What I wanted was a simple structure dependent on drawing as a base on which the brushing, spontaneous and pulsating, gave a beat to the painting somewhat analogous to the beat in music. I wanted, and I hope I arrived at, a painting style in which planning does not exclude intuitive and sometimes random play.' The paintings of the 1970s, with their closely hatched brush-strokes within a planned geometrical framework, represent an individualistic departure from the free style of COLOUR FIELD painting of the 1960s.

TYTGAT, EDGARD (1879–1957). Belgian painter and graphic artist, born in Brussels. He spent his early years in Bruges, moved back to Brussels in 1888 and in 1893 was employed in his father's lithography workshop, where he learned drawing. From 1900 he studied at the Académie des Beaux-Arts, Brussels, where he was influenced by the Symbolists and particularly by Puvis de Chavannes. In 1907 he settled at Watermael-Boitsfort, where he became a friend of Rik WOUTERS. He passed the First World War in London, earning his living as an engraver and book illustrator while continuing to paint the objects and scenes around him in an extremely perceptive manner using a Late-Impressionist style. Returning to Brussels in 1920 he became artistic director of a wallpaper factory while still continuing to paint, and in 1923 he settled at Woluew-Saint-Lambert. His work in the 1920s was influenced by EXPRESSIONISM although he also painted scenes of fairs and roundabouts and children's games in a style approaching the *faux naïf*, as is illustrated by his *Dimanche Après-Midi ou Le Marchand de Coco* (Mus. Royaux des Beaux-Arts, Brussels, 1927). Tytgat was an adult who saw the world through the eyes of a child, creating a poetic world of fairy story and legend with a refined and somewhat self-conscious naïvety frequently inspired by popular prints of the 18th and 19th c. It has been said that 'in the ensemble of Flemish Expressionists Tytgat is essentially the narrative artist who founded no school'. During the 1950s he turned from representations of popular life to more imaginative themes such as *L'Embarquement d'Iphigénie vers l'Île du Sacrifice* (Mus. Royaux des Beaux-Arts, Brussels, 1950) and *The Last Journey of a Proud Noblewoman* (Royal Mus. of Fine Arts, Antwerp, 1951). In 1928 a special number of the review SÉLECTION was devoted to him. He had retrospective exhibitions at the Palais des Beaux-Arts, Brussels, in 1931 and 1951.

U

UBAC, RAOUL (1910–). French painter, sculptor and graphic artist, born at Malmédy, Belgium. After having begun as a Forestry Inspector he went to Paris in 1929 and entered the Sorbonne to study classics. Abandoning this, he studied painting at the Académie de la Grande Chaumière, Montparnasse. Between 1928 and 1934 he travelled extensively in Europe and while in Cologne joined the association *Progressive Künstler* headed by Max ERNST and Otto FREUNDLICH. From *c.* 1934 to 1942 he devoted himself to photography, joining the SURREALIST group in Paris and contributing Surrealist photographs to the journal *Minotaure*. In 1942 he abandoned both Surrealism and photography, returning to drawing and painting, in which he moved more and more in the direction of abstraction. In 1946 he began to make double-sided reliefs in slate, which he called *ardoises*. He had one-man shows at the Gal. Maeght in 1950, 1955 and 1958. He exhibited gouaches at the Redfern Gal., London, and the Lou Cosyn Gal., Brussels, in 1946 and in 1949 at the Hanover Gal., London. Ubac also left a large graphic *œuvre*, including woodcuts and book illustrations, and interested himself in tapestry design.

UDALTSOVA, NADEZHDA (1886–1961). Russian painter. She studied in Moscow and went to Paris in 1912 with POPOVA. There they studied under METZINGER and LE FAUCONNIER. Returning to Moscow in 1914, they painted in the manner of Analytical CUBISM uninfluenced by the Russian folk art movement, though later they adopted a non-representational mode of abstraction. Udaltsova's painting *At the Piano* (1914) was acquired by the SOCIÉTÉ ANONYME and is now in Yale University Art Gal.

UECKER, GÜNTHER (1930–). German sculptor born at Wendorf, Mecklenburg, studied in Berlin and Düsseldorf. From the late 1950s he specialized in the use of white nails, which he welded on to a ground in order to form objects whose main function was to produce specialized light effects in space. In his *Light Forest* (1959) the nailheads had the uniformity yet slight irregularity of a dense natural growth and produced a new surface floating above the surface of the board into which they were driven. During the 1960s he made use of light boxes and rotating discs and later experimented with neon tubes in his light sculptures. He was a member of the Düsseldorf ZERO group and collaborated with Otto PIENE and Heinz MACK

in the creation of what they called 'light spaces' and 'light mills' (*Mühle*). His work had affinities with KINETIC ART, OP ART and LUMINISM. A large exhibition of his 'nail pictures' was staged in 1980 in St. Gallen, and in connection with this his writings 1954–77, including 'nail projects' and his ideas of 'nail-aesthetics', were published in book form.

UGARTE ELESPURU, JUAN MANUEL. See LATIN AMERICA.

UGLOW, EUAN (1932–). British painter, born in London. He attended the Camberwell School of Arts and Crafts, 1948–51, and in 1951 obtained a State Scholarship to the Slade School. In 1952 he received a Spanish State Scholarship and in 1953 the Prix de Rome. He first exhibited with the LONDON GROUP in 1956 and was made a member in 1960. He was represented in touring exhibitions organized by the Arts Council in 1960–1, 1962 and 1964, and in 1972 won first prize at the 8th John Moores Exhibition at the Walker Art Gal., Liverpool. From 1961 he was a part-time teacher at the Slade School and the Camberwell School of Arts and Crafts. In 1974 a large one-man exhibition of his work at the Whitechapel Art Gal. was sponsored by the Arts Council. Whether his subject was still life, figure or portrait, Uglow's paintings reflected an explicit and unimpassioned naturalism. As Myles Murphy maintained in his Introduction to the catalogue of the 1974 exhibition, Uglow was at one and the same time intensely interested in investigating the visual aspect of the perceptual world and in achieving a painting style that would convey the impression of authoritativeness and timelessness in a manner originated by the EUSTON ROAD SCHOOL.

UHDE, WILHELM (1874–1947). German critic and connoisseur who settled in Paris in 1904. He was one of the earliest to recognize PICASSO and BRAQUE and to buy their paintings, purchasing his first Picasso in 1905. In 1908 he organized an important exhibition of Impressionists at Basle and Zürich and in succeeding years exhibitions of contemporary French painters in Berlin and New York. He was among those who brought the Douanier ROUSSEAU to prominence, wrote the first monograph upon him and was instrumental in organizing the first retrospective exhibition of his work. He subsequently made himself a leader in the cult of the NAÏVE painters, 'discovering' and

bringing to notice among others SÉRAPHINE, VIVIN, RIMBERT and BOMBOIS. In 1949 the French translation of his book *Cinq Maîtres primitifs: Rousseau, Vivin, Bombois, Bauchant, Séraphine* was published in Paris.

UHLMANN, HANS (1900–75). German sculptor born in Berlin. He was first a pupil and afterwards, until 1933, a teacher at the Institute of Technology, Berlin. He began sculpture in 1925 and had his first one-man show at the Gal. Gurlitt, Berlin, in 1930. In 1933 he exhibited with the NOVEMBERGRUPPE. From 1933 to 1935 he was a political prisoner and was forbidden by the National Socialist regime to exhibit. On his release he was the first German artist to work on abstract constructs from metal sheets, wires and rods, which were first exhibited at the Gal. Gerd Rosen, Berlin, where he had a one-man show in 1947. After the war he exhibited frequently in Germany and abroad and won international recognition. In 1952 he was awarded a prize for his drawings at the São Paulo Bienale and in 1955 he was included in 'The New Decade' exhibition of 22 European painters and sculptors at The Mus. of Modern Art, New York. In 1950 he was awarded the Kunstpreis der Stadt Berlin and was appointed Professor at the Academy of Fine Arts, Berlin. Uhlmann was opposed to the outlook of EXPRESSIONISM but was an advocate of the spontaneity and directness in artistic creation which has been favoured by many different contemporary schools of aesthetics. He himself said: 'The meaning of constructing and forming—the act of creation— this special way of life—is to me the greatest possible freedom. It also means freedom from the private feelings (but not without strong feelings) and this also means to be free from dulling tendencies of a didactic or moralising nature. ... Important to me are the entirely spontaneous drawings which have to be jotted down, mostly without any conscious thought of translation into sculptural terms. I want to create sculpture in a similarly spontaneous way.'

ULLRICH, DIETMAR (1940–). German painter, born in Breslau and trained at the Academy of Fine Arts, Hamburg. He qualified as an art teacher in 1965, held a scholarship to London from the German Academic Exchange Service in 1965–6, and a scholarship from the Kulturkreis im Bundesverband der Deutschen Industrie in 1971. He was one of the four members of the ZEBRA group formed in 1965. He worked in a style of precise, almost PHOTOGRAPHIC realism and in some of his 'sport' paintings he caught attitudes and gestures as if 'frozen' by a snapshot camera. His blown-up figures took on the semblance of bloated puppets against a featureless background. Drama and expressiveness were confined to the subject; the painting itself was completely objective and devoid of expressiveness. Ullrich exhibited widely in Germany from 1963 onwards both with the *Zebra*

group and in collective exhibitions organized on a broader basis.

ULTVEDT, PER-OLOF (1927–). Finnish-Swedish painter, sculptor and film-maker, born at Kemi, Finland. He began at the Helsinki Academy of Art in 1945 as a painter, producing paintings and drawings with animal subjects. He then turned to KINETIC ART and from 1958 produced 'animated MOBILES', large constructions of welded metal and wooden planks and beams with movements driven by motors. His most elaborate work in this mode, made in collaboration with Ulf Linde, *The Face of a Newspaper* (1964), was a moving COLLAGE animating and fantasizing the machines and apparatus of a printing shop. A powerful wooden construction *Hommage à Christoffer Polhem* was included in an outdoor sculpture exhibition at Vondel Park, Amsterdam, in 1965. In 1966 he collaborated with TINGUELY and Niki de SAINT PHALLE in building the gigantic structure *She* (*Hon*), 28 m long by 8 m high by 9 m wide, in the Moderna Mus., Stockholm.

Ultvedt also made mazes and labyrinths, constructed ASSEMBLAGES from kitchen utensils, articles of furniture, etc., and in his moving constructions often sought to create hallucinatory impressions in the manner of OP ART.

UNANIMISM. A concept originated by BOCCIONI and taken over by other FUTURIST painters, e.g. CARRÀ. A Unanimist picture purported to represent collective movement and to express crowd emotion or collective sentiment. See also RUSSOLO, Luigi.

UNDERWOOD, LEON (1890–1975). British painter, sculptor and graphic artist, born in London. He studied at the Regent Street Polytechnic and the Royal College of Art. He began to teach at the Royal College in 1920 but resigned in 1923 and opened his own Brook Green School, where he founded his reputation as a teacher, having among others Henry MOORE, Eileen AGAR, Gertrude Hermes and Raymond Coxon as pupils. In 1927 he published his novel *The Siamese Cat* illustrated by his own woodcuts and in 1931 he founded the magazine *The Island*. In 1928–9 he travelled in Mexico and for some years afterwards produced paintings, drawings and wood engravings which betrayed the impression made upon him by Mexican indigenous art. In the 1940s he similarly travelled in West Africa, wrote upon African traditional art and produced paintings and sculpture showing the effect this had made upon him. After one-man shows at the Kaplan Gal. in the 1960s he had a full-scale retrospective exhibition in 1969 at The Minories, Colchester.

Underwood was one of the most original and versatile artists of his generation, and one of the most neglected. He was out of sympathy with the main trends of modernism in both Europe and America, speaking of it as a 'generation of iconoclasts' and describing abstraction as 'artfully

making emptiness less conspicuous'. In his Introduction to Christopher Neve's monograph, John Rothenstein said of him: 'No artist of his generation of remotely comparable achievement has been so little honoured; indeed so neglected.' From the 1960s critics began to speak of him as the 'father of modern sculpture in Britain', having in view the influence of his teaching at the Royal College and his own schools. He was instrumental in evolving an important part of the formal idiom of modern sculpture, but he dissociated himself from it, regarding the interest in form for form's sake as a sign of lack of purpose and a symptom of modern decadence.

His first major oil painting was the *Venus in Kensington Gardens* (1921). Other outstanding works in oils were *The Ember* (1926), *Shores of Knowledge* (1930), which has something of CHIRICO's strange otherworldliness, and the African *Men and Birds* (1953). During the 1920s his sculpture in many ways paralleled and anticipated the formal experiments of Henry Moore. Outstanding works were *The Cathedral* (1930-2) and *African Madonna* (1935) in lignum vitae. His bronzes of the 1950s and 1960s were more baroque in spirit and anticipated the post-war trend towards 'open space' sculpture. Outstanding among them were *Hill Rhythm* (1952), *Water Rhythm* (1953), *Self Encounter* (1960) and *Joy as it Flies* (1961).

UNGER, CARL (1915-). Austrian painter, born at Wolframitzkirchen, near Znaim. After studying in Vienna under BOECKL he worked in Paris in 1936 and in London in 1938. After passing through EXPRESSIONIST and CUBIST phases his work became abstract *c.* 1949, partly under the influence of KANDINSKY, whose works he saw at a comprehensive exhibition in Paris. His LYRICAL ABSTRACT compositions and landscapes retained a link with the world of natural objects from which they were derived. He became a founding member of the Vienna Art Club in 1949, was awarded the Austrian State Prize for painting in 1952 and was appointed Professor at the Vienna Academy of Applied Arts. Besides painting he also designed stained glass windows and did mosaics and lithographs.

UNION OF YOUTH (SOUIZ MOLODEZHI). An association of Russian *avant-garde* artists formed in St. Petersburg in late 1909 and established formally in February 1910. The association existed primarily as an exhibition society and as a sponsor of public discussions and spectacles related to modern trends in the visual arts. The Union was financed by the businessman and collector Levkii Zheverzheev (1881-1942). The first exhibition, put on in St. Petersburg and Riga in 1910, was restricted to Russian artists, prominent among whom were FILONOV and ROZANOVA. Subsequent exhibitions, either in St. Petersburg or in Moscow, presented many members of the *avant-garde* such as KLIUN, MALEVICH and

TATLIN. The last exhibition was in 1913-14 in St. Petersburg. The Union became a centre of the Russian FUTURIST movement and in December 1913 it staged Vladimir Mayakovsky's play *Vladimir Mayakovsky. A Tragedy* with décor by Filonov and Iosif Shkolnik (1883-1926) assisted by Rozanova, and the Futurist opera *Victory over the Sun*, for which Malevich designed the sets and costumes. The Union—with which most members of Russia's *avant-garde* were associated in one way or another—broke up in 1914.

UNISM. See STRZEMINSKI, Władysław.

UNITED STATES OF AMERICA. Barbara Rose begins her book *American Art since 1900* with the statement: 'Nearly two centuries after winning political independence from England, America was still an artistic colony of Europe. Although American literature renounced European models in the nineteenth century, American art did not achieve a similar maturity until the United States emerged as a dominant global power after World War II. Until that time, American artists continued to be torn between their allegiance to Europe's high culture and their wish to initiate a genuinely American style. The struggle to resolve this conflict is the history of twentieth-century American art.'

The last quarter of the 19th c. was marked by an ascendancy of the cosmopolitan trend and the century closed with the quietist and unadventurous Impressionism of the group known as The Ten, which included J. H. Twachtman (1853-1902), T. W. Dewing (1851-1938) and Childe Hassam (1859-1935). In the third quarter of the 19th c. painting had been a popular and flourishing craft which thrived from one end of the States to the other; by the end of the century it had lost touch with popular taste and no longer afforded a livelihood for many. The first decade of the 20th c. saw academicism firmly entrenched and an intolerant exploitation of derivative and artificial pastiche. Academy exhibitions were dominated by conservative nonentities frankly hostile to creative talent. In the absence of commercial galleries there was no avenue by which young and non-conforming artists could reach the public. It is against this background of smug and complacent debility in the world of official art that one must assess the importance of the photographer, dealer and propagandist Alfred STIEGLITZ, who in 1905 opened in New York the 'Photo-Secession Gallery' or 291 Gallery, as it was known, at which he showed works by the European *avant-garde*, highly influential in the formation of young American artists, and which served as a rallying point for independent and creative American artists such as John MARIN, Marsden HARTLEY, Max WEBER, Arthur DOVE and Georgia O'KEEFFE. Though his methods and personality were different, the influence of Stieglitz for the transformation of American taste at the beginning of the century was akin to that of

Roger FRY in the United Kingdom. Stieglitz himself described his campaign as 'trying to establish for myself an America in which I could breathe as a free man'.

Meanwhile among the expatriate American artists working in Europe Stanton MACDONALD-WRIGHT, who had once been a pupil of Robert HENRI and who was exhibited by Stieglitz in 1917, together with Morgan RUSSELL, founded in 1913 the movement of SYNCHROMISM, akin to the colour ORPHISM of DELAUNAY, which was first brought to New York by an exhibition at the Carroll Gal. in 1914 and which stimulated some American artists to experiment with non-representational painting exploiting colour harmonies.

The other dominating personality of the decade was Robert Henri, who has become something of a legendary figure for his pioneering crusade against academic isolationism and his unceasing endeavour to bring art back into touch with the living society of the day. He was the inspiration for the formation of The EIGHT, whose exhibition in 1908, long remembered, became a landmark for the impact which it made. Henri's group too provided the impetus for a new school of SOCIAL REALISM which came to be known as the ASH-CAN school, often spoken of as the counterpart of the American sociological novelists such as Theodore Dreiser, Sherwood Anderson and Frank Norris. The core of Henri's group consisted of William GLACKENS, John SLOAN, George LUKS and Everett SHINN, all of whom had begun life as newspaper illustrators or artist-reporters. George BELLOWS, who was a later pupil of Henri, won popular success from the start with his early *42 Kids* (1907) and was accepted as a typical expression of his time for his gusto, his crude vitality, his normality and his brash search for the monumental in the realm of the commonplace. His approach was opposite to that of Jerome Myers, who romanticized the street life of the poorer districts of New York.

In the manner of their revolt from the official art of the academies Henri and Stieglitz were at opposite poles. Henri represented the ideal of a popularist, socially-oriented national American art, Stieglitz that of a progressive *avant-garde* interested in the innovative movements from Europe. Stieglitz found Henri and his Ash-Can school artistically conventional and depressing, while Henri's democratic egalitarianism was blind to the aesthetic modernism which alone held appeal for Stieglitz. Henri made it possible for artists to reject academic taste and practice without embracing aesthetic modernism; Stieglitz made it his ambition not only to bring before a discriminating American public the best of contemporary creative art in Europe but also to offer a forum to those innovatory American artists who, finding American soil uncongenial to them, had hitherto emigrated to France and worked there. Stieglitz was a fine creative artist and innovator in his own medium; Henri was not. There was rivalry and incomprehension between them. In 1910 Stieglitz arranged his first collective show of modernist American artists to coincide with the exhibition of Independent Artists organized by Henri and his circle; both parties disparaged the other. These two trends in anti-official, non-academic art—the modernist *avant-garde* and the broad-based, socially-oriented nationalistic Realism—continued in American art more or less in opposition until the Second World War.

The next great event in the history of art in America was the famous ARMORY SHOW, whose effect in opening up awareness in the American continent of innovative trends in contemporary European art has been compared with the similar effect of Roger Fry's two Post-Impressionist exhibitions upon the British public. The Armory Show, which opened on 17 February 1913 in the vast Armory on Twenty-fifth Street and was subsequently shown at the Art Institute, Chicago, and in Boston, was a mammoth exhibition designed to present a comprehensive impression of current *avant-garde* movements abroad alongside what was most vital in contemporary American art. It has beeen called 'the most important event in the history of American modernism'. The reactions of the majority of the press and critics, and of the public, was similar to, though still more violent than, the reaction to the Post-Impressionist shows in Britain, ranging from indignant outrage through horror to mockery and contempt. But such reactions must not be judged out of their historical context. As Professor Sam Hunter wrote in his book *American Art of the 20th Century* (1973): 'The puritanical reaction of the American public to modern forms was no more intense than had been the inhospitable receptions of the French to advanced movements in art since Manet and the Impressionists. While we were less than prepared, at the popular level, for the impact of the Armory Show, the more sophisticated art public of France showed little more foresight or understanding before twentieth-century art forms, despite the succession of great artist-martyrs in the preceding century. Uninformed American opinion, however, was magnified by the growth of pressure groups which in the spirit of conformity refused to tolerate anti-establishment ideals. The values of the new art were based precisely on new expressions of individualism. They corresponded to the radical empiricism of contemporary science and to the adventurous spirit apparent in other areas of thought during the first two decades of the new century, conveying a new sense of enlightenment, emancipation, and hope in many spheres of human endeavour. But to the public these values became an intellectual corollary of socialism, anarchism and radical politics. The division between popular values and those of our best minds was more sharply accentuated as we entered upon the modern period of standardized mass culture.'

Although the American section of the exhibition, selected by Glackens, was three-quarters of

the total of 1,600 exhibits, it was the foreign contingent which usurped the interest and the publicity. There is little doubt that the exhibition had opened with high hopes on the part of many that it would vindicate native American art against all comers. In his opening speech the collector John Quinn said: 'The members of this Association have shown you that American artists—young American artists, that is—do not dread, and have no need to dread, the ideas or culture of Europe. They believe in the domain of art only the best should rule.' The effect of the exhibition, however, was to show that native American art by and large was not yet able to challenge European supremacy, as it was to do in the 1940s. In the words of the American writer Barbara Rose: 'If nothing else, the Armory Show established the hegemony of European art for another thirty years.' Glackens himself remarked with an air of disillusion: 'We have no innovators here. Everything worth while in our art is due to the influence of French art. We have not arrived at a national art . . .'

Nevertheless disillusion was not the keynote. The impact made by the show was positive as well as negative and in the long term its positive effects were paramount. Some artists who at this time were painting in a CUBIST manner reverted to naturalism by the end of the decade and devoted themselves to depicting the American regional scene. But many continued to experiment with the new styles upon American soil and from this time abstractionism became a strong and exciting force in American art. With the new vision that was opened up established values in the world of art were shaken: even many of the realists in Henri's circle were stimulated to pay more attention to the structural aspects of their work. From this time other galleries than the 291 of Stieglitz began to exhibit *avant-garde* art and the way was opened for innovative movements and techniques to strike root in American soil. Before long a superficial 'modernism' became a vogue and its influence was felt even in the practical and decorative arts. Although the public museums were unaffected, the impact of the Show on private collecting was a potent factor and the nucleus of several of the most famous American collections dates from this time. Through the efforts of such collectors as John Quinn, Dr. Albert Barnes, Walter Arensberg, Arthur Jerome Eddy and Lillie P. Bliss modern art became a permanent feature of American culture. The Bliss collection later became the nucleus of The Mus. of Modern Art when this was formed in 1929. The Eddy collection is now in the Chicago Institute of Art and the Arensberg collection, as also that of A. E. Gallatin, is in the Philadelphia Mus. of Art. The Phillips Memorial Gal., founded in 1918 with the collection of Duncan Phillips, was the first American public gallery devoted to contemporary art, and Katherine DREIER with her collection founded the SOCIÉTÉ ANONYME in 1920, which was the first modern art museum in America.

Later in 1913 the exhibition, already referred to, of the Synchromists Stanton Macdonald-Wright and Morgan Russell was put on by the Carroll Gal. and was ably championed by the journalist Willard Huntington Wright (better known as the popular detective-story writer S. S. Van Dine), brother of Macdonald-Wright. Huntington Wright's book *Modern Painting: Its Tendency and Meaning* (New York and London, 1915), published in the same year as Arthur J. Eddy's *Cubists and Post-Impressionists*, was a pioneer work on the interpretation of modernism in art. He argued, what is now a commonplace but then was revolutionary, that despite its superficial strangeness the *avant-garde* art of the 20th c. was simply emphasizing those qualities of rhythm, form and balanced construction in virtue of which the art of all ages is appraised. In 1916 Huntington-Wright with the support of the magazine *Forum*, for which he wrote a monthly art chronicle, organized the FORUM EXHIBITION of Modern American Painters, whose purpose was to isolate the modernist American painters from the rank and file in a carefully selected exhibition in order to demonstrate that they could stand up to their European counterparts. The 17 artists who took part were working under the influence of the Cubists, the FAUVES or the Synchromists. In the same year the Panama-Pacific exhibition in San Francisco first brought FUTURISM to America though John Marin and particularly Joseph STELLA had already adopted Futurist methods. At the same time the 'democratic' principle of Robert Henri came once more to the surface and in 1916 the SOCIETY OF INDEPENDENT ARTISTS was formed with William Glackens as its first President, followed the next year by John Sloan, to continue the work of the Association of American Painters and Sculptors, which had been dissolved after the Armory Show. The purpose of the society was to hold open annual exhibitions as a counterblast to those of the National Academy of Design. Although it continued to exhibit into the 1940s, its first exhibition, held in 1917, was the largest and most important with more than 2,000 entries from c. 1,000 artists. It was at this exhibition that Marcel DUCHAMP, a Vice-President of the society, submitted his famous urinal under the title *Fountain by R. Mutt* and resigned when it was rejected. His gesture was, indeed, a *reductio ad absurdum* of the 'democratic' principle in artistic matters.

By the end of the decade American Cubist painting which was derivative upon European Cubism had faded from the artistic scene, for all the artists represented in the Forum Exhibition had reverted to one or another form of naturalistic painting with the exception of O'Keeffe and Dove, both of whom continued to mature a highly personal form of abstraction. About 1920 several artists, including Maurer, Stella, Dove and John COVERT, experimented for a short while with COLLAGES which had more in common with the MERZ constructs of SCHWITTERS than with Synthetic Cubism. On the

other hand there emerged, and continued through the 1920s, a distinctively American form of Cubism which applied Cubist modes of abstraction to industrial scenes and ordinary everyday things, transforming them into lucid, hard-edged structures on the borderline of abstraction but without losing the recognizability of the object. Instead of the neutral objects, musical instruments and studio appurtenances used by the early European Cubists, artists such as Charles DEMUTH, Charles SHEELER and the so-called PRECISIONISTS—Morton SCHAMBERG, Ralston CRAWFORD, Niles Spencer (1893–1952), Preston DICKINSON, George C. AULT—motivated by a desire to create a more relevant national art, chose native American subjects and landscapes in terms of their adaptability for abstract design. Pictures typical of this tendency are *American Landscape* (The Mus. of Modern Art, New York, 1930) by Charles Sheeler, *Grain Elevators from the Bridge* (Whitney Mus. of American Art, 1942) by Ralston Crawford, *Erie Underpass* (The Metropolitan Mus. of Art, New York, 1949) by Niles Spencer, and *My Egypt* (Whitney Mus. of American Art, 1927) by Charles Demuth. It was characteristic of the artists of this school that they found machinery and the factory not only adapted to the lucid and simplified semi-geometrical patterns at which they aimed but also admirably suitable images to express the American machine age. Pictures which reflect the ambiguous and sometimes ironic attitude they adopted towards the machine are Schamberg's construction of a mitre-box and plumbing trap entitled *God* (Philadelphia Mus. of Art, c. 1918) and Demuth's picture of a factory entitled *Incense of a New Church* (Columbus Gal. of Fine Arts, 1921). In the work of these artists one may also see a certain shift from the complicated aesthetic doctrines of innovative European art to a more direct and even bare structuring of the unemphatic visual fact.

In the 1920s also there began to emerge another form of realism without Cubist overtones which was to dominate American painting through the 1930s and well on into the 1940s. The 1930s were the years in which America was rapidly changing from a predominantly rural and small-town community into a land of giant urban complexes and omnivorous industry. There was a nostalgia for the old simple American virtues, which were fast becoming obsolescent. After the wave of immigration which had followed the First World War regional differences were tending to disappear. Linked with a spirit of isolationism there had grown up a nostalgia for America's own past and with it a demand for an art which should record realistically and unpretentiously, albeit anachronistically, the simple American virtues of yore and the regional scenes and types which perhaps lived on more vividly in imagination than always in fact. It was an unromantic realism which presented its subject unglamorously and without deep emotional commitment except for an air of disenchantment and spiritual vacancy that clung to

the work of the outstanding masters. It was the counterpart in visual art of the novels of Sinclair Lewis and Sherwood Anderson. The new realists repudiated the *avant-garde* ideas which had been introduced to America by Stieglitz and his circle and later by the Armory Show as foreign degeneracy and an intellectual disease, regarding themselves as plain picture-makers rather than as artists in the aesthetic sense. As a result there grew up among critics and museum curators a dual standard of assessment, one based upon 'aesthetic' values for European art and a different standard based upon the expression of certain values of American ethos for American realist art. Writing about these realists under the name of 'romantic realists' (we think that '*unromantic*' is nearer to their intention), Professor Sam Hunter has said: 'The new romantic realists fashioned their paintings gracelessly and unaesthetically, working out of a clumsy artisan tradition and from sudden moments of vision. They lacked any profound sense of style. Pictorially, they were as limited, average and undistinguished as the humiliated landscape, broken-down architecture, and drab scenes they made the stock-in-trade of their subject matter. It was an underprivileged art that seemed disinclined to draw attention to itself; yet the least attractive aspects of American life were presented without apology.' While clearly apt, this description is not entirely fair. There is certainly sometimes, although not always, a deliberate clumsiness in their work and the gaucherie of the *faux naif*. But the work of the finest Regionalists strikes with a crushing if inexplicable impact, there is an overwhelming sense of 'presence' and one stands before a 'magic' realism, not necessarily based upon minutiae of detail, as vivid and as urgent as anything achieved by the SURREALISTS and without the aid of Surrealist fantasy or depth appeal. To secure this impact without fantasy or sentimentality is a mark of inborn artistic greatness.

These new realists, sometimes called Painters of the AMERICAN SCENE, consisted of two groups. The urban realists had their stronghold in the Art Students' League, of which John Sloan was made director in 1931. Their aim, actively promoted by two former students of Robert Henri, Kenneth Hayes MILLER and Yasuo KUNIYOSHI, was to renew and perpetuate the tradition of the Ash-Can school of realism. The Regionalists were unable to come to terms with the contemporary world of urban industrialization, rejected contemporary innovative means of artistic expression, and set themselves to record nostalgically the regionalism from which America was emerging. Led by Thomas Hart BENTON, the group included Edward HOPPER, Grant WOOD, Andrew WYETH, John Steuart CURRY, and on the fringe Charles BURCHFIELD and Ben SHAHN. The American Scene painters were criticized by innovative American artists on the ground that they were too restrictive: a national American art, they felt, could not be

firmly rooted simply by painting American subject matter, whether contemporary or anachronistic, unless contemporary means of artistic expression were deployed. Some idea of the spirit which pervaded the Regionalist school may be gathered from the following defence by Benton as its great popularity began to decline in the 1940s: 'The coteries of highbrows, of critics, college art professors and museum boys, the tastes of which had been thoroughly conditioned by the new esthetics of 20th Century Paris, had sustained themselves in various subsidised ivory towers, and kept their grip on the journals of esthetic opinion all during the 1930s. These coteries, highly verbal but not always notably intelligent or able to see through momentarily fashionable thought patterns, could never accommodate our popularist leanings. They had, as a matter of fact, vested interests in esthetic obscurity, in highfalutin symbolisms and devious and indistinct meanings. The entertainment of these obscurities, giving an appearance of superior discernment and extraordinary understanding, enabled them to milk the wealthy ladies who went in for art and the college and museum trustees of the country for the means of support. ... The intellectual aspects of art are not art, nor does a comprehension of them enable art to be made. It is in fact the over-intellectualisation of modern art and its separation from ordinary life intuitions which have permitted it ... to remain psychologically tied to the "public be damned" individualism of the last century and thus in spite of its novelties to represent a cultural lag.' It is ironic that this spirit prevailed on the verge of the emergence of a specifically American school of abstraction which at last lifted America to a position of world prominence in art and so brought to fruition what had been the ambition of American artists from the beginning of the century.

Arthur Dove and Georgia O'Keeffe were painting virtual abstractions from the 1920s. Stuart DAVIS began a series of abstract paintings in the manner of Synthetic Cubism in 1927, and during the 1930s his simplifications became increasingly abstract while he gave a peculiarly American flavour to his compositions. Burgoyne DILLER and Ilya BOLOTOWSKY were already painting geometrical abstracts in the 1930s. In sculpture David SMITH was influenced from 1933 both by the aesthetics of PICASSO and Julio GONZÁLEZ and by the NEO-PLASTICISM of MONDRIAN. Arshile GORKY's mural (1935–6) for the Administration Building, Newark Airport was a work of geometrical abstraction. And many of the artists who were later to become prominent in the NEW YORK SCHOOL of ABSTRACT EXPRESSIONISM were already experimenting with abstraction or near-abstraction in the 1930s. They included Jackson POLLOCK, Ad REINHARDT, Willem DE KOONING, Hans HOFMANN, etc. But before turning to Abstract Expressionism various other developments of the 1930s remain to be mentioned.

During the 1930s the FEDERAL ARTS PROJECT/ WPA, preceded by the Public Works Art Project, was set up with the twofold purpose of keeping America's artists employed during the years of the Depression and exploiting the artistic potential of the country for the embellishment of public buildings and places. The Federal Arts Project was linked with educational schemes and with the encouragement of free artistic expression. It furthered the democratization of art by bringing art to the people, brought artists together on collective projects, gave them a new professionalism in the eyes of the public and provided them with the opportunity and the materials with which to practise and perfect the skills of their craft. It encouraged a florescence of the art of muralism, in some cases linking up with the Muralists of Mexico— both OROZCO and RIVERA were working in the U.S.A. at this time. It is unfortunate that very few of the 1,200 or so murals commissioned during the lifetime of the Project have survived. Although much the greater part of the art produced under the Project was figurative, in principle no distinction was made between figurative and abstract art and this added strength to the minority movement which right through the 1930s continued to claim that abstract art need be no less 'American' than that of the Regionalists and that a truly national art could not be established simply by the choice of local subject matter without evolving appropriately new means of expression. The WPA was sufficiently broadly based to take in art from Social Realism to abstraction.

Many of the artists who were employed on the WPA project were committed, in their lives or in their art, to involvement in current social issues. Their belief that the artist should be committed, fully engaged in contemporary social problems, and that his art should become an integral part of society found expression in the Artists' Congress, formed in 1936 with the object of making propaganda against Fascism, social inequalities and economic depression. Its executive secretary was the abstract painter Stuart Davis and its first meeting was addressed by Lewis Mumford. The spirit of Social Realism as expressed in Raphael Soyer's statement that painting 'must describe and express people, their lives and times' infused much of the work of those Painters of the American Scene who devoted themselves to subject matter taken from the environment of urban industrialism. But there existed also other artists, to whom the term 'Social Realists' has sometimes been more specifically applied, who believed that their art should be turned into an instrument for social protest or reform. As they placarded and satirized social evils and injustices, the dehumanizing effect of industrialism, poverty, unemployment, etc., their pictures and murals had the same sort of spirit and purpose as campaign posters for programmes of reform. Best known among them was Ben Shahn. Others were Philip EVERGOOD, Jack LEVINE, William GROPPER and the black painter Jacob LAWRENCE. By and large the American Scene painters

perpetuated the Ash-Can tradition, recording the social scene objectively, whereas the propagandist school of Social Realists used their art as an instrument to enforce social reform and depended more upon the techniques of magazine illustration and caricature—though in saying this one must remember that a number of artists who occupied a central position in the Ash-Can school started as illustrators for the press and continued to earn their living in this way. Nor can any sharp line be drawn between the two classes of Social Realists. Some pictures by the American Scene painters such as Reginald MARSH and the brothers Soyer could be put in the category of social protest, some by Ben Shahn could be regarded as recordings of the social scene—without its slogan even his famous lithograph *The Welders*, done after the war for the C.I.O.'s Political Action Committee, could be so regarded—while Philip Evergood and Jack Levine often satirized the evils of city life in much the same way as Thomas Hart Benton. But in broad principle a distinction of attitude and intention existed.

Certain aspects of SURREALISM—the abstract rather than the political or erotic aspects—had already registered their impact in America before the group of Surrealist immigrants settled in New York during the early 1940s. Gorky, GUSTON, GOTTLIEB, BAZIOTES and Pollock were well versed in Surrealist aesthetics before the end of the 1930s. The allegorical religious paintings of Philip Evergood and Stephen Greene (1918–) had overtones of Surrealism, as had the mysterious paintings of Morris GRAVES, with their Oriental inspiration and personal symbolism, and some of the work of Edwin DICKINSON. There is a flavour of Surrealism also in some of the paintings of Peter BLUME, such as his *South of Scranton* (The Metropolitan Mus. of Art, New York, 1931) which won popular acclaim with the First Prize at the Carnegie International Competition in 1934. Ivan ALBRIGHT has been called a Surrealist, although his 'microscopic myopism' was in fact a veristic depiction of very deliberately arranged assemblages of real things. The Kafkaesque paintings of George TOOKER expressing the frustration, alienation and claustrophobic hopelessness of city life perhaps verge most closely upon the Surrealistic. In general however, American artists dealt with the fantastic or incongruous in the world of reality rather than the spontaneous subconscious imagery which was the main concern of the European Surrealists.

The Cubist-Realism of the 1920s and still more the paintings of the American Scene in the 1930s were not an advance upon the innovative European art which had been introduced by the Armory Show; rather they bespoke a recession towards an art with a broader basis of appeal but an appeal deriving primarily from its subject matter. Nevertheless *avant-garde* art persisted as a minority trend throughout these two decades. Arthur Dove and Georgia O'Keeffe continued to explore their personal modes of abstraction.

Younger artists continued the interest. The German-born Hans Hofmann, who had known the leaders of Fauvism and Cubism and had been principal of an important art school in Munich from 1915 to 1932, emigrated to the U.S.A. and opened his own school in New York in 1934 with a summer school at Provincetown. He taught, as he had taught in Munich, that the imitation of objective reality is 'not creation but dilettantism, or else a purely intellectual performance, scientific and sterile'. This coincides with the saying of the great American abstractionist Stuart Davis: 'The act of painting is not a duplication of experience, but the extension of experience on the plane of formal invention.' Hofmann also taught his theory ('push and pull') of a tension between the flat surface of the picture plane and the sense of depth evoked by the elements of colour and form which the painter disposes upon that surface. Josef ALBERS, who had been on the staff of the German BAUHAUS and who made a lifelong study of the interaction of colours, began to teach at the experimental Black Mountain College, North Carolina, in 1933. Both these had an influence on the younger American painters which it would be difficult to overestimate. The Armenian Arshile Gorky emigrated to the U.S.A. in 1920 at the age of 16 and came to New York in 1925. Absorbing and adapting to his own uses the various modes of Cubism, abstraction and Surrealism, he evolved a personal style which has been described as 'the first major American contribution to world art'. Willem de Kooning arrived in New York from Amsterdam in 1926 and Jackson Pollock from Wyoming in 1929. Through the 1930s Milton AVERY demonstrated the use of patterned zones of flat colour in the manner of the later MATISSE, influenced several of the contemporary artists and looked forward to ROTHKO and Gottlieb. The one artist who learned most from the Armory Show—he described it as 'the greatest shock to me—the greatest single influence I have experienced in my work'—who explored the whole range of abstraction and succeeded best in adapting it for the interpretation of the American spirit, was Stuart Davis. Davis wrote: '. . . all my pictures are referential [to the American scene]. They all have their originating impulse in the impact of the contemporary American environment.' He was influenced by Synthetic and decorative Cubism, was inspired by the colour of Matisse and the forms of LÉGER, but he made all his sources his own and gave to them all an American inflexion. It has been said of him that he was 'the first American artist to appropriate successfully the means of French art toward the end of making distinctively American pictures'. He was the most important link between the early phases of American *avant-garde* art and the efflorescence of post-war abstraction.

In 1936, the year in which Alfred H. Barr, Jr. organized the exhibition 'Cubism and Abstract Art' at The Mus. of Modern Art, New York, these various strands were focused together by the for-

mation of an association of AMERICAN ABSTRACT ARTISTS with the objects of making New York a centre of abstract art, holding annual exhibitions and disseminating the principles of abstract art by lectures, publications, etc. Some of the members were members of the Paris ABSTRACTION-CRÉATION group. Some inclined towards the abstraction of De STIJL, e.g. the Swiss-American Fritz GLARNER in *Relational Painting* (1946) and Burgoyne Diller in *Second Theme # 21* (1944-6). Some inclined to the post-Cubist style of PICASSO, e.g. Lee KRASNER and Carl HOLTY. Some, such as Ad Reinhardt and the Russian-born Ilya Bolotowsky were nearer to late Cubism or PURISM. Both Jean HÉLION and Fernand Léger visited the U.S.A. in the latter part of the 1930s and MONDRIAN settled there in 1940.

The abstract artists were supported by the painter-critic George L. K. Morris and by the painter and collector A. E. Gallatin, who had installed his Mus. of Living Art in New York University. In 1939 Solomon Guggenheim founded the Mus. of Non-Objective Art, which later became the Solomon R. Guggenheim Museum. The Mus. of Modern Art, which had been formed in 1929, moved to new premises in 1939; but in 1940 it was the subject of a public demonstration by the American Abstract Artists against its conservative policies. Despite these activities and support, abstract painting was very much in the background of popularity at the end of the decade. By the middle of the 1940s its cause had been won.

In the 1940s American painting came into its own and the centre of world art moved from Paris to New York. The decade is marked by no new influences or trends whose anticipations could not be observed in the 1930s, but a new synthesis and a new awareness emerged. The style known as Abstract Expressionism—although it was neither wholly abstract nor wholly Expressionist—became the first genuinely American movement in art to achieve world-wide recognition and importance. Helped by direct contacts with *émigré* leaders of the great European *avant-garde* movements, and inspired also no doubt by fellow-feeling for the critical world situation, American painting transcended its former provincialism and aesthetic isolationism in the aspiration towards a new universality. The European styles, on the other hand, which by the end of the 1930s were already showing signs of inanition, were stimulated to fresh life and vigour when transferred to American soil. The movements which played the most important role in the emergence of this new American art were SURREALISM and geometrical abstraction or CONSTRUCTIVISM, especially NEO-PLASTICISM and, rather later, SUPREMATISM. The influence of Surrealism was the more immediate, while the full impact of Constructivism manifested itself more gradually. From the mid 1940s there began a tendency, most natural in the circumstances, to emphasize the novelty of what was being done while attenuating its links with previous non-American traditions. Among the refugees who prepared the way for a

new efflorescence in the field of geometrical abstraction the most prominent was Piet Mondrian, who had had his followers in America from the early 1930s. Those influenced by Neo-Plasticism included Fritz Glarner, Burgoyne Diller, Ilya Bolotowsky, I. Rice PEREIRA and Harry HOLTZMAN. But it was a two-way interaction. Mondrian himself was influenced in the 1940s by the new environment and his latest paintings were characterized by a novel movement and liveliness which owed something to American boogie-woogie and the hectic street life of New York. Also influential in the field of geometrical or quasi-geometrical abstraction were the ex-Bauhaus artists MOHOLY-NAGY, GABO, Albers, FEININGER, ITTEN and the architects GROPIUS and Mies van der Rohe. OZENFANT transferred his school for the teaching of Purism from London to New York and Léger brought new life to the somewhat stereotyped versions of Cubism which were current in the 1930s. The strong Surrealist group included MATTÁ, who came to America in 1939, Salvador DALÍ, Max ERNST, André MASSON, Kurt SELIGMANN, Marc CHAGALL, Yves TANGUY, while the poet André BRETON held court in New York as he had previously done in Paris.

In the spring of 1942 an exhibition of 'Artists in Exile' was put on at the Matisse Gal., New York. The American Abstract Artists and the Federation of Modern Painters and Sculptors held exhibitions. But until 1947 the most important centre for the new manifestations in art was the Art of this Century Gal. opened by Peggy Guggenheim, who had married Max Ernst. There she not only showed her collection of works by innovative European artists but provided a forum for the emergent American art—Jackson Pollock became the star exhibitor at the gallery—and she made a special point of covering both the Surrealist and the abstract schools.

From Surrealism the American artists took over mainly the methods and theory of psychic improvisation and the use of free association in order to bring to the surface those hidden depths of imagery which also find expression in ancient mythology and primitive art. Many artists of this persuasion were, like Mattá, interested in the pre-Conquest art of the Amerindian peoples and some, such as Baziotes, Gottlieb, Rothko, Gorky, STAMOS, followed MIRÓ and Mattá in using organic or biomorphic shapes which well up undirected from the subconscious mind. By these means, and by the use of chance or STOCHASTIC techniques, they hoped to produce an art which would be a 'symbolic equivalent' for the universal emotions and the submerged primitivism which, according to the teaching of psychoanalysts, dominates human mentality below the level of conscious thought. In this way they believed that they could tap the universal fountain of creativity in their art. On the other hand the sensationalism, the sexual blatancy and the political extremism of European Surrealism failed to make much impression on

American Abstract Expressionism.

As the new painters grew in self-confidence their work became more heroic and monumental in scale while greater attention was paid to the sensuous qualities of the painting materials and to the techniques of their manipulation, less and less attention to representational content. It was argued that the painting process *was* the content. By the end of the decade it was possible to distinguish two distinct groups within what was loosely known as Abstract Expressionism, both groups in reaction against the Surrealist subject matter which had been accepted in the earlier years. De Kooning and Pollock were prominent in the group for whose work the critic Harold Rosenberg coined the term ACTION PAINTING in 1951. Like GESTURAL PAINTING in Europe, the activity of painting was regarded as an expression of the artist's emotions and moods, the art work being thought of as a revelatory record of process and performance rather than as finished product. Emphasis was placed upon spontaneity and impulse rather than deliberation and planned production. The other group, led by Barnett NEWMAN, Ad Reinhardt and Mark Rothko, painted in large areas of relatively undifferentiated colour. The work of Clyfford STILL, Franz KLINE and Robert MOTHERWELL fell between the two groups, being a highly personal amalgam of both.

The most important single influence in diverting the Surrealist trend away from symbolic figuration towards expressive abstraction was Jackson Pollock when in 1947 he began to use commercial and aluminium pigments and with his 'drip' technique converted AUTOMATISM into a method of pure abstraction. Although Mark TOBEY was working with an Orientally-inspired 'all-over' space at an earlier date, to Pollock was mainly due the 'ALL-OVER' style of composition which was continued, among many others, by Cy TWOMBLY and whose wider implications remained of lasting importance in the following decades. By eliminating enclosed images and centres of interest within the boundaries of a painting this style destroyed the very concept of 'relational' composition which had been central to all earlier tradition and upon which even Mondrian had insisted. For if there are no centres of interest within the work, there can be no relations among them, no composition in the traditional sense of the word, but the whole painting becomes the unit of attention. A similar result was achieved by the monochromatic or near-monochromatic paintings of Newman and Reinhardt, which also helped to lay the basis for the concept of 'holistic' or 'non-relational' art later insisted upon by the MINIMAL artists, Robert MORRIS, Donald JUDD, Frank STELLA, etc. With his 'drip' paintings Pollock also did away with the distinction between figure and ground and with it the conception of 'virtual' or illusory three-dimensional space, however shallow, which the Cubists had maintained. The 'staining' technique which he adopted in the early 1950s was taken over by Helen FRANKENTHALER and

Morris LOUIS as the technical basis for the school of COLOUR FIELD painting, which exploits colour as a pure perceptual phenomenon. To Newman is traced the idea, which became important in the later abstract styles, of integrating the internal structure of the painting with the framing edge so that a single image occupies the whole area of the canvas and the painting becomes a single uniformly articulated field.

In connection with the progressive abandonment of figurative and symbolic content a school was founded with the name 'The Subject of the Artist' and held open lectures and meetings led by Baziotes, Rothko, Motherwell, Newman and others. It was argued that every true painting must have its subject and that in the absence of representational content the painting process itself is the subject. Against the background of existentialist philosophy, the artists were also alert to the need for emotional 'meaning' in their works. From this school grew up the Artists' Club, formed as a discussion group in 1949. But however keenly aware these artists were of the importance and novelty of what they were doing, recognition was slow in coming—a fact which doubtless had its effect indirectly in causing them to exaggerate even more the narrowly national character of their innovations and the radicalness of their breach with European tradition. In 1951 a group of artists calling themselves 'The Irascible Eighteen' picketed The Metropolitan Mus. demanding the formation of a department of American Art, and an exhibition 'Ninth Street Show' was organized by the Artists' Club. By the mid 1950s, however, Abstract Expressionism had won international acclaim and in 1958-9 an exhibition 'New American Painting' toured Europe.

In the early 1950s a new wave of artists adopted Abstract Expressionist methods, including Philip GUSTON, Conrad MARCA-RELLI, James BROOKS, Bradley Walker TOMLIN, Lee Krasner, Jack Tworkov, Ad Reinhardt, Grace HARTIGAN, Adja YUNKERS, Hedda STERNE, Esteban VICENTE. But by the mid 1950s the original impetus of the movement had to a large extent spent itself and reaction was in the ascendant. In 1965 the work of the Abstract Expressionists was exhibited retrospectively at the Los Angeles County Mus. under the title 'New York School'. It had already become part of American art history.

The reaction from Abstract Expressionism—or the new advance, for it had both aspects according to how one looks at it—took two main paths. One was manifested in POP ART, also called NEO-DADA, leading on to what came to be known as the New Humanism. The other declared itself in various new modes of abstraction actuated generally by a different spirit from Abstract Expressionism. The names COLOUR FIELD PAINTING and HARD EDGE PAINTING were given and they came to be known collectively as POST-PAINTERLY ABSTRACTION after an exhibition organized by the critic Clement Greenberg at the Los Angeles County Mus. in

1964. Although different in spirit, these new modes of abstraction took over and developed certain features from the painting of Jackson Pollock and Barnett Newman. They were not entirely new or unanticipated. In 1951 Robert RAUSCHENBERG, for example, exhibited five adjacent panels of canvas uniformly covered with white house paint and from 1954 Ad Reinhardt was exhibiting invisibly structured monochromatic black canvases.

The new abstraction was fundamentally opposed to the 'autobiographical', self-revelatory character of Abstract Expressionism as typified especially in the work of de Kooning. In turning towards an objective, impersonal approach these artists were on common ground with a much wider, international aesthetic outlook which manifested itself among other things in the French 'New Wave' novel of Alain Robbe-Grillet and Nathalie Sarraute and in certain of the teachings of John Cage. Because of their distaste for subjective emotionalism they were opposed to the painterly facture and expressive brush-stroke of de Kooning and others of the Abstract Expressionists. They were not only sceptical as to the possibility of communicating subjective feeling by abstract, non-representational means but the whole idea of using painting as a vehicle for the communication of personal emotion was abhorrent to their outlook. Their aim, therefore, was to eliminate the tactile and illusory aspects of pigment colour, exploiting only the expressive power of purely optical colour.

COLOUR FIELD PAINTING. Taking over the method used in 1951 by Jackson Pollock of allowing pigment to soak directly into raw, unprimed canvas, Helen Frankenthaler evolved a lyrical use of colour as a purely optical phenomenon without illusory contrast of figure–ground and without establishing foreground and background. The staining and pouring technique eliminated those painterly, tactile surface modulations which had been previously used to convey personalized emotions. Her work made a strong impression on Kenneth NOLAND and Morris Louis and after adopting this technique Louis took the presentation of pure optical colour further than ever before. From the dematerialization of colour achieved by Louis the 'dematerialization of the art object' became the aim of his successors, as in the monochromatic spray paintings of Jules OLITSKI with their purely optical colour haze, the vibrant elliptical dots of Larry POONS on saturated colour fields and the curved colour discs of Robert IRWIN.

HARD EDGE. Like Morris Louis, Kenneth Noland was influenced by Helen Frankenthaler's painting to a new use of colour although his work was more structured than that of Louis. He also derived from Newman the use of the shaped canvas, particularly the chevron and the target and in the 1960s the longitudinal format with parallel horizontal stripes of colour, and based the internal structure upon the shape of the canvas. The term 'Hard Edge' was applied particularly to

the work of Ellsworth KELLY and Al HELD. Others who worked in this manner were Leon Polk SMITH, Sven LUKIN, Gene DAVIS, Tom DOWNING, Howard MEHRING, Paul FEELEY, Charles HINMAN, Raymond PARKER. The most general features of the style were an impersonal facture instead of the expressive brush-stroke which had been favoured by one group of Abstract Expressionists, and insistence on the purely optical aspects of colour with the elimination of 'tactile' qualities. The image was located on the surface of the canvas not behind the surface, the distinction between foreground and background disappeared and the image/ground distinction was either eliminated or rendered ambiguous. Enclosed images were large and sharply defined, often being incomplete *Gestalten* which called for completion outside the area of the canvas by the observer. Colour was not used as a vehicle for the communication of personal emotion but as a purely optical experience. There was a preference for juxtaposition of colours at a high degree of intensity and saturation and for contrasting close-valued colours in such a way as to exploit after-images across their borders and subliminal colour effects.

Hallucinatory and marginal optical effects were exploited by some of the younger artists such as Richard ANUSZKIEWICZ, Nicholas KRUSHENICK and Mon Levinson and in 1965 The Mus. of Modern Art, New York, staged an exhibition 'The Responsive Eye' devoted to this kind of work. But in general OP ART featured less in the mainstream of American painting than by its contributions to the space-distorting three-dimensional structures executed by Minimal artists who exploited new man-made materials.

Along with the repudiation of symbolic, emotional and all non-visual meanings and the use of the shaped canvas to determine internal structure, Post-Painterly Abstraction also shared in the new aesthetic outlook of the 1960s a dislike for 'virtual' qualities in what used to be called the 'picture image'. This was clearly manifested in the attempt, most fully and dogmatically declared in Minimal art, to present the physical materials of the art work exactly as they are with no apparent or 'virtual' properties which they do not possess outside the art work. These various tendencies culminated in the 'deductive structures' of Frank Stella, who was also influenced in certain respects by Jasper JOHNS. Similar tendencies were apparent in the work of Charles Hinman, Ron Davis and the cool, unemotional abstraction of Walter Darby BANNARD, Larry ZOX, Robert Irwin, Edward AVEDISIAN, Robert HUOT and others.

POP ART was also the manifestation of a reaction from the subjective and idealistic inspiration of Abstract Expressionism. It was as objective, as extroverted and as impersonal in its attitudes as Post-Painterly Abstraction and displayed in addition a positive attitude of irreverence for the traditional standards of fine art, symbolized in Rauschenberg's erasure of a drawing by de

Kooning. Despite its close link with the mass media and the repeatedly asseverated claim to bridge the gap between art and common life, Pop art originated from the same artistic milieu as Abstract Expressionism and was directed towards the same sort of public. It was not in fact a popular art and its widespread publicity relied mainly upon sensational features. Pop art took its subject matter and its imagery from contemporary commercial and advertisement art, the comic strip and the popular press, the blatancy of the billboard; and by its solemnly ironical reproductions of everyday brand goods and the sex idols of the commercial cinema it placarded the spiritual vacuity of an aesthetically bankrupt mass culture. Larry RIVERS, Robert Rauschenberg and others took over the expressive brush-stroke of Action Painting, but this too was mechanized and depersonalized into a standard stereotype so that instead of an expressive gestural language it became a coolly objective caricature. In certain works of Roy LICHTENSTEIN a single brush-stroke meticulously reproduced becomes the sole content of the work.

The origins of American Pop art have sometimes been traced to DADA and Marcel Duchamp through John Cage, with whom both Rauschenberg and Jasper Johns, a precursor, were connected. In its concern with the commonplace and banal it also had roots in the paintings of the American Scene in the 1930s. Its debunking of traditional conceptions of fine art and its elevation of the triviality and vulgarity of contemporary mass culture into material for art were shared with the British Pop art which had preceded it. None the less American Pop art was a genuine manifestation of the spirit which prevailed in the 1960s and led on to many of the most characteristic developments in the art of the following decade. From the point of view of art history its most significant feature was the high level of craftsmanship and design which, particularly in the work of Jasper Johns and Roy Lichtenstein, was concealed beneath the surface vulgarity or triviality.

Larry Rivers began by taking as his subject matter the debased pictorial clichés of American patriotic folklore and combined them with the brushwork of Action Painting reduced to a depersonalized formula. And after exhibiting his bare white panels in 1951 followed by the all-black paintings in which expressive modulation was conferred upon the surface by crushed newspaper, etc., Rauschenberg began to build up his canvases with waste materials and refuse, rags and tatters, fragments of newspaper illustrations, old nails, pieces of rope, etc. in the manner of SCHWITTERS. By bringing to life the refuse and trash of urban civilization as material for aesthetic constructions American Pop art anticipated such European movements as ARTE POVERA and echoed certain features of the JUNK ART of Richard STANKIEWICZ, John CHAMBERLAIN, Robert MALLARY, etc. The third and perhaps the most important of the precursors of Pop art was Jasper Johns, who com-

bined distinguished craftsmanship and supreme excellence of design with banality of subject matter. His *Flags* were characteristically ambiguous. Actually they *were* flags because a flag is nothing more than a specific design and in these paintings the flag-design occupied the whole area of the painting. Yet functionally they were not flags to be waved but in their craftsmanship and in the manipulation of paint they had the qualities of fine paintings. In a similar way Roy Lichtenstein's paintings were not straight representations of people and things but representations (or replicas) of the shoddy representations in popular comics, posters and advertisement art. His subject matter was contemporary kitsch in all its vulgarity and banality. Hence his art *was* kitsch, vulgar and banal. But it was deliberately and knowingly so from the point of view of one who knew what was artistically better and it was executed with a superb technique and often with a hidden excellence of composition which removed it entirely from the realm of the kitsch. A similar aesthetic ambiguity was inherent in Claes OLDENBURG's replicas of common foodstuffs blown up to monumental proportions, in the road signs and mechanical facial types of Robert INDIANA, and in the sex symbols, traffic signs and commercial images of Tom WESSELMANN and James ROSENQUIST. Jim DINE, who emerged to prominence in the 1960s, associated the painterly techniques of Action Painting with the realistic reproduction of a large repertory of commonplace consumer goods. Andy WARHOL, who early achieved international renown, celebrated the vacuous uniformity of mass-controlled mentality by his serial compositions of mass-produced brand articles and stereotyped cinema beauties. Others who are classified with the Pop movement are Wayne THIEBAUD, Mel RAMOS, Frank GALLO and Allan D'ARCANGELO. The 'boxes' of Joseph CORNELL, George BRECHT and Lucas SAMARAS combined features falling into the general category of Pop with a certain romanticized Victorian nostalgia, although Cornell was influenced by the Surrealism of the 1940s and 1950s. Closely related to the impulses by which Pop was actuated were the groups and assemblages of MARISOL, Edward KIENHOLZ, Red GROOMS and William KING. From the intellectual milieu of Pop also stemmed the concepts of performance and ENVIRONMENT art and the art of the HAPPENING propounded in 1958 by Allan KAPROW, together with the deliberate repudiation of the ideals of permanence and craftsmanship which had hitherto always been associated with fine art.

Inspired by no less intensity of creative fervour, the American renaissance in sculpture emerged somewhat later than in painting. The death of Gaston LACHAISE in 1935 left America with no major native sculptor. Alexander CALDER kept the Constructivist idea alive through the 1930s and onwards, but his background was mainly European, combining the impact made upon him by Mondrian with his innovations in KINETICISM. His

truly monumental stabiles date from the 1960s. Reubén NAKIAN, who exercised an important influence on the newer sculpture, was a technically accomplished traditionalist until the 1940s. The originator of the new style of welded metal sculpture, which lay at the heart of the sculptural renaissance, was David SMITH, who began to work in this style during the latter 1940s after having been employed on war work during the early part of the decade. The more intractable materials and the lengthy and laborious processes of metal welding seem poorly adapted to the impulsive and improvisatory character of the techniques of Surrealist automatism which had been taken over by Abstract Expressionism. Nevertheless the fantasy and rhythmical calligraphic quality of Smith's openwork 'drawings in space' had much in common with the gestural expressiveness of the Abstract Expressionist painters. His masterpieces in this style are considered to be *Cathedral* (1950), *Blackburn—Song of an Irish Blacksmith* (1950) and *Hudson River Landscape* (1951). Other sculptors whose work in the 1950s had a similar quality of gestural expressiveness and apparent spontaneity were David HARE, Herbert FERBER, Seymour LIPTON, who all incorporated Surrealist imagery, Ibram LASSAW and Theodore ROSZAK. The more baroque moulded forms of Nakian have been likened to the apparently spontaneous casualness of de Kooning.

Other sculptors outside the new welded metal school were working in ways more closely linked to geometrical Constructivism, although still with pronounced personal overtones. Such were Richard LIPPOLD, José de RIVERA, whose geometrical constructions were industrially manufactured, Edward HIGGINS, Gabriel KOHN. Supreme in this manner also were the more geometrical and monumental works of David Smith from the late 1950s and the 1960s, such as his *Zig* series and his *Cubi*, when together with the British sculptor Anthony CARO he seemed to move closer to the spirit of the Post-Painterly Abstraction of Kenneth Noland. There was also some influence from GIACOMETTI in the late 1950s and early 1960s. The 1960s was a decade of radical innovations which broke through the traditional barriers between painting and sculpture and led far outside the traditional notions of what sculpture is.

JUNK SCULPTURE and ASSEMBLAGE. David Smith had incorporated machine parts in his Expressionist sculpture. Robert Rauschenberg incorporated junk and waste materials in his 'combine' paintings from the mid 1950s and Robert Mallary embodied sand, wood, textiles, etc. in his pigmented surfaces. But the systematic employment of broken and discarded industrial material, the debris and refuse of modern urban life, which led the critic Lawrence Alloway to coin the term 'Junk Art' was characteristic of a Californian school of which Richard Stankiewicz, John Chamberlain and Lee BONTECOU were the chief representatives. The movement had two main motivations. On the one hand there was a desire, shared with much of Pop art, to debunk the idea that only certain special and valuable materials are worthy of 'fine' art, and on the other hand an inverted romanticism underlay the desire to 'rescue' for artistic purposes the refuse and rejects of everyday life. Similar motivations were later to be found in European *Arte Povera.*

There is no clear-cut distinction between Junk art and the art of Assemblage since the junk artists did in fact often 'assemble' waste materials into expressive constructions. The term 'assemblage' is often used, however, of artists who assembled or combined unusual artistic materials into three-dimensional sculptural conformations for expressive purposes. In reaction against the welded metal sculpture which was considered to be an analogue of Abstract Expressionism in painting, but nevertheless working with expressive ends, they may be considered to be a second generation of expressively abstract sculptors. Artists who fall within this broad category, although very different in their individual manners of working, were Louise NEVELSON (who also did carved wooden 'environments' in the 1950s), Mark di SUVERO (although his predilection for old wooden beams, etc. brings him close to the Junk artists), H. C. WESTERMANN, Peter AGOSTINI. The 'boxes' of Cornell, Brecht and Samaras have a clear affinity with the sculpture for which Nevelson is best known and might also arguably be classed as art of assemblage. Many of the sculptors who practised assemblage were closely linked to the spirit of Pop art and one should distinguish assemblage in the Pop tradition from the Junk art style which relied on arousing nostalgia for discarded materials, although the line of distinction is a fine one. Another branch of Assemblage may be distinguished as the tableaux produced by artists such as Bruce CONNER and Paul THEK, whose predilection for the horrific and the bizarre brought them, with Edward Kienholz, into the category of FUNK ART.

The terms 'assemblage', 'situation', 'environment', 'tableaux', etc. are very loosely used for purposes of classification and have different applications with different writers. Whatever classification is used, it will be found that the work of any one artist comes within several categories. Here 'assemblage' has been used to cover works constructed from several materials and also tableaux where diverse objects are assembled, in a box or otherwise, for simultaneous display. Assemblages may come within the categories of Pop art, Expressionist art, Junk art or Funk art. They may be abstract or realistic. The term 'situation' will here be used also in a sense covering tableaux consisting of one or more persons and objects presented in an expressive situation. The best-known creators of situations in this sense were Edward Kienholz and George SEGAL. Kienholz's use of diverse materials, including real objects such as automobiles, beds, etc., together with constructed objects, and his emphasis upon

the horrific and macabre brought him within the ambit of Assemblage and Funk art. Segal restricted himself in the main to plaster casts of persons and things, the emotional impact of the work deriving from the situation created. More than that of any other sculptor his work expressed the spirit of Existentialism and the feeling of spiritual isolation which is often linked with it.

ENVIRONMENT. The word 'environment' is commonly used in a dual sense and will be so used here. It is used ɔ ˋ art which operates in such a way as to modify the environment in which it is set, such as the ensembles of George SUGARMAN and some of the sculpture of Louise Nevelson, Tony Smith and Ronald Bladen. In this sense it has affinities both with Assemblage and with Minimal art. It is also used to cover those situations which are created to envelop the spectator, affecting his total orientation, and in this sense it has affinities with the Happening.

Many of the artists who worked with light created such enveloping environments and much of the art of LUMINISM was therefore a form of environmental art. Artists who experimented in this mode were CHRYSSA, Dan FLAVIN, Keith Sonnier, Lucas Samaras.

From the mid 1960s the deliberate desire to 'dematerialize' the art work grew apace until finally the work of art as such disappeared. The 'Happening' is unprogrammed theatre of a special kind and might equally be classed as an art of performance. The 'Environment' became a complicated multi-sensational situation which enveloped the observer with stimuli affecting and often disorienting several or all the senses. EARTHWORKS or Land art, instead of planning a work of art to fit a site, turned the site itself into the art work. BODY ART operated with the artist's own body, sometimes in almost complete disregard for the observer. CONCEPTUAL art, finally, aspired to retain the *concept* of a specific work of art while repudiating the embodiment of the concept in visible and material form. These various manifestations of the tendency to 'dematerialize' had their counterparts in Europe, Britain, Japan, etc. and became international. They are described under the relevant headings. At the same time there persisted in the U.S.A. new movements in figurative art, often in a manner of PHOTOGRAPHIC REALISM. (See also MINIMAL ART.)

UNIT ONE. A group of British artists formed in 1933. The original members of the group were: the sculptors Henry MOORE and Barbara HEPWORTH; the painters Edward WADSWORTH, Ben NICHOLSON, Paul NASH, Frances HODGKINS, Edward BURRA, John BIGGE and John ARMSTRONG; and the architects Wells Coates and Colin Lucas. Frances Hodgkins subsequently resigned from the group and her place was taken by Tristram HILLIER. The group held one exhibition, in 1933, and a book, *Unit One. The Modern Movement in English Architecture, Painting and Sculpture*, edited by Herbert Read, was published in 1934. The group had its headquarters at the Mayor Gal., Cork Street, London, and its secretary was Douglas Cooper.

As stated by the editor in his Introduction, the group 'arose almost spontaneously among a few artists well-known to each other, out of a consciousness of their mutual sympathies and common necessities'. They had no common doctrine or programme which could be expressed in manifestos like those of the SURREALISTS or the FUTURISTS or VORTICISTS. In the words of Paul Nash: 'Unit One may be said to stand for the expression of a truly contemporary spirit, for that thing which is recognized as peculiarly *of today* in painting, sculpture and architecture.' And Herbert Read added: 'What it is can never, in fact, be defined.' Despite its short life the group made a considerable impact on British art of the 1930s.

URCULO, EDUARDO. See SPAIN.

URQUHART, TONY. See CANADA.

URSULA (URSULA BLUHM, 1921–). German painter, born at Mittenwalde. She began to paint in 1950 and worked frequently in Paris, where she was 'discovered' by Jean DUBUFFET and included in his collection of ART BRUT. She combined some of the characteristics of NAÏVE art with a personal manner of SURREALISM and her inventions ranged from the demonic to fairy-tale fantasy. Her work was widely exhibited in Germany and France and was included in most important international exhibitions of Surrealist and fantastic art.

URTEAGA, MARIO (1875–1957). Peruvian NAÏVE painter, born in Cajamarca. Little or nothing is known about his life. In 1937 his work won first prize at an international competition in Vino del Mar, Chile, and he was honoured by the Institute for Contemporary Art, Lima, in 1955. He painted ceremonies and scenes from his native land, reproducing the intense light of the Altiplano in a mixture of clear and sombre colours with realism, pathos and occasional humour but without ostentation or exaggeration. His picture *The Burial of an Illustrious Man* (1936), depicting a typical funeral procession of Quechua Indians and cholos, was acquired by The Mus. of Modern Art, New York.

URTEIL, ANDREAS (1913–63). Yugoslav-Austrian sculptor born at Gakavo, Yugoslavia, studied at the Vienna Academy under WOTRUBA, 1953 9. He was one of the most gifted of the younger generation of sculptors who followed Wotruba. He worked in wood, stone and bronze and gradually freed his figures from their stiff, frozen poses, combining abstraction with the suggestion of dynamic movement and life. He had a retrospective exhibition at the Vienna Mus. des 20. Jahrhunderts in 1963.

USAMI, KEIJI (1940–). Japanese painter and lumino-kinetic artist (see LUMINISM; KINETIC ART), born in Osaka, self-taught as a painter. At his first exhibition, in the Minami Gal., Tokyo, in 1963, he showed monochromatic white canvases delicately modulated with almost invisible marks. From 1965 he worked with combinations from cut-outs of human figures. Afterwards he took an interest in the use of laser for aesthetic purposes and was a pioneer among artists who were conducting audio-visual laser research, showing a 'laser light-object' in his exhibition 'Laser-Beam Joint' at Tokyo in 1968 and at the Jewish Mus., New York in 1969.

U.S.S.R. See RUSSIA AND THE U.S.S.R.

UTRILLO, MAURICE (1883–1955). Natural son of Suzanne VALADON, he was given the name by which he is known by the Spanish art critic Miguel Utrillo. He was unruly and addicted to alcohol from his schooldays, underwent a cure for alcoholism at the asylum of Sainte-Anne in 1900 and from 1912 spent periods of varying length in hospitals and institutions. He began to paint in 1902 under pressure from his mother, who hoped that this would have a remedial value, and between 1902 and 1904 he produced some 150 paintings of considerable originality without formal training. He continued to paint, giving away his canvases for a song in order to obtain money for drink. He first exhibited at the Salon d'Automne in 1909 and his first one-man exhibition, at the Gal. Eugène Blot, was in 1913. Gradually his work began to be known to critics and connoisseurs, he was commissioned by Diaghilev to do the décor and costumes for the ballet *Barabau*, and from 1919 exhibitions multiplied, his fame grew, prices rose and fakes began to be circulated under his name. In 1928 he was made Chevalier de la Légion d'honneur. He painted mainly urban landscapes. The 'white period' of urban snow-scenes by which he is best known was between 1908 and 1914.

Utrillo has been spoken of as a 'primitive'. But in fact, although he was without formal training, his sense of composition was highly sophisticated and his works have little or nothing of the characteristic features of NAÏVE art. He had a natural and instinctive but very exact feeling for the relation and values of tones and he spontaneously created a sense of atmosphere, although he often painted from coloured postcards. After *c*. 1912 his colours began to grow more lively and from 1916 his work became more realistic although it lost much of its specific charm. His major work was done between 1904 and 1915. In 1935 he married Lucie Pauweis (*née* Valore), widow of a Belgian banker, and she cared for him and managed his affairs, for the demand for his earlier pictures was constantly increasing and their value growing. In 1950 he represented France at the Venice Biennale. Although Utrillo contributed nothing to the *avant-garde* movements of contemporary art, he was a natural painter of outstanding originality who depicted in an indescribable way the solitude and emotional emptiness of the urban scene.

V

VACCHI, SERGIO (1925–). Italian painter, born at Castenaso, Bologna, and studied at Bologna and Rome. In the 1950s he was noted for an individualistic style of ART INFORMEL with SURREALIST overtones.

VAILLANCOURT, ARMAND. See CANADA.

VALADON, SUZANNE (1865–1938). Born at Bessines, Haute-Vienne, Marie-Clementine Valadon, later called Suzanne, became an acrobat in a Parisian circus at the age of fifteen. Forced to abandon her circus career because of a fall, she frequented the studios of Montmartre and was a model for Puvis de Chavannes, Renoir, Toulouse-Lautrec and Degas. In 1883 she gave birth to a son, afterwards known as the artist UTRILLO. She had a talent for drawing and was encouraged particularly by Degas, in whose studio she practised engraving. In 1894 she showed five drawings at the Salon of the Société Nationale des Beaux-Arts. About 1909 she took up painting and exhibited at the Salon d'Automne, of which she was made a member in 1920. Her reputation as an artist became established and her work was frequently exhibited in France and abroad. Valadon was a 'natural' artist who owed little to formal training or to the artists with whom she associated, although she claimed to have been influenced by the decorative style of the NABIS, whose works she saw at the Exposition Universelle of 1889. Her forte lay in the representation of female nudes, whom she chose for solidity rather than beauty or grace, though she also painted portraits and still lifes. Her work is valued for its keen observation and for the vigour and spontaneity of her drawing.

VALDÉS, MANUEL. See EQUIPO CRÓNICA.

VALDIVIESO, ANTONIO R. See SPAIN.

VALENTI, ITALO. See CORRENTE.

VALLOTTON, FÉLIX (1865–1925). Swiss-French painter and graphic artist born at Lausanne. He went to Paris in 1882 and attended the Académie Julian, where he met DENIS, BONNARD, VUILLARD and others, joining with them in the formation of the NABIS in 1890. Following an exhibition of Japanese prints at the École des Beaux-Arts in 1890, he began to make his own collection of Japanese prints during the 1890s and their influence is apparent in the economy of his drawing.

From 1893 he exhibited at the Salon des Indépendants and in 1903 at the first Salon d'Automne, adopting a manner of cool realism in opposition to the FAUVES. He began to do woodcuts c. 1890 and together with such artists as Gauguin and MUNCH he was in part responsible for the revival of woodcut techniques which took place in the early years of this century. His influence is apparent in the work of the BRÜCKE. A touring exhibition of about 120 of his works was organized by the Arts Council of Great Britain together with the Swiss Pro Helvetia Foundation in 1977.

VALORI PLASTICI. An art journal founded in Rome by Mario Brogli in November 1918. It continued until 1921. The first number contained articles by CHIRICO, CARRÀ and SAVINIO setting forth the aesthetics of the METAPHYSICAL School. Later, as Chirico turned against *avant-garde* movements, it became the chief organ of classical reaction. In both these aspects it exercised a considerable influence outside Italy. Inside Italy it was one of the few organs which under the Fascist regime brought information about current European trends to the notice of the Italian public. One of the numbers in 1919 was devoted to the work of the CUBISTS and articles also appeared on the De STIJL artists. The main tenor of this journal, however, supported by Chirico and Carrà, was in favour of a return to the Italian classical tradition of naturalism and fine craftsmanship, while European *avant-garde* movements were criticized for forsaking the principles of that tradition.

VALTAT, LOUIS (1869–1952). French painter born at Dieppe. After a classical education at Versailles he studied under Gustave MOREAU at the École des Beaux-Arts from 1887 and then at the Académie Julian. He first exhibited at the Salon des Indépendants in 1889 and from 1903 at the Salon d'Automne. He met MAILLOL at Collioure in 1894 and lived in the south of France until 1914, knowing Renoir and Signac. In 1900 he was given a contract by the dealer VOLLARD. From 1914 he lived in retirement in the valley of the Chevreuse but maintained a prolific output until he lost his sight in 1948. Valtat's earliest paintings were in DIVISIONIST style, but he spontaneously anticipated the FAUVIST manner as in his *Apple Trees* (1896) and *The Fisherman* (1902), and the canvases which he exhibited in 1903 at the Salon d'Automne were ahead of Fauvism and helped towards the foundation of that movement. Even as early as

1. Mario Sironi: *The Rider*, 1922. Oil on canvas.

2. Ardengo Soffici: *Tuscan Hill, Florence*, 1925. Oil on canvas.

3. Giorgio Morandi: *Still Life*, 1946. Oil on canvas. 37 × 46 cm.

4. Alberto Burri: *Sacking with Red*, 1954. Acrylic and mixed media on canvas. 86 × 100 cm.

5. Lucio Fontana: *Spatial Concept 'Attessa'*, 1967. Red canvas. 180 × 140 cm.

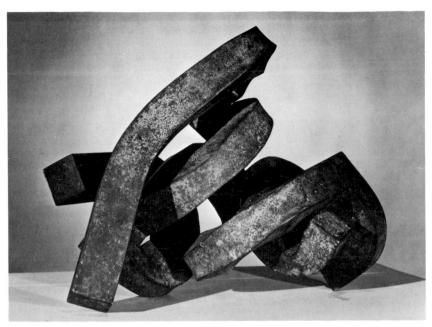

6. Eduardo Chillida: *Modulation of Space I*, 1963. Iron.
55 × 70 × 40 cm.

7. Julio González: *Angel*, 1933.

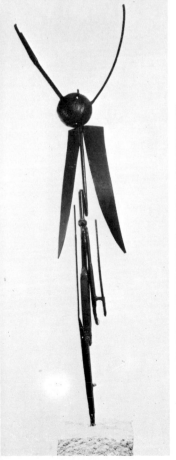

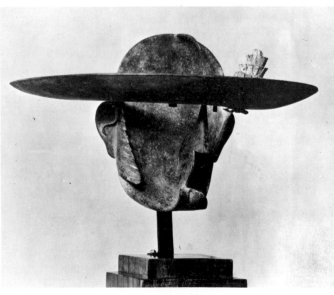

8. Pablo Gargallo: *Picador*, 1928. Wrought iron. 24 × 34 cm.

9. Antoni Tàpies: *Ochre Gris LXX*, 1958. Oil on canvas. 260 × 194 cm.

10. Juan Genovés: *Grouping*, 1966. Oil on canvas. 130 × 120 cm.

11. José Clemente Orozco: *Zapatistas*, 1931. Oil on canvas. 114 × 132 cm.

12. Diego Rivera: *All Souls Day*. Detail from a mural.

13. David Alfaro Siqueiros: *The Guardian of the Peace*, 1950.
Oil on canvas. 51 × 41 cm.

14. Rufino Tamayo: *Torso*, 1978. Oil on canvas.
79 × 95 cm.

15. James Wilson Morrice: *Return from School*, 1900–3. Oil on canvas. 46 × 74 cm.

16. Lawren S. Harris: *Maligne Lake, Jasper Park*, 1924. Oil on canvas. 122 × 152 cm.

17. Jock Macdonald: *Fleeting Breath*, 1959. Oil on canvas. 122 × 150 cm.

18. Emily Carr: *Forest, British Columbia,* c. 1932. Oil on canvas. 130 × 91 cm.

19. Jack Bush: *Dazzle Red*, 1965. Oil on canvas. 206 × 264 cm.

20. Paul-Emile Borduas: *The Seagull*, 1956. Oil on canvas. 146 × 113 cm.

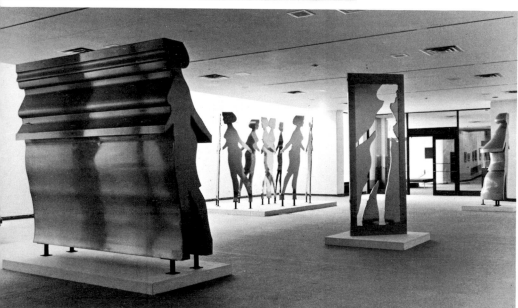

21. Michael Snow: *Walking Women*, 1967. Stainless steel and wood, 11 component parts. Height 229 cm.

22 (*above left*). William Dobell:
Dame Mary Gilmore, 1957. Oil on
hardboard. 91 × 74 cm.

23 (*above right*). John Olsen:
Journey into You Beaut Country,
1961. Oil on board. 153 × 102 cm.

24. Fred Williams: *Landscape with Goose*, 1974. Oil on canvas. 183 × 153 cm.

25 (*above left*). Russell Drysdale:
Moody's Pub, undated. Oil on wood.
51 × 62 cm.

26 (*above right*). Noel Counihan: *At the
Start of the March, 1932*, 1944. Oil on
hardboard. 66 × 58 cm.

27 (*left*). Arthur Boyd: *The Hunter
(Aboriginal Head on a Horse with
Soldier)*, 1959. Oil and tempera on
board. 133 × 105 cm.

28 (*below*). Godfrey Miller: *Figure
Group*, 1950–8. Oil on canvas.
66 × 99 cm.

29. Sidney Nolan: *Kelly and Figure*, 1964. Oil on board. 22 × 152 cm.

30. Walter Battiss: *Symbols of Life*.

31. Alexis Preller: *Angel King*.

32. Henri Rousseau: *The Snake Charmer*, 1907. Oil on canvas. 165 × 186 cm.

33. Louis Vivin: *Les Halles and the Church of St. Eustace*. Oil on canvas. 48 × 64 cm.

34. Séraphine Louis: *The Tree of Paradise*, 1929. Oil on canvas. 195 × 129 cm.

35. Alfred Wallis: *St. Ives*, *c*. 1928. Oil and drawing in crayon on board. 28 × 38 cm.

36. L. S. Lowry: *Waiting for the Shop to Open*, 1943. Oil on canvas. 43 × 53 cm.

37. Morris Hirshfield: *Girl in a Mirror*, 1940. Oil on canvas. 102 × 56 cm.

38. Grandma Moses: *The Mailman Has Gone*, 1949. Oil on canvas. 43 × 55 cm.

39. Ivan Generalić: *Landscape*. Oil on canvas.

40. Ivan Rabuzin: *On the Hills, Virgin Wood*, 1960. Oil on canvas. 69 × 116 cm.

1895 he was employing pure colours in a manner which the Fauves only took up later. He was not formally a member of the Fauvist group but may be described as a natural Fauve. While most of the Fauves abandoned the style after a few years, Valtat continued to explore and mature the use of pure colours throughout his life. Particularly in his landscapes he applied his pigment in large circular sweeping strokes which lent vigour and energy to them, an effect which became even stronger after about 1920. Valtat was a dedicated painter whose œuvre comprised landscapes, still lifes, figure studies, portraits and flower pieces. Though remaining outside movements and groups he made an important contribution to the growth of contemporary art.

VAN DEN BERGHE, FRITS. See BERGHE, Frits van den.

VANDERCAM, SERGE (1924–). Danish painter and sculptor, born in Copenhagen. He began work as a photographer and was self-taught as a painter. He lived near Brussels and was associated with the JEUNE PEINTURE BELGE group. His earliest paintings were violently expressive ART INFORMEL colour abstractions but towards the end of the 1950s he was painting quieter and more subdued canvases in the manner of LYRICAL ABSTRACTION. In the 1960s he practised a vigorously expressive form of figural painting, exemplified in a series on the theme *Homme de Tollund*, and his work tended to become increasingly naturalistic. He showed his first terracottas in 1959 and later produced ceramics.

VAN DOESBURG, THEO. See DOESBURG, Theo van.

VAN GINDERTAEL, ÉMILE. See MILO, Jean.

VAN HASSELT, WILLEM (1882–1963). Dutch-French painter, born in Rotterdam. After studying at the École des Beaux-Arts, Rotterdam, and in London, he settled in Paris in 1903. From 1923 he became known through one-man exhibitions and in 1937 he won a Gold Medal at the Exposition Universelle. He was elected a member of the Institut in 1935 and President of the Académie des Beaux-Arts in 1951. He painted landscapes and interiors in a Late-Impressionist style of great refinement.

VANNI, SAMUEL (1908–). Finnish painter, studied at the Drawing School of the Finnish Arts Association and under AALTONEN, Helsinki, and then at the Académie Julian, Paris. He exhibited much in Europe, including the Venice Biennale of 1966, and in Finland, where he was a pioneer and leader of geometrical abstraction, particularly those forms of it which verge on OP ART. His election to membership of the Finnish Academy in 1964 may be considered a symbol of the acclim-

atization of this type of art in Finland. His public works include murals for the Workers' Education Centre and the Post Office Savings Bank, Helsinki.

VANTONGERLOO, GEORGES (1886–1965). Belgian sculptor and painter born at Antwerp. He studied painting and sculpture there and in Brussels. After being wounded in the First World War he made his way to the Netherlands, where he was interned from 1914 to 1918. During this time he was in contact with MONDRIAN, Van DOESBURG and Barth van der LECK and together with them made it his endeavour to evolve new plastic concepts in keeping with the needs of the modern world, becoming one of the most active as well as one of the youngest members of the group on the foundation of the journal *De* STIJL in 1917. In 1919 he went to live at Menton and in 1927 he settled in Paris, where he remained until his death. In 1931 he was made Vice-President of the ABSTRACTION-CRÉATION association when the centre of abstraction in art moved to Paris. He knew Ellsworth KELLY during the years 1948 to 1954 when the latter was evolving in Paris what later became his HARD EDGE style.

Vantongerloo was a pioneer of the mathematical approach to abstract art and in his early years was perhaps the most radical artist of his day in the application of this method. He rejected the central idea of Mondrian's NEO-PLASTICISM that only constructions based upon the right angle and orthogonals reflect the universal harmony of nature, believing that this is only one way among many whereby it is possible to achieve the systems of harmonious relations which embody spiritual values corresponding to a basic human need. Up to *c*. 1930 his constructions resembled projections into three dimensions of the flat planes favoured by Mondrian and Van Doesburg and he painted canvases of classical perfection within the restrictions of Neo-Plasticism though more strictly mathematically based. Afterwards he experimented in his paintings and constructions with a personal style based on the functions of curves and spirals set against straight lines. Following strange wire constructions of the 1940s he produced in the 1950s objects in plexiglass, self-penetrating and transparent, which created their own spatial colour. With these objects he claimed to reveal the 'immeasurable' or aesthetic qualities which reflect the hidden and ineffable splendour of the universe. Vantongerloo's views were set forth in his two publications *L'art et son avenir* (Antwerp, 1924) and *Painting, sculptures, reflections* (New York, 1948).

VAQUERO TURCIOS, JOAQUÍN. See SPAIN.

VARISO, GRAZIA. See GRUPPO T.

VARLEY, FRED. See CANADA.

VARLIN (WILLI GUGGENHEIM, 1900–77). Swiss painter born in Zürich. After training as a

lithographer he studied painting in Berlin. His style was EXPRESSIONIST, but closer to the French Expressionism of SOUTINE than to German Expressionism. Among his favourite subjects were hospitals, barracks and offices. From *c*. 1922 he lived and worked at Cros de Cagnes in the Alpes Maritimes.

VASARELY, JEAN-PIERRE. See YVARAL.

VASARELY, VICTOR (1908–). Hungarian-French painter, born at Pecs. After beginning medical studies in Budapest, he went first to the Podolini-Volkmann Academy and then in 1929 joined the 'Mühely' Academy of Alexander Bortnyk, called the 'Budapest Bauhaus'. There MOHOLY-NAGY was among his teachers and he was introduced to the work of CONSTRUCTIVISTS such as MALEVICH, MONDRIAN and also KANDINSKY, GROPIUS, etc. He settled in Paris in 1930 and devoted himself to graphic work, turning to painting in 1943. It was *c*. 1947 that he adopted the method of geometrical abstraction for which he is best known. He was a member of the group associated with the Gal. Denise René from its foundation in 1944, and was associated with the Salon de Mai, the Salon des Surindépendants and the SALON DES RÉALITÉS NOUVELLES. He was energetic in contributing to the development of the GROUPE DE RECHERCHE D'ART VISUEL (GRAV). At the beginning his painting was influenced by the work of HERBIN, a debt which he acknowledged. But he laid particular and increasing emphasis upon visual ambiguities of the sort which were cultivated later by OP ART and he is generally regarded as the main originator and one of the most successful practitioners of Op art.

From *c*. 1955 Vasarely wrote a number of manifestos, which became a primary record of the use of optical phenomena for artistic purposes and were a main influence, together with his painting, on younger artists in this field. In his own work, which he called 'cinétisme', he explored the means and methods of creating a hallucinatory impression of movement through visual ambiguity, using for this purpose alternating positive–negative shapes interrupted in such a way as to suggest secondary shapes which are not realized. The aim of such art is not beauty or aesthetic experience in the usual sense but intense visual experience through perceptual discomfort.

From the late 1940s Vasarely exhibited both in Paris and in most European countries and America. He achieved a world-wide reputation as perhaps the leading artist in his field. In 1964 he won the Guggenheim Prize, New York, in 1965 the First Prize at the São Paulo Bienale and in 1967 the Foreign Ministers' Prize at the Tokyo Biennale. His works are represented in most of the important public collections throughout the world. Vasarely believed that an artist is a 'workman' who makes prototypes which can be reproduced at will. He was fascinated by the idea of movement

and experimented with KINETIC ART as well as Op art. He also collaborated with architects in such works as his relief in aluminium for Caracas University (1954), and the French Pavilion at 'Expo '67' in Montreal.

Vasarely opened his own museum at Gordes in 1970 and in 1976 designed a Foundation near Jas-de-Bouffon in Aix-en-Provence consisting of 6 hexagonal buildings 87 m long. Seven large rooms 8 m high were covered with polychromatic geometrical shapes, uniting external and internal 'landscape' in a 'polychrome city of delight'.

VASSILIEFF, DANILA (1898–1958). Australian painter and sculptor, born near Rostov on Don. He entered a military academy in 1909 and fought as a Lieutenant-Colonel in the First World War and with the White Army. In 1921 he was captured and imprisoned by the Red Army, but escaped to Persia. From there he made his way to China and in 1923 arrived in Australia, where he worked as a railway contractor near Darwin. Here, without previous formal training, he began painting. From 1930 to 1932 he lived and painted in Brazil; from 1932 to 1934 he travelled and worked in South America and the West Indies.

Vassilieff exhibited in London in 1934 and 1935. In 1936 he arrived in Sydney and held an exhibition at the Macquarie Gals. A year later he settled in Melbourne, living at first in the inner-city suburb of Fitzroy, which provided him with the subjects of many of his paintings, and later at Eltham. His work was executed in a free, linear arabesque, by means of which he sought to capture the immediacy of life as he found it. In 1950 he began carving in Lilydale limestone and created work of unusual distinction. The importance of Vassilieff's introduction of EXPRESSIONIST methods to Melbourne was recognized by Arthur BOYD, Albert TUCKER and John PERCEVAL.

VAUGHAN, KEITH (1912–77). British painter, born at Selsey Hill, Sussex. During the 1930s he worked for an advertising agency, painting in his spare time, and was largely self-taught as a painter. He remained outside the main current of British painting until the latter half of the 1940s, when he became a friend of John MINTON and Graham SUTHERLAND and was influenced by them. He had his first one-man show in 1944 and from 1946 he taught at Camberwell School of Arts and Crafts. During the 1950s his style became flatter and more abstract in the manner of de STAEL. In 1954 he designed an abstract ceramic mural for Corby New Town, Northamptonshire, and in 1958 he obtained the 'Design of the Year' award for woven fabrics. He was Resident Painter at the State University, Iowa, in 1969 and in the same year joined the staff of the Slade School. In 1963 he was commissioned by the London County Council to do a mural for the Aboyne Road Estate and in 1964 he was awarded an Honorary Fellowship at the Royal College of Art. He had

retrospective exhibitions at the Mappin Gal., Sheffield, in 1969 and at the University of York in 1970. An exhibition of recent paintings at the Waddington Gals. in 1976 combined a gift for fantasy in paintings based on the poems of Rimbaud and Baudelaire with near-geometrical abstractions reflecting landscape mood.

VAUGHAN, PHILIP (1945–). British painter and sculptor, born in Dorset. He studied architecture at Cambridge University and then art at the Hornsey College of Art, 1965–6, and at the Chelsea School of Art, 1966–9. In 1969–72 he designed and made the Neon Tower on the Hayward Gal., London, with the technical collaboration of Roger Dainton. He held a research assistantship in kinetics at the Newcastle Polytechnic, 1970–2, and subsequently worked as a part-time lecturer there. Vaughan specialized in the KINETIC uses of coloured neon light for aesthetic purposes.

VAUTIER, BEN. See HAPPENING.

VECCHI, GABRIELE DE. See GRUPPO T; ITALY.

VEČENAJ, IVAN (1920–). Yugoslav naïve painter, born in the Croatian village of Gola, near Hlebine (see NAÏVE ART). He was of peasant stock and lived the life of a peasant, working on the land. He began to paint c. 1943 and started to use oil colours in 1954, painting both on canvas and behind glass. He became affiliated with the Hlebine school and is considered the outstanding figure among the second generation of painters in that school. Like other members of the school he painted scenes from village life and still lifes of fruit and flowers against a landscape background. His most original works were his pictures of biblical themes, and his *Moses* (1965), his *Suffering Job* (1965) and his *John the Apostle* (1969) made a powerful impression on critics in many countries where they were seen. They have a restless, tortured quality reminiscent of Callot, in the tangled and storm-tossed branches of trees as well as the postures of the figures, and at times achieve a hallucinatory impact which is reminiscent of the SURREALISM of DALÍ. This dramatic violence, seen also in some of his portrait studies such as the *Old Peasant* (1965), contrasts with the monumental stability of the still lifes. In all his pictures, even the most violently dramatic, there are details of background or subsidiary animal figures which retain the childlike simplicity of a fairy-tale world. From the mid 1950s Ivan Večenaj exhibited in many countries of Europe and in the U.S.A. His reputation among the naïve painters of the world is high.

VEČENAJ, STJEPAN (1928–). Yugoslav NAÏVE painter, younger brother of the foregoing, born in Gola. He started painting in 1957 and was also a member of the Hlebine school. He first exhibited in 1962 and from that time showed in many countries of Europe and widely in the U.S.A., including New York, Chicago, Washington, Philadelphia, Pittsburgh and San Francisco. He painted village scenes, working in oils on canvas and behind glass.

VEDOVA, EMILIO (1919–). Italian painter born in Venice. He had no formal training as an artist but painted from an early age and began to exhibit in 1936. He was strongly opposed to the Fascist regime, took part in movements for Liberation and was a member of the CORRENTE association. In 1946 he was a member of the FRONTE NUOVO DELLE ARTI and he was one of the GRUPPO DEGLI OTTO PITTORI ITALIANI formed in 1952. He had one-man shows in most of the main centres of Italy and also in Munich, New York and South America. After passing through phases of EXPRESSIONISM and CUBISM he achieved a style which had the violent improvisatory character of ART INFORMEL under the influence of WOLS. Partly no doubt because of his political convictions critics have seen in his abstract work an expression of a passionate impulse for freedom and claustrophobic dread of oppression.

VEGA, JORGE DE LA. See LATIN AMERICA.

VELASQUEZ, ANTONIO J. (1908–). NAÏVE painter born in Caridad, Honduras. He was first a telegraph worker and then a barber in the Pan American School of Agriculture near Tegucigalpa and was Mayor of the village of San Antonio de Oriente. He took up painting in 1933 and did landscapes and scenes from his village, working with the typical naïve attention to detail and in rich but unsubtle colours. He had his first one-man exhibition in Washington and he was represented in the exhibition of '20th Century Latin American Naive Art' at La Jolla, California, in 1964 and in many international exhibitions of naïve art.

VELDE, BRAM VAN (1895–1981). Dutch painter born at Zoeterwoude, near Leyden, brother of the painter Geer van VELDE. In 1907 he was apprenticed to a house painter and interior decorator at The Hague and was sent by him to Worpswede in 1922 to complete his training and from there to Paris in 1925. Apart from a short period in Majorca between 1932 and 1936, he lived in Paris until 1965, when he moved to Switzerland and settled in Geneva.

At Worpswede Van Velde learned to paint in an EXPRESSIONIST manner and his work remained Expressionist in spirit throughout his career. On his arrival in Paris he adopted a FAUVIST palette, painting landscapes and flower pieces in vividly expressive colours, and later strengthening his composition by the incorporation of formal simplifications from the CUBIST school. But even before 1930 the subject of his paintings would often recede and virtually disappear behind the flecks and lines of colour, and these early works

have therefore been regarded as heralding the abstract style which he developed in the late 1930s. By 1945, after the interval caused by the Second World War, he had matured a highly personal style of expressive abstraction, no longer giving titles to his paintings. He had one-man shows at the Salon de Mai in 1946, at the Gal. Maeght in 1952, at the Gal. Warren in 1955, and a major exhibition at the Knoedler Gal., New York, in 1968. His abstracts consisted of vaguely defined, almost formless shapes of colour often marked by broad but flaccid outlines and expressive but apparently purposeless brush-strokes standing out from a monochrome background, usually of blue. The imposed shapes, as it were by their very fluidity of form, obstinately trigger off suggestions of figures, faces, masks, objects, but just as pertinaciously frustrate identification and, it has been said, appear intended to demonstrate the futility of all endeavour for precision. The colour is subdued, fluid, thin, transparent and appears to be floating without substance. The pictures were slowly and carefully worked in order to convey the impression of careless spontaneity and their very real beauty and sensitivity is deliberately hidden behind an appearance of makeshift casualness. Of all abstract paintings these works have been held to embody most completely the spirit of Existentialism and it was no doubt for this reason that they were particularly valued by Samuel Beckett. A representative collection of Van Velde's works is in the Art and History Mus., Geneva.

VELDE, GEER VAN (1898–1977). Dutch painter born at Lisse, brother of Bram van VELDE, self-taught as a painter. He went to Paris in 1925 and lived there continuously apart from the war years, which he spent in Cagnes-sur-Mer. He exhibited at the Salon des Indépendants in 1926 and 1930 and also contributed to the Salon d'Automne, the Salon des Tuileries and the Salon de Mai. His first one-man show in London was at the Guggenheim, Jun. Gal. in 1938 and in 1948 he exhibited at the Kootz Gal., New York, with his brother. He had one-man shows at the Gal. Maeght, Paris, in 1946 and 1952. He is best known for his expressive abstracts painted in light, translucent colours, often based upon delicate shades of blue. His compositions were more geometrical than those of his brother but behind the semi-geometrical shapes and lines there appear to lie hidden suggestions of unidentifiable still lifes or interiors. His work has been compared with that of Jacques VILLON; but instead of the areas of contrasting colour employed by Villon, Van Velde generally managed to give to his paintings an over-all unity of tone as a background to his delicate modulations.

VELDE, HENRY VAN DE (1863–1957). Belgian painter born at Antwerp. He was a Neo-Impressionist and from 1901 he taught at the Academy of Art, Weimar. From 1892 he also devoted himself to furniture design and interior decoration and he founded a Seminar of Applied Art at Weimar, 1902–14. During the First World War he lived in Brussels and Switzerland, then in 1926 became Professor of the History of Architecture in the University of Ghent and founded a School of Applied Art at Ghent. His publications included *Zum Neuen Stil* (Munich, 1955, with bibliography of his writings) and the autobiographical *Geschichte meines Lebens* (Munich, 1962).

VELIČKOVIĆ, VLADIMIR (1925–). Yugoslav painter and architect born in Belgrade. After studying architecture in Belgrade he worked for a while in 1962–3 under HEGEDUŠIĆ at Zagreb. Influenced by SURREALISM he painted fantastic still lifes and interiors, which later developed into monumental apocalyptic compositions, usually in grisaille, which combined EXPRESSIONISM with illusionistic realism.

VENARD, CLAUDE (1913–). French painter born at Paris of a Burgundian mercantile family. He had little or no formal training apart from evening classes in applied art between 1928 and 1933. He travelled widely during the 1930s in Belgium and the Netherlands, Morocco and Algeria. He was a member of the group FORCES NOUVELLES, which in opposition to abstractionist tendencies made it their aim to revive the tradition of expressive naturalism. Venard was an artist for whom painting was the very breath of life and although his work remained always representational, he was constantly searching for new means of formal expression. During the late 1940s and 1950s stylization of his subject became increasingly vigorous and dynamic and his colour more vivid. Besides the main Paris Salons he exhibited at the Gal. Charpentier in 1959.

VENTO, JOSÉ. See SPAIN.

VERHEYEN, JEF (1932–). Belgian painter born in Iteghem, studied at the Academy and Institute of Fine Arts, Antwerp, 1948–52. In 1958 he published a manifesto announcing a new system of *Essentialisme*, akin to COLOUR FIELD PAINTING, which repudiated the use of contrasting colour schemes and advocated the importance of experiencing 'existential colours'. In 1960 he became a founding member of a new Flemish school which advocated the elimination or dematerialization of the picture surface in favour of experiencing 'pure' monochromatic colour.

VERISM. An extreme form of Realism in which the artist makes it his aim to reproduce the exact appearance of an object with minute attention to detail, repudiating idealization and imaginative abstraction. The term was applied, for example, to the most realistic Roman portrait sculpture. In modern times it has been applied to the MAGIC REALISM of some SURREALISTIC painters and to some forms of PHOTOGRAPHIC REALISM.

VERONESI, LUIGI (1908–). Italian painter born at Milan and studied in Milan and Paris. He was a CONSTRUCTIVIST in style and was a founding member of the ABSTRACTION-CRÉATION association. He was one of the pioneers of geometrical abstraction in Italy. From 1953 he exhibited at the Gal. del Millione and he also made abstract films and designed abstract theatrical sets.

VER SACRUM. The finest of the Vienna ART NOUVEAU periodicals, the organ of the Vienna SECESSION, published 1898–1903. It was not so much a record of decorative art and architecture as a miscellany of literature, illustration and graphic work.

VERSTER, ANDREW. See SOUTH AFRICA.

VESHCH/GEGENSTAND/OBJET. A tri-lingual (Russian, German, French) periodical founded in Berlin by El LISSITZKY and Ilya Ehrenburg in 1922 with the object of publicizing Russian CONSTRUCTIVISM in the rest of Europe. Lissitzky modified for a European audience the doctrinaire rejection of non-utilitarian art by Soviet Constructivism. In the initial editorial he wrote: 'We have called our review *Objet* because for us art means the creation of new "objects". . . . But no one should imagine in consequence that by objects we mean expressly functional objects. Obviously we consider that functional objects turned out in factories—aeroplanes and motor cars—are also products of genuine art. Yet we have no wish to confine artistic creation to these functional objects.'

VESNIN, LEONID ALEKSANDROVICH (1880–1933), VIKTOR ALEKSANDROVICH (1882–1950) and ALEKSANDR ALEKSANDROVICH (1883–1959), brothers. Architects and designers who collaborated on many projects in Russia and the Soviet Union. Before 1917 they supported the traditions of Russian Classicism although they also maintained an interest in industrial and commercial construction, as for the Dynamo Store in Moscow (1917). Until *c.* 1923 they tended to work independently (Leonid on housing, Viktor on industrial complexes, Aleksandr on volumetrical and planar experiments—which brought him into close contact with EXTER, POPOVA, RODCHENKO and other members of the Russian *avant-garde*, especially within the framework of INKHUK). From 1923 to 1933 they worked as a group, supported CONSTRUCTIVISM and functionalism, and were co-founders of OSA (*Obedinenie sovremennykh arkhitektorov*—Association of Contemporary Architects) in 1925 (Aleksandr became chairman). In the late 1920s they worked on important projects such as the Lenin Library, Moscow, House-Communes for Stalingrad and Kuznets, Palace of Soviets, Moscow, etc. With the censure of Constructivism in the 1930s and with the death of Leonid the Vesnin brothers reduced their architectural practice considerably.

VÉZELAY, PAULE (1893–). French-British painter, born in southern England. She was a talented and versatile artist, doing painting, drawing, sculpture, COLLAGES and engraving. She also turned her hand to book illustration and fabric designing. Educated in England, she spent the years 1926 to 1939 in Paris, returning to London in 1939. Her first exhibition was at the Dorian Leigh Gal., London, in 1921. She turned to abstract painting *c.* 1928 and developed a fresh and charming manner of quasi-geometrical abstraction, avoiding the extremes of ART INFORMEL and TACHISM. She joined the ABSTRACTION-CRÉATION association in 1934, was on the committee of the SALON DES RÉALITÉS NOUVELLES and in 1957 became President of a British branch of GROUPE ESPACE. She exhibited at the Gal. Jeanne Bucher and the Gal. Colette Allendy, Paris, and at the Lefevre and Gimpel Fils Gals., London. She was also represented at the Salon des Surindépendants and in international exhibitions of abstract art. Combined with an almost childish impression of simplicity her work had elegance, charm and purity.

VIANI, ALBERTO (1906–). Italian sculptor born at Quistello, Mantua, and studied at the Academy of Art, Venice, where he was a pupil of Arturo MARTINI. He was a member of the FRONTE NUOVO in 1946. After having worked under the influence of Martini in a classical and somewhat archaizing style, he turned to abstraction and worked with simplified volumes in the manner of BRANCUSI. He worked mainly in polished marble and retained in his abstract work the elegance and technical finish which had been characteristic.

VIBRISME. See RIJ-ROUSSEAU, Jeanne.

VICENTE, ESTEBAN (1906–). Spanish-American painter, born at Segovia. After studying at the Real Academia de Bellas Artes de San Fernando, Madrid, he lived in Paris, 1927–32, and went to the U.S.A. in 1936. His first one-man exhibition was at the Kleemann Gal., New York, in 1937. In the 1950s he came to prominence as a member of the second wave of ABSTRACT EXPRESSIONISTS. His teaching posts included Black Mountain College and the universities of California, New York and Yale and he was Artist in Residence at Princeton University from 1965. His works were included in a number of important exhibitions of current American art during the 1950s and 1960s.

VICTORIA, SALVADOR (1929–). Spanish painter born at Rubielos de Mora, Teruel, studied at the Valencia School of Fine Art and in Madrid. He was awarded a scholarship by the Ministry of National Education in 1956, a stipend by the Juan March Foundation in 1964 and the Foundation's

scholarship to study abroad in 1967. He spent several years in Paris, where he studied contemporary modes of abstraction. His own style in the early 1970s evidenced a measured and balanced abstraction, expressive but verging towards the geometrical. He used subtly varied distinctions of hue for co-ordinating the movement of his forms, and towards the end of the 1970s he began to introduce an idiosyncratic method of COLLAGE into some of his canvases. His work is represented in several public collections in Spain and in the Brooklyn Mus., New York.

VIDAL, JOSÉ SOLER. See SPAIN.

VIDAL, MIGUEL ÁNGEL. See LATIN AMERICA.

VIEIRA DA SILVA, MARIA ELENA (1908–). Portuguese-French painter, born in Lisbon. She went to Paris in 1928 and studied first sculpture with DESPIAU and BOURDELLE, then painting with FRIESZ and LÉGER and engraving with HAYTER. In 1930 she married the Hungarian painter Arpad SZENÈS. She first came to notice *c.* 1936 with curious pictures consisting of flecks of colour against a neutral or greyish background suggesting landscapes reduced to linear and geometrical forms and giving the impression of space without recourse to traditional devices of perspective. Her work had something in common with that of BISSIÈRE, whose pupil for a time she was. But her use of upright bundles of lines and her shooting and spiky linear organization were her own. She passed the years 1940 to 1947 in Brazil, where her reputation grew. Returning to Paris after the Second World War, she rapidly came to the fore as one of the most gifted painters in the style of expressive abstraction within the ÉCOLE DE PARIS, exhibiting at the Salon de Mai, the Gal. Loeb and in many foreign capitals. She obtained a prize at the São Paulo Bienale in 1953 and at the Carnegie International in 1958. From 1948 she exhibited frequently in New York and London and her work is represented in most important public collections. She became a French citizen in 1956.

VIGELAND, GUSTAV (1869–1943). Norwegian sculptor born in Mandal. He studied sculpture at Oslo and Copenhagen, and later (1892–5) in Paris and Italy. He worked for a few months with Rodin, whose style he perpetuated. His great technical proficiency, both in bronze and in granite, was employed in the service of monumental realism. Little known outside Norway, he devoted more than forty years of his life to the sculptural groups, more than 150 in number, of Frogner Park, Oslo, a project which, with a Vigeland Mus. annexed, was financed by the city. These allegorical groups, with their muddled and unclear symbolism, bludgeon the senses by their colossal magnitude while overwhelming with the monotonous tastelessness of their inapposite realism. Critics have differed in their verdicts. Jean Selz in his *Modern Sculpture* (English trans. 1963) wrote: 'I remember my stupefaction as I entered the huge park (its sculpture is more abundant than its shrubbery) and came upon a swarm of human bodies. Men, women and babies are detached in small groups or bunched together in fantastic clusters, gesticulating madly. Some of them seem about to turn somersaults. All are frozen in a convulsion of stone and bronze. They line the sides of staircases or railings, disappear into mazes, revolve upon the *Wheel of Life*, clamber up a gigantic fountain, or submerge themselves in the inextricable tangle which forms the centrepiece of this strange spectacle: *The Monolith*, a 97-foot [29·5 m] obelisk covered with a hundred or more figures who look quite annoyed at having to hold such uncomfortable poses. Vigeland was not really devoid of ideas. Some were wild enough to have qualified him as a surrealist, had they been differently expressed, but he had no style of his own. For want of it, his ambitious undertaking remains a literary project of very dubious quality. It does not touch us.' But the English sculptor and critic Herbert Maryon in his *Modern Sculpture* (1933) judged Vigeland's achievement to be greater than that of Rodin, 'fuller in its observation of life, deeper and wider in the thought enshrined, and fitter in its design and treatment of material'. He quotes with approval a remark attributed to the Indian poet Rabindranath Tagore: 'You told me this was the greatest thing in Norway: you did not tell me that it was the greatest thing in Europe.' Perhaps the most precise comment is that of G. H. Hamilton in *Painting and Sculpture in Europe, 1880 to 1940*: 'The megalomaniac scope of Vigeland's achievement, however unsympathetic to contemporary taste and tangential to the history of modern sculpture, is a memorable episode in the history of Symbolism. Were its quality only better, the fountain of the Frogner Park might, for its size, allegorical intricacy, and for the artist's life-long dedication to his ideal, be described as sculptural Wagnerism.'

VILCASAS, JOAN. See SPAIN.

VILLA, EDUARDO (1920–). South African sculptor. Born in Bergamo, Italy, he studied there and in Milan and Rome. He went to South Africa in 1947 and lived from that time in Johannesburg. From the 1950s he distinguished himself by his work in metal, producing abstract and semi-abstract forms often large in scale. His sculptures had no obvious identification with the well-known bronzes of traditional Africa, nor with the wooden carvings that so strongly influenced artists of the CUBIST period in Europe. Nevertheless there was an African flavour to his work. Although this was largely mechanistic, he cannot be included among CONSTRUCTIVIST sculptors. The works were certainly ASSEMBLAGES, but the parts were not engineers' shapes and once assembled they asserted a strange sense of growth, almost like that of plant

life. Latterly he used the characteristic highly polished flanges and metal sheets in compositions which had some affinity with the work of the generation of sculptors which followed Anthony CARO in Britain. Actually, however, it is difficult to see any direct influence in Villa's work, which followed a growth cycle of its own.

VILLACÍS, ANIBAL (1927–). Ecuadorian painter born in Ambato. Villacís began painting early without formal training. From the age of 16 onwards he taught arts and crafts in elementary and high schools in his home town. At the age of 21 he won a fellowship to study in Europe and between 1953 and 1956 spent one year in Paris and two in Madrid, where he studied at the Academia de San Fernando. After that he settled again in Ecuador but returned to Europe on several later occasions and also travelled to Brazil, Colombia, Venezuela and the U.S.A. In the 1950s his work combined figurative with abstract elements generally with highly textured surfaces. During this period Villacís began a series of children's heads, *Rostros de Niños*, which he later alternated with more abstract paintings. In the 1960s he began the 'Pre-Colombino' series inspired by pre-Hispanic and Colonial traditions of his native country. In these he created graffiti-like patterns evoking pre-Hispanic pottery designs, using gold leaf and silver or marble dust as a base or primer and then covering it with several layers of paint and scraping away the desired designs. The technique was a revival of one used by baroque polychrome sculptors and painters in Colonial times. Villacís conveys in his paintings the tactile qualities and weathered appearance of ancient sculpture and architecture within a contemporary framework. His cool greens, off-whites and earth colours are evocative of ceramic, stone and adobe surfaces. He exhibited regularly from 1950 onwards including exhibitions at the Sala Minerva, Madrid (1954), the Mus. Nacional, Bogotá (1956), the Mus. de Arte Colonial, Quito (1956), and the Pan American Union, Washington (1962). In 1964 he participated in the second Bienale of Córdoba in Argentina, in 1966 in 'Art of Latin America Since Independence' at Yale and the University of Texas at Austin, and in the Salon Bolivariano of Cali, Colombia, where he won a prize, and in 1972 in the Third Coltejer Bienale in Medellín, Colombia. He won first prize at the 13th Salon de Octubre of Guayaquil in 1970 and second prize at the Salon Nacional de Artes Plásticas of Quito in 1975. He was one of seven members of *Grupo VAN* founded in Quito in 1967 and exhibited several times with the group.

VILLAUBÍ, JOSÉ. See SPAIN.

VILLEGLÉ, JACQUES DE LA (1926–). French photographer and *affichiste* born at Quimper. He collaborated with Raymond HAINS in making films from *c.* 1950 and together they origi-

nated in 1949 the use of torn posters as an artistic medium, calling themselves *affichistes* and holding an exhibition of *affiches lacérées* in 1957. Unlike Hains, Villeglé combined his pieces of torn posters into COLLAGES with aesthetic pretensions. In 1960 he was a founding member of the group NOUVEAUX RÉALISTES. See also AFFICHISTE.

VILLON, JACQUES (GASTON DUCHAMP, 1875–1963). French painter born at Damville, Eure, elder brother of Raymond DUCHAMP-VILLON and Marcel DUCHAMP. After studying law he went to Paris in 1894 and earned his living by drawing for the papers, mainly the *Courrier Français*. At the same time he studied at the École des Beaux-Arts under Cormon. From 1904 he exhibited at the Salon d'Automne of which he was a founding member. His painting was influenced by the theories of the CUBIST school *c.* 1911 and his studio became the centre for the PUTEAUX group of artists from whom emerged the SECTION D'OR, which he helped to organize. In 1913 he sold 9 paintings in the ARMORY SHOW in New York. During the 1920s he did graphic work and reproductions for a living. In the late 1920s he evolved a technique of abstraction in which he claimed to represent the essence of objects by 'signs' rather than by reproducing their properties; his work became more naturalistic from *c.* 1934 and it was not until the 1950s that he developed a style of abstraction without relation to natural appearances. Recognition came late to him. He won the Grand Prix for Graphic Work at Lugano in 1949 and the Carnegie Prize at Pittsburgh in 1950, the Grand Prix for Painting at the Venice Biennale of 1956 and the Grand Prix in the Brussels International Exhibition of 1958. He was made Commandeur de la Légion d'honneur and Commandeur des Arts et Lettres in 1954. He had a large retrospective at the Mus. National d'Art Moderne, Paris, in 1951 and at the Gal. Charpentier in 1961, and an exhibition of his graphic work at The Mus. of Modern Art, New York, in 1953.

VIOLA, MANUEL (1919–). Spanish painter born at Saragossa. With no formal training as an artist he went to France in 1939 and made contact with PICASSO, members of the SURREALIST circle and other expatriate Spanish artists. Returning to Spain in 1949 he gradually abandoned a highly expressive style of figurative painting for expressive abstraction, concentrating on the contrasting values of light and shadow, and in 1958 joined the group EL PASO. His abstract style has been described as a personal and more baroque revival of Spanish Tenebrism. In his art as in his life he combined erudition with temperamental anarchism. He exhibited widely in Spain and at New York, Lima, Quito, Guayaquil, Santiago de Chile and Buenos Aires. He was represented in a number of collective exhibitions of contemporary Spanish art, including the exhibition 'Arte 73' organized by the Juan March Foundation. Among the public col-

lections outside Spain which possess works of his are the Solomon R. Guggenheim Mus., New York, and the Museums of Modern Art at Cologne, Liège and Prague.

VIRÁGHOVÁ, ZUZANA (1885–). Czech NAÏVE painter born in Košice, began painting in 1959. Her work was included in the exhibitions 'Slovak Amateur Art', Bratislava, 1960, Prague, 1962; 'Naïve Art in Czechoslovakia', Brno, Bratislava, Prague, Ostrava, 1963–4; in exhibitions of naïve art at Salzburg, Graz, Linz, 1964, and in 'Women as Artists', Paris, 1965. Her landscapes were softer, depicting the south Slovakian countryside in a more lyrical and poetic manner than is common among naïve artists.

VIRIUS, MIRKO (1889–1943). Yugoslav naïve painter, born in the village of Djelekovac of a Czechoslovakian father and a Croatian mother. He began to paint in school but this was interrupted by the First World War, in which he was a prisoner in Russia and was put to work in an ironworks. There his health broke down and he was drafted to a laundry for war prisoners, where he was able to resume drawing in his free time. Returning to Yugoslavia in 1918, he worked on the land at Djelekovac. In 1936 he resumed painting and was associated with GENERALIĆ and MRAZ in the Hlebine school of naïve painters (see NAÏVE ART). He became a friend of the peasant writer Pavlek Miškina and belonged to the Leftist Peasant Party. In consequence of this he was consigned to a concentration camp in Zemun after the outbreak of war and died there in 1943.

Virius was a natural and accomplished draughtsman. His best work was done in oils on canvas rather than in the glass-painting technique which was favoured by Generalić. Though he had all the traits of a naïve artist, he was a natural realist and he preferred themes from peasant life to landscape or still life. The spirit of social consciousness showed more strongly in his work than in that of other members of the group. He is regarded as the second greatest painter of the Hlebine school and within his preferred field some connoisseurs have ranked him as the equal or even the superior of Generalić. His work was shown outside Yugoslavia first at the São Paulo Bienale of 1955, when the impression it made was so great that its sale was forbidden by the Yugoslav state. Since that time it has been exhibited in many countries.

VISCONTI, ELYSEU. See LATIN AMERICA.

VISSER, CAREL NICOLAAS (1928–). Dutch sculptor and graphic artist born at Papendrecht, studied at the Delft School of Art and the Academy of Art, The Hague. He made abstract sculptures of iron, ferro-concrete and wood in a manner deriving from the geometrical abstraction of the De STIJL movement and exemplifying the post-war revival of CONSTRUCTIVISM. His constructions were frequently iron or steel slabs piled upon each other. He exhibited at the Mus. Rodin, Paris (1956, 1961), the Stedelijk Mus., Amsterdam (1960), the Bertha Schaefer Gal., New York (1961), and elsewhere, and was represented in the Venice Biennale, 1958, and other international exhibitions.

VITULLO, SESOSTRICE (1899–1953). Argentinian-French sculptor, born at Buenos Aires and studied at the Buenos Aires School of Art. He settled in Paris in 1925 and came strongly under the influence of BOURDELLE. He carved images of the people and animals of his native land, using a great variety of materials and gradually working towards a strong and roughly primitive style with solid, compact forms and sharply defined planes. The strength and vigour of this style is evidenced particularly in his monument to José de San Martin. Although he was almost unrecognized through most of his life, an important retrospective exhibition at the Mus. National d'Art Moderne, Paris, in 1952 brought him to notice.

VIVANCOS, MIGUEL G. (1895–1972). Spanish NAÏVE painter born in Mazarron, Andalusia. He worked in Barcelona as chauffeur, miner, glazier, longshoreman, etc., fought in the Spanish Civil War and escaped to France in 1938. During the German Occupation he was in a concentration camp. He went to Paris in 1944, where he was employed in a commercial firm doing painting on silk and began to paint on his own. In Paris he attracted the attention of André BRETON, who wrote about him and introduced his work to dealers. He had one-man shows in several Paris galleries during the 1950s and was included in international exhibitions of naïve art. He painted mainly architectural scenes and cityscapes with minute accuracy of detail in a manner akin to that of VIVIN and FEJEŠ.

VIVIANI, GIUSEPPE (1899–1965). Italian painter and graphic artist born at Agnano. He was chiefly known for his large paintings in pure colours with the dreamlike atmosphere and nightmare motifs of SURREALISM. He was awarded a prize for his graphic work at the Venice Biennale of 1950.

VIVIN, LOUIS (1861–1936). Born at Hadol in the Vosges, he worked in the Post Office from 1881 until his retirement at the age of 62. He had a passion for painting from childhood. In 1889 he showed a picture entitled *Le Flamand rose* in an exhibition of works by Post Office employees and during the 1890s he would from time to time show his pictures at the Foire aux Croûtes near Sacré-Cœur, Montmartre. In 1925 he was 'discovered' by Wilhelm UHDE and won recognition as one of the most interesting of the French NAÏVE painters. In 1948 the Gal. Bing made a large posthumous exhibition of his works and many of them have

been acquired by important public collections. He painted genre scenes, hunting scenes, flower pieces and latterly views of Paris in a meticulously realistic manner. His pictures often have a 'noetic' element such as is characteristic of some children's and primitive art, giving details of individual bricks or structural devices which could not be actually seen at the distance from which the picture is painted, or combining simultaneous viewpoints which could not be actually seen together, while more distant buildings are presented without diminishing perspective. His work was unequal, sometimes barely escaping the banal but sometimes achieving superb heights of 'popular' unsophisticated art.

VKHUTEMAS (HIGHER TECHNICAL-ARTISTIC STUDIOS). A freely organized polytechnic set up in Moscow in 1918 by combining the former Institute of Painting, Sculpture and Architecture with the Stroganov Art School. It was described by GABO as follows (quoted by C. Gray in *The Great Experiment: Russian Art 1863–1922*): 'It was both a school and a free academy where not only the current teaching of special professions was carried out (there were seven departments: Painting, Sculpture, Architecture, Ceramics, Metalwork and Woodwork, Textile and Typography) but general discussions were held and seminars conducted among the students on diverse problems where the public could participate, and artists not officially on the faculty could speak and give lessons.... During these seminars, as well as during the general meetings, many ideological questions between opposing artists in our abstract group were thrashed out. These gatherings had a much greater influence on the later development of constructive art than all the teaching.' Among the artists who had studios and taught in the Vkhutemas were: MALEVICH, TATLIN, KANDINSKY and PEVSNER. Gabo said that although not officially on the staff, he also taught sculpture there. The programme of the Vkhutemas was controlled by the leftish Institute of Artistic Culture (INKHUK), which in the later 1920s supported the trend towards SOCIALIST REALISM on the one side and on the other side that form of CONSTRUCTIVISM which favoured the art of industrial design above fine art.

In 1925 the name was changed from Vkhutemas to Vkhutein (Higher Technical Institute) and in 1931 the school was reorganized under central Party control.

VLAMINCK, MAURICE DE (1876–1958). French painter, born in Paris of Flemish stock on his father's side and brought up at Vésinet. From 1893 he was a mechanic and racing cyclist, and had no formal training as an artist. His parents were musicians and he earned a living by playing the violin in café orchestras, contributing to anarchist papers and writing pornographic novels. In 1900 he met DERAIN and shared a studio with him at Chatou. His painting at this time was individualistic and energetic with strong though sombre colours. In 1901 he was impressed by the Van Gogh exhibition at the Gal. Bernheim-Jeune and adopted a lighter palette with violent rather than subtle colours and an expressive facture carrying the expressive manner of Van Gogh to greater extremes. He was introduced by Derain to MATISSE, who persuaded him to exhibit with the FAUVES at the Salon des Indépendants and Salon d'Automne in 1905. In 1906 the dealer VOLLARD purchased the whole of his work. He then came under the influence of Cézanne and from c. 1908 to 1914 painted with greater attention to formal construction. He was an intimate of the group of artists who surrounded PICASSO at the BATEAU-LAVOIR, but held aloof from CUBISM, finding its intellectualism uncongenial. Vlaminck was a man who gloried in his untrained talent and 'arrogantly undisciplined abilities', aggressively depreciating history and culture. He professed to believe that each generation of artists should start again from scratch, relying solely on instinct, and he used to boast that he had never set foot inside the Louvre and to declare that he would have the École des Beaux-Arts burnt down. He was nevertheless one of the first to experience the enthusiasm for NEGRO art.

After the end of the First World War Vlaminck settled in the country at Valmondois and then at Rueil-la-Gadelière, combining painting with his delight in racing cars. He painted mainly landscapes and still lifes in a still vigorous and sometimes harsh style of Expressive Realism, but usually in more sombre colours. He had a retrospective exhibition at the Palais des Beaux-Arts, Paris, in 1933 and in New York in 1939. He illustrated some 20 books with woodcuts and lithographs and wrote several books of memoirs: *Tournant dangereux* (1929), *Portraits avant décès* (1943), *Paysages et personnages* (1953).

VOGELER, HEINRICH. See WORPSWEDE.

VOLLARD, AMBROISE (1865–1939). French dealer, connoisseur and art publisher. He established his own gallery in the rue Laffitte in 1893, where in 1895 he gave the first important exhibition of CÉZANNE. From that time the gallery became the centre of innovative art in Paris. Among the artists whom he brought to public notice were Rodin, Pissarro, Renoir, Degas and BONNARD. He gave his first exhibition to PICASSO in 1901 and to MATISSE in 1904. In 1905 he bought out the studio of DERAIN and in 1906 that of VLAMINCK. He was the first to commission prominent artists to illustrate literary classics and contemporary works, publishing volumes which were of interest primarily for the illustrations. He thus encouraged many leading artists of the time to engage in graphic work. His portrait was painted many times, among others by Cézanne, Renoir, Picasso, ROUAULT, Bonnard, Maurice DENIS (in his *Hommage à Cézanne*). His autobiographical *Souvenirs d'un Marchand de Tableaux* throws interest-

ing light on the artistic life of Paris during the early decades of the century. An exhibition devoted to his work as publisher was staged at The Mus. of Modern Art, New York, in 1977, for which was published the book *Ambroise Vollard, Editeur* by Una Johnson.

VOLPI, ALFREDO (1896–). Brazilian painter born at Lucca, Italy. He was taken to Brazil as an infant and settled in São Paulo. In his early years he worked as a stone cutter, carpenter and house painter and began to paint in 1914. His early work included figurative landscapes and genre scenes in a style combining Neo-Impressionism and SOCIAL REALISM. From 1925 onwards he began exhibiting at the Society of Fine Arts (where he received an award in 1928), the National Salon and the 2nd May Salon of 1938 in São Paulo. He had his first one-man show at the Gal. Itá in São Paulo in 1944. Although he participated in numerous collective exhibitions after that, he did not have another individual show until 1955 at the Gal. Terneiro in São Paulo. In 1937 he made the acquaintance of the figurative EXPRESSIONIST Brazilian sculptor Bruno GIORGI (known for his sculpture *The Warriors*, at Brasilia's Civic Centre) and often visited his studio. After the mid 1940s Volpi's painting became increasingly schematized with figures, landscapes, houses, windows, flags (which had become semi-abstract by the early 1950s) in slightly tilted vertical and horizontal formations reminiscent of Paul KLEE, as in *Houses by the Sea* (1953). He also painted religious figures of saints and virgins inspired by Brazilian popular art and flags arranged in various formations over a flat painterly surface. In 1950 he travelled to Europe, visiting France and Italy, where he especially admired Giotto's Padua frescoes. After returning to Brazil in 1951 he participated in the 1st Salon of Modern Art in Rio de Janeiro (1952), where he was awarded a prize. In 1952 he won an acquisition prize at the Venice Biennale. In the 1950s he was influenced by CONCRETE ART, which was then popular in Brazil. The Concrete painter Hermelindo Fiaminghi and the Concrete poet Decio Pignatari worked in Volpi's studio at this time. In 1961 95 of Volpi's paintings were exhibited at the São Paulo Bienale and in 1962 he won the critics' 'best Brazilian painter' award in Rio. He also won prizes in the 2nd 'Panorama of Contemporary Brazilian Painting' show at the Mus. de Arte Moderna, São Paulo, in 1970. He later began exploring the optical properties of colour in completely abstract geometrical paintings whose painterly quality and festive colours were reminders of his earlier landscapes and flags. In 1972 Volpi had a retrospective at the Mus. de Arte Moderna, Rio. He also painted numerous murals in São Paulo, Rio and other cities. In 1966 he painted one for the Ministry of Foreign Affairs in Brasilia.

VOLTEN, ANDRÉ (1925–). Dutch sculptor born at Andijk and studied for one year at the School of Arts and Crafts, Amsterdam. He was best known for his linear low reliefs made from metal strip welded on to multiplex plywood. These were based upon patterns such as those of MONDRIAN and the De STIJL school but were more complex. They were constructed from orthogonals and used only verticals and horizontals but no horizontal was aligned with any other and no rectangle repeated any other. He also did monumental freestanding structures, constructing these too from horizontal and perpendicular elements. He exhibited at the Venice Biennale of 1965.

VOLTI (VOLTI ANTONIUCCI, 1915–). Italian-French sculptor born at Albano, studied at the École des Beaux-Arts, Nice, and then from 1932 in Paris. On his return from the war in 1943 he found all his works destroyed by bombardment and started again. He exhibited at the Salon d'Automne, the Salon de Mai and the Salon de la Jeune Sculpture, of which he was one of the founders. He had his first one-man show in 1946 and in 1957 a retrospective at the Maison de la Pensée Française. In 1963 he was one of the founders of the Biennale Internationale de Sculpture Contemporaine. The subject of his work, which was often monumental, was almost always the female nude and he treated it with breadth and vigour.

VON SCHLEGELL, DAVID (1920–). American sculptor born at St. Louis, Mo. After attending the University of Michigan, 1940–2, he studied at the Art Students' League under his father, William Von Schlegell, and Yasuo KUNIYOSHI, 1945–8. His first one-man exhibitions were at the Swetzoff Gal., Boston, in 1955 and 1961 and at the Poindexter Gal., New York, in 1960. Among the collective exhibitions in which he participated were: Whitney Mus. of American Art, 'Contemporary American Sculpture, Selection 1', Jewish Mus., New York, 'Primary Structures', in 1966 and Los Angeles County Mus. of Art, 'American Sculpture of the Sixties', 1967.

VORDEMBERGE-GILDEWART, FRIEDRICH (1899–1962). German abstract painter, born at Osnabrück. He studied architecture and sculpture at the Technische Hochschule in Hanover and there knew El LISSITZKY. He was also in touch with ARP, SCHWITTERS and Van DOESBURG, coming through the latter into the ambit of the Dutch movement De STIJL, to which he remained faithful throughout his artistic career. He was a member of the ABSTRACTION-CRÉATION association. When non-representational art was proscribed in Nazi Germany he emigrated first to Switzerland in 1937 and then in 1938 settled in the Netherlands and obtained Dutch nationality. In 1954 he returned to Germany, being appointed head of the Department of Visual Communication at the Hochschule für Gestaltung in Ulm. As well as paintings he made relief constructions in which actual objects, such as drawing implements, were juxtaposed with

painted geometrical shapes. His compositions were often given numbers in place of titles, as for example *Composition No. 158* (Stadtsgal., Stuttgart, 1946) and *Composition No. 169* (Mus. of Art, Philadelphia, 1934–8). These compositions were precisely calculated in terms of formal relations and he made it his object to achieve in them a maximum effect with the greatest economy of means. It was his declared aim to bring about a reconciliation between art and technology. His meticulously planned work was tasteful as decoration in a suitably severe environment but was lacking in charm and barren of emotional appeal.

VORSTER, GORDON. See SOUTH AFRICA.

VORTICISM. Name given to the doctrines of a violent and explosive 'rebel' group which in the years immediately before the First World War aspired to become the first organized movement towards abstraction in English art. Historically the movement originated from a rift within the group of artists associated with Roger FRY in the Omega Workshops scheme, triggered off by a personal quarrel between Fry and Wyndham LEWIS. Lewis, together with ETCHELLS, WADSWORTH and Cuthbert HAMILTON, seceded from the Omega Workshops in October 1913 and the breach was accompanied by acrimonious publicity and accusations. The 'rebels', as they began to call themselves, gave point to their hostility by supporting the FUTURIST propagandist MARINETTI at a public dinner organized in his honour by his English admirer NEVINSON, and they made their sympathies with Futurism plain in their contributions to a 'Post-Impressionist and Futurist Exhibition' organized by the critic Frank Rutter at the Doré Gals. in October 1913. Despite its rancorous trappings it is manifest that the split represented a genuine antipathy between the POST-IMPRESSIONIST aesthetics of Fry and the more vigorous abstractionism sought by the splinter group. The intransigence of the latter was manifested again at a mixed exhibition called 'The Camden Town Group and Others' held at Brighton, December 1913–January 1914, in connection with the formation of the all-inclusive LONDON GROUP with the intention that all different styles and groups might find common ground. There the rebels exhibited in a separate 'Cubist Room', for which Lewis wrote a tendentious essay asserting the birth of a new movement opposed equally to Futurism and the BLOOMSBURY aesthetics. At this exhibition they were joined by the young and brilliant painter David BOMBERG. They again exhibited to the perplexity of the more orthodox critics at the first official London Group exhibition in March 1914. By this time the 'rebels' had been joined by the sculptor EPSTEIN and the writers Ezra Pound and T. E. Hulme. The best exposition of the emerging principles common to the work of the new group is to be found in Hulme's lecture 'Modern Art and its Philosophy', delivered on 22 January 1914, and in his review of the London

Group exhibition. Both are included in his *Speculations* (1924). The term 'Vorticism' was coined by Pound at the end of 1913 to suggest the idea of a whirling force which should draw out and concentrate in a new synthesis all the positive elements in the turmoil of innovatory theories. It may also have had reference to a statement by BOCCIONI that all artistic creation must originate in a state of emotional vortex. But the visual image suggested by the term was quite inappropriate to the harsh, angular, diagonally oriented style of the new work.

In March 1914 the Rebel Art Centre was founded at 38 Great Ormond Street in rivalry with the Omega Workshops. The 'rebels' were joined by other artists, including Jessica DISMORR, Lawrence ATKINSON, William ROBERTS and the sculptor GAUDIER-BRZESKA. The unity of the Centre was soon disrupted by quarrels between Lewis and Hulme, while Bomberg stood apart from it and held a one-man show at the Chenil Gal. in July 1914. Epstein also remained aloof from it. A degree of unity was restored, however, by an ill-considered move on the part of Marinetti supported by Nevinson. By his theatrical appearances, culminating in June 1913 with a 'Grand Futurist Concert of Noises' performed at the Coliseum by 23 of RUSSOLO's 'noise organs' (described by Pound as 'a mimetic representation of dead cats on a fog-horn'), Marinetti had made Futurism the latest zany fashion and catch-phrase in London. In the *Observer* of 7 June he, with Nevinson, put out a Futurist manifesto calling on 'the English public to support, defend and glorify the genius of the great Futurist painters or pioneers and advance forces of vital English Art' and signing it with the names of the 'rebel' artists. This was roundly denounced by all of them. On 2 July the first number of BLAST, edited by Lewis, appeared with a Vorticist manifesto. A second number of *Blast* was issued a year later; a Vorticist Exhibition was held at the Doré Gals. in June 1915, and in January 1917 the American collector John Quinn was persuaded by Pound to organize a Vorticist Exhibition in New York.

The turbulent, bombastic, quarrelsome and confused origins of Vorticism are not unusual to the emergence of an artistic movement and could be paralleled from DADA, Futurism, SURREALISM and others. But the incidence of the Second World War prevented Vorticism from achieving a maturity in the light of which unity and direction might have been seen beneath the muddied cross-currents of its beginnings. By the end of the war the movement was virtually dead and an attempt to revive it in the heterogeneous GROUP X proved abortive. Its significance became apparent only later. In the words of Richard Cork, written in 1974: 'Only now is it coming to be seen both as a stimulating precedent for England's second wave of abstract artists in the 1930s, and as an admirably outspoken attempt to blast an insular, backward-looking nation out of its slumbering complacency.' So far as it achieved a unified intention, this was,

again in the words of Richard Cork, 'to arrive at an original synthesis, poised half-way between the kinetic dynamics of Futurism and the static monumentality of Cubism, and rejecting French preference for domestic studio motifs as firmly as it replaced the Italians' rapturous worship of mechanical imagery with a more detached, classical approach'. As stated in *Blast*, the aim was 'to establish what we consider to be characteristic in the consciousness and form content of our time: then to dig to the durable simplicity by which that can be most grandly and distinctly expressed'.

A very high proportion of the Vorticist works have been lost or destroyed, making it difficult to assess the artistic value of the achievement objectively. An exhibition 'Wyndham Lewis and Vorticism' staged at the Tate Gal. in 1956, by giving undue prominence to Lewis, was ill balanced and unhistorical. His statement in his introduction to the catalogue: 'Vorticism, in fact, was what I, personally, did, and said, at a certain period' was bitterly rebutted by Roberts and Bomberg. A more balanced presentation was given in the Arts Council exhibition 'Vorticism and its Allies' at the Hayward Gal., London, in 1974.

VOSTELL, WOLF (1932–). German artist, born at Leverkusen. After studying photolithography and other graphic techniques in Cologne, 1950–3, he studied painting and experimental typography at Wuppertal, 1954–5, then studied at the École des Beaux-Arts, Paris, 1955–6, and at the Düsseldorf Academy, 1956–7. He constructed COLLAGES from fragments of torn posters, calling them 'décollages', the opposite of 'collages' since they were produced by tearing down posters and other printed matter which had been pasted up. He often painted over the surface to make the underlying material indistinct and added scribbled lines. From *c.* 1958 he made his name by organizing HAPPENINGS in Ulm, Wuppertal, Berlin, New York and he called them 'Décollages-Happenings' to indicate that they were random or subversive fragments from life built up into a 'total work'.

VOULKOS, PETER (1924–). American sculptor born at Bozeman, Mont., studied at Montana State College and California College of Arts and Crafts in Oakland. He taught at several institutions, including Black Mountain College, Los Angeles County Art Institute and the University of California at Berkeley from 1959. Voulkos early mastered ceramic techniques and during the 1950s developed a novel approach to ceramics as a sculptural medium. Influenced by ABSTRACT EXPRESSIONISM he experimented with the expressive potential of clay surface and forms, using epoxy paints and glazes. Towards the end of the 1950s he was making monumental ceramic sculptures built up on an armature of cylinders. From about 1960 he turned to bronze, casting slabs and blocks in his own foundry, and building up constructions in a similar manner to his previous work, combining geometrical forms with roughly expressive ones. In the later 1960s he abandoned the method of juxtaposition for more clear-cut and logically designed geometrical constructions such as the aluminium and bronze *Hiro* (Los Angeles County Mus. of Art, 1964–5). Besides the innovatory nature of his own work Voulkos influenced a group of young West Coast sculptors and took the lead in an experimental movement in polychrome sculpture and the unorthodox uses of bronze.

VRIES, HERMAN DE (1931–). Dutch painter and experimental artist born at Alkmar. He studied architecture and began painting in 1953 without formal instruction. In 1955 he began to make 'collages trouvées' with commonplace and READY-MADE objects. In 1956 he began monochrome painting and became chiefly known for his all-white paintings, COLLAGES and constructions. From 1962 he relied deliberately on chance in these, justifying this procedure on the ground that in this way he secured 'objectification' by the elimination of the 'personal'—not the 'human'—element. (See STOCHASTICISM.) He called his work 'visual information' rather than 'art'. His *Random Objectification with Decreasing Density* (1965) was 'based on statistical tables for agricultural, biological and medical research'. He was a member of the group NUL. He exhibited at the Stedelijk Mus., Amsterdam, at the Køpcke Gal., Copenhagen, the De Cordova Mus., Lincoln, Mass., among others, and he was represented in a number of international exhibitions of *avant-garde* art.

VRUBEL, MIKHAIL ALEKSANDROVICH (1856–1910). Russian painter and designer born at Omsk. He attended the St. Petersburg Academy of Fine Arts and studied under Pavel Chistiakov, 1880–4, then worked as restorer of frescoes in the Church of St. Cyril, Kiev, and in 1887 designed murals for the Cathedral of St. Vladimir, Kiev. In 1889 he moved to Moscow, where he made close contact with Savva Mamontov and the Abramtsevo group. This encouraged him to interest himself in applied art, especially stage design and panels for Moscow villas. In 1890–1 he did illustrations for Lermontov's works. He was deeply interested in Slavonic mythology and the image and concept of the Demon became central to his painting, culminating in such remarkable canvases as *The Demon Downcast* (1902). During the 1890s he was influenced by ART NOUVEAU and Symbolism and the use of blue, violet and purple with idiosyncratic textures became evident in his works. In 1898 he was in close contact with MIR ISKUSSTVA, in 1902 the first symptoms of approaching insanity became apparent, in 1906 he went blind and he died in a lunatic asylum in 1910. Vrubel stands out as the great precursor of much that was best in Russian 20th-c. painting.

VUILLARD, EDOUARD (1868–1940). French painter born at Cuiseaux, Saône-et-Loire. Ker-

Xavier ROUSSEL, Maurice DENIS and the producer Lugné-Poë were fellow pupils of his at the Lycée Condorcet and he made friends with BONNARD and SÉRUSIER while studying at the Académie Julian. He was therefore closely linked with the NABIS although he was not himself attracted by Symbolism. The main influences upon his work were Gauguin and Japanese colour prints and he developed a style of flat, strongly patterned areas of colour which he also used for decorative panels, stage sets and colour prints. By the turn of the century he was already master of a quiet but subtle and sensitive manner of painting *intimiste* interiors in a Late-Impressionist style. From 1903 to 1914 he exhibited regularly at the Gal. Bernheim Frères; he was one of the founders of the Salon d'Automne in 1903 and exhibited there until 1911. From *c.* 1900 his friendship with the wealthy Hessel couple brought him commissions from the world of financiers, politicians, actresses, etc. and his paintings constitute a delightful document of the French upper middle classes during the first three decades of the century. He continued to represent his subjects in their intimate surroundings and particularly noteworthy are his series of artists depicted in their studios, which he did between 1925 and 1937. He exhibited little after 1914 but a large retrospective exhibition of his work was given at the Mus. des Arts Décoratifs in 1938. He also did a number of decorative commissions, including two murals for the Champs-Élysées theatre in 1913, *La Comédie* for the theatre of Chaillot in 1938 and *La Paix protégeant les Muses* for the Palais des Nations at Geneva. He is best known for his small *intimiste* interiors which he painted in his own technique using distemper instead of oil to bind the pigments.

VUJČEC, FRANJO. See NAÏVE ART.

W

WADSWORTH, EDWARD (1889–1949). British painter born at Cleckheaton, Yorkshire. He studied engineering at Munich, 1906–7, while attending the Knirr Art School there in his spare time. Giving up engineering in 1907, he studied at the Bradford Art School and from there obtained a scholarship to the Slade, where he worked 1908–12. He showed at the NEW ENGLISH ART CLUB in 1911 and with the FRIDAY CLUB at the Alpine Gal. in 1912 and 1913. In 1913 two of his paintings were added to the Second POST-IMPRESSIONIST Exhibition organized by Roger FRY at the Grafton Gals. He joined Fry's Omega Workshops but seceded with Wyndham LEWIS and joined the Rebel Art Centre of the VORTICISTS, contributing illustrations and a translation from KANDINSKY's *Über das Geistige in der Kunst* to the first number of BLAST and reproductions of his works to the second. He exhibited as a founding member in the 1914 exhibition of the LONDON GROUP and was also represented in its 1915 exhibition. In 1914 he participated in the 'Twentieth Century Art' exhibition at the Whitechapel Art Gal. and he contributed to both the London Vorticist exhibition of 1915 and the New York exhibition of 1917. While serving with the Royal Naval Volunteer Reserve, 1917–18, he worked on designing dazzle camouflage for ships and was engaged among other things on the camouflaging of the *Aquitania*. He held a one-man show in 1919 at the Adelphi Gal., at which was exhibited his large painting (10 ft by 8 ft; 3 m by 2·4 m) *Dazzle-Ships in Drydock at Liverpool* (National Gal. of Canada, Ottawa). Most of Wadsworth's paintings up to this time have been destroyed or have disappeared and are now known only from records or photographs.

In 1920 he exhibited in January at the Leicester Gals., and later at the Mansard Gal. with GROUP X, a set of smaller water-colours and drawings of the Black Country which he had done the previous year in a realistic style with CUBIST overtones. The lucidity, precision and clarity of his work were enhanced when in 1922/3 he changed from oil painting to tempera, and during the rest of the 1920s, abandoning Cubistic leanings, he painted in a more straightforwardly realistic manner, showing a penchant for maritime subjects and perfecting 'a type of highly composed, hyper-realistic marine still-life'.

In 1933 Wadsworth joined UNIT ONE, contributing a set of apophthegms to Herbert Read's book *Unit One* in 1934. At this time his painting was abstract, often using images vaguely akin to those of ARP but endowing them with a coy vitality and pseudo-movement. He reverted to a more realistic style in 1934 and resumed his interest in maritime subject matter. In his perspectives and still more in his habit of magnifying the size of commonplace objects such as shells, corks, floats, compasses, bollards, etc., while endowing them with an almost MAGIC REALISM by the clarity of his technique, he sometimes imparted a SURREALISTIC flavour to his compositions. The years 1934 to 1944 were called by Mark Glazebrook his 'typical decade', and certainly some of his most mature marinescapes and maritime compositions come from this period. Examples are *Corrosion*, one of a set of paintings, *Aspects of an Industry*, commissioned by the publicity department of I.C.I. Limited, and *Pendent* (alternative title *Punch-Balls*), exhibited at the Venice Biennale in 1952. In this period he also did a mural for the De la Warr Pavilion at Bexhill and two large pictures for the Smoke Rooms of the *Queen Mary*.

A Memorial Exhibition was held at the Tate Gal. in 1951. What was able to be recovered either of original pictures or of photographic documentation from his early period was shown at the Arts Council exhibition 'Vorticism and its Allies' in 1974. In 1974 also a retrospective exhibition was given by the Colnaghi Gal., London, which contained the most comprehensive collection of Wadsworth's woodcuts, lithographs and etchings hitherto assembled.

WAGEMAKER, JAAP (1906–1972). Dutch painter born at Haarlem, where he attended the School of Arts and Crafts. About 1955 he turned his attention from expressive naturalism to the evocative force of materials and he became the leading Dutch painter in the style of MATTERISM. He used earthy colours, heavy impasto and loaded his *pâte* with materials such as sand, slate, shells, etc. His work had affinities both with that of DUBUFFET and with that of BURRI. He had an exhibition at the Stedelijk Mus., Amsterdam, in 1957.

WAKELIN, ROLAND (1887–1971). Australian painter, born at Greytown, New Zealand, but settled permanently in Sydney in 1912. He studied at the Wellington Technical College (1904–12) and his student work reveals the influence of James McLaughlin Nairn, a former teacher there. In Sydney he studied painting at the classes of the Royal Art Society of New South Wales under

Dattilo Rubbo, who encouraged his pupils to experiment with modern ideas and concepts brought to Sydney by Norah Simpson in 1913. (See AUSTRALIA.) In consequence he adopted a Neo-Impressionist style (e.g. *The Fruit Seller of Farm Cove*, Australian National Gal., Canberra, 1915). It startled local critics and artists by its use of small strokes of pure, unmodulated colour. Despite constant criticism, and with little encouragement, Wakelin continued to experiment, simplifying form, distorting perspective and employing a brush technique and a range of colour which, although not particularly radical by European standards, was seen as an affront to local taste. These experiments culminated in the 1919 'Colour-Music' paintings such as *Synchromy in Orange-Red Major* (1919), produced according to ideas embraced initially by Roy de MAISTRE, his former fellow-student at Rubbo's. They sought to explore the relationship between colour and music by fashioning a colour–music scale. These were the first abstract paintings to be exhibited in Australia. During the next two years, however, Wakelin was strongly influenced by MELDRUM's theory of tonal painting. A visit to England and Paris reinforced his faith in modern art, exemplified in his paintings of 1925–35. In these Cézanne became the dominant influence (e.g. *Blue's Point, Sydney Harbour*, Auckland City Art Gal., 1933). During the late 1930s Wakelin developed a more conventional technique and a highly personal and romantic approach to painting which owed less to 20th-c. innovation. With little change this style determined the nature of his paintings for the remainder of his life.

He had a retrospective exhibition at the Art Gal. of New South Wales in 1967.

WALCH, CHARLES (1898–1948). French painter, born at Thann, Haut-Rhin, of a peasant family. Obtaining a State scholarship, he studied at the École des Arts Décoratifs from 1918 to 1922. From 1925 he exhibited at the Salon des Indépendants, the Salon d'Automne and the Salon des Tuileries. He received a Gold Medal at the Exposition Universelle of 1937 and was awarded the Légion d'honneur in 1948. Standing aloof from the *avant-garde* schools, he developed a style of poetic naturalism which belonged to the French EXPRESSIONIST tradition. He was a natural colourist and his works had sometimes a hint of naïve stylization and a suggestion of SURREALIST perspective. They were restrained and carefully constructed. Of a modest disposition, he had his first one-man show in 1938. A retrospective exhibition was arranged by the Mus. National d'Art Moderne, Paris, in 1949. As a consequence of poliomyelitis in infancy he was compelled to work with his left hand.

WALDBERG, ISABELLE (1917–). Swiss sculptor born at Ober-Stammheim and trained in Zürich. She went to Paris in 1936 and worked with

Marcel GIMOND, Robert WLÉRICK and Charles MALFRAY, also studying primitive art at the Sorbonne. Her first sculptures were classical nudes in the manner of Gimond, but in 1942 she went to New York and in consequence of the impact made by GIACOMETTI's *Palais à quatre heures* she switched to an extreme form of SURREALISM, employing strange and unusual materials. Her first exhibition was in 1943 and she was represented in the International Surrealist exhibition of 1947. In 1962 she was awarded the Bourdelle prize.

WALKER, DAME ETHEL (1861–1951). British painter, born at Edinburgh. She was interested in becoming an artist from her school days but she did not have formal teaching until the early 1890s, when she attended the Putney School of Art. She also worked at the Westminster School under Frederick BROWN and followed him to the Slade School when he was made Professor in 1892. By the end of the century Ethel Walker had mastered the kind of derivative Impressionist painting which was at that time practised in the NEW ENGLISH ART CLUB and for their keen perceptiveness and a particular personal grace her paintings were not inferior to the best work done by STEER and other leading lights of the Club. Many of her works from this period are in provincial museums and galleries of England. It was after the First World War, however, that she developed the mature style upon which her reputation chiefly rests. Influenced by both the Impressionists and Puvis de Chavannes, she painted pictures which are imaginative idealizations of a Golden Age. Examples of this mature work are *Nausicaa* (1920) and *The Zone of Love* (1931–3), both in the Tate Gal., London. She was made A.R.A. in 1940 and a Dame of the British Empire in 1943. She was given a joint exhibition with Gwen JOHN and Frances HODGKINS at the Tate Gal. in 1952.

WALKOWITZ, ABRAHAM (1878–1965). Russian-American painter born at Tyumen. He studied at the National Academy of Design and at the Académie Julian, Paris. Returning from Paris in 1910, he became a member of the circle of Alfred STIEGLITZ, by whom he was given his first exhibition, at the 291 Gal. in 1912. Walkowitz had become thoroughly familiar with the progressive movements of European art in the first decade of the century and was one of the most influential among the foreign-born artists who introduced them to America before the ARMORY SHOW. His own work was little influenced by CUBISM but moved towards a patterned rhythmical abstraction akin to that of Max WEBER. Among the best known in this style are *Bathers* (1910) and *Dance Rhythms* (c. 1920). He was represented in the Armory Show and in the FORUM show which followed. But after this he fell into obscurity although he was doing some of his most original work in the 1920s. These were linear abstracts, strongly rhythmical in character, based upon

figures in motion. It is now known that he began drawings in this manner as early as *c.* 1912. A well-known example is the drawing *New York* in water-colour and ink (Whitney Mus. of American Art, 1917). His theories were set out in *A Demonstration of Objective, Abstract, and Non-Objective Art* (1945).

WALLIS, ALFRED (1855–1942). British NAÏVE painter, born in Devonport. He lived near St. Ives in Cornwall and worked as a fisherman. He started to paint in his late sixties, mainly ships and harbour scenes, which he did not from life but from some atavistic imagined vision. He painted on irregularly shaped pieces of cardboard, within which he fitted the designs of his pictures. He was 'discovered' in 1928 by the St. Ives group of painters and his simplifications and abstractions made a strong impression upon them, particularly Christopher WOOD and Ben NICHOLSON. He rapidly became the best known of British primitive artists. Among other public collections his pictures are included in the Tate Gal., and The Mus. of Modern Art, New York.

WALSER, KARL (1877–1943). Swiss painter born in Biel, brother of the poet Robert Walser. He was trained at the School of Arts and Crafts, Strasbourg, and subsequently worked in Berlin as illustrator and theatrical painter. He travelled to the Netherlands, Belgium, Spain, Italy, Russia and Japan, returning to Switzerland in 1917. From 1922 to 1925 he again worked as a theatrical painter in Berlin but in 1925 he settled in Zürich.

WARHOL, ANDY (ANDREW, 1928(?)–87). American painter, draughtsman, graphic artist and film producer, born at Forest City, Pa., of Czechoslovak immigrant parents. He studied at the Carnegie Institute of Technology, Pittsburgh, from 1945, taking a degree of Bachelor of Fine Arts in Pictorial Design in 1949, and subsequently worked as an advertisement draughtsman in New York. His first one-man exhibition was at the Hugo Gal., New York, in 1952. By the early 1960s his name was the most widely known in and outside America, and the most controversial, of all the American POP artists. He took his subject matter from popular commercial 'art'—magazine photographs of popular film stars, horror comics, advertisement illustrations of mass-produced consumer goods, and so on—and he turned this material into fine art without destroying its character as KITSCH. He made frequent use of the device of repetition as in his very well-known paintings *100 Soup Cans* (Hessisches Landesmus., Darmstadt, 1962) and *Green Coca-Cola Bottles* (Whitney Mus. of American Art, 1962). (Jasper JOHNS had done *Two Painted Bronze Beer Cans* in 1960). Some critics have said that, as with other Pop artists, one of his purposes in using banal themes was to bring these back to visibility in all their banality and ugliness. But the technique of repetition seems to run

counter to this and he himself said in regard to his series *Death and Disasters*, also made up from newspaper photographs: 'When you see a gruesome picture over and over again, it doesn't really have any effect.' He was opposed to the concept of a work of art as a piece of craftsmanship, hand-made for the connoisseur and expressing the personality of the artist, and he said: 'The reason I'm painting this way is that I want to be a machine.' He was obsessed by the ideas of similarity and repetitive mass-production and said: 'I want everybody to think alike. I think everybody should be a machine.' In keeping with this outlook he made much use of the silk-screen technique, used clippings of 'dehumanized' illustrations from the mass media, turned out his works like a manufacturer and called his studio 'The Factory'. In 1975 he wrote in *The Philosophy of Andy Warhol*: 'Business art is the step that comes after Art. I started as a commercial artist, and I want to finish as a business artist.' In 1965 he announced his retirement as an artist in order to devote himself to films, but he continued as a draughtsman and continued to make constructions.

Warhol was a superbly talented natural draughtsman but the majority of his graphic work was devoted to frivolous subject matter—banal illustrations from children's books, greeting cards, portraits based upon popular images from the cheaper magazines, etc. Among the best examples of his draughtsmanship may be cited *A Gold Book by Andy Warhol*, published in 1957. In the 1950s he did a remarkable series of drawings with COLLAGES representing footwear, using them as symbolic images standing for the personality of the owners. His late drawings of cats and dogs succeeded as nothing else in depicting the 'generic' personality of these domestic pets as popularly conceived. His paintings and drawings of Chairman Mao done in the early 1970s were thought by some to reveal crypto-Communist leanings, but in fact display the same objective impersonality as characterizes his earlier work with its veneer of *faux naïveté*. A major exhibition of his graphic work from 1942 to 1975 circulating to Stuttgart, Düsseldorf, Bremen, Munich, Berlin and Vienna revealed its enormous variety and the incomparable skill beneath the mannerisms.

WAROQUIER, HENRI (or HENRY) DE (1881–). French painter, born in Paris. He took courses in architecture but was self-taught as a painter, modelling himself on the works of the Impressionists and Seurat which he saw in the galleries of VOLLARD and Durand-Ruel. From *c.* 1901 to 1910 he worked under the influence of Far Eastern art, developing a manner of stylization strongly reminiscent of the Japanese. From 1912 he made frequent journeys to Italy and *c.* 1917 began to paint imaginary landscapes in sombre hues, but after a few years reverted to nature and did a series of naturalistic landscapes from Italy in

1920 and from Spain in 1921. During the 1920s he extended his repertory to still lifes and figure paintings and did work which brought him within the current expressive naturalism. In the 1930s the expressive aspect of his work began to predominate and he was obsessed with the epic representation of the tragic. An important retrospective exhibition of his work from 1917, in which this aspect predominated, was arranged at the Kunsthaus, Zürich, in 1946.

WASHINGTON COLOUR PAINTERS. Name given to a group of painters who in reaction from ABSTRACT EXPRESSIONISM emphasized the optical effects of colour, often using the techniques of staining and pouring acrylic paints. The group comprised Morris LOUIS, Kenneth NOLAND, Howard MEHRING, Gene DAVIS, Thomas DOWNING. The title originated from an exhibition of that name staged by the Washington Gal. of Modern Art in 1965.

WASSERMANN, DER. An artists' community formed in 1918 by the Austrian painter Anton FAISTAUER at Salzburg.

WATTS, ROBERT M. (1934–). American painter, sculptor and experimental artist, born at Burlington, Iowa. He studied engineering at the University of Louisville, 1944, and then art at Columbia University and the Art Students' League, 1951. He taught mechanical engineering and art at Rutgers University from 1953. He changed from painting to sculpture in 1956, took up light-sound-motion constructions in 1957 and began to design HAPPENINGS in 1958. He had one-man exhibitions from 1953 and was represented in a number of group exhibitions, including 'Art in Motion', Stedelijk Mus., Amsterdam (circulating in Europe), 1961–2; 'The Art of Assemblage', The Mus. of Modern Art, New York, 1961; 'The Popular Image', Washington Gal. of Modern Art, 1963; 'Mixed Media and Pop Art', Albright-Knox Art Gal., Buffalo, 1963.

WAWRO, JEDRZEJ (1864–1937). Polish NAÏVE sculptor, born at Gorzen Dolny, near Kraków. The son of a farmer, he worked as a miner, stonecutter, logger and junk merchant. In 1925 he began carving figures of saints, which have a resemblance to popular religious effigies such as might be seen in Pomerania. His works have been exhibited in Paris, Amsterdam, Brussels, Belgrade, Zagreb, Ljubljana, etc.

WEBER, HUGO (1918–71). Swiss-American painter and designer born at Basle. He was a student at the University and Kunstgewerbeschule, Basle, 1942–6. In 1939 he went to Paris and studied there until 1945, at the Atelier Gimond and with MAILLOL, ARP and GIACOMETTI. He lived in Paris and America and travelled widely. In America he taught at the Institute of Design, Chicago,

1946–55, and at New York University from 1963. His first one-man exhibitions were at the Art Institute of Chicago and Colorado Springs Fine Art Center in 1951 and at Gal. 16, Zürich, in 1952. He continued to exhibit widely in America and Europe, mainly Switzerland and Paris, both in individual and in collective shows. Among the collective exhibitions in which he participated were; Salon des Réalités Nouvelles, Paris; Art Institute of Chicago, 'Directions in American Painting', 1951; Solomon R. Guggenheim Mus., 'Younger American Painters', 1954; Salon des Comparaisons, Paris, 1956; Gal. Creuze, Paris, '50 Years of Abstract Painting', 1957; Kunsthaus, Zürich, '16 Basler Maler', 1960. He produced two films: *Vision in Flux*, 1951, and *Process Documentation by the Painter*, 1954.

WEBER, MAX (1881–1961). Russian-American painter, born at Bialystok, emigrated to the U.S.A. and settled in New York in 1891. He studied at the Pratt Institute, Brooklyn, under Arthur Wesley Dow, 1898–1900, and for the next five years taught drawing in public schools in Virginia and Minnesota. He went to Paris in 1905 and was a student at the Académie Julian. He was one of the first to recognize Henri ROUSSEAU and he also knew PICASSO, DELAUNAY and MATISSE, with whom he studied in 1907–8. Returning to New York he became a member of the STIEGLITZ group and was exhibited at the 291 Gal. in 1910, arranging an exhibition of Henri Rousseau in the same year.

Weber was early influenced by the FAUVES and helped introduce to New York their explosive colours and flat patterns. With the advent of CUBISM he combined in a bold pastiche the formal structure and shallow planes of early Cubism with the brilliant colouring of the Fauves. Yet his own painting retained an expressive character foreign to the more objective quality of French art. Thus his *Figure Study* (Albright-Knox Art Gal., Buffalo, 1911) derives from Picasso and Cézanne in its formal structure while still retaining overtones of EXPRESSIONISM. His *Interior with Still Life* (Whitney Mus. of American Art, 1912) is a typically Cubist composition in its fractionation of planes but retains the warm colours of the Fauves. About 1915 he was painting in a manner which approximated more closely to Synthetic Cubism, as in *Chinese Restaurant* (Whitney Mus. of American Art, 1915), but after c. 1917 he reverted to a non-Germanic, Fauvist form of Expressionism akin to that of SOUTINE or sometimes ROUAULT, which he only in the late 1930s began to combine with more abstract forms. At this time he also did Talmudic and ceremonial scenes based on personal fantasies remembered from childhood, such as *Adoration of the Moon* (Whitney Mus. of American Art, 1944). During his Cubist period, c. 1915, Weber was one of the first to experiment with Cubist sculptures. He had a one-man show at the Gal. Bernheim-Jeune in 1924 and retrospectives at The Mus. of Modern Art, New York, in 1930 and

the Whitney Mus. of American Art in 1949, and a major retrospective at the University of California, Santa Barbara, in 1968. His principal writings were: *Cubist Poems*, London, 1914; *Essays in Art*, New York, 1916; *Primitives*, New York, 1926; *Max Weber* (autobiographical monograph), 1945.

WEEKS, JAMES (1922–). American painter born at Oakland, Calif., studied at San Francisco Art Institute, the Hartwell School of Design, and then briefly at the Escuela de Pintura y Escultura, Mexico City. He taught at San Francisco Art Institute, Hartwell School of Design and California College of Arts and Crafts, among others. His first one-man exhibition was at the Lucien Labaudt Gal., San Francisco, in 1951. He had a retrospective exhibition at the San Francisco Mus. of Art in 1965. Among the collective exhibitions in which his work was represented were: Birmingham Mus. of Art, Birmingham, Ala., 'Figure Painting', 1961, and State University of Iowa, 'Five Decades of the Figure', 1962. Works of his are owned by the American Federation of the Arts and the Corcoran Gal. of Art, Washington, among others.

WEIDEMANN, JACOB (1923–). Norwegian painter born at Steinkjer and studied at the School of Arts and Crafts, Oslo, and the Academy of Art, Stockholm. In 1957 he exhibited geometrical abstracts in heavy impasto whose rich and varied colouring has been thought to carry on the old tradition of Norwegian romantic naturalism. He later developed a personal style of gouaches and water-colours as well as oil paintings which in their expressive abstraction revealed a deeply lyrical feeling for the Norwegian forested landscape. In 1966 he represented Norway at the Venice Biennale. Among his public commissions were murals for the Norsk Hydro, Oslo (1961), and for the church of Steinkjer (1967).

WEIGHT, CAREL (1908–). British painter. He studied at Hammersmith College of Art and Goldsmiths' College. He was an official War Artist, taught at the Royal College of Art, 1947–57, and was Professor of Painting from 1957 until his retirement in 1973. He was made A.R.A. in 1955 and R.A. in 1965 and was appointed Trustee at the Royal Academy in 1975. His first one-man show was at the Cooling Gal. in 1933, after which his works were much exhibited, including the exhibition of British Art at the Pushkin Mus., Moscow, in 1958, a retrospective at Reading Mus. and Art Gal. in 1970 and one-man exhibitions at the New Grafton Gal. in 1974 and 1976. Among others his works were purchased by the Vatican Mus., Tate Gal., Arts Council, Ashmolean Mus., Oxford, Chantrey Bequest, Contemporary Art Society, Imperial War Mus., Victoria and Albert Mus., the National Gals. of Adelaide and Melbourne, Australia, and Wellington, New Zealand, and the National Gal. of Wales. He was General Editor of a series of monographs 'Painters on Painting'.

WEINER, LAWRENCE. See CONCEPTUAL ART.

WEINRIB, DAVID (1924–). American sculptor born at Brooklyn, studied at Brooklyn College and the State University of New York at Alfred. He taught at the School of Visual Arts, New York. He exhibited during the 1960s at the Howard Wise Gal., New York, and participated in collective exhibitions including Los Angeles County Mus. of Art, 'American Sculpture of the Sixties', 1967. His work belonged to the category of MINIMAL ART and was akin to that of Tom DOYLE, combining in one piece dissociated and often disparate elements often contrastingly coloured.

WELZ, JEAN. See SOUTH AFRICA.

WEREFKIN, MARIANNE VON (1870–1938). Russian painter born at Tula, near Moscow, studied at St. Petersburg with JAWLENSKY under Ilya Repin (1844–1930). In 1896 she moved with Jawlensky to Munich, where she became a member of the NEUE KÜNSTLERVEREINIGUNG. When KANDINSKY and his friends left the NKV to found the BLAUE REITER she remained with the older association together with Jawlensky. Later, however, she broke with it and exhibited with the *Blaue Reiter*. In 1914 she left Germany for Switzerland and settled at Ascona. Her painting at first displayed Symbolist characteristics in the tradition of the NABIS. But under the influence of FAUVISM and through contact with the founders of the *Blaue Reiter* and Alfred KUBIN she evolved a decorative-mystical style of painting in bright, flat colours.

WERKMAN, HENDRIK NICOLAAS (1882–1945). Dutch artist, born at Groningen. After supporting himself as a journalist and working printer, he opened his own printing shop in Groningen in 1917. He started painting in 1920 under the influence of Van Gogh, having been impressed by an exhibition of his works in 1896, and in the same year he joined the artist group De Ploeg. On the failure of his printing business in 1923 during the economic crisis following the First World War he set up in an attic, supporting himself by jobbing commissions, and began to produce his *Druksels* (Print Pictures), abstract typographical experiments produced by unorthodox techniques. Despite the name these were not produced in editions but each one was unique. He also published a magazine of typographical experiments *The Next Call*, which he circulated internationally and which brought him into contact with CERCLE ET CARRÉ. During the German Occupation in the Second World War he produced an underground magazine *De Blauwe Schuit* (*The Blue Barge*) and continued to make his *Druksels*. He was captured by the Nazis and shot three days before the liberation of Groningen.

His typography, influenced to some extent by DADA and by the New Typography of LISSITZKY and MOHOLY-NAGY, was less dated than most work of the time and had an important influence on modern graphic design. In 1939 it attracted the attention of Willem Sandberg, who arranged a posthumous exhibition at the Stedelijk Mus., Amsterdam, in 1945. A representative exhibition was staged at the Whitechapel Art Gal., London, in 1975. The most important collection of his works, *Druksels* and paintings, is in the Stedelijk Mus., Amsterdam.

WERNER, THEODOR (1886–1969). German painter, born at Jettenburg, near Tübingen, and trained at the Stuttgart Academy of Art, 1908–9, after which he travelled widely, 1909–14, in Germany, Italy and the Netherlands with annual visits to Paris. After serving in the First World War he lived near Stuttgart, 1919–29, and then went to Paris for five years, 1930–5. During this time he was friendly with BRAQUE and MIRÓ and was associated with the ABSTRACTION-CRÉATION group. From 1935 to 1945 he lived in Potsdam; in 1946 he moved to the western sector of Berlin and in 1960 to Munich. In 1937 his work was included in an international exhibition at the Jeu de Paume Mus., Paris. Although he exhibited regularly at Stuttgart from 1911, except under the National Socialist regime when his work was prohibited, his work was virtually unknown elsewhere in Germany until 1947, when it was exhibited at the Gerd Rosen Gal., Berlin. In 1949 he joined the ZEN group in Berlin. His first one-man show in the U.S.A. was at the Grace Borgenicht Gal., New York, in 1954. In 1955 he was included in 'The New Decade' exhibition of 22 European painters and sculptors at The Mus. of Modern Art, New York.

Werner developed slowly from Post-Impressionism through a brief CUBIST period until he found his own style during his residence in Paris in the 1930s, when his pictures were dominated by rhythmically curved and interlacing lines and mobile elliptical forms. About the mid 1940s he abandoned representational imagery entirely, using jagged and fragmented open forms embedded in sumptuously coloured and irregularly spotted backgrounds. After *c.* 1950 the predominance of line in his paintings receded and colour effects were used to give the illusion of a 'fourth' dimension. Werner himself said: 'Works of art are a kind of bulletin of the condition of man, his state of being, his participation in life and his dangerous alienation from life. . . . Today the objective is the primacy of the capacity to organize, the primacy of the creative act, producing a new synthesis of means in order to arrive at form by way of individual movements. This means achievement of the metaphysical quality for all work and not only for the work of art.' Like Fritz WINTER, Werner belonged to those artists who endeavoured to invest forms with cosmic and metaphysical significance. Werner Haftmann wrote of Werner and Winter in *Painting*

in the Twentieth Century (1961): 'They have enlarged the old German Romantic idea of the "image of the life of the earth" (*Erdlebenbild*) into a new dimension, which might be called "the image of the inner depths of the world" (*Weltinnenbild*).'

WESSELMANN, TOM (1931–). American painter born in Cincinnati. He studied at Hiram College and took a degree in psychology at Cincinnati University. He began making cartoons while in the army and afterwards studied art at Cincinnati Art Academy and then at the Cooper Union. His first one-man exhibition was at the Tanager Gal., New York, in 1961, after which he became known as one of the prominent figures in American POP ART and exhibited frequently both in the U.S.A. and abroad. He abandoned ABSTRACT EXPRESSIONISM for COLLAGES and constructions in mixed media, bringing representation and reality together to create a tension or ambiguity between the real world and the world of art. His ASSEMBLAGES built up from television sets, air conditioners, clocks, etc., and sometimes incorporating sound effects, had the unreal reality of shop display windows. Like other Pop artists he favoured banal objects and environments of everyday life, and he became known for the overt erotic imagery of his series *Great American Nude*, in which the nude became a depersonalized sex symbol set in a realistically depicted commonplace environment. During the 1970s the image became more and more explicitly sexual. He also did painted plexiglass sculptures and anatomical fragments set against large schematized landscapes.

WESTERIK, CO (JACOBUS, 1924–). Dutch painter born at The Hague. After studying at The Hague Academy, 1942–7, he later taught at the Free Academy, 1955–8, and then at the Royal Academy. He painted everyday themes with social import in a manner of PHOTOGRAPHIC REALISM and in such detail as to give them a magical impact. His work had both humour and irony. He had an important exhibition at the Gemeentemus., The Hague, in 1964.

WESTERMANN, HORACE CLIFFORD (1922–81). American sculptor born at Los Angeles, studied at the Art Institute of Chicago School, 1947–54, and won the Campana Prize in 1964. He began with sculpture in 1953 and had his first one-man exhibition at the Allan Frumkin Gal., Chicago, in 1957. He then exhibited frequently in Chicago, New York and the West Coast and was represented in a number of collective exhibitions both in the U.S.A. and internationally, including: The Mus. of Modern Art, New York, 'The Art of Assemblage', 1961; Tate Gal., 'The New Realism', 1964; Los Angeles County Mus. of Art, 'American Sculpture of the Sixties', 1967; DOCUMENTA IV, Kassel, 1968. His work was very varied and highly individual, therefore difficult to classify. In some

respects he had affinities with DADA. He was recognized as a master of ASSEMBLAGE, closer to the POP mode of assemblage than to JUNK ART. It was marked particularly by the unexpected use of materials and the exploitation of craftsmanship, an aggressive originality and a predilection for themes bordering on FUNK ART. His early work gave prominence to erotic and sinister themes, often exploiting the imagery of war and death. In the later 1950s he produced a series of eccentric 'houses' and 'towers' with titles such as *Madhouse, Suicide Tower*, etc. He had a penchant for rather obvious visual puns, e.g. *Walnut Box* (1964), a walnut box filled with walnuts, and *Westermann's Table* (1966), a plywood column on which was bolted a pile of real books.

WHITE, CHARLES (1918–79). Black American painter, born in Chicago. He was one of the most dedicated of black artists, creating portraits which by their monumental dignity and timeless endurance reflect the strength and pride of the Negro character. His work was widely exhibited, including one-man shows at the Forum Gal. and at the Heritage Gal. in Los Angeles.

WHITMAN, ROBERT (1935–). American experimental artist born in New York, studied at Rutgers and Columbia universities. He had his first one-man show at the Hansa and Reuben Gals., New York, in 1959 and a further one-man exhibition at the Jewish Mus. in 1968. From 1960 he made his name as one of the most active pioneers of HAPPENINGS ('The American Moon', 'The Night Time Sky', etc.), *avant-garde* theatre pieces and cinema pieces. In this field his influence was analogous to that of KAPROW. From the late 1960s he also executed a number of sculptural installations in which he incorporated sound and movement. Notable among them was *Pond* at the Jewish Mus. in 1968. By the use of strobe lights, slide projectors, mirrors and banal words intoned in an incantatory manner over a loudspeaker this installation created a paroxysm of sight and sound which impelled spectator participation by creating an experience both mystifying and overwhelming. It had a strong influence on subsequent ENVIRONMENT ART in America. Whitman also executed a series of 'movie pieces' in which filmed actions interlocked with real actions and events.

WIEGELE, FRANZ (1887–1944). Austrian painter, born in Nötsch, Carinthia. Originally trained as a blacksmith, he studied at the Academy of Art, Vienna, 1907–11. He exhibited with the HAGENBUND in 1911, then travelled to Paris, the Netherlands, and Africa, 1912–14, and in 1917 worked in Zürich. In 1925 he returned to Nötsch, where he lived until his death in an air-raid in 1944. His painting was naturalistic, revealing an interest in light effects, and he was an accomplished draughtsman. Like KOLIG he concentrated on the portrayal of the human figure.

WIELAND, JOYCE (1931–). Canadian painter, film-maker and experimental artist, born in Toronto, where she studied commercial art at the Central Technical School. In 1954 she began working at Graphic Associates, a small independent film company, where she met her future husband, Michael SNOW. Her first commercial exhibition was with Snow at the Westdale Gal., Hamilton, Ont., in 1958; her first one-man show at the Here and Now Gal. in 1960. At a major show at the Isaacs Gal., Toronto, in 1962 she exhibited a small group of very large stained canvases that combined the theme of female sexuality with that of time, all in floating lyrical colour.

After moving to New York with her husband, she became involved in film-making, while continuing to paint. In 1963 at the Isaacs Gal. she showed a series of canvases, many of them small, divided into compartments suggesting film frames. She also began encasing images in plastic bag-like forms, again suggesting the sequence of film frames. In 1967–8 her work was shown with that of John Meredith, another Toronto artist, in an exhibition circulated across the country by the National Gal. of Canada. She was given retrospectives at the Vancouver Art Gal. in 1968 and at Glendon College, York University, Toronto, in 1969. She staged a great extravaganza of a solo exhibition at the National Gal. of Canada, Ottawa, in 1971, 'True Patriot Love'. Somewhat retrospective in nature, the show traced the development of the nationalist theme in her work, but concentrated largely on the stuffed wall-hangings and quilts that had most recently consumed her interest.

While living in New York Joyce Wieland made frequent visits to Canada, and in the early 1970s she settled in Toronto again, with Michael Snow. Although she continued to produce quilts—some, like *Laura Secord* (National Gal. of Canada, 1973–4), on a vast scale—film occupied more and more of her time. Her films include: *Larry's Recent Behaviour* (1963); *Water Sark* (1964–5); *Reason over Passion* (1969), a ninety-minute journey across Canada; *Pierre Vallières* (1972); *Solidarity* (1973). In her first commercial film, *The Far Shore* (1976), she continued to explore in a rich and complex way the questions of Canadian nationalism.

WIEMKEN, WALTER KURT (1907–40). Swiss painter and draughtsman born at Basle, studied in Munich and Paris and afterwards travelled extensively through Europe, including Spain, Belgium and France. He was at his best in his drawings and gouaches, which ranged from delicate country scenes and portraits to a heavily expressive genre such as *Wartezimmer bei einem Arzt* of 1931. There was often an element of expressive fantasy in his work, as may be seen in *Der Mörder* (1930) and *Traum* (1932), and sometimes a SURREALIST conjunction of incompatibles, as in *Gegensätze*

111. Metzgerei, dahinter Bordellszene mit Kruzifix (1934). Both his drawings and his paintings are represented in the Werner Coninx coll., Zürich.

WILEY, WILLIAM (1937–). American painter and sculptor born at Bedford, Ind., studied at the California School of Fine Arts, 1956–60, obtaining the School's Painting Award in 1959. In 1960 he obtained First Prize at the San Francisco Mus. of Art and in 1961 First Prize and Guest Honor Award at the Art Institute of Chicago. During the 1960s he taught at the California School of Fine Arts. His first one-man show was at the Richmond Art Center in 1960 and from 1960 onwards he exhibited at the Staempfli Gal. and the Allan Frumkin Gal., New York. Among the collective exhibitions in which he was represented were: Whitney Mus. of American Art, 'Young America', 1960, and 'Fifty California Artists', 1962; Los Angeles County Mus. of Art, 'American Sculpture of the Sixties', 1967.

WILFRED, THOMAS (RICHARD EDGAR LØVSTRØM, 1889–1968). Danish-American experimental artist, born at Naestved. After studying music and the arts in Denmark, London, and at the Sorbonne, he settled in the U.S.A. in 1916. He was interested in developing LUMINISM and was probably the earliest to conceive of light as an independent art medium instead of thinking of light patterns as interpretations or echoes of musical compositions. From 1905 he experimented with light structures using an incandescent lamp and pieces of coloured glass enclosed in a cigar box. In 1919 he built his first 'Clavilux', which, by a five-manual keyboard of sliding keys and intergrouping colour couplers, a battery of six main projectors and a number of auxiliary flood-lights, controlled the passage of light through rotating and adjustable mirrors and coloured glass slides on to a screen, where it could be made to produce subtle and complicated gradings and mixtures of colour. In 1928 he made his first self-contained, automatically operated Clavilux. He subsequently made more than 20 works of this kind and many other light structures, including a 210 ft (64 m) long *Mobile Mural* (1929) at the Sherman Hotel, Chicago, and his *Lumia Suite*, Op. 158, which from 1964 was on view in the Auditorium Lounge of The Mus. of Modern Art, New York. In 1930 he founded the Art Institute of Light for scientific research into the artistic uses of light. He was represented in many group exhibitions both in the U.S.A. and in Europe, including: 'Fifteen Americans', The Mus. of Modern Art, New York, 1952; 'Art in Motion', Moderna Mus., Stockholm, 1961; 'Kunst-Licht-Kunst', Eindhoven, 1966; 'Light, Motion, Space', Walker Art Center, Minneapolis, 1967; 'Focus on Light', New Jersey State Mus., Trenton, 1967; 'Light and Motion', Worcester Art Mus., 1968. In 1968 he was awarded an honorary Ph.D. at Philadelphia College of Art. In an article contributed to the *Journal of Aesthetics and Art Criticism* in December 1948 he spoke of using the new art as a vehicle to 'express the human longing for a greater reality, a cosmic consciousness, a balance between the human entity and the great common denominator, the universal rhythmic flow'.

WILLENBECHER, JOHN (1936–). American painter and experimental artist born at Macungie, Pa., studied at Brown and New York universities. He exhibited from 1963 with the Richard Feigen Gal., New York and Chicago, and the Feigen-Palmer Gal., Los Angeles. Among the collective exhibitions in which he was represented were: Albright-Knox Art Gal., Buffalo, 'Mixed Media and Pop Art', 1963; University of Pennsylvania Institute of Contemporary Art, 'Current Art', 1965; Whitney Mus. of American Art, 'Young America', 1965; Stedelijk van Abbe Mus., Eindhoven, 'Kunst-Licht-Kunst', 1966. His work during the 1960s lay on the border of POP ART and experimental art involving the creation of 'environments' with light and sound.

WILLIAMS, AUBREY (1926–). British painter, born in British Guiana. He spent two years there with a primitive Indian tribe, the Warrau, who made him a blood brother. He studied at the St. Martin's School of Art, London, and exhibited in England, Paris and New York. His work was included in travelling exhibitions in the Netherlands, Germany, Belgium, Switzerland, Italy and in the exhibition 'Commonwealth Art Today' at the Commonwealth Institute, London, in 1962–3. His painting was mainly expressive abstraction, relying on colour and 'gestural' quality in the manner of TACHISM.

WILLIAMS, FREDERICK (1927–82). Australian painter and graphic artist born in Melbourne. After studying at the National Gal. School there, 1944–9, he worked at the Chelsea Art School and the Central School of Arts and Crafts, London, 1951–6. His earliest etchings, often with music-hall subjects, were produced about this time and were first exhibited at the Melbourne Gal. of Contemporary Art on his return to Australia in 1957. From the late 1950s also began his paintings revealing a distinctively personal vision of the Australian landscape such as *Charcoal Burner* (National Gal. of Victoria, 1959) and *You Yangs Pond* (Art Gal. of South Australia, 1963). By increasing reductivism his paintings in the 1970s became uniquely evocative of the primeval mystery and remoteness of Australian landscape (e.g. *Mount Kosciusko*, 1976) and he was regarded as the most original of Australian landscape painters.

In 1964 Williams travelled to Europe with a Helena Rubinstein Travelling Art Scholarship. Among his other awards were the Wynne Prize for Landscape (1966 and 1976) and the Print Prize of the Council of Australia (1967). His work was included in important collective exhibitions such as

'Australian Painting', Tate Gal., 1963, and his one-man shows included 'Landscape of a Continent' at The Mus. of Modern Art, New York, 1977. His work is represented in many leading public collections including all Australian state galleries.

WILLIAMS, NEIL (1934–). American painter, born at Bluff, Utah, and studied at the California School of Fine Arts. His first one-man exhibition was at the Green Gal., New York, in 1964 and during the 1960s he became known as one of the artists practising the more experimental forms of MINIMAL and SYSTEMIC painting, in particular the exploitation of the shaped canvas. He was represented in a number of collective exhibitions featuring the newest developments in American art.

WILLIAMSON, CURTIS. See CANADA.

WILSON, SCOTTIE (1889–1972). British NAÏVE painter born in Glasgow of working-class parents. He did military service in India and worked for some years in Canada as an itinerant dealer in miscellaneous odds and ends. Unlike most naïve artists his paintings were not 'realistic' renderings of scenes from the daily life with which he was familiar but were pure decorative fantasies incorporating stylized birds, fishes, butterflies, swans, flowers and totem heads. The last of these he saw at Vancouver and they were rather fancifully thought by some commentators to represent the powers of evil in contrast to the powers of good symbolized in the images taken from nature. All his work, however, was decorative rather than symbolic or profound. He was first exhibited at the Gimpel Gal., London, in 1947 and subsequently in Paris, Basle and elsewhere in Europe and America. A posthumous exhibition of some 120 works was staged by the Fieldborne Gal., London, in 1977. He is represented in a number of public and private collections, including the Tate Gal., and the Museums of Modern Art in Paris and New York.

WINTER, FRITZ (1905–78). German painter, born of a mining family at Altenbögge in the Ruhr. He was trained as an electrician and himself worked for a time as a miner. Then, aided by a scholarship, he studied at the Dessau BAUHAUS, from 1927 under KLEE, KANDINSKY and SCHLEMMER. In 1929 he visited KIRCHNER at Davos and in 1930 he knew GABO, working with him for a short while in Berlin. In 1937 his work was condemned as DEGENERATE by the National Socialist regime and he was forbidden to exhibit. He served in the German army on the Polish and Russian front, 1939–45, was wounded and made a prisoner of war. On his return to Germany in 1949 he became a founding member of ZEN and contributed to the first post-war exhibition of the *Deutscher Künstlerbund* in Berlin. In 1951 he visited HARTUNG in Paris and was awarded a prize in the Venice Biennale. His first one-man show in America was at

the Hacker Gal., New York, in 1952. In 1953 he was visiting lecturer at the Landeskunstschule, Hamburg, and in 1955 he began to teach at the College of Fine Arts, Kassel.

Winter's style went through many phases according to the influences to which he was exposed, beginning with the works of Van Gogh which made a strong impression on him during a visit to the Netherlands in 1927. About 1930 he began painting in *haute pâte* with thickly textured layers of pigment mixed with sand, cement, etc. and built up almost into low relief. From 1932, however, his style became more imaginatively inventive and using the unbounded picture space of Kandinsky, he populated it with biomorphic forms or quasi-architectural constructions. From 1934 to 1944 he abandoned painting. The series of paintings he began in 1944, which he named *Triebkräfte der Erde* (*Force-Impulses of the Earth*), united his previous styles and have been thought to suggest the mysterious telluric forces of the earth. During the 1940s he matured his own style, though in the 1950s—perhaps as a result of his visit to Hartung—his work underwent a further change. Against a three-dimensional picture space created solely by a background of contrasting colours he set 'floating' forms or 'signs' which had no representational significance and suggested nothing in the natural world. These were streaks and bars of dense colour, often modulated blacks or greys, which created a vibrant effect. In the 1960s he further broke down his picture space into zones of colours differentiated by the directional application of pigment and free of graphic detail. Winter's use of pure colour for the creation of visual space paralleled the work of COLOUR FIELD painters both in the U.S.A. and in Britain, but the path by which he pursued this end was quite individual. It represented, rather, a development of Kandinsky's unbounded picture space. Winter is regarded as the most important and original of the post-war German artists who pursued the path of pure abstraction without contrivance or mannerism. During the 1970s his work enjoyed wider popularity and was reproduced frequently for calendars, etc.

WINTERSBERGER, LAMBERT MARIA (1941–). German painter born in Munich. He studied ecclesiastical art and mosaic at Munich and then painting at the Accademia di Belle Arte in Florence, 1961–4. In 1969 he was awarded the painting prize at the 6th Paris Biennale for Young Artists. From 1965 he had one-man shows in major German centres and participated in a number of collective exhibitions in Germany and abroad. His work had affinities with the NEW REALISM and with POP ART. He painted gigantic finger-nails, mouths, wounds, other bodily parts, with meticulous realism. But the models for his paintings were advertisement images rather than the parts themselves. His paintings aspired to the objectivity and anonymity, the lack of engage-

ment, which was typical of the New Realism both in Europe and in America.

WIRKKALA, TAPIO (1915–). Finnish sculptor and designer born at Hanko. After studying at the School of the Institute of Applied Art, Helsinki, he worked as an advertising artist until the outbreak of war in 1939. He first became interested in sculpture during his war service in Karelia and became famous for his *Lion* made for the city of Petroskoi and now in the Naval College, Helsinki. In 1946 he won a prize in a competition organized by the Littala glass works, in 1947 he won first and second prizes in the Bank of Finland's competition for new bank notes and in 1950 he was awarded the Grand Prix for laminated wood objects at the Milan Triennale. Wirkkala specialized in abstract sculpture from laminated wood and layers of veneer—his work *The Whirlwind* in this medium, inspired by the shapes of aeroplane propellers, is particularly well known. Among his more monumental works are a 10 m long relief in laminated wood for the office of the Bank of Finland at Vaasa, a 3 m high glass sculpture for Jablones in Czechoslovakia and a 40 m² relief in laminated wood for the Finnish pavilion at 'Expo '67', Montreal. Wirkkala combined in his work a feeling for the stark bleakness of the Lapland wilderness with the beauty of the most modern technology.

WITKIN, ISAAC (1936–). British sculptor born in Johannesburg. He came to England in 1956 and studied at St. Martin's School of Art, 1957–60, and then was assistant to Henry MOORE, 1961–3. He subsequently taught at St. Martin's School of Art and at Maidstone College of Art and Ravensbourne School of Art, Kent. In 1965 he was made Artist in Residence at Bennington College, Vermont. Witkin was one of the pupils of Anthony CARO who helped to create the new *avant-garde* which came to public notice in the exhibition 'The New Generation' at the Whitechapel Art Gal., London, in 1965. Other group exhibitions in which he was represented include: 'Primary Structures', Jewish Mus., New York (1965); 'British Sculpture of the Sixties', Tate Gal. (1970); 'The Condition of Sculpture', Hayward Gal. (1975). His sculptures made use of large mild-steel plates, gracefully curvilinear, built into complex structures. He eschewed the bareness and ordinariness of much *avant-garde* COOL sculpture.

WLÉRICK, ROBERT (1882–1944). French sculptor, born at Mont-de-Marsan and trained at the École des Beaux-Arts, Toulouse, 1899–1903. In 1904 he went to Paris, where he was encouraged by Rodin and exhibited at the Société Nationale in 1905 and at the Salon d'Automne. He was a founding member of the Salon des Tuileries. His style was naturalistic and restrained, with attention to the rhythmical play of muscles and with considerable psychological insight in his portraits. He was adept at capturing a characteristic attitude or pos-

ture in a movement sequence. Among his monumental works were an equestrian statue of Marshal Foch, the statue of Condorcet at Ribemont, and the fountain of Castelnaudary. At Mont-de-Marsan a museum is devoted jointly to the works of Wlérick and DESPIAU.

A retrospective exhibition of Wlérick was given at the Birmingham City Mus. and Art Gal. in 1976.

WOESTIJNE, GUSTAVE VAN DE (1881–1947). Belgian painter, born at Ghent and studied at the Ghent Academy. In 1898 he underwent a mystical religious experience and settled in LAETHEM-SAINT-MARTIN, where he remained until 1909, and founded the First Laethem Group together with his brother, the poet Karel van de Woestijne, Valerius de SAEDELEER and George MINNE. He passed a noviciate at the Abbaye de Mont-César but renounced the intention to take orders and married. In this period he painted mainly religious and allegorical pictures which gave visual expression to his religious mysticism. He was in sympathy with the Symbolist influences which weighed strongly on the Laethem group and was attracted by the English Pre-Raphaelites. His *Dimanche Après-Midi* (Mus. Royaux des Beaux-Arts, Brussels, 1914) shows influence from the drawing of Gauguin. He passed the First World War in Wales, returning to Belgium in 1920, and in 1925 became Director of the Academy at Malines until 1938, when he moved to Brussels. During the 1920s his EXPRESSIONISM became at once more dramatic and more imaginative and as time went on the form was simplified and the colour became more vivid. Examples of his later style are *Paysage Fantastique* (c. 1924) and *Le Baiser de Judas* (1937), both in the Mus. Royaux des Beaux-Arts, Brussels. Although primarily a religious painter, Van de Woestijne was also notable in the fields of landscape and portraiture. He is regarded as one of the founders of Belgian mystical and contemplative Expressionism.

WOLS (ALFRED OTTO WOLFGANG SCHULZE-BATTMANN, 1913–51). German-French painter, born in Berlin but grew up in Dresden, his father being head of the Saxony Chancellery. He began work as a violinist and also studied ethnology and the anthropology of primitive peoples at the Institute of African Studies, Frankfurt. Although he had shown a talent for drawing from early childhood, he was converted to serious interest in art by MOHOLY-NAGY and studied for a while at the BAUHAUS. He went to Paris in 1932, where he earned a living by photography under the name Wols and won recognition at the Exposition Universelle of 1937. He was interned at the outbreak of war but liberated in 1940 and lived in poverty in the south of France, drawing and painting. On the termination of war he returned to Paris and was befriended by J.-P. Sartre and Simone de Beauvoir, for whom he did illustra-

tions. He achieved recognition for his paintings with one-man shows at the Gal. Drouin in 1947 and at the Hugo Gal., New York, in 1950. But his irregular life, poverty and excessive drinking undermined his health and he died in 1951. His posthumous fame far outstripped his reputation during his lifetime and he came to be regarded as the 'primitive' of ART INFORMEL and one of the great original masters of expressive abstraction. His work had an important influence on the TACHIST art of the late 1940s and 1950s. His œuvre consisted of a few large paintings, many finely executed water-colours and a large number of drawings. He worked spontaneously and achieved abstraction as a mode of self-expression. His water-colours have been characterized as 'psychotically withdrawn' and were described by Michel Seuphor as délires organisés.

WOLVECAMP, THEO. See EXPERIMENTAL GROUP.

WOOD, CHRISTOPHER (1901–30). British painter born at Knowsley, Lancashire. He suffered an attack of polio at the age of fourteen and was incapacitated for three years. After studying architecture briefly at Liverpool University, he went to London in 1920 and there won the admiration of Augustus JOHN, who saw his sketches at a casual meeting in the Café Royal. In 1921 he went to Paris on the invitation of Alphonse Kahn and took up the study of painting seriously at the Académie Julian and then at the Grande Chaumière. In a remarkably brief time he won the friendship and regard of many of the Paris avant-garde, including PICASSO and Jean Cocteau (who wrote the Introduction to the catalogue of his first London exhibition), so that, in the words of John Rothenstein, he enjoyed a position in the Paris art world 'approached by no English artist of his generation and by very few others'. He had his first London exhibition at the Beaux-Arts Gal. together with Ben NICHOLSON in 1927. He worked with the Nicholsons in Cornwall, 1926–8, and with them 'discovered' the primitive painter Alfred WALLIS. He travelled very widely both on the Continent and in England. He was killed in a train accident in August 1930. After his death he became something of a legend as the youthful genius cut off before his prime.

Wood was subject to many influences and though his exceptional talent was generally recognized, his personal style did not fully mature. His work was lyrical and poetic yet with a smatch of primitiveness which Gwen Raverat felicitously referred to as 'fashionable clumsiness'. He had an exhibition of drawings at the Claridge Gal. in 1928, an exhibition at Tooths in 1929 and a fourth exhibition, with Nicholson, at the Gal. Georges Bernheim in 1930. A retrospective exhibition was given at the Wertheim Gal. in 1931 and a memorial exhibition, organized by the Redfern Gal., was shown at the New Burlington Gal. in 1938. A

memorial volume *Christopher Wood* was published by the Redfern Gal. in 1959 containing a souvenir by Max Jacob and a shortened version of an essay by Eric Newton. In his book on Wood, Eric Newton described him as a 'poet-painter'.

WOOD, GRANT (1892–1942). American painter born at Anamosa, Iowa. After studying woodwork and metalwork at the Handicraft Guild of Minneapolis and opening a handicraft shop at Cedar Rapids, he studied painting at the Art Institute, Chicago, in 1912. During the First World War he worked at camouflage and afterwards taught art at Cedar Rapids. He went to Paris c. 1920 and studied briefly at the Académie Julian, returning to Cedar Rapids in 1924. In 1927 he obtained a commission to make stained glass windows for the Cedar Rapids Veteran Memorial Building and went to Munich in 1928 to supervise their manufacture. Influenced by the early Flemish painting which he saw in museums there, he abandoned his earlier Impressionist style and began to paint in the meticulous, sharply detailed veristic manner for which his work is chiefly known. Adapting this style to the depiction of the ordinary people and everyday life of Iowa, he came within the category of the REGIONALIST group of the Painters of the AMERICAN SCENE. He first came to national attention when his painting *American Gothic* won a bronze medal at an exhibition of the Art Institute of Chicago in 1930. Although at the time it aroused violent controversy and was deplored as an insulting caricature of plain country people, the painting gradually gained acceptance and has since been described as one of the most popular paintings in America. Wood himself said of it: 'I tried to characterise them [i.e. the sitters, his sister and his dentist] honestly, to make them more like themselves than they are in actual life.' To the same year belongs his *Stone City, Iowa* (Joslyn Art Mus., Omaha, 1930). In 1931 he introduced an element of humorous fantasy in *The Midnight Ride of Paul Revere* (The Metropolitan Mus. of Art, New York) and in 1932 he painted his famous satirical *Daughters of the Revolution*, which was described by certain Sons of the American Revolution as 'three sour-visaged and repulsive-looking females, represented as disgustingly smug and smirking because of their ancestral claim to be heroes of the American Revolution'. This may have been Wood's quiet revenge for the opposition to the dedication of his stained glass windows put up by the ladies because they had been made in Germany. There is a sly wit in his *Parson Weems' Fable* (Art Institute of Chicago, 1939), in which he illustrates the story of George Washington owning up to chopping down the cherry tree.

In 1932–3 Wood was the founder of the Stone City art colony. During the 1930s he supervised several Iowa projects of the FEDERAL ARTS PROJECT. Among the works which he himself did under the Project were murals for the Post Office Department Building, Washington, D.C., and for the

Library of the Iowa State College at Ames, Iowa. Wood had a retrospective exhibition at the University of Kansas in 1959.

A combination of perceptive insight and dry caricature make Wood's figure paintings outstanding among the works of the American Regionalist school. His landscapes have often an air of the deliberately primitive or *faux naïf* which lends them charm. A tension set up between his scrupulously veristic detail and the psychological impact of an overwhelming sense of 'presence' raises his finest paintings above the rank and file of Regionalist painting to the level of truly memorable art.

WORLD OF ART, THE. See MIR ISKUSSTVA.

WORPSWEDE. A village near Bremen which became a main centre of the German *Naturlyrismus* (lyrical interpretation of nature) movement in the last decade of the 19th c. Fritz Mackensen (1866–1956) and Otto Modersohn (1865–1943) settled there in 1899 and they were joined by Heinrich Vogeler (1872–1942), Fritz Overbeck and others. They exhibited as a group at the Glaspalast, Munich, in 1895. The 'Worpswede school' is sometimes regarded as one of the roots from which 20th-c. German EXPRESSIONISM emerged.

WOSTAN, STANISLAS WOJCIESZYNSKI (1915–). Polish-French painter and sculptor, born at Kozmin. After studying at the Academy of Fine Arts, Poznań, he went to Paris in 1945 and became a member of the ÉCOLE DE PARIS. He worked largely in cement and coloured plaster, exhibiting in 1953 a number of cement low reliefs on the theme of the Wailing Wall. He also carved in wood and worked in hammered bronze. His style both in sculpture and in painting united primitive features with violent EXPRESSIONISM.

WOTRUBA, FRITZ (1907–75). Austrian sculptor, born at Vienna. He first trained as an engraver and took up sculpture as a pupil of Anton HANAK at the Vienna Academy. In 1938 he emigrated to Switzerland and remained there during the war. He returned to Vienna in 1945 and was made first Professor and later Rector of the Academy. Wotruba carved directly in stone, preferring a hard stone with a coarse texture. Starting from a naturalistic style reminiscent of MAILLOL, he advanced towards abstraction by reducing the figure to bare essentials and eliminating the inessential. It was the method used by BRANCUSI, but unlike the subtle abstractions of Brancusi, Wotruba reduced his figures to solid, block-like structures. These carvings, which he left in a rough state, carried a suggestion at once of the monumental and the primitive. He brought about a revival of sculpture in Vienna and he was the real founder of the new Austrian school of abstract sculpture. In 1948 a major exhibition of his work was given at the Venice Biennale and in 1964 he exhibited at the Marlborough-Gerson Gal. in New

York. In the same year he executed a large relief frieze for Marburg University. His reputation was international and he is represented in important public collections at New York, London, Zürich, Antwerp, etc.

WOUTERS, RIK (1882–1916). Belgian sculptor and painter born in Malines, where he was apprenticed as a wood-carver in his father's furniture workshop. He learned the techniques of modelling and casting at the Académie des Beaux-Arts, Brussels, and between 1907 and 1914 he completed a number of bronzes in a romantic Impressionist style. Notable among them are the full-length *Portrait de Mme Giroux* (1912) and the *Portrait de James Ensor* (1913). His masterpiece in sculpture is considered to be the bronze *Au Soleil* of 1911. Wouters began to paint without formal instruction in 1904 and by 1912 he was giving more importance to his painting than to his sculpture. He adopted the FAUVE colours and in 1912 exhibited at the Giroux Gal. with the Brabant Fauvists, whose leader he became. He painted in oils with a water-colour technique, applying fluid colours in irregular patches and allowing the white of the canvas to shine through and give transparency to the picture. In 1912 he visited Paris and was impressed by the works of Cézanne which he saw there. In consequence his compositions became more solidly constructed and he was reinforced in his attempts to convey the impression of light without dissolving form. Examples are *Le Flûtiste* (1913) and *Nature morte—Humeur sombre* (1915), both in the collections of the Mus. Royaux des Beaux-Arts, Brussels.

Wouters was called up in 1914, deserted after the fall of Antwerp and was interned successively at Zeist, Amersfoort and Amsterdam. In 1916 he died as a result of operations for cancer of the eye. Although he lived only four years after his style matured and those years were interrupted by the war, Wouters is regarded as one of the major artistic talents of Belgium in this century. In 1916 a major retrospective exhibition of his works was staged in Amsterdam and a large exhibition was given at the Mus. National d'Art Moderne, Paris, and in Antwerp in 1957. A further retrospective was held at Malines in 1966.

WUNDERLICH, PAUL (1927–). German painter, sculptor and graphic artist, born in Berlin. He studied at the Landeskunstschule at Hamburg from 1947 to 1951 and taught graphic techniques there from 1951 to 1960. He spent the years 1960 to 1963 in Paris and in 1962 won the M.S. Collins Prize for lithography in Philadelphia. In 1964 he obtained the Japan Cultural Award, Tokyo, and in 1967 a Marzotto prize for painting. From 1963 he taught at the Hochschule für Bildende Künste, Hamburg, where he had considerable influence upon the younger artists. He had many one-man shows in Germany and several exhibitions of his graphic work in the U.S.A. In London the Red-

fern Gal. gave him an exhibition in 1968. His work consisted largely of blown-up heads, bony or mannered and stylized figures in vaguely suggested interiors with Neo-SURREALIST suggestions executed with meticulously exact technique.

WYETH, ANDREW (1917–). American painter born at Chadds Ford, Pa., son of a well-known muralist and illustrator of children's books, Newel Convers Wyeth. His brother-in-law was the New Mexico painter and portraitist Peter Hurd, and his son James also gained a reputation as a painter. Andrew Wyeth was taught by his father. Although he denied that he was a realist in the traditional sense and claimed 'I'm a pure abstractionist in my thought', he painted scenes and people from the American Middle West in a style of sharply detailed realism which brings him within the category of the REGIONALIST group of AMERICAN SCENE painters. His pictures convey a sense of human solitariness within an exaggerated spaciousness and the tension between the meticulously detailed technique and the mood of desolation and melancholy which many of them impose gives them an atmosphere entirely their own. His figure paintings such as *Adam* (1963) and *The Patriot* (1964) are scrupulous portraits of individuals which are nevertheless converted into depictions of American character types. Wyeth first came to general notice with his painting *Christina's World* (The Mus. of Modern Art, New York, 1948), after which he grew to be one of the most popular of the Painters of the American Scene, very widely exhibited and much collected. While recognizing his popularity as a painter of the American Scene and his stature among this class of painters, critics have remained somewhat ambivalent in their judgements. Professor Sam Hunter wrote of him: 'Wyeth's major paintings have been done in the flat and unemphatic technique of tempera. Despite their photographic sharpness of focus and painstaking effort, they are often surprisingly awkward technically, and not altogether convincing visually. More than one critic has noted that his humanity is curiously lifeless, his anatomies naïvely misarticulated for all their stupefying and meticulous detail. . . . It is the sense of vacuity in Wyeth's art, with its patinated, "antiqued" surfaces and heavily nostalgic American way of life, which finally leaves the viewer with a sense of frustration and discouragement. . . . What most appeals to the public, one must conclude, apart from Wyeth's conspicuous virtuosity, is the artist's very banality of imagination.'

Another critic has said: 'Wyeth does regularly achieve something terrific. At his best he is able to freeze the essence of a particular moment in a specific place—the ominous sound of distant thunder, the simple dignity of an aging farmhouse. . . . If ever an American artist endowed the commonplace with the breadth of universal experience, it is Wyeth. As he depicts seemingly minor events in the life of his subjects, he reveals with immense skill and deep perception the longings and limitations of America and Americans. This was the goal of the American Scene painters.'

A major retrospective exhibition of Wyeth's work was held at the Royal Academy, London, in 1980.

WYNTER, BRYAN (1915–75). British painter born in London, studied at the Slade School, 1938–40. In 1945 he settled at Zennor, Cornwall, where he lived in comparative seclusion until 1964, when he moved to St. Buryan, Cornwall. From 1947 to 1957 his works were exhibited at the Redfern Gal., London, from 1959 at the Waddington Gals. and elsewhere and he contributed to a number of major collective exhibitions. In 1976 he was given a memorial retrospective exhibition at the Hayward Gal. arranged by the Arts Council. During the decade 1946–56 he did very original decorative and expressive landscapes in gouache. From 1956 he painted the abstracts which were his best-known work. Although he himself acknowledged the debt to BRAQUE's *Ateliers*, the affinity between these paintings and the best work of Roger BISSIÈRE is patent. Like Bissière's these abstract paintings were closely related to landscape. Wynter himself said of them: 'My paintings are non-representational but linked to the products of nature in as much as they are developed according to laws within themselves and are a static record of the processes that have brought them about. . . . These paintings, then, are not pure abstractions. Nor do I abstract from "nature". I approach "nature" from the other side. I used to be a landscape painter. Am I still influenced by landscape? The landscape I live among is bare of houses, trees, people; is dominated by winds, by swift changes of weather, by moods of the sea; sometimes it is devastated and blackened by fire. These elemental forces enter into the paintings and lend their qualities without becoming motifs.' From about the mid 1960s his style changed to more openly patterned compositions with a more decorative quality but without the intensity of inspiration which infused his earlier abstractions. From 1960s he also did KINETIC constructions, which he called IMOOS (Images Moving Out Onto Space), moving kaleidoscopic shapes lighted behind concave distorting mirrors.

X

XCERON, JEAN (1890–1967). Greek-American painter born at Isari. He went to the U.S.A. in 1904, studied at the Corcoran School of Art, Washington, 1910–16, and then in New York. He was in Paris from 1927 to 1937, and had many one-man exhibitions there and elsewhere in Europe. His first one-man show in New York was at the Garland Gal. in 1935, after which he exhibited in many places in the U.S.A. He was a member of AMERICAN ABSTRACT ARTISTS and the Federation of Modern Painters and Sculptors. From a CUBIST style he developed in the direction of abstraction and evolved a highly personal style of strongly constructed quasi-geometrical composition which nevertheless displayed a certain playfulness and freedom. He exhibited with the SALON DES RÉALITÉS NOUVELLES from 1947 to 1952 and was represented in a number of group shows in America, including 'The Sphere of Mondrian', Houston Mus. of Fine Arts, 1957, and an exhibition circulating in South America from The Mus. of Modern Art, New York, in 1963–4. He had a retrospective exhibition circulating to seven museums in the Southwest and West Coast, 1948–9, and at the Solomon R. Guggenheim Mus. in 1952.

XENAKIS, COSMAS (1925–). Greek experimental artist, painter and architect, born at Brăila in Romania. He studied in Athens and in Paris. Throughout his career he adopted a geometrical approach to pictorial problems, evolving an original manner of CONCRETE ART and avoiding tendencies to EXPRESSIONISM.

XENAKIS, IANNIS (1922–). Greek artist born at Brăila in Romania. After fighting with the Greek resistance movement he arrived in Paris in 1947. Chiefly known as a composer and architect, he adopted a mathematical approach to both and collaborated for a while with LE CORBUSIER. In the visual arts he pioneered the use of multiple laser in light environments. At 'Expo '67' in Montreal he created in the French Pavilion a vast 'Polytope' made up of large concave and convex mirrors suspended on electrified cables producing 'visual melodies' by the simultaneous action of light sources. He created a still more strange and elaborate form of total spectacle at the Roman Baths off the Boulevard St. Michel (Cluny) in 1972. He was among the most prominent creators of 'total environments' involving both spectacle and sound.

XUL SOLAR (OSCAR AGUSTÍN ALEJANDRO SCHULZ SOLARI, 1887–1963). Argentine painter born in San Fernando, B. A. He renounced a government job, compressed his German-Italian name to Xul Solar and became what Gilbert Chase referred to as 'a spiritual voyager in the world of the imagination' and a self-taught painter. Between 1912 and 1925 he travelled to the Mediterranean in a short-lived career as a sailor, then to Florence, Paris, London and Berlin. In 1917 he went to Milan with his friend the Argentine CUBIST painter Emilio PETTORUTI. Xul Solar was known as a 'Superrealist' in Argentina. He worked on a small scale chiefly in tempera and water-colour, exhibited relatively little and sought no prizes, preferring the conceptual and symbolic aspects of an art career. He did, however, have a first exhibition in Milan in 1920 and showed several times in Argentina from 1924 on. When he returned to Buenos Aires in 1924 he joined the literary and artistic *avant-garde* circle of the *Martinfierristas* and exhibited in the Salon Libre along with Pettoruti. He also participated in the exhibitions of the Primer Nuevo Salon in Buenos Aires in 1928 with Basaldua, Horacio BUTLER, FIGARI, FORNER, Guttero, Pettoruti, Norah Borges and others. His work has been divided into three phases. The first runs from 1917 to 1930 and comprises colourful forms of geometric tendency with stylized emblems, signs, objects, sometimes with numerals, letters and words spelling out the subject of the picture as in *Chief of Dragons* of the 1920s. Many pictures of this period also deal with double or multiple transparent images. The second period runs from 1930 to 1960 and shows a predominance of architectural and topographical themes, sparse modelling, nearly traditional perspective and a more restrained monochromatic colour scheme as in *Transparent Mountains with Village* (1948) and *Three Projects for Façades in the Delta* (1954) inspired by the houses built on piles in the Parana river delta near Buenos Aires. The third period runs from 1960 to his death three years later and focuses more on the alphabet, which he organized into original decorative patterns, and a return to the lyric colour of his earlier works. His paintings of this last phase are interspersed with words from two languages he invented, a universal language he called *Panlengua* and a Pan American language, *Neocriollo*. Examples of this period include *Syllabic Block Letters* (1960) and *Lu Diabo Muy Sabe Piu Por Viejo Ke Por Diabo* (*The Devil Knows More Because he is Old Than Because he is a Devil*, 1962). The latter title is a

composite of several words of Latin root and phonetic spellings. Like Joaquín TORRES-GARCÍA, Xul Solar wished to invent a universal and timeless idiom combining language with plastic elements. But unlike Torres he was less interested in the CONSTRUCTIVIST aspects of painting than in its function as a visual conveyor of abstract ideas. He attempted to integrate visual reality with the fictitious world of the imagination. His esoteric spiritual and intellectual quests in astrology, mysticism, linguistics, musical notations, also incorporating strange figures and animals, gained the admiration of the SURREALIST poet and art historian Aldo Pellegrini, who wrote the introduction to Xul Solar's 'Homage' exhibition at the 3rd Córdoba Bienale (Argentina) in 1966, and Jorge Luis Borges, whose own writing expresses an interest in the linguistics of fictitious worlds.

Xul Solar also invented a very complicated universal game based on chess, which he called *Panjuego* (Pangame), quite different from DUCHAMP's intellectual games. Borges referred to his paintings as 'documents for the ultraterrestrial world, of the metaphysical world in which the gods take on the imaginative forms of dreams'. The works of his 'alphabetical' phase have sometimes been compared in appearance to Paul KLEE's pictographic compositions. Xul Solar was given an important retrospective exhibition at the Mus. Nacional de Belles Artes in Buenos Aires in 1964. His influence on younger Argentinian artists was enormous.

Y

YACULOV, GEORGII BOGDANOVICH (1882–1928). Russian painter and stage-designer born at Tiflis (Tbilisi). He attended the Moscow Institute of Painting, Sculpture and Architecture from 1901 to 1904, when he was called up for the Russo-Japanese front and spent some time in Manchuria, where he was deeply impressed by the peculiar light effects of that area. In 1905 he began to develop his theory of light. He had his first professional exhibition with the Moscow Association of Artists in 1907 and thereafter was much exhibited in Russia and abroad. In 1910–11 he was involved as decorator in spectacles, private balls, etc., and in 1913 he travelled to Paris, where he met the DE-LAUNAYS and found that some of his ideas on light corresponded with their theories of ORPHISM or SIMULTANISME. After doing military service, 1914–17, he helped plan the interior of the Café Pittoresque, Moscow, together with RODCHENKO, TATLIN and others and from 1918 he was active as a theatrical designer. In 1919 he signed the Imagist manifesto and in the same year became Professor at VKHUTEMAS. In the early 1920s he was again active principally as a stage designer and in 1924 he designed a monument for the 26 Baku Commissars. In 1925 he travelled to Paris, worked on décor for DIAGHILEV's production of *Le Pas d'Acier* (realized in 1927), then returned to Moscow later in the year. He died of pneumonia in 1928.

YAMAGUCHI, TAKEO (1902–). Korean painter, born at Seoul and worked in Tokyo, where he was prominent in the development of Japanese abstract art. He studied in Paris, 1927–31, and was influenced by LÉGER and ZADKINE. After painting semi-abstractions in the manner of Léger, he began after the war to paint simplified geometrical forms reminiscent of Japanese hieroglyphics. During the 1960s he further simplified to triangles and rectangles painted with many layers of monochrome colour and with attention to surface texture. An example of this style is his *Taku* (The Mus. of Modern Art, New York, 1961).

YARWOOD, WALTER. See CANADA.

YENCESSE, HUBERT (1900–). French sculptor, born in Paris, son of the sculptor Ovide Yencesse, who was Director of the École des Beaux-Arts, Dijon. In 1919 he began to study at the École des Beaux-Arts, Paris, and in 1921 he first exhibited at the Salon d'Automne, becoming a member in 1927. In 1934 he was awarded the Blumenthal Prize and from 1934 to 1936 he worked with MAILLOL. From the mid 1930s his sculpture was exhibited in most European countries and in America and he gained the reputation of being the leading representative of the French classical tradition in sculpture. Like Maillol his favourite subject was the female nude. But unlike the static calm and serenity of Maillol's nudes, he rejected the 'studio nude' and represented his figures in movement, preferably in the movement of dance. In order to capture the characteristic rhythm and posture he would make preliminary sketches from many aspects and then model from memory. His drawings, both pencil and wash, had great sensitivity and were valued by connoisseurs. His works are in many public collections. Among his important commissions were: figures for the Palais des Nations, Geneva (1938); bronze *Buste de la République*, Salle des Assemblées, 1944; bronze *Memorial* to the victims of Belfort prison camp (1949); statue *France* to commemorate the French Free Forces, Brookwood Cemetery, England (1957); steel *Hommage à Maillol*, Banyuls-sur-Mer (1963). In 1973–4 he executed a series of medals for the Paris mint. He taught at the École des Beaux-Arts, 1950–70. He was created Chevalier de la Légion d'honneur and Officier des Arts et Lettres in 1972.

YOSHIDA, MINORU. See GUTAI GROUP.

YOSHIHARA, JIRO (1905–). Japanese painter born in Osaka. During the 1930s he was known as an *avant-garde* artist whose work demonstrated the influence of advanced European art. In the 1950s he took the lead in the formation of the GUTAI group at Osaka. His own work then developed into simplified abstraction consisting of irregular circular forms left blank against a painted background. They were done under the influence of Zen Buddhism and invited the same sort of total experience as was advocated by the SITUATION group. In 1967 he was awarded First Prize at the Tokyo Biennale.

YOUNG, ROBERT (1938–). Canadian painter and graphic artist born at Vancouver. After studying art history at the University of British Columbia, 1956–62, he studied painting at the City and Guilds School of Art, London, 1962–4, and then at the Vancouver School of Art, 1964–6. From 1969 he had exhibitions in London, Kingston, Doncaster, Liverpool, Ontario, Vancouver. In

1975 he participated in the *Time* magazine Canadian Canvas Exhibition and in 'Realismus + Realität', Darmstadt. His works are in a number of public collections, including: London Borough of Camden; Provincial Government of British Columbia; Canada Council Art Bank; University of British Columbia; University of Guelph; Vancouver Art Gal.; The Canadian Broadcasting Corporation; Banff School of Fine Arts. He worked in a style of mannered and aggressive realism and he did many portraits which have something of the impact of PHOTOGRAPHIC REALISM.

YOUNGERMAN, JACK (1926–). American painter and sculptor born at Louisville, Ky. After studying at the universities of North Carolina, 1944–6, and Missouri, 1947, he attended the Académie des Beaux-Arts, Paris, 1947–8, and remained in Europe until 1954. He exhibited at the Salon de Mai and the SALON DES RÉALITÉS NOUVELLES and had a one-man show at the Gal. Arnaud in 1951. He designed stage sets for *Histoire de Vasco*, produced by Jean Barrault, and for *Deathwatch* by Jean Genet. His first one-man show in the U.S.A. was at the Gres Gal., Washington, in 1957, after which he exhibited at the Betty Parsons Gal., New York, from 1957 through the 1960s. Like Ellsworth KELLY he changed from European CONSTRUCTIVISM to a mode of HARD EDGE painting in flat, uninflected and vivid colours bounded by flowing curves such as *Black Yellow Red* (1964) and *Totem Black* (1967). He was represented in the exhibitions 'American Abstract Expressionists and Imagists' at the Solomon R. Guggenheim Mus. in 1961 and 'Systemic Painting' in 1966. During the 1960s he exploited a liking for compositions involving ambiguity between figure and ground so that the figure and background were reversible. He also did brilliantly coloured lithographs and silk-screens in which abstract shapes were sharply outlined, and latterly he experimented with sculpture.

YRRARÁZAVAL, RICARDO. See LATIN AMERICA.

YTURRALDE, JOSÉ MARIA. See SPAIN.

YUHARA, KAZUO (1930–). Japanese sculptor born in Tokyo and studied at the Tokyo University of Arts. He went to Paris in 1965 and exhibited at the Salon de la Jeune Sculpture and the Paris Biennale. He was also represented at the Guggenheim International Exhibition of 1967. His sculpture was abstract and expressive of mood and contemplation.

YUNKERS, ADJA (1900–). Russian-American painter and graphic artist born at Riga, the son of wealthy parents. He lived in St. Petersburg until 1914. In 1916 he served in the Imperial Guard, but after the 1917 Revolution he went to Germany and had his first exhibition at the Maria Kunde Gal., Hamburg, in 1918. After some years travelling in Italy, Spain, West Africa and Paris, he went to Havana in 1924 and there worked as interior decorator, advertising manager and editor of a review which he founded. After a short stay in Mexico he settled in Paris until 1933, when he moved to Sweden. There he edited the art magazines *Creation* and *Ars* and inaugurated a series of portfolios of contemporary Swedish graphic artists. He migrated to the U.S.A. in 1947 and taught at the New School for Social Research, New York, 1947–54, and the Cooper Union, 1956–67. He received a Guggenheim Foundation Fellowship in 1949, renewed in 1954, and a Ford Foundation grant in 1959. He had retrospectives at the Baltimore Mus. of Art in 1960 and the Stedelijk Mus., Amsterdam, in 1962. In 1969 he was represented in The Mus. of Modern Art, New York, exhibition 'New American Painting and Sculpture'. His work was extensively exhibited both in America and in Europe. He is chiefly known as a graphic artist of great power and expressive impact. The distortions for psychological effect of his earlier works have been compared to those of MUNCH, but during the 1950s and 1960s he became increasingly abstract. This is particularly true of the large pastels of the 1960s, which combined Impressionist colour with an expressive vigour akin to that of ACTION PAINTING. An example is the pastel *Passage de la Lune* (Dore Ashton coll., 1961). In the late 1960s he also did COLLAGES from painted canvases, and luxury illustrations including illuminations for the poem 'Blanco' by Octavio Paz.

YVARAL (JEAN-PIERRE VASARELY, 1934–). French painter born in Paris, son of Victor VASARELY, studied at the École des Arts Appliqués, Paris. He was a member of the NOUVELLE TENDANCE and a founding member of the GROUPE DE RECHERCHE D'ART VISUEL (GRAV). His work belonged to the category of OP ART and he concentrated mainly on the use of black and white in moiré patterns and other devices to create the sensation of virtual movement or ambiguous patterns of approaching and receding forms within a sharply restricted depth dimension. His *Accélération Optique* of 1962 was owned by the Contemporaries Gal., New York. He also used plastic cords crossing within a shallow space to create an ambiguous impression of crumpling and movement, as in *Acceleration No. 5, Series A*, of 1962. Of Yvaral's use of the moiré effect Frank Popper has said: 'As with his other works, the central aim is to present the phenomenon in its maximum degree of purity, so that nothing intervenes between the object and our perception of the object in its visual presence. This is particularly true in the case of the works which employ radiating threads, where the interference effects create a remarkable effect of dematerialisation. The "work" only seems to exist in terms of the evanescent, but immediately perceptible, shifting of the lines of intersection.'

Z

ZACK, LÉON (1892–). Russian-French painter, born at Nijni-Novgorod. He studied classics at the University of Moscow while at the same time attending schools of painting. He lived in Florence from 1920 to 1922; then after a year in Berlin, where he designed costumes and sets for the Russian ballet, he settled in Paris. There he exhibited at the Salon d'Automne and the Salon des Indépendants and was a founding member of the Salon des Surindépendants. From 1952 he exhibited at the Salon de Mai. His first one-man show was at the Gal. Percier in 1927 and from that time he had a number of one-man shows in Paris and was represented in collective exhibitions in many countries. His work was at first figurative with a tendency to geometrical stylization. In the 1950s he turned to religious art, designing stained glass windows for St. Sulpice, Paris, in 1957 and for the Sacré-Cœur, Mulhouse, in 1959. From *c.* 1954 his easel painting abandoned figuration for geometrical abstraction, gradually changing in the direction of a more expressive mode of TACHISM with sensitively worked blotches disposed in the middle of a monochromatic textured surface. He had exhibitions of such abstract works at the Gal. Kléber in 1955 and 1957.

ZADKINE, OSSIP (1890–1967). Sculptor, born at Smolensk, Russia, of a family of boat-builders. He worked mainly in Paris and became a French citizen in 1921. In 1906 he was sent by his father to Sunderland in the north of England to learn English but made his way to London in order to study sculpture. Owing to poverty he returned to Smolensk, but was sent back to London in 1907 with means to study at the Polytechnic Institute. After returning once more to Smolensk he came to Paris in 1909 and after studying for some months at the École des Beaux-Arts, set up as a sculptor and mingled with the artistic life of Montparnasse. He came into contact with the CUBIST circle, with whom his work at that time had something in common although the dramatic and baroque character of his temperament was foreign to the restraint imposed by Cubist doctrine. He did, however, investigate perhaps more profoundly than any other contemporary artist the problems involved in representing volumes by concave surfaces and he used his discoveries for expressive effects. It is for his use of hollows and concave inflections that is most generally known. Among the more interesting examples of this technique are his bronze *Menades*, inspired by the fragmentary *Victory* of Paeonius, and the *Orpheus* (1948), carved from a tree-trunk with a formal analogy to a Greek *Apollo Citharoedus*.

In 1915 he joined the French army but was invalided out after being gassed. He worked in Paris through the 1920s and 1930s, passing from Cubist compactness of form to his own more dramatic style, became interested in polychrome wood sculpture and investigated the intrinsic sculptural qualities of bronze. He spent the Second World War in New York, returning to Paris in 1944, where he taught at the Académie de la Grande Chaumière. In 1950 he obtained a prize for sculpture at the Venice Biennale. In 1953 he completed the monumental bronze *To a Destroyed City* which, standing at the entry to the port of Rotterdam, proclaims anger and frustration at the city's destruction and the courage which made possible its rebuilding. In 1958 Zadkine was given a large retrospective exhibition at the Maison de la Pensée, Paris.

ZALCE, ALFREDO. See MEXICO.

ZAMORANO, RICARDO. See SPAIN.

ZAO WOU-KI (1920–). Chinese painter born in Peking. He studied at the National Academy of Fine Arts, Hangchow, and taught there from 1941 to 1947. He settled in Paris in 1948 and obtained French citizenship. His first one-man show was at the Gal. Creuze, Paris, in 1949. From 1950 he exhibited at the Gal. Pierre, Paris, and from 1952 at the Cadly-Birch Gal., New York. He also exhibited at the Salon de Mai. From delicate figurative work his style evolved towards a subtle and precise abstraction which combined Oriental calligraphic traditions with Western ideas of expressive abstraction. His works were credited with a reflective and serene mysticism and the gift of crystallizing in abstract forms the specific kinds of beauty typical of different times of day and different seasons of the year. He was a painter of mood.

ZARITSKY, YOSSEF (1891–). Israeli painter born at Kiev, studied at Kiev and Moscow and emigrated to Israel in 1923. Painting mainly in water-colour he established a reputation for his *intimiste* landscapes, which after the war gradually passed into LYRICAL ABSTRACTIONS reminiscent of the ÉCOLE DE PARIS. He was responsible for founding the NEW HORIZONS group in 1948.

ZEBRA. A group formed at Hamburg in 1965 for exhibition and promotional purposes by the four German artists Dieter ASMUS, Peter NAGEL, Nikolaus STÖRTENBECKER and Dietmar ULLRICH. Their work belonged to the general category of PHOTOGRAPHIC REALISM with precise and clearly articulated figures against flat, unmodulated background colours. But their painting was not naturalistic, effects of light, surface texture and perspective being largely suppressed and the colour often arbitrary. Subjective expression and sentimentality were excluded from their style of depiction though sentimental appeal often intruded in the choice of subjects. The influence of photography could be seen in the mannerism of depicting an apparently arbitrary part of a scene with objects and figures appearing to be accidentally cut off and sizes sometimes distorted in the way that a camera may do. Colour and form were not integrally related but a convention was often followed to depict living things in greys or near-greys and inanimate objects in bright colours. A distance was usually maintained between the figural content and the unstructured poster-like background. The drawing of all four artists had a certain, perhaps partly cultivated, harshness and lack of delicacy.

The works of the group were exhibited from 1968 in Recklinghausen, Kassel, Nuremberg, Cologne, Karlsruhe and elsewhere in Germany and at the Fischer Fine Art Gal., London, in the spring of 1975.

ZEID, FAHR-EL-NISSA, PRINCESS (1903–). Turkish painter born in Prinkipo. After studying in Turkey she attended the Académie Ransom, Paris, in 1928. During the 1930s she travelled extensively through Europe and she had a one-man show in Istanbul in 1941. Towards the end of the 1940s she turned to abstraction and exhibited large abstract compositions of symphonic colour combinations at the Gal. Colette Allendy (1950) and the Gal. de Beaune (1951). She was the mother of the painter Mehmed D. NEJAD.

ZEMLJA. An association of progressive Croatian painters founded in Zagreb, Yugoslavia, by Krsto HEGEDUŠIĆ in 1929. The work of the group was in the manner of SOCIAL REALISM, strongly influenced by folk art; the artists of the group were socially committed and their work represented a protest against oppression. The association was officially banned in 1935. One of the ideological aims of the group was to vivify the effete academic art of the time by direct contact with folk art and peasant life (this was the significance of the name *Zemlja*—Earth). In accordance with this interest Hegedušić and others of the group visited the village of Hlebine near the Hungarian frontier and as a result of contact between Hegedušić and the young peasant Ivan GENERALIĆ Hlebine became the most widely known centre of Yugoslav NAÏVE ART.

ZEN GROUP. A group of German artists including Hans TRIER, Emil SCHUMACHER, Bernhard SCHULTZE and Theodor WERNER, who practised a German form of ART INFORMEL with emphasis upon automatic calligraphic writing. The painting of the group was thought to express the spirit of Zen Buddhism.

ZERO. A group formed in Düsseldorf in 1957 by Heinz MACK and Otto PIENE, both of whom were interested in KINETIC ART and in LUMINISM. They were joined later by Günther UECKER. The views of the group were put forward in a periodical also named *Zero*, two numbers of which appeared in 1958 and a third in 1961. The meaning attached to 'zero' was a zone of silence from which new sounds would emerge. In visual art it was interpreted as the abandonment of concrete shape and form for effects of pure colour and light. Piene, for example, experimented with the use of balloons filled with transparent coloured gases for the creation of what he called 'light ballets'. The group fell broadly into the ambit of the NOUVELLE TENDANCE movement and among other things experimented with collective work. They exhibited at the Howard Wise Gal., New York, in 1961, at the Institute of Contemporary Art, Pennsylvania University, Philadelphia, in 1964 and at the Kestner-Gesellschaft, Hanover, in 1965. The group was disbanded in 1966.

ZIMMER, HANS-PETER. See SPUR.

ZIMMERMANN, MAC (1912–). German painter born in Stettin and studied at the Schule für Gestaltende Arbeit there, 1934–8, and in Hamburg, 1938. After the war he taught in the Academies of Dessau and Berlin and from 1958 at the Munich Academy. His *Metamorphoses* and *Mythological Gardens* depicted strange baroque figures with the detailed MAGIC REALISM of the SURREALIST school, setting them against dreamlike and otherworldly scenes.

ZINKEISEN, ANNA (1906–76). British painter born at Kilcreggan, Dunbarton, and studied at the Royal Academy Schools, to which she won a scholarship in 1921. She first exhibited at the Royal Academy in 1924 at the age of 18 and about the same time opened a studio with her sister Doris. Her work was extremely versatile, embracing both commercial art and gallery art. Among her portraits were *Prince Philip*, *Lord Beaverbrook* and *Sir Alexander Fleming*. She did extensive advertisement and poster work, among the best known being the *soigné* aristocrat featured in the De Reszke advertisements. She did magazine covers, book jackets and book illustrations including A. P. Herbert's *Plain Jane*. She became well known as a flower painter and was commissioned to paint the Queen's coronation bouquet. She was an official War Artist and was distinguished particularly for her paintings of the Lon-

don Blitz and her detailed records of wounds done for the benefit of the medical profession. She was married to Colonel Guy Heseltine.

ŽIVKOVIĆ, BOGOSAV (1920–). Yugoslav NAÏVE sculptor, born at Leskovac, Serbia. He joined the liberation forces in 1941, was captured and tortured. Trained as a furrier, he had to abandon his trade and became a doorman in Belgrade. He began to carve figures in wood *c.* 1957. His carvings had a medieval stiffness and a dignity combined with a strange imaginative appeal. Oto Bihalji-Merin wrote of his work: 'The men and fabulous creatures he creates are strange, surprising, and at the same time familiar, as though one had come across them while reading an old fairy tale. Animal heads on human bodies, centaurs, miraculous beasts resembling the decorated initials of old Serbian manuscripts, and men and women not far removed from those on tombstones in country cemeteries and along the local roads. Flower stalks and tall columns composed of human figures, houses, exotic animals, and rank vegetation reveal both the skill and imagination of this naïve artist and his sense of total composition.' He first became known with the help of a painter, Mario Maskarelli, in 1960. His work has been shown in many exhibitions including a travelling exhibition to Moscow, Leningrad, Budapest, Vienna (1962–3), New York (1963), Zürich (1965), Munich and Bratislava (1966), Amsterdam (1967), Paris and Mexico (1968). One of his columns is in the Mus. National d'Art Moderne, Paris.

Živković had a considerable following among naïve sculptors of Serbia, including Dragiša and Milan STANISAVLJEVIĆ.

ZOBEL, FERNANDO (1924–). Spanish painter born at Manila. After studying at various art schools in the Philippines he took a Ph.D. at Harvard University in 1949 and from 1949 to 1951 was a research worker in bibliography. From 1951 to 1960 he held the Chair in Fine Arts at Manila Atheneum. In 1963 he was the prime mover in founding the Cuenca Mus. of Spanish Abstract Art, where his own extensive collection of Spanish abstract art is housed. His painting belonged to the style of LYRICAL ABSTRACTION with subtle blendings of nebulous colour often set against a large empty background, sometimes combined with calligraphic features. Among the public collections in which he is represented are the British Mus., the Fogg Art Mus., Harvard, the Brooklyn Mus., New York, the Aschenbach Foundation, San Francisco, the National Mus. of the Philippines, Manila.

ZORACH, WILLIAM (1887–1966). American sculptor born at Eurburg, Lithuania, emigrated to the U.S.A. in 1891. He attended evening classes at the Cleveland Institute of Art, 1902–5, while working with a firm of commercial lithographers, then studied at the National Academy of Design, 1908–10. In Paris he studied at the Académie de la Palette under J. D. FERGUSSON, 1910–11, and was at this time deeply influenced by the FAUVES, exhibiting pictures in this style at the Salon d'Automne. Returning to the U.S.A. in 1911, he had his first one-man show at the Taylor Gals., Cleveland, in 1912 and then at the Daniel Gal., New York, from 1915. About this time he became interested in sculpture and *c.* 1922 abandoned painting for sculpture. His work over the years gained in formal rigour and although he was not at any time a CUBIST, the salient characteristics of his work were solid contours, block-like bulk and the emphasis on essential volumes with suppression of details. These qualities persisted throughout (e.g. *Mother and Child*, The Metropolitan Mus. of Art, 1927–30, and *Head of Christ*, The Mus. of Modern Art, New York, 1940) and in this formal austerity, as in his practice of direct carving, he exercised a powerful influence on the course of American sculpture. He had retrospectives at the Art Students' League in 1950 and 1969 and at the Whitney Mus. of American Art in 1959. Among his important commissions were: the metal *Spirit of the Dance*, Radio City Music Hall, New York, 1932; *Benjamin Franklin* for the Benjamin Franklin Post Office, Washington, D.C., 1936–7; *Builders of the Future*, New York World's Fair, 1939; *Man and Work*, Mayo Clinic, Rochester, Minn., 1954; relief carvings for Municipal Court Building, New York, 1958.

ZORN, ANDERS (1860–1920). Swedish painter and etcher born at Mora. On his travels during the 1880s, which included visits to London, Paris, Spain, Algiers and Istanbul, he proved himself to be a brilliant water-colourist, his manner becoming gradually more Impressionistic. In 1888 he returned to painting in oil, and about the same time moved to Paris. In portraits, in Parisian street scenes, and in views of the surroundings of his home at Mora in Dalecarlia, his swift and elegant Impressionistic technique found its fullest scope, although he became known chiefly for his pictures of bathing peasant girls. After 1896 when he settled at Mora his work tended to mere virtuosity. As a successful portraitist in a manner which came to resemble Sargent's, Zorn made several tours in the U.S.A. His best work was probably his etchings, done in a technique of more or less parallel lines across the plate, which was the counterpart of his rapid manner of painting. Here again it is the earlier works from the 1890s that have been judged the finest.

ZOX, LARRY (1936–). American painter born at Des Moines, Iowa, and studied at the University of Oklahoma, Drake University and the Des Moines Art Center. His first one-man exhibition was at the American Gal., New York, in 1962 and during the 1960s his work became known and was

exhibited both in individual shows and in collective exhibitions of the newer experimental art. He was classified among MINIMAL and SYSTEMIC painters and developed simple geometrical forms in a direction approaching the hallucinatory effects of OP ART although he is not classified among the Op artists such as ANUSZKIEWICZ. He was represented in the exhibition 'Young America' at the Whitney Mus. of American Art in 1965 and in 'Systemic Painting' at the Solomon R. Guggenheim Mus. in 1966. He was awarded a Guggenheim Foundation Fellowship in 1967.

ZULOAGA Y ZABALETA, IGNACIO (1870–1945). Spanish painter born at Eibar in the Basque country, son of Placido Zuloaga, a well-known goldsmith and metal worker of an old Basque family of armourers. As a youth he studied in Paris, where he was influenced by the works of Manet and was on friendly terms with Rodin, Gauguin, Degas, Mallarmé and the Spanish painter Rusiñol. He later visited Toledo, studied artists of the Florentine Quattrocento and also learnt much from the works of Goya and Velazquez. He painted for preference Spanish scenes, bullfights, gipsies, brigands, as well as portraits and figure studies. There is a Zuloaga museum in Madrid.

ZUMETA, JOSÉ LUIS. See SPAIN.

ZWARC, MAREK (1892–1958). Polish-French sculptor born at Zgierc. He went to Paris in 1909 and studied at the École des Beaux-Arts. After the First World War he abandoned sculpture for painting but from c. 1923 to 1939 took up religious sculpture, principally low reliefs of biblical subjects in bronze. After the Second World War he returned to Paris in 1945 and worked chiefly in wood. His works were naturalistic and expressive, with a simplification of forms suggestive of folk art but fraught with dramatic intensity. Among his better-known works are *Résistance* (French Institute, London, 1949) and *Auschwitz* (Tel-Aviv Mus., 1953).

ZWOBODA, JACQUES (1900–67). French sculptor born at Neuilly-sur-Seine. He took up sculpture in consequence of the impression made on him by works of Rodin, and studied at the École des Beaux-Arts. During the early 1930s he executed a number of monuments, including the statue of Simon Bolívar at Quito. About 1935 he abandoned sculpture and taught drawing at the Académie de la Grande Chaumière and the Académie Julian, taking up sculpture again c. 1950. The greatest work of this latter period was a funerary monument to his wife. His work subsequently became less figurative and he achieved a rhythmical interplay of masses and voids in sculptures which verged upon abstraction.

SELECTIVE BIBLIOGRAPHY

PLACE of publication is not stated for books published in London or New York. Articles in periodicals are not included. Exhibition catalogues are cited when they contain information or important critical comment not available elsewhere.

I. GENERAL WORKS

1. *Dictionaries, Lexicons, Anthologies, etc.* (Works which are restricted to one country or movement are listed under the specific headings.)

Battcock, Gregory (ed.). *The New Art. A critical anthology.* 1966
Benezit, E. *Dictionnaire critique et documentaire des peintres, sculpteurs, dessinateurs et graveurs.* 8 vols. Paris, 1948–55
Charmet, Raymond. *Dictionnaire de l'art contemporain.* Paris, 1965
Chipp, Herschel B. *Theories of Modern Art.* Berkeley, Calif., 1969
Édouard-Joseph, R. *Dictionnaire biographique des artistes contemporains, 1910–1930.* 3 vols. Paris, 1930–4. Supplement, Paris, 1937
George, W., Cogniat, R., and Fourny, M. *Encyclopédie de l'art international contemporain.* Paris, 1958
Hazan, Fernand. *Dictionnaire de la peinture moderne.* Paris, 1954
— *Dictionnaire de la sculpture moderne.* Paris, 1960
Herbert, Robert L. *Modern Artists on Art. Ten unabridged essays.* Englewood Cliffs, 1964
Hess, W. *Dokumente zum Verständnis der modernen Malerei.* Hamburg, 1956
Huyghe, René. *Larousse Encyclopedia of Modern Art.* Eng. trans., 1965
Knaurs Lexikon Moderner Kunst. Munich, 1955
Lake, C. and Maillard, R. *A Dictionary of Modern Painting.* 1964
Maillard, R. (ed.). *A Dictionary of Modern Sculpture.* 1962
Muller, Joseph-Émile. *A Dictionary of Expressionism.* Eng. trans., 1973
Murray, Peter and Linda. *The Penguin Dictionary of Art and Artists.* 1968 (1959)
Phaidon Dictionary of Twentieth-Century Art. 1973
Richardson, Tony and Stangos, Nikos (ed.). *Concepts of of Modern Art.* 1974
Seuphor, Michel. *A Dictionary of Abstract Painting. Preceded by a history of abstract painting.* Eng. trans., 1958
— *The Sculpture of this Century. Dictionary of modern sculpture.* 1959
Thieme, U. and Becker, F. (ed.). *Allgemeines Lexikon der bildenden Künstler.* 37 vols. Leipzig, 1907–50
Thomas, Karin. *Sachwörterbuch zur Kunst des 20. Jahrhunderts.* Cologne, 1973
Vollmer, H. (ed.). *Allgemeines Lexikon der bildenden Künstler des XX. Jahrhunderts.* 5 vols. and supplement. Leipzig, 1953–62

2. *General Studies, Histories, etc.*

Adams, Hugh. *Art of the Sixties.* 1978
Arnason, H. H. *A History of Modern Art: painting, sculpture, architecture.* 1977 (1969)
Bann, Stephen. *Experimental Painting: construction, abstraction, destruction, reduction.* 1970
Bazin A. (ed.). *History of Modern Painting.* 1951
Bihalji-Merin, Oto. *Twentieth-Century Sculpture.* Belgrade, 1955
Brion, Marcel (ed.). *La Peinture contemporaine, 1900–1960.* Paris, 1962
Cabanne, Pierre and Restany, Pierre. *L'Avant-garde au XXe siècle.* Paris, 1969
Canaday, J. E. *Mainstreams of Modern Art.* 1959
Cassou, Jean. *Panorama des arts plastiques contemporains.* Paris, 1960
Courthion, Pierre. *L'Art indépendant. Panorama international de 1900 à nos jours.* Paris, 1958
Dorival, Bernard. *Twentieth-Century Painters.* 2 vols. 1958
Dunlop, Ian. *The Shock of the New: seven historic exhibitions of modern art.* 1972
Evans, Myfanwy (ed.). *The Painter's Object.* 1937
Giedion-Welcker, Carola. *Contemporary Sculpture. An evolution in volume and space.* 1961 (1956)
Grohmann, W. (ed.). *Art of our Time.* 1966
Haftmann, Werner. *Painting in the Twentieth Century.* 2 vols. Eng. trans., 1960
Hamilton, G. H. *Painting and Sculpture in Europe, 1880 to 1940.* 1967
Hofstätter, Hans H. *Malerei und Graphik der Gegenwart.* Baden-Baden, 1969
Kultermann, U. *The New Sculpture: environments and assemblages.* 1968
Langui, Émil. *50 Years of Modern Art.* 1959
Lucie-Smith, Edward. *Movements in Art since 1945.* 1969
Meier-Graefe, A. J. *Die Kunst unserer Tage von Cézanne bis heute.* Munich, 1927
Muller, Joseph-Émile and Elgar, Frank. *A Century of Modern Painting.* 1972
Neumeyer, A. *The Search for Meaning in Modern Art.* Englewood Cliffs, 1964
Osborne, Harold. *Abstraction and Artifice in Twentieth-Century Art.* 1979
Ozenfant, Amédée. *Foundations of Modern Art.* 1931
Poggioli, Renato. *The Theory of the Avant-garde.* Eng. trans., Cambridge, Mass., 1968
Popper, Frank. *Art: action and participation.* 1975
Ragon, Michel. *La Peinture actuelle.* Paris, 1959

Raynal, M. (ed.). *History of Modern Painting*. 3 vols. Geneva, 1949–50
— *Modern Painting*. Rev. edn., 1960
Read, Herbert. *Art Now. An introduction to the theory of modern painting and sculpture*. 1960 (1933)
Rosenberg, H. *The Tradition of the New*. 1959
Shattuck, Roger. *The Banquet Years: the arts in France 1885–1918*. 1959
Smith, Bernard (ed.). *Concerning Contemporary Art*. 1975
Soby, J. T. *Contemporary Painters*. 1948
Sweeney, J. J. *Plastic Redirections in Twentieth-Century Painting*. Chicago, 1934
Trouché, A. and Cloaguen. H. *L'Art actuel en France*. Paris, 1973

Waddington, C. H. *Behind Appearance: a study of the relations between painting and the natural sciences in this century*. 1969
Walker, John A. *Art since Pop*. 1975
Wilenski, R. H. *The Meaning of Modern Sculpture*. 1932
— *The Modern Movement in Art*. 1927
Woods, G., Thompson, P., and Williams, J. (ed.). *Art without Boundaries*. 1950
Zaunschirm, Thomas. *Die fünfziger Jahre*. Munich, 1980
Zervos, Christian. *Histoire de l'art contemporain*. Paris, 1938
Painting and Sculpture of a Decade, 54–64. Cat. Tate Gal., 1964

II. SPECIFIC WORKS

AALTO, ALVAR

Aalto, A. and Fleig, K. (ed.). *A. Aalto. Collected works*. Zürich, 1963

AALTONEN, WÄINÖ

Okkonen, O. *Wäinö Aaltonen*. Stockholm, 1941

ABEELE, ALBIJN VAN DEN

D'Haese, Jan and Abeele, Raf van den. *Albijn van den Abeele 1835–1918*. Laethem-Saint-Martin, 1968

ABSOLON, KURT

Kurt Absolon. Exh. Cat. Würthle Gal., Vienna, 1961

ABSTRACTION

Abstrakte Kunst. Theorien und Tendenzen. Baden-Baden, 1958. Reissue of *Das Kunstwerk*, Nos. 8 and 9.
Alvard, J. and Gindertael, R. Van (ed.). *Témoignages pour l'art abstrait*. Paris, 1952
American Abstract Artists. *The World of Abstract Art*. 1957
Barr, A. H., Jr. (ed.). *Cubism and Abstract Art*. The Mus. of Modern Art, N.Y., 1936
Blanshard, F. B. *Retreat from Likeness in the Theory of Painting*. 1949
Blok, Cor. *Geschichte der abstrakten Kunst 1900–1960*. Cologne, 1975
Brion, Marcel. *Art abstrait*. Paris, 1956
Capon, Robin. *Introducing Abstract Painting*. 1973
Clot, R. J. *La Querelle des images*. Geneva, 1960
Grenier, Jean. *Entretiens avec dix-sept peintres non-figuratifs*. Paris, 1963
Hess, Thomas B. *Abstract Painting: background and American phase*. 1950
Leymarie, Jean. *Abstract Art since 1945*. 1971
Mathieu, G. *Au-delà du tachisme*. Paris, 1963
Osborne, Harold. *Abstraction and Artifice in Twentieth-Century Art*. 1979
Poensgen, G. and Zahn, L. *Abstrakte Kunst: eine Weltsprache*. Baden-Baden, 1958
Restany, Pierre. *Lyrisme et abstraction*. Milan, 1960
Seuphor, Michel. *Abstract Painting from Kandinsky to the Present*. 1962
— *A Dictionary of Abstract Painting: preceded by a history of abstract painting*. Eng. trans., 1957
Vallier, Dora, *L'Art abstrait*. Paris, 1967
Worringer, Wilhelm. *Abstraction and Empathy*. Eng. trans., 1953
Paths of Abstract Art. Exh. Cat. ed. E. B. Henning, Cleveland Mus. of Art, 1960

Geometrical Abstraction in America. Exh. Cat. ed. John Gordon, Whitney Mus. of American Art, 1962
Abstraction. Towards a new art. Exh. Cat. Tate Gal., 1980
See also ABSTRACT EXPRESSIONISM, CONCRETE ART, CONSTRUCTIVISM, TACHISM

ABSTRACT EXPRESSIONISM

Artforum. Special issue, September 1965
Ashton, Dore. *The Life and Times of the New York School*. 1972
— *The Unknown Shore*. 1962
Everitt, Anthony. *Abstract Expressionism*. 1975
Geldzahler, H. *New York Painting and Sculpture: 1940–1970*. 1970
Goodall, Donald B. *Partial Bibliography of American Abstract-Expressive Painting, 1943–1958*. 1958
Hess, Thomas B. *Abstract Painting: background and American phase*. 1950
Janis, Sidney. *Abstract and Surrealist Art in America*. 1944
Sandler, Irving. *Abstract Expressionism. The triumph of American painting*. 1973
Tuchman, Maurice (ed.). *The New York School. Abstract Expressionism in the 40s and 50s*. 1971
American Abstract Expressionists and Imagists. Exh. Cat. ed. H. H. Arnason, Solomon R. Guggenheim Mus., N.Y., 1961

ABSTRACTION-CRÉATION

Abstraction-Création 1931–1936. Exh. Cat. Mus. d'Art Moderne de la Ville de Paris, 1978

ACTION PAINTING

Rosenberg, Harold. *The Tradition of the New*. 1959
See also ABSTRACT EXPRESSIONISM

ADAM, HENRI-GEORGES

George, Waldemar and Jianou, I. *Henri-Georges Adam*. Paris, 1968
Henri-Georges Adam. Exh. Cat. Stedelijk Mus., Amsterdam, 1955
Henri-Georges Adam. Exh. Cat. Los Angeles County Mus. of Art, 1955

ADAMI, VALERIO

Valerio Adami. Exh. Cat. Mus. Contini, Marseilles, 1977

ADLER, JANKEL

Hayter, S. W. *Jankel Adler*. 1948
Klapheck, A. *Jankel Adler*. Recklinghausen, 1966

AFRICA

Mount, Marshall Ward. *African Art. The years since 1920.* 1973
Art from Africa. Exh. Cat. Commonwealth Inst., London, 1981

AFRO

Venturi, Lionello. *Afro.* Rome, 1954
— *Italian Painters of Today.* 1959

AGAM, YAACOV

Agam, Yaacov. *Agam.* Neuchâtel, 1966. A collection of Agam's writings.
Metken, Gunter. *Yaacov Agam.* 1974
Popper, Frank. *Yaacov Agam.* n.d.
Reichardt, Jasia. *Yaacov Agam.* 1966. Text based on conversation with Agam.

AÏZPIRI, PAUL

Descargues, Pierre. *Paul Aïzpiri.* Paris, 1952

ALBERS, JOSEF

Albers, Josef. *Despite Straight Lines.* Cambridge, Mass., 1977. Statements and poems by Albers with an analysis of his graphic constructions by François Bucher.
— *Interaction of Color.* 2 vols., 1963
Gomringer, Eugen (ed.). *Josef Albers.* 1968
Spies, Werner. *Josef Albers.* 1971
Wissmann, Jürgen. *Josef Albers.* Recklinghausen, 1971
Josef Albers. Paintings, prints, projects. Exh. Cat. ed. G. H. Hamilton, Yale Univ. Art Gal., 1956
Josef Albers. Exh. Cat. The Mus. of Modern Art, N.Y., 1964

ALBRIGHT, IVAN

Kuh, Katharine. *The Artist's Voice.* 1962
Ivan Albright. Exh. Cat. Art Inst. of Chicago, 1964

ALECHINSKY, PIERRE

Alechinsky, P. *Les Étampes de 1946 à 1972.* Geneva, 1973
Putman, Jacques. *Pierre Alechinsky.* 1967.
Alechinsky oder 20 Jahre Impressionen. Exh. Cat. Gal. van de Loo, Munich, 1967
Pierre Alechinsky. Exh. Cat. Kunsthaus, Zürich, 1975

ALIX, YVES

Allard, Roger. *Yves Alix et son œuvre.* Paris, 1944

ALTMAN, NATAN

Etkind, M. *Natan Altman.* Moscow, 1971

ALTOON, JOHN

John Altoon. Exh. Cat. San Francisco Mus. of Art, 1967

AMARAL, TARSILA DO

Amaral, Aracy. *Tarsila. Sua obra e seu tempo.* 2 vols. São Paulo, 1975
Tarsila 1918–1968. Exh. Cat. Mus. de Arte Moderna, Rio de Janeiro, 1969

AMIET, CUNO

Baur, A. *Cuno Amiet.* Basle, 1943
Jedlicka, G. *Amiet.* Berne, 1948
Mandach, C. von. *Cuno Amiet.* Berne, 1939. Catalogue of prints.
Tatrinoff, A. *Cuno Amiet.* Solothurn, 1958
Der Maler Cuno Amiet und die Brücke. Exh. Cat. Kunsthaus, Zürich, 1979

ANDRE, CARL

Andre, Carl and Frampton, Hollis. *12 Dialogues 1962–1963.* Nova Scotia, 1979
Carl Andre. Exh. Cat. Gemeentemus., The Hague, 1969
Carl Andre. Exh. Cat. Solomon R. Guggenheim Mus., N.Y., 1970
Carl Andre. Sculpture 1959–78. Exh. Cat. Whitechapel Art Gal., London, 1978

ANTES, HORST

Linfert, Carl. *Junge Künstler.* Cologne, 1963
Garten der Lüste. Exh. Cat. Bundesgarten Schau, Karlsruhe, 1967
Horst Antes. Exh. Cat. Gimpel Fils, London, 1973

ANTI-ART

Richter, Hans. *Dada: art and anti-art,* 1966

ANTI-FORM

Kahler, Erich. *The Disintegration of Form in the Arts.* 1968

ANTIPODEAN GROUP

Smith, Bernard. *The Antipodean Manifesto.* 1976

ANUZKIEWICZ, RICHARD

Richard Anuzkiewicz. Exh. Cat. Van Deusen Gal., Kent State Univ., 1968

APOLLINAIRE, GUILLAUME

Adéma, Pierre Marcel. *Apollinaire.* Eng. trans., 1954
Breunig, L. C. (ed.). *Apollinaire on Art: essays and reviews 1902–1918.* Eng. trans., 1918
Guillaume Apollinaire. Exh. Cat. Bibliothèque Nat., Paris, 1969

APPEL, KAREL

Claus, Hugo. *Karel Appel. Painter.* Eng. trans., 1963
Dotremont, Christian. *Karel Appel.* Brussels, 1950
Lambert, Jean-Clarence. *Karel Appel. Works on paper.* 1980
Karel Appel. Exh. Cat. Stedelijk Mus., Amsterdam, 1965
Appel. Exh. Cat. Wildenstein Gal., London, 1975

ARCHIPENKO, ALEXANDER

Archipenko, Alexander and others. *Archipenko. Fifty creative years, 1908–1958.* 1960
Dauber, Theodor and Goll, Iwan (ed.). *Archipenko-Album.* Potsdam, 1921
Hildebrandt, Hans. *Alexander Archipenko.* Berlin, 1923
Karshan, Donald H. (ed.). *Archipenko.* Tübingen, 1974. With catalogue raisonné of prints.
— *Archipenko. International visionary.* Memorial volume published for the National Collection of Fine Arts by the Smithsonian Inst., Washington, 1969
Raynal, Maurice. *Archipenko.* Rome, 1923
Alexander Archipenko. A retrospective memorial exhibition. Exh. Cat. Univ. of California at Los Angeles Art Gal., 1967

ARMAN

Martin, Henry. *Arman.* 1973
Arman. Exh. Cat. Stedelijk Mus., Amsterdam, 1964

ARMITAGE, KENNETH

Lynton, Norbert. *Kenneth Armitage.* 1962
Penrose, Roland. *Kenneth Armitage.* Amriswil, 1960
Spencer, Charles. *Kenneth Armitage.* 1973
Kenneth Armitage. Exh. Cat. Arts Council of Great Britain, 1972

ARMORY SHOW

Arts and Decoration. Special issue, March 1913
Association of American Painters and Sculptors. *For
and Against. Anthology of commentary on the Armory
Show of 1913.* 1913
Brown, Milton W. *The Story of the Armory Show.* 1963
Kuhn, Walt. *The Story of the Armory Show.* 1938
The Armory Show: 50th anniversary exhibition. Exh.
Cat. Munson-Williams-Proctor Inst., Utica, 1963

ARMSTRONG, JOHN

Read, Herbert (ed.). *Unit One. The modern movement in
English architecture, painting and sculpture.* 1934
John Armstrong 1893–1973. Exh. Cat. Arts Council and
Royal Academy, London, 1975

ARP, JEAN

Arp, Jean. *On My Way. Poetry and essays 1912–1947.*
1948
Cathelin, Jean. *Jean Arp.* 1959
Giedion-Welcker, C. *Jean Arp.* 1958
Jean, Marcel (ed.). *Collected French Writings: poems,
essays, memories.* Eng. trans., 1974
Marchiori, G. *Arp.* Milan, 1964
Read, Herbert. *Arp.* 1968
Seuphor, Michel. *Arp. Sculptures.* 1964
Trier, E. *Jean Arp. Sculpture 1957–1966.* 1968
Arp. Exh. Cat. ed. J. T. Soby, The Mus. of Modern
Art, N.Y., 1958
Arp. Graphik 1912–1955. Exh. Cat. ed. H. Bolliger,
Berne, 1959

ART AUTRE

Tapié, Michel. *Un art autre.* Paris, 1952

ART BRUT

La Compagnie de l'art brut. *L'Art brut.* 10 vols. Paris,
1964–76
Thevoz, Michel. *Art brut., Geneva,* 1976
Catalogue de la collection de l'art brut. Paris, 1971

ART DECO

Battersby, M. *The Decorative Thirties.* 1972
Delhaye, Jean. *Art Deco: posters and graphics.* 1977
Hillier, Bevis. *Art Deco of the 20s and 30s.* 1968
Lesieutre, Alain. *The Spirit and Splendour of Art Deco.*
1974
Rowe, William. *Original Art Deco Designs.* 1973
Walters, Thomas. *Art Deco.* 1973

ARTE POVERA

Celant, Germano (ed.). *Arte Povera: conceptual, actual
or impossible art?* 1969

ART INFORMEL

Paulhan, Jean. *L'Art informel.* Paris, 1962
See also TACHISM

ART NOUVEAU

Amaya, M. *Art Nouveau.* 1966
Hofstätter, Hans H. *Geschichte der europäischen
Jugendstilmalerei. Ein Entwurf.* Cologne, 1963
Madsen, S. T. *Art Nouveau.* 1967
Pevsner, N. *Art Nouveau in Britain.* 1965
Rheims, M. *The Age of Art Nouveau.* 1966
Sainton, Roger. *Art Nouveau Posters and Graphics.* 1977
Schmutzler, R. *Art Nouveau.* 1964
Selig, H. (ed.). *Jugendstil, der Weg ins 20 Jahrhundert.*
Heidelberg, 1959
*Art Nouveau und Jugendstil. Kunst und Kunstgewerbe
aus Europ und Amerika zur Zeit der Stilwende.* Exh.
Cat. Kunstgewerbemus., Zürich, 1952

Art Nouveau: art and design at the turn of the century.
Exh. Cat. The Mus. of Modern Art, N.Y., 1963
Secession. Europäische Kunst um die Jahrhundertwende.
Exh. Cat. Haus der Kunst, Munich, 1964
Art Nouveau in Britain. Exh. Cat. Arts Council of Great
Britain, 1965

ART OF THE REAL

*The Art of the Real: an aspect of American painting and
sculpture 1948–1968.* Exh. Cat. introd. E. C.
Goossen, The Mus. of Modern Art, N.Y., 1969

ARTS COUNCIL OF GREAT BRITAIN

The Arts Council of Great Britain. *The Arts Council of
Great Britain: what it is and what it does.* 1968
H.M. Stationery Office. *The Promotion of the Arts in
Britain.* Central Office of Information, Reference
Pamphlet 114, 1975
Blaug, Mark (ed.). *The Economics of the Arts.* 1976
Minihan, Janet. *The Nationalization of Culture.* 1977
White, Eric W. *The Arts Council of Great Britain.* 1975

ASH-CAN SCHOOL

Braider, Donald. *George Bellows and the Ashcan School
of Painting.* 1971
Perlman, B. B. *The Immortal Eight. American painting
from Eakins to the Armory Show.* 1962
The Eight. Exh. Cat. Brooklyn Mus., N.Y., 1943
New York Realists. Exh. Cat. Whitney Mus. of
American Art, 1970

ASSELIN, MAURICE

Cargo, Francis. *Asselin et son œuvre.* Paris, 1924

ASSEMBLAGE

Kaprow, Allan. *Assemblage, Environments and
Happenings.* 1966
The Art of Assemblage. Exh. Cat. ed. W. G. Seitz, The
Mus. of Modern Art, N.Y., 1961
Assemblage. A new dimension of creative teaching. Exh.
Cat. The Mus. of Modern Art, N.Y., 1972

ATLAN, JEAN-MICHEL

Ragon, Michel and Verdet, André. *Jean Atlan.* Geneva,
1960
Jean Atlan. Exh. Cat. Mus. Nat. d'Art Moderne, Paris,
1963

AUBERJONOIS, RENÉ

Mermod, H. L. *René Auberjonois. Dessins, textes,
photographies.* Lausanne, 1958
Ramuz, C. F. *René Auberjonois.* Lausanne, 1943

AUJAME, JEAN

Descargues, Pierre. *Jean Aujame.* Paris, 1949

AUSTRALIA

Bonython, K. *Modern Australian Painting, 1960–1970.*
1970
— and Lynn, E. *Modern Australian Painting, 1970–
1975.* Adelaide, 1976
Hetherington, John. *Australian Painters: forty profiles.*
1964
Smith, Bernard. *Australian Painting 1788–1970.* 1971
— *The Antipodean Manifesto.* 1976
Sturgeon, Graeme. *The Development of Australian
Sculpture 1788–1975.* 1978

AUSTRIA

Faistauer, Anton. *Neue Malerei in Österreich.* Vienna,
1923

Feuchtmüller, Rupert and Mrazek, Wilhelm. *Kunst in Österreich 1860–1918*. Vienna, 1964
Novotny, Fritz. *Hundert Jahre österreichischer Landschaftsmalerei*. Vienna, 1948
Schmidt, G. *Neue Malerei in Österreich*. Vienna, 1956
Schmied, Wieland. *Malerei des phantastischen Realismus: die Wiener Schule*. Vienna, 1964
Sotriffer, Kristian. *Modern Austrian Art*. Eng. trans., 1965
Vergo, Peter. *Art in Vienna 1898–1918. Klimt, Kokoschka, Schiele and their contemporaries*. 1975
Entwicklung der österreichischen Kunst von 1897 bis 1938. Exh. Cat. Akademie der bildenden Künste, Vienna, 1948
Austrian Painting and Sculpture. Exh. Cat. Arts Council of Great Britain, 1960
100 Jahre Künstlerhaus, 1881–1961. Exh. Cat. Genossenschaft der bildenden Künstler, Vienna, 1961

AUTO-DESTRUCTIVE ART
Metzger, Gustav. *Auto-Destructive Art*. 1965

AUTOMATISM
See SURREALISM

AVERY, MILTON
Kramer, Hilton. *Milton Avery: paintings 1930–1960*. 1962
Milton Avery. Exh. Cat. Baltimore Mus. of Art, 1952

BACON, FRANCIS
Rothenstein, J. and Alley, R. *Francis Bacon*. 1964
Russell, John. *Francis Bacon*. 1979
Sylvester, David. *Interviews with Francis Bacon 1962–1979*. 1980
Trucchi, Lorenza. *Francis Bacon*. Eng. trans., 1976
Francis Bacon. Exh. Cat. Marlborough Fine Art, N.Y., 1968
Francis Bacon. Exh. Cat. Grand Palais, Paris, 1971
Francis Bacon. Exh. Cat. The Metropolitan Mus. of Art, N.Y., 1975. With introd. by H. Geldzahler and bibliography.

BAERTLING, OLLE
Nilson, Tage. *Olle Baertling*. Stockholm, 1951
Pentacle. Exh. Cat. Mus. des Arts Décoratifs, Paris, 1968

BAIZERMAN, SAUL
Saul Baizerman. Exh. Cat. Walker Art Center, Minneapolis, 1953

BAJ, ENRICO
Petit, Jean (ed.). *Baj: catalogue of the graphic work and multiples*. Geneva, 1973
Omaggio a Baj. Exh. Cat. In *Alternative Attuali 2*. 1965
Enrico Baj. Exh. Cat. The Metropolitan Mus. of Art, N.Y., 1975

BAKIĆ, VOJIN
Bihalji-Merin, Oto. *Twentieth-Century Sculpture*. Belgrade, 1955
Vojin Bakić. Exh. Cat. Mod. Gal., Belgrade, 1965

BAKST, LEON
Alexandre, Arsène. *The Decorative Art of Léon Bakst*. 1913
Einstein, C. *Léon Bakst*. Berlin, 1927
Levinson, André. *Bakst. The story of the artist's life*. 1922

Spencer, Charles. *Léon Bakst*. 1974
Léon Bakst. Exh. Cat. The Fine Art Soc., London, 1976

BALLA, GIACOMO
Dorazio, Virginia D. (ed.). *Giacomo Balla: an album of his life and work*. Venice, 1970
Giacomo Balla. Exh. Cat. Gal. Civica d'Arte Moderna, Turin, 1963
Giacomo Balla 1871–1958. Exh. Cat. Gal. Nac. d'Arte Moderna, Rome, 1971
See also FUTURISM

BALTHUS
Camus, A. *Balthus*. 1949
Soby, J. T. *Balthus*. The Mus. of Modern Art Bulletin, Vol. 24, No. 3, 1956
Balthus. Exh. Cat. Mus. des Arts Décoratifs, Paris, 1966
Balthus. Exh. Cat. Tate Gal., London, 1968

BARGHEER, EDUARD
Baumgart, F. *Der Maler Eduard Bargheer*. Stuttgart, 1955

BARLACH, ERNST
Barlach, E. *Ernst Barlach, ein selbsterzähltes Leben*. Munich, 1948
Carls, C. D. *Ernst Barlach. Das plastische, graphische und dichterische Werk*. Berlin, 1968
Dross, F. *Ernst Barlach. Leben und Werk in seinen Briefen*. Munich, 1952
Franck, H. *Ernst Barlach. Leben und Werk*. Stuttgart, 1961
Schult, F. *Ernst Barlach*. 2 vols.: *Das graphische Werk* (Hamburg, 1958); *Das plastische Werk* (Hamburg, 1960). Catalogue raisonné.
Stubbe, Wolf (ed.). *Barlach Zeichnungen*. Munich, 1961
Werner, Alfred. *Ernst Barlach*. 1966

BARRAUD, MAURICE
Bovey, Adrien. *Maurice Barraud*. Lausanne, 1940
Cailler, P. and Darel, H. *Catalogue illustré de l'œuvre gravé et lithographié de Maurice Barraud*. Geneva, 1944

BASKIN, LEONARD
Roylance, D. *Leonard Baskin. The graphic work 1950–1970*. 1970
Leonard Baskin. Exh. Cat. Bowdoin College, Brunswick, Maine, 1962

BAUCHANT, ANDRÉ
Gauthier, M. *André Bauchant*. Paris, 1943
Uhde, Wilhelm. *Cinq maîtres primitifs*. Paris, 1949
See also NAÏVE ART

BAUHAUS
Bayer, H., Gropius, W., and Gropius, I. (ed.). *Bauhaus, 1919–1928*. Boston, 1959. Based on an exhibition at The Mus. of Modern Art, N.Y., in 1938.
Hirschfeld-Mack, L. *The Bauhaus. An introductory survey*. 1963
Naylor, Gillian. *The Bauhaus*. 1968
Peters, H. *Die Bauhaus-Mappen 'Neue europäische Graphik' 1921–28*. Cologne, 1957
Roters, Eberhard. *Painters of the Bauhaus*. Eng. trans., 1969
Wingler, H. M. (ed.). *The Bauhaus*. Cambridge, Mass., 1969
— *Graphic Work from the Bauhaus*. 1969

BAUHAUS (*cont.*)

Die Maler am Bauhaus. Exh. Cat. Haus der Kunst, Munich, 1950
Painters of the Bauhaus. Exh. Cat. Marlborough Fine Art, London, 1962

BAUMEISTER, WILLI

Baumeister, Willi. *Das Unbekannte in der Kunst.* Stuttgart, 1947
Grohmann, Will. *Willi Baumeister. Leben und Werk.* Cologne, 1963. Eng. trans., *Willi Baumeister: life and work,* n.d.

BAYER, HERBERT

Bayer, Herbert. *Herbert Bayer: painter, designer, architect.* 1967
Dorner, A. *The Way beyond 'Art'. The work of Herbert Bayer.* 1947

BAZAINE, JEAN

Bazaine, J. *Notes sur la peinture d'aujourd'hui.* Paris, 1953
Maeght, A. *Bazaine.* Paris, 1954

BAZIOTES, WILLIAM

Tuchman, Maurice (ed.). *The New York School. Abstract Expressionism in the 40s and 50s.* 1971
William Baziotes. A memorial exhibition. Exh. Cat. Solomon R. Guggenheim Mus., N.Y., 1965

BEARDEN, ROMARE

Bearden, Romare and Holty, Charles. *The Painter's Mind.* 1969
Dover, Cedric. *American Negro Art.* 1960
Washington, M. Bunch. *The Art of Romare Bearden.* 1973
Romare Bearden: the prevalence of ritual. Exh. Cat. The Mus. of Modern Art, N.Y., 1971

BEAUDIN, ANDRÉ

Limbour, Georges. *André Beaudin.* Paris, 1961

BECHTOLD, ERWIN

Cirlot, J. E. *La pintura de Erwin Bechtold.* Barcelona, 1962

BECKMANN, MAX

Beckmann, P. *Max Beckmann.* Munich, 1965
Buchheim, L. G. *Max Beckmann.* Feldafing, 1959
Busch, G. *Max Beckmann. Eine Einführung.* Munich, 1960
Fischer, F. *Max Beckmann.* Cologne, 1972
— *Max Beckmann. Symbol und Weltbild.* Munich, 1972
Kessler, Charles S. *Max Beckmann's Triptychs.* Cambridge, Mass., 1970
Lackner, S. *Max Beckmann.* 1977
Reifenberg, B. and Hausenstein, W. *Max Beckmann.* Munich, 1949. With catalogue of 660 paintings, 1905–49
Max Beckmann. Exh. Cat. ed. P. Selz, The Mus. of Modern Art, N.Y., 1965
Max Beckmann 1884–1950. Exh. Cat. Arts Council of Great Britain, 1965
Max Beckmann. Exh. Cat. Marlborough Fine Art, London, 1974. Contains Beckmann's lecture 'On My Painting'.
Max Beckmann Graphik. Exh. Cat. Innsbruck, 1976

BELGIUM

Colin, P. *La Peinture belge depuis 1830.* Brussels, 1930
Fierens, P. and others. *L'Art en Belgique.* Brussels, 1938

Genaille, R. *La Peinture en Belgique de Rubens aux surréalistes.* Brussels, 1958
Haesaerts, P. *Histoire de la peinture moderne en Flandre.* Brussels, 1960
Keyser, E. de. *La Sculpture contemporaine en Belgique.* Brussels, 1972
Langui, É. *L'Expressionisme en Belgique.* Brussels, 1970
Mertens, Phil. *La Jeune Peinture belge.* Brussels, 1975
Seuphor, Michel. *La Peinture abstraite en Flandre.* Brussels, 1963
Belgische Malerei seit 1900. Exh. Cat. Mus. des 20. Jahrhunderts, Vienna, 1962
Ensor to Permeke. Nine Flemish Painters, 1880–1950. Exh. Cat. Royal Academy, London, 1971

BELL, CLIVE

Bell, Clive. *Art.* 1914
— *Since Cézanne.* 1922
Bywater, William G., Jr. *Clive Bell's Eye.* Detroit, 1975

BELL, LARRY

Larry Bell, Robert Irwin, Doug Wheeler. Exh. Cat. Tate Gal., London, 1970

BELL, VANESSA

Shone, Richard. *Bloomsbury Portraits.* 1976
Vanessa Bell. Memorial exhibition. Exh. Cat. Adams Gal., London, 1962
Vanessa Bell. Memorial retrospective. Exh. Cat. Arts Council of Great Britain, 1964
Vanessa Bell. Drawings and designs. Folio Fine Art, London, 1967
Vanessa Bell. Paintings and drawings. Exh. Cat. Anthony d'Offay Gal., London, 1973

BELLING, RUDOLF

Rudolf Belling. Exh. Cat. Gal. Ketterer, Munich, 1967. With bibliography.

BELLMER, HANS

Hans Bellmer. Exh. Cat. Kestner-Gesellschaft, Hanover, 1967

BELLOWS, GEORGE

Bellows, Emma S. *The Paintings of George Bellows.* 1929
Boswell, Peyton, Jr. *George Bellows.* 1942
Braider, Donald. *George Bellows and the Ashcan School of Painting.* 1971
Morgan, Charles H. *George Bellows. Painter of America.* 1965
Young, M. S. *The Paintings of George Bellows.* 1973
George Bellows. Paintings, drawings and prints. Exh. Cat. Art Inst. of Chicago, 1964

BENOIS, ALEXANDRE

Benois, Alexandre. *The Russian School of Painting.* 1916

BENTON, THOMAS HART

Baigell, M. *Thomas Hart Benton.* 1973
Benton, Thomas Hart. *An American in Art: a professional and technical autobiography.* Lawrence, Kansas, 1969
— *An Artist in America.* 1937
— *Thomas Hart Benton.* American Artists Group, 1945. Autobiographical monograph.
Craven, Thomas. *Thomas Hart Benton.* 1939
Fath, Creekmore. *The Lithographs of Thomas Hart Benton.* 1969. With catalogue of prints and comments by the artist.

Thomas Hart Benton. Exh. Cat. Univ. of Kansas, Lawrence, 1958

BÉOTHY, ÉTIENNE

Seuphor, Michel. *Béothy.* Paris, 1956

BERGHE, FRITS VAN DEN

Langui, É. *Frits van den Berghe, 1883–1939. L'Homme et son œuvre.* Antwerp, 1968
— *Frits van den Berghe, 1883–1939. Catalogue raisonné de son œuvre peint.* Brussels, 1966
Frits van den Berghe. Exh. Cat. Kunsthaus, Hamburg, 1969
Frits van den Berghe. Exh. Cat. Palais des Beaux-Arts, Brussels, 1962

BERGMANN, ANNA-EVA

Aubier, D. *Anna-Eva Bergmann.* Paris, 1964

BERKE, HUBERT

Hubert Berke. Exh. Cat. Gesellschaft für Kunst, Mainz, 1962

BERLEWI, HENRYK

Henryk Berlewi. Exh. Cat. Maison de France, Berlin, 1964. With bibliography.

BERMAN, EUGENE

Berman, Eugene. *Imaginary Promenades in Italy.* 1956
Levey, Julian. *Eugene Berman.* 1947
Eugene Berman. Retrospective. Exh. Cat. Inst. of Contemporary Art, Boston, 1941

BERNARD, ÉMILE

Chesneau, E. and Cheyron, J. *Hommage de la ville de Pont-Aven à Émile Bernard.* Pont-Aven, 1960
Mornand, P. *Émile Bernard et ses amis, Van Gogh, Gauguin, Toulouse-Lautrec, Cézanne, Odilon Redon.* Geneva, 1957
— (ed.). *Lettres de Paul Gauguin à Émile Bernard, 1888–1891.* Geneva, 1954
Rewald, John. *Post-Impressionism: from Van Gogh to Gauguin.* 1978 (1962)
É. Bernard et Pont-Aven. Exh. Cat. Hirschl and Adler Gal., N.Y., 1957
Émile Bernard. Exh. Cat. Kunsthalle, Bremen, 1967

BERNI, ANTONIO

Plá, R. *Antonio Berni.* Buenos Aires, 1945
Troche, Michel and Gassiot-Talbot, G. *Berni.* Paris, 1971

BERNIK, JANEZ

Bihalji-Merin, Oto. *L'Art contemporain en Yugoslavie.* Mus. Nat. d'Art Moderne, Paris, 1961–2
Kržišnik, Zoran. *Janez Bernik.* Maribor, 1966

BERTHOLLE, JEAN

Descargues, Pierre. *Bertholle.* Paris, 1952

BERTONI, WANDER

Wander Bertoni. Sculptures, 1945–1959. Exh. Cat. Kapfenburg, 1959. With index of works.

BERTRAND, GASTON

Delevoy. R. L. *Gaston Bertrand.* Antwerp, 1953; Paris, 1955

BEUYS, JOSEPH

Beuys, Joseph. *Multiplizierte Kunst.* Munich, 1977
— *Zeichnungen.* Cologne, 1972

Tisdall, C. *Joseph Beuys.* 1979
Joseph Beuys. Cat. of the Emanuel Hoffmann Stiftung, Kunstmus., Basle, 1969–70
Joseph Beuys: The secret block of a secret person in Ireland. Exh. Cat. Mus. of Modern Art, Oxford, 1974

BEVAN, ROBERT

Bevan, R. A. *Robert Bevan, 1865–1925. A memoir by his son.* 1965
Dry, Graham (ed.). *Robert Bevan, 1865–1925. Catalogue raisonné of the lithographs and other prints.* 1968

BIEDERMAN, CHARLES

Biederman, Charles. *Art as the Evolution of Visual Knowledge.* 1948
— *Letters on the New Art.* 1951
— *The New Cézanne.* 1952
— *Search for New Arts.* 1979
Hill, Anthony. *D.A.T.A.—Directions in Art, Theory and Aesthetics.* 1968
Osborne, Harold. *Abstraction and Artifice in Twentieth-Century Art.* 1979
Rickey, George. *Constructivism. Origins and evolution.* 1968
Charles Biederman. The Structurist Relief 1935–1964. Exh. Cat. Walker Art Center, Minneapolis, 1965
Charles Biederman. Exh. Cat. Hayward Gal., London, 1969

BIGGE, JOHN

Read, Herbert (ed.). *Unit One. The modern movement in English architecture, painting and sculpture.* 1934

BILL, MAX

Maldonado, T. *Max Bill.* Buenos Aires, 1955. With bibliography.
Max Bill. Exh. Cat. Gimpel and Hanover Gal., Zürich, 1963
See also CONCRETE ART

BIROLLI, RENATO

Bini, Sandro. *Renato Birolli.* Milan, 1941
Tullier, A. *Birolli.* Milan, 1951
Venturi, Lionello. *Italian Painters of Today.* 1959
Renato Birolli. Exh. Cat., Milan, 1960

BISCHOFF, ELMER

Nordness, Lee (ed.). *Art: USA: Now.* 2 vols. 1963

BISHOP, ISABEL

Johnson, Una E. *Isabel Bishop. The prints and drawings of Miss Bishop with two essays by the artist.* Brooklyn Mus., N.Y., 1964
Nordness, Lee (ed.). *Art: USA: Now.* 2 vols. 1963

BISSIER, JULIUS

Schmalenbach, Werner. *Bissier.* Stuttgart, 1963
Vallier, D. (ed.). *Julius Bissier. Brush drawings.* Eng. trans., 1966
Julius Bissier. 70th year retrospective. Exh. Cat. Inst. of Contemporary Art, Boston, 1963

BISSIÈRE, ROGER

Fouchet, Max-Pol. *Bissière.* Paris, 1955
Bissière. Exh. Cat. Mus. des Arts Décoratifs, Paris, 1966

BLAKE, PETER

Pop Art in England. Exh. Cat. Kunstverein, Hamburg, and Arts Council of Great Britain, 1976

BLANCHET, ALEXANDRE

Fosca, H. *Alexandre Blanchet*. Lausanne, 1929
Alexandre Blanchet. Exh. Cat. Kunstmus., Winterthur, 1963

BLAUE REITER

Buchheim, L. G. *Der Blaue Reiter und die 'Neue Künstlervereinigung München'*. Feldafing, 1959
Grote, Ludwig. *Der Blaue Reiter. München und die Kunst des 20. Jahrhunderts*. Munich, 1949
Kandinsky, Wassily and Marc, Franz (ed.). *The 'Blaue Reiter' Almanac*. New documentary edition, ed. Klaus Lankheit, Eng. trans. by Henning Falkenstein, 1974
Röthel, Hans Konrad. *The Blue Rider*. 1971
Vergo, Peter. *The Blue Rider*. Oxford, 1977
Wingler, H. M. *Der Blaue Reiter*. Feldafing, 1959
The Blue Rider Group. Exh. Cat. Royal Scottish Academy, Edinburgh, 1960

BLOC, ANDRÉ

Delloye, C. *André Bloc*. Paris, 1959

BLOOM, HYMAN

Hyman Bloom. Exh. Cat. Inst. of Contemporary Art, Boston, 1944
Hyman Bloom. Retrospective. Exh. Cat. Albright-Knox Art Gal., Buffalo, 1954

BLOOMSBURY GROUP

Bell, Clive. *Old Friends. Personal recollections*. 1956
Bell, Quentin. *Bloomsbury*. 1968
Johnstone, J. K. *The Bloomsbury Group*. 1954
Lumsden, Ian G. *Bloomsbury Painters and their Circle*. Fredericton, N.B., 1976–7
Rantavaara, Irma. *Virginia Woolf and Bloomsbury*. Annales Academiae Scientiarum Fennicae, Series B.T. 82, Helsinki, 1953
Rosenbaum, S. P. (ed.). *The Bloomsbury Group. A collection of memoirs, commentary and criticism*. 1976
Shone, Richard. *Bloomsbury Portraits*. 1976

BLUEMNER, OSCAR

Oscar Bluemner. American colorist. Exh. Cat. Fogg Art Mus., Cambridge, Mass., 1967

BLUME, PETER

Peter Blume. Paintings and drawings in retrospect: 1925–1964. Exh. Cat. Currier Gal. of Art, Manchester, N.H., 1964
Peter Blume. Exh. Cat. Kennedy Gal., N.Y., 1968

BOCCIONI, UMBERTO

Argan, G. C. *Umberto Boccioni*. Rome, 1953
Ballo, G. *Boccioni. La vita e l'opera*. Milan, 1964
Boccioni, Umberto. *Gli scritti editi e inediti*. Milan, 1971
Golding, J. *Boccioni's Unique Forms of Continuity in Space*. Newcastle upon Tyne, 1972
Grada, R. de. *Boccioni. Il mito del moderno*. Florence, 1962
Marinetti, F. T. (ed.). *Umberto Boccioni. Opera completa*. Foligno, 1927
The Graphic Work of Umberto Boccioni. Exh. Cat. The Mus. of Modern Art, N.Y., 1961
See also FUTURISM

BÖCKSTIEGEL, PETER AUGUST

Das Graphische Werk Peter August Böckstiegels. Bielefelder Kunstverein, Bielefeld, 1932
Peter August Böckstiegel. Exh. Cat., Münster, 1956

BODMER, WALTER

Moeschlin, W. J. *Walter Bodmer*. Basle, 1952

BODY ART

Maisonneuve, J. and Bruchon-Schweitzer, M. *Modèles du corps et psychologie esthétique*. 1981
Vergine, Lea. *Il corpo come linguaggio*. Milan, 1974

BOECK, FÉLIX DE

Bourgeois, Pierre. *Félix de Boeck*. Brussels, 1964

BOECKL, HERBERT

Hofmann, Werner (ed.). *Herbert Boeckl. Zeichnungen und Aquarelle*. Vienna, 1968
Pack, Claus. *Der Maler Herbert Boeckl*. Vienna, 1964. With catalogue of works.

BOMBERG, DAVID

Lipke, William. *David Bomberg. A critical study of his life and work*. 1967
David Bomberg, 1890–1957. Exh. Cat. Arts Council of Great Britain, 1967

BOMBOIS, CAMILLE

Bodmer-Bing, H. *Camille Bombois*. Paris, 1951
Uhde, Wilhelm. *Cinq maîtres primitifs*. Paris, 1949
See also NAÏVE ART

BONNARD, PIERRE

Beer, F. J. *Bonnard*. Paris, 1947
Bonnard, Pierre. *Correspondances*. Paris, 1944
Courthion, Pierre. *Bonnard, peintre du merveilleux*. Paris, 1945
Dauberville, Jean and Henri. *Bonnard . . . Catalogue raisonné de l'œuvre peint*. Paris, 1966
Fermigier, André. *Bonnard*. 1971
Roger-Marx, C. *Bonnard. Lithographe*. Paris, 1952
Rumpel, H. *Bonnard*. Paris, 1952
Sutton, Denys. *Bonnard*. 1957
Terrasse, Antoine. *Pierre Bonnard*. Paris, 1967
— and Heron, Patrick. *Bonnard. Drawings from 1893–1946*. 1972
Vaillant, Annette. *Bonnard*. 1966
Pierre Bonnard. Exh. Cat. by John Rewald, The Mus. of Modern Art, N.Y., 1948
Bonnard and his Environment. Exh. Cat. The Mus. of Modern Art, N.Y., 1964

BONNET, ANNE

Davay, Paul. *Anne Bonnet*. Antwerp, 1954
Anne Bonnet en de Abstracte Schilderkunst. Bulletin des Mus. Royaux, Brussels, 1953

BONTECOU, LEE

Ashton, Dore. *Modern American Sculpture*. 1968
Americans 1963. Exh. Cat. ed. Dorothy C. Miller, The Mus. of Modern Art, N.Y., 1963

BORDUAS, PAUL-ÉMILE

Borduas, Paul-Émile. *Écrits/Writings*. Nova Scotia, 1979. Bilingual edition.
— *Textes: Refus Global, Projections libérantes*. Montreal, 1974
Gagnon, François-Marc. *Paul-Émile Borduas*. Ottawa, 1976
Robert, Guy. *Borduas*. Montreal, 1972
La Collection Borduas du Musée d'Art Contemporain. Montreal, 1976

BORÈS, FRANCISCO

Grenier, J. *Borès*. Paris, 1961

BOTERO, FERNANDO

Carter, Radcliff. *Botero*. 1981

BOURDELLE, ÉMILE-ANTOINE

Bourdelle, Antoine. *Écrits sur l'art et sur la vie*. Paris, 1955
— *La Matière et l'esprit dans l'art*. Paris, 1952
Descargues, Pierre. *Bourdelle*. Paris, 1954
Jianou, I. and Dufet, M. *Bourdelle*. Paris, 1965
Antoine Bourdelle. Exh. Cat. Charles E. Slatkin Gal., N.Y., 1961

BOUSSINGAULT, JEAN-LOUIS

Dunoyer de Segonzac, André. *Boussingault*. Paris, 1944

BOYD, ARTHUR

Hetherington, John. *Australian Painters: forty profiles*. 1964
Philipp, Franz. *Arthur Boyd*. 1967
Smith, Bernard. *The Antipodean Manifesto*. 1976
Boyd. Exh. Cat. Whitechapel Art Gal., London, 1962

BRANCUSI, CONSTANTIN

Brezianu, Barbu. *Brancusi in Romania*. 1976
Geist, Sidney. *Brancusi. A study of the sculpture*. 1968
— *Brancusi. The sculpture and drawings*. 1975
Giedion-Welcker, C. *Brancusi 1876–1957*. 1959
Jianou, I. *Brancusi*. Paris, 1963
Sandulescu, Nicolae. *Brancusi*. Bucarest, 1965
Zervos, Christian. *Constantin Brancusi. Sculptures, peintres, dessins*. Paris, 1957

BRANGWYN, FRANK

Boyd, James D. (ed.). *The Drawings of Sir Frank Brangwyn, R.A., 1867–1956*. Leigh-on-Sea, 1967
Bunt, Cyril G. E. *The Water-Colours of Sir Frank Brangwyn, R.A., 1867–1956*. Leigh-on-Sea, 1958
De Belleroche, William. *Brangwyn's Pilgrimage*. 1948
Furst, H. E. A. *The Decorative Art of Frank Brangwyn*. 1924
Galloway, Vincent. *The Oils and Murals of Sir Frank Brangwyn, R.A., 1867–1956*. Leigh-on-Sea, 1962
Rutter, Frank (ed.). *The British Empire Panels designed for the House of Lords by Frank Brangwyn, R.A.* 1933
Sandilands, George S. *Frank Brangwyn, R.A.* 1928
Frank Brangwyn. Centenary exhibition. Exh. Cat. Nat. Mus. of Wales and Welsh Arts Council, 1967
Catalogue of the works of Sir Frank Brangwyn, R.A., 1867–1956. William Morris Gal., Walthamstow, 1974
Sir Frank Brangwyn, R.A., 1867–1956. Exh. Cat. Kaplan Gal., London, 1975
Frank Brangwyn. Exh. Cat. Polytechnic Art Gal., Brighton, and Graves Art Gal., Sheffield, 1980

BRAQUE, GEORGES

Appelbaum, Stanley (trans.). *Georges Braque. Illustrated notebooks 1917–1955*. 1971
Bissière, Roger. *Georges Braque par Bissière*. Paris, 1920
Cogniat, Raymond. *Braque*. Eng. trans., Lugano, 1970
Cooper, Douglas. *Braque: the great years*. 1973
Gieure, M. *G. Braque*. 1956
Hofmann, W. *Georges Braque. His graphic work*. 1962
Leymarie, Jean. *Braque*. Geneva, 1961
Mangin, N. S. (ed.). *Braque. Catalogue de l'œuvre, peintures 1928–57*. Paris, 1959
Mourlot, Fernand. *Braque. Lithographie*. 1963
Mullins, Edwin B. *Braque*. 1968
Richardson, John. *G. Braque*. Greenwich, Conn., 1961
Russell, John. *G. Braque*. 1959
Valsecchi, Marco and Carrà, Massimo (ed.). *L'opera completa di Georges Braque*. Milan, 1971

Wember, P. G. *Braque. Das graphische Gesamtwerk, 1907–1955*. Bremen, 1955
Georges Braque. Exh. Cat. The Mus. of Modern Art, N.Y., 1949
G. Braque. Exh. Cat. Edinburgh Festival Society, 1956

BRAUER, ERICH

Schmied, Wieland. *Malerei des phantastischen Realismus: die Wiener Schule*. Vienna, 1964

BRAUNER, VICTOR

Jouffroy, A. *Victor Brauner*. Paris, 1959
Victor Brauner. Exh. Cat. Mus. Nat. d'Art Moderne, Paris, 1972

BRAYER, YVES

Crespelle, J.-P. *Yves Brayer. Dessinateur et aquarelliste*. Paris, 1961

BREITNER, GEORGE HENDRIK

Hefting, P. H. *G. H. Breitner*. Amsterdam, 1968
Breitner en Amsterdam. Exh. Cat. Stedelijk Mus., Amsterdam, 1947

BRIANCHON, MAURICE

Heyd, Richard. *Brianchon*. Paris, 1954
Zahar, Marcel. *Maurice Brianchon*. Geneva, 1949

BRITAIN

Bertram, A. *A Century of British Painting, 1851–1951*.
Farr, Dennis. *English Art 1870–1940*. 1978
Forma, W. *Five British Sculptors (Work and Talk): Henry Moore, Reg Butler, Barbara Hepworth, Lynn Chadwick, Kenneth Armitage*. 1964
Hardie, William. *Scottish Painting: 1837–1939*. 1977
Hubbard, H. *A Hundred Years of British Painting, 1851–1951*. 1951
Lambert, R. S. (ed.). *Art in England*. 1938
Piper, David (ed.). *The Genius of British Painting*. 1975
Rothenstein, John. *British Art since 1900. An anthology*. 1962
— *Modern English Painters*. 3 vols. 1952–74
Russell, John. *From Sickert to 1948. The achievement of the Contemporary Art Society*. 1948
Shone, Richard. *The Century of Change: British painting since 1900*. 1977
Watney, Simon. *English Post-Impressionism*. 1980
Masters of British Painting 1800–1950. Exh. Cat. The Mus. of Modern Art, N.Y., 1956
British Painting 1910–1945. Exh. Cat. Tate Gal., London, 1967
English Art Today. Exh. Cat. British Council, Palazzo Reale, Milan, 1976

BROOKS, JAMES

James Brooks. Retrospective Cat. Whitney Mus. of American Art, 1963

BRUCE, PATRICK HENRY

Synchromism and Related Color Principles in American Painting, 1910–1930. Exh. Cat. Knoedler Gal., N.Y., 1965

BRÜCKE

Buchheim, L. G. *Die Künstlergemeinschaft Brücke. Gemälde, Zeichnungen, Graphik, Plastik, Dokumente*. Feldafing, 1956
Selz, Peter. *German Expressionist Painting*. Berkeley, Calif., 1957
Wentzel, H. *Bildnisse der Brücke-Künstler voneinander*. Stuttgart, 1961

BRÜCKE (cont.)

Zigrosser, C. D. *The Expressionists. A survey of their graphic art.* 1957
Ausstellung Künstlergruppe Brücke: Jahresmappen 1906–1912. Berne, 1958
Brücke, 1905–1913. Eine Künstlergemeinschaft des Expressionismus. Exh. Cat. Folkwang Mus., Essen, 1958
Painters of the Brücke. Exh. Cat. Tate Gal., London, 1964
Le Fauvisme français et les débuts de l'expressionisme allemand. Exh. Cat. Mus. Nat. de l'Art Moderne, Paris, 1966
Der Maler Cuno Amiet und die Brücke. Exh. Cat. Kunsthaus, Zürich, 1979

BRUSSELMANS, JEAN

Degand, L. *Jean Brusselmans.* Brussels, 1939
Delevoy, Robert L. *Jean Brusselmans. Catalogue raisonné établi par G. Brys-Schatan.* Brussels, 1972
Haesaerts, P. *Jean Brusselmans.* Brussels, 1939
Jean Brusselmans. Exh. Cat. Palais des Beaux-Arts, Brussels, 1952
Jean Brusselmans. Retrospective. Exh. Cat. Cercle Royale Artistique et Littéraire de Charleroi, 1955
Ensor to Permeke. Nine Flemish Painters, 1880–1950. Exh. Cat. Royal Academy, London, 1971

BRYEN, CAMILLE

Gindertael, R. Van. *Bryen.* Paris, 1960

BUCHHEISTER, CARL

Lange, R. *Carl Buchheister.* Göttingen, 1964

BUFFET, BERNARD

Bergé, P. *Bernard Buffet.* Paris, 1958
Buffet, Bernard. *Les Oiseaux.* 1960
Descargues, Pierre. *Bernard Buffet.* Paris, 1952
Druon, Maurice. *Bernard Buffet.* Eng. trans., 1965

BURCHFIELD, CHARLES

Burchfield, Charles. *Charles Burchfield.* American Artists Group, 1945. Autobiographical monograph.
Jones, Edith H. (ed.). *The Drawings of Charles Burchfield.* 1968
Charles Burchfield. Exh. Cat. Whitney Mus. of American Art, 1968

BURRA, EDWARD JOHN

Cooper, Douglas. *Edward Burra.* In Herbert Read (ed.), *Unit One,* 1934
Rothenstein, John. *Edward Burra.* 1965
Edward Burra. Exh. Cat. Tate Gal., London, 1973

BURRI, ALBERTO

Brandi, Cesare. *Burri.* Rome, 1963
Sweeney, J. J. *Burri.* Rome, 1955
Alberto Burri. Exh. Cat. Mus. of Fine Arts, Houston, 1963
Alberto Burri. Exh. Cat. Kunstverein, Darmstadt, 1967

BURY, POL

Martinez, Carmen. *Pol Bury. Recueil de textes écrits depuis 1959.* Paris, 1977

BUTLER, HORACIO

Butler, Horacio. *La pintura y mi tiempo.* Buenos Aires, 1966
Payró, Julio E. *Horacio Butler.* Buenos Aires, 1954

BUTLER, REG

Forma, W. *Five British Sculptors (Work and Talk).* 1964
Reg Butler. Exh. Cat. Hanover Gal., London, 1963

CADMUS, PAUL

Paul Cadmus. Cat. of Exh. of prints and drawings, Brooklyn Mus., N.Y., 1968

CAILLAUD, ARISTIDE

Aristide Caillaud. Exh. Cat. Mus. Nat. d'Art Moderne, Paris, 1975

CALDER, ALEXANDER

Arnason, H. H. *Calder.* 1972 (1966)
— and Mulas, U. (ed.). *Calder.* 1971
Calder, Alexander. *Calder. An autobiography with pictures.* 1967
Caradente, Giovanni. *Calder. Mobiles and Stabiles.* UNESCO, 1968
Alexander Calder. Exh. Cat. The Mus. of Modern Art, N.Y., 1951
Alexander Calder. A retrospective exhibition. Exh. Cat. Solomon R. Guggenheim Mus., N.Y., 1964
A Salute to Alexander Calder. The Mus. of Modern Art, N.Y., 1969
Calder. Exh. Cat. Munich and Zürich, 1975
Calder's Universe. Exh. Cat. The Mus. of Modern Art, N.Y., 1977

CALDERARA, ANTONIO

Mendes, M. *Calderara, pitture da 1925 al 1965.* Milan, 1965

CAMDEN TOWN GROUP

Baron, Wendy. *The Camden Town Group.* 1979
Camden Town Group. A review. Exh. Cat. Leicester Gals., London, 1930
The Camden Town Group. Exh. Cat. Arts Council of Great Britain, 1951
Drawings of the Camden Town Group. Exh. Cat. Arts Council of Great Britain, 1961

CAMPENDONK, HEINRICH

Engels, M. T. *Heinrich Campendonk.* Recklinghausen, 1958
Wember, P. *Heinrich Campendonk.* Krefeld, 1960

CAMPIGLI, MASSIMO

Carrieri, R. *Campigli.* Venice, 1945
Cassou, J. *Campigli.* Paris, 1957
Franchi, R. *Massimo Campigli.* Milan, 1944
Raynal, M. *Campigli.* Paris, 1949
Russoli, F. *Campigli: pittori.* Milan, 1965

CANADA

Duval, Paul. *Four Decades. The Canadian Group of Painters and their contemporaries, 1930–1970.* Toronto, 1972
Harper, J. Russell. *Painting in Canada. A history.* Toronto, 1966
Hill, Charles C. *Canadian Painting in the Thirties.* Ottawa, 1975
Hubbard, R. H. *The Development of Canadian Art.* Nat. Gal. of Canada, Ottawa, 1963
— *The Artist and the Land. Canadian landscape painting 1670–1930.* Madison, 1973
Hunkin, Harry. *The Group of Seven: Canada's great landscape painters.* Edinburgh, 1979
Lord, Barry. *The History of Painting in Canada: toward a people's art.* Toronto, 1974
Mellen, Peter. *The Group of Seven.* Toronto, 1970
Ostiguy, Jean-René. *Un siècle de peinture canadienne, 1870–1970.* Quebec, 1971
Reid, Dennis. *A Concise History of Canadian Painting.* Toronto, 1973

Townsend, William (ed.). *Canadian Art Today.* 1970
Withrow, William. *Contemporary Canadian Painting.*
Toronto, 1972

CANTATORE, DOMENICO

Carrière, R. *Cantatore.* Milan, 1955
Gatto, A. *Domenico Cantatore.* Milan, 1934

CANTRÉ, JOZEF

Ridder, André de. *Joseph Cantré.* Antwerp, 1952

CAPOGROSSI, GIUSEPPE

Argan, G. C. and Fagiolo, M. *Capogrossi.* Rome, 1967
Seuphor, M. *Capogrossi.* Venice, 1954

CARLES, ARTHUR BEECHER

Rose, Barbara. *American Art since 1900.* 1975
A Memorial Exhibition of Arthur B. Carles. Exh. Cat.
Pennsylvania Academy of the Fine Arts and
Philadelphia Mus. of Art, 1953

CARO, ANTHONY

Rubin, William. *Anthony Caro.* 1975
Whelan, Richard. *Anthony Caro.* 1974
Anthony Caro. Exh. Cat. Whitechapel Art Gal.,
London, 1963
Paolozzi and Caro. Exh. Cat. Rijksmus. Kröller-Müller,
Otterlo, 1967
Anthony Caro. Exh. Cat. Arts Council of Great Britain,
1969

CARR, EMILY

Hembroff-Schleicher, Edythe. *m.e.: a portrayal of Emily
Carr.* Toronto and Vancouver, 1969
Pearson, Carol. *Emily Carr As I Knew Her.* Toronto,
1954
Shadbolt, Doris. *Emily Carr.* Vancouver, 1971
Tippett, Maria. *Emily Carr: a biography.* Toronto, 1980
Turpin, Marguerite. *The Life and Work of Emily Carr.
A selected bibliography.* Vancouver, 1965

CARRÀ, CARLO

Carrà, Carlo. *Guerrapittura.* Milan, 1915
— *La mia vita.* Rome, 1943
— *Pittura metafisica.* Milan, 1945
— and others. *Le Néoclassicisme dans l'art
contemporain.* Rome, 1923
Carrà, Massimo. *Carrà: tutta l'opera pittorica.* Milan,
1967
Pacchioni, Guglielmo. *Carlo Carrà.* Milan, 1959
Carlo Carrà. Exh. Cat. Palazzo Reale, Milan, 1962
See also FUTURISM

CASORATI, FELICE

Carluccio, L. *Felice Casorati.* Milan, 1964
Galvano, A. *Felice Casorati.* Milan, 1947

CAULFIELD, PATRICK

Finch, Christopher. *Patrick Caulfield.* 1971
Junge Engländer: Monro, Hoyland, Tucker, Caulfield.
Exh. Cat. Kunststudio Westfalen, Bielefeld, 1971
Patrick Caulfield. Exh. Cat. Waddington Gals.,
London, 1975

CAVAILLÈS, JULES

Fels, Florent. *Jules Cavaillès.* Paris, 1943

CAVALCANTI, EMILIANO DI

Martins, Luís and Mendes de Almeida, Laulo. *Emiliano
di Cavalcanti. 50 años de pintura, 1922–1971.* São
Paulo, 1971

Retrospectiva di Cavalcanti. Exh. Cat. Mus. de Arte
Moderna, São Paulo, 1972

CÉSAR

Cooper, Douglas. *César.* Amriswil, 1960
César. Exh. Cat. Boymans-van Beuningen Mus.,
Rotterdam, 1976

CHABOT, HENDRIK

Doelman, C. *Hendrik Chabot.* Amsterdam. Eng. trans.,
1967

CHADWICK, LYNN

Hodin, J. P. *Lynn Chadwick.* 1961
Forma, W. *Five British Sculptors (Work and Talk).*
1964

CHAGALL, MARC

Ayrton, Michael (ed.). *Marc Chagall. Paintings.* 1948
Bucci, Mario. *Chagall.* 1971
Cassou, Jean. *Chagall.* 1965
Chagall, Marc. *Ma vie.* Paris, 1931. Eng. trans., *My
Life,* 1965
Haftmann, Werner. *Marc Chagall.* Eng. trans., 1973
Lassaigne, Jacques. *Chagall.* Paris, 1957
— (ed.). *Chagall. Dessins et aquarelles pour le ballet.*
Paris, 1969
— (ed.). *Marc Chagall. Unpublished drawings.* Geneva,
1968
Leymarie, Jean (ed.). *The Jerusalem Windows.* Monte
Carlo, 1962
McMullen, Roy. *The World of Marc Chagall.* 1968
Meyer, F. *Marc Chagall.* Eng. trans., 1964. With
catalogue of works.
— (ed.). *Marc Chagall: the graphic work.* 1957
Mourlot, F. (ed.). *Marc Chagall. Lithographs.* 4 vols.
1960– . With notes and catalogue.
Pieyre de Mandriargues, André. *Chagall.* Paris, 1975
Sorlier, Charles. *Les Céramiques et sculptures de
Chagall.* Monaco, 1972
Souverbie, Marie-Thérèse. *Chagall.* 1975
Sweeney, J. J. *Marc Chagall.* 1946
Venturi, Lionello. *Marc Chagall.* 1956
Werner, A. *Chagall.* 1967
Marc Chagall. Exh. Cat. Mus. des Arts Décoratifs,
Paris, 1959
Marc Chagall. Works on paper. Exh. Cat. Solomon R.
Guggenheim Mus., N.Y., 1976

CHAMBERLAIN, JOHN

John Chamberlain. Exh. Cat. Solomon R. Guggenheim
Mus., N.Y., 1971

CHAPELAIN-MIDY, ROGER

Champigneulle, Bernard. *Chapelain-Midy.* Geneva,
1965

CHILLIDA, EDUARDO

Volboudt, Pierre (ed.). *Chillida.* 1967
Eduardo Chillida. Exh. Cat. Mus. of Fine Arts,
Houston, 1966

CHIRICO, GIORGIO DE

Chirico, Giorgio de. *Memorie della mia vita.* Rome,
1945. Eng. trans., 1971
Ciranna, Alfonso. *Giorgio de Chirico. Catalogo delle
opera grafiche . . . 1921–1969.* Milan, 1969
Faldi, G. *Giorgio de Chirico.* Venice, 1955
George, W. *Chirico: avec des fragments littéraires de
l'artiste.* Paris, 1928

CHIRICO (cont.)
Giorgio de Chirico. Exh. Cat. The Mus. of Modern Art, N.Y., 1955
See also METAPHYSICAL PAINTING and SURREALISM

CHRISTO
Alloway, Lawrence (ed.). Christo. 1969
Bourdon, David. Christo. 1970

CHRYSSA
Hunter, Sam. Chryssa. 1974

ČIURLIONIS, M.K.
Vorob'ev, Nikolai. M.K. Čiurlionis. Der litauische Maler und Musiker. Leipzig, 1938

CLAVÉ, ANTONI
Alexandre, A. Clavé. Munich, 1952
Cassou, Jean. Antoni Clavé. Barcelona, 1960
Cogniat, Raymond. Antoni Clavé. Madrid, 1956
George, Waldemar. L'Univers de Clavé. Paris. 1944
Liebermann, Alex. Clavé: peintre et décorateur de théâtre. 1952
Madrigal, Carlos. Antoni Clavé. Buenos Aires, 1951
Salgues, Ives. Clavé. Paris, 1955
Wescher, Herta. Clavé. Zürich, 1956

COBRA
Schierbeek, Bert. The Experimentalists. Amsterdam, n.d.
Cobra 1949–51. Exh. Cat. Stedelijk Mus., Amsterdam, 1962
Cobra. Exh. Cat. Boymans-van Beuningen Mus., Rotterdam, 1966

COLLAGE
Janis, H. and Blesh, R. Collage: personalities, concepts, techniques. 1967
Laliberté, Norman and Mogelon, Alex. Collage, Montage, Assemblage: history and contemporary techniques. 1972
Wescher, H. Collage. Cologne, 1968. Eng. trans., 1971
Wolfram, Eddie. History of Collage. 1975

COLLINS, CECIL
Comfort, Alex. Cecil Collins. Paintings and drawings. 1946
Rothenstein, John. Modern English Painters. Wood to Hockney. 1974

COLVILLE, ALEX
Dow, Helen J. The Art of Alex Colville. 1972
Alex Colville. Exh. Cat. Marlborough Fine Art, London, 1970
Alex Colville. Exh. Cat. Kunsthaus, Düsseldorf, 1977

COMPUTER ART
Alsleben, K. Ästhetische Redundanz. Hamburg, 1962
Franke, Herbert W. Computer Graphics—Computer Art. 1971
Hyman, Anthony. The Computer in Design. 1973
Moles, A. Théorie de l'information et perception esthétique. Paris, 1956. Eng. trans., Information Theory and Esthetic Perception, 1966
Nake, F. Computer-Grafik. Stuttgart, 1967
Nees, Georg. Generative Computergraphik. Munich, 1969
Prueitt, Melvin L. Computer Graphics. 1975
Reichardt, Jasia. The Computer in Art. 1971
Ronge, Barbara. Art et ordinateur. Tournai, 1971. German trans., Art und Computer, Cologne, 1973

Ronge, Hans (ed.). Kunst und Kybernetik. Cologne, 1968
Sumner, Lloyd. Computer Art and Human Response. Charlottesville, 1968
Cybernetic Serendipity. Exh. Cat. I.C.A., London, 1968

CONCEPTUAL ART
Meyer, Ursula. Conceptual Art. 1972
Biennial Report, 1972–4. Tate Gal., London

CONCRETE ART
Bjerke-Petersen, Vilhelm. Konkret Konst. Stockholm, 1956
Staber, Margit. Konkrete Kunst. St. Gallen, 1966

CONSAGRA, PIETRO
Apollonio, Umbro. Pietro Consagra. Rome, 1957
Argan, G. C. Pietro Consagra. Neuchâtel, 1962
Pietro Consagra. Recent sculpture. Cat. Marlborough-Gerson Gal., N.Y., 1967

CONSTANT, GEORGE
Haaren, H. van. Constant. Amsterdam, 1966

CONSTRUCTIVISM
Bann, Stephen (ed.). The Tradition of Constructivism. 1974
Barr, A. H., Jr. (ed). Cubism and Abstract Art. The Mus. of Modern Art, N.Y., 1936
Martin, J. L., Nicholson, Ben, and Gabo, Naum (ed.). Circle. International Survey of Constructive Art. 1971 (1937)
Nash, J. M. Cubism, Futurism and Constructivism. 1974
Rickey, George. Constructivism. Origins and evolution. 1968
Seuphor, Michel. L'Art abstrait: ses origines, ses premiers maîtres. Paris, 1950
Torres-García, Joaquín. Universalismo Constructivo. Buenos Aires, 1944
Konstruktivisten. Exh. Cat. Kunsthalle, Basle, 1937
Construction and Geometry in Painting from Malevich to Tomorrow. Exh. Cat. Gal. Chalette, N.Y., 1960
Konkrete Kunst. 50 Jahre Entwicklung. Exh. Cat. Kunstgesellschaft, Zürich, 1960
Geometric Abstraction in America. Exh. Cat. Whitney Mus. of American Art, 1962
Constructivism in Poland 1923–1936. Exh. Cat. Mus. of Fine Arts, Łódz, 1973

CORINTH, LOVIS
Berend-Corinth, C. (ed.). Die Gemälde von Lovis Corinth. Munich, 1958. Catalogue raisonné.
Biermann, Georg. Der Zeichner Lovis Corinth. Dresden, 1924
Corinth, Lovis. Gesammelte Schriften. Berlin, 1920
— Selbstbiographie. Leipzig, 1926
Netzer, R. Lovis Corinth. Graphik. Munich, 1958
Osten, G. von der. Lovis Corinth. Munich, 1959
Lovis Corinth. Exh. Cat. Tate Gal., London. 1959

CORNEILLE
Corneille. Exh. Cat. Stedelijk Mus., Amsterdam, 1966

CORNELL, JOSEPH
Ashton, Dore. A Joseph Cornell Album. 1974
Waldman, Diane. Joseph Cornell. 1977
Joseph Cornell. Exh. Cat. Pasadena Art Mus., 1966–7
Joseph Cornell. Exh. Cat. Solomon R. Guggenheim Mus., N.Y., 1967

CORPORA, ANTONIO

Ballo, Guido. *Corpora. Opere 1951–1956*. Rome, 1956
Venturi, Lionello. *Italian Painters of Today*. 1959
Zervos, Christian. *Corpora: œuvres 1951–1957*. Paris, 1957

COUNIHAN, NOEL

Dimack, Max. *Noel Counihan*. Melbourne, 1974

COUTAUD, LUCIEN

Mazars, Pierre. *Lucien Coutaud*. Geneva, 1963

COUTURIER, ROBERT

Jianou, I. *Couturier*. Paris, 1969

COUZIJN, WESSEL

Schuurman, K. E. (ed.). *Wessel Couzijn*. Amsterdam, 1967
Wessel Couzijn. Exh. Cat. Stedelijk Mus., Amsterdam, 1968

CRAIG, GORDON

Bablet, Denis. *Edward Gordon Craig*. Paris, 1962
Craig, Edward Anthony. *Gordon Craig: the story of his life*. 1968
Craig, Gordon. *Index to the Story of My Days*. 1957
Marotti, Ferruccio. *Edward Gordon Craig*. Bologna, 1961

CREEFT, JOSÉ DE

Campos, Jules. *José de Creeft*. 1945
Devree, Charlotte. *José de Creeft*. American Federation of Arts, 1960

CRIPPA, ROBERTO

Giani, G. *Crippa*. Venice, 1956
Jouffroy, A. *Crippa*. Milan, 1962
Roberto Crippa. Exh. Cat. Kunsthalle, Mannheim, 1965

CROOKE, RAY AUSTIN

Hetherington, John. *Australian Painters: forty profiles*. 1964

CROTTI, JEAN

George, Waldemar. *Jean Crotti et la primauté du spirituel*. Geneva, 1959
Jean Crotti; ou, L'Héritier de la Pandora. Exh. Cat. Mus. d'Art et d'Histoire, Fribourg, 1973

CRUZ-DIEZ, CARLOS

Boulton, Alfredo. *Cruz-Diez*. Caracas, 1975

CSÁKY, JOSEPH

George, W. *Csáky*. Paris, n.d.

CSONTVARY-KOSZTKA, TIBOR

Németh, Lajos. *Csontvary*. 1964
Ybl, Ervin. *Csontvary*. Eng. trans., Budapest, 1959

CUBISM

Apollinaire, Guillaume. *Les Peintres cubistes. Méditations esthétiques*. Paris, 1913
Barr, A. H., Jr. (ed.). *Cubism and Abstract Art*. The Mus. of Modern Art, N.Y., 1936
Cabanne, Pierre. *L'Épopée du cubisme*. Paris, 1963
Cooper, Douglas. *The Cubist Epoch*. 1971
Gleizes, Albert and Metzinger, Jean. *Du 'Cubisme'*. Paris, 1912
Golding, John. *Cubism: a history and an analysis, 1907–1914*. 1959

Gray, C. *Cubist Aesthetic Theories*. Baltimore, 1953
Habasque, G. *Cubism: biographical and critical study*. 1959
Janneau, G. *L'Art cubiste. Théories et réalisations. Étude critique*. Paris, 1929
Kamber, G. *Max Jacob and the Poetics of Cubism*. 1971
Nash, J. M. *Cubism, Futurism and Constructivism*. 1974
Rosenblum, R. *Cubism and Twentieth-Century Art*. 1961
Schmeller, A. *Cubism*. 1956
Schwartz, P. Waldo. *The Cubists*. 1971
Wadley, N. *Cubism*. 1972
Le Cubisme (1907–1914). Exh. Cat. Mus. Nat. d'Art Moderne, Paris, 1953

CUBO-FUTURISM

Barooshian, Vahan D. *Russian Cubo-Futurism*. The Hague, 1974

CUEVAS, JOSÉ LUIS

Cuevas, José Luis. *Cuevas por Cuevas*. Mexico City, 1965
Traba, Marta. *Los cuatro monstruos cardinales*. Mexico City, 1965

CURATELLA MANES, PABLO

Romero Brest, Jorge. *Pablo Curatella Manes*. Buenos Aires, 1967

CURRY, JOHN STEUART

Schmeckebier, Laurence E. *John Steuart Curry's Pageant of America*. 1943

DADA

Ades, Dawn. *Dada and Surrealism*. 1974
Ball, Hugo. *Flight out of Time. A Dada diary*. Ed. John Elderfield. Eng. trans., 1974
Barr, A. H., Jr. (ed.). *Fantastic Art, Dada, Surrealism*. The Mus. of Modern Art, N.Y., 1968 (1937)
Coutts-Smith, Kenneth. *Dada*. 1970
Hugnet, G. *L'Aventure dada, 1916–1922*. Paris, 1957
Lippard, Lucy R. (ed.). *Dadas on Art*. 1971
Mehring, W. *Berlin Dada. Eine Chronik mit Photos und Dokumenten*. Zürich, 1959
Motherwell, R. (ed.). *The Dada Painters and Poets: an anthology*. 1951
Ribemont-Dessaigne, G. *Déjà jadis; ou, Du mouvement Dada à l'espace abstrait*. Paris. 1958
Richter, Hans. *Dada: art and anti-art*. 1966
Sanouillet, Michel. *Dada à Paris*. Paris, 1965
Schifferli, P. (ed.). *Die Geburt des Dada . . . Dichtung und Chronik der Gründer*. Zürich, 1957
Tzara, Tristan (ed.). *Seven Dada Manifestos*. 1977
Verkauf, Willy (ed.). *Dada. Monograph of a movement*. 1957
Young, A. *Dada and After*. 1980
Dada, Dokumente einer Bewegung. Exh. Cat. Kunstverein für Rheinlande und Westfalen, Düsseldorf, 1957
Dada, Surrealism and their Heritage. Exh. Cat. The Mus. of Modern Art, N.Y., 1968

DAEYE, HIPPOLYTE

Corbet, August. *Hippolyte Daeye*. Antwerp, 1949

DALÍ, SALVADOR

Dalí, Salvador. *La Conquête de l'irrationnel*. Paris, 1935
— *Dali by Dali*. 1970
— *Diary of a Genius*. 1966
— *The Secret Life of Salvador Dali*. 1961
Descharnes, R. *The World of Salvador Dali*. 1962

DALÍ (cont.)

Dopagne, Jacques. Dali. 1974
Gerard, Max. Dali. 1968
Larkin, David (ed.). Dali. 1974
Morse, A. R. Dali. A study of his life and work. 1958
Paintings, Drawings, Prints: Salvador Dali. Exh. Cat.
 The Mus. of Modern Art, N.Y., 1946
Salvador Dali. Retrospective, 1920–1980. Exh. Cat.
 Paris, 1979

DAVIE, ALAN

Bowness, Alan (ed.). Alan Davie. 1967
Alan Davie. Paintings 1950–1972. Exh. Cat. Royal
 Edinburgh International Festival and Royal Scottish
 Academy, 1972

DAVIS, ARTHUR B.

Arthur Bowen Davis, 1862–1928. A centennial exhibition.
 Exh. Cat. Munson-Williams-Proctor Inst., Utica,
 N.Y., 1962

DAVIS, STUART

Blesh, Rudi. Stuart Davis. 1960
Davis, Stuart. Stuart Davis. 1945
Elliott, James. 'Stuart Davis.' Bulletin of Los Angeles
 County Mus. of Art, Vol. 14, No. 3, 1962
Goossen, E. C. Stuart Davis. 1959
Stuart Davis. Exh. Cat. The Mus. of Modern Art, N.Y.,
 1945
Stuart Davis. Exh. Cat. Walker Art Center,
 Minneapolis, 1957
Stuart Davis. Memorial exhibition. Exh. Cat. National
 Collection of Fine Arts, Washington, 1965

DEGENERATE ART

Brenner, H. Die Kunstpolitik des Nationalsozialismus.
 Reinbek bei Hamburg, 1963
Hinz, Berthold. Art in the Third Reich. 1980
Rogner, K. P. (ed.). Verlorene Werke der Malerei: in
 Deutschland in der Zeit von 1939 bis 1945 zerstörte
 und verschollene Gemälde. Munich, 1965
Roh, Franz, 'Entartete' Kunst. Kunstbarbarei im Dritten
 Reich. Hanover, 1962

DEHOY, CHARLES

Fierens, Paul. Charles Dehoy. Brussels, 1941

DEINEKA, ALEKSANDR

Sysoev, V. P. Deineka, 1899–1969. Moscow, 1973

DE KOONING, WILLEM

Hess, Thomas B. Willem de Kooning. 1959
Janis, Harriet and Blesh, Rudi. De Kooning. 1960
Rosenberg, Harold. Willem de Kooning. 1978
Tuchman, Maurice (ed.). The New York School.
 Abstract Expressionism in the 40s and 50s. 1971
Willem de Kooning. Exh. Cat. The Mus. of Modern Art,
 N.Y., 1968

DELAUNAY, ROBERT

Albrecht, Hans Joachim. Farbe als Sprache: Robert
 Delaunay, Josef Albers, Richard Paul Lohse. Cologne,
 1974
Cohen, A. A. (ed.). The New Art of Colour. 1978
Delaunay, Robert. Du cubisme à l'art abstrait.
 Documents inédits. Paris, 1957. Ed. P. Francastel,
 catalogue raisonné by G. Habasque.
La Tourette, F. Gilles de. Robert Delaunay. Paris, 1950
Schmidt, G. Robert Delaunay. Baden-Baden, 1964
Vriesen, G. and Imdahl, M. Robert Delaunay: Lichte
 und Farbe. Cologne, 1967. Eng. trans., 1969

DELAUNAY-TERK, SONIA

Cohen, A. A. Sonia Delaunay. 1975
Damase, Jacques. Sonia Delaunay. Rhythms and
 colours. 1972
Sonia Delaunay. Exh. Cat. Mus. Nat. d'Art Moderne,
 Paris, 1967
Sonia Delaunay. Exh. Cat. Redfern Gal., London,
 1974
Sonia Delaunay. Exh. Cat. Smithsonian Inst.,
 Washington, 1980

DEL PRETE, JUAN

Merli, Joan. Juan del Prete. Buenos Aires, 1946

DELVAUX, PAUL

Butor, Michel and others. Delvaux. Brussels, 1975
De Bock, Paul-Aloise. Paul Delvaux. Brussels, 1967
Gaffé, R. Paul Delvaux; ou, Les Rêves éveillés. Brussels,
 1945
Langui, É. Paul Delvaux. Venice, 1949
Nadeau, Maurice (ed.). Les Dessins de Paul Delvaux.
 Paris, 1967

DEMUTH, CHARLES

Farnham, Emily. Charles Demuth: behind a laughing
 mask. Norman, 1971
Murrell, William. Charles Demuth. Whitney Mus. of
 American Art, 1931
Charles Demuth. Retrospective. Exh. Cat. The Mus. of
 Modern Art, N.Y., 1950

DENIS, MAURICE

Barazzetti-Demoulin, S. Maurice Denis. Paris, 1945
Denis, Maurice. Du symbolisme au classicisme. Théories.
 Paris, 1964
— Histoire de l'art réligieux. Paris, 1939
— Journal, 1884–1943. 3 vols. Paris, 1959
— Nouvelles théories . . . sur l'art moderne. Paris, 1922
— Théories, 1890–1910. Paris, 1912
Jamot, P. Maurice Denis. Paris, 1949

DENNY, ROBYN

Thompson, David. Robyn Denny. 1971

DERAIN, ANDRÉ

Cailler, P. Catalogue de l'œuvre sculptée d'André Derain.
 Geneva, 1965
Derain, André. Lettres à Vlaminck. Paris, 1955
Diehl, G. Derain. 1964
Faure, E. A. Derain. Paris, 1923
Hilaire, G. Derain. Geneva, 1959
Salmon, A. A. Derain. Paris, 1929
Sutton, Denys. André Derain. 1959
Derain. Exh. Cat. Arts Council of Great Britain,
 1967

DESNOYER, FRANÇOIS

Bouret, Jean. François Desnoyer. Paris, 1944
Dorival, Bernard. François Desnoyer. Paris, 1943

DESPIAU, CHARLES

Deshairs, Léon. C. Despiau. Paris, 1930. With catalogue
 of works, 1898–1929.
George, Waldemar. Despiau. 1958

DESPIERRE, JACQUES

Zahar, Marcel. Jacques Despierre. Paris, 1950

DEWASNE, JEAN

Descargues, Pierre. Jean Dewasne. Paris, 1952
Jean Dewasne. Exh. Cat. Kunsthalle, Berne, 1966

DEXEL, WALTER

Hofmann, Werner. *Der Maler Walter Dexel*. Starnberg, 1972
Walter Dexel. Exh. Cat. Wilhelm Lehmbruck Mus., Duisberg, 1966
Walter Dexel. Exh. Cat. Westfälischen Landesmus., Münster, 1979

DICKINSON, EDWIN

Goodrich, Lloyd. *The Drawings of Edwin Dickinson*. New Haven, Conn., 1963
Kuh, Katharine. *The Artist's Voice*. 1962

DIEBENKORN, RICHARD

Richard Diebenkorn Retrospective. Exh. Cat. Washington Gal. of Modern Art, 1964

DIETRICH, ADOLF

Buck, Hans. *Adolf Dietrich als Zeichner*. Zürich, 1964
Hoenn, Karl. *Adolf Dietrich*. Frauenfeld, 1942
Riess, Margot. *Der Maler und Holzfäller Adolf Dietrich*. Zürich, 1927

DILLER, BURGOYNE

Burgoyne Diller, 1906–1965. Exh. Cat. New Jersey State Mus., Trenton, 1966

DINE, JIM

Bonin, W. von and Cullen, Michel. *Jim Dine: complete graphics*. 1970
Jim Dine. Exh. Cat. Whitney Mus. of American Art, 1970

DIX, OTTO

Conzelmann, O. (ed.). *Otto Dix*. Hanover, 1959
Löffler, F. *Otto Dix. Leben und Werk*. Vienna, 1967
Otto Dix. Gemälde und Graphik von 1912–1957. Exh. Cat. Deutsche Akademie der Künste, Berlin, 1957
Otto Dix. Bilder, Aquarelle, Zeichnungen. Das graphische Gesamtwerk, 1913–1960. Gal. Meta Nierendorf, Berlin, 1961

DOBELL, WILLIAM

Gleeson, James. *William Dobell*. Rev. edn., 1969
Smith, Bernard. *The Antipodean Manifesto*. 1976
William Dobell, 1926–64. Exh. Cat. Art Gal. of N.S.W., 1964

DOBSON, FRANK

Frank Dobson. Exh. Cat. Arts Council of Great Britain, 1966

DOESBURG, THEO VAN

Baljeu, Joost. *Theo van Doesburg*. 1974
Doesburg, Theo van. *Principles of Neo-Plastic Art*. Eng. trans., 1969
Theo van Doesburg. Exh. Cat. Art of this Century Gal., N.Y., 1947
Theo van Doesburg. Exh. Cat. Stedelijk van Abbe Mus., Eindhoven, 1968

DOMELA NIEUWENHUIS, CÉSAR

Bayer, Raymond. *César Domela*. Phoenix No. 12, Amsterdam, 1949
Brion, Marcel. *Domela*. Paris, 1961
César Domela. Exh. Cat. Mus. de Arte Moderna, Rio de Janeiro, 1954
César Domela. Exh. Cat. Stedelijk Mus., Amsterdam, 1955
See also STIJL, DE

DONATI, ENRICO

Selz, P. *Enrico Donati*. Paris, 1965

DONGEN, KEES VAN

Chaumeuil, L. *Van Dongen: l'homme et l'artiste. La Vie et l'œuvre*. Geneva, 1967
Des Courières, E. *Van Dongen*. Paris, 1925
Diehl, G. *Van Dongen*. Munich, 1969
Doelman, C. *Kees van Dongen, Schilder*. Rotterdam, 1947
Fierens, P. *Van Dongen*. Paris, 1927
Kyriazi, J. M. *Van Dongen après le fauvisme*. Lausanne, 1976
Van Dongen. Exh. Cat. Mus. Toulouse-Lautrec, Albi, 1960

DOTTORI, GERARDO

Marinetti, F. T. *Dottori pittore perugino*. Perugia, 1959

DOVE, ARTHUR

Wight, Frederick S. *Arthur G. Dove*. Berkeley and Los Angeles, 1958
Arthur Dove, 1880–1946. A retrospective exhibition. Exh. Cat. Andrew Dickson White Mus. of Art, Cornell Univ., Ithaca, 1954
Arthur Dove. The years of collage. Fine Arts Center, Univ. of Maryland, 1967

DRYSDALE, RUSSELL

Burke, Joseph (ed.). *The Paintings of Russell Drysdale*. Sydney, 1951
Dutton, Geoffrey. *Russell Drysdale*. 1964
Russell Drysdale. A retrospective exhibition of paintings from 1937 to 1960. Art Gal. of N.S.W., 1960

DUBUFFET, JEAN

Dubuffet, Jean. *Écrits de Jean Dubuffet*. Paris, 1967
Franzke, Andreas. *Jean Dubuffet*. Basle, 1976
Limbour, G. *Tableau bon levain à vous de cuire la pâte: l'art brut de Jean Dubuffet*. Paris, 1953
Loreau, M. *Catalogue des travaux de Jean Dubuffet*. Lausanne, 1966
The Work of Jean Dubuffet. Exh. Cat. The Mus. of Modern Art, N.Y., 1962
Jean Dubuffet. A retrospective exhibition. Exh. Cat. Arts Council of Great Britain, 1966
Jean Dubuffet: paysages castillans, sites tricolores. Exh. Cat. Centre Nat. d'Art Contemporain, Paris, 1974

DUCHAMP, MARCEL

Cabanne, Pierre. *Dialogues with Marcel Duchamp*. 1971
D'Harnoncourt, Anne and McShine, Kynaston (ed.). *Marcel Duchamp*. Joint compilation by The Mus. of Modern Art, N.Y., and Philadelphia Mus. of Art, 1974
Golding, Richard. *Marcel Duchamp: The Bride Stripped Bare By Her Bachelors, Even*. 1973
Hamilton, Richard and Hamilton, G. H. *The Bride Stripped Bare By Her Bachelors, Even*. 1976
Lebel, Robert. *Marcel Duchamp*. 1959. With catalogue raisonné.
Masheck, Joseph. *Marcel Duchamp in Perspective*. 1975
Sanouillet, Michel and Peterson, Elmer (ed.). *The Essential Writings of Marcel Duchamp*. 1975
Schwarz, Arturo (ed.). *The Complete Works of Marcel Duchamp*. 1969
Tomkins, Calvin. *The World of Marcel Duchamp*. 1966
Almost Complete Works of Marcel Duchamp. Exh. Cat. Tate Gal., London, 1966
Marcel Duchamp. Exh. Cat. Centre Georges-Pompidou, Paris, 1977

DUCHAMP-VILLON, RAYMOND

Hamilton, G. H. and Agee, William C. *R. Duchamp-Villon.* 1967
Pach, Walter. *Raymond Duchamp-Villon, sculpteur, 1876–1918.* Paris, 1924
Jacques Villon, Raymond Duchamp-Villon, Marcel Duchamp. Exh. Cat. Solomon R. Guggenheim Mus., N.Y., 1957
Sculpture de Duchamp-Villon. Exh. Cat. Gal. Louis Carré, Paris, 1963
Raymond Duchamp-Villon. Exh. Cat. Knoedler Gal., N.Y., 1967

DUFY, RAOUL

Buchheim, L. G. *Raoul Dufy. Festliche Welt: Zeichnungen und Radierungen.* Feldafing, 1955
Cassou, Jean. *Raoul Dufy, poète et artisan.* Geneva, 1946
Cogniat, Raymond. *Raoul Dufy.* Paris, 1962
Courthion, Pierre. *Raoul Dufy. Documentation complète sur le peintre, sa vie, son œuvre.* Geneva, 1952
Laffaille, Maurice. *Raoul Dufy. Catalogue raisonné de l'œuvre peint.* Geneva, 1972
Lassaigne, Jacques. *Dufy: biographical and critical studies.* Geneva, 1954
Werner, A. *Raoul Dufy.* 1970 (1953)
Raoul Dufy. Exh. Cat. Haus der Kunst, Munich, 1973
Raoul Dufy. Exh. Cat. Mus. Nat. d'Art Moderne, Paris, 1976

DUNOYER DE SEGONZAC, ANDRÉ

Dorival, B. *Dunoyer de Segonzac.* Geneva, 1956
Genevoix, M. *Dunoyer de Segonzac.* Paris, 1960
Jamot, Paul. *Dunoyer de Segonzac.* Paris, 1941 (1929)
Lioré, A. and Cailler, P. *Catalogue de l'œuvre gravé de Dunoyer de Segonzac.* Geneva, 1958
Roger-Marx, Claude. *Dunoyer de Segonzac.* Geneva, 1951

EAKINS, THOMAS

Goodrich, Lloyd. *Thomas Eakins: his life and work.* 1933
McKinney, R. *Thomas Eakins.* 1942
Porter, F. *Thomas Eakins.* 1959

EECKHOUDT, JEAN VAN DEN

Gide, André, Bussy, Simon, and others. *Jan van den Eeckhoudt.* Brussels, 1948

EGGELING, VIKING

O'Konor, Louise. *Viking Eggeling, 1880–1925. Artist and Film-Maker. Life and Work.* Eng. trans., Stockholm, 1971
Viking Eggeling, 1880–1925. Tecknare och filmkonstnär. Exh. Cat. Nationalmus., Stockholm, 1950

EGGER-LIENZ, ALBIN

Hammer, H. *Albin Egger-Lienz.* Innsbruck, 1930. With index of works.

EHRLICH, GEORG

Tietze-Conrat, E. *Georg Ehrlich.* 1956

EIGHT, THE

Perlman, B. B. *The Immortal Eight. American painting from Eakins to the Armory Show.* 1962
The Eight. Exh. Cat. Brooklyn Mus., N.Y., 1943

ENSOR, JAMES

Avermaete, R. *James Ensor.* Antwerp, 1947

Croquez, A. *L'Œuvre gravé de James Ensor.* Geneva, 1947. With catalogue raisonné.
Ensor, James. *Les Écrits de James Ensor.* Brussels, 1921
Fierens, P. *Les Dessins d'Ensor.* Brussels and Paris, 1944
— *James Ensor.* Paris, 1943
France, H. de. *James Ensor: proeve van gecommentarieërde bibliografie—essai de bibliographie commentée.* Brussels, 1960
Gindertael, Roger Van. *Ensor.* Eng. trans., 1975
Haesaerts, P. *James Ensor.* 1959
Tannenbaum, L. *James Ensor. The Mus. of Modern Art, N.Y.,* 1951. With Exh. Cat.
Ensor. Exh. Cat. Rijksmus. Kröller-Müller, Otterlo, and Boymans-van Beuningen Mus., Rotterdam, 1961
James Ensor. Exh. Cat. Kunsthalle, Basle, 1963
Ensor. Exh. Cat. Moderna Mus., Stockholm, 1970
Ensor to Permeke. Nine Flemish Painters, 1880–1950. Exh. Cat. Royal Academy, London, 1971

EPSTEIN, JACOB

Buckle, R. (ed.). *Epstein, Drawings.* 1962
— *Jacob Epstein, Sculptor.* 1963
Dieren, B. van. *Epstein.* 1920
Epstein, Jacob. *Epstein. An autobiography.* 1955

ERNST, MAX

Alexandrian, Sarane. *Max Ernst.* Eng. trans., 1971
Bousquet, Joë and Tapié, Michel. *Max Ernst.* Paris, 1950
Diehl, Gaston. *Max Ernst.* Eng. trans., 1973
Ernst, Max. *Beyond Painting, and other writings by the artist and his friends.* 1948
— *Écritures.* Paris, 1970
— *Une semaine de bonté.* Eng. trans., 1976
Gatt, Giuseppe. *Max Ernst.* 1970
Lieberman, W. S. (ed.). *Max Ernst. The Mus. of Modern Art, N.Y.,* 1961. With Exh. Cat.
Quinn, Edward. *Max Ernst.* 1977
Russell, J. *Max Ernst. Life and work.* 1967
Schneede, Uwe M. *The Essential Max Ernst.* 1972
Spies, Werner (ed.). *Textes et citations de Max Ernst.* Basle, 1975
— and Metken, Sigrid and Günter (ed.). *Max Ernst. Catalogue of works.* 4 vols. Houston and Cologne, 1969–79
Waldberg, P. *Max Ernst.* Paris, 1958
Max Ernst. Exh. Cat. Mus. Nat. d'Art Moderne, Paris, 1975
See also SURREALISM

ESCHER, M. C.

Locher, J. L. *The World of M. C. Escher.* 1974
MacGillavry, C. *Symmetry Aspects of M. C. Escher's Periodic Drawings.* Utrecht, 1965
The Graphic Works of M. C. Escher. Exh. Cat. Gemeentemus., The Hague, 1967

ESTÈVE, MAURICE

Francastel, P. *Estève.* Paris, 1956
Hommage à Maurice Estève. Soc. Internationale d'Art XXe Siècle, Paris, 1975
Maurice Estève. Exh. Cat. Kunsthalle, Düsseldorf, 1961

EUSTON ROAD SCHOOL

The Euston Road School. Exh. Cat. Arts Council of Great Britain, 1948

EVENPOEL, HENRI

Hellens, Franz. *Henri Evenepoel.* Antwerp, 1947
Lambotte, Paul. *Henri Evenepoel.* Antwerp, 1908

EVERGOOD, PHILIP

Lippard, Lucy R. *The Graphic Work of Philip Evergood: selected drawings and complete prints.* 1966
Twenty Years Painting by Philip Evergood. Exh. Cat. Whitney Mus. of American Art, 1946
Philip Evergood. Whitney Mus. of American Art, 1960

EXPRESSIONISM

Buchheim, L. G. *The Graphic Art of German Expressionism.* 1950
Cheney, Sheldon. *Expressionism in Art.* 1948 (1934)
Dube, Wolf-Dieter. *The Expressionists.* 1972
Kandinsky, Wassily and Marc, Franz (ed.). *The 'Blaue Reiter' Almanac.* New documentary edition, ed. Klaus Lankheit, Eng. trans. by Henning Falkenstein, 1974
Kuhn, C. L. *German Expressionism and Abstract Art. The Harvard Collections.* Cambridge, Mass., 1957
Meisel, Victor H. (ed.). *Voices of German Expressionism.* Englewood Cliffs, 1970
Muller, Joseph-Émile. *A Dictionary of Expressionism.* Eng. trans., 1973
Myers, B. S. *Expressionism. A generation in revolt.* 1963 (1958)
Raabe, Paul (ed.). *The Era of Expressionism.* Eng. trans., 1974
Richard, Lionel. *Phaidon Encyclopedia of Expressionism.* 1978
Selz, Peter. *German Expressionist Painting.* Berkeley, Calif., 1957
Whitford, F. *Expressionism.* 1970
Willett, John. *Expressionism.* 1970
Zigrosser, C. D. *The Expressionists. A survey of their graphic art.* 1957

EXTER, ALEKSANDRA

Nakov, A. B. *Alexandra Exter.* Paris, 1972
Alexandra Exter Marionettes. Exh. Cat. Leonard Hutton Gal., N.Y., 1975

FAHLSTRÖM, ÖYVIND

Öyvind Fahlström. Exh. Cat. Sidney Janis Gal., N.Y., 1971

FAISTAUER, ANTON

Fuhrmann, Franz. *Anton Faistauer 1887–1930.* Salzburg, 1972
Roessler, A. *Der Maler Anton Faistauer.* Vienna, 1947

FALK, ROBERT

Sarabjanow, D. *Robert Falk.* Dresden, 1974

FANTASTIC REALISM

Schmied, Wieland. *Malerei des phantastischen Realismus: die Wiener Schule.* Vienna, 1964
Solier, René de. *L'Art fantastique.* Paris, 1961

FAUTRIER, JEAN

Bucarelli, Palma. *Fautrier.* Milan, 1960
Paulhan, Jean. *Fautrier l'enragé.* Paris, 1962
Ragon, Michel. *Fautrier.* Paris, 1957

FAUVISM

Apollonio, U. *Fauves and Cubists.* 1960
Chassé, C. *Les Fauves et leur temps.* Lausanne, 1963
Crespelle, Jean Paul. *The Fauves.* Eng. trans., 1962
Denvir, Bernard. *Fauvism and Expressionism.* 1975
Diehl, Gaston. *Les Fauves.* Paris, 1975 (1943)
Duthuit, Georges. *The Fauvist Painters.* 1977

Elderfield, John. *The 'Wild Beasts': Fauvism and its affinities.* 1976
Muller, Joseph-Émile. *Fauvism.* 1967
Vauxcelles, Louis. *Le Fauvisme.* Geneva, 1958
Les Fauves. Exh. Cat. The Mus. of Modern Art, N.Y., 1952

FAZZINI, PERICLE

Pallucchini, R. *Pericle Fazzini.* Rome, 1965

FEDERAL ARTS PROJECT

McKinzie, Richard D. *The New Deal for Artists.* 1973
O'Connor, Francis V. (ed.). *Art for the Millions: essays from the 1930s by artists and administrators of the WPA Federal Arts Project.* 1973
— *The New Deal Art Projects: an anthology of memoirs.* 1972

FEELEY, PAUL

Paul Feeley Retrospective. Exh. Cat. Solomon R. Guggenheim Mus., N.Y., 1968

FEININGER, LYONEL

Hess, Hans. *Lyonel Feininger.* 1961. With catalogue raisonné.
Ness, June L. (ed.). *Lyonel Feininger.* 1975. Essays and letters by the artist.
Lyonel Feininger. Exh. Cat. The Mus. of Modern Art, N.Y., 1944
Lyonel Feininger. Exh. Cat. Haus der Kunst, Munich, and Kunsthaus, Zürich, 1973

FERBER, HERBERT

Goossen, E. C. *Three American Sculptors: Ferber, Hare, Lassaw.* 1959
The Sculpture of Herbert Ferber. Exh. Cat. Walker Art Center, Minneapolis, 1962

FERGUSSON, JOHN DUNCAN

Geddes, Jean. *Café Drawings in Edwardian Paris. From the sketch-books of J. D. Fergusson.* 1974
Honeyman, T. J. *Three Scottish Colourists.* 1950
Morris, Margaret. *The Art of J. D. Fergusson. A biased biography.* 1974

FIGARI, PEDRO

Herrera Maclean, C. A. *Pedro Figari.* Buenos Aires, 1943
Pillement, G. *Pedro Figari.* Paris, 1930

FILLA, EMIL

Matajcek, A. *Emil Filla.* Prague, 1938

FLANNAGAN, JOHN B.

Flannagan, Margherita (ed.). *Letters of John B. Flannagan.* 1942
Forsyth, Robert J. *John B. Flannagan.* Notre Dame, 1963
The Sculpture of John B. Flannagan. Exh. Cat. The Mus. of Modern Art, N.Y., 1942

FLAVIN, DAN

Dan Flavin. Exh. Cat. Nat. Gal. of Canada, Ottawa, 1969

FLOUQUET, PIERRE-LOUIS

Mertens, Phil, Sosset, L.L., and Bourgeois, P. *Pierre-Louis Flouquet.* Paris, Brussels, N.Y., 1975

FLUXUS

Becker, J. and Vostell, W. *Happenings. Fluxus, Pop Art, Nouveau Réalisme.* Reinbek bei Hamburg, 1968

FONTANA, LUCIO

Ballo, Guido. *Lucio Fontana*. Eng. trans., 1971
Crispolti, Enrico. *Lucio Fontana*. Brussels, 1974
— *Lucio Fontana. Catalogue raisonné des peintures, sculptures et environments spatiaux*. Brussels, 1970
Giani, G. *Spazialismo*. Milan, 1956
Pica, A. *Fontana e lo Spazialismo*. Venice, 1953
Tapié, Michel. *Devenir de Fontana*. Turin, 1961
Lucio Fontana. Exh. Cat. Kunsthaus, Zürich, 1976
Lucio Fontana 1899–1968. A retrospective. Exh. Cat. Solomon R. Guggenheim Mus., N.Y., 1977

FORAIN, JEAN-LOUIS

Dodgson, Campbell. *Forain*. 1936
Guérin, M. *J.-L. Forain, aquafortiste*. 2 vols. Paris, 1912
— *J.-L. Forain, lithographe*. 1910.
Puget, L. *La Vie extraordinaire de Forain*. Paris, 1957
Salaman, M. C. *Modern Masters of Etching: J. L. Forain*. 1925

FORNER, RAQUEL

Giani, G. *Raquel Forner*. Milan, 1960
Guillermo de Torre, J. *Raquel Forner*. Buenos Aires, 1954
Merli, J. *Raquel Forner*. Buenos Aires, 1952

FORUM EXHIBITION

Wright, W. H. *The Forum Exhibition of Modern American Painters*. 1916

FOUJITA, TSUGUHARU

Bauer, G. and Rey, R. *Foujita*. Paris, 1958
Morand, P. *Foujita*. Paris, 1928

FRANCE

Courthion, P. *Paris in our Time. From Impressionism to the present day*. Lausanne, 1957
Dorival, B. *Les Étapes de la peinture française contemporaine*. 3 vols. Paris, 1948
— *Les Peintres du vingtième siècle. Du cubisme à l'abstraction*. Paris, 1957. Eng. trans., *Twentieth-Century Painters*, 1958
— *The School of Paris in the Musée d'Art Moderne*. 1962
Francastel, P. *Histoire de la peinture française. Du classicisme au cubisme*. Paris, 1955
Gauss, C. E. *The Aesthetic Theories of French Artists, 1855 to the Present*. Baltimore, 1949
Gordon, J. E. *Modern French Painters*. 1922
Gosling, Nigel. *Paris 1900–1914: the miraculous years*. 1978
Hunter, S. *Modern French Painting 1855–1956*. 1956
Huyghe, R. *French Painting. The contemporaries*. 1939
Jullian, Philippe. *Montmartre*. Oxford, 1977
Kahnweiler, D.-H. *My Galleries and Painters*. Eng. trans., 1971
Kunstler, C. *La Sculpture contemporaine. La Sculpture française*. Paris, 1961
Marchiori, G. *Modern French Sculpture*. 1964 (1943)
Roger-Marx, C. *La Gravure originale en France de Manet à nos jours*. Paris, 1939
San Lazzaro, G. di. *Painting in France, 1895–1949*. 1949
Sloane, J. C. *French Painting between the Past and the Present*. Princeton, N. J., 1951
Soby, J. T. *After Picasso*. 1935
Wilenski, R. H. *Modern French Painters*. 1940
École de Paris. Exh. Cat. Royal Academy, London, 1951
The School of Paris. Exh. Cat. Walker Art Center, Minneapolis, 1959

FRANCIS, SAM

Meyer, Franz and others. *Sam Francis. Paintings 1947–72*. Dallas, 1972
Selz, P. *Sam Francis*. 1975
Sam Francis. Exh. Cat. Mus. of Fine Arts, Houston, 1967
Sam Francis. Exh. Cat. Stedelijk Mus., Amsterdam, 1968

FRANKENTHALER, HELEN

Rose, Barbara. *Frankenthaler*. 1972
Helen Frankenthaler. Exh. Cat. Jewish Mus., N.Y., 1960
Helen Frankenthaler. Exh. Cat. Whitney Mus. of American Art, 1969

FRANKL, GERHART

Tietze, Hans. *Gerhart Frankl*. Vienna, 1930
Gerhart Frankl. Paintings and works on paper. Exh. Cat. Arts Council of Great Britain, 1969

FRATER, WILLIAM

Course, R. J. *The Gallery on Eastern Hill*. 1970
Hetherington, John. *Australian Painters: forty profiles*. 1964
William Frater. Exh. Cat. Nat. Gal. of Victoria, 1966

FRENCH, LEONARD

Buckley, Vincent. *Campion Paintings*. Melbourne, 1962

FREUD, LUCIAN

Lucian Freud. Exh. Cat. Arts Council of Great Britain, 1974

FRIESZ, OTHON

Gauthier, M. *Othon Friesz*. Geneva, 1957
Salmon, A. *Émile-Othon Friesz*. Paris, 1920

FRINK, ELISABETH

Mullins, Edwin B. (ed.). *The Art of Elisabeth Frink*. 1972

FROST, TERRY

Terry Frost. *Paintings, drawings and collages*. 1977

FRY, ROGER

Bell, Quentin. *Roger Fry*. 1964
Fry, Roger. *Cézanne*. 1927
— *Last Lectures*. 1939
— *Transformations*. 1926
— *Vision and Design*. 1920. New, annotated edn. by J. B. Bullen, Oxford, 1981
Hannay, Howard. *Roger Fry, and other essays*. 1937
Spalding, Frances. *Roger Fry. Art and life*. 1980
Sutton, Denys (ed.). *Letters of Roger Fry*. 2 vols. 1972
Woolf, Virginia. *Roger Fry. A biography*. 1940

FUCHS, ERNST

Schmied, Wieland. *Malerei des phantastischen Realismus: die Wiener Schule*. Vienna, 1964
Solier, René de. *L'Art fantastique*. Paris, 1961

FUNI, ACHILLE

Chirico, Giorgio de. *Achille Funi*. Milan, 1940

FUNK ART

Selz, P. *Funk*. Berkeley, Calif., 1967

FUTURISM

Andreoli-Devillers, J. P. *Futurism and the Arts: a bibliography, 1959–73.* Toronto, 1975
Apollonio, Umbro. *Futurist Manifestos.* 1973
Ballo, G. *Preistoria del futurismo.* Milan, 1960
Baumgarth, Christa. *Geschichte des Futurismus.* Hamburg, 1966
Bruni, G. and Drudi Gambillo, M. *After Boccioni. Futurist paintings and documents from 1915 to 1919.* Rome, 1961
Carrieri, R. *Futurism.* Milan, 1963
Compton, Susan P. *The World Backwards: Russian Futurist books 1912–16.* 1978
Crispolti, E. *Il secondo futurismo.* Turin, 1962
Drudi Gambillo, M. and Fiori, T. (ed.). *Archivi del futurismo.* Rome, 1958–62
Falqui, E. *Bibliografia e iconografia del futurismo.* Florence, 1959
Flint, R. W. (ed.). *Marinetti. Selected writings.* 1972
Gerhardus, Maly. *Cubism and Futurism.* Oxford, 1979
Kirby, Michael. *Futurist Performance.* 1971
Martin, Marianne W. *Futurist Art and Theory 1909–1915.* 1968
Nash, J. M. *Cubism, Futurism and Constructivism.* 1974
Rye, Jane. *Futurism.* 1972
Tisdall, Caroline and Bozzolla, Angelo. *Futurism.* 1977
Futurism. Exh. Cat. The Mus. of Modern Art, N.Y., 1961
Futurismo 1909–1919. Exh. Cat. Arts Council of Great Britain, 1972

GABO, NAUM

Gabo, Naum. *Of Divers Arts.* 1962
Gabo. Constructions, sculpture, paintings, drawings, engravings. 1958. With introductory essays by Herbert Read and Leslie Martin.
'Naum Gabo and the Constructivist Tradition.' Special issue of *Studio International*, April 1966
Pevsner, Aleksei. *A Biographical Sketch of my brothers Naum Gabo and Antoine Pevsner.* Amsterdam, 1964
Naum Gabo, Antoine Pevsner. Exh. Cat. The Mus. of Modern Art, N.Y., 1948
Naum Gabo. Exh. Cat. Tate Gal., London, 1966
Plus by Minus: today's half-century. Exh. Cat. Albright-Knox Art Gal., Buffalo, N.Y., 1968
Naum Gabo. The constructive process. Exh. Cat. Tate Gal., London, 1976

GALLÉN-KALLELA, AKSELI

Okkonen, O. *A. Gallén-Kallela.* Helsinki, 1949

GARGALLO, PABLO

Courthion, Pierre. *Gargallo.* Paris, 1937
Pablo Gargallo. Exh. Cat. Mus. du Petit Palais, Paris, 1947

GAUDIER-BRZESKA, HENRI

Brodzky, H. *Gaudier-Brzeska 1891–1915.* 1933
Cole, Roger. *Burning to Speak: the life and art of Henri Gaudier-Brzeska.* Oxford, 1978
Ede, H. S. *Savage Messiah.* 1931
Levy, Mervyn. *Gaudier-Brzeska. Drawings and sculpture.* 1965

GAUL, WINFRED

Woods, Gerald and others. *Art without Boundaries, 1950–70.* 1972
Winfred Gaul. Signeaux, Signalen. Exh. Cat. Palais des Beaux-Arts, Brussels, 1967

GENERALIĆ, IVAN

Bašičević, Dimitrije. *Ivan Generalić.* Zagreb, 1962
Bihalji-Merin, Oto. *Ivan Generalić: Yugoslav pastorals.* Baden-Baden, 1961
Tomašević, Nabojša. *The Magic World of Ivan Generalić.* Eng. trans., 1976

GENERALIĆ, JOSIP

Generalić, Josip. *Autobiographie.* Zagreb, 1971

GERMANY

Brion, Marcel. *German Painting.* Eng. trans., 1959
Dienst, Rolf-Gunter. *Deutsche Kunst: eine neue Generation.* Cologne, 1970
Finke, Ulrich. *German Painting from Romanticism to Expressionism.* 1975
Grote, L. *Deutsche Kunst im 20. Jahrhundert.* Munich, 1954
Grzimek, W. *Deutsche Bildhauer des 20. Jahrhunderts.* Munich, 1969
Händler, Gerhard. *German Painting in our Time.* Eng. trans., 1956
Hütt, W. *Deutsche Malerei und Graphik im 20. Jahrhundert.* Berlin, 1969
Lehmann-Haupt, H. *Art under a Dictatorship.* 1954
Röthel, H. K. *Modern German Painting.* 1958
Schmied, Wieland. *Malerei nach 1945 in Deutschland, Österreich und der Schweiz.* Frankfurt and Vienna, 1974
Thoene, P. *Modern German Art.* 1938
Vogt, P. *Geschichte der deutschen Malerei im 20. Jahrhundert.* Cologne, 1972
German Art of the Twentieth Century. The Mus. of Modern Art, N.Y., 1957

GERTLER, MARK

Carrington, N. (ed.). *Mark Gertler. Selected letters.* 1965
Rothenstein, John. *Modern English Painters. Lewis to Moore.* 1976 (1956)
Woodeson, John. *Mark Gertler.* 1972

GHIKA, NIKOLAS

Spender, Stephen and Fermor, Patrick Leigh. *Ghika. Paintings, drawings, sculpture.* 1964
Ghika. Paintings 1934–1968. Exh. Cat. Whitechapel Art Gal., London, 1968

GIACOMETTI, ALBERTO

Bucarelli, Palma. *Giacometti.* Rome, 1962
Dupin, Jacques. *Alberto Giacometti.* Paris, 1963
Leiris, Michel (ed.). *Alberto Giacometti. Thoughts and quotations.* Basle, 1971
Lord, James. *A Giacometti Portrait.* 1965
Meyer, Franz. *Alberto Giacometti.* Stuttgart, 1968
Alberto Giacometti. Exh. Cat. The Mus. of Modern Art, N.Y., 1965. With autobiographical statement.
Alberto Giacometti. Sculpture, paintings, drawings. Exh. Cat. Arts Council of Great Britain, 1965
Alberto Giacometti. Exh. Cat. Tuileries, Paris, 1969

GIACOMETTI, AUGUSTO

Poeschl, E. *Augusto Giacometti.* Zürich, 1928
Zendralli, A. M. *Augusto Giacometti.* Zürich, 1936

GIACOMETTI, GIOVANNI

Amiet, C. *Giovanni Giacometti. Ein Jugendbild.* Zürich, 1936
Giovanni Giacometti. Exh. Cat. Kunsthaus, Zürich, 1934

GILBERT, ALFRED

Bury, A. *Shadow of Eros. A biographical and critical study of the life and works of Sir Alfred Gilbert.* 1952
Hatton, J. *The Life and Work of Alfred Gilbert.* 1903
McAllister, I. *Alfred Gilbert.* 1929

GILL, ERIC

Gill, Eric. *Art.* 1950 (1935)
— *Autobiography.* 1940
Speaight, R. *The Life of Eric Gill.* 1966
The Engraved Work of Eric Gill. Exh. Cat. Victoria and Albert Mus., London, 1963

GILMAN, HAROLD

Lewis, Wyndham and Fergusson, L. F. *Harold Gilman: an appreciation.* 1919

GINNER, CHARLES

Charles Ginner. Paintings and drawings. Exh. Cat. Arts Council of Great Britain, 1953

GLACKENS, WILLIAM

Du Bois, Guy Pène. *William J. Glackens.* Whitney Mus. of American Art, 1931
Glackens, Ira. *William Glackens and the Ashcan Group. The emergence of Realism in American art.* 1957
Watson, Forbes. *William Glackens.* 1923
William Glackens. Exh. Cat. Whitney Mus. of American Art, 1939
William Glackens in Retrospect. Exh. Cat. City Art Mus., St. Louis, 1966

GLARNER, FRITZ

Fritz Glarner. Exh. Cat. San Francisco Mus. of Art, 1971

GLASGOW SCHOOL

The Glasgow Boys. Exh. Cat. Scottish Arts Council, 1968

GLEIZES, ALBERT

Chevalier, Jean. *Albert Gleizes et le cubisme.* Basle, 1962
Gleizes, Albert. *Souvenirs. Le cubisme, 1908–1914.* 1957
— and Metzinger, Jean. *Du 'Cubisme'.* Paris, 1912
Albert Gleizes 1881–1953. A retrospective exhibition. Exh. Cat. Solomon R. Guggenheim Mus., N.Y., 1964. With bibliography.

GNOLI, DOMENICO

Domenico Gnoli. Exh. Cat. Kestner-Gesellschaft, Hanover, 1968

GOERG, ÉDOUARD

Diehl, Gaston. *Édouard Goerg.* Paris, 1947
George, Waldemar. *Édouard Goerg.* Geneva, 1965

GOERITZ, MATHIAS

Zuñiga, Olivia. *Mathias Goeritz.* Mexico City, 1963

GONCHAROVA, NATALIA

Chamot, Mary. *Gontcharova.* Paris, 1972
George, Waldemar. *Nathalie Gontcharova: œuvres anciennes et récentes.* Paris, 1956
Loguine, Tatiana (ed.). *Gontcharova et Larionov.* Paris, 1971
Larionov and Goncharova. Retrospective exhibition. Exh. Cat. Arts Council of Great Britain, 1961
Gontcharova. Larionov. Exh. Cat. Mus. d'Art Moderne de la Ville de Paris, 1963

GONZÁLEZ, JULIO

Aguilera Cerni, V. *Julio González.* Rome, 1962
Degand, Léon. *Julio González.* Amsterdam, 1964
Withers, Josephine. *Julio González. Sculpture in iron.* 1978
Julio González. Exh. Cat. Mus. Nat. d'Art Moderne, Paris, 1952
Julio González. Exh. Cat. The Mus. of Modern Art, N.Y., 1956
Julio González. Exh. Cat. Tate Gal., London, 1970

GORE, SPENCER

Rothenstein, John. *Modern English Painters. Sickert to Smith.* 1976 (1952)
Spencer Frederick Gore 1878–1914. Exh. Cat. Arts Council of Great Britain, 1955

GORIN, JEAN

Sartoris, Alberto. *Jean Gorin.* Venice, 1975
Jean Gorin. Exh. Cat. Stedelijk Mus., Amsterdam, 1967

GORKY, ARSHILE

Levy, J. *Arshile Gorky.* 1966
Rosenberg, H. *Arshile Gorky: the man, the time, the idea.* 1962
Schwabacher, Ethel. *Arshile Gorky.* 1957
Arshile Gorky. Paintings, drawings, studies. Exh. Cat. The Mus. of Modern Art, N.Y., 1962
Arshile Gorky. Exh. Cat. Arts Council of Great Britain, 1976

GOSTOMSKI, ZBIGNIEW

Peinture moderne polonnaise: sources et recherches. Exh. Cat. Mus. Galliera, Paris, 1969

GOTTLIEB, ADOLPH

Adolph Gottlieb. Exh. Cat. Jewish Mus., N.Y., 1957
Adolph Gottlieb. Exh. Cat. Whitney Mus. of American Art and Solomon R. Guggenheim Mus., N.Y., 1968

GRAHAM, JOHN D.

Allentuck, Marcia Epstein. *John Graham's System and Dialectics of Art.* 1971
George, Waldemar. *John D. Graham.* Paris, n.d.
Graham, John D. *System and Dialectics of Art.* 1937

GRANT, DUNCAN

Fry, Roger. *Duncan Grant.* 1930 (1923)
Mortimer, Raymond. *Duncan Grant.* 1944
Rothenstein, John. *Modern English Painters. Lewis to Moore.* 1976 (1956)
Rowdon, John. *Duncan Grant.* 1934
Shone, Richard. *Bloomsbury Portraits.* 1976
Duncan Grant. Retrospective exhibition. Exh. Cat. Tate Gal., London, 1959
Duncan Grant. Ninetieth birthday exhibition. Exh. Cat. Nat. Gal. of Modern Art, Edinburgh, 1975
Duncan Grant and Bloomsbury. Exh. Cat. The Fine Art Soc., Edinburgh, 1975
Duncan Grant. Ninetieth birthday display. Exh. Cat. Tate Gal., London, 1975

GRAVES, MORRIS

Kuh, Katharine. *The Artist's Voice.* 1962
Rubin, Ida E. (ed.). *The Drawings of Morris Graves, with comments by the artist.* Boston, 1974
Soby, J. T. *Contemporary Painters.* The Mus. of Modern Art, N.Y., 1948

Wight, F. S. and others. *Morris Graves*. Berkeley and Los Angeles, 1956

GREENE, BALCOMB

Balcomb Greene. Exh. Cat. Whitney Mus. of American Art, 1961

GRIS, JUAN

Cooper, Douglas (ed. and trans.). *Letters of Juan Gris*. 1956
Gaya Nuño, J. A. *Juan Gris*. Eng. trans., 1975
Kahnweiler, D.-H. *Juan Gris. His life and work*. Eng. trans., 1947
Raynal, Maurice. *Juan Gris*. Paris, 1920
Schmidt, G. *Juan Gris und die Geschichte des Kubismus*. Baden-Baden, 1957
Juan Gris. Exh. Cat. The Mus. of Modern Art, N.Y., 1958

GROMAIRE, MARCEL

Besson, G. *Marcel Gromaire*. Paris, n.d.
Gromaire, François. *Marcel Gromaire*. Paris, 1949
Zahar, M. *Gromaire*. Geneva, 1961
Exposition Gromaire. Peintures, aquarelles et dessins, gravures. Exh. Cat. Mus. des Beaux-Arts, Besançon, 1956
Marcel Gromaire. Exh. Cat. Mus. d'Art Moderne de la Ville de Paris, 1980

GROPPER, WILLIAM

William Gropper Retrospective. Exh. Cat. Los Angeles County Mus. of Art, 1968

GROSZ, GEORGE

Berenson, R. and Muhlen, N. *George Grosz*. 1965
Bittner, Herbert. *George Grosz*. 1965
Grosz, George. *A Little Yes and a Big No. The autobiography of George Grosz*. 1946
— *Ecce Homo*. Facsimile edition with Eng. trans., 1966
Schneede, Uwe M. *George Grosz*. 1979
George Grosz. Exh. Cat. Whitney Mus. of American Art, 1954
George Grosz 1883–1959. Exh. Cat. Akademie der Künste, Berlin, 1962

GROUP OF SEVEN

Hunkin, Harry, *The Group of Seven: Canada's great landscape painters*. Edinburgh, 1979
MacDonald, Thoreau. *The Group of Seven*. Toronto, 1944
Reid, Dennis. *A Bibliography of the Group of Seven*. Ottawa, 1971
Retrospective Exhibition of Painting by Members of the Group of Seven, 1919–1933. Nat. Gal. of Canada, Ottawa, 1936. See also cats. of exhibitions by the Nat. Gal. in 1969 and 1970

GRUBER, FRANÇOIS

François Gruber. Exh. Cat. Tate Gal., London, 1959

GRÜNEWALD, ISAAC

Hodin, J. P. *Isaac Grünewald*. Stockholm, 1949
Strömbom, S. *Isaac Grünewald*. Stockholm, 1934

GUBLER, MAX

Institut für Kunstwissenschaft, Zürich. *Max Gubler. Gesamtkatalog*. In preparation.
Jedlicka, G. *Max Gubler*. Frauenfeld and Stuttgart, 1970
Vogt, M. *Max Gubler*. Neuchâtel, 1952
Max Gubler. Exh. Cat. Kunsthaus, Zürich, 1975

GUIETTE, RENÉ

Guiette, Robert. *René Guiette*. Antwerp, 1950

GUSTON, PHILIP

Ashton, Dore. *Yes, But . . .: a critical study of Philip Guston*. 1976
Philip Guston. Exh. Cat. Solomon R. Guggenheim Mus., N.Y., 1962
Philip Guston. Exh. Cat. Jewish Mus., N.Y., 1966

GÜTERSLOH, ALBERT PARIS

Gaza, A. *Albert Paris Gütersloh*. Vienna, 1948
Gütersloh, A. P. *Zur Situation der modernen Kunst*. Vienna, 1963

GUTTMANN, ROBERT

Heller, A. *Robert Guttmann*. Litevna, 1932
Phribný, A. and Tkáč, S. *Naive Painters of Czechoslovakia*. Prague, 1967

GUTTUSO, RENATO

Marchiori, Giuseppe. *Renato Guttuso*. Milan, 1952
Renato Guttuso. Exh. Cat. Kunstverein, Darmstadt, 1967
Renato Guttuso. Exh. Cat. Mus. Ludwig, Cologne, 1977

HAACKE, HANS

Burnham, J. *Beyond Modern Sculpture*. 1968
Rickey, George. *Constructivism. Origins and evolution*. 1968

HAESE, GÜNTER

Günter Haese. Exh. Cat. Marlborough Fine Art, London, 1965
Cat. of XXXIII Biennale, Venice, 1966

HAMILTON, RICHARD

Richard Hamilton. Exh. Cat. Tate Gal., London, 1970
Richard Hamilton. Exh. Cat. Solomon R. Guggenheim Mus., N.Y., 1973
Richard Hamilton. Exh. Cat. Arts Council of Great Britain, 1975
Pop Art in England. Exh. Cat. Kunstverein, Hamburg, and Arts Council of Great Britain, 1976

HANAK, ANTON

Ankwicz von Kleehoven, Hans. *Anton Hanak*. Vienna, 1921
Eisler, Max. *Anton Hanak*, Vienna, 1921
Steiner, H. *Anton Hanach*. Munich, 1969
Hanak. Exh. Cat. Künstlerhaus, Vienna, 1963

HAPPENING

Becker, J. and Vostell, W. *Happenings. Fluxus, Pop Art, Nouveau Réalisme*. Reinbek bei Hamburg, 1968
Kaprow, Allan. *Assemblage, Environments and Happenings*. 1966
Kirby, Michael. *Happenings. An illustrated anthology*. 1965
Lebel, Jean-Jacques. *Le Happening*. Paris, 1966
Popper, Frank. *Art: action and participation*. 1975
Restany, Pierre. 'Happening.' In P. Cabanne and P. Restany, *L'Avant-garde au XXe siècle*, Paris, 1969
Szeemann, H. and Sohm, H. *Happening and Fluxus*. Cologne, 1970
Tarrap, Gilbert. *Le Happening: analyse psycho-sociologique*. Paris, 1968
Vostell, W. *Dé-coll/age Happenings*. 1966

HARD EDGE PAINTING

New Abstraction. Exh. Cat. Jewish Mus., N.Y., 1963

HARE, DAVID

Goossen, E. C. *Three American Sculptors: Ferber, Hare, Lassaw.* 1959

HARTH, PHILIPP

Adriani, Bruno. *Philipp Harth.* Berlin, 1939
Gerke, F. (ed.). *Philipp Harth.* Mainz, 1962

HARTLEY, MARSDEN

Hartley, Marsden. *Adventures in the Arts.* 1921. Autobiographical.
McCausland, Elisabeth. *Marsden Hartley.* Minneapolis, 1952
Wells, H. W. (ed.). *Selected Poems: Marsden Hartley.* 1945
Marsden Hartley. Exh. Cat. Stedelijk Mus., Amsterdam, 1960

HARTUNG, HANS

Gindertael, R. Van. *Hans Hartung.* Paris, 1962
Grohmann, W. *Hans Hartung: Aquarelle 1922.* St. Gallen, 1966
Tardieu, J. *Hans Hartung.* Paris, 1962
Hans Hartung. Exh. Cat. Mus. d'Art Moderne de la Ville de Paris, 1980

HAYTER, S. W.

Limbour, G. *Hayter.* Paris, 1962
Reynolds, Arthur G. *The Engravings of S. W. Hayter.* 1967
S. W. Hayter: paintings, drawings and engravings from 1927 to 1957. Exh. Cat. Whitechapel Art Gal., London, 1957

HEARTFIELD, JOHN

Herzfelde, Wieland. *John Heartfield: Leben und Werke dargestellt von seinem Bruder.* Dresden, 1962
Selz, Peter (ed.). *Photomontages of the Nazi Period. John Heartfield.* 1977
Siepmann, Eckhard. *John Heartfield.* Berlin, 1977

HECKEL, ERICH

Dube, Annemarie and Wolf-Dieter. *Erich Heckel. Das graphische Werk.* 1965
Köhn, H. *Erich Heckel.* Berlin, 1948
— *Erich Heckel: Aquarelle und Zeichnungen.* Munich, 1959
Rave, P. O. *Erich Heckel.* Leipzig, 1948
Vogt, P. *Erich Heckel.* Recklinghausen, 1965
Erich Heckel. Werke der Brückezeit 1901–1917. Exh. Cat. Württembergischer Kunstverein, Stuttgart, 1957
Erich Heckel. Exh. Cat. Gal. Roman Norbert Ketterer, Lugano, 1966

HEERUP, HENRY

Wilman, H. *Henry Heerup.* Copenhagen, n.d.

HEGEDUŠIĆ, KRSTO

Bihalji-Merin, Oto. *Krsto Hegedušić.* Prague, 1965

HEILIGER, BERNHARD

Flemming, H. T. *Bernhard Heiliger.* Berlin, 1962

HÉLION, JEAN

Paintings of Jean Hélion. Exh. Cat. The Mus. of Modern Art, N.Y., 1964

HELD, AL

Al Held. Exh. Cat. San Francisco Mus. of Art, 1968
Al Held Retrospective. Exh. Cat. Whitney Mus. of American Art, 1974

HENRI, ROBERT

Henri, Robert. *The Art Spirit.* 1923
Homer, William Innes. *Robert Henri and his Circle.* 1969
Read, Helen Appleton. *Robert Henri.* 1931
Robert Henri: an exhibition held in observance of the centennial of the artist's birth. Univ. of Nebraska, Lincoln, 1965

HEPWORTH, BARBARA

Bowness, Alan. *Barbara Hepworth. Drawings from a sculptor's landscape.* 1966
— (ed.). *The Complete Sculpture of Barbara Hepworth, 1960–69.* 1971
Gibson, William. *Barbara Hepworth, Sculptress.* 1946
Hammacher, A. M. *Barbara Hepworth.* 1968 (1958)
Hodin, J. P. *Barbara Hepworth.* 1961
Read, Herbert (ed.). *Barbara Hepworth. Carvings and drawings.* 1952
Shepherd, Michael. *Barbara Hepworth.* 1963

HERBIN, AUGUSTE

Degand, L. *Auguste Herbin. Ein Ausschnitt aus seinem Schaffen.* Basle, 1955
Herbin, Auguste. *L'Art non-figuratif, non-objectif.* Paris, 1949
Jakovsky, A. *Auguste Herbin.* Paris, 1933
Massat, René. *Herbin.* Paris, 1953
Auguste Herbin. Exh. Cat. Kestner-Gesellschaft, Hanover, 1967

HERMAN, SALI

Hetherington, John. *Australian Painters: forty profiles.* 1964
Smith, Bernard. *The Antipodean Manifesto.* 1976
Thomas, Daniel. *Sali Herman.* Sydney, 1971

HÉROLD, JACQUES

Charpier, J. *Jacques Hérold, le cristal et le vent.* Paris, 1960

HILL, ANTHONY

Alloway, Lawrence. *Nine Abstract Artists: their work and theory.* 1954
Bann, Stephen (ed.). *The Tradition of Constructivism.* 1974
Rickey, George. *Constructivism. Origins and evolution.* 1968

HILLIER, TRISTRAM

Hillier, Tristram. *Leda and the Goose.* 1954. Autobiography.
Read, Herbert (ed.). *Unit One. The modern movement in English architecture, painting and sculpture.* 1934
Rothenstein, John. *Modern English Painters. Wood to Hockney.* 1974

HILTON, ROGER

Roger Hilton. Exh. Cat. Arts Council of Great Britain, 1974

HITCHENS, IVON

Bowness, Alan (ed.). *Ivon Hitchens.* 1973
Heron, P. *Ivon Hitchens.* 1955

HOCKNEY, DAVID

Hockney, David. *The Blue Guitar.* 1977. Etchings.
— *David Hockney by David Hockney.* 1976. Autobiography.
— *Pictures by David Hockney.* 1979
— *Travels with Pen, Pencil and Ink.* 1978. Drawings and prints, 1961–77.

Livingstone, M. *David Hockney*. 1980
Rothenstein, John. *Modern English Painters. Wood to Hockney*. 1974
David Hockney. Paintings, prints and drawings 1960–1970. Whitechapel Art Gal., London, 1970
Pop Art in England. Exh. Cat. Kunstverein, Hamburg, and Arts Council of Great Britain, 1976

HODGKIN, HOWARD

Howard Hodgkin. Exh. Cat. Arts Council of Great Britain, 1976

HODGKINS, FRANCES

Evans, Myfanwy. *Frances Hodgkins*. 1948
Howell, Arthur R. *Frances Hodgkins: four vital years*. 1951
Rothenstein, John. *Modern English Painters. Sickert to Smith*. 1976 (1952)
Ethel Walker, Frances Hodgkins, Gwen John. A memorial exhibition. Exh. Cat. Tate Gal., London, 1952

HODLER, FERDINAND

Bender, Ewald. *Die Kunst Ferdinand Hodlers*. Zürich, 1923–41
Hugelshofer, W. *Ferdinand Hodler*. Zürich, 1952
Loosli, C. A. *Hodler*. Paris, 1931
Mühlestein, H. *Ferdinand Hodler 1853–1918*. Zürich, 1942
Ferdinand Hodler. Self-Portraits. Exh. Cat. Kunsthalle, Basle, 1979

HOEHME, GERHARD

Argan, G. C. and De la Motte, M. *Gerhard Hoehme*. Rome, 1969
Gerhard Hoehme. Exh. Cat. Mus., Ulm, 1967

HOFER, CARL

Festgabe an Carl Hofer zum 70 Geburtstag. Berlin, 1948
Hofer, Carl. *Erinnerungen eines Malers*. Berlin, 1953
Jannasch, A. *Karl Hofer*. Potsdam, 1946
Karl Hofer. Exh. Cat. Akademie der Künste, Berlin, 1966

HOFLEHNER, RUDOLF

Hofmann, W. *Rudolf Hoflehner*. 1965

HOFMANN, HANS

Greenberg, C. *Hans Hofmann*. Paris and London, 1961
Hofmann, Hans. *Search for the Real, and other essays*. Cambridge, Mass., 1967
Hunter, Sam. *Hans Hofmann*. 1963
Hans Hofmann. Retrospective exhibition. University Art Mus., Los Angeles, 1957
Hans Hofmann. Exh. Cat. The Mus. of Modern Art, N.Y., 1963

HOPPER, EDWARD

Du Bois, Guy Pène. *Edward Hopper*. 1931
Goodrich, Lloyd. *Edward Hopper*. 1971
Hopper, Edward. *Edward Hopper*. 1945
Edward Hopper Retrospective. Exh. Cat. The Mus. of Modern Art, N.Y., 1933
Edward Hopper. The Art and the Artist. Exh. Cat. Whitney Mus. of American Art, 1980
Edward Hopper. Retrospective. Exh. Cat. Hayward Gal., London, 1981

HOYLAND, JOHN

John Hoyland. Exh. Cat. Whitechapel Art Gal., London, 1967

HRDLICKA, ALFRED

Alfred Hrdlicka. Druchgraphik und Steinenskulpturen. Exh. Cat. Salzburg, 1963

HUMBLOT, ROBERT

Rey, Robert. *Robert Humblot*. Paris, 1957

HUNDERTWASSER

Restany, P. *Hundertwasser*. Paris, 1957
Hundertwasser: Vollständiger Œuvre-Katalog. Kestner-Gesellschaft, Hanover, 1964
Hundertwasser. Exh. Cat. Haus der Kunst, Munich, 1975

INDIANA, ROBERT

Robert Indiana. Exh. Cat. Inst. of Contemporary Art, Univ. of Pennsylvania, Philadelphia, 1968
Robert Indiana. Graphics. Exh. Cat. St. Mary's College, Notre Dame, 1969

IPOUSTÉGUY, JEAN

Ipoustéguy. Exh. Cat. Claude Bernard Gal., Paris, 1966

ITALY

Ballo, Guido. *La linea dell'arte italiana del simbolismo alle opera moltiplicate*. 2 vols. Rome, 1964
— *Modern Italian Painting, from Futurism to the Present Day*. 1958
Cairola, Stefano (ed.). *Arte italiana del nostra tempo*. Bergamo, 1946
Carrieri, R. *Avant-Garde Painting and Sculpture (1890–1955) in Italy*. Milan, 1955
Marchiori, Giuseppe. *Arte e artisti d'avanguardia in Italia, 1910–1950*. Milan, 1960
Quarta, G. and Sossi, F. *L'arte contemporaneo in Italia*. Rome, 1971
Salvini, R. *Modern Italian Sculpture*. 1962
Soby, J. T. and Barr, A. H., Jr. *Twentieth-Century Italian Art*. The Mus. of Modern Art, N.Y., 1949

ITTEN, JOHANNES

Itten, Johannes. *The Art of Color. The subjective experience and objective rationale of color*. 1961
— *Design and Form. The basic course at the Bauhaus*. 1964
Johannes Itten. Exh. Cat. Kunsthaus, Zürich, 1964

JACQUET, ALAIN

Cabanne, P. and Restany, P. *L'Avant-garde au XXe siècle*. Paris, 1969

JANCO, MARCEL

Motherwell, R. (ed.). *The Dada Painters and Poets: an anthology*. 1951
Seuphor, M. *Marcel Janco*. Amriswil, 1963
Dada, documents et témoignages. Exh. Cat. Tel Aviv, 1958

JAWLENSKY, ALEXEI VON

Grohmann, W. *Alexej von Jawlenski*. Paris, 1934
Weiler, Clemens. *Alexej Jawlensky*. Cologne, 1959
— *Jawlensky: heads, faces, meditations*. 1971

JENKINS, PAUL

Sawyer, K. B. *The Paintings of Paul Jenkins*. 1961

JENSEN, ALFRED

Alfred Jensen. Exh. Cat. Solomon R. Guggenheim Mus., N.Y., 1961

JENSEN (cont.)

Jensen. Exh. Cat. Stedelijk Mus., Amsterdam, 1964
Alfred Jensen und Franz Kline. Exh. Cat. Kunsthalle, Basle, 1964

JESPERS, OSCAR

Ridder, André de. Oscar Jespers. Antwerp, 1948

JEUNE PEINTURE BELGE

Mertens, Phil. La Jeune Peinture belge. Brussels, 1975

JOHN, AUGUSTUS

Earp, T. Augustus John. 1934
Easton, Malcolm and Holroyd, Michael. The Art of Augustus John. 1974
John, Augustus. Chiaroscuro. Fragments of autobinography. 1952
Rothenstein, John. Augustus John. 1944

JOHN, GWEN

Rothenstein, John. Modern English Painters. Sickert to Smith. 1976 (1952)
Gwen John. Exh. Cat. Arts Council of Great Britain, 1968
Gwen John. Retrospective centenary exhibition. Exh. Cat. Anthony d'Offay Gal., London, 1976

JOHNS, JASPER

Crichton, M. Jasper Johns. 1977
Fields, Richard S. (ed.). Jasper Johns. Prints 1960–1970. 1970
Kozloff, Max. Jasper Johns. 1967
Steinberg, Leo. Jasper Johns. 1963
Jasper Johns. Exh. Cat. Jewish Mus., N.Y., 1964
Jasper Johns. Exh. Cat. Whitechapel Art Gal., London, 1964

JONES, ALLEN

Jones, Allen. Projects. Tübingen, 1971
Stünke, Heinz. Allen Jones. Das graphische Werk. Cologne, 1969
Allen Jones. Exh. Cat. Marlborough Fine Art, London, 1972
Pop Art in England. Exh. Cat. Kunstverein, Hamburg, and Arts Council of Great Britain, 1976

JONES, DAVID

Cleverdon, D. The Engravings of David Jones. 1981
Ironside, Robin. David Jones. 1949
Rothenstein, John. Modern English Painters. Lewis to Moore. 1976 (1956)
David Jones 1895–1974. Watercolours and drawings. Exh. Cat. Scottish Nat. Gal. of Modern Art, Edinburgh, 1979

JOOSTENS, PAUL

Neuhuys, Paul. Paul Joostens. Brussels, 1961

JORN, ASGER

Atkins, Guy. Asger Jorn. 1964
— Jorn in Scandinavia, 1930–1953. 1968
— Asger Jorn. The final years. 1977
— and Schmidt, Erik. Bibliographie over Asger Jorns Skrifter til 1963. Copenhagen, 1964. In Danish and English.

JUDD, DONALD

Battcock, Gregory (ed.). Minimal Art. A critical anthology. 1968
Judd, Donald. Complete Writings 1959–75. 1975
Don Judd. Exh. Cat. Whitney Mus. of American Art, 1968
Don Judd. Stedelijk van Abbe Mus., Eindhoven, 1970
Don Judd. Exh. Cat. Pasadena Art Mus., 1971

KAHNWEILER, DANIEL-HENRI

Kahnweiler, D.-H. Acht Gespräche. Zürich, 1954. Conversations with Picasso.
— Aesthetische Betrachtungen. Cologne, 1968
— Juan Gris. His life and work. Eng. trans., 1947
— My Galleries and Painters. Eng. trans., 1971. With bibliography.
— Der Weg zum Kubismus. 1958 (1920)
Pour Daniel-Henry Kahnweiler. Stuttgart and N.Y., 1964. Collection of essays in honour of 80th birthday.

KANDINSKY, WASSILY

Bill, Max and others. Wassily Kandinsky. Boston, 1951
Grohmann, W. Wassily Kandinsky, Life and Work. 1959
Kandinsky, Wassily. Punkt und Linie zu Fläche: Beitrag zur Analyse der malerischen Elemente. Munich, 1926. Eng. trans., 1947
— Rückblicke. Berlin, 1913. Autobiographical. Eng. trans., Reminiscences, in R. L. Herbert (ed.), Modern Artists on Art, New Jersey, 1964. French trans., Regards sur le passé et autres textes, 1912–1922, Paris, 1974
— Über das Geistige in der Kunst insbesondere in der Malerei. Munich, 1912. Eng. trans., Concerning the Spiritual in Art, 1964
— and Kandinsky, Nina (ed.). Watercolours, Gouaches and Drawings. Basle, 1972
— and Marc, Franz (ed.). The 'Blaue Reiter' Almanach. New documentary edition, ed. Klaus Lankheit, Eng. trans. by Henning Falkenstein, 1974
Overy, Paul. Kandinsky: the language of the eye. 1969
Röthel, H. K. Kandinsky. Das graphische Werk. Cologne, 1970
Washington Long, R. C. Kandinsky. Oxford, 1980
Weiss, Peg. Kandinsky in Munich: the formative Jugendstil years. 1979
Vassily Kandinsky, 1866–1944. A retrospective exhibition. Exh. Cat. Solomon R. Guggenheim Mus., N.Y., 1962
Wassily Kandinsky. Exh. Cat. Scottish Nat. Gal. of Modern Art, Edinburgh, 1975

KANE, JOHN

Kane, John. Sky Hooks. The autobiography of John Kane. 1938

KAPROW, ALLAN

Kaprow, Allan. Assemblage, Environments and Happenings. 1966

KARFIOL, BERNARD

Karfiol, Bernard. Bernard Karfiol. 1945
Slusser, J. P. Bernard Karfiol. 1931

KELLY, ELLSWORTH

Coplans, John. Ellsworth Kelly. 1973
Goossen, E. C. Ellsworth Kelly. 1973
Waldman, Diane. Ellsworth Kelly. Drawings, collages, prints. 1971. With catalogue raisonné of graphics and bibliography.

KEMÉNY, ZOLTAN

Zoltan Kemény. Exh. Cat. Mus. Nat. d'Art Moderne, Paris, 1966

KENT, ROCKWELL

Armitage, Merle. *Rockwell Kent.* 1932
Kent, Rockwell. *It's Me O Lord.* 1955
— *Rockwell Kent.* 1945
— *Rockwellkentiana.* 1945

KEPES, GYORGY

Alfieri, B. *Gyorgy Kepes.* Ivry, 1958
Kepes, Gyorgy. *Language of Vision.* Chicago, 1944
— *The New Landscape in Art and Science.* Chicago, 1956
— (ed.). *The Visual Arts Today.* Middletown, Conn., 1960

KERMADEC, EUGÈNE

Kermadec. Exh. Cat. Kunsthalle, Berne, 1958

KIENHOLZ, EDWARD

Edward Kienholz. Work from 1960s. Exh. Cat. Washington Gal. of Modern Art, 1968
Edward Kienholz. 11 + 11 Tableaux. Exh. Cat. Moderna Mus., Stockholm, 1970
Edward Kienholz. Exh. Cat. Kunsthaus, Zürich, 1975
Edward Kienholz. Exh. Cat. Gal. Maeght, Paris, 1977

KIESLER, FREDERICK

Kiesler, Frederick. *Inside the Endless House.* 1964. The artist's journal, 1956–64
Frederick Kiesler. Exh. Cat. The Mus. of Modern Art, N.Y., 1951
Endless House. Exh. Cat. The Mus. of Modern Art, N.Y., 1960
Frederick Kiesler. Environmental sculptures. Exh. Cat. Solomon R. Guggenheim Mus., N.Y., 1964

KINETIC ART

Bann, Stephen and others. *Four Essays on Kinetic Art.* 1966
Brett, Guy. *Kinetic Art.* 1968
Chapuis, A. and Droz, E. *Automata. A historical and technological study.* 1958
Malina, Frank J. (ed.). *Kinetic Art. Theory and practice.* 1974. Articles from *Leonardo.*
Popper, Frank. *Origins and Development of Kinetic Art.* 1968
Rickey, George. *Constructivism. Origins and evolution.* 1968
— 'The Morphology of Movement, a study of kinetic art.' In Gyorgy Kepes (ed.), *The Nature and Art of Motion,* 1965
Tovey, John. *The Technique of Kinetic Art.* 1971
Lumière et Mouvement. Exh. Cat. Mus. d'Art Moderne de la Ville de Paris, 1967
Kinetics. Exh. Cat. Arts Council of Great Britain, 1970

KIRCHNER, ERNST LUDWIG

Dube, Wolf-Dieter. *E. L. Kirchner. Das graphische Werk.* 2 vols. Munich, 1967
Eingler, H. M. *Ernst Ludwig Kirchner. Holzschnitter.* Feldafing, 1954
Gordon, Donald E. *Ernst Ludwig Kirchner.* Cambridge, Mass., 1968
Grohmann, W. *E. L. Kirchner.* 1961
Ketterer, R. N. and Henze, W. *Ernst Ludwig Kirchner. Zeichnungen und Pastelle.* Munich, 1980
E. L. Kirchner. German Expressionist. Exh. Cat. North Carolina Mus. of Art, 1958
Ernst Ludwig Kirchner. Exh. Cat. Kunstverein für die Rheinlande und Westfalen, Düsseldorf, 1960
Kirchner. Exh. Cat. Städelsches Kunstinstitut, Frankfurt am Main, 1980

KISLING, MOÏSE

Charensol, Georges. *Moïse Kisling.* Paris, 1948
Einstein, Carl. *Moïse Kisling.* Leipzig, 1922

KITAJ, R. B.

Creely, R. (ed.). *Pictures.* 1977
Pictures from an Exhibition. Exh. Cat. Hanover and Rotterdam, 1970
Pop Art in England. Exh. Cat. Kunstverein, Hamburg, and Arts Council of Great Britain, 1976

KLAPHEK, KONRAD

Dienst, Rolf-Gunter. *Deutsche Kunst: eine neue Generation.* Cologne, 1970
Konrad Klaphek. Exh. Cat. Kestner-Gesellschaft, Hanover, 1966

KLEE, PAUL

Besset, M. *Paul Klee par lui-même et par son fils Felix Klee.* Paris, 1963
Brion, M. *Klee.* Paris, 1955
Cooper, Douglas. *Paul Klee.* 1949
Courthion, P. *Klee.* Paris, 1953
Giedion-Welcker, C. *Paul Klee.* 1952
Grohmann, W. *Paul Klee.* 1967. With catalogue of works.
— *Paul Klee. Handzeichnungen.* Cologne, 1959
Grote, L. (ed.). *Erinnerungen an Paul Klee.* Munich, 1959
Haftmann, Werner. *The Mind and Work of Paul Klee.* 1954. Eng. trans., 1967
Hall, Douglas. *Paul Klee.* Oxford, 1977
Huggler, M. (ed.). *The Drawings of Paul Klee.* 1965
— *Paul Klee.* 1971
Jaffé, Hans L. C. *Klee.* 1972
Klee, Felix (ed.). *The Diaries of Paul Klee 1898–1918.* Berkeley, Calif., 1964
Klee, Paul. *Notebooks. 1. The Thinking Eye. 2. The Nature of Nature.* Ed. Jürgen Spiller, 1973
— *On Modern Art.* 1966 (1948)
— *Pedagogical Sketchbook.* 1968. First published as a Bauhaus Book, *Pädagogisches Skizzenbuch,* 1925.
Kornfeld, E. W. *Verzeichnis des graphischen Werkes von Paul Klee.* Berne, 1963
Lynton, Norbert. *Klee.* 1975
Plant, M. *Paul Klee. Figures and faces.* 1978
Roy, Claude. *Paul Klee aux sources de la peinture.* Paris, 1963
San Lazzaro, G. di. *Klee.* 1957
Short, Robert. *Paul Klee.* 1979
Soby, J. T. *The Prints of Paul Klee.* 1947
Paul Klee, 1879–1940. Exh. Cat. Solomon R. Guggenheim Mus., N.Y., 1967
A Tribute to Paul Klee. Exh. Cat. Nat. Gal. of Canada, Ottawa, 1979
Klee. Das Frühwerk 1883–1922. Exh. Cat. Stadt. Gal. im Lenbachhaus, Munich, 1980

KLEIN, YVES

Caumont, Jacques and Gough-Cooper, J. *Yves Klein. Selected writings.* 1974
Wember, Paul. *Yves Klein.* 1969
Yves Klein. Exh. Cat. Jewish Mus., N.Y., 1967
Yves Klein. Exh. Cat. Kunsthalle, Berne, 1971

KLIMT, GUSTAV

Comini, Alessandra. *Gustav Klimt.* 1975
Coradeschi, Sergio (ed.). *L'opera completa di Klimt.* Milan, 1978
Eisler, M. *Gustav Klimt.* Vienna, 1920

KLIMT (*cont.*)

Hofmann, W. *Gustav Klimt und die Wiener Jahrhundertwende.* Eng. trans., 1971
Nebehay, Christian M. (ed.). *Gustav Klimt: Dokumentation.* Vienna, 1969
Novotny, F. and Dobai, J. *Gustav Klimt.* 1968
Pirchan, E. *Gustav Klimt.* Vienna, 1956
Vergo, Peter. *Art in Vienna 1898–1918: Klimt, Kokoschka, Schiele and their contemporaries.* 1975
Gustav Klimt, 1862–1918. Exh. Cat. Graphische Sammlung Albertina, Vienna, 1962
Gustav Klimt and Egon Schiele. Exh. Cat. Solomon R. Guggenheim Mus., N.Y., 1965

KLINE, FRANZ

Dawson, F. *An Emotional Memoir of Franz Kline.* 1967
Franz Kline Memorial Exhibition. Exh. Cat. Washington Gal. of Modern Art, 1962
Franz Kline. Exh. Cat. Whitechapel Art Gal., London, 1964
Franz Kline, 1910–1962. Exh. Cat. Whitney Mus. of American Art, 1968

KLINGER, MAX

Kirk, J. and Varnedoe, T. (ed.). *Graphic Works of Max Klinger.* 1977
Pastor, W. *Max Klinger.* Berlin, 1918
Singer, H. W. (ed.). *Briefe Max Klingers.* Leipzig, 1924
— *Max Klinger: Radierungen, Stiche und Steindrucke.* Berlin, 1909

KNATHS, KARL

Four American Expressionists. Exh. Cat. Whitney Mus. of American Art, 1949
Karl Knaths. Exh. Cat. Phillips Gal., N.Y., 1957

KNIGHT, LAURA

Dunbar, Janet. *Laura Knight.* 1975

KOKOSCHKA, OSKAR

Bultman, B. *Oskar Kokoschka.* 1961
Hodin, J. P. *Oskar Kokoschka: the artist and his time.* 1966
Hoffmann, Edith. *Kokoschka: life and work.* 1947
Kokoschka, Oskar. *My Life.* 1974
— *Oskar Kokoschka: Schriften 1907–1955.* Munich, 1956
Russell, John. *Oskar Kokoschka. Watercolours, drawings, writings.* 1962
Tomeš, Jan. *Oskar Kokoschka. London views, British landscapes.* 1972
Vergo, Peter. *Art in Vienna 1898–1918: Klimt, Kokoschka, Schiele and their contemporaries.* 1975
Wingler, Hans Maria. *Introduction to Kokoschka.* 1958
— *Oskar Kokoschka. The work of the painter.* 1958
Kokoschka. A retrospective exhibition of paintings, drawings, lithographs, stage designs and books. Exh. Cat. Tate Gal., London, 1962
Oskar Kokoschka. Exh. Cat. Haus der Kunst, Munich, 1976

KOLBE, GEORG

Binding, R. G. *Vom Leben der Plastik, Inhalt und Schönheit des Werkes von George Kolbe.* Berlin, 1933
Kolbe, George. *Auf Wegen der Kunst. Schriften, Skizzen, Plastiken.* Berlin, 1949
Pinder, W. *Georg Kolbe. Werk der letzten Jahre.* Berlin, 1937
Valentiner, Wilhelm. *George Kolbe. Plastik und Zeichnung.* Munich, 1922

KOLIG, ANTON

Milesi, R. *Anton Kolig.* Klagenfurt, 1954
Welz, Friedrich. *Anton Kolig.* Salzburg, 1948

KOLLWITZ, KÄTHE

Bittner, Herbert (ed.). *Kaethe Kollwitz. Drawings.* 1959
Klipstein, A. (ed.). *The Graphic Work of Käthe Kollwitz. Complete illustrated catalog.* 1955
Kollwitz, H. (ed.). *The Diary and Letters of Käthe Kollwitz.* Chicago, 1955
Longstreet, S. (ed.). *The Drawings of Käthe Kollwitz.* 1967
Schumann, W. *Käthe Kollwitz.* Gütersloh, 1953
Strauss, G. *Käthe Kollwitz.* Dresden, 1950
Zigrosser, C. D. *Prints and Drawings of Käthe Kollwitz.* 1969. With bibliography.

KOSICE, GYULA

Habasque, G. *Kosice.* Paris, 1966
Kosice, Gyula. *Arte Hidrocinetico. Movimiento Luz Agua.* Buenos Aires, 1969

KRICKE, NORBERT

Trier, E. *Norbert Kricke.* Recklinghausen, 1963

KROLL, LEON

Kroll, Leon. *Leon Kroll.* 1946
Leon Kroll. Exh. Cat. Cleveland Mus. of Art, 1945

KUBIN, ALFRED

Horodisch, Abraham. *Alfred Kubin. A pocket bibliography.* Amsterdam, 1962
Kubin, Alfred. *Aus meiner Werkstatt. Gesammelte Prosa mit 71 Abbildungen.* 1971
— *Mein Werk. Dämonen und Nachtgesichte.* Dresden, 1931
Raabe, P. (ed.). *Alfred Kubin. Leben, Werk, Wirkung.* Hamburg, 1957
Sebba, Gregor (ed.). *Kubin's Dance of Death and other drawings.* 1973. Reissue of *Die Blätter mit dem Tod,* 1918, and *Fünfzig Zeichnungen,* 1923
Die Alfred Kubin Stiftung. Graphische Sammlung Albertina, Vienna, 1961
Gedächtnisausstellung Alfred Kubin, 1877–1959. Exh. Cat. Bayerische Akad. der Schönen Künste und Kunstverein, Munich, 1964

KUHN, WALT

Adams, Philip R. *Walt Kuhn.* Cincinnati, 1960
Bird, Paul. *Fifty Paintings by Walt Kuhn.* 1940
Walt Kuhn. Exh. Cat. Cincinnati Art Mus., 1960
Painter of Vision: Walt Kuhn. Exh. Cat. Univ. of Arizona Art Gal., Tucson, 1966

KUNIYOSHI, YASUO

Kuniyoshi, Yasuo. *Yasuo Kuniyoshi.* 1945. Autobiography.
Kuniyoshi. Exh. Cat. Whitney Mus. of American Art, 1945
Kuniyoshi. Exh. Cat. Nat. Mus. of Modern Art, Tokyo, 1954
Yasuo Kuniyoshi. Exh. Cat. Nat. Mus. of Modern Art, Tokyo, 1975

KUPKA, FRANTIŠEK

Cassou, Jean and Fédit, Denise. *Frank Kupka.* Paris, 1965
Vachtová, L. *Frank Kupka. Pioneer of abstract art.* 1968
Kupka. Exh. Cat. Mus. Nat. d'Art Moderne, Paris, 1958
Kupka, 1871–1957. Exh. Cat. Solomon R. Guggenheim Mus., N.Y., and Kunsthaus, Zürich, 1976

LABISSE, FÉLIX

Desnos, R. *Labisse*. Paris, 1945
Labisse, F. *Félix: le sorcier des familles*. Paris, 1957
Félix Labisse. Exh. Cat. Antwerp, 1968

LACASSE, JOSEPH

Bilcke, Maurits and others (ed.). *Joseph Lacasse par lui-même*. Antwerp, 1974
Joseph Lacasse. Exh. Cat. Drian Gal., London, 1962

LACHAISE, GASTON

Gallatin, A. E. *Gaston Lachaise*. 1924
Kramer, Hilton. *The Sculpture of Gaston Lachaise*. 1967
Gaston Lachaise. Exh. Cat. Los Angeles County Mus. of Art, 1963, and Whitney Mus. of American Art, 1964

LAERMANS, EUGÈNE

Colin, P. *Eugène Laermans*. Brussels, 1929
Maret, François. *Eugène Laermans*. Brussels, 1959
Ridder, André de. *Eugène Laermans*. Antwerp, 1950

LAETHEM-SAINT-MARTIN

Haesaerts, P. *L'École de Laethem-Saint-Martin*. Brussels, 1945
— *Laethem-Saint-Martin. Le village élu de l'art flamand*. Brussels, 1964
Ridder, André de. *Laethem-Saint-Martin. Colonie d'artistes*. Paris, 1945

LA FRESNAYE, ROGER DE

Cogniat, R. and George, W. *Œuvre complète de Roger de La Fresnaye*. Paris, 1950–
Seligman, G. *Roger de La Fresnaye*. 1969. With catalogue raisonné.

LAM, WIFREDO

Charpentier, Jacques. *Lam*. Paris, 1960
Gomez Sicre, José. *Cuban Painting Today*. Havana, 1944
Leiris, M. *Wifredo Lam*. Milan, 1970
Xiguéra, Gérard. *Wifredo Lam*. Paris, 1974

LANDUYT, OCTAVE

Torczyner, H. *Octave Landuyt*. Ghent, 1962

LANSKOY, ANDRÉ

Grenier, J. *André Lanskoy*. Paris, 1960

LANYON, PETER

Causey, Andrew. *Peter Lanyon*, 1971
Peter Lanyon. Exh. Cat. Tate Gal., London, 1968
Peter Lanyon. Exh. Cat. Gimpel Fils, London, 1975

LA PATELLIÈRE, AMÉDÉE DE

Alazard, J. *Amédée de La Patellière*. Paris, 1953

LAPICQUE, CHARLES

Lescure, Jean. *Lapicque*. Paris, 1956

LAPOUJADE, ROBERT

Jeanson, F. *Lapoujade*. Brussels, n.d.

LAPRADE, PIERRE

Gebhard, L. *Pierre Laprade*. Paris, 1930

LARDERA, BERTO

Jianou, I. *Lardera*. Paris, 1968
Seuphor, M. *Berto Lardera*. Neuchâtel, 1960

Lardera: la rose des vents. Exh. Cat. Knoedler Gal., N.Y., 1969

LARIONOV, MIKHAIL

Eganburi, Eli. *Natalia Goncharova. Mikhail Larionov*. Moscow, 1913
George, Waldemar. *Larionov*. Paris, 1966
Loguine, Tatiana (ed.). *Gontcharova et Larionov*. Paris, 1971
Larionov and Goncharova. Retrospective exhibition. Exh. Cat. Arts Council of Great Britain, 1961
Gontcharova. Larionov. Exh. Cat. Mus. d'Art Moderne de la Ville de Paris, 1963

LASANSKY, MAURICIO

Mauricio Lasansky. Retrospective. Exh. Cat. American Federation of Arts, 1960
Mauricio Lasansky. The Nazi Drawings. Exh. Cat. Iowa City, 1966

LASSAW, IBRAM

Goossen, E. C. *Three American Sculptors: Ferber, Hare, Lassaw*. 1959
Ibram Lassaw. Exh. Cat. M.I.T., 1957

LATASTER, GER

Maisonneuve, A. *Ger Lataster*. Paris, 1966

LATIN AMERICA

Arellano, Jorge Eduardo. *Pintura y escultura en Nicaragua*. Managua, 1978
Argul, José Pedro. *Las artes plásticas del Uruguay*. Montevideo, 1966
Bardi, P. M. *Profile of the New Brazilian Art*. 1970
Barney Cabrera, Eugenio. *Tomas para la historia del arte en Colombia*. Bogotá, 1970
Bayón, Damián. *Aventura plástica de Hispanoamérica*. Mexico City, 1974
— (ed.). *America latina en sus artes*. Mexico City, 1974
— *El artista latinoamericano y su identidad*. Caracas, 1977
Boulton, Alfredo. *Historia de la pintura en Venezuela*. Caracas, 1968
Brughetti, Romualdo. *Historia del arte en la Argentina*. Mexico City, 1965
Carracho, Victor. *La escultura en Chile*. Santiago, 1964
Castedo, Leopoldo. *A History of Latin American Art and Architecture*. 1969
Catlin, Stanton L. *Art of Latin America since Independence*. New Haven, 1966
Chase, Gilbert. *Contemporary Art in Latin America*. 1970
Córdova Iturburu, C. *La pintura argentina del siglo XX*. Buenos Aires, 1960
Eastman, Carlos. *Cinco artistas sudamericanos*. Buenos Aires, 1966
Gesualdo, Vicente. *Enciclopedia del arte en America*. 5 vols. Buenos Aires, 1968
Gomez Sicre, José. *Cuban Painting Today*. Havana, 1944
Hirstein, L. *The Latin American Collection of the Museum of Modern Art*. 1974
Llerena, José Alfredo. *La pintura ecuatoriana del siglo XX*. Quito, 1942
More, Humberto. *Actualidad pictorica ecuatoriana*. Guayaquil, 1974
Navarro, J. G. *Artes plásticas ecuatorianas*. Mexico City, 1945
Ortega Ricaurte, Carmen. *Diccionario de artistas en Colombia*. Bogotá, 1965

LATIN AMERICA (cont.)

Paz Castillo, Fernando and Rojas Guardia, Pablo. *Diccionario de las artes plásticas en Venezuela.* Caracas, 1973

Pellegrini, Aldo. *Panorama della pintura argentina contemporánea.* Buenos Aires, 1967

Pontual, Roberto. *Dicionário das artes plásticas no Brasil.* Rio de Janeiro, 1969

Presta, Salvador. *Arte argentino actual.* Buenos Aires, 1960

Rodman, Selden. *Renaissance in Haiti.* 1948

Romera, Antonio. *Asedio a la pintura chilena.* Santiago, 1969

— *Historia de la pintura chilena.* Santiago, 1951

Romero Brest, Jorge. *La pintura brasilena contemporánea.* Buenos Aires, 1945

— *El arte en la Argentina.* Buenos Aires, 1969

San Martín, Maria Laura. *Pintura argentina contemporánea.* Buenos Aires, 1961

Silva Brito, Mario da. *Historia do modernismo brasileiro.* Rio de Janeiro, 1971

Traba, Marta. *Historia abierta del arte columbiano.* 1974

Ugarte-Elespuru, Juan Manuel. *Pintura y escultura en el Peru contemporáneo.* Lima, 1970

Villacorte Paredes, Juan. *Pintores peruanos de la republica.* Lima, n.d.

Villaroel Chaure, Victor. *Arte contemporáneo.* La Paz, 1952

Les Arts de l'Amérique Latine. Exh. Cat. UNESCO travelling exhibition, UNESCO, Paris, 1977

Recent Latin American Drawings, 1969–1976. Exh. Cat. International Exhibitions Foundation, 1977–8

LAUNOIS, JEAN

Jean Launois. Exh. Cat. Mus. de la Roche-sur-Yon (Vendée), 1977

LAURENÇIN, MARIE

Allard, Roger. *Marie Laurençin.* Paris, 1921

Day, George. *Marie Laurençin.* Paris, 1947

Gere, Charlotte. *Marie Laurençin.* 1977

Wedderkop, H. von. *Marie Laurençin.* Leipzig, 1921

LAURENS, HENRI

Goldscheider, C. *Laurens.* 1959

Hofmann, Werner. *The Sculpture of Henri Laurens.* 1970

Laurens, M. (ed.). *Henri Laurens, sculpteur, 1885–1954.* Paris, 1955

Henri Laurens, the Silent Sculptor. Exh. Cat. Buchholz Gal., N.Y., 1947

Henri Laurens. Exh. Cat. Palais des Beaux-Arts, Brussels, 1949

Henri Laurens. Exh. Cat. Mus. Nat. d'Art Moderne, Paris, 1951

Laurens. Monumental sculpture. Exh. Cat. Marlborough-Gerson Gal., N.Y., 1966

LAVERY, SIR JOHN

Sparrow, W. Shaw. *John Lavery and his Work.* 1911

LEBEL, JEAN-JACQUES

See HAPPENING

LEBENSZTEIN, JAN

Jan Lebensztein. Exh. Cat. Mus. Nat. d'Art Moderne, Paris, 1963

LEBRUN, RICO

Rico Lebrun. Exh. Cat. Los Angeles County Mus. of Art, 1967

LECK, BARTH VAN DER

Barth van der Leck. Exh. Cat. Stedelijk Mus., Amsterdam, 1959

LE CORBUSIER (C. E. JEANNERET)

Boesiger, W. *Le Corbusier.* 1972

— *Le Corbusier et Pierre Jeanneret. Œuvre complète.* Zürich, 1930–

Hervé, Lucien (ed.). *Le Corbusier: Artist-Writer.* Neuchâtel, 1970

Hohl, R. *Le Corbusier: the painter.* Basle, 1971. Quotations from Le Corbusier with Eng. trans.

Jardot, M. *Le Corbusier. Dessins.* Paris, 1955

Jeanneret, C. E. and Ozenfant, A. *La Peinture moderne.* Paris, 1925

Jordan, R. Furneaux. *Le Corbusier.* 1972

Papadaki, S. (ed.). *Le Corbusier. Architect, painter, writer.* 1948

LE FAUCONNIER, HENRI

Romain, J. *Le Fauconnier.* Paris, 1922

Le Fauconnier. Exh. Cat. Stedelijk Mus., Amsterdam, 1959

LÉGER, FERNAND

Cassou, Jean and Leymarie, Jean. *Fernand Léger. Drawings and gouaches.* 1973

Cooper, Douglas. *Fernand Léger et le nouvel espace.* Geneva, 1949

Couturier, M. A. and others. *Fernand Léger. La Forme humaine dans l'espace.* Montreal, 1945

Delevoy, R. L. *Léger: biographical and critical study.* Geneva, 1962

Descargues, Pierre. *Fernand Léger.* Paris, 1955

Golding, J. and Green, C. *Léger and Purist Paris.* 1970

Kuh, Katharine. *Léger.* Urbana, 1953

Léger, Fernand. *Functions of Painting.* 1973. An anthology of the artist's writings, 1913–60

Maurois, André. *Fernand Léger.* Basle, 1970

Schmalenbach, Werner. *Fernand Léger.* 1976

Fernand Léger, 1881–1955. Exh. Cat. Mus. des Arts Décoratifs, Paris, 1956

Fernand Léger, 1881–1955. Exh. Cat. Haus der Kunst, Munich, 1957

Fernand Léger. Five themes and variations. Exh. Cat. Solomon R. Guggenheim Mus., N.Y., 1962

Fernand Léger. Exh. Cat. Gal. du Grand Palais, Paris, 1971

LEHMBRUCK, WILHELM

Hoff, A. *Wilhelm Lehmbruck. Leben und Werk.* Berlin, 1961

Hofmann, Werner. *Wilhelm Lehmbruck.* 1958

Petermann, E. *Die Druckgraphik von Wilhelm Lehmbruck.* Stuttgart, 1964

Trier, E. *Wilhelm Lehmbruck. Die Kniende.* Stuttgart, 1958

Wilhelm Lehmbruck. Exh. Cat. Scottish Nat. Gal. of Modern Art, Edinburgh, 1979

LE PARC, JULIO

Popper, Frank. *Art: action and participation.* 1975

— *Le Parc et le problème de group.* Paris, 1966

Romero Brest, Jorge and others. *Le Parc.* Buenos Aires, 1967

LEVINE, JACK

Getlein, F. *Jack Levine.* 1966

Jack Levine. Exh. Cat. Inst. of Contemporary Art, Boston, 1953

LEWIS, PERCY WYNDHAM

Farrington, Jane. *Wyndham Lewis*. 1980
Handley-Read, C. (ed.). *The Art of Wyndham Lewis*.
1951
Lewis, Percy Wyndham. *Wyndham Lewis the Artist.
From 'Blast' to Burlington House*. 1939
Michel, W. and Fox, C. J. (ed.). *Wyndham Lewis on
Art: collected writings, 1913–1956*. 1969
— and Kenner, H. (ed.). *Wyndham Lewis: paintings and
drawings*. 1971. With catalogue raisonné.
Wyndham Lewis and Vorticism. Exh. Cat. Tate Gal.,
London, 1956
Vorticism and its Allies. Exh. Cat. Arts Council of Great
Britain, 1974

LEWITT, SOL

Sol Lewitt, Exh. Cat. Gemeentemus., The Hague, 1970
Lewitt, Sol. Exh. Cat. The Mus. of Modern Art, N.Y.,
1978

LHOTE, ANDRÉ

Jakovsky, A. *André Lhote*. Paris, 1947
Lhote, André. *Écrits sur la peinture*. Brussels, 1946

LICHTENSTEIN, ROY

Coplans, John (ed.). *Roy Lichtenstein*. 1974
Morphet, R. *Roy Lichtenstein*. Hertford, 1969
Waldman, Diane. *Roy Lichtenstein. Drawings and
prints*. 1971
Roy Lichtenstein. Exh. Cat. Stedelijk Mus., Amsterdam,
1967
Roy Lichtenstein. Exh. Cat. Tate Gal., London, 1968
Roy Lichtenstein. Retrospective. Exh. Cat. Solomon R.
Guggenheim Mus., N.Y., 1969

LICINI, OSVALDO

Marchiori, G. *Licini. Con 21 lettere del pittore*. Rome,
1950

LIEBERMANN, MAX

Friedländer, M. J. *Max Liebermann*. Berlin, 1924
Liebermann, Max. *Gesammelte Schriften*. Berlin, 1922
Scheffler, Karl. *Max Liebermann. Sein graphische
Werk*. Berlin, 1923
Stuttmann, F. *Max Liebermann*. Hanover, 1961
Max Liebermann und seine Zeit. Exh. Cat. Haus der
Kunst, Munich, 1980

LIMOUSE, ROGER

Laprade, Jacques de. *Roger Limouse*. Paris, 1943

LINDNER, RICHARD

Ashton, Dore. *Richard Lindner*. 1969
Dienst, Rolf-Gunter. *Richard Lindner*. 1970
Kramer, Hilton. *Richard Lindner*. 1975
Tillim, Sidney. *Richard Lindner*. Chicago, 1960
Richard Lindner. Retrospective. Exh. Cat. Leverkusen,
1968

LINDSTRÖM, BENGT

Lidén, Anders (ed.). *Bengt Lindström. Un souffle frais
de vie*. Uddevalla, 1968

LINT, LOUIS VAN

Sosset, L. L. *Louis van Lint*. Antwerp, 1951

LIPCHITZ, JACQUES

Arnason, H. H. *Jacques Lipchitz. Sketches in bronze*.
1969
Bork, Ber van. *Jacques Lipchitz: the artist at work*.
1966

Goldwater, Robert. *Jacques Lipchitz*. 1959
Hammacher, A. M. *Jacques Lipchitz. His sculpture*.1961
Lipchitz, Jacques. *My Life in Sculpture*. 1972
— *Sculpture and Drawings from the Cubist Epoch*. 1978.
A chronological catalogue of works.
The Sculpture of Jacques Lipchitz. Exh. Cat. The Mus.
of Modern Art, N.Y., 1954
Jacques Lipchitz. A retrospective selected by the artist.
Exh. Cat. University Art Mus., Berkeley, Calif., 1963

LIPSI, MORICE

Gindertael, R. Van (ed.). *Morice Lipsi*. Neuchâtel, 1965

LIPTON, SEYMOUR

Elsen, Albert. *Seymour Lipton*. 1969
Seymour Lipton. Recent works. Exh. Cat. Marlborough-
Gerson Gal., N.Y., 1971

LISMONDE, JULES

Lebeer, L. *Lismonde*. Brussels, 1956

LISSITZKY, EL

Lissitzky-Küppers, Sophie. *El Lissitzky: life, letters,
texts*. Eng. trans. 1980 (1968)
Richter, H. *El Lissitzky. Sieg über die Sonne. Zur Kunst
des Konstructivismus*. 1958
El Lissitzky. Exh. Cat. Eindhoven and Hanover, 1965

LOHSE, RICHARD

Richard Paul Lohse. Exh. Cat. Kunsthaus, Zürich, 1976
See also CONCRETE ART

LORJOU, BERNARD

Bouret, Jean and others. *Bernard Lorjou*. Paris, 1950

LOUIS, MORRIS

Fried, Michael. *Morris Louis*. 1970
Krauss, Rosalind E. *Morris Louis*. Auckland, N.Z., 1971
Morris Louis, 1912–1962. Exh. Cat. Solomon R.
Guggenheim Mus., N.Y., 1963
Morris Louis. Exh. Cat. Tate Gal., London, 1974

LOWRY, L. S.

Collis, Maurice Stewart. *The Discovery of L. S. Lowry*.
1951
Levy, Mervyn, *L. S. Lowry, A.R.A.* 1961
— *The Paintings of L. S. Lowry*. 1975
Marshall, T. *Life with Lowry*. 1981
Rhode, S. *L. S. Lowry*. 1979
Spalding, J. *Lowry*. 1979
L. S. Lowry. Exh. Cat. Arts Council of Great Britain,
1966
L. S. Lowry. Exh. Cat. Royal Academy, London, 1976

LUBARDA, PETAR

Bihalji-Merin, Oto. *Lubarda: The Battle of Kossovo*.
Belgrade, 1956
Lubarda. Exh. Cat. Belgrade, 1956

LUCE, MAXIMILIEN

Tabarant, A. *Maximilien Luce*. Paris, 1928

LUDWIG, ERNST

Ernst Ludwig. Exh. Cat. Haus der Kunst, Munich, 1980

LUKS, GEORGE

Cary, Elizabeth L. *George Luks*. 1931
The Work of George Benjamin Luks. Exh. Cat. Newark,
N.J., 1934
George Luks, 1867–1933. Retrospective exhibition. Exh.
Cat. Heritage Gal., N.Y., 1967

LUMINISM

Hess, T. and Ashbery, J. *Light in Art*. 1971
Jones, T. D. *The Art of Light and Color*. 1973
Klein, A. B. *Coloured Light: an art medium*. 1937
Malina, Frank J. (ed.). *Kinetic Art. Theory and practice*. 1974. Articles from *Leonardo*.
Rickey, George. *Constructivism. Origins and evolution*. 1968
Rimington, A. W. *Colour-Music. The art of mobile colour*. 1912
Sharp, Willoughby. 'Luminism and Kineticism.' In Gregory Battcock (ed.), *Minimal Art*, 1968
Light, Motion, Space. Exh. Cat. Walker Art Center, Minneapolis, 1967
Lumière et Mouvement. Exh. Cat. Mus. d'Art Moderne de la Ville de Paris, 1967

LUNDQVIST, EVERT

Söderberg, R. *Evert Lundqvist*. Stockholm, 1962

LURÇAT, JEAN

Roy, C. *Jean Lurçat*. Geneva, 1956
Vercors (ed.). *Tapisseries de Jean Lurçat, 1939–1957*. Belvès, 1957
Lurçat. Exh. Cat. Kunstverein, Düsseldorf, 1962

MAAS, PAUL

Dasnoy, A. *Paul Maas. Catalogue raisonné de son œuvre peint, établi avec la collaboration de Madame Denise Hartog*. Brussels, 1969

MACDONALD, J. E. H.

Hunter, E. R. *J. E. H. MacDonald, a bibliography and catalogue of his work*. Toronto, 1940

MACDONALD, JOCK

Pollock, R. Ann and Reid, Dennis. *Jock Macdonald*. Ottawa, 1969

MACDONALD-WRIGHT, STANTON

A Retrospective Showing of the Work of Stanton MacDonald-Wright. Exh. Cat. Los Angeles County Mus. of Art, 1956
The Art of Stanton Macdonald-Wright. Exh. Cat. Smithsonian Inst., Washington, 1967

MACIVER, LOREN

Loren MacIver—Rice Pereira. Exh. Cat. Whitney Mus. of American Art, 1953

MACK, LUDWIG HIRSCHFELD

Two Masters of the Weimar Bauhaus: Lyonel Feininger, Ludwig Hirschfeld Mack. Art Gal. of N.S.W., 1974

MACKE, AUGUST

Erdmann-Macke, E. *Erinnerung an August Macke*. Stuttgart, 1962
Macke, W. (ed.). *August Macke, Franz Marc. Briefwechsel*. Cologne, 1964
Vriesen, G. *August Macke*. Stuttgart, 1957. With catalogue of works.
August Macke. Gedenkausstellung zum 70 Geburtstag. Exh. Cat. Westfälischer Kunstverein, Münster, 1957
August Macke. Exh. Cat. Städt. Gal. im Lenbachhaus, Munich, 1962
See also BLAUE REITER

MAFAI, MARIO

Cairola, Stefano (ed.). *Arte italiana del nostra tempo*. Bergamo, 1946
Venturi, Lionello. *Italian Painters of Today*. 1959

MAGICAL REALISM

Roh, F. *Nach-Expressionismus. Magischer Realismus, Probleme der neuesten europäischen Malerei*. Leipzig, 1925
Schmied, Wieland. *Neue Sachlichkeit und Magischer Realismus in Deutschland 1918–1933*. Hanover, 1969

MAGNELLI, ALBERTO

Alberto Magnelli. Exh. Cat. Kunsthaus, Zürich, 1963
Magnelli. Exh. Cat. Mus. Nat. d'Art Moderne, Paris, 1968

MAGRITTE, RENÉ

Gablik, Suzi. *Magritte*. 1970
Hammacher, A. M. *René Magritte*. 1974
Mesens, E. L. T. *Peintres belges contemporains: Magritte*. Brussels, 1947
Scutenaire, L. *Magritte*. Brussels, 1964
Soby, J. T. *René Magritte*. 1965
Torczyner, Harry. *Magritte: the true art of painting*. 1979
Waldberg, P. *René Magritte*. Brussels, 1965
Magritte. Exh. Cat. The Mus. of Modern Art, N.Y., 1965
Magritte. Exh. Cat. Marlborough Fine Art, London, 1976. Retrospective loan exhibition with letters and essays by the artist.

MAILLOL, ARISTIDE

George, Waldemar. *Aristide Maillol*. 1965
Rewald, John. *Maillol*. 1939
— *The Woodcuts of Aristide Maillol. A complete catalogue with 176 illustrations*. 1943
Ritchie, A. C. *Aristide Maillol. With an introduction and survey of the artist's work in American collections*. 1945
Aristide Maillol. Exh. Cat. Petit Palais, Paris, 1937
Aristide Maillol Retrospective. Exh. Cat. Solomon R. Guggenheim Mus., N.Y., 1976

MALEVICH, KASIMIR

Andersen, Troels (ed.). *K. S. Malevich. Essays on art, 1915–1933*. 2 vols. 1969
Karshan, Donald H. (ed.). *Kasimir Malevich. The graphic work: 1913–1930*. Jerusalem, 1975
Malevich, Kasimir. *The Non-Objective World*. Chicago, 1959. Eng. trans. of *Die gegendstandlose Welt*.
Nakov, A. B. *Malevich*. Cambridge, 1976
Kasimir Malevich, 1875–1935. Exh. Cat. Whitechapel Art Gal., London, 1959
Kasimir Malevich, 1875–1935. Exh. Cat. Stedelijk Mus., Amsterdam, 1970
Kasimir Malevich, 1875–1935. Exh. Cat. Tate Gal., London, 1976

MALRAUX, ANDRÉ

Courcel, M. de. *Malraux. Life and work*. 1976
Madsen, Axel. *Malraux. A biography*. 1977

MAMBOUR, AUGUSTE

Bosmant, J. *Auguste Mambour*. Brussels, 1965

MANESSIER, ALFRED

Cayrol, J. *Manessier*. Paris, 1955

MANGUIN, HENRI

Cabanne, Pierre. *Henri Manguin*. Neuchâtel, 1964
Le Centenaire de Manguin. Exh. Cat. Gal. de Paris, 1959
Manguin. Tableaux fauves. Exh. Cat. Gal. de Paris, 1962

MANSHIP, PAUL

Gallatin, A. E. *Paul Manship*. 1917
Murtha, E. *Paul Manship*. 1957
Vitry, P. *Paul Manship*. Paris, 1927
Paul Manship. Exh. Cat. Smithsonian Inst.,
Washington, 1958

MANZÙ, GIACOMO

De Micheli, Mario. *Giacomo Manzù*. Milan, 1971
Rewald, John. *Giacomo Manzù*. 1967. With
bibliography.
Manzù. Exh. Cat. Palazzo Reale, Milan, 1947
Giacomo Manzù. Exh. Cat. Hanover Gal., London,
1953
Manzù. Exh. Cat. World House Gal., N.Y., 1957
Giacomo Manzù. Sculpture and drawings. Exh. Cat. Tate
Gal., London, 1960

MARC, FRANZ

Bünemann, H. *Franz Marc*. Munich, 1948
Lankheit, K. *Franz Marc*. Cologne, 1976
Marc, Franz. *Briefe 1914–16 aus dem Felde*. Berlin,
1959
Robinson, Max. *Franz Marc*. Paris, 1963
Schardt, A. J. *Franz Marc*. Berlin, 1936. With catalogue
of works.
Franz Marc. Exh. Cat. Städt. Gal. im Lenbachhaus,
Munich, 1963

MARCA-RELLI, CONRAD

Arnason, H. H. *Marca-Relli*. 1963
Tyler, Parker. *Marca-Relli*. Paris, 1960

MARCHAND, ANDRÉ

Brabant, G. P. *André Marchand*. Paris, 1954

MARCOUSSIS

Cassou, J. *Marcoussis*. Paris, 1930
Lafranchis, J. *Marcoussis. Sa vie, son œuvre*. Paris, 1961

MARIN, JOHN

Helm, M. *John Marin*. Boston, 1948
Norman, D. (ed.). *The Selected Writings of John Marin*.
1949
Reich, S. *John Marin: a stylistic analysis and catalogue
raisonné*. 2 vols. Tucson, 1970
Seligmann, H. J. (ed.). *Letters of John Marin*. 1931
John Marin. Exh. Cat. The Mus. of Modern Art, N.Y.,
1936
John Marin. Exh. Cat. Inst. of Contemporary Art,
Boston, 1947

MARINETTI, F. T.

Altomare, Libero. *Incontri con Marinetti e il futurismo*.
Rome, 1954
Flint, R. W. (ed.). *Marinetti. Selected writings*. 1972
Pavolini, Corrado. *Marinetti*. Rome, 1924
Settimelli, Emilio. *Marinetti, l'uomo e l'artista*. Milan,
1921
Viviani, Alberto. *Il poeta Marinetti e il futurismo*.
Rome, 1954
See also FUTURISM

MARINI, MARINO

Bardi, P. (ed.). *Marino Marini. Graphic work and
paintings*. 1960
Trier, E. *The Sculpture of Marino Marini*. 1961

MARISOL

Medina, José Ramón. *Marisol*. Caracas, 1968

MARQUET, ALBERT

Besson, G. *Marquet*. Paris, 1947 (1929)
Jourdain, F. *Marquet*. Paris, 1959
Marquet. Exh. Cat. Orangerie des Tuileries, Paris, 1975

MARSH, REGINALD

Goodrich, Lloyd. *Reginald Marsh*. 1972
Sasowsky, N. *Reginald Marsh: etchings, engravings,
lithographs*. 1956
Reginald Marsh. Exh. Cat. Whitney Mus. of American
Art, 1955
*East Side, West Side, All Around the Town. A
retrospective exhibition of paintings, watercolours and
drawings by Reginald Marsh*. Exh. Cat. Univ. of
Arizona Art Gal., Tucson, 1969

MARTIN, KENNETH

Kenneth Martin. 2 vols. 1975. Vol. 1: anthology of texts
by Martin; Vol. 2: texts on Martin.
Kenneth Martin. Exh. Cat. Tate Gal., London, 1975

MARTINI, ARTURO

Argan, G. C. *Martini*. 1959
Bontempelli, M. *Arturo Martini*. Milan, 1948
Franchi, R. *Arturo Martini*. Milan, 1951
Perocco, G. *Arturo Martini*. 1962

MASSON, ANDRÉ

Hahn, O. *André Masson*. 1965
Leiris, M. (ed.). *André Masson. Drawings*. 1972
— and Limbour, G. *André Masson et son univers*. Paris,
1947. Eng. trans., *André Masson and his universe*, 1947
Masson, André. *Anatomie de mon univers*. Paris, 1943.
Eng. trans., *Anatomy of my universe*, 1943
— *Entretiens avec Georges Charbonnier*. Paris, 1958
— *Métamorphose de l'artiste*. 2 vols. Geneva, 1956
— *Le Plaisir de peindre*. Paris, 1950

MATHIEU, GEORGES

Charpentier, Jean. *Georges Mathieu*. Paris, 1965
Mathieu. Exh. Cat. Mus. des Beaux-Arts de la Ville de
Paris, 1963

MATISSE, HENRI

Aragon, Louis. *Henri Matisse dessins: thèmes et
variations*. Paris, 1943
Barnes, A. C. *The Art of Henri Matisse*. 1933
Barr, A. H., Jr. *Matisse: his art and his public*. 1951
Cowart, Jack and others. *Matisse. Paper cut-outs*.
Detroit, 1977
Diehl, G. *Henri Matisse*. Paris, 1958
Elderfield, John. *The Cut-outs of Henri Matisse*. 1978
— *Matisse in the Collection of the Museum of Modern
Art*. 1978
Escholier, R. *Matisse: a portrait of the artist and the
man*. 1960
Flam, Jack D. *Matisse on Art*. 1973
Gowing, Lawrence. *Matisse*. 1979
Guichard-Meili, J. *Matisse*. 1967
Jacobus, John. *Henri Matisse*. 1973
Lassaigne, J. *Matisse: biographical and critical study*.
Geneva, 1959
Legg, Alicia. *The Sculpture of Matisse*. 1972
Lieberman, W. S. *Matisse. 50 years of his graphic art*.
1957
Reverdy, P. and Duthuit, G. *The Last Works of Henri
Matisse*. 1958
Scheiwiller, Giovanni. *Henri Matisse*. Milan, 1947
*Henri Matisse. Retrospective exhibition of paintings,
drawings and sculpture*. Philadelphia Mus. of Art,
1948

MATISSE (*cont.*)

Henri Matisse. Retrospective. Exh. Cat. Univ. of California Art Gal., Los Angeles, 1966
Henri Matisse. Dessins et sculpture. Exh. Cat. Mus. Nat. d'Art Moderne, Paris, 1975. With catalogue of works, etc.

MATTA

Rubin, W. S. *Matta.* The Mus. of Modern Art Bulletin, Vol. 25, No. 1, 1957
Matta Coïgitum. Exh. Cat. Arts Council of Great Britain, 1977

MAURER, ALFRED

McCausland, E. *Alfred H. Maurer.* 1951
A. H. Maurer, 1868–1932. Exh. Cat. Walker Art Center, Minneapolis, 1949

MEADOWS, BERNARD

Bernard Meadows. Exh. Cat. Arts Council of Great Britain, 1960
Bernard Meadows. Exh. Cat. Stedelijk Mus., Amsterdam, 1965

MEC ART

Cabanne, P. and Restany, P. *L'Avant-garde au XXe siècle.* Paris, 1969

MEDLEY, ROBERT

Robert Medley. Exh. Cat. Whitechapel Art Gal., London, 1963

MEIDNER, LUDWIG

Brieger, L. *Ludwig Meidner.* Leipzig, 1919
Grochowiak, T. *Ludwig Meidner.* Recklinghausen, 1966

MEIER-DENNINGHOF, BRIGITTE

Kultermann, U. *Meier-Denninghof.* Cologne, 1960
Meier-Denninghof. Exh. Cat. Kestner-Gesellschaft, Hanover, 1966

MEISTERMANN, GEORG

Linfert, Carl. *Georg Meistermann.* Recklinghausen, 1958

MELDRUM, MAX

Colahan, Colin. *Max Meldrum, his Art and Views.* Melbourne, 1919
Meldrum, Max. *The Science of Appearances.* Sydney, 1950

MENDELSON, MARC

Séaux, Jean. *Marc Mendelson.* Antwerp, 1952

MÉRIDA, CARLOS

Nelken, M. *Carlos Mérida.* Mexico City, 1961

MERKEL, GEORG

Buschbeck, E. *Georg Merkel.* Vienna, 1927
Tietze, H. *Georg Merkel.* Vienna, 1922

MESENS, E. L. T.

Scutenaire, L. *Mon ami Mesens.* Brussels, 1972

MEŠTROVIĆ, IVAN

Schmeckebier, L. E. *Ivan Meštrović, Sculptor and Patriot.* 1959
Works of Ivan Meštrović. Exh. Cat. Victoria and Albert Mus., London, 1959

METAPHYSICAL PAINTING

Apollonio, U. *Pittura metafisica.* Milan, 1945
Carrà, Massimo. *Metaphysical Art.* Eng. trans., 1971
Masciotta, M. *La pittura metafisica in letteratura.* Milan, 1941

METELLI, ORNEORE

Courthion, Pierre. *Orneore Metelli.* Rome, 1946

METZINGER, JEAN

Metzinger. Pre-Cubist and Cubist works. Exh. Cat. International Gal., Chicago, 1964

MEUNIER, CONSTANTIN

Christophe, L. *Constantin Meunier.* Antwerp, 1947

MEXICO

Cardoza y Aragón, L. *Mexico: pintura de hoy.* Mexico City, 1964
Charlot, Jean. *The Mexican Mural Renaissance 1920–1925.* New Haven, 1967
Fernández, J. *Mexican Art.* 1965
Haab, A. *Mexican Graphic Art.* 1957
Helm, MacKinley. *Modern Mexican Painters.* 1968
Myers, B. A. *Mexican Painting in Our Time.* 1956
Reed, Alma. *The Mexican Muralists.* 1960
Rodríguez, Antonio. *A History of Mexican Mural Painting.* 1969
Stewart, V. *45 Contemporary Mexican Artists.* Stanford, Calif., 1951
Suárez, Orlando S. *Inventario del muralismo mexicano.* Mexico City, 1972
Tibol, Raquel. *Historia general del arte mexicano.* Mexico City, 1969

MICHAUX, HENRI

Ajuriaguerra, J. de and Jaeggi, F. *Le Poète Henri Michaux et les drogues hallucinogènes.* Basle, 1963
Bellour, Raymond. *Henri Michaux; ou, Une Mesure de l'être.* Paris, 1965
Bertelé, René. *Henri Michaux.* Paris, 1946
Bréchon, Robert. *Michaux.* Paris, 1959
Jouffroy, A. *Henri Michaux.* Paris, 1961
Leonhard, Kurt. *Henri Michaux.* Eng. trans., 1967

MIHELIĆ, FRANCE

Mihelić. Exh. Cat. Mus. of Modern Art, Belgrade, 1967

MIKL, JOSEF

Josef Mikl. Exh. Cat. Mus. des 20. Jahrhunderts, Vienna, 1964

MILLER, GODFREY

Henshaw, John (ed.). *Godfrey Miller.* Sydney, 1965

MILLER, KENNETH HAYES

Kenneth Hayes Miller. Exh. Cat. Whitney Mus. of American Art, 1931
Kenneth Hayes Miller. Exh. Cat. Art Students League, N.Y., 1953

MILNE, DAVID

Jarvis, Alan. *David Milne.* Toronto, 1962
Tovell, Rosemarie L. *David Milne: painting place.* Ottawa, 1976

MILO, JEAN

Gindertael, R. Van. *Jean Milo.* Paris, 1953
Haesaerts, L. *Jean Milo.* Antwerp, 1954

MINAUX, ANDRÉ
Chevalier, Denys. *André Minaux*. Paris, 1949

MINGUZZI, LUCIANO
Marchiori, G. *Luciano Minguzzi. Sculpture from 1951 to 1961*. Milan, 1962

MINIMAL ART
Battcock, Gregory (ed.). *Minimal Art. A critical anthology*. 1968
Minimal Art. Exh. Cat. Gemeentemus., The Hague, 1968

MINNE, GEORG
Puyvelde, Leo Van. *Georg Minne*. Brussels, 1930
Ridder, André de. *George Minne*. Brussels, 1947

MIRÓ, JOAN
Bonnefoy, Yves. *Miró*. 1967
Dupin, Jacques. *Joan Miró, Life and work*. 1962
Greenberg, Clement. *Joan Miró*. 1948
Hunter, Sam. *Joan Miró. His graphic work*. 1958
Jouffroy, Alain and Teixidor, J. *Miró. Sculptures*. 1974
Penrose, R. *Miró*. 1970
Picon, Gaetan. *Joan Miró. Catalan notebooks*. Eng. trans., 1977
Rubin, W. S. (ed.). *Miró in the Collection of the Museum of Modern Art*. 1973
Scheidegger, E. (ed.). *Joan Miró. Gesammelte Schriften, Fotos, Zeichnungen*. Zürich, 1957
Joan Miró. Exh. Cat. The Mus. of Modern Art, N.Y., 1959
Joan Miró. Exh. Cat. Mus. Nat. d'Art Moderne, Paris, 1962
Joan Miró. Exh. Cat. Arts Council of Great Britain, 1964
Miró. Bronzes. Exh. Cat. Hayward Gal., London, 1972

MODERSOHN-BECKER, PAULA
Heise, C. G. *Paula Becker-Modersohn. Mutter und Kind*. Stuttgart, 1961
Pauli, G. *Paula Modersohn-Becker*. Munich, 1922
Stelzer, O. *Paula Modersohn-Becker*. Berlin, 1958
Paula Modersohn-Becker. Zeichnungen, Pastelle, Bilder. Exh. Cat. Kunsthaus, Zürich, 1977

MODIGLIANI, AMEDEO
Ceroni, A. *Amedeo Modigliani: dessins et sculptures*. Milan, 1965
— *Amedeo Modigliani peintre*. Milan, 1958
Cocteau, Jean. *Modigliani*. Paris, 1950
Hall, Douglas. *Modigliani*. 1979
Longstreet, S. (ed.). *The Drawings of Modigliani*. 1972
Mann, Carol. *Modigliani*. 1980
Modigliani, J. *Modigliani. Man and myth*. 1959
Pfannstiel, A. *A. Modigliani et son œuvre. Étude critique et catalogue raisonné*. Paris, 1956
Ponente, Nello. *Modigliani*. 1969
Russoli, Franco. *Modigliani*. 1959
Scheiwiller, G. (ed.). *Modigliani. Selbstzeugnisse, Photos, Zeichnungen, Bibliographie*. Zürich, 1958
Sichel, Pierre. *Modigliani*. 1967
Werner, A. *Amedeo Modigliani*. 1967
— *Modigliani, the Sculptor*. 1965
Modigliani. Paintings and drawings. Exh. Cat. Los Angeles County Mus. of Art and Mus. of Fine Arts, Boston, 1961
Modigliani. Paintings, drawings, sculpture. Exh. Cat. The Mus. of Modern Art, N.Y., 1963

MOHOLY-NAGY, LASZLO
Haus, Andreas. *Moholy-Nagy. Photographs and Photograms*. 1980
Kostelanetz, R. (ed.). *Moholy-Nagy*. 1970
Moholy-Nagy, Laszlo. *The New Vision and Abstract of an Artist*. 1946
— *Painting, Photography, Film*. 1969
— *Vision in Motion*. Chicago, 1947
Moholy-Nagy, Sibyl. *Experiment in Totality*. 1950. With biography.
Moholy-Nagy. Exh. Cat. Stedelijk van Abbe Mus., Eindhoven, 1967
Laszlo Moholy-Nagy. Exh. Cat. Mus. of Contemporary Art, Chicago, 1969
Laszlo Moholy-Nagy. Exh. Cat. Arts Council of Great Britain, 1980

MONDRIAN, PIET
Elgar, F. *Mondrian*. 1968
Jaffé, Hans L. C. *Piet Mondrian*. 1970
Mondrian, Piet. *Plastic Art and Pure Plastic Art, 1937, and other essays, 1941–1943*. 1945
Ottolenghi, Maria Grazia (ed.). *L'opera completa di Mondrian*. Milan, 1974
Seuphor, Michel. *Piet Mondrian, Life and Work*. 1957
Sweeney, J. J. *Piet Mondrian*. 1948
Piet Mondrian, 1872–1944. Exh. Cat. Whitechapel Art Gal., London, 1955
Piet Mondrian, 1872–1944. Exh. Cat. Toronto Art Gal., 1966

MOORE, HENRY
Clark, Kenneth. *Henry Moore Drawings*. 1974
Cramer, Gerald and others. *Henry Moore. Catalogue of graphic work*. Vol. 1: 1931–1972. Vol. 2: 1973–1975. Geneva, 1973–
Fezzi, Elda. *Henry Moore*. 1972
Finn, David (ed.). *Henry Moore. Sculpture and environment*. 1977
Grohmann, Will. *The Art of Henry Moore*. 1960
Hall, Donald. *Henry Moore: the life and work of a great sculptor*. 1966
James, Philip (ed.). *Henry Moore on Sculpture: a collection of the sculptor's writings and spoken words*. 1966
Moore, Henry. *Carvings and Bronzes 1961–1970*. 1970
— *Sculpture and Drawings 1921–1969*. 1971
— *Sculptures in Landscape*. 1978
The Henry Moore Gift. 1978. Illustrated catalogue of sculptures and drawings given by Moore to the nation. 1978
Read, Herbert. *Henry Moore: a study of his life and work*. 1965
— (ed.). *Henry Moore. Sculptures and drawings*. 2 vols. 1955–64
Russell, John. *Henry Moore*. 1973
Wilkinson, Alan G. (ed.). *The Drawings of Henry Moore*. 1977
Henry Moore. Exh. Cat. Tate Gal., London, 1968
Henry Moore. Graphics in the making. Exh. Cat. Tate Gal., London, 1975

MORANDI, GIORGIO
Arcangeli, F. *Giorgio Morandi*. Milan, 1964
Raimondi, Giuseppe. *Anni con Giorgio Morandi*. Milan, 1970
Vitali, Lamberto. *Giorgio Morandi: pittore*. Milan, 1964
— *L'opera di Giorgio Morandi*. Bologna, 1966
— *L'opera grafica di Giorgio Morandi*. Turin, 1965
Morandi. Exh. Cat. Arts Council of Great Britain, 1970

MORANDI *(cont.)*

Morandi. Exh. Cat. Mus. Nat. d'Art Moderne, Paris, 1971

MOREAU, GUSTAVE

Holten, R. von. *L'Art fantastique de Gustave Moreau.* Paris, 1960
Mathieu, Pierre-Louis. *Gustave Moreau.* 1977
Paladilhe, Jean. *Gustave Moreau.* 1971
Gustave Moreau. Exh. Cat. Mus. Nat. du Louvre, Paris, 1961
Odilon Redon, Gustave Moreau, Rodolphe Bresdin. Exh. Cat. The Mus. of Modern Art, N.Y., 1961

MOREAU, LUC-ALBERT

Allard, Roger. *Luc-Albert Moreau.* Paris, 1920

MORGNER, WILHELM

Seiler, H. *Wilhelm Morgner.* Cologne, 1956

MORLOTTI, ENNIO

Testori, G. *Morlotti.* Ivry, 1957

MORREN, GEORGE

Bernard, Charles. *George Morren.* Brussels, 1950

MORRICE, JAMES WILSON

Buchanan, D. *James Wilson Morrice. A biography.* Toronto, 1936

MORRIS, ROBERT

Battcock, Gregory (ed.). *Minimal Art. A critical anthology.* 1968
Robert Morris. Exh. Cat. Whitney Mus. of American Art, 1970
Robert Morris. Exh. Cat. Tate Gal., London, 1971

MOSER, KOLOMAN

Vergo, Peter. *Art in Vienna 1898-1918: Klimt, Kokoschka, Schiele and their contemporaries.* 1975

MOSES, GRANDMA

Kallir, Otto. *Grandma Moses.* 1973
Moses, Anna Mary. *My Life's History.* 1952

MOTHERWELL, ROBERT

Robert Motherwell. Exh. Cat. The Mus. of Modern Art, N.Y., 1965
Robert Motherwell. Exh. Cat. Arts Council of Great Britain, 1978

MOYNIHAN, RODRIGO

Rodrigo Moynihan. Retrospective exhibition. Exh. Cat. Royal Academy, London, 1978

MÜLLER, JAN

Jan Müller. Retrospective. Exh. Cat. Solomon R. Guggenheim Mus., N.Y., 1962

MÜLLER, OTTO

Buchheim, L. G. *Otto Müller. Leben und Werk.* Feldafing, 1963
Troeger, E. *Otto Müller.* Freiburg, 1949

MUNARI, BRUNO

Munari, Bruno. *Design as Art.* 1971
— *The Discovery of the Circle.* 1966
— *Discovery of the Square.* 1965

MUNCH, EDVARD

Benesch, Otto. *Edvard Munch.* 1960

Deknatel, F. B. *Edvard Munch.* Boston, 1950
Dunlop, Ian. *Edvard Munch.* 1977
Elderfield, John (ed.). *The Masterworks of Edvard Munch.* 1979
Messer, Thomas M. *Edvard Munch.* 1970
Moen, A. *Edvard Munch. Graphic art and paintings.* 3 vols. Oslo, 1956-8
Stang, Ragnar. *Edvard Munch: the man and the artist.* 1979
Svenaeus, Gösta. *Edvard Munch.* 2 vols. Lund, 1973
The Graphic Work of Edvard Munch. Exh. Cat. Arts Council of Great Britain, 1964
Edvard Munch. Exh. Cat. Solomon R. Guggenheim Mus., N.Y., 1965
Edvard Munch. Exh. Cat. Arts Council of Great Britain, 1974

MUNKÁCSY, MIHALY VON

Perneczky, Géza. *Munkácsy.* 1970

MÜNTER, GABRIELE

Eichner, J. *Kandinsky und Gabriele Münter.* Munich, 1957
Röthel, H. K. *Gabriele Münter.* Munich, 1957
Gabriele Münter, 1877-1962. Exh. Cat. Städt. Gal. im Lenbachhaus, Munich, 1962

NADELMAN, ELIE

Kirstein, Lincoln. *Elie Nadelman.* 1973
Murrell, William (ed.). *Elie Nadelman.* 1923
The Sculpture of Elie Nadelman. The Mus. of Modern Art, N.Y., 1948

NAÏVE ART

Bihalji-Merin, Oto. *Modern Primitives: naive painting from the late seventeenth century until the present day.* 1971
Goldwater, Robert. *Primitivism in Modern Painting.* 1938
Jakovsky, Anatole. *Lexikon der Laienmaler.* Basle, 1967
— *La Peinture naïve.* Paris, 1950. Eng. trans., *Naive Painting,* 1979
Janis, S. *They Taught Themselves: American primitive painters of the twentieth century.* 1965 (1942)
Kelemen, B. *Yugoslav Naive Painting.* Zagreb, 1969
Larkin, D. (ed.). *Innocent Art.* 1974
Lupman, J. and Winchester, A. *Primitive Painters in America 1750-1950.* 1950
Phribný, A. and Tkáč, S. *Naive Painters of Czechoslovakia.* Prague, 1967
Uhde, Wilhelm. *Cinq maîtres primitifs.* Paris, 1949
Winterberg, Ernst. *Naive Malerei aus Jugoslawien.* Frankfurt, 1966

NAKIAN, REUBEN

Nakian. Retrospective. Exh. Cat. The Mus. of Modern Art, N.Y., 1966

NANNINGA, JAAP

Lampe, G. *Jaap Nanninga.* Amsterdam, 1964

NARKOMPROS

Fitzpatrick, S. *The Commissariat of Enlightenment.* 1970

NASH, JOHN

Lewis, John. *John Nash. The painter as illustrator.* 1978
Temple, Nigel. *John Nash and the Village Pictureque.* 1979

NASH, PAUL

Bertram, Anthony. *Paul Nash. The portrait of an artist.* 1955

Causey, Andrew. *Paul Nash*. Oxford, 1980
Eates, M. *Paul Nash: the master of the image, 1889–1946*. 1973
— (ed.). *Paul Nash: paintings, drawings and illustrations.* 1948
Laver, James and Nash, Margaret (ed.). *Fertile Image.* 1951. Photographs by Nash.
Postan, A. *The Complete Graphic Works of Paul Nash.* 1973
Read, Herbert. *Paul Nash*. 1944
Paul Nash's Photographs. Document and image. Exh. Cat. Tate Gal., London, 1975

NAY, ERNST

Haftmann, Werner. *Ernst Wilhelm Nay*. Cologne, 1960

NEGRET, EDGAR

Carbonell, Galaor. *Negret. Las etapas creativas.* Bogotá, 1976
Traba, Marta. *Seis artistas contemporaneas colombianos.* Bogotá, 1963

NEGRO SCULPTURE

Laude, Jean. *La Peinture française, 1905–1914, et 'l'art nègre'.* 2 vols. Paris, 1968

NEJAD, NEHMED

Lassaigne, Jacques and Boudaille, E. *Nejad.* Paris, 1955

NELLENS, ROGER

Roger Nellens. Exh. Cat. Marlborough Fine Art, London, 1976

NESCH, ROLF

Hentzen, A. *Rolf Nesch: Graphik, Materialbilder, Plastik.* Stuttgart, 1960

NEVELSON, LOUISE

Glimcher, Arnold B. *Louise Nevelson.* 1972
Louise Nevelson. Exh. Cat. Whitney Mus. of American Art, 1967
Louise Nevelson: prints and drawings. Exh. Cat. Brooklyn Mus., 1967

NEVINSON, C. R. W.

Nevinson, C. R. W. *Paint and Prejudice.* 1937
Sitwell, O. *C. R. W. Nevinson.* 1925

NEWMAN, BARNETT

Hess, Thomas B. *Barnett Newman.* 1971
Rosenberg, H. *Barnett Newman.* 1978
Barnett Newman. The Stations of the Cross, Lema Sabachthani. Exh. Cat. Solomon R. Guggenheim Mus., N.Y., 1966
Barnett Newman. The Mus. of Modern Art, N.Y., 1971. Retrospective monograph.
Barnett Newman. Exh. Cat. Gal. Nat. du Grand Palais, Paris, 1972
Barnett Newman. Exh. Cat. Tate Gal., London, 1972

NEW REALISM

Becker, J. and Vostell, W. *Happenings. Fluxus, Pop Art, Nouveau Réalisme.* Reinbek bei Hamburg, 1968
Kutlermann, U. *New Realism.* Greenwich, Conn., 1972
Aspects of a New Realism. Exh. Cat. Milwaukee Art Center, 1969

NEW YORK REALISTS

New York Realists, 1900–1914. Exh. Cat. Whitney Mus. of American Art, 1937

NEW YORK SCHOOL

Ashton, Dore. *The Life and Times of the New York School.* 1972
Sandler, Irving. *The New York School: the painters and sculptors of the fifties.* 1978
Tuchman, Maurice (ed.). *The New York School. Abstract Expressionism in the 40s and 50s.* 1971

NICHOLSON, BEN

Alley, R. *Ben Nicholson.* 1962
Baxandall, D. *Ben Nicholson.* 1962
De Sausmarez, Maurice (ed.). *Ben Nicholson.* 1969
Lynton, Norbert (ed.). *Ben Nicholson. Thoughts and quotations.* Basle, 1968
Read, Herbert. *Ben Nicholson.* 1962
— *Ben Nicholson: paintings, reliefs, drawings.* 2 vols. 1948–56
Russell, John. *Ben Nicholson: drawings, paintings and reliefs, 1911–1968.* 1969
Schmalenbach, Werner. *Ben Nicholson.* Zürich, 1959
Ben Nicholson. Exh. Cat. Tate Gal., London, 1969

NICHOLSON, WILLIAM

Nichols, R. *William Nicholson.* 1948
Rothenstein, John. *Modern English Painters. Sickert to Smith.* 1976 (1952)
Steen, Marguerite. *William Nicholson.* 1943

NOGUCHI, ISAMU

Hunter, Sam. *Isamu Noguchi.* 1979
Kuh, Katharine. *The Artist's Voice.* 1962
Noguchi, Isamu. *A Sculptor's World.* 1967. Autobiographical.
Takiguchi, Shuzo and others. *Noguchi.* Tokyo, 1953
Isamu Noguchi. Exh. Cat. Whitney Mus. of American Art, 1968

NOLAN, SIDNEY

Lynn, Elwyn. *Sidney Nolan: myth and imagery.* 1967

NOLAND, KENNETH

Fried, Michael. *Kenneth Noland.* 1970
Moffett, Kenworth. *Kenneth Noland.* 1977
Kenneth Noland. Exh. Cat. Jewish Mus., N.Y., 1965
Three American Painters. Kenneth Noland, Jules Olitski, Frank Stella. Exh. Cat. Fogg Art Mus., Cambridge, Mass., 1965
Kenneth Noland. Exh. Cat. Solomon R. Guggenheim Mus., N.Y., 1977

NOLDE, EMIL

Gosebruch, M. *Emil Nolde. Watercolours and drawings.* 1972
Haftmann, Werner. *Emil Nolde.* 1960
— *Emil Nolde. The forbidden pictures.* 1965
Emil Nolde. Exh. Cat. The Mus. of Modern Art, N.Y., 1963

OBJET TROUVÉ

Stribling, M. L. *Art from Found Materials: discarded and natural.* 1970

OBREGÓN, ALEJANDRO

Traba, Marta. *Seis artistas contemporaneas colombianos.* Bogotá, 1963

OKADA, KENZO

Washburn, Gordon B. *Kenzo Okada: paintings 1952–65.* Tokyo, 1966

O'KEEFFE, GEORGIA

O'Keeffe, Georgia. *Georgia O'Keeffe. Autobiography.* 1976
Georgia O'Keeffe. Exh. Cat. Whitney Mus. of American Art, 1970

OLDENBURG, CLAES

Baro, Gene. *Claes Oldenburg: drawings and prints.* 1969
Oldenburg, Claes. *Claes Oldenburg: proposals for monuments and buildings 1965–69.* Chicago, 1969
— *Raw Notes.* Nova Scotia, 1973
Rose, Barbara. *Claes Oldenburg.* 1976. Monograph published on occasion of retrospective exhibition at The Mus. of Modern Art, N.Y.
Claes Oldenburg. Exh. Cat. Moderna Mus., Stockholm, 1966

OLITSKI, JULES

Three American Painters. Kenneth Noland, Jules Olitski, Frank Stella. Exh. Cat. Fogg Art Mus., Cambridge, Mass., 1965

OLIVEIRA, NATHAN

Wight, F. S. *Nathan Oliveira.* Los Angeles, 1963

OLSEN, JOHN

Spate, Virginia. *John Olsen.* 1963

ONOSATO, TOSHINOBU

Toshinobu Onosato. Exh. Cat. Miami Gal. of Art, 1962

ONSLOW-FORD, GORDON

Onslow-Ford, Gordon. *Towards a New Subject in Painting.* San Francisco, 1948

OP ART

Barrett, C. *An Introduction to Optical Art.* 1971
Carraher, Ronald G. and Thurston, Jacqueline B. *Optical Illusions and the Visual Arts.* 1966
Gregory, R. L. and Gombrich, E. H. (ed.). *Illusion in Nature and Art.* 1973
Horemis, Spyros. *Optical and Geometrical Patterns and Designs.* 1970
Oster, G. *The Science of Moiré Patterns.* 1969
Rickey, George. *Constructivism. Origins and evolution.* 1968

OROZCO, JOSÉ CLEMENTE

Cardoza y Aragón, L. *José Clemente Orozco.* Buenos Aires, 1944
— and Charlot, Jean (ed.). *José Clemente Orozco. El artista en Nueva York.* Mexico City, 1971
Fernández, Justino. *Orozco. Forma e idea.* Mexico City, 1956
Helm, MacKinley. *Man of Fire. J. C. Orozco.* 1953
Orozco, José Clemente. *Autobiografia.* Mexico City, 1945. Eng. trans., *An Autobiography,* 1962
— *Textos de Orozco.* Mexico City, 1955
Reed, Alma, *Orozco.* 1956

ORPHISM

Spate, Virginia. *Orphism.* Oxford, 1980

OSSORIO, ALFONSO

Dubuffet, J. *Peintures initiatiques d'Alfonso Ossorio.* Paris, 1951
Tapié, M. *Ossorio.* Turin, 1961

OUDOT, ROLAND

Guéguen, P. *Roland Oudot.* Paris, 1942

Roger-Marx, C. *Roland Oudot.* Geneva, 1952
Vouga, Daniel. *Roland Oudot.* Eng. trans., 1970

OZENFANT, AMÉDÉE

Nierendorf, K. *Amédée Ozenfant.* Berlin, 1931
Ozenfant, Amédée. *Foundations of Modern Art.* 1931
— and Jeanneret, C. E. *After Cubism.* Paris, 1918
— and Jeanneret, C. E. *La Peinture moderne.* Paris,1925

PAALEN, WOLFGANG

Paalen, Wolfgang. *Form and Sense.* 1945
Regler, G. *Wolfgang Paalen.* 1946

PAOLOZZI, EDUARDO

Kirkpatrick, Diane. *Eduardo Paolozzi.* 1970
Middleton, Michael. *Eduardo Paolozzi.* 1963
Schneede, Uwe M. *Paolozzi.* 1971
Eduardo Paolozzi. Exh. Cat. Tate Gal., London, 1971
Eduardo Paolozzi. Exh. Cat. Marlborough Fine Art, London, 1976

PASCIN, JULES

Ancona, P. d'. *Modigliani, Chagall, Soutine, Pascin: some aspects of Expressionism.* Milan, 1952
Werner, A. *Jules Pascin.* 1962
Jules Pascin. Exh. Cat. Haus der Kunst, Munich, 1969

PEAKE, MERVYN

Watney, John. *Mervyn Peake.* 1976

PEARLSTEIN, PHILIP

Philip Pearlstein. Exh. Cat. Univ. of Georgia Mus. of Art, 1970

PECHSTEIN, MAX

Fechter, P. *Das graphische Werk Max Pechsteins.* Berlin, 1921
Lemmer, K. *Max Pechstein und der Beginn des Expressionismus.* Berlin, 1949
Osborn, M. *Max Pechstein.* Berlin, 1922
Der Junge Pechstein. Exh. Cat. Hochschule für Bildende Kunst, Berlin, 1959

PELLAN, ALFRED

Lefebvre, Germain. *Pellan.* Toronto, 1973
Robert, Guy. *Pellan. His life and his art.* Montreal,1963

PERCEVAL, JOHN

Plant, Margaret. *John Perceval.* Melbourne, 1971

PERMEKE, CONSTANT

Avermaete, R. *Permeke.* Brussels, 1970
Haesaerts, P. *Permeke, sculpteur.* Brussels, 1939
Langui, É. *Constant Permeke.* Antwerp, 1947
Stubbe, A. *Permeke.* Brussels, 1930
Vermeylen, A. *Permeke.* Louvain, 1931
Ensor to Permeke. Nine Flemish Painters, 1880 1950. Exh. Cat. Royal Academy, London, 1971

PETTORUTI, EMILIO

Córdova Iturburu, C. *Pettoruti.* Buenos Aires, 1963
Payró, Julio E. *Emilio Pettoruti.* Buenos Aires, 1945

PEVSNER, ANTOINE

Giedion-Welcker, C. *Antoine Pevsner.* Neuchâtel, 1961
Massat, R. *Antoine Pevsner et le constructivisme.* Paris, 1956
Pevsner, Aleksei. *A Biographical Sketch of my brothers Naum Gabo and Antoine Pevsner.* Amsterdam, 1964
Naum Gabo, Antoine Pevsner. Exh. Cat. The Mus. of Modern Art, N.Y., 1948

PHOTOGRAPHIC REALISM

Battcock, Gregory (ed.). *Super Realism. A critical anthology.* 1975
Chase, Linda. *Hyperrealism.* 1975

PHOTOMONTAGE

Ades, Dawn. *Photomontage.* 1976

PICABIA, FRANCIS

Canfield, William A. *Francis Picabia. His art, life and times.* 1977
Sanouillet, M. *Picabia.* Paris, 1964
Picabia. Exh. Cat. I.C.A., London, 1964
Picabia. Exh. Cat. Grand Palais, Paris, 1975

PICASSO, PABLO

Ashton, D. (ed.) *Picasso on Art.* 1972
Barr, A. H., Jr. and Penrose, R. *Pablo Picasso, 1967–68.* Basle, n.d.
Cirlot, J. E. *Picasso: birth of a genius.* 1972
Daix, Pierre and Boudaille, G. *Picasso: the Blue and Rose periods. A catalogue raisonné 1900–1906.* 1966
— and Rosselet, Joan. *Picasso: the Cubist years 1907–1916.* 1979
Elgar, Frank and Maillard, R. *Pablo Picasso.* 1972
Gedo, Mary Mathews. *Picasso: art as autobiography.* Chicago, 1981
Geiser, B. *Pablo Picasso: 55 years of his graphic work.* 1955
Hilton, Timothy. *Picasso.* 1975
Jaffé, Hans L. C. *Pablo Picasso.* 1964
Keller, H. (ed.). *Picasso Drawings.* Basle, 1971
Leymarie, Jean. *Picasso: the artist of the century.* 1972
Longstreet, S. (ed.). *The Drawings of Picasso.* 1974
Mourlot, F. (ed.). *Picasso. Lithographs.* 1970
O'Brian, P. *Pablo Ruiz Picasso: a biography.* 1976
Penrose, Roland. *Picasso.* 1971
— *The Sculpture of Picasso.* 1967
Ramié, G. *Picasso's Ceramics.* 1975
Rubin, W. S. (ed.). *Pablo Picasso: a retrospective.* 1980
— (ed.). *Picasso in the Collection of the Museum of Modern Art.* 1972
Russell, Frank. *Picasso's Guernica.* 1980
Schiff, Gert (ed.). *Picasso: in perspective.* New Jersey, 1976
Spies, Werner. *Picasso Sculpture.* 1972
Zervos, Christian. *Pablo Picasso Œuvre.* 23 vols. 1932–
Hommage à Pablo Picasso. Gravures. Exh. Cat. Bibliothèque Nat., Paris, 1967
Hommage à Pablo Picasso. Peintures, dessins, sculptures, céramiques. Exh. Cat. Grand Palais and Petit Palais, Paris, 1967

PIGNON, ÉDOUARD

Lefèbvre, Henri. *Pignon.* Paris, 1956

PILLET, EDGARD

Fall, Georges (ed.). *Pillet.* Paris, 1967

PIPER, JOHN

Betjeman, John. *John Piper.* 1944
Rothenstein, John. *Modern English Painters. Wood to Hockney.* 1974
West, Anthony. *John Piper.* 1979
Woods, S. John. *John Piper.* 1955

PIPPIN, HORACE

Rodman, Selden. *Horace Pippin.* 1947

PISIS, FILIPPO DE

George, W. *Filippo de Pisis: Castello Estense.* Ferrara, 1951
Raimondi, G. *Filippo de Pisis.* Florence, 1952
Solmi, S. *Filippo de Pisis.* Milan, 1941

PISSARRO, LUCIEN

Meadmore, W. S. *Lucien Pissarro. Un cœur simple.* 1962

PLANSON, ANDRÉ

Mac-Orlan, Pierre. *André Planson.* Geneva, 1954

POLIAKOFF, SERGE

Ragon, M. *Poliakoff.* Paris, 1956
Vallier, D. *Serge Poliakoff.* Paris, 1959

POLLOCK, JACKSON

Friedman, B. H. *Jackson Pollock: energy made visible.* 1973
O'Connor, F. V. and Thaw, E. V. *Catalogue Raisonné of Paintings, Drawings and other works.* 4 vols. 1978
O'Hara, F. *Jackson Pollock.* 1959
Robertson, B. *Jackson Pollock.* 1960
Rose, Bernice. *Jackson Pollock, Works on Paper.* 1969
Tomassoni, Italo. *Pollock.* 1968
Jackson Pollock. Exh. Cat. The Mus. of Modern Art, N.Y., 1967

POP ART

Alloway, Lawrence. *American Pop Art.* 1974
Amaya, M. *Pop as Art. A survey of the new Super Realism.* 1965
Compton, M. *Pop Art.* 1970
Dienst, Rolf-Gunter. *Pop Art.* Wiesbaden, 1965
Finch, C. *Image as Landscape. Aspects of British art, 1950–1968.* 1969
Hunter, Sam. *Neorealismo, Assemblage, Pop Art in America.* Milan, 1969
Lippard, L. R. *Pop Art.* 1966
Lucie-Smith, E. 'Pop Art.' In Tony Richardson and Nikos Stangos (ed.), *Concepts of Modern Art,* 1974
Melville, E. *English Pop Art. Figurative art since 1945.* 1970
Pierre, José. *Pop Art: an illustrated dictionary.* 1977
Russell, J. and Gablik, S. *Pop Art Redefined.* 1969
Weber, J. *Pop Art: Happenings und neue Realisten.* Munich, 1970
Wilson, Simon. *Pop.* 1974
Mixed Media and Pop Art. Exh. Cat. Albright-Knox Art Gal., Buffalo, 1963
The Popular Image Exhibition. Exh. Cat. Washington Gal. of Modern Art, 1963
American Pop Art. Exh. Cat. Stedelijk Mus., Amsterdam, 1964
Neue Realisten und Pop Art. Exh. Cat. Akad. der Künste, Berlin, 1964
Pop Art. Exh. Cat. Arts Council of Great Britain, 1969
Pop Art in England. Exh. Cat. Kunstverein, Hamburg, and Arts Council of Great Britain, 1976

POUGNY, JEAN

Berninger, H. and Cartier, J.-A. *Pougny. Catalogue de l'œuvre Russie-Berlin 1910–1923.* Tübingen, 1972
Gindertael, R. Van. *Pougny.* Geneva, 1957
Pougny. Exh. Cat. Kunsthaus, Zürich, 1975

POUSETTE-DART, RICHARD

Monte, James K. *Richard Pousette-Dart.* 1974
Tuchman, Maurice (ed.). *The New York School. Abstract Expressionism in the 40s and 50s.* 1971

638 SELECTIVE BIBLIOGRAPHY

PRAMPOLINI, ENRICO

Courthion, P. *Enrico Prampolini*. Rome, 1957
Menna, F. *Enrico Prampolini*. Rome, 1967
Pfister, F. *Enrico Prampolini*. Milan, 1940

PRESTON, MARGARET

Smith, U. *Margaret Preston's Monotypes*. Sydney, 1949
Margaret Preston. Exh. Cat. Art Gal. of N.S.W., 1942

PRIMARY STRUCTURES

*Primary Structures: younger American and British
sculptors*. Exh. Cat. Jewish Mus., N.Y., 1966

PRYDE, JAMES

Hudson, Derek. *James Pryde, 1866-1941*. 1949

PURISM

Green, Christopher. 'Purism.' In Tony Richardson and
Nikos Stangos (ed.), *Concepts of Modern Art*, 1974
Le Corbusier and Ozenfant, A. 'Purism.' In R. L.
Herbert (ed.), *Modern Artists on Art*, Englewood
Cliffs, 1964
Osborne, Harold. *Abstraction and Artifice in Twentieth-
Century Art*. 1979

PURRMANN, HANS

Gerke, F. (ed.). *Hans Purrmann. Gemälde,
Handzeichnungen und Druckgraphik aus der
Sammlung Franz-Josef Kohl-Weigand*. Mainz, 1966
Göpel, E. *Leben und Meinung des Malers Hans
Purrmann*. Wiesbaden, 1961

PUVREZ, HENRI

Avermaete, Roger. *Henri Puvrez*. Antwerp, 1950

PUY, JEAN

Gay, P. *Jean Puy*. Paris, 1944

RABIN, OSKAR

Sjeklocha, Paul and Mead, Igor. *Unofficial Art in the
Soviet Union*. Berkeley and Los Angeles, 1967

RAMAH, HENRI-FRANÇOIS

Roberts-Jones, Philippe. *Ramah*. Brussels, 1968

RAUSCHENBERG, ROBERT

Forge, Andrew. *Rauschenberg*. 1970
Wissmann, Jürgen. *Robert Rauschenberg*. Stuttgart,1970
Robert Rauschenberg. Exh. Cat. Jewish Mus., N.Y.,1963
*Robert Rauschenberg. Paintings, drawings, and
Combines, 1949-1964*. Exh. Cat. Whitechapel Art
Gal., London, 1964
Rauschenberg. Cat. Smithsonian Inst., Washington,
1977
Robert Rauschenberg. Exh. Cat. Tate Gal., London,
1981

RAY, MAN

Penrose, Roland. *Man Ray*. 1975
Ray, Man. *Self Portrait*. 1963
Ribemont-Dessaigne, Georges. *Man Ray*. Paris, 1924
Schwarz, Arturo. *Man Ray*. 1977
Man Ray. Exh. Cat. Los Angeles County Mus. of Art,
1966
Man Ray. Exh. Cat. New York Cultural Center and
I.C.A., London, 1975

RAYONISM

Eganburi, Eli. *Natalia Goncharova. Mikhail Larionov*.
Moscow, 1913

Marcadé, V. *Le Renouveau de l'art pictural russe, 1863-
1914*. Lausanne, 1972
Osborne, Harold. *Abstraction and Artifice in Twentieth-
Century Art*. 1979

REBEYROLLE, PAUL

Descargues, P. *Rebeyrolle*. Paris, 1970

REDER, BERNARD

Rewald, John. *Sculptures and Woodcuts of Reder*.
Florence, 1957
Bernard Reder. Exh. Cat. Whitney Mus. of American
Art, 1961
Bernard Reder. Retrospective. Exh. Cat. Tel Aviv Mus.
of Art, 1963

REDPATH, ANNE

Bruce, George. *Anne Redpath*. Edinburgh, 1974

REINHARDT, AD

Ad Reinhardt. Exh. Cat. Jewish Mus., N.Y., 1967

RENQVIST, TORSTEN

Ellenius, A. *Torsten Renqvist*. Stockholm, 1964

RETH, ALFRED

George, W. *Alfred Reth*. Paris, 1955

REVERÓN, ARMANDO

Boulton, Alfredo. *La obra de Armando Reverón*.
Caracas, 1966

RICHARDS, CERI

Rothenstein, John. *Modern English Painters. Wood to
Hockney*. 1974
Sanesi, Roberto. *The Graphic Works of Ceri Richards*.
Milan, 1973
Thompson, David. *Ceri Richards*. 1963
Ceri Richards. Exh. Cat. Marlborough New London
Gal., 1965

RICHIER, GERMAINE

Cassou, Jean. *Germaine Richier*. Berlin, 1961
Crispolti, Enrico. *Germaine Richier*. Milan, 1968
Germaine Richier. Exh. Cat. Gimpel Fils, London, 1975

RICHTER, HANS

Richter, Hans. *Autobiography*. Neuchâtel, 1965
— *Dada: art and anti-art*. 1966
Hans Richter. Ein Leben für Bild und Film. Exh. Cat.
Kunstgewerbemus., Zürich, 1959
Hans Richter. 40 Jahr Rollenbild. Exh. Cat. Folkwang
Mus., Essen, 1961

RIEDL, FRITZ

Pack, Claus. *Die Bildteppiche von Fritz Riedl*. Vienna,
1962

RILEY, BRIDGET

De Sausmarez, Maurice. *Bridget Riley*. 1970
Rothenstein, John. *Modern English Painters. Wood to
Hockney*. 1974
Bridget Riley. Paintings and drawings. Exh. Cat. Arts
Council of Great Britain, 1971 and 1973

RIOPELLE, JEAN-PAUL

Robert, Guy. *Riopelle; ou, La Poétique du geste*.
Montreal, 1970
Schneider, Pierre. *Riopelle, signes mêlés*. Paris, 1972

RIVERA, DIEGO

De la Torriente, Lolo. *Memoria y razón de Diego Rivera*. Mexico City, 1959
Gual, E. F. *D. Rivera*. Buenos Aires, 1966
Secker, H. F. *Diego Rivera*. Dresden, 1957
Wolfe, Bertram D. *The Fabulous Life of Diego Rivera*. 1968

RIVERS, LARRY

Hunter, Sam. *Larry Rivers*. 1969
Larry Rivers. Exh. Cat. Rose Art Mus., Brandeis Univ., 1965
Larry Rivers. Exh. Cat. Art Inst. of Chicago, 1970
Larry Rivers. Exh. Cat. Gimpel Fils, London, 1977

ROBERTS, WILLIAM

Rothenstein, John. *Modern English Painters. Lewis to Moore*. 1976 (1956)
William Roberts. A retrospective exhibition. Exh. Cat. Tate Gal., London, 1965

RODCHENKO, ALEKSANDR

Elliott, David (ed.). *Alexander Rodchenko*. Oxford, 1979
Karginov, German. *Rodchenko*. 1979

ROHLFS, CHRISTIAN

Vogt, Paul. *Christian Rohlfs*. Cologne, 1956
— (ed.). *Christian Rohlfs. Aquarelle und Zeichnungen*. 2 vols. Recklinghausen, 1958–60

ROHNER, GEORGES

Rey, Robert. *Georges Rohner*. Paris, 1957

ROSAI, OTTONE

Parronchini, P. *Ottone Rosai*. Milan, 1941
Santini, P. C. *Ottone Rosai*. Florence, 1960

ROSENQUIST, JAMES

James Rosenquist. Exh. Cat. Nat. Gal. of Canada, Ottawa, 1968

ROSSO, MEDARDO

Borghi, M. *Medardo Rosso*. Milan, 1950
Papini, Giovanni. *Medardo Rosso*. Milan, 1945
Soffici, A. *Medardo Rosso*. Florence, 1929
Medardo Rosso. Exh. Cat. The Mus. of Modern Art, N.Y., 1963

ROSZAK, THEODORE

Theodore Roszak. Exh. Cat. Walker Art Center, Minneapolis, 1956

ROTHKO, MARK

Seldes, Lee. *The Legacy of Mark Rothko*. 1978
Waldman, Diane. *Mark Rothko*. 1978
Mark Rothko. Exh. Cat. The Mus. of Modern Art, N.Y., 1961
Mark Rothko. Exh. Cat. Whitechapel Art Gal., London, 1961
Mark Rothko. Exh. Cat. Nationalgal., Berlin, 1971

ROUAULT, GEORGES

Chapon, François. *Rouault. Œuvre gravé*. Monte Carlo, 1978
Courthion, P. *Georges Rouault*. 1978 (1962)
Dorival, B. *Georges Rouault*. Paris, 1956
Venturi, Lionello. *Georges Rouault*. Lausanne, 1959
Rouault. Exh. Cat. Mus. Nat. d'Art Moderne, Paris, 1971

ROUSSEAU, HENRI

Alley, R. *Portrait of a Primitive: the art of Henri Rousseau*. Oxford, 1978
Bouret, Jean. *Henri Rousseau*. Greenwich, Conn., 1961
Keay, C. *Henri Rousseau*. 1976
Perruchot, H. *Le Douanier Rousseau*. Paris, 1957
Rich, Daniel Catton. *Henri Rousseau*. 1942
Salmon, A. *Henri Rousseau dit le Douanier*. Paris, 1927
Uhde, W. *Henri Rousseau*. Dresden, 1921
Vallier, D. *Henri Rousseau*. 1964
Henri Rousseau. Exh. Cat. The Mus. of Modern Art, N.Y., 1964

ROUSSEL, KER-XAVIER

Werth, L. *Ker-Xavier Roussel*. Paris, 1930

RUSSIA AND THE U.S.S.R.

Belloli, C. *Il contributo russo alle avanguardia plastiche*. Milan, 1964
Bowlt, J. *Russian Art of the Avant-garde: theory and criticism 1902–1934*. 1977
Gibian, G. and Tjalsma, H. W. (ed.). *Russian Modernism*. Ithaca, 1976
Gray, Camilla. *The Great Experiment: Russian art, 1863–1922*. 1962
Hamilton, G. H. *The Art and Architecture of Russia*. 1954
Krascennibbicowa, M. Gibellino. *L'arte russa moderna e contemporanea*. Rome, 1960
Rice, T. Talbot. *A Concise History of Russian Art*. 1963
Sjeklocha, Paul and Mead, Igor. *Unofficial Art in the Soviet Union*. Berkeley and Los Angeles, 1967
Uman'sky, K. *Neue Kunst in Russland, 1914–1919*. Potsdam, 1920
Two Decades of Experiment in Russian Art, 1902–1922. Exh. Cat. Grosvenor Gal., London, 1962
Russian Avant-garde 1908–1922. Exh. Cat. Leonard Hutton Gal., N.Y., 1971
Von der Fläche zum Raum/From Surface to Space. Russland/Russia 1916–24. Exh. Cat. Gal. Gmurzynska, Cologne, 1975

RUSSOLO, LUIGI

Russolo, M. Z. *Russolo, l'uomo, l'artista*. Milan, 1958

RYBACK, ISSACHAR

Cogniat, Raymond. *I. Ryback*. Paris, 1934

RYSSELBERGHE, THÉO VAN

Pogu, G. *Théo van Rysselberghe*. Paris, 1963

SAEDELEER, VALERIUS DE

Walravens, Jan. *Valerius de Saedeleer*. Antwerp, 1949

SALON DES INDÉPENDANTS

Coquiot, Gustave. *Les Indépendants, 1884–1920*. Paris, 1921

SAMARAS, LUCAS

Samaras, Selected Works. 1960–1966. Exh. Cat. Pace Gal., N.Y., 1966
Lucas Samaras. Samaras Album: Autointerview, Autobiography, Autopolaroid. Whitney Mus. of American Art, 1971

SANTOMASO, GIUSEPPE

Apollonio, U. *Giuseppe Santomaso*. Amriswil, 1959
Haftmann, Werner. *Santomaso*. Bari, 1964
Marchiori, G. *Santomaso*. Venice, 1954
Venturi, Lionello. *Santomaso*. Rome, 1955

SAVINIO, ALBERTO

Alberto Savinio. Exh. Cat. Gissi Gal., Turin, 1967

SCHEIBE, RICHARD

Redslob, E. *Richard Scheibe.* Berlin, 1955

SCHIELE, EGON

Benesch, Otto. *Egon Schiele as a Draughtsman.* Vienna, 1950
Comini, A. *Egon Schiele's Portraits.* 1975
— *Schiele in Prison.* 1974. Prison diary and drawings while interned.
Fischer, W. and Rose, Hans (ed.). *Egon Schiele. Drawings and watercolours.* 1969
Kallir, Otto. *Egon Schiele.* 1966
Künstler, G. *Egon Schiele als Graphiker.* Vienna, 1946
Mitsch, Erwin. *The Art of Egon Schiele.* 1975
Nirenstein, Otto. *Egon Schiele. Persönlichkeit und Werk.* Vienna, 1930
Roessler, A. *Erinnerungen an Egon Schiele.* Vienna, 1922
Whitford, Frank. *Egon Schiele.* 1981
Wilson, Simon. *Egon Schiele.* 1980
Gustav Klimt and Egon Schiele. Exh. Cat. Solomon R. Guggenheim Mus., N.Y., 1965
Egon Schiele. Drawings and watercolours. Exh. Cat. Marlborough Fine Art, London, 1979

SCHIRREN, FERDINAND

Voorde, Urbain van de. *Ferdinand Schirren.* Brussels, 1963

SCHJERFBECK, HELENE

Johansson, G. (ed.). *Helene Schjerfbeck.* Helsinki, 1945

SCHLEMMER, OSKAR

Hildebrandt, H. *Oskar Schlemmer.* Munich, 1952
Maur, Karin von. *Oskar Schlemmer.* 2 vols. Munich, 1980. With catalogue raisonné.
Schlemmer, Oskar. *Briefe und Tagebücher.* Munich, 1958

SCHMIDT-ROTTLUFF, KARL

Grohmann, W. *Karl Schmidt-Rottluff.* Stuttgart, 1956
Rathenau, E. (ed.). *Karl Schmidt-Rottluff. Das graphische Werk seit 1923.* 1964
Schapiro, R. *Karl Schmidt-Rottluff: graphische Werk bis 1923.* Berlin, 1924

SCHNEIDER, GÉRARD

Gérard Schneider. Exh. Cat. Kootz Gal., N.Y., 1958

SCHÖFFER, NICOLAS

Habasque, G. and Ménétrier, J. *Nicolas Schöffer.* Neuchâtel, 1963
Schöffer, Nicolas. *La Tour-lumière cybernétique.* Paris, 1973

SCHOLZ, WERNER

Gadamer, H. G. *Werner Scholz.* Recklinghausen, 1968

SCHRIMPF, GEORG

Pfortner, M. *Georg Schrimpf.* Berlin, 1940

SCHRÖDER-SONNENSTERN, FRIEDRICH

Gorsen, P. *Friedrich Schröder-Sonnenstern: eine Interpretation.* Frankfurt, 1962

SCHUMACHER, EMIL

Sylvanus, E. *Emil Schumacher.* Recklinghausen, 1959
Emil Schumacher. Exh. Cat. Westfälischer Kunstverein, Münster, 1962

SCHWITTERS, KURT

Berggruen & Cie. *Kurt Schwitters: collages.* Paris, 1954. Includes text by Schwitters.
Merz. 1972. Catalogue of paintings, collages and sculptures.
Schmalenbach, Werner. *Kurt Schwitters. Leben und Werk.* Cologne, 1967
Steinitz, K. T. *Kurt Schwitters. Erinnerungen aus den Jahren 1918–30.* Zürich, 1963. Eng. trans., 1968
Themerson, S. *Kurt Schwitters in England.* 1958
Kurt Schwitters. Retrospective. Exh. Cat. Marlborough-Gerson Gal., N.Y., 1965

SCIALOJA, TOTI

Dorfles, G. *Scialoja.* Rome, 1959

SCIPIONE

Apollonio, U. *Scipione.* Venice, 1945
Marchiori, G. *Scipione.* Milan, 1939

SCOTT, WILLIAM

Alley, R. *William Scott.* 1963
Bowness, Alan (ed.). *William Scott. Paintings.* 1964
William Scott. Paintings, drawings and gouaches. Exh. Cat. Tate Gal., London, 1972

SEAGO, EDWARD

Edward Seago, 1910–1974. Exh. Cat. Marlborough Fine Art, London, 1974

SEARLE, RONALD

Bock, Henning and Dehaye, Pierre. *Ronald Searle.* 1978

SEGAL, GEORGE

Seitz, William, *George Segal.* 1972
Dine, Oldenburg, Segal. Exh. Cat. Art Gal. of Toronto, 1967
George Segal. 12 Human Situations. Exh. Cat. Mus. of Contemporary Art, Chicago, 1968

SEMANTIC ART

Lattanzi, L. *Semantic Painting.* 1962

SEOANE, LUIS

García-Sabell, D. *Luis Seoane.* Vigo, 1954

SÉRAPHINE

Uhde, Wilhelm. *Cinq maîtres primitifs.* Paris, 1949

SÉRUSIER, PAUL

Chassé, C. *The Nabis and their Period.* Eng. trans., 1969
Denis, Maurice. *Sérusier, sa vie, son œuvre.* Paris, 1943
Sérusier, Paul. *L'ABC de la peinture.* Paris, 1950 (1921)

SERVAES, ALBERT

Bruyne, Edgar de. *Servaes.* Brussels, 1932
Huys, P. *Albert Servaes. Een kunstenaarsloopbaan (op dokumenten van Georges Chabot).* Ghent, 1962
Muls, J. and Bossche, Louis van den. *Albert Servaes.* Bruges, 1926

SERVRANCKX, VICTOR

Bilcke, Maurits. *Servranckx.* Brussels, 1964
Duchateau, Marcel. *Servranckx.* 1964
Victor Servranckx. Retrospective. Exh. Cat. Mus. d'Ixelles, Brussels, 1965

SEVERINI, GINO

Courthion, P. *Severini.* Milan, 1945
Pacini, P. *Gino Severini.* Florence, 1966

Severini, Gino. *Du cubisme au classicisme. Esthétique du compas et du nombre.* Paris, 1921
— *Témoignages. 50 ans de réflexion.* Rome, 1963
Venturi, Lionello. *Gino Severini.* Rome, 1961
Gino Severini. Exh. Cat. Boymans-van Beuningen Mus., Rotterdam, 1963

SHAHN, BEN

Morse, John D. (ed.). *Ben Shahn.* 1972. Illustrated anthology of his writings.
Shahn, Ben. *The Shape of Content.* Cambridge, Mass., 1957
Shahn, Bernarda B. *Ben Shahn.* 1972
Soby, J. T. *Ben Shahn.* 1963
— *Ben Shahn: his graphic art.* 1957

SHEELER, CHARLES

Dochterman, Lillian. *The Quest of Charles Sheeler.* Iowa City, 1963
Rourke, Constance. *Charles Sheeler. Artist in the American tradition.* 1938
Sheeler. Exh. Cat. The Mus. of Modern Art, N.Y., 1939
Charles Sheeler. A retrospective exhibition. Exh. Cat. Univ. of California at Los Angeles Art Gal., 1954
Charles Sheeler. Exh. Cat. Smithsonian Inst., Washington, 1968

SHINN, EVERETT

Perlman, B. B. *The Immortal Eight. American painting from Eakins to the Armory Show.* 1962
New York Realists. Exh. Cat. Whitney Mus. of American Art, 1937
The Eight. Exh. Cat. Brooklyn Mus., 1943

SICKERT, WALTER

Baron, Wendy, *Sickert.* Oxford, 1973
Browse, Lillian. *Sickert.* 1960
Emmons. R. *The Life and Opinions of Walter Richard Sickert.* 1941
Lilly, Marjorie. *Sickert. The painter and his circle.* 1971
Sickert, Walter. *A Free House! or, the Artist as Craftsman.* Ed. Osbert Sitwell. 1947
Sutton, Denys. *Walter Sickert: a biography.* 1976
Woolf, Virginia. *Walter Sickert. A conversation.* 1934

SINGIER, GUSTAVE

Charbonnier, G. *Singier.* Paris, 1957

SIQUEIROS, DAVID ALFARO

De Micheli, Mario. *Siqueiros.* 1968
Reed, Alma. *The Mexican Muralists.* 1960
Rodríguez, Antonio. *Siqueiros.* Mexico City, 1974
Tibol, Raquel. *David Alfaro Siqueiros.* 1969

SIRONI, MARIO

Anceschi, L. *Mario Sironi.* Milan, 1944
Pica, A. *Mario Sironi, Painter.* Milan, 1955
Valsecchi, M. *Mario Sironi.* Rome, 1962

SITNIKOV, VASILY

Sjeklocha, Paul and Mead, Igor. *Unofficial Art in the Soviet Union.* Berkeley and Los Angeles, 1967

SLEVOGT, MAX

Imiela, H. J. *Max Slevogt.* Karlsruhe, 1968
Sievers, J. and Waldmann, E. *Max Slevogt. Das druckgraphische Werk.* Heidelberg, 1962–
Waldmann, E. *Max Slevogt.* Berlin, 1923

SLOAN, JOHN

Brooks, Van Wyck. *John Sloan. A painter's life.* 1955
Gallatin, A. E. *John Sloan.* 1924
Morse, Peter. *John Sloan's Prints.* New Haven, 1969. Catalogue raisonné and bibliography.
St. John, Bruce. *John Sloan.* 1971
— (ed.). *John Sloan's New York Scene.* 1965
Sloan, Helen Farr. *American Art Nouveau. The poster period of John Sloan.* Lock Haven, Pa., n.d.
— *The Life and Times of John Sloan.* Wilmington, Del., 1961
Sloan, John. *John Sloan.* 1945
John Sloan, 1871–1951. Exh. Cat. Whitney Mus. of American Art, 1951
The Art of John Sloan. Exh. Cat. Bowdoin College, Brunswick, Maine, 1962
John Sloan, 1871–1951. Exh. Cat. Nat. Gal. of Art, Washington, 1971

SLUYTERS, JAN

Wessem, J. N. van. *Jan Sluyters.* Amsterdam, 1966

SMET, GUSTAVE DE

Hecke, P. G. van and Langui, É. *Gustave de Smet, sa vie et son œuvre.* Brussels, 1945
Puyvelde, Leo van. *Gustave de Smet.* Antwerp, 1949
Gustave de Smet. Retrospective. Exh. Cat. Palais des Beaux-Arts, Brussels, 1950
Gustave de Smet. A retrospective exhibition. Exh. Cat. Koninklijk Mus. voor Schone Kunsten, Antwerp, 1961
Ensor to Permeke. Nine Flemish Painters, 1880–1950. Exh. Cat. Royal Academy, London, 1971
Ensor–Magritte. Exh. Cat. Palais des Beaux-Arts, Brussels, 1975

SMITH, DAVID

Gray, Cleve (ed.). *David Smith.* 1968
Hunter, Sam. *David Smith.* The Mus. of Modern Art Bulletin, Vol. 25, No. 1, 1957
Krauss, Rosalind E. *Terminal Iron Works: the sculpture of David Smith.* 1971
McCoy, Garnett. *David Smith.* 1973. With letters etc. by the artist.
David Smith. Exh. Cat. Los Angeles County Mus. of Art, 1965
David Smith. Exh. Cat. Fogg Art Mus., Cambridge, Mass., 1966
David Smith. Exh. Cat. Tate Gal., London, 1966
David Smith. Exh. Cat. Solomon R. Guggenheim Mus., N.Y., 1969

SMITH, GRACE COSSINGTON

Grace Cossington Smith. Exh. Cat. Art Gal. of N.S.W., 1973

SMITH, JACK

Jack Smith. Paintings and drawings 1949–1976. Sunderland, 1977. With interview and essays by the artist.

SMITH, MATTHEW

Hendy, Philip. *Matthew Smith.* 1962
Rothenstein, John. *Modern English Painters. Sickert to Smith.* 1976 (1952)
Matthew Smith. Paintings from 1909 to 1952. Exh. Cat. Tate Gal., London, 1953
Matthew Smith. Memorial exhibition. Exh. Cat. Royal Academy, London, 1960

SMITH, RICHARD

Richard Smith. Exh. Cat. Whitechapel Art Gal.,
London, 1966
Richard Smith. Seven exhibitions 1961–1975. Exh. Cat.
Tate Gal., London, 1975
Pop Art in England. Exh. Cat. Kunstverein, Hamburg,
and Arts Council of Great Britain, 1976

SMITH, TONY

Tony Smith. Recent sculpture. Exh. Cat. Knoedler Gal.,
N.Y., 1971. Interview with artist, chronology, etc.

SMITS, JAKOB

Haesaerts, P. *Jacob Smits.* Antwerp, 1948

SOCIÉTÉ ANONYME, INC.

*Collection of the Société Anonyme: Museum of Modern
Art, 1920.* Cat. The Mus. of Modern Art, N.Y., 1950

SOFFICI, ARDENGO

Papini, Giovanni. *Ardengo Soffici.* Milan, 1933
Soffici, Ardengo. *Ricordi di vita artistica e letteraria.*
Florence, 1931

SOLDATI, ATANASIO

Venturi, Lionello. *Soldati.* Milan, 1954

SOLDI, RAÚL

Baliari, Eduardo. *Raúl Soldi.* Buenos Aires, 1966

SONDERBORG

Hahn, O. *Sonderborg.* Stuttgart and Paris, 1964

SOTO, JESÚS RAFAEL

Boulton, Alfredo. *Soto.* Caracas, 1973

SOULAGES, PIERRE

Juin, H. *Soulages.* 1962
Sweeney, J. J. *Soulages.* 1973
Pierre Soulages. Exh. Cat. Gimpel and Hanover Gal.,
London and Zürich, 1967

SOUTH AFRICA

Alexander, F. L. *Art in South Africa: painting, sculpture
and graphic work since 1900.* Cape Town, 1962
Berman, Esmé, *Art and Artists of South Africa.* Cape
Town, 1970
— *The Story of South African Painting.* Cape Town,
1975
Jager, E. J. de. *Contemporary African Art in South
Africa.* Cape Town, 1973
Jeppe, Harold. *South African Artists 1900–1962.*
Johannesburg, 1963

SOUTINE, CHAÏM

Ancona, P. d'. *Modigliani, Chagall, Soutine, Pascin:
some aspects of Expressionism.* Milan, 1952
Castaing, M. and Leymarie, J. *Soutine.* 1963
Forge, Andrew. *Soutine.* 1965
Szittya, Emil. *Soutine et son temps.* Paris, 1955
Werner, Alfred. *Soutine.* 1978
Soutine. Exh. Cat. The Mus. of Modern Art, N.Y.,
1950
Chaïm Soutine, 1894–1943. Exh. Cat. Arts Council of
Great Britain, 1963
Chaïm Soutine. Exh. Cat. Marlborough-Gerson Gal.,
N.Y., 1973

SOYER, MOSES AND RAPHAEL

Foster, J. K. *Raphael Soyer. Drawings and watercolours.*
1968

Gutman, W. K. *Raphael Soyer. Paintings and drawings.*
1960
Smith, Bernard. *Moses Soyer.* 1944
Soyer, Moses. *Painting the Human Figure.* 1967
Soyer, Raphael. *Raphael Soyer.* 1946
Willard, Charlotte. *Moses Soyer.* Cleveland, 1962
Raphael Soyer. Exh. Cat. Whitney Mus. of American
Art, 1967

SPAIN

Aguilera Cerni, Vicente. *Panorama del nuevo arte
español.* Madrid, 1966
Areán, Carlos Antonio. *La escuela pictorica
barcelonesa.* Madrid, 1961
— *Joven figuracion en España.* Madrid, 1963
— *Veinte años de pintura de vanguardia en España.*
Madrid, 1961
Bozal, Valeriano. *El realismo entre el desarrollo y el
subdesarrollo.* Madrid, 1966
— *El realismo plastico en España de 1900 a 1936.*
Madrid, 1967
Campoy, Antonio Manuel. *Pintores españoles
contemporaneos.* Madrid, 1968
Cirlot, J. E. *Pintura catalana contemporanea.* Barcelona,
1961
Galván, José Moreno. *Introduccion a la pintura española
actual.* Madrid, 1959
— *Spanish Painting: the latest avant-garde.* Eng. trans.,
n.d.
García-Viñó, Manuel. *Pintura española neofigurativa.*
Madrid, 1968
Gaya Nuño, Juan Antonio. *La pintura española del
medio siglo.* Barcelona, 1952
Larco, Jorge. *La pintura española moderna y
contemporanea.* Madrid, 1964
Rodríguez Aguilera, Cesáreo. *Antologia española de
arte contemporáneo.* Barcelona, 1955
Before Picasso, after Miró. Exh. Cat. The Mus. of
Modern Art, N.Y., 1960
New Spanish Painting and Sculpture. Exh. Cat. Solomon
R. Guggenheim Mus., N.Y., 1960 and 1966

SPAZIALISMO

Giani, G. *Spazialismo.* Milan, 1956

SPAZZAPAN, LUIGI

Venturi, Lionello. *Luigi Spazzapan.* Rome, 1960

SPENCER, STANLEY

Collis, Maurice Stewart. *Stanley Spencer. A biography.*
1962
Leder, Carolyn (ed.). *Stanley Spencer Diary.* 1976
Robinson, D. *Stanley Spencer.* 1979
Rothenstein, E. *Stanley Spencer.* 1945
Rothenstein, John (ed.). *Stanley Spencer.* 1979
Spencer, Gilbert. *Stanley Spencer, by his brother Gilbert.*
1961
Stanley Spencer, R. A. Exh. Cat. Royal Academy,
London, 1980

SPILLIAERT, LÉON

Edebau, F. *Léon Spilliaert.* Antwerp, 1950
Haesaerts, P. *Léon Spilliaert.* Brussels, 1941
Spilliaert. Exh. Cat. Palais des Beaux-Arts, Charleroi,
1961
Ensor to Permeke. Nine Flemish Painters, 1880–1950.
Exh. Cat. Royal Academy, London, 1971
Ensor-Magritte. Exh. Cat. Palais des Beaux-Arts,
Brussels, 1975

SPYROPOULOS, JANNIS

Christou, Chryanthou. *Jannis Spyropoulos*. Athens, 1962
Spitéris, Tony. *Jean Spyropoulos*. Athens, 1958

STAËL, NICOLAS DE

Cooper, Douglas. *Nicolas de Staël*. 1961
Duthuit, G. *Nicolas de Staël*. Paris, 1950
Gindertael, Roger Van. *Nicolas de Staël*. Paris, 1951
Lecuire, P. *Voir Nicolas de Staël*. Paris, 1953
De Staël. A retrospective exhibition. Exh. Cat. Mus. of Fine Arts, Boston, 1965
Nicolas de Staël. Exh. Cat. Mus. de Colmar, 1977

STAMOS, THEODOROS

Sawyer, Kenneth B. *Stamos*. Paris, 1960

STANČIĆ, MILJENKO

Krleža, Miroslav. *M. Stančić*. Zagreb, 1964

STEER, PHILIP WILSON

Ironside, Robin. *Wilson Steer*. 1943
Laughton, Bruce. *Philip Wilson Steer 1860–1942*. Oxford, 1971
MacColl, D. S. *Life, Work and Setting of Philip Wilson Steer*. 1945

STEINBERG, SAUL

Steinberg, Saul. *The Art of Living*. 1952
— *Steinberg. Dessins*. Paris, 1955
Steinberg: Zeichnungen und Collagen. Exh. Cat. Kunsthalle, Hamburg, 1968

STEINLEN, THÉOPHILE-ALEXANDRE

Aveline, C. *Steinlen*. Paris, 1926
Jourdain, F. *Un grand imagier, Alexandre Steinlen*. Paris, 1954

STELLA, FRANK

Rosenblum, Robert. *Frank Stella*. 1971
Rubin, W. S. *Frank Stella*. 1970
Three American Painters. Kenneth Noland, Jules Olitski, Frank Stella. Exh. Cat. Fogg Art Mus., Cambridge, Mass., 1965
Frank Stella. Exh. Cat. Arts Council of Great Britain, 1970
Frank Stella since 1970. Exh. Cat. Fort Worth Art Mus., 1978. With bibliography.

STELLA, JOSEPH

Baur, John I. H. *Joseph Stella*. 1971
Jaffé, Irma B. *Joseph Stella*. Cambridge, Mass., 1970

STENBERG, VLADIMIR

Nakov, A. B. *Stenberg*. Paris, 1975
Russian Constructivism: Laboratory Period. Exh. Cat. Art Gal. of Ontario, Toronto, 1975

STIEGLITZ, ALFRED

Frank, Waldo (ed.). *America and Alfred Stieglitz. A collective portrait*. 1934
Homer, William Innes. *Alfred Stieglitz and the American Avant-garde*. 1977
Norman, Dorothy. *Alfred Stieglitz. Introduction to an American seer*. 1960

STIJL, DE

Frampton, Kenneth. 'De Stijl.' In Tony Richardson and Nikos Stangos (ed.), *Concepts of Modern Art*, 1974
Jaffé, Hans L. C. *De Stijl*. Eng. trans., 1970

Mondrian, Piet. *Plastic Art and Pure Plastic Art, 1937, and other essays, 1941–1943*. 1945
Overy, Paul. *De Stijl*. 1969
De Stijl. Exh. Cat. Stedelijk Mus., Amsterdam, 1951
De Stijl. Exh. Cat. The Mus. of Modern Art, N.Y., 1953

STILL, CLYFFORD

Clyfford Still. Exh. Cat. Inst. of Contemporary Art, Univ. of Pennsylvania, Pa., 1963
Clyfford Still. Exh. Cat. Albright-Knox Art Gal., Buffalo, 1966

STRZEMINSKI, WŁADYSŁAW

Constructivism in Poland. Exh. Cat. The Mus. of Modern Art, N.Y., 1976

STUCK, FRANZ VON

Ostini, Fritz von. *Das Gesamtwerk Franz von Stucks*. Munich, 1909
Singer, H. W. (ed.). *Zeichnungen von Franz Stuck*. Leipzig, 1912

STUPICA, GABRIJEL

Bihalji-Merin, Oto. *Gabrijel Stupica. Seine Brautbilder und Selbstporträts*. Brussels, 1964
Menaše, Luc. *Gabrijel Stupica*. Ljubljana, 1959

STURM, DER

Schreyer, L. *Erinnerungen an Sturm und Bauhaus*. Munich, 1956

SUGAÏ, KUMI

Pieyre de Mandiargues, André. *Sugaï*. Paris, 1960
Kumi Sugaï. Exh. Cat. Kestner-Gesellschaft, Hanover, 1963

SUPERREALISM

Lucie-Smith, E. *Super Realism*. 1979

SURREALISM

Balakian, Anna. *Surrealism: the road to the absolute*. 1972 (1959)
Breton, André. *Manifestoes of Surrealism*. Eng. trans., Michigan, 1969
— *What is Surrealism?* 1978. Selected writings introduced by Franklin Rosemont.
Gascoyne, David. *A Short Survey of Surrealism*. 1935
Haslam, M. *The Real World of the Surrealists*. 1978
Henning, Edward B. *The Spirit of Surrealism*. Cleveland Mus. of Art and Indiana U.P., 1979
Jean, Marcel. *The History of Surrealist Painting*. Eng. trans., 1960
Matthews, J. H. *The Imagery of Surrealism*. 1977
Nadeau, Maurice. *The History of Surrealism*. Eng. trans., 1973
Passeron, René. *Phaidon Encyclopedia of Surrealism*. Oxford, 1978
Picon, Gaetan. *Surrealism, 1919–1939*. 1977
Ray, Paul C. *The Surrealist Movement in England*. 1971
Read, Herbert (ed.). *Surrealism*. 1936
Rubin, W. S. *Dada, Surrealism, and their Heritage*. 1968
— *Dada and Surrealist Art*. 1969
Schneede, Uwe M. *Surrealism: the movement and the masters*. 1973
Waldberg, D. *Trésors du surréalisme*. Brussels, 1968
Waldberg, P. (ed.). *Surrealism*. 1978
Wilson, Simon. *The Surrealists*. Oxford, 1974

SURVAGE, LÉOPOLD

Putnam, S. *The Glistening Bridge. Léopold Survage and the spatial problem in painting.* 1929
Léopold Survage. Exh. Cat. Yale Univ. Art Gal., New Haven, Conn., 1950

SUTHERLAND, GRAHAM

Arcangelo, F. *Graham Sutherland.* Eng. trans., 1975
Cooper, Douglas. *The Work of Graham Sutherland.* 1961
Coulonges, H. *Sutherland.* Paris, 1968
Mann, F. H. (ed.). *Graham Sutherland. Das graphische Werk 1922–1970.* Munich, 1970
Melville, Robert. *Graham Sutherland.* 1950
Quinn, Edward (ed.). *Graham Sutherland: complete graphic work.* 1979
Rothenstein, John. *Modern English Painters. Wood to Hockney.* 1974
Sackville-West, Edward. *Graham Sutherland.* 1953 (1943)
Soavi, G. *The World of Graham Sutherland.* Turin, 1973
Graham Sutherland. Exh. Cat. Tate Gal., London, 1953

SYNCHROMISM

Synchromism and Related Color Principles in American Painting, 1910–1930. Exh. Cat. Knoedler Gal., N.Y., 1965

SYNTHETISM

Rookmaaker, H. R. *Synthetist Art Theories.* Amsterdam, 1959

SYSTEMIC ART

Systemic Painting. Exh. Cat. Solomon R. Guggenheim Mus., N.Y., 1966

TACHISM

Alvard, J. and Gindertael, R. Van. *Témoignages pour l'art abstrait.* Paris, 1952
Lapoujade, R. *Les Mécanismes de fascination.* Paris, 1955
Ragon, M. *Expression et non-figuration.* Paris, 1951
Rey, Robert. *Contre l'art abstrait.* Paris, 1957
Tapié, Michel. *Un art autre.* Paris, 1952
Watelin, J. *La Peinture moderne en délire.* Paris, 1957
Zahar, M. *Le Désordre dans l'art contemporain.* Paris, 1950

TAEUBER-ARP, SOPHIE

Scheidegger, E. (ed.). *Zweiklang. Sophie Taeuber-Arp, Hans Arp.* Zürich, 1960
Schmidt, G. (ed.). *Sophie Taeuber-Arp.* Basle, 1948
Sophie Taeuber-Arp. Exh. Cat. Mus. Nat. d'Art Moderne, Paris, 1964

TAMAYO, RUFINO

Cogniat, R. *Rufino Tamayo.* Paris, 1951
Genauer, E. *Rufino Tamayo.* 1973
Goldwater, Robert. *Rufino Tamayo.* 1947
Paz, Octavio. *Tamayo en la pintura mexicana.* Mexico City, 1959
Westheim, P. *Tamayo.* Mexico City, 1957
Rufino Tamayo, Myth and Magic. Exh. Cat. Solomon R. Guggenheim Mus., N.Y., 1979

TANGUY, YVES

Sage, Kay and others. *Yves Tanguy. Un recueil de ses œuvres.* 1963
Yves Tanguy. Exh. Cat. The Mus. of Modern Art, N.Y., 1955

TANNING, DOROTHEA

Bosquet, Alain. *La Peinture de Dorothea Tanning.* Paris, 1966

TÀPIES, ANTONI

Bonet, Blai. *Tàpies.* Eng. trans., 1969
Boudaille, G. *Antoni Tàpies.* Paris, 1968
Cirici Pellicer, Alejandro. *Antoni Tàpies. Testigo del silencio.* Barcelona, 1970. Eng. trans., 1972
Cirlot, J. E. *Significación de la pintura de Tàpies.* Barcelona, 1962
— *Tàpies.* Barcelona, 1960
Gatt, Giuseppe (ed.). *Antoni Tàpies.* Bologna, 1967
Gimferrer, P. *Tàpies and the Catalan Spirit.* 1975
Linhartová, V. *Antoni Tàpies.* 1972
Penrose, R. *Tàpies.* 1974
Tapié, Michel. *Antoni Tàpies.* Barcelona, 1959
Antoni Tàpies. Exh. Cat. Solomon R. Guggenheim Mus., N.Y., 1962

TATLIN, VLADIMIR

Vladimir Tatlin. Exh. Cat. Moderna Mus., Stockholm, 1968
Art in Revolution. Exh. Cat. Arts Council of Great Britain, 1971

TCHELITCHEW, PAVEL

Kirstein, L. (ed.). *Pavel Tchelitchew. Drawings.* 1947
Tyler, Parker. *The Divine Comedy of Pavel Tchelitchew: a biography.* 1967
Tchelitchew. Exh. Cat. The Mus. of Modern Art, N.Y., 1942
Pavel Tchelitchew. Exh. Cat. The Mus. of Modern Art, N.Y., 1964

TERECHKOVITCH, KONSTANTIN

Gauthier, M. *Constantin Terechkovitch.* Geneva, 1948

THEOPHILOS, HADJIMICHALIS

Elytis, O. *The Painter Theophilos.* Athens, 1973
Makris, Kitsos. *The Painter Theophilos at Pilion.* Volos, 1939
Hadjimichalis Theophilos. Exh. Cat. Mus. des Arts Décoratifs, Paris, 1961

THÉVENET, LOUIS

Lyr, René. *Louis Thévenet.* Antwerp, 1954

THOMSON, TOM

Davies, Blodwen. *Tom Thomson.* Vancouver, 1967
Murray, Joan. *The Art of Tom Thomson.* Toronto, 1971
Reid, Dennis. *Tom Thomson: The Jack Pine.* Ottawa, 1975

THÖNY, WILHELM

Koschatzky, W. *Wilhelm Thöny. Zeichnungen und Aquarelle.* Salzburg, 1963

TILSON, JOE

Tilson. Exh. Cat. Boymans-van Beuningen Mus., Rotterdam, 1973
Pop Art in England. Exh. Cat. Kunstverein, Hamburg, and Arts Council of Great Britain, 1976

TINGUELY, JEAN

Hultén, K. G. Pontus. *Jean Tinguely, 'Méta'.* Eng. trans. 1975

TOBEY, MARK

Choay, Françoise. *Mark Tobey.* Paris, 1961
Roberts, Colette. *Mark Tobey.* 1960

Schmied, W. *Mark Tobey*. Eng. trans., 1967
Mark Tobey. Exh. Cat. Whitney Mus. of American Art, 1957
Mark Tobey. Exh. Cat. The Mus. of Modern Art, N.Y., 1962

TOMLIN, BRADLEY WALKER

Bradley Walker Tomlin. Exh. Cat. Whitney Mus. of American Art, 1957

TONKS, HENRY

Rothenstein, John. *Modern English Painters. Sickert to Smith*. 1976 (1952)

TOOROP, JAN

Janssen, M. *Jan Toorop*. Amsterdam, 1927
Knipping, John B. *Jan Toorop*. Amsterdam, 1947

TORRES-GARCÍA, JOAQUÍN

Cassou, J. *Torres-Garcia*. Paris, 1955
Jardí, Enric. *Torres-Garcia*. Eng. trans., Boston, 1974
Payró, Julio E. *Torres-Garcia*. Buenos Aires, 1966

TOSI, ARTURO

Argan, G. C. *Tosi*. Florence, 1942
George, Waldemar. *Arturo Tosi. Peintre classique et peintre rustique*. Milan, 1933
Scheiwiller, Giovanni. *Arturo Tosi*. Milan, 1942

TRÖKES, HEINZ

Grohmann, H. *Heinz Trökes*. Berlin, 1959
Linfert, Carl (ed.). *Trökes Tagenachtbuch*. Cologne, 1963

TROVA, ERNEST

Schmidt, J. R. (ed.). *Trova 1947–1972*. St. Louis, 1972
Trova. Selected Works 1953–1966. Exh. Cat. Pace Gal., N.Y., 1967

TROYER, PROSPER DE

Ghelderode, Michel de. *Prosper de Troyer*. Kortrijk, 1930
Marlier, G. *Prosper de Troyer en het Vlaams Expressionisme*. Mechelen, 1960

TUCKER, ALBERT

Uhl, Christopher. *Albert Tucker*. Melbourne, 1969

TUCULESCU, ION

Comarnescu, Petru. *Ion Tuculescu*. Eng. trans., 1973

TUNNARD, JOHN

John Tunnard. Exh. Cat. Arts Council of Great Britain, 1977

TURCATO, GIULIO

Marchis, G. de. *Giulio Turcato*. Venice, 1968

TURNBULL, WILLIAM

William Turnbull. Sculpture and painting. Exh. Cat. Tate Gal., London, 1973

TWOMBLY, CY

Cy Twombly. Bilder 1953–1972. Exh. Cat. Kunsthalle, Berne, and Städt. Gal. im Lenbachhaus, Munich, 1973

TWORKOV, JACK

Jack Tworkov. Exh. Cat. Whitney Mus. of American Art, 1964

TYTGAT, EDGARD

Dasnoy, Albert. *Edgard Tytgat. Catalogue raisonné de son œuvre peint, établi avec la collaboration de Giselle Ollinger-Zinque*. Brussels, 1965
Lebeer, L. *Edgard Tytgat, Graveur*. Brussels, 1937
Milo, J. *Edgard Tytgat*. Paris, 1930
Perre, P. van der. *Bibliographie des livres illustrés par Edgard Tytgat*. Brussels, 1931
Roelants, M. *Edgard Tytgat*. Antwerp, 1948
Edgard Tytgat. Exh. Cat. Palais des Beaux-Arts, Brussels, 1951

UECKER, GÜNTHER

Sharp, Willoughby. *Günther Uecker. 10 Years of a kineticist's work*. 1966
Wiese, Stephan von. *Guenther Uecker: Schriften*. St. Gallen, 1979

UGLOW, EUAN

Euan Uglow. Exh. Cat. Arts Council of Great Britain, 1974

ULTVEDT, PER-OLOF

Key-Aberg, S. *Per-Olof Ultvedt*. Konstrevy, 1958

UNDERWOOD, LEON

Neve, Christopher. *Leon Underwood*. 1974

UNITED STATES OF AMERICA

Agee, William C. *The 1930s: painting and sculpture in America*. 1968
Aronson, C. *Artistes américains modernes de Paris*. Paris, 1932
Ashton, Dore. *Modern American Sculpture*. 1968
Barker, Virgil. *From Realism to Reality in Recent American Painting*. 1959. Essays on the rise of non-figurative painting in America.
Baur, John I. H. *New Art in America: fifty painters of the 20th century*. 1957
— *Revolution and Tradition in Modern American Art*. Cambridge, Mass., 1951
Blesh, Rudi. *Modern Art, U.S.A.: men, rebellion, conquest, 1900–1956*. 1956
Brown, Milton W. *American Painting from the Armory Show to the Depression*. Princeton, 1955
Brumme, C. L. *Contemporary American Sculpture*. 1948
Cahill, Holger and Barr, A. H., Jr. *Art in America in Modern Times*. 1934
Cheney, Martha C. *Modern Art in America*. 1939
Cortissoz, Royal. *American Artists*. 1923
Cummings, Paul. *A Dictionary of Contemporary American Artists*. 1971
Dover, Cedric. *American Negro Art*. 1960
Duffus, R. L. *The American Renaissance*. 1928
Geldzahler, Henry. *American Painting in the Twentieth Century*. 1965
Goodrich, Lloyd and Baur, John I. H. *American Art of the Twentieth Century*. 1962
Hunter, Sam. *American Art of the 20th Century*. 1973
Janis, Sidney. *Abstract and Surrealist Art in America*. 1944
Kerber, Bernhard. *Amerikanische Kunst seit 1945. Ihre theoretischen Grundlagen*. Stuttgart, 1971
Kootz, Samuel. *Modern American Painters*. 1930
— *New Frontiers in American Painting*. 1943
Kuh, Katharine. *The Artist's Voice. Talks with seventeen artists*. 1962
Kuspit, Donald B. *Clement Greenberg, Art Critic*. Univ. of Wisconsin, 1980
Larkin, Oliver. *Art and Life in America*. 1949

UNITED STATES OF AMERICA (*cont.*)

Lewis, Samella. *Art: African American*. 1978. Black artists in America.

Motherwell, Robert and Reinhardt, Ad (ed.). *Modern Artists in America*. 1951–

Pach, Walter. *Modern Art in America*. 1928

Park, A. E. *Mural Painters in America: a biographical index*. Pittsburgh, 1949

Richman, R. (ed.). *The Arts at Mid-Century*. 1954

Rose, Barbara. *American Art since 1900*. 1967

Schnier, Jacques. *Sculpture in Modern America*. Berkeley, Calif., 1948

Smith, Ralph C. *A Biographical Index of American Artists*. Baltimore, 1930

Wheeler, M. (ed.). *Painters and Sculptors of Modern America*. 1942. Selected articles from *The Magazine of Art*.

Wight, Frederick S. *Milestones of American Painting in our Century*. 1949

Abstract Painting and Sculpture in America. Exh. Cat. The Mus. of Modern Art, N.Y., 1951

The New American Painting. Exh. Cat. The Mus. of Modern Art, N.Y., 1959

Roots of Abstract Art in America 1910–1930. Exh. Cat. Smithsonian Inst., Washington, 1965

American Sculpture of the Sixties. Exh. Cat. Los Angeles County Mus. of Art, 1967

American Art of the Mid-Century. The Subject of the Artist. Exh. Cat. Nat. Gal. of Art, Washington, 1978

UNIT ONE

Read, Herbert (ed.). *Unit One. The modern movement in English architecture, painting and sculpture*. 1934

URTEIL, ANDREAS

Andreas Urteil. Exh. Cat. Mus. des 20. Jahrhunderts, Vienna, 1963

UTRILLO, MAURICE

Carco, Francis. *Maurice Utrillo: Legende und Wirklichkeit*. Zürich, 1958

George, Waldemar. *Utrillo*. 1960

MacOrlan, P. *Utrillo*. Paris, 1952

Pétridès, P. (ed.). *L'Œuvre complète de Maurice Utrillo*. 2 vols. Paris, 1959–62

Tabarant, A. *Utrillo*. Paris, 1926

VACCHI, SERGIO

Arcangeli, F. *Sergio Vacchi*. Milan, 1959

VALADON, SUZANNE

Basler, A. *Suzanne Valadon*. Paris, 1929

— *La Trinité maudite: Valadon, Utrillo, Utter*. Paris, 1952

Mermillon, M. *Suzanne Valadon*. Paris, 1950

Storm, J. *The Valadon Drama*. 1959

VALLOTTON, FÉLIX

Godefroy, L. *L'Œuvre gravé de Félix Vallotton (1865–1925)*. Lausanne, 1932

Hahnloser, H. *Félix Vallotton, 1865–1925*. 2 vols. Zürich, 1927–8

— *Félix Vallotton et ses amis*. Paris, 1936

Jourdain, F. *Félix Vallotton. Avec . . . une bibliographie et une documentation complète*. Geneva, 1953

St. James, Ashley. *Vallotton: graphics*. 1978

VALTAT, LOUIS

Cogniat, R. *Louis Valtat*. Neuchâtel, 1963

Louis Valtat. Exh. Cat. Gal. de Paris, 1977

VANTONGERLOO, GEORGES

Vantongerloo, Georges. *Georges Vantongerloo: paintings, sculptures, reflections*. 1948

Georges Vantongerloo. Exh. Cat. Marlborough Gal., London, 1962

Georges Vantongerloo, 1886–1965. Exh. Cat. Gal. Lopes, Zürich, 1977

VASARELY, VICTOR

Dewasne, Jean. *Vasarely*. Paris, 1952

Joray, Marcel. *Vasarely*. 3 vols. Neuchâtel, 1967, 1970, 1974

VAUGHAN, KEITH

Keith Vaughan. Exh. Cat. Whitechapel Art Gal., London, 1962

VEDOVA, EMILIO

Haftmann, Werner (ed.). *Vedova: Blätter aus dem Tagebuch*. Munich, 1960

Venturi, Lionello. *Italian Painters of Today*. 1959

VELDE, BRAM VAN

Putman, J. *Bram van Velde*. Paris, 1962

— (ed.). *Bram van Velde*. 1959

Bram van Velde. Exh. Cat. Knoedler Gal., N.Y., 1962

VELDE, HENRY VAN DE

Casteels, M. *Henry van de Velde*. Brussels, 1932

Hammacher, A. M. *Le Monde de Henry van de Velde*. Antwerp and Paris, 1967

Osthaus, K. E. *Van de Velde: Leben und Schaffen des Künstlers*. Brussels, 1920

Velde, Henry van de. *Geschichte meines Lebens*. Munich, 1962

VER SACRUM

Nebehay, C. M. *Ver Sacrum, 1898–1903*. Vienna, 1976

VIEIRA DA SILVA, MARIA

Solier, René de. *Vieira da Silva*. Paris, 1956

VILLON, JACQUES

Eluard, Paul. *Jacques Villon; ou, L'Art glorieux*. Paris, 1948

Lassaigne, Jacques. *Jacques Villon*. Paris, 1950

Morel, Abbé Maurice and others. *Souvenir de Jacques Villon*. Paris, 1963

Stahly, F. *Jacques Villon: son œuvre gravé*. Zürich, 1954

Vallier, Dora. *Jacques Villon. Œuvres de 1897 à 1956*. Paris, 1957

Jacques Villon. His graphic art. Exh. Cat. The Mus. of Modern Art, N.Y., 1953

Jacques Villon. Master of graphic art. Exh. Cat. Mus. of Fine Arts, Boston, 1964

Jacques Villon. Exh. Cat. Grand Palais, Paris, 1975

VISSER, CAREL

Blok, C. *Carel Visser*. Amsterdam, 1968

VIVIANI, GIUSEPPE

Carli, E. *Giuseppe Viviani*. Florence, 1957

VIVIN, LOUIS

Jakovsky, A. *Louis Vivin*. Paris, 1953.

Uhde, Wilhelm. *Cinq maîtres primitifs*. Paris, 1949

VLAMINCK, MAURICE DE

Cabanne, P. *Vlaminck, Landscapes*. Paris, 1966

Genevoix, M. *Vlaminck. L'Homme*. Paris, 1954

Perls, K. G. *Vlaminck*. 1941
Sauvage, M. *Vlaminck, sa vie et son message*. Geneva, 1956
Selz, J. *Vlaminck*. Paris, 1966

VOLTEN, ANDRÉ
Hartsuyker, E. *André Volten*. Amsterdam, 1966

VORDEMBERGE-GILDEWART, FRIEDRICH
Arp, Jean (ed.). *Vordemberge-Gildewart: époque néerlandaise*. Amsterdam, 1949
Jaffé, Hans L. C. *Vordemberge-Gildewart. Mensch und Werk*. Cologne, 1971
Lohse, R. O. (ed.). *Vordemberge-Gildewart. Eine Bild-Biographie. Dokumente, Fotografien, Zeichnungen, und Bilder*. Ulm, 1959

VORTICISM
Cork, Richard. *Vorticism and Abstract Art in the First Machine Age*. 2 vols. 1976
Wees, William C. *Vorticism and the English Avant-garde*. 1972
Wyndham Lewis and Vorticism. Exh. Cat. Tate Gal., London, 1956
Vorticism and its Allies. Exh. Cat. Arts Council of Great Britain, 1974

VRUBEL, MIKHAIL
Iaremich, S. P. *Mikhail Aleksandrovich Vrubel: life and work*. Moscow, 1911

VUILLARD, EDOUARD
Chastel, A. *Vuillard 1868–1940*. Paris, 1946
Roger-Marx, C. *L'Œuvre gravé de Vuillard*. Monte Carlo, 1948
— *Vuillard*. 1946
Russell, J. *Vuillard*. 1971
Salomon, J. *Auprès de Vuillard*. Paris, 1953
Edouard Vuillard. Exh. Cat. The Mus. of Modern Art, N.Y., 1954

WADSWORTH, EDWARD
Cork, Richard. *Vorticism and Abstract Art in the First Machine Age*. 2 vols. 1976
Drey, O. R. *Edward Wadsworth*. 1921
George, Waldemar and others. *Edward Wadsworth*. Antwerp, 1933
Rothenstein, John. *Modern English Painters. Lewis to Moore*. 1976 (1956)
Edward Wadsworth 1889–1949. Paintings, drawings, prints. Exh. Cat. Colnaghi Gal., London, 1974

WAGEMAKER, JAAP
Doelman, C. *De informele kunst van Jaap Wagemaker*. Amsterdam, 1962

WAKELIN, ROLAND
Roland Wakelin. Retrospective. Exh. Cat. Art Gal. of N.S.W., 1967

WALCH, CHARLES
Besson, G. *Charles Walch*. Souillac-Mulhouse, 1947
Gay, Paul. *Notre ami Charles Walch*. Saint-Jeoire-en-Faucigny, 1949

WALKER, ETHEL
Ethel Walker, Frances Hodgkins, Gwen John. A memorial exhibition. Exh. Cat. Tate Gal., London, 1952

WARHOL, ANDY
Coplans, John. *Andy Warhol*. 1971. Published on occasion of retrospective exhibition at Pasadena Art Mus.
Crone, Rainer. *Andy Warhol*. 1970. Catalogue raisonné and bibliography.
Gidal, Peter. *Andy Warhol: films and paintings*. 1971
Warhol, Andy and others. *Andy Warhol*. Stockholm, 1968. Published on occasion of exhibition at Moderna Mus., Stockholm.
Andy Warhol. Exh. Cat. Tate Gal., London, 1971
Andy Warhol. Das zeichnerische Werk 1942–1975. Exh. Cat. Wurtembergerischer Kunstverein, Stuttgart, 1976

WAROQUIER, HENRI DE
Auberty, J. and Adhémar, J. *Henri de Waroquier*. Paris, 1951
Fargue, Léon-Paul. *Vingt dessins de nus de Henri Waroquier*. Paris, 1946
Laprade, P. *Henri de Waroquier*. Paris, 1927

WEBER, MAX
Cahill, Holger. *Max Weber*. 1930
Weber, Max. *Max Weber*. 1945
Max Weber. Exh. Cat. Whitney Mus. of American Art, 1949
Max Weber. Exh. Cat. Santa Barbara Art Gal., Univ. of California, 1968

WEREFKIN, MARIANNE VON
Hahl-Koch, J. *Marianne Werefkin und der russische Symbolismus*. Munich, 1967

WERKMAN, HENDRIK NICOLAAS
Hendrik Nicolaas Werkman. Exh. Cat. Stedelijk Mus., Amsterdam, 1945
Hendrik Nicolaas Werkman. Exh. Cat. Whitechapel Art Gal., London, 1975

WERNER, THEODOR
Theodor Werner. Exh. Cat. Marlborough Gal., London, 1959

WESSELMANN, TOM
Tom Wesselmann. Early still lifes 1962–1964. Exh. Cat. Newport Harbor Art Mus., 1970

WESTERIK, CO
Co Westerik. Exh. Cat. Gemeentemus., The Hague, 1964

WESTERMANN, H. C.
H. C. Westermann. Exh. Cat. Los Angeles County Mus. of Art, 1968

WHITE, CHARLES
White, C. *Images of Dignity. The drawings of Charles White*. 1967

WIEGELE, FRANZ
Milesi, R. *Franz Wiegele*. Klagenfurt, 1957

WILLIAMS, FREDERICK
Brack, John. *Four Contemporary Australian Landscape Painters*. Melbourne, 1968
— and Mollison, J. *Fred Williams: etchings*. Sydney, 1968
Kempf, F. *Contemporary Australian Printmakers*. Melbourne, 1976

WINTER, FRITZ

Haftmann, Werner. *Fritz Winter.* Berne, 1951
— *Fritz Winter. Triebkräfte der Erde.* Munich, 1957
Fritz Winter. Exh. Cat. Kunstverein, Hanover, 1966

WOESTIJNE, GUSTAVE VAN DE

Hecke, Firmin van. *Gustave van de Woestijne.* Antwerp, 1949

WOLS

Dorfles, Gillo. *Wols.* Milan, 1958
Haftmann, Werner. *Wols en personne.* 1963
Inch, Peter. *The Life and Work of Wolfgang Schulze.* Todmorden, 1978

WOOD, CHRISTOPHER

Newton, Eric. *Christopher Wood, 1901–1930.* 1938

WOOD, GRANT

Garwood, Darrell. *Artist in Iowa. A life of Grant Wood.* 1971 (1944)

WOTRUBA, FRITZ

Canetti, Elias. *Fritz Wotruba.* Vienna, 1955
Heer, Friedrich (ed.). *Fritz Wotruba.* Neuchâtel, 1961
Fritz Wotruba. Exh. Cat. Mus. des 20. Jahrhunderts, Vienna, 1963
Fritz Wotruba. Exh. Cat. Kestner-Gesellschaft, Hanover, 1967

WOUTERS, RIK

Avermaete, R. *Rik Wouters. Catalogue de l'œuvre.* Brussels, 1962
Delen, A. J. J. *Rik Wouters.* Antwerp, 1922
— *Rik Wouters. Sculptures et dessins.* Brussels, 1947
Wouters, Nel. *La Vie de Rik Wouters à travers son œuvre.* Brussels, 1944
Rik Wouters. Exh. Cat. Cercle Royale Artistique et Littéraire de Charleroi, 1947
Rik Wouters. Exh. Cat. Mus. Nat. d'Art Moderne, Paris, 1957
Rik Wouters. Retrospective. Exh. Cat. Mechelen, 1966
Ensor to Permeke. Nine Flemish Painters, 1880–1950. Exh. Cat. Royal Academy, London, 1971

WUNDERLICH, PAUL

Brusberg, Dieter (ed.). *Paul Wunderlich. Werkverzeichnis der Lithographien von 1949–1965.* Hanover, 1966

YETH, ANDREW

Pitz, Henry C. *The Brandywine Tradition.* 1969
Wyeth, A. and Meryman, R. *Andrew Wyeth.* 1968

Andrew Wyeth. Exh. Cat. Albright-Knox Art Gal., Buffalo, 1963
Andrew Wyeth. Dry brush and pencil drawings. Exh. Cat. Fogg Art Mus., Cambridge, Mass., 1963
Andrew Wyeth. Temperas, watercolors, dry brush, drawings, 1938 into 1966. Pennsylvania Academy of the Fine Arts, Pa., 1966

WYNTER, BRYAN

Bryan Wynter. Exh. Cat. Arts Council of Great Britain, 1976

ZADKINE, OSSIP

Hammacher, A. M. *Zadkine.* 1958
Jianou, I. *Zadkine.* Paris, 1964
Ossip Zadkine. Exh. Cat. Nat. Gal. of Canada, Ottawa, 1956
Zadkine. Exh. Cat. Arts Council of Great Britain, 1971
Zadkine. Exh. Cat. Mus. Rodin, Paris, 1973

ZAO WOU-KI

Roy, Claude. *Zao Wou-Ki.* Paris, 1957

ZEBRA

Die Gruppe Zebra. Exh. Cat. Gal. Defet, Nuremberg, 1969
ZEBRA. Exh. Cat. Fischer Fine Art Gal., London, 1975

ZERO

Piene, Otto and Mack, Heinz. *Zero.* Cambridge, Mass., 1973
Group Zero. Exh. Cat. Inst. of Contemporary Art, Univ. of Pennsylvania, 1964

ŽIVKOVIĆ, BOGUSAV

Bihalji-Merin, Oto. *Bogosav Živković. The world of a primitive sculptor.* 1962

ZORACH, WILLIAM

Baur, John I. H. *William Zorach.* 1959
Wingert, Paul S. *The Sculpture of William Zorach.* 1938
Zorach, William. *William Zorach.* 1945
— *Zorach Explains Sculpture.* 1947
Zorach: paintings, watercolors and drawings, 1911–1922. Exh. Cat. Brooklyn Mus., N.Y., 1969

ZULOAGA Y ZABALETA, IGNACIO

Beryes, I. de. *Ignacio Zuloaga o una manera de ver a España.* Barcelona, 1944
Lafuente Ferrari, E. *La vida y el arte de Ignacio Zuloaga.* San Sebastián, 1950

LIST OF ILLUSTRATIONS

LISTED alphabetically by artist. References are to the plate section (bold roman numeral) and illu..tration number within that section (arabic numeral). Colour illustrations are indicated by an asterisk. Other symbols denote copyright holders.

† * **Agam,** Yaacov: *Double Metamorphosis*, 1968–9. Oil on aluminium. 93 × 75 cm. (36½ × 29½ in.). Musée National d'Art Moderne, Paris. **VI-27**

‡ * **Albers,** Josef: *Homage to the Square 'Ascending'*, 1953. Oil on composition board. 110 × 110 cm. (43¼ × 43¼ in.). Collection of the Whitney Museum of American Art. **V-39**

* **Archipenko,** Alexander: *Medrano II*, 1915. Painted tin, glass, wood and oilcloth. Height 125 cm. (49¼ in.). The Solomon R. Guggenheim Museum, New York. Photo: Robert E. Mates. **II-13**

† **Arman:** *Poubelles I*, 1960. Assembled items. 65 × 40 × 10 cm. (25½ × 15¾ × 4 in.). Kaiser-Wilhelm Museum, Krefeld. **VII-10**

Armitage, Kenneth: *Children Playing*, 1953. Bronze. 23 × 32 cm. (9 × 12½ in.). Collection of the artist. **III-36**

‡ **Arp,** Jean: *Constellation*, 1932. Painted wood relief. 70 × 85 cm. (27½ × 33½ in.). Philadelphia Museum of Art: The Louise and Walter Arensberg Collection. **III-3**

‡ **Atlan,** Jean: *Warrior of Baal*, 1953. Oil on canvas. 163 × 130 cm. (64 × 51 in.). The Tate Gallery, London. **IV-21**

* **Avery,** Milton: *Mother and Child*, 1944. Oil on canvas. 102 × 78 cm. (40 × 30¾ in.). Private collection, Courtesy of Andrew Crispo Gallery, New York. **V-19**

Bacon, Francis: one of *Three Studies for Figures at the Base of a Crucifixion*, c. 1944. Oil on board. 94 × 74 cm. (37 × 29 in.). The Tate Gallery, London. **III-24**

* **Balla,** Giacomo: *Girl Running on a Balcony*. 1912. Galleria D'Arte Moderna, Milan. **II-22**

Barlach, Ernst: *The Avenger*, 1924. Bronze. 44 × 58 × 20 cm. (17½ × 22½ × 8 in.). Tate Gallery, London. **I-26**

Battiss, Walter: *Symbols of Life*. **VIII-30**

Baumeister, Willi: *Aru 2*, 1955. Oil on board. 130 × 100 cm. (51½ × 39½ in.). Leonard Hutton Galleries, New York. **IV-23**

‡ * **Bazaine,** Jean: *The Sea at Noon*, 1960. Oil on canvas. 40 × 80 cm. (15¾ × 31½ in.). Musée National d'Art Moderne, Paris. **IV-35**

* **Baziotes,** William: *White Bird*, 1957. Oil on canvas. 152 × 122 cm. (60 × 48 in.). Gift of Seymour H. Knox. Albright-Knox Art Gallery, Buffalo. **V-32**

† **Beckmann,** Max: *Departure*, 1932–3. Oil on canvas. Triptych. Centre panel: 215 × 115 cm. (84¾ in. × 45½ in.). Side panels: 215 × 101 cm. (84¾ in. × 39¾ in.). Collection, The Museum of Modern Art, New York. Given anonymously (by exchange). **I-28**

Bellows, George: *Polo at Lakewood*, 1910. Oil on canvas. 114 × 160 cm. (45 × 63 in.). Columbus Museum of Art, Ohio. **V-4**

Benton, Thomas Hart: *City Scenes: Steel*, 1930–1, Mural in tempera. New School for Social Research, New York. **V-16**

‡ **Berghe,** Frits van den: *The Prisoner*, 1927. Oil on

canvas. 103 × 82 cm. (40½ × 32¼ in.). Musée des Beaux-Arts, Liege. **I-37**

Biederman, Charles: *Structuralist Relief, Red Wing No. 20*, 1964–5. Relief in oil and metal. 105 × 91 × 15 cm. (41¼ × 36 × 6 in.). Tate Gallery, London. **VI-31**

* **Bill,** Max: *Four Stabilized White Nuclei*, 1964–71. Oil on canvas. 233 × 283 cm. (91¾ × 111½ in.). Kunsthaus, Zürich. **IV-17**

* **Blake,** Peter: *Got a Girl*, 1960–1. Oil on hardboard and wood, photo-collage and gramophone record. 92 × 152 cm. (36¼ × 59¾ in.). Whitworth Art Gallery, Manchester. **VII-7**

* **Boccioni,** Umberto: *The Rising City*, 1910. Oil on canvas. 200 × 301 cm. (78¾ × 118½ in.). Collection, The Museum of Modern Art, New York. Mrs. Simon Guggenheim Fund. **II-19**

Boccioni, Umberto: *Development of a Bottle in Space*, 1912. Silvered bronze (cast 1931). 38 × 32 × 60 cm. (15 × 12½ × 23½ in.). Collection, The Museum of Modern Art, New York. Aristide Maillol Fund. **II-6**

Bomberg, David: *The Mud Bath*, 1912–13. Oil on canvas. 152 × 224 cm. (60 × 88¼ in.). The Tate Gallery, London. **II-26**

‡ * **Bonnard,** Pierre: *Nude in the Bath*, 1935. Oil on canvas. 93 × 147 cm. (36½ × 58 in.). Musée du Petit Palais, Paris. Photo: Bulloz, Paris. **I-2**

Bontecou, Lee: *Untitled*, 1959. Canvas on a frame of welded steel. 251 × 148 × 80 cm. (98¾ × 58¼ × 31½ in.). Nationalmuseum, Stockholm. **VII-31**

Borduas, Paul-Emile: *The Seagull*, 1956. Oil on canvas. 206 × 264 cm. (81 × 104 in.). National Gallery of Canada, Ottawa. **VIII-20**

Boyd, Arthur: *The Hunter (Aboriginal Head on a Horse with Soldier)*, 1959. Oil and tempera on board. 133 × 105 cm. (52½ × 41½ in.). Fischer Fine Art Ltd., London. **VIII-27**

‡ **Brancusi,** Constantin: *Maiastra*, 1911. Bronze and stone. 90 × 17 × 18 cm. (35½ × 6¾ × 7 in.). The Tate Gallery, London. **III-31**

‡ ***Braque,** Georges: *The St. Martin Canal*, 1906. Oil on canvas. 50 × 61 cm. (19¾ × 24 in.). Christie's, London. **I-4**

‡ **Braque,** Georges: *Violin and Jug*. 1910. Oil on canvas. 117 × 73 cm. (46 × 28¾ in.). Kunstmuseum, Basle. **II-3**

‡ **Braque,** Georges: *The Black Birds*, 1957. Oil on canvas. 129 × 181 cm. (50¾ × 71¼ in.). Mme Aimée Maeght Collection, Paris. **II-37**

* **Bruce,** Patrick Henry: *Composition II*, before 1918. Oil on canvas. 97 × 130 cm. (38 × 51 in.). Yale University Art Gallery. **II-31**

‡ **Buffet,** Bernard: *Pietà*, 1946. Oil on canvas. 172 × 255 cm. (67¾ × 100½ in.). Musée National d'Art Moderne, Paris. **III-43**

Burra, Edward: *Dancing Skeletons*, 1934. Gouache. 79 × 56 cm. (31 × 22 in.). The Tate Gallery, London. **III-21**

The Publishers wish to thank the artists and their copyright holders, museums, art galleries and private collectors for their co-operation with the illustrations. The symbols in the above list represent the following copyright byelines: † © DACS 1988; ‡ © ADAGP 1988; § © ADAGP/DACS 1988; ¶ © COSMOPRESS, Geneva & DACS, London 1988; ‖ © Anthony Hill. All rights reserved DACS 1988. We would also like to thank Phaidon Press Ltd., Oxford, the Cooper-Bridgeman Library and Vision International, London, for the illustrations obtained from them. While every effort has been made to trace and clear copyright, we apologize for any instance where this has not been possible.

OXFORD

MORE OXFORD PAPERBACKS

Details of a selection of other books follow. A complete list of Oxford Paperbacks, including The World's Classics, Twentieth-Century Classics, OPUS, Past Masters, Oxford Authors, Oxford Shakespeare, and Oxford Paperback Reference, is available in the UK from the General Publicity Department, Oxford University Press (JN), Walton Street, Oxford OX2 6DP.

In the USA, complete lists are available from the Paperbacks Marketing Manager, Oxford University Press, 200 Madison Avenue, New York, NY 10016.

Oxford Paperbacks are available from all good bookshops. In case of difficulty, customers in the UK can order direct from Oxford University Press Bookshop, 116 High Street, Oxford, Freepost, OX1 4BR, enclosing full payment. Please add 10 per cent of published price for postage and packing.

THE CONCISE OXFORD DICTIONARY OF MUSIC

Third Edition

Michael Kennedy

The third edition of this famous music dictionary has been thoroughly updated and revised. Biographies and technical terms alike—nearly everything has been written afresh. There is a vastly increased coverage of early music, and of music and musicians of the twentieth century. The articles on major composers now include comprehensive lists of works. As a result, this will prove the indispensable compact music dictionary for the 1980s.

THE CONCISE OXFORD DICTIONARY OF OPERA

Second Edition

Harold Rosenthal and John Warrack

Since its first publication *The Concise Oxford Dictionary of Opera* has established itself as an invaluable source of information on all aspects of opera. It contains entries on individual operas, composers, librettists, singers, conductors, technical terms, and other general subjects connected with opera and its history. This enlarged second edition includes many new articles on composers and performers, details of casts at first performances, and much additional information on the development of opera in different countries. Many of the existing entries have been rewritten and updated.

'You will . . . discover here an enormous amount of information not available elsewhere.' *Daily Telegraph*

THE OXFORD COMPANION TO CLASSICAL LITERATURE

Compiled by Sir Paul Harvey

This is a comprehensive classical dictionary with a literary emphasis. It includes six illustrations, fourteen maps, and a date-chart of classical literature.

'Outstandingly comprehensive . . . covering every aspect of the classical background (and foreground) from the history of Rome to the hendecasyllable, ancient religion to the design of the trireme.' *Sunday Times*

Oxford Paperback Reference

THE OXFORD COMPANION TO CHESS

Edited by David Hooper and Kenneth Whyld

* Embraces all branches of chess

* More than 200 games included, plus 650 entries describing named openings and their variations

* History and major figures, plus laws, strategies, and terms are given complete coverage

'a masterpiece representing a landmark in the literature of our game' *British Chess Magazine*

Oxford Paperback Reference

THE OXFORD GUIDE TO WORD GAMES

Tony Augarde

This is a unique guide to all kinds of word games and word play, from crosswords and scrabble to acrostics, rebuses, and tongue-twisters. Not only does it reveal the origins of games, outlining their fascinating history, but it describes how to play them, and their often equally interesting variants. Illustrating his descriptions with examples and diagrams, Tony Augarde builds up an intriguing and amusing picture of the British love of verbal ingenuity.

'very good value and fun' *Sunday Telegraph*

THE CONCISE OXFORD DICTIONARY OF
FRENCH LITERATURE

Edited by Joyce M. H. Reid

This abridgement of the classic *Oxford Companion to French Literature* preserves the unique quality of the original work and at the same time extends its scope with the addition of some 150 new entries to bring it up to date. The *Dictionary* retains the distinctive features of the *Companion*, including its coverage of a great variety of major and minor writers, genres and movements in French literature. Like its parent volume, the *Dictionary* contains entries on other relevant aspects of French history, philosophy, and culture.

THE OXFORD COMPANION TO THE
DECORATIVE ARTS

Edited by Harold Osborne

The Oxford Companion to the Decorative Arts is an authoritative guide to those arts whose products, although made for a purpose, are chiefly valued for their craftsmanship and the beauty of their appearance.

Under the editorship of Harold Osborne, who also edited *The Oxford Companion to Art,* expert contributors provide introductions to all the main fields of craftsmanship. This invaluable handbook includes entries not only on important craftsmen and schools throughout the world, but also on particular cultures and periods. A celebration of the pride and skills of generations of craftsmen.

The text is illustrated throughout with photographs and linedrawings, and there is a selective bibliography of nearly 1,000 titles.

'Admirable as a reference book, but guaranteed to encourage leisurely browsing.' *Yorkshire Post*

Oxford Paperback Reference

THE CONCISE OXFORD COMPANION TO THE THEATRE

Edited by Phyllis Hartnoll

The Concise Oxford Companion to the Theatre is an essential handbook for the theatre-goer or the drama student. It contains entries on actors and actresses from Sarah Bernhardt to Alec McCowen; on theatrical companies and theatre buildings from the Abbey Theatre in Dublin to the Yvonne Arnaud Theatre in Guildford; and on dramatists from Sophocles to Samuel Beckett. The range of the volume is international, and also includes explanations of technical terms, and notes on practical and historical aspects of stagecraft and design.

For this concise version, based on Phyllis Hartnoll's third edition of *The Oxford Companion to the Theatre,* each article has been considered afresh, and most have been recast and rewritten, often with the addition of new material.

THE CONCISE OXFORD HISTORY OF BALLET

Horst Koegler

This is the most comprehensive one-volume reference book on ballet in the English language. There are over five thousand entries on every aspect of ballet over the past four hundred years: ballets themselves, choreographers, composers, designers, theatres, ballet schools, companies, dancers, and technical terms.

The author, Horst Koegler, is a well-known German ballet critic, and his dictionary is an indispensable work of reference for anyone who is interested in ballet, whether as a professional, amateur, or spectator.

Oxford Paperback Reference

THE CONCISE OXFORD DICTIONARY OF ENGLISH LITERATURE

Second Edition

Revised by Dorothy Eagle

This handy and authoritative reference book is essential for anyone who reads and enjoys English literature. It contains concise yet informative entries on English writers from the *Beowulf* poet to Samuel Beckett and W. H. Auden, defines literary movements and genres, and refers the reader to sources for more than a thousand characters from books and plays. It also includes a host of sources of influence on English literary achievement such as foreign books and writers, art, and major historical events.

The Concise Oxford Dictionary of English Literature is an abridgement of Paul Harvey's classic *Oxford Companion to English Literature*.

671224